Philadelphia

Three Centuries of American Art

*This exhibition is supported by grants
from the National Endowment for the Arts
and the Atlantic Richfield Foundation*

*Bicentennial Exhibition
April 11 — October 10, 1976*

PHILADELPHIA

Three Centuries
of American Art

PHILADELPHIA MUSEUM OF ART

COVER: Charles Willson Peale, *Staircase Group* (no. 137)

Copyright 1976 © by the Philadelphia Museum of Art

Library of Congress catalog card number: 76-3170

Printed in the United States of America

Second Printing, 1990

LIBRARY OF CONGRESS CATALOGING IN PUBLICATION DATA

Philadelphia Museum of Art.
Philadelphia: Three Centuries of American Art.

Bibliography; indexes
1. Art, American—Philadelphia—Exhibitions. 2. Art—Philadelphia—
Exhibitions. I. Title.
N6535.P5P5 1976 709′.73′074014811 76-3170
ISBN 0-87633-016-2

Contents

Lenders to the Exhibition

Seymour Adelman, Philadelphia

Alessandra Gallery, New York

Brooke Alexander, Inc., New York

Mrs. Raymond Pace Alexander, Philadelphia

American Antiquarian Society, Worcester,
Massachusetts

American Philosophical Society, Philadelphia

American Telephone & Telegraph Co.,
New York

Dr. and Mrs. Morton Amsterdam, Bala Cynwyd,
Pennsylvania

Anonymous (36)

Arch Street Presbyterian Church, Philadelphia

Arnot Art Museum, Elmira, New York

The Art Institute of Chicago

The Athenaeum of Philadelphia

Atwater Kent Museum, Philadelphia

Laurence Bach, Philadelphia

The Baltimore Museum of Art

Katharine Beale Barclay, Wynnewood,
Pennsylvania

The Barra Foundation, Inc., Philadelphia

Anne Chew Barringer, Radnor, Pennsylvania

Richard W. Barringer, Jr., Haverford,
Pennsylvania

Mr. and Mrs. James Biddle, Andalusia,
Pennsylvania

Morris Blackburn, Philadelphia

Estate of Barbara Blondeau

Mr. and Mrs. Joseph Bobrowicz, Philadelphia

Gerald Bordman, Philadelphia

Luther W. Brady, Philadelphia

The Brooklyn Museum, New York

Mr. and Mrs. T. Wistar Brown, 4th, Ardmore,
Pennsylvania

Mrs. Charles L. Bybee, Houston, Texas

Edward J. Byrne Studio, Doylestown,
Pennsylvania

Mr. and Mrs. Henry Cadwalader, York Harbor,
Maine

Captain John Cadwalader, USNR (Ret.),
Blue Bell, Pennsylvania

Margaretta Oliver Caesar, Evergreen, Colorado

The Campbell House Museum, St. Louis

The Carpenters' Company of the City and
County of Philadelphia

John B. Carson, M.D., Newtown Square,
Pennsylvania

Mrs. Gardner Cassatt, Bryn Mawr, Pennsylvania

Mrs. Alfred D. Chandler, Wilmington,
Delaware

Chester County Historical Society, West Chester,
Pennsylvania

Christ Church, Philadelphia

Eleanor and Van Deren Coke, Albuquerque,
New Mexico

Mr. and Mrs. Bertram D. Coleman, Bryn Mawr,
Pennsylvania

Colonial Williamsburg Foundation,
Williamsburg, Virginia

The Columbus (Ohio) Gallery of Fine Arts

Sophie Chandler Consagra, Wilmington,
Delaware

The Corning Museum of Glass, Corning,
New York

Francis James Dallett, Villanova, Pennsylvania

Thomas L. Davies, Berwyn, Pennsylvania

Mr. and Mrs. Leonard Davis, New York

Delaware Art Museum, Wilmington

The Detroit Institute of Arts

Mr. and Mrs. H. Richard Dietrich, Jr.,
Chester Springs, Pennsylvania

The Dietrich Corporation, Reading,
Pennsylvania

Charlotte Dobrasin, Philadelphia

Drexel Museum Collection, Drexel University,
Philadelphia

Helen Williams Drutt, Philadelphia

Helen Drutt Gallery, Philadelphia

Miss Edith Emerson, Philadelphia

Woodruff Jones Emlen, Bryn Mawr,
Pennsylvania

The Episcopal Academy, Merion, Pennsylvania

Walter Erlebacher, Elkins Park, Pennsylvania

The Wharton Esherick Museum, Paoli,
Pennsylvania

Charles C. Fahlen, Philadelphia

Fairmount Park Commission, Philadelphia

Mr. and Mrs. Donald L. Fennimore,
Wilmington, Delaware

Fine Arts Library, University of Pennsylvania,
Philadelphia

First Pennsylvania Bank, N.A., Philadelphia

First Troop, Philadelphia City Cavalry

York K. Fischer, West Cornwall, Connecticut

Fogg Art Museum, Harvard University,
Cambridge, Massachusetts

The Franklin Institute, Philadelphia

Robinson Fredenthal, Philadelphia

Free Library of Philadelphia

Mr. and Mrs. F. Galuszka, Philadelphia

Girard College, Stephen Girard Collection,
Philadelphia

Girard Estate, City of Philadelphia, Trustee

Dr. and Mrs. Joseph A. Glick, Wilmington,
Delaware

Mr. and Mrs. Robert Graham, New York

Philip H. Hammerslough Collection,
West Hartford, Connecticut

Harcus Krakow Rosen Sonnabend Gallery, Boston

Harvard University Portrait Collection, Cambridge, Massachusetts

Margaret Grant Hawley, Philadelphia

Dr. and Mrs. William Hayden, Paris, Texas

Mr. and Mrs. J. Welles Henderson, Philadelphia

Mrs. T. Charlton Henry, Philadelphia

Mr. and Mrs. Richard B. Herman, Philadelphia

Dr. Edward L. Hicks, Philadelphia

Hirshhorn Museum and Sculpture Garden, Smithsonian Institution, Washington, D.C.

Historical Society of Pennsylvania, Philadelphia

Mrs. Bess Hurwitz, Doylestown, Pennsylvania

INA Museum, INA Corporation, Philadelphia

Independence National Historic Park, Philadelphia

Miss Anna Warren Ingersoll, Penllyn, Pennsylvania

Catherine Jansen, Philadelphia

Jefferson Medical College, Thomas Jefferson University, Philadelphia

Jim Thorpe Lions Club, Borough of Jim Thorpe, Pennsylvania

Lloyd P. Jones Gallery and Court of the Sculpture of R. Tait McKenzie, University of Pennsylvania, Philadelphia

Mr. and Mrs. George M. Kaufman, Norfolk, Virginia

The Kling Partnership, Philadelphia

Knoll International, Inc., Philadelphia

Norman and Margaret Krecke, Philadelphia

William G. Larson, Philadelphia

Mr. and Mrs. P. Blair Lee, Philadelphia

The Library Company of Philadelphia

Library of Congress, Washington, D.C.

Mr. and Mrs. Bertram K. Little, Brookline, Massachusetts

Jimmy C. Lueders, Philadelphia

Mrs. W. Logan MacCoy, Haverford, Pennsylvania

Maryland Historical Society, Baltimore

Mask and Wig Club of the University of Pennsylvania, Philadelphia

Henry P. McIlhenny, Philadelphia

Mrs. Sol Mednick, Philadelphia

Mr. and Mrs. John W. Merriam, Wynnewood, Pennsylvania

The Metropolitan Museum of Art, New York

The Miller-Plummer Collection of Photography, Philadelphia

Mitchell/Giurgola Architects, Philadelphia

Mr. and Mrs. Set Charles Momjian, Huntingdon Valley, Pennsylvania

The Honorable Samuel W. Morris, Pottstown, Pennsylvania

Museum of Art, Carnegie Institute, Pittsburgh

Museum of Fine Arts, Boston

The Museum of Modern Art, New York

Hitoshi Nakazato, New York

National Collection of Fine Arts, Smithsonian Institution, Washington, D.C.

The National Gallery of Canada, Ottawa

The National Museum of History and Technology, Smithsonian Institution, Washington, D.C.

National Portrait Gallery, Smithsonian Institution, Washington, D.C.

The National Trust for Historic Preservation— Cliveden

Nelson Gallery—Atkins Museum, Kansas City, Missouri

The Newark Museum, Newark, New Jersey

The New-York Historical Society

Dr. and Mrs. Perry Ottenberg, Merion, Pennsylvania

Pennsylvania Academy of the Fine Arts, Philadelphia

Philadelphia City Archives

The Philadelphia College of Art

Philadelphia Gun Club

The Philadelphia Saving Fund Society

Marie Merkel Pollard, Dallas, Texas

Lydia Bond Powel, Stonington, Connecticut

Provident National Bank Collection, Philadelphia

Reading Company, Philadelphia

Mr. and Mrs. David P. Redfield, Doylestown, Pennsylvania

Lola S. Reed, M.D., Phoenixville, Pennsylvania

Arthur Robinson, Harrison, New York

Abby Aldrich Rockefeller Folk Art Collection, Williamsburg, Virginia

Dr. Stanley W. Roman, New York

Rosedown Plantation, St. Francisville, Louisiana

Charles Rudy, Ottsville, Pennsylvania

The St. Louis Art Museum

Sagamore Hill National Historic Site— National Park Service, Oyster Bay, New York

Gordon K. Saltar, Arden, Delaware

San Antonio Art League

Dr. and Mrs. Ira Leo Schamberg, Jenkintown, Pennsylvania

Schweitzer Gallery, New York

Estate of Howell Lewis Shay

Phillips Simkin, Philadelphia

Judy Skoogfors, Philadelphia

Leif Skoogfors, New York

E. Newbold Smith, Paoli, Pennsylvania

Edward Wanton Smith, Jr., Darien, Connecticut

Joseph Sorger, Philadelphia

Dr. Isaac Starr, Philadelphia

Mrs. Samuel S. Starr, Media, Pennsylvania

Mr. and Mrs. Anthony A. P. Stuempfig, Philadelphia

Charles V. Swain, Doylestown, Pennsylvania

Mr. and Mrs. Joseph Tanenbaum, Bayside, New York

David Beckwith Taylor, Jr., Leland, Mississippi

Dr. Edward Teitelman, Camden, New Jersey

Mr. and Mrs. George E. Thomas, Philadelphia

Trump and Company, Flourtown, Pennsylvania

Mrs. Andrew Van Pelt, Radnor, Pennsylvania

George Vaux, ARPS, Bryn Mawr, Pennsylvania

Venturi and Rauch, Architects and Planners, Philadelphia

Peggy Macdowell Walters, Roanoke, Virginia

Mr. and Mrs. Samuel Ward, Moylan, Pennsylvania

Washington County Museum of Fine Arts, Hagerstown, Maryland

Webster, Inc., Fine Art, Chevy Chase, Maryland

The Westmoreland County Museum of Art, Greensburg, Pennsylvania

Richard T. Wharton, Stamford, Connecticut

Mrs. Thomas Raeburn White, Philadelphia

Mrs. Jacob H. Whitebook, Elkins Park, Pennsylvania

Whitney Museum of American Art, New York

Robert M. Winokur, Horsham, Pennsylvania

The Henry Francis du Pont Winterthur Museum, Winterthur, Delaware

Dr. and Mrs. Melvyn D. Wolf, Flint, Michigan

The Naomi Wood Collection, Woodford Mansion, East Fairmount Park, Philadelphia

Yale University Art Gallery, New Haven

Harvey Z. Yellin—Samuel Yellin Collection, Philadelphia

Foreword

THE CREATION OF THIS EXHIBITION represents a tremendous community effort and commitment, without which this study of three centuries of achievement could not have occurred. That it should have been chosen as the principal contribution of the Philadelphia Museum of Art to the city's program during the Bicentennial year seems most appropriate, for now the American people are deeply involved in assessing their heritage. Mature understanding of the past is the soundest basis for a responsible future.

As one of its many contributions to the betterment of Philadelphia during 1976, the City proposed construction of the Museum's new Special Exhibition Galleries, and the citizens voted approval of the necessary bond issues. As a result of this decision, the Museum has been able almost to treble its space for presenting the special exhibitions which attract hundreds of thousands of people each year. With this construction, the vast Museum building of more than five hundred thousand square feet is finally complete after fifty years. Mayor Frank L. Rizzo's administration has been assiduous in its attention to the many complicated details of construction to assure completion of the project on schedule.

The funding of the exhibition, the largest ever attempted by the Museum, has been a complicated matter. In addition, firm in our conviction that this considerable effort and sacrifice would be justified only by the methodical publication of its material, the Museum has received funding for this comprehensive catalogue and for another publication of selections designed for general enjoyment. The Museum, therefore, most deeply appreciates the generous grants received from the National Endowment for the Arts and from the Atlantic Richfield Foundation for the exhibition and from the Provident National Bank for the publication program, in particular for the more general volume. One must cite especially the respective officials of these institutions for their interest and support: Nancy Hanks and John

R. Spencer; R. D. Bent, W. Bruce Evans, and Thomas C. Veale; and Paul M. Ingersoll.

The breadth of the representation in the exhibition was made possible only through the outstanding cooperation of the distinguished institutions which have done so much to forward the arts of Philadelphia and whose significant collections record their accomplishment: the Historical Society of Pennsylvania, the Library Company of Philadelphia, the Pennsylvania Academy of the Fine Arts, and the Free Library of Philadelphia. Unfailingly, they have provided information and made material available for study; they have been unreservedly generous in their loans. The spirit of cooperation on the part of their directors—James E. Mooney, Edwin Wolf 2nd, Richard J. Boyle, Keith Doms—and their staffs exemplifies the sense of community commitment traditionally associated with these institutions. The Franklin Institute and the American Philosophical Society, each of which has played such an active role in the intellectual growth of Philadelphia's citizens, have also been most generous in helping the Museum staff repeatedly.

Some six hundred objects have been lent by over two hundred individuals and institutions. The Museum is greatly in their debt. Again and again, lenders have patiently provided information for documentation and publication. Often this has meant poring over long-stored family records, seeking even the most casual reference to a piece treasured for generations. Even more impressive was the courteous acceptance of our request for the loan of objects for the unusually long period of six months. Such willingness on the part of the many private lenders and institutions may well be seen as a reflection of the community's and indeed the nation's commitment to the Bicentennial.

Perhaps no single element of this ambitious exhibition is more impressive than the spirit of cooperation and involvement on the part of the community of scholars who willingly banded together to assure as thorough an examination of the subject as could be achieved. The Museum has worked on the exhibition for three years, but it has depended upon longer years of experience and study on the part of each participant and upon the advice of scholars who have made aspects of the exhibition their life's work.

Darrel Sewell supervised the creation of the whole exhibition. Perhaps he might aptly be compared to a master of ceremonies for a grand extravaganza. Each of the scholars has been given full rein in his area of responsibility, but at all times Mr. Sewell has maintained an overview and a balance. As arduous as the task has been, it has inevitably been even more notable for its excitements and rewards.

Many hours were invested in choosing the objects. Virtually no piece was included without first having been seen, and many related objects were studied in the process of

selection. Since it was established from the outset that the breadth of the city's achievement in the arts could only be conveyed by limiting, for the most part, the representation of each artist to one work, it was essential that each work be chosen for its quality and distinction. Beatrice B. Garvan was responsible for the choice of eighteenth century decorative arts and architecture; Dorinda Evans, for eighteenth and early nineteenth century painting; David A. Hanks, for nineteenth and twentieth century decorative arts and architecture; Darrel Sewell, for nineteenth century painting; Anne d'Harnoncourt, for twentieth century painting and sculpture; Elsie S. McGarvey, for textiles and costumes; Ellen S. Jacobowitz, for prints; Ann B. Percy, for drawings and watercolors; Caroline P. Wistar and William F. Stapp, for photographs. They were assisted in various ways by Lu D. Bartlett, Kneeland McNulty, Christine A. Jackson, Patricia A. Chapin, Kathryn B. Hiesinger, and repeatedly by the advice of many others. Research for the exhibition has been greatly facilitated by the efforts of Abigail Schade, Dorothy Spencer, Page Talbott, and Carol Wojtowicz.

Our Conservator's long experience with the work of Philadelphia's finest artists has been an invaluable touchstone in the selection of paintings and other works. Indeed, the exhibition owes a great deal to Theodor Siegl.

Similarly Thomas K. Robinson, the Museum's Furniture Restorer, has played an active role in the staff's lengthy discussions of the fascinating questions presented by the august pieces of Philadelphia furniture. Thanks to his sensitive work, they shine out as stars of the exhibition.

Jane B. Copeland has been in charge of coordinating the infinite number of details inevitably attendant upon such an ambitious exhibition.

The responsibility for receiving, transporting, and recording the many objects has rested with Barbara Susan Chandler, Registrar, and her admirably efficient staff.

Recognizing that even a catalogue as ambitious as this can only begin to explore such a wide-ranging achievement, the Museum has made great efforts to publish related articles and to encourage critical assessment. The organization of such efforts has to a significant degree been carried by Sandra A. Horrocks, Manager of Public Relations.

Many participated in the writing of the catalogue entries. Each author's entry is initialed, and the authors' names are cited in full in the list of Contributing Writers. That so many scholars were willing to share the research gleaned in their fields of specialized study is in itself a splendid contribution to that community of scholarship which will play an increasingly important role in an era of restricted research.

The awesome task of editing such a variety of scholarly material has been carried by Christine K. Ivusic. Assisting in this effort were Jean B. Toll, production editor, and Janet Landay, editorial assistant. Coordinating the illustrations has rested with Janet M. Iandola. At all times, this group has worked closely with George H. Marcus, who has, in turn, coordinated the inevitable complexities of publishing this catalogue and has prepared the more general publication.

To assure a consistency of quality in the illustrations of the two publications, the Museum has been most fortunate in having the services of as distinguished a photographer as Will Brown. Once again John Anderson has coped with a complicated design problem for the Museum, achieving in this catalogue yet another distinguished and elegant publication.

It has been a source of particular satisfaction to everyone involved that the last of the works by Philadelphia's distinguished artists to be part of the exhibition is in fact the plan of the installation itself, designed in 1976 by one of the outstanding architectural firms in the city's history, Venturi and Rauch, Architects and Planners. Each of us has been rewarded by a new perception of well-known objects in discussing their placement with Robert Venturi and Stanford Hughes.

This exhibition is indeed the achievement of many. And when, to these names, one adds the Board of the Museum, which made the commitment before the sources for funds were identified; every person on the Museum's staff—for all have contributed in some way to this ambitious effort; the lecturers in our Division of Education; the Museum's Volunteer Guides; and the city's many teachers who will work with this material to nurture new perceptions in others —one can be proud. Justly proud, because this exhibition reflects the present commitment of many to what others have done in the past, as the best example of what many may accomplish in the future. Such a spirit of regeneration is the ultimate justification for the Bicentennial activities of the American people.

Evan H. Turner
Director

Acknowledgments

THIS EXHIBITION, as it finally appears in the form of its installation and publications, is the result of the dedicated work of many people whose talents comprise one of the Museum's major resources. In addition to those already cited, we were fortunate to be assisted by the skill and experience of many members of the Museum's staff who helped in infinite ways. Their ingenuity solved seemingly endless logistical and technical problems, and their goodwill and interest were a constant source of encouragement. Donna M. Fee, Rebecca Himowitz, Kathryn L. Kaercher, Claire E. Lukacs, Frederick N. Norgaard, Barbara L. Phillips, and Anne W. Sims of the Department of American Art were presented with a great variety of tasks which they carried out with patience and unflagging energy. Caroline G. Griffith, Executive Secretary to the Director, cheerfully coordinated the voluminous correspondence relating to the exhibition from its earliest stages.

For their expertise and spirit of cooperation in bringing the publication project to fruition, we are greatly indebted to the following: Thomas Brennan, Brenda Gilchrist, Joanne Greenspun, John Kremitske, Elizabeth Landreth, Francis O'Donnell, Jill Rose, Carol Rothrock, Sarah Williams, and Bonnie Yochelson. In addition, Barbara S. Sevy, Librarian of the Museum, and her entire staff have been unfailingly attentive and patient with innumerable details of research.

For advice about selection and for aid in locating objects, we have benefited from the scholarship and the resourcefulness of a great many people. Earlier exhibitions of American arts at the Philadelphia Museum of Art devoted to life in Philadelphia, to Philadelphia silver, and to the furniture of Connelly and Haines provided inspiration and invaluable research material, and we are grateful to Henry P. McIlhenny and Louis C. Madeira, who helped to organize these exhibitions and whose research on the Museum's collections provided a constant reference for our work. The Women's

Committee greatly facilitated the search for eighteenth and nineteenth century objects, an effort which was coordinated with indefatigable enthusiasm by Mrs. Charles H. Baird. The artists themselves—both those whose work is included in the exhibition and many other important ones—have been most generous in making their work and archival material available, corresponding with authors, assisting with loans, and responding to questions about their work and careers. To them we offer special thanks. In addition to the valuable suggestions made by the lenders to the exhibition, many others have helped to make the selection of objects a rewarding task. They are: W. Graham Arader, III, H. Parrott Bacot, William B. Becker, Mrs. Alfred Bendiner, Benjamin D. Bernstein, Edward Bernstein, Michael Biddle, Marilynn Johnson Bordes, Adelyn D. Breeskin, Jeffrey R. Brown, Kathryn C. Buhler, Elizabeth G. Bullock, Russell Burke, Robert Buttel, Laraine Carter, George M. Cheston, Mr. and Mrs. Nathan Cohen, Mrs. Percy Coombs, Wanda Corn, Mrs. Thomas J. Curtin, Mr. and Mrs. Daniel Dietrich, Edward H. Dwight, Adeline W. Edmunds, Mr. and Mrs. Malcolm Eisenberg, the late Eugene Feldman, Linda Ferber, Alan M. Fern, Lois Fink, Janet Flint, Elinor Gordon, Dorothy Grafly, Margaret Calder Hayes, Wilbur H. Hunter, Antoinette Kraushaar, Richard Langman, Barton H. Lippincott, John A. Mahey, C. William Miller, R. Peter Mooz, Richard Murray, Hyman Myers, G. Holmes Perkins, Edgar P. Richardson, Lessing J. Rosenwald, Rodris Roth, Mr. and Mrs. Ernest Sandler, Robert D. Schwarz, Charles Coleman Sellers, David Sellin, Raymond V. Shepherd, Jr., Sarah A. G. Smith, Lita Solis-Cohen, David Stockwell, Robert T. Trump, and Judy Walton.

Through the help of many institutions and individuals, research for the exhibition has been a pleasure for the authors, researchers, and editors who worked to prepare it. The libraries and archives available in the Philadelphia area itself were one of the original sources of inspiration for the exhibition. Their collections relating to the history of the arts in Philadelphia were an invaluable aid as well as a formidable reminder of how much remains to be done. Without their resources, which were made available to us at a time when many of these institutions were occupied with plans for their own exhibitions in the Bicentennial year, the exhibition and its catalogue would not have been possible. In addition to the lending institutions, the following local resources have been most helpful: City of Philadelphia, Archives and Department of Wills; Haverford College Library, Haverford, Pennsylvania; Institute of Contemporary Art, Philadelphia; Mutual Assurance Company, Philadelphia; Philadelphia Contributionship; Philadelphia Yearly Meeting of Friends, Records Department; The Union League, Philadelphia; and Violet Oakley Memorial Foundation, Inc., Philadelphia, administered by Miss Edith Emerson.

The following institutions and resources outside of the city have been indispensable: Archives of American Art, Smithsonian Institution, Washington, D.C.; Bicentennial Inventory of American Paintings, Smithsonian Institution, Washington, D.C.; George Eastman House, International Museum of Photography, Rochester, New York; New York Public Library; The Charles Willson Peale Papers, National Portrait Gallery, Washington, D.C.; and The Henry Francis du Pont Winterthur Museum Library, Winterthur, Delaware.

Other institutions have been most gracious in their willingness to make their collections and curatorial records available to us: Anglo-American Art Museum, Louisiana State University, Baton Rouge, Louisiana; Bowdoin College Museum of Art, Brunswick, Maine; The Corcoran Gallery of Art, Washington, D.C.; Greenfield Village and Henry Ford Museum, Dearborn, Michigan; Mary Baldwin College, Staunton, Virginia; Museum of Early Southern Decorative Arts, Winston-Salem, North Carolina; Museum of Fine Arts, Springfield, Massachusetts; Peale Museum, Baltimore, Maryland; Shelburne Museum, Shelburne, Vermont; and Tri-County Conservancy of the Brandywine, Chadds Ford, Pennsylvania.

Staff members of these institutions and many private individuals have contributed their knowledge and patiently provided research materials and help of all kinds. For their interest, and for their willingness to meet our often massive or obscure demands, we particularly wish to thank: Jane Adlen, Rita J. Adrosko, the late Ethel Asheton, Elizabeth Bailey, Mrs. David Barclay, Karen F. Beall, David Behmlander, Dennis Boylan, Georgia Bumgardner, Helen Buttel, Ward Childs, Susan G. Cosgrove, Barbara Curtis, Charlotte Daley, Suzanne Delahanty, Ulysse Desportes, Mr. and Mrs. Antelo Devereux, Jr., Lotte Drew-Bear, William Voss Elder III, Elizabeth and Rowland Elzea, Sandra Emerson, John Fatula, Bella Fishko, Louise Floyd, Nicholas G. Frignito, Henry Geldzahler, Lucretia Giese, Stephen Goff, Cynthia Goodman, Frank H. Goodyear, Jr., Jay Gorney, Christine Hahler, John F. Harbeson, Elizabeth H. Hawkes, Howell J. Heaney, John R. Herbert, Clayton K. Hewett, Richard Hood, Henry Hotz, Lucy Hrivnak, Dale Jensen, Jacob Kainen, Milton Kaplan, Lynn Kaufman, Diane Walsh Kazlauskas, Dorothy A. Keith, David Kiehl, Beatrice Kirkbride, Sam Koop, Mrs. Albert Laessle, Eleanor Lambert, Florence H. Larson, Mrs. John LeClair, Susan Leidy, Miriam Lesley, Louise Lippincott, Irene Little, Marian Locks, Robert F. Looney, Laura Luckey, Coy Ludwig, Sarah Fussell Macauley, David J. Mancini, Aladar Marburger, Christa C. Mayer-Thurman, Garnett McCoy, Glenn McMillan, Burr G. Miller, Carl S. Miller, Harvey S. Shipley Miller, Lillian B. Miller, Elena Millie, Agnes Mongan, Charles F. Montgomery, Stephanie Morris, Craig Morrison, Albert and Pearl Nipon, Eleanor L. Nowlin, Charles H. O'Donnell, Raleigh Perkins, Anthony W. Perry, Karin E. Peterson, Dorothy W. Phillips, Miriam Phillips, Mrs. Salvatore Pinto, Henry Pitz, John Platt, Priscilla Price, Laura L. Reid, Walter Ristow, Ann Rogers, Stanley Rogosner, Ann Rorimer, Louise Ross, Ann Saÿen, Robert Schoelkopf, William Scott, Mitzi Shalit, Michael Sheele, Louis W. Sipley, Helen Farr Sloan, Murphy D. Smith, Walter L. Smith, Jr., Natalie Spassky, Jane S. Spillman, Lynn E. Springer, Mrs. Benton M. Spruance, Peter Benton Spruance, Linda Stanley, Phoebe B. Stanton, Tasha Stonorov, Robert Stubbs, Joanne Verberg, Donald S. Vogel, Theron R. Ware, Deborah Dependahl Waters, Carolyn J. Weekley, George A. Weymouth, Maxwell Whiteman, Stephen G. Williams, David R. Wilmerding, Linda Wohlforth, Ben Wolf, William E. Woolfenden, Virginia M. Zabriskie.

Finally, a number of distinguished people, now deceased, have in the past done much to nurture this Museum's commitment to the American achievement, a commitment which has led to the creation of this exhibition: Edwin Atlee Barber, Mrs. Thomas Eakins, Mrs. William D. Frishmuth, R. Wistar Harvey, Calvin S. Hathaway, Fiske Kimball, Henri Marceau, J. Stogdell Stokes, and Miss Beatrice Wolfe.

Introduction

THE PHILADELPHIA MUSEUM OF ART was chartered one hundred years ago as an outgrowth of Philadelphia's 1876 Centennial Exposition. In many ways, the enthusiasm for America's contemporary accomplishments and renewed awareness of its past, symbolized by the Centennial, launched the study of American arts of the eighteenth century, which has been pursued with increasing methodology in the years since. Yet without the progress that has been made in the field of American studies in the past decade alone, this exhibition could not have occurred. It therefore seems most appropriate that the Museum should now choose, as a major Bicentennial effort, to study the arts of its own city in depth.

With the exception of New York and Boston, no other large American city can boast of the rich and continuous history of artistic creativity that has characterized Philadelphia over the past three hundred years. Yet until now, a wide-ranging examination of the arts and architecture related to a single major city in the United States has rarely been undertaken, in contrast to the proliferation of such studies of European cities. Research in the field of American art has tended to concentrate instead upon the development of a national art, focusing on the style of a delimited period of time, the definition of "movements," surveys of a particular medium or subject, or the work of a single artist. The nature of this exhibition thus provides an opportunity to re-evaluate the broad conclusions of earlier studies. Much is known of Philadelphia's accomplishments in certain areas—the paintings of the Peale family, the furniture of the Federal period, the impact of the Philadelphia Saving Fund Society skyscraper in the history of modern architecture, to name a few. Other fields —for example, nineteenth century photography or the distinctive architecture of the city in the late nineteenth to early twentieth century—have received little attention.

The investigation of the art of each century has presented its particular research problems: the re-examination of the large body of scholarship devoted to eighteenth century painting, sculpture, architecture, and the decorative arts; the assimilation of recent interest in the nineteenth century that has been revealed in exhibitions and monographs devoted to individual artists, craftsmen, and architects; or the reassessment of the work of early twentieth century artists in the light of the general re-evaluation of the modern movement in the United States which has been made in the last ten years. Finally, research into the most contemporary activity in all the arts has required a very different type of investigation, of necessity less precise and historical than study of even the most recent past, but also uniquely stimulating in the opportunity it offers for direct contact with the artists themselves.

The intent of the exhibition is frankly exploratory rather than definitive. It covers three centuries and a wide assortment of media in an attempt to arrive at a broad picture of the artistic activity in an American city throughout its history rather than to pursue a specific theme or thesis. Nor can this exploration hope to be entirely comprehensive. With its strong international and national ties, Philadelphia has traditionally been a center of sophisticated taste, its residents purchasing work made elsewhere or giving commissions at first to itinerant artists and later to artists associated with other centers. The relatively few examples chosen to represent imported objects or those created locally by visiting artists can only suggest the extent of the city's importation of objects and talent. In addition, many artists who were born in the city or studied at its schools have not been included because their contact with Philadelphia was relatively brief. Thomas Cole, John Marin, Stuart Davis, and Man Ray are painters whose names are often associated with Philadelphia but who had no extended involvement with the city. Understandably, given its aim, the exhibition includes a great variety of objects. Well-known works of a period are shown with those that are less familiar. The range of accomplishment in any single period is evident in the juxtaposition of painting, sculpture, architecture, and the decorative arts with prints, books, photographs, textiles, and costumes. Presented chronologically, these comparisons not only emphasize the aspects of style shared by these diverse arts at any given time but also introduce the idea of continuous change and evolution.

To allow the greatest freedom in the presentation of information relating to each object and to emphasize the complex interrelationship of art education, exhibition, patronage, and the community of artists in the city, the format of a chronological arrangement, divided into fifty year periods, with an entry for each object, was chosen for the catalogue and is reflected somewhat less literally in the installation.

It was agreed in principle that the number of objects

selected in various categories should remain in some constant proportion to each other within each fifty year period, the assumption being that while some types of art were, on the whole, more immediately familiar than others, they were not more important in an historical survey of a regional center for the arts and that the city would have supported creative activity in each category at all times. This assumption was fully justified and led to the discovery of previously little known material. Yet the major types of artistic production varied from period to period. For example, great quantities of furniture and decorative arts were made in the third quarter of the eighteenth century in comparison to the number of paintings; somewhat the reverse occurs during the twentieth century as the handmade or specifically commissioned object becomes a work of art which provides an alternative to the mass produced object. The works finally chosen reflect the pattern of creativity and production in each successive period.

Inevitably, balance in the choice of objects has presented problems, and this has been particularly difficult for works created since World War II. Possibilities for selection were numerous; thus it is important that the examples representing the last two decades be seen as indicative of the period's excitement and variety rather than inclusive, for alternatives could repeatedly have been well justified. Aesthetic considerations have played a major role in the choice of all the works exhibited. While effort has been made to choose the most representative examples of each kind of object, for eighteenth and many nineteenth century works the tendency has been to select objects of high style because these works reflect the most complete demonstration of the artist's talents. Yet, while much of the material represents the most sophisticated taste in the fashion of its day, some of the most delightful objects in the exhibition do not fit into this category. John Engle's *Cobbler Figure* or Joseph Shoemaker Russell's watercolors, the samplers and quilts created by skilled amateurs, or works created for popular enjoyment or edification, such as the American Sunday-School Union prints or the Dentzel merry-go-round figures, add yet another dimension to the investigation of art activity in Philadelphia.

The definition of Philadelphia's physical and cultural boundaries for the purposes of the exhibition proved to be a complex matter. The nucleus was defined as the community which developed along the grid pattern of streets connecting the Delaware and the Schuylkill rivers. However, the area encompassed by Philadelphia's artistic spectrum has to varying degrees been expanded to reflect the patterns of creativity in different periods. Thus, the activity of the earliest inhabitants of Penn's "green countrie town" extended in clusters along the Delaware River Valley. By the second quarter of the eighteenth century the perimeters of the city were clearly defined, and its development as a sophisticated Colonial center was generally recognized. Indeed, by the time of the

American Revolution, Philadelphia was the cultural center of the nation, and artists were increasingly attracted, even from great distances, to supply the needs of local citizens. This practice became even greater in the decade 1790–1800, when the city was briefly the new nation's capital.

Because of its own strength as a center for the evolution and dissemination of style in artistic production, the cosmopolitan city of Philadelphia apparently offered no contemporary market for the distinctive crafts of the Pennsylvania German community around Lancaster, only sixty-eight miles away—although every effort has been made to find evidence to the contrary. However, by the end of the nineteenth century, with the growing ease of transportation and the number of widely distributed publications on art, that pattern had changed completely. In this century, through their study and teaching in the city's art schools, their friendships with the city's collectors, their exhibitions in the commercial galleries and their visits to museums, artists from such points as New Hope (thirty-three miles away) and Chadds Ford (twenty-three miles away) are active participants in the city's art scene.

The emergence of New York as the unrivaled national center of avant-garde artistic activity in the twentieth century has also affected many patterns in the cultural life of Philadelphia. The two vast cities are within commuting distance of each other, offering Philadelphia artists and craftsmen easy access to the cultural resources of New York but at the same time diverting the attention of the local public and patrons from the artistic activity in their own city.

During the eighteenth century, as a result of the large community of craftsmen and the number of painters, whether residents or itinerants with sufficient numbers of commissions to keep them in the city for some time, Philadelphia became a center for the training of artists. Unlike painting, for which no set pattern of instruction existed in the Colonies, training in the crafts followed the general form of the medieval guild system. The young artisan began as an apprentice, and the indenture of apprenticeship which bound him to a master craftsman was a contract supervised by city government. However, the training of both painters and craftsmen had the same aims: mastery of the technical skills of the craft and of the ability to assimilate the style models for his art, whether from concrete examples, from prints or drawings, or from written theory. For the apprentice craftsman, the sophistication of work demanded of Philadelphia artisans itself provided specialized training of the highest quality. Objects imported from England, the work of a continuing stream of newly immigrant artisans, and, after midcentury, the growing number of pattern books

provided additional examples of the latest innovations in fashion and technique.

In architecture, the building of important public structures as well as private houses, such as Benjamin Chew's Cliveden, exemplified not the realization of a complete, detailed design by a professional architect, but a general scheme proposed by a gentleman architect—as at Independence Hall, Pennsylvania Hospital, Christ Church, and St. Peters—and constructed with the practical knowledge of a master carpenter.

Throughout the eighteenth century, and well into the nineteenth, the skills of a craft learned through the apprenticeship system became more specialized as the production of furniture and the decorative arts became increasingly a commercial enterprise. But for the aspiring painter, opportunities for training were scarcer and less well defined. While craftsmen customarily employed apprentices to assist in the production of their work, professional painters worked independently, and painting itself was less well defined as a trade. In addition to portraits, artists painted coaches, signs, banners, and did gilding to earn their living. Lacking the continuous experience of apprenticeship, a young painter had to find technical instruction wherever he could, usually depending upon the friendly advice of an older artist and studying the works of others as the opportunity presented itself. The portraits painted by Benjamin West before he went to Europe in 1759 reveal his experimentation with a variety of styles and reflect the influence of artists, such as William Williams, John Wollaston, and Gustavus Hesselius, whose painting techniques he could study in Philadelphia. Other paintings by West before 1759, such as the landscape and the seascape in the Pennsylvania Hospital, or the classical subject which is exhibited here, indicate his growing interest in painting as an activity with concerns other than portraiture. Prints and the influence of learned friends, such as William Henry, whose books discussed painting as a noble art based in theory rather than as a manual skill, made West aware of the need, not only to study the work of the old masters at first hand but also to find a broader artistic environment in which to work. A number of young Philadelphians were to follow West's example during the second half of the eighteenth century, and his London studio served as a center in which American artists could work and study his collection of paintings, while his influence provided them entrance into private collections and lectures at the Royal Academy.

The lack of systematic training in the arts in America and the benefits to be derived by forming an artists' association were particularly clear to those returning to this country after study in England. In 1795, Charles Willson Peale was instrumental in founding the Columbianum in Philadelphia, which was intended to support regular exhibitions and a school. The organization failed; but this attempt coincided with a growth of civic interest in the establishment of an art institution, not for artists alone, but with the larger goal of improving public taste.

The Pennsylvania Academy of the Fine Arts was founded in 1805 "to promote the cultivation of the Fine Arts." Its founders were largely art amateurs, not artists, and the initial organization of the Academy made no provision for temporary exhibitions or instruction. In order to meet these needs, Philadelphia painters, sculptors, engravers, and architects instituted the Society of Arts in 1810. The Society proposed to hold classes in drawing—a common base for all its members—and, in 1811, with Denis Volozan and John James Barralet as instructors, a beginner's class in drawing and a class in drawing from the antique were established. At the same time, the Academy board established an honorary membership of Academicians, to which leading artists were elected, with the responsibility for administering the Academy school. A life class was begun, and Dr. Nathaniel Chapman was chosen to give a series of lectures on anatomy. Such promising hopes for the local education of the artist were in fact due to be disappointed. The Society's classes were discontinued by 1814, and the lectures and life classes at the Academy continued only sporadically through the middle of the century. The Academy nonetheless served as a focal point for artists in Philadelphia—if often the center of controversy—and its annual exhibitions, which began in 1811, provided artists and the public with the opportunity to see and compare a great variety of work from other centers. Other kinds of training outside the Academy became increasingly available to the artist in the form of design and drawing books, private study with established artists, and, after midcentury, in the curriculum of public schools.

The considerable variety of art available for artists to see in Philadelphia and the lack of methodical art instruction, especially during the first third of the nineteenth century, resulted in the creation of a number of elaborate compositions and attempts at the virtuoso manipulation of paint, which were not matched by the painter's technical ability. Sophisticated in their goals yet naive in their method, these paintings often have the appeal of an independent artistic statement that is lacking in the work of more carefully trained but less audacious artists. The art of such painters as Bass Otis, William Winner, and Robert Street is the subject of new interest today.

During the first half of the century, most sculpture in metal, wood, and stone was made for decorative or memorial purposes by anonymous craftsmen, and sculptors for the most part learned by apprenticeship. No formal program existed for the teaching of sculpture as a fine art until later in the century. Even William Rush, the most famous of Philadelphia's sculptors in the early nineteenth century, described himself as a carver.

The first examples of manufactured items in the late eighteenth century were prophetic of the steady growth of more commercially made objects intended for a wide market rather than custom-made for an individual. While craftsmen who produced unique objects on commission had traditionally expanded their trade by importing objects to sell, they now gradually organized themselves into groups to produce and sell objects in greater quantities.

From the end of the eighteenth century, the rapid commercial growth of the printing and publishing industries became a major factor in the city's economic and cultural life. The development of lithography in the early nineteenth century led to the mass production of a variety of subjects at a comparatively low cost; for example, prints were made for advertising or for widespread distribution by such agents as the American Sunday-School Union. As a result, images that were often remarkably sophisticated in subject and of high technical quality now became available and easily accessible to great numbers of people.

Beginning with F. O. C. Darley in 1842, increasing numbers of artists began to identify themselves as professional illustrators. By midcentury, publishing as a fine art reached a high point with the appearance of John James Audubon's *Viviparous Quadrupeds,* printed by John T. Bowen from 1845 to 1848.

The commercial growth of printmaking was paralleled by similar developments in the other arts which previously had been devoted primarily to custom work. By 1850, cabinetmakers and silversmiths had become businessmen who, while still undertaking specific commissions, concentrated more upon manufactured stock items to be sold from their own stores or supplied to other merchants. With this trend to production for a mass market, the regional elements of style characteristic of eighteenth century American furniture and decorative arts increasingly merge into the homogeneity of a national style. In this way, like items produced in different cities came to have similar stylistic characteristics. Only the most elaborate examples of furniture and decorative arts, such as presentation silver or furniture produced en suite to special order or for display at one of the expositions, provide evidence of the craftsman's distinctive abilities.

Apprenticeship continued as the basic method of craft training in furniture and the decorative arts well into the nineteenth century. However, the increasing specialization and complexity of production techniques and the separation of design from production coincident with the growth of industrialization gave rise to new schools to answer the challenge of new skills. From its founding in 1824, the Franklin Institute provided classes in mathematics and engineering, drafting and mechanical drawing, and art techniques useful to the craftsman. In the same way, the Institute's annual exhibitions, held from 1824 to 1858, served as a trade fair

to show both the work of artisans and current industrial products, created in Philadelphia as well as nationally, and jury prizes were offered for quality in design and workmanship. The establishment of free public schools in Philadelphia effectively reduced the need for the complete program offered by the Institute, but it continued to offer courses in mechanical drawing and practical engineering until 1923. In addition, its building served as a temporary home for other newly formed educational institutions throughout the nineteenth century. One of these was the School of Design for Women, established in 1844 by Mrs. Sarah Peter, to provide career training for women. The Pennsylvania School of Industrial Art, organized in 1877–78, in conjunction with the establishment of the Pennsylvania Museum, was also located temporarily at the Franklin Institute until 1893. Two additional schools that provided training in the arts were established before the end of the century. The Spring Garden Institute, founded in 1850, offered courses in industrial arts for young men. Drexel Institute, founded in 1891 by Anthony J. Drexel, provided art education and secretarial and engineering instruction for men and women. Before Drexel was reorganized in 1913 to emphasize secretarial and engineering skills, its art classes provided thorough art training on the academic model, and the classes in illustration, taught by Howard Pyle, established a school of his followers that lasted well into the twentieth century.

The growth of systematic collecting as a form of art patronage and the increasing availability of the work of other contemporary American artists and of European artists generated a new spirit of competition in the fine arts in Philadelphia. In 1850, the ubiquitous John Sartain complained that local art dealers were selling inferior European works to the detriment of Philadelphia artists. However, at the same time, the artists were taking advantage of opportunities in other cities, such as New York and Boston, to exhibit their work, to become active in national organizations, and to have their work reproduced and distributed by publishers. And, as the exhibition records of the Academy indicate, there was scarcely a Philadelphia collector during the mid-nineteenth century who did not own examples of the work of Sully, Hamilton, Rothermel, Schussele, or Richards.

In 1855 the Academy made a renewed effort to establish a regular, supervised program of instruction under the leadership of P. F. Rothermel and John Sartain. A class for women had been established in 1844, and during the next twenty years the number of male and female students steadily increased. In 1868, Christian Schussele was hired as the first Professor of Drawing and Painting. Furness and Hewitt's design for the new Academy building included a series of art classrooms as an integral part of the plan, incorporating suggestions from Howard Roberts and Thomas

Eakins, both recently returned from study in France, as to the most effective disposition of the rooms for teaching painting and sculpture.

In 1876, Thomas Eakins began teaching at the Academy, and in 1882 he was made Director of the School. An outspoken, innovative, and occasionally controversial teacher, Eakins was often characterized as "radical" in comparison to Schussele's conservatism. As a result of his French academic training, Eakins emphasized drawing and painting of the living model; courses in anatomy and perspective were intensified; and sculpture was introduced as a supplementary method of studying human form. Although Eakins introduced his students to illustration, portraiture, landscape, relief sculpture, still-life, and photography in formal courses and as shared enthusiasms, he insisted on the study of the human figure as the basis of art, and he defined the Academy's purpose as providing training for professional artists and not enthusiastic amateurs. He appeared a dogmatic and single-minded teacher to those who did not share his point of view, and his insistence on the use of a nude model in life classes for both men and women provided his detractors with a moral focus for what was actually an aesthetic issue. The disagreement became so great that finally, amidst much controversy, Eakins was fired in 1886. Nonetheless, in varying degree, his ideas continued to be a factor in the training of the city's artists well into the new century.

Thereafter teaching at the Academy was continued by Eakins's former students—among them Thomas Anshutz, James B. Kelly, and Thomas Hovenden—who continued his general program of instruction but were more relaxed in their acceptance of other trends in art. By the mid-1890s, with the hiring of instructors such as William Merritt Chase, Cecilia Beaux, Charles Grafly, and Robert Vonnoh, a variety of teaching methods was introduced, and the traditional academic discipline of drawing and painting from the nude model became less the central concern of academic study than a preliminary discipline that prepared the student to cope with the stylistic freedom of art movements in the twentieth century. During these years, even as teaching methods grew more flexible, the Academy became an institution to react against as well as to attend. The resignation of a group of Eakins's students to form the Philadelphia Art Students' League in 1886 and the formation of the Charcoal Club by Robert Henri and his friends in 1893 were initial rebellions against the Academy as a traditional establishment. Yet the Academy often remained receptive to the work of its own rebellious offspring: for example, after the sensational 1908 exhibition of "The Eight" closed in New York it traveled to Philadelphia to be shown in the Academy galleries.

Through the nineteenth century, instruction in architecture had been based on an apprenticeship system in which the aspiring architect worked in an architect's office, supplementing his training with courses in the engineering principles required by the growing complexity of materials and construction methods. In addition to the courses in engineering offered by other schools and institutes, the University of Pennsylvania began to offer courses in architecture in 1874, and in 1890 an independent Department of Architecture was established, offering a four-year undergraduate program of training based upon the French Beaux-Arts model. Theophilus Chandler, who had been one of a group of local architects supporting the foundation of the architecture school, secured the appointment of Warren Powers Laird as head of the department in 1891, and with the appointment of Paul Cret as chief architectural critic for the department in 1903, the architecture school became pre-eminent in the country for the next twenty years. Reflecting new attitudes toward architecture, planning, and the landscape, training at the University turned in the mid-1950s from the Beaux-Arts tradition to a committed concern for the problems of present-day society.

While the facilities for the training of artists and craftsmen had developed impressively in Philadelphia during the nineteenth century, opportunities to study the work of other artists increased as well. The annual exhibitions of the Pennsylvania Academy and the Academy's growing collection of paintings and prints were of the greatest importance.

During the earlier years of the century, artists could turn to the pictures hanging in various public buildings in Philadelphia. A variety of portraits and subject pictures could be seen at Peale's Museum, the Pennsylvania Hospital, the Library Company of Philadelphia, the Historical Society of Pennsylvania, and the American Philosophical Society's meeting rooms, among others. By midcentury, the numbers of commercial galleries were increasing, and single events also focused attention on the visual arts: an art exhibition was part of the Sanitary Fair held in 1864, housed in temporary structures on Logan Square, to raise money for Civil War field hospitals.

However no single exhibition in the history of Philadelphia—or even that of the nation—surpassed the influence or importance of the vast Centennial Exposition of 1876. Initially planned for Memorial Hall but extended into adjacent buildings as the numbers of large canvases increased, the Fine Arts Section at the Exposition was designed to show the American accomplishment in comparison with works created by foreign artists. Not too surprisingly, given the speed with which the material was gathered together and the variety of juries or commissions responsible for the selection, the exhibition was uneven in its representation. Nonetheless, the painting and sculpture of many well known artists were first seen here by hundreds of thousands of Americans. The interest generated

at the Exposition by the work of craftsmen, artisans, and manufacturers and the increasing role which mass-produced objects played in daily life were major factors in the creation of the Pennsylvania Museum and School of Industrial Art in the same year. Founded on the example of the South Kensington Museum in London (now the Victoria and Albert Museum), itself an outgrowth of the 1851 Crystal Palace exposition, the Pennsylvania Museum's collection concentrated on the decorative arts of the past and the present, "with a special view to the development of the art industries of the state." Its classes became steadily more ambitious and, recognizing the need for technical information, more specialized, as in the mid-1880s, leaders in the Commonwealth's textile industry funded a special section to develop skills to further the growth of that industry.

As Philadelphians traveled more, whether to New York or abroad, the numbers and the quality of private collections increased. By the turn of the century, such leading collectors as John G. Johnson and the Widener, Wilstach, and Elkins families were gathering together important works which would assure future generations of artists exposure to Europe's great masters. The need for appropriate housing for these collections, in conjunction with a community decision to connect Philadelphia with its extensive park system, led the city just after the turn of the century to undertake the Benjamin Franklin Parkway and construction of the present Philadelphia Museum of Art building, the most ambitious reflection of the Beaux-Arts training associated with the University of Pennsylvania School of Architecture. The Fairmount Park Art Association, chartered in 1872, "to promote and foster the beautiful in the City of Philadelphia," was instrumental in preparing the Parkway plan and has continued to serve as an important public patron in the sponsorship of sculpture for public sites and monuments throughout the city.

In addition to schools for professional training established by the end of the century, an alternative concept of art education led to the founding of the Graphic Sketch Club by Samuel S. Fleisher in 1899. The club offered art instruction at no charge to whomever wished to attend. Motivated originally by the Ruskinian idea that every human being, whatever his means and background, should have an opportunity to express the love of beauty that all have in common, the institution, now named in honor of its founder, continues on the same principles to the present day.

By 1900, the creation of a number of art clubs and organizations became an important factor in the city's art life. The earliest of these were the Sketch Club, founded in 1860 and still active today, and the shortlived Philadelphia Society of Artists, founded in 1879. There were, successively, the Plastic Club for women artists, the T-Square Club for architects, the Pyramid Club, the Pennsylvania Society of Miniature Painters, the Philadelphia Watercolor Club, and Artists Equity. The Art Club, founded in 1887, served essentially the same function as the Century Club in New York, providing a working place for artists and art amateurs in the opulent clubhouse designed by Frank Miles Day. Each of these clubs provided facilities for artists and demonstrated a concern for their well-being in a somewhat different fashion; but their proliferation is a keynote of the arts in Philadelphia worthy of further study. The tradition of regular exhibitions characteristic of many of these organizations continues today in the galleries of the Art Alliance and the Print Club.

Philadelphia ceased to be a leading center for the production of furniture and decorative arts by the end of the nineteenth century. The items exhibited from this period were in fact reactions against a prevailing taste. Frank Furness's desk, the furniture and buildings of William Price's reform aesthetic, or the table and chairs that Theophilus Chandler designed for himself were, like the most advanced work of the contemporary painters, intended for a very small group of individuals who were in sympathy with the artists. A distinctive style of picturesque architecture which developed in the early twentieth century continued to flourish in such outlying areas of Philadelphia as Chestnut Hill until the outbreak of World War II. Architects adapting designs of the past to present-day needs worked closely with such able craftsmen-entrepreneurs as Samuel Yellin and Dr. Henry C. Mercer, whose productions reflected a deliberate historicism.

During the period 1900–1914, Pennsylvania Academy traveling scholarships enabled many of its students to travel in Europe where they were not only impressed by the newest trends of Fauvism and Cubism but also adopted the avant-garde as an idea. In the light of their European experience and their contact with New York, they felt Philadelphia to be an essentially reactionary community. As Charles Sheeler was later to recall: "During the years following the Armory Show life in Philadelphia seemed much like being shipwrecked on a deserted island. Whatever was happening that was stimulating and conducive to work was taking place in New York. With Philadelphia Modern Art, as it was then called, was of the same status as an illegitimate child born into one of the first families, something to live down rather than welcome for the advantageous possibility of introducing new blood into the strain" (Archives of American Art, Sheeler, Reel 1, Frame 83).

While the history of the avant-garde in Philadelphia must be viewed in its relationship to a constant tradition of carefully observed naturalism, a small group of artists associated with the city, most of whom were graduates of the Academy, were nevertheless participants in the development of a new American aesthetic. The organizers of the New York Armory Show in 1913 had already recognized

the originality of the early work of Morton Schamberg, yet the radical evolution of his art in the tragically few years remaining in his life surely surpassed all expectations. Born within ten years of each other, H. Lyman Saÿen, Charles Sheeler, Charles Demuth, and Arthur B. Carles brought their knowledge of Cubist composition and Fauve color to bear on the creation of an indigenous, thoroughly American, modern art. Because of Saÿen and Schamberg, Philadelphia had, as early as 1916, a most remarkable exhibition at the McClees Galleries of contemporary French masters such as Picasso, Braque, Brancusi, and Marcel Duchamp.

Although Saÿen and Schamberg died early, virtually unknown, and Sheeler essentially left Philadelphia in 1919, Carles, Henry McCarter, and later Franklin Watkins became leading figures in what proved to be one of the most stimulating periods of interaction among artists, collectors, and exhibitions in the history of Philadelphia. During the 1920s and the 1930s the vigorous efforts and enthusiasm of a circle of men, including Carroll S. Tyson, a sensitive painter and brilliant collector of French Impressionist art; Earl Horter, a gifted draftsman who, according to his means at a given moment, was also a collector and marchand-amateur of most unusual perception; artists such as Henry McCarter, George Biddle, and Wallace Kelly; the brilliant lawyers R. Sturgis Ingersoll and Maurice Speiser, who devoted much attention to the arts; and a small but committed group of their friends (among them Vera and Samuel White) managed to bring the visual arts much more to the forefront of community concern in the city.

The discussions and enthusiasms of this group not only nurtured sophistication in the contemporary art created and collected in Philadelphia but helped to prepare a sympathetic audience for the large contemporary exhibitions organized by Carles and his Philadelphia colleagues at the Academy—*Representative Modern Masters* in 1920, which included works by the Impressionists, Cézanne, and Matisse, and *Later Tendencies in Art* in 1921. Two years later, Carles and Henry McCarter persuaded Dr. Albert C. Barnes to show a selection of his recent acquisitions, which included a number of paintings by Soutine. The violent public criticism provoked by the exhibition contributed to Dr. Barnes's subsequent decision to withdraw his great collection from public exposure. The members of this group were collecting works by leading French artists even as the pictures were completed, and with the aid of the often provocative public statements of Dr. Barnes, their interests even became issues in the local press. The commitment of these artists and collectors contributed significantly to the rapid and astonishing growth of the Philadelphia Museum of Art during this period.

Major exhibitions have brought the Philadelphia artists and public increasingly varied fare during the twentieth century. The Academy annuals continued until 1968, and both the Academy and the Philadelphia Museum have sponsored a long series of shows devoted to national as well as regional artists and styles. The Fine Arts Section of the Sesqui-Centennial Exposition in 1926 was one of the relatively successful aspects of that event, and the three vast international sculpture exhibitions sponsored by the Fairmount Park Art Association in 1938, 1940, and 1949 emphasized the city's own ongoing commitment to public sculpture.

Instead of the relatively few training resources available in the eighteenth century city, Philadelphia now offers several distinguished schools for the art student. The various nineteenth century schools have expanded and become nationally known institutions. At the Academy, beginning in the early years of the century, the teaching careers of Grafly, Garber, Breckenridge, Laessle, and McCarter, themselves Academy students, set a pattern for long periods of teaching there that persisted well beyond midcentury with painters such as Watkins, Speight, and Stuempfig, thereby providing instruction that was remarkable for its continuity.

The School of Design for Women merged with Moore Institute in 1923, carrying on a program oriented essentially to women students but steadily broadening its curriculum to prepare its students for professions in a wide variety of fields related to the arts, including fashion. The decision to change the name of the Pennsylvania Museum School of Industrial Art to the Philadelphia College of Art, which followed the decision to separate it first from the Textile College and then later (in 1963) from the Museum, reflected a significant change of attitude in the teaching program. Today, the student preparing for a career in industrial design may still receive special training there, but the College also provides a curriculum to answer the needs of the painter and the sculptor.

This century has seen the creation of a number of new institutions devoted to the teaching of art. Temple University created the Tyler School of Art on a separate campus in 1934, while in the late 1950s the University of Pennsylvania introduced courses in painting, sculpture, and printmaking. The interaction of classes and collections associated with the Pennsylvania Academy in the later years of the nineteenth century has a contemporary counterpart in the Foundation created in 1922 by Dr. Barnes.

In the years since World War II, Philadelphia's art schools have continued to grow and flourish. In contrast to the Academy, with its continuing tradition of instructors drawn from among its most successful former students, the Philadelphia College of Art, Moore College of Art, Tyler School of Art, and the University of Pennsylvania have attracted artists from across the country to teach and live in Philadelphia. Current art school programs offer a wide

variety of courses in ceramics, printmaking, photography, and weaving as well as painting, sculpture, and design. Although drawing from antique casts has virtually disappeared from the modern fine arts curriculum it is still practiced at the Academy, and life drawing and painting classes, until recently fallen somewhat out of favor, now fill with increasing numbers of students.

The city has become an important American center for the collecting of contemporary art, and several institutions now offer varied exhibition programs devoted to the modern field, most notably the Institute of Contemporary Art founded in 1963 at the University of Pennsylvania. One of the most interesting developments (which Philadelphia shares with the rest of the country) is the resurgence of interest in crafts, now viewed as works of art rather than as objects for everyday use. Another stimulus to the creation and display of recent art has been the foresighted adoption by the city in 1959 of an ordinance requiring that one percent of the cost of all new public buildings be spent on their adornment.

Philadelphia is today enjoying an impressively productive period of artistic activity. Appropriately, interest in the arts is directed to understanding and preserving the past as well as to the creation of what is new. An exhibition devoted to a survey of three hundred years can only begin to suggest the vitality of tradition and the vigor of original creativity in the contemporary city. The history of the arts in Philadelphia cannot be seen in one place; it resides in its architecture and public spaces, in institutions which preserve its past, and in the work of its living artists, architects, and craftsmen.

Darrel Sewell
Curator of American Art

Contributing Writers

RB-S ROBIN BOLTON-SMITH
Curator of 18th and 19th Century Painting
and Sculpture
National Collection of Fine Arts
Smithsonian Institution
Washington, D.C.

JC JOHN CALDWELL
Andrew W. Mellon Fellow, 1975–1976
The Metropolitan Museum of Art
New York

PC PATRICIA A. CHAPIN
Department of Costume and Textiles
Philadelphia Museum of Art

CC CAROL C. CLARK
Instructor in Art History
Texas Christian University
Fort Worth, Texas

PHC PHILLIP H. CURTIS
Curator of Decorative Arts
The Newark Museum
Newark, New Jersey

Ad'H ANNE d'HARNONCOURT
Curator of 20th Century Painting
Philadelphia Museum of Art

SD SANDRA DOWNIE
Field Curator for the Bureau of Museums
Pennsylvania Historical and Museum Commission
Harrisburg, Pennsylvania

DE DORINDA EVANS
Visiting Curator of American Art, 1974–1975
Philadelphia Museum of Art

DF DONALD L. FENNIMORE
Assistant Curator
The Henry Francis du Pont Winterthur Museum
Winterthur, Delaware

KF KATHLEEN FOSTER
Acting Instructor, History of Art
Yale University
New Haven

BG BEATRICE B. GARVAN
Associate Curator of American Art
Philadelphia Museum of Art

FG FREDERICK GUTHEIM
Professor of American Civilization
The George Washington University
Washington, D.C.

DH DAVID A. HANKS
Curator of American Art
Philadelphia Museum of Art

KH KATHRYN B. HIESINGER
Curator of European Decorative Arts after 1700
Philadelphia Museum of Art

CJ CHRISTINE A. JACKSON
Department of Costume and Textiles
Philadelphia Museum of Art

ESJ ELLEN S. JACOBOWITZ
Assistant Curator of Prints
Philadelphia Museum of Art

RFL RUTH FINE LEHRER
Curator
Alverthorpe Gallery
Jenkintown, Pennsylvania

LAL LYNNE A. LEOPOLD
Curator, 1974–1975
INA Museum, INA Corporation
Philadelphia

EMcG ELSIE S. McGARVEY
Curator of Costume and Textiles
Philadelphia Museum of Art

GM GORDON M. MARSHALL III
Assistant Librarian
The Library Company of Philadelphia

SKM SUSANNA KOETHE MORIKAWA
Ph.D. Candidate in the Humanities
Syracuse University
Syracuse, New York

SAM STEFANIE A. MUNSING
Curator, Historical Prints
Library of Congress
Washington, D.C.

DO DAVID ORR
Assistant Professor of American Civilization
University of Pennsylvania
Philadelphia

PJP PETER J. PARKER
Curator of Manuscripts
Historical Society of Pennsylvania
Philadelphia

AP ANN B. PERCY
Associate Curator of Drawings
Philadelphia Museum of Art

BR BERNARD F. REILLY
Curator of Maps and Prints
The Library Company of Philadelphia

JR JOSEPH RISHEL
Curator of European Painting before 1900
Philadelphia Museum of Art

AS ABIGAIL SCHADE
Department of American Art
Philadelphia Museum of Art

DS DARREL L. SEWELL
Curator of American Art
Philadelphia Museum of Art

TS THEODOR SIEGL
Conservator
Philadelphia Museum of Art

WS WILLIAM F. STAPP
Staff Lecturer
Philadelphia Museum of Art

PT PAGE TALBOTT
Research Assistant, 1975
Department of American Art
Philadelphia Museum of Art

GT GEORGE E. THOMAS
Professor of Architectural History
Drexel University
Philadelphia

DDT D. DODGE THOMPSON
Administrator for Curatorial Affairs
Philadelphia Museum of Art

RW RICHARD WEBSTER
Associate Professor of History and American Studies
West Chester State College
West Chester, Pennsylvania

KMW KENNETH M. WILSON
Director, Collections and Preservation
Greenfield Village and Henry Ford Museum
Dearborn, Michigan

CW CAROLINE P. WISTAR
Assistant Curator of Photography
Philadelphia Museum of Art

Measurements are given in height, width, and depth unless otherwise specified

Abbreviated citations appear in full in the Bibliography of Frequently Cited Works on page 648

Cross references to other works in the catalogue are referred to by catalogue number

Biographies of artists or makers appear with the first representation of their work

1676-1726

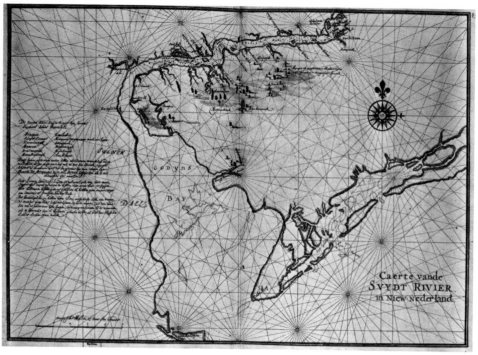

1.

I. *Chart of South River (Delaware River)*

c. 1669–74?

Mark: Library of Congress stamp (lower left)

Inscription: Caerte van de / SVYDT RIVIER./In Niew Nederland (lower right)

Pencil, ink, and watercolor on laid paper, backed on laid paper, possibly of Dutch manufacture

Watermark: Indistinct

21 13/16 x 29 1/8" (55.4 x 74 cm)

Library of Congress, Washington, D.C. Geography and Map Division. Bequest of Henry Harrisse

PROVENANCE: J. Blaeu until 1674(?); in the stock of Gerard Hulst van Keulen until 1885; sold at auction to Frederick Muller, 1885; sold by catalogue to Henry Harrisse, 1887

LITERATURE: Baltimore Museum of Art, *The World Encompassed: An Exhibition of the History of Maps* (October 7—November 23, 1952), no. 237; Newark, New Jersey Historical Society, *Early Maps of North America* (December 12, 1961—January 20, 1962), no. 19

ACCOUNTS OF PENNSYLVANIA frequently begin with the Charter to William Penn, but the real estate that became his province had been fought over and partially settled even before Penn's birth in 1644. In the 1630s, Dutch and Swedish trading companies were scrambling to pick up empires from the leavings of Spain, Portugal, and a newly

vigorous England. The English to the north and south seemed, at first, uninterested in the lands that lay along the Delaware; the river was, after all, uncharted.

Charts and maps in the seventeenth century were just as much tools of empire as ships and guns. They formed the basis of policy—albeit frequently poorly informed—and they provided traders, factors, and settlers with the means of getting where they were going. This chart, showing the sea approaches to the Delaware Valley, is a copy of what may well have been the earliest chart of the Delaware. It shows the river from Cape May to the head of navigation at Trenton. West is at the top of the chart and, although a compass rose and rhumb lines give bearings to several capes and islands, navigating upriver remained difficult.

This chart is a copy by an unknown hand of an even earlier map presumably drawn for the Dutch West India Company as early as 1638 or 1639. In 1638 the Portuguese were successfully beginning to force the company from its foothold in Brazil; understandably, the company's council in Holland began to pay renewed attention to New Netherland. The copy suggests that the original was complete with navigational aids for the upper river to assist the company's sailing masters. One can understand that the company did not wish their mapmakers, C. and J. Blaeu, appointed in 1638, to engrave the chart because multiple copies would have exposed their trading posts to interlopers. To avoid this, the company issued only manuscript charts (*caerten par-*

ticulieren) to their sailing masters (Cornelis Koeman, *Collections of Maps and Atlases in the Netherlands,* Leiden, 1961, pp. 144–45).

Henry Harrisse bought the South River ("Svydt Rivier") map, as well as a number of others, from Frederick Muller of Amsterdam in 1887. Now in the collection of the Library of Congress, all appear to be copies of earlier originals. Similarities of handwriting, drafting, and coloring techniques, as well as the presence of blindscoring on many of the maps and charts, suggest that those purchased by Harrisse came from the same workshop, although not necessarily from the same copyist. One of these maps, *De Eylanden en Vastelanden van West Indien,* records that the original had been made by Johannes Vingboons, once a cartographer for the Dutch West India Company. This identification led Harrisse to assume all the others were also by Vingboons and to entitle the volume from which the South River map comes "Manuscript Maps of New Netherland and Manhattan drawn on the spot by Joan Vingboons in 1639." One can understand his enthusiasm but must question his attribution.

The Harrisse volume of "Manuscript Maps" contains the South River map, a chart of the Hudson, and the famous "Manatus," a map of Manhattan. There is more than subject matter to justify Harrisse's grouping. The three show a marked similarity in style and execution, suggesting that the same copyist worked on all three. I. N. Phelps Stokes has effectively shown that one of the three, the "Manatus," was not the work of Vingboons (*The Iconography of Manhattan Island,* New York, 1916, vol. 2, pp. 173–228). His arguments rest largely upon the existence of a second copy of the "Manatus" by the same hand now in the Villa Costello near Florence. Internal and external evidence dates the Costello manuscript chart no later than 1669. Because of similarities in style and paper, Stokes concludes that the Harrisse "Manatus" was done at the same time as the Costello copy and not by Vingboons in 1639. He has failed, however, to suggest an attribution for it or for its companion chart of the South River in Harrisse's collection.

If Stokes is correct, then both copies of the "Manatus" were made when the Blaeus were still mapmakers for the Dutch West India Company. Presumaby the Harrisse South River map was done at the same time. Five years after its probable execution the Blaeu office was broken up, with some of its stock going to Johannes van Keulen, whose firm subsequently became mapmakers for the Dutch West India Company. It seems probable that the Harrisse maps became part of the stock of the van Keulens who continued in business until 1885, when Frederick Muller bought their stock at

auction. From these circumstances, one can conclude that both the "Manatus" and the South River were done in the Blaeu shop about 1669.

Although it is possible to date the Harrisse copy of the South River map, one cannot determine why it was made. It may have been the Blaeus' record copy; clearly it was never used as a navigational chart. And, although it was copied long after trading posts and settlements had been established at Fort Christina (Wilmington) and New Amstel (New Castle), these facts are not recorded. Instead the copyist has inserted a list of the Indian nations along the Delaware and a description of the life of the noble savage: "The life of these people is completely free. Their soothsayers or devil's preachers have little control over them. Their sachems cannot order them about nor can they inflict capital punishment. Marriages have no permanence. As a rule everyone has one woman; the chief has more. And they lightly leave their wives who then go like whores from one to another. Ordinarily they cast out their women when they are with child or have given birth to a child. Because of this the land stays sparsely populated" (Library of Congress, Geography and Maps Division, adapted from translation by A. Philip Vos, 1962).

PJP □

FRANCIS LAMB (ACT. 1667–1700)

Little is known of Francis Lamb. He was one of twenty-seven London mapsellers in business between 1660 and 1700. He also engraved and published plates for a number of atlases in the 1680s (Sarah Tyacke, "Map-sellers and the London Map Trade c. 1650–1710," in *My Head Is a Map: Essays and Memoirs in Honour of R. V. Tooley*, ed. by Helen Wallis and Sarah Tyacke, London, 1973, p. 66).

THOMAS HOLME (1624–1695)

Born in 1624, possibly in Yorkshire, Thomas Holme served as a captain in the Parliamentary Army during the Civil War. In 1655 he was one of those Parliamentary soldiers to receive a land grant in Ireland. By 1657 he had become a member of the Society of Friends and was imprisoned for nonconformity after the Restoration, in 1661. Holme owed his prominence among Irish Friends in part to his publication of several religious tracts. When Penn began to advertise his venture among Friends in 1681, Holme soon became a "first purchaser" of 5,000 acres in Pennsylvania. On April 18, 1682, Penn appointed him surveyor general of the province, and five days later Holme left for his lands and duties in the colony.

Holme arrived before Penn but immediately set to work with others to choose a site for Philadelphia. When the Proprietor arrived in October 1682 and approved the site, Holme surveyed the new city between South and Vine streets, river to river. He also prepared a draft of this survey which was published in London in 1683 as the *Portraiture of Philadelphia*. Holme soon became prominent in the political life of the colony, serving as a member of the Provincial Assembly in 1682 and representing Philadelphia on the Provincial Council between 1683 and 1685. Before the Proprietor returned to England in 1684, he evidently secured a promise from Holme to prepare a second, more important, promotional map, *The Improved Part of the Province,* which took him some two years to complete. In 1694, after two lengthy trips to England, Holme was appointed one of the Commissioners of Property. He died the following year.

FRANCIS LAMB AND THOMAS HOLME

2. *Map of the Province of Pennsylvania*

1687

Signature: F. Lamb Sculp (lower left of sheet six)

Inscription: A MAP OF / THE PROVINCE OF / PENNSILVANIA. / Containing the three Countyes of / CHESTER, PHILADELPHIA, & BUCKS. / *as far as yet Surveyed and Laid out, ye Divisions / or distinctions made by ye different Coullers, respects / the Settlements by way of Townships.* / By Tho: Holme Surveyr Genll (righthand side of sheet three); TO THE WORTHEY WILLIAM PENN ESQ. / PROPRIETOR OF / PENNSILVANIA / IN AMERICA. / *This Map is Humbly Dedicated* / By John Thornton & Robert Greene. (lefthand side of sheet one)

Engraving on six sheets of laid paper, not trimmed or joined

Each sheet 22 x 26″ (55.9 x 66 cm); image 16½ x 18¾″ (42 x 47.6 cm)

Historical Society of Pennsylvania, Philadelphia

PROVENANCE: Thomas Lloyd(?); Isaac Norris II; probably descended in Norris family until c. 1908; Historical Society of Pennsylvania, c. 1908 (acquired with Norris Family Papers)

LITERATURE: Oliver Hough, "Captain Thomas Holme, Surveyor-General of Pennsylvania and Provincial Councillor," *PMHB*, vol. 19, no. 4 (1895), pp. 413–27, vol. 20, no. 1 (1896), pp. 128–31, 248–56; Walter Klinefelter, "Surveyor General Thomas Holme's 'Map of

the Improved Part of the Province of Pennsylvania,'" *Winterthur Portfolio 6* (1970), pp. 41–74

IT WAS NATURAL that William Penn should turn to Thomas Holme, his surveyor general, for a map that would show investors, doubters, and even political enemies the progress of Pennsylvania since the Charter and the appearance of Thornton and Seller's *Map of the Bounds of Pennsylvania* in 1681. In the text accompanying that map, Penn noted its deficiencies and hoped that "time and better Experience [would] correct and compleat it." Penn asked Holme to take on the task just before the Proprietor returned to England in August 1684; Holme thought that he could complete the job by the end of the year, but it took longer than either imagined. Instead of merely compiling the surveys filed by his deputies in the land office, Holme soon discovered that he had stepped into a mare's nest. His deputy for Chester County, for example, refused to turn in some of his surveys because he had been surveying lands without warrants from the Proprietor. Penn's practice of granting lands without specifying where they were to be taken up encouraged such irregularities. Malfeasance and nonfeasance in the surveying and granting of lands delayed the completion of his draft until early 1687. Penn, in the meantime, fumed from England: In September 1686 he wrote Thomas Lloyd, president of the Provincial Council, "Tell Tho[mas] Holmes, we want a map to that degree, that I am ashamed here; bid him send what he has by the first; he has promest it two years since . . . all cry out, where is your map, what no map of your Settlements!" (Frederick B. Tolles, ed., "William Penn on Public and Private Affairs," *PMHB*, vol. 80, no. 2, April 1956, p. 246).

The draft finally reached Penn early in the summer of 1687 (Gary B. Nash, ed., "The First Decade in Pennsylvania: Letters of William Markham and Thomas Holme to William Penn," *PMHB*, vol. 90, no. 4, October 1966, p. 491). Penn turned to John Thornton, publisher of his earlier map, and to Robert Greene to oversee its publication. They placed the draft in the hands of Francis Lamb who engraved it in six copper plates, evidently with considerable care. Because the original draft seems not to have survived, one cannot know how many liberties Lamb took with Holme's draft, but one suspects that Lamb provided the delightfully ornate cartouche on sheet one, complete with fishermen, their boat, and, more appropriately, deer. The design is altogether typical of the conceptual vocabulary of contemporary English and Continental mapmakers.

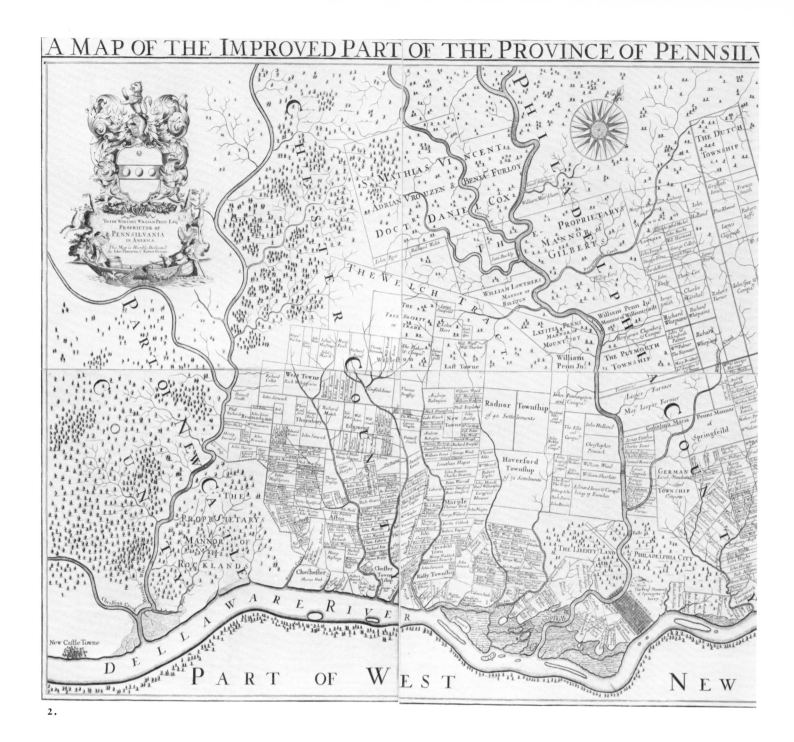

2.

One is immediately struck by the size of Lamb's map. Drawn on a scale of one mile to the inch, it appears to contain much more than the 55-by-33-mile area shown. Its orientation is undoubtedly determined by the area drawn. Across the bottom of the map are the old settlements from New Castle to the Proprietor's manor at Pennsberry (Pennsbury) at the bend of the Delaware. The Schuylkill almost divides the map vertically, with Chester County to the left, and Philadelphia and Bucks to the right. In the upper righthand corner of sheet three is a much reduced copy of Holme's familiar grid plan of Philadelphia originally done for the Proprietor in 1683 and essential to this real estate promoter's map. In a pamphlet addressed to the Free Society of Traders in 1683, Penn told of his plan to give each purchaser a lot in the city: "All Purchasers of One Thousand Acres, and upwards, have the [river] Fronts (and the High Street) and to every five Thousand Acres Purchase, in the Fronts about an Acre" (Walter Klinefelter, "Surveyor General Thomas Holme's 'Map of the Improved Part of the Province of Pennsilvania,'" *Winterthur Portfolio 6*, 1970, p. 47).

The promotional nature of the map is evidenced by several emphases which Holme provided. Not all purchasers could be accommodated with city lots; they were to be given lots in the Liberties to the north of the city, lands that Holme clearly laid out. Additionally, Holme seems to have made the streams unusually wide so that they perhaps appeared navigable, a great boon to up-country settlers with no roads. Finally, Holme seems to have paid scant attention

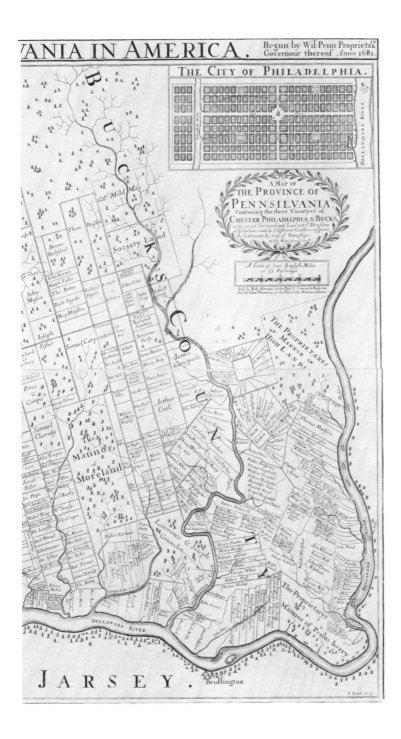

grandson of Council President Lloyd. Marie Korey (*The Library of Isaac Norris at Dickinson College,* Carlyle, Pa., 1976) has found four of Lloyd's books among those of Norris's at Dickinson. Certainly the Society's set is not the one advertised in *The London Gazette,* for it lacks the printed "General Description" that comprised the seventh sheet. Furthermore, no known copy in the United States has the seventh sheet. But the condition of the Historical Society's set of six sheets suggests that they may be the earliest impressions in this country. The impression is crisp and clear. Even the faint lines that guided Lamb's lettering on the plate are evident. Whether this copy is definitely Lloyd's proof set cannot be known; but the Society's set is certainly an early impression of the first edition.

PJP □

CESAR GHISELIN (C. 1663–1733)

In 1689, when Louis XIV called for the melting of silverplate and imposed limitations upon its manufacture in France, Huguenot silversmiths like the Ghiselins and Nyses, who were born and trained in France and Holland, had little further prospect there for success in their trade. The upheaval caused by the revocation of the Edict of Nantes in 1685, which had ended official protection for Protestants, was vividly described by William Penn in a letter to James Harrison in Pennsylvania: "In France not a meeting of Protestants left. They force all by not suffering them to sleep, to conform. They use drums or fling water on the drowsy, till they submit or run mad. They pray to be killed, but the King has ordered his dragoons that are his Inquisitors & converters, to do anything but kill and ravish. Such as fly & are caught, are executed or sent to the galleys to row" (HSP, Penn Papers, Domestic and Miscellaneous Letters, August 25, 1685).

Cesar Ghiselin, son of Nicholas and Ann Gontier Ghiselin, was probably born about 1663 amid the increasing unrest in Rouen. In 1674, another son, John, was married there. A third son, Nicholas, emigrated to England where he was naturalized in 1681–82. Cesar, still underage, probably went with him before continuing on to America. He arrived, with John Pearse, also a silversmith, in Chester, Pennsylvania, on October 11, 1681, a year before William Penn, aboard the English ship, *Bristol Factor* (London, Public Record Office, Searcher's Book E/190/1144/2; Controller's Book E/190/1142/3). The ship carried skilled craftsmen—Thomas Wharton, tailor, Andrew Bradford, printer, Nehemiah Allen, cooper, Josiah Carpenter, brewer, Thomas Paschall, pewterer, John Fisher, blacksmith, and Abraham Hooper, cabinetmaker—who

to the settlements along the Delaware that had been peopled by Dutchmen, Finns, and Swedes before Penn's Charter had passed the seals. Yet, despite these deficiencies—perhaps because of them—Penn welcomed the map.

The London Gazette for January 5, 1687/88, carried the announcement that Greene and Thornton had the map for sale: For 10 shillings one could obtain this new and exact map "Giving the figure of every particular Persons piece or parcels of land taken up there," on seven sheets of paper,

"rouled and coloured." Before publication, however, Penn ordered some proof copies to be pulled for exhibition at the Bristol Fair in September 1687 (Albert Cook Myers, ed., *Narratives of Early Pennsylvania, West New Jersey and Delaware, 1630–1707,* New York, 1912, p. 292). There is a strong possibility that the Historical Society of Pennsylvania's copy is one of these proof sets. It is neither colored nor rolled. When the Society received the six sections they were bound in a volume containing the bookplate of Isaac Norris II (1701-1766),

5

formed the core of the eighteenth century artistic and commercial enterprises in Philadelphia. Since Ghiselin was known as a silversmith upon his arrival in America, it may be assumed he had already completed his apprenticeship. His next appearance in reliable records is in Philadelphia's First Tax List of 1693 where his property was valued at £100; in the same year he was mentioned in the will of Peter Debuc: "Unto my loving friend Ceasar Guislin . . . Goldsmith, the sum Twenty four pounds . . . which hee oweth unto me, & also a barr of Gold, weighing an Ounce and Eight penny Weight which he now hath in his Custody, the said Caesar delivering upp to my Executor Eight Ounces he hath of Mine in Broken Gold & powder" (City Hall, Register of Wills, Will no. 93, 1693). In 1701, William Penn patronized Ghiselin (APS, William Penn, Cash Book), and in 1704 Nehemiah Allen, his shipmate on the *Bristol Factor,* charged him for packing twenty-six barrels of pork (HSP, Nehemiah Allen, Account Book, 1698–1736), suggesting that he was in the sea trade as well as silversmithing.

Ghiselin married Catherine, daughter of Pierre Reverdy, a Huguenot who had fled from Poitou to England and had settled in Annapolis, Maryland, by 1693 (Harrold E. Gillingham, "Cesar Ghiselin, Philadelphia's First Gold and Silversmith 1693–1733," *PMHB,* vol. 57, no. 3, July 1933, p. 254). Their first son, Nicholas (m. Elizabeth Evans of Philadelphia, 1722), died in 1732. (Nicholas's eldest son, William, was the only Ghiselin descendant to advertise as a goldsmith [*Pennsylvania Gazette,* November 14, 1751].) Cesar and Catherine's second son was born about 1705 in Annapolis, where they were counted as members of St. Ann's Church.

By 1708, Ghiselin was back in Philadelphia (HSP, Logan Papers, vol. 4, pp. 50–51). He made a ferrule for Pentecost Teague's cane in the same year (HSP, Etting Collection, Pentecost Teague, Receipt Book, 1700–1717), and was by this time buying and collecting silver and gold in large quantities, from which he produced finished objects. Septima, the youngest Ghiselin, was baptized in Christ Church, Philadelphia, January 13, 1717, after which the family moved back to Annapolis, and Ghiselin's activities and sales drop out of Philadelphia ledgers and accounts. The move may have been occasioned by Reverdy family business or a promising partnership with John Steele, a goldsmith with whom Ghiselin had recorded business in 1722; in any case Ghiselin bought land in Annapolis and became a warden of St. Ann's Church, implying permanent settlement. His wife, Catherine, died in 1726, and Ghiselin again returned to Philadelphia where, judging by his inventory, he set up bachelor quarters and a working

3.

silversmithing shop. Shortly after, in 1728, he made his will, describing himself as "at this time sick and weak in body . . . ," but he fulfilled his most notable commission in 1732, a plate and beaker donated to the Christ Church vestry by Margaret Tresse, spinster daughter of Thomas Tresse, a wealthy contemporary of Ghiselin. He died on March 7, 1733, leaving an estate valued at £609 6s. 9d.

3. *Porringer*

1685–88
Mark: CG (in oval twice on rim)
Inscription: M/AM/HM (engraved top of handle); LM/TO/SM (engraved underside of handle)
Silver
Length 6″ (15.2 cm); diameter 4″ (10.2 cm)

Philadelphia Museum of Art. Given by Mrs. W. Logan MacCoy. 57-93-1

PROVENANCE: Anthony Morris and Mary (Jones) Morris (d. 1688); Hannah Morris; Luke Morris; Samuel Morris; Israel Morris; Wistar Morris; Charles and Mary H. M. Wood; W. Logan and Marguerite P. (Wood) MacCoy

LITERATURE: Helen Comstock, "A Porringer by Cesar Ghiselin," *Antiques,* vol. 67, no. 1 (January 1955), frontis., p. 53; PMA, *Silver,* no. 110

CESAR GHISELIN was the earliest silversmith to practice in Philadelphia— a distinction previously accorded Johannis Nys—and this porringer made by him is the earliest piece of Philadelphia silver known. The early date, confirmed by its ownership, is consistent with its shape and construction. It is almost flat on the bottom in the seventeenth century manner. The sides have a slight curve rising from a stepped base and are finished in a narrow everted rim. Later Philadelphia examples have a raised or domed bottom with deep sides, stronger curves, a wider

rim, and were considerably more capacious than seventeenth century models. The porringer was made in all workable metals, especially silver and pewter, and occasionally iron, and was used for thick soups, gruels, and stews. The pierced handle allowed heat to disseminate, and its broad, flat shape provided a sure grip. The pattern in this cast handle is derived from Huguenot patterns, such as hearts, cloverleafs, and moons, different from the later keyhole-like piercings produced by the Philadelphia silversmiths Philip Syng and Joseph Richardson, who trained within an English tradition.

The wills and inventories of generations of the Morris family, beginning with Anthony, include plate; Anthony's inventory of 1721 lists five porringers. This porringer, marked with Anthony and his wife Mary's initials, was made by Ghiselin probably as a present for Mary at the time of son John's birth in 1685; or, following Colonial custom, it may have been made in memory of Mary, who died in 1688.

Morris, his wife, and their son, Anthony, had immigrated to America in 1681–82 and settled in Burlington, New Jersey, where Morris invested in land and built a shipping wharf on the Delaware and a house on Burlington's main artery, High Street. But anticipating the rapid growth of Philadelphia —and the arrival there of friends and family—Morris sold his New Jersey interests in 1685 and came to Philadelphia, where his enterprise as a brewer, which he passed on to his son, was exceeded only by William Frampton's.

Before it became known that Ghiselin was in Philadelphia by mid-October 1681, this porringer had always been associated with Morris's third marriage in 1693 to Mary Coddington of Newport, who died in 1699. Had that been the case, the porringer would have descended in her line and been so marked; instead, it is initialed for Hannah Morris (1714-1741), daughter of Anthony by his fourth and last wife, Elizabeth Watson. Hannah died unmarried and her will left money to her brothers Luke and Isaac, and the "residue to my honored Mother Elizabeth Morris" (Moon, *Morris Family,* vol. 1, p. 115). The initials HM had been squeezed onto the handle under the original monogram of Anthony and Mary, crudely engraved by the same hand that engraved the initials M/AP 1762 on the bottom of one of a pair of braziers (no. 5). The porringer probably remained in Anthony's household as a useful feeding dish, a fact which its condition exhibits, until his widow, Elizabeth, had it marked in memory of Hannah, whom she outlived by thirty-six years. Elizabeth presented the braziers to Anthony and Phoebe in 1762, and probably gave this porringer to Luke

Morris, Hannah's half-brother, at about the same time. The initials LM to SM on the underside of the handle confirm this, as Luke died without issue and the porringer was marked and presented to Samuel Morris, son of Luke's half-brother, Anthony. It had been in family possession until given to the Philadelphia Museum of Art.

BG □

CESAR GHISELIN (c. 1663–1733)
(See biography preceding no. 3)

4. *Tankard*

Before 1690

Mark: CG (upside down in heart, three times on top, twice on bottom); oz/32 p/6 (scratched on bottom)

Inscription: BS/W/1714 (engraved on handle)

Silver

Height 7¹¹⁄₁₆″ (19.5 cm); width 8½″ (21.6 cm); diameter 5½″ (14 cm)

Philadelphia Museum of Art. Purchased. 56–82–1

PROVENANCE: Barnabas and Sarah Wilcox; Samuel and Abagail (Wilcox) Powell; Anthony and Sarah (Powell) Morris; Samuel and Rebecca (Wistar) Morris; Richard and Sarah (Wyatt) Wistar; John and Charlotte (Newbold) Wistar; Bartholomew and Susan (Laurie) Wistar; Bartholomew and Annabella (Cresson) Wistar; Bartholomew and (?) Wistar; Mary (Wistar) Ambler; Wistar Ambler

LITERATURE: *Antiques,* vol. 68, no. 6 (June 1955), frontis.; PMA, *Silver,* no. 113; Helen Comstock, "The Connoisseur in America," *Connoisseur* (October 1955), pp. 141, 142

THIS STRAIGHT-SIDED, flat-topped, wide-handled tankard by Cesar Ghiselin is the earliest form of this popular and prestigious vessel made by the Colonial silversmith. Used for cider, beer, rum, ale, and punch, the capacious form originated in northern Europe and can be found in the work of ceramicists and pewterers, as well as silversmiths, wherever these drinks were available and popular.

Ghiselin's apprenticeship must have provided him with models commensurate with his skills, but he also had access in Philadelphia to the silverplate brought in by the new settlers. Anthony Morris, for whom he made a porringer (no. 3), had brought plate with him, and English imported pieces were available in Philadelphia from the outset. Thus, except for the upright crossed-T form of the thumbpiece and the use of a *p* rather than the English *dwt* notation for pennyweight, this tankard appears most similar to English prototypes. However, it is almost three ounces lighter than comparable examples made contemporaneously elsewhere

4.

in the Colonies, which at fourteen shillings per ounce for silver (Fales, *Silver,* p. 231) was a considerable saving. Ghiselin achieved this thinness through the use of a flatting mill, a mechanical device consisting of two heavy rollers through which he pulled sheets of silver, an unusual if not unique piece of equipment in seventeenth century America. The flatting mill facilitated production of large pieces, using less silver, and explains the uniform thinness of Ghiselin's raised forms. His applied moldings were simple products of the draw press; and the thumb-piece is an unsophisticated example of cast ornament.

Ghiselin's silver production is more similar to the work of his contemporaries Robert Sanderson and John Coney of Boston (Hood, *Silver,* pls. 19, 30), who were products of the London "school," than to that of Jacobus van der Spiegel and Cornelius Kierstade of New York (Hood, *Silver,* pls. 10, 45), where a Dutch baroque vocabulary was dominant. Huguenot craftsmen, especially silversmiths, who emigrated en masse from France to England in the post-Restoration period brought with them their predilection for simplified form and decoration, which was combined with the robust forms of English silver. Sanderson and Coney apprenticed in this combined tradition while Cesar Ghiselin brought the French fashion directly from Rouen to Philadelphia, and the somewhat fragile simplicity of pieces known by him is a distinctive characteristic. His work is very different from that of his contemporary, Johannis Nys, who came to Philadelphia via New York and who used the cut-card moldings, cast ornaments, and handsome engraving typical of the Dutch baroque style. As both Ghiselin and Nys became successful silversmiths and left handsome estates, it is not possible to attribute Ghiselin's style to a preference for "Quaker simplicity."

The initials on the handle of this tankard stand for Barnabas and Sarah Wilcox, who came from the parish of Bedminster near Bristol, England, to Philadelphia in 1682. Carrying their certificate from the Bristol Monthly Meeting of the Society of Friends, they were accompanied by their children, George (b. 1667), Joseph (b. 1669), Hester, (b. 1673), and Abagail (b. 1679). "Barnaby Wilcox," as he was listed by John Reed in his schedule of "first purchasers" (*An Explanation of the Map of the City and Liberties of Philadelphia,* Philadelphia, 1846, p. 17), was a member of the Pennsylvania Assembly in 1685 and a Philadelphia court justice in 1686, 1687, and 1690 (Moon, *Morris Family,* vol. 1, p. 241). Barnabas died in 1690, leaving an estate administration; but Sarah, his wife, left an inventory in 1692 which included £559 3s. 6d. in cash, gold, and plate, as well as £13 14s. 5½d. worth of pewter dishes, basins, and flagons, and twelve new porringers (City Hall, Register of Wills, Will no. 85, 1692). In 1700, Abagail Wilcox married Samuel Powel, known as the carpenter, and they became the grandparents of Samuel Powel, mayor and merchant (see no. 51). The prominence of the Wilcox family is apparent from the list of witnesses who signed Abagail and Samuel's wedding certificate—William and Hannah Penn, Edward Penington, and Joseph Shippen (Moon, *Morris Family,* vol. 1, p. 242).

This is one of two tankards by Ghiselin which descended in the Wilcox-Wistar family. The two became separated at the death of Bartholomew and Annabella Cresson Wistar. The second tankard, family owned, is presently on loan to the Historical Society of Pennsylvania. The significance of the date 1714, inscribed on the handle sometime after this tankard was fashioned, is not clear.

BG □

JOHANNIS NYS (1671–1734)

Emigration from Europe following Huguenot persecutions in France and Holland had been encouraged by the Dutch West India Company during the 1650s and 1660s, and the arrival of the Nys family in New York was the direct result of economic enterprise and political upheaval. Well before the full force of English colonization policies was felt, and some ten years before Penn laid his plan on the land called Pennsylvania, the Dutch population in New York was a prosperous community. Probably the Nyses were in New York by 1671 when a Johannis Nys was baptized there in the Dutch church. Subjected to the same stresses as the Ghiselins (see biography preceding no. 3), the Nyses came to New York, probably directly from Holland, as they do

not appear in English port records investigated thus far. But whether they had moved to Holland during the unrest preceding the passage of the Edict of Nantes in 1598, or whether they emigrated in the post-Edict crisis via Holland, is probably buried in foreign records.

John M. Phillips has suggested that Nys was apprenticed to Jacobus van der Spiegel of New York because the mask decoration on the handle tips of tankards by both craftsmen (MFA, *Silversmiths,* pls. 84, 113) appears to be cast from the same mold. Although possibly true, a tankard by Peter van Dyck and another by Bartholomew Schaats (Buhler and Hood, vol. 2, pls. 587, 574) are also very close. There was a flourishing silversmithing enterprise in New York by 1670–80. Handsome beakers, tankards, spoons, and caudle cups in the Dutch baroque style, with elaborate engraved, cast, and chased ornament, were made for the Van Cortlandts, the Ten Eycks, and the Van Deursens (Buhler and Hood, vol. 2, pls. 548, 554, 567, 571). Details on pieces by Nys, such as cut-card decoration at the top of base moldings and tightly twisted thumbpieces on tankards, even though greatly simplified, nevertheless confirm a New York apprenticeship for him.

On March 4, 1693, Johannis Nys married Margrietie Keteltas, a relative of the New York silversmith Heuricus Boelen. The date of his move to Philadelphia is uncertain; he does not appear on the First Tax List of 1693 for Philadelphia County. He probably came with an influx, mainly from New York, around 1695 during an economic boom. Philadelphia was growing faster than New York at this time, and Nys's move made economic sense, for while there were many silversmiths in New York, only Cesar Ghiselin was in the forefront in Philadelphia before Nys arrived.

There was more than one Nys family in the Philadelphia area at this time, but there does not seem to be any relationship between Johannis Nys and a Han de Nys yeoman (d. 1736) of Northern Liberties, who left land to his son John de Nys (City Hall, Register of Wills, Will no. 449, 1736), a joiner, who owned city property on Pewter Platter Alley, who had a cabinetmaking shop specializing in funeral equipment on Second Street opposite the Baptist meetinghouse, and who eventually moved to Lower Dublin Township (*Pennsylvania Gazette,* November 9, 1732). His name was spelled variously as John De Nyce, de Nys, Nys, and Nice.

Johannis Nys's name was not entered on the Poor Tax List for 1709 although he appeared as "Johan Nys goldsmith" in William Penn's Cash Book in February 1700 (APS). He proceeded to make silver objects for prominent Philadelphians such as Isaac Norris, James Logan, Francis

Knowles, Andrew Hamilton, and Anthony Morris. He had a close working association with Francis Richardson (Fales, *Joseph Richardson,* pp. 5, 8); he later made silver pieces to Richardson's order; and he was present at Richardson's wedding to Elizabeth Growden in 1705 ("Early Marriages in Newport, Rhode Island, from Friends' Records," *The New England Historical and Genealogical Register,* vol. 18, 1864, p. 241). In 1715, Nys was located three blocks from John de Nys, the joiner, on Front Street at the corner of Carpenter's Alley, in a house owned by Arthur Holton, a baker (City Hall, Register of Wills, Will no. 38, 1715). Nys appears in ledgers and accounts as John De Noys or John Neys (HSP, Isaac Norris, Journal, 1712, 1716) and as John Nise (HSP, Joseph Taylor, Ledger A, 1718). James Logan (HSP, Account Book, 1712–20) carried his name as John De Nys. Nys was most active between 1701 and 1719, when his name appears in various Philadelphia records and accounts. He moved to Kent County, Delaware, in 1723 and died there in 1734.

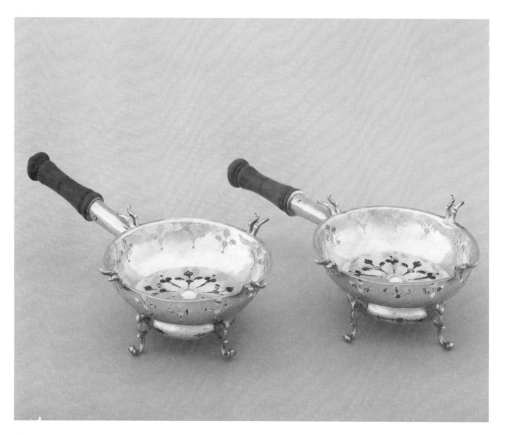

5.

5. *Pair of Braziers*

1695–99
Mark: IN (in heart over four pellets, on rim each side of handle socket)
Silver; turned wood handles (replaced)
Height 3¼″ (8 cm); length 13¼″ (33 cm); diameter top 6″ (15.2 cm)

(a) Inscription: M/AM (on bottom)

Philadelphia Museum of Art. Given by Mr. and Mrs. Elliston P. Morris. 67–209–1

PROVENANCE: Descended in Morris family

(b) Inscription: M/AM 1680, M/AP 1762, S/AM 1780, IM 1806, to S/RW, to SW, to H/RW 1843, R·W·H 1885 (on bottom)

Philadelphia Museum of Art. Given by R. Wistar Harvey. 40–16–700

PROVENANCE: Descended in Morris family to Richard and Sarah (Morris) Wistar; descended in Wistar family to R. Wistar Harvey

LITERATURE (a and b): Samuel W. Woodhouse, Jr., "John De Nys, Philadelphia Silversmith," *Antiques,* vol. 21, no. 5 (May 1932), pp. 217–18; Helen Comstock, "The Connoisseur in America," *Connoisseur* (April 1956), illus.

p. 215; *PMA Bulletin*, vol. 38, no. 196 (January 1943), illus. cover; PMA, *Silver*, no. 288; Moon, *Morris Family*, vol. 1, illus. facing p. 40

SINCE JOHANNIS NYS probably came to Philadelphia about 1695 and since Mary Coddington Morris died in 1699, this pair of braziers made by Nys for Anthony and Mary Coddington Morris constitute the earliest pieces of his work known to date. The initials M/AM on the bottom of both braziers appear contemporary with the pieces; on brazier b the date 1680 is by a later hand as are the other inscriptions documenting family inheritance. Anthony Morris's Ledger (HSP, Etting Collection) records an active account for John "Nise" throughout 1705–8, the period covered by the Ledger. At least once, Morris lent money to Nys, a customary practice in early accounts.

This form, known first as a spirit-lamp stand, then as a chafing dish, and, finally, a brazier, was an ambitious undertaking for Nys. Comprised of raised and cast parts and a central shaft with threaded sleeve soldered to the removable coal plate, construction of the brazier involved good mechanics and a knowledge of the heat tolerances of solder. This pair of "chaf dishes," as they were listed in Anthony Morris's inventory of 1721, were the work of a master silversmith. Their construction follows the Dutch practice wherein the spiky supports for the vessel to be warmed are attached directly to the rim of the brazier, and the cast legs are fastened to the base of its ash pit. Practically, the braziers needed perforations on the side to let heat escape, on the coal plate to let ash fall through, and near the bottom to allow air to fan the coals. The pierced designs in the body and coal discs of these braziers resemble the abstract form of the royal fleur-de-lis seen in fourteenth and fifteenth century secular French decorative work, especially on the broad, flat heads of iron halberds and in woven textiles embellished with embroidery. It is quite different from the pierced motifs of cast porringer handles (see no. 3) which bore symbols of marriage and fecundity in hearts, half-moons, and clover-leaf shapes related to the pattern of stone tracery in cathedral windows. Nys varied his fleurs-de-lis to conform to shape and purpose with a sensitivity more characteristic of the French than the Dutch. His combination of the two elements from his past, Dutch construction and French design, in an object made for eminent English-Philadelphia Quakers celebrates the aesthetics of the first settlement before the demands of conformity established a conservative homogeneity.

As a form, braziers were made in pairs; and water kettles, saucepans, and trays (without feet) were placed on the flanges. Their feet were generally fitted with wooden discs or balls to protect table tops from

conducted heat. But these scroll feet show no evidence of such attachment, suggesting Morris's use of heavy tablecloths or a marble-topped serving table. The brazier was used in the first half of the eighteenth century, after which it was replaced by the dish cross, which was sometimes fitted with a small adjustable burner (see no. 97).

BG □

6. *Side Chair*

1690–1700

American black walnut

38½ x 18¾ x 16⅜" (97.8 x 47.6 x 41.6 cm)

Philadelphia Museum of Art. Purchased by subscription and museum funds. 23-23-53

PROVENANCE: J. B. Kerfoot (b. 1885), Freehold, New Jersey; Charles F. Williams (d. 1923), Norristown, Pennsylvania

LITERATURE: S. W. Woodhouse, Jr., "An American 17th Century Chair," *PMA Bulletin*, vol. 20, no. 91 (January 1925), p. 70, illus. p. 66; Trenton, New Jersey State Museum, *From Lenape Territory to Royal Province*, by Suzanne Corlette (April 30–September 12, 1971), no. 167

BARLEY-TWIST TURNINGS are the distinctive characteristic of this side chair made in Philadelphia or possibly in Burlington, New Jersey, before the turn of the eighteenth century. This form, with a combination of turned and block members, was a variation on the block and ball turnings (see no. 23) more frequently seen in the earliest American furniture.

In England barley-twist turnings developed during the reign of Charles II, from 1660 on, and were used as legs and supports on high chests inlaid in the Dutch manner, on veneered tables and oak gateleg tables, as well as on legs, backs, and stretchers of chairs (see Geoffrey Wills, *English Furniture 1550–1760*, London, 1971, pls. 67, 70, 73, 74). An almost identical version of the chair on exhibit is pictured in R. W. Symonds, *The Present State of Old English Furniture* (London, 1921, fig. 16). They can be found in parish churches in northeast England, at Saint Mary's, Thirsk, for one, and they appeared with various seats such as plain plank with straight framework, as in this example, with barley-twist seat rim, with turkey-work upholstery, and although rarely, with caning.

The label on a matching chair at the Winterthur Museum reads as follows: "This chair belonged originally to the first Robert Pearson. He emigrated to America A.D. 1680. Settled on Crosswicks Creek. The chair was manufactured A.D. 1699, the same

date as the 'Old Chest' " (PMA, Archives, J. Stogdell Stokes to Dr. Woodhouse, November 6, 1924). The chair shown here was found "in a forgotten corner of the attic of one of the oldest houses in the neighborhood of Hamilton Square, New Jersey" (Stokes to Woodhouse, November 8, 1924). Although the above facts are not conclusive proof that Robert Pearson had not brought the form with him when he arrived in 1680, recent wood analysis indicates American walnut in the main turned pieces. Robert Pearson had a spacious, if routinely designed, four-room house in Nottingham, New Jersey, and his possessions were valued at £519 6s. 4d. when he died in March 1703/4. His son, Robert, and wife, Catherine, inherited the estate. When Robert died in 1751 his estate was valued at £1,800, but his inventory was not precise enough to identify single chairs (Trenton, N.J., State Library, Libre I, p. 44, 5301c–5314c).

This type of chair has always been called a "Crosswicks" chair because other walnut pieces which feature barley-twist turnings have been found in that vicinity. The town of Burlington, settled by Quakers and flourishing before Philadelphia was founded, and the village of Crosswicks, settled in 1681, were at first centers for commerce and

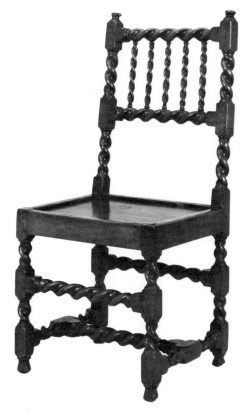

6.

crafts. Crosswicks had several mechanic shops, four stores, a gristmill and sawmill, two Friends Meeting Houses, and seventy homes by 1716 when the Provincial Assembly met there. Philadelphia Quakers, such as Thomas Chalkley, held Friends assemblages there in 1698; and the later diaries of Hannah Callender and Elizabeth Drinker describe visits to friends and relatives living there. But there is no mention of specific craftsmen or their shops, and no New Jersey will or inventory has yet specified a "turner" although there were hundreds of "carpenters" identified, such as Robert Rhea of Freehold, New Jersey, who initialed a wainscot chair in 1695. More likely these chairs, and other forms similarly elaborate, were products of an English-trained Philadelphia craftsman like the turner Matthew Robinson, who was married in Philadelphia in 1698, and whose inventory taken at his death in 1743 listed fifty unfinished chairs of various styles (City Hall, Register of Wills, Will no. 16, 1743).

BG □

7. *Spice Chest*

1690–1720
Walnut; poplar and cedar; brass hardware
30 x 18¼ x 9½" (76.2 x 46.4 x 24.1 cm)
Private Collection

PROVENANCE: Francis P. Garvan, New York; Parke-Bernet Galleries, Inc., New York, October 31, 1970, no. 142 (Garvan sale)

LITERATURE: Nutting, *Furniture,* vol. 1, no. 357

LATE SEVENTEENTH and early eighteenth century inventories called this appealing miniature size a spice chest. By the middle of the nineteenth century, when importation was easier and homemade remedies unwise, these chests then took on a more romantic connotation which included the storage of ribbons, trinkets, and laces. Technically, this piece is a cabinet-on-frame. Nine small drawers in the upper section are concealed by the locked panel door, and this upper unit sits on a base whose beveled top molding was designed to hold it firmly while allowing the door to swing open over it. Numerous joiners and turners, so differentiated in contemporary wills and inventories, might have combined their talents to produce this detailed piece.

Especially subtle on this example and on one at the Historical Society of Pennsylvania (Hornor, pl. 4) is the repetition of the rhythmic curves of the arcaded apron on the "joined" base section with those on the flat plane of the stretchers in the "turned" leg section. The profile of these curves, cut from the same pattern on the front and sides,

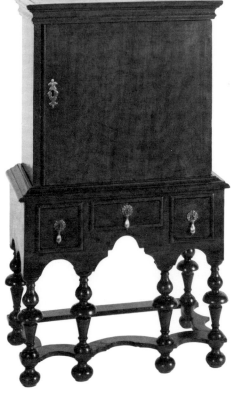

7.

affords a visual unity between turned and joined parts. The problem of attaching the turned legs to the case was ever present. In this cabinet the round top of the leg was simply flattened at the front, a pragmatic means of adjusting the legs to the horizontal plane of the case. A similar design problem in this period occurred where the flat cross-grained section on the horizontal stretchers interrupted the smooth sheen of the trumpet-shaped legs and their ball feet. The polish achieved on the turner's lathe had a different character from that on flat, planed surfaces, a difference which was minimized when the case was veneered or the whole painted, as was usual in this period. The half-round mold surrounding the drawers in the base and upper section is a seventeenth century feature which was necessary on veneered pieces of this form to protect the vulnerable and brittle veneers from damage and splitting. As this piece is made of solid wood, the mold becomes a decorative if vestigial ornament.

The sizes of the drawers in spice chests and cabinets varied, although in most examples they were symmetrically organized with a deep square drawer centered in the upper section. This was supported in the design by two smaller square drawers which flanked a shallow horizontal one, centered in the base section. Spices in their dried forms came in many shapes and were used in varying quantities. Thus, the drawers varied in capacity. Most spices "stored" well. Cinnamon sticks or nutmegs, peppercorns

and cloves, had to be soaked or ground before releasing their flavor or magic in food and medicines. Unlike tea, which required an airtight cannister to retain its aroma, the seeds and fruits of the exotic plant materials imported as spices in the East and West Indies trade were adequately housed in unlined wooden drawers.

One never traveled far or for long without medicinal remedies, and the portable quality of these chests was their special feature. The ornate base unit was left at home with its unlocked drawers harboring more routine materials like rose petals, sage, or gentian. Elizabeth Drinker's Diary (HSP, vols. 1–5, 1759–1807) contains endless descriptions, from a mother's concerned view, of an eighteenth century Philadelphia family's life—a series of agues, chills, fevers, and "ye flux," daily and recurring problems. The "megrum," a regular Philadelphia complaint between a headache and a depression, was treated as follows: "Mugwort and sage a handfull of each, Camomel and Gentian a good quantity, boyle it in Honey, and apply it behind and on both sides ye Head very warm, and in 3 or 4 times it will take it quite away" (Boston, Massachusetts Historical Society, Captain Laurence Hammond, Journal, 1677–94, "Physical Receipts").

Small, closely printed books containing recipes, "Chiefly simple and easily Prepared: Useful in Families, and fitted for the Service of Country People" (R. Boyle, *Medicinal Experiments,* London, 1694), accompanied settlers and fit into the drawers of the spice cabinet. A copy of Boyle's book in the Library Company of Philadelphia bears the bookplate of James Affleck, London cabinetmaker, active 1749–74; the manuscript signature of Ebenr Hazard on the title page; "James Rush 1826," in manuscript on the inside front cover; and, finally, the inscription, "James Rush's presented by Erskine Hazard, March 12, 1832." These signatures attest to the longevity of the home manual for ministrations of medicines as well as the thoughtful and pragmatic parting gift of James Affleck to his migrating relative, Thomas Affleck. Symbolically, when the little book was deposited in the Library Company in 1832, its counterpart, the spice cabinet, became a collector's item.

BG □

JOSEPH YARD (D. 1738)

Joseph Yard, a Quaker, appears on the First Tax List of 1693 for Philadelphia County, where his total worth is estimated at £30. Neither his birth nor his marriage to Susannah is recorded in Philadelphia or New Jersey archives, and it may be assumed that he was already married when he first

appears in records. He was a master mason by 1698 when he was commissioned to build Gloria Dei, and he appears to have been working on Holy Trinity Church in Fort Christina (Wilmington) during the same period. The next record of his activity places him in the Trenton area by 1734 (William Nelson, "Beginnings of the Iron Industry in Trenton, New Jersey," *PMHB*, vol. 35, no. 2, April 1911, p. 237). Joseph Yard, "bricklayer," died at Wellingborough, Burlington County, New Jersey, on May 1, 1738. His estate was valued at £242 16s. 11d. (HSP, Archives of the State of New Jersey, vol 30, Calendar of Wills, p. 553).

JOHN SMART (D. 1727)

John Smart, carpenter, appears on the First Tax List of 1693; in 1694 he is documented as a joiner working on a ship (HSP, Account Book of a Philadelphia Merchant, 1694–98). There is no record in Philadelphia archives of his marriage to Elizabeth, who died December 20, 1719 (HSP, GS, Philadelphia Monthly Meeting Records, Births, 1686–1829, p. 307), nor of the birth of his son John, who married Anna Knowles in 1757 and whose children were baptized at Gloria Dei and Christ Church. He worked with Joseph Yard at Gloria Dei during 1698 and 1699, and at Holy Trinity Church about the same time. John Smart must have had some means, for he purchased land from Letitia Penn's executors in America in 1703 (City Hall, Archives, Deed Book E3, vol. 5, p. 454) and made five more land transactions between 1703 and 1709. His estimated worth was £100 on the Poor Tax List of 1709 (Parker, "Rich and Poor," p. 18). He worked for Thomas Chalkley steadily between 1720 and 1722 (LCP, Thomas Chalkley, Account Book); and they had collaborated earlier, by 1712, when John Smart had built for Chalkley the Letitia Street house (now in Fairmount Park), adjoining one he had built on his own speculation. John Smart died in 1727, leaving a will, and was buried at Christ Church on August 5 (HSP, GS, Christ Church, Burials, 1709–85).

JOHN HARRISON (D. 1708), JOSEPH HARRISON (D. 1735), AND JOHN HARRISON, JR. (D. 1760)

John Harrison and his sons, John, Jr., and Joseph, formed an important team of competent Philadelphia carpenters. The elder Harrison was probably apprenticed in London and earned his "freedom" there in the 1690s. In Philadelphia by 1695, he was a founding member of Christ Church and was credited with the design and construction of its first structure (see no. 26). In 1700,

he and his sons were completing the interior of Gloria Dei. Harrison's will, written in January 1703/4, was witnessed by the bricklayer Joseph Yard, who also worked at Gloria Dei, and Francis Cooke; in it Harrison mentions his wife Mary and his son Joseph, but not John, Jr., or Daniel, who were minors at that date. Charles Read, James Logan's future father-in-law, was a trustee of Harrison's will, implying a family friendship or connection that later would be continued when Joseph Harrison worked at Stenton for Logan in 1716 and 1717 (HSP, James Logan, Account Book, 1712–20, p. 362). Harrison's will was probated April 14, 1708, and his total property inventoried at £722 5s. 3d., a sizable amount at this date in Philadelphia.

Harrison's sons carried on their father's trade and worked on most of the important public buildings in the city. In 1709, just after their father's death, John, Jr., and Joseph were assessed for a Poor Tax of 3s. and 3s. 1½ d., respectively, and their mother, "Widow" Harrison, was assessed a tax of 6s. 3d. (Parker, "Rich and Poor," p. 13). Joseph died in 1735, but John, Jr.'s, name is prominent in the building accounts of the State House (no. 30). He was a member of Christ Church and probably worked on the brick building during John Kearsley's tenure as overseer of works; in 1759 he and Edmund Woolley "measured" the recently completed steeple at Christ Church. Harrison purchased his freedom in 1717 for 5s. 6d. (Joseph Jackson, *Early Philadelphia Architects and Engineers,* Philadelphia, 1923, vol. 2, pp. 36–44) along with numbers of other master artisans who were petitioning the Philadelphia Common Council and Assembly for protection of their numbers in order to control the craft's standards. Although such restrictions were common in England, and usually rigidly enforced by the guilds or companies, the regulation of crafts was then informal in Philadelphia; in 1727 the Carpenters' Company, of which John Harrison, Jr., was one of the founders, was organized to regulate the trade's quality and prices. One result of this was the practice of "measuring," which was designed to protect both craftsman and client. John Harrison, Jr., married Catherine Conoyhall at Christ Church on February 27, 1727/28 (HSP, Christ Church Records, Marriages, p. 4053), and died in 1760.

JOSEPH YARD, JOHN SMART, AND JOHN HARRISON AND SONS

8. *Gloria Dei (Old Swedes' Church)*

Delaware Avenue and Swanson Street
1698–1700, altered 1703, tower c. 1774, belfry c. 1803
Stone foundation, brick walls, painted wood trim, cedar shingle roof
20 x 36 x 66′ (6.1 x 11 x 20.1 m)

REPRESENTED BY:

Cornelius Tiebout (1773–1832) after Thomas Birch (1779–1851)
Old Swedes' Church
c. 1800
Color stipple engraving
5¾ x 8⅝″ (14.6 x 21.9 cm)
Mr. and Mrs. J. Welles Henderson

LITERATURE: Tatum, pl. 9; Rev. John Craig Roak, *A Historical Sketch of Gloria Dei Church,* Philadelphia, 1947; Moss, "Churches" (in preparation)

GLORIA DEI, "A House to the Glory of God," popularly known as Old Swedes' Church, is the most important monument of the earliest European settlement in the Delaware Valley. It was built by its Swedish congregation on a high piece of ground bordering the Delaware River above its confluence with the Schuylkill. This spot filled the Swedes' requirement—firm ground accessible to navigable waterfront—which grew out of their need for defense and their economy based on husbandry and agriculture. Peter Lindstrom's map of New Sweden, drawn in 1654–55 (Scharf and Westcott, vol. 1, illus. p. 73), shows the tight pattern of settlement along the shores of the Delaware.

The early settlement, which had included land purchased either from the Indians or from the Swedish crown, extended from Cape Henlopen at the entrance to the Chesapeake Bay to the falls of the Delaware at Trenton. This stretch of property, some 200 miles long and 8 miles deep was difficult, if not impossible, to defend; its first governor, Johan Bjorusson Printz, spent most of his term from 1643 to 1653 building forts or blockhouses, the most strategic by 1647 being at the mouth of the Schuylkill.

Finally conquered in 1655 by the Dutch under Peter Stuyvesant, the Delaware Valley Swedish settlements as a whole were disturbed only with relation to their land titles and fees, a problem which arose again when the English captured the Dutch settlement at New Amsterdam (New York) in 1664, and again with William Penn's Proprietary Grant in 1682, which included

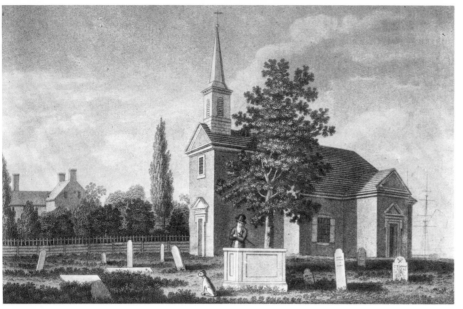

8.

some of the Swedish settlements above the disputed Pennsylvania-Maryland boundary. Neither the Dutch nor the English pre-empted the individual holdings granted by the Swedish crown, but both required new surveys, new deeds in accordance with the surveys, and quit-rents which increased with each conqueror. The Swedes were caught between the two most aggressive mercantile and colonizing enterprises of the seventeenth century, Holland and England. The threats to their settlement were answered by blockhouses, but the conquerors' battles were generally waged elsewhere, and the resulting subjugation merely infused their culture rather than upset it.

The two most important infusions for Gloria Dei were the brickmaking introduced by the Dutch, which changed the Swedes' architecture from hewn log to masonry construction, and the comfortable religious climate of the English settlement. The State Church of Sweden and the State Church of England were the only ones to maintain their apostolic origins after the Reformation. Holding the same sacraments and articles of faith, Gloria Dei was, from its founding, in harmony with Philadelphia's Anglicans. Marriage and death records at Christ Church and Gloria Dei were not exclusive and contain records of families who used both.

There had been considerable controversy over the site of Gloria Dei—north or south of the mouth of the Schuylkill. The parish had been located by 1646 at Tenakong (Tinicum) in a wooden church consecrated by Magister Johan Campanius. The dispute over a new site was finally settled by "lot," with Wicaco, north of the Schuylkill, being chosen. The Tinicum residents were mollified by a special ferry that was to be run

on church days for their convenience (Scharf and Westcott, vol. 1, p. 139). To the parishioners resident in New Jersey, the location did not matter. The Swedes preferred to travel by water, and lists of church members invariably note a river or creek location ("Notes and Queries," *PMHB*, vol. 2, no. 2, 1878, pp. 224–28). Beginning in 1675, the congregation met in a blockhouse at Wicaco, built in 1669 as defense against Indian attacks, until that log structure was replaced with a brick church built by subscription.

The cornerstone of the new church was laid in 1698, with William Penn and Deputy Governor William Markham present; two years later, Gloria Dei was dedicated on the First Sunday after Trinity, with the Reverend Eric Björk presiding. Both Swedes and English attended the dedication ceremony. A contemporary description of the event stated that Magister Johannes Kelpius "furnished not only instrumental music for the occasion, but acted as choristers as well; while the three resident pastors, Rudman as Provost, Björk as celebrant, and Auren as assistant, all robed in surplice and chasuble, conducted the consecration services." Pastor Rudman wrote to Sweden, "Through God's great blessing, we have completed the great work and built two fine churches [Gloria Dei and Holy Trinity Church] superior to any built in this country" (Rev. John Craig Roak, *A Historical Sketch of Gloria Dei*, Philadelphia, 1947, p. 11).

In the earliest building contract recorded in Philadelphia, the Swedish congregation hired Joseph Yard, a Quaker master mason, to work the foundations. The stone was quarried nearby and the lime, delivered

unslaked to Yard, was prepared on the site. The church was originally required to be 40 feet long, 30 feet wide, and 12 feet high, but was built within the contract to be 66 feet long, 36 feet wide (outside to outside measure), and 20 feet high (Moss, "Churches"). The foundations were 3 feet thick at ground, and 2 feet thick at the windows. Yard and his helpers were paid £86 in silver on this bid job, an unusual contract as Philadelphia's payments were thereafter based on measured work. Yard and his team contracted additionally to raise the gable ends and to plaster the interior for £45. The walls were constructed of bricks ferried from Pumpkins Neck near Salem, New Jersey, in Flemish bond, with glazed headers, a feature which distinguishes the old rectangular structure from the newer tower and upper sections of the vestibule-buttresses. The polygonal apse was probably specified (the church records are not detailed in this respect, but a similar apse was also constructed at Holy Trinity Church), although it is possible that this may have been a virtuoso performance on the part of Joseph Yard.

By 1703, the walls cracked, possibly because of the apse design, and were beginning to bulge; the thrust of the steep roof was too strong for the side walls, a problem which appeared again in Holy Trinity Church, which had been built by the same workmen and completed in 1699. Vestibule-buttresses were then added north and south, at the first level, to reinforce the structure; somewhat later they were raised and given their handsome door framing, as is revealed by the brickwork. The tower was added about 1774 at the same time as the gallery at the west end of the nave; and the belfry, about 1803 (Moss, "Churches").

Two units of carpenters were also under contract to the parish. John Smart and John Britt were the first to work on the door cases, pulpit and canopy, pews, and the roof. They were supposed to have been finished by October 31, 1698, having started in March (*Records of Holy Trinity [Old Swedes'] Church from 1697 to 1773*, Wilmington, 1890, p. 28). Britt quit and John Smart was let go when he could not fulfill his contract. John Harrison, joiner and carpenter, also from Philadelphia, was employed in 1700 to finish the job. With his sons, he made the pews, with their doors of pine and top rail of walnut, the banisters, and the pulpit.

In 1832 the disposition of the interior elements was altered: The pulpit was moved to the east end and the holy table was centered below it; the lectern, and the font, which had been brought from Gothenburg, Sweden, in 1642, and later removed from the church at Tinicum to Wicaco, were moved to each side. Gloria Dei is deemed quaint by its location and shape, but the

additions, rather than the original exterior and interior, are responsible for the church's unique "personality." Although the sloping roof of the tower that becomes an extension of the main roof is somewhat reminiscent of parish churches in Scandinavia, the addition of the tower, some seventy years after the church was built, precludes any original intent to recall the homeland.

BG □

EDWARD EVANS (1679–1754)

Edward Evans was patronized by Philadelphia's leading citizens: William Penn and his daughter Letitia—"By Letitia Penn. pd. Ed. Evans Joyner for a Chest of Drawers she gave Mary Sotcher £7.0.0" (APS, William Penn, Cash Book, 1701)—James Logan, William Trent, Governor Andrew Hamilton, and Isaac Norris. Yet it was puzzling why, after Evans's first recorded commission, which appears in William Penn's Cash Book for the year 1700, Evans did not appear in the ledgers and receipts of lesser merchants. Nor did genealogical facts clarify Evans's position in Philadelphia. He was not closely related to the young governor John Evans, who was sent by Penn with his son William Penn, Jr., in 1704 (HSP, Probate Records, 1571–1700, Penllyn, Merionethshire, Wales) nor was he one of the carpenter-joiners sent by Penn to work at his plantation at Pennsbury in 1685–88 (HSP, Penn Papers, Domestic and Miscellaneous Letters, Penn to James Harrison, 1684–85). It is William Trent's one-volume Ledger, kept between 1703 and 1709 (HSP), that provides evidence that Evans was a ship's joiner. Entries in Trent's Ledger (p. 202) noting payment to Evans, "By expense accot & work done £72.19.7," or "By Sundry accots," suggest frequent association and payment. Evans had a running account on Trent's sawmill the same year (1703) that Evans entered venture cargo into the sea trade. Trent credited Evans via "Jnº Tucker, merchants" (Bermuda), with an "ovell table" and "for acct of Pork & Beefe" in May 1703.

Maritime commerce had been carefully calculated by William Penn and his surveyor general, Thomas Holme, when they "located" Philadelphia. The fact that ship-building was a successful enterprise here by 1676 (HSP, Gregory Marlow, Account Book, 1676–1703) influenced Holme and encouraged Penn to invest in the industry, and he sent William West to found a shipyard—Penn's first such venture—in 1684 (Marion V. Brewington, "Maritime Philadelphia, 1609–1837," PMHB, vol. 63, no. 2, April 1939, p. 103). In a second shipyard enterprise, Penn, William Trent, and William Penn, Jr., were partners, with James Logan as bookkeeper, and they

sponsored Bartholomew Penrose (d. 1711), a skilled shipwright from Bristol. The first craft launched at the Penrose yard was the 150-ton *Diligence*. The accounts for the *Diligence* are summarized, if not itemized, in Trent's Ledger, with James Steel, a wealthy Philadelphia merchant, as debtor. The *Diligence* was on the ways between 1704 and 1707, the years when Edward Evans was most active in Trent's accounts. It thus seems safe to assume that Evans was employed on the *Diligence*. That he was the ship's joiner may be determined by a comparison with the accounts of the ship *Mary*, built in the Charles West shipyard in 1740, in which the builder was paid £567 12s. 10d.; the smith, £206 10s. 3d.; the blockmaker, £25; the carver, £19; and the joiner, £42 10s. (HSP, Coates-Reynell Papers, John Reynell, Day Book; see also Louis F. Middlebrook, "The Ship *Mary* of Philadelphia, 1740," *PMHB*, vol. 58, no. 2, April 1934, p. 140). The ship's joiner did all the cabin work, paneling, bunks, and cupboards. The payment to Evans, £72 19s. 7d., recorded in Trent's Ledger thus indicates work done for a large ship, or an elaborate interior, which was often the case, and possibly included this desk dated 1707, the year the *Diligence* was launched.

Trent's extant Ledger ends in 1709. Isaac Norris's extant ledgers commence in 1709, and Evans is recorded there from June 1709 through March 1715. In 1714, "5 mo.," Norris paid Evans £12 "By Sloop Charles pr Joynˢ Work" (HSP, Isaac Norris, Ledger, 1709–40, p. 93). Evans traded in other "sundries," such as peltry, nails, and lumber, in addition to materials for his craft, a typical practice in the early city when commodities brought good prices due to uncertain production and importation. In February 1714, Evans made an oval table and a stand for James Logan, did other miscellaneous jobs for him, and was paid in full (HSP, James Logan, Receipt Book, 1702–9; Account Book, 1712–20, p. 98). The last dated accounts presently available for Edward Evans, joiner, are for the year 1715, although he lived until 1754. They indicate clearly that he continued working on shipboard at least until 1715 and probably until the general depression in the shipyard industry in 1721 (Brewington, cited above, p. 107) which may have turned him to farming. Evans probably never opened a furniture-making establishment on his own or in partnership; no advertisements appear, nor references to a shop.

Evans was the son of William Evans, a carpenter probably trained in London, and Jane (or Jean) Hodges Evans. The family had emigrated from London and settled on 323 acres in Willingboro Township, New Jersey, in 1683. There were two older sons, William, Jr. (c. 1666–1728), who purchased

300 acres in Evesham, New Jersey, in 1687, and became a farmer; and Thomas (m. Ann? c. 1684), noted only as a yeoman, who moved to Gwynedd, Pennsylvania, about 1698. Too young to have apprenticed with his father, Edward was ready for his training two years before his mother died in 1697, and she may have placed him with one of the Budds, John (d. 1704) or Thomas (d. 1699), joiner and cooper, respectively, working in Burlington and Philadelphia. His commission from Letitia Penn to build a chest of drawers for Mary Sotcher, wife of the superintendent of Pennsbury Manor in 1701, suggests that Evans's apprenticeship was in joinery rather than straight carpentry and was learned from John Budd, who built the Francis Colling Meeting House in Burlington in 1698 (McElroy, "Furniture," p. 168). Association with the Budds would also explain Evans's appearance among ships' joiners, as the Budds, located in Southwark (Philadelphia) before the Penrose shipyard was founded, were well known to Penn.

Thomas Budd's death in 1699 may have released Evans from his apprenticeship with less than a year to go, or, as was often the custom, caused him to be "transferred" to another situation, for it was not until the end of 1700 that Evans appears in Penn's accounts. John Budd died in 1704; in October 1704, Evans was awarded his "freedom," becoming a member of the Corporation and acquiring the rights of a citizen (Scharf and Westcott, vol. 1, p. 183). This "freedom," purchased after apprenticeship or at twenty-one if one owned property, also allowed Evans to be hired for city contracts and may have been a necessary condition for jobs at the new Penrose shipyard. In 1710, Evans and Cesar Ghiselin signed a petition to further some necessary repairs to wharves and bridges for which freeman status was required. It is clear from Evans's "career" that he was not one of the Edward Evanses listed in the London Joyner's Company records as having completed apprenticeships there in 1674 and 1685 (McElroy, "Furniture," p. 178), a fact confirmed by Penn's patronage, for the small items Penn purchased were made by craftsmen trained in America, possibly as promotional material, to be exhibited upon Penn's return to England as positive proof of quality and opportunity for settlers in his Pennsylvania.

Evans's marriage to Lucia can be dated sometime before their daughter Mary died in 1703 (HSP, GS, Philadelphia Monthly Meeting Records, Births and Burials, 1686–1824, p. 286). Some of their other children, Hannah (d. 1714), William (d. 1740), and Jane (d. 1745), were recorded at death; none, at birth. Thus, as Evans died leaving eight children, his genealogical record is incomplete.

Evans purchased a lot of ground in 1702 from Thomas Wharton, tailor, for £60 "Bounded Eastward with the Second Street Southward with the Said Lot late of Thomas Hills and Northward with the residue of the Said Thomas Whartons Lot" (City Hall, Archives, Deed Book H5, p. 510), which he retained until his death. By 1709, Evans had acquired modest property; his Poor Tax was estimated at 1s. 10½d. (Parker, "Rich and Poor," p. 12). In 1710 he was primary legatee in the administration of the estate of John Evans, joiner. The inventory did not state where John lived, nor did it contain any reference to a building or farm equipment, and there was a bare minimum of personal furnishings listed. All kinds of joiner's tools plus "a table unfinished, a case for drawers, walnut scantling, gum boards and three pine logs" suggest that John was living with Edward Evans and was probably Evans's nephew, son of William, Jr., and Elizabeth of Evesham, New Jersey (Haverford College Library, Quaker Collection, Dictionary of Quaker Biography).

Evans's wife Lucia died in 1714. He was married for the second time to the twice-widowed Elizabeth Edmundson Tregeny Finney in Christ Church, May 17, 1717. On December 30, 1719, Charles Finney, Elizabeth's stepson, sold to Edward and Elizabeth his claim to part of his father's plantation in Tacony for £80 (City Hall, Archives, Deed Book F3, p. 58). On January 5, 1719, Edward and Elizabeth deeded 220 acres of the Tacony plantation to Jonathan Dickinson for £230 (City Hall, Recorder of Deeds, Book F3, p. 62). As Charles Finney charged Elizabeth's estate with residency expenses, as well as care during her last illness, it appears that Edward and Elizabeth lived on Finney property at least until her death in 1733. Evans married a third time to the much younger Elizabeth Griffith, at the Gwynedd Friends Meeting House, May 20, 1735. His relatives Cadwalader and Evan Evans (nephew, 1684–1747) were among the witnesses (HSP, GS, Gwynedd Monthly Meeting Records, Marriages). At this date Evans owned a farm in Towamensing Township, Montgomery County, an area known today as Evansburg. He and Elizabeth had several children, the most famous of whom was the cabinetmaker David Evans, born in 1748 (see biography preceding no. 48). An inventory taken by John Jones and John Daire lists farm equipment, minimal furniture, and carpenters tools of low value (10s.), indicating that Evans had long since given up the active profession of ship's joiner, confirming the observation of Christopher Sower in a letter of December 1, 1724: "There is a lack of all artisans, for, when an artisan has collected a sum of money in 3 or 4 years, maybe even in 1 or 2

years, he buys a farm and moves into the country" ("An Early Description of Pennsylvania," *PMHB*, vol. 45, no. 3, 1921, p. 252).

9. *Fall Front Writing Cabinet*

1707
Mark: EDWARD EVANS/1707 (stamped inside bottom of drawer centered above open well in upper section)
Inscription: Revd. E. Grant/Bedford/ W. Chester Co./New York (in ink on back)
Walnut; white cedar and white pine drawer linings; brass hardware
66½ x 44½ x 19⅞″ (168.9 x 113 x 50.5 cm)
Colonial Williamsburg Foundation, Williamsburg, Virginia

PROVENANCE: Rev. Thomas Grant (d. 1802); Rev. Ebenezer Grant (d. 1812); Mrs. Abraham Schulyer Nielson; Mrs. Robert Wilberforce

LITERATURE: John M. Graham, II, "An Early Philadelphia Desk," *Antiques,* vol. 77, no. 1 (January 1960), pp. 100–101; Helen Comstock, *American Furniture* (New York, 1962–66), illus. nos. 96, 97, 97A

THIS WRITING CABINET by Edward Evans is so like English prototypes, which, in turn, were based on a Dutch form, that it must have been made from a pattern or copied after an actual piece. Yet tempting as it is to ascribe an English apprenticeship to Edward Evans on this basis, it is precisely the details rather than the whole which reveal his American skills. The form was popular in England in the last quarter of the seventeenth century and in America, especially the Dutch colony of New York (see Museum of the City of New York, *Furniture by New York Cabinetmakers, 1650–1850,* by V. I. Sabelle Miller, 1956, cover, p. 20). The English cabinetmaker John Guilbaud, whose name appears in royal accounts in 1690, labeled a walnut fall front writing cabinet, c. 1695, almost identical in size, form, and interior plan to this one by Evans (Geoffrey Wills, *English Furniture, 1550–1760,* Middlesex, England, 1971, illus. pp. 103, 108, 109, 111).

The base units on both examples are divided into four drawers, two small at the top, two deep ones underneath. Both desks sit on four flattened ball feet. The base moldings are slightly different, Evans's having a concave profile, the English piece an ogee form. The large, compound projecting stepped moldings at the waists are also similar, but Evans has missed the subtle relationship between the cornice molding and waist that gives Guilbaud's piece unity and a more elegant "crowning." The bolection moldings above the paneled

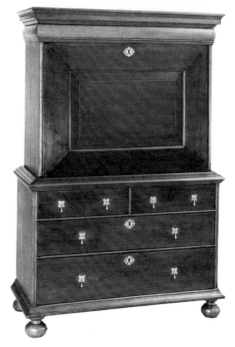

9.

flaps, closely fitted and matched to the side pieces, form drawer fronts, and both have leather writing surfaces set into the fall front piece. The half-round moldings between the drawers and cabinets in lower and upper sections are joined into the framework of the two pieces in similar fashion. The pigeonholes in the upper section pull out in units, two in Evans's piece, three in Guilbaud's. There were usually small compartments behind the cabinet or drawers in European examples. Evans, probably working from a scale drawing or sketch by a London-trained Philadelphia cabinetmaker, missed that feature in his upper case section. The most obvious difference between the two desks is the colorful and richly decorated surface of the English piece with its burl walnut veneer panels edged with herringbone and cross-banding, and the severely plain, solid case construction of Evans's work. Veneering was among the skills of some early Philadelphia cabinetmakers (McElroy, "Furniture," p. 198), and a few had the equipment necessary to make the paper-thin surfaces. If Evans had had a complete London apprenticeship in cabinetmaking, his desk would not have been so plain. But he was a ship's joiner and not a cabinetmaker, and his writing cabinet, although it lacks carrying handles on the sides, may well have been his pièce de résistance for the *Diligence,* launched in 1707. Storage-writing units like

this were used on shipboard, either whole or in parts, and this desk would not have been too big for the captain's cabin of a 150-ton ship. Evans stamped his name and date on the bottom of one of the small drawers in the upper section of this desk. (Sixty years later Edward James, also a ship's joiner by trade, stamped his initials on the inside of the case of the tall clock, no. 74.) The custom belonged to early maritime joiners. The first entry in 1676 in the Account Book of Gregory Marlow (HSP) reads: "For A Marking hamor: by: W. E [W^m Eb^urn]" charged against the ship *Glob,* the first built at Philadelphia. It was also customary in English practice to stamp fine furniture that was not otherwise labeled (Heal, *Furniture Makers,* illus. p. 261). In America, Windsor chairmakers adopted the practice more generally than cabinetmakers. Ships had their own special traditions, and joinery may have been stamped for luck or salutation comparable to a christening.

Exactly how this desk found its way to the Grant family is unclear. If it was made for William Trent and Company, investors in the *Diligence,* and stayed ashore, it is quite possible that it remained with Trent as an office piece in New Jersey and was purchased later by Grant from an estate sale. Thomas Grant, a woodworker himself, died intestate in 1802 in New Brunswick, Middlesex County, New Jersey. His inventory included a tankard valued at £4; a bookcase and desk, £6; a card table, six mahogany chairs, six common chairs, and a drawers and writing desk, £2. The last notation describes Evans's case piece and clearly distinguishes it from its contemporary counterpart (no. 18). This piece is a "drawers and writing desk" which did not include a bookcase. Appraised at less than half the value of the more stylish bookcase desk, Evans's writing cabinet must have been plain and old fashioned, although still strong and useful in 1802.

BG □

PETER STRETCH (1670–1746)

Peter Stretch was born in Leek, Staffordshire County, England, in 1670 and was first apprenticed to his uncle Samuel Stretch who had an established reputation as a clockmaker there. In 1702, bearing a certificate of removal from the Monthly Meeting of the Society of Friends in Staffordshire, Stretch and his wife Margery Hall and their son Thomas (1695–1765) immigrated to Philadelphia. The Stretch family seems to have settled at the corner of Front and Chestnut streets and stayed there. Long after his death it was known as "Peter Stretch's Corner."

By 1708, Stretch, William Till, and William Fisher were "desired to see that the youth be orderly, at both meeting houses, untill the next monthly meeting"; by 1710, Stretch had an indentured carpenter John Balle, who was requesting to return to Ireland; and in the same year the Friends Meeting requested Stretch and Richard Hill to take care of the estate and well-being of five orphaned children of a recent émigré, Nathan Shenton (HSP, GS, Philadelphia Monthly Meeting Records, Minutes, vol. 2, pp. 55, 138, 154). In 1712, Stretch was called upon, with Abraham Bickley, "to see that things be decently managed at the marriage" of Richard Witten and Elizabeth Aylif (HSP, GS, cited above, vol. 2, p. 253); and Stretch was frequently appointed to present certificates of removal. Only the most reliable were selected to carry these burdens.

In 1717 the Minutes of the Town Council show a payment to Stretch of £8 18s. 10d. for working on the town clock. In 1722 he had a long account with Thomas Chalkley, Quaker preacher and West Indies trader, which includes the following entries: "To Peter Stretch for a time pss and Men'ding one of the clocks 0.14.0; to 1 Eight Day Clock with a blew Case figur'd with Gold; to 1 Dyal with a black Case figur'd with Gold" (LCP, Thomas Chalkley, Account Book, April 26, 1722). Thomas Penn purchased a compass, scales, and weights from Stretch in 1733, which suggests that his shop carried other hardware and scientific instruments associated with clockmaking (HSP, James Logan, Account Book, 1712–20, p. 252); and he sold imported wares as well, as he advertised in the *Pennsylvania Gazette,* May 12-19, 1737, "Lost or Stolen from Peter Stretch, Watchmaker in Philadelphia . . . a fashionable Silver Watch, made by Stroud, London, having the Graduations for the Minutes arched, and a small Gold Rose between every Hour for the half Hour, a Key and Seal and a Black Silk String. . . . Forty Shillings Reward."

Peter Stretch had five more children: Sarah (b. 1705); Joseph (b. 1709); Elizabeth; Daniel, who moved to Salem, New Jersey in 1714; and William, also a clockmaker, to whom Peter left all his clocks, imported and unfinished at his death, and his tools. Thomas, his eldest son, had an established reputation making tall case clocks before Peter died; in 1753 he made the clock for the State House. Peter served on the Common Council from October 5, 1708, until his death in 1746. He was an exemplary citizen who moved easily within the political fabric dominated by the Society of Friends.

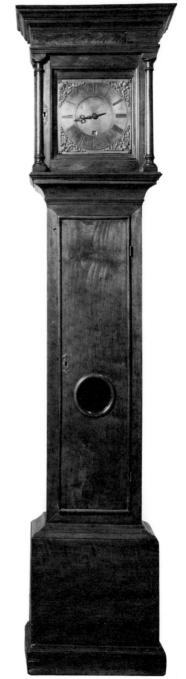

10.

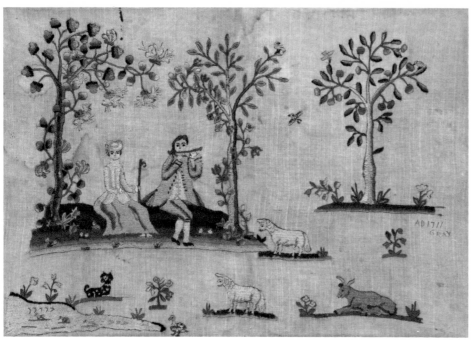

11.

10. *Tall Case Clock*

c. 1710

Inscription: Peter Stretch (engraved script bottom of dial)

Mahogany case; pine back, pine and mahogany blocks

83 x 20½ x 11″ (210.8 x 52.1 x 27.9 cm)

Philadelphia Museum of Art. Given by Miss Carolyn Wood Stretch. 47-35-1

PROVENANCE: Descended in Stretch family

LITERATURE: Carolyn Wood Stretch, "Early Colonial Clockmakers in Philadelphia," *PMHB*, vol. 56, no. 3 (July 1932), pp. 225-35

THE EASE with which Peter Stretch handled the form and precision of the tall case clock reveals his heritage and apprenticeship with his uncle Samuel. Thomas Tompion and Daniel Quare, both Quakers, were well known for their superb work and were contemporaries of Peter's uncle. Although Peter Stretch's clock cases are not so ornate nor his backplates engraved like those of the greatest English clocks, their works are a tribute to his training and workmanship.

The earliest form of the tall case clock in Philadelphia was about eighty inches high and the hood had a flat top, enclosing a square face. One hand with an arrow-like head pointed the hours; the days of the month were inserted into the dial; and the long door into the pendulum was plain. By 1710, clocks had minute and second hands and a round bull's eye glass "window" in the long door, framed by a half-round molding.

Its molded base stood directly on the floor. By 1720, Philadelphia tall case clocks had arched dials with the maker's name inscribed in an oval cartouche, and the case was raised on bun or bracket feet. Sometime after 1730 the upper arch space was enlivened with moons, stars, and tilting ships; and pediment hoods were scrolled, decorated with frets, or carved.

This tall case clock is one of about twenty known to have been made by Peter Stretch (Carolyn Wood Stretch, "Early Colonial Clockmakers in Philadelphia," *PMHB*, vol. 56, no. 3, July 1932, pp. 225-35), who worked in all the above-described styles. In this example, the clockworks are of the earliest style, being driven by a cord instead of a chain, and the case is an example of the second style, and in mahogany, rare this early in Philadelphia.

BG □

11. *Embroidered Picture*

1711

Signature: AD 1711/GRAY (center right edge)

Wool and silk on plain-weave linen (56 x 54), inked embroidery guidelines

Stitches: Long and short, outline, split chain, eyelet-hole, French knot

22 x 28″ (55.9 x 71.1 cm)

Philadelphia Museum of Art. Purchased: Thomas Skelton Harrison Fund. 43-77-1

PROVENANCE: Descended in Gray family to Miss Cora C. Irvin; on loan to the Philadelphia Museum of Art, 1922

LITERATURE: "Earliest Pennsylvania Sampler," *PMA Bulletin,* vol. 18, no. 72 (November 1922), p. 20, illus. p. 17

DURING THE LATE seventeenth and early eighteenth centuries, the needlework done by Philadelphians reflected the dominant cultural tradition of Britain. Embroidered pictures as a distinct form of needlework appear to have developed in England during the sixteenth and seventeenth centuries. They employed a limited repertoire of motifs, including the common pastoral theme of a fashionable shepherd and shepherdess in an idyllic setting. Influenced by the contemporary development of English tapestry, the typical work reflected the Jacobean aversion to empty space. This picture, however, with its more open arrangement, probably derives its form from the contemporary embroidery, today known as crewelwork, in which floral sprigs and conventional designs were used to decorate furnishings and clothing. This aesthetic was contemporary with the fashion for imported India chintz.

The inks which delineate the pattern and the name are not identical: the former penetrate the canvas, and the latter lie on the surface of the linen. This discrepancy may indicate that the picture was postdated (correctly or incorrectly) by a member of the same family in which it descended, or that the name was marked by the maker on a predrawn ground. Predrawn designs were adapted or copied from many sources, including books, engravings, or other completed works. The drawing was often done by professionals, but could be accomplished by a creative needleworker. This picture is worked in wool worsted yarns (crewels) on a coarse, plain-weave linen ground, with the faces, hands, flute, and crook finished in silk. During this period, silk was not so widely available in America as in England, and its use was usually restricted to details.

The last private owner of this work was a descendant of George Gray, the first of that family to appear in Philadelphia records, having submitted a certificate to the Philadelphia Monthly Meeting of the Society of Friends in 1692 from the Quarterly Meeting, "held in Richard Sutton's house," Barbados (W. W. Hinshaw, *Encyclopedia of American Quaker Genealogy,* vol. 2, Ann Arbor, 1938). His son, also George Gray, owned the Lower Ferry over the Schuylkill River.

PC □

JOHANNIS NYS (1671–1734)
(See biography preceding no. 5)

12. *Tankard*

1714
Mark: IN (in heart three times on lid, once on side)
Inscription: JSL (double cipher engraved on front); 33½ oz (engraved on base)
Silver
Height 7¼″ (18.4 cm); diameter base 5⅜″ (13.6 cm)
Philadelphia Museum of Art. Purchased. 57-20-1

PROVENANCE: Descended in Logan family to Robert R. Logan; Maurice Brix; Parke-Bernet Galleries, Inc., New York, October 19–20, 1955, no. 273 (Brix sale)

LITERATURE: Helen Comstock, "The Connoisseur in America," *Connoisseur* (April 1956), illus. p. 216; John Marshall Phillips, "Johannis Nys," *Bulletin of the Associates in Fine Arts at Yale University,* vol. 6, no. 1 (September 1933), pp. 13–15, illus. p. 14; PMA, *Silver,* no. 307

MADE FOR James and Sarah Logan, this tankard is typical of Johannis Nys's best work. Firmly built with a grand sweeping handle, it has the tightly scrolled thumbpiece, cut-card banding, and flat top characteristic of the New York region where Nys was trained. The engraved cipher in interlocking foliate script is enclosed with a manteling often found on silver of this period, especially in New York and, with a slight variation, in New England, suggesting the early use of a ciphering and manteling manual (Hood, *Silver,* illus. nos. 86, 87, 92, 97).

Along with routine household expenses for sugar and malts, James Logan entered his purchase of this tankard in his Account Book under the date "11th month [January] 15th day 1714/15," exactly a month and a week after his marriage to Sarah Read: "Sundry Accots Drs to Cash/Household Goods for a Tankard 32 Ounces £11.19.5/for 6 spoons 15½ Ounces £5.6.3/paid Jnº Denys for Making them £3.12," a total of £23 17s. 8d. (HSP, James Logan, Account Book, 1712–20, p. 96). Logan was forty years old at the time of his marriage, and although by Colonial standards a middle-aged man, he and Sarah produced seven children.

Born in Lurgan, Ireland, Logan had learned Hebrew, Greek, Latin, and basic mathematics by the time he was sixteen. Apprenticed to a linen draper while living in Dublin, Logan finally entered the profitable Bristol trade where he met William Penn. Subsequently engaged as Penn's secretary in 1698, Logan served the Penn family and the colony of Pennsylvania with tact and diplomacy until his death.

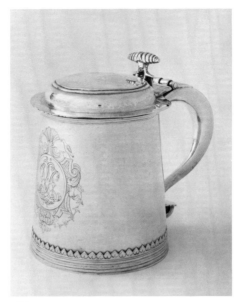

12.

Most content at his country house, Stenton, which he built in 1728, he spoke of the "worldly" affairs and developing factious politics of Pennsylvania, "These duties make my life so uncomfortable that it is not worth the living" (Scharf and Westcott, vol. 1, p. 162n.). A scholar and a man of style, Logan had consuming intellectual interests, and his correspondence with the scientists Linnaeus, Fothergill, and Sir Hans Sloane are recorded in his letter books. Logan was recalled in 1736 to be president of the Provincial Council after the death of Governor Patrick Gordon. This was an important moment in the growth of Philadelphia: A site for the State House was located and authorized; and the meeting of the Six Nations, represented by one hundred Indian chiefs, convened at the Great Meeting House at Second and High streets, at which Logan presided. He was chief justice of the Province between 1731 and 1739, and Provincial Council meetings were often held at Stenton. A practicing Quaker, Logan was not, however, totally convinced of the extremes of pacifism which caused great controversy throughout the colony's early history; and by 1747, when Franklin's "Plain Truth" pushed Quaker dominance in Philadelphia affairs aside for the last time, James Logan was content to hand over the reins to his son William, who was already deeply committed to public service.

BG ☐

FRANCIS RICHARDSON (1681–1729)

Newport, New York, Long Island, and Maryland attracted the first generation of Richardsons to America. All were related, and most were members of the Society of Friends, which encouraged close ties among the branches of the American family. Although Philadelphia was not their first home, it may have been the ultimate destination of Francis and Rebecca Howard Richardson, who immigrated to New York shortly after their marriage in December 1680. They were friends of William Penn and carried with them a warrant for Philadelphia property at Second and Walnut streets, which was confirmed by Penn's patent in 1684. On June 25, 1681, Deputy Governor William Markham of Pennsylvania, who was visiting in New York, wrote to William Penn: "This is to acquaint thee that about ten daies since arrived Francis Richardson with thy Deputy" (Seaman, *Thomas Richardson,* p. 37).

New York was a "metropolis" compared to Philadelphia at this date; Penn was still promoting his "greene countrie town"; and Burlington, New Jersey, was the larger settlement on the Delaware. The Richardsons opted for New York. Francis, Jr., was born there soon after their arrival, followed by a daughter, Rebecca. Richardson acquired a considerable fortune in the mercantile trade out of New York, especially through his Quaker "family"—William Richardson, Walter Newberry, and Edward Shippen in New England, and Arthur Cook and John Delavall in Philadelphia. Francis's estate was valued at £1,860 7s. 4d. at his death in 1688 after barely seven years in America. Soon after, Rebecca Richardson took her two children to Newport where in September 1689 she married Edward Shippen, a widower and Quaker who had been a victim of persecution in Puritan Boston. Thus the family moved to Penn's town, where their business connections continued uninterrupted within the flourishing commerce among Quaker merchants, whose power was rapidly establishing a Quaker "center of operations in Philadelphia." The Shippens took up Francis, Sr.'s, land at Second and Walnut streets and built a house and garden which were the showplace of the seventeenth century city. Gabriel Thomas described it in 1698: "Edward Shippey [*sic*], who lives near the capital city, has an orchard and gardens adjoining to his great house that equals any I have ever seen, being a very famous and pleasant summer house, erected in the middle of his garden, and abounding with tulips, carnations, roses, lilies etc...." (Watson, *Annals,* vol. 1, pp. 368–69).

Since there was obviously no financial

need, Francis, Jr., could have chosen law or medicine had he not been inclined to silversmithing; his stepbrothers, Edward and Joseph Shippen, chose the merchant's role. Although family tradition maintains that Francis and Edward were sent to England for their training (Seaman, *Thomas Richardson*, p. 38), a chronology of the two does not indicate a trip in time for Richardson's emergence as a silversmith in William Penn's Cash Book accounts for 1701 (APS), when Penn purchased a pair of silver shoe buckles from him for Letitia Penn; and Richardson's name does not appear in the apprentice records at Goldsmith's Hall in London (Fales, *Joseph Richardson*, p. 5). Rather it would seem that family connections gave Richardson his opportunity for apprenticeship and that he went into the shop of a master smith in Newport or Boston. Although it is not known which shop Richardson apprenticed in, extant pieces known to be by him bear closest resemblance to the works of John Edwards and Edward Webb in Boston and Samuel Vernon and John Coddington in Newport. Mary Howard Coddington of Newport, an aunt-in-law of silversmith John Coddington, was Rebecca Richardson Shippen's sister, and it seems logical that Francis was sent to Newport in her care. In 1693, Mary Coddington became the third wife of Anthony Morris and moved to Philadelphia (see no. 5).

Fales suggests that Richardson was apprenticed to Johannis Nys in Philadelphia (*Joseph Richardson*, pp. 5, 269n.). They were certainly closely associated in 1720, if not partners. Some porringers probably made by Nys for Richardson and notations of the Huguenot *p* instead of the English *dwt* in Richardson accounts add to the apprenticeship theory. But since Nys (and Ghiselin) preceded Richardson in the silver craft in Philadelphia and both used the *p* form, Richardson may have conformed to their practice to keep his exchanges and accounts with them straight.

Although most of Richardson's silver was not weight-marked, this tankard and a porringer made for his wife were. New England silversmiths, especially in Newport, often did not inscribe weights, thus Richardson's inconsistency may be further evidence of his New England training. Richardson's mark—block letters inscribed in a heart—was a form used in all the American colonies before 1740. He used two variations, one with the initials in an inverted heart, another with an elongated heart, the letters slightly askew. Neither mark is just like Nys's and Ghiselin's, but both are very like those of Samuel Vernon in Newport and John Coney and Jeremiah Dummer in Boston. Richardson's later mark—FR in a shield with a crown above—is most like one

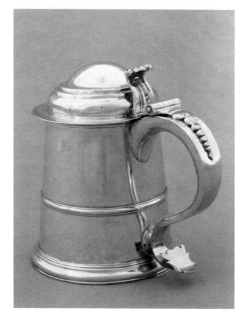

13.

used by John Edwards in Boston (see Buhler and Hood, vol. 1, pp. 322–32, "Reproductions of Marks"), and Richardson may have had his made there when on his buying trip in 1704.

Although the place where Richardson learned his trade is uncertain, in July 1703 and August 1704 he was in Boston buying tools and furniture. Accompanied by his stepbrother, Edward Shippen, he visited Walter Newberry, the son of his father's friend, and attended Quaker meetings in the Boston area. Richardson returned to Philadelphia intent upon setting up his own household, probably contemplating marriage with Elizabeth Growden, daughter of a wealthy landowner in Trevose, Bucks County, Pennsylvania, which took place in April 1705 (Fales, *Joseph Richardson*, p. 267n.).

Richardson's first home and shop were on Letitia Court, at the center of the early city. He and Elizabeth had six children, two of whom, Francis III, born in 1706, and Joseph, born in 1711, survived. Elizabeth died in 1714. After two trips to London in 1716 and 1719, Richardson combined silversmithing with the merchant's shop and trade. As very little silver with his mark survives, he presumably was a merchant as often as a silversmith. He employed a full-time journeyman silversmith and traded commissions with Johannis Nys, who worked on the same street. In 1726, Richardson married Letitia Swift and moved to a larger shop on the west side of Front Street. One child of that marriage died in infancy. Both of Richardson's surviving sons became silversmiths. Joseph (see biography preceding no. 35), working with him when he died, inherited the tools, shop, and house jointly with his

stepmother. Francis III (Frank) was already established and on his own when Richardson died in Philadelphia.

13. *Tankard*

c. 1715

Mark: FR (in inverted heart three times on side)

Inscription: B/WM (engraved on handle); OZ/30.2 (scratched on bottom)

Silver

Height 7″ (17.8 cm); width 7⅞″ (20 cm); diameter 5½″ (14 cm)

Dr. Isaac Starr, Philadelphia

LITERATURE: PMA, *Silver*, no. 328; *PMA Bulletin*, vol. 19, no. 79 (October 1923), illus. cover; Fales, *Joseph Richardson*, illus. p. 14

THIS TANKARD by Francis Richardson, with slightly tapering sides encircled with a molded midband, a raised domed lid without a finial, a ribbed open-scrolled thumbpiece, and a vertebra-like ornament tapering down the handle, is quite different from the straight-sided, flat-topped forms made by Ghiselin and Nys (see nos. 4, 12), Richardson's predecessors in Philadelphia. The features on Richardson's tankard are of English derivation and were popular in New England. For example, a tankard very similar in form to this one was made by John Edwards in Boston (Buhler and Hood, vol. 1, illus. p. 72). While it is possible that Richardson used an English tankard as his model, the evidence of his porringer style, the patch box, gold clasp decorated with the Tudor rose, and the little shoe buckles made for Letitia Penn (Fales, *Joseph Richardson*, illus. pp. 11, 15, 16), suggests an apprenticeship in a versatile shop working after London fashion. As there was not one in Philadelphia at this time, Richardson must have gone to New England for his training.

The initials B/WM stand for William and Mary Tate Branson, who lived on Second Street between High and Chestnut near Francis Richardson. Branson had emigrated from Berkshire, England, to Philadelphia on the *Golden Lion,* having received from his father, Nathaniel Branson, shoemaker, the deed to 250 acres of land purchased from Penn. Branson called himself a shopkeeper in 1720 and a merchant in 1726. By 1723 he had invested in iron mining ("Notes and Queries," *PMHB*, vol. 33, no. 3, 1909, p. 370), and in 1736 he purchased 2,000 acres on the French Creek adjoining the iron furnaces. His wife Mary died in 1727; by 1731, Branson was married to Elizabeth (?), and subsequently to Sarah Wilcox in 1738. He had four daughters, Rebecca Van Leer, Hannah Flower, Mary

Hockley, and Elizabeth Lardner, wife of
Lynford Lardner (see no. 37). Branson died
in 1760, surviving all but Elizabeth Lardner,
who inherited "all the plate in my dwelling
house" (City Hall, Register of Wills,
Will no. 309, 1760).

BG □

PHILIP SYNG, SR. (1676–1739)

The Syng name derives from the
following traditional story that the king
was so pleased with Philip's choral music
that he changed the family name from
Millington to Syng and granted him
a coat of arms with the following motto:
Coelestia Caninus ("of heavenly things we
sing"). Hence the name Syng. The family
had English origins but had settled in Ireland
by the time of James I. Philip Syng, Sr.,
was born in Ireland in 1676. He married
Abigail Murdock in 1700 (HSP, GS, Alfred
R. Justice Genealogical Data, Syng, p. 39).
Their first son, Philip, Jr. (see biography
preceding no. 25), was born in Ireland
in 1703, followed by John (b. 1705) and
Daniel (b. 1707), all of whom became
silversmiths.

The Syng family Bible records the family's
emigration from Bristol, England, to
Annapolis, Maryland, "7th month [Sep-
tember] 29th d. 1714." By November, they
were living in Philadelphia, as Abigail's
death was recorded in Christ Church records.
During 1719–21, *The American Weekly
Mercury* frequently carried the following
advertisement: "Good long Tavern Tobacco
Pipes Sold at 4s per Gross . . . by Richard
Warder Tobacco Pipe Maker living under
the same Roof with Philip Syng Gold Smith,
near the Market Place." A later advertise-
ment placed by John Syng probably
described the location more accurately:
"Goldsmith, in Market–Street over against
the Market House, next Door but one to the
Crown, in Philadelphia" (*Pennsylvania
Gazette,* July 4–11, 1734).

Syng remained at work in Philadelphia
until Philip, Jr., reached twenty-one years of
age, his craft training completed. In Sep-
tember 1724, Syng married Hannah
Whillden Leaming (widow of Thomas
Leaming) at Cape May, New Jersey. He
moved to Annapolis where, after the death
of Hannah, he married Susanna Price at
St. Ann's Church. Syng's second son, John,
died in Annapolis in 1738, a year before his
father. It is unclear whether John had moved
to Annapolis to work with his father, but
John's son (Philip, b. 1737) inherited one-
quarter of Philip, Sr.'s, estate in the right of
his father and settled in Annapolis as a
brass founder.

14.

*John East. Flagon, 1707–8. Silver, height 11½"
(29.2 cm). Christ Church, Philadelphia*

14. *Flagon*

1715
Mark: PS (in square three times on lid,
three times on body to right of handle)
Inscription: The Gift of/coll Robert
Quary/ to Christ Church in Philadelphia/
this 29th 8br 1712
Silver
Height 11½" (29.2 cm); diameter top
4¼" (10.8 cm), diameter base 7⅜"
(18.7 cm)
Christ Church, Philadelphia

PROVENANCE: Christ Church, 1715

LITERATURE: Philadelphia, Christ Church,
Manuscript Collection; E. Alfred Jones, *The
Old Silver of American Churches* (Letchworth,
England, 1913), pl. 112, pp. 365–68; PMA,
Silver, no. 489

HANDSOME VESSELS of silver designed for use
in the Anglican Communion service were
among the earliest presentation pieces in
American silver, and the flagon was one of
the finest forms. Although often made for
domestic use in England, in America the
flagon was primarily a church piece. Used
to fill the Communion cup, or chalice, the
commodious flagon was a ceremonial
necessity in a parish of any size.

In 1708, Queen Anne gave to Christ
Church three pieces by John East, a chalice
and paten, and a flagon (see illustration)
that was matched seven years later with this
flagon by Philip Syng. With minor differ-
ences, the two vessels are a pair in form,

dimension, and weight. Syng has managed
to duplicate the raised base, the encircling
band, the grand sweep of the handle,
and the "cushion" form of the flat top
designed by John East. The hinge work
on the Syng piece is not quite so precise
or "finished" as on the English model,
the thumbpiece is higher, and the cast scroll
ornament has soft contours compared to
the concise clarity of the East flagon.
If Syng "copied" here, his work reveals
a full apprenticeship. The engraved inscrip-
tions are clear and in the same style script.

Colonel Robert Quary's will, written in
December 1706, but not probated until May
11, 1713, included £50 to the "Poore house
Keepers" and "I doe give and bequeath
unto Christ Church in Philadelphia the
sume of Sixty pounds curant mony of this
Place to bee Layd out in Silver Plate
for the use of the Comunion Table to bee
paid by my Executrix into the hands of
the Vestry and Church wardens of the said
Church for the Time being" (City Hall,
Register of Wills, Will no. 268, 1713). The
date inscribed on Syng's flagon, "29th 8br
1712," commemorates the date of Quary's
death. The estate was not settled until
the summer of 1713. Vestry minutes make
no mention of when the £60 was received
from Quary's wife, Sarah, but Philip Syng
made this flagon and a baptismal basin
soon after his arrival in Philadelphia in
September 1714, probably his first important
commission in the city. The vestry also
purchased two English-made plates with
Quary's bequest.

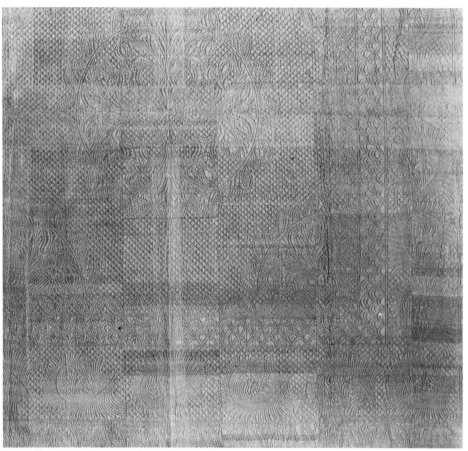

15. *Detail*

Colonel Quary had been governor of South Carolina from 1684 to 1690, a judge of the Admiralty for New York and Pennsylvania about 1697, and was Surveyor General of the Customs in America in 1704. William Penn considered Quary and John Moore his arch enemies, guilty of "a foul insubordination to him" as founders and leaders of the "Hot Church Party" (Christ Church), which opposed the dominance of the Quakers over the commerce and politics of the city (Watson, *Annals,* vol. 1, p. 380). After petitioning the Bishop of London in 1695 for an Anglican preacher to be sent to Philadelphia, Robert Quary wrote to Governor Nicholson on behalf of the vestry of Christ Church in 1696/97: "We hope your excellency will also mind his Grace [the Archbishop of Canterbury] of Plate for the Communion Table and a Library" (William S. Perry, *Historical Collections Relating to the American Colonial Church,* Hartford, 1871, pp. 5, 6).

BG □

15. *Whole Cloth Quilt*

Probably 1720–30
Silk, cotton chintz (55 x 73), and wool wadding; quilted with silk thread

Stitch: Running
100⅜ x 101³⁄₁₆″ (2.5 x 2.6 m)

Philadelphia Museum of Art. Bequest of Lydia Thompson Morris. 32-45-124

PROVENANCE: Elizabeth Coates Paschall (1702–1767); descended in family to Lydia Thompson Morris

IN HER WILL, made in 1753, Elizabeth Coates Paschall (see biography preceding no. 38) bequeathed most of her personal possessions to her unmarried daughter, Beulah (City Hall, Register of Wills, Will no. 210, 1768). Specified among these was "my Silk bed quilt," which, based on family tradition, may tentatively be identified as the quilt shown here. In the estate ledger of Thomas Coates (HSP, Collection of Business, Professional, and Personal Account Books, 1679–1904, Thomas Coates, Ledger, 1705–26) accounts drawn against her father's estate in May 1721 show that Elizabeth Coates Paschall expended the sum of £2 for "a Quilt," and several later entries in the same ledger, made in the name of her sister Sarah, indicate that cash was paid for "Quilting." Since Elizabeth Coates's marriage to Joseph Paschall took place on March 26, 1721, quilting expenses at this time were undoubtedly connected with the establishment of her new household.

The fine materials and the intricate stitching and design of the pattern suggest that this was probably the work of a professional quilter, rather than an example of domestic production. Although it has long been felt that all fine eighteenth century needlework found in this country should be accorded foreign attribution, this quilt, as well as other embroideries more definitely assigned to American, and specifically Philadelphian, manufacture, dispute the suggestion that Colonial workmanship was inferior to its European counterparts. Quakers placed emphasis on useful education; their fine silk samplers (see no. 32) and more mature projects such as the needlework Bible cover (see no. 39) are detailed and closely worked. Household accounts, such as Thomas Coates's Ledger and the Coates-Reynell Papers (Historical Society of Pennsylvania), document that work was regularly sent out in Philadelphia, more likely when a special skill such as fine quilting was simply not available among household members.

This quilt is worked all over in a running stitch. In the center is a circular medallion composed of a conventional pineapple design repeated in each of the four quarters, the whole surrounded by a wreath of laurel leaves. In each of the four corners of the inner square, the quarter design is repeated with the remaining inner area filled with a diamond pattern. Four borders surround the inner square: a wreath of laurel, a scalloped pattern, a series of scrolled feathers within a diamond pattern, and another wreath of leaves, repeating the inner motif.

The face of the quilt is made up of a number of narrow silk strips, about 15 inches wide, sewn together along their length. The reverse consists of three lengths of India chintz, each about 33½ inches wide, also sewn along their length. The chintz is plain-woven, and the yarn appears to be Z-singles. Its pattern shows repeated flowers, leaves, and small figures in red, green, and brown, with black outlines, on a natural ground. The design was primarily block-printed with madder colors; the stems and outlines appear to have been "penciled" directly with mordant, following a stencil. This type of commonplace chintz was imported into Britain from India in bulk during the seventeenth century, achieving its greatest popularity late in that century and into the next. Export and use prohibitions were enacted in Britain against chintz in 1700 and 1720, but loopholes did exist, and the fabric remained legally available for re-export to the Colonies throughout the entire period.

PC □

16.

farthingale of the late sixteenth and early seventeenth centuries. The pannier was a frame made of whale boning or reed connected by bands and attached to each side of a flat front corset, causing the skirt to fall straight in front. The oval look that panniers achieved was wide when seen from the front, but narrow when seen sideways.

EMcG □

16. Petticoat

1700–1730
Light-blue silk, lined in blue moreen, and wool wadding; quilted with silk thread
Waist 24″ (60.1 cm); center back length 35½″ (90.2 cm)
Philadelphia Museum of Art. Given by the Misses Elizabeth C. and Frances A. Roberts. 00-49

ALTHOUGH THE PROVENANCE of this petticoat is not documented, the fact that it was given to the Philadelphia Museum of Art by descendants of the Welsh Quaker John Roberts (1648–1724), whose land was near Haverford Township (see Holme map, no. 2), just beyond what is now the western city line of Philadelphia, indicates that it probably descended in the Roberts family. The intricate quilting, with its pineapple and scrolled feather motifs, suggests a close relationship with the Elizabeth Coates Paschall quilt (no. 15). Of similarly sophisticated workmanship, this petticoat was also probably the product of a professional quilter. Coates's ledger entries indicate that professional quilting was readily available in Philadelphia in the early eighteenth century, and undoubtedly many women took advantage of this service.

Decorative quilting for clothing, popular as early as the seventeenth century, grew to

rage proportions by the early eighteenth century in the Colonies as well as in England. In fact, elaborate quilted petticoats were responsible for the introduction of a new fashion, that of the split skirt, which was cut to reveal the petticoat, or underskirt. The shape of the petticoat, and thus of the silhouette of the dress over it, would have been achieved through the use of panniers, or hip bolsters, an adaptation of the

17. Daybed

1710–50
Hardwood, probably maple, painted black; woven rush
40 x 79 x 24⅝″ (101.6 x 200.7 x 62.5 cm)
Philadelphia Museum of Art. Given by Mrs. Joseph L. Eastwick. 51-112-1

PROVENANCE: Charles F. Williams (d. 1923), Norristown, Pennsylvania

THE DAYBED, or couch, served a multipurpose in the Colonial home. Usually about six feet long, furnished with a thin mattress called a squab and optional pillows at the head end, the daybed served as a bench, a recliner, or as a full-length, if narrow, portable bed. Although not deliberately substituted for the fourposter, daybeds were put into use when households expanded, as Elizabeth Drinker described in her Diary, July 14, 1771, "23 persons in ye house this night" (HSP, vol. 2, 1758–1807). More versatile if not more comfortable than the easy chair and sofa, which replaced it by 1750, the daybed was a sturdy, lightweight piece of furniture made by the chairmaker with as much variety of form, quality, and decoration as the slat-back chair (no. 24).

17.

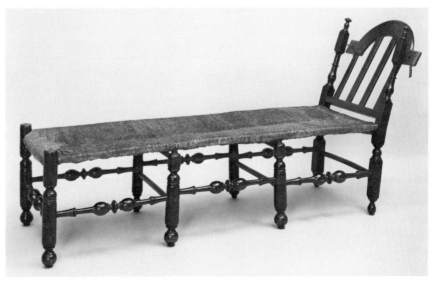

Solomon Fussell (Washington, D.C., Library of Congress, Stephen Collins Papers, Solomon Fussell, Account Book, 1738–50) made two daybeds for Joshua Fisher in 1746/47 at a cost of £2.8., each one costing approximately the same as "6 best 5 slat Chairs Dyd" (Hornor, p. 58). In this example, typical of the earliest form of the daybed in America, the banister back is capped with an arched cresting rail. English examples used caning on the back and seat which was more elegant, probably more flexible, and thus more comfortable than the woven rush used by Americans. The raked headposts to which the backrest was attached with chains were made out of the finest grained hardwood, usually maple, in order to support the weight of a reclining person. The bottom rail of the headrest was doweled into the square section of the headposts, which allowed the pivot necessary to achieve more or less recline. This example is especially well constructed. The stretchers are received by the legs at different levels and thus keep the legs in good line as well as retain their strength at all points. The egg- and disc-turned stretchers narrow to an arrow form where they are doweled into the rounded turned legs, a decorative subtlety with purpose.

The squab and pillows on a daybed varied according to the wealth or intended use of the owner. Woven wools, plush, furniture checks woven of linen or cotton in red, green, or blue, and even silk damasks are described in inventories before 1750. The daybed was often made to match a set of chairs, which would also have had prim banister backs (Hornor, pl. 461) and cushions made to match en suite.

Late versions of the daybed have cabriole legs, vase-shaped, curved splats, and elegant damask upholstery on a sacking (stretched-canvas) bottom. At that stage in their development they were used for reclining, not as a bench or bed; as their versatility decreased, they were replaced by sofas, settees, easy chairs, and window seats.

BG □

D. JOHN (N.D.)

The chalk inscription on this desk reads simply D. John. The D is formed with a large loop at the top and bottom in a very rounded "free" scroll hand. The D looks similar to an old-style Q. The J is a long slow curve with a loop at the bottom and at the top, which overlaps the flourish at the end of the D. The o is part of the stem of a tall script h; the n is a separate letter. The numbers 6/20 following the name are in early eighteenth century handwriting. The problem presented by the discovery of this

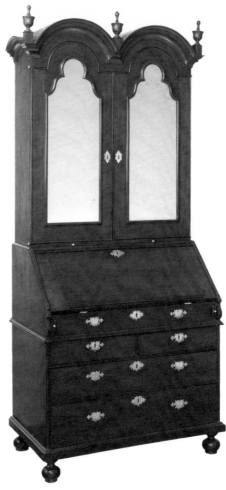

18.

signature was to match it with that of an early Philadelphia joiner.

A Philip John, joiner, son of Richard (1649–1717) and Margaret John, prominent Quakers in Calvert County, Maryland, who had emigrated from Bristol, England, was resident in Douglas Township, Philadelphia County, at the time of his death in 1741. He and his wife Jane had at least four children, Daniel, David, John, and Margaret. An inventory appraisal taken by Timothy and Joseph Millford gave his "working tools" a relatively high value at £5 (City Hall, Register of Wills, Will no. 298, 1742). Items listed of greater value were Negro slaves, £25, and horses and mares, £10. The bed and its furniture were valued less, at £4. This would indicate that either his tools were extensive, or specialized, or both. They were at the least more than the routine carpenter's tools, like those owned by a David John of Chester County in 1756. As Philip had six sheep, six horned cattle, plows, guns, and a canoe, he combined farm-

ing with joinery. Philip's wife and sons were named executors of the will written in 1741, probated in 1742 (City Hall, Register of Wills, Will no. 298, 1742). David John, the youngest son, renounced his executorship in a resolution attached to the document, which he signed, and which offers a handwriting comparison with the inscription on this desk. Allowing for the difference between a finely pointed pen and cabinetmaker's chalk, they are very similar. There was no Daniel John signature, but it remains perfectly possible that he was also trained as a joiner. Nothing further emerged from church, tax, and business records that can be precisely identified as this family's data; the same names proliferated throughout the nineteenth century in Philadelphia and New Jersey.

18. *Desk and Bookcase*

c. 1720

Inscription: D JOHN 6/20 (in chalk script on bottom of bookcase section)

Walnut; poplar drawer sides and bottoms; mirrored glass; brass hardware

Height 90″ (228.6 cm); width 40″ (101.6 cm); depth base 22¾″ (57.8 cm), upper section 11¾″ (29.8 cm)

Philadelphia Museum of Art. Given by Mrs. John Wintersteen. 63-33-1

PROVENANCE: Ella Parsons; American Art Association, New York, May 22–24, 1935, illus. no. 646 (sale no. 4184); Mrs. John Wintersteen

THE DESK AND BOOKCASE, an important type of case furniture, was popular in England from 1680 to 1760. The early form shown here was advertised by various names according to the interior fittings of the upper section: "Scretor Chests of Drawers" (Heal, *Furniture Makers,* p. 92), "scrutore," "bureau cabinet" (Geoffrey Wills, *English Furniture 1550–1760,* London, 1971, pp. 104, 117), and in Philadelphia in 1720, as a "Scruitore and bookcase" (LCP, Thomas Chalkley, Account Book, 1720, p. 48). This desk and bookcase is identified as such by its upper section, which is fitted with tall compartments for account books or ledgers, small drawers for receipt books and writing equipment, and, as its locks indicate, bonds and deeds. Many English pieces are nearly identical to this but are entirely fitted with small drawers behind the glass doors, suggesting a lady's writing desk rather than a central household piece. These were called "bureau cabinets" (Wills, cited above, illus. pp. 116, 121).

Most English examples were distinguished by a highly decorative surface treatment, which included lacquerwork and japanned surfaces (F. Lewis Hinckley, *A Directory of*

Queen Anne, Early Georgian and Chippendale Furniture, New York, 1971, pp. 96, 97), and black or red grounds embossed with chinoiserie and highlighted with gold leaf. Early Philadelphians loved japanned work and great quantities were imported (LCP, Thomas Chalkley, Account Book, 1720, pp. 48, 50), but to date, not a piece of Philadelphia japanned work has survived. It was an early decorative fad and may have been frowned upon by seventeenth century Quakers who criticized gilded surfaces. Thus, while the English baroque form is apparent in the double-arch top of this Philadelphia piece, like the Edward Evans fall front writing cabinet (no. 9), it lacks the surface luster of English prototypes. The base section is close in design to the Evans piece but is given more height by the blind drawer panel that conceals a well, accessible through an interior sliding piece, which in later examples becomes an actual drawer (see no. 84). The double-astragal molding on the case also outlines the drawers, a feature of the best English cabinetry. Beveled mirror panels set into the doorframes are bordered with curvaceous architectural moldings, which push the cornice moldings into conforming rounded shapes. Three urn finials perch precariously on top.

This is a rare American form. Only a few somewhat similar examples are known (Nutting, *Furniture,* vol. 1, pls. 682, 683; *Antiques,* vol. 97, no. 4, April 1970, illus. p. 441), and desks of this specific type appear in only two inventories out of some four hundred investigated (University of Pennsylvania, Van Pelt Library, Index of American Cultures, Philadelphia, 1725–75). The 1776 inventory of William Logan's townhouse included "a Mahogany Desk and Book Case wᵗ Lookᵍ Glass Doors £16.0.0" in the front parlor (HSP, Logan Papers, Case 4, Thomas Fisher, Ledger of the Estate of William Logan 1772–83, p. 17). James Steel's 1741 inventory listed "a Desk and Bookcase with glass doors" at £25, the high value probably indicating a veneered or japanned piece with mirrored glass (City Hall, Register of Wills, Will no. 261, 1741). Hornor (p. 55) mentions a few others with "glass" or as "glazed," but these are imprecise references to mirrored glass, an unusual feature, which raised the value of a piece. Its presence signifies an early form; after midcentury clear glass was used most often.

More furniture was imported into the Southern Colonies than into Philadelphia before 1770, and Maryland families who built great houses would have owned English desks which must have been the prototype, either as a model or a measured drawing, for this piece. Philip John's parents were prominent and well-to-do seventeenth century Marylanders, and it is possible that

they owned household furniture of this quality.

Where Philip John received his training as a joiner is still unknown, but his sons Daniel and David had either their father's experience or drawings to work from during their apprenticeships. This desk was probably made by Daniel or David John about 1720.

BG □

SIMON EDGELL (C. 1688–1742)

Simon Edgell was born in England, probably London, about 1688. Nothing is known of his early life until he was admitted as a yeoman to the Pewterer's Company in London in 1709. Shortly after, he came to America and is recorded as being in Philadelphia as early as 1713. He located his shop on High Street (Market Street) and was admitted as a freeman of the city in 1717. A number of newspaper notices in the *Pennsylvania Gazette* indicate that he not only produced pewter but also dealt in a general line of merchandise and even attempted public office as the Sealer of Weights and Measures for the city. He died in 1742. The extensive inventory of his shop equipment and materials indicates that he was engaged in a particularly large pewtering enterprise.

19. *Dish*

1713–42
Mark: SIMON EDGELL (on underside, enclosed in circle with bird standing on bar over three stars and crossed boughs); S·EDGELL (in rectangle on underside)
Inscription: G/IE (stamped on underside)
Pewter
Diameter 16¹¹⁄₁₆″ (42.4 cm)

19.

Yale University Art Gallery, New Haven. The Mabel Brady Garvan Collection

PROVENANCE: Francis D. Brinton, West Chester, Pennsylvania; Louis Guerineau Myers, New York, before 1926; purchase, Francis P. Garvan, New York, 1929; Yale University Art Gallery, 1931

LITERATURE: Louis Guerineau Myers, *Some Notes on American Pewterers* (New York, 1926), pp. 36–39; Laughlin, *Pewter,* vol. 2, pp. 39–40; Graham Hood, *American Pewter* (New Haven, 1965), pp. 50–51

PEWTER, AN ALLOY composed principally of tin with varying amounts of copper, bismuth, antimony, and lead, is a fragile metal. Comparatively soft and with a low melting point, it is highly susceptible to the deleterious effects of daily use. It is not surprising, therefore, that although it was as common in eighteenth century households as china is today, very little of it has survived. This is especially true of pre-Revolutionary pewter, which today represents less than one-tenth of all that made in America from 1640 to 1840. Of the 137 pewterers recorded as having worked in America before 1775, only 42 have left us with examples of their work.

One of this number was Simon Edgell, an early Philadelphia pewterer who worked in the city from 1713 to 1742. Although little is known of him during his twenty-nine years in Philadelphia, the inventory of his estate is enlightening. Not only does it testify to the ubiquitous use of pewter for domestic, ecclesiastical, and commercial purposes, but also to Edgell's success in supplying that market. Included in the extensive list were 120 teapots, 144 tankards, 328 quart-sized mugs, 1,752 porringers, and 1,635 dishes. Yet of this number, fewer than a dozen objects are known to exist today which bear Edgell's mark.

Possibly the most interesting of these is the dish illustrated here. Measuring over sixteen inches in diameter, it is one of the largest American examples on record. The only larger example known (Winterthur Museum) measures nineteen inches in diameter and is also the product of Edgell's shop. Both provide eloquent testimony to the ability of his shop, probably the largest in the Colonies at that time, to provide special-order items that the average pewterer could not supply. These dishes are a rare survival today, belying their popularity as carrying and serving utensils for food. American dishes of this type number fewer than one dozen and most date prior to 1750. Of an eminently practical nature, the dish did not fall into disfavor after the mid-eighteenth century as one might conclude from this, for it continues to serve in the same capacity today. Only the medium

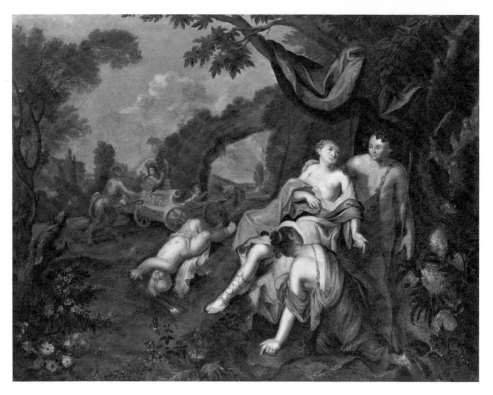

20.

differs, a change which began to appear about the time of the Revolution with the increasing use of porcelain and the development of English creamwares.

Although a comparatively soft metal, pewter can be work-hardened by hammering. The fact that this dish has survived in such a good state of preservation may in large part be due to the fact that Edgell hammered it over its entire surface, an expensive optional extra for the purchaser. Most plates and dishes were work-hardened only along the booge, just inside the brim. This dish, carefully hammered all over, is an impressive example of Edgell's skill as a hammerman and of the high-quality work produced by his shop.

DF □

GUSTAVUS HESSELIUS (1682–1755)

Born in Sweden, Hesselius immigrated to America with his brother in 1711. He settled in Wilmington, Delaware, but made several visits to Philadelphia before finally moving to the city permanently about 1730. He was the major portrait painter in Philadelphia and the Middle Colonies at that time, but like other Colonial artists, he also painted ships, houses, signs, church altarpieces, drew arms on coaches, gilded frames, and cleaned pictures. As a cultured man, he became a prominent citizen in Philadelphia and was

successful enough in his various trades to buy two houses. A contemporary, writing in 1733, described Hesselius's portraits as by "no bad hand, who generally does Justice to the men, especially to their blemishes" (Frederick B. Tolles, "A Contemporary Comment on Gustavus Hesselius," *Art Quarterly,* vol. 17, no. 3, Autumn 1954, p. 271). Hesselius, who died in Philadelphia, may have had John Meng and James Claypoole, Sr., as pupils (Fleischer, "Hesselius," p. 185). His son John (see biography preceding no. 37) was also a painter; and his granddaughter married Adolph-Ulric Wertmüller (see biography preceding no. 136).

20. *Bacchus and Ariadne*

c. 1725
Oil on canvas
23½ x 31½″ (59.7 x 80 cm)
The Detroit Institute of Arts. Gift of Dexter M. Ferry, Jr.

PROVENANCE: Descended in artist's family to Mary Young (Hesselius) Dundas (Mrs. Francis Henry Hodgson), Philadelphia, 1948

LITERATURE: Peale's Baltimore Museum, *Catalogue of the Fourth Annual Exhibition . . .* (1825), no. 55 (probably *Bacchus and Ariadne;* attributed to John Hesselius as *Venus and Adonis*); PMA, *Gustavus Hesselius, 1682–1755* (June 29—July 17, 1938), pp. 16, 27 (as *Pluto*

and Persephone); E. P. Richardson, "Gustavus Hesselius," *Art Quarterly,* vol. 12, no. 3 (Summer 1949), pp. 223–24, 226; Quimby, *Painting,* pp. 139, 141, 143, 146; William H. Gerdts, *The Great American Nude* (New York, 1974), p. 19

THIS WORK and its companion, *Bacchanalian Revel* (Pennsylvania Academy of the Fine Arts), are considered to be the earliest mythological paintings done in America and have been assigned on the basis of style to Hesselius's early period with an approximate date of 1725. Both paintings descended in the family of the artist and both appear to be based upon engravings, although the exact sources have not been determined. The treatment of the subject matter is so unusual that the identification of each is by no means absolute. We can only be sure that both contain obvious references to Bacchus, the ancient god of wine.

In the Detroit painting, called *Bacchus and Ariadne,* the chariot drawn by leopards provides the most convincing evidence that the man standing to the right is Bacchus. He appears to be wearing a wreath of grape leaves which, along with the background satyr, gives strong support to this theory. The rest of the painting makes this picture more enigmatic than its companion, which has been convincingly identified as the child Bacchus being cared for by the nymphs of Nysa. Since Bacchus, in the Detroit picture, is shown in an affectionate posture, the woman next to him is interpreted as Ariadne, the princess of Crete; the foreground woman as an attendant; and the baby in midair as Cupid. The rarely seen feature is that Cupid is wingless and carries a torch rather than arrows, which suggests that possibly this figure is the child Bacchus who was born from a burning mother. If this is the case, the painting, in medieval narrative fashion, shows Bacchus twice, and the women at the right could even be his foster parents, the nymphs of Nysa. The resemblance to the nymphs in the companion piece is close enough for this identification to be plausible.

Since these Bacchian pictures descended in the artist's family, they were evidently not commissioned; and since the figures in both are anatomically inconsistent and spatially unrelated, the pictures undoubtedly contain imaginative borrowings from different European prints. The compositions are clearly in the baroque tradition and give some indication of Hesselius's artistic roots.

If this painting dates from the 1720s, as is generally accepted, it is one of the earliest surviving oil paintings that could have been executed in Philadelphia.

DE □

21. *High Chest (Cabinetmaker's Model)*

c. 1725
American black walnut; poplar, pine, and
cedar drawers; brass hardware
45½ x 20¼ x 12″ (115.6 x 51.4 x 30.5 cm)
Private Collection

PROVENANCE: Francis P. Garvan, New York

LITERATURE: Nutting, *Furniture*, vol. 1, pl. 383

THIS CABINETMAKER'S MODEL of a high chest
reflects aspects of the economic, social, and
artistic intercourse converging upon the
Delaware Valley in the early eighteenth
century. The great midcentury Philadelphia
mercantile enterprises of the Fishers and
Whartons were joined by matrimony to the
Redwoods of Newport (HSP, William
Redwood, Ledger, Journal, 1749–62), while
early in the century Job Townsend, founder
of the Townsend-Goddard school of
Newport cabinetmaking, frequently shipped
on consignment to New Jersey between 1725
and 1765. Within the close-knit correspon-
dence of the Society of Friends, Quaker
merchants, operating in centers like
Newport, Rhode Island; Burlington, New
Jersey; Philadelphia; and the West Indies,
exploited the overlapping channels of trade
and passage. Thus, not only did their exten-
sive ledgers and account books record pounds
and pence, credit and interest, between these
ports, but also goods shipped and people
resettled within the broad outlines of the
Quaker family.

This is the earliest form of the high chest
belonging to the Philadelphia-Burlington
school of cabinetry, and some aspects of its
design were the result of trade contacts
flourishing by sea. For instance, both Boston
and Newport cabinetmakers used this
"square" form of the cabriole leg with
sharp-edged knees which follow the rec-
tangular contour of its original sawed shape.
The tight form of the Spanish foot on this
example appeared on chairs made in Boston
and imported into Philadelphia by Plunket
Fleeson before 1742 (Louis B. Wright,
George B. Tatum, John W. McCoubrey,
Robert C. Smith, *The Arts in America: The
Colonial Period,* New York, 1966, pl. 189).
These crisply carved ankle moldings and feet
were never a feature of Newport work but
were extensively used in Boston and in the
earliest Delaware Valley cabinetry. This
particular shape of the solid bonnet which
almost closes the void in the center and ends
in a sharply molded profile is most similar to
Boston examples; in Newport the void was
often completely filled in; while in Philadel-
phia a predilection for rounder, less severe
contours soon replaced this form with

21.

sweeping scrolls ending in graceful volutes.
The tightly controlled carved shell is also
typical of early Boston design, and the turned
drops (restored) at the base are the vestigial
remains of the two front legs on six-legged
chests (see no. 22), a design popular in New
England throughout the early eighteenth
century but rarely found in Philadelphia,
where cabinetmakers came to prefer rococo
shells and naturalistic leafage.

Primary and secondary woods plus the
individual assemblage of special features
suggest an attribution to a joiner like Thomas
Stapleton (d. 1739), who trained in Boston
and returned to Philadelphia. Its proportions
and shaped-plank construction with molded
drawers and attached case moldings are
crafted and fitted as if this were a full-scale
high chest. The absence of working locks,
the details of very solid joinery, and the
medium size of this piece remove it from the
category of spice box or ribbon-lace chest.
It exhibits a tentative try at a new form for a
developing market which had a predilection
for understated grandeur. During the
formative period when this high chest was
made, Quakers still preferred to celebrate

worldly success with learning and land, but
eventually the protests of strict Friends
against gleaming mahogany, shiny plate,
elegant bright-colored silks, and gilded
looking glasses were voices in a wilderness.
BG □

22. *High Chest and Dressing Table*

1725
American black walnut; yellow pine and
cedar; brass hardware
High chest 66¹⁵⁄₁₆ x 42⅛ x 23¼″ (170 x
107 x 59 cm); dressing table 30¹¹⁄₁₆ x
33¹⁵⁄₁₆ x 23⅝″ (77.9 x 86.2 x 60 cm)
Philadelphia Museum of Art. Given by
Lydia Thompson Morris. 28-7-12, 13

PROVENANCE: Catherine (Johnson) Wistar;
Rebecca (Wistar) Morris; Catherine (Wistar)
Morris; Catherine (Morris) Brown; Lydia
Thompson Morris

LITERATURE: Hornor, pp. 10, 29, pls. 12, 13

THIS HIGH CHEST and dressing table have
been in continuous family ownership since
they were made for Catherine Johnson of
Germantown shortly before her marriage to
Caspar Wistar in 1726. Whether purchased
as dowry or as furniture for their house is
unknown, but family provenance indicates
that these pieces belonged to Catherine and
were handed down through the female line
carrying the name Wistar. The Johnsons
were successful tanners and property holders
well before Caspar Wistar arrived in Phila-
delphia in September 1717 from Hilsbach,
Germany. By the time of his marriage to
Catherine, he was established and well-to-do.
He had come into the port free of debt for
his passage, and family history records that
he obtained his livelihood at first by picking
apples. He was next employed by a brass
button manufacturer and soon took over the
business. Wistar invested his proceeds in
land, and at the time of his death in 1752
his estate was valued at £26,667 11s. 5½d.,
one of the largest fortunes in the first half
of the eighteenth century (HSP, Inventory
of Caspar Wistar, April 13, 1752).

Wistar's inventory lists the contents of the
house on Market Street between Second and
Third where he lived most of his life, and
which he left to his son Caspar (see no. 84).
The contents of "the Front Chamber" on the
first floor in back of the parlor included
"a Bed with home made blue Furniture and
window Curtains £15, 6 rush bottom Chairs
and 2 Arm Dᵒ £2.10, Chest of Drawers and
Table £4.0.0, a Looking Glass £3.0.0, brass
Tongs, fire Shovel, Fender Dogs & Bellows

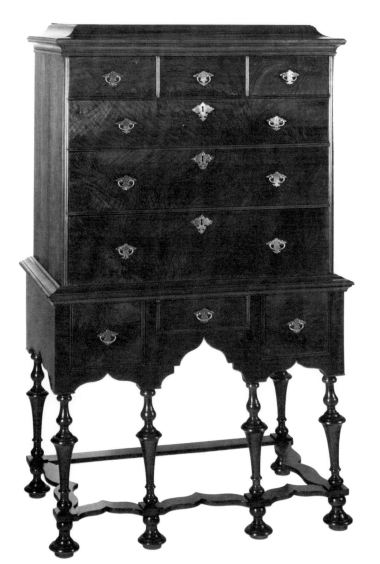

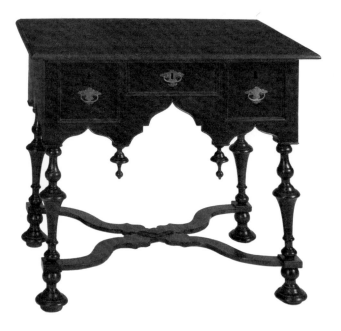

22.

£1.5.0, 3 Bowls and 3 half doz China Cups £2.0.0, 12 Table Cloths, 2 Napkins & 3 doz Towels £6.16.0." The item "Chest of Drawers & Table £4.0.0" describes this set, pieces which appear in the inventories of other wealthy citizens. In the back chamber, a "double Chest of Drawers £7.10" was probably the chest purchased in 1748 for £9 from Francis Trumble (HSP, Caspar Wistar, Receipt Book, 1747–84, June 29, 1748). Trumble supplied the Wistars and other early Philadelphians with quantities of furniture from his large business at the "Sign of the Scrutore" (*Pennsylvania Gazette,* August 8, 1754), but he does not appear in records until 1740 and could not have made these pieces. Joseph Richardson, Wistar's neighbor at his first residence on Front Street, owned a high chest very similar to this one (private collection); and Anthony Morris, who also lived on Front Street, and whose

will Caspar Wistar witnessed in 1721, had a "chest of drawers & table" in his front chamber valued at £10 (Moon, *Morris Family,* vol. 1, p. 118). Sets of this form were stylish before 1730, although few survive. They remained popular through the mid-century and developed in scale and elaboration (see no. 104) until the advent of the neoclassical forms of post-Adamesque London, which were imported into Philadelphia. In England, the high-chest–dressing-table unit was abandoned at the end of the seventeenth century, but in America, and especially in Philadelphia, they were made in sets until the last quarter of the eighteenth century.

By the time of Catherine and Caspar's marriage in 1726, Philadelphia craftsmen trained in London were fashioning native black walnut into familiar forms. The case, drawer fronts, legs, and stretchers of these

pieces are solid walnut. The drawer fronts are not veneered, as Hornor has stated (p. 10), although their highly figured, grained surfaces give the effect of veneer. Comparable English examples have more elaborate surfaces, veneers, inlay, banding at the edge of the drawers, japanning, or gilding. In America, availability of equipment may have been a problem, although Charles Plumley was equipped to do veneering in Philadelphia before his death in 1708 (McElroy, "Furniture," p. 198). But the accomplished craftsman who made these pieces was highly skilled in the development of scale and form—an issue in American furniture—undisguised by decorative additions. The elegant proportions like those on the secretary bookcase reveal a thorough apprenticeship in the cabinetmaking trade, in a step beyond that of the joiner. The double mold on the case

around the drawers is an early detail also found on the secretary bookcase, outlining as well as protecting the edges of the drawers. A single mold outlines the swinging cusp curves of the skirt on the high chest and dressing table, offering a finished rounded edge which makes a smoother than usual transition between the "flat" case and the turned legs (see no. 7). The trumpet-turned legs are especially crisp, and the "drops" on the dressing table are subtle summaries of the leg form reduced to ornamental appendage. The curves of the flat stretchers on the high chest repeat in the horizontal plane the curves of the case apron, giving the base structure of these pieces a vitality and visual interest transferred, in later periods, to the urns, flames, and scrolls on bonnets and pediments.

BG □

23. *Gateleg Table*

1720–30

Walnut; brass hardware

Height 28″ (71.1 cm); length 30¼″ (76.8 cm); width open 39″ (99.1 cm), closed 12″ (30.5 cm)

Philadelphia Museum of Art. Purchased by subscription and museum funds. 23-23-59

PROVENANCE: Guy Warren Walker; Charles F. Williams (d. 1923), Norristown, Pennsylvania

23.

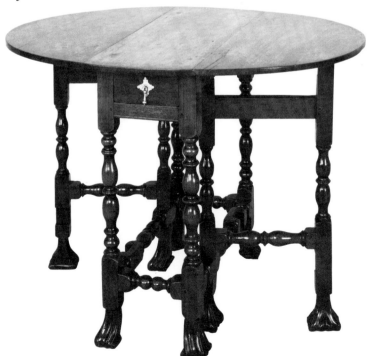

LITERATURE: Luke V. Lockwood, *Colonial Furniture in America,* vol. 2 (New York, 1913), fig. 685; Hornor, pl. 7

ALTHOUGH A PLENTIFUL and popular form in the New England Colonies, the gateleg table was almost passé by the time Philadelphia was founded in 1682. But old styles lingered, for there were many furniture craftsmen already in Pennsylvania by 1682 who had been trained abroad or who brought furniture with them.

This extraordinarily small example of the form attains a certain elegance from its size, which is repeated in the scale of the turned details. Woodworking craftsmen who came to America in the late seventeenth century were known as turners or joiners, but gateleg tables were entirely the work of the turner, who skillfully transformed its functional scheme into a glossy decorative piece. The "mechanism" on this example was especially difficult because of its small size. The legs were first cut into a square profile as were the horizontal members—the stretchers and "gates." These pieces were then turned on a lathe and honed with a variety of chisels until the bulbous curved shapes were finished. On this table, the gatelegs which support the drop leaves have less turn in proportion to their length than the stationary legs, enabling their square sections to remain high enough to receive the stretchers. As the gates open and close, these

must clear the stretchers of the stationary legs. The slight cut into the square section of the gateleg allowed a smooth fit into the stationary frame, completing the mechanism with finesse.

The table stands upon a foot form known variously as Spanish or paintbrush. It came to England via the Portuguese trade and was popular there in the reign of James I and in provincial areas through the time of Charles II. The form came to America, especially Boston, just after the first settlement. The Spanish foot was an easier form to carve than the large scroll, which was more popular in England, because its line followed the square profile of the block from which it was fashioned. When compared to its more usual rigid shape (see no. 21), the feet on this table are especially "soft" and elegant, as if made of sable bristles.

BG □

24. *Armchair*

1725–50

Maple and hickory, painted; rush seat 44¾ x 23 x 18½″ (113.7 x 58.4 x 47 cm)

Philadelphia Museum of Art. Given by Titus C. Geesey. 69-284-14

THE SLAT-BACK CHAIR was long a Philadelphia favorite. The earliest visual evidence that the form was in use in Philadelphia is the portrait of *John Kelpius* by Dr. Christopher Witt, 1705 (Historical Society of Pennsylvania). Thereafter, ledgers and other documents record the slat-back chair, which overlaps at the end of its reign with the varied styles of the Windsor, which eventually replaced it in popularity.

The graceful, arched shape of the slats was a Delaware Valley feature, and the chair's comfort was enhanced by the concave curve given to the slats by a special device in their manufacture, the slat press. A draw knife honed the slats into their flexible thinness; mortising chisels fitted the slats into their slots in the back posts; braces and bits drilled holes for stretchers and seat rails; leather-padded hammers pounded the chair together; and the final weaving of the rush seat secured all parts.

The slat-back form originated in Yorkshire, England, and spread easily throughout the British dominions, largely through the triangle trade with the American Colonies and the West Indies. Venture cargo was an important aspect of the cabinetry and chairmaking businesses in early America, and Philadelphia merchants shipped these chairs, disassembled and bundled, to Antigua and Barbados in exchange for molasses and rum. John Greenwood's painting *Sea Captains Carousing at Surinam,* c. 1767–68

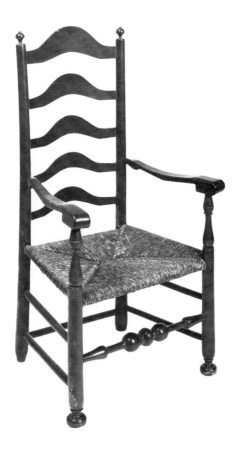

24.

(St. Louis Art Museum), shows in convivial disarray the simplest form of the slat-back chair, with three slats and plain-turned legs strengthened by double straight stretchers. Peter Baynton, a Philadelphia and Burlington merchant and master of his own ship, the *Britannia,* carried on an extensive trade with the West Indies via South Carolina in the 1720s. One of Baynton's varied cargoes included a marble-topped table valued at £15; remnants of broadcloth, £20; a pair of slippers, £1 5s.; boxes of glasses; playing cards; and "slat chairs" (HSP, Peter Baynton, Account Book, 1721–26).

Although the craftsmen who made these chairs are more elusive in manuscript records, the size of sets ordered—usually in half-dozen lots—as recorded in eighteenth century inventories, suggests that there must have been numbers of chairmakers working in Philadelphia from 1700 on. Thus far, only one, Solomon Fussell, has left a record (in his Account Book, Ledger, Day Book, and Journal), covering his chairmaking activities between 1738 and 1750 (Washington, D.C., Library of Congress, Stephen Collins Papers). Implicit in Fussell's accounts is the economy of early chairmaking in Philadelphia, in which payments for finished products were frequently made with the raw material—in Fussell's case, maple—which was the primary wood used for the frame-work of the slat-back chair. Fussell's accounts also reveal the infinite variations possible within the scope of the materials, the skills of the shop, and the tastes and needs of the clientele.

Contemporary accounts termed the slat-back chair as "best kind, 5 arched slat, turned front, armchair, finished red," a description which fits this chair. In 1745, William Hogg ordered the "best" type, "6 five-slat Chairs turned fronts" (Fussell, Account Book, p. 205). The term "turned front" refers to the decorative ball and disc turning at the center of the front stretcher. "Best" referred to the quality of the maple used in the frame, the number of slats (five or six), and the type of weave in the rush seat or the quality of the rush—fine or superfine being specified. Such qualifications also determined the price, which ranged from £1 10s. for a set (usually six) of five-slat chairs to £1 16s. for "6 *best* five-slat chairs," "best" again implying quality of material (rather than the addition of decorative features such as turnings or flower painting, which were specified if present). Sarah Hogg ordered a "3 slat nurse chair" in 1747, and Benjamin Franklin bought three "best" and a "nurse" (for nursing mothers) chair with "crook'd feet" in 1742 (Fussell, Account Book, p. 171). The "crook'd" foot was a provincial English feature found on Windsor chairs manufactured at Wycombe, England, in the seventeenth century and abandoned by most Philadelphia chairmakers by 1720 in favor of the turned ball foot (half worn away on this example). Fussell's pointed "crook'd" foot appears on the early work of his apprentice, William Savery, who developed it into the trifid form, even though the more graceful Queen Anne forms of slipper foot and rounded pad foot were already in use in Philadelphia.

Along with a variety of sizes and forms, slat-back chairs came in several colors. Solomon Fussell offered black, brown, orange, and white, and he did not charge extra for paint, which was imported in Spanish brown, yellow ochre, Venetian red, and yellow. Color did not determine the chairs' location in a house; they were placed alongside more formal furniture of walnut and mahogany. Presumably, slat-back chairs were painted, repainted, repaired, and repainted again. This chair has had several coats; at least two, Venetian red and Spanish brown, are evident.

BG □

1726-1776

Philip Syng, Jr., was born September 29, 1703, in the diocese of Cloyne, Cork, Ireland, the son of Philip (see biography preceding no. 14) and Abigail Murdock Syng. The family immigrated to Philadelphia in 1714 where the elder Syng set up his silver-smithing shop "near the Market Place" (*American Weekly Mercury*, May 19, 1720). Philip, Jr., apprenticed in his father's shop, and in November 1725, after completing his apprenticeship, he sailed for London on the ship *John*, probably to obtain patterns and tools for his craft. While abroad, he became friends with Benjamin Franklin, and in 1727 he became one of the original members of Franklin's Junto. Syng returned to Philadelphia June 20, 1726, on the *Yorkshire Gray*. On February 5, 1729/30, he married Elizabeth Warner at Christ Church. In 1732, he became a founding member of the State in Schuylkill Fishing Company. At this time his silver trade was already established, and he had accounts with Joseph Richardson from whom he purchased watch chains and snuffboxes in exchange for shoe buckles and spoons (Fales, *Joseph Richardson*, p. 289n.), and at least once he supplied Richardson with gold, "12dwt. 4g." (Samuel W. Woodhouse, Jr., "American Craftsmanship in Gold," *Antiques*, vol. 20, no. 1, July 1931, p. 32). Syng, too, worked with gold, one of his finest creations being a girdle (belt) buckle, c. 1752 (Winterthur Museum); and he made several gold items for the Powels—teaspoons, stock buckles, and buttons (LCP, Powel Collection, Samuel Powel, Ledger, 1760–64, pp. 41, 109).

Syng must have been from the outset a gregarious community man. He inoculated the three-year-old Matthew Pratt for smallpox ("Autobiographical Notes of Matthew Pratt, Painter," *PMHB*, vol. 19, no. 4, 1895, p. 460); in 1737 he was a Grand Warden of the Grand Lodge of Pennsylvania Masons (Harrold E. Gillingham, "The Cost of Old Silver," *PMHB*, vol. 54, no. 1, 1930, p. 36); and in 1742 he became a charter member of the Library Company of Philadelphia. In 1746 he acted as attorney for John Langdale, a tanner who left to settle in Virginia (*Pennsylvania Gazette*, March 16, 1746/47). In 1747, Syng was involved with Joshua Maddox and Benjamin Franklin in anti-Quaker policies which resulted in a lottery to raise money to build defenses for the city, and in the same year he was experimenting with Franklin on the lightning rod. He was a vestryman of Christ Church from 1747 to 1749, during which time Lawrence Hubert, an engraver from London, had moved into Syng's establishment, presumably to work with him (*Pennsylvania Gazette*, May 19, 1748).

In 1750, Syng was one of the first city wardens appointed to provide for the regula-tion of the tax to support city services, such as the watch, street lighting, and water pumps (Mitchell and Flanders, eds., *Statutes of Pennsylvania*, vol. 5, p. 111); and in the same year, the College and Academy of Philadelphia (University of Pennsylvania) was founded and Syng was appointed a trustee. He provided Richard Peters with seals for Cumberland and York counties; for Nicholas Scull (1687–1761), surveyor; for William Parsons (1701–1757), surveyor general; and in 1750, for the Union Fire Company. In May 1752 he was ordered to provide a seal for the Philadelphia Contribu-tionship Insurance Company, of which he was a director, and the design—four hands united—has been ascribed to him. In 1753 he acted as judge and manager of the election of directors and treasurer for the same company (Philadelphia, Contribution-ship Insurance Company, Minutes, 1752–54). He was treasurer for the City and County of Philadelphia from 1759 to 1770 (HSP, Penn Collection, Philip Syng, Receipt Book, 1759–70), during which time he signed the Non-Importation Agreement of 1765, was a member of the Provincial Commission of Appeals, and was treasurer of the American Philosophical Society.

In 1763, Syng was joint executor with Joseph Richardson for the estate of Philip Hulbeart, silversmith (see biography pre-ceding no. 60). He went into partnership with Joseph Fox, William Allen, Benjamin Chew, and John Ross to "erect and carry on a linen manufactory" ("Notes and Queries," *PMHB*, vol. 12, no. 4, 1888, p. 500). During this time, he was turning out silver pieces for the Drinkers (HSP, Elizabeth Drinker, Diary, March 23, 1759), the Shippens (Lita H. Solis-Cohen, "Living with Antiques," *Antiques*, vol. 99, no. 3, March 1971, illus. p. 389), the Powels (LCP, Samuel Powel, Ledger, p. 109), Thomas Coombs (Philadelphia Museum of Art, 69-201-1), and the Maddoxes (see no. 41), as well as Indian ornaments for the Friendly Association. Syng's last recorded piece before retiring from the trade was a tankard (£14) made for Edward Shippen in 1771 (Lewis Burd Walker, "The Life of Margaret Shippen, Wife of Benedict Arnold," *PMHB*, vol. 24, no. 3, 1900, p. 266).

Philip and Elizabeth Syng had twenty-one children (Philip Syng Physick Conner, *Syng of Philadelphia*, Philadelphia, 1891). Their first son, Philip III, was baptized at Christ Church in January 1733 and appren-ticed with his father, but Philip III died in 1760. No records or silver pieces survive to determine if other Syng children became silversmiths.

Philip's brother, John, a goldsmith, was established in the family house and shop on Market Street; Philip was located on Front Street in a four-story brick house with a separate brick nursery and workshop. His property was insured by the Philadelphia Contributionship Insurance Company (Policy no. 5, July 4, 1752). He remained at this location until 1772, when he rented it to Richard Humphreys (see biography preceding no. 102), returning there in 1783. Syng owned several other properties: a house on King Street rented to a Mr. Aris; a home on the west side of Second Street rented to William Ghiselin, son of Cesar; and a house on the south side of Chestnut Street between Front and Second, all of which were insured by the Contributionship Insurance Company.

A letter from Thomas Potts to Benjamin Franklin, 1774, relates that "Good Mr. Philip Syng has retired into the country about ten miles from the city, where I frequently see him" (Charles R. Barker, "Colonial Taverns of Lower Merion," *PMHB*, vol. 52, no. 3, 1928, p. 215). Syng became a real if short-term farmer at his Prince-of-Wales Farm, hauling his grain to Charles Humphrey, miller, from 1778 to 1783. Why he sold the farm and returned to Philadelphia is not clear, but by 1785 he was located on the north side of Mulberry between Front and Second streets. He died in 1789 and was buried at Christ Church.

25. *Wine Cann*

c. 1726

Mark: PS (in shield three times under top rim next to handle)

Inscription: IN/to IL (engraved on bot-tom); oz/9 dwt/15 gr/12 (scratched on bottom)

Silver

Height 4³⁄₁₆″ (10.6 cm); width 4⅝″ (11.8 cm); diameter base 3⅛″ (8 cm), top 3⅛″ (8 cm)

Private Collection

PROVENANCE: Isaac Norris (1671–1735); James Logan (1674–1751); William Logan (1718–1776)

LITERATURE: PMA, *Silver*, no. 496; David Stockwell, "A 1757 Inventory of Silver," *Antiques*, vol. 69, no. 1 (January 1956), pp. 58–59

THE EARLIEST FORM of the cann, sometimes called a mug, was a small version of the tankard, but without a cover. Like the larger vessel, the cann was first made with straight sides tapering from a larger base to a molded rim, and was held by a proportionately large sweeping hollow handle. Francis Richardson, Jr. and Sr., made this early form in Philadelphia in 1728 and 1730, respectively (Fales, *Joseph Richardson*, figs. 6, 18); and it was made by John Coney in Boston and

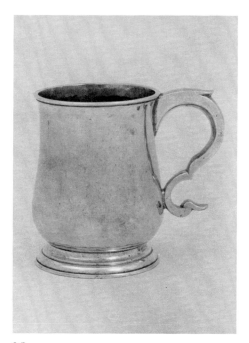

25.

Simeon Soumain in New York between 1710 and 1725 (Buhler and Hood, vol. 1, p. 38, vol. 2, p. 54).

From the outset, the cann was as popular as the tankard, and because of its lighter weight and commensurate lower cost, it was more abundant in supply and more widely distributed than the larger, prestigious tankard. The cann was made in varying sizes, often in pairs. The pint size (slightly over 5 inches high and weighing 11 to 15 ounces) was most common and was used for lesser amounts of the same cider and rum drinks which the tankard was designed to serve.

The half-pint cann, of which this is an example, was under 5 inches high and weighed between 8 and 10 ounces. Although it would be easy to conclude that this was merely the least expensive version, its size differentiation suggests more—the changes in drinking habits and attitudes toward home furnishings which created a demand for this diminutive vessel. The change was a natural outgrowth of the West Indies trade and the plethora of Philadelphia merchants engaged in shipping and trading there. Although the wealthy brewers of the first settlement probably commissioned the most plate in the form of tankards, wine, which had its own ritual, began to replace cider and beer. Glass was the preferred vessel, but it was rarer than silver before 1750 and its fragility precluded its purchase as an investment. Silver—fashioned especially to serve wine, and preferable to pewter or earthenware because it represented an inheritable and negotiable investment for heirs—well suited the purpose.

The seductive and curvaceous shapes of the rococo style, which made its appearance in English silver about 1725, did not come into full use in Philadelphia until 1740. The "bellied" shape of this cann, together with the broken C-scroll handle, the flared raised base, and matching flared rim show Philadelphia's "sturdy" interpretation of the rococo style at a very early date, shortly after Syng's return from London.

This wine cann was either presented to James Logan by Isaac Norris I or inherited by Logan when Norris died in 1735. The two men worked in close association for the Proprietary interests. Norris was mayor in 1725, a member of the Governor's Council for more than thirty years, and was named a trustee of the Province of Pennsylvania in William Penn's will. This cann does not appear on the inventory of plate belonging to Isaac Norris II in 1757; thus it may be assumed that it went directly to Logan from the elder Norris rather than as a present from Isaac Norris II, who had married Logan's daughter, Sarah, in 1739 (David Stockwell, "A 1757 Inventory of Silver," *Antiques,* vol. 69, no. 1, January 1956, p. 59). Of the eight items in this inventory made by the elder or younger Syng, two "Kans" were noted: one, "a small Kan (PS) bis . . . 6.2.0," and second, "a Larger D° [ditto] was fathers . . . 8.9.0." The latter, like this example, was marked PS three times under the rim; but the weights of each are different. However, their design and the number and position of marks punched on both canns suggest that they were ordered at about the same time. Too variant to be kept together as a pair, they were separated, one to Logan, one to Isaac Norris II. The mark PS in the shield is generally known as a Syng mark, but it is rare and thus difficult to assign to the elder or the younger Syng. Stockwell makes no comment about the mark, but if, as he suggests, this cann belongs to the work of the elder Syng (1679–1739), it would represent the earliest example of this rococo form in Philadelphia, since Syng, Sr., arrived in the city in 1712 and moved to Maryland in 1723. The motif enclosing the PS was unfortunately not mentioned in the Norris inventory, which might have supported the theory that the cann was fashioned by the elder Syng. It seems more likely, however, that it was the earliest mark of Philip Syng, Jr., who adopted it upon completion of his apprenticeship at the time his father moved to Annapolis.

BG □

JOHN KEARSLEY (1684–1772)

John Kearsley was born in England in 1684, immigrated to America in 1711, and in 1717, settled in Philadelphia, where he

was a practicing doctor. Before any formal medical training was available in the Colonies, he held clinics and teaching sessions for students aspiring to study at London or Edinburgh, and he contributed to the literature on yellow fever, smallpox, malaria, and other fevers "incidental to the Province" (*DAB*, vol. 9, p. 274). His scientific contributions in 1737–38 concerning the eclipse of the sun and observations of a comet were published in the *Transactions of the Royal Society* in 1741.

Kearsley took an active civic role in Philadelphia, serving on various committees, one for the issuance of paper money in 1722 and one in 1729 for the planning of a meetinghouse for the Provincial General Assembly, of which he was a member. He was concerned with several of the great buildings of the city, Christ Church, St. Peter's Church (no. 54), and the State House (no. 30). He married twice, first to Anne Magdalene, widow of Theophilus Caillé, and then, in 1748, to Margaret Brand. One child was born, but did not survive him; his nephew carried his name into a less glamorous public arena as a Tory, worthy of tarring and feathering in 1775 (Watson, *Annals,* vol. 2, p. 375). At his death in 1772, Kearsley founded and endowed the Christ Church Hospital, dedicated to the support of clergymen's widows and poor women within the communion of the Church of England.

ROBERT SMITH (1722–1777)

The parochial registers of Dalkeith, Scotland, include the following entry: "January 1722 John Smith and Martha Lawrie had a son born January 14th baptised called Robert. Witnesses Robert Lawrie and James Barrowman" (Dalkeith, Parish Registers). According to these records, Robert was the fourth son born to the family. His father, described as "baxter in Logton [Loughton]," died February 25, 1731. His mother, "spouse to the Deceased John Smith baxter," died October 4, 1765.

The eldest son, John (1716–1735), operated the family baking business until his untimely death, aged nineteen, when the family lost its primary source of support. Being a younger son, Robert was apprenticed outside the immediate family enterprise but within the extended family of Smiths working in the Dalkeith area. Both genealogical and building records in Dalkeith reveal a large family of Smiths working there as masons. From 1701 to 1710, James Smith, generally thought to be from Nairnshire, and who followed William Bruce as the most important architect in Scotland, was working at Dalkeith House for the Duchess of Buccleuch. Both extant

building accounts for that house and court records reveal cousins or uncles of Philadelphia's Robert Smith as "Robert Smith, elder, mason in Dalkeith aged 71 years or thereby; and Robert Smith, younger, mason in Dalkeith, aged 32 years or thereby" (Edinburgh, Scottish Records Office, GD 224/391), working for James Smith. Craft traditions of masons and carpenters were especially strong in Scotland and frequently the pride of the extended family. The name Smith carried connotations of building excellence, at least in the immediate area of Dalkeith and Edinburgh, where his family was known (APS, David Hall, Letter Book, August 1759).

In 1740, William Adam, successor to James Smith in Scottish architectural annals, was working at Dalkeith House. At that time, Robert Smith would have been eighteen and almost through his apprenticeship. Adam, whose domestic designs proliferated over the Midlothians, had also worked for the Hamilton family in Lanarkshire. Whether Robert Smith was actually one of Adam's team is not known, but it might not be a coincidence that the first certain date for Robert Smith in Philadelphia is 1749 (a year after Adam's death), when he worked for James Hamilton at Bush Hill on the Schuylkill north of the city.

The alternate possibility remains that Robert Smith had been in Philadelphia earlier, working as a journeyman with one of the masters at the State House, where Hamilton's carpenter, Ebenezer Tomlinson, was Edmund Woolley's righthand man. However, the scope of the work at Bush Hill, for which Hamilton paid Smith more than £562 between July 1749 and July 1751, exclusive of the accounts for other craftsmen and materials, would indicate a mature and experienced craftsman, whose name surely would have emerged earlier in Philadelphia annals had he been employed there (HSP, James Hamilton, Cash Book, 1739–57).

A close connection with the master masons of Scotland, especially those working near Edinburgh, would explain Robert Smith's extraordinary ability to produce adequate design as well as to supervise fine work. The fact that he owned his own copy of Campbell's *Vitruvius Britannicus* in Philadelphia by 1756, Batty Langley's more popular *Treasury of Designs,* which he purchased in 1751, as well as Isaac Ware's edition of *Palladio* by 1754, indicates a degree of sophistication and know-how based on a fruitful apprenticeship. It would also explain his obvious familiarity with the building vocabulary of well-known Scottish buildings, from the grand-scale seventeenth century designs of William Bruce and James Smith to the eighteenth century houses by William Adam. A firsthand knowledge of Adam's public buildings explains Robert

Smith's earliest large-scale designs for Nassau Hall at Princeton (1753–56) and later the design for the Walnut Street Jail (no. 98). Mount Pleasant of 1761–62 (in Fairmount Park), another building probably by Smith that is deeply indebted to Scottish prototypes, was built for Smith's volatile countryman and fellow member of the Masons and St. Andrew's Society, Captain John Macpherson (see Beatrice B. Garvan, "Mount Pleasant, a Scotch Anachronism at Philadelphia," *JSAH,* vol. 34, no. 4, December 1975).

Smith married Esther Jones, daughter of Samuel Jones, an Irishman who had settled in Chester County. Their certificates of removal, issued from the Sadbury Monthly Meeting and dated November 9, 1743 (HSP, GS, Philadelphia Monthly Meeting, Certificates of Removal, p. 166), indicate that Samuel Jones and his two children gave up farming after his wife's long illness and death and removed to Philadelphia. When Esther married Smith on December 23, 1749, she was read out of Meeting for "marrying outside." From 1757 through 1760, she was listed in "A Directory of Friends in Philadelphia, 1757–1760" on Lombard Street (*PMHB,* vol. 16, no. 2, 1892, p. 220), although the list does include "some few families not altogether in Unity." Elizabeth Drinker, who regularly visited among Friends, records: "Spent this afternoon with sister at Robert Smith's, Lombard Street . . ." (HSP, Elizabeth Drinker, Diary, April 21, 1760). Esther Smith had been reinstalled as a Friend, which allowed her to bury her husband in the Arch Street Meeting Burial Ground in February 1777.

Known as a carpenter, a builder, and, finally, as an architect, Smith enjoyed widespread patronage (see Charles C. Peterson, "Notes on Robert Smith," in *Historic Philadelphia,* pp. 119–23) and was probably Philadelphia's biggest "contractor." For, beside his building contracts, which chronologically must overlap, he was a member of the American Philosophical Society in 1769, a central figure in the affairs of the Carpenters' Company, a member of the Committee of Correspondence from the First Continental Congress in 1774, and designer-builder of the chevaux-de-frise in the Delaware River in 1777 and the Continental Army barracks at Billingsport, New Jersey. He invested in real estate in Princeton about the time he was building Nassau Hall, and he had his own speculative buildings located two miles south of Philadelphia, which turned into the inn called the "Sign of the Buck" (*Pennsylvania Gazette,* April 27, 1767). The variety of buildings reasonably attributed to Smith attest to his versatility. No architectural drawings for Philadelphia buildings by Smith have turned up thus far; however,

the sensitivity of his pencil is displayed in the caricatures he drew and signed of his friends Moses Levy, William Lewis, and William Rawle (Lewis, *Land Title,* illus. facing pp. 108, 112). He had prestige in his own time as a carpenter-architect, and his reputation is guaranteed by his buildings still in use today.

JOHN KEARSLEY AND ROBERT SMITH

26. *Christ Church*

Second Street, above Market Street
1727–44; steeple 1752–54
Brick structure; granite water table; stone detailing; wood trim; iron gates and railing
Height interior ceiling 47' (14.3 m); tower 28 x 28' (8.5 x 8.5 m); steeple height 196' (59.7 m)

REPRESENTED BY:
William Strickland (1788–1854)
Christ Church
1811
Oil on canvas
48 x 52" (122 x 132 cm)
Historical Society of Pennsylvania, Philadelphia

LITERATURE: Wise and Beidleman, *Colonial Architecture,* pp. 164–73; Shoemaker, "Christ Church," pp. 187–90, 193–98

"THEY ARE BRINGING the priest and the sword among us," shouted the Quakers when Joshua Carpenter, trustee for the Anglican community, sought ground for the first Christ Church in 1694. Carpenter secured land from a Quaker, Griffith Jones, later a city alderman (1702) and mayor (1704), close but not central to the developing hub of the city. The first church could not have been a wealthy parish, for the thirty-six founders who in 1696/97 signed a letter to Maryland's Governor Nicholson thanking him for his support of the Christ Church enterprise were not, with few exceptions, either community leaders or great merchants.

The first buildings of Christ Church and the Great Meeting (see no. 47) were begun at the same time and progressed at the same pace. Whereas the Quakers specified a large brick structure, the Anglicans chose or compromised with a small one of wood. Either economic considerations or the ready ability of their member and master carpenter John Harrison (see biography preceding no. 8) must have determined the material, for certainly brick was plentiful, as it was being produced in quantity by 1695 from clay mined and baked within the town limits. No descriptions of this earliest Christ

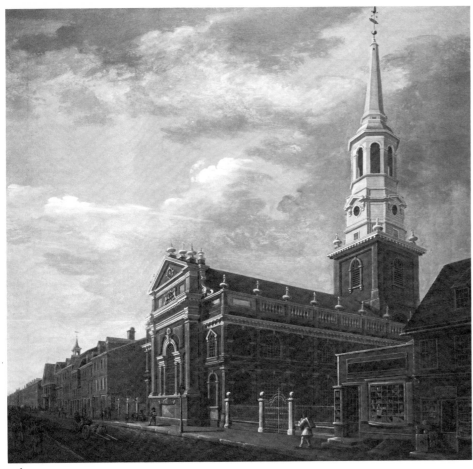

26.

Church exist, but one drawing, which is
said to depict it, shows a low, gambrel-roofed,
clapboard structure with deep overhanging
eaves (Horace M. Lippincott, *Early
Philadelphia, Its People, Life and Progress,*
Philadelphia, 1917, illus. p. 68), a feature
of early carpentry work in the city, repeated
at Joshua Carpenter's own house, for
example (Tatum, pl. 3).

By 1725, the church building had "become
ruinous and must shortly be rebuilt" (Peter
Evans to Lord Bishop of London, in Shoe-
maker, "Christ Church," p. 188). Although
records suggest that the building was added
to (Christ Church, Vestry Minutes, 1717–40),
this is unlikely, for the first church must
have been of wood construction, and brick
additions to a wooden church would have
been unsound building practice. By 1726, the
congregation had reached eight hundred
and had entirely outgrown the old church.
"It was therefore Resolved, by two several
Vestrys, in the Year Seventeen hundred
twenty Seven, that a sum of money, should
be raised by Subscription, for erecting a new,
more large, & comodious Building wch
goode design, wth much care and industry,
hath been carried on, the foundation of a
Steeple laid, & the Body of the new Church,

on the outside almost finished . . ." (Christ
Church, Subscription Book, May 7, 1739, in
Shoemaker, "Christ Church," p. 189).

The Reverend Evan Evans, sent to Christ
Church by the Society for the Propagation
of the Gospel in Foreign Parts in 1700, had
much to do with the expansion of the
congregation, which resulted in their new
and handsome brick church. A capable and
popular Welshman, who also preached
regularly to the parishes in Chester,
Chichester, Concord, and Radnor, he had
a special rapport among the Welsh tract
settlers and felt they were "not irrecoverable"
to the Church of England ("The Library,"
PMHB, vol. 69, no. 3, July 1945, p. 241).
It was Evans who in 1707 went to England
and returned with Queen Anne's gifts to
Christ Church, a flagon (see no. 14), paten,
chalice, and books, requested by the Colonials
as their prerogative from the Crown.

The rebuilding, begun in 1727, included
adding 33 feet to the west end of the old
church. Kearsley's summary of the enterprise,
written in 1760, said, "At your request I
herein send you the whole amount of the
Expense in Rebuilding and Finishing Christ
Church as it now stands viz The Expense
in Laying the Foundation of the Church and

Steeple from its Westermost Boundries
to the Second Column Eastward, Containing
2 windows and a Large Door on Each Side
with the windows at the End . . ." (Christ
Church, John Kearsley to Evan Morgan,
December 17, 1760, in Shoemaker, "Christ
Church," p. 190). The east end was also
brought into the scheme. Its end wall, which
includes the pediment, elaborate cornices,
three-part window, and high water-table
level, appears "pasted on," for none of its
architectural members are continuous with
those on the rest of the end wall and the sides
of the building. Rather, a pattern of applied
ornament, including the urns and the
scrolled corbels, makes the transition at the
roof line, and the solid paneled sections at
the east-end corners of the roof railing are a
visual warning that a change is coming.
The rest, lower down, is architecturally
confusing, as cornices do not match in level
or in detail. The three-part window is
delineated by brick pilasters supporting a
compound molded architrave, while the
pilasters between the side windows are
simply capped and meet a deep Doric
cornice which intersects the east-end wall
below the capitals or cornice at its corners.
This end was probably finished about 1735
and the tower at the west end completed,
except for its steeple, by 1739 (Christ Church,
Subscription Book, May 7, 1739).

The congregation continued to grow and
galleries were built on the interior in two
stages. Those at the west end were made of
"old Stuff and Rough ½ faced Boards" for
immediate use, but were finished to match
the whole with "Fluted Columns arches with
the architraves in the Body of the Ch the
Seats, as also the ornaments in the Chancell
also the Balustrade on the outside of the
Church . . ." (John Kearsley to Evan
Morgan, December 17, 1760, in Shoemaker,
"Christ Church," p. 190).

In 1750 another subscription for building
was undertaken, this to finish the steeple
and hang some bells. The Penns, by this
time Anglican rather than Quakers, pledged
£50 to the enterprise. Robert Smith, who
had just worked for James Hamilton at
Bush Hill, was commissioned to build the
steeple, and he and the carpenter John
Thornhill completed the project for £114
4s., which was "measured" and approved by
Edmund Woolley and John Harrison, Jr.,
on April 6, 1759 (Christ Church, Robert
Smith Folder, Drawer 26). Smith had to do
repairs in the summer of 1771 and was trying
to collect for them that August and Septem-
ber. His son, John Smith, working with him,
signed a receipt for £10 for part payment
on September 9. Eden Haydock had the
subcontract for sheet lead on the steeple roof.
The steeple, as painted by William Strickland
presumably faithful to Smith's original
design (except for the bishop's miter symbol

33

on the weather vane of c. 1787–94), is, with some exaggeration of its height, the same as in the Scull and Heap view (no. 46). But George Heap's prospectus for his view appeared in September 1752 (*Pennsylvania Gazette,* September 28, 1752), although Smith could barely have begun his work by that date. (His drawings, however, were probably available and must have looked like plate 44 in Biddle's *Young Carpenter's Assistant.*) Heap's vantage point shows the east-end wall halfway down into the balustrade level. Strickland's vantage point stresses the continuing importance of the building to the townscape while at the same time emphasizing the prosperity of the Anglican community.

As John Kearsley was charged with the responsibility of seeing the job done, and he wrote the summary accounting, he is generally given the credit for the design (see Shoemaker, "Christ Church," p. 190). The basilica design, with its high nave and low side aisles, can be found in several churches by Sir Christopher Wren—St. Andrew, Wardrobe, for one, built in 1692. John Kearsley, a well-educated, scientifically oriented man, was in correspondence with his English counterparts, such as Peter Collinson. He probably owned his own copy of James Gibbs's *Book of Architecture* (1728), or William Kent's *The Designs of Inigo Jones* (1727). The latter features the elaborate vocabulary found at Christ Church, including the recessed, blind brick windows and the pediments supported by wide, soft scrolls. However he could not have used Robert Smith's favorite, Batty Langley's *Treasury of Designs,* as a source for the design of Christ Church since it was not published until 1750; even Langley's first book of 1741 would have been too late for it. Kearsley's design concentrated on the facades of the church; less evidence exists for his development of the floor plan.

The carpenters are not individually recognized in extant building accounts, although nowhere in Philadelphia is the expertise of the master carpenter better exploited than at Christ Church. If the team of John Harrison, Jr., was responsible for this work, they would have been guided by their familiar sources, William Halfpenny's *Carpenter and Architect* (1724), or Moxon's *Mechanick Exercises* (any of several editions which appeared from 1677 on and were standard dictionaries for carpenters working in Wren's tradition).

The fabric of Christ Church is a compilation of pragmatism, design adaptation, craft traditions, and the educated skills of the gentleman architect, of which John Kearsley was a fine example. Until a Robert Smith developed the term "architect" to mean designer, engineer, and contractor, there was necessarily a close collaboration between a Kearsley and a Harrison, the latter responsible for alterations in the design affecting the weight of timbers, possible sizes of windows in proportion to wall surface, and, in some cases, the scale of ornament or its relative position. Although alterations have taken place on the interior of the church, the elevations remain true to the daring and independence of thought of Christ Church's building team.

BG □

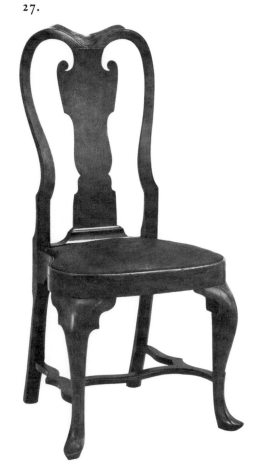

27.

27. Side Chair

1730–40
Inscription: II (incised on frame and slip seat); III (incised on inside back rail)
Walnut; cowhide slip seat (original)
40 x 19¾ x 19½″ (101.6 x 50.2 x 49.5 cm)
Philadelphia Museum of Art. Given by Mr. and Mrs. J. Welles Henderson.
73-259-1

PROVENANCE: Mrs. Rachel W. Bilderback; with Israel Sack; J. Welles Henderson
LITERATURE: Hornor, p. 194, pl. 302

THE PRIM RECTILINEAR SHAPES crafted by Philadelphia's earliest chairmakers went through several stages before reaching this curvilinear form known as a compass-bottom chair. Spiral twists, split balusters, and solid paneled backs were gradually replaced by stiles and splats which conformed to the curve of the human spine and were infinitely more comfortable than even the slat-back chair (see no. 24). Rush or plank seats were replaced by upholstery, and the loose, soft pillow was replaced by a padded seat covered with leather, as seen here, or textile. The earlier sharp-edged profile of the cabriole leg is here softened, even flattened, at the knee, and the curve of the leg continues without interruption to a slender pointed foot overlaid with a raised carved "tongue," an Irish detail. The straight line of the inside of the leg, together with the stretchers, indicates the reluctance of the early Philadelphia chairmaker to free the form entirely from traditional methods of structural security.

Changes abroad, manifested by an "easing" of forms, began in France in the seventeenth century, traveled to Holland and England, and subsequently to America. The shape of the stiles and splat on this example is related to contemporary Netherlandish examples (see Mario Praz, *An Illustrated History of Furnishing,* New York, 1964, pl. 122) with backs tall in proportion to legs and the sweeping curve of the stiles barely contained within the curve of the seat frame. A set of chairs owned by the Wister family (Hornor, pl. 306), and others with stretchers, indicates even more clearly the northern European origins of the design. The exact mate to this side chair at the Winterthur Museum (Downs, *American Furniture,* pl. 112) bears a partial inscription attesting to Shoemaker (Schumacher) ownership; that the two were once a set is obvious from the incised number on the inside back seat rail of this chair. The set was probably made for Benjamin Shoemaker (1704–1767), mayor of Philadelphia in 1753.

In the 1730s, Plunket Fleeson, an upholsterer familiar with New England fashion, stocked "Boston chairs," a rush- or leather-bottomed chair with a curved, upholstered splat and turned legs, which were made in his shop rather than imported, as was the custom. Nearby, Solomon Fussell and his apprentice, William Savery, were making slat-backs with "crook'd feet." Soon after, Fleeson advertised for sale a new style—the compass-bottom chair—and at least one was purchased from him by the acting governor of the province, Anthony Palmer (Hornor, p. 194). By 1750, these were known as "walnut compass chairs" (HSP, John Reynell, Ledger, 1745–67) and were sold in sets. Caspar Wistar's inventory of 1752 lists "6 Leather bottom Wallnut

Chairs" in his parlor, thus probably in the new style, while in the back room he had "6 Boston Chairs" (HSP, Wistar Papers, Caspar Wistar, Inventory, 1752).

Fleeson was born in Philadelphia in 1712. His first advertisement in the *Pennsylvania Gazette,* August 2–9, 1739, states, "lately from London and Dublin, at the Sign of the Easy Chair, near Mr. Hamilton's in Chestnut-Street...." It is not certain whether he went abroad to apprentice or whether he traveled upon completion of his training to obtain patterns. Although Fleeson was an upholsterer and did not make chair frames, he stated in 1744 that he had his own chairmakers working with walnut wood.

Located next door to Fleeson, and already an established chairmaker by 1728 when he took an apprentice (McElroy, "Furniture," pp. 176–77), Caleb Emlen (1699–1748) may have made chair frames for Fleeson in his shop. No precise record of Emlen's production has yet appeared. However, if the pragmatic Fleeson brought the latest designs from abroad in 1739, and Emlen fabricated the frames for him to upholster, it would explain the appearance of the sophisticated, well-developed cabriole form of this side chair, similar to that of an upholstered back stool (Hornor, pl. 308) and of an easy chair (Hornor, pl. 311) made for James Logan, where Fleeson's upholstery became preeminent. Emlen died in 1748, after which this particular style compass-bottom chair was not advertised. This, plus the scarcity of the model, suggests a short-lived production, corroborated by the fact that they are rarely mentioned in ledgers, advertisements, wills, and inventories. By midcentury, this compass-bottom form was replaced by a more ornate version with mahogany frames embellished with rococo carving.

BG □

BENJAMIN FRANKLIN (1705/6–1790)

Printer, inventor, scientist, writer, raconteur, politician, statesman, diplomat, and philosopher—the list of accomplishments of America's first Renaissance man seems endless. But it was Franklin's first profession as printer which throughout his life seemed to give him the most satisfaction. Born in Boston, one of the seventeen children of Josiah and Abiah Folger Franklin, he was educated at the Boston Grammar School and George Brownell's writing and arithmetic academy. As a child, Franklin worked in his father's soap and candle manufactory until apprenticed to his brother James, a printer of difficult temperament. After repeated quarrels, Benjamin struck out on his own for Philadelphia at the age of seventeen.

Arriving in October 1723, he found employment in the printing establishment of Samuel Keimer. Urged by Governor William Keith to establish his own press, Franklin left for London in 1724. Keith's promise of financial aid in the project evaporated, forcing Franklin to find work with English printers. Within two years, he was back in Philadelphia working again for Keimer. It was here that Franklin met George Webb (c. 1708–1731?), the author of *Batchelors-Hall.* A jolly ne'er-do-well with a talent for failure, Webb had run away from Oxford University to become an actor, and having failed at that, indentured himself for four years to a crimpman in return for passage to America.

When Webb arrived early in 1727, his contract was purchased by Keimer, an ill-tempered, disorganized scourge, who intended to use Webb as a compositor in his printing shop. Franklin was Keimer's foreman and thus Webb's superior and instructor in the printing art. In 1729, when Franklin struck off on his own in the printing business with another of Keimer's employees, Hugh Meredith, Webb stayed behind—but not for long. As Franklin delicately put it, he soon "found a Female Friend that lent him [money] to purchase his Time of Keimer" (Franklin, *Autobiography,* p. 119).

Free of his indenture, Webb offered himself as a journeyman printer to Franklin and Meredith, whereupon Franklin let slip his plans to start a newspaper in competition with William Bradford's *American Weekly Mercury.* Swearing Webb to secrecy, Franklin outlined his ideas for a paper far more lively and "newsy" than Bradford's ponderously dull *Mercury.* By promising future employment to Webb, Franklin thought his secret safe, but ever the opportunist, Webb took Franklin's plan to Keimer, who promptly published proposals for his own newspaper to be called *The Universal Instructor in all Arts and Sciences; and Pennsylvania Gazette.* It began actual publication on December 24, 1728, with Webb himself as editor.

The element of surprise gone, Franklin counterattacked in a most unusual way. He resolved to make Bradford's *American Weekly Mercury* so interesting that the *Universal Instructor* would fail; and to that end Franklin began a series of "entertainment pieces" called "The Busy-Body" which satirized the competition. He wrote only the first four numbers and part of two others in the series, with his friend Joseph Breintnall (see biography preceding no. 29) writing the rest. As Franklin had hoped, Keimer's newspaper failed and he offered to sell the paper to Franklin for a trifle. Franklin and Meredith assumed ownership on October 2, 1729, changed the name to

The Pennsylvania Gazette and within a short period had it on a paying basis. Franklin had lived up to his own maxim: He that can have patience, can have what he will.

Webb's fortunes declined following a brief success with his poem *Batchelors-Hall,* and after 1731 he seems to have vanished. Perhaps Webb was embarrassed by his poor treatment of Franklin and fled the Quaker city for points south, where vague references to a "George Webb printer" can be found. But it is not certain if this is the same man.

Sole proprietor of *The Pennsylvania Gazette* by 1730, Franklin prospered by hard work, frugality, an ability to make influential friends, a marked ability for self-advertisement and, above all, the freshness and charm of his writings. His *Poor Richard's Almanack* became very popular and made Franklin a household word throughout the Colonies and, in conjunction with his newspaper and state printing contracts, financially secure.

In 1748, Franklin formed a partnership agreement with his printing-house foreman, David Hall, and was free to turn his attention to the world of public affairs. Although he continued to oversee his various business ventures, the decade of the 1750s marked Franklin's metamorphosis from a "simple printer" to statesman, scientist, diplomat, and philosopher. Yet for all the later successes which won him fame and glory (see nos. 110b, 203), Franklin cherished most his early years as an artisan-printer in Philadelphia.

28. *Batchelors-Hall; A Poem.*

1731
By George Webb; printed by Benjamin Franklin

Folio pamphlet, 12 pages; imported paper; late nineteenth century red morocco quarter-leather binding

Type: Franklin double pica leaded, pp. 3–4, 7–12; Franklin English leaded, pp. 5–6

Watermark: Pro Patria / crown GR

12 x 7½ x 1/16" (30.4 x 19 x 2 cm)

American Philosophical Society, Philadelphia

PROVENANCE: James Hamilton (c. 1710–1783)

LITERATURE: [Elizabeth Magawley?], "The Wits and Poets of Pennsylvania, A Poem, Part I," *American Weekly Mercury,* no. 594 [no. 592], April 29, 1731; Evert A. and George L. Duyckinck, *Cyclopaedia of American Literature,* 2 vols. (New York, 1855), vol. 1, pp. 101–2; Scharf and Westcott, vol. 1, p. 232; Watson, *Annals,* vol. 1, pp. 432–43, vol. 3, p. 300;

28.

M. Katherine Jackson, *Outlines of the Literary History of Colonial Pennsylvania* (Lancaster, Pa., 1906), pp. 45–50; John Clyde Oswald, *Printing in the Americas* (New York, 1937), pp. 120, 281–82; Lawrence C. Wroth, *The Colonial Printer*, 2d rev. ed. (1938), reprint (Charlottesville, 1964), pp. 43–47, 59; Douglas C. McMurtrie, *A History of Printing in the United States . . . Vol. II. Middle & South Atlantic States* (New York, 1936), pp. 307–12; Tolles, *Meeting House*, pp. 137–38; Carl Bridenbaugh, *Cities in the Wilderness: Urban Life in America 1625–1742*, 2d ed. (New York, 1955), pp. 457–58; Franklin, *Autobiography*, pp. 108, 116–21, 300; C. William Miller, *Benjamin Franklin's Philadelphia Printing 1728–1766. A Descriptive Bibliography: Memoirs of the American Philosophical Society*, vol. 102 (Philadelphia, 1974), pp. vii–lxxi, 22

IN THE SUMMER of 1731, the Philadelphia Friends Meeting was becoming concerned that a dangerous tendency seemed to be loose among some of their young people. A group of wayward young Friends already sported at horse races and fox hunts, wagering on both and drinking to excess, and now a potential den of vice to attract still more young men was abuilding on the shores of the Delaware River north of Gunner's Run, just outside the city limits in the Northern Liberties (present-day Kensington). Worried that this would "prove to have a pernicious consequence," the Friends Meeting on July 31 appointed a committee to meet with the young Friends to dissuade them from continuing with the project. Of the ten or so involved, five were Quakers: Isaac and Charles Norris, Griffin Owen II, Thomas Masters, and Lloyd Zachary. But when confronted by the committee, the group replied that work was too far along on the square, one-room clubhouse to stop.

The defense of the original Batchelors Hall did not begin or end with the conference of the young Quakers and the delegation from the Monthly Meeting in the summer of 1731. Earlier in the year George Webb had taken up his pen to defend in verse that "proud Dome on Delaware's stream" against public criticism. "E. M." (Elizabeth Magawley?) characterized Webb's general talent as "like Bantoft's fam'd for the best Hack" (*American Weekly Mercury*, April 29, 1731). But "E. M." relented a little concerning *Batchelors-Hall*, admitting that "through the Piece Poetick Genius shines."

Webb acknowledged, as critics of the Hall had charged,

> Sometimes the all-inspiring bowl
> To laughter shall provoke and cheer the soul;
> The jocund tale to humor shall invite,
> And dedicate to wit a jovial night.

But he rejoindered many times in the course of his poetic defense that,

> 'Tis not a revel or lascivious night,
> That to this hall the Batchelors invite.

Rather the opposite was the true purpose of the club. "To mend the heart and cultivate the mind" were the bachelors' goals. Philosophy and natural science were discussed and a botanical garden was to be maintained for the study of the medical properties of various plants "whose virtues none, or none but Indians know." In short, rather than being a harmless diversion, Webb held Batchelors Hall to be an example of inquiring minds seeking a beneficial outlet and deserving of praise from the community, not censure.

As eighteenth century public defenses went, *Batchelors-Hall* was mildly amusing, reasonably argued, and blessedly short. To Webb's effort two other "bachelors," Jacob Taylor and Joseph Breintnall, added a poetical preface and verses to the author, respectively. The rather pedestrian nature of these additions can be seen in Breintnall's lines:

> Censorious Tongues, which nimbly move,
> Each vertuous Name to persecute,
> Thy Muse has taught the Truth to prove,
> And be to base Conjectures mute.

The propaganda value of the poem was somewhat limited, as it was printed as a gift book with Webb or one of the other participants underwriting the cost of publication. The March 25—April 1, 1731, announcement in the *Pennsylvania Gazette* specified that "but a small Number [were] printed, so that few will be left for Sale after the designed Presents are made by the Author." Apparently, few were left over since the advertisement appeared only once. Webb or whoever was paying for the publication of *Batchelors-Hall* never sought to influence public opinion at all, at least in the modern sense, but rather only those governmental and policy leaders responsible for the control of the public morals. This is demonstrated by the only known surviving copy, this example, which was a presentation copy to James Hamilton, son of Andrew Hamilton, later to be governor of Pennsylvania, and a potentially powerful ally in any difficulties which either Batchelors Hall or George Webb might encounter. This copy is inscribed, presumably by Webb, "Mr. J. Hamilton" on the title page, and with James Hamilton's signature and the date 1731 on page five.

Batchelors-Hall is worthy of notice not for its poetical merit but as a prime example of early American fine or special printing. Few Colonial printers displayed concern for the design of the object they were producing. As a result, most books and pamphlets possessed wordy and unattractive title pages with too many styles and sizes of type. The text was often a continuation of the defects of the title page and, if anything, more crowded. The overall poor quality of Colonial printing may be explained by the stringent general economic conditions prevailing and the dependence on foreign sources of supply for materials. Presses, type, and most of the ink and paper had to be imported from England. In particular, American printers could not afford the best or latest type faces and instead purchased used fonts or older and less costly castings. But the lack of duplicate fonts above all caused an often unattractive product because type faces were used long after they should have been replaced.

Franklin too faced these problems, yet he consistently turned out a better product than his fellow printers. As is readily apparent from the title page of *Batchelors-Hall*, Franklin had to use type that had worn unevenly or had become nicked and broken. This is particularly evident in the large type used to print the words A POEM. The lower hairline of the E has a break in it, and the M shows signs of wear, causing an uneven registration. In addition, the bodies of the C and H in BATCHELORS-HALL (set in French Canon No. 1) have nicks, and the capital E has a tilted lower arm.

Despite this, Franklin managed to create a clean, attractive title page with a spacious elegance uncommon in Philadelphia printing. The rules (lines) are unbroken and relatively straight, and the ornaments

both in choice and arrangement reflect Franklin's sense of design. By leading (expanding the amount of space between lines) the double pica and English fonts used in the body of the text, Franklin made it easy to read and pleasing to the eye. The overall effect of *Batchelors-Hall* is more than just a good piece of printing. It shows the hand of an artist.

For many reasons *Batchelors-Hall* deserves to be considered, if not superior to, then at least the equal of, Franklin's 1744 printing of James Logan's translation of Cicero's *Cato Major,* long considered his masterpiece. Working under more difficult circumstances, with inferior materials, and printing the poem of a man who had betrayed him, Franklin could have been forgiven for turning out a merely passable product. But he did not.

In addition, in the case of the *Cato Major,* Franklin had several English examples to guide him in designing the title page of his edition, if in fact he designed it at all, for when it was printed, Franklin already had moved to the front office and probably let his shopworkers do the basic design work. Undoubtedly he supervised the work, but in the case of *Batchelors-Hall* Franklin alone was responsible for the finished product. He had no previous edition to guide him, and it was his first piece of commissioned fine printing. He personally set the type, pulled the press, and folded the finished sheets. That his later work improved mainly in materials used and better type, proves how very good his first fine book really was. In fact, the Philadelphia tradition of fine printing was begun in 1731 with George Webb's *Batchelors-Hall.*

GM □

JOSEPH BREINTNALL (D. 1746)

Joseph Breintnall, like many of his contemporaries, was doomed by fate, a paucity of records, and the overshadowing presence of James Logan (see no. 12) and Benjamin Franklin (see no. 28) to be an also-ran in the quest for historical fame.

No large body of work has survived which might establish him as a major figure in America's early literary development, but enough remains of what probably was a sizable output to rate more than passing notice. He co-authored with Benjamin Franklin a series of humorous essays entitled "The Busy-Body," which ran in the *American Weekly Mercury* from February 4, 1728/29, to September 25, 1729. By Franklin's own reckoning he wrote only "the first four Numbers, part of No. 5, part of No. 8, the rest by J. Breintnall" (Labaree and others, *Franklin,* vol. 1, pp. 113–14). Witty, spirited, and often wickedly satirical,

"The Busy-Body" reveals Breintnall to be an above-average proseman.

But this poetic legacy has not fared so well. A contemporary critic, "E. M.," stated that, among Colonial poets,

> For choice of Diction, I would B___ret___nl choose,
> For just Conceptions and a ready Muse;
> Yet is that Muse too labor'd and prolox
> And seldom, on the Wing, knows where to fix.
> ([Elizabeth Magawley?], "The Wits and Poets of Pennsylvania, A Poem, Part I," *American Weekly Mercury,* April 29, 1731)

As a "public service" Breintnall also wrote the broadside verses which *Pennsylvania Gazette* apprentices and newsboys delivered to subscribers on New Year's Day to solicit tips. Breintnall had evidently been doing this a long time, for Jacob Taylor was requested by Joseph Rose, a printer in Franklin's shop in November 1741, to take over this chore as "Mr. Joseph Breintnall, their former Bard, is now so fatigued with business, that he can't perform his usual Kindnesses that way" (Rose to Taylor, November 11, 1741, in "Notes and Queries," *PMHB,* vol. 3, no. 1, 1879, pp. 114–15). Few examples of Breintnall's poetic efforts in this genre have survived, however.

With the exception of his prefatory "Verses to the Author" for George Webb's *Batchelors-Hall,* Breintnall's poetry was apparently unsigned and appeared mainly in newspapers and other ephemeral publications. J. Smith, in his *Descriptive Catalogue of Friend's Books* (London, 1867, vol. 1, pp. 69–70), attributes to Breintnall a verse in an obituary notice by the Quaker John Salkeld, published in the *American Weekly Mercury,* January 3, 1739. Such anonymous verses were common in Philadelphia newspapers of the 1730s and 1740s, and many similar efforts were undoubtedly also by Breintnall.

But no man, however talented, was able to support himself in Colonial America with his pen alone. Breintnall was a merchant early in his career. In August 1717, he applied to the Philadelphia Monthly Meeting for a certificate of good standing to take with him on a trading voyage to the Barbados, but it is not known if he ever made this journey. The English Quaker and scientist Peter Collinson knew him to be "an enterprising merchant," although like all who knew and mentioned Breintnall, he gave no specifics as to the nature of his business or his level of success (N. G. Brett-James, *The Life of Peter Collinson,* London, 1925, p. 125). Breintnall evidently owned property in Philadelphia, and his marriage to Esther Parker in the Philadelphia Meeting followed accepted Quaker

custom. He may have had a son, John, but this is not certain. His family life, education, and place of birth remain a mystery.

Breintnall was slightly more visible as a public servant. He served three consecutive terms as sheriff of Philadelphia County, from 1735 to 1738. Here, too, he probably would have escaped much notice but for the report of the Committee for Settling Corporation Accounts to the Common Council in the year following his death that no fines collected by the sheriff during his tenure had been remitted to the city coffers. The sum due the city, £84 11s., had to be written off as uncollectable.

Were it not for Benjamin Franklin, the most fascinating aspects of Breintnall's character might also have been unrecorded. Franklin described him as "a copyer of Deeds for the Scriveners; a good-natur'd friendly middle-ag'd man, a great lover of Poetry, reading all he could meet with, and writing some that was tolerable; very ingenious in many little nicknackeries, and of sensible conversation" (Franklin, *Autobiography,* p. 117). But this modest account overlooks the important role Breintnall played in Franklin's life.

As a copier of deeds, Breintnall worked for many Philadelphia scriveners. But he also designed the printed legal forms, "the correctest that ever appear'd among us," which were a large part of Franklin's stationery business when he opened his own shop in 1730. Breintnall also contributed to another of Franklin's profitable ventures— the ink business. Breintnall's special-formula ink became one of the five distinct types Franklin sold to great financial advantage during his early business career. Another of the "many little nicknackeries" Breintnall performed for the rising young Franklin was the design of a series of ciphers of lettering exercises which served to make Franklin's first and second American editions of George Fisher's *American Instructor,* 1748 and 1753, unique and salable. And it would appear that Breintnall was instrumental in steering part of the printing for the Philadelphia Monthly Meeting Franklin's way. In particular, Franklin credits Breintnall's intercession as the reason the fledgling Franklin and Meredith firm was awarded the lucrative contract to finish printing William Sewel's massive *History of the Rise, Increase and Progress of the Christian People called Quakers* (1728), underwritten by the Meeting.

Franklin repaid Breintnall's many kindnesses, at least in part, by satisfying two of Breintnall's passions—reading and sensible conversation. Breintnall became one of the founding members of the Junto, Franklin's discussion group. And later, in 1731, when Franklin founded the first public circulating subscription library in America,

The Library Company of Philadelphia, Breintnall was its first secretary. Peter Collinson, who became the London book agent for the Library Company, introduced Breintnall to the world of science through correspondence with him on library business. Breintnall bombarded the good-natured Collinson with his observations of various botanical subjects and several descriptions of American occurrences of the aurora borealis. Through Collinson's membership in the Royal Society, these descriptions and Breintnall's account of his survival of a rattlesnake bite were published in the Society's *Transactions*.

During the 1730s, Breintnall conducted two original experiments involving solar heat. The first demonstrated the difference in intensity of the sun's rays in winter and summer by melting lead with a convex burning glass secured from Collinson. His second showed that absorption and conduction of heat are a function of color. He first performed this experiment in 1730. Urged by Franklin (who had experimented along similar lines) to refine his procedure, he repeated it again in August 1737, using a greater variety of colored materials and carefully controlled circumstances. Breintnall must have had an inquiring intellect, for his interest in the relationship between color and heat stemmed from his observation that people in the Tropics favored white or light-colored clothing over dark.

Breintnall also demonstrated an interest in all aspects of botany, particularly in the methods and effects of grafting, about which he questioned Collinson repeatedly. Through Breintnall, Collinson established contact with the American botanist, William Bartram. Their letters contain many appreciative references to Breintnall and his efforts at specimen collection and preservation. But other than these oblique references and two volumes of leaf prints, we know little of his botanical efforts.

Historically, Breintnall perhaps performed his most important service as a contact, bringing together those more gifted than he, and by his ingenious "nicknackeries" which solved problems and generated profits for others.

29. *Nature Prints of Leaves*

1731–42
Folio volume, 130 pp.
Printer's ink on half sheets of heavy laid paper
Watermark: Pro Patria (probably from Benjamin Franklin's stock)
12³⁄₁₆ x 15³⁄₈″ (31 x 39 cm)

The Library Company of Philadelphia

29.

LITERATURE: LCP, Du Simitière Scraps, no. 20, "Note on the collection and preservation of leaves," n.d., Breintnall, probably to Collinson; Du Simitière Scraps, no. 33, June 1733; LCP, Minutes, vol. 1, pp. 150–51, May 5, 1746; Stephen Bloore, "Joseph Breintnall, First Secretary of the Library Company," *PMHB*, vol. 59, no. 1 (1953), pp. 42–56; "A World of Flowers: Paintings and Prints," *PMA Bulletin*, vol. 58, no. 277 (Spring 1963), pp. 236–42; Eric P. Newman, "Newly Discovered Franklin Invention: Nature Printing on Colonial and Continental Currency," *The Numismatist*, vol. 77 (February–May 1964), no. 2, pp. 147–54, no. 3, pp. 299–301, no. 4, pp. 457–65, no. 5, pp. 613–23; *Annual Report of the Library Company of Philadelphia for the Year 1969* (Philadelphia, 1970), pp. 35–36

OF ALL THE "BOOKS" printed in Philadelphia, none are quite so unique as Joseph Breintnall's two volumes of leaf prints. Not truly books at all, the leaf prints are a variegated lot of loose sheets with impressions of plant leaves on one and sometimes both sides of a sheet, all of which were bound during Breintnall's lifetime as a secure record of his output. Breintnall may have made other impressions of any given single sheet, but it is unlikely that he ever made another complete set, as the length of time required to complete the two volumes was nearly eleven years—1731 through mid-1742.

In his thorough study of the relationship between nature printing and Colonial currency, Eric P. Newman stated, "By 1733 he [Breintnall] listed prints of 127 species for sale" ("Newly Discovered Franklin Invention: Nature Printing on Colonial and Continental Currency," *The Numismatist*, vol. 77, no. 2, February 1964, pp. 152–53). Newman was probably referring to Breintnall's advertisement in Franklin's *Pennsylvania Gazette*, April 26, 1733, offering a reward for the return of a lost "sheet and a half of Prints of Leaves, being part of a compleat Set." The "set" referred to was not the completed two volumes but probably the 127 species which Breintnall sent to his friend Peter Collinson in October 1733.

In Breintnall's manuscript notations on the back and sides of the leaf prints, there is no mention of the prints being offered for sale; nor are they numbered, as one would expect had they been part of sets offered to the public. Instead, there are numerous notations, such as, "Done July 18th 1742 I impress'd 6 or 8 sheets more for my Fr[ien]ds. Kent, Bard, Pratt, Browne, Shoemaker &c." And, finally, no sale advertisements appeared in any Philadelphia newspapers during the period Breintnall

was actively leaf printing. Thus it would appear that scientific interest, friendship, and pleasure, rather than monetary gain, were his motives in practicing this most interesting and ingenious "nicknackery."

Breintnall's method of leaf printing was comparatively simple. Obtaining specimens from William Bartram's garden or from his own travels, he inked both sides of a leaf with regular printer's ink or a special concoction of his own devising, placed the leaf between a folded sheet of paper, and pulled it through a printing press. At first Breintnall evidently used borrowed equipment because the blank sides of some early sheets show faint traces of printing type transferred from the tympan of a full-sized printing press, probably one in Franklin's shop. By June 1734, Breintnall had his own press, probably a small engraving press, made especially for him. He apparently used it a great deal as it had to be repaired a number of times, for the thick, uneven leaves were hard on the platen and bed of such a small press.

Breintnall experimented with different methods of inking the leaf, using first a roller and then, in 1734, alternating the roller with a standard printer's leather ball. In the late 1730s he had a velvet inking ball made, which produced his best prints, showing the minutest details of the smallest leaf, feather, or cloth sample. Breintnall quickly learned that no single method of preparing the leaves for impression sufficed for all species. Small, veined, or delicate specimens had to be printed when freshly

Benjamin Franklin and David Hall
Twenty Shilling Note, 1756. Leaf print on paper
3½ x 2⅞" (8.9 x 7.3 cm). Courtesy
Historical Society of Pennsylvania, Philadelphia

picked or, if dried, resoaked in water to make them less brittle. Large, sappy leaves had first to be dried, usually under piles of newspaper or between the pages of a book, then lightly moistened with water, blotted, and finally inked. Breintnall dried one particulary soft and fleshy leaf for eight years before taking a print.

To conserve paper, he sometimes used scraps from Franklin's shop, blotting sheets from his own copying desk, or he folded the same sheet in threes or fours to print more than one leaf at a time. The largest number of leaf prints he appears to have pulled at one time was eight, but normally he printed one leaf at a time, even on sheets with several leaves.

Breintnall was not the first person to make a leaf or nature print. That honor may belong to Leonardo da Vinci, who included a nature print of a Salvia leaf in his *Codex Atlanticus* (1490–1515). Nature printing was made public knowledge in 1556 when Alexis of Piedmont (Girolamo Ruscelli) published instructions for taking prints of leaves in his famous "Book of Secrets." In William Warde's translation of that work, the instructions are listed under the heading "To counterfait all manner of Greene leaves which shall seeme naturall" (Alexis of Piedmont [Girolamo Ruscelli] *The Secretes of the Reverende Maister Alexis of Piedmount . . .*, translated . . . by William Warde, London, 1568, "the seconde parte," ff. 49, recto and verso). It is possible but unlikely that Breintnall took his inspiration from these instructions, for his contemporary, Isaac Norris II, had several editions of Alexis of Piedmont's book in his library.

Nor was Breintnall the first American to make a nature print. The Swedish botanist Carl Linnaeus stated that nature printing had been done in Pennsylvania by a man named Hesselius in 1707. But the painter Gustavus Hesselius (see biography preceding no. 20) did not arrive in Philadelphia until 1711. However, Francis Daniel Pastorius, scientist and mystic, who died in Philadelphia in 1719, made leaf prints in the margins of his copy of Michael Pexenfelder's *Apparatus Eruditionis* (Nuremberg, 1670), in the manner of the painted borders of fifteenth century Flemish manuscripts. Peter Kalm, who knew both Pastorius and Linnaeus, may have been the source of the basic information and the error in names that of a later transcriber.

Nevertheless, Breintnall's nature prints remain unique. It is possible that this amazing man independently reinvented the process of nature printing. And regardless of previous practitioners, Breintnall's leaf prints remain among the most beautiful and delicate ever made.

The technologically adroit Franklin discovered a method for making a type

metal cast of a leaf impression which he used in the printing of currency for New Jersey and Pennsylvania. He had mastered the technique by 1736 when a nature print of rattlesnake herb with explanatory text appeared on page four of his *Poor Richard's Almanack for the Year 1737*. Perhaps Breintnall had a hand in perfecting the technique, for when the type metal leaf print reappeared in 1739 on the back of Pennsylvania twenty shilling paper notes it was vastly improved. Later, a piece of cloth was included as a background in type metal nature prints (see illustration). The combination of the two textures made the money Franklin printed very difficult to counterfeit, which proved to be a major selling point, for he was awarded the Colonies' printing contract for paper currency year after year. That Breintnall was involved in this invention is apparent from examples in his leaf print books of his experiments in reproducing the texture of cloth or feathers as early as 1734. Again, Franklin had found a way to "make money" out of Breintnall's "nicknackeries"!

GM □

ANDREW HAMILTON (1676–1741)

Andrew Hamilton was a Scotsman born in 1676, not to be confused with Lieutenant-Governor Andrew Hamilton, who was appointed by William Penn in 1701 and died in 1703 (see Joshua Francis Fisher, "Andrew Hamilton, Esq., of Pennsylvania," *PMHB,* vol. 16, no. 1, 1892, pp. 1–27). Hamilton was attorney general of Pennsylvania by 1717, a job which he resigned in 1726 to make a trip to England. Upon his return in 1727, he was appointed prothonotary by Governor Gordon, and in 1728 and 1729 he was city recorder. In 1729 he, Thomas Laurence, and Dr. John Kearsley (see biography preceding no. 26) were appointed as a building committee for the State House, and in 1730 they were made trustees of the State House Fund, authorized to buy land for the new building (Scharf and Westcott, vol. 1, p. 206). Kearsley and Hamilton disagreed on both the location and the appearance of the State House as presented by Hamilton. The designs of the latter were backed by the Assembly in 1732, after which Kearsley's name continues to be listed as on the building committee, but his active involvement may have ended (Edward M. Riley, "The Independence Hall Group," in *Historic Philadelphia*, p. 11). Andrew Hamilton continued to arbitrate with the workmen and oversee construction until his death from yellow fever in the summer of 1741. He had been judge of the vice-admiralty in 1737 and speaker of the Assembly in 1739. He retired in that year and built Bush Hill, a country

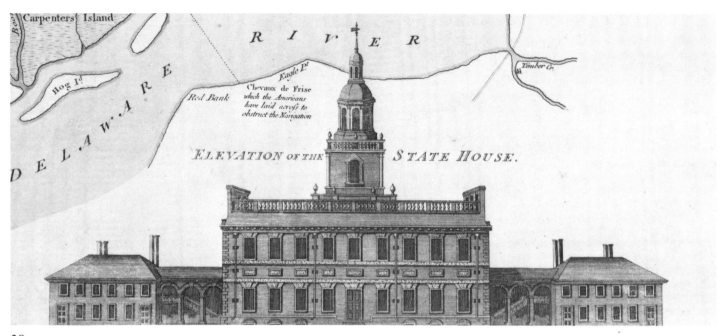

30.

place north of the city overlooking the meadows of the Schuylkill (shown on Varlé map, no. 143). His illustrious career as a Philadelphia lawyer is most celebrated for his brilliant defense of liberty of speech and the press in the case of John Peter Zenger, which he argued and won before the Supreme Court of New York in 1736.

Andrew Hamilton's son, James (1710–1783), inherited his city property on Chestnut Street at Third, and Bush Hill. Like his father, he followed a career in civic service, becoming mayor in 1745, lieutenant-governor in 1748, and governor in 1752.

EDMUND WOOLLEY (c. 1695–1771)

Edmund Woolley, carpenter, was born about 1695, probably in England, one of six children of Edmund Woolley, tailor, who arrived in Philadelphia before 1705. In that year, the family purchased property on the east side of Second Street adjoining Edmund's sister and brother-in-law, Cicely and Joshua Tittery (City Hall, Archives, Deed book EF 32, p. 131). No information concerning Woolley's apprenticeship has come to light, but he was admitted freeman of Philadelphia on April 22, 1717, upon payment of the fee of £1 12s. 6d. (*Minutes of Common Council, City of Philadelphia, 1704–1776*, Philadelphia, 1847, p. 25). He was not a founding member of the Carpenters' Company, but joined it later and was listed in the 1786 *Rule Book* as a deceased member. He married Mary, daughter of Robert and Grace Parsons, in 1764 (*Pennsylvania Archives*, 2d series, vol. 2,

p. 269). Mary Woolley died about 1757, and in 1760, Edmund married Sara, daughter of Richard Wright of Burlington, New Jersey, in St. Paul's Episcopal Church.

Edmund Woolley was employed at the State House by 1732, and was still working there, on the tower, in 1754 (HSP, Norris Papers, Miscellaneous Accounts, General Loan Office, 1750–56). He was also involved in numerous other building projects in Philadelphia—at the Charity School (*Pennsylvania Gazette,* January 11, 1741) and the Library Company (LCP, Minutes, 1739, vol. 1, p. 93), and as far away as Lancaster for Edward Shippen and James Hamilton. Thomas Nevell was apprenticed to Woolley (APS, Edward Shippen, Letter Books, January 1754), and was one of the young carpenters working with him on the State House; in 1781, Nevell made some repairs to the roof when the steeple was removed (*Pennsylvania Archives,* 1st series, vol. 9, pp. 46–47).

Edmund Woolley's will, written in 1760 and probated in 1771, specified that his books of architecture and his library of books other than those on architecture were to be sold, implying that he owned the necessary design resources for his trade. Unfortunately, the titles are not known, except for William Halfpenny's *Practical Architecture* (London, 1730), his copy of which is now in the Library Company of Philadelphia. However, details of the State House are traceable to James Gibbs's *Book of Architecture* and Campbell's *Vitruvius Britannicus,* both of which were then available to him at the Library Company (see

Helen Park, "A List of Architectural Books Available in America before the Revolution," *JSAH,* vol. 20, no. 3, October 1961, pp. 115–30).

In his will he designated that his children, Stephen and Mary, erect "a good brick wall 14 inches thick worked with Blue Headers on the outside and six feet in heighth to the top of the covering which shall be of good stone or shingles," to enclose a forty square

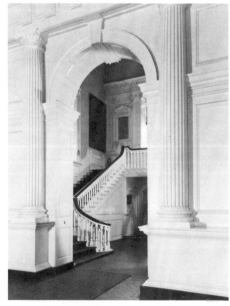

*Independence Hall. View from main hall into **tower** and stair*

40

foot family burial ground off his property on Magazine Street in the Northern Liberties (City Hall, Register of Wills, Will no. 103, 1771, p. 152). Jacob Hiltzheimer's Diary records: "June 23, 1771 Sunday Clear, in afternoon went to Church afterward, went to the Burial of Edmund Woolly Carpenter was Buried in to a Burying ground of his own near the Barracks" (HSP, Jacob Hiltzheimer, Diary).

ANDREW HAMILTON AND
EDMUND WOOLLEY

30. *The State House (Independence Hall)*

Chestnut Street, between Fifth and Sixth streets
1732–48; tower 1750–53; steeple 1828
Brick structure; granite detailing; wood trim; shingle
Main block, 104′ x 44′ 4″ (31.7 x 13.5 m); tower, 31′ x 39′ 3″ (9.4 x 12 m)

REPRESENTED BY:
Matthew Albert Lotter (1741–1810)
Elevation of the State House
From *A Plan of the City and Environs of Philadelphia*
1777
Engraving
32¼ x 26¼″ (81.9 x 66.6 cm)

Private Collection

PROVENANCE: Province and State of Pennsylvania, 1732–1818; City of Philadelphia, 1818–1951; National Park Service, 1951

LITERATURE: Harold Donaldson Eberlein and Cortlandt Van Dyke Hubbard, *Diary of Independence Hall* (Philadelphia, 1948); Charles E. Peterson, "Early Architects of Independence Hall," *JSAH*, vol. 11, no. 3 (October 1952), pp. 23–24; Edward M. Riley, "The Independence Hall Group," in *Historic Philadelphia*, pp. 7–42

CENTRALLY LOCATED among the English settlements in America, Philadelphia by the mid-eighteenth century was in effect, if not in fact, the capital of the Colonies. And at the center of operations of the midcentury city was the State House, designed in 1732 and still under construction in 1735, when it housed the first meeting of the Assembly. Work on the interior details dragged on until 1747–48, when the Council Chamber was finally completed (Edward M. Riley, "The Independence Hall Group," in *Historic Philadelphia*, p. 14). The engraved view at the bottom of Matthew Lotter's map of 1777, representing the "symbol of the age," presented to the European world America's most recent splendid public building, deleting any competing structures or

friendly neighbors like the wooden Indian sheds which appear in the view engraved about 1778 by Trenchard and published in the *Columbian Magazine* in 1790. The view shown on Lotter's map had appeared first at the top of the Scull and Heap map of 1750 and was repeated in the *Gentleman's Magazine,* September 1752, although the steeple was not yet in place (see no. 46).

The State House captured the imagination of artists and diarists who illustrated and discussed the building and the action within from various vantage points. John Lewis Krimmel's *Fourth of July,* painted in 1815 (Historical Society of Pennsylvania), shows it with flags flying as a backdrop for the spirited holiday celebrations. It continued to serve as a focal point for patriotic events, perhaps the most elaborate affair being Lafayette's visit in 1824 (see no. 218), when a triumphal arch eclipsed its facade, and for almost two hundred years the State House and its Liberty Bell have served as icons for Americans.

Andrew Hamilton, John Kearsley, and Thomas Laurence had been appointed in 1729 as a building committee, with Hamilton filling the role of overseer of the works, much as Kearsley had done at Christ Church (no. 26). The initial design concept of the State House, so different from other Philadelphia buildings of its day, must be attributed to Hamilton. It stands alone in its architectural style, especially considering that the original building was conceived not with the great tower, but with a small cupola designed simply to support a bell; in the earliest known drawing of the State House, an elevation and two plans from about 1832 (HSP, John Dickinson Papers), the cupola appears too small for the scale of the building and possibly was an afterthought added to the composition of the three structures. James Gibbs's *Book of Architecture* of 1728, especially plate 64 showing "A Draught done for a Gentleman in *Essex,*" has been referred to as the inspiration, if not the actual prototype, for the architecture of the State House. Other than the general conception of flanking depen-

dency buildings attached to the main block with colonnades, Gibbs's engraved buildings are nothing like the State House. Gibbs always used an odd number of bays across a facade, thus emphasizing the doorway, while the drawing for the State House shows each dependency with four bays, the two in the center being doors (as built, each dependency has six bays, the two end ones being doors). On the main building there are four windows on each side of the door, while Gibbs usually had three or five, again the emphasis being upon the satisfying symmetry achieved by "breaking the tie." In most cases, Gibbs gave his doorways distinction by framing them with classical orders or setting them forward in projecting bays, which was characteristic of almost all other important Philadelphia buildings and continued to be as long as such designers as Samuel Rhoads and Robert Smith built in the early Georgian tradition (see nos. 48, 85). The smooth, subtle surfaces of the State House do not reappear in Philadelphia architecture until the 1780s (see no. 122).

The secure, if redundant, rhythm of Sir Christopher Wren's smooth brick facades punctuated by white stone belt courses, window architraves, inset panels, roof balustrades, and chimneys strung across the gable end of flat roofs also describes the superficial but salient and most visible idiosyncrasies of the State House. Buckingham House in St. James Park, London, built by a follower of Wren (see illustration), looks more like Philadelphia's State House than any Gibbs building. Designed about 1703 by William Winde for the Duke of Buckingham, and engraved in *Vitruvius Britannicus* in 1715, Buckingham House was notable in its own time and influential in building throughout the eighteenth century. As Andrew Hamilton was a mature and successful man when he went to London, it is almost certain that he at least saw this renowned house, and although Bush Hill as Andrew Hamilton built it in 1739 is blurred for posterity by the additions of 1748, its smooth, even brick surfaces without quoining or projecting pediments

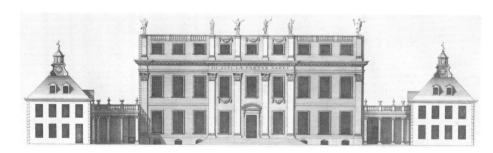

Elevation of Buckingham House, London, c. 1715, from Colen Campbell, Vitruvius Britannicus
Engraving, 9⅞ x 14⅞″ (25.1 x 37.8 cm)

exhibit a provincial domestic version of Wren's style. If, as is supposed, Hamilton had much to say about the setting and overall scheme of the State House, a distinguished London building would seem reasonable as a prototype for it. In scale with the State House, its facade extending 140 feet, Buckingham House has four bays on either side of the central doorway and is flanked by hip-roofed dependencies, each of four bays, connected by a short colonnade. The main unit has a third story with a balustrade hiding any roof behind it. The London building shows engaged Corinthian pilasters and swag decorations under and over important windows, which however are not used on the State House. Instead it features rectangular molded panels, an ornament favored by Wren and used at Emmanuel College, Cambridge (1667–73), and in designs for Hampton Court Palace (John Summerson, *Architecture in Britain, 1530 to 1830*, Baltimore, 1970, illus. p. 245), where the double belt course was also used.

The early drawing of the State House has traditionally been attributed to Andrew Hamilton. But a receipt dated 1735 submitted to John Penn's agent, James Steel, reads: "The Honourable John Penn Esquire Dr To drawing the Elivation of the Frount one End the Roof Balconey Chimneys and Torret of the State House With the fronts and Plans of the Two offiscis And Piazzas Allso the Plans of the first and Second floors of the State House. Edmund Woolley £5.0.0" (HSP, Penn Manuscripts, Accounts, vol. 1, p. 32). As this receipt describes the drawing precisely, it is accepted today as by Woolley rather than Hamilton. Thus Woolley together with his carpenter, Ebenezer Tomlinson, were the architect-builders of the State House, in charge of the numerous craftsmen employed on its construction. John Harrison, Jr. (see biography preceding no. 8), and John Shuter were carpenters; Daniel Jones, James Stoops, and Benjamin Fairman were chief bricklayers, assisted by Thomas Shoemaker, Robert Hinds, Thomas Pegler, Joseph Hitchcock, and Thomas Boude. The stonemasons included Jonathan Palmer, James Savage, and Thomas Redman. William Holland was the marble mason; Edward Palmer supplied lime; Thomas Kerr was the plasterer; Bryan Wilkinson and Samuel Harding were carvers. Thomas Ellis was the glazer, along with Thomas Godfrey, who was also the chief measurer. William Leach and Gustavus Hesselius were the painters, and Thomas Stretch built the large clock, which was to "strike on the Bell in the Tower."

The tower was built by Woolley in answer to the need for a better staircase; the stone foundation for the steeple was laid in 1750, and the upper work begun in the spring of 1751. The bell was ordered from England to be marked: "Proclaim Liberty Thro' all the Land to all the Inhabitants thereof—Levit.xxv.10." The *Pennsylvania Packet* carried the notice on June 7, 1753: "Last week was raised and fixed in the state house steeple, the new great bell, cast here by Pass and Stow, weighing 2080 pounds" The first bell ordered from England had cracked and had to be recast twice in Philadelphia. Within a few decades, the steeple decayed; it was removed in 1781, and the bell put in a small cupola in front of the brick tower, which had only a shallow roof with a sharp spire (see inset on Varlé map, no. 143). The steeple seen today was built by William Strickland (see biography preceding no. 202) in 1828, similar to the Woolley original.

The interior woodwork of the first floor is typical of the best large-scale work done in Philadelphia through 1765, and probably influenced the more pretentious domestic structures, for example, Mount Pleasant, Port Royal in Frankford (demolished), and Cliveden (no. 62). The main entrance hallway (see illustration) is highly ornamented with deep cornice moldings and shallow-keyed arched niches, which, in turn, frame pedimented arches ornamented with carved consoles and masks. Door and window frames have mitered corners in their architraves; deep, half-round, fluted Doric pilasters support the cornice from their bases on the dado molding.

The second-floor rooms, used for various committee purposes, and the long paneled banqueting hall reveal fine utilitarian joinery devoid of the splendid carved embellishments in the assembly or court chambers below. Woolley's carver was Samuel Harding, about whom little is known. He owned property by 1751 on the south side of Almond Street, which he left to Elizabeth Downey of Wicaco. He died in 1758 and was buried at Christ Church. Among the extant accounts for the State House are Harding's bills submitted to Isaac Norris: "To 53 Mundulyouns [modillions] in ye passage carved with three leaf grass 3 foot each . . . on each side of the door to two keystones for ditto frames with fases" (HSP, Norris Papers, Edmund Woolley's Accounts with the Province of Pennsylvania, 1750–56, Miscellaneous Accounts). Harding's stair balusters and his Ionic capitals (unusual in Philadelphia) on the Palladian window in the bell tower are grand in scale and strongly carved.

In 1830 the architect John Haviland (see biography preceding no. 215) set about restoring the interior of the State House to its Colonial character. Recently the Independence National Historical Park has continued this work, and their extensive records and reports are available for study.

Several paintings, especially John Trumbull's *Declaration of Independence* (Yale University Art Gallery) and Robert Edge Pine's *Signing of the Declaration of Independence* (Historical Society of Pennsylvania), offer early visual evidence for the restoration, of which the latter is the most accurate. Although the State House is the pivotal artifact of the emergence of America as an independent power, amazingly little is known about its golden age.

BG □

GUSTAVUS HESSELIUS (1682–1755)
(See biography preceding no. 20)

31. *Lapowinsa*

1735/37
Inscription: Lapowinsa (upper left)
Oil on canvas
33 x 25" (83.8 x 63.5 cm)
Historical Society of Pennsylvania, Philadelphia

PROVENANCE: Thomas Penn, London, c. 1737; descended in family to Granville Penn, London, by 1834

LITERATURE: HSP, Pennsylvania Journals, vol. 1 (1720–36), p. 162; HSP, *Catalogue of the Paintings . . .* (Philadelphia, 1872), no. 121 (attributed to Hesselius or Feke); William J. Buck, "Lappawinzo and Tishcohan," *PMHB*, vol. 7, no. 2 (1883), pp. 215–18; PMA, *Gustavus Hesselius, 1682–1755* (June 29—July 17, 1938), no. 8, pp. 11, 17, 23–24; HSP, *Catalogue of the Paintings and Miniatures . . .*, by William Sawitzky (Philadelphia, 1942), pp. 73–74; Flexner, *First Flowers*, pp. 96, 100, 350; Fleischer, "Hesselius," pp. 25, 60–65, 75–83, 195–97; Roland E. Fleischer, "Gustavus Hesselius: A Study of His Style," in Quimby, *Painting*, pp. 127–33, 136–37, 149, 156–57

JOHN AND THOMAS PENN, sons of William Penn, probably commissioned this portrait of *Lapowinsa* ("going away to gather food"), a chief of the Lenni-Lenape tribe, for, according to the Penn records, June 12, 1735, John Penn directed that £16 be "Paid on his Order to Hesselius the Painter" (Pennsylvania Journals, vol. 1, 1720–36, p. 162). The payment appears to be for this portrait, *Lapowinsa*, and that of another chief, *Tishcohan*, both having descended in the Penn family.

Lapowinsa and Tishcohan were Delaware Indian chiefs who, on May 9, 1735, tentatively agreed to the Walking Purchase treaty, concluded in 1737. To settle a land dispute, the Penn brothers suggested that the Colonists be granted only as much Indian land as could be walked across in 1½ days—about 25 miles by Indian standards. Unknown to the Indians, the Penns had already sold thousands of acres of the same

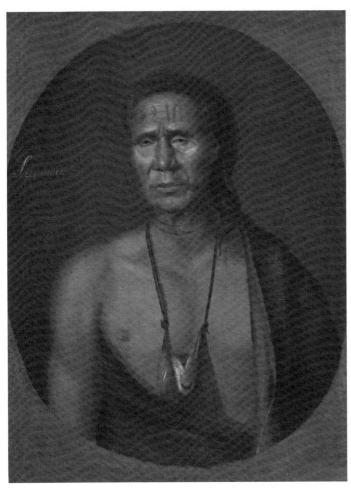

31.

land to William Allen and others as early as 1728; and when the day of the infamous "walk" arrived in 1737, the Penns used expert hikers and a carefully surveyed, predetermined route. The result was that the walkers averaged nearly 3¾ miles per hour and covered about 60 miles in the designated time.

Lapowinsa and Tishcohan seem to have been painted just after the Walking Purchase agreement and before the actual "walk." Fleischer believes that the portraits were commissioned by the Penns, possibly as a token of friendship with the Indians, and were even begun on May 9, 1735, in commemoration of the initial agreement ("Hesselius," p. 65).

Of the few paintings which can be assigned to Hesselius with some degree of certainty, the Indian portraits are by far his most sensitive and expressive. As Fleischer points out, Hesselius did not have a stylistic formula, as seen in the work of John Wollaston and Robert Feke, nor their hard and crisp linearity ("Hesselius," p. 180). Hesselius's portraits are more individualistic and the brushwork has the freedom and spontaneity often found in the European

baroque tradition. Lapowinsa's head, so sympathetically conceived, has the honesty and freshness of a portrait from life, whereas the smoother and more meticulous painting of the body suggests that it is a later and somewhat idealized addition by the artist. Hesselius's loose yet sensitive treatment seems to have produced a follower only in the work of Matthew Pratt (no. 65).

DE □

ELIZABETH HUDSON (1721–1783)

Elizabeth Hudson was born in 1721, the daughter of William and Jane Evans Hudson, and the granddaughter of William Hudson, a member of the Colonial Assembly and mayor of Philadelphia in 1725 and 1726. She was a "preacher" in the Society of Friends and in 1747, in the company of Jane Hoskins, made a religious visit to Quakers in England and Ireland. In 1752, at the age of thirty-one, Elizabeth became the second wife of Anthony Morris, a widower sixteen years her senior with six young children. Her husband, a brewer by trade, held several elective offices in Phila-

delphia, and was one of the signers of the Non-Importation Agreement in 1765. Elizabeth Hudson Morris survived Anthony Morris, and died in 1783 (see Moon, *Morris Family,* pp. 317–44).

32. *Sampler*

1737
Inscription: Elizabeh/Hudson/her/ Samplar/Workd in the 15 year/of her age 1737 (lower right corner)
Silk on linen canvas (gauze, 62 x 63)
15½ x 11¼" (39.4 x 28.6 cm)
Stitches: Satin, cross, outline, queen

Philadelphia Museum of Art. Purchased with funds given by the Robert L. McNeil, Jr., Trusts. 66–149–1

PROVENANCE: Elizabeth Hudson; descended in family to great-great-granddaughter, Elizabeth M. Keim

LITERATURE: PMA, *Samplers,* pp. 14, 16, fig. 26

IN THE SEVENTEENTH CENTURY, English samplers were made on a narrow width of linen cloth with bands of embroidered designs and needlework lace. They were used primarily as a record of needlework patterns and stitches for the decoration of borders of linens and clothing. By the eighteenth century, samplers more and more were made as an example of a young girl's skill with a needle, and played an important role in her education. Their shape became shorter and wider, and frequently they were framed for display.

This sampler, worked in 1737 by Elizabeth Hudson at the age of fifteen, is one of a group of samplers which all have very similar designs and inscriptions. The two earliest known, dated 1727, were made by Mary Morris and Ann Marsh (both in private collections). Others from this group were worked by Ann Robins in 1730, Sarah Howell in 1731 (Bolton and Coe, *American Samplers,* pp. 53, 72, pls. 60, 61), and M. Sandiford also in 1731 (private collection). These samplers are framed by a conventionalized border of Indian pinks (carnations). The horizontal cross borders are composed of serpentine arrangements of carnations, roses, irises, acorns, and strawberries, reminiscent of the types of designs found in English samplers in the seventeenth century. The leaves, buds, and flowers on Elizabeth Hudson's sampler reflect the growing influence of naturalism in the eighteenth century. Alternating with the cross borders are lines of verse from primers and devotional reading, which reflect the guarded religious education these girls received. The most common verse used in these samplers is an adaptation of Genesis 28:10–12 in which God's provident care of

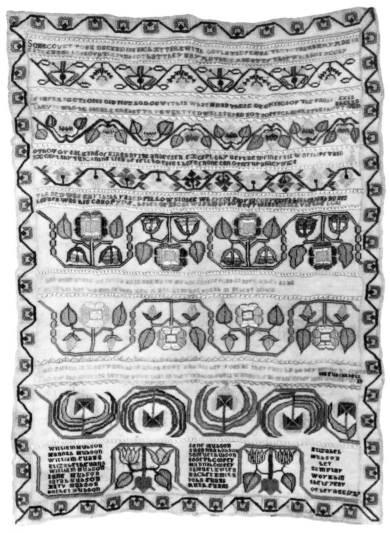

32.

Jacob is described. Elizabeth Hudson's text records the following verse:

Some covet to be decked in rich attire
with gould and pearl that others may
admir/Esteem and honour them and that
they may advance a beauty that will soon
decay/If imperfections did not lodge
within what mean these deckings of the
fading skin/They in whose noble breast
true vertue dwells need not so much adorn
their outwad shells/O Thou Great King
of Kings arise and reign except thy vertue
springs all worships vain/Except thy
quicaning life to be felt to rise theres none
can offer up a sacrifice/The bed was earth
the rased pillow stone whereon poor Jacob
rested his head and bones/Heaven was
his canopy the shades of night was his
drawn curtains to exclude the lght/This
poor state of Jacob as it seems to me his
cattle fond as soft a bed as he/Yet to his
joy his god is fond God is not always found
in beds of down/Tho Zion sit in misery
and do in ashes move and all her foes as
they pass by do her deride [. . .]d feard/

Tho like the spoiled turtle dove that in the
rock doth dwell wailing the absence of
her love whose evil no/Tongue can tell.

At the bottom of the samplers are family
names framed by a serpentine border. The
genealogical listing on Elizabeth Hudson's
sampler includes the names of her grand-
parents and parents, her brothers and sisters,
and her aunts and uncles, eighteen names in
all arranged within a tulip border design.

The similarity of these samplers suggests
that they must have been made in a school,
under the direction of one teacher. The
school was probably located near the homes
of Elizabeth Hudson and Mary Morris, who
lived in the vicinity of Chestnut and Walnut
streets between Front and Third. Since their
fathers, William Hudson and Anthony
Morris, were "Overseers of the Public School
founded in Philadelphia by the People of
God called Quakers" at the time of their
daughters' schooling, the school they
attended was probably approved by the
Society of Friends if not under their care
(Haverford College, Quaker Collection,

Penn Charter Papers, Box 14). Students from
other areas were attracted to this school as
well: Ann Marsh came from Worcester,
England; M. Sandiford came from Barbados;
and Sarah Howell from Chester,
Pennsylvania.

Samplers of this style continued to be
taught throughout the eighteenth century in
the Philadelphia area. Ann Marsh carried
on this tradition in her school in Philadelphia
from 1771 to 1788 and one of her students,
Sally Wister, worked such a sampler in 1773
(Albert Cook Meyers, ed., *Sally Wister's
Journal,* Philadelphia, 1902, p. 159). Ann
Tatnall, from Wilmington, worked a similar
sampler in 1786 (Bolton and Coe, *American
Samplers,* p. 78, pl. 61).

In 1683 the Provincial Assembly for the
colony of Pennsylvania declared that all
children were to be instructed in "reading
and writing; So that they may be able to
read the Scriptures"; at twelve they were to
be taught some "useful trade or skill"
(J. William Frost, *The Quaker Family in
Colonial America,* New York, 1973, p. 96).
In 1754 a girls' school, taught by Anthony
Benezet, was established in Philadelphia to
provide advanced education in "Reading
Writing, Arithmetic and English Grammar"
(Haverford College, Quaker Collection,
Minutes of the Overseers of the Public
Schools, April 25, 1754). Needlework was
not taught in this Quaker school but one of the
books used was *A Serious Call to a
Devout and Holy Life* (London, 1725).
In the chapter devoted to "the method of
educating our daughters," William Law
states that they should be brought up to "all
kinds of labour that are proper for women,
as sewing, knitting, spinning, and all other
parts of housewifery: not for their amuse-
ment, but that they may be serviceable to
themselves and others, and be saved from
those temptations which attend an idle
life" (p. 256).

SD □

PETER DAVID (1707–1755)

The minutes of the Common Council of
the City of New York carry the names of
several David families in 1701. Joshua David,
Sr., and Jr., were members of the French
Church. The twin sons, Josué (Joshua) and
Pierre (Peter), of Joshua, Jr., were baptized
in August 1691 (*Collections of the Huguenot
Society of America,* vol. 1, New York, 1886).
This Peter David married Marritje Kierstede
in 1711, but contrary to record, he was not
the Philadelphia silversmith.

A John David, Sr., and Jr., were listed as
"freeholders or freemen" in September 1701,
living and voting in the East Ward, but no
other vital statistics of that family have yet
emerged (*Minutes of the Common Council
of the City of New York,* 1675–1776, New

York, 1905, vol. 2, p. 173). But later genealogical evidence places the silversmith in this David family. The *Records of Indentures of Apprentices* in New York from 1718 to 1727 (New-York Historical Society, 1909, p. 166) carries the following entry "Registred for Mr. Peter Quintard, the 3rd day of October Anno Dom 1724/ Indenture of Peter David an infant of about fifteen years of agge and an orfen by and with the consent of John David and John Dupuy cherurguien to Peter Quintard, Goldsmith from June 12, 1722 for seven years."

This document was signed by Peter David, Jean David, and J. Dupuy in the presence of Elias Chardavoyne, Jr., and George Minson. These dates place Peter's birth in 1707, a fact confirmed by the record of his baptism in the Dutch Church, New York, that year. Peter Quintard, eight years David's senior, came as an infant from Bristol, England, and was baptized in the French Church in 1700. He registered as a freeman in 1731 and married Jean Ballereau. In 1735, Quintard advertised in the *New York Gazette*, "Goldsmith living near the new Dutch church in the City of New York"; Peter David may have stayed with Quintard until the latter moved to Norwalk, Connecticut, in 1737.

The first "official" date for Peter David's residence in Philadelphia is October 4, 1736, when his son, John, was baptized at Christ Church (HSP, GS, Christ Church, Baptisms, p. 357). His marriage to Jane (?) is not recorded in Philadelphia church records, nor does it appear in state records; thus, Peter David may have married in New York before moving to Philadelphia. Their daughter, Anne, was baptized on January 17, 1740, but died in July 1743. By this time, Peter David was actively engaged in Philadelphia's silver commerce, trading in 1739 with Joseph Richardson: "Peter David Dr . . . to 3 sett of Silver Buttons wt 7d—12Gr to fashion 03.0—[Pd.] By 3 pr of Small Studs . . ., By a pr of Small Sleave Buckels" (HSP, Joseph Richardson, Ledger, 1734–40). He was living on Second Street and renting his ground floor to Joseph Redmond who had a store there and was offering as "Just imported . . . a parsel of plate . . . , a choice collection of paintings, done by the most eminent hands, . . . spinnet hammers, . . . tin ware of all sorts . . ." (*Pennsylvania Gazette*, May 23, 1751).

Jane David died in September 1752 (HSP, Records of Christ Church, Burials). In January 1753, Peter David stood as godfather for Sarah Cox at Gloria Dei. In July 1753 he married Margaret Swanson Parham, widow of Sir John Parham (HSP, Records of Gloria Dei, Baptism and Marriages, 1750–89, vol. 1, pp. 14, 272). Their daughter, Jane, was baptized at Gloria Dei on April 23, 1754, but lived only to three

years (HSP, *A Record of the Inscriptions on the Tablets and Grave-Stones in the Burial Grounds of Christ Church*, 1864). At this time Peter David appeared on the list of taxables of Chestnut, Middle, and South wards (William Savery, "List of the Taxables of Chestnut, Middle, and South Wards, Philadelphia, 1754," *PMHB*, vol. 14, no. 4, 1890, p. 415). He died in 1755 and was buried from Christ Church.

An administration on his estate was issued as follows: "Know all men by these present that we Margaret David wid & Relict of Peter David late of Phila. Silversmith decd. David . . . of Philada aforesd Innholder and John David of ye same place Silversmith are held and firmly bound . . ." (City Hall, Register of Wills, Administration no. 21, 1755). It was traditional to grant innholding licenses to widows; thus Peter may have married the occupation when he married Margaret Parham, having turned over his silversmithing tools and equipment to his son, John, who had completed his apprenticeship. Margaret was one of the Swedish Swanson family who were bought out of their Southwark property by William Penn. A newspaper article of March 6, 1907, provided some clues to Margaret David's property—two large tracts of land near Wicacoe Avenue and Front Street in the "Neck." Margaret David, who needed money, "borrowed £100 or $500 on the property in question from John Stamper. This Mrs. David was a Miss Swanson. She was a woman of great force of character and business ability and so manipulated the property left by her father that she bequeathed a large fortune, for those days, to her heirs. The farms which she mortgaged to John Stamper were sold before her death to Joseph Wharton and in process of time came into the possession of the late William T. Elkinton and is now owned by his estate. According to Mrs. Parham, the remainder of Mrs. David's large holdings fell, by the death of two co-executors, into the hands of an unscrupulous trustee who calmly appropriated them" (HSP, Howard Edwards, comp., Supplement to an Essay on Original Land Titles in Philadelphia, vol. 3, Philadelphia, 1893, p. 154). Joseph Wharton's Ledger (HSP, 1736–93) carried accounts for Peter and Margaret David between 1753 and 1760. Margaret died in 1795; John David and his son, John, carried the name into the nineteenth century.

33. *Coffeepot*

1740

Mark: PD (in rectangle with curved right end, twice on each side of handle)

Inscription: SL/EF (on bottom)
Silver

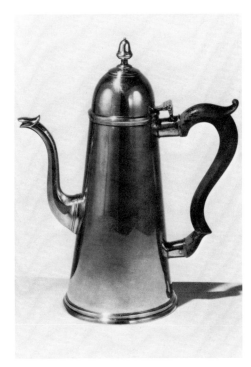

33.

Height 10¾" (27.3 cm); width 9⅛" (23.2 cm); diameter base 4¹³⁄₁₆" (12.2 cm)

Mr. and Mrs. Henry Cadwalader, York, Maine

LITERATURE: PMA, *Silver*, no. 68

TALL, STRAIGHT-SIDED, with a high domed lid and a faceted bird-neck spout, this type of pot, popular in New York for coffee or chocolate, may be unique in Philadelphia. The few known pieces of David's silver show more of his New York Huguenot training in form and decoration. This coffeepot and a small pear-shaped teapot (The Detroit Institute of Arts) probably owe their design to New York pieces by Jacob Gerritse Lansing, Peter Van Dyck, and Simeon Soumain, known to David during his New York years. This form, was also made before 1750 by provincial English smiths such as William Parry of Exeter, and it was a popular form in New England, made after English models by Zachariah Brigden and Jacob Hurd of Boston, to name but two. By midcentury in Philadelphia as well as London, the curvaceous rococo shapes (see nos. 44, 58) had replaced this straight-sided form.

Manuscript records confirming the provenance and date of this coffeepot have not yet emerged. The initials SL to EF probably record its presentation to Elizabeth Fisher, daughter of Thomas and Sarah Logan Fisher, by Sarah Read Logan (Mrs. James).

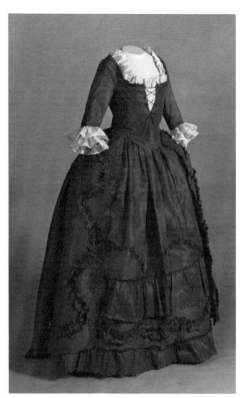

34.

A tankard made by Peter David about 1745 for William Faris, a Bristol-born watchmaker, who moved from Philadelphia to Annapolis, is in the bellied rococo form with a double scrolled handle. It is a typical midcentury Philadelphia piece fashioned some ten or more years after David's settlement in Philadelphia (Buhler and Hood, vol. 2, illus. p. 182).

BG □

34. *Dress*

1740–50
Dark-green taffeta; linen underdress with lace
Waist 27″ (68.6 cm); center back length 60″ (152.4 cm)
Philadelphia Museum of Art. Given by Mrs. Rodolphe Meyer de Schauensee and Mrs. James M. R. Sinkler in memory of Mrs. Lewis Audenreid. 50–28–3a, b

PROVENANCE: Williamina Wemyss Moore (1705–1784); descended in family to her great-great-great-granddaughters

LITERATURE: McClellan, *Costume,* p. 208, fig. 198

FOR MOST of the eighteenth century, dress styles remained fairly constant—wide skirts supported by panniers, split overskirts, three-quarter-length sleeves, and low décolletages —although the size and shape of panniers, fit of bodice, neckline, and manner of trimming varied greatly. This dress of dark-green taffeta has a bodice and overskirt seamed at the waist. The boned bodice, which ends in tabs, is very tight fitting and laced in front in a manner typical of the first half of the century; a stomacher, a stiff, richly ornamented busk, might have been worn under the lacing. The extremely low, rounded neckline reveals the linen under-dress, which is edged in a lace ruffle at the neckline and at the ends of the sleeves. Such an underdress, edged in lace at neckline and sleeves and revealed through the opening of the bodice, is seen in Robert Feke's 1749 portrait of *Margaret McCall* (no. 36). The skirt, trimmed with pinked ruchings along the front edge, is open wide to expose the full matching underskirt with its two tiers of pleats and ruchings above the hem.

This dress was worn by Williamina Wemyss Moore, born in Scotland, the daughter of the fourth Earl of Wemyss. Because of his espousal of the cause of the Pretender, he fled with his family to the Colonies in 1716. In 1722, Williamina married Judge William Moore, of Moore Hall, a two hundred acre tract on Pickering Creek in Charlestown Township, west of Philadelphia. Judge Moore was a member of the Pennsylvania Assembly (1733–40) and president of the County Courts of Chester (1741–76). Although a Tory, he continued to live at Moore Hall until his death in 1783. Williamina died a year later.

EMcG □

JOSEPH RICHARDSON, SR. (1711–1784)

Joseph Richardson was born September 17, 1711, in Philadelphia, the second son of Francis (see biography preceding no. 13) and Elizabeth Growden Richardson. He was trained by his father, and at the latter's death in 1729, he inherited his tools, shop, and trade. Although not officially through his apprenticeship at this time, close working relationships within the Richardson family must have encouraged independent work, and Joseph fell into his role with a self-confidence exhibited in his earliest pieces and which he passed on to his own sons, Joseph, Jr., and Nathaniel.

By 1735, Richardson, in association with his brother, Francis, Jr., was making teapots and coffeepots, salvers, and other objects for Stephen Armitt, whose brother Joseph purchased a gold locket and an "archt clock and case" in 1739 (Gillingham, "Cabinet-makers"). The production of these varied objects demonstrates that all phases of Richardson's work as a silversmith were encompassed from the outset of his career, even well before his first marriage to Hannah Worral in 1741. Hannah died in 1746/47 and on the "26th of the Twelfth month 1747, Joseph Richardson and Mary Allen declared their intentions of marriage with each other . . . her father Nathaniel Allen declared his consent," and with their appearance at the next Monthly Meeting, "They were permitted to consummate the same" (HSP, GS, Philadelphia Monthly Meeting Records, Minutes, vol. 3, 1730–85, pp. 161–62).

Joseph, Sr.'s, strong and sure craftsmanship dominated his design. While there were a few virtuoso pieces—the grand tea kettle and stand for Clement Plumstead, 1755 (Buhler and Hood, vol. 2, p. 189, illus. no. 843), the small snuffbox made for Mary Coates as a gift from Governor Dinwiddie, 1757 (Philadelphia Museum of Art), and this gold shoe buckle—Richardson's work as a whole exhibits superb craftsmanship and conservative design. Richardson died on October 4, 1784, and was buried in the Friends Burial Ground in a coffin made by William Savery (see biography preceding no. 40). His life and work have been well documented; the most recent study is the detailed work by Fales, *Joseph Richardson.*

35. *Shoe Buckle*

c. 1740–50
Mark: IR (joined capitals in oval on back of each end)
Gold
1⅞ x 1¹¹⁄₁₆″ (4.8 x 4.3 cm)
Yale University Art Gallery, New Haven. The Mabel Brady Garvan Collection

PROVENANCE: Charles G. Wade, Drexel Hill, Pennsylvania; Francis P. Garvan, New York

LITERATURE: S. W. Woodhouse, Jr., "American Craftsmanship in Gold," *Antiques,* vol. 20, July 1931, fig. 1; Buhler and Hood, vol. 2, no. 831

IN THE EIGHTEENTH CENTURY gold was used for personal adornment, if not so often as today, in the same forms and to be worn in the same places. Coats and vests featured gold buttons engraved with initials and ciphers; sleeves were held at the cuffs by gold links and shirts were fastened down the front with gold studs; necklaces were clasped with gold fittings engraved with flowers, baskets, and initials; and gold rings were plain, engraved, or fitted with stones. However, the gold shoe buckle is distinctly a relic of the eighteenth century. Vulnerable even if reserved for formal occasions, shoe buckles had a poor rate of survival, and this example in elaborate cast gold is rare if not unique. Evidence that shoe buckles were made and purchased appears in accounts and inventories, sometimes listed simply as "buckle." Because the form was used for belts, stocks, or neckpieces, as well as to fasten the leg gusset of men's knickers, the designation *shoe* buckle is necessary.

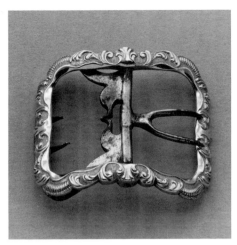

35.

Many portraits of men, especially those by the well-known portraitist Ralph Earl, show the variety of the buckle form. Silver or "paste" with brilliants were usual sartorial equipment, even necessary devices, for holding a gentleman together. The size and the shape of this gold buckle are typical of the type used decoratively on men's soft kidskin shoes or silk pumps worn for "dress" affairs or when receiving at home. Unlike today, in the first half of the eighteenth century, the most elaborate finery was not paraded to Meeting on First Day or to service at Christ Church.

This buckle, although small in scale, exhibits Joseph Richardson's supreme skills with the metal, the mechanics of the form, and the adaptation of rococo decoration to a narrow band or frame. The hinge, or chape, itself has a curved profile, and the "wishbone" prongs fastened to it are centered. The frame of the buckle, cast, then chased and polished to provide a contrast of surface textures, employs typical rococo ornamentation of shells and curled foliage and, at the corners, a rounded, tight gadroon which allows the outer profile of the buckle a softness commensurate with rococo surface treatment. Richardson used the same techniques to advantage on his grand tea kettle and stand, and on the snuffbox presented to Mary Coates by Governor Dinwiddie. This buckle may be the earliest representation of Joseph Richardson's mastery of rococo form and decoration.

BG □

ROBERT FEKE (C. 1707–PROBABLY 1751/52)

Presumably born in Oyster Bay, Long Island, Feke may well have been the son of a minister of the same name who was also a blacksmith. Feke's early life, shrouded in mystery, has provoked theories, for which

there is varying support, that he was a surveyor or a mariner before he became a full-time artist. His earliest portrait, inscribed with his name, appears to date from about 1731 and is a half-length of a child, more plastic in its use of light and shade than many of his later portraits. In 1741 he painted his most ambitious work, a group portrait of the family of Isaac Royall, Jr. Although Feke is considered self-taught, the group portrait reveals that he was influenced by John Smibert's more sophisticated portrait of Bishop Berkeley's family, painted about 1730, in two versions. Feke's style also reflects the stylized portraits of the early Hudson River painters, who based their compositions on mezzotints after portraits by English artists such as Sir Godrey Kneller and Peter Lely. From what can be substantiated, we know that Feke was in Newport, Rhode Island, from about 1742, either intermittently or full-time, until 1745. He visited Philadelphia in 1746 and again from the fall of 1749 until the spring of 1750. Between the two trips to Philadelphia, he can be traced to Newport again (1747) and to Boston (1748), where he painted some of his finest portraits. Feke returned to Newport by 1751 and perhaps died there.

36.

36. *Margaret McCall*

1749
Oil on canvas
49 x 39" (124.5 x 99.1 cm)
Dietrich Corporation, Reading, Pennsylvania

PROVENANCE: Samuel McCall?; daughter, Ann (McCall) Willing?; descended in family to Mrs. Charles Willing, until 1887; Judge J. I. Clark Hare, until 1905; estate of J. I. Clark Hare, until 1968; purchase, Dietrich Corporation, 1968

LITERATURE: PAFA, *Historical Portraits*, no. 471, p. 108 (as "Anonymous, *Miss Willing?*"); Henry Wilder Foote, *Robert Feke: Colonial Portrait Painter* (Cambridge, Mass., 1930), pp. 70, 92–93, 205–8; R. Peter Mooz, "New Clues to the Art of Robert Feke," *Antiques*, vol. 94, no. 5 (November 1968), pp. 702–7; PAFA, *Painting and Printing*, no. 8, p. 15; R. Peter Mooz, "Robert Feke: The Philadelphia Story," in Quimby, *Painting*, pp. 196, 200, 205–7

THE DATING and identification of this portrait are based on circumstantial evidence which, for lack of an alternative, should be accepted, but with recognition of a possible flaw.

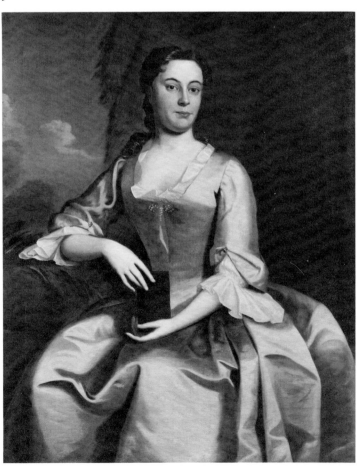

Essentially the date is based on the identification of the sitter while the identification of the sitter is based, to a disturbing degree, on the date.

What is known is that, according to Samuel McCall's Account Book (HSP, 1743–49, folio 349), on November 6, 1749, McCall paid Robert Feke £18 "on Accott of painting." The account number 146 is repeated consistently for entries which pertain to Margaret McCall, one of Samuel's sisters, which suggests that the payment was for a portrait of Margaret. Thus, if a portrait of Margaret could be found, it could be dated 1749. This portrait of an unknown woman was identified as Margaret McCall (1731–1804) because it was obviously by Feke, had descended in a family related to the McCalls, and the apparent age of the sitter was appropriate for 1749. The strongest supportive evidence is Mooz's belief that stylistically this portrait, as opposed to Feke's recently identified portraits of her sisters, belongs to Feke's second period in Philadelphia, 1749–50.

The seated pose and the position of the hands and book are derived from an English mezzotint by John Simon, of about 1705–10, after Jonathan Richardson. Feke reversed the pose so that the dependence on the engraving is not so obvious, and there must have been an intermediate source, for instance, a tracing in reverse from the engraving. The position and even the folds in the dress follow most closely Feke's portrait of *Mrs. William Bowdoin* done in Boston probably in 1748. Both are dependent, in reverse, on the engraving, but the Philadelphia portrait departs from it in the turn of the head. The *Margaret McCall* portrait is an especially attractive example of Feke's spare elegance and consciousness of edges, as well as his reliance upon mezzotints for his stock types of stiff but fashionable poses.

Although Feke's work is rather uneven, between his two trips to Philadelphia in 1746 and again in 1749–50, there appears to be a stylistic change toward a more sculptural treatment of the sitter and a more even paint surface, particularly noticeable in Feke's second portrait of *Tench Francis* (private collection) and *Mrs. William Peters* (Historical Society of Pennsylvania). It is the more sculptural style of this second visit which apparently most affected Benjamin West's early portraits.

DE □

JOHN HESSELIUS (1728–1778)

Probably born in Philadelphia, John Hesselius was the son of Gustavus (see biography preceding no. 20). The first documented reference to him occurs in 1739 when he bought paper for his father at Benjamin Franklin's shop. Ten years later, he paid for lessons at the Philadelphia Dancing Assembly. His earliest portraits show a strong influence, not from his father, but from the itinerant artists Robert Feke and, later, John Wollaston (see biographies preceding nos. 36, 43). In 1750–51, John Hesselius painted portraits in Virginia and Maryland. He then seems to have lived in Philadelphia for about three years before becoming an itinerant portrait painter in Virginia, Maryland, Delaware, and New Jersey. He returned to Philadelphia at the time of his father's death in 1755, but it was not until 1759 that he settled, this time permanently, in Anne Arundel County, Maryland. Although he married a wealthy widow there in 1763 and became a plantation owner, he continued to paint portraits until at least 1777. At the time of his death, Hesselius had accumulated what was then considered a fortune. He owned about nine hundred acres near Annapolis, not including his wife's farm, and thirty-one slaves. His final inventory lists, among his possessions, three violins, a harpsichord, flute, guitar, and chamber organ (inherited from Gustavus), indicating that he was also a musician (see Richard K. Doud, "John Hesselius, Maryland Limner," *Winterthur Portfolio 5,* 1969, pp. 129–53).

37. *Lynford Lardner*

1749

Signature: Jno Hesselius pinx (center right)

Inscription: Lynford Lardner AEtats 34/Jno Hesselius pinxt 1749 (on reverse under relining)

Oil on canvas

39¼ x 32″ (99.7 x 81.3 cm)

Private Collection

PROVENANCE: Lynford Lardner; descended in Lardner family

LITERATURE: Philadelphia, The Philip H. and A. S. W. Rosenbach Foundation Museum, Lynford Lardner, Account Book, 1748–51, p. 29; PAFA, *Exhibition of Portraits Presented by the National Society of the Colonial Dames of*

37.

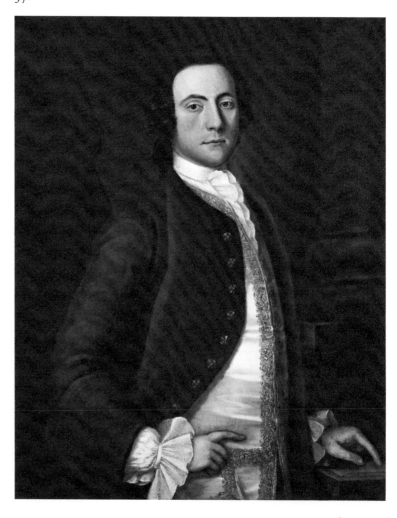

America . . . (December 8, 1958—January 11, 1959), no. 13 (attributed to Robert Feke); R. Peter Mooz, "Robert Feke: The Philadelphia Story," in Quimby, *Painting*, p. 211

JOHN HESSELIUS'S 1749 portrait of *Lynford Lardner* is published here with the correct attribution for the first time. The identity of the artist was discovered only when the portrait was cleaned and the old relining removed in 1973, revealing a signature on both sides of the original canvas. As Hesselius's earliest documented work, this portrait is of prime importance in any attempt to determine the Philadelphia origins of his style.

Lynford Lardner (1715–1774) acted as an attorney for Thomas and Richard Penn, handling their financial affairs in America while they were in England; and, from 1746 to 1752, he was Keeper of the Great Seal of the Province of Pennsylvania. According to his Account Book (Philadelphia, Rosenbach Foundation), he paid £6 to "John Hesselius for drawing my Picture" on January 18, 1749 (old calendar), evidently this portrait. On October 27, 1749, Lardner had married Elizabeth Branson and hired Robert Feke to paint wedding portraits, for, on November 15, 1749, he recorded: "Paid Phyke Face Painter for my own & Wife's Picture." Mooz has suggested, because of the price, that these lost portraits by Feke were half-lengths (in Quimby, *Painting*, p. 210).

A three-quarter-length portrait of Lardner's wife, smaller than this portrait of him and following a standard Feke pose, also survives and belongs to a descendant. It does not appear to be by Robert Feke, yet it is stylistically inconsistent with this portrait, being more painterly and more in the manner of Gustavus Hesselius. Some minor repainting in the face adds to the difficulty of determining its authorship. There are a number of surviving portraits that correspond to the style accepted as belonging to Gustavus, but the resemblance is not close enough for an attribution. In some cases, the portrait is tentatively assigned to his son as a very early work simply because the artistic relationship between father and son is still by no means clear.

Lynford Lardner is stylistically much closer to the work of Robert Feke (see no. 36) in its sharp definition of form than to the work of Gustavus. The Lardner portrait reveals that, by the age of twenty-one in 1749, John Hesselius was a much more accomplished artist than usually realized and was apparently influenced, even this early, by Robert Feke, who visited Philadelphia that year. Yet it is not an imitative work: The face, for instance, is more delicately painted than was usual with Feke, and the hands are different. Hesselius based the pose either on a mezzotint which, in this case, may be the 1693 engraving by John Smith after Godfrey Kneller's *Charles Montagu,* or possibly an intermediate portrait.

The close relationship between Feke's work and John Hesselius's early work has been noted before, such as in regard to Hesselius's signed and dated (1750) portrait of *Mrs. James Gordon,* painted in Virginia. There has even been speculation that Hesselius was Feke's pupil. The Feke influence prevailed until about 1758 when Hesselius adopted John Wollaston's way of modeling flesh and use of almond-shaped eyes as in Hesselius's portrait of the *Rev. Abraham Ketaltas.* Later, Hesselius, in turn, played a major though short-lived role in the development of Charles Willson Peale's early style, having been his first instructor in Maryland, c. 1762/63 (see Sellers, *Portraits and Miniatures,* p. 51).

Lynford Lardner is significant not only as Hesselius's first known work but as one of the few surviving Philadelphia paintings from this period. With so many pieces of the puzzle missing, the conclusions that can be drawn as to artistic influence are frustratingly few. Yet *Lynford Lardner* contains an unexpected suggestion that John Hesselius's influence in Philadelphia may be greater than has been believed. The portrait is remarkably similar to the early work of Benjamin West ten years later, particularly in the distinctive way in which the nose is drawn. This nose was to become less characteristic of Hesselius than of early West, where it becomes a mannerism, as seen in the portrait of *Jane Galloway* (no. 56).

DE □

ELIZABETH COATES PASCHALL (1702–1767)

Elizabeth Coates Paschall was the eldest daughter of Thomas and Beulah Jacques Coates. She was named executrix of her father's estate at age seventeen. In 1721 she married Joseph, son of Thomas and Margaret Jenkins Paschall. Her husband was elected to the Common Council of Philadelphia in 1732 and was a founder, along with Benjamin Franklin, of the first Volunteer Fire Company in 1736. When Joseph Paschall died in 1742, Elizabeth and her three children moved to a portion of the Frankford plantation acquired by Elizabeth's father in 1714. Purchasing acreage from her brother Samuel, Elizabeth built the country house Cedar Grove in 1748. Removed from its original site and re-erected in Fairmount Park, Cedar Grove and its entire contents were presented to the Philadelphia Museum of Art by Miss Lydia Thompson Morris in 1928.

38. *Canvas-work Chair Seat*

c. 1750
Wool and silk on linen canvas (23 x 27)
Stitch: Rice
15¹¹⁄₁₆ x 24¹³⁄₁₆″ (40 x 63 cm)

Philadelphia Museum of Art. Bequest of Lydia Thompson Morris. 32–45–128

PROVENANCE: Elizabeth Coates Paschall; descended in family to Lydia Thompson Morris

DURING THE EIGHTEENTH CENTURY, domestic decoration often depended upon the home-maker's facility with the needle. This chair

38.

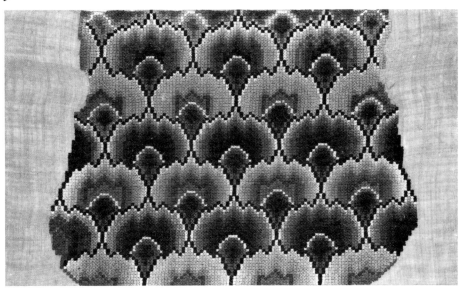

seat is embroidered in the rice stitch (crossed-corners stitch, William and Mary stitch), a variation of the basic cross stitch, and a suitable stitch for covering large areas of ground. Although known since medieval times, it does not appear to be particularly common, and the conventionalized carnation pattern of this chair seat is usually associated with the Irish stitch (see no. 39). The design is embroidered on a coarse, unbleached, plain-weave linen canvas in single-ply worsted yarn (crewel) in shades of yellow, gray, blue, purple, and red, and the pattern elements are highlighted in double strands of ecru silk.

Each pattern unit fans out to a maximum width of 4⅞ inches, or 29 stitches. The height of each carnation is 4⅝ inches, or 32 stitches. Each stitch covers four warp and four weft threads, resulting in a count of approximately 6 stitches per inch. The selvage, running along the sides, is composed of ten doubled warp threads on each side.

The excellent condition of this piece indicates that it was not much used. Very little color fading had occurred. The upright edges have been cut, however, and the sides of the ground show strain, evidence that it was probably blocked at one time. It may in fact, have been installed at Cedar Grove in the early nineteenth century; a matching chair seat, a fragment of which is also in the Museum's collection, was worked on a slightly larger canvas by Elizabeth Paschall's granddaughter, Sarah Paschall, who married Isaac Wistar Morris and inherited Cedar Grove.

PC □

39. *Needlework Bible Cover*

c. 1750
Wool worsted and silk on linen canvas (28 x 32)
Stitch: Irish
13¾ x 20¾″ (34.9 x 52.7 cm)
The Honorable Samuel W. Morris, Pottstown, Pennsylvania

PROVENANCE: Deborah or Anthony Morris, Jr.; descended in Morris family

LITERATURE: Schiffer, *Historical Needlework*, pp. 122–23

WHILE PROTECTING the fragile binding of its 1723 London Bible, a book that was expected to last through several generations, this needlework Bible cover also added a mark of creative individuality.

The elaborate and unusual cover pattern, worked in wool worsted in shades of green, yellow, and red, with accents of black worsted and ecru silk, is done on an extremely fine linen canvas, and features a

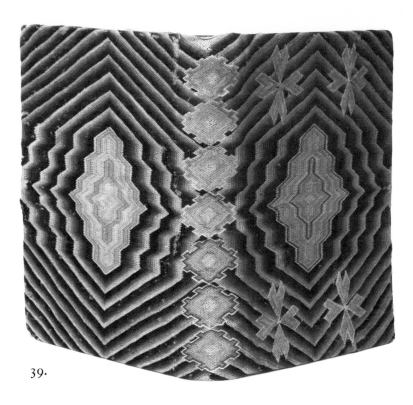

39.

medallion and cross design. The effective blending of color is typical of the patterns associated with the Irish (Florentine) stitch, as seen in the later needlework pocketbooks (no. 50). The term Irish stitch was used in the seventeenth, eighteenth and nineteenth centuries for the stitch now known broadly as Florentine—an upright stitch over four threads. Except for those of the vertical bars of the four crosses on the front of the Bible, the stitches of this example lie parallel to the top of the book; the bars are embroidered with stitches perpendicular to the others, creating a low relief in these elements of the pattern.

Although the earliest entry in the Bible itself is marked "1737" by Anthony Morris, Jr. (1705–1780), who married Elizabeth Hudson (see biography preceding no. 32), it is likely that the book had been previously owned by his unmarried sister, Deborah Morris (1723/4–1793). The probable provenance derives from the inscription, "Debrah Morris/Her Book" (title page); Anthony, Jr.'s, dated family records (back pages); and the subsequent inscription on the page following Deborah's inscription, "The Gift of Anthony Morris Jun. to his Son/Samuel Morris Jun. in June 1756." It is interesting to note that a similar edition of this Bible was given to Anthony, Jr., and Deborah Morris's brother, Samuel (Sr.), by their father, also Anthony Morris.

The cover was probably an early addition. Its design, as well as the fineness of its materials, suggests that it may, in fact, have been worked before 1750 by Deborah Morris or by Anthony's first wife Sarah Powel Morris (1713–1751).

PC □

WILLIAM SAVERY (1721/22–1787)

Nothing is known of William Savery's early years except that he was born in 1721/22. He was apprenticed in Philadelphia to Solomon Fussell, probably from 1735 to 1741 (Winterthur Museum, John Wister, Receipt Book, 1736–45), where he learned the art of chairmaking and some cabinetry. In 1750 he called himself a "chairmaker," and his shop was located on Second Street between Chestnut and Market. In 1745 he was a member of the Fellowship Fire Company, and in 1757 he was one of the keepers of the keys for the engine stationed in the yard of the Greater Meeting at Second and Market streets. Benjamin Franklin appointed him a ward assessor in 1754; in 1756 he was a supporter of the Friendly Association (HSP, Parrish Collection, Pemberton Papers, Friendly Association Minutes, 1756).

Savery and Mary Peters came before the Society of Friends to marry on May 30, 1746. Throughout his life Savery was an active Friend and, consequently, was patronized by that group. From 1765 to 1769, John Pemberton paid him £74 18s. 8d.; the Drinkers and Abel and Rebecca Chalkley James maintained accounts with him as well.

Dr. Phineas Bond and John Wilson also purchased from him (Gillingham, "Cabinet-makers").

On January 30, 1772, Elizabeth Drinker wrote: "This Morn'g about 7 o'Clock a fire broke out at Thos. West in second Street which communicated to those of John Wallace, one Smith next door, and to W^m Saverys—the Roofs and upper Appartments of those 4 Houses, with a great quantity of Furniture & Merchandise were consumed" (HSP, Elizabeth Drinker, Diary, vol. 1, January 30, 1772). Savery must have rebuilt, probably without the benefit of insurance as he does not appear in Contributionship Insurance or Mutual Assurance company records of policyholders before that date, but he did apply to the Contributionship in October of that year for £350 insurance (Philadelphia, Contributionship Insurance Company, Minutes, October 6, 1772). His rebuilding most likely was complete then, for he offered space to Joshua Brooks "just arrived from England, with a neat assortment of Forest cloths . . ." (*Pennsylvania Packet,* October 26, 1772). At this time he was working for John Cadwalader, as were Thomas Affleck and Benjamin Randolph, and in 1773, Savery supplied Cadwalader with furniture for his plantation in Shrewsbury, New Jersey.

William Savery's will and inventory probably reveal more about him than most other extant documents (City Hall, Register of Wills, Will no. 310, 1787). He died in 1787, leaving his wife, Mary; sons, Thomas and William; and daughters, Ann Poultney and Elizabeth. He had been prosperous enough to own some plate—two silver porringers and a pint cann worth £12. His eight-day repeating clock was a favorite possession, which he left to his son William who had apprenticed in Goshen, Chester County, in 1764 and returned a "tanner" in 1771. Savery owned stock, and debts were owed to him, suggesting a continuing business activity.

He had remained at his house on the east side of Second Street near Market Street all his life and his shop was integral with it. His house must have been comfortable, but not elegant. His important furniture was of maple according to his preference. There were some walnut pieces, and some which were not specified, such as the beds which were low-posted, therefore plain and probably painted, mere frames for the feather beds and bolsters worth £8 compared to £1 for a bed frame. The shop inventory was longer than the household one and included his tools, from planes to presses and lathes; unworked planks; unfinished tables; parts of chairs; and a few finished pieces, among them, card tables, tea tables, dining tables, and a high-post bedstead.

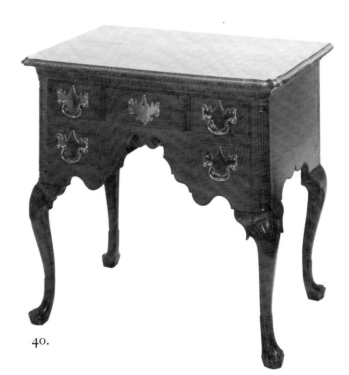

40.

40. *Dressing Table*

c. 1750
Figured curly maple; pine, poplar, and cedar; brass hardware
30¼ x 33¼ x 19¾″ (76.8 x 84.5 x 50.2 cm)
Private Collection

PROVENANCE: Dirck and Margaret Johnson [Jansen]; John (d. 1810) and Rachel (Livezey) Johnson; Samuel Johnson (d. 1847); son and daughter, Samuel and Elizabeth (d. 1905) Johnson; nephew, Samuel Johnson (d. 1920); Women's Club of Germantown (1920); purchased from Johnson estate sale (1930s) by Johnson descendant

MAPLE, A PLENTIFUL AND POPULAR WOOD, was used extensively by Philadelphia craftsmen in the manufacture of tables, chairs (see no. 24), and daybeds. Although hard, finely grained, and thus difficult to work and turn, maple rewarded the craftsman's skills with crisp, clear outlines, sharp incised lines which did not rub away with time, and exceedingly strong forms. Maple took a high shine and held it and was especially colorful and bold when the curly or "tiger stripe" grain was emphasized. According to Peter Kalm, writing in 1748, "the Joiners say that among the trees of this country they chiefly use the wild cherry trees, and the curled maple. . . . a species of the common red maple, but likewise very difficult to be got. You may cut down many trees without finding the wood which you want."

Family tradition attributes this dressing table to William Savery, who apprenticed with Solomon Fussell. Most of their accounts list maple as the primary raw material. Not all cabinetmakers worked with it, however; walnut and later mahogany were preferred because they were more easily carved and thus more desirable when surface embellishment became the fashion.

This dressing table exhibits several features which have been identified as Savery's through comparison with his labeled pieces. The most apparent is the graceful "lift" at the center of the skirt which then drops into the anchor-shaped fillip. The edges of the skirt are finely traced with an uninterrupted, scored line, similar to ones seen on maple chair stiles in Savery's earliest working period (see Downs, *American Furniture,* pl. 110). The drawer organization is also Savery's. Instead of the more usual Philadelphia arrangement of one long horizontal drawer above and three below, Savery preferred three drawers across the top and two below on either side of the knee space (see S. W. Woodhouse, Jr., "Philadelphia Cabinetmakers," *PMA Bulletin,* vol. 20, no. 91, January 1925, illus. facing p. 62). This dressing table follows Savery's preferred design while at the same time adjusting to local preference for a single top drawer: Savery visually divides the drawer into three units by carving out spaces to form the three raised panels.

Savery not only worked with maple, but preferred it in his own furnishings. His inventory taken in 1787 by Daniel Trotter and Jesse Williams featured "6 maple chairs and 1 arm chair @ £4.0.0. . . . a maple chest of Drawers £5.0.0. . . . and a D° dressing table £1.10.0." The only single furniture

items of greater value were, characteristically, the bed furniture, feather bolsters, pillow and mattress, and a mahogany desk valued at £7 10s. (City Hall, Register of Wills, Will no. 310, 1787). However, in the extensive inventory of unfinished pieces in his shop, mahogany, walnut, poplar, gum, and red cedar planks appear, but not maple, suggesting that this wood was out of fashion by 1787 in Philadelphia, superseded by the demand for inlaid decoration of satin, holly, and olive woods in mahogany cases. Nor does Savery's inventory list carver's tools; rather "a lott of chair makers tools . . . 33 moulding plains . . . 9 smoking plains, one plow and one groving . . . 2 pannel saws, 3 tennon, one sash . . . 1 joiner's screw cramp . . . 6 slatt Racks . . . 2 framing benches . . . a lott of slats lists and nails for Rush bottom chairs . . . 2 turning lathes" reveal that Savery was primarily a joiner. Whether only a joiner or whether carving was also a skill he acquired is unknown, but whoever created the shells on the knees of this dressing table, echoing their superb deep scalloped shape with matching feet, had a faultless sense of proportion and design and a sure hand, unexcelled and even unmatched on other Philadelphia pieces of the period.

The Johnson family (see no. 22), who owned this piece, were tanners located in Germantown. John Johnson, who married Rachel Livezey in 1769, frequently did business in Philadelphia. Samuel Powel's accounts list numerous repairs made by Johnson to Powel's chariot, phaeton, harnesses, and so forth, from 1768 through 1771. Johnson was executor to Anthony Duché's Southwark estate in 1772 where he was identified as "John Johnson G'town Sadler" ("Notes and Queries," *PMHB,* vol. 12, no. 4, 1888, p. 486). Thomas Livezey, Johnson's father-in-law, was a versatile and well-read man and an intimate friend of Joseph Galloway. Solomon Fussell and Savery were founding members of the Union Library Company in 1746 (incorporated with the Library Company of Philadelphia, 1768–69), and a Germantown library association used John Johnson's house for their meetings. These Germantown/Philadelphia contacts, however indirect, support a Philadelphia-made attribution for many Germantown-owned pieces. Savery was still apprenticed to Fussell in 1741 when John Wister, who was to build Grumble-thorpe in Germantown in 1744, purchased pieces from them (Winterthur Museum, John Wister, Receipt Book, 1736–45). A set of maple-framed rush-seated chairs with "spoon backs," cabriole legs with champfered corners, "crook'd feet," and turned stretchers, all Savery characteristics, descended in the Johnson family with this dressing table.

BG □

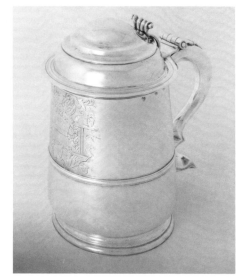

41.

PHILIP SYNG, JR. (1703–1789)
(See biography preceding no. 25)

41. *Tankard*

c. 1750

Mark: PS (in heart three times under lip to left of handle)

Inscription: Given to S. B. Collet/1837 (on bottom, later inscription); 46 oz 6 dwt (scratched on bottom)

Silver

Height 8⅝″ (21.9 cm); diameter lip 5⅛″ (13.0 cm), base 5¼″ (13.3 cm)

Yale University Art Gallery, New Haven. The Mabel Brady Garvan Collection

PROVENANCE: Joshua Maddox; Mary (Maddox) Wallace; Joshua Maddox Wallace; John Bradford Wallace; Susanna (Wallace) Collett; John William Wallace; Rebecca (Wallace) Spencer (Mrs. John Thompson Spencer); Francis P. Garvan

LITERATURE: PMA, *Silver,* illus. no. 548; John Marshall Phillips, *Early American Silver Selected from the Mabel Brady Garvan Collection at Yale University,* New Haven, 1960, illus. no. 21; Buhler and Hood, vol. 2, pp. 178–81, illus. no. 825

THIS GRAND AND CAPACIOUS TANKARD is the culmination of Philip Syng, Jr.'s, work for Joshua Maddox (1687–1759). Although there is no record that this tankard was a presentation piece, its unusual form and ceremonial scale suggest that possibility. The splendid engraved coat of arms shows a much more sophisticated design than on an earlier cann made by Syng for Maddox, as well as the hand of a skilled engraver, probably Laurence Hubert, who advertised in the *Pennsylvania Gazette* on May 19, 1748, "Engraving on Gold, Silver, Copper or

Pewter, done by Laurence Hubert, from London, at Philip Syng's, Goldsmith, in Front Street."

Philip Syng had made one trip to London in 1725 where he may have seen other tankards of this form, but it was also unusual there. One small cann by Boston silversmith William Pollard is the closest American example but that has a flared lip totally absent on this tankard. Overall, this piece has "early" features, including Syng's heart-shaped punch. The encircling body band and straight tapering sides, rather than the more usual Philadelphia bellied form, are characteristic of pre-1745 work. However, the slow curve at the bottom which appears "caught up" by the deeply molded cast foot compares with the contemporary Galloway coffeepot (no. 44), although the body curves of the latter move into the rococo while this tankard stands at the threshold of the new style. Its broken C-scroll handle, distinctly a rococo feature, guarantees that this piece, in spite of the heart-shaped mark, is by Syng, Jr., and not his father, and also serves to date the tankard after Maddox's marriage to Mary Gative in Christ Church, February 20, 1727/28. Maddox had purchased at least three pieces of plate before this tankard: a salver by Henry Pratt (PMA, *Silver,* illus. no. 317), a cann by Philip Syng (Kathryn C. Buhler, "Some Engraved American Silver," *Antiques,* vol. 48, no. 5, November 1945, illus. p. 271), and a set of castors made by the New York smith Simeon Soumain (Buhler and Hood, vol. 2, illus. no. 604). All are engraved with the Maddox coat of arms in an ornate mantle which is in the schematic and symmetrical prerococo style. All versions of the arms are similar enough in the use of the winged griffins, or eagles, at the shoulder, and the mask engraved with feathers at the center bottom, but different in engraving technique and design organization, to suggest the variety of armorial handbooks available to the silversmith.

By 1730, Maddox's name appears in the city records. He signed a statement with a group of merchants agreeing to transact business in the New Castle currency (Scharf and Westcott, vol. 1, p. 205). He was a vestryman of Christ Church and a warden from 1732 to 1733. Although not trained to be a lawyer, he became a justice of the Court of Common Pleas and in 1741 of the Orphans' Court (Lewis, *Land Title,* pp. 149–50). In 1747, Maddox was one of the increasingly powerful men supporting Franklin's decimation of the Quaker nonresistance policy in Philadelphia. Along with other prominent merchants, including Edward Shippen, Charles Willing, and William Masters, he was manager of a lottery to erect a battery (see no. 46); Syng and Benjamin Franklin were among those given the authority to use its proceeds to build

defenses. Privateering had wreaked havoc with the West Indies trade since war with Spain and France had been announced from the Court House, and shipments to and from England were easy prey until enraged merchants like Shippen, Maddox, Willing, Kearsley, Branson, and Franklin made retaliation possible. The treaty of Aix-la-Chapelle in 1748 restored peace, and commerce resumed with vigor. Joshua Maddox rode the crest of the new wave of prosperity based upon a more open political situation; he was now an alderman and associate justice of the City Court. It seems reasonable that this tankard was fashioned in recognition of Maddox's prominence. He continued as a merchant until his death in 1759, poignantly recorded by Elizabeth Drinker: "Spent ye Afternoon at Uncle Jervis's: saw as we were returning Home towards Evening, Neigh'r Maddox's shop shut, call'd to inquire ye Cause and were inform'd, that he departed this life about half an hour before" (HSP, Elizabeth Drinker, Diary, vol. 1, April 18, 1759). His wife, Mary, inherited his possessions. She died in Somerset County, New Jersey, aged 102 (*North American Intelligencer,* Philadelphia, August 27, 1883), leaving a will specifying: "And I do give unto my said Daughter Mary All my Shop Goods and Household Furniture with my Plate, Except one Two Quart Silver Tankard, One Silver Salver, One Quart silver Salver, Saucepan, and set of Castors, I do give unto my said Grandson Joshua Maddox Wallace to have them in Possession till he come to the Age of Twenty one Years." These pieces, some of which are mentioned above, engraved with the Maddox crest, were selected for inheritance by Joshua Maddox's namesake (HSP, Wallace Papers, vol. 5, p. 36).

BG ☐

42. *Dress*

Possibly 1752
Brocaded bright-blue ribbed silk, trimmed with bands of silver lace
Waist 25″ (63.5 cm); center back length 69″ (170 cm)
Philadelphia Museum of Art. Given by Thomas Francis Cadwalader. 55-98-6a, b

PROVENANCE: Ann Willing (Francis); descended in family to great-great-grandson, Thomas Francis Cadwalader
LITERATURE: Sophie Cadwalader, comp., *Recollections of Joshua Francis Fisher* (Boston, 1929), p. 43

MAGNIFICENT FRENCH DAMASKS and brocaded English fabrics, including those made at Spitalfields, as well as other silks, velvets,

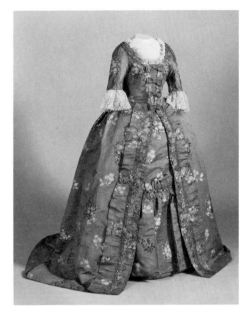

42.

and gold and silver laces, were imported into Philadelphia in great quantities in the eighteenth century to be fashioned into garments by the local mantuamakers or dressmakers. Although mid-eighteenth century dresses worn by Philadelphians were generally more restrained in design than their European counterparts, this does not mean that they were not elaborate or finely detailed in their own right. This brocaded silk dress is said to have been worn by Ann Willing, the daughter of the merchant Charles Willing. She was raised in her family's house on Third Street and Willing's Alley, and traveled with her father in England extensively from 1749 to 1751. In 1762, she married Captain Tench Francis (see no. 111). Family tradition has held that Ann Willing wore the dress, prior to her marriage, to a ball given at the State House on November 9, 1752, to celebrate the birthday of King George II. Elaborately trimmed along the neckline and edge with silver lace, the dress displays deep, fashionable lace ruffles at the three-quarter-length sleeves. The overskirt, attached to the tightly fitted bodice, is split in front to reveal the pleated and ruffled matching underskirt. The square neckline, cut low in front, is typical of the 1750s and 1760s. In back, sacque-style box pleats, popular from the beginning of the century, flow loosely into a slight train.

EMcG ☐

JOHN WOLLASTON (C. 1710–AFTER 1767)

Wollaston, born in England, was probably the son of a London portrait painter, active c. 1700–1735. A few portraits by the younger Wollaston, dating from the mid 1730s, survive and show that his style was essentially formed before he reached America. By May 1749, he established himself in New York, with little competition, and painted portraits there for three or four years. He appeared next in Annapolis by March 1753, but before this he seems to have at least visited Philadelphia, since Governor James Hamilton paid him for two portraits here on October 20, 1752 (HSP, James Hamilton Papers). His travels at this point are less certain, but earlier speculation that Wollaston returned to England in 1752–53 has no real support. From surviving portraits, it appears that he was painting in Maryland in 1754 and in Virginia from 1755 to about 1757. It is thought that he was probably again in Philadelphia before June 1758 (Groce, "Wollaston," p. 141) and at least by September of that year, when Philadelphia's Francis Hopkinson published a poem praising his work. Although he was a prolific painter, Wollaston's output in Philadelphia was not very great, which suggests that he was not here for long. The next firm date in Philadelphia is May 19, 1759, when Wollaston was paid for a portrait (LCP, Samuel P. Moore, Day Book, May 19, 1759). Groce ("Wollaston," p. 141) at this point identifies the artist with a John Wollaston in India, contending that in London in 1757, despite his absence, he was appointed a "writer" for the Bengal establishment of the British East India Company. The strongest support for Groce's argument is Charles Willson Peale's rather garbled recollection, many years later, that Wollaston "visited all the principal towns painting, to Charleston, S. Carolina and from thence he returned to England. I was in London [1767–69] when he returned from the East Indies very rich. He carried to the East Indies two daughters, one or both of them married and thus acquired great fortunes. They died, and the father, soon after he arrived in London, went to Bath where I believe he died" (Groce, "Wollaston," p. 138). Peale's story is corroborated by the fact that a "Miss Woolaston" married a wealthy British officer in the East Indies in 1766. Nevertheless, Wollaston was in Charleston in 1765 (Anna Wells Rutledge, *Artists in the Life of Charleston through Colony and State from Restoration to Reconstruction,* Philadelphia, 1949, p. 118) and sailed from there on May 31, 1767, for London. A possible explanation is that Wollaston's daughters were brought to India by English relatives and were not rejoined by Wollaston until 1767 in London. He may well have died in Bath, as Peale believed.

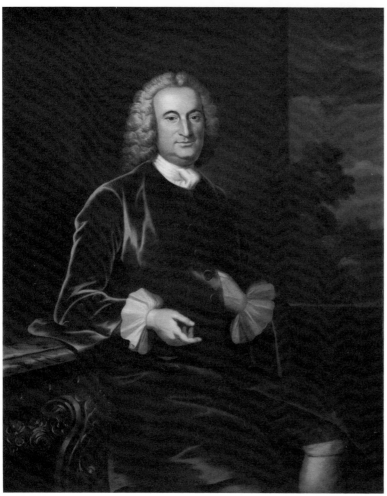

43.

to pose only for the head. The posture and elegant gestures in John Hesselius's *Lynford Lardner* (no. 37), Claypoole's *Joseph Pemberton* (no. 77), and this portrait of *Joseph Turner* are all based on print prototypes without being slavish imitations. This sometimes results in anatomical inconsistencies, as in Lardner's right hand, which is not balanced on his hip. Wollaston represented the latest English style with poses not quite so rigid as Robert Feke's, and yet often his work has the appearance of a stock production, especially in the numerous half-lengths without hands. The coloring in the male portraits, as in *Joseph Turner,* tends to be predominantly brown whereas the formula for women is more attractive since they may be dressed in blue, pink, or yellow satin trimmed with carefully depicted lace. The marble-topped table in Turner's portrait was a standard Wollaston prop appearing even in his early English work, such as *Sir Thomas Hales* (New-York Historical Society).

Wollaston in the late 1750s seems to have exerted a stronger influence on portrait painters in Philadelphia than any previous visitor in terms of the number of artists affected by his modeling of surfaces and the mannerism of the almond-shaped eyes. Undoubtedly much of his appeal resulted from the fact that he was trained in London as opposed to the American background of a growing number of Colonial artists.

DE □

43. *Joseph Turner*

c. 1752
Oil on canvas
50 x 40″ (127 x 101.6 cm)
Chester County Historical Society, West Chester, Pennsylvania

PROVENANCE: Joseph Turner; niece, Elizabeth (Oswald) Chew; daughter, Henrietta Chew; niece, Elizabeth Henrietta Montgomery; through her line descended to Mary (Montgomery) Norton; Chester County Historical Society, 1973

LITERATURE: Theodore Bolton and Henry Lorin Binsse, "Wollaston, an Early American Portrait Manufacturer," *Antiquarian,* vol. 16, no. 6 (June 1931), p. 52; Groce, "Wollaston," p. 136

JOHN WOLLASTON's portrait of Joseph Turner was probably painted about the same time Wollaston portrayed Turner's nieces, Elizabeth Oswald (Chester County Historical Society) and Peggy Oswald (Cliveden), since the three portraits are approximately

the same size and the original frames are identical. Because of the ages of the sitters, the portraits were most likely painted during Wollaston's earliest visit to the Philadelphia area.

Turner (1701–1783), who came to America from England in 1713/14, evidently preferred English-born painters, for he hired an earlier itinerant English painter, John Smibert, to paint his portrait in 1740, the only portrait known to survive from Smibert's Philadelphia visit. In both portraits, Turner is shown next to a window, which Smibert uses to show him as a sea captain (signified by a background ship), and which Wollaston uses to portray him as a landowner. In 1747, Turner became a Provincial Councillor and for many years he was in commercial partnership with Chief Justice William Allen in the Union Iron Works.

Very often Colonial painters based their poses on those in British mezzotints, sometimes copying them but more usually using them as a point of departure for a slight variation. Consequently the sitter had

PHILIP SYNG, JR. (1703–1789)
(See biography preceding no. 25)

44. *Coffeepot*

c. 1753
Mark: PS (in rectangle on base three times, separated by two leaf motifs)
Inscription: oz/59 dwt/1 gr/12 (engraved on base); Ora E Semprs (Denys arms impaling Burton, engraved c. 1890)
Silver; wood handle (not original)
Height 11⅞″ (30.2 cm); width 8¾″ (22.2 cm); diameter base 5¼″ (13.3 cm)
Philadelphia Museum of Art. Purchased: John D. McIlhenny Fund. 66–20–1

PROVENANCE: Joseph Galloway; descended in family to Lady Grace Ellen (Burton) Denys (m. Sir Frances E. Denys, 1890)

LITERATURE: Ruth Davidson, "In the Museums: American Silver and Pewter," *Antiques,* vol. 91, no. 1 (January 1967), p. 128; Beatrice Bancroft Wolfe, "A Coffee Pot Made by Philip Syng, Junior," *PMA Bulletin,* vol. 61, no. 289 (Spring 1966), pp. 40–44

THIS SUPERLATIVE COFFEEPOT belonged to Joseph Galloway at the height of his career. Syng's elaborate chased and repoussé decoration swirling over the surface is especially fine, and represents a sophisticated combination of the robust form favored in Philadelphia with free rococo ornament found on English examples made between 1730 and 1740. A pot (Glasgow Art Gallery and Museum) almost identical in size, shape, and decoration to this one appeared in Edinburgh in 1771 made by Ker and Dempster (A. A. Auld, "Silver—Some Recent Acquisitions," *Scottish Art Review,* vol. 2, no. 3, 1969, illus. p. 23), which adds evidence to the thesis that Philadelphia, producing the form by 1753, was even closer to London than all English provincial cities before 1775. There must have been a pattern for this particularly showy form, and careful investigation might lead to a single London shop. Syng's acanthus knop is identical to the Scottish one and differs from a version by Joseph Richardson, Sr. (Historical Society of Pennsylvania). So, too, the position of the chased and repoussé waves, scrolls, and garlands are similar on the Syng and Ker and Dempster pots, whereas Richardson's ornate pieces in reverse pear shape feature repoussé more than chasing. The flowers are fuller, with less detail. Richardson's pots have a higher belly and the form emerges from the decoration, solid in its swirls (Philip Hammerslough Collection; Fales, *Joseph Richardson,* illus. p. 82).

Laurence Hubert, who arrived at Syng's shop in 1748 from London and advertised as an engraver, may well have brought this design with him and may have actually laid it out on the pot for Syng to "work." Such collaborations were common. Hubert surely brought heraldic designs (see no. 41) and cipher variations whether as engravings or drawings, for such visual aids were essential tools of the trade. The highly ornate surface on this coffeepot was unusual in the work of Syng who, ironically, made fewer pieces in this style than his Quaker contemporary Joseph Richardson. The surety and strength of the overall design reflect the wealth and self-confidence of the Galloways, while celebrating Syng's artistry with silver.

Joseph Galloway, a wealthy Quaker lawyer from Anne Arundel County, Maryland, was born in 1730, the son of Peter Galloway, owner of White's Hall plantation (HSP, Pemberton Papers, Maryland Estates, Folio vol. 68). In 1753, Galloway married Grace Growden, daughter of Laurence Growden, owner of Durham iron furnaces and one of only eight people in 1760 who owned a four-wheeled coach in Philadelphia. From 1757 to 1776, Galloway was a member of the Provincial Assembly. From 1766 to 1775 he held the chair as speaker of the Assembly. Richard Peters, writing to Thomas Penn in 1765, described Galloway as "a young noisy Quaker lawyer" ("Notes and Queries," *PMHB,* vol. 31, no. 2, 1907, p. 247). Together with Isaac Norris and Benjamin Franklin, Galloway was in the forefront of Pennsylvania politics during the course of events which divided the Whigs and Torys. First a Whig and then a Tory, Joseph was so vocal and prominent that when he bowed out of the Whig delegation to the Continental Congress in 1775 and joined the Royal Army in New York in 1776, he lost the support of both parties. He was sent to Philadelphia on duty with the British army in 1777, but had to evacuate in 1778. He and his daughter, Betsy, left for England. Grace, his wife, remained behind to try to salvage their £40,000 estate confiscated by the Colonials, much of which was her dower. Her diary records her humiliation and chagrin at being forced from her grand house: "this Day all My estate was advertised to be sold During the life of Mr. G in Bradfords paper: I am Just Distracted and know Not How to Act..." ("Diary of Grace Growden Galloway Kept at Philadelphia from June 17th, 1778 to July 1st, 1779," *PMHB,* vol. 55, no. 1, January 1931, p. 88). This coffeepot was preserved with the Galloway estate, a good part of which was restored to Betsy, the surviving daughter, who died in 1782 in Philadelphia, and Joseph, who died in England in 1803.

BG □

JOSEPH RICHARDSON, SR. (1711–1784)
(See biography preceding no. 35)

45. *Coffeepot*

c. 1754
Mark: IR (in rectangle on bottom)
Inscription: R/I.M (engraved on bottom); Joseph and Mary Richardson 1748/ Juliana R. Wood (later inscription)
Silver; wood handle
Height 10″ (25.4 cm); diameter base 4⅛″ (10.4 cm)
Private Collection

PROVENANCE: Joseph and Mary (Allen) Richardson (m. 1748); descended in family

LITERATURE: PMA, *Silver,* no. 346; Fales, *Joseph Richardson,* fig. 33

THIS COFFEEPOT, made for Richardson's own use and engraved with his and his wife's initials on the bottom, is the earliest example of this form bearing his mark. The deep, single-bellied shape, raised on an encircling molded foot, has the same base contour as the cann form (an example of which is in the Historical Society of Pennsylvania) which Richardson had been making since 1737.

If, as Fales suggests, Richardson's model was a similar pot made by John Swift in London, 1753–54, and imported by his mother's Growden relatives (*Joseph Richardson,* fig. 54), this coffeepot must

44.

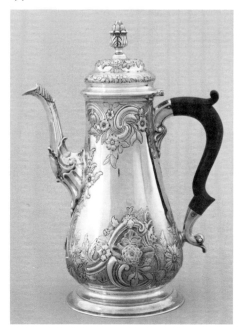

45.

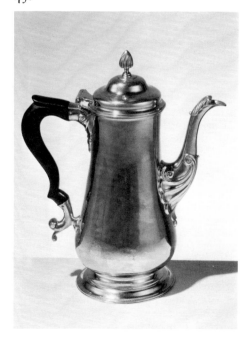

assume a date closer to 1754, since Richardson used the same mold to produce the elegant spout on this coffeepot and on the coffeepot (Historical Society of Pennsylvania) he fashioned in 1754 for Sarah Shoemaker's wedding silver.

BG □

GEORGE HEAP (c. 1715–1752)

The life circumstances of George Heap are obscure and he has remained an elusive personality. No definite information about his youth is known; it has been assumed that he was the son of John Heap and Ann Bingham (Nicholas B. Wainwright, "Scull and Heap's East Prospect of Philadelphia," *PMHB*, vol. 73, no. 1, January 1949, p. 16). In 1738 he married Mary Classon, by whom he had three children by the time of her death in 1745. In 1746 he married Mary Jacobs by whom he had four children. Of the seven children, four died in infancy. A successful businessman, Heap purchased one hundred acres of land on March 10, 1744 (*Pennsylvania Archives*, 3d series, vol. 24, 1894–97, p. 20). Minutes of the Provincial Council state that he was elected coroner in 1749 and 1750.

In 1752, Heap worked with Nicholas Scull on a map of Philadelphia; probably their association derived from the marriage between members of their families. Heap's reputation as an artist is based on the existence of two collaborative works with Scull—the 1752 map and this engraving.

NICHOLAS SCULL (1687–1761)

Nicholas Scull, Jr., was born near Philadelphia in 1687, two years after his father had emigrated from Ireland to America. His youth is documented only by his apprenticeship to the colony's first surveyor general, Thomas Holme (see biography preceding no. 2), from whom Scull undoubtedly learned many of the skills which he was to employ later in life. In 1708 he married Abigail Heap by whom he had two daughters, Abigail and Mary, who married into the Biddle family. Scull was innkeeper of the Bear Tavern where, on November 8, 1731, the first directors' meeting of the newly founded Library Company of Philadelphia met under the guidance of Benjamin Franklin. As an Indian interpreter and surveyor, Scull was often called upon by the provincial government to settle land disputes. The Minutes of the Provincial Council of 1744 and 1745 record Scull as sheriff of the county, and in 1748 he became surveyor general, a position he maintained almost until his death in 1761. During these thirteen years he produced several maps of Philadel-

phia and Pennsylvania—especially noteworthy is his *Improved Part of the Province of Pennsylvania*—and assisted on Evans's 1755 *Map of the Middle British Colonies* (no. 49). The popularity of his 1752 map of *Philadelphia and Parts Adjacent* is attested to by the many copies executed by European artists. The original print was surmounted by what is considered the first published view of the State House. The artist of the latter was George Heap with whom Scull collaborated on this map. It appears that Scull's function on both works was as a consulting surveyor, whereas Heap actually drew the views.

46. *An East Prospect of the City of Philadelphia*

1754
Signature: G. Vandergucht Sculp.

Inscription: AN EAST PROSPECT OF THE CITY OF PHILADELPHIA; taken by GEORGE HEAP from the JERSEY SHORE, under the Direction of NICHOLAS SCULL Surveyor General of the PROVINCE of PENNSYLVANIA

Engraving, ii/ii, edition of 250

Four plates, each 21¼ x 20⅛" (54.0 x 51.1 cm)

The Episcopal Academy, Merion, Pennsylvania

LITERATURE: HSP, Thomas Penn, Letter Book, vols. 2–5, 1750–57; HSP, Penn Papers, Official Correspondence, vols. 5–6, 1750–58; Richard Peters, Letter Book, 1755–57; Scharf and Westcott, vol. 1, pp. 14–15; "Notes and Queries," *PMHB*, vol. 22, no. 3 (1898), p. 379; J. C. Wylie, "Some Selections from the Peters Papers," *PMHB*, vol. 29, no. 4 (1905), pp. 460–65; Joseph Jackson, "Washington in Philadelphia," *PMHB*, vol. 56, no. 2 (April 1932), p. 113; Stokes and Haskell, *Early Views*, p. 18, pl. 14b; Joseph Jackson, "Iconography of Philadelphia," *PMHB*, vol. 59, no. 1 (1935), pp. 57–61; Samuel Freeman and Co., Philadelphia, *Historical Collection of the Late Samuel Castner, Jr.* (March 8–9, 1943), no. 105; Nicholas B. Wainwright, "Scull and Heap's East Prospect of Philadelphia," *PMHB*, vol. 73, no. 1 (January 1949), pp. 16–25; Boise Penrose, "The First Book About America Printed in England," *PMHB*, vol. 73, no. 1 (January 1949), pp. 3–8; *Philadelphia Reviewed*, p. 8; Tatum, pp. 151–52; repro. endpapers; *Prints Pertaining to America*, no. 19; Snyder, "Views," pp. 674–75; Jan Morse, ed., *Prints in and of America to 1850* (Charlottesville, 1970), p. 68; Lynn Glaser, *Engraved America: Iconography of America Through 1800* (Philadelphia, 1970), pp. 56–58; Nancy E. Richards, "The Print Collection at Winterthur, Part I," *Antiques*, vol. 100, no. 4 (October 1971), pp. 587–88; Snyder, *City of Independence*, pp. 42–44, item 17A, fig. 17

THE PRIDE OF AMERICANS in their new homeland, coupled with English curiosity

about the New World, resulted in the demand for and publication of many city and rural views. The large number of works representing Philadelphia in the eighteenth century can be attributed in part to the vigorous advertising campaign initiated by the Penn family in Europe. The print represented here was commissioned by Thomas Penn, Pennsylvania's principal Proprietor, to give to his friends as a symbol of his pride in Philadelphia's achievements and to encourage immigration and investment.

Penn enlisted his agent, Richard Peters, to find an artist in America to make the panoramic drawing. After several unsuccessful efforts, Peters found George Heap who, obviously aware of the earlier views of New York and Boston by William Burgis, had independently made his own drawing. It turned out to be surprisingly acceptable, and a financial arrangement was reached whereby Heap assumed all costs of production, to be raised by subscription, and Penn was allowed to purchase the number of prints he desired (HSP, Penn Papers, Official Correspondence, vol. 5, p. 307). The sale to subscribers was advertised in the *Pennsylvania Journal* and the *Pennsylvania Gazette* from September 28 to December 26, 1752: "A Prospect of the City of Philadelphia, Taken from the East. By George Heap. Conditions, That the Prints shall be Seven Feet four Inches in Length, taking in the Extent of nar a Mile and Half. That, in order to have the Work executed in the best Manner, the Plates shall be engraved in *England*, and well printed, on fine white and strong Paper. That the Price of each Prospect be *Twenty Shillings*, Money of *Pensilvania*; one Half to be paid at the Time of subscribing, the Remainder on Delivery of the Prints. That if a sufficient Number are not subscribed for before the first Day of *December* next, the Subscription shall be void, and the Money returned to the Subscribers on Demand. . . ."

As the printing industry in America could not accommodate plates of this size, the customary procedure was to send the drawing to England for engraving. Heap insisted on carrying his own design but died en route. Nicholas Scull purchased the work from Heap's widow. Scull, because of his talents as surveyor general, had probably been consulted by Heap but did not actually participate in the drawing. As it was heavily soiled by this time, John Winter was hired to make a copy of it. The second drawing, accompanied by text for the inscription and the battery insert, was shipped to Thomas Penn, arriving in England in early July 1753. Gerard Vandergucht, a well-known English engraver, was commissioned to engrave the four large plates; it was announced in the *Pennsylvania Gazette*, November 1, 1753; and the printing began in June 1754.

Five hundred of the first state were printed and, due to its great success, 250 of the second state (with Calvern changed to Calvinist Church and the k to c in Scull) were issued. In addition, Vandergucht drew a smaller version which was hoped would be a more popular size. Engraved by Thomas Jeffreys and finished in 1756, this was a more accurate and realistic composition, but does not seem to have sold well.

Compared to European printing accomplishments at the time, the American effort appears naive and unimpressive. Heap's composition is more reminiscent of earlier Italian views; it is possible that he was aware of a 1614 panoramic view of Venice by Willem Blaeu (Juergen Schulz, *The Printed Plans and Panoramic Views of Venice: Saggi e Memorie di storia dell'arte*, vol. 7, Florence, 1970, illus. pp. 156–57). According to Peter Parker (see no. 1), members of Blaeu's workshop were active in the production of maps of the Delaware Bay. Thus they may have made Blaeu's prints available in America at an early date. The fact that Blaeu and his workshop executed both maps and panoramas further confirms the idea that the panoramic view evinces a mapmaker's mentality and is a three-dimensional projection of a two-dimensional city plan.

In Heap's view, the city is laterally stretched out on the horizon, and a thriving port scene occupies the greatest proportion of the picture surface in the foreground. An impressive view is sought by emphasizing the height of the city's monuments, but the neighboring homes are stylized, block-like shapes acknowledging only the compactness created by the immediate juxtaposition of the famous Philadelphia row houses. Heap has accumulated the information about his subject like the maker of a map or plan, probably indicative of Scull's influence, and then has depicted it without regard for topographic accuracy. However, the panoramic view shows more detail and provides more information than a ground plan. No specific vantage point can be determined, although a spot opposite the center structures is suggested by the placement of the buildings in the area of Christ Church parallel to the picture plane. Heap then uses an elementary perspective system, placing the adjacent buildings at slight angles, not an accurate depiction of how they would actually have appeared and an indication that he had no knowledge of mathematical formulas for achieving such realistic views. The unbounded Delaware can be recognized as a waterway only by the ships resting on its stylized waves. Their flags recall that the country is still under English rule. While the masts of the vessels accentuate the soaring verticality of the architectural accomplishments, the delicate interplay of varied lines in the ships and water relieves the rectilinearity of the backdrop. Considering the inaccessibility of artistic training in the New World, the work is quite appealing and captures the activity, growth, and achievement of Penn's town. The cumulative size of the four sheets stresses and records the monumental and impressive character of the subject desired by Heap and Penn.

ESJ

JUDGE RICHARD PETERS objected to Thomas Penn's request for a perspective view of Philadelphia saying that it would be a dull scene because there were so few spires breaking the skyline (HSP, Penn Papers, Official Correspondence, vol. 5, p. 61, October 28, 1750). Compared to Paul Revere's 1768 view of Boston, which boasts fourteen spires, or Thomas Johnston's 1759 view of Quebec, which shows eleven, Philadelphia's spires might be considered sparse. But views of other American cities—New York (Archibald Robertson, 1778), Charleston, South Carolina (B. Roberts, before 1739), and Newport, Rhode Island (S. King, 1795)—show fewer than Philadelphia. Penn pursued the project in spite of artistic problems, and Philadelphia's waterfront was undoubtedly more important to the Penns than its church spires, as it had more wharves and larger houses than any of the other Colonial cities, confirming the success of the Quaker "experiment." Boston and Newport developed the long town wharf on direct access with their Town House and Colony House respectively, but Philadelphia's waterfront provided a number of sizable public shipping wharves as well as equally large privately owned ones.

Waterfront was valuable property. Penn's "Concessions" of 1681 apportioning city lots in relation to the amount of country acreage purchased kept control of the city's ground, but also promoted investment and development. Penn hoped that the city would spread evenly over his grid, using both the Delaware and the Schuylkill for commerce (see no. 2), but if a perspective view of the Schuylkill's banks had been taken at the time of this view, only a few country seats would have appeared—Bush Hill, the Proprietors' land at Springettsbury, George Gray's at Gray's Ferry—with post-and-rail fencing enclosing their pasture land, and luxurious grasses in the river meadows, which flooded each spring.

Heap's view of the Delaware waterfront celebrates Philadelphia's prosperity, but misses its bustle. Platform-like docks appear as extensions of street paving, which was not the case, although some were very broad, from 100 to 200 feet square. Nicholas Scull's plan of Philadelphia (1752) includes some 64 names identifying wharves, which

extended riverbank lots into the river's commerce and were built on heavy pilings driven into the river floor; these wharves were often expensive maintenance problems due to the frequent river freezes. The town docks extended into the river less than the private ones, as they had to be supported by public subscription. The *London Magazine* of October 1761 (p. 575) offered the following promotional description of the waterfront: "A fine quay 200 feet square, to which ships of four and five hundred tons may come up, with wet and dry docks for building and repairing of ships, magazines, warehouses and all manner of conveniencies for importing and exporting of merchandise.... The River De La War is navigable for large vessels above 200 miles, and the Schuylkill for large ships as far as Philadelphia."

Samuel Powel, Jr., added the following notes about his Delaware wharf to his Day Book: "Measured on the Ice the Depth of Water to the Eastward of our wharf (the wharf being 6 foot above the water) and find the Depth to be at 20 foot Distance, 16 foot, at 40 foot distance 18 foot, at 80 foot distance 22¼ foot . . . at 320 foot distance 49½ foot; and from Plumsted's wharf to the Island the Distance is 1100 foot and the soundings as follows: at 20 foot distance, 16 foot . . . at 300 foot distance, 50 foot 9 inches, at 400 foot distance 52 foot . . . at 1100 foot distance, 8 foot" (LCP, Samuel Powel, Day Book, 1735–38). Powel's wharf was south of the Drawbridge (Reference no. 13), below Stamper's wharf and next to the Spruce Street public dock. Plumsted's was four wharves south of Powel's and opposite Windmill Island. The river's great depths, indicated by Powel's figures, allowed the largest mercantile vessels to load and unload at dockside, a convenience and an economy which Thomas Holme took into account when he located the exact site for Philadelphia.

The view shows numbers of mastless craft tied up at wharves. The largest shipyards were south (Penrose's) or north (West's) of the area encompassed by this view, and it is possible that once the hulls were complete, the masts and rigging were added at the owner's dock. However, it was probably artistic license that caused so many unrigged vessels to be tied up at the waterfront. The slightly later, smaller version of this view published by Thomas Jeffreys in 1756 shows no vessels at all moored at the wharves and an entirely different foreground of ships, suggesting that George Heap was concerned primarily with reproducing the shoreline and buildings accurately. The ships probably were a conventional element added later, and with variations in the several versions—this one in 1754, Jeffrey's two years later, and the

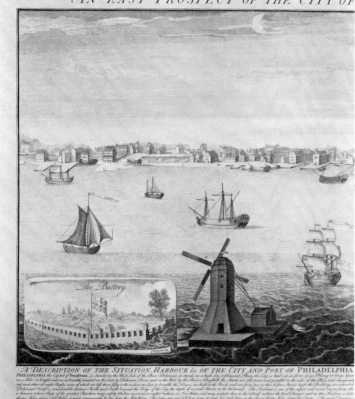

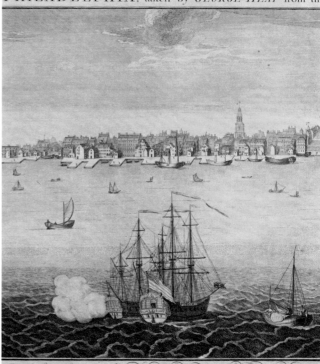

fold-out that appeared in the October 1761 edition of the *London Magazine*.

Heap probably took this view from a high spot on the Jersey shore, perhaps the roof of the large house of David Cooper (labeled on the Varlé map, no. 143), which lines up with the tower of Christ Church (Reference no. 1), the focal point and center of this view. A more logical choice for the center, providing less distortion, would have been the foot of Market or Chestnut streets. But Heap either favored the elevated vantage point of Cooper's roof, which allowed him a view of the tops of wharves and some prospect into the city itself, or chose the location because it was free of the large windmill, which would have obstructed much of the southern end of the city. As it is, Heap pulled the view back toward himself, distorting the position of Windmill Island, which would have obscured the new battery, recently built by the Friendly Association.

The visual prominence of the inset depicting the fortifications gives evidence that the politics of Quaker pacifism was no longer powerful enough to prevent the active self-defense essential for mercantile shipping, which was being threatened by French privateering in the Great War.

Typical of the bastion-type fort, and located just south of the town to serve as sentinel for the anchorage, the battleworks were armed with twenty-seven heavy cannons. It served until 1773, when Fort Mifflin was commenced below Philadelphia at Mud Island.

Heap's delineation of the tower of Christ Church dominates the architecture in this view. Robert Smith was just designing it when Heap was at work (see no. 26), and, therefore, it was not yet a physical part of the Philadelphia skyline. The fact that it is drawn in greater detail than any other structure and is very flat, with no suggestion of depth even though the buildings just east of it are turned slightly to the south, confirms the use of Smith's elevations to complete his view. The east-end wall of Christ Church rises excessively over the surrounding rooftops in this view, and the steeple, which is at the west end of the building, seems here to be part of the east facade. So, too, the State House tower appears out of place (Reference no. 2), even given the distortion of the perspective, for it is actually on the south side of the main building, set on the south side of Chestnut Street (Reference no. 12). This tower was also in the works in

1751 (see no. 30) and Heap's drawing for the view, furnished in 1752, shows enough detail to suggest that again he consulted with a builder, in this case, Edmund Woolley, the State House carpenter, to complete his view. Certainly these two spires added immeasurably to Philadelphia's artistic interest, which Peters had claimed was lacking when he wrote to Penn in 1750.

The neatness and regularity of Philadelphia impressed most visitors, and this effect was due not only to its plan of streets crossing at right angles but also to its architecture. Ann Warder's Diary records in 1786: "In the evening we took a nice walk, which gave me a clearer idea of the town, that it is in my opinion as far superior to New York as Westminster to the city. The regularity of the streets and buildings with their entire plainness I much admire, scarce a house but the color resembles our Mark Lane Hall painting" ("Extracts from the Diary of Mrs. Ann Warder," June 12, 1786, in *PMHB,* vol. 17, no. 4, 1893, pp. 447–48). And in 1765, Lord Adam Gordon from Aberdeenshire, Scotland, who traveled up the east coast of America, made the following comment in his Journal:

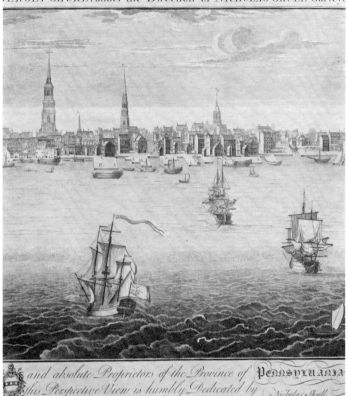

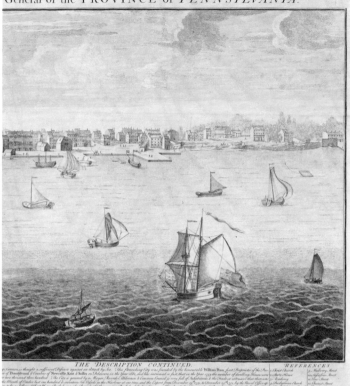

The city of Philadelphia is perhaps one of the wonders of the world, if you consider its size, the number of inhabitants, the regularity of its streets, their great breadth and length, their cutting [one] another all at right angles, their spacious public and private buildings, quays and docks, the magnificence and diversity of places of worship, the plenty of provisions brought to market, and the industry of all its inhabitants. One will not hesitate to call it the first town in America, but one that bids fair to rival almost any one in Europe . . . it consists of more than 3600 houses . . . everybody of note has a residence in town, which is all built of brick and well paved with flat foot walks in each side of the street. (Washington, D. C., Library of Congress, "Journal of an Officer in the West Indies who Travelled over a Part of the West Indies and North America," 1765, typescript of MS in British Museum)

The personality of eighteenth century Philadelphia architecture was its homogeneity. Most of the earliest English inhabitants of the city had lived through the Great Fire of London in 1666 and had seen the style of the rebuilding, credited to Sir Christopher Wren. Penn had cautioned about fire at the outset of Philadelphia's settlement in 1682 and hoped to minimize that hazard, as well as other Old World ills, by spacing buildings and surrounding them, at least the domestic structures, with orchards and gardens. Had the town spread evenly across its site to the Schuylkill, there would have been room for his dream of a "greene countrie town"; however, Heap's view shows clearly that mercantile opportunity erased the memory of past cataclysms and that the prosperity of the second generation in Philadelphia determined its architectural character. Three- and four-story buildings with varying degrees of formal architectural organization are squeezed between Third Street and the waterfront, not only by Heap's somewhat primitive technique, but in fact.

It is difficult to visualize the eighteenth century visitor's impression of neatness and order, but compared to Boston and New York, which grew without preconceived plans, and Newport, built mostly of wood, Philadelphia was quite advanced. Regulated from the Meeting House and the Council, it was built by craftsmen trained in the environs of London, from which most of its citizens came. The brick architecture with white stone or wood detailing was a natural outgrowth of late seventeenth century settlement. The plain, rectangular shape of the buildings, with gable, hip, and occasionally gambrel roofs, regular fenestration, prominent hooded doorways, belt courses, and balustrades, were all elements of English town and shire architecture. This style is typical of Amersham, Buckinghamshire, for example, a town frequented by William Penn. Small houses in London and Bristol were models for Philadelphia builders, who used the same design books as their English counterparts. With brick clay plentiful at and near Philadelphia, and the necessary limestone also at hand, kilns were put into operation soon after the city was founded and thus the homogeneity of Philadelphia architecture was set. The uniformity of style was deliberate and not a result of economics or stylistic naiveté. Like the complex activities occurring within the simple form of the Meeting House, the real business of the city transpired within, and if any of the foreign visitors had taken "house tours," the descriptions of plainness might never have been written.

BG ☐

47.

47. *Greater Meeting House*

Second and Market streets (demolished)
1754
Brick structure; wood trim; shingles
55 x 73′ (16.8 x 22.2m)
REPRESENTED BY:
Greater Meeting House, detail from Henry
Dawkins, *The Paxton Expedition*, 1764
(no. 64)

LITERATURE: "Notes and Queries," *PMHB*, vol.
33, no. 2 (1909), pp. 250–51; Tatum, pl. 8;
Edwin B. Bronner, "Quaker Landmarks in Early
Philadelphia," in *Historic Philadelphia*,
pp. 210–12

"IN THE FORENOON went to Market Street
Meeting which I think is full double the size
of Gracechurch street. It has five doors, one
each side the minister's gallery, near which
I sit though much courted by beckoners to
come under it, which I refused, though not
without feeling some pleasure, as sister
Hannah had given me a very different
account of their Friends" ("Extracts from
the Diary of Mrs. Ann Warder," June 11,
1786, in *PMHB*, vol. 17, no. 4, 1893, p. 446).
The Greater Meeting House at Second and
High (Market) streets was the communi-
cation center for the "holy community," the
Quaker population of eighteenth century
Philadelphia. More than one English visitor,
like the newly arrived Mrs. Warder,
wondered at its size, and from it measured
the success of those in the city who built it.
So, too, the permanent residents felt the

presence of this building and the pervasive
force the Quaker elders exerted on the life
and commerce of the city. Emanating from
its conference rooms through the Monthly
Meetings and into the community were rules
regulating the lives of its members, the
welfare of the poor and the sick, the educa-
tion of the young, the manumission of slaves,
the arbitration of disputes public and private.
Through it loans were granted and advice
on estate management was offered. This was
the "outward plantation" of which George
Fox had spoken. While encouraging it, he
had warned: "My friends, That are gone
and are going over to Plant, and make
outward Plantations in *America*, keep your
own Plantations in your Hearts, with the
Spirit and Power of God, that your own
Vines and Lillies be not hurt" ("An Epistle
to all Planters And such who are Transplant-
ing Themselves into Foreign Plantations in
America" [1682], in *The Works of George
Fox*, Philadelphia, 1831, vol. 8, p. 218). It
was William Penn's advice on diligence and
frugality that had set a climate for the young
city, where those who followed the doctrine
of industry and thrift had the prospect
of joining the ranks of the well-to-do.
The idea of building a meetinghouse at
Second and High streets was proposed at a
Bank Street Monthly Meeting in 1694. Used
for Afternoon, Monthly, and Quarterly
Meeting, the Bank Street building was then
in bad repair, and Centre Meeting proved
too far for city residents in winter, and
impossible in a wet spring. The Centre
Meeting, designated by Penn to be the city's
largest, was located exactly at Philadelphia's
center (see its representation in the town-
plan insert on Holme's map of Pennsylvania,
no. 2) and housed the Annual Meeting to
which Pennsylvania residents from all
outlying districts were encouraged to attend
once a year. It is doubtful, however, that the
Centre Meeting was ever considered by the
city Quakers with the symbolic importance
that Penn had given it, and the proposal to
build the Great Meeting was but one indica-
tion that the idealism drafted into the plan
of Philadelphia was soon abandoned by the
Colonists, even those who understood Penn's
"experiment." Although his writings do not
specifically comment upon the erection of
the Great Meeting, other alterations in his
plan, for example the rapid subdivision of
waterfront land which eradicated his
"greene countrie town" in deference to
commercial enterprise, were disappointments
to him. There is no indication in his writings
that Penn doubted that his "simplicity of
truth" could contend with a competitive
commercial situation like that developing in
Philadelphia, for the rules emanating from
the Meeting House were meant to deal with
any ambiguities that arose. With the

construction of the Great Meeting "off
center," the symbolic centrality of the
Meeting House was abandoned, much as in
Boston, where the Puritans' first Meeting
House, placed on direct axis to the long
wharf and featured at the commercial
center of the town, before too long was
physically eclipsed by the Town House,
which flaunted the pre-eminence of a new
merchant class not beholden to an old
oligarchy. (This is shown clearly in Paul
Revere's engraving of 1770, *The Bloody
Massacre*, reproduced in *American
Printmaking*, pl. 34.)
Although the records of the Provincial
Council do not mention the earliest complex
of buildings located between Second and
Front streets on High, there are two extant
manuscript plans for this area and one
description suggesting that at least some of
this first city "center" was completed by
1695. The two small plans are both endorsed
by Edward Penington, surveyor general:
The first, in the Winterthur Museum, with
red colored outlines around some of the plots
of ground, is dated 1695; the second, in the
Historical Society of Pennsylvania (Stauffer
Collection) is dated 1688 (see reproduction
from a tracing in Watson's manuscript
Annals, in *PMA Bulletin*, vol. 27, no. 149,
May 1932). On both, the Great Meeting is
drawn in its square shape with an indication
of the extent of its yard. It is shown about
half a block above the unit described by
Gabriel Thomas in 1698: "There is lately
bilt a Noble Towne House or Guild Hall,
also handsom Market House and a
convenient Prison" ("An Historical and
Geographical Account of Pennsylvania . . . ,"
in Albert Cook Myers, *Narratives of Early
Pennsylvania, West New Jersey and
Delaware, 1630–1707*, New York, 1912,
pp. 326–28). In 1693 the Council had
authorized a bell tower to stand at the
crossing of Second and High streets to call
citizens to the markets (*Colonial Records of
Pennsylvania*, Philadelphia, 1852, vol. 1,
pp. 388–91), and reserved that space for
public market use. Thus, just before the
Friends' committee set about purchasing
their new ground, the center of the city's
commerce was set, not by the Centre Square
Meeting House as Penn had envisioned it
with all of the city's activities evenly
dispersed around it, but by the mercantile
exigencies of the waterfront colony.
The committee chosen in 1694 to
investigate a new site for a larger meeting-
house consisted of the three wealthiest and
most prominent members of the Friends,
Edward Shippen, Samuel Carpenter, and
Anthony Morris (see no. 3). The ground at
Second and High streets was purchased
from Deputy Governor William Markham
for £50. The price was more than reason-
able, and it may be assumed that the

Anglican governor knew he was pleasing this powerful faction of Philadelphia's population when he "gave" them the ground (albeit with what later proved to be an unclear title). The first building was begun in 1695 and was the largest meeting place for Friends constructed for half a century. Thomas Duckett and William Harwood built the 50-foot-square structure with a small skylight-belfry (numbered 7, it is visible on the Scull and Heap view of Philadelphia, no. 46) and a cellar below for £1,000 (J. W. Lippincott, "Early Meeting Houses of Friends," *The Friend,* vol. 62, nos. 40, 42, 1889, pp. 316–17, 331). In 1699, William Harwood was engaged to build a gallery for £16 to accommodate the expanding membership.

In 1695, when the Friends built their Great Meeting at this location, they were politically in control of Philadelphia but barely included a majority of the population. But by 1708, when the Common Council passed a law for building a court house on the ground that had been reserved for the market, the power base was subtly beginning to shift, as is suggested by the selection of the Anglican Joshua Carpenter rather than a Quaker to work with the mayor on the court house proposal. The location of the new Court House (1708–10, seen at center in the Dawkins engraving) in the middle of the main street was entirely within the tradition of English and Scottish shire towns. As High Street was 100 feet wide, there was plenty of circulation space for vehicular traffic and foot passage around the building (seen quite clearly in the Scull and Heap view) and into the market stalls that were at first contained within its arcades, but by midcentury had tailed a number of blocks up High Street, which soon became known as Market Street. Colonial distances were measured from this point at Second and High. Kings' deaths, coronations, proclamations of war and peace were announced from the balcony of the court-market house. This area remained central to the political and economic life of the colony until the State House, begun in 1732, carried the political scene off to Fifth and Chestnut streets, leaving behind the commercial interests, the regulation of fairs and market days, shops and workshops, and the bustle of purchasers and workers.

Some fifty years after it was built, the Great Meeting House was surveyed for repairs. In 1754, it was determined that "the lower floor should be wholly new, and the whole roof new shingled." This was followed by recommendations for enlarging the building toward the west, and finally "to take the old house down and build a new one, to extend as far as our ground westward" (J. W. Lippincott, "Early Meeting Houses of Friends," *The Friend,* vol. 62, no.

42, 1889, p. 332). William Rakestraw, son of the early brickmaker, charged £6 12s. 6d. for "pulling down old Meeting House." The new Greater Meeting House, so-called because it replaced the Great Meeting, was to be rectangular, 55 feet wide by 73 feet long, built of brick for a cost of £2,146. Jonathan Zane was one of the principal carpenters. The bricks were supplied by Joseph Lownes, Isaac Roberts, and John Coats, Jr.; the lumber, by Joshua Humphreys, Joseph Watkins, William Dilworth, and David Roe; the hardware, by John Cresson, Joshua Howell, Isaac Greenleafe, and Hugh Roberts. Laborers were paid five shillings per day, servant men were loaned throughout the building project, and all the workers donated to the enterprise in kind or in money ("Notes and Queries," *PMHB,* vol. 33, no. 2, 1909, pp. 250–51).

Quaker meetinghouses always had more than one door for the simultaneous women's and men's business meetings. This design problem was handled in numerous ways within a certain pragmatic aesthetic. At the Greater Meeting there was a door on the gable end on Second Street and on the north side; at the Merion Meeting, built in the Welsh architectural tradition, there were three doorways (see no. 266); at the Arch Street Meeting, begun 1804, there are at least five doorways, two in each of the separate wings for the yearly men's and women's business meetings, and a large central space for an Annual Meeting.

Dawkins's view shows a typical five-bay-facade meetinghouse, which, except for its size, could easily have been mistaken for a domestic building. The centered doorway on the long side was reached by four stone steps, and the gable end was also symmetrically organized with three bays and central doorway. The doors, unadorned or rusticated, were framed with engaged pilasters and capped with triangular pediments. The east door had a plain gable-roof porch in 1764, and one had also been added to the north door by 1800. Dawkins's view does not show a deep pent eave or window frames or ledges. William L. Breton's view (Tolles, *Meeting House,* illus. facing p. 63) does, however, show these details and was probably an accurate representation of the building, although it was demolished while Breton was still a young man. Dawkins does show an inset stone between the small third-story windows on the east end, probably a date plaque like that on the gable end of the Free Quaker Meeting at Fifth and Arch streets. Otherwise, the building was very plain, without quoining, dentil moldings, or window lintels. It did have a belt course like the Pine Street Meeting of 1753 as did well-built domestic structures.

Quaker meetinghouses were distinguished for being undistinguished. With

the exception of comments on the grand size of Philadelphia meetinghouses, few, if any, diarists discussed their architectural characteristics. The earlier Great Meeting, square in shape and set in its yard surrounded by a wall, probably looked more institutional than the Greater Meeting which followed it and which met its neighbors with barely an alley between. As block development eradicated private city gardens and party walls became the norm, so the Meeting House yard was consumed by the building's enlargement. Unlike the Puritan Meetings in New England, a steeple was considered unnecessary ornament by the Quakers, and bell cupolas were specified only for Quaker market or school buildings. Thus Thomas Penn's request to Richard Peters for a "view of Philadelphia" met with the response: "Philadelphia will make a most miserable Perspective for want of Steeples" (HSP, Penn Papers, Official Correspondence, vol. 5, p. 61, October 28, 1750).

There is no question that by the time of the Revolution, if not before, the Quakers were on the defensive in Philadelphia. Not only had their congregation diminished, but even the sons of the Founder, Richard and John Penn, had joined the Anglican community. Some left the fold of the Greater Meeting in the cause of patriotism and returned after the war to form the "Wet Quakers," who at their Free Meeting House at Fifth and Arch streets followed the worship but not the discipline of the orthodox group. The confluence of trade in the area of the Greater Meeting on High Street became so disturbing to those Quakers seeking to cultivate their "inward plantation" that they elected to remove and sell their lot and building in 1804, which was replaced by a commercial structure (visible in the distance in William Strickland's painting of Christ Church, see no. 26). Their move to a new meetinghouse at Arch and Fourth streets, in use in 1805, completed in 1811 (see no. 182), symbolized their earnest direction while setting the principles and life style of the "simplicity of truth" against the increasingly colorful city of Philadelphia.

BG □

SAMUEL RHOADS (1711–1784)

Samuel Rhoads was a merchant, real estate speculator, mayor of Philadelphia (1774), and a carpenter-builder. Benjamin Franklin called him a "Mechanician," while his lawyer, William Rawle, described his attributes thus: "He was a respectable merchant of Philadelphia, belonging to the Society of Friends—without the talent of speaking in public, he possessed much acuteness of mind,

his judgment was sound, and his practical information extensive" (Henry D. Biddle, "Colonial Mayors of Philadelphia," *PMHB,* vol. 19, no. 1, 1895, p. 68).

Samuel Rhoads was born in Philadelphia in 1711, the second son of John Rhoads and Hannah Willcox, who were married September 10, 1692. His grandfather, John Rhoads, had emigrated from Winegreaves County, Derbyshire, England. As a third-generation Philadelphian, Samuel Rhoads was well known within the city. Apprenticed to a carpenter, possibly Samuel Powel (1673–1756), he was a member of the Carpenters' Company (elected before 1736), and later, from 1780 to 1784, its master and treasurer.

Rhoads and William Parsons, surveyor, were elected members of the Common Council of Philadelphia in 1741, and both were employed by the city to clear up boundary disputes as the city grew westward. Along with his great friend, Benjamin Franklin, Rhoads was elected a member of the Provincial Assembly from 1762 to 1764, and again from 1771 to 1774. He was a delegate to the First Continental Congress, which met at Carpenters' Hall on September 4, 1774, but his duties as mayor in May of 1775 prevented him from serving as delegate to the Second Congress.

Samuel Rhoads married Elizabeth Chandler on May 12, 1737. They had three children: Mary, who married Thomas Franklin of New York in 1764; Samuel, Jr., who married Sarah Pemberton in 1765; and Hannah, who never married. Before his death in 1784, Samuel Rhoads had been elected a member of the American Philosophical Society and served as its vice-president. He was a director of the Library Company of Philadelphia and a manager of the Pennsylvania Hospital from its founding in 1751 until his retirement in 1781. His mercantile activities extended into the West Indies, his social contacts, throughout the Delaware Valley, and his political acumen pervaded pre- and post-Revolutionary Philadelphia.

DAVID EVANS, SR. (1733–1817), AND DAVID EVANS, JR. (ACT. 1794–1806)

The names of four David Evanses overlap frequently in eighteenth century records, with the designations "senior" and "junior" used to distinguish them as elder and younger. Three David Evanses were carpenters; a fourth, their relative, was the cabinetmaker David Evans (1748–1820), son of Edward Evans (see biography preceding no. 9), with whom they are often confused.

David Evans (1733–1817), carpenter, was the son of Evan Evans (1684–1747) and Elizabeth Musgrave, who were married at Gwynedd Friends' Meeting, Montgomery

County, Pennsylvania, in 1713. Born in 1733, he had at least two brothers, Musgrave and Jonathan, the latter apprenticed to Michael Point in 1734 (HSP, GS, List of Original Certificates of Removal in Possession of Philadelphia Monthly Meeting, 1686–1758, no. 820). He became a carpenter and in 1755 married Letitia Thomas. In 1761 he was living next door to the new Union Library at the corner of Pear (now Chancellor) and Third streets (E. V. Lamberton "Colonial Libraries of Pennsylvania," *PMHB*, vol. 42, no. 3, 1918, pp. 198–99). As a prominent Quaker in the Southern District Monthly Meeting, he traveled to Boston in 1775 with John Parrish, bricklayer, to present the Friends held there by the British with £8, but General Washington would not let them enter the town because smallpox was then rampant. In 1768, Evans was a charter member of The American Society held at Philadelphia for Promoting Useful Knowledge.

Evans's apprenticeship is not documented. However, he had an elder cousin by the same name who died in 1783 and who bequeathed "unto my cozen David Evans all my carpenters tools . . ." (City Hall, Register of Wills, Will no. 339, 1783) suggesting that the two men had been working together. One of them, together with Robert Smith, has been credited with the design of the Philadelphia Almshouse, about 1762, which was being built in 1766 (see no. 71).

It seems reasonable that Evans was described as senior in Pennsylvania Hospital's records after 1783, when his cousin died, and that his experience on a neighboring institutional building, whether as designer or assistant to the designer, secured for him the commission to complete the work on the Pennsylvania Hospital. He had had more than a routine apprentice experience as his elder cousin had owned at least one design book, Abraham Swan's *British Architect,* which he presented to the Library Company in 1764. Most carpenters owned building manuals like Langley's *Treasury of Designs,* but Swan's was a volume for design, not construction.

Evans's son, of the same name, worked with him much as Evans, Sr., had with his elder cousin. Designated in Hospital records as junior, son David worked with his father on the Pennsylvania Hospital (Pennsylvania Hospital, MS, vol. 6, p. 515). Thus it was the father who was presented with Rhoads's plans to work out a design for completion of the institution, and the son who in 1794 came in with a satisfactory ground plan of the whole. The project seems to have proceeded under the direction of these two carpenters.

From 1799 until 1803, Evans, Sr., was living at 83 Union street. Evans, Jr., was listed at 87 Union Street. In 1805, Evans, Sr.,

is listed as "gentleman," and with his son was located at Spruce above Seventh Street. In 1806, Evans, Sr., was still there but Evans, Jr., ceases to be listed and no will or administration was recorded to note his death. Evans, Sr., moved to 81 Union Street in 1807 and to 221 Spruce Street in 1809, where he remained until his death in 1817.

JOSEPH FOX (1709–1779)

Joseph Fox, one of Philadelphia's foremost craftsmen, was the son of Justinian and Elizabeth Yard Fox. After his father died in 1718, he was apprenticed to James Portues, one of the ten founders of the Carpenters' Company. When Portues died unmarried in 1737, he left a large estate to his two former apprentices, Edward Warner and Joseph Fox, whose relative economic independence then allowed them to enter public service.

Fox became a city commissioner in 1745, just before he married Elizabeth Mickle on September 25. He was city assessor in 1748 and a member of the Provincial Assembly in 1750, responsible for the committee of accounts. He was chosen speaker in 1764 after Isaac Norris, again in 1765, and was succeeded by Joseph Galloway in 1766, but took over again in 1769. He worked closely with Benjamin Franklin revising the minutes of the Assembly for publication.

His active role in the French and Indian War in 1756 caused Fox to be disowned by the Society of Friends, and he was never reinstated. He built the barracks in the Northern Liberties in 1758 and was master there until 1775. He was a member of the Stamp Act Congress and was active early in the Revolution, being a member of the Committee of Correspondence when Paul Revere came to Philadelphia in May 1774 with news from Boston. Fox took the Oath of Allegiance in 1777, but remained within the city during the British occupation. Probably due to his prominence and his popularity, his house was burned by the British.

Fox was one of the earliest contributors to the Pennsylvania Hospital and was selected by Samuel Rhoads to act with him as contractor for the building. In 1757 he was appointed a superintendent of the State House after the death of Edward Warner. He was an early member of the Carpenters' Company and master from 1763 to 1779; in 1773 he loaned £300 toward the construction of Carpenters' Hall (no. 85), having subscribed the largest individual amount, £24, at the beginning of the project in 1770 (Charles E. Peterson, "Carpenters' Hall," in *Historic Philadelphia,* p. 99). As a manager of the Walnut Street Jail (no. 98), he and Edward Duffield gave one of the customary "raising" suppers for a large

group of citizens and the managers of the new jail. Joseph Fox died in Philadelphia in 1779 (see Anne H. Cresson, "Biographical Sketch of Joseph Fox, Esq. of Philadelphia," *PMHB*, vol. 32, no. 2, 1908, pp. 175–99).

SAMUEL RHOADS, DAVID EVANS, SR., DAVID EVANS, JR., AND JOSEPH FOX

48. *Pennsylvania Hospital*

Pine Street, between Eighth and Ninth streets

East wing, 1754–56; west wing, 1795–96; central pavilion exterior, 1796–99, interior completed 1812

Inscription: In the Year of Cnrist,/ MDCCLV;/George the second happily reigning;/(For he sought the Happiness of his People)/Philadelphia flourishing,/(For its Inhabitants were publick-spirited),/ This Building,/By the Bounty of the Government,/And of many private Persons,/Was piously founded,/For the Relief of the Sick and Miserable./May the God of Mercies/Bless the Undertaking! (on cornerstone east wing, by Benjamin Franklin)

Brick structure; stone and marble detailing; shingles

South facade 276′ (84.1 m); width central pavilion 62′ (18.9 m); east and west wings 80 x 27′ (24.4 x 8.2 m); terminal wings east and west ends 27 x 110′ (8.2 x 33.5 m)

REPRESENTED BY:

George Isham Parkyns
(c. 1749/50–c. 1820)
South Front of the Pennsylvania Hospital
c. 1801
Watercolor on paper
10⅛ x 15″ (25.7 x 38.1 cm)
Private Collection

LITERATURE: [Benjamin Franklin], *Some Account of the Pennsylvania Hospital, From Its First Rise to the Beginning of the Fifth Month, Called May, 1754* (Philadelphia, 1754); Thomas G. Morton and Frank Woodbury, *The History of the Pennsylvania Hospital 1751–1895* (Philadelphia, 1895)

THE IDEA for a hospital dedicated to the care of the sick and the insane was proposed in 1751 by Dr. Thomas Bond and was encouraged and promoted through the press of Benjamin Franklin. It was strange to the populace and was central in many political debates, but was finally approved because of Benjamin Franklin's then novel scheme of "matching funds," a conditional clause written into the petition to the Assembly, which solved the financial quandary of raising £4,000 to begin construction. Of it he said in his *Autobiography*, "I do not remember

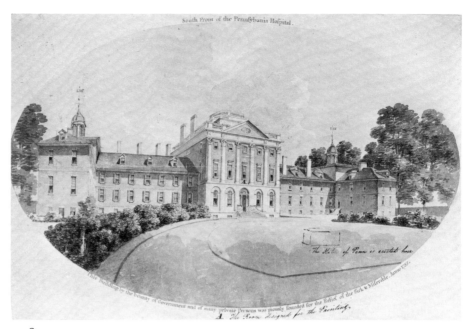

48.

any of my political Manoeuvres, the Success of which gave me at the time more Pleasure. Or that in after-thinking of it, I more easily excus'd my-self for having made some Use of Cunning" (p. 201). Although the old House of Employment and the Almshouse had previously been serving the city with institutional care as an infirmary, the new hospital was proposed to provide specialized service and offer the skills of trained medical men. It was organized and in service in a rented house from 1752 to 1753, while the managers searched for a suitable site upon which to build. The land was purchased on September 11, 1754, and was added to in 1760 by a grant from the Penns, completing a square of 4³/₁₀ acres bounded by Spruce, Pine, Eighth, and Ninth streets, all open land in 1754. Samuel Rhoads and Joseph Fox were commissioned on December 7, 1754, and their elevations and plans were completed and presented two weeks later, on December 21.

The Hospital was designed to be built in three sections, with each part including full services. The east wing was first discussed January 10, 1755, and the working plan and estimate of £3,000 for completion of the wing was presented on March 10. Rhoads was designated contractor, and he and Fox proceeded, employing as many different workmen as possible, securing gifts in kind and free services as donations along the way. Some idea of the extent of this enterprise exists in the Pemberton accounts with the Pennsylvania Hospital (HSP, Pemberton Papers, 1759–60)—Israel Pemberton had "invested" £1,000 himself to promote the enterprise—and they include long lists of

workmen and their specialized contributions. The construction, beginning with the laying of the white cornerstone in the southeast corner of the east wing foundation in the early spring of 1755, climaxed with the roof raising on October 27. The managers made their inspection two months later, on December 27, and the first patients were transferred from the overcrowded rented house to the newly finished and equipped hospital on December 17, 1756. By this time, Benjamin Franklin was president of the board, and his worldwide contacts and solicitations encouraged further private subscriptions to the building project. Original £10 donations grew to as high as £35 from such wealthy merchants as Oswald Peel, William Coleman, Benjamin Chew, and John Macpherson.

No Philadelphia building, with the exception of the State House, has as complete a visual record as the Pennsylvania Hospital. In 1761, after only the east wing had been completed, Dawkins and Steeper engraved the *South-East Prospect of Pennsylvania Hospital* (no. 59) on behalf of the trustees, to further interest in the hospital, and to raise funds for its completion. Their engraving shows the complete Rhoads architectural scheme for the Hospital, drawn presumably from the architect's plans. Hulett and Garrison's view of 1767 (no. 71) shows only the east wing as built, without the projected central and west sections. William Birch's view, taken from the southeast, is dated 1799 and shows the completed building, including the drum and roof structures. Two years later, W. Cooke was paid £21 to engrave Parkyns's southwest view of the Hospital

for use on its diploma (Thomas G. Morton and Frank Woodbury, *The History of the Pennsylvania Hospital 1751–1895,* Philadelphia, 1895, p. 78).

When the east wing was completed, entrance to the Hospital was gained from Eighth Street (see no. 59). Iron railings set into the steps lead up to the first-floor level. Glazed-header bricks are prominent, and the gray stone, keyed, flat window arches, and belt course were by this time traditional in Philadelphia building. Unlike the construction of the State House (no. 30) or Christ Church (no. 26), the building of the Hospital seems to have been well under Rhoads's control both in design and materials. The solid proportions and deliberately blocky organization of wings and facades placed at right angles to one another may have at first been pragmatic, but the building has its own character in comparison with the smooth rectangle constructed by Woolley at the State House. Especially successful and interesting is Rhoads's use of the two hip-roof units, which are separated by the tower-like square central section itself capped with a cupola.

Thus, the terminal wing placed at right angles to the 80-by-27-foot rectangular section, which eventually was attached to the grand central pavilion, was a conspicuous design itself if viewed from Eighth Street, but absurdly incomplete if viewed from any other vantage point (see no. 71). The intent to complete the building was always present. The Pennsylvania Hospital may have set the precedent for those in succeeding generations who built the United States Capitol and the Philadelphia Museum of Art in similar stages, counting on the visual disturbance of incompletion to raise the necessary funds to proceed.

Samuel Rhoads's original design proposal in 1754 included an illustration of the Royal Infirmary in Edinburgh designed by William Adam (*Vitruvius Scoticus,* pl. 150), which he may have submitted for shape and scale, as the Hospital was one of the earliest institutional schemes proposed and constructed in the city. When Rhoads's materials were turned over to David Evans, Sr., in 1790 for completion of the building, he was obliged to follow the original plan for the west wing in order to achieve architectural balance; however, the central unit must be attributed largely to him, working with his son. In 1789, Evans was working with the newest neoclassical fashion in Philadelphia, William Thornton's design for Library Hall (no. 122), an idiom he applied to his work at the Hospital. It is interesting to note that the central pavilion of the Scottish building presented by Rhoads shows a small dome, engaged pilasters on the upper two stories, and a five-bay facade. The belt course

Entrance Hall of Pennsylvania Hospital

at the base of the pilasters divides the smooth surface of the upper stories from the pattern of dressed stone at the ground level. All these features were employed by Evans, although he altered them by flattening the pilasters, insetting arch-topped windows with fanlights in the first story, and replacing the Scottish baroque scrolls and Flemish-type pediment with an oval window in a triangular pediment. These elements were first made fashionable in London in the 1770s by William Adam's sons, Robert and John, and appear more specifically in Sir William Chambers's design for Somerset House (1776–80). The south facade of the Hospital's central unit shows Philadelphia's version of the Adam brothers' neoclassical style, where smooth monochromatic brick replaced the glazed headers, and color and scale relationships changed enough to indicate that institutional architecture had begun to move out of a domestic scale.

The south facade became the main entrance to the Hospital with marble stairs leading up to a large central double door. By 1796 most of the central block was completed, but the design of the dome caused much consternation among the Hospital's managers. In 1798 they were still calling special meetings "to re-consider and decide upon the propriety of completing the said Dome" ("Notes and Queries," *PMHB,* vol. 12, no. 4, 1888, p. 498). Finally, on July 9, 1798, it was resolved that "the Dome be omitted and the Sky Light to enlighten the Theatre for Surgical Operations be finished . . ." (Morton and Woodbury, cited above, p. 78). The circular drum, a familiar

and handsome feature of the building's exterior, was completed the following year, allowing the extraordinary sky-lit clinical amphitheater, the first in America, on the top floor. This feature was probably suggested and promoted by John Dorsey, who was instrumental in the design of the grand double staircase in the entrance hall. The master carpenter for the central section of Pennsylvania Hospital was Joseph Willis, whose work was measured and accounts verified by William Garrigues and John Morris in 1800. Isaac Zane and Robert Wellford (see biography preceding no. 185) were paid for fixing chimneypiece ornaments and for oval scalloped paterae. The turner John Stow was paid for "collums with basis and cap," for newel-posts and banisters, and for "3 ivory center pieces for scroll," known as "newel buttons." Finally, Martin Jugiez, who had done architectural carving for the Powel House, Cliveden (no. 62), and Mount Pleasant in the 1760s, made "2 large ¾ Ionic Cappitals at 25 doll pr. and D°—2 large ½ Ionic D° at 18 pr," which are features of the decoration of the staircase-rotunda space (see illustration).

BG □

JAMES TURNER (D. 1759)

Isaiah Thomas, the first historian of American printing, described James Turner as a "remarkably good workman . . . the best engraver which appeared in the colonies before the revolution" (*A History of Printing in America,* Worcester, Mass., 1810, reprint Albany, 1878, vol. 2, p. 52). Virtually nothing is known of Turner's training; his talents seem to have been fully matured by the time he moved from Marblehead to Boston in the early 1740s. Almost immediately he established a working relationship with Rogers & Fowle, publishers of *The American Magazine.* In 1743 he executed a type metal cut of Boston Harbor for the temporary wrapper of the November issue. The following year he did another view of the harbor for the title page of the collected numbers. Rogers & Fowle also published Turner's first known map, a woodcut *Plan of the Town and Harbour of Louisbourgh* [Nova Scotia], which appeared in *The American Magazine* in 1745.

There can be little doubt that the views of Boston caught the attention of Benjamin Franklin, who was the Philadelphia distributor for the magazine. Although he did not know Turner personally, Franklin entrusted him with engraving Lewis Evans's drawings of the plates for *An Account of the New Improved Pennsylvanian Fireplaces* (Philadelphia, 1744). Thus began the rela-

tionship with Franklin and his circle that was to be of such importance to Turner's career. Soon after the appearance of the "Louisbourgh" map, Franklin recommended that James Alexander, attorney for the Proprietors of East Jersey, engage Turner to engrave the plates for the pamphlet exposition of the Proprietors' claims in a land suit (Labaree and others, *Franklin*, vol. 3, p. 32). Turner accepted the commission, his most important to date. For the Alexander pamphlet, published in 1747 in New York by Franklin's friend James Parker, Turner engraved three plates: the East Coast from Boston to Cape Hatteras, copied from Popple's 1733 *Map of the British Empire in America*; the boundaries of New Jersey; and the specific claims of the Proprietors (James Wheat and Christian Brun, *Maps and Charts Published in America before 1800: A Bibliography*, New Haven, 1969, nos. 294, 397, 398).

Turner's Boston work included more than illustrations and maps. Although he continued to work for Franklin and his friends, he also made or engraved important silver. The Derby tankard now at the Essex Institute and several pieces of armorial engraving for Samuel Burt in Boston have been identified as Turner's (Martha Gandy Fales, "Heraldic and Emblematic Engravers of Colonial Boston," in *Boston Prints and Printmakers, 1670–1775*, Boston, 1973, pp. 203–10). These pieces and the bookplate Turner did for John Franklin about 1750 (Fales, cited above, illus. p. 206) reveal a high degree of technical competence not always present in his illustrations. Yet both armorials and illustrations are undeniably flat. Perhaps the only exception to the planographic quality of Turner's Boston work is the seal of the Pennsylvania Hospital, which he did for Franklin in 1751 or 1752.

The date and reasons for Turner's removal to Philadelphia are not clear. He may have arrived as early as 1753, possibly at the suggestion of Franklin (Fales, cited above, p. 206). The move certainly seems to have been worthwhile, for both the quality and the quantity of his work improved. His bookplates for Isaac Norris II and John Ross have a sculptural quality lacking in much of his Boston work. In 1754, Turner began work on the plate for this map, which appeared the following year. In 1756 he engraved Joshua Fisher's *Chart of Delaware Bay and River* (no. 99), an edition that was suppressed by Governor Robert Hunter Morris for fear that it would aid the French. Finally, in 1758, Turner began work on Scull's *Improved Part of the Province of Pennsylvania*. Together, these three are the most important maps of Pennsylvania to appear in eighteenth century Philadelphia, a fact that Thomas Jeffreys, the London mapseller, clearly recognized when he in-

cluded two of them in his 1768 atlas of North America.

Turner's association with Franklin's circle had provided him with three major commissions. In gratitude, Turner wrote Deborah Franklin in May 1758 that he was overcome by the "sense of the many instances of Mr. Franklin's goodness to myself" (Labaree and others, *Franklin*, vol. 8, p. 59n.). Turner was never able to express his thanks personally; he died of smallpox in 1759 before Franklin returned from England.

LEWIS EVANS (C. 1700–1756)

Like James Turner, Lewis Evans owed a measure of his success to his association with Franklin and his circle, but Evans seems to have had a more fully developed sense of his own worth. There is no doubt that he made a strong impression upon those he met. Young Edward Shippen spoke of him as a "conceited and half-read author" (HSP, Balch-Shippen Collection, vol. 1, p. 24, Edward to Joseph Shippen, October 9, 1749). William Allen, later chief justice of the province, found that Evans had an "impertinent and forward way of talking" (Gipson, *Evans*, p. 39). Even to his close friend John Bartram, Evans was a "queer fellow." Yet his considerable talents as a naturalist, surveyor, and draftsman attracted the attention and patronage of Benjamin Franklin in Philadelphia, Thomas Pownall in New York, and Peter Collinson in London. But Evans was always his own man; that he became embattled and controversial can be explained as much by contemporary politics as by his singular personality.

Lewis Evans, "gentleman," was born in Llangwnadl Parish, Carnavonshire, Wales, about 1700. During his early years he acquired smatterings of a classical education, practical training as a surveyor, a firsthand knowledge of India and South America, a case of Gallophobia, and a habit of speaking his mind. He arrived in Philadelphia in 1736, seemingly "without prospects." Almost at once he sought out James Logan (see no. 12) for whom he made a map of the Walking Purchase of 1737. Shortly thereafter, Evans attached himself to Franklin who, although five years Evans's junior, was already publisher of the *Pennsylvania Gazette* and clerk of the Provincial Assembly. Franklin's accounts show that among other things Evans worked in the new post office. Presumably it was through Franklin that Evans met John Bartram and Conrad Weiser, whom he accompanied to Onondaga Castle in New York province to meet with the Indians of the Six Nations and to gather natural history specimens in 1743. The following year the relationship with the Franklins became even closer: Evans drew

the designs for Franklin's fireplace, and Deborah Franklin became godmother at Amelia Evans's christening at Christ Church (Gipson, *Evans*, p. 5).

In 1746, Franklin put Evans in the way of a major commission: an adaptation of Cadwalader Colden's map of New York, as well as a survey of some of the lands belonging to the Proprietors of East Jersey. Both were subsequently engraved by Turner.

The publication of the Jersey maps brought Evans new opportunities and a new patron, Richard Peters, secretary of the provincial land office and a member of the Governor's Council. The conclusion of King George's War in 1748 stabilized relations between the French and English in the Ohio Valley. Opportunities for land speculation and the Indian trade seemed limitless, but both trade and land titles depended upon who owned what. Evans spent the remaining years of his life attempting to answer these questions, and it was almost inevitable that someone's ox would be gored.

His first effort was *A Map of Pennsylvania, New-Jersey, New-York and Delaware*, published in Philadelphia in 1749. While the map was still in draft, Evans presented it to Richard Peters who promptly advanced him ten pounds on behalf of the Proprietors of Pennsylvania (HSP, Peters Papers, Peters to Thomas Penn, July 24, 1749). The map is a remarkable compendium—seven lengthy paragraphs explain its geographical features, including a note on the geological origins of the "Endless Mountains." Despite Evans's claim that he had "omitted Nothing in my power to render this Map as complete as possible," his effort satisfied no one. Peters and Penn faulted him for not showing the north and west bounds of the province and for not including Lake Erie. Others were annoyed that he had relied too heavily upon Colden and James Alexander for the New York and New Jersey boundaries (*Weekly Post-Boy* [New York], May 1, 1749).

Apparently in an effort to meet these criticisms, especially those of Peters and Thomas Penn, Evans redrafted the 1749 map early in 1750, the only known impression of which is in the collection of the Library of Congress. Evans drew the western boundary of the province to include Logstown, the important trading post near Pittsburgh. The Ohio country was becoming increasingly important to Pennsylvania. Thomas Penn fretted continuously over French incursions into the Valley as well as those of Virginia's Ohio Company (HSP, Thomas Penn, Letter Books, vol. 2, p. 295, Penn to Governor Hamilton, February 12, 1749/50). To settle the provincial boundary once and for all, Thomas Penn hoped to have an actual survey. Instructions were issued to Evans to "gain intelligence of the Southern and Western Bounds," but his trip was to be

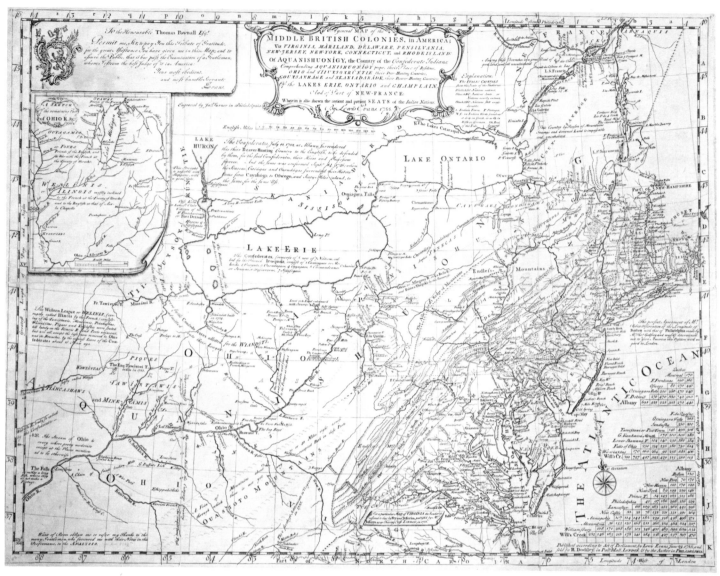

49.

surreptitious: "Make Excursions in adjacent parts, as you will judge necessary for preventing any suspicion of your being employed by us" (Gipson, *Evans,* pp. 36–37).

The work would be hazardous, and Evans clearly intended to make it worth his while. He asked the Proprietors for one hundred guinëas, plus expenses, a sum Thomas Penn thought exorbitant. Penn demurred; Evans became increasingly impatient. Friction grew, and finally, in late 1753, Evans deserted the Penns entirely, offering his services to the Baltimores whose boundary dispute with the Penns had still not been satisfactorily resolved. The defection was briefer but as unsatisfactory as his relationship with the Penns had been. It is hardly surprising to find him petitioning the Provincial Assembly for support for a new "Map of this and four of the neighboring colonies." The Assembly promptly voted him fifty pounds (Gipson, *Evans,* pp. 47–57).

Evans's *Map of the Middle British Colonies,* engraved by Turner, was published June 23, 1755, against a background of renewed conflict with France. In June 1754 the commissioners of the Northern Colonies met at Albany to discuss a common defense. On July 3, Washington had surrendered Fort Necessity to the French. And on June 7, 1755, Braddock's army marched off to Fort Duquesne and defeat. Events assured success for the map both here and in Britain.

Unfortunately Evans's success was short-lived. His friendship with Pownall and Franklin landed him in deep trouble. Upon the unfortunate death of General Braddock, William Shirley succeeded to command of the British forces in America. Rather than commit troops to defend the Pennsylvania and Virginia frontiers against the French, Shirley concentrated forces in New York. Evans and Pownall both found Governor Robert Hunter Morris's decision to reinforce Shirley's troops with Pennsylvanians highly irresponsible because it left the frontier undefended. Evans accused the governor of treason, but he had taken on the wrong man. Evans moved to New York shortly after making the accusation, but Morris's wrath followed him. On March 9, 1756, Evans was brought before the Mayor's Court on a charge of slander, and he remained in the custody of the court until June 8. He died in New York June 11 (Walter Klinefelter, "Lewis Evans and His Maps," *Transactions of the American Philosophical Society,* n.s., vol. 61, pt. 7, Philadelphia, 1971, pp. 50–52).

49. *Map of the Middle British Colonies*

1755
Signature: Eng by Jas Turner in Phila
(on plate, left of cartouche)
Inscription: *A general* MAP of the/MIDDLE
BRITISH COLONIES, in AMERICA:/Viz
VIRGINIA, MARILAND, DELAWARE, PENSIL-
VANIA,/NEW-JERSEY, NEW-YORK, CONNEC-
TICUT, and RHODE ISLAND:/ Of AQUANI-
SHUONIGY, the Country of the *Confederate
Indians*;/*Comprehending* AQUANISHUO-
NIGY *proper, their Place of Residence,*/
OHIO *and* TIIUXSOXRUNTIE *their Deer-
Hunting Countries,*/COUXSAXRAGE *and*
SKANIADARADE, *their Beaver-Hunting
Countries*;/*Of the* LAKES ERIE, ONTARIO
and CHAMPLAIN,/ *And of Part of* NEW-
FRANCE:/Wherein is also shewn the
antient and present SEATS of the *Indian
Nations.*/*By Lewis Evans. 1755.*
Engraving on laid paper, lined with
Japanese mulberry tissue
20⅛ x 26¾" (51 x 68 cm)
Historical Society of Pennsylvania,
Philadelphia

PROVENANCE: Purchase, Historical Society of
Pennsylvania, 1893

LITERATURE: Baltimore Museum of Art, *The
World Encompassed: An Exhibition of the
History of Maps* (October 7–November 23,
1952), no. 255; Gipson, *Evans;* Walter
Klinefelter, "Lewis Evans and His Maps,"
*Transactions of the American Philosophical
Society,* n.s., vol. 61, pt. 7 (Philadelphia, 1971),
throughout; Henry N. Stevens, *Lewis Evans, His
Map,* 2d ed. (London, 1920); James Wheat and
Christian Brun, *Maps and Charts Published in
America before 1800: A Bibliography* (New
Haven, 1969), no. 298, p. 65

SOMEWHAT DISINGENUOUSLY Lewis Evans
informed his public that his 1755 *Map of the
Middle British Colonies* was a "premature
Publication," occasioned by the "present
Conjuncture of Affairs in America, and the
generous Assistance of the Assembly of
Pensilvania" (Evans, *Analysis of a General
Map of the Middle British Colonies,* Phila-
delphia, 1755, p. iii). A thirty-six-page
pamphlet issued separately from the map,
the *Analysis* had two purposes: to explain
many of the topographical features of the
map and to argue convincingly for the
English occupation of western Pennsylvania
and the Ohio Valley. Encouraged by
Franklin, Richard Peters, and Thomas
Pownall, who was later to become governor
of Massachusetts, Evans had been collecting
materials for the map and the accompanying

Analysis since his 1738 map of the Walking
Purchase. Publication was hardly premature.
Evans certainly gauged the market correctly
—in 1755 alone Franklin's shop printed two
editions of the *Analysis,* and through
Pownall's London connections two editions
of the pamphlet and the map were brought
out there in the same year. So successful was
the map that it was pirated no fewer than
fifteen times before 1800; it became the
"master" map for the region for fifty years.

The map is on a much larger scale than
anything Evans had previously attempted.
He incorporated his 1749 *Pennsylvania,
New-Jersey, New-York and Delaware* on a
smaller scale but met the complaints of the
Penns and Peters by adding the western
bounds of Pennsylvania and the Great Lakes.
He added western New England, incorporat-
ing the work of several others, including
Pownall, to whom the map is dedicated.
His delineation of Virginia he acknowl-
edged to be based on the great Fry and
Jefferson map. Evans continued to measure
longitude from Philadelphia, a practice he
had begun on his 1749 map and one con-
tinued by other mapmakers after the
Revolution. And because the thirty-six pages
of his *Analysis* contained much more infor-
mation than the 1749 map, Evans provided
an alphabetical key on the top and righthand
margins.

The focus of the map is clearly the Ohio
Valley, which Evans saw as "the Object of
British and French Policy" (*Analysis,* p. iii).
Despite his brief disenchantment with
Pennsylvania, it seems that Evans always
recognized the importance of the Ohio
Valley to Pennsylvania. In a "Brief Account
of Pennsylvania," written for Richard Peters
in 1753, he clearly spelled out, frequently on
the basis of personal observation, the
complex relationship between the allegiance
of the Six Nations and the control of the
Indian trade in the Ohio: one could not have
one without the other. He commented, "We
sometimes treat with them at Onondago,
but oftener at Philadelphia . . . it is our
Interest to strike Them with a Grandeur
superior to what they see at Canada. At
Onondago they have Councillors, in both
the French & English Interest, for the sake
of picking what they can out of both, their
very Substance depends upon their wavering
between these two rival Nations" (HSP,
"Brief Account of Pennsylvania," pp. 6–7).

Evans was a realist: he neither denied the
legitimacy of the French claims to Canada
nor the unfortunate possibility that the
French might alienate the Iroquois con-
federacy, thus closing English trade to the
Ohio. But for him the responsibility for
solving the second problem lay with
Whitehall. "It is impossible to conceive," he
wrote, that "had his Majesty been made
acquainted with its Value, the large Strides

the French have been making . . . in their
Incroachments on his Dominions; and the
Measures still taken to keep the Colonies
disunited . . . his Majesty would have sacri-
ficed, to the Spleen of a few bitter Spirits,
the best Gem in his Crown. It is not yet too
late . . ." (*Analysis,* p. 31). Evans was never
one to mince words. It is little wonder that
only his map—and not the *Analysis*—was
pirated.

Turner's plate and Franklin's printing of
the accompanying pamphlet are both com-
petent jobs. In execution they are much
simpler than contemporary European pro-
ductions, but this is to fault neither the
engraver nor the printer. Evans was the
proprietor and publisher of both map and
pamphlet. One can presume that Turner
followed Evans's drawing exactly, even to
the row of identical carets that represent the
Alleghenies. And, as the pamphlet was a
piece of job printing, Franklin undoubtedly
respected his client's pocketbook.

Unfortunately Evans did not live long
enough to profit from the enormous success
of his map, but his patrons and friends
Pownall and Franklin saw to it that his
daughter Amelia did. In 1776, Pownall
resuscitated both the *Analysis* and Turner's
plate. He added to both and reissued them
as his *Topographical Description,* forward-
ing the profits to Amelia.

PJP □

50. *Needlework Pocketbooks*

(a) c. 1755
Inscription: SAMVAL MORGAN (inside
band at opening)
Wool and silk on linen canvas, cardboard
interlining, silk lining, plain-weave silk
tape, silk thread
Stitches: Irish, cross
Open 9⅛ x 6¹³⁄₁₆" (23 x 17.3 cm), closed
4½ x 6¹³⁄₁₆" (11.5 x 17.3 cm)
Anne Chew Barringer, Radnor,
Pennsylvania

PROVENANCE: Samuel Morgan; descended in
family to Anne Chew Barringer

(b) 1774
Inscription: R M 1774 (inside band at
opening)
Wool on linen canvas, cardboard
interlining, wool twill tape, silk lining,
silk thread
Stitches: Irish, cross
Open 7½ x 5¹³⁄₁₆" (19 x 14.8 cm), closed
4⅛ x 5¹³⁄₁₆" (10.5 x 14.8 cm)
Anne Chew Barringer, Radnor,
Pennsylvania

50b. 50a.

LITERATURE: Hornor, pl. 83; Helen Comstock, "Philadelphia Chair," *Connoisseur*, vol. 137 (March 1956), p. 144

THE ONLY STRAIGHT LINE on this chair is the back seat rail, and that is almost hidden by the slight swell of the slip seat. From all angles the contour and profile are determined by a series of rhythmic curves, slow and sinuous on the arms, crisp and sharp on the back splat. These structural configurations are ornamented with restrained surface carving—scrolls and a convex shell on the cresting, leafage on the knees, and a concave shell dropped from the front seat rail. This chair form, popular in England during the reign of George I, was first called in America the "compass-bottom" chair. It is based on the lighter, almost fragile, form of the earlier period (see no. 27), but here the strength of the stretcherless design and the self-confidence of the artisan create a sculptural tour-de-force which is in no way a compromise to purpose. The smooth twisting arm, seen often on English pieces, is intriguing from any angle, and comfortable as well, and the wide sweep of the curved seat allowed billowing skirts to spread. Only the easy chair form (see no. 78) offered such individual comfort with "welcoming arms."

Tradition says this armchair belonged to Samuel Powel (1739–1793) and stood in the parlor of his fine house at 244 South Third Street, which he purchased from Charles Stedman early in 1769, the same year he married Elizabeth Willing, daughter of Charles, a prominent merchant. A graduate of the College of Philadelphia in 1759, Powel was privileged to travel abroad for polish and contacts, and he expressed a youthful arrogance when in 1764 he wrote to his uncle, Samuel Morris, in Philadelphia: "Your two friends [Samuel Powel and his friend Dr. Morgan] have been lolling in the lap of ease. Italia, nurse of the softer arts, has detained them from mixing with the turbulent throng" (Moon, *Morris Family*, vol. 2, p. 460). Although full of youthful frivolity, he had a serious side, and had been made a Fellow of the Royal Society in London. After his return to Philadelphia, Powel became a member of the Common Council in 1770, and a justice of the Common Pleas and Quarter Sessions Court in 1772; he was an alderman in 1774 and mayor of Philadelphia in 1775 and again in 1789.

The origins of this armchair are unknown, but if the stylistic dating to about 1755 is accurate, it was either purchased earlier by Powel's family or it came as part of his wife's furnishings. Powel owned other property before he bought his house, the accounts of which Samuel Morris kept for him while Powel was abroad from 1760 to

PROVENANCE: Ruth or Rachel Morgan; descended in family to Anne Chew Barringer

NEEDLEWORK POCKETBOOKS were fashionable in America in the period 1740–90 and achieved their greatest popularity between 1760 and 1780 (Susan B. Swan "Worked Pocketbooks," *Antiques,* vol. 107, no. 2, February 1975, pp. 298–303).

The two primary shapes, shown here, are worked in a jagged diamond pattern in worsted (crewel) yarns using the Irish stitch over the entire ground; this stitch is commonly associated with this design and incorporates characteristic shading into its geometric patterns.

In these examples, wear has revealed the composition of the canvas as coarse linen thread, with weft threads doubled at intervals across a single warp thread. This thread configuration is the result of the pull of the thread itself; the vertical stitch covers four threads, each rising or falling two threads on the diagonal. Both pocketbooks are lined with silk, but wool was also used on contemporary examples. There are no fasteners in evidence on either.

The first example (a), inscribed SAMVAL MORGAN, is in the common double form, folding in the middle, with pockets on the inside at both sides. Each pocket opens with green silk pleats; there is a silk-covered cardboard divider in each. This form was usually although not exclusively used by a man to carry currency and papers. The name has been worked in cross-stitch, incorporated into a band of the same stitch across the top of one of the pockets on the inside. The diamonds, in shades of red, blue, green, yellow, orange, and purple, are outlined in a white silk yarn. The tapes are of plain-weave silk.

The second pocketbook (b), inscribed RM 1774, is of the single form, consisting of one pocket with a flap, like that of an envelope, folding over the opening. The edge of the flap curves to a point at the middle. The pocket has two sections, each with a divider of cardboard covered with silk. Like the above example, the inscription is worked in a cross-stitch; the pattern, in similar diamond design and Irish stitch, is outlined in black wool. The tapes are of blue wool, woven in the twill weave. The indigo silk lining contains a red, triple-lined stripe, incorporated into the piece as the back edge of the pocket.

Samuel Morgan (died c. 1759) was the father of Ruth and Rachel, and son of John Morgan (died c. 1744), who built Venor farm in Radnor in 1715. His pocketbook may have been worked by his wife, Magdelen, or by one of his daughters. Neither Ruth nor Rachel had any known descendants, and the pocketbook passed to their sister, Sarah.

PC □

51. *Armchair*

c. 1755
American black walnut and pine; twentieth century silk damask upholstery
Height 42¼" (107.3 cm); width front 25½" (64.8 cm), back 16¾" (42.5 cm); depth 22" (55.9 cm)

Philadelphia Museum of Art. Purchased: Thomas Skelton Harrison Fund. 55–69–1

PROVENANCE: Samuel Powel (1738–1793); Mrs. Edgar Wright Baird

1767. Entries in the Ledger in Morris's writing include repairs to a tall clock by Thomas Stretch in 1765 (LCP, Samuel Powel, Ledger, 1760–64, p. 46) and payment to James Claypoole for glazing a print in 1762 (p. 42). Powel's accounts from 1770 to 1772 describe the remodeling of the Third Street house by Robert Smith and the purchase of quantities of upholstery and carpeting, but very little furniture was itemized, suggesting that he already owned sufficient quantities by this date. His Ledger shows an account with Thomas Affleck from 1768 to 1773 (a period much too late for this chair) amounting to a total of over £107 (p. 78).

Powel was held in high esteem by George Washington, who noted in his diaries many evenings spent at Powel's elegant house. The Earl of Carlisle, who was "harbored" at the Powels' house in 1778, wrote: "I am lodged in one of the best houses in the town, and indeed it is a very excellent one, perfectly well furnished" (Moon, *Morris Family,* vol. 2, p. 481).

BG ☐

51.

BENJAMIN WEST (1738–1820)

The first native American artist to achieve international fame, West was born October 10, 1738, in Springfield, Pennsylvania, the son of an innkeeper. According to his own account, he began to draw at age six. About a year later he was given some oil paints and six engravings by Edward Pennington, a Philadelphia merchant related to the West family, who soon after invited Benjamin to visit him, probably in 1747. West met the English artist William Williams (see biography preceding no. 69) in Philadelphia during one of these visits and received some instruction from him. Apparently from 1756 until his departure for Italy, he was a permanent resident of Philadelphia. From the books and prints borrowed from Williams, West developed his ambition to go to Italy, finally realized in late 1759. Until this time, West's ideas on art must have been largely formed by contemporary portraits—such as those by Wollaston, Feke, John Hesselius, William Williams, and John Green—by engravings, and by the few European paintings available to him, for example, Governor James Hamilton's *St. Ignatius,* which West copied. Books on theory were especially important to Americans as one of the few connections with European ideas, and most of West's lifelong attitudes on the supremacy of history painting and the importance of working from nature were formed at a very early age by his avid reading of Jonathan Richardson and Charles-Alphonse Du Fresnoy. In Italy (1760–63), West studied Renaissance and Baroque painting, especially the work of Anton Raphael Mengs and Pompeo Batoni in Rome. In 1763, West visited London and was received with such enthusiasm that he remained there for the rest of his life, becoming a charter member of the Royal Academy in 1768, historical painter to the king in 1772, and president of the Royal Academy from 1792 until his death in 1820, with only one year's interruption. West was famous for his large canvases of heroic scenes taken from the Bible and from ancient and modern history, many of which were painted for his patron George III and exhibited at the annual Royal Academy exhibitions. West's prestige, at its height from the late 1760s to the late 1790s, was enormous. Beginning in 1764, his London studio was virtually a "school" without precedent, for three generations of American artists.

West was the first artist to be made an honorary member of the Pennsylvania Academy of the Fine Arts (July 1805). The Academy also, in its early stages (1807), borrowed, with the intention of buying, some of West's London paintings for the edification of the students (APS, Charles Willson Peale, Letterbook, vol. 8, pp. 29–30, 70, 77). West, in turn, acted as a distant yet distinguished adviser to the Academy's founders on the selection of "Casts from the Greek figures most proper for study" (HSP, Benjamin West Papers, West to Rawle, September 21, 1805). In 1811, West also gave his large painting *Christ Healing the Sick in the Temple* to the Pennsylvania Hospital as "a model for the improvement of American Artists" (HSP, Pennsylvania Hospital MSS, Visitor's Book of "Christ Healing the Sick," 1817–18, p. 122). In 1836 the Academy bought the finished version of his huge *Death on a Pale Horse* of 1817.

West had intended to return to Philadelphia in 1803 but was discouraged by the advice of his physician as well as by the realization that his history paintings would not be financially successful (HSP, Dreer Collection, Painters and Engravers, vol. 3, Rembrandt Peale, Reminiscences, n.d., p. 4). West died in London and was buried with the most honored in St. Paul's.

52. *The Death of Socrates*

c. 1756
Signature: [...] Henry / B West [pi]nxit (on step, lower left)
Oil on canvas
34 x 41" (86.4 x 104.1 cm)

Private Collection

PROVENANCE: William Henry (1732–1786); descended in family

LITERATURE: John Galt, *Life and Studies of Benjamin West, Esq.* (London, 1816, reprint Gainesville, Florida, 1960), pp. 36–37; Dunlap, *History,* vol. 1, p. 41; HSP, Henry MSS, memo by Anne M. Smith, vol. 2, folio 93, March 26, 1855; Francis Jordan, Jr., *Life of William Henry of Lancaster, Pennsylvania, 1729–1786* (Lancaster, 1910), pp. 26–33; Sawitzky "West," p. 461; James Thomas Flexner, "Benjamin West's American Neo-classicism," *New-York Historical Society Quarterly,* vol. 36, no. 1 (January 1952), pp. 6–7, 19–34; Allentown [Pa.] Art Museum, *The World of Benjamin West* (May 1—July 3, 1962), pp. 14, 19, 50; Peter S. Walch, "Charles Rollin and Early Neoclassicism," *Art Bulletin,* vol. 49, no. 2 (June 1967), pp. 123, 125–26; Ann C. Van Devanter, "Benjamin West's *Death of Socrates,*" *Antiques,* vol. 104, no. 3 (September 1973), pp. 437–39

BENJAMIN WEST's earliest history picture, *The Death of Socrates,* is his only signed American work. Although mentioned in Galt's 1816 biography of the artist, it was lost to the art world from about the late 1840s until 1952, when its location was rediscovered by Flexner.

52.

West in his London studio, he was producing large-scale scenes from Roman history, such as *Agrippina Landing at Brundisium with the Ashes of Germanicus*, 1768 (Yale University Art Gallery; 1770 replica at Philadelphia Museum of Art), which were at least as sophisticated as the work of his best European contemporaries.

In England, history painting had long been accepted theoretically as the highest form of art but there were few serious contenders for the role of leading history painter when West arrived. Although the time was ripe for him in England, he became even more revered in Philadelphia. West's importance in Philadelphia art was theoretical and inspirational rather than practical, for there was no demand for large-scale history painting here. His great contribution was that he fired the imagination and raised the ambitions of Philadelphia artists.

DE □

The central section of the painting is based on an engraving designed by Hubert François Gravelot, which appeared in Charles Rollin's *Ancient History of the Egyptians, Carthaginians, Assyrians, Babylonians, Medes and Persians, Macedonians and Grecians* (vol. 4, 2d ed., London, 1738–40, frontis.). However, only three figures—Socrates, the slave who has handed him the deadly hemlock, and the seated figure at lower right—are really dependent upon the engraving. Much of the work is original, unlike Benbridge's *Achilles Among the Daughters of Lycomedes* (no. 55) or Bordley's *Temple of Apollo* (no. 106). West expanded the scene on both sides, converting it into a horizontal composition, with the soldiers and Socrates' disciples at the left and the arrangement of the prison background as his own invention or derivation from other engravings.

West was about eighteen when he painted the picture in Lancaster, Pennsylvania, where he was visiting friends in order to execute portrait commissions. There he met William Henry, a wealthy gunsmith, who urged him to devote himself to historical subjects and commissioned him to paint the death of Socrates, based on the story in Henry's edition of Rollin's *Ancient History* (still owned by the Henry family). West accepted the commission, altering the slave

in the engraving to a semi-nude figure modeled by one of Henry's workmen. The finished painting attracted "much attention," according to Galt (*Life and Studies of Benjamin West, Esq.,* London, 1816, reprint, 1960, p. 37).

Although West's unusually dark outlines and heavy shading undoubtedly result from his reliance on engraved precedents, the color of the background light and its careful reflection are based ultimately on the observation of nature. West added a *repoussoir* figure at the left foreground, creating a symmetrical balance which reveals some knowledge of traditional composition, probably derived from other engravings or the work of an artist who painted landscape or subject pictures, such as the theatrical scenery painter William Williams.

The Death of Socrates expresses an heroic ideal, a moment when man's dignity approaches that of the gods. It is intended to elevate and ennoble in contrast to the mere mythological illustration of Benbridge's *Achilles Among the Daughters of Lycomedes.* The difference is prophetic, for history painting in the spirit of *The Death of Socrates* was to become the special domain of Benjamin West alone among English and American painters of the eighteenth century. None reached his fame in this genre.

By the time Philadelphians began to visit

JOHN LEACOCK (1729–1802)

The Leacock family, like the majority of seventeenth century émigrés from England to the New World, went to the West Indies. John Leacock (1689–1752), father of the silversmith, left Barbados sometime before 1716 and came to Philadelphia as a dealer in molasses and textiles (HSP, Stauffer Collection, vol. 21, p. 1607). He married Mary Cash (1694–1765) in Christ Church on July 3, 1715. John, Jr., was born December 21, 1729 (APS, Cash-Leacock Family Bible).

Exactly how or from whom John Leacock, Jr., received his training as a silversmith is still obscure, but his brother Joseph (1734–1804) was a watchmaker, and his sister Mary (1720–81) married David Hall, printer and partner of Benjamin Franklin, whose wife was related to Leacock's mother. (John's son, Samuel, born about 1754, was later apprenticed to Hall, and specialized in copperplate printing.) On September 5, 1749, Leacock attended a Freemason's gathering at which Philip Syng, Jr., silversmith, was present. This is the earliest association of Leacock and Syng, but it was social rather than professional and only suggests an apprenticeship (Julius F. Sachse, comp., "Roster of the Freemason's Lodge Philadelphia No. 2, of the Moderns," *PMHB*, vol. 31, no. 1, 1907, p. 19).

Leacock must have been given his "freedom" when he advertised in the *Pennsylvania Gazette* on November 7, 1751, that he was in business at the "Sign of the Cup" on Water Street. He married Hannah McCally on August 2, 1752 (HSP, Records of Gloria Dei, Baptisms and Marriages,

vol. 1, p. 270). Shortly after, his father died, leaving an inheritance (City Hall, Recorder of Deeds, John Leacock, Administration no. 51, December 1752), which may have enabled him to move in November 1753 from Walnut to Front Street, opposite Mr. Norris' Alley. His sign became "The Golden Cup," and he advertised as a goldsmith and jeweler in the *Pennsylvania Gazette,* November 29, 1753.

With his signing of the petition to the Proprietors for ground upon which to build St. Peter's Church (no. 54) in August 1754, Leacock entered the public arena. By 1759, he was a member of the State in Schuylkill Fishing Company, a sporting club whose membership was made up of prominent citizens. Leacock joined the long list of merchants who signed the Non-Importation Agreement in 1765 in protest against the stamp excise tax levied by the English Parliament, no small gesture, for much of his incidental business supplying specialty items was imported from London: "Just imported . . . from London, and to be sold by JOHN LEACOCK, GOLDSMITH in Front-Street, Philadelphia, viz. Chased silver tea pots, newest fashion . . . salts with or without glasses . . . chased tweeser cases . . . chrystal coffin stones and cyphers for mounting rings . . . green smelling bottles tip'd with silver . . ." (*Pennsylvania Gazette,* January 25, 1759). Leacock was active as a silversmith at least through April 1766 when he billed Baynton, Wharton, and Morgan for £131 16s. worth of Indian medals (Gillingham, "Indian Silver," p. 126).

In October 1767, however, Leacock took up horticulture with a passion. Armed with Philip Miller's *Gardener's Dictionary,* he purchased a small plantation in Lower Merion Township and set about raising field crops, fruits, and vegetables (APS, John Leacock, Commonplace Book, April 16, 1678). Perhaps the death of his wife in December of the same year sent him off on the vigorous pursuit of a vineyard, which he set up in a partnership. In 1733 he advertised for a lottery to support his public vineyard: ". . . it is intended, that the cuttings of the Vines shall be free, and without any expence, for any patrons who choose to apply for them, who will engage to plant them in suitable pieces of ground, for the encouragement of Vineyards . . . Gratis. J. L." (*Pennsylvania Gazette Supplement,* March 3, 1773). Long the dream of Philadelphia, large-scale vineyard projects nevertheless came to naught.

Leacock married for the second time on June 17, 1770, to Martha Ogilby, and in two years he was caught up in organizations protesting the Stamp Act. The most colorful of these was the Society of the Sons of St. Tammany, of which Plunket Fleeson, upholsterer, was also a member. Leacock made up poems and songs which he performed for the group, as well as plays (Francis Von A. Cabeen, "The Society of the Sons of Saint Tammany of Philadelphia," *PMHB,* vol. 26, no. 2, 1902, p. 220). In a drama which centered around the battles of Lexington and Concord entitled *The Fall of British Tyranny or, American Liberty Triumphant,* John Leacock, through the pseudonym "Dick Rifle," added his name to a short list of eighteenth century American playwrights (Francis James Dallett, Jr., "John Leacock and the Fall of British Tyranny," *PMHB,* vol. 78, no. 4, October 1954, pp. 456–75).

Leacock and family were back in Philadelphia by 1780 where he campaigned and won election to the office of city coroner. At the same time, he was listed in Francis White's Philadelphia directory for 1785 as an innkeeper on Water Street between Arch and Race. Cabinetmaker David Evans made wooden venetian blinds for him in January 1789, and in April, Evans noted, "John Leacock Esqre Dr. to making a walnut bookcase & Scalloped Doors & Pitch Pedimens head" (HSP, David Evans, Day Book, January 6, April 25, 1789). In 1793, Leacock was living in a house on South Fifth Street which he bought in 1800. He died November 16, 1802, and was buried at Christ Church Burial Ground.

53. *Whistle and Bells*

c. 1756–58

Mark: I.I. (in rectangle on underlip of whistle)

Inscription: S. MORRIS (on side of whistle); 1760 (scratched on underlip of whistle)

Silver and coral

Length 5¼″ (13.3 cm)

Philadelphia Museum of Art. Given by Mrs. Thomas D. Thacher. 70–81–1

THE WHISTLE AND BELLS, with its utilitarian coral teething stick fitted into the end, was not merely an ornament but was used often, if records concerning the repair of these objects serve as evidence to that fact, especially in the replacement of the piece of coral. They were treasured enough to appear in contemporary children's portraits, and numbers of them are preserved in public and private collections today.

This example by Leacock is an elegant solution to the design problems raised by the rather ungainly long shaft. The whistle end tapers comfortably and protrudes far enough so that the bells do not interfere with the blowing. In the middle, the bells hang from four eye loops, and four more from raised scrolled loops. The bells are suspended from the shaft on small figure-eight chain loops. Spinning the toy rapidly back and forth provided a shimmering whirl and a pleasant, continuous ring. The stick of coral, which was firmly fitted into the silver shaft, was both a handle and a teether. The chased scrolls and flowers on each end, around the octagonal knop and surrounding the loop on each bell, are characteristic of Philadelphia design work at midcentury and suggest an earlier date for this piece than Leacock's snuffbox (no. 68). Both Philip Syng, Jr., and Joseph Richardson, Sr., chased in this manner before 1760 (see nos. 44, 35; Fales, *Joseph Richardson,* pls. 44, 48, 54), but this type of chasing is comparatively rare in Philadelphia silver. The sleeve which holds the coral suggests the cut-card decoration similar to that on a tankard by Johannis Nys (no. 12), which confirms an early date for this piece.

The care with which the design of this whistle and rattle was worked suggests that it was custom-made for Captain Samuel Morris's child rather than a stock item.

53.

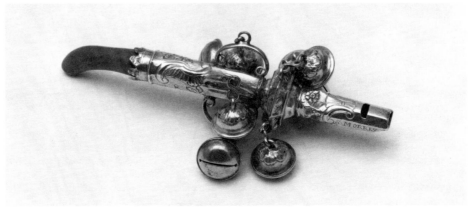

Morris had been a member of the State in Schuylkill Fishing Company for eleven years when John Leacock became its eighty-eighth member (*A History of the Schuylkill Fishing Company of the State in Schuylkill, 1732–1888,* Philadelphia, 1889, p. 346). Since much of Philadelphia business was conducted through social encounters, Leacock was a sympathetic artisan for Morris to patronize and Morris was an important customer for Leacock to please. Already a revered citizen, Morris became governor of the Schuylkill Fishing Company in 1765 and held that office for forty-six years.

Morris married Rebecca Wistar, December 11, 1755, at Christ Church, Philadelphia. Their first child, Samuel, born in 1756, died in infancy. Sarah was born in January 1758 (Moon, *Morris Family,* vol. 1, p. 351). Although there were eight more children to come, based on stylistic evidence this whistle and bells was probably presented to Samuel or Sarah. It was not mentioned in Morris wills or inventories, for it descended at births instead of deaths.

BG □

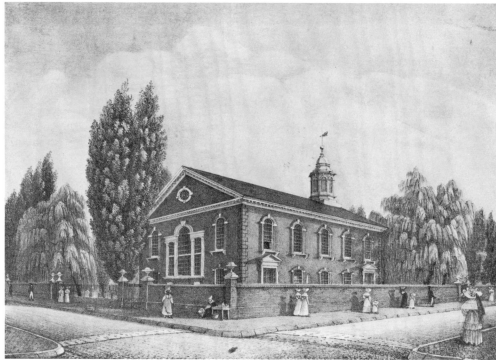

54.

JOHN KEARSLEY (1684–1772) AND ROBERT SMITH (1722–1777)

(See biographies preceding no. 26)

54. *St. Peter's Church*

Third and Pine streets
1758–63; tower 1842
Brick structure; stone detailing; wood trim; shingles
90 x 60' (27.4 x 18.3 m)

REPRESENTED BY:

W. L. Breton (c. 1773–1855)
St. Peter's Church from the Northeast
1829
Lithograph
8¹⁄₁₆ x 11 ⁹⁄₁₆" (20.5 x 29.4 cm)

The Library Company of Philadelphia

LITERATURE: Christ Church, Vestry Minutes, 1702–83; Christ Church, Drawer 26; Wise and Beidleman, *Colonial Architecture,* p. 173, 5 illus. (unnumbered); Shoemaker, "Christ Church," pp. 190–93

BY 1753 attendance at Christ Church was so great that "many Persons ... [were] obliged to stay home and neglect divine Service, or go into dissenting Meetings" (Rev. Dr. Jenney to Subscribers, March 21, 1753, Christ Church, Drawer 11, p. 190). Thus the vestry decided to build another church for the convenience of those members living in Society Hill. Thomas and Richard Penn gave Proprietary ground for the purpose at Third and Pine streets, and a long

formal contract was drawn up between the vestry and Robert Smith, "house carpenter," on August 5, 1758, with precise specifications for the new building. John Kearsley, at the head of the vestry's list, probably had much to do with the design, as he had at Christ Church (no. 26), working closely with Robert Smith in actually drawing up the specifications. Smith had already done work for Christ Church, constructing its steeple in 1754, and he would have been a logical choice for this commission.

The design for St. Peter's Church, called a "Chapel of Ease" in its day to distinguish it from, but tie it firmly to, its parent, Christ Church, was probably based on Christ Church in Surrey, England, not because anybody had seen it recently, but because it was engraved in William Maitland's *History of London,* published in 1756. It is reasonable to imagine that given his interest in architecture, Kearsley must have known of this publication, even purchased it for its encyclopedic approach to London architecture. The plate, a *South-East Prospect of Christ Church Surrey* (vol. 2, facing p. 1384), shows a single-gable-roofed rectangle with quoined corners, and arch-topped rusticated windows, finished with sills and supporting brackets, which like St. Peter's are larger on the upper level than on the lower. The architectural organization of the end wall of the two churches is alike; both have Palladian windows flanked by higher arch-topped windows. Under those, at

ground level, the English church used pedimented doors, while St. Peter's used windows. However, Kearsley and Smith seem to have simply switched an east-end door and a long side window from the Surrey design to draw their new church. The design of the tower in the engraving of the Surrey church has many features similar to Smith's earlier work at Philadelphia's Christ Church, including the organization of the architectural elements in the bell tower; but Maitland's book was not available at that time, and that design was probably based on a plate from Gibbs.

Smith signed the agreement dated August 5, 1758 (Christ Church, Drawer 26), which included detailed specifications: "Dimensions to be ninety feet long above the Base or water table, sixty feet wide also above the base." The walls were to be "thirty-seven feet high, of bricks and mortar, gable ends in the pediments." The corners were to be decorated with "Rustick Work" and there were to be two doors each on the north and south walls, twelve feet high by five feet wide. The second story was to have circular beaded windows encasing "good English glass" in sash, ten by fourteen inches. Four circular beaded windows and a circular one in the pediment were specified for the east end. The three-part Palladian window, similar in construction to that at Philadelphia's Christ Church, was a feature which Robert Smith liked and used again with the same window plan, at Zion

Lutheran Church, built 1766–69. The west end was to have six circular beaded windows, and a cupola, with a "Vase" made of gilded copper. (The present tower at the west end was added in 1842, after Breton's view was drawn.) The modillion cornice was listed in the specifications and built, but the "fine large Urns properly pland & fixed at the Corners & tops of the Pedement at the Ends of the Building" were never installed. The "Circular Ceiling" on the inside was to be left ready for "lath & plaister." Three coats of paint "of a good stone colour" would complete the shell of the church for £2,310, if accomplished by November 1, 1759. But it was not accomplished until 1761, probably because the vestry had constant trouble raising the funds to pay Smith. The church was dedicated September 4, 1761 (Shoemaker, "Christ Church," p. 193).

The brickwork at St. Peter's reveals the highest quality of material and construction. John Browne, brickmaker, noted in his Day Book on September 17, 1760, "load of bats to the church 5000," and in October, "to Bricks delivered John Palmer 16,200 at 37" (private collection, John Browne, Day Book, 1750–61). Browne may not have supplied all the bricks, as he was also supplying "The Presbyteering" (the addition to the Old Presbyterian Church on the south side of Market Street at White Horse Alley). With the brick laid in Flemish bond with king closers, rather than the glazed headers that give a staccato pattern to Pennsylvania Hospital (no. 48), the effect at St. Peter's is smooth. Specialty work included convex and concave molded bricks, creating an "ogee" transition from the wall into the water-table level, and quoins laid in American or stretcher bond edged with beveled brick. Plain bricks on edge create arched window frames, highlighted by stone keystones and window ledges supported by consoles.

The superb joinery and detail exhibited at St. Peter's is testimony to the skills and sense of scale and design of John Thornhill, Smith's master carpenter. Research has not been able to illuminate Thornhill's background or training, but his work seems close to the joinery at Frampton Court, near Bristol, England, where William Halfpenny may have worked (Christopher Hussey, *English Country Houses, Early Georgian, 1715–1760,* London, 1955, p. 127). If Thornhill had trained in Bristol, it would explain the depth of his panels, the inconspicuous but rich variety of detail on the interior, and the grand scale of the door frames, which, with their closed triangular pediments on the north side and semicircular ones on the south, probably have other design sources. The center-opening doors, eight-paneled with diagonal board and battens on the inside like the one at Mount Pleasant, are like those illustrated in the

Universal Magazine for May 1750 (illus. facing p. 230), signed by "Architector" (William Salmon), whose design owed a lot to Batty Langley's *Treasury of Design,* published in 1750. Smith owned the Langley in 1751, and the *Magazine* was in Philadelphia some months after publication. Thornhill would have had access to them then if he had not learned this style of construction during his apprenticeship.

Specifications for the interior design of St. Peter's are not in the records; therefore, the unusual location of the pulpit at the west end, opposite the altar table at the east end, and the original placement of the organ in the north loft, are generally attributed to Robert Smith. The introduction of these features may have had something to do with the interruption of Smith's work, between August 1761 and April 1764, when he was presumably working at Mount Pleasant (1761–62) and at Mary Maddox's on Third Street (January 1, 1763) (see Beatrice B. Garvan, "Mount Pleasant, a Scotch Anachronism at Philadelphia," *JSAH,* vol. 34, no. 4, December 1975).

The woodwork of the pulpit wall appears "applied" when compared to the rest of the interior finished in 1763 (see illustration). Its alternating tiers of arches and rectangles in shallow relief appear as disparate decorative units within the strongly architectonic style of the rest of the woodwork. A very large square panel, capped by an open pediment and enframed with a mitered-ear molding, floats unattached above a horizontal dado-like capping molding. It coincides with the horizontal mold on the hood of the pulpit, but does not relate to any of the balcony levels just beside it. The "keystones" in the arches are carved with the lively foliage typical of the architectural carving of Nicholas Bernard and Martin Jugiez, who were at work in Philadelphia before Hercules Courtenay. They are purely decorative here in comparison to their exact counterparts in the cupboards on either side of the fireplace in the great chamber at Mount Pleasant. This pastiche at St. Peter's may have been executed by James Whiley, a carpenter who was trained as a journeyman for Thomas Nevell in 1759. He was working at St. Peter's before 1765, when records show he received payment, about the time this pulpit wall was completed. Smith's bill for £285 13s. 3d. for completion of the pulpit and chancel may have included payment for Whiley, as no amount was entered for him in vestry minutes. Thornhill too must have been busy then at Mary Maddox's or Benjamin Franklin's house, also Smith projects, or at Edward Stiles's Port Royal in Frankford (see John A. H. Sweeney, *Winterthur Illustrated,* Winterthur, Del., 1963, illus. pp. 63, 65), where the woodwork is almost identical to that at

Mount Pleasant and St. Peter's. But entries in the minutes note in a report that payment was not made until March 1763, and then for double the contract amount, £4,765. 19s. 6½d. (Christ Church, Vestry Minutes, 1702–83). Whether the delays, changes in specifications or partial completion of the interior added to the cost is not discussed, although some land purchase extending the lot may also have been included. Subsequent, unspecified payments to Smith continued in £50 units until 1772. His note to Francis Hopkinson, Esq., dated August 1, 1771, reveals his anxiety over tardy church accounts: "I have occasion for some cash for my people employ'd at the repaires of the steeple, I shuᵈ be obliged to you if youᵈ pay the bearer thirty pounds and have it so. Robᵗ Smith" (Christ Church, Robert Smith Folder, Drawer 26).

Smith had access to the best workmen in the city and he sought each for his own specialty. Matthis Young supplied and installed the window glass itemized on a statement written by the silversmith William Young, a vestryman, and Francis Hopkinson paid it. Hugh and George Roberts supplied builders' hardware, screws, nails, and the like. Eden Haydock presumably did sheet-lead work at St. Peter's as he did at Christ Church. John Stagg and Timothy Berrett did painting work. Berrett was a fancy painter who did "bordering" at Samuel Powel's house in 1769 and was known for

Pulpit Wall of St. Peter's Church

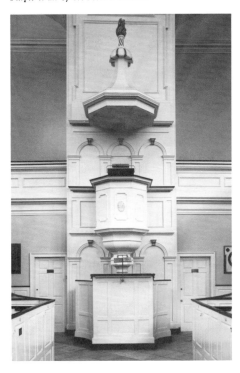

painting and gilding coats of arms on phaetons and carriages, and painting floor cloths. He probably did the gilding on the organ case (Christ Church, Vestry Minutes, March 20, 1772). Daniel Carter supplied a table, and Jacob Iden, two chairs for the modest amount of 8s.

The grand pipe organ at St. Peter's was installed by December 10, 1764, when the Records note "George Smith for working ye Bellows of St. Peter's Church organ, one quarter of £0.15.0." It was put in by Jacob Beyerle, and Philip Feyring probably built it for £1,000. Beyerle was still trying to collect for it in November 1775. Its elaborately carved casing may have been inspired by a plate in Batty Langley or James Gibbs, with carving probably by Bernard and Jugiez. The gilded florettes as "metopes" alternating with triglyphs at the cornice are enlargements of the same carved form found at Mount Pleasant in the mitered corners of the overmantels. The winged figures on either side of the organ case are attributed to William Rush.

BG □

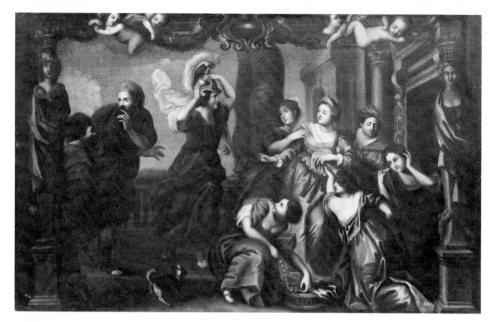

55.

HENRY BENBRIDGE (1743–1812)

Benbridge, like Matthew Pratt and probably James Claypoole, Jr., is one of the few Colonial artists native to Philadelphia. His father died when he was eight, but his stepfather, a prosperous merchant, was sympathetic to his early interest in art. Benbridge's first valuable instruction may have come from the English artist John Wollaston who paid a second visit to Philadelphia in 1758 and seems to have been a major influence on Benbridge's earliest style. In 1764, as soon as he was financially able, Benbridge left to study painting in Italy. There, like Benjamin West who had preceded him in 1760, Benbridge was much affected by the work of Anton Raphael Mengs and especially Pompeo Batoni. His great opportunity came in 1768 when the English author James Boswell commissioned him to go to Corsica to paint the popular general Pascal Paoli. When finished, the ambitious, full-length portrait was shipped to England, and Benbridge followed in 1769. His painting was much praised, and he was well received in London by Benjamin West, but he decided to return to Philadelphia in 1770 because of his affection for the city of his birth. This does not seem to have held him here, for he moved to Charleston in 1772 and was imprisoned eight years later when the British took the city. Upon being freed, he visited Philadelphia in 1783 for probably less than a year. Benbridge lived and traveled in the South as a successful artist and did not return to Philadelphia until just before his death in 1812.

55. *Achilles Among the Daughters of Lycomedes*

c. 1758–64
Oil on canvas
26¼ x 42¼″ (66.7 x 107.3 cm)
Gordon K. Saltar, Arden, Delaware

PROVENANCE: Henry Benbridge; half-sister, Elizabeth (Gordon) Saltar; descended in family to Gordon K. Saltar

LITERATURE: Washington, D.C., Corcoran Gallery of Art, *American Painters of the South,* by Hermann Warner Williams and Henri Dorra (April 23–June 5, 1960), no. 23, p. 15; PAFA, *Painting and Printing,* no. 2, pp. 8–9; Stewart, *Benbridge,* pp. 15–16

HENRY BENBRIDGE's historical painting *Achilles Among the Daughters of Lycomedes* is a copy, in reverse, of a tapestry design by Rubens of about 1620–22. Because of the reversal, the painting is undoubtedly based on an engraving. Although Rubens's design was engraved at least four times, Benbridge's source was most likely the English engraving by Bernard Baron of 1724.

Achilles is shown dressed as a woman hiding among the daughters of King Lycomedes so that, as his mother wished, he would not be called upon to fight with the Greeks in Troy. However, Odysseus, disguised as a peddler, identified Achilles by the latter's undue interest in a helmet. Once convinced to fight, Achilles became one of Greece's great warriors but died in Troy, as had been predicted.

The painting has been dated by Stewart prior to Benbridge's departure for Italy in 1764. Charles Willson Peale recalled that Benbridge, at about the age of seventeen, in 1760, painted the walls and ceilings of his family's house with life-sized subjects taken from prints. Some of the murals were from prints after Raphael's tapestry cartoons; thus Benbridge's use of a print source in *Achilles* was certainly not unusual (APS, Charles Willson Peale, Autobiography, p. 99; Letterbook, vol. 12, p. 84).

The only other known mythological painting by Benbridge is a similar-sized work, *The Three Graces* (collection of Gordon K. Saltar), a pastiche after Rubens (Stewart, *Benbridge,* p. 16). Although the chronology of Benbridge's work is still uncertain, *The Three Graces* was probably also a pre-Italian work, and it is instructive that this painting as well as the *Achilles* descended in the Benbridge family. Neither picture was commissioned. Such paintings, copied or adapted from engravings, served chiefly as an exercise and a demonstration of artistic skill. There was, of course, no market for large, original historical compositions in America even if it were possible to paint them. Perhaps because of this and the recognition of West's greater ability, Benbridge turned to portrait work exclusively. He sounded relieved when he wrote from London in 1770 that West was giving up portraiture to devote himself to history painting and thus could more easily recommend Benbridge in the other line (Stewart, *Benbridge,* p. 18).

DE □

74

BENJAMIN WEST (1738–1820)
(See biography preceding no. 52)

56. *Jane Galloway*

Probably 1759
Oil on canvas
49¾ x 39¼″ (126.4 x 99.7 cm)
Historical Society of Pennsylvania,
Philadelphia

PROVENANCE: Samuel Galloway, probably until
1768; Jane (Galloway) Shippen; descended in
family to Elizabeth Swift Shippen; Historical
Society of Philadelphia, gift of Elizabeth Swift
Shippen, 1914

LITERATURE: Scharf and Westcott, vol. 2, p. 1031;
Sawitzky, "West," pp. 439, 442, 444, 455;
Flexner, *First Flowers*, pp. 187, 189, 354;
E. P. Richardson, *Painting in America* (New
York, 1956), p. 71; J. Reaney Kelly, *Quakers in
the Founding of Anne Arundel County,
Maryland* (Baltimore, 1963), p. 98; J. Reaney
Kelly, " 'Tulip Hill,' Its History and Its
People," *Maryland Historical Magazine,* vol. 60,
no. 4 (December 1965), pp. 349–403; Wainright,
Paintings and Miniatures, p. 80

JANE GALLOWAY (1745–1801) was born in
West River, Anne Arundel County,
Maryland, the daughter of wealthy Quakers.
Orphaned at age three, "Jenny," according
to her mother's will, was to be placed "under
the Care of my Son-in-Law Samuel Galloway
till she arrive to the age of Eighteen years
and then to be Removed to Philadelphia"
(Annapolis, Maryland Hall of Records,
Records of the Prerogative Court, Wills 25,
Folio 308–10). This Samuel Galloway was
Jenny's oldest stepbrother and a successful
merchant. In 1756, Samuel began construc-
tion of Tulip Hill, one of the finest surviving
Georgian mansions in Maryland. From
Jenny's accounts, 1756–60 (Maryland Hall of
Records, photostat), it appears that while
Tulip Hill was being built Jenny spent much
of her time visiting relatives in Philadelphia
where her portrait must have been painted.

William Sawitzky first dated West's
portrait about 1757, on the basis of style, and
this has been accepted by all subsequent art
historians. However, since none of West's
American paintings are dated, there is no
certain work against which the *Jane
Galloway* can be stylistically compared. In
1757, Jane was twelve years old, younger
than she looks in her portrait, but this date
is still possible. Since West left for Italy in
1759, that year is the latest possible date for
Jane's portrait. Her own account entry
for July 6, 1759, provides the interest-
ing detail that Jenny bought "a blue satin
Hatt." This is in all likelihood the one she
wears in her portrait, in which case the
picture was painted in 1759. Furthermore,
by what appears to be more than mere

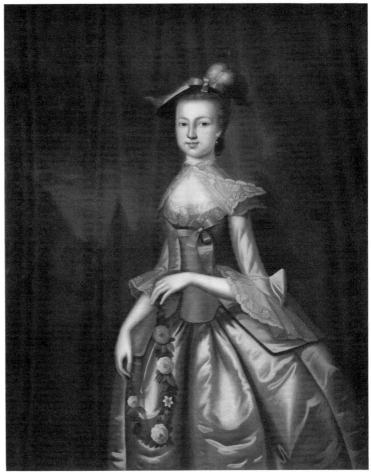

56.

coincidence, one of the few other early
portraits by West, *Thomas Mifflin*
(Historical Society of Pennsylvania), may
be connected to the *Jane Galloway,* for
Thomas was the stepchild of Jenny's
stepsister, Sarah Fishbourne Mifflin. From
the account papers, it is apparent that
Jenny was visiting Sarah in Philadelphia.
Thomas's portrait has been given the
approximate date 1758–59, so it is quite
possible that the two portraits are
contemporaneous. Jenny's portrait was prob-
ably commissioned by Samuel Galloway
since it was in Tulip Hill in 1762, when a
young admirer, John Thomas, saw it there
and was inspired to write a love poem.

The subtle coloring in *Jane Galloway*
makes it one of West's most attractive early
portraits. Sawitzky sees the influence of
Gustavus Hesselius in "the delicacy of color
and a certain tenderness" ("West," p. 442),
while Richardson says West actually
"imitated" Gustavus (*Painting in America,*
New York, 1956, p. 71). But there are other
possible sources for this delicacy of color,
such as in William Williams's work,
although his only surviving portraits are

from a later date (see no. 69). The almond
shape of Jane Galloway's eyes conforms to a
mannerism associated with John Wollaston,
who was in Philadelphia as late as May 1759,
while the sculptural treatment of the folds
in her dress is found in the work of both
Feke and Wollaston. *Jane Galloway* does
not appear to be imitative of the work of
any one artist but is rather a mixture of
contemporary influences with some
originality—a tribute to West, considering
his youth.

DE □

57. *Tea Table*

1760
Mahogany
Height 28¼″ (71.7 cm); diameter top
35″ (88.9 cm)
Philadelphia Museum of Art. Bequest of
R. Wistar Harvey. 40–16–2

PROVENANCE: Cornelius Stevenson; M. Stevenson
Easby; R. Wistar Harvey, until 1940

LITERATURE: Marian Sadtler Carson, "Philadelphia Chippendale at Its Best in the Collections of the Philadelphia Museum," *American Collector,* vol. 16, no. 11 (December 1947), pp. 10–13, fig. 6

THE EIGHTEENTH CENTURY knew this tripod form as a "pillar and claw" table (HSP, Coates-Reynell Business Papers, 1751–54, Reynell to Claypoole). Today it is known variously as a tea table, a tray top table, and a tilt top table. In Philadelphia, the tea table had developed into its largest and most ornate form by 1770. This example has elements of rococo design in its scalloped top and cabriole legs. The strength of each aspect of the design—the splay of the legs, the architectural flutings on the shaft, and the wide "birdcage" supporting the solidly molded top—were characteristic of Philadelphia's version of this table form.

Philadelphia craftsmen made three variations of this basic design, which usually occurred in the shaft. This piece shows a leaf-carved urn shape, in which the leaf tops curl and form a ruffled collar, which in turn supports a short, fluted, tapered pillar. Also typical of Philadelphia was a flattened ball form in place of the urn. Although also carved with foliage and scrolls, the ornamentation stayed within the contour of the ball. The fluted shaft was longer and more tapered, giving a usually smaller top a graceful lift. The third variation had a plain

or partially carved shaft which had two "swellings," rarely had fluting, and usually had the smallest top of the three.

The birdcage mechanism, used more frequently in Philadelphia than elsewhere, allowed the top to turn or flip into a vertical position. Although hardly the "tuck-a-way" table known in New England, this versatility enabled the table to be placed in a corner or against a wall, to be drawn out at tea time. The top, scrolled like the edges of a fine silver tray, held an entire tea service and, in this large size, the required porcelain cups and saucers for several people. Smaller versions were used as candlestands and kettle stands or for more intimate teas in bedrooms.

The subtlety and success of the design rest upon the spring of the ankles in the cabriole legs, which are tenoned into the base of the shaft, their sturdy dimensions alleviated by the foliate carving which slides easily over the knees. On the shaft the alternation of carved decoration—from a convex bead, to a concave plane, to a convex ribbon and flower, to a plain band and, finally, into the carved urn—serves to bind the chunky shaft into concentric rings which lighten and strengthen the visual effect. And, finally, the grand proportion of the top, carved from the most colorful cut of mahogany, in which the carefully matched grain creates its own smooth but deep pattern, gives this table its distinction.

BG □

57.

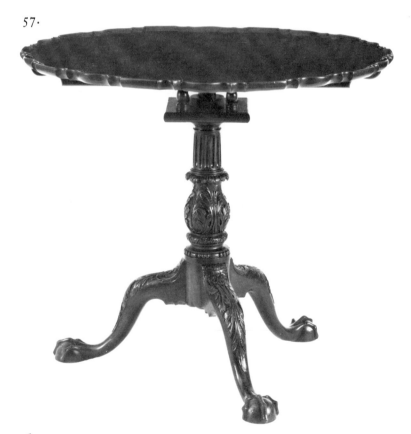

JOSEPH RICHARDSON, SR. (1711–1784)
(See biography preceding no. 35)

58. *Teapot*

1760–70
Mark: IR (in rectangle on bottom)
Inscription: ESS (foliate reverse cipher c. 1815); oz/18 dwt/17 p/1 (scratched on bottom)
Silver; wood handle (not original)
Height 6½″ (16.5 cm); width 9¾″ (24.8 cm); diameter base 2⅞″ (7.3 cm)

Philadelphia Museum of Art. Given by Mrs. Thomas J. Curtin. 69–277–1

LITERATURE: Philadelphia, *The University Hospital Antiques Show 1969* (April 22–26, 1969), no. 74; *PMA Bulletin: Annual Report,* vol. 68, no. 309 (Spring 1974), illus. p. 37; Fales, *Joseph Richardson,* fig. 42

THE SOPHISTICATION of eighteenth century customs and furnishings led to specialization of forms, not only in the service of alcoholic beverages, but for tea, coffee, and chocolate, which demanded vessels of different sizes and shapes and a range of special paraphernalia. This reverse pear-shaped teapot is typical of a midcentury silver container. The shape was enlarged for coffee, or given a stepped, domed lid for a sugar bowl; the addition of feet secured the stance for a creamer; and Richardson's ornate tea kettle (Yale University Art Gallery) is, if disguised, an enlarged reverse pear shape. The rounded form of this teapot is exaggerated by the undulation of surfaces from the high shoulders down to the smallest diameter just above the flared foot. The resulting top-heavy effect is further emphasized by the engraved decoration encircling the lid and edge of the top and by the position of the spout and a handle, which swings in a horizontal arc, adding to the breadth of the form at its widest point. While few features of the rococo style could be termed pragmatic, in this inverted form the deep, narrow "well" caught saturated tea leaves and prevented dregs from floating into the spout.

The foliate cipher was an added embellishment suitable to this form. The reverse cipher reads, from right to left, ESS, for Elizabeth Sandwith Skyrin (b. 1793), daughter of John and Ann Drinker Skyrin (HSP, GS, Northern District Monthly Meeting, Philadelphia, Marriages, 1772–1907), and niece of Elizabeth Sandwith Drinker (Mrs. Henry). Elizabeth's great-aunt, Mary Sandwith, died in 1815 and her will (written in 1802) left most of her estate to Elizabeth's mother, with a specific note that Elizabeth Downing, Sandwith Downing, and Elizabeth Sandwith Skyrin were each to have £5 "to buy a piece

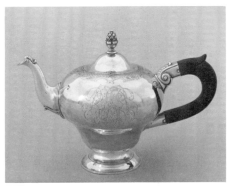

58.

of plate" (City Hall, Register of Wills, Will no. 122, 1815). If the rococo teapot was purchased in 1815 when Mary Sandwith died, it was well after the style had ceased to be the height of fashion. Joseph Richardson, Jr., was still making the inverted pear form in 1780, but this teapot bears his father's mark and was probably made c. 1760–70. It may have been leftover stock or a sample piece from the earlier period; but in any case, Joseph, Jr., engraved the cipher later, about the time of purchase, c. 1815. This teapot should not be confused with one owned by Mary Sandwith and described in a notation of 1809: "Was sent to the Bank of North America and delivered to the Cashier, a Wooden box with a card nailed on the top, on which is written 'Plate belonging to Mary Sandwith and William Drinker . . . containing . . . 1 silver tea pot, cypher wss marked 17 oz. 2 dwt 00 gr. stamped EB . . .'" (HSP, Sandwith-Drinker Papers, vol. 5, p. 56). A comparison of the engraving on a Joseph Richardson, Sr., teapot made for the Morgans of Haddonfield, New Jersey, in 1762, and now in the Bayou Bend Collection, shows Joseph, Sr.'s, hand at work on both the cipher and the ornamental engraving. On the exhibited teapot Joseph, Sr., did the ornamental engraving while the cipher with its loose, interlocking tendrils was done by Joseph, Jr. It is very similar to lettering done by Joseph, Jr., in the 1780s, rarely in cipher form, but in consecutive initials enclosed in the wreaths and ribbons of the neoclassical style. This rococo teapot called for a cipher and thus becomes evidence for, and a nice example of, the sensitivity and continuity of the Richardson craft tradition.

BG □

HENRY DAWKINS (ACT. C. 1753–86)

Henry Dawkins was born in England and immigrated to America around 1753. The first acknowledgment of his activity in New York was a bookplate (Metropolitan Museum of Art) for the lawyer John Burnet dated 1754. In the October 20, 1755, issue of *The New York Mercury,* Dawkins announced that he had left the mathematical instrument-maker, Anthony Lamb, and "has now set up his business . . . opposite the Merchants Coffee-House, in New York, where he engraves in all sorts of mettals." By 1757, Dawkins had moved to Philadelphia where he married Priscilla Wood on October 2. In the following year he advertised his new business in the *Pennsylvania Journal and Weekly Advertiser* on January 19: "HENRY DAWKINS, Engraver from London, Who lately wrought with Mr. James Turner; having now, entered into business for himself, next door to the sign of Admiral Boscawen's head, in Arch-Street, where he engraves all sorts of maps, Shopkeepers bills, bills of parcels, coats of arms for gentlemen's books, coats of arms, cyphers and other devices on Plate likewise seals and mourning rings cut after the neatest manner and at the most reasonable rates" (see illustration with no. 61).

In 1774, Dawkins returned to New York. In May 1776 he was arrested and imprisoned for counterfeiting Massachusetts, Connecticut, and Continental currency (Peter Force, ed., *American Archives: A Documentary History of the United States,* 5th series, Washington, D.C., vol. 3, 1776–83, p. 316). Within six months, on October 19, 1776, Dawkins petitioned for his own death (Peter Force, ed., cited above, pp. 268–69); his request obviously was not granted, as the first New York coat of arms of 1778 (New York Public Library) bears his signature. Wilfred P. Cole suggests that Dawkins either was released or escaped from prison in 1776 or 1777 ("Henry Dawkins, Engraver," M.A. thesis, University of Delaware, 1966, p. 26n.). However, the former seems more plausible as it is unlikely that he would have received commissions from government officials if he had left illegally. Ironically, two years later Dawkins was paid for engraving official Continental currency. The *Journals of the Continental Congress* (vol. 18, p. 922) mentions a sum of $1,500 paid to Henry Dawkins on October 13, 1780, "on account for engraving and altering the border and back pieces for striking the bills of credit of the United States." The last that is known of Dawkins is the advertisement of the sale of his work in the *Freeman's Journal* by the printer Francis Bailey on May 2, 1786, in Philadelphia.

JOHN STEEPER (N.D.)

Little information has been recorded about Dawkins's associate John Steeper. An advertisement in the *Pennsylvania Gazette* dated March 25, 1762, indicates that Steeper had established a business: "LIKEWISE ENGRAVING performed in all its Branches, in the Neatest Manner, by JOHN STEEPER." Scharf and Westcott note Steeper's collaboration with Dawkins on the *Pennsylvania Hospital* view, but erroneously date the print 1755. No other mention is made of Steeper's work as an engraver.

HENRY DAWKINS AND JOHN STEEPER

59. *A South-East Prospect of Pennsylvania Hospital*

1761
Inscription: A South-East Prospect of the Pensylvania Hospital, with the Elevation of the intended Plan./This Building, by the Bounty of the Government, And of many private Persons, Was Piously founded, for the Relief of the Sick and Miserable/A Dom, 1755./Montgomery and Winter Del. Printed and Sold by Robt Kennedy Philada (lower left); Steeper & H. Dawkins Sculpt (lower right); TAKE CARE OF HIM/& I WILL REPAY/THEE (center, in seal of hospital)
Engraving with watercolor, i/ii (only known impression of first state)
8⅜ x 13¾" (21.3 x 34.9 cm)
Private Collection

LITERATURE: Scharf and Westcott, vol. 2, p. 1670; Stauffer, vol. 2, no. 468; *Prints Pertaining to America,* no. 60; Snyder, "Views," pp. 675, 678, fig. 4; Wilford P. Cole, "Henry Dawkins, Engraver," M.A. thesis, University of Delaware, 1966, pp. 63–65; MMA, *American Paintings and Historical Prints from the Middendorf Collection* (October 4—November 26, 1967), no. 57, p. 84; *American Printmaking,* no. 26, p. 24; *Made in America,* no. 2, p. 1; Sotheby Parke Bernet, New York, May 18, 1973, no. 16 (Middendorf sale); Snyder, *City of Independence,* pp. 53–57, item 24, fig. 22, pl. 1

IN THE ERA prior to the Revolution, Philadelphia architecture provided printmakers with salable subject matter illustrating the new country's achievements (see nos. 46, 71). One structure which has continued to interest artists to the present day is the nation's first hospital, the Pennsylvania Hospital (no. 48), founded in 1751 under the guidance of Benjamin Franklin and Dr. Thomas Bond. The brick building stands today on its original site, bounded by Eighth, Ninth,

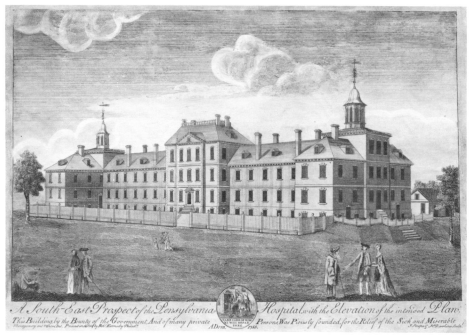

A South-East Prospect of the Pennsylvania Hospital, with the Elevation of the intended Plan. This Building, by the Bounty of the Government, And of many private Persons, Was Piously founded, for the Relief of the Sick and Miserable. A Dom. 1755.

59.

Spruce, and Pine streets. At the time of this engraving, only about one-third of the Samuel Rhoads's design of 1754, the east wing, had been realized (see no. 71). It was hoped that an engraving to be given to the Proprietors would stimulate interest and that its sale would raise funds to complete the building. The hospital trustees granted the commission for the engraving to Robert Kennedy, a local printer, publisher, and bookseller, who hired Winter and Montgomery to produce sketches, presumably from the architect's drawings (which no longer exist) since the building was still unfinished at the time of the engraving. Henry Dawkins and John Steeper engraved the plate, and the projected publication was announced in the *Pennsylvania Gazette* on October 22, 1761: "A Prospective View of the PENNSYLVANIA HOSPITAL taken by Messieurs Winters and Montgomery, for the subscribers (with the approbation of the Managers of the said Hospital) which is now engraving, and may be expected in two Weeks. The PUBLIC may be assured that it will be finished in the neatest manner &c. The Subscriber presumes that this Undertaking will be highly favoured by all Lovers of the Institution. Those gentlemen that would chuse to have them coloured, framed and glazed, are requested to send their commands to the Subscriber, in Third-street, between Market and Arch Streets, and opposite Mr. Joseph Fox's. Robert Kennedy."

On November 5, 1761, Kennedy announced that the plates were ready for printing (*Pennsylvania Gazette*); and on November

26, he advertised again in the *Gazette:* "THE PERSPECTIVE VIEW of the Pennsylvania Hospital, taken with your Approbation, is now finished, in a neat Manner. . . . I am enabled to sell them as follows, plain 23.6d. coloured in the neatest Manner 45, coloured, framed, gilt and glazed with Bristol Glass 11s.6d. with London Crown Glass 13s. double framed, frosted and gilt in the neatest Manner 169.6d. To prevent Imposition, my Prints are distinguished by their true Perspective, and masterly Work. . . ."

The print is dated 1761 on the basis of these advertisements. This print is the only known impression of the first state. The numbers 1 and 2 on the lawn and the inscription found on the second state of the print "Built A Dom. 1755 from N 1 to 2" refer to the only portion completed in 1755. This wing opened in 1756; the west wing, in 1796, and the center section was added between 1794 and 1805 from designs of David Evans, Jr. The lines quoted on the print "piously founded for the relief of the sick and miserable" are part of an inscription by Benjamin Franklin which was carved into the cornerstone of the east wing facing Eighth Street.

This engraving should not be confused with a different view of the hospital by another local printer and artist, James Claypoole, Jr. (see biography preceding no. 77), advertised in the *Pennsylvania Journal,* October 22, 1761. The fact that Claypoole regarded the subject as a venture profitable enough to justify competing with the commissioned view testifies to the popularity of

such subjects in the eighteenth century. Presumably, Claypoole's image was rejected by the committee because it was less flattering than the Dawkins and Steeper representation, which not only succeeded in depicting the grandeur of this building, but also included pleasing genre details which made the view more appropriate for Colonial living rooms. The accuracy of Dawkins's work with regard to architectural details can be seen in comparison with John G. Exilious's depiction of 1814 after the completion of the entire structure (Tatum, no. 35). Aside from problems with proportion and perspective, the east wing in both prints is identical; variations in the other two pavilions can be attributed to changes in design dating after Dawkins's engraving. Although the incorrect perspective and crude attempt at three-dimensionality show a naive understanding and lack of training in artistic skills, by contrast the technical use of the engraving tools suggests that Dawkins and Steeper were skilled craftsmen.

It should be noted that they were probably not educated to be professional artists. In the Colonial period, "artist" and "engraver" were separate classifications; the engraver was generally skilled in utilitarian arts but seldom possessed artistic ability. Dunlap suggests that Dawkins was "originally an ornamenter of buttons, and other metallic substances," but he does not mention any training in printmaking (*History,* vol. 1, pp. 156–57). In practice, most demands Dawkins received for prints were for objects such as bookplates and trade cards which did not require formal academic artistic training. They were decorative designs which, in Dawkins's case, were usually skillfully copied directly from British examples and in which embellishment was the praised attribute. However, when prints of an artistic nature were demanded, engravers like Dawkins and Steeper were the only available native sources.

ESJ □

PHILIP HULBEART (D. 1763)

Philip Hulbeart, Philadelphia silversmith, was the son of William Hulbeart of Bristol, England. Very little is known of Hulbeart's life in Philadelphia as he was probably not a resident in the city for more than five years. He may have completed his apprenticeship in Bristol or London and immigrated to America under the aegis of his uncle of the same name who had been in Philadelphia since 1738 (HSP, Joseph Wharton, Ledger B, 1748–61). Hulbeart advertised as a "Goldsmith, next door to the Boatswain—and Call near the Drawbridge" in the

Pennsylvania Gazette, November 5, 1761. This was his first appearance in the public press, and he advertised imported pieces and his own wares, plus the raw materials of his trade such as borax and pumice stone. He may have made silver ornaments for the Friendly Association: a silver cross with a PH in an oblong cartouche is extant (Gillingham, "Indian Silver," pp. 101, 111). At the time of his death, two silversmiths, Joseph Richardson, Sr., and Philip Syng, Jr., rather than Hulbeart's brother William, were appointed to settle his estate. An account book at the Winterthur Museum, recording the distribution of Hulbeart's shop and equipment and the names of twenty goldsmiths working in Philadelphia in 1763 who purchased parts of it, reveals more about Syng and Richardson than Hulbeart (see Fales, *Joseph Richardson,* Appendix B, for detailed summary of Hulbeart estate). However, an advertisement in the *Pennsylvania Gazette,* March 17, 1763, details the contents of Hulbeart's shop, and a later advertisement in the *Pennsylvania Journal,* May 31, 1764, announces: "For sale by public vendue . . . the following house and lots of ground late the estate of Philip Hulbeart goldsmith deceased." There were five pieces included in the sale.

60. *Tankard*

c. 1761
Mark: PH (in square, twice on base)
Inscription: CNCS (reverse cipher in foliated script, s interwoven with N)
Silver
Height 9″ (22.9 cm)

Philip H. Hammerslough Collection. On permanent loan to the Wadsworth Atheneum, Hartford, Connecticut

PROVENANCE: Philip H. Hammerslough
LITERATURE: Hammerslough, vol. 3, illus. p. 5

THE SPECIAL EXUBERANCE with which midcentury Philadelphia silversmiths approached large forms is a feature of this tankard. Slightly higher than the Syng example (no. 41), with a smooth sweep of contour from the lifted dome to its smallest diameter, this tankard is a little fuller than need be in each dimension. The base lifts the body up, giving vitality to what might otherwise have been a ponderous form. In contrast, the Syng tankard has a commanding monumentality. Both artists have carried this scheme through to the last detail, including the style of markings.

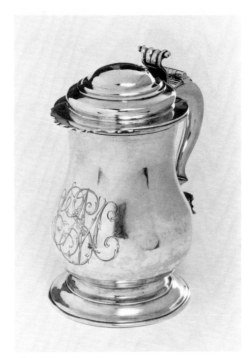

60.

The tankard is engraved with intertwined initials, which are as yet unidentified. The engraving is deep and well cut, and the foliate form of the letters was devised from the same pattern of ciphers and monograms as the one used by Joseph Richardson on his tankard for Hannah Ladd of Burlington, New Jersey (Hammerslough, vol. 1, illus. p. 23).

In addition to this tankard, there are three other pieces marked by Hulbeart: an Indian cross, a pair of tongs, and an opulent cream pot (Philadelphia Museum of Art), which is a fantasy of ornament in contrast to this tankard, which stands splendidly aloof. Although little is known about Hulbeart, the variety and skill evident in his work have insured his place in the eighteenth century community of craftsmen.

BG □

BENJAMIN HARBESON (1728–1809)

Born in 1728, Harbeson, a Presbyterian, married Eliphel Harper in 1754. On November 27, 1755, he placed this advertisement in the *Pennsylvania Gazette:* "Benjamin Harbeson. Tinplate worker (who is removed on the other side of Market-Street, at the corner of Strawberry alley, nearly opposite to where he removed from) continues to make and sell all sorts of tin-ware wholesale and retail, and all sorts of best London pewter, copper tea kettles, coffee pots and saucepots, brass kettles, sorted iron and brass wire and sundry other goods cheap." These items were well illustrated on Harbeson's trade card (see illustration), which was engraved by Henry Dawkins (see biography preceding no. 59) about 1764.

From 1768 to 1772, Benjamin Harbeson was entered in Benjamin Randolph's Account Book; in 1768 he was owed £47 18d. 10s., which Randolph paid against the account of John and Lambert Cadwalader (NYPL, Philadelphia Merchant's Account Book, 1768–86, p. 18). Levi Hollingsworth purchased a copper warming pan from Harbeson in November 1768 and, in 1769, pewter dishes, a tankard, tin lamps, lanterns, and a fish kettle (HSP, Levi Hollingsworth Papers, 1768–1817). Samuel Powel bought a copper plate warmer from him in 1769 for £3, which must have been a large free-standing rack on legs, which was placed and rotated next to the open fire (LCP, Samuel Powel, Ledger, p. 106).

In 1771, Harbeson's wife, Eliphel, died, leaving five children. Benjamin was married again in February 1772 to Margaret Coombe, who bore him five children. They were hosts to the Rev. James Sproat who visited Philadelphia in 1778 and preached to convalescents at the Barracks (John W. Jordan, "Extracts from the Journal of Rev. James Sproat, Hospital Chaplain of the Middle Department 1778," *PMHB,* vol. 27, no. 4, 1903, pp. 442–44). Margaret died in 1789, aged forty-nine. Harbeson's third wife, Catherine, outlived him, until 1814. Harbeson was well-to-do, if not wealthy. He purchased a tract of eleven acres in Roxborough Township, which had belonged to Christopher Sower, for £6,000 Continental money, and a house and lot on Front Street between High and Chestnut from the confiscated estate of Isaac Allen in the postwar inflated currency for £12,000 (Scharf and Westcott, vol. 1, p. 420n.).

Like many pre-Revolutionary craftsmen, Harbeson carried civic responsibilities in addition to his shop and trade. He signed the Non-Importation Agreement of 1765; he was on the second Committee of Correspondence in 1775 encouraging home manufacturers; he was a delegate to the Provincial Convention held at Philadelphia, June 23, 1775; and he became captain of the Second Battalion of Philadelphia Associators in December 1776. Harbeson resumed his business after the war at the sign of the "Golden Tea Kettle" on Market Street by 1778 when his advertisement reads "on as reasonable terms as the times will allow." By 1788, Harbeson was among the most prominent metalworkers in Philadelphia, when he led the coppersmiths' unit in the Grand Federal Procession from Third and South streets through Philadelphia to Bush Hill, near Fairmount. On "a car, fourteen by

seven feet drawn by four horses, with three hands at work at stills and tea kettles, under the direction of Mr. Benjamin Harbeson" (Scharf and Westcott, vol. 1, p. 451), the coppersmiths joined 5,000 others making up the parade of floats in the Fourth of July celebration of the ratification of the Constitution by ten states. The entire craft population of the city turned out for the affair, each category represented by its leaders, its banners, mottoes, and demonstrations of practice.

Harbeson was still active in his trade in 1794 and was advertising again as a tinsmith and coppersmith at 44 South Second Street. In 1800, it was Benjamin Harbeson and Son, Coppersmiths, at 75 Market Street (Harrold E. Gillingham, "Old Business Cards of Philadelphia," *PMHB,* vol. 53, no. 3, July 1929, pp. 213–14). On Sunday morning, September 24, 1809, "Mr. Benjamin Harbeson, senior, of this City, (died) after a lingering illness. Mr. Harbeson was remarkable for his industry and punctuality, was an indulgent parent, a benevolent man, and his deportment through the course of a long life, 81 years exemplary, and held out a suitable example for imitation" (J. Granville Leach, *The Record of Some Residents in the Vicinity of the Middle Ferry, Philadelphia,* Lancaster, Pa., 1924, p. 34).

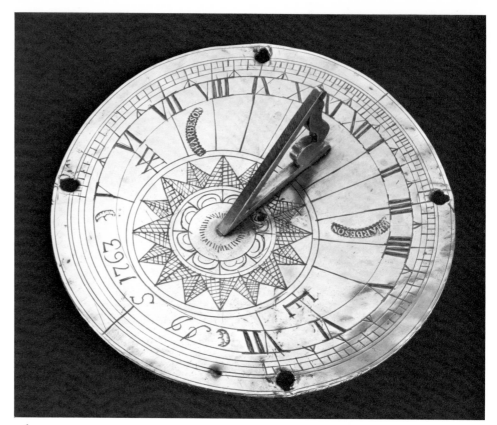

61.

61. *Sundial*

1763
Mark: B HARBESON (in scalloped-edged arched rectangle, stamped twice, between III and IV, VII and VIII)
Inscription: ID 1763
Brass
Diameter 5¾″ (14.6 cm); height gnomon 1½″ (3.8 cm), angle of gnomon 39°
Philadelphia Museum of Art. Purchased: Joseph E. Temple Fund. 20-99-1

PROVENANCE: Maurice Brix, Philadelphia

SUNDIALS were used to set or to verify less reliable timepieces such as pocket watches. They were made by silversmiths, clockmakers, scientific instrument makers and, in this instance, by a coppersmith. Sundials like this one were placed in gardens; small ones, made of silver or bone, were presentation pieces for pocket use. William Penn gave the latter type, "a silver dial," to Thomas Lloyd (Harrold E. Gillingham, "An Historic Pocket Sun-Dial," *PMHB,* vol. 51, no. 4, October 1927, p. 381).

Most sundials are marked for usual daylight hours but this one begins at 5 A.M. and goes to 7 P.M. (Lynne A. Leopold, "Benjamin Harbeson Sundial," MS, Uni-

versity of Pennsylvania, 1973). Hours are divided into eighths; the longer lines mark the quarter hours and half hours. The sundial determines solar time, and if the gnomon is accurately constructed for the latitude where it is to be used, then clock time can be calculated by taking the difference between mean solar time (the 24-hour day) and true solar time and adding the sum to the sundial time. The angle of the gnomon required for Philadelphia is 39° north 56' 57½″. Harbeson's reads 39°, although the surface of the dial is too bent to read minutes and seconds with precision. Some correction of longitude is necessary depending upon the position of the sundial east or west of 0° longitude, Greenwich, England. The corrections for clock time are not indicated on this dial, although smaller pocket versions frequently had various latitudes inscribed. The lines mark the hours, but their width and that of the gnomon (⅛″) render this sundial a more ornamental than sensitive scientific instrument.

There were instrument makers in Philadelphia working with more elegance and refinement—James Ham and David Rittenhouse, for example. Although Harbeson's timepiece does the job, his imprecise engraving, crude compass rose, and inexpert grasp of engraving tools suggest that this

was not within his usual oeuvre. The form of the two stamps bearing Harbeson's name are typical of marks found on the bottom of copper and brass kettles. A comparison of this mark with the one on Harbeson's trade card shows the curves reversed. His trade card engraved by Dawkins reads: "N.B. My work is all stampt as above." More examples must appear before we can determine if Harbeson used more than one mark.

BG □

BENJAMIN CHEW (1722–1810)

Benjamin Chew was born in the district of New Castle, Maryland, to Quakers, Dr. Samuel and Mary Galloway Chew. As a young man he was apprenticed to the Philadelphia lawyer Andrew Hamilton (see biography preceding no. 30). After Hamilton's death in 1741, Chew left Philadelphia to complete his law training in London at the Middle Temple. He returned to Philadelphia temporarily after the death of his father in 1743 and was admitted to the bar of the Pennsylvania Supreme Court, while actually living and practicing in Delaware. He moved to Philadelphia by 1754 with his wife Mary

Thomas, who died the next year leaving him with four daughters. In 1757, Chew married Elizabeth Oswald, heir to the fortune of merchant Joseph Turner; their only son, Benjamin Chew, Jr., was born in 1758.

Benjamin Chew held numerous public offices. He was attorney general from 1755 to 1769, a member of the Council from 1755 to 1775, and register-general of Pennsylvania in 1765. He continued in his private law practice until 1774, when he became chief justice of the Supreme Court of Pennsylvania.

Chew's predecessor on the bench of the Supreme Court, William Allen, loaned his country house, Mount Airy, near Germantown, to the Chew family for the summer of 1763, and Chew liked it so well that he immediately bought from Edward Penington, for £650, the eleven nearby acres on which he built Cliveden (Raymond V. Shepherd, Jr., "Cliveden," *Historic Preservation*, vol. 24, no. 3, July—September 1972, p. 10). In 1771 Chew also owned an elegant house in Philadelphia on Third Street, next door to Samuel Powel (see no. 51), which he maintained throughout his life.

Like Joseph Galloway (see no. 44), Chew espoused all the rational and legal reasoning for Colonial independence but could not advocate revolution. Thus he was suspect in Philadelphia in 1776 and he and John Penn were "deported" to live in the central part of New Jersey. The famed battle of Germantown took place in and around Cliveden in 1777, and although it was damaged by the Colonial cannonade, the British remained secure within the gray stone facade. After the Revolution, Chew returned to Philadelphia. In 1779 he sold Cliveden, still in

disrepair, to a young merchant, Blair McClenachen. In 1791, Chew became judge and president of the High Court of Errors and Appeals of Pennsylvania, a position he held until 1808. In 1797 he reacquired Cliveden from McClenachen (and the house remained in Chew ownership until 1972). Benjamin Chew died January 20, 1810.

Chew's library at Cliveden attests to his skills as well as his means; it includes volumes in several languages, plantation and horticultural manuals, histories, and sets of law volumes. But the architectural books that he may have consulted for the design of his house are not evident. Many were available in the city, and his own drawing reveals a visual, if not working, knowledge of Palladio. Jacob Knorr, his carpenter, may have had the necessary volumes, but it seems more likely that his friend William Peters (1702–1789) introduced him to the books at the Library Company. Likewise, no scientific instruments or drafting tools have survived among Chew's possessions, indicating again that his architectural expertise may have been restricted to illustrative materials available. Drafting was often part of the eighteenth century gentleman's education, and most country houses of that period reflect more of the owner than the builder in basic concept and design. The influence of Chew's English years and his Maryland heritage is evident in his specifications for Cliveden's interior scale and space, which are grander than most Philadelphia domestic structures of the 1760s.

JACOB KNORR (D. 1805)

Master carpenter Jacob Knorr (as he signed his will) lived and worked primarily in the Germantown area. His two best-known enterprises were the school building of Germantown Academy (1760–61) on School House Lane (see Joseph Jackson, *A History of the Germantown Academy*, Philadelphia, 1910, pp. 37–38) and Cliveden, the country house of Benjamin Chew. Although Knorr was never a member of the Philadelphia Carpenters' Company, his work at Cliveden was measured by two of its most prominent members, Robert Smith and John Thornhill. Whether Knorr's location removed the economic necessity for his belonging to the Carpenters' Company or whether carpenters from Germantown and other outlying towns were specifically excluded from that organization is not in the written record.

Nothing is known of Knorr's apprenticeship, and his name does not appear in relevant Philadelphia records. Probably he settled in Germantown immediately after his arrival in the Colonies. His property was

bordered on two sides by Abington Avenue and Main Street (City Hall, Register of Wills, Will no. 16, 1805). His house number is thought to have been 3607 Germantown Avenue, a building which was demolished in 1933 (Margaret B. Tinkcom, "Cliveden: The Building of a Philadelphia Countryseat, 1763–1767," *PMHB*, vol. 88, no. 1, January 1964, p. 19 n. 32). According to a property description, he had a workshop on the same piece of ground as his house; at the time of his death it contained quantities of boards, scantling, "pannel" boards, and shingles, indicating that he or his sons were still in the building business when he died in 1805.

Knorr's parentage remains unknown. He and his wife Hannah had seven children, George, Catherine, Sarah, Hannah, Elizabeth, Susanna, and Jacob. In 1804, when Knorr wrote his will, George and Jacob, or their survivors, were appointed executors of his estate, but only George survived to carry out and sign the accounts in November 1821 after his mother's death. Presumably some of the other children survived to inherit, but the accounts are summary and say only "the girls." Jacob Knorr specified that after his wife's death his house was to be sold for the benefit of his children.

In 1807, when his will was probated, Jacob Knorr's estate was worth $5,024.60 in business property, $190.13 in personal property, and $2,960 in real estate. Samuel Myers and William Keyser took a detailed inventory of the house and workshop in 1820. The contents reveal a good deal about Knorr and offer material for comparison with a Philadelphia craftsman's possessions, William Savery's for example (see biography preceding no. 40). The household furnishings were largely in walnut, including an "eight day clock & walnut case $30 . . . a folding stand & cover both walnut $1.25 . . . a walnut tea table $1.00 . . . 1 walnut desk $12.00 . . . [and] a walnut case of drawers $3.00." Among other furniture, obviously not of walnut, were "12 green windsor chairs $4.80 . . . [and] 1 large looking glass, damaged $2.00." By this time walnut was out of fashion, but the repeated mention of the wood in this inventory suggests that in outlying areas it remained a valuable item and was not rapidly replaced with mahogany or veneered pieces according to the fashion in Philadelphia.

His workshop included the obvious "1 chest & carpenters tools $40.00," the high value suggesting a complete set of tools in good condition. A surveyor's compass and apparatus valued at thirty dollars attest to his skill at surveying and a high degree of expertise in stone building. He had several long ladders, one of cedar. He had his own turning lay (lathe) and workbench, and a turning wheel, evidence perhaps that

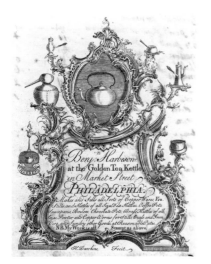

Henry Dawkins (act. c. 1753–86), Trade Card for Benjamin Harbeson, c. 1764. Engraving and etching on laid paper, 13¼ x 8¼" (33.8 x 20.7 cm). Courtesy Historical Society of Pennsylvania, Philadelphia

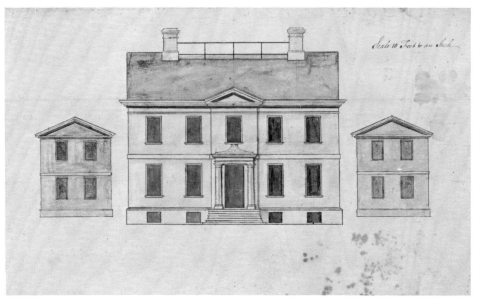

62. *Elevation*

specialization was not developed outside of Philadelphia, and that carpenters ran their own moldings and turned their own columns.

Knorr owned several lots of books, one of which, of only four volumes, was given the highest value of eight dollars. It is tempting to assume that these were architectural design books from which he drew the handsome woodwork and classical orders found at the Germantown Academy and Cliveden.

BENJAMIN CHEW AND JACOB KNORR

62. *Cliveden*

6401 Germantown Avenue
1763–67
Dressed stone facade; stucco over rubble sides and rear; wood trim; and shingle roof
53′10″ x 44′4″ (16.4 x 13.5 m)

REPRESENTED BY:
Benjamin Chew
Cliveden: Front Elevation
1763
Ink and wash
7¾ x 12½″ (19.7 x 31.8 cm)
Benjamin Chew
Cliveden: First Floor Plan
1763
Ink
6¼ x 7⅝″ (15.9 x 19.4 cm)
Private Collection

PROVENANCE: Benjamin Chew, 1763–79; Blair McClenachen, 1779–97; Benjamin Chew, 1797; descended in family

LITERATURE: Margaret B. Tinkcom, "Cliveden: The Building of a Philadelphia Countryseat, 1763–1767," *PMHB*, vol. 88, no. 1 (January 1964), pp. 3–36; Margaret B. Tinkcom, "Cliveden," in PMA, *Architectural Drawings*, pp. 3–5; Raymond V. Shepherd, Jr., "Cliveden," *Historic Preservation*, vol. 24, no. 3 (July–September 1972), pp. 4–11

FEW PRELIMINARY DRAWINGS or plans have survived for American eighteenth century houses; among those that do exist, Cliveden's must be the most complete. The nine drawings include a full sequence of projections and possible schemes for this important country seat in Germantown. They offer a succession of evidence of the thought processes of an owner who was his own architect and, in many cases, his own contractor. Benjamin Chew let out the subcontracts and duly entered his disbursements in a small book devoted to the project. His first drawing for the structure shows the entrance door on a gable end, and flanking pavilions with one window on each story, connected with a masonry screen. This may have been based on an engraving, *View of the Palace at Kew from the Lawn*, published in the *Gentleman's Magazine*, August 1763, a copy of which was found tucked away with Chew's papers (Margaret B. Tinkcom, "Cliveden: The Building of a Philadelphia Countryseat, 1763–1767," *PMHB*, vol. 88, no. 1, January 1964, illus. p. 20). But it was also inspired by Palladio's design for the Villa Pisani, published in Isaac Ware's 1738 edition of *Palladio*, a book owned by Robert Smith in Philadelphia by 1750. Chew's next design added a third story to the Palladian design, thereby diminishing the importance of the

dependencies. The three final elevations, one of which is exhibited, turned the house ninety degrees, which placed the main door on the longer side. At this point, Palladio disappeared as a design source, and a more usual Philadelphia facade emerged, making the house much less interesting on the exterior. However, this may have been a compromise in design required for the achievement of the superb spaces desired for the interior.

Whether William Peters, Chew's friend who had built his country seat Belmont (in Fairmount Park) in the 1740s, influenced him is uncertain, but his writing appears on two of the floor plans. Belmont has a large parlor with stair "tower" behind; and the T-shaped hallway on a plan suggested for Cliveden, bearing Peters's notations, is very close to the Cliveden plan exhibited and to the house as built, including the dimensions of the rooms. Peters's plan (Tinkcom, *PMHB*, cited above, illus. p. 11) offered symmetrical fenestration on east and west gable ends, as well as on the main south and north facades, but Cliveden was built more pragmatically with the windows on gable ends arranged to serve the interior spaces rather than the exterior architectural organization. In 1766, subsequent to this plan, Chew added a curved arcade at the northwest corner which connected the kitchen dependency building with the diningroom (northwest room), resulting in additional windows in the west wall while converting a north window to a doorway.

The elevation exhibited lacks the elaborate dormer windows, roof urns, complexity of chimneys, bold modillion cornice, pedimented Doric doorway with fluted engaged columns, and flat granite, keyed window arches of the house as built (see illustration). But these were decorative additives. The elevation does portray the overall organization of the main block into a five-bay facade with a shallow projecting central bay, capped by a triangular pediment. There is a clear delineation of horizontals and verticals at the encircling belt course, interrupted where the central pavilion thrusts through the belt.

The dependency buildings are placed to the rear of the main facade in plan, elevation, and actuality (the engraving of the palace at Kew shows them forward). Chew's first drawing showed them parallel to the plane of the central unit; the second brought them forward, connected to the front of the main block along their rear wall by means of an arcade. But with the reorientation of the main building in the final drawings, the dependencies slipped behind. Finished with equal detail and joined to the main block by the use of the same stucco-type surface as the sides of the house, the dependencies become appendages quite different from the similar structures at Mount Pleasant (in

62. *Plan*

Fairmount Park), which take a "sentinel" position.

If it was the plan rather than the elevation that determined Cliveden's interior space, it was an imaginative and grand scheme. Welcoming and full of light, the reception area is defined by a screen of fluted Doric columns, two engaged, two freestanding, setting the scale for interior space and architectural detail. Although the joiners under the direction of Jacob Knorr of Germantown were not members of Philadelphia's Carpenters' Company, their craftsmanship reveals skills at least equal to their exclusive Philadelphia rivals, best demonstrated by the details of scale relationship between columns and architrave, doors and their pediment cappings, and chimneybreasts and windows. When compared to Robert Smith and John Thornhill's stiffly academic application of design book maxims at Mount Pleasant, built two years before Cliveden, Knorr's aplomb at Cliveden represents an unusual and successful collaboration between owner and builder.

BG □

EDMUND MILNE (1724–1822)

Edmund Milne's birthplace is still uncertain. It is not recorded in surviving church records of Philadelphia, nor did a family by that name appear on early tax lists extant. He may have come as an indentured servant or journeyman if he had completed his apprenticeship abroad. His close association with Joseph Richardson, Sr., and men trained in Richardson's shop

suggests he may have been working abroad and heard from the London goldsmiths George Ritherdon or William Winne about large orders from the Richardson shop, and was inspired to emigrate (Fales, *Joseph Richardson*, pp. 212–13). By 1761, Milne had an account in the London firm of How and Masterman; the Richardsons had begun their account with that firm in 1759.

Milne's first advertisement in the *Pennsylvania Gazette,* December 29, 1757, locates him on Market Street, next door to the "Indian King." Charles Dutens, a goldsmith who had moved from New York to Philadelphia by 1755, had previously occupied the building with his partner, David Harper, trained in the Richardson shop (Fales, *Joseph Richardson,* p. 65). Dutens went to the West Indies in 1757 and Milne moved in. Whether Harper, who died in Guadeloupe in 1761, took Milne as a partner is unclear, and Milne's advertisement makes no reference to a partnership, which must have supplied him with his shop and his contacts.

In 1761, Milne had moved his shop "At the Crown and Pearl in 2nd Street one door from the corner of Market St" (*Pennsylvania Journal,* November 19, 1761), and was working for the Friendly Association, another important Richardson enterprise, making Indian silver ornaments (HSP, Penn Papers, Accounts, Receipt to George Croghan from Milne, vol. 3, p. 43). Toward the end of 1761, Milne "intended for England"; in October 1761, Joseph Richardson wrote the How and Masterman firm to credit Milne with £ 154 6s. 4d. on his account (Fales, *Joseph Richardson,* p. 238). Milne was probably in London from January 1762 until December 1763, buying and making his mercantile contacts. He did not close his Philadelphia shop, but employed "several capable hands" to

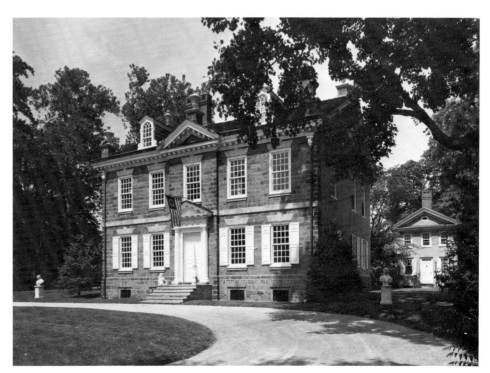

Cliveden (Main Facade and East Dependency)

continue in his absence (*Pennsylvania Gazette,* November 26, 1761). On his return in December 1763, he added two pearls to his sign and an extensive list of "an elegant assortment from London, just imported," the most complete eighteenth century list of a goldsmith's shop stock extant. In October 1764, Milne again noted: "Imported, a large assortment of the newest fashioned plate and jewellry" (*Pennsylvania Journal,* October 11, 1764). Milne imported his wares on the ships of Captain Budden or Captain Spark, reliable seamen entrusted with gold, plate, and currency (also the captains chosen by Joseph Richardson).

The Proprietary Tax List of 1769 lists Milne in the High Street Ward with one horse, one servant (a domestic), and a tax of £25 1s. 4d., low when compared to Philip Syng's (£149 12s.), but close to David Hall's tax of £34 16s. for that year. According to Milne's advertisement for a runaway servant in the *Pennsylvania Gazette,* August 3, 1769, he had two indentured servants: one, James Samuel Gordon, a jeweler by trade, from Scotland; the other "James Logan, a well set boy about 16 . . . born in the north of Ireland." In 1773, Milne employed William Squibb from Ireland as an indentured servant for two years "at the business of a silversmith" (HSP, Record of Indentures in Philadelphia, 1771–73). Milne's most famous commission was probably "for His Excel^cy Gen^l Washington . . . To Mak^g 12 Silv^r Camp Cups . . ." in August 1777 ("The Editor's Attic," *Antiques,* vol. 11, no. 2, February 1927, p. 107).

Little is known about Milne's personal life. Like Daniel King, Milne leaves no record as a public officeholder, possibly because of his affiliation in the Second Baptist Church. A son was buried at Christ Church, June 14, 1783; a daughter, Eliza, married John Russell in 1793. On January 12, 1785, "Edmund Milne's house and kitchen, situate on the West Side of Sixth Street between Mulberry and Sassafrass Streets" were insured by the Green Tree Company (Philadelphia, Mutual Assurance Company, Minutes). He died a "Gentleman of *Northern Liberties*" on February 4, 1822 (Harrold E. Gillingham, "The Cost of Old Silver," *PMHB,* vol. 54, no. 1, January 1930, p. 41) leaving his estate to his wife, Amelia (City Hall, Register of Wills, Will no. 22, 1822).

63.

63. *Locket (Clasp)*

1764
Mark: EM (in rectangle on back)
Inscription: M. Smith/1764 (engraved on back)
Gold
Length 1¹⁄₁₆″ (2.7 cm); width ¹¹⁄₁₆″ (1.7 cm)

Yale University Art Gallery, New Haven. John Marshall Phillips Collection

PROVENANCE: John M. Phillips
LITERATURE: Buhler and Hood, vol. 2, no. 864

EXTANT EXAMPLES from Edmund Milne's varied production reveal his expertise in his craft. His extensive imported stock may have supplied him with prototypes, but the variety of objects he made—jewelry, candlesticks, cruet stands, scoops, tankards, and teapots—attests to a productive Philadelphia shop.

Gold was as popular as silver for small accessories, and silversmiths, who also advertised as goldsmiths, worked with both precious metals. Edmund Milne made gold buttons for a Mr. Fitzsimonds about 1764 (Samuel W. Woodhouse, Jr., "American Craftsmanship in Gold," *Antiques,* vol. 20, no. 1, July 1931, p. 32). In 1769, Samuel Powel paid Milne £20 14s. 11d. "for setting a bracelet etc.," which, as is indicated by the price, must have included "rose diamonds not manufactured," meaning they were genuine and not manufactured "brilliants," called "paste," which Milne advertised in 1763.

Milne made this gold clasp for M. Smith in 1764. The clasp was frequently made in a locket form, as in this example, and strands of beads were attached to the small holes at each side. Most were fitted for three strands; this, with four, is unusual. The locket is hollow, with a spring wedge fastener at one end. The cover is engraved with a basket of flowers, one of the many pleasant designs, such as birds, butterflies, bees, and bouquets, which were used on contemporary jewelry designed for feminine taste.

BG □

HENRY DAWKINS (ACT. C. 1753–86)
(See biography preceding no. 59)

64. *The Paxton Expedition*

1764
Inscription: THE PAXTON EXPEDITION, *Inscribed to the Author of the* FARCE, *by* HD.

Come all ye Brave Delphia's, and Listen to Me.
A Story of Truth, Il'l unfold unto thee
It's of the Paxtonians, as You shall Hear;
Who Caused this City in Arm's to Appear.

Brave P . . . n then Assembled his Council with Speed.
The Inhabitants too, for there Ne'er was more need
To Go to the State House, and there to Attend;
With all the Learn'd Arguments that could be pen'd.

To shew their Loyalty, some they did Sign,
Others wav'd in their minds, but at last did decline
For to Go to the Barrack's their duty to Do;
Over some Indians, who never wer'e true.

There was Lawyers & Doctors, & Children in Swarms,
Who had more need of Nurses, than to carry Arms
The Qs. so peaceable as you will Find;
Who never before to Arm's wer'e Inclind.

To kill the Paxtonians, they then did Advance,
With Guns on their Shoulder's, but how did they Prance;
When a troop of Dutch Butchers's, came to help them to fight,
Some down with their Gun's ran away in a Fright.

Their Cannon they drew up to the Court House,
For fear that the Paxtons, the Meeting wold force,
When the Orator mounted upon the Court Step's
And very Gently the Mob he dismis'd.

Watermark: Crowned fleur-de-lys
Engraving
9¼ x 13¾″ (23.5 x 35 cm)
The Library Company of Philadelphia

PROVENANCE: Pierre Eugène du Simitière, until 1785

LITERATURE: LCP, Du Simitière Papers, pp. 169–70; Stauffer, vol. 2, no. 467, p. 80; Fielding, no. 335, p. 90; Phillips, *Maps and Views,* no. 254, p. 46; William Murrell, *A History of American Graphic Humor* (New York, 1933), vol. 1: 1747–1865, no. 9; Stokes and Haskell,

84

Early Views, p. 21; Helen Comstock, "Spot News in American Historical Prints, 1755–1800," *Antiques,* vol. 80, no. 5 (November 1961), pp. 446–47, fig. 2; Snyder, "Views," pp. 675–76; Wilford P. Cole, "Henry Dawkins, Engraver," M.A. thesis, University of Delaware, 1966, pp. 67–73; Shadwell, *American Printmaking,* no. 27; Clifford Shipton and James E. Mooney, *National Index of American Imprints through 1800,* vol. 2 (Worcester, Mass., 1969), no. 9777; Lynn Glaser, *Engraved America: Iconography of America Through 1800* (Philadelphia, 1970), p. 58; *Made in America,* no. 4; Snyder, *City of Independence,* pp. 74–80, item 30, fig. 28

IN THE DECADES prior to the Revolution, political controversies and social discontent occasioned the rise of pamphlets and cartoons. The events following the massacre in 1764 of a group of Conestoga Indians by Scotch-Irish settlers from Paxton, Pennsylvania, inspired a writer, calling himself "A Native of Donegall," to write a sixteen-page satirical pamphlet. Entitled *The Paxton Boys, A Farce* (Philadelphia, 1764), it presents the viewpoints of the various parties. It is this pamphlet that Dawkins refers to in his inscription.

Dawkins's print was thus actually made to illustrate the satirical pamphlet and was bound into the second edition of the latter and published with it in 1764. This impression of Dawkins's print and the pamphlet, along with other material documenting the Paxton incident, belonged to Pierre Eugène du Simitière, noted portrait painter and museum curator. They were purchased by

the Library Company in 1785 with other Du Simitière material gathered in preparation for a general history of North America.

The farce was a commentary on one of the many controversies at that time—the settling of the Pennsylvania frontier. The appeal of Quaker pacifism and tolerance, as well as William Penn's continuous efforts to bring settlers to his territory, attracted immigrants seeking freedom from oppression as well as members of the European upper class. A result of this influx was a rapid expansion into western Pennsylvania and into territory occupied by the Indians. To avoid land-ownership disputes and Indian resentment, Penn arranged for the peaceful purchase of Indian property. But by 1740 such methods were no longer effective due to the conflict between England and France involving profitable Indian trade in this area. The French and Indian War resulted, accompanied by individual Indian raids on defenseless frontier settlers. A series of encounters followed before the Indians were finally subdued in 1763 by British troops under Colonel Henry Bouquet at Fort Pitt in the final battle of the war.

But trouble for the settlers did not end with the peace treaties. Frontiersmen in western Pennsylvania, mostly of Scotch-Irish descent, could not abide by friendly policies established by eastern Pennsylvanians who had never faced a raiding Indian. In a letter to Secretary Richard Peters from Reverend John Elder of Paxton, the spirit which was eventually to erupt in massacre is explained:

Paxton, 9th November, 1755 ... There are within this few weeks upwards of forty of his majesty's subjects massacred on the frontiers of this and Cumberland counties, besides a great many carried into captivity, and yet nothing but unseasonable debates between the two parties of our legislature, instead of uniting on some probable scheme for the protection of the province. What may be the end of these things, God only knows; but I really fear that unless vigorous methods are speedily used, we in *these back settlements* will unavoidably fall a sacrifice, and this part of the province be lost (Watson, *Annals,* vol. 1, p. 117)

Several years later the growing concern exploded, as men from Paxton marched on a group of Conestoga Indians near Lancaster:

On Wednesday, Dec. 14, 1763, the Paxton boys, numbering fifty-seven men, mounted and armed, came to Conestoga after riding all night. They surrounded the Indian huts and attacked them at daybreak. Only six persons were found, and those, including the old chief, were murdered in cold blood in their beds. The fourteen who were absent were taken by the neighbors and lodged in Lancaster jail for safety. The Governor issued a proclamation ordering the offenders to be arrested. In defiance, the Paxton boys marched to Lancaster, broke into the jail, and murdered every one of the fourteen, not a hand being raised to defend them. (Scharf and Westcott, vol. 1, p. 241)

Other Indians, fearing further assault, sought refuge in Philadelphia, which in turn created indignation in the west. On January 3, 1764, settlers from the Lancaster County area united and on February 4, 1764, marched toward Philadelphia where armed citizens awaited them.

Cannon were sent to the barracks, a stockade thrown up there, and videttes sent out on the roads of approach. Next day was Sunday; defensive preparations were continued, a redoubt thrown up in the centre of the barracks parade-ground, and the gateways stockaded and loop-holed. At eleven o'clock that night an express came in with news of the mob's approach. Another arrived at two o'clock, and the alarm-bells began to ring. The people rushed out to obey the summons, and by sunrise on Monday the whole town was under arms. The old association artillery company mustered again and took charge of two cannon at the court-house. Business was suspended, shops did not open, the ferries were dismantled, and couriers charging back and forth along the streets kept up the excitement. (Scharf and Westcott, vol. 1, p. 242 n. 1)

64.

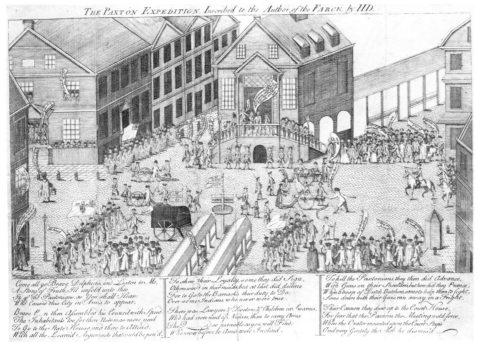

THE PAXTON EXPEDITION, Inscribed to the Author of the FARCE, by HD.

Accompanied by three others, Benjamin Franklin met the Paxton boys at Germantown, and there, through negotiations, a conflict was avoided.

Dawkins's engraving depicts the controversy at the climactic moment when Franklin announces his success to the townspeople on the balcony of the Court House at Second and Market streets. The six stanzas of satirical verse below the image explain the action and lampoon the reluctant muster of the Quakers; the characters are used to add further incisive commentary. Edgar P. Richardson has identified the author of the verse as David James Dove, an English immigrant and schoolteacher. A letter dated February 8, 1765, written by William Franklin, governor of New Jersey, states that William Allen, chief justice of the Pennsylvania Supreme Court, commissioned Dove to write the verse and paid for the production of the copperplate (Snyder, *City of Independence*, pp. 79–80).

In this first known interior view of Philadelphia, Henry Dawkins has not sought to reconstruct the site accurately but to record an historical event in a place with great symbolic significance—the Court House, which was the center of Colonial dispute and arbitration. Dawkins completes the scene with other contemporary structures: the Quaker Meeting House (no. 47) at left, market stalls behind the Court House, the Jersey stalls in the foreground next to the old pillory, and the house of the druggist John Speakman in the right background.

Before the advent of newspapers in the eighteenth century, information was communicated to the public through publications printed on large single sheets of paper or on smaller pages in pamphlet form. The subject matter often had propagandistic value related to current issues and was presented in various forms such as a sermon, poetry, essay, or illustration accompanied by relevant text. The primary emphasis was placed on the immediate dissemination of an idea, not the artistic endeavor. This accounts for the rudimentary character of this engraving which makes no attempt at accurate representation. The message was intended to be pertinent and direct and was aimed at the entire population, not a select, educated class.

ESJ □

MATTHEW PRATT (1734–1805)

Born in Philadelphia, the son of a goldsmith, Pratt served an apprenticeship from 1749 to 1755 with his uncle, James Claypoole, Sr., a limner, house painter, and glazier. By 1755 he had learned enough to set up his own trade as a general painter with Francis Foster. His work at this time

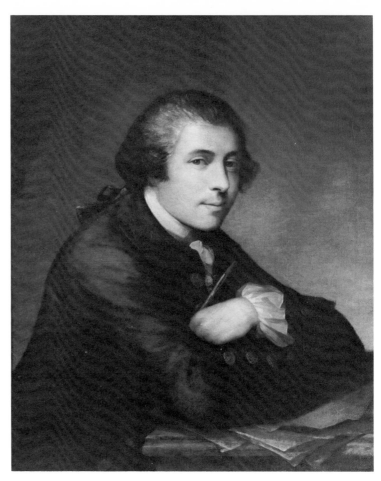

65.

even included repainting fire engines (John W. Jordan, "The Fellowship Fire Company of Philadelphia, Organized 1738," *PMHB,* vol. 27, no. 4, 1903, p. 479). Two years later, he left the business in Foster's hands and went off on a mercantile venture to Jamaica. On his return in May 1758, he began to paint portraits and was greatly encouraged. He probably knew Benjamin West before West left Philadelphia in 1760 for Rome because Pratt traveled to London in 1764 with West's father and West's fiancée, a relative of Pratt's. He lived with the Wests in London from 1764 until 1766 when he moved to Bristol. From there, he sailed to Philadelphia in 1768 and resumed his portrait painting. After two years, he made his third and final voyage, a short trip to Ireland in 1770 to claim his wife's legacy. In 1771–72 he painted some portraits in New York and apparently went from there to Virginia where, in Williamsburg, he exhibited some of his copies after West and advertised in March 1773 as a portrait painter. His location and activities from here on are less certain. Sawitzky (*Matthew Pratt, 1734–1805,* New York, 1942, p. 16) records that Pratt was appointed a sergeant in 1781, which implies that he was involved in the

Revolutionary War. By about 1785, Pratt was painting signs in Philadelphia, and in 1787 he joined John Drinker in opening a drawing school. Although he was a friend of Charles Willson Peale, he did not exhibit at the Columbianum but turned increasingly to ornamental work. This culminated in the formation in 1796, of Pratt, Rutter & Co., specialists in all kinds of decorative painting. Since Pratt is not listed in the 1798 Philadelphia directory, he may have been living with his wealthy son. He died in Philadelphia leaving some autobiographical notes which are the chief source of information on his life. First used in Dunlap's *History,* the notes were later published in full a couple of years before they were destroyed (Charles Henry Hart, "Autobiographical Notes of Matthew Pratt, Painter," *PMHB,* vol. 19, no. 4, 1895, pp. 460–67).

65. *Self-Portrait*

c. 1764
Oil on canvas
30 x 24¾" (76.2 x 62.9 cm)

National Portrait Gallery, Smithsonian Institution, Washington, D.C.

PROVENANCE: Matthew Pratt; descended in artist's family to Mrs. Clarence (Pratt) Tiers, 1910–19; daughter, Mrs. George M. Hamilton, until at least 1942; her son and daughter; purchase, National Portrait Gallery, 1969

LITERATURE: PAFA, *Historical Portraits,* no. 352, p. 83; William Sawitzky, *Matthew Pratt, 1734–1805* (New York, 1942), pp. 10–11, 63–64; Washington, D.C., International Exhibitions Foundation, *American Self-Portraits, 1670–1973,* by Alfred V. Frankenstein and Ann C. Van Devanter (1974), no. 4, p. 22

THE DATING AND ATTRIBUTION of most of Pratt's work are difficult problems. There is only one signed and dated picture by him, *The American School* (Metropolitan Museum of Art), painted in London, 1765. Aside from this, the paintings that can be attributed to him with some degree of certainty include those, like the *Self-Portrait,* that belonged to his collateral descendants and others that are specifically mentioned in contemporary references. Then there are paintings attributed to him on the basis of style, some of which are certainly open to question.

The artist's *Self-Portrait* is of special interest as a relatively early work. Stylistically, the rather crude use of thick paint in this portrait is related to his earliest known works—the portrait of his young wife, usually dated to the year of their marriage, 1760, and the portrait of Benjamin Franklin, a copy of a 1761 engraving after Benjamin Wilson's portrait of 1759. These three paintings share the same provenance, and their broad treatment may derive from Pratt's training with the artisan James Claypoole, Sr. Yet the *Self-Portrait* shows the more relaxed pose of contemporary English portraiture, and the facial features are better integrated with the head. Therefore the *Self-Portrait* is considered to be an early London work of about 1764, the year of Pratt's arrival there. It may have been painted as a demonstration of Pratt's skill, showing himself as an artist with sheets of drawing paper and a brass portecrayon. A recent X-ray of the painting reveals two other portraits underneath, but neither provides a clue as to when or where the *Self-Portrait* was painted. The painting has been reproduced with the artist seated in a chair (see Sawitzky, cited above, p. 63), which was painted out in 1970 because it was considered a later addition.

While in London, from 1764 to 1766, Pratt copied some of Benjamin West's paintings. He was strongly influenced, after the date of the *Self-Portrait,* by West's carefully modeled, more finished, and sharply defined European style. But following Pratt's return to Philadelphia, his portraits show a freer brushwork, more delicate color, and a softer line, as in the portrait of *Mrs. Peter DeLancey* (Metropolitan Museum of Art).

His late coloring, tending toward shades of violet, recalls James Peale's portraits, but Pratt's treatment is always more painterly.

Although in 1772 Pratt was fully employed painting portraits in Philadelphia, after about 1785 he resorted increasingly to sign and ornamental painting, indicating that Charles Willson Peale cornered most of the portrait commissions (APS, Charles Willson Peale, Letterbook, vol. 12, p. 82). The enterprising Peale described Pratt as "a mild and friendly man not ambitious to distinguish himself," which may help to explain Pratt's lack of success (APS, Charles Willson Peale, Autobiography, p. 101, typescript). John Neagle (see biography preceding no. 233) remembered that Pratt's signs "were like the works of an artist descended from a much higher department" and "were broad in effect and loaded with colour. There is no niggling in his style or touch" (Dunlap, *History,* vol. 1, p. 103).

DE □

JONATHAN SHOEMAKER (1726–1793)

Jonathan Shoemaker was one of twin boys born to Jacob and Elizabeth Roberts Shoemaker of Philadelphia in 1726. The family, who had lived in Germantown for three generations, were turners. Jacob, Jonathan's grandfather, emigrated from Mainz, Germany, in 1683, and his son, Jacob, Jonathan's father, inherited all his "turning tools and all the other timber materials utensils and Tools belonging to the Trades of Turning and Wheel Making" (McElroy, "Furniture," pp. 204–5). In 1715 the family transferred from Abington to the Philadelphia Monthly Meeting of the Society of Friends. Like the silversmithing Richardsons, the Shoemakers were a dynasty of specialized craftsmen, and records of their expertise emerge often in Philadelphia accounts and ledgers. Their shop was next door to Caspar Wistar's property on Market Street opposite "Indian King Tavern" (*Pennsylvania Gazette,* January 28, 1776).

Jonathan Shoemaker was called a joiner by April 1750, when he made a table and coffin for Stephen Paschall (HSP, Stephen Paschall, Ledger A, April and August, 1750, p. 210). In 1752 he purchased a workshop and lot on the west side of Second Street (City Hall, Archives, Deed Book G-12, p. 378), and in 1767 he moved to Third near Arch Street and Say's Alley. He took on an apprentice, Samuel Mickle, about 1760, during his busiest and most productive years. Mickle, born in Haddonfield, New Jersey, in 1746, stayed on with Shoemaker as a journeyman before returning to New Jersey in 1776 to marry Margery Price (HSP, GS, Haddonfield Monthly Meeting, Camden, New Jersey). In 1763 Shoemaker had an

account with Benjamin Randolph (Winterthur Museum, Receipt Book), and again, in 1768, he appeared in Randolph's Account Book (NYPL, Philadelphia Merchant's Account Book, 1768–86, p. 30). One payment was made to Shoemaker "By Stock."

Jonathan Shoemaker married Sarah Lownes, daughter of silversmith Joseph Lownes, on October 27, 1767, at Haverford Meeting. He died in 1793, a victim of the fierce epidemic of yellow fever that swept the city in the summer of that year. Their children at the time of his death were Jacob, Joseph, Thomas, Susanna, and Elizabeth (City Hall, Register of Wills, Will no. 380, 1793).

66. *Armchair*

c. 1765

Mahogany; twentieth century silk damask upholstery

39¾ x 29 x 22″ (101 x 73.7 x 55.9 cm)

Philadelphia Museum of Art. Bequest of William M. Doughten. 56–122–2

PROVENANCE: Descended in the Shoemaker-Pickering-Doughten families

LITERATURE: Hornor, pp. 147, 219, pl. 159

EIGHTEENTH CENTURY ARMCHAIRS were rarely made larger than this one. It has a tall back and low legs when its proportions are compared to other such chairs of its period, for

66.

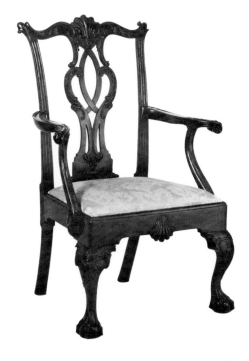

example, the Caspar Wistar armchair at Cedar Grove, in Fairmount Park (Hornor, pl. 154), and the armchair attributed to Benjamin Randolph in the Garvan Collection at Yale. The three are imposing, dramatic, and well-worked-out designs, with the Shoemaker example retaining a certain American naiveté in its proportion. The well-carved back splat (probably missing a carved ribbon and tassel in its central elliptical void) is excessively tall, a feature that is emphasized by the curved "ears" of the rail, which push up and out rather than turn down toward the stile as in the Yale armchair. The arm supports are molded and carved at the seat rail terminal, but compared to the Wistar example they are prim and thin in proportion to the sweep of the arms and the splay of the front legs.

With the exception of the relative length of legs and back, this chair is the same design as a set of three side chairs at the Winterthur Museum (Downs, *American Furniture,* pl. 125), this armchair being taller by about one-half inch. The center shell on the cresting rails of the Winterthur chairs is similar to the shell on the front seat rail of the armchair, while alternately the armchair's cresting shell and Winterthur's seat rail shells match each other. Sometimes such subtleties were coincidental, other times intentional, as on the Cadwalader card tables (no. 91), where the central skirt motifs are reversed to "join" the pair.

A story often repeated about this chair tells that a British officer living in the Shoemaker house during the occupation of Philadelphia in 1777 commissioned a set of chairs from Jonathan Shoemaker, but the occupation was over before the set was completed and the officer left this sample chair behind. Not only does this grand armchair not need a romantic story to secure its place in the arts of Philadelphia, but its style places it in the 1760s well before the beginning of the Revolution.

BG □

67. *Side Chair*

c. 1765
Mahogany; twentieth century French wool cord upholstery
35¼ x 23½ x 21″ (89.5 x 59.7 x 53.3 cm)

Philadelphia Museum of Art. Purchased: Germantown Tribute Fund. 28–118–1

CHAIRS with this distinctive back, one of Philadelphia's most elaborate designs, were ordered by several clients in large sets with but slight variations. One set belonged to John Dickinson (Hornor, pl. 119); another, to Isaac Cooper (Hornor, pl. 341); and a third, to Charles Thomson (Hornor, pl. 225). A fourth set includes four at the Winterthur Museum (Downs, *American Furniture,* pl. 137), one at the Metropolitan Museum of Art, and this chair, one of a pair at the Philadelphia Museum of Art. It has not been possible to determine whether the sets were carved by one or a number of craftsmen. All have floral carving on the stiles except the Charles Thomson set, which has molded stiles; and the Thomson set also differs in that it is upholstered over the seat rail, the others all having slip seats. All of the sets have light and wispy carving on the cresting, emanating from a lozenge-shaped ear, ending before the overlapping strands of the crest rail change direction and flow down to form the serpentine splat.

This chair has especially fine carving and detail on the back splat. Waves of scrolls cushion the "impact" where C-scrolls meet, and the raised, molded edges of the serpentine increase the effect of the sweep by doubling the line. The vines of flowers and buds on this version crisscrossing down the stiles are the fullest and most naturalistic of all the examples known. The knee carving is sharp and deep, forming a typical swirl of foliage encompassing the corner blocks and spilling over the knee, but it does not have the clarity of contour nor the precision demanded by the fine workmanship on the back. Again on this version the claw-and-ball feet are the most successful. The ball is softly flattened, but fully supportive, while the ankle and claws are clear and crisp.

BG □

67.

JOHN LEACOCK (1729–1802)
(See biography preceding no. 53)

68. *Snuffbox*

1765–67
Mark: I•L (capitals in rectangle inside cover)
Inscription: J [or I] M (foliate script on top)
Silver and cowrie shell
Length 3½″ (8.9 cm)

Philip H. Hammerslough Collection. On permanent loan to the Wadsworth Atheneum, Hartford, Connecticut

PROVENANCE: Philip H. Hammerslough

LITERATURE: Hammerslough, vol. 2, p. 37

THE SNUFFBOX had made its appearance in England by 1650. In America it was natural that the paraphernalia which accompanied the use of the "pernicious weed," as Cowper called it, should appear equally early. John Coney made snuffboxes by 1700; the earliest known Philadelphia example is by Joseph Richardson in 1757 (Philadelphia Museum of Art), although there is written reference to the form well before this date.

The snuffbox can be distinguished by its size and by the fact that its interior is usually gilded to prevent the tarnishing action of powdered tobacco. Its relative, the tobacco box, while also gilded, is larger overall and held the tobacco in dried roll form, which was grated and used like snuff, or chewed. The patch box resembled the snuffbox in all respects but was smaller and more delicate in decoration. Designed in rounded forms, either ovals, circles, hearts, or rectangles with "soft" corners, the snuffbox was made to be comfortably held or pocketed. It was decorated with engraved floral motifs and coats of arms, with cast ornament, or in repoussé, and personalized with ciphers, inscriptions, and dates. The use of a cowrie shell as the main body of the box somewhat solved the problem of tarnish, and the different-sized shells provided a uniqueness to each form, which is part of the charm of these objects. Silver was malleable enough to be shaped over the pointed end of the cowrie and smoothed around the curved end, yet strong enough to provide a durable hinge; and its surface complemented the texture of the shell. Most silversmiths purchased these shells and others from ship captains who collected or purchased them while in southern waters for this purpose. Cesar Ghiselin's inventory included shells; the Richardsons used them (Fales, *Joseph Richardson,* pl. 118); and Daniel Parker in Boston used them (Buhler and Hood, vol. 1, no. 206).

The engraved designs and initials on the cover of this box are rococo in organization

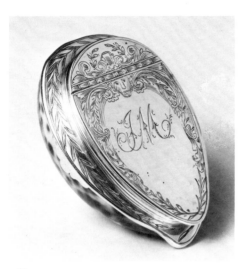

68.

and motif, but the flat technique of the engraving, especially just above the hinge, and the stylized foliage around the shell forecast the bright-cut method to come into fashion later (see no. 131). John Leacock's Commonplace Book (APS) includes notes on the techniques of engraving; however, when the shell and waves at the rounded end and the mask at the top of the hinged lid are compared with other contemporary engraving, Leacock's work appears unsure and naive. It may have been done by his son, Samuel, who worked on line engraving in his father's shop and with his uncle, David Hall, the printer. As Samuel did not set out on his own until 1775, his work in 1765–67, just before his father left the silversmithing trade, would have looked thus inexperienced.

The initials JM (or IM), which would help to establish a terminal date for this box, are unidentified. The State in Schuylkill Fishing Company, of which Leacock was an early enthusiast, included the names of John Mifflin, John Morrell, Isaac Milnor, and John Morris, whose initials suit and whose dates coincide with the production of this little box.

BG □

WILLIAM WILLIAMS (1727–1791)

William Williams was born in Bristol, England, the son of a man of the same name who may have been a mariner. Williams's interest in painting apparently began when, as a grammar school student, he enjoyed watching an elderly Bristol artist paint landscapes and portraits in oils. Yet Williams's career was chosen while he was still young and he became an apprentice seaman. On a voyage bound for the West Indies he was shipwrecked on the Mosquito

Coast, Central America, where he seems to have lived for a short time among the Indians. He appeared in Philadelphia as a painter in 1747 and gave some instruction to the nine-year-old Benjamin West, whose later recollections have become a major source of information on Williams. In Philadelphia at this time, Williams painted ship ornamentation, landscape, stage scenery (1759), and portraits. He was evidently a cultivated man who enjoyed music and made some attempts at poetry. Williams set out for the West Indies again about 1760. He afterward advertised in Philadelphia in January 1763 that he was "lately returned from the West-Indies" and intended to resume his business of "Painting in General" at his former residence and would also teach the flute and drawing in an evening school for young gentlemen. By May 1769, Williams was in New York and, this time, he advertised that his ability ranged from history pictures to sign painting, that he could paint landscapes and portraits, do lettering, teach drawing, and gild, clean, and repair old pictures. Williams returned to England by 1776 (Helen Burr Smith, "The Two William Williams'," *The New-York Historical Society Quarterly,* vol. 35, no. 4, October 1951, p. 380) and, after a few days in London, lived in Bedfordshire for about eighteen months. Later, in London, West portrayed Williams as one of the seamen in *The Battle of La Hogue* (1778). Williams seems to have traveled from London in about 1781 to Bristol where, in reduced circumstances, he lived in an almshouse from 1786 until his death in 1791. His papers, which came into the possession of a friend, Thomas Eagles, included the manuscript for a novel, *The Journal of Llewellin Penrose, A Seaman.* When Eagles's son had Williams's adventure story published in 1815, it was popular enough to require a second edition. It has usually been considered as at least partially autobiographical.

69. *Deborah Hall*

1766
Signature: Wm Williams 1766 (lower left)
Oil on canvas
71¼ x 46½" (181 x 118.1 cm)
The Brooklyn Museum, New York.
Dick S. Ramsay Fund

PROVENANCE: David Hall, Sr.; son, William Hall; wife, Jane (Trenchard) Hall; niece, Rebecca Kinsey; cousin, Mrs. Jonathan Ingham; George Trenchard Ingham; Augusta (Ingham) Evans until c. 1942

LITERATURE: William Sawitzky, "Further Light on the Work of William Williams," *The New-York Historical Society Quarterly Bulletin,*

vol. 25, no. 3 (July 1941), p. 112; Flexner, *First Flowers,* pp. 180–81; Sheldon Keck, "The Care and Cleaning of Your Picture," *The Brooklyn Museum Bulletin,* vol. 10, no. 3 (Spring 1949), p. 6, fig. 3; David Howard Dickason, *William Williams, Novelist and Painter of Colonial America, 1727–1791* (Bloomington, Ind., 1970), pp. 149, 152, 178; E. P. Richardson, "William Williams—A Dissenting Opinion," *The American Art Journal,* vol. 4, no. 1 (Spring 1972), pp. 16, 18

DEBORAH HALL (1751–1770) was the daughter of the printer David Hall, Benjamin Franklin's junior business partner until 1766 when Hall became the head of a new firm of Hall & Sellen. In the same year, perhaps as a mark of new prosperity, David Hall had his three children painted in life-size by William Williams. The portraits of Deborah's younger brothers, William and David, are at the Winterthur Museum. These three paintings are the earliest known full-length portraits painted in Philadelphia.

The portrait of Deborah, like those of her brothers, has the delightful pastel colors of the eighteenth century rococo style and an unusually theatrical background. Williams seems to have enjoyed fantastic landscapes with castles, winding streams, and craggy cliffs as seen in the background of his portrait of David and his *Imaginary Landscape* of 1772 (Newark Museum). It is thought that possibly this interest is a reflection of Williams's experience with painting stage scenery and that Benjamin West, almost twenty years earlier, may have seen similar landscapes by Williams, which then inspired the child West to attempt his imaginary landscape with a cow (Pennsylvania Hospital).

The backdrop in *Deborah Hall* is more believable than in her brother David's portrait and is probably, like the foreground prop of the rose bush, dependent upon an engraved English portrait. Although her portrait appears overloaded with props, all of them were considered necessary to convey her character and social status. The antique statuary in the niches of the garden wall, the foreground classical relief of Apollo chasing Daphne (who preserves her virginity by metamorphosing into a laurel tree), the roses, and the tame squirrel on a leash are probably intended to indicate wealth, proper upbringing, good taste, and a gentle disposition. In addition, the beautiful Deborah is portrayed in what must be one of the most elaborate Colonial dresses painted in this period, although the sitter undoubtedly posed only for the head.

The fact that there are signed portraits by more than one Colonial artist named William Williams has recently raised some controversy (see E. P. Richardson, "William Williams—A Dissenting Opinion," *The American Art Journal,* vol. 4, no. 1, Spring

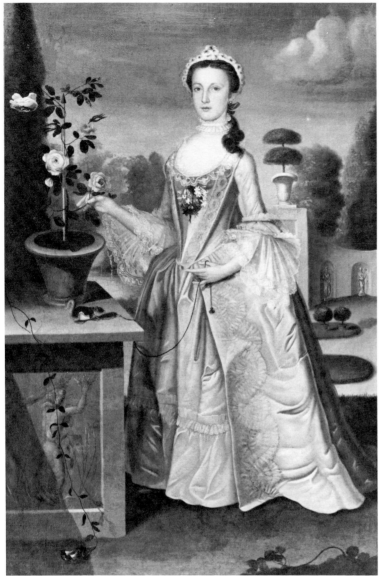

69.

70. *Wedding Dress*

1766

Inscription: Sarah Newbold's wedding gown/8 May/Jonathan Barton 5. mo 7. 1766 (written in ink in back of neck)

Dark-brown ribbed silk, faced with dark-brown cotton, lined with linen

Waist 30″ (76.2 cm); center back length 52″ (130 cm)

Philadelphia Museum of Art. Given by Mrs. Francis B. Gummere and Mrs. Thomas F. Branson. 29–111–1a

PROVENANCE: Sarah Newbold (Barton), 1766; probably descended in Barton family

LITERATURE: *PMA Bulletin,* vol. 57, no. 271 (1961), illus. p. 22

THIS DRESS was worn by a Quaker, Sarah Newbold, at her marriage in 1766 to Jonathan Barton. Quakers dressed with a reserved measure of simplicity in style and line, a plainness rooted in their religious principles, which held that frivolity in dress was an unnecessary expense and should not be considered. This tenet however did not in practice exclude the use of fine and expensive materials for clothing. Quaker silhouettes in the eighteenth century differed from the oval-shaped, pannier-supported shapes of the non-Friends. The Quaker lines were achieved strictly through the use of two or three petticoats, one of which would have

70.

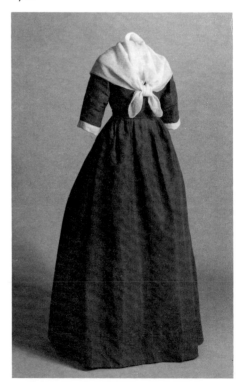

1972, pp. 5–23; William H. Gerdts, *The Great American Nude,* New York, 1974, p. 211n.), and a few attributions to the William Williams who painted Deborah Hall are still quite uncertain. His masterpiece appears to be the *Self-Portrait* (Winterthur Museum), which he must have painted after his return to England. It is markedly different from the portraits of the Hall children in its greater sophistication and more painterly approach.

As far as is known, Williams's competition in Philadelphia would have come from the two Hesseliuses and from Feke and Wollaston in the late 1740s and 1750s. In the 1760s, when we have some idea of Williams's style, his chief rivals would have been the Scottish migrant Cosmo Alexander and

Matthew Pratt on his return from England. James Claypoole, Jr., almost a generation younger, had engraved a view for Hall but did not receive the portrait commission. A further challenge would have been England's mysterious John Green, here possibly between 1757 and 1765, some of whose later work is known. Portrait commissions were often created with a sense of urgency because an itinerant foreign-trained artist, such as Wollaston or Alexander, was available. This seems to have cut into Williams's trade. Although he was preferred to Claypoole, Jr., for the Hall commission, the small number of Williams's surviving portraits suggests that his total output was not large.

DE □

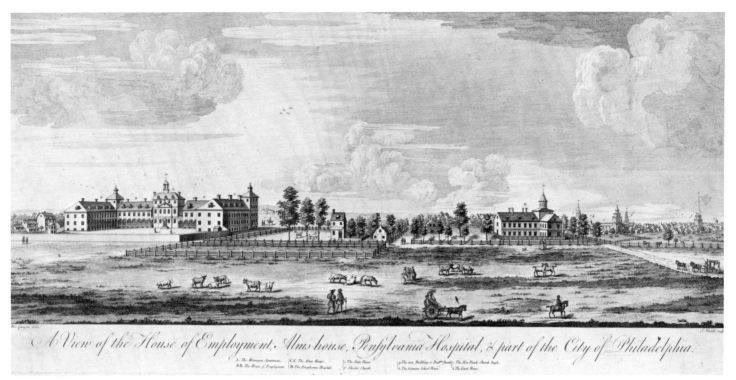

A View of the House of Employment, Alms-house, Pensylvania Hospital, & part of the City of Philadelphia.

A. The Managers Apartment. C.C. The Alms House. e. The State House. g The new Building or Pres.ⁿ Church. The New Dutch Church Steeple.
B.B. The House of Employment. D. The Pensylvania Hospital. f. Christ Church. h. The German School House. i. The Court House.

71.

been quilted or made of flannel stiffened with crinoline.

Unadorned and untrimmed, this nut-brown ribbed-silk dress of simple yet stylish lines and excellent material shows how style and elegance were adopted within the idea of Quaker plainness, thrift, and prudence. The unboned bodice is fitted with the round neckline and three-quarter-length sleeves in the style popular in this period of the eighteenth century. The skirt, evenly pleated around the waist, is attached to the bodice in the back. The front of the dress is finished as a flap attached at the sides and held in place over the bodice with pins, since Quakers frowned on buttons and other forms of adornments. A coarse linen lining is sewn to the bodice while the skirt's hem is faced with dark-brown cotton.

The plain white lawn fichu, or kerchief, worn over the bodice, would either have been knotted in front, as in this example, or crossed in the front and fastened under the belt. To complete the outfit, a gauze or linen indoor cap would have been worn on the head, and a silk or woolen shawl in earth shades would have graced the shoulders and arms.

EMcG □

JAMES HULETT (D. 1771)

Unlike many American engravers in the eighteenth century, James Hulett practiced printmaking in England as a profession. According to G. Reed, Keeper of Prints in the British Museum at the end of the nineteenth century (see Thomas G. Morton and Frank Woodbury, *History of Pennsylvania Hospital 1751–1895*, Philadelphia, 1895, p. 321n.), Hulett was active from 1750 to 1760. He is known primarily for his work for booksellers. Engravings of particular interest are *Hampton Court Bridge* (1754), after Canaletto; the plate for Coetlogon's *History of Arts and Sciences* (1745); Robert Walpole's *The Life of Queen Anne* (copied after Dubosc); one of the editions of Fielding's *History of Joseph Andrews* (London, 1742); and G. Smith's *The Laboratory, or Schools of Arts* (1750; 18 sheets after G. Smith). Several of these works include portraits, a fact which has caused authors to confuse Hulett with a seventeenth century portraitist by the same name.

NICHOLAS GARRISON, JR. (ACT. C. 1740–80)

Nicholas Garrison, Jr., first came to America in the 1740s in the service of his father, a Moravian sea captain. He settled in Bethlehem, Pennsylvania, after his marriage on July 29, 1758, to Johanna Grace Parsons, the daughter of William Parsons. In 1762 the family moved to Philadelphia, where Garrison worked as a grocer. Moravian records indicate that they were forced out of the city during the Revolution and were residing in New Jersey by September 27, 1777 ("Notes and Queries," *PMHB*, vol. 35, no. 3, 1911, p. 373). On February 26, 1778, Garrison left for Bethlehem and by 1780 had settled in Berks County. In that year a French traveler, Marquis de Chastellux, described Garrison as "a seaman who imagined he had some talents for drawing and amused himself with teaching the young people . . ." (*Philadelphia Reviewed*, p. 19). Garrison is known by the engravings after his views of Nazareth, Bethlehem, and this print by Hulett.

JAMES HULETT AND NICHOLAS GARRISON

71. *A View of the House of Employment, Almshouse, Pennsylvania Hospital, and Part of the City of Philadelphia*

c. 1767
Signature: Nic. Garrison delint (lower left corner); J. Hulett sculp. (lower right corner)
Inscription: *A View of the House of Employment, Alms-house, Pensylvania Hospital, & part of the City of Philadelphia*
Engraving
i/ii
13½ x 18⅝″ (34.3 x 47.3 cm)
Private Collection

PROVENANCE: J. William Middendorf Collection; Kennedy Galleries, New York, 1959; Henry Graves, Jr., New York

LITERATURE: Thomas G. Morton and Frank Woodbury, *History of Pennsylvania Hospital 1751–1895* (Philadelphia, 1895), pp. 321–22; Stokes and Haskell, *Early Views,* pp. 22–23; *Philadelphia Reviewed,* no. 19; *Prints Pertaining to America,* no. 61; Snyder, "Views," pp. 676, 680, fig. 8; *American Printmaking,* no. 28; Jan Morse, ed., *Prints in and of America to 1850* (Charlottesville, 1970), p. 346; Nancy E. Richards, "The Print Collection at Winterthur, Part I," *Antiques,* vol. 100, no. 4 (October 1971), p. 589; Sotheby Parke Bernet, New York, May 18, 1973, no. 20 (Middendorf sale); Snyder, *City of Independence,* pp. 80–82, item 35, fig. 30, pl. 2

IN HULETT'S ENGRAVING of the House of Employment, the Almshouse, and the Pennsylvania Hospital (see nos. 48, 59), a unique eighteenth century panoramic view of Philadelphia from the south is combined with the more popular representation of specific civic structures. At that time, the site of these buildings, between Eighth, Eleventh, Spruce, and Pine streets, was sparsely settled country and not the heart of the city, which is seen in the background. With no distraction from neighboring structures, the institutions were especially impressive sights worthy of admiration and symbolic of civic charity and pride.

The Pennsylvania Assembly, in response to overcrowded conditions at the old Almshouse on Pine, Spruce, Third, and Fourth streets, had voted in February 1766 to build a new edifice (Watson, *Annals,* vol. 3, p. 334). Funds were to be raised through contributions and the balance by the imposition of a tax. Initial organizational meetings, documented in the Minutes of the Almshouse manager, May 16, 21, and 31, 1766 (City Hall, Philadelphia Archives), centered on the design of the building, which not surprisingly was based on the plans for the as yet unfinished Hospital, by a member of their own committee, Samuel Rhoads.

Judging from the following description, Hulett's depiction is quite accurate:

The new buildings were generally known as the Bettering-House, or Almshouse for the Relief and Employment of the Poor, and were built on the lot from Tenth to Eleventh and Spruce and Pine streets. The alms-house fronted on Tenth street and the house of employment on Eleventh street, each building being in the form of an L, one hundred and eighty by forty feet, two stories high with attics, and a tower thirty feet square and four stories high at the corner of the two portions. In the centre between the two was a building three stories high with attics, surmounted by a belfry or cupola. Run-

ning around the lower story and opening upon the interior yard was an arcade. (Watson, *Annals,* vol. 3, p. 334)

The Almshouse was opened in October 1767, and 284 persons were admitted. In a print of the second Almshouse by William Birch, dated 1800, the center section has been removed. The question is then raised regarding the date of the destruction of this three-story pavilion. References can be made to maps of the area although they are not an entirely reliable source for the appearance of a building—designers of maps are generally more concerned with the location of a structure than its ground plan. Thus, it is not certain that the structure was still a unified entity as it appears in John Ried's map of 1774 (Robert J. Hunter, "The Origin of the Philadelphia General Hospital," *PMHB,* vol. 57, no. 1, January 1933, p. 33), but its form had been altered sometime before the 1796 map executed by P. C. Varlé in which two separate L-shaped buildings are represented (see no. 143). A report by J. P. Brissot de Warville suggests that this portion had been torn down by 1788: "This hospital is constructed of bricks, and composed of two large buildings; . . . There is a separation in the court, which is common to them" (Hunter, cited above, p. 50).

The lack of existing documentation has also made it impossible to resolve other problems. One issue centers on the patronage of the print. It has been suggested that the Hulett engraving was commissioned to encourage contributions or to commemorate the opening. Both would suggest that the engraving was done before October 1767, when the building was completed, and that Garrison's design was probably taken from the architect's plan. However, there is no way to confirm this. It is also possible that both Garrison's design and Hulett's engraving were done after the building was constructed, and thus Garrison's design may represent an eyewitness account; such topographical views were common and popular at the time.

It is also unclear whether Hulett ever came to the United States. He probably did not, but, as with the Scull and Heap view (see no. 46), a drawing was sent to him in England to be reproduced. At that time, it was a common practice in England for professional engravers to make prints after other works for dissemination to a wider public.

The last question is related to whether the source for the print was a painting or a drawing; the latter seems more likely because of the customary practice at the time and also, according to Chastellux's accounts, we know that Garrison produced drawings, but we know nothing about paintings by him. More convincing, the Hospital Minutes state that "in 1768, a large, colored engraving of the Hospital and Poor House, drawn by

Nicholas Garrison, was presented to the Hospital" (Morton and Woodbury, cited above, p. 321). For these reasons, it seems unlikely that a painting of the same scene (now in the Pennsylvania Hospital) can be attributed to Garrison and thus be the work Hulett used as a model. The painting may even have been done after the Garrison or Hulett work.

ESJ □

WILLIAM WILL (1742–1798)

The fifth child of John Will, a German pewterer, William was born in Neuweid, Germany, and came to New York in 1752 with his parents. He was in Philadelphia by 1764 where he married Barbara Colp in that year. On her death he married Anna Clampfer in 1769. He had eleven children from the two marriages, only three of whom outlived him. He served in numerous public offices, as lieutenant colonel in the Pennsylvania Militia, representative of the General Assembly, and six terms as sheriff of the City and County of Philadelphia. He was a prolific pewterer; and his father, his two brothers, Philip and Henry, and his son George were also pewterers. He died in Philadelphia.

72. *Tankard*

c. 1764–70
Mark: x/wᵐ WILL (dotted x in serrated rectangle, inside bottom)
Inscription: DK/1815 (engraved in serrated circle on side of barrel)
Pewter
Height 6⁵⁄₁₆″ (16 cm); diameter 5″ (12.7 cm)

Dr. and Mrs. Melvyn D. Wolf, Flint, Michigan

PROVENANCE: Charles Hefner, Reading, Pennsylvania; John J. Evans, Jr., Wilmington, Delaware; Dr. and Mrs. Melvyn D. Wolf

LITERATURE: Allentown (Pa.) Art Museum, *Early American Pewter* (January 7—March 14, 1966), pl. 12, fig. 91; Suzanne C. Hamilton, "William Will, Pewterer," M.A. thesis, University of Delaware, 1967, p. 163, pl. 28; Laughlin, *Pewter,* vol. 3, pl. 86, fig. 723; Suzanne C. Hamilton, "The Pewter of William Will: A Checklist," *Winterthur Portfolio 7* (1972) p. 153; Flint (Mich.) Institute of Arts, *American Pewter,* text by Marvin Pearson (December 14, 1973—January 13, 1974), fig. 184

THIS TANKARD, one of thirty-three presently known to have been made by William Will, is the only example with a flat lid. It relates closely to New York examples which constitute the bulk of surviving American flat-topped tankards. Such vessels of either

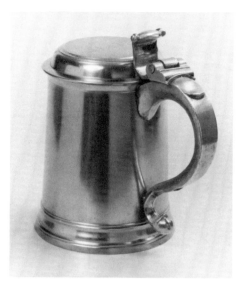

72.

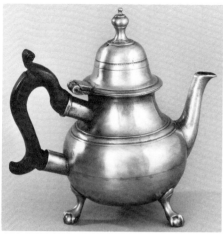

73.

73. *Teapot*

1764–75
Mark: x/wᵐ WILL (dotted x in serrated rectangle, inside bottom)
Pewter; wood handle (not original)
Height 7″ (17.8 cm); width 7¾″ (19.7 cm)

Philadelphia Museum of Art. Given by Lessing J. Rosenwald. 29–49–1

PROVENANCE: Joseph Kindig, Jr., York, Pennsylvania; M. L. Blumenthal, Elkins Park, Pennsylvania; Leonard M. and Margaret W. Rieser, Chicago; Lessing J. Rosenwald

LITERATURE: Homer Eaton Keyes, "The Editor's Attic," *Antiques,* vol. 11, no. 3 (March 1927), pp. 188, 190, 191; *Pewter Collectors Club of America, Boston Exhibition, 1935* (Boston, n.d.); Suzanne C. Hamilton, "William Will, Pewterer," M.A. thesis, University of Delaware, 1967, p. 174; Suzanne C. Hamilton, "The Pewter of William Will: A Checklist," *Winterthur Portfolio 7* (1972), pp. 157, 158

TEA AND COFFEE, introduced into America during the late seventeenth century, grew so rapidly in popularity as to prompt Israel Acrelius to note in his *Description of the Former and Present Condition of the Swedish Churches in . . . Pennsylvania* (Stockholm, 1759) that both "are so general as to be found in the most remote cabins." Accordingly, numerous amenities were developed for the preparation and consumption of these beverages, chief among them being the teapot and coffeepot. A variety of materials were used to make these vessels, but pewter was among the most popular. Numbers of native pewterers supplied Americans with such objects, but the bulk of pewter used in this country during the eighteenth century came from England. Nearly 50 tons of finished pewter, valued at about £3,000, were imported from England in 1697 alone. This increased annually to over 250 tons, costing more than £20,000 by 1767. Surviving American-made pewter shows commensurate English influence. However, because pewter was cast in molds and not worked free-form, as with silver or clay, and because the expense of these molds did not allow them to be capriciously replaced, pewterers tended to adapt only infrequently to changes in style.

Nevertheless, this teapot made by William Will is the exception and shows Will's awareness of current style and his concern with working in the latest fashion. Probably made toward the earlier part of Will's career, 1764 to about 1775, this teapot is one of five known to have used ball and claw feet (restored here), a motif rare even in

silver. As such, the explanation for the use of this design element by Will is speculative. No other English or American pewterers of Will's or his father's generation are known to have used this motif. Only a handful of silversmiths, notably Samuel Casey of Newport, Rhode Island, and Bancroft Woodcock of Wilmington, Delaware, have left us with silver objects which incorporate cabriole legs with ball and claw feet in their design. However, it is important to note that Philadelphia chairmakers and cabinetmakers used this motif almost exclusively in their work at the time Will arrived in the city, and it is probable he derived his highly original interpretation from this source. Inasmuch as most American pewterers looked to their English counterparts for inspiration in the design of their wares, this teapot is a most unusual instance of a stylistic link between Philadelphia furniture and pewter. The teapot testifies to Will's fertile inventiveness in seeking out stylish forms and motifs to incorporate into the design of his pewter, thus putting it on a competitive basis with its counterparts in silver, porcelain, and earthenware.

DF ☐

EDWARD JAMES (D. 1798)

Edward James was probably the son or nephew of the cabinetmaker James James, who worked for Thomas Wharton in 1758, although in 1751, Edward was "bound to William Nicholson a tavern keeper (Gillingham, "Cabinet-makers"). From there he must have been apprenticed elsewhere, for in 1760 he emerges as a joiner. He lived and worked in Southwark for most of his life, and his use of a stamp or brand suggests that his training, like that of Edward Evans (see biography preceding no. 9), was as a ship's joiner, a fact confirmed by early sources listing him alternately as a ship's joiner and

pewter or silver were very much in vogue in the Colonies during the first half of the eighteenth century. By approximately 1750, however, their straight lines were replaced by the curvilinear style as embodied in the tulip-shaped tankard with domed lid. Because of Will's known awareness of current style and the ingenuity he exercised in adapting his pewter to conform to changes in taste, it is interesting to find such an outdated form as a flat-topped tankard made by him. It is probable that he made it toward the beginning of his career in 1764, with New York examples fresh in his mind, having spent twelve years in that city with his father John, also a pewterer, before settling in Philadelphia. A number of extant pewter objects bearing Will's mark are identical to examples marked by his father.

Handles on tankards and mugs as well as three-footed cream pots are the most notable examples. The same molds were obviously used by both men at different times and in different cities. This tankard is an interesting case in point, for a virtually identical one exists which bears John Will's mark. The molds used to make this tankard were probably originally owned and used by John Will in New York and may have been given to William at the time he left his father's house for Philadelphia, possibly as a paternal gesture toward his twenty-two-year-old son who was embarking on his own to another city at least three days' distance on horseback. Using these and other molds probably supplied by his father, William Will began what was to become the most important pewtering shop in Philadelphia during the last quarter of the eighteenth century. The initials DK and date 1815 engraved on the barrel of this tankard are unidentified.

DF ☐

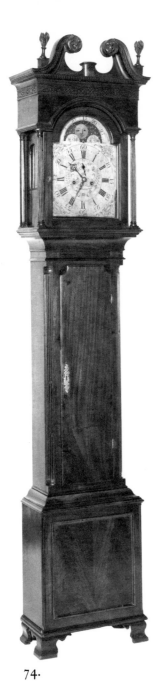

74.

a cabinetmaker at 25 or 27 Queen Street from 1791 to 1796 (APS, Prime file).

A member of the Society of Friends, he applied for a certificate to the Salem, New Jersey, Meeting "on account of marriage," April 30, 1742. In May 1752, Edward James was "disowned" by the Friends "for drinking & abusing his Wife." In 1753 the Friends noted that he offered a paper "condemning his neglect of attending Meetings of worship and the necessary care of his wife & family..." (HSP, GS, Philadelphia Monthly Meeting, Minutes, 1730–85, vol. 3, pp. 104, 218). James's wife died, and he married again in 1772, but out of Meeting. He died in 1798 in Southwark.

WILLIAM HUSTON (C. 1730–1791)

William Huston was born probably about 1730, the son of James Huston of Philadelphia and the brother of James Huston, a tavern keeper born in 1721. William was advertising from the Middle Ward in 1754. In August 1765, he married Sarah Williams (*Pennsylvania Archives,* Marriage Licenses, vol. 2, 2d series) and had four children between 1766 and her death in 1771. In 1775 he married Mary Buck at Gloria Dei. Huston was identified as a watchmaker in 1767 in the will of Peter McDowell, yeoman (City Hall, Register of Wills, Will no. 351, 1770). In 1773 he had taken an indentured servant, George Dalton, although whether for shop or house is not specified. He and his brother James appeared on the 1769 Proprietary Tax for the Middle Ward. William's tax was £43 12s. 2d.; his brother's, £30. In 1774, William "c'lk ma'r," Middle Ward, paid a Provincial Tax of £25 2s. (*Pennsylvania Archives,* vol. 16, 3d series).

William predeceased his father, who noted in his will that "my trusty friends John Wood Watchmaker & John David Silversmith" were to rent his house and ground bounded by Second Street and Strawberry Alley and use the proceeds to support the children of his son William. When the youngest child reached maturity, they were to sell the land and divide the proceeds among the grandchildren (City Hall, Register of Wills, Will no. 46, 1791). Thus, it was probably John Wood who taught William Huston about clockmaking. James Huston, Sr., may also have worked with Wood as the latter bequeathed a house in Front Street, south of Chestnut, "which had been built by William Huston but sold by the Sheriff, to him" (George H. Eckhardt, *Pennsylvania Clocks and Clockmakers,* New York, 1955, p. 180).

EDWARD JAMES AND WILLIAM HUSTON

74. *Tall Case Clock*

1765–70
Mark: Will^m Huston Philad^a (in script on dial below hands); EJ (branded into case, five times)
Label: Made and Sold by/Edward James/Cabinet & Chairmaker in/Swanson Street near Swedes Church/Philadelphia
Mahogany case
99¼ x 18½ x 9⁷⁄₁₆″ (252 x 47 x 24 cm)
Philadelphia Museum of Art. Purchased: Germantown Tribute Fund. 30-124-1

PROVENANCE: John C. Da'Costa, III; sale, William D. Morley Inc., Philadelphia, December 15, 1930, no. 61

LITERATURE: William MacPherson Hornor, Jr., "Edward James and 'Philadelphia Chippendale,'" *International Studio,* vol. 92, no. 381 (February 1929), p. 34; George H. Eckhardt, *Pennsylvania Clocks and Clockmakers,* New York, 1955, pp. 111, 144, 180

FROM THE STUNNING use of the wood grain in the bottom panel to the graceful arched scrolls at the pediment, this tall case clock, which still works well today, is an elegant achievement, attesting to the skills of the two craftsmen who made it. Beautifully proportioned and tightly joined, the mahogany case has strong ogee-bracket feet, open flame finials, blind fretwork, and quarter columns and freestanding colonnettes, all features of the best midcentury Philadelphia tall clocks.

The fit of the Huston clock face has been questioned; however, there is no physical evidence to suggest or support a hypothesis that the works have been replaced or altered. It would seem rather that each artisan was following his own pattern; and the close, but not perfectly matched, curves, like the carved parts on case pieces, might have resulted from an assemblage by the two craftsmen, who were probably working in separate shops.

BG □

WILLIAM SAVERY (1721/22–1787)
(See biography preceding no. 40)

75. *High Chest*

1765–75
Label: All Sorts of/Chairs and Joiner's/Work/Made and Sold by/William Savery/at the Sign of the Chest of/Drawers, Coffin, and Chair,/a little below the Market, in/Second Street,/
PHILADELPHIA
Mahogany; brass hardware
94 x 45 x 24″ (238.8 x 114.3 x 61 cm)
Private Collection

PROVENANCE: Probably Joseph Wharton (1707–1776); Charles (1743–1838) and Hannah (Redwood) Wharton; William (1790–1856) and Deborah (Fisher) Wharton; Joseph and Anna (Lovering) Wharton; Joshua Bertram and Joanna (Wharton) Lippincott; Joseph Wharton Lippincott

LITERATURE: Hornor, pp. 101–2, frontispiece; PMA, *A Loan Exhibition of Authenticated Furniture of the Great Philadelphia Cabinet-Makers,* by Wm. MacPherson Hornor, Jr. (April 13—May 13, 1935), no. 71

THERE IS NO RECORD in the Wharton family papers at the Historical Society of Pennsylvania of the original purchase or ownership

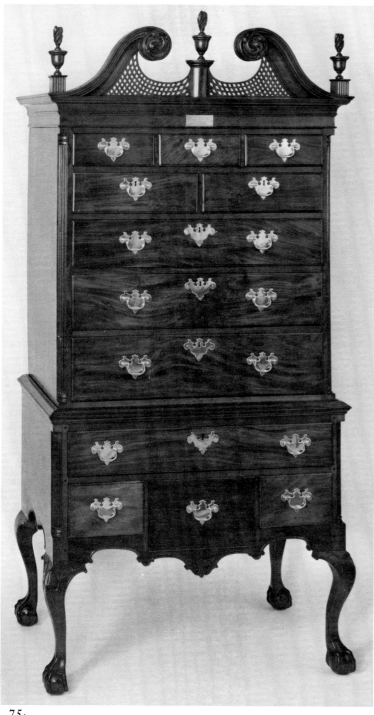

75.

@ $4.50 [in his west garrett], 1 Trunk old papers $0.25, 1 mahogany bureau with 4 drawers @ $5.00, 1 mahogany chest with 12 drawers $15.00, 1 mahogany chest with 12 drawers $15.00, [in the east room], 2nd floor, 2 mahogany dressing tables with 4 drawers in each $9.00, 1 mahogany side board with marble top $7.00, 1 secretary containing sundry account books and papers, $25.00." Several of these pieces have been identified and are in museum collections. The two twelve-drawer mahogany chests listed at $15.00 (a relatively high value in this inventory) undoubtedly are this one by Savery and another now in the Bayou Bend Collection (Hornor, pl. 174), possibly made by Thomas Affleck, who also worked for the Whartons, Fishers, and Redwoods.

Savery's high chest exhibits the earliest mature form of the distinctive Philadelphia "highboy," and its elegant proportions celebrate the achievement of a Philadelphia-trained craftsman. Thomas Affleck's chest for Levi Hollingsworth (no. 109) and the Howe tour de force (no. 104) confirm the developing emphasis on surface embellishment, but case design, scale, and proportion reached its finest expression in this example by Savery. Strong, with an architectonic quality, the widely spaced scrolls of the bonnet are restrained like those on the chest-on-chest (no. 76); only the finials perched at the outer limits of the pediment break through the architectural profile determined by the fluted quarter columns. The paired C-scrolls carved on the knees are reminiscent of the Fisher wing chair (no. 78), as are the claw and ball feet, which do not give the effect of being burdened with the weight they carry. The elegant, long toes on the feet have articulated knuckles, exactly like those on a marble-topped pier table attributed to Affleck in the Philadelphia Museum of Art, an unusual detail, which, if it could be traced, would help to identify a carver working for the shops of the two Quaker cabinetmakers.

BG □

76. Chest-on-Chest

1765–75
Mahogany; poplar and cedar; brass hardware
98½ x 48 x 23½" (250.2 x 121.9 x 59.7 cm)

Philadelphia Museum of Art. Purchased: Elizabeth S. Shippen Fund. 26–19–1

LITERATURE: Helen Comstock, *American Furniture* (New York, 1962), no. 308; Marian Sadtler Carson, "Philadelphia Chippendale at Its Best in the Collections of the Philadelphia Museum," *American Collector,* vol. 16, no. 11 (December 1947), illus. p. 11

of this high chest. Its first owner was probably Joseph Wharton (1707–1776), who married first Hannah Carpenter in 1729, and then Hannah Ogden in 1753. His records contain little about his household furnishings, although one entry, which is in his son's hand, does record a payment to John Duglass for "two mahogany tables, twelve chairs, one arm ditto & one waiter" (HSP, Wharton Papers, Joseph Wharton, Ledger B, 2/9/1775). It is possible, how-

ever, that the chest entered the Wharton family through the Redwoods when Hannah Redwood married Charles Wharton in 1784, or through the Fishers when Deborah Fisher married William Wharton, as both families are known to have owned furniture by Savery.

Charles Wharton's inventory, taken in 1838 (City Hall, Register of Wills, Will no. 54, 1838), lists in his "loft 1 burcase with 11 drawers @ $6.00, 1 burcase with 4 drawers

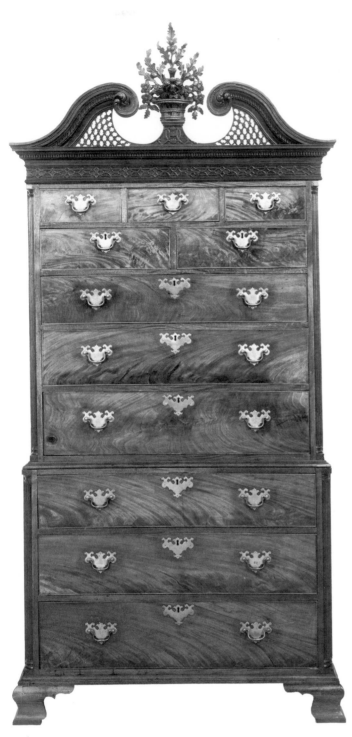

76.

while celebrating the superb quality of materials sought by and available to the Philadelphia cabinetmaker. It has been attributed to Jonathan Gostelowe, but it has a number of Thomas Affleck characteristics. In proportion and scale it is most like one designed by Affleck for David Deschler, which is entered in the latter's Receipt Book covering the years 1772–96 (private collection). The base sections in both have three deep drawers in graduated sizes and sit on strong, sculptural, ogee-bracket feet. The upper cases have three drawers over two drawers, then three single drawers in graduated sizes, a design characteristic of Philadelphia which appears with equal frequency on cabriole high chests.

The detailing and carved decoration on this chest-on-chest are especially fine. Instead of the more usual drawer edges which overlap the case frame, these are precisely and finely outlined with a bead molding, which sets them off from the structural framework. The pattern of the flame grain in the mahogany provides a rich, smooth swirl surpassed only by exotic burl veneers found on European examples of this form. The edge moldings "contain" this pattern within firm rectangles, enhancing the colorful, decorative feature of the mahogany while re-emphasizing the rectilinear form of the whole case.

The pediment was "framed out" by the joiner, and like the legs on high chests or tables, was sent out to be carved. Philadelphia cabinetmakers used two styles of pediment, both based on the triangular architectural frame frequently seen over interior doorways and chimneypiece over-mantels contemporary with large-scale case furniture. The Carpenters' Company *Rule Book* (pl. 26) described them as "Plain pediment" and "Pediment with a broken cornice." The scroll pediment exhibited here was the most popular variation of the "broken cornice," giving the rococo curves a more powerful statement than is found on chairbacks or carved feet. The profile of the scrolled pediment becomes enormously important to the design of the entire case, and its crowning position is the more conspicuous due to the smooth verticality of the chest-on-chest form. Compared again to the Affleck-Deschler chest, which has a higher lift to the scrolls and elaborate reverse curves in the carved foliage, this pediment, with its flattened scroll and deeply molded archivolt, contains and "finishes" all the power of the upward thrust of the form and does not fly off into its own space. While lattice design on most Philadelphia pieces was plain and created "diamond" spaces, the pierced latticework here, in a design of alternating solids formed by florettes on the lattice crossings and voids, offers a transition to the curved forms above.

THE CHEST-ON-CHEST is often considered the most successful casework design of mid-eighteenth century Philadelphia. Like the high chest on raised cabriole legs, its proportion, scale, and surface design varied. The piece often cost a bit more than the cabriole high chest because there was more joinery; Thomas Affleck charged James

Pemberton £21 for a "Chest of Mahogany drawrs Chest on Chest," and £6 "to a Chamber Table to Sute ditto" (HSP, Pemberton Papers, vol. 27, p. 175, James Pemberton account with Thomas Affleck, June 20, 1775).

This chest-on-chest represents the highest achievement both in design and cabinetry,

The blind fretwork encircling the top of the chest was part of the top rather than the pediment and was derived from a number of sources such as Chippendale's *Director* and Abraham Swan's *A Builder's Treasury of Staircases,* to name the most popular among those used in Philadelphia. It is very close in design to the fretwork on a cabriole high chest at the Smithsonian Institution (Helen Comstock, *American Furniture,* New York, 1962, pl. 313), but identical frets are rarely found unless on matched pieces. Philadelphia frets have a distinctive running horizontal quality (see no. 104) quite different from English designs, which were vertically divided into "phrases." The clever manipulation of the geometric forms in frets, which had to be "centered" as well as to reach a logical break at the corners, must have been a challenge for the craftsman who was constantly creating new designs.

The central finial was the final flourish of the carver. The basket, urn, or pedestal supporting foliage, flowers, flames, and cartouches crowned looking glasses and appeared on desks, chest-on-chests, cabriole high chests, and architectural overmantels. Most Philadelphia carvers had a hand in their design, using sources such as Chippendale, Swan, and Thomas Johnson's *Book of Ornaments.* Affleck often employed James Reynolds for carving on case pieces. Reynolds carved distinctive phoenix bird forms for central ornaments on an Affleck chest-on-chest made for William Logan's daughter Sarah (Metropolitan Museum of Art), and another illustrated in Hornor (pl. 152). Motifs such as the basket of flowers and oak leaves seen on this piece also appeared on looking glass pediments, especially in this form in which the foliage is flattened into a fanlike spray and the central flower form falls forward to be seen only from below. The basket finial on this piece has weight and enough mass to appear in scale with the case, while offering a satisfying explosion of forms in carved relief at the top.

Because the chest-on-chest form has suffered more dismemberment over the years than the cabriole high chest, fewer of these pieces survive. The top drawer unit could be removed and feet built for it, creating a tall boy chest. The three bottom drawers needed only the addition of a flat top to become a bureau. Pediments were frequently removed, set aside, and lost or broken. The flat-top chest-on-chest was also made in Philadelphia; preference for the flat-top, rather than the limitation of ceiling heights, resulted in later alterations of this grand mid-eighteenth century form.

BG □

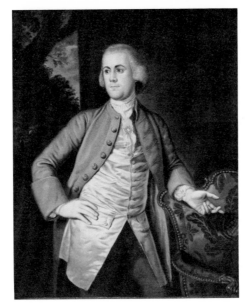

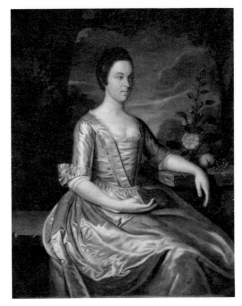

77.

JAMES CLAYPOOLE, JR. (C. 1743–1800)

It was not until the 1950s that a signed portrait by James Claypoole, Jr., was discovered. The little that is known of his life has been pieced together by Richardson ("Claypoole"). Probably born in Philadelphia, Claypoole was the son of the artisan, James Claypoole, Sr., who taught Matthew Pratt. None of the father's work is known, but a pair of portraits have been tentatively attributed to him on the basis of provenance (North Carolina Museum of Art, *Carolina Charter Tercentenary Exhibition,* March 23—April 28, 1963, nos. 61–62); and he was apparently apprenticed to Gustavus Hesselius in 1741 (HSP, Penn Papers, Thomas Penn to James Steel, order to pay bill to James Claypoole, August 19, 1741).

Claypoole, Jr., first appears as the engraver of a view of the projected Pennsylvania Hospital in 1761. The following year, Charles Willson Peale visited the younger Claypoole's Philadelphia studio and saw his portraits (APS, Charles Willson Peale, Letterbook, vol. 12, p. 81). Peale reported that Claypoole intended to visit Benjamin West, "with whom he had been intimate," in London in order to improve his painting. Claypoole left Philadelphia sometime between 1769 and 1771, but according to Peale, a storm forced his ship into the West Indies, and he disembarked at Jamaica. He continued to paint there, possibly until his death, his work including portraits, miniatures, and coach painting. Recent research supporting the theory that Claypoole returned in 1779 to Pennsylvania requires further study (Evelyn Claypool Bracken, *The Claypoole Family in America,* Indiana, Pa., 1971, vol. 1,

p. 55). A conflict in documented contemporary references to James Claypoole suggests that more than one James Claypoole is involved.

77a. *Joseph Pemberton*

c. 1767/68
Oil on canvas
51 x 41″ (129.5 x 104.1 cm)

Pennsylvania Academy of the Fine Arts. Gift of Henry R. Pemberton, 1967

PROVENANCE: Descended in Pemberton family until 1967

LITERATURE: Scharf and Westcott, vol. 2, p. 1031 (attributed to John Hesselius); PAFA, *Historical Portraits,* no. 328 (attributed to John Hesselius); Richardson, "Claypoole," pp. 172–74; PAFA, *Painting and Printing,* no. 3, p. 10; John Wilmerding, ed., *The Genius of American Painting* (New York, 1973), p. 73

77b. *Mrs. Joseph Pemberton*

c. 1767/68
Oil on canvas
50½ x 41″ (128.3 x 104.1 cm)

Pennsylvania Academy of the Fine Arts. Gift of Henry R. Pemberton, 1968

PROVENANCE: Descended in Pemberton family until 1968

LITERATURE: Scharf and Westcott, vol. 2, p. 1031 (attributed to John Hesselius); PAFA, *Historical Portraits,* no. 327 (attributed to John Hesselius); Richardson, "Claypoole," pp. 172–74; PAFA, *Painting and Printing,* no. 4, p. 11

THE PORTRAITS of Joseph Pemberton and his wife, Anne Galloway Pemberton, reveal Claypoole's preference for strong outlines and his keen awareness of three-dimensional form and differences in texture. More than most of his contemporaries, Claypoole strove to create a convincing illusion of corporeal reality, but with uneven results. For instance, his heads are often sculptural in detail and yet still appear flat as a whole. The Pemberton pair, modeled in silver grays, make it seem no wonder that Claypoole advertised in Jamaica in 1780 that he could paint "figures in Chiara Oscura" (Richardson, "Claypoole," p. 166). His style appears to be related to Wollaston's, but there are other possible sources. The Pemberton portraits are much more ambitious in size and quality and more carefully finished than Claypoole's few surviving initialed and dated half-length portraits of 1768–69. In this respect, the Pemberton pair appear closer to a signed, full-length portrait painted in Jamaica in 1774. This disparity in the quality of Claypoole's work possibly indicates that he took greater care with larger commissions. Richardson, who attributed the portraits to Claypoole, dates them about 1767 or 1768, between the year that Joseph Pemberton, a wealthy Philadelphia Quaker, married Anne Galloway, and the date that Pemberton paid James Claypoole, Sr., £3 for "gilding the carv'd work of Two Picture Frames," most likely those on the Pemberton portraits (HSP, Pemberton Papers, vol. 20, p. 69, bill of August 2, 1768, paid September 9).

Joseph Pemberton's studied pose and gesture conform to a type which was fashionable enough to have been used even by the famous Swiss artist, Angelica Kauffmann, when she painted the Philadelphia doctor John Morgan on his visit to Rome in 1764. The props in the portraits are a device, commonly used at this time, to indicate the status and aristocratic breeding of the sitters.

DE □

THOMAS AFFLECK (1740–1795)

Aberdeen, Scotland, where Thomas Affleck was born, was much smaller than Philadelphia at the start of the eighteenth century. Two ships were trading at her port, and some 130 people were employed in the woolen and linen industries. About fifty of these were Quakers who met and preached in churchyards at burials or in secret in their own houses (Walter Thom, *History of Aberdeen,* Aberdeen, 1811, vol. 2, p. 17). There are no extant Aberbeen Friends

records after 1725. The town grew slowly and trade was not established with Philadelphia until 1766.

The name Affleck, thought to be a phonetic contraction of Auchinleck, does not appear in Aberdeen records until 1710 when the elder Thomas Affleck, tobacconist, married Lilias Glennic and settled there. Three children were born to them as recorded in the Minutes of the Aberdeen Monthly Meeting: Thomas (1711), Elspet (1712), and William (1715/16). Lilias Affleck died in 1724 and Thomas remarried to Jean Elmslie of Kilbleen, the "7th month 9th day," 1725. Thomas, Jr., was born to them in 1740, suggesting that his elder half brother of the same name died as a young man.

Traditionally, younger sons were apprenticed into a trade. By 1754–56, when Thomas was sent to Edinburgh to apprentice as a cabinetmaker, the furniture trade there was a well-developed and profitable industry. William Adam had built country seats in the Lothians—at Arniston, Hopetoun, and Dumfries. The first edition of Chippendale's *Director* was heavily subscribed to by the Scottish lairds, and the cabinetmaking shops of William Mathie, carver. Alexander Peter, joiner, John Schaw, and Thomas Welsh competed with London firms for clients. Alexander Peter used Chippendale's *Director* in 1759. In his known work at Dumfries House between 1756 and 1760, the similarities to Thomas Affleck's work in Philadelphia in the 1770s bears comparison beyond the obvious sources in Chippendale (Frances Bamford, "Two Scottish Wrights at Dumfries House," *Furniture History,* vol. 9, 1973, pp. 80–88), suggesting that Affleck may have been apprenticed to Peter.

Why Affleck left Edinburgh and went to London in 1760 is not clear, but the sophistication of his joinery compared to most other contemporary Philadelphia craftsmen suggests that he did so to polish his skills. A handsome clothes press (Metropolitan Museum of Art) attributed to him is very close to one by Giles Grendey, c. 1750, with whom he may have served. The piece features scalloped, paneled doors, a sorting shelf between upper and lower cupboard sections, and an open triangular pediment favored by Affleck over the more usual scroll pediment (Ralph Edwards and Margaret Jourdain, *Georgian Cabinet-Makers,* London, 1944, fig. 44).

In 1763, Affleck left London for America. The sons of Joshua Fisher (see biography preceding no. 99), Thomas, Samuel, and Miers, were to be Affleck's closest friends. Thomas Fisher wrote to his father from London, "7th mo. 20th, 1763 ... Honour'd Father ... The bearer Thos Affleck intended to settle in Philadelphia, & knowing the satis-

faction of being introduced to some acquaintance there shall I just say he is a friend of David Barclay and a person from whose character I have reason to esteem. Our friends the Barclays as well as several others & myself in particular will take it kind thou will render him thy world civility & any advice & assistance that may be necessary..." (HSP, William Logan Fox Papers, Thomas Fisher, Diary, 1763, p. 171). Thus, Affleck moved within the Quaker community and not, as has been generally thought, under the patronage of the Penns. When Joshua Fisher greeted the Penns upon their arrival on November 21, 1763, with a formal address of welcome, presumably young bachelor Affleck was aboard the same ship. Thomas carried certificates of removal from the Aberdeen Monthly Meeting and the London Two Weeks Meeting, which he presented for approval at Philadelphia on November 25, 1763 (HSP, GS, Arch Street Meeting, Certificates of Removal, nos. 1571–72). His Elmslie kinsmen, Alexander, William, and John, a turner who was to have a long association with Affleck, had emigrated in 1759 and 1760 and may have encouraged Affleck to come.

Affleck's first shop was on Union Street (Delancey Street). By 1768 he had moved to Second Street below the Drawbridge, opposite Henry Lisle's house, "where he carries on the cabinet-making business in all its various branches" (*Pennsylvania Chronicle,* December 12, 1768). In 1769, "Mr. Thomas Affleck being proposed was unanimously admitted as Resident member" of the St. Andrew's Society (APS, St. Andrew's Society of Philadelphia, vol. 1, May 30, 1769, microfilm). He rarely attended the meetings held at the Bunch of Grapes Tavern, not needing either companionship or financial support beyond that offered within the Quaker life.

There is very little documentation describing Thomas Affleck's shop or the workers he employed. His name appears in Benjamin Randolph's accounts once, for July 7, 1770 (NYPL, Philadelphia Merchant's Account Book, 1768–86, p. 126), where Randolph's shop owed him £3 3s. for lumber. Thus far Affleck's name has not appeared in other merchant accounts purchasing food, clothing, or equipment. The absence of his name in the ledgers of the Fishers, Whartons, Drinkers, Walns, Hollingsworths, Pembertons, and Jameses may again confirm that he was entirely self-sufficient and that he paid for his daily requirements with furniture from his shop. Introduced to the Quaker grandees in Philadelphia through Joshua Fisher and patronized within their tight circle, Affleck hardly needed to advertise his shop. The Quaker custom of visiting, as described by Elizabeth Drinker in her

lengthy Diary, provided the best publicity of all—fine pieces in their neighbors' houses: "I went this Afternoon, Sally and Nancy with me, to Owen Jones's. John Nancarrow came home with us, Sarah Fisher and J. Drinker drank Coffee with Sister, Rob't Waln & Wife here this Even'g" (HSP, Elizabeth Drinker, Diary, vol. 2, October 30, 1777).

In the summer of 1771, Affleck married Isabella Gordon, daughter of Lewis Gordon, a lawyer practicing in Northampton County. Isabella was not a Quaker and the Philadelphia Meeting demanded a "paper" from Thomas in which he "condemned his transgressions of the rules of our discipline and Christian testimony in marrying by a priest a person not of our religious society. . . ." His first letter was refused, but he was reinstated in October 1771: "The paper he offered last Month . . . was read" (HSP, GS, Philadelphia Monthly Meeting, Minutes, vol. 3, p. 451). The Afflecks had four children who survived them: Lewis, William, Mary, and Margaret. Sons Thomas and John had died in 1783. Isabella died in 1782, and Affleck did not remarry (HSP, GS, Pine Street-Orange Street Monthly Meeting, p. 733).

Affleck took some part in the political life of the colony. He collected the First and Second Poor Tax in 1772 and 1773 (HSP, Norris Papers, Mary Norris, Receipts, vol. 1, p. 124), and was an overseer of the poor in 1772. He was active in protests against armed conflict in 1776. On September 2, 1777, Affleck, along with Henry Drinker, Phineas Bond, Miers Fisher, Charles Jervis, Thomas Wharton, Samuel Fisher, William Smith Broker, was seized and put in the Mason's Lodge.

They had been called dangerous persons by the Supreme Executive Council on August 31, 1777 (HSP, Elizabeth Drinker, Diary, vol. 1, September 2, 1777). In October the group was sent to Winchester, Virginia, for the duration, leaving their families behind in British-occupied Philadelphia. Affleck was among those who addressed a petition seeking their release. Elizabeth Drinker recorded: "Went toward Lancaster *via* Lampeter on Friend's mission to 'Council' to see the President re *Friends* . . . Tommy Afflick mett us at Conostoga Ferry, we were glad to see each other . . . [he] came to Lancaster to Solicite his release" (HSP, Elizabeth Drinker, Diary, vol. 2, April 9, 1778). On April 20–22, she wrote: "Fine clear windy weather, such as will dry ye roads—Billy Lewis, Owen Biddle, T. Afflick, and Dan'l. la Fever came this morn'g . . . this has been a Holy day hereaway . . . We stay'd within all day, had several visitors, T. Barton call'd—Thos Afflick, Tim'y. Matlack, and David Rittenhouse drank tea

with us" (HSP, Elizabeth Drinker, Diary, vol. 2, April 20, 22, 1778).

Affleck appeared in the 1769 Proprietary Tax list for Dock Ward, but owned no property at the time (*Pennsylvania Archives,* 3d series, vol. 14, p. 170). By 1772 he had taken an apprentice, John Kincaid, to serve for six years; in 1773 he took Frederick Schneider as a servant to serve three years, and Frederick Weidligh to serve in the shop (*Records of Indentures . . . of the City of Philadelphia, October 3, 1771, to October 5, 1775,* Baltimore, 1973). His later tax record, 1774–82, confirmed his prosperity (*Pennsylvania Archives,* 3d series, vol. 14, pp. 231, 484, 760; vol. 15, pp. 232, 716, 737; vol. 16, p. 277).

Affleck moved to Elmslie's Court in 1791. After his death in 1795, his eldest son, Lewis, cabinetmaker, carried on at that address until 1797, then moved to 22 North Ninth Street in 1798. Notice of Affleck's death appeared in the March 5, 1795, issue of the *American Daily Advertiser*. His will specified that his four children were to share equally in his estate, that Lewis as the eldest should not receive double portion (City Hall, Register of Wills, Will no. 26, 1795). His household property, inventoried by Stephen Armitt, joiner, on March 26, 1796, was valued at £539 10s. 6d., out of a total of £4,396 63s. Affleck lived in a typical three-bay, three-story Philadelphia house with an attached shop. His furnishings were routine, except for a clock and case valued at £13 10s., twice as much as a set of eight mahogany chairs, and more than the mahogany bedstead in the front chamber, or the desk and bookcase, each valued at £10. His library of books was worth £27, an atlas, £2 5s., and Chippendale designs, £1.

78. *Easy Chair*

c. 1768
Mahogany and pine; twentieth century wool damask upholstery
45½ x 37 x 35¼″ (115.5 x 94 x 89.5 cm)
Edward Wanton Smith, Jr., Darien, Connecticut

PROVENANCE: Samuel R. Fisher (1745–1834); Deborah (Fisher) Wharton (1795–1889); Esther Fisher (Wharton) Smith; Edward Wanton Smith; Sarah A. G. Smith; Edward Wanton Smith, Jr.

LITERATURE: Hornor, p. 211, pl. 237

FISHER FAMILY FURNITURE has long been attributed to Thomas Affleck, and pieces thus identified, like the side chairs made for Miers and Hannah Fisher ("Exhibition of Furniture in the Chippendale Style," *PMA Bulletin,* vol. 19, no. 86, May 1924, pls. 4, 9), which have the same knee carving and claw

and ball foot as on this easy chair, have led to Affleck's reputation as the outstanding joiner in mid-eighteenth century Philadelphia. Unlike William Savery, who trained in Philadelphia and began as a chairmaker, and whose work culminated in pieces like the maple dressing table (no. 40) and the Wharton high chest (no. 75), Affleck, from the time of his arrival, made fine furniture for clients who were as familiar as he was with London fashion.

The joinery and carved detail on this easy chair made for Samuel Fisher are different in design and detail from the Randolph-Courtenay easy chair (no. 89). Where the Randolph chair was hewn of oak, the major structural wood in the upper section of this chair is pine. The arm tacking rails at the seat ring meet in a lap joint with the wing support post and are gained into the rear wing upholstery rail in the same way as the back frame is gained into the mahogany seat ring. The arms are tenoned into and through the carved scroll of the front arm stump. Likewise, the corner blocks at the back of the seat rail are tenoned through the back leg, extending the line of the tenon formed by the side rail. This unusual construction affords structural strength, allowing the use of smaller pieces than in the Randolph-Courtenay chair. The position of the tacking rails and arm scrolls indicates that this chair was designed for a down cushion, whereas the Randolph chair had a tight seat.

Whether James Reynolds carved the mahogany legs on this chair is unknown. Cadwalader and Logan accounts record that

78.

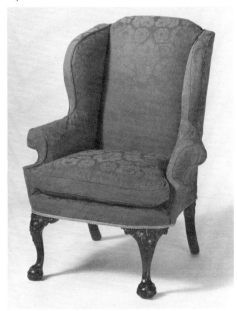

he did carving for Affleck, but it is possible that Affleck also did some of his own. His predilection for bold gadrooning, foliage, and ornament, which conform and add visually to the structure of this piece, distinguishes his designs of this period from those of carver John Pollard (see biography preceding no. 90) in Benjamin Randolph's workshop. The claws on the ball foot resemble those of a bird's grasp rather than a beast's, as they come straight down over the ball instead of grasping it from the splayed position of a deeply flexed ankle. Reynolds, accustomed to carving birds perched on domes or rocks for looking glass pediments, would have used this form. It differs from the lion's paw school of carving in which Hercules Courtenay must have trained.

The superb C-scroll motif carved in high relief on the knees accentuates and follows the roundness of the cabriole form. It does not disguise it under a cap of foliage nor seek to diminish the full form by having the scrolls lift at their base, creating the concave effect of Pollard's knee carving on the Cadwalader pier table (Metropolitan Museum of Art) and illustrated throughout Thomas Johnson's *Book of Ornaments.* Reynolds's looking glasses (see no. 95) employ such scrolls, forming open and closed profiles with clustered flowers and foliage woven into their framework, building up form rather than breaking it down. The carving on these legs may well be his work, distinguished by a clarity and a deceptively simple elegance.

BG □

THOMAS AFFLECK (1740–1795)
(See biography preceding no. 78)

79. *Armchair*

c. 1768
Mahogany; twentieth century silk damask upholstery
42⅜ x 28¾ x 24½″ (107.6 x 73 x 62.2 cm)

Philadelphia Museum of Art. On deposit from the Commissioners of Fairmount Park

PROVENANCE: John Penn and Ann (Allen) Penn?; Benjamin Chew?; Waln family; Robert Waln Ryerss; William Ryerss, until 1940

LITERATURE: Marian Sadtler Carson, "Thomas Affleck, A London Cabinetmaker in Colonial Philadelphia," *Connoisseur,* vol. 167, no. 673 (March 1968), pp. 187–91; Raymond V. Shepherd, Jr., "Cliveden," *Historic Preservation,* vol. 24, no. 3 (July–September, 1972), p. 11

THE MARLBOROUGH FORM, of which this chair is an example, became popular in Philadelphia in the 1760s as an alternative to the twists, scrolls, and curves of the

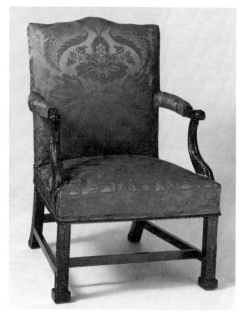

79.

rococo, which had been the fashion for thirty years. Decidedly a more masculine style, Marlborough chairs have plain skirts, straight legs, supportive stretchers, rectilinear lines, and an appearance of stability. However, within its vocabulary, there are many variations. The number of surviving examples indicates that many families must have owned Marlborough-style armchairs like this one in preference to the curvaceous easy chairs. Thomas Wharton owned a set with uncarved channel-molded legs, curved arm posts, foliate-carved knuckles, and saddle seats which dipped in the front, quite different in proportion and design from this chair, but also traditionally attributed to Thomas Affleck (Hornor, pl. 268).

Chippendale's 1762 *Director,* plate 19, identified this form as a French chair; Philadelphia inventories labeled it an elbow chair; and it is frequently called a Marlborough chair, a term pertaining to its square straight leg and block foot. Chairs and tables featuring this straight leg, although with great variety in detail, were Affleck's specialty.

The Marlborough style was especially popular in Scotland at midcentury. Alexander Peter, the Edinburgh cabinetmaker with whom Thomas Affleck may have apprenticed, made chairs in this style between 1756 and 1760 for Dumfries House. His dining chairs with straight legs and blind fretwork and a sideboard table with fretwork designs on the legs and rails were derived directly from Chippendale's 1762 *Director,* plate 57 (Christopher Gilbert, "Thomas

Chippendale at Dumfries House," *Burlington Magazine,* vol. 111, no. 800, November 1969, fig. 31).

The Marlborough style was not prominent, if in fact it appeared at all, in Philadelphia before 1763 when Thomas Affleck arrived. Because he owned Chippendale's 1762 *Director,* cabinetwork, tables, and chairs stylistically derived from that edition, and which have prestigious Quaker-family provenance, usually carry an Affleck attribution. So, too, the Penn furniture, including this chair, since it had been thought that Affleck came to Philadelphia as the Penns' cabinetmaker. Although there is no precise evidence beyond stylistic similarity that all such Marlborough forms came from Affleck's shop, a careful study of Edinburgh shop practices and construction details might establish craft procedure for Affleck-attributed pieces.

Another set of Marlborough chairs also attributed to Affleck, very similar to this example and possibly made for Richard Penn (examples at Colonial Williamsburg, Metropolitan Museum of Art, Winterthur Museum), appears more elaborate. The legs are carved with inset panels of husks suspended from graceful loops instead of the Gothic fretwork of this chair from a set made for John Penn.

But other cabinetmakers were also working with the *Director* and producing the Marlborough form. The cabinetmaker John Folwell derived his design for a breakfront bookcase at Mount Pleasant (Fairmount Park) from plate 91 of the *Director.* His cabinet for the Rittenhouse orrery (Van Pelt Library, University of Pennsylvania) features the strong Marlborough legs, chamfered on their inside corners and decorated with blind fretwork and block feet. And Folwell's speaker's chair for the State House, with Gothic fretwork design carved on the legs and leaf carving on the arm posts, shows a scheme similar to this chair.

This chair is one of twelve presumably made by Affleck for John Penn's townhouse on Third Street next to the Powel house. The townhouse had been built by William Byrd of Westover Plantation, Virginia, and when Ann Allen, daughter of Chief Justice William Allen, married Penn in 1768, her father gave the house to them. They furnished it as befit a governor whose lady spent much of her life decorating grand houses.

No inventory of its contents has come to light, nor are there any written descriptions of its furnishings during Penn occupancy. In 1771 the Penns returned to England and sold the house to Benjamin Chew for £5,000, a very high price unless the furniture was included. Two subsequent inventories, taken in 1795, previous to a later sale of

another Penn townhouse in 1788 and of Lansdowne, their country home, reveal the extent of the John Penn households, and there is no reason to assume that the Third Street house was simply furnished. In 1795, Ann Penn sold Lansdowne to James Greenleaf and most of its furniture to Robert Morris for £1,000. According to Raymond V. Shepherd, Jr., since much of the furniture now at Cliveden (no. 62), Benjamin Chew's country house, has Penn provenance, the all-inclusive sale of the Third Street townhouse might explain the Penn association which adheres firmly to Chew's Marlborough sofa and, by design and provenance, this matching chair. The Chew manuscripts record very little furniture purchased for the townhouse or for Cliveden. The looking glasses by Reynolds (see no. 95) are the exception, suggesting that most of the townhouse furniture was moved to Cliveden after Elizabeth Chew's (Mrs. Benjamin) death in 1830 and before the 1840 inventory of Cliveden which records the back stools and the Marlborough sofa.

Since neither of the Penn auction sales in 1788 or 1795 carried entries which could pertain to the Marlborough armchairs, of which this is an example, or Chew's sofa (Marie G. Kimball, "The Furnishings of Lansdowne, Governor Penn's Country Estate," *Antiques,* vol. 19, no. 6, June 1931, p. 455), it is probable that Chew was the intermediate owner of both. However, the chairs never appeared on Cliveden inventories, suggesting that Chew, acting for the Penns, may have sold them soon after taking over the house in 1771, preferring the Marlborough back stools and sofa which are at Cliveden today, or they may have been sold privately in pairs by Elizabeth Chew after the death of her husband in 1810. They have appeared in pairs with nineteenth century provenance, owned by the Walns, Mortons, and Fishers, suggesting that any sales by Chew were "private." Samuel W. Fisher presented his pair to the Friends Hospital in April 1817 (on loan to Philadelphia Museum of Art from Friends Hospital).

BG □

80. *Pole Screen*

c. 1770
Mahogany; early eighteenth century English needlework screen
62¼ x 19 x 16" (158.1 x 48.3 x 40.6 cm);
screen 22 x 19" (55.9 x 48.3 cm)

Philadelphia Museum of Art. Given by Mrs. Harry A. Batten in memory of her husband Harry A. Batten. 67–266–1

USUALLY PLACED CENTRALLY on an inside wall, the fireplace was an architectural and decorative focal point in most Colonial homes. The chimneybreast, often highly carved, its mantel shelf adorned with porcelain garnitures, was the most decorative woodwork in the room, and the fireplace itself was outfitted with shiny brass andirons of varying form and design (see nos. 81, 82).

The pole screen, a slender, portable, adjustable stand, protected the sitter closest to the fire from excessive one-sided heat, and shielded the eyes from tiresome flickering for sewing or reading. Not all homes had pole screens, and few were graced with examples as finely designed as this one. It appears to be one of three, the second in a private collection, the third at the Winterthur Museum (Downs, *American Furniture,* no. 236). They may have been among the Cadwalader possessions sold by Davis and Harvey in 1904 as no. 321, "Two fine antique mahogany fire screens," matching other Cadwalader pieces with hairy paw feet; but the carving is quite different from that by Hercules Courtenay on the tea table (no. 101) and easy chair (no. 89), which also featured the animal foot. Although no certain attribution can be made to the carver of this pole screen, the jewel-like leafage and flowers which spill over the knees and onto the ankles are miniatures of the foliage carved by Nicholas Bernard and Martin Jugiez on the cupboard consoles in the great chamber at Mount Pleasant.

Bernard and Jugiez were primarily carvers; the latter called himself a cabinetmaker in 1773 when he took Daniel Fegan as an apprentice. Their bills show that they did architectural carving as well as work on furniture for joiners. John Cadwalader paid them £70 4s. 7½d. in 1771 (HSP, Cadwalader Collection, General John Cadwalader Section: Bills and Receipts, 1770–71), presumably for room decoration; and they earned £24 4s. in 1770 for carving on furniture made for Cadwalader by Thomas Affleck (see biography preceding no. 78). Advertising as carvers and gilders, Bernard and Jugiez were first located on Walnut Street between Front and Second. In 1767 they had a "looking glass store" on Chestnut at the corner of Third Street where they sold prints and papier-mâché work. Benjamin Randolph's copy of *Father Abraham's Pocket Almanac* records a purchase of "6 paper muche friezes" from them (LCP, September 1773); they also worked for Randolph in 1771 (Winterthur Museum, Benjamin Randolph, Receipt Book, August 4, 1771). Bernard and Jugiez separated in 1783 when Bernard was listed in the Federal Tax as a shopkeeper in the South Ward, and Jugiez, a carver in the Middle Ward. Bernard died sometime after

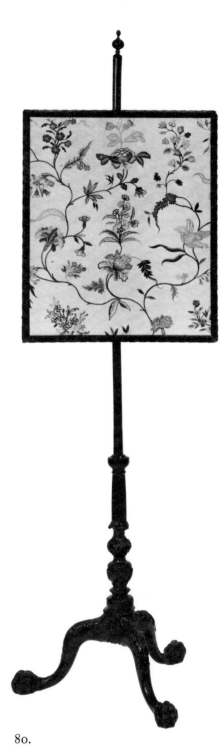

80.

1783; Jugiez continued until 1800 at 25 Walnut Street. He died in 1815, leaving $100 to a nephew, Jerome Jugiez, for his namesake Martin, not yet twenty-one, and all the residue to Bernard's descendant, "my beloved friend John Bernard," who was also his executor (City Hall, Register of Wills, Will no. 55, 1815).

BG □

Daniel King, brass founder, married Rebecca Richardson on May 22, 1756. Their son, Daniel, Jr., also to be a brass founder, was born in 1757. By 1760, King had set up his foundry at 68–70 South Front Street at the corner of Norris' Alley. On March 25, 1761, he presented an account for making 100 insurance marks for the Philadelphia Contributionship Insurance Company, charging £12 10s. (Philadelphia, Contributionship Insurance Company, Minutes, 1752–67). He supplied William Wharton with a pair of brass andirons in 1764 in exchange for the family hats (HSP, Wharton Papers, William Wharton, Ledger, 1761–1803). In the February 13, 1766, edition of the *Pennsylvania Gazette,* King, giving his address as Front Street near the Drawbridge, offered his solution to eighteenth century vandalism:

> Whereas, I the subscriber, brass founder
> . . . have been informed that a number of the inhabitants of this city have had their brass knockers wrenched from off their doors, and others rightly in danger of sharing the same fate through the wanton frolicks of sundry intoxicated bucks and blades of this city; and whereas I have lately been challenged by one (who does not deny, and whom everyone shrewdly suspects to be one of the associates in the aforesaid mischiefs) to make a brass knocker that shall be capable to withstand his mad fury; this is to inform the public that I have invented a brass knocker, the construction of which is peculiarly singular, and which will stand proof against the united attacks of those nocturnal sons of violence in their abominable and detestable executions.

The period 1760 to 1776 spans Daniel King's most active production. He had a long account with Benjamin Randolph, from 1768 to 1776. Although neither Ledger nor Receipt Book specifies exactly what King supplied, Randolph's entry "to shop" meant that the account was charged against shop expenses. King probably supplied hardware, escutcheons, locks, hinges, and handles (NYPL, Philadelphia Merchant's Account Book, 1768–86; Winterthur Museum, Benjamin Randolph, Receipt Book). In 1770, King presented John Cadwalader with a bill for £44 12s. 6d. for "a Large Brass Nocker of the New Conscrution . . . 8 Dove tale hinges . . . , 2 scugings and drops for the Blank Doors, one pare of the Best Rote fier Dogs with Corinthen Coloms . . . , one pare of the best Plane Chamber Dogs . . ." (HSP, Cadwalader Collection, General John Cadwalader Section: Bills and Receipts, September 1–10, 1770). As Randolph, Wharton, and Cadwalader demanded

highest quality, Daniel King's production achieved renown.

In February 1772, King took on Margaret Kelly as an indentured servant ("Servants and Apprentices," p. 108). In 1781, King and his son owned land on Shippen's Lane (Bainbridge Street). From 1784 to 1786 both father and son were privates in the Eighth Company, Second Philadelphia Battalion, commanded by Colonel James Read (W. A. Newman Dorland, "The Second Troop Philadelphia City Cavalry," *PMHB,* vol. 47, no. 1, January 1923, p. 73).

In the Grand Federal Procession of 1788, King led the brass founders. Francis Hopkinson, chairman of the Committee of Arrangement, reported: "Mr. Daniel King, in a car drawn by four gray horses, with emblematical colors, and a furnace in blast during the whole procession. The motto of the colors, 'In vain the earth her treasure hides.' The whole was executed by Mr. King, at his own expense" (Scharf and Westcott, vol. 1, p. 451).

King may have "retired" at this time to 4562–64 Germantown Avenue, Germantown (Thomas H. Shoemaker, "A List of the Inhabitants of Germantown and Chestnut Hill in 1809," *PMHB,* vol. 16, no. 1, 1892, p. 46n.), where his property had one of the higher appraisals (£1,070), on which he paid 5s. 35d. tax. In 1794, he became a private, this time in the Second Troop, Philadelphia City Cavalry, under Captain Singer. In the same year his son moved the foundry operation to 76 South Front Street.

Now a widower, King married Elizabeth Shimburg at St. Michael's and Zion Church in 1799. His son had married Margaret

Smith at St. Paul's on January 24, 1792 (HSP, Records of St. Paul's Church, Marriages, 1759–1829).

The *American Daily Advertiser* on February 21, 1806, records his death: "Died yesterday in the Seventy-fifth year of his age, at his late dwelling in Germantown, Daniel King Senr., a respectable inhabitant of the city of Philadelphia." Unlike many Quaker or Anglican craftsmen, there is no evidence that King was involved with city government or that he held any honorary offices, a fact which, combined with his membership in the Zion Church, proves again the importance of religious affiliation in early Philadelphia.

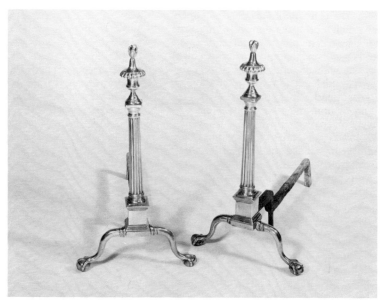

81.

ATTRIBUTED TO DANIEL KING

81. *Andirons*

c. 1770
Brass and iron
28 x 13 x 22" (71.1 x 33 x 55.9 cm)
Dietrich Corporation, Reading, Pennsylvania

THIS PAIR of tall fluted columnar andirons exhibits a popular type which was manufactured in mid-eighteenth century Philadelphia. Their design source may have come directly from prominent London merchants such as William Henshaw and Thomas Aitken who were trading with Philadelphians (Heal, *Furniture Makers,* pp. 5, 79), but the third edition of Thomas Chippendale's *Director* probably provided most

Philadelphia craftsmen working in several media with sources for form and design. The bedpost was easy to adapt into an andiron form, whether fluted or entwined with flowering vines, and this pair exhibits the "Malborough" block at its base, a feature of Thomas Affleck's furniture design (see no. 79). Made in sections and socketed or screwed together, each unit was cast separately in a sand mold by the brass founder. Like the pair with paw feet (no. 82), this pair has claw feet grasping a flattened ball, also a form used by chair- and cabinetmakers. The andirons are topped by flaming, urn-shaped finials, a familiar feature on tall chests and secretary bookcases (see no. 84). The manufacture of andirons was probably a collaborative effort with the wood carver who created forms for the brass founder's molds. Daniel King was the most prominent brass craftsman working at mid-century, and this elegant pair of andirons although unmarked, have enough features in common with a marked pair at Winterthur to support their attribution to him.

BG □

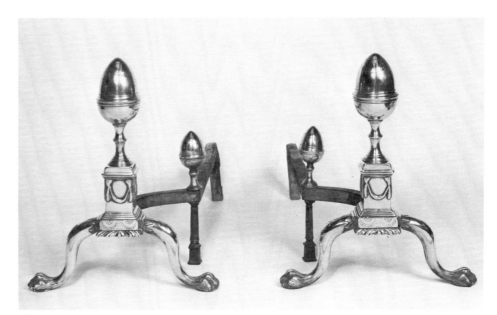

82.

ATTRIBUTED TO DANIEL KING

(1731–1806)

(See biography preceding no. 81)

82. *Andirons*

c. 1770
Brass and iron
18 x 14″ (45.7 x 35.6 cm)
American Philosophical Society, Philadelphia

PROVENANCE: Descended in Wistar family to Mrs. Henry Goddard Leach, until 1975

LITERATURE: Hornor, pp. 97, 98, pl. 106

ALTHOUGH FAMILY TRADITION maintains that Caspar Wistar's brass foundry produced these andirons, Wistar accounts thus far known list brass buttons by the hundreds in all sizes but nothing so large as andirons (HSP, Gratz Collection, Miscellaneous Business Papers, Box 20, 1738, Wistar MS, boxes 1, 2). Caspar Wistar's inventory of 1752 (HSP, p. 16) itemizes his brass-making equipment as: "264 ¼ cast brass £11.0.2 ½, 246 ½ copper shruff £15.7.9 ¾, 161 ½ brass Do £11.8.9 ½, 246 brass pans for buttons £24.12.0, 2850 brass in sheets for Do £391.17.6, 94 brass wire and button shanks £18.16.0, 11 cast pot brass £0.9.2, 22 turnings £12.10.0, plate brass, wire and borax as per neat and Neave's." By 1739, Wistar was deeply committed to glass manufacturing in New Jersey and it is doubtful that his brass-

works ever produced items so large as andirons. An advertisement in the *Pennsylvania Gazette* in 1769 placed by his son Richard, who carried on the foundry after his father's death, states that he "continues to make the Philadelphia brass buttons, noted for their strength, and such as were made by my deceased father and warranted for 7 years," which does not suggest that Richard expanded upon the items his father produced.

The similarity in details on these andirons and on the tall pair attributed to Daniel King (no. 81), such as the engraved swags on the tops, the plinth decoration, the applied gadrooned molding at the edge of the base plinth—missing, but for which there is evidence on the other King pair—and the lozenge on the knees, strongly support an attribution to Daniel King for these andirons also. The hairy paw foot, rare enough on Philadelphia furniture, is a unique survival on this pair of andirons. A bill presented to John Cadwalader by Daniel King in February 1771 listing "chimeley hucks with Ear heads, to cutting 2 large fenders and new moldens to Do," and as an afterthought, "By a carved foot for the andirons" (HSP, Cadwalader Collection, General John Cadwalader Section: Bills and Receipts, 1771), indicates that special details could be ordered for custom-made andirons and that King cast the feet from a carved model, which he presumably commissioned from a cabinetmaker.

BG □

83. *Candlestands*

c. 1770
Brass and iron
(a) Height 65¾″ (167 cm)
(b) Height 67⁵⁄₁₆″ (170.9 cm)

Philadelphia Museum of Art. Charles F. Williams Collection. Purchased by subscription and museum funds. 23-23-89, 90

PROVENANCE: Charles F. Williams

PENNSYLVANIA was the Colonial center of the iron industry in America, and the ingredients for blast furnaces—ore, limestone, and wood for charcoal—were in abundant supply. By 1730, William Branson had a steel furnace on High Street in Philadelphia. Metalworkers flourished, for their products were necessary for farming, cabinetmaking, silversmithing, transportation, domestic containers, and utensils. By 1750, the great demand for metalwork in Philadelphia gave rise to individual specialties, such as those of the blacksmith, whitesmith, and the ornamental ironworker.

The most important "design" work of the ironmonger was architectural—fences, railings, and balusters, some of which survive at Christ Church (no. 26), where S. Wheeler stamped his name in the main gate in 1795, on railings at Mount Pleasant (1761–62), and the stair baluster at Solitude (1785) in Fairmount Park. Brass too was in full production in various Philadelphia foundries such as those of Caspar Wistar and Daniel King, and had been readily available in Philadelphia by 1720. Brass knobs, always highly polished, were often added to iron

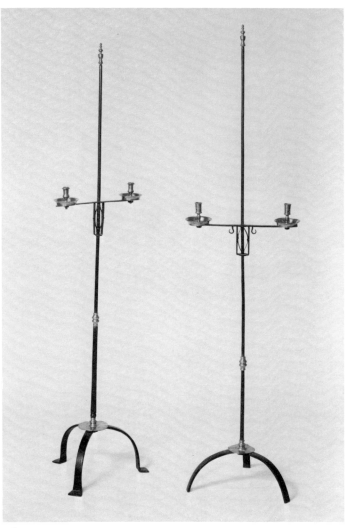

83.

PROVENANCE: Caspar and Mary (Franklin) Wistar; Abraham and Catherine (Wistar) Sharpless; Caspar Wistar Sharpless (1805–1865); Miss Helen Sharpless; George H. Lorimer

THIS SECRETARY BOOKCASE belonged to Caspar Wistar, Jr. (1740–1811), youngest son of Caspar and Catherine Johnson Wistar (see no. 22). Caspar, Jr., was twelve years old at the time of his father's death in 1752. His oldest brother, Richard (b. 1727), moved into the Wistar home on Market Street, and seems to have stayed there until Caspar, who had inherited the property, came of age. Caspar, Jr., inherited a considerable estate from his father, including a house in Germantown, two plantations in Bucks County, a tract of 248 acres at Macungie, Pennsylvania, and the house and lot on Market Street (HSP, GS, Leach Collection, Wistar).

Caspar married Mary Franklin, daughter of Walter Franklin of New York, on November 7, 1765. He moved to New York at the time of his marriage and Richard managed his Philadelphia affairs: "Glad to hear that my house is likely to be attended . . . there are no papers of much consequence in my desk but there are some I would not choose to be seen, they with the Desk will be quite safe in J. Grunthe's stone cellar" (HSP, Society Collection, Caspar Wistar to Richard Wistar, December 19, 1765).

Caspar and Mary Wistar left New York City and settled on a farm at Wallabought on the East River facing Governor's Island. They built a handsome house there in 1770 and remained until 1786 when, because of Caspar's health, they moved to his inherited property at Pennsbury, Brandywine, in Chester County, with their children, Samuel, Tommy, Kitty, Sally, and Mary. A note from Tommy, Sally, and Kitty to Cousin Tommy Wistar at Walnford in Frankford regretting an invitation to visit reads, "We are very much engaged in building and the Horses cannot possibly be spar'd—Dadda has had one fit of the ague and fever. The fever is now on him and [he] is quite delerious and incapable of answering thy kind invitation to him and Mamma" (HSP, Society Collection, letter, May 13, 1786).

Caspar died at Pennsbury in 1811. His wife had predeceased him, and his estate was divided among his children (Chester County, Pa., Abstract of Wills, Caspar Wistar, Jr., No. 11–415). His daughter, Mary, who also predeceased him, left her household goods to her sisters Catherine and Sarah. Thomas died in 1814 leaving his share of his father's estate—the house and lot on Market Street, the New York property inherited from his mother, and land in York, Pennsylvania—to Catherine. Thus,

railings as newel finials (Philip B. Wallace, *Colonial Ironwork in Old Philadelphia,* New York, 1930, pp. 29, 94, 123).

Iron candlestands were probably routine in every house where candles were used instead of the cheaper rush lights or fat-burning lamps, products of the ironmonger or the whitesmith. Three-legged stands with two candle arms, adjustable, portable, and relatively stable, were made in all sizes to stand on tables or on the floor.

These floor-standing candleholders were probably wrought by the ironmonger and then polished by the whitesmith. The addition of brass was ornamental, promoting these otherwise utilitarian furnishings to the parlor. The base of candlestand a, with a flat "penny" foot which added stability, was fashioned the same way as penny foot, "knife blade" shaft andirons. Like shaft andirons, the candlestands are ornamented with brass collars around the shafts and brass urn finials.

Precise stylistic dating is difficult since

designs were passed down through apprenticeship rather than design books. Utilitarian objects like iron pots and candlestands were produced in timeless styles and pragmatic forms, but more elaborate forms disappeared with style changes, to say nothing of replacement due to technological advances in lighting. These are especially fine examples of Philadelphia eighteenth century ironwork, and a rare survival.

BG □

84. *Secretary Bookcase*

c. 1770
Inscription: C Wistar 1791 (in pencil on side of left interior envelope drawer)
Mahogany; poplar and cedar; brass hardware
109¾ x 45 x 25″ (278.7 x 114.3 x 63.5 cm)
Philadelphia Museum of Art. Given by George H. Lorimer. 29–178–1

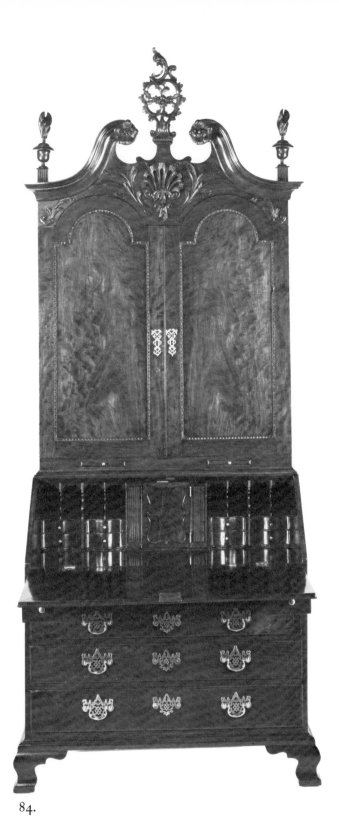

the same profile, but the same rhythm of solids and voids appears between the volutes which frame the swirling asymmetrical cartouches original to both pieces. The pierced, applied rocaille shell is very similar to the drawer shells on the high chest; both have ruffled edges and a free contour. Where here the shell is pierced, the drawer shells on the high chest are cut deeply and both have a drop ornament below the C-scroll which begins the curling foliage. The foliage on both pieces also shows similar carving, with the more linear form on the secretary bookcase conforming to the shape of the pediment, while the tighter curls on the high chest are suited to its smaller rectangular format. On both pieces the corner finials are placed within the "architecture," unlike the Savery and Howe high chests (nos. 75, 104) where the finials perch on the outer limits of the pediment. The urns supporting the loose swirl of flames have similar capping, although on this piece they are higher and more in proportion with the case. The solid paneled doors are framed with a carved molding in a narrow, simplified egg and dart pattern, a distinctive and unusual detail found also on a slightly wider secretary bookcase with rectangular paneled curtains (Hornor, pl. 201), which belonged to Charles Wharton (now in Bayou Bend Collection, Museum of Fine Arts, Houston), who bought many of his pieces from Affleck in the 1770s.

The inscription "C Wistar 1791" must have been written on the inside drawer when Caspar was ill, even infirm, as a means of differentiating his and his wife's pieces for their children's inheritance. It is traditionally maintained that this secretary bookcase was wedding furniture of Abraham and Catherine Sharpless, but their country life and the early nineteenth century date of their marriage do not fit either the scale or the technical details of this piece. It was rather the wedding furniture of Catherine's parents, Caspar and Mary Franklin Wistar.

BG □

84.

Catherine, who had married Abraham Sharpless at the Birmingham Meeting on December 16, 1802, inherited most of Caspar and Mary Wistar's household possessions including this handsome secretary bookcase.

It was probably made soon after her parents' marriage in 1765, probably to furnish Caspar, Jr.'s, house at Wallabought in 1770. Its tightly organized architectural strength is a feature of the best Philadelphia furniture design before 1775. The pediment has much in common with a high chest (no. 109) attributed to Thomas Affleck. Not only do the swan-neck moldings have

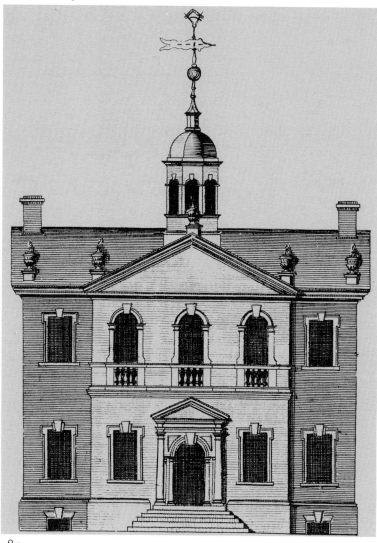

85.

ROBERT SMITH (1722–1777)
(See biography preceding no. 26)

85. *Carpenters' Hall*

Chestnut Street, between Fourth Street
and Whalebone Alley
1770–71; doorway 1792
Brick and granite facade; wood trim
50 x 30′ (15.2 x 9.1 m)

REPRESENTED BY:
Attributed to Thomas Bedwell (act.
1779–95) (after Robert Smith)
Carpenters' Hall: North Elevation
From *The Rules of Work of the
Carpenters' Company of the City and
County of Philadelphia,* 1786
Engraving
9 x 6″ (20.3 x 10.5 cm)

The Carpenters' Company of the City
and County of Philadelphia

LITERATURE: Charles E. Peterson, "Carpenters'
Hall," in *Historic Philadelphia,* pp. 96–128

THE CARPENTERS' COMPANY was formed
"for the purpose of obtaining instruction in
the science of architecture and assisting such
of their members as should by accident be in
need of support." Unwritten but implicit
was the need to oversee quality of workman-
ship and to dictate prices. In 1727, when
Philadelphia building was accelerating
beyond the control of the joiners' recognized
leaders, free enterprise was thought to be
undesirable, and successive petitions were
presented to the Council for legislation to
make legal what had been local custom,
especially apprenticeship terms and contract
and measuring regulations. According to
Roger Moss, when these measures failed, the
carpenters organized themselves in 1727.
They began a library with books bequeathed
in 1734 by a founder, James Portues, and
eventually printed their small handbook of

rules and prices for the edification and
regulation of their membership. Charles
Peterson's introduction to the reprint edition
of the *Rule Book* describes its significance:
"There is no mystery about its scarcity: the
little volume had been in its own time highly
restricted as a trade secret. Any member
showing it to outsiders was liable to expul-
sion and when he died, the Company
promptly called on the widow for his copy.
Even Thomas Jefferson, writing from
Charlottesville, was unable to obtain one
as late as 1817" (p. ix).

The engravings of the north elevation and
the floor plan of Carpenters' Hall that appear
in the *Rule Book* were probably made from
the architect's drawings (which are now
lost) for the 1786 publication. Robert Smith
is given credit for the design, and with the
exception of the doorway added in 1792 and
the roof urns, the building stands as designed
(see no. 314), set back from Chestnut Street
between Fourth Street and Whalebone Alley.
The ground was purchased in 1768 by three
members of the Carpenters' Company:
Benjamin Loxley, Thomas Nevell, and
Robert Smith. On April 18, 1768, the follow-
ing entry was made in the record: "Takeing
into Consideration the Improvement of their
Lott Mr. Smith Exhibited Sketch for a
Building to be thereon Erected & the
Members Ware desired to Consider When
Will be a proper time to Begin the Building
&c" (Charles E. Peterson, "Carpenters'
Hall," in *Historic Philadelphia,* p. 98).

Exactly how the design for Carpenters'
Hall developed does not emerge from
Company records, but it may be traced
through Smith's background, his architec-
tural library, and the style of other buildings
credited to him. While he must have used
Langley's *Treasury of Designs* for wood-
work details, the north facade and probably
the plan are free and naive translations of
Palladio. And what could have been more
appropriate for Philadelphia's first profes-
sional architect than to turn to the source
of the architectural renaissance of the
eighteenth century for his design for the
carpenters' own trade building at
Philadelphia!

Palladio's Villa Almerico ("La Rotonda")
is built on a Greek cross plan, a square with
four projecting portico porches, two stories
high, crowned with a dome and cupola.
His Villa Trissino was also similar in plan,
but the porches did not project beyond the
body of the square building. The Greek
cross form appears for the first time in
Philadelphia at Carpenters' Hall. Smith, who
had been trained in and around Edinburgh,
combined the sophisticated concept of the
Palladian villa with one of Scotland's most
important burgh building forms, the toll-
booth (townhouse), which was often
cruciform in plan. These buildings were

usually placed in the middle of a square or on market streets (John G. Dunbar, *The Historic Architecture of Scotland*, London, 1966, p. 199), and their towers held the town clock and bells, like the Court House at Philadelphia (see no. 46, Reference no. 6). Their pedimented entrances on opposite sides with a cupola rather than a spire on the roof, masonry construction, large central space on the first floor, with smaller rooms for special functions on the second, followed traditional urban Scottish form, adapted by Smith for this building. The cruciform was more obviously used in late Stuart ecclesiastical building in Scotland, such as in the church at Lauder in Berwickshire by Sir William Bruce, or in William Adam's elevation of Hamilton Church (*Vitruvius Scoticus*, pl. 13).

The north facade at Carpenters' Hall may have been drawn from Palladio's designs for the Palazzo Barbarano and Palazzo Chiericati, which appear in the edition owned by Smith (Carpenters' Company of Philadelphia). Palladio used alternating curved and triangular pediments over the second story windows, which Smith simplified into a keyed archivolt. But the frame of the arch, with a single miter at the sill level, is intersected by a narrow decorative belt course before it continues into flat pilasters, which, in turn, rest upon the building's main projecting belt course, details also to be found on the Palazzo Barbarano. The turned balusters shown in the *Rule Book*, which create a balcony effect below the second story windows of Carpenters' Hall, are the same form as those in Palladio, although as built they have a double swelling in the shaft. Robert Smith left off the window pediments and he did not rusticate the first floor level at Carpenters' Hall, but he did frame all the rectangular windows with crossettes (a double miter of the architrave) and put in a decorative keystone, even in the flat lintels. Although the Palladian designs do not show shutters, they had in fact been added to his villas—made of fielded panels, a universal design used for centuries.

The main entrance doorway, shown in the *Rule Book* as designed by Smith but built with some variation in 1792, may also have been drawn from Palladio. However, the overall form, with keyed arch springing from engaged pilasters, flanked by three-quarter-round Doric columns supporting a triangular pediment, had its first appearance in the Philadelphia area at Mount Pleasant (1761–62, Fairmount Park), and by 1770 must have been very much a part of the joiner's standard design practice. A simpler version, with larger fanlight, appears on the south facade of Carpenters' Hall, where the color contrasts of granite belt course, balusters, and keystones have been deleted from the second story level.

86.

Although the site of the deliberations of successive Philadelphia societies, as well as of the First Continental Congress in 1774, the building attracted little notice. Solomon Drowne from Rhode Island called it "very pretty" (Drowne to his parents, October 3, 1774, in Harrold E. Gillingham, "Dr. Solomon Drowne," *PMHB*, vol. 48, no. 3, 1924, p. 231), but artists who painted city views, including William Birch and John C. Wild, ignored it. D. J. Kennedy did a friendly watercolor in the 1860s (Historical Society of Pennsylvania), and we are left with a few verbal comments like John Adams's in 1774 when the Congress was to meet: "The general cry was, that this was a good room, and the question was put, whether we were satisfied with this room? And it passed in the affirmative" (Charles Francis Adams, 2d, *The Works of John Adams*, Boston, 1865, vol. 2, p. 358).

BG □

JANE HUMPHREYS (BORN C. 1759)

Jane Humphreys was born about 1759, the Quaker daughter of Joshua and Sarah Williams Humphreys who settled in the Welsh tract in the area that is today known as Lower Merion Township. Joshua, her brother, has been called "the father of the American Navy." Jane is reported to have "died at an advanced age, unmarried" (Frederick Humphreys, *The Humphreys Family in America*, New York, 1883, pp. 989–1011).

86. *Sampler*

1771
Inscription: 1771/Jane Humphreys her Work made/in the 12 Year of her Age Dec 6 (center bottom)
Silk on linen (107 x 93)
Stitches: Satin, buttonhole, eyelet, chain
13 x 15" (33 x 38.1 cm)
Philadelphia Museum of Art. Given by Miss Letitia A. Humphreys. 14–307

PROVENANCE: Descended in Humphreys family

LITERATURE: Bolton and Coe, *American Samplers*, pl. 36; PMA, *Samplers*, p. 16, fig. 28; Mary Gostelow, *A World of Embroidery* (London, 1975), pp. 278–79

JANE HUMPHREYS'S SAMPLER is an impressive arrangement of needlepoint lace, including drawnwork, cutwork, and hollie point, framed and embellished with buttonhole, eyelet, and satin stitches. Seventeenth century English samplers often incorporated bands of needlepoint lace. This sampler was produced during a late eighteenth century revival of the needlepoint lace sampler; it had evolved into a distinct form and included inserts or panels of this work. Most of the American examples from this period originated in Pennsylvania and range in date from 1762 to 1790. The specific arrangement of a central basket of flowers surrounded by circular inserts is featured in at least ten samplers from the areas of Delaware and Chester counties, with individual examples

from Philadelphia and from Salem County, New Jersey.

A "SCHOOL for Teaching all Manner of Berlin or Dresden NEEDLE-WORK, in the genteelest and most elegant Manner," was advertised in the *Pennsylvania Gazette,* June 24, 1762. As far as can be determined, at this period Dresden, or Berlin, work referred to the combination of needlepoint lace and embroidery found in Jane Humphreys's sampler of 1771.

In Deborah Morris's Ledger (HSP), in which she recorded the expenses of her orphaned niece (Sarah Powel), Deborah reported cash advances in 1760 for "Thread for cut work 5 [d.]," and in 1762, "12 mo/fraim & Glass 10s. 6 & Peeling to put under cutwork 2s. 6." These expenses are listed under the sections in the Ledger described as "Sarah Powel to Cash advance for Education" and were probably connected with specific instruction in needlework. In these early records, the term drawnwork does not appear; the term cutwork probably described both processes.

In drawnwork, selected warp and weft threads are drawn out, and the remaining threads are pulled together with fine stitches in different patterns. The basket, flowers, border, and name panel are formed in this manner in Jane Humphreys's sampler.

In the cutwork process, sections are cut away, and remaining threads are used as the foundation for a pattern. In this sampler, vertical and horizontal crossbars remain, strengthened with buttonhole stitches; the circular and square designs are built up in segments using the same buttonhole stitch. The very fine workmanship of the cutwork is comparable to that of the drawnwork.

The third type of needlepoint lace used on the sampler is a specialized form called hollie point, reportedly used for liturgical embroidery in the Middle Ages in England. In the seventeenth and eighteenth centuries, hollie point circles often formed the crowns of baby caps and were used for baby clothes because of their light weight. In 1758, Elizabeth Drinker reported in her Diary (HSP) that she "Crown'd a Boys Cap for M. Marole," and in 1759, "Crown'd a Boys Cap for M. Carrey." In the former year she had also "Help'd to make Baby Cloaths for Betty Smith at Point," undoubtedly referring to needlepoint lace. The tight, fine pattern of the hollie point circles on this sampler are formed in a twisted buttonhole stitch, with the design revealed through working individual stitches farther apart. The edges of the insertion are finished with a buttonhole stitch.

Embroidery in satin and chain stitches outlines the figures, and the satin stitch forms the stems and the bases of some of the blossoms.

PC □

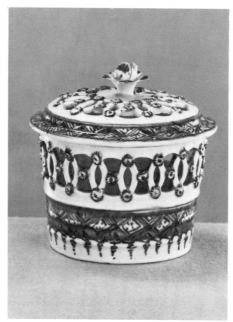

87a.

GOUSSE BONNIN (1741–1773/80)

Gousse Bonnin was one of three children of a prosperous Antigua merchant, Henry Bonnin. Educated at Eton College, England, and married in 1766 at St. Martin's in the Fields, London, to Dorothy Palmer of Buckinghamshire, Bonnin came to America with his wife and one child in 1768. Although he had expected a Crown grant of twenty thousand acres in East Florida, Bonnin arrived in Philadelphia in August 1769 and within a month was borrowing money for a ceramic enterprise—the manufacture of black-lead crucibles. He returned to England briefly to receive the royal letters of patent but came back to Philadelphia, and by December 1769, he had joined George Anthony Morris in an endeavor to manufacture blue and white soft-paste porcelain, to be known as "American China." Bonnin returned to England in September 1773 after this enterprise failed late in 1772. He lived a fashionable life in Bristol and Worcester until his death.

GEORGE ANTHONY MORRIS (1742/45–1773)

George Anthony Morris was born in Philadelphia, the son of Joseph and Martha Fitzwater Morris, who lived on Front Street. Little is known about Morris's life, but he owned property in Southwark which he rented to Gousse Bonnin in 1771.

BONNIN AND MORRIS CHINA MANUFACTORY (1770–72)

87a. *Openwork Dish with Cover*

1771–72
Mark: P (in blue underglaze, on bottom of dish and interior of cover)
Soft-paste porcelain; lead glaze
Height 3¾″ (9.5 cm); diameter 4⅛″ (10.4 cm)

Colonial Williamsburg Foundation, Williamsburg, Virginia

PROVENANCE: Robert Roberts and Catherine Deshler (m. 1775); descended in Roberts and Canby families

LITERATURE: Hood, *Bonnin and Morris,* p. 33, figs. 35, 36

87b. *Sauceboat*

1771–72
Mark: P (in blue underglaze, on bottom)
Soft-paste porcelain; lead glaze
Height 4″ (10.2 cm); length 7⅜″ (18.7 cm)

The Brooklyn Museum, New York. Dick S. Ramsay Fund

PROVENANCE: Dr. Samuel Woodhouse, Jr.

LITERATURE: Hood, *Bonnin and Morris,* pp. 30–31, figs. 8, 9

87c. *Pickle Tray*

1771–72
Mark: P (in blue underglaze, on bottom)
Soft-paste porcelain; lead glaze
Height 1¼″ (3.1 cm); diameter 4½″ (11.4 cm)

Philadelphia Museum of Art. Given by Mrs. Benjamin Rush. 50-32-1

PROVENANCE: Descended in Rush family until 1950

LITERATURE: Hood, *Bonnin and Morris,* p. 31, fig. 10

87b.

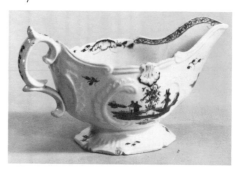

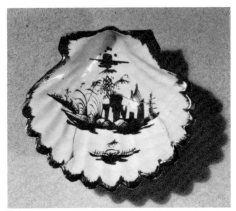

87c.

BONNIN AND MORRIS's china manufactory flourished for barely two years, from 1770 to 1772 (*Pennsylvania Chronicle*, January 1, 1770; *Pennsylvania Journal*, November 11, 1772). After an enterprising, possibly precipitous start, much went wrong. When Bonnin arrived in Philadelphia, expectations for commercial success were high due to the Non-Importation Agreement signed in 1765, which was designed to give impetus to established American manufacturers and to encourage new ones. Seemingly protected, Bonnin and Morris strove to replace the enormously popular blue and white patterns of English Worcester and Bow with an all-American soft-paste porcelain.

The range of forms to be produced was competitive and ambitious. Besides complete sets for dining and tea tables, fruit baskets, "boxes for the toilet," sauceboats, and picklestands were advertised. To date, there are twelve surviving pieces positively identified as Bonnin and Morris products by documentation or relationship to archaeological evidence.

This openwork dish with cover may have been intended for use as a potpourri or as a purely ornamental form. The perforations in the cover suggest the former. Other pieces of Bonnin and Morris ware, like shell-shaped sweetmeat dishes and pierced baskets, were more ornamental than useful, for the survival of these special forms suggests that they could not possibly have held up under extended use.

The sauceboat, decorated with a chinoiserie scene on the side (similar to Chaffers's Liverpool wares), sprig patterns, and a geometric border along the inside edge of the spout, is an eclectic example with motifs typical of the Bow factory. Its body is most like Liverpool ware, including the C-scroll handle, which would scarcely support the sauceboat when full. Its shape offers an interesting comparison with the Humphreys silver sauceboats (no. 103) made at the same time, and serves to illustrate the far less sophisticated status of porcelain manufacturing in the Colonies.

The small pickle tray with cone-shaped feet is lighter in weight and thinner than the other pieces. The painted design is strong but "muddy," lacking the detail and shading which would have made the scene intelligible.

The imperfections, bubbles, pits, deep pooling, and uneven distribution of the glaze are probably the key to the failure of the porcelain. Not only do these pieces reveal the problems, but shards (at the Philadelphia Museum of Art) recovered in the archaeological investigation of the factory site reveal under microscopic analysis that the ware cracked or split in the final firing. If Bonnin and Morris imported their workmen, who presumably were trained in their craft and in manufacturing techniques, it must have been the materials which were variant from European ones, and the workmen were unable to adjust their formulas to American clays.

Two types of material, one a pink fire-clay, the other a fine yellow clay, were tempered with mica and quartz particles and combined with bone-ash. The glazes, one a sea blue-green color where it pooled in crevices, the other a gray lead color, were not fully developed.

Philadelphia's appetite for the finest available porcelain soon won out over enthusiastic early support for a home product, and as Bonnin and Morris were forced from the outset to lure skilled workers from English factories with promises of high wages and paid passage, they could not afford to produce the quantity of pieces necessary for their market. Importation continued to be profitable, even cheaper; a two-handled Worcester sauceboat cost two shillings, a Wedgewood Queensware sauce tureen with cover and ladle cost the same, while a single-handled Bonnin and Morris sauceboat with no cover or ladle cost from one to three shillings, nine pence (Hood, *Bonnin and Morris*, p. 22).

Forced to admit that other products were more serviceable, plentiful, and reasonable, Bonnin gave up hope for the factory and ceased production in November 1772.

BG □

88. *Sofa*

1770–80
Mahogany; white oak and pine; twentieth century wool tabby upholstery woven to match original fragment found on front seat rail
38 x 83½ x 34″ (96.5 x 212 x 86.3 cm)
Philadelphia Museum of Art. Given by Mrs. J. Hamilton Coulter and Mrs. C. Stow Myers. 69–279–1

PROVENANCE: Susan (Montgomery) Bland; daughters, Mrs. J. Hamilton Coulter and Mrs. C. Stow Myers

PHILADELPHIA had many skilled upholsterers, who advertised themselves as "upholders," produced sofas and other covered furniture, and sold the textiles and findings necessary to complete their opulent and comfortable designs. Samuel Powel employed Susannah Bond, Thomas Lawrence, Samuel How,

88.

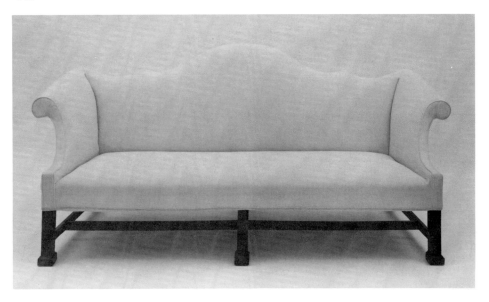

John Webster, and Samuel Grove for upholstery work (HSP, Ledger); John Cadwalader used John Webster and Plunket Fleeson (HSP, Cadwalader Collection, General John Cadwalader Section: Bills and Receipts, 1770–71); and John Macpherson also patronized Lawrence and Fleeson (PMA, John Macpherson, Receipt Book, 1772). To work for these wealthy merchants was as much an advertisement as the newspaper announcements featuring "new fashion'd French corner chairs, conversation stools, sofas, Venetian window blinds, and bedsteads of all sorts" (*Pennsylvania Packet,* January 30, 1775), or as suggestive as shop signs like that of Plunket Fleeson: "At the Sign of the Easy Chair in Chestnut above 3rd Street."

Journeymen joiners were regularly employed in upholstery shops to construct the strong frames which would support the layers of material, webbing, and tape, but it was the skill of the upholsterer that determined the ultimate shape of the finished piece and it was he who ordered the frame. Plunket Fleeson's bill to Cadwalader in 1771 shows that the upholsterer did, in fact, supply the finished pieces: "To a Large Sopha stuff'd & finish'd in canvis with the matres also & a case made for do. £5.15.0" (HSP, Cadwalader Collection, General John Cadwalader Section: Bills and Receipts, January 15, 1771). Yet there is only one known sofa that is inscribed by an upholsterer—that at the Winterthur Museum by John Linton, who was working in Philadelphia during the second half of the eighteenth century (Downs, *American Furniture,* pl. 274).

The legs of the Philadelphia sofa were usually straight, finished plain, and ended in block feet, a detail achieved by applying a molding to the bottom of the leg. The moldings had been removed from this sofa, but their profiles remained in the old finish, and have been restored. Casters were frequently used to afford mobility, but more important, to protect decorative and vulnerable feet. The legs were given added strength by the use of intersecting stretchers which created a rigid supporting framework.

The most distinguished features of the Philadelphia camelback sofa are exhibited in this example—its mass, the sweep of the outward scroll of the arms, and the subtle, sometimes sprightly, curves of the back. This form always had a tight seat, and sometimes a thin hair or down cushion called a "matress." Most were upholstered over the front rail and finished with a wood molding or brass roundheaded tacks on ⅝ inch centers. On specially ordered sofas carved cabriole legs with claw and ball feet, applied fretwork on rails or legs, or highly polished molded and fluted surfaces were provided.

Philadelphia's principal upholsterer was Plunket Fleeson, who began his career in 1739 (see no. 27). His success lay in his ability to make comfort fashionable, and his bill to John Cadwalader in 1770 reveals his precise businesslike method when acting as his own agent with his clients: "To Sundries for a large sopha viz. 15 yds girth, 3 yds drill, 13 yds canvis, 23 os curled hair—tacks & thread, 11 yds. lace-finishing in canvis & making a Case. £5.9.10" (HSP, Cadwalader Collection, General John Cadwalader Section: Bills and Receipts, October 18, 1770). Fleeson acted from his own shop, but he also provided his services to large cabinetmaking establishments such as Benjamin Randolph's, which was located almost next door on Chestnut Street (see no. 89). Fleeson did extensive work for Randolph between 1774 and 1776, amounting to £254 14s. 7d., but they had begun the association at least as early as 1768 (NYPL, Philadelphia Merchant's Account Book, 1768–86, p. 16), and probably about 1763–64, when Randolph first opened his Chestnut Street shop.

Fleeson not only dominated the upholstery trade in Philadelphia, but also contributed his energies and imagination to the community. He was an ensign in the Second Company of Associators in 1749, a founder of the Hibernia Engine Company in 1752, a justice of the peace, an active tradesman-merchant who signed the tax protest in the form of the Non-Importation Agreement of 1765, a patriot in the Revolutionary cause, a justice of the Court of Common Pleas and Quarter Sessions, and presiding justice of the City Court from 1781 to 1785. His administration of that office reveals a careful, thoughtful, pragmatic person who commanded respect and who acted with dispatch (Anna Wharton Morris, "Journal of Samuel Rowland Fisher, of Philadelphia, 1779–1781," *PMHB,* vol. 41, nos. 2 and 3, April and July 1917, pp. 154, 329). In Fleeson's will, probated in 1791 (City Hall, Register of Wills, Book W, p. 163), he left handsome bequests of property in the city, a silver tankard, and a teapot to at least four children, and grandchildren, one of whom bore his name.

BG □

BENJAMIN RANDOLPH (1721–1791)

Benjamin Randolph circled June 17 in his *Father Abraham's Pocket Almanac for the Year 1775* (Library Company of Philadelphia) and noted on the opposite page that he was "aged 54." His connections throughout his life were about equally divided between New Jersey and Philadelphia and he owned property in both places, but his parentage is still uncertain. The family was Quaker, having left New England due to persecutions, but Benjamin was an active member of St. Paul's Episcopal Church in Philadelphia. The family name in Piscataway, Middlesex County, New Jersey, was Fitz-Randolph, and his brother James kept the prefix. From his earliest appearance in Philadelphia records, Benjamin dropped it, as did an uncle Benjamin whose daughter Anne was baptized in Philadelphia's First Presbyterian Church in 1730. Numerous Benjamin Randolphs appear in the records of Piscataway and Woodbridge, New Jersey, but none of them can be identified with the Philadelphia Benjamin Randolph.

Benjamin Randolph married Anna Bromwich at St. Paul's on February 18, 1762. He was already in the joinery trade, and his Receipt Book (Winterthur Museum) notes that he paid William Brame (*sic*) for repairing his father-in-law's house on Sassafras Street in October 1763, suggesting that Randolph was trained to do cabinet joinery rather than house carpentry. By May 1763, Randolph was renting his living quarters from the joiner John Jones, with whom he may have apprenticed although records have not yet appeared to confirm it. Randolph's father-in-law died in November 1763, leaving Anna Randolph with a comfortable inheritance which they seem to have nurtured, as the rental properties were benefiting their two daughters, Mary and Anna, in 1781, several years after their mother's death.

Exactly when his cabinetmaking enterprise began is uncertain, but on June 9, 1763, he purchased Windsor chairs from Francis Trumble, an indication that he was not yet satisfying his own domestic needs. However, in 1764, he was becoming established. He bought a horse from his brother for £20; saddle and bridle equipment from the merchant Joseph Jacobs in September (HSP, Joseph Jacobs, Ledger, 1728–69); a cow for £7 10s.; two guns from Joseph Wood for £17; and he was paying rent for his Negroes in March 1764. But Benjamin and Anna were still renting from Jones in October 1764. At this time he was a partner in a New Jersey sawmill with his brother Daniel, and he had other accounts in New Jersey for lumber supplies. Stephen Johnes of Maidenhead, one of a large and wealthy clan, hauled cedar boards to his workshop in 1764. In February 1766, Benjamin Randolph's house and kitchen were on the north side of Mulberry Street near Fifth, the two separate buildings given a value of £150 by the Philadelphia Contributionship Insurance Company. He was a vestryman at St. Paul's Church, where John Jones was also a member, and the upholsterer Plunket Fleeson, a vestryman

(St. Paul's Episcopal Church, Records, pp. 3, 31).

In 1765 and 1766, Randolph's whole enterprise seems to have shifted and expanded. He moved to a property owned by William Milnor on Arch Street, where he began by securing space for his Negroes in January 1765, added the "seller" in April, and indicated he was living there by June (Winterthur Museum, Receipt Book). In July he began paying a ground rent to James Hamilton, whose Chestnut Street property would soon become his permanent location. He was buying cedar planks from Cornelius Robinson, half-inch poplar from Samuel Trimble, and large quantities of boards through Charles Vandike in September. In December 1765 he paid rent for John Pollard (see biography preceding no. 90), who was to become a key to his cabinetmaking enterprise, suggesting that Pollard had recently arrived and that he would pay off his passage by working for Randolph. At that time, Randolph was purchasing 19,000 feet of boards from David Tryon and 3,068 more through John Hill, indicating that he was doing house joinery rather than cabinetmaking, a fact probably confirmed by his purchase of a passel of bricks in January 1766. He was still paying Pollard's rent in June 1766. Daniel Randolph's sawmill was supplying boards, and more were purchased from James Bringhurst in September, as well as "a passal inch ¼ pine bords," from John Cook in December. That month he was "pinting my House in Arch Street" and purchasing a "crate of earthenware" from Benjamin Armitage, a merchant who supplied his cabinetmaking business with hardware for several years. Randolph's appearance in the records of the Almshouse at Tenth and Spruce streets in 1766, furnishing window sash (Samuel W. Woodhouse, Jr., "More About Benjamin Randolph," *Antiques,* vol. 17, no. 1, January 1930, p. 23), probably records a gift in kind, often the custom among craftsmen who contributed to Philadelphia's early institutions.

In December 1766, Hercules Courtenay appears in Randolph's records for the first time; he too, like Pollard, probably joined Randolph's enterprise to pay off his travel debt. It may have been Pollard and Courtenay, journeymen carvers who later advertised that they were recently from London, who opened up Randolph's enterprise. In 1767, Randolph purchased another shop, from Quaker carpenter Thomas Shoemaker, located on Chestnut Street, adjoining the property of Henry Mitchell, joiner. From this time he called himself "cabinetmaker," hung up his "Sign of the Golden Eagle," and advertised "all Sorts of Cabinet & Chair work."

From 1767 on there are no further references to Randolph's paying rent, except

ground rent to James Hamilton on whose Chestnut Street lot Randolph built a large shop and house in 1769. Thomas Nevell was the contractor, although some small notations, such as payment to Forscht Brale for digging a "sellar," appear in his Receipt Book (Winterthur Museum). Nevell's account amounted to £480 14s. 3d., and was not itemized. With his relocation to the large shop, Randolph began to show accounts for the purchase of quantities of walnut and mahogany and wages of several craftsmen.

Randolph's accounts for the next eight years appear in a ledger in the New York Public Library (catalogued as Philadelphia Merchant's Account Book, 1768–86), which although unidentified can be ascribed to Randolph by cross references with his Receipt Book in the Winterthur Museum and Captain John Macpherson's Receipt Book in the Philadelphia Museum of Art. The earliest entries in his Account Book, dated October 1, 1768, summarize his accounts for that period (p. 3). Courtenay and Pollard, Armitage, Benjamin Kendall, and Joseph Alston, Sr., appear with accounts totaling £1,071 14s. 5d., showing that Randolph was deep in his business by this date. Peter Lasley, a joiner, entered the shop in 1769 and continued there until the shop closed during the Revolution; John Maggs, an apprentice, achieved journeyman status within Randolph's shop; and John Hanlin, another journeyman joiner, worked for Randolph from 1768 to the Revolution, when he left to join Hercules Courtenay's artillery company. Thus, Randolph's establishment must have been among the largest, if not the largest, in pre-Revolutionary Philadelphia. His clients were those building the great Philadelphia houses: John Cadwalader, Vincent Lockerman (see no. 101), John Dickinson, Michael Gratz, Thomas Bond, Samuel Fisher, and Captain John Macpherson, to name a few.

In 1769, James Smithers, engraver, made the plate for Randolph's elaborate trade card, illustrated with fanciful furniture forms taken directly from Thomas Johnson's *Book of Ornaments,* probably brought to the shop by Pollard or Courtenay. His charge to Randolph was £10 19s. 1¼ d. for the plate and impressions.

During 1775, Randolph received prominent visitors in his home, including Thomas Jefferson and George and Martha Washington. It was during Jefferson's stay that Randolph made the famous lap writing desk used for his penning of the Declaration of Independence. Randolph's pocket almanac for that year gives a sketchy record of his activities. Richard Broderick, sawyer, who later worked for David Evans, Jr., was charging Randolph for his services all through the year, during which time

Randolph contracted to pack possessions into crates for removal or travel for the army. In August he notes that "Mr Jefforson & [Peyton] Randolph wint away August 1" and in September "Collol Washington Dr," is charged for postage and two pair cords. Washington "went to the Camp at Boston 21 July 1775" and "27 Nov. 1775 Mrs. Washington went to the camp from here." On the last page of the almanac, he lists his own equipment and their purchase price: "carbine £4., Broadsword £2., Belt £1.2.6, cartradge box 0.10.0, 1 pair pistles £2.10.0, saddle houser's gun & buckit and bags £4., Bridle etc £1.5.0 and a suite of cloths £7.0.0." He settled his accounts with sawyers John Atkins and Philip Blomfield and joined the war effort.

Randolph's shop, tools, and remaining stock, except what he carried home, were put up for sale in 1778 in preparation for his retirement to property he acquired in Wading River, New Jersey. He had owned Speedwell Saw Mills with his brother Daniel, but bought him out in 1778. Benjamin tried to sell it in 1779 and again in 1780 (Charles S. Boyer, *Early Forges and Furnaces in New Jersey,* Philadelphia, 1963, p. 202), but could not and, therefore, invested in its iron possibilities after 1783.

Benjamin Randolph's second marriage was to Mary Fennimore, a widow, in whose family the famous Randolph "sample" chairs descended. He made his will in September 1790. Randolph died in December 1791 and was buried from St. Paul's, where his first wife and brother Stephen were also buried (St. Paul's Episcopal Church, Records, p. 414). His will was probated February 14, 1792 (Trenton, New Jersey, Wills, vol. 3, 1791–95, Libre 34, p. 398, File 11460C).

HERCULES COURTENAY (1744?–1784)

Hercules Courtenay descended in the family of Sir William Courtenay (b. 1533) of Kilrush County, Westneath, Ireland. Genealogical research has shown that Sir William's grandsons were Edward Courtenay of Powderham, born in 1631, and Hercules, the Philadelphia carver's grandfather. This establishes the relationship of the Philadelphian to Hercules Courtenay of Baltimore (1736–1816) as second cousins, clearing up a longstanding confusion about them.

The Philadelphia Hercules Courtenay advertised first in 1769 that he was lately from London (*Pennsylvania Gazette,* August 7, 1769); however, he had already arrived in 1765, for he signed the Non-Importation Agreement that year. On December 23, 1766, Benjamin Randolph paid Jacob Chrystler "on acct of Hercules Corteney [*sic*]" (Winterthur Museum, Receipt Book), sug-

gesting that they were already working together, a fact confirmed by an entry on July 16, 1767, made by Joseph Graisbury, tailor, in his Ledger (HSP, Reed and Forde Papers, Joseph Graisbury, Ledger): "Mr. Randolf joyner in Chestnut Street To making your carver Courteney a barygane Coat 0.16.0." Indenture and apprentice records for this period have disappeared, but it is likely that Courtenay, like John Pollard (see biography preceding no. 90), moved in with Randolph until his passage debt was paid. As he was a witness in 1767 to Randolph's deed for the purchase of the Chestnut Street shop from Thomas Shoemaker, he must have reached his majority by then.

According to church records, Courtenay married Mary Shute by license at Gloria Dei on May 19, 1768 (HSP, Old Swedes' [Gloria Dei] Church, Baptisms and Marriages, 1750–89), a daughter having been born to them a year earlier, on March 24, 1767 ("Notes and Queries," *PMHB*, vol. 24, no. 1, 1900, p. 118). Mary was disowned by the Society of Friends for marrying "out of Meeting" in June 1769. They had at least two more children, Daniel (d. 1775) and Hercules, Jr.

In 1768, Randolph's Account Book (NYPL, Philadelphia Merchant's Account Book, 1768–86) carries long entries by Courtenay's name, always entered as debtor under the shop. The summary for 1768 on page 3 shows he was paid £10 7s. 6d. and John Pollard, £10 8s. 3d., suggesting that only a moderate amount of carving was then undertaken and that the two carvers were doing about the same amount of work. If their room and board had been deducted from this total, there is no notation to that effect. But payment to Courtenay and Pollard indicates a journeyman rather than apprentice status for the two. In October and November 1769, Courtenay's account with Randolph was £59 74s. After this, Randolph's accounts with Pollard were greater, and Courtenay began to appear in the records of Philadelphians building fine houses with carved interiors: John Dickinson, Samuel Powel, and John Cadwalader. For Cadwalader, he carved in 1770 an interesting variety of things: "To a tablet the judgment of Hercule £8.10.–"; for the central panel of his fireplace, "To 67 feet 10 inches of leaf glass for Front Parlour £3.7.10 . . ."; "to 6 Flowers for Knees of Doors, Back Parlour £1.4.0; To 3 swell Freezes for Front Room Doors £10.10.0 . . . to a turret with a Lyons Head in it over chimney £2.5.0" (HSP, Cadwalader Collection, General John Cadwalader Section: Bills and Receipts, April 17, 1770). In 1772 he carved six busts, and ornament for Cadwalader's coach. Courtenay's occupation elsewhere after 1770 suggests that Pollard

is responsible for the interesting, if not always successful, design of Randolph's "sample" chairs with their scroll feet, which lost the lion's paw strength supplied from Courtenay's training.

Courtenay's 1769 advertisements in the *Pennsylvania Gazette* from August 7 through September 18 read "From London" and that he "undertakes all manner of carving and gilding . . . at his house between Chestnut and Walnut on Front Street," an indication that he did not have a large shop, but worked "at home." His first recorded apprentice was James Connelly in 1773, probably the brother of George, who was apprenticed to John Pollard at the same time (*Records of Indentures . . . of the City of Philadelphia*, October 3, 1771, to October 5, 1775, Baltimore, 1973). He was listed without property value in the Provincial Tax of 1774 in the Walnut Ward (*Pennsylvania Archives*, 3d series, vol. 14, Tax Lists). In 1775 he was a captain in the Pennsylvania Regiment of Artillery under Colonel Proctor, and John Hanlin, another of Randolph's journeymen, was a bombadier in Courtenay's company in 1777 (*Pennsylvania Archives*, 5th series, vol. 3, p. 1055). He was summoned to be court-martialed in 1778 for leaving his howitzer in the field at Brandywine, but was excused by the Commander in Chief and pardoned without censure ("Orderly Book of General Edward Hand, Valley Forge, January, 1778," *PMHB*, vol. 41, no. 2, 1917, p. 202), and by March 1778, had left the military.

Courtenay may have been wounded in the war, or the inflation and general depression

89.

may have cut the demand for his special skills, for he and his wife Mary were tavern keepers paying tax for George Gray's estate from 1779 to his death in 1784. In 1783, his occupational tax was estimated at £50, and his dwelling, at £900, with plate, £1 (Hornor, p. 317). Courtenay died in Philadelphia on October 26, 1784, and was buried in the Friends ground. No will or administration has survived. His wife Mary was listed in the Philadelphia city directories until 1801 as a resident in a boardinghouse at 135 South Water Street (between the Drawbridge and Spruce Street), and at 31 Spruce Street in 1802. After 1809, she is not listed.

BENJAMIN RANDOLPH AND HERCULES COURTENAY

89. *Easy Chair*

1770–72
Mahogany; quartered white oak; twentieth century silk damask upholstery
45¼ x 24⅜ x 27¹⁵⁄₁₆″ (115 x 62 x 71 cm)
Philadelphia Museum of Art. Purchased: Museum Fund. 29-81-2

PROVENANCE: Mary W. (Fennimore) Randolph (d. 1816); Nathaniel Fennimore; Samuel Stockton Zelley and Rebecca (Fennimore) Zelley; Howard W. Reifsnyder; American Art Galleries, New York, April 24–27, 1929, no. 674 (Reifsnyder sale)

LITERATURE: F. K. W[ister] and H[orace] H. F. J[ayne], Jr., "Exhibition of Furniture of the Chippendale Style," *PMA Bulletin*, vol. 19, no. 86 (May 1924), pp. 146–49; Herbert Cescinsky, "An English View of Philadelphia Furniture," *Antiques*, vol. 8, no. 5 (November 1925), pp. 273–75, illus. frontispiece; S. W. Woodhouse, Jr., "Benjamin Randolph of Philadelphia," *Antiques*, vol. 11, no. 5 (May 1927), p. 367

ALTHOUGH A WELL-KNOWN EXAMPLE of Philadelphia furniture, this easy chair is atypical of the Philadelphia style. The carved mahogany skirt and the thrusting wood-framed arms produce a design that is active and aggressive, not at all like the easy chair attributed to Affleck (no. 78), which expresses all the grace, ease, and elegance of Philadelphia's community of craftsmen.

Benjamin Randolph has always been given the credit for this chair. It descended through his second wife's line, providing a solid provenance and, by association, attribution. But Randolph was trained as a joiner, and his cabinetry enterprise did not fully begin until John Pollard and Hercules Courtenay began to work for him in 1765 and 1766. In 1767, when he located on Chestnut Street at the "Sign of the Golden Eagle," Randolph was

in the midst of the furniture trade, and it is reasonable to assume that this easy chair was a collaboration within this enclave.

Surprisingly, the easy chair form was probably first promoted and structurally designed in Philadelphia by Plunket Fleeson, who had set up his upholstery shop in 1739 (see no. 88). The frame of the upper section is of quartered white oak, sawn and shaped. The seat frame is thick and heavy, with 1½-inch-square side rails and a 5-inch-wide front rail, roughly hewn into a curve to open the seat for upholstery webbing; it was joined in pinned mortise and tenon as are the side rails, through the back legs. The arm posts are independent of the leg unit and are set into the side seat rails and crudely wedged. The legs are doweled through the front corner of the seat rail in the Queen Anne fashion, without pins or blocks. The carved skirt was first glued, then screwed to the seat frame in three sections. A closely related easy chair at the Winterthur Museum, possibly made for the Biddle family, with whom Randolph had an account in 1774, shows similar details, with the exception of the fitting of the arm posts, which are wedged from the top (Downs, *American Furniture,* pl. 94).

The interior joinery of the Philadelphia Museum's chair is tentative and crude, but rugged. The tall shape of the back, carried over from English styles of the 1720s, and the unusual treatment of the arms, again like the Winterthur example, may have been inspired by the "French" chairs featured in the 1762 edition of Chippendale's *Director.* But there is little real connection, for even Chippendale's designs for large sofas appear fragile when compared to it. In practice, the English "French" chair was often solid, even squat like this chair, showing that its form derives from an English apprentice experience rather than a design-book source.

The carving reflects the style of the 1740s, and the skirt owes its contour and design organization to work being done in the shop of the English cabinetmaker and chairmaker Giles Grendey in St. John's Square,

Clerkenwell, London, and more precisely to a set of chairs made by him about 1740 (Percy Macquoid, *A History of English Furniture: The Age of Mahogany,* London and New York, 1906, p. 120, fig. 103). The characteristics of the English and the Philadelphia chairs appear too similar to be the result of coincidence, yet no early or mid-eighteenth century drawing or engraving illustrating this form appeared in America for shops to copy. Such portable patterns as those tucked into the scrapbook of the carver Gideon Saint at the Metropolitan Museum of Art—carving designs drawn on long folded pieces of paper and pricked along the contours of the rococo patterns—must have been routine equipment for a carver and thus were motifs traced and applied to furniture of all kinds. Hercules Courtenay, who had arrived from London by 1765, must have come fresh from his apprenticeship and brought the experience of one of the great London shops if not actual patterns.

The carving on the English chairs is fuller and deeper than that on the Philadelphia chair, where the scrolls have a more linear quality, but the robust effect of each is equal, especially the way in which the deep central masks project and "answer" the boldly curved and deeply carved knees, which end in the hairy, or lion's paw, foot. Another piece attributed to Grendey, a dwarf clothes press in the Victoria and Albert Museum (Heal, *Furniture Makers,* fig. 28), has the same flared apron or skirting with an almost identical profile edged with leafy scrolls set against a diapered background; however, instead of the central foliage motif—repeated on Courtenay's carved tea table (no. 101)— the easy chair features a mask, which seems to have been simplified from a looking-glass frame design illustrated in Johnson's *Book of Ornaments* of 1756. Plate 17 from Johnson shows a border with mask enframed in a medallion and diapering, again closely similar to the skirt of this easy chair. Thus, even if Courtenay had trained in or around Grendey's shop and brought patterns with him, he would also have

referred frequently to familiar engraved design sources. Someone in Randolph's shop had a volume of Johnson, as James Smithers used it as a source for engraving Randolph's trade card; probably this was Pollard, as his carving style seems closest to Johnson's fanciful shapes.

After the chair was framed and carved, it was sent to Plunket Fleeson for upholstery. Recent examination of this chair has shown that the seat rail bears evidence of clusters of handwrought nails, probably for holding webbing, and at least one row of brass-headed decorative tacks with square shafts were pounded in on ⅝ inch centers just above the carved skirt. There is no sign that fabric had been tacked to the underside of the seat frame, nor were any minute fragments of original upholstery found. The seat was interlaced with strips of canvas webbing, and then lined with sacking (canvas) and stuffed with horsehair. The seat and back were probably covered with at least two layers— English chairs often had three—first, ordinary canvas or tow; then linen; then the final cover. The "finish" was not nailed on in contemporary fashion, but probably held in position as in English upholstery by "a cord soed round and bound with Lace" (Christopher Gilbert, "The Temple Newsam Furniture Bills," *Furniture History,* vol. 3, 1967, p. 18). This technique allowed the cover to be changed for cleaning or redecoration without full upholstery services, thus protecting the frames from excessive tacking. This chair was upholstered in this manner.

BG □

JOHN POLLARD (1740–1787)

The origin of the Pollard family has been a subject of lengthy study (see Maurice J. Pollard, *History of the Pollard Family of America,* New Hampshire, 1964, vol. 2). Pollards appear in Boston and Ipswich by

89. *Detail*

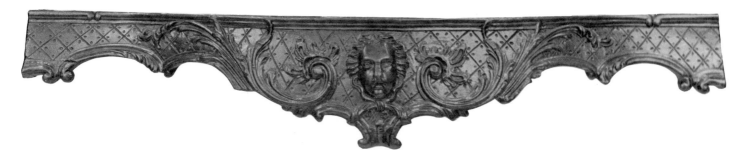

1715; in Virginia, Rhode Island, and Vermont; and in Barbados by 1725. In Philadelphia their records in the Christ Church archives are extensive, and a large family by that name was founded by John Pollard in 1685 in Piscataway, New Jersey, in the same area as Benjamin Randolph's family.

John Pollard's first recorded appearance in Philadelphia is in the Receipt Book of Benjamin Randolph (Winterthur Museum), who paid Pollard's rent in December 1765. In June 1766, Randolph made a payment to Andrew Forsythe for Captain Harry Gordon, on whose boat Pollard may have come; and, again, he paid rent on Pollard's behalf to John Henderson in July 1766. His next appearance is in Randolph's Account Book for November 2, 1766, where he is listed along with Hercules Courtenay, carver (see biography preceding no. 89), and Benjamin Armitage, hardware merchant, with "Shop" as debtor (NYPL, Philadelphia Merchant's Account Book, 1768–86). By 1769, Pollard was listed in the Proprietary Tax as a joiner, with no value indicated, and thus was probably still in Randolph's domicile. Just when he hung up his "Sign of the Chinese Shield" on Chestnut between Third and Fourth streets opposite Carpenters' Hall is not clear, but he was in partnership with Richard Butts there by 1773.

Pollard, who was born in 1740, must have finished training by 1761. He had joined Randolph by December 1765, and probably was in on the formation of his shop at the "Sign of the Golden Eagle" in 1767. The fact that John Pollard chose a Chinese shield as his shop sign indicates that he was well acquainted with the Chinese themes in English rococo carving. Pollard and Butts took an apprentice named George Connelly, probably a brother of the Connelly taken on by Courtenay at the same time, "to learn the trade of house carpenter," suggesting that Butts was a joiner rather than carver ("Servants and Apprentices," p. 103), and in 1783 they added a Henry Dubosq to the shop. By 1774, in the Provincial Tax, Pollard was called "carver."

Little information appears in the records about Pollard's family, probably because he was not immediately a member of the church. As an adult he was baptized at Christ Church, June 30, 1776, having married in 1774; their daughter, Susanna, was born June 20, 1775 (HSP, GS, Records of Christ Church, Baptisms, 1769–94). His wife Margaret died before 1778, and he married Catherine Sousth at Gloria Dei, March 30, 1778. Their son, George Washington Pollard, was baptized in Christ Church in January 1780. John Pollard died in Philadelphia and was buried in St. Peter's Churchyard. His tombstone reads: "In

memory of Mr. John Pollard late of this city Carver who departed this life Sept. 6, 1787 aged 47 years" (William White Bronson and Charles P. H. Heburn, eds., *The Inscriptions in St. Peter's Church Yard, Philadelphia,* Camden, 1879, p. 140).

BENJAMIN RANDOLPH (1721–1791) (SEE BIOGRAPHY PRECEDING NO. 89) AND JOHN POLLARD

90. *Side Chair*

1770–72
Inscription: VIII (on back seat rail)
Mahogany; American white cedar; twentieth century silk damask upholstery
36⅞ x 21⅞ x 18⅜" (93.7 x 55.6 x 46.7 cm)
Private Collection

PROVENANCE: General John Cadwalader?; Major R. G. Faneshaw; Sotheby Parke Bernet, New York, November 12–16, 1974, no. 1478B

LITERATURE: Janet Green, "Superb American Chippendale Chairs Discovered by Sotheby Parke Bernet," *Early American Antiques,* vol. 3, no. 2 (February 1975), p. 17, illus. cover

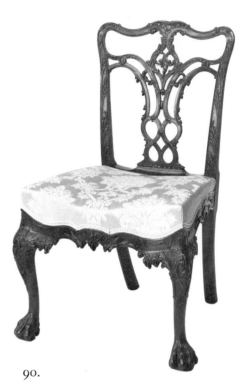

90.

THE "FRENCH TASTE" in Philadelphia reached an apogee in this chair, number VIII in a set of at least thirteen, probably made for the Cadwalader family en suite with their card tables (no. 91). Others from the set are in another private collection (nos. VIIII [*sic*] and x), and one each in Colonial Williamsburg (no. XIII), the Winterthur Museum (no. II), and the Metropolitan Museum of Art (no. VII).

John Cadwalader was a demanding client who spread his patronage among the best Philadelphia workmen, ordering the most elaborate furnishings for his new house on Second Street. A pier table in the Metropolitan Museum of Art with Cadwalader provenance shows a carver fresh from a high-style London workshop, before any other influences softened or tempered his style. If the provenance of the table, set forth clearly and seemingly irrefutably, and the date 1769 are precise (Wainwright, *Cadwalader,* pp. 122–23), Cadwalader began his quest for the highest style Philadelphia could produce even before his father-in-law, Edward Lloyd, died in 1770, leaving a considerable fortune to his daughter, Elizabeth Lloyd Cadwalader. According to his extant receipts, it was after this date that most of his furniture purchases took place. The Randolph shop was newly established when Cadwalader arrived with two marble "slabs" to be framed into tables (Wainwright, *Cadwalader,* pp. 122–23), and it seems probable that Pollard filled the order,

for the hint of chinoiserie in the central figure on the Metropolitan's table would be appropriate for a carver soon to hang up his "Sign of the Chinese Shield."

A portrait by Charles Willson Peale shows Lambert Cadwalader leaning on the back of a chair very similar to this one, but with a plain molded stile instead of carved leafage (Wainwright, *Cadwalader,* illus. p. 115). An English chair, close in type, with molded stile is shown in the catalogue of the Irwin Untermyer collection (*English Furniture,* Cambridge, Mass., 1958, pl. 137). Randolph may have had an imported model that was owned by Lambert Cadwalader, or he may have made other simplified versions of this form which have not yet turned up. English design often called for "buff'd over seats," and on this example the sweep of the curves along the seat rail is enhanced by the contrast of textile with wood. Plunket Fleeson's bill to Cadwalader in October 1770 "to covering over rail finish'd in canvas 32 chairs £13.13.0," was a sizable one, and may have included this set.

A precedent for matched sets, like the Cadwalader pieces, revealing a deliberate interior design, may be found in the furnishing of Dumfries House, Ayrshire, Scotland, planned by the Earl of Dumfries and the Scottish architect, William Adam. Two settees with serpentine-curved fronts, cabriole legs, and scroll feet were ordered from the firm of Thomas Chippendale and James Rannie in London in 1758, and a pair of card tables and a set of fourteen armchairs were designed with scrolled feet and

carved ornament to match them (see Christopher Gilbert, "Thomas Chippendale at Dumfries House," *Burlington Magazine,* vol. 111, no. 800, November 1969, pp. 663–67, figs. 27, 30, 35). This concept of a matched set was repeated in Philadelphia in 1770–72 in this set of chairs and the pair of card tables (no. 91). Unlike the Dumfries furniture made in Edinburgh, which Thomas Affleck (see biography preceding no. 78) may have known, the large Chippendale set was supplied from London between 1758 and 1759, during the time Pollard and Courtenay were in training there.

The wonderful robust proportions of these chairs probably were the design of the shop master himself, Benjamin Randolph, using proportions set forth in Chippendale's *Director.* In measurement, especially in the relation of seat width to back, the scale is English rather than American. Chippendale's ribbon-back chairs, which he himself liked—"If I may speak without vanity, [they] are the best I have ever seen (or perhaps have ever been made)" (*Director,* 2d ed., 1755, pl. 16)—were exceedingly rare. This chair exhibits two variations on the ribbon forms provided in the *Director,* with the four loops at the bottom of the splat forming one, and the curious splay of the splat into the upright stiles forming another.

The splats of the chairs belonging to this set were carved from larger pieces of wood than those used for looking-glass frames, but were pieced together like the chinoiserie work of Ince and Mayhew, a London firm specializing in carved work. They show a

technique different from that usually found on American-made chair splats, where fewer changes of direction and little necessity to carve against the grain occur. The back legs in the typical Philadelphia "stump" form receive the tenon of the side rails in the open manner and are pinned. This form of leg construction was familiar joinery from the 1720s to 1740s in England, but was considered "provincial" there by 1750.

The carved detail on this chair is more like Pollard's work on the pier table at the Metropolitan than that on the card tables, probably carved by Hercules Courtenay, which the set was designed to match. The flutter of the ruffles above the scrolls on the side rails of the chair; the high, rounded free form of the foliage, especially at the edges of the leg blocks; and the organization of the carving on the surface are closely linked to the pier table. And, in turn, the pier table owes much to the work of William Vile, working in the rococo style in London and at the center of the St. Martin's Lane Slaughter's Coffee-House set (see no. 95). Its long, sinuous, graceful legs, standing on small feet and a plinth, with a fillip of foliage above the ankle, are very similar to those on a jewel cabinet made by William Vile about 1762 (Heal, *Furniture Makers,* fig. 29). The carved front seat rail of the Randolph "sample" chair at the Princeton University Art Museum has a long, tenuous scroll "gathering" in the middle, which is simpler but similar in contour to that of the jewel case.

Pollard had a number of design books available from which he could have drawn

his details for this chair if the shop did not have an actual model to copy, while a few of the carved details, like the feathery foliage of the back stiles, the central leaf motif in the center splat, and the slightly "dished" seat, are found on Philadelphia chairs of different designs and types obviously from more than a single shop. While this chair and the rest of the set must have been made with reference to the card tables, it seems reasonable that such a large commission would have been parceled out within the shop and thus more than one hand would have been at work on the order, resulting in certain variations in execution.

BG □

BENJAMIN RANDOLPH (1721–1791) AND HERCULES COURTENAY (1744?–1784)
(See biographies preceding no. 89)

91. *Pair of Card Tables*

1770–72
Mahogany; pine, white oak, and poplar
Height 28″ (71.1 cm); length 39½″ (100.3 cm); width open 30½″ (77.5 cm)

(a) Captain John Cadwalader, U.S.N.R. (Ret.), Blue Bell, Pennsylvania

PROVENANCE: General John Cadwalader (1742–1786); descended in family

91a. 91b.

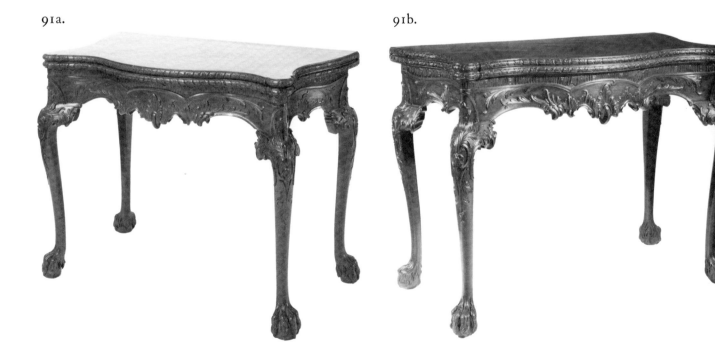

(b) Dietrich Corporation, Reading, Pennsylvania

PROVENANCE: General John Cadwalader (1742–1786); Charles Woolsey Lyon, Millbrook, Connecticut

LITERATURE: Wainwright, *Cadwalader,* pp. 118–19

THE SWEEPING, SERPENTINE FORMS of this pair of card tables made for General John Cadwalader about 1770–72 are a clear indication that the provinces were attracting superior craftsmen whose products could compete with those of the mother country. John and Lambert Cadwalader had signed the Non-Importation Agreement of 1765 and were assiduous in supporting it as a protest against the Stamp Act. Whether John Cadwalader set out to patronize Philadelphia craftsmen in order to promote the development of home products, as intended in the Non-Importation Agreement, or whether the timing suited his house furnishing schedule is not certain, although his extant bills and receipts suggest the former. The ornate elegance of objects produced for Cadwalader by the Thomas Affleck and Benjamin Randolph shops, and simpler pieces for second floor use made by William Savery, suggest that these objects must have been specially ordered by Cadwalader since few pieces with known provenance are as self-consciously grand. And as if to confirm their political propensities, John and Lambert Cadwalader had large portraits painted by Charles Willson Peale in which great care was taken to depict their fine furniture (see no. 92).

The form of these card tables may be unique in Philadelphia furniture. The more usual Philadelphia high-style card table had a top with straight sides ending in rounded "turrets" at the corners fitted to hold a mug or glass and often covered with green or red baize. The front and sides of the body of the table had plain surfaces and were straight, with a single drawer on the front. Below this was a deep, flared, carved skirt like those on the Randolph-Courtenay easy chair (no. 89) and tea table (no. 101) and two tables illustrated in Hornor (pls. 234–35). Another card table form, and one which Cadwalader ordered from Thomas Affleck (Wainwright, *Cadwalader,* pp. 121–22), was straight-legged, and the top was sharply rectangular with gadrooned edges and foliate leg brackets.

Quite clearly, these tables, designed differently from known Philadelphia examples, were intended for more than card playing; probably they were placed as pier tables and used for tea tables as well. The "commode" drawers for storage of game counters, cards, and dice are tucked behind the gate of the swinging leg, leaving the front free for ornament and giving the tables their light-ness and elegance, as well as relating them closely to the side chairs based on the same design (see no. 90).

Chippendale's 1762 *Director,* which Randolph probably used as his inspiration for the form of the side chairs, did not include card tables, but carvers' manuals of the 1750s, such as Thomas Johnson's *Book of Ornaments,* featured this sweeping shape. Whereas Chippendale's designs stressed form and solid proportion, as seen in the side chairs, the fanciful schemes illustrated for carvers lacked structural stability. But Johnson's 1758 edition of *One Hundred and Fifty New Designs* shows twenty-one slab frames, most of which feature long, carved, curved lines which "organize" freer foliate-carved elements (pls. 18–24). Cadwalader's card tables were designed within this aesthetic, and the raised carved bands outlining the tables' profiles give ordered symmetry while following the serpentine shape. The pinched effect at the knees gives the tables a spare, gaunt line compared to the usual robust Philadelphia shape, and is typical of Johnson's exaggeration. The carving on the tables adds to the effort to diminish mass, also a new design concept for midcentury Philadelphia, which featured high-relief carving that emphasized the mass of an object (see no. 104). The design and form of the side chairs belonging to the suite follow the more usual Philadelphia aesthetic —plastic carving on a robust form. In 1758, Chippendale and Rannie had made a pair of card tables for Dumfries House very much like these, which also matched a large set of chairs. Those tables have a similar attenuated design, cabriole legs which end in scroll feet, and the carved "shield" motif which joins the vertical foliate carving on the rounded knees with the curvaceous serpentine skirt. Whether such suites were routine in London shop production is unknown, but the idea for these tables and matching chairs did not come to Philadelphia in any design book yet known. Courtenay or Pollard, Randolph's carvers, may well have drawn the design for these tables as a direct result of an English apprenticeship and suggested the suite to Cadwalader.

The carved surface of these tables is very close to the technique Courtenay employed on the easy chair, and on certain architectural carving known to be by him, for example the fireplace surround in the drawing room of the Powel house (Philadelphia Museum of Art). It is quite different from the Cadwalader pier table at the Metropolitan Museum of Art and the side chairs in this suite, which, however, show the work of another carver, John Pollard. On the tables the foliage is flattened into flame-like ruffles which spring from the molded scrolls at the edge of the table, while the same design on the chairs projects in lumpy leaf-like forms.

The same flattened ruffles flange from the C-scrolls on the knees of the Courtenay easy chair and the ends of the leaves flip and twist in a similar linear manner. The ribbon-and-flower carved banding on the edges of the table was used most often in Philadelphia in architectural carving and is an unusual subtlety visually unifying all vertical surfaces on these tables. The pattern of stylized foliage which seems to slide easily down the slender legs of the tables flattens and blends into the contour of the leg where it ends about halfway to the feet, whereas on the side chairs there is an extra flip at the end of the design, setting the leafage into higher relief. The hairy paw feet are also different on the tables and chairs: Those on the tables have much longer toes, clearly delineated, with long nails, and grasp a conical ball firmly without much "bend" at the ankles. This version of the hairy paw foot came clearly from the *Director* (pl. 27), and appeared in all editions. If, as seems probable, Randolph himself constructed the chairs which feature this distinctive foot, in the broad London proportion of his labeled examples, then the form of the feet on the easy chair and side chairs was Randolph's "shape." Those of the side chairs are especially strong and grasp a more typically Philadelphia flattened ball form. The feet on the card tables, quite different in form and probably drawn from the *Director,* were part of the original conception of lightness specified by Courtenay, who must have used variants of the form earlier, during his apprenticeship, and who had worked before with the problem of matching long and short legs within a set.

The possibility remains that Cadwalader inherited some part of this suite (and had pieces made to match) from his wife's father, Edward Lloyd, whose estate inventory in 1770 showed that the Cadwaladers received ten mahogany side chairs and two armchairs to match, valued at £19, and six mahogany chairs from the "Room over the Passage" (HSP, Cadwalader Collection, General John Cadwalader Section: Estate of Edward Lloyd, Inventory, 1770). But it is more likely that Cadwalader, who never seems to have been engaged in business or trade after his wife's inheritance, commissioned the set about 1770 to furnish his newly built and fashionable house with Philadelphia-made products. Randolph's name does not appear among the Non-Importation Agreement signers, but Courtenay's does, and it may have been through him that Cadwalader was introduced to the design possibilities available to him. It may also have been Courtenay and Cadwalader who first conceived of the "sample" chair scheme, a direct challenge to English imports, and real evidence that anything could be made in Philadelphia.

BG ☐

CHARLES WILLSON PEALE (1741–1827)

Born in Queen Anne's County, Maryland, Peale was to become the most famous eighteenth century artist to settle permanently in Philadelphia. He received his first lessons in painting, c. 1762/63, from John Hesselius in Annapolis, Maryland. At that time, Peale was an amateur painter and clock repairer as well as an established saddler. In December 1766, Peale set out for London, subsidized by a group of Maryland gentlemen, to study painting under Benjamin West. He returned in 1769, and worked in Annapolis for a while, served in the Continental Army for three years, and then settled in Philadelphia in 1778 as an artist, inventor, and the proprietor of a picture gallery (1782), which developed into the first significant natural history museum (1786) in America. Eventually, the most famous curiosity in Peale's museum was, without question, the giant, prehistoric mastodon skeleton which was excavated under Peale's guidance.

His philosophy was deist, and the exploration of nature his unending preoccupation: "I love the study of Nature for it teacheth benevolence" (HSP, Peale Papers, Records and Memoranda of the Philadelphia Museum, 1803–37, March 8, 1803). This philosophy was reflected in Peale's museum, which he considered a School of Nature (HSP, Etting Collection: Artists, Peale to D. Delozier, April 9, 1802, p. 64). Although he did not take on any outside student of consequence, his ideas on painting were given immortality through four of his sons and his brother James who became well-known artists. A third generation of Peale artists continued his preference for exactness in representation and his interest in landscape and still life as well as portraiture. Peale believed that drawing was merely imitation and could be learned by anyone of intelligence. Partly for this reason, he assumed a leading role in the attempt to establish an academy in 1794, and he was instrumental in the founding of the Pennsylvania Academy of the Fine Arts in 1805. Peale gave up painting in the spring of 1796 in favor of his talented sons and in order to concentrate on his expanding museum. He could not, however, resist adding to his museum's portrait gallery of distinguished men on a visit to Washington in 1804, which sparked a return to his painting career. With renewed enthusiasm, Peale continued to paint portraits in Philadelphia until about a year before he died.

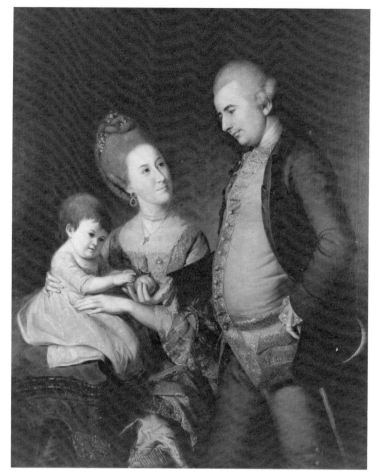

92.

92. *John Cadwalader Family*

1772
Signature: C W Peale/pinx^t 1771 (lower left)
Oil on canvas
51½ x 41¼″ (130.8 x 104.8 cm)
Captain John Cadwalader, U.S.N.R. (Ret.), Blue Bell, Pennsylvania

PROVENANCE: Descended in Cadwalader family

LITERATURE: Theodore Bolton, "Charles Willson Peale, The First Catalogue of His Portraits," *Art Quarterly,* vol. 2, no. 4 (Autumn 1939), Suppl., p. 420; Sellers, *Portraits and Miniatures,* pp. 44–45; Wainwright, *Cadwalader,* pp. 45, 112, 137, 140; Sellers, *Peale,* 1969, pp. 87, 103–4; PAFA, *Painting and Printing,* no. 22, p. 29

A RECENT INSPECTION revealed that this painting is signed and dated 1771. But, because of related, surviving correspondence, the date should remain as the spring or summer of 1772. Sellers has noted that Peale inscribed the earliest possible date on a picture not paid for, so that the delay would be more apparent (*Portraits and Miniatures,*

pp. 18, 69). This seems to be the case here, since the Cadwalader family portrait appears on a 1775 list Peale kept of portraits with outstanding payments (Sellers, *Portraits and Miniatures,* p. 20).

The first reference to this portrait occurs on July 29, 1772, when Peale wrote from Philadelphia to his friend John Beale Bordley: "I am once more making a Tryal how far the Arts will be favoured in the City, I have now on hand . . . one composition of Mr. John Cadwalader Lady & Child in half Length Sise, which is greatly admired. . . I have some prospect of the Quakers incouragement for I find that none of the Painters heretofore have pleased in Likeness —whether I can a little time will show" (APS, Charles Willson Peale, Letterbook, vol. 1). Peale was organizing a small exhibition of his recent work in order to gauge his prospects in Philadelphia, and the reception accorded the *John Cadwalader Family* would affect his decision to move to Philadelphia.

William Williams, Matthew Pratt, and Henry Benbridge all left while Peale was visiting Philadelphia, so there was little

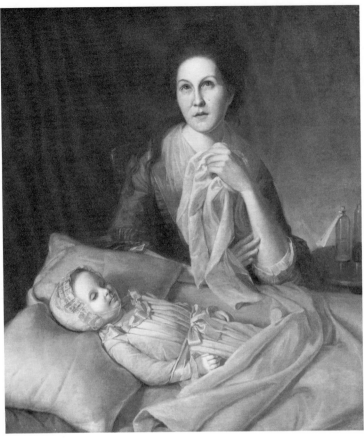

93.

competition when Peale finally moved here, although Pratt later returned (and Benbridge briefly). Peale seems to have been able to offer, as in the *John Cadwalader Family,* more than just the requisite likeness. The higher circles of Philadelphia society apparently liked his large, ambitious canvases, the even quality of his work, his use of props, and the easy, relaxed elegance of the sitter's pose.

John Cadwalader, a wealthy merchant who was appointed brigadier-general of the Pennsylvania Militia in 1776, commissioned the portrait just after moving into a grand house on Second Street. He was now furnishing the house fashionably with imported prints (some historical), small landscapes, and family portraits.

The circular composition of the *John Cadwalader Family* evidently pleased Peale because he used it again in his portrait of *Mrs. Samuel Chase and Daughters* (Maryland Historical Society). However, unlike the latter, this intimate family portrait is in the English tradition of a conversation piece. The figures are located in their new home on Second Street and little Ann is seated on one of a pair of card tables by Benjamin Randolph and Hercules Courtenay (no. 91).
DE □

CHARLES WILLSON PEALE (1741–1827)
(See biography preceding no. 92)

93. *Rachel Weeping*

1772 and 1776
Oil on canvas
37⅛ x 32¼″ (94.3 x 81.9 cm)
The Barra Foundation, Inc., Philadelphia

PROVENANCE: Descended in Peale family to Charles Coleman Sellers, Carlisle, Pennsylvania, until 1972; The Barra Foundation, Inc., 1973

LITERATURE: APS, Charles Willson Peale, Diary, vol. 2, August 18, 1776; James Thomas Flexner, *America's Old Masters* (New York, 1939), p. 193; Sellers, *Peale,* 1947, vol. 1, pp. 114–15, 134; Sellers, *Portraits and Miniatures,* p. 164; Baltimore Museum of Art, *From El Greco to Pollock: Early and Late Works by European and American Artists* (October 22– December 8, 1968), no. 35; Sellers, *Peale,* 1969, pp. 106–7, 122

CHARLES WILLSON PEALE'S painting of his first wife, Rachel, weeping over the loss of their baby is an unusually personal and unflinchingly direct portrayal of death. The infant concerned is most likely their child Margaret who died in 1772. Peale's letter to

Henry Benbridge probably refers to the death of this child, for Peale wrote on May 1, 1773, that his wife had recovered from smallpox, but tragically "we lost the Babe" (APS, Charles Willson Peale, Letterbook, vol. 1, p. 38).

The first version, 1772, consisted of only the lower half of the present picture and was a literal record of Margaret's likeness, with her chin bound and her hands tied, before her burial, similar to the taking of a death mask. The top section of the canvas (center seam still visible) was probably added in 1776: Peale's diary entry for August 18, 1776, reveals that he worked "on the head of Mrs. Peale in the picture with the dead Child" (APS, Charles Willson Peale, Diary, vol. 2). With the dramatic inclusion of the mother, the impact of the corpse was softened somewhat and the painting was transformed into an unusual kind of mourning picture, which was a tribute to Rachel's love and a departure from the commemorative and allegorical forms of contemporary portrayals of death. Although Rachel is the main focus, the title of the painting is not Peale's but rather that under which the work was first published.

Peale hung the work in his studio with a curtain over it on which he placed the following message: "Before you draw this curtain Consider whether you will afflict a Mother or Father who has lost a Child" (Sellers, *Peale,* 1969, p. 106). He later considered entering it in the 1818 Pennsylvania Academy annual exhibition under the title, *A Mother's Resignation on the Death of Her Infant,* as a companion to the portrait of his daughter and her child, *A Mother Caressing Her Convalescent Child.* But *Rachel Weeping* was not meant for a wide and consequently impersonal audience. In a letter to his son Rembrandt, Peale had introduced his idea with some hesitation: "You will wonder that I should think of making it a Picture for the Exhibition" (APS, Charles Willson Peale, Letterbook, vol. 15, April 13, 1818, p. 39). Fear of the indifference of the idly curious finally seems to have made Peale decide against publicly exhibiting *Rachel Weeping.*
DE □

CHARLES WILLSON PEALE (1741–1827)
(See biography preceding no. 92)

94. *The Peale Family*

1773 and 1808–9
Signature: C. W. Peale painted these Portraits of his Family/in 1773./wishing to finish every work he had undertaken/ ——compleated This picture in 1809! (right center)

Oil on canvas
56½ x 89½″ (143.5 x 227.3 cm)
The New-York Historical Society

PROVENANCE: Descended in Peale family until 1854; "Peale's Museum Gallery of Oil Paintings," October 6, 1854, sale no. 145; purchase, Thomas J. Bryan, 1854

LITERATURE: Philadelphia, Peale Museum, *Historical Catalogue of the Paintings in the Philadelphia Museum* [Peale Museum] (1813), no. 211; New-York Historical Society, *Catalogue of American Portraits* (New York, 1941), p. 233; Sellers, *Peale,* 1947, vol. 1, p. 116; Sellers, *Portraits and Miniatures,* pp. 157–58; Sellers, *Peale,* 1969, pp. 79–80, 104–5, 122, 326; New-York Historical Society, *Catalogue of American Portraits* (New Haven, 1974), vol. 2, pp. 609–11

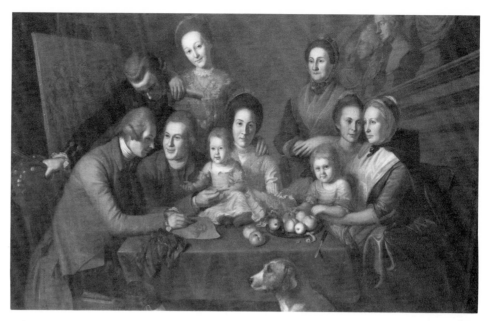

94.

THE OCCASION FOR Peale's family portrait is a drawing lesson. Turning from work on the Three Graces, Peale, palette in hand, supervises his brother St. George, who is drawing their mother and one of Peale's children. The other family members are Peale's wife, Rachel, another child, his brother James, his two sisters, and the family nurse, who stands at the right.

This was Peale's first really ambitious painting after his return from England and was evidently intended as a studio exhibition piece. It is not only a celebration of family solidarity, but, more important, an advertisement of Peale's versatility and improved ability after his trip to London. Peale now thought in terms of exhibition pieces since he and his brother James had organized a small exhibition of their work as recently as 1772 to test their reception in Philadelphia.

Peale must also have had John Smibert's large *Bermuda Group* (sometimes called *Dean Berkeley and His Entourage*), 1739 (Yale University Art Gallery), in mind when he did *The Peale Family* for there is a resemblance, particularly in the lefthand side of both paintings. Peale had probably seen the *Bermuda Group* in Smibert's studio in Boston in 1765. From West, he seems to have learned to use stronger modeling; he was also much influenced by Copley, whom he had met in Boston in 1765 and who was in Philadelphia in 1771–72. Like Copley in his Boston portraits, but even more so, Peale creates form essentially by outline rather than color, and there is the same elimination of brushstroke texture to establish a more convincing illusion of reality. Peale's shading is softer, his coloring more delicate, and he is less interested in textural contrast than Copley. Both artists painted still lifes, sometimes incorporated into their portraits, as in *The Peale Family.*

Peale's style is distinctive and his faces have a certain sameness in being characteristically oval, as shown here. His flesh coloring became less sallow and more integrated and natural in the late 1780s, apparently because he realized that the red lake he used earlier had faded. He therefore changed his procedure and repainted some of his earlier work (Sellers, *Portraits and Miniatures,* p. 12). This change and his later tendency to experiment with color, partly under Rembrandt Peale's advice, account for the inconsistent flesh tones in some of his portraits.

The Peale Family is one of his corrected pictures. He wrote to Rembrandt on September 11, 1808, that he was repainting the background and his own head to effect a better likeness (APS, Charles Willson Peale, Letterbook, vol. 9, p. 83). In order to paint himself in this peculiar position, a mirror was useless, so Peale improvised (for him, a delight) by working from the self-portrait plaster bust seen in the middle of the group of three busts on the mantel. (West is at the left; an English benefactor at the right.) The three sculptures were done in England where Peale had developed an interest in modeling. According to the above letter, Peale also added his palette and took out the still-visible words, "Concordus Anima," written across the Three Graces. With the addition of the family dog, the finished work was placed not in the studio but in the museum, where it must have added weight to the strong imprint of his personality on everything in the collection.

DE □

JAMES REYNOLDS (C. 1736–1794)

On October 27, 1794, the *American Daily Advertiser* carried the following notice: "On Monday evening last departed this life in the 58th year of his age, Mr. James Reynolds, carver and gilder of this city; and on Tuesday evening his remains, attended by a number of respectable citizens, were interred in Christ Church burial ground, Arch Street. His children will have reason long to lament the loss of a kind indulgent father—His relations and acquaintance, a faithful friend—and society, an active honest man."

Little is known about Reynolds's life, and neither his birth nor his marriage is recorded in Philadelphia. Since he did not sign the Non-Importation Agreement of 1765, he may not yet have been in Philadelphia at that date. He was a member of Christ Church by November 9, 1766, when "Mary, dau of James and Elizabeth Reynolds," was baptized. She was followed by Elizabeth (1770), James (1772), Henry (1774), and Sarah (1776) (HSP, GS, Christ Church, Baptisms, p. 609).

James Reynolds was born about 1736, finishing his apprenticeship about 1757. His craftsmanship and style of work indicate a London apprenticeship, perhaps in one of the shops in St. Martin's Lane where the designs of the French engraver Hubert-François Gravelot were then inspiring carvers and gilders with the delicate flamboyance of the French rococo (see Desmond Fitz-Gerald, "Gravelot and His Influence on English Furniture," *Apollo,* vol. 90, August 1969, pp. 140–47). These

artisans, recently called "Slaughter's Coffee-House set," included besides Gravelot, the painter Francis Hayman; Yeo, a seal engraver; Louis-François Roubiliac, sculptor; George Michael Moser, chaser; and William Hogarth. The shops and their apprentices and journeymen followed a lively, naturalistic style loathed by the traditionalists led by Lord Burlington and William Kent (see Mark Girouard, "Coffee at Slaughter's: English Art and the Rococo—1," *Country Life*, vol. 139, no. 3593, January 13, 1966, pp. 58–61). Their work featured asymmetrically organized compositions of swinging interlacing foliage and scrolls, with rocaille shells and exotic birds hardly discernible as distinct shapes within a panoply of linear design.

Gravelot had brought this style—and the idea of the finely engraved pattern book—from France. It soon caught on in England, and there can be little doubt that James Reynolds, like most emigrating master craftsmen, brought with him parts, if not the whole edition, of Thomas Johnson's *One Hundred and Fifty New Designs,* issued in monthly installments between 1756 and 1758 and considered the handbook for the rococo carver. *Lloyd's Evening Post or British Chronicle* for February 8–11, 1765, lists a selection of such design books available, the first four of which were Johnson publishing enterprises: "By the same author Book of Decorations for all kinds of Ornamental Furniture on 56 copper plates. Quarto . . . His new and Genteel Girandoles . . . Also his new Book of Ornaments for Chimneys, Glasses, Tables etc." Henry Copland's *New Book of Ornaments* (1746) appeared in the same advertisement. A special book for looking glass frame carvers by Matthias Lock was published in 1768. The result of these visual aids, used together with paper patterns traced in the masters' shops, is evident in Philadelphia and especially in the work of James Reynolds.

Reynolds advertised in the *Pennsylvania Gazette* as "just arrived" on September 3, 1767. From his early shop location on Front Street, between Walnut and Chestnut streets in 1768 and later, in 1770, opposite the London Coffee House, Reynolds received and supplied the citizenry with elegant and expensive products, if one can judge from the prominent names among his patrons. John Penn ordered from him, and the amount of £139 in Penn's Receipt Book (Washington, D.C., Library of Congress, Edmund Physick Papers, John Penn, Receipt Book, 1774–1849) was probably the account for one or more of eleven looking glasses listed in Penn's 1788 inventory sale, including "an elegant oval looking glass in white and gold frame" (see Marie G. Kimball, "The Furnishings of Governor Penn's Town House," *Antiques,* vol. 19,

no. 5, May 1931, p. 378). He made the "burnish gold" frames for three half-length paintings for £54 in 1771 for John Cadwalader. In 1775, Reynolds sold a large mahogany pier glass for £15 and a pair of carved white ovals for £20 to Joseph Pemberton (HSP, Pemberton Papers, vol. 27, p. 90), and in 1778 he worked for Samuel Powel (LCP, Samuel Powel, Ledger, p. 69). In 1782 and 1783 he framed and sold prints of famous Americans by and for Du Simitière (William John Potts, "Du Simitière, Artist, Antiquary, and Naturalist . . . ," *PMHB,* vol. 13, no. 3, 1889, pp. 370–71), and he had an account with George Washington for picture frames and mirrors in 1793 ("Washington's Household Account Book, 1793–1797," *PMHB,* vol. 29, no. 4, 1905, p. 397). As well as carving for the citizenry, Reynolds supplied the joiners with ornaments for their case pieces. Thomas Affleck seems to have used his services frequently. The William Logan papers reveal that he carved the phoenix bird for the chest-on-chest made for Sally Logan (Metropolitan Museum of Art), and he did unspecified work for Affleck for his Cadwalader account (HSP, Cadwalader Collection, General John Cadwalader Section: Bills and Receipts, October 13, 1770). His last recorded commission was for a pair of urns costing £1 8s. for the pew in Christ Church redecorated in November and December 1790 for the use of George Washington and long known as the "President's Pew."

Extant records show that Reynolds, like most craftsmen who owned their own shop, imported goods to be sold along with those they made. In 1771, Reynolds received two barrels packed with "walnut sconces," which were differentiated by "gilt edge" or "edge and shell" or "edge only" (Nancy Goyne, "Furniture Craftsmen in Philadelphia 1760–1780," M.A. thesis, University of Delaware, 1963, p. 75), and from 1768 on, his advertisements specified that he sold wallpaper with papier-mâché borders and imported ceiling ornaments. John Cadwalader bought 269 yards of "Border Palmyra scrowl" for £20 3s. 6d. in 1770 and 270 yards of border leaf and reed for £13 10s.

In 1781, Reynolds moved his shop to Third between Market and Arch streets, which he identified as at the "Sign of the Golden Boy." Reynolds was featured, along with Martin Jugiez, on the float of the carvers in the Grand Federal Procession of 1788 (Scharf and Westcott, vol. 1, p. 450). He moved his shop again in 1792 to 143 North Third Street. When his sons James and Henry took over the business after his death in 1794, they moved the enterprise to 56 Market Street, near Strawberry Alley.

95.

95. *Looking Glass*

1772
Painted pine
Height 38½" (97.7 cm); width 24" (61 cm)

National Trust for Historic Preservation: Cliveden

PROVENANCE: Benjamin Chew (1722–1810); descended in Chew family; National Trust for Historic Preservation, 1972

LITERATURE: Hornor, p. 278, pl. 435

IT IS FAIRLY SAFE TO SAY that every Philadelphia household had at least one looking glass as part of its furnishings. Whether a dressing glass (see no. 121) or a small "courting mirror," portable enough for the carriage or pocket, or a large pier glass designed to multiply the candle illumination in large rooms, the looking glass was a necessity. However, its embellishment varied tremendously, and this example by James Reynolds for Benjamin Chew represents the most elaborately carved form produced in Philadelphia. Benjamin Chew's Receipt Book (Cliveden, Chew Papers) records: "Rec'd April 20th 1772 of B. Chew Fifty one pounds 10 in full of my Account and all

dues and Demands. James Reynolds." This was not the only entry for Reynolds, but the amount when compared to John Cadwalader's 1771 payment of £11 15s. for a "Glass 36:19 in a Carv'd white frame" (Wainwright, *Cadwalader*, p. 124) suggests that Chew's £51 purchased a pair of small looking glasses, of which this is one, and a pair of large pier glasses (Hornor, pl. 438), all still hanging in the parlor at Chew's house, Cliveden, in Germantown (no. 62). The small pair, or girandoles, hang on either side of the fireplace in the parlor; the large pier glasses, over the sofa on the inside parlor wall and between the east windows.

The same type of ornately carved looking glasses were being made in England for wealthy patrons from about 1745 to 1760 by the Linells, frame carvers and gilders working within the Slaughter's Coffee-House set. Reynolds, and later his sons, advertised on their label exactly the same product that was being made in London, "all kinds of looking glasses in carved and gold, carved and white, or carved Mahogany Frames." Most of the frames presently attributed to Reynolds are carved and painted white. This frame form—a variation of the oval, with broken profiles of twisting foliage, C-scrolls, and clusters of flowers tenuously held within motifs which create an inner and outer frame—epitomizes the vitality that the rococo style introduced into the decorative arts. The flatness of the looking glass form is exploited by the creation of extravagant shapes and fantastic design. There is the hint of chinoiserie at the top of the design of this girandole (it originally had candle sockets), but the rest of the carving is Philadelphia's version of the Linells' style. Painted white, sometimes tipped with gold, the shapes presented prominent silhouettes against the strong colors that inventories and receipts indicate were used in Colonial rooms.

Reynolds may have been the Philadelphia carver who brought Thomas Johnson's *Book of Ornaments* into Philadelphia. No copy is listed in the various early catalogues of the Library Company, nor to date has a copy turned up in a Philadelphia library. Reynolds's training would have developed his skills far enough to draw his own patterns, and all the motifs which appear on frames attributed to him can be recognized in various plates in Johnson's handbook. Reynolds's patronage, accounts, shop, and production suggest that he modeled his enterprise on the London school, as did so many craftsmen when they first arrived in America. But Reynolds's style remained fresh and alive and he continued to work in the rococo style into the 1780s, long after it had been replaced in London by the neoclassical fashions promoted by the Adam brothers.

BG □

HENRY WILLIAM STIEGEL (1726–1785)

Henry William Stiegel was born in Cologne in 1726 and came to America in 1750, settling in Schaefferstown, near Lancaster, Pennsylvania, where many of his fellow countrymen had settled. He was an ironworker, who in 1752 married Elizabeth Huber, his employer's daughter. In 1758, upon the death of his father-in-law, Stiegel, along with Charles and Alexander Stedman of Philadelphia, assumed control of the ironworks, which he named Elizabeth Furnace. In addition, Stiegel and the Stedmans purchased another ironworks, subsequently called Charming Forge, located some miles distant at what is now Womelsdorf. Stiegel was an energetic and industrious man who carried on the business with considerable success.

With profits from the iron business Stiegel established three glasshouses. The first, apparently of small scale, with production limited principally to bottles and window glass, was built at his Elizabeth Furnace ironworks and was placed in operation in September 1763. Along with his partners, the Stedmans, he founded the small town of Manheim, near Lancaster, and in November 1765 opened a glasshouse there where bottles, window glass, and some tablewares were produced. This is the origin of Stiegel's American Flint Glass manufactory (or American Flint Glass Works). He established his third glasshouse, also in Manheim, in 1769, where a wide variety of tablewares as well as bottles were produced, some of which were of flint glass. These products included amethyst, blue, and possibly emerald-green glasswares, some pattern-molded; colorless glass sketchily engraved in a simple "peasant" style with birds, hearts, foliate, and geometric motifs; and—from 1772 to 1774—a limited number of enameled glasses decorated with similar designs.

Stiegel's intent was to fill the Colonists' demands for glass from a domestic source. To do so, he imported glassblowers from the Bristol area of England in order to produce the English glass styles then in demand. He also imported some workmen from his native land to produce the simple glasswares his fellow Pennsylvania Germans had been accustomed to in their homeland. He succeeded in both areas to such a degree that with few exceptions it is difficult today to distinguish between glass his factory may have produced and that made in England or in Germany.

Despite his efforts, his firm failed in the economic adversity brought on by the approaching Revolution, and probably partly as a result of his own extravagances. According to an entry in his Manheim account books, the "Glass House shut down" on May 5, 1774 (McKearin, *Glass*, p. 84).

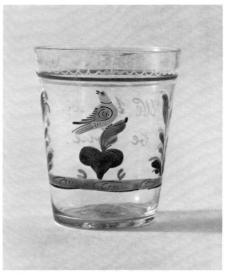

96a.

Late that fall, bankrupt and penniless, Stiegel was placed in debtors' prison, from which he was released by Christmas of the same year, despite the fact that his creditors had not been satisfied. Afterward, he slipped into obscurity and died on January 10, 1785, at the home of his nephew, George Ege, at Charming Forge, near Lancaster.

ATTRIBUTED TO STIEGEL'S AMERICAN FLINT GLASS MANUFACTORY (1765–74)

96. *Tumblers*

Probably 1772–74
(a) Inscription: We two will/be True
Colorless glass (probably soda lime), enameled decoration
Height 3½" (8.8 cm); diameter rim 2¹⁵⁄₁₆" (7.5 cm)

Philadelphia Museum of Art. Charles F. Williams Collection. Purchased by subscription and museum funds. 23-23-188

(b) Inscription: My love you/Like me do
Colorless glass (probably soda lime), enameled decoration
Height 4⅛" (10.4 cm); diameter rim 3¼" (8.25 cm)

The Corning Museum of Glass, Corning, New York

LITERATURE: HSP, Frederick William Hunter, *Stiegel Glass* (Cambridge, Mass., 1914), pp. 202ff., fig. 147; McKearin, *Glass*, pp. 81–93, pl. 30, figs. 5, 6, 7; McKearin, *Blown Glass*,

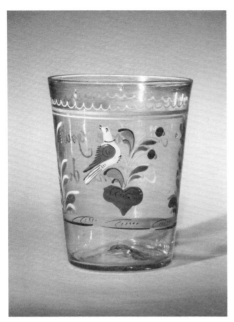

96b.

pp. 16–24, 278, pl. 79, fig. 4; James H. Rose, "18th Century Enameled Beakers with English Inscriptions," *Journal of Glass Studies,* vol. 1 (1959), pp. 94–102, figs. 6–10; R. A. Robertson, *Chats on Old Glass,* rev. with a new chapter on American glass by Kenneth M. Wilson (New York, 1969), pp. 131–33, pl. 58

THESE TWO ENAMELED TUMBLERS are among only twelve presently recorded bearing English inscriptions. Seven are inscribed "We two will be True"; and three, "My love you Like me do." One of the other two bears the motto "Friendship Amity"; the twelfth and smallest bears the word "Liberty." Ten of these are recorded by James H. Rose ("18th Century Enameled Beakers with English Inscriptions," *Journal of Glass Studies,* vol. 1, 1959, pp. 94–102). The other two are in the collections of Jerome Strauss and the Philadelphia Museum of Art, the latter being published here for the first time. These twelve tumblers have much in common. All are quite thin; all are probably of soda-lime glass, though none has been analyzed; all are of the same shape, though they vary in size; all are decorated with the same colors of opaque enamels—white, brick-red, gray-blue, yellow, a peculiar Nile green, and black. In addition, all are inscribed in English. These factors point to a common origin, especially for the ten inscribed "We two will be True" and "My love you Like me do."

Their origin and dates are not definitely known. They are part of a long tradition of German enameled glass, though that type of glass was not only produced in Germany, but was also made throughout most of the Continent, but not in England. Therefore it is possible that they were made in Europe for sale to the Pennsylvania German market and that they were imported through a port such as Philadelphia or Baltimore. But in view of the import restrictions imposed by the British government before the Revolution, this would have required trans-shipment from England, which makes this theory seem unlikely. Thus, if they are of European origin, they probably date from after the American Revolution.

Three Colonial American sources are possible: Stiegel's American Flint Glass Manufactory, or American Flint Glass Works, as he also advertised it (*Pennsylvania Gazette,* March 17, 1773); the Philadelphia Glass Works, established in 1771 (McKearin, *Blown Glass,* p. 24); or John Frederick Amelung's New Bremen Glassmanufactory, established in New Bremen, Maryland, in 1785. Because of the heaviness of known Amelung glass, the latter source seems unlikely. Since it is known that Stiegel advertised enameled glass in the *Pennsylvania Packet,* July 6, 1772, and there are no advertisements of the Philadelphia Glass Works for enameled glass, the most logical American source for these tumblers seems to be Stiegel's glassworks.

Positive proof is still lacking, however, and until definite evidence is found, these tumblers must be attributed as possibly having been made at Stiegel's second Manheim Glass Works, between 1772 and May 1774.

KMW □

DAVID HALL (ACT. 1766–79)

David Hall, silversmith, was a contemporary of David Hall (1717–1772), printer. Benjamin Rush identified them thus in 1772, as "David Hall (Printer)" and "David Hall Silversmith 2ᵈ Street" (LCP, Benjamin Rush, Ledger A).

On February 5, 1765, Hall insured his home—a wooden house with brick kitchen, between Chestnut and High streets—with the Philadelphia Contributionship Insurance Company. In the February 20, 1766, issue of the *Pennsylvania Gazette,* Hall advertised as a "Goldsmith of Second Street near Chestnut," where he was selling chinaware and offering "drilled, clasped and wooden handles neatly fixed to china tea pots." The Proprietary Tax List of 1769 records his tax as £34 16s. In 1774, Hall paid a Provincial Tax from the Chestnut Street Ward of £47.

A collection of weights which have descended in the Humphreys family bear David Hall's initials, as well as a rare one, marked RH, belonging to the elder silversmith Richard Humphreys, with whom Hall probably apprenticed. Hall's later career selling chinaware suggests that he took over some of Humphreys's clientele when the latter retired.

97. *Dish Cross*

c. 1773
Mark: D·HALL (in capitals in rectangle, 4 times, once on each arm)
Inscription: John Houston/Susanna Houston (top of arms, later inscription)
Silver
Width 10″ (25.4 cm)

Private Collection

PROVENANCE: John Houston (1743–1809) and Susanna (Wright) Houston (1752–1829); purchase, Samuel Frederic Houston (1866–1952), Chestnut Hill, Pennsylvania; Mrs. Henry P. Brown (1888–1970)

FOLLOWING CLOSELY upon the brazier, the dish cross proved a more versatile and safer device for keeping hot dishes off the table. It also served to lift punch bowls inclined to "sweat" from the surface of fine mahogany. It was made adjustable by moving the arms on their central pivot and by sliding the dish holders toward or away from the center.

This dish cross has typical Philadelphia characteristics, especially the flaring shell forms of the dish rest and the fretwork-type sheath which slides on the square profile of the arms. The terminals of the arms in small rosettes and the "flower" feet are reminiscent of the naturalism of the rococo style in favor ten years earlier.

The dish cross is inscribed with the names of its first owners, John Houston and Susanna Wright Houston. John Houston was born in 1743 in the Pequea Valley, Leacock Township, Lancaster County, Pennsylvania, to a Scotch-Irish immigrant, John Houston (1705–1769), and his wife Martha Stewart Houston. One of a large Presbyterian family of eight children, John was sent to Scotland for his education at the University of Glasgow in 1761. He was enrolled in Adam Smith's class in Public Moral Philosophy, in James Clow's Logic and Metaphysicks, and also studied Latin, humanities, and mathematics. In 1766 he attended medical school at the Academy of Philadelphia (University of Pennsylvania), graduating in 1769. Houston Hall at the University of Pennsylvania is named for him. Established as a medical doctor in York, Pennsylvania, Houston married on June 17, 1773, Susanna Wright, daughter of John

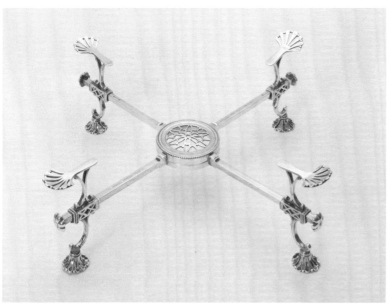

97.

(b. 1710), who had emigrated from Manchester, England. During the Revolution, Houston served for seven years as surgeon in General Wright's Company. After the war he lived a country gentleman's life, and from 1790 until his death in 1809 he served as justice of Hempfield Township, Lancaster, Pennsylvania (HSP, GS, Margaret E. Houston, "The Houstons of Pequea," n.d.).

BG □

ROBERT SMITH (1722–1777)
(See biography preceding no. 26)

98. *Walnut Street Jail*

Walnut Street, between Fifth and Sixth streets
1774–76; workshops 1795 (demolished c. 1835)
Stone structure; cedar roof; brick chimneys; wood cupola
Main block 184 x 32′ (56.1 x 9.7 m); wings, length 90′ (27.4 m)

REPRESENTED BY:
Joseph Bowes (n.d.)
Plan & Elevation of the Jail at Philadelphia
From *Philadelphia Monthly Magazine,*
vol. 1, no. 2, February 1798
Engraving
13¼ x 7⅞″ (33.6 x 18.7 cm)
Historical Society of Pennsylvania, Philadelphia

LITERATURE: Thomas Condie, "A Historical View of the Criminal Law of Pennsylvania, with an Account of the Jail and Penitentiary House of Philadelphia, and of the Interior Management Thereof," *Philadelphia Monthly Magazine,* vol. 1, no. 2 (February 1798), pp. 94–101; Thorsten Sellin, "Philadelphia Prisons of the Eighteenth Century," in *Historic Philadelphia,* pp. 326–30

KNOWN AS "THE CAGE," the first structure in Philadelphia designed to isolate convicted criminals was built in 1682/83, next to the market bell in the center of High (Market) Street at Second; by 1695, a second prison, a brick building 26 feet long by 14 feet wide, with a long walled yard attached, was completed also in the center of High Street, just below Second. Both appear on the manuscript plan of Philadelphia drawn by Edward Penington, surveyor general, in 1698 (see no. 47). By 1723, these must have proved inadequate, for another jail complex was constructed at Third and High streets, consisting of two stone buildings, one for convicted criminals, the other for nonviolent offenders, untried prisoners, debtors, and the like. This early concern for vagrants, thieves, runaway apprentices, even hardened criminals, was to bring Philadelphia's penal structures and philosophy to world attention after the Revolution. In Penn's time, when these prisons were built, capital punishment, common in the Old World for numbers of felonies, was abolished except in instances of premeditated murder or treason, and degradation of the criminal by branding, ear clipping, pillories, and posts was anathema to Penn's peaceful purpose. But along with other alterations of Penn's plan, the rules and

methods developed for dealing with prisoners later sharpened, and public corporal punishments of the unenlightened were instituted.

By 1773, the High Street complex again proved inadequate. Samuel R. Fisher, a prominent but cantankerous Tory who spent 1779 to 1781 in the old buildings, described them in his Journal: "In many of the Rooms being about 100 persons in all Men & Women, who live in a very dirty manner. . . . this place is such a sink of wickedness, that it can scarcely be expected any tender feelings can remain long with them . . ." ("Journal of Samuel Rowland Fisher, of Philadelphia, 1779–1781," *PMHB,* vol. 41, no. 3, 1917, pp. 308, 311).

It was to alleviate this situation that a full block of ground had been purchased on Walnut Street facing the State House yard and extending back to Prune (now Locust) Street (Thorsten Sellin, "Philadelphia Prisons of the Eighteenth Century," in *Historic Philadelphia,* p. 326). Robert Smith was selected to design and supervise construction of a new prison and workhouse. Whether the architect or the Philadelphia Society for Assisting Distressed Prisoners, established in 1776 (Scharf and Westcott, vol. 1, p. 444), created the design based on a penal philosophy they worked out is not yet clear. Robert Smith probably had most to do with the size and divisions within the building, innovative in its single cell design, and with the exterior design. The jail was in partial use by January 1776, but was commandeered later that year by the Colonials and again in 1777 by the British, as a military prison. Finally, in 1784, it was fully occupied by prisoners who had been crammed into the small High Street buildings, and the latter were torn down.

The new jail was built of cut stone, 184 feet fronting on Walnut Street. Two wings from the east and west ends extended south, 90 feet each, toward Prune Street, and a 20 foot high stone wall extended the security and surrounded the yard. The key accompanying the plan and elevation of the jail published in 1798 provides a detailed explanation of the units within. The main building (A) was entered by stone stairs (a), first into a 7½ foot wide entry with arched stone ceiling and then through an iron grated door (1) into the 11½ foot wide corridor (9), which allowed access to official offices and keepers' apartments (3–7, 8, 10), each 20 by 8 feet. On the second floor were located bedchambers (over 3–6, 9, 10) and the infirmary (over 7); below the ground floor were the men's dining room (under 9), baker's room and oven (under 2), and kitchen (under 3). Apartments for women prisoners were located in the west wing (B) and included bedchambers and storerooms (14), their yard (15), and a washhouse (17).

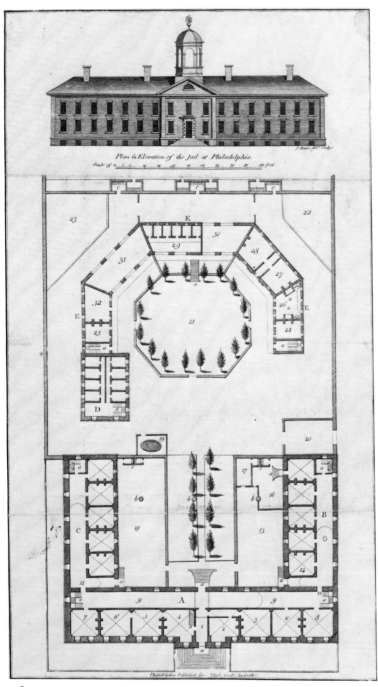

Plan & Elevation of the Jail at Philadelphia.
Scale of 90 feet.

98.

were attached to the solitary unit. Shops (26–28, 30–32) for nail makers, stone sawyers, stone polishers, and carpenters occupied the ground floor of the half octagonal building. On the second floor level there was a balcony from which all "apartments" were entered. Its staircase ascended from the walled yard (21) encircled by trees. The stone wall surrounding the complex had one entrance on Sixth Street (20) and a series of necessaries (c) set into the south boundary.

Although the jail was almost 100 feet shorter than the Pennsylvania Hospital (no. 48), the solidity of the stone block and the dour gray color, unadorned with white trim or roof ornament, appeared equally monumental, if forbidding. The design of the Walnut Street Jail has much in common with Robert Smith's earlier tour de force in stone, Nassau Hall at Princeton (see Henry Dawkins's view of about 1763, Stokes and Haskell, *Early Views,* illus. pl. 19), which was conceived also to house numbers of people in single units in decent comfort. But Nassau Hall's rooms are hardly cells and all are above ground, while the jail has two stories, with a deep basement level for additional cells. Where Nassau Hall has a five-bay central projection, the jail has a three-bay central unit; but each has a triangular pediment capping the projection, with a window in the triangle, and each is crowned with a cupola of similar design, the one at the jail appearing larger in proportion to the facade, perhaps so that it could be seen over the wall. There is no evidence that the jail's cupola served as a lookout tower.

There may have been a consensus of managers and architect about the facilities to be built into the structure, but the facade was probably all by Smith. It is very close to William Adam's design for an Orphans Hospital in Edinburgh published in *Vitruvius Scoticus* (pl. 146), where a three-bay central projection is flanked by five-bay horizontal wings, which in turn have three-bay wings meeting at right angles. Quoining delineates the edges of the three projecting sections at Edinburgh, while at the jail Smith used plain raised pilasters without the details of capitals or base. Crowned with a shallow domed cupola, and entered by stone steps through a rusticated doorway, the jail has a clearly defined central and single axis, in this case quite different from Smith's Nassau Hall, where three doorways were featured on the facade.

The construction of the jail was notable for Smith's use of stone groin vaults (indicated on the plan by dotted diagonal lines) to support tile floors and stone construction on upper levels, making it the most fireproof building Philadelphia had produced to that time. Benjamin Franklin and Samuel Rhoads had corresponded

Vagrant women and "women of bad character" were housed on the second story of this section.

Men prisoners accused and committed for trial, vagrants, and runaway servants were employed in the east wing (c). Their bath (19) was located just outside their yard (18) to be accessible to the Penitentiary House, or solitary cells (D). Set off slightly from contact with less depraved criminals, the serious offenders were in solitary, a 40 by 25 foot

brick building with two floors of eight cells each. Doors locked and bolted at the top of each stairway, and the cells had padlocks securing bars running through staples down to the floor. Each cell had one high window, but there were no beds or tables; in the corner of each was a leaden pipe privy, which was "flushed" by a roof cistern filled by a pump from the cellar well.

In 1795 the workshops (E) were erected on the ground behind the original jail and

several years earlier at great length about fireproof buildings, and the details of some of this correspondence may have inspired Smith to put French practice into use in Philadelphia: "In some of the Paris Buildings the Floors are thus formed. The Joists are large and square, & laid with two of their Corners up and down, whereby their sloping Sides afford Butments for intermediate Arches of Brick. Over the whole is laid an Inch or two of Loom, and on that the Tiles of the Floor, which are often six-square, & painted" (Franklin to Rhoads, February 10, 1771, "Unpublished Letters of Benjamin Franklin," *PMHB,* vol. 15, no. 1, 1891, p. 39). Brick arches were then used in Philadelphia house construction where chimney stacks were supported through the middle of the building, and at Mount Pleasant (in Fairmount Park), Smith's masons used the arch at the base of the compound chimney set into the north end. But it was unusual to support floors and interior partitions in that manner, although it was common in northern English construction where masonry rather than wood was the primary material at all floor levels.

The building of the jail was a city event, and Elizabeth Drinker watched its progress on her regular "rounds": "Took a walk this afternoon to the new Prison: workmen very busy there—walk'd in ye Negro's Burying Ground, and went in to J. Dickinson's new House, came home to Coffee" (HSP, Elizabeth Drinker, Diary, vol. 1, October 7, 1774). Jacob Hiltzheimer noted on September 10, 1774: "Took supper at the new gaol, opposite the State house yard—a part of the gaol was raised to-day. Joseph Fox and Edward Duffield, of the managers, gave the workmen a supper, and afterwards they asked a few of their friends to the north-east corner room, where something was provided for them separately: William Fisher, Mayor; Thomas Lawrence, Senʳ; Reynold Keen; Robert Smith; James Pearson; Judah Foulke; William Jones; William Gray, and myself" ("Extracts from the Diary of Jacob Hiltzheimer, of Philadelphia, 1768–1798," *PMHB,* vol. 16, no. 1, 1892, p. 97).

The Walnut Street Jail received a good deal of notice in Europe, and America's penal system was the object of several exploratory trips, including de Tocqueville's. Jacques-Gérard Milbert, a French artist, wrote: "Philadelphia has three prisons: the state prison, debtors' prison, and the penitentiary. Although all are clean and well run, the Walnut Street penitentiary is the best example of the system of moral improvement that Europe is apparently ready to try at last" (Constance D. Sherman, ed., "A French Artist Describes Philadelphia," *PMHB,* vol. 82, no. 2, April 1958, p. 211).

The most festive and pleasant occasion held within the confines of the jail must have been Jean-Pierre Blanchard's balloon ascension from the yard on Wednesday, January 9, 1793. Dressed in a plain blue suit and wearing a "cock'd" hat with white feathers, his blue and spangled boat lifted by a yellow-colored silk and netted balloon, he was applauded by President Washington along with a crowd who had paid admission to witness the feat (*American Daily Advertiser,* January 10, 1793).

BG □

JOSHUA FISHER (1707–1783)

Joshua Fisher was born near Lewes, Delaware, the fourth child of Thomas Fisher and Margery Maud. Family tradition suggests that he was largely self-taught in "elegant letters," as well as mathematics and surveying, accomplishments not uncommon for one living among the Delaware River pilots at Lewes (Smith, *Fisher Family,* p. 23). Fisher spent his early years as a hatter and Indian trader in Lewes. His trade goods came from Philadelphia where he found a market for his pelts. At twenty-six he married Sarah Rowland who bore him six children who survived infancy. Fisher apparently achieved some prominence in Sussex: he became coroner for the County and deputy-surveyor for the Lower Counties.

It was probably during the 1730s that Fisher began his surveys of the Delaware with the assistance of his brother-in-law, Samuel Rowland, a river pilot (Smith, *Fisher Family,* p. 24). Some early writers credit Fisher with being the first to test Thomas Godfrey's mariner's quadrant (Smith, *Fisher Family,* p. 27). Like Fisher, Godfrey was a self-trained philomath who enjoyed a considerable reputation in Philadelphia. Their collaboration suggests that Fisher had developed connections in the city before he decided to move there in 1746.

Once in Philadelphia, Fisher devoted himself to making a secure place for his family. By 1753 his firm, Joshua Fisher & Sons, was well established in new quarters on South Front Street. The following year he turned his attention once again to the charting of the Delaware. Richard Peters and Thomas Penn, who had been so helpful to Lewis Evans (see biography preceding no. 49), were both aware of and encouraged Fisher's efforts. In 1755 Penn asked that six copies of the new chart engraved by James Turner (see biography preceding no. 49) be sent to him in England. But, in 1756, when the chart was finally ready, Governor Robert Hunter Morris ordered that Fisher

delay distribution because of the "daily expectation of a French War" (Wroth, "Fisher's Chart," p. 96).

But the chart had already been published: copies had been dispatched to England, and Benjamin Franklin had bought four copies for his own use. Yet surprisingly few copies of the first edition survive. Fisher may voluntarily have suppressed it; such would have been consistent with his later political behavior. In 1763, Fisher signed a welcoming memorial to John Penn and, two years later, although a Quaker, Fisher supported the Non-Importation Agreement for which he collected signatures. In short, Fisher had completely identified with the city's mercantile establishment.

Sometime in the 1770s, Fisher evidently resolved to reissue his chart, this time improved by the addition of the course of the Delaware from Reedy's Island (below New Castle) to the docks at Philadelphia. Surprisingly, Fisher family histories provide scant information about this effort, and Lawrence C. Wroth, the most careful student of Fisher to date, acknowledges some doubt about Fisher's superintendence of the edition, although the engraving of the chart is commonly attributed to Henry Dawkins (see biography preceding no. 59). However, the presence of this watercolor copy of the second edition (Historical Society of Pennsylvania) argues strongly for Fisher's authorship: the cartouche on this copy replaces the Penn family arms with four fishes.

The Revolution brought an end to Fisher's productive career. Although allied with the city's mercantile elite (two of his children had married into the Logan and Gilpin families), Fisher attempted a Quaker-like neutrality during the war. The Committee on Safety confiscated his property, subjected him to house arrest, and exiled several of his sons to Winchester, Virginia. Fisher died in February 1783 just before the Treaty of Paris was signed.

The importance of Fisher's work seems to have been more clearly recognized by English mapsellers than by his family or by his fellow Philadelphians. In London both Faden and Dury pirated the chart in 1776. Sayer and Bennett followed in 1777, a remarkable tribute to this self-educated merchant whose only published map was his *Chart of Delaware Bay.*

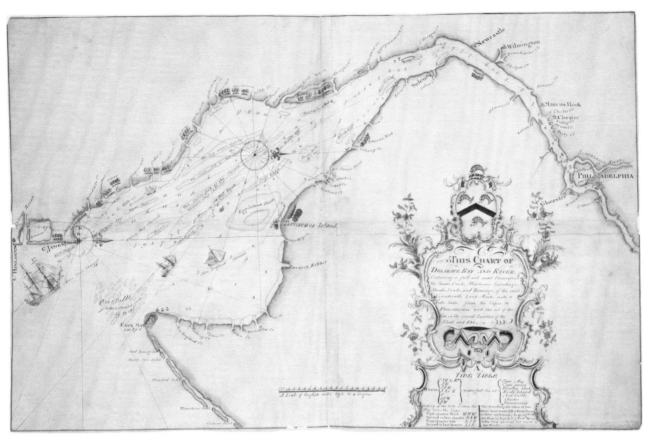

99.

99. *Chart of Delaware Bay*

c. 1774

Inscription: THIS CHART OF/DELAWARE
BAY AND RIVER,/*Containing a full and
exact Desscription of/the Shores, Creeks,
Harbours, Soundings,/Shoals, Sands, and
Bearings, of the most/Considerable
Land-Marks with a Tide-Table, from the
Capes to /*PHILADELPHIA *and the set of the/
Tide on the several Quarters of the/
Flood and Ebb.*

Ink and watercolor on laid paper, lined
with Japanese mulberry tissue
17³⁄₁₆ x 27⅛″ (43.7 x 68.9 cm)

Historical Society of Pennsylvania,
Philadelphia

LITERATURE: Wroth, "Fisher's Chart"

THIS WATERCOLOR COPY of the second edition
of Fisher's chart of the Delaware shows the
course of the Delaware from slightly above
Philadelphia to Cape May and Cape Hen-
lopen. Like the Blaeu South River chart
(no. 1), it is oriented with west at the top;
the river flows from right to left. The chart
shows the mouths of most of the creeks

entering the river as well as the shoals and
sandbars that continue to make navigation
difficult today. Several compass roses and a
series of soundings both inside and out of
the three charted channels attest to the
utility of the original.

The chart is clearly not the engraver's
copy. Engravers frequently traced what they
had to transfer to a copperplate, leaving
either pinpricks or deepened impressions on
the lines of the original. There is no evidence
of either having been done although,
admittedly, this version has been subjected to
some conservation work. The chart presents
another puzzle as well: the cartouche in the
lower right, with its three fishes, is sup-
posedly a punning reference to Joshua
Fisher, its creator, but this is not the device
used by Fisher and his sons on their business
seal. That seal shows two birds, possibly
kingfishers, one above the other (Wroth,
"Fisher's Chart," p. 105; HSP, Stauffer
Collection, Folio 563). Yet a comparison of
the watercolor with the manuscript draft of
the first edition (Historical Society of
Pennsylvania) shows marked similarity in
both drafting and lettering techniques,
suggesting that this may well be Fisher's
own copy prepared at the same time the

engraver's draft of the second edition was
being readied.

Fisher began collecting materials for the
first edition of his chart fully forty years
before this watercolor was prepared. He
then lived in Lewes where he had been "eye
witness of many vessels and cargoes lost, &
people sometimes with them, for want of
knowledge, in the Bay" (Wroth, "Fisher's
Chart," p. 96). The first edition, suppressed
by Governor Morris in 1756, brought
mariners upriver as far as Reedy's Island
where most of the shoals end and the river
narrows. Considering the importance of
eighteenth century Philadelphia as a port,
it is hard to believe that Delaware Bay had
received such scant cartographical attention
before Fisher. Until 1756, English and
American sailing masters had only *Virginia,
Maryland, Pennsylvania, East & West
Jersey* in the 1706 edition of the *English
Pilot* (Wroth, "Fisher's Chart," p. 92). And,
because of Governor Morris's actions, they
would have to wait another twenty years
for Fisher's chart.

How Fisher collected data for the improve-
ments in the second edition may never be
known. But certain errors of the first had
to be corrected. The scale of 69 English

100.

100. *Riding Cape*

c. 1774

Green-brown-and-tan plaid wool, with green velvet collar; lined in light-brown wool

Center back length 49″ (124.4 cm)

Philadelphia Museum of Art. Given by Mrs. Richard Wood. 72–118–1

PROVENANCE: Captain Samuel Morris (1734–1812); descended in family to great-great-granddaughter, Nancy (Morris) Wood

RIDING CAPES were a necessary and vital accessory in the eighteenth century. Unprotected from the elements, a rider needed the warmth and water-resistant qualities of a wool cape. A slit up the back seam allowed the cape to part, draping on either side of the horse when the rider was astride, while the short shoulder cape gave added protection.

This cape is said to have been worn during the Revolutionary period by Captain Samuel Morris, a skilled horseman and sports enthusiast, first president of the Gloucester Fox Hunting Club and one of the founders of the First Troop, Philadelphia City Cavalry (see no. 126). Because of his affiliation with this organization and his later taking up the sword against England in defense of the Colonies, Samuel Morris was disowned by the Society of Friends and read out of Meeting. However, he continued to wear Quaker dress, speak plain language, and worship as a Friend.

CJ □

BENJAMIN RANDOLPH (1721–1791) AND HERCULES COURTENAY (1744?–1784) (See biographies preceding no. 89)

101. *Tea Table*

1774

Mahogany; cherry and pine

29½ x 25¾ x 17½″ (74.9 x 65.4 x 44.5 cm)

Philadelphia Museum of Art. Given by H. Richard Dietrich, Jr. 74–223–1

PROVENANCE: Vincent Lockerman (d. 1785); Elizabeth (Lockerman) Bradford (m. 1805); Thomas Budd Bradford (d. 1871); William Bradford (b. 1894)

SMALL AND ELEGANT in scale and detail, this table represents the best of Philadelphia's furniture-making enterprise. It stands well, but lightly, on its claw and ball feet, and its long, attenuated legs flow into the flared

apron with no visual interruption. Rhythms of carved foliage repeat the freedom achieved by the scrolls framing the edge of the skirt, and although there is a center of interest—a ruffled scroll—the effect is smooth, light, and intriguing. Flowers at the corners effectively soften the transition between the carved frame and the plain tray pedestal.

The carving of this table has much in common with that of the easy chair (no. 89) and the Cadwalader card tables (no. 91) and likewise should be ascribed to Hercules Courtenay. The flared apron, its most conspicuous ornament, is carved with scrolls set against a punchwork background, unusual in Philadelphia carving (a similar effect is achieved by the diaper pattern on the flared skirt of the easy chair). The high curves outlined with scrolls which meet "against" each other, breaking a smooth horizontal, and the central motifs— a mask on the chair, an abstract flower on the table—are framed by foliate scrolls. There is a balance of motif and an expertise in the handling of the deep skirts on both pieces which give them a close, if not precise, relationship. But where the technique gave the easy-chair carving organization and strength, here the effect is light, even dainty. This variety of surface decoration was typical of the school of the English joiner-carver Giles Grendey, which also featured the hairy paw foot.

The cabriole legs are merely extended chair legs, with a strong curve inward at the ankle, like those of the easy chair, exploiting the strength of the wood to its structural limits. Most Philadelphia tables have a straighter, less elegant, cabriole leg, or the foot splays out beyond the profile of the knee, to complete the curve (see Hornor, pls. 234–35). The feet also are strong and sculptural, a feature of Courtenay's skills, and fully support the table, although they do not project beyond the profile of the tray top.

In November 1774, Vincent Lockerman did some shopping at the "Sign of the Golden Eagle" on Chestnut Street. Benjamin Randolph's Receipt Book for December 3, 1774 (Winterthur Museum), notes that Randolph paid £15 to William Martin, upholsterer, for Lockerman's account, which was active in 1774. His total purchases, summarized by "to stock" in Randolph's Account Book, amounted to £38 8s., which would have covered the cost of a set of chairs and this small table (NYPL, Philadelphia Merchant's Account Book, 1768–86).

According to the 1785 inventory of the house of Vincent Lockerman in Dover, Delaware, this table stood in the parlor, which was fitted out with the following: "1 Large looking glass with gilted fraim, 2 large Mahogany Dining Tables, 1 mahogany china table, 6 mahogany chairs, with damask

nautical miles to a degree was altered to 69½ miles. Several place names were changed. Yet Fisher refused to move Cape Henlopen to its actual position. Instead, he adhered to a more southerly position which, by royal order of 1685, would have given more Delaware lands to the Penns in their seemingly never-ending boundary disputes with the Baltimores. Lewis Evans, in his 1755 *Map of the Middle British Colonies* (no. 49), had drawn the actual site of Cape Henlopen, but Fisher persisted in both editions in padding Penn's territorial claims. Fisher even noted on the first edition that he had "located" the cape with the help of Thomas Godfrey and his quadrant. One can only conclude that Fisher served his constituency well (Wroth, "Fisher's Chart," pp. 101–4).

The Historical Society's watercolor is an exact if slightly smaller copy of the engraved second edition. It may derive from the same source as the engraving. Only in the cartouche and ornamentation do significant differences appear, although the handwriting is undeniably Fisher's. The ornamental swags on the edges of the cartouche lack the linear precision that an engraver's copy might have. There is, instead, more attention to texture than to line. There is also a puzzling awkwardness to the decorations below the text in the cartouche. Despite the lack of Fisher's signature on the watercolor, the work is most probably his own—a record copy of his one major effort at cartography.

PJP □

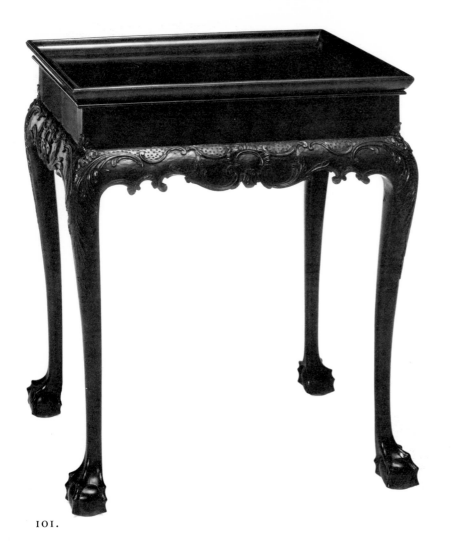

101.

bottoms, 1 ditto arm ditto, 1 mahogany tea table, 1 pair brass andirons and brass shovel and tongs, 2 tea boards, 2 window cushings." There were also two "beaufet" (built-in cupboards) in the parlor which contained complete tea equipment, glasses of all sizes and types, and a one gallon china punch bowl (Dover, Delaware State Archives, Wills and Inventories, September 13, 1785). Presumably this small table, which, finished on three sides, does not follow the precise definition of a tea table although it has usually been so called, stood between two deep windows fitted with upholstered seats and was pulled out when in use, the deep tray top covered with a padded cloth to fit. The parlor was the most handsomely furnished room on the first floor; the other spaces, an entry and a "hall," contained walnut furniture and other miscellaneous furnishings suggesting hard use rather than fine entertainment.

Vincent Lockerman's grandparents came to America from Holland in 1639, settling in New York. Vincent established himself in Dover; however, he and his son Vincent, Jr., were active in affairs in Philadelphia and spent some business time there. They were both signers of the Non-Importation Agreement in 1765; Vincent's granddaughter, Elizabeth, married Thomas Bradford of Philadelphia in 1805, and the table descended in the family, who continued to live in the original Lockerman house.

BG □

RICHARD HUMPHREYS (1750–1832)

Thomas Humphreys, father of the silversmith, was a founding member of the Friends Meeting established on the island of Tortola in 1741. Thomas's marriage to Rebecca Bishop, daughter of Townsend Bishop, was the first one recorded in the Meeting Minutes and was witnessed by Thomas Chalkley, revered Quaker minister visiting from Philadelphia. Chalkley succumbed to the prevalent fevers shortly

thereafter, as did Rebecca Humphreys, in 1743. Thomas married a second time to Sarah Lake in 1744, and five children were born to them: Hannah (1745), Sarah (died in infancy), Thomas (1748/49), Richard (1750), and Sarah (1753). In 1754, Thomas Humphreys took a trip to America for his health and visited Meetings as far as Flushing, New York (Charles F. Jenkins, *Tortola*, London, 1923, p. 62). There were no certificates of removal issued to him from intermediate stops he may have made at Delaware or Philadelphia, but he had extensive contacts and may have made some apprenticeship arrangements for his two sons at that time.

The Humphreys were a distinguished Tortola family, close friends of Governor John Pickering, and a family typical of the one hundred British subjects living there. As Quakers, many were self-conscious about their plantations being cultivated by slave labor. The Meeting, decimated by sickness, was finally closed in 1762, and the last letter to the London Meeting was sent in 1763 from Thomas Humphreys and John Pickering. At this time numbers of Friends freed their slaves.

Just when Thomas and Sarah Humphreys died is unknown, but John Pickering, as Humphrey's closest friend, probably made the final apprenticeship arrangements for Richard and Thomas. The latter became a tanner, married Sarah Clark in 1774, and settled in Abington, Philadelphia County, until his death in 1800 (HSP, GS, Philadelphia Monthly Meeting Records, Births and Burials, p. 149). Richard went to relatives in Wilmington, and his life became inextricably tied in with the community of Elliotts and Humphreys active in the George's Creek and Duck Creek Meetings of the Society of Friends from the beginning of the eighteenth century. Richard Humphreys was clearly not one of the contemporary Welsh Humphreys who were prominent in the shipbuilding and lumber business in Philadelphia, but belonged to the Delaware-Tortola Humphreys descended from Thomas.

Richard Humphreys does not appear in Philadelphia records until his marriage to Hannah Elliott in 1771 when his "removal" from Wilmington "to m[arry] Hannah d[aughter] of John Elliot" in Philadelphia was recorded (HSP, GS, Arch Street Meeting, Certificates of Removal, no. 1996). Then, after their marriage, Hannah presented a certificate of removal from Philadelphia to the Wilmington Monthly Meeting, dated April 26, 1771. The Humphreys remained in Wilmington, attending the wedding of John Elliott, Jr., to Margaret Harvey, the same year. Richard Humphreys's apprenticeship must have been just completed before he married in 1771.

It has been generally assumed that Richard apprenticed with Philip Syng, Jr. (see biography preceding no. 25), in Philadelphia, as he took over Syng's business in 1772 (*Pennsylvania Packet,* August 24, 1772). However, Syng was not a Friend and it is highly unlikely that his shop would have been selected over Joseph Richardson's (see biography preceding no. 35) by Friends placing an orphan, yet there is no indication in the extensive Richardson records that Humphreys had any early associations with Richardson's shop directly or indirectly through Syng.

A William Young had married Joanna Humphreys in Philadelphia in 1723 (HSP, GS, Christ Church, Marriages, 1709–1850, p. 4046); and if the William Young, silversmith, who completed his apprenticeship with Joseph Richardson in 1759 (Fales, *Joseph Richardson,* p. 226) was their son, a family association rather than a Society of Friends relationship may have offered Richard a Philadelphia apprenticeship with Young. Otherwise, he must have been placed with either Bancroft Woodcock, goldsmith, in Wilmington, active from 1754 to 1772 (J. Hall Pleasants and Howard Sill, *Maryland Silversmiths 1715–1830,* Baltimore, 1930, p. 242), or William Faris, who had first settled in Wilmington in 1750 before training in Philadelphia, finally settling in Annapolis in 1754 (R. J. Dickson, *Ulster Emigration to Colonial America 1718–1775,* London, 1966, p. 129).

The earliest known piece of silver by Richard Humphreys may have been made while he was still in Wilmington for Annabella Elliott, sister to his wife Hannah, who married Caleb Cresson there in 1772 (MFA, *Silversmiths,* pl. 121). It was a smooth, plain tea caddy with an old-fashioned engraved cartouche enclosing a reverse cipher which exhibits Humphreys's cautious skill. That he was in business at this time is confirmed by advertisements in the *Pennsylvania Journal* on November 7, 14, and 21, 1771, placed by William Young for "Fresh Quantities of Dr. Hill's American Balsam to be sold by William Sitgreaves merchant in Philadelphia, Christopher Sour [*sic*] at Quakertown, and Richard Humphreys at Wilmington."

Closely related to the Elliott family of looking glass craftsmen and cabinetmakers in Philadelphia, Humphreys had good reason to move from Wilmington to Philadelphia, and he established himself in a house and shop rented from Philip Syng in 1772 on the west side of Front Street. He was barely settled in Philadelphia when his wife Hannah, aged twenty-one, died, "the 2nd mo. 17th 1773" (HSP, GS, Philadelphia Monthly Meeting Records, Births and Burials, p. 455). Humphreys did not purchase a residence in the city until

1785, although he had invested in smaller income-producing properties.

In May 1774, Humphreys married Ann, daughter of Daniel Morris of Upper Dublin Township (HSP, GS, Philadelphia Monthly Meeting, Certificates of Removal, 1687–1758, no. 652). They had five children living in 1794: Hannah, Tacy, Thomas, Richard, and Ann. Thomas carried on as a silversmith from 1809 to 1814, but predeceased his father. Hannah married James Cresson, who visited Tortola in 1786/87 in an effort to straighten out further family affairs there. No records emerged to suggest that Richard Humphreys returned to Tortola as an adult. His older brother, Thomas, visited the island in 1770 after his Philadelphia apprenticeship, also presumably on family business, and his return certificate, signed at the Tortola Meeting, carried only five names (HSP, GS, Arch Street Meeting, Certificates of Removal, 1758–72, no. 1954), indicating further dissolution of Quaker Meetings and business transacted on the island.

Humphreys's removal certificate from Wilmington to Philadelphia, dated "8th mo. 11th 1773" (HSP, GS, Wilmington Monthly Meeting Records, p. 125), states that he was "satisfactory in all respects except that of selling negroes." This may refer to the settling of his father's Tortola plantation estate, or that his Wilmington enterprise was considerable enough to employ slaves. William Jarvis had a skilled Negro silversmith, and others were known, especially in the Southern Colonies.

Humphreys makes no later note of his early business organization, nor of his Tortola inheritance, but the extensive philanthropy in his will put into practice what the Friends preached. His estate was valued at $108,998.50 when inventoried. The house furnishings were routine and included 13 mahogany chairs, 3 walnut bureaus, a looking glass, a bedstead, a small stove, desk bookcase, sofa, and 107 ounces of silver plate. Most of his wealth was in stocks and notes, from which he willed $10,000 to be placed "in trust to the Benevolent Society or Institution by whatever name it shall then be or hereafter shall be established having for its object the benevolent designs of instructing the descendants of the African Race in school learning, in the various branches of the mechanical arts and trades, and in agriculture in order to prepare and fit and qualify them to act as Teachers . . . the said Institution to be located not far distant from the City of Philadelphia and to be under the care, management and control of such persons only as are or may be members of the Yearly Meeting of the Religious Society of Friends." The Humphreys Foundation, established as an institute for Negro youth in 1837, was transferred to Cheyney State

College in 1902 (*Friends' Journal,* vol. 8, no. 7, April 15, 1962, pp. 170–82).

In 1776, Humphreys risked censure from the Friends Meeting by joining the military. He was "disowned" for it, but was reinstated in 1783 when he "attended with a paper acknowledging his violation of our Christian testimony in divers respects" (HSP, GS, Philadelphia Monthly Meeting, Minutes, vol. 3, 1730–85, p. 583). In 1781 he moved from Syng's house to Front Street near the Drawbridge at "The Sign of the Coffee Pot" next door to the Honorable Robert Morris (*Pennsylvania Gazette,* October 31, 1781). About this time, he became a member of the Gloucester Fox Hunting Club. In 1784 he was a trustee of the Mutual Assurance Company, and his investment properties on Sixth Street between Mulberry and High streets were insured by them. He had transferred his membership from the Philadelphia Monthly Meeting to the Southern District Meeting, perhaps to avoid the post-Revolutionary conflicts with the Philadelphia Meeting over "war veterans," which resulted in the building of the Free Quaker Meeting House at Fifth and Arch streets.

In 1785, Humphreys was listed as a goldsmith between Second and Third on Market (High) Street, and from 1791 to 1797, at 54 High Street. From 1793 he called himself a silversmith and crockery merchant, moving his shop again in 1798 to 227 High Street, probably his 1785 location. His residence at this time was 32 Sansom Street from which he was buried in 1832, aged eighty-two. His obituary reads, in part, "seventh day, second month 11, 1832. Died, on the evening of the 5th inst . . . Richard Humphreys, for many years a much respected citizen of Philadelphia, and a worthy member and elder in the Society of Friends" (*The Friend,* vol. 5, no. 18).

102. *Urn*

1774
Mark: R. HUMPHREYS (script in conforming rectangle on lid and base, twice on bezel)
Inscription: *the* Conti^l Congress/TO/ *Cha^s Thomson*/Secr^y *in Testimony/of their Esteem and/Approbation/1774/ Smither Sculp* (in foliate cartouche); NIL DESPERANDUM (on scroll below)
Silver
Height 21½" (54.6 cm)
David Beckwith Taylor, Jr., Leland, Mississippi

PROVENANCE: Charles Thomson; wife, Mary (d. 1831); John Thomson; Joseph Chamberlain; Charles Thomson Chamberlain; David Beckwith Taylor

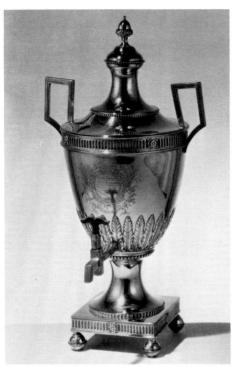

102.

LITERATURE: Hood, *American Silver*, pl. 174, p. 162; PMA, *Silver*, no. 179 (illus.).

WHEN, IN 1773, Captain Ayres complied with the demands of the citizens' committee and sailed away from Philadelphia with his full cargo of tea on the ship *Polly,* a possibly incendiary incident "fizzled." Although not the specific occasion for the presentation of this urn, it is curious that the Continental Congress—or was it the silversmith Richard Humphreys whom they commissioned?—chose a *tea* urn as the form of the presentation piece for Secretary Charles Thomson.

Richard Humphreys was established in Philadelphia in 1772, and this urn must have been among his most important early commissions as well as the most innovative design of his career. Like Joseph Richardson's tea kettle made for Clement Plumstead, this urn stands as Richard Humphreys's major work. Both vessels were designed for serving hot water at an elegant tea table: the Richardson piece employed a base burner; the Humphreys, an iron rod which was heated on the stove and inserted into a supporting collar on the inside.

This urn is the first object of neoclassical design manufactured in the Colonies. The Adam brothers in England, who had developed the spare forms embellished with applied ornament, were still exploring the new style in the architectural medium. There was no time lag in the creation of this piece. It is probably based directly on an English prototype, perhaps one imported by Humphreys, between 1772, when he set

up his shop, and the tea embargo in 1773. The strong possibility also exists that one of the members of the Continental Congress, Joseph Galloway or Edward Biddle, the Pennsylvania delegates on the Committee on Rights, dealt with Humphreys and ordered the urn based on London's latest fashion. Newspaper advertisements placed later by Humphreys indicate that he kept up with the latest styles in London, and in substantial items, not the miscellany more frequently advertised by silversmiths.

Robert Adam's drawing for the Richmond Race Cup made by Daniel Smith and Robert Sharp in silver gilt in 1770 is a much more elaborate piece, but it has several features in common with this urn. Both have a narrow band of fluting at the base level, Humphreys's punctuated in the middle of each side with an encircled rosette motif, Adam's with the rosette at the corners. Both have a stylized leaf pattern around the base of the body of the urn; the Adam piece has two such bands, one with a freer pattern. Both pieces are divided by horizontal divisions and applied ornamental bandings.

A cup and cover by Louisa Courtauld and George Cowles made in 1771 has the above features plus the acorn finial, a rare knop in Philadelphia silver (Robert Rowe, *Adam Silver 1765–1795,* New York, 1965, pls. 7, 19). And a hot water jug by London maker John Carter has similar leaf ornament, beading at the shoulder, and stands on a circular base which rests on a square plinth raised on four ball feet. It too has square-profile handles. A covered cup by William Cripps (1774–75) shows the same fluted banding and beading at the base of the body (Charles Oman, *English Silversmiths' Work,* London, 1965, pls. 155, 161).

The "crook'd" handles are most like those found on pitchers, and only the earliest neoclassical examples show this type of shoulder attachment. It is the one feature in Humphreys's design which appears physically and aesthetically out of scale within his scheme. The rectangular profile of the spout affords some balance, but English urns of this size had large looped handles, one end attached at the shoulder, the other at the base of the leaf design, adding to a graceful, linear symmetry. With the exception of the foliate cartouche engraved by James Smither typical of fine Philadelphia midcentury work in the rococo vocabulary still in use in 1774 this urn is about fifteen years ahead of its time in Philadelphia. It must have been talked about when it was presented to Thomson and, despite the Revolution, it is surprising that more pieces from the 1770s with this early type of neoclassical ornament have not turned up. Humphreys did make a small crude chatelaine hook in the shape of an urn with the monogram of his first wife, HH, engraved on it, which must pre-

date her death in 1774, but most of his superb design was in the familiar restrained rococo form (see no. 103).

Charles Thomson was born in 1729 at Maghera, Derry, Ireland, and came to America in 1739. By 1774 he knew every politician of rank in the Colonies, corresponded with many of them, and had their full trust and confidence. He, John Dickinson, Joseph Reed, Thomas Mifflin, Joseph Galloway, Robert Morris, and Benjamin Franklin were at the heart of the gathering Revolutionary storm; and Thomson, an unwavering devotee of independence, assumed his formal secretarial duties in the following manner as described by himself: "Sept. 1, 1774. I was married to my second wife [Hannah Harrison] on a Thursday; on the next Monday, I came to town to pay my respects to my wife's aunt and the family. Just as I alighted in Chestnut Street, the door keeper of Congress (then first met) accosted me with a message from the President requesting my presence. . . . I walked up the aisle, and standing opposite to the President, I bowed, and told him I waited his pleasure. He replied, 'Congress desire the favor of you, sir, to take their minutes.' I bowed in acquiescence and took my seat at the desk" (Harold D. Eberlein and Cortland Van Dyke Hubbard, *Portrait of a Colonial City, Philadelphia 1670–1838,* Philadelphia, 1939, p. 101).

Thomson may have been America's first intelligence chief as the person responsible for the "communications" of the Congress. His discretion was complete. The story is that he burned all his papers and records before his death. Relatively few have entered the public domain, and his action may explain why no notice or acknowledgment appears in Thomson's manuscript notes concerning the presentation of this urn from the Congress.

On Tuesday, October 25, 1774, Samuel Ward of the Committee on Rights entered into the record: "Met, appointed letters to be written to Georgia etc; made some resolves, ordered a piece of plate for the Secretary, £50 sterling" (Worthington C. Ford, ed., *Journals of the Continental Congress 1774–1789,* vol. 1: 1774, Washington, 1904, p. 104). In 1776 the Congress voted Thomson $200 to "be granted and paid out of the public treasury . . . in consideration of his faithful services for one year, ending the 10th day of May last" (Worthington C. Ford, ed., *Journals of the Continental Congress 1774–1789,* vol. 5: 1776, Washington, 1904, p. 442). Thus, the urn did not set a precedent but represents American design on the threshold of independence.

BG □

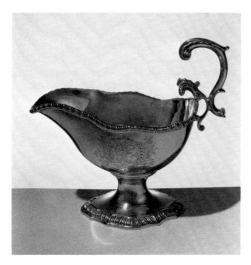

103a.

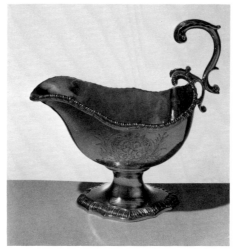

103b.

Height 8¾″ (22.2 cm); diameter base 4¾″ (12 cm)

Private Collection

PROVENANCE: George Emlen and Sarah (Fishbourne) Emlen; Joseph Mickle Fox and Hannah (Emlen) Fox; Samuel Mickle Fox and Mary Rodman (Fisher) Fox; Joseph Mickle Fox and Emily Ann (Read) Fox; William Logan Fox

RICHARD HUMPHREYS (1750–1832)
(See biography preceding no. 102)

103a, b. *Pair of Sauceboats*

1775
Mark: RH (in shaped rectangle, on bottom); R HUMPHREYS (in script, in conforming rectangle, bottom of each)
Inscription: GE (in shell and foliate cartouche, left side of each)
Silver
Height 6¾″ (17.1 cm)
Private Collection

PROVENANCE: George Emlen and Sarah (Fishbourne) Emlen; Joseph Mickle Fox and Hannah (Emlen) Fox; Samuel Mickle Fox and Mary Rodman (Fisher) Fox; Joseph Mickle Fox and Emily Ann (Read) Fox; Eliza (Fox) Tilghman

LITERATURE: Hood, *Silver,* p. 155; PMA, *Silver,* nos. 166, 167

103c, d. *Pair of Canns*

1775
Mark: R. HUMPHREYS (in script, in conforming rectangle bottom of each)
Inscription: GE (in shell on front of each, opposite handle); (c) 63997 (scratched on bottom); (d) 62834 (scratched on bottom)
Silver
Height 5″ (13.7 cm); diameter base 3⅝″ (9.2 cm), top 3⅜″ (8.5 cm)
Private Collection

PROVENANCE: George Emlen and Sarah (Fishbourne) Emlen; Joseph Mickle Fox and Hannah (Emlen) Fox; Samuel Mickle Fox and Mary Rodman (Fisher) Fox; Joseph Mickle Fox and Emily Ann (Read) Fox; William Logan Fox

103e. *Tankard*

1775
Mark: R HUMPHREYS (in script, in conforming rectangle on bottom)
Inscription: GE (in shell and foliate cartouche on front handle); oz/35 dwt/5 (scratched on bottom); George Emlen m. 1775 Sarah Fishbourne/Hannah Emlen m. 1820 Joseph Mickle Fox/Samuel Mickle Fox m. 1849 Mary Rodman Fisher/Joseph Mickle Fox m. 1883 Emily Ann Read (engraved on bottom)
Silver

THESE SAUCEBOATS are the most elegant known exhibiting the rococo form in American silver. Gadrooning is used lightly on the base as a surface ornament and is controlled by the subtle curves of the stand where it is framed by two smooth raised surfaces. The lip of the vessel is also edged with a gadrooned mold which changes direction as it moves over the curves and sweeps into the first handle. The finesse with which Humphreys made the compound handle and the asymmetrical balance which it introduces lifts the usually squat form of the sauceboat into the fanciful realm of the rococo.

The tankard and pair of canns are traditional forms, and their elegance and engraved ornament are combined with an expertise which matches that seen in the sauceboats. The thumbpiece of the tankard is especially lively version of the Philadelphia type, retaining a pre-rococo symmetry and formal order abandoned by the engraver. The quality of the engraving on the tankard is such

103c.

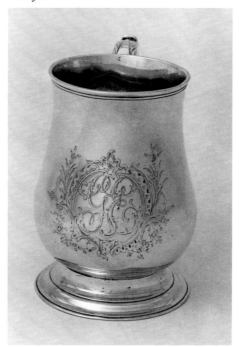

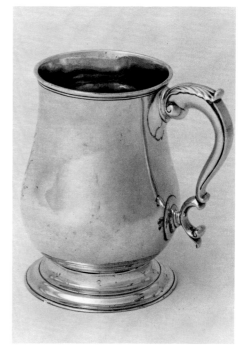

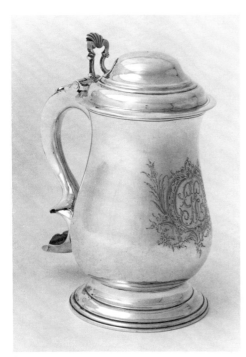

103e.

that it may have been the model for the other pieces. Its position is most successful, just above the belly, providing prominent ornament while enhancing the form. There are close similarities in graver's technique and in the cartouche design on this tankard and on the Thomson urn signed by James Smithers (no. 102).

George Emlens appear in Philadelphia from the seventeenth century to the present time. The early George Emlens commissioned and purchased elegant silver in unusual quantities and seemingly in sets from a single silversmith. George Emlen II (1695–1754) had purchased from Nys at the time of his marriage to Mary Heath in 1717, but in 1737/38, he purchased from Joseph Richardson, Sr., a double set of tea equipment, two teapots, waiters, sugar dishes, slop bowls, a milkpot, a spoon boat, a breakfast bowl, and a pair of tongs for a total of £69 (HSP, Joseph Richardson, Account Book, vol. 1, 1733–40). George Emlen IV (1741–1812) purchased these sauceboats, canns, and tankard as well as a matching pair of salts also by Humphreys (Philip H. Hammerslough collection) about the time of his marriage to Sarah Fishbourne in 1775. Engraved with his initials only, they may have been ordered before his marriage or with the intention that they should be inherited through the male line. As an expert craftsman not only was Humphreys an obvious choice for Emlen's patronage, but they were associated through the Society of Friends and both were board members of the Mutual Assurance Company, which owns

a handsome castor by Humphreys. The Emlen and Humphreys families were related by marriage, and Ann Morris Humphreys's home was not far from George Emlen's country place at Camp Hill in Whitemarsh.

Silver objects bearing Humphreys's mark suggest a strong apprenticeship, enhanced by a natural eye for design and proportion. The forms he made were all within the conservative Philadelphia vocabulary, except for the great presentation urn (no. 102). He had one recorded apprentice, John Myers, in 1772 ("Servants and Apprentices," p. 105), but his shop seems to have been very small compared to that of the Richardsons. The relative scarcity of Humphreys's pieces suggests that he mainly made special pieces to order and imported objects from London, such as "two very elegant chafing Dishes, of the newest fashion, the only ones of the kind that have ever been imported to this place and offered for sale" (*Pennsylvania Evening Post,* September 3, 1779).

BG □

104a. *High Chest*

c. 1775

Inscription: JAMES MILLIGAN 1783 (in script in silverpoint, on back of upper case); JAMES MILLIGAN 1784 (in script in chalk, within scrolled frame on back of upper case)

Mahogany; pine, poplar, and cedar; brass hardware
96¾ x 45½ x 24½″ (245.7 x 115.5 x 62.2 cm)

Philadelphia Museum of Art. Given by Mrs. Henry V. Greenough. 57–129–1

PROVENANCE: James Milligan (1739–1818); Samuel Milligan (1789–1854); Hannah (Morris) Milligan (n.d.) or brother, Samuel Milligan (n.d.); Herbert Marshall Howe (1844–1916); daughter, Amanda (Howe) Steel (Mrs. Henry V. Greenough)

LITERATURE: Moon, *Morris Family,* vol. 5, p. 199, illus. facing p. 198; David Stockwell, "Aesop's Fables on Philadelphia Furniture," *Antiques,* vol. 60, no. 6 (December 1951), pp. 522–25; F. K. W[ister] and H[orace] F. K. J[ayne, Jr.], "Exhibition of Furniture of the Chippendale Style," *PMA Bulletin,* vol. 19, no. 86 (May 1924), pp. 159–60, illus. cover

104b. *Dressing Table*

c. 1775

Mahogany; pine, poplar, and cedar; brass hardware (not illustrated)

29⅜ x 35 x 23¼″ (74.6 x 88.9 x 59 cm)
Private Collection

PROVENANCE: James Milligan (1739–1818); Eliza Davids (n.d.); with David Stockwell

LITERATURE: Hornor, pp. 103, 111, 118, pl. 118

TOTALLY DIFFERENT from the Affleck (no. 109) and Savery (no. 75) versions of the high chest of drawers, but employing all the decorative devices developed in mid-eighteenth century Philadelphia, this pair of case pieces, known familiarly as the "Fox and Grapes," referring to the tale in *Aesop's Fables,* is a tour de force in Philadelphia cabinetmaking. The high chest and its matching dressing table are formally plain in structure yet bold in ornamentation. Their scale is commanding, and their carved decoration is conceptually and technically the most sophisticated produced before the Revolution. Another set, known as the "Pompadour" (Metropolitan Museum of Art), also ornate and featuring thematic decoration on the lowest central drawer, is smaller in overall proportion, and the carving is in lower relief. The "Fox and Grapes" pieces are massive, and a close analysis of them shows that the relationship of the seemingly disparate decorative features complement and deliberately add to the effect of mass. These pieces reveal the limit to which the robust form could be carried without becoming gross.

Detail of Plate 21 from Thomas Johnson, One Hundred & Fifty Designs, 1761. Engraving. Courtesy the Metropolitan Museum of Art. Harris Brisbane Dick Fund, 1926

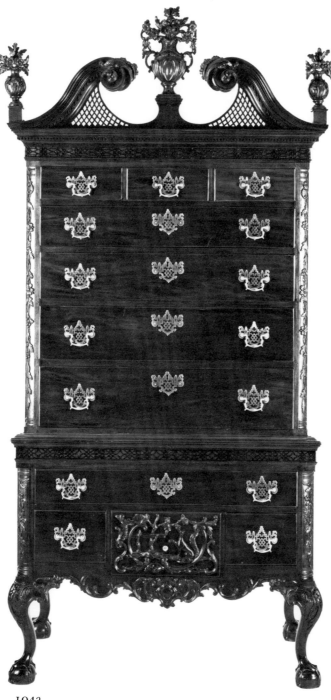

104a.

American carvers rarely exceeded the structural boundaries of the pieces they were working on. Here, too, although there was every opportunity to produce a more flamboyant design, the joiner's architectonic outline has determined the whole, and the carver's naturalistic fantasy appears under control. The legs on both pieces owe their wonderfully broad and secure stance to the S-curve which is pushed to its limit, with the necessary continuous vertical line barely encompassed from the knee into the foot. The flex at the ankle and the wide-spaced toes on the flattened ball are boldly modeled, and there is full support of the actual as well as the aesthetic mass of the case above. This design of the cabriole leg is most like the Randolph-Courtenay pieces, especially the easy chair (no. 89), but is quite different from the Randolph-Pollard handling of carved knees, where structural strength is de-emphasized. Most of this effect is in the shape, but here the stylized, crisply organized foliage on the knees repeats the sweeping curve of the leg and reinforces it. The broad, flattened outline of the carved leaf veins and stems which cap the knee shows a different hand at work than on the rounded, soft profiles characteristic of the rest of the case carving. As these elements were usually sent

out for special work, it is possible that more than one carver worked on these pieces. So, too, the quarter columns, which are separate units inserted into the joined sections, were probably also sent out to be carved. Instead of the more usual fluting on quarter columns, these are decorated with vines and flowers hanging in a garland from a ring. While this ornamentation conforms to the rounded contour, it blurs the crisp architectural outlines and gives the same effect as carved bead moldings at the edge of panels (see no. 84) or on the edges of tables (see no. 91). It ties up the scheme of carving which "frames" the joined case.

Compared to more typical examples (see no. 109), in which the upper and lower sections of the high chest have one centered ornamental drawer—usually a shell with flying foliage surrounding it—this ornate design is successful because the carved units are in scale with the parts they decorate and are related overall by their position, enframing a relatively plain although colorful series of horizontal drawers. And lest there is any aesthetic question about control, two bands of wide fretwork, each different, encircle the upper and lower sections, much like a belt course on a building. The profiles of the frets were very clearly delineated under accumulated layers of varnish and have been restored on the high chest and dressing table. Where two fretwork bands were used, as here, they were often different, but most case pieces had only one such band, at the top just under the pediment and frequently a part of it. Where the flower garlands at the corners created a rich softness, the crisp frets were designed in complementary but restrained curves in keeping with their purpose.

The pediment with its original finials is a separate unit. The curve of the void created by the pierced screen and the scrolled volutes is a subtle repetition of the long C-scroll which frames the fox on the carved drawer. It is quite different from the void on the chest-on-chest (no. 76) and the much higher reach and more vertically shaped void on the Affleck piece (no. 109). The carved twisting foliage which turns back into the scroll of the volutes originally flipped up and turned back toward the central finial. But, unlike the pattern for the fretwork which was possible to recreate exactly, there is no pattern for the finial plumage and thus it was not restored.

The finials are especially fine and complete, given their precarious perch. The plinths supporting the small urns appear original, their plainness matching the rather flat plinth supporting the central urn and flowers. Bits of the foliage on the central bouquet have broken off. There is no evidence that any part of the finials had been

gilded, although these elements on pier looking glasses would have been so finished. The flatness of these carved pieces suggests that they were created for the thin profile of a looking glass, a fact confirmed by the "dropped center" flower.

The design sources for the urns and their flowers and for the Aesop's fable scene on the lower drawer were from Thomas Johnson's *One Hundred and Fifty New Designs* (2d edition, London, 1761). Plate 42 in Johnson illustrates an urn with rounded shape accentuated by C-scroll profiles and ruffle-like fluting. The carved counterparts of the handles on the urn are harmonious, if brittle, appendages. The effect of asymmetry and visual interest is achieved by the carver in the loose, naturalistic organization of the flowers and foliage. This design of plant material bursting from narrow-necked vessels appears in several plates in Johnson. For example, the carved corner garlands which hang from a ring and taper to an elongated leaf form are like those seen in plate 25.

Plate 21 in Johnson (see illustration) served as the source for the carver of the central drawers on both pieces. Johnson's design was for a large, sectioned looking glass, where Aesop's "Fox and Grapes" fable is presented with some subtlety. The fox sits with his bushy tail flipped up, as it appears on the carved examples, but the grapes he is after are tempting and out of reach, being harvested by putti in the upper section of the looking glass. The Philadelphia carver has carefully placed the grapes at the top of the fox's nose, lest there be any mistake about the incident portrayed. The moral to the tale advises: "'Tis matter of skill and address, when a man cannot honestly compass what he would be at, to appear easy and indifferent upon all repulses and disappointments."

There was a fascination with *Aesop's Fables* among English and American craftsmen, and because the stories had a poignant punch line, a single panel or motif could summarize the action and suggest the outcome. They appeared on textiles; and suites of carved English furniture were upholstered with Fulham tapestries depicting various fables (H. H. Mulliner, *Decorative Arts in England 1660–1780*, London, c. 1924, fig. 187). Some copies of Chippendale's 1762 *Director* included Aesop-inspired designs, two of which were shown as textiles in pole screens. Philadelphia printers produced three different editions of *Aesop's Fables* in 1777, some of which were illustrated with wood engravings (David Stockwell, "Aesop's Fables on Philadelphia Furniture," *Antiques*, vol. 60, no. 6, December 1951, p. 523), but the design source for Philadelphia carvers was the more sophisticated English pattern books.

The carving of the mantel block in the Powel drawing room (Philadelphia Museum of Art) depicting Aesop's "A Dog and a Shadow" fable is generally accepted to be the work of Hercules Courtenay, whose bill for carving appears in Powel's accounts. It is similar to the carving on the drawers of these pieces, but has stronger, thicker curves and projects in higher relief. Whoever the carver, he had a fine sense of scale, as the scene on the dressing table is as handsome as that on the high chest while proportionately smaller in scale. The rolling, carved scrolls applied to the apron of both case pieces match the drawer carving in form and style.

The original owner of these pieces is unknown. James Milligan, whose name and the date 1783 are written on the back of the upper case section of the high chest, probably purchased both pieces from one of the many sales of confiscated property taking place in Philadelphia between 1781 and 1783. Elizabeth Drinker's Diary suggests that family provenance of Philadelphia objects was interrupted during and just after the Revolution. On June 15, 1779, "George Pickering came this afternoon for ye non-association fine . . . he took a looking-glass worth between 40 and 50 sh., 6 new fashion'd Pewter Plates and a 3 qt. pewter Bason." On September 14, 1779, she wrote, "This morning in meeting time (myself at home) Jacob Franks and a Son of Cling ye Vendue master came to seize for ye Continental Tax: they took from us one walnut Dining Table, one mahogany Tea-Table, 6 hansom [*sic*] walnut chairs, open backs crow feet and a shell on ye back and on each knee—a mahogany fram'd service looking glass, and two large pewter dishes, carried them off from ye Door in a Cart to Clings" (HSP, Elizabeth Drinker, Diary, vol. 2, 1779).

As comptroller of the United States Treasury from September 1782 to March 1783, James Milligan was responsible for continuing settlement of claims of citizens on the government. In 1780 he was auditor general, ordering country agents to bring in their local accounts for settlement (HSP, Griffith and Paschall Collection, letter to Col. Benjamin Flower, May 6, 1780). Thus, Milligan was in an advantageous position for purchasing. His name did not appear in Vendue Master Benjamin Fuller's Ledger, 1766–83, nor was it possible to determine what estates were sold just before 1783. Joseph Galloway's property was on the market at that time, but the accounts kept of his wife's estate (1782) did not itemize furniture sold. Milligan dealt with Robert Morris's "balance" in September 1783 (HSP, Stauffer Collection, vol. 6, p. 486), and this scale and elaboration would seem to suit what we know of Morris.

Milligan was born in Kirkudbright, Scotland, in 1739, the son of Quintin

Milligan. He emigrated about 1760 and became involved in the Indian trade near Pittsburgh. He returned to England and Scotland in 1770, but came back to Philadelphia before the Revolution. In June 1776 he was appointed quartermaster of the Third Battalion of Associates. In 1777 he was an ensign in the Seventh Pennsylvania Regiment (Moon, *Morris Family,* vol. 2, p. 450). On July 25, 1787, he married Martha Morris, daughter of Samuel and Hannah Cadwalader Morris. The latter died at the Milligan house in the same year; Samuel Morris had died in 1782. Milligan is listed in the 1793 Philadelphia city directory as "gentleman" at 131 South Second Street. He probably did not set up as elaborate a household as these pieces of furniture would indicate until after the Revolution, when he secured his government position. He must have been successful in his earlier Indian trade and accumulated some capital; his administration at his death in 1818 (City Hall, Register of Wills, Will no. 273, 1818) stated that his estate "did not exceed the value of $40,000." As his signature and the date on the high chest imply purchase or ownership four years before he married Martha Morris, the furniture probably does not carry Morris or Cadwalader provenance.

The Milligans had one son, Samuel (1789–1854), who married Ann Morris in 1820 and, after her death, Abigail Griswold in 1839. Samuel, a lawyer, retired from the city and died at "Knoll," near Phoenixville, in New Providence Township, the property of his uncle, Samuel C. Morris, where the furniture probably remained until the 1880s when the two pieces were separated in an as yet unidentified transaction.

BG □

JOHN NORMAN (C. 1748–1817)

The only records of Norman's career pertain to his activities in America. Norman came to Philadelphia in 1774 from London. Almost immediately he set up shop as an engraver, advertising as an "Architect and Landscape-Engraver" in the *Pennsylvania Journal,* May 11, 1774. Between 1774 and 1779, Norman formed several business liaisons, such as the firms Norman & Ward and Norman & Bedwell, producing engravings, dies, and children's books. About 1780 he moved to Boston, where he published the *Boston Magazine* in 1783 and a 1794 edition of Swan's *The British Architect.* There he died at the age of sixty-nine on June 8, 1817.

105.

JOHN NORMAN AFTER ABRAHAM SWAN

105. *The British Architect*

1775
Robert Bell, printer
Printed book, including 60 engraved plates, bound in one volume
Folio volume, 17¼ x 21¼" (43.8 x 54 cm) (open); plates 16¾ x 10" (42.5 x 25.4 cm)

The Franklin Institute, Philadelphia

PROVENANCE: John Lenthall (d. 1882)

LITERATURE: Fiske Kimball, *Domestic Architecture of the American Colonies and Early Republic* (New York, 1922), pp. 60, 123–24; Alexander J. Wall, "Books on Architecture Printed in America, 1775–1830," in *Bibliographical Essays: A Tribute to Wilberforce Eames* (Cambridge, Mass., 1924), pp. 299–311; Prime, *Arts and Crafts,* 2, pp. 19–26; Lawrence C. Roth, *The Colonial Printer* (Portland, Me., 1938), pp. 289–90; Fiske Kimball, "Gunston Hall," *JSAH,* vol. 13, no. 2 (May 1954), pp. 3–8; Charles B. Wood, III, "English and American Architectural Books," *Winterthur Portfolio 2* (1965), pp. 127–37; Helen Park, *A List of Architectural Books Available in America before the Revolution* (Los Angeles, 1973), pp. 71–72

THIS EDITION of Swan's *The British Architect* warrants recognition as the first architectural book published in America. The book was published by John Norman, a British engraver working in Philadelphia, who also executed the plates, which are copies in reverse of those issued in the original London edition of 1745. Less carefully drawn than their models, the designs for ornament are somewhat ambiguous in the degree of relief intended. The text is a straightforward transcription of that in the London edition.

Publication of the American edition was financed by subscription, and a list of the contributors was included in the volume. A similar endeavor was projected for the publication of an edition of Swan's *Designs in Architecture,* and an advertisement for subscribers appears in *The British Architect.* This project, however, was never realized.

The use of Swan's book in America far antedates Norman's edition of 1775. Abraham Swan, a British carpenter, brought out the original edition of his treatise thirty years earlier. The presence of the work in the Colonies is traceable to as early as 1760 (Helen Park, *A List of Architectural Books Available in America Before the Revolution,* Los Angeles, 1973, pp. 71–72).

English architectural books were valued because the apprentice system was relatively ineffective and provided little more than the rudiments of construction technique. There was also no distinct profession of architect as such in America—the design of buildings was the work of either the owner or the builder. A multitude of English carpentry manuals and pattern books of building designs flowed into the Colonies to provide models and instruction. The pattern books included plans and elevations. The manuals contained detailed instructions for basic joining and other technical procedures. Swan's treatise combined elements of both categories, including designs of the various orders and patterns for ornamental wood- and stucco-work, as well as practical instructions for execution of trussed roofs and several types of staircases.

In terms of style, *The British Architect* introduced the rococo into America. Its applications are intended for interior embellishment and decorative detail. Examples of the literal use of Swan's designs in several extant American houses built in the 1760s pinpoint the book's influence.

Curiously enough, when the Philadelphia edition was published, the rococo, or Georgian style, was soon to give way to the more strictly neoclassical Federal manner. The library of Thomas Jefferson, a principal exponent of the latter style, conspicuously lacked any of Swan's works among its numerous architectural books. Norman's 1775 edition and his later edition of 1794 did, however, serve to perpetuate the rococo canon of ornament in America well beyond the Revolution. The popularity and currency of the work are attested to by the list of subscribers, numbering 187, mainly house carpenters and master builders—a veritable congress of Colonial artisans.

BR □

1776-1826

106.

landscape in oils to survive after Bordley's death (Sellers, *Portraits and Miniatures,* p. 37) was a view from his house on Wye Island, a work which is now lost but which was mentioned by his daughter (Elizabeth Bordley Gibson, *Biographical Sketches of the Bordley Family,* Philadelphia, 1865, p. 152), with the statement that this "was his first and only experiment with the brush." But Bordley was painting in oils at least by 1772 (APS, Charles Willson Peale, Letterbook, vol. 1, p. 24), five years before his daughter was born. From her comment, it would appear that he gave up oil painting. In any event his total output must have been very limited.

This delightful landscape is, on the one hand, rare as an instance of a Peale-Bordley collaboration and, on the other hand, typical (as a copy after a famous English engraving) of an art form current in the Colonies.

DE □

JOHN BEALE BORDLEY (1727–1804)

Bordley was born in Annapolis and spent most of his life in Maryland, often wintering in Philadelphia. When he was ten years old, his schoolmaster in Chestertown, Maryland, was Charles Willson Peale's father. Having trained as a lawyer, Bordley became a judge of the Admiralty in 1767 and later a plantation farmer and an amateur artist. He retained his association with the Peale family, initiating the subscription to send Charles Willson Peale to London for study. He and Peale remained close lifelong friends. In 1791, Bordley moved to Philadelphia permanently.

106. *The Temple of Apollo*

1776
Oil on canvas
16½ x 23½" (41.9 x 59.7 cm)
Philadelphia Museum of Art. Given by Mr. and Mrs. William F. Machold.
75-125-1

PROVENANCE: Edward Shippen; Augusta Twiggs Shippen (West) Morris; daughter, Sarah A. (Morris) Machold

THIS LANDSCAPE is copied from William Woollett's engraving in reverse of Claude Lorrain's *Landscape with the Father of Psyche Sacrificing at the Milesian Temple*

of Apollo. Woollett's engraving, approximately the same size as Bordley's oil, was done in England in 1760. Bordley's painting follows it quite closely, even appearing to imitate the technique at times.

The mythological subject is taken from the *Metamorphoses* of Apuleius. This scene shows the king, Psyche's father, sacrificing before the altar of Apollo in order to obtain his aid in finding a husband for the beautiful Psyche. The shrine at the right contains a statue of Apollo, seated and holding a lyre.

Landscapes by the seventeenth century French artist Claude Lorrain were very popular at this time in England, and English taste set the fashion for the Colonies. But American exposure to English and European art was necessarily limited mainly to engraved copies, which were sometimes made by artists for self-instruction.

On July 29, 1776, Charles Willson Peale made the following entry in his leatherbound pocket diary: "Mr. Bordley came to my Room and began a Coppy of print for Claude Loraine" (APS, vol. 2). This notation most likely refers to Bordley's *Temple of Apollo,* done from a print which Peale may well have owned. Peale encouraged Bordley's artistic endeavors, frequently acting as critic. According to Peale's Letterbooks (American Philosophical Society), Peale wrote Bordley in 1770 and twice in 1772 offering advice on Bordley's landscapes.

Until this landscape after Claude was discovered, it was thought that the only

CHARLES WILLSON PEALE (1741–1827)
(See biography preceding no. 92)

107. *Thomas Wharton*

1777
Oil on canvas
50 x 40" (127 x 101 cm)
Richard T. Wharton, Stamford, Connecticut

PROVENANCE: Descended in Peale family; "Peale's Museum Gallery of Oil Paintings," October 6, 1854, sale no. 122; purchase, William F. Wharton, 1854; descended in family to Richard T. Wharton

LITERATURE: Theodore Bolton, "Charles Willson Peale, the First Catalogue of His Portraits in Oils and in Miniature," *Art Quarterly,* vol. 2, no. 4 (Autumn 1939), Suppl., p. 439; Sellers, *Portraits and Miniatures,* pp. 246–47; Charles Coleman Sellers, *Charles Willson Peale with Patron and Populace* (Philadelphia, 1969), p. 82

THOMAS WHARTON (1735–1778), a Philadelphia merchant, played a major role in early Colonial agitation against the British. Having taken a stand against the Stamp Act (1765), he later, in March 1777, became the first president of Pennsylvania after the Declaration of Independence.

An undated entry before September 17, 1777, in Peale's Diary (APS, vol. 4) records that he painted "two portraits in large of His Excellency Thomas Wharton and Lady" since his return to Philadelphia in July. The phrase "in large" is meant to distinguish these works from Peale's miniature painting. In 1783, Peale mentioned the companion portrait of Mrs. Wharton, now lost, record-

107.

ing the price, which indicates that it was a three-quarter length, and stating that it was commissioned by Wharton (Sellers, *Portraits and Miniatures*, p. 247). There are two surviving life-size portraits of Wharton by Peale, but this three-quarter length with a background view of Philadelphia appears to be the one referred to in the diary. Sellers considers the bust-length of Wharton (Philadelphia Museum of Art) to be a later copy intended for the Peale Museum.

Wharton died in May 1778 before he had paid for the companion portraits, and as a result, Peale seems to have intended to present the portrait shown here to the Supreme Executive Council of Pennsylvania, but finally abandoned the idea in 1814 (see Sellers, *Portraits and Miniatures*, pp. 246–47). Mrs. Wharton probably acquired her portrait in late 1785 when Peale requested payment, while the two portraits of her husband remained in the Peale Museum.

DE □

WILLIAM WILL (1742–1798)
(See biography preceding no. 72)

108a. *Salt*

c. 1778
Pewter
Height 2⅜″ (6 cm)

Charles V. Swain, Doylestown,
Pennsylvania

PROVENANCE: Carl Jacobs, Southwick, Massachusetts; John Ruckman, Doylestown, Pennsylvania, until 1967; Charles V. Swain

LITERATURE: Charles V. Swain, "Interchangeable Parts in Early American Pewter," *Antiques*, vol. 83, no. 2 (February 1963), pp. 212–13; Charles V. Swain, "Unmarked Pewter Comparisons," *Pewter Collectors Club of America Bulletin*, vol. 5, no. 54 (June 1966), pp. 98–100; Suzanne C. Hamilton, "William Will, Pewterer," M.A. thesis, University of Delaware, 1967, pl. 26, p. 158; Laughlin, *Pewter*, vol. 1, pl. 30, fig. 210; Suzanne C. Hamilton, "The Pewter of William Will: A Checklist," *Winterthur Portfolio* 7 (1972), pp. 147–48

108b. *Cream Pot*

c. 1778
Pewter
Height 5⅞″ (14.9 cm)

Lola S. Reed, M.D., Phoenixville,
Pennsylvania

PROVENANCE: Carl Jacobs, Southwick, Massachusetts; John Ruckman, Doylestown, Pennsylvania, until 1967; Charles V. Swain, Doylestown, Pennsylvania; Lola S. Reed, M.D.

LITERATURE: Charles V. Swain, "Interchangeable Parts in Early American Pewter," *Antiques*, vol. 83, no. 2 (February 1963), pp. 212–13; Suzanne C. Hamilton, "William Will, Pewterer," M.A. thesis, University of Delaware, 1967, p. 138; Laughlin, *Pewter*, vol. 3, pl. 95, fig. 777; Suzanne C. Hamilton, "The Pewter of William Will: A Checklist," *Winterthur Portfolio* 7 (1972), p. 137

THIS DIMINUTIVE CREAM POT AND SALT, although unmarked, are soundly attributable to William Will and exemplify not only the form of fashionable pewter in Philadelphia between 1764 and 1798, Will's working dates, but also the means whereby this resourceful pewterer supplied his customers with all the utensils they required. The expense of brass molds prevented many American pewterers from building large inventories of molds, each for casting a separate type of vessel. The inventory of the pewterer Thomas Byles, taken in Philadelphia in 1771, is indicative of this. Whereas it included over 2,300 pounds of pewter valued at about £87, his "Brass Moulds" weighed only 1,183 pounds but were valued at well over £147.

To circumvent unnecessary expense while at the same time supplying any object a

108a.

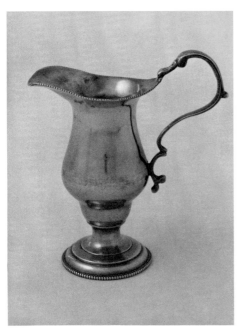

108b.

customer might request, a number of pewterers, Will being among the most innovative, combined castings from different molds, as seen in this cream pot, which is built upon a mold used for the salt. Extending this principle of interchangeable parts, the pewterer could easily work within the limits of the molds he owned by combining and recombining elements, thereby greatly extending the range of forms he could produce at minimal expense. Thus, the same mold that made the salt and cream pot bases could also supply the stem of a chalice, and another mold could be used to make the lid of a tankard or sugar bowl and the foot of a chalice. Traditionally, the technique of interchangeability has been thought to have developed in the nineteenth century with the advent of mass production. It is apparent, however, that the combining of a few standardized production elements, such as this salt, to supply efficiently and economically a large variety of objects was a principle readily understood and used by craftsmen such as Will and others well before the turn of the century.

DF □

THOMAS AFFLECK (1740–1795)
(See biography preceding no. 78)

109. *High Chest and Dressing Table*

1779
Walnut; poplar, pine, and cedar; brass hardware

(a) High chest 94 x 42 x 20¾″
(238.7 x 106.6 x 52.7 cm)

Philadelphia Museum of Art. Given by Mrs. W. Logan MacCoy. 64–142–1

(b) Dressing table 30½ x 48 x 19¾″
(77.4 x 121.9 x 50.1 cm)

Mrs. W. Logan MacCoy

PROVENANCE: Levi and Hannah (Paschall) Hollingsworth (m. 1768); granddaughter, Jane Morris?; brother, Wistar [and Mary (Harris)] Morris (m. 1863); Charles and Mary (Morris) Wood (m. 1883); Marguerite P. (Wood) MacCoy

LITERATURE: Calvin S. Hathaway, "Levi Hollingsworth's High Chest of Drawers," *PMA Bulletin*, vol. 61, nos. 287–88 (Fall 1965/Winter 1966), pp. 5–9

POSSESSING THE SKILLS to meet increasingly sophisticated demands, and an eagerness to partake of the Quaker community, Thomas Affleck was introduced to the great merchants of the day from the time of his arrival in Philadelphia in 1763 when he was met by Joshua Fisher. The influential John Cadwalader ordered furniture from Affleck costing £114 3s. in 1770 and did business with him continuously until 1774 (HSP, John Cadwalader, Account Book, 1771–78, p. 118). James Pemberton ordered pieces from Affleck in 1775 costing £117; and Affleck proceeded to produce work for John Penn, William Logan, Robert Waln, Charles Wharton, and in this instance Levi Hollingsworth.

Hollingsworth was born in 1739 in Maryland. He moved to Philadelphia by 1760 and successfully entered the waterfront trade. He was a member of the Gloucester Fox Hunting Club and the State in Schuylkill Fishing Club and was a founder of the First Troop, Philadelphia City Cavalry. He married Hannah Paschall, daughter of Stephen, in March 1768.

Hollingsworth and Affleck were closely involved in business transactions, including joint ownership of a large tract of land on the Lackawaxen Creek in Northampton County, and Affleck paid for his rum purchases from Hollingsworth with mahogany furniture (HSP, Paschall-Hollingsworth Papers, account with Thomas Affleck, 1779).

Receipts from Hollingsworth's estate reveal

that he kept up with the latest style changes. He bought a set of eight mahogany chairs from Affleck in 1779, and in 1812 he purchased twenty-four side chairs and two armchairs in the "fancy" style, painted to simulate maple, from Haydon and Stewart (HSP, Hollingsworth Papers, 1768–1817, receipts dated May 21, 1779, April 22, 1812).

Although there are no records in Hollingsworth's accounts which document the purchase of this high chest and dressing table, their attribution to Affleck is based upon provenance, technical construction, and the leg carving, which compares to the carving on the knees and feet of the eight mahogany chairs Hollingsworth ordered from Affleck which also share the same provenance.

Levi and Hannah left eight surviving children. Hannah's will stated: "I bequeath the chest of drawers in my bedroom to my grand-daughter Jane Morris in full confidence that the similar chest in her father's house will be considered as belonging to her sister Hannah" (City Hall, Register of Wills, Will no. 187, 1833). This set is one of a pair of Hollingsworth high chests (mentioned in Hannah's will) and dressing tables which were made to identical specifications and employ the same ornamentation. Immediately recognizable as the "Philadelphia highboy," this high chest achieves distinction in its lightness and vertical thrust from the firm but easy stance of the carved legs to the pediment, where a superb alternation of solids and voids leads the eye into the cartouche. The dressing table, carrying the same rhythmic profile on its skirt and sides, answers the verticality of the high chest with a serviceable horizontality which must have first been covered with its "bureau cloth," then laden with brushes and patch boxes.

Even if the carving were done in another shop, the spring given to the legs through the ankles was fully developed and integrated into the design by the cabinetmaker before the carver began his work. The centered rocaille shells on the drawers are carved with assurance, their fluttery edges set against a stippled circular enframement. Such elements were seen most often gilded, on looking glass pediments. The lively tendrils framing the shells and the asymmetrical flip of the pediment cartouche are the only rococo tendencies on these architectonic pieces.

Affleck is known to have made superb chest-on-chest forms in which the pediment as a separate element was often supplied to order by the carver's shop. These two pieces exhibit a command of scale and an elegant sense of proportion and design, free of excessive ornamentation, recognizable within the better documented oeuvre of Affleck.

BG □

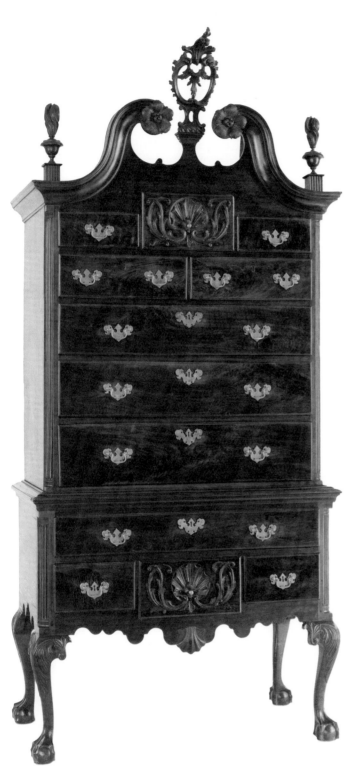

109a.

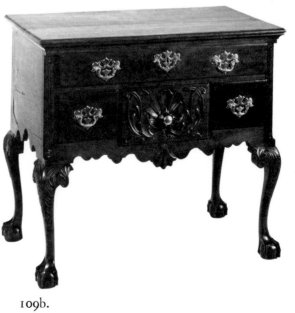

109b.

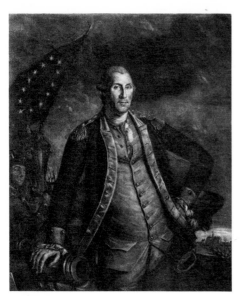

110a.

CHARLES WILLSON PEALE (1741–1827)
(See biography preceding no. 92)

110a. *George Washington*

1780

Inscription: *Chas Willson Peale Pinxt et fecit/His Excellency* GEORGE WASHINGTON *Esquire, Commander in/Chief of the Federal Army/This Plate is humbly Inscribed to the Honorable the Congress of the United States of America,/By their Obedient Servant,/Chas Willson Peale.*
(below image)
Mezzotint, i/ii
13⅞ x 9⅞″ (35.2 x 25 cm)

Metropolitan Museum of Art, New York. Bequest of Charles Allen Munn, 1924

LITERATURE: William S. Baker, *The Engraved Portraits of Washington: With Notices of the Originals and Brief Biographical Sketches of the Painters* (Philadelphia, 1880), p. 204; William S. Baker, "The History of a Rare Washington Print," *PMHB*, vol. 13, no. 3 (May 1889), pp. 257–64; Charles H. Hart, *Catalogue of the Engraved Portraits of Washington* (New York, 1904), no. 2; MFA, *A Descriptive Catalogue of an Exhibition of Early Engravings in America* (December 12, 1904–February 5, 1905), no. 400; Joseph Jackson, "Washington in Philadelphia," *PMHB*, vol. 56, no. 2 (April 1932), pp. 131–32; Stauffer, vol. 2, no. 2428; Horace Wells Sellers, "Engravings by Charles Willson Peale, Limner," *PMHB*, vol. 57, no. 2 (April 1933), pp. 163–65, no. 3; Sellers, *Portraits and Miniatures,* no. 916; William H. Pierson, Jr., and Martha Davidson, eds., *Arts of the United States* (New York, 1960), no. 1846; Detroit Institute of Arts, *The Peale Family, Three Generations of American Artists,* ed. Charles H. Elam (1967), no. 53; *American Printmaking,*

no. 66; MMA, *American Paintings and Historical Prints from the Middendorf Collection* (October 4–November 26, 1967), no. 66; Harold E. Dickson, *Arts of the Young Republic* (Chapel Hill, N.C., 1968), no. 124; Sotheby Parke Bernet, New York, May 18, 1973, no. 96 (Middendorf sale)

110b. *Benjamin Franklin*

1787

Inscription: HIS EXCELLENCY B. FRANKLIN L.L.D. F.R.S. PRESIDENT OF PENNSYLVANIA, & LATE MINISTER OF THE UNITED STATES OF AMERICA AT THE COURT OF FRANCE. (outer border); *C. W. Peale pinxt et Fecit, 1787.* (inner border)
Mezzotint
6⁷⁄₁₆ x 5¹¹⁄₁₆″ (trimmed) (16.3 x 14.5 cm)

The Library Company of Philadelphia

LITERATURE: William S. Baker, *American Engravers and Their Works* (Philadelphia, 1875), p. 125; MFA, *A Descriptive Catalogue of an Exhibition of Early Engravings in America* (December 12, 1904–February 5, 1905), no. 396; Stauffer, vol. 2, no. 2423; Horace Wells Sellers, "Engravings by Charles Willson Peale, Limner," *PMHB*, vol. 57, no. 2 (April 1933), pp. 171–72, no. 4; Drepperd, *Early Prints,* p. 54; Sellers, *Portraits and Miniatures,* nos. 171, 280; William H. Pierson, Jr., and Martha Davidson, eds., *Arts of the United States* (New York, 1960), no. 1845; E. P. Richardson, "Charles Willson Peale's Engravings in the Year of National Crisis, 1787," *Winterthur Portfolio 1* (1964), pp. 169–71; *American Printmaking,* no. 72; Sotheby Parke Bernet, New York, May 18, 1973, no. 111 (Middendorf sale); *Made in America,* no. 13

THE AMERICAN REVOLUTION provided a host of new celebrities to satisfy a continuing interest in portraiture; and following the popular European tradition of immortalizing national leaders and prominent citizens, the faces of America's heroes decorated the walls of private homes and houses of state. In Peale's print of George Washington, after his 1779 full-length oil painting (Pennsylvania Academy of the Fine Arts), the influence of court painting and English mezzotint portraits is obvious: the subject is dressed in the costume of his office; he stands before an expressive background, which, in the best tradition of history painting, symbolizes his most ambitious deeds; his left hand rests on his hip while the other hand is placed on a cannon, which here replaces the usual pedestal or table; and he is surrounded by various objects which further accentuate his glory. All signs of struggle and destruction are avoided to emphasize the grandeur

and nobility of the victor. Washington faces us as the confident and august hero whose static, relaxed pose expresses the controlled mind and emotions which guided America to freedom.

Peale has represented Washington as the victorious commander in chief at the Battle of Princeton, New Jersey, on January 3, 1777. The engagement is identified by the famous college building, Nassau Hall, in the background (which Peale, as noted in his diary, February 22, 1799, visited to make sketches) and, in the full-length painting, by the captured German battle flags of Trenton and the British ensign at Washington's feet. Both the painting and the print depict Washington in the most recent regulation uniform. The 1779 painting shows the ribbon across his chest, which was instituted in 1775. The ribbon disappears in the 1780 print and is replaced by epaulettes ornamented with three stars (replacing rosettes) in accordance with a proclamation of June 18, 1780. As the costume is so up-to-date, it seems surprising that Peale chose to represent the old flag with thirteen stars on a blue field, which, although still in use at the time of the Battle of Princeton, was replaced by the stars and stripes as of June 14, 1777.

This is one of over sixty portraits of Washington by Peale, and the painting is the fourth of seven portraits done from life over a span of twenty-three years (1772–95). The painting was commissioned by the Supreme Executive Council of Pennsylvania in a resolution of January 18, 1779. The Council's awareness of the European painting tradition and its propaganda value is evident in their resolution:

WHEREAS: The wisest, freest and bravest nations in the most virtuous times, have endeavored to perpetuate the memory of those who have rendered their Country distinguished services, by preserving their resemblances in Statues and Paintings: This Council, deeply sensible how much the liberty, safety and happiness of America in general and Pennsylvania in particular, is owing to His Excellency General Washington, and the brave men under his command, do resolve. That His Excellency General Washington be requested to permit this Council to place his Portrait in the Council Chamber, not only as a mark of the great respect which they bear to His Excellency, but that the contemplation of it may excite others to tread in the same glorious and disinterested steps, which lead to public happiness and private honor. And that the President be desired to wait on His Excellency the General, with the above request, and if granted, to enquire when and where it will be most agreeable to him, for Mr. Peale to attend him. (William S. Baker,

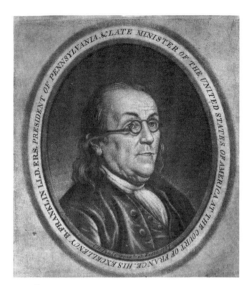

110b.

"The History of a Rare Washington Print," *PMHB*, vol. 13, no. 3, May 1889, pp. 257–58)

Washington must have sat for Peale between January 20, 1779, the date of Washington's reply to the Council's request, and February 2, 1779, the day of Washington's departure from Philadelphia (*Pennsylvania Packet,* February 4, 1779). The painting was an immediate success. Don Juan Marrailes, a Cuban who acted unofficially as a representative of Spain, requested five copies, four of which were to be sent abroad (*Pennsylvania Packet,* February 11, 1779). The replicas, which were to be delivered to France, Spain, and Holland, were the first American paintings to hang in European palaces.

On August 26, 1780, the publication of the print after Peale's painting was announced in the same paper:

The subscriber takes this method of informing the Public, That he has just finished a Mezzotinto PRINT, in poster size* of His Excellency GENERAL WASHINGTON, from the original picture belonging to the state of Pennsylvania. Shopkeepers and persons going to the West Indies may be supplied at such a price as will afford a considerable profit to them, by applying at the South-west corner of Lombard and Third-streets, Philadelphia.

N.B. As the first impression of this sort of prints are the most valuable, those who are anxious to possess a likeness of our worthy General are desired to apply immediately. CHARLES WILLSON PEALE.

*14 inches by 10 inches, besides the margin.

The advertisement was repeated in the following months with the price of two dollars added. Of over 880 known portraits of Washington, this is the earliest signed and dated engraving, and only five impressions of this print are known. It has been suggested by William S. Baker that this print is the closest approximation to the original painting before vandals defaced it (*Freeman's Journal,* September 12, 1781).

Peale probably had learned the mezzotint technique while in London, where it was a popular and perfected medium in the eighteenth century. He made only three prints of Washington (1778, of which no existing impressions are known, 1780, and 1787). It is likely that he did not devote more time to this method due to the lack of an established printing industry in America at the time. There were no trained craftsmen to prepare plates; proper tools were scarce; and few men were available to market the product. Peale necessarily attended to many of these functions himself. Yet his technical skill shows no evidence of these handicaps and ranks high with European contemporaries.

In 1787, Peale did an oval mezzotint of Benjamin Franklin after his 1785 portrait of Franklin (Pennsylvania Academy of the Fine Arts). It was the first of a series of prints from his Portrait Gallery which were intended as souvenirs for visitors. Peale wrote to his friend Dr. David Ramsey on February 2, 1787, and to Washington on February 27, outlining his intention (E. P. Richardson, "Charles Willson Peale's Engravings in the Year of National Crisis, 1787," *Winterthur Portfolio 1,* 1964, pp. 169–70). He announced his project in the *Pennsylvania Gazette* on March 30. Peale had embarked on this venture for financial reasons, hoping that his prints would receive the same favorable response in the States as in England; but his endeavor was not successful.

The fact that Peale chose to reproduce his paintings in print form for dissemination to a broad audience suggests that he had a commercial purpose in mind: to accentuate the initial excitement and interest engendered by his canvases and, in turn, to stimulate further commissions. The choice of the mezzotint technique was based on its potential for capturing a full range of tonal values and certain qualities of light and texture found in the original paintings. Peale probably first became aware of these capacities in England, where the mezzotint was closely associated with the painting tradition in the seventeenth and eighteenth centuries and was especially popular for the reproduction of English portraiture. The importance of these prints for the early American artist cannot be underestimated. According to newspaper advertisements at the time, they were highly accessible, unlike the paintings they reproduced, and thus provided a valuable source for transmitting artistic trends as well as the latest fashions from the Old World to the New. Many American artists possessed print collections and frequently borrowed specific motifs or ideas from them for their own compositions. To an untrained artist who lacked direct exposure to current European painting trends, these imported prints became an important educational tool. For their patrons, the prints often served as patterns for fashionable attire.

ESJ □

111a. *Vest*

c. 1780
Embroidered and quilted white satin, lined in linen, backed with white wool
Center back length 23½″ (59.6 cm)
Philadelphia Museum of Art. Given by Mrs. N. Dubois Miller. 43-17-7

PROVENANCE: Tench Francis (1730–1800); descended in family to great-great-granddaughter, Mrs. N. Dubois Miller

111b. *Vest Pattern*

1780–1800
Embroidered ivory corded silk
39 x 22″ (99 x 55.8 cm)
Philadelphia Museum of Art. Given by Dr. A. S. W. and Philip H. Rosenbach. 49–41–2

111a.

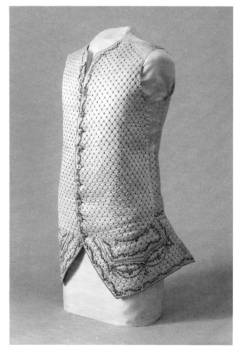

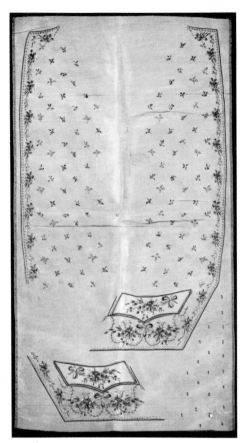

111b.

During the eighteenth century, men quite rivaled women in the splendor and elaboration of their costumes. Although the breeches and coat of an outfit were often made of the same material, the vest (or waistcoat) was usually of a finer fabric, handsomely embroidered or brocaded. Coats were cut so that the vest was always revealed, as it was by far the most elegant part of a gentleman's attire. They were displayed with great pride, as is apparent in portraits of the period (see no. 92). More often than not, the vest was fully worked, whereas the breeches and coat were merely embroidered along their edges.

Philadelphia has always been noted as a center for the manufacture of men's clothing, and it may be assumed that the city's eighteenth century tailors were adept at their trade. The wealthy and fashionable followed the styles of England and France, often importing their garments sight unseen; frequently ill fitting, these costumes required the alteration and work of an experienced tailor. Partly made garments also were imported from France. These were in the form of flat patterns on lengths of silk material, on which the intricate outlines of coats, breeches, and vests were traced and embroidered in elaborate floral designs of

Oriental influence. These patterns were then individually fitted, cut, and sewn together. For practical reasons, the backing for vests was supplied by the tailor and was usually of less expensive materials—plain cotton, linen, or wool—a practice still followed today.

Most likely this vest was made in Philadelphia from a flat pattern such as the one shown here. It was worn by Tench Francis, who in 1762 married Ann Willing (see no. 42). He was a captain of the Philadelphia militia and his financial service to the Revolutionary cause was second only to that of Robert Morris. Although Francis spent much of his time in France, he was a noted American of his day and a leading citizen of Philadelphia. After the war he became associated with the First Bank of North America.

EMcG ☐

HENRY BENBRIDGE (1743–1812)
(See biography preceding no. 55)

112. *The Enoch Edwards Family*

c. 1783
Oil on canvas
30 x 23¾" (originally 25" wide)
(76.2 x 60.3 cm)
Philadelphia Museum of Art. Given by Miss Fannie Ringgold Carter. 49–53–1

PROVENANCE: Descended in family of the artist to Miss Fannie Ringgold Carter

LITERATURE: David Sellin, "A Benbridge Conversation Piece," *PMA Bulletin,* vol. 55, nos. 263–64 (Autumn 1959/Winter 1960), pp. 3–9; Stewart, *Benbridge,* no. 65, pp. 20, 28, 60–61

BENBRIDGE'S HALF-SISTER, Frances Gordon, married Dr. Enoch Edwards in 1779; thus this portrait of Enoch standing before an enormous classical urn between his wife and sister may well have been a gift from the artist. Benbridge included himself in the picture at the lower left. He also painted a group portrait of the family of his other half-sister, Elizabeth Gordon, *The John Saltar Family,* which is so similar in arrangement and size that very possibly the two were intended as companion conversation pieces.

The date for this painting is based on the fact that it must have been done in the Philadelphia area, where the Edwardses lived. Benbridge left Philadelphia for Charleston in 1772 and as far as is known he did not return until a visit in 1783 (Stewart, *Benbridge,* p. 20).

The care with which the small heads are painted in *The Enoch Edwards Family* gives some indication of Benbridge's ability in another field in which he was known, miniature painting. William Dunlap, the historian and painter who had also studied under West in London, reported in 1834 that Benbridge was thought to have painted "drapery well, particularly silks and satins" but his shadows were "dark and opaque," which Dunlap considered a fault. His figures were "solidly painted, well drawn ... but hard" (Dunlap, *History,* vol. 1, pp. 143–44). Alan Burroughs has expressed uneasiness over what appeared to be a confusing similarity in style between Pratt and Benbridge ("Book Reviews," *Art Bulletin,* vol. 25, September 1943, pp. 279–80). David Sellin even proposed that Pratt could have instructed Benbridge (Sellin, cited above, p. 3). Since 1960, a number of misattributions to Pratt have been judiciously weeded out, the end result being that the style of the two artists has been more carefully differentiated and Dunlap's characterization appears now more perceptive than was realized.

Describing Benbridge, Charles Willson Peale concluded that the climate in Charleston, unlike Philadelphia, "perhaps made him indolent for it is certain he did not acquire much celebrity" (APS, Charles Willson Peale, Letterbook, vol. 12, pp. 84–85). Peale's letter is dated October 28, 1812. Benbridge had died in obscurity in Philadelphia nine months earlier, unknown to Peale who later wrote that Benbridge died in Charleston (APS, Charles Willson Peale, Autobiography, typescript, p. 99).

DE ☐

113. *Doorframe*

1780–83
Pine, cedar, glass
136 x 43½ x 8" (345.4 x 110.4 x 20.3 cm)
Philadelphia Museum of Art. Purchased: Joseph E. Temple Fund. 21–23–1

LITERATURE: Wise and Beidleman, *Colonial Architecture,* p. 77, illus. opp. p. 78

THIS DOORFRAME was the "frontispiece" of the house that stood at 224 Pine Street, which has generally been known as the Stamper-Blackwell house. Tradition has it that about 1761 John Stamper, mayor of Philadelphia in 1759, bought from Richard and Thomas Penn the city block bounded by Pine, Lombard, Second, and Third streets (Harold D. Eberlein and Horace M. Lippincott, *Colonial*

Houses of Philadelphia and Its Neighborhood, Philadelphia, 1912, pp. 42–47). No such deed is recorded in City Hall's extensive records of title transfers under Stamper in the Grantee Index or under Penn in the Grantor Index. The tangle of title regarding the property at 50 (new number 224) Pine Street has led to confusion about the date of construction of the house built there. But John Stamper's principal residence was on South Second Street. His property had 44 feet of frontage with 130 feet of depth on what was then called Chester Alley, renamed Stamper's Alley after his death in 1782.

John Stamper had two children: Joseph (d. 1785), who married Sarah Maddox; and Mary, who married first William Bingham, Sr. (d. 1769), in 1745, and second, Michael O'Brien, after 1782. Joseph Stamper owned outright 60 feet at 68 Pine Street at the southeast corner of Third Street (HSP, William Bingham Collection, Wills, John Stamper, 1782). When he died in 1785 his widow moved, and the lot was developed and used by descendants.

Where William and Mary Bingham lived until William's death in 1769 is not known, but presumably it was in one of his properties listed in a partition (City Hall, Deed Book D5, p. 215), dated December 18, 1780, all of which were within the block bounded by Second and Third streets between Market and Arch, including the Bunch of Grapes Tavern. Their daughter Hannah, who married John Stephen Benezet in 1775, continued to live in that area until her second marriage to Reverend Robert Blackwell in 1783. Hannah's brother, William Bingham, Jr., had inherited a large property from the estate of his father on the west side of Delaware Third Street opposite Coombs Alley, and also a large Bank and Water streets' lot located between Sassafras and Vine streets. Presumably to equalize the inheritance from William Bingham, Sr., William, Jr., paid his mother, sister, and brother James a total of £300. This settlement may have taken place to clarify the son's accounts after his marriage to the very young and very wealthy Ann Willing. It may also have been a reckoning with his mother and siblings for the large piece of ground on the south side of Pine Street which John

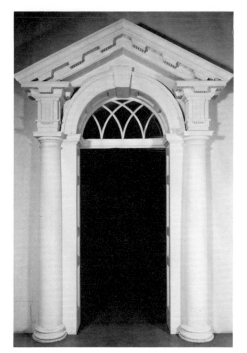

113.

Stamper turned over to him at the time of the son's marriage. It was described in Stamper's will in 1782 and in an abstract from his will dated 1792, found among the Bingham papers: "Also all that my other messuage and tenement wherein my grandson William Bingham now dwells and lot or piece of ground therein to belonging situate on the South side of Pine Street aforesaid the said lot to begin at the East side of the said house and to extend in front on Pine Street— Westward about one hundred and seventy eight feet to my said sons Board fence ... and in depth one hundred and forty two feet to Chester Alley together with the appurtenances" (HSP, William Bingham Collection, Wills, 1792).

In 1803, Robert Blackwell had his Pine Street property surveyed by Reading Howell, and the dimensions and position east of Third Street were exactly the same (HSP, Wallace Collection, vol. 4, p. 70), thus identifying securely the provenance of 50 Pine Street. Stamper referred to it as "my other messuage" indicating that he probably still held ownership and he assigned its yearly ground rent to his daughter Mary Bingham. However, William Bingham's receipts indicate that he paid to John Cooper £14 6s. for "repering the dorments and putting in three rafters" (HSP, Etting Collection, vol. 2, misc. MS, October 19, 1781), suggesting that he moved into one of Stamper's speculative properties, possibly this building, and added a third floor or at least the dormers. He also was purchasing quantities of boards, scantling, and shingles,

112.

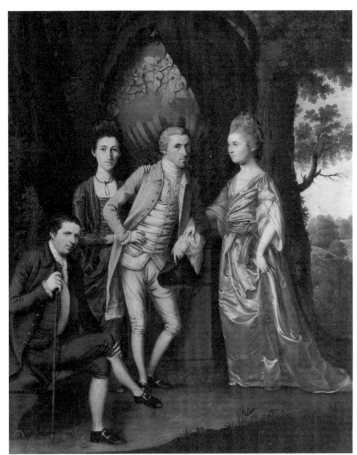

145

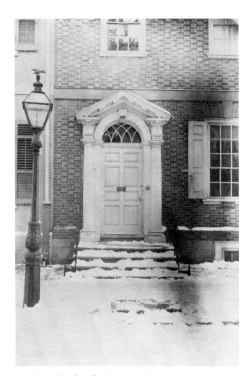

Bingham-Blackwell House, c. 1870. Courtesy Historical Society of Pennsylvania, Philadelphia. Wallace Collection

and was repairing "the stebel and cotch-hous." Bingham had sold his inherited Front Street property in September 1781 for £375 via his agent Lewis Weiss, and if one looks ahead to their future life style and their interest in architectural details, it seems clear that William and Ann Bingham "dressed up" one of Stamper's properties, in this case 50 Pine Street, between October 26, 1780, the date of their marriage, and May 1783, when they embarked for England where they stayed for five years.

In November 1783 William's widowed sister Hannah married the Reverend Robert Blackwell. From a wealthy New York family, a graduate of the College of New Jersey, with degrees earned in England, Blackwell was a widower resident in Gloucester County, New Jersey, when he was called to Philadelphia to assist Bishop White at Christ Church. He rented a house between Front and Second streets at 14 Pine, almost next door to Bishop White, from Samuel Emlen, and he and Hannah continued to reside there until late in 1788, when his receipt book noted that he had paid his tax for 1789 in New Market Ward for "Mansion and lot £4.17.19," and for his three rental properties in Stamper's Alley. By 1790 he was planting fruit trees, building stalls and a yard, and adding a back kitchen at 50 Pine Street, and Henry Brame was painting in the main building (HSP, Robert Blackwell,

Receipt Book, 1793–1802). The Binghams had returned from England and were proceeding to build their showplace at the corner of Third and Spruce streets. They turned over the Pine Street house to the Blackwells, a fact confirmed in a short entry in Blackwell's Receipt Book for February 27, 1793, signed by William Bingham, "Rec'd of the Rev. Robert Blackwell £4/5/4 for taxes for Wm. Binghams lot in Pine Street for 1792/ £150.16 on acct of joint property for the estate."

This doorframe, or "frontispiece," from what may now be called the Bingham-Blackwell house, was not typical of Philadelphia before the Revolution. The usual doorframe, drawn from Batty Langley, William Salmon, James Gibbs, or Abraham Swan, carried the engaged columns or pilasters to a height equal to the top of the arch of the lunette window, upon which rested a full architrave, usually of the Doric order, which in turn supported either a flat head or a triangular pediment. Typical examples may be seen at the Powel house, the tower entrance at the State House (no. 30), Mount Pleasant, or Carpenters' Hall (no. 85). But the doorframe of the Bingham-Blackwell house is identical to the entrance of the Corbit House in Odessa, Delaware, built by carpenter Robert May in 1772–74 (John A. H. Sweeney, *Grandeur on the Appoquinimink*, Newark, Delaware, 1959, appendices A and B), where it was listed as costing £18. The forms had been used in

Maryland and northern Virginia before 1776 —for example, at Whitehall, Anne Arundel County, about 1765 and Gadsby's Tavern in Alexandria—and at the Amstel House in New Castle, Delaware, before 1770. Robert May was a Maryland resident, although he moved to Coventry, Chester County, Pennsylvania, in 1789. One of his suppliers, Samuel Young, lived in Philadelphia in Bingham-Willing rental property on Pine Street between Front and Second, but Robert May has eluded Philadelphia records, and there is no intention here to attribute the Bingham-Blackwell house doorframe to him.

The Bingham-Blackwell type of doorframe, where the capitals support the pediment on a compound entablature that does not continue horizontally over the door, appeared only after the Revolution in Philadelphia. Plates 15 and 16 in Owen Biddle's *Young Carpenter's Assistant* show this style clearly (the old style is presented in plates 17 and 18). The heavy proportion of this doorway was probably dictated by the earlier Stamper building to which it was affixed. The glazed headers, Flemish-bond brickwork with queen closers, and the three-bay design of the house were typical Philadelphia style during fifty years preceding the Revolution. Whether Bingham had a doorway like that at Whitehall in mind, or whether the workmen he employed were émigrés from farther south is not known, but this style of doorway became very popular soon after north of the city, in

114.

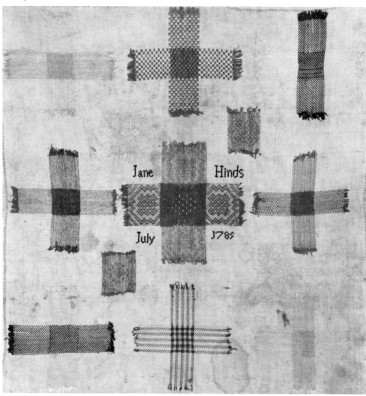

Frankford and Germantown, and it appeared on small buildings all over the city, including the prestigious Morris house on South Eighth Street, built by John Reynolds about 1786. The remodeled entrance front of William Hamilton's Woodlands handled the type gracefully, using an arched roof over the lunette window, whereas the Bingham-Blackwell doorframe of 1780–83 incorporates old proportions into a new vocabulary, not entirely successfully. Later when the columns became flattened pilasters, clustered and attenuated; fanlights, as delicate as spiders' webs (see no. 151); and keystones purely decorative, with no pretensions of supporting the arch, this door style became a carpenter's conceit.

Interior woodwork elements of this house that are now in the Winterthur Museum seem to support a date in the 1780s. The layers of decorative carved moldings, which created smaller scale light-shade patterns than those before 1770, forecast the gouge and punch woodwork of the 1790s. If Blackwell also ordered interior work in the late 1780s he may have based his designs on what he remembered from his tutoring days at Philipse Manor in Yonkers, New York, where he was employed after graduation from college. At Philipse, the interior carved decoration—at the cornice and on the frieze of the architraves of open pediment doorframes, the scrolls of leafage, and highly carved overmantel, including a central plaque carved with masks in high relief—is a concept very similar to that of the Pine Street house. The date of the Philipse interior is not known, but stylistically it is of the period about 1768 to 1771, when Robert Blackwell was living there. Blackwell died in this house in 1831, and it was still in Blackwell-Willing ownership in 1852.

BG □

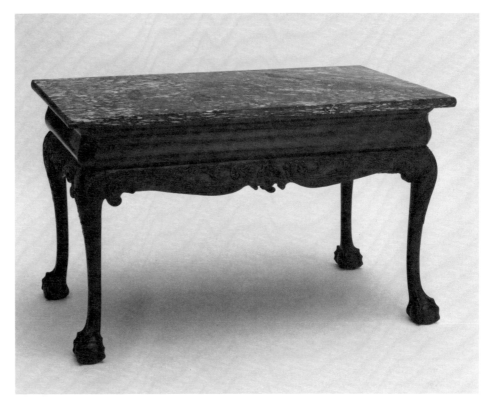

115.

JANE HINDS (N.D.)

114. *Darning Sampler*

1785
Inscription: Jane Hinds/July 1785
(within the four angles of the center cross)
Silk on linen (40 x 40)
Stitches: Surface darn (triple laidwork, simple twill, herringbone twill, plain), cross, hem
16¼ x 15¾" (41.3 x 40 cm)
Philadelphia Museum of Art. Given by Miss Mabel L. H. Thomas. 25-15-2

PROVENANCE: Descended in the artist's family to Miss Mabel L. H. Thomas

THIS WORK is done in the classic surface-darning sampler form, which originated in England or Holland about the middle of the eighteenth century. By the late eighteenth century, this type of sampler was worked in America, usually as part of the school curriculum and as a prerequisite to more advanced embroidery. Although some schools used specific formats and colors, it may be generally said that the darns were interwoven on the surface in two or more colors over grounds with even threads as an aid in execution and for the detection of mistakes. Usually each square was done in a different darning pattern, and although formerly the "invisible" mend was worked over an actual tear or cut-out, as in this sampler, later examples were done in a neater "show" form with no actual rent.

This sampler is composed of eight small crosses, their joint being the square of the mend, worked in simple patterns, including plain, twill, herringbone, and triple laidwork surrounding a larger cross of more intricate design. Four patterned squares fill the rectangles of ground formed by the arms of each cross. The colors include green, yellow, blue, red, pink, and brown on natural linen. The signature and date appear within the corners of the larger figure in cross-stitch with black wool. The whole is framed by a simple hemstitch border. The naiveté and balance of the arrangement give a strength

and directness to its composition which is appealing to a modern eye.

Jane Hinds is unknown except for her sampler. She may have been related to the Robert Hinds, bricklayer, who worked on the State House.

PC □

115. *Pier Table*

c. 1785
Mahogany; cherry back rail
29⅛ x 26 x 51⅜" (74 x 66 x 130.5 cm)
Philadelphia Museum of Art. On deposit from the Commissioners of Fairmount Park. 10-1940-13

PROVENANCE: Robert Waln, Jr. (1765–1836); descended in Waln family; Robert Waln Ryerss; William Ryerss, until 1940

LITERATURE: Hornor, pp. 137, 218, pl. 131; Marion Sadtler Carson, "Thomas Affleck, A London Cabinetmaker in Colonial Philadelphia," *Connoisseur,* vol. 167, no. 673 (March 1968), p. 190

MARBLE-TOP PIER TABLES were a Philadelphia favorite. In city houses they were placed

between windows under looking glasses. In dining rooms they were used as sideboard tables, a pragmatic solution for hot dishes or the spills of alcoholic punch. In country houses they were often placed in hallways, which were more spacious than their counterparts in townhouses.

This pier table is very low in comparison to most of its type, suggesting parlor or library placement, where a person could use the surface for writing or reading. It is finished on three sides, thus requiring a wall position. The table has majesty and lightness in its proportions, a characteristic enhanced by the swelled ogee frieze, left elegantly unadorned. The high polish and softly undulating surface contrast with the stylized foliage carved along the supporting frame, pointing to the common practice of parceling out elements to the carver which were then assembled by the joiner-cabinetmaker. The frame of this piece was clearly carved without its accompanying upper section, as a sensitive carver would probably have carried his design up into the ogee on the subtly chamfered corners.

Although Thomas Affleck has been credited with this piece, there is no extant documentary evidence to support the attribution. Affleck fulfilled commissions for John and Richard Penn's townhouses, and for John Penn's country seat, Lansdowne. This pier table would justify Penn provenance, but it does not appear on the 1788 inventory of the John Penn sale (Marie G. Kimball, "The Furnishings of Governor Penn's Town House," *Antiques*, vol. 19, no. 5, May 1931, p. 378). Thus it is unlikely that Robert Waln, Jr. (1765–1836), purchased it at this auction. Waln owned two elegant establishments after his marriage to Phoebe Lewis in 1787: Waln Grove, Waln's country seat in Frankford, and a townhouse on Second Street. Jacob Hiltzheimer, January 20, 1797, described Waln and his home: "He is a young man of uncommon understanding, a good speaker and can answer any one opposed to him with temper and good reasoning. He has an elegant house, richly furnished, with a large lot and garden in the rear" ("Extracts from the Diary of Jacob Hiltzheimer of Philadelphia, 1768–98," *PMHB*, vol. 16, no. 4, 1892, p. 421).

In 1827, Waln added two wings to the main block of Waln Grove: one to the left of a wide hall, a library considered the most handsome room in the house; and on the other side, a large drawing room used as a meeting room of Orthodox Friends. This pier table would have suited such a library room where its "old fashioned" profile matched the Queen Anne style side chairs, also the property of Robert Waln (Hornor, pl. 41).

BG □

ROBERT FULTON (1765–1815)

Robert Fulton was born in 1765 in New Britain (now Fulton) Township, Pennsylvania. His family moved into nearby Lancaster in 1766 and Fulton's father died two years later. The boy was interested equally in art and science, and like many frontier artisans, picked up diverse skills. He painted signs, made mechanical and decorative designs for guns, drew portraits, experimented with quicksilver, and constructed a paddle boat for his own use in fishing. In 1782, Fulton went to Philadelphia to earn his living as a painter, although he also worked for a jeweler, did mechanical and architectural drafting, drew maps, and designed carriages. He produced a number of portraits and landscapes, possibly under the guidance of Charles Willson Peale and Peale's brother James. In 1785, Fulton was listed as a miniature painter in the Philadelphia city directory. On June 5, 1786, he advertised in the *Pennsylvania Packet* that "ROBERT FULTON, Miniature Painter & Hair Worker, Removed from the north east corner of Walnut and Second streets, to the west side of Front street, one door above Pine-street, Philadelphia" (Prime, *Arts and Crafts*, vol. 2, pp. 12–13).

Later that year he sailed for London with a letter of introduction to Benjamin West from Benjamin Franklin, whose portrait Fulton had painted in Philadelphia. Fulton had other attachments to West: the older artist had painted portraits of Fulton's parents in the 1750s, and West's nephew, David Morris, had married Fulton's sister Mary. Fulton joined the group of American students under West's tutelage and even lived in his household in London for several years. Influenced by West, Fulton painted several historical scenes, including *Lady Jane Grey the Night before Her Execution* and *Louis XVI in Prison, Taking Leave of His Family*. About 1791, Fulton established himself as a portrait painter in Devonshire, where he met the Earl of Stanhope and the Duke of Bridgewater, whose interest in science paralleled Fulton's. Fulton began experimenting with canals, submarines, and, later, steam navigation, and finally sacrificed his painting in favor of civil engineering, although as late as 1793 he exhibited portraits in London at the Society of Artists and the Royal Academy.

Hoping to interest the French government in his plans for submarine mines and torpedoes, Fulton went to Paris about 1797. About 1800 he painted the first panorama exhibited in Paris, a scene of the burning of Moscow, but sold the patent for the design of the special building in which to display it in order to finance his torpedo experiments.

Fulton was concerned with establishing an appreciation of the arts in America. Accord-

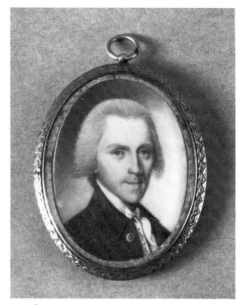

116.

ing to Henry Tuckerman, before returning to the United States, "he wrote from London urging the citizens of Philadelphia to secure West's pictures as the nucleus of a national gallery; and when unsuccessful, bought the Ophelia and Lear at the Royal Academy sale, and bequeathed them to the New York association of artists In these and various ways Fulton proved an early and efficient friend to, as well as votary of, Art" (Tuckerman, p. 56). Although he was elected a member of the Pennsylvania Academy in 1813, Fulton did little painting in the years after his return to America in 1806, preferring to perfect his experiments in steam navigation, which culminated in the successful voyage of the steamship *Clermont* in 1807. Fulton died eight years later in New York City.

AS

116. *John Wilkes Kittera*

c. 1785–86
Watercolor on ivory
1⅝ x 1¼″ (4.1 x 3.1 cm)
Historical Society of Pennsylvania, Philadelphia

PROVENANCE: Mary Kittera Snyder, Selinsgrove, Pennsylvania, until 1901

LITERATURE: Alice Crary Sutcliffe, "The Early Life of Robert Fulton," *Century Magazine*, vol. 76 (1908), p. 787, illus. p. 786; Alice Crary Sutcliffe, *Robert Fulton and the "Clermont"* (New York, 1909), illus. p. 27; Theodore Bolton, *Early American Portrait Painters in Miniature* (New York, 1921), p. 72; Harry B. Wehle and Theodore Bolton, *American Miniatures 1730–1850 . . . & A Biographical Dictionary of the Artists* (Garden City, N.Y., 1927), p. 21;

MMA, *Catalogue of an Exhibition of Miniatures Painted in America 1720–1850* (March 14–April 24, 1927), p. 30; Alan Burroughs, *Limners and Likenesses: Three Centuries of American Painting* (Cambridge, Mass., 1936), p. 111; Eleanore J. Fulton, "Robert Fulton as an Artist," *Lancaster County Historical Society Papers,* vol. 42, no. 3 (1938), pp. 53, 66, illus. facing p. 64; Thomas Hamilton Ormsbee, "Robert Fulton, Artist and Inventor," *American Collector,* vol. 7, no. 8 (September 1938), p. 7; James Thomas Flexner, "Fulton and Morse: Two Yankee Inventor-Painters," *Art News Annual,* vol. 27 (1958), p. 50 (illus.); Wainwright, *Paintings and Miniatures,* p. 143, illus. p. 101

ALTHOUGH ROBERT FULTON went on to fame in the field of engineering, his early miniature portrait of John Wilkes Kittera (1752–1801) bears witness to the potential of his abbreviated artistic career. Kittera, a member of the Philadelphia bar and later United States district attorney for eastern Pennsylvania, was originally from Lancaster and probably a boyhood friend of Fulton. Painted in the mid-1780s, the portrait resembles the work of the Peales, who may have instructed the young artist in miniature painting. The pursed-lipped expression, wiry treatment of the hair, oval shape of the head, sloping shoulders, and lively use of color are reminiscent of James Peale's miniatures of the 1780s and 1790s. Fulton's miniature work evolved into elaborately romantic, highly finished artificial portraits after his exposure to English portraiture during his twenty-year residence abroad.

RB-S ☐

117.

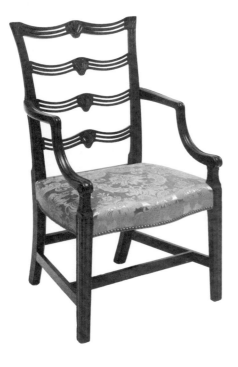

117. *Armchair*

c. 1785–95

Mahogany; twentieth century pink damask slip seat

39¼ x 24 x 19¾″ (99.7 x 61 x 50.2 cm)

Mr. and Mrs. Bertram Coleman, Bryn Mawr, Pennsylvania

PROVENANCE: With Joseph Kindig, Jr., Lancaster, Pennsylvania

LITERATURE: Anne Castrodale, "Daniel Trotter, Philadelphia Cabinetmaker," M.A. thesis, University of Delaware, 1962, pl. 15

THIS TYPE OF CHAIR, usually called a ladder-back, has frequently been attributed to the workshop of Daniel Trotter, a Philadelphia cabinetmaker who was active from about 1768 to 1800. This attribution is based on a set of six chairs which Stephen Girard bought from Trotter in August 1786 according to an existing bill of sale. These chairs, now at Girard College, incorporate many elements seen in this armchair: a back formed by four horizontal members, each consisting of three curved swags; molded, tapered front legs carved on two sides; square canted rear legs; and box stretchers.

According to Anne Castrodale ("Daniel Trotter, Philadelphia Cabinetmaker," M.A. thesis, University of Delaware, 1962), there is no known prototype for this chair, although individual elements in the design can be traced to English sources. The central plume pattern on the horizontal back members of the Girard chairs is here replaced by an anthemion-like scroll and leaf design, sometimes called the honeysuckle pattern, and a small rosette. The anthemion was a popular motif in English architecture and furniture at the end of the eighteenth century.

Although in the past most ladder-back chairs of this design have been referred to as "Trotter-type" chairs, there are many differences in construction, carving, and design between some of these attributed examples and the documented chairs made for Girard. Some of these discrepancies may be explained by the presence of different craftsmen working for Trotter (he employed four apprentices between 1790 and 1800 and had turners and carvers doing piecework for him), but such differences may also be the result of practices of different shops.

The Cabinetmaker's Philadelphia and London Book of Prices (Philadelphia, 1796, p. 132) lists "A Splat Back Chair, Honeysuckle Pattern, with mahogany rails; straight seat, no low rails—14s. 6d." Such an entry indicates that this type of chair was commonly produced by the Philadelphia school of cabinetmakers and, thus, at this time should not be identified with one craftsman.

PT ☐

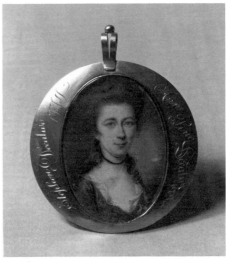

118.

CHARLES WILLSON PEALE (1741–1827)
(See biography preceding no. 92)

118. *Mrs. Stephen Decatur (Ann Pine)*

c. 1786

Watercolor on ivory

2 x 1½″ (5.1 x 3.8 cm)

Private Collection

PROVENANCE: Stephen and Ann (Pine) Decatur; niece, Mrs. Levi Twiggs (Priscilla Decatur McKnight); Mrs. Frank H. Getchell; daughter, Lillie Shippen Getchell

CHARLES WILLSON PEALE's early miniature portraits reflect the influence of the miniatures of Copley, which he may have seen in Boston in 1767, and contemporary English examples, which he saw in Benjamin West's studio during his two-year sojourn in London. While abroad, Peale is said to have supplemented his income by painting miniatures. Like the mid-eighteenth century English models, Peale's miniature portraits were executed in subtle opaque colors and were crisply and precisely modeled. His fine stipple technique broadened in the painting of the hair, costume, and background.

In 1786, Peale, whose time became increasingly absorbed by his museum and his other varied interests, wrote that he was giving up miniature painting in favor of his younger brother and assistant, James (Sellers, *Peale,* 1969, p. 215), whom he had instructed in this genre. Consequently, miniatures by the two brothers done in the late 1780s and early 1790s so resemble each other as to be sometimes indistinguishable.

Mrs. Stephen Decatur (1752–1812) was

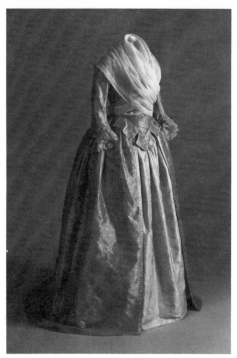

119.

the wife of Captain Stephen Decatur, an officer in the new American navy, and mother of the famous commodore. The dress and loose coiffure in her portrait suggest that the miniature was painted in the latter part of the 1780s. It may indeed be the miniature for which Charles Willson Peale received a payment from Stephen Decatur of £14 on August 7, 1786 (Sellers, *Portraits and Miniatures*, p. 63). The neutral blue-gray background done in short stubby strokes and the lively but delicate tonalities of the rust-colored dress and delicately stippled skin are characteristic of Peale miniatures during this decade. The careful delineation of the dress, the wiry long strokes of the hair, cupid's bow mouth, slight suggestion of a double chin, and small sloping shoulders—Peale distinguishing marks—are also traits James Peale's miniatures retained throughout his long and prolific career. The portrait of Mrs. Decatur is framed in a gold case, inscribed with the date of her marriage, 1774. Her husband's profile portrait, an engraving after Saint-Mémin, is encased on the opposite side.

RB-S □

119. *Dress*

c. 1787–92
Blue silk brocade
Waist 26″ (66 cm); center back length 61½″ (156.2 cm)
Philadelphia Museum of Art. Given by Mrs. W. Logan MacCoy. 55-78-2

PROVENANCE: Rebecca Hughes (1770–1792); descended in Morris family to Mrs. W. Logan MacCoy

BY THE 1780s, the cut of dresses had become simpler, and fabrics were rather delicate in texture and color. Panniers disappeared, to be replaced by a back bustle held out by small pads or cushions, or a half underskirt stiffened with whalebone and heavy muslin. This dress, with a low-cut rounded neckline, is made of a fine textured pale-blue silk brocaded in an allover pattern of delicate, light ivory flowers and leaves. The back of the bodice is closely fitted with three seams stiffened by stays of whalebone—one at the center and the other two slanting down from the shoulder—the three coming together in a long point at center back. In front, the bodice fastens in a point with three tabs along the waistline on each side. The lower edges of the three-quarter-length sleeves, which follow the curve of the elbow, are cuffed and trimmed with three satin-covered buttons and lace. The full skirt is open in front and pleated into the bodice following the long point in back. The separate ivory-brocaded half underskirt shown here is gathered with a drawstring. The fine buffon, or fichu, which crosses the bust and ties in the back, gave the silhouette its "pouter-pigeon" look, popular in the late eighteenth century.

This dress was probably worn by Rebecca Hughes (1770–1792), the niece of Levi and Hannah Paschall Hollingsworth. It is almost identical in style to the one worn by Rebecca's Quaker cousin, Mary Hollingsworth (no. 144), although of course this outfit is much more elaborately trimmed.

EMcG □

JOSEPH ANTHONY, JR. (1762–1814)

Joseph Anthony, Jr., was the son of Joseph and Elizabeth Sheffield Anthony of Newport. Too young in 1776 for military service, Joseph probably began his apprenticeship at fourteen. His father's cousin, Isaac Anthony (1690–1773), had been a silversmith in Boston and Newport. Isaac's mark, an IA in an oval, is very similar to Joseph's

earliest mark, IA in a rectangle. Isaac may have provided Joseph's entrée into a Newport shop such as that of John Tanner (1713–1785) and Joseph Rogers who were in partnership there in 1773. A pair of canns made by Joseph Anthony for Commodore Barry are very similar to a cann made by Daniel Rogers (d. 1792), who was apprenticed to Tanner until 1774.

Joseph, Sr., a sea captain, carried passengers and cargo to and from Philadelphia in his sloop *Peace and Plenty* from 1768 to 1782, when he decided to move to Philadelphia. Rhode Island, and especially Newport, had suffered a crushing depression after the Revolution from which it never fully recovered even though it continued to be popular with Philadelphians as a summer resort. The Anthonys were a prosperous mercantile family before they moved to Philadelphia; soon after their arrival they owned property in the North and Lower Delaware wards and were involved in loans in the amount of $26,000 to William Bingham's land purchases (Margaret L. Brown, "William Bingham," *PMHB*, vol. 61, no. 4, October 1937, p. 423).

Joseph, Sr., with whom Joseph, Jr., has often been confused, had an account with Benjamin Randolph in 1774–75, amounting to £203 5s. 10d., which was probably for cargo; this account was not settled until 1786 (NYPL, Philadelphia Merchant's Account Book, 1768–86, p. 139). The father's address from 1791 to 1798 was at 225 High Street. His firm, known as Joseph Anthony and Son, Merchants, was located at 5 Chestnut Street (Harrold E. Gillingham, "Old Business Cards of Philadelphia," *PMHB*, vol. 53, no. 3, 1939, pp. 208–9).

As Joseph, Jr.'s, first advertisements appeared in the *Pennsylvania Packet* on October 4, 1783, and in the *Pennsylvania Journal*, no. 1631, on the same date, he probably came with his family in 1782 having just completed his apprenticeship. He was located on Market (High) Street two doors east of the Indian King Tavern, which would place his shop at number 45, on the south side between White Horse Alley and Third Street. Anthony never owned property above Fourth Street; his last house, on which he took a mortgage in 1802, was at 304 Market Street, near Third. An insurance policy issued to him in 1793 for this building offers a fine description of the elegance achieved with the narrow street facade of an important silversmith's shop:

Dimensions 22 feet front and 50 feet Deep, Lower Story Front occupied as a Goldsmith and Jewelers Show shop with Counters that has flat panels and Mahogany Tops. There is a neat cornice and the south part is all of compass work. There are shelves with mahogany sashes in Front

above and Mahogany Doors below glass of 12 by 18 and two circular Bulks with glass of the same size and Frontispiece with Fluted pilasters.... Entry two setts of Fluted pilasters with arched soffets Cornice round and Washboards and Surbase... Front Room Floors Narrow boards and no Nails to be seen... Back-buildings 34 feet by 14 and three Stories high Third story occupied as a Workshop with a Forge.... (Philadelphia Mutual Assurance Company, Policy 388, December 11, 1793)

Anthony made frequent use of the newspaper to promote his business and to list his extensive stock (*Pennsylvania Packet*, no. 3411, January 5, 1790; no. 3636, September 24, 1790; no. 3698, December 7, 1790; no. 3813, April 16, 1791; no. 3824, April 29, 1791). He not only manufactured and sold his own silver but imported from London a full complement of goldsmith's wares, including octagonal plated tea urns, chased and engraved; steel and gilt hat buckles; inlaid knife cases; gold and silver spangles; gold and silver embroidery pearls; chimneypieces of Derbyshire manufacture; elegant mahogany and leather backgammon tables; and horsemen's trumpets. From the outset he had good business connections in Philadelphia through his father and also as a result of his marriage in 1785 to Henrietta Hillegas, daughter of Michael Hillegas, United States Treasurer.

Soon after setting up shop, Anthony made a handsome, if old-fashioned, pear-shaped footed coffeepot for George Washington, which must have brought immediate attention to his work. Two tankards, one of which is exhibited here, made on commission from the Penns in 1788, were additional proof of his skill and distinguished patronage. The family was related to the painter Gilbert Stuart through the marriage of Joseph's aunt, Elizabeth Anthony, to Gilbert Stuart, Sr., in 1751. Anthony's son, Joseph (1786–1804), was painted by Stuart about 1800 when the artist was briefly in Philadelphia. Gilbert also painted Joseph, Sr., in three versions, about 1794. No portrait of the silversmith by Stuart has yet emerged (Mantle Fielding, "Paintings by Gilbert Stuart Not Mentioned in Mason's Life of Stuart," *PMHB*, vol. 38, no. 3, 1914, p. 315). However, Benjamin Trott, who copied many of Gilbert Stuart's paintings, did a miniature portrait of Joseph Anthony, Jr. (see no. 146). Joseph Anthony carried on his business until his death in 1814, having announced in the *American Daily Advertiser*, November 1, 1811, that he was in partnership with his sons Michael and Thomas at the sign of the Goldsmith's Arms, 94 High Street.

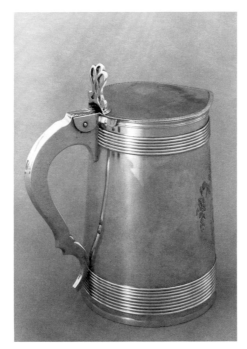
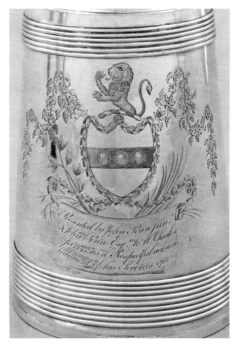

120.

120. *Tankard*

1788

Mark: I Anthony (in script in rectangle, twice on underside of cover)

Inscription: *Presented by John Penn Jun^r / & John Penn Esq^rs to M^r Charles / Jarvis as a Respectful acknow / ledgment of his Services 1788* (in script under Penn coat of arms); *T Willey* (in script on left side of handle, later inscription)

Silver

Height 6⅞″ (17.4 cm); diameter base 5″ (12.7 cm)

Philadelphia Museum of Art. 50–53–1

PROVENANCE: Charles Jarvis (1731–?); Captain William Lithgow Willey, Cambridge, Massachusetts; Samuel T. Freeman and Co., Philadelphia, April 17–20, 1950, no. 230 (Henry Dolfinger sale)

LITERATURE: Francis H. Bigelow, *Historic Silver of the Colonies and Its Makers* (New York, 1948), p. 161; Fales, *Silver*, pp. 29–30

SOMETIMES CALLED a barrel-hooped tankard, this elegant example by Joseph Anthony lacks the barrel contour; the reeding, a subtle adaptation of barrel hoops, also enlivened the vertical parts of chairs and tables of the period. The tankard has a straight and flattened profile typical of post-Revolutionary styles in architecture and the decorative arts. The prim controlled form is in part the result of the use of rolled sheet silver. The body of

the tankard was cut and soldered. The base and top likewise were cut and worked; and the base soldered and the top hinged in place. The hollow handle also was formed from four flat pieces and soldered, not cast in solid silver as on earlier forms. The profile of the handle, although based upon the broken scroll of the rococo period, lacks the full curve or the "flip" at the end of the handle.

The engraved cartouche is fully neoclassical, the Penn arms surrounded by a garland of leaves seemingly suspended from a double swag of floral garlands. Especially notable are the finely engraved round and oval motifs which support the ribbons of foliage. The entire design is presented in a superlative engraving technique.

The year 1788 was one of celebration in Philadelphia—for everyone except the Penns. The Constitutional Convention had convened from May to September 1787, and the Grand Federal Procession, called for July 4, 1788, was the finale celebrating the ratification—a day which began with "a full peal from Christ Church steeple and a discharge of cannon from the ship 'Rising Sun'... anchored off Market Street" (Scharf and Westcott, vol. 1, p. 447).

But it was the death knell for the Penn proprietary interests in Pennsylvania. John Penn, onetime governor and the son of Richard Penn, and John Penn, Jr., son of Thomas Penn, presented a petition in 1787 "To the Honorable the Representatives of the

Commonwealth of Pennsylvania, the Memorial of John Penn Junior and John Penn" for settlement with the state of ownership of Pennsylvania lands held under their crown patents.

John Penn, Sr., bought two tankards from Anthony in February 1788 (HSP, Shippen Family MSS, vol. 32, February 13, September 3, 1788). They are identical in form, weight, and inscription except for the difference in names. This inscription reads: "Presented by John Penn Jun^rs & John Penn Esq^rs to M^r Charles Jarvis as a Respectful acknowledgment of his Services 1788." Nothing is known about the services Jarvis performed. Contrary to F. H. Bigelow's often repeated genealogical data, Jarvis was a Philadelphia lawyer of Irish descent.

In 1788 he was an agent for the estate of Isaac Norris II on behalf of Norris's wife, Mary, and son, Isaac (1760–1802), and he also performed legal services for the Pembertons. It seems reasonable that Jarvis and Gunning Bedford, whose name is inscribed on the matching tankard (Philip Hammerslough collection), acted as personal agents in one or more of the Penns' land claims. The fact that the two men do not appear in official Penn records suggests that their services concerned the conclusion of the Penns' personal affairs prior to their departure from Philadelphia.

Jarvis was born in 1731. His great-uncle (1676–1739) of the same name was apprenticed with Sir Godfrey Kneller and was a fashionable painter who knew and corresponded with James Logan (HSP, GS, Albert Justice Collection, vol. 13, p. 33). Charles was the grandson of Martyn Jarvis (1674–1742), a shoemaker who married Mary Champion on Long Island. Jarvis moved to Philadelphia and owned property by 1705 on Second Street between Market and Chestnut. His daughter was the mother of the diarist, Elizabeth Sandwith Drinker. Jarvis was listed as living in the Middle Ward by 1754, and in 1757 he was presumably at the family house, as their proximity to the Greater Meeting House was probably the reason why he, William Savery, and Jacob Shoemaker, Jr., held keys to the engine of the Fellowship Fire Company stored in the Meeting House yard.

On February 27, 1765, Jarvis married Elizabeth Boore at Christ Church (HSP, GS, Christ Church, Marriages, p. 4315), while his sister, Elizabeth, had married Enoch Davise at St. Paul's in 1761 (HSP, GS, St. Paul's Church, Marriages, p. 257). Charles's branch of the family retained their Quaker ties, as evidenced by an entry in Elizabeth Drinker's Diary, August 7, 1768, "Charles Jervis and Wife drank tea with us. ..." Jarvis was one of the men exiled to Winchester, Virginia, in 1777, along with Henry Drinker, Thomas Affleck,

and others (HSP, Elizabeth Drinker, Diary, December 2, 1777). His son, Samuel (1779–1857), moved to New York, and perhaps inherited this tankard.

BG □

JONATHAN GOSTELOWE (1744–1795)

Jonathan Gostelowe, carrying a pair of dividers and a scale, led the Gentlemen Cabinet and Chair Makers in the Grand Federal Procession of 1788. His prominence in his own time as both a citizen and a cabinetmaker has earned for him a full column in the *Dictionary of American Biography*. Born in Philadelphia in 1744 and apprenticed to the cabinetmaker George Claypoole (HSP, Thomas Wharton, Receipt Book, July 12, 1762), he married Mary Duffield, a niece of Edward Duffield, clockmaker, in 1768. She died in 1770, and he married Elizabeth Towers in April 1789 at Christ Church. There was no issue from either marriage.

Gostelowe's first shop was located on Front Street near Chestnut about 1764. He worked there with several apprentices until 1776, when he left to serve the Revolutionary army as assistant commander of military stores (Gillingham, "Cabinet-makers"). He took the oath of allegiance on June 28, 1777 (*Pennsylvania Archives,* 3d series, vol. 3, p. 12). Gostelowe seems to have served in Philadelphia as commissary from 1779 to 1781, located in the South Ward (Raymond B. Clark, Jr., "Jonathan Gostelowe," M.A. thesis, University of Delaware, 1956). According to Clark, he resigned from the military in 1781 and may have returned to his cabinetmaking practice at that time, although it was not until 1783 that he opened his shop on Church Alley between Market and Arch and Second and Third streets. The location of his shop is documented by a label that appears on a handsome serpentine-front chest of drawers in the Philadelphia Museum of Art: "Jonathan Gostelowe, CABINET AND CHAIR-MAKER, At his shop in CHURCH ALLEY, about midway between Second and Third-streets, BEGS leave to inform his former Customers, and the Public in general, That he hath again resumed his former occupation at the above mentioned place: A renewal of their favours will be thankfully received; and his best endeavours shall be used to give satisfaction to those who please to employ him."

In 1788 he made the baptismal font and communion table for Christ Church, where he had held a pew since 1783, and later, in 1792, was a vestryman. He and his wife

Elizabeth moved in 1790 to 68–70 High Street (APS, Prime file), to property which had belonged to Robert Towers, Elizabeth's father. Gostelowe solicited for an apprentice in the *Independent Gazetteer,* March 13, 1790. William Birch's engraving of *High Street, with the First Presbyterian Church, Philadelphia* (Clarence Wilson Brazer, "Jonathan Gostelowe, Philadelphia Cabinet and Chair Maker," *Antiques,* vol. 9, no. 6, June 1926, illus. p. 385), shows Gostelowe's shop on Market Street to be a two-story building, and his house just beyond.

In 1793, Gostelowe was advertising a sale at auction of furniture, shop stock, and his tools, "having declined Business ..." (*American Daily Advertiser,* May 10, 1793). He also advertised the sale of his Market Street properties: "One is an old accustomed Apothecary's Shop and Store for Window Glass, Painters' Colours, &c., the other an eligible situation for either the Grocery or Dry Goods Business ..." (*American Daily Advertiser,* January 16, 1793).

Gostelowe owned other city property which he also advertised for sale. He retired to a twenty-five acre farm on the Ridge Road, which he had received as a bequest from his first wife, but continued in 1794 to attend to his committee responsibilities at Christ Church. Gostelowe died February 3, 1795, and was buried at Christ Church. His widow remarried to Matthew Locke in July 1798 and moved to New Jersey.

121. *Dressing Glass and Stand*

1789
Inscription: JG ET (in script made with cut steel pins, on pincushion inside center of long drawer)
Mahogany; spruce, pine, and cedar; mirror frame, tulip wood and gilded gesso; brass hardware
32 13/16 x 19 1/4 x 14″ (83.4 x 48.9 x 35.6 cm)
Yale University Art Gallery, New Haven. The Mabel Brady Garvan Collection

PROVENANCE: Jonathan and Elizabeth (Towers) Gostelowe, 1789; Sarah (Towers) Evans, 1808; Robert Towers Evans, 1815; Martha P. Evans, 1858; Eliza Ferguson (Evans) Fraser, Brandywine Manor, Pennsylvania, 1895; Mrs. Gertrude H. Camp, Whitemarsh, Pennsylvania, 1920; sale, Anderson Galleries, New York, January 18–19, 1929, no. 173

LITERATURE: Clarence Wilson Brazer, "Jonathan Gostelowe, Philadelphia Cabinet and Chair Maker," *Antiques,* vol. 9, no. 6 (June 1926), pp. 385–92, figs. 3, 4; Meyric R. Rogers, "The Mabel Brady Garvan Collection of Furniture," *Yale Alumni Magazine* (January 1962), p. 11 (illus.)

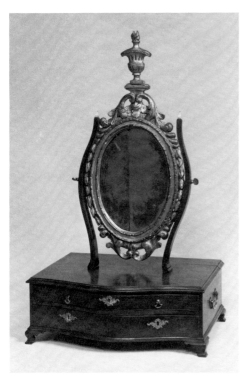

121.

THIS DRESSING GLASS AND STAND was designed for the walnut serpentine-front chest of drawers (also in the Yale University Art Gallery) that Gostelowe made for his wife Elizabeth in 1789 at the time of their marriage. The large chest has four tiers of drawers, the top tier divided into two, effecting a transition to the drawer organization of the dressing stand, also serpentine, with a fine raised bead edging the drawers, side carrying handles, ogee-bracket feet, and a molded-edge top. The casework of the dressing stand is a miniature of the commodious chest, with the exception of the bold champfer and fluted canted corners of the larger piece. The brass fittings are elaborate on both pieces, with pheasants perched on the ball sockets on the big chest, and elegant fluttering rococo foliage decorating the keyholes.

The swinging mirror is supported by two molded vertical members shaped to accommodate the oval carved-and-gilded looking glass frame. Little transition is made from the masterful sweep of the drawer units into these stiff, upright pieces, suggesting that this may have been Gostelowe's first attempt at the form. The carved frame seems crowded between its "clamps," but the lively design of curling foliage at the top and bottom, employing voids as well as solids, gives a light feeling to a frame which otherwise would have been out of scale with its supporting dressing box. The urn, which springs incongruously from behind the rolling leafage, is surmounted by an open-flame finial, derived from Thomas Johnson's design book of 1758. The profile of the frame is reasonably controlled, especially along the sides. It may possibly all have been carved by James Reynolds, a friend and neighbor of Gostelowe, as the carving has elements in common with the frames Reynolds made earlier for Benjamin Chew (see no. 95).

The interiors of the drawers are fitted with many tiny compartments with lids and ivory knobs. The original pale blue silk pincushion with the initials of the bride and groom, JG and ET formed by cut steel pins, is still in place in the center of the top drawer.

BG □

WILLIAM THORNTON (1761–1827)

William Thornton, son of William and Dorcas Zeagers Thornton, was born on May 27, 1761, on the island of Tortola in the West Indies. Following the custom of the islands, he was sent abroad to England for his education. He visited relatives there: first, his aunts at Lancaster, then his step-father, Thomas Thomasson, at the Strand in London. Following an apprenticeship as a druggist's clerk, he entered the College of Edinburgh to study medicine, and continued at St. Bartholomew's Hospital in 1783. After completing his degree requirements and touring in Europe, he returned to Tortola in 1786 (Charles F. Jenkins, *Tortola,* London, 1923, p. 89). He was visiting in New York later that year, but settled in Wilmington, Delaware, from which he entered the intellectual and political life of Philadelphia. He was elected a member of the American Philosophical Society in 1788, and by 1789 had moved from Wilmington into rented rooms at a fashionable boardinghouse at Fifth and High streets (Charles E. Peterson, "Library Hall: Home of the Library Company of Philadelphia, 1790–1880," in *Historic Philadelphia,* p. 145).

Whether Thornton practiced medicine in Philadelphia for his livelihood is not known, but he was deeply involved with John Fitch in the development of the steamboat, working actively on the mechanics and design, saying, "I believe I was the only person in the Company, who had seen a Steam Engine" (Peterson, cited above, p. 145). He probably had studied physics abroad, but architecture seems to have been a less formal occupation, and he suggested that his design for Library Hall was one of his first: "When I travelled I never thought of architecture, but I got some books and worked a few days, then gave a plan in the ancient Ionic order which carried the prize." He further revealed his lack of expertise as an architect when he wrote about his 1792 winning design for the United States Capitol: "I lamented not having studied architecture, and resolved to attempt this grand undertaking and study at the same time. I studied some months and worked almost night and day" (Library of Congress, William Thornton Manuscript Collection, June 25, 1802).

After his marriage in Philadelphia to fifteen-year-old Anna Marion Brodeau in 1790, he returned to Tortola, where he practiced medicine and wrote a treatise on the elements of the written language entitled *Cadmus,* published by Robert Aitkin and Son in Philadelphia in 1793. Thornton was brought up a Quaker within the same community as Richard Humphreys, silversmith (see biography preceding no. 102), and suffered similar moral conflicts about the slave economy of the sugar plantations. Writing to his friend Dr. Coakley Lettsom in 1787, he said, "When I was in England I thought the sugar sweet, but saw not the bitter tears that moistened the ground on which it grew, but when I had been awhile in my native country and viewed the situation of the blacks, I regretted often that I was born a slave-holder" (Jenkins, cited above, p. 63n.). In 1791, before he decided to move permanently to North America, probably because Tortola's hot, wet climate was injurious to his health, he petitioned the council of the Virgin Islands with regard to freeing the seventy slaves who were part of his inheritance.

His decision to move in 1792 was probably prompted by Thomas Jefferson's advertisement for the Capitol design contest, which he entered and eventually won. Thornton became one of three commissioners for the building of the federal city on the Potomac, and George Washington appointed him first superintendent of the Patent Office in 1793. He and his wife settled on a large farm in Maryland. After joining the army in the War of 1812, he departed from the Society of Friends. He died at his farm in 1827, survived by his wife.

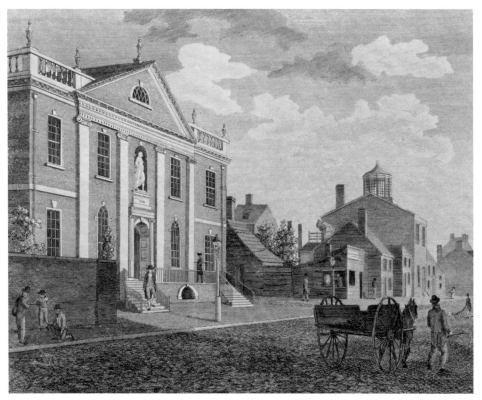

122.

122. *Library Hall*

Fifth Street, between Chestnut and
Walnut streets

1789–90; addition 1792–95 (building
demolished 1887)

Inscription: Be it remembered,/In Honor
of the PHILADELPHIAN Youth,/(Then
chiefly Artificers)/That in MDCCXXXI/
They cheerfully,/At the Instance of
BENJAMIN FRANKLIN,/One of their
Number,/INSTITUTED the PHILADELPHIA
LIBRARY,/which, though small at first,/
Is become highly valuable,/And
extensively useful;/And which the Walls
of this Edifice/Are now destined to
contain and preserve:/The first STONE of
whose FOUNDATION/Was here placed/
The thirty-first Day of AUGUST, An: Dom:
MDCCLXXXIX/Benjamin Gibbs, Josiah
Hewes,/John Kaighn, Mordecai Lewis,/
Thomas Morris, Thomas Parke,/Joseph
Paschall, Benjamin Poultney,/Richard
Wells, Richard Wistar,/then being
Directors Samuel Coates, Treasurer,/
William Rawle, Secretary,/Zachariah
Poulson, jun^r Librarian. (carved in marble
block, now in the Library Company of
Philadelphia)

Brick, stone, and marble facade; wood
trim

40 x 48' (12.2 x 14.6 m); addition
70 x 20' 6" (21.3 x 6.2 m)

REPRESENTED BY:

William Birch (1755–1834)
Library and Surgeons' Hall, Fifth Street
1799
From *The City of Philadelphia,* 1800
Engraving
8¼ x 10⅞" (21 x 27.8 cm)

Private Collection

LITERATURE: "A Short Account of the Library,"
in *A Catalogue of the Books Belonging to the
Library Company of Philadelphia* (Philadelphia,
1789) pp. iii–xi; "The Neighborhood of Fifth
and Chestnut Streets," *Public Ledger,* April 20,
1887; Charles E. Peterson, "Library Hall: Home
of the Library Company of Philadelphia,
1790–1880," in *Historic Philadelphia,* pp. 129–47

THE BOOKS and scientific paraphernalia
collected by the Library Company after its
founding in 1731 continually outgrew the
spaces borrowed or rented for them. The
Library was first located in Pewter Platter
Hall (on Church Street off Second) and
then in the house of its librarian, William
Parsons. In 1740, two years before its charter
was granted, the Library Company moved to
the second floor of the west wing of the
State House. In 1773, having amalgamated
with the Union Library Company (in 1769),
it moved to the second floor of Carpenters'
Hall, where the collection was admired and
used by members of the First Continental

Congress in 1774 and the Constitutional
Convention delegates in 1787.

About 1784, the Library Company had
elected to move into its own quarters, and
the search for a suitable central location
began. At the same time, the American
Philosophical Society was trying to build,
and the two organizations almost agreed
upon "balancing" structures on Walnut
Street at the southeast and southwest corners
of the State House yard, opposite the jail.
However, both wanted the southeast corner
site as each considered it more "central" to
the town (Peterson, cited above, p. 130).
Nothing came of the joint venture, and a
committee consisting of Josiah Hewes,
Richard Wells, Thomas Morris, and Dr.
Thomas Parke was then appointed to locate
ground. Two lots at Fifth and Chestnut
streets were purchased from Mary Norris
and George Logan in August 1789, and a
third, the corner lot, at a sheriff's sale in
July 1789. Library Hall would thus occupy
a conspicuous site on the east side of Fifth
Street, facing west and the State House yard
across the street. Not only was the political
life of post-Revolutionary Philadelphia
focusing on the State House, but institutions
celebrating the cultural attainments of the
city were seeking permanence and recogni-
tion by clustering around the venerable
building in which it was still expected that
the national government would convene.

Philadelphia architecture had achieved a
comfortable homogeneity of style and mate-
rial before the Revolutionary War. With
independence came an active expansion of
artistic enterprise. Although the Library
Company had owned Stuart and Revett's
Antiquities of Athens (vol. I) by 1762 and
Thomas Major's *Ruins of Paestum* by 1768,
the pre-Revolutionary architect-builders had
continued to work within the baroque
tradition of Christopher Wren, by then
grown lukewarm. The traditional Philadel-
phia sources, James Gibbs, Colen Campbell,
and Abraham Swan, are revealed in the
underlying design of Library Hall. But
added to this are neoclassical details as
published and exploited by John and Robert
Adam in England and their pragmatic
exponents William and James Pain, whose
Practical House Carpenter was so popular
that it was republished in Philadelphia by
1797 (Fiske Kimball, *Domestic Architecture
of the American Colonies and of the Early
Republic,* New York, 1922, p. 150n.).

Thornton must have seen the latest build-
ings of London and Edinburgh when he was
a student there in the 1780s. The Adam
brothers were renowned in both centers, and
their distinctive style based on recent archae-
ology at Pompeii and Herculaneum was
prominent on public and private buildings.
There is no evidence that Jefferson showed
Thornton around Paris in 1784–85, although

they were both there, and Jefferson delighted in pointing out the city's architectural wonders to other Americans such as architect Charles Bulfinch (Fiske Kimball, *Thomas Jefferson*, New York, 1968, p. 39).

None of the original drawings submitted in the competition for the design of a new library is extant, nor are the sketches or suggestions put forth by David Evans, carpenter and shareholder, when the idea of a building was first presented. They all were turned down and may have been too old-fashioned for the building committee which included Richard Wells. He was to be closely associated with the design and building of the President's House in 1792 (also engraved by Birch), which would employ the same smooth, linear architectural vocabulary as Library Hall, suggesting that he liked the Adamesque English style. As Wells also worked with Thornton and Fitch on the steamboat, Thornton may have had fore-warning about the committee's tastes and hopes. Library Hall's hip-roofed rectangle with its central projecting pediment, albeit a shallow one, was not new, but the flattened marble pilasters with their antique ionic capitals, and the sculpture niche over the entrance were. Clement Biddle's Philadelphia directory for 1791 described it as "in a modern stile."

Thornton probably used plate 9 in volume 2 of Abraham Swan's 1757 edition of *A Collection of Designs in Architecture* as the basis for his winning design scheme (Peterson, cited above, p. 133); and the notes that the Library board wrote into their minutes of October 1, 1789, stating that there would be "an alteration in the Steps and Stone basement and some deviations in the ornament and disposition of the doors and windows," explain the differences between Swan's plate and the building. The window decoration was altered from Swan's version of Gibbsian rustication to simple arches with Gothic sash, and plain rectangular window molds appear in a full second story. Thornton added a belt course in marble and replaced the suggestion of a coat of arms in Swan's pediment with the "Gothic" fan, a lunette window illustrated in the Carpenters' Company *Rule Book* of 1786. It is in harmony with the arched doorframe and sculpture niche, and with the round-headed windows which flank the doorway on the first floor, although the sash pattern is different, and is literally repeated as an unusual central feature of the stone steps.

Library Hall was notable in its own day. The *Columbian Magazine* published a *View of Several Public Buildings in Philadelphia* in 1790, which shows the building not quite completed. In 1792, the trustees of the private library of James Logan, which had been deeded to the City of Philadelphia in 1760 and was the first free library in

America, elected to attach itself to the eminent and successful enterprise at Library Hall in its own contiguous quarters. Thus, an addition to the building, a long rectangle on the back, was begun in 1792 and completed in 1795. This does not appear in Birch's view of the structure. Library Hall was one of the three buildings engraved in 1796 in vignettes on the Varlé map (no. 143). J. C. Wild's *Panorama* taken from the steeple of the State House in 1838 shows Library Hall with its seventeen urns in place on the roof balustrade. One of these survives at the Library Company along with François Lazzarini's marble statue of Benjamin Franklin in a toga, leaning on a stack of books, carved for the niche over the doorway, and the cornerstone.

A description published in the Philadelphia *Public Ledger* on April 20, 1887, when the building was demolished, stated: "There was some little change from the uniformity of plain brick walls, the ornament was such as was easy to be obtained in native marble, with the addition of well-made mouldings in wood, in panel, balustrade, with classic urns. . . . The great steps on Fifth street were of a width and depth of more than ample liberality. They were, in fact, almost a building by themselves, and gave to the lower part of the edifice a solidity which was well assisted by the broad, noble doorway and the heavily faced niche, with ornaments above it. Taken from any point of view this building, although not gorgeous, was striking and respectable." In 1956 the American Philosophical Society building was constructed on the original site of Library Hall, and its facade reproduces the 1789 design as originally built.

BG □

JOHN HEWSON (c. 1745–1821)

John Hewson was one of the first calico printers recorded in Philadelphia, and his work helped to lay the foundation upon which Philadelphia's great textile industry was built. With experience gained at Bromley Hall in London—"one of the most considerable Manufactories and Bleach-yards in England," as he himself announced in an advertisement in the *Pennsylvania Gazette* of July 20, 1774—and a recommendation from Benjamin Franklin, Hewson and his family immigrated to Philadelphia in the fall of 1773. The following summer he established his calico works at Kensington in the Northern Liberties, near the Aramingo Canal, which provided the clear water needed for the process of bleaching.

Although imported fabrics were generally more sophisticated, Hewson's prints soon became popular in Philadelphia. It is said that in 1775, Martha Washington, upon hearing of the establishment while staying with friends in Philadelphia, visited the Hewson factory, and bought his prints for dresses and household effects.

In 1775, although he had been in the Colonies for only two years, Hewson enlisted in the Philadelphia militia and fought in the war, but was captured near Burlington, New Jersey, in April 1778. He escaped soon after, however, and returned to Philadelphia to find his works and materials destroyed by the British.

Receiving help from public and private sources to re-establish his manufacturing venture, he and a partner, William Lang, a calico printer from England whom he probably had known at Bromley Hall, established the firm, "Hewson and Lang, Linen Printing," as advertised in the *Pennsylvania Packet* of November 9, 1779. In 1788 he participated in the Grand Federal Procession in Philadelphia with a demonstration of the processes involved in fabric printing. A year later, the printer received a "Plate of Gold" as an award for "the best specimen of calico printing done in the State" (Harrold E. Gillingham, "Calico and Linen Printing in Philadelphia," *PMHB*, vol. 52, no. 2, April 1928, p. 104) from the Pennsylvania Society for the Encouragement of Manufactures of the Useful Arts, probably the same as the "Gold Medal" bequeathed to his son, John. Hewson retired in 1810, leaving the business to this son.

123. *Printed Coverlet*

c. 1780–1800
Plain-weave cloth of a mixed cotton and linen yarn (66 x 56)
102¾ x 105″ (260.9 x 266.7 cm)
Philadelphia Museum of Art. Given by Joseph B. Hodgson, Jr. 30–100–1

PROVENANCE: John Hewson; daughter, Ann (Hewson) Hodgson, 1821; descended in family to grandson, Joseph B. Hodgson, Jr.

LITERATURE: Harrold E. Gillingham, "Calico and Linen Printing in Philadelphia," *PMHB*, vol. 52, no. 2 (April 1928), pp. 105–6; Nancy Andrews Reath, "A Philadelphia Calico-Printer," *PMA Bulletin*, vol. 26, no. 138 (January 1931), pp. 25–28; *PMA Bulletin*, vol. 57, no. 271 (Autumn 1961), p. 27; Florence M. Montgomery, *Printed Textiles: English and American Cottons and Linens, 1700–1850* (New York, 1970), pp. 96–98; Pettit, *Fabrics*, pp. 169, 171, illus. p. 168; Safford and Bishop, *Quilts and Coverlets*, fig. 36; *Treasures of the Philadelphia Museum of Art* (Philadelphia, 1973), p. 67

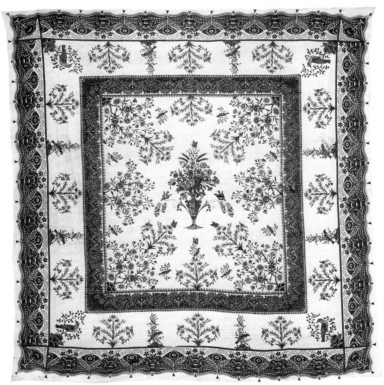

123.

THIS COVERLET is a handsome example of John Hewson's work and of early Philadelphia calico printing. The cloth was woven on a narrow loom in two widths, as is typical of coverlets until perhaps 1820, and sewn together with a seam down the middle. The print is delicate in design, with a vase of flowers in the center field, surrounded by sprigs of leaves, with flowers, birds, and butterflies. The same vase appears in two other Hewson prints in the Philadelphia Museum of Art, and an almost identical coverlet is in the Winterthur Museum (Florence B. Montgomery, *Printed Textiles: English and American Cottons and Linens, 1700–1850*, New York, 1970, frontispiece). Block printed by hand, the colors include two shades of madder red, brown, black, golden yellow, and blue, with an overprinting of green on a natural ground. Each of the three borders surrounding the center square is of a separate design: the outer one is edged in dainty, simulated fringe and spaced tassels; the middle shows an open airy design, typical of Hewson, with alternating foliage and birds; and the inner one is a closely printed floral design. The corners of the borders are printed with separate blocks, typically found in the work of early printers.

Hewson's designs were generally influenced by imported printed India chintz textiles, but this coverlet may have been specifically inspired by an Italian copy of an East Indian Tree of Life palampore, which

he owned and bequeathed to his daughter along with the coverlet (City Hall, Register of Wills, Will no. 152, 1821) and which is now in the Philadelphia Museum of Art. The feeling of space and openness also reflects a similarity with contemporaneous English furnishing fabrics and American crewelwork embroidery.

There is no doubt that Hewson was a seasoned craftsman and artist. His fine work most likely required not only printing with wood blocks but also the cutting and stamping of copper plates, which he may have used in the detailing of his designs, in addition to hand "penciling."

EMcG □

RICHMONDE (N.D.)

Richmonde was a chairmaker on Arch Street, Philadelphia. He was mentioned in the journal of an old Philadelphia family (see J. Stogdell Stokes, "The American Windsor Chair," *PMA Bulletin*, vol. 21, no. 98, December 1925, p. 53). The writer comments on a pleasing chair which he had seen: "My inquiry into the manner of these chairs is that they were made by one Richmonde on Sassafras Street, a joiner of much repute who has come from the motherland—Saw Richmonde and ordered the chairs. . . ." Since very little is known about Richmonde, this journal entry is particularly interesting.

JOHN LETCHWORTH (1759–1843)

The career of John Letchworth has been the subject of extensive research, and because of the presence of Letchworth's chairs in public buildings his work is relatively well known. Letchworth's chairmaking, however, is almost incidental to his involvement as an itinerant Quaker preacher in the second half of his life. According to Perry Hoberg ("John Letchworth, Windsor Chairmaker and Quaker Minister," MS, Winterthur Museum, 1963, p. 1), "John Letchworth, Windsor chairmaker, presents an interesting Quaker artisan seeking to fulfill the ideal of the Friends' discipline apparently taking to heart the desired unity of purpose between the 'meeting house and country house.' From the evidence of his activities there would appear to be some connection between his training in the plain style of chairmaking with the general habit of living in plainness or simplicity."

Before the Revolution, Letchworth served an apprenticeship with a Windsor chairmaker. In 1783 he married Elizabeth Kite, and in the following year he operated a shop between Chestnut and Walnut on Third Street. On the basis of directory listings and tax assessments, it appears that Letchworth continued to work as a Windsor chairmaker until 1807, most of which time his shop and house were on South Fourth Street between Walnut and Chestnut.

JOSEPH HENZEY, SR. (1743–1796) OR JOSEPH HENZEY, JR. (ACT. 1802–6)

Joseph Henzey (Henszey), Sr., was listed in the Philadelphia tax lists of 1772, 1775, 1780, and 1786 as a Windsor chairmaker, according to Nancy Goyne Evans (letter to the author, June 30, 1975). He was succeeded by a son of the same name who was listed in the Philadelphia directories as a Windsor painter and chairmaker. In 1795 Henzey, Sr., was a steward of the Pennsylvania Hospital. In a notice in the *Pennsylvania Packet,* February 6, 1796, Joseph Burden announced that his partnership with Joseph Henzey was dissolved and that he (Burden) "carries on the business of Windsor Chair Making, at his shop, in Third Street, No. 99. . . ."

ROBERT TAYLOR (D. 1817)

Robert Taylor was living in Philadelphia by 1792, according to Nancy Goyne Evans (letter to the author, June 30, 1975). He probably trained as a turner, as his early work was in this craft. Taylor was in partnership with Daniel King in 1799 and 1800, and in 1801 he shared a shop at 99

South Front Street with the cabinetmaker Alexander Shaw. From 1802 until 1817, Taylor worked alone at various addresses on South Front Street as a Windsor chairmaker. In 1814 he was listed as a county commissioner as well as a chairmaker. He died in 1817 and his wife was listed as widow of Robert, Windsor chairmaker, in the 1818 Philadelphia city directory.

RICHMONDE

124a. *Armchair*

c. 1775–90
Oak, hickory, and maple
40 x 20¾ x 17¾" (101.6 x 52.7 x 45 cm)
The Naomi Wood Collection, Woodford Mansion, East Fairmount Park, Philadelphia

PROVENANCE: J. Stogdell Stokes; Naomi Wood

LITERATURE: PMA, *Catalogue of a Loan Exhibition of Windsor Chairs* (1925), p. 10; J. Stogdell Stokes, "The American Windsor Chair," *PMA Bulletin,* vol. 21, no. 98 (December 1925), p. 53

JOHN LETCHWORTH

124b. *Side Chair*

1785–1807
Mark: I LETCHWORTH (branded in capitals on bottom)
Hardwoods, painted green
36½ x 21¼ x 19¾"
(92.7 x 53.9 x 50.1 cm)
Philadelphia Museum of Art. Given by Lydia Thompson Morris. 28-7-75

PROVENANCE: Lydia Thompson Morris

LITERATURE: Hornor, pl. 472

JOSEPH HENZEY, SR., OR JOSEPH HENZEY, JR.

124c. *Armchair*

1790–1806
Mark: I HENZEY (stamped on bottom of seat)
Maple; hardwoods, painted black with traces of white
38 x 24⅜ x 21¾" (96.5 x 61.9 x 55.2 cm)
Richard W. Barringer, Jr., Radnor, Pennsylvania

PROVENANCE: Sarah (Morgan) Johnson; daughter-in-law, Martha (Morris) Johnson; daughter, Elizabeth (Johnson) Brown; daughter, Mary (Brown) Chew; son, Benjamin Chew; son, Benjamin Chew, Jr.; nephew, Richard W. Barringer, Jr.

LITERATURE: Hornor, pl. 480

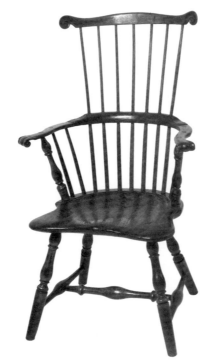

124a.

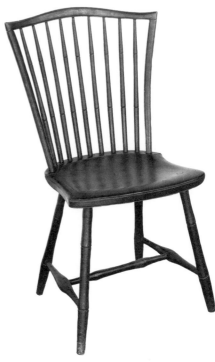

124b.

ROBERT TAYLOR

124d. *Armchair*

1802–6
Label: Windsor & Fancy Chairs & Settees,/WHOLESALE & RETAIL/ROBERT TAYLOR,/WINDSOR & FANCY CHAIR-MAKER,/ informs his Friends and the public, that he continues to carry on the Windsor/ and Fancy Chair-making business in all its various branches, and upon the most reasonable terms./At No. 99 South-Front Street (near Walnut-street)/where he has constantly on hand the most fashionable plain, gilt and orna/mental chairs./Orders from masters of vessels, and others who may favour him with their/custom, shall be attended to with accuracy and dispatch./Cabinet Ware may be had at the same place.
Mahogany, maple; hardwoods, painted brown and black
35½ x 19¼ x 16¾" (90.1 x 48.8 x 42.5 cm)
Private Collection

PROVENANCE: Girard National Bank (Philadelphia National Bank); Joseph Wayne, Jr.

LITERATURE: Hornor, p. 298, pls. 501–2

THE TERM "WINDSOR CHAIR" includes a wide assortment in form and color of simple turned chairs commonly used in American houses and public buildings from the middle of the eighteenth century. The early production of these chairs in America centered in Philadelphia, where, by the 1760s, Windsor chairmaking was a thriving business (see Nancy A. Goyne, "American Windsor Chairs: A Style Survey," *Antiques,* vol. 95, no. 4, April 1969, pp. 538–43). According to Goyne ("Francis Trumbull of Philadelphia, Windsor Chair and Cabinetmaker," *Winterthur Portfolio 1,* 1964, p. 229), the first advertisement for a Philadelphia-made Windsor chair was for one by David Chambers in 1748. These early Windsor chairs were high-back armchairs with wide saddle seats and vase-shaped arm supports.

Although it is difficult to date Windsor chairs precisely, even when they are marked with the name of the maker, certain elements help date them within general periods. For instance, the comb-back armchair by Richmonde (124a) probably was made before 1790. The deeply carved seat, the sharply turned legs and arms, the attenuated vase supports on the arms, and the heavy stretcher all point to an early date. On the other hand, the chair was probably made later than 1775 because the legs are tapered at the end, as opposed to ending in rounded cylinders with ball feet, the common

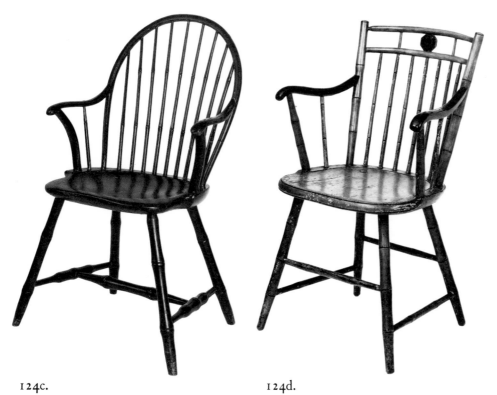

124c.

124d.

termination on the earliest Philadelphia Windsors.

The use of bamboo turnings on Windsor chairs generally indicates a date after 1780. The Windsor side chair by John Letchworth (124b) and the Henzey armchair (124c), have flatter seats and simpler turnings than the Richmonde chair. The Letchworth chair is usually called a hoop-back or sack-back chair; and the Henzey chair, with its unusual arched back, is called a fan-back. Both chairs relate to the Hepplewhite and Sheraton styles which favored either square or rounded backs and overall simple lines.

Early nineteenth century Windsor chairs are closely related to fancy chairs also popular at the time. For example, the armchair with mahogany arms made by Robert Taylor (124d) includes a hexagonal plaque decorated with an urn and leaves. Such plaques were frequently used on fancy chairs, which were painted, simplified versions of high-style chairs such as those in the Hepplewhite or Regency modes. This chair is one of a set traditionally thought to have been purchased by the directors of Girard Bank for use in that institution (Hornor, p. 298), but this is not documented. The paper label on the chair includes the 99 South Front Street address where Taylor worked from 1802 to 1806. Girard Bank was not in existence before 1812, however, and even then there were no directors, for it was run as Girard's private bank. The practice of linking a piece of

furniture to Stephen Girard, the famous merchant, is common, however.

Few Windsor chairs have retained their original colors, but they were originally painted in many shades, including green, red, black, yellow, white, mahogany, and pink. In private homes they were used in the front parlor as well as in the back bedroom and kitchen. Windsor chairs were ordered by the State Assembly of Pennsylvania from Joseph Henzey, Sr., in 1791, and John Letchworth made Windsor chairs for the new Philadelphia City Hall in 1791. So extensive was the production of Windsor chairs in Philadelphia that "before 1790 Philadelphia, the style setter, had shipped over 6000 windsors to other colonies, the West Indies and abroad" (Dean A. Fales, Jr., *American Painted Furniture 1660–1880,* New York, 1972, p. 85).

PT □

JOSEPH RICHARDSON, JR. (1752–1831), AND NATHANIEL RICHARDSON (1754–1827)

Joseph Richardson, Jr., and Nathaniel, his younger brother, were master silversmiths trained in their father's large shop. When Joseph, Sr. (see biography preceding no. 35), retired in 1777 they continued the business. While their partnership lasted, Joseph, Jr., and Nathaniel produced a prodigious

amount of silver. Given a well-established base of operations, they invested in the West Indies sugar and flour trade and began importing scales and weights and silver items from England again after the Revolution.

Nathaniel, a bachelor, gave up silversmithing in 1790 and joined with Isaac Paxton in a hardware-ironmongery business. Joseph, Jr., continued on in the trade, changing the punch to read JR, taking on apprentices, and fulfilling orders until about 1801. Like his father before him, Joseph, Jr., entered public service connected with his business, and was appointed by George Washington to be assayer of the United States Mint in 1795, a difficult post which he held for thirty-five years (Fales, *Joseph Richardson,* pp. 153–97). Joseph's son, John, did not continue as a silversmith after his father's death in 1831. The Richardson family "shop" had lasted 130 years.

125. *Pair of Candlesticks*

c. 1790
Mark: INR (in rectangle, twice on bezel, twice on edge of each foot)
Inscription: MB (in script, engraved on molded base)
Silver
Height 5⅜″ (13.6 cm); width base 2⅞″ (7.3 cm)
Museum of Fine Arts, Boston

PROVENANCE: Probably Maria Benezet (d. 1799), m. 1795 George Willing (d. 1827); Mary (Willing) Clymer (d. 1852), m. 1795 Henry Clymer; George Clymer and Maria (O'Brien) Clymer, m. 1815; descended in family to Dr. George Clymer

LITERATURE: MFA, *Silversmiths,* no. 325, fig. 126; Kathryn Buhler, *American Silver 1655–1825 in the Museum of Fine Arts, Boston* (Greenwich, Conn., 1972), vol. 2, no. 522, p. 613

THESE SHORT, FLUTED, columnar candlesticks are an elegant interpretation of the neoclassical form, although the bobeches do not quite compensate for what should be Ionic or Corinthian capitals at the top of their shafts. The use of fluted columns with ornate capitals for candlesticks about eight to twelve inches high was general practice in England during the 1770s, at the height of the style promoted by the Adam brothers. Silver lent itself especially well to fluting and stop-fluting and, later, reeding, and the columnar design was natural for sets (usually four) of candlesticks.

These candlesticks are a unique design of an exceedingly rare form in American silver. Their diminutive size may indicate that

they were for dressing table use where it was desirable to have the light reflection in a dressing glass, or for use on the candle slides of a secretary desk where, again, a low flame was most useful. As Maria Benezet Willing, possibly the first owner, died without a will, her wedding silver and furnishings were probably held by her husband, George. He remarried in 1800 to Maria's half-sister, Rebecca Blackwell, at which time the candlesticks were probably presented, as was the custom, to family members in memory of the deceased, in this case, his sister, Mary Willing Clymer, who had married the same year as he and his first wife Maria.

BG □

126. *Punch Bowl*

c. 1790
Hard-paste porcelain, glazed
Height 5″ (12.7 cm); diameter 11¼″ (28.5 cm)
First Troop, Philadelphia City Cavalry

PROVENANCE: Presented to Samuel Morris, Jr. (1734–1812), by the Gloucester Fox Hunting Club; son, Israel W. Morris (1778–1870); descended in family to Effingham B. Morris, Jr. (1890–1955); First Troop, Philadelphia City Cavalry

LITERATURE: Moon, *Morris Family*, vol. 1, pp. 353–56

ACCORDING TO FAMILY TRADITION, this punch bowl was presented to Samuel Morris

"before 1797" (Moon, *Morris Family,* vol. 1, p. 353) by members of the Gloucester Fox Hunting Club. Named manager of the hunt club at its formation in 1766, Morris became its first president after the Revolution and remained in that office until his death in 1812 (William Milnor, Jr., "Memoirs of the Gloucester Fox Hunting Club" [1830], in *History of the Schuylkill Fishing Company of the State in Schuylkill, 1732–1888,* Philadelphia, 1889, pp. 405–29). The hunt was disbanded temporarily during the Revolution when twenty-two of its members, including Morris, enrolled in the Philadelphia Troop of Light Horse (later the First Troop, Philadelphia City Cavalry). That the punch bowl descended in the Morris family to Effingham B. Morris, Jr., and was presented by him to the First Troop, brings the bowl—in terms of its provenance—nearly full circle.

While the hunting scenes on the bowl would seem to indicate a special commission by members of the Gloucester Hunt, and the costumes worn by the hunters on the bowl reflect in certain detail the uniform of Gloucester hunt members (see Milnor, cited above, p. 409), a number of other versions of the bowl, also made for American clients, exist. Among other such bowls are those in the collection of the Winterthur Museum (see J. A. Lloyd Hyde, *Oriental Lowestoft,* New York, 1936. p. 95, pl. 18) and a version in the Maryland Historical Society originally owned by Samuel Sprigg, governor of Maryland, 1819–22 (see Jean McClure Mudge, *Chinese Export Porcelain for the American Trade, 1785–1835,* Newark, Del., 1962, p. 105, fig. 61).

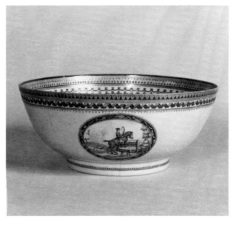

126.

Characteristic of the first porcelains ordered by Americans from China, after the entry of America in the China trade in 1785, this series of hunt bowls bears no specifically American designs but stock decorative motifs developed for English and European markets. Still unidentified, the sepia hunting scenes and landscapes are probably derived from English sporting and landscape prints. The rural views and the rims of the bowl are dressed in elaborate blue and gilt borders in the French taste, which add a note of luxury to the service of that "frequent and grateful beverage" which Samuel Morris enjoyed (see John F. Watson, *Historic Tales of Olden Time concerning the Early Settlement and Progress of Philadelphia and Penna.,* Philadelphia, 1833, p. 127).

KH □

127. *Punch Bowl*

c. 1790
Hard-paste porcelain, glazed
Height 5¾″ (14.6 cm); diameter 14⅜″ (36.6 cm)
Philadelphia Museum of Art. Bequest of Mrs. Alexander H. Scott. 63-102-4

ALTHOUGH THE HOUSES which inhabit the landscape medallions on the exterior of this punch bowl have traditionally been identified as The Woodlands, William Hamilton's summer house on the Schuylkill (see no. 143) built about 1770, the landscapes actually represent three different buildings, none of which resemble Woodlands to any considerable extent. Of the three views on the bowl, only that with the classical temple-fronted porch (closer to an eighteenth century garden ornament than to domestic

125.

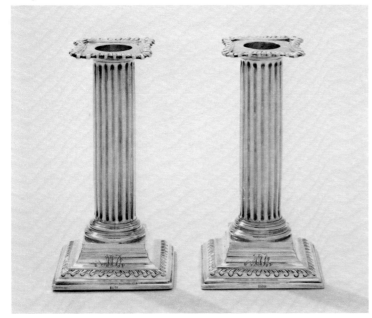

architecture) bears any likeness to the Greek revival riverfront facade of Woodlands.

Philadelphia landowners did celebrate their properties on Chinese export porcelain, as evidenced by Isaac Cooper Jones's service decorated with views of Rockland (no. 193). However, the scenes on this Chinese-made punch bowl are probably stock designs derived from English engravings. They appear, for example, on an identical bowl in the collection of Dr. and Mrs. Roger Gerry, Roslyn, New York.

KH □

128. *Wall Brackets*

c. 1790
Wood and gilt
21 x 17 x 8" (53.3 x 43.1 x 20.3 cm)
Mr. and Mrs. George M. Kaufman, Norfolk, Virginia

PROVENANCE: Robert Kennedy Wurts, Philadelphia, 1935; with Charles Woolsey Lyon, Milbrook, New York; Lansdell K. Christie; Sotheby Parke-Bernet, New York, *The Lansdell K. Christie Collection of Notable American Furniture*, October 21, 1972, no. 17 (illus.), sale no. 3422

LITERATURE: Hornor, p. 284, pls. 443, 445

THESE WALL BRACKETS are from a set of four, three of which (including these two) are original; a fourth was reproduced to match. Wall brackets, particularly those from the eighteenth century, were usually made to hold small clocks, urns, or other decorative objects.

A bracket similar to the ones shown here is illustrated in Sheraton's 1803 *Cabinet Dictionary* (pl. 20), where it was stated that "Clock brackets are used to place a clock on. . . . For this purpose, I have given three designs . . ." (p. 93). Hornor (p. 284) states:

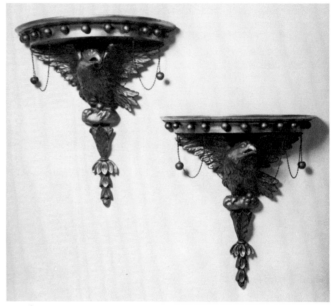

128.

"Brackets were a fitting object for the carver's art. . . . Before the Revolution several of the carvers took pleasure in turning out these brackets. The quantities were small and each one more or less reflected the genius and artistic knowledge of the maker. Subjects could be derived from corbels found in architectural books to which they all had access or from the decorative features introduced into furniture."

DH □

129. *Side Chair*

1790–1800
Mahogany; light wood string inlay; twentieth century green leather upholstery
37 x 21¼ x 19½" (93.9 x 53.9 x 49.5 cm)
Private Collection

PROVENANCE: Sarah (Morgan) Johnson; daughter-in-law, Martha (Morris) Johnson; daughter, Elizabeth (Johnson) Brown; daughter, Mary (Brown) Chew; son, Benjamin Chew; son, Benjamin Chew, Jr.

THIS SIDE CHAIR is one of a set of eight, which, according to family tradition, were made for the country house Vanor (Vainor). Built in 1715 by John Morgan in Radnor, Pennsylvania, Vanor was enlarged in the nineteenth century and remained standing until 1938 when the objects in the house were distributed among the relatives of Benjamin Chew, the last resident of the house.

Stylistically, the chairs date from about 1790 to 1800 and were probably owned by Sarah Morgan Johnson, the granddaughter

of Vanor's first owner, John Morgan, who died in 1814. The chairs are almost identical to those made by John Aitken for George Washington (see no. 145), the major difference being in the top rail, for which there are many variants in Sheraton's designs. In the Vanor chairs, the vase form terminates in carved leaves instead of in volutes as in the Washington chairs. The discrepancies between the two sets of chairs are very small considering the wide range of details which could have been used by a Philadelphia cabinetmaker well versed in English design books.

PT □

JOSEPH RICHARDSON, JR. (1752–1831)
(See biography preceding no. 125)

130. *Chatelaine Hook*

1790–1800
Mark: J•R (in rectangle, inside strap, at end)
Inscription: SW (engraved foliate script, on front)
Gold
Length 2⅜₁₆" (5.8 cm)
Yale University Art Gallery, New Haven. The Mabel Brady Garvan Collection

PROVENANCE: Sarah (Wetherill) Lippincott (1776–1840)

LITERATURE: Buhler and Hood, vol. 2, no. 858

THE PRAGMATIC CHATELAINE HOOK was one of the simplest and most common items made by the silversmith. Gold ones are rare,

127.

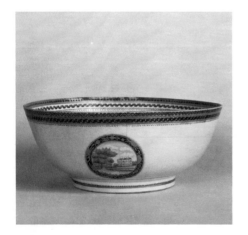

and this example is distinguished by that fact. The shape was determined by the need for a smooth fit over the waistband of a skirt or apron, although chatelaine hooks were occasionally suspended from a cord or ribbon tied around the waist. The backpiece was always longer than the front to balance the weight of the items suspended from chains. The opening and bar allowed small chains with snap hooks to be fastened to it. Household keys were attached with a length of chain according to the height of a keyhole, door, desk, or box. Small scissors, thimbles, pincushions, and needle cases were also sometimes suspended. Other examples, in silver, by Joseph Richardson, Jr. (Philadelphia Museum of Art), have six small holes instead of the bar, and linked chains—often made of steel for strength—soldered firmly into holes in the end of the flared hook.

The chatelaine hook usually was decorated, like lockets (see no. 63), with pleasing designs of baskets of flowers or foliate initials. Some were strongly made, small, thick, with no decoration, such as the one made for Rebecca Richardson (Fales, *Joseph Richardson,* fig. 120); others had distinctive contours, such as the urn-shaped chatelaine hook Richard Humphreys made for his wife (private collection). They were usually as fully marked by the smith as more elaborate pieces, and with the addition

129.

of the owner's initials on the front, they became personal treasures.

As many examples exist, the custom of carrying keys must have survived several changes in women's fashions. Their size, finesse of manufacture, and precious material indicate their importance in feminine sartorial equipment, like the more complicated, equally necessary, knee or shoe buckles (see no. 35) featured by the gentlemen.

This elegant example bears the maiden initials of Sarah Wetherill and may have been given to her when she reached twenty-one or just before her marriage to Joshua Lippincott in 1799.

BG □

DANIEL DUPUY, SR. (1719–1807)

A descendant of the Huguenot Bartholomew Dupuy, Daniel Dupuy, Sr., was born in New York on April 3, 1719. He was apprenticed to his sister's husband, the goldsmith Peter David (see biography preceding no. 33), and probably went to Philadelphia with David, who by 1738 was working on Front Street (Hannah Benner Roach, "Notes on John Hallowell, Daniel Dupuy, George Morrison and George Warner, Residents in Middle Ward, Philadelphia in 1754," *Pennsylvania Genealogical Magazine,* vol. 21, no. 4, 1960, p. 329).

In 1746, Dupuy married Eleanor Dylander, the widow of the rector of Old Swedes' Church and a descendant of Peter Matson who in 1676 was granted 300 acres of land near the Schuylkill River. This manor, called Clover Hill (now known as Gray's Ferry), became the country seat of the Dupuy family (Rev. B. H. Dupuy, *The Huguenot Bartholomew Dupuy,* Louisville, Ky., 1908, pp. 391–92). In the city, Dupuy owned two adjoining houses on South Second Street, which he purchased in 1754 (Roach, cited above, p. 238).

Two of Dupuy's sons, John (1747–1838) and Daniel, Jr. (1753–1826), were silversmiths by training, although John worked primarily as a watchmaker. An advertisement in *Staatsbote,* May 7, 1777, indicated that Daniel Dupuy, Jr., moved to Reading, Pennsylvania, in 1777, where he practiced "the gold and silversmith's work in all its branches." According to Ensko (pp. 129, 132), however, Daniel, Jr., had returned to Philadelphia by 1782 and continued to work as a goldsmith and silversmith at 16 South Second Street until 1812. In 1783, for instance, he worked in "Second Street near the Market" where, with his brother, he sold "a variety of Cream Urns, table and tea Spoons . . ." (*Pennsylvania Packet,* July 12, 1783).

130.

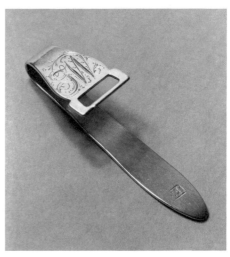

In 1784, Daniel, Sr., moved to 114 Sassafras, and his two sons worked with him at that address for one year (Seymour Wyler, *The Book of Old Silver,* New York, 1937, p. 333). By 1785, John and Daniel, Jr., again worked apart from their father at their former residence on South Second Street, "between Market and Chestnut Streets," although they probably lived with their father on Sassafras. It is likely that Daniel Dupuy, Sr., was in partnership with his nephew John David (son of Peter) from 1792 to 1805 (Roach, cited above, p. 330).

131. *Sugar Urn and Cream Urn*

1790–1800

Mark: Sugar urn, DD (in square at two corners on bottom), OZ 19 (on one corner of bottom), 8019 (on opposite corner); cream urn, DD (in square on one corner on bottom), OZ 5″ 2 (on one corner on bottom), 8019 (on one corner on bottom) bottom)

Inscription: EHC (engraved cipher in foliate script)

Silver

Sugar urn height 11″ (28 cm), diameter 4¾″ (12.1 cm); cream urn height 3″ (7.5 cm), diameter 4½″ (11.8 cm)

Philadelphia Museum of Art. Given by Mrs. Elsie DuPuy Graham Hirst in memory of her son Thomas Graham Hirst. 60–107–1a, b; 60–107–2

PROVENANCE: With David Stockwell, 1960

LITERATURE: Mrs. Alfred Coxe Prime, *Three Centuries of Historical Silver* (Philadelphia, 1938), p. 34; PMA, *Silver,* nos. 86, 90

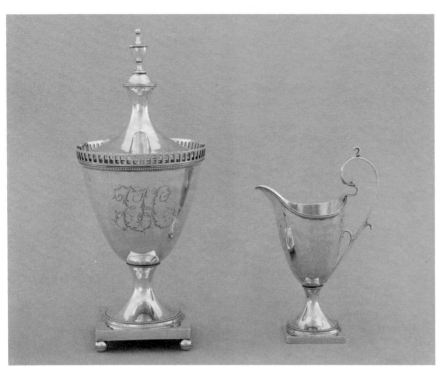

131.

THE SUGAR AND CREAM URNS made by Daniel Dupuy are characteristic shapes of the late eighteenth and early nineteenth centuries. The urn was a basic form of the classical period and was meant to symbolize the purity and restraint of the republican ideal. Both pieces include juxtaposed geometric shapes such as the oval, square, and circle which make up the vocabulary of the classical style. Peculiar to Philadelphia is the use of the pierced gallery on the sugar urn and the dainty beaded molding on both pieces.

The cast handle on the cream urn is exceptionally elegant and the raised helmet shape is extremely graceful. Dupuy made other cream jugs of this type, but this urn stands out as one of his most successful endeavors.

The finial in the form of an urn was popular in the classical period, particularly as a decorative ornament surmounting another urn form, in this case a sugar urn. The small ball feet, which became popular around the turn of the eighteenth century, are decorated with the fine beading seen elsewhere on the urn and add to the overall delicacy of the object.

The fact that both father and son were silversmiths working at the same time in Philadelphia means that the mark on the cream and sugar urns could be that of either craftsman. Traditionally this mark has been attributed to the father, but in light of the probable date of these two pieces, they could have been made by either of the two men.

PT □

DAVID RITTENHOUSE (1732–1796)

The inheritance of some tools and geometry and mathematics books directed the young David Rittenhouse to science (George H. Eckhardt, "David Rittenhouse—His Clocks," *Antiques*, vol. 21, no. 5, May 1932, p. 228), and he would become, along with Benjamin Franklin, a central figure in the scientific and intellectual life of mid-century Philadelphia. Born in the country (now Fairmount Park) and raised on a farm in Norristown (Norriton), Rittenhouse was brought up in the Mennonite tradition of industry and thrift. By 1749, when he was only seventeen, he was already constructing accurate clocks, and a clockworking enterprise was flourishing at the Norristown farm by 1756. In February 1766, Rittenhouse married Eleanor Coulston, and in 1770 they moved to a city house at the corner of Seventh and Mulberry streets, although the shop at Norristown continued in operation albeit sporadically.

The great orrery at the University of Pennsylvania (1771–72), the zenith sector at the United States Naval Museum at Annapolis (c. 1781), and the tall case clock with planetarium at Drexel University (c. 1774) are masterpieces of his combination of scientific inquiry and technical skills. In addition to these historic pieces, he made numerous surveyor's compasses for his own use and for friends, one of which George Washington used to survey Mount Vernon in 1796 (Silvio A. Bedini, *Early American Scientific Instruments and Their Makers,* Washington, D.C., 1964, p. 145).

Rittenhouse's studies and preparations for the famous transit of Venus in 1769 are documented by extensive entries in the *Transactions of the American Philosophical Society,* and the Society today owns one of his most elegant pieces, his transit telescope, as well as an astronomical clock made at the same time. Rittenhouse was active in the American Philosophical Society, its secretary in 1771, and its president succeeding Benjamin Franklin. A detailed study of his associations and his life can be found in Brooke Hindle's biography (Princeton, 1964).

Rittenhouse was well known and highly regarded in his own day. Charles Willson Peale and John Trumbull painted his portrait, and Giuseppe Ceracchi modeled his bust. Edward Savage did an engraving after the Peale painting, adding a grand telescope to the setting. The United States Mint struck a bronze medal of Rittenhouse, its first director, in 1792. Jefferson wrote to Rittenhouse in July 1778: "Nobody can conceive that nature ever intended to throw away a Newton upon the occupations of a crown ...I doubt not there are in your country many persons equal to the task of conducting government: but you should consider that the world has but one Rittenhouse, and that it never had one before" (Maurice Jefferis Babb, "David Rittenhouse," *PMHB* vol. 56, no. 3, 1932, pp. 217–18).

David Rittenhouse died at his home in Philadelphia on June 26, 1796, and was buried under the floor of his observatory in the garden. Of the unusual burial Moreau de St. Meng wrote in his Journal: "What a contrast between man's nothingness and his genius."

132. *Tall Case Clock and Orrery*

1785–95
Mahogany with veneer overlays; curly maple, figured-crotch mahogany, poplar; brass
102 x 23½ x 15¼″ (259 x 59.6 x 38.7 cm)
Private Collection

LITERATURE: Howard C. Rice, Jr., *The Rittenhouse Orrery* (Princeton, 1954), pl. 9

THIS TALL CASE CLOCK represents well the superlative skills of David Rittenhouse, Philadelphia's midcentury "mechanic." Inserted in a grand and elaborate case of the late eighteenth century, it shows a rare combination of inventive genius and aesthetic ability. The organization and relation of the works to the case are more pleasing in scale and proportion than on the more famous clock at Drexel University, which has an

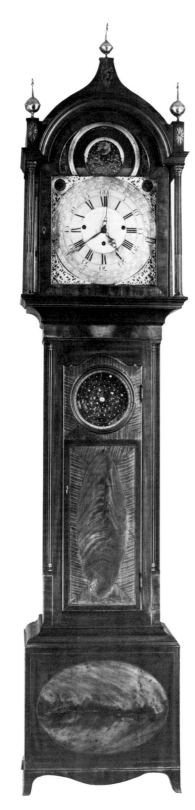

132.

impressive bonnet but a very short waist. The exhibited clock also has a grand bonnet, but the shaft is wider and longer, giving stronger aesthetic support to the top. The miniature orrery set into the long door is dramatic and intriguing, and carries the design of the moon dial above the clockface farther into the cabinetwork than was usual, although circular glass windows had been inserted in clock doors since the time of Peter Stretch.

Benjamin Randolph's Ledger (NYPL, Philadelphia Merchant's Account Book, 1768–86, p. 195) carries an entry with David Rittenhouse as debtor for £ 10 9s. from April to October 1774, which he paid in full in 1775. This may have been the transaction recorded for the Drexel clock case. No such entry for this case, which stylistically must be dated later, has emerged from the record, nor did any description of the pieces appear in various estate records investigated. The use of inlaid paterae ornaments on the bonnet, stop-fluted colonettes, mirrors, veneer panels on the long door, and string inlay on the base unit suggests its manufacture by a sophisticated cabinet shop. The fit of the mechanics is perfect, and Rittenhouse must have commissioned this case especially for his mechanical composition, which was probably devised for his own use.

Rittenhouse's contribution to the orrery form, besides adding precision to the relationship of the planets to the sun, was his vertical installation of the device. The orrery had been a teaching tool in England since 1713, when John Rowley made an elegant one for Charles Boyle (Rice, cited above, pl. 1), but all depended upon a horizontal placement. Rittenhouse worked for some time to perfect his mechanism, which was to be driven by a clockwork instead of a wind-up handle. Because of its great size the University of Pennsylvania's orrery had both weights and a winch, while this clock's orrery rotated successfully from gears that led from the main time-keeping system. The technicalities and the mechanism of this clock have been elucidated by conservator Stephen E. Kramer: "The main dial of clock shows, in addition to the time, the month and date, and the position of the sun in the zodiac. The upper dial outer area depicts the daily passage of the sun; the horizontal shutter gives the times of sunrise and set, and the height of the sun's path in the sky; there is provision to give the annual variation in the difference of sundial time and clock time. The upper dial inner area depicts the phase of the moon and gives the time of the moon's daily passage overhead. The two small dials control the chiming of twelve tunes. The dial in the door shows the positions of the Earth and the five visible-by-eye planets" (PMA archives).

BG □

JOSEPH RICHARDSON, JR. (1752–1831)
(See biography preceding no. 125)

133. *Indian Peace Medal*

1793
Mark: JR (in capitals in rectangle on reverse)
Inscription: E Pluribus Unum (on coat of arms of United States, obverse); GEORGE WASHINGTON/PRESIDENT 1793 (reverse)
Silver
6 x 3¾″ (15.2 x 9.5 cm)
Private Collection

LITERATURE: Harrold E. Gillingham, "Early American Indian Medals," *Antiques,* vol. 6, no. 6 (December 1924), p. 313, illus. frontis.

UNTIL INTERRUPTED by the French-Indian alliance against the English colonies in 1756, William Penn's 1697 convenant with the Indians at Philadelphia worked well. Thousands of pounds were raised by the Quaker founders of the Friendly Association, which was dedicated to "Regaining and Preserving Peace with the Indians by Pacific Measures." Interest-paying capital shares in the Association were sold and with the proceeds silver symbols of peace were purchased from Philadelphia craftsmen (HSP, Coates-Reynell Papers, Friendly Association, Case 17, Box 7). These included brooches, crosses, arm bracelets, gorgets, and pendants, engraved and stamped with symbolic pictures and mottoes.

A gorget by Joseph Richardson, Sr., in the Historical Society of Pennsylvania is engraved with the same scene as on a peace medal struck by Richardson in 1757 from a die cut by Edward Duffield, known today only by an 1847 restrike. The scene shows a Quaker, probably representing William Penn, extending a winged peace pipe to a seated Indian who reaches across a campfire to accept the offer. The Indians wore these ornaments as status symbols and hung them from a thong or chain worn around the neck, as seen in this example.

In 1792 the United States had a Constitution and elected officers, and Pennsylvania had a new state government. At this time a deputation of Indians came to the State House in Philadelphia to acknowledge the new leadership. George Washington rather than William Penn now became their figurehead, and to him they pledged the renewal of their treaties in exchange for a policy of fair treatment. This medal, made in 1793 for one of the attending chiefs, was intended to acknowledge the Indians' allegiance to the government, portrayed by the Great Seal of the United States (obverse), and to its "chief" (reverse). The tree and peace pipe motif appeared on most silver ornaments

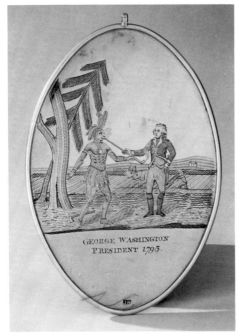

1 3 3 .

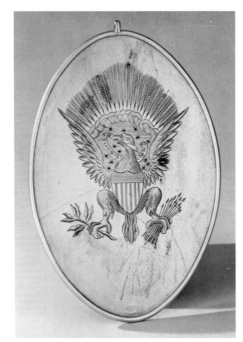

JAMES PEALE (1749–1831)

Born in Chestertown, Maryland, James was overshadowed during most of his life by his older brother, Charles Willson Peale (see biography preceding no. 92). His father, a schoolmaster, died a year after James's birth. When he was of age, James became a journeyman in his older brother's saddlery. Later he was apprenticed to a carpenter, but when Charles returned from England in 1769 as a trained artist, James again became his assistant. He helped in the studio and framed pictures but, by the spring of 1771, his brother had taught him to paint from life.

James served with the Continental Army during the Revolution and retired as a captain in 1779. He then settled in Philadelphia as a member of Charles's household until 1782, when he married the sister of James Claypoole, Jr. (see biography preceding no. 77), and set up his own residence. He became so proficient in miniature painting, charging three guineas per portrait, that Charles left this field to him in 1786. By 1788, James was painting landscapes as well. Occasionally, he was also commissioned to copy portraits from his brother's museum gallery. James attempted some group compositions and, as his eyesight began to fail, he left miniature painting about 1810 for larger portraits and still lifes. He seems to have begun concentrating almost exclusively on still life in the 1820s, exhibiting them at the Pennsylvania Academy from 1824 to 1830. In his later years his interest in landscape was renewed, and his painting became progressively broader and more romantic. He died in Philadelphia. Of his seven children, at least five are known to have painted, three of whom were particularly talented: Margaretta Angelica, Sarah Miriam, and Anna Claypoole Peale (see biography preceding no. 212).

DE

made for the Indian chiefs. The significance of the tree was expressed by the Indians as follows: "Brethren! We make fast the Roots of the Tree of Peace and Tranquility which is planted in this place. Its roots extend as far as the utmost of your Colonies; if the French should come to shake this tree, we would feel it by the Motion of its Roots, which extend to our Country" (Harrold E. Gillingham, "Indian and Military Medals from Colonial Times to Date," *PMHB,* vol. 51, no. 2, April 1927, p. 103).

In this example, the two unified trees— a pine, perhaps representing the Northern Colonies, and an elm, the Middle Colonies— may have signified to the Indians that agreements and treaties extended to them by the government of the new United States were of broader scope than the old Friendly Association and included all its geographical regions. The peace pipe is now held by both participants in a mutual gesture, whereas in the pre-Revolutionary version the Quaker was offering the pipe and the Indian reaching for it. In addition, the earlier design showed the Quaker and Indian facing each other over a campfire, suggesting active negotiation on neutral, if not Indian, ground. Here the Indian is now on white man's ground, as seen by the team of oxen plowing in neat furrows, showing a further step in the white man's taming of lands and people. In both versions the Indian tomahawk lies on the ground, but although the Quaker did not wear a sword, George Washington wears one in the 1793 design. Whether a symbol of the white man's dominance or a

mode of costume is not clear, but this feature supposedly was questioned at the State House meeting: "Why does not the President bury his sword, too?"

The design of this peace medal reveals little artistic enterprise, although the graving technique is sure. Fales points out that James Smither, Jr., and Joseph Richardson, Jr., carried on business together amounting to about £600 in an account predating Richardson's Ledger A of 1796 (Fales, *Joseph Richardson,* p. 306n.). Thus it is possible that Smither, Jr., engraved the Indian medals for Richardson. James Smither, Sr., had engraved the presentation urn made by Richard Humphreys for Charles Thomson in 1774 (see no. 102), and his son continued the trade, advertising his location at Walnut Street near Front and his business of engraving and seal cutting in 1790. He probably had a sketch for his design, but it was not traced precisely as there are slight variations on other examples. One, at the Historical Society of Pennsylvania, shows no space between the tree trunks and only three sets of branches on the pine tree. On the obverse, in the Great Seal of the United States, the eagle's tail is fuller, he grasps a slightly denuded olive branch, and the thirteen stars are clustered differently around his head. On both the eagle is centered; the halo of clouds and design of expanding rays above the eagle fill the oval at the top, leaving a void below which, in the 1795 Treaty of Greeneville medal, was filled with an inscription.

BG □

1 3 4 .

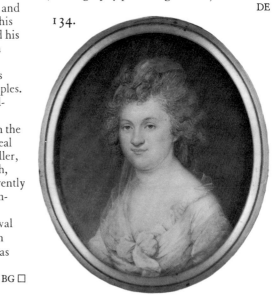

134. *Elizabeth De Peyster Peale*

1795
Signature: IP/1795 (lower right)
Watercolor on ivory
3 x 2½″ (7.6 x 6.3 cm)
INA Museum, INA Corporation,
Philadelphia

PROVENANCE: Elizabeth (De Peyster) Peale;
daughter, Mrs. William A. Patterson; George
W. Thomas; Edmund Bury; Linden T. Harris

LITERATURE: Charles H. Elam, ed., *The Peale
Family, Three Generations of American Artists*
(Detroit, 1967), p. 76, illus. no. 78

REFLECTING THE CURRENT MODE in English
miniatures, American miniature portraits in
the last decade of the eighteenth century
grew in size and were executed in increas-
ingly lighter, less opaque shades of
watercolor, which enhanced the translucent
qualities of ivory. James Peale's 1795
portrait of Elizabeth De Peyster Peale
(1765–1804), Charles Willson Peale's second
wife, is distinguished by a softened
treatment of outlines, delicacy in modeling
and coloration, and a charming attention
to the description of her fashionable coiffure
and white organza dress. He has not
attempted to conceal his sister-in-law's large
nose and heavy face and neck. In contrast to
English models, in which "Men were
shown as noble and refined, women as
gentle, gracious, handsome.... Personality
was of secondary importance to social
class" (Flexner, *Distant Skies*, p. 23), the
American miniaturist paid full attention to
perceived facts. This earnest veracity
combined with a decorative sense and
delicacy in technique accounts for the
distinctive appeal of James Peale's miniature
portraits.

RB-S □

JAMES PEALE (1749–1831)
(See biography preceding no. 134)

135. *General Cromwell Pearce*

1790–1800
Inscription: Genl Cromwell Pearce/
1772–1854/James Peale/Pinxt (reverse)
Watercolor on ivory
1½ x 1¼″ (3.8 x 3.2 cm)
Mrs. Andrew Van Pelt, Radnor,
Pennsylvania

PROVENANCE: Lucy Wharton Drexel, c. 1911

ALTHOUGH JAMES PEALE never studied
abroad, instruction from his brother, Charles

Willson Peale, and exposure to the work of
foreign-trained artists such as Robert Field,
Walter Robertson, and Pierre Henri Elouis,
who were working in Philadelphia in the
1790s, had a marked effect on his style.
His miniatures of the late 1780s were
stylistically close to his brother's, but by the
mid-1790s he was developing a distinctive
style of his own. Like the work of so many
native-born and -trained artists of the period,
his portraits were bright in color, replete
with intense observation, and refreshingly
simple and direct. "Perhaps his very lack of
skill forced the painter to look long and
hard at his subject, in contrast to the highly
skilled European artist who was able to
turn out in quantity highly stylized and
fashionable but often shallow likenesses"
(Brooklyn Museum, *Face of America: The
History of Portraiture in the United States,*
November 14, 1957—January 26, 1958,
n.p.). James Peale's miniature portraits
fall somewhere between the hard, simple,
but vital touch of the itinerant self-taught
artist and the sophisticated artificiality of
English prototypes.

This portrait of General Cromwell Pearce
(1772–1854), a captain of the militia in the
1790s, colonel in the War of 1812, and in
1825 an associate judge of the Chester
County Court, is painted in the broader
technique of his work of the 1790s. The
close attention to the details of dress, treat-
ment of the hair, bow-shaped mouth, oval
head, and small shoulders are earmarks of
James Peale's miniature portraits.

RB-S □

ADOLPH-ULRIC WERTMÜLLER
(1751–1811)

Born in Stockholm, the son of a prosper-
ous pharmacist, Wertmüller had decided to
become an artist by the time he was fourteen.
He studied sculpture first and then aban-
doned it in favor of painting, probably in
emulation of his cousin, Alexander Roslin,
who was an established portrait painter in
Paris. Wertmüller followed Roslin to Paris
in 1772, where he studied under Joseph-
Marie Vien, who three years earlier had
taught Jacques-Louis David. Wertmüller
entered the French Academy in 1773, but
still seems to have been largely influenced
by Vien, for he followed him and David to
Rome in 1775 and did not return to France
until 1779.

Within a few years, Wertmüller became a
member of the French Royal Academy, the
Swedish Art Academy, and first painter to
the king of Sweden, Gustaf III, who com-
missioned him to paint a full-length portrait
of Marie Antoinette in 1784. Three years

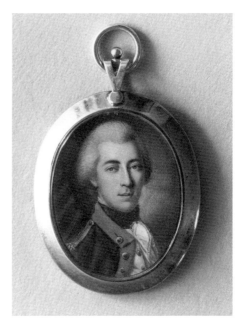

135.

later Wertmüller painted his most famous
work, *Danaë and the Golden Rain*. From
1790 to 1795, he traveled in Spain, seeking
commissions and thereby avoiding the
Revolution in France.

Finally, he was persuaded to leave Cadiz
with a Swedish friend on a ship bound for
Philadelphia. He had decided that if
America was not to his liking he would
return on the same ship, but instead he was
favorably impressed. He fell in love with his
landlady's daughter, the granddaughter of
Gustavus Hesselius, and spent the rest of his
life in the Philadelphia area except for a
stay of four years in Europe, 1796 to 1800,
to settle financial affairs. He bought a farm
in Delaware in 1803 and thereafter, as the
result of a lack of portrait commissions and
his failing eyesight, became occupied with
farming and mercantile ventures.

136. *Robert Lea*

1795
Signature: A.W. s.p.t [?]/1795 (center
right)
Oil on wood
11½ x 10″ (27.9 x 25.4 cm)
Private Collection

PROVENANCE: Mrs. Thomas Lea (Sarah
Shippen); descended in family to present owner

LITERATURE: Washington, D.C., National Gallery
of Art, National Museum [National Collection
of Fine Arts], *Exhibition of Early American
Paintings, Miniatures and Silver* (December 5,
1925—January 3, 1926), p. 26, no. 93

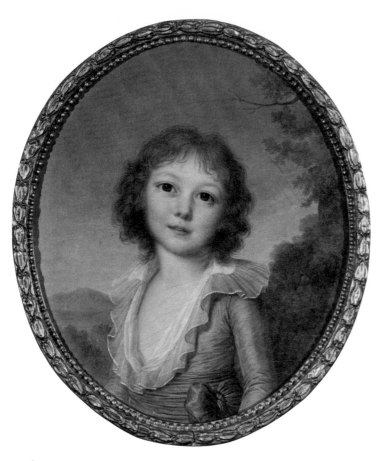

136.

was better calculated, being near sighted; and in these his high finishing was better appreciated" (*The Crayon*, vol. 2, no. 14, October 3, 1855, p. 1). Nevertheless, Rembrandt Peale admired Wertmüller's large *Danaë* (1787), especially the colors, enough to try to buy it after the artist's death. The provocative pose of his nude woman shocked Philadelphians but did not dissuade them from flocking to see it on exhibition.

The reason for Wertmüller's comparative lack of success in Philadelphia appears to be largely due to his high prices. According to Franklin D. Scott, Wertmüller charged approximately twice as much as Stuart, Sully, and Peale (Franklin D. Scott, *Wertmüller, Artist and Immigrant Farmer*, Chicago, 1963, p. 21). Also, Wertmüller's work, in general, may have brought the same criticism as had his portrait of George Washington, which was said to have "a forced and foreign air" (*Analectic Magazine*, June 1815, p. 492). Even Dunlap made note of his "unchaste, false style" (Dunlap, *History*, vol. 1, p. 432).

DE □

CHARLES WILLSON PEALE (1741–1827)
(See biography preceding no. 92)

137. *Staircase Group*

1795
Oil on canvas
89⅝ x 39½″ (originally 90⅝ x 40½″)
(227.6 x 100.3 cm)

Philadelphia Museum of Art. Purchased: The George W. Elkins Collection. E45-1-1

PROVENANCE: Peale family; purchase, "Peale's Museum Gallery of Oil Paintings," October 6, 1854, no. 100, by Lewis H. Newbold or Joseph Harrison; Joseph Harrison, Philadelphia, 1854; Mrs. Joseph Harrison, 1874–1906; estate of Mrs. Joseph Harrison; purchase, Harrison sale, February 23, 1910, no. 229 (attributed to Rembrandt Peale, *Peale Brothers*), by Sabin W. Colton, Jr.; Mrs. Sabin W. Colton, Jr., Bryn Mawr, Pennsylvania, by 1923; son, Dr. Harold S. Colton, 1933–45; on loan to the Philadelphia Museum of Art 1933–45; purchase, Philadelphia Museum of Art, 1945

LITERATURE: *The Columbianum or American Academy of the Fine Arts* (1795), no. 61; *Historical Catalogue of the Paintings in the Philadelphia Museum* [Peale Museum] (1813), no. 209; Theodore Bolton, "Charles Willson Peale, the First Catalogue of his Portraits in Oils and in Miniature," *Art Quarterly*, vol. 2, no. 4 (Autumn 1939), suppl., p. 434; Sellers, *Peale*, 1947, vol. 2, pp. 71–72; Virgil Barker, *American Painting* (New York, 1950), p. 320; Sellers, *Portraits and Miniatures*, p. 167; Sellers, *Peale*, 1969, p. 271

THIS PORTRAIT OF ROBERT LEA is unusually well documented since it is listed in Wertmüller's account book, *"Notte de tous mes ouvrages,"* now in the Royal Library, Stockholm. A copy of the account book transcribed in 1920 (Pennsylvania Academy of the Fine Arts) reveals that after the first Philadelphia entry on June 22, 1794, Wertmüller had considerable employment. At the time young Lea was painted, the artist was much occupied with making copies of his portrait of George Washington which he had painted for himself in November 1794, probably not from life.

On July 25, 1795, Wertmüller noted in his account book (p. 72) that he had finished the oval portrait of Mrs. Lea's son, a child of about six years old, with a landscape background. He received payment for this portrait on August 5, 1795, undoubtedly from Mrs. Lea, whose husband had died, together with payment for a bust-length of Mrs. Lea herself (now lost). Although Wertmüller's notation is not entirely clear, it appears that the combined price for both portraits was seventy dollars.

The dates 1792–1800 on Robert's portrait may not be accurate. Wertmüller, in 1795,

estimated the boy's age as six, but a letter from Robert's grandfather, Edward Shippen, with whom Robert, his sister, and mother lived from 1793 or 1794 until after the boy's death, supports a birth date of 1792 and gives a different death date. Shippen wrote on May 23, 1801, to his famous daughter, Peggy, who was living as an exile with her notorious husband, Benedict Arnold, in London: "You have probably heard of your Sister Sally's loss of her little boy, who died about 2 or three months ago. He was a beautiful child about 8 or 9 years old" (Lewis Burd Walker, "Life of Margaret Shippen, Wife of Benedict Arnold," *PMHB*, vol. 26, no. 2, 1902, p. 238).

The beauty and charm of the portrait, with its delicate pastel colors, are, of course, not dependent upon the subject alone. Wertmüller had a more celebrated background than other contemporary Philadelphia artists, and he belonged stylistically to the more sophisticated, contemporary school of French painting. Yet Rembrandt Peale's evaluation of Wertmüller was unfavorable: "His large paintings, though highly finished, were not much admired, and he was chiefly employed in small portraits, for which he

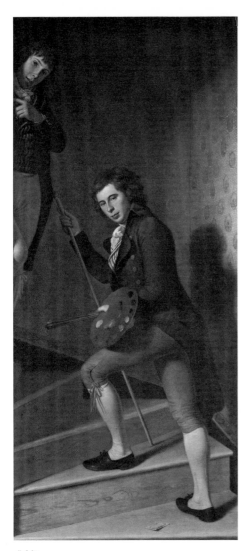

137.

THIS PAINTING has been reproduced in numerous books and encyclopedias on art and is certainly one of the most famous "deceptions" in early American painting. Peale's purpose was clearly to deceive the viewer into confusing art and reality and thus to impress the public with his extraordinary ability. It was painted as a showpiece for the first and only exhibition of the Columbianum, or American Academy of the Fine Arts. With Peale as the motivating force, this academy was the first attempt in the United States to form an art school on the prestigious model of the Royal Academy in London. Although the school was to fail, the opening exhibition was held as planned in May 1795 in the Senate chamber of the State House. This was the first contemporary group exhibition in America; among its 137 entries were paintings, drawings, sculpture, and architectural and naval designs. William Russell Birch, Groombridge, Ceracchi, and James, Raphaelle, and Rembrandt Peale

were among the most interesting contributors.

Peale's *Staircase Group* shows two of the artist's sons, Titian and Raphaelle, in life-size, ascending a winding staircase. In one sense, the painting is an advertisement of Raphaelle's debut in the painting profession. Raphaelle is in the foreground, holding a palette and maulstick; Titian peers out from a few steps above. Before painting the picture, Peale apparently had an actual staircase constructed, upon which he placed his sons. The finished painting was inserted into a doorframe with a real step added at the bottom to continue the illusion. Thus, Peale made it appear as if his sons were climbing a real staircase behind a doorway into the Columbianum exhibition room. Later, the painting was moved to Peale's museum, where the deception was so successful that according to another son, Rembrandt Peale, George Washington mistook the painted figures for real and bowed politely to them as he passed (*The Crayon*, vol. 3, April 1856, p. 100).

Part of the success of the illusion is due to Peale's clever use of foreshortened or projecting elements, such as the palette and Titian's knee, which enter the viewer's space and appear to break the flat surface of the painting. The composition is a calculated succession of diagonals building to a climax at the intersection of Raphaelle's maulstick and the diagonal formed by Titian's knee, Raphaelle's hand, and the shadow running to the upper right corner. The smoothness of the paint, the sharpness of detail, and the meticulous treatment of the wood grain on the steps all add to the trompe l'oeil effect. The gap between the spectator and the painted figures is further bridged by their "consciousness" of the spectator. On the painted step is a ticket with an inscription which is now illegible. It has been recorded (Philadelphia Museum of Art archives) that the painting was originally signed on this ticket.

To be most effective, the picture should be seen at a distance of about five to eight feet. Farther away, the perspective of the steps becomes more distorted, and closer the figures appear more obviously painted. At any distance, the top two steps are not so convincing optically as the rest.

Years later, in 1823, Rubens Peale, another son, requested that his father paint a second staircase deception. This work, a self-portrait on a 9½ by 6½ foot canvas, was intended for Rubens's museum in Baltimore. Although the painting is now lost, according to the descriptions in Peale's autobiography it showed the artist descending a staircase with a palette and maulstick. The stairs were continued by two carpeted real steps, and the whole was placed within a doorframe just as before.

One of the most revealing passages in Peale's autobiography is particularly relevant to the *Staircase Group:* "If a painter . . . paints a portrait in such perfection as to produce a perfect illusion of sight, in such perfection that the spectator believes the real person is there, that happy painter will deserve to be caressed by the greatest of mortal beings" (APS, Charles Willson Peale, Autobiography, typescript, p. 338).

DE □

SAMUEL WILLIAMSON (ACT. 1794–1813)

Although short-lived, Samuel Williamson's career as a silversmith was extremely successful. After a six-year apprenticeship with the Philadelphia silversmith Joseph Lownes (see biography preceding no. 152), Williamson started his own shop at 70 South Front Street in 1794.

From 1797 to 1800 he was a partner of Samuel Richards. Their shop was in Elmslie's Alley, where they were listed as "goldsmiths and jewellers." After Williamson dissolved his partnership with Richards, he moved to 118 South Front Street and continued to work there until 1813.

One indication of Williamson's prosperity was the steady increase in employees at his shop. In 1807, he had six men working for him; in 1809 the number rose to eight; and to eleven by 1811. Furthermore, between October 1803 and October 1804, Williamson produced silver items valued at more than ten thousand dollars.

Despite his obvious success as a silversmith, however, Williamson decided to close his business in late 1813 and move to a farm in Uwchlan Township, Chester County, Pennsylvania. Here he remained as a farmer until he died in 1843. The reason for his move is not known. Perhaps he had long harbored a desire to retire to the country, as indicated by notations about real estate in his Order Book as early as 1809.

Williamson's silversmithing activities are unusually well documented in his Day Book, 1803–6, and Order Book, 1807–13 (Winterthur Museum, Joseph Downs Manuscript Collection). His career has been further elucidated by Ellen Beasley ("Samuel Williamson," M.A. thesis, University of Delaware, 1964).

138a. *Porringer*

c. 1794–1805

Mark: WILLIAMSON (in rectangle on bottom of bowl); PHILADELPHIA (in circle on bottom of handle)

Inscription: LRT (script monogram in oval and bird crest engraved on handle)

Silver

Diameter 7½″ (19 cm)

Philip H. Hammerslough Collection. On permanent loan to the Wadsworth Atheneum, Hartford, Connecticut

LITERATURE: *Hammerslough,* vol. 4, p. 14

138b. *Pair of Candlesticks*

c. 1805–1813

Mark: s.w. (in rectangle on base and in bobeche of each)

Silver

Height 5¼″ (13.3 cm)

Philip H. Hammerslough Collection. On permanent loan to the Wadsworth Atheneum, Hartford, Connecticut

LITERATURE: *Hammerslough,* vol. 4, p. 12

THE PORRINGER was a form used continuously in American silver from the seventeenth century through the end of the eighteenth century. Although this example clearly reflects decorative styles of the neo-classical period, the overall form is basically the same as that made one hundred years earlier, with rounded sides and a convex boss in the center of the bottom. The engraved oval on the handle is a common decorative motif in neoclassical silver and was particularly favored by Williamson. However, the cast handle is an unusual linear design which bears no clear resemblance to traditional patterns.

Although the porringer was anachronistic by the 1790s, the style of the cipher and the use of bright-cut ornaments indicate a date for this porringer at the end of the eighteenth century. Williamson's accounts reveal that he hired an engraver to do this work. The Williamson mark on the bottom is one of six that he used during his nineteen years of silversmithing.

The candlesticks appear to date from the later years of Williamson's career as they reflect the heavier and more ebullient treatment of forms of the Empire period. The beaded ornament may have been purchased from another Philadelphia silversmith since only one type of border, gadrooning, was listed as having been produced by Williamson's employees. The bobeches are detachable, which may explain why Williamson put his mark there as well as on the base of each.

PT □

GIUSEPPE CERACCHI (1751–1801)

Born in Rome, the son of a jeweler, Ceracchi trained as a sculptor at the Accademia di San Luca under Tomaso Righi and, while still young, distinguished himself with commissions in Florence and Milan. During his formative years in Rome, a large foreign market was developing for restorations and copies of antique statuary, as well as portrait busts in the new classicizing mode; this undoubtedly helped determine his particular bent. In England from about 1775 to 1779, Ceracchi exhibited at the Royal Academy and executed a number of successful busts before moving to Vienna and then Amsterdam. There, in 1785, he was commissioned to design a monument to Baron Derk van der Capellen tot de Pol, an outspoken democrat, but upon the completion of his monument in Rome in 1789, Ceracchi discovered that his patrons had lost their political power and he was not to be paid.

With his hopes dashed, Ceracchi decided to come to America to seek the commission voted by the Continental Congress for an equestrian monument to George Washington. He arrived in Philadelphia probably about February 1791, and, by the fall, he had submitted a model for a colossal "Monument Designed to Perpetuate the Memory of American Liberty," which included four allegorical groups against a rock surmounted

138a.

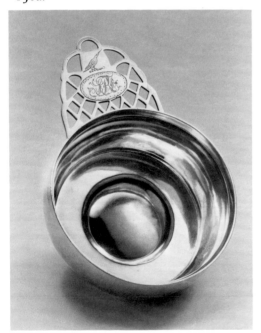

138b.

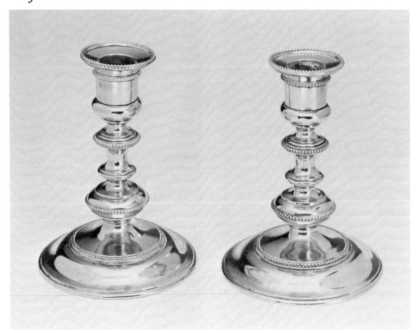

by an equestrian statue of Washington in Roman dress. Although the terra-cotta model, six feet high, was admired, no decision was made either to accept or reject it, and Ceracchi returned to Amsterdam in the summer of 1792.

In 1793, while working in Rome on a grandiose monument for the Palatine Elector, Ceracchi's liberal political views incurred the papal government's disfavor, and he had to flee from Rome and then from Florence. Having lost his contract by the fall of 1794, he returned to Philadelphia still hoping to execute his monument for Congress. This failed, however, and he left for Paris in deep disillusionment in the summer of 1795. There he made the mistake of presenting Napoleon, "The Liberator," with a detailed military plan for the conquest of Italy. After Rome was captured, Ceracchi tried unsuccessfully to collect for losses caused by his previous banishment. His bitterness over Napoleon's indifference was probably the cause of his abortive plot against the dictator's life which led to his own death on the scaffold.

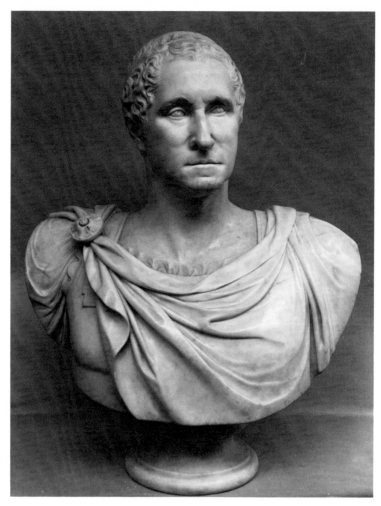

139.

139. *George Washington*

1795
Signature: Ceracchi faciebat/
Philadelphia/1795 (on reverse)
Marble
28⅞ x 23¼ x 12″ (73.3 x 59.1 x 30.5 cm)
The Metropolitan Museum of Art.
Bequest of John L. Cadwalader, 1914

PROVENANCE: Josef de Jaudenes y Nebot, Cadiz, Spain, c. 1795–1812; purchase, Richard W. Meade, Philadelphia, c. 1812–28; Mrs. Richard W. Meade, 1828–52; Gouverneur Kemble, Cold Spring, New York, 1852–75; Kemble estate, 1875–1904; purchase, John L. Cadwalader, 1904–14

LITERATURE: G. I. Montanari, *Della Vita e Delle Opere di Giuseppe Ceracchi, Scultore Romano* (Rimini, 1841), p. 19; Dunlap, *History,* vol. 1, p. 405, vol. 2, p. 462; Elizabeth Bryant Johnston, *Original Portraits of Washington* (Boston, 1882), p. 170; Morgan and Fielding, *Life Portraits,* no. 1, pp. 208, 209; Eisen, *Portraits,* vol. 3, pp. 845–46; Albert T. E. Gardner, "Fragment of a Lost Monument," *MMA Bulletin,* vol. 6, no. 7 (March 1949), pp. 189–97; Desportes, "Giuseppe Ceracchi," pp. 141–78; Ulysse Desportes, "'Great Men of America' in Roman Guise," *Antiques,* vol. 96, no. 1 (July 1969), pp. 72–75

GEORGE WASHINGTON is known to have sat for only three sculptors, Joseph Wright in 1783, Jean-Antoine Houdon in 1785, and Giuseppe Ceracchi in 1791/92. All three requested the sittings in hopes of obtaining the commission, voted by the Continental Congress in 1783, for an equestrian statue of Washington. Wright evidently made a mold of Washington's face which broke in the course of its removal so that his bust was considered defective. Houdon, on the other hand, modeled a clay bust from life (Mount Vernon) and successfully made a life mask (Pierpont Morgan Library), both of which were the basis for a number of copies.

Ceracchi's bust, originally done in terracotta, is less well known than the type created by Houdon. Unlike the others, it was modeled in Philadelphia and portrayed Washington in the artificial guise of a Roman emperor. With the decision on the equestrian project postponed, Ceracchi took the terra-cotta bust of Washington to Europe in the summer of 1792, and from it, according to a letter he sent Jefferson from Florence (Desportes, "Giuseppe Ceracchi," p. 160), he carved a bust in marble. Later he returned to Philadelphia with the marble bust, or a version of it, and at Ceracchi's urgent request Washington sat again for alterations in 1795. The result was this unusual life portrait in marble.

A bust of Washington by Ceracchi in the Musée des Beaux-Arts in Nantes has caused considerable debate as to whether it is the original (1791/92) terra-cotta from life (see Craven, *Sculpture,* p. 54). The Nantes maquette, 28½ inches high, over-life-size, is quite different from the 1795 marble and was apparently used as the basis for at least four marble busts, three of which are of colossal or over-life-size. The features are slightly more exaggerated than in the 1795 marble, the neck is wider, and the hair thicker, as if the head were intended to be seen from some distance. Rembrandt Peale said that Ceracchi's original bust was in marble, apparently meaning the 1795 one, and "much superior to the Colossal head . . . and the copies of it which are usually seen" (*Guide to the Philadelphia Museum,* Philadelphia, n.d., p. 6). But Peale's use of the term "original" should be interpreted loosely since Ceracchi's procedure was to carve marble busts from life models in clay. The

Nantes version was probably done earlier than the 1795 marble at the time Ceracchi was concerned with his first designs for the equestrian monument; whether it is the first maquette from life or a version of it is a question that may never be answered.

Ceracchi offered the 1795 marble bust to Washington as a gift which, although refused, remained in the president's house. Curiously, the draft of Washington's refusal (Desportes, "Giuseppe Ceracchi," pp. 176–77) is dated after Ceracchi, failing to gain the larger commission, sent a bill for the bust. In the end, Ceracchi reclaimed his "original marble bust" and sold it to a minister from the court of Madrid.

Dunlap and other contemporaries admired Ceracchi's bust (damaged in 1889) and praised, above all, the expression of the mouth as being very like Washington. In general, however, the simplicity of Houdon's idealization was preferred. Most observers were disconcerted by the cropped hair and Roman dress of Ceracchi's *George Washington,* which seemed to disguise their hero.

DE □

GILBERT STUART (1755–1828)

Stuart was born in North Kingstown, Rhode Island, where his father, a Scotsman, operated a snuff mill. In 1761 the mill failed and the family moved to Newport, where, sometime between 1769 and 1770, Stuart had his first lessons in drawing and painting from the Scottish artist Cosmo Alexander. When Alexander left Newport, he took Stuart with him as his apprentice on a painting tour of the South and, in 1771, to Edinburgh. By 1773, Stuart had returned to Newport, after Alexander's death, and was painting portraits in the smooth, linear style of his early teacher, with similar, simple compositions.

In 1775, Stuart followed one of his friends from Newport to London, where after a couple of years of failure as a portraitist and organ player, Stuart was forced to appeal to Benjamin West for help. West, with characteristic generosity, provided Stuart with a room in his house until Stuart gained a footing in the art world and set out on his own in 1784. Stuart's success in London really began with the exhibition of his ambitious full-length *Skater* (Washington, D.C., National Gallery of Art) at the Royal Academy in 1782. By this time his portraits had acquired the elegant ease and free brushwork of his better known English contemporaries; his coloring in particular won the admiration of fellow artists.

Despite the improvement in his financial status, Stuart was rarely solvent and even

had to flee to Dublin in the summer of 1787 to escape his creditors. He stayed in Ireland until probably late 1792, when he decided that it would be financially advantageous to return to America.

After several months in New York, he moved to Philadelphia with the intention of painting America's most famous citizens. At first, his studio was on Chestnut Street; he then moved to Germantown, probably in the summer of 1796, in order to expand the size of his studio. Apparently Stuart was never without work in Philadelphia, but three years after the seat of government moved to Washington, D.C. (in 1800), Stuart followed. He painted in the new capital for two years and then, encouraged by a Massachusetts senator, he moved to Boston and remained there for the rest of his life. He died on July 9, 1828, at the age of seventy-two.

140. *George Washington*

c. 1795/96
Oil on canvas
29 x 23¾" (73.7 x 60.3 cm)
Harvard University Portrait Collection, Cambridge, Massachusetts. Gift of Sydney F. Tyler

PROVENANCE: Fisher family, Philadelphia, possibly from c. 1796 to 1921; purchase, Mrs. George F. Tyler, 1921; Sydney F. Tyler, until 1969

LITERATURE: Mantle Fielding, *Gilbert Stuart's Portraits of George Washington* (Philadelphia, 1923), no. 6; Lawrence Park, *Gilbert Stuart: An Illustrated Descriptive List of His Works* (New York, 1926), vol. 2, no. 6; Morgan and Fielding, *Life Portraits,* no. 6, p. 253; Eisen, *Portraits,* vol. 1, p. 46; Cambridge, Fogg Art Museum, *American Art at Harvard* (April 19–June 18, 1972), no. 23

THERE IS EVERY REASON to believe that Gilbert Stuart returned to the United States in 1793 because he expected that a fortune could be made by painting portraits of George Washington. Washington was a popular hero in Europe as well as America, and, while his government was in Philadelphia, the city was able to attract artists from abroad as never before. There was a sudden influx of English and European artists to Philadelphia in 1794/95, mostly because England and nearly all of Europe were then at war with France, divided by her own civil war, but also because artists such as Ceracchi, Wertmüller, Savage, and Stuart were attracted to the subject of Washington as the embodiment of an heroic ideal, a reincarnation of the admired warrior-statesman of Roman times.

Stuart's portraits of Washington are the most famous likenesses of the first president and perhaps the most idealized. The American art critic John Neal wrote in 1823,

Stuart's Washington, I have heard my father say, who knew him well, was less what Washington was, than what he ought to have been. The painter has infused into it, an amplitude and grandeur, that were never the attributes of Washington's *face.* It is true that there was a settled majesty;—an oppressive and great steadiness in the countenance of Washington, that awed and confounded men. His passions were tremendous, even in their repose; and it was impossible to become familiar with him.... If George Washington should appear on earth, just as he sat to Stuart, I am sure that he would be treated as an imposter, when compared with Stuart's likeness of him. (Harold E. Dickson, "Observations on American Art, Selections from the Writings of John Neal [1793–1876]," *The Pennsylvania State College Bulletin,* vol. 37, no. 6, February 5, 1943, pp. 2–3)

Stuart himself admitted that he was awed by Washington and that he had greater difficulty in capturing his character than anyone else's (Dunlap, *History,* vol. 1, p. 197).

Contemporary accounts as to which of Stuart's portraits of Washington was painted first, and when, are sometimes contradictory. In all, Stuart did three different bust-length portraits from life which were the basis for a number of replicas and improvisations. Stuart seems to have arrived in Philadelphia in late November 1794, and, according to Dunlap (*History,* vol. 1, p. 197), presented a letter of introduction to the president just after his arrival. He must have painted Washington's portrait by April 20, 1795, because by that date he was accepting orders for copies.

Stuart's first portrait of Washington established the so-called Vaughan type, showing the right side of the face. From this portrait, he painted approximately seventeen replicas including the early and particularly fine Harvard portrait shown here. The question of the chronological order of the copies is in dispute, but most art historians accept the more sketchy "Vaughan" portrait at the National Gallery of Art as the original. It is from this portrait, first owned by Samuel Vaughan and engraved in London in 1796 as having been painted by "Mr. Stuart in 1795," that the type takes its name. The Harvard portrait is generally listed as sixth in sequence and is regarded as closest to the Gibbs replica at the Metropolitan Museum of Art, thought to have been retouched by the artist while Washington was sitting. Stuart's later portraits of the Vaughan type became more emblematic and

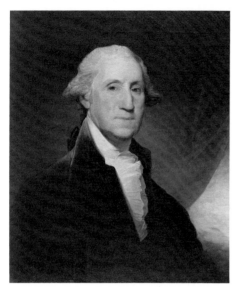

140.

portrayed Washington as younger in appearance. The type does not seem to have satisfied Stuart as the ultimate conception of Washington for he discarded it in favor of his second and third attempts from life, both more idealized than the first.

Stuart's next painting from life, the "Lansdowne type" showing the left side of the face, was completed as a full-length about a year after the Vaughan portrait, in April 1796. It was commissioned in two versions by William Bingham; one of them, probably the first, was given to Lord Lansdowne in England, and the other one, retained by Bingham, now belongs to the Pennsylvania Academy of the Fine Arts. This version was copied, as were all Stuart's portraits of Washington, by other artists.

The result of a third sitting from life was the "Athenaeum type," so named because the original, showing the left side of the face, belongs to the Boston Athenaeum (on deposit at the Boston Museum of Fine Arts). While the Lansdowne and Vaughan portraits were painted in Philadelphia, the Athenaeum portrait was executed in Germantown in the autumn of 1796 at Mrs. Washington's request. Stuart kept the original and made more copies of it than of any other.

Only the Athenaeum portrait was actually commissioned by the Washingtons; the rest were a mercantile venture. Stuart claimed that the first sketch he made of Washington was so unsuccessful that he rubbed it out, so that the Vaughan likeness, although the earliest, was evidently not his first attempt. What made it so difficult to paint the Vaughan picture was that Stuart was striving

for an image for posterity. The result was intended for proliferation, almost as a cult image, in copies and engravings. This portrait type did not fulfill Stuart's ambitions and is consequently the least famous, its special merit deriving from the fact that it was the first and least calculated portrayal.

DE □

JAMES MUSGRAVE (ACT. 1795–1813)

First listed in the Philadelphia directories in 1798, James Musgrave had a long career as a goldsmith, jeweler, and exchange broker. From 1798 until 1809, Musgrave worked at 44 South Second Street; from 1810 until 1813 his shop was at 74 Spruce Street. In light of the listing in the 1813 directory, "James Musgrave, late goldsmith," one might assume that Musgrave's career as a gold- and silversmith was over by this date. From 1816 until the end of his working years his business was at the southeast corner of Chestnut Street, and his name last appeared in the directories in 1840, following a five-year partnership with his son.

Musgrave advertised in the *Federal Gazette* on November 19, 1796, that he had just received, probably from London, "an assortment of plated ware and jewellry, plated tea and coffee urns, coffee pots, tea ditto, castors from 5 to 8 bottles, sugar and cream basons, bottle stands, baskets" He also stated that "all kinds of work in the gold and silver line" were "executed as usual." Musgrave, like Joseph Lownes (see biography preceding no. 152), was an importer as well as a craftsman; but unlike Lownes, who continued to make silver throughout his career, Musgrave abandoned his craft and became solely a businessman.

141. *Coffee and Tea Service*

c. 1795
Mark: Musgrave (semi-script in small conforming rectangle under foot of coffeepot, two times on foot of teapot, on bottom of cream pot, four times on bottom of slop bowl)
Inscription: H (in script on each)
Silver
Coffeepot height 14⅜″ (36.5 cm), width foot 4⅜″ (11.1 cm); teapot height 11¼″ (28.6 cm); width 3¾″ (9.5 cm); sugar urn height 10½″ (26.6 cm), width foot 3⅝″ (9.2 cm); cream pot height 5½″ (14 cm), length base 2⅝″ (6.7 cm); slop bowl height 5½″ (14 cm), width foot 4⅜″ (11.1 cm)

Mr. and Mrs. H. Richard Dietrich, Chester Springs, Pennsylvania

PROVENANCE: John Barry (1745–1811); nephew, Patrick Hayes

LITERATURE: *Silver Supplement to the Guidebook to the Diplomatic Reception Room* (Washington, D.C., 1973), pp. 76–77; *University Hospital Antiques Show* (Philadelphia, 1969), p. 64

IN THE *Pennsylvania Packet,* November 16, 1800, James Musgrave advertised that "he has on hand a large assortment of silver ware, such as coffee and tea pots, sugar bowls, milk pots and slop bowls in sets or separate, fluted or plain." This tea and coffee service includes such pieces as those described in Musgrave's advertisement.

This service was owned by an Irish-born merchant, John Barry (1745–1811), who came to America in 1760 and settled in Philadelphia. He commanded the brig *Lexington* in 1776 and was the first commissioned officer in the United States Navy to capture a foreign ship, the British tender *Edward*. He captured two vessels in 1781 when returning from France, but was wounded while doing so. Barry was the first senior officer to receive the rank of commodore when the navy was reorganized in 1794 (*Silver Supplement to the Guidebook to the Diplomatic Reception Room,* Washington, D.C., 1973, p. 76). The initial H on each piece is for Barry's nephew Patrick Hayes, who sailed with Barry as a cabin boy.

The melon shape of the four larger pieces was a popular one in the classical period. Also common in this period were the cast urn finials and engraved borders. The delicate beading around the tops and at the bases on all but the cream pot was a popular motif in Philadelphia silver (see no. 138). The bright-cut decorative band on these pieces is exceptionally fine, as is the engraved manteling surrounding the script H on a shield.

PT □

SAMUEL BLODGET, JR. (1757–1814)

Samuel Blodget (or Blodgett), Jr., was born in Goffstown, New Hampshire, on August 28, 1757, the son of a businessman, Samuel, and his wife, Hannah White Blodget. After serving as a captain in the Revolutionary Army, Samuel entered the trade of a merchant, first at Exeter, New Hampshire, and, more successfully, at Boston. There he took advantage of new post-Revolutionary shipping patterns—the destination of the East Indies instead of the closer islands of the West Indies—which revived the commerce of Boston and Salem, decimated by war losses. Living in Boston,

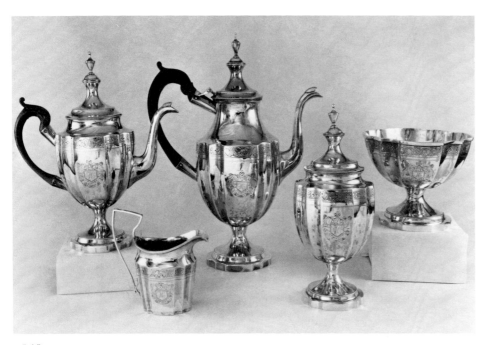

141.

REPRESENTED BY:

William Birch (1755–1834)
Bank of the United States, in Third Street
1799
From *The City of Philadelphia*, 1804
Engraving
8½ x 11⅛" (21.6 x 28.3 cm)
Private Collection

Attributed to Claudius Le Grand (n.d.)

Capital
1795–97
Painted mahogany
17⁵⁄₁₆ x 23⁹⁄₁₆ x 23⁹⁄₁₆" (44 x 59.9 x 59.9 cm)
Philadelphia Museum of Art. Given by
Thomas H. Marshall. 98–117

PROVENANCE: Bank of the United States,
1797–1812; Girard's Bank, 1812–62; Girard
National Bank, 1864–1926; American Legion
(lease), 1930–44; Office of Board of Directors
of City Trusts, from 1944

LITERATURE: James O. Wettereau, "The Oldest
Bank Building in the United States," in *Historic
Philadelphia*, pp. 70–79

TOWERING, IMPRESSIVE, solid and secure, the
Bank of the United States, with its pedi-
mented Corinthian portico and front steps
inviting access from three directions, must
readily have inspired the confidence required
for depositors to settle their wealth within.
The great triangular pediment is ornamented
with the arms of the United States. The
symbolism of power was implicit in the
design of the facade, and Alexander
Hamilton's proclamation that "public utility
is more truly the object of public banks than
private profit" (James O. Wettereau, "The
Oldest Bank Building in the United States,"
in *Historic Philadelphia*, p. 71) describes the
fabric of the building as well as its fiscal
policy. From the date of its charter in 1791,
the Bank attracted investors and operated
efficiently until 1811, and but for the political
ineptitude of some of its directors, it might
have continued. However, its charter was
not renewed by the Eleventh Congress in
1811, and the building was purchased in
1812 by Stephen Girard for use as his
private bank.

The land for the Bank on South Third
Street at the head of Dock Street was pur-
chased from Ann Pemberton on February
28, 1794, and construction was underway
toward the end of 1795. Samuel Blodget, Jr.,
designed the Bank building within the
English Palladian vocabulary favored by
Sir William Chambers. It was not an
unusual design, and numbers of English and
Irish domestic structures employed the same
features—two-story portico, balustrade,
which almost hides the flattened hip roof,
and seven-bay facade with an ornamental

Blodget had made his fortune by 1788 and
was then manager of the Boston Tontine.
He was a friend of Ebenezer Hazard, a
Philadelphia broker and merchant who had
the idea of selling some of Blodget's Boston
Tontine shares in Philadelphia (William
H. A. Carr, *Perils Named and Unnamed*,
New York, 1967, p. 40). Blodget came to
the city in 1789, and married Rebecca Smith,
daughter of William Smith, provost of the
University of Pennsylvania, soon after his
arrival. He moved into Hazard's offices, and
opened the Universal Tontine Association,
with Hazard as secretary. The enterprise did
not succeed, and Blodget called on President
Washington hoping to secure a position
superintending construction of government
buildings in Washington, D.C. Just where
he acquired designer skills is not clear, but
his deep involvement with the investment
community in Philadelphia and his election
to a directorship in the Insurance Company
of North America in 1792, the outgrowth of
the tontine organization, probably provided
the necessary contacts. In 1798 he was one
of the directors of the Permanent Bridge
Company (see no. 157).

Blodget was not trained in architecture,
but seems to have pursued it as an avocation,
the experience of European travel perhaps
inspiring him in this pursuit. By the time the
Bank of the United States was finished,
Blodget had moved to Washington, D.C., to
work on federal buildings, and to promote
the real estate speculations that eventually
led to his financial embarrassment and to
debtor's prison. He competed with Benjamin
Latrobe at least once, when Vice-President
Burr commissioned him to refit the Senate
Chamber for the impeachment of Justice
Chase in 1805. He died in relative obscurity
in Baltimore in 1814.

142. *Bank of the United States*

120 South Third Street
1795–97

Marble and brick exterior; copper roof
94 x 72' (without portico)
(28.6 x 22 m)

entrance. Blodget's scheme was probably drawn from the Royal Exchange in Dublin, designed by Thomas Cooley in 1769, which was engraved in Robert Pool and John Cash's views of Dublin in 1780 (John Summerson, *Architecture in Britain 1530–1830*, Baltimore, 1970, illus. p. 445). If amateur architect Blodget drew his scheme from that view, the workmen employed must have contributed some design features based upon their skills and the builders' manuals available. Fluted Corinthian columns were described in most books, and the smooth, flat engaged pilasters were already familiar elements in Philadelphia, having appeared earlier on Library Hall (no. 122) and the Pennsylvania Hospital (no. 48). The window casings with decorative swelled lintels formed of reeds bound with crossed ribbons were a mid-eighteenth century scheme, and the cornices projecting over their lintels were a feature of James Gibbs's designs. William Pain's *Practical Builder* probably provided details of the interior, which was torn out around 1898, before the renovation of the banking room by James Windrim about 1900. The carved wood capital exhibited is all that remains of the decoration of that space, which was designed in the Corinthian order in harmony with the facade.

The unique combination of scale and materials gave this building its place in the annals of Philadelphia architecture. The *Gazette of the United States* on December 27, 1797, extolled its design: "On viewing this building, the first impression is, one plain and beautifully proportioned whole.... an elegant exhibition of simple grandeur and chaste magnificence" (Wettereau, cited

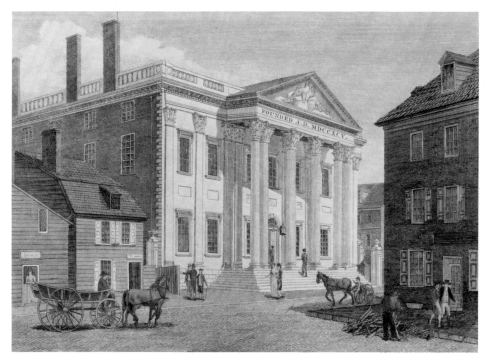

142.

142.

above, p. 73). As a house, its scale would have been grand in England, but as a public or commercial building it would have been thought small, while in Philadelphia it proved an extraordinary contrast with the small domestic structures which surrounded it, to say nothing of the clapboard gambrel-roofed building shown in Birch's engraving, possibly part of Howell's tanyard on Dock Creek, next to the alley along the Bank's south side. Equally striking was the homogeneity of material employed on the facade. Where William Thornton's Library Hall and David Evans's central section of Pennsylvania Hospital had combined white marble with smooth red brick, Blodget intended that the whole building be sheathed with marble. That work was under the supervision of Claudius Le Grand, who processed all the pieces at his stonecutting yard located at Tenth and Market streets. Of his work Benjamin Latrobe commented: "The white marble columns of the bank are full of bluish and yellowish veins, but they have, notwithstanding, a very beautiful appearance. Sufficient attention has not been paid to the successive heights of the blocks, nor are the joints level [see no. 275]. The plain workmanship has been well executed" (J. H. B. Latrobe, ed., *The Journal of Latrobe*, New York, 1905, pp. 83ff.). Economy forced the directors to alter the specifications for the sides from marble to brick, which when viewed from Birch's angle, turns the grandiose scheme intended by Blodget into a vernacular recognizable in the

domestic building across the street. Even the window casing style was compromised when inserted into the brick south facade.

The gleaming marble, when new, made an extraordinary contrast with the old brick of the city. In a sense the Bank forecasts the architectural style of Washington, D.C., which Blodget was so interested in even before he produced this design. Owen Biddle included a frontal view of the Bank in his *Carpenter's Assistant*, where he described it as a "superb Building ... an elegant specimen of the Corinthian Order"; a similar but less-detailed view had appeared in Varlé's 1796 map of the city (no. 143). Startling and new to Philadelphians in 1797, the architectural style of the Bank recalled the eighteenth century Palladian vocabulary with its alternating rhythms of ornament, windows with pilasters, and inset horizontal plaques punctuating the vertical elements. The Bank of the United States was Philadelphia's only architectural effort which came close to the scale and pretension of English Palladianism.

BG □

JOSEPH T. SCOTT (ACT. 1795–1800)

In Philadelphia directories, Joseph T. Scott styled himself "geographer and engraver," but no records seem to have survived to indicate from whom he learned these trades.

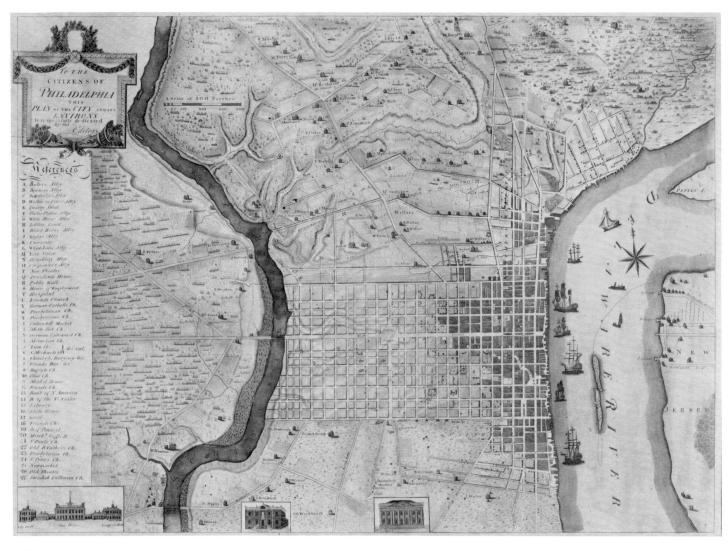

143.

In 1795 the Philadelphia printers Francis and Robert Bailey published Scott's *United States Gazetteer,* his first important work. His relations with the politically well-connected Baileys continued at least until 1798, when they published the first two of four volumes of Scott's *New and Universal Gazetteer.* Scott apparently was something of an entrepreneur: the front page of Francis Bailey's Waste Book for 1795 (Historical Society of Pennsylvania) records that although Scott assigned a number of copies of the *United States Gazetteer* to the Baileys to defray printing costs, he nevertheless retained ownership of the copyright and of the edition.

One can only guess how Scott came to engrave for Charles Varlé. It is possible that the Baileys, who held a number of important government job-printing contracts, introduced Scott to Varlé, who enjoyed the support of Henry Knox, Washington's first secretary of war. Scott did two maps for Varlé, a reworking of Bellin's map of Haiti in 1795 and the plan of Philadelphia in 1796.

PETER CHARLES VARLÉ
(ACT. 1794–C. 1835)

According to Richard Stephenson, Varlé was born and educated in Toulouse (Library of Congress, Geography and Maps Division, "Charles Varlé, Nineteenth Century Cartographer," transcript, n.d.). Stephenson records that Varlé emigrated to Haiti at the beginning of the French Revolution to work as a civil engineer. He remained until native uprisings in 1794 forced him to flee to the United States, and he settled that year in Philadelphia, enrolling almost immediately in the Pennsylvania militia. Varlé's former superior in Haiti found him a job with Henry Knox in the War Department as an engineer, but his tenure there was short. When Knox left the government, Varlé worked for him in Maine in 1795 and then moved briefly to Massachusetts where he worked on the Middlesex Canal, connecting Boston Harbor with the Merrimack River. In 1798, Varlé moved to Maryland as superintendent of the Susquehanna Canal Company. The remainder of Varlé's life was closely associated with Maryland, and Baltimore in particular. He did a number of careful surveys in connection with his advocacy of a canal linking Chesapeake Bay and the Delaware River as well as several directories for Baltimore. His most important Philadelphia work was his plan of the city, published in 1796.

JOSEPH T. SCOTT AFTER
PETER CHARLES VARLÉ

143. *Plan of Philadelphia*

1796

Signature: P. C. Varlé Geographer &
Engin^r, Del. (lower left); Scott sculp.
Philad^a (lower right)
Inscription: To the/Citizens of/
Philadelphia/this/plan of the city
and its/environs/Is respectfully dedi-
cated/By the/Editor. (upper left)
Hand-colored engraving on laid paper,
lined with Japanese mulberry tissue
Watermark: J. Whatman
18⅛ x 25⁷⁄₁₆″ (46.1 x 64.5 cm)
Historical Society of Pennsylvania,
Philadelphia

LITERATURE: Stokes and Haskell, *Early Views,*
p. 83; James Wheat and Christian Brun, *Maps
and Charts Published in America before 1800:
A Bibliography* (New York, 1969), no. 465,
p. 99

IN THE 1790s Philadelphia began to attract
an increasing number of artists and artisans
who hoped to find markets for their talents
in the new nation's capital. Nicholas Boudet,
for example, came to the city from the West
Indies in 1793; the Birches and William
Groombridge arrived from England by 1794.
To be sure, necessity rather than professional
ambition brought Varlé to Philadelphia, but
once here, he quickly set about catering to
the same vanities and pride of place that
inspired his fellow immigrants.

Varlé's plan of Philadelphia was produced
in a remarkably short time. Between his
arrival in 1794 and its publication in 1796,
his work in the War Department and for
Henry Knox in Maine hardly permitted him
time to do original surveys. Instead, he
"edited" the work of others. The area
depicted in the plan includes the original
city and its near northern, western, and
southern suburbs. For the city proper, Varlé
drew heavily upon a plan published in 1794
by A. P. Folie. Like Folie, he projected the
city's streets all the way to the Schuylkill—
although the city remained clustered east of
Broad Street—and he included a reference
key to significant buildings and streets. He
also borrowed and reoriented a number of
Folie's ships in the Delaware River as well
as his compass rose. The picture of the State
House that appears in the inset at the lower
left was lifted from Folie's cartouche, but the
sources for the illustrations of Library Hall
(no. 122) and the Bank of the United States
(no. 142) in the other insets are unknown.

But Varlé added a number of details not
included in the Folie plan and depicted
topographical features more clearly. Centre

Square, labeled Public Square, first projected
by Holme (see no. 2, town plan inset) but
missing on Folie's plan, has been restored.
The area shown is greater than that in Folie's,
and Varlé located the sites of many of the
country houses of the city's gentry around
Philadelphia, perhaps to curry their favor.
Curiously, by accident or by design, Varlé
created a kind of equality among the gentry:
with the exception of Bush Hill and William
Hamilton's house, The Woodlands, all the
country seats appear the same size, and their
boundaries are no more than suggested.
For the locations of many of these houses,
Varlé probably drew upon Scull and Heap's
1752 map of Philadelphia, and he drew upon
William Faden's piracy of it (1777) to show
the "Entrenchments of the English in the
late War," noted by dotted lines running
southward and roughly east-northeast from
the Upper Ferry on the Schuylkill.

Varlé's plan, engraved by Joseph T. Scott,
was sufficiently well received to warrant a
second edition, which appeared in 1802,
several years after he had left the city for
Baltimore. The second edition proposed an
extension to the city, westward across the
Schuylkill, with a system of squares,
diagonal streets, and oval open spaces,
reminiscent of L'Enfant's plans for Wash-
ington, D.C. (John Reps, *The Making of
Urban America,* Princeton, 1965, p. 264).

The first and second editions of Varlé's
plan, as well as the earlier Folie one, illustrate
just how different the mapping of Philadel-
phia had become by this time. No longer
were maps just to be records of what had
happened, although they all showed that;
they were instead projections of what the
city might become. And, as reproduced
prints, they provided inexpensive incentives
to continuing growth.

PJP □

144. *Dress*

c. 1795–99
Light-beige satin
Waist 24″ (70 cm); center back length
62″ (157.4 cm)
Philadelphia Museum of Art. Given by
Miss Mary Morris Boykin. 71-68-1

PROVENANCE: Mary Hollingsworth (Morris);
descended in family to great-great-grand-
daughter, Mary Morris Boykin

WITHOUT NEGLECTING the precept of sim-
plicity, Quaker clothes often had stylish
origins in London or even Paris, although
they were interpreted more modestly.
Quakers simply took the current styles and
made up their dresses in exquisite materials,

but without trimming. This dress was worn
by Mary Hollingsworth, probably before her
marriage in 1799 to Israel Wistar Morris
(son of Samuel Morris), for its style suggests
a somewhat earlier date. It is cut very much
like the fancier pale-blue dress thought to
have been worn by her cousin Rebecca
Hughes (no. 119), the only difference being
the absence of any real adornment.

The front of the bodice has three tabs on
each side along the waistline; it is fitted in
back with three rows of boning which end
in a long point at the center back. The
neckline is slightly lowered in back, but cut
round and low in front. The closely pleated
skirt is open in front to reveal a full petticoat,
quilted in similar material. The cuffed
sleeves curve and follow the shape of the
elbow.

EMcG □

JOHN AITKEN (ACT. C. 1790–1814)

JOHN AITKEN must have been a prosperous
and prestigious member of the Philadelphia
cabinetmaking community in order to have
secured three orders from President Wash-
ington, but little is known about his career
as a cabinetmaker. A Scottish immigrant
who arrived in Philadelphia around the time
of the Revolution, Aitken had a shop at the
southeast corner of Chestnut and Second
streets at least as early as 1790, for in that
year he advertised, "He still carries on the
cabinet and chair manufactory where he has

144.

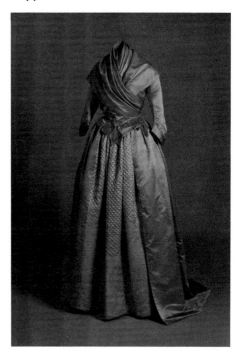

for sale, chairs of various patterns, some of which are entirely new, never before seen in this city and finished with an elegancy of stile peculiar to themselves, and equal in goodness and neatness of workmanship to any ever made here. Likewise desks, bureaus, book cases, bed steads, tea tables, card ditto, dining ditto etc." (*Federal Gazette,* June 9, 1790). Included with this advertisement was an illustration of a heart-back chair in the Hepplewhite style.

Aitken was first listed in the Philadelphia directories beginning in 1791 when he was working at 53 South Second Street, near Chestnut, probably the same address as the one mentioned in the above advertisement. According to the information in the directories, Aitken moved to 50 Chestnut Street between Second and Third streets in 1793 where he continued to work until 1801 when he was listed at 34 South Sixth Street.

Newspaper notices contradict the directory listings, however. On March 17, 1794, Aitken informed "his friends and the public in general that he has removed his Cabinet Ware Rooms to No. 60 Union Street," and on August 1 of the same year he announced that the "Copartnership of John Hall and Co., Cabinet-Makers is this day dissolved" (*Federal Gazette*). An advertisement in 1797 for a runaway apprentice, John Robinson, does confirm that Aitken was working at 50 Chestnut Street in that year (*Federal Gazette,* September 1, 1797).

In 1800, Aitken announced that "he has removed to the store No. 79 Dock, near Third Street, lately occupied by Cocks & Co., where he has a large and general assortment of Cabinet Furniture, suitable for the home and exportation trade" (*Federal Gazette,* January 13, 1800). Aitken may have been a partner of William Cocks, under the name of "Cocks & Co. Cabinetmakers and Upholsterers" at the corner of Sixth and Chestnut streets. The first reference to this partnership appeared in the *Federal Gazette,* August 5, 1797. As discussed above, Aitken also is known to have had his own shop at 50 Chestnut Street at this same time. In July 1798, Cocks and Company moved to 79 Dock Street where they "carried on the business in an extensive manner" (*Federal Gazette,* July 14, 1798). Aitken organized the sale of Cocks's estate when he died in 1799 (*Federal Gazette,* August 15, 1799). Aitken retained the former shop of Cocks and Company at 79 Dock Street and continued to run his own Sixth Street shop as well, for in 1803 he was listed at both addresses. By 1807, Aitken had only one shop, at Chestnut and Sixth, where he continued to work until 1814.

Another John Aitken, a silversmith, worked near the cabinetmaker John Aitken throughout the early years of the latter's career. In 1793 they worked next door to

each other. The silversmith later became a metalsmith, jeweler, and copperplate engraver and was the first person in America to produce sheet music through the stamping process. Because of the physical proximity of the two craftsmen, one might assume that they were related, perhaps father and son.

145. *Side Chair*

c. 1797
Mahogany; yellow and blue-green silk and white horsehair upholstery
36 x 20½ x 17½" (91.5 x 52.1 x 44.5 cm)
Smithsonian Institution, Washington, D.C.

PROVENANCE: George Washington; Martha (Custis) Washington; granddaughter, Eleanor Parke (Custis) Lewis purchase, United States government, 1878

LITERATURE: HSP, George Washington, Philadelphia Household Account Book, February 21, 1797; Ethel Hall Bjerkoe, *Cabinetmakers of America* (New York, 1957), p. 32; Helen Comstock, "Mount Vernon Centennial," *Antiques,* vol. 64, no. 1 (July 1953), p. 36; Morrison Heckscher, "The Organization and Practice of Philadelphia Cabinetmaking Establishments, 1790–1820," M.A. thesis, University of Delaware, 1964, pp. 91–92

MUCH FURNITURE has been associated with George Washington since the early nineteenth century, but there are few examples of American-made furniture with such a distinguished pedigree of Washington ownership as the set of twenty-four side chairs made by John Aitken for the Mount Vernon banquet hall (Aitken also sold the president a tambour secretary and a sideboard, now at Mount Vernon).

The documentation for the twenty-four chairs, one of which is shown here, is contained in Washington's Philadelphia Household Account Book (HSP, March 2, 1793—March 25, 1797). An entry for February 21, 1797, reads, "The President's acco't proper p^d Jn^o Aitken for 2 doz: chairs, 2 side boards &c.—402.20" The chairs still have their original upholstery of blue-green and yellow silk and white horsehair, a fact which is confirmed by an entry in the journal of Joshua Brookes, a visitor to Mount Vernon in 1799, who noted, "The drawing room . . . is elegantly furnished . . . mahogany chairs with yellow damask seats . . ." (New-York Historical Society, Joshua Brookes, Journal, February 4, 1799).

When Martha Washington drew up her will in 1800, she left to her granddaughter, Eleanor Parke Custis, "twelve chairs with green bottoms to be selected by herself" (Fairfax [Va.] County Court House, Martha Washington, Will, September 22, 1800).

Because of the combination of blue and yellow in the seat, the overall color may have appeared to be green. After Mrs. Washington died in 1802, twelve chairs went to Nelly Custis Lewis and twelve were sold at auction to Reverend Dr. John Weems of Port Tobacco Parish, Maryland. The chair exhibited here was part of the Lewis collection of "Washingtoniana" which was purchased by the United States government and put on deposit at the United States Patent Office from 1878 until 1881, when it was removed to the United States National Museum (Theodore T. Belote, "Descriptive Catalogue of the Washington Relics in the United States National Museum," *Proceedings of the United States National Museum,* vol. 49, October 19, 1915, pp. 1–2).

Sources for the Aitken chairs include plates 25, 33, and 36 in Sheraton's 1793 *Drawing-Book,* which are designs for parlor and drawing room chairs. According to Charles Montgomery, similar chairs were also made in New York (*Federal Furniture,* p. 147). Typical of Philadelphia construction is the use of stringing on the tapered front legs and the raked rear legs. The stylized floral and leaf medallion on the upholstered seat was a popular motif on Empire-style furniture of the early nineteenth century; its use on this chair seems to be a relatively early example in America.

PT □

145.

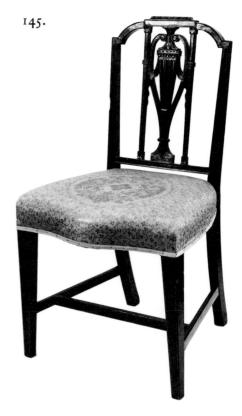

BENJAMIN TROTT (c. 1770–1843)

According to Dunlap, who knew him personally, Trott was born in Boston and "commenced his career as a portrait painter in miniature, about the year 1791; which will allow us to guess that he was born not far from 1770" (Dunlap, *History*, vol. 1, pp. 414–17). Dunlap's account is still the source of most of the biographical information on Trott. Nothing is known of his training, but by 1793 he was successfully painting miniatures in New York, when Gilbert Stuart arrived there from Dublin. Trott made miniature copies on ivory of some of Stuart's portraits, and when Stuart moved to Philadelphia in 1794, Trott followed.

While Philadelphia remained the center of his activity for almost thirty years, Trott traveled extensively in search of commissions. He returned to New York late in 1797, but left after a short stay because of an outbreak of yellow fever. Sometime in 1798, he and Elkanah Tisdale were painting miniatures in Albany. By 1802, Trott was living at "the Falls of the Schuylkill" on the outskirts of Philadelphia, near Stuart and the engraver David Edwin (H. E. Dickson, "A Misdated Episode in Dunlap," *Art Quarterly*, vol. 9, no. 1, Winter 1946, pp. 33–36). Dunlap recorded that "in 1805 Mr. Trott visited the western world beyond the mountains, travelling generally on horseback, with the implements of his art in his saddle-bags. This was a lucrative journey."

Back in Philadelphia a year later, Trott shared a house on Sansom Street with Thomas Sully and his family, both before and after Sully's trip to Europe in 1809 and 1810. Trott never seems to have traveled abroad himself. In 1812 a critic, G.M., noted, "Mr. Trott is purely an American—he has never been either in Paris or London" (see Theodore Bolton, "Benjamin Trott, An Account of His Life and Work," *Art Quarterly*, vol. 7, no. 4, Autumn 1944, p. 267).

His clients for miniatures included some of the city's most prominent citizens. Trott exhibited annually from 1811 to 1814 with the Society of Artists and also assisted in teaching the Society's drawing classes (Edward J. Nygren, "The First Art Schools at the Pennsylvania Academy of the Fine Arts," *PMHB*, vol. 95, no. 2, April 1971, p. 232). It was probably his allegiance to the Society of Artists that led him to refuse his election to the first group of Academicians of the Pennsylvania Academy of the Fine Arts in 1812 (PAFA, *Pennsylvania Academicians*, March 10—April 8, 1973, n.p.).

Dunlap portrayed Trott as an irritable, insecure man, who was jealous of rival miniaturists Walter Robertson and Edward G. Malbone. Trott worked in Norfolk, Virginia, and Charleston, South Carolina, in 1819, then returned to Philadelphia and married. The union was not a happy one, and he moved to Newark in 1823 to take advantage of New Jersey's divorce laws. His business having diminished, he went to New York in 1829 where he tried painting full-size portraits, none of which have survived. Trott was in Boston in 1833 and by 1838 in Baltimore, where he remained until at least 1841. He died in Washington, D.C., two years later.

AS

146. *Joseph Anthony, Jr.*

c. 1798
Watercolor on ivory
2⅞ x 2¼″ (7.3 x 5.7 cm)

Yale University Art Gallery, New Haven. The Mabel Brady Garvan Collection

PROVENANCE: Joseph Anthony, Jr.; Elizabeth Anthony; Thomas Duncan Smith; Mary (Barnes) Smith; Thomas Duncan Smith; Edmund Bury; Francis P. Garvan, New York, 1936

LITERATURE: Theodore Bolton and Ruel Pardee Tolman, "A Catalogue of Miniatures by or Attributed to Benjamin Trott," *Art Quarterly*, vol. 7, no. 4 (Autumn 1944), p. 289

BENJAMIN TROTT's irritable nature and professional insecurity led to constant experimentation and consequently to an uneven degree of success in his work and to an inconsistency in quality. However, his best miniatures rank with the finest and place him among this country's best painters in this genre. His bold, dashing brushwork and clear, natural coloration are reminiscent of the oil technique in Gilbert Stuart's portraits, which he was copying in minature.

Trott's portrait of Gilbert Stuart's first cousin, the Philadelphia silversmith Joseph Anthony, Jr. (see biography preceding no. 120), done in the late 1790s, portrays Anthony as a relaxed and pleasant gentleman. It is executed with Trott's characteristic vibrant combination of long, angular brushstrokes over washes of color to model the face, a broad treatment of the clothing and hair, and crosshatching of the dark background.

RB-S □

GILBERT STUART (1755–1828)
(See biography preceding no. 140)

147. *Mrs. Thomas Lea*

c. 1798
Oil on canvas
29 x 24″ (73.6 x 60.9 cm)
Private Collection

146.

PROVENANCE: Mrs. Thomas Lea (Sarah Shippen); descended in family to present owner

LITERATURE: "Notes and Queries," *PMHB*, vol. 23, no. 3 (1899), p. 414; Charles Henry Hart, "Gilbert Stuart's Portraits of Women," *Century Illustrated Magazine*, vol. 58 (1899), p. 737; Lawrence Park, *Gilbert Stuart, An Illustrated Descriptive List of His Works*, vol. 1 (New York, 1926), no. 478; Charles M. Mount, *Gilbert Stuart, A Biography* (New York, 1964), p. 370; Washington, D.C., National Gallery of Art, *Gilbert Stuart, Portraitist of the Young Republic, 1755–1828* (1967), no. 31

THOMAS LEA's WIFE, Sarah Shippen, was one of three celebrated beauties, the daughters of the chief justice of Pennsylvania, Edward Shippen. At their request, Gilbert Stuart painted their father in 1796, at which time Shippen reported, Stuart "is said to have been eminent in London; it is thought to be a strong likeness" (Lewis Burd Walker, "Life of Margaret Shippen, Wife of Benedict Arnold," *PMHB*, vol. 26, no. 2, 1902, p. 225). The success of this portrait undoubtedly prompted the suggestion that Sally (Sarah) also sit for Stuart. It must have been her idea to have Stuart copy Wertmüller's portrait of her son Robert (no. 136) as a locket miniature in her own portrait.

The freshness of color, the loose drawing, and the lush application of paint in Stuart's *Mrs. Thomas Lea* are in total contrast to the Peale tradition. There is a sensuous indulgence in the texture of brushstroke and the viscosity of paint which is alien to Charles Willson Peale's flat surface and linear style. Stuart's European training led him to place

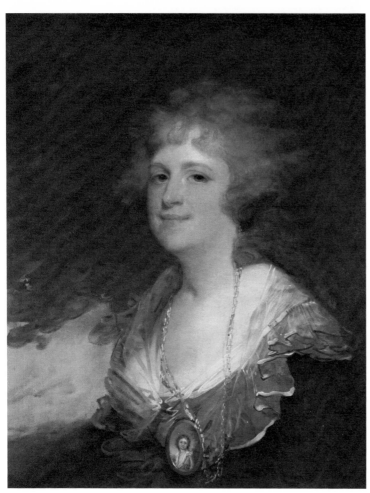

147.

Thomas Sully took the chair. Neagle "had already drawn up a preamble and resolutions for the occasion and announced the fact." After some discussion, it was decided to publish a testimonial in all the public papers (John Neagle, Diary, private collection, Haverford, Pennsylvania).

DE □

JOHN VALLANCE (C. 1770–1823)

John Vallance had immigrated to Philadelphia from Scotland by 1790, when he began engraving plates for Dobson's *Encyclopaedia.* According to Dunlap, Vallance studied with James Trenchard. One of his fellow students was James Thackara, with whom he maintained a partnership from 1791 to 1797. Ebenezer Hazard, among the first to edit historical records in America, felt that Vallance and Thackara were among Philadelphia's very best engravers (Hazard to Jeremy Belknap, *Massachusetts Historical Society Collections,* 5th series, vol. 3, part 2, Boston, 1877, p. 250).

Vallance exhibited at the Pennsylvania Academy of the Fine Arts between 1811 and 1823, and was in partnership, about 1817–19, with Benjamin Tanner and Francis Kearney, doing banknote and certificate engraving, book illustrations, maps, and advertisements. Though a competent engraver, Vallance lacked style. His colleague Alexander Lawson criticized his technique as being too stiff and dry (see biography preceding no. 171). Nonetheless, to Vallance fell the task of engraving the *Encyclopaedia*'s most elaborate illustration, the frontispiece.

ROBERT SCOT (ACT. 1781–1820)

Scot appears to have arrived in Philadelphia from his native England around 1781; in 1785 he advertised himself as "Late Engraver to the State of Virginia" (Prime, *Arts and Crafts,* vol. 2, p. 73). He went into partnership with his pupil Samuel Allardice. Scot was the chief engraver of the plates in Dobson's *Encyclopaedia* and as such received top billing in advertisements for one of the numbers as it came out (*Pennsylvania Packet,* April 8, 1790).

In 1793, Scot was appointed Engraver to the United States Mint in Philadelphia, a position he is known to have held until at least 1820. Scot is credited with the design of the dies for the copper cent of 1793, as well as numerous plates engraved for Philadelphia publishers.

less emphasis on likeness alone and more on the aesthetic consideration of the portrait as a picture. As Joseph Jackson observed, Stuart was "one of the first to emphasize method and technique," and "art did not advance technically [in Philadelphia] until Gilbert Stuart came" (*Encyclopedia of Philadelphia,* vol. 1, Harrisburg, 1931, p. 165).

Stuart's contemporaries repeatedly tried to divine the supposed secret of his colors, particularly the transparency of his tints. It was not enough to copy the colors from Stuart's palette: the way in which he applied them appeared to be the elusive key. John Neagle, about 1825, reverently recorded Stuart's conversation with him in this regard: "*Gilbert Stuart* told me that *Rubens's* method of coloring was to *lay each tint in its place, separately & distinctly, alongside of each other,* before any blending was used, & then they were united by Means of a . . . brush, & *without teasing or corrupting the freshness of the tints*; Mr. Stuart also said that this was *his own practice,* & declared that even Rubens's colours . . . might be totally destroyed by unskilfully teasing them

while fresh" (HSP, John Neagle, Common Place Book, p. 36).

Stuart's portraits were undoubtedly considered more "stylish" than Peale's since they more closely reflected contemporary English models. As the eccentric, temperamental "genius" who arrived in Philadelphia with a European reputation, as had Wertmüller, Stuart provided a sharp contrast to Peale's "anyone can paint if trained" attitude. Women, especially, liked Stuart's portraits. In 1804 one even begged Stuart to begin her portrait while she was standing in Peale's studio in the presence of both Peale and his son Rembrandt (Sellers, *Portraits and Miniatures,* p. 4), obviously much to the embarrassment of the Peales. The elder Peale and Stuart were unquestionably rivals: Peale tended to paint Philadelphians; Stuart, important visitors. This may have affected Peale's decision, about 1796, to concentrate on his museum.

Stuart was so admired by the next generation of Philadelphia artists that after his death John Neagle called a meeting of artists on July 21, 1828, to honor his memory, and

148. *Encyclopaedia; or, a Dictionary of Arts, Sciences, and Miscellaneous Literature*

1790–98
Published by Thomas Dobson
Volumes 1 and 6 (of 18); laid paper;
full-bound in calf
Volume 1, 10½ x 8⅛ x 2⅜″ (26.6 x 20.6
x 6 cm); volume 6, 10½ x 8⅛ x 2⅛″
(26.6 x 20.6 x 5.3 cm)

The Library Company of Philadelphia

PROVENANCE: Benjamin Rush?; son, Dr. James
Rush, 1813

LITERATURE: Joseph Hopkinson, *Annual Dis-
course* (Philadelphia, 1810), pp. 16–17; James
Mease, *A Picture of Philadelphia* (Philadelphia,
1811), p. 86; Charles Evans, *American Bibliog-
raphy*, vol. 8 (Chicago, 1914), no. 22486, pp.
27–28; Joseph Jackson, *Encyclopedia of Phila-
delphia*, vol. 2 (Harrisburg, 1931), pp. 589–91;
Lawrence Wroth, *The Colonial Printer* (Port-
land, Me., 1938), pp. 293–94; Darrel Hyder,
"Philadelphia Fine Printing, 1780–1820,"
Printing and Graphic Arts IX, no. 3 (September
1961), pp. 71–73; Georgia C. Haugh, "The
Beginnings of American Book Illustration," in
Book Illustration [ALA Rare Book Confer-
ence], ed. Frances J. Brewer (Berlin, Germany,
1963), p. 38; Rollo G. Silver, *The American
Printer 1789–1825* (Charlottesville, 1967),
pp. 153–54; S. Padraig Walsh, *Anglo-American
General Encyclopedias: A Historical Bibliog-
raphy 1700–1967* (New York, 1968)

IN THE EVER-TANTALIZING PURSUIT of a
perfect system of organizing and dispensing
knowledge, a group of Edinburgh scholars
led by Colin McFarquar, George Gleig, and
printer Andrew Bell devised the first two
editions of the highly popular *Encyclopaedia
Britannica*. The publishers hit upon the
novel idea of drawing upon different
scholars to write about their areas of spe-
cialization: the illustrious surgeon Andrew
Bell—not the printer—contributed entries
on anatomy and surgery; James Tyler wrote
many scientific entries; two blind physicians
authored the essay "Blind." Proprietor Bell
himself engraved all the plates of the ten
quarto volumes, which were published in
Edinburgh from 1788 to 1797. The third
edition of the *Encyclopaedia Britannica*
greatly impressed Thomas Dobson (1751–
1823), an expatriate Scottish publisher in
Philadelphia, who resolved to copy it for
Americans as it was being issued in
Edinburgh.

Little is known of Dobson's early life. He
probably came to America sometime after
1783, establishing himself as a printer and

148. *Volume 1, Frontispiece and Title Page*

publisher on Chestnut Street, soon coming
to the attention of important American
literary and political figures. In 1788, Francis
Hopkinson wrote to Thomas Jefferson that
"there is a Scotchman who carries on pub-
lishing and Bookselling in a large way, a
Mr. Dobson. He has reprinted several
English Books, and I believe is connected
with some House in Scotland for he seems
to have a substantial Capital, and a large
Stock" (Julian Boyd, ed., *Papers of Thomas
Jefferson*, vol. 14, Princeton, 1958, p. 33).
By then Dobson must have been hard at
work on the *Encyclopaedia*. Dobson also
was the author of several religious texts,
including *Letters on the Existence and
Character of the Deity* (1799), *Thoughts on
the Scriptures* (1807), and *Thoughts on
Mankind* (1811).

A publishing venture of the size and scope
of the *Encyclopaedia* was unprecedented in
America, and Dobson had difficulties in
rounding up enough competent engravers
to cope with the thirty-one plates required
for the first volume and the sixty plates
required for the second. Dobson so monopo-
lized the engraving trade in Philadelphia
that the merchant Ebenezer Hazard was un-
able to find an engraver for his friend Jeremy
Belknap of Boston. In April 1791, Hazard
wrote to Belknap: "I have made some
enquiry . . . but cannot yet find a good
engraver who is disengaged. Dobson keeps
them hard at work . . . Scott and Thackara
and Vallance are our best hands, but they are

retained by Dobson" (*Massachusetts His-
torical Society Collections*, 5th series, vol. 3,
part 2, Boston, 1877, p. 250). Hazard could
not even persuade the busy engravers to
give him an estimate for making Belknap's
plate.

More than half of the 542 plates in
Dobson's *Encyclopaedia* were engraved by
Robert Scot, James Thackara, and John
Vallance. Other engravers included James
Trenchard, James Smither, Jr., Francis
Shallus, James Akin, Samuel Scoles, Samuel
Allardice, Thomas Clarke, William Barker,
Joseph Seymour, Joseph Bowes, Benjamin
Jones, and Henry W. Weston. The Phila-
delphia foundry of Baine & Co. was com-
missioned to cast the type, and a local mill
manufactured heavy paper, made especially
for the publication, which Belknap noted
was very expensive (Hazard to Belknap,
cited above, p. 259). Purchasers had the
option of bindings ranging from thrifty
paper boards at $135 per set, through sheep
and calf, to the most opulent red Russia or
gilt Morocco at $207 per set (*American
Daily Advertiser*, May 19, 1798). Printers
were in continuing short supply; Dobson
had to contend with a young country inex-
perienced in large-scale ventures and poorly
supplied with the technical requisites.

Dobson started with only 243 subscribers
for the run of 1,000 copies of the first volume
in 1790; by the time the eighth volume
appeared, the first volume needed a reprint-
ing, the press run was doubled, and the

148. *Volume 6, Plate 168*

diagrams, and activities of the allegorical and historical figures combined to make the plate a showpiece for its engraver John Vallance. He acquitted himself well, if a little statically, but it cannot be denied that his copy has a distinctly provincial character to it.

The *Encyclopaedia Britannica*'s original dedication to George III was obviously unsuitable for Americans, so Dobson addressed his work "to the Patrons of the Arts and Sciences; the promoters of useful and ornamental Literature in the United States of America, whose communications have enriched this extensive and important work; and by whose generous encouragement this arduous enterprise has been brought to its completion" (vol. 1, p. i).

"Gentlemen eminent in the respective sciences" made many contributions to Dobson's edition, especially in the areas concerning America. Benjamin Smith Barton's notes on Indians and William Bartram's notes on North American flora added substance to the general entry on America, which was rewritten by Jedediah Morse, who also wrote the section on geography. However, American biography was not included, nor was there any discussion of native artists or writers. While it is tantalizing to speculate on the possibility of contributions by Franklin, Rush, Hopkinson, and other American statesmen and gentlemen-scholars, little concrete evidence has been found concerning Dobson's authors.

The most noticeable changes are evident in the areas covering the events of the American Revolution. The authors of the *Encyclopaedia Britannica* blamed the whole affair on the French diplomatic machinations to separate the Colonies from Mother Britain out of purely jealous motives, a theory challenged by the American text:

> Instead of contemplating it, with the characteristic philosophy of their country, as the result of a contest between the desire of power, and the abhorrence of oppression, they have sought the origin of the evil in any source rather than their own misconduct; and have endeavoured at once, to hush the reproaches of their political conscience, and to gratify the cravings of their national animosity, in wild conjectures of a scheme formed by their neighbours to divide the British Empire, and in declamatory invectives against the Gallic faith and honour. (vol. 1, p. 576)

In size and format, Dobson did little more than copy the *Encyclopaedia Britannica,* although he was able to produce eighteen volumes. The plates received only subtle changes: American flags were substituted for Union Jacks, eagles for the royal coat of arms or George III's cipher. The American

subscription list had more than quadrupled (Joseph Hopkinson, *Annual Discourse,* Philadelphia, 1810, pp. 16–17). From January to March 1790, the first number was issued in parts forming the first half of the first volume, which was completed in June 1790. Thereafter a half volume appeared every ten weeks at the rate of three volumes annually. Not even a fire which destroyed much of the type and some of the plates in 1793 was able to slow the pace of publication, which finished concurrently with the third edition of the *Encyclopaedia Britannica* in 1797. The enduring popularity of the *Encyclopaedia* prompted Dobson to publish three supplemental volumes from 1800 to 1803, although all bore an 1803 date on the imprint.

In 1798, after the eighteen volumes were completed, the elaborate frontispiece and the title pages for each volume were published

and furnished to the subscribers. The frontispiece spoke dramatically for the whole publication, with its broad scope, variety of subjects, and grandeur of conception. Knowledge in all its branches is represented by a throng of philosophers, astronomers, mathematicians, artists, savants, alchemists, surveyors, craftsmen, strategists, heralds, and musicians—shown with all their accouterments in a classical architectural setting. An aerial balloon surveys the gathering, while in the distance Adam and Eve stand in a verdant landscape surrounded by a group of animals, and three pyramids break the skyline. In a well-stocked library togaed figures, thirsty for information, clamber among the books.

Even for an engraver merely copying another frontispiece, the plate was very ambitious by American standards. The delicate detail of the numerous instruments,

edition placed a discreet vine leaf over the nakedness of a classical figure in one of the "Drawing" plates (though not over all the nudes). In illustrations containing a number of vignettes the copied versions tend to be completely or partially reversed from Bell's originals, probably depending on the skill of the copying engraver. Apart from some maps, no illustrations appear to be unique in their entirety in the American edition, and essentially the plates were faithful copies of those in the *Encyclopaedia Britannica*.

The "Drawing" plates in the *Encyclopaedia* were among the earliest American-produced drawing models which students could copy to learn the correct principles of art; very few drawing books had been published in eighteenth century America, and they did not really catch on until after 1810. The plate exhibited (pl. CLXVIII), one of several "Drawing" illustrations engraved by Robert Scot, concentrates on the figure, although a small landscape appears at the bottom. Above, classical figures outlined in pure line engraving show correct proportions and rippling musculature, while two putti display a somewhat fleshier anatomy. Below are three fully realized engraved figures, two goddesses of the type commonly found on banknote and certificate vignettes gazing at Augustus Caesar, shown as a seated statue. The small landscape of a country house and garden indicates several perspectives similar to those found in eighteenth century *vues optiques*; it has little to do with the classical figures on the rest of the page. Scot was sufficiently talented as an engraver to copy the *Encyclopaedia Britannica*'s plate as it appears, instead of simply reversing the figures.

From A to Zymosimeter, Dobson's *Encyclopaedia* offered Americans the most comprehensive and attractive packaging of information then available. The plates, while perhaps lacking in the imagination and flair of those in Diderot's elegant production, were concise and numerous, representing the best work of American artisan-engravers. Imitations were quick to follow, but none had the luster or the technical achievement of Dobson's. The *Encyclopaedia*'s legacy was shared not only by the literate public but by the Philadelphia book industry, which, for the first time, was forced to "think big." Dobson and his work played a large part in giving Philadelphia its publishing hegemony in the nineteenth century.

SAM □

WILLIAM BIRCH (1755–1834)

From his early years in Warwickshire, William Birch was a keen observer of the English countryside and town life. After serving an apprenticeship under the London

149. *High Street, from the Country Market-place Philadelphia: with the Procession in Commemoration of the Death of General George Washington, December 26th, 1799*

goldsmith Thomas Jeffrys, Birch struck out on his own, painting miniatures in enamels. He traveled extensively in England compiling a group of oil landscapes which he engraved and published in 1791 as *Délices de la Grande Bretagne*. Finding life in London sluggish following the deaths of his two close friends Sir Joshua Reynolds and the Earl of Mansfield (also a good patron), Birch decided to immigrate to America where he had distant relatives.

He arrived in Philadelphia in 1794, armed with a letter of introduction from Benjamin West to William Bingham, who hired him as a drawing instructor for his daughters. Birch built himself a furnace and re-established his career as a miniaturist and enamelist. His most noted work in enamel was a miniature after Gilbert Stuart's "Lansdowne" portrait of Washington.

During 1797 and 1798, Birch prepared a novel publishing undertaking that was to become his most famous legacy, a book of views entitled *The City of Philadelphia,* published in 1800. While traveling throughout the mid-Atlantic region to procure subscriptions for this volume, Birch began to formulate his next publishing venture, a group of views of American country seats. These illustrated a civilized rural landscape, in contrast to the wilder nature that Joshua Shaw was to depict in an even grander publication some years later (no. 208). In both productions Birch was aided by his son Thomas, better known as a marine painter (see biography preceding no. 188).

Encouraged by the warm reception accorded the publication of the Philadelphia views, Birch proposed a companion volume for New York. However, a changing economy unfortunately made the project unfeasible, and only a large view of the city from the river and an unsigned view of the State Prison (see *Made in America,* p. 16) remain of his hope. This, combined with insufficient encouragement for enamel painting, led him to note sadly, "I found my profession dwindling to contempt" (HSP, Birch Papers, Autobiography, vol. 2, p. 7).

Birch spent the remainder of his career at Neshaminy on the Delaware River north of Philadelphia. He worked largely with enamel paintings (see no. 195), which he exhibited frequently at the Society of Artists, the Pennsylvania Academy of the Fine Arts, the Artists' Fund Society, and the Columbianum. Birch attempted to engrave portraits in stipple, but found that it simply was not his forte and that the portrait engraver David Edwin could easily surpass him.

It is for his lasting contribution to the iconography of Philadelphia and to that of the young United States that William Birch is best remembered, and he could write with pride, "There is reason to suppose that from that ardent attempt of the Arts, as to favourable a season, when Europe was everywhere at war, that the present bustle in the solid improvements in our Citys, and internal projections in the Country did originate" (HSP, Birch Papers, Autobiography, vol. 1, p. 48).

149. *The City of Philadelphia*

1800

Title Page: The/City of Philadelphia/ in the State of Pennsylvania/North America;/as it appeared in the Year 1800/ consisting of Twenty Eight Plates/Drawn and Engraved by W. Birch & Son./ Published by W. Birch, Springland Cot, near Neshaminy Bridge on the Bristol Road, Pennsylvania. Decr 31st 1800.

Etching and engraving with watercolor 16¼ x 37¼″ (open) (41.1 x 94.6 cm)

Historical Society of Pennsylvania, Philadelphia

LITERATURE: HSP, Birch Papers, Autobiography, 2 vols., vol. 1, pp. 47–48, vol. 2, p. 7; Scharf and Wescott, vol. 2, p. 1056; Stauffer, nos. 159–88; Stokes and Haskell, *Early Views,* p. 44; Phillips, *Maps and Views;* Joseph Jackson, *Encyclopedia of Philadelphia,* vol. 1 (Harrisburg, 1931), pp. 296–99; Martin P. Snyder, "William Birch: His Philadelphia Views," *PMHB,* vol. 73, no. 3 (July 1949), pp. 271–315; Martin P. Snyder, "Birch's Philadelphia Views: New Discoveries," *PMHB,* vol. 88, no. 2 (April 1964), pp. 164–73; Dickson, *Arts,* pp. 64–65; *American Printmaking,* pp. 46–47, pls. 88, 89

AN ENGLISHMAN recently arrived in Philadelphia, Birch wished to pay tribute to his new home in the manner he knew best, pictorially. While the city had been recorded throughout the eighteenth century, there was no complete document of Philadelphia's buildings, activities, commerce, and stature. William Birch determined to produce an album of these aspects of the city, and, possibly unwittingly, created the first such urban record in America.

Birch's advertisement in the *Federal Gazette* of January 29, 1799, indicated that he had planned "about thirty Plates; the Frontispiece will be a general view of the City, from the great tree at Kensington, with the Port and River, and the following Plates its dissection exhibiting the principal buildings, with the prospective of the streets as connected with them, the most picturesque points of view &c. as calculated to give the idea of this Metropolis." Birch wanted to do more than pay homage to Philadelphia, for, as he noted, "no other work of the kind had ever been published by which an idea of the early improvements of the country could be conveyed to Europe, to promote and encourage settlers to the establishment of trade and commerce . . ." (HSP, Birch Papers, Autobiography, vol 1, p. 47).

In collecting sketches, Birch was assisted by his son Thomas and by Samuel Seymour, a young artist whom Birch was instructing and who later produced a number of dazzling folio engravings after Thomas Birch's paintings of naval battles (see no.

188). Existing drawings reveal Birch's method of working. A small rough sketch was made at the site, indicating bare outlines of perspective, buildings, and notes on detail, and it was then squared off for enlarging. (One such drawing, previously unrecorded, depicting the State House, Congress Hall, and Town Hall, has been recently discovered at the Library Company of Philadelphia.) The small sketches formed the basis for watercolor drawings, slightly larger and much more finished in detail; these in turn were enlarged to the size of the copperplates, about 11 by 13 inches.

Although a portraitist, Birch rarely individualized the faces of the Philadelphians who populated his street scenes of what was then the largest metropolis in America. Birch's original title, as used in his manuscript subscription book (Historical Society of Pennsylvania), was "Philadelphia Dissected: Or, the Metropolis of America." He wanted to include as many aspects of the city as possible. Places of worship, amusement, and commerce; moments of historical significance and every-day life; visitors and natives, artisans and merchants—all played a role in Birch's urban theater.

The first four plates to appear in 1798 were views of High (Market) Street, the Bank of the United States, the State House, and the State House garden. The plates of High Street and the Bank (no. 142) were revised for inclusion in the first complete edition of views; the last two were reworked for subsequent editions. Birch reworked the first plate, *High Street, From the Country Market-place Philadelphia,* early in 1800 to correct some perspective difficulties, but more important, to include a scene of the procession in commemoration of the death of George Washington that had been held on December 26, 1799. A military guard escorted the black-draped catafalque, which was preceded by a riderless horse. The streets of the city were lined with mourners, while others crowded windows and rooftops to watch the cortège pass. The vignette of the onlooker who has turned away from the parade and weeps unashamedly into his handkerchief is one of the most moving moments in early American art.

Most of the plates were engraved in 1799, a few more in 1800, so by the end of the year Birch could write in his introduction: "This Work will stand as a memorial of [Philadelphia's] progress for the first century; the buildings, of any consequence, are generally included, and the street-scenes all accurate as they now stand; the choice of subjects are those that give the most general idea of the town. . . ." Birch arranged the plates "as is most convenient to review the City; after the Title, the General View of the City, the River, and Port . . . then the Plan of the City, and the Dissections. . . ." Prints

depicting the northern section of the city were followed by those along the Market Street axis, and then South Philadelphia, as it was then built.

The whole volume was introduced by a handsome title page, the work of the calligraphic engraver William Barker, who also engraved the plan of the city, which was copied from that of T. Stephens in a 1796 Philadelphia directory. To advertise the publication, Birch and Samuel Seymour jointly engraved a larger version of the frontispiece, published in 1801. As was customary, choice of coloring and binding was left to the purchaser. An uncolored set in boards cost an economical $28; the more opulent leather-bound volume with hand-colored plates could be bought for $44.50.

Birch's work was well received, and his subscription book is studded with both the best Philadelphia names and those of leading American political and cultural figures. Thomas Mifflin, Charles Carroll of Carrollton, William Hamilton of The Woodlands, Gilbert Stuart, Benjamin Henry Latrobe, Edward Savage, and James Thackara were among the more than two hundred subscribers to the first edition. Birch recounts that Thomas Jefferson also owned a copy, and "that during the whole of his presidency it layed on the sophia . . . till it became ragged and dirty, but was not suffered to be taken away" (HSP, Birch Papers, Autobiography, vol. 1, p. 47).

Birch tells us that there was "scarsely one sett of the work in Philadelphia that was not sent to Europe" (HSP, Autobiography, MS, p. 47); certainly European publishers were quick to copy the more interesting plates to accompany their publications of travel accounts. Charles Janson's *The Stranger in America* (London, 1807) pirated five of Birch's views in sepia aquatints, and later copies were made in Stockholm to embellish Klinkowström's narrative of 1824.

A second edition of 1804 and a third edition of 1809 (see Martin P. Snyder, "Birch's Philadelphia Views: New Discoveries," *PMHB,* vol. 88, no. 2, April 1964, pp. 164–73), as well as a final salvo in 1820, kept the Philadelphia views in print; a few new plates were added, but most of the views were re-issues with minor alterations. Martin Snyder's articles best chronicle the complicated publication history of individual prints and their variants in each edition. For the second edition all plates received uniform dating to "1800," Campbell's imprint was removed, a uniform signature of "William Birch Enamel painter" substituted for that of "William Birch & Son," and the title page amended to read "20 copperplates" and "Second Edition 1804." Richard Folwell printed the typeset text; presumably he had also printed that of the first edition, as the alterations were made in identical type. Over

120 new subscribers, including Stephen Girard, Robert Fulton, and Philip Syng Physick, were added to the list following the plates.

Birch saw the third edition as a seed for individual collections of Philadelphia views, and to that end had the bound copies interleaved with "guards" to which additional prints could be attached (Snyder, "New Discoveries," cited above, p. 166). "All the plates of minor importance" were eliminated (introduction to third edition). Unfortunately some of the deleted plates were the liveliest cityscapes, including the views of, and from, the Market; *Preparation for War;* and the State House garden. The substitutions were static architectural renderings of some of the more recent Philadelphia buildings—the Gothic Philadelphia Bank, and the new Masonic Hall.

Demand for the *City of Philadelphia* continued well into the 1820s, and Birch issued a final edition in 1827–28. Possibly he was motivated by the interest aroused by Cephas Childs's *Views in Philadelphia* published at the same time. Among the names on the page in the manuscript notebook headed "Subscribers to Eleven of the Principle Views of Birch's Philadelphia" was William Strickland, architect of several buildings depicted in the plates. Noted on the plates of the fourth edition were the changes that had taken place since the first edition of 1800: The great Treaty Tree in Kensington had blown down during a storm in 1810; the Old Chestnut Street Theatre had been destroyed by fire in 1820; the Presbyterian Church and the Centre Square Pump House had been dismantled; and the United States Bank was now commonly known as "Girard's Bank." A plate of four subjects engraved in stipple—Thornton's Library Hall, the Pennsylvania Hospital, High Street Market, and Old Swedes' Church—was added. Birch wrote a new introduction, restating his original purpose, and adding: "It would be useless for the proprietor to say anything about the historical part or further descriptive of the city, there are other works that have taken that up largely, this is intended as a book of reference, that will stand in further ages as correct."

With each successive edition Birch seems to have removed the plates most valued for their vitality by today's audiences. Snyder submits that this was due to Birch's underlying allegiance to architecture (which was most strongly witnessed by his *Country Seats*). Possibly Birch felt that costumes dated prints too quickly. The fourth edition was published on the coattails of Childs's *Views in Philadelphia* rather than as a continuance of the original series; Birch was seventy-two by then, and Snyder suggests that "the last edition must be regarded as a

competitive venture only" (Martin P. Snyder, "William Birch: His Philadelphia Views," *PMHB*, vol. 73, no. 3, July 1949, p. 292).

Restrikes appeared intermittently throughout the nineteenth and early twentieth centuries, some by Robert DeSilver in 1841, others by John McAllister, Jr., and possibly also by his son. Countless reproductions in varying techniques have appeared and continue to appear to this day, attesting to the ageless popularity of Birch's Philadelphia views.

SAM □

EDWARD SAVAGE (1761–1817)

Edward Savage was born on November 26, 1761, in Princeton, Massachusetts, the son of Seth Savage and Lydia Craige. In 1696, Seth's father, Edward, had immigrated to America from Ireland, where the Savage family had settled following their flight from France after the revocation of the Edict of Nantes in 1685. No other information about the family is known, and little has been recorded about the early artistic career of the young Edward. It appears that he began as a goldsmith, a common occupation for an engraver since the fifteenth century, but had turned to painting by 1789 when he received his first commission, a portrait of George Washington for Harvard University (Mantle Fielding, "Edward Savage's Portraits of George Washington," *PMHB,* vol. 48, no. 3, 1924, pp. 195–96).

In 1791, Savage journeyed to London where, like many of his compatriots, he presumably studied with Benjamin West. His prints of Washington, Franklin, and General Knox, published in London, suggest that he spent much of his time learning the art of engraving. He traveled to Italy before returning to Boston where he married Sarah Seaver on October 13, 1794. By the summer of 1795 he had moved to Philadelphia to join his brother, a prosperous merchant. He displayed a panoramic painting of the cities of London and Westminster, probably by William Winstanley (Dickson, *Arts,* p. 37, n. 12), the first such work shown in this city. On February 22, 1796, he opened the Columbian Gallery on Chestnut Street, "containing a large collection of ancient and modern Paintings and Prints" (Prime, *Arts and Crafts,* vol. 2, p. 33).

By 1801 the family had moved to New York where in 1802 Savage established the new Columbian Gallery of Painting; later he added a natural history museum to this enterprise (an annex of the City Museum, which had been founded by the Tammany Society and was owned successively by Gardiner Baker, Baker's widow, and William J. Waldron). In the new Columbian Gallery, Savage accumulated over two hun-

dred works of art, the largest number ever shown together in New York. He came to be known as a great showman interested in the exhibition of objects. In 1810, Savage disposed of a portion of his collection to his former curator John Scudder who eventually sold it to P. T. Barnum. Savage returned to Massachusetts where he opened the Columbia Museum (absorbed by the New England Museum in 1825). He died in Princeton on July 6, 1817.

Savage is well known both as a painter and printmaker. Like many contemporary artists, he showed a preference for portraiture. He produced engraved portraits of many famous individuals but added other subject matter to his repertoire of prints, notable among which are the *Eruption of Mount Etna* (1799), one of the earliest color prints produced in America; *Liberty as Goddess of Youth* (1796); and the unfinished plate (Massachusetts Historical Society) after Robert Edge Pine's painting *Declaration of Independence.* Most of Savage's prints were produced while he resided in Philadelphia; he abruptly terminated this activity with his departure for New York in 1801.

Two prominent artists, David Edwin and John Wesley Jarvis, were employed by Savage in Philadelphia. Edwin had been trained as a printmaker in England and, under Christian José, in Holland and thus can logically be regarded as Savage's inspiration for his experimentation in aquatint and color printing. Savage's association with Edwin and Jarvis has called into question the attribution of several of his works; various authors have asserted that Edwin and Jarvis are the real authors of many of Savage's prints, and thus should be credited for their quality (although no credit was given to them on the works themselves or in the advertisements of their sale). Comments by Edwin and Jarvis, as well as by other acquaintances of Savage, are quoted in Dunlap's book as further proof of this, particular mention being made of Savage's *Family of George Washington,* which was begun in 1790 but not completed until March 1798, three months after Edwin entered Savage's employment. Both artists terminated their relationship with Savage at precisely the time Savage ceased to make prints. Criticisms have also been made about Dunlap's account, stating that his own dislike of Savage caused him to misrepresent and degrade the artist. Some have claimed that the other responsibilities of Edwin would not have allowed him time to accomplish certain plates in specific years. And, finally, the quality of Savage's later work has suggested that the attacks on him are unfounded (see "The Great Savage (1796–1801)," in Harold E. Dickson, *John Wesley Jarvis,* Baltimore, 1949, pp. 35–57).

150a.

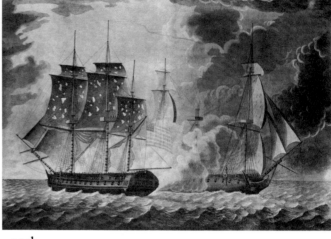

150b.

150a. *The Constellation and l'Insurgent—The Chace*

1799

Inscription: CONSTELLATION & L'INSUR-
GENT—the CHACE (center); *Painted &
Engraved by E. Savage.* (lower left);
*Philadᵃ Published by E. Savage May 20ᵗʰ
1799.* (lower right)

Aquatint and etching

15¼ x 21⅜″ (38.7 x 54.3 cm)

American Antiquarian Society, Worcester,
Massachusetts

150b. *Action between the Constellation and l'Insurgent*

1799

Inscription: ACTION *between the* CONSTEL-
LATION *and* L'INSURGENT,/*On the* 9ᵗʰ
February 1799,/*Off the Island of Sᵗ
Christophers, when after an hard fought
battle of one hour and a quarter the Frigate
of the Directory yielded/to superior skill
and bravery. Killed on board L'Insurgent
29. Wounded 46. Constellation 1 killed.
3 wounded.* (center); *Painted & Engraved
by E. Savage.* (lower left); *Published by
E. Savage May 20, 1799.* (lower right)

Aquatint and etching

15¼ x 21¼″ (38.7 x 54 cm)

American Antiquarian Society, Worcester,
Massachusetts

PROVENANCE: Charles H. Taylor, until 1948

LITERATURE: Stauffer, vol. 2, nos. 2757–58; Edna
Donnell, "Early American Fighting Frigates,"
American Collector, vol. 2 (January 1943),
pp. 6–8; "Prints of the American Navy,"
Connoisseur, vol. 112 (December 1943), pp.
119–20; "The Great Savage (1796–1801)," in
Harold E. Dickson, *John Wesley Jarvis* (Balti-
more, 1949), p. 50; Irving S. Olds, *Bits and
Pieces of American History* (New York, 1951),
nos. 94–95; Irving S. Olds, "Early American
Naval Prints," *Art in America,* vol. 43, no. 4
(December 1955), pp. 23–24; MMA, *American
Paintings and Historical Prints from the Mid-
dendorf Collection* (October 4—November 26,
1967), nos. 69a, b; *American Printmaking,* nos.
86–87; Dickson, *Arts,* p. 65, illus. nos. 135–36;
Edgar Newbold Smith, *American Naval
Broadsides: A Collection of Early Naval Prints
(1745–1815),* (New York, 1974), pp. 49–53

ALTHOUGH THE PEACE TREATIES which fol-
lowed the Revolutionary War were signed in
1783, harassment from pirates and, with the
resurgence of war in Europe, from the
French warranted the building of an
American navy. Previously, America's sea
battles had been fought with privately owned
ships. In 1794 the construction of three major
ships was underway: the *United States* built
at Philadelphia; the *Constitution,* at Boston;
and the *Constellation,* at Baltimore. The
ships were constructed according to a
basically British design but with major
improvements designed to increase their
speed. The construction program was carried
out under Secretary of War Henry Knox,
but there is no definite knowledge of the
designer or craftsmen.

The first battles fought by these ships did
not occur until 1798. In May of that year,
alliance with France was terminated, and
orders were given to seize all French ships
which endangered commerce. One of the
most important encounters, represented in
the prints shown here, occurred on February
9, 1799. Commodore Thomas Truxton on
the *Constellation* met the French *l'Insur-
gent* under the command of Captain
Berreault near Saint Christopher Island in
the West Indies. Within two hours, the
French captain surrendered.

Such conflicts provided dramatic and
immediate subject matter which attracted
both artist and collector. By May 1799,
Edward Savage had depicted and published
pictures of the climactic moments in the
battle: "Mr. Savage has nearly finished two
large plates in aqua tinta, the one repre-
senting the chase of the *Insurgente* by the
Constellation, and the other, the hard fought
and glorious action between those two
frigates. We believe these plates are the first
in that style ever attempted by an American
artist. We are happy to say, that the execution
of them is worthy of a subject so highly
flattering to the national pride of Americans"
(*Gazette of the United States,* May 15, 1799,
in Prime, *Arts and Crafts,* vol. 2, pp. 72–73).

These were probably the first naval
engravings by a native artist as well as two
of the earliest aquatints produced in the
United States. Only four sets of Savage's
prints are known. On June 17, 1799, Savage
wrote to George Washington: "This last
winter I discovered the method of Engraving
with aquafortis. In order to prove my experi-
ment I executed two prints which is my first
specimen in that stile of Engraving. One is
the Chace, the other action of the
Constellation with the L'Insurgent. I have
put two of those prints into the case for you
to see that Method of working on Copper"
(*American Printmaking,* p. 46, no. 87).
It is possible that Savage learned the tech-
nique from David Edwin. Another source
could be George Isham Parkyns, an English-
man credited with the introduction of this
technique into America around 1794.

The artist has depicted the victor so that
the construction and power of the American
vessel are stressed over that of its French foe.
In *The Chace,* the splendid broadside of the

Constellation overwhelms *l'Insurgent* in the distance, and the billowing sails and rapid movement of the ship in the water show off the excellent craftsmanship accomplished in the new nation. The view in the *Action* accents the military prowess of the frigates with their numerous cannons and impressive masts. Although its sails are tattered, the *Constellation* is otherwise unsoiled, thus emphasizing its victory; in contrast, the loser is lost in the smoke of cannon fire. Both ships are treated like portraits of American heroes (see no. 110), emphasizing their august qualities in dramatic and courageous incidents which won the nation's freedom.

Savage's ability to capture the spirit of the event and to create a well-organized composition is also evident in his portraits, but a concern for an exact likeness does not seem to have interested him. His drawing has been reduced to a stylized system of lines and tones, for example, in the waves and clouds, without any attention to verisimilitude. Perhaps his talents were subordinated to his interest in the practice of a new technique which, aside from its representational usage, is handled quite skillfully. The charm and character of the composition and the construction of the ships recall the British sailing vessels in the foreground of the Scull and Heap view of Philadelphia (no. 46) produced over forty years earlier.

ESJ □

151. *Lemon Hill*

East Fairmount Park
1799–1800
Inscription: 1800 (on rainwater conductor head)
Stucco over stone facade; dressed granite base; wood trim
54 x 36′ (16.4 x 10.9 m)

REPRESENTED BY:
John A. Woodside (1781–1852)
Lemon Hill
1807
Oil on canvas
20⅜ x 26⅝″ (51.7 x 67.2 cm)
Historical Society of Pennsylvania, Philadelphia

PROVENANCE: Henry Pratt, 1799–1836; Isaac S. Lloyd, 1836–44; City of Philadelphia, from 1844

LITERATURE: Thomas P. Cope, *Lemon Hill in Its Connection with the Efforts of Our Citizens and Councils to Obtain a Public Park* (Philadelphia, 1856); Virginia Norton Naudé, "Lemon Hill," *Antiques*, vol. 82, no. 5 (November 1962), pp. 531–33; Virginia N. Naudé, "Lemon Hill Revisited," *Antiques*, vol. 89, no. 4 (April 1966), pp. 578–79

THE ARCHITECT OF LEMON HILL, Henry Pratt's country house set upon a promontory overlooking the Schuylkill, is unknown. It is possible that Pratt himself designed the house with the aid of one of the fine architects working in Philadelphia in 1799, the year he purchased his land at a sheriff's sale of the confiscated property of Robert Morris (City Hall, Recorder of Deeds, Deed book D76, p. 488). The forty-two acres and ninety-three perches of ground that Pratt bought on the east side of the Schuylkill River were part of a property considered highly desirable from the time of William Penn, who reserved the area as a proprietary manor called Springettsbury (see no. 2).

Included in the purchase of this fractional parcel of a three-hundred acre piece were several of Morris's buildings, including a stone greenhouse thirty feet square (United States Direct Tax of 1798, Northern Liberties East). A description from 1795 suggests that the greenhouses were even larger than the tax record indicated: "A large & Elegant Green House with a Hot House of 50 feet Front on each side, on the back Front a House for a Gardener with a Kitchen one large and five small rooms also two large rooms on the back or North Front of the Hot Houses, with an Excellent Vault under the Green House, and a Covered room for preserving roots & in Winter, the whole being a Strong Stone building with the necessary Glasses, Casements, Fruit Trees, Plants Shrubs &c in good Order . . ." (HSP, Robert Morris, Miscellaneous Business Papers, A Schedule of Property within the State of Pennsylvania Conveyed by Robert Morris to the Honble Jas Biddle Esqr and Mr. Wm. Bell in Trust for the use and account of the Pennsylvania Property Company).

Henry Pratt, son of the painter Matthew Pratt (see biography preceding no. 65), was an exceedingly successful merchant. Henry Simpson claimed: "No calamity of trade or commerce unmanned him or threw him upon a bed of nervous sickness" (Henry Simpson, *The Lives of Eminent Philadelphians Now Deceased*, Philadelphia, 1859, p. 820). He married three times: Frances Moore, daughter of Richard Moore, on June 22, 1778; Elizabeth Dundas on October 27, 1785; and Susanna Care, daughter of Peter Care, on September 11, 1795. Pratt established his house and store in the Upper Delaware Ward. In 1796 he purchased a double house with a six-bay facade on Front Street below Race, which had been considered a "mansion" when built in the 1760s. Although this townhouse was not in the new style that emerged in Philadelphia after the Revolution, Pratt's house furnishings, which have descended in family ownership, were. His store, also a three-story brick building, was on the east side of Water Street and the north side of a small alley later known as Pratt's Alley (HSP, Franklin Surveys, No. 2719, 1839). Pratt owned other city property, also registered as insured by the Franklin Company, on Pine Street between Seventh and Eighth streets, and on Lombard between Sixth and Seventh.

151.

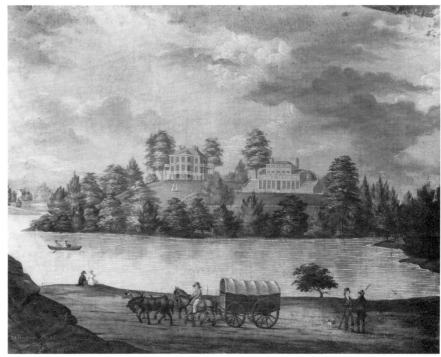

Pratt's new house at Lemon Hill was erected in 1799 during the interval between the tax assessor's records of May and December (Virginia N. Naudé, "Lemon Hill Revisited," *Antiques,* vol. 89, no. 4, April 1966, pp. 578–79). It is not known if Pratt intended to live at Lemon Hill, but he did develop horticultural specialties there which attracted great attention, and the estate soon became known as "Pratt's Garden."

When Pratt built Lemon Hill he conceived it in the new Adamesque Federal style; its distinctive feature is the series of oval rooms, one on each of the three floors, which project from the 54 by 36 foot rectangle on the southwest facade. The idea of an oval room on axis was first seen in American building in James Hoban's designs for the White House (1792) and Charles Bulfinch's Pleasant Hill (c. 1791), created for Joseph Barrell, wealthy merchant of Charlestown (Somerville), Massachusetts (Harold Kirker, *The Architecture of Charles Bulfinch,* Cambridge, Mass., 1969, pp. 45–53). Lemon Hill is the earliest known Philadelphia building to exploit this novel scheme.

In plan, Lemon Hill is very like the Castlecoole, Enniskillen, County Fermanagh, Ireland, which was designed by Richard Johnson, about 1791–98. It features a three-bay oval, on axis, on its northwest facade, and its interior shows the restraint of detail and elegance of proportion, and even the curved mahogany doors, that are features of Lemon Hill's oval rooms. Houses like Castlecoole are illustrated in James Malton's *Picturesque and Descriptive View of the City of Dublin* (London, 1792–95), a book that was popular in Philadelphia. A copy of Malton was owned by Bulfinch, and Lemon Hill also bears a close resemblance to houses he built in the 1790s in New England: the Knox house at Thomaston, Maine (1792–94); the Jonathan Mason house, Boston (c. 1800); and the James Swan house in Dorchester, Massachusetts (c. 1796).

But in all aspects Lemon Hill is most like Bulfinch's early design for Barrell's Pleasant Hill. If there was any exchange between Pratt and Bulfinch other than social encounter when the architect was in Philadelphia in 1789, or any trip by the merchant to Boston, the record does not confirm it. But Bulfinch wrote back to Boston in 1789 about his impressions of William Bingham's grand house on Third Street (Ellen Susan Bulfinch, ed., *The Life and Letters of Charles Bulfinch, Architect,* Boston, 1896, pp. 75–76), and he must have seen Robert Morris's greenhouses, a conspicuous feature near Fairmount at that time. The greenhouses may have been the prototype for Bulfinch's scheme for Barrell's two-hundred-foot structure described as "a Green and Hot House," built into the steep slope of the

Charles River bank. Not only were the settings of Lemon Hill and Pleasant Hill similar, but such other details as the windows with plain sills, the narrow balcony extending across the "oval" facade, and the interior curved flying staircases were features the two houses had in common. Pleasant Hill was even more like Castlecoole in plan than Lemon Hill, for both the Bulfinch and the Irish house achieved a horizontal composition by the addition of bays to the wings flanking the oval, whereas that subtlety is not evident at Lemon Hill, and the house appears to be a tall rectangle anchored by its broad porches.

John Woodside's view of Lemon Hill in 1807 and one taken by D. J. Kennedy in 1870 (Historical Society of Pennsylvania) show a deep hip roof with the roof over the oval intersecting it like a dormer. In 1872, two years after his first sketch, Kennedy drew the house again from another angle, giving it the flat roof appearance it has today. Whether roof alterations took place during a Park maintenance program is not recorded in the minutes, and to date physical analysis has not determined that there were any changes in the roof's contour.

The entrance facade, facing north, has a wide double door enframed with a grand fanlight and sidelights of an unusually delicate muntin pattern. Above the doorway is a tall Palladian window with flat, fluted Doric pilasters and a keyed arch. Although it is old-fashioned in architectural detail and undistinguished in its execution, its floor-to-ceiling scale adds a dramatic burst of light and an illusion of space to the interior on the second floor.

The interior of Lemon Hill is plain but elegant. There are no ornate plaster ceilings or mantelpieces, but the curved mahogany-paneled doors, curved mantelpieces, ornamental niche set into the wall of the sweeping staircase, wide louvered and paneled shutters, and the gray-and-white checkered marble floor in the front hall are sophisticated details. The oval room was the dining room on the ground floor, a drawing room on the first floor, and a salon or receiving parlor on the second. There is access to the balcony through the tall double-hung windows in the dining room, and to the porches, from the stairhall on the east end and a parlor on the west end.

The marvels of Lemon Hill were described in 1829 by a Southern visitor to Philadelphia:

But the most enchanting prospect is towards the grand pleasure grove & green house of a Mr. Prat[t], a gentleman of fortune, and to this we next proceeded by a circutous rout, passing in view of the fish ponds, bowers, rustic retreats, summer houses, fountains, grotto, &c., &c. The grotto is dug in a bank [and] is of a

circular form, the side built up of rock and arched over head, and a number of Shells [?]. A dog of natural size carved out of marble sits just within the entrance, the guardian of the place. A narrow aperture lined with a hedge of arbor vitae leads to it. Next is a round fish pond with a small fountain playing in the pond. An Oval & several oblong fish ponds of larger size follow, & between the two last is an artificial cascade. Several summer houses in rustic style are made by nailing bark on the outside & thaching the roof. There is also a rustic seat built in the branches of a tree, & to which a flight of steps ascend. In one of the summer houses is a Spring with seats around it. The houses are all embelished with marble busts of Venus, Appollo, Diana and a Bacanti. One sits on an Island on the fish pond. All the ponds filled with handsome coloured fish.

The grounds are planted with a great variety of shrubbery & evergreens of various kinds of the pine & fir, and the hot house is said to be the largest in the US. It is filled to overflowing with the choicest Exotics: the Chaddock Orange of different kinds & the Lemon loaded with fruit. There are two coffee trees with their berries. Some few shrubs were in flower & others seeded, & I was politely furnished with a few seed of 2 varieties of flowers (Myrtle & an accacia). In front of the hot house, one at each end, is a Lion of marble, well executed, & a dog in front. On the roof is a range of marble busts. (John Hebron Moore, "A View of Philadelphia in 1829: Selections from the Journal of B. L. C. Wailes of Natchez," *PMHB,* vol. 78, no. 3, July 1954, pp. 359–60)

The greenhouse complex is prominent in all known views of Lemon Hill and was even exaggerated by the English manufacturers who produced transfer-printed ceramics illustrating Philadelphia's bucolic attributes (see nos. 237, 238). A sale of the contents of the greenhouse was held at Lemon Hill on June 5, 1838, and the listing of some 2,701 lots described the plants with botanic and English names. Especially prominent are the varieties of citrus, among them, *Vulgaris* (Seville orange), *Myrtigalie* (myrtle-leaved orange), and *Medica* (median lemon), from which the property originally received its name and its renown (D. & C. A. Hill, Auctioneers, Philadelphia, *Catalogue of Splendid and Rare Green House and Hot House Plants to be Sold by Auction at Lemon Hill . . .,* June 5, 1838, Henry Pratt sale). All kinds of plant material were included, from *Phormium tenax* (New Zealand flax) to *Lotus jacobaens* (dark-flowering lotus), as well as small trees, varieties of lilies, carnations, and jasmine.

The Lemon Hill property was purchased by the City of Philadelphia in July 1844

primarily to protect the purity of the city's water supply; in 1849 it was proposed that the site be improved as a "Public Promenade." In 1851, Frederic Graff, the son of the engineer of the Waterworks at Fairmount (no. 183), presented a plan for the property, which included roads, paths, and rests (Thomas P. Cope, *Lemon Hill in Its Connection with the Efforts of Our Citizens and Councils to Obtain a Public Park*, Philadelphia, 1856, p. 8). By then most of Pratt's exoticisms had disappeared, and from 1847 to 1854 huge stone icehouses were in operation near the riverbank, on the Lemon Hill property. It was not until September 28, 1855, that the resolution proposed by the Committee on City Property was also passed by the Common Council and Lemon Hill became the first ground to be incorporated as Fairmount Park (no. 313).

BG □

JOSEPH LOWNES (1754–1820)

Born in 1754, Joseph Lownes is particularly noteworthy because of his finely engraved trade card (Fales, *Silver,* illus. p. 211), published about 1790, which shows the types of silver Lownes had for sale, including sugar and cream urns similar to those by Dupuy (no. 131) and sauceboats. Most prominent on the trade card is a large urn with handles, similar in form to this presentation urn made by Lownes for Captain William Anderson.

Lownes was listed as a goldsmith and silversmith in the Philadelphia directories from 1785 until 1819. During that time he worked on South Front Street, first at 130 and then at 124 "in the house formerly occupied by John David" (*Pennsylvania Packet,* December 18, 1798). This David may be the silversmith who was a partner of Daniel Dupuy. In addition to making a wide assortment of silver objects including "sugar basons, slop bowls, tankards, canns and cadees," Lownes also imported from London a "very elegant assortment of plated ware" (*Pennsylvania Packet,* April 9, 1792). From 1816 to 1819, Lownes worked with Josiah Lownes, his son.

An interesting reference to Lownes appears in the Diary of Jacob Hiltzheimer, who wrote, "Before dinner took a walk down Third Street to South and then up Front Street and called on Lownes, the silversmith, and paid him for the six silver tankards which I had made for my children, from the sale of my large ox" (March 29, 1794, quoted in Martha Gandy Fales, *American Silver in the Henry Francis Du Pont Winterthur Museum*, Winterthur, Del., 1958, no. 119).

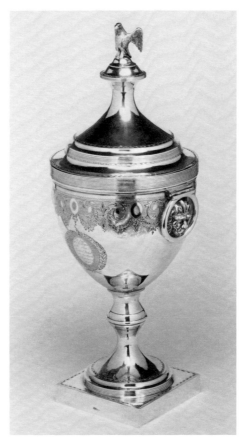

152.

152. *Presentation Urn*

c. 1799
Mark: J LOWNES (in conforming rectangle on base)
Inscription: To Capt/Wm Anderson/of the ship/London Packet/from the Mari/ne Insurance/Office (in oval on obverse); We Regard/Your Valor (on reverse)
Silver
Height 18″ (45.7 cm); width 7¼″ (18.4 cm)

Philip H. Hammerslough Collection. On permanent loan to the Wadsworth Atheneum, Hartford, Connecticut

PROVENANCE: Philip H. Hammerslough
LITERATURE: Alice Winchester, "Antiques," *Antiques,* vol. 81, no. 6 (June 1962), p. 613, illus. p. 612; Hammerslough, vol. 3, pp. 128–29

GIFTS OF SILVER from insurance companies to sea captains were common in the late eighteenth century. As the inscription on this presentation urn by Joseph Lownes indicates, it was presented to Captain William Anderson by the Marine Insurance Office of Philadelphia, which insured his ship, the *London Packet,* probably in

appreciation for his meritorious action in protecting the ship and its cargo against a French privateer.

The battle between the *London Packet,* a ship built in Baltimore, Maryland, in 1790, and the French ship was reported in the *American Daily Advertiser* on October 4, 1799, in a letter from a passenger on the ship to one of its owners:

> On the 10th of this month, we had a very severe engagement with a French privateer of 16 guns and 150 men. She engaged us one hour and three quarters, one half of which time she was close alongside. Considering the desperate attempt they made we got off well. A little before she attempted to board us, they hoisted the bloody flag, which proved to be a bloody one to them, as every man who attempted to board suffered instant death. I am sorry to inform you that we had three men killed, one of whom was our second mate, Mr. Lindsay, a spirited and active officer; and two wounded, one of whom was Captain Anderson, who received a ball in his right breast.

Made about 1799, this presentation urn includes many decorative elements characteristic of the classical style, including the eagle finial, floral swags, and cast lion mask within a hinged ring, a motif commonly used in brass pulls on furniture. The concentric circles on the domed cover and on the foot were also used on silver tankards and on ceramic mugs of the same period.

PT □

BENJAMIN HENRY LATROBE (1764–1820)

Benjamin Henry Latrobe, born in England, trained there as an architect and engineer. He first came to Philadelphia in March 1798, although he had arrived in America two years earlier and had already completed architectural and engineering assignments in Virginia, including extensive work for Jefferson's State Capitol at Richmond. Latrobe's Bank of Pennsylvania in Philadelphia (1798–1801, demolished) was his first major project here, and he described the building as "different from all that preceded it in form, arrangement, construction, and character" (Benjamin Henry Latrobe, *Anniversary Oration, Pronounced before the Society of Artists of the United States, etc.,* Philadelphia, 1811, p. 28). His subsequent solution to the problem of Philadelphia's water supply in 1798–1800 represented an immense personal success, bringing him laurels from both engineers and architects in the new Republic. During his first stay in Philadelphia he also designed several domestic residences. He later worked in Washington, D.C., and in Baltimore,

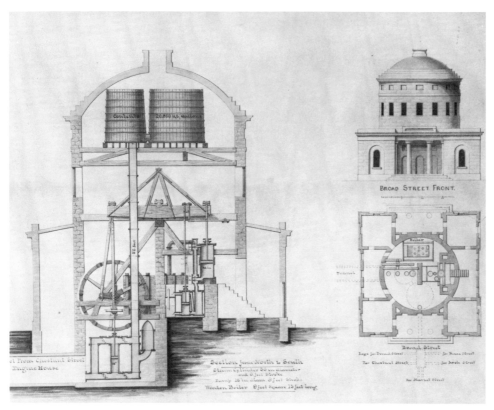

153.

153. *Centre Square Pump House*

Centre Square

1799–1801 (demolished by 1828)

Brick structure; white marble facade and columns; wood trim

60 x 60 x 60' (18.2 x 18.2 x 18.2 m)

REPRESENTED BY:

Frederick C. Graff (1774–1847)
Centre Square Water Works
c. 1828
Colored drawing
15½ x 20" (39.3 x 50.8 cm)

Historical Society of Pennsylvania, Philadelphia

LITERATURE: Benjamin Henry Latrobe, *View of the Practicability and Means of Supplying the City of Philadelphia with Wholesome Water, in a Letter to John Miller, Esquire, from B. Henry Latrobe, Engineer. Dec. 29, 1798* (Philadelphia, 1799), p. 19; *An Answer to the Joint Committee of the Select and Common Councils of Philadelphia, on the Subject of a Plan for Supplying the City with Water etc.* (Philadelphia, 1799), pp. 1–2; *Report to the Select and Common Councils on the Progress and State of the Water Works on the 24th of November, 1799* (Philadelphia, 1799), p. 28; *Report of the Committee for the Introduction of Wholesome Water into the City of Philadelphia* (Philadelphia, 1801), p. 7; Benjamin Henry Latrobe, *Anniversary Oration, Pronounced before the Society of Artists of the United States, etc.* (Philadelphia, 1811), pp. 17, 28, 32; Costen

where he conceived a bold and powerful structure for the Roman Catholic cathedral. Its great scale challenged Latrobe's engineering skill, which was brilliantly utilized in the handling of the vaulting.

The Philadelphia Waterworks and his later work in New Orleans gained Latrobe a reputation unmatched by any American peer, either architect or engineer. There are significant examples of his work in seven states, and his engineering practice was considered to be the largest and most varied of any comparable contemporary (Barbara E. Benson, ed., *Benjamin Henry Latrobe and Moncure Robinson: The Engineer as Agent of Technological Transfer*, Eleutherian Mills, Del., 1975, p. 13).

A humanist, Latrobe possessed a better than average familiarity with Greek and Latin. He preferred the classical idiom in his work and benefited continually from his impressive library, which contained, besides the fundamental Greek and Roman architectural sourcebooks, volumes on archaeological excavations and classical aesthetics.

Latrobe always felt a special affinity for Philadelphia, which he described in an oration in 1811: "Descended from the earliest European settlers in this state and this city; although the course of my business has for some years separated me from you for the greatest part of every year, I feel that my home is here . . ." (*Anniversary Oration*, cited above, p. 32).

Fitz-Gibbon, "Latrobe and the Centre Square Pump House," *Architectural Record*, vol. 62 (July 1927), pp. 19–22; Talbot Hamlin, *Benjamin Henry Latrobe* (New York, 1955), p. 166; Carroll W. Pursell, Jr., *Early Stationary Steam Engines in America: A Study in the Migration of a Technology* (Washington, D.C., 1969), pp. 40–42; William H. Pierson, Jr., *American Buildings and Their Architects*, vol. 1 (New York, 1970), pp. 357–60; Barbara E. Benson, ed., *Benjamin Henry Latrobe and Moncure Robinson: The Engineer as Agent of Technological Transfer* (Eleutherian Mills, Del., 1975), p. 13

BENJAMIN LATROBE's Centre Square Pump House, although small in scale and relatively simple by today's standards, was a remarkable edifice. As a technological achievement, it represents an important landmark in the supplying of "wholesome" water to a major American metropolitan community. The Pump House was one of two constructed for the water supply system, which used steam engines built by Nicholas Roosevelt at his Soho Works in New Jersey (Carroll W. Pursell, Jr., *Early Stationary Steam Engines in America: A Study in the Migration of a Technology,* Washington, D.C., 1969, pp. 40–42). Water was pumped from the first pump house, located at the foot of Chestnut Street, at the Schuylkill River, through a covered brick tunnel to Centre Square. From there the water was distributed by a gravity-feed system through wooden pipes (some later replaced by cast-iron pipes, the first of their type to be installed in America) to sixty-three private homes, four breweries, and a sugar refinery. Public bathing establishments, hesitatingly suggested by Latrobe, were never erected, probably because "American industry" would not tolerate such frivolities (Benjamin Henry Latrobe, *View of the Practicability and Means of Supplying the City of Philadelphia with Wholesome Water, in a Letter to John Miller, Esquire, from B. Henry Latrobe, Engineer. Dec. 29, 1798*, Philadelphia, 1799, p. 19).

The central situation of the Pump House within the city was also of major importance, as recognized in the Report of 1799: "This edifice, on account of its conspicuous situation is destined to be ornamental, as well as useful to the city: for placed as it is, a fair mark for the critic of taste, it is not probable the Corporation would have been easily pardoned by the present age or by posterity, had they determined to place a homely mass of buildings in the best situated square belonging to the citizens of Philadelphia . . ." (*Report to the Select and Common Councils on the Progress and State of the Water Works on the 24th of November, 1799*, Philadelphia, 1799, p. 28). The position held by the little Pump House had earlier been the site of a Meeting House (see no. 2, town plan insert) and a Revolutionary War drill

field. Quickly the Pump House acquired the status of a public building, although it was created for purely pragmatic reasons, and its central location enabled it to become the focus for civic occasions and public events—for example, the celebrations depicted in John Lewis Krimmel's painting *Independence Day Celebration in Centre Square, Philadelphia* (no. 204). Indeed, John Hills's circular map of the city about 1810–12 (no. 177) has Centre Square at its center point, and a view of the Pump House is incorporated in a panel below.

The Pump House also represents several important developments in American architecture. The basic piling of geometric shapes (cube to cylinder to shallow dome) presented a very dramatic appearance in its day. Perhaps some inspiration may have come from the radical architecture of Claude-Nicholas Ledoux, but its basic proportions and exterior considerations were ultimately determined by its function (William H. Pierson, Jr., *American Buildings and Their Architects,* vol. 1, New York, 1970, p. 359). The recessed porticoed cylinder with shallow dome is in the tradition of Hadrian's Pantheon in Rome, founded in the second century A.D. However, the oculus of the Pump House did not admit light as in the Pantheon, but served a more mundane function, that of smokestack. In a similarly unclassical use of classical forms, huge cast-iron Doric columns served as smokestacks at the Philadelphia Gas Works, erected at the foot of High Street in 1836. Symbolically, the Pump House was a temple to the young industrial age, housing its engineering triumph, the steam engine.

The building also represents an early use in America of archaeologically correct Greek forms. The twin porticoes, employed *in antis,* rested on the stereobate, their proportions and execution similar to archaic Greek originals, for example, those found at Paestum and in Sicily. In this sense, the building was a harbinger of the Greek revival, which was soon to change America's residential and public image.

Latrobe was a firm advocate of architecture in the service of government to encourage national culture and civic pride. In 1811 he commented that "the fine arts may indeed be pressed into the service of arbitrary power, and—like mercenary troops, do their duty well, while well paid" (*Anniversary Oration,* cited above, p. 17). Latrobe, a true classicist at heart, commented favorably on Roman building only when it served the public interest. He condemned the Roman amphitheaters but praised the aqueducts, and his Pump House seemed to embody the ennobling qualities he sought in antiquity. Functionally, its oculus vented smoke, its cylinder protected the tall water reservoir, and its cube base enclosed the engines and

offices. As a facade, the little building presented a clean surface, broken only by the regular rhythm of its fenestration and the charming accent of William Rush's fountain statue *Nymph and Bittern* placed before it.

DO □

JOHN LANDES (N.D.)

John Landes was undoubtedly a professional weaver, but he is known only by his signature inscribed in ink on the front cover of his design book. Both his surname and the Germanic script on the pages of the book indicate that he was of German background.

154. *Weaving Design Book*

c. 1790–1810
Signature: John Landes (on front cover)
Seventy-seven sheets; laid paper (recently laminated between synthetic tissue); leather binding
Colored inks
Watermark: AL
16¹⁄₁₆ x 13⁵⁄₁₆ x 1¹⁄₁₆″ (40.3 x 33.3 x 1.1 cm)
Philadelphia Museum of Art. Given by Mrs. William D. Frishmuth. 07–212

BECAUSE THIS BOOK of weaving designs does not contain drafts or instructions for producing the intricate patterns, it may be assumed that the book functioned as a catalogue, or sample book, to be inspected by a prospective customer. The patterns represented could be reproduced exactly in double cloth, plain weave on an ordinary hand loom with multiple harnesses. The designs could be roughly translated into a working diagram by tying up harnesses relating to each block of color along a horizontal or vertical line corresponding to the respective dark or light threads. The date 1800 found on the Philadelphia newspaper that forms part of the binding indicates the weaver's activity around this time.

PC □

155. *Coverlet*

c. 1790–1810
Two sets of natural cotton and blue wool warp and weft threads (41 x 44)
91½ x 78″ (232 x 198.1 cm)
Philadelphia Museum of Art. Given by Mrs. Martha Moore Fogg. 24-11-3

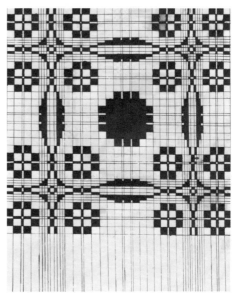

154.

COVERLETS OF THIS TYPE were the result of a collaboration between the weaver and the purchaser. The homemaker often prepared and dyed the yarns, and commissioned a coverlet to be woven to her specifications, choosing among the weaver's samples, or often, from a book or catalogue with penned examples, such as that of John Landes (no. 154). This coverlet is of the same pattern as that exhibited in Landes's book. The central design is a common double-cloth motif, the single snowball. The clean definition in pattern is achieved through the use of two sets of warp and weft threads, hence the name "double" weave, actually interwoven at specific intervals according to the given pattern. This may be accomplished only on a loom with more than four or five harnesses, depending on the pattern, and later might also have been done on a loom with a Jacquard attachment. Weavers followed a draft, the set of instructions for an individual pattern, represented in a profile or a diagram. In this early period, looms were narrow, and thus this coverlet is composed of two widths of cloth sewn together.

PC □

WILLIAM GROOMBRIDGE (1748–1811)

Groombridge was born in Tunbridge, Kent, England, and is said to have been a pupil of the English landscape artist (George?) Lambert (Dunlap, *History,* vol. 2, p. 48). He exhibited at the Free Society, the Society of Artists, and the Royal Academy

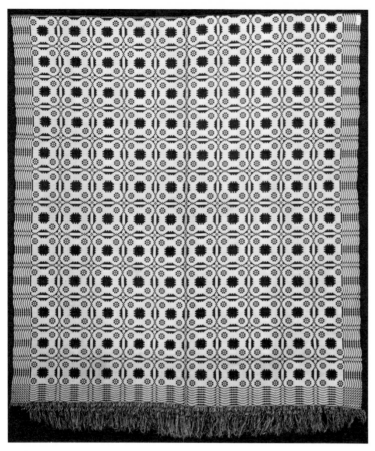

155.

from 1773 to 1790, his entries ranging from landscape and landscape with figures to portraits and miniatures. His address in the London exhibition catalogues from 1775 to 1783 is given as London and in 1785 it is given as Canterbury. Between these years, it is quite possible that he visited the Continent, for he painted a view of Dieppe in 1783. Francis Guy, a rival landscape artist, claimed in 1813 that Groombridge had studied in the royal academies of London, Rome, and Paris (J. Hall Pleasants, "Four Late Eighteenth Century Anglo-American Landscape Painters," *Proceedings of the American Antiquarian Society,* vol. 52, October 1942, p. 255), which is possibly an exaggeration but at least lends weight to the supposition that Groombridge was in France. His last known English work is dated 1792, and what appears to be his earliest known American landscape bears a date of 1793 (Helen Comstock, "History in Houses: The Morris-Jumel Mansion in New York," *Antiques,* vol. 59, no. 3, March 1951, p. 216).

In Philadelphia by 1794, Groombridge became involved in the early planning of the Columbianum and was one of the leaders of the faction opposing the group led by Charles Willson Peale. Groombridge and a number of others, mainly Englishmen, were

opposed to the republican spirit of the original organization, the seeming emphasis on founding a school alone, and probably to Peale's domination. Their splinter group, the "National College," planned to organize an exhibition but met early failure. At about this time Groombridge's wife, Catherine, also a painter, opened a school for girls in Philadelphia, which was in existence until 1804.

There is good reason to believe that Groombridge was chiefly occupied as the drawing master in his wife's school. Dunlap remembered meeting Groombridge in New York in about 1796 and reported Groombridge's difficulty in selling landscapes, which is probably why he painted miniatures and portraits as well (Dunlap, *History,* vol. 2, p. 47). Charles Willson Peale recalled that Groombridge did not paint many pictures in Philadelphia (APS, Charles Willson Peale, "Autobiography," typescript, p. 106). In 1804, Mrs. Groombridge advertised a boarding and day school for ladies, the Columbia Academy, in Baltimore, where the couple probably moved in that year.

Groombridge's main competition in Baltimore was the more successful Francis Guy who specialized in views of the surrounding country seats. Although Groombridge died a relatively unsuccessful painter

in 1811, a number of his landscapes, a few still lifes, and a portrait by him were exhibited posthumously at the Pennsylvania Academy of the Fine Arts.

156. *Fairmount and Schuylkill River*

1800

Signature: W. Groombridge/Pinx[t] 1800 (lower left)

Oil on canvas

25 x 26″ (63.5 x 66 cm)

Historical Society of Pennsylvania, Philadelphia

PROVENANCE: Purchase, Historical Society of Pennsylvania, 1913

LITERATURE: William Sawitzky, *Catalogue Descriptive and Critical of the Paintings and Miniatures in the Historical Society of Pennsylvania* (Philadelphia, 1942), p. 199; J. Hall Pleasants, "Four Late Eighteenth Century Anglo-American Landscape Painters," *Proceedings of the American Antiquarian Society,* vol. 52 (October 1942), p. 231, no. 2; Wainwright, *Paintings and Miniatures,* p. 296

GROOMBRIDGE's *Fairmount and Schuylkill River* reveals that the artist's style was fully formed by the time he arrived in the United States. In fact, this work is very close to his *View of Canterbury* painted in 1787 in England and has the same foreground screen of trees (see Colonel Maurice H. Grant, *A Chronological History of the Old English Landscape Painters (in oil) from the XVIth Century to the XIXth Century (Describing More Than 800 Painters),* Leigh-on-Sea, England, 1958, vol. 3, fig. 322). Groombridge's work derives directly from the English picturesque tradition of the late eighteenth century, with its autumnal trees, sunsets, and winding rivers painted in rather subdued colors. He was influenced by the late work of England's Richard Wilson (1713–1783), who had a delayed impact on English landscape painting, but Wilson's influence may have been indirect, through an artist such as George Barret.

Recently an English art historian observed that the world appeared as a "more coloury affair" to Groombridge than to most of his English contemporaries, mentioning specifically the decorative value of his middle and far distances (Grant, cited above, vol. 4, p. 308). Dunlap too remarked upon the vividness of Groombridge's coloring and found it unnaturally discordant in his American autumnal scenes (Dunlap, *History,* vol. 2, p. 47). Others, however, felt that Groombridge had captured the American fall coloring, which foreign artists and their imitators would not understand (Pleasants, cited above, p. 227). Apparently,

even while in England, Groombridge vacillated between the hollow application of a traditional style and his own inclination to stress the decorative aspects of a landscape.

Fairmount and Schuylkill River, one of the few known paintings by Groombridge, may well have been commissioned by the owner of the large house in the middle distance. This house has been mistakenly identified as Strawberry Mansion (Pleasants, cited above, p. 231), but it is not a representation of any of the preserved houses in Fairmount Park. Possibly the house once stood farther down the river. Despite Flexner's assertion that Groombridge's landscapes were based not on nature but on other pictures, Groombridge exhibited work in England which he claimed had been done from nature, and this house has a distinctive, unpretentious quality about it which suggests that it did in fact exist (Flexner, *Distant Skies,* p. 121). Much of the rest, such as the sailboat and the foreground trees, was very likely an imaginative elaboration, done for charming effect.

DE □

156.

RICHARD PETERS (1744–1828)

Richard Peters, son of William and Mary Breintnall Peters, was born at their country seat Belmont (now in Fairmount Park) on June 22, 1744. He graduated from the College of Philadelphia in 1761 and was admitted to the bar in 1763, specializing in land titles. He was register of the Admiralty in 1771; when the Revolution began, his parents returned to England but he became a captain in the Associators. In 1777 he and some Philadelphia shipwrights designed a floating bridge to be used for Washington's crossing of the Delaware at Yardley which, had it been completed, might have deprived America of one of the most famous nautical adventures in its history. Peters became secretary of the Board of War in 1776, and in 1781 held the office of Secretary of War of the United States (Thompson Westcott, *The Historic Mansions and Buildings of Philadelphia,* Philadelphia, 1877, p. 388). He was a member of the Continental Congress in 1782–83. A founder of the Philadelphia Society for Promoting Agriculture in 1785, he led the farmers in the Grand Federal Procession of 1788 (Scharf and Westcott, vol. 1, p. 448).

Peters was a distinguished judge of the the United States District Court and held a figurehead position at receptions when national heroes, such as George Washington (1789) and Lafayette (1824), came in triumph to the city. He and his wife Sarah Robinson Peters (1753–1804), whom he married in 1776, lived at Belmont. Peters

wrote treatises on grasses and trees, and took great interest in regional improvements, such as the Market Street Bridge. He was known for being "unceremonious, communicative, friendly . . . enlivened by flashes of the gayest pleasantry," for which he earned the Indian name of Tegohtias, "Talking Bird" (Thompson Westcott, cited above, p. 391). Richard Peters died on August 22, 1828.

WILLIAM WESTON (ACT. IN AMERICA 1792–1800)

William Weston, a hydraulic engineer from Gainsborough, England, presented a draft and building instructions for the coffer-dam construction of the foundations and piers of the Market Street Bridge. He came to America in 1792, commissioned to plan the Schuylkill and Susquehanna Canal. By the time he returned to England barely eight years later, he had employed his training and experience from New York to Virginia. He did the surveys for the Middlesex Canal (Talbot Hamlin, *Benjamin Henry Latrobe,* New York, 1955, p. 546). In 1795 he was employed by the Western Inland Lock Navigation Company to construct dams and locks at the falls on the Mohawk River to provide canal transport between Oneida Lake and the Mohawk River (Charles B. Stuart, *The Lives and Works of Civil and Military Engineers of America,* New York, 1871, p. 51). Just before he returned to England he advised New York City on sources for its water supply.

THOMAS VICKERS (D. 1820)

Thomas Vickers was the grandson of Thomas and Esther Vickers of Shrewsbury, New Jersey; his father may have been Abraham Vickers (d. 1757), who settled in Bucks County, Pennsylvania, by 1726. He and his wife Margaret had eight children, and their home in 1805 was on High Street near Schuylkill Sixth Street in the area west of Broad Street called Kensington. His widow Margaret continued to be listed at that address in Philadelphia directories until 1834. It was a small house, but it did contain a pianoforte, gilt looking glass, sideboard, and card table with a total value estimated at $239.35 when inventoried by Philip Sumner in July 1821 (City Hall, Register of Wills, Administration no. 237, 1820). His total estate, valued at $22,000, included 6 shares of Schuylkill Bank stock, 25 shares of Masonic Hall stock, and income from a Washington Benevolent Society loan.

Vickers's eldest son, Thomas, died in 1822 and his will makes reference to his brother James and brothers-in-law George Prager and Peter Lare, who were all noted as brick-layers and stonemasons. Thus, Thomas Vickers probably employed his extended family as his working crew. In May 1799 he laid the first brick in the three-arch aqueduct that was to be one link in Philadelphia's waterworks system (Scharf and Westcott, vol. 1, p. 500). After the Market Street Bridge project, he was employed by the Chesapeake and Delaware Canal Company (Hamlin, cited above, p. 579). Vickers died in Philadelphia in November 1820.

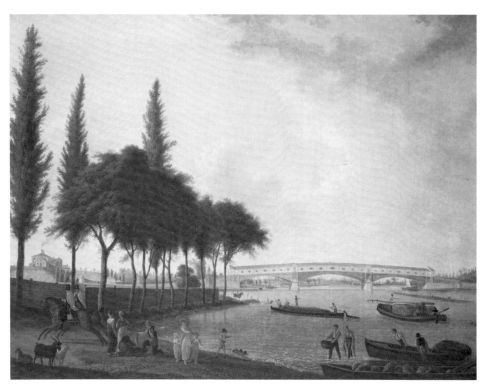

157.

RICHARD PETERS, WILLIAM WESTON,
THOMAS VICKERS, AND OTHERS

157. *Permanent Bridge*
(Market Street Bridge)

Schuylkill River at Market Street
1801–5 (destroyed 1875)
Inscription: In the year 1801 119 years
after the founding of the City of Philadel-
phia—and in the 25th year after the
separation of America from the Govern-
ment of Great Britain—This Pier was
built under the direction of R. Peters
J. Dunlap G. Fox J. Perot J. Wingham
S. Wheeler J. Lownes R. H. Morris
W. Sheaff T. Savery C. Biddle E. Hazard
J. Dorsey W. Poyntell Architect,
W. Weston Master Workmen S. Robin-
son, M. Delaney, T. Vickers (on brass
plate in center of eastern pier)
Stone foundation, pine superstructure,
and cedar shingles
1300 x 42′ (396 x 12.8 m); height above
river 31′ (9.4 m); height of structure
13′ (3.9 m)

REPRESENTED BY:

John J. Barralet (1747–1815)
Market Street Bridge
c. 1810
Oil on canvas

36 x 48″ (91.4 x 121.9 cm)
Historical Society of Pennsylvania,
Philadelphia

Cornelius Tiebout (1773–1832) after
Owen Biddle (1774–1806)
*Frame of the Bridge over the River
Schuylkill at Philadelphia*
c. 1805
From Owen Biddle, *The Young Carpen-
ter's Assistant,* Philadelphia, 1810
Engraving
9 x 22″ (22.8 x 55.8 cm)

Philadelphia Museum of Art Library

LITERATURE: [Richard Peters], *A Statistical
Account of the Schuylkill Permanent Bridge
Communicated to the Philadelphia Society of
Agriculture 1806* (Philadelphia, 1807); Biddle,
Carpenter's Assistant, pp. 49–53, pl. 41

MARKET STREET was a principal axis of the
city of Philadelphia from the earliest settle-
ment, and transportation across the Schuyl-
kill at its western end was always deemed
essential. The Permanent Bridge was the
ninth "conveyance" designed to provide a
route by which the farm products from
Chester County could reach the markets of
the city. Until an act passed in 1798 author-
ized the organization of the Permanent
Bridge Company, floating bridges served this
function and were replaced as necessary.

Their problem was described by Richard
Peters in his account of the building of the
bridge: "The character of this river is wild,
and, in times of floods, rapid and formidable;
to any structure of slight materials, ruinous
and irresistible" (Peters, cited above, p. 6).
Not only was the river unpredictable, but
there was deep tidal fluctuation at the
Market Street location, as well as irregu-
larities of depths and of the quality of the
bottom. In one spot there was thirteen
feet of mud, in another, bare rock.

Richard Peters, as president of the board
of directors of the Permanent Bridge Com-
pany, worked steadily on the project as it
evolved, and is sometimes credited with its
design. In fact, Timothy Palmer of New-
buryport, Massachusetts, a self-taught
architect, produced the drawings for the
wooden upper frame; William Weston, a
transient English engineer, offered a plan
and instructions for building the coffer
dams; and Adam Traquair and Peters
designed the cover, which Owen Biddle
executed.

The keys to the success of the bridge—
and its most expensive and experimental
aspect—were the foundation and piers built
of stone by Thomas Vickers. Weston's
method of construction was adjusted and
adapted by Vickers in consultation with
Peters; in 1803, at the end of the masonry
project, Weston wrote to Peters: "I most
sincerely rejoice at the final success that has
crowned your persevering efforts, in the
erection of the western pier, it will afford
you matter of well founded triumph, when
I tell you, that you have accomplished an
undertaking unrivalled by any thing of the
kind that Europe can boast of" (Peters,
cited above, p. 45).

Vickers used a pile engine to ram 42-foot-
long piles, with iron points, through the
mud into the rock bed. He reinforced the
frame created by the piles with crossbeams
and joists, afterward making it watertight
with planking. It was then pumped dry, and
masonry piers were built within. The
western coffer dam alone used 800,000 feet
(board measure) of timber and 7,500 tons
of masonry (Biddle, *Carpenter's Assistant,*
p. 50). On the eastern end, where the bed
was solid rock, the first course of stone was
bolted directly to the rock. It took almost
two years to build both end piers and their
wing walls and abutments.

Peters described the superstructure of the
bridge as "a unit in symmetry and move-
ment; and all its parts support each other,
like a phalanx in tactics" (Peters, cited
above, p. 33). The wooden frame, built
under the supervision of Samuel Robinson,
carpenter, was constructed of king posts and
braces or trusses, which combined with the
strength of the stone piers to support the

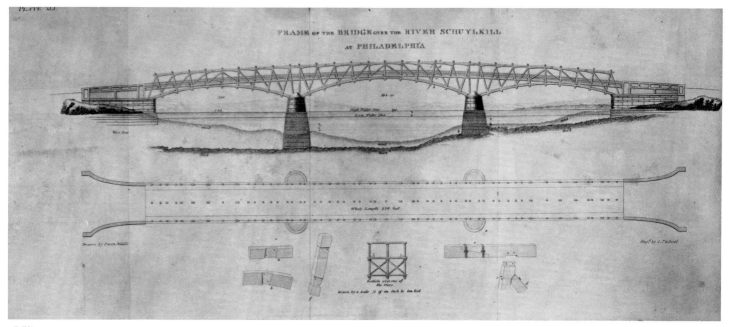

157.

arches. A cross section shows the frame in three sections, the center dividing the two-way traffic and carrying the most weight. At its center the curved platform rose to eight feet above the horizontal and included five-foot-wide walkways on each side, protected with posts and chains. The flooring, in two layers, was 5½ inches thick. Secure for use, the bridge was opened to toll traffic on January 1, 1805, although the cover was not completed by that time.

The cover was added to protect the timber construction, greatly increasing the longevity of the bridge, but its design was as handsome as it was pragmatic. The cover followed the slow curve of the platform, and the inside was lit by elliptical windows designed in graduated sizes, set into the plain side panels, in a subtle repetition of the curves of the arches below. The exterior was painted with great care, the understructure to resemble cut stone, the upper with blind porticoed doorways and convex strips "sprigged on the weather boarding" to imitate paneled sections. The technique of painting the surface and then dashing it while still wet with very dry sand, stone, dust, and a small proportion of plaster of Paris created a "stone" surface appearance. It was applied in two coats and then scored to simulate cut stone.

The roof was shingled and then "fire-proofed" with a mixture of boiled fish oil, resin, and clarified turpentine, with the addition of preboiled flaxseed oil and ground

ochre as a thickener. While this substance was wet, a mixture of calcinated plaster and stone dust or fine sand was sifted or "dashed" on the surface. It was claimed that "live coals, in quantities have been thrown on roofs thus coated, without injury. It does not scale with frost or melt with the hottest sun" (Peters, cited above, p. 38).

The final embellishments of the bridge were two sculptures of reclining female figures by William Rush, representing Commerce and Agriculture, placed on the east and west pediments. A marble obelisk was set up on the western approach, which was inscribed in part: "No pier of regular masonry into as great a depth of water is known to exist in any other part of the world."

The Permanent Bridge not only provided reliable access to farms and country seats but also opened up the west bank of the Schuylkill for real estate development. The bridge was enlarged by the Pennsylvania Railroad to accommodate tracks in 1849, and was destroyed by fire, presumably from the sparks from the trains, in 1875. It was a wonder in its day and was almost as popular as the Waterworks at Fairmount (no. 183) for nineteenth century artists, including William Birch, who engraved it in 1805 before it was finished, and again in 1806, adding an insert to show the finished cover. The views, including the painting by Barralet, portrayed a peaceful river with little more than an edge ripple at the shore,

certainly with no hint of its turbulence at high tide after a summer storm. One of the many country seats on the west bank of the Schuylkill, probably Lansdowne, appears in the distance of the Barralet view, under the center span of the bridge. The complex at the left is Powelton Farm.

BG □

THOMAS SULLY (1783–1872)

Sully did not become an American citizen until 1809. He was born at Horncastle in Lincolnshire, England, and was brought to Charleston, South Carolina, in 1792 by his parents, who were both English actors. His first instruction in painting came from his brother-in-law, Jean Belzons, and his oldest brother, Lawrence, whom he followed to Richmond, Virginia, in 1799. Thus, his earliest instructors were miniature painters, as was his young friend, Charles Fraser. About two years later the two Sully brothers moved from Richmond to Norfolk, and it was there that Thomas commissioned Henry Benbridge to paint his portrait in order to watch Benbridge paint (Dunlap, *History,* vol. 2, pp. 106–7). At this time Sully was painting miniatures from life.

Lawrence died in 1803, and Thomas married his widow two years later. Soon afterward he and his adopted family left for New York, with the encouragement of one

158.

of his former sitters. Anxious to learn more about the art of painting, Sully commissioned a portrait from the best painter in New York, John Trumbull, who had studied under Benjamin West, and later Sully traveled to Boston in 1807 to seek the advice of the famous Gilbert Stuart (see biography preceding no. 140). Stuart received him with great kindness; in 1816, he spoke of Sully as "very clever and ingenious" (John W. McCoubrey, *American Art, 1700–1960, Sources and Documents,* Englewood Cliffs, N.J., 1965, p. 23). Sully spent about three weeks absorbing Stuart's free instruction. The next year, he moved from New York in hopes of improving business, and settled permanently in Philadelphia in 1808.

Sully had undoubtedly been encouraged by Stuart to go to London, and fortunately Philadelphia's Benjamin Chew Wilcocks was so sympathetic to Sully's proposed travel plans that he and several others provided money for the trip. The artist carried with him introductory letters to West from William Rawle of Philadelphia and from Charles Willson Peale (APS, Charles Willson Peale, Letterbook, vol. 10, p. 71). It is to West's credit that he advised Sully to study osteology and to seek further advice of a portrait painter. Sully turned to Sir Thomas Lawrence for guidance and, after about a year in London, returned in 1810 to become Philadelphia's leading portrait painter.

In addition to portraits, Sully painted subject pictures, historical compositions, landscapes, and "fancy pictures," such as *Portia and Shylock* (1835), the huge *Washington's Passage of the Delaware* (1819), *Wissahickon Creek* (1845), and *Girl at a*

Cottage Window (1848), as well as a large number of copies after other artists, including Rubens, Van Dyck, Reynolds, and West. In 1819 he joined James Earle, a carver, in a commercial gallery venture which lasted until 1847 and included the sale of foreign as well as American work. One of Sully's greatest honors was to paint the recently crowned Queen Victoria in London in 1838, a portrait commissioned by the Society of the Sons of St. George in Philadelphia. This was his second and last trip to the country of his birth. Another honor, which Sully declined, came in 1843, when he was invited to be president of the Pennsylvania Academy of the Fine Arts, the first artist to receive this honor.

Sully had long been involved with the Academy, having been elected an Academician in 1812, but, like most of Philadelphia's artists, he resented the domination of the institution by wealthy laymen. In 1851, he prepared his *Hints to Young Painters and the Process of Portrait Painting,* revised in 1871 and published two years later, which was a short compendium of practical advice and painting recipes, similar to Rembrandt Peale's "Notes of the Painting Room" but on a more elementary and personal level. Sully died on November 5, 1872, in his ninetieth year.

DE

158. *Memorial to His Mother, Sarah*

c. 1801

Inscription: ss (on vase); SACRED TO THE/ MEMORY/OF/SARAH SULLY

Watercolor and chopped hair mixed with watercolor on ivory(?)

Diameter 1½″ (3.8 cm)

Yale University Art Gallery, New Haven. The Lelia A. and John Hill Morgan Collection

PROVENANCE: Mrs. E. O. Bolling, Virginia, 1921

LITERATURE: Biddle and Fielding, *Sully,* p. 332

MINIATURES were intended as symbols of an emotional bond shared by two people, be it love, friendship, filial piety, or, as here, grief over the loss of a loved one. The mourning miniature was a popular piece in an age when death and mourning were much more openly acknowledged than today. The classically garbed female weeping by a tomb with its funerary urn and weeping willow is the traditional image for such miniatures. Thomas Sully's 1801 miniature, a memorial to his mother, Sarah, must have been painted at the onset of his professional career.

As a miniaturist he far surpassed his brother and teacher, Lawrence, and even-

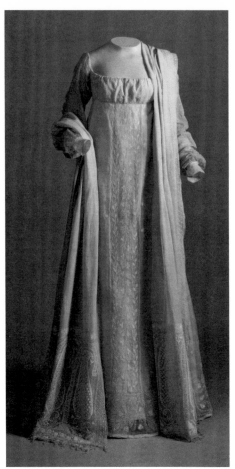

159.

tually developed a polished sophisticated style of strong contrasts, artificial poses, and smooth finishes, with which he depicted his elegant society sitters. Like many contemporary portrait painters, Sully painted most of his miniatures early in his career, increasingly abandoning the medium for the more lucrative oil portrait.

RB-S □

159. *Dress and Shawl*

c. 1800–1805

Ivory cotton mull, embroidered with white cotton thread, and lined in silk

Waist 28″ (71.1 cm); center back length 48½″ (123.1 cm)

Philadelphia Museum of Art. Given by Thomas Francis Cadwalader. 55-98-7a, b

PROVENANCE: Descended in Cadwalader family

THE HEAVY and often cumbersome garments of the eighteenth century gave way to the gentleness and charm of a simplified neo-classic mode, introduced in France by the

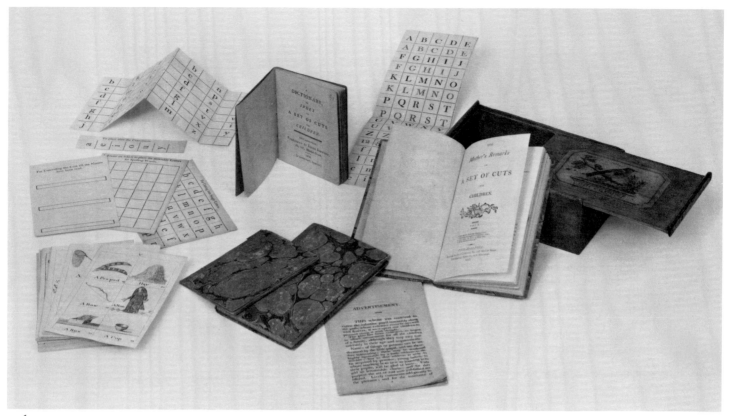

160.

Empress Josephine and quickly taken up throughout the Continent and in England and America. This Empire style sheath dress has a high waistline and an extremely short, gathered bodice ending just under the arm; the full sleeve is gathered at its upper edge and tapers down to small gathers sewn into a tight wristband. The fashion for a short bodice and a low-cut neckline made a high bustline necessary. This was achieved, according to Aline Bernstein, by "false breasts of papier mache, covered with linen pasted on, held together in front and tied in the back with linen tapes. The false breasts seemed to be widely used much as our brassieres of today are used to raise the breast" (*Masterpieces,* p. xvii).

Exquisite white embroidery embellishes the ivory mull fabric in an overall floral motif; a band of embroidered vine and leaf scrolling descends along the center front and encircles the hem. The ends of the long matching shawl are embroidered with a large palmette and floral design, motifs borrowed from imported Indian shawls, which became a fashion "rage" after sheer or flimsy clothing was introduced.

EMcG ☐

160. *Douceurs (Gifts)*

1803–4
Published by Jacob Johnson, Philadelphia
(a) *Box*
Label: DOUCEURS./PUBLISHED by
J. JOHNSON. Nᵒ. 147 Market Street
PHILADª/W.R. SC.
Pine
2½ x 6¾ x 4½″ (6.3 x 17.1 x 11.4 cm)

Historical Society of Pennsylvania, Philadelphia

(b) *Advertisement*
1803
Eight page pamphlet, unbound
Laid paper
6¼ x 4″ (15.8 x 10.1 cm)

Historical Society of Pennsylvania, Philadelphia

(c) *A New Spelling Alphabet for Children*
Six loose sheets
Laid paper (five sheets of heavy weight, one sheet of lighter weight)
Watermark: [indistinct] (on the lighter-weight sheet)
Variable dimensions

Historical Society of Pennsylvania, Philadelphia

(d) *A Set of Cuts for Children*
Fifty-four alphabet sheets
Engravings
Wove paper
5⅝ x 3⁷⁄₁₆″ (each) (14.2 x 8.7 cm)

Historical Society of Pennsylvania, Philadelphia

(e) *The Mother's Remarks on a Set of Cuts for Children*
1803
Printed by T. S. Manning, Philadelphia
Two printed books; parts 1 and 2; 84 pages each; marble paper over boards
Wove paper
5¾ x 3¾ x ⅜″ (each) (14.6 x 9.5 x 1 cm)

Historical Society of Pennsylvania, Philadelphia

(f) *A Dictionary, or Index to a Set of Cuts for Children*
1804
Printed by J. Rakestraw, Philadelphia
Printed book; 16 leaves; marble paper over boards
Laid paper
4⁹⁄₁₆ x 3⅜″ (10.6 x 8.5 cm)

The Library Company of Philadelphia

160d.

(g) *A List of Nouns, or Things which may be Seen*

1804

Printed book; 10 leaves; marble paper over boards

Wove (nine leaves) and laid (one leaf) paper

4³⁄₁₆ x 3³⁄₈″ (10.6 x 8.5 cm)

The Library Company of Philadelphia

LITERATURE: HSP, "Minutes of Meetings of [the] Book Sellers Co. of Philadelphia, 1802–1803"; *Johnson's Pennsylvanian and New-Jersey Almanack 1805* (Philadelphia, 1804); advertisements in *Father Abraham's Almanac for the Year of Our Lord, 1805* (Philadelphia, 1804); [Benjamin Johnson], *The Philadelphia School Dictionary of the English Language . . . Second Edition* (Philadelphia, 1806), 4 pp. of advertisements; *Johnson's Almanac for the Year 1808 . . . Calculated by Joshua Sharp* (Philadelphia, 1807); [Jacob Johnson], *Johnson's Juvenile Catalogue for 1808* (Philadelphia, 1808), throughout; *Johnson's Almanac for the Year 1810 . . . Calculated by Joshua Sharp* (Philadelphia, 1809); Stauffer, vol. 1, p. 217; Emily Ellsworth Ford Skeel, ed., *Mason Locke Weems: His Works and Ways in Three Volumes, Letters 1784–1825*, vol. 2 (New York, 1929), pp. 412–13; John Clyde Oswald, *Printing in the Americas* (New York, 1937), pp. 163, 165–67; H. Glenn Brown and Maude O. Brown, *A Directory of the Book-Arts and Book Trade in Philadelphia to 1820, Including Painters and Engravers* (New York, 1950), p. 67 and throughout; Rollo G. Silver, "Printers' Lobby: Model 1802," *Studies in Bibliography,* vol. 3 (1950–51), pp. 207–28; A. S. W. Rosenbach, *Early American Children's Books* (repr., New York, 1971), pp. 115–17, 338–39, and throughout; d'Alte A. Welch, *A Bibliography of American Children's Books Printed Prior to 1821* (Worcester, Mass., 1972), pp. 105, 129, 300–301

OF THE MORE THAN NINETY children's works that Jacob Johnson published in the years 1794 to 1822, none was more unusual in format, design, attention to detail, and beauty than *Douceurs*. One would expect a publisher's pièce de résistance to come as a triumphal note near the end of his career, but from the very beginning, Johnson did things differently, and so successfully that even the irrepressible itinerant bookseller-biographer Parson Weems complained to Philadelphia publisher-printer Mathew Carey:

> In consequence of your suffering nearly the whole of the Children & Chap book business to be monopolized by Friend [Jacob] Johnson he is now underselling all the Trade. In Charleston [South Carolina], where I fixed a store for you, I found a Book store of Friend Jacobs, to the Widow Keeper of which he gives 25 per cent. I was obliged to give 15 per cent to a very good man, but I am afraid it will not last longer than this Gentleman can get books from Mr. Johnson at, 25 per cent. . . . I am vexed that you should allow him such an infernal profit on his Chap & Toy books as to enable him to give for selling only a *box*, as much as you can afford for endeavors to sell *myriads*. (Emily Ellsworth Ford Skeel, ed., *Mason Locke Weems: His Works and Ways in Three Volumes, Letters 1784–1825,* New York, 1929, vol. 2, pp. 412–13)

Jacob Johnson was able to capture the lion's share of the juvenile book trade in the middle and southern states not just by giving the 25 percent discount to his agents which so irked Weems but by establishing satellite bookstores manned by members of his family and forming "special relationships" with other dealers and publishers. By 1804 three Johnsons were selling children's books in Philadelphia: Jacob and Benjamin Johnson at 147 and 31 Market Street, respectively, and Robert at 2 North Third Street. All three advertised together and carried the same stock, which included general books as well as school texts and juveniles. Jacob was the dominant member of the triangle; most of the publishers' advertisements in the newspapers listed only his name although the booksellers' catalogues carried the names of all three Johnsons.

Also in 1804, Jacob set up his nephew Charles Johnson, a carpenter and grocer, in the ink manufacturing business. Ironically it was Mathew Carey who, as president of

160d.

the Philadelphia Company of Booksellers, awarded Jacob a gold medal with the value of fifty dollars for domestically made ink found superior to London inks, which had long dominated the American market. In 1814 the firm changed its name to the Philadelphia Ink Company. As of 1937 it was still in business, still run by the original Johnson family, and still at its original site at Tenth and Lombard streets. The ink manufactory gave Jacob Johnson an outside source of capital which provided an edge over his competitors.

But it was his system of satellite bookstores that proved to be his most potent weapon in the competitive battles. In 1806 when Benjamin Johnson moved from 31 to 249 Market Street, Joseph Bennet, Titus Bennet, and Joseph Walton moved in and appeared on the Johnson advertisements as Bennet and Walton. The very next year Robert Johnson moved from 2 North Third Street to a more prestigious location at 193 Market Street. Benjamin C. Buzby moved into the old location and, unlike Bennet and Walton, who appear to have gone their own ways, stayed in the Johnson "family" until 1814. The firm of Benjamin and Thomas Kite at 28 North Third Street also joined Johnson, apparently as co-publishers, further extending the Johnsons' grip on the Philadelphia juvenile book market.

Although all the Johnsons are listed as printers in Philadelphia directories, in prac-

tice they appear to have preferred that others do their printing. This is particularly true of Jacob's mainstay—children's books. He relied heavily on Thomas S. Manning (active 1803–20) and James Rakestraw (active 1803–20) to supply his family's bookstores and his agents and outlets in other cities.

It is safe to say that in the first two decades of the nineteenth century Jacob Johnson, along with Samuel Wood of New York City and Isaiah Thomas of Worcester, Massachusetts, were the dominant figures in American children's book publishing and marketing. Of the three, it was Johnson who was the leader in exploring new ways of "giving satisfaction to his numerous little customers and their parents" (John Clyde Oswald, *Printing in the Americas,* New York, 1937, p. 163). He added a more secular approach to children's books than was to be found in Isaiah Thomas's New England moralistic tales and tracts. He was of course "careful to avoid any sentiment that could weaken the cause of virtue," all the while providing more pure fun for his little readers (Oswald, cited above, p. 163). Indeed this increased secular spirit spawned a reaction. Hannah More took up the English moral cudgel in the 1790s and the American Tract Society and American Sunday School Union hefted the American bludgeon of virtue in the 1820s.

But it was in packaging and design that Jacob Johnson was to have his most lasting effect on the book arts of Philadelphia. Not really an innovator, he was a skilled adapter and imitator, primarily of English publications, especially their emphasis on pictures and "fun-while-learning." Quick to see the potential of "box" books in a frontier environment, he produced two such titles a short time after their introduction in England.

In a newspaper advertisement in the *Philadelphia Repository and Weekly Register* early in 1804, Johnson announced two box books: *A Cabinet of Various Objects* and *A New Spelling Alphabet for Children.* Both were very small, two inches square or smaller, and came in a sliding-top pine box about three by five inches. The first, which carried the printed title, *A Description of Various Objects,* was composed of thirty engravings on loose sheets with two miniature books of explanations. The other, *A New Spelling Alphabet,* came with a number of single letters on cards and one miniature book in an equally small box. They sold for seventy-five and eighty-five cents, respectively, and were at the time his most expensive children's books.

That same year he published his most lavish box book, which included *The Mother's Remarks on a Set of Cuts for Children,* printed by Thomas S. Manning in 1803; 326 engravings on 54 cards or plates;

and 2 volumes of explanations. The engraved plates were copied from an English edition published by Darton and Harvey in 1799. Plates I through XVIII and XLVII through LIV were copies in reverse by William Ralph, an engraver without much original talent who worked on a number of Johnson's books. Two obviously English plates (XLVII and XLVIII) were not copied, and the plate numbers XLVII through LIV were renumbered in the American edition. The artist of the original English plates may have been Lady Eleanor Fenn, who worked and wrote under the pseudonym Mrs. Lovechild, or a Mrs. Priscilla Wakefield, from whose works a number of quotations were made in the accompanying text volumes. Little effort was made to Americanize the texts with the exception of that for plate XLVI, number 272, which now describes Johnson's bookstore. Interestingly, an extra card with a slot cut into it was included for covering up the pictures until the child had read the word printed underneath. Thus, in spite of its seemingly modern flash card approach to teaching, it was the word and not the visual image that was the primary message to be learned. The picture was a reward or a treat not a necessity in this pre-television era.

Both A. S. W. Rosenbach and d'Alte Welch, authors of the standard bibliographies of American children's books, thought that *The Mother's Remarks* was a part of a group of things originally issued in a box with a printed label reading *Douceurs,* but did not know the exact contents Jacob Johnson intended. The original conception of the contents of this sumptuous box book is revealed in a recently discovered catalogue issued by Johnson in 1807:

Douceur, or Gift, consisting of three hundred engravings on cards. Two volumes of remarks on the same; a small dictionary; book of nouns intended as an introduction to grammar, and some other matters—the whole in a handsome box, [$] 2.00
"This is truly an interesting and valuable gift—has everything to recommend it. The mother's remarks on the cuts are full of instruction and amusement, and well calculated to arrest the minds of children, and to show them the charms of virtue." (*Johnson's Juvenile Catalogue for 1808,* Philadelphia, 1808, p. 10)

The dictionary mentioned was *A Dictionary, or Index to a Set of Cuts for Children,* printed by J. Rakestraw in 1804, which contained the words listed under the individual pictures in *The Mother's Remarks* plates, grouped by the number of syllables, followed by a short definition and the number of the picture. Also part of the *Douceurs* box was *A List of Nouns, or Things which may be Seen,* probably also

printed by J. Rakestraw in 1804. The listed nouns are those in the pictures and are arranged in six columns with words sounding alike, opposites, and different words for the same object paired.

It is clear from the 1808 catalogue that although both the *Dictionary* and *List* are smaller than the text volumes for *The Mother's Remarks* and bear different publication dates, they were meant as part of the *Douceurs* set. If further proof is needed, the copies of both the *List* and the *Dictionary* are bound in the identical red marbled paper covers as are the *Remarks* text volumes, although the former came to the Library Company of Philadelphia at a later date and from a different source than the Historical Society of Pennsylvania's *Remarks.*

The "and other matters" mentioned in the 1808 catalogue entry consisted of three cards with capital and lower-case letters, one with vowels, and another ruled into blank squares. When in use it resembled a cross between Scrabble and Bingo with the letters moved on the ruled frame card to form simple two-, three-, and four-letter words. It must have been fun for a child in the young Republic, used to static memorization from a horn book or word list, to be able to make up his or her own words.

At two dollars a set, the complete *Douceurs* box book may have been too expensive for some of Jacob Johnson's customers, small or large. However, as the variant publication dates on the different parts seem to indicate, he intended all along that the parts could be sold separately. In fact the first advertisement for the *Douceurs* as a complete set appears to have been in the 1808 catalogue. And in 1804 a portion of the plates and descriptions from *The Mother's Remarks* were renumbered and reissued by Johnson under the title *The Father's Gift.* It is also possible that the alphabet cards from the *Douceurs* box were originally part of another, earlier box book, the *New Spelling Alphabet for Children,* issued in late 1803 or early 1804. To add further confusion to an already complex picture, there appear to be two versions of "the book of nouns" called for in the 1808 catalogue, both issued in 1804.

Considered on any basis, the *Douceurs* remains the most complex, expensive, and interesting children's book issued in America during its period. It shows Jacob Johnson's eye for business as well as beauty and design, and as an object it demonstrates how well he lived up to the slogan with which he closed all his advertisements and catalogues: "J. Johnson proposes to devote most of his attention to the juvenile department of his store, with an expectation of giving satisfaction to his numerous little customers and their parents" (Oswald, cited above, p. 163).

GM □

EDWARD GREENE MALBONE (1777–1807)

Born in Newport, Rhode Island, Edward Greene Malbone was one of six children of the common-law marriage of Patience Greene and John Malbone, a prominent merchant. Malbone was a precocious and inventive child, according to his sister, Mrs. Henrietta Whithorne, who described his early artistic interests at length in a letter published by William Dunlap in his 1834 *History*. Malbone painted landscape scenery for a local theater and may have received some instruction from Samuel King, the Newport painter and instrument-maker, with whom Malbone's friend Washington Allston, then at school in Newport, was studying.

In 1794, the seventeen-year-old Malbone established himself as a miniature painter in Providence where he remained until his father's death in 1795. He declined an offer of a trip to England out of concern for his orphaned sisters and shortly afterward moved to Boston where he renewed his acquaintance with Washington Allston, then attending Harvard. Malbone gave Allston some instruction in painting miniatures, as he had given Dunlap, and in later years the miniaturists Joseph Wood and Charles Fraser. Malbone remained in Boston through March 1797, and then worked in New York, Newport, and Philadelphia. On April 30, 1798, the Philadelphia *Federal Gazette* carried the notice: "MALBONE, EDWARD G.— Miniature Painting, From Newport, Rhode Island, Intends practising his art during his stay in this City, which will be but a few weeks. N.B. He expects no money from his employers unless they are perfectly satisfied with his Likenesses and the execution of his work, specimens of which may be seen at his lodgings, No. 110, Union Street" (Tolman, *Life and Works,* cited below, p. 20). Malbone probably stayed in Philadelphia until early 1799. By mid-1800 he was back in Newport briefly then in New York and Charleston, and in May 1801 he left for England with Allston.

In London, Malbone came into the sphere of Benjamin West, who received him so enthusiastically, according to Mrs. Whithorne, "that it could not fail to give him confidence in himself, holding out every inducement for him to remain in Europe; and having free access to the school of the arts his improvement was very rapid. He now painted the 'Hours' and several female heads, which were highly eulogised by the president, Mr. West, saying that no man in England could excel them" (Dunlap, *History,* vol. 2, p. 25). He also visited John Trumbull, Henry Fuseli, and the English miniaturists Richard Cosway and Samuel Shelley. Malbone viewed the public art collections in London and declared, to Allston's horror, that he preferred the work of Sir Thomas Lawrence to that of the old masters.

After his return to the United States in late 1801, he struggled against failing health, apparently due to tuberculosis. He spent four months in Philadelphia in 1804 while the socialite Rebecca Gratz arranged commissions for him, in return for which he painted a miniature of her sister, Rachel (Tolman, *Life and Works,* cited below, p. 37). Malbone continued to travel and work on the East Coast, but he was forced to rest for weeks at a time. His doctors advised a warmer climate and he went to Jamaica in 1806. After seventeen days in Port Antonio, he started a return trip to Newport, but died at the home of a cousin in Savannah in his thirtieth year.

AS

161. *General Thomas Cadwalader*

1804
Watercolor on ivory
3 x 2⁵⁄₁₆" (7.6 x 5.9 cm)
Private Collection

PROVENANCE: Probably General Thomas Cadwalader, 1804–41; descended in family to present owner

LITERATURE: Ruel Pardee Tolman, *The Life and Works of Edward Greene Malbone 1777–1807* (New York, 1958), p. 153, no. 78

162.

EDWARD GREENE MALBONE, whose short career spanned the "golden age" of American miniature painting—the last decade of the eighteenth century and the first decade of the nineteenth—is generally considered America's outstanding miniaturist. His handsome portrait of Thomas Cadwalader (1779–1841), later a general in the War of 1812, is exemplary of his brilliant technique: strong but intricate modeling in almost imperceptible hatching, fine drawing, and beautifully clear color harmonies. Malbone's deft handling of this delicate medium, the ivory's surface washed with pure, soft shades, and the fine delineation of features and detail, impart to his work the airy, delicate perfection of its British prototypes. But most important, as his friend and follower, the South Carolinian miniaturist Charles Fraser, wrote in Malbone's obituary: "He imparted such life to the ivory and produced always such striking resemblances, that they will never fail to perpetuate the tenderness of friendship, to divert the cares of absence, and to aid affection in dwelling on those features and that image, which death has forever wrested from it" (Tolman, *Life and Works,* cited above, p. 62)—an excellent summary of the raison d'être of the miniature portrait.

RB-S □

161.

JAMES PEALE (1749–1831)
(See biography preceding no. 134)

162. *Portrait of a Young Lady*

1805
Signature: I.P./1805 (lower right)
Watercolor on ivory
3 x 2½″ (7.6 x 6.4 cm)
Mrs. Jacob H. Whitebook, Elkins Park,
Pennsylvania

PROVENANCE: Erskin Hewitt, 1934; Mrs. Norvin
E. Green, Sky Cliff, New York

LITERATURE: Jeannette Stern Whitebook, "Some
Philadelphia Miniatures," *Antiques,* vol. 82,
no. 4 (October 1962), p. 391, no. 2, illus. p. 390

THE EVOLUTION from the more aristocratic,
reserved portraiture of the Federal period to
the romantic naturalism of the Jeffersonian
era was reflected in new stylistic tendencies
in miniature painting. Larger in size, the
miniature now hung in full view on a chain
or ribbon rather than enclosed inside a
locket. Naturalism in color as well as styling
characterized the hair of both men and
women.

James Peale's miniature portraits done
after 1800 are characterized by an increased
simplicity in the treatment of details, reflect-
ing a simplification in the dress of the day,
a looser hatching and stippling technique,
and greater ease in drawing. His portrait of
an unknown girl painted in 1805 is appeal-
ingly direct and charming in the delineation
of the fashionably disheveled hairdo and
stylish low-cut Empire dress.

RB-S □

BENJAMIN SMITH BARTON (1766–1815)

An important member of the group of
naturalists and physicians responsible for
Philadelphia's pre-eminence in science at the
turn of the nineteenth century, Benjamin
Smith Barton was a friend and sometime
collaborator of Benjamin Rush, Alexander
Wilson, William Bartram, and Charles
Willson Peale. Like most Philadelphia
naturalists, Barton was an accomplished
draftsman. Born in Lancaster, Pennsylvania,
in 1766, he was the son of an Episcopalian
minister who was himself an amateur natu-
ralist; Barton's maternal uncle was David
Rittenhouse (see biography preceding no.
132), the leading American astronomer of
his time. After attending medical school at
the College of Philadelphia, Barton left for
Europe, studying medicine at the University
of Edinburgh, and perhaps in Germany as
well. On his return to Philadelphia in 1789
he joined the staff of his former college
(incorporated in 1791 with the University of
Pennsylvania), where he gave the first
natural history course ever taught in
America.

Barton was occasionally criticized as vain
and overambitious by his fellow scientists in
Philadelphia (Jeannette E. Graustein, "The
Eminent Benjamin Smith Barton," *PMHB,*
vol. 85, no. 4, October 1961, pp. 428–35).
In his career, however, he was entirely suc-
cessful and was a member—and sometimes
an officer—of many learned societies in
Philadelphia and in Europe. He was also
the successor to Benjamin Rush in the most
distinguished medical professorship at the
University of Pennsylvania and the author
of significant and wide-ranging works in
natural history and biology, of which
perhaps the most important was his *Elements
of Botany* (Philadelphia, 1803), the first
general treatment of the subject written and
published in America.

Almost nothing is known of Barton's
training as a draftsman. In a letter of 1785,
when he was nineteen, written while he was
on a surveying expedition to map the
western boundary of Pennsylvania, he men-
tioned having made "drawings of several
curious and beautiful flowers, together with
the falls of the river Youk" (William P. C.
Barton, *A Biographical Sketch . . . Read
before the Philadelphia Medical Society . . .
of Their Late President, Professor Barton,*
Philadelphia, 1816, pp. 6–7). The quality of
his drawings suggests that he must have
received further training, perhaps as part of
his medical and scientific studies in America
or abroad. After Barton's death, his nephew
spoke of his uncle's "scrupulous correctness"
in drawings, in which he was "religiously
conscientious not to let any things of this
nature to pass with his name, unless they
were true and faithful representations"
(Barton, *A Biographical Sketch,* cited above,
p. 7).

163. *Rattlesnake Skeleton*

c. 1805
Watermark: J WHATMAN 1804
Pen and dark brown ink; brush and
brown wash with traces of green on white
paper
14¾ x 39⅜″ (irregular; two sheets pasted
together) (37.5 x 101.5 cm)
American Philosophical Society, Phila-
delphia

PROVENANCE: The artist's family until 1818;
son, Thomas Pennant Barton, Dutchess
County, New York, until 1859; found in the
former Barton residence, Montgomery Place,
by General and Mrs. John R. Delafield, in their
possession 1936–70; purchase, American
Philosophical Society, 1970

ALTHOUGH *Rattlesnake Skeleton* probably
dates from about 1805, Barton had been
interested in the rattlesnake for some time.
In 1796 he published in Philadelphia
*A Memoir Concerning the Fascinating
Faculty Which Has Been Ascribed to the
Rattle-snake, and Other American Serpents,*
based on a paper he had read before the
American Philosophical Society two years
before. This is a remarkable essay in which
he refuted the belief then widely held in
America and Europe that the rattlesnake
was capable of fascinating or enchanting
birds and other small animals in such a
manner that they offered themselves as
victims. Forthrightly contradicting such
eminent European scientists as Linnaeus,
Barton proved by a combination of empirical
experiments and close observation of the
snakes in natural surroundings that they had
no such power, and he concluded that
observers had probably been misled by what
were actually efforts of female birds to
protect their young. Thus, according to
Barton, was science "enabled to draw aside
the veil, which for ages, has curtained super-
stition and credulity . . . [and] to rear and
prop the dignity of the mind" (p. 69). This

163.

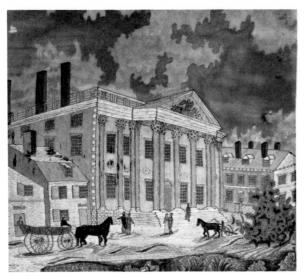

164.

dedication to veracity and rationality is communicated by the precision and care of his drawings.

Despite these sentiments, and others like them, which remind one of the *philosophes* of the eighteenth century, Barton confessed that he was so repelled by snakes that he was unable to begin a long contemplated series of experiments "upon the respiration, the digestion, and the generation of the serpents of Pennsylvania" that involved "slowly and cautiously dissecting and examining their structure and their function" (p. 45). In 1800 he published a supplement to his earlier work on the rattlesnake, and in 1801 he was continuing his experiments, two of which he printed in the first volume of *The Philadelphia Medical and Physical Journal* (1805, pp. 166–69), where he described them as excerpts from his manuscript "Anatomy and Physiology of the Rattlesnake." By the time of this partial publication, Barton appears to have overcome his revulsion for snakes. *Rattlesnake Skeleton,* which bears an 1804 watermark, is part of a series of anatomical drawings of the rattlesnake at the American Philosophical Society that Barton probably did about 1805 as illustrations for his planned, but never published, treatise on "The Anatomy and Physiology of the Rattlesnake."

Whatever its connection with Barton's scientific investigations, *Rattlesnake Skeleton* is itself a remarkable object. The beautifully precise strokes of Barton's pen reveal the skeleton as a structure of formal, almost abstract, grace. This quality, together with the starkness of its placement on the large, otherwise bare sheet, makes the drawing a significant artistic expression that in a sense foreshadows twentieth century work along similar lines by Edward Weston and Georgia O'Keeffe.

JC □

164. *Embroidered Picture*

c. 1800–1810
Silk, ink, and watercolor on silk
Stitches: Long and short, French knot, running
11⅝ x 14⅛″ (29.5 x 35.8 cm)
Philadelphia Museum of Art. Bequest of Lydia Thompson Morris. 32-45-49

PROVENANCE: Descended in Morris family

THE EMBROIDERER of this picture obviously traced or had copied William Birch's engraving *Bank of the United States, in Third Street,* first published in 1800 (see no. 142) in his *City of Philadelphia* (no. 149) and reprinted in later editions. The prominence of the bank in the early eighteenth century coincided with the fashion of rendering architectural and other scenes in silk.

Birch's view was freely adapted in part; the building on the right, seen in the print, was removed, and its place fancifully worked with bushes and foliage. However, the other elements of the picture, including the detailing and arrangement of the figures, are very close to the original.

The picture is worked in silk on silk, primarily using the long and short stitch, with the French knot and running stitch adding texture in the foreground. The colors of the silk thread vary in shades of brown, cream, green, blue, and red, with some black and white. The sky is painted in watercolor, as are the columns, pediment, and other details. The addition of paint is typical for the period, and often was employed to portray finer details.

PC □

165. *Library Bookcase*

1800–1810
Mahogany, mahogany and holly veneers; mahogany and pine; brass drawer pulls; glass doors
107 x 73½ x 23″ (271.7 x 186.6 x 58.4 cm)
Yale University Art Gallery, New Haven. The Mabel Brady Garvan Collection

PROVENANCE: Richard Willing (1775–1858); Edward Shippen Willing (1810–1906); J. Rhea Barton Willing (d. 1913); Louis Guerineau Myers; American Art Gallery, February 24, 1921, no. 642 (Louis G. Meyers sale); Francis P. Garvan

LITERATURE: Meyric R. Rogers, "The Mabel Brady Garvan Collection of Furniture," *Yale Alumni Magazine,* vol. 25 (January 1962), p. 15; Alice Winchester, "Antiques," *Antiques,* vol. 82, no. 3 (September 1962), p. 257, illus. frontis.

PHILADELPHIA, as the seat of government of the new nation, was the center of initiative in the period just after the Revolution. It was also the social and cultural center to which foreign visitors flocked to admire classical virtues in practice in a city famous for its neatness and regularity.

A younger generation was building houses in the new Federal style—William Bingham's on Third Street at Spruce, Edward Burd's by Benjamin Latrobe, Henry Pratt's Lemon Hill (no. 151), or John Penn's Solitude—and a new generation of trained cabinetmakers furnished them with the latest designs of which this library bookcase is a fine example. The style presented a different scale from the robust colonial; it required different techniques, special knowledge of the idiosyncracies of exotic woods, and a sure hand with cutting tools, demanding almost surgical precision. This kind of specialized work was done in large shops, and pieces like this library bookcase were products of a team effort. It is thus difficult to isolate or investigate individual craftsmen; it may suffice to recognize the product of a shop.

This library bookcase, its mate (White House), and a similar smaller one (Philadelphia Museum of Art) have long been attributed to John Aitken (see biography preceding no. 145). Washington's patronage had catapulted Aitken's name into the record, and he became an "anchor," much as Savery had been before the Revolution. But there were many other master cabinetmakers working in Philadelphia contemporary with Aitken, such as Samuel Claphamson, Jacob Wayne, John Douglass, and Henry Ingle. They began to count upon publications like the 1788 *Cabinet-Maker's London Book of Prices* and in Philadelphia, the *Philadelphia Cabinet and Chair Maker's Book of Prices*

(1794, 1795), which, by standardizing prices, eventually set some of the workers' wages. This standardization resulted in furniture produced en masse which lacked the elegance of individual designs yet supported quality and value.

On this example the cross-band inlay around the door panels and the flat unshaded design of the inlaid corner fans are characteristic of Philadelphia work in this period. The inlay flanking the upper center door imitates the fluted pilaster of an earlier period. Other cabinetmakers, for example John Seymour of Boston, used colorful strips for this effect but completed the design with a small capital, or if using such banding as an abstract motif, made the form into concentric rectangles, giving the narrow ornamentation a sense of completion (Montgomery, *Federal Furniture,* pls. 184, 185). The pediment of this library bookcase is similar to other contemporary examples from New York and New England. In the center a pleasant, unsophisticated fluted urn with handles is crowned with a liberty cap which seems to be suspended from long scrolled foliate streamers. Tiny daisy-like flowers float between the two motifs. Flanking plinths have an inlaid panel, where the design is a simple tall "weeping" stalk emerging from another urn form. This is repeated in reduced form, on the smaller end plinths, and the urn is repeated in silhouette, above, by the finials.

An investigation of the Willing papers did not produce a receipt for this case piece and its twin, but the will and inventory of Richard Willing were quite precise. While tradition had it that they were owned by the more famous Thomas Willing (1731–1821), president of the First Bank of the United States, an extensive inventory, taken by Henry Hollingsworth and Bernard Daklagren in February 1821, room by room, revealed no significant case pieces. Richard was his third son, and Richard's estate papers are complete with dispositions and pedigree of possessions: "The large portrait by C. W. Peale of my honored Father, drawn in 1781, I give according to promise to my daughter Ellen. . . . The print of General Washington, executed in London, from the Portrait by Stuart, was sent out by Lord Lansdowne to my sister Bingham, and she gave it to my Father and he to me, I give to my son Edward" (City Hall, Register of Wills, Will no. 210, 1858). At the bottom of his "Distribution of my Family Plate and other articles amongst my children" is the note: "I give to my son Edward Shippen Willing, in fulfilment of my intention my 2 Bookcases, in my chamber, with all the Books I possess in them."

The attached inventory showed that Richard Willing's house was a Philadelphia type, two large rooms on a floor with an

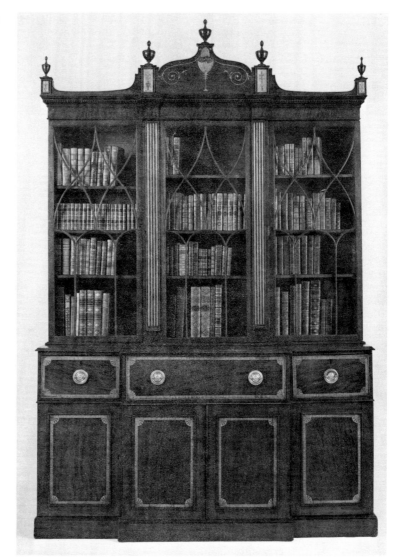

165.

entry hall, three stories high with the second and third floor extending back over a kitchen in what was called "the back building," an ell less than half the width of the front two rooms. The two bookcases and their contents were in the second floor front chamber, along with a high-post bedstead, two mahogany bureaus, a washstand, a breakfast table, a recumbent chair, eight side chairs with cushions, an armchair, a towel rack, a mahogany bedside table, a looking glass, another mahogany chest, three portraits, four canes, a pair of pistols and a gun, two vases and cologne, a gold-headed cane, an engraving of the coronation of Napoleon, a lithograph of "old Mansion," a sword, a dressing case, and a carpet. The books had the highest value, ninety dollars; the cases at thirty dollars equaled the guns. It was an eclectic selection of personal items, quite different from the stylish ensemble of the

parlor list which included a rosewood center table, Parian groups, sofa, divan, and étagère.

Richard Willing married Eliza Moore in 1804; they were listed in Paxton's 1818 directory as living at 42 Pine Street and in McElroy's 1845 directory at 105 South Third Street. Their son, Edward Shippen Willing, who inherited the bookcases, married Alice Barton, daughter of John Rhea Barton, in 1835. One of their daughters, Ava (b. 1870), married John Jacob Astor in 1891 and, after his death, Lord Ribblesdale in 1919. Their son, J. Rhea Barton Willing, the last Willing to own the bookcases, died unmarried in 1913.

BG □

CHARLES-BALTHAZAR-JULIEN FÉVRET DE SAINT-MÉMIN (1770–1852)

Born in 1770 into a Burgundian noble family in Dijon, Charles Févret de Saint-Mémin intended to pursue a military career, and in 1784 entered the École Militaire in Paris. The French Revolution interfered with his plans, however, and in 1790 Saint-Mémin and his family fled to Fribourg, Switzerland, where he lived quietly after serving briefly with the émigré army of the Prince de Condé. In 1793, after all their property in France had been confiscated by the revolutionary regime, Saint-Mémin and his father started for Santo Domingo, where they hoped to retain a sugar plantation that belonged to the family. Taking a roundabout route, they sailed for Canada and proceeded down the Hudson to New York, where they learned that a rebellion in Santo Domingo had made it inadvisable to go farther.

Almost penniless after an abortive effort to support themselves by vegetable gardening, Baron de Saint-Mémin and his son were able to live with John R. Livingston at his house, Mount Pitt, on the East River. An amateur artist, the young Saint-Mémin made drawings of his surroundings in America as he had in Switzerland. One of them, a view from Mount Pitt, was so successful that he was prompted to make a print of it for sale, and for a few years he devoted himself to views and maps.

He soon turned, however, to the more lucrative field of portraiture. Saint-Mémin was aware of the vogue in Paris for portraits taken with the physiognotrace, a device invented by Gilles-Louis Chrétien in 1786 for reproducing on paper the exact profile and features of a sitter, and he concluded that a market for similar work existed in the United States. Over the next fourteen years Saint-Mémin used the device to produce more than eight hundred portraits. His procedure was to make a life-size outline of his sitter with the physiognotrace, filling in details by hand with black and white chalk and sometimes gray wash. Although Saint-Mémin occasionally sold the drawing alone, more often he engraved a small copperplate from it. The life-size drawing, the plate, and twelve prints were available for twenty-five dollars for men, thirty-five for women.

In 1798 Saint-Mémin's mother and one of his sisters came to America and opened a girls' school in Burlington, New Jersey, which served as his headquarters for a number of years. Saint-Mémin spent a good deal of time in nearby Philadelphia and recorded the likenesses of many of the notable government figures. The search for commissions took him to other parts of the country as well, as far south as Charleston and north to Niagara Falls. Despite what appears to have been a considerable success, Saint-Mémin

never regarded art as more than a temporary profession. An album of his prints assembled late in his life is marked "Gagne-pain d'un exilé" ("breadwinner of an exile") (Dijon, Musée, *Charles-Balthazar-Julien Févret de Saint-Mémin, artiste, archéologue, conservateur du Musée de Dijon,* 1965, no. 133).

Although he became an American citizen, he longed to return to France, which he visited from 1810 to 1812 (Philippe Guignard, *Notice historique sur la vie et les travaux de M. Févret de Saint-Mémin,* Dijon, 1853, p. 14). After the restoration of the Bourbons in 1814, he returned to France with his family, joyfully breaking his physiognotrace, the symbol of his forced career as an artist.

Back in his native land, Saint-Mémin was appointed lieutenant colonel by Louis XVIII, and in 1817 he was made curator-director of the museum of Dijon, a somewhat ironic position since that institution housed many works which had belonged to his family before the Revolution. From that time until his death in 1852 he chiefly occupied himself with his duties at the museum, where he wrote catalogues of the collections, purchased many important works, gave paintings from his own collection, and struggled with the problem of inadequate funds—occasionally "de-accessioning" works to provide for the purchase or restoration of others (Dijon, Musée, *Saint-Mémin,* cited above, pp. 13–21).

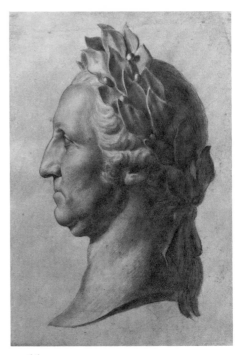

166.

166. *Sculptural Head of George Washington*

c. 1805–10
Inscription: [illegible] (lower right corner)
Black chalk, gray wash, and pencil on pink prepared paper
20 x 14¼″ (50.8 x 36.2 cm)
Private Collection

PROVENANCE: Clarence J. Bement; Hampton L. Carson

LITERATURE: Davis & Harvey, Philadelphia, January 21, 1904, no. 926 (Hampton L. Carson sale); John Hill Morgan and Mantle Fielding, *The Life Portraits of Washington and Their Replicas* (Philadelphia, 1931), p. 417, no. 2; Fillmore Norfleet, *Saint-Mémin in Virginia: Portraits and Biographies* (Richmond, 1942), p. 219, no. 1

SAINT-MÉMIN'S PORTRAIT DRAWINGS made with the physiognotrace are predominantly of black chalk. For the profile outlines, however, he appears to have used a pencil, probably because of the requirements of the machine. In this drawing of a sculptural

head of George Washington, the pencil outline of the profile, eyes, and lips indicates that it was indeed taken by means of the physiognotrace. This profile, however, is not at all similar to Saint-Mémin's drawing of Washington made from life in 1798 (John Hill Morgan and Mantle Fielding, *The Life Portraits of Washington and Their Replicas,* Philadelphia, 1931, p. 416, no. 1, illus. opp. p. 418). This disparity, together with the appearance of the head itself, which here suggests white or gray marble, indicates that Saint-Mémin's model for this drawing was a piece of sculpture.

Rather surprisingly, however, the drawing does not correspond exactly with any known sculptural representation of Washington. Sculptural portraits of Washington with a laurel wreath were modeled by Patience and Joseph Wright and by the Marquise de Bréhan, but Saint-Mémin's drawing resembles none of these. In stylistic terms it is similar to representations of Washington by the French sculptor Jean-Antoine Houdon, and Saint-Mémin as it happens did produce a print based on Houdon's original bust of Washington taken from life and now at Mount Vernon. The drawing, however, though similar in style and in spirit to Houdon's work, varies in small but important details from every extant Houdon portrait of Washington, in none of which is the general wearing a laurel wreath. There were, however, other representations of Washington by Houdon that have since been lost or destroyed (Gustavus A. Eisen, *Por-*

traits of Washington, New York, 1932,
vol. 2, pp. 798–817), and one of them may
have served as Saint-Mémin's model.
Another possibility is that in his drawing
Saint-Mémin altered a known Houdon
sculpture, perhaps in an effort to reflect his
own knowledge of Washington's appear-
ance. The most likely model, if this were the
case, would probably have been Houdon's
full-length sculpture of Washington in the
Capitol at Richmond, which Saint-Mémin
visited in 1805 or 1806 and again in 1807–8
(Fillmore Norfleet, *Saint-Mémin in Vir-
ginia: Portraits and Biographies,* Richmond,
1942, pp. 38–48). All Houdon's images of
the general derive from the sculptor's visit
to Mount Vernon in 1785. Saint-Mémin, on
the other hand, drew Washington in Phila-
delphia in 1798—apparently only once—
when the general was sixty-six, and it is
possible that he consciously altered the fea-
tures of Houdon's image to reflect the older
man he himself had seen, with a more
sharply pointed nose and looser flesh under
the neck.

Stylistically this drawing of Washington
accords best with works done by Saint-
Mémin from 1805 to 1810, which are char-
acterized by an increasing delicacy and
assurance. In fineness of line, the drawing
most resembles Saint-Mémin's superb por-
trait of Jean-Victor Moreau of 1808 in the
Metropolitan Museum of Art, and in tech-
nique it recalls the French academic style of
the late eighteenth century.

Saint-Mémin appears to have had
"lessons" as a young man from François
Devosge (Dijon, Musée, *Saint-Mémin,* cited
above, p. 10), a history painter who orga-
nized an important school of drawing in
Dijon along the lines of the École des
Beaux-Arts in Paris. Under Devosge, Saint-
Mémin's early work very likely consisted of
drawing from casts of antique sculpture, and
the result of his education is apparent in this
drawing made some twenty years later. With
delicate lines of black chalk, Saint-Mémin
beautifully indicates the silvery sheen of light
glancing off marble, creating thereby a
memorable, neoclassical image of Washing-
ton as a noble Roman.

JC □

PARKS BOYD (C. 1771–1819)

Born in Philadelphia, Boyd is first listed
as a pewterer in 1797, four years after he
married Sarah Loudon. He worked at the
trades of pewtering and brassfounding,
producing high-quality objects of excellent
workmanship in Philadelphia at various
addresses until his death.

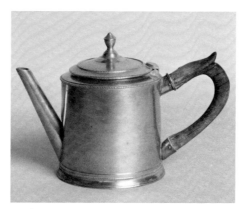

167a.

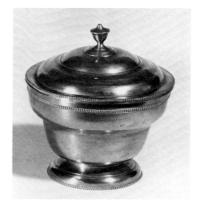

167b.

167a. *Teapot*

1797–1819
Mark: P. BOYD/PHIL^A (in rectangle with
eagle's head in serrated semicircle, inside
bottom)
Pewter, wood
Height 6″ (15.2 cm)
Museum of Fine Arts, Boston

PROVENANCE: James Pennypacker, Reading,
Pennsylvania; Charles Montgomery, Walling-
ford, Connecticut; Mrs. Stephen S. FitzGerald,
Weston, Massachusetts; Museum of Fine Arts

LITERATURE: MFA, *American Pewter,* by
Jonathan Fairbanks (1974), p. 78

167b. *Sugar Bowl*

1797–1819
Pewter
Height 5¼″ (13.3 cm)
The Brooklyn Museum, New York

PROVENANCE: John W. Poole, New York;
Brooklyn Museum

LITERATURE: Brooklyn Museum, *American
Pewter,* by John M. Graham (1949), no. 20,
fig. 8; Charles V. Swain, "Two lids from the
same mold," *Pewter Collectors Club of America
Bulletin,* no. 49 (September 1963), pp. 176–77;
Laughlin, *Pewter,* vol. 1, fig. 199, vol. 2,
pp. 61–63, vol. 3, pp. 145–46; Katherine Ebert,
Collecting American Pewter (New York, 1973),
p. 17

THE USE OF PEWTER was at its height in
America during the eighteenth century.
Watson (*Annals,* vol. 1, p. 204) recalled in
1832 that as little as fifty years earlier
"pewter platters and porringers made to
shine along a 'dresser' were universal" in
American homes. During this period, how-
ever, pewter was experiencing increasing
competition from imported Chinese porce-
lain and newly developed English salt-glazed
stonewares and creamwares, which were
decorative, light in color and weight, as well
as more resistant to breaking than redware
pottery. Parks Boyd entered the pewtering
business at 35 Elfreth's Alley in 1797, just as
his chosen profession was undergoing its
greatest pressure.

About this time a new alloy was developed
by English pewterers and quickly exploited
by Americans. Lauded as a new develop-
ment, Britannia ware was basically pewter
but with the addition of hardening agents
to give a silvery luster. Being harder, it could
be worked thinner and by means other than
casting in molds. Vessels could thus be made
cheaply and quickly by spinning on a lathe,
stamping to shape in a press, or seaming of
sheet metal. This new freedom is reflected
in the teapot and sugar bowl shown here
made by Parks Boyd between 1797 and 1819.
Although both are cast in molds, the teapot
embodies the simplified, straightforward
lines of contemporary silver teapots which
were made by seaming sheet metal, while the
sugar bowl derives its undulating curvilinear
profile in imitation of vessels spun over a
wooden chuck on a lathe. These new tech-
niques saved time and money and, coupled
with competitive merchandising which
began to be applied to pewtering as early
as 1810, infused a new vigor into the sagging
industry, delaying its eventual demise to
about the time of the Civil War.

DF □

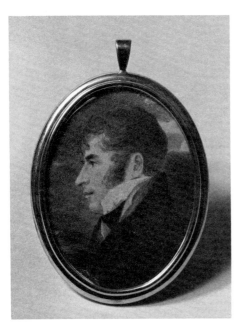

168.

ATTRIBUTED TO WILLIAM BIRCH
(1755–1834)
(See biography preceding no. 149)

168. *Commodore Stephen Decatur*

1806
Watercolor on paper
3⅜ x 2⅝″ (8.5 x 6.6 cm)
Private Collection

PROVENANCE: Stephen and Ann (Pine) Decatur; niece, Mrs. Levi Twiggs (Priscilla Decatur McKnight); Mrs. Frank H. Getchell; daughter, Lillie Shippen Getchell

THE PROFILE PORTRAIT of Stephen Decatur (1779–1820), attributed to William Birch, is executed in the freer technique of watercolor on paper, a technique which seems to have been used more for profile than full-faced miniature portraits. The modeling of the face is achieved with thin washes, while the dress, hair, and background are painted with heavier strokes of color overlaid with very broad hatching. The youthful appearance and the dress date this portrait to the middle of the first decade of the nineteenth century, contemporary with Gilbert Stuart's well-known portrait of Decatur (Independence Park Collection, Philadelphia), done in 1806. The black stock seems to be a carry-over from Decatur's military dress. This portrait may be one of the profiles to which Decatur refers in his letter to William Birch, February 13, 1806: "I will thank you to forward to this place one

of your profiles of me as early as possible" (quoted in Charles Lee Lewis, "Decatur in Portraiture," *Maryland Historical Magazine,* vol. 35, 1940, p. 366).

RB-S □

JOHN DAVEY, SR., AND JOHN DAVEY, JR. (ACT. 1797–1822)

Knowledge about the Daveys as Philadelphia cabinetmakers is scanty, suggesting that they may not have been at work in the city until 1797 when Stafford's directory first lists "John Davie, cabinetmaker," on South Fifth Street between South and Shippen streets. From 1799 to 1801, John Davey, cabinetmaker, was at 114 Shippen Street. Robinson's directory for 1807–11 places Davey on Cox's Alley. Probably the address was 32 Cox's Alley, where John Davey, Jr., was first listed in Kites directory for 1814. From 1816 to 1818, John Davy (no junior or senior noted) appeared at 134 Cedar (South) Street.

John Davey's name does not occur as one of the master cabinetmakers involved with the journeyman's strike in Philadelphia in 1796, nor does he appear as a journeyman. He may have come from London or Baltimore, where cabinetry of this quality and in this style was flourishing. He must have had a thorough apprenticeship in a productive urban shop and a working knowledge of the latest design books such as Hepplewhite's 1788 *Guide,* in which the "secretary drawer," a feature of this secretary bookcase, was first published.

169. *Secretary Bookcase*

1805–10

Inscription: (on small drawers inside writing flap and on bottoms of drawers behind lower doors) John Davey (in pencil, three times); John Davey, Philadelphia (in pencil, three times); John Davey, Maker (in pencil, once); John Davey, Jr. Philadelphia (in pencil, once); John Davey, Jr. (in pencil, once); (in pencil on inside of front section of cornice) C. J. Ewing/Media

Mahogany, mahogany veneers; West Indian satinwood interior, mirror glass
95⅞ x 41⅝ x 22⅜″
(243.5 x 105.7 x 56.8 cm)

The Metropolitan Museum of Art, New York. Purchase 1962, The Fletcher Fund; Rogers Fund; Gift of Mrs. Russell Sage; Gift of George Coe Graves, The Sylmaris Collection, By Exchange

PROVENANCE: Charles J. Ewing, Media, Pennsylvania; with Ginsburg and Levy, New York

LITERATURE: Davidson, *Antiques,* fig. 13

THE REVOLUTIONARY WAR slowed artistic production in most American cities, including Philadelphia. Cabinetmakers and carvers, such as Benjamin Randolph and Hercules Courtenay, sold their tools and equipment and went to war. Quakers remained at work, William Savery for one. Affleck had been deported for the duration, but later continued the styles of the 1760s deep into the post-Revolutionary period. Then, new patrons appeared on the records of the young craftsmen who were setting up shop and promoting new styles known familiarly as Hepplewhite and Federal. Although the styles existed peacefully together, the new craftsmen employed in large shops "unionized," and the older generation, deprived of their patronage, dwindled. Yet it was probably an elder craftsman—Benjamin Randolph—who first hinted at the new style in his now historic lap writing desk made for Thomas Jefferson in 1776. A pacesetter in the neoclassical style, Jefferson's desk may represent its earliest expression in Philadelphia cabinetry.

This secretary bookcase by John Davey, Sr., and Jr., exhibits the degree to which the sophisticated elegance inherent in the neoclassical vocabulary could be carried. Where the earlier eighteenth century secretary desk was a tour de force based on a build-up of three dimensional, often curved, forms, the secretary bookcase in the new style disguises its strength. It was rectilinear in its form and in the design of its surfaces, although curved motifs were often "centered" and became dominant decorative features. Linear decoration achieved with contrasts of line and color delineated form, and disguised mass. Feet were straight bracket or splayed French. Inlay substituted for carving, and projecting pilasters or moldings were minimized in favor of shallow mottled patterns of wood grains enhanced with a high surface sheen.

This secretary bookcase by the Daveys exhibits the best of these characteristics. Storage drawers are hidden behind the doors in the base section; the center "drawer" is a deception which reveals a desk interior when pulled out; and the drawer front falls out and is supported by a curved suspension hinge, thus providing a firm writing surface. The tall oval mirror panels set into the doors of the upper cabinet provide the ultimate in sparkle and reflection. Mirror panels were used much earlier in cabinetwork (see no. 18), but their function within the design may have been secondary to a more pragmatic consideration—to reflect candlelight. In this piece the mirror becomes one of the decorative surfaces, a hard shiny texture handsomely included in the design aesthetic by its attenuated elliptical shape, a climax to the manipulation of the ellipse in the base section. Subtle transitions from the right angles to the central curves were

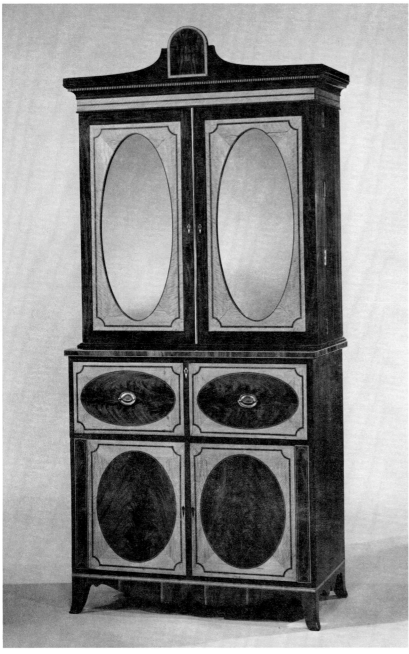

169.

were easily and inexpensively imported. But Philadelphia offered little market for large casework pieces employing showy design or technique, in addition to which the extremes of climate in Philadelphia were unkind to veneers or inlay. Therefore the required skills were probably not "apprenticed" in early Philadelphia and reappear only with a post-Revolutionary commerce which reopened trade and stimulated immigration.

The impact of post-Revolutionary enterprise and investment as well as the appearance of a plethora of English goods held back during the war brought the Adamesque vocabulary into all American cities at about the same time; thus there are many motifs common to all furniture of the period. Regional characteristics did develop, however, and within those, shop specialities, which can now be recognized.

When comparing this piece with the library bookcase made for Richard Willing (no. 165), it becomes clear that Philadelphia patrons continued to vary in their desire for elaboration. This piece may be an early "sample" of what the Davey shop could produce, although the prominence of the signature of Davey, Jr., is unusual if he was still apprenticing when the family arrived, about 1796. The provenance did not provide any clues toward a more precise dating of this secretary bookcase. It was probably made about 1805–10, toward the end of Davey, Jr.'s, apprenticeship.

BG □

170. *Armchair*

1800–1810

Black ash frame, painted gray-white with gilt; twentieth century silk damask upholstery
35¼ x 24¼ x 22½"
(89.5 x 61.6 x 57.2 cm)

Philadelphia Museum of Art. Bequest of Fiske and Marie Kimball. 55–86–3

PROVENANCE: Eliza and Edward Shippen Burd; Burd School for Orphan Girls; American Art Galleries, New York; Fiske and Marie Kimball

LITERATURE: American Art Galleries, "The Historical Shippen-Burd Collection from Philadelphia," March 7, 8, 1921, no. 99 (illus.); Marie G. Kimball, "The Furnishings of Lansdowne, Governor Penn's Country Estate," *Antiques,* vol. 19, no. 6 (June 1931), p. 454 (illus.); Helen Comstock, *American Furniture* (New York, 1962), fig. 420; Dean A. Fales, Jr., *American Painted Furniture 1660–1880* (New York, 1972), fig. 180; Robert Bishop, *Centuries and Styles of the American Chair 1640–1970* (New York, 1972), p. 213 (illus.)

achieved by string inlay and mirror veneering, which take the profile of one and the character of the other. Light-colored woods with shaded graining introduced an undulating surface effect, contributed to color contrast, and suggested softness while providing a surface conducive to holding a high shine. The whole unit is outlined in dark mahogany, carefully and sparingly invaded by light-colored bands at the bottom edge above the skirt, in a fine rounded "string" at the sides where, earlier, a pilaster might have been employed. This is echoed harmoniously by the central decoration in the cornice, a flattened plinth. Overall, this piece is a carefully calculated scheme of alternating colors and shapes, a pastiche of surfaces with emphasis upon a highly polished linear design.

Veneering and inlay were common in fine European and English cabinetry from the Elizabethan period on. Oddly enough there were probably more craftsmen in Philadelphia in 1700 trained to do this specialized work than in 1770. Small veneered objects such as tea caddies, knife boxes, and trays

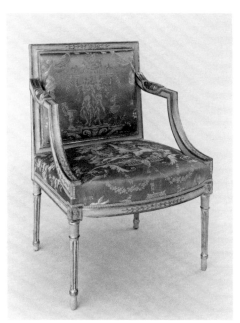

170.

THIS ARMCHAIR is part of a famous set which originally belonged to Edward Shippen Burd of Philadelphia. Its subsequent history has proved to be as interesting if not so important as its aesthetic significance. The set that has survived consists of a large sofa and twelve armchairs. It is a rare example of very sophisticated American painted furniture in the Louis XVI style.

So close is the design to French furniture of the period that when the suite was sold at the American Art Galleries on March 8, 1921, it was identified as of French origin. The tapestry upholstery was, in fact, French, from the Beauvais factory. The suite was catalogued as follows: "The Marie Antoinette Drawing-Room Suite, Louis XVI Period of the Sixteenth Century. Consisting of a large settee and twelve armchairs. The frames carved with branches of laurel leaves and berries tied with looped ribbons, and finished in green and white enamel enhanced with gilding. All of the pieces are upholstered in fine Beauvais tapestry of the period. Woven in colored silks on wool, the designs being classical subjects *en cam* on rose-du-Barry ground, with additional embellishments of trophies, crossed branches of flowers and leaves, festoons and other harmonious designs on a silver-gray ground."

After the auction the suite was returned to Paris where it was thought that a set of royal provenance would be desirable for collectors in France. At the Beauvais factory the tapestry covers were removed and the set was discovered to be of American manufacture, probably because of the use of American

black ash, as well as the construction techniques. The suite was then shipped, without its tapestry covers, to French & Co. in New York. In 1929, Fiske Kimball, director of the Philadelphia Museum of Art, purchased the suite for his own use at Lemon Hill in Fairmount Park. The set came to the Museum in 1955 as part of the bequest of Fiske and Marie Kimball. Since the original Beauvais tapestry covers could not be acquired the chairs were upholstered in an appropriate silk damask in 1958.

Although the chairs have been dated about 1780, such details as the leaf carved in relief on the back of the arms would suggest a later date, probably the first decade of the nineteenth century. Since Edward Shippen Burd married Eliza Howard Simms on August 20, 1810, it seems possible that the set was purchased around that time for their house at the southwest corner of Ninth and Chestnut. Eliza and Edward Shippen Burd were the parents of eight children, all of whom died young, the last one in 1845. Edward Burd never recovered from the loss of his last child and died on September 17, 1849. Mrs. Burd remained in the house, devoting her attention to the church and to works of charity. In 1856 she began to organize what was to become the Burd School for Orphan Girls. She died on April 6, 1860, and left a large sum for the building and endowment of the Burd School at Sixty-third and Market streets. The Louis XVI suite of furniture was left to the school.

The story that this suite belonged to Queen Marie Antoinette possibly developed toward the end of Mrs. Burd's life. The Louis XVI style had been popular in this country in the late eighteenth century. Furniture finished in gold leaf or painted white or gray with gilt was regarded as the highest style. This French taste had been introduced by Thomas Jefferson who, along with James Monroe, John Adams, and others, had acquired French furniture while in France. Washington also bought Louis XVI furniture at the sale of the estate of Marquis de Moustier, the first French minister to the United States.

It is interesting that Louis XVI furniture was being produced by Joseph Barry & Son as late as 1833. According to the Exhibition Committee Report on Cabinet Ware of the Franklin Institute for that year, Barry described a suite of furniture made in his own shop: "The Bargier [bergère] Chair by Messrs.' Barry & Co. covered with the Gabelins Tapestry is a rare specimen of the Stile of furnishing in the reign of Louis XVI, the Tapestry being actually purchased at the sale after the Queen's Death by Gouvernier Morris to furnish a part of the mansion of the late Robert Morris. Mr. Barry, we understand, can furnish the whole set if wanted, Say, 12 chairs with two sofas."

Sheraton's *Appendix* (pl. 6) referred to such chairs as "Drawing Room Chairs." This term and chairs from Sheraton's book were used by Joseph B. Barry & Son for their trade card (see illustration with no. 180). One might be tempted to assign the Shippen Burd chairs to Barry's shop, but there has not been enough evidence to support such an attribution. A similar chair bearing the label of Ephraim Haines is owned privately, and other Philadelphia shops could have produced this set as well.

DH □

ALEXANDER LAWSON (1773–1846)

Young America's first great line engraver, Alexander Lawson, was born to a farm family in the village of Ravenstruthers, Lanarkshire, Scotland. Orphaned at fifteen, he went to work for his brother, a merchant in Liverpool. In spite of formidable opposition from his brother, young Alexander pursued his love for art. He haunted bookshops and printsellers' establishments hungrily absorbing information from illustrated books and single prints. Although painting and watercolor drawing were the rage of the English art world, Lawson preferred engravings.

Determined to become an engraver, he began to train himself, scratching designs into a smooth copper coin with a penknife. He had a blacksmith make a copy of a graver from an illustration in a book and he proceeded to engrave practice scrolls and wreaths on the beer mugs of friends. Enamored of the French engraving style, he resolved in the early 1790s to go to France to study, but the French Revolution prevented direct travel between the two countries. A circuitous route to France by way of America was possible, and he embarked early in 1794, arriving in Baltimore in May.

Lawson quickly moved on to Philadelphia, gave up his dream of France, applied for his naturalization certificate, and secured employment with the firm of James Thackara and John Vallance who were at work on the plates for Thomas Dobson's *Encyclopaedia* (no. 148). He stayed with Thackara and Vallance for two years, honing his engraving skills and studying drawing in his spare hours. In 1796, he felt confident enough to strike out on his own.

Lawson's first major independent works were four plates for Stafford's edition of James Thomson's *The Seasons,* printed by W. W. Woodward in 1797. These few plates established Lawson's reputation, and he was selected by Dobson to execute the plates for the supplemental volumes of his *Encyclopaedia* (1800–1803). For a short period, he

was in partnership with J. J. Barralet (see biography preceding no. 194). But Lawson was too much of a perfectionist to work long with anyone. In describing his two years with Thackara and Vallance, Lawson displayed the high standards he demanded of himself and others:

> They thought themselves artists . . . and yet their art consisted in copying, in a dry, stiff manner with the graver, the plates for the Encyclopaedia, all their attempts at etching having miscarried. The rest of their time, and that of all others at this period, was employed to engrave card-plates, with a festoon of wretched flowers and bad writing—then there was engraving on type metal—silver plate—watches—door-plates—dog-collars and silver buttons, with an attempt at seal-cutting. Such was the state of engraving in 1794. (Dunlap, *History,* vol. 2, pp. 123–24)

This intense love for his craft and art led him, when economically possible, to spurn work that did not interest him. His greatest achievement, the plates for Alexander Wilson's *American Ornithology* and Charles Lucien Bonaparte's *American Ornithology . . . not Given by Wilson* (4 vols., 1825–33), were labors of love which repaid him only in reputation and a sense of personal satisfaction. George Ord (1781–1866), a friend and companion of Alexander Wilson and collaborator with Lawson on a number of natural history projects, stated that after seeing his work on the third volume of Bonaparte's *American Ornithology,* the naturalists of London had declared to a man that "such work could not be produced in England." Writing from Italy in July 1830, Bonaparte added further accolades: "Were you to hear what all the Italian artists are saying of your engravings . . . it is then you would be really proud" (Townsend Ward, "Alexander Lawson," *PMHB,* vol. 28, no. 2, April 1904, pp. 207–8).

In spite of the increasing demand for his work and critical praise, Lawson steadfastly refused to take on pupils other than his son and one of his two daughters. He wisely foresaw that engraving would be a thankless and underpaid art in America for many years and that only those with his own qualities of self-denial and enthusiasm would succeed.

Lawson was unusually diligent in his work habits, reworking over a plate until it met his rigid standards. He formed only one lasting friendship with another artist, John Lewis Krimmel (see biography preceeding no. 204), for whom he was both guide and patron. Lawson left unfinished at his death a massive engraving, 25 by 16 inches, of Krimmel's painting *Election Day in Philadelphia,* on which he had worked

over two years. Even lacking a few finishing touches, it was a masterpiece of intricate detail.

Lawson's successful career was somehow a lonely one. As a perfectionist, dedicated to quality, he was an exception among his more pragmatic American peers.

GEORGE MURRAY (ACT. C. 1796–1822)

Born in Scotland, Murray was a pupil of the celebrated English engraver Anker Smith. He was still working in London in 1796, but before the turn of the century, he immigrated to the United States, settling in the southern states. He appeared in Philadelphia in 1800, but little else is known of the first years of his American career.

By 1810 he had become prominent in the Philadelphia Society of Artists and was beginning to organize the engraving firm of Murray, Draper, Fairman & Co., specializing in banknote and commercial engraving. Murray's noncommercial efforts were line engravings of landscapes and animals, and a few undistinguished portraits. Two plates of birds grace the pages of Alexander Wilson's *American Ornithology.*

His financial affairs may have been adversely affected by reckless real estate speculations, but he continued in his successful commercial engraving partnership until his death (Stauffer, vol. 1, pp. 186–87; Groce and Wallace, p. 462).

JOHN G. WARNICKE (ACT. 1811–18)

John G. Warnicke (or Warnick), an engraver specializing in stipple work whose origins and early training are unknown, began working in Philadelphia in 1811 and continued until his death in 1818. The great body of his work has largely escaped notice, although Stauffer considered his stipple engraving of Benjamin Franklin an excellent piece of work. Perhaps his fine contribution to Alexander Wilson's *American Ornithology* (vols. 5–9) will prompt further scholarly attention (Groce and Wallace, p. 662).

ALEXANDER WILSON (1766–1813)

Born in the Seed Hills of Paisley, in Refrewshire, Scotland, Alexander Wilson was the third child of Alexander or Saunders Wilson, reformed smuggler turned successful weaver, and Mary M'Nab, a graceful woman from the village of Row, some twenty miles from Paisley. Young Alexander was precocious and his parents, hoping he

would be another Reverend John Witherspoon, sent him to the Paisley Grammar School. But he found the disputational tutorials of a young divinity student boring and confusing and displayed little interest in his "professional" education.

The year 1776 marked the beginning of a long decline for the Wilson family. Changes in fashion, the loss of much of the Colonial market caused by the American Revolution, and the birth of the power loom combined to depress the artisan weaving industry in Paisley, forcing Saunders Wilson to return to smuggling. Alexander's mother died of tuberculosis just before his tenth birthday. Within a fortnight his father had remarried and the family's rapid increase in size meant the end of Alexander's formal education. His father was often away smuggling or in prison, and it fell to Alexander to provide the family's food by poaching, an occupation which sharpened skills he would later use to acquire the specimens for his *American Ornithology.*

Alexander went to work, first as a herd boy and then as a weaver. Barely thirteen when apprenticed, he seemed to thrive in such a difficult environment, becoming the model independent artisan—healthy, sober, and self-motivated. His habit of reading at the loom and composing poems as he worked made him a local curiosity. He formed a circle of poetasters, and while still a weaver, published several poems anonymously in local newspapers. Following a second depression in the weaving industry, Wilson became an itinerant peddler, tramping central Scotland writing poems with greater success than selling his wares. One of his anonymous poems was well received and attributed by critics to Robert Burns, Wilson's idol. His appetite whetted by the comparison, he published a volume of poems under his own name, but it did not bring him financial success or the public attention he so ardently desired.

A literary failure, depressed by poverty, and deep in legal difficulties (including a brief term in prison) caused by a satirical attack on a powerful merchant, Wilson spurned the Old World for the New. With a nephew, William Duncan, he embarked for America on May 23, 1794. Practically penniless and forced to sleep on the open deck, he reached New Castle, Delaware, in July and walked the thirty-three miles to Philadelphia, marveling at the scenery and the variety of birds along the way. Upon his arrival, Wilson found that the financial rewards for the weaving trade were as meager in the Quaker city as they had been in his native country.

But with his seemingly innate capacity to bounce back, the largely self-educated Wilson obtained a job as a country school-

master, a profession he pursued for the next ten years in central New Jersey and eastern Pennsylvania. During this period he published in local newspapers a number of poems which were distinguished by their love of nature and descriptive passages of natural wonders. In 1801, Wilson delivered a public oration at Milestown, Pennsylvania, which revealed him to be, like many recent immigrants, an ardent Jeffersonian Republican (Alexander Wilson, *Oration on the Power and Value of National Liberty,* Philadelphia, 1801).

By good fortune, in February 1802, Wilson became master of the school at Gray's Ferry on the Schuylkill, below Philadelphia; this move made him a neighbor of William Bartram, the naturalist. A man of wide experience and education, Bartram soon became friend, patron, and intellectual father to the engaging Scotsman. Wilson was allowed free access to Bartram's personal library where he became acquainted with the great works of American natural history. It was Bartram's influence which made Wilson transform his amorphous love of the wild into the careful study of birds. His visits with Bartram also seemed to dispel for a time the fog of melancholy which surrounded Wilson. At Bartram's, Wilson was able to forget about his poverty and the drudgery of teaching school by studying the birds of the surrounding countryside.

Still Wilson was despondent, for he felt unable to record completely with words his ornithological observations. According to William Dunlap, it was another friend and fellow countryman, the engraver Aexander Lawson, who coaxed Wilson into drawing as a means of relieving his troubled spirits (Dunlap, *History,* vol. 2, pp. 191–92). But it is a myth that Lawson was responsible for the emergence of Wilson's artistic ability; Wilson had done watercolor sketches of animals and birds while still in Paisley; thus it is likely that Lawson merely redirected Wilson's attention to his former pastime and instructed him in advanced techniques. Suddenly possessed with a mission and a method, Wilson flung himself into drawing birds from both live and stuffed specimens.

Wilson read about the species of birds he was drawing and observing in the books in Bartram's collection and those which his friend procured for him from the Library Company of Philadelphia, and soon Wilson found himself correcting various authors' opinions. These corrections became so numerous that Wilson resolved to collect, draw, and describe accurately all the birds of America with the intention of publishing the results. Everyone doubted the possibility of such an undertaking, but Wilson was not a man to let natural or man-made obstacles stand in his way; his fifty-one-day walk to Niagara Falls and back in the fall of 1804

testified to this. *The Foresters,* Wilson's greatest poetic celebration of nature, resulted from this trek and was published in 1805, to warm reviews, in Joseph Dennie's magazine *The Port Folio.*

Still relatively poor and feeling oppressed by his teaching duties, Wilson was once again growing despondent when Samuel F. Bradford hired him on April 1, 1806, as an assistant editor for his projected edition of Abraham Rees's *Cyclopedia.* Wilson could now sustain himself and work on his "birds" to the detriment of neither. When Bradford finally was persuaded to become the publisher of his "bird book," it was as if Wilson had been storing energy in some secret reserve for just this moment: he worked at such a furious pace that even the industrious Lawson was put to shame. Now securing subscribers in far-off New Orleans, now writing a descriptive text which blended poetry and science—Wilson seemed to do everything and to be everywhere at once. In the lulls between volumes he undertook arduous journeys to gather specimens for his sketches. Between the publication of volumes 2 and 3 he struck out for Pittsburgh, and then made his way down the Ohio and Mississippi rivers by skiff and horseback to Natchez and New Orleans, observing and collecting specimens and subscribers as he traveled. The geographical and physical difficulties of his many expeditions defy adequate description, surpassing in ten years the thirty years of effort by J. J. Audubon (see no. 272). Suddenly while he was at work on volumes 8 and 9, having tricked death many times, Wilson fell ill with severe dysentery. Weakened by overwork, he died within a few days on August 23, 1813. His friend George Ord finished assembling volumes 8 and 9, which were published in 1814.

Alexander Wilson never enjoyed financial gain from this work, and only during the last few years of his life did the long-awaited fame he sought begin to be his. The American Philosophical Society, the Academy of Natural Sciences of Philadelphia, and the Columbian Society of Artists honored him with election to membership. But the man who made American ornithology a science remained unknown even to his few close friends, obscured by the monument to birds and nature he had created. Upon his death it was discovered that Alexander Wilson's personal library consisted of but one volume, and that he had left everything, including the rights to the *American Ornithology,* to Sara Miller, a woman he had intended to marry, but had never felt worthy of nor financially secure enough to ask.

171a. *Robin (Turdus Migratorius)*

c. 1804–7

Study for pl. 2, fig. 2, of *American Ornithology,* vol. 1

Pencil, ink, and watercolor on wove paper, mounted on late nineteenth century wove paper

7½ x 10″ (19 x 25.4 cm)

Historical Society of Pennsylvania, Philadelphia

PROVENANCE: Ferdinand J. Dreer, mid-nineteenth century

ALEXANDER LAWSON, GEORGE MURRAY, BENJAMIN TANNER (SEE BIOGRAPHY PRECEDING NO. 194), AND JOHN G. WARNICKE AFTER ALEXANDER WILSON

171b. *American Ornithology*

1808–14

Title page: American Ornithology; or, The Natural History of the Birds of the United States: Illustrated With Plates Engraved and Colored from Original Drawings taken from Nature. By Alexander Wilson. Vol. IV. Philadelphia: Published by Bradford and Inskeep. Printed by R. and W. Carr. 1811.

Printed and engraved book; watercolors and varnish

Wove paper from Thomas Amies's mill; modern library buckram

13⅜ x 10¼ x 9/16″ (34 x 26 x 1.4 cm)

Free Library of Philadelphia

PROVENANCE: Francis T. Sully Darley (1833–1914)

LITERATURE: [Review], *The Medical Repository,* 2d series, vol. 6, no. 12 (August–October 1808), pp. 155–62; [Review], *The Port Folio,* 3d series, vol. 8, no. 1 (July 1812), pp. 1–16; Dunlap, *History,* vol. 2, pp. 336–53; Tom Taylor, ed., *Autobiographical Recollections by the Late Charles Robert Leslie, R.A.* (London, 1860), vol. 1, pp. 245–48; Alexander B. Grosart, ed., *The Poems and Literary Prose of Alexander Wilson, The American Ornithologist,* 2 vols. (Paisley, Scotland, 1876); Frank L. Burns, "Alexander Wilson, IV: The Making of the American Ornithology," *The Wilson Bulletin,* n.s., vol. 20, no. 4 (December 1908), pp. 165–85; Frank L. Burns, "Alexander Wilson, VII: Biographies, Portraits and a Bibliography of the Various Editions of His Works," *The Wilson Bulletin,* n.s., vol. 21, no. 4 (December 1909), pp. 169–86; Lawrence C. Wroth, *Typographic Heritage* (New York, 1949), pp. 44–45; Robert

171a.

Cantwell, *Alexander Wilson, Naturalist and Pioneer* (Philadelphia and New York, 1961), throughout; Darrell Hyder, "Fine Printing in Philadelphia 1780–1820," M.A. thesis, University of Delaware, 1961; Darrell Hyder, "Philadelphia Fine Printing 1780–1820," *Printing and Graphic Arts,* vol. 9, no. 3 (September 1961), pp. 69–99; Charles B. Wood III, "Prints and Scientific Illustration in America," in John D. Morse, ed., *Prints in and of America to 1850* (Charlottesville, 1970), pp. 161–91

RECENT CRITICAL OPINION has not been kind to America's first illustrated masterpiece, Alexander Wilson's *American Ornithology.* Darrell Hyder dubbed Wilson "no artist" and said that Alexander Lawson's plates "are soon dismissed" ("Philadelphia Fine Printing 1780–1820," *Printing and Graphic Arts,* vol. 9, no. 3, September 1961, p. 88). An earlier commentator, Donald C. Peattie, characterized Wilson's drawing as "frequently childish and wretched" and chided Lawson's engravings as "only passable throughout, and the water-coloring [was] like something done by a child." Admitting that there were some worthy drawings, Peattie still maintained that overall Wilson's birds were "flat, two dimensional, and all too obviously dead" (Donald Culross Peattie, *Green Laurels,* New York, 1938, p. 229). Other twentieth century critics have been somewhat kinder, but generally Alexander Wilson's achievement has dimmed in their eyes.

His contemporaries were of a different opinion. *The Port Folio* magazine, a cultural arbiter of the period, gave the consensus of opinion in its review of the first five volumes: "With respect to the mere mechanical execution, this work stands, we believe, at the very head of all that has yet appeared in America: and, with the exception of the

great work of Bewick, has scarcely an equal among the Ornithological publications of England. . . . These traits are transmitted with equal elegance by the engravers; and the paper, the type and everything connected with the impression, reflects the highest honour on those concerned in it" (*The Port Folio,* 3d series, vol. 8, July 1812, p. 2).

There was but one sour note in the entire litany of praise—*The Port Folio* was not fond of Wilson's enthusiastically lyrical descriptive prose (and poetry) in the accompanying text. They would have preferred him to provide the information on bird life in a more methodical and less discursive manner to facilitate the comparison of various species.

Yet it was precisely this blend of enthusiasm with scientific observation in the text which attracted Wilson's contemporaries, for his purpose was to animate people to re-examine the natural order of the world around them—which they took largely for granted—in a new, more scientific manner. And judged against the full-blown romantic reveries with which the works of later nineteenth century naturalists (including Audubon) were filled, Wilson's literary excesses seem tame.

In addition the obstacles that Wilson had to overcome to turn his dream into reality required him to be visionary, romantic, fanatic, and drudge all in one. Only a fanatic would have continued in the face of the reactions he received to his first volume. When on a canvassing trip to drum up subscribers he called on Daniel D. Tompkins, the new governor of New York, and like Wilson a firm Jeffersonian Republican. Instead of a warm reception from a "political brother" he was curtly given the boot by Tompkins who added, "I would not give you a hundred dollars for all the birds you intend to describe, even had I them alive" (Robert Cantwell, *Alexander Wilson, Naturalist and Pioneer,* Philadelphia and New York, 1961, p. 162).

Even those "first literary characters in the eastern section of the United States," whose expectations of the book had been exceeded and who admired and respected the planned work, had an objection. They caviled about the price, while admitting the book's beauty and importance. Wilson was discouraged enough to write from Boston to a friend on October 10, 1808, "If I have been mistaken in publishing a work too good for the country, it is a fault not likely to be soon repeated and will pretty severely correct itself," but added quickly, "I shall not sit down with folded hands, whilst anything can be done to carry my point: since God helps them who help themselves" (Alexander B. Grosart, ed., *The Poems and Literary Prose of Alexander Wilson, The American Ornithologist,* Paisley,

Scotland, 1876, vol. 1, p. 143). Help himself he did, traveling over 15,000 miles in all, scattering 2,500 prospectuses as he went. Largely by his own personal efforts, Wilson secured enough subscribers to keep the project going. In this process he created a market which other American naturalists would tap, though not without problems of their own. But thanks to Wilson, selling an expensive illustrated scientific work would never again be so difficult.

Before Wilson encountered these obstacles, he had to overcome the skepticism of those who would eventually become warm friends and fellow laborers on the project. When he first broached his idea to his friend and fellow countryman Alexander Lawson on March 12, 1804, the engraver thought him mad. The sheer cost of the idea was preposterous to Lawson: raw copper for a single engraved plate was $5.66, engraving it was $50 to $80, and coloring would add another $.25 to the cost of each printed impression, or $12,500 for a printing of 500 copies. If Wilson drew 100 birds (half of the number William Bartram then thought native to America) the total cost for the plates alone would be approximately $20,000. Assuming Wilson planned to issue the work in parts with 10 plates to a part, the cost for an edition of 500, including paper, printing, type, and other incidentals would be $12 a part or $6,000 total costs for that one part. A reasonably good ship could be had for that amount but a book— no only a portion of a book—could not sell for $12 in a land where the biggest sellers were the Bible, the almanac, and cheap English novels. Surely the man must be mad!

Lawson also had harsh words for his friend's drawings, which he thought awkward. Lawson may be forgiven his initial reaction, for by 1804, Wilson had not been drawing in a concerted way very long, and had chosen to attempt the most difficult of all subjects, birds. In addition, Wilson's teaching duties forced him to sketch only at night by flickering candlelight and, except for Lawson's own few lessons, Wilson was self-taught.

By 1806, Wilson's drawing had improved greatly. The salary of $900 a year for his new editorial position and the free time he began to enjoy revived his ornithology project. He began work by persuading his employer to become the publisher of his *American Ornithology.* Wilson could not have made a better choice than Samuel F. Bradford, for the plump, sociable, and ambitious Bradford was changing the direction of his firm from political to literary and artistic publications and buying up rival printing firms at a pace that made him one of the most powerful publishers in the United States. Bradford, for his part,

171b.

perceived in Wilson a man capable of accomplishing whatever he set his mind to do and resolved to make Wilson's *Ornithology* the most beautiful book printed in America. Nonetheless, when the actual agreement to publish was made with Wilson, Bradford made as sharp and careful a bargain as any Yankee: his firm, Bradford and Inskeep, agreed to publish the first volume and would continue with the project only if Wilson personally could secure two hundred subscribers. The price per volume was to be twelve dollars!

With a publisher secured, Wilson became a whirlwind of activity. He began simultaneously to edit Rees's *Cyclopedia* and to write and draw for his *Ornithology*. Wilson had already tried his hand at etching in November 1805 but was dissatisfied with the result. Still he thought that he would do everything for his *Ornithology* short of pulling the press himself. It appears from his letters that early in 1806 he engraved and etched versions of the first two plates, probably intended for the prospectus. However, in a letter to William Bartram dated April 8, 1807, enclosing a copy of the printed portion of the prospectus, Wilson stated that Alexander Lawson would have one of the plates completely finished that afternoon and that as soon as copies were printed he would send him one. Therefore, although many authorities have repeated George

Ord's assertion that the two plates Wilson engraved and etched in 1805–6 were used in volume 1, it is likely that they were not. Copies of Wilson's plates have survived but so far as can be determined none was bound into a copy of the first volume at the time of issue. It is possible that Lawson took these plates and retouched them, adding his name to the plate as the engraver after Wilson had printed a number of trial impressions for himself, but this is not certain.

The same letter to Bartram contained a startling assertion: "I am going to set the copper-plate printer at work to print each bird in its natural colours, which will be a great advantage in colouring, as the black ink will not then stain the fine tints" (Grosart, cited above, vol. 1, p. 140). What exactly Wilson meant by this statement is not clear, but he was too knowledgeable for it to have been an idle remark. Perhaps he tried some form of aquatinting in basic colors or of tinting the printing ink to make it less overpowering and failed. Whatever Wilson did, no trace of any method of actual color printing of the plates for his *American Ornithology* has been discovered.

The technique used in the plates was a combination of engraving and etching with watercolors and varnish applied after the basic image was printed in black ink. Wilson

was dissatisfied with the work of only one of his engravers, George Murray, and allowed him to execute but two plates for volume 1. But his admiration knew no bounds for the work of Tanner, Warnicke, and in particular Lawson: he praised them in general in the introduction to volume 1 (1808) and by name in the preface to volume 5 (1812).

Wilson was also pleased, and with good reason, with the materials which Bradford and Inskeep, his publisher, were using for his work. "No expense," Bradford had said, and so it was. As a matter of national pride the best American materials were to be used for what all concerned thought would be our first printed masterpiece. The printers Robert and William Carr used the newest and finest transitional typeface (later named "Oxford") from the Philadelphia foundry of Binny and Ronaldson (see no. 197). The text was set in great primer roman, a size well suited to the area of the page, and great care was taken that it be composed with few errors, well inked, and firmly and evenly impressed. The result was the equal of William Bulmer's and Thomas Bensley's London "éditions de luxe." At a time when most of the paper used in good American printing was still imported, Wilson and Bradford chose a fine heavy wove paper from Thomas Amies's mill in Montgomery County, Lower Merion Township, Pennsylvania. Amies carried the nationalism of the work to an extreme by declaring that he would use only American rags in making Wilson's paper. All of this care taken on the mechanical components of the books was well worth it, for even those modern critics contemptuous of the plates (including Darrell Hyder) have praised the "look of the book."

If there was one problem area for Wilson in obtaining native materials, it was in the colors used for the plates. He admitted as much in the preface to volume 2 (pp. vi–vii). It was "not without regret and mortification," he confessed, that for colors he was "principally indebted to Europe." But he added, "In the present volume, some beautiful native ochres have been introduced; and one of the richest yellows is from the laboratory of Messrs. Peale and Son, of the Museum of this city [Philadelphia]. Other tints of equal excellence are confidently expected from the same quarter."

But his confidence was misplaced, for throughout the entire first edition, even the portion completed after his death, there remained a problem with the coloring. In spite of all Wilson's precautions—providing live and stuffed specimens as well as his own ink and watercolor sketches to guide the colorists—and Lawson's best supervisory efforts, a great deal of variation in the color values and precision of color application

occurs in different copies of the first edition. Perhaps it was Thomas Amies's jingoistic use of American rags, or Rembrandt Peale's homemade colors, or the use of young, inexperienced colorists, or residual acid from the etching process, or the sulfuric atmosphere of our own century which caused the images of the first edition's plates to offset so consistently onto the facing page of text and for certain colors, notably the reds and browns, to transfer almost totally in some cases to the facing page. Although the overall quality of the plates in surviving copies improved in the later volumes (probably because Wilson had lost most of his colorists and was performing this chore himself), it is clear that the subtle beauty and scientific accuracy of Wilson's watercolor sketches were impossible to capture exactly, given the technical limitations of American reproductive artistry. It is doubtful that the delicate shadings of his watercolors (for example the reds of the Robin's breast feathers in Wilson's exhibited sketch) and the minute detail—Wilson counted the scales on the Robin's legs—which he incorporated into all of his original drawings could have been duplicated by any reproductive technique then extant or by any engraver then active.

Charles Robert Leslie, the English painter who as an apprentice to Samuel F. Bradford had colored many of the plates and who knew the capabilities of the age's multiplying arts, stated that although Wilson's *Ornithology* "may have been equalled in typography, it has not before or since been equalled in its matter or its plates. Bewick comes nearest to it; but . . . his figures, admirably characteristic and complete as they are in form, have not the advantage of the much larger scale of Wilson's, or of colour" (Tom Taylor, ed., *Autobiographical Recollections by the Late Charles Robert Leslie, R. A.,* London, 1860, vol. 1, p. 247). It may be that the only possible answer to the modern critics of Wilson's plates is that to judge them one would have had to have seen them before the destructive elements inherent in book production could wreak their havoc. But enough of the original beauty survives in such plates as the *Snow Owl* to more than satisfy the critical eye.

Wilson's own answer to the critics of his work, were he alive today, would probably be that nature herself was the only medium capable of rendering absolute truth. What he was attempting was as scientifically accurate a facsimile as it was possible for mortal man to achieve. To which we can only add that, for pure "art" in American ornithology, one must turn to John James Audubon, but for the first synthesis of science and art in America one must come to Alexander Wilson's *American Ornithology*.

GM □

172.

172. *Wedding Dress*

1809
Silver-gray silk satin
Waist 27½″ (69.8 cm); center back length 51″ (129.5 cm)

Philadelphia Museum of Art. Bequest of Lydia Thompson Morris. 32-45-61

PROVENANCE: Lydia (Poultney) Thompson, 1809; descended to granddaughter, Lydia Thompson Morris

WHEN THE EMPIRE STYLE became popular in Philadelphia early in the nineteenth century (see no. 159), some Quakers also discarded their old-fashioned dress and turned to this style, although much more modestly. In 1809, when Lydia Poultney married James B. Thompson, she wore this simple, stylish dress of lovely silver-gray satin made of the finest silk. True to Quaker form, however, the dress is devoid of trim or adornment, or even the smallest ruffle, but it is beautiful in its plainness and simplicity. In Empire fashion, the dress is cut with a short bodice, gathered directly under the bustline. The neckline is square, and the sleeves are short and puffed. The long straight skirt is slim, its slightly flared hem extending into a short train in back.

EMcG □

EPHRAIM HAINES (1775–1837)

Born a Quaker in Burlington County, New Jersey, Ephraim Haines was apprenticed to the Philadelphia cabinetmaker Daniel Trotter in 1791. Eight years later, Haines married Trotter's daughter, Elizabeth. When Trotter died in 1800, Haines inherited his business and likewise the patronage of Stephen Girard, formerly one of Trotter's most important customers.

While he worked for Girard, Haines made both expensive and inexpensive furniture for him and undertook repairs. The largest and most costly commission, however, was a set of ebony parlor furniture which included nineteen pieces in all. Girard furnished the ebony from his own warehouses and Haines organized the group of specialized craftsmen who made the set. Haines was the designer and overseer of this project, but he did not participate in the actual making of the furniture.

Shortly after the ebony parlor set was finished, Haines began to concentrate on selling lumber. He specialized in rare and "valuable wood, supplying mahoganies to other cabinetmakers and to builders" (Carson, "Connelly and Haines," p. 391). On the basis of the inventory taken at Haines's death, one can assume that his lumber business was a lucrative one. His household items were valued at $1,429.25, and his total assets, including cash, stocks, and real estate, amounted to $42,656.97.

HENRY CONNELLY (1770–1826)

Little is known of Henry Connelly before he opened a cabinetmaking shop at 16 Chestnut Street. His well-known label, engraved by John Draper and Company, was first used between 1800 and 1802 when he worked on Chestnut Street (Carson, "Connelly and Haines," illus. cover). When he moved to 44 Spruce Street, Connelly had printed a second version of his label, an example of which can be seen on a sideboard now at the Philadelphia Museum of Art (Carson, "Connelly and Haines," p. 37). During his most productive years as a cabinetmaker, Connelly worked at 72 South Fourth Street.

It was during those years that Connelly was employed by Stephen Girard, the man to whom Connelly's brother was apprenticed. Connelly became the primary cabinetmaker for Girard, a position Ephraim Haines had previously filled. From 1808 to 1821, Connelly made, mended, and reupholstered furniture for Girard. Although Girard did not need much furniture for himself in his later years, he commissioned Connelly to make furniture for him to give

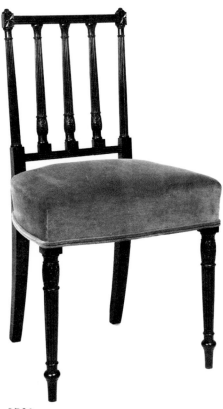

173a.

UNKNOWN MAKER

173b. *Armchair*

c. 1805–15
Mahogany; twentieth century upholstery
34⅜ x 22½ x 20¼" (87.3 x 57.1 x
51.4 cm)
Henry P. McIlhenny, Philadelphia

LITERATURE: Carson, "Connelly and Haines,"
no. 53

HENRY CONNELLY

173c. *Card Table*

1817
Mahogany; eastern white pine
30 x 36⅜ x 19½" (76.2 x 92.3 x 45.9 cm)
Girard College, Philadelphia. Stephen
Girard Collection

PROVENANCE: Stephen Girard, 1807; Girard
College, 1831

LITERATURE: Carson, "Connelly and Haines,"
no. 3, illus. p. 40; "The Editor's Attic,"
Antiques, vol. 33, no. 1 (January 1938),
pp. 11–12

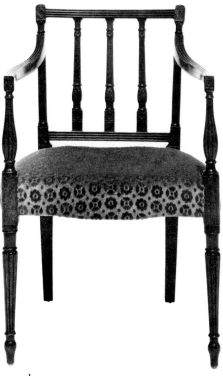

173b.

as presents, such as the set of furniture for Miss Deborah Kenton, one of the girls who was in Girard's household.

Connelly also worked for other Philadelphians, including the banker Henry Hollingsworth and such merchants as Richard Ashurst and Charles Graff. In 1823, Connelly retired from business. A year before he died, he was listed in the directories as a gentleman, indicating that his retirement was a comfortable one. His business had been profitable; when he died, his household furniture was valued at $1,213.25.

The lives of Connelly and Haines are well documented in an unpublished paper by Wendy Wick, University of Delaware, 1974.

EPHRAIM HAINES

173a. *Side Chair*

1806–7
Ebony; ash and pine; twentieth century red velvet upholstery
35¾ x 20⅜ x 18" (90.8 x 51.7 x 45.7 cm)
Girard College, Philadelphia. Stephen
Girard Collection

PROVENANCE: Stephen Girard, 1807; Girard
College, 1831

LITERATURE: Carson, "Connelly and Haines,"
no. 36; "The Editor's Attic," *Antiques,*
vol. 33, no. 1 (January 1938), pp. 11–12

THE NAMES Henry Connelly and Ephraim Haines have been linked since the 1935 exhibition at the Philadelphia Museum when two chairs made by Haines were shown. Before that time, Connelly had been credited with those characteristics which are now attributed to a Haines-Connelly "school" ("The Editor's Attic," *Antiques,* vol. 33, no. 1, January 1938, pp. 11–12).

There is no question as to the craftsmen responsible for the ebony side chair (173a) made for Stephen Girard between 1806 and 1807. One of ten such chairs, it is part of a set for which bills of sale exist, the final bill of sale for the side chair being November 21, 1807. The set also included two armchairs, a sofa, two pier tables, and four stools. Girard ordered the set from Ephraim Haines who, in turn, hired specialized craftsmen to do the work. The legs of the chairs, for instance, were turned by Barney Schumo, and were carved by John Morris, at a cost of $4.25 for each chair. The fact that ebony is a particularly hard wood may explain the high cost.

The Girard furniture serves as a basis for many attributions to Haines. The mahogany armchair (173b) bears a particularly close resemblance to the ebony side chairs made for Stephen Girard. Specifically, the bulb foot, the thin, tapered, reeded legs, and the character of the carving relate to the Girard chairs. But the fact that Haines employed

many other craftsmen to carry out Girard's order undermines any attempt to attribute a piece of furniture to him on the basis of the Girard set since the same specialists probably worked for other shops.

The dolphin pedestal card table (173c), one of a pair, was made by Henry Connelly for Stephen Girard in 1817 at a cost of $45. According to Wendy Wick, it is likely that the tables were made as a wedding present for Girard's favorite niece, Henriette, since Connelly's bill to Girard for the tables was dated on the day of her marriage (October 17, 1817). Since these tables remain in the Girard College collection, one could assume that they were either returned to Girard sometime after the wedding or were not taken by the young couple at all.

When the tables are open, the tops show an eighteen-rayed, figured mahogany veneer. The richness of the carving and the use of inlaid cross-banding on the bases are exceptional features of these tables.

PT □

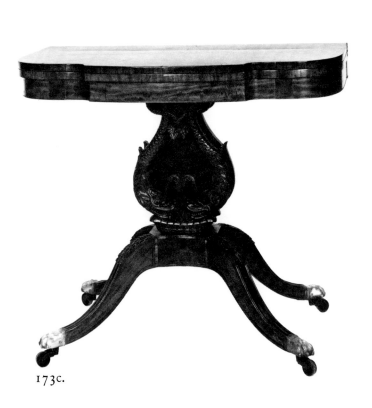

173c.

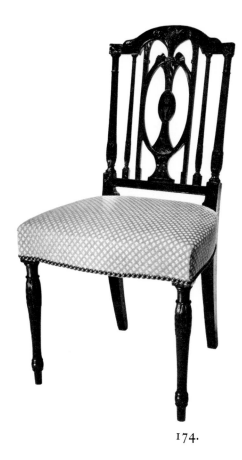

174.

174. *Side Chair*

c. 1800–1810

Mahogany; black ash seat rails and corner blocks; marquetry; twentieth century upholstery

36 x 18¼ x 17″ (91.4 x 46.4 x 43.2 cm)

Mr. and Mrs. George M. Kaufman, Norfolk, Virginia

PROVENANCE: William and Mary (Sloan) Frick; descended in family to Mary Carroll (Frick) Montgomery; with Israel Sack, 1970

LITERATURE: *American Antiques from Israel Sack Collection,* vol. 2 (New York, 1970), p. 533

ONE OF FOUR richly decorated side chairs that belonged to William (1790–1855) and Mary Sloan Frick (1796–1866), this chair was given to them as a wedding gift, according to family tradition. On the basis of style, the chairs were probably made between 1800 and 1810, considerably earlier than the date they were married; therefore, one would assume that the chairs were not made for the Fricks, but rather were given to them. The Fricks were married in Germantown, probably about 1820, and moved to Baltimore after their marriage, where Frick had a distinguished career as a lawyer and judge. Other pieces of the set

consisting of a four-chairback settee and four matching armchairs are in the collection of the White House. (The settee is illustrated in *The White House, An Historic Guide,* Washington, D.C., 1962, pl. 5.) Two almost identical armchairs with upholstery rather than marquetry set in the oval panel of the back are in the Winterthur Museum (Montgomery, *Federal Furniture,* pl. 93).

Plate 6 of Sheraton's *Appendix* shows an armchair with similarly turned legs with acanthus leafage carved at the top. Of the four side chairs one has its original corner blocks. None of the chairs has any indications of numbering. On other chairs of the same period the vase and flower motif was painted rather than inlaid.

DH □

ANTHONY RASCH (c. 1778–1859?)

Born about 1778 in Passau, Bavaria, Anthony Rasch was the third son of Count Tauffkirchen-Kleeberg. He left Passau and sailed from Hamburg at about the age of twenty-six, presumably a fully trained silversmith. He arrived at the port of Philadelphia in April 1804, but his petition for naturalization filed at the District Court of Pennsylvania in 1811 records that he resided

outside the state until 1809. He is first listed in the Philadelphia city directory for that year; the March 10, 1809, issue of the *Aurora General Advertiser* announced the formation of a co-partnership between Rasch and Simon Chaudron (see biography preceding no. 186). They remained together until August 1812, at which time they dissolved their partnership by mutual consent.

From 1813 to 1817, Rasch worked on High Street and then moved to 165 Chestnut Street where, according to a bill to J. S. Skerritt from Anthony Rasch & Co., dated August 11, 1817, he worked as a silverplate manufacturer (HSP, Loudoun Papers, Box 34). Rasch continued to work alone until 1818 when he took into partnership George Willig, Jr., an arrangement which lasted until 1819.

In January 1820, Rasch announced in the *Louisiana Gazette* that he had just established himself in New Orleans to carry on the business of silversmithing. Although he apparently retained close ties with Philadelphia, he remained in New Orleans keeping a shop at 75 Chartres Street until 1859. After this year he no longer appears in the city directory, indicating that he may have died at that time (Donald L. Fennimore, MS in preparation, Winterthur Museum).

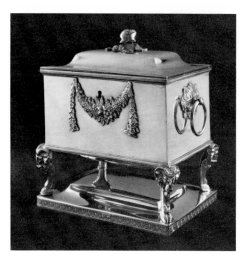

175.

175. *Tea Caddy*

c. 1810

Mark: ANT_y RASCH (on bottom); (French import stamp for 1893, top of lid and front of top molding); oz/5 cwt/5 (scratched on bottom)

Silver

7 1/16 x 6 1/2 x 4 5/8" (18 x 15.9 x 11.8 cm)

The St. Louis Art Museum. Gift of the Decorative Arts Society, Mr. and Mrs. George S. Rosborough, Jr., and Mrs. Mason Scudder

PROVENANCE: With Robert Trump, Philadelphia, 1966

LITERATURE: Lynn E. Springer, "A 19th Century Philadelphia Tea Caddy," *The Bulletin of City Art Museum of Saint Louis,* vol. 5, no. 4 (January–February 1970), pp. 2–4, illus. p. 3

A RARE FORM in American Empire silver, this tea caddy is one of the most ambitious examples of Anthony Rasch's silver. Although small in scale, its architectonic form, derived from a classical sarcophagus, is monumental in feeling.

The form had been revived in the Renaissance and later in furniture designs by Jacques Androuet Du Cerceau and Giovanni Battista Piranesi among others, demonstrating the perpetual interplay among the various decorative arts. At the same time, its form and such motifs as the cast ram's heads and hoof supports, applied guilloche swag, stamped anthemion band and beading, and leaf medallion escutcheon are derived more directly from the designs of neoclassicists such as Robert Adam and Adam Weisweiler. The swag and ram's head are also found in plate 23 of Percier and Fontaine. Thomas Hope also used this form in a design for a tea chest with perpendicular handles (*Household Furniture,* pl. 22, no. 2).

Although this tea caddy was fashioned from a sheet of rolled silver, a technique widely used by the beginning of the nineteenth century, the hinged cover was raised in a more traditional manner. Its shape is repeated on the bottom of the container, which is also raised, and again on the base. The cast rose and leaf finial suggests a French rather than an English source.

Tea was still highly prized in the early nineteenth century, so that the chamber of this caddy, which was divided as customary into two areas—one for Chinese and the other for Indian tea—could be locked for safekeeping.

Although the provenance of this piece is not known, it is interesting that it was taken into France in 1893 where it remained until the 1960s when it was returned to the United States. The minute swan touch-mark on the cover indicates the year that it passed through French customs. Although many French émigrés came to this country at the beginning of the nineteenth century, at the end of the century, American expatriates began to reverse the pattern. The movement of this piece illustrates this new cultural pattern.

DH □

176a. *Covered Sauce Tureen and Ladle, Dish, Cup and Saucer*

c. 1810

Hard paste porcelain, glazed

Sauce tureen diameter 5 5/8" (14.2 cm), with tray 8" (20.3 cm), with lid 5 1/4" (13.3 cm); ladle length 6 3/4" (17.1 cm); dish 1 1/4 x 11 x 9 7/8" (3.1 x 27.9 x 25 cm); cup height 2 5/8" (6.7 cm), diameter 2 1/2" (6.3 cm); saucer height 1 1/4" (3.1 cm), diameter 5 1/8" (13 cm)

John B. Carson, M.D., Newtown Square, Pennsylvania

PROVENANCE: Henry (1781–1854) and Sarah (Humphreys) Hollingsworth; descended in the

176a.

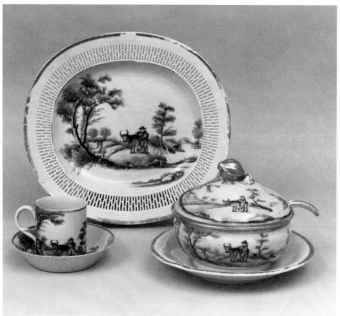

176b.

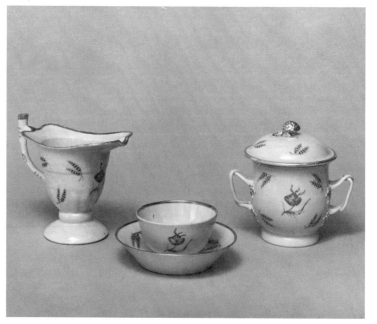

Hollingsworth and Humphreys families to John B. Carson, M.D.

LITERATURE: Mudge, pp. 102–3, figs. 52, 53, 54, as the service of Isaac and Mary Morris; Jean McClure Mudge, "Chinese Export Porcelain, a Symbol of the China Trade and a Prize for 19th Century Philadelphians," *University Hospital Antiques Show* (1972), p. 170, no. 10, figs. 5, 6

176b. *Sugar Bowl, Creamer, Cup and Saucer*

c. 1810

Hard paste porcelain, glazed

Sugar bowl height, with lid 5½″ (13.9 cm), diameter 4″ (10.1 cm); creamer height 5½″ (13.9 cm); cup height 2″ (5 cm), diameter 3½″ (8.8 cm); saucer diameter 5½″ (13.9 cm)

Mrs. W. Logan MacCoy, Haverford, Pennsylvania

PROVENANCE: Israel (1778–1870) and Mary (Hollingsworth) Morris (1776–1820); descended in the Morris family to Mrs. W. Logan MacCoy

ACCORDING TO FAMILY TRADITION, both porcelain dinner services, from which selected pieces are shown here, were decorated in China after designs by Mary Hollingsworth Morris. The designs and the porcelain are said to have been carried between Philadelphia and Canton by Mary's brother, Henry Hollingsworth, who was engaged in the China trade. The first set to be made, decorated in brown with a landscape scene of a cow and farmer (176a), arrived from China with gilt trim too ornate for the Quaker tastes of the Morrises. The Hollingsworths subsequently acquired the set, and Henry was sent back to Canton bearing Mary's new design with simple flower and wheat sprays (176b).

Both the rarity of such genre subjects as the cow and farmer in porcelain exported to America and the naiveté of the drawing style support the history of the attribution to Mary Morris, although both sets bear the gilding that was "too ornate" for Quaker taste. The more usual Philadelphia commission included a conventional Chinese pattern embellished with family monogram or cipher. Benjamin Fuller, who invested in a number of voyages made by Philadelphia's first ship to enter the China trade, the *Canton*, ordered in 1787 "the best Nankeen china light blue and white except [my] Coat of Arms which must be of the Colours there picturd . . ." (HSP, Benjamin Fuller, Letter Book, 1787–91, p. 53, Fuller to Thomas Truxton, Canton, China, December 8, 1787).

Breaking with the Philadelphia taste for standard Chinese patterns and the European neoclassical designs that increased in vogue from the mid-1790s, Mrs. Morris's original designs are unique in the history of the Philadelphia market. The existence of pieces from a somewhat weaker variant service (Mudge, fig. 54) suggests that such originality had its admirers in Philadelphia.

KH □

WILLIAM KNEASS (1780/81–1840)

William Kneass was born in 1780 or 1781 in Lancaster, Pennsylvania, the first son of Christopher and Anna Justina Kneass. Genealogical records indicate that the family moved to Philadelphia sometime before the birth of William's brother Christian in 1787 (Anna J. Magee, "Memorials of the Kneass Family of Philadelphia," *Publications of the Genealogical Society of Pennsylvania,* vol. 7, no. 2, 1919, p. 109). Kneass received his formal education in Philadelphia, where he also learned line and stipple engraving, possibly from James Thackara, for whom Kneass executed a small portrait engraving of Oliver Goldsmith in 1802 (Fielding, *American Engravers Supplement,* p. 168).

In 1804, the same year as his marriage to Mary Honeyman, Kneass set up shop as an engraver. Few examples of his early work survive but his commissions were apparently numerous enough for him to go into partnership with his brother John in 1808, a short-lived venture. There is some disagreement about his subsequent partnerships: Groce and Wallace indicate that he became partners with George Delleker in 1817 and with James Young in 1818 (p. 373), but H. Glenn Brown and Maude O. Brown believe that it was his brother John who formed these partnerships (*A Directory of the Book-Arts and Book Trade in Philadelphia to 1820,* New York, 1950, pp. 71–72).

How Kneass established a working relationship with John Hills, the cartographer of the circular map, is uncertain. Hills must have been impressed by Kneass's ability, because earlier, for his 1797 plan of Philadelphia, Hills had used a London engraver. No records have been located to document when Kneass began working for Hills, but from the publishing history of the map it would appear that work may have begun as early as 1806 and that Kneass retouched several of the plates for each of the subsequent editions.

Kneass's contemporaries evidently regarded him as a competent engraver. Late in 1806 he received a commission from a Pittsburgh printer, Zadok Cramer, to do illustrations for Cramer's 1807 edition of the *Dictionary of the Holy Bible.* Several

other commissions followed, including the well-known, forceful plan of a slave ship done for James Parke's Philadelphia edition of Clarkson's history of the African slave trade, published in 1808. Like most illustrations of the period, these plates were etched rather than engraved.

In the next few years, Kneass began to experiment with aquatint. In 1813 he exhibited a view of Quebec, after Strickland, at the Pennsylvania Academy of the Fine Arts; in the same year he produced a series of aquatints after Pavel Svinin's views of St. Petersburg. Few examples of Kneass's prints survive from the period 1815 to 1824. He did a number of title plates and illustrations for the *Port Folio* and *Analectic* magazines, but this work seems less accomplished than his aquatints. In 1824 he was appointed engraver at the Philadelphia Mint where his tenure was, in the main, uneventful. He died in office in 1840.

JOHN HILLS (ACT. 1777?–1817)

The career of John Hills is less well documented than that of William Kneass. If he was the draftsman "John Hill, Lt 23d Regt and Asst Engineer," who signed the *Plan of the Attack of the Forts Clinton & Montgomery upon Hudsons River,* drawn in 1777 and published in 1784, he must have come to America with General Howe's own regiment, the Royal Welsh Fuzileers, as an assistant engineer. As such he may have attended the royal military academy at Woolwich, where drawing and map-making were essential parts of the curriculum. However, since the officer lists of the American establishment do not list engineers, the only evidence for Hills's membership in the regiment comes from the inscription on the map itself.

Hills settled in Philadelphia by 1786, when he advertised his services as draftsman and surveyor on Front Street, opposite the Coffee House (*Pennsylvania Packet,* October 28, 1786). He seems to have been somewhat peripatetic in the city, living first at Front and Water streets, then moving west to 256 Market Street, and finally, in 1808, to South Eighth Street. He disappears from the city directories after 1817 (Brown and Brown, cited above, p. 61). Evidently his abilities were well regarded. He had a number of important commissions from the city's gentry, including maps of Edward Shippen Burd's country house, Ormiston Villa, and John Penn's Solitude that survive in the Historical Society of Pennsylvania. In 1796 he completed his *Plan of the City of Philadelphia,* which he sent to London to be engraved by John Cooke under the supervision of Boydell (*American Daily Advertiser,* April 28, 1797). When it was advertised for sale, Hills priced it at $3.00 "plain."

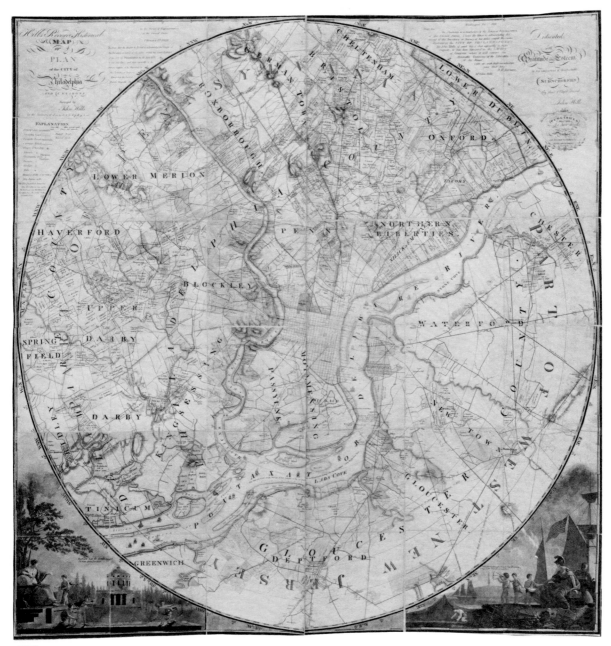

177.

WILLIAM KNEASS AFTER JOHN HILLS

177. *Map of Philadelphia and Environs*

c. 1810–12

Inscription: Hills Record & Historical/
MAP/or A/PLAN/of the CITY of/Philadel-
phia/and environs/Surveyed by/John
Hills/In the Summers of 1801, 2, 3, 4, 5,
6, 7, 8, 9, & 10. (sheet 1); Dedicated/with
Gratitude and Esteem/To his numerous
& Respectable/SUBSCRIBERS/By their
Obliged Friend/John Hills/PUBLISHED/
May 1st 1808/as the ACT directs/and

Sold by the/Author/and Principal Book-
sellers in/Philadelphia./Wm Kneass,
Sculp. (sheet 3)
Nine hand-colored engravings on laid and
wove papers, arranged in three ranks of
three sheets (here numbered for reference
across from upper left, 1–9), joined and
lined with Japanese mulberry tissue
Watermark: Whitmore/1812 (sheet 8)
39¾ x 39½″ (101 x 100.7 cm)

Historical Society of Pennsylvania, Phila-
delphia

PROVENANCE: John Stokes, Philadelphia

LIKE P. C. VARLÉ's MAP of Philadelphia
(no. 143), John Hills's circular map has few
pretenses to utility; it was conceived as a
decorative wall hanging. But Hills went
further than Varlé. His is a cadastral map,
showing the boundaries of many of the
country seats around Philadelphia, thereby
flattering the vanities of the owners. Hills,
it seems, was thoroughly aware of the attrac-
tions that maps and prints held for English
collectors, and we can assume that he
believed that Americans would find them
equally attractive.

The circular map shows an area ten miles
around the site of Philadelphia's Centre

Square, whose Waterworks (no. 153) are shown in the panel at the lower left. What prompted Hills to produce his map is not known. John Andrews and William Faden had each produced a circular map of London, in 1782 and 1788, respectively, and Faden's had been reissued in 1802, just about the time that Hills set to work on his Philadelphia map, but neither of those undertakings was so elaborate. Extending north to Cheltenham, south past Woodberry, New Jersey, east past Pennsauken, and west to Springfield Township, Hills's map shows, for example, the boundaries of William Bingham's Lands Down (Lansdowne), north of the Upper Schuylkill Ferry. According to the inscription on sheet 1, Hills began collecting materials for the map in 1801, and the many surveys Hills did for private clients are presumably incorporated. Hills, of course, had no official position in either New Jersey or Pennsylvania so that his services had to be privately commissioned. It is entirely possible that the prospect of being included on subsequent editions of the map may have attracted potential clients.

No effort has been made to examine all editions of the map. (There must have been at least four.) The copy on exhibition demonstrates how Hills, who acted as his own publisher, assembled his editions. Recent conservation work has revealed that the map had originally been printed from nine different copperplates, and that this copy is a composite of impressions done probably at three different times. Sheet 5, showing the city, was printed on laid paper, suggesting that it was an early impression and that Hills did not find any necessity to change it later. Sheet 8, bottom center, is on laid paper dated 1812. Sheets 7 and 9, with their decorative panels, were printed on wove paper; some information may have been added to the original plates for this copy. Sheets 1, 2, 3, 4, and 6 were printed on yet a different stock, of later manufacture, suggesting that the plates may have been substantially reworked to record both new surveys and Hills's deposit of the map with the Library of Congress.

The decorative panels below are substantially within the tradition of eighteenth century map cartouche decoration. Yet Hills has given his figures much more natural poses. Even Minerva's warlike equipment, lower right, has been transformed into the arms of Pennsylvania and New Jersey. Hills provided a description of the figures in a prospectus, part of which is pasted on the bottom of another state of the map in the collection of the Library Company of Philadelphia:

SCIENCE resting herself on the center square of the city of Philadelphia, instructing youth in the Fine Arts. By her side is a terrestrial globe; in her right hand are a pair of compasses and scale, showing that all things are to be measured; in front are youth surveying, and one explaining to her the forty-seventh proposition of Euclid, &c.

Hills continues with a brief description of the city:

At present the city is divided into fourteen wards, and contains, with Southwark, the Northern Liberties and Kensington, 124 streets, 11 lanes, 74 alleys and 40 courts, with 13,107 houses, of which 240 were built in 1809.

The righthand panel Hills describes as follows:

MINERVA seated on Trade, near the capes of Peutaxet, or Delaware bay, instructing the youth of Pennsylvania and Jersey in navigation and commerce. On her left hand is an Aborigine smoking his calumet of peace, and smiling at the productions of agriculture; by her side is the emblem of Industry, showing that all things are obtained by perseverance; at her back is Commerce and Navigation; at her feet are the implements of husbandry, the shield of Jersey and Pennsylvania, bearing the arms of each state; and near the beach is Fishery, &c. and the youth are represented taking the altitude with Mr. Godfrey's (commonly called Hadley's) quadrant, in the form it was first used by him, he being the inventor of this admirable instrument in 1732, in the city of Philadelphia.

Benjamin Henry Latrobe, the architect of the Centre Square Waterworks, once expressed the hope that Philadelphia might become the Athens of America (J. Meredith Neil, *Towards a National Taste,* Honolulu, 1975, p. 84). John Hills provided evidence that some sort of transformation was already taking place. Perhaps Hills, a transplanted Englishman, might be excused for confusing an imperial Roman Minerva with Athena but, one suspects, he was much closer to the mark than Latrobe in expressing the views of many of his patrons: Philadelphia's future depended not upon self-conscious aesthetic creations so much as upon trade, industry, and science, the secular *trivium.*

PJP □

REMBRANDT PEALE (1778–1860)

Charles Willson Peale's second son, Rembrandt, was born in Bucks County, Pennsylvania, during the Revolutionary War. Under his father's guidance, he had an unusually precocious start, and was painting oil portraits at thirteen. His one portrait from life of George Washington was commissioned as early as 1795 by a South Carolinian in Philadelphia with the encouragement of the elder Peale. Rembrandt's training was greatly extended when, in 1802, he traveled to London, where he studied with West and enrolled as a student at the Royal Academy. His brother Rubens accompanied him in order to exhibit a mastodon skeleton which the Peales had excavated in New York. While in London, Rembrandt published two studies on the skeleton and exhibited two portraits at the Royal Academy.

Late in 1803, he returned to America and, after spending some months in Charleston and Baltimore, settled in Philadelphia. He painted a number of portraits for his father's museum and traveled to Washington, New York, and Boston in search of commissions. In 1805, Rembrandt was one of the founders of the Pennsylvania Academy of the Fine Arts of which he became an Academician in 1812 and a member of the board of directors in 1811–13. In 1808 and 1809–10 he was again in Europe, chiefly in Paris, where he painted portraits of distinguished Frenchmen for his father's museum.

The grandiose, historical compositions in the Parisian studios apparently raised his ambitions for, upon his return to Philadelphia, he painted a large equestrian portrait of Napoleon. This was advertised in the newspapers in 1811 as being on display in his newly opened picture gallery, during the same period that the Society of Artists of the United States was holding its first annual exhibition, in which he had also entered six portraits. Peale's calculated attempt to make a favorable impression collapsed a year later, when his historical picture *The Roman Daughter* was shown at the Pennsylvania Academy and was criticized as unoriginal. This infuriated him. Not long after, he moved to Baltimore (in 1814) and opened a picture gallery including a "Gallery of Heroes" and natural history museum, in emulation of his father.

Peale met with so little success in his Baltimore endeavors that in 1820 he executed his largest historical composition, *The Court of Death* (Detroit Institute of Arts), in hopes of making money by exhibiting it on tour. Within thirteen months, he had earned about $9,000 in admission fees, which convinced him to leave the Baltimore museum to his brother Rubens and establish a studio in New York in 1822. The next year he was in Philadelphia where he painted an idealized portrait of George Washington from memory as well as from other portraits of the first president. He returned to New York in 1825 and was subsequently elected president of New York's American Academy of Fine Arts.

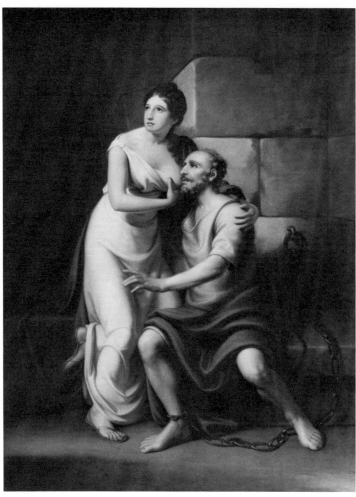

178.

Hunter, "Rembrandt Peale's *The Roman Daughter*," *Antiques*, vol. 102, no. 6 (December 1972), p. 1073; William H. Gerdts, *The Great American Nude* (New York, 1974), p. 44

ALTHOUGH REMBRANDT PEALE painted at least seven history pictures, only two survive: his huge *Court of Death* of 1820 and the early *Roman Daughter* of 1811. *The Roman Daughter* is based on a Roman legend of remarkable filial devotion reported by, among others, Valerius Maximus in the first century A.D. (*Factorum et Dictorum Memorabilium*, Book 5, chaps. 4 and 7). The story concerns an elderly political prisoner, Cimon, condemned to starve to death, and his courageous daughter, Pero, who secretly sustained him, during prison visits, with milk from her own breast. When the scheme was discovered, Cimon was pardoned. As a story of heroic loyalty and sacrifice, with emphasis on the virtuous character of Pero, it seemed appropriate to Rembrandt Peale for his first attempt at history painting upon his return from France. His father, Charles Willson Peale, posed for Cimon.

Undoubtedly, the first depiction of the story that Peale ever saw was Rubens's *Cimon and Pero*, which was in Annapolis in 1799, brought from Antwerp by a banker named Stier (Rembrandt Peale, "Reminiscences," *The Crayon*, vol. 2, no. 12, September 19, 1855, p. 175; and HSP, John Sartain Collection, vol. 24, Rembrandt Peale, "Notes of the Painting Room," p. 67). Years later, when Peale was selecting a subject for his first history painting, the memory of Rubens's picture must have provided incentive in his choice of this same subject. Rubens had represented the moment when Pero's scheme is discovered; and his sensuous figures were seminaked with Pero's breasts fully exposed. Peale, who felt that the exact moment of discovery had been painted often enough, chose to show the first day of the plot between father and daughter. In contrast to Rubens's painting, Peale's presentation is a more prudish version of the story, in the edifying formula of neoclassical history painting.

The high finish and smooth surface of Rembrandt Peale's painting and the somber colors indicate that he was strongly influenced by the style of his French contemporaries Jacques-Louis David and Baron Gérard. Peale's approach is thus a clear rejection of the more painterly, late style of Benjamin West. Another Philadelphian, Denis A. Volozan, originally from France, painted history pictures at this time in the French manner, but his efforts were on a smaller scale and were not thought to merit the attention that Peale's did.

A review of the 1812 Pennsylvania Academy exhibition focused on *The Roman Daughter* as the picture which attracted the most notice, concluding that it was "meri-

178. *The Roman Daughter*

1811

Oil on canvas

84½ x 62¼" (214.6 x 158.1 cm)

Webster, Inc., Fine Art, Chevy Chase, Maryland

PROVENANCE: The artist, until 1823 or later; G. Blake, Boston, 1832; "Boston Museum," 1834–c. 1902; Sullivan family, Boston, c. 1902–70; Webster, Inc., Fine Art, 1970

LITERATURE: G.M., "The Second Annual Exhibition of the Society of Artists and the Pennsylvania Academy," *Port Folio*, vol. 8, no. 1 (July 1812), pp. 20–21; APS, Rembrandt Peale to Charles Willson Peale, April 1, 1823; APS, Charles Willson Peale, Letterbook, vol. 18 (April 13, 1823), p. 234; Dunlap, *History*, vol. 2, pp. 52–54; C. Edwards Lester, *The Artists of America* (1846; reprint, New York, 1970), p. 208; Dickson, "Neal," pp. 19–20; Sellers, *Peale*, 1969, pp. 360–61; Robert Rosenblum, "Caritas Romana after 1760: Some Romantic Lactations," *Art News Annual*, vol. 38 (New York, 1972), p. 51, illus. p. 50; Wilbur H.

Revisiting Europe in 1828–30, he spent much of his time copying old masters in France and Italy. After his third and last trip to Europe, 1832–33, he settled permanently in Philadelphia and devoted his final years to reproducing Washington's likeness and traveling about the country to lecture on life portraits of Washington, illustrated by his own portraits and copies he had made of portraits by others. He became the first drawing master at Central High School, 1840–44, following the publication in 1835 of his book, *Graphics: a manual of drawing and writing, for the use of schools and families*, which ran through at least four editions. His other publications include the 1831 *Notes on Italy, written during a tour in the years 1829 and 1830*, and his 1839 *Portfolio of an Artist*, a book of selections, chiefly from poetry. He intended to have his manuscript "Notes of the Painting Room," (HSP, John Sartain Collection, vol. 24), a ramble of practical advice, published by public subscription but only the prospectus was ever printed. He died in Philadelphia.

torious," but the artist should have "chosen a subject wherein he could have displayed his talents to more advantage, and better fitted for public exhibition" (*Port Folio,* cited above, pp. 20–21). Rembrandt was initially pleased with the praise given his "first attempt at original composition" (Dunlap, *History,* vol. 2, p. 53), and then very upset by the rumor spread by Pavel Petrovitch Svinin (see biography preceding no. 182) that he had plagiarized a painting in Gérard's studio in Paris. Although he proved his accuser to be misinformed, he could never look back on the incident without some bitterness. Gérard's version of the subject, exhibited at the Salon of 1791, is now lost (Rosenblum, cited above, p. 50).

The Roman Daughter did not find a ready buyer. Rembrandt repainted parts of it both after the exhibition and again in 1823, when Thomas Sully saw it and spoke "highly in praise of the improvement of the Roman Daughter" (APS, Charles Willson Peale, Letterbook, vol. 18, p. 234). Rembrandt's friend, John Neal, writing in the same year, mentioned that he had heard that Rembrandt had made a copy said to be better than the original (Dickson, "Neal," p. 20). This seems to be an error caused by mistaking the repainted picture for another version. In 1823, Rembrandt still owned *The Roman Daughter* and was trying to sell it in New York by subscription, possibly a kind of raffle (APS, letter to Charles Willson Peale, April 1, 1823). Whether he succeeded is not known. *The Roman Daughter,* because of its size and subject matter, seemed destined during the nineteenth century never to leave the exhibition room, for which it really had been created.

DE □

CATHERINE BENSON (N.D.)

179. *Stuffed-work Quilt*

1800–30
Cotton, front (91 x 82) and reverse (42 x 36); cotton stuffing, cording, fringe, and thread
Stitches: Running
122¼ x 124⅛″ (311 x 317 cm)
Philadelphia Museum of Art. Given by Mrs. Samuel Bryan Scott. 41-111-1

PROVENANCE: Descended in Benson family to Ella Graham (Benson) Morris; daughter, Mrs. Samuel Bryan Scott (Margaretta Morris)

ALL-WHITE stuffed or corded work was most popular during the Federal period, in the late eighteenth and early nineteenth centuries. The earliest known use of cording and stuffing in a bed quilt is the so-called

Sicilian quilt portraying the legend of Tristan, made about 1400, part of which is in the Victoria and Albert Museum.

Catherine Benson's work is done in the running stitch, at more or less ten stitches to the inch, in a pattern involving a central basket of flowers surrounded by a ring of scalloped, stylized laurel leaves, and then by serpentine vines with flowers and fruits and a square of acanthus leaves. The quilt is finished with a border of laurel and a simple drawnwork fringe. The face is of fine muslin, pieced to form the whole, and the reverse is of loosely woven cotton. Stuffing and cord have been passed through temporarily separated threads on the back in order that the elements of the stitched design might appear in relief.

PC □

JOSEPH B. BARRY (1757?–1839)

Born in Dublin and trained in London, Joseph Barry had arrived in Philadelphia by 1790. In James Hardie's *Philadelphia Directory and Register* for 1794, Barry was listed as a partner of Alexander Calder at 75 Dock Street. The following year he became a

member of the firm of Lewis G. Affleck and Company. Barry moved from firm to firm and address to address during the 1790s. In 1798 he went briefly to Savannah on a business venture. On October 5, 1798, he advertised in the *Columbian Museum & Savannah Advertiser*: "Lately landed from Philadelphia and for sale at Messrs. Meins & MacKay's stores . . . A most compleat assortment of elegant and warranted well finished MAHOGANY FURNITURE." Two months later he returned to Philadelphia. A second business merchandising outlet venture was to Baltimore. On February 9, 1803, he advertised in the *Federal Gazette & Baltimore Daily Advertiser*: "CABINET FURNITURE, of the newest London and French patterns." It is possible that Barry established business outlets in other cities.

In 1810, Barry took his son into his business, which he announced in the Philadelphia *Aurora General Advertiser*: "Joseph B. Barry, *Cabinet-Maker and Upholsterer,* Presents his grateful acknowledgements to his friends and the public in general for the very liberal encouragement he has so long experienced. He now respectfully informs them that he has this day taken into partnership, his Son, Joseph Barry. The business

179.

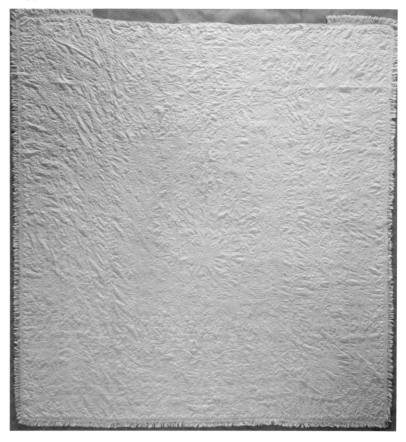

180.

LITERATURE: Hornor, pls. 432–34; MMA, *19th-Century America, Furniture*, no. 34 (illus.); Robert T. Trump, "Joseph B. Barry, Philadelphia Cabinetmaker," *Antiques*, vol. 107, no. 1 (January 1975), pp. 159–63, figs. 3, 4

ONE OF THE MOST SPECTACULAR PIECES of Philadelphia Empire furniture, this pier table combines a number of cabinetmaker methods of decoration: turning, carving, gilding, molding, veneering, and ormolu mounts. In addition to its aesthetic importance, the table also has underneath its top one of the most important trade labels known (see illustration). As Hornor points out, the furniture illustrated on this label—the stretchered pier tables, upholstered round-seated drawing room chairs, sideboard with knife boxes, and lady's dressing commode—are all reproduced from Sheraton's 1802 *Appendix*. The words "& Son," which were added to the label about 1810, help to date the table after 1810. Barry's earliest known trade card, illustrated before 1810, is very similar to this, although simplified (*Antiques*, vol. 34, no. 1, July 1938, illus. p. 36; *Antiques*, vol. 34, no. 4, October 1938, pp. 207–8). A similar trade card (Baltimore Museum) was used by the Baltimore cabinet-maker William Camp, at 25 Water Street (Robert Bishop, *Centuries and Styles of the American Chair 1640–1970*, New York, 1970, fig. 314). The arrangement was identical, although different Sheraton forms were chosen.

The design of the carved and pierced griffin panel also depends on a Sheraton design—the "Ornament for a Frieze or Tablet," (*Drawing Book*, pl. 56, dated 1791). An

will in Future be conducted under the firm of JOSEPH B. BARRY & SON, (at the old established warehouse, No. 134, South Second street), in the same extensive manner it has hitherto been, and hopes for a continuance of their patronage. They have now in their ware-rooms a variety of the newest and most fashionable Cabinet Furniture, superbly finished in the rich Egyptian and Gothic style, which they will dispose of on the most reasonable terms."

Barry's most distinguished known client was Thomas Jefferson who noted in his personal account book that on April 14, 1800, "gave Joseph Barry ord on J. Barnes [Jefferson's agent] for 193 D. cabinet work." It is possible that the items listed were purchased for the government and that Jefferson was later reimbursed, as he frequently notes that he repaid his steward for furniture bought for the president's house (Marie G. Kimball, "The Original Furnishings of the White House," pt. 2, *Antiques*, vol. 16, no. 1, July 1929, pp. 33–37).

In 1811, Barry went to Europe; on his return in 1812 he advertised in the *Aurora General Advertiser*: "Cabinet Ware-Rooms, No. 134 South Second Street. Jos. B. Barry Having lately returned from Europe informs their friends and the public, that during his stay in London and Paris, He made some selections of the Most Fashionable and Elegant Articles in Their Line,

which in addition to their elegant stock on hand, forms a display of furniture, well worth the attention of the respectable citizens of Philadelphia."

Barry died in 1839, and his son continued the business.

180. *Pier Table*

c. 1810–15

Label: Pier Tables/A Lady's Dressing Commode/Joseph B Barry & Son/CABINET MAKER & UPHOLSTERER/N 132. South Second Street/—PHILADELPHIA—/sideboard with vase knife cases/Drawing-Room Chairs/orders for the West Indies or elsewhere Executed in the neatest manner and/Attended to with the Stricktest punctuality (underneath top)

Mahogany; mahogany veneer on top; burl banding; brass, ormolu

38¹³⁄₁₆ x 53⅞ x 23⅞"
(98.6 x 136.8 x 60.6 cm)

Mr. and Mrs. T. Wistar Brown, 4th, Ardmore, Pennsylvania. On loan to the Metropolitan Museum of Art, New York

PROVENANCE: Louis Clapier; daughter, Mary Louisa (Clapier) Coxe; son, John Redman Coxe; daughter, Mary Louisa Coxe; grandson, Thomas Wistar Brown III

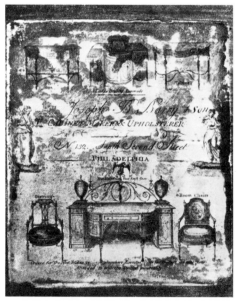

Label for Joseph B. Barry & Son, c. 1810 (after Hornor, pl. 432)

earlier source for the griffin panel and, in fact, for a number of elements in the table is seen in plate 11 of Giovanni Battista Piranesi's *Diverse maniere d'adornare i cammioi ed ogni altra parte degli edifici.* The lyre which appears in the Piranesi plate between two winged lions is incorporated in the Barry design above the panel. The masks which appear to be carved on the Piranesi design appear as bronze mounts on the Barry table. The spiral garlands around the columns are derived from such French sources as plate 168 in Mésangère. Such columns and the U-shaped platform base were favored by both Baltimore and Philadelphia cabinetmakers. Also typical of Philadelphia is the combination or ormolu mounts with low relief carving. New York cabinetmakers preferred lavish stenciling and carving, while Boston craftsmen at the other extreme used ornament sparingly with brass and ormolu mounts, depending on the veneered surface for effect.

This pier table was originally owned by Louis Clapier, a victualler, whose house is prominently seen in Krimmel's *Procession of Victuallers* (no. 211). Born in Santa Domingo, Clapier was living in Philadelphia by 1801, as he is listed in the directory for the first time in that year. He married Mary Heyl, and their daughter was born in 1806. His inventory in 1837 listed: "1 pr table $10 Small front parlor/2 pr table c $12 large front parlor."

DH □

181. *Pier Glass*

c. 1810–15
Eastern white pine; poplar; linen banding to form crosses; gilt
67¾ x 46" (172 x 116.9 cm)
Trump and Company, Flourtown, Pennsylvania

PROVENANCE: Probably Louis Clapier; daughter, Mary Louisa (Clapier) Coxe; son, John Redman Coxe; daughter, Mary Louisa Coxe; grandson, Thomas Wistar Brown III

THIS PIER GLASS by an unknown maker may also have belonged to Louis Clapier since it was owned by his daughter Mary Louisa Clapier Coxe. It may have originally hung above the pier table (no. 180) whose provenance, according to family tradition, is more certain. The size and scale of this glass are in keeping with the Clapier table; its U-shaped cornice echoes the base of the table. Both are architectonic in their use of pilasters, capitals, and cornices; of particular note on the looking glass are the elegant, delicately carved

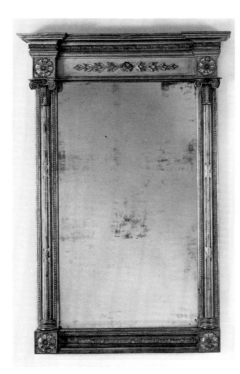

181.

composite capitals. Motifs seen on this glass which found favor with Philadelphia craftsmen include the columns and top molding with a form of fasces seen also in the R. and W. Wilson presentation urn (no. 306), and the flat leaves in the capital. The acorn and leaf motif seen in the cornice occurs in the Fletcher wine cooler (no. 234). The cast composition acanthus leaf molding would have been readily available to manufacturers of looking glasses and picture frames. It occurs, for example, in a picture frame, dated 1812, in the same collection.

DH □

PAVEL PETROVITCH SVININ (1787/88–1839)

Born in 1787 or 1788 into a family of untitled Russian nobility, Pavel Petrovitch Svinin was educated in Moscow and attended the Imperial Academy of the Fine Arts in St. Petersburg. He did not, however, choose a career as an artist and instead in 1806 took a position with the foreign service, joining after a brief visit to England the Russian fleet in the Mediterranean as an attaché to Vice Admiral D. N. Seniavin (White, "Sketches," pp. 5–8). After returning to Russia late in 1807, Svinin worked for a time as a translator in the Ministry of Foreign

Affairs. He continued to paint, evidently as an amateur, and in September 1811 he was elected to membership in the Imperial Academy. In the same month he sailed for America to take up a post as secretary to the Russian consul general in Philadelphia.

Although he traveled widely throughout the United States, Svinin managed to be an active participant in the cultural affairs of Philadelphia. In 1812 he contributed two drawings to be engraved for the *Port Folio,* along with an article on the Cossacks, and in 1813 published his *Sketches of Moscow and St. Petersburg* (Philadelphia, 1813) with nine colored engravings after his drawings.

Svinin was also interested in American art; he visited Gilbert Stuart in his Boston studio and was an admirer of Thomas Sully and Thomas Birch, among other Philadelphia artists, although he is known to have quarreled with Rembrandt Peale (see no. 178) (Yarmolinsky, *Svinin,* pp. 33–40). John Lewis Krimmel, Alexander Wilson, and the French émigré artist C. B. J. Févret de Saint-Mémin must have impressed him as well, for he made watercolors after their work.

After a stay of twenty months, Svinin left the United States in 1813 with the French general Jean-Victor Moreau, whom he accompanied to Europe to join the Russian army. Following a visit to England in 1814, Svinin returned to Russia, where in 1815 he published his *Picturesque Voyage in North America* ([*Opyt zhivopisnago puteshestviia po Severnoi Amerike*], St. Petersburg, 1815), the first account of the United States by a Russian, with six engravings from the portfolio of watercolors he had made during his travels. Svinin remained in Russia for the rest of his life, publishing a literary and scientific magazine as well as an ethnography of Russia and two historical novels. He died in St. Petersburg in 1839 (White, "Sketches," p. 24).

182a. *Members of the City Troop and Other Philadelphia Soldiery*

1811–13
Watercolor over pencil on buff paper
9 x 7¼" (22.9 x 18.4 cm)
The Metropolitan Museum of Art, New York. Rogers Fund, 1942

PROVENANCE: The artist until 1839; found in Soviet Union, 1925; R. T. H. Halsey, Annapolis, Maryland; purchased from Halsey estate by Metropolitan Museum of Art, 1942

LITERATURE: Yarmolinsky, *Svinin,* no. 20; White, "Sketches," p. 26

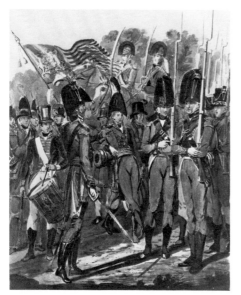

182a.

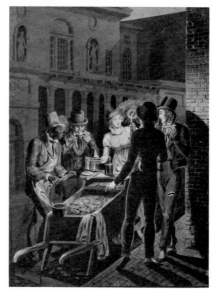

182b.

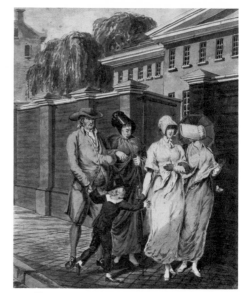

182c.

182b. *Night Life in Philadelphia: An Oyster Barrow in Front of the Chestnut Street Theater*

1811–13
Watercolor over pen and brown ink on buff paper
9 7/16 x 6 13/16″ (23.9 x 17.3 cm)
The Metropolitan Museum of Art, New York. Rogers Fund, 1942

PROVENANCE: The artist until 1839; found in Soviet Union, 1925; R. T. H. Halsey, Annapolis, Maryland; purchased from Halsey estate by Metropolitan Museum of Art, 1942

LITERATURE: Yarmolinsky, *Svinin*, no. 17; *PMA Bulletin*, vol. 35, no. 186 (May 1940), p. 33; Margaret Jeffery, "As a Russian Saw Us in 1812," *MMA Bulletin*, n.s., vol. 1, no. 3 (November 1942), p. 135; *The New-York Historical Society Quarterly*, vol. 32, no. 4 (October 1948), p. 273; White, "Sketches," p. 32; MMA, *Two Hundred Years of Watercolor Painting in America* (December 8, 1966–January 29, 1967), no. 27

182c. *Sunday Morning in Front of the Arch Street Meeting House, Philadelphia*

1811–13
Watercolor over pencil on buff paper
9 x 7 5/16″ (22.9 x 18.2 cm)
The Metropolitan Museum of Art, New York. Rogers Fund, 1942

PROVENANCE: The artist until 1839; found in Soviet Union, 1925; R. T. H. Halsey, Annapolis, Maryland; purchased from Halsey estate by Metropolitan Museum of Art, 1942

LITERATURE: Yarmolinsky, *Svinin*, frontis.; *PMA Bulletin*, vol. 35, no. 186 (May 1940), p. 32; MMA, *Two Hundred Years of Watercolor Painting in America* (December 8, 1966–January 29, 1967), no. 21

UNLIKE MOST EARLY VISITORS to the United States, who tended to be British and generally critical of their former colony, Svinin usually viewed America sympathetically. Even in the dark hours of the War of 1812 he predicted commercial and military ascendancy for the new nation, although he was by no means blind to the difficulties of the moment. "The real strength of the United States consists of the militia," he wrote, but since it lacked experience it was "no wonder that the American army is in bad condition." There was no lack of "personal courage," but good discipline was wanting (Svinin, *A Picturesque Voyage in North America*, 2d ed., St. Petersburg, 1818, p. 20).

Svinin's watercolor scene of *Members of the City Troop and Other Philadelphia Soldiery* appears to illustrate his views. Resembling well-dressed gentlemen more than battle-hardened veterans, one of them lounging against a cannon, these soldiers recall the days immediately after the War of 1812 was declared, before the weakness of the American position became apparent. The bright tones of red, green, and blue of the elegant uniforms and the brilliant gold of the cannon are in contrast to Svinin's usually more subdued colors and emphasize the ceremonial nature of the occasion, per-

haps a muster or parade in the summer of 1812.

Svinin enjoyed living in Philadelphia, which he considered the most beautiful city in the United States, and he devoted fifteen of his portfolio of fifty-two American watercolors to the city and its people. Often using an architectural landmark as a backdrop for a genre scene, Svinin recorded the appearance of such buildings as the Bank of the United States (no. 142), Christ Church (no. 26), and the Pennsylvania Academy of the Fine Arts.

In *Night Life in Philadelphia* the dimly lit and gracefully ornamented facade of the first Chestnut Street Theater, which was built from 1791 to 1794, remodeled after a design by Benjamin Henry Latrobe in 1801, and destroyed by fire in 1820 (Tatum, no. 46, pp. 168–69), frames an oyster seller plying his trade. Svinin's use of architectural settings quite literally as backdrops is demonstrated by two inconsistencies in his rendering of the scene. The shadows on the theater front indicate that the time is mid-afternoon, in striking contrast to the total darkness of the foreground areas not lit by the candle; moreover, the sidewalk on which the figures stand rises quite sharply toward the right, while the theater appears to be on relatively flat land. The artist thus appears to have based his finished watercolor, in this case and probably in others as well, on sketches made at different times and locations.

Svinin clearly intended his watercolors to serve as illustrations for a full-length treatise on the United States, which he unfortunately never wrote—his *Picturesque Voyage in North America*, with only six engravings,

was intended as a preliminary study (Yarmolinsky, *Svinin*, p. 32). Thus in the absence of his journal or notes taken during his travels the precise meaning of a particular scene is sometimes unclear. *Night Life in Philadelphia* has been described as "young men with their ladies eating oysters at night" (Jeffery, cited above, p. 138). However, it seems more likely that the one woman represented in the picture is a servant girl from a nearby house or tavern sent to fetch oysters in the container she holds in her right hand, meanwhile engaging in conversation, perhaps mildly flirtatious, with the two men to her left.

The diversity of religious expression in the United States both interested and appalled Svinin. As he told his Russian readers, "It would be greatly curious if someone took on the task of writing the history of different religions in the United States of America. The number, the strangeness, and the contrasts would present a fascinating picture of the errors and passions of the human mind" (Svinin, cited above, p. 34). Although he was usually critical and even derisory of most religious sects, Svinin respected the Quakers, praising them for their honesty and charity, and he attributed to their influence the "deep silence and quiet" of Sundays in Philadelphia. "On these days, in the streets of Philadelphia one meets only the somber faces of people deep in meditation; one cannot see one smile, as if the whole city

were in mourning" (Svinin, cited above, p. 56). Society was by no means homogeneous, however, and "luxurious living has of late increased amazingly among all classes of the population" (quoted in Yarmolinsky, *Svinin*, p. 17).

In *Sunday Morning* Svinin depicts a mild clash between the old, Quaker mores and the new, less restrained style. On the sidewalk outside the Arch Street Meeting House, erected by the Quakers between 1803 and 1811 (Edwin B. Bronner, "Quaker Landmarks in Early Philadelphia," in *Historic Philadelphia*, pp. 212–13), a plainly dressed family representing the old order comes unexpectedly across two fashionably clad young ladies. As his son reaches out for the yellow butterfly, which floats, appropriately, before the young women, the father restrains him, meanwhile scowling fiercely at the breach of established religious customs.

JC □

FREDERICK GRAFF (1774–1847)

Forty-two consecutive years as superintendent of the Philadelphia Waterworks (1805–47) helped to make Frederick Graff the one person most identified with this pioneer enterprise. Born in Philadelphia, third in a line of builders and engineers,

Graff was associated with the city's water system from its beginning, when he worked as a draftsman under the direction of Benjamin Henry Latrobe, architect and engineer of the Centre Square Waterworks (no. 153). He served Latrobe in increasingly responsible assignments in Philadelphia and Norfolk until in 1804 he received his first independent commission on a South Carolina canal. The next year he returned to his native city to head up the Waterworks.

His role in designing and supervising the construction and expansion of the technologically sophisticated Fairmount Waterworks made him the foremost authority in the field and he was consulted by engineers of other projects in New York, Boston, Baltimore, and Pittsburgh. Grateful for Graff's public service, the City in 1844 commissioned a portrait bust, which was later placed in a Gothic revival monument that still stands near the engine house of the Waterworks.

On his death, he was succeeded by his son Frederic (1817–1890), a highly respected civil engineer who was responsible for improvements to the Fairmount Waterworks in the 1850s and the late 1860s.

183. *Fairmount Waterworks*

Fairmount on the Schuylkill
1812–22, and later additions and alterations
Stone covered with stucco

REPRESENTED BY:
Frederic Graff (1817–1890)
Section of Millhouse
1847
Watercolor, ink, and pencil
15 x 17 9/16″ (38.1 x 44.6 cm)
Philadelphia Museum of Art. Bequest of Mrs. Frederic Graff

Frederic Graff (1817–1890)
Designs for Cast Iron Railing for Fair Mount Water Works
1847
Watercolor, ink, and pencil
13 7/8 x 17 5/8″ (35.2 x 44.8 cm)
Philadelphia Museum of Art. Bequest of Mrs. Frederic Graff

LITERATURE: *Report of the Watering Committee . . . Read January 9, 1823*, 2d ed. (Philadelphia, 1827), pp. 4, 11, 13; *Annual Report of the Watering Committee, for the Year 1852* (Philadelphia, 1852), pp. 26–32, 37; *Annual Report of the Chief Engineer of the Water Department, 1868* (Philadelphia, 1868), pp. 6, 8; Scharf and Westcott, vol. 1, pp. 605, 800, vol. 3, pp. 1853–54; Thomas Gilpin, "Fairmount Dam and Water Works, Philadel-

183.

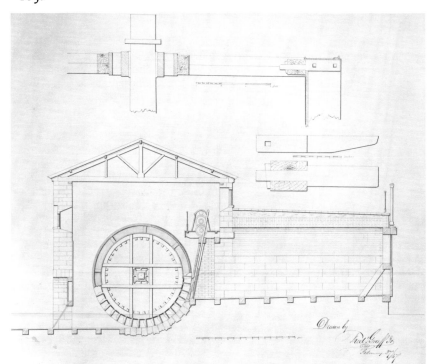

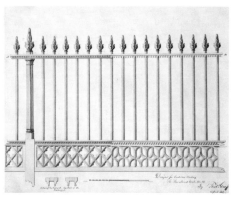

183.

phia," *PMHB,* vol. 37, no. 4 (1913), pp. 471–79; Harold Donaldson Eberlein, "The Fairmount Water Works, Philadelphia," *Architectural Record,* vol. 62 (July 1927), pp. 57–67; White, *Philadelphia Architecture,* p. 24, pl. 14; Nelson Manfred Blake, *Water for the Cities* (Syracuse, 1956), pp. 41, 86–88; Wainwright, *Early Lithography,* pp. 97, 105, 108, 130–32, 170, 177, 211, 219, frontis., pls. 55, 95, 133; Tatum, pp. 63–64, 88, pls. 51, 52; Charles Coleman Sellers, "William Rush at Fairmount," in FPAA, *Sculpture,* pp. 8–14; *Philadelphia Inquirer,* June 18, 1975

FRANCES TROLLOPE, that English observer of Jacksonian America, was a woman hard to please. Yet when she saw the Fairmount Waterworks, she had to admit that it was "one of the very prettiest spots the eyes can look upon" (Frances Trollope, *Domestic Manners of the Americans* [1832], ed. Donald Smalley, New York, 1949, p. 261). She was struck by the vast yet simple machinery, the chaste classical building enclosing it, and the many examples of nature improved, appreciating at once its synthesis of technology, architecture, landscape, and sculpture.

When the city's initial Waterworks at Centre Square (no. 153), begun by Benjamin Latrobe in 1799, proved insufficient for the expanding metropolis, City Council in 1812 approved construction of a new steam-powered works from the designs of Frederick Graff, Latrobe's chief draftsman on the Centre Square project. The new facility began operations in September 1815 in a stuccoed stone house on the east bank of the Schuylkill at the foot of Fairmount. Water was pumped into a reservoir atop the hill from where it was gravity fed to homes and hydrants. The steam engines were costly and troublesome, however, and in 1819 the shift to waterpower was begun. A dam designed by Ariel Cooley of New England was thrown across the river to the bypass locks of the Schuylkill Navigation Company on the west side (see no. 257), and the machinery and millhouse, both evidently

designed by Frederick Graff, were built next to the steam engine house. A forebay (see no. 226) blasted from the wall of limestone formed the races for what would later be eight breast waterwheels, which were placed with four pairs of double-acting force pumps in the lower part of the millhouse. After striking the wheels, the water flowed into the river below the dam, and the wheels powered the pumps which pushed water from the flumes into a main that extended beneath the forebay and up the hill to the reservoirs. It was an ingenious, self-contained system worthy of its 1975 designation as a National Engineering Landmark by the American Society of Civil Engineers.

Stuccoed pavilions with Doric tetrastyle porticoes terminate each end of the building and a brick-paved terrace extends the length of the eastern front, facing the forebay. In the absence of an accepted industrial style the Roman revival of the end pavilions, perhaps inspired by LeNôtre's Temple d'Amour at Chantilly (Tatum, p. 63), was the most appropriate available. It conjured up images of Roman civilization and its famed engineering feats, including the great aqueducts of ancient water systems.

From the beginning the Watering Committee appreciated the scenic virtues of the site, and the landscaped area was expanded to more than twenty acres as the operation grew in the 1820s and it eventually became the nucleus of the extensive Fairmount Park system (see no. 313). Sculpture by William Rush, a member of the Watering Committee, was introduced to enhance the setting. His allegorical *Schuylkill Chained* and *Schuylkill Freed* (no. 219) were finished in 1825 and placed above the two entrances to the millhouse. A couple of years later, Rush's *Nymph and Bittern* was moved from the abandoned Centre Square Waterworks to a niche above the forebay, and in 1829 his *Mercury* was placed atop a gazebo (see no. 257) which served as a rest spot halfway up the rocky mount. The present gazebo at the east end of the dam was erected in 1835; at the same time, the engine house was altered to a public saloon and Rush's statues of *Mercy* and *Justice* (no. 218), carved for the Lafayette triumphal arch in 1824, were later displayed in it.

The Fairmount Waterworks became one of Philadelphia's best-known sites and a favorite promenade. This blending of new technology with the natural scenery of old landscape was a self-confident expression of man's peaceful, beneficial mastery of nature. Views of it were recorded in virtually every medium, including transfer prints on earthenware and porcelain (see nos. 237, 238).

There were a number of later alterations to the Waterworks. Some of these changes, such as the erection of iron railings in the

late 1840s, were minor, while others were more extensive. The present appearance of the Waterworks is largely the result of work done in the 1860s, when the terrace was raised and the central temple structure and the flanking wooden huts were built above the mill building. The tower seen projecting above the Works in late nineteenth century illustrations was the standpipe designed and erected by Frederic Graff in 1852 to supply a new reservoir near Twenty-second and Poplar streets. The brick Italianate facade protected the pipe from frost and added a picturesque element to the scene until it was demolished about 1920 during the construction of the Philadelphia Museum of Art.

Attempts were made to keep the Waterworks abreast of changing technology, and beginning in 1865 the waterwheels were replaced by turbines. By 1911, however, the facility was no longer practical and was closed; the forebay was filled in and the buildings were converted to an aquarium. Although vacant since 1962, the classical ensemble still serves as a splendid foil for the majestic Museum of Art looming above it (see no. 516).

RW □

THOMAS WHITNEY (D. 1823)

Thomas Whitney's advertisement in the *Federal Gazette* of April 12, 1798, is the earliest appearance of his name in Philadelphia records. He must have come from London somewhat earlier, as the advertisement noted that he had just moved from 72 to 74 South Front Street. The Philadelphia city directory for 1801 also lists a John Whitney "mathematical instrument maker and optician" at that address, suggesting that this was a family enterprise. This location was obviously suited for supplying the waterfront trade with fine technical equipment, and the shop also offered sailors' pocket knives, scissors, and bunting by the yard. Its location was next door to the brass foundry of Daniel King, Jr., where the Whitneys undoubtedly purchased the raw materials for their manufacture of navigational and surveying instruments.

Directory listings call Whitney a "manufacturer of surveyors and other mathematical instruments." In 1803 he supplied a concave glass for the microscope at the American Philosophical Society; in the same year, he contributed his own observations on the use of the sextant with an artificial horizon, which was written up by Andrew Ellicott (APS, "Concerning the Use of Water for an Artificial or Portable Horizon," 1803, recorded by John Vaughn, secretary). Whitney was not a member of the Society,

and his later work seems to have been directed toward the surveyor.

By 1805, according to the directories, Whitney and his wife Mary and son Thomas had moved to North Sixth Street "near the large new Stone bridge 2 miles from High," where he remained until his death in 1823. John Whitney does not appear in directories after 1801, nor was the name mentioned in the administrations of either Thomas Whitney, Sr., or Jr.

An inventory of the Whitney home taken by William Caswell, Thomas Wakeham, and Joseph Maylin on October 27, 1823, indicated a well-furnished moderate-sized building, three rooms on a floor; its contents confirmed that Whitney was an active craftsman as well as an educated man. The north room held two globes and cases at $8; a lot of books at $5; a map of the United States, $2; and the furniture, a small table and stand and chest of drawers, at $1.75. Whitney had a separate two-story building, probably behind his house, as his workshop, but his tools were not itemized, except for six vises and three turning lathes (City Hall, Register of Wills, Will no. 293, 1823). Whitney had a relatively large library, which included the *British Encyclopaedia, Domestic Encyclopedia, Dictionary of Arts and Sciences,* Watt's *Logick,* Bioris's *Mathematical Instruments,* Guthrie's *Geographical and Commercial Grammar,* Ferguson's *Mechanical Exercises, Directions for the Use of the Quadrant, Geographical Description of the United States,* all of which, and more, were inherited by his son Thomas, who died in 1829 (City Hall, Register of Wills, Will no. 144, 1829).

184. *Surveyor's Compass*

c. 1812

Inscription: Thos Whitney Maker/ Philadelphia (engraved in script in center of dial)

Brass, silvered dial, steel needle

Length 14⅝″ (37.1 cm); width 10″ (25.4 cm); compass diameter 6″ (15.2 cm)

Private Collection

THIS SURVEYOR'S COMPASS with sights is the most ambitious and complete among several extant examples by Thomas Whitney. Two others, one in the American Philosophical Society, the other in the Franklin Institute, have sighting bars only on the north-south axis, while this compass also includes them on the east-west axis. The three are approximately the same size—the compasses are all exactly six inches in diameter, the arms are cut from the same pattern, and the north-

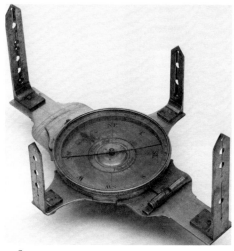

184.

south sighting bars are the same height. But they differ in the style and quality of the engraving on the face of the compass—the exhibited example shows the most attention to design and engraving technique—and in the number of holes in the sighting arms. All three were traditional in form: their compasses keep east to the right of north; the more pragmatic, land surveyor's form switches west and east to allow bearings to be read directly from the compass. All are calibrated into quarters from 0 to 90 degrees at east and west so that no conversions need be made. The vernier, placed just above north on the arm, allows adjustments to be made so that magnetic bearings read as true bearings. The fine and regular markings on the brass arms may have been made with a dividing engine, although slight variations in the depth and length of the incised degree lines suggest a sure but human hand.

The surveyor's compass was used throughout the eighteenth century for land surveying in conjunction with a Gunter's chain. The chain measured distances; the compass with alidades measured angles. These tall sighting arms with slits, on four axes, were an American adaptation for hilly terrain, and made the compass more versatile, as the surveyor could read from four positions. The special American problem of surveying uncleared land kept the combinations of compass and traverse survey in use well into the nineteenth century, when a sighting telescope for long distances was in full use in England and Europe. Although surveyors usually had a rudimentary knowledge of the construction of their compasses and could make simple repairs, instruments like this one demanded special tools and meticulous calibration, estimation of magnetic deviations due to materials, and hand-cut adjusting screws for leveling and fastenings.

Thomas Whitney followed the virtuoso era of David Rittenhouse (see biography preceding no. 132), whose specialized scientific instruments were widely celebrated. Whitney marks the beginning of a broader technology often handled by teams of craftsmen. His compasses are individual only in detail, and were probably made in large numbers for use by the military, in commercial development, and for company and private land surveys.

BG □

ROBERT WELLFORD (ACT. C. 1798–1839)

Robert Wellford, ornamental plaster manufacturer, probably belonged to the family of Wellfords on the Eastern Shore of Virginia at Fredericksburg. The extent to which plaster ornaments marked with Wellford's name were employed in Virginia, on ceilings and mantelpieces, suggests more than just chance business connections and shipments into that area. John Wharton's house, built probably about 1798 in Accomack County, Virginia, used Wellford ornaments, which, if manufactured in Philadelphia, may be the earliest documented examples of his enterprise (Ralph Whitelow, *Virginia's Eastern Shore,* Richmond, 1951, pp. 181–83).

Wellford is first listed in the Philadelphia directories in 1801 at 49 Chestnut Street. Deeds dated 1812 and 1815 mention his wife, Martha, but no will or administration is extant. In 1803 he supplied the ornamentation for four mantelpieces at Powelton (Charles B. Wood III, "Powelton; An Unrecorded Building by William Strickland," *PMHB,* vol. 91, no. 2, April 1967, p. 149); at that time he was in a partnership, Wellford & Anderson, and was located at 42 South Third Street. In 1811 he advertised that he was the proprietor of the "original American composition ornament manufactory, 96 S. 8th St., 5th door below Walnut" (C.O.C., "Two American Mantelpieces," *MMA Bulletin,* vol. 14, no. 2, February 1919, p. 37). On March 11, 1818, he advertised in the *Aurora General Advertiser* that he sold "Improved American manufactured composition ornaments . . . answering most effectually the general intention of wood carving, and much superior for ornamenting stone patterns, and models for Iron Founders . . . No. 145 South Tenth Street [below Locust] Philadelphia." He moved his shop several times, but his 145 South Tenth Street address, purchased from Edward Shippen Burd, remained in his tenure until 1836. In 1839 he had retired and was listed at 12 Perry Street, after which his name disappears from Philadelphia records.

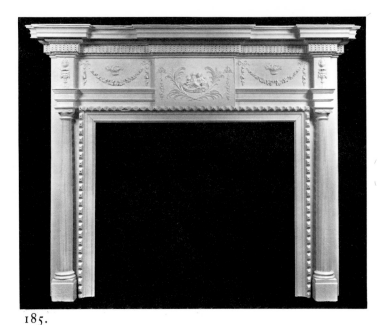

185.

185. *Mantelpiece*

1805–15
Pine with applied plaster ornament
64³⁄₁₆ x 82¹¹⁄₁₆″ (163 x 210 cm)

Philadelphia Museum of Art. Purchased:
Joseph E. Temple Fund. 22–88–1

PROVENANCE: Samuel Freeman & Co.,
Philadelphia, 1922

LITERATURE: *PMA Bulletin* (November 1922),
pp. 3, 4

ROBERT WELLFORD supplied the joiners of
Philadelphia with plaster ornaments to
decorate their mantelpieces, ceilings, over-
doors, and dado friezes. His advertisement
in *Paxton's Philadelphia Annual Advertiser*
in 1818 stated that he would include with
the purchase of his ornaments printed
instructions for "tempering and fixing"
them. This kind of plaster decoration grew
out of the English fashion for small repeat
patterns of geometrical or stylized natural
shapes that had appeared in the architectural
settings created by the Adam brothers in
England in the mid-eighteenth century.
Previously, plasterwork demanded special
molds, scaffoldings, and the precise mixes
of materials required for the plaster to hold
together. "Running" a plaster frieze or
ceiling had always been a messy job, but, as
his advertisement proclaimed, Wellford's
technique allowed such ornaments to be
"readily fixed by screwing them up to the
joists, which prevents making dirt in
finished buildings."

This mantelpiece is an especially ornate
example of Wellford's collaboration with
his joiner colleagues. The flat panels of pine
are heavily decorated with plaster ornament,
while the vertical elements and the edge
moldings are carved wood. The fluted Doric
engaged columns on Tuscan bases support
an entablature ornamented with a narrow
banding of plaster in a fine swag design.
The delicacy of the plasterwork contrasts
sharply with the deeply cut fireplace facing
molding, which is the epitome of the gouge
and punch style developed in Philadelphia
after 1790. It was a style that Owen Biddle
did not like; in his *Carpenter's Assistant,* he
advises: "In ornamenting a mantle the
young carpenter would do well to endeavour
at an imitation of something natural, and
not to cover his work with unmeaning holes
and cuttings of a gouge" (p. 28). But the
style flourished, and moldings like the one
below the mantelshelf were carved in small
units and glued into suitable positions on an
architectural framework. The same molding
patterns can be found in a much larger
scale on exterior architectural cornices.

The center panel of this mantel shows a
goddess riding in a chariot, probably the
goddess of plenty, who holds a cornucopia
aloft, her chariot enmeshed in a cradle of
foliage. It is very similar to the cut used by
Wellford at the head of his advertisement
showing the Triumph of Columbus, a motif
that appears on the dining room mantel of
the first Harrison Grey Otis house in Boston
(1795–96). Wellford used the centering
device of leafage on other pieces where the
vignette of the Battle of Lake Erie was
centered. The position, pose, and costume of
the figures are typically neoclassical, and
Wellford's design probably derived from
ormolu mounts, marble cutters' patterns, or
prints. The baskets and swags of foliage and
fruit decorating the recessed side panels were
Wellford favorites and appear on other
mantels by him (Sweetbriar, in Fairmount
Park; Winterthur Museum; Metropolitan
Museum of Art), which also include figures
as their central motif. In examples which
center a design of an eagle above a sarcoph-
agus, the horizontal design of a grapevine
entwined around a shaft is used instead of
swags in the flanking panels; ordered in any
length, it was a versatile ornamental device.
The urns and fruit above the engaged
columns on this mantel are made up of two
units, and the same "pineapple" at the top
was used at the end of the grapevine on the
sarcophagus mantel. Thus, a joiner or cus-
tomer could select from numerous motifs,
and the infinite variety of combinations
which resulted made the mantelpiece the
prominent embellishment of early nine-
teenth century Philadelphia interiors.

BG □

SIMON CHAUDRON (1758–1846)

According to research by W. H. Britton,
Simon Chaudron was born in Vignery,
Champagne, France, the son of François and
Marguerite Guilliée Chaudron. As a young
man he studied watchmaking in Switzer-
land. While living in Paris, he was initiated
into the Masonic Lodge Noeuf Soeurs, an
ancient organization whose distinguished
membership included Voltaire and Franklin.

In 1784, at the age of twenty-six, he moved
to Santo Domingo where in 1791 he married
Jeanne Geneviève Mélanie Stollenwerck.
Of their thirteen children, the first two were
born in Plaisance, Santo Domingo, and
eleven in the United States.

Chaudron visited Philadelphia in 1790
and again in 1793. The later trip may have
been in preparation for his move to Phila-
delphia with his family in late 1793 or early
1794, probably to escape the uprisings in
Haiti. He was listed in the Philadelphia
directories in 1799 as a watchmaker and
jeweler at 12 South Third Street. (Before
that he had been in partnership with Billon.)
His name appears each year at different
addresses through 1818. In 1816 his son
Edward is listed in his father's place as
watchmaker and jeweler.

On January 4 and February 17, 1800,
Chaudron advertised in the *Federal Gazette*:

Chaudron, Simon Goldsmith/for sale, by
the Subscriber No. 12, South Third Street,
A large assortment of Elegant Watches,
Gold Chains and Jewellery, Suitable for
the Spanish and West India Markets.
Also a quantity of French Silver Plate.
Mourning Rings, with an elegant
Portrait of the late illustrous General
Washington.

For Sale, on low terms for cash or a short Credit, An elegant and extensive assortment of Jewellery suitable for Spanish Main and West India Market: Plain Watches of every description, Enamelled Rings, Seals and Necklaces.

S. Chaudron No. 12 South Third Street, Also 400 Cases Claret of the first quality, 12 bottles each.

In 1818, Chaudron's occupation was listed in the directory at 168 Spruce as an editor of a French journal, *L'Abeille Américaine*. Chaudron's ability as a writer is seen in the publication of a volume of his work, containing his writings from 1796 to 1815 (*Poésies choisies de Jean-Simon Chaudron, suivies de l'oraison funèbre de Washington, par le même auteur,* Paris, 1841). His *Funeral Eulogy of Gilbert De LaFayette* was published in New Orleans in 1835.

Chaudron and his family moved in 1819 to Demopolis, Alabama, a town established by Bonapartist refugees in 1817. He had been preceded by three of his sons who had cleared land to erect houses for their families in the newly formed Vine and Olive Colony. According to family history, Chaudron moved to Mobile, Alabama, in 1825 where he specialized in the repair of chronometers, watches, and clocks.

Since Chaudron was never listed as a silversmith in the Philadelphia directories, it is likely that he was the head of a shop that probably employed a number of silversmiths. Anthony Rasch (see biography preceding no. 175) was one such workman who was first indentured to Chaudron and

then was taken into the firm. It was called first Chaudron & Co., then, according to their mark, Chaudron's and Rasch (clearly still Chaudron's firm).

In addition to his success as an entrepreneur, Chaudron, like Michel Bouvier (see biography preceding no. 240), became a distinguished citizen. In 1793 he attended the inauguration of Washington which he recorded in his *Oration on the Death of Washington*. He was the secretary of the French Society for the Relief of Unfortunate Frenchmen, and he belonged to a social organization called Les Grivois. During his stay in Philadelphia, Saint-Mémin (see biography preceding no. 166) did a portrait of Chaudron (Corcoran Gallery of Art).

186. *Coffee and Tea Service*

c. 1812–15

Mark: Chaudron (stamped twice on base of coffeepot and once on bottom of teapot and sugar bowl); 44 (scratched on bottom of sugar bowl); 45 (on slop bowl); 46 (on cream pot)
Inscription: (Family crest engraved on each piece)
Silver; wood handles
Teapot height 8½″ (21.5 cm), width 9¼″ (23.4 cm), diameter 5½″ (13.9 cm); coffeepot height 11″ (27.9 cm), width 11¹⁄₁₆″ (28 cm), diameter 6¼″ (15.8 cm); sugar bowl and cover, height with lid 8½″ (21.5 cm), width 8¼″ (20.9 cm), diameter 5¼″ (13.3 cm); cream pot

height 7¼″ (18.4 cm), width 5³⁄₁₆″ (13.1 cm), diameter 3¾″ (9.5 cm); slop bowl height 5½″ (13.9 cm), diameter top 7⅝″ (19.2 cm)
The Newark Museum, Newark, New Jersey

PROVENANCE: Descended in Henry family to Snowden Henry III, West Orange, New Jersey; with August Scheiner Antiques, Newark, 1963

LITERATURE: Newark, *Classical America,* p. 90, pl. 94; Katherine Morrison McClinton, *Collecting American 19th Century Silver* (New York, 1968), p. 37 (illus.); Davidson, pp. 146–47, fig. 202

FAMILY TRADITION maintains that this coffee and tea service was presented to John Snowden Henry by the Marquis de Lafayette on his second visit to Philadelphia in 1824. Actually, however, Lafayette presented this service to an unknown "host and hostess" at an earlier date, since Chaudron had left Philadelphia by 1819, and the set was acquired later by the Henry family as payment of a legal fee.

The most striking detail of the service is its stamped banding of spread eagles and alternate medallions with leaf sprays, symbols of the new Republic derived from French sources. The French Empire style was transferred to this city by émigré craftsmen and merchants such as Chaudron, Jean-Baptiste Dumoutet, Claudius Chat, and John Tanguy.

DH □

WILLIAM CHARLES (1776–1820)

Charles was born in Edinburgh, Scotland, and lived in England before coming to America around 1805. Presumably, his emigration was occasioned by an unfavorable reaction to his trenchant caricatures; to avoid persecution, he immigrated to New York where he practiced as an engraver and publisher at Charles' Repository of Arts. He was not very successful there, which is probably why he moved to Philadelphia, where his name is first recorded in the city directories in 1815. Here, he added bookseller and stationer to his other occupations and at times collaborated with the young printer Joseph Yeager, with whose assistance Charles illustrated and published a number of toy books and novels (see Harry B. Weiss, "William Charles, Early Caricaturist, Engraver and Publisher of Children's Books," *NYPL Bulletin,* vol. 35, no. 12, December 1931, pp. 835–39). Among his other works produced in Philadelphia were prints for Rees's *Cyclopedia* (1810–24), *Pinkerton's Travels* (1810–17), *The Tour of Dr. Syntax in Search of the Picturesque,* and an edition of the *Vicar of Wakefield.*

186.

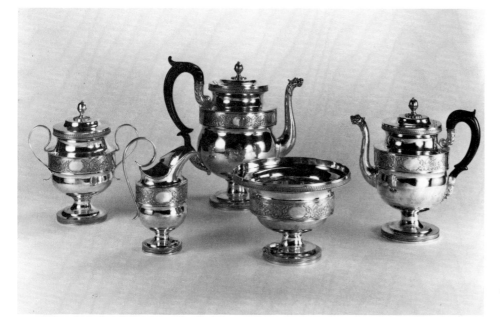

Charles is best known for his series of caricatures made between 1807 and 1817, especially those on the War of 1812. The popularity of these prints encouraged Charles and S. Kenney, a Philadelphia publisher, to offer folios containing four cartoons at $1.50 a month to subscribers and $2.00 for individual issues. The project was unsuccessful and was abandoned, but the prints could be purchased for fifty cents each. Charles died in Philadelphia on August 9, 1820, and was buried in the graveyard of the new Market Street Baptist Church.

187. *The Cock Fight— or Another Sting for the Pride of John Bull*

1813

Inscription: THE COCK FIGHT—or another sting for the Pride of JOHN BULL. (below image)/Charles del et Sculp (below image, lower right)

Etching with watercolor

10½ x 14¼″ (25.5 x 36 cm)

Historical Society of Pennsylvania, Philadelphia

LITERATURE: Drepperd, *Early Prints,* p. 212; Stauffer, vol. 2, p. 55, no. 319; Frank Weitenkampf, "Political Caricature in the United States in Separately Published Cartoons," *NYPL Bulletin,* vol. 56, no. 3 (March 1952), p. 115; *Made in America,* pp. 18–19, no. 24

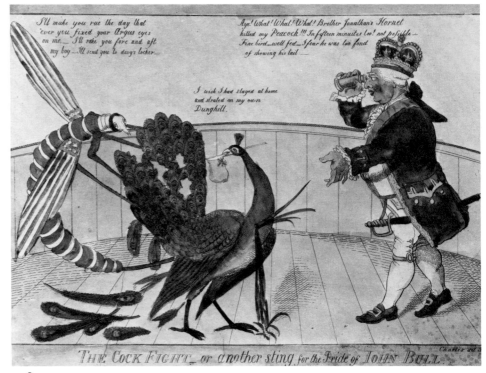

187.

LIKE PORTRAITS, marine prints, and allegories (see nos. 110, 150, 194), caricatures were used to comment on contemporary issues. Although they provide a single viewpoint, these topical illustrations offered an immediate response to actual events and, as such, can be seen as a record of the nation's history. Most American cartoons, dating back to the first one by Benjamin Franklin (inside cover of *Plain Truth,* 1747), were crudely executed, yet their simple and direct humor appealed to a large audience (see no. 64) and thus offer insight into the attitudes and feelings of the American people.

The inspiration for William Charles's *Cock Fight* derives from a naval conflict during the War of 1812. The eastern seacoast had been blockaded by British vessels patrolling the waterways to keep American ships from sailing across the Atlantic. On February 24, 1813, the American *Hornet* under Master-Commandant James Lawrence encountered the British *Peacock* commanded by Captain William Peake. The *Peacock* was defeated after a fifteen-minute battle. A collaborative American-British effort made to save the damaged ship proved futile. Survivors were boarded onto

the *Hornet* where the admirable treatment they received from their captors resulted in a note of gratitude upon their arrival in New York (B. J. Lossing, *Pictorial Field-Book of the War of 1812,* New York, 1869, p. 699, n. 2). Although the Americans were victorious in many such single-ship encounters, they were unable to penetrate the British fleet.

News of individual victories spread quickly throughout the United States. Lawrence and his crew were eventually honored with medals requested by Congress, and the incident became a popular subject for representation. Some artists chose to depict straightforward battle scenes as Savage had done in *The Constellation* (no. 150); others like Amos Doolittle (see William Murrell, *A History of American Graphic Humor,* New York, 1938, vol. 2, no. 52) and William Charles turned to caricature.

In Charles's version, the names of the ships have been translated into visual forms, each gaily decorated with the insignia of its country. As the Hornet pierces the Peacock with its lethal sting, it scolds the bird: "I'll make you rue the day that ever you fixed your Argus eyes on me—I'll rake you fore and aft my boy—I'll send you to davy's locker—." In response the Peacock groans: "I wish I had stayed at home and struted on my own Dunghill." According to mythology, the "eyes" in the peacock's tail were those of Argus, the many-eyed herdsman

and watchman, placed there by Hera after he was slain by Hermes. Thus *Peacock* was an appropriate name for a vessel whose purpose was to watch over and guard the sea. When the Hornet threatens to send the Peacock to "davy's locker," he refers of course to Davy Jones, the spirit of the sea and the sailor's devil, and the nautical slang for the grave of those who perish at sea. "Dunghill," perhaps a synonym for "territory," may also be a reference to the dunghill cock, or one who is cowardly and without a fighting spirit.

On the right, George III bemoans his loss: "Aye! What! What! What! Brother Jonathan's Hornet killed my Peacock!!! In fifteen minutes too! not possible—Fine bird —well fed—I fear he was too fond of showing his tail—." Brother Jonathan is the sharp and clever Yankee predecessor of Uncle Sam (Frank Weitenkampf, "The Cartoonists' Uncle Sam," *Antiques,* vol. 46, no. 1, July 1944, pp. 16–17), while John Bull is another name for England and personifies the frank and solid qualities of the English character.

A year after the encounter, a limerick appeared which suggests that the English "Peacocks" were meeting American resistance and were thus unable to fulfill their function:

O, Johnny Bull, my joe, John, your *Peacocks* keep at home,
And ne'er let British seamen on a *Frolic* hither come,

For we've *Hornets* and we've *Wasps,*
John, who as you doubtless know,
Carry stingers in their tails, O, Johnny
Bull, my joe.
("Brother Jonathan's Epistle to Johnny
Bull," 1814, Lossing, cited above, p. 698)

Charles's commentaries owe much to the satirical caricatures which were popular in England at the time. The figures bellow out their message in an effort to rouse the reader's passions and spirit; their success depended on their timeliness and ability to affect or crystallize public opinion. The simplified composition, robust and exuberant characters, crudely executed pastel colors, and freedom of linework show the influence of James Gillray and Thomas Rowlandson.

ESJ □

SAMUEL SEYMOUR (ACT. 1796–1823)

William Dunlap states that Samuel Seymour was born in England. The date of his arrival in America is not known, but he is first listed in Philadelphia city directories in 1796, and his name continues to appear until 1823. Seymour studied engraving and painting along with Thomas Birch under the tutelage of William Birch (see biography preceding no. 149); his characteristic technique combining line and stipple engraving in the English manner was no doubt due to the elder Birch's training. After completing a career of general engraving of certificates, book illustrations, and the ambitious engravings after the paintings of Thomas Birch, Seymour was selected as draftsman on Stephen Long's expedition to the Rocky Mountains (1819–20) and his second exploration of the upper reaches of the

Mississippi (1823). His drawings illustrating the published accounts of the expeditions were among the earliest depictions of the American West. Seymour presumably returned to Philadelphia after the journeys, although no work made by him after 1823 is known.

FRANCIS KEARNEY (1785–1837)

After studying at the Columbian Academy in New York under the Robertson brothers, Francis Kearney (sometimes spelled Kearny) served his apprenticeship with a New Jersey engraver, Peter Maverick. According to Dunlap, Kearney taught himself the different intaglio methods using vade mecums and encyclopedias, since Maverick was not a very accomplished technician (Dunlap, *History,* vol. 2, p. 211). After several years of independent practice in general engraving work, Kearney moved from New York to Philadelphia in 1810, where he worked until returning to his native Perth Amboy in 1833.

In 1816, Kearney entered into a constantly evolving partnership with Benjamin Tanner (see biography preceding no. 194) and other engravers, including John Vallance (see biography preceding no. 148), specializing in banknote engraving, for which there was a growing demand. Cornelius Tiebout joined the firm of Tanner, Vallance, Kearney & Co. from 1817 to 1824. Benjamin Tanner's brother Henry was a sometime partner. However, by 1824 Kearney was working independently, possibly due to some financial disagreements with Benjamin Tanner alluded to by Dunlap. In 1829, Kearney joined the short-lived lithographic firm of Pendleton, Kearney & Childs. His best-known lithograph is *Shakers Dancing near Lebanon.*

Kearney engraved numerous portraits and book and periodical illustrations, some of which he published independently as a portfolio. His *Illustrations to Ivanhoe* were published in the *Port Folio* before Kearney issued them separately in 1822. The wrapper explains that they were published "by way of experiment, to ascertain how far the efforts of native artists in this country will be encouraged." Few complete sets exist, and the large number of the illustrations appearing in scrapbooks attest to the popularity of these engravings after Richard Westall's designs. Today Kearney's most popular prints are the aquatints of naval battles of the War of 1812, although in his lifetime his reputation was built by a line engraving of the *Last Supper* after Leonardo, over 1,500 copies of which sold at five dollars each (Dunlap, *History,* vol. 2, p. 212).

THOMAS BIRCH (1779–1851)

Born in Warwickshire, England, Thomas Birch came to the United States in 1794 with his father William, the well-known enamel painter and miniaturist (see biography preceding no. 149). The elder Birch enlisted his son's assistance in taking the views of the city for which he is best known, while training him and the aspiring engraver Samuel Seymour. Sometimes John Wesly Jarvis and Thomas Sully joined the sketching outings (Dunlap, *History,* vol. 2, p. 259).

Thomas Birch's first major effort in oil painting appears to be the view of Philadelphia from the Treaty Tree at Kensington, which Seymour engraved and William Birch published in 1804. Thomas continued to paint landscapes throughout his career, although he first established himself as a portrait painter, especially watercolor

188a.

188b.

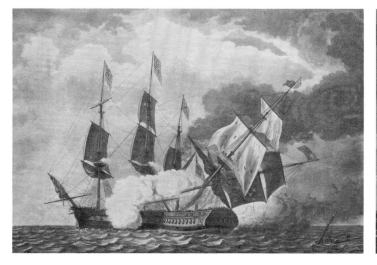

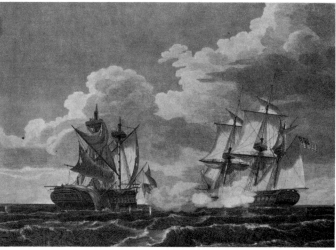

miniatures. Birch was active at the Pennsylvania Academy of the Fine Arts, the Society of Artists, and Artists' Fund Society, exhibiting frequently throughout his productive career, which was spent entirely in Philadelphia.

Always fascinated by the sea and shipping, Thomas began to specialize in marine paintings fairly early in his career. William Dunlap suggests that Birch's patriotism for his adopted land was stirred by the victorious "bit of striped bunting" (*History*, vol. 2, p. 260), inspiring his series of American naval battles of the War of 1812. His style followed the Dutch marine tradition rather than the more detailed works of the French painter Joseph Vernet, some of which he is known to have copied and exhibited. Birch had direct access to European paintings through his father's collection, which included works by and after Van Ruisdael and Van Goyen. His landscapes and seascapes followed nature without romantic embellishments of ruins and follies. The naval battles were painted as accurately as possible; Birch generally interviewed as many of the crew as he could to gather details to use in the paintings. Birch was the first American ship portraitist, and his paintings were copied by countless artists and craftsmen in America and Europe.

FRANCIS KEARNEY AFTER THOMAS BIRCH

188a. *Engagement between the Constitution and the Guerrière*

c. 1813

Signature: Designed by T. Birch (bottom left); F. Kearney Aquatint (bottom right)

Inscription: *Engagement between the U.S. Frigate Constitution* CAPT. HULL *rating 44 Guns & the* BRITISH FRIGATE GUERRIERE CAPT. DACRES *rated 38 Guns;/August 19ᵗʰ 1812; which terminated in the complete destruction of the Enemy's Ship after a close Action of 30 minutes Loss of the British 15 killed 62 wounded 24 missing— American loss 7 killed 7 wounded*

Aquatint and etching with watercolor
18½ x 22⅞" (47 x 58.1 cm)

E. Newbold Smith, Paoli, Pennsylvania

PROVENANCE: Francis P. Garvan, New York; Kennedy Galleries, New York

LITERATURE: Irving S. Olds, *Bits and Pieces of American History* (New York, 1951), pp. 110–11; Helen Comstock, "Naval Views by Thomas Birch," *Connoisseur,* vol. 126 (December 1950), pp. 202–3; Irving S. Olds, "Early American Naval Prints," *Art in America,* vol. 43, no. 4 (December 1955), p. 54, illus. p. 27; Edgar Newbold Smith, *American Naval Broadsides: A Collection of Early Naval Prints (1745–1815)* (Philadelphia and New York, 1974), p. 81, pl. 34

SAMUEL SEYMOUR AFTER THOMAS BIRCH

188b. *The United States Capturing the Macedonian*

1815

Signature: Painted by T. Birch A.C.S.A. (bottom left); Engraved by S. Seymour (bottom right)

Inscription: THIS REPRESENTATION OF THE U.S. FRIGATE UNITED STATES, STEPHEN DECATUR ESQᴿ COMMANDER, CAPTURING HIS BRITANNIC MAJESTY'S FRIGATE MACEDONIAN, JOHN S. CARDEN ESQᴿ COMMANDER/*Is respectfully inscribed to Capt Stephen Decatur his Officers and Gallant Crew by their devoted humble Servant/*James Webster./

Etching and engraving with watercolor
First state
18 x 25¾" (45.7 x 65.4 cm)

E. Newbold Smith, Paoli, Pennsylvania

LITERATURE: Helen Comstock, "Naval Views by Thomas Birch," *Connoisseur,* vol. 126 (December 1950), 202–3; Irving S. Olds, "Early American Naval Prints," *Art in America,* vol. 43, no. 4 (December, 1955), p. 55, Edgar Newbold Smith, *American Naval Broadsides: A Collection of Early Naval Prints (1745–1815)* (Philadelphia and New York, 1974), pp. 111, 114, pl. 54

THE YOUNG UNITED STATES had barely a chance to settle down after the Revolutionary War and savor the fruits of independence before it was at war again, defending "Free Trade and Sailors' Rights." The War of 1812 brought American marine painting to heights hitherto unattainable— for the first time there was a navy, albeit small; there were more artists working in America than during the Revolution; and landscape painting in general was gaining greater acceptance. The need to recognize the victories in order to encourage the military forces was filled by marine prints engraved by immigrant artists such as Thomas Birch and Michel Felice Corné.

The early part of the war, at the Canadian front, had been disastrous for the Americans. Fortunately for the United States, England was also fighting a naval war with France, so only a few ships could be spared for the west Atlantic. No one imagined that the mighty British navy would have any difficulty when confronted with the fledgling American fleet; however, Yankee ingenuity had designed ships to outclass the English equivalents; they were more maneuverable, fired a larger broadside, and were so heavily planked with stout oak that a great deal of enemy fire was deflected. As news of setbacks on the Canadian front continued to demoralize the nation, the American *Constitution* ("Old Ironsides"), commanded by Isaac

Hull, happened upon H.M.S. *Guerrière,* and after an amazingly short action of half an hour, de-masted and captured the English ship before sinking her. Birch painted several stages of the maneuvers, which were copied more frequently than any other depiction of an event of American history before the Civil War.

Kearney chose to copy the scene showing the *Constitution*'s broadside toppling the mast of the hapless *Guerrière,* the original of which is in the United States Naval Academy in Annapolis. The stately American ship, hardly battle-scarred, flags flying and her decks swarming with men, is separated from the enemy only by a large pall of smoke. The falling mast pulls sails and rigging away from the tight composition at the center of the picture. Kearney was able to heighten the dramatic effect with broad areas of aquatint tone.

While the *Constitution* was winning battles, artists and craftsmen were quick to realize the financial potential of such a stunning victory, and ceramics, textiles, looking glasses, medals, and reverse-glass paintings sported the smoke of the *Constitution*'s guns and the *Guerrière*'s shattered rigging. Birch had contracted with the Philadelphia publisher Joseph Delaplaine to produce "a Series of Engravings of the American Naval Actions from the commencement of the Revolution to the Present time . . ." (HSP, Gratz Papers, Thomas Birch and Joseph Delaplaine, Agreement, April 13, 1813). Most of the prints after Birch's paintings were published by another Philadelphia publisher, James Webster, and none with Delaplaine's imprint are known. Possibly some of the rare issues without imprints were intended for Delaplaine, who is better known for his series of portraits of American notables.

Kearney was the co-publisher of another Thomas Birch painting of a later stage in the battle, also undated. Other eminent American engravers of depictions of the battle between the *Constitution* and the *Guerrière* included Samuel Seymour, Benjamin Tanner (who did several views), Cornelius Tiebout, William Strickland (see biography preceding no. 202), and William Kneass (see biography preceding no. 177). Many more European artists carried the American victory to drawing rooms all over the Continent. One artist must have derived a special sort of pride from his copy: William Birch was commissioned to make an enamel copy for a snuffbox presented to Isaac Hull by a grateful New York City in 1813.

After the enormous popularity of prints relating the victory of the *Constitution* over the *Guerrière,* there was a rush to portray every battle favorable to American morale. Perhaps the second most enduring image was that of the engagement between the

frigates *United States* and H.M.S. *Macedonian*. The popular Stephen Decatur commanded the American ship, which in December 1812 was the first to bring in a British man-of-war as a prize. Sailing from the battle site near the Canary Islands, the *United States* paraded her prisoner past Newport, New London, through the Long Island Sound and Hell's Gate, and into New York harbor. Hardly had Decatur docked his prize when Birch and the attendant printmakers were hard at work depicting various episodes of the battle.

Samuel Seymour and Benjamin Tanner produced prints perhaps closest of all to Birch's paintings; Tanner in fact engraved all six of the Birch paintings of the *Macedonian* and the *United States*. Seymour and Tanner's prints are remarkably similar, differing only in the title, imprint, and in the small portrait bust of Stephen Decatur after Stuart's painting, which appears in the center of the bottom margin. Both prints are a combination of etching and engraving; the handling of the sky and clouds is individual. Tanner's sky is perhaps more dramatic than Seymour's; Seymour in turn portrays a brisker, choppier sea. Tanner's *Macedonian* appears somewhat worse for wear, losing a few more spars to the *United States*'s broadsides. Both engravers surround the round portraits with a cartouche of flags, cannon, shot, anchors, and laurel leaves, although Tanner has a larger pile of cannon balls. Tanner's print was, in fact, first published in 1813, shortly after the battle. A second state of the same year showed that James Webster was the publisher, as he was again for the same picture engraved by Samuel Seymour two years later. Seymour produced an aquatint of the battle after a drawing of J. J. Barralet, which was far less successful than the line engravings.

Among American engravers, especially in Philadelphia where Birch's paintings were first exhibited, there was great (and healthy) competition to produce the finest renderings on copper. The *American Daily Advertiser* of June 12, 1815, carried a revealing review by its art critic, Philo-Pictor:

As I am on the subject of Engraving, I beg leave to touch on some very fine Prints, that are before the Public, and are got up in a very superior style—I allude to one of our Naval Engagements, during the last War, from the burine [sic] of Tanner and Seymour—I declare, (except perhaps the Battle of La Hogue, by Woolet,) I have never seen two finer prints than has been executed by B. Tanner; and Samuel Seymour—there seems to have been a rivalry between these two gentlemen, who should produce the best plate on the same subject, I do not take upon myself to decide, (it is a *tender point*) there they are, open to the public's

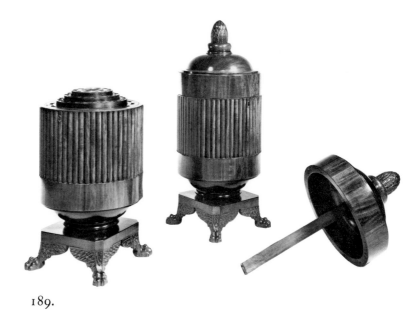

189.

inspection.... Birch, deserves much of the credit from the manner in which he has treated the subjects.

... I shall finish here, Sir, with a wish that our Paper Makers could contrive to make a sort equal to the French, then our Engravers would have more justice done them—the ink seems inferior—and it strikes me, the Printer, in some measure, fails in his performance.

SAM □

DAVID SACKRITER (ACT. 1807–45)

Although he was listed continuously as a cabinetmaker in Philadelphia business directories, David Sackriter is relatively unfamiliar to furniture historians. One of the knife boxes in this exhibition is the only piece known that bears his name. Perhaps one explanation for Sackriter's obscurity is that he may have specialized in making knife boxes. In England, and perhaps in Philadelphia as well, knife cases were "not made in regular cabinet shops," but rather "by one who makes it his main business" (Sheraton, *Drawing-Book*, p. 392).

Sackriter may have been the son of Jacob Sackriter, a tanner, whose name was listed in the city directory of 1811 as Sacriter and later, in 1813, as Sackriter. David Sackriter worked at 149 Cedar (now South) Street from 1807 to 1810. In 1811 he was listed at Seventh Street, below Cedar, and from 1813 to 1817, at the corner of Bedford and Seventh streets. The last address is probably the same as the Seventh Street address since Bedford Street was just south of Cedar Street.

From 1818 to 1845, Sackriter's business was at 259 South Seventh Street, between

Walnut and Spruce on the west side of the street. While working at this address, he belonged to the Society of Journeyman Cabinetmakers, but he was not a member of the Franklin Institute as were many Philadelphia cabinetmakers.

David Sackriter was joined in 1842 by Daniel P. Sackriter, probably his son. In 1843, Daniel was listed at a separate address, 76 Bedford, but in 1845, his address was both 259 South Seventh and 76 Bedford streets, and he was listed as a cabinetmaker at both addresses until 1849.

189. *Pair of Knife Boxes*

1814
Signature: David Sackriter/Jan. 12, 1814 (in pencil on bottom of one box)
Mahogany veneer on mahogany
27½ x 11¼ x 11¼" (69.8 x 28.5 x 28.5 cm)
Mrs. Charles L. Bybee, Houston, Texas

KNIFE BOXES have always been considered a rare form for America, and until the late eighteenth century most knife cases used in this country were imported from England. By the early nineteenth century, however, native cabinetmakers began to try their hands at these small, virtuoso pieces.

Few examples of American-made knife boxes of the early 1800s survive, and each of those that do is a very distinctive interpretation of its craftsman's creativity. Because of this singularity in treatment, it is particularly noteworthy that three pairs of almost identical American knife boxes are known today: those in the exhibition match a pair of knife cases at the Hill-Physick-Keith house in Philadelphia, once owned by the

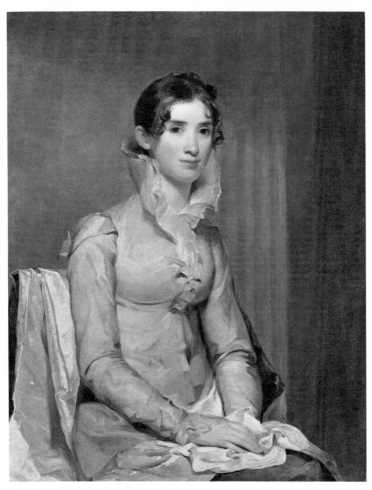

190.

Cadwalader family, and another pair privately owned. The measurements of the three pairs are the same except for a slight difference in the size of the finial.

The construction of the boxes is extremely lavish. The entire cylindrical body is made of a solid piece of mahogany which has been hollowed out, and the convex flutes are carved of the same piece, not applied. The top, too, is solid mahogany, three-quarters of an inch thick, with an applied veneer. Decorative carving is limited to the base and finial, with the stylized leaf below the chamfered corner of the plinth repeated on the bud-like finial.

The name and the date are written in pencil on the bottom of one of the knife cases. Since Sackriter was continuously listed in the Philadelphia directories as a cabinet-maker, it seems more than likely that he was responsible for construction of these knife cases. However, because of the absence of secondary woods, one cannot conclusively rule out the possibility that the boxes were made in England and imported and sold by him.

PT □

THOMAS SULLY (1783–1872)
(See biography preceding no. 158)

190. *Mrs. Joseph Klapp*

1814
Oil on canvas
36¼ x 28⅛″ (92 x 71.4 cm)
The Art Institute of Chicago. Gift of Annie Swan Coburn to the Mr. and Mrs. L. L. Coburn Memorial Collection

PROVENANCE: Descended in Klapp family to Dr. William H. Klapp, Philadelphia, by 1921; Langdon Williams, Philadelphia; with M. Knoedler & Co., New York, by 1950

LITERATURE: *PMHB*, vol. 33, no. 1 (1909), p. 65, no. 957; Biddle and Fielding, *Sully*, p. 200, no. 992; The Art Institute of Chicago, *Paintings in The Art Institute of Chicago* (Chicago, 1961), p. 443

THOMAS SULLY'S PORTRAIT of Mrs. Joseph Klapp (Anna Milnor Klapp) is recorded in his register of completed work (Historical Society of Pennsylvania), with the infor-

mation that it was begun on June 3, 1814, and finished July 6. The sitter's husband, a Philadelphia physician, was portrayed during the same period as a companion portrait. Sully charged one hundred dollars for each painting, a relatively high price at that time, especially considering that the artist was only thirty-one, the same age as both of his sitters.

The two most important formative influences on Sully's style were England's Thomas Lawrence and America's Gilbert Stuart. Stuart's influence is most evident in some of Sully's early portraits such as *Mrs. Joseph Klapp,* which is one of the most successful and beautiful of this period; Lawrence was a greater influence on Sully's later, more romantic mood portraits, a good example being *Sarah Sully and Her Dog Ponto* (no. 282) of 1848.

The portrait of Mrs. Klapp is a wonderful study of silver grays complimented by pale rusts and slate blues. This is a carefully calculated and tightly controlled harmony, with a repetition of three major colors in varied shades and subtle contrasts in value adding to the effect of rich variety within a limited scheme. Sully came to develop the idea that "the most excessive power of contrast of colouring is given by a *brownish-yellowish-red* placed in contact with a broken *gray* color," as he told Neagle in 1828 (APS, John Neagle, Notebook 3, "Hints for a Painter with regard to his Method of Study &c.," p. 19). Sully followed Du Fresnoy, a widely read writer on painting, by combining all the principal colors in the background (Charles A. Du Fresnoy, *The Art of Painting,* trans. William Mason, London, 1783, p. 43). Although seemingly painted with great ease, Sully's portrait is a highly sophisticated contrivance. For instance, the blue streak under the ruff at the base of the neck, with yellow ochre applied on top, creates a pale brown shadow with unusually convincing depth.

Sully displays admirable skill in rendering a variety of textures: lustrous and stiffly wrinkled, filmy and soft, opaque or transparent. He works with fluid brushstrokes and reveals a fascination with the textural possibilities of oil paint itself. This interest both in color and the properties of paint is reminiscent of Stuart's *Mrs. Thomas Lea* (no. 147).

Stuart was so important to Sully's early work that in a biographical sketch written late in life Sully recalled that Stuart was his teacher "after I returned from Europe. I was with him five or six months in Boston" ("Recollections of an Old Painter," *Hours at Home,* vol. 10, no. 1, November 1869, p. 70). He is confused here because his return from England directly to Philadelphia in 1810 can be documented (John Hill Morgan, *Gilbert Stuart and His Pupils,* New York,

1939, pp. 37–38). His instruction from Stuart had occurred in Boston in 1807 before he left for Europe. Stuart's portraits were exhibited in the early annual exhibitions of the Pennsylvania Academy and were so highly praised that his influence could easily have continued as a strong force after Sully's return to Philadelphia, as is evidenced by this portrait of *Mrs. Joseph Klapp*. In fact, Sully copied a number of Stuart's portraits after the European trip and admired Stuart's work all his life.

DE □

THOMAS SULLY (1783–1872)
(See biography preceding no. 158)

191. *Colonel Jonathan Williams*

1815
Charcoal and stump on gray paper
14⅜ x 12⅜" (36.5 x 31.4 cm)
Philadelphia Museum of Art. Given by
E. A. Belmont. 40-32-108

PROVENANCE: The artist, until 1872; Jane (Sully) Darley, 1872–77; purchase, E. A. Belmont, Philadelphia, before 1940

LITERATURE: Biddle and Fielding, *Sully*, p. 321, no. 1985 (for date of oil portrait)

THIS PRELIMINARY DRAWING for the oil portrait of Colonel Jonathan Williams is an excellent example of Sully's approach, which he outlined in his *Hints to Young Painters,* first published in 1873. Unlike Gilbert Stuart, Sully did not compose his portraits directly on the canvas, but rather used a series of small preliminary studies, sometimes in charcoal or pencil, usually followed by a small oil sketch. The sitter posed for these studies, and the approved result was then transferred to the final canvas. The studies were chiefly intended to establish the pose and costume, with the head sometimes faintly drawn in. It is evident from the large number of surviving sketches, both in the Museum's collection and elsewhere, that the sitter's position and the details of clothing were of great importance to Sully, and also that he was in the habit of preserving his sketches.

The use of preliminary portrait studies, usually less detailed than this one, was a fairly common technique, employed by Charles Willson Peale (probably only in his later work; Sellers, *Portraits and Miniatures,* p. 11), Rembrandt Peale (HSP, John Sartain Collection, vol. 24, Rembrandt Peale, "Notes of the Painting Room," p. 55), and John Neagle (Diary, January 3, 1832, private

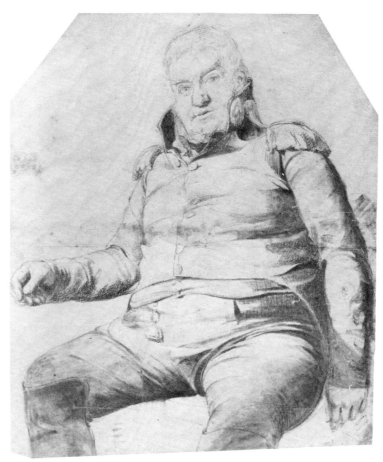

191.

collection). In fact, Neagle so admired Sully's process that he described it with admiration in his notebook in 1825 for future reference, being careful to add that Sully finished the head from life (APS, John Neagle, Notebook 3, "Hints for a Painter," pp. 41–42).

According to Sully's description, he used a short first sitting to determine the pose. This drawing is the result of a second sitting, lasting two hours, in which Sully worked with charcoal on a gray ground. The result was then copied in enlarged form onto the canvas. In subsequent sittings, with oils, Sully concentrated on the likeness; there was usually a total of six sessions. Neagle's account of Sully's procedure differs here in that he claims two sittings were occupied with establishing the head with oils on pasteboard before the likeness was transferred to the canvas. Then, too, Sully's sketches show that he sometimes fixed the pose at the beginning with rapid oil sketches or made detailed pencil sketches of arms or legs to be incorporated later into the whole. With portraits of women, the drapery was often done from a lay figure, and Sully's wife and daughters sometimes posed for the hands and arms so that maxi-

mum advantage could be taken of the sitter's time. Obviously, Sully varied his technique and took greater care with larger, more important commissions such as Colonel Williams's.

Jonathan Williams (1750–1815) was a kinsman of Benjamin Franklin and president of the American Philosophical Society, in addition to his military career. Sully's completed oil portrait of him is a fine full-length (58 by 94 inches, U.S. Military Academy, West Point) which follows this drawing quite carefully but, of course, with the feet and background added, as well as the chair and table. The head is elaborated and made more attractive but not essentially changed.

Sully's practice of making sketches developed about 1803 before he went to England. It had its disadvantages, for he discovered that Philadelphians enjoyed having free studies made but would then sometimes decide against having the portrait done (Dickson, "Neal," no. 6, p. 82).

The use of preliminary sketches appealed most to the artist who wanted the end result to look both as spontaneous and as accurate as possible, who varied his compositions, and who was concerned with accessories and the

233

total effect. With oils, there was always the danger that the mistakes of indecisiveness would make the colors muddy. Sully and Neagle were also conscious of important precedent. Both were impressed with the fact that their method had been used by artists no less distinguished than Sir Joshua Reynolds and Sir Thomas Lawrence, the two most honored English portraitists (HSP, John Neagle, "Common Place Book," pp. 28, 67).

DE □

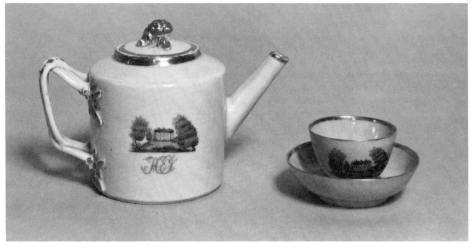

193.

BENJAMIN TROTT (C. 1770–1843)
(See biography preceding no. 146)

192. *Rebecca Biddle*

c. 1815
Watercolor on ivory
3⅛ x 2⁹⁄₁₆″ (7.9 x 6.5 cm)
The Metropolitan Museum of Art, New York. Fletcher Fund, 1933

LITERATURE: Theodore Bolton and Ruel Pardee Tolman, "A Catalogue of Miniatures by or Attributed to Benjamin Trott," *Art Quarterly,* vol. 7, no. 4 (Autumn 1944), p. 279, no. 4, illus. p. 259, fig. 3

THE PORTRAIT OF REBECCA BIDDLE attributed to Benjamin Trott is an example of one of his better miniatures in the latter part of his career. His work generally declined in quality after about 1819. Over a preparatory pencil sketch, Trott washed on thin color to define shadow areas and then began his vigorous hatching and crosshatching, thereby almost miraculously building his sensitively

192.

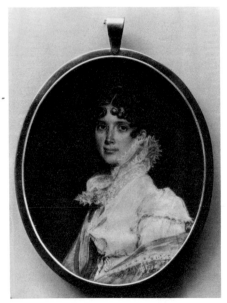

modeled face. The profile pose of the body with head turned full-face is found in many of his portraits, here accentuated by the high ruffled collar. Her fashionable full-sleeved Empire dress and contrasting colorful shawl are drawn with Trott's characteristic broad, vital brushwork. The background is carefully stippled and hatched in short strokes in contrast to his other background technique of washing on thin broad areas of color, while leaving much of the ivory bare.

RB-S □

193. *Teapot, Tea Bowl and Saucer*

c. 1816
Inscription: HEJ (gilt monogram)
Hard-paste porcelain, glazed
Teapot height 4″ (10.1 cm), diameter 6½″ (16.5 cm); tea bowl height 1⁵⁄₁₆″ (3.3 cm), diameter 2¼″ (5.7 cm); saucer height ¾″ (1.9 cm), diameter 3½″ (8.8 cm)

Woodruff Jones Emlen, Bryn Mawr, Pennsylvania

PROVENANCE: Hannah Elizabeth Jones (1816–?); descended in family to Woodruff Jones Emlen

IN 1815, GEORGE THOMPSON deeded to Isaac Cooper Jones twenty-six acres on the east bank of the Schuylkill River and a plastered stone house known as Rockland (City Hall, Archives, Isaac Jones). Isaac Jones was engaged in the China trade; to celebrate both his new summer house and the birth of his daughter Hannah, Jones imported from Canton a fifty-piece service, including this teapot, tea bowl and saucer of diminutive proportions, decorated with sepia scenes of Rockland and Hannah's monogram HEJ.

Although the building which decorates the porcelain is highly generalized and lacks Rockland's distinguishing curved front porch, its two-storied, squarish silhouette and sloping site resemble those of Rockland.

Like Mary Hollingsworth Morris (no. 176), Isaac Jones may have supplied original designs for the decoration of the service, although the style of the design resembles that of English landscape prints. Other children's sets are known, including a miniature tea set (private collection) decorated with a crest and the initial L, ordered from China about 1800–1810 by the Lyle family, owners of The Woodlands (Mudge, p. 86; illus. fig. 35, p. 109).

KH □

BENJAMIN TANNER (1775–1848)

Benjamin Tanner, born in New York on March 27, 1775, moved to Philadelphia in 1799 following the completion of his apprenticeship to the engraver Peter C. Verger. He was married on September 6, 1806 (*American Daily Advertiser,* September 10, 1806), to Mary Bierson, daughter of the publisher John Bierson. In 1811 he founded with his younger brother, Henry Schenck Tanner, a map-engraving and publishing business. In 1817, Benjamin joined with Francis Kearney and Cornelius Tiebout in a banknote engraving firm, and in 1818 he became a member of a second firm, Tanner, Vallance, Kearney and Company, which was located on the same site but devoted to general engraving. He collaborated with his brother in the invention of "stereography," a method of using steel plates to engrave check blanks so that they could not be altered without detection; he was engaged in printing this product from 1835 to 1845. Tanner retired in 1845 due to problems with his

eyesight which proved to be caused by a brain abscess. Treatment in Baltimore was not successful, and he died there on November 14, 1848. Tanner is best remembered for his line and stipple engravings, particularly portraits and historical subjects related to the Revolution and the War of 1812. Advertisements about his prints and their selling prices can be found in local contemporary newspapers.

<div style="text-align: right">ESJ</div>

JOHN JAMES BARRALET (1747–1815)

Born of French ancestry in Dublin, John James Barralet was trained at the Dublin Society's school under the painter James Mannin. He set up a studio in Dublin and gave painting and drawing lessons. About 1770 he went to London where he began to exhibit with the Society of Artists, the Free Society of Artists, and at the Royal Academy, showing forty-seven landscapes and historical drawings between 1770 and 1780. Barralet was elected a Fellow of the Society of Artists in 1777, although he continued to derive his livelihood from a drawing academy he had opened in 1773. In 1779 he returned to Dublin and competed unsuccessfully for the position of master at the Dublin Society's school following Mannin's death. After working as a theatrical scene painter, a book illustrator, and a glass stainer, he immigrated to Philadelphia in 1795.

Barralet became involved in the city's art circles almost immediately. He was one of eight English artists who split from the newly formed art association, the Columbianum, on February 2, 1795, to form their own short-lived organization (Edward J. Nygren, "The First Art Schools at the Pennsylvania Academy of the Fine Arts," *PMHB,* vol. 95, no. 2, April 1971, p. 221). When the school of the Pennsylvania Academy was established in 1812, Barralet was part of the committee to set regulations and was himself elected professor in the antique department. He gained a reputation as a designer of book illustrations, many of which were engraved by Philadelphia's leading engravers, including Cornelius Tiebout, Benjamin Tanner, and Alexander Lawson (see biography preceding no. 171).

Barralet also learned to engrave his own drawings, perhaps from necessity since he was known to be difficult to work with. The engraver David Edwin called him "the most eccentric man I ever knew" (Dunlap, *History,* vol. 2, p. 43), and William Dunlap described him as slovenly, poor, imprudent, and flighty. His partnership with Alexander Lawson quickly dissolved because Barralet squandered their funds, and also ruined several of Lawson's plates by retouching them. Barralet regularly exhibited drawings,

watercolors, and paintings (see no. 157) with the Society of Artists, and at the Pennsylvania Academy from 1811 through 1814. Barralet is also credited with the invention of a ruling machine for banknote engraving and a superior black ink for copperplate printing. He died in Philadelphia in 1815.

<div style="text-align: right">AS</div>

BENJAMIN TANNER AFTER JOHN J. BARRALET

194. *America Guided by Wisdom*

c. 1815

Inscription: DRAWN BY JOHN J. BARRALET— ENGRAVED, BY B. TANNER./DESCRIPTION/ On the fore ground, Minerva, the goddess of Wisdom, is pointing to a Shield,/supported by the Genius of America, bearing the Arms of the United States, with/the motto UNION AND INDEPENDENCE, by which the country enjoys the prosper-/ity signified by the horn of plenty, at the feet of America. The second ground/is occupied by a Triumphal Arch with an Equestrian Statue of WASHINGTON/placed in front, indicating the progress of the liberal arts./ AMERICA GUIDED BY WISDOM:/An Allegorical representation of the United States, denoting their Independence and prosperity./DESCRIPTION/On the third ground, Commerce is represented by the figure of Mercury, with/one foot resting on bales of American manufactures, pointing out the advantages/of encouraging and pro-

tecting Navigation, (signified by an armed vessel under/sail) to Ceres, who is seated with implements of Agriculture near her./ The Bee Hive is emblematic of industry; and the female spinning at the cot-/tage door, shews the first and most useful of domestic manufactures.

Etching and line engraving with watercolor, i/ii
15⁹⁄₁₆ x 22¹⁄₁₆" (38.6 x 56 cm)

Atwater Kent Museum, Philadelphia

LITERATURE: Charles le Blanc, *Manuel de l'amateur d'estampes* (Paris, 1890), vol. 4, p. 3; W. S. Baker, *American Engravers and Their Works* (Philadelphia, 1875), p. 170; Stauffer, vol. 2, p. 513, no. 3115; Drepperd, *Early Prints,* pp. 117–18; *Prints Pertaining to America,* p. 16, no. 6; E. McClung Fleming, "From Indian Princess to Greek Goddess: The American Image, 1783–1815," *Winterthur Portfolio 3* (1967), p. 50, fig. 11; Dickson, *Arts,* pp. 60–61, pl. 128; J. D. Morse, ed., *Prints in and of America to 1850* (Charlottesville, 1970), p. 343; Nancy E. Richards, "The Print Collection at Winterthur, Part I," *Antiques,* vol. 100, no. 4 (October 1971), p. 590

WHILE ARTISTS like Peale continued to use the popular subject matter of portraits enhanced with a symbolic setting (see no. 110) to express the new freedom, pride, and self-confidence of Americans, other artists turned to allegorical representations which derived from the European fashion of history painting. Analogies were constructed between American democracy and the ancient Republic of Rome in order to

194.

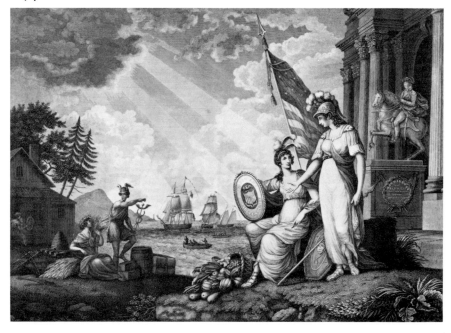

ennoble contemporary subjects and to call to mind the virtues of self-government.

The War of 1812, which put a seal on American national independence and peace, probably served as the inspiration for *America Guided by Wisdom,* drawn by John Barralet and engraved by Benjamin Tanner. Minerva, goddess of wisdom and righteous warfare and patron of the arts, guides America to military victory; her helmet, spear, and shield refer to her military prowess as well as to the judicious control over body and mind considered necessary for freedom and the advancement of the arts.

Next to Minerva sits the figure of America whose attributes and posture are borrowed from the usual portrayal of Britannia who, ironically, in this case suffered defeat (see George Richardson, *Iconologia: or a Collection of Emblematical Figures,* London, 1789, pl. 19, fig. 71; Robert C. Smith, "Liberty Displaying the Arts and Sciences," *Winterthur Portfolio 2,* 1965, p. 97, fig. 6). She is equipped with a spear which bears an American flag instead of the standard liberty cap, a shield with the American eagle and colors, and an olive branch, symbolizing peace. This may be an ironic attribute, since the "Olive Branch" was the name of the last petition of the American Congress to George III requesting that conditions be ameliorated and differences settled peacefully. When no answer was received, war was declared. In addition, the representation of America may also be identified with Liberty, for she is dressed in what Richardson describes as the appropriate attire for Liberty: "White robes, to denote the various blessings that this goddess bestows on mankind in promoting their happiness and welfare" (Smith, cited above, p. 97).

Allegorical representations of America were a popular subject at the time (see no. 195) and thus many artistic sources were available to Barralet. As Barralet was a professor of the antique school at the Pennsylvania Academy of the Fine Arts, he was probably familiar with many works on this subject. For example, Barralet included in his America many of the attributes of Liberty depicted by Samuel Jennings in his painting *Liberty Displaying the Arts and Sciences* of 1792 (Library Company of Philadelphia; smaller version, Winterthur Museum). According to Smith, Jennings derived his Liberty directly from Richardson's illustration of Britannia. The main difference between Jennings's and Barralet's portrayals is that Jennings's woman is dressed in contemporary garb, a new adaptation of history painting begun by Benjamin West.

The Roman triumphal arch and the equestrian statue of George Washington, alluding to the Roman emperor Marcus Aurelius, stress the noble qualities of victory.

The structure recalls the eighteenth century revival of Greek and Roman architecture as symbols of grandeur and power, purity and self-restraint. The depiction of Washington emphasizes the valor and devotion of America's own Revolutionary leaders, who are now worthy of association with the legends of Rome. As in the Peale portrait of Washington, the hero is dressed in contemporary clothing, not the garments of the past.

The newly achieved self-sufficiency of the nation is represented by the figures at the left. Mercury, the Roman messenger of the gods, god of commerce, and protector of trade, dressed in a winged hat, points to the distant ships, symbols of both commercial and military activity, and places a foot on the crates filled with products of a new civilization. He is directing the trade of American industry as symbolized by the woman spinning, the beehive, and Ceres, the goddess of agriculture. The wealth of the country's produce is suggested by the horn of plenty at America's feet.

Three different states of this image have been found. One is described here. The second state has the additional inscription "Published March 27th 1820, by B. TANNER, Engraver, No 74 South Eighth Street Philadelphia." The last version shows changes in the engraver and publisher: "Engraved By Tanner, Vallance, Kearny & Co. Published by Tanner, Vallance, Kearny & Co. No. 10 Library St. Philadelphia. Printed by W. B. Acock."

ESJ □

WILLIAM BIRCH (1755–1834)
(See biography preceding no. 149)

195. *Brooch*

1815–20
Signature: w. b. (lower left)
Enamel on copper, gold frame
1¼ x 1⅞" (3.2 x 4.8 cm)
Philadelphia Museum of Art. Purchased: Joseph E. Temple Fund. 12-104

ALTHOUGH WILLIAM BIRCH is best remembered today for his engravings, especially his views of Philadelphia (no. 149), he always considered himself first as an enamelist (HSP, "The Life of William Russell Birch, Enamel Painter, Written by Himself," typescript). Birch was highly schooled in this technique, and turned out numerous pins, boxes, miniatures, and the like, for which he received great acclaim. He was also a master of the art of copying, reproducing scenes or figures from other

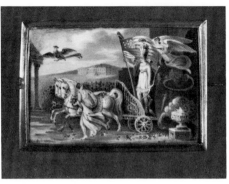

195.

works and incorporating them into enameled objects.

One excellent example of his copying appears in a minute gold-bound pin depicting the Triumph of Independence, proclaiming America's victory over England in the War of 1812. This scene is based on either a lost painting by a French artist in Philadelphia, Mme Anthony Plantou, or on Alexis (?) Chataigner's engraving after it, *The Peace of Ghent and Triumph of America,* about 1815 (E. McClung Fleming, "From Indian Princess to Greek Goddess: The American Image, 1783–1815," *Winterthur Portfolio 3,* 1967, illus. p. 49). Birch's scene is greatly simplified in comparison to the engraving, but the chariot group, eagle and victory, and the temple facade, triumphal arch, and urn have been borrowed intact. Liberty, or America, is shown as a classical figure dressed in Roman garb and crowned with a feathered headdress, riding in a chariot drawn by three prancing horses. Aloft, the American flag with fifteen stripes and stars flies proudly in the wind. In the background is a tiny depiction of the Capitol in Washington, still under construction, which does not appear in the engraving.

CJ □

GEORGE M. MILLER (DIED C. 1818)

George M. Miller was a Scotsman who is thought to have arrived in America in the late 1790s. Little is known of his life other than that he modeled miniature wax portraits and life-size busts, probably in clay, which were cast in plaster. The small waxes that survive are all profiles in bas-relief usually in colored wax, about three inches high, and mounted on glass, sometimes colored, or slate. Morgan and Fielding, without giving the source, state that Miller was in Philadelphia in 1798 (*Life Portraits,* p. 419).

He was working in Baltimore from at least January 1810 until 1812 and was certainly in Philadelphia by 1813 in time to enter four portraits in the Pennsylvania

Academy exhibition. His commissions must have been limited since a life-size bust, "the original model," of Bishop William White was exhibited and listed "for sale" at the Academy in 1814. In a letter of November 10, 1814, to the managers of the Athenaeum he offered to lend them four busts, apparently as an advertisement, in addition to several pieces (now lost) which show his interest in antique subjects: two antique funeral urns, a small full-length figure of Antinous, and a bust of Adonis (APS, *A Catalogue of Portraits and Other Works of Art...*, Philadelphia, 1961, pp. 101–2). Miller also did a life-size wax figure of Venus in color which was exhibited at the Apollodorean Gallery in Philadelphia from 1812 to 1815 (University of Delaware, Index of American Sculpture, George M. Miller file).

Dunlap claimed that Miller "would have been an artist of eminence if he could have made bread enough to support himself and wife, by the profession of modelling." Miller, in a further attempt to eke out a living, sold medallions from Italy, repaired broken sculpture, and made casts from work by other artists (Dunlap, *History,* vol. 2, p. 263; Craven, *Sculpture,* p. 56). He is not listed in the Philadelphia directories after 1817. Possibly he returned to Baltimore in that year and died there. The death of a George Miller, age fifty-nine, was announced in Baltimore's *American & Commercial Daily Advertiser* for October 14, 1817. Although other death dates have been given, there is as yet no evidence against Dunlap's date of 1818.

196. *Captain John Gillies*

1816

Signature: G M Miller (lower right under medallion)

Inscription: G M Miller Madellion/ opposite The Theatre Chesnut [*sic*] Street/Philadelphia/March 18th—1816 (on reverse)

Colored wax mounted on slate

Diameter 5″ (12.7 cm)

Francis James Dallett, Villanova, Pennsylvania

PROVENANCE: Descended in family from sitter's wife, Ann (Dallett) Gillies, to Francis James Dallett

LITERATURE: Francis James Dallett, "Athenaeum Sculpture," *Athenaeum Annals,* vol. 1, no. 1 (November 1955), p. 2

THE POPULARITY OF WAX PORTRAITS was at its height in the late eighteenth and early nineteenth centuries. As a medium, wax was particularly attractive to female amateur artists as well as to more expert modelers.

196.

The process of modeling in wax is relatively easy and it is not difficult for an amateur to become proficient in executing relief profiles. Greater skill is required in the delicate undercutting necessary for more complicated textural and three-dimensional effects and in the subtle nuances which distinguish a striking likeness from a passable one. The wax medium had the advantage of being inexpensive, and copies of the relief could easily be taken with a plaster mold. On the other hand, the medium's disadvantage becomes evident later when the wax is liable to melt or crack with appreciable changes in temperature.

Philadelphia had a number of talented portrait modelers in wax, including Rachel Wells, sister of the more famous Patience Wright in London, and the itinerant German-born, J. C. Rauschner, some of whose work was quite similar to George Miller's.

Miller's portrait of a fellow Scot, Captain Gillies, is comparatively well preserved and somewhat unusual in that it can be precisely dated by the label on the reverse. One suspects that Gillies, who had recently turned fifty, was persuaded by his wife to have his likeness modeled inexpensively as a fashionable portrait in relief. It is possible in this instance to see more of Miller's technique than usual, for the stiff jabot is apparently supported by paper under the wax.

Miller's reputation was at its height in 1816. He was thought to possess such "considerable talent" that he was proposed in that year as the sculptor for a marble statue of George Washington for the state of North Carolina. He agreed to undertake the work, but his sponsor ultimately withdrew support over the thought of a mere modeler attempting to sculpt in marble (Craven, *Sculpture,* p. 56).

DE □

ARCHIBALD BINNY (1762/63–1838)

Like many of Philadelphia's eighteenth century artists and artisans, Archibald Binny had fled his homeland seeking safety and success in Penn's cosmopolitan and tolerant city. Born in 1762 or 1763 in Edinburgh, the youngest son of John Binny, a brewer, Archibald elected to become a typefounder rather than follow in his father's trade, and it was said that he had cast the type for the standing pocket edition of the Bible while still in Edinburgh.

Binny became active in the constitutional reform movement of the 1790s. Sparked by the successes of the French Revolution, middle-class artisans and workingmen formed clubs to promote annual parliaments, universal suffrage, and a general cleanup of England's moss-backed political system. Apparently Binny wrote against the government, but was not a major leader, at least not important enough to warrant mention in standard treatments of the club movement. Sometime in 1795, well before the collapse of the club movement and the mass arrests of 1796–97, Binny removed from Scotland to America, landing in New York with his wife, Elizabeth, and their son. The type-founding equipment he smuggled out of Scotland and brought with him was valued by American customs officers at $888. With a grubstake this large, he must have been more than a journeyman typefounder in Edinburgh and certainly was not a penniless immigrant.

Within a year of their arrival, Binny's first wife died and was buried at the old Pine Street Presbyterian Church in Philadelphia. A widower with a young son, he married Charlotte Prager of Philadelphia several years later. His son entered the typefounding business, but all of Archibald's eight children by his second wife preferred to follow their father's second vocation—farming.

By November 1, 1796, Binny was in Philadelphia, for on that date he formed a partnership with James Ronaldson. The firm prospered as Binny displayed a knack for making good quality type quickly and economically, and perfected several inventions, most notable of which was a quick-release casting form which cut molding time by a third.

The period from 1812 to 1815 saw Binny slowly withdrawing from the management of the company. Finally in 1815, at the height of the influence and dominance of Binny and Ronaldson, the elder Binny retired to a farm christened "Porto Bello" in St. Mary's County, Maryland, leaving James Ronaldson to continue the firm alone. It is ironic that the former Scottish radical and friend of the rights of man spent his remaining years living like a proper English country squire

on a southern plantation which included a large number of slaves among its work force.

Farmer Binny died on April 25, 1838, aged seventy-five. He left no body of personal papers; apparently they were lost when the family removed to Maryland.

JAMES RONALDSON (1769–1841)

A native of Edinburgh, James Ronaldson was born in 1769, the fourth child of William Ronaldson, a baxter, burgess, and member of the guild of master bakers. James followed his father's trade while in Edinburgh. According to one biographer, he first visited Philadelphia in 1791, liked what he saw, and moved to the city permanently in 1794, opening a bakery which lasted until destroyed by fire in 1796 (M. Tait, "James Ronaldson: Baker, Typefounder, Philanthropist, and His Connexions in and around Edinburgh," *The Book of the Old Edinburgh Club,* vol. 28, Edinburgh, 1953, pp. 44–45). Another biographer asserts that James Ronaldson was a passenger on the same ship that brought Archibald Binny to New York and that their partnership was formed on board ship (Henry Lewis Bullen, "James Ronaldson's Cemetery at Philadelphia," *Inland Printer,* vol. 84, 1930, p. 76).

Whichever account is correct, it is certain that on November 1, 1796, he entered into a partnership with Archibald Binny as typefounders, renting a house on Cedar (South) Street at Eleventh, which became their foundry and living quarters. What Ronaldson brought to the union is unclear, though most likely it was capital and general business talent. Ronaldson was able to exploit his partner's skill, and by matching and even undercutting the prices of English imported type, solidly established the firm in a field notable only for its past failures. Following Binny's departure in 1815, Ronaldson continued in the business until 1823, resigning in favor of his younger brother, Richard, who had left his jeweler's business in Edinburgh to join his elder brother.

Ronaldson was a man of boundless energy and restless intellect and was fully prepared by nature and circumstance to follow in the path of Benjamin Franklin (see biography preceding no. 28). As well as owning and running the typefoundry alone after 1815, Ronaldson owned and managed the Hillsburgh Mills, just outside of Philadelphia. Although its main product was spinning cotton yarn, Ronaldson added a weaving department to manufacture blue and white denim, which again successfully competed with imported English fabric. Somehow James Ronaldson also found time to establish, in partnership with Archibald Binny, a china manufactory in their typefounding works on South Street, where they made yellow and red tea sets. From 1808 through 1818 their factory was known as the Columbian Pottery, producing Queensware which the noted Dr. Mease referred to as being equal to Staffordshire.

One other enterprise was to occupy Ronaldson's attention in his "retirement"— a cemetery. The decade of the 1820s saw the formation of a number of cemetery companies to provide an alternative to either church burial grounds or potter's fields and to insure ownership of the plot in perpetuity (a practice not then common in either of the existing types of cemeteries). In 1827, Ronaldson formed the Philadelphia Cemetery Company (chartered 1833) "for the interment of deceased human beings other than people of color," and "to give people in moderate circumstances opportunity for burial within their means" (Sharf and Wescott, vol. 1, pp. 619–20; Tait, cited above, pp. 48–49). In addition, certain lots were provided free to the deserving poor of any creed and a section was set aside for "friendless Scots." Nor was this all. He designed and supervised the layout of the cemetery which was located between Bainbridge and Fitzwater and Ninth and Tenth streets, and all the plantings and construction, making it one of the finest cemeteries in the country at the time. One novel feature of his plan for the cemetery was the identical gatehouses, designed by Ronaldson, one for the gravedigger and the other as a sort of halfway house where the recently deceased person might be laid with an alarm bell attached to his arm to alert the keeper in the event he spontaneously revived.

Ronaldson also designed and built a row of single brick houses with high marble steps known as Ronaldson Row, overlooking the cemetery. He occupied the corner house himself to keep an eye on his enterprise. One peculiarity of the design was that a separate set of steps and doorway was built at the right front of each house, rather than joining them side by side as was more customary. This was done, he explained, "to prevent tattling women from gossiping on the door-steps."

Unmarried, Ronaldson spent what spare time he had in the service of the community. He established the first soup kitchen in the Southwark district of Philadelphia, was a founding member of the Scots' Thistle Society, a generous contributor to the Pennsylvania Hospital, and personally interviewed boys attending the "model schools" established by his friend Thomas Lancaster near his Southwark soup kitchen.

For a number of years he headed an informal body of mechanics, mechanical engineers, and other skilled craftsmen which merged with other organizations in 1824 to form the Franklin Institute with Ronaldson as its first president, an office he held until his death in 1841.

197. *Specimen of Printing Type*

1816

Printed by William Fry

Title page: Specimen of Printing Type, from the Letter Foundry of James Ronaldson, successor to Binny & Ronaldson. Cedar between Ninth and Tenth streets, Philadelphia. 1816.

Printed book, forty-three leaves, printed one side only; binding modern quarterly leather and marble boards; fine well-calendered, wove paper

Watermark: Amies's "dove-with-twig-in-mouth" or "Amies" (on some leaves)

Small octavo, leaf size 8¼ x 5¼″ (20.9 x 13.3 cm)

The Library Company of Philadelphia

PROVENANCE: Mathew Carey (?); grandson, Isaac Lea, until 1878

LITERATURE: Joseph Sabin, *A Dictionary of Books Relating to America,* 29 vols. (New York, 1868–1936), no. 73068; P. J. Conkwright, "Binny & Ronaldson's First Type," *Printing and Graphic Arts,* vol. 1 (1953), pp. 27–35; P. J. Conkwright, "Binny & Ronaldson's $ Sign," *Printing and Graphic Arts,* vol. 3 (1955), pp. 59–61; Ralph R. Shaw and Richard H. Shoemaker, *American Bibliography: A Preliminary Checklist for 1801–1829* (New York, 1958 to date), vol. 16, no. 38834; Darrel Hyder, "Philadelphia Fine Printing 1780–1820," *Printing and Graphic Arts,* vol. 9, no. 3 (September 1961), pp. 93–95; Rollo G. Silver, *Typefounding in America, 1787–1825* (Charlottesville, 1965), pp. 19–27; Daniel Berkeley Updike, *Printing Types, Their History, Forms, and Use: A Study in Survivals,* 3d ed. (Cambridge, Mass., 1966), vol. 2, pp. 153–54; Rollo G. Silver, *The American Printer 1787–1825* (Charlottesville, 1967), pp. 87, 161–63; F. C. Bigmore and C. W. H. Wyman, *A Bibliography of Printing with Notes and Illustrations* (London, 1974), vol. 2, p. 270; Dawson's Book Shop, Los Angeles, May 1975, Catalogue no. 433, item 479 (Jackson Burke sale, Part 2)

THE DISTINCTION of being one of the most attractive American trade catalogues ever printed belongs to the third catalogue issued by the firm of Binny and Ronaldson in 1816. Although Archibald Binny had officially retired by that time, the type used in printing the specimen book was of his design and execution, and was the mainstay of the firm. James Ronaldson admitted his debt to Binny by dedicating the 1816 catalogue to "his genius and labour." He generously added in his preface that "the Letter Foundry owes more of its improvement and simplification to him than to any other individual, since its invention; and the difficulties incident to transferring this business to America, will not be duly appreciated but by bearing in

SEVEN LINES PICA.

Columbia.
$1234567.

197.

mind that at least seven prior establishments had failed."

To memorialize the efforts of his former partner, Ronaldson spared no expense in the production and designed the layout of the specimen pages with great care. All of the text was set more compactly than in most specimen books. Ronaldson used no hyphens at the end of lines, allowing them to break wherever the measure ran out. This format was particularly suited to the smaller types, displaying them to maximum advantage.

Although no printer is specified in the catalogue, it can be assumed that Ronaldson continued to use William Fry, who had printed the firm's 1809 and 1812 catalogues. Fry, by this time free of his partner, Joseph R. Kammerer, had a proven talent for fine printing, and to Ronaldson's attractive design Fry added excellent execution. A fine, well-calendered paper from Thomas Amies's mill, probably a writing paper, was used to provide an off-white, elegant background. The type was carefully composed and evenly inked, as is especially evident in the specimens of the large typefaces. The "seven lines pica" of the Columbian face exhibited is a perfect example. The impression throughout is very even for the period and reflects the use of the new Columbian press which Fry had acquired in 1814. Darrel Hyder has called this little octavo pamphlet "without equal in the forty years following the Revolution ... [and] with this achievement a sort of summit is reached" ("Philadelphia Fine Printing 1780–1820," *Printing and Graphic Arts,* vol. 9, no. 3, September 1961, p. 95).

This specimen book is a demonstration of Philadelphia's dominance of the American printing scene in the late eighteenth and early nineteenth centuries, which was strongest in the typefounding industry. Ronaldson was correct in praising himself

and Binny for succeeding in a field where so many had failed before. In the beginning, between 1796 and 1800, prejudice against domestically manufactured type was so high that even when it was offered three-cents-a-pound cheaper, American printers still preferred foreign type. These same printers complained in the next breath about their deplorable dependence on foreign sources for materials. It was only by sheer hard work, sharp business practices, their quality product, and a modicum of luck that Binny and Ronaldson survived.

In spite of setbacks, Binny and Ronaldson persisted, casting the first dollar sign ($) in 1802, and beginning to evolve the transitional, or modified, serif type style for which they became famous. By 1806 their firm employed over thirty men and boys and scarcely a book was printed in Philadelphia or the mid-Atlantic states that was not set in type of their manufacture.

Part of the reason for their success was Archibald Binny's talent as an inventor. It would be nice to think that the loan of Benjamin Franklin's typefounding tools and materials by his son-in-law William Duane in 1806 sparked Archibald Binny to make three significant improvements on the existing methods of casting type. His improved printer's type mold and a new method for smoothing or rubbing printing type were patented on January 29 and February 4, 1811, respectively, while he secured a patent for various improvements for molds on May 17, 1814. Historians of typography have doubted the uniqueness of these improvements and they may have had little effect on the clean lines of Binny and Ronaldson's famous transitional typefaces. But contemporary opinion held that they almost doubled the amount of type one foundryman could make.

Like all artists and craftsmen, Binny and

Ronaldson on occasion had to supply a product which they did not like, but which their customers demanded. In his preface to the 1816 specimen book, Ronaldson apologized for the ugliness of their Long Primer No. 2 and small Pica No. 2, dubbed by Updike "Fat grotesque" and which he held Binny and Ronaldson responsible for forcing on American printers (Daniel Berkeley Updike, *Printing Types, Their History, Forms, and Use: A Study in Survivals,* Cambridge, Mass., 1937, vol. 2, p. 154). Ronaldson's answer was simple; he too thought the face ugly and distorted, but his customers demanded it. Artistically both Binny and Ronaldson preferred their transitional faces derived from Scotch-Roman and the then recent French typefaces, and history has supported their judgment. After falling out of fashion in the 1820s, their transitional face was cast again in the 1890s by the successors of Binny and Ronaldson, the American Type Founders Company, using Binny's original molds and punches. Renamed Oxford, this type was used by the discriminating Updike for the 1922 edition of his classic history of type. Resurfacing again in the 1950s in a slightly modified form dubbed Monticello, Binny and Ronaldson's transitional face was appropriately used to print Rollo G. Silver's authoritative study, *Typefounding in America 1787–1825* (Charlottesville, 1965).

Thus it was their inventive genius in the technical, artistic, and economic aspects of their trade which allowed Archibald Binny and James Ronaldson to become the dominant force in the manufacture and design of type in the early years of the Republic. The political capital may have been moved from Philadelphia in 1800, but the Quaker City would still be the vital center of the American printing industry for decades to come.

GM □

ATTRIBUTED TO JOSHUA M. WATSON

198. *Sketchbook*

1816–17
Inscription: Joshua M. Watson/La Favorita/Guernsey (inside back cover)
Sketchbook, 110 pages, pencil, ink, and watercolor on wove paper
5 11/16 x 11 x 15/16" (14.4 x 27.9 x 2.4 cm)
The Barra Foundation, Inc., Philadelphia

THIS NEWLY DISCOVERED SKETCHBOOK records a visit made to the Philadelphia area during the period from September 1816 to July 1817, and illustrates a voyage south, down the Susquehanna River to the Columbia Bridge and to Washington, D.C., and Mount Vernon. The inscription "Joshua

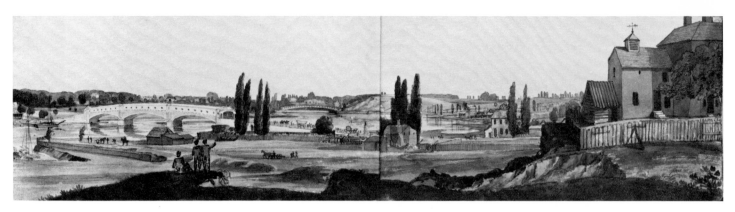

198. *View of the Middle and Upper Bridges on the River Schuylkill Taken from the Old Waterworks, Philadelphia, 5th October 1816*

M. Watson La Favorita Guernsey" inside the back cover and the caption on page 16 "Returning to Liverpool from America . . . July 16th 1817" indicate that Watson was a visiting Englishman; and the similarity between the handwriting of the inscription and the notes made on the sketchbook pages suggests that Watson was also the artist. Although biographical information is unclear, it may be possible, despite the discrepancy in middle initials, to identify Joshua M. Watson with J. R. Watson, a British naval officer who, according to Groce and Wallace, painted watercolors in the United States shortly before 1820. Engravings after Captain J. R. Watson, R.N., appeared in both Joshua Shaw's *Picturesque Views of American Scenery* (no. 208), published in 1820–21, and C. G. Childs's *Views in Philadelphia* (1830). A Captain Watson also exhibited two watercolors, *View from the Porcelain Factory, near the Schuylkill, Permanent Bridge,* and a view of Exeter, England, at the Pennsylvania Academy in 1829.

While in Philadelphia, Watson apparently stayed at Eaglesfield, the house built by Robert Eglesfield Griffith on the west bank of the Schuylkill, for a number of drawings in the sketchbook show not only the elevation of the house, but also its grounds and outbuildings and views from its porch and breakfast room. There are sketches of other estates near the city, such as Solitude, Sedgeley, Belmont, and The Woodlands, seen in Watson's sketchbook, along with views of the scenery along the Schuylkill and the Wissahickon and of Philadelphia and Fort Mifflin from points on the Delaware.

Watson generally employed the horizontal format of a single page or two facing pages to make his panoramic views. Varying degrees of finish among the drawings suggest that Watson's working method was based upon techniques of landscape sketching that originated in England in the late eighteenth century, and rapidly became

popular as a fashionable accomplishment, available to the interested amateur through lessons and printed drawing books. Rough indications of topography and architecture were first made in pencil, occasionally with written notes of color areas. Important architectural elements were then detailed with ruled lines, and the drawing was worked up in washes and fine strokes of ink or transparent watercolor.

The exhibited sketch, inscribed "View from the Middle and Upper Bridges on the River Schuylkill taken from the Old Waterworks Philadelphia 5th October 1816," is one of the most colorful and detailed of Watson's views. Taken from the site of the inlet of the water supply for the Centre Square Pump House, located at Chestnut Street on the Schuylkill bank, it shows the Market Street Permanent Bridge (no. 157) and in the distance the Upper Ferry Bridge, with Fairmount to the right, and Lemon Hill and its greenhouses (no. 151) just above it. This view may perhaps relate to the watercolor exhibited at the Academy by Captain Watson in 1829. In the foreground along the east bank of the river, factory buildings show the beginning development of industry along the waterfront, although, in fact, Watson may have simplified the industrial development to emphasize the picturesque quality of the view. On the previous page a drawing of a scene similar to the right side of this view shows a confusion of small buildings, and, just beside the building at the extreme right, a tower that was probably the shot tower erected by Paul Beck between Arch and Race streets on the Schuylkill riverfront.

DS □

WILLIAM RUSH (1756–1833)

Born in Philadelphia, William Rush was the son of a ship's carpenter. As a boy, he carved ships out of blocks of wood and drew figures in chalk or paint. It became apparent

that he was not to be a carpenter, and he was apprenticed to the best carver in Philadelphia, Edward Cutbush from London. Cutbush was "a man of spirited execution, but inharmonious proportions" (Watson, *Annals,* vol. 1, p. 575). Rush served from three to five years in Cutbush's shop, at the end of which time he was considered superior to his master. His early ship figureheads were admired especially for their lifelike suggestion of movement, and Rush is credited as the first American shipcarver to use walking attitudes in these designs.

Rush probably set himself up as an independent carver about 1773. In 1777 he joined the Philadelphia Militia. After the war he took lessons in modeling from Joseph Wright, who worked in clay and wax and was also a painter. This instruction occurred either between 1783 and April 1785, when Wright is known to have been in Philadelphia, or between 1789 and 1793, after Wright returned from New York. Thus Rush was able to expand into terra-cotta portrait busts. His production consisted chiefly of busts in wood, carved ship ornamentation, tobacconist figures, eagles, and later, wood sculptures for architectural settings. Although Rush relied on his own inventiveness, he had also educated himself through published sculpture designs and the figureheads on visiting foreign ships. According to Watson, who knew Rush, his figureheads drew such admiration in foreign ports that they were sketched by other carvers (Watson, *Annals,* vol. 1, p. 576). Rush's work for the United States Navy as well as for private shipowners kept him solvent and he was able to employ assistants including his son John who became an equal partner in his shop by about 1819.

In addition to his business, Rush became involved, with Charles Willson Peale, in the early organization of the Columbianum in 1794 and, more important, he later helped to organize the Pennsylvania Academy of the Fine Arts in 1805. At this time he was held in such esteem that he and Peale were

the only two professional artists elected to the first board of directors.

In 1810, Rush became the first president of the Society of Artists, a group including Thomas Sully and Rembrandt Peale whose membership overlapped with that of the Pennsylvania Academy. The Society of Artists believed that the Academy had lost sight of its avowed purposes, particularly in regard to establishing a school and organizing an annual exhibition. Their intention was to merge with the Academy, as they eventually did, when reform was effected.

Like Charles Willson Peale, Rush, in his own work, emphasized the importance of working from a living model (Dunlap, *History,* vol. 1, p. 316). His contemporaries valued his "bold and striking" effects in the inexpensive media of clay and wood, but since his work usually had no higher purpose than to ornament a ship and he did not carve in the more prestigious medium of marble, his potential for lasting fame was deemed limited. A reviewer for the 1812 Pennsylvania Academy exhibition is emphatic on this point: "We have no hesitation in giving it as our decided opinion, that, if his studies had been directed to the higher branches of his art, with proper opportunities, he would have rivalled the most eminent sculptors of the present age" ("Review of the Second Annual Exhibition," *Port Folio,* vol. 8, no. 1, July 1812, p. 145). This is true praise in an age in which antique casts established the precedent. Aside from his few essays into allegorical, and thus more ambitiously intellectual, subjects (see nos. 218, 219), Rush, unlike a sculptor such as Ceracchi, does not seem to have tried for greater fame. He exhibited at the Pennsylvania Academy until a year before his death in Philadelphia.

DE

ATTRIBUTED TO WILLIAM RUSH

199. *Eagle*

c. 1810–20
Pine, painted
24¾ x 29¾ x 28″ (62.8 x 75.5 x 71.1 cm)
Philadelphia Museum of Art. Given by Thomas A. Andrews. 89–35

LITERATURE: PMA, *William Rush, 1756–1833, The First Native American Sculptor,* by Henri Marceau (1937), p. 30, fig. 8; Philip M. Isaacson, *The American Eagle* (Boston, 1975), pp. 74–75, fig. 80

THE FINAL DECISION on a design for the Great Seal of the United States in 1782 formally introduced the eagle into American iconography, and as the Republic grew so did the use of the eagle. Early representations used the emblem in other political contexts, including designs for state shields and campaign buttons, and by 1810 the eagle was the universal symbol of the American spirit, appearing on items associated with military organizations and volunteer fire companies as well as on bottles, buttermolds, and a multitude of other objects (Philip M. Isaacson, *The American Eagle,* Boston, 1975, pp. 47–48).

This eagle is one of several in Philadelphia attributed to William Rush. Although none is signed and there is documentation for only one eagle, that made by Rush for the Pennsylvania Academy of the Fine Arts, the style and sophistication of these pine carvings indicate that no other Philadelphia artist, and indeed probably no other wood carver in the young nation, would have been capable of executing such work. Rush's eagles never achieved the stature of his

allegorical figures, however, and are generally more closely akin to his marine carvings executed in the 1790s. Unlike the Massachusetts native Samuel McIntire, whose carvings of eagles are all formal and similar to the stilted eagle on the Great Seal, William Rush created a series of eagles with unique postures, the sizes varying enormously among the carvings, reflecting the movement suggested by the natural bird (Isaacson, cited above, pp. 54, 71).

The obvious model for Rush's carved eagles would have been the American bald eagle from Peale's Museum in Philadelphia, especially since Rush and Peale were close friends. This bird was kept alive and caged from about 1795 to 1805, and upon its death stuffed and exhibited with the other museum specimens. However, there is very little similarity between the Rush eagles and the stuffed bird, and the carver's digression from both this natural model and the Great Seal eagle, as well as the considerable variation among his own carved eagles, suggests to some degree his creative genius.

Tradition accords the ownership of this Rush eagle to the "old Hibernia Engine House," one of Philadelphia's numerous volunteer fire companies, but this is nearly impossible to substantiate. The Hibernia did use an eagle as part of its badge, but its eagle was represented in front of a harp; other fire companies used the eagle independent of other symbols, and this carved piece could just as easily have belonged to another company. There is no mention of the purchase of an eagle in the Minutes of the Hibernia Fire Company, referred to as Hibernia Engine, between 1800 and 1822 (HSP, Minutes of the Hibernia Fire Company), and the question of ownership is further complicated by the establishment of the Hibernia Hose Company in 1823. There are no extant records for this company, but it is possible that Rush executed an eagle for it shortly after its organization, at the height of his work on allegorical figures for the city.

Thomas A. Andrews, who gave the eagle to the Philadelphia Museum of Art, was superintendent of Horticultural Hall. In this position he might have had access to a piece of sculpture somewhere within Fairmount Park. This does not appear to be the eagle from the top of the gazebo at the Fairmount Waterworks (see no. 183), however, and the connection of Andrews with either Hibernia Company seems remote since they were located near Second and Walnut streets, and his residence and office were both in West Philadelphia. When the volunteer firefighting system was disbanded in 1871, it is quite possible that such a piece would have been removed from an engine house, but Andrews's name does not appear in Hibernia Engine roll books dating from 1840 to 1868

199.

(HSP, Hibernia Fire Company Roll Books), and no connection between him and these companies has been uncovered.

This is the most unusual of William Rush's eagles, and is closer stylistically to his later allegorical figures than to the early eagles, which all must be dated about 1810. The detailed carving does not portray the bird primarily as an anatomical specimen, as is the case with the other eagles, but rather the carving subtly indicates the bird's skeleton through the massing of its feathers. Rush's concentration on the features of the legs and body appears unique, and the delineation of the wing feathers, although accurate and distinct, is shallow; in most of Rush's other eagles the best of his carving proficiency is most evident in his execution of the wings.

This eagle clearly reflects the stylistic changes obvious in the 1824 figures of *Mercy and Justice* (no. 218) and the 1825 pieces for the Waterworks (no. 219). The eagle in the *Schuylkill Chained* is represented somewhat more explicitly than this one, but its stance and expression still exhibit a considerable stylistic development from the earlier eagles. The pose of this eagle is quite unusual because its gaze is directed straight ahead, rather than to its right or left, and downward. The placing of its wings, poised for flight, is also rarely represented, and entirely unlike the other Rush eagles. The careful attention given to the feathers on the legs and body and the shallow delineation of the wing feathers suggest placement fairly near the ground, since mounting at any considerable height would make the wing detailing virtually impossible to see. Perhaps it stood atop a ship's pilot house or somewhere within, or outside of, the house of a volunteer fire company, rather than on high as a lofty decorative element (one Rush eagle hung high inside the Walnut Street Theatre, another outside the Pennsylvania Academy). Its distinctive stylistic features suggest the mature representation of William Rush about 1820, as his work evolved from a crisp, literal style toward one smoother and more expressionistic.

LAL □

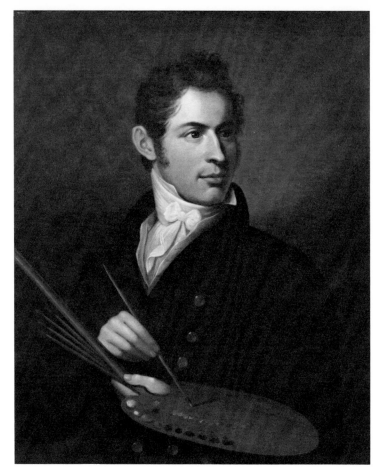

200.

FRANCIS MARTIN DREXEL (1792–1863)

Drexel was born in Dornbirn, Tyrol, Austria, the son of a prosperous merchant. In 1803 he was sent to a convent school in Italy but had to return home in 1805 because Napoleon's Austrian campaign had ruined the family business. With his country under foreign rule and his father impoverished, Francis's formal education ended abruptly and he was apprenticed to an unidentified painter in the village of Wolfurt. After three years, to avoid being drafted into the enemy army, Francis escaped in 1809 to neutral Switzerland.

Drexel was a man of initiative who was constantly on the move and forever taking risks. Painting mainly houses and coaches, he wandered through Switzerland, France, and Italy, always a few steps ahead of the draft and passport authorities. At one point, he assisted an aquatinter for two weeks in Geneva and then took instruction in painting at the local art school in Lausanne in 1814. Finally he decided that his ambition to become a financially successful portrait painter might be realized only in America, and he sailed from Amsterdam to Philadelphia in the spring of 1817.

He set up his studio at 131 South Front Street and entered his first Pennsylvania Academy exhibition in 1818 with eleven paintings (probably oils), four chalk drawings, and two engravings. Here he established his diversity not only in media but in his subject matter, which included contemporary portraits, imaginary heads or figures from classical and biblical times, and studies from antique casts. The competition from an artist such as Thomas Sully, among others, was formidable, but Drexel, in his own words, "continued to do middle well" with his portrait painting (Boies Penrose, "The Early Life of F. M. Drexel, 1792–1837," *PMHB,* vol. 60, no. 4, October 1936, p. 343). He added miniatures to his repertoire and gave some drawing lessons.

But after a number of years he grew restless; this time his wanderlust took him to South America in 1826. There he spent about four years as an itinerant artist in Equador, Peru, Chile, and Bolivia. His scheme included selling his aquatint portraits of General Simón Bolívar which he had published at his own expense in Philadelphia. None of Drexel's portraits of Bolívar were done from life. He returned to his family in Philadelphia in 1830, and although he had not gained as much as he had hoped financially, he had temporarily satisfied his thirst for adventure. Drexel continued as a portrait painter in Philadelphia from 1830 until his trip to Mexico in 1835.

By now he had apparently begun to speculate in foreign exchange, which led to his interest in banking. In 1837 he left his career in painting to open a brokerage office in Louisville, Kentucky, which he transferred

a year later to Philadelphia. Thus began the well-known Philadelphia investment house which bears his name and which began by dealing particularly in "uncurrent money." He died a wealthy man at age seventy-two when he was struck by a railroad train. The main sources on Drexel's life are his autobiography and his journal of the trip to South America (see Penrose, cited above, p. 329).

200. *Self-Portrait*

1818

Oil on canvas (now backed by board)

30 x 24⅛" (76.2 x 61.3 cm)

Mrs. Andrew Van Pelt, Radnor, Pennsylvania

PROVENANCE: The artist; daughter, Caroline (Drexel) Watmough; husband, John Watmough; with Ferdinand Keller; gift to niece, Katharine (Drexel) Penrose; daughter, Mrs. Andrew Van Pelt

DREXEL'S HANDSOME *Self-Portrait* is undoubtedly the one he exhibited at the Pennsylvania Academy in 1818 at the outset of his Philadelphia career. It is therefore really an advertisement for an enterprising and intense young artist, aged twenty-six, shown painting in his best clothes. The modeling of the head with its sharp delineation of the features and strong shadows reveals that Drexel was grounded in the European neoclassical tradition. There is a hardness in Drexel's self-portrait which is quite unlike the work of Thomas Sully and closer to that of Rembrandt Peale who had trained in France. On the other hand, the flat, rather primitive painting of the hands is characteristic, in varying degrees, of much of Drexel's work. This naiveté accounts for the fact that he attracted patrons from among the less sophisticated and those who could not afford the higher prices of Sully or Neagle.

Drexel probably used this head as a model for his later self-portrait of the artist surrounded by his family. In this larger group portrait (Mary J. Drexel Home, Philadelphia), which includes his wife and daughter, he is shown in the center, standing before his easel with palette and paint box. The family portrait, again undoubtedly painted as an exhibition picture, was shown at the Pennsylvania Academy in 1825.

DE ☐

201.

SARAH RUSH MEREDITH (N.D.)

201. *Sampler*

1818

Inscription: Behold where in a mortal form/Appears each grace divine/The virtues all in Jesus met/With mildest radiance shine/The noblest love of human kind/Inspir'd his holy breast/In deeds of mercy words of peace/His kindness was exprest/Sarah Rush Meredith her work/1818

Silk and cotton on cotton (?) canvas (24 x 22)

Stitches: Cross, queen, satin, tent

20¾ x 17½" (52.7 x 44.5 cm)

Philadelphia Museum of Art. The Whitman Sampler Collection. 69–288–255

THE FORM of this sampler is directly related to the earlier cross-border sampler of the seventeenth and eighteenth centuries. The development of the border as a definite frame, proportionate to the rest of the work, is a uniquely American trend, and one of the identifying features of this period. A tendency toward increased naturalism,

with attention to the whole composition, is also typical. Contemporary English samplers had become increasingly scattered in design —the unity of the whole sacrificed to the intricacies of the individual form—and the border was at most a narrow convention.

The work of Sarah Rush Meredith is framed by a border that is still angular, but shows more naturalistic elements. The sawtooth inner border, in a geometric satin stitch, is a common form, seen also in the sampler of Elizabeth Hudson (no. 32). Surrounded by floral motifs worked in a freer hand, the lines of verse extol the virtue and kindess of Jesus, most probably copied from a poem or hymn. The floral baskets, balancing the composition and containing the date, appear here as in the Humphreys sampler (no. 86), and the arrangement of three baskets may refer symbolically to the Trinity.

PC ☐

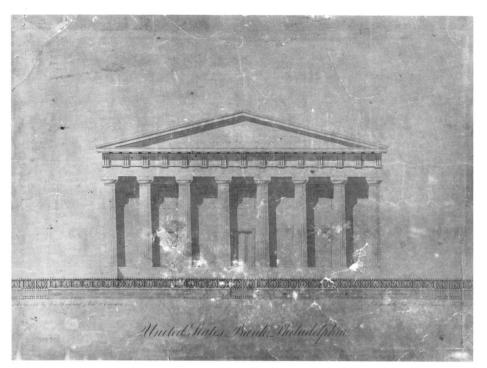

202.

Chestnut Street between Fourth and Fifth streets
1818–24
John Struthers, marble mason
Inscription: A.D. 1821/W. Strickland archt/I. Struthers Mason. (on inner architrave of northern and southern porticoes)
Brick, faced with coursed Chestnut Hill marble ashlar; brick walls and vaults; New York sandstone foundation
Plan 87' 2" x 160' 1½" (26.6 x 48.8 m)

REPRESENTED BY:
Samuel H. Kneass (1806–1858)
United States Bank, Philadelphia
c. 1824
Ink and colored wash
21⅝ x 29½" (50.5 x 70.5 cm)
Historical Society of Pennsylvania, Philadelphia

LITERATURE: Hamlin, *Greek Revival*, pp. 56–61, 73–81; Philadelphia, Independence National Historical Park, "Old Philadelphia Custom House: History and Restoration" (National Park Service Report, 1947); Gilchrist, *Strickland*, pp. 4, 53–57; White, *Philadelphia Architecture*, p. 24, pl. 15; Agnes Addison Gilchrist, "Additions to *William Strickland: Architect and Engineer, 1788–1854*," *JSAH*, vol. 13, no. 3 (October 1954), pp. 2–16; Tatum, pp. 65–66, 137, 171, pl. 54

"IT WAS THE TOMB of many fortunes; the Great Catacomb of investment; the memorable United States Bank," wrote Charles Dickens when he gazed upon the Second Bank of the United States, "a handsome building of white marble, which had a mournful, ghost-like aspect, dreary to behold" (*American Notes*, p. 141). Unconsciously the British writer had summarized the Bank's significance as a monument of the nation's political, economic, and cultural history. The Bank's cultural role was the fulfillment of the best hopes of its directors; its political and economic importance was a bitter disappointment, if not a tragedy, for the same men. When they announced the architectural competition for the Bank in May 1818, the directors requested "a chaste imitation of Grecian Architecture, in its simplest and least expensive form." Their first choice was William Strickland's design, which was both simple and Grecian. Its most imposing aspects, the octastyle Doric portico of the front and rear, were copied directly from Stuart and Revett's engraving of the Parthenon in *The Antiquities of Athens* (1762). Although the Bank was to be elevated on a terrace, it was still to be

WILLIAM STRICKLAND (1788–1854)

"He found us living in a city of brick, and he will leave us in a city of marble," remarked Joseph R. Chandler, editor of the *United States Gazette,* about William Strickland in 1833. For nearly a quarter of a century, William Strickland was known as "City Architect," and some of Philadelphia's finest architecture during the 1820s and 1830s bears testimony to Chandler's tribute.

Strickland was born in 1788 on a New Jersey farm, but his father was a carpenter, not a farmer, and by 1790 the family was living in Philadelphia. In 1803, Strickland was apprenticed to Benjamin Henry Latrobe, the country's leading architect. After leaving Latrobe two years later, Strickland worked as a surveyor, engraver, and painter (see no. 26), as well as an architect, but had designed only four buildings before he won the competition that was to catapult him into the leading ranks of the profession, that of the Second Bank of the United States. Soon he had all the architectural commissions he could handle—at least eighteen during the six years that the Bank was being built. Best known for his Greek revival designs, particularly the Second Bank, United States Naval Asylum (no. 227), and Merchants' Exchange (no. 245), Strickland worked in at least nine different styles. An example of his Gothic revival style is St. Stephen's Episcopal Church at Tenth and Ludlow streets; the steeple of Independence Hall (no. 30), of 1828, represents a venture into the Georgian style and stands as an early

example of historic restoration, since it is a replica of the steeple that had been removed in 1781.

Strickland's versatility is demonstrated by his career as an engineer. In 1826 he was appointed engineer in charge of the Eastern Division of the Pennsylvania Mixed System, which included a canal from Columbia to the Allegheny Mountains and a railroad between Philadelphia and Columbia (later to become the Main Line of the Pennsylvania Railroad). Two years later he was working as supervising engineer of the Delaware Breakwater, then being built off Lewes, Delaware, and still used to protect the harbor leading to Philadelphia.

Strickland was elected to numerous societies, serving as a member of the building committee of the American Philosophical Society; a director of the Pennsylvania Academy of the Fine Arts for twenty-seven years; recording secretary and lecturer on architecture at the Franklin Institute; president of the short-lived American Institution of Architects; and a member of the Royal Institution of Civil Engineers.

After the Panic of 1837 and the ensuing depression, Strickland was unable to find much architectural work in Philadelphia and eagerly accepted the challenge of the design and construction of the Tennessee State Capitol in 1845. He died in Nashville, April 1854, five years before the Capitol's completion; by resolution of the Tennessee legislature his body was interred beneath the north portico of the Capitol.

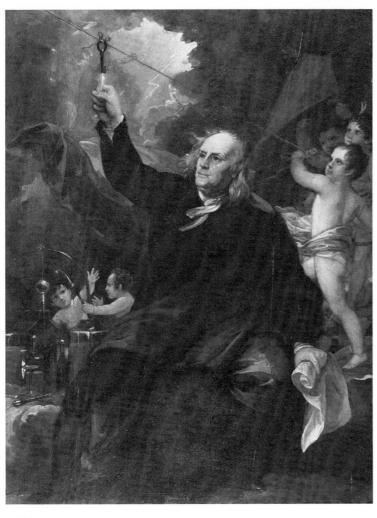

203.

surrounded by city buildings, which made a peristyle design visually superfluous and functionally impractical. Consequently Strickland's indebtedness to the Parthenon was restricted to the porticoes.

While the fenestration remains utilitarian Georgian in proportion and detail, the organization of interior space and progression of rooms are essentially Roman in conception. An arched lobby leads from an elliptical vestibule along a central axis to the transverse, atrium-like barrel-vaulted banking room. The secondary rooms (president's room, cashier's room, and the like) are symmetrically arranged around the central banking room. Because of the function of the building, and perhaps partly because of the architect's limitations, the building is symmetrical only along the longitudinal axis, and this internal organization is reflected by the exterior: the large windows and fanlight in the middle of each side illuminate the tall banking room. This deliberate planning goes beyond Georgian symmetry to reflect Strickland's devotion to romantic classicism,

and although purists might criticize him for shifting from a Greek facade to a Roman plan, others could find his flexibility in the use of classical precedents a virtue. As one of the country's first public buildings based on a famous antique monument, the Bank helped to establish the viability and popularity of the Greek revival style, and the erection of twenty-four branch banks throughout the nation did much to spread it.

Upon its completion in 1824, the building became the headquarters for the Bank of the United States, a chartered banking monopoly with a unique and lucrative relationship with the national government. This relationship became the center of an historic political controversy which pitted President Andrew Jackson against Nicholas Biddle, president of the Bank of the United States, and presidential candidate Henry Clay. Regardless of who had the better arguments or purer motives, Jackson had the power, and he used it in 1832 to veto the renewal of the Bank's charter. The institution expired in 1836, but Biddle continued the banking

business within the marble walls under a state charter. This venture failed in 1841 because of business conditions caused in part by the Bank's demise, and the building was vacant when Dickens viewed it a year later. In 1844 the federal government purchased the building and hired Strickland to alter it for a Customs House, which it remained until the new Customs House at Second and Chestnut streets opened in 1935. In 1939 the National Park Service acquired the former Bank, declared it a National Historic Landmark, and had the Works Progress Administration partially restore it. After its incorporation into Independence National Historical Park in 1956, the Bank's exterior was restored and its interior rehabilitated, and the building was reopened in October 1974 as a portrait gallery of eminent early Americans.

RW □

BENJAMIN WEST (1738–1820)
(See biography preceding no. 52)

203. *Benjamin Franklin Drawing Electricity from the Sky*

c. 1811/20
Oil on paper, backed by wood
12¼ x 10″ (31.1 x 25.4 cm)
Philadelphia Museum of Art. Given by Mr. and Mrs. Wharton Sinkler. 58–132–1

PROVENANCE: Descendants of the artist until March 19, 1898; Christie, Manson and Woods, London, *Catalogue of the Collection of Pictures, Drawings and Sketches by Benjamin West,* March 19, 1898, no. 140; Godefroy Mayer, Paris, c. 1899; *No. 30, Old Paintings, Drawings . . .,* Paris, 1910, no. 83 (Godefroy Mayer sale); with Kennedy and Co., New York, c. 1910; with The Hayloft, Whitemarsh, Pa., 1927; Wharton Sinkler, Philadelphia

LITERATURE: Dunlap, *History,* vol. 1, p. 86; Tuckerman, p. 101; Sellers, *Franklin,* pp. 401–2

PAINTED LATE IN WEST'S LIFE, this small picture is an apotheosis of Benjamin Franklin. He is shown with cloak flapping in the wind, straddling the clouds in the midst of a thunderstorm—a glorification of the moment when Franklin discovered that lightning is actually static electricity. The famous experiment occurred in Philadelphia in June 1752, when Franklin tied a key, as a conductor, to a kite string and flew the kite during a storm. When the lightning hit the string and traveled down its length, Franklin received an electrical shock from the end of the key, just as he had predicted. During the experiment Franklin was assisted

by his twenty-one-year-old son, William, and not by scantily clad cherubs as in the painting (one in Indian garb to establish location). Moreover, Franklin was only forty-six at the time of the experiment, not the old man that West depicts. Clearly, West's picture is fanciful, although the Leyden jars used for storing static electricity at the left are accurate and prove that West had some knowledge of popular electrical experiments.

According to C. R. Leslie, after West sent his painting *Christ Healing the Sick* to the Pennsylvania Hospital, he decided to give the hospital a full-length self-portrait on wood and "a small sketch of a picture of Dr. Franklin." Leslie's description of the Franklin sketch in West's studio fits this painting exactly (Dunlap, *History,* vol. 1, p. 86); he must have seen it sometime between his arrival in London in 1811 and West's death in 1820. However, the sketch could, of course, predate 1811.

As Sellers has observed, West might well have intended the Franklin painting as a preliminary sketch for a larger work which would be paired with his self-portrait. After all, Leslie did refer to it as a "sketch," and West did offer in 1816 to supply the Pennsylvania Hospital with pictures over two fireplaces (Sellers, *Franklin,* p. 402). Although intended as a gift, the picture remained in the West family.

Franklin died in 1790 without ever having been painted from life by West. This likeness is a reconstruction probably based on portraits by several artists. It is thought that West made use of an engraving after Jean-Baptiste Weyler's miniature of about 1782 (Sellers, *Franklin,* p. 399), but he could also have used a bust that he owned, which was probably a plaster cast after Jean-Jacques Caffieri's bust of 1777 (Arthur S. Marks, "Benjamin West and the American Revolution," *The American Art Journal,* vol. 6, no. 2, November 1974, p. 28). *Benjamin Franklin Drawing Electricity from the Sky* is painted in the freer, more Rubensesque, and more dramatic manner typical of West's late work.

DE □

JOHN LEWIS KRIMMEL (1786–1821)

The first important American genre painter, Krimmel was born Johann Ludwig Krimmel in Ebingen, Württemberg, on May 30, 1786. He left Germany in 1809 for Philadelphia, where his brother George Frederick had established himself as a merchant (Naeve, "Krimmel," pp. 2–6). At first Krimmel supported himself by painting portraits, but by 1812 he had found a position as drawing instructor at a girls' boarding school (Dunlap, *History,* vol. 2, pp. 235–36; Naeve, "Krimmel," p. 11). Although he

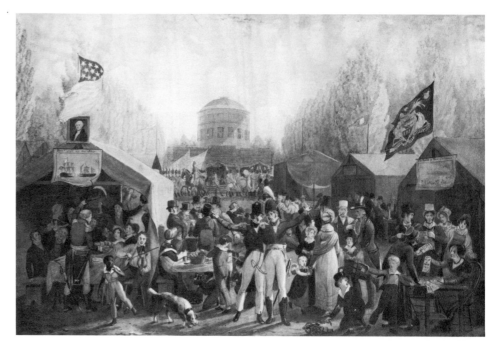

204.

exhibited his work regularly in Philadelphia and occasionally in New York, the genre subjects he preferred to paint were unpopular with collectors, and Krimmel was forced to rely on his teaching position for a living during most of his brief career (Dunlap, *History,* vol. 2, pp. 235–36). Krimmel's frugality, however, was such that in 1817 he was able to return to Europe, where he remained for two years. He traveled through Germany, Austria, and Switzerland, and his sketches of Alpine scenery are probably the first ever made by an American artist (Winterthur Museum). After his return to America in 1819, Krimmel's career seems to have taken an upturn: he resigned his position as a drawing instructor, prints after his work were published (see no. 211), and he received a major commission for an historical painting. Krimmel was making studies for this work, a six-by-nine-foot canvas of William Penn's landing at New Castle, at the time of his accidental death by drowning in 1821 (Naeve, "Krimmel," p. 21; Dunlap, *History,* vol. 2, p. 236).

Krimmel's training as a draftsman began in Germany under Johann Baptist Seele. According to Dunlap, he "had been well instructed in drawing and the management of colors" before his arrival in America (*History,* vol. 2, pp. 234–35), but this statement is difficult to evaluate since none of Krimmel's early drawings appear to have survived. He may have received additional training in Philadelphia at the Society of Artists (Naeve, "Krimmel," p. 8). In any event, by 1812, Krimmel was participating with Thomas Sully, Rembrandt Peale,

Charles Bird King, and other Philadelphia artists in weekly meetings at Sully's house, where the assembled artists drew a literary subject selected by one of them (Theodore E. Stebbins, Jr., "A History of American Drawings and Watercolors," in preparation). Krimmel was thus exposed to the drawing styles of a number of his contemporaries at these meetings, which were probably inspired by English practices and which preceded by fifteen years the similar Sketch Club of New York. Certainly Krimmel profited from his knowledge of Sully's drawings in his own figure studies in light, graceful washes. Most remarkable, however, are his watercolors of 1813–18, also found in the Winterthur sketchbooks. These are unique in American art of the period for their freshness and for a translucent quality, unknown in the watercolors of contemporary artists like Charles Willson Peale and William Dunlap, and otherwise found only in English work.

204. *Independence Day Celebration in Centre Square, Philadelphia*

1819
Signature: J. L. Krimmel 1819 (lower right corner)
Watercolor with black and brown ink over pencil on white paper
12 x 18″ (30.4 x 45.7 cm)
Historical Society of Pennsylvania, Philadelphia

PROVENANCE: The artist's estate sale, August 14, 1821; given by James L. Claghorn to the Historical Society of Pennsylvania, January 13, 1873

LITERATURE: Scharf and Westcott, vol. 2, opp. p. 936; Joseph Jackson, "Krimmel, 'The American Hogarth,'" *International Studio,* vol. 93, no. 385 (June 1929), p. 33; Naeve, "Krimmel," no. 20, fig. 5; Hermann Warner Williams, *Mirror to the American Past: A Survey of American Genre Painting* (New York, 1973), p. 43, fig. 22; Wainwright, *Paintings and Miniatures,* p. 299, illus. p. 137

KRIMMEL's *Independence Day Celebration in Centre Square, Philadelphia,* depicts a boisterous gathering of soldiers and townspeople to celebrate the forty-third anniversary of the Declaration of Independence in 1819. The artist's admiration of the English artists William Hogarth and David Wilkie is apparent in the vivid incidents of the foreground; yet as has recently been pointed out, he is indebted to William Birch (see biography preceding no. 149), for his general practice of showing a crowd of small figures participating in a particular outdoor event at an identifiable location (Hermann Warner Williams, *Mirror to the American Past,* New York, 1973, p. 40). In fact, the scene—in front of the Centre Square Pump House (no. 153) designed by Benjamin Latrobe for Philadelphia's first municipal water system—would have been recognized instantly by Krimmel's contemporaries. So, too, would the War of 1812 slogan, "Don't give up the Ship," on the naval battle poster at the left and the reference to Andrew Jackson's victory, "The Battle of New Orleans," on a similar placard at the right. Beneath it, and perhaps reflecting the rising nationalism of the years after the end of the 1812 war, is a woman sitting at a table selling copies of the patriotic songs "Yankee Doodle" and "Hail Columbia" while the two men behind her hold flyers referring to Oliver Hazard Perry's victory on Lake Erie and to "The Tars of Columbia." Next to them a small boy fires a toy pistol; another prepares to ignite a miniature cannon. A little girl runs crying to her mother, absorbed in the tales of an old soldier who points to his battle scars. In the center two men are evidently boasting about the roles of their respective services in the recent war; to their left three boys steal the wares of a woman peddler whose attention is distracted by a lively discussion between several men gathered around an oyster stand. At the far left, a party of civilians and military men raise their glasses in a toast, to the accompaniment of a fiddle player, while in the background the noise and movement continue, with marching soldiers, an officer on horseback giving orders, and a fife and drum corps.

Krimmel had painted a similar though more restrained celebration view a few years before, *View of Centre Square, on the 4th of July,* about 1810–12 (Pennsylvania Academy of the Fine Arts). Yet this watercolor, though undoubtedly derived from Krimmel's earlier work, is based on fresh studies made on the actual site. Among his sketchbooks at the Winterthur Museum is a sheet with two ink and wash drawings, apparently made the day after the celebration, in which Krimmel explored various points of view and recorded the appearance of the tents set up for the event. In another sketch he again studied the site and recorded as well the subjects of what were evidently banners carried on the occasion—Revolutionary War events, the "Battle of Trenton" and the "Death of General Mercer," and another of "General Jackson, the Hero of the South." At the bottom of the drawing Krimmel set out what appears to be a list of food he had seen being sold at the celebration, including pomegranates, gingerbread, oysters, lobsters, and "crabfish."

The preparatory sketches and the careful details of the final watercolor suggest that Krimmel viewed *Independence Day* as an important effort and expected it to stand on its own as a finished work of art. It is probable, however, that he also planned the watercolor as the model for a print. In June 1819 an engraving, *The Conflagration of the Masonic Hall, Chestnut Street, Philadelphia,* based in part on work by Krimmel, was published, and it seems likely that he completed *Independence Day,* with its patriotic subject and broadly humorous incidents, for a similar purpose. No print from it appears to have been made, however. The watercolor remained in the artist's studio until his death (Naeve, "Krimmel," p. 93).

JC □

THOMAS HAIG (ACT. C. 1811–33)

According to Aitken's 1811 Philadelphia city directory, Thomas Haig was trained as a creamware potter and emigrated from Scotland about 1811. He established the Northern Liberty Pottery Works at 106 Poplar Lane. When Haig died in Philadelphia about 1833 the business was continued by two sons, Thomas (1810–1893) and James (d. 1878), until 1885. Other children of Thomas Haig included Elizabeth, Ann (a china burnisher), Christiana, and John (City Hall, Register of Wills, Will of Ann Haig, 1858, Will no. 58).

In 1858, Thomas and James added stoneware to the factory's production. As with other Philadelphia potteries the Haig factory managed to survive by adapting its production to include firebrick, chemical wares, and crucibles as well as household earthenwares at their expanded factory located at 456–60 North Fourth Street. In the late 1870s the factory was moved to 971–75 North Second Street. By the end of the nineteenth century the Haig factory, under the management of John S. Jennings, was producing relief plaques, hanging baskets, puzzle mugs, cow creamers, "fancy" earthenware pitchers, and miniature redwares. Throughout the nineteenth century the Haig factory was synonymous with the pre-eminence of earthenware manufacture in Philadelphia.

ATTRIBUTED TO THOMAS HAIG'S NORTHERN LIBERTY POTTERY

205. *Coffeepot*

c. 1815–30
Red earthenware, glazed
10¾ x 9⅜" (27.3 x 23.8 cm)
The Metropolitan Museum of Art, New York. Rogers Fund, 1922

PROVENANCE: Jacob Paxon Temple, Chester County, Pennsylvania, until 1922; with Anderson Galleries, New York; purchase, The Metropolitan Museum of Art

LITERATURE: New York, Anderson Galleries (January 23–28, 1922), no. 115 (Jacob Paxon Temple sale); MMA, *19th Century America, Furniture,* no. 48 (illus.)

IN 1825, THE FRANKLIN INSTITUTE, in its annual competition, awarded an Honorable Mention to "Thomas Haig of Philadelphia for his very excellent specimens of red and black earthenware (if sent in time would have won)" (*Address of the Committee on Premiums . . .,* Philadelphia, 1825, p. 7). The Haig entry included both black and red glazed coffeepots, teapots, pitchers—plain and diamond patterned—cake molds, strainers, and pans made from "clay taken in city." The committee of judges reported that the earthenware pieces were "superior in quality

205.

to those imported from England. Body-perfectly burned, deprived of all absorbent qualities. Glase [*sic*]—good, free from cracks; neat workmanship" (*Address of the Committee on Premiums,* p. 22). In 1826, Haig, as proprietor of the Northern Liberty Pottery, received a bronze medal awarded by the Franklin Institute "to the makers of the best red earthenware" (*Address of the Committee on Premiums,* p. 264). He continued to produce nineteenth century Empire style redwares in eighteenth century shapes with "engine turned" incised bands.

Thomas Haig was typical of many Philadelphia potters engaged in the production of earthenware during the early nineteenth century. These potters supplied a home market with common earthenwares that successfully competed with English and European imports in terms of quality and cost. With an ample supply of raw materials, a trained labor force, extensive markets, and excellent transportation facilities, Philadelphia became a major center for the production of household and industrial earthenwares. The tea sets and tablewares attributed to Haig are outstanding examples of Philadelphia craftsmanship and artistic excellence applied to inexpensive common items.

PHC □

SIMON CHAUDRON (1758–1846)
(See biography preceding no. 186)

206. *Fish Knife*

c. 1820

Mark: CHAUDRON (in ribbon on back of blade near handle)

Silver, ivory handle

Length 11⅜" (28.8 cm); width 3⅝" (4.2 cm)

The Art Institute of Chicago. Gift of The Antiquarian Society

PROVENANCE: Private collection, New York; Parke-Bernet Galleries, Inc., New York; with R. T. Trump & Company, Philadelphia

THE DOLPHIN MOTIF which was used in decorative schemes in ancient Greece and Rome was revived by William Kent and others in the early eighteenth century. It again became popular in the early nineteenth century with the revival of classical decoration in furniture and silver, seen for example in the supports for the Philadelphia sofa (no. 232) and the Connelly card table (no. 173). In the Chaudron fish knife this motif is the central element of the design, where it is delicately held within cutout ogee arches. The undulating dolphin forms a

206.

counterpoint of curves and counter curves against the elliptical blade and the cutout arches. The chased delineation of the dolphin itself, naturalistically conceived, echoes these curves. The octagonally shaped ivory handle with a partially fluted end is gracefully joined to the blade through a neatly pinned socket and is soldered to the blade at its flat triangular terminus.

DH □

207. *Judd's Hotel, Philadelphia*

1817/25

Oil on canvas

30 x 25" (76.2 x 63.5 cm)

Philadelphia Museum of Art. Collection of Edgar William and Bernice Chrysler Garbisch. 68–222–4

PROVENANCE: Harry Stone Gallery, New York, by 1940; with Victor D. Spark, New York, by 1955; Edgar William and Bernice (Chrysler) Garbisch, 1955–68

LITERATURE: Henry Clifford and others, "Life in Philadelphia," *PMA Bulletin,* vol. 35, no. 186 (May 1940), p. 17, no. 42; National Gallery of Art, *American Primitive Paintings from the Collection of Edgar William and Bernice Chrysler Garbisch* (Washington, 1957), vol. 2, p. 51

VERY LITTLE HAS BEEN pieced together about this intriguing picture of the speedy arrival of a coach-and-four just outside Judd's Hotel by an unknown artist. It appears to have been painted from the second story window of 32 South Third Street. According to the Philadelphia directories, Judd's Hotel was

in existence from 1817 to 1825 and was located at 27 South Third, next to Francis Walnut who, according to his sign, was a hairdresser at 29 South Third. This hotel had the singular advantage of being the terminus of the daily passenger coach route from Trenton at least from 1820 until 1821, when the directories gave this information on the Trenton stage. By 1823 the ownership of the hotel had apparently passed from Anson Judd to Dana Judd Upson, probably a grandson.

The carriage in this painting has been identified as "the fastest mail coach in the United States, the New York–Philadelphia express—'through to each destination in one day'" (Carl W. Drepperd, *American Pioneer Arts and Artists,* Springfield, Mass., 1942, p. 60). A New York advertisement of 1819 includes a woodcut of a coach which is almost identical to the one in the painting and announces that passengers "will leave the U.S. Mail Coach office, 30 south Third-street daily at 5 o'clock, and arrive in New York the same day *in the Coach,* which will cross the North River by Steam Boats. This line will be under the same direction as the Mail Line is, and will carry *six passengers only inside* . . ." (Joseph Jackson, *Encyclopedia of Philadelphia,* Harrisburg, 1931, vol. 2, illus. p. 432). Chester Bailey, the Philadelphia agent for this line, resided at the United States Mail Coach office at 30 South Third from the time Judd's Hotel opened until 1825 when possibly Bailey forced the hotel's demise by opening the Mansion House Hotel at 122 South Third. Very possibly the coach in the painting is the New York coach which would then be passing Judd's Hotel on the way to the United States Mail Coach office.

Judd's Hotel is interesting chiefly because it captures an early Philadelphia scene, giving some impression of street life and the architecture of the city at that time. The iron structures on the sidewalk curb were used to suport awning strung out from the buildings—a convenience discarded long ago.

DE □

JOHN HILL (1770–1850)

Among the many English artists immigrating to America in the early nineteenth century, John Hill stands out as one of the most highly trained and successful. Like his compatriot William Birch (see biography preceding no. 149), who had made the move twenty years earlier, the London-born Hill did not come to America to make his fortune, but perhaps was attracted by the greater opportunities and excitement afforded by a new country where engravers were relatively uncommon.

During his apprenticeship with the London printmaker and publisher Martin, Hill discovered the secret of the aquatint process, having been unable earlier to pay the asking price of two guineas from an engraver who claimed to have invented the method. Hill experimented diligently with its intricacies until he became a master of the medium. He made numerous plates, largely topographical, for a variety of books, the most notable of which was Henry Pyne's *Microcosm: Or a Picturesque Delineation of the Arts, Agriculture, Manufactures, &c. of Great Britain,* published in London by William Miller in 1808. The project of aquatinting 121 plates with more than six hundred vignettes took Hill over six years, during which he lived with Pyne.

Hill produced numerous plates for other London publishers; his London Account Book (Metropolitan Museum of Art) indicates the wide range of material reproduced during the years from 1798 to 1815, and his great exposure to the latest trends of English and Continental landscape, architecture, and decorative arts. Rudolph Ackermann selected Hill as one of four engravers to work on the plates after Pugin and Rowlandson's designs for the enormously successful *Microcosm of London,* published over a three-year period beginning in 1808; similar series on the universities of Moscow, Oxford, and Cambridge followed annually thereafter.

In 1816, at the age of forty-six, Hill chose to abandon his London career and immigrate to America. After a short stay in New York, where William James Bennett, who was to be his leading rival in the New York aquatint market, had just arrived from England, Hill established his engraving business in Philadelphia, where his mastery of the aquatint medium was unrivaled.

Among the first to recognize his talents was the young Philadelphia publisher Moses Thomas, for whose *Analectic* magazine Hill provided plates in 1817, and for whom Hill also aquatinted twelve illustrations for *A Series of Progressive Lessons Intended to Elucidate the Art of Flower Painting in Water Colours.* The July 1819 issue of the *Analectic* was embellished with a Hill aquatint of York Springs, Pennsylvania, after a sketch by Joshua Shaw, with whom Hill was to collaborate on his first ambitious American publishing venture, *Picturesque Views of American Scenery.*

Among the earliest singly issued plates coming out of Hill's workshop was the large aquatint of the *Conflagration of the Masonic Hall* in Philadelphia, after a joint drawing by John Lewis Krimmel and S. Jones (Tatum, fig. 74). It was a rare topical print for Hill; he completed the large aquatint for the Society of Artists just three months after the blaze.

Upon the completion of the *Picturesque Views of American Scenery* in 1821, Hill contracted with New York publisher Henry Megarey to produce a lavish portfolio of Hudson River scenery after paintings by William Guy Wall; at the same time Hill sold Megarey the publication rights to designs he had compiled, issued in 1821 as the *Drawing Book of Landscape Scenery.*

Work on the Hudson River plates necessitated the removal of Hill and his family to New York in 1822, where he worked until 1838. The *Hudson River Portfolio* brought Hill deserved success and fame upon its publication in 1827; the plates were in great demand and continued to be printed well into the 1830s.

Over the next decade Hill produced views of Niagara Falls after William James Bennett's paintings and of West Point, copied from George Catlin's sketches; plates for Fielding Lucas's *Progressive Drawing Book;* as well as coloring work for other New York engraving and lithographic firms. Hill's son, John William, who had studied with his father, became a well-known topographical artist in his own right and published several large aquatints with his father.

Hill's age, combined with the rise of lithography and consequent decreasing demand for large folio aquatints, most likely prompted his 1836 retirement to a farm in the hills of Rockland County, New York. His last dated aquatint, *Shoal of Sperm Whale off the Island of Hawaii,* after Thomas Birch, was published in 1838. Hill's wife Ann died in 1847, and Hill died three years later, ending a full and productive life during a golden era of American printmaking.

207.

208. *View near the Falls of Schuylkill*

208. *Picturesque Views of American Scenery*

1820–21
Title page: Picturesque Views. of
American Scenery. 1820 Painted by
J. Shaw. Philadelphia Published by
M. Carey & Son, Engraved by J. Hill.
Twenty etchings and aquatints with
watercolor and printed descriptions on
wove paper, quarter bound in brown calf
21⁹⁄₁₆ x 14⅝ x ¹⁵⁄₁₆"
(54.7 x 37.1 x 2.3 cm)
The Library Company of Philadelphia

PROVENANCE: James Cox (c. 1790–1834)

LITERATURE: New-York Historical Society, John
Hill, Day & Account Book, 1820–34; Stauffer,
vol. 1, p. 1343; Fielding, *American Engravers
Supplement,* nos. 644–62; I. N. Phelps Stokes,
The Iconography of Manhattan Island (New
York, 1915–28), vol. 3, pp. 566–67; Frank
Weitenkampf, "John Hill Aquatinter, and His
'Landscape Album,'" *Bulletin of the New York
Public Library,* vol. 24, no. 6 (June 1920), p. 330;
Frank Weitenkampf, "Early American Land-
scape Prints," *Art Quarterly,* vol. 8, no. 1 (Winter
1945), pp. 40–67, fig. 11; Frank Weitenkampf,
"John Hill and American Landscape in Aqua-
tint," *American Collector,* vol. 17 (July 1948),
pp. 6–8; Richard J. Koke, "John Hill, Master of
Aquatint 1770–1850," *New-York Historical
Society Quarterly,* vol. 43, no. 1 (January 1959),
pp. 51–117; Richard J. Koke, *A Checklist of the
American Engravings of John Hill (1770–1850)*
(New York, 1961)

"IN NO QUARTER OF THE GLOBE are the majesty
and loveliness of nature more strikingly
conspicuous than in America. The vast
regions which are comprised in or subjected
to the republic present to the eye every
variety of the beautiful and sublime." This
introduction to *Picturesque Views of
American Scenery,* which was to become
the cornerstone of published American
landscape views, went on to lament the lack
of topographical art, commenting that
"America only, of all the countries of
civilized man, is unsung and undescribed."
While American views had appeared occa-
sionally in European and American publi-
cations throughout the latter half of the
eighteenth and early nineteenth centuries,
limitations of size and edition kept them
small and unspectacular. Even the pioneer-
ing *City of Philadelphia* (no. 149) by
William Birch was better considered as
urban portraiture, and his more bucolic
Country Seats of North America has been
not unfairly likened to a microcosmic
Better Homes and Gardens.

While it is unclear whether Joshua Shaw
approached Moses Thomas first, or vice
versa, regarding the novel idea of a lavish

JOSHUA SHAW (1777–1860)

Before arriving in Philadelphia in 1817 as
traveling caretaker to Benjamin West's
painting *Christ Healing the Sick,* Joshua
Shaw had earned moderate success as a
painter of landscape, still life, and livestock
in England. He came as part of a wave of
English landscapists—William Birch,
William Guy Wall, William Winstanley,
George Beck, and William James Bennett—
who first consciously recorded American
views for reproduction and circulation to a
wide audience.

In 1819, Shaw, a former Manchester sign
painter, began a tour throughout the eastern
states to collect sketches and subscriptions
for a proposed album of American topog-
raphy, which appeared as *Picturesque Views
of American Scenery* in 1820–21. Shaw
compiled a *United States Directory* in 1822,
which remains one of the most attractive
publications of its kind, filled with fine
specimens of American engraved advertising
art.

During his twenty-five years in Philadel-

phia, Shaw was active in the politics of
professional artists' societies, forming the
Artists' Fund Society in 1835 as an alterna-
tive to the Pennsylvania Academy of the
Fine Arts. Two years later he left the Artists'
Fund to found the Artists & Amateur Asso-
ciation, but soon thereafter resigned after
quarreling with other organizers over
money. Shaw's contentious nature made him
unpopular with his colleagues; William
Dunlap called him an "ignorant, conceited
English blockhead" (*Diary of William
Dunlap,* New York, 1931, p. 508).

In addition to his career as a painter of
landscapes and seascapes, which were fre-
quently exhibited in New York, Philadel-
phia, Baltimore, and Boston, Shaw invented
a percussion-wafer priming device for fire-
arms, winning him awards from both the
American and Russian governments. Shaw
moved from Philadelphia to Bordentown,
New Jersey, around 1843, continuing to
paint and exhibit until stricken with
paralysis. He died at the age of eighty-three
in Burlington, New Jersey.

album of American landscape, Shaw set off from Philadelphia in 1819 to collect sketches and subscriptions for the undertaking. Thomas hired John Hill to aquatint the plates, work for which Hill was uniquely experienced among his Philadelphia colleagues. The *Picturesque Views of America Scenery* was to be published in numbers; the first issue, appearing in 1819, made the tentative promise "to continue the series and to present to the public view most of those spots which are remarkable for their historical interest or natural beauty," if public encouragement was sufficiently substantial. No sooner had Hill aquatinted the title page with Thomas's imprint and the 1819 date when bankruptcy forced the publisher to abandon his sponsorship, which was assumed by neighboring bookseller and publisher Mathew Carey. Hill substituted Carey's name and carefully transformed the 1819 into 1820, only using stipple instead of aquatint. Careful examination of the ground makes the change apparent; it has been misread by some scholars as "1829," leading to the misconception that there was an 1829 edition of the views. Only one copy of the Thomas imprint title page is known, that at the New-York Historical Society. The prospectus appearing on the wrappers of the second number, which appeared in 1820, stated confidently that six numbers, each containing six views and the odd vignette, would be forthcoming at three-month intervals and would cost ten dollars per number. (Presumably subscribers were not given the option of a cheaper uncolored version—the edition was, quite simply, "deluxe.")

Hill's American Account Book (New-York Historical Society) details the expenses and time undertaken: local coppersmith Joseph Keim supplied the plates; Carey furnished the American-made paper; the lettering of each plate was engraved by local calligraphic artist Robert Tiller; Hill's fifteen-year-old daughter was paid 4s. 6d. for her printing labor. As the volume of production increased, local printers William Green and Charles Harrison were employed to pull the impressions. Hill spent approximately five months etching, aquatinting, and proofing each plate—some in sepia and others in black ink. When completed, the prints were farmed out to colorists, one of whom was the young Thomas Doughty; Hill and his family then boxed the prints, some for Carey, others for shipment to England.

Shaw's drawings concentrated on locations along the coastal regions of the eastern seaboard, although the prospectus claimed that he would visit every state of the Union. His highly topical picture of the great fire of Savannah in January 1820 secured a profitable number of subscribers. Three of

the scenes copied by Hill were not after Shaw's own sketches: drawings by J. R. Watson of the Royal Navy (see no. 198) for views of the Falls of St. Anthony in Minnesota, the tomb of Washington, and a view of the spot where the British general Ross died in Maryland during the War of 1812. Each view was accompanied by a letterpress description on the virtues of the site which frequently waxed lyrical in describing the light, flora, and fauna, or historical significance. In some instances the time of day when the view was taken was noted, other times hardcore information given. The description accompanying *Washington's Sepulchre, Mount Vernon,* noted that "a painter's license has been taken in regard to the number and size of the trees with which the hillock is covered, by anticipating what a few years will probably bring about." Bollings Dam near Petersburg, Virginia, was recommended as an excellent place to catch shad; certain other spots were especially suited to lovers of the picturesque, either because of their solitary wilderness such as Passaic Falls in New Jersey (which was surely crowded by the flocks of artists who depicted the cascade), or the sense of history experienced at the monument at West Point (near Baltimore).

The *View near the Falls of Schuylkill,* one of the four vertical compositions in the series, was published as the sixth print of the second number. The view along the creek with the rocks rising up on either side emphasizes the steep landscape. The atmosphere is imbued with the rosy light of sunset as a traveler leads his horse homeward down the rock-strewn path. The superb coloring is in itself a tribute to the armies of nameless colorists to whom eighteenth and nineteenth century printmakers sent their works for embellishment before the advent of chromolithography. Not even Thomas Doughty (see biography preceding no. 226) signed his characteristic monogram to the plates he colored for Hill. The letterpress text extols the inspirational virtues of the landscape, calling it "romantic and picturesque." Two other Philadelphia-area views had also appeared in the first number, both of the area around the Schuylkill.

As John Hill's biographer, Richard Koke, notes, some of the depictions predate the Hudson River school in showing nature as an untamed American wilderness ("John Hill, Master of Aquatint 1770–1850," *New-York Historical Society Quarterly,* vol. 43, no. 1, January 1959, p. 82). The stormy sky of *Hell Gate* in New York, the striking *View by Moonlight near Fayetteville,* and the eerie atmosphere called forth in *Spirit Creek; near Augusta, Georgia* were completely in the spirit of romanticism and

unlike anything previously produced in America.

As Hill was completing the etching of the twentieth plate in February 1821, Carey instructed him to stop work on the fourth number, possibly as a result of sluggish sales and Carey's other wide-ranging commitments. Hill printed the plates of the third number, paying the expenses out of his own pocket. The last plate, a view of Boston, is known only in a proof state of the etched outlines in the collection of the New-York Historical Society.

The *Picturesque Views* proved their own worth, warranting an 1835 reprinting by Thomas Ash of Philadelphia. Its groundbreaking precedent encouraged numerous subsequent artists to produce American landscapes for reproduction, while it at the same time stimulated a higher level of competence in the reproductive techniques themselves.

SAM □

GENNARINO PERSICO (DIED C. 1859)

Nothing is known of Gennarino Persico's early life. He came to America from Naples, and may have arrived in 1818 at the same time as his brother, the sculptor Luigi Persico. Luigi worked in Lancaster, Harrisburg, Philadelphia, and Washington, but the record of Gennarino's travels is less clear. In 1820, Luigi wrote from Philadelphia to Benjamin Champneys of Lancaster: "I expect that taking the liberty of presenting you my brother, bearer of this, will not displease you. . . . He has some Mercantile business, and he intends to stay a few weeks in your place. He paints miniatures also" (W. U. Hensel, "An Italian Artist in Old Lancaster," *Lancaster County Historical Society Papers,* vol. 16, no. 3, 1912, pp. 93–94).

By 1822, Gennarino had a studio in Philadelphia at 86 Chestnut Street and was painting miniatures and giving drawing lessons. He also began to submit his work to the exhibitions of the Pennsylvania Academy, showing in 1822 a chalk drawing and a "Madona and Child—Miniature *after* Pacicco di Rosa." He exhibited again at the Academy in 1823, 1824, 1826, and 1831, displaying "Hebe, a drawing in crayon," several miniatures of the Madonna, and a *Venus.* In 1823, Persico married Elizabeth McKnight Kennedy, daughter of a Reading, Pennsylvania, banker, but the marriage was not happy (Hensel, cited above, p. 94).

The city directories record Persico's presence in Philadelphia until 1833 when he is listed as a portrait and miniature painter with a studio on Walnut below Third and a home at 66 South Eighth Street. He moved to Richmond, Virginia, sometime in the 1830s and opened an academy for young

209.

ladies which he operated until after his wife's death in 1842 when it failed. Persico returned to Naples, but was back in Richmond working as an artist from 1852 to about 1859.

AS

209. *Dr. Joseph Plantou*

c. 1820
Signature: Persico (lower right edge)
Watercolor on card
2½ x 2¾" (6.3 x 6.9 cm)
Mrs. Andrew Van Pelt, Radnor, Pennsylvania

PROVENANCE: Purchase, Lucy Wharton Drexel, c. 1911; descended to present owner

LITERATURE: MMA, *Catalogue of an Exhibition of Miniatures Painted in America 1720–1850* (March 14—April 24, 1927), p. 43

GENNARINO PERSICO's immigration to Philadelphia followed the example of other European miniaturists such as Jean-Henri Elouis, Pierre Henri, Jean-Pierre de Vallée, and Philippe Peticolas, who all painted miniatures in Philadelphia in the 1790s. Persico's portrait of Dr. Joseph Plantou, a French physician, reveals the artist's European origins and training. In contrast to British miniaturists, nineteenth century Continental painters preferred a circular shape and continued to use a smooth opaque or finely hatched dark background. Also characteristic of the Continental miniaturist is Persico's precise, fine modeling, specifically defined dress, linear treatment of hair and details, upright pose, and direct, if enigmatic, gaze of the sitter.

RB-S □

REMBRANDT PEALE (1778–1860)
(See biography preceding no. 178)

210. *Thomas Sully*

1820/22
Oil on canvas
23 x 19" (58.4 x 48.3 cm)
Mrs. T. Charleton Henry, Philadelphia

PROVENANCE: Peale Museum, Baltimore, probably until c. 1855; T. Charleton Henry, c. 1920

THOMAS SULLY PAINTED Rembrandt Peale's portrait when he was on a visit to Baltimore in 1820, and the picture was presented to Mrs. Peale possibly in gratitude for hospitality (NYPL, Thomas Sully, Journal, April 29, 1820, typescript). Not long afterward, Rembrandt wrote Sully that he was pleased to find that in Baltimore, evidently in contrast to Philadelphia, art was admired for itself rather than for its subject. Rembrandt continued to praise Sully's portrait of him, adding: "I hope you will improve in Your Appearance before I have an Opportunity of making a return in kind" (HSP, Dreer Collection, Painters and Engravers, vol. 3, July 4, 1820). This is the first indication that Rembrandt Peale intended to paint Sully's portrait.

The earliest opportunity came during Sully's next visit to Baltimore where Rembrandt was ensconced as proprietor of the new Peale's Museum. Sully arrived in Baltimore in November 1820 and painted there during the winter and following summer (NYPL, Thomas Sully, Journal, November 20, 1820). From Sully's Journal it appears that there would not have been an opportunity again for Rembrandt to paint Sully's portrait until 1823 in Philadelphia, after Rembrandt had left the Baltimore museum to his brother early in 1822. Yet the frame on the portrait is original and, as the plaque indicates, the portrait belonged to Peale's Baltimore museum, so the portrait was most likely painted in Baltimore in 1820/22. Rembrandt had just finished his huge *Court of Death* in late August 1820. After this, it is difficult to locate him. The *Court of Death* was exhibited in Baltimore and then taken or possibly sent on tour for about a year. At least by August 4, 1821, Rembrandt was in Baltimore again (APS, Peale Papers, Rembrandt to Titian Peale), and he could have painted Sully before he went on tour in 1820 or at this time.

The portrait of Sully is most interesting as a confrontation between two artists who were both still professionally at their peak—Rembrandt aged forty-two and Sully aged thirty-seven—and who had been friendly rivals as young men for the same patronage in Philadelphia. In comparing the two artists,

contemporary critics tended to conclude that Rembrandt's portraits lacked grace and that Sully's, although tastefully elegant, were not true likenesses ("Review of the Second Annual Exhibition," *Port Folio,* vol. 8, no. 1, July 1812, pp. 21, 22, 25). Rembrandt felt that "it is impossible to be too accurate in drawing the Features," while Sully confessed that he did not like Rembrandt's manner of painting as "he was too careful and painstaking" (HSP, John Sartain Collection, Rembrandt Peale, "Notes of the Painting Room," vol. 24, p. 57; Thomas Sully, "Recollections of an Old Painter," *Hours at Home,* vol. 10, no. 1, November 1869, p. 73). Even Rembrandt's father warned him: "The only objection I know of in your work is that you make too long sittings your sitters get tire'd of the business . . ." (APS, Charles Willson Peale, Letterbook, vol. 17, February 9, 1823, p. 205).

The two artists were to paint each other's portraits again in 1859, this time on commission. Rubens Peale wrote of the arrangement: "Mr. [Joseph] Harrison has engaged Rembrandt to paint a portrait of Mr. Tho. Sully and Mr. Sully to paint a portrait of Rembrandt for him, this will be quite interesting, that the two oldest artists are to paint each others portrait" (APS, Mills Collection, Peale Papers, letter, January 30, 1859). Harrison entered the two portraits in the Pennsylvania Academy exhibition of 1860, held a few months before Rembrandt died.

DE □

JOSEPH YEAGER (C. 1792–1859)

Although no documentation is available, works printed by Joseph Yeager in 1808 and 1809 at the age of sixteen and seventeen suggest that sometime in his youth he had training as an engraver. By 1814 he had produced prints for several Philadelphia publications and had collaborated with William Charles (see biography preceding no. 187) in the illustration of children's books. In 1824 he joined with William H. Morgan, a carver and gilder, in a publishing business located at 114 Chestnut Street. The dates on his prints show that he simultaneously owned an engraving establishment which he operated from his home at 37 Chestnut Street between 1819 and 1836. His address changed several times in the next twenty-three years. In all listings up to 1848 his occupation appeared as "engraver"; from that date until his death on June 9, 1859, his name was followed by "Pres. Harrisburg and Lancaster Railroad Co." In his obituary in the *Daily Evening Bulletin* on June 10, 1859, he is described as a politician; no other material regarding his activities in this profession has been found. The same

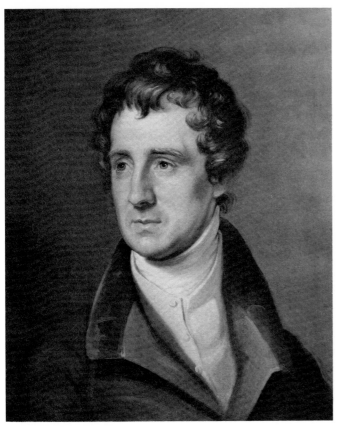

210.

notice mentions his age as sixty-seven at the time of his death and his burial in Laurel Hill Cemetery.

Of all the works he accomplished during his career as an engraver, comparatively few are signed and, of these, the majority are etched portraits and engraved views. The best account of the life of Joseph Yeager is that by Harry B. Weiss, "Joseph Yeager, Early American Engraver, Publisher of Children's Books, and Railroad President," (*NYPL Bulletin,* vol. 36, no. 9, September 1932, pp. 611–16).

JOSEPH YEAGER AFTER JOHN LEWIS KRIMMEL (1786–1821)
(See biography preceding no. 204)

211. *The Procession of Victuallers*

1821

Inscription: Drawn by J. L. Krimmel. (lower left); This view is taken from M. Carey & Sons Book Store S.E. corner of 4th and Chestnut Strs Engraved by J. Yeager. (lower right); PROCESSION OF VICTUALLERS/OF PHILADELPHIA, ON THE 15TH OF MARCH 1821. CONDUCTED UNDER THE DIRECTION OF MR WILLIAM WHITE./ *The occasion that gave rise to this* SPLENDID PROCESSION, *was conveying the meat of the stock of exhibition Cattle to Market, which for number, quality, beauty and variety, has never been slaughtered at any one time in this, or probably in any other country. 100 Carts were/required to convey them to market, and the whole was sold within twenty four hours. there were 42 head of Oxen, weighing 53024 lbs. the suet and fat 15221 lbs., 1 Calf, 20 Hogs, 19 Sheep, 7 Kids, 5 cub Bears, and 2 Fawns, making a total of 86731 lbs./The praise worthy exertions of our respectable citizens (whose names are subjoined) in the improvement of cattle fed the following number, with their weight.* Lewis Clapier Esqr *16 of the Gough breed, 21662 lbs. and 8 of the common drove cattle, 9209 lbs.* Mr William White. *4 oxen,/4451 lbs. 7 Kids, 5 cub Bears, and 2 Fawns.* George Sheaff Esqr *4, 4721 lbs.* Peter Wager Esqr *4 4496 lbs.* Major Pissant, *1 ox 1550 lbs. and 1 Calf, 552 lbs.* Mr P. Lowry, *1 Stear, 1977 lbs.* Mr H. Boraff *2, 2044 lbs.* Mr S.

Painter *2, 2362 lbs. 1 Sheep, by* Wm Bradley, *8, by* A. Clements *& 10 by* S. West./ *Philadelphia Published and sold by Joseph Yeager Nº 37 Chester Street./Printed by Charles Woodward Jr* (bottom center); WE FEED THE HUNGRY (crest)

Aquatint and etching with watercolor, ii/ii

14⅜ x 23¾" (36.5 x 60.3 cm)

Philadelphia Museum of Art. Given by the Estate of Charles M. B. Cadwalader. 61–7–17

LITERATURE: Stauffer, vol. 2, no. 3438; Drepperd, *Early Prints,* p. 121; William H. Pierson, Jr., and Martha Davidson, *Arts of the United States* (New York, 1960), no. 1893; *Philadelphia Reviewed,* no. 45; Helen Comstock, "Spot News in American Historical Prints 1805–1821," *Antiques,* vol. 81, no. 1 (January 1962), p. 100; Dickson, *Arts,* pl. 174, p. 73; *Made in America,* no. 33; Sotheby Parke Bernet, New York, May 18, 1973, no. 144 (Middendorf sale)

THERE WERE VERY FEW genre prints in the early years of America. To people pre-occupied with settling a new land and establishing their independence, such subjects seemed frivolous. One etching of a genre scene, *The Accident on Lombard Street,* by Charles Willson Peale, appeared in 1787, but it remained an isolated example. It was not until the second decade of the nineteenth century that genre as a legitimate and popular subject matter developed in the United States.

In Philadelphia this new trend was initiated mainly by the works of John Lewis Krimmel. In several oils and watercolors, he recorded the local sites and characters of a century ago. His scenes are straightforward presentations without satirical commentary, unlike those of Hogarth with whom he is often compared. One especially popular work, *The Procession of Victuallers* (presumably lost), attracted the attention of several printmakers. At least two lithographs after it are known (see Harry T. Peters, *America on Stone,* New York, 1931, fig. 90, pp. 256–57), by G. DuBois and L. Haugg, and this aquatint and etching by Joseph Yeager.

According to the description on the print, "the occasion that gave rise to this Splendid Procession, was conveying the meat of the stock of exhibition Cattle to Market" on March 15, 1821. The part of the two-mile parade shown here begins with the butchers and continues through the two hundred butchers' carts, each carrying portions of the meat, drawn by boys in white frocks. An advertisement in *Relf's Philadelphia Gazette and Daily Advertiser* on March 13, 1821, gives further information concerning the route and purpose of the event:

The object of the above is not gain, but for the encouragement of the breed of Cattle, so essential in every country. The meat will be sold at a low market price, and it is desirous to be disposed in one city.
Wm. White, Victualler
No. 449 North Front St.

Other newspaper articles gave the schedule and locations where the livestock could be viewed (*American Daily Advertiser,* March 13, 14, 1821). Two more notices appearing in the *Philadelphia Gazette* on March 12 and 16, 1821, the day after the parade, illustrate the wide appeal of the occasion, which attracted 300,000 spectators:

SHEW OF CATTLE
The shew of extraordinarily fine Live-Stock has attracted the most universal attention. Thousands of spectators have crowded the yards for several days.

The procession it is expected will be one of the most brilliant spectacles ever exhibited since the celebrated Federal Procession.
March 12, 1821

CATTLE SHOW.
The Immense Procession, showy decorations and wonderful display of fat Beef yesterday we believe has had no parallel in this or any other country, nor will such an exhibition, of the mammoth kind perhaps ever occur again, if we except next Thursday at 2 o'clock, when the monstrous large prizes in the Grand State Lottery will be distributed at the Washington Hall.... The ship in the procession appeared [,] the ship Lottery that imported the specie, to pay the prizes, and the work of the coopers intended for barrels and kegs for the dollars....
March 16, 1821

The eyewitness account represented here has all the splendor and pageantry usually associated with military parades. The degree of affluence as indicated by the dress of the townspeople and the large quantity of meat to be marketed attests to the self-sufficiency and progress of the new country. The fact that the artist has chosen to depict this subject illustrates a change in the interests and concerns of the American people; the wars were over and attention could now focus on more domestic matters. A poem in the *Philadelphia Gazette* on March 16 vividly illustrates this point:

We have plenty of money and plenty
of meat,
We have nothing to do, yet plenty to eat;
Patriots to whom Pennsylvania is dear,
Yes many we hope like Louis Clapier:
We have sailors and soldiers all willing
to fight,

Who will never want beef while exists
Wm. White.
We have favorites of fortune, both Allen
and Hope,
Whose luck's so proverbial, none with
them can cope,
Internal improvement, too, when happy
and free,
We'll plough inland rivers, give Neptune
the sea.
HOPES
Lucky Offices

Krimmel's viewpoint, taken from "M. Carey & Sons Book Store, S.E. Corner of 4th and Chestnut Strs," allows him to record the greatest amount of detail; a closer view would have forfeited the architectural backdrop, elegantly dressed spectators, and general excitement of the occasion. In his effort to record every object, Krimmel has created a picture with documentary value. In the clothing, for example, he displays the latest fashion. The women wear late Empire style gowns, white stockings, low kid shoes, neck ruffs, and Grecian hair styles adorned by lace-trimmed bonnets with brims. The coats of the men are short with high collars and broad lapels, and the boys wear fashionable long pants (R. B. Davidson, "Paintings as Documents: II, Costume in Painting," *Antiques,* vol. 58, no. 5, November 1950, p. 370). It can be assumed that the architecture and other paraphernalia are represented with the same accuracy and authenticity. Together, these details show how far the city had developed and how much life had changed since the days of the *Paxton Expedition* (no. 64).

The naive charm of the scene may be reminiscent of earlier prints, but the technical skill demonstrated by Yeager proves that America had matured enough to have her own trained, professional engravers.
ESJ □

ANNA CLAYPOOLE PEALE (1791–1878)

Born in Philadelphia, Anna Claypoole Peale was the fourth child of James Peale and the granddaughter of James Claypoole, Sr. Raised in the close-knit Peale family of artists, she learned oil painting from her father, as well as his techniques with watercolors on ivory for miniatures. She also may have received instruction from her uncle, Charles Willson Peale, whom she accompanied when he traveled to Washington in 1818 to paint portraits for his Philadelphia museum. Anna Claypoole Peale first exhibited at the age of twenty with the Society of Artists at the Pennsylvania Academy when she showed a "Fruit Piece (first attempt)" in 1811. Three years later she was represented by a "frame containing three miniatures." In 1817 she exhibited a still life of grapes and six miniatures, which prompted Charles Willson Peale to write to his son Raphaelle: "Anna Peale in miniature is becoming excellent she has an abundance of work at an advanced price" (APS, Charles Willson Peale, Letterbook, vol. 14, p. 196).

Anna painted miniatures in Baltimore, Philadelphia, Washington, New York, and Boston. From 1822 to 1827 she maintained a studio in Baltimore (Baltimore Museum,

211.

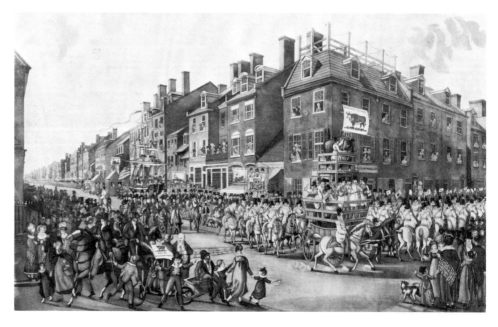

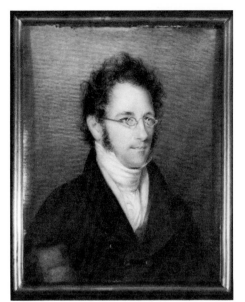

212.

Two Hundred and Fifty Years of Painting in Maryland, May 11—June 17, 1945, p. 24), where a critic, reviewing the first annual exhibition at Peale's Museum, wrote: "One of her miniatures, painted some time ago, appeared at the last London exhibition, and was declared by the president equal to all but *one,* and superior to all but *three,* in the whole collection. Miss P. has very much improved of late, in force and precision; her likenesses are better, her finish firmer and more resolute, and her lace and muslin truer" (*American & Commercial Daily Advertiser,* October 25, 1822). The next month an advertisement for Peale's Museum in Baltimore reported that Anna Claypoole Peale's miniatures were on view there (*American & Commercial Daily Advertiser,* November 7, 1822).

Anna was married twice, in 1829 to Dr. William Staughton, who died the same year; and in 1841, to General William Duncan (1772–1864). Her work was signed and exhibited under various names. She participated regularly in the shows at the Pennsylvania Academy until 1842, to which she was elected a member in 1824, and she also exhibited miniatures at the Boston Athenaeum in 1828 and 1831. Among her clients for miniatures were General and Mrs. Andrew Jackson and President James Monroe. She lived her last years with her artist sisters Sarah and Margaretta, and died at the age of eighty-seven in Philadelphia.

AS

212. *Rubens Peale*

1822
Signature: Anna C. Peale 1822 (lower left edge)
Label: Mr Rubens Peale/painted by/Mrs. Staughton/formerly Miss A/Peale. afterwards/Mrs Gen Duncan/belonging to/Miss Mary S Peale/1507 Walnut (on reverse)
Watercolor on ivory
2¾ x 2¼" (7 x 5.7 cm)
Private Collection

PROVENANCE: Mary S. Peale, Philadelphia; Peale Mills, Atlanta, Georgia; Mr. and Mrs. Lawrence A. Fleischman, Detroit, 1960; with Kennedy Galleries, New York

MINIATURE PAINTING was an area of artistic endeavor that the nineteenth century female artist could pursue more easily than most. In the Boston area Sarah Goodridge painted her relatives and friends in a prosaic, literal manner, while Sara Frothingham worked in New York. Anna Claypoole Peale and her niece, Mary Jane Simes, also painted miniatures, the aunt's having slightly more sophistication and charm.

Anna's portrait of her cousin Rubens, wearing his wire spectacles, is a charming and sensitively executed work, apparently more accurate than some of her portraits, which sometimes resemble each other. It is painted in her characteristic fine hatching technique in the face and figure, and more broadly treated in the background.

RB-S □

RAPHAELLE PEALE (1774–1825)

Charles Willson Peale's son Raphaelle was born in Annapolis, Maryland, two years before the family moved to Philadelphia. He was the eldest child to survive infancy and the first to be named after an artist. Having been trained as a painter by his father, he completed a half-length portrait of his youngest brother Rubens in 1791 which showed potential; and he ambitiously entered more pictures than any of the other Peales in the Columbianum exhibition of 1795. He proved his versatility by exhibiting not only five portraits, but five still lifes, and three deceptions. Unfortunately the still lifes and deceptions, which were identified by title, are lost.

In the same year, 1795, his father apparently decided that Rembrandt was the most talented of his sons. This meant that he was given the chance to paint a life-size portrait of George Washington in oils. Raphaelle took advantage of Washington's presence in the Peale studio to produce a small watercolor profile, but from then on his work was never really considered as important as Rembrandt's. From the winter of 1795 to the spring of 1797, the two brothers painted portraits in Charleston and Baltimore. Upon his return to Philadelphia, Raphaelle began to paint miniatures, probably having been taught the art by his uncle, James Peale. Much of Raphaelle's time was now devoted to the Peale Museum, where he helped his father in preserving dead animals and mounting them in lifelike attitudes against painted habitat backgrounds. In the Peale

213.

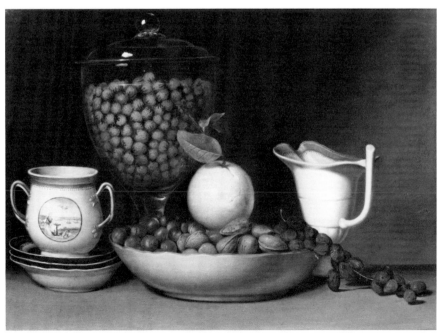

tradition, he patented a preservative for ships' timbers in 1798 and afterward developed a new plan for heating houses and a method for purifying sea water. In 1803 he published a theory on the movements of celestial bodies. It was in this same year that his luck suddenly changed.

The inventor of the physiognotrace, a device for tracing small silhouette profiles on paper, permitted Raphaelle to take the invention on a tour of the South, which extended into New England as well. The tour was initially extremely successful and Raphaelle became wealthy by the enormous number of profiles he cut. But the novelty wore off and he returned with a sense of failure. He began to drink heavily about 1806, and in 1809 he was recognized as an alcoholic and temporarily cured.

Raphaelle exhibited only two miniatures in the first exhibition at the Pennsylvania Academy in 1811, but the next year, he added three still lifes to his one miniature and, thereafter, increasingly exhibited more still life. The decision to concentrate on this genre was certainly affected by the fact that his alcoholism was now compounded by gout, which made his hands swell. In 1815 his father mentioned in a letter to Benjamin West that Raphaelle had a talent for still life and could also capture a striking likeness in a portrait but without "that dignity and pleasing effects which is absolutely necessary to ensure a great demand" (APS, Charles Willson Peale, Letterbook, vol. 13, p. 152, September 11, 1815).

From about 1818 until September 1821, Raphaelle traveled again in the South and Maryland, sometimes very ill with gout and drowning his pain with alcohol. He was in Charleston again in the winter of 1824 but returned in time to help with the decorations in preparation for Lafayette's visit in September. Although Raphaelle was perhaps the finest early still life painter in Philadelphia, he could now find employment only by writing poetry to be inserted in cakes. He died in Philadelphia in March 1825.

213. *Still Life with Strawberries*

1822

Signature: Raphaelle Peale Pinxt 1822 (bottom right)

Oil on board

16 x 22″ (40.6 x 55.9 cm)

Mr. and Mrs. Robert Graham, New York

PROVENANCE: With a Mr. Feldman, Philadelphia, 1940; with James Graham and Sons, New York, by 1941; Robert C. Graham, New York, by 1946

LITERATURE: Wolfgang Born, *Still Life Painting in America* (New York, 1947), p. 13; Washing-

214.

ton, D.C., National Gallery of Art, *The Reality of Appearance; The Trompe L'Oeil Tradition in American Painting* (March 21—October 31, 1970), by Alfred Frankenstein, p. 36, no. 7; Gerdts and Burke, *Still-Life*, p. 31

STILL LIFES BY CHARLES WILLSON PEALE, his son Raphaelle, and his brother James became the foundation for a continuous tradition in Philadelphia. Charles set a standard in *The Peale Family* (no. 94) where he includes a carefully contrived still life of peaches and apples, a piece of peel (as a pun), and a paring knife jutting into space. All these elements reappear in Raphaelle's work, but, unlike his father, Raphaelle specialized in still life and considered it worthy of pursuit.

Raphaelle's *Still Life with Strawberries*, dated 1822, could well be the composition entitled *Still Life—Strawberries, Nuts, &c.* which he exhibited at the Pennsylvania Academy in 1824. As an arrangement, it is even more complex and belabored than was usual with Raphaelle, as if it were self-consciously meant for exhibition. The nearly perfectly circular orange in the center unifies the intriguing build-up of various rounded forms. The stem of raisins at the lower right introduces a diagonal which is extended by the orange stem and repeated in the beak of

the creamer, creating some movement and sense of diagonal recession in this otherwise strictly frontal and rather static composition. This sweeping movement, leading from lower right toward upper left, is rather typical of Raphaelle and is used to lead into the picture in the same way that he sometimes uses a knife to lead diagonally in from the foreground.

Still Life with Strawberries conforms to what was virtually a formula among the Peales for still life painting: an arrangement on a table with a band-like edge drawn parallel to the picture plane, a shallow space, and a neutral background. The lighting is created arbitrarily so that the lighter edge of each object is silhouetted against dark, and vice versa, with the end result that the edges are emphasized.

In this still life, the outlines of forms are sometimes conditioned by neighboring objects. For instance, the handle on the creamer is lopsided, the glass container is asymmetrical, the saucers clearly encroach upon the bowl of nuts, and the position of the sugar bowl handles is totally unnatural. Clearly the arrangement of shapes was more important than exactitude to the sensitive Raphaelle. The portrayal of texture is sporad-

ically effective and the colors, as usual, subdued. It is his exploration of form, carefully multiplying the number of strawberries behind glass and the nuts without, that makes this painting more charming than the simplified beauty of his more abstract compositions.

DE □

RAPHAELLE PEALE (1774–1825)
(See biography preceding no. 213)

214. *After the Bath*

1823
Signature: Raphaelle Peale 1823/Pinx[t] (on towel lower right)
Oil on canvas
29 x 24″ (73.7 x 61 cm)
Nelson Gallery—Atkins Museum, Kansas City. Nelson Fund

PROVENANCE: Private collection, Connecticut, until 1931; Downtown Galleries, New York City, until 1934; purchase, William Rockhill Nelson Gallery and Atkins Museum of Fine Arts, 1934

LITERATURE: Wolfgang Born, *Still Life Painting in America* (New York, 1947), p. 14; E. P. Richardson, *Painting in America* (New York, 1956), p. 131; Milwaukee Art Center and

The Birth of Venus. Engraving after James Barry, in E. Hamilton, The English School . . ., London, 1833, vol. 1, no. 21

M. Knoedler & Co., New York, *Raphaelle Peale, 1774–1825, Still Lifes and Portraits* (January 15—March 31, 1959), no. 10; Sellers, *Peale*, 1969, p. 420; Gerdts and Burke, *Still-Life*, pp. 30, 238 n. 7

THE SUCCESS OF RAPHAELLE PEALE's *After the Bath* as a piece of visual trickery is due chiefly to the sharp contrast between the meticulously depicted cloth in the foreground and the sketchily painted figure behind. The manner in which each is painted reinforces the supposed identity of the other: since the white cloth appears real, the rough figure behind must be painted and vice versa.

With his usual sense of humor, Raphaelle created *After the Bath* to tease his nagging wife into thinking that he had hidden a salacious painting of a female nude under one of her best linens. He triumphed when she raced to his easel to pull off the cloth and reveal the depravity of her husband. Of course, she found herself in the ridiculous position of scratching at one of his paintings, proving that he had greater ability than she had ever acknowledged.

The emphasis in the Peale family on accuracy of representation led inevitably to experimentation with "deceptions" (later called trompe l'oeil). In order for a painting to be mistaken for reality, as intended, the dimensions of nature must be followed with an apparent continuity between painted and real space and a smooth, invisible execution. Raphaelle's *After the Bath* is more successful as an illusion than his father's *Staircase Group* (no. 137) because the space Raphaelle creates is shallow and thus not subject to the inherent flaws of painted perspective. Then, too, the painting of a living person, never absolutely still, does not have the illusionistic potential of a still life, in this case, a piece of white cloth.

The source for the nude behind the cloth in *After the Bath* is an engraving (see illustration) after *The Birth of Venus*, 1772, by England's James Barry. The drawing of the hand, hair, foot, and nearby flowers matches Barry's *Venus* almost line for line. This painting was engraved at least twice and then lithographed (see E. Hamilton, *The English School, A Series of the Most Approved Productions*, London, 1833, vol. 1, no. 21). An X-ray of Raphaelle's work reveals that the nude was never continued under the cloth, so the engraving was never completely copied. *After the Bath* is therefore almost certainly the same painting as *Venus Rising from the Sea—a Deception,* which Raphaelle exhibited for sale at the Pennsylvania Academy of the Fine Arts in 1822. This is, then, no ordinary nude.

One of Raphaelle's entries in the 1795 Columbianum exhibition carried the enigmatic title, "A Covered Painting," indicating that as early as 1795 Raphaelle had dis-

covered the irresistible appeal of the secret subject, hidden from view. From here it is but a small jump to the cloaked "naughty" picture which can poke fun at censorship.

After the Bath is considered Raphaelle's masterpiece both in terms of abstract design and clever illusion. It is perhaps the most famous deception in American art.

DE □

JOHN HAVILAND (1792–1852)

Because of the international reputation gained as architect of the Eastern State Penitentiary, John Haviland has been traditionally considered a prison architect, when, in fact, less than 15 percent of his known projects were prisons. During the peak of his career, the 1820s, he appears to have been equally respected for his Greek revival works, which his biographer believes "may be counted among the major examples of the Greek taste, archaeologically imitative or otherwise, in America" (Matthew Baigell, "John Haviland in Philadelphia," *JSAH,* vol. 25, no. 3, October 1966, p. 208). Three of his finest extant examples of the Grecian style in Philadelphia are St. Andrew's Episcopal Church (now St. George's Greek Orthodox Cathedral) at 256 South Eighth Street, Pennsylvania Institution for the Deaf and Dumb (now Philadelphia College of Art) at Broad and Pine streets, and the Franklin Institute (now Atwater Kent Museum) at 15 South Seventh Street, all built between 1822 and 1825.

John Haviland was born December 12, 1792, at Gudenham Manor, Sussex, England, the son of a country squire. After studying under the London architect and scholar James Elmes from 1811 to 1815, Haviland traveled first to Russia and then, in September 1816, to the United States, where he settled in Philadelphia. Perhaps to advertise his skills he wrote *The Builder's Assistant,* a three-volume work published in 1818, 1819, and 1821, one of the earliest American builder's handbooks to illustrate the correct Greek orders and to discuss picturesque taste. Shortly after the second volume appeared he began to receive important commissions, beginning with the Greek revival First Presbyterian Church in 1820 and the Gothic revival Eastern State Penitentiary in 1822. The 1820s were flush times for Haviland as he superintended construction of the buildings he designed and engaged in speculative building ventures, which included such projects as the Philadelphia Arcade and the Pagoda and Labyrinth Gardens. It all came crashing down in 1829, when Haviland went bankrupt and then compounded his troubles by misusing federal funds entrusted to him for the construction of the Naval Hospital.

Thereafter he ironically pinned his prestige on prisons, which he designed throughout the country on the strength of his early reputation with Eastern State Penitentiary. He also found minor commissions in smaller communities such as Pottsville, Pennsylvania, where he was responsible for an early iron-front bank (1830–32).

Despite his sullied local reputation, Haviland became a founder of the American Institution of Architects in 1835 and was later honored by election as a corresponding member of the Royal Institute of British Architects. In addition to writing *The Builder's Assistant,* he revised and enlarged Owen Biddle's *Young Carpenter's Assistant* in 1833. Haviland died in March 1852 and was buried in the crypt of St. Andrew's Episcopal Church of which he was a member in addition to being its architect. His body was exhumed in 1921, when the building was acquired by the St. George's Greek Orthodox congregation, and reinterred on the grounds of the former Divinity School of the Episcopal Church in West Philadelphia.

215. *Eastern State Penitentiary (Cherry Hill)*

Fairmount Avenue, between Corinthian and Twenty-second streets
1822–36
Jacob Souder, superintendent of masonry
Coursed granite ashlar
Plan 650 x 650′ (198 x 198 m)

REPRESENTED BY:

The State Penitentiary, for the Eastern District of Pennsylvania
1855
From the *Pennsylvania Journal of Prison Discipline,* vol. 2, April 1856
Lithograph
6³⁄₁₆ x 9⁷⁄₁₆″ (15.7 x 24 cm)

The Free Library of Philadelphia

LITERATURE: Thomas B. McElwee, *A Concise History of the Eastern Penitentiary of Pennsylvania* (Philadelphia, 1835), pp. 5–15; Thompson Westcott, *The Official Guide Book to Philadelphia* (Philadelphia, 1875), pp. 109–12; Scharf and Westcott, vol. 3, pp. 1834–35; White, *Philadelphia Architecture,* p. 25, pl. 23; Dickson, *Pennsylvania Buildings,* pl. 54; Negley K. Teeters and John D. Shearer, *The Prison at Philadelphia: Cherry Hill* (New York, 1957), pp. 3–5, 17–19, 56–59, 65–69, 141–44; Agnes Addison Gilchrist, "John Haviland before 1816," *JSAH,* vol. 20, no. 3 (October 1961), pp. 136–37; Tatum, pp. 79, 89, 179, 183, pl. 77; Norman B. Johnston, "John Haviland, Jailor to the World," *JSAH,* vol. 23, no. 2 (May 1964), pp. 101–5; John C. Poppeliers, "John Haviland," in *Architectural Drawings,* pp. 28–29; Matthew Eli Baigell, "John Haviland," Ph.D. dissertation, University of Pennsylvania, 1965, pp. 7–29, 36–38, 61–62, 93–100, 214–86; Matthew Baigell, "John Haviland in Philadelphia," *JSAH,* vol. 25, no. 3 (October 1966), pp. 197–208; Matthew Baigell, "John Haviland in Pottsville," *JSAH,* vol. 26, no. 4 (December 1967), pp. 306–9; David J. Rothman, *The Discovery of the Asylum* (Boston, 1971), pp. 79–108

IN 1829 the Boston Prison Discipline Society contended that "there is such a thing as architecture adapted to morals; that other things being equal, the prospect of improvement, in morals, depends in some degree, upon the construction of buildings" (David J. Rothman, *The Discovery of the Asylum,* Boston, 1971, p. 83). At the same time in Philadelphia, the Commonwealth of Pennsylvania was acting on the Bostonians' premise by moving prisoners into the partially completed Eastern State Penitentiary. In 1821 the Pennsylvania legislature had appropriated funds to begin construction of a prison based on the "Pennsylvania System," a penal reform that would presumably bring an "improvement in morals." The system was based on separation of prisoners from the influences that bred their socially deviant behavior. This required not just incarceration but also isolation from fellow prisoners to the point of solitary confinement.

The prisoner was to communicate with only his conscience and the Bible left in each cell, and occupy himself working at a basic craft, such as weaving or shoemaking. As Charles Dickens noted, the prisoner became "a man buried alive; to be dug out in the slow round of years; and in the meantime dead to everything but torturing anxieties and horrible despair" (*American Notes,* pp. 145–46). In time this maddening condition was ameliorated by another, more traditional, prison condition—overcrowding. Although the Pennsylvania System would not be legally abolished until 1915, the extreme isolation of the prisoner was greatly modified by the time of the Civil War.

In 1821 the Commonwealth of Pennsylvania purchased as the prison's site an eleven-acre estate, Cherry Hill, outside of what was then the city limits, and the next year adopted John Haviland's proposal for the complex. The prison's distinctive feature was its radial plan, the distribution of seven cell blocks from a central rotunda like spokes from the hub of a wheel. The rotunda served as the surveillance center, and each cell block contained a series of eight-by-ten-foot cells arranged on each side of a central corridor and opening onto slightly larger, high-walled private exercise yards. Haviland's radial plan was not unique—it had been executed abroad earlier on a smaller scale for jails and insane asylums—but Haviland carried the concept to its fullest realization, and his name has been associated with it ever since as the plan has been adopted for prisons around the world.

Battlemented octagonal turrets mark the corners of the blank ashlar prison wall, and massive square towers flank the central entrance gate with its portcullis. The prison's lugubrious presence is the result not of the architect's eccentricity but of the prison commissioners' directive that the exterior should "convey to the mind a cheerless blank indicative of the misery that awaits the unhappy being who enters within its walls" (Negley K. Teeters and John D. Shearer, *The Prison at Philadelphia: Cherry Hill,* New York, 1957, p. 59). In meeting the commissioners' requirements, Haviland was doing more than suggesting the strength of a righteous state and incarceration within a castle's dungeons. By employing the military style of the castellated Gothic he was also reflecting the third element of the prison trinity (separation, labor, and obedience) in which military regimentation was found to be the most efficient means of maintaining order. Haviland's source for the exterior design is not clear. It might have been the thirteenth century Harlech Castle in northern Wales or the Worcester (England) Prison of 1814; both had long screen walls and turrets flanking their entrances. In any regard Haviland stamped the facade's design

215.

with his characteristic "bilateral reciprocity of parts" (Matthew Eli Baigell, "John Haviland," Ph.D. dissertation, University of Pennsylvania, 1965, p. 36). By balancing the central entrance towers with the corner turrets at the end of the screen walls, he divided the front into three roughly equal parts, a practice he repeated in most of his works.

Over the years five additional cell blocks were built and the original ones were enlarged, but the basic radial plan has remained intact. The street sides have changed even less. When the penitentiary was vacated and turned over to the City of Philadelphia in 1970, its exterior looked about the same as it had nearly 150 years earlier.

RW □

REMBRANDT PEALE (1778–1860)
(See biography preceding no. 178)

216. *George Washington*

1824/60
Signature: Rembrandt Peale (lower left)
Oil on canvas
36 x 29″ (91.4 x 73.7 cm)
The Westmoreland County Museum of Art, Greensburg, Pennsylvania.
William A. Coulter Purchase Fund

PROVENANCE: Thomas Harris Powers, Broadmoor, Colorado, 1923; M. Knoedler and Co., Inc., New York, by 1957

LITERATURE: PAFA, *Exhibition of Portraits by Charles Willson Peale and James Peale and Rembrandt Peale* (April 11—May 9, 1923), p. 123, no. 127; Morgan and Fielding, *Life Portraits,* no. 9, p. 377

GEORGE WASHINGTON SAT FOR Rembrandt Peale for only one portrait and that was at the urging of Charles Willson Peale in the fall of 1795, at about the time that Washington was sitting for Gilbert Stuart (see no. 140). The resulting head (Historical Society of Pennsylvania), one of Rembrandt's finest achievements, with its fresh coloring and lifelike quality, became the basis for a long chain of trial attempts to create the ideal Washington portrait. Rembrandt soon developed a plan to form a composite portrait, which would be superior to the best life portraits, by combining their selected merits. The first such portrait (Peabody Institute, Baltimore), painted about 1798, was a copy of his father's 1795 portrait of Washington with revisions based on Rembrandt's 1795 portrait.

In 1823, long after Washington's death, and when Stuart's Athenaeum portrait was being universally acclaimed as *the* portrait of the "Father of the Country," Rembrandt,

216.

who had a highly competitive instinct and had made sixteen previous attempts, resumed his experimentation to the exclusion of nearly all else. Finally he "shut himself up" in his Philadelphia studio for three months in a state of "poetic frensy" and produced a hieratic bust, afterward designated as the "Porthole" portrait because of the painted oval surround simulating stonework. This picture of a demigod Rembrandt advertised as "The National Portrait and Standard Likeness of Washington." He produced about seventy copies dependent upon a tracing of the same head either to the left or reversed. No one knows which is the original, but the version he took on tour in 1823–25, one of the largest and most elaborate of its type (72 by 54 inches), was at least one of the earliest. Bought by Congress in 1832, it shows Washington facing left and wearing a black velvet mantle, his "Senatorial costume," surrounded by trompe l'oeil stonework with painted "carvings" of an oak leaf border, a keystone mask of Jupiter, and the ponderous inscription "Patriae Pater" at the bottom.

The earliest portraits of the Porthole type were apparently in this costume, but, by 1824, Peale developed an alternative version in military uniform, of which this portrait is an unusually fine example. The Porthole portrait in military uniform, the most frequently copied by the artist, was the basis for the development in 1824 of the third and last famous variation, the large equestrian portrait of Washington. Although the accessories changed, the formula for the head, repeated through tracings, was more rigid than in Stuart's replicas, and this results in a greater evenness of quality.

Gilbert Stuart is, of course, the artist with whom Rembrandt wanted to be compared, at a time when, as Rembrandt announced, "the very faults of Stuart's Portrait" were "almost consecrated" (*Guide to the Philadelphia Museum,* Philadelphia, n.d., p. 9). Dunlap reported with disgust that he saw Rembrandt's portrait on tour in New York with a poor copy (by Rembrandt) of Stuart's head of Washington, "without frame, placed on the floor" for comparison so that all could pronounce the inevitable judgment

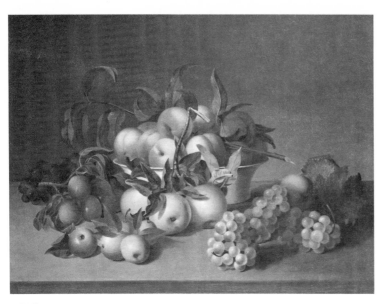

217.

(*History*, vol. 2, p. 55). In hopes of proving his point, Rembrandt solicited written testimonials from men who had known Washington that this was the best likeness. By now the first president was a legend, and Rembrandt had been able to capture his legendary moral strength on canvas in such a popular fashion that possession of the copyright meant financial security, as he had hoped. From the 1830s, Rembrandt concentrated on multiplying the head and campaigning, in the family tradition of showmanship, for its universal acceptance.

Rembrandt's Porthole portrait is derived chiefly from the two 1795 portraits from life painted by himself and his father, but differs from his earlier such combination by being more schematized, almost caricatured as a more forceful head. The smooth painting with nearly imperceptible brushstrokes betrays his background training in France where a high finish was desirable. Rembrandt had come to believe that "facility combined with neatness, accuracy and finish, constitute the perfection of Art; and this can only be attained by perseverance and practice" (Rembrandt Peale, *Graphics, The Art of Accurate Delineation*, Philadelphia, 1867, p. 74). In contrast to Stuart, Rembrandt portrays Washington as younger, more rigorous, even divinely inspired, with a slightly upward gaze not used in Stuart's portraits. Whereas Stuart suggests, Rembrandt defines, with the result that there is an element of overkill in his portrait which has lost some of its appeal today.

DE □

JAMES PEALE (1749–1831)
(See biography preceding no. 134)

217. *Still Life with Peaches*

c. 1824/31
Signature: [... present?] for Mr James R[u?]sh from Mr James Peale (on reverse, across top of stretcher)
Oil on canvas
19½ x 26" (49.5 x 66 cm)
The Library Company of Philadelphia

PROVENANCE: Dr. James Rush; bequeathed by him to the Library Company, 1869

LITERATURE: Edwin Wolf 2nd, "Report of the Librarian," *The Annual Report of the Library Company of Philadelphia for the Year 1970* (Philadelphia, 1971), p. 44

JAMES PEALE's *Still Life with Peaches*, although little known, is an extremely fine example of his work. According to the inscription, the painting was apparently originally a gift to Dr. James Rush. It is evident from Rush's correspondence that he was not only Peale's friend but his family doctor (LCP, Correspondence of James Rush, vol. 4). The gift could well have been suggested by Rush as payment for medical services.

James and his nephew Raphaelle exhibited still lifes as early as 1795 in the Columbianum exhibition, and they were the first American painters of importance to specialize in this genre. Although they influenced each other, their work remained essentially different. James was more interested, for instance, in texture than was Raphaelle. In his work, one is more conscious of contrasts, as, in

Still Life with Peaches, in the sheen on the apple, fuzz on the peach, and the bloom on the grapes. The leaves were undoubtedly chosen because they are crinkled with dryness, which adds to the tactile appeal of the painting. James wanted a greater richness of total effect and was less concerned with the individual object. Generally, Raphaelle was more conscious of shape (see no. 213). His forms are more solidly modeled, James's more painterly. This is characteristic of a basic difference in their approaches.

The contemporary response to Raphaelle's still life painting appeared in a review of the 1814 Pennsylvania Academy exhibition: "We admire exceedingly the correct manner in which he represents each individual object, and if he displayed more judgement in the *arrangement* and *grouping* of his pictures, they would rival the best productions of the Flemish or Dutch school" ("Review of the 4th Annual Exhibition of the Columbian Society of Artists and the Pennsylvania Academy," *The Port Folio*, vol. 4, no. 1, July 1814, p. 97). James's work was more consistent than Raphaelle's and more in keeping with the accepted Dutch baroque tradition, usually in a greater subordination of the parts to the whole and in an overall effect of abundance. Contemporaries found this more agreeable than Raphaelle's sparse but more original compositions, and James's still lifes sold better.

Still Life with Peaches is typical of James Peale in subject matter and color, but more interesting than usual in its arrangement. The characteristic oval of his composition has been made more complicated by subtle interruptions which sometimes suggest greater spatial depth and at other times are used for rhythmic purposes. Such sophistication leads one to believe this is probably a late work.

DE □

WILLIAM RUSH (1756–1833)
(See biography preceding no. 199)

218. *The Attributes of William Penn: Mercy and Justice*

c. 1824
Pine, formerly painted
Height 96" (243.8 cm)
Philadelphia Museum of Art. On deposit from the Commissioners of Fairmount Park

PROVENANCE: Gift of the artist to the City (?); Assembly Room of the Fairmount Waterworks, 1848, Commissioners of Fairmount Park, 1867

LITERATURE: "The Visit of General Lafayette," *The Port Folio*, vol. 18, no. 270 (October 1824), pp. 335–36; *The Saturday Evening Post*, vol. 8,

no. 423 (September 5, 1829), p. 3; PMA, *William Rush, 1756–1833, The First Native American Sculptor*, by Henri Marceau (1937), p. 56, figs. 44, 45; Gilchrist, *Strickland*, p. 66, pl. 50; Charles Coleman Sellers, "William Rush at Fairmount," in FPAA, *Sculpture*, p. 26

IN JANUARY 1824, both houses of Congress unanimously passed a resolution instructing President Monroe to communicate to the Marquis de Lafayette "the assurances of grateful and affectionate attachment still cherished for him by the Government and people of the United States." Lafayette, comrade-in-arms and friend of Washington, hero of Monmouth and Yorktown, had expressed a desire to return to America after forty years' absence, and President Monroe offered a ship of the line to expedite the voyage.

The year-long triumphal tour of "The Nation's Guest" included all of the twenty-four states. From New Hampshire to Virginia, Lafayette was accorded ceremonial homage with parades, banquets, balls, and illuminations. Philadelphia, where the young French nobleman had received his honorary commission as a major general from the Continental Congress a half-century earlier, was not to be surpassed in its appreciation.

On Monday, September 27, Lafayette was accompanied across the Delaware River at Trenton by Governor Williamson of New Jersey, where he was met by Governor Schulze of Pennsylvania. At Rush Field, south of Frankford, Lafayette was met by some 10,000 troops, which accompanied the retinue to the State House (Independence Hall) where the crowds were estimated to be from 100,000 to 200,000 persons. From Kensington in the Northern Liberties to the State House the retinue passed through thirteen triumphal arches designed by architect William Strickland, aided by his pupil Samuel Honeyman Kneass. The final triumphal arch, the Grand Civic Arch (see illustration), spanned Chestnut Street in front of the State House. The Grand Civic Arch was the most elaborate of Strickland's designs, and received extensive description in the press:

> This arch displayed great taste and judgment in the design, and skill in the execution. It was constructed of frame work covered with canvas, admirably painted in imitation of stone. The plan was derived from the triumphal arch of Septimus Severus at Rome. Its dimensions were forty-five feet front, by twelve in depth—embracing a basement story of the Doric order, from which the principal arch springs to the height of twenty-four

218. *Mercy* *Justice*

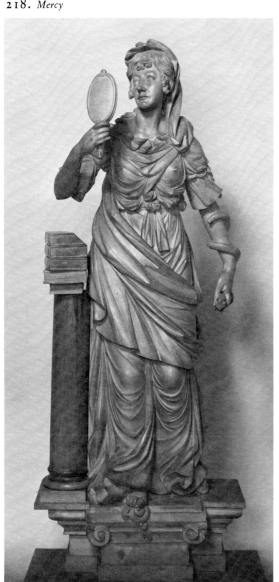

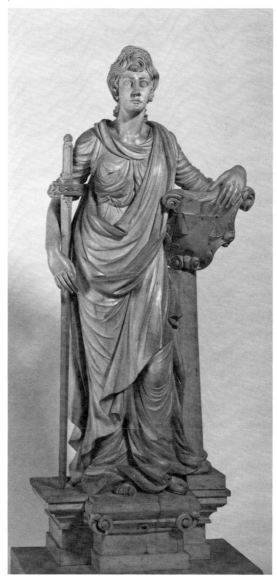

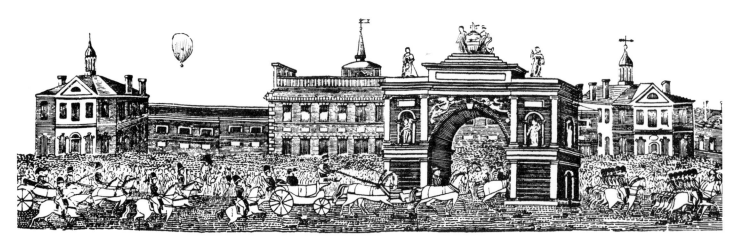

General Lafayette's Arrival at Independence Hall, Philadelphia, September 28th, 1824.
Lithograph, 2¼ x 7¼" (5.7 x 18.4 cm). Courtesy Free Library of Philadelphia

feet above the pavement. The spandrels, or abutments on each front were decorated with figures of Fame, painted in basso relievo, having their arms extended, and mutually holding a civic wreath over the key-stone of the arch. The wings on each side of the centre, were of the Ionic order, being decorated with niches and statues representing liberty, victory, independence and plenty—each having appropriate mottos, inscribed in corresponding pannels. The whole of the building was surmounted by an entablature, thirty-eight feet from the pavement and supporting a flight of steps in the centre, upon which were placed the arms of the city, executed in a masterly manner by Sully. On each side of the arms were placed the statues of Justice and Wisdom, with their appropriate emblems, sculptured by Mr. Rush, in a very superior style. They had all the beauty and lightness of drapery, of the Grecian school; and so excellent was the workmanship, that it was not until after positive assurances, that a spectator would give up the belief that they were executed in marble. The arch was designed by Mr. Strickland, and executed under the direction of Messrs. Warren, Darley, and Jefferson, scene painters of the new Theatre. The superficial surface of painted canvas amounted to upwards of three thousand square feet. ("The Visit of General Lafayette," *The Port Folio,* no. 270, October 1824, pp. 335–36)

Although no preparatory drawings for the Grand Civic Arch are known to exist, Strickland wrote a commemorative hymn to Lafayette which was published with an engraving of the triumphal arch. The sheet music was issued by G. E. Blake of Philadelphia, copyrighted on September 6, 1824,

while, according to a note under the engraving, the arch was already under construction.

The triumphal arch was appropriately named, for its program included a symbolic, almost heraldic, image of City and State. In the spandrels were two Fames supporting "a civic wreath over the key-stone of the arch," an allusion to Pennsylvania which even then was known as the Keystone State. Flanking Thomas Sully's Seal of Philadelphia were the two Rush figures, traditionally known as *Wisdom* and *Justice*. In fact, although never recognized in the contemporary press, the Rush figures are also an allusion to the State, for they bear the attributes of its first Proprietor, William Penn. Rush derived the attributes for *Mercy* and *Justice* from the 1770 engraving of Penn by Pierre Eugène DuSimitière (Library Company of Philadelphia), which was based in part on plates 116 and 118 of William Gibbs's *Book of Adventure* (London, 1728). More important, Rush also referred to these plates in Gibbs's well-known work in establishing his sculptural types.

It is certain that Rush did not originally intend the *Mercy* and *Justice* for the Grand Civic Arch, but rather for another project which was never realized. It may be that Rush intended the pieces for niches on the garden side of the State House, a use that Benjamin Franklin recommended for a statue of William Penn as early as 1774. The physical proof that Rush did not originally intend the *Mercy* and *Justice* to be seen on the Grand Civic Arch, in the round, is that he excavated the back of both pieces. In order to display the two pieces of sculpture in the round on the triumphal arch, Rush had to tack linen to the back of the two pieces to cover the excavation. In 1829 the *Mercy* and *Justice* were placed on

opposite sides of Independence Square where the "rough and unshaped" linen attracted humorous criticism in the local press (*Saturday Evening Post,* vol. 8, no. 423, September 5, 1829, p. 3).

In 1848, *Mercy* and *Justice* were removed to the Assembly Room of the Fairmount Waterworks, below the present site of the Philadelphia Museum of Art, where they were shown for the first time in niches. There they remained until 1937 when the Museum's director, Henri Marceau, gave William Rush his first retrospective exhibition and elevated him from the ranks of ship-carver to his due consideration as America's first native-born sculptor of distinction.

DDT □

WILLIAM RUSH (1756–1833)
(See biography preceding no. 199)

219a. *The Schuylkill Chained*

1825
Spanish cedar (originally painted)
39 x 87½ x 25" (99.1 x 222.3 x 63.5 cm)
Philadelphia Museum of Art. On deposit from the Commissioners of Fairmount Park

219b. *The Schuylkill Freed*

1825
Spanish cedar (originally painted)
43 x 87 x 29" (109.2 x 220.9 x 73.7 cm)
Philadelphia Museum of Art. On deposit from the Commissioners of Fairmount Park

PROVENANCE: Fairmount Waterworks, until 1937; on deposit, Philadelphia Museum of Art, 1937

LITERATURE: City Hall, Archives, *Committee on Water, Bills Received, 1804–1854,* R. S. 120.43, March 1825, bill; City Hall Archives, *Select Council, Minutes in Ms., 1796–1869,* R. S. 120.3, May 5, 1825, p. 283; [Joseph S. Lewis], *Report of the Watering Committee to the Select and Common Councils, Read January 12, 1826* (Philadelphia, 1826), p. 10; Scharf and Westcott, vol. 3, p. 1853; PMA, *William Rush, 1756–1833: The First Native American Sculptor,* by Henri Marceau (1937), pp. 21, 57–58, nos. 49, 50; Gordon Hendricks, "Eakins' William Rush Carving His Allegorical Statue of The Schuylkill," *Art Quarterly,* vol. 31, no. 4 (Winter 1964), p. 399n.; Craven, *Sculpture,* p. 24 [219b]; MMA, *19th-Century America: Paintings,* no. 34 [219b]; Charles Coleman Sellers, "William Rush at Fairmount," in FPAA, *Sculpture,* pp. 11–12

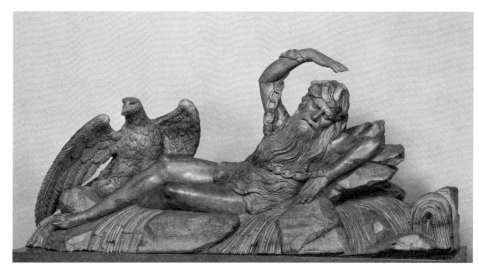

219a.

WILLIAM RUSH'S ALLEGORICAL FIGURES of *The Schuylkill Freed* and *The Schuylkill Chained* were carved as pediments for the entrances to the millhouse of the Fairmount Waterworks (no. 183). They can be seen in their original position, with *The Schuylkill Freed* on the left, over the entrances to the long central pavilion, in Thomas Doughty's 1826 *View of the Waterworks* (no. 226).

Rush, as one of the most active members of Philadelphia's Watering Committee, helped choose the location on the Schuylkill in 1812 for a new waterworks to replace the pumping station, no longer adequate, in Centre Square. In 1819, with the conversion from steam to water power, new buildings were needed to house the machinery. Rush was chairman of the Watering Committee's subcommittee on building, so when the Schuylkill buildings were completed in 1822, it was natural that Rush would be asked to provide sculptural decoration.

Rush, with the help of his son John, carved the Schuylkill figures, to be seen from below and within the larger context of Frederick Graff's neoclassical design for the Waterworks complex. When the wood sculptures were finished in 1825, the Watering Committee paid to have them painted to simulate stone, probably marble (paint removed in 1939), which would be in keeping with the stuccoed, stone millhouses and the neoclassical preference for stone rather than wood.

As sculpture, the figures are strangely inconsistent. They appear to be a compromise between a neoclassical ideal as seen in the classical head and attire of the female, and a desire for greater expressiveness through movement and emotion. The pained expression on the male's face and his more erratic movement symbolize the resistance of the ancient Schuylkill to its newly chained

or "improved" state. This piece was appropriately placed on the side nearest the dam. The female, who, according to Rush's bill is "Emblematic of the water works," is shown as a serene conqueror whose hand guides the churning waterwheel. Behind her is the ascending main which pours the water into an urn symbolizing the reservoir on top of Fairmount. The modern title assigned to *The Schuylkill Freed* is misleading, as Hendricks has pointed out, but his alternative, *The Schuylkill Harnessed,* is not completely satisfactory since she is a personification of the Philadelphia Waterworks rather than the river.

219b.

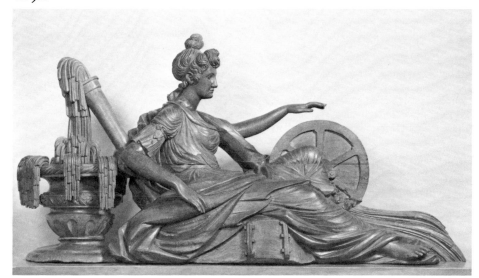

Marceau was the first to notice that *The Schuylkill Chained* was probably inspired by an engraving of an antique sculpture of the River Nile in *The Artist's Repository or Encyclopedia of the Fine Arts,* published by Charles Taylor in London in 1813 (vol. 1, p. 245, pl. 107). Rush is known to have owned the 1808 edition, and although the resemblance is not exact, the similarity in the legs is unmistakable. *The Schuylkill Chained* resembles this figure much more closely than the source suggested by Sellers, an engraving in Domenico de Rossi, *Raccolta di statue antiche e moderne,* Rome, 1704 (pl. 36). The type of the reclining female figure in the

Frederick Graff (1774–1847). Doorway to Mill House at Fairmount (detail). Watercolor.
Courtesy The Franklin Institute, Philadelphia

companion piece, *The Schuylkill Freed,* was in such general use that it undoubtedly does not have a specific source. For instance, a similar figure was regularly used as a symbol of the port of Philadelphia, with anchor and cornucopia, in the *American Daily Advertiser* during the 1820s.

An undated drawing by Frederick Graff of one of the millhouse doorways includes what appears to be a preliminary design for one of Rush's sculptures (see illustration). This drawing (Franklin Institute), published here for the first time, does not correspond to either of the finished sculptures. Rather, it conforms, as does *The Schuylkill Chained,* to the ancient tradition of representing a river in pedimental sculpture by a bearded old man or a river god, but the figure holds a distributory main, indicating acceptance of the presence of the Waterworks. If this image is the precursor for *The Schuylkill Chained,* which it most approximates, then Rush's final design for this figure is all the more extraordinary. The drawing represents the Schuylkill as a more classical river god, closer to the illustration in *The Artist's Repository* and a more perfect compliment to *The Schuylkill Freed* in position and in attitude. Rush apparently altered the representation of the river to emphasize the wildness of its natural state and to create an emotional conflict, even a tension, between the conqueror and the conquered, by reinterpreting the Waterworks as an enslavement.

DE □

CHARLES H. WHITE (1796–1876)

Charles Haight White was born in Shrewsbury (now Rumson), Monmouth County, New Jersey, according to research by Anthony A. P. Stuempfig. He moved to Philadelphia on September 2, 1811, and was indentured to the merchant Benjamin Paxon. The Philadelphia directories first list White in 1818 at North Seventh Street where he remained until 1824. On January 14, 1819, he married Rebecca Stockton of Burlington County, New Jersey; they had ten children, six of whom died before the age of twenty-one. Only one child, Charles, Jr., was to go into the cabinetmaking business and only for one year (1861). In 1820 there were six men in his shop and in 1824 he rented 109 Walnut Street, a double facade building, from John Elliot, the looking glass manufacturer.

In 1824 the Franklin Institute initiated a competition offering premiums and medals for examples of the useful arts ranging from furniture to cooking stoves. Charles White was one of the judges for the first exhibition as were John Harland and Joseph Barry. The purpose of these exhibitions was outlined as follows:

By bringing together the various products of our workshops, we shall soon discover what manufactures flourish in the country, what objects are successfully prepared by our mechanics, and in what respects they are deficient . . . perfection in workmanship is to be encouraged, as well as novelty in invention. But to obtain perfection of workmanship necessarily requires that a sufficient time should be allowed to the mechanic to prepare with care those objects which he wishes to submit to the scrutinizing eye of the public. Under this impression, and with a view of holding the exhibition at that time of the year when the greatest concourse of strangers in our city can be expected, the Board have resolved that the exhibition shall be held at the time of the Quarterly meeting in October of every year. (*First Quarterly Report, April 15, 1824,* Franklin Institute)

In these competitions between 1824 and 1851, Charles White won five silver medals and one honorable mention.

In 1828, John Ferris White (1807–1852?) joined his brother Charles in the business. Bills of sale with both White names appear as early as 1831, and it is likely that the partnership began when White bought the 107 Walnut Street building in 1828 from Anthony Chardon, the wallpaper maker. Charles and J. F. White were listed together in the directories from 1837 to 1851.

Of particular interest to understanding Charles White's work are two documents owned privately, one a description of his house and cabinetmaking shop and the second, an English design book by John Taylor (*The Upholsterer's and Cabinet Maker's Pocket Assistant: Being a Collection of Designs . . .* vol. 2, London, 1825) with the following inscription on the cover: "CHARLES H. WHITE/107 WALNUT ST./ PHILADELPHIA."

220. *Work Table*

c. 1824–28

Label: CHARLES H. WHITE/CABINET AND CHAIR MANUFACTURER/N° 109/WALNUT STREET/PHILADELPHIA

Inscription: No 1 (in pencil in script underneath top, inside of back, and underneath bottom of both drawers)

Baywood mahogany with mahogany and burl veneer; mahogany, white pine, and poplar; twentieth century brass pulls

28½ x 20 x 15″ (72.4 x 50.8 x 38.1 cm)

Philadelphia Museum of Art. Purchased: Thomas Skelton Harrison Fund. 73-63-1

PROVENANCE: With Alan Rubin, London

THIS WORK TABLE can be dated between 1824 and 1828, since its label gives White's Walnut Street address where his shop was located during those years. Similar work tables are seen in English Regency designs. A very similar pedestal and base were used in a design for a music stool in Nicholson's *Cabinet Maker.* A shaped platform supported by paw feet and acanthus leaves is seen in the Nicholson plate as are some of

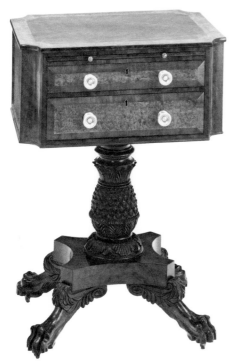

220.

Characteristic of Federal furniture made in Philadelphia, Baltimore, and New England is the use of contrasting light and dark veneer. As seen in this work table, this style continued in favor with Philadelphia craftsmen into the classical period. The carving on the pedestal support and paw feet is restrained compared to the more vigorous overall carving on a comparable New York piece. The tight proportions of the White table are less massive than its New York counterpart, which typically made elaborate use of stenciling.

DH □

221. *Sideboard, Knife Boxes, and Cellarette*

c. 1825
Mahogany and mahogany veneer; brass and ebony marquetry panels, brass and mahogany panels, brass

Inscription: Sideboard knife Boxes and Celleret $200 (in pencil inside bottom of central drawer of sideboard); J. F. O'Neill Upholsterer (back of sideboard, in late nineteenth century script)

Sideboard, 50 x 91 x 27″ (127 x 231 x 68.6 cm); knife boxes 21⅝ x 13½ x 14½″ (54.8 x 34.3 x 36.8 cm); cellarette, 29 x 28⅓ x 23″ (73.5 x 72 x 58.5 cm)
Philadelphia Museum of Art. Bequest of Miss Elizabeth Gratz. 09–2a, b, c

Philadelphia Museum of Art. Given in memory of Caroline S. Gratz, by Simon Gratz. 25–76–2

PROVENANCE: Simon Gratz? (1773–1839), Philadelphia; daughter, Elizabeth Gratz (d. 1908) [sideboard and knife boxes]; Simon Gratz? (1773–1839), Philadelphia; son, Edward Gratz (d. 1869); son, Simon Gratz (1837–1925) [cellarette]

LITERATURE: *PMA Bulletin,* vol. 7, no. 26 (April 1909), p. 39; illus. p. 34; Otto, *American Furniture,* fig. 164

THIS ENSEMBLE represents one of the most ambitious and richly decorated examples of Philadelphia Empire furniture. The inscription in the drawer of the sideboard indicates that they were originally *en suite,* although the sideboard and knife boxes were separated from the cellarette and came as gifts to the Museum at different times and from different members of the Gratz family. Additional evidence of their being together is that the identical cut brass inlaid panels are seen in the panels on the doors of the sideboard and in the panel on top of the cellarette.

Sideboards with cellarettes were common in English Regency furniture, as seen in plate 94 of George Smith's *Designs* and in plate 36 of Rudolph Ackermann's *Repository of the Arts,* London, 1817. The cellarette in the Smith plate incorporates reclining lions placed on a platform on each side of the container, a device which was used in an adapted form in the Gratz example. A cellarette of similar sarcophagus form and coved lid is seen in plate 98 of Smith's

the motifs of the pedestal support. The same arrangement is seen in Nicholson's design for a circular table. Of note in White's table is the pineapple and leaf pedestal; similar leaves were illustrated in plates 20 and 120 of Smith's *Guide.* A composite description of the work table appears on pages 33–34 of the *Philadelphia Book of Prices for 1828.* The standard work table came with "four turned legs," but "a pillar and four claws" could be ordered in place of the four legs for $1.75 extra. Also of interest is an advertisement in the *Daily Chronicle,* October 30, 1830, in which a very similar table is pictured. This table was being sold by another White, Joseph, at his cabinet wareroom at 91 South Sixth Street.

Charles White exhibited on numerous occasions in the Franklin Institute's annual exhibitions. A similar work table in a private collection was labeled by John Locilor who may have seen White's furniture on exhibition. In 1826, the Committee on Cabinet Furniture reported "that they have carefully examined the several articles expressed in their list and are of unanimous opinion that the parlour secretary is the best piece of Cabinet Furniture both for design and neatness of execution offered for a premium. We would further state that the two splendid sofas exhibited by the same are in the first style of workmanship and would if accompanied with the chairs merit the prize...." ("Report of the Committee on Cabinet Furniture," *Records of the Committee on Exhibitions,* October 1826, Franklin Institute, Archives).

221.

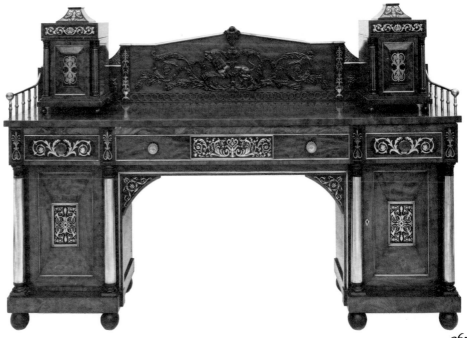

Designs. The intertwining grape and leaf motif, appropriate for a cellarette, was also common in Regency designs, seen for example in a "Wine Cooler after the Antique," plate 45 of Smith's *Guide* and also in a frieze applied to a scrolled chair back illustrated in Ackermann's *Repository*. The design for the sideboard may be derived from plates of Smith's *Guide*.

The design carved in relief in the center panel of the gallery is derived from plate 5, dated 1793, of Sheraton's *Appendix*. Similar designs are also seen in Robert Adam's *Designs for Vases and Foliage, Composed from the Antique,* published in London in 1821.

The sideboard has ebony inlay, an unusual feature in American furniture. Ebony inlay was considered special in French furniture as well, as indicated by a specific reference to that wood in the description of a secretaire-chiffonier in plate 297 of Mésangère (1809). Typical of Philadelphia Empire furniture is the flat carving in low relief.

Although this ensemble has been attributed to Joseph Barry's shop, the only documentary evidence which has been found to support this is in the *American Daily Advertiser* for September 11, 1824, where Barry advertised: "6 Ladies Toilets, Egyptian Figures, fitted up complet—" and "2 Rich Sideboards, Buhl work and richly carved—." Although Barry seems to be the only Philadelphia cabinetmaker to *advertise* "buhl work," during the 1820s, other Philadelphia shops could have produced this type of furniture. A thorough search of Gratz family papers and an examination of the furniture itself has not revealed any clues as to its maker.

In 1853, according to their account book, Louisa, Caroline, and Elizabeth Gratz bought furniture totaling $5,755.60 from a number of leading Philadelphia firms (HSP, Estate Papers of Louisa, Caroline, and Elizabeth Gratz, MS 61–259). The three unmarried sisters apparently lived together in their Locust Street house. Elizabeth had probably inherited the sideboard from her father, Simon Gratz, and she left it to the Museum as a bequest in 1909. It is also likely that Elizabeth Gratz's brother, Edward, inherited the cellarette from their father, and Edward most likely left it to his son, Simon, who gave it to the Museum in 1925, in memory of Caroline Gratz (presumably his mother). This evidence leads one to suspect that the ensemble originally belonged to Simon Gratz, although it could also have belonged to either of his two unmarried brothers, Hyman or Joseph.

The Gratz family was a distinguished family of Sephardic Jews. Michael Gratz had come to this country in 1759 and became a successful merchant and banker. The Gratz family is known to have bought Philadelphia furniture of the highest quality in both the eighteenth and the nineteenth centuries.

A high chest of drawers and dressing table were made for Michael Gratz in 1769, the year he married Miriam Simon. These pieces are now in the Winterthur Museum (Downs, *American Furniture,* figs. 133, 198). Another fine Philadelphia sideboard was made in about 1810 for Rebecca Gratz, the most celebrated member of the family, who was the prototype of the heroine of Scott's *Ivanhoe.*

In addition to the sideboard, knife boxes, and cellarette ensemble, other pieces from the Gratz house in the collection of the Philadelphia Museum of Art include a winged secretary and a fall front desk. (The secretary is derived from plate 125 of Mésangère.) All three Gratz pieces are related in their lavish use of brass marquetry. In contrast to these Philadelphia examples is the Empire furniture made in Boston which makes restrained use of brass inlay and ormolu mounts.

DH □

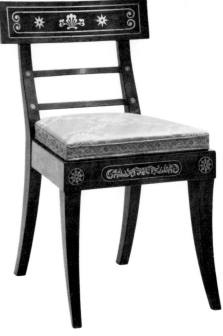

222a.

222. *Side Chairs*

c. 1825

(a) Inscription: No. IX (incised on bottom of front rail)

Mahogany and mahogany veneer; cut brass inlay; rosewood inset in back and front seat rail; white ash (?); slip seat, Eastern white pine, twentieth century upholstery

31½ x 19 x 23″ (80 x 48.3 x 58.4 cm)

Philadelphia Museum of Art. Purchased: Thomas Skelton Harrison Fund. 74–143–1

(b) Mahogany veneer; inlay of exotic wood, probably rosewood, ebonized; ash and pine

32⅜ x 18½ x 23″ (82.2 x 46.9 x 58.4 cm)

Lydia Bond Powel, Stonington, Connecticut

LITERATURE: MMA, *American Art from American Collections: Decorative Arts, Paintings, and Prints of the Colonial and Federal Periods* (March 6—April 28, 1963), no. 34 (illus.)

BOTH THESE CHAIRS, with their wide crest tablets and rectangular outlines, represent a Philadelphia style. Both chairs are notable for their restraint and elegance, in contrast to the carved and stenciled chairs favored in

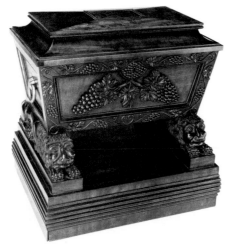

221. *Cellarette*

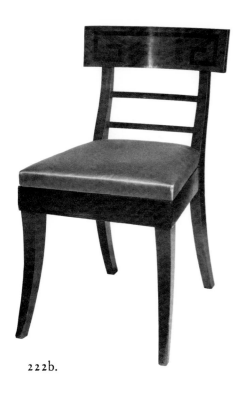

222b.

New York in the 1820s. Philadelphians preferred a more chaste decoration: when carving was employed it was restrained and in low relief and, in the case of these chairs, geometric brass inlay and fine woods are the only decorative devices used. The chair with the modified Greek key design was part of a large set at Powelton, the great Greek revival country house, originally situated on the west bank of the Schuylkill in Philadelphia's Blockley Township. The main body of the house was built for Elizabeth Willing Powel in 1800–1802. In 1825, her nephew John Hare Powel (1786–1856) commissioned William Strickland to design the portico (which was completed in 1826); the house was again remodeled by Thomas U. Walter in 1840. Certainly these klismos chairs were appropriate for such a classical revival house, the first near Philadelphia to use a giant stone portico based on a Greek temple front (see Charles B. Wood, III, "Powelton: An Unrecorded Building by William Strickland," *PMHB,* vol. 91, no. 2, April 1967, pp. 145–63).

Although it is tempting to speculate, it is unlikely that Strickland or Walter designed the furniture. There is, however, a recorded instance of Strickland's designing furniture for St. Stephen's Church in Philadelphia, and Thomas U. Walter is known to have designed furniture for Philadelphia cabinet-makers. Strickland's teacher, Benjamin Latrobe, designed a suite of furniture based on Greek forms for the White House during the Madison administration (1809–17). Although the furniture was destroyed in the

fire of 1814, drawings for it survived, including a handsome klismos chair.

The side chair with the brass inlay is derived from early nineteenth century English and French designs, seen for example in plate 13 of Percier and Fontaine. This chair is also from a larger set. Of the set of chairs with brass inlay, at least twelve have survived. Six are now in a private collection in Texas, two in a private collection in Virginia, two in the Bayou Bend Collection of the Museum of Fine Arts of Houston, and two in the Philadelphia Museum of Art. Several of the chairs with the rosewood inlay are known to have survived.

John Hare Powel was a gentleman farmer, art collector, and amateur architect. The eccentric Powel was described by the diarist Sidney George Fisher in 1843, "He goes to Europe and gets tired, he comes [home and lives] in a sort of bivouac as he says, his plate and pictures and furniture all locked up at Powelton, where he is building a very large and costly house which he will never inhabit" (Wood, cited above, p. 155).

Powel's chaste classical taste continued even when the French rococo style became popular as is reflected in a letter of September 16, 1851, which he wrote to the architect Richard Upjohn who was then designing an Italianate townhouse for him: He "would rather rest his eyes upon a Medici vase or a candelabrum of Pompeii than feast upon all of the fashionable display of French decorators" (Wood, cited above, p. 150).

DH □

HARVEY LEWIS (ACT. 1805–26)

Harvey Lewis was working as a silversmith in Philadelphia by 1804, because on August 27 of that year he took on Henry Clark as an apprentice for a term of four years, nine months, and twenty-one days (City Hall, Archives, Records of Indentures, vol. 2, p. 189). Lewis is first listed in Robinson's city directory for 1805, in partnership: "Lewis and Smith, silversmiths 2 south 2d." According to directories, this partnership lasted until 1810. The 1807 city directory lists Charles F. Smith separately as a storekeeper at 2 South Second Street; thus it seems possible that he was Lewis's business partner. However, according to Fales (*Joseph Richardson,* p. 159), Harvey Lewis borrowed money from Joseph Richardson in a joint bond, dated September 18, 1805, in the amount of $2,097.61 with two other goldsmiths, James Howell and Joseph D. Smith. The latter, then, rather than Charles F. Smith, may have been Lewis's partner. Lewis and Smith paid off their debt in full in November 1813, which suggests they collaborated until that time. Lewis is listed as a silversmith in Philadelphia directories through 1825.

223. Inkstand

c. 1815–25

Mark: H. LEWIS (in serrated rectangle stamped twice on bottom)

Inscription: In evidence of the cherished Love and/Esteem of Elizth Powel for her/favorite Sophia H. Olis (engraved on cover)

Silver

Height 3⅝″ (9.2 cm); diameter top 3⁹⁄₁₆″ (9 cm)

Yale University Art Gallery, New Haven. The Mabel Brady Garvan Collection

PROVENANCE: Francis P. Garvan, New York, 1931

LITERATURE: Sotheby and Co., London, January 29, 1931, no. 66 (illus.); John Marshall Phillips, *American Silver* (New York, 1949), pl. 32; Newark, *Classical America,* no. 98 (illus.); Buhler and Hood, no. 2, fig. 926; Fales, *Silver,* fig. 31, p. 33

THIS INKWELL is based on the ancient form of a tripod incense burner, which was adapted for French Empire designs. For instance, an incense burner supported by sphinxes is seen in plate 27 of Percier and Fontaine. A silver-gilt sweetmeat dish, made in 1794–97, by the Parisian goldsmith Marc Jacquart uses the form of an incense burner as well as three winged-sphinx supports on a tripartite plinth. (MMA, *Three Centuries of French Domestic Silver,* by Faith Dennis, 1960, pl. 187). Winged sphinxes were also used in a silver-gilt coffeepot of 1794–1814 by Martin Guillaume Biennais (Dennis, cited above, pl. 64). Similar forms are found in English Regency silver, seen, for example, in a vase with cover and a cup by the London goldsmith Paul Storr (N. M. Penzer, *Paul Storr,* London, 1954, pls. 16, 72).

223.

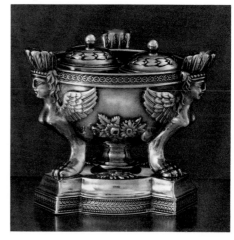

Rather than using an Egyptian head as in the Jacquart dish or a Greek goddess, employed on the Biennais coffeepot, Lewis has transformed the sphinx heads on his inkwell into what appear to be American Indian princesses, with feathered headdresses. The feathers resemble acanthus leaves protruding from a row of beading; each headdress on the Lewis inkwell was probably intended to hold quills. Kathryn Buhler has pointed out (Buhler and Hood, vol. 2, fig. 926) that similar acanthus leaf forms were used as spoon holders on a silver-gilt conserve dish with stand, 1793–1810, by Biennais (Dennis, cited above, pl. 58).

French-inspired antique details on this inkwell include the appliqués of flowers and leaves on the body and the leaf and beaded banding on the plinth. As with the Rasch tea caddy (no. 175), the combination of strong details and a classical form makes this small object seem much larger than its actual size. An almost identical inkwell by Lewis is at Woodlawn Plantation, Virginia.

DH □

HARVEY LEWIS (ACT. 1805–26)
(See biography preceding no. 223)

224. *Ewer*

c. 1825
Mark: H. LEWIS (in serrated rectangle, six times on bottom, four times in each corner of base, and twice on bottom of body)
Inscription: MᶜK (engraved on side within cartouche)
Silver
Height 15⅛″ (38.4 cm); width 10¾″ (27.3 cm); diameter 6¾″ (17.1 cm)
Maryland Historical Society, Baltimore

PROVENANCE: Descended in family to William Duncan McKim (or Isaac McKim); nephew; son, William McKim; son, Hollins McKim; daughter, Anne Vorhees McKim

SYMBOLS OF THE SEA dominate this ewer, or water pitcher. Its cast handle is in the form of a sea serpent with prunt-like scales. Beneath the handle is the cast head of Neptune, god of the sea, flanked by his trident and spear, symbols of sea power. Beneath Neptune are two entwined dolphins, another symbol of the sea. The band of cast rococo ornament around the body just below the neck includes sea shells. Sea motifs were popular in silver produced after the War of 1812, but the unusual number here was possibly at the customer's request. This ewer may have belonged to William Duncan McKim (1779–1834) or more likely to his

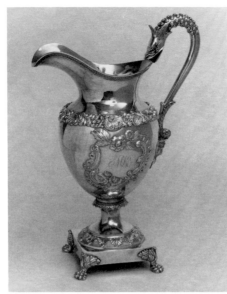

224.

brother Isaac McKim (1788–1875). The latter married Ann Hollins in 1808 but had no children. He was a partner of John McKim & Son, merchants in the China trade and a founder of the Baltimore and Ohio Railroad. His transoceanic mercantile interests may have led to the order of a ewer of this design. Among other projects, he built a ship, bearing his wife's name *The Ann McKim,* which he sent around the world. A model of this ship is in the Maryland Historical Society. The McKims were originally from Philadelphia, and undoubtedly had many relations here which might explain their ordering silver from Harvey Lewis.

There is a repoussé rococo cartouche on each side of the pitcher. Both Harvey Lewis and Thomas Fletcher were using rococo ornament in the 1820s, indicating the revival of that style in this country, or perhaps a continuation in a receptive city where the rococo style had never really died. A similar pitcher with a serpent handle by the Hartford silversmiths Ward & Bartholomew is in the collection of the New-York Historical Society (Philip Hammerslough and Peter Bohan, *Early Connecticut Silver 1700–1840,* Middletown, Conn., 1970, pl. 144). Similar designs for ewers are seen in plate 8, no. 4, and plate 34, no. 3, of Percier and Fontaine.

DH □

BASS OTIS (1784–1861)

Otis, thought to have been the son of a blacksmith, was born in Bridgewater, Massachusetts. Little is known of his early life other than that he was apprenticed to a scythe maker and taught himself to paint. Dunlap states that he began by working with a coach painter (*History,* vol. 2, p. 227). He was painting portraits in New York in about 1808, possibly in partnership with the artist John Wesley Jarvis (Tuckerman, p. 57); by 1812 he had moved to Philadelphia.

Otis took advantage of the exhibition of the Society of Artists at the Pennsylvania Academy of the Fine Arts in 1812 to enter eight portraits, five of which were singled out by a reviewer and praised for their "correctness of likeness" (Gordon Hendricks, "A Wish to Please, and a Willingness to Be Pleased," *The American Art Journal,* vol. 2, no. 1, Spring 1970, p. 16).

Joseph Delaplaine, a Philadelphia publisher and entrepreneur, hired Otis by 1816 to paint portraits to be engraved for a multivolume work, *Delaplaine's Repository of the Lives and Portraits of Distinguished Americans.* His scheme developed into not only a set of engravings but a portrait gallery which opened probaby in 1817 and was later sold to Rubens Peale in 1825 for his New York museum. Delaplaine's procedure is revealed in a letter he wrote in 1819 to the mayor of Philadelphia requesting that he donate a portrait of himself painted either by Thomas Sully or Bass Otis. Delaplaine's reason for employing Otis so often is obvious: Otis charged thirty dollars to Sully's one hundred dollars, and only twenty dollars for copies after portraits by others (HSP, Gratz Collection, American Literary Miscellaneous, Case 6, Box 21, Delaplaine to James N.

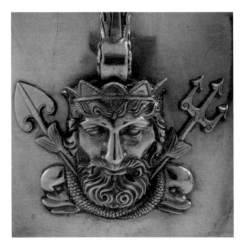

224. *Detail*

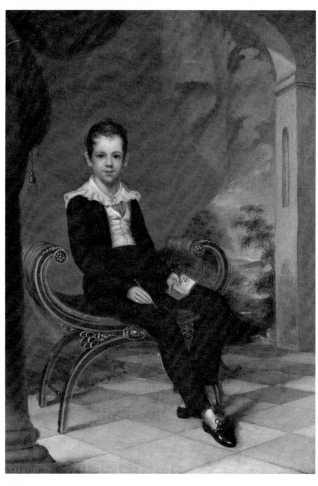

225.

Barker, November 23, 1819). On this mission for Delaplaine's enterprise, Otis traveled in 1816 through Virginia and Washington to paint portraits of Madison, Jefferson, and Monroe, apparently all from life. Probably on his return and while still basking in the glory of having painted such famous men, he gave a few lessons to John Neagle (see biography preceding no. 233), who was destined to surpass him in reputation as a portrait painter. Otis apparently felt some professional jealousy of Neagle, since he later cast doubt on his abilities to one of Neagle's sitters, Pat Lyon (Sartain, *Reminiscences,* p. 193).

In middle age, Otis seems to have been often employed in copying. Yet in 1823, Charles Willson Peale wrote his son Rembrandt that he had met Otis on the Delaware steamboat and that, impressed with his "extraordinary talents, he entertained me by his inventions of several sorts," in particular a story demonstrating Otis's ability to improvise (APS, Charles Willson Peale, Letterbook, vol. 17, p. 238). Otis is supposed to have invented a perspective protractor in 1815 and is considered to be among the first

Americans to produce a lithograph. He lived in Philadelphia until 1845, then moved to New York again, and from there, in about 1847, to Boston. He returned to Philadelphia in 1858 and continued to exhibit here until two years before his death in 1861.

225. *Seated Boy*

1825
Signature: B OTIS. 1825 (lower left)
Oil on canvas
20¾ x 14¾″ (52.7 x 37.4 cm)
The Westmoreland County Museum of Art, Greensburg, Pennsylvania. William A. Coulter Purchase Fund

PROVENANCE: With Victor D. Spark, New York, 1960

LITERATURE: The Westmoreland County Museum of Art, *Two Hundred and Fifty Years of Art in Pennsylvania,* by Paul A. Chew (1959), p. 32, no. 84

BASS OTIS EXHIBITED a number of small full-length portraits from 1827 to 1830 at the

annual Pennsylvania Academy exhibitions, and this portrait of an unknown boy on an Empire bench might well be one of them. Otis also painted miniatures which, like the small portraits, were less expensive to commission than life-sized paintings.

Although at times Otis's work is quite close to that of John Neagle, it is more linear in style. Perhaps his art has never been studied because it has neither the sophistication of Sully nor the consistent quality of Jacob Eichholtz. But his reputation for unevenness has also been unjustly perpetuated by misattributions. Dunlap, however, recognized that he "had strong natural talents, and a good perception of character. Many of his heads are well coloured" (*History,* vol. 2, p. 227). This is certainly true of the *Seated Boy,* where the delicately painted head and unusually attractive harmony of red and blue show Otis at his best. The surroundings indicate the boy's social rank and suggest a poetic disposition. Among Otis's known work, this portrait must rank as one of his most successful.

DE □

1826-1876

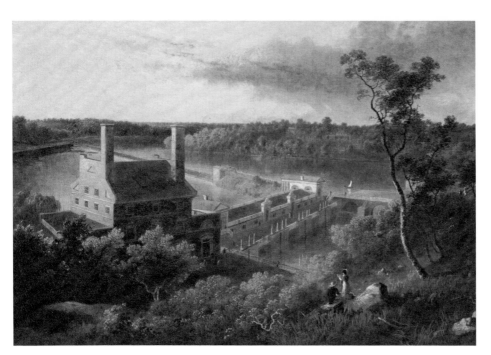

226.

1843, to New Orleans in 1844, and throughout New York state. From 1845 to 1847, Doughty was in England, Ireland, and France, where he exhibited a painting at the Paris Salon in 1847. After 1848 he spent his winters in New York City and his summers on painting trips, although his health was poor and his works were not selling well. A growing number of critics found his paintings reduced to stock formulas, and Doughty complained bitterly of a conspiracy "by a certain 'clique' to bolster up *certain* artists at the expense of all others" (quoted in PAFA, *Doughty,* p. 19). In 1856 a writer in *The Crayon* suggested a show of his pictures to relieve his financial needs. Doughty died in New York in July 1856.

AS

THOMAS DOUGHTY (1793–1856)

Thomas Doughty was born in Philadelphia on July 19, 1793, and is first listed in its city directories in 1814 as a leather currier in partnership with his brother, Samuel. The listing changes to "Doughty Thomas, painter" in 1816, but in 1818 and 1819 appears again as "currier." In 1820, Doughty is listed as "Doughty Thomas, landscape painter."

Doughty's only artistic training, according to the account he gave William Dunlap in 1834, was "one quarter's tuition at a night school in drawing in 'Indian ink' " (Dunlap, *History,* vol. 2, p. 380). He apparently developed his painting style by copying the European landscapes he might have seen in the Pennsylvania Academy of the Fine Arts and in collections of his patron, Robert Gilmor of Baltimore, and he relied on the advice of such eminent friends as Rembrandt Peale and Thomas Sully. In 1825, Peale recommended Doughty to Thomas Jefferson for the position of art instructor at the University of Virginia (PAFA, *Doughty,* pp. 13–14).

Doughty had exhibited a landscape at the Pennsylvania Academy in 1816, but it was not until 1822 that he began to exhibit regularly. The eight landscapes that he sent to the Academy in 1822 greatly impressed the young Thomas Cole, who was then living in Philadelphia. In 1824, Doughty was elected an Academician of the Pennsylvania Academy, and in 1827 the National Academy of Design made him an honorary member. Around 1829, Doughty was in

Boston, where he became acquainted with the lithographers John and William Pendleton.

He returned to Philadelphia in 1830 and, with his brother John, began publishing a monthly magazine, *The Cabinet of Natural History and American Rural Sports* (no. 242). Its failure in 1832 sent Doughty back to Boston, where he entered the most successful phase of his painting career, although he supplemented his income by giving landscape painting and drawing lessons. Dunlap notes that in 1834, Doughty, "in conjunction with Harding, Alvan Fisher, and Alexander, got up a splendid and popular exhibition of the works of the four, much to the benefit of the company" (Dunlap, *History,* vol. 2, p. 381).

Doughty's popularity is documented by his exhibition record at such galleries as the Boston Athenaeum from 1827 through 1854, the National Academy of Design from 1827 through 1850, the British Institution, the Royal Academy, and the Society of British Artists, Suffolk Street, in London, as well as at the Pennsylvania Academy, until 1856. The catalogues of the Artists' Fund Society list him as an honorary member in 1838, 1840, 1843, and 1844. Doughty's work was also distributed widely by the Apollo Association and the American Art-Union, which bought more than fifty of his canvases.

A trip Doughty made to London about 1837 was cut short by his ill health, and he moved to New York on his return. He traveled considerably in the last decade of his life, to Washington in 1842, to Boston in

226. *View of the Waterworks on Schuylkill—Seen from the Top of Fair Mount*

1826
Signature: DOUGHTY/1826 (lower right)
Oil on canvas
16¼ x 24″ (41.3 x 61 cm)
Private Collection

LITERATURE: PAFA, *Doughty,* p. 22, illus. no. 7

THE SITE of the new Waterworks at Fairmount (no. 183) was developed into a park that became one of the showplaces of Philadelphia during the nineteenth century. The small figures in Doughty's painting, admiring the architecture of the Waterworks, enjoying the vista of the river and the greenhouses at Lemon Hill (no. 151) from the observation platform near the dam, and sketching on the hillside below the reservoirs, illustrate the simple pleasures available to the sightseer early in the century. John P. Sheldon, a visitor to the city in 1825, three years after the Waterworks was completed, described his impressions in a letter:

I will not attempt to tell you how much I was delighted with the beauty, magnificence, and strength of the works. The scenery in their immediate vicinity is of the most delightful kind. The superb dam—the beautiful though small expanse of water above it, and the fine lively stream below, with its handsome bridges, combined with the delightful gardens, shaded seats, wooded hills rising here and there from the brink of the water by the side of the smooth lawns—present in the *tout ensemble,* a paradise, where the lover of nature could almost delight to dwell, even as a stranger.... (John P. Sheldon to Gen.

James Watson Webb, December 4, 1825, "Notes and Queries," *PMHB*, vol. 18, 1894, p. 124)

The particular charm of the site as Sheldon describes it, a felicitous combination of manmade elements and natural setting, provides the subject of one of Doughty's best paintings. Seen from just below the reservoirs at the top of Fairmount, the diagonal lines of the dam and the buildings make a pleasing incursion into the gentle wildness of the landscape and provide the artist with a strong compositional motif that tempers his use of the conventions of picturesque landscape. The energy of the small calligraphic strokes of paint that represent leaves and grass and twisting branches in Doughty's early paintings appears to contrast the aliveness of nature with inert architectural forms. The soft light that suffuses the artist's later, idealized landscapes here evokes the mood of a specific place.

Doughty exhibited views of the Waterworks at the Academy in 1822 and 1824, and this view from the top of Fairmount, with a companion *View of Fairmount Water Works, &c. Seen from the Opposite Side of Schuylkill*, was exhibited at the Academy in 1827. With minor changes, it was engraved by W. E. Tucker and published by Cephas G. Childs in 1829.

DS □

WILLIAM STRICKLAND (1788–1854)
(See biography preceding no. 202)

227. *United States Naval Asylum (Biddle Hall, United States Naval Home)*

Gray's Ferry Avenue and Twenty-fourth Street
1826–33
John Struthers, marble mason; John O'Neill, master carpenter
Inscription: WILLIAM STRICKLAND Architect/JOHN STRUTHERS Mason/1830 (on inner face of portico's architrave)
Coursed Pennsylvania marble ashlar; coursed granite ashlar basement; brick-vaulted floors and ceilings; cast-iron porches
Approx. 385 x 135′ (117.3 x 41.1 m)

REPRESENTED BY:
John Caspar Wild (c. 1804–1846)
Naval Asylum
From *Views of Philadelphia, and Its Vicinity*, 1838
Lithograph
4⅞ x 6¾″ (12.3 x 17.1 cm)
Free Library of Philadelphia

227.

LITERATURE: Hamlin, *Greek Revival*, p. 79; Gilchrist, *Strickland*, pp. 7–8, 73–76; White, *Philadelphia Architecture*, p. 25, pl. 22; Tatum, pp. 66, 172, pl. 56; William B. Bassett, "United States Naval Asylum, Biddle Hall," *Historic American Buildings Survey Report, PA-1094* (Washington, D.C., 1965), pp. 1–17; Dora Wiebenson, *Sources of Greek Revival Architecture* (University Park, Pa., 1969), p. 66

MOYAMENSING, particularly its western region near the preindustrial Schuylkill River, struck a balance in the early nineteenth century between urban and rural environments in which the capricious wilderness had been brought under the control of civilization but was not yet corrupted by the satanic city. This suburban setting was considered ideal for a public institution such as the United States Naval Asylum which now stands amid row houses at Gray's Ferry Avenue and Twenty-fourth Street. In August 1826 the Department of the Navy acquired the twenty-four-acre site and in December of that year chose William Strickland architect for the combined home and hospital for retired naval personnel.

Strickland, in turn, provided one of his best buildings. A great local institution, Pennsylvania Hospital (no. 48), and English and European homes for service pensioners served as precedents for the plan. For the facade of the central pavilion, the design's focal point, Strickland chose the broad Ionic octastyle portico of the Temple of Ilissus, the standard Ionic order of the Greek revival, which he found in his favorite text, the first volume of Stuart and Revett's

Antiquities of Athens (1762). Strickland then employed ancient and modern elements to transform this design framework into a notable work of architecture.

To produce a large functional building that would take advantage of its healthful site yet not become so massive that it would be heavy and gloomy was a challenge that Strickland met boldly and imaginatively. He placed the chapel, dining room, and offices in the central pavilion, and extended sleeping quarters on each side in the flanking wings placing common rooms at the corners. Making early use of structural cast-iron, he next introduced the governing element of the design, the open porches or "piazzas," supported on cast-iron columns along each wing. These provided each veteran with effortless access to the open air and lightened the effect of the marble ashlar walls, "merging into one integrated whole the monumentality of the central entrance motif and the functional delicacy and openness of the wings" (Hamlin, *Greek Revival*, p. 79).

The Naval Asylum was enlarged in 1844, when Strickland designed two Greek revival dwellings, the Governor's Residence and the Surgeon's Residence, for the grounds. They stand on either side of the main structure, which was later named Biddle Hall in honor of Commodore James Biddle, the Asylum's first governor. In 1868 hospital functions were transferred to Laning Hall, a new building behind Biddle Hall that was erected from the designs of John McArthur, Jr.

RW □

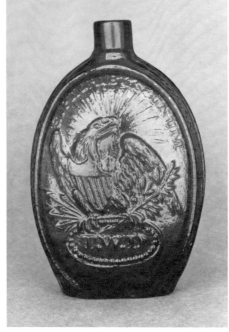

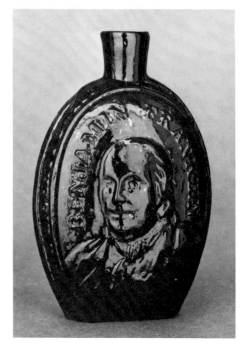

228a.

228b.

228c.

THOMAS W. DYOTT (1777–1861)

Thomas W. Dyott was born either in England or in Scotland. He arrived in Philadelphia probably in 1804 or early 1805, apparently from London by way of the West Indies. He brought with him formulas for a nonmercurial medicine for venereal complaints and for several medicines of a celebrated Dr. Robertson of Edinburgh, whose grandson he claimed to be.

Little is known of his earliest activities in this country. Although he began to practice as a doctor and to sell his medicines in Philadelphia in 1805, it was not until about 1811 that he added M.D. after his name. He quickly developed a large patent medicine business, and is listed in the Philadelphia city directories in 1807 as having a patent medicine warehouse.

Dyott was a successful entrepreneur, and by 1809 he had moved to larger quarters at 116 North Second Street, where he was listed as "medical Dispensary and proprietor of Robertson's family medicine." By September 1811 he again moved to larger quarters, this time to 137 North Second Street, and shortly thereafter also occupied number 139. This address, at the northeast corner of Second and Race streets, became a well-known landmark.

Dr. Dyott expanded his business rapidly by intensive and widespread advertising as well as by agent representation. In 1809 he had at least fourteen agents in twelve towns and cities throughout seven states; by mid-1810 he had forty-one agents in thirty-six

towns in twelve states along the Atlantic seaboard, western Pennsylvania, and Ohio. By 1814 he also had agents in fourteen towns in New York state, and later claimed to have representation "throughout the country" and "everywhere in the United States."

His extensive proprietary medicine business required large quantities of bottles and vials, most of which he imported from England, for he claimed the products of American glasshouses were of inferior quality. He began in 1809 to put up some of his medicines, including "Dr. Robertson's family medicine prepared only by T. W. Dyott" in American-made square flint-glass bottles.

These "flint"-glass bottles and vials were probably made for him at the old Kensington Glass Works, which had been established in the 1770s and went out of production between 1812 and the fall of 1815. With such an extensive need for bottles and vials, it was only natural that Dyott would become associated with glass manufacturing. By 1815 he acquired an interest in the Olive Glass Works in Glassboro, New Jersey. By the fall of 1817, he was sole agent not only for that glassworks, but also for the Gloucester Glass Works at Clementon, New Jersey; and by December he also became the sole agent for the Union Glass Works, presumably at Port Elizabeth, New Jersey. The latter firm failed late in 1818 or in 1819. It was probably at that time that Dr. Dyott became associated with the new Kensington Glass Works as agent, and possibly as a

member of the firm. The new Kensington Glass Works had been started in 1816 by Hewson, Connell & Company, on a lot adjoining the old glassworks in Kensington.

By 1821, Dr. Dyott had apparently increased his interest in the firm to a controlling if not a sole interest. By 1824 he was the sole proprietor of the Kensington Glass Works, which he expanded to five glass factories on the site of what came to be known as "Dyottville." The name of the Kensington Glass Works was also changed to Dyottville Factories or Dyottville Glass Factories in late 1832 or in early 1833. By that time, 400 persons were employed in this extensive establishment, of whom 130 were apprentices. Dr. Dyott operated Dyottville, which occupied about four hundred acres along the Delaware River, as a self-contained model glassworks community on a paternalistic basis. He was especially concerned for the welfare of his young apprentices. To that end he set forth strict rules of "temperance and decorum" which his journeymen and apprentices had to follow, and he required every apprentice to attend school, as well as chapel on Sunday.

The production of the Kensington Glass Works and the Dyottville Glass Factories was tremendous, as indicated by his numerous advertisements offering quantities of flasks, bottles, and vials for sale. By the mid-1830s, these factories were yielding Dr. Dyott a yearly income of from $25,000 to $30,000. Much of this Dr. Dyott reinvested in the company.

He also turned to other business ventures,

including newspaper publishing and banking. In 1835 he began publication of *The Democratic Herald and Champion of the People,* which lasted only two and a half years, and in May 1836 he opened his Manual Labor Bank at the northeast corner of Second and Race streets.

In November 1838, it was necessary for Dr. Dyott to plead insolvency. He was charged with alleged fraud and swindle, and on June 1, 1839, he was rendered guilty on seven indictments, although it was never proved that he intended to commit those acts. On August 31, 1839, he was sentenced to three years' imprisonment. He served about a year and a half of his sentence and then received an absolute pardon from Governor Porter. After another short stay in the debtors' section of the Moyamensing Prison, Dr. Dyott was finally freed.

Afterward, he returned to his proprietary drug and medicine business, but on a much lesser scale than before. He apparently was in business with his sons, for the city directory of 1844 lists the business as Thomas W. Dyott and Sons. After his bankruptcy and prison sentence, he seemed to have been sympathetically received back into respectable society and served the community "faithfully and honorably" until he died in 1861 at the age of eighty-three. (See McKearin, *Dr. Dyott,* pp. 9–154.)

THOMAS W. DYOTT'S KENSINGTON
GLASS WORKS

228a. *Flask*

1826–35
Inscription: BENJAMIN FRANKLIN (in deep arc around and above head of Franklin, obverse); T. W. DYOTT.M.D. (in arc around and above head of Dyott, reverse); ERIPUIT COELO FULMEN./SCEPTRUMQUE TYRANNIS [He snatches the thunderbolt from the sky and the sceptre from tyrants] (on edges toward obverse); KENSINGTON GLASS/WORKS PHILADELPHIA (on edges toward reverse)
Aquamarine glass, probably soda lime
Height 8″ (20.3 cm)
Philadelphia Museum of Art. Purchased: Joseph E. Temple Fund. 99–252

LITERATURE: Van Rensselaer, *Bottles and Flasks,* p. 5, group 1, no. 36; McKearin, *Glass,* pp. 463, 468–70, 482, fig. 11, p. 530, no. 96—GI-96, p. 531, fig. GI-96; McKearin, *Dr. Dyott,* p. 96, no. 96—GI-96, fig. 8

228b. *Flask*

1826–30
Inscription: GENERAL WASHINGTON (in deep arc around and above head of Washington, obverse); E. PLURIBUS UNUM (in arc above sun rays over eagle, reverse); T.W.D. (in oval frame below eagle, reverse); ADAMS & JEFFERSON JULY 4. A.D. 1776 (on edge toward obverse); KENSINGTON GLASS/WORKS PHILADELPHIA (on edge toward reverse)
Sapphire blue glass, probably soda lime
Height 6½″ (16.5 cm)
Philadelphia Museum of Art. Bequest of George H. Lorimer. 38–23–121

LITERATURE: Van Rensselaer, *Bottles and Flasks,* p. 62, pl. 17, fig. 1-G5-D1; McKearin, *Glass,* pp. 459, 517, 518, fig. GI-14, pl. 256, figs. 4, 5; The Corning Museum of Glass, *The Story of American Historical Flasks,* by Helen McKearin, (Summer 1953), pp. 24, 25, GI-14, figs. 48, 49; McKearin, *Dr. Dyott,* p. 35, fig. 6, p. 36, fig. 7, p. 37, fig. 8, p. 95, fig. 1

228c. *Flask*

1826–35
Inscription: BENJAMIN FRANKLIN (in arc around and above head of Franklin, obverse); T. W. DYOTT.M.D. (reverse); WHERE LIBERTY DWELLS/THERE IS MY COUNTRY (on edges toward obverse); KENSINGTON GLASS/WORKS PHILADELPHIA (on edges toward reverse)
Dark-brownish amber glass, probably soda lime
Height 6⅞″ (17.5 cm)
Philadelphia Museum of Art. Purchased: Joseph E. Temple Fund. 99–1155

LITERATURE: Van Rensselaer, *Bottles and Flasks,* p. 43, pl. 5, fig. 38 G1, p. 109, pl. 40, 38 G1; McKearin, *Glass,* pp. 463, 530, 531, fig. GI-94, pl. 246, figs. 9, 10; McKearin, *200 Years,* p. 344, pl. 112, fig. 2; McKearin, *Dr. Dyott,* p. 36, fig. 7, p. 37, fig. 8, p. 96, fig. 6, no. 96—GI-94; N. Hudson Moore, *Old Glass: European and American* (New York, 1924), pp. 373, 374

THE QUART-SIZED FLASK 228a, of aquamarine colored soda lime glass, was blown in a mold made up of two vertical leaves, with each side bearing half of the base. The short cylindrical neck was rewarmed at the fire and tooled to a plain, smooth finish. This is the type of neck which has been erroneously called a "sheared" neck. The base is abruptly hollowed and scarred with a pontil mark. The Franklin-half of the mold is the same used to produce another quart flask (McKearin, *Glass,* GI 97), which has Franklin's bust on each side. To the Franklin mold leaf was added the inscription ERIPUIT COELO FULMEN. SCEPTRUMQUE TYRANNIS. A new leaf bearing Dyott's bust and inscription was made to complete the mold for the flask shown here. This type flask was probably first produced about 1826–28 (McKearin, *Dr. Dyott,* pp. 96, 97). It was also made in amethyst, aquamarine, colorless glass with a faint amethyst tint, deep green, and a deep emerald green. It is comparatively rare in the aquamarine colored glass shown here.

The pint-sized flask 228b shows a bust of General Washington in uniform in a three-quarter view facing left. On the reverse is the American spread eagle, head turned to the right, with five arrows clutched in its right talon and a branch in its left. It was made in a mold of two vertical leaves, with each side bearing half of the base, with plain-tooled, short cylindrical neck. The base bears a pontil mark. The inscriptions were cut in the mold for another flask (McKearin, *Glass,* no. GI-16) to commemorate the almost simultaneous deaths of John Adams and Thomas Jefferson on the fiftieth anniversary of the signing of the Declaration of Independence. This type flask was first produced in 1826 (McKearin, *Dr. Dyott,* p. 95, fig. 1) and was made in dark amber, red amber, golden yellow, aquamarine, deep green, and light emerald green. It is common in most colors, but rare in this sapphire blue, only three or four examples being known.

The pint-sized flask 228c with a bust of Benjamin Franklin on the obverse and of T. W. Dyott on the reverse was also blown in a mold of two vertical leaves with each side bearing half of the base and has a plain-tooled, short cylindrical neck. This same mold was used for another flask (McKearin, *Glass,* GI-95) with the inscriptions WHERE LIBERTY DWELLS THERE IS MY COUNTRY and KENSINGTON GLASS WORKS PHILADELPHIA added. The inscription on the Franklin leaf is a quotation attributed to Franklin that would have been familiar to purchasers of this flask, since it appeared in speeches and in print as a headline or as an introduction to patriotic outpourings. This flask probably first appeared about 1826. It was made in red amber, aquamarine, light green, light emerald green, and light yellow green (McKearin, *Dr. Dyott,* p. 96, fig. 6) in addition to the brownish amber color shown here.

KMW □

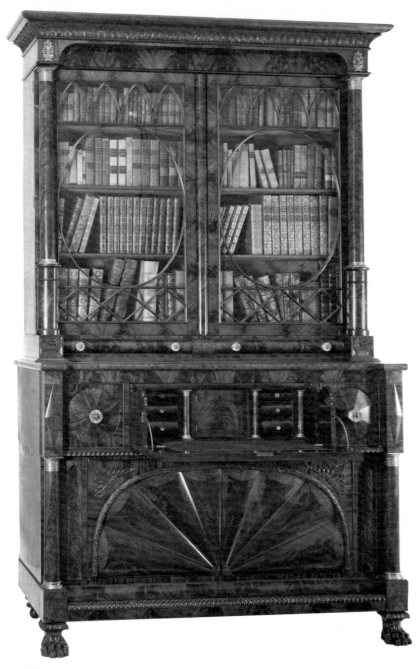

229.

honorable mention. In 1826 he won a bronze medal for a sideboard, and the following year, a silver medal for the best "cabinet bookcase and secretary" (no. 229).

In 1830, Quervelle advertised in the *United States Gazette* that he had "been employed as well by some of the first individuals of the city as by the general government." This later reference may be to a number of pier tables Quervelle supplied in 1827 to President Andrew Jackson for the East Room of the White House. Quervelle's "Cabinet and Sofa Manufactory" had expanded enough by 1830 for him to advertise that "orders from any part of the Union will be promptly executed."

By the time of his death in 1856 he had become a rich man. He owned a number of houses on Lombard, Pine, and Locust streets, had become a partner in the Bristol Iron Works, and held a large number of securities. Like Michel Bouvier (see biography preceding no. 240), Quervelle transferred his manufactory interests to real estate and other business activities. (See Robert C. Smith, "Philadelphia Empire Furniture by Antoine Gabriel Quervelle," *Antiques*, vol. 86, no. 3, September 1964, pp. 304–9.)

229. *Secretary Bookcase*

1827

Label: This Secretary & Book Case was Exhibited/by Anthony G. Quervelle/at the Franklin Institute in 1827/and Obtained the Silver Medal/from Competent judges/of the Same. (in ink on paper label inside rear bottom of left and right drawers); ANTHONY G. QUERVELLE's/ CABINET AND SOFA MANUFACTORY,/126/ SOUTH SECOND STREET A FEW DOORS BELOW DOCK,/PHILADELPHIA. (printed label, in five drawers)

Stamp: PATENT G R (on brass lock)

Mahogany and mahogany veneer; stained burl ash; poplar, pine, and cedar; glass doors and pulls

109½ x 66½ x 25½"

(278.1 x 168.9 x 64.7 cm)

Philadelphia Museum of Art. Given by Mr. and Mrs. Edward C. Page in memory of Robert E. Griffith. 60–159–1

PROVENANCE: Robert Englefield Griffith; son, Dr. Robert Griffith; daughter, Mrs. Edward Coleman; nephew, Robert Englefield Griffith; daughter, Elizabeth (Griffith) Page (Mrs. Edward C. Page)

LITERATURE: Newark, *Classical America*, no. 56; Robert C. Smith, "Philadelphia Empire Furniture by Antoine Gabriel Quervelle," *Antiques*, vol. 86, no. 3 (September 1964), p. 305, fig. 6; Otto, *American Furniture*, fig. 137; Marshall B. Davidson, ed., *The*

ANTHONY G. QUERVELLE (1789–1856)

By 1817 the Parisian-born Quervelle had come to Philadelphia, where, on January 30 of that year, he married Louise Geneviève Monet, also of Paris. They had two sons, Pierre-Gabriel and Antoine Louis. Her father was a machine manufacturer in Philadelphia; nothing is known of his family, though there was a cabinetmaker named Jean-Claude Quervelle (1731–1778) who worked at Versailles as *ébéniste du garde-meuble de la Couronne*.

Quervelle would have received his training in Paris. In Philadelphia he was listed

as a cabinetmaker in the city directories from 1820 until his death. He became a United States citizen on September 29, 1823, when he was living and working at Eleventh and Lombard streets. In 1825 he moved to 126 South Second Street, where he opened his United States Fashionable Cabinet Ware House, and in 1849, to 71 Lombard Street.

Like other leading Philadelphia cabinetmakers, Quervelle competed in the early exhibitions of mechanical arts of the Franklin Institute, founded in 1824. In the second annual exhibition, held in 1825, he showed two pier tables, which won him

American Heritage History of American Antiques from the Revolution to the Civil War (New York, 1968), pp. 112–13; Robert C. Smith, "The Furniture of Anthony G. Quervelle, Part IV: Some Case Pieces," *Antiques*, vol. 105, no. 1 (January 1974), pp. 182, 188–89, fig. 4

AN OUTSTANDING EXAMPLE of the arts of Philadelphia, this secretary bookcase is also among the great masterpieces of American furniture. Its thorough documentation, which includes five of Quervelle's labels, and the fact that he chose to exhibit it at the Franklin Institute's 1827 exhibition of mechanical work, where it was awarded a silver medal, are surely indications of his pride in the piece. According to the Franklin Institute's "Report of the Committee on Premiums and Exhibitions of the Fourth Annual Exhibition," of 1827: "They have carefully examined the different articles submitted to their inspection and are of opinion that the secretary and bookcase deposited by Mr. Anthony Quervelle is the best piece of furniture of that description exhibited for premium, and we would further remark that the parlour secretary and ladie's dressing table by the same are fair specimens of the present style of work" (*Journal of the Franklin Institute*, vol. 4, 1827, p. 403).

As Robert Smith pointed out, the design of this piece resembles the center section of a winged desk-and-bookcase illustrated in plate 23 of Smith's *Guide*, a book that appears to have been a main source of inspiration for Quervelle. The same brilliantly figured mahogany veneers and circular insets, as well as the same overall architectonic composition, appear both in Smith's design and in Quervelle's piece. The applied lozenges on the fall board are elements seen in designs by Giovanni Battista Piranesi.

The design of the muntins in the bookcase door is seen in plate 12 (no. 6) of the *Philadelphia Book of Prices* of 1828, while the gadrooning, flat carving, and the use of contrasting woods in the interior compartment and at the edge of the fan are also to be found in Philadelphia cabinetwork of the period. The radiating fan, similar to one illustrated in Mésangère (plate 158), is a feature also found on other documented Philadelphia pieces. Here, as is often the case in American furniture, motifs borrowed from several different European sources have been successfully combined in one piece.

DH □

ANTHONY G. QUERVELLE (1789–1856)
(See biography preceding no. 229)

230. *Sofa Table*

c. 1827–30
Mark: ANTH^Y G. QUERVELLE'S CABINET & SOFA/*Manufactory*/126 So. 2^d Street/ PHILAD^A (stamped five times, twice under top, once beneath stretcher, and on each base support)
Rosewood veneer; yellow poplar and white pine; intarsia marble; gilt
28⅜ x 42⅛ x 26⅜" (72 x 107 x 67 cm)
The St. Louis Art Museum. Purchase: Funds given in loving tribute to William A. and Carolyn C. McDonnell by their devoted son and daughter-in-law Sanford N. and Priscilla B. McDonnell

PROVENANCE: With Robert T. Trump, Philadelphia

LITERATURE: Lynn E. Springer, "A Philadelphia Empire Table," *Bulletin of the City Art Museum of Saint Louis*, vol. 7, no. 1 (May-June 1971), pp. 8–10, illus. p. 9; Robert C. Smith, "The Furniture of Anthony G. Quervelle, Part I: The Pier Tables," *Antiques*, vol. 103, no. 5 (May 1973), pp. 984–94, illus. p. 990

THIS SOFA TABLE is notable for its elegance and restraint. Its tight, carefully thought-out design is achieved rhythmically—the paired scroll supports are repeated in the scroll beneath the stretcher; the convex bosses with applied gilt decoration on the spiral of each scroll are echoed in the bun-shaped feet and the circular motifs of the marble inlaid top. All the members of the table are delineated and brought into a unified design by a stenciled gilt line.

The rich, dark, rosewood veneer and gilt decoration contrast with the subtle coloration of the intarsia marble secured by a frame at the top. The design of the marble's central panel is of pale, mottled brown and gray, achieved through the piecing together of marble cut from the same block, while off-white, gray, and tan inlays form the border.

Design sources for this table are seen in plate 25 of Smith's *Guide* (published in 1826) and figure 1948 of J. C. Loudon's *Encyclopaedia of Cottage, Farm and Villa Architecture* (London, 1839).

A striking parallel to this sofa table is seen in pattern 26 of the 1833 broadside advertising the furniture of Joseph Meeks and Sons of New York (John N. Pearce, Lorraine W. Pearce, and Robert C. Smith, "The Meeks Family of Cabinetmakers," *Antiques*, vol. 85, no. 4, April 1964, p. 415). Clearly the Quervelle sofa table was a precursor of the late classical style which became very popular in the 1830s and 1840s, and which the Meeks broadside so well illustrated.

DH □

230.

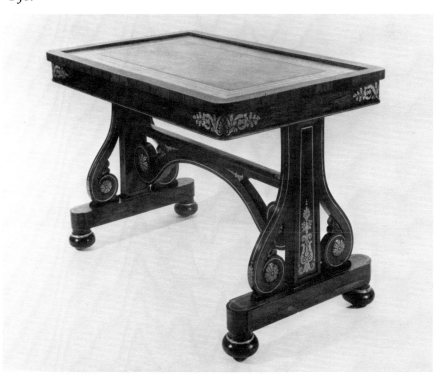

ATTRIBUTED TO ANTHONY G. QUERVELLE
(1789–1856)
(See biography preceding no. 229)

231. *Pier Table*

c. 1825–35
Inscription: [...] respectfully invites all the persons who may be in want of Cabinet Furniture to call and view the largest and most fashionable assortment of furniture ever yet offered for sale in this city. From the well known character of this establishment the public may depend upon every article being made of the best materials and workmanship which will be sold on very reasonable terms for cash or acceptance. (part of a Quervelle advertisement from an unidentified newspaper, glued to frame)
Mahogany and mahogany veneer; satinwood, rosewood, and crotch mahogany marquetry; white pine and poplar; gilt; marble; mirror
41 x 44 x 20¾″ (104.1 x 111.7 x 52.7 cm)
Joseph Sorger, Philadelphia

LITERATURE: Robert C. Smith, "The Furniture of Anthony G. Quervelle, Part I: The Pier Tables," *Antiques,* vol. 103, no. 5 (May 1973), p. 987, pl. 1

ATTRIBUTED TO Anthony G. Quervelle, this is one of the most elaborate of Philadelphia classical revival pier tables. In 1829, President Andrew Jackson ordered from Quervelle

two such pier tables with scroll supports similarly carved and gilded with grapes and other fruit at the sides, a lion's paw at the base, and an eagle's head at the top (First Auditors' Miscellaneous Treasury Accounts, November 25, 1829, in Kathleen M. Catalano, "Cabinetmaking in Philadelphia [1820–1840]," M.A. thesis, University of Delaware, 1972). The foliated double cups and heavy gadrooning are features commonly seen on Philadelphia pier tables, but the turned half-column supports on each side of the mirror back are an unusual element. Another Philadelphia pier table employing similar front supports is in the collection of the Chicago Historical Society (Robert C. Smith, "The Furniture of Anthony G. Quervelle, Part I: The Pier Tables," *Antiques,* vol. 103, no. 5, May 1973, p. 987, fig. 7). The handsomely shaped platform, characteristic of Philadelphia pier tables, is indented with ogee curves flanking a marquetry semicircular fillet of concentric bands and star motif, which, reflected in the back mirror, gives the illusion of being a full circle. Pier tables similar to this are seen in Smith's *Guide* (pls. 27 and 64).

Petals emerging from a scroll is a popular late classical convention that goes back through Thomas Sheraton (*Appendix,* pl. 24) to the Italian artist Giovanni Battista Piranesi, one of the principal innovators of neoclassical ornament (*Diverse maniere d'adornare i cammini,* Rome, 1769, pls. 6, 30, 44).

DH □

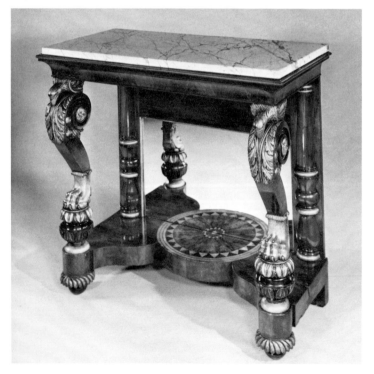

231.

232. *Sofa*

c. 1825–30
Mahogany and mahogany veneer; poplar and pine
40 x 102 x 25½″ (101.6 x 259 x 64.7 cm)
Joseph Sorger, Philadelphia

LITERATURE: Robert C. Smith, "The Furniture of Anthony G. Quervelle, Part V: Sofas, Chairs, and Beds," *Antiques,* vol. 105, no. 3 (March 1974), p. 512, fig. 1

ALTHOUGH A LARGE NUMBER of handsome pieces of furniture of the 1820s have been attributed to Quervelle on the basis of similarity of style, clearly what has been defined is a Philadelphia regional style, since examples of labeled furniture by Charles H. White (see biography preceding no. 220) and others use very similar forms, carving, and decorative motifs. This type of Philadelphia sofa is one of the most elaborate of this period. As Robert Smith has pointed out, regional characteristics of Philadelphia Empire sofas include the substantial proportions, which survive from the city's eighteenth century furniture forms, and uncarved rear feet which tend to be merely flat, saw-cut versions of the front ones, in this example, of a typical dolphin design.

The visual focus of this sofa is its highly unusual central tablet which displays in relief carving a scene with an Indian princess, symbol of the United States. The source for this design may be *The Diplomatic Medal* ordered by George Washington and executed by Augustin Dupré in Paris in 1790 (E. McClung Fleming, "From Indian Princess to Greek Goddess: The American Image 1783–1815," *Winterthur Portfolio 3,* 1967, p. 42, fig. 3). Both depict an Indian princess seated amid bundles of merchandise; she is barefoot, wears a feathered skirt and bonnet, and bears a quiver and cape over her shoulder, but a cornucopia, which appears in her left hand in the medal, is placed at her feet in this tablet. In the medal the Indian princess is welcoming Mercury (Commerce) to her shores, but Mercury is omitted in the tablet, and in its place is another symbol frequently associated with the princess, an American flag, which she holds in her right hand.

DH □

JOHN NEAGLE (1796–1865)

Neagle was born in Boston on November 4, 1796, while his parents were there on a visit from Philadelphia. His father, from the county of Cork, Ireland, died when Neagle was four, and his mother was remarried to a grocer. Dunlap, the best source on Neagle's life, wrote that Neagle was encouraged to

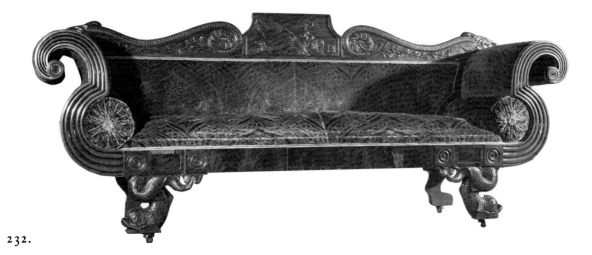

232.

draw at an early age by a school friend, Edward F. Petticolas, later known for his miniature portraits (*History*, vol. 2, pp. 372–77). For a brief time the boy was sent to the drawing school of the Italian artist Pietro Ancora, who, according to the later Pennsylvania Academy exhibition catalogues, painted chiefly still lifes and copies after earlier Italian religious pictures. At the age of fourteen Neagle was apprenticed, by his own choice, to Thomas Wilson, a coach and ornamental painter ("John Neagle, The Artist," *Lippincott's Magazine of Literature, Science and Education,* vol. 1, May 1868, p. 477). It was through Wilson that Neagle met and received some instruction from Bass Otis (see biography preceding no. 225), who had arrived in Philadelphia in 1812.

By 1817, Neagle had set himself up as a portrait painter and is so listed, for the first time, in the Philadelphia city directory, at 140 Chestnut Street, one block south of the studio of Bass Otis. This proximity to Otis may have led to Neagle's decision in 1818 to travel south where he felt there would be less competition. From Lexington, Kentucky, he went on to the Mississippi and then to New Orleans by boat. Traveling in search of business became too costly, however, and before long he was back in Philadelphia, where he is listed in the 1819 city directory. During the early 1820s, Neagle frequented Thomas Sully's studio and, in 1826, he married Sully's stepdaughter. Aside from Sully, the other major artistic influence in his life was Gilbert Stuart, whom he visited in Boston in 1825.

Neagle established his reputation by exhibiting a full-length portrait of a blacksmith, *Pat Lyon at the Forge,* at the Pennsylvania Academy in 1827. He was active in the Academy, as a director from 1830 to 1831, and in the Artists' Fund Society, where he was a founder and the first president from 1835 to 1844. His sporadic diary covering the years 1825–54 (private collection), his six

notebooks (American Philosophical Society), and his Common Place Book (Historical Society of Pennsylvania) indicate that Neagle was a kindly, modest man interested in professional theory and the opinions and practices of other artists. He had perhaps the finest collection of engravings and drawings of any artist in Philadelphia by the 1840s.

Unlike many of his contemporaries, Neagle never visited Europe or left the United States, which may explain why he never attempted an historical picture. He painted chiefly portraits and some landscapes before his work was curtailed by a paralytic stroke toward the end of his life. He died in Philadelphia on September 17, 1865, some years before the death of his friend and mentor Thomas Sully.

233. *Miss Anna Gibbon Johnson*

1828

Signature: J. NEAGLE./1828 (center left)

Oil on canvas

45¾ x 34¾" (116.2 x 88.2 cm)

Pennsylvania Academy of the Fine Arts, Philadelphia. Bequest of Helena Hubbell, 1929

PROVENANCE: Bequeathed to the Pennsylvania Academy of the Fine Arts by sitter's daughter, Helena Hubbell, Philadelphia, 1929

LITERATURE: PAFA, *Catalogue of an Exhibition of Portraits by John Neagle* (1925), no. 89; PAFA, *The One Hundred and Fiftieth Anniversary Exhibition* (January 15—March 13, 1955), no. 41

NEAGLE'S COLORFUL PORTRAIT of *Miss Anna Gibbon Johnson* is unusually well documented. Not only is it signed and dated, but the receipt for payment of the portrait has recently been discovered at the Historical Society of Pennsylvania. According to the receipt, the portrait was commissioned by

Anna's father, Colonel Robert G. Johnson of Guilford Hall Farm, Salem, New Jersey. Johnson paid $120 for the painting, with frame and packing box, on May 21, 1828 (HSP, Helena Hubbell Collection, Folder 13), a comparatively high price for Neagle, who charged only $50 for a three-quarter-length portrait in 1832 (Neagle, Diary, private collection). The difference in price may indicate that the portrait was considered a special effort.

Anna Johnson visited Philadelphia frequently and was, as evidenced by her portrait, a highly fashionable young woman. Romantically inclined, she spent idle moments transcribing her favorite poems into a personal album (Historical Society of Pennsylvania). Many of the poems are about love; some are religious. One of the more serious is "Fugit Hora," copied in Philadelphia in 1829, including the lines, "As drop by drop of beauty melts away," and "In vain we cling to Scenes of long past bliss and long to weave them into form again."

There are a number of influences at work in Neagle's portrait of Anna. The bright coloring and use of a staircase recall Sir Thomas Lawrence, whose ideas would have been transmitted to Neagle through Sully. Neagle constantly quoted Sully in his notebooks and his Common Place Book, not as a dutiful son-in-law but as an admiring and reflective fellow artist. The use of broken pure color is reminiscent of Gilbert Stuart, whom Neagle had visited in Boston only three years before. Stuart was known to advise an unsparing use of color, but Neagle's colors appear a little garish compared to Stuart's, and the scumbling effect characteristic of Neagle is also unlike Stuart, who told his pupils: "Preserve as far as practicable the round, blunt stroke in preference to the winding, flirting, wisping manner" (Flexner, *Distant Skies,* p. 81).

A primeval background is unusual for Neagle, but it resembles some contemporary

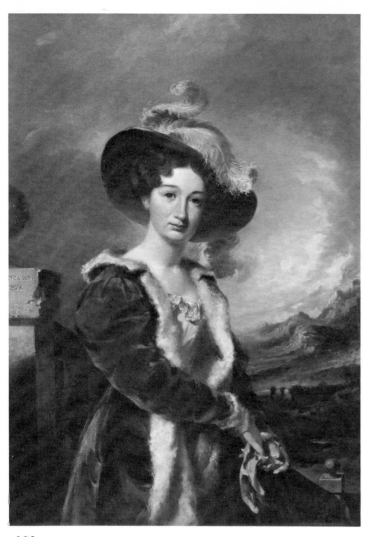

233.

poetic landscapes, such as Thomas Cole's *Landscape with Dead Tree* of 1827 (Rhode Island School of Design), which has a similar swirling blend of mountains and clouds. Cole was in Philadelphia at this time, exhibiting his landscapes at the Academy of Fine Arts, and Neagle was undoubtedly aware of them. He was also well aware, particularly at this time, of contemporary British watercolor landscapes which bordered on the visionary (APS, John Neagle, "Lessons on Landscape painting with the most approved mode of composing tints in Watercolours," 1827). From the pentimenti in Neagle's picture, it is apparent that the staircase originally extended farther back at the lower right so that it would have been even longer than it is now. It would be consistent with the sitter's personality as well as contemporary thought for this background to be not merely decorative but deliberately symbolic, probably of a pilgrimage through life.

DE □

280

THOMAS FLETCHER (1787–1866)

Thomas Fletcher was born in Alstead, New Hampshire. His family moved several times after the Revolution, and by 1808, he was living in Boston. On November 9, 1808, he and Sidney Gardiner announced their partnership in a lengthy advertisement in Boston's *Columbian Centinel*. For three years thereafter they were successful jewelers (they were listed in the Boston directories in 1809 and 1810), supplying gold, silver, and fancy hardware.

In 1811 they moved to Philadelphia, where, according to a letter dated December 16, 1811, from Fletcher to his father, he felt they would have greater success. A notice in the *Aurora General Advertiser* three days later informed the public

that they have taken the Stand, No. 24, South Second Street, Lately occupied by Mr. Vauclain, Where they intend carrying on extensively the Manufactory of Silver Plate and Jewellery, of every kind.

They have for sale A Handsome Assortment of Goods, In their line, which they offer very low, Consisting of:—

Gold and Silver Watches, Plated Tea and Coffee Setts, Candlesticks and Branches, Sconces, Elegant Cut Glass and common Castors, Baskets, Salt Stands, Liquor Frames, Fish Knives, Rich strung Pearl Setts, comprising Necklace, Ear-Rings, bracelets, Broach and Wreath.

Pearl Set and Filagree Ear-Rings, Finger Rings, Bracelets and Broaches, Elastic Gold Necklaces, Bracelet Bands, &c.

Mourning Rings, Pins and Bracelets, Gold Chains, Seals and Keys, and a variety of low priced Jewellry and Plated Goods.

Silver spoons, Ladles, Tea Setts, and all other plate work made to order.

Cash paid for Diamonds, Pearls and other Gems.—Pearls elegantly set.

In 1813, Fletcher and Gardiner were first listed in the Philadelphia directories as silversmiths and jewelers, both individually and as a firm, located at the southeast corner of Fourth and Chestnut streets. Through aggressive importing, manufacturing, and marketing procedures, the firm, by the early 1820s, became one of the most active manufactories in the country, known for their monumental silver presentation pieces honoring American heroes of the War of 1812. Fletcher, who seems to have been the firm's principal designer, went to England in 1815 for eight months, where he not only bought large amounts of English plate but saw the work of some of England's most fashionable silversmiths. Sidney Gardiner was, until 1822, the stay-at-home partner, probably managing the manufactory, while Fletcher, obviously the business head of the firm, took care of financial matters and selected and bought the imported goods that constituted the mainstay of the business. In 1822, Gardiner went to Mexico to secure an important order, and, according to family history, he died in Vera Cruz in 1827 at the age of forty-two, leaving a wife and young children. The firm continued to be listed as Fletcher and Gardiner until 1836; an 1832 lithograph by M. E. D. Brown, *The Gold & Silver Artificers of Phila. in Civic Procession, 22d Feby, 1832,* shows both names over the door of their shop.

From 1837 to 1839, Fletcher was in partnership with Calvin W. Bennett under the name of Fletcher and Bennett. According to the Philadelphia city directories, Fletcher moved to 188 Chestnut in 1838 or 1839 where he operated the Morris House, a temperance hotel, until about 1850. Fletcher's last years may have been spent in Delanco, New Jersey, where he died at the age of seventy-nine. (See Elizabeth Wood Ingerman, "Thomas Fletcher: A Philadelphia Entrepreneur of Presentation Silver,"

Winterthur Portfolio 3, 1967, pp. 136–71; and Donald L. Fennimore, "Thomas Fletcher and Sidney Gardiner," *Antiques*, vol. 102, no. 4, October 1972, pp. 642–49.)

234. *Wine Cooler*

c. 1828–30
Mark: T/F/P (stamped twice on opposite sides, on outer rim of base, each on diagonally lined ground in cartouches; profile head in circle; eagle with shield in circle)
Inscription: EKH (engraved on side at top below rim); FROM A.E.A./J.W.A./J. DE K.A./F.J.O.A./OCT. 1903 (engraved under base at later date)
Silver
12⅛ x 9½″ (30.7 x 24.1 cm)
Private Collection

A SEPIA WASH DRAWING presumably by Thomas Fletcher for this wine cooler is among the Fletcher drawings at the Metropolitan Museum of Art. The unusual marking on this piece also occurs on a covered two-handled urn in the Garvan Collection (Yale University Art Gallery; Buhler and Hood, vol. 2, no. 928), where the same letters appear with the mark FLETCHER & GARDINER. The T and F refer to Thomas Fletcher; the P, to Philadelphia.

A rare and ambitious form in American silver, the wine cooler was more common in English and French silver of the period. Based on a classical Greek prototype, called a "calyx krater," the form was used for mixing wine and water from the sixth to

234.

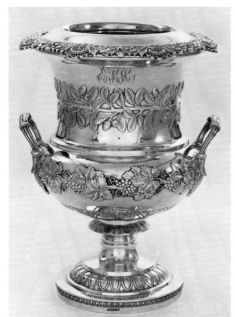

the fourth centuries B.C. Percier and Fontaine illustrated several such forms; plate 33, in particular, shows the same conventionalized acanthus leaves and handles just below midpoint. *A Collection of Vases, Altars, Paterae, Tripods, Candelabra, Sarcophagi* (London, 1814), by Henry Moses, illustrates similar forms in plates 40–45; and plate 86 pictures a candelabrum that has the acorn and leaf motif.

Dating from almost the same time as this wine cooler is a covered cup made by Rebecca Eames and Edward Barnard for the Weymouth Regatta Club (Charles Oman, *English Silversmiths' Work Civil and Domestic; An Introduction*, London 1965, fig. 210). This cup, which has the London hallmark for 1827–28, has a similar band of leaves and grapes and the same form of base, with flared neck and raised leaf decoration on the foot.

DH □

ANNA CLAYPOOLE PEALE (1791–1878)
(See biography preceding no. 212)

235. *Marianne Beckett*

1829
Signature: Anna C. Peale 1829 (scratched, lower right)
Watercolor on ivory
3 x 2½″ (7.6 x 6.4 cm)
Historical Society of Pennsylvania, Philadelphia

PROVENANCE: Miss Lena Cadwalader Evans, 1939
LITERATURE: Westmoreland County Museum of Art, *250 Years of Art in Pennsylvania*, by Paul A. Chew (1959), no. 86, pl. 35; Detroit Institute of Arts, *The Peale Family, Three Generations of American Artists*, ed. Charles H. Elam (1967), no. 188 (illus.); Wainwright, *Paintings and Miniatures*, pp. 16–17, illus. p. 158

ANNA CLAYPOOLE PEALE's portrait of Marianne Beckett, later Lady Whichcote, is painted in the freer manner typical of her later work. It is rectangular, rather than the traditional oval shape. As opposed to its previous role as jewelry and dress accessory, from the late 1820s, the miniature portrait increased in size and was more frequently rectangular to fit into leatherette cases with hinged covers or wooden or metal frames for display on a table or wall. The heavier, broader treatment and use of darker, more opaque colors reflected the changing taste in dress and blended with the miniature's new setting, the heavily draped, profusely cushioned drawing room.

RB-S □

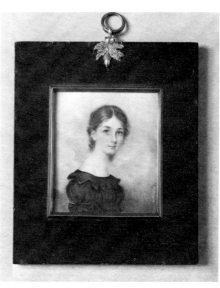

235.

236a. *Uniform of the First Troop, Philadelphia City Cavalry*

1825–30
REPRESENTED BY:
Horstmann Uniform Company
First Troop Uniform (tunic, breeches, helmet, belt, cartridge case, sword, scabbard, gauntlets, spurs, boots)

Wool broadcloth, cotton, cotton braid, leather, silver, metal

Philadelphia Museum of Art. Given by Dr. Wharton Sinkler, Jr. 48-15-1a–l

J. R. Smith (1775–1849) after W. M. Huddy (act. 1837–47)
Riding Dress, First Philadelphia City Troop
1839
From *The U.S. Military Magazine*
Color lithograph
11½ x 9¼″ (29.2 x 23.4 cm)

Philadelphia Museum of Art. Purchased: Thomas Skelton Harrison Fund. 42-30-88

236b. *Uniform of the Second Troop, Philadelphia City Cavalry*

c. 1825
REPRESENTED BY:
Second Troop Uniform (jacket, breeches, helmet, belt, cartridge case, sword, scabbard, boots)
1899
Wool broadcloth, wool knit, silk braid, leather, silver, metal

Philadelphia Museum of Art. Given by Mr. and Mrs. Henry A. Peirsol, Jr. 67-92-1-11

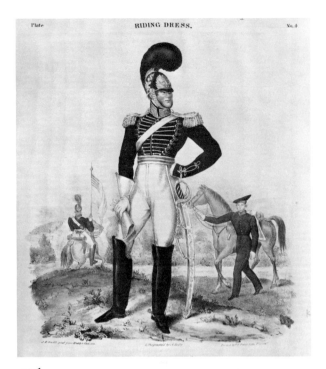

236a.

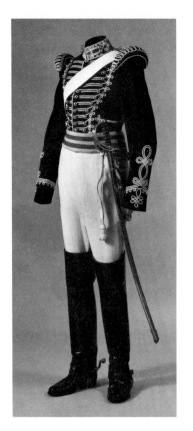

236a.

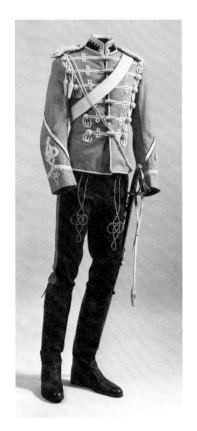

236b.

THE FIRST TROOP, Philadelphia City Cavalry, is the oldest continuing unit of the United States armed services today. It was founded in 1774 by a group of prominent Philadelphians, members of the Gloucester Fox Hunting Club (see no. 126), who organized the troop for "the defense of the rights of their threatened country." The troop served as a unit from 1776 to 1783 and was present at several major battles; the troop's cartridge case inscription commemorates two of these engagements—the battles of Trenton and Princeton. The troop also served as bodyguard for General Washington during the Revolutionary War and has escorted every president of the United States who has visited Philadelphia.

The style and format of the First Troop uniform have not changed since the late 1820s. It is a combination of light and heavy cavalry dress. The navy blue wool tunic, in Hussar style, is adorned with rows of white braid and silver buttons; similarly braided padded epaulets extend the shoulders and a stiffened red wool band collar, encrusted with braid, encircles the neck. The breeches are plain white cotton knit and fit snugly into the high black leather boots, equipped with spurs. Additional accouterments include a tall helmet crested with feathers, a dress sword in a plain scabbard, and a black leather cartridge case with silver emblem and monogram of the troop.

This same riding dress uniform is shown in the 1839 plate from Huddy and Duval's *U.S. Military Magazine* dedicated to the troop itself. An earlier version of the First Troop uniform, from the period of the War of 1812, is seen in a watercolor by Svinin (no. 182a). The later—now traditional—uniform is somewhat different from it: the jacket is now cut in back to the waist only, the helmet is no longer a bicorne, and the boots are higher and the epaulets, more rounded and higher.

Called the Philadelphia Light Dragoons during the Revolution, the Second Troop, Philadelphia City Cavalry, developed from the Independent Troop of Horse of Philadelphia City, which fought gallantly during the 1760s in the French and Indian wars. In 1794 it was called out to help suppress the Whiskey Insurrection, and later joined with the First Pennsylvania Cavalry Regiment during the War of 1812. The members, in addition, performed escort duty to Presidents Washington and Adams, and the Marquis de Lafayette when he visited Philadelphia in 1824 (see no. 218). The troop was disbanded around 1850, but in 1896–97 several of the descendants of the original group, wishing to recall its past achievements and glory,

decided to re-establish the unit, bringing it into the National Guard of Pennsylvania.

The full dress uniform shown here—scarlet Hussar jacket with white braid and buttons, blue knit breeches with broad red stripe, white leather baldric with cartridge case, saber belt of white leather (worn under the jacket), black fur busby with white plume and red busby bag, and short cavalry boots—was adopted when the Second Troop was reorganized and was first worn on October 2, 1899. However, its style dates back to the mid-1820s in keeping with the uniform of the First Troop.

CJ □

JOSEPH STUBBS (ACT. ENGLAND 1820–34)

Stubbs was one of several Staffordshire potters engaged after 1820 in producing transfer-printed wares whose trade was restricted almost exclusively to the American market. While more than twenty American views, including scenes of Boston, Philadelphia, New York, and New Jersey, can be credited to Stubbs's production, only a few English views have been recorded (Ellouise Baker Larsen, *American Historical Views on Staffordshire China,* New York, 1939,

p. 115; Sam Laidacker, *Anglo-American China*, Bristol, Pa., 1951, pp. 81–82).

Stubbs apparently succeeded his father, Benjamin, about 1820 as proprietor of the Dale Hall works. In 1829 the residence at Longport of "Josh. Stubbs Esq." was described as having "a very extended prospect southward along the Vale on whose northern banks the Potteries are established," and the potter himself, as "a gentleman long . . . esteemed for his excellencies of character" (Simeon Shaw, *History of the Staffordshire Potteries,* 1829, reprint London, 1970, p. 35). Between about 1828 and 1830, Stubbs entered into partnership; pottery produced during this period is marked accordingly "Stubbs and Kent" (W. L. Little, *Staffordshire Blue,* London, 1969, pp. 99–100).

In 1834, two years before his death, Stubbs seems to have retired from business. His molds and engraved plates, offered for sale in that year, were advertised as being of "the most modern and approved patterns suitable for the American and Home trade" (Wolf Mankowitz and Reginald G. Haggar, *Concise Encyclopaedia of English Pottery and Porcelain,* New York, 1968, pp. 211–12).

237a. *Tureen and Tray*

c. 1830

Inscription: Fairmount/near/Philadelphia (on back, in underglaze blue)

Glazed earthenware, transfer-printed in underglaze blue

Tray length 14¼″ (36.1 cm), width 11¾″ (29.8 cm); tureen length 16½″ (42 cm), width 10½″ (26.6 cm)

Private Collection

237b. *Platter*

c. 1830

Inscription: Fair Mount/ near/ Philadelphia (on back in underglaze blue)

Glazed earthenware, transfer-printed in underglaze blue

Width 20½″ (52.1 cm); depth 16¾″ (42.5 cm)

Philadelphia Museum of Art. Bequest of R. Wistar Harvey. 40-16-434

AN ENGRAVING of the Fairmount Dam and Waterworks by R. Campbell after a drawing by Thomas Birch (see biography preceding no. 188) was published by Edward Parker in 1824. Birch's design for the engraving was based on several of his views of the subject, including a painting of 1821 at the Pennsylvania Academy of the Fine Arts, executed at the time the waterworks and dam complex was completed (see no. 183). This great American engineering triumph,

celebrated by Birch in his paintings, was given international recognition by Joseph Stubbs through his printed earthenwares. Stubbs seems to have borrowed only the background of Birch's design showing the dam with the stuccoed stone house and the Greek revival pumping stations and, on the banks above, Lemon Hill and its greenhouse (no. 151), and Sweetbriar, owned by Samuel Breck (1797–1838). In the foreground, Stubbs created an isolated hillock on the west bank of the Schuylkill, from which a man and woman observe the scene. Stubbs's invention compares to the engraving by J. Cone after a design by Thomas Doughty (see biography preceding no. 226), published by C. G. Childs in 1828.

Since Stubbs's engraver necessarily had to adapt Birch's design to tablewares of differing proportions, there are minor differences in the views printed on tureen and platter. Both pieces, however, bear the handsome eagle, flower, and scroll border that characterizes Stubbs's American market products.

KH □

HENSHALL & CO. (ACT. ENGLAND 1775–1830)

A group of transfer-printed wares has only recently been attributed to the Henshall firm on the basis of a marked plate bearing the same fruit and flower border that characterizes other pieces in the series (W. L. Little, *Staffordshire Blue,* London, 1969, pp. 71–72). Little is known about the firm, which apparently involved partnerships between members of the Henshall-Williamson family during the period 1775–1830. The last documented partnership between Hugh Henshall Williamson and Robert Williamson was dissolved in 1830 (Wolf Mankowitz and Reginald G. Haggar, *Concise Encyclopaedia of English Pottery and Porcelain,* New York, 1968, p. 107), although by 1829 proprietorship of

237a.

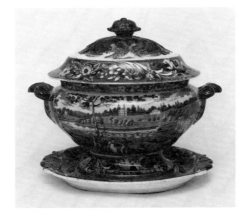

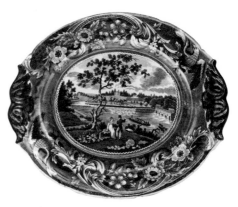

237b.

the manufactory of pottery at Longport is credited solely to "Messrs. Williamson" (Simeon Shaw, *History of the Staffordshire Potteries,* 1829, reprint London, 1970, p. 35). The firm produced transfer-printed pottery for American and English markets as indicated by the views on marked and attributed examples (see Geoffrey Godden, *Encyclopaedia of British Pottery and Porcelain Marks,* London, 1964, p. 321; Edith Gaines, ed., "Add Henshall & Co." *Antiques,* vol. 99, no. 1, January 1971, p. 110).

238. *Mug*

c. 1830

Inscription: THE DAM/ AND/ WATER WORKS/ PHILADELPHIA (printed on bottom in underglaze blue in floral cartouche)

Glazed earthenware, transfer-printed in underglaze blue

Height 5⅞″ (14.9 cm); width 7¾″ (19.1 cm); diameter 4⅝″ (11.7 cm)

Philadelphia Museum of Art. Purchased. 22-82-1

LITERATURE: Sam Laidacker, *The Standard Catalogue of Anglo-American China* (Scranton, Pa., 1938), p. 75, as "unknown"; Ellouise Baker Larsen, *American Historical Views on Staffordshire China* (New York, 1939), pp. 192–94, as "unknown maker"; W. L. Little, *Staffordshire Blue* (London, 1969), p. 72

LIKE JOSEPH STUBBS'S Dale Hall works (see biography preceding no. 237), the Henshall firm derived its view of the Fairmount Dam and Waterworks for their printed earthenwares from an original engraving by R. Campbell after Thomas Birch's design published in 1824 by Edward Parker. Henshall & Co. produced two versions of the scene with different foregrounds. Following the Birch engraving, the mug is decorated with a stern-wheeler that steams downriver in front of the dam. Other

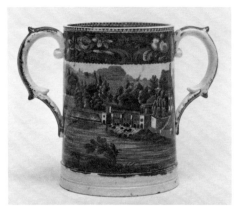

238.

examples in the Philadelphia Museum of Art show a steamboat with side wheel. All versions bear the fruit and flower border and printed titles within floral cartouches (on the reverse) that have provided the basis of attribution for such wares to the Henshall firm.

KH □

SMITH, FIFE AND COMPANY (ACT. C. 1830)

In addition to the Tucker factory (see biography preceding no. 249), other Philadelphia manufacturers attempted the production of porcelain in the first half of the nineteenth century. One Philadelphia factory that produced several outstanding examples of porcelain was Smith, Fife and Company.

While several pieces of marked Smith, Fife porcelain survive, very little is known about the factory and its owners. Similarities in the style of certain Smith, Fife pieces to those produced by the Tucker factory suggest that the company may have been formed by former Tucker potters.

At the 1830 Franklin Institute competition the committee of judges could not "omit paying a merited compliment to Messrs. Smith, Fife, and Company of this city, for two beautiful porcelain pitchers . . . and the Committee had only to regret that their display was not more extensive" (Woodhouse, "Philadelphia Porcelain," p. 135).

Even though the factory was in business for only about one year, the few remaining examples of Smith, Fife porcelain attest to Philadelphia's leading role in the production of American porcelain prior to 1850.

239. *Pitcher*

c. 1830
Signature: Smith Fife & Co./ Manufacturers/ Phila. (painted on bottom in red script over the glaze)
Inscription: T.MCA (script monogram in gold, on front below spout)
Porcelain
7½ x 8½" (19 x 21.5 cm)
The Brooklyn Museum, New York. Dick S. Ramsay Fund

PROVENANCE: Thomas McAdam, until 1844; family of Samuel W. Woodhouse

LITERATURE: Barber, *Marks,* pp. 20–23, figs. 5–6; Barber, *Pottery and Porcelain,* pp. 548–50, fig. 302; John Spargo, *Early American Pottery and China* (New York, 1926), pp. 220, 242–47; Woodhouse, "Philadelphia Porcelain," p. 135, fig. 4; "The Glass and China Cupboard," *Antiques,* vol. 45, no. 2 (February 1944), p. 88; Arthur W. Clement, *Notes on American Ceramics 1607–1943* (Brooklyn, 1944), pp. 29–30, pl. 42; Clement, *Pioneer Potters,* pp. 82–84, pl. 22; Marvin Schwartz and Richard Wolfe, *A History of American Art Porcelain* (New York, 1967), p. 22, pl. 8

ACCORDING TO FAMILY TRADITION this pitcher, referred to by the Woodhouse family as the "Franklin Institute pitcher," was one of a pair exhibited in the 1830 competition. Another pair of pitchers and four other small objects were also attributed to the factory, but the whereabouts of these are not known (Clement, *Pioneer Potters,* p. 83).

The shape of this pitcher is identical to the Tucker "Grecian shape" and features an overglaze enamel floral spray consisting of detailed roses, tulips, and forget-me-nots and heavy gilding reminiscent of Tucker decoration. These similarities to Tucker porcelain support the theory that Smith, Fife was organized by former workers in the Tucker factory.

Letters by Benjamin and William Tucker also support this possibility. In 1830,

239.

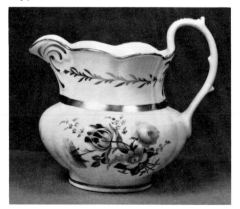

Benjamin Tucker noted, "A similar unsuccessful attempt has been made by some of my son's own workmen who had vainly persuaded themselves they had obtained by their observations in his factory a knowledge of his art" (PMA, Letter Book of Benjamin Tucker, December 4, 1830). Writing to John F. Anderson of Louisville, Kentucky, on December 20, 1830, William Tucker stated, "This is to inform you that Smith and Fife have absconded from this city without giving any intelligence where they were going, leaving their debts unpaid. Since which time the Sheriff has seized upon the scanty remains of their moulds etc. which will go but a short distance toward liquidating their debts—as I expect they intend going to your city, I thought it best to appraise you of these facts, so that you may not be taken in by them (PMA, Letter Book of Benjamin Tucker).

PHC □

MICHEL BOUVIER (1792–1874)

Michel Bouvier was born in March 1792 in Pont Saint-Esprit on the Rhone River in southern France. He was apprenticed to and trained by his father, a *menuisier ébéniste.* After serving in the army under Napoleon, Bouvier immigrated to New York in 1815, where he soon became a successful carpenter. In 1817 he settled permanently in Philadelphia and established his own cabinetmaking shop. He is first listed in the Philadelphia city directories as a cabinetmaker in 1819. Among his first important patrons was his compatriot Joseph Bonaparte, Napoleon's brother and the ex-king of Spain, who built a large house at Point Breeze on the Delaware River near Bordentown, New Jersey, in 1818. After this house was destroyed by fire in 1820, a second house was constructed on the same site under Bouvier's supervision. Bouvier's shop probably also provided much of the furniture for the new mansion. Through his work for Bonaparte, Bouvier came to the attention of Stephen Girard, a fellow French émigré who had amassed a fortune in America. Additional commissions came from other wealthy Philadelphia patrons, including James Skerret, the owner of Loudon.

When he was thirty-six and a widower with two children, Bouvier met Louise Vernou, the daughter of a French nobleman and the granddaughter of one of Washington's officers. They were married on May 29, 1828, at St. Augustine's Catholic Church, and subsequently had ten children. At this time his "cabinet and sofa warehouse" was located at 91 South Second Street; but in addition to making custom pieces for his regular clients, Bouvier started a wholesale and retail business in mahogany boards, logs, and veneers, and in "hair seating" for

upholsterers. With wood scraps at his disposal, he also became a supplier of firewood, and, as Pennsylvania anthracite became acceptable as a fuel in the late 1820s and early 1830s, Bouvier also became a coal dealer. To transport these commodities, he bought two drays and a van, which he put to use in yet another sideline business—moving household goods. He also offered to do general house repairs. Later he listed himself as a manufacturer of veneers and a dealer in mahogany and marble.

As the city of Philadelphia expanded in the late 1840s, Bouvier began buying real estate in and around the area, as well as tracts of potential coalfields in West Virginia. His business successes enabled him to take his family on a visit to Europe in 1853, and to build a house at 1240 North Broad Street (now demolished), which at the time was one of Philadelphia's most lavish. He died in Philadelphia on June 9, 1874. (See John H. Davis, *The Bouviers: Portrait of an American Family,* New York, 1969.)

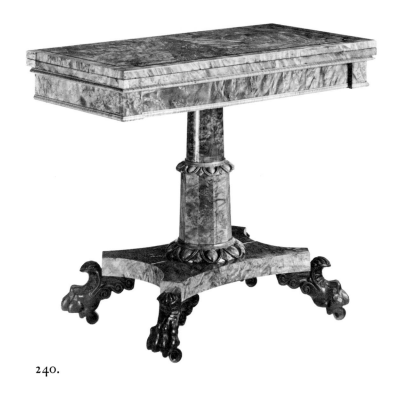

240.

240. *Card Table*

c. 1830

Mark: M. BOUVIER,/ Keeps constantly on hand,/ CABINET WARE,/Mahogany, hair-seating &c./ At No. 91 So: 2d St./PHILADa (stenciled in well of card table)

Inscription: Given to Susan Ross Larkin on/her wedding day—1830—in Phila/& given by her to her daughter on her/wedding day—1878—Susan G. Adsit./From Susan G. Adsit to her/daughter May Adsit Cook/and then given in turn to/her daughter Susan Ross Cook/1931 (in well of card table)

Maple; white pine feet; mahogany playing surface; rosewood cross-banding in top; white pine, tulip, yellow birch, and chestnut

30 x 35⅞ x 18⅜" (closed) (76.2 x 91.1 x 46.6 cm)

Mr. and Mrs. Donald L. Fennimore, Wilmington, Delaware

PROVENANCE: Susan Ross Larkin; daughter, Susan G. Adsit; daughter, May (Adsit) Cook; Susan Ross Cook, all of Philadelphia; with Pennsylvania dealer (?); Howard M. Barnes, Doylestown, Pennsylvania; auction, Buckingham, Pennsylvania, 1972

LITERATURE: Donald L. Fennimore, "A Labeled Card Table by Michel Bouvier," *Antiques,* vol. 103, no. 4 (April 1973), pp. 760–63, illus. p. 760

AMONG THE GREAT documented pieces of Philadelphia classical revival furniture, this card table has not only the maker's label but an inscription listing its owners until 1931

as well as the exact date (1830) it was first acquired. The stenciled label gives the address where Bouvier's cabinet and sofa warehouse was located between 1825 and 1844. The stencil also pictures a dressing table from plate 348 of Mésangère, a design source frequently used by Bouvier and other Philadelphia cabinetmakers.

Similar designs to this card table are found in Nicholson's *Cabinet Maker,* plate 72, and Loudon's *Cottage, Farm, and Villa Architecture,* fig. 1953. The Bouvier table differs, however, in the use of curly maple veneer, which was widespread in Philadelphia. Work veneered in maple was listed in *The Journeyman Cabinet and Chairmakers' Pennsylvania Book of Prices for 1811* as an extra that cost twenty cents. The carved and ebonized white pine feet and the claw under a curled leaf with scrolls behind are also characteristic of Philadelphia work. *The Philadelphia Cabinet and Chair Makers Union Book of Prices,* published in 1828, includes a description of this type of table, described as a "Pillar and Claw Card Table," at $5.50.

DH □

HUGH BRIDPORT (1794–c. 1869)

Born in London, Hugh Bridport studied with the miniature painter Charles Wilkin and at the Royal Academy, where he exhibited three miniatures in 1813. He came to Philadelphia about 1816 and opened a drawing academy with his brother, George,

at 6 South Eighth Street. Bridport participated in the Pennsylvania Academy's exhibition of 1817, showing seven paintings, including landscapes and two miniatures. In 1818 he and the architect John Haviland (see biography preceding no. 215) conducted an architectural drawing school, and Bridport engraved all the plates for Haviland's book, *The Builder's Assistant,* published in 1818. Both Bridport and Haviland responded to an advertisement in the Philadelphia newspapers on May 12, 1818, in which "Architects of science and experience" were invited to submit plans for a building to house the Second Bank (no. 202), and Benjamin Latrobe wrote in 1818 that William Jones, first president of the Second Bank, "is accused by public opinion of having thus favored the individual [Strickland], whose project was greatly inferior to the beautiful model of Mr. Bridport..." ("Notes and Documents, A Latrobe Letter in the William Jones Collection," *PMHB,* vol. 67, no. 3, 1943, p. 293).

Although Bridport is listed as an architect in the city directory for 1819, he continued to paint and teach drawing, and exhibited two miniature portraits of gentlemen at the Academy in 1820. In 1824 he was elected an Academician. Dunlap recorded that Bridport was "residing in Philadelphia principally, but occasionally exercising his art of miniature painting in other parts of the country" (*History,* vol. 2, p. 274), including Massachusetts in 1820 and Troy, New York, in 1822.

In 1824 he was one of the original members of the Franklin Institute, and assisted Haviland in teaching the drawing school. The next year Bridport served as a judge for the annual exhibition of manufacturers at the Franklin Institute and in 1826 he became a teacher in the drawing school, a position he retained until 1833.

His listing in the Philadelphia city directories, although it does not appear every year, continues through the 1820s and 1830s as a portrait painter and miniaturist at various addresses along with his wife, Rachel, a dressmaker. Beside painting, Bridport did engravings of works by Neagle, Stuart, and Trott (Stauffer, vol. 2, pp. 47–48), and drew portraits on stone for some of the early Philadelphia lithographers (Stauffer, vol. 1, p. 29). He continued to exhibit paintings, mostly miniatures, at the Academy's annual shows and with the Artists' Fund Society through 1845. After 1848, he is listed as "gentleman" in the city directories.

AS

241. *Unknown Man*

c. 1830
Mark: Painted by/H. Bridport./Phila. (on reverse of frame)
Watercolor on ivory
3 x 2½" (7.6 x 6.3 cm)
Mrs. Andrew Van Pelt, Radnor, Pennsylvania

PROVENANCE: Lucy Wharton Drexel, 1911

LITERATURE: Charles Henry Hart, *Descriptive Catalogue of the Collection of Miniatures Owned by Lucy Wharton Drexel* (Philadelphia, 1911), no. 73

THE TIGHT TREATMENT and sleek finish of Hugh Bridport's portrait of a man, done around 1830, characterized most miniatures executed after the third decade of the century. Although New York was fast becoming the artistic center of the nation, Philadelphia artists continued to paint many of the best miniatures. Bridport's portraits are executed with a fluency and clarity in technique and a fine sense of color also found in those of George Catlin, done in the early 1820s in Philadelphia, and in James R. Smith's unassuming portraits of Philadelphians.

Growing middle-class demand for literal transcriptions of reality in portraiture was satisfied by surface detail, hard, clean outlines, a sleek finish, and strong contrasts of light and shadow, which "did not derive from the daguerreotype and its successors even though its results are often characterized as photographic" (Virgil Barker, *A Critical Introduction to American Painting,*

New York, 1931, p. 12). Trained in England, Bridport, like Thomas Sully, Robert Fulton, and Henry Inman, had developed his highly finished technique, use of dark, opaque coloration, and strong contrasts from an earlier, looser, and more delicate style.

RB-S □

THOMAS DOUGHTY (1793–1856) (SEE BIOGRAPHY PRECEDING NO. 226) AND OTHERS

242. *The Cabinet of Natural History and American Rural Sports*

1830–33
Title page: The Cabinet of Natural History and American Rural Sports with illustrations. Vol. 1 Philadelphia Published by J. & T. Doughty 1830
Printed book, vol. 1 of 3 vols., 298 pp., with lithographic plates, engravings, and woodcuts, bound in half leather
11½ x 9⅜ x 1⅝" (29 x 23 x 4 cm)
The Library Company of Philadelphia

LITERATURE: *The Ariel,* March 31, 1832; Whitman Bennett, *A Practical Guide to American Nineteenth Century Color Plate Books* (New York, 1949), p. 35; Wainwright, *Early Lithography,* p. 22; PAFA, *Doughty,* pp. 16–17

THE LONG-STANDING INTEREST of Americans in their native flora and fauna is witnessed by the numerous colorplate books which began to appear in America at the beginning of the nineteenth century. Among the most important early contributions of native

241.

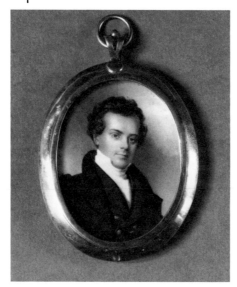

authorship and production were William Bartram's books on the flora of North America and John and Thomas Doughty's *Cabinet of Natural History and American Rural Sports.* The latter was an especially interesting undertaking as it was issued monthly in serial form.

The peripatetic Thomas Doughty was painting numerous landscapes in the mid-Atlantic states during the 1820s, many of which were published in portfolios, gift books, and periodicals. Both Thomas and his brother John were keen naturalists, and in 1830 they began to publish a journal which would combine the artistic talents of one and the zoological knowledge of the other. Their purpose, as stated in a blurb printed on the wrapper of the first issue, was to embrace "every interesting object of Natural History scattered over our widely extended continent. The representations given, shall be as perfect as possible, and always from nature, whenever it is in our power to obtain a subject to sketch from.... This work will be issued monthly, in a quarto form, and printed with a new type, on fine royal paper. Each number will contain twenty-four pages of closely printed matter, and embellished with two beautiful coloured plates, of Birds and Quadrupeds." The cost of a subscription was eight dollars per year. The articles on mammals were to be authored by "a Gentleman" of Philadelphia, and the editors freely acknowledged their heavy debt to Alexander Wilson's writings on ornithology.

The Doughty brothers also hoped to reach a diverse audience, noting in the introduction to the first volume, "No branch of human learning is more intimately connected with the other sciences, than that of Natural History.... Even the fine arts, though generally considered as peculiarly appertaining to the domain of the imagination, greatly depend upon a knowledge of Natural History." However, readers were also told that the editors would not hesitate to present nature in its best light, rather than in any "mean and uncouth" states. Romanticism held full sway!

Thomas Doughty called on his old friend and neighbor Cephas Childs for technical assistance in the execution of his first illustration, *The Ruffled Grouse or Pheasant,* which bears the imprint, "From Nature by T. Doughty on Stone C. G. Childs Direx." Doughty's lithographs were all printed by Childs's firm, which became Childs & Inman by the time of his third plate. Childs also engraved the calligraphy on the title page to the first volume, after lettering by T. M. Raser. Curiously the first plate illustrating the initial issue of the *Cabinet* was not one of the lithographs, but an etching of *The Common Deer* by newly arrived mezzotint engraver John Sartain (see biography

preceding no. 319). Apart from the frontispieces and title pages it was to be the only engraving in the *Cabinet*'s three volumes, although occasional woodcuts by Richard Gilbert were included.

The sources of the illustrations were always identified, and it should be remembered that "From Nature" generally indicated that the drawing was made from a stuffed specimen, and "From Life" was more often than not a caged animal in a traveling menagerie. Some pictures failed on account of their obvious lifelessness; the *Argali* (mountain goat) looks as wooden as the taxidermist's stand on which it was stretched. Doughty always composed a habitat suitable to the wildlife depicted, whether the bleak terrain in which the *Newfoundland Dog* might roam; ubiquitous rivers, lakes, and waterfalls for ducks and birds; or a thunderous sky every bit as threatening as the quills of the *American Porcupine*. Richardson has remarked that Doughty "was never a strong or well-trained painter. His style was monotonous in color and naïve in composition" (E. P. Richardson, *Painting in America*, New York, 1956, p. 157). In the relatively small, quarto format it was difficult to infuse landscape with the grandeur, and animals with the magnificence, that Audubon achieved in his enormous folio plates (see no. 272); however, there is a directness and honest sympathy for nature in Doughty's lithographs for the *Cabinet* unmatched by many grander publications.

In the plate showing the *Summer Duck* (wood duck), which is typical of Doughty's work for the *Cabinet,* the subject is seen at close range, with a suggestion of its usual environment in the background. The summer duck, found throughout the eastern United States, generally inhabits forested areas near rivers and streams. Doughty has placed this specimen on a branch above a clump of bulrushes at the water's edge; on the opposite shore, rocky hills rise up steeply. The setting is reminiscent of much of the upstate New York scenery Doughty was so fond of sketching and painting, and he must have been familiar with this species and its habitat.

The soft crayon used to draw on the lithographic stone gives a pleasant haziness, a painterly quality that one might expect from a painter-lithographer. Doughty's black-and-white lithographs were greatly enhanced by hand coloring, making the illustrations more varied and vivid. The overall effect fits in much more easily with the prevailing taste for romanticism than do the crisp line engravings by Alexander Lawson that illustrated Alexander Wilson's *American Ornithology* (no. 171).

Some of the illustrations were sufficiently gory to please even the most bloodthirsty of sportsmen, and were included even

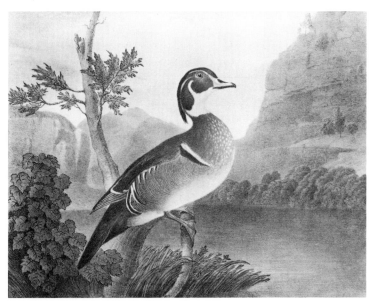

242. *Summer Duck (Wood Duck)*

though they would not appeal to more romantic sensibilities. A review in the *Ariel* of March 31, 1832, praised one of the plates above all others: "The delineation of the Horned Owl fastening upon a rabbit is extremely happy;—you see before you the bird gloating over its victim and spreading its huge wings in exultation at the success of its exertions—the finish is high and perfect."

While Doughty was supplying the publication with two plates each month, the economic situation in the United States deteriorated to a point where businesses and banks failed daily. The editors of the *Cabinet* were obliged to inform readers on the wrappers that "Notes of solvent Banks, of a less denomination than Five Dollars, [would be] taken in payment for subscriptions." An influenza epidemic took its toll on the illustrations; readers were also told that most of the young ladies hired to color the lithographs were stricken and the plates were late. By 1832 the Doughtys felt confident enough to state that the second volume would be "in a style altogether superior to the 1st vol.; the drawings will be of the most elegant kind; and we will challenge a comparison with any other work ever published in the United States, for beauty and correctness of delineation. We shall, probably, omit the regular series of wood-cuts; but the extra quality of the drawings, and the superior style of the engravings which will appear through the course of the next volume will more than twofold counterbalance the omission we contemplate" (wrapper, vol. 1, no. 12).

Since each issue was worked on two months in advance of publication it is possible that John Doughty knew of his

brother's discontent when he made the above statement, for by May 1832 he issued a notice on the wrapper of the third number of volume 2 of the dissolution of their partnership. The responsibility for producing the illustrations was assumed by M. E. D. Brown, a former pupil of the Boston lithographers John and William Pendleton, and Doughty returned to Boston to resume full-time painting and teaching. He had contributed twenty-three lithographs and three designs for title-page vignettes, which established the pattern for the magazine. Brown's prints followed much the same format, although perhaps they showed greater professionalism in the handling of the medium. Other artists contributing designs included J. G. Clonney, Peter Rindisbacher, and Sir Edwin Landseer.

A change in artists was not enough to help the struggling *Cabinet,* and John Doughty had to make a direct appeal to his readership: "It is with feelings of regret, that the Editor of the work is compelled to state, that unless he should receive a greater patronage than he has at present, he will be obliged to discontinue the 'Cabinet of Natural History,' after the present volume of 13 Nos. [sic] is completed.... as many no doubt withdrew under the pressure of the times. He would respectfully ask of those, to reconsider the case, and sustain him, at any rate, for one or more years; to these gentlemen the price of the work can be of no object.... Under this hope, the Editor proposes to visit the Southern States where the work appears much called for ..." (wrapper to vol. 2, no. 6).

The appeal, combined with the trip, gave Doughty enough capital to publish four numbers of the third volume. For some

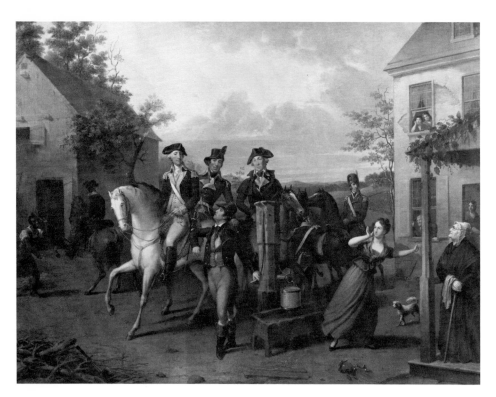

243.

In 1823, Eichholtz left Lancaster and set up his studio in Philadelphia, where he carried on a lively trade in portraits, many of which were of notable Philadelphians. He showed his work in the exhibitions of the Society of Artists in 1811, 1812, 1813, and 1814, and at the Pennsylvania Academy almost yearly from 1823 until 1842. He was elected an Academician in 1824. Several of his portraits were engraved by his friend and onetime neighbor on Sansom Street, John Sartain. By 1832, Eichholtz was successful enough to move back to Lancaster, where he died in 1842.

AS

243. *An Incident of the Revolution*

1831

Signature: J. EICHHOLTZ 1831 (lower right on step)

Oil on canvas

48½ x 66″ (123.2 x 167.6 cm)

Museum of Fine Arts, Boston. M. and M. Karolik Collection

PROVENANCE: W. C. Mullen, Upsal, Pennsylvania, 1912; with John Levy, New York, 1945; Maxim Karolik

LITERATURE: Karolik, *Painting,* pp. 248–49, illus. no. 112; Beal, *Eichholtz,* no. 906, p. 263, illus. p. 367; Los Angeles County Museum of Art, *American Narrative Painting* (October 1–November 17, 1974), p. 42, no. 11 (illus.)

EICHHOLTZ EXHIBITED THIS PAINTING at the 1831 Pennsylvania Academy exhibition under the title *Revolutionary Anecdote.* In the catalogue he explained that it was a "first attempt in historical composition" and he quoted from Green's *Anecdotes of the War* to describe the action and point out the moral of the scene: The famous general Charles Lee had the reputation for negligence in dress and eccentricity in his manners. Riding in advance of Washington and his troops one day, he was mistaken for a servant by a kitchen maid, who put him to work in return for a cold meal. Eichholtz shows the climactic moment when Washington arrives and the embarrassed girl realizes her mistake. Undaunted, Lee turns to an aide-de-camp with the moral of the story: "You see, young man, the importance of wearing your coat whole at the elbows, when, if even a general neglects it, a country girl can turn him to a scullion" (PAFA, *21st Annual, 1831,* no. 38, p. 17).

Painted at the end of his successful decade of portrait painting in Philadelphia, *An Incident of the Revolution* is one of Eichholtz's few history paintings. At the 1831 Academy

reason the last several plates by M. E. D. Brown were not printed by Childs & Inman (who were about to dissolve their partnership), but by the Boston firm of Pendleton, and New York lithographer Edward Mesier. Possibly Thomas Doughty's old connections were able to give him a better price; they were not sufficient, however, to save a pioneering venture.

The printing history of the *Cabinet*'s plates illustrates some of the complicated interrelationships between early lithographers in Philadelphia, New York, and Boston. Doughty probably learned the technique of lithography from the Pendletons, when he was their neighbor in Graphic Court in Boston. John Pendleton had been in partnership with Doughty's good friend Cephas Childs in Philadelphia, and Childs printed all the plates for the first volume of the *Cabinet* and some of the second. When Doughty left the *Cabinet* to return to Boston in 1832, Childs & Inman ceased printing the *Cabinet*'s illustrations, a task shared between New York lithographer Edward Mesier, and a former Pendleton employee M. E. D. Brown, who in turn hired another former Pendleton apprentice, Nathaniel Currier. When Brown returned to Boston in 1833, Currier set up his business in New York; the first print known to have been issued from his workshop bore the signature of M. E. D. Brown. The last few plates of the third volume of the *Cabinet* were printed in Boston by the Pendletons, with whom

Doughty had remained friendly. Out of the intermingling friendships grew the fierce competition which became the story of lithography in mid-nineteenth century America.

SAM ☐

JACOB EICHHOLTZ (1776–1842)

Born in Lancaster, Pennsylvania, Jacob Eichholtz showed interest in drawing as a child and was given lessons by a local sign painter, but received no further training. He set up business as a coppersmith about 1802, and divided his time between his trade and painting portraits for local clients. In 1808, when Thomas Sully visited Lancaster to execute a commission, Eichholtz lent him his studio. In turn, Sully offered the aspiring artist instruction and encouragement, although he noted in a letter that Eichholtz's "attempts were hideous" (Dunlap, *History,* vol. 2, p. 230).

Eichholtz showed his portrait of Nicholas Biddle to Gilbert Stuart in Boston around 1811. The criticism he received was stringent; Eichholtz reported, "If I had vanity before I went, it left me all before my return" (Dunlap, *History,* vol. 2, p. 229). Nonetheless, in 1812 at the age of thirty-six, he left his trade and turned exclusively to painting. He frequently traveled as far as Philadelphia, Harrisburg, and Baltimore to paint portraits

exhibition the work was juxtaposed in the same gallery with John Trumbull's 1789 *The Sortie of Gibraltar,* borrowed from the Boston Athenaeum. In comparison to Trumbull's dramatic scene of heroic death in battle, Eichholtz's amusing incident in a farmhouse yard at first appears to have more in common with the conventions of genre than with the tradition of history painting. Unlike a typical genre scene, however, wherein the narrative is acted out by stock characters in a series of familiar, self-explanatory incidents, *An Incident of the Revolution* illustrates an actual event from history, although a minor one, and teaches a moral lesson. The choice of subject indicates an entirely different conception of the kind of event appropriate for an historical composition, but Eichholtz's description of his work and his lengthy catalogue text explaining the event suggest that he was conscious of the precedent—stated theoretically by Reynolds and exemplified by West, Trumbull, Sully, and Rembrandt Peale, among artists whose work he might have seen at the Academy—that the representation of historical subjects was a more elevated pursuit for an artist than portraiture.

As E. P. Richardson has pointed out (Beal, *Eichholtz,* pp. xix–xxii), Eichholtz developed his painting style through practice and not according to current art theory. His study of the work and writings of other artists had the pragmatic end of improving his ability to paint portraits, and not to prepare him to work in a higher realm of art. But he sympathized with those who aspired toward history painting. In a letter to Thomas Sully, dated January 19, 1817, Eichholtz expressed the hope that Sully's "historical powers will now be called into action." And he continued, "It is certainly the wish of many of your friends that your talents be devoted to nobler subjects than portraits" (Beal, *Eichholtz,* p. 377).

The large composition of *An Incident of the Revolution,* with its buildings and landscape, the idealized figure of Washington—as portrayed by Sully in *The Passage of the Delaware* and by Rembrandt Peale (see no. 216)—and the numerous other figures carefully posed to emphasize the narrative, is not merely an elaboration of Eichholtz's usual, factual portraiture. It reflects his understanding of the tradition of history painting, which he admired but did not usually practice.

DS □

WILLIAM ALLBRIGHT (BORN C. 1795)

Born in Pennsylvania, Allbright was a landscape painter, limner, and drawing teacher who worked primarily in Philadelphia. His activities are for the most part undocumented. In 1824 and 1829, Allbright is recorded as residing in Baltimore, and according to the 1850 census he was then in Philadelphia. His drawings on stone for *The Floral Magazine and Botanical Repository* evidently represent his single professional venture into the lithographic technique.

244. *The Floral Magazine and Botanical Repository*

1832–34
Published by D. & C. Landreth Nursery and Seedsmen
Plates lithographed by the firms M. E. D. Brown, Childs & Inman, Kennedy &

Lucas, and J. F. & C. A. Watson; title page engraved by J. & W. W. Waitt, vignette engraved by J. B. Longacre after J. [*sic*] Allbright

Printed periodical, six issues bound in one volume, including 31 hand-colored lithographic plates and engraved title page
Volume open 11½ x 18¾″ (29.2 x 47.6 cm); plates approximately 11⅛ x 8⅞″ (28.3 x 22.5 cm)

The Library Company of Philadelphia

LITERATURE: Groce and Wallace, p. 5; Katharine McClinton, "American Flower Lithographs," *Antiques,* vol. 49, no. 6 (June 1946), pp. 361–63; Frank Luther Mott, *A History of American Magazines 1741–1850,* vol. 1 (Cambridge, Mass., 1938), p. 519; Wainwright, *Early Lithography,* pp. 22, 25

AMONG THE EARLIEST MAGAZINES to be printed by lithography in America, *The Floral Magazine and Botanical Repository* was first issued in July 1832. A total of six

244. *Camellia Japonica*

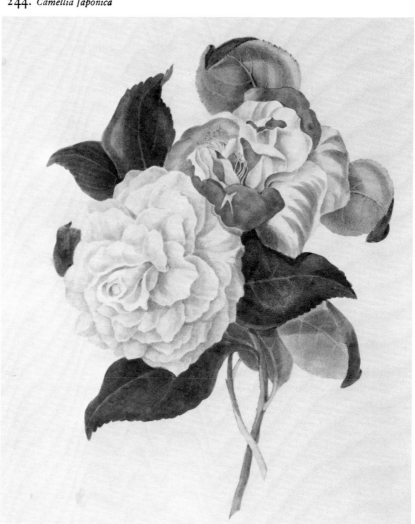

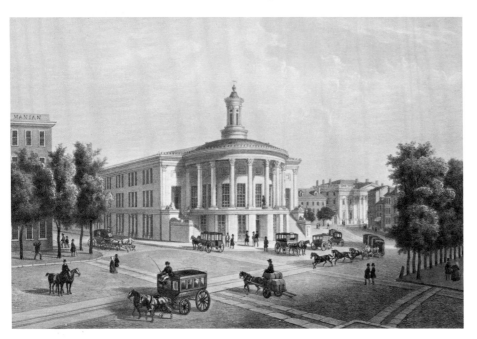

245.

issues, each with hand-colored lithographic plates of exotic flowers and citrus, appeared at irregular intervals until the fall of 1834.

The production of *The Floral Magazine* entailed the joint efforts of publisher, lithographer, and artist, the guiding spirit being the publishers D. and C. Landreth, proprietors of Philadelphia's largest nursery and seed establishment, founded in 1789. Ostensibly a good promotional vehicle for the nursery, the magazine familiarized the public with a variety of available flowers, including the then fashionable *Camellia japonica*.

Although not the first Philadelphia magazine to be illustrated with a significant number of lithographs—the illustrated *Cabinet of Natural History and American Rural Sports* (no. 242) began publication in Philadelphia in 1830—*The Floral Magazine* was modeled on botanical periodicals published in London, such as *The Botanical Register* and in particular *Curtis's Botanical Magazine; or Flower Garden Displayed,* which had widespread currency in America. Although the plates in the English periodicals were engraved rather than lithographed, the format and content of these publications were followed in the Landreths' magazine—colored plates facing a page or two of descriptive text. The innovation of *The Floral Magazine,* beside its use of lithography, was the inclusion of hints for cultivation. These were aimed at an audience less interested in strictly botanical information than the more science-oriented British amateur gardener.

The plates in *The Floral Magazine* were also more ornamental in design than the engravings in the British magazines, which frequently showed details and cross-sections. *The Floral Magazine* was further enhanced by the suitability of its illustrations for ladies' drawings and needlework.

The relatively new and inexpensive technique of lithography, with its shadowy tones and soft contours, was well suited to a decorative rather than scientific treatment of subjects. *The Floral Magazine* emerged at a time when these qualities were being exploited by the first commercial lithographic houses of Philadelphia with the production of prints of views, portraits, animals, and birds. Kennedy & Lucas, the city's first lithographic establishment, founded in 1828, printed two of the plates in *The Floral Magazine.* Several others were printed by Childs & Inman, the most prolific of the Philadelphia lithographers, and J. F. and C. A. Watson. Most of the plates (seventeen of thirty-one) were the work of the firm of M. E. D. Brown. But the first flowering of commercial lithography in Philadelphia was short-lived. During the magazine's two-year run, the presses of Childs & Inman and Kennedy & Lucas both shut down.

The role of the artist in lithography publishing varied considerably during this period. Sometimes lithographic firms retained their own draftsmen to execute drawings on stone to be printed. Albert Newsam (see biography preceding no. 267) was such an employee of Childs & Inman. In other instances an artist would contract the lithographic firm to print from stones already prepared by him, as Thomas Doughty did for the plates in his *Cabinet of Natural History and American Rural Sports.*

Apparently this was the procedure followed for *The Floral Magazine,* where the initiative for the project must have been taken by the publishers, D. & C. Landreth. Allbright's role in the enterprise was probably limited to the execution of the flower drawings on stone, as is noted on each plate. He was presumably among many Philadelphia artists who adopted the lithographic technique as an innovative and inexpensive medium.

The cessation of *The Floral Magazine* coincided with the end of this brief flourishing of commercial lithography in Philadelphia. But its example prompted later, similar ventures in New York and Boston, such as Thomas Fessenden's *The Horticultural Register and Gardener's Magazine* (Boston, 1835–38).

BR ☐

WILLIAM STRICKLAND (1788–1854)
(See biography preceding no. 202)

245. *Philadelphia Exchange Company (Merchants' Exchange)*

Third, Walnut, and Dock streets
1832–34
John Struthers, marble mason; John O'Neill, master carpenter
Inscription: W. STRICKLAND ARCHITECT/ J. STRUTHERS MASON (on inner face of curved portico's architrave)
Brick, faced with coursed Pennsylvania marble ashlar; brick-vaulted ceilings
95' 4¾" x 152' 8½" (29.2 x 47 m); height 113' 5⅛" (34.5 m)

REPRESENTED BY:
Deroy (n.d.) after Augustus Kollner (1813–1906)
Merchants' Exchange
1848
Hand-colored lithograph
7⅜ x 10⅞" (18.8 x 27.6 cm)
Philadelphia Museum of Art. 37-39-123

LITERATURE: Joseph Jackson, *Development of American Architecture, 1783–1830* (Philadelphia, 1926), pp. 206–7; Hamlin, *Greek Revival,* pp. 79–80; Gilchrist, *Strickland,* pp. 10, 85–87; Agnes Addison Gilchrist, "The Philadelphia Exchange: William Strickland, Architect," in *Historic Philadelphia,* pp. 86–95; White, *Philadelphia Architecture,* pls. 26, 27; Tatum, pp. 67–68, 137, 173, pl. 59

BY THE EARLY NINETEENTH CENTURY Philadelphia's commerce had outgrown the modest accommodations of the coffeehouses that had served as the city's merchants' exchanges since William Bradford had opened the London Coffee-House at Front

and Market streets in 1754. Accordingly, the Philadelphia Exchange Company was formed in 1831, and William Strickland was commissioned to design an exchange building on the triangular lot bounded by Third, Walnut, and Dock streets. It was a good location, easily accessible to the waterfront and the city's three major financial institutions—Girard's Bank (formerly the Bank of the United States, no. 142) on Third Street, the Bank of North America, and the Second Bank of the United States (no. 202) on Chestnut Street.

Strickland took full architectural advantage of the slightly elevated, relatively isolated site. His biographer suggests that when he viewed the site from the east he was evidently impressed by the commanding presence of the former Bank of the United States with its Corinthian portico, which determined the order to be used for the Exchange (Agnes Addison Gilchrist, "The Philadelphia Exchange: William Strickland, Architect," in *Historic Philadelphia*, p. 90). That was but the first step. The problem was to develop a design that would make the most of the triangular lot. This Strickland achieved by facing the front of the building east toward an apex of the lot and designing a curved Corinthian colonnade ranging across the second and third stories. For the Exchange's crowning glory, Strickland turned to his favorite text, Stuart and Revett's *Antiquities of Athens,* and perhaps also inspired by the London Exchange, completed in 1821, he placed on the roof a lantern copied from the Choragic Monument of Lysicrates, whose form and ornament complemented that of the graceful colonnade below. Tripartite windows carry the design rhythmically around the sides to the rear where the imposing tetrastyle portico rests on squat piers.

After the occupancy of various tenants and renovations in the late nineteenth century, the building's interior was gutted and rebuilt in 1900 from the designs of Louis Hickman. In 1922 it became the city's produce exchange, and for the next thirty years it was surrounded by galvanized awnings, trucks, and the odors of fresh and not-so-fresh fruits and vegetables. But better days returned in 1952 when the Exchange became part of Independence National Historical Park, and its exterior was restored by the National Park Service. It stands today as a monument to the good taste of Philadelphia's merchants of the 1830s and William Strickland's sensitive understanding of the Greek style.

RW □

THOMAS USTICK WALTER (1804–1887)

Thomas U. Walter's career developed in a manner not unlike that of his mentor, William Strickland (see biography preceding no. 202). The son of a bricklayer, Walter was apprenticed to Strickland and supplemented his practical training with an education in mathematics and engineering and lessons in draftsmanship. Like Strickland, Walter established his reputation in his twenties, when he won an important architectural competition; in 1833 he edged out many well-known colleagues, including Strickland, to become the architect of Founder's Hall at Girard College. Until that time he had designed few buildings of note: Spruce Street Baptist Church, where he was superintendent of the Sunday School; Philadelphia County Prison in Moyamensing (see no. 258); and Portico Square on Spruce Street between Ninth and Tenth. After the Founder's Hall competition, however, he received many important commissions, among them the remodeling of Nicholas Biddle's eighteenth century house, Andalusia, into an imposing Greek revival mansion based on the Temple of Theseus. He also supervised the completion of William L. Johnston's Jayne Building (no. 285) and designed its tower.

Walter's Philadelphia career essentially ended in 1851, when he was appointed to succeed Robert Mills as government architect in Washington, D.C. There he executed his most famous work, the dome of the United States Capitol, which incorporated both his engineering knowledge and his architectural skill. He did other work on the building, including the new wings housing the Senate and House of Representatives chambers, and executed designs for a number of other projects in the Washington area. Failing health forced Walter to resign his federal post in 1865, and he returned to his home city where he was later associated with John McArthur, Jr., in the design and construction of City Hall (no. 334).

Throughout his career Walter was concerned with the development of architecture as a profession. In 1836 he helped to organize the American Institution of Architects, which, though it never flourished, paved the way for the formation in 1856 of the American Institute of Architects of which Walter was a charter member. He succeeded Richard Upjohn as the organization's second president, a position he held the last fifteen years of his life. He was also a member of the American Philosophical Society and the Franklin Institute, and he served the latter as professor of architecture and, in 1846, as president. Walter's reputation extended beyond his profession, and among his honors were honorary doctorates from Harvard College and the University of Lewisburg (Bucknell).

246. *Founder's Hall, Girard College (Main Building)*

Corinthian and Girard avenues
1833–47
Findley Highlands, marble mason
Inscription: GIRARD COLLEGE FOR ORPHANS, FOUNDED A.D. 1833. EASTERN PORTICO FINISHED 1840./ THOMAS U. WALTER, ARCHITECT FINDLEY HIGHLANDS, MARBLE MASON. (on inner face of eastern architrave); GIRARD COLLEGE FOR ORPHANS, FOUNDED A.D. 1833. WESTERN PORTICO FINISHED 1841./ THOMAS U. WALTER, ARCHITECT FINDLEY HIGHLANDS, MARBLE MASON. (on inner face of western architrave); GIRARD COLLEGE FOR ORPHANS, FOUNDED A.D. 1833. SOUTHERN PORTICO FINISHED 1844./ THOMAS U. WALTER, ARCHITECT FINDLEY HIGHLANDS, MARBLE MASON. (on inner face of southern architrave); GIRARD COLLEGE FOR ORPHANS, FOUNDED A.D. 1833. NORTHERN PORTICO FINISHED 1846./ THOMAS U. WALTER, ARCHITECT FINDLEY HIGHLANDS, MARBLE MASON. (on inner face of northern architrave)
Chester County marble columns and coursed ashlar on south side, Montgomery County marble on other sides and interior; coffered cast-iron portico ceilings; brick-vaulted ceilings and foundation
111 x 169' (33.8 x 51.5 m)

REPRESENTED BY:
Thomas U. Walter
Front Elevation, Main Building
Watercolor
11¾ x 21¹⁄₁₆" (29.8 x 53.5 cm)
Girard Estate, Philadelphia

LITERATURE: R. A. Smith, *Philadelphia as It Is in 1852* (Philadelphia, 1852), pp. 119–30; Henry W. Arey, *The Girard College and Its Founder* (Philadelphia, 1872), pp. 30–37, 44–56; Cheesman A. Herrick, *History of Girard College* (Philadelphia, 1927), pp. 1–8, 16–39, 106–16; Hamlin, *Greek Revival,* pp. 81–88; White, *Philadelphia Architecture,* p. 26, pl. 28; Agnes Addison Gilchrist, "Girard College: An Example of the Layman's Influence on Architecture," *JSAH,* vol. 16, no. 2 (May 1957), pp. 22–25; Tatum, pp. 72, 175–76, pls. 67, 68; Walton D. Stowell, "Thomas U. Walter, F.A.I.A.," in PMA, *Architectural Drawings,* pp. 38–40

FEW BUILDINGS embody the interactions of patron, aesthete, and architect as vividly as Founder's Hall of Girard College, and few buildings can claim such luminaries in each of the roles. The patron was Stephen Girard (1750–1831), multimillionaire merchant, banker, and philanthropist, whose will created Girard College as a school for fatherless boys and included a description of the basic dimensions and appearance

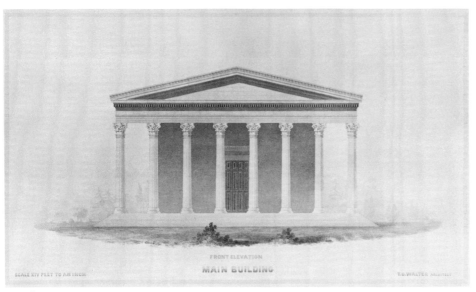

246.

that the main building was to have. The aesthete was Nicholas Biddle (1786–1844), then president of the Bank of the United States and a powerful Philadelphia taste-maker. The architect was Thomas U. Walter, who had been in the profession only three years when he won the archi-tectural competition over his former master, the noted William Strickland, as well as Isaiah Rogers of Boston and the firm of Town and Davis of New York. In the end the building's design was dictated more by the taste of Biddle than the desires of Girard or the professional preferences of Walter. With seemingly unlimited funds at hand, Biddle was determined to build America's most monumental and archaeologically exact Greek temple, and he virtually insisted on the peristyle Corinthian form. Girard's determination of the hall's size (four rooms, fifty feet square, on each of the three floors) and details of construction (vaulted ceilings and roof with marble throughout) forced Walter to draw upon his full architectural genius to meet these demands and still produce a visually pleasant structure. This he succeeded in doing, but he could not at the same time make it a functional school building; criticized since its completion for its bad acoustics and lighting, the hall was abandoned for teaching purposes in 1916. Yet in a sense its form fits its function, for above all else, it is a monument to the college's founder. And like a Greek temple housing the effigy of a god, Founder's Hall includes a statue of Stephen Girard, as well as his sarcophagus.

The building committee obviously departed from the benefactor's requests, and was often lashed with critical attacks that the hall was too expensive (nearly two

million dollars, in the deflated currency of the 1840s), too slow in construction (fifteen years), and too ornamental. The critics were right, but Biddle still had his way, and in the end Founder's Hall was widely admired. Although the structure was incomplete when he visited it in 1842, the critical Charles Dickens thought it would "be perhaps the richest edifice of modern times" (*American Notes*, p. 143). Today it is con-sidered the climax of the Greek revival style in the United States.

RW □

THOMAS FLETCHER (1787–1866)
(See biography preceding no. 234)

247. *Presentation Urn*

c. 1833
Mark: T. FLETCHER (on bottom of body around edge of circle); PHILA. (in rec-tangle inside circle)
Inscription: Presented/by the Stockholders of the /SCHUYLKILL NAVIGATION COMPANY/ —to—/THOMAS FIRTH ESQ./under a reso-lution of the 7. of January 1833 (engraved on front of the body); In testimony/of their sense of his long continued, faithful/ and disinterested/service as a MANAGER in conducting/their concerns, under circumstances often/of great discourage-ment,/and bringing them at length to an/eminently prosperous condition (engraved on back)
Silver
20⅛ x 13" (51.1 x 33 cm)
Joseph Sorger, Philadelphia

PROVENANCE: Thomas Firth, Philadelphia
LITERATURE: MMA, *19th Century America, Furniture*, no. 51

AMBITIOUS PRESENTATION SILVER became increasingly popular in the 1820s and 1830s, and the firm of Fletcher and Gardiner ap-parently received more commissions for such work than any other American firm. One of their earliest urns of this type was presented to Commodore Isaac Hull for his services in the War of 1812. A pair of similar urns made by Fletcher and Gardiner in 1823–24 (Newark, *Classical America*, no. 104) was presented to Governor De Witt Clinton for his support of the Erie Canal project. The design of this urn and the De Witt Clinton urns is based on English prototypes, which, in turn, were modeled after a classical example excavated in 1771 from Hadrian's Villa, and later owned by the Earl of Warwick.

On a trip to London in 1815, Fletcher may have seen one of the many copies of the "Warwick" vase which were commissioned through Rundell, Bridge and Rundell, English silver retailers, and made either by Benjamin Smith or Paul Storr. Twisted handles and the grapevine motif appear on all these vases, but the shapes of the urns vary. Storr, like Fletcher, also used figural finials; a miniature statue of Neptune with trident appears, for example, on the top of a silver cup presented to Lord Nelson by the Durkey Company to celebrate his victory at the Battle of the Nile in 1799 (Hugh Honour, *Goldsmiths and Silversmiths*, London, 1971, p. 239). The square base with large paw feet is seen on many examples of Fletcher and Gardiner silver. In this example, scenes of the Schuylkill River decorate the plinth. The view of the Upper Ferry Bridge is taken from a George Lehman engraving, published in 1829. The symbolic classical figure on the finial is seated on an urn and holds a cornucopia from which the river waters flow.

The Schuylkill Navigation Company presented this urn to Thomas Firth, one of its managers. According to Watson (*Annals*, vol. 8), the state legislature chartered the company to construct a lock canal from Fairmount in Philadelphia to Port Carbon in Schuylkill County, a distance of about 110 miles. Designed by Ariel Cooley of Springfield, Massachusetts, the project required numerous dams, canals, and locks. In 1825, the first boats that traversed the entire length arrived in Philadelphia. The project had been backed by Stephen Girard, who recognized the value of the anthracite coal deposits in the interior of Pennsylvania, especially in the Lehigh Valley. In addition, the dams provided waterpower, which the Schuylkill Navigation Company would offer for sale. This led to the development of

industrial mill towns such as Manayunk (originally known as Flat Rock). A tremendous and speculative project, the navigation system was achieved with difficulty through the efforts of managers such as Thomas Firth. In 1833, Thomas Fletcher was commissioned to design a piece of silver to be presented to each of five of the company's Philadelphia managers, and this urn given to Firth was one of those Fletcher designed.

DH □

THOMAS FLETCHER (1787–1866)
(See biography preceding no. 234)

248. *Cake Basket*

c. 1835
Mark: T. FLETCHER PHILAD (stamped on bottom inside oval ring)
Silver
10½ x 14¼ x 10¾″ (28 x 36.1 x 27.3 cm)
Private Collection

PROVENANCE: Mrs. Barrent Lefferts; daughter, Kate Lefferts

247.

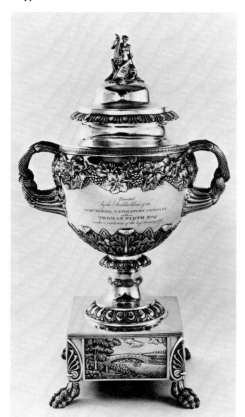

ACCORDING TO MISS LEFFERTS, who inherited this cake basket from her mother, the piece probably descended in her mother's family, the Wetherills of Philadelphia. A sepia ink drawing for a basket almost identical to this one, except for the four legs of scroll and acanthus leaf design instead of a single oval pedestal base, is in the collection of Thomas Fletcher's drawings in the Metropolitan Museum of Art. Although the drawing is inscribed on the bottom: "For Nicholas Biddle (see over). Presented to him by United States Bank," nothing is inscribed on the reverse side. No handle is shown, although the sockets for the handles are included. The Biddle cake basket was part of a large service, the most costly Fletcher commission known. According to James Biddle, a descendant of Nicholas Biddle, the set was melted down for silver when the Second Bank failed.

Classical motifs dominate the basket. The alternating anthemia and leaf motifs were common on Philadelphia furniture and silver in the first quarter of the nineteenth century. Similar ornamentation is seen in figures 1 and 2 of Nicholson's *Cabinet Maker*. Fletcher was also an early American exponent of the rococo revival style, which was evident in French and English designs of the 1820s and 1830s. Rococo details on this basket include the asymmetrical cartouche and the floral designs on the handle.

DH □

TUCKER AND HEMPHILL CHINA FACTORY
(1826–38)

William Ellis Tucker (1800–1832) was the son of Benjamin and Theodosia Irwins Tucker of Philadelphia. In 1826, Tucker leased from the Philadelphia City Council the old city waterworks at Chestnut and Schuylkill Second streets and began the experimental production of porcelain. Tucker first experimented with the production of creamware before turning his talents to porcelain. After trying over twenty different porcelain formulas, Tucker selected one as his "secret" combination. The first dated tests in Tucker's Day Book for the production of porcelain appear under the heading, "October 10, 1826." The recipes for glazes and enamels utilized by the factory, while secretly coded by Tucker, were copied from various printed sources available in the library of the Franklin Institute.

As with most early attempts at porcelain production, the Tucker factory was burdened with financial problems. Between 1825 and 1830, Tucker, with financial backing from his father, invested $17,000 in the manufacture of porcelain. Attempting to alleviate the financial burdens, Tucker acquired a succession of partners: John N. Bird, April 1826

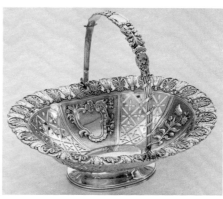

248.

—January 1827; John Hulme, April 1828—June 1828; and Judge Joseph Hemphill, 1832–38, who carried on after Tucker's death in 1832. In 1828, Tucker's younger brother, Thomas (1812–1890), joined the factory as an apprentice and later became chief decorator.

In 1827, 1828, and 1832, the Tucker factory received medals from the Franklin Institute annual competition for the best porcelain made in the United States. In 1828 the Franklin Institute judges reported "they have compared the sample called technically 'first choice,' with the best specimens of French china, and found it superior in whiteness and the gilding well done" (*Report of the Committee on Premiums and Exhibitions, 1828*, p. 408). By 1832 the Institute reported that "the body of the article is considerably equal, if not superior to that of the imported" (*Report of the Committee on Premiums and Exhibitions, 1832*, p. 391). In 1876 it was said of Tucker porcelain, "In appearance it somewhat resembled the French porcelain of the day, and in durability, and in use that of Berlin. The forms were copies of French and English" (Charles W. Elliott, *Pottery and Porcelain from Early Times Down to the Philadelphia Exhibition of 1876*, New York, 1876, p. 234).

After William Tucker's death on August 22, 1832, Hemphill, the last of the three partners in the Tucker concern, assumed sole ownership of the factory and retained Thomas as manager and chief decorator. In 1838, Thomas Tucker married Mary Earp of Philadelphia.

With a $7,000 investment from Hemphill in 1832, the factory was relocated at Twenty-third and Chestnut streets and increased in size to accommodate new slip pans and three kilns. (Thomas Tucker's line drawings of the factory's kilns and other equipment are in the Philadelphia Museum of Art.) The eventual closing of the factory in 1838 was a result of the tariff controversies, the national bank failures of 1837, and the personal financial problems of Judge Hemphill.

After the closing of the factory, Thomas Tucker maintained a china store at 100

Chestnut Street, where he sold imported French and English porcelain until 1841 when he withdrew from the pottery business and became a cotton broker. Many pieces of porcelain thought to be from the Tucker factory may be European pieces decorated by Thomas Tucker after the closing of the firm.

According to contemporary accounts, Tucker porcelain was considered equal to imported wares. While this assessment may partly be due to patriotic pride, present-day confusion between Tucker and European porcelain attests to the similarity of style and quality. Yet Tucker porcelain never captured the American market. Because of the lack of an adequate tariff, European porcelain could be imported into the United States and sold for a lower price than American porcelain. Given the choice, most customers let price influence their final selection. Nevertheless, Tucker porcelain enjoyed a wide market that included customers in Pennsylvania, New Jersey, New York, Massachusetts, Delaware, Maryland, Kentucky, and Virginia.

The Tucker company was the first large-scale manufactory of porcelain in the United States, and the most significant American porcelain factory during the early nineteenth century.

249.

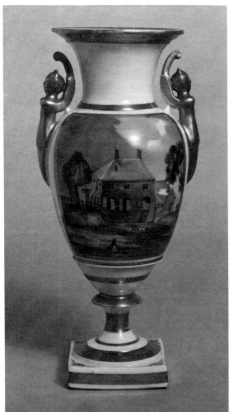

249. *Vase*

c. 1832–35
Decorated by Thomas Tucker
Porcelain, in two parts connected by iron joining rod or shaft
14¼ x 7″ (36.1 x 17.7 cm)
Philadelphia Museum of Art. Given by Eliza Amanda Tucker in memory of Thomas Tucker. 31-55-1

PROVENANCE: Thomas Tucker; wife, Mary (Earp) Tucker; daughter, Eliza Amanda Tucker, until 1931

LITERATURE: Barber, *Pottery and Porcelain,* p. 146, pl. 66; Woodhouse, "Philadelphia Porcelain," pp. 134–35, fig. 2; Joseph Downs, "The Greek Revival in the United States," *American Collector,* vol. 12, no. 10 (November 1943), p. 19; Helen Comstock, "Some Aspects of the Greek Revival in America," *Connoisseur,* vol. 113, no. 492 (June 1944), p. 117; PMA, *Tucker China,* pp. 4–8, pl. 2; Curtis, "Tucker Porcelain," p. 41

THOMAS TUCKER was the artist responsible for the decoration and design of this unique vase, which provides a rare pictorial documentation of the first Tucker factory. The polychromed enamel vignette painted over the glaze features the old city Waterworks, prior to Graff's Fairmount complex, showing the main building with two smaller buildings attached. The top of one building is pierced by a typical bottle kiln. Three small white pitchers, shown on the fence, are possibly a reference to the jugs William Tucker entered in the 1826 Franklin Institute competition. Concerning the Tucker entry, a Philadelphia newspaper reported, "These three small jugs do not exhibit any improvement of a decisive character over the small specimen exhibited by others at the exhibition of 1824" (*United States Gazette* [Philadelphia], November 16, 1826).

The vase was made as a family curiosity commemorating the first porcelain factory. Its amphora shape and gilded caryatid handles are characteristic French and English Empire forms which Tucker copied throughout the factory's twelve-year history. The handles illustrate a distinctive Tucker eccentricity—small ceramic braces, placed between the figures and the body of the vase to keep the handles from sagging during the firing. Bases of many Tucker urns and vases also turn slightly upward at the corners. This warping was a result of excessive shrinkage during the initial "biscuit" firing.

PHC □

TUCKER AND HEMPHILL CHINA FACTORY (1826–38)
(See biography preceding no. 249)

250a. *Tea Light*

c. 1833–35
Inscription: no. 7 (painted in black on the base)
Porcelain, in four parts
Height 11¼″ (28.5 cm); diameter 4¾″ (12 cm)
Philadelphia Museum of Art. Bequest of Bertha L. Landis. 44-21-1a-d

PROVENANCE: Bertha L. Landis

LITERATURE: Rosetta Schuyler Montgomery, "Tucker China," *Muncy Historical Society and Museum of History Quarterly Magazine of History and Biography,* vol. 6, no. 6 (April 1939), pp. 137–43, illus. p. 139; "Special Events," *Antiques,* vol. 71, no. 5 (May 1957), p. 64, illus.; PMA, *Tucker China,* p. 32, pl. 11; Harold Newman, *Veilleuses 1750–1860* (New York 1967), pp. 187–90, fig. 121; Curtis, "Tucker Porcelain," pp. 59–60

250b. *Pattern Book*

c. 1835
Inscription: Pattern of China, made at the China Fac-/tory sw corner of Schuylkill 6th and/ Chestnut Streets from the year 1832 until/ the year 1838—at which time I discontinued/ the making of China. Thomas Tucker (in ink on first illustrated page)
Pen and ink drawings on paper; leather binding
18 x 11¾″ (45.7 x 29.8 cm)
Philadelphia Museum of Art. Given by Mrs. William D. Frishmuth. 07-212

PROVENANCE: Thomas Tucker; wife, Mary (Earp) Tucker, until 1890

LITERATURE: Barber, *Pottery and Porcelain,* p. 147; PMA, *Tucker China,* no. 353, pls. 13, 14; Curtis, "Tucker Porcelain," pp. 51ff.

FROM THE SEVENTEENTH to the mid-nineteenth century, Philadelphia was a major center of American ceramic production, which ranged from common redware to porcelain. Throughout this period Philadelphia offered the proper ceramic "environment." Increasing population and ever-expanding markets, internal trade, advances in transportation and communication, and readily available raw materials provided the essential ingredients for the development of native porcelain production during the first half of the nineteenth century. This tradition

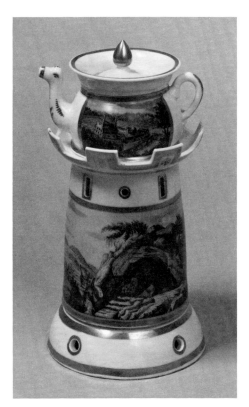

250a.

of porcelain production had been established in Philadelphia during the eighteenth century (see no. 87).

The Tucker porcelain factory was a part of the growing commercialization and industrialization that characterized Philadelphia during the nineteenth century. Not only did the factory succeed in producing a superior grade of porcelain from native materials (kaolin from the West Chester, Pennsylvania, farm of Israel Hoopes, and feldspar from Wilmington, Delaware), but it managed to achieve a quality of decoration equal to that of European porcelain factories. Tucker decoration ranged from floral designs, landscapes, and patriotic devices to portraits of important persons and scenes of Philadelphia.

One Philadelphia scene which occurs on numerous Tucker pieces is the Fairmount Dam and Waterworks (no. 183) illustrated on this tea light (or *veilleuse*). A reporter from the Philadelphia *United States Gazette,* who visited the Tucker factory in 1833, commented on the many types of decoration utilized by the factory: "Other artists were drawing landscapes, Philadelphia scenery, the waterworks, neighboring farms, &c" (Clement, *Pioneer Potters,* p. 81). In 1832 decorators employed by the factory received four cents each for painting landscapes and floral designs (PMA, *Formula and Price Book of Thomas Tucker*).

The term *veilleuse* derives from the French *veiller,* to keep a night vigil. A *veilleuse,* or tea light, was used as a warmer for food and drink. It was normally composed of a hollow pedestal on which sat a covered bowl or teapot, which had a projecting bottom that fit into the pedestal to bring the contents of the pot nearer to the heat. First used as a utilitarian object, by 1830 the tea light had become a purely ornamental item to grace the parlor of the well-furnished Empire residence.

The main section of this tea light features a black painted landscape over a golden yellow painted ground in imitation of French porcelain of the 1820s and 1830s. The landscape itself is reminiscent of contemporary German porcelain, and includes a rustic cottage, trees, peasants, and mountains. These black or sepia decorations were always hand-painted rather than transfer-printed at the Tucker factory. Many of these painted scenes achieve a subtleness of detail rarely seen on other porcelain of the same period.

Thomas Tucker's pattern book illustrates three designs for tea lights. Two consist of a pedestal with a crenelated top in two sizes, priced at $1.60 and $2.00. The third design illustrates an urn-shaped pedestal priced at $2.50. In addition to these three plates the pattern book includes forty-eight pages of pen and ink drawings of various shapes together with their size, number, and price. A second pattern book, also in the Museum's collection, contains eighty-nine plates with watercolor decoration. In addition, the Museum owns the complete Tucker factory papers, which include letter books, account books, formula and price books, day books, and line drawings.

PHC □

TUCKER AND HEMPHILL CHINA FACTORY (1826–38)
(See biography preceding no. 249)

251. *Vase*

c. 1835
Decorated by Thomas Tucker
Porcelain; ormolu handles
21⅞ x 12⅛" (55.2 x 31.2 cm)
Philadelphia Museum of Art. Purchased: Joseph E. Temple Fund. 16-185

PROVENANCE: Thomas Tucker; wife, Mary (Earp) Tucker, 1890; daughter, Ella Gertrude Tucker, until 1916

LITERATURE: Barber, *Pottery and Porcelain,* pp. 145–47, illus. frontis.; Edwin A. Barber,

"Recently Acquired Ceramics," *PMA Bulletin,* vol. 14, no. 55 (July 1916), pp. 41–42; W. M. Hornor, "Tucker and Hemphill Porcelain Works," *Antiques,* vol. 13, no. 6 (June 1928), pp. 480–84, fig. 6; Woodhouse, "Philadelphia Porcelain," pp. 134–35, fig. 3; PMA, *Tucker China,* nos. 294–95, pl. 5; Horace H. F. Jayne, "Tucker Porcelain: Thomas Tucker's Share," *Antiques,* vol. 72, no. 3 (September 1957), pp. 237–39, fig. 2; MMA, *19th-Century America, Furniture,* no. 67; Curtis, "Tucker Porcelain," p. 60

AS THE CHIEF FACTORY DESIGNER and decorator, Thomas Tucker created the lavish polychrome floral patterns characteristic of Tucker porcelain. Roses, tulips, daisies, wild flowers, and forget-me-nots were extravagantly combined in wreaths, festoons, garlands, and bouquets. This overabundance of floral and foliate devices, borrowed from European examples, was typical of the romantic naturalism of the Empire style and early rococo revival period. English and German factories were copying French floral designs, and European porcelain pieces were almost completely covered with enamel and three-dimensional flowers. While many of the floral motifs were taken from nature, botanical prints were the main design sources for decorators.

This vase, one of the most outstanding examples of Tucker porcelain in terms of its size and the quality of decoration, combines the expert painting, gilding, and enameling that mark the best of the Tucker production. While freely painted, the floral wreaths are contained within a classical framework of gilt and salmon-colored bands.

250b.

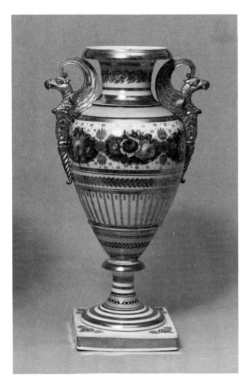

251.

Tucker decoration consistently featured ornate gilding. Tablewares and vases frequently include gilt flowers, wreaths, medallions, trophies, monograms, and initials. The factory's gilders or burnishers were paid on a piecework basis; a worker earned fifteen cents for gilding and burnishing a "vase full gilt" (PMA, Formula and Price Book of Thomas Tucker, p. 31). This cost would be added to the retail price as would all other decoration.

Tucker gilding, which seems to have been applied by a unique process, has provided a possible new means of authenticating Tucker porcelain. Examined under a short-wave ultraviolet light, the gilt decoration displays an unusual halo of white outlining the gold. It is thought that the mercury used in the gilding process evaporated during the firing and that the halo is probably the result of a contamination of the surrounding area by a thin film of the gold and mercury combination. This is not seen on French, German, or English porcelain from the same period.

The classically shaped form, with its square plinth in imitation of French vases, is further ornamented with extraordinary gilt ormolu handles with an eagle or griffin terminal. The handles were designed by John Henry Frederick Sachse (see no. 268), an artist at Cornelius & Son, lamp and chandelier manufacturers (see biography preceding no. 288), who cast the handles. According to family history the handles

were regilded by Cornelius & Son in the late nineteenth century (PMA, Archives, Ella Gertrude Tucker to Edwin Atlee Barber, April 24, 1900). The use of attached metal handles was a common practice at the Sèvres factory in the early nineteenth century. The Tucker factory, established to supply the American market with native porcelain in imitation of European styles, utilized the same device in its production.

Tucker family history states that Thomas Tucker saw this vase in a secondhand shop window on Second Street, Philadelphia, recognized it as one he had decorated, and purchased it. While the family believed it to be one of a kind, in 1944 the Museum acquired a vase identical to this. Although Tucker never mentioned a mate to his vase, they were probably made as a pair. Another pair of similarly shaped vases (Valley Forge Historical Society) also features identical ormolu handles.

PHC □

UNION FLINT GLASS WORKS (1826–44)

The Union Flint Glass Works (also known as the Union Glass Works) was formed by William Granville; William Swindell; William Bennett, who had previously worked at the New England Glass Company and at John Gilliland's South Ferry Glass Works in Brooklyn, from 1823 to 1826; William Emmett, who had formerly worked at the South Boston Flint Glass Works and at the New England Glass Company; Joseph Capewell, of Cambridge;

and James Venables of Boston. A tract of land in the Kensington section of Philadelphia, along the Delaware River, was purchased for $3,600 on November 1, 1825. Construction of the glasshouse was begun the same month and the works was in operation early the next year. During that year, Granville and Swindell dropped out of the firm and were replaced by Charles Baldwin Austin, who became agent and head of the firm, which was then called Charles B. Austin and Company. Austin, an Englishman who came to New York City in January 1819, was a skilled glass cutter. He is listed as such in the New York city directories for 1821–24, and in the Brooklyn directories for 1825–26 as operating a glass factory in "near district," Brooklyn.

Richard Synar (or Synor) probably joined the Union Flint firm at the same time as Austin, in 1826. He is listed in the Brooklyn directories for 1825–26 as a glassblower and worked either at Gilliland's or Austin's factory (Long Island Historical Society, *Preliminary Notes Toward a History of the Brooklyn Flint Glass Company,* Brooklyn, 1968, no. 24).

Under Austin's direction, the Union Flint Glass Works prospered, and at one time the firm employed approximately one hundred hands. It is known to have produced blown, pressed, and cut glasswares. Specimens of their cut glass were shown at the fourth exhibition of the Franklin Institute in 1827, and again in 1831. In 1840 and 1842 the firm received special mention for their work—in the latter year, for their colored glass. Proof of production of pressed glass before 1830 is

252a.

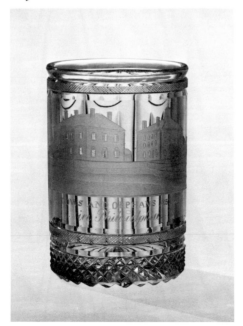

252b.

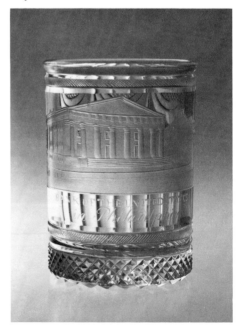

provided by a more than two-year-long feud with the New England Glass Company for infringement of the 1826 patent for pressing glass doorknobs. By 1831 the firm of Charles B. Austin and Company had warehouses at 10 Minor Street and also at 23 Dock Street in Philadelphia.

After Austin's death in 1840, when the management was undertaken by William Bennett, the firm was hampered by internal strife. Bennett, Bennett's wife, Sara Synar, and Joseph Capewell were involved in litigation with Austin's widow. The firm was dissolved in 1844 and the glasshouse shut down. In 1847 the works was acquired by Hartell and Lancaster and operated for many years (McKearin, *American Glass*, p. 597; McKearin, *Blown Glass*, p. 87).

ATTRIBUTED TO THE UNION FLINT GLASS WORKS

252a. *Tumbler*

c. 1830–40
Inscription: WIDOWS AND ORPHANS ASYLUM/in Philadelphia
Non-lead colorless glass, blown, cut, and engraved
Height 4⅜″ (11.1 cm); diameter rim 3¼″ (8.2 cm), base 3″ (7.6 cm)
The Corning Museum of Glass, Corning, New York

PROVENANCE: George McKearin; purchase, Corning Museum of Glass, 1955

252b. *Tumbler*

c. 1830–40
Inscription: BANK OF THE UNITED STATES/in Philadelphia
Non-lead colorless glass, blown, cut, and engraved
Height 4⅜″ (11.1 cm); diameter rim 3¼″ (8.2 cm), base 3″ (7.6 cm)
Mr. and Mrs. Bertram D. Coleman, Bryn Mawr, Pennsylvania

LITERATURE: McKearin, *Glass*, pp. 153, 597, pl. 49, fig. 9; McKearin, *Blown Glass*, pp. 87, 88, 278, pl. 79, fig. 5; Revi, *Cut and Engraved Glass*, p. 10, fig. right; MMA, *19th-Century America, Furniture*, fig. 55

THE VIEW of the Widows and Orphans Asylum on tumbler 252a is a faithful copy from the engraving by George Strickland in C. G. Childs's *Views in Philadelphia*. According to McKearin (*Blown Glass*, p. 278) the Orphans Asylum was originally established by the ladies of the Second Presbyterian Church of Philadelphia in 1814, but was destroyed by fire on January

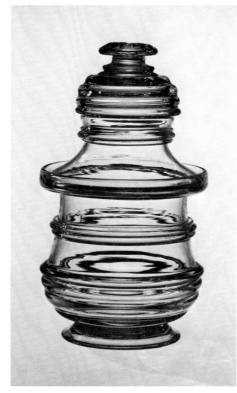

253a.

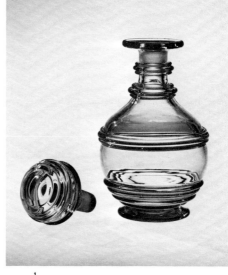

253b.

24, 1822. The home was rebuilt from designs by Strickland, as depicted in the engraving, by the Indigent Widows and Single Woman's Society.

The view of the Second Bank of the United States (see no. 202) on tumbler 252b is also a faithful copy after Strickland in *Views in Philadelphia*.

Because of their form, subject matter, and disposition and style of cutting and engraving, these two tumblers are obviously from the same source. That source (or sources, for the tumblers may have been blown at the same glasshouse but cut and engraved at an independent shop) is unknown. The form of the tumblers and the style of engraving are characteristic of the 1830s. Since the views on each of them are of topical interest primarily to Philadelphians, and the Union Flint Glass company was the most important one in the area, as well as being noted for its fine cut and engraved wares, these tumblers are tentatively attributed to that glasshouse. The attribution is further strengthened by the fact that a third, companion tumbler, also engraved with a Philadelphia view, is known; and all three were found in the vicinity of Philadelphia. The third tumbler shows a view of the Bank of Pennsylvania. The view may have been taken from an

engraving by William Birch (Historical Society of Pennsylvania; see White, *Philadelphia Architecture*, p. 22, pl. 4).

But because the two tumblers shown here are apparently made of soda lime glass rather than flint (lead) glass, which presumably was the principal product of the Union Flint Glass Works, the possibility exists that they were made abroad, probably in France; thus the attribution to the Union Flint Glass Works must remain tentative. KMW □

UNION FLINT GLASS WORKS (1826–44)
(See biography preceding no. 252)

253a. *Sugar Bowl with Cover*

c. 1830–40
Colorless flint (lead) glass
Height 8½″ (21.6 cm), without cover 4¹³⁄₁₆″ (12.2 cm); diameter rim 5″ (12.7 cm)
The Corning Museum of Glass, Corning, New York

PROVENANCE: Richard Synar; granddaughter, Mrs. Laura M. T. Vail, Highland, New York; Albany Institute of History and Art; Corning Museum of Glass, 1971

253b. *Decanter and Stopper*

c. 1830–40
Colorless flint (lead) glass
Height 9⅞″ (25.1 cm), without stopper
6⅞″ (17.4 cm); diameter 4⁹⁄₁₆″ (11.6 cm)
The Corning Museum of Glass, Corning,
New York

PROVENANCE: Richard Synar; granddaughter,
Mrs. Laura M. T. Vail, Highland, New York;
Albany Institute of History and Art; purchase,
Corning Museum of Glass, 1971

LITERATURE: *Journal of Glass Studies,* vol. 14,
1972, p. 160, fig. 52

THIS COVERED SUGAR BOWL and "quart"
decanter are part of the collection of about
thirty pieces of glass (including two pitchers
bearing this same decoration) which de-
scended from Richard Synar, glassblower
at the Union Flint Glass Works. Like the
cut glass decanter (no. 254), they are
attributed to the Union Flint Glass Works
on the basis of family history.

Both pieces are of free-blown and tooled
glass with matching triple-ringed decoration.
The design of applied triple-banded decora-
tion is of English origin, brought to America
by such glassmakers as Thomas Cains, who
arrived in April 1812 and established the
Phoenix Glass Works in South Boston,
Massachusetts. A covered footed sugar bowl
bearing this same triple-banded decoration
(Corning Museum) descended in the Cains
family (Kenneth M. Wilson, *New England
Glass and Glassmaking,* New York, 1972,
pp. 198–229, fig. 162). It has numerous
stylistic relationships to this sugar bowl
and may have served as the design source by way
of William Emmett, one of the founders of
the Union Flint Glass Works and a former
employee of Thomas Cains in South Boston
(McKearin, *Blown Glass,* p. 87).

KMW □

ATTRIBUTED TO THE UNION FLINT
GLASS WORKS (1826–44)
(See biography preceding no. 252)

254. *Decanter and Stopper*

c. 1835
Colorless heavy flint (lead) glass
Height 11¼″ (28.6 cm), without stopper
8⅝″ (21.9 cm); diameter 4¾″ (12.1 cm)
The Corning Museum of Glass, Corning,
New York

PROVENANCE: Richard Synar; granddaughter,
Mrs. Laura M. T. Vail, Highland, New York;
Albany Institute of History and Art; Corning
Museum of Glass, 1971

254.

LITERATURE: Paul V. Gardner and Kenneth M.
Wilson, "American Glass," in Phoebe Phillips,
ed., *The Collectors' Encyclopedia of Antiques*
(New York, 1973), p. 476, fig. d

THIS DECANTER is one of a pair which
descended in the family of Richard Synar
with other pieces which according to family
history were made at the Union Flint Glass
Works. The fact that the firm was known
in its day for its fine quality cut glass, that
it was headed by a glass cutter, and that there
are several thick, heavy blanks for cutting
among the pieces in the Synar collection
lends support to the family history, and to
an attribution to the Union Flint factory
for this decanter.

Its style is derived from English sources
which began to supersede the "strawberry
diamond and fan" motifs about 1815 and
began to come into vogue in America some-
what later. Like the broad, plain patterns
of pressed glass of about 1835–65, this style
is characteristic of American cut glass of
this period.

KMW □

ATTRIBUTED TO THE UNION FLINT
GLASS WORKS (1826–44)
(See biography preceding no. 252)

255. *Lamp*

1835–40
Flint (lead) glass
Height 13⅜″ (34 cm); width base 4⅛″
(10.5 cm)
The Corning Museum of Glass, Corning,
New York

PROVENANCE: Louise S. Esterly, Reading,
Pennsylvania

LITERATURE: McKearin, *Glass,* p. 597; McKearin,
Blown Glass, p. 87; Paul V. Gardner and
Kenneth M. Wilson, "American Glass," in
Phoebe Phillips, ed., *The Collectors' Encyclo-
pedia of Antiques* (New York, 1973), p. 464,
fig. b

THIS RARE AND UNUSUAL whale oil, or fluid
burning, lamp is attributed to the Union
Flint Glass Works on the basis of the close
relationship and arrangement of its cut
motifs to those on a cut glass mug also in
the Synar collection of the Corning Museum.

The lamp attains elegance by the quality
of its glass and standard of workmanship.
Its bold design combines an unusual and
elaborate square, pressed base with a blown
and cut font and standard bearing a distinc-
tive combination of cut motifs. The lamp
bears testimony to the opinion of Thomas
Porter, author of *Picture of Philadelphia
from 1811–1831,* who visited the Union Flint
works and inspected their blown and cut
glass. He reported "no hesitancy in pro-
nouncing the workmanship to be of the
most elegant kind" (McKearin, *Blown Glass,*
p. 87).

KMW □

THOMAS BIRCH (1779–1851)
(See biography preceding no. 188)

256. *Winter Landscape*

1835
Signature: Thos Birch 1835 (lower left)
Oil on canvas
18 x 27″ (45.7 x 68.5 cm)
Dietrich Corporation, Reading,
Pennsylvania

BIRCH'S *Winter Landscape* of 1835 is, in
scale, much more typical of his work than
his large shipwreck painting, *The Rescue*
(no. 260) of 1837. He seemed to prefer to
work with a smaller canvas, using prelimi-
nary pencil sketches often taken from life.

Although his landscapes usually include people, the figures were obviously of secondary interest to him. He must have felt that they provided a certain amount of human interest necessary to sell his work. Some of his figures are known to have been taken from William H. Pyne's *Etchings of Rustic Figures, for the Embellishment of Landscape* (London, 1815).

Most of Birch's winter landscapes are, like this one, late afternoon sleighing scenes. He incorporates the same picturesque elements—broken fences, bridges, farmhouses, and scraggy trees laced with snow—in seemingly endless combinations. Occasionally an oval format is used as in this example. This landscape, one of his most successful compositions, is unusually colorful: the distant sunset spreads over an opaque sky and reflects against the white fields. Birch's snowscapes were always decorative and yet do not appear to be unnaturally contrived.

Birch's white landscapes may have had an impact on another Philadelphia artist, Thomas Doughty (see biography preceding

256.

255.

no. 226). Doughty's *Winter Landscape,* 1830 (Boston, Museum of Fine Arts), of a sleigh ride in a rosy sunset, is obviously dependent upon Birch although it epitomizes a difference between the artists by its more dreamlike and fantastic representation, with snow covering rather extraordinary sandbanks.

DE □

NICOLINO (VISCONTE DI) CALYO (1799–1884)

Descended from the Viscontes di Calyo of Calabria, Nicolino was born in Naples but fled Italy in 1821 following his involvement in an uprising against Ferdinand, king of the Two Sicilies. He traveled in Europe for several years, continuing the art studies he had begun at the Naples Academy, and settled briefly in Malta in 1829. His father's connections with Queen Maria Cristina brought him a position at the Spanish court which he abandoned in 1833 after the outbreak of civil war.

By 1834 he had established himself in Baltimore, but was drawn to New York City the following year to record the devastation of the Great Fire of December 1835. Following the success of these views he moved his household and his business to New York, where city directories list him as a "professor of painting" or "portrait and landscape painter" from 1838 to 1855. In New York his home became a social center for European exiles in America—including Napoleon III—as well as something of a museum for Calyo's immense collection of artwork, souvenirs, and curios.

As an artist, Calyo became known during these years for his watercolor and gouache views of Baltimore, New York, and Philadelphia, including a famous set of genre

figures and scenes of street life entitled *Cries of New York,* later published as prints. He also toured from Boston to New Orleans between 1847 and 1852 with his forty-foot panorama *The Connecticut River* and a series of scenes from the Mexican War.

Calyo apparently remained in New York, off and on, for the greater part of his career, briefly revisiting Spain to hold an appointment as painter to Queen Maria Cristina; by 1874 further unrest in Spain brought him back to the United States, where he continued to work actively until his death in New York, at the age of eighty-five.

257. *View of the Waterworks*

1835–36
Signature: Painted on the spot/ by N. Calyo (lower left)
Watercolor and gouache on paper
26⅛ x 36¼″ (66.3 x 92 cm)
Private Collection

"THE SITUATION OF FAIRMOUNT is exceedingly picturesque, and the works themselves are constructed with great neatness," wrote C. G. Childs in his *Views in Philadelphia* of 1827–30. "It is a favorite resort of the citizens, and the view of it is highly interesting, blending as it does the beauty of nature with the ornaments of useful art, and the gaiety of animation of groups of well dressed people." Such celebrity and artistic advantages brought numerous artists to the site of the Waterworks (no. 183), including Calyo, although it is not clear exactly when he visited Philadelphia. His two views of the Waterworks—this one, and another also in a private collection—may have been done

257.

as early as 1834, just after his arrival in the United States, and while his studio was established in Baltimore. There is no evidence to indicate that they were a pair, however; and slight variations in size, style, and detailing suggest different dates, this view perhaps done as late as 1836. Calyo's Italian training dominates his method in both views, conditioning his liberal use of gouache, which imparts an opaque, slightly chalky surface to his work, setting it apart from the "English" style of transparent watercolor more familiar to American artists of the period. His general approach to the subject is consistent, however, with the techniques and attitudes of the Hudson River school painting of the 1830s.

Calyo's other Waterworks view, which may be the earlier of the two, is taken from the top of "Fair Mount," looking down on the Waterworks from the promenade beside the reservoirs, much like the view in Doughty's painting of 1826 (no. 226). Although this angle creates complex problems in perspective (which Calyo handles with less than perfect ease), it was nevertheless a relatively common viewpoint in prints of the 1830s, perhaps because it represented the view most prized by visitors, as well as the perspective which afforded the greatest panorama of the river. If changes in the landscaping can be trusted, the view shown here was done later. The more varied and sophisticated treatment of the foliage and detail, the greater richness of tone, and the more

coherent treatment of space seem to indicate a more mature style. However, this appearance of increased competence may owe something to the simpler, more manageable vantage point. This prospect, while more conventional than the difficult bird's-eye angle from the hill, was in terms of location somewhat uncharacteristic of the average Waterworks view, which usually showed the mill buildings from directly across the river or from upstream. The major exception—probably familiar to Calyo—was Thomas Birch's oil painting of 1821 (Pennsylvania Academy of the Fine Arts) and two etchings done after it, all showing the locks and the Waterworks seen from the middle of the Upper Ferry Bridge. Calyo chooses to move to the left ramp of the bridge, however, thereby creating a more graceful composition and a more informative perspective on the Waterworks themselves. It is worth noting that this unusual west bank viewpoint reappeared, along with a hill-top panorama, in a series of three lithographs published in 1838 by J. T. Bowen.

Further attempts at dating this work must rely on the documentary accuracy of Calyo's view, which appears complete, and is accompanied by the artist's written assurance that it was "painted on the spot." Mr. and Mrs. Laurence Eisenlohr, whose history of the Waterworks is in preparation, examined Calyo's work and pointed out that he must have been on the scene after the summer of 1835 (when a Rush gold eagle was placed

on the roof of the gazebo at the dam, and the portico was added to the engine house) and before the spring of 1836 (when the retaining wall beneath the south garden was extended to include a new plot of land annexed to the complex the year before). However, further study of the view demonstrates not only Calyo's accuracy, but also his considerable alterations. He seems to have manipulated foliage at will, eliminated architectural detail (for example, the large windows on the facade of the engine house), and artificially extended the foreground, making the river falsely narrow. And, as the Eisenlohrs note, Calyo exaggerates the height and importance of the newly refurbished engine house, thereby suggesting that its opening as a refreshment "saloon" for visitors created the stimulus for Calyo's project.

These alterations, undertaken for the sake of composition and focus, cast a new light on Calyo's insistence that it was "painted on the spot." This affidavit, which appears on several of his other topographical views—notably his records of New York's Great Fire of 1835—mainly serves to emphasize Calyo's originality, distinguishing his work from the more common sort of view pirated from other engravings or embellished beyond recognition. It does not necessarily imply photographic accuracy, or even that the work was completed outdoors, although Calyo, like many of his contemporaries, certainly did sketch and possibly even paint on the scene. But in this case the sheer size and unwieldiness of the page as well as the neatness and elaborateness of the detail make it likely that he executed most, if not all, of the final version in his studio. Certainly there are none of the spontaneous qualities we have come to associate with later *plein air* painting, but instead a deliberateness of composition and detail that reveals the traditional treatment of landscape subjects found in American art before 1850.

Like most painters of his day, including those with professed topographical intentions, Calyo organized what he saw—even if "on the spot"—in terms of picturesque formulas, and felt fully licensed to rearrange appearances for the sake of artistic effect. In addition to changes for the sake of clarity or emphasis, he laid out the landscape in alternating planes of sunlight and shadow and concocted a foreground *repoussoir* device to balance his composition and promote an easy transition into the distance. As an accomplished professional, Calyo carried all of this off without loss of authenticity, and in fact his additional artifices—the birds on the river, the tiny figures on the banks, or the jaunty boatman, smoking and tending his teakettle—only add to the charm and interest of the scene, capturing exactly "the gaiety of animation" that C. G.

258.

Childs had so admired in this "exceedingly picturesque" locale.

It has been remarked that a Calyo view of the Waterworks appeared on Stafford-shire china (Baltimore Museum, *250 Years of Painting in Maryland,* 1945). Although research has not produced details about the particular view chosen or the specific manu-facturer, the idea remains a likely one, for views of the Waterworks appear frequently among the thousands of pieces designed and exported expressly for the American market in the 1830s and 1840s (see nos. 237, 238). If the makers of English transfer ware were quick to appreciate the commercial appeal of a subject valued by Philadelphia's proud citizens and tourists, certainly they could also appreciate the virtues of Nicolino Calyo's crisp and sympathetic view.

KF □

THOMAS USTICK WALTER (1804–1887)
(See biography preceding no. 246)

258. *Debtors' Wing, Philadelphia County Prison (Women's Department, Moyamensing Prison)*

Tenth and Reed streets
1836 (demolished 1968)
Inscription: T. U. WALTER,/ARCH[T] (on inner face of abacus)
Coursed Connecticut red sandstone ashlar
50′ ½″ x 87′ 2″ x 32′ 4″ (15.3 x 26.6 x 9.8 m)

REPRESENTED BY:
J. T. Bowen (1801– c. 1856) after
J. C. Wild (c. 1804–1846)
Moyamensing Prison
1838
Hand-colored lithograph
5¼ x 7″ (13.3 x 17.7 cm)
The Library Company of Philadelphia

Winged Orb
1835
Cast-iron architectural element
9⅝ x 36 x 3″ (91.4 x 24.4 x 7.6 cm)
Independence National Historical Park, Philadelphia

LITERATURE: Scharf and Westcott, vol. 3, pp. 1835–37; Negley K. Teeters, *They Were in Prison: A History of the Pennsylvania Prison Society, 1787–1937* (Philadelphia, 1937), pp. 331–34; Frank J. Roos, Jr., "The Egyptian Style: Notes on Early American Taste," *Magazine of Art,* vol. 33 (April 1940), pp. 218–23,

255; White, *Philadelphia Architecture,* p. 26, pl. 29; Tatum, pp. 37–38, 73, 80, 85, 109, 179; Walton D. Stowell, "Thomas U. Walter, F.A.I.A.," in PMA, *Architectural Drawings,* pp. 41–42; Richard G. Carrott, "The Neo-Egyptian Style in American Architecture," *Antiques,* vol. 90, no. 4 (October 1966), pp. 482–88

EGYPTIAN CIVILIZATION has long fascinated the Western world, inspiring visions of pyramids, sphinxes, and mummies, and notions of grandeur, wisdom, and mystery. This fascination grew into a conscious revival of Egyptian forms after Napoleon's Nile campaign of 1798–99 led to the publication of two significant archaeological works about this ancient civilization, *Voyage dans la basse et la haute Egypte* (1802) by Dominique Vivant, Baron de Denon, and *Description de l'Egypte,* in twenty-one volumes, published between 1809 and 1828.

The funerary associations of the Egyptian style made it particularly popular for ceme-tery gates, but it was initially considered too awesome for prisons, which were the object of a great deal of reform zeal in the 1820s and 1830s. The objection was challenged in 1835 by John Haviland (see biography preceding no. 215), who designed his famous Egyptian revival "Tombs" in New York adjoining an Egyptian courthouse, physically and symbolically tying justice to punish-ment. With the legitimacy of Egyptian revival prison architecture thus established, Thomas U. Walter was free to use it in 1836 for the Debtors' Wing of the Philadelphia County Prison, which he had designed in the castellated Gothic style four years earlier (seen at left in Bowen's lithograph). Walter modeled the distinctive recessed entrance porch with its lotus-form columns after the Temple of the Sun on the Island of Elephan-tine, which is illustrated in *Description de l'Egypte.* He employed Egyptian details— battered window surrounds, winged orbs, and cavetto cornices, in addition to the lotus-form columns—with sufficient restraint to project a stability and an awesomeness that is reinforced by the superhuman scale of the two stories of windows set within a single battered frame. Its facade was so well designed, in fact, that some critics consider it the first full-fledged Egyptian revival building in the United States.

In 1841 the Pennsylvania General Assembly forbade imprisonment for indebtedness, so the Debtors' Wing was put to a variety of other uses, including the detention of witnesses, women, and those awaiting trial or serving short sentences. The building was con-demned shortly after World War II, but it was not vacated until August 1963, when a new detention center was completed in the Torresdale section of the city. The entire facility was demolished in 1968.

RW □

258.

JOHN NOTMAN (1810–1865)

John Notman was born in Edinburgh, Scotland, July 22, 1810, the son of a stonemason. His father descended from a long line of stonemasons and he evidently enjoyed comfortable circumstances, since he sent his son to the Royal Institution for the Encouragement of the Fine Arts in Scotland. There Notman made a special study of drawing before being apprenticed, first to a builder and later to the London architect and cabinetmaker Michael Angelo Nicholson. During his twenty-first year, Notman immigrated to the United States, probably directly to Philadelphia. His name first appears in Philadelphia directories in 1837, when he was listed as a carpenter, but his success with the Laurel Hill Cemetery commission quickly moved him into the ranks of architects. He married Martha Pullen in St. Luke's Episcopal Church, May 1841, and the couple moved to a brick row house at 1430 Spruce Street, where they lived until Notman's death in March 1865. Notman was a charter member of the American Institute of Architects in 1857, and also was a member of the Historical Society of Pennsylvania, the Musical Fund Society, the Athenaeum, and the Library Company, and served as manager of the Art-Union of Philadelphia for one year (1848), indicating his interest as an art collector.

Notman is probably best remembered for his church architecture in the Gothic and Romanesque revival styles, and was praised at the time of his death for his three best-known Philadelphia churches, St. Mark's, St. Clement's, and Holy Trinity. Yet his importance in America's architectural history of the 1840s and 1850s exceeds these narrow limits. He worked in the full range of antebellum architectural styles, but was particularly adept and innovative in the use of the Italian. Andrew Jackson Downing praised his design for Riverside (1837–39), Burlington, New Jersey, the home of the Episcopal Bishop of New Jersey, George Washington Doane, as "one of the best examples of the Italian style in this country." Two architects who received their training in his office emerged as leaders in the profession after Notman's death, James H. Windrim, who became Supervising Architect of the United States in 1889, and George W. Hewitt (see biography preceding no. 335), who with his brother William D. Hewitt, greatly determined the appearance of late nineteenth century Philadelphia.

259. *Laurel Hill Cemetery*

Ridge Avenue and Schuylkill River, above Thirty-fifth Street
Designed 1836

REPRESENTED BY:

E. J. Pinkerton (act. 1840–46)
General View of Laurel Hill Cemetery
c. 1836–46
Lithograph
5¼ x 10" (13.3 x 25.4 cm)
Free Library of Philadelphia

LITERATURE: Philadelphia, Laurel Hill Cemetery Company, Minutes of Directors, 1838–83; HSP, Franklin Fire Insurance Company, Policy No. 1967, Surveys of December 20, 1839 and May 12, 1885; *Guide to Laurel Hill Cemetery near Philadelphia* (Philadelphia, 1844); R. A. Smith, *Smith's Illustrated Guide to and through Laurel Hill Cemetery* (Philadelphia, 1852); Thompson Westcott, *The Official Guide Book to Philadelphia* (Philadelphia, 1875), pp. 305–10; *Rules and Regulations of Laurel Hill Cemetery of Philadelphia* (Philadelphia, 1892), pp. 8–14; White, *Philadelphia Architecture*, p. 27, pls. 31, 32; Francis James Dallett, "John Notman, Architect," *The Princeton University Library Chronicle,* vol. 20 (Spring 1959), pp. 127–39; Jonathan Fairbanks, "John Notman: Church Architect," M.A. thesis, University of Delaware, 1961, pp. 10–26; Tatum, pp. 86–87, 182–83, pl. 87; George Thomas, "The Statue in the Garden," in FPAA, *Sculpture*, pp. 36–45

TRADITIONAL BURIAL GROUNDS in church yards became impractical under the crush of urban growth in the early nineteenth century, and beginning in 1825, six cemeteries independent of clerical control were begun in Philadelphia. They were small and plain and successful, encouraging James Ronaldson (see biography preceding no. 197) in 1827 to design a more elaborate, landscaped private cemetery at Tenth and Bainbridge streets. The Laurel Hill Cemetery Company expanded upon Ronaldson's precedent and in 1836 purchased the estate of Joseph Sims along the east side of the Schuylkill River, about four miles north of the city's center. The concept of an extensive, rural cemetery had already been executed for Père Lachaise in Paris, the General Cemetery Company at Kensal Green near London, and Mount Auburn in Cambridge, Massachusetts.

The young John Notman patterned Laurel Hill's plan most directly after H. E. Kendall's 1832 proposal for the General Cemetery Company. Twisting roads wind through the undulating grounds overlooking the river and the open land on the west bank (see no. 332), which in 1836 was divided into country estates that became part of Fairmount Park (no. 313) in 1867. Responding to Washington Irving's recommendation that "the grave should be surrounded by everything that might inspire tenderness and veneration for the dead, or that might win the living to virtue" (*Guide to Laurel Hill Cemetery near Philadelphia,* Philadelphia, 1844, p. 19), the managers enhanced the architect's rambling plan by placing on the grounds at least one specimen of every valuable tree and shrub capable of growing in Philadelphia's climate. Laurel Hill was to be more than a burial ground; it was to be an arboretum as well, and one highlighted by notable monuments. Designed by such architects as Notman and Walter and carved by such stonecutters as John Struthers, these monuments add yet another dimension to the cemetery, that of a sculpture garden. It is small wonder that Laurel Hill became a great public attraction, leading to the enforcement of strict rules of conduct for its visitors.

The Egyptian style was a favorite for cemetery gatehouses, because it evoked the image of a dead civilization and of the pyramids, which were universally recognized as both tombs and monuments for the

259.

deceased. Mount Auburn Cemetery had been rendered in the Egyptian style, and, in fact, proposed plans laid before Laurel Hill's directors by William Strickland (see biography preceding no. 202) and Thomas U. Walter (see biography preceding no. 246) were both executed in that mode. Yet the directors chose the Roman Doric design of John Notman, evidently for its quiet monumentality. Although architectural taste of the next decade would have preferred a more picturesque Gothic or Elizabethan design for the wooded rural setting, the directors' preference for the classical was understandable for the time and place—a city under the architectural influence of Latrobe, Strickland, and Haviland.

A concession to the picturesque was the Gothic revival mortuary chapel, which was completed in 1838, evidently from Notman's design, although it had been begun three years earlier as part of a Roman Catholic academy that failed during its planning stages. Next to the chapel was the more fancifully picturesque superintendent's cottage and office, which was executed in a vaguely Italianate manner that would become popular for cottage and garden structures in the next two decades. The chapel was rarely used and was demolished in 1883, and the cottage was dismantled over the next two years. Joseph Sims's eighteenth century country house, The Laurels, stood atop the knoll overlooking the river until 1844, when the cemetery directors ordered its removal.

Notman's design for the gatehouse employs classical elements more for their effect than for archaeological correctness, and as such it seems more closely associated with the classicism of English Palladianism than that of the romantic revivals. For example, its symmetrical plan flanked by curving engaged-colonnade screens is not unlike country house plans to be found in such design books as James Gibbs's *Book of Architecture* (1728), while the Doric columns and frieze are similar to the Doric order in Abraham Swan's *British Architect* (1745). Furthermore, the Doric colonnade is gapped in the middle in a nonclassical manner in order to afford access to the arched gateway.

The design's monumentality has been compromised over the years for the sake of convenience. In 1885 the insertion of second-story rooms in the gatehouse and the addition of kitchens behind the screens led to punching windows through previously solid walls. Later the kitchens were raised to two stories and the balustrade was removed, diminishing the scale of the Doric colonnade. RW □

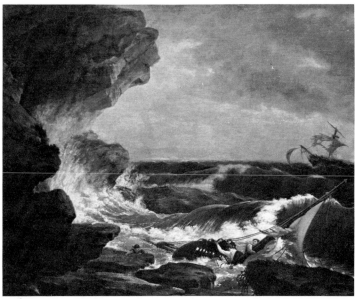

260.

THOMAS BIRCH (1779–1851)
(See biography preceding no. 188)

260. *The Rescue*

1837
Signature: Thos Birch 1837/ Phila. (lower center)
Oil on canvas
40 x 60″ (101.6 x 152.4 cm)
Washington County Museum of Fine Arts, Hagerstown, Maryland

PROVENANCE: Harry Shaw Newman, New York, by 1958; purchase, Washington County Museum of Fine Arts, 1964

LITERATURE: Doris Jean Creer, "Thomas Birch: A Study of the Condition of Painting and the Artist's Position in Federal America," M.A. thesis, 1958, University of Delaware, p. 67, no. 98

THE NIGHTMARISH SHIPWRECK with survivors tossed against a rocky shore in a violent storm was a favorite theme in late eighteenth and early nineteenth century French and English painting. Shipwrecks were a common occurrence, and the fear of sinking in a gale or being swept against a rugged coast was very real. The shipwreck became a sensational subject, capable of gripping the public with an awesome sense of dread.

Some of Birch's shipwreck paintings were commissioned by survivors and were therefore based upon their descriptions. This view, *The Rescue*, perhaps his largest, is one of his most dramatic, but is undoubtedly purely imaginary. Birch seems to have begun painting shipwreck scenes soon after he turned to marine painting. He exhibited one in the first Pennsylvania Academy exhibi-

tion of 1811 and others in later exhibitions, some of which he offered for sale. The unusually large size of *The Rescue* indicates that it was probably meant for exhibition; yet, although the work is dated 1837, Birch's entries in the Academy exhibitions from 1835 to 1843 do not include a shipwreck; thus it may have been created as a showpiece to draw visitors to his studio.

Birch was inspired by William Falconer's popular poem *The Shipwreck*, published in England in 1762, which by 1830 had run through at least twenty-four British editions and several in America (T. S. R. Boase, "Shipwrecks in English Romantic Painting," *Journal of the Warburg and Courtauld Institutes*, vol. 22, 1959, p. 335). Birch exhibited a shipwreck described as "after Falconer" in 1829 and again in 1843 and 1847. When the Levantine trader *Britannia* sank off Cape Colonna, Greece, Falconer had been one of three survivors, and he later drowned in a wreck. *The Rescue*, clearly focusing on the plight of three survivors, is very likely based upon Falconer's tale. As in the poem, the three survive by clinging to the masts and rigging, deliberately cut down for that purpose, and float to the mainland at the foot of a rocky cliff.

The high, foreboding cliff to the left and the low foreground rocks best recall the shipwreck paintings of the 1750s by the French romantic seascapist Joseph Vernet, some of whose work was exhibited at the Pennsylvania Academy beginning in 1811. Birch made copies after Vernet and was generally influenced by the popular prints of Vernet's work. In *The Rescue*, Birch exploited the full dramatic potential of the catastrophe, reducing the scale of the men and the ship in size to emphasize man's helplessness before nature. Vernet's work,

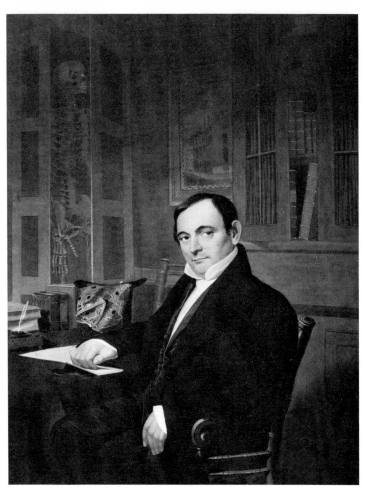

261.

He opened his school across from the American Academy of the Fine Arts in Manhattan and was instrumental in the revival of this dormant institution, becoming keeper and librarian of the Academy's collection of paintings and casts. However, his clash with John Vanderlyn (whose studio later shared space in the Academy's building along with Smith's drawing school) over the propriety of Vanderlyn's nude *Ariadne*—all too accessible, in Smith's opinion, to the impressionable minds of his young students—led to Smith's resignation and John Trumbull's rise to power in the Academy. The uncongenial atmosphere in New York following this incident led Smith to return to Boston in 1827, although not before lambasting all parties, including the new National Academy of Design, in a series of newspaper columns signed "Neutral Tint." Dunlap's unsympathetic account of this episode (*History,* vol. 3, pp. 23, 36), colored by his dislike for the outspoken and irascible Smith, did much to blacken Smith's reputation after his death.

While in New York, Smith had issued the first edition of his popular *Juvenile Drawing Book,* c. 1822; in Boston he published *Picturesque Anatomy* in 1829, again to unanimous praise. After moving to Philadelphia in 1829 he continued to write art instruction manuals, including *The Art of Drawing the Human Figure,* 1831, and *Chromatology,* 1839. His drawing academy, which was consolidated with his residence on Sansom Street in 1835, flourished for fifteen years in Philadelphia. As a teacher, Smith's reputation rested on the popularity of his books as well as the successes of his many students, who included Rothermel, Cummings, Agate, Gifford, and Leutze. His device for teaching perspective drawing—a contraption with movable wooden sticks and strings—gained him considerable fame and brought students, among them Sully, who exchanged pointers on oil painting in return for Smith's instruction in perspective. In addition, he enjoyed respect and patronage as a painter, particularly for his views and portraits, many of which were engraved, and he exhibited his work continuously at the Pennsylvania Academy (1824–31) and the Artists' Fund Society (1835–41). In his later years, Smith—now somewhat mellower in outlook—moved again to New York, made his peace with the National Academy of Design (exhibiting there from 1844 to 1846 and briefly lecturing on perspective), opened yet another school, and lived quietly until his death in 1849 (see NYPL, Edward S. Smith, "John Rubens Smith," c. 1930, typescript).

although theatrical, is more carefully and traditionally composed and does not overwhelm the viewer by bringing the crisis to the edge of the foreground.

Birch's earlier landscapes and seascapes were tighter and more linear, in accordance with his training with an engraver. *The Rescue* exemplifies the free brushwork of Birch's later work and his special capacity for convincing portrayal of the luminous depth of the sea, as seen in the transparent rising, foreground breakers. Although never a mariner himself, Birch was admired by contemporaries for his realistic depiction of shorelines and ships at sea.

DE □

JOHN RUBENS SMITH (1775–1849)

Born in London, the grandson of a landscape painter and son of John Raphael Smith, a well-known engraver, John Rubens Smith learned watercolor, miniature, and printmaking techniques from his father and studied drawing at the Royal Academy.

He exhibited his first portrait at the Academy in 1796, at the age of twenty-one, and continued to show his works in London through 1811. During a brief visit to the United States in 1802, Smith met Charles de Saint-Mémin and was encouraged by his example and inspired by the prospects for a flourishing portrait trade in America. Four years later, bearing letters of introduction from Benjamin West, Smith immigrated to Boston permanently.

Already an experienced teacher, Smith perceived the low quality of art education in America as a personal challenge and almost immediately opened a drawing academy in Boston—the first in a long series of such schools. With Allston, Stuart, and others he helped found the short-lived Boston Academy of Fine Arts in 1810, and then involved himself in a variety of artistic pursuits, including watercolor portraiture, lithographed views of the city, and stipple engraving. But prospects for greater success in the larger, more cosmopolitan city of New York led him to settle in Brooklyn in 1815.

261. *Philadelphia Physician*

1838

Signature: Painted by J R Smith/1838 Phila (lower right)

Watercolor and white gouache on paper, laid down

17 x 13¹⁄₁₆″ (43.1 x 33.1 cm)

Museum of Fine Arts, Boston. M. and M. Karolik Collection

PROVENANCE: Dr. Lewis, c. 1844; Maxim Karolik, 1960

LITERATURE: Karolik, *Drawings,* vol. 1, no. 668, fig. 140

ALL ASPECTS OF John Rubens Smith's English training are shown to advantage in his large and polished *Philadelphia Physician*. The careful hatching of the face and hands demonstrates Smith's engraver's touch as well as his command of standard techniques for miniature painting in watercolors, and the studied elegance of pose and supporting detail show his mastery of the conventions of the "status" portrait. Smith portrays a well-dressed gentleman of fashion (note the scarf draped over the top hat on the table) as well as a man of erudition; his bookcase is left open to reveal impressive leather-bound volumes; a closet door stands ajar to indicate his interest in anatomy; pen and ink are at hand; and the sitter himself is posed —although somewhat deliberately—with his fingers holding a place in a slim notebook. Smith spared no pains with this drawing, and executed at least one preparatory sketch (in pencil and watercolor, 8 by 7¼ inches, now in a private collection) before launching into the finished version. Precise academic perspective (Smith's specialty as a teacher), close observation of physiognomy, a conventional, slightly dramatic light source, and a controlled use of white gouache and the white paper surface for highlights among the sober, careful washes—all these skills contribute to an effect of poise and dignity that reflects on the competence of both artist and sitter; if not psychologically penetrating, the portrait nevertheless exudes the grace, assurance, and accomplishment of both John Rubens Smith and his Philadelphia physician.

The mutual pride of artist and sitter in this one work may be seen in a reminiscence of Smith's grandson, who particularly remembered, as a boy, a watercolor portrait "which was very highly prized by the owner, a prominent physician" (NYPL, Edward S. Smith, "John Rubens Smith," c. 1930, p. 64). Smith's own estimation of the work may have led him to exhibit it twice: first at the Pennsylvania Academy in 1840, as "A Physician," and then at the National Academy of Design in New York in 1844,

as "Portrait of a Physician." It is impossible, however, to determine whether these two titles refer to the same portrait, or even to the watercolor shown here. If so, the owner of the New York entry—Dr. Lewis, and perhaps the "prominent physician" mentioned above—may provide a clue to the identity of the sitter, who could be Dr. Lewis himself. There is a strong possibility that the first owner of any given portrait would be the sitter or a member of his immediate family, but unfortunately a confusion of Lewises in Philadelphia and New York at that time makes further speculation difficult. Nevertheless, the lack of positive identification, while it may decrease the historical value of the portrait, does not obscure the "meaning" of this work as a straightforward record of social and professional position, nor does it obstruct our appreciation of John Rubens Smith's solid skills at the age of sixty-three.

KF □

REBECCA SCATTERGOOD SAVERY (1770–1855)

Rebecca Scattergood Savery was born on July 29, 1770, the daughter of John and Elizabeth Head Scattergood. On November 24, 1791, Rebecca married Thomas Savery, the son of the Philadelphia cabinetmaker William Savery, who was himself a carpenter and builder (see biography preceding no. 40).

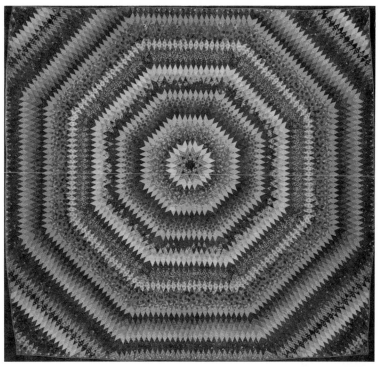

262.

Thomas Savery was an elder in the Arch Street Meeting of the Society of Friends and was active in Philadelphia affairs, including the original Anti-Slavery Society in Philadelphia and the Harmony Engine Company of the Volunteer Fire Department. In 1839, at the age of sixty-nine, Rebecca made this quilt for her first granddaughter, Sarah Savery, born in that year to her son Thomas and his second wife, Hannah Webb Savery. Rebecca died sixteen years later, at the age of eighty-five (see A. W. Savery, *A Genealogical and Biographical Record of the Savery Families and of the Severy Family,* Boston, 1893).

262. *Patchwork Quilt*

1839

Inscription: Mrs. H. Y. Pennell Quilt— made in 1839 has 3903 patches. Made by Rebecca Scattergood Savery my great grandmother for mother (in ink on a square of muslin attached to corner of quilt)

Cotton chintz, cotton wadding

119½ x 115″ (303.5 x 292.1 cm)

Philadelphia Museum of Art. Given by Mrs. Lewis Barton and Mrs. David Barton. 75-5-1

PROVENANCE: Sarah (Savery) Mellor; daughter, Mrs. H. Y. Pennell; daughter, Sarah (Pennell) Barton; granddaughter, Nancy (Barton) Barclay

THE CRAZE FOR COTTON PATCHWORK in America, which began in the early part of the nineteenth century, continued until perhaps 1870 (with subsequent revivals).

The design on the face of the quilt shown here is an impressive example of the traditional "sunburst" pattern. Diamond-shaped patches of cotton chintz radiate in octagonal-shaped concentric rings from an eight-pointed star. Each individual ring is composed of patches of the same chintz, except at the outer corners where the maker appears to have run short of certain colors; the rings have been combined with other rings of related colors to form bands around the central figure. The approximately thirty-four or more different chintz patterns form an important catalogue of contemporary fabric design. The patches have been turned in and attached to one another by means of a running stitch, which also served for the quilting. These patches were probably worked in pie-shaped segments along the lines of the design to facilitate the detailed work, and then the segments were joined to the whole.

The reverse is composed of five widths, each from 18 to more than 24 inches wide, of a roller-printed design composed of large Gothic pillars and arches on a floral ground in shades of brown on white. The selvages are not available for inspection, but the original size of each width was probably close to 25 inches. The vertical repeat of the pattern measures 14⁹⁄₁₆ inches. The fabric has been glazed, the cloth coated first in wax or some other substance and then highly polished to produce the glaze. The type and style of print and the relatively loose construction of the plain-weave cotton leads one to believe that this backing was an inexpensive product appropriate for use on the reverse. Quilting serves to attach the face, wadding, and reverse along the lines of the joining of the patches. In the tradition of the nineteenth century, as opposed to the eighteenth century, this quilting was predominantly used to reinforce rather than to decorate. Because it was a rather monotonous task, it was often accomplished in a quilting bee, a social event which occasioned the gathering of a number of women.

PC □

263.

263. Armchair

c. 1835–40

Inscription: No 2 (in pencil script on inside back of chair rail)

Maple; bird's eye maple veneer; pine seat rails; twentieth century upholstery

44¼ x 26⅞ x 18¼″
(112.3 x 68.2 x 46.3 cm)

Mr. and Mrs. James Biddle, Andalusia, Pennsylvania

PROVENANCE: Nicholas Biddle (1786–1844); wife, Jane Margaret (Craig) Biddle (1789–1856); son, Charles J. Biddle (1819–1873); son, Charles Biddle (1837–1923); son, Charles J. Biddle (1890–1972); son, James Biddle (b. 1929)

ALTHOUGH THE MAKER of this maple armchair is unknown, the chair was among the original furnishings of Andalusia, the country home of Nicholas Biddle, located north of Philadelphia on the Delaware River. The chair was probably made to order for Biddle about 1835–40. When the Second Bank of the United States (no. 202), of which Biddle was president, declared bankruptcy, Biddle suffered severe financial reverses and all of his possessions were sold at auction in 1841. But his sons, not subject to the bankruptcy proceedings, were able to repurchase Biddle's effects and return the household goods to their mother who could legally hold them.

Some bills of sale for Andalusia furnishings are known to have survived, such as for a chandelier from Cox & Co., New York, and for two chandeliers from a Paris firm; and two maple center tables in the classical style bear the label of Anthony Quervelle. It is not known whether this armchair was originally in the main house, which was extensively remodeled for the Biddles according to designs by Thomas U. Walter between 1834 and 1837, or in the Gothic revival cottage, which Walter designed in 1837.

This chair is attributed to a Philadelphia maker because of its long history of Philadelphia ownership and because of the traditional popularity of maple for furniture in this city. The furniture at Andalusia is predominantly of maple. In fact, even the doors of the main house were painted at Walter's request to simulate maple. It is a remote possibility that Walter designed some of the furniture at Andalusia, including this armchair. Walter was a juror for the cabinet-making section of the Franklin Institute exhibitions of 1842 and 1849, and he designed chairs for the United States House of Representatives, as well as for Philadelphia cabinetmakers.

Although this chair has Gothic arches along the crest rail and trefoil finials above the rear stiles, its form is based on a common fifteenth century prototype, one example of which is seen in Henry Shaw's *Specimens of Ancient Furniture Drawn from Existing Authorities* (London, 1836, pl. 6). Here it was included with medieval and Gothic examples and was described as an "Ancient chair in the Vestry Room of York Cathedral/ Date about the time of Richard 2nd."

Nicholas Biddle (1786–1844), the brilliant financier, was born and educated in Philadelphia. In 1801 he was graduated as valedictorian from Princeton and then began to study law. Before finishing, however, he accepted the position of secretary to John Armstrong, minister to France, and accompanied him to Paris, where he was at the time of the coronation of Napoleon. On completing this duty he traveled extensively in Europe and returned to London where he became secretary to Monroe, then United States minister to England. In 1807 he returned to Philadelphia and began the practice of law, devoting much of his attention to literature and writing papers chiefly on the fine arts. He was elected to the state legislature in 1810 and the state senate in 1814. His first speech was made in favor of the United States Bank which was his first step in his financial career. As the democratic candidate in 1817 he was defeated by the Federalists, and when the United States Bank was rechartered in 1819, President Monroe appointed him a government director. In 1823 he was appointed president, which position he held until 1839.

DH □

264.

Dunlap had hailed him as an artist who "paints signs with talent beyond many who paint in higher branches" (Dunlap, *History,* vol. 2, p. 471); years later he was similarly lauded by Scharf and Westcott. Woodside continued painting almost until his death in 1852 at age seventy-one. It was said in his obituary that "he was one of the best sign-painters in the State, and perhaps in the country, and was the first to raise this branch of art to the degree of excellence here, which it has now attained" (*Public Ledger,* February 28, 1852).

264. *Lady with Guitar*

1840–50
Signature: WOODSIDE (lower right)
Oil on panel
32⅜ x 21⅝ x 3⅞″ (82.2 x 54.9 x 9.8 cm)
INA Museum, INA Corporation, Philadelphia

LITERATURE: "Life in Philadelphia," *PMA Bulletin,* vol. 35, no. 186 (May 1940), nos. 71 or 72, p. 41

FIRE ENGINE PANELS reflect regional differences of apparatus design and decoration. Panels like this one by John Woodside were displayed on the sides of the condenser cases of so-called Philadelphia-style hand pumpers (see no. 317). The condenser case was a raised unit with the engine's pumping arms extending from both ends, and its visibility invited decoration.

Volunteer firemen were fiercely proud of their engines, and kept their apparatus in top mechanical and physical repair. The engines were manufactured in standard colors, and each company had its engine individually painted to match its hats, capes, and belts. The company name was painted on the engine or displayed on a brass plate at the top of the condenser case and the sides and ends of the engine itself were stylishly decorated. The decorative panels on the sides of the condenser case were removable, enabling the volunteers to exhibit them at parades and other special occasions or to protect them from exposure to heat, water, and inclement weather.

This engine panel is one of a pair painted by Woodside, showing ladies with musical instruments. In *Lady with Guitar,* a woman holds a piece of sheet music, and her guitar leans against the rocks to her right; the matching panel (Insurance Company of North America) shows a woman playing the harp. Both are depicted in romantic outdoor settings.

This panel is made of solid mahogany, carved to expose tenons to fit into the condenser case at top and bottom. Carved scrolls adorn the sides; those at the top are integral

JOHN ARCHIBALD WOODSIDE
(1781–1852)

Born in Philadelphia in 1781, John Woodside came to be one of Philadelphia's best known sign and ornamental painters, although little is known of his artistic training. He may have been apprenticed for a time to the painter Matthew Pratt or to one of Pratt's associates. In June 1802, Woodside worked for William Berrett, a coach and sign painter. In early 1803 he opened his own shop in Philadelphia and painted fire buckets for local residents as well as the regimental colors for several outlying Pennsylvania counties (HSP, John A. Woodside, Day Book).

Although primarily a sign painter, Woodside had skill surpassing that normally associated with an artisan. He exhibited paintings at the annual exhibitions of the Pennsylvania Academy between 1817 and 1836; mostly still lifes or portrayals of animals. Although Woodside's choice of color and his compositional techniques served him well in the translation from

signboard to canvas, his work lacked the polish of his contemporaries trained as artists (Wolfgang Born, "Notes on Still Life Painting in America," *Antiques,* vol. 50, no. 3, September 1946, p. 159).

In addition to sign painting, Woodside also did ornamental work for a number of Philadelphia organizations. He painted colors for military units, including drums and elaborate banners for parade use, and was occasionally commissioned to do commemorative paintings of military heroes. But he was best known for his work for the volunteer fire companies of Philadelphia, for whom he painted designs on buckets, hats, and capes, as well as parade banners and panels for the sides of prized engines and hose carriages. He easily adapted his sign painting techniques to create attractive compositions for these pieces, and the maidens from his signboards became Greek goddesses, angels, and genteel ladies (Flexner, *Distant Skies,* p. 195).

His reputation spread and he was commissioned to paint panels for a New York company in the late 1840s. As early as 1834,

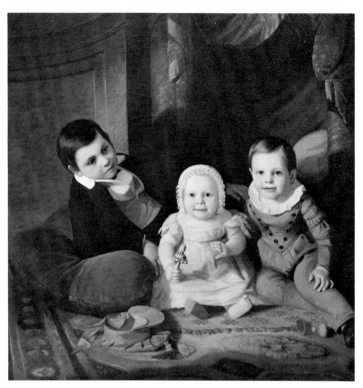

265.

with the original wood, those below are applied. An elaborate carved element has been added below the painting, with a heavy rocaille shell surrounded by elaborate scroll work. Extending to the edges of the panel, this applied carving continues the scroll design from above. The entire carved design was originally gilded.

Paintings on engine panels reflect the mottoes, themes, or names of the volunteer fire companies. Patriotic themes were common and depicted well-known political figures, usually Washington or Franklin, or important events from American history. Mythological themes were also popular. The significance of *Lady with Guitar* and its mate is less apparent, but may allude to the idea of harmony. Thus, although tradition claims that the panels were executed for the Fame Fire Company, it seems more likely that they were painted for the Harmony Fire Company, since its pumpers had narrow condenser cases, and the Harmony Fire Company purchased engines from Agnew in 1842 and 1847.

Woodside's engine panels from the 1820s and 1830s are precise and elaborate in style. Later panels, such as the *Lady with Guitar,* are less stilted; the clothing is draped more comfortably, and the figures are less aloof. His late panels are muted in color and the figures are defined in a softer manner.

Analysis of Woodside's style thus provides assistance in dating this panel. The woman's attire is more of a costume than a specific contemporary fashion, and resembles most closely the Renaissance revival clothing of the 1830s, but her hair style is closer to styles about 1850. But folk art rarely relates directly to contemporary styles, and in view of the overall romanticism of the clothing and setting, Woodside was probably portraying an idyllic woman in an idyllic setting. The unknown carver of the heavy rocaille shell and other elements place the work in the period of the rococo revival, also closer to 1850, but the use of the shell as a decorative element suggests more about the carver's personal taste than contemporary carving designs. The detailed carving below the paintings on these panels is an unusual feature; most panels have carving only at the sides. Based on Woodside's painting style, as well as the decorative features of the panel, a date between 1840 and 1850 is suggested.
LAL □

JOHN F. FRANCIS (1808–1886)

According to a copy of John F. Francis's will found by Alfred Frankenstein (*After the Hunt,* pp. 135–37) in the Orphan's Court of Philadelphia, Francis died in Jeffersonville, Montgomery County, Pennsylvania, on November 15, 1886, at the age of seventy-

eight. Frankenstein's subsequent discovery of obituary notices, family records, and Francis's manuscript lists of portraits show that the artist was born in Philadelphia and followed a career as an itinerant painter, living and working at various times in Philadelphia, Washington, Nashville, Harrisburg, Pottsville, Sunbury, and other areas in central Pennsylvania, and Chillecothe, Ohio. The same researches led to thirty-one previously unpublished portraits and still lifes by Francis.

Francis is listed as resident in Philadelphia in 1840. He participated in the Artists' Fund Society shows of 1840, 1841, and 1844, and in the Pennsylvania Academy exhibitions of 1847, 1855, and 1858. In 1851, Francis entered a "Fruit Piece" in the fine arts section of the Franklin Institute annual exhibition, which won a Third Premium prize.

Although a considerable number of facts about Francis's life are known and more than sixty paintings by him have been identified, other information relating to his training and the chronology of his career as an artist remains undiscovered.

In a letter written after Francis's death and published in the Norristown, Pennsylvania, *Herald and Free Press,* December 6, 1886, Dr. Charles Collins, minister of the Jeffersonville Presbyterian Church, recalled that Francis "spoke with pride of his former associations among the opulent and distinguished in society. Forty or fifty years ago, he ranked himself among the then well-known Philadelphia portrait painters, Sully, Darley, Brewster, etc." (Alfred Frankenstein, "J. F. Francis," *Antiques,* vol. 59, no. 5, May 1951, p. 375).

265. *Three Children*

1840
Signature: Jno. F. Francis pt 1840
(on back before relining)
Oil on canvas
42 x 42″ (106.6 x 106.6 cm)
Museum of Fine Arts, Boston. M. and M. Karolik Collection

PROVENANCE: Found in upper New York State; with Victor Spark, New York, 1944; Maxim Karolik

LITERATURE: Karolik, *Painting,* p. 262, illus. p. 263

THIS GROUP PORTRAIT, dated 1840, is the largest and most ambitious of the known portraits by John F. Francis, and in contrast to the work that such established portraitists as Sully, Neagle, Rembrandt Peale, Street, Winner, and Otis exhibited in 1840, it must have appeared original in concept and

independent in technique. A square canvas in place of the standard portrait rectangle allows Francis to show the children in the directly artificial pose of later group photographs. Instead of conventional sitting or standing poses which express childish grace through carefully adjusted harmonies of form, these three children appear to have been brought together for the purpose of having their portrait made, in a sumptuous interior that is spatially logical only as a setting for them. Pose and setting serve the narrative purpose of creating individual character beyond simple likeness; the lively attentiveness and bright, fussy clothing of the two youngest children contrast with the lounging attitude and sober introspection of the eldest boy in a manner that invites affectionate remembrance of three stages of childhood.

While records of Francis's life indicate that he began his itinerant career before being resident in Philadelphia in 1840, his painting style appears to be based upon models available to him in Philadelphia. The smooth pink flesh tones and the strong, varied colors that appear in costume and furnishings are similar to those in Sully's work of the 1830s and 1840s. But Francis's color is more opaque than Sully's and is organized into an overall scheme of repeated tones, instead of remaining as isolated areas of local color. Especially in details of dress and setting, paint remains as discrete, varied strokes of pigment that emphasize large volumes and create form by the juxtaposition of colors, rather than being shaped into smooth, defining contours.

The identity of the three children is unknown, and a search of city records for information about the patrons provides inconclusive evidence. The catalogue of the Karolik collection suggests that this might be the painting owned by A. Nesbit that was exhibited at the Pennsylvania Academy exhibition of 1855 as *A Group of Children*. However, Rutledge's cumulative record of exhibitions establishes that Francis exhibited *A Group of Three Children* belonging to James Hunt at the Artists' Fund Society exhibition of 1840, the year this portrait is dated.

DS □

LOUIS MARIE FRANÇOIS RIHOUET (ACT. FRANCE 1818–55)

Louis Marie François Rihouet was one of the many successful porcelain dealers and decorators who flourished in Paris during the nineteenth century. Purchasing undecorated white ware directly from manufacturers, such retail merchants provided both the new Parisian bourgeoisie and foreign clients with luxury table services that could be readily personalized with decorative monograms and coats of arms.

Born in 1791 at Perrier, Rihouet moved to Paris in 1818 where he opened a shop at 49, rue de l'Arbre Sec (Regine de Plinval de Guillebon, *Porcelain of Paris, 1770–1850,* trans. by Robin R. Charleston, New York, 1972, p. 294). In 1824, Rihouet was granted the title of Supplier to the King. By about 1830 business was so successful that the salesroom was moved to larger quarters at 7, rue de la Paix. Rihouet continued to direct the firm until 1855 when he seems to have established a partnership with Lerosey. In that year, the firm under its joint directorship exhibited a dessert service in the "style Pompadour" at the Paris Universal Exhibition (*Exposition des produits de l'industrie de toutes les nations, 1855, Catalogue Officiel,* Paris, n.d., p. 124). Lerosey succeeded Rihouet, and the firm continued under his name until 1900.

266. *Dessert Plates and Sauce Tureen*

c. 1840
Decorated by Louis Marie François Rihouet
Mark: Rihouet/à paris (on back in overglaze red script)
Inscription: Museum de Philadelphie. (Etats-Unis.) (on back of plate in overglaze black script); 1er Temple des Quakers à Philadelphie./(Etats-Unis.) (on back of plate in overglaze black script)
Hard-paste porcelain
Plates diameter 9″ (22.8 cm); sauce tureen, height with lid 7½″ (19 cm), diameter 8⁵⁄₁₆″ (21.1 cm)

Philadelphia Museum of Art. Given by Mrs. John Penn Brock. 64–115–10, 16, 21a, b

PROVENANCE: Descended in Rush and Biddle families to Mrs. John Penn Brock

LITERATURE: C. S. Hathaway, "Philadelphie," *PMA Bulletin,* vol. 60, nos. 283–84 (Fall/Winter 1965), pp. 31–33

266.

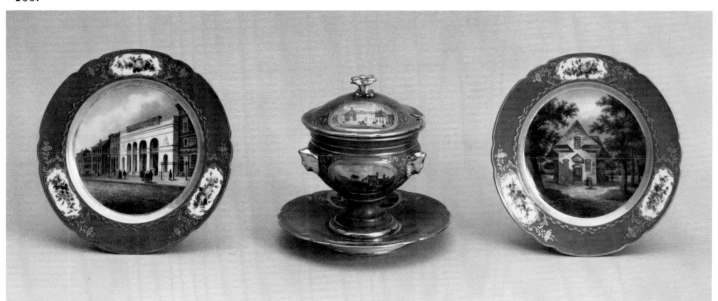

DESCENDED TO THE DONOR through Rush and Biddle forebears, the large porcelain dessert service, of which three pieces are shown here, has been stated variously to have been commissioned by Richard Rush when he was minister to France (1847–49) and to have been ordered for Phoebe Anne Ridgway (d. 1857), wife of Dr. James Rush. Prominent Philadelphians had long been in the practice of decorating their dining tables with French porcelain. Gouverneur Morris visited the factories at Sèvres and Angoulême in 1789–90, ordering porcelain from the latter because he thought it "handsome and cheaper than that of Sèvres" (Louis Schreider III, "Gouverneur Morris: Connoisseur of French Art," *Apollo,* vol. 93, no. 112, June 1971, p. 478; de Guillebon, cited above, p. 300). In order to attract such important clients as Rush after the Napoleonic wars, Parisian porcelain dealers reproduced American views on their tablewares. In the Rihouet service, such views were taken from the most popular engravings of the period, notably those published in Childs's *Views in Philadelphia* and from French versions pirated from Childs, such as those that appear in Roux de Rochelle's *États-Unis d' Amérique* (Paris, 1837). The style of the service with its neo-rococo border of floral reserves suggests the formal and conservative nature of Rihouet's production, and of the foreign clientele that such taste attracted.

One of the plates is decorated with "Premier Temple des Quakers à Philadelphie" (The Friends Meeting House), which was built in 1695 by Welsh settlers, actually at Merioneth (now Merion), and named after the settlers' birthplace in Merionethshire, Wales.

The original engraving by J. W. Steel after a painting by Hugh Reinagle (c. 1790–1834) was published in Childs's *Views in Philadelphia.* The view was republished in 1837 with only slight modifications in Roux de Rochelle's *États-Unis,* but credited to Thienon and Boisseau as designer and engraver, respectively. In adopting a slightly higher and more distant viewpoint, smoothing out the rough granite masonry of the house, and trimming the forest back from its somewhat overgrown state, Rihouet follows the French source, and in so doing, alters the pioneering unruliness of the American view by characteristic French order and reserve.

The second plate shows the "Museum de Philadelphie," actually the Arcade at Chestnut between Sixth and Seventh streets, designed by John Haviland (see biography preceding no. 215) and finished in 1828–29. The museum, founded by Charles Willson Peale and directed after his death in 1827 by his son Rubens, was transferred in 1828 from the State House to the Arcade where it

remained until 1838 (Richard P. Ellis, "The Founding, History and Significance of Peale's Museum in Philadelphia, 1785–1841," *Curator,* vol. 9, no. 3, September 1966, p. 254). In its first city directory advertisement after the move to the Arcade in 1828, the museum is described as "the oldest and largest establishment in the United States [with] collections of the Animal and Mineral kingdoms of nature … of implements and ornaments of our aboriginal tribes … and of Portraits of American Statesmen and Warriors of the Revolution…." The view is after a drawing by Jean-Baptiste Arnout engraved by Hyacinthe Traversier, and published in Roux de Rochelle's *États-Unis* of 1837. In his decoration of the plate, Rihouet follows the Arnout-Traversier version, although he adopts a higher and more distant viewpoint and extends the scene farther to the left than it appears in the engraving.

The lid of the sauce tureen is decorated with "Philadelphie" and Buénos Ayres"; the tureen with "Castel Nuova," "Le Cajamar," and "Borgaitto, Italie"; and the plateau with "Pont à Narni" and "Narni, Italie."

Betraying the strictly Philadelphian character of the scenes that decorate most pieces in the service, this tureen shows the range of Rihouet's foreign market through its Italian and South American views. The lid however is decorated with Old City Hall, the State House (Independence Hall), and Congress Hall, Philadelphia's most important historical complex even in the nineteenth century. The view is after a drawing of the State House by George Strickland, engraved in 1828 by Childs and published in his *Views in Philadelphia.* A somewhat modified view entitled "Hôtel de Ville de Philadelphie" was republished in Roux de Rochelle's *États-Unis* of 1837 where Traversier is credited as engraver. Rihouet again follows the French version with its simplified background, in which a single gentleman on horseback replaces Strickland's military parade.

KH □

ALBERT NEWSAM (1809–1864)

The best account of the life of Albert Newsam was related by one of his closest friends, Joseph O. Pyatt, in *Memoir of Albert Newsam* (Philadelphia, 1868). Newsam was born in Steubenville, Ohio, on May 20, 1809. His father, William Newsam, was a boatman on the Ohio River. Still young when both of his parents died, Newsam was sent to live with Thomas Hamilton, an Irish hotelkeeper. A deaf-mute from birth, Newsam was not able to pursue the usual activities and education of a child, which may account for his early interest in drawing, a private

pursuit which did not require communication with others.

At age eleven he was taken from his home by William P. Davis, who falsely promised advantages which the family could not refuse. Instead, Albert's talent was exploited by Davis to entice sympathy and money from the charitable. With Davis posing as Newsam's deaf-mute brother, the two journeyed to Philadelphia, where Davis sold the boy's work on street corners. Not long after their arrival, Bishop White, the new president of the Institution for the Deaf and Dumb, fortuitously passed the street corner where Newsam was displaying his craft. Bishop immediately recognized his ability and arranged for his care and education at the Institution, and the imposter, Davis, left town. With proper instruction, Newsam's artistic skills improved considerably.

Newsam remained in the Institution until 1827, when he was apprenticed to C. G. Childs to learn engraving. He also received instruction in painting from Hugh Bridport, George Catlin, and R. G. Lambdin. He continued as an artist in Childs's firm when lithography became the principal business; his interest in art history and new technical developments, as well as his growing collection of prints, prepared him for the new medium. He remained with the firm throughout its changes in ownership, and was with P. S. Duval, his last employer, for thirty-five years. In October 1859 he was paralyzed on his right side; he died on November 20, 1864.

Newsam's contemporaries spoke of the man and his work with admiration and fondness. A letter written to Joseph Pyatt from P. S. Duval best describes his artistic ability and limitations, especially his well-known talent in the field of portraiture:

Newsam's principal talent was his copying. He was so faithful in reproducing the original that if there was any part of it that had to be altered, he could rarely fail in making the alterations. It was with difficulty he could avoid copying minutely. I have seen him copy the finest copperplate engraving—a style so different from lithographs—with such perfection that his copy could scarcely be detected. When he had to copy portraits from life, which was often the case before the invention of daguerreotypes or photography, his infirmity had great influence upon the expression of his subject, which may be easily accounted for, not being able to converse with persons sitting for him, their physiognomy would invariably assume the expression of wearisome monotony, and it was with difficulty that he could avoid copying the same expression in his lithographic portrait. Persons who have sat for an artist will easily understand how tedious a task it is

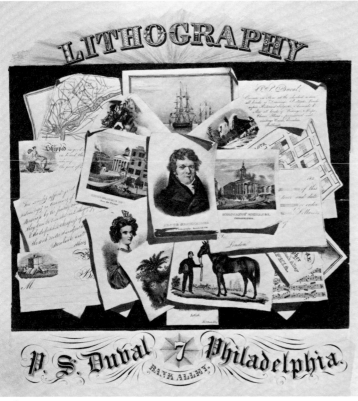

267.

to sit for a mute artist; it is a well-known practice of portrait painters to keep their model lively and animated by conversing with them on a topic of a pleasant nature; therefore it is not to be wondered at that some of the portraits he took from life should sometimes lack expression and animation. (Joseph O. Pyatt, *Memoir of Albert Newsam,* Philadelphia, 1868, pp. 148–49)

267. *Trade Card for P. S. Duval*

c. 1840
Signature: A. Newsam/Artist/No. 7 Bank Alley (bottom center)
Inscription: LITHOGRAPHY (above image); P. S. Duval Philadelphia./7 Bank Alley (below image)
Lithograph with watercolor
15⅝ x 14¹¹⁄₁₆″ (39.6 x 37.3 cm)
Historical Society of Pennsylvania, Philadelphia

LITERATURE: Wainwright, *Early Lithography,* p. 66, no. 220, illus. p. 67; *Made in America,* no. 56

TRADE CARDS WERE AMONG the most widely used forms of advertisement by businesses in the eighteenth century (see illustration with no. 61). The idea originated in England where tradesmen employed engravers to create decorative and attractive designs illustrating their wares. With the introduction of the less expensive technique of lithography in the United States in the early nineteenth century, trade cards became available to a wider public.

By the time C. G. Childs opened his printing establishment in 1829 on Chestnut Street, lithographic houses had already been established in New York and Boston, and several minor operations existed in Philadelphia. Albert Newsam was employed as the chief artist in the Childs firm and was involved mainly in the production of portraits. Although the firm gained a considerable reputation, the venture was not a financial success. Hoping to salvage the business, Childs hired several distinguished artists and brought over from France Philadelphia's first known trained photographer, Peter S. Duval, in 1831. These endeavors failed to help, however, and, like other discouraged owners of local lithographic houses, Childs decided to quit, leaving the business to his partner, the landscape artist George Lehman, and to his chosen successor Duval (see Wainwright, *Early Lithography,* pp. 6–45, 61–74).

The address on Duval's card indicates that his trade card must have been produced after 1835 when the new owners moved to Dock Street and Bank Alley (see *Plan of Philadelphia,* reference A, no. 143). Since the advertisement lists only Duval's name, the trade card was probably published to announce Duval's sole ownership, shortly after Lehman's retirement in 1840. As Newsam was the chief artist at the time, and several of his works and trade cards are reproduced on the Duval trade card, one may assume he was also the artist of this lithograph.

The subjects on the lithograph portray the products advertised in Duval's billhead: "PORTRAITS FROM LIFE, ON STONE, LANDSCAPES FROM NATURE, ANATOMICAL & ARCHITECTURAL DRAWINGS, Machinery, Music Titles, Maps, Plans, Circulars, Checks, Bill Heads, Bills of Lading, Price Currents, Fac-similes, Transfer from Steel, Copper, Wood and Autograph, Printing in Color, &c., &c." (*The Mercantile Register, or Business Man's Guide, Containing a List of the Principal Establishments, including Hotels, and Public Institutions in Philadelphia,* Philadelphia, 1846, n.p.).

Of particular interest are the portrait of the inventor of lithography, Aloys Senefelder; the Merchants' Exchange (no. 245) as seen from Duval's shop; Duval's building and the Bank of Pennsylvania as seen from the Merchants' Exchange; and the lion produced for the American Sunday-School Union.

The various objects appear to have been placed on a flat surface, with corners turned up and shadows drawn in to create an illusionistic, three-dimensional effect in the trompe l'oeil tradition. Although the works look as though they have been casually arranged, the print is actually a carefully balanced composition of the subjects and distribution of light and dark elements. The coloring, added by hand after printing the black, relieves the severity of the black and white contrasts, enhancing the card's appeal.

ESJ □

ROBERT CORNELIUS (1809–1893)

Cornelius was born in Philadelphia, but little is known of his early years. His name is usually associated with his father's metal-work firm, Cornelius and Co., manufacturers of lamps and chandeliers (see biography preceding no. 288), to which Robert devoted the major part of his professional career. Although he was actively concerned with photography for only three years, they were intensive ones. He became one of the first, along with John W. Draper, Samuel F. B. Morse, Alexander S. Wolcott, and John Johnson of New York, to produce portraits by the daguerreotype method. Information about this new process, which produced a unique image, was published in various city newspapers in America as early

as March 1839, before Daguerre made public his invention in Paris, on August 19, 1839.

When and where Cornelius first learned about the process and began his experiments is unknown, but he supplied the silvered copper plates to Joseph Saxton, who produced the first daguerreotype in Philadelphia and the earliest documented daguerreotype in existence in America (presumably on October 16, 1839, according to Saxton), a view of the old arsenal and cupola of the Philadelphia High School (Historical Society of Pennsylvania)..Julius F. Sachse, a contemporary photographic historian, stated that Cornelius told him that shortly after he viewed Saxton's daguerreotype, he had a camera constructed in his factory and produced daguerreotype portraits of himself (private collection) and his children, presumably in October or early November 1839 ("Early Daguerreotype Days, An Historical Reminiscence," *American Journal of Photography,* vol. 13, no. 151, July 1892, pp. 310–11).

Although Cornelius's early daguerreotypes are not dated, *The Proceedings of the American Philosophical Society* (1838–40, vol. 1, no. 9) records that daguerreotypes by Cornelius were exhibited at their meetings on December 6, 1839, March 6, 1840, and May 15, 1840. Only the last meeting specifies that the daguerreotypes of Mr. Du Ponceau and Mr. Vaughan (American Philosophical Society) were portraits: on April 23, 1840, daguerreotype portraits by Cornelius were exhibited at the Franklin Institute. Both the Philosophical Society and the Franklin Institute were instrumental in promoting knowledge of photography and its early development through exhibitions and the many articles published in their journals.

During the years 1839–41, Cornelius worked with Dr. Paul Beck Goddard, professor of chemistry at the University of Pennsylvania, to whom Sachse credits the discovery of bromine as an accelerator in the development of the daguerreotype (presumably in December 1839), although there is no proof that he was the first to do so (see Taft, *Photography,* pp. 461–62 n. 55; Newhall, *Daguerreotype,* p. 356 n. 12). In the spring of 1840, Cornelius with Goddard entered into the novel field of commercial photography, establishing one of the first daguerreotype portrait galleries in America and the first of its kind in Philadelphia, at the northeast corner of Eighth and Lodge streets. That Goddard was active in this gallery is confirmed by Marian S. Hornor ("Early Photography and the University of Pennsylvania," *The General Magazine and Historical Chronicle,* vol. 43, no. 2, January 1941, pp. 5–6), who referred to Goddard as the "silent partner" of Cornelius. By July 1, 1841, Cornelius moved to a larger studio at

810 Market Street. What seems to be the last account of Cornelius's daguerreotype activity appears in *The Proceedings of the American Philosophical Society* (1841–43, vol. 2, no. 21, p. 163). The report of the April 15, 1842, meeting states that daguerreotype portraits by Cornelius were presented and noted for their high polish of the plate and absence of cross lines. At some point in 1842, with the introduction of gas for illumination, Cornelius was inspired to devote full-time thereafter to the family metalwork business, abandoning his photographic pursuits. Cornelius was one of the first in America to perfect the daguerreotype process, making it practical to produce portraits by this method on a commercial scale. The tremendous growth of the photographic portrait business within the next decade owed much to the inspiration and output of this pioneer daguerreotypist. Within the decade there existed at least one portrait daguerreotype gallery for every major city and town in the United States as well as a large number of itinerant daguerreotypists. Moreover, Taft (*Photography,* p. 69) notes that the superiority of the American daguerreotype compared to its European counterpart was generally recognized.

268.

268. *John Henry Frederick Sachse*

1840
Stamp: R. Cornelius (lower left); PhiladA (lower right, on brass mat)
Quarter plate daguerreotype (not in original frame)
3½ x 3″ (9 x 7.5 cm)
Private Collection

PROVENANCE: John Henry Frederick Sachse; descended in family to present owner

LITERATURE: Julius F. Sachse, "Early Daguerreotype Days, An Historical Reminiscence," *American Journal of Photography,* vol. 13, no. 151 (July 1892), pp. 312–13; Julius F. Sachse, *Philadelphia's Share in the Development of Photography* (reprint from *Journal of the Franklin Institute,* April 1893), no. 5, illus. p. 10; Marian S. Hornor, *Early Photography and the University of Pennsylvania: Portraits Made Possible in 1839 by Prof. Goddard; Other Contributions* (reprint from *The General Magazine and Historical Chronicle,* vol. 43, no. 2, January 1941), p. 11

ALTHOUGH THE DATE of this daguerreotype is not documented, according to Julius F. Sachse, son of the sitter, Cornelius photographed John Henry Frederick Sachse, artist-designer in the Cornelius

metalwork factory, as a trial sample shortly before opening his studio for commercial business in February 1840 (Julius F. Sachse, *Philadelphia's Share,* cited above, p. 17, no. 5). In general, daguerreotypists seldom dated or signed their works. If a studio address is stamped on the brass mat and if one can establish when the daguerreotypist was in business at this address, an approximate date of a given piece can be determined.

The quality of this portrait daguerreotype is indeed remarkable considering its early date and comparing it to the few existing American daguerreotype portraits of the period 1839–45. Newhall (*Daguerreotype,* p. 124) implies that successful daguerreotype portraits were generally not obtainable in 1840 due to the necessity of a minimum exposure time of about five minutes, the maximum being seventy minutes. Even with the use of heavy head clamps the sitter was not able to remain completely immobile for such a lengthy exposure. By 1841 improvements in the daguerreotype process, such as the use of bromine as an accelerator took effect, reducing the exposure time to five seconds, the average being from twenty to forty seconds, thus making it practical to produce portraits effectively on a commercial scale.

The clarity of this piece and the precision of detail would have been impossible without subjecting the plate to bromine. The contemporary account of Cornelius's method ("Daguerreotype Miniatures," *The National Gazette,* June 27, 1840, p. 3) states "it is only necessary to sit for half a minute, or perhaps a minute." Goddard, the discoverer

of the bromine process (Sachse, "Early Daguerreotype Days-III," *American Journal of Photography,* vol. 13, no. 152, August 1892, p. 356), imparted his discovery only to Cornelius, and the two kept the secret of the bromine accelerator for two years until Goddard published the process in the latter part of 1841.

The brilliance of the image and the absence of cross lines in this daguerreotype is attributed to Cornelius's skill in polishing the silvered copper plate. The degree of control Cornelius maintained in the production of his daguerreotype was unusual and contributed to the further assurance of a successful finished product. Sachse notes that all the necessary equipment—camera, plates, brass mats, coating, boxes—was made by Cornelius; the only items he purchased were the lenses, which he obtained from McAllister & Son, local opticians. A yellow label, printed in black and stuck to the back of the plate, and a metallic gilt square frame with oval opening were identifying features of work from the Cornelius studio.

Compared to Robert Cornelius's first portrait daguerreotype (a self-portrait, private collection), the improvements made within a few months are remarkable. Admittedly owing a great deal to the chemical improvements made by his partner, Goddard, Cornelius was nevertheless one of the first in America to perfect "daguerreotype miniatures" (the term he employed in his advertisements; see *Public Ledger,* July 1, 1841), an achievement which places Cornelius in the forefront of those American photographic pioneers who carried the daguerreotype process beyond scientific experimentation into the area of a fine art.

CW □

269. *Dress*

c. 1840
Eighteenth century ivory silk brocade; lined in cotton
Waist 25¾″ (65.4 cm); center back length 52¼″ (132.7 cm)
Philadelphia Museum of Art. Given by Miss Emma Thomas. 62-93-5

PROVENANCE: Martha Gray Grubb, Philadelphia; cousin, Martha (Gray) Thomas; daughter, Emma Thomas

THIS FASHIONABLE "romantic" style dress could well have been a creation inspired by the engravings in *Godey's Lady's Book* and many of its details may be found in the Godey volume exhibited (no. 270). The dress was fashioned from an eighteenth

century ivory silk—probably a family heirloom when the dress was designed around 1840—brocaded in a pattern of gentle curving vertical vines and floral sprays in shades of red and green.

Typical of the style is the focus of attention above the waist. The bodice, with a slightly raised waistline, is boned at the center front and has a slight point at its lower edge. The round neckline is trimmed with a pleated band extending diagonally over the bust from center front to the shoulder. The sleeves are extremely decorative and detailed, reinforcing the emphasis above the waist: they are finely pleated at the top and at the wrist cuff (held in place by narrow bands), and released in between to form a full puff. The amply pleated skirt is sewn to the bodice with an insert of fine cording. Cotton is used to line the bodice and the facing of the skirt hem.

Ideally, waistlines were narrow and much to be envied. This fashion required the use of a tight corset, generally of heavy twill and boning. To create the proper shape of the full skirt, several petticoats were worn. These undergarments were usually very ornate and trimmed with embroidery, pin tucks, and lace.

EMcG □

270. *Godey's Lady's Book*

1830–98
Title page: Godey's Lady's Book, and Ladies' American Magazine. Edited by Mrs. Sarah J. Hale, Mrs. Lydia H. Sigourney, and Louis A. Godey. Volume XXI.—July to December. 1840. Philadelphia: Louis A. Godey, 211 Chestnut Street.
Printed periodical, 12 issues with engraved plates, some hand colored, bound together 9¾ x 6⅛ x 1⅜″ (24.8 x 15.6 x 3.5 cm)
Philadelphia Museum of Art. Bequest of Henry R. Hatfield. 43-27-36

LITERATURE: Ralph Nading Hill, "Godey's Lady's Book Editor: Suffragette without an Ax," *Philadelphia Inquirer,* March 30, 1959; Robert Kunciov, ed., *Mr. Godey's Ladies* (Princeton, 1971); PMA, Archives, Dorothy Dignam, "A Tribute to Philadelphia's Lady of Fashion" (1974)

IN 1837, Mrs. Sarah Josepha Hale (1788–1879) finally accepted Louis Antoine Godey's offer of a merger of her Boston-based *Ladies' Magazine* with his Philadelphia *Lady's Book.* This union resulted in the very popular *Godey's Lady's Book,* with Mrs. Hale, a novelist and poet—the author of "Mary Had a Little Lamb"—as its successful editor for the next forty years.

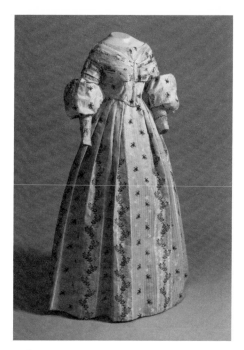

269.

Godey's Lady's Book was widely read throughout the country, reaching its peak circulation of 150,000 copies just prior to the Civil War. With its potpourri of features and articles, it was not unusual to find original contributions by Hawthorne, Longfellow, Poe, Oliver Wendell Holmes, and Harriet Beecher Stowe side by side with tinted fashion plates, as well as useful household hints by Mrs. Hale herself.

Fashion plates had been a feature of the periodical under Louis Godey's supervision, and continued under Mrs. Hale, although she really only tolerated them. Initially, these had been redrawings of French engravings with distorted figures and vain, frivolous designs too extreme for the American woman (or so thought the intellectual Mrs. Hale). She was determined to improve and to "Americanize" these prints, if she had to have them in her magazine. Later, in the 1850s, Mrs. Hale added sentimentality to the fashion plates with the addition of coy titles.

The first Godey's "improved" fashion plate (see illustration), 1843, showing four models in front of the *Lady's Book* offices at 211 Chestnut Street. The plates were hand colored, and as many as 150 women were employed in producing them. Concern was often expressed that the colors varied from plate to plate, since when one color ran out another was often simply substituted. Indeed, one Christmas issue appeared with holly leaves in purple (PMA, Archives, Dorothy Dignam, "A Tribute to Philadelphia's Lady of Fashion," 1974). Two plates

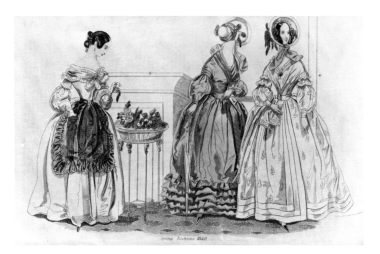

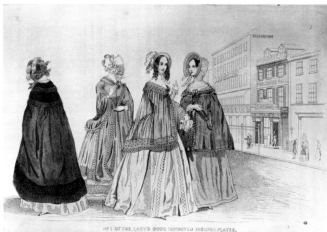

270. *Spring Fashions 1840*

No. 1 of the Lady's Book Improved Fashion Plates, 1843. Hand-colored engraving, 6 x 8⅞". Philadelphia Museum of Art

were inserted into each issue, showing the various styles for that season. Mrs. Hale was herself a gifted designer who supervised all the pictorial fashion material, although she never signed her efforts.

Since patterns had not yet made their appearance, *Godey's* costume plates were an aid to the dressmaker searching for ideas and inspiration, just as today's fashion magazines keep readers up-to-date with current modes. The dressmaker could, with handsome materials and skill in sewing. create close copies of costumes from a *Godey's Lady's Book* engraved fashion plate.

EMcG □

271. *Autograph Quilt*

1842–43

Inscription: Fifth 1843 Month/Samuel P. Hancock (center square; 56 other squares contain individual and paired signatures and/or inscriptions)

Face: Cotton chintz, satin, brocade, and chiffon silk, silk embroidery thread, inked designs and signatures; reverse: figured cotton

Height 8′ 1¼″ (2.5 m); width top 10′ 7¼″ (3.3 m), bottom 6′ (2 m)

Philadelphia Museum of Art. Given by five granddaughters of Samuel Padgett Hancock: Mrs. Levis Lloyd Mann, Mrs. H. Maxwell Langdon, Mrs. George K. Helbert, Mrs. Nelson D. Warwick, Mrs. Granville B. Hopkins. 45–35–1

PROVENANCE: Descended in Hancock family

APPLIQUÉ QUILTS WERE AS POPULAR AS patch-work quilts in the nineteenth century, and, in fact, the techniques employed in both

were often effectively combined, as in this autograph quilt. The autograph quilt was usually made to honor an important occasion and featured signatures that were incorporated into decorative blocks. In this quilt, each square contains a unique design that frames the signature, dates, and information, and is embellished in ink with tiny sprigs and figures. A form of indelible ink for such purposes had been in use from as early as 1750. The signatures themselves enhance the beauty of the quilt; this was a calligraphic age, and the fine art of penmanship formed a significant part of the learning process.

The variety and elaborate combination of materials make this quilt striking and also demonstrate the wide range of contemporary styles and techniques. For instance, several of the central squares have been embellished with Berlin wool and Berlin needlepoint patterns, worked in silk and wool on cotton. Berlin work was popular in the United States from about 1830 until after the country's Centennial. Most of the patterns and materials were imported from Germany, hence the name. This fashion represented the first use of colored needlepoint patterns; printed on point paper, they were usually worked with the very soft German zephyr wool worsted and silk yarns on various types of canvas.

The squares, many of which have been pieced together by the patchwork method (see no. 262), have then been appliquéd directly to the cotton backing with slip stitching. All of the surface embroidery was completed before the pieces were joined to the square. Some of the squares also appear to have been wadded.

This quilt was probably made for Samuel Padgett Hancock by his fiancée, Charlotte Gillingham, the daughter of Jonathan Gillingham, a prominent iron merchant in Philadelphia, and Phebe Ware Gillingham

on the occasion of Charlotte and Samuel's wedding on February 22, 1844. The dates appearing with signatures fall within the years 1842–43. Most of the names included are those of relatives of Charlotte and Samuel. "Samuel P. Hancock 1843" occupies the central square, with Charlotte's name less prominently featured to the left. Samuel's name is surrounded by an elaborately embroidered floral wreath, his wife's by inked doves and foliage. Because much of the same fabric is used throughout the piece, it could be presumed that the quilt was, in fact, made by one person, and then presented to the others for their mark. The use of "thy" and "my" in reference to some relationships may mean that either the bride or the groom reproduced some of the signatures.

PC □

JOHN T. BOWEN (1801–1856)

Born in England just after the turn of the century, John T. Bowen was undoubtedly trained as an engraver and a colorist. The care evident in the application of color in his later complex lithographs bespeaks the hand of an artisan trained in the techniques of engraving. John James Audubon, with his typical backhanded praise for those who made him famous, characterized Bowen as "an intelligent, sturdy English artisan who, like many others, had made money by his profession but lost all by speculating in stocks" (Alice Ford, *John James Audubon,* Norman, Okla., 1964, p. 387).

Exactly when Bowen came to the United States, when he lost his money, or when and where he was trained is unknown. He is first recorded working in New York City in 1834 as a print colorer. A year later he had

branched into lithography, but print coloring continued to be his specialty.

In 1838, Thomas Loraine McKenney and James Hall, facing problems with the first volume of their *History of the Indian Tribes of North America,* invited Bowen to come to Philadelphia to supervise the production of the plates. The change of cities proved to be vital for Bowen's career. In New York he had been a lithographic job printer churning out hundreds of pedestrian prints, among which only the large historical lithographs executed in conjunction with Alfred Hoffy rose above the ordinary. But in Philadelphia Bowen was reborn. His jobbing days were over. Shortly after his arrival, he published a lithograph drawn by J. C. Wild or Hoffy depicting the fire at the newly completed Pennsylvania Hall set by an anti-abolitionist mob to prevent abolitionists from using it. After its success, other historical scenes, flower prints, portraits, plates for *The Architects' Magazine, and Book of Designs,* political cartoons, large landscapes, and fashion plates soon flowed from his shop.

The work which had brought Bowen to Philadelphia, McKenney and Hall's *Indian Tribes,* followed an erratic course. The first volume was almost finished when he arrived, but Bowen made four additional plates and colored three or four others to complete the final two parts. This was issued in collected form in 1838. Over the next six years, Bowen printed the plates for the second and third volumes, which were also issued in parts. Then the first volume was reissued with Bowen redrawings of the early Lehman and Duval illustrations, their names deleted. Although a commercial disaster, it gave Bowen a reputation as the best lithographer in the nation.

In 1839, John James Audubon engaged Bowen to produce the miniature plates for his octavo edition of *The Birds of America,* which was a great success. The original edition of 300 copies was soon exhausted and had to be reprinted, and the print order eventually stood at 1,475 copies of each part, a phenomenal number for a work of its size and cost. Seventy people were employed on the production of the *Birds,* most of whom worked in Bowen's shop in Philadelphia. This number, together with about forty who were working on the *Indian Tribes* and several score more engaged on other projects, made Bowen's the largest lithographic establishment in America.

Bowen was a proud entrepreneur and liked to show visitors around his work rooms as he lectured about lithographic processes. The *Saturday Courier* of April 2, 1842, hailed Bowen's shop as "an ornament to the city and an honor to the age." Bowen made himself constantly visible by sending com-

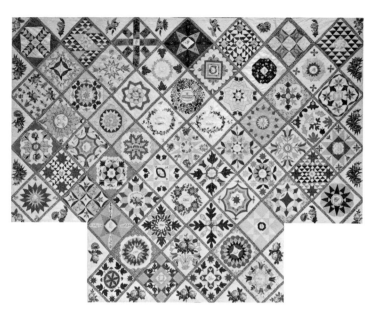

271.

plimentary copies of many of his best prints to the newspapers for the free advertising their favorable reaction brought. Several of his lithographs were entered every year in the Franklin Institute's annual exhibition and in 1840, Bowen's were judged "uncommonly fine and reflecting credit on American arts," winning honorable mention in the fine arts category. It was the general critical consensus that Bowen was the first American to make his lithographs equal to the best steel and copper engravings.

From 1839, when he began work on the octavo *Birds,* to the end of his life, Bowen was almost constantly engaged by the Audubons on one natural history project or another. Although Bowen continued to execute all forms of lithography, he became increasingly preoccupied with works on natural history. The removal of his business from the area of the Delaware River, the commercial center of Philadelphia, to 12 South Broad Street reflected Bowen's waning interest in his commercial business and his increasing devotion to science and art.

Just prior to his death, Bowen had finished work on yet another natural history project, John Cassin's *Illustrations of the Birds of California, Texas, Oregon, British and Russian America* with plates drawn by W. E. Hitchcock. It was Cassin who helped Lavinia Bowen to settle her husband's estate. The estate was not large, for Bowen had not modernized his shop when chromolithography and steam presses became popular. His remained a hand operation and he invested in people, not equipment. He was too careful, too much the perfectionist, too fond of hand coloring "to venture farther than the use of printed tints [lithotints],

which he eventually used 'in light and varied colors' " (Wainwright, *Early Lithography,* p. 58).

Lavinia Bowen ran the business alone for two years, eventually forming a partnership with John Cassin in 1858. As Bowen & Company, the firm survived until 1868 and continued to specialize in natural history books and prints. In 1860 the firm executed 100 plates for Baird, Cassin, and Lawrence's *Birds of North America,* and later did very good quality work for the young Philadelphia ornithologist Daniel Giraud Elliot.

JOHN JAMES AUDUBON (1785–1851)

Born Jean Rabine (or Jean-Jacques) Fougère Audubon on April 26, 1785, at Les Cayes (now Aux Cayes) in the French colony of Saint-Domingue (now Haiti), John James Audubon was the son of Captain Jean Audubon, a French seafaring merchant and planter, and his Creole mistress, Jeanne Rabine. Following his mother's death, the six-year-old Jean and a half-sister were taken to their father's home in Couëron, near Nantes, and after a suitably discreet period both were formally adopted by his legal wife, Anne Moynet.

On the banks of the Loire, Audubon awakened to the joys of nature, collected his first specimens, executed his first drawings, and received a rudimentary education during the turbulent years of the French Revolution. At Couëron, Audubon became friends with the naturalist Charles-Marie d'Orbigny, who introduced the young man to the systematic study of nature through the writings of Georges-Louis Leclerc, Comte de Buffon, and other Continental

naturalists, and to American ornithology through the works of Mark Catesby and the Frenchman L. J. P. Vieillot. Thus, although scientific nomenclature eluded him throughout his works, Audubon did not spring fullblown from the American wilderness, an unschooled, intuitive, backwoods ornithological genius, as his later admirers and even he himself often liked to imagine.

In the summer of 1803, to escape conscription into Napoleon's army, to acquire some business training, and to avoid the increasing social problems caused by the circumstances of his birth, he was sent to Mill Grove, his father's farm near Philadelphia. The Pennsylvania countryside distracted him from his limited business duties and he was decidedly unsuccessful in trying to become a farmer. Instead he hunted and tramped the woods, devising his system for drawing birds from freshly shot specimens wired into lifelike poses, played the flute and fiddle, danced the minuet, skated, fenced, and generally led the life of a dashing pensioner, which he was, if not in title, then in fact.

His allowance left little for frills, but money was not needed to captivate Lucy Bakewell, the eighteen-year-old daughter of a nearby plantation owner. Five years would elapse before Lucy Bakewell and Audubon would be married, but from the first meeting she devoted all her energy to his vision of himself as *un homme de la forêt*. Were it not for the strength and patience of this unusual woman, Audubon would have been just another obscure ne'er-do-well frontier romantic, which young America produced in great abundance.

Following their marriage in 1808, the Audubons moved to Kentucky to establish a general store at the falls of the Ohio River. He was now entirely dependent on his own abilities to support his growing family. But his only business talent was a gift for failure. Enterprise after enterprise floundered in the next twelve years through inattention and poor judgment.

A chance meeting between Audubon and Alexander Wilson (see biography preceding no. 171) in May 1810 at Audubon's store in Louisville proved to be important to both men. Wilson, having already begun publishing his *American Ornithology,* was not in the mood to discover a potential rival and was slighted by what he thought was a cool reception. In Audubon, Wilson's visit awakened a fierce ambition and competitive urge. From that day on Audubon was determined to surpass this competitor. His efforts to belittle Wilson's achievement continued even after the Scotsman's death in 1813, as a feud with George Ord, Wilson's editor and literary executor.

With the failure of a steam-grist and lumber mill at Henderson, Kentucky, in 1819, his attempt at a business career came

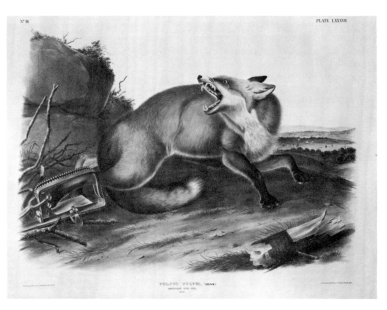

272. *Vulpus Fulvus, Desm. (American Red Fox)*

to an end. To support his family, Audubon painted portraits of frontier gentry, gave art lessons, and for a time worked as a taxidermist in the new Western Museum in Cincinnati. But the dream of publishing his bird drawings and thereby becoming famous became an *idée fixe*. In 1820, Audubon, like Wilson before him, set off down the Mississippi in search of specimens and adventure. The burden of moving the family to New Orleans and keeping food on the table fell to his wife. Fully one-third of the 435 *Birds of America* engravings were based on drawings done during his five years in Louisiana.

By 1824, Audubon thought he had enough drawings to begin publishing, and he set off to conquer Philadelphia and New York. In the Quaker City he found the admirers of Alexander Wilson in control of the artistic-publishing establishment. Only Charles-Lucien-Jules-Laurent Bonaparte was impressed with his work and used several of Audubon's drawings for plates in his *American Ornithology.* Alexander Lawson (see biography preceding no. 171) felt his work too large and not true to nature. According to William Dunlap, when the two men met, Lawson praised Audubon's drawings as being quite good for a self-taught artist, adding sardonically "but we in Philadelphia are accustomed to seeing very correct drawing." To which Audubon replied that he had studied for seven years with "the greatest masters in France." Lawson squelched Audubon by saying "then you made dom [damn] bad use of your time" (Dunlap, *History,* vol. 2, p. 404). But although Audubon claimed instruction by Jacques-Louis David and other famous artists, there is no record of his having received any formal training, except from

Thomas Sully, in oil painting techniques, after he arrived in Philadelphia in 1824 (Ford, *Audubon,* cited above, pp. 142, 374).

Audubon's reception in New York, while somewhat warmer, was still not satisfying. He found admirers but no publisher. His project was too big, too costly, too time-consuming for cost-conscious American publishers. Finally on May 27, 1826, Audubon set sail for England. His reception there was warm and immediate. Audubon's long hair and frontier buckskins had the same effect on the English that Benjamin Franklin's plain dress and coonskin cap had had on the French court of Louis XVI. He became a social phenomenon—the personification of Rousseau's "natural man." His drawings were exhibited at the Royal Institution and publicly praised.

Within four months of his arrival he found an engraver-publisher, William Home Lizars in Edinburgh, and began to issue *The Birds of America* in numbers, five plates to each part. The project proved too demanding for Lizars and the work was transferred to the firm of Robert Havell & Son in London. The last plate, number 435, was pulled by Robert Havell, Jr., in June 1838, twelve years after the first one had been issued. The money Audubon was paid as each part came out and the generosity of friends as well as total strangers enabled him to travel, first to France where he repeated his English triumph, but with Gallic intensity, and then back to America for more field work.

The decade of the 1830s was the most active of his life. In those ten years he made three round-trip voyages to England, and managed to squeeze in long expeditions to Florida (1832), Labrador (1833), and Texas. In addition he traveled up and down

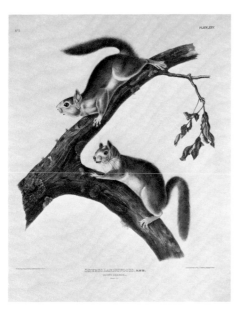

272. *Sciurus Lanigunosus, Bach (Downy Squirrel)*

the East Coast of America, by road, canal boat, and later in the decade, on the new railroads, all the while somehow adding new bird drawings and overseeing their publication, writing the text for the plates, and hunting the rarest bird of all—subscribers.

Two projects consumed the decade of the 1840s: the American republication of *The Birds of America* and *The Viviparous Quadrupeds of North America.* The octavo edition of the *Birds,* issued in one hundred parts (or seven volumes) with the plates re-engraved and printed by Bowen, was vitally important to Audubon. It greatly increased his fame in America and marked the first publication of the full 500 plates and the first with the plates and text combined.

Audubon never lived to finish his second major project, *The Viviparous Quadrupeds.* He made one last grand expedition up the Missouri River to collect specimens for the project in 1843. As the publication began, Audubon's health failed. When John Bachman, the author of the *Quadrupeds'* accompanying text, visited Audubon in May 1848 at his home near Washington Heights, New York, he reported that only the outline of his friend's former physical appearance remained and that "his noble mind [was] all in ruins." Death came to John James Audubon on January 27, 1851.

JOHN T. BOWEN AFTER
JOHN JAMES AUDUBON

272. *The Viviparous Quadrupeds of North America*

1845–48
Title page: The Viviparous Quadrupeds of North America By John James

Audubon, F.R.S. &c. &c And The Revᵈ. John Bachman, D.D. &c. &c. Vol. I [and II] Published by J.J. Audubon, New York 1845 [and 1846]

Printed books, vols. 1 and 2, with colored lithographic plates on imperial wove paper 27¾ x 21½ x 1½″ (70.5 x 54.6 x 3.8 cm)

Mrs. W. Logan MacCoy and Morris Wood. On loan to the Philadelphia Museum of Art

LITERATURE: Alice Ford, ed. *Audubon's Animals. The Quadrupeds of North America* (New York, 1951), throughout; Wainwright, *Early Lithography,* pp. 54, 57; Howard C. Rice, Jr., "The World of John James Audubon: Catalogue of an Exhibition," *The Princeton University Library Quarterly,* vol. 21, nos. 1 and 2 (Autumn 1959—Winter 1960), throughout; Alice Ford, *John James Audubon* (Norman, Oklahoma, 1964), throughout; Victor H. Cahalane, ed., *The Imperial Collection of Audubon Animals. The Quadrupeds of North America* (New York, 1967), pp. ix-xvi; Utica, New York, Munson-Williams-Proctor Institute, *Audubon: Watercolors and Drawings* (April 11—May 30, 1965), pp. 51-57

The Viviparous Quadrupeds of North America, often called "Audubon's *other* book" or just "the animals," has long lived in the shadow of his *Birds.* For collectors and bibliophiles its production seemed to lack the epic struggle and triumph of his various ornithological works, while its images have not entered into the public consciousness the way those of the *Birds* have. Postage stamps, greeting cards, calendars, dishes, and even wallpaper have served to make Audubon's "bird pictures" a commonplace of our culture. Yet in a curious way, it is his later work, *The Viviparous Quadrupeds,* which is more satisfying both scientifically and artistically. Perhaps it was because the Audubon of the 1840s—now sure of his fame and success—could demand more from his audience than he had dared in both the elephant folio and in the royal octavo editions of his *Birds of America.*

The Quadrupeds is the better of his two major works because there is less of Audubon the conscious *homme de la fôret,* the artistic trickster, the commercial promoter. Because this book was to cover a field where no one else had yet ventured, there were no rival reputations to battle and the standards to be met could be his own. For the first time, Audubon was genuinely free to do what he wanted without the ghost of Wilson or some other artist to haunt him.

The Reverend John Bachman, Audubon's friend and patron since 1831 and the man who would compose the text for the *Quadrupeds,* warned Audubon early in 1839 of the dangers of being a true pioneer: "Don't flatter yourself that this Book is child's play

—the birds are a mere trifle compared to this. I have been at it all my life and do not fear the bugs of Europe—but we have all much to learn. The skulls and teeth must be studied—color is variable as the wind. Down—down into the earth they grovel, and in digging and studying we grow giddy and cross" (Ford, *Audubon,* cited above, p. 368). But Audubon with typical optimism and enthusiasm proposed issuing immediately a printed prospectus announcing the future publication of *The Viviparous Quadrupeds.* This brought another, more gentle, letter of caution from Bachman: "Are you not too fast in issuing your prospectus . . .? The animals have never been carefully described, and you will find difficulties at every step. Books cannot aid you much. Long journeys will have to be undertaken. . . . The Western Deer are no joke [to classify], and the ever varying Squirrels seem sent by Satan himself, to puzzle the Naturalists" (Victor H. Chalane, ed., *The Imperial Collection of Audubon Animals,* New York, 1967, p. ix).

And then Bachman added, almost as an afterthought, "Say in what manner I can assist you." It was to prove the rashest statement of his life. Audubon became convinced by either Bachman's entreaties or a flash of reason, that because no scientific framework already existed perhaps this time he needed help. An arrangement was made whereby Audubon would do the pictures, aided by his sons Victor and John Woodhouse Audubon, and Bachman would write the text from his own research and observations and from notes supplied by the Audubons. In his only glance at humility, Audubon agreed that Bachman would share title-page honors.

During the planning stage, in 1839, Bachman estimated that they should publish no more than 100 species. As it turned out, he would describe more than double that number of land mammals and Audubon and his son John would paint 147 species (and 8 "varieties") on 150 plates. The plate size adopted was 28 by 22 inches, and as Bachman put it, "the figures [were to] be given without reference to any scale, those of a skunk full size, those above [in size] as taste or space will dictate" (Chalane, cited above, p. x). Audubon thought he could finish the animal portraits in two years and that Bachman would require an additional year to write the text because of the difficulties of locating obscure printed references and the necessities of field studies for species not previously described. The timetable therefore called for publication of the complete work within three years, that is, in 1843.

But even with the romantic notions of Audubon held in check by the realism of Bachman, these estimates were, to say the

least, off the mark. A few plates were rushed out in 1842 to impress the subscribers and to enter in the Franklin Institute's annual exhibition for publicity. But it was not until 1848, a full eight years after Audubon began painting, that the last of the plates was finished and although Bachman had finished the writing in 1852, the third volume of text was not published until 1854— eleven years behind schedule and three years after John James Audubon's death.

The primary cause for the delay was the serious difficulties both Audubon and Bachman encountered in securing specimens. Audubon had been hard at work procuring animals and sketching them well before the formal agreement between him and Bachman was concluded in January 1840. Letters were dispatched in 1839 to New England and Canada asking for rabbit specimens to be sent preserved in a cask of rum; European correspondents were asked for rodents and squirrels; and in 1843 almost nine months was consumed by a trip to the vicinity of the Yellowstone River to collect specimens and make sketches of the large western Plains animals. The trip yielded far fewer specimens than Bachman expected, while the journey was physically debilitating to Audubon, then fifty-eight years old, and his production of pictures was particularly slow in the year following.

For his part, Bachman was constantly impeded by the problem of securing citations, for he was in Charleston, South Carolina, a long way from Audubon in New York and the major libraries in the northern states. His churchly obligations impinged constantly on his time but he arranged his schedule so that the maximum time possible was spent on research and writing. Family problems, not the least of which were the death of his wife in 1842 and of his two daughters (who had married Audubon's sons) shortly thereafter, caused emotional problems which made writing impossible. But the biggest stumbling block to the rapid progress of the text was the difficulty of communication. As Audubon's health began to fail, he became even more difficult to work with, often refusing to show his journal of the western expedition to Bachman, relenting, and then withdrawing it again. The notes which Audubon sent along with his sketches and watercolors, often scribbled in the margins, became more crabbed, disjointed, and confused. At one point, Bachman grew testy about trying to make sense of Audubon's marginal comment on a beautiful watercolor of a beaver and sent the artist a terse note back: "It would require a Philadelphia lawyer to make out the meaning" (Ford, *Audubon,* cited above, p. 411). As long as four years elapsed between a request from Bachman for information from a book procurable only in New

York and a reply with the portion in question copied out to Bachman's satisfaction. Once Bachman gave up work entirely on the project for a year, because of Audubon's inattention to his requests, and he was wooed back only by the sons' promises to satisfy them immediately. The crushing blow came when failing vision forced suspension of work on the final text volume, which was completed only when Bachman dictated it from memory and sketchy notes.

The production of the pictures used in *The Viviparous Quadrupeds of North America* was considerably more complex than that of the *Birds*. Audubon had boasted that his guides for every plate in the *Birds* were sketches of live specimens, a boast, which, while not completely true, was almost so. He never made that claim for the *Quadrupeds*. He used anything he could get his hands on—skins, stuffed specimens in New York collections; sketches of those in the British Museum, done by his son John; memory—and in several instances he traced animal figures that he had done as background illustrations for the *Birds*. In spite of this he rendered the animals superbly, generally without the stiff, ungainly poses of other early painters of animals. He tried to convey the impression of movement without undue distortion and, for the most part, was successful. Only the larger Plains animals presented problems, and much of the flatness of the image can be traced to the necessity of reducing the image from life size to the dimensions of the plate. It must be admitted, however, that for those animals with which he was personally unfamiliar, his pictures were poor in quality both in the detail of the animals' environment and in their attitudes and configurations.

Not all of the plates of lower quality were caused by poor information. Audubon's health and the pressure of publication deadlines increasingly took their toll of the images of even the animals he knew intimately. Early on, John Woodhouse Audubon had been doing the backgrounds for the plates, and with his father's mounting physical difficulties he assumed an increasingly dominant role in the overall work. By 1846 he had assumed completely the task of translating his father's sketches into oil paintings and then transferring the images to the lithographic stone. It is generally acknowledged that he executed at least half of the 150 plates for the *Quadrupeds* and the actual number may be considerably higher. And although he lacked the fluidity and boldness of his father's touch, he did more than just credit to his father's project.

In addition to all the special problems that plagued the production of the *Quadrupeds,* there was one that had plagued Alexander Wilson and has continued to be the nemesis of every natural history book to the present

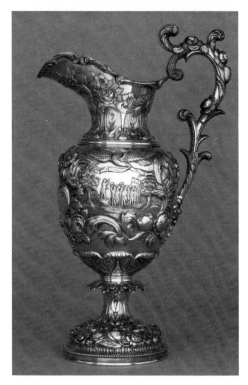

273.

day—color. Although Bowen was the best American lithographer of the period and had had long experience with the works of natural history, some of the pigments used in mixing the colors had a tendency to separate or to change in value from plate to plate and even from one pull of a plate to the next. The reddish-browns and the blue-black gave the most problems, and it is difficult, if not impossible, to find a complete set of the *Quadrupeds* in which one or more of the plates does not exhibit color that is too vivid and totally unlike the actual coloration of the animal itself or in which the color has not overpowered all the fine detail.

For some reason as yet unknown, the plates depicting the various species of squirrels turned out uniformly the best. And of the many sets examined, the squirrel plates in the possession of the Philadelphia Museum of Art are the finest. Every hair can be seen, every ripple in the fur is apparent, and the colors are translucent.

As with all major works of natural history, *The Viviparous Quadrupeds of North America* was issued in parts, thirty in all, with five imperial folio plates to each part. Each part was to cost $10, or $300 complete, and was issued between 1845 and 1848. The three volumes of text, which included five additional octavo lithographed plates, were issued to subscribers in 1846, 1851, and 1854. (Victor G. Audubon was the publisher of the last two volumes.) Although none of the original subscribers canceled their order

—as many had done with the folio edition of the *Birds*—the Audubons realized little if any profit on the edition. It was with the popular octavo, or miniature, edition, with the altered title, *The Quadrupeds of North America,* issued in three volumes in 1851–54, that a profit was realized.

GM □

OSMON REED (ACT. 1833–63)

Osmon Reed was first listed in DeSilver's Philadelphia directories in 1833 as a watchmaker at 176 North Second Street. From 1830 to 1850, "Isaac Reed & son, clock & watch maker," was listed at the same address. In 1842, Osmon Reed moved to 74 High Street and was listed as Osmon Reed & Co. In 1858 he moved to 1713 Green Street and in 1861 to 327 Walnut. His name does not appear after 1863, which may have been the year he died.

273. *Presentation Ewer*

1843

Mark: O. REED (in rectangle five times on inside rim of bottom); PHIL^A (in serrated rectangle five times on inside rim of bottom, followed by eagle pseudo-mark)

Inscription: WHIG (on one side in banner); POST PRAELIA PRAEMIA (on same side in banner borne by eagle); Presented by the/Whigs of the City and County of Philadelphia/to the/Hon. James C. Jones/Governor of Tennessee/As a token of their admiration of his/lofty eloquence and gratitude for his gallant/services in the Gubernatorial canvass of/—1843—/which resulted in the establishment of Whig/principles and opened the Presidential campaign/with sure harbingers of the triumphant election of/Henry Clay/in/1844 (on front); ASHLAND (on opposite side, in ribbon on lawn)

Silver

Height 17¾″ (45 cm); width 7″ (17.7 cm)

Philadelphia Museum of Art. Purchased: Joseph E. Temple Fund. 02–6

PROVENANCE: James C. Jones (1809–1859)

LITERATURE: "A Department of Metal Work," *PMA Bulletin,* no. 2 (April 1903), p. 5 (illus.); Katherine Morrison McClinton, *Collecting American 19th Century Silver* (New York, 1968), p. 53 (illus.); Hood, *Silver,* pp. 228, 231, fig. 256

THE OCCASION for this presentation ewer—indicated by both the inscription and the scene in repoussé on the side—was a success-

ful political campaign for the Whig party. The recipient was a member of the General Assembly of 1839, James C. Jones, who had demonstrated such a talent for "stump speaking" that he was chosen district elector on the Harrison ticket in 1840. In the gubernatorial race of 1841 in Tennessee, the Whigs selected him to run against James K. Polk because of his ability to carry on a "log-cabin campaign." Tall, robust, and athletic, Jones was the opposite of the polished and methodical Polk, and his raillery and humor made him popular with the large crowds that attended his debates with Polk. Jones was elected governor by a majority of 3,243 votes.

In the next gubernatorial canvass of 1843, the Whigs again chose Jones (who won by a 3,837 vote majority) to run against Polk:

The canvass of 1843 was watched with deep and widespread interest throughout the United States, and in Tennessee bets as high as $3,000 were made between Whigs and Democrats. The "Frankfort Commonwealth" said that "should the Whigs, as we confidently anticipate, carry the election in Tennessee, we believe the result will be considered as decisive of the presidential election of 1844." . . . The "National Forum" thought the contest in Tennessee would decide the complexion of the United States Senate, also "it is the first regularly contested battle of the campaign which is to decide who is to be the next president." Governor Jones, in a letter to Prentiss, said: "This is the battle-ground of the nation." The election of Jones was greeted by the Whigs throughout the Union with boundless enthusiasm. The Whigs of Philadelphia passed a vote of thanks to him, and the "Boston Atlas" suggested that a suitable gift as a memorial be presented to him by the Whigs of the United States. (James Phelan, *History of Tennessee,* Boston and New York, 1882 pp. 411–12)

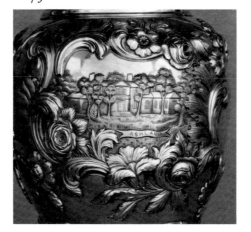

273. *Detail*

As the inscription on the ewer indicates, Jones's victory in the 1843 gubernatorial election was considered significant as a forecast of the hoped for election of the Whig candidate, Henry Clay, in the 1844 presidential campaign. A figure, presumably Jones, is shown on one side of the ewer "stump speaking" to an enthusiastic crowd. The banner reading *Post Praelia Praemia* ("After the Battle Come Rewards") confidently predicts a victory that never came to pass.

Henry Clay's house, Ashland, near Lexington, Kentucky, where he lived from 1811 to 1852, is shown on the opposite side (see illustration). The house was designed by Benjamin Latrobe about 1810; the source for the depiction of Ashland on the ewer may have been a drawing by W. Lewis, *The Seat of the Hon. Henry Clay near Lexington,* published in 1843. As the home of one of America's great statesmen, Ashland was among the "household words of the American people" (Calvin Colton, *The Life and Times of Henry Clay,* New York, 1846, pp. 42–43). Here many distinguished statesmen were entertained, including Lafayette, President Monroe, William Lowndes, Martin Van Buren, and Daniel Webster. In the seclusion of Ashland, Clay planned many of his campaigns, and Governor Jones was surely a frequent visitor. The picture of Ashland on this ewer, therefore, was a readily recognizable symbol of the Whig party.

The ewer is a masterpiece of Philadelphia repoussé silver, incorporating into its design flowers such as dogwood and roses, which grew in abundance in Tennessee. Its large size and vigorous design signify the enthusiasm of victory. Although the form of the ewer is derived from a classical prototype, the decoration is an exuberant early example of the rococo revival. The form, the elaborate use of repoussé, and the figural handle relate to a silver ewer made by Vincenzo Belli for Cardinal Francesco Antamois about 1780 during the height of the rococo period (Hugh Honour, *Goldsmiths and Silversmiths,* London, 1971, illus. p. 201).

DH □

CRAWFORD RIDDELL (D. 1849)

From 1835 until his death in 1849, Crawford Riddell (or Riddle, as he was frequently listed in Philadelphia city directories) was an active member of the cabinetmaking trade as a producer of furniture and as a superintendent of the Society of Journeymen Cabinet Makers. He was first listed in the city directories as a cabinetmaker at 162 Pine Street in 1835. Because of his position as agent for the Journeymen Cabinet Makers from 1837 to 1844, it is difficult to

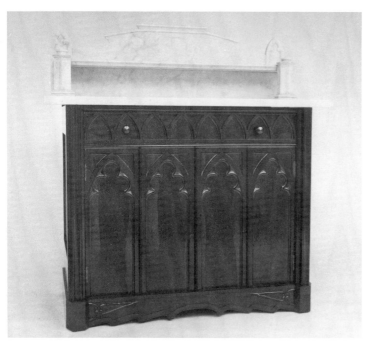

274a.

PROVENANCE: Made as a gift for Henry Clay, 1844; Daniel and Martha Turnbull, Rosedown Plantation

LITERATURE: Merrill Folsom, *More Great American Mansions and Their Stories* (New York, 1967), p. 137

A. J. DOWNING was not an admirer of Gothic furniture: "Well-designed furniture in this style is rarely seen in this country, and is far from common on the other side of the Atlantic. The radical objection to Gothic furniture, as generally seen, is that it is too elaborately gothic—with the same high pointed arches, crockets and carving usually seen in the front of some cathedral. Elaborate exhibition of style gives it too ostentatious and stately a character" (A. J. Downing, *Furniture for the Victorian Home from the Architecture of Country Houses,* 1850, reprint, Watkins Glen, N.Y., 1968, p. 70).

Such a description would fit the Gothic bedroom suite, of which two pieces are shown here, that belonged to Daniel and Martha Turnbull, wealthy cotton planters and the original owners of Rosedown (subsequently acquired by Mr. and Mrs. Milton Underwood and completely restored to its original condition). But the bedroom suite was deliberately "ostentatious and stately" since it was intended to go in the White House had Henry Clay won the presidential election in 1844.

According to tradition the set was ordered from the Journeymen Cabinet Makers' Furniture Warehouse in Philadelphia and included:

One bedstead spring bed hair mattress state pillows satin covers crimson & canopy complete	$1300.00
One large armour complete	300.00
One large wash stand	100.00
6 gothic chair satin covers	72.00
One splendid dressing bureau cut chandeliers gold bronze	125.00
One scheval glass full size chandeliers to correspond with those on dressing bureau	110.00
One octagon table to correspond with furniture 4 drawers 2 drawers fitted up pocket book style	110.00
One wash stand same as above	80.00
	2197.00
Off	17.00
	$2180.00

When Clay was defeated, Turnbull convinced Crawford Riddell to sell him the bedroom suite. Turnbull had to add a wing to the north side of his house to accommodate the furniture, which is known at Rosedown Plantation as the Henry Clay Suite. The massive bed has the "pointed arches, crockets and carving" that Downing found excessive,

determine which furniture produced during this period bearing his label was actually made by him.

An 1840 advertisement in McElroy's directory describes the stock that Riddell carried in the "Journeymen Cabinet Makers' Ware-rooms, No. 48 S. 5th Street below Walnut, Philadelphia":

> The largest assortment of Furniture of the latest and most approved designs to be found in any establishment in the United States, is constantly on hand at the above Ware-rooms, to an inspection of which the public are respectfully invited.
>
> The Furniture is all manufactured by the best Journeymen in the trade—apprentices and incompetent workmen being positively excluded—consequently every article sold will be warranted.
>
> Strangers visiting the city will please make the establishment a visit, whether in the capacity of purchasers or otherwise.
>
> N.B. Furniture forwarded to any part of the Union, and warranted against any injury from packing.

As the superintendent of the Society, Riddell was awarded a silver medal at the Franklin Institute exhibition of 1838 for an assortment of cabinetwork including "a Large Wardrobe, 4 music stools, 2 Pier Tables, a Pair of Card Tables, 2 Portable desks, 1 Ladies Work table, 8 chairs, and a Recumbent Chair." And in 1840 he received an honorable mention for a secretary (*Report of the Committee on Premiums and Exhibitions,* Franklin Institute, Philadelphia, 1840, p. 11).

In 1846, Riddell established his own cabinetmaking shop at 173 Chestnut Street where he sold "every description of Cabinet Furniture, feather beds . . ." (HSP, Skerritt Papers, Bill to James Skerritt, 1847). When Riddell died in 1849, George J. Henkels succeeded to his business "on Chestnut Street, opposite the State House" where he remained until that building was destroyed by fire in 1854 (Robson, *Manufacturers,* p. 422).

274a. *Washstand*

1844
Mark: CRAWFORD RIDDELL'S/JOURNEYMEN CABINET MAKERS/FURNITURE WARE HOUSE/ 48/ S. FIFTH ST./ PHILAD. (stenciled on bottom of top drawer)
Rosewood, rosewood veneer; poplar, white marble top
41¼ x 21 x 43½" (104.8 x 53.3 x 110.5 cm)
Rosedown Plantation, St. Francisville, Louisiana

274b. *Chair*

1844
Rosewood, rosewood veneer; twentieth century upholstery
36 x 19¼ x 18¼" (91.4 x 48.9 x 46.4 cm)
Rosedown Plantation, St. Francisville, Louisiana

and although smaller in scale, other pieces in the set display the same virtuoso carving and familiarity with Gothic motifs.

The washstand not only has a series of carved pointed arched panels on the cabinet but also a carved marble splash board that has Gothic arches. Chamfered three-sided columns on each side of the base echo the bases of the massive columns on the bed. A small towel rack pulls out from the side of the washstand, contributing to the overall efficiency of the piece.

The back of the chair is carved with Gothic arches, and the upholstered splat tapers to a pointed arch at the top. The base, however, reflects a more conservative style. The raked back legs are similar to those on klismos chairs popular in the 1820s and the carved and turned front legs are reminiscent of those on chairs of the Regency style.

PT □

WILLIAM LANGENHEIM (1807–1874) AND FREDERICK LANGENHEIM (1809–1879)

Because the Langenheim brothers were in partnership together in the photographic business for most of their careers, and because their works are almost always

274b.

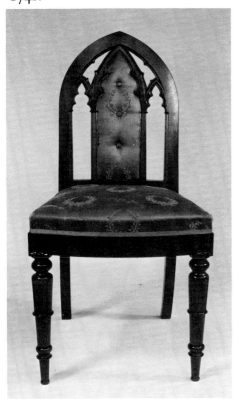

attributed to both of them, they are usually referred to as either W. and F. Langenheim or as the Langenheim brothers. They were born in Brunswick, Germany. William immigrated to America in 1824, joined the military, and fought in the Mexican War. In 1837 he served in the military campaign against the Seminole Indians in Florida. He came to Philadelphia in the spring of 1840 to work as an agent for the German newspaper *Die Alte und Neue Welt* and shortly thereafter was joined by Frederick who arrived in Philadelphia from Germany at about the same time.

The Langenheim brothers became involved in the new enterprise of photography by chance when they were introduced to the Viennese Peter Friedrich Wilhelm Voigtländer, builder of daguerreotype cameras and lenses designed by Joseph Petzval, and became Voigtländer's agent in America (see Newhall, *Daguerreotype,* p. 50). By June 1842, having been successful in the sale of photographic equipment, they opened up a daguerrean studio in the Merchants' Exchange Building where they remained until 1874. In 1845 the Langenheims took a photographic expedition to Niagara Falls, producing eight sets of five daguerreotypes each of the falls, framed together side by side to give a panoramic effect. These unique sets received wide acclaim from various European heads of state and from Daguerre himself.

In 1846, Frederick bought and patented as assignee in the United States the process of coloring daguerreotypes, which had been invented by Johann Baptist Isenring, a Swiss daguerreotypist. By May 1, 1846, William purchased, in England, exclusive American rights to William Henry Fox Talbot's United States patent for making paper prints from paper negatives by the "talbotype" or "calotype" method. But this negative-positive process was a commercial failure in the United States because photographers could not afford the Langenheims' high license fee to practice this method, which could not at any rate compete with the more popular daguerreotype process. As a result, the Langenheims were the only professional photographers to make extensive use of the talbotype process, producing among other works, a series of portraits and views in and around Philadelphia, including a scrapbook of their talbotypes, entitled "Views of North America Taken from Nature" (Missouri Historical Society, St. Louis).

In 1849 the Langenheim brothers introduced the "hyalotype" process to Philadelphia, a modification of Niépce de Saint Victor's experiments in France, which produced glass positives made from albumen glass negatives. Frederick obtained a patent for the improvement of the glass negative

process on November 19, 1850, while John A. Whipple of Boston had invented and received a patent a few months earlier for virtually the same process, which he termed the "crystallotype." The Langenheims further developed the use of the hyalotype by applying it to the production of magic lantern slides for projection. These transparent positives were a novelty in the United States, and their production and sale soon became a lucrative industry with Philadelphia as its center.

The Langenheims also adapted the use of the albumen glass negative to the production of stereographs both on paper and on glass. Although stereoscopic photography had already begun in Europe, the Langenheims were the first to develop and popularize this method in America, founding the American Stereoscopic Company to sell and distribute transparencies and paper prints made from hyalotype negatives. In 1855 they published a series of stereoscopic views on glass, albumenized paper, and porcelain, taken at various sites along the southern route of the Reading, Catawissa, Williamsport, and Elmira railroads between Philadelphia and Niagara Falls. At the same time, they photographed views of the coal regions near Pottsville on the Mine Hill Railroad. These photographs and other series of glass stereographs taken in 1855–56 (Parke-Bernet 84, New York, February 7, 1970, nos. 433–37) are among the earliest examples of landscape photography in the United States.

Weston J. Naef states that "perhaps as a result of Frederick Langenheim's early activity, Philadelphia came to have the first really defined school of landscape photography in the United States" (*Era of Exploration—The Rise of Landscape Photography in the American West, 1860–1885,* Boston, 1975, p. 28). Other contemporary Philadelphia landscape photographers included Carey Lea, Coleman Sellers, Edward L. Wilson (editor and publisher, from 1864–88, of one of the country's most influential photography periodicals, *The Philadelphia Photographer*), W. T. Purviance, and John Moran.

In 1856 the Langenheims produced a large series of paper stereoscopic views of Philadelphia, New York, and environs. They regularly exhibited daguerreotypes, talbotypes, hyalotypes, and magic lantern slides in the fine arts division at the Franklin Institute annual exhibitions and received more medals from these exhibitions than any other photographers (Louis W. Sipley, "The Daguerreotype," *Pennsylvania Arts and Sciences,* vol. 4, no. 1, 1939, p. 20). By the 1860s the brothers were devoting the majority of their photographic business to the production of magic lantern slides.

When William died in 1874, Frederick

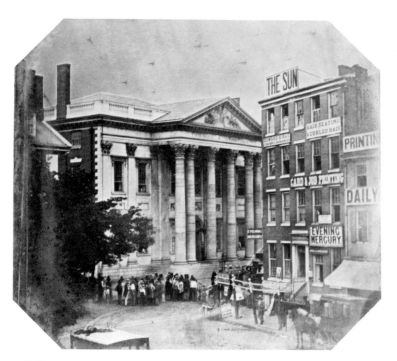

275.

vol. 1, p. 677). This daguerreotype is possibly one of the earliest examples of on-the-spot reporting of a contemporary event in the United States by photographic means.

CW □

retired, selling the photographic business to Casper W. Briggs. More than any other pioneer photographers, the Langenheims introduced a considerable number of European photographic processes to America, and with the exception of the talbotype process, they made a commercial success of each one.

275. *Northeast Corner of Third and Dock Streets*

1844
Label: Library Company of Philadelphia/ Presented to The Ridgeway Branch/By John A. McAllister (front of case); 1844 (in pen on label)
Half plate daguerreotype
7 x 5⅞″ (17.8 x 15 cm)
The Library Company of Philadelphia

PROVENANCE: John A. McAllister (1786–1877)

ALTHOUGH THE LANGENHEIM BROTHERS are usually associated with the use of talbotype, hyalotype, stereographs, and magic lantern slides, rather than with the daguerreotype, which had previously been produced in Philadelphia by Joseph Saxton, Robert Cornelius, Paul Beck Goddard, and others, this piece demonstrates a rather unique skill for its time—the successful depiction of an outdoor scene by the daguerreotype method. In the 1840s outdoor daguerreotype views were rare because the light source and motion of

the subject shot at random could not be controlled. Moreover, the market demand for daguerreotypes was in portraiture rather than scenes, views, or events, which at this time were recorded by the more traditional medium of lithography or wood engraving.

This view of the Girard Bank was probably taken from the Langenheims' studio in the Merchants' Exchange Building across the street from the bank. Every detail, including signs on the buildings, is revealed with clarity and distinction. Since daguerreotypes are made by a direct positive process, a mirror image is produced unless a correcting mirror or prism is placed in front of the camera lens, as is the case with this piece. The absence of blurred elements is thus all the more remarkable, for the use of a correcting mirror required at least a 30 percent increase in exposure.

The event recorded appears to be the taking over of the Girard Bank by the military during the so-called Native American Riots in May 1844. The riots were instigated by several associations of native-born Americans who were attempting, among other measures, to enforce a twenty-one year residency requirement for "foreigners" before they could vote or hold office. Irish Catholics formed the main opposition to attempted changes in the naturalization laws. Much damage was done to city buildings and many citizens were severely wounded, some fatally. On May 9, 1844, Major General Patterson called out a military division and established headquarters at the Girard Bank to cope with the assembled crowd (Scharf and Westcott,

JOHN NOTMAN (1810–1856)
(See biography preceding no. 259)

276. *The Athenaeum of Philadelphia*

219 South Sixth Street
1845–47
Coursed red sandstone ashlar with rusticated red sandstone ground story
50 x 125′ (15.2 x 38.1 m)

REPRESENTED BY:
John Notman
The Athenaeum (As Proposed)
c. 1845
Watercolor on paper
11¾ x 20¾″ (29.8 x 52.7 cm)
The Athenaeum of Philadelphia

John Notman
Original Miniature Drawing of the Athenaeum Building
c. 1847
Watercolor on paper
5½ x 7¾″ (14 x 19.6 cm)
The Athenaeum of Philadelphia

LITERATURE: Robert C. Smith, *John Notman and the Athenaeum Building* (Philadelphia, 1951); Arthur M. Kennedy, "The Athenaeum: Some Account of Its History from 1814 to 1850," in *Historic Philadelphia*, pp. 260–65; White, *Philadelphia Architecture*, p. 27, pl. 37; Dickson, *Pennsylvania Buildings*, pl. 59; Tatum, pp. 92, 98, 184, pl. 91; Roger W. Moss, Jr., "The Athenaeum of Philadelphia," *Nineteenth Century*, vol. 1, no. 1 (January 1975), pp. 16–17

JOHN NOTMAN immodestly recommended his design for the Athenaeum of Philadelphia to its directors as "an excellent specimen of the Italian style of architecture" (Robert C. Smith, *John Notman and the Athenaeum Building*, Philadelphia, 1951, p. 14). The directors evidently agreed, and in June 1845 they commissioned him as architect of their new building, and a month later named him superintendent of construction. Completed in October 1847, the Athenaeum stands as not only an excellent example of the Renaissance revival but also an early example of the style in America and the first of its kind in Philadelphia. It is modeled after the Manchester Athenaeum (1836) and the London Reform Club (1837), both by Sir Charles Barry, whose designs were stripped of columns and pilasters in favor of the

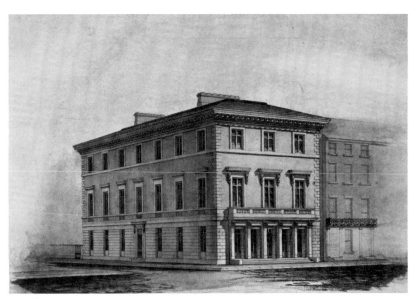

276. The Athenaeum (As Proposed)

articulated windows and bold cornices of the Italian Renaissance.

The Athenaeum's final appearance evolved during its construction. Within a week after the laying of the cornerstone in November 1845, the directors, under the burden of growing expenses, ordered Notman to discard the planned marble facade for red sandstone, making the Athenaeum one of the city's earliest major buildings constructed of that newly fashionable material. Also with an eye on economy, the initial plan for a ground-story lecture hall with raked floor was replaced by a level lecture room, which would be more easily rented for other uses. Two other significant changes were made, evidently the result of the architect's sense of design rather than the directors' sense of economy: the placing of a lantern light in the roof over the broad, open stairs and the addition, outside the entrance, of inverted candelabra (which have since been replaced by small stone balls). The basic design and function of the Athenaeum, however, have not changed since Notman planned it. It remains a clubhouse in the Tuscan (or Roman) *palazzo* revival manner. The facade is distinguished by a rusticated ground story, angle quoins, and front balcony, and the interior is dominated by a handsome open stair hall with Corinthian columns *in antis* at the second story. The only significant interior change was Frank Furness's 1870 remodeling of a third floor room that was then the quarters of the Philadelphia chapter of the American Institute of Architects.

Over the years the Athenaeum has lived up to the claim of Samuel Breck, one of its early presidents, that the institution "will be classed with libraries of respectable standing, well stocked with works in the learned and modern languages . . . easy of access to those

who choose to consult them" (quoted in Smith, cited above, pp. 15–16). Founded in 1814, it was initially quartered above Mathew Carey's bookshop until it moved into Philosophical Hall four years later. Its present home is the city's oldest library building in continuous use, and in addition to having served as a reference library for the public and its eight hundred elected stockholders, it has temporarily housed the Historical Society of Pennsylvania, the American Institute of Architects, the American Catholic Historical Society, the Philadelphia Law Library, and many other groups. It currently serves also as the national headquarters of the Victorian Society of America.

RW □

GEORGE J. HENKELS (1819–1883)

Born in Philadelphia, George Henkels was trained as a chairmaker. His father manufactured firearms and helped erect the first steam-powered factory in the city. Henkels first appeared in the Philadelphia directories in 1843, listed at 371 South Third Street and subsequently at various other addresses. According to Robson, in 1847, Henkels succeeded Crawford Riddell (see biography preceding no. 274) and moved into Riddell's showrooms on "Chestnut St., opposite the State House" (Robson, *Manufacturers,* p. 422), but directory listings record that Riddell maintained a furniture warehouse at 173 Chestnut Street until his death in 1849. By 1867, Henkels was located at the corner of Thirteenth and Chestnut streets, where he worked briefly with George and B. W. Lacy and, also briefly, with John A. Henkels, a relative.

In the years immediately following the Civil War, Henkels carried on the most extensive trade of any furniture house in Philadelphia. He was also known for helping the wounded who were brought to Philadelphia during the Civil War. Henkels met the ships at the docks with ambulances which he had designed and made, consisting of spring beds and mattresses placed in furniture vans. Henkels retired from active business in 1877. He died at the age of sixty-four, leaving thirteen children (see Kenneth Ames, "George Henkels, Nineteenth-Century Philadelphia Cabinetmaker," *Antiques,* vol. 104, no. 4, October 1973, pp. 641–50).

In addition to manufacturing fine furniture Henkels was a prolific writer of articles on politics, economics, and other subjects for Philadelphia newspapers. Most interesting for the art historian were the catalogues and booklets he wrote for his customers,

276. Original Miniature Drawing of the Athenaeum Building

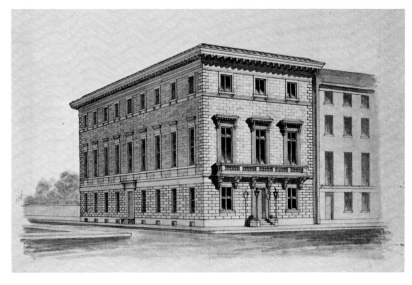

including a *Catalogue of Furniture in Every Style* (1850). In his *Essay on Household Furniture* (Philadelphia, 1850, p. 16), he included a description of his showrooms at 173 Chestnut from an account in a Philadelphia monthly magazine.

We first visited the workshop, a four story building, measuring fifty-two by fifty feet. The cellar of this is a store-room for lumber, mostly of the imported kinds. ... The first story, which we next visited, contains turning lathes and other machinery, and in this we found ten men employed. The second story, which is a general workshop, had sixteen men engaged in manufacturing various articles of furniture. The third story is the carver's room, where the elaborately ornamented chairs and sofas of the styles of Louis Quatorze and later times are manufactured, and gives employment to twenty-one

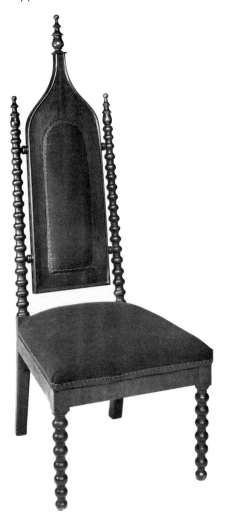

277.

men. The fourth story is the varnishing room, where we found fourteen men engaged. On the roof there is a flat arranged for drying, and covered with an awning during summer. A large furnace heats the building; but an extra heat is employed in the third story, in order to thoroughly test the furniture and make it fit for any climate or situation. Everything we saw was complete and perfect in its way.

Leaving the workshop we came upon the main building, which includes the show rooms. This is one hundred and eighty-seven feet long by twenty-seven feet wide, and four stories in height. Besides this there is a supplementary story used as a hair room. The fourth story is employed partly as a store and varnishing room—five varnish finishers being employed there. In the front room of this story, is the upholstery room, where we found nine men busily engaged in giving the last touches to some splendid sofas and chairs.

Descending to the third story we found in the front part, a half dozen sewing women engaged in manufacturing curtains, of heavy damask, and of a very rich pattern, for the house of a noted *millionaire*. Leaving them and casually inspecting some exceedingly rich chamber furniture, we came upon the enamelers, three of whom were employed in finishing this new and effective style of goods. In this story is the foreman's office, with the storeroom for hardware and looking-glass plates.

We next entered the second story, which is the principal show room, and inspected the furniture displayed. The first thing which attracted our attention was a *suite* of heavy and rich window-curtains, with an elaborate cornice—the whole got up with great taste and proper regard to the picturesque. ...

There are several other buildings attached to the manufactory, with stone-cutting and marble-polishing room, lumber-yards, &c., but these we had not time to visit. Altogether, about one hundred and eighty hands are employed by Mr. Henkels, besides two furniture cars and their drivers, with relays of horses. This, with the necessarily enormous amount of capital involved, may give some idea of the business annually done. ...

277. Side Chair

c. 1845–50
Label: GEORGE J. HENKELS (printed on paper underneath front seat rail, part of label missing)
Walnut, chestnut; twentieth century upholstery
40½ x 15⅜ x 16¼″
(102.9 x 39.1 x 41.3 cm)
Lee B. Anderson, New York

THE SIMPLE YET EFFECTIVE design of this child's chair combines elements of both the Elizabethan revival—sausage-turned legs and stiles—and the Gothic—the pointed crest rail. A similar chair is illustrated in Downing (*Country Houses,* fig. 295).

According to Downing, "Elizabethan furniture is too expensive for cottages, but a very simple and cheap modification of it—which is of Swiss origin—has now become common in the cabinet-shops, is afforded at very low prices, and is particularly well suited to cheap cottages and farm-houses in the *Bracketed* style" (p. 452). The twisted legs, a commonly used element in Elizabethan features, were, according to Downing, "the natural symbol or emblem of affectionate embrace," a particularly appropriate conceit for a child's chair (p. 346).

Downing also illustrated a number of Elizabethan chairs of modern designs, suited to the library or drawing room. They were covered "with velvet, or other rich stuffs, and bordered with fringe." Such chairs could be found "in the principal warehouses in our largest cities," such as that of George J. Henkels.

The use of the Gothic revival details gives this small chair a sense of monumentality. Its back, conceived of as a separate plane, is attached to the stiles by spool-like turnings which give the back the appearance of mechanical movement.

DH □

JOHN E. CARVER (1803–1859)

Very little is known about John E. Carver. He evidently began his career as a carpenter and extended his operations as a builder in 1839 at the same time that he was running a drawing school with William L. Johnston (see biography preceding no. 285) on Carpenters' Court. By 1841 he was calling himself an architect and in 1855 he added "engineer" to his title. Carver's financial interests were as diversified as his professional talents; for example, he invested in rental properties, a billiard saloon, and at least one public utility, the Columbia Gas Company.

Carver appears to have been fond of the Gothic revival style. His most noted building is the Church of St. James the Less. Although Carver was hired to superintend the construction of the church, the quality of the craftsmanship and his own revisions to the plans testify to his well-developed skills. Other works known to be by Carver include the Church of the Redemption (1847), an Episcopal free mission church in the English Gothic style that once stood at Twenty-third and Callowhill streets; and the Grange, an eighteenth century house in Havertown that he remodeled extensively in 1850 in the rural Gothic fashion popularized by Andrew Jackson Downing's books. Carver is known to have participated in the Academy of Music competition in 1854, but none of his drawings appear to have survived. His library included the standard architectural classics, beginning with Stuart and Revett's *Antiquities of Athens,* Loudon's *Encyclopaedia,* and Wilkes's *French Cathedrals* (City Hall, Department of Records, Administration no. 168, April 19, 1859), which suggests that he was fluent in all of the historical styles. He also possessed contemporary journals, such as the *Journal of the Franklin Institute* and *The Builder,* as well as books on mathematics and engineering.

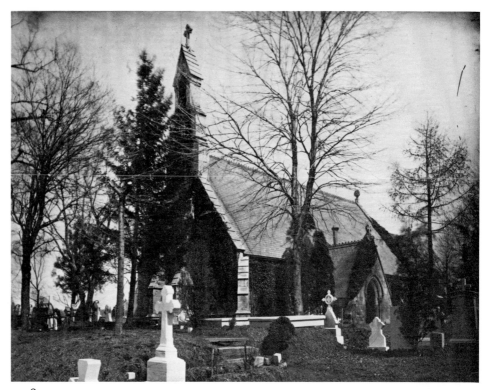

278.

278. *Church of St. James the Less*

Clearfield Street and Hunting Park Avenue
1846–49
Random granite ashlar, slate roof
36 x 97′ (10.9 x 29.5 m)

REPRESENTED BY:

George W. Hewitt (1841–1916)
Church of St. James the Less
Photograph

Courtesy The Franklin Institute, Philadelphia

LITERATURE: Tatum, p. 82; Peter Collins, *Changing Ideals in Modern Architecture, 1750–1950* (Montreal, 1965), pp. 100–110; Phoebe B. Stanton, *The Gothic Revival and American Church Architecture* (Baltimore, 1968), pp. 3–29, 91–114; Millicent E. Norcross Berghaus, *The Church of St. James the Less, 1846–1971* (Philadelphia, 1971)

OUT OF THE WAY and often overlooked, the Church of St. James the Less, located at the site of what at one time was the Falls of the Schuylkill, is nevertheless one of Philadelphia's finest architectural landmarks. As the first church in the United States to be built under the supervision of the Ecclesiological Society, it is not only an outstanding example of the Gothic revival but also an influential piece of architecture whose importance extended beyond the confines of its historical style. The goal of the Ecclesiological Society, organized in 1836 at Cambridge University by a group of Anglican reformers, was to combat creeping secularism and to enrich church liturgy and architecture. The Society promoted the study of medieval arts, and their work resulted in the restoration of many of England's rural Gothic churches.

In the early 1840s, when Robert Ralston, a prominent Philadelphia merchant and High Church enthusiast, wanted to establish an Episcopal parish in his growing suburban neighborhood, he understandably contacted the Ecclesiological Society. The Society forwarded to him a set of slightly revised measured drawings by the English architect G. G. Place of the thirteenth century St. Michael's Church at Long Stanton, Cambridgeshire. The vestry of St. James the Less adopted the plans in the spring of 1846 and signed the contract that October with the understanding that the costs would not exceed three thousand dollars. Before the project was completed, however, the vestry became so proud of the building that it spent ten times its initial stipulation. John E. Carver was hired as superintendent of construction, and shortly thereafter revised Place's plans in order to lengthen the nave by one bay and to add a vestry to a corner of the chancel. During the construction, William Butterfield, the noted English architect, contributed designs for the London-made silver plate, the east and west windows, and the chancel. He also sent the vestry a copy of *Instrumenta Ecclesiastica: A Series of Working Designs for the Furniture, Fittings, and Decorations of Churches and their Precincts* (1847), which he had prepared for the Society and which was to be the source for all later additions and alterations to the church.

St. James the Less has remained remarkably intact over the years. In 1908 a bell tower and mausoleum designed by John T. Windrim in consultation with Henry Vaughan was built at the order of Rodman Wanamaker in memory of his brother Thomas, but it was placed on the edge of the churchyard and does not detract from the church. A high stone wall effectively isolates the church from the heavy traffic and urban decay nearby. A visit to St. James the Less, entering along the cobblestone drive and approaching the church yard with its gravestones based on Butterfield's *Instrumenta Ecclesiastica,* is akin to stumbling across a piece of old English countryside, an experience made all the more enchanting by the fact that this enclave is within a large American industrial city.

As the first American church copied from a medieval model, St. James the Less played a key role in the development of the Gothic revival style in the United States. As a product of English reform philosophy, it was also an American expression of the idea that architecture could be an instrument of social progress. St. James exhibits "principles of

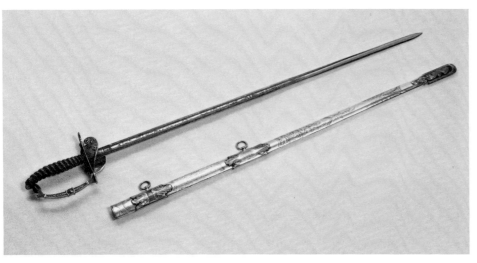

279.

architectural design, a sense of materials, a feeling for pervasive scale, and an expression of function in design which Americans instinctively understood and enjoyed, and from which they were to profit" (Phoebe B. Stanton, *The Gothic Revival and American Church Architecture,* Baltimore, 1968, p. 114).

RW □

BAILEY & CO. (EST. 1847)

Bailey & Co. was considered the leading jeweler and silversmith of Philadelphia and the first firm to introduce silver of the full British sterling standard (.925 percent silver with .075 percent copper added for hardness). By raising the standard, they hoped to compete more successfully with English imports. It was also thought that this improvement in the quality of silver made the objects "more beautifully white, susceptible of higher polish, and less liable to oxidation and consequent discoloration."

Bailey's wares were well known throughout the country, but the South was their principal outlet. All the processes of production, including "the designing and drawing of the patterns, the melting and refining of the metal, to the last finishing touch of the graver, are executed upon their own premises, and under their personal inspection" (Freedley, *Philadelphia Manufactures,* pp. 348–49). In 1859 the annual production of silver by the firm was valued at $100,000.

Founded by Joseph T. Bailey, the firm of Bailey & Kitchen was first listed in DeSilver's Philadelphia directory in 1833. It was recorded as Bailey & Co. from 1849 to 1878,

although Bailey listed himself alone as J. T. Bailey, jeweler, in 1847, 1848, and occasionally in subsequent years. After Bailey's death in 1854, the business was continued by his brothers. In 1878 the firm of Bailey, Banks and Biddle was formed, composed of J. T. Bailey, George W. Banks, and Samuel Biddle.

The firm continued to produce its own silver, mostly jewelry and flatware, but like other retail firms of the day, they imported much of their stock.

279. *Sword and Scabbard*

After 1847
Inscription: Presented by his fellow citizens of PHILADELPHIA to/Charles John Biddle/late Captain of Voltigeurs & Brevet Major U.S. Army in/memorial of their high sense of his GALLANTRY & CONDUCT/on the well fought Fields of the Campaign of 1847 in/the Valley of Mexico (engraved on side of scabbard); CONTRERAS/CHURUBUSCO/MOLINO-DEL-REY/CHAPULTEPEC/SAN COSME/CITY OF MEXICO (engraved on copper gilt mount); Ames Mfg. Co/Chicopee/Mass (engraved on top of blade); E. pluribus Unum (engraved in banner held by eagle); Made by/BAILEY & Cᵒ/136/Chestnut St. PHILᴬ (engraved on back of scabbard)
Silver, copper gilt; steel blade and hilt; semiprecious stone set in hilt
Length 37⅝" (95.5 cm); width 5⅛" (13.1 cm)

Private Collection

PROVENANCE: Charles John Biddle (1819–1873); descended in family to the present owner

AMERICAN PRESENTATION SWORDS were given by the Continental Congress after the Revolution and by cities and organizations as a mark of esteem, or in recognition for heroic action. Following the War of 1812 and the Mexican War, numerous presentation swords were commissioned, such as this sword and scabbard, which were given to Charles John Biddle, the son of the noted financier Nicholas Biddle. The scabbard, made by Bailey & Co., has given the craftsman of this object the opportunity to exercise his skills in engraving, chasing, and cast ornamentation. Only a few small areas have been left undecorated, and both classical and rococo revival motifs have been used. The sword was made by the Ames Manufacturing firm, formed in 1832 in Chicopee, Massachusetts, which manufactured a large number of swords for the army and navy.

After graduating from Princeton University in 1837, Charles Biddle studied law and was admitted to the bar in 1840. He served as a captain in the United States Army during the Mexican War and fought at Contreras, Churubusco, Molino del Rey, and Chapultepec. After the capture of Mexico City, he was promoted to the rank of major for gallant and meritorious services. These actions were the occasion for the presentation of this sword.

After the war, Biddle returned to the practice of law in Philadelphia. In 1861 he was appointed a colonel in the Pennsylvania volunteers, and in October of that year while on military duty in Virginia, he was elected a representative from Pennsylvania to the Thirty-seventh Congress. After the close of the war he became one of the owners and editor-in-chief of the Philadelphia *Age,* a leading Democratic paper, a position he held throughout the remainder of his life.

DH □

HUGH CANNON (C. 1814–C. 1864)

Nothing is known of Hugh Cannon's early life. Fielding suggests that he was born in Ireland, although Groce and Wallace record his birthplace as Pennsylvania. Philadelphia city directories first record the presence of "Cannon Hugh, marble-mason" in 1837. In 1840, Cannon entered a marble bust of "the late Chief Justice Marshall" in the Artists' Fund Society exhibition, and in 1841 he sent busts of Henry Clay and Edwin Forrest to the Apollo Association in New York, but the directories do not list him as a sculptor until 1846. In 1850 the Philadelphia merchant Daniel W. Coxe presented Cannon's marble portrait busts of Nicholas Biddle and Henry Clay and Cannon's self-portrait to the Pennsylvania Academy of the Fine Arts where they were on view regularly. Other

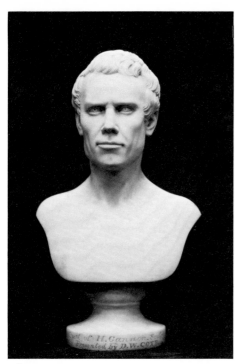

280.

portraits by Cannon were exhibited at the Academy in 1851 and 1855. In the 1850s, Cannon is listed variously in the directories as a sculptor, carver, and agent. His name appears for the last time in the 1863 Philadelphia directory with no occupation mentioned, and in 1869, Ann Cannon is listed as the widow of Hugh.

AS

280. *Self-Portrait*

c. 1846–50
Inscription: Bust of H. Cannon. Sculpt/ Presented by D. W. COXE (front of base)
Marble
26 x 16½ x 9″ (66 x 41.9 x 22.9 cm)
Pennsylvania Academy of the Fine Arts, Philadelphia. Gift of D. W. Coxe, 1850

LITERATURE: Rutledge, *Cumulative Record,* p. 42; PAFA, *Held in Trust, One Hundred Sixty-six Years of Gifts to the Pennsylvania Academy of the Fine Arts* (June 23—August 26, 1973), p. 8, no. 31

CASTS FROM ANTIQUE SCULPTURE were displayed at the Pennsylvania Academy as models for artist's work along with history paintings, but a notion of sculpting as an elevated professional activity, requiring a mind as well as a hand trained to create ideal form, did not have a parallel development with painting. In Philadelphia, as in most other American cities, local sculptors were considered craftsmen until well into the

nineteenth century. They learned their skills in the shops for carving furniture and figure heads and in the foundries and marble yards of the city. William Rush (see biography preceding no. 199), whose own training as a sculptor had been of this practical kind, listed himself as a carver in the city directories throughout his life. Until about 1850 the demand for sculptural ornament for buildings and for funerary monuments was met by artists who listed themselves in the directories as carvers, masons, or ornamental ironworkers, whatever their abilities or aspirations. They usually left their work unsigned, and when their names do appear, they are more frequent as signatures on the statuary in Laurel Hill Cemetery (no. 259) than in the exhibition records of the Academy.

Since few portrait busts by Cannon are known, it is likely that he earned his living by anonymous work, even after he began to advertise himself as a sculptor in 1846. His self-portrait is evidence of the talent for sculpting likenesses that apparently won him the patronage of Daniel W. Coxe and encouraged Cannon to promote himself from "carver" to "sculptor." It is a straightforward image, based not on an abstract concept of style but on an aptitude for observing and recording a matter-of-fact likeness in skillfully carved and finished marble.

DS □

MARCUS AURELIUS ROOT (1808–1888)

Marcus Root was an artist, photographic historian, and one of Philadelphia's most prominent and prolific daguerreotypists, producing nearly seventy thousand daguerreotypes during his life. He was perhaps the most vocal supporter in America of photography as a fine art, at a time when many of his colleagues thought of photography primarily as a moneymaking proposition or as a scientific curiosity.

Root was born in Granville, Ohio, and attended the University of Ohio in 1827. Shortly thereafter he took up drawing and sketching. While producing portraits of government employees in the Ohio State Capitol in Columbus, he began the study of handwriting which later led to the profession of penmanship instruction. He came to Philadelphia to study painting with Sully, but Sully discouraged him, and Root abandoned the idea of becoming a portrait painter and returned to teaching writing. He established penmanship studios in various Pennsylvania cities, finally settling in Philadelphia in 1835 (see Marcus Root, *The Camera and the Pencil or the Heliographic Art,* Philadelphia, 1864, reprint 1971, pp. 365–66, intro. by Beaumont Newhall, pp. 5–9).

From 1839 to 1846 the city directories list him as a writing instructor, but by 1847 he is listed as a "photographist" as well. In 1839, Root received instruction from Robert Cornelius (see biography preceding no. 288). Between 1839 and 1849 with the help of various partners, he opened daguerreotype galleries in Mobile, Alabama; St. Louis; and New Orleans.

In 1842, Root joined John Jabez Edwin Mayall's daguerreotype business at 140 Chestnut Street, buying out the gallery from Mayall when the latter went to London in 1846. No doubt he received invaluable advice and training from Mayall, who was later to become the leading portrait photographer in England. At some point early in his photography career, Root was joined in the daguerreotype business by Collins (possibly the daguerreotypist T. P. or D. C. Collins). Root established a daguerreotype gallery in New York City in 1849 with his brother Samuel (see biography preceding no. 304), and in 1852 he opened a gallery in Washington, D.C.

Root sold his Philadelphia business in 1856 with the idea of moving to New York to pursue his career, but before doing so he took a trip to Ohio, where he was severely injured by a train which hit the railroad platform where he was standing. During his four-year convalescence he wrote the first history, technical manual, and aesthetic treatise of photography as a fine art, *The Camera and the Pencil or the Heliographic Art,* published in 1864 by J. B. Lippincott & Co. The book is a valuable list of contemporary events but is not an accurate record of prior historical events (see Taft, *Photography,* pp. 475n., 148). After Root's accident, it seems that his daguerreotype business slowed down considerably, for there is little mention of his activities in Philadelphia. The city directories list only his home addresses after 1856, although he exhibited work at Photographic Hall at the 1876 Centennial exhibition ("Photography and the Great Exhibition," *Philadelphia Photographer,* vol. 13, no. 151, July 1876, p. 198).

281. *Anne Sophia Penn Chew*

c. 1846–56
Stamp: M. A. Root (lower left); 140 Chestnut St. (center); Philadᵃ (lower right, all on brass mat)
Inscription: ASPC (etched on verso of plate)
Half plate daguerreotype
5½ x 4¼″ (14 x 10.7 cm)
Anne Chew Barringer, Radnor, Pennsylvania

PROVENANCE: Descended in Chew family

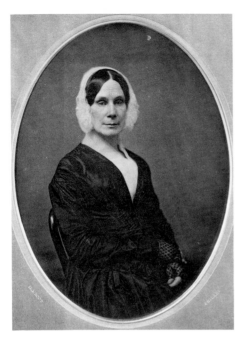

281.

IN HIS BOOK *The Camera and the Pencil,* Root emphasized throughout that "... expression is a 'sine qua non in art' " and the "index of the soul." Moreover, he maintained that the average daguerreotypist who had no formal artistic training was a mere "mechanic" and lacked the knowledge and ability to arrange the sitter in the most natural and characteristic state. From the little that is known of the sitter of this portrait, Anne Sophia Penn Chew (1805–1892), it would seem that Root has produced a portrait which reflects her character.

Granddaughter of Chief Justice Benjamin Chew, builder of Cliveden, and daughter of Benjamin Chew, Jr., and Katherine Banning, Anne was one of eight children, four of whom died at birth. According to her great-great-niece, Anne Sophia Penn Chew Barringer, she never married but became the mainstay and matriarch of Cliveden after her father died in 1844 until her death in 1892 at the age of eighty-seven. She is remembered for her resolute will, courage, forthrightness, and gracious manner, characteristics which Root has emphasized in the sobriety of her dress, the severity of her hair style, her firm, close-shut mouth, and alert expression, as she sits erectly against the back of a simple wooden chair. Her character is further typified by the absence of props and background decoration. Only very slight touches of color have been added to the cheeks and fingers. To have completed this portrait in oil, pastel, watercolor, or india ink (finishing touches which Root could supply to his customers) would not, most likely, have suited the taste of this

sitter, and therefore would have misrepresented her character. Gilding applied by the gold toning technique gives an overall warm hue to the portrait.

This gilding process which heightened the brilliance of the daguerreotype image was invented by the Frenchman Hippolyte-Louis Fizeau in 1840 and was universally and quickly adopted by reputable daguerreotypists. The address 140 Chestnut Street stamped on the mat indicates that this daguerreotype was made between 1846 and 1856, the years in which Philadelphia business directories list Root at this studio location. It was, moreover, the period during which Root reached the height of his career in the production of daguerreotypes.

CW □

THOMAS SULLY (1783–1872)
(See biography preceding no. 158)

282. *Sarah Sully and Her Dog Ponto*

1848
Signature: TS 1848 (lower left)
Oil on canvas
61 x 41" (155 x 104.1 cm)
San Antonio Art League, San Antonio, Texas

PROVENANCE: Bequeathed by the artist to daughter, Blanche Sully (1814–1898); Garrett C. Neagle, Philadelphia, by 1909; Miss Sarah Sully Rawlins, Philadelphia, by 1921; Jane (Darley) Coate and Mrs. E. H. Brodhead, until c. 1937; with Albert Duveen; Frederick G. Oppenheimer; San Antonio Art League, 1945

LITERATURE: Thomas Sully, *Hints to Young Painters and the Process of Portrait Painting* (Philadelphia, 1873, reprint, New York, 1965), pp. 28–29; Charles Henry Hart, "Thomas Sully's Register of Portraits 1801–1871 [Part 3]," *PMHB,* vol. 33, no. 2 (1909), p. 188, no. 1638; Biddle and Fielding, *Sully,* p. 288, no. 1719; Allentown [Pa.] Art Museum, *The World of Benjamin West* (1962), no. 91

THOMAS SULLY PAINTED PORTRAITS of his wife, Sarah (1779–1867), several times during their long life together, but none of these portraits shows her in quite such a personal way as in this painting. On March 11, 1848, Sully wrote to his brother-in-law: "I think Sarah [Mrs. Sully] has become still more anxious for the comfort of animals. The notice that a dog or horse is ill-treated in the neighborhood will quite destroy her tranquility" (Biddle and Fielding, *Sully,* p. 73). According to Sully's register of portraits of 1801–71 (see Biddle and Fielding, *Sully*), this full-length portrait of Sarah with her dog, Ponto, was begun on August 25, 1848, and finished on October 3. Although fairly

large in scale, it was not intended for exhibition but as a gift for the artist's daughter, Blanche, and is so designated in the register.

Sarah is shown in a gentle mood of reverie, lost in her thoughts and unaware of the spectator. Such an introspective attitude is in keeping with the new subjectivity and expression of emotion which were characteristic of early nineteenth century romanticism.

The broad, generalized handling leading to idealization in Sully's late work appealed to his sitters and had much in common with the work of Sir Thomas Lawrence, president of the London Royal Academy from 1820 to 1830, and Lawrence's followers in England. Sully admired the "dignity, elegance and taste" of Lawrence's portraits and, in 1838, thought, probably by contrast, that his own were on "too low a Scale of color" and too weak in effect (HSP, John Neagle, Common Place Book, pp. 64, 69). The contemporary criticism of Sully in Philadelphia was usually that his portraits were beautiful and elegant but not true likenesses. When Sully asked the American artist Charles R. Leslie for criticism in 1837, he was told that his pictures looked as if they were so insubstantial that they could be blown away (Biddle and Fielding, *Sully,* p. 27).

Sully's early portraits, such as *Mrs. Joseph Klapp* (no. 190), are generally considered his best, his later work sometimes sinking into a sweet sentimentality and losing any force of characterization. But it is not tenable to draw a precise chronological line between Sully's good and bad work: he was always an uneven painter. *Sarah Sully and Her Dog Ponto* is a case in point, since it is an exceptionally fine work, yet painted when the artist was sixty-five.

DE □

ROBERT STREET (1796–1865)

Robert Street was born in Germantown, Pennsylvania. Nothing is known of his artistic training or activities until 1815 when he exhibited *The Wood-Gatherer* at the Pennsylvania Academy of the Fine Arts. The painting was shown at the Academy again in 1817, and Street also participated in the Academy exhibitions of 1818 and 1822. That he was producing ambitious compositions and enjoying increasing public recognition is documented in a short biography published in a later catalogue of his paintings: "His well known historical paintings, the 'Maniac Assaulting his Keeper,' 'Celedon and Amelia,' 'Haman accused,' and 'Prophecy of Simeon' (figures the size of life were before the public in the years 1821, 2 and 3, at Mr. James Earle's rooms,

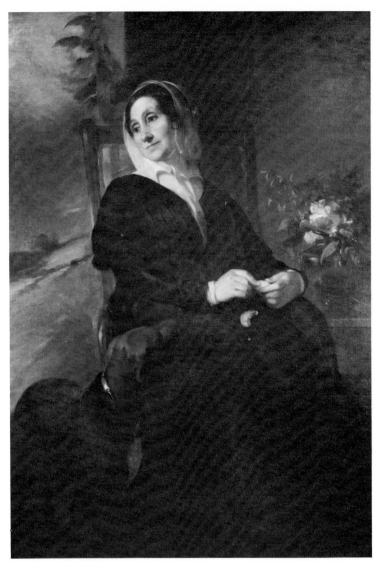

282.

kind from the corpse" and ended by recommending "the continuance of the patronage of the community which for a series of years has been so liberally imparted" (p. 16).

Street also participated in group shows with the Artists' Fund Society until 1845; at the Franklin Institute in 1847 and 1851; at the Pennsylvania Academy until 1861; and at the Apollo Association in New York in 1838 and 1839. He was married three times. His sons, Rubens Correggio, Austin del Sarto, Theophilus, and Claude Lorraine, also became artists in Philadelphia.

AS

283. *Portrait of Howell Evans*

1848
Signature: R. Street/Pinxt. 1848 (lower right)
Oil on canvas
30 x 25⅛″ (76.2 x 63.8 cm)
Atwater Kent Museum, Philadelphia

PROVENANCE: With Kennedy and Co., New York, 1945

LITERATURE: Kurt M. Semon, "Who Was Robert Street?" *American Collector,* vol. 14, no. 5 (June 1945), illus. p. 19

IN 1848, HOWELL EVANS was the young proprietor of a printing shop at Fourth Street below Chestnut and at the beginning of a long and successful career in printing. The pride that he took in his spacious, well equipped workshop, distinctively furnished with a statue of Minerva displayed on a type desk and an exotic bird perched on a gaslight fixture, probably inspired him to commission this portrait of himself as an up-and-coming young businessman.

The figure of Evans standing in the middle of his shop holding a broadside which reads "Cards and Fancy Printing by Evans" is painted with the ruddy fleshtones and the contrast of stark black and rich, liquid whites that is typical of Street's portraits of men. This painting is the only known interior view by Street, who usually painted half-length portraits against a simple background, and discrepancies in his rendering of the space of the room and the relative sizes of its inhabitants are evidence that he was unfamiliar with a system of perspective. But the care with which the equipment of the shop and the actions of its workmen are recorded and the meticulous trompe l'oeil still life of paper scraps in the foreground show the talent for detail and the sure sense of decorative color that distinguish Street as an artist.

Although it lacks the unity of coherent space, the *Portrait of Howell Evans* has the

the Masonic Hall, the Saloon, Library street and Maelzell's room, Fifth, below Walnut street, and in several cities of the Union" (*Catalogue of Robert Street's Exhibition at the Artists' Fund Hall,* Philadelphia, 1840, p. 15).

In 1824, Street exhibited three of these historical paintings in Washington, D.C., and in that year he also painted a portrait of Andrew Jackson which later hung in the White House. Contemporary exhibition records show that Street painted a variety of subject pictures, landscapes, and still lifes, and occasionally full-length portraits. But the staples of his artistic career were the half-length portraits for which he is known today: the men characteristically shown with ruddy complexions, dark coats, and creamily painted shirt fronts; the women with costumes often rendered in surprisingly bright colors and abstract form.

In 1834, Dunlap reported that "Street, of Philadelphia, aimed at historical composition and died in Washington city" (*History,* vol. 2, p. 471). Street wrote Dunlap about the error, and the New York *Mirror* of February 28, 1835, carried the correction: "*Mr. Street, the artist.*—Mr. Dunlap has received a letter from R. Street, Esq., an artist mentioned in his work on 'The Rise and Progress of the Arts of Design in the United States,' by which it appears, that, happily, Mr. Street is not dead, as there asserted, but is prosperously pursuing his art in Philadelphia."

In 1840, Street exhibited 172 of his paintings at the Artists' Fund Hall along with more than fifty paintings by "deceased, or old masters." Notes to the Street catalogue, signed by eleven "residents of Philadelphia," chronicled Street's success "in numerous instances of portraiture, of the most difficult

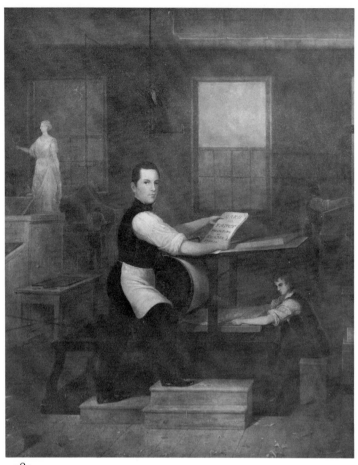

283.

satisfying completeness of a compilation of material facts painted with the naive authority that often makes Street's pictures more appealing than those of his more self-consciously academic colleagues.

SKM □

284. *Gas Jet Eagle*

c. 1848
Iron
69 x 100″ (175.3 x 254 cm)
Atwater Kent Museum, Philadelphia

PROVENANCE: Northern Liberties Gas Works; Phinias T. Green

THIS EAGLE was traditionally thought to have been part of a display of symbolic figures made of iron pipes fitted with gas jets, which could be illuminated. These figures decorated Independence Hall in 1848 to welcome home the Philadelphia troops who had fought in the Mexican War. The

provenance of the eagle substantiates this story: The eagle was presented to the Atwater Kent Museum by Phinias T. Green, onetime city councilman and a member of the board of the Northern Liberties Gas Works. Green had found the eagle at the Northern Liberties Gas Works, which had been part of the Philadelphia Gas Works in the nineteenth century.

Scharf and Westcott (vol. 1, p. 686) described a display mounted by the Philadelphia Gas Works "in honour of victory and peace and the availability of gas for the purpose of ornamental illumination." The arrangements for the celebration were made by the superintendent of the Gas Works, John C. Cresson:

The display took place in front of the State-House, by permission of Councils. By the shaping of gas-pipes and the multiplication of jets from them figures in fire were made. The Goddess of Peace, seated on a chair holding in her right hand the olive-branch, was the principal figure, and nearly thirty feet high. At her feet and by her side were the emblems of commerce, manufactures and agriculture,—

the anchor, boxes, barrels, chests, wheels, the plow, with a ship in the distance. Above all hovered the eagle with wings of fire, surrounded with a halo of stars, and bearing a scroll with the national motto, while below was the simple inscription, "Peace." There were four thousand burners which lighted up this piece.

From this description it seems likely that this eagle is the one which was included in the victory celebration. But other such displays may also have been set up after the success of the first extravaganza, and the American eagle would probably have been a necessary symbol in any mid-nineteenth century exhibition.

PT □

WILLIAM L. JOHNSTON (1811–1849)

William L. Johnston was emerging as an important Philadelphia architect when he was struck down by tuberculosis at the age of thirty-eight. To that point his professional development had followed a pattern familiar to the early nineteenth century. He first appears in Philadelphia directories in 1839 when he was operating a drawing school on Carpenters' Court with John E. Carver, then listed as a builder, but later known as an architect (see biography preceding no. 278). The next year Johnston was cited as a house carpenter, and by 1841 he was calling himself an architect.

Very little is known about Johnston's work. He was responsible for the Roman revival Mercantile Library (1844, demolished c. 1925) on South Fifth Street, the Odd Fellows Hall (1846, demolished c. 1906) on North Sixth Street, and the florid Italian design of the Hood Cemetery entrance (1849) in Germantown. He also probably designed the First Methodist Chapel (1840, later demolished) at Eleventh and Wood streets and might have done George W. Carpenter's Greek revival mansion Phil-Ellena (1844, demolished c. 1900) in Germantown. He almost certainly built a number of houses and commercial buildings before 1849, when he received the Jayne Building commission, which has earned him a niche in architectural history.

WILLIAM L. JOHNSTON AND
THOMAS USTICK WALTER (1804–1887)
(See biography preceding no. 246)

285. *Dr. Jayne's Building
(Jayne Building)*

84 Chestnut Street
1849–50 (demolished 1957–58)
Solomon K. Hoxsie, granite cutter

Inscription: JAYNE (center of front be-
neath cornice); D^R DAVID JAYNE & SON,
DRUGGISTS (outer face of ground story
architrave)
Brick, with granite front and rear; interior
iron columns and wooden girders sup-
porting floors
99′ ⅛″ (excluding tower) x 42′ 2″ x
133′ 6″ (302.1 x 128.2 x 406.9 m)

REPRESENTED BY:
John M. Butler (act. 1841–after 1860)
Jayne Building
c. 1850–60
Engraving
21½ x 15⅛″ (54.6 x 38.4 cm)
The Library Company of Philadelphia

LITERATURE: *Public Ledger,* November 9, 1855;
Hexamer Industrial Survey, vol. 5 (1867–71),
pl. 415, vol. 7 (1873), pl. 613; *Public Ledger,*
July 17, 1872; Scharf and Westcott, vol. 1, p. 618;
Charles E. Peterson, "American Notes: Ante-
Bellum Skyscraper," *JSAH,* vol. 9, no. 3
(October 1950), pp. 27–28; Robert C. Smith,
"American Notes: The Jayne Building Again,"
JSAH, vol. 10, no. 1 (March 1951), p. 25; White,
Philadelphia Architecture, p. 28, pl. 45; Dickson,
Pennsylvania Buildings, pl. 65; Winston Weis-
man, "Philadelphia Functionalism and Sullivan,"
JSAH, vol. 20, no. 1 (March 1961), pp. 3–19;
Tatum, pp. 84, 137, 181, pl. 84

BECAUSE OF ITS HEIGHT and design, the
Jayne Building has been widely hailed as a
proto-skyscraper. When it was completed
in 1850 it loomed over the city with only a
few church spires extending higher than its
wooden tower, which quickly became a
Philadelphia landmark and a popular point

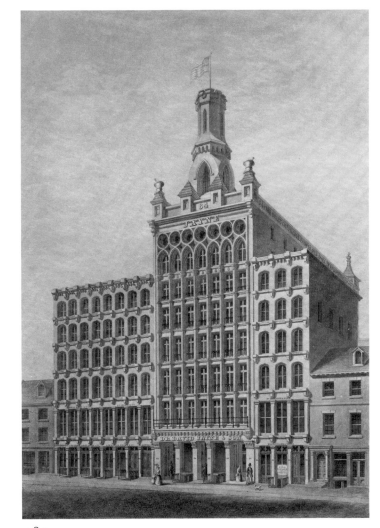

285.

284.

from which to view the city. While height
was to become increasingly desirable with
escalating commercial real estate values,
here it was probably motivated more by
prestige and publicity than by the price of
land.

The Jayne Building's contribution to the
development of modern architecture was
not merely its height but its design, the
manner in which the architect adapted the
verticality of the Gothic style to a tall com-
mercial building on a narrow urban lot.
By recessing the spandrels, architect William
L. Johnston was able to emphasize the
verticality of the clustered columns, grace-
fully resolving their upward thrust by
merging the vertical lines into Gothic arches
and continuing them above into oculi with
inset quatrefoils. But the building was
visually anchored by the ground story with
its solid granite piers and large show win-
dows. "The composition that results is
extremely functional in that it provides
considerable light and air for the interior

and is at the same time expressive of structure and height" (Winston Weisman, "Philadelphia Functionalism and Sullivan," *JSAH,* vol. 20, no. 1, March 1961, p. 12).

Because of its vertical design the Jayne Building stands as a seminal work in the development of the skyscraper. Its exploitation of Gothic verticality was being emulated well into the twentieth century in such structures as New York's Woolworth Building (1910–13) by Cass Gilbert and the Chicago Tribune Building (1922–24) by Hood and Howells. More fundamental, however, was the design concept of emphasizing the verticality of the skeletal framework. Almost immediately after the completion of the Jayne Building this idea was applied locally within a utilitarian Italianate stylistic form. The best practitioner of this style was Stephen D. Button, whose finest extant example of this mode is the Leland Building (1855), 37–39 South Third Street. The most significant buildings incorporating this facade composition into a steel frame are the Wainwright Building (1890–91) in St. Louis and the Guaranty Building (1894–95) in Buffalo, designed by Louis H. Sullivan.

The Jayne Building, however, did not spring spontaneously from the soil of Philadelphia. Its architectural antecedents have been traced back to New England where in 1824 Alexander Parris's Quincy Market in Boston and William Holden Greene's Granite Block in Providence seem to have first used skeleton construction in stone. In 1842, Isaiah Rogers gave the skeleton construction a vertical emphasis in the Brazer's Building in Boston. Johnston, in his scheme of 1849, translated the idea into the Gothic style and extended it eight loft stories for the Jayne Building.

After Johnston's death in October 1849, Thomas U. Walter was called in to supervise the completion of the project. Walter was responsible for adding one story to the height and crowning the building with the blatantly symbolic mortars and pestles and the two-story castellated tower, similar to the central tower of Philadelphia County Prison (Moyamensing) (see no.258), which he had designed in 1832. Towers were then becoming very popular for commercial buildings: a cupola already capped a restaurant (1849) at 733 Market Street, and Samuel Sloan's castellated design for Colonel Bennett's Tower Hall (1855) was to make it a popular commercial site for nearly half a century. It could, in fact, be argued that New York's Empire State Building (1930–31) is a logical extension of this same concept of architectural advertising.

The Jayne tower was destroyed in a spectacular fire in 1872 and was never replaced. Except for its cornice and parapet, the Chestnut Street front of the building

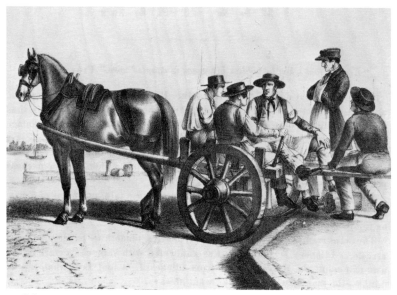

286. *Idle Talk*

survived the fire intact, but the rear was so badly damaged that the granite had to be replaced by brick. The interior was substantially rebuilt; a new steam elevator was installed, evidently for freight only (like the original one), and iron columns seem to have been installed on each floor at this time. The building continued to serve as the patent medicine manufactory and outlet for Dr. David Jayne and Son until 1926. Jayne was one of those nineteenth century entrepreneurs who invested in his community's growth and immodestly left his mark on the city in the form of Jayne's Granite Building on Dock Street and Jayne's Marble Buildings and Jayne's Hall on Chestnut Street. They are all gone now, including the famous Jayne Building, which was demolished in 1957–58.

RW □

AUGUSTUS KOLLNER (1813–1906)

Little was known of Augustus Kollner before the publication of Nicholas B. Wainwright's article on his life in 1960 ("Augustus Kollner, Artist," *PMHB,* vol. 84, no. 3, July 1960, pp. 325–51). According to Wainwright, Kollner was born in Württemberg, Germany, and showed an early talent for drawing. By the age of sixteen he was employed by the Stuttgart publisher Carl Ebner as an engraver. In 1830, Kollner published the first of his many studies of horses, a subject which was to dominate his work for over seventy-five years. Kollner moved to Paris, where he produced much the same sort of work for Thierry Frères as he had for Ebner, the trade cards and book

illustrations which were the staple diet of most commercial printing houses. At some point Kollner had learned the technique of lithography, and he combined the style of draftsmanship developed as an engraver with the planographic media to produce a number of extraordinarily delicate designs which had the strength of the engraved line.

Like hundreds of other artists before and after him, Kollner followed the lure of greater opportunity and immigrated to the United States, arriving at Washington, D.C., in 1839. He found employment with a local lithographer, Philip Haas, and worked for a year at drawing views of scenery around Washington for book illustrations and designing title pages, banknotes, and trade cards.

In 1840, Kollner succumbed to his perennial wanderlust and left the Haas firm to set off on a long sketching tour of the mid-Atlantic states, ending up in Philadelphia, where he established a small studio. Although he was trained as a printmaker, Kollner's chief ambition lay in oil painting, and his first trade card (Library Company of Philadelphia), printed by the large firm of P. S. Duval (see no. 267), mentioned nothing of his other skills: "A. Kollner Painter Portraits of Ladies and Gentlemen on horseback, military persons. . . . Portraits of horses, correct and in every position from nature executed (in oil or water colours)."

Kollner could not compete with Sully, Eichholtz, Neagle, Otis, and a host of professional portrait painters, and was forced to earn his living as a free-lance lithographer for Philadelphia printing houses. Happily for him, the chief artist of Huddy and Duval's *U.S. Military Magazine* retired, and Kollner was chosen by Duval to depict

military stalwarts, many on prancing chargers.

Kollner continued to sketch scenery in and around Philadelphia, throughout Pennsylvania, Maryland, New Jersey, New York, and into Canada. Around 1847 he issued a portfolio of twelve etchings, *Studies of Horses in Different Positions,* and joined in a partnership with lithographer Henry Camp and jeweler-lithographer Louis Brechemin. Kollner's output of commercial work increased enormously, and the following year he produced one of his greatest achievements, fifty-four views of American and Canadian cities published by the large New York and Paris house of Goupil, Vibert & Company, which were lithographed by Deroy and printed by Cattier in Paris. The large, often beautifully colored views are among the best records of pre-photographic America. Rather than being architectural portraits, Kollner's cityscapes are alive with people and traffic—and the inevitable horses.

During the early 1850s, Kollner produced a variety of illustrations for the American Sunday-School Union, which weekly issued children's books with morally uplifting stories and pictures. Kollner also lithographed birth certificates (*Taufscheins*) for the large German community, with whose activities he was much involved. A sample brochure (Pennsylvania Academy of the Fine Arts) that Kollner published shortly after assuming control of the former partnership with Camp and Brechemin indicated the wide variety of his work, embracing all kinds of advertising cards, labels, maps, architectural plans, certificates, and banknotes, and stated, "What speaks yet in his favour is: you will find copies of his engravings in the pattern books of almost all other Lithographers in this City." Eschewing chromolithography and modern steam presses, Kollner worked at his own speed, choosing the work he wanted to do.

Although too old for regular military service, Kollner enlisted in a cavalry troop for some three months during the Civil War, where he spent most of his time making sketches of horses, some of which were published in another series of etchings.

By the mid-1860s, Kollner had all but given up commercial work, devoting himself to his own drawings and paintings, some of which he exhibited at the Pennsylvania Academy over the subsequent decades. He painted tirelessly, producing hundreds of sketches, finished watercolors, and oil paintings of classical, biblical, equine, and topographical subjects, most of which he kept himself. Kollner seems to have continued working right until his death in 1906, after over sixty-six productive years in Philadelphia, leaving a wide-ranging record of his world.

286. *Common Sights in Town & Country*

1850

Title Page: Common Sights In Town & Country. Delineated & described for Young Children. Philadelphia American Sunday-School Union Nº 146 Chestnut Street

Inscription: Henry V. Stillwell September 8153 [*sic*]; drawings of three heads, two with military plumed helmets (inside front flyleaf, in pencil)

Printed book, with lithographs, on wove paper

8¹⁵⁄₁₆ x 11⅜″ (22.7 x 28.9 cm)

Historical Society of Pennsylvania, Philadelphia

PROVENANCE: Henry V. Stillwell, until 1911

LITERATURE: Peters, *America on Stone,* pp. 254–55; Nicholas B. Wainwright, "Augustus Kollner, Artist," *PMHB,* vol. 84, no. 3 (July 1960), pp. 333–36; Wainwright, *Early Lithography,* pp. 81, 94, 119, 150, 211, 216, 219, 220

WHEN THE AMERICAN Sunday-School Union chose Philadelphia as the site for its national headquarters in 1845, the society immediately embarked on a vast publishing venture, boasting that it issued a book a week. Most of the books were illustrated, and Augustus Kollner's ability to draw people and animals in city or rural surroundings with equal ease made him a favorite artist for many of its publications.

Common Sights in Town & Country, published in 1850, was the first of several books by Kollner dealing with everyday people and problems in familiar settings. A moralizing text set in bold, legible type accompanies each of the scenes, which provide uncommon glimpses of some of the people who made Philadelphia hum—the oysterman and his stand, the iceman making his rounds, farmers bringing their fresh produce into market, draymen racing their carts over cobbled streets.

The illustration accompanying the text "Idle Talk" is as much a depiction of a beautifully groomed horse, waiting patiently with his attached cart while a group of porters discuss their affairs, as it is a caution against listening to or spreading gossip. The background and wharf setting are minimal, allowing the figures to stand out boldly, the clean profile of the horse contrasting with the jagged pattern created by the men's hats clustered together. Kollner's draftsmanship is sure; loving care has been put into the depiction of the horse, evident in the attention to correct proportion, highlights on the glossy coat and mane, and the domination of the picture space by the animal.

Companion volumes followed at roughly two-year intervals: *Common Sights on Land & Water* (1852), *City Sights for Country Eyes* (1856), and *Country Sights for City Eyes* (1858). Many copies of the *Common Sights on Land & Water* bear the title page of the first book, *Common Sights in Town & Country.* Wainwright argues that the Union ran out of title pages, and simply used the surplus from the previous work, which was of the same size and format, as well as similar in content.

Of all the picture books Kollner made for the American Sunday-School Union, the series beginning with *Common Sights in Town & Country* is undoubtedly the handsomest and most unusual in design. Without the bright color resorted to by so many publishers of children's books, Kollner's designs in black and white had to rest on their own merit, and they have endured much longer than the temporary stylishness of similar chromolithographs.

SAM □

SOPHONISBA PEALE SELLERS (1786–1859)

Sophonisba Augusciola Peale Sellers was born on April 24, 1786, one of the daughters of the artist, Charles Willson Peale (see biography preceding no. 92). Unlike her more famous brothers and sisters she did not become a painter. On September 23, 1805, she married Coleman Sellers, the son of Nathan Sellers and Elizabeth Coleman Sellers. When Coleman Sellers died in 1834, Sophonisba was named as administratrix of his estate. Sophonisba's great-grandson, Charles Coleman Sellers, is the author of a number of standard references on Charles Willson Peale.

She kept house for her son-in-law, Alfred Harrold, a widower, during his absence in England from 1840 to 1845. An inventory of her possessions taken at this time included a "small quilting frame" and a large Chest of Bedquilts" (APS, Peale-Sellers Papers, Sophonisba Sellers, Expenses while keeping house for her son-in-law, Afred Harrold: 1840–45).

When in 1850, Sophonisba Sellers lost the sight in one eye due to cataracts, her granddaughter, Sophy Sellers, commented: "She was speaking . . . to us, of what a blessing it was that she was still so well able to use her needle for the benefit of others" (APS, Sophy Sellers to Libby, May 17, 1850, Mill Bank).

When Sophonisba Sellers died in 1859, no mention of a quilt was made in her will.

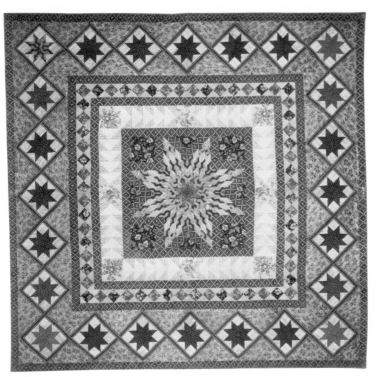

287.

287. *Patchwork Quilt*

c. 1850

Face: cotton chintz patches; reverse: cotton chintz, wool padding, quilted with cotton thread

115⅜ x 113″ (293 x 287 cm)

Philadelphia Museum of Art. Given by Mrs. Horace Wells Sellers. 35-38-4

PROVENANCE: Descended in Sellers family

LITERATURE: Safford and Bishop, *Quilts and Coverlets*, pl. 128

THE CENTRAL DESIGN of this patchwork quilt is usually called the "Star of Bethlehem," but variations are known by numerous local names. The eight-pointed star is framed by successive square bands of geometric design. The wide outer border contains similar eight-pointed figures that communicate an almost Eastern feeling. The individual chintz patterns are oriented identically within each pattern unit; these units are repeated throughout the scheme, and provide an effective design feature. The selection of patterns gives a strong and cohesive feeling to the final product.

The collection of chintz is an impressive representation of contemporary patterns. The natural colors—blue, yellow, white, black, tan, red, and purple, with shades of green and brown—have become muted with age. Sophonisba's sophisticated sense of design in this patchwork quilt is probably due to her exposure to art as a member of the Peale family of painters.

PC □

CORNELIUS & BAKER (1835–69)

Cornelius & Co., manufacturers of lamps, chandeliers, and gas fixtures, was founded in 1827 by Christian Cornelius, a silver plater, and his son, Robert (see biography preceding no. 268). In 1831, when Robert became a partner in the firm, the company became Cornelius & Son. In 1835, I. F. & W. C. Baker joined the company and the name was changed to Cornelius & Baker. Finally in 1869 that partnership was dissolved and the name of the firm reverted to Cornelius & Son. According to a contemporary account, the firm's Cherry Street factory was five stories high, with a room or department for each distinct manufacturing process. The manufacturing process was described as follows:

> One room is occupied entirely by a number of men who are constantly employed in fitting together such gas work as chandeliers, pendants, brackets, etc; and in a second, the numerous class of solar lamps designed for standing on the table, or suspended from the ceiling, or adjusted

to the wall. From all these rooms the goods are taken to the packing department, whence they are shipped to all parts of the Union, to Cuba, South America, Canada, China and India. Besides these rooms in which these processes are conducted, there are numerous others devoted to special purposes. Some of the ornamental work is painted in parti-colors to please fanciful tastes; some are bronzed, while others are enamelled or covered with a coating of fine gold. . . . In the prosecution of such an immense business there is a vast deal of turning of metals. Many hands are employed in cutting screws, a branch requiring great care and skill. All the screws of the different classes are made of one size; so that if the branch of a chandelier exported by this house to China should find its way to Russia, it would fit exactly into any of the chandeliers exported there. (Robson, *Manufacturers,* p. 510)

Among some of the more important commissions of the firm were lighting fixtures for the hall of the House of Representatives and the Senate chamber, Washington, D.C.; the hall of Representatives, Nashville, Tennessee; and the academies of music in Philadelphia, Boston, and Brooklyn. The growth of the Cornelius firm is particularly remarkable since, in the eighteenth and early nineteenth centuries, almost every chandelier, girandole, mantel lamp, and candelabrum were imported from Europe. According to Tallis, "it argued considerable enterprise and perseverance on the part of the [American] manufacturers, that they attained so much excellence as to be willing to vie in the [1851 Crystal Palace] exhibition with the oldest and most celebrated houses in the world" (vol. 1, p. 68). Cornelius & Co. also exhibited in the Philadelphia Centennial exhibition.

288. *Chandelier*

c. 1850

Brass; ormolu; glass globes and rings (replaced)

Height 56″ (142.2 cm); diameter 42″ (106.7 cm)

Philadelphia Museum of Art. Given by Mrs. George Arthur Saportas. 27-47-1

PROVENANCE: George David Rosengarten, Philadelphia; Mrs. George Arthur Saportas

THE NUMBER OF OBJECTS SENT from the United States to the great London Crystal Palace exhibition of 1851 "was neither what was expected of them, nor, we believe, did it adequately represent their capabilities. There were, nevertheless, many things in their

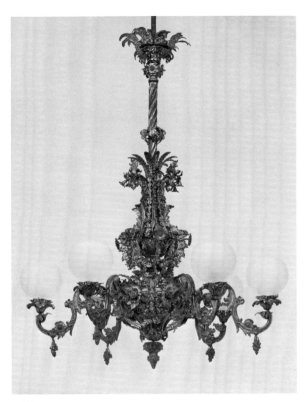

288.

collection which presented features of peculiar interest, and which did credit to their industry, ingenuity, and skill ..." (Tallis, vol. 1, p. 67). Among those American manufacturers to be given credit was Cornelius & Baker, who included in their exhibit two magnificent chandeliers which were described as "graceful, and of extreme purity of glass, and beautifully cast. The branches, formed by arabesque scrolls, profusely ornamented with birds and flowers, delicately sculptured, or in bold relief, with centres of richly-cut glass, claimed universal approval for their elegance and lightness of design" (Tallis, vol. 1, p. 68).

The Art-Journal catalogue, *The Crystal Palace Exhibition* (London, 1851, p. 212, pl. 21), illustrated the Cornelius display and one of the chandeliers, with the accompanying description:

Two elegant samples of the Art-manufactures of America may be found in a pair of Gas Chandeliers, made and contributed by Messrs. Cornelius & Baker, of Philadelphia. They stand about fifteen feet and a half high, by six feet wide, having fifteen burners with plain glass globes, and are of brass lacquered. The design is very rich in ornament, and possesses some novelty in the succession of curves ingeniously and tastefully

united: the gas-keys represent bunches of fruit, thus combining beauty with utility.

However, neither the description nor the illustration in the Art-Journal catalogue fit the description of this chandelier, one of a pair in the Museum's collection. Another almost identical pair of chandeliers is in the North Carolina Museum of Art in Raleigh (Elizabeth Culbertson Waugh, *North Carolina's Capital, Raleigh,* Chapel Hill, N.C., 1967, illus. pl. 89), which was originally in the Thomas Devereux Hogg house in Raleigh built in 1850 and according to family tradition also was in the Cornelius exhibit at the London Crystal Palace exhibition. A letter dated June 11, 1927, from Mrs. George Saportas, the donor of one of the Philadelphia Museum chandeliers, also states, "The chandelier that I want to give the Museum came from London in 1850 or 52, the Exhibition they had there at that time" (PMA, Archives).

The pair of chandeliers in the Philadelphia Museum was originally owned by George David Rosengarten (1801–1890) and hung in the drawing room of his house at the southeast corner of Sixteenth and Chestnut streets in Philadelphia. Born in Hesse Cassel, Germany, Rosengarten came to this country in 1819 and settled in Philadelphia. In 1823, with some of his countrymen, he founded a company that manufactured fine chemicals.

For some years he was also a director of the Pennsylvania Railroad. One of the original subscribers to the Academy of Music, he took a great interest in music and was a good musician himself.

DH □

CORNELIUS & BAKER (1835–69)
(See biography preceding no. 288)

289. *Pair of Standing Lamps*

c. 1850
Label: KEROSENE OIL/CORNELIUS & BAKER/ PHILADELPHIA (imprinted on oval metal plate, soldered to side of each kerosene well)
Brass; ormolu; glass globes
Height without globe 31½″ (79.1 cm); width base 10⅛″ (25.7 cm)

The Baltimore Museum of Art. Bequest of Ellen H. Bayard

PROVENANCE: Benjamin Chew Howard; daughter, Ellen Gilmor (Howard) Bayard; daughter, Ellen Howard Bayard, all of Baltimore

AMONG THE MOST STRIKING designs manufactured by Cornelius & Baker, these "Atlas" lamps combine various motifs from classical vocabulary—ram's heads, wreaths, paw feet, acanthus foliage (already seen on various pieces of early nineteenth century Philadelphia silver), and the figure of Atlas upholding the globe.

A contemporary account provides a description of the firm's manufacturing process:

There is a great variety in the character of the labor bestowed on articles manufactured here. Every grade of workman, from the common laborer to the artist and chemist is engaged.... The various processes through which the articles pass in this department [the dipping rooms] are exceedingly curious and interesting. Here every thing is done by chemical agents.... Burnishing is an important process. Much of the beauty and character of the work depends upon a judicious selection of the parts to be brought out by the burnisher. ... After the brass is burnished it is again cleansed by means of acids, and finally washed in hot water.... [In the lacquering room] the various pieces are taken from their paper bed and placed upon the hot iron, after being carefully brushed. When heated to a certain degree, the articles are taken ... to a table, where the lacquer is applied with flat brushes made of camel's hair....

The different parts and ornaments are now ready to be placed in the hands of the

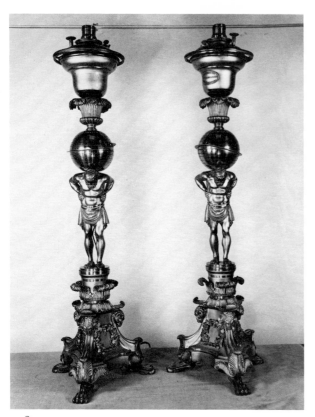

289.

fitter, or finisher, and are therefore selected and carried to the respective places arranged for putting them together. One room is occupied entirely by a number of men who are constantly employed in fitting together such gas work as chandeliers, pendants, brackets, &c.; another to girandoles and candelabras; and a third to the numerous class of solar lamps designed for standing upon the table, or for being suspended from the ceiling or against the wall. From all these apartments the goods are taken to meet once more in the packing-room previous to bidding a final farewell to their birth-place.

Some of the ornamental work is painted in parti-colors to please fanciful tastes; some is bronzed with different shades; while other work is covered with a coating of fine gold, or tastefully enameled. (*Description of the Establishment of Cornelius & Baker, Manufacturers of Lamps, Chandeliers & Gas Fixtures, Philadelphia*, Philadelphia, 1860, pp. 8–18)

Although the kerosene wells attached to these lamps are original, the interchangeable parts of Cornelius lamps enabled them also to fit candelabra (a pair with slightly smaller Atlas figures is in the Baltimore Museum of Art).

The provenance of these lamps is distinguished. According to the will of Ellen

Howard Bayard, the lamps came from Belvedere, in Baltimore, which was built by John Eager Howard (1752–1827), onetime governor of Maryland. In 1787 he married Margaret, daughter of Chief Justice Benjamin Chew, and the lamps were probably ordered by their son Benjamin Chew Howard (1791–1872), who was born at Belvedere.

Benjamin C. Howard was a prominent lawyer who served as councilman for Baltimore in 1820. In 1824, he was elected to the Maryland House of Delegates; from 1829 to 1833 and from 1835 to 1839 he served as a Democratic congressman in the United States House of Representatives; in 1840–41 he was a senator from Baltimore in the Maryland General Assembly. In 1843 he was appointed a reporter of the United States Supreme Court; in 1861 he resigned that post to run, unsuccessfully, for governor of Maryland on the Peace party platform.

DH □

R. & W. WILSON (1825–83)

Although Robert Wilson was listed as a silversmith in the Philadelphia directories as early as 1814, his partnership with his brother William did not begin until 1825,

when they were first listed together as "silver spoon manuf." An advertisement in 1850 in the *Public Ledger* outlined the firm's goods:

SILVER WARE—SPOONS, FORKS, PLATE, etc.— on hand, a large and general assortment of Spoons, Forks etc. of a variety of patterns and prices consisting of 300 dozen. Also Tea Sets, Pitchers, Sugar Bowls and Cream Pots, Dessert Knives, Cups, Goblets, Cake Knives, Pie Knives, Napkin Rings, etc.

Also—SHEFFIELD PLATED WARE, from the celebrated Factory of James Dixon & Son, made expressly to order. Large and Small Waiters, Castors, Cake Baskets, Kettles, Fruit Knives and also a large assortment of Birmingham Castors, Cake Baskets, Vegetables Dishes and Covers, Toast Racks, etc. There are 100 Castors and 75 Baskets to select from at WILSON'S Silver Ware Manufactory S.W. Cor. Fifth and Cherry.

Located at this address from 1816 until 1858, the Wilson shop was one of Philadelphia's most distinguished and long-lived manufacturers of fine silverware. Robert Wilson was not listed after 1846, which may have been the year he died. William took his son into the business in 1858. According to the *Pennsylvania Historical Review* of 1886, the business was incorporated in 1883 "under the title of The William Wilson & Son Silversmiths Company, the president being Horace S. Woodbury" (p. 161).

DH

290. *Salts and Spoons*

c. 1850–60
Mark: R. W. Wilson/PHILADA
Inscription: MJF (engraved script inside salts and on handle of spoons)
Silver; gilt wash interior
Salts 2¾ x 5¼ x 2½" (7 x 13.3 x 6.4 cm); spoons length 3⅞" (9.8 cm)
Charles V. Swain, Doylestown, Pennsylvania

PROVENANCE: With Israel Switt, Philadelphia

THESE SILVER SALTS and spoons were made and sold as a set, enclosed in a black leather case which had stamped decoration and was lined inside with blue velvet and on the lid with white silk. In addition to the marks of R. and W. Wilson on the individual pieces, the printed inscription inside the case lid of "WILSON'S SILVER PLATE, SPOON & FORK Manufactory Fifth and Cherry Sts PHILADELPHIA Also importer of Plated and Britannia Ware, etc" further confirms the maker of the set.

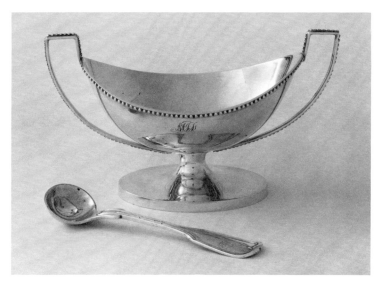

290. *Salt and Spoon*

Wilson's silver reflects the preference for the rococo style of the mid-nineteenth century; two other pairs of salts by that firm, for instance, are in the form of shells with heavily ornamented bases. The boat-shaped salts, however, are derived from the Greek kylix form and indicate an ongoing interest in the classical style which paralleled the rococo revival.

The form of these salts is somewhat unusual in American silver, but it was popular in England in the Regency period, when it was particularly suitable for soup and sauce tureens with matching oviform lids. Considering the availability of silver in other styles at R. and W. Wilson's, one can assume that the choice of this neoclassical set indicated a personal preference.

The matching salt spoons, which have wider bowls than other spoons, are engraved with the same interlocking script initials as the salts. Like the salts, the spoons have gilt wash bowls. The fiddle-handled spoon with threaded pattern, a single or double ridge outlining the handle, was, according to Fales, never widely used in this country, although it was popular in England (*Silver,* p. 860). The same preference for an English design can be seen in the matching salts.

PT □

BAILEY & CO. (EST. 1847)
(See biography preceding no. 279)

291. *Tea and Coffee Service*

c. 1853
Mark: BAILEY & CO./PHILAD. (in rectangles stamped on bottom of tea kettle and burner, which also have pseudo-marks, cream pitcher, teapot, sugar bowl, and slop bowl); BAILEY & CO./136/CHESTNUT ST PHILA. (stamped on bottom of urn and burner, which also have pseudo-marks); 15398 (scratched on bottom of urn, cream pitcher, and teapot); 283 (scratched on bottom of tea kettle); 135 (scratched on bottom of cream pitcher, teapot, sugar bowl, and slop bowl)
Silver
Urn 15¾ x 11⁵⁄₁₆ x 11¹¹⁄₁₆″ (40 x 28.7 x 29.6 cm); tea kettle on stand, height 16⁵⁄₁₆″ (41.4 cm), width 10¹⁵⁄₁₆″ (27.7 cm), diameter 7⅝″ (19.3 cm); teapot height 8¾″ (22.2 cm), width 10″ (25.4 cm), diameter 6½″ (16.5 cm); cream pitcher height 6⅜″ (16.1 cm), width 7⁹⁄₁₆″ (19.2 cm), diameter 8¹¹⁄₁₆″ (22 cm); sugar bowl height 7⁵⁄₁₆″ (18.5 cm), diameter 6″ (15.2 cm), width 8″ (20.3 cm); slop bowl height 5¼″ (13.3 cm), diameter 6″ (15.2 cm)

Smithsonian Institution, The National Museum of History and Technology, Washington, D.C.

PROVENANCE: Marion Leigh Wells, Washington, D.C.

291.

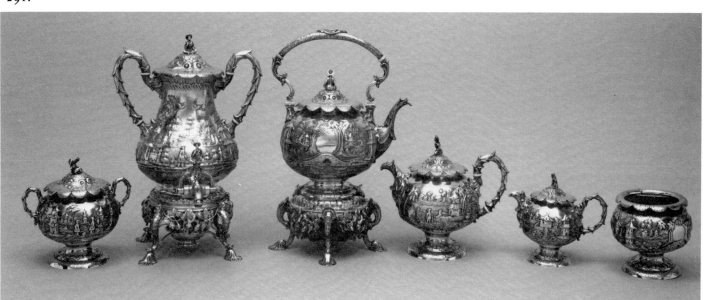

THIS SET may have been exhibited at the New York Crystal Palace exhibition of 1853 as it is nearly identical to one of the tea services illustrated in the catalogue of the exhibition: "We introduce upon this page favorable examples from the American department. The silver BREAKFAST and TEA SERVICES, and the COFFEE URN, are contributed by Messrs. BAILEY & Co., of Philadelphia, who are, we understand extensive manufacturers in that city" (Silliman and Goodrich, p. 64). The exhibited set, however, is missing the coffeepot illustrated in Silliman and Goodrich. The urn has an additional mark of an elephant, which might indicate that it was made in India and imported by Bailey's, as similar elephant marks were used on Indian colonial silver.

This exotic rococo revival service incorporates detailed Chinese scenes in repoussé around the body of each piece. Such chinoiserie motifs, which had been popular during the rococo period, were revived in the 1840s and 1850s, and items decorated with such motifs were exhibited at the London Crystal Palace exhibition of 1851.

The overall repoussé work, in which no surface is left undecorated, is characteristic of much nineteenth century silver. In particular it recalls the work of Samuel Kirk of Baltimore, whose firm is thought to have introduced the style in 1828. Kirk was born in Doylestown, Pennsylvania, in 1793, and at seventeen was apprenticed to James Howell, a Philadelphia silversmith. By 1815, Kirk had completed his Philadelphia apprenticeship, for in that year he entered a partnership with John Smith in Baltimore (Rainwater, p. 90). It is possible that the intricate repoussé style sometimes referred to as the Baltimore, or Kirk, style originated in Philadelphia. Certainly Philadelphia's ornate eighteenth century silver (see no. 44) provided a native prototype for overall repoussé work.

Philadelphia's tendency to hold on to past styles may indicate that the Chinese motifs used in the 1820s were more of a survival than a revival. An early nineteenth century tea set by Edward Lownes, privately owned, shows that other Philadelphia silversmiths were doing overall repoussé at the same time as Kirk. This repoussé style continued to be popular throughout the nineteenth century and into the twentieth century, not only in Baltimore and Philadelphia but throughout the country. So common was the style that some Philadelphians still commonly refer to any nineteenth century silver as "repoussé."

Bailey & Co. also exhibited a repoussé set in the 1876 Centennial exhibition (*Centennial Masterpieces,* vol. 2, p. 85). As changes in taste occurred, the style fell into disfavor,

and so much was melted down that surprisingly few pieces survive today.

According to Mrs. Marion Leigh Wells, onetime owner of this set, the service was presented to "Governor Cummings" from Pennsylvania. However there was no governor of Pennsylvania by this name. Albert Baird Cummins (1850–1926) from Pennsylvania was governor of Iowa, 1902–8, and United States senator, 1908–26. It is quite possible that he owned the set at one time.

DH □

JOSEPH C. HOXIE (1814–1870)

Born in Rhode Island, August 1814, Joseph Hoxie married a Connecticut woman whose three older brothers were in the building trade, and by 1840 he was working as a builder in Hoboken, New Jersey. By late 1848 he had moved to Camden, New Jersey, and established an architectural partnership in Philadelphia with his brother-in-law, Stephen D. Button (1813–1897). The partnership was ended by mutual consent in 1852 when Button married and moved out of the Hoxie household. Although he spelled his surname with an "s" before arriving in Philadelphia, Hoxie does not appear to have been related to Solomon K. Hoxsie (1812–1871), the noted granite cutter who did the stonework on many of Hoxie and Button's commercial buildings.

Energetic and imaginative, Hoxie tied his very successful professional practice to the rise of the railroad, using it both for patronage and for transportation. His Germantown Depot (1855) for the Philadelphia, Germantown, and Norristown Railroad is an example of a modest suburban terminal, but one of his best was the florid Italianate design for the Harrisburg Station (1857, demolished 1877) of the Pennsylvania Railroad. These same lines enabled Hoxie to carry his business into the small industrial cities of Pennsylvania and Ohio, generating so many projects, churches in particular, that he sometimes had to call on his former partner for drawings.

Hoxie exhibited facility in all the historical styles of his day, but he worked most frequently with the flexible Italianate. Because of the wide geographical distribution of his works, there was a tendency to fall into a potboiler pattern, and most of his churches are in either the Roman Corinthian mode of Philadelphia's Arch Street Presbyterian Church (1853–55) or the Italian Gothic of Harrisburg's Market Square Presbyterian Church (1858–60). Yet some of Hoxie's buildings show him to have been an imaginative designer aware of the emerging

trends in his profession. Separately and in conjunction with Button, Hoxie produced particularly innovative commercial buildings. The warehouse of John Brock and Sons (1850) on Delaware Avenue has an early cast-iron front in which iron plates simulating rusticated ashlar are anchored to the brick walls. More unusual, however, were his utilitarian Italianate designs. Probably the best example of his stripped style was the Horstmann Factory (1852–53, demolished 1930s) in which the mass of mundane bricks was relieved by unadorned abutments rising between recessed windows. Hoxie designed dwellings by the handful, and two in particular display his imaginative treatment of site and materials: the city house of John Eisenbrey, Jr. (1850), at 814 Pine Street is a sensitive marriage of the Greek and Italian styles executed in the newly fashionable brownstone, with a rich walnut interior and a spacious side garden; and the polychromatic Ebenezer Maxwell House (1859) in Germantown, with its spindly mansard tower and Elizabethan gables, stands as one of the finest picturesque suburban villas found in the Philadelphia area.

292. *West Arch Street Presbyterian Church (Arch Street Presbyterian Church)*

Arch and Eighteenth streets
1853–55
Joseph DeNegre, builder
Brick, faced with mastic
Plan 86 x 150′ (26.2 x 45.7 m); height 96′ (29.2 m), originally 170′ (51.8 m)

REPRESENTED BY:
West Arch Street Presbyterian Church
c. 1855
Lithograph
29¹¹⁄₁₆ x 25⁹⁄₁₆″ (75.4 x 65 cm)
Arch Street Presbyterian Church, Philadelphia

LITERATURE: City Hall, Department of Records, Registry Unit no. 3S11–38; Arch Street Presbyterian Church, The Cash Book of the Treasurer of the Building Committee (1852–56); *Public Ledger,* March 10, 1853; Thompson Westcott, *The Official Guide Book to Philadelphia* (Philadelphia, 1875), p. 276; Alfred Nevin, *History of the Presbytery of Philadelphia* (Philadelphia, 1888), p. 164; William P. White and William H. Scott, *The Presbyterian Church in Philadelphia* (Philadelphia, 1895), p. 51; Tatum, pp. 95, 187, pl. 98; Richard J. Webster, "Stephen D. Button, Italianate Stylist," M.A. thesis, University of Delaware, 1963, pp. 75–76

292.

BECAUSE OF ITS SITE on a busy center city street and near the larger, more advantageously located Cathedral of SS. Peter and Paul, the Arch Street Presbyterian Church, "the most elaborate example of the Italianate Revivals in Philadelphia" (Tatum, p. 95), generally escapes the attention of natives. It was not always so. As it was being erected, one critic predicted that the church's imposing beauty would "surpass any similar structure in the country" (*Public Ledger*, March 10, 1853). Later the building was commended for "its fine proportions, its elegance and good taste" (Philadelphia, Free Library, Print and Picture Department, Churches, caption, 1861 photograph), and as late as the Centennial it was considered "one of the finest church edifices in the city" (Thompson Westcott, *The Official Guide Book to Philadelphia*, Philadelphia, 1875, p. 276).

Nineteenth century critics were impressed by two elements: the dome, which gave the building its grandness, and the eclecticism of styles, a new architectural taste that was developing during the 1850s. Although the two corner "minarets," or bell towers, and the towering cupola were removed sometime before 1895, the full copper dome still allows the building to hold its own against the much larger structures that have risen around it. The dome, which dominates the

exterior and bathes the richly decorated interior in soft natural light, also contributes to the happy blend of styles. The baroque character of the design was more striking before the dome lost its cupola and the ornate bell towers and urn-laden balustrade were removed, but it is still there. The tracery of the round-arch windows, on the other hand, have Gothic qualities, which one writer called Norman, and uniting it all is the rich Roman Corinthian order of the tetrastyle portico and pilasters. No eclectic design is copied from a single model or text, of course, but the architect of this church could not have been unaware of St. Paul's Cathedral in London (1675–1710). The similarity of the cupolas and bell towers of the two buildings (John Summerson, *Architecture in Britain, 1530 to 1830*, Baltimore, 1970, illus. p. 224) is more than coincidental, and Wren's 1673 Great Model of the Cathedral was probably the source for the handling of the facades and dome of the Arch Street church.

The present Arch Street Presbyterian Church was organized as the Eleventh Presbyterian Church in 1828. The congregation worshiped on Vine Street west of Twelfth until it moved to the new church at Eighteenth (then called Schuylkill Fifth) and Arch streets in late 1854. It was known as the West Arch Street Presbyterian Church

JOSEPH SHOEMAKER RUSSELL (1795–AFTER 1854)

Joseph Shoemaker Russell was born in New Bedford, Massachusetts, to Abram and Sarah Schumacher [*sic*] Russell, a prominent family who lived in one of the larger houses on the Main Street (Nina Fletcher Little, "Joseph Shoemaker Russell and His Water Color Views," *Antiques*, vol. 59, no. 1, January 1951, p. 52). His mother had belonged to the Schumacher family of Germantown (see biography preceding no. 66), which may have provided Joseph with the impetus or contacts to set up in Philadelphia. He married Priscilla Haffords in 1815 in New Bedford, but in 1818 he is found in the Philadelphia directory listed as a lamp-oil merchant at 55 Chestnut Street. His shop was one in from the corner of Chestnut and Strawberry streets; the sign over the display window read simply "Lamp Oil," but it colorfully portrayed a whale and whaling ship against a blue sea (Little, cited above, fig. 2). Russell stocked not only the refined fuel but also a wide variety of lighting devices, items which he paid particular attention to in the interiors he painted. In 1835, Russell lived at 42 South Eighth Street but by 1850 was ensconced with his family in Mrs. A. W. Smith's boardinghouse located above Montgomery and Shinn's store on Broad Street at the corner of Spruce. The date of his death is unknown.

293. *Mrs. Smith's Boardinghouse, Broad and Spruce Streets*

1853
Watercolor on paper

(a) *Exterior (above Montgomery and Shinn's Store)*
Inscription: Mrs. A. W. Smith's Broad St corner of Spruce & Montgomery & Shinn's Store/1853 (beneath picture)
8½ x 11¼" (21.5 x 28.5 cm)

(b) *Parlor*
Inscription: Mrs. A. W. Smith's Parlour Broad & Spruce Street 1853 (beneath picture)
8⅝ x 11¼" (21.9 x 28.5 cm)

293a.

293b.

(c) *Dining Room*
Inscription: Dining Room at Mrs. Smith's/1853 (beneath picture)
8½ x 11¾″ (21.5 x 29.8 cm)

(d) *Mr. Russell's Bedroom*
Inscription: Mr. J. S. Russell's Room at Mrs. Smith's Broad Street/1853 (beneath picture)
8½ x 11¼″ (21.5 x 28.5 cm)

Mr. and Mrs. Bertram K. Little, Brookline, Massachusetts

LITERATURE: Nina Fletcher Little, "Joseph Shoemaker Russell and His Water Color Views," *Antiques,* vol. 59, no. 1 (January 1951), pp. 52–53

THE TALL, NARROW Philadelphia row house built of brick with white wood trim and scrubbed soapstone steps served domestic as well as commercial purposes. This set of watercolors shows the pragmatic and varied use of the typical Philadelphia architectural unit. Regular fenestration on the two-bay facade was not always repeated on the side; in this case the absence of windows on the first floor probably indicates that the building was not altered from a house to a shop but was built to be used as illustrated. The shop of Montgomery and Shinn carries a prominent sign, but the entrance to Mrs. A. W. Smith's boardinghouse, located on the second, third, and presumably fourth floors, and from which Mrs. Priscilla Russell exits, was not advertised. The boardinghouse, long a Philadelphia tradition, was considered noncommercial and proper enough to be considered "home," while residence in a hotel was strictly for transients. The size and allocation of the interiors which Joseph

Russell painted suggest that there must have been a fourth floor, but this is not shown on his elevation drawing which is more concerned with his carriage and life than in the building's details.

The interior views show rooms sparsely furnished if compared to the description of a house of the period found in "A Sketch of Fashionable Life, A Tale," in *Godey's Lady's Book* of 1833: "The splendid pier-glass, the damask sofas and curtains, gave an air not only of luxury, but comfort and sociability. In the center stood a mosaic circular table, covered with annuals, and the popular works of the day; the Edinburgh, North American, and Quarterly Reviews . . ." (vol. 6, p. 97). Patrons distributed around the perimeters of the parlor must have brought their own accouterments of culture into the room as the tables and the space itself are totally uncluttered, which may be because the season portrayed is summer, and the rooms would thus have been cleared for better air circulation. The ingenious device supplying gas to the lamp on the ornate marble-topped table becomes the most prominent feature of the parlor scene. The large medallion-patterned ingrain carpet (see no. 294) is tan and rose, and yellow striped wallpaper, gray woodwork, blue door, and green shutters pulled in from the outside reveal the practical approach to interior decoration probably more characteristic of a semi-public space than a private dwelling.

The dining room shows blue and gray wallpaper, white woodwork, and again a blue door. The painted rush-seat chairs from two sets were typical of those found in country houses, and were manufactured and sold in Philadelphia in great quantities.

The bright colors in the bedroom—red chair seats, yellow trunk, blue glass, dolphin-pattern candlesticks on the mantelpiece—are set against tones of gray wallpaper and matching gray woodwork. The clear drawing of the turned acorn-finial bedposts suggests that Russell had an apt eye for detail, and thus his careful watercolors of his temporary domicile not only are charming but become splendid documents of mid-century interior design.

BG □

294. *Ingrain Carpet*

1850–60

Wool (two-ply worsted warp; three-ply weft)

15′ x 14′8″ (4.6 x 4.5 m)

Philadelphia Museum of Art. Purchased with funds donated by the Barra Foundation. 74–91–2

ABOUT 1735, in Kidderminster, England, an area well known for its quality woven wool cloth, home weavers began to produce a sturdy, colorful, reversible, two-ply, double-thick textile which became known as Kidderminster carpeting. Its patterns, determined by the thirty-six-inch width of the house loom, and the rectilinear technique of weaving through the warp (instead of hand knotting), made this carpeting unique, and it immediately began to compete with more expensive pile carpets. It was soon copied, and became generally known as "Scotch," "Scots," or "ingrain" carpeting.

This type of carpeting was extensively imported for use in Colonial homes. It

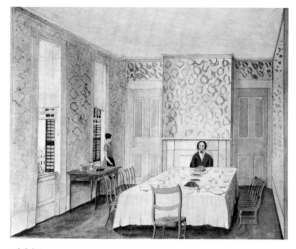

293c.

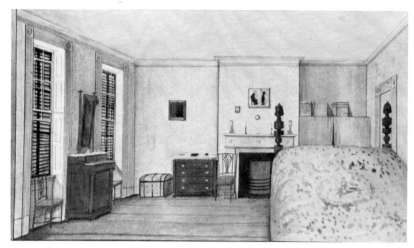

293d.

figures prominently in a description of the furnishing of Benjamin Franklin's house in a letter his wife Deborah wrote to him in London in October 1765: "On the flower a Carpit I bought cheep for the goodnes[. I]t is not quite new[. T]he large Carpit is in the blewroom . . .[I]n the parlor thair is a Scotch Carpet which was found much Folte with . . . [I]f you Cold meet with a turkey Carpet I shold like it . . . [I]n the Northroome . . . a small Scotch Carpet on the flower . . . (Labaree and others, *Franklin,* vol. 12, pp. 296–97).

The organization of the Kidderminster manufactory was informal: raw wool was delivered through the town, and finished carpets were later collected for sale. Because of this, perfect pattern repeats were rare and color nuances from home dyeing made it exceedingly difficult to get a well-matched large room carpet from the thirty-six-inch-wide strips. It was probably just such design imperfections that caused Deborah Franklin's complaint, for when the carpet's flat tapestry-like surface was well woven, it was a colorful, tough, pragmatic textile, with the added versatility of being reversible. Weavers from Kidderminster settled in Philadelphia, especially in the Kensington area, and set up handlooms in three- and four-man shops, following the same informal manufacturing system as in England. With the invention of the Jacquard loom (still a hand-worked process) in France in 1800, which allowed greater precision in pattern repeats, and its introduction into Philadelphia by 1820 (Cornelia B. Faraday *European and American Carpets and Rugs,* Grand Rapids, 1929, p. 311), ingrain carpeting became more generally available. And with the invention

of the power loom in 1839 by Erastus Bigelow, production increased from the eight-yard-per-day average for the hand loom, to twenty-five to twenty-seven yards per day. With this augmented supply and its more reasonable price, ingrain carpet replaced straw matting and painted floor cloths—as well as Axminsters which often imitated Oriental carpets, Brussels, or Wiltons (a more expensive pile carpet)—in use in drawing rooms of grand houses.

The Kensington area of Philadelphia, north of Vine Street between Front and Twentieth streets, rapidly developed into one of the most important textile manufacturing centers in America. Daniel Currie's Norris Street enterprise, which began in 1867 with four handlooms, had by 1884 expanded into a 40 by 80 foot four-story mill housing thirty-three power looms devoted to the production of ingrain carpet (*Kensington: An Historical and Industrial Review,* Philadelphia, 1891, p. 237). The use of steam power in textile mills allowed increased production of thirty rolls of carpet per week in a factory employing only twenty-five people at eighteen looms.

The medallion pattern of this carpet, in reds and blues and yellows and greens on a beige ground, was probably adapted for the power Jacquard loom from a Brussels or Axminster design of about 1830–40, also manufactured in strips. Early eighteenth century patterns were small geometrical repeats in three or four colors. Gradually they enlarged, like this one, into rows or bands of medallions connected by linear floral motifs squared off into a practical pattern repeat. The obverse and reverse of this carpet give entirely different impressions

of design and color, unlike the New England carpets with less complex color patterns, which have a "summer-winter" effect, similar to the wool bed coverlets which were produced contemporaneously.

Thus far no ingrain carpet has appeared with a manufacturer's name or mark in a selvage. Ingrain carpets found in various parts of the eastern United States reveal

294.

different qualities of wool (presumably the wool was produced regionally, if not locally, for the manufacturing process), different patterns, and regional color characteristics.

This carpet is woven on two-ply colored worsted warp threads with two sets of colored woolen weft yarns, which interchange to form a double cloth. The multicolor, smooth effect created by the hard non-fuzzy wool threads is more elegant than most New England (Maine and Massachusetts) products, which used red as the dominant color in fuzzy and thick wool yarns. Genre scenes like *Breaking Home Ties* (no. 372) and those of Joseph Russell (see no. 293), which illustrate ingrain carpet; magazine illustrations; newspaper advertisements; and trade catalogues confirm regional design characteristics verifiable by analysis of the fabric.

Later nineteenth century ingrain patterns were selected according to purpose rather than for their fine, if derivative, designs: "On grounds of lovely grays, sage, olive, pearl, canary and various shades of brown, strewn in the curious marks, odd little figures, leaves, flowers, etc. in red, yellow, blue, green and orange; these are appropriate for parlors, while dark brown-black, dark 'invisible' green, and tan colors with scrolls and arabesque figures are for libraries, and for dining rooms . . ." (Henry T. Williams and W. C. S. Jones, *Beautiful Homes,* New York, 1878, p. 47). The trend toward large floral effects continued until the end of the century, when again the pile carpet became increasingly important and the flat ingrain types were reserved for hotels, offices, churches, and shops.

BG □

PAUL WEBER (1823–1916)

Gottlieb Daniel Paul Weber was born in Darmstadt, Germany, the son of a court musician. He studied with August Lucas and Jacob Becker at the Stadel'schen Institute in Frankfort from 1842 to 1844 and at the Academy in Munich from 1844 to 1848. In 1846 and 1847 he toured the Orient with the entourage of Prince Luitpold von Bayern. The next year he completed training with Dyckmans in Antwerp and came to Philadelphia in 1849.

During the twelve years he lived in Philadelphia, Weber annually exhibited his work at the Pennsylvania Academy and won a silver medal in 1858. His work included landscapes based on German and Near Eastern subjects as well as the Hudson River area and the Pennsylvania countryside. He also showed at the Academy on several occasions from 1862 to 1905, at the Boston Athenaeum from 1853 to 1874, and several times at the National Academy of Design.

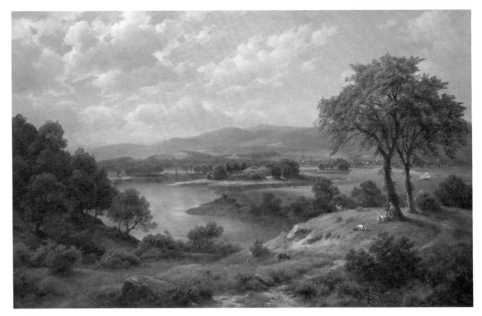

295.

Eleven of his paintings were exhibited at the Great Central Fair in Logan Square in 1864.

Weber traveled in Scotland and Germany in 1857. He returned to Darmstadt in 1861 and was appointed court painter to the Grand Duke of Hesse-Darmstadt. A stay in Paris in 1864 brought him in contact with the Barbizon school. He was awarded a gold medal at the London Crystal Palace exhibition in 1865 and also exhibited a *View near Munich* in the German section of the Centennial exhibition in 1876.

Little is known about Weber's later life, except that he died in Munich in 1916. Retrospective exhibitions of his work were held in 1917 and 1918, one at the Heinemann Gallery in Munich. He was the father of the American painter Carl Weber.

AS

295. *Hudson River Landscape*

1854
Signature: Paul Weber Pha. 1854
(lower right)
Oil on canvas
35 x 49" (88.9 x 124.5 cm)
Arnot Art Museum, Elmira, New York

PROVENANCE: Matthias H. Arnot, 1910

LITERATURE: Elmira, New York, Arnot Art Museum, *Catalogue of the Permanent Collection* (1973), p. 82, illus. p. 84

WEBER WAS A FULLY MATURE ARTIST by the time he arrived in the United States in 1849; consequently, although he traveled extensively in the Northeast and painted a number of scenes in the Catskills and along the Hudson River, his style does not reflect the ideas of Asher B. Durand and other Hudson River school artists. But the American landscape did provide Weber with a new repertoire of subjects which he interpreted according to the landscape formula of his German training. Thus Weber's paintings lack the consistent attitude toward nature found in the work of his Hudson River school contemporaries, and range from the theatrical (*The Mountain Stream* in the Reading Museum) to straightforward records of a particular locale (*Landscape: Evening* in the Pennsylvania Academy).

Hudson River Landscape exemplifies Weber's ability to combine the details of an actual site with generalized effects of light and landscape. The small town, the island in the middle of a meandering river, and the profiles of distant mountains may have been drawn from nature, but a harmonious scheme of opaque color in medium value, skillfully organized to create effects of light and space, and the summary treatment of trees and other vegetation carefully arranged as a play of shapes mitigate the appearance of a specific place.

Weber's technical proficiency and appealing color were popular with Philadelphia critics and patrons. When Weber's work was exhibited at the Pennsylvania Academy exhibition in 1858, Sidney George Fisher was inspired to make one of his rare comments on art—that Weber was "the best landscape painter in this country" (Nicholas Wainwright, ed., *A Philadelphia Perspective, the Diary of Sidney George Fisher Covering the Years 1834–1871,* Philadelphia, 1967, p. 298).

SKM □

JAMES HAMILTON (1819–1878)

James Hamilton was born in Entrien, near Belfast, Ireland, and came to Philadelphia with his parents at the age of fifteen. Evidently he showed unusual promise because his education, including drawing lessons, was paid for by William Erwin, who later secured a position for him in a counting house. Unhappy in the business world, however, Hamilton took his drawings to the engraver John Sartain, who later reported that "there was sufficient proof of talent to justify the warmest encouragement, and earnest advice was given him not to be diverted from his purpose, but to devote himself to Art as the *one* vocation of his life" (John Sartain, "James Hamilton," *Sartain's Union Magazine of Literature and Art,* vol. 10, January–June 1852, p. 331). Hamilton studied art in Philadelphia and supported himself by giving drawing lessons; in later years, his pupils included Thomas and Edward Moran. The *Biographical Encyclopedia of Pennsylvania in the Nineteenth Century,* published in 1874, records that Hamilton's watercolor sketches attracted the attention of Thomas Birch, Joshua Shaw, and John Neagle, as well as Sartain, all of whom assisted in their sale.

Hamilton began exhibiting with the Artists' Fund Society at the Pennsylvania Academy in 1840 with four works, including a watercolor study, a marine view, and a landscape, and he continued to show there for the next three years, serving on the Society's board of control in 1844. *A Scene on the Delaware,* owned by John Sartain, brought him his first great acclaim in 1843 when it was shown at a special exhibition at the Pennsylvania Academy. Hamilton exhibited regularly at the Academy throughout his career, displaying altogether about three hundred paintings. He was elected a member in 1861. He showed at the National Academy of Design in 1846, 1847, and 1867, at the Boston Athenaeum from 1860 to 1872, with the Philadelphia Society of Artists in 1879, and probably also in Washington, Baltimore, and Cincinnati. His painting *Break, break, break, on thy cold grey stones, o sea!* was shown at the Centennial exhibition in 1876.

Hamilton's fame was greatly increased by the many illustrations he made from sketches by the physician-explorer Elisha Kent Kane. Published in Kane's *The U.S. Grinnell Expedition in Search of Sir John Franklin* in 1854, and in the two-volume *Arctic Explorations: The Second Grinnell Expedition in Search of Sir John Franklin 1853, '54, '55,* the illustrations brought Hamilton favorable notice from critics and popular success.

Commenting in 1852 on Hamilton's early career, Sartain wrote that he "was then, as

now, a most devoted admirer and student of the works by Turner, as far as we are able to know them by engraved copies" (Sartain, "James Hamilton," cited above, p. 331). In 1854, Hamilton journeyed to England for two years, studying Turner's paintings at first hand, and also the work of Pyne, Stanfield, and other English landscapists. In the period following his return to Philadelphia, he painted many of his best known works, including *Old Ironsides, The Ancient Mariner, Egyptian Ruins,* and *The Last Days of Pompeii.* Although the landscape around Philadelphia, the Delaware Bay, and the seacoast, where he often sketched, were the sources of many of his paintings, Hamilton's predilection for marine views, ranging "from the most serenely imaginative to the wildest natural scenes" (Tuckerman, p. 565), his use of rich color, and dramatic effects of dark and light built up in thickly textured, loosely painted surfaces prompted his contemporaries to name him "the American Turner." His paintings were surprisingly popular at a time when careful study from nature and obvious finish were preferred. S. G. W. Benjamin named Hamilton the "ablest marine painter of this period" ("Fifty Years of American Art, 1828–78," *Harper's New Monthly Magazine,* vol. 59, September 1879, p. 490).

In 1875, Hamilton sold most of the paintings in his studio at auction, and with the proceeds he set out with his family on a trip around the world. He settled briefly in San Francisco, and died there suddenly in March 1878.

AS

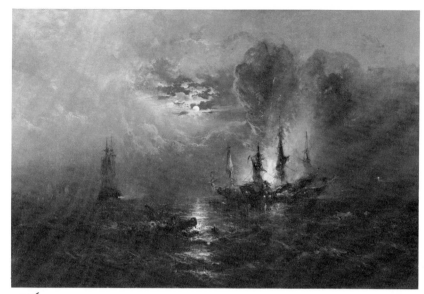

296.

296. *Capture of the Serapis by John Paul Jones*

1854
Signature: Jas. Hamilton Pinxt. Phil. 1854 (on reverse)
Oil on canvas
58 x 87¼" (147.3 x 221.6 cm)
Yale University Art Gallery, New Haven. The Mabel Brady Garvan Collection

PROVENANCE: J. M. Butler, 1857; Mrs. D. D. Colton(?), San Francisco, 1887; Mabel Brady Garvan

LITERATURE: Rutledge, *Cumulative Record,* p. 90; Brooklyn Museum, *James Hamilton 1819–1878,* by Arlene Jacobowitz (March 28—May 22, 1966), illus. no. 11; John Wilmerding, *A History of American Marine Painting* (Boston, 1968), p. 198, illus. no. 135

HAMILTON's *Capture of the Serapis* represents an episode from Revolutionary naval history—the fierce struggle in French waters between the *Bon Homme Richard,* commanded by John Paul Jones, and the British ship *Serapis* on the moonlit night of September 23, 1779. The confrontation lasted over three hours, ending in a British surrender, but the *Bon Homme Richard* was so badly damaged that she sank the following day, and Jones and his crew returned to France on the captured *Serapis.* Hamilton's first version of the battle appeared as an engraving in John Frost's *The Pictorial History of the American Navy,* published in 1845 (Brooklyn Museum, *James Hamilton 1819–1878,* by Arlene Jacobowitz, p. 35); and he made a later watercolor and tempera sketch of the same subject, 1859–61 (Independence National Historical Park).

The drama of the engagement between the *Serapis* and the *Bon Homme Richard* had impressed contemporary artists, and naval prints such as one published by John Boydell in 1780 as well as a study by W. A. K. Martin exhibited at the Pennsylvania Academy in 1853 might have served as inspiration for Hamilton's painting. His concentration upon the histrionic aspects of the scene provoked a fervid response by "one of the artist's friends" in Tuckerman's essay on the artist:

Into this solemn hush of night, this intense calm, he has flung the roar and crash and carnage of that terrible sea-tragedy. The two vessels are side by side in deadliest grapple. The flames from the burning *Bonne Homme Richard*, red and ghastly as if with the blood of the dead below, swirl and coil about the masts and rigging, and stream up far into the heavens, "staining the white radiance" of the night. Wild figures rush across the decks, the flash of the guns gleams fierce and vindictive through the darker flame of the conflagration, and reflected in the water beneath, writhes a distorted repetition of the lurid scene. Nothing could be finer or more dramatic than the contrast of sentiment here. The deadly struggle of human passion below, imparts to the moonlight an added pitying tenderness, as it were, and the moonlight in turn enhances the awfulness of the tragedy. In this picture the human element is active, nature is passive. (Tuckerman, p. 565)

Hamilton's subordination of specific detail for broad effects, his use of strong color, and the sensuous appeal of richly textured paint invited comparison to the work of J. M. W. Turner. The passage from Tuckerman suggests that Hamilton found an eager audience for his paintings, but both Hamilton (prior to his trip to England in 1854) and his critics knew Turner's paintings largely through engravings and written accounts, and their discussion of Hamilton's work was obviously conditioned by their opinion of Turner's style. A review of a landscape Hamilton exhibited at the Pennsylvania Academy in 1845 included the statement that "the artist has given us a vast conglomerate of colors that would puzzle a geologist to classify with any known substances—masses of green and yellow that TURNER himself could not conjure into trees, and a splash of *something* that a trout might break his nose against" ("Notices of the Fine Arts," *Godey's Magazine and Lady's Book*, vol. 35, 1847, p. 53). But John Sartain called attention to Hamilton's admiration for Turner and defended his paintings as not "overdone with non-essential detail and minute forms.... Whatever is intended to

297.

be the prevailing sentiment pervades the work throughout, everything tending to the one purpose." And Sartain defended the "extensive additions to the superstructure" of the "edifice of Art" made by "the late Mr. Turner and his British contemporaries" as opposed to "the modern German daguerreotype manner" and the "affectation observable in the historic school delighting in the cognomen of 'Pre-Raffaellean' " ("James Hamilton," cited above, pp. 332–33).

SKM □

JOSEPH BOGGS BEALE (1841–1926)

Joseph Boggs Beale was the oldest child of a prominent Philadelphia dentist. He attended Central High School where he learned "Grecian painting" and "painting (with watercolors) photographs" from Alexander J. MacNeill (Nicholas B. Wainwright, "Diary of Joseph Boggs Beale," *PMHB*, vol. 97, no. 4, October 1973, pp. 489, 490). In 1860 he enrolled in the antique class at the Pennsylvania Academy of the Fine Arts. In 1862, Beale competed successfully against his nineteen-year-old classmate Thomas Eakins (see biography preceding no. 328) and two others for a faculty position at Central High, although he continued to study at the Pennsylvania Academy and with the artist Isaac L. Williams. He taught drawing at the high school for five years and later at the Polytechnic College and at Crittenden's Commercial College (Franklin Spencer Edmonds, *History of Central High School*, Philadelphia, 1902, p. 320).

Beale's career as an illustrator began

during the Civil War when he sent to Frank Leslie illustrations of the Gettysburg campaign, in which he served as a volunteer. He later worked as an illustrator for *Frank Leslie's Weekly* and in New York for *Harper's,* for the *Daily Graphic,* and for various other publications. He also worked as a book illustrator in Chicago until he lost most of his work in the Great Fire. He returned to Philadelphia and in 1874, Caspar W. Briggs, a Philadelphia manufacturer of lantern slides, commissioned him to do a series of drawings from *Pilgrim's Progress,* which were transferred onto twelve-inch-square glass slides for presentation to church schools and meetings of the Epworth League, a lecture society. The series was so successful that Beale began a new career making black and white wash drawings of historical episodes, famous stories, and anecdotes of contemporary city life. Beale was a friend of the Philadelphia artists Albert Rosenthal, William Merritt Chase, and Thomas Eakins, with whom he often rowed. He died in Germantown.

AS

297. *Ornamental Drawing*

1854
Signature: J.B.B. 54 (lower left); BEALE (on leaf, center right)
Charcoal with white on buff paper
10¼ x 12¼" (26 x 31.1 cm)

Katharine Beale Barclay, Wynnewood, Pennsylvania

PROVENANCE: Descended in Beale family

THE DIARY THAT BEALE KEPT from January 1, 1856, to July 26, 1865, and a group of his drawings in a private collection in Philadelphia from approximately the same period provide an extraordinary insight into the kind of art education available in Philadelphia at midcentury. In addition to Beale's accounts of his own varied artistic production—drawing and painting from engravings and photographs, sketching from nature, doing ornamental penmanship and coloring photographs to earn extra money, and, after 1860, attending the antique class and anatomy lectures at the Pennsylvania Academy—his notes of meetings with other artists and of visits to the Academy and art galleries in Philadelphia show how advice and examples of the work of other artists were casually available to the young student.

The text for drawing classes at Central High School when Beale was a student there was Rembrandt Peale's *Graphics,* and Beale's diaries refer to other drawing books that he owned or borrowed, among them Prout's *Hints on Light and Shadow,* Harding's *The Principles and Practice of Art,* and "a book on the human figure by J. R. Smith" (John Rubens Smith, *The Art of Drawing the Human Figure,* 1831).

Beale's diaries reveal him as an eager student; unlike the young William Trost Richards whose early writings and drawings show a concern for developing an artistic sensibility as well as technique, Beale had a pragmatic interest in learning how to make pictures. The drawings referred to above (private collection) represent his practice in the vocabulary of artistic devices taught by drawing books—sketches in pencil of leaves

and branches and complete landscape vignettes; charcoal and chalk drawings of ornamental details, such as the one illustrated; and studies of imaginary landscapes depicted in three values of gray illustrate the diligence and preparation characteristic of the young professor of drawing, writing, and bookkeeping at Central High School, appointed at the age of twenty-one.

This drawing shows Beale practicing the technique of defining form in outline, using the tone of the paper as a middle value, and building volume with light and dark chalk. The foliate ornament that appears to emerge from a precisely machined tube suggests that Beale was using as his model a manufacturer's sample book, perhaps for ornamental ironwork or light fixtures—or a decorative detail from his own house.

DS □

298. *Wedding Dress*

1854
Pale-lavender silk taffeta with woven figured border; trimmed with fringe
Waist 26″ (66 cm); center back length 56″ (142.2 cm)

Philadelphia Museum of Art. Given by Agnes Davisson Loughran. 58-6-1

PROVENANCE: Catherine Laughlin Heron (Reilly), 1854; descended in family to grandniece, Agnes Davisson Loughran

BY THE MID-NINETEENTH CENTURY, France was accepted as the hub of fashion, a pattern that would become strengthened with the first *haute couturier,* the Englishman turned Parisian, Charles Frederick Worth (1825–1895). His creations spread styles throughout the West and fully established the French dominance over fashion.

When, for example, Paris fashion dictated a fully gathered skirt requiring a stiff crinoline or hoop undergarment, fashionable Philadelphians immediately followed this mandate. This lovely silk taffeta dress, worn by Catherine Laughlin Heron on the day of her wedding to the Reverend Paul J. Reilly in 1854, was surely over such a crinoline hoop. Usually this under-petticoat was made with a horsehair warp and wool weft, and was often further stiffened with rows of cording around the hem. The skirt is extremely voluminous with three-tiered, fully gathered flounces edged in a wide decorative border woven in lighter threads, with groups of small red and green flowers centered in ovals. The skirt is sewn to a closely fitted and boned bodice with a high neckline, and a short capelet is attached to the bodice. Double-tiered bell-shaped sleeves are trimmed with matching bands and fringe

—what would then have been considered the latest in style.

Most likely this dress was fashioned for the Philadelphia bride using an innovation in dressmaking procedure that made its appearance during the 1850s. Material was sold in "ready-made dress lengths of printed or brocaded materials especially produced to be made up into flounced dresses, and sold with accompanying plates to show how the patterns may be utilized" (Davenport, *Costume,* vol. 2, p. 880). It was an extravagant method, undoubtedly wasteful of material, but it enabled every seamstress to produce dresses of even the richest variety, before paper patterns came into use.

EMcG □

299. *Dressing Gown*

1854
Scarlet wool; trimmed in black appliqué and embroidered in yellow, tan, and black soutache braid; lined in quilted red silk
Center back length 57″ (144.7 cm)

Philadelphia Museum of Art. Given by Agnes Davisson Loughran. 58-6-4a, b

PROVENANCE: Catherine Laughlin Heron (Reilly), 1854; descended in family to grandniece, Agnes Davisson Loughran

"ONE OF THE MORALISTS of the [Victorian] age tried to point out that it was a sign of degeneracy that women were turning to more comfortable dress, wearing dressing gowns for breakfast and an increasing

298.

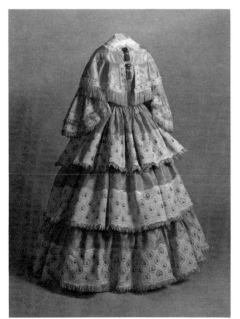

299.

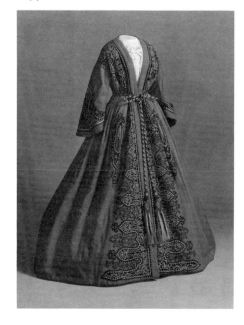

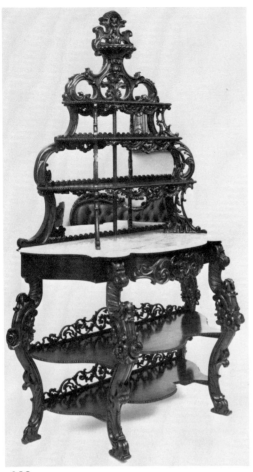

300.

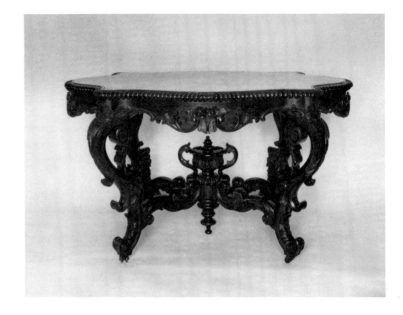

number of tea gowns were appearing in the afternoon. He reasoned that comfortable dresses would lead to freer and easier manners. Young ladies were not given these privileges, and the wearing of tea gowns was reserved for married women only" (M. D. C. Crawford and Elizabeth G. Crawford, *The History of Lingerie in Pictures,* New York, 1952, p. 67). The dressing gown was worn over the appropriate underpinnings: chemise, corset, corset cover, and several petticoats, all embroidered and trimmed. However, the hoop skirt, the wire or bone contraption which helped form the proper silhouette, was left off until the last minute when the dress went on.

This handsome scarlet wool dressing gown is from the trousseau of Catherine Laughlin Heron (see no. 298), whose father and uncle were Philadelphia merchants, owners of clipper ships trading with the Orient. The gown reflects a feeling of the Orient and the then fashionable interest in the Zouave. The flared, fully pleated skirt is attached to the top at the waist, outlined by an insertion of fine cording. The wide bell-shaped sleeves are attached at the dropped shoulder line with similar cording. There are interesting oval slit pockets on either side of the center

front and all edges are outlined with appliquéd black cloth and intricately interwoven and embroidered yellow, tan, and black soutache braid. The robe is lined in matching red silk, quilted in a diamond motif, and has a decorative silk-cord girdle finished with Oriental tassel pendants.

EMcG □

300. *Center Table and Étagère*

c. 1855

Rosewood; walnut; marble

Center table 28 x 51⅝ x 33" (71 x 131.1 x 83.8 cm); étagère 87½ x 57¾ x 23½" (222.5 x 146.8 x 59.6 cm)

The Campbell House Museum, St. Louis, Missouri

PROVENANCE: Robert Campbell, St. Louis; son, Hugh Campbell, St. Louis

THESE TWO PIECES of furniture and at least three other rococo revival sets were undoubtedly bought in Philadelphia by Mary and Robert Campbell for their home on Lucas Place, one of St. Louis's most fashionable

streets, where they had moved in 1851. At that time, Robert Campbell's brother, Hugh, still lived in Philadelphia. In the summers of 1855 and 1856, Mary Campbell and her children visited Hugh Campbell's family, while her husband remained in St. Louis taking care of business. On June 21, 1855, Mary Campbell wrote her husband from Philadelphia:

I am very glad to hear you are having our back building enlarged. It will contribute greatly to our comfort. I have not done anything in the furniture line yet. I hoped you would be here by the 1st of July and could give your opinion about everything. I will go and select it before I go to Long Branch or rather order it to be made. I do not know exactly how to order it. Had we better get new dining room furniture or will the old answer? and I suppose we will not alter the front room like Mr. Woods. I have been so indisposed that I have felt but little ambition about the furniture. I am sorry you have such hot weather.... Write what you think that we better get in the way of dining room furniture. (St. Louis, Campbell House Museum, Archives)

Five days later she wrote: "I have not been able to go to the furniture stores at all but will go very soon" (St. Louis, Campbell House Museum, Archives).

Although Mary Campbell's letters do not confirm that she actually bought furniture in Philadelphia, her intention to do so seems very firm. More concrete evidence of a Philadelphia origin for the Campbell furniture is the fact that among the furnishings of their double drawing room was a spectacular set of carved gilt overmantel and pier mirrors one of which bears under its shelf the paper label of the Philadelphia looking glass and picture frame manufacturer James S. Earle. Mirrors and furniture of this quality and elaboration were not produced by St. Louis or Cincinnati furniture firms in the 1850s. Also, it seems likely that if mirrors were brought out to St. Louis via canals and rivers, then furniture could easily have been brought there too. Other Philadelphia-made objects owned by the Campbells include a gilt chandelier, a porcelain dinner service, and a piano marked: "Shoemacker & Co./ PHILAD^A." This center table and étagère share stylistic similarities with other Philadelphia rococo revival furniture. The center table, for example, is similar to one which once belonged to James Skerret of Philadelphia and which is still at Loudoun, his house in Germantown.

The furniture in the Campbell House is remarkable for many reasons. For their house in St. Louis, the Campbells bought furniture in the latest style to fill several rooms. Philadelphia furniture warehouses such as that of George J. Henkels were prepared to meet this demand: "The leading purpose of this establishment is to supply a complete assortment of first-class furniture for an entire house, by which all the articles from the attic to the kitchen correspond in style, modified, of course, by their situation" (Freedley, *Philadelphia Manufactures*, pp. 273–74).

Comparisons of rococo revival furniture in Philadelphia with that in New York and Boston demonstrate that regional distinctions prevailed throughout the nineteenth century, at least in the more elaborate custom orders. A similar rosewood pier table by the Boston firm of A. Eliaers was in the New York Crystal Palace exhibition (Silliman and Goodrich, p. 164). The Boston table has a more delicate and restrained composition than the Philadelphia table and lacks the heaviness characteristic of Philadelphia rococo furniture.

The étagère is an ambitious piece which is conceived in terms of curve and counter-curve. The rhythmic movement and monumental composition give it great power.

Robert Campbell, an Irish immigrant, was a fur trader, then a banker, merchant, and landowner. His Rocky Mountain Fur Company rivaled the Chouteau-Astor interests, also centered in St. Louis. After Campbell's death, the house and its furnishings were inherited by his son, Hugh, who continued to live in the house until his death in 1931, making surprisingly few changes. There were only two owners of this furniture until the sale of Hugh Campbell's estate in 1941, when the Campbell House Foundation acquired it. The remarkable contents remained virtually intact for almost one hundred years.

DH ☐

NAPOLEON LE BRUN (1821–1901)

Napoleon LeBrun was born in Philadelphia in 1821, the son of a French native who expatriated after serving as a diplomat in the United States during the Jefferson administration. LeBrun was the inheritor of what Montgomery Schuyler called the "tradition of 'good taste' " ("The Work of N. LeBrun & Sons," *Architectural Record*, vol. 27, no. 5, May 1910, p. 381). He was the fourth generation in a line of noted American architects beginning with Benjamin Henry Latrobe, whose protégé William Strickland served as the master of Thomas U. Walter, who in turn trained young LeBrun. LeBrun struck out on his own in 1841 and five years later established his name when he was appointed architect of the Cathedral of SS. Peter and Paul on Logan Square. He was a member of the Musical Fund Society and served as its manager for a period, and was chosen in 1847 to enlarge its hall, which had been built in 1824 from the designs of Strickland. This undertaking and his own musical talent (he was a fine organist) gave him invaluable experience and insight in designing musical auditoriums before he won the competition for the Academy of Music seven years later.

After the Civil War, LeBrun moved to New York, where in his later years he formed a partnership with his sons Michael and Pierre, and practiced as N. LeBrun and Sons. He served two terms as president of the New York chapter of the American Institute of Architects and for eighteen years represented that chapter on the State Board of Architectural Examiners, Department of Building. During the 1880s and 1890s the firm designed the New York Fire Department structures. LeBrun died in New York in 1901.

G. RUNGE (1822–1900)

G. Runge was born in Bremen, Germany, in 1822. He studied architecture and engineering at Karlsruhe before moving to the United States during his mid-twenties, probably about 1849. He evidently entered into his partnership with Napoleon LeBrun by 1854, prepared the working drawings for the Academy of Music project and apparently supervised the operation, even though Charles Conrad was cited in newspapers as superintendent of construction. Runge is reported to have returned to Germany by early 1859, but his name appears in city directories as late as 1861, when he was listed as living at 42 North Sixth Street. He died in Germany in 1900.

NAPOLEON LE BRUN AND G. RUNGE

301. *American Academy of Music (Academy of Music)*

Broad and Locust streets
1855–57
Charles Conrad, superintendent of construction
Inscription: 1857/AMERICAN/ACADEMY OF MUSIC
Brick with rusticated and dressed brownstone ground story and cast-iron cornice
132 x 220′ (39.6 x 67.5 m)

REPRESENTED BY:
Academy of Music
c. 1870–90
Photograph
10½ x 8½″ (26.6 x 21.5 cm)
The Athenaeum of Philadelphia

Napoleon LeBrun and G. Runge
Interior Elevation, Academy of Music
c. 1855–57
Watercolor and ink on paper
32¼″ x 43½″ (82 x 110.5 cm)
Historical Society of Pennsylvania, Philadelphia

LITERATURE: LCP, Charles A. Poulson, Scrapbooks, vol. 9, p. 21; White, *Philadelphia Architecture*, p. 28, pl. 44; Dickson, *Pennsylvania Buildings*, pl. 69; Tatum, pp. 94–95, 186–87, pls. 96, 97; Leo L. Beranek, *Music, Acoustics and Architecture* (New York, 1962), pp. 8, 165–68; John C. Poppeliers, "Napoleon LeBrun and G. Runge," in PMA, *Architectural Drawings*, pp. 54–55; Robert Allan Class, "The Philadelphia Academy of Music: The Restoration," *Charette*, vol. 46, no. 6 (June 1966), p. 10; James V. Kavanaugh, "Three American Opera Houses: The Boston Theatre, The New York Academy of Music, The Philadelphia American Academy of Music," M.A. thesis, University of Delaware, 1967, pp. 52–72; *Philadelphia Inquirer*, December 5, 1968.

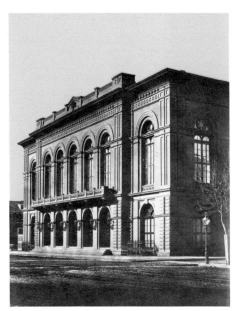

301.

Although the Academy of Music is historically important as the oldest opera house in continuous use in the United States, it is best known for its acoustics, which to the ears of acousticians make it "unquestionably the finest opera house in the United States" (Leo L. Beranek, *Music, Acoustics and Architecture,* New York, 1962, p. 165). Since the science of acoustics is not yet exact, and was even less so in the 1850s, there is an element of good fortune in the Academy's exemplary acoustics, yet the results were not totally accidental. The American Academy of Music was organized by local businessmen boosters in 1852, but the public response was disappointing until the Boston Theatre and New York Academy of Music opened in the fall of 1854. Then in a flush of competitive pride, Philadelphians began buying Academy stock and an architectural competition was held that fall.

The winners of the competition, LeBrun and Runge, brought to this task experience and training, LeBrun as architect of the acoustically fine Musical Fund Hall in Philadelphia and Runge as a former student of construction and engineering in Germany. After receiving their commission the architects focused their attention on acoustics, which determined the interior plan, materials, and decoration. LeBrun is reported to have traveled to Milan to examine the acoustically perfect Teatro della Scala (1778), as evidenced in the nearly identical dimensions of interior elements and arrangements of the Academy and La Scala (James V. Kavanaugh, "Three American Opera Houses: The Boston Theatre, The New York Academy of Music, The Philadelphia American Academy of Music," M.A. thesis, University of Delaware, 1967, p. 65).

Operating on the theory that sound, like light, travels in straight lines and is best when not reflected, the architects sheathed the walls with soft pine boards beneath the plaster, keeping the surfaces as smooth as reasonable, and successively declined the balconies, with each higher balcony set back from the one below it. However, the one element that has been acclaimed as unique—the brick well twenty feet in diameter beneath the parquet—appears to have nothing to do with the acoustics. Although it has been popularly claimed that the well turns the floor into a giant resonance drum, modern acoustical engineers insist that a wooden floor heavy enough to support an audience would prevent such a small well from affecting the hall's acoustics. It is more likely that it was designed to hold an auxiliary water supply in case of fire.

The interior, with its glittering contrasts of cream-colored woodwork, gilt carvings, and crimson hangings, was designed in the neobaroque style that was then emerging in France. The Academy's exterior, on the other hand, was finished in what has been called the "Philadelphia Market-house style," the "temporary" result of insufficient funds, which left incomplete the architects' plans to face the building with marble in the Corinthian order (see Tatum, pl. 96). Admittedly the brick-and-brownstone front cannot match the elegance of the interior, yet its strong arches rise above the rusticated base to provide a handsome, unified design. Perhaps one can better appreciate the exterior by considering what it might have been. Stephen D. Button's design, which received the second prize in the competition, anticipated the elegant dome of the Opéra of Paris by seven years, but it was out of proportion to the proposed building, and its utilitarian

fenestration and stuccoed walls fell short of the monumentality of the winning design (see Richard J. Webster, "Stephen D. Button, A.I.A.," in PMA, *Architectural Drawings,* pp. 54–55).

In 1957, the Academy's centennial year, a nine-year restoration project was begun by Stewart, Noble, Class and Associates, Architects. It was not a slavish restoration that returned to the original in every respect, but a creative restoration employing today's technology. This undertaking raised the issue of the unfinished exterior, but to have completed LeBrun and Runge's plans would not have meant the restoration of a familiar site but the creation of an essentially new facade, and it would have been extravagantly expensive. In 1968 the building's financial future was secured by the transfer of its air rights to the Academy House, a thirty-three-story apartment complex behind the Academy of Music.

RW □

MAX ROSENTHAL (1833–1919)

Born in Poland in 1833, Max Rosenthal was sent to Paris at the age of thirteen to study lithography with the Alsatian Martin Thurwanger. Thurwanger came to America in 1848 at the behest of the Smithsonian Institution, and it is possibly due to his influence that Rosenthal immigrated to America in 1849 or 1850, followed shortly by his older brothers, Louis N., Morris, and Simon, all trained lithographers. Settling in Philadelphia, Max and Louis quickly established themselves as keen competition for the firms of P. S. Duval (see no. 267), Thomas Sinclair, and Wagner & McGuigan. The Rosenthal brothers soon won premiums at

301.

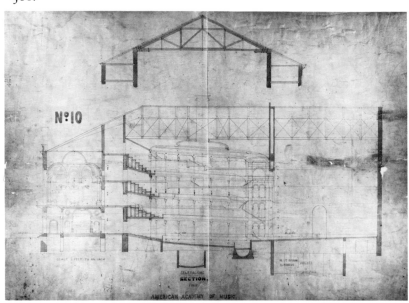

the Franklin Institute for their dazzling chromolithographic work, producing numerous advertisements and book illustrations throughout the 1850s. Max Rosenthal was primarily the designer, embellishing the commonplace trade cards with lush vegetation, rocaille work, and fanciful putti. In a more straightforward vein, he drew numerous colorplate illustrations for Samuel Sloan's architectural publications. After his retirement from the lithographic firm in 1884, Rosenthal worked primarily in etching, mezzotint, and oil, undertaking a huge series of portraits in collaboration with his son Albert. Max Rosenthal lived in Philadelphia until his death in 1919; his chromatic fantasies of the 1850s remained unequaled by any rival firm.

SAM

COLLINS & AUTENRIETH
(ACT. C. 1854–1902)

Around 1852, Edward Collins, a Philadelphian studying architecture in Germany, met German architect C. M. Autenrieth and persuaded him to join in an architectural practice in Philadelphia. That office prospered for almost half a century. The architects' early work covered the full range of types of buildings as well as styles, from the additive Gothic of their competition project for the Masonic Temple of 1855 to the neo-Renaissance mode of the Pittsburgh Railroad Station (about 1856). After the Civil War, Collins and Autenrieth continued as an important office, winning the competition for the main Centennial building (unexecuted; see no. 339), entering the competition for the Pennsylvania Academy of the Fine Arts (no. 335), and providing the plans for the Carnivora house at the Philadelphia Zoo. The zoo project and the Central Presbyterian Church, on North Broad Street, demonstrated their increasing effort to utilize high Victorian polychromy within the formal classical frame, which remained their general preference. By the end of the century the retardataire quality of the firm's designs restricted their work to industrial structures and additions to earlier projects for long-standing clients. Among the better known of those projects are the eastern and western extensions to Lit Brothers department store on Market Street, which mimic in terra-cotta and brick the delicate arcades of its mid-century iron construction.

GT

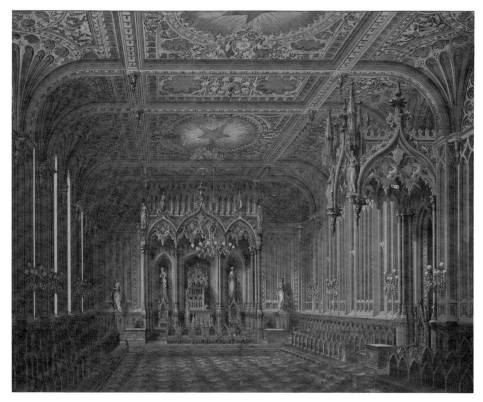

302.

MAX ROSENTHAL AFTER COLLINS & AUTENRIETH

302. Grand Lodge Room of the New Masonic Hall, Chestnut Street, Philadelphia

1855
Printed by L. N. Rosenthal
Signature: On Stone by Max Rosenthal/ Collins & Autenrieth, Del./Sloan & Stewart, Architects. (in lower margin, below image)
Inscription: To the R.W. Grand Master, Grand Officers, and Members of the Grand Lodge of Penn^a, and the Order in general, this print is respectfully dedicated/by/L. N. Rosenthal./of No. 9/ PUBLISHED & LITH. IN COLORS BY L. N. ROSENTHAL, PHILAD^A P^A (below image); Entered, according to act of Congress, in the year 1855, by L. N. Rosenthal, in the Clerk's Office, of the District Court, of the Eastern District of Pennsylvania. (in border)
Chromolithograph
24½ x 28¹⁵⁄₁₆″ (62 x 73.3 cm)
The Library Company of Philadelphia

LITERATURE: Wainwright, Early Lithography, p. 144; Tatum, p. 179, pl. 76; Made in America, pp. 54–55, no. 78

PERHAPS NOWHERE IN PHILADELPHIA was the Gothic taste realized as magnificently as in the second Masonic Hall on Chestnut Street, which replaced an earlier Gothic Masonic Hall (Tatum, pl. 74) built in 1808–11 by William Strickland (see biography preceding no. 202). Designed in 1853 by Samuel Sloan and John Stewart (who were in partnership between 1852 and 1857), the new structure had lavishly appointed interiors. Another Philadelphia firm, Collins & Autenrieth, supplied the drawings for what was in turn one of the Rosenthals' most superb chromolithographs.

The Grand Lodge Room on the second floor of the hall was ornamented and furnished in the most chromatic orchestration of the Gothic vocabulary, pulling out all the stops in an adaptation of an ecclesiastic arrangement at a high altar. The designers arranged chairs carved with Gothic motifs along the walls like choir stalls, leading to a raised dais bearing an elaborate throne flanked by statues in niches. The walls were supported by columns terminating in a delicate polychromed web of fan tracery sprinkled with Masonic devices.

The space was calculated to have a breathtaking effect; dominating hues of blue and gold evoked the pageantry of a medieval throne room, a suitable setting for the solemn rites of the Masons. Where previously a classical temple had served to inspire a sense of occasion, the European cathedral

349

303a.

now recalled a glorious past. The Grand Lodge Room's designers felt free to draw upon recognized architectural conventions as well as to add their own imagination to create one of the Gothic revival's most dazzling showcases.

Louis N. Rosenthal took even more than his usual care in achieving a harmony of tonality, perfect registration, and format; the chromolithograph glows, jewel-like and vibrant, long after the original has fallen to the ravages of time.

In 1873 the Masons opted for larger quarters in their present hall at Broad and Filbert streets, abandoning Sloan & Stewart's temple only eighteen years after its dedication in 1855. Afterward, the hall housed first a Dime Museum, then a neo-Egyptian collection, before burning down in 1885.

SAM □

JAMES E. MC CLEES (1821–1887)

Born in Chester County, Pennsylvania, McClees moved to Philadelphia in 1829. Little is known of his early training as an artist but his first contact with the photography profession came in 1844 when he became an operator in Montgomery P. Simon's daguerreotype studio. In 1846 he established a photography business in part-nership with Washington Lafayette Germon (1823–1878) at 625 Chestnut Street, and in 1853 they purchased the patent for crystallo-types (negatives on albumenized glass and later on collodionized glass) from Whipple and Jones of Boston. At the Franklin Insti-tute exhibitions of 1850–52, McClees's and Germon's daguerreotypes were given con-sistently high praise. In 1854, McClees went to Boston to receive instruction from the photographer John W. Black. In 1855 the McClees-Germon partnership was dissolved: Germon remained at Seventh and Chestnut streets, and McClees moved his studio to 160 Chestnut Street.

In this year, McClees went to Europe to investigate the new improvements in photo-graphic techniques and to search for artists to hand-color his photographic portraits. In the same year, 1855, most likely after his European trip, McClees published an adver-tising brochure and technical history (the original of which is in the collection of the International Museum of Photography, George Eastman House, Rochester, New York). From it we learn that McClees not only produced daguerreotypes (stereoscope, crayon, or vignette daguerreotypes) in all sizes, but was proficient in other photo-graphic media, such as the ambrotype and crystallotype. He could produce prints on paper or canvas, using any of the above processes, by copying daguerreotypes, or from life, and have them finished by an artist-employee in India ink, black or colored crayon, watercolor, or oil. He claimed the pantotype process (similar to the daguerreo-type but produced upon canvas instead of metal) as unique to his studio.

In 1860, McClees moved his studio to 910 Chestnut Street; in 1865, to 1310 Chest-nut Street; and last, to 1700 Chestnut Street toward the end of his photography career. In 1867 he sold his business to William Bell and thereafter became a prominent Phila-delphia art dealer—as founder of the McClees Gallery located at 1417 Chestnut Street (*Philadelphia Photographer,* vol. 24, June 1887, p. 373).

303a. *Jefferson House, Southwest Corner of Seventh and Market Streets*

1855
Inscription: Jefferson House/So. West Corner of Seventh/and Market St. (center, below photograph); photograph —by McClees/1855 (lower left corner; both in Charles A. Poulson's hand, in ink, on scrapbook sheet)
Albumen print
8½ x 6⅞″ (21.6 x 17.5 cm)
The Library Company of Philadelphia

PROVENANCE: Charles A. Poulson (1790–1866)

LITERATURE: J. E. McClees, *Elements of Photog-raphy . . . Principles Upon which the Different Styles of Heliographic Pictures are Produced* (Philadelphia, 1855; facsimile reprint, 1974, intro. by Beaumont Newhall), pp. 27–28

303b. *View of Ruins Caused by the Great Fire, Northeast Corner of Sixth and Market Streets*

1856
Inscription: McClees/View of the ruins caused by The Great fire Northeast Corner of Sixth and Mar/ket, which began on the night of Weds. April 30, 1856—From the Northwest. (in ink, in Charles A. Poulson's hand, on strip of scrapbook paper, lower left corner)
Albumen print
7 x 9¼″ (17.7 x 23.5 cm)
The Library Company of Philadelphia

PROVENANCE: Charles A. Poulson (1790–1866)

LITERATURE: LCP, Charles A. Poulson, Scrap-book, vol. 5, p. 21

IT IS LIKELY that both of these prints were made from albumen glass negatives (crystallotype). Although McClees stated in his brochure that the use of collodion for coating glass negatives was highly important for the production of portrait prints, he believed the use of albumen was sufficient for producing prints of views. McClees was one of the first professional photographers in Philadelphia, along with the Langenheim brothers, to make extensive use of the glass negative and resulting prints with any degree of success. Although he is better known for daguerreotype portraits and prints made from these portraits, the two photographs shown here offer proof of McClees's talent in handling outdoor views.

Wainwright (*Early Lithography*, p. 73) commented, "Even in the field of views the lithograph had been challenged by the photograph as early as 1855, when J. E. McClees photographed a whole series of the city's most prominent and favorite scenes." McClees advertised these views in the *Bulletin* and reprinted the notice in his brochure with specific mention of the print of Jefferson House:

> J. E. McClees, successor to McClees & Germon, No. 160 Chestnut street, has published a series of photographic views of different places of local interest. Among them will be found views of The Chestnut Street Theatre; Farmers' and Mechanics' Bank; The State House; the old building at the south-west corner of Seventh and Market streets, in which Jefferson wrote the Declaration of Independence; Jefferson College; the United States Mint; Chambers' Church; Dr. Wylie's Church; Views on the Wissahickon, etc., etc. These pictures are all in the highest style of the photographic art, and they will prove valuable acquisitions to the portfolios of the collections of views of the public buildings of the city. Their truthfulness as copies of the originals cannot of course be doubted. (J. E. McClees, *Elements of Photography,* cited above, pp. 27–28)

In 1776, Thomas Jefferson rented the entire second floor of the home of Mr. and Mrs. J. Graff, Jr., parents of Frederick Graff, designer of the Fairmount Waterworks (no. 183), and it was here that Jefferson wrote the Declaration of Independence. In 1855, John A. McAllister, Jr., a noted collector and historian, did an intensive study of the actual location of the writing of the Declaration of Independence, and as a result the Graff house, depicted in this print, became the accepted locality. Shortly thereafter, the building, which came to be known as Jefferson House, was photographed for documentary purposes (Joseph Jackson, *Encyclopedia of Philadelphia*, Harrisburg, 1932, vol. 3, p. 882), probably at the behest of

303b.

McAllister who, desiring the most accurate means of documenting Jefferson House, chose McClees and the photographic medium. The print is notable for its sharpness of detail—for example, the writing on the theater and city museum posters propped against the left side of the house can be discerned. Only the lettering on the awning is blurred due to the motion of the wind.

The print of the Great Fire, which began late on the night of April 30, 1856, can be seen as an early documentary photograph, although it was not then possible to reproduce photographs in the news media. The scene, which depicts a tragic event which destroyed forty-four buildings and caused the loss of about a half-million dollars, captures the dramatic atmosphere of destruction: the dark somber tones of the charred buildings and the fallen rubble stand out in vivid contrast and precise detail against the hazy film of smoke which obscures the buildings and ruins in the background, although the tower of Independence Hall can be discerned. This print was acquired, probably for its artistry as well as its documentary value, by Charles A. Poulson, editor of the *American Daily Advertiser* and author of many articles on Philadelphia for various local newspapers.

CW □

SAMUEL ROOT (1819–1889)

Younger brother of the more famous photographer, Marcus Root (see biography preceding no. 281), Samuel was born in Granville, Ohio, where he remained until adulthood when he moved to Philadelphia to learn the art of photography from Marcus. He then settled in New York, where he ran a photographic gallery with Marcus from 1849 to 1851 at Franklin and Broadway. In 1851, Samuel decided to branch out on his own and bought out Marcus's share of ownership in this gallery.

In the latter part of December 1853, Edward Anthony, a dealer in daguerreotype equipment, awarded Samuel the second prize of two silver cups at Gurney's Gallery in New York on the occasion of the first photographic competition held in the United States. The event was specifically organized to select the best whole plate daguerreotype submitted to an award committee made up of prominent daguerrian artists.

In 1856, Samuel moved to Dubuque, Iowa, where he opened up another photography gallery, remaining there until he retired from the photographic business in 1882. Notices in the *Philadelphia Photographer* record that Samuel exhibited photographic portraits at the National Photographic Association's annual exhibitions from 1870 to 1874, and in 1876 at the Centennial exhibition in Philadelphia. Other than these brief notices, little is known of his exhibition activities and at present only a few examples of his work have been discovered. However, his obituary in *The Photographic Times and American Photographer* (vol. 19, no. 393, March 29, 1889, pp. 158–59) states that he was considered one of the leading portrait photographers, and photographed such notable personalities as Jenny Lind, Henry Clay, Edwin Forest, George William Curtis, George M. Dallas, and Bayard Taylor. He died in 1889 in Rochester, New York, while on an extended visit to the home of his sister-in-law.

304. *Rembrandt Peale*

1855
Label: Portrait of Rembrandt Peale/taken
& presented by/Saml. Root, 1855/ Photo-
graphed by McClees/March 1860/by
Gutekunst, Nov. 1860/by Gutekunst
photographer/March 1882 (in pencil, in
Gutekunst's hand, on backing of plate);
Portrait of Rembrandt Peale/taken and/
presented by Sam Root/1855/Given by
F. J. Dreer (in ink, on backing, verso)
Whole plate daguerreotype
7¼ x 5⅞″ (18.5 x 15 cm)
Historical Society of Pennsylvania,
Philadelphia

PROVENANCE: Ferdinand Julius Dreer, until 1902
LITERATURE: Dunlap, *History*, vol. 2, illus. p. 180

BETWEEN 1850 AND 1855, when this portrait
was made, the daguerreotype had reached
its greatest period of activity and perfection.
The number of professional and part-time
daguerreotypists is estimated to have reached
several thousand, and the annual output of
daguerreotypes as high as three million,
ranging from the very small and inexpensive
daguerreotype for lockets and rings to the
large and more costly double-whole plate
size (8½ by 13 inches). After 1856, with the
development and widespread use of cheaper
and easier methods of producing portraits,
such as ambrotype, tintype, the carte-de-
visite, and cabinet-size paper prints, the
daguerreotype portrait production steadily
decreased.

However, this portrayal of Rembrandt
Peale demonstrates that the daguerreotype
portrait was never to be excelled by any other
photographic medium for its acute rendition
of detail. The material of the frock coat can
be identified as satin; the articulation of the
skin texture is such that even the lines and
imperfections can be discerned; and the
absence of any rigidity in the pose and facial
expression is notable, the whole being a very
relaxed yet dignified portrait. Beyond that,
the quality of this whole plate daguerreotype
indicates that as a portrait photographer
Samuel Root lived undeservedly in the
shadow of his older brother Marcus.

It seems logical that Rembrandt Peale, one
of Philadelphia's most prominent portrait
painters, would permit his portrait to be
taken by only the most accomplished photog-
rapher. Toward the end of his career, Peale
gave much reflection to the art of daguerreo-
type portraiture and the competition it
offered to portraiture in other media. In his
article "Portraiture" in *The Crayon* (vol. 4,
1857, p. 45), he implied that the mechanical
nature of photography would not permit its
consideration as an art form: "Daguerreo-
types and photographs all have their relative

304.

merit; and as memorials of regard, are not
to be despised. . . . The task of the portrait
painter is quite another thing—an effort of
skill, taste, mind and judgment—demanding
the opportunity of study, during many
sittings. . . ."

The existence of an advertising card for
"Mr. Peale's Daguerrian Rooms, opposite
the Franklin House . . ." (private collection),
offers the possibility that Rembrandt Peale
took up this profession, although there is no
documented evidence of his or any member
of his family's activity in this field. The
relationship between Root and Peale is not
known, but in general in America the influ-
ence of the painter on the daguerreotypist and
vice versa was great. Peale's words illustrate
this point, ". . . for even now it has become
necessary for the portrait painter to make
his portraits not only *as true* but expressly
more true than the daguerreotypes . . ."
("Portraiture," *The Crayon*, vol. 4, 1857,
p. 44).

CW □

FELIX OCTAVIUS CARR DARLEY (1822–1888)

Although Darley, the best-known Ameri-
can book illustrator of the pre-Civil War
period, left Philadelphia at the age of
twenty-six, he had a distinct early activity
before his move to New York in 1848, and
his career as an illustrator can be said to have
been launched here. He was born in Phila-
delphia, the son of an English actor and
actress, John and Eleanora Westray Darley.
An artistic family connection is indicated by
his brother's marriage to Thomas Sully's
daughter (see Charles Henry Hart,
"Thomas Sully's Register of Portraits, 1801–

1871," *PMHB*, vol. 32, no. 4, 1908, p. 391).
Another brother, E. H. Darley, was a portrait
painter working in Philadelphia, primarily
in the early 1830s (Groce and Wallace,
p. 165). However, Darley himself is not
reported to have received any systematic
artistic training, but rather to have developed
his talents in illustration on his own. An
early biographical sketch (Stoddart,
"Darley," pp. 193–97) describes him as
having been placed as a young man in a
mercantile house by his father, sketching
local characters and trying his hand at a few
illustrations.

It seems that he was first employed as a
professional illustrator in 1842–43 by no less
a figure than Edgar Allan Poe. Poe lived in
Philadelphia from 1838 to 1844 and served as
editor for the *Gentleman's Magazine*
(1839–40) and *Graham's Magazine*
(1841–42); his literary achievements during
this period included the publication of thirty-
one of his short stories, marking his stay
here as the most productive part of his career
(see Arthur H. Quinn, *Edgar Allan Poe,
A Critical Biography,* New York, 1969,
p. 403). According to Bolton (p. 138), Poe
accepted some of Darley's sketches for pub-
lication in 1842 in *The Saturday Museum,*
a newly established weekly paper, and he
retained Darley at the end of January 1843
to illustrate for *The Stylus,* a literary maga-
zine he was attempting, unsuccessfully, to
publish on his own. On June 21 and 28,
1843, Poe's "The Gold Bug" was first pub-
lished in the *Dollar Newspaper* with two
illustrations by Darley and was reprinted in
The Saturday Courier on June 24 and July
1 and 8 (see Quinn, *Poe,* cited above, pp.
369, 392). A possible connection between
Darley, who was only twenty or twenty-one
at the time, and Poe might have been through
Darley's in-laws, the Sullys. Matthew Sully,
Thomas's brother, had appeared on the stage
with Poe's mother in Norfolk, Virginia, in
1803, and Matthew's son Robert was a youth-
ful friend of Poe's in Richmond in the early
1820s, according to Quinn (*Poe,* cited above,
p. 85). In any case, Poe and his younger
contemporary Darley shared the circum-
stance of having both parents professional
actors—no small social stigma at the time.
In April 1843, with the first "installment" of
Scenes in Indian Life, a series of outline
compositions subsequently published in book
form, Darley's career was effectively
launched; there is no indication of Poe's
employing him further.

Emphasis has always been placed on
Darley's ability to caricature and on the
humorous aspects of his work. He provided
illustrations for the multivolume *Library of
Humorous American Works,* published in
Philadelphia by Carey and Hart (first series
1846–49). Apparently one of his last efforts
in Philadelphia was his cover design and

cartoons for *The John-Donkey,* a short-lived (January 1—October 21, 1848) comic weekly inspired by *Punch* and published in Philadelphia by G. B. Zieber and Co. and others (see W. Murrell, *A History of American Graphic Humor,* New York, 1933, vol. 1, vol. 2, fig. 159; Hamilton, nos. 1593, 1597). Around the time *The John-Donkey* ceased publication, or sometime previously in 1848, Darley apparently moved to New York (see "America's First Comic Weekly," *Public Ledger,* March 8, 1908; Stoddart, "Darley," p. 195).

Darley provided illustrations for perhaps fifty or more books in Philadelphia before he moved to New York (his enormous oeuvre of book illustrations has been catalogued by Bolton and Hamilton). Among the first illustrations he made in New York were for works by Washington Irving, *The Sketch Book of Geoffrey Crayon* (1848), *Illustrations of Rip Van Winkle* (1848), and *Illustrations of the Legend of Sleepy Hollow* (1849), and he became known as the "greatest and most sympathetic" illustrator of Irving's works, at least in the period of the author's lifetime. Irving's "Knickerbocker" *History of New York* (New York: G. P. Putnam, 1850) has been called Darley's "first really noteworthy work on the woodblock" (Weitenkampf, "Darley," p. 101), and thereafter his reputation was established as one of the major and most prolific illustrators in the country. In 1856, Stoddart claimed that Darley was "more widely known as an illustrator of books than any other artist in this country" ("Darley," p. 197). He is especially well known for his illustrations of James Fenimore Cooper's novels, as published in a 32-volume series by W. A. Townsend, New York, in 1859–61; some of those illustrations were issued sepa-rately, as was the case with the illustrations to Irving. Darley also illustrated Laurence Sterne, Longfellow, Tennyson, John Green-leaf Whittier, Harriet Beecher Stowe, Hawthorne, Poe, Dickens, and Shakespeare, as well as other less familiar names. He contributed illustrations to over 200 vol-umes, according to Bolton and Hamilton, and this does not even include his work for journals (*Harper's Magazine, Harper's Weekly, Every Saturday, The Riverside Magazine for Young People, Our Young Folks, Appleton's Journal, Illustrated Christian Weekly,* and others) and miscellaneous works such as banknote vignettes or draw-ings for reproduction as prints for framing (Weitenkampf, "Darley," pp. 102, 105, 113, fig. 9).

In 1852 he was elected an Academician of the National Academy of Design; he exhib-ited there between 1861 and 1874 and at the Pennsylvania Academy from 1847 to 1864 and in 1880. In 1859 he married and moved to Claymont, Delaware, near Wilmington, where he lived until his death. He traveled in Europe in 1866–67 (William B. Stevens, Jr., "The unpublished European sketchbook of F. O. C. Darley," *Antiques,* vol. 94, no. 11, November 1968, pp. 708–11) and wrote his own travel book, entitled *Sketches Abroad with Pen and Pencil* (New York: Hurd and Houghton, 1868). Foreign influ-ences, however, are infrequently mentioned in connection with his work, although those of Retzsch and Cruikshank are exceptions. In fact, Darley was noted for his illustration of American authors, for the indigenousness of his subject matter, and for his feeling for American life and types. "The subjects covered by his drawings touch on many sides of our national life and history, and much of it was based on actual observation.

Western scenes, with Indians, trappers, hunters, emigrants; farmers and country life in various aspects; drovers, blacksmiths, wheelwrights, tanners, carpenters, coopers, miners, surveyors, sailors, peregrinating quack doctors, peddlers, Fourth of July orators; city types such as policemen, news-boys, street musicians, corner loafers; camp meetings, turkey shoots; cattle, horses; and so on and on" (Weitenkampf, "Darley," p. 105).

Bolton points out (p. 142) that at the outset of his career Darley was unrivaled in the field of book illustration, whereas during the latter half he shared popularity with the coming generation of great illustrators. He is listed as illustrator in association with Homer, Pyle, Abbey, Frost, and Remington in several volumes published in the 1880s. Darley died in 1888, aged sixty-five.

305. *Illustrations for Compositions in Outline from Judd's Margaret*

(a) *Margaret annoyed by her brother*

c. 1847–56
Signature: F. O. C. Darley—fecit (in brown ink, lower left, in mount)
Brown ink on beige paper
7¼ x 9⅟₁₆″ (image) (18.4 x 23 cm)
Delaware Art Museum, Wilmington

PROVENANCE: Mrs. Douglas Davidson, until 1938

LITERATURE: Brooklyn Museum, *A Century of American Illustration* (March 22—May 14, 1972), no. 2 (illus.)

305a.

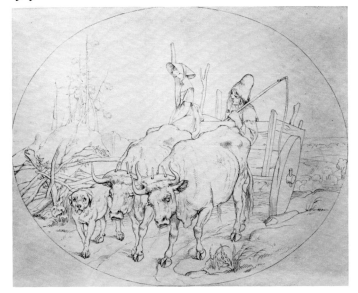

305c.

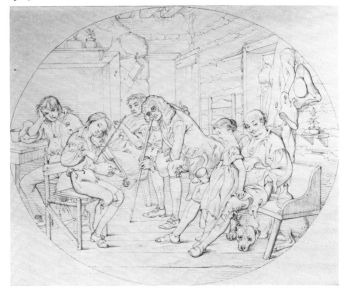

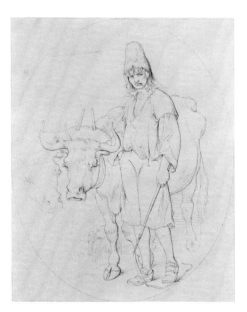

305b.

(b) *Hash*

c. 1847–56
Signature: F. O. C. Darley—fecit (in brown ink, lower left) *"Marshalahashbaz" otherwise "Hash" & his team—Illustrated by F. O. C. Darley—from "Margaret" by Sylvester Judd—1845* (on verso in brown ink in an old hand)
Brown ink on beige paper
9¹⁄₁₆ x 7¼″ (image) (23 x 18.4 cm)
Philadelphia Museum of Art. Bequest of Anna Hazen Howell. 36–42–4

(c) *Chilion played, and they were silent*

c. 1847–56
Brown ink on beige paper
7¼ x 9⅛″ (image) (18.4 x 23.1 cm)
Delaware Art Museum, Wilmington

PROVENANCE: Mrs. Douglas Davidson, until 1938
LITERATURE: Brooklyn Museum, *A Century of American Illustration* (March 22—May 14, 1972), p. 38

DARLEY UNDERTOOK the illustration of Sylvester Judd's *Margaret. A Tale of the Real and Ideal, Blight and Bloom* (published in Boston in 1845) on his own rather than as a commissioned work, and when the drawings were published in 1856 they were an immediate success. Cited early as among his finest works (Stoddart, "Darley," p. 196; Tuckerman, p. 476), they are examples of what can

be called his "outline" style, as opposed to the tonal drawings that he more commonly employed for his illustrations. The outline compositions were usually reproduced lithographically rather than by wood engravings; in them single figures or elaborate compositions are rendered purely by line, with great clarity and economy. There is no use of tones at all: form is suggested by an occasional doubling of a contour, and a subtle thickening of some of the lines adds variety. Darley did not illustrate many books with these "compositions in outline," but those he did do span almost his whole career, beginning with his earliest published works, which appeared in Philadelphia in 1843, the *Scenes in Indian Life* and *In Town & About; or Pencilling, & Pennings.* Later and more accomplished examples of this linear style are two of his early illustrations to Irving—the *Illustrations of Rip Van Winkle* (1848) and the *Illustrations of the Legend of Sleepy Hollow* (1849)—and the *Compositions in Outline from Judd's Margaret* (1856). *Compositions in Outline from Hawthorne's Scarlet Letter* appeared much later, in 1879, in Boston. Compared to the cleanness and economy of line of the scenes from *Margaret, Rip Van Winkle,* and *Sleepy Hollow,* the *Scarlet Letter* compositions are overelaborated and thereby much less pleasing.

This style of illustration was by no means original with Darley. The best-known prototypes that come to mind are Flaxman's outline engravings, but closer in spirit and in time to Darley's works are the outline compositions of the German Moritz Retzsch (1779–1857). That Darley was probably acquainted early with Retzsch's work is indicated by a sheet hand-lettered and signed by Darley "F. O. C. Darley—1843," apparently copied after the title page to a publication of Retzsch's works (Delaware Art Museum). In general, Darley's work may be viewed in relation to the late eighteenth century strain of anti-illusionism discussed by Robert Rosenblum ("Toward the *Tabula Rasa,*" in *Transformations in Late Eighteenth Century Art,* Princeton, 1967, pp. 146–91), who traces from Gavin Hamilton, Blake, and Romney to Flaxman and others around 1800 a tendency toward the suppression of modeling, light and shade, perspective, and atmosphere and a consequent reduction of pictorial vocabulary to the simple linear clarity of the "outlined but bodiless" figure or object.

Tuckerman (p. 472) describes *Margaret. A Tale of the Real and Ideal* as "a remarkable story of New England primitive life, . . . intense in its psychological phases, graphic in its details of still-life, powerful and subtle in its grasp of character, and vivid in its sense of beauty; yet unfinished in style, with little dramatic harmony; crude in execution, though original and vital in material."

Written by a Maine clergyman and set in the last quarter of the eighteenth century in New England, the story concerns Margaret, the orphaned child of a wealthy New York merchant's daughter and a Hessian mercenary, who is brought up in a rural frontier household. Her foster brother Hash is the rough, out-of-door, working hand of the family, and her foster brother Chilion the "Apollo of the household, skilled in all resources of handicraft, and a master of the violin" (*Compositions in Outline by F. O. C. Darley from Judd's Margaret,* New York: Redfield, 1856, lithographs by Konrad Huber after Darley, pp. 2–3). Darley's illustrations appeared as a volume of thirty plates accompanied by explanatory notes rather than by the full text of the novel.

Although the illustrations for *Margaret* were published only in 1856, well after Darley had moved to New York, some of them were done earlier, in Philadelphia, since two of the drawings were exhibited at the Pennsylvania Academy in 1847, *Chilion played and they were silent* and *She spent the hour . . . ,* an illustration not included in the published version (PAFA, *Exhibition of Paintings, Statues and Casts,* 1847, nos. 463, 464). In the preface to the 1856 publication, it is said that around eight years previously Judd discovered that Darley had undertaken to illustrate his book of his own accord, and the author made efforts to have the drawings published. Stoddart noted in 1856 that "the 'Margaret' outlines . . . have been in his [Darley's] hands now eight or nine years, during which time he has labored at them constantly, and grown up from youth to manhood in art"; the scenes then were nearly finished and to be published shortly ("Darley," p. 196).

The numerous drawings for Judd's *Margaret* in the collection of the Delaware Art Museum give an idea of Darley's working methods. The preface to the 1856 *Compositions* says that between the time he began the work and its publication Darley not only increased the number of drawings in outline he had done to illustrate the story but reworked each one, revising it and "enriching its effect." For most of the scenes either pencil and/or ink or tracing paper studies survive: there are three ink and pencil versions for *Margaret annoyed by her brother,* two on tracing paper that are very similar to the scene as published, and one on illustration board which shows the dog at the left instead of at the right, as in the print, seen from the rear rather than from the front. Since the individual figures line up when one tracing-paper drawing is superimposed on the other, but their positions do not, one may suppose that in order to adjust the arrangements of the figures in his compositions, Darley used a method whereby he traced and retraced his studies, moving the figures

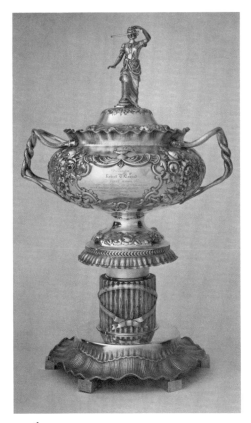

306.

about until he was satisfied. The drawing exhibited here represents a variant arrangement in which the pose of each figure is different from the published lithograph (pl. III of the *Compositions in Outline*).

In the case of *Hash*, the drawing exhibited is in reverse of the lithograph (pl. IV of the *Compositions in Outline*) and again varies in certain details; it is obviously not the version from which the plate was made. In the published scene Hash's pipe has disappeared, his shoes have straps rather than buckles, and he slouches in a relaxed stance with one knee bent and with his right hand in his pocket, while his left resting on the oxen's yoke holds a whip. The studies for *Hash* in the Delaware Art Museum, one in pencil and one on tracing paper, are in the same direction as the lithograph and show different details in the composition; one is inscribed in pencil above the oxen, "engrave from these."

There are several pencil studies and one tracing-paper drawing in the same collection for *Chilion played, and they were silent,* which relate either to the version pub-

lished in the *Compositions in Outline* (pl. IX) or to the quite different arrangement seen in the drawing exhibited here. One fragment of a study shows the figures of Margaret and her foster father, Pluck, with only minor details distinguishing the study from the figures in the published version, and the traced version of the entire scene is almost identical to the lithograph. But two further pencil studies are related to the drawing of the scene exhibited here, in which almost every figure differs in pose from the published version.

Since all three drawings exhibited here differ so substantially from the lithographs (and each is enframed by an oval in a rectangle rather than by the arched or round-cornered rectangles of the lithographs), it is likely that they are part of an entirely different, earlier series of illustrations for the story; we know in any case that Darley reworked the scenes for a number of years. The published versions show a greater ease of composition and dramatic movement than the drawings do, but the drawings have a quaint, attractive, slightly archaic stiffness that the later versions lack. In Tuckerman's words (p. 473), these illustrations, "pure, genuine, and powerful, through the simplest but most subtle lines of the draughtsman, . . . placed him [Darley] at once in the front rank of original, graceful, expressive artists."

AP □

R. & W. WILSON (ACT. 1825–83)
(See biography preceding no. 290)

306. *Presentation Urn*

c. 1856
Mark: R. & W. WILSON (stamped once on bottom of vase and once on each foot)
Inscription: presented to/ Robert T. Conrad/ FIRST MAYOR/ of the Consolidated City of Philadelphia./ as a testimonial of regard for his public services/ and affection for his private virtues./ June 4th 1856. (engraved in rococo cartouche on side)
Silver
Height 27″ (68.5 cm); width 16¾″ (42.5 cm); diameter 12¼″ (31.1 cm)
Drexel Museum Collection. Drexel University, Philadelphia

PROVENANCE: Robert Taylor Conrad (1810–1858), Philadelphia; Rev. Dr. Conrad, until 1892

THE GREAT FAVOR shown the famous Warwick vase in the nineteenth century is seen in its innumerable appearances in the decorative arts. Thomas Fletcher used it in modified form for the Thomas Firth presentation vase (no. 247). A Warwick vase on

a pedestal sculpted in marble by Nicola Marchetti of Carrara was exhibited in the New York Crystal Palace exhibition of 1853. Illustrated by an engraving in Silliman and Goodrich (p. 91), it was a popular piece, as shown by the accompanying commentary: "The famous antique vase, known as the Warwick Vase, is a favorite subject among artists, if we may judge by the numbers reproduced in bronze, terra-cotta, parian, etc. which meet one in every quarter of the exhibition." Here, in this presentation urn, the Warwick vase has again been adapted and placed on an elaborate pedestal.

A design for an urn on fasces also had an earlier neoclassical precedent, seen, for example, in Mésangère (fig. 606), which shows a similar scheme. The finial is in the form of a classical figure of Justice, blindfolded and holding scales. The overall design and such decorative details as the asymmetrical cartouche, flowers, and leaves in repoussé, and the ruffled base, however, are in an exuberant rococo revival style.

The figure of Justice and the fasces are symbols of authority appropriate for a presentation piece to Robert Taylor Conrad, a judge who later became mayor of Philadelphia. In addition, on one side of the vase is an allegorical scene also in repoussé. A chain surrounds an empty reserve panel. At bottom a boy, holding a flag, rides an eagle in flight. At each side a female figure, holding a wreath, sits on a bale of hay. The one on the left rests her hand on an anchor and the one on the right rests her hand on a sheath of wheat above a scythe. And at top is depicted the 1854 seal of the City of Philadelphia, which was never used.

Robert Taylor Conrad was born in Philadelphia, the son of a prosperous publisher. Although Conrad was trained for a legal career and admitted to the bar in 1831, he was more interested in journalism and literature. From 1831 to 1834 he was associated with the *Daily Commercial Intelligencer* and wrote plays and poetry on the side. His first play, *Conrad, King of Naples,* was successfully performed at the Arch Street Theater on January 17, 1832. His most famous play, *Jack Cade,* made him a literary figure in Philadelphia.

Around 1836, Conrad was appointed judge of the court of criminal sessions in Philadelphia, which disrupted his literary career for several years. However, in 1845 he became an associate editor of the *North American* and in 1848 assisted in editing *Graham's Magazine.* Among other publications Conrad wrote during those years were several poems and a series of sonnets which were published in 1852.

In 1853 the Pennsylvania legislature passed an act enlarging the city of Philadelphia by adding twenty-nine districts, boroughs, and townships, which comprised

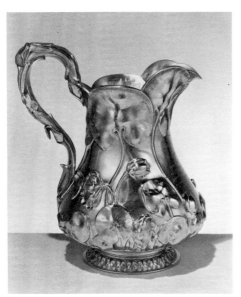

307.

the rest of Philadelphia County. Conrad became the candidate of the combined Whig and American parties for mayor of the newly consolidated city. According to Scharf and Westcott, "there were only two nominees for the office of Mayor—Robert T. Conrad, Whig, and Richard Vaux, Democrat.... Conrad had the support of the Know-Nothings, and when the ballots came to be counted it was found that he had 29,507 votes, and Richard Vaux 21,011. Conrad was sworn into office on the first Monday of July (1854), and the city of Philadelphia with enlarged boundaries had fairly entered upon the experiment of a new government" (vol. 1, p. 715). During his tenure, Conrad skillfully handled the difficult problem associated with consolidation of the enlarged city. After the expiration of his term in 1856, he was presented with this urn, in recognition of his years as a faithful public servant.

DH □

J. E. CALDWELL & CO. (EST. 1848)

Founded in 1838 under the name of Bennett & Caldwell, the firm of J. E. Caldwell & Co. was organized in 1848 with James E. Caldwell, a watchmaker and jeweler from Poughkeepsie, New York, and John C. Farr. According to "Philadelphia and Popular Philadelphians" (*The North American*, 1891, p. 125), Farr retired in 1856, and Edwin Langton and Richard A. Lewis became Caldwell's partners. In 1867, J. Albert Caldwell, Joseph H. Brazier, and George W. Banks joined the firm, and in 1877 the firm took on Frederick Shaw and

Richard N. Caldwell, the youngest son of James Caldwell. When James Caldwell died in 1881, a co-partnership was formed which included two of his sons, Albert and Richard, who had already been active members of the firm. J. E. Caldwell succeeded Albert in 1874 and was president until his death in 1919.

J. E. Caldwell & Co. became the largest and the leading jewelry house in Philadelphia and a rival of Tiffany & Company in New York. In addition to making and retailing objects in silver, Caldwell's carried a large stock which included watches, art glass, bronze statues, brass goods, paintings, and furniture—much of which was imported. They exhibited at the 1876 Centennial.

Although no longer under family ownership, Caldwell's continues today, with much the same reputation and quality of merchandise it has always had, although none of the manufacturing is now done by the firm. Their main store at Chestnut and Juniper streets is in the same location as it has been for fifty years.

307. *Pitcher*

c. 1857
Mark: J. E. CALDWELL & CO./ PHILA./ STERLING (with eagle, shield, and pseudo-marks stamped on bottom of base)
Inscription: Presented to/ Captain P. L. Nobre/of the/BARQUE IRMA,/by the Underwriters on the/ vessel and cargo, as a token of their/ appreciation of his services, in bringing/ her safely into port through extraordinary/ perils./ Philad–December, 1857 (engraved in plain reserve panel on side under lip)
Silver
10 1/16 x 7 1/4″ (25.5 x 18.4 cm)
Philadelphia Museum of Art. Given by Mrs. Walter S. Detwiler. 65–136–1

PROVENANCE: Captain P. L. Nobre; great-great-granddaughter, Mrs. Walter S. Detwiler, Philadelphia

LITERATURE: *PMA Bulletin*, vol. 61, no. 290 (Summer 1966), p. 82, illus.; MMA, *19th-Century America, Furniture*, pl. 143; Hood, *Silver*, fig. 269

THE OCCASION FOR THE PRESENTATION of this pitcher was an heroic rescue at sea. On September 22, 1857, a violent gale drove Captain P. L. Nobre's ship, the barque *Irma,* ashore on the reef off Cat Island, San Salvador. By discharging half of the cargo, Nobre was able to get off the reef two days later and to recover her cargo afterward. Later in November, the ship arrived safely in

Philadelphia (*Shipping and Commercial List*, New York, November 14, 1857).

Although the records of Caldwell & Company have not survived, this pitcher was probably made by a craftsman working for the firm. The fourth floor of Caldwell's building at 902 Chestnut Street was "a complete shop for manufacturing jewelry, repairing, etc., silversmith work, etc., and where a large force of hands is employed" (*Illustrated Philadelphia*, New York, 1889, p. 7).

The water-lily motif was particularly appropriate for a presentation piece to a ship's captain. The maker followed designs current in England and the Continent in the 1850s, known perhaps through published sources, if not firsthand. The catalogue of the London 1851 Crystal Palace exhibition, for example, illustrated similar designs, and a parianware pitcher with lilies was exhibited in the New York Crystal Palace exhibition (Silliman & Goodrich, p. 78). The naturalistic treatment is especially successful in this pitcher, as shape and ornament become one, anticipating Art Nouveau schemes that would be popular forty years later.

DH □

ISAAC REHN (ACT. 1845–75)

Nothing is known of Rehn's early years. For the first part of his career in Philadelphia, 1845–48, he was a painter, although no evidence of his work or records of participation in local exhibitions has yet been discovered. When he became a daguerreotypist is not known, but in 1849 he concluded his painting career and turned to the profession of photography. Shortly thereafter he went to Boston and became the partner of the daguerreotypist James A. Cutting. There he and Cutting experimented with and modified the wet collodion negative process invented by Frederick Scott Archer of England in 1851. Marcus Root later termed the object produced by their modifications the "ambrotype"; in England it was referred to as a "collodion positive." In essence, Rehn and Cutting discovered that when a thin underexposed and/or underdeveloped collodion negative is backed with a black substance, such as velvet, dark paper, or a piece of glass painted black, it gives the effect of a positive. On July 4 and 11, 1854, Cutting obtained three United States patents to cover their modifications of the collodion process (see Taft, *Photography*, p. 474 n. 143), two of which covered changes in the composition of collodion, while the third covered the sealing of the cover glass to the developed negative plate. Newhall (*Daguerreotype*, p. 108) states that the patents were strictly enforced by Rehn (who had a one-fourth

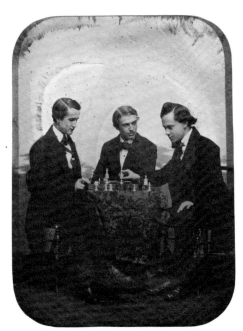

308.

ownership) and Cutting, making it impossible for anyone to produce ambrotypes without using some of the patented modifications. And until 1868, when the patents expired, users paid a royalty to the owners or risked court action.

In 1853, Rehn introduced the ambrotype to Philadelphia, and by November 1854 he exhibited his ambrotypes at the Franklin Institute exhibitions. From 1854 to 1856, Rehn traveled throughout the country with Cutting selling the rights to their patents and teaching the process involved. By 1858, with the decline in popularity of the ambrotype, Rehn became involved in photolithography, exhibiting under the title of I. Rehn & Co. at the 1858 Franklin Institute exhibition. During the 1860s and 1870s, Rehn delved into the production not only of ambrotypes, but paper prints ranging in size from the very small stereoscopic print to life-size enlargements made with his solar camera. The *Philadelphia Photographer* (vol. 5, no. 54, June 1868, pp. 190–91) published an article on Rehn's invention of sensitizing the surface of canvas upon which enlargements could be printed by means of the solar camera. Moreover, Rehn became involved in the unexplored field of microphotography. In 1860 he was awarded a contract to photograph drawings for the United States Government Patent Office.

The Philadelphia directories list Rehn as a photographer at various studio addresses from 1860 to 1869 and from 1874 to 1875. In 1872 he was listed as a lithographer and in 1873 as a photolithographer under the name of Rehn and Dickes. From 1861 to

1863, Rehn's photography business was listed as Rehn and Hurn, his partner being John W. Hurn. From 1864 to 1869, it seems that various members of Rehn's family—John, Edwin, and William—were in the photography business with him under the name of Rehn & Sons. After 1875 there is no further evidence of Rehn's photography pursuits, and it may be assumed that he retired from business at this time.

308. *J. Elliot, John D. Huhn, and Henry Cowperthwait Playing Chess*

1856
Stamp: Ambrotype/By Rehn/ 260 Chestnut St. (on brass mat, lower left); Patented July 4 & 11, 1854 (on brass mat, lower right)
Inscription: Taken December 25th, 1856/By/Mr. Rehn Chestnut St./below 10th Southside/Jno. [?] T. [?] Elliot, John D. Huhn, Henry Cowperthwait (in pencil, inside case, behind ambrotype)
Ambrotype
5½ x 4¼″ (14 x 10.7 cm)
The Franklin Institute, Philadelphia

PROVENANCE: J. Mitchell Elliot

ALTHOUGH THIS AMBROTYPE lacks the wide range of tones of the daguerreotype, one can hardly dismiss this technique as a "cheap imitation" of the latter. The ambrotype process was easier, less expensive, and had a shorter exposure period than the daguerreotype. Moreover, the image was not necessarily reversed, and there was none of the daguerreotype's glare to contend with; in fact the image is visible at almost any angle of light. Ambrotypes were in vogue for only a short period, 1855–57 (superseded by the tintype and the paper print), and are thus far less common than daguerreotypes.

The treatment of subject matter in this piece is somewhat exceptional. The depiction of three gentlemen engaged in a chess game on Christmas day is unusual, for most ambrotypes were straightforward portraits executed as family mementos rather than as picturesque objects for artistic display. Here, although the three men are clearly portrayed, the viewer becomes involved with the composition as a whole rather than with the individual portraits of the chess players. From the patent date of July 4 and 11 stamped on the mat one assumes that Rehn still owned a one-quarter share in the patents or had paid a royalty fee for their use.

The ambrotype, like the daguerreotype, was made in standard sizes and enclosed in a daguerreotype case with brass mat. Here

the thermoplastic or "union" case is employed. The material used to back the glass negative is black varnish. Unfortunately, the balsam which was used to seal the protective glass on the front, covering the glass negative plate, has corroded and come in contact with the collodion emulsion, causing stains on the image.

CW □

JOHN F. FRANCIS (1808–1886)
(See biography preceding no. 265)

309. *Still-Life with Wine Bottles and Basket of Fruit*

1857
Signature: J. F. Francis pt 1857 (lower right)
Oil on canvas
25 x 30″ (63.5 x 76.2 cm)
Museum of Fine Arts, Boston. M. and M. Karolik Collection

PROVENANCE: Reuben R. Springer, bequest to the Cincinnati Museum Association, 1884; with Coleman Auction Galleries, New York; with Victor Spark, New York, 1946; Maxim Karolik

LITERATURE: Wolfgang Born, *Still-life Painting in America* (New York, 1947), pp. 23–25; Karolik, *Painting*, p. 264, illus. p. 265; Alfred Frankenstein, "J. F. Francis," *Antiques*, vol. 59, no. 5 (May 1951), p. 376 (illus.); Frankenstein, *After the Hunt*, illus. no. 106; James Thomas Flexner, *That Wilder Image* (Boston and Toronto, 1962), pp. 291–92, illus. p. 291; MMA, *19th-Century America, Paintings*, no. 103 (illus.)

IN ADDITION to portraits, Francis sold still life paintings in Philadelphia as early as the 1840s, and after 1850 he turned increasingly to still life. Never a trompe l'oeil artist in the Peale tradition, Francis was concerned instead with the complex play of color and volume in objects of different textures, and his rich opaque pigment indicates an enjoyment of the paint surface itself. According to Gerdts and Burke, "Francis's work is among the most painterly of all that produced at mid-century" (*Still-Life*, p. 60).

As Alfred Frankenstein points out, Francis "exploits the smallest repertoire of any important American still life painter (*After the Hunt*, p. 137). His known still life paintings are studies of three more or less elaborate motifs: elegant desserts, composed of porcelain and glassware, fruits and cakes, often with a landscape in the background; simple fruit in an ordinary straw basket, sometimes spilling onto a table; and the more complex luncheon types, of which *Still-Life with Wine Bottles and Basket of Fruit* is one

309.

of the best examples. A similar composition, *Grapes in a Dish* (Newark Museum), replaces the basket with a compote of fruit, but otherwise shows the same elements disposed in a different arrangement. In both paintings, the objects are arranged to create a gentle play of repeated forms, and the particular shape of each element is studied rather than constructed from a geometric ideal. Francis's sensitive use of color is apparent in the subtle scheme of yellow, tan, and brown, punctuated by pastel blue, orange, and the dark colors of bottles and raisins, creating a variety of tones and complex shadings that emphasize the carefully examined play of forms.

SKM □

CHRISTIAN SCHUSSELE (1824?–1879)

Born in Alsace, Christian Schussele learned lithography and studied drawing with Guérin at the Academy in Strasbourg. He went to Paris about 1842 and studied with Paul Delaroche (1797–1856) and later in the atelier of Adolphe Yvon (1817–1893). The uprisings of 1848 caused Schussele to immigrate to Philadelphia, where the Alsatian lithographer Caspar Muringer (his future father-in-law) lived.

In making and designing numerous brilliant chromolithographs for P. S. Duval (see no. 267), Schussele's work brought plaudits from far and wide. *The Iris,* an annual by John S. Hart printed by Duval with "gorgeous illuminated pages, all from

original designs, and all printed in ten different colours . . . in the style now so deservedly popular," was lauded by no less a person than Queen Victoria, who ordered a dozen copies of a later edition which she saw at an exposition, saying that "it was the prettiest book she had seen from America, and reflected great credit on the city of Philadelphia" (quoted in Wainwright, *Early Lithography,* p. 62).

In 1851, Schussele exhibited a painting, *The Artist's Recreation,* at the Pennsylvania Academy, which drew favorable critical response and was sold on the first day of exhibition to the Art Union of Philadelphia. The same year he won a First Premium at the Franklin Institute for *Lager Beer Saloon,* which the judges deemed "excellent in design and execution." Schussele preferred painting to printmaking; and the success of his 1854 canvas *Clear the Track,* which was purchased by J. L. Claghorn, president of the Academy, and engraved by John Sartain, enabled him to make painting a full-time profession.

Schussele became active in Philadelphia art circles as a member of the Philadelphia Sketch Club, as president of the Artists' Fund Society, and as a yearly participant in the annual exhibitions at the Pennsylvania Academy. He also exhibited at the Boston Athenaeum in 1848, 1859, 1868, and 1870. He was elected a member of the Academy in 1860 and president of the Academicians in 1862. Schussele was a member of the Fine Arts Committee of the Great Central Fair held in Logan Square in June 1864 for the benefit of the United States Sanitary

Commission; he exhibited nine paintings, including *The Organ Grinder*.

Schussele was affected by a form of palsy in 1863 and his worsening condition caused him to seek a cure in France in 1865. After an unsuccessful operation in Paris, he returned to Philadelphia in 1868 to accept the position of superintendent of the Academy's school, newly reorganized by John Sartain. He also became professor of painting and drawing; although he painted with difficulty and completed few canvases, Schussele was able to retain his post at the Academy until his death in 1879 at the home of his son-in-law in Merchantville, New Jersey.

Today Schussele is remembered primarily as the teacher and subsequently the colleague of Thomas Eakins at the Pennsylvania Academy, representing the conservative approach to the teaching of art to which Eakins's new methods were opposed. Academically trained himself, and a believer in the traditional academic curriculum based on a thorough apprenticeship in drawing from the antique, Schussele exerted an important influence on Philadelphia artists through his emphasis on technical proficiency and careful composition. A scrapbook of his drawings (Pennsylvania Academy of the Fine Arts) gives evidence of Schussele's interest in life drawing and his careful preparation for his paintings through composition sketches and posed and costumed studies of individual figures.

John Sartain considered Schussele well qualified for the position of superintendent of the first proper art school at the Pennsylvania Academy, and Thomas Anshutz found him a competent and open-minded teacher. He inspired loyalty and affection from his students, including Eakins; and another student, Emily Sartain, eulogized Schussele in an obituary for the *Philadelphia Inquirer*: "Trained under a great French artist, possessing naturally a singularly true artistic taste combined with exceptionally acute powers of criticism and direction, and, above all, being of a most gentle, generous disposition, he was rarely well fitted for the discharge of the responsible duties to which he was called. Than Professor Schussele, never has a preceptor been more sincerely respected or held more warmly in affectionate regard" (Hendricks, *Eakins Life and Work,* p. 122).

AS

310. *The Organ Grinder*

1857
Signature: C. Schuesele/Philade/1857 (lower right)
Oil on canvas
29 x 36¼" (73.6 x 92 cm)
Schweitzer Gallery, New York

PROVENANCE: H. H. G. Sharpless, 1864; with McClees Gallery, 1940

LITERATURE: Los Angeles County Museum of Art, *American Narrative Painting* (October 1–November 17, 1974), p. 127, illus. p. 126

The Organ Grinder, exhibited at the Pennsylvania Academy in 1858, is typical of the early genre paintings that brought Schussele popularity, as compared to his later, large-scale commissions, such as *Franklin before the Lords in Council, Zeisberger Preaching to the Delawares of Goshgoshunk,* and *Men of Progress,* which reflect the official recognition of his talents.

The simple narrative scene is meticulously arranged, built up from detailed drawings of each element into a frieze of action that occurs in a delimited foreground space enclosed by the board fence and defined by the foreshortened plank, hoop, bucket, and cask. The carefully studied figures of children create a rhythmic play of opposing forms on each side of the organ grinder, allowing Schussele to display his skill in representing the human figure from every angle. Schussele's care with the composition of his painting is repeated in its color scheme: bright, appealing colors and sharp details in the foreground are set against a broadly painted landscape of pastel tan, blue, and green.

SKM □

NEWBOLD HOUGH TROTTER (1827–1898)

Trotter was born, educated, and spent most of his life in Philadelphia. According to a contemporary account he attended the Orthodox Friends' Infant School, then a school kept by Daniel Fuller, and later an academy run by Thomas D. James at Eleventh and Market streets (*A Biographical Album of Prominent Pennsylvanians,* Philadelphia, 1889, pp. 357–58). He entered the Friends' Haverford College in 1841, and upon graduation embarked on a business career.

For many years Trotter vacillated between the business world and the art world. For several years he worked for the wholesale dry goods firm of Wood, Abbott and Company in Philadelphia and then became a partner in Birkinbine, Martin, and Trotter, machinists, to build waterworks and gas-making plants. Trotter may have studied at the Pennsylvania Academy about 1854. He began exhibiting at the Academy in 1858 with *Mischief—Cat and Workbox* and *Terrier and Rat.* In 1861 he joined the Germantown Home Guards and subsequently fought at the Battle of Antietam. On his return to Philadelphia, he joined his brother-in-law in a hardware business which dissolved in 1867, at which time he turned to painting fulltime.

Always interested in natural history, Trotter became known as a painter of animals, although he also painted landscapes. A project to illustrate the mammals of North America for *Hayden's Journal* about 1884 was canceled for lack of funds, but not until Trotter had completed more than thirty paintings. He exhibited frequently at the Pennsylvania Academy between 1858 and 1887, at the National Academy shows between 1871 and 1886, and at the Boston Athenaeum between 1859 and 1867. He served as vice-president of the Artists' Fund Society and was a member of the Pennsylvania Academy, and the Art Club of Philadelphia. Trotter also exhibited regularly with the Philadelphia Society of Artists, of which he was a director and secretary. At least one of his paintings, *Wounded Buffaloes Pursued by Prairie Wolves,* was shown at the Centennial exposition in Philadelphia in 1876 and was purchased by General Sherman for the army headquarters in Washington (Scharf and Westcott, vol. 3, p. 2328). Trotter received commissions for three paintings from the War Department and for a painting of Sherman on horseback from the general himself. Trotter died in Atlantic City in 1898.

AS

311. *Mischief—Cat and Workbox*

1858
Signature: Newbold H. Trotter/1858 (lower right)
Oil on canvas
19½ x 24″ (49.5 x 60.9 cm)
Private Collection

PROVENANCE: Miss Trotter, 1858

IN THIS DELIGHTFUL PAINTING, *Mischief—Cat and Workbox,* Trotter captures the indignant surprise of his well-fed and pampered house cat startled in the act of mischief. The culprit and the workbox are painted in strong colors set against a neutral brown background. A red cloth provides a contrast for the still life composition of brightly colored needle packets, threads, a red strawberry sewing cushion, hooks, and other domestic tools, all closely observed and painted in careful detail. A blue ribbon around the cat's neck adds a particularly charming touch of color. The name "Trotter," partially legible on the yellow envelope with a New York postmark, is an amusing reference to the artist in the tradition of trompe l'oeil.

Mischief—Cat and Workbox is simple and unpretentious in contrast to the more ambitious and sentimental works for which Trotter was known later in his career, such as *They Know Not the Voice of Strangers,* a flock of sheep shrinking from sheep-stealers; *Signs of Invasion,* an elk discovering the debris of a lumber camp; and *They Only Know the Voice of Strangers,* polar bears near the remnants of a crushed ship. Trotter also tried his hand at landscapes and history painting, such as his series on the progress of travel in Pennsylvania, commissioned by the director of the Pennsylvania Railroad, Henry H. Houston (John Denison Champlin, Jr., *Cyclopedia of Painters and Paintings,* vol. 4, New York, 1887, p. 301).

SKM □

310.

311.

THOMAS MORAN (1837–1926)

Born in Bolton, Lancashire, England, Thomas Moran arrived in the United States in 1844, at the age of seven, in the train of his large, industrious and artistic family of hand-loom weavers. After first settling in Baltimore, the family moved to Philadelphia, apparently attracted by the excellence of the school system as well as favorable prospects in the local textile industry. An indefatigable draftsman even as a boy, Moran was apprenticed to a local firm of wood engravers in 1853 and became a proficient engraver, etcher, and lithographer before the decade was out.

Encouraged by the sale of his watercolors and inspired by the example of his older brother, Edward—already an established marine painter—he took up oil painting around 1855, moved into his brother's studio, and declared himself a professional artist, exhibiting his first works at the Pennsylvania Academy in 1856. He traveled to England with Edward in 1861, spending much of his time copying the works of Turner and Claude Lorrain; he subsequently revisited Europe several times during his career to study both art and scenery.

His reputation as a landscape painter was made, however, by his travels in America: first, joining Dr. F. V. Hayden's expedition to the Yellowstone region in 1871, then accompanying Major John Wesley Powell's surveying party in the area of the Grand Canyon in 1873, and later making his own numerous trips to the Far West and Mexico as late as 1910. The watercolors, wood engravings, etchings, and panoramic oils

produced as a result of these trips introduced the American public to their new national park lands and placed the artist—now known to his friends as Tom "Yellowstone" Moran—in the first ranks of the native landscape school.

After his first great success in 1872 with *The Grand Canyon of the Yellowstone*—which traveled widely and was purchased by Congress for an astonishing ten thousand dollars—Moran moved his family to Newark, New Jersey, and then to New York City, finally establishing a studio in East Hampton, Long Island, in the 1880s. In 1916 he moved to Santa Barbara, California, where he continued to paint almost until his death in 1926. By that time he was the oldest living member of the National Academy of Design, having been elected an Academician in 1884. He also belonged to numerous watercolor and etching societies and showed his work with success throughout the United States and Europe (see Fritiof Fryxell, *Thomas Moran, Explorer in Search of Beauty,* East Hampton, N.Y., 1958, pp. 3–40).

312. *Ruins on the Nile*

1858
Signature: T MORAN./1858 (bottom center, on stone)
Watercolor and gouache over pencil, on pale blue paper, laid down
21 x 16½″ (53.3 x 41.9 cm)
Philadelphia Museum of Art. W. P. Wilstach Collection. W93-1-148

PROVENANCE: W. P. Wilstach, 1893

LITERATURE: PMA, *Catalogue of the Wilstach Collection* (1910), no. 484 (1913), no. 501

THOMAS MORAN'S FAME stems from his huge oils and brilliant watercolors of America's western landscapes, works which were later categorized as no more than glorified topography—the last, inflated flowers of the Hudson River school. The actual distinctiveness of his work, the poetic quality of his imagination, and the longevity of the romantic tradition in America become apparent in *Ruins on the Nile,* an early and seemingly uncharacteristic, "un-American" watercolor, executed by Moran in 1858, more than a decade before he set foot in Yellowstone National Park.

In 1858 the twenty-one-year-old Moran exhibited at the Pennsylvania Academy for the third time. That spring he showed, among other things, a watercolor whose title ran to four lines of verse:

> There is a temple in ruin stands,
> Fashioned by long-forgotten hands,
> Two or three columns, and many a stone,
> Marble and granite, with weeds
> overgrown.

This description aptly fits *Ruins on the Nile,* whose scale and finish also seem to indicate an "exhibition piece," and it is possible that *Ruins on the Nile* and the verse-title refer to the same watercolor. In any case, both titles relate to a painting exhibited a year before (now lost), *Among the Ruins—there he lingered,* which Moran considered his first important oil. This title is from a passage in Shelley's *Alastor, or the Spirit of Solitude,* covering the poet-hero's pursuit of a visionary truth and beauty across a panorama of bygone civilization. Wandering through "the awful ruins of the days of old" he visits

> Athens, and Tyre, and Balbec, and the
> waste
> Where stood Jerusalem, the fallen towers
> Of Babylon, the eternal pyramids,
> Memphis and Thebes, and . . .
> . . . Among the ruined temples there,
> Stupendous columns, and wild images
> Of more than man, . . .
> He lingered, poring on memorials
> Of the world's youth, . . .

Like the lone watcher lingering beneath "stupendous columns" in Moran's watercolor, Shelley's poet "ever gazed and gazed," until meaning

> Flashed like strong inspiration, and he saw
> The thrilling secrets of the birth of time.

Moran, less than twenty when he first fell under the spell of *Alastor,* was only three

360

years younger than Shelley himself when he wrote the poem in 1815. The romantic, the literary, and the morbid involved Moran more at this time than at any other period of his life, and many of the qualities traditionally ascribed to youth in general and Shelley's poetry in particular applied to Moran—panoramic imagination, visionary idealism, and an almost rapturous pantheism (see Wilkins, *Moran*, p. 28; and Sheldon, *Painters*, p. 123).

Moran's identification with Shelley and his alienated artist-hero was natural, and it apparently continued until at least 1863 when he exhibited *On the Lone Chorasmian Shore*, based on a later passage from the same poem. In the light of this taste for Shelley, *Ruins on the Nile* may be seen as a reworking of the theme of the now lost oil of 1857. The unidentified verses that accompanied the watercolor in the 1858 catalogue were perhaps Moran's own; certainly the lines are not from *Alastor* for they lack the sophistication of Shelley's style. However, they do paraphrase the sentiments of the poem just as Moran's composition freely interprets the vagueness of Shelley's settings.

This generality in the landscape—it is not specifically Egyptian in feeling, but seems more like a hybrid Middle Eastern site, stocked with a variety of provincial Roman ruins—offers another reason to doubt its modern title. More important, this vagueness displays the visionary, anti-topographical sensibility that Moran was to maintain throughout his career. *Alastor* was a poem rarely, if ever, illustrated, largely owing to the nebulous, almost nonexistent quality of its narrative, yet it is this very ambiguity which seems to have inspired Moran to one of his most exotic flights of imagination. Like Shelley, he conjured up this scene without ever seeing Baalbek, Thebes, or Babylon; photographic description was irrelevant in "sets" that were largely atmospheric. Moran constructed his landscape with just enough conviction in its architectural and geographical details to render an evocative and otherwise fantastic composite just slightly credible. Mood and meaning dominate the landscape, not detail. "I place no value upon literal transcripts of nature," said Moran in 1879, while at the height of his success as a painter of western views. "My general scope is not realistic; all my tendencies are toward idealization" (Sheldon, *Painters*, p. 123).

This attitude toward nature and imagination, and his sympathies with the romantic period, help explain Moran's early attraction to the work of J. M. W. Turner. Despite Ruskin's celebration of Turner's truth-to-nature, Moran saw his other side, comparing Turner to "the greatest poets," those who, like Shelley, "deal not with literalism or

312.

naturalism. . . . He generalizes nature always," sacrificing "the literal truth of the parts to the higher truth of the whole." "And," concluded Moran, "he was right. Art is not nature" (Sheldon, *Painters*, p. 124).

In 1861, Moran was to spend several months in London studying and copying Turner, but *Ruins on the Nile* indicates that as early as 1858 he had an astounding command of Turner's "generalizing" style. Part of this familiarity may have been gained from prints, for Moran owned at least two sets of Turner's engravings by this time and is known to have copied several in watercolor (Wilkins, *Moran*, p. 28). He also may have seen Turner's work firsthand in America, but even this was hardly necessary, as Philadelphia was at that time the home of the "American Turner," James Hamilton (see biography preceding no. 296). Though not yet forty, Hamilton was a well-known and respected artist whose style and imagination showed the impact of Turner's middle and late works. He advised and encouraged the young Moran, sometimes buying his watercolors, and Moran was later to admit that he owed more to Hamilton than to any

other artist (Wilkins, *Moran*, p. 24). Interestingly enough, it seems that the respect was mutual, for Hamilton followed Moran's *Alastor* sequence with one of his own dealing with Egypt, ruins, or both, in the years between 1861 and 1864 (Rutledge, *Cumulative Record*).

These early influences formed Moran's style to such an extent that one of his original watercolor compositions from 1858 was sold many years later in London as an authentic "Turner" and with justifiable confusion (Wilkins, *Moran*, pp. 38–39). *Ruins on the Nile* shows the brilliant color and confident drawing of Turner's work, as well as his virtuoso orchestration of techniques: opaque pigments and flat washes on tinted paper combined with transparent glazes, dry-brush scumbling, and hairline detail. More surprising, Moran understood Turner's imaginative manipulation of light, which he used here in a suitably irrational and suggestive fashion. In addition, he duplicated the effect of monumentality and spaciousness so often contained even in Turner's smallest works. Nevertheless, Moran's attempt to overreach the master produced just the slightest hint of caricature; the result, though

astonishingly accomplished, is still clumsier, more obvious, and more melodramatic than the model. Moran later refined this early style to a level of greater subtlety, individuality, and almost dangerous facility, but he never developed the abstraction of Turner's last works, indicating a fundamental conservatism, or perhaps an "American" literalness, that kept his imagination anchored to observed reality.

In fact, one does not have to go back as far as Shelley's generation and Turner's *Decline of Carthage* to find an American tradition behind Moran's work. The subject, the treatment, and the sensibility shown in this watercolor are descended directly from the work of America's greatest romantic landscape painter, Thomas Cole, who shared Moran's enthusiasm for ruins, Turner, and the romantic poets. Cole's *Desolation* of 1836 (the fifth and last canvas in his *Course of Empire* cycle), with its lone, vine-covered column, suggests the extent of Moran's sympathies with Cole as well as the extent of his compositional debt. It is no surprise to find that the entire *Course of Empire* cycle was exhibited at the Pennsylvania Academy in 1852; and it seems likely that the young Moran, who, according to his biographers, literally committed the work of local artists to memory, was familiar with these paintings.

As the inheritor of Cole's panoramic vision of nature and history, Moran was basically out of step with the more naturalistic, Ruskinian phase of the Hudson River school in the 1850s. At odds with the scientific, optimistic spirit of the midcentury, Moran independently continued the pessimistic side of the preceding generation, choosing to develop Cole's most melancholy aspects and Shelley's most despairing moments. As William Gerdts has pointed out, Moran's personal romanticism was one of nostalgia (*Thomas Moran,* Riverside, Calif., 1963, p. 16), an outlook that naturally dwelt on scenes of loss, destruction, and the passage of time. If this aesthetic was already retardataire in 1858, the sheer fact that Moran perpetuated it across a distinguished and successful seventy-year career seems to imply more than blind tenacity. His work must have harmonized with a late romantic mood in America, a strange mixture of dreaminess and cynicism that was not so far removed, in fact, from the spirit of *Alastor,* and was symptomatic of the contradictory ideals of the post-Civil War period. Seeing the philosophy and the skill behind his earliest watercolors, one understands the success Moran would find exploiting this nostalgia in landscape subjects more sublime, more theatrical, and more unbelievable even than those of the imagination: the vanishing Eden of the American West.

KF □

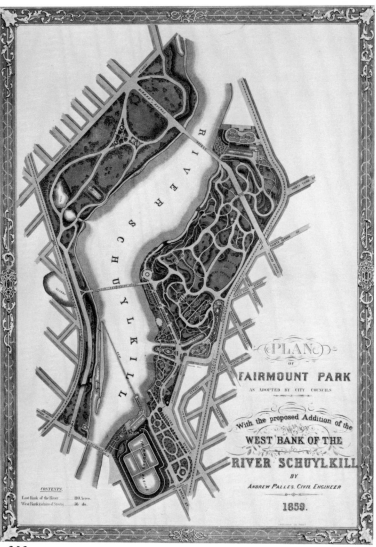

313.

313. *Fairmount Park, Philadelphia*

First design 1858

REPRESENTED BY:

Louis Napoleon Rosenthal (act. 1850–75) after Andrew Palles (n.d.)
Plan of Fairmount Park
1859
Lithograph
28¹³/₁₆ x 20⁵/₁₆″ (73.2 x 51.6 cm)

Library of Congress, Washington, D.C.

LITERATURE: Tatum, pp. 88, 103, 185, pl. 88; George B. Tatum, "The Origins of Fairmount Park," *Antiques,* vol. 82, no. 5 (November 1962), pp. 502–7; George F. Chadwick, *The Park and the Town* (New York, 1966), pp. 190–91, 203; John Maass, *The Glorious Enterprise* (Watkins Glen, N.Y., 1973), pp. 16–24, 34; Esther M. Klein, *Fairmount Park: A History and a Guidebook* (Bryn Mawr, Pa., 1974);

FPAA, *Sculpture,* throughout; Theo B. White, *Fairmount Park,* photographs by George Thomas (Philadelphia, 1975)

THE FAIRMOUNT WATERWORKS and Laurel Hill Cemetery, two seminal nineteenth century ventures into the field of landscape architecture, formed the nucleus for the Fairmount Park system, generally considered the largest municipal park in the world. Fairmount Waterworks (no. 183) was a public utility designed to supply Philadelphia with fresh water. When it began operation on the east bank of the Schuylkill in 1815 its five acres of grounds were landscaped as a formal public garden, which was expanded in size with the Works during the 1820s. Laurel Hill Cemetery (no. 259), on the other hand, was a private endeavor that was begun twenty years later and never became an official part of the Park. Nevertheless, its extensive size and acclaimed beauty drew crowds to its undulating, care-

fully planted grounds, introducing Philadelphians to a fine example of the English style of landscape gardening. With the popularity of landscaped nature thus proven, city councils in 1855 followed the example of New York's 1851 Park Act and reserved as a public common adjacent to the Waterworks the forty-five-acre Lemon Hill estate (no. 151), which had been acquired eleven years earlier in an effort to protect the purity of the city's water supply. In the late 1850s two other properties were added to what was now known as Fairmount Park, but the greatest expansion came after the Civil War, when over 220 acres were acquired on the west side of the river at about the same time that the unspoiled Wissahickon Valley (see no. 208) was annexed in northwest Philadelphia. Fairmount Park was officially formed in 1867 by the Pennsylvania General Assembly, and the Fairmount Park Commission was charged with its care and administration.

In 1858, well before the Commonwealth's formation of the park, the city held a design competition for the park and apparently adopted the plan of Andrew Palles, a civil engineer. Palles's proposal concentrated primarily on the east side of the river between the Waterworks and Girard Avenue, creating a labyrinth of roads and paths that contrasted with the formal plan of the Waterworks. Although the plan was not executed, presumably because of the Civil War, it indicates both the popularity of the English style of landscape architecture and the eventual direction of the park's development. By the 1850s the Hudson River school of painting, the turgid essays of the nurseryman and writer Andrew Jackson Downing, and the Gothic revival style of architects like James Renwick and A. J. Davis had interpreted "picturesque" ideas from abroad and encouraged Americans to follow the "natural," that is, the irregular and unpredictable, in landscape gardening (Tatum, p. 88). It was not until after the Civil War that the park took on a deliberate design. In 1867 the Fairmount Park Commission solicited suggestions from Robert Morris Copeland of Boston and Frederick Law Olmsted and Calvert Vaux of New York, the country's leading landscape architects. Five years later the Commission rejected Olmsted's proposal in favor of a modest plan for the east park submitted by Hermann J. Schwarzmann (see biography preceding no. 339), then an assistant engineer of Fairmount Park. As chief engineer and architect of the Centennial exhibition, a post he received in late 1873, Schwarzmann also laid out many of the roadways of the west park.

Conscious of the park's prominence in the city's life and leisure, twentieth century planners have generally related well to its presence. Erection of the monumental Phila-

delphia Museum of Art (see no. 411) during the 1920s on the site of the park's origins offered a classical gateway that was complimentary to the former Waterworks and on a scale appropriate for the park's expanse. The Museum was connected with City Hall (no. 334) in 1937 when the grandiose Benjamin Franklin Parkway (no. 411) was completed, extending the park into the center of the city. Highway planners, however, introduced a major incursion into this peaceful environment when, in 1953, over the protests of conservationists, digging was begun for the Schuylkill Expressway, which cuts a wide swath along the river's west bank.

As the park was created for the people's enjoyment, recreation has been its main focus. The opening of the Philadelphia Zoological Gardens in 1874 and the great Centennial celebration in 1876 (no. 339) offered exotic attractions a century ago, much as the Robin Hood Dell concerts and theater-in-the-round provide entertainment today. The natural scenery, however, which initially drew visitors to the area, has remained Fairmount Park's strongest attraction. Art and engineering have enhanced this natural beauty. An impressive array of sculpture (see nos. 443, 447) by some of the finest sculptors of the past century has been commissioned and funded by the Fairmount Park Art Association, a citizen group organized in 1872, and a series of bridges by engineers and architects sensitive to the natural surroundings have been erected; one of the best is the Henry Avenue Bridge over Wissahickon Creek (no. 410). The Schuylkill's calm surface and great width have made it a favorite site for rowing regattas since before the Civil War. After the war, barge clubs built the picturesque Boat House Row along East River Drive and rowers in their sleek sculls became subjects for some of Thomas Eakins's finest paintings (see no. 337). While some of the many eighteenth and early nineteenth century country houses scattered about the park have been put to use as youth hostels, canoe clubs, or residences, others, such as Mount Pleasant, Lemon Hill, Solitude, and Cedar Grove, have been restored as historic houses and are open for visits by the public. Yet, in addition to hiking and horseback riding, the most popular activities remain family picnics in the summer and ice skating along the frozen stretches of the Wissahickon in the winter.

RW □

FREDERICK DEBOURG RICHARDS (1822–1903)

Born in Wilmington, Delaware, Richards made his home in Philadelphia by 1848. From existing accounts, one might consider

him primarily a landscape painter rather than a photographer, and he probably established a photography business primarily to supplement his income as an artist. *The New-York Historical Society's Dictionary of Artists in America* lists him as having worked as an artist in New York from 1844 to 1845, in Philadelphia from 1848 to 1866, and in Paris in 1868. However, McElroy's Philadelphia directory lists him in 1848 as a "photographist." He established a daguerreotype gallery at 144½ Chestnut Street about 1848–55, where he became well known for producing "life-size" daguerreotypes—14½ by 16½ inches.

Existing records of Richards's photographic activity and works are scanty save for a number of items (presently unavailable for study) formerly in the American Museum of Photography, now owned by the 3M Company, St. Paul, Minnesota. The American Museum was the first in the United States devoted exclusively to photography, and was originally founded in Philadelphia by Louis Walton Sipley in 1940. According to Newhall (*Daguerreotype,* p. 81), an advertisement announcing the availability of daguerreotype copies by Richards of *Jenny Lind* appeared in the *Daguerrian Journal* on August 1851. Richards displayed daguerreotypes in the Fine Arts Division of the annual Franklin Institute exhibitions, which were given consistently high commendation in 1851, 1852, and 1854; and in 1858, although the wording in the catalogue is somewhat indefinite, he displayed paper prints, some of which were copies of engravings and paintings. *The Journal of the Franklin Institute* (vol. 5, February 1853, pp. 285–87) gives an account of Richards's improvement on the stereoscope.

On February 22, 1861, Richards took three photographs of President-elect Lincoln raising the flag in front of Independence Hall; and a wood engraving of this scene made from Richards's photographs appeared on the cover of *Harper's Weekly,* for March 9, 1861.

Richards was a regular participant in the Pennsylvania Academy exhibitions from 1848 to 1891, displaying oils and occasionally watercolors and etchings of Pennsylvania landscapes. He also exhibited his paintings, watercolors, and etchings at the American Institute, the American Art Union, and the National Academy. His various studio addresses in Philadelphia are listed in the city directories from 1866 to 1898. It would seem that, after 1865, Richards for the most part withdrew from the photographic field in order to devote full attention to his primary profession as a painter and etcher of landscapes.

314a.

center city and Germantown, photographed by Richards mostly in 1859, although a few were taken in 1857 and 1858. They were preserved by the local antiquarian Charles A. Poulson, who perhaps commissioned Richards to record these buildings for posterity.

The angle at which Richards has chosen to record Carpenters' Hall (no. 85) is strikingly impressive. The two buildings flanking the cobbled pathway draw one's attention immediately along the receding diagonal to Carpenters' Hall where the sunlight illuminates the facade. The sharpness of detail throughout is noteworthy. The building on the northwest corner of Carpenter and Sixth streets, though in dilapidated condition, documents what was once the Washington Tavern in 1790, the New Theater Hotel in 1822, becoming the Falstaff Inn around 1834. It was demolished shortly after this photograph was taken.

CW □

GEORGE J. HENKELS (1819–1883)
(See biography preceding no. 277)

315. *Armchair*

c. 1860
Black walnut; leather upholstery
33½ x 29½ x 25″ (85 x 75 x 63.5 cm)
Jim Thorpe Lions Club, Borough of
Jim Thorpe, Pennsylvania

PROVENANCE: Asa Packer, Jim Thorpe, Pennsylvania

LITERATURE: Kenneth Ames, "George Henkels, Nineteenth-Century Philadelphia Cabinetmaker," *Antiques,* vol. 104, no. 4 (October 1973), pp. 641–50

THE BASIS OF THE ATTRIBUTION of this dolphin-backed armchair and much of the furniture at the Asa Packer house to George Henkels is Samuel Sloan's *Homestead Architecture* (Philadelphia, 1861). Sloan, one of Philadelphia's most notable and influential mid-nineteenth century architects, published twelve plates of furniture available at Henkels's showrooms. Many examples of the elaborate furniture depicted in the engravings survive in the Packer house, including the armchair from the library which is seen at the far left in Sloan (fig. 198), along with four other pieces of library furniture which were described as "what is called *Renaissance* in France and *Antique* in this country." Although *Homestead Architecture* notes that this chair was a recent "importation from one of the best establishments in Paris," a wood analysis has shown that the chair is probably of American manufacture. However it copies

314a. *Northwest Corner of Carpenter and Sixth Streets*

1857
Inscription: Photograph, June 1857, By Richards North West Corner of Carpenter/and Sixth Street North of/Chestnut Street/Gray's brewery building is partially seen on the right/of the picture:—where the "sign" is now, was, in my remembrance/a picture, full length, of Sir John Falstaff, as represented in the Chest/nut Street Theatre by William Warren, the Manager (in Poulson's hand, in ink, on mat)
Salt print
7⅞ x 5⅝″ (19.1 x 14.1 cm)
The Library Company of Philadelphia

PROVENANCE: Charles A. Poulson (1790–1866)
LITERATURE: LCP, Charles A. Poulson, Scrapbook, vol. 3, p. 41

314b. *Carpenters' Court and Hall*

1859
Inscription: May 1859 (in pencil on print, lower right)
Label: Photograph;/May, 1859,/By Richards,/Carpenters' Court and Hall (in perspective)/Chestnut St. bet. Third & Fourth St. (in Poulson's hand, in ink, on mat)
Salt print
8¾ x 6″ (21.3 x 15.2 cm)
The Library Company of Philadelphia

PROVENANCE: Charles A. Poulson (1790–1866)
LITERATURE: LCP, Charles A. Poulson, Scrapbook, vol. 3, p. 89

THESE SALT PAPER PRINTS, probably made from collodion glass negatives, are among many views of private residences and public institutions of historical significance in

364

314b.

Heiss also did lithographs of several Philadelphia manufacturing establishments. Although carefully executed, these were not colored and were undoubtedly made for commercial rather than decorative purposes.

Although Heiss's name appeared infrequently in the city directories before 1870, there were frequent listings for his brother Goddard, a coppersmith, with whom he lived and worked for many years. In the 1859 and 1861 directories, Heiss was listed as a portrait painter, but his name never appeared in the business directory section as portrait painter or lithographer. From 1870, he was listed only as a distributor of artists' materials and apparently was not actively employed as either painter or lithographer. He continued to sell supplies to local artists until his death in 1885.

316. *Hope Hose and Steam Fire Engine Company No. 2 Engine*

1860

Printed by Thomas S. Wagner

Inscription: Lithographed and Coloured by Geo. Heiss, 313 N. 2nd St. above Vine St. (lower left, under engine); Reaney, Neafie & Co Builders (lower right, under engine); HOPE HOSE & STEAM (left of inset illustration); FIRE ENGINE Co No 2 (right of inset illustration); Printed by T. S. Wagner, 38 Hudson St Phila (bottom center, beneath inset illustration)

315.

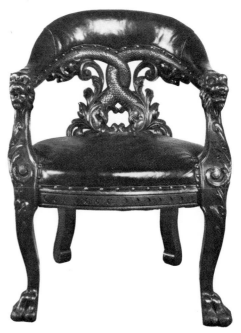

a French source exactly. According to Ames, the same chair appears in *Meubles executés dans leur fabrique* by Ribaillier, Sr., and Mazaroz (Paris, 1857, pl. 25). Its style demonstrates the transition from rococo to Renaissance revival. Characteristic of the latter is the vigorously carved intertwining dolphins and the grotesque lion terminals of the arms.

Asa Packer, a coal mining magnate, was one of the wealthiest men in Pennsylvania. He was elected to Congress for two terms, and in 1869 was the Democratic candidate for governor. He founded Lehigh University in 1865. In 1876 he served as a commissioner for the Centennial exhibition in Philadelphia. His house, the finest Victorian mansion in the town of Jim Thorpe, Pennsylvania, stands prominently on the hills overlooking the valleys he mined. To furnish his home, Packer naturally turned to a Philadelphia craftsman, in this instance George Henkels.

DH □

GEORGE G. HEISS (C. 1823–1885)

Heiss was born in Philadelphia. Although nothing is known of his artistic training, he was actively engaged as a painter during the early 1840s (Rutledge, *Cumulative Record*, p. 96). His work, primarily portraits, some of which were copies, was shown at the Artists' Fund Society annual exhibitions from 1840 to 1843.

Heiss's name first appeared in the Philadelphia city directories in 1854, when he was listed as a lithographer. About this time, he became well known for his minutely detailed prints of volunteer firemen's apparatus. Although most of these were published in the mid-1850s, a small lithograph of the Diligent Fire Engine Company included the notation: "Lithographed 1857 by Geo. G. Heiss . . . Drawing taken in 1844." Heiss continued to draw lithographs of firemen's apparatus into the early 1860s and made prints of at least three of Philadelphia's earliest steam fire engines. During the 1850s,

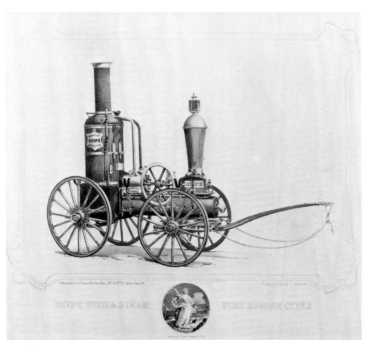

316.

Hand-colored lithograph
21⅛ x 24⅛″ (matted and framed)
(53.7 x 61.3 cm)

INA Museum, INA Corporation,
Philadelphia

LITERATURE: M. J. McCosker, *The Historical Collection of the Insurance Company of North America* (Philadelphia, 1945), pp. 118, 143; PMA, [INA] *Historical Collection: Fire and Water* (December 31, 1951—January 20, 1952), no. 38

GEORGE HEISS'S LITHOGRAPH of the first engine owned by Hope Hose and Steam Fire Engine Company No. 2 of Philadelphia is a simple representation of the apparatus without a background scene. Beneath the engine is a small inset illustration of the mythological figure Hope, the company's symbol. (The company was originally called the Hope Hose Company, but used the qualifier "No. 2" to avoid confusion with the Hope Fire Engine Company, established earlier.)

The Hope Hose Company, established in 1805, was one of a growing number of hose companies joining Philadelphia's volunteer fire fighting force. Volunteer companies had been in existence since 1736 when Benjamin Franklin founded the Union Fire Company; but without a centralized water supply, there was no use for hose. With the completion of Latrobe's Centre Square Pump House (no. 153) in 1801 and its complementary network of hydrants, water became readily available throughout the city for the first time; thus the use of hose to supply water to

hand pumpers replaced the bucket brigade.

Hope Hose owned several hose carriages during its early years, usually retaining the old apparatus when a new carriage was purchased. By the late 1850s, the company decided to expand its operations and purchased its first engine. The engine was designed by Joseph L. Parry and built by Reaney, Neafie & Co., in Kensington, manufacturers of locomotive and stationary engines from the mid-1840s. The firm had quickly recognized the need for an efficient steam fire engine, for early models were expensive, inefficient, and incredibly heavy. Parry's designs minimized these problems; they called for a single engine, which worked from a single pump and horizontal steam cylinder with a vertical fire tube boiler. The engine purchased by Hope Hose was called third-class; it was lightweight enough to be hand-drawn and could only throw water through a single hose line. A first-class steamer built by Reaney, Neafie & Co. for the Philadelphia Hose Company was horse-drawn and capable of discharging two streams of water simultaneously. But in a contest between these two engines and an earlier Cincinnati-built piece, the Hope Hose engine, though smallest of the three, is said to have thrown water 212 feet (Watson, *Annals*, vol. 3, p. 430).

The introduction of the steam fire engine eventually brought about the dissolution of the volunteer system because a steamer required little manpower, and the large volunteer companies had more and more idle members. So much antagonism devel-

oped between companies that it hampered fire fighting efforts, and in 1871 the city abolished the volunteer system and formed a paid department.

Heiss's print shows a side view of the engine, with precise delineation of the engraved plates and the painting on the cylinder body. On the traditional maker's plate on the engine, Heiss misspelled the firm's name "Neaey" (instead of "Neafie"). A plate below the air chamber simply shows "HOPE." A third plate on the upper portion of the boiler reads, "2 ADOPTED JAN. 7, 1858 HOPE COMPLETED JUNE 24, 1858," indicating the dates the engine was ordered and completed. Plates with the names of maker and company were common on volunteer apparatus, but a plate detailing an individual engine's history was unusual.

The mythological figure of Hope, which appears on the side of the steam cylinder, in a panel of glass in the engine lamp, and in the inset illustration, is depicted in her traditional pose: standing on a rocky shore, she clasps an anchor, the symbol of hope, and watches over a floundering vessel.

This lithograph was printed by Thomas S. Wagner, a well-known Philadelphia lithographer, who began working as an artist for Duval in the late 1830s and set up his own firm in 1844. For the next fifteen years, he was in partnership with James McGuigan, and their firm grew to be one of the largest in the city, with more than forty presses by the mid-1850s and steam equipment shortly thereafter (Peter C. Marzio, "American Lithographic Technology before the Civil War," *Prints in and of America to 1850,* Charlottesville, 1970, pp. 237, 243–44). A severe fire and other financial problems brought an end to the partnership in 1859. Wagner continued printing lithographs independently, including this one, until his death in 1863.

LAL □

THOMAS W. MASON (C. 1820–1899)

Thomas W. Mason spent most of his life in Philadelphia, and was listed in the city directories from 1850 until 1898. Although a machinist by trade, he concentrated on specialized pieces, and was listed variously as a modelmaker, patternmaker, and instrument maker. He may have been a distant relative of Richard and Philip Mason, Philadelphia fire engine manufacturers in the late eighteenth and early nineteenth century.

Mason did not list his profession as modelmaker until 1860, but his work in this specialty had been known in Philadelphia for many years prior to this date. As early as 1842 a model he executed of the hose

carriage of the Philadelphia Hose Company received mention in the newspaper: "We never before saw a more accurate imitation of a vehicle of the kind—frontispiece, side badges, plating &c., are executed in a masterly style, although the whole concern is not more than eight inches in height" (*Public Ledger,* May 14, 1842).

Mason made a great many models of engines over the years, and as his technical skills became well known, fire companies undoubtedly commissioned him to do models of their apparatus. He came to be recognized as an outstanding artisan of fire engine models, and was one of the few professional modelmakers in the city.

Mason's work load was probably heaviest during the late fifties and early sixties, at the height of volunteer enthusiasm and during the time when hand pumpers were being replaced by steam engines, although he may also have executed a number of models during the seventies immediately after the dissolution of the volunteer system. In later years, Mason listed himself as a pattern-maker and machinist once again, as well as a modelmaker, reflecting the decline in demand for models of fire engines.

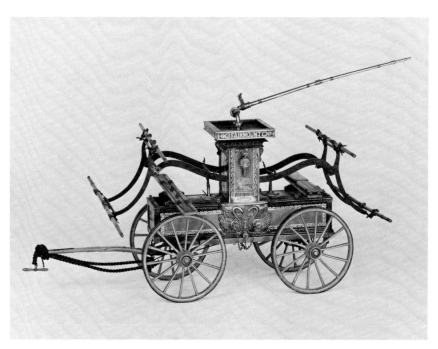

317.

317. *Fairmount Fire Company Engine Model*

c. 1842–70

Signature: T. Mason, Philadelphia (engraved on brass plates at bottom of two painted side panels on condenser case)

Inscription: FAIRMOUNT (on four sides of decorative brass cornice at top of condenser case); INSTITUTED FEB: 22 1823 (painted on rear of engine body)

Painted and natural wood, brass

12 x 24 x 7½″ (30.5 x 61 x 19.1 cm)

INA Museum, INA Corporation, Philadelphia

LITERATURE: PMA, [INA] *Historical Collection: Fire and Water* (December 31, 1951—January 20, 1952), no. 84; M. J. McCosker, *The Historical Collection of the Insurance Company of North America* (Philadelphia, 1945), pp. 64, 66; M. J. McCosker, *The Historical Collection of the Insurance Company of North America* (Philadelphia, 1967), pp. 80, 84

THIS MODEL REPRESENTS a specific fire engine, and accurately portrays the details of the original apparatus. Models were given as gifts to generous patrons by the company; they were made for special occasions, perhaps to commemorate the retirement of a piece of apparatus; or they were retained by the company as a proud possession. Later, they were also executed for salesmen for promotional purposes.

This model represents the hand pumper purchased by the Fairmount Fire Company in 1842, the company's last piece of hand-operated equipment. The engine was built by John Agnew, "dean" of Philadelphia engine manufacturers, and shows the advanced development of the Philadelphia-style engine, although this piece was classified as second class and was not so powerful as some of Agnew's other engines.

The pumping brakes and platforms fold out from their compact transport position to reveal a double-deck, end-stroke engine, a style perfected by Philadelphians, particularly Agnew, and so efficient that it was widely adopted elsewhere. A hose was connected from the hydrant to the suction opening, the lower connection on each side of the engine, and hoses were attached at the four discharge positions, two on each side above the suction, to direct pressurized water on the fire. The play pipe on the top of the condenser case was used most often in contests, to determine which company could pump water highest or farthest. This engine was hand-drawn, as was all apparatus before the introduction of steam equipment, and was operated by about sixteen men. Four stood on the ground and four on the platforms, and they could pump at a top speed of about a hundred strokes per minute for three minutes, at which point they would have to be replaced. Several different crews would rotate in and out at the various positions in this manner.

This model depicts the intricate decoration on the Agnew engine, but the company remained low key about the apparatus at the

time of its acquisition (and the minutes of the Fairmount Fire Company, which might have provided a detailed description, are no longer extant). Philadelphia newspaper readers only knew that: "Yesterday, the members of the Fairmount Fire Company . . . took home a new engine from the manufactory of Mr. Agnew. The engine is a splendid affair" (*Public Ledger,* June 21, 1842). According to tradition Francis Harris was the painter and Samuel Hemphill, the carver, but there is no documentation for this.

Mason's model clearly shows the decoration on the engine and the painted side panels which represent the figures of the *Schuylkill Chained* and the *Schuylkill Freed* (no. 219) executed by William Rush for the Fairmount Waterworks. The front panel depicts a woman in Grecian drapery wearing a Trojan hat and holding a red, white, and blue shield decorated with an eagle; she personifies Liberty or perhaps the United States. The rear panel depicts a draped woman holding the shield of the City of Philadelphia with a banner reading PROMPT TO ACTION, the motto of the Fairmount Fire Company, prominently displayed above the shield; this figure personifies the Fairmount Fire Company. The front area of the piano-box body illustrates another mythological figure, perhaps that of Leda, being drawn down the Schuylkill River past the Fairmount Waterworks by two swans. The company extended their use of local landmarks even further, and used Rush's figure of the *Nymph and Bittern* as decoration on their stovepipe hats.

The body of the engine and the wheels are painted bright red, with gold and black trim, the colors of the original engine as seen in a painting by an unknown artist, which showed the engine in front of the fire house, located in the Spring Garden section of Philadelphia (Mercer Museum, Doylestown, Pennsylvania). The pumping arms are natural wood finish, and the engine is highlighted by brasswork at the top of the condenser case, depicting the company's name, and along the sides and bottom on the panels on the case, as well as by a delicate brass play pipe. The suction and discharge connections are surrounded by a carved side panel showing two swans drinking from a cup. Engine lamps adorn the upper portions of the side panels.

It is difficult to date the model precisely. Although the hand pumper was replaced by a steam engine in 1860 the older piece was kept in reserve throughout the Civil War, lengthening considerably the years during which it remained in Spring Garden. The model could have been made between 1842, when the engine was acquired, and about 1870, around the time it was sold to the Baltimore Veteran Firemen's group.

Mason made another model of this engine, now in a private collection in Maryland, which although modified somewhat during the twentieth century, has the same plates reading "T. Mason, Philadelphia," and definitely represents the Fairmount engine. It would be impossible, however, to determine which model was made first.

The skill and accuracy displayed in Thomas Mason's execution of this model of the Fairmount Fire Company engine is one more indication of the importance of the volunteer fire fighting system in Philadelphia history and of the volunteers' interest in art as well as technology. This model is so intricately decorated that one can easily visualize the original piece in all its magnificence.

LAL □

ROBERT WOOD (ACT. 1839–C. 1885)

Robert Wood was born on July 4, 1813, in the Spring Garden district of Philadelphia. While still quite young, he left school and was apprenticed to a blacksmith in Southwark. After his apprenticeship was completed, he worked for his employer as a journeyman (Robson, *Manufacturers*, p. 82). He was first listed in the Philadelphia directories in 1839 as a blacksmith at 191 South Fourth Street. According to a contemporary source, "Mr. Wood was a poor boy, and began life as an ordinary blacksmith, in a little one-story shop in Ridge Avenue, in Philadelphia, which shop occupied a portion of the site of the extensive ornamental iron and bronze works now owned by Robert Wood & Co" (Horace Greeley and others, *The Great Industries of the U.S.*, Hartford, 1872, p. 387).

A description of the interior of Robert Wood's factory provides a fascinating insight into Wood's business and the ornamental iron business in 1875:

Near the entrance to the building, on the ground floor, a vast collection of dogs of all descriptions is to be seen . . . all cast in iron Further on, we reach a splendid iron staircase, of Moorish design, which leads to the show rooms on the second floor. These consist of a spacious hall, filled with beautiful objects of every description that can be made of iron. Fountains, twenty feet high, and approached by terraces, throw their jets into the air, whilst zinc water-fowl float in their capacious basins, amidst aquatic plants of the same metal, delicately painted to imitate nature. Arbors and rustic furniture . . . deer . . . colonnades of lamp posts. . . . Household articles, of every class, and stable fittings, handsomely ornamented, are there, the whole forming a collection of genuine works of art. In an upper room, properly lighted, sits the draughtsman, whose designs, after approval, are transferred to the pattern room, where they are copied in wood, and thence passed to the moulding room to be reproduced in iron. The lathes, drills, stamping machines, hammers, etc., are driven by a beautifully finished engine of thirty horse power For forging purposes, a large blacksmith shop is attached, and even the packing cases are made on the premises. All the patterns ever made in the place are preserved in a fire-proof building, erected for that purpose, and their money value amounts to hundreds of thousands of dollars. Lithographs are also made of every article manufactured on the premises. (Robson, *Manufacturers*, p. 81).

From 1850 to 1860, Wood listed his firm as an iron rail foundry. The Philadelphia directories list Wood in partnership with Elliston Perot from 1858 to 1865. They advertised in the business register of Cohen's Philadelphia directory for 1860: "ORNAMENTAL IRON WORKS. WOOD & PEROT, 1136 RIDGE AVENUE, —PHILADELPHIA. WOOD, MILTENBERGER & CO. 57 CAMP STREET,— NEW ORLEANS, IRON RAILINGS, FOR PUBLIC CEMETERIES, SQUARES, CHURCHES, &C. VERANDAHS, BALCONIES, BANK COUNTERS, STAIRS, STATUARY, CHAIRS, TABLES, VASES, LAMP POSTS, ANIMALS, And all description of Ornamental Iron Work." In 1860, Wood and Perot were listed in McElroy's directory as manufacturing "ornamental iron works, railings, verandahs, fountains, iron statuary, etc.," perhaps an indication of the expansion of their business into iron garden furniture. In 1867, Thomas S. Root was first listed in the directories as Wood's business partner. And in 1881 Wood was listed as an iron and bronze founder.

The firm was known for its casting of bronze statuary, "with larger facilities for accomplishing such work than are possessed by any other house in the United States . . . while there is but one other house in the United States which attempts it" (Greeley,

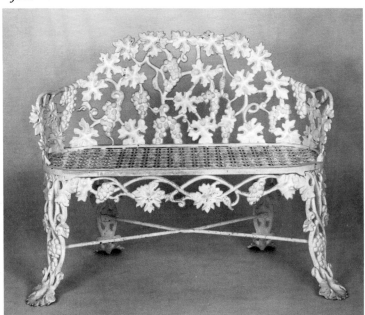

318.

cited above, p. 386). Their reputation in bronze casting was known both in this country and abroad and included such important commissions as Henry Kirke Brown's colossal bronze statue of Lincoln which stands in Union Square in New York. Wood was last listed in the directories in 1885.

318. *Garden Bench*

c. 1860–65

Mark: ROBERT WOOD · MAKER · RIDGE ROAD · PHIL^A · (in casting on front seat rail)

Cast iron

32⅝ x 43½ x 23¾"
(82.9 x 110.5 x 60.3 cm)

Girard College, Philadelphia. Stephen Girard Collection

EVIDENCE FOR THE LONG POPULARITY of the grapevine pattern in cast-iron furniture is seen in its continued use from its first introduction about 1850 to the present day. Although the exact pattern of this bench does not appear in any of Robert Wood's catalogues, benches of similar design, with slight variations, are illustrated (*Robert Wood & Co.'s Portfolio of Original Designs of Ornamental Iron Work of Every Description,* Philadelphia, c. 1870, figs. 90, 118). Designs in cast-iron were readily copied by ornamental iron foundries, and a version of this design was probably produced by most of them. A similar bench design, for example, appears in the 1870 catalogue for ornamental ironwork of James, Kirkland & Co., of New York (fig. 143). All the designs in Wood's catalogue are attributed to Wood & Perot and include a wide variety of forms that were cast in iron. In addition to ornamental furniture, there were baptismal fonts, brackets, fountains, gates, hot air registers, mausoleums, monuments, pavilions, pulpits, railings, and verandahs (see *Robert Wood & Co.'s Portfolio,* cited above).

The date of manufacture of this bench may be about 1860–65. Although Wood was listed in the directories as early as 1839, he was primarily a blacksmith. In 1860 he was first listed as producing ornamental iron, and by 1867 the firm had become "Robert Wood & Company." Since the words "and company" are missing from the mark on this iron bench, one can assume that the piece was made before 1867.

DH □

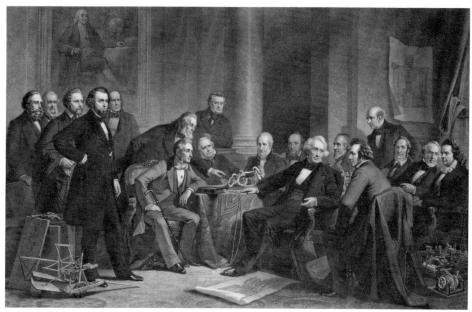

319.

JOHN SARTAIN (1808–1897)

Like William Birch and John Hill, John Sartain arrived in the United States fully trained as an artist and with substantial professional experience in London. Young Sartain had been apprenticed to the engraver John Swaine until art historian William Young Ottley arranged for Sartain to do a series of engravings to illustrate one of his books on the Florentine school of painters, published in 1826. In 1830, Sartain arrived in New York with letters of introduction to the artistic community; however, a conversation with Thomas Sully persuaded Sartain to settle in Philadelphia, where he lived out the duration of his life.

Like John Hill (see biography preceding no. 208), Sartain brought with him a special talent to assure his success: the ability and desire to work in mezzotint, a medium which had never been popular in America largely as the result of a lack of competent practitioners. Sartain noted that he had abandoned line engraving because it was very tedious compared with mezzotint (*Reminiscences,* pp. 119–20). Mezzotint was one of the most arduous intaglio processes, each plate requiring many hours of rocking in preparation for the actual creative process of scraping the design. Sartain almost singlehandedly sparked a revival of mezzotint; Peter Pelham, Samuel Okey, Charles Willson Peale, and Edward Savage were among the very few eighteenth century American printmakers to have used the technique for purposes other than experimentation. Most found the technique too demanding, necessitating the labors of numerous apprentices

found in larger London establishments but not in the small American workshop.

When commissions for engravings and mezzotints were slow, Sartain filled his time painting portraits, which he exhibited at the Artists' Fund Society and the Pennsylvania Academy of the Fine Arts, where he held various offices. He took credit for the mezzotint revival in America, remembering that "the practice of mezzotinto engraving in this country originated with me, and as a consequence I had all the privations to go through of waiting for sufficient demand to furnish bread: this the three principal cities of the Union did not quite do for some years, although I had no competitor" (Joseph Jackson, *Encyclopedia of Philadelphia,* vol. 4, Harrisburg, 1933, p. 1069). In fact, Henry Sadd, another Englishman, produced some excellent mezzotint portraits and history subjects during the 1840s before moving on to Australia.

Sartain's first American success was a mezzotint after John Neagle's painting, *Patriotism and Age.* Recognition brought him commissions for illustrations for magazines, including Burton's *Gentlemen's Magazine, Graham's Magazine, Campbell's Foreign Semi-Monthly Magazine,* and *The Eclectic Magazine,* the last two in which he had a proprietary interest. In 1848, Sartain bought controlling interest in the *New York Union Magazine,* which he brought to Philadelphia and published as *Sartain's Magazine.*

Despite the time-consuming process of making mezzotints, Sartain was one of the most prolific engravers of his day, issuing hundreds of plates in all sizes for all pur-

poses of illustration and decoration. During the late 1850s he began to produce some very large engravings, including *Christ Rejected* after Benjamin West, *King Solomon and the Ironworker* and *Men of Progress* after Christian Schussele, and the *Battle of Gettysburg* after Peter Frederick Rothermel.

Sartain was art director of the 1876 Centennial exposition in Philadelphia and traveled to Europe as an American representative to several international art exhibitions. His autobiography, *The Reminiscences of a Very Old Man, 1808–1897,* was published posthumously. Four of his eight children were full- or part-time printmakers: Samuel (1830–1906), Henry (1833–1895), William (1843–1924), and Emily (1846–1927).

The increasing sophistication of photomechanical engraving techniques at the end of the nineteenth century, combined with the difficulty of making mezzotints, ended the revival that Sartain had created during the forty years of his active engraving career, ending at the same time a rich chapter in the history of illustration.

JOHN SARTAIN AFTER CHRISTIAN SCHUSSELE (1824?–1879)
(See biography preceding no. 310)

319. *Men of Progress— American Inventors*

1862
Published by John Skirving
Signature: Artist's proof John Sartain (in pencil, lower right corner of margin)
Inscription: Dr. Morton Bogardis [*sic*]/ Colt/McCormick/Saxton/Peter Cooper/ Goodyear/Prof^r Henry Mott/D^r Nott/ Emerson/Morse/Burden/Hoe/Bigelow/ Jennings/Blanchard/Howe./*American Inventors* (in pencil, bottom margin); *The orig^l Picture by C. Schussele, Phil^a 1861. Entered according to Act of Congress in the year 1862, by John Skirving, in The Clerk's Office of the District Court for the Eastern District of Pennsylvania. Eng^d on steel by John Sartain, Phil^a 1862* (in plate, below image); John Gossert Phila. June 17 1895/Alex. McClure/John Gossert (in pencil, on verso)
Mezzotint and etching on wove paper
21⅝ x 35⅝″ (55 x 90.5 cm)
Historical Society of Pennsylvania, Philadelphia

PROVENANCE: John Gossert, until 1895?

LITERATURE: Sartain, *Reminiscences,* p. 232; Weitenkampf, *American Graphic Art,* p. 117; Wainwright, *Early Lithography,* pp. 62, 69

"THE GENTLEMEN here assembled have justly earned the title by which our print is designated—MEN OF PROGRESS—for, from their lively perception of the wants of mankind, and from their ingenuity in devising suitable appliance to provide for those needs, is derived the peculiar character of the present age as an age of progress" (John Skirving, *Key to the Engraving Men of Progress— American Inventors,* p. 3). The impressive gathering engraved by John Sartain after Christian Schussele is an imaginary *conversazione* representing some of the finest tinkering minds of the nineteenth century. Their skills ranged from medicine to mechanics, and all contributed to the material growth of the United States as a nation and as a worldwide industrial power.

The original painting was bought by inventor Peter Cooper, in whose Cooper Union it still hangs; a copy is in the National Portrait Gallery in Washington, D.C. A watercolor study for the group is also recorded, but its present whereabouts is unknown. A life study for the portrait of Samuel F. B. Morse is in the Museum of History and Technology of the Smithsonian Institution in Washington.

The painting, signed and dated 1862, was not finished at the time John Skirving, a marine, architectural, and panorama artist turned entrepreneur, decided to publish an engraved copy. His contract with John Sartain specified a steel plate, "thirty-six inches in length and of proportionate height the style to be in the mixed manner of line and stipple and mezzotint combined and the quality of the execution to be equal to the very best that the Engraver is capable of. The engraving to be completed within a year from the time the painting is ready . . ." (HSP, Society Collection, Sartain, March 9, 1861).

Sartain's fee of $2,500 was to be paid in installments indicative of his manner of working: $200 upon the transferral of the tracing to the plate, $200 upon completion of the etched outlines, $300 after the plate was worked up to receive the mezzotint ground, $200 when the rocked surface was ready for scraping, $200 after "the entire general effect has been scraped up," $300 when the engraving was finished and the plate ready for the final touches and corrections, and the balance of $1,300 upon completion of the whole project. Proofs of these various stages are in the Philadelphia Museum of Art.

A letter from Sartain to Jordan L. Mott indicated that Schussele received a very low fee, "under the condition that should the picture ever be sold, no matter at what price, there would then be due to him the sum of two hundred dollars ($200.=) in addition to that already paid" (HSP, Society Collection, Sartain, Sartain to Mott, July 1, 1865).

The same letter shows that Mott, one of the inventors depicted, had loaned Skirving $2,500 to finance the print's publication. At the time of Skirving's death in 1865 only $900 had been repaid, and it fell to Sartain to make settlement of the balance by offering a duplicate of the original painting to be made by Schussele as well as the steel plate, on which Mott had a lien.

Schussele's painting followed the conventions of nineteenth century group portraiture, with the sitters attempting to look informal, although their grave countenances belie the somewhat studied casual arrangement. A portrait of Benjamin Franklin, father of all American inventors, seated by some of his scientific equipment, presides over the marble chamber. A number of inventions and plans lie on the floor, as if casually discarded after a discussion. Schussele broke the monotony of what might have been a frieze of faces by having standing and bending bodies contrast with the seated figures. A brilliant paisley table cover is balanced against the dark splendor of the massed frock coats, a chromatic touch that not even Sartain was able to translate into the velvety black and white of mezzotint.

At the far left of the picture, Dr. William Green Morton (1819–1868) stands close to James Bogardus. A dentist, Morton first discovered the anesthetizing effects of ether; he is the only medical doctor represented in the group. Bogardus (1800–1874) is best known for his development of cast-iron architecture, but his engraving talents led to the invention of a machine for engraving banknote plates, and he won the award for the best scheme for the Penny-Post in England. Slightly in front of Morton and Bogardus stands Samuel Colt (1814–1862), the inventor of the repeating pistol. A plank bearing Schussele's engraved signature and the date 1861 is at Colt's leg; on the edge of the board rests one of his patented revolvers. Joseph Saxton (1799–1873), inventor of chronometers and gauges, and the setter of United States standards of weights and measures, stands beside Colt at the rear of the room, behind the distinguished figure of Cyrus Hall McCormick (1804–1894), who is placed next to a small model of his famous reaper. When first exhibited at the 1851 Crystal Palace exposition the outlandish contraption was ridiculed by the London *Times* as "a cross between an Astley Chariot and a flying machine," an opinion recanted after mowing and reaping exhibitions and the award of the Grand Prize Medal of the year (Skirving, *Key,* cited above, p. 9).

A seated group around the central table makes a pretense of studying a telegraph which occupies the center of the picture. Iron magnate, locomotive builder, and educational benefactor Peter Cooper (1791– 1883) leans over the shoulder of the dapper

Charles Goodyear (1800–1860), the only man in the entire group eschewing a black frock coat for one of pearl gray, a shiny Malacca cane resting on his knee. At Goodyear's feet is a galosh, upturned to show the vulcanized rubber sole. The portrait of Goodyear had to be posthumous, as he died in 1860, before Schussele began the painting.

Also studying the telegraph is Jordan L. Mott (1798–?), whose contribution to fuel conservation came through his development of a furnace burning refuse coal. Professor Joseph Henry (1797–1878), pioneer of electromagnetic studies as well as the first secretary and director of the Smithsonian Institution, stands behind Mott. Also seated is a dour preacher, Eliphalet Nott (1773–1866), who dabbled in the properties of heat when he was not in the pulpit, obtaining over thirty patents for applications of heat to steam engines, fuel conservation, and economical stoves. Frederick Sickels (1819–1895) was another physicist dealing with heat conservation, and his patented "cut-off" for steam engines saved considerable coal and wood. The manuscript inscription in Sartain's hand wrongly identifies Sickels as "Emerson," the inventor of sawing machines.

Schussele's original painting depicts Swedish-born hydrographer and shipbuilder John Ericsson (1803–1889) behind Nott and Sickels; he is omitted for no apparent reason in Sartain's engraving. Ericsson's most famous contribution to his adopted country was the iron-clad battleship *Monitor,* whose victory over the Confederacy's *Merrimac* on March 9, 1862, demoralized the South and prompted Bostonian Epes Sargent to write that "Ericsson is the one name on everybody's lips. It will be historical in connection with this war" (Washington, D.C., Library of Congress, Ericsson Papers, Sargent to Ericsson, March 11, 1862). Sartain says nothing of the omission in his *Reminiscences,* and the fact is also overlooked by Ericsson's biographers. Skirving's published key to Schussele's painting includes Ericsson's biography, and yet none of Sartain's proofs indicates the removal of a figure. Possibly Ericsson was a last-minute inclusion in the august body, after the battle of the *Monitor* and *Merrimac;* it would have been fairly simple for Schussele to paint in another figure, but possibly Sartain's work had progressed to the point where addition or correction was impossible. The lost watercolor sketch did not include Ericsson or Sickels, and was most likely the model used by Sartain.

The dominant figure in the group of inventors is undoubtedly Samuel Finley Breese Morse (1791–1872). The former history painter and president of the National Academy of Design turned to the telegraph after painting proved economically unfeasible. The forward position of his chair and a stronger lighting mark him out for distinction, as he turns to his neighbor Richard March Hoe (1812–1886) while gesturing at the telegraph in front of him. Seen between the heads of Morse and Hoe is the profile of Henry Burden (1791–1871), whose 1857 patent for a horseshoe-making machine is indicated by a small model on the table beside him. Hoe's legacy to technology is signified by the books piled up on the floor around him; as inventor of the type-revolving printing press, he enabled newspapers to multiply their circulations enormously, striking off fifteen thousand sheets per hour.

Standing up behind Burden and Hoe, as if better to see the telegraph, is the man who put Bigelow carpets on the floor. Erastus Brigham Bigelow (1814–1879), while working at drudge labor in a Massachusetts cotton mill, invented several types of looms, culminating in those for different patterns of woven carpets. Skirving's biography of Bigelow notes that "the linament of his head, which the engraving gives with great fidelity, is such as one might look for after having heard his history" (*Key,* cited above, p. 22). Affixed to the wall behind Bigelow is the plan for one of his looms. Skirving does not mention whether or not the patterned carpet on which the American inventors stand is a Bigelow.

The last three inventors—Isaiah Jennings, Thomas Blanchard, and Elias Howe, Jr.— all possessed a strong mechanical bent. Jennings (1782–1862) invented threshing machines, steam boilers, cotton machinery, instantaneous matches, lighting fluid, and a wide variety of improvements to other machinery. Blanchard (1788–1864) also invented a number of machines, but is best remembered for his turning lathes, much used in gun manufacturing and woodworking. The fashion industry can pay homage to Howe (1819–1867), developer of the modern sewing machine.

While not all of the names have become household words, Schussele's painting, circulated by means of Sartain's print, served as a visible reminder of a remarkable group who were the direct ancestors of Ford and Edison.

Sartain's steel plate which Jordan Mott received in part payment for his loan to Skirving came into the possession of the *Scientific American,* but was destroyed in a fire which ravaged the magazine's offices (Sartain, *Reminiscences,* p. 232). However, impressions of the print best bear witness to Sartain's skillful manipulation of burin and scraper. He excelled at the portrait mezzotint, and *Men of Progress* is in itself a group exhibition of Sartain's finest work.

SAM □

PETER FREDERICK ROTHERMEL
(1817–1895)

Peter Frederick Rothermel was born in Nescopeck, Luzerne County, Pennsylvania. Trained as a land surveyor, he took lessons in drawing in Philadelphia from John Rubens Smith, whose encouragement led Rothermel to a period of study with Bass Otis. Rothermel became active in the promotion of the Artists' Fund Society and served on its board of control in 1840, 1843, and 1844 and as vice-president in 1844. He began exhibiting with the Society in 1838 and continued from 1840 through 1845. He also exhibited at the Apollo Association and the American Art Union regularly from 1840 to 1852.

Although he started as a portraitist, Rothermel's first widespread recognition followed the exhibition of his historical painting *Discovery of the Mississippi by Hernando De Soto* at the Artists' Fund Society in 1843. It was later purchased by the American Art Union. He began to exhibit at the Pennsylvania Academy in 1843 and served on the board of directors from 1846 until 1855. Rothermel also was on the Academy's committee on exhibitions and, as chairman of the committee on instruction, was especially active on behalf of the Academy's schools, urging the purchase of copies of Greek and Roman casts, the awarding of annual prizes to students, and improvements in the life school (*National Cyclopedia of American Biography,* vol. 4, New York, 1897, p. 546).

In 1856, Rothermel toured England, Belgium, Germany, and Italy, and lived in Rome for two years where he continued to paint historical pictures. He exhibited three pictures, *Saint Agnes, L'escalier des géants à Venise,* and *Le virtuose,* at the Paris Salon of 1859 and then returned to Philadelphia where he became an instructor at the Academy. Rothermel was elected to membership in the Academy in 1860. He showed twenty canvases at the Great Central Fair for the benefit of the U.S. Sanitary Commission in June 1864.

Shortly after the Civil War, the legislature of Pennsylvania commissioned his best known and most ambitious canvas, a scene of Pickett's charge at the Battle of Gettysburg. After three years of research, Rothermel unveiled the painting, which measured sixteen by thirty-two feet, at the Academy of Music in Philadelphia on December 20, 1870 (Edwin B. Coddington, "Rothermel's Paintings of the Battle of Gettysburg," in *Pennsylvania History,* vol. 27, no. 1, January 1960, p. 24). *The Battle of Gettysburg,* for which Rothermel received $25,000, was shown at the Centennial exposition and engraved by John Sartain before it was eventually hung in Harrisburg. Rothermel

displayed a total of eight paintings at the Centennial, including *Christian Martyrs at the Colosseum*, *The Trial of Sir Henry Vane*, and *Macbeth Meditating the Murder of Duncan*, and received a commendation "for excellence in historical painting" from the judges (Clement and Hutton, p. 225). He continued to exhibit at the Pennsylvania Academy until 1888, as well as showing his work often at the National Academy of Design, of which he was an honorary member, and at the Boston Athenaeum. Rothermel was also an active member of the Philadelphia Society of Artists.

Eminently popular in his own time, Rothermel was hailed by some critics as "the greatest of all great American painters" (John W. Jordan, *Encyclopedia of Pennsylvania Biography*, vol. 6, New York, 1916, p. 2130) and as "a master of composition involving the management of large masses of figures" (Fielding, p. 310). Rothermel died at his summer home in Linfield, Montgomery County, Pennsylvania, in August 1895.

AS

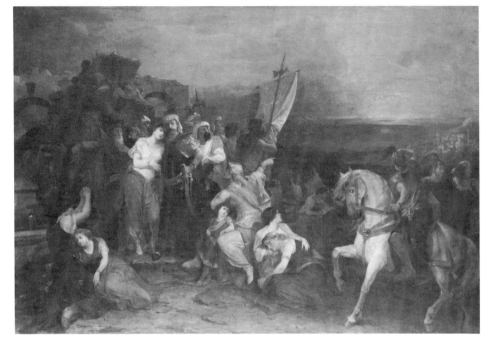

320.

320. *The Last Sigh of the Moor*

1864

Signature: P. F. Rothermel 1864 (lower left)

Oil on canvas, mounted on panel

48 x 72″ (121.9 x 182.9 cm)

Pennsylvania Academy of the Fine Arts, Philadelphia. Gift of Caroline Gibson Taitt, 1910

PROVENANCE: J. T. Tait, 1864; Caroline Gibson Taitt

LITERATURE: Rutledge, *Cumulative Record*, p. 189; PAFA, *Acres of Art* (June 22—July 30, 1972), no. 87

THIS PAINTING WAS EXHIBITED in the 1864 Pennsylvania Academy exhibition under the title *L'Ultimo Suspiro del Moro*. The subject is based on a Spanish legend made popular through Washington Irving's *Chronicle of the Conquest of Granada*, first published in 1829, which relates Ferdinand and Isabella's victory in 1492 over the city of Granada, the last Moorish stronghold in Spain. The scene illustrates the retreat of the Moorish King Abū'Abdi-Llāh, or Boabdil as he was known to the Spanish, and his retinue after the surrender of Granada to the "Catholic Monarchs." In his book, Irving describes the event:

At two leagues' distance, the cavalcade, winding into the skirts of the Alpuxarres, ascended an eminence commanding the last view of Granada. As they arrived at this spot, the Moors paused involuntarily, to take a farewell gaze at their beloved city, which a few steps would shut from their sight forever While they yet looked, a light cloud of smoke burst forth from the citadel, and presently a peal of artillery, faintly heard, told that the city was taken possession of, and the throne of the Moslem kings was lost forever
The unhappy monarch, however, was not to be consoled; his tears continued to flow. "Allah Achbar!" exclaimed he, "when did misfortunes ever equal mine?" From this circumstance, the hill, which is not far from Padul, took the name of Feg Allah Achbar; but the point of view commanding the last prospect of Granada is known among Spaniards by the name of *El ultimo suspiro del Moro;* or "The last sigh of the Moor." (Washington Irving, *Chronicle of the Conquest of Granada*, rev. ed., New York, 1869, pp. 614–15)

In Rothermel's composition, Boabdil is standing with his wife, Morayma, on the prospect, surrounded by his retinue. Seated before him, his mother, Ayxa, berates him for his show of grief, while the vizier Aben Comixa tries to console the king, and the rest of the party mourn their last view of Granada. In the distance, smoke rises above an imaginary view of the city. Apparently commissioned by J. T. Tait, the painting is typical of Rothermel's complex literary themes. Although he also painted portraits and genre scenes, he gained renown for his ambitious and grandiose history paintings based on sources such as contemporary literature, the Bible, Shakespeare, and histories.

Tuckerman ranked Rothermel as the leading Philadelphia history painter at mid-century and noted "his facility of composition and his aptitude for grouping, costume and scenic effects" (Tuckerman, p. 437). Reflecting the taste of the next generation, critic Earl Shinn most admired Rothermel's genius as a colorist and wrote that he would prefer to see him paint "color-dreams" in which Rothermel could allow his imagination and "subtle sense of tone-harmony of an Eugène Delacroix" to flower, unhindered by rigid historical fact. Noting that he was "capable of flinging together lovely groups, sumptuous costumes, and contrasted flesh-tints," Shinn reported that "when he has sent works to the Paris *salon*, they have been hung in conspicuous places as noticeable acquisitions" (*Centennial Masterpieces*, vol. 1, pp. 149–50). Often compared to another renowned contemporary history painter, Emanuel Gottlieb Leutze, Rothermel was particularly successful in his native city of Philadelphia: "Rothermel belongs to the very foremost rank of living historical painters of this country, and in the opinion of many of those best able to form a correct judgment, takes the lead of all" ("Notices of Art and Artists," *Sartain's Magazine*, vol. 4, 1849, p. 414).

SKM ☐

372

DAVID JOHNSTON KENNEDY
(1816/17–1898)

Almost entirely a self-taught artist, David Johnston Kennedy was born in Port Mullin, Scotland, and worked alternately as a stone-cutter, haberdasher's assistant, and carter before immigrating to Ontario with his family in 1833. His only training in art—a few lessons from a local artist named Robert McMeiken—came just before leaving Belfast. Forced by his father to work cutting stone—which he hated—and farm the family's land, Kennedy left frontier Canada in 1835 to live with one of his sisters in Philadelphia. In the spring of 1836 he moved to Nashville, Tennessee, where he worked in a drygoods store and enjoyed some success painting miniatures on the side, but poor health brought him back to Philadelphia, and by 1837 he was in Canada again, helping his father. Two years later he returned to Philadelphia, embarked on various business ventures, and married Morgianna Corbin, granddaughter of Benjamin Fay, the president of the Pennsylvania Academy of the Fine Arts.

In December 1839 his wife's contacts helped him find a clerkship in the city's newly opened Broad and Cherry Street office of the Philadelphia and Reading Railroad, and after quickly rising to the position of Purchasing and General Agent, Kennedy remained with the firm for more than twenty years. During his business career he continued to paint in his spare time, occasionally showing his watercolors at the Steam Power

Printing Plant of Baker and Kennedy (which he helped run) at 326 Chestnut Street. Officially he exhibited his work only once: two landscape views of Scotland and Ireland at the Artists' Fund Society in 1841.

Failing eyesight forced his retirement in 1861, but hardly interrupted his artistic career; he continued to accept assignments as a draftsman and devoted much of his time to finishing his many watercolor drawings of Philadelphia scenes, a collection of views that he worked on until his death in 1898. Kennedy had hoped to publish them as a book entitled *Lights and Shades of Other Days, Reminiscences of the Past,* and though this project was never realized, his albums—containing more than 650 drawings—found their way intact to the Historical Society of Pennsylvania, where further acquisitions brought together almost the entirety of his work (Boston, MFA, D. J. Kennedy, Autobiography, typescript).

321. *Skating Scene (The Schuylkill River and Its Surroundings)*

1864

Inscription: The Schuylkill River and its surroundings, sketched from the Pennsylvania/Railroad embankment west of Mr. Lipp's house and brewery, previous to the/purchase of property by the Fairmount Park commissioners for Fairmount Park,/Philadelphia. Sketched February

20th 1864 by D. J. Kennedy (on verso, in ink; variant of the same inscription, written in purple ink, has been pasted to the lower edge of the front of the drawing)
Watercolor and gouache over pencil, on paper, laid down
9 1/16 x 16 1/4" (23 x 41.3 cm)
Historical Society of Pennsylvania, Philadelphia

DAVID J. KENNEDY'S HUNDREDS of drawings of Philadelphia, executed between 1836 and his death in 1898, provide a one-man artistic survey unequaled in the city's history and almost without parallel in the United States. In many ways livelier and more faithful than the camera, Kennedy's observations encompassed more than the obvious historical sites and standard picturesque views; his energetic pencil documented circuses, cigar stores, factories, lumber yards, taverns, bridges, and a variety of scenes that are charming, informative, and unusual today precisely because they were absolutely ordinary then. Some of his work was done at the suggestion of Ferdinand J. Dreer, who commissioned Kennedy as a topographic draftsman, but most of it was undertaken for his own pleasure, "the results of spare moments carefully applied," showing—in Kennedy's own words—"how much can be accomplished if we are diligent in what we undertake" (Autobiography, in "The David J. Kennedy Collection," *PMHB,* vol. 60, no. 1, 1936, p. 71).

321.

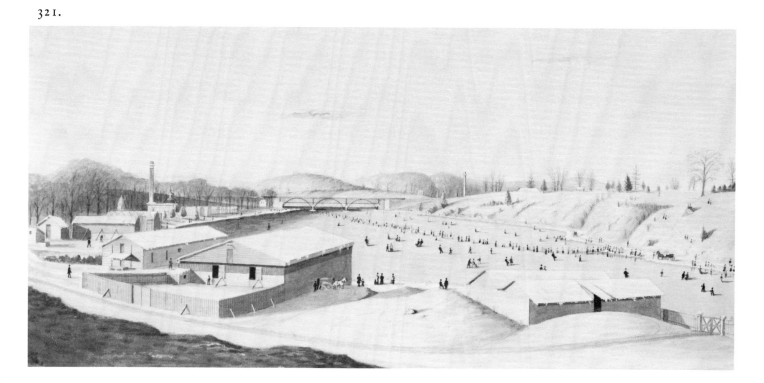

Skating Scene is typical of Kennedy's style, although it is one of only two such subjects known in his work (the other is *Winter on the River Delaware,* done after a lithograph by James Queen). The pale, graduated tints of the sky, the clear washes used in the landscape, and the bright, pure touches of local color added to the figures demonstrate the traditional transparent watercolor technique that Kennedy must have learned as a boy in Great Britain, modified here by the addition of opaque white for a snow effect. Amateurish, but effective, his simple method lends decorative charm and life to a scene that is full of careful topographic documentation.

The view here, as Kennedy takes pains to explain in his inscription, is from the railroad embankment (visible at lower left) on the west bank of the Schuylkill, just upstream from the city waterworks; the artist is looking north toward the old Girard Avenue Bridge, with Fairmount Park and the Spring Garden and Northern Liberty waterworks visible on the far bank (see Ernest Hexamer's *Map of Philadelphia,* published by Barnes in 1867). The buildings of the Lips Brewery in the foreground, and other similar sheds along the left bank of the river, occupy land that, as Kennedy tells us, the city would soon purchase to enlarge the park. Several breweries subsequently helped develop this section of the Schuylkill into a resort area especially popular with Philadelphia's German community, though a photograph of "Lips Brewery and Gardens" (Historical Society of Pennsylvania) carries a caption that hastens to assure us that these establishments "were usually conducted in an orderly fashion." While it hardly seems likely that the sleigh in the foreground is being loaded with beer for the orderly refreshment of the skaters on the river below, Kennedy's watercolor makes it apparent that this section of the river was an amusement center in winter as well as in summer.

KF □

WILLIAM TROST RICHARDS (1833–1905)

Born and raised in Philadelphia, Richards was earning a comfortable living at the age of seventeen by designing ornamental gas fixtures for the local manufacturing firm of Archer, Warner, and Miskey. In his spare time he drew on blocks for wood engravings and studied—from 1850 to 1855—with the German-born artist Paul Weber. Not long after his first paintings were shown at the Pennsylvania Academy in 1852, Richards began to work part-time in order to devote more of his energy to art, and by 1854 he was sharing a studio on Chestnut Street with

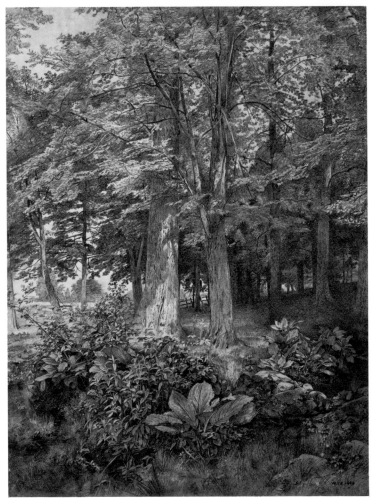

322.

the landscape painter Alexander Lawrie. In August 1855 he left for Europe for the first time, to study and travel in France, Switzerland, Italy, and Germany. Returning from Düsseldorf the following spring, Richards married Anna Matlack and resumed his program of painting by day and designing chandeliers by night. Two years later he gave up his old job altogether and began to support his family with the income from teaching and the patronage of his close friend, George Whitney. In 1863, at the age of thirty, he was elected an Academician at the Pennsylvania Academy, the same year he joined the American Pre-Raphaelite group, called the "Society for the Advancement of Truth in Art."

Richards visited Europe again in the fall of 1867, spending the bulk of his time in Paris, Darmstadt, and in Switzerland. On the return voyage, Richards was so fascinated by the effects of a violent storm at sea that he resolved to begin marine painting, an activity that was to absorb much of the rest of his career. At this time he

began to experiment with watercolor and gouache and to devote his summer trips along the Atlantic seaboard to the study of the coast and the sea. In 1875 he bought a summer house in Newport, dividing his time between Rhode Island and his home in Germantown. After 1878 he made several summer visits to Great Britain, which he alternated with summers spent on the Oldmixon farm in Chester County, Pennsylvania, and at Gray Cliff, the house he built on Conanicut Island, Rhode Island. He spent winters in Cambridge, Massachusetts, at Oldmixon, or—after 1890—in Newport, which became his permanent residence until his death in 1905.

Richards won bronze medals at the 1876 Centennial exhibition and the Paris exposition of 1889. He showed regularly at the National Academy of Design, the American Watercolor Society, the Royal Academy in London, and the Pennsylvania Academy of the Fine Arts, which awarded him a Temple Silver Medal in 1885 and their Gold Medal of Honor in the year of his death.

322. *Corner of the Woods*

1864

Signature: w.t.r. 1864 (lower right)

Pencil on thin, buff-colored pulp paper, laid down

23¼ x 17½" (59 x 44.4 cm)

Museum of Fine Arts, Boston. M. and M. Karolik Collection

PROVENANCE: William Trost Richards; daughter, Eleanor (Richards) Price; daughter, Edith Ballinger Price; Maxim Karolik

LITERATURE: Karolik, *Drawings,* vol. 1, p. 265, no. 620; Brooklyn Museum, *William Trost Richards, American Landscape and Marine Painter, 1833–1905,* by Linda S. Ferber (June 20—July 29, 1973), no. 35, p. 64

THE IDEAL PAINTING embraces "the inexhaustible perfection of Nature's details," wrote the English critic John Ruskin in 1843 in *Modern Painters.* The conscientious artist must ask, "Can my details be added to? Is there a single space in the picture where I can crowd in another thought?" In the late 1840s the philosophy behind these remarks inspired a group of young English artists known as the Pre-Raphaelites, who in turn, along with Ruskin, influenced much of American landscape and still-life painting in the 1850s and 1860s. William Trost Richards's *Corner of the Woods* illustrates the impact of this dual influence and also helps define the distinctiveness of the Pre-Raphaelite movement in America. For as Roger B. Stein has pointed out, the eloquent defense of the Pre-Raphaelites found in Ruskin's widely read books had a far greater impact on American audiences than the actual paintings of Dante Gabriel Rossetti, Holman Hunt, John Everett Millais, and other members of the English Pre-Raphaelite Brotherhood (*John Ruskin and Aesthetic Thought in America, 1840–1900,* Cambridge, Mass., 1967). It was Ruskin's interpretation of their work that influenced artists in the United States, an interpretation that was inextricably bound up in his earlier writings with a promotion of his own favorite modern painter, J. M. W. Turner.

Ruskin saw the study of nature as the essence of Turner's greatness and the cornerstone of Pre-Raphaelite reform, and though it was in fact only one aspect of the Brotherhood's search for truth and legitimacy in art, it was accepted by American readers as their single most important item of dogma. This response was not totally Ruskin's creation, however, for as Stein notes, his ideas fell on fertile ground in a country where landscape painting had been elevated by the preceding generation to new heights of didacticism and artistic nationalism. The study of nature was seen to yield spiritual rewards as well as a sense of American identity, and therefore Ruskin's call for a purified art based on reverence for natural fact fell on sympathetic ears.

William Trost Richards was only a peripheral member of the group known as the American Pre-Raphaelites, but there were few more sympathetic to their ideals. It is not known when Richards discovered Ruskin, but his style began to lean toward the bright color and fine detail of Pre-Raphaelite painting after his visit to Düsseldorf in 1856. The Germans excelled, in Richards's own words, in "the mechanical of art," and in response to their technique his own style became tighter and more linear. He also could have absorbed Ruskinian sentiments from the paintings and writings of American artists like Frederick Church and Asher B. Durand, whose work stressed the personal, moral necessity of the search for "truth" in nature as well as the larger demands for an authentic native school in art (Brooklyn Museum, *Richards,* cited above, pp. 21, 24). In addition, Richards probably saw the exhibition of British art shown in New York, Boston, and Philadelphia in 1857–58, which included a generous survey of the art of the English Brotherhood. The impact of this exhibition on his work was immediately apparent in a series of precise, almost botanical *plein air* studies of a type that had become increasingly popular in the 1850s (see William H. Gerdts, "The Influence of Ruskin and Pre-Raphaelitism on American Still Life Painting," *American Art Journal,* vol. 1, 1969, pp. 81ff.).

After 1858, Richards produced many detailed drawings of single plants and flowers, often inscribed with names and measurements, and a series of tiny oils that focus an almost impossible amount of attention on the foliage at the artist's feet. "So carefully finished in some of them are the leaves, grasses, grain-stalks, weeds, stones, and flowers, that we seem not to be looking at a distant prospect, but lying on the ground with herbage and blossom directly under our eyes," wrote Tuckerman in 1867, ranking Richards among those who practice "the extreme theory of the Pre-Raphaelites" (p. 524). This type of work soon brought Richards to the attention of the English-born artist, Thomas C. Farrer, Ruskin's most fervent disciple in America, who nominated Richards for membership in his newly formed Society for the Advancement of Truth in Art. Buoyed by the Ruskinian gospel published in the group's magazine *The New Path,* Richards began to work on larger, more spacious forest interiors, each with a wealth of carefully documented detail, and each executed outdoors, according to Ruskin's strictest principles. Several of his most striking works from this period are scenes like *Corner of the Woods,* done in pencil or charcoal on an unprecedented scale and observed from corner to corner as if with the anonymous, unselective eye of the camera (for example, *In the Woods,* 1865, Brooklyn Museum; or *Woods,* 1865, High Museum of Art, Atlanta).

Richards's artistic sensibilities cannot be erased entirely, however; sheer monumentality and completeness do not necessarily convince us that he was merely a passive lens. His focus wanders, for example, in the treetops and the distance, while returning to dwell with subjective fondness on the plants clustered around the stream in the foreground. Moreover, Richards cannot disguise the fact that he loves to draw and takes pride in his pains—scraping with his fingernail, smudging, using the light-wove texture of the paper for glints of light—techniques which call attention to the hand of the artist just as they attempt to mask it. The incredibly subtle range of grays produced by this effort bears a wealth of Pre-Raphaelite "truth" and a surprisingly sensuous effect; the material is transformed in the process of being lovingly recorded, yielding a work that is more personal, perhaps, than Richards knew or intended, but precisely what Ruskin had in mind.

KF □

RUBENS PEALE (1784–1865)

Rubens Peale, the fourth son of Charles Willson Peale, was born with defective eyesight, which seemed to preclude any career as a professional painter. He became, instead, a naturalist and museum director, managing his father's Philadelphia Museum from 1810 to 1822 and taking over his brother Rembrandt's Baltimore Museum from 1822 to 1825. He then left this position to establish his own gallery in New York, Peale's New York Museum, modeled, as was the Baltimore Museum, after the original in Philadelphia. This endeavor prospered for a while and then failed in the panic of 1837. Rubens was forced to sell out to P. T. Barnum and retire to his father-in-law's farm near Schuylkill Haven, Pennsylvania. Although he became a farmer, he continued to collect natural curiosities and even acted as the neighborhood taxidermist.

It was not until the age of seventy-one, in 1855, that, with the encouragement of his daughter, Mary Jane, he decided to take up painting. His subject matter was chiefly still life, birds, and landscape, which he painted for his own pleasure. Rubens was joined in his studio by Mary Jane, two of his sons, and a daughter-in-law during the "painting season" at the farm. After his wife's death in 1864, the elderly Rubens moved to Philadelphia with his daughter, where they set themselves up as painters, copying each

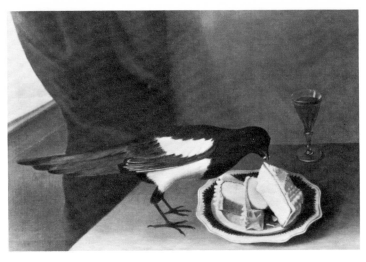

323.

at the last annual exhibition of the Pennsylvania Academy of Fine Arts" (Anna Wells Rutledge, *Artists in the Life of Charleston,* Philadelphia, 1949, p. 166).

In 1850, Winner was elected an Honorary Member, Professional, of the National Academy of Design where he exhibited regularly from 1844 to 1875, and he was an active member of the Philadelphia Society of Artists. In 1876 he exhibited two portraits at the Centennial exhibition. In addition, he participated in shows sponsored by the Apollo Association and American Art Union and the Boston Athenaeum. Winner died in Philadelphia.

AS

324. *Crazy Nora*

c. 1860–65
Oil on canvas
24 x 18″ (61 x 45.7 cm)
Historical Society of Pennsylvania, Philadelphia

PROVENANCE: A. Cuthbert Thomas, 1897

LITERATURE: *PMA Bulletin,* vol. 35, no. 186 (May 1940), p. 41, no. 68, illus. p. 39; Hermann Warner Williams, Jr., *Mirror to the American Past, A Survey of American Genre Painting 1750–1900* (Greenwich, Conn., 1973), pp. 168, 170; Wainwright, *Paintings and Miniatures,* p. 307, illus. p. 214

HER REAL NAME WAS HONORA POWER, and she was from Limerick, Ireland. Her father, a farmer, died when she was quite young, leaving her an orphan with an annuity of £50. At his death she went to reside with her sister, whose dissolute husband spent all the property of both Honora and her sister. She then came to America, and lived out as a servant—at one time at a young ladies' boarding-school at Third and Walnut Streets. About this time she, attending St. Mary's Church, became interested in Mr. Hogan's preaching and appearance. The terrible riot at St. Mary's in 1822, in which the pews and altar of the church were destroyed, and the excitements attending the troubles of the church during the Hogan controversies, upset her mind, and from being a smart, honest, and good servant she became a helpless object of charity. In a few years her excitement calmed down, and she endeavored to earn her own living. . . . She was sane on many points and methodical in her ways. During the day she was continually on the tramp, and was . . . so well known that she was employed as a dun to collect difficult debts, in which employment she was indefatigable. . . . She thus supported herself almost to the day of her death, which

other's work as well as still lifes by Raphaelle and James Peale. About nine months after their arrival in Philadelphia, Rubens was taken ill while painting and died the same day, July 17, 1865.

323. *Magpie Eating Cake (English Magpie)*

1865
Signature: Rubens Peale/June 1865 (lower right)
Oil on canvas
19 x 27⅛″ (48.2 x 68.8 cm)
Private Collection

PROVENANCE: With Lawrence A. Fleischman, Detroit; Edwin Hewitt, New York; Kennedy Galleries, Inc., New York

LITERATURE: Charles Coleman Sellers, "Rubens Peale: A Painter's Decade," *Art Quarterly,* vol. 23, no. 2 (Summer 1960) no. 124, p. 150; Washington, D.C., National Gallery of Art, *The Reality of Appearance; the Trompe L'Oeil Tradition in American Painting,* by Alfred Frankenstein (March 21—October 31, 1970), no. 9, p. 38

RUBENS RECORDED IN HIS DIARY that he began the "English magpie, &c" on May 24, 1865 (Sellers, "Rubens Peale," cited above, p. 150). Since it is dated as completed in June 1865, it must have been one of his last paintings.

Unlike the more sophisticated still lifes by his brother, Raphaelle, and his uncle, James (see nos. 213 and 217), Rubens's work has a flat, airless quality and a certain naive charm. He sometimes enjoyed painting his subject from above, as seen here; however, when he did this, he was inclined to be inconsistent in perspective as, for instance,

in the drawing of the magpie. The cake and glass of wine are elements common to other still lifes by Rubens, but the magpie is not. As a naturalist he was careful to identify the bird as an English species and it is quite likely that the model for the painted bird was one that he had even stuffed himself. He does not show the bird as dead game in the traditional manner of animal still lifes, but alive and with a window behind to suggest that it is wild. All this is reminiscent of the habitat environments which the Peales painted as backgrounds for the stuffed animals in their Philadelphia Museum. But here, instead of an outdoor environment, Rubens painted an interior setting and a slightly humorous one at that. The emphasis in the picture is not so much on a still life arrangement as on the careful depiction of a magpie, with the addition of a decorative but simple setting.

DE □

WILLIAM E. WINNER (C. 1815–1883)

Little has been discovered about William Winner's early life except that he was probably born in Philadelphia around 1815. He began exhibiting with the Artists' Fund Society in 1836 and became a member of its Board of Control in 1843. He exhibited regularly at the Pennsylvania Academy until 1869 and again from 1878 to 1881, showing a variety of portraits and genre, historical, and religious scenes. He was elected a member of the Pennsylvania Academy in 1860. An article in the Charleston, South Carolina, *Evening News,* December 11, 1848, reported that Winner was in that city taking orders for portraits and that he had on display his painting *Christ Restoring the Daughters of Jairus,* "classed as among the best exhibited

occurred Feb. 15, 1865, when she was about sixty-seven years of age. . . . Her costume usually consisted of a not very full nor long dress, compressed at the waist with a belt and buckle; over this was worn a camlet cloak fastened at the neck, mostly of plaid material. She wore a pair of high-top boots and a man's hat—in winter a rather broad-brimmed stove-pipe hat, and in summer a tall straw hat. (Watson, *Annals,* vol. 3, p. 452)

Among the humorous and sentimental interpretations of contemporary life such as *Domestic Felicity* and *Tired of Skating* that William Winner painted for over four decades, his small portrait of *Crazy Nora* stands as an unidealized record of personality. In place of softened form and appealing color, tightly painted detail and drab tones render all the hard surfaces of a Philadelphia street in the mid-nineteenth century. The unbroken row of buildings and the small, oblivious figures in the background isolate the figure of Crazy Nora in an impersonal setting, and Winner's acute perception of her isolation within herself creates a compelling portrayal of a disturbed mind.

DS □

GOTTLIEB VOLLMER (1816–1883)

Gottlieb Vollmer was born in Ludwigsburg in the kingdom of Württemberg, Germany (Scharf and Westcott, vol. 3, pp. 2333–34, portrait of Vollmer facing p. 2333). His father, a cabinetmaker, came to this country in 1830, leaving his son Gottlieb at home to complete his apprenticeship, and to pass the military examination. In 1832, Gottlieb followed his parents to America, settling in Philadelphia. Two years later, his father died, and the support of his mother and five brothers and sisters became his responsibility. Later he married Wilhelmina Gebhardt, by whom he had six children.

He was first listed in the Philadelphia directories in 1842 as an upholsterer; he continued to be listed as such individually and in partnership, first with George Klauder from 1843 to 1844 and then with H. Montre until 1854. The following year he was listed as an upholsterer and a maker of cabinet furniture at Eleventh and Chestnut streets, where his firm had been located since 1844. Although after 1861 Vollmer seldom listed upholstery as part of his enterprise, this was still part of his growing furniture business. His Ledger of 1863–67 and Journal of 1867–69 (Historical Society of Pennsylvania) refer to upholstery work and odd jobs, including cleaning furniture covers and hanging curtains. By 1882 his furniture factory was located at 22–28 South

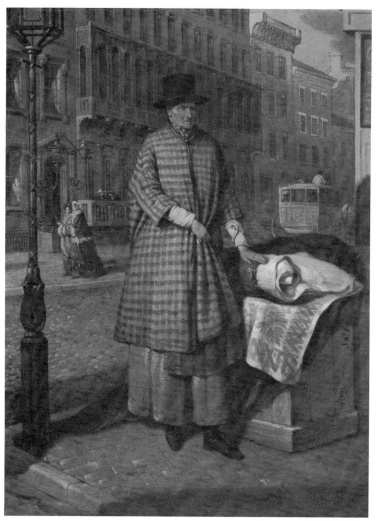

324.

Fifteenth Street, with warerooms at 1108 Chestnut and 1105 Sansom Street. A wardrobe by Vollmer was exhibited at the 1876 Centennial exhibition (*Masterpieces of the Centennial,* vol. 2, illus. p. 73).

Vollmer died in 1883, leaving his business to his eldest son, Charles, who had been trained in Philadelphia and Paris. The firm was listed as G. Vollmer & Son from 1884 until 1891.

325. *Armchair*

c. 1865
Ebonized cherry; twentieth century silk damask upholstery
31 x 24 1/16 x 29 1/8″ (79 x 61 x 74 cm)
Philadelphia Museum of Art. Given by the heirs of Mr. and Mrs. James Dobson. 41–89–5

PROVENANCE: James Dobson, Philadelphia; descended in Dobson family

THIS CHAIR IS PART of a large furniture suite consisting of a pair of sofas, an ottoman, two pairs of armchairs, four side chairs, a stool, a mirror, and six window cornices. According to descendants of the original owners, the set was made and upholstered by Gottlieb Vollmer and purchased by James Dobson in 1875 for his home, Bella Vista, Falls of Schuylkill.

The original damask upholstery was woven at Dobson Mills in Manayunk, according to tradition. The Falls of Schuylkill Woolen Mills (Dobson Mills) was established in 1855 by John Dobson, who had previously operated a mill at Manayunk. In 1861 his brother James joined the firm. Extensive additions were made after 1862 so that by 1873 the firm was the largest individual enterprise in the United States. According to a contemporary account:

> Both the proprietors are natives of Oldham, England, where they each entered the mills at eight years of age and

377

were thoroughly educated to a practical knowledge of their business. An illustration of their active energy is afforded in the fact that one of their largest structures, destroyed by fire, May 14, 1869, was rebuilt, refitted with machinery, and running by the following October. Their success had been unprecedented, and within eighteen years their business has grown to an annual production of about $4,000,000 worth of goods. With a still rapidly increasing demand, the capacity of the mills is constantly enlarged. The superior excellence of their manufactures is attested by the fact that they have been selected to make the rich carpetings for the United States Senate chamber, both houses of the Pennsylvania Legislature, the Government Offices in Philadelphia, all the vessels of the American Steamship Company, and many other public institutions, as well as to supply immense quantities of their superior blankets, etc., to the Army and Navy Hospitals and other public and private institutions. (Robson, *Manufacturers*, p. 53)

Stylistically the carving on this and other chairs in the suite suggests a date of about 1865, although family tradition states that they were made about 1875. The modified rococo shape and finely carved rose and leaf motifs on the armchairs attest to the high standards of the Vollmer factory. The interest in upholstery can be seen in the way the tufted back is carried over the crest rail, anticipating the fashion in the following decade for overall upholstered and tufted furniture. Two additional ebonized side chairs acquired by the Museum with the Vollmer set date from about 1880.

325.

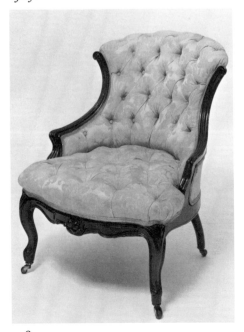

Another set of rococo revival furniture by the Vollmer firm was acquired in 1860 by President James Buchanan for the Blue Room of the White House. With the exception of the ottoman, which remains in the White House (Davidson, *Antiques*, vol. 2, pp. 258–59), the set and its accompanying bill of sale, dated 1860, are in the Museum of History and Technology, Smithsonian Institution. The White House set was gilded rather than ebonized, and its ponderous proportions seem to be more typical of Philadelphia work than the Dobson suite, which is delicate by contrast. The Buchanan set was upholstered in damask, perhaps, as with the ebonized set, from the Dobson Mills. This set was retained in the Blue Room until the end of the McKinley administration. A photograph showing it in situ is illustrated in *The White House: An Historic Guide* (Washington, D.C., 1962, p. 109).

DH □

DANIEL PABST (1827–1910)

Much of what is known about Daniel Pabst comes from his granddaughter, Edna Reisser Shenkle, whose recollections were recorded in 1969 by Calvin Hathaway (1907–1974), curator of decorative arts (PMA, Archives). According to her, Pabst was born on June 11, 1827, probably in Langenstadt, a small town in Hesse-Darmstadt, where he lived as a boy. Since he was not robust and did not wish to put in three years of military service, he immigrated to the United States when he was almost twenty years old. He came directly to Philadelphia, although Mrs. Shenkle knew of no relatives whose presence would have drawn him here. Pabst married Helena Gross, who also was born in Germany, and they had seven children, four of whom died in infancy. Pabst was very helpful to newly arrived German immigrants, taking them into his household while they were studying and learning their way in the new country.

According to *The Industries of Philadelphia*, Pabst opened his business near Second and Dock streets in July 1854. However, he is first listed in the Philadelphia directories in 1856 as a cabinetmaker at 222 South Fourth Street, in partnership with Francis Krause. An assessment of his work and an indication of the extent of his business at 269 South Fifth Street, at about 1881, are given in *The Industries of Philadelphia*:

Cabinet making is carried on to an immense extent in Philadelphia, and in a style of workmanship that has given the city a splendid reputation throughout the country. Some cabinet makers are more enterprising than others, as is practically demonstrated by the enterprising Daniel

Pabst, who manufactures all furniture after original designs. He is a highly accomplished artisan and possesses very remarkable originality as a designer.... He employs 50 hands, the most expert mechanics to be found in the city. The manufactures produced by Mr. Pabst, are acknowledged to be the best made in Philadelphia, as they are a combination of originality, beauty, strength, and superior workmanship. The Pabst furniture is known throughout the United States. (Philadelphia, c. 1881, p. 270)

Pabst's earliest documented piece (and the only known labeled example of his work) is a sewing box still owned by his descendants, dated 1854. The documentation of other furniture made by Pabst is based on the names of his customers, as listed by his daughter, Edna Pabst Reisser (PMA, Archives). They include some of Philadelphia's richest and most prominent citizens: John Bullitt, Henry Disston, John Wyeth, the Newbolds, the Wistars, General Thomas McKean, the Harrisons, John and William Welsh, Lowber Welsh, Thomas Preston, Frank Furness, John Doyle, and Theodore Roosevelt, Sr., the father of President Theodore Roosevelt.

His furniture designed in the 1860s in the Renaissance revival style includes that executed about 1869 for Henry Charles Lea's Walnut Street house. Pabst's furniture of the 1870s reflects the "Modern Gothic" style, introduced into Philadelphia by Frank Furness, Christopher Dresser, and others. The high quality of his work is indicated by the award he won at the Centennial exhibition: "A LARGE WALNUT SIDEBOARD. *Report.*— Commended for utility, durability, and beauty" (*Reports on Awards. Group VII, U.S. Centennial Commission International Exhibition 1876*, Philadelphia, 1876?, p. 5).

Daniel Pabst retired at the age of fifty-five, but he continued to make furniture for his own pleasure. He died in Philadelphia at the age of eighty-two.

ATTRIBUTED TO DANIEL PABST

326. *Cabinet*

c. 1865

Inscription: EI (in monogram, carved in relief on front of pediment)

Walnut

97⅞ x 46⅝ x 20¼" (248.6 x 118.4 x 51.4 cm)

Miss Anna Warren Ingersoll, Penllyn, Pennsylvania

PROVENANCE: Edward Ingersoll; son, Charles Edward Ingersoll; daughter, Anna Warren Ingersoll

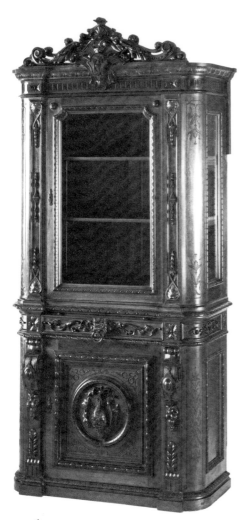

326.

often characteristics of Pabst. The roundel panel in the center of the lower section of this cabinet contains a fowl suspended by a ribbon, while the mate to this cabinet has a fish and an eel; both motifs are suggestive of the cabinets' dining room use.

Edward Ingersoll (1817–1893), whose initials are carved in relief on the cornice, was a distinguished Philadelphia lawyer and author. In 1850 he married Anna C. Warren of Troy, New York, and they had seven children. A recognized exponent of radical democracy, Ingersoll was sympathetic to the cause of the Confederacy, on constitutional grounds. On April 13, 1865, he made a speech in New York City criticizing certain of the federal government's war measures, for which he was attacked by the Philadelphia press.

DH □

327. *Child's Dress*

c. 1865
Sheer ivory wool; trimmed with red velvet ribbon and lace
Waist 24½″ (62.2 cm); center back length 30″ (76.2 cm)
Philadelphia Museum of Art. Given by Mr. and Mrs. Bertram Lippincott. 52–23–1

PROVENANCE: Joanna Wharton; daughter, Mrs. Bertram Lippincott

CHILDREN'S CLOTHES AND OUTFITS as we know them today were virtually nonexistent in earlier periods, for the young were always dressed as miniature replicas of their elders, down to the last button and bow. Although the nineteenth century saw more practicality in children's garments, they were still limited by Victorian conventions and pruderies. Little girls' skirts were shortened, but they were held out by the same contraptions as were their mothers' skirts—crinolines, hoops, or bustles, whichever was currently in style. The first half of the century also saw little girls further hampered by pantalets, a white cotton undergarment ruffled and trimmed with lace and embroidery which peeped out below the skirt and covered the legs for "decency's sake."

Although spared the necessity of these pantalets, young Joanna Wharton would have worn a crinoline hoop and several crisply starched and ruffled petticoats under this delightful sheer ivory wool dress. A very close copy of a dress pictured in a November 1864 fashion plate from *Godey's Lady's Book* (see Davenport, *Costumes*, vol. 2, p. 930, no. 2764), it features long, shaped "Renaissance," or "Medici," sleeves shirred and trimmed with narrow red velvet ribbon, while matching shirring and trimming appear on the bodice top. The skirt is full,

flared and gored, further trimmed with a waistband and diamond-shaped tabs edged in the red velvet ribbon of the sleeves and bodice.

This is a fine example of the art of dressmaking, of copying a design pictured in a fashion plate and creating a garment without the aid of the dress patterns in use today.

EMcG □

THOMAS EAKINS (1844–1916)

Eakins was born in Philadelphia on July 25, 1844, and, except for a period of study in Europe during 1866–70, lived in the city his entire life. He received his early education at home, and it is likely that he had his first lessons in drawing from his father, Benjamin Eakins, a writing master and professional calligrapher who encouraged his son's interest in art. Eakins entered Zane Street Grammar School in 1853, and in 1857 he was admitted to Central High School where he excelled in the rigorous curriculum of science, mathematics, and languages that made graduation the equivalent of earning a college degree. In his class at the high school were William Sartain, Charles Fussell, Max Schmitt, who was to be the subject of one of Eakins's most famous rowing pictures, and W. J. Crowell, later his brother-in-law. Eakins also earned perfect grades in his art classes, and a number of drawings from his high school and grade school years (now in the Hirshhorn Collection) show his skill with the ornamental calligraphy of the writing master's style and the perspective

327.

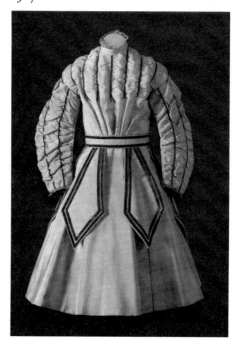

By tracing the descendants of Daniel Pabst's customers, Calvin Hathaway was able to locate Pabst's furniture still in family possession. These pieces exhibit ornamental motifs much used by Pabst and share the high quality of workmanship characteristic of his shop. A set of dining room furniture attributed to Pabst made for Henry Charles Lea about 1869 came to the Philadelphia Museum of Art as a bequest of Arthur Henry Lea in 1938. Some of the furniture made for Edward Ingersoll about 1865 can also be attributed to Pabst with a fair degree of certainty, including this handsome cabinet, which is one of a pair ordered for his Germantown house, Fernhill. Photographs in the Philadelphia Museum of Art archives show the dining room of this house in the 1890s with the cabinets in situ. Designs for Renaissance revival furniture of the 1860s seen in German, French, and English sources were transmitted to this country, and Pabst undoubtedly knew of them, but the ornamental detail and the quality of the carving of this cabinet are

drawing and conventions of pictorial representation taught in the art classes of the public schools.

After his graduation in 1861, Eakins was listed in the city directories of 1863 and 1864 as a teacher, and in 1866 as a writing teacher. In 1862 he competed for the position of Professor of Drawing, Writing and Bookkeeping at Central, losing the competition to Joseph Boggs Beale (see biography preceding no. 297), who was three years his senior. In the same year he entered the Pennsylvania Academy to draw from casts of antique sculpture and to attend lectures in anatomy and perspective. In 1864–65 he attended anatomy lectures at Jefferson Medical College and probably in 1865 he was admitted to the life classes at the Academy.

In September 1866, Eakins sailed for France, and in late October he was admitted to the École des Beaux-Arts to study painting with Jean-Léon Gérôme and sculpture with Alexandre Dumont; for a brief period in August and September of 1869, he also worked in the independent atelier of Léon Bonnat. The intense concentration and self-criticism that Eakins brought to his years of study in Paris is apparent in the letters that he wrote to his family and friends during the period. Unlike many of his American contemporaries in Paris, he did not prepare finished pictures to exhibit at the Salons, but devoted himself to the course of study prescribed at the École—drawing from casts, drawing and painting studies from the nude model, studying anatomy, and painting composition sketches.

Feeling that he had benefited as much as he could from a formal course of study, Eakins left Paris for Spain in late November 1869 with his friend Henry Humphreys Moore. The two artists stopped in Madrid, where Eakins studied the paintings of Velázquez and Ribera, then proceeded to Seville, where they were joined by William Sartain in January 1870. Only during a six-month stay in Seville did Eakins consolidate the technical preparation of his student years in his first complete painting, *Street Scene in Seville.*

After his return to Philadelphia in the summer of 1870, Eakins again attended the anatomy classes at Jefferson, and began the systematic development of his artistic skills in a series of portraits of his family and friends in interior settings, and in familiar scenes of rowing, sailing, and hunting.

During 1870–75, Eakins maintained his contacts with France, sending work in 1873, 1874, and 1875 for Gérôme to criticize, and exhibiting at the Salon of 1875. He began to show his work in the United States with the exhibition of *Max Schmitt in a Single Scull (The Champion Single Sculls)* and a portrait of M. H. Messchert at the Union League in 1871, and sent two watercolors to

the exhibition of the American Society of Watercolorists in New York in 1874. Like a number of other young Americans recently returned from study in Paris or Munich, Eakins no doubt saw the 1876 Centennial as an opportunity to establish his reputation in a major exhibition. Five of his works were included in the art section of the Centennial, although his largest and most ambitious painting, *The Gross Clinic,* was refused and was hung instead in the United States Army Post Hospital Exhibit.

After the Centennial, Eakins actively participated in the increased number of exhibitions open to young artists. From the recommencement of the Academy annual exhibitions in 1876, he showed his work regularly until 1885. He began exhibiting at the National Academy of Design in the controversial exhibition of 1877, in which a large representation was given to the work of young artists, and continued to exhibit there through 1882. In 1878 he exhibited in the first exhibition of the newly formed Society of American Artists, and in 1880 became a member of this group, whose exhibitions were considered radical presentations of new trends in art. In the 1870s, Eakins's work received favorable notice from critics such as Earl Shinn and William C. Clark, Philadelphians who understood his artistic goals and followed the progress of his work. Toward the end of the decade and in the early 1880s, however, critics often considered his work too harsh in technique and controversial in subject to be satisfying as art. Although he achieved considerable prominence and was recognized as a talent to be considered seriously, by the early 1880s the formulas of adverse criticism that persisted in the majority until the end of the nineteenth century had been established.

Eakins's belief in the effectiveness of the course of instruction he had pursued at the École and his security in his own talent, developed in years of dedicated hard work, prepared him for the teaching that was an integral part of his life as an artist. In 1874 he was invited to teach in the evening life classes organized by the Philadelphia Sketch Club, and he quickly earned a reputation as an inspiring teacher. In January 1876 students in the Club life class—among them William J. Clark, Alexander Milne Calder, John J. Boyle, J. B. Kelly, Thomas Anshutz, Charles Fussell, and William Sartain—petitioned for the use of the life-class room in the new Academy building, and Eakins was named assistant to Christian Schussele to teach the evening life classes without pay. A controversy over Eakins's teaching methods developed and led to his dismissal as instructor, although he remained as chief demonstrator in the anatomy classes taught by Dr. W. W. Keen. By the end of March 1877, Eakins was teaching, again without

salary, at the newly formed Art Students' Union, which offered day as well as evening life classes. In March 1878, however, he was reinstated at the Academy, and after the death of Schussele in August 1879, Eakins was named professor of painting and drawing. In 1882, at the age of thirty-nine, he was appointed director of the Academy schools.

Eakins modified the traditional framework of study at the Academy to conform with his own student experience in France. He did not discard the traditional academic curriculum—drawing from the antique, drawing and painting from the live model, perspective and anatomy—but changed the emphasis on these components in such a way that his teaching approach was contrasted to the conservatism of Schussele (discussed in a contemporary article by William C. Brownell, "The Art Schools of Philadelphia," *Scribner's Monthly Magazine,* vol. 18, no. 5, September 1879). He advocated that the student begin immediately to draw and paint directly from the nude model. To increase understanding of physical structure, anatomy lectures were supplemented with dissection, and modeling classes were instituted as an aid to the understanding of form. The range and thoroughness of Eakins's commitment to technical studies are evident in the manuscripts of lectures on perspective (now in the collection of the Philadelphia Museum of Art), in his participation on the committee that supervised Eadweard Muybridge's photographic studies of motion at the University of Pennsylvania in 1884–85, and in his own parallel experiments in the photography of motion.

Eakins's uncompromising insistence on the study of the nude model, always a controversial issue with the public and some students, precipitated his dismissal from the Academy in February 1886. But aside from the moral issue, additional causes can be found in disagreement over fundamental questions of aesthetics and teaching method; and it seems possible, as Alan Burroughs pointed out ("Thomas Eakins, the Man," *The Arts,* vol. 4, no. 6, December 1923, pp. 302–23), that Eakins's dismissal was as much a reaction against the atelier system as the propriety of his teaching methods. A number of Eakins's students—among them Charles Grafly and Alexander Stirling Calder—signed a petition protesting his forced resignation, and by the end of February, a group of them had formed the Art Students' League in Philadelphia where Eakins taught—again without pay—until 1892. In 1882 he had begun to make weekly trips to New York where he taught at the Brooklyn Art Guild until 1884. He taught at the Art Students' League in New York for seven years, beginning in 1888, lectured on anatomy at the National Academy from

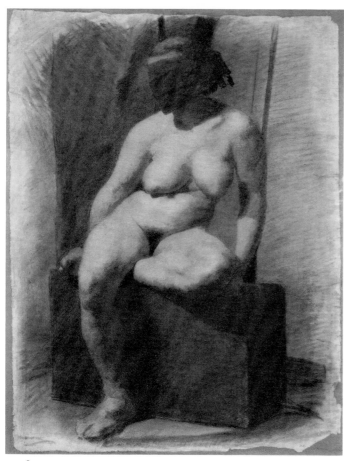

328.

O'Donovan did the figures. In 1893 he modeled three relief panels for the Trenton Battle Monument. Although not invited to participate in any of the projects for the decoration of buildings at the World's Columbian Exposition in Chicago in 1893, he sent ten paintings to the art exhibition and was awarded a bronze medal. By the mid-1890s, Eakins began to exhibit again. He was invited to send his work to the 64th Pennsylvania Academy exhibition in 1894–95, and he continued to exhibit there regularly until his death, winning the Temple Gold Medal for his portrait of *Archbishop Elder* in 1904. In 1896 he was invited to exhibit in the Carnegie international exhibitions and in 1899 to serve on their jury of award. In 1903 he was elected both an Associate and an Academician of the National Academy of Design, and his work won gold medals at the Louisiana Purchase Exposition in St. Louis in 1904 and at the Pan-American Exposition in Buffalo in 1901. Adverse criticism of his work continued to a degree, but his perseverance in his artistic goals and the power of his talent in realizing them were increasingly admired by younger artists, such as Robert Henri. The gradual revival of interest in his work and the memorial exhibitions held after his death in June 1916—at the Metropolitan Museum and at the Academy in 1917—established the basis for Eakins's recognition today as one of America's greatest painters.

1888 to 1895, at the Cooper Union from 1891 to 1898, and began a series of anatomy lectures at Drexel Institute in 1895, but the use of a nude model in a class of male and female students again caused his dismissal.

By the mid-1880s the misfortune of Eakins's teaching career was paralleled by a general lack of public interest in his work. The work of artists trained in Munich or Barbizon that had seemed innovative in the last years of the 1870s had become the established style, rapidly changing under the influence of Impressionism and a conscious attitude of aesthetic sensibility, and Eakins's method of painting seemed outmoded. He began to limit the scope of his subject matter to portraits and to exhibit less regularly at the Academy and the National Academy of Design. The jury of the Society of American Artists, where Eakins had shown *The Gross Clinic* in 1879, refused to show *The Agnew Clinic*, and in 1891, at the request of the Academy's board of directors' exhibition committee, it was not shown in the annual exhibition. In 1892, Eakins resigned from the Society of American Artists, giving as his reason refusal of his work for the past three years. The depth of Eakins's bitterness about his official rejection

as a teacher and an artist can be judged from his statement in a letter of 1894 that "my honors are misunderstanding, persecution & neglect, enhanced because unsought" (PAFA, Archives, Eakins Folder, April 23, 1894).

In 1884, Eakins had married Hannah Susan Macdowell, the daughter of William H. Macdowell, a well-known Philadelphia engraver. A student at the Academy during the years 1876–82, she was not only a talented pupil, but approached art as a serious, professional occupation. After their marriage, she subordinated her own career as a painter to his, and her clear understanding of Eakins's artistic goals was a constant source of intelligent encouragement and support. The sculptor Samuel Murray, whom Eakins met as a student at the Art Students' League in 1887, and other friends among artists and professional people in Philadelphia formed a dedicated group of admirers during the years of public indifference to his work.

Despite the lack of recognition, Eakins did not cease to work altogether, and in 1891–92 he collaborated with the sculptor William O'Donovan on a commission for the Brooklyn Civil War Memorial Arch, modeling the horses for the equestrian statues of Lincoln and Grant, for which

328. *Nude Woman, Seated, Wearing a Mask*

1865–66
Inscription: T.E. (lower right, by Mrs. Eakins)
Charcoal on paper
24¼ x 18⅝″ (61.6 x 47.3 cm)
Philadelphia Museum of Art. Thomas Eakins Collection. 29–184–49

PROVENANCE: Thomas Eakins; Mrs. Thomas Eakins and Miss Mary A. Williams, 1916–29

LITERATURE: Goodrich, *Eakins,* no. 1, p. 161, illus. pl. 1; New York, Whitney Museum of American Art, *Thomas Eakins,* by Lloyd Goodrich (1970), p. 36 (illus.); Hendricks, *Eakins Life and Works,* pp. 28, 338, fig. 33; University Art Gallery, State University of New York at Binghamton, *Strictly Academic: Life Drawing in the Nineteenth Century,* intro. by Albert Boime (March 30—September 1, 1974), pp. 84–85, illus. no. 48; William H. Gerdts, *The Great American Nude, A History in Art* (New York, 1974), p. 118, illus. p. 119, figs. 6–14; Sellin, "The First Pose," illus. p. 14, fig. 8

THE LARGE NUMBER OF OIL SKETCHES, perspective drawings, finished paintings, photographs, and sculpture that are recognized as Eakins's work provide an unusually complete record of the range of his interests and of the development of his powers as an artist. But his student days at the Pennsylvania Academy and at the École des Beaux-Arts are obscure, and relatively few drawings and paintings remain from the time in which he was learning to be an artist through the repetitive practice of drawing and painting, first from casts of antique sculpture, then from nude models in life classes, which was the basis of the academic curriculum.

This drawing of a *Nude Woman, Seated, Wearing a Mask* is the kind of figure study that would have been required of Eakins in the life classes at the Pennsylvania Academy in 1865, or early in the period of his work with Gérôme, before March 1867, when he began to paint his studies of the model instead of drawing them in charcoal. Because the model is masked to conceal her identity—a standard practice in the life classes at the Academy until at least 1878—it has been assumed that the drawing was made before Eakins went to Europe in the fall of 1866. If so, it shows a precocious talent and indicates that Eakins not only had formed an interest in what he later called the "grand construction" of the figure (William C. Brownell, "The Art Schools of Philadelphia," *Scribner's Monthly Magazine,* vol. 18, no. 5, September 1879), but had developed an individual drawing style even before he went to Paris.

The elimination of detail and the sketchy definition of the model's lower arms and her right leg from the knee down to concentrate on the large masses and anatomical balance of her shoulders, torso, and thighs suggest that Eakins studied the model with a clear idea of the aspects of her pose that he wanted to record. The drawing technique of modeling the figure in strong contrasts of light and dark, rubbing in and lifting off areas of charcoal with a drawing stump and finishing with delicate, fine strokes that emphasize shapes and enliven the taut skin of the figure is quite different from the traditional method of defining form in outline and modeling it with hatched lines that would have been most commonly available as an example to Eakins at the Pennsylvania Academy. Figure studies by Christian Schussele in an album of his drawings belonging to the Academy use this technique—possibly learned by Schussele when he was a student at the Strasbourg Academy, or in Paris—and show a more superficial interest in the particularities of pose and anatomy than does the *Masked Nude.*

Gordon Hendricks has suggested that masks could have been worn by models at the École des Beaux-Arts when Eakins was a student there and that Mrs. Eakins considered a group of figure drawings—of which the *Masked Nude* is one—to have been made in Paris (Hendricks, *Eakins Life and Works,* p. 338). Yet, in comparison to the sophisticated technique of the figure studies produced by advanced students in the life classes at the École the drawing of *Masked Nude* appears crude in spite of its forcefulness as a study of anatomy. The bluntness with which the *Masked Nude* is drawn effectively renders the gross figure of the model without appearing to be a technique developed for its own sake. Whether this represents Eakins's concentration on the aspects of figure drawing that interested him with disregard for conventions of art that he considered inessential—an attitude consistent with his later work and teaching—or whether it is an immature step in the development of a more facile technique remains a question. Recent study of the teaching methods at the Pennsylvania Academy and the École des Beaux-Arts and of other artists who were friends and teachers of Eakins has provided more information about the kind of training he received and helps to explicate the artistic problems he describes in his letters from Paris. But the undated works traditionally assigned to his student years provide an incomplete and puzzling visual record of how Eakins—a dedicated but independently minded student—formed his personal style within the academic framework.

Back in Philadelphia, soon after he began to work independently as a painter, Eakins abandoned drawing as part of his working method, except as an aid to the construction of perspective, preferring instead to make studies for his paintings in oil or watercolor. As a teacher, he encouraged his students to begin immediately to paint from the model in order to study the large forms and structure of the figure without the distractions of outline and finicky detail that he felt were implicit in conventional drawing techniques.

DS □

EDWARD A. GOODES (1832–1910)

According to Anthony A. P. Stuempfig, who provided much of this information, Edward Ashton Goodes was born in Wilmington, Delaware, the sixth child of a tailor who had emigrated from England three years earlier. He moved to Philadelphia about 1850 when "Goodess, E. A., sign painter, 460 Poplar" is first listed in the Philadelphia city directories. The next year the listing becomes "Goodes & Thompson, artists," and in 1852, "Goodes & Thompson, portrait painters" moved to 593 Poplar. Goodes's partner, Almerin D. Thompson, formerly of Massachusetts, had lived in Wilmington, and it is probable that Goodes

had served an apprenticeship to Thompson there. The business dissolved after 1852 and Goodes apparently spent most of his productive years as a sign painter, although he was frequently listed in the directories as an artist along with his brother, Ebenezer A. Goodes. In 1854, "E. A. Goodess" exhibited a portrait of Washington at the Franklin Institute. Edward Goodes is reputed to have worked for Philadelphia fire and beer companies, among others. Although the Pennsylvania Academy lists his participation in its exhibitions of 1853 and 1855, and from 1864 to 1868, showing a variety of works, including marine and landscape scenes, still lifes, and a religious painting, only four of his paintings are extant and little is known of his professional life. In 1853, Goodes married Anna Dobbins of Philadelphia, who bore him two sons. He died in Philadelphia at the age of seventy-eight.

AS

329. *Fishbowl Fantasy*

1867
Signature: Ed. A. Goodes. 1867 (lower left)
Oil on canvas
30 x 25⅛" (76.2 x 63.8 cm)
Private Collection

PROVENANCE: Roland Ellis, Philadelphia; Albert Ten Eyck Gardner, New York; Mr. and Mrs. Robert Gardner, Philadelphia, 1967; with Hirschl & Adler Galleries, New York

LITERATURE: New York, Hirschl & Adler Galleries, *Twenty-five American Masterpieces* (April 23—May 11, 1968), no. 10 (illus.); New York, Public Education Association, *The American Vision* (October 8—November 2, 1968), no. 40 (illus.); Washington, D.C., National Gallery of Art, *The Reality of Appearance; the Trompe L'Oeil Tradition in American Painting,* by Alfred Frankenstein (March 21—October 31, 1970), pp. 13, 53, illus. p. 52; James Thomas Flexner, *Nineteenth Century American Painting* (New York, 1970), p. 192, illus. p. 200; Gerdts and Burke, *Still-Life,* p. 72, illus. p. 242

ALTHOUGH A FEW OTHER PAINTINGS by Edward Goodes are known, his reputation as an artist rests solely upon the fame of this disquieting still life. The flower paintings of Severin Roesen, a German-trained artist who lived in Williamsport, Pennsylvania, might have served as an example for Goodes—a larger painting by Roesen (Metropolitan Museum of Art) shows a similarly profuse variety of garden flowers arranged in a glass fish bowl—but the lavishness and abundance of nature which comprise the subject of Roesen's painting are only a starting point for Goodes. His flowers spill out of the top of the bowl as thrusting, twining, linear forms that

have an energetic life of their own, and the bowl, instead of showing stems through its clear glass, improbably contains three plump goldfish and serves as the reflecting surface for a glimpse of two well-dressed women walking along a city street. The accessories of a woman's costume—a hat, a piece of lace, a fan, a cross on a chain—appear to have been discarded on the table that holds the flowers. The gloves, which retain the shape of the hands that wore them, and the name "Isabel" appearing on a card and as a salutation on the folded letter have an individuality beyond their significance as components of a still life arrangement. The tight linear designs in the lace, on the fan, casket, and writing desk, repeated color notes of pink in the gloves, the bit of down on the top of the fan, the ribbon loosely wrapped around a bundle of papers, and the casual clutter of letters, apparel, and bric-a-brac create an intense effect of personal taste and character.

How far Goodes intended the painting to be a symbolic portrait of the woman to whom these objects belonged is impossible to tell. In any case, the harsh colors and brittle linearity of forms deny the simple voluptuousness implied in such an arrangement, and the concerted stare of the goldfish and transient action of the street scene prevent the passive contemplation of it. Instead of the placid sensuality expected of a Victorian still life, tensions of form and color in this crowded intermingling of flowers and objects provoke the mind. Whether it signifies an obsession with personality or a love of observing detail, Goodes's *Fishbowl Fantasy* invites the kind of speculation about its meaning that is not usually associated with the work of an American artist in the nineteenth century.

DS □

JOSEPH A. BAILLY (1825–1883)

Born in Paris, Joseph Alexis Bailly was the son of a manufacturer of cabinet furniture. He studied at the French Institute and worked in his father's factory as a turner and carver. Conscripted against his will in the revolution of 1848 and guilty of firing on his own captain, he escaped to England, where he studied briefly with the sculptor Edward Hodges Baily before coming to the United States (*Centennial Masterpieces,* vol. 1, pp. 55–56).

After short stays in New Orleans, New York, and Buenos Aires, he arrived in Philadelphia in 1850 and started a wood-carving business. An energetic and versatile worker, Bailly found a ready market in Philadelphia for his skills. Although he established himself as a wood-carver, and like other craftsmen listed himself as a carver in the

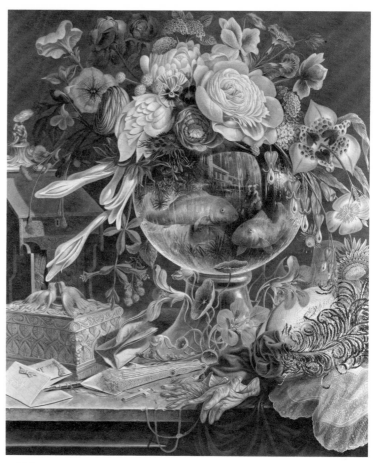

329.

city directory in 1851, he soon became the one artist that local patrons commissioned for decorative projects or public monuments that aspired to the realm of fine art.

In 1851, Bailly won a prize for "1 Wax Statue, 1 Wax Boquet; 1 Card Frame, 2 Carved chairs" at the Franklin Institute annual exhibition. The next year the catalogue noted an "Oak Carving by A. J. Baily, Philadelphia; for excellence of design and elaborate execution, we award A First Premium." He contributed twelve busts of General Grant and General Meade to the Great Central Fair held in Logan Square in 1864, to be auctioned off for the benefit of the United States Sanitary Commission. Bailly also worked in the Philadelphia cabinetmaking firm of Gottlieb Vollmer (see biography preceding no. 325) before opening a sculpture studio about 1854. Among his first works are the six standing female attributes of Masonry that he and his partner Charles Bushor carved for Masonic Hall in 1855 (FPAA, *Sculpture,* p. 63). In 1856 he listed himself, with Bushor, as a sculptor and carver, and in 1859 he began to list himself only as a sculptor. When the Academy of Music (no. 301) was built in 1855–57, Bailly carved its ornamental

sculpture. A "very rapid and very indefatigable worker" (William J. Clark, Jr., *Great American Sculptures,* Philadelphia, 1878, p. 104), he worked in stone and bronze as well as wood and produced a great deal of portrait statuary. In 1860 he was elected an Academician by the Pennsylvania Academy.

In 1863 and 1865, Bailly patented some of his statuettes, including at least one of Lincoln (Albert Ten Eyck Gardner, *Yankee Stonecutters, The First American School of Sculpture 1800–1850,* New York, 1945, p. 60). He also made a number of funeral monuments for Laurel Hill Cemetery, among them a stone figure of Grief for the tomb of General Francis E. Patterson and a bronze statue of William Emlen Cresson. His figure of Franklin was on the Public Ledger Building for many years, and his statue of Washington, carved in 1869, stood in front of Independence Hall before being moved to City Hall in the 1880s and replaced at Independence Hall with a bronze replica. In 1875, Bailly submitted a design for the figure of William Penn atop City Hall which resembles the statue later designed for that position by Alexander Milne Calder (FPAA, *Sculpture,* p. 105).

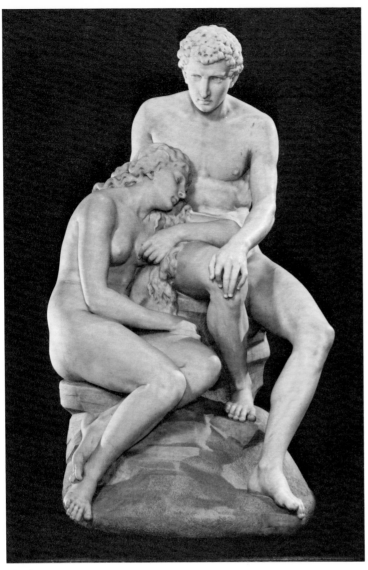

330.

During his career in the city, Bailly engaged in nearly every kind of work available to a sculptor—carving furniture, making funerary sculpture, allegorical figures, portrait busts, and large-scale monuments for civic decorations. Considering this wide range of activity, it is not surprising that he also tried his hand at the popular mode of literary and sentimental subjects interpreted in carefully finished marble.

He exhibited this group of Adam and Eve disconsolate after their expulsion from Eden under the title of *Paradise Lost* at the Academy in 1863. In that year it was shown as a plaster study to be executed in marble; in 1864, as a life-size plaster model; and in 1868, as the finished group in marble. In contrast to the sleekly rhythmic figures of the attributes of Masonry that Bailly had carved in wood for Masonic Hall in 1855, the skillful arrangement and anatomical accuracy of the figures of Adam and Eve show Bailly's talent in achieving the balance of sensuous form and narrative content that constituted an international style in the mid-nineteenth century.

DS □

J. E. CALDWELL & CO. (EST. 1848)
(See biography preceding no. 307)

331. *Mantel Clock*

c. 1865–75
Mark: J. E. CALDWELL & Cº/PHILADELPHIA (painted on face of clock); JUVENAUX (stamped on back plate of works underneath bell); Number 637 (stamped on back plate of works and scratched on side of back cover)
Marble; gilded bronze
23¼ x 14¾ x 8⅝" (59 x 37.5 x 21.9 cm)
Philadelphia Museum of Art. Purchased: Edgar Viguers Seeler Fund and Marie Josephine Rozet Fund. 74-144-1

PROVENANCE: With Peter Hill, United States Antiques, Washington, D.C.

ALTHOUGH RETAILED by J. E. Caldwell, this clock is probably of French origin, since its works are stamped Juvenaux, a French firm. It is possible that the case was made by Caldwell's, with imported bronze mounts and works. According to *Illustrated Philadelphia: Its Wealth and Industries* (New York, 1889, p. 114), Caldwell's not only included "thousands of the finest imported and domestic movements in all desirable casings" but also "clocks in marbles, bronze and ormulu." In the nineteenth century, France was known for its production of ornamental clocks: "The extent to which French industry and skill are employed in the production of time-keepers, great and small,

At the 1876 Centennial, Bailly exhibited an equestrian statue of President Antonio Guzman Blanco of Venezuela in the rotunda of Memorial Hall and a figure of Spring (*Aurora*), which was engraved for a book on the masterpieces of the exhibition. He was professor of modeling at the Pennsylvania Academy in 1876 and 1877 and exhibited there frequently from 1851 to 1880. Among his students were Howard Roberts, Alexander Milne Calder, and John J. Boyle. Bailly died in Philadelphia in June 1883.

AS

330. *The Expulsion*

1863–68
Signature: J. Bailly (on back)
Marble
61¼ x 39 x 33" (155.5 x 99 x 83.8 cm)
Pennsylvania Academy of the Fine Arts, Philadelphia. Bequest of Henry C. Gibson, 1892

LITERATURE: PAFA, *Acres of Art* (June 22–July 30, 1972), no. 6; William H. Gerdts, *American Neo-Classic Sculpture, The Marble Resurrection* (New York, 1973), no. 126, p. 116, illus. p. 117; PAFA, *Held in Trust, One Hundred Sixty-Six Years of Gifts to the Pennsylvania Academy of the Fine Arts* (June 23–August 26, 1973), no. 4, p. 1; Sellin, "The First Pose," illus. p. 11

costly and low-priced can only be realised on an occasion like that which brings together in one focus specimens of the more important works in any *specialité*" (George Wallis, "The Exhibition of Art-Industry in Paris, 1855," *Art Journal*, vol. 1, 1855, p. xviii).

This clock succeeds in its bold, architectonic, mannered design. A detail such as the mask placed in the center of a pediment was a common Renaissance revival motif; it can be seen in the vestibule of the Paris Opera and on Philadelphia's City Hall (see no. 334). Its location at the base of the clock instead of at the top is unusual, while the arch motif is repeated at the top above the dial.

In its design and its materials, the clock is conceived as an architectural unit which achieves impressive monumentality. It would have been a handsome addition to a marble mantel in an Italianate Philadelphia house, with accompanying vases, or possibly it could have been placed on a pedestal by itself. The Renaissance style on which it is based is described in a contemporary account: "To resuscitate Antiquity was the aim of those grand Italian artists of the 15th and 16th centuries, and indeed they succeeded in reproducing in their creations the eternal and immutable laws of the Beautiful as thoroughly as the Ancients during the periods of their greatest achievements in Art. . . . For the most part very simple relations, elaborated and established by practical experience through century after century, the hallowed traditions of proportion, transmitted from generation to generation through all the later periods of Art, have imparted to the Renaissance epoch a degree of refinement and perfection in which it may vie with the best time of Grecian Art" ("On Italian Renaissance in Its Relations to Architecture and the Industrial Arts," *The Workshop*, vol. 1, no. 8, 1868, p. 29).

DH □

THOMAS MORAN (1837–1926)
(See biography preceding no. 312)

332a. *View from Pencoyd Point, West Laurel Hill Cemetery*

332b. *View up the Schuylkill from West Laurel Hill Cemetery*

1870
Signature: T. Moran/1870 (lower right, on *View from Pencoyd Point*); T. Moran (lower right, on *View up the Schuylkill*)
Oil on canvas
30 x 45" (76.2 x 114.3 cm)
Private Collection

PROVENANCE: John Jay Smith; descended in family to present owner

BEFORE THE 1870s when he began to paint the vast canvases of the western landscape and shimmering views of Venice, for which he became famous, Moran exhibited a number of landscape views of the Pennsylvania countryside. *Evening on the Susquehanna* and *Autumn on the Wissahickon* alternate with the poetic subjects, such as *Ruins on the Nile* (no. 312), which he showed at the Academy during the late 1850s and through the 1860s. Commissioned by John Jay Smith, founder of Laurel Hill and West Laurel Hill cemeteries, these views from West Laurel Hill show that Moran responded to the quieter beauties of the local landscape with the same imaginative force that he used later for more grandiose effects.

Moran expressed his romantic view toward landscape as follows: ". . . all my tendencies are toward idealization. . . . a place, as a place, has no value in itself for the artist

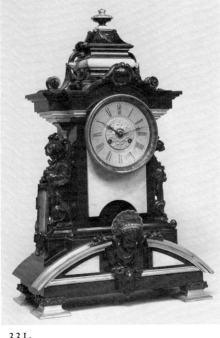

331.

only so far as it furnishes the material from which to construct a picture. Topography in art is valueless" (Sheldon, *Painters*, p. 125).

Endowed with an exceptional visual memory, Moran used his sketches from nature to recall his impressions of a scene as he painted in his studio, and he portrayed them with a freshness and vividness beyond the scope of less imaginative painters. His comment on Turner's approach reflects his own philosophy toward art: "All that he asked of a scene was simply how good a medium it was for making a picture; he cared nothing for the scene itself. Literally speaking, his landscapes are false; but they

332a.

332b.

333.

contain his impressions of Nature, and so many natural characteristics as were necessary adequately to convey that impression to others" (Sheldon, *Painters*, p. 123).

In these views of the Schuylkill, painted the year after West Laurel Hill was founded, Moran takes great artistic license in rendering his impression of the area. Considered as a pair, the two paintings show Moran's use of two traditional landscape devices—a closed view through a dark frame of foliage into the landscape beyond, and an open panoramic view to the horizon along a diagonal created by carefully controlled patterns of light and shade. Instead of being united by a similar approach, the differences between the two paintings allow Moran to demonstrate the full range of his landscape technique in low contrasting moods. The bold, thrusting shape of the foreground tree in the *View from Pencoyd Point* is a device that Moran had used in his lithograph of 1869 entitled *Solitude*, and the strong form of the tree, and its bright autumnal coloring set the assertive tone of the painting. In the *View up the Schuylkill*, the play of luminous greens in a raking light and the pastel colors of the river and the distant landscape create a placid vista that invites meditative appreciation of the beauties of the sight.

SKM □

333. *Trotting Cracks of Philadelphia*

1870
Published by H. Pharazyn
Inscription: TROTTING CRACKS OF PHILA-DELPHIA RETURNING FROM THE RACE AT POINT BREEZE PARK,/HAVING A BRUSH PAST TURNER'S HOTEL, ROPE FERRY ROAD, PHILADELPHIA, 1870./*Respectfully Dedicated to the Lovers of Horses and the Sporting Public in general by the Publisher.*/PUBLISHED BY H. PHARAZYN, 1725 LOMBARD STREET, ENTERED ACCORDING TO ACT OF CONGRESS, IN THE YEAR 1870, IN THE DISTRICT COURT OF THE UNITED STATES FOR THE EASTERN DISTRICT OF PENNSYLVANIA.

Lithograph with watercolor on wove paper
23⅝ x 29⅛″ (60 x 74 cm)
The Library Company of Philadelphia

LITERATURE: Peters, *America on Stone*, p. 325, pl. 115

ALTHOUGH THE ORIGIN of the Pharazyn family is obscure, several of its members were connected with the arts during the third quarter of the nineteenth century. Philadelphia directories from 1848 to 1876 indicate that a W. H., Henry W., Alfred, and Maria Pharazyn worked interchangeably as colorists and jewelers; thereafter, Henry W.'s listings also included saloon keeper, painter, chair painter, frame and looking glass maker, and dealer in carpets,

furniture, and patent medicines. He could also have added "print publisher," for several prints are known to have been issued with his imprint during the 1860s, including the turbulent depictions of Philadelphia railroad and steamship disasters. Pharazyn is not known to have published any prints after 1870, the year *Trotting Cracks of Philadelphia* and a companion piece, *Stars of the Turf on Harlem Lane, New York*, sent clouds of dust swirling over large folio sheets.

The gleaming horses of the *Trotting Cracks* delight the eye today as much as they did in Victorian America. Trotting races were highly popular by the 1860s, and Philadelphians flocked to two courses, north and south of the city. Even diarist Sidney George Fisher, who disdained participation with "the vile atmosphere & disgusts of a vulgar crowd" admitted that the grand spectacle of a mass of gleaming equipages never ceased to excite him. Pharazyn's print shows such a crowd, racing home from the grandstand at Point Breeze Park, a popular racetrack in South Philadelphia, past one of the many taverns on the Philadelphia road. The anonymous artist took pains to individualize the horses and their drivers, delineating the intense expressions and depicting the skillful concentration required to maneuver the straining horses past cheering onlookers on the gingerbread verandah of the hotel. By contrast to the vivid motion conjured up by the rendition of flying dust, gleaming bodies, and whirling wheels, the background is relatively flat, providing a backdrop to the activity at the front of the picture. Commenting on the key identifying the racers, Harry Peters notes that "the horses are all named, as usual in the subtitle; the artist's name, as usual also, is not given. Those were the days when horses were far more important than artists" (*America on Stone*, p. 325). *Trotting Cracks* was not drawn by the same artist who produced the very crude disaster prints for Pharazyn, and like the legion of anonymous artists working for the better known firm of Currier & Ives, his name remains lost to us.

SAM □

JOHN MCARTHUR, JR. (1823–1890)

Although eulogized as "a sort of oracle in regard to building matters" by one obituary ("Death of John McArthur, Jr.," *The American Architect and Building News*, vol. 29, no. 734, January 18, 1890, p. 35), John McArthur, Jr., appears not to have been consistently innovative as his famous Philadelphia City Hall might suggest. Some of his designs were quite handsome, such as Dr. David Jayne's residence (1865–66, demolished 1922), but most fell short of greatness, and a few, such as the First Pres-

byterian Church of Frankford (1859), were rather clumsy. "Among architects," the obituary noted, however, "his virtue and ability, together with his zeal in the defense of professional rights, made him greatly regarded." This fact helps to explain why he won the City Hall competition three times before the project was finally commenced, served in various federal posts, and was a leader in the organization of the Pennsylvania Institute of Architects in 1861 and the Philadelphia Chapter of the American Institute of Architects in 1869.

McArthur was born in Bladenock, Scotland, May 1823. Both his father and uncle were carpenters, and it was his uncle who brought the lad of ten to Philadelphia and later put him into a carpentry apprenticeship. While serving his apprenticeship, McArthur attended night school at Carpenters' Hall and received drawing and design lessons at the Franklin Institute. The first competition he won was for the House of Refuge in 1848. This utilitarian building, based on Isaac Holden's plan of the Pennsylvania Hospital for Mental and Nervous Diseases (1836–41, demolished 1959), and the connections of his uncle helped the emerging architect to gain positions first as superintendent and later architect on similar projects in Philadelphia and Wilmington, Delaware. McArthur was very active during the 1850s, designing a host of commercial structures, churches, and dwellings, generally in the versatile Italianate style; plans for his large buildings—hotels, hospitals, prisons— were derived from earlier, well-known models, as suggested by his House of Refuge. During the Civil War he served as architect under the quartermaster general's department in Philadelphia, where he was responsible for erecting twenty-four temporary hospitals and new structures at the Schuylkill Arsenal. After the war, McArthur retained his association with the government as architect to the Navy Department for a brief time during which he designed the Laning building (1868) at the United States Naval Asylum in Philadelphia (no. 227).

In 1871 he was appointed superintendent of public buildings for the Treasury Department in Philadelphia, which involved him in supervising Alfred B. Mullett's Post Office and Court House (1873–74, demolished 1935) at Ninth and Market streets. At the same time McArthur was working on his own project for City Hall, a Second Empire design that exceeded the great federal works of even Mullett, the reputed master of this style. Sensing the potential immortality that City Hall held for its architect, McArthur in 1874 turned down the opportunity to serve as supervising architect for the Treasury Department, because the municipal building of his adopted city was, in his words, of "more account to any architect than the

334.

management of the public buildings of the United States at a beggarly salary, and hampered and pestered by political intriguers" (quoted in Lawrence Wodehouse, "John McArthur, Jr. (1823–1890)," *JSAH,* vol. 28, no. 4, December 1969, p. 281). McArthur's senses were true. He remains best known, and for many solely known, as the architect of Philadelphia City Hall.

334. *Philadelphia City Hall (Public Buildings of the City of Philadelphia)*

Penn Square
1870–1901
Thomas U. Walter, consulting architect; Alexander Milne Calder, sculptor; William C. McPherson, superintendent of construction; William Struthers & Sons, marble contractor

Inscription: JUSTICE (over arched portal in center of south pavilion); CORNER STONE/ OF THE/ PUBLIC BUILDINGS OF THE CITY OF PHILADELPHIA/ LAID JULY 4. 1874/

In the presence of the Mayor of the City, the Select and Common Councils, Heads of Departments, and other/ distinguished Civil, Military and Naval Officials, and a large concourse of citizens./ By ALFRED R. POTTER. Esq.,/ R.W. GRAND MASTER OF MASONS OF PENNSYLVANIA AND MASONIC JURISDICTION THEREUNTO BELONGING, ASSISTED BY HIS GRAND OFFICERS/ AND ACCORDING TO THE ANCIENT CEREMONIES OF THE CRAFT./ Orator—BENJAMIN HARRIS BREWSTER./ President of the United States —ULYSSES S. GRANT. Governor of Pennsylvania—JOHN E. HARTRANFT. Mayor of Philadelphia—WILLIAM S. STOKLEY/ COMMISSIONERS FOR THE ERECTION OF THE PUBLIC BUILDINGS/ Act of Assembly, August 5, 1870./ John McArthur, Jr. Architect SUPERINTENDENT—WILLIAM C. MCPHERSON/ PRESIDENT—SAMUEL C. PERKINS./THOS. J. BARGER, SAMUEL W. CATTELL, MAHLON H. DICKINSON, THOS. E. GASKILL, JOHN L. HILL, RICHARD PELTZ,/ WILLIAM BRICE, LEWIS C. CASSIDY, ROBT. W. DOWNING, A. WILSON HENSZEY, HIRAM MILLER, WM. S. STOKLEY,/ SECRETARY— FRANCIS DE HAES JANVIER. TREASURER—

PETER A.B. WIDENER. SOLICITOR—CHARLES
M.T. COLLIS. (west side of basement of
clock tower)
Dressed and rusticated granite blocks on
ground story; brick upper stories faced
with marble ashlar; iron frame of upper
stages of tower faced with marble ashlar
Height of tower 548′ (167 m)

REPRESENTED BY:
City Hall
c. 1901
Chromolithograph on paper
27 x 22⅝″ (68.5 x 57.4 cm)

INA Museum, INA Corporation,
Philadelphia

Office of John McArthur, Jr.
*Details of Vestibule of Controller's Offices,
New City Hall*
c. 1875
Ink, wash, and pencil on paper
32⅜ x 34⅝″ (82.2 x 87.9 cm)

Philadelphia City Archives

Office of John McArthur, Jr.
*City Hall: Sections and Elevation of
Cast-Iron Frame of Tower*
c. 1881
Ink on linen
41 x 27⅜″ (104.1 x 69.5 cm)

Philadelphia City Archives

LITERATURE: Frederick Faust, *The City Hall,
Philadelphia: Its Architecture, Sculpture and
History* (Philadelphia, 1897); Joseph Jackson,
Early Philadelphia Architects and Engineers
(Philadelphia, 1923), pp. 253–68; Carroll L. V.
Meeks, "Picturesque Eclecticism," *The Art
Bulletin,* vol. 32, no. 3 (September 1950),
pp. 226–35; White, *Philadelphia Architecture,*
p. 30, pl. 54; Dickson, *Pennsylvania Buildings,*
pl. 71; Tatum, pp. 107–19, 125, 193–94, pl. 117;
John Maass, "John McArthur, Jr., A.I.A.," in
PMA, *Architectural Drawings,* pp. 62–64; John
Maass, "Philadelphia City Hall," *Charette,*
vol. 44, no. 1 (January 1964), pp. 23–26; John
Maass, "Philadelphia City Hall: Monster or
Masterpiece?," *Journal of the American Institute
of Architects,* vol. 43, no. 2 (February 1965),
pp. 23–30; Lawrence Wodehouse, "John
McArthur, Jr. (1823–1890)," *JSAH,* vol. 28,
no. 4 (December 1969), pp. 271–83; Howard
Gillette, Jr., "Philadelphia's City Hall: Monu-
ment to a New Political Machine," *PMHB,*
vol. 97, no. 2 (April 1973), pp. 233–49; George
Gurney, "The Sculpture of City Hall," in
FPAA, *Sculpture,* pp. 94–103

PHILADELPHIA CITY HALL stands without
peer, overshadowing its neighbors, dominat-
ing the skyline, and determining the design
scheme of the city's business district—"a
majestic and lovely show, . . . silent, weird,
beautiful," as Walt Whitman called it. The
building may be silent, but its critics have
not been. City Hall was conceived, born, and
nurtured in controversy. The first dispute

began in 1860, apparently motivated by sore
losers who refused to accept the choice of
John McArthur, Jr., as the winner of the
architectural competition held that year for
a new municipal building to replace the late
eighteenth century City Hall at Fifth and
Chestnut streets (Supreme Court Building),
part of the Independence Hall complex
(no. 30). That debate ended, however, when
the project was abandoned at the outbreak of
the Civil War. After McArthur won a second
competition in 1869, another dispute erupted,
centered this time on the proposed site,
Independence Square, which opponents
sensibly argued was inappropriate for the
monumental Second Empire design and
would overwhelm the city's most important
historic shrine. The Pennsylvania General
Assembly resolved matters the next year first
by creating the Commission for Erection of
Public Buildings, which named McArthur
architect, and second by calling for a special
election in which Philadelphians demo-
cratically chose Centre Square as the site
for their municipal building.

By this time, however, controversy was an
inextricable part of City Hall's destiny and
raged on until only recently. At first it was
promoted by real estate interests frustrated
by the choice of the site, then by politicians
who chafed at losing patronage to the state-
created, self-perpetuating commission, and
after World War I by people of taste who
promoted the views of their anti-Victorian
generation. As late as 1952 the city seriously
entertained tearing down City Hall, then
considered "dismal and depressing with an
unfortunate psychological effect on all people
who use it." Only the tower, which would
stand curiously, one might even say ob-
scenely, in the midst of a traffic island, was
to be saved. The expense of demolishing the
marble and granite pile postponed such
action until 1957, when Mayor Richardson
Dilworth's Committee on the Efficient and
Appropriate Housing of City Functions
found the building "ideal for public and
workers alike." Talk of demolition was
scuttled and City Hall was rehabilitated
and preserved instead.

City Hall was designed in a French
Renaissance style whose nineteenth century
roots sprang from the Paris of Napoleon III.
When Napoleon III became emperor of
France in 1852, he embarked on a building
program focused primarily on completion
of the Louvre in a self-consciously historic
French style which was to become known
as the Second Empire. When this mode
migrated to the United States in the late
1850s, however, "it was a consciously
'modern' movement, deriving its prestige
from contemporary Paris, not from any
period of the past like the Greek, the Gothic,
or even the Renaissance Revivals" (Henry-
Russell Hitchcock, *Architecture: Nineteenth

and Twentieth Centuries,* Baltimore, 1958,
p. 170). Beginning with Boston's City Hall
(1862–65) by Gridley Bryant and Arthur
Gilman, the new style was quickly estab-
lished as the *au courant* mode for govern-
ment buildings and for nearly two decades
would be applied to city halls from Sydney,
Australia, to Camden, New Jersey.

When McArthur began the Philadelphia
project he was following popular fashion,
but by the time the building was formally
completed in 1901 the Second Empire style
was out of date. The crass assurance that the
style projected in the years following the
Civil War had been undermined by the
Panic of 1873 and the exposure of Grant's
scandals. McArthur, however, continued to
direct his energy into his work to give that
transitory fashion its fullest expression, and
through the rich use of sumptuous sculpture,
to transform a public building into an
encyclopedia of allegorical statements. Boldly
plastic dormers enrich the mansard roofs
which rise to steep peaks on each of the
corners and swell into bulbous forms atop
the four center pavilions. Monumental
vaulted corridors (see no. 395) lead through
each heavily wrought center pavilion to a
central courtyard which remains the most
heavily traveled public square in the city
and one of the finest urban spaces in the
country.

Above it all looms the tower, "full of
original combinations" that climax in the
gigantic bronze statue (see no. 369) of
William Penn, founder of Pennsylvania
and its City of Brotherly Love. By gentle-
men's agreement no center city buildings
rise above this statue. It stands as a beacon
for visitors to Philadelphia and serves as a
reminder of the strengths of a people who
responded to an "inner light" and established
a Holy Experiment which spawned those
freedoms that Americans have preserved
and honored for two centuries.

RW □

FRANK FURNESS (1839–1912)

In 1857, Frank Furness began his archi-
tectural training in the office of Philadelphia
architect John Fraser. After learning the
rudiments of the art, he entered the New
York atelier of Beaux-Arts–trained Richard
Morris Hunt, who exposed Furness to con-
temporary theory and to French and English
design ideas. After army service during the
Civil War, in which he won the Medal of
Honor, Furness re-entered Hunt's office, and
then returned to Philadelphia in 1866. The
following year he formed the successful
partnership with John Fraser and George W.
Hewitt that lasted nearly a decade.

In 1871, Furness and Hewitt established
their reputations as designers with their

334. *Details of Vestibule of Controller's Offices*

334. *Sections and Elevation of Cast-Iron Frame of Tower*

victory in the competition for the Pennsylvania Academy of the Fine Arts. A broad range of commissions in a wide variety of styles followed, all colored by Furness's highly original sense of design, proportion, and ornament. Later projects, in the 1890s and the early years of the twentieth century, were less original, responding to changes in architectural taste. Among their numerous projects still extant, Furness's office built the Centennial National Bank at Thirty-second and Market streets (1876), the First Unitarian Church at Chestnut and Van Pelt streets (1883–86), and the Bryn Mawr Hotel, now Baldwin School (1890). Apart from their work, they produced a number of important young architects, beginning in 1873 with Louis Sullivan, and including John Stewardson and later George B. Howe (see biography preceding no. 456).

GEORGE WATSON HEWITT (1841–1916)

Until recently, George W. Hewitt has been remembered because he was the partner of Frank Furness, and because of Louis Sullivan's description of him in his *Autobiography*, in which Hewitt was recalled as

"a slender, moustached person, pale and reserved, who seldom relaxed from pose. It was he who did the Victorian Gothic in its pantalettes" (p. 193). That Hewitt had greater abilities is evident from his success after breaking with Furness in 1876.

Hewitt was born in Burlington, New Jersey, and took his early training in the office of John Notman, before joining John Fraser and Frank Furness in the firm of Fraser, Furness and Hewitt in 1867. In 1876 he established his own practice, and later formed a partnership with his brother, William D. Hewitt, specializing in country and city mansions, churches, hotels, and railroad stations. At the end of the century, the Hewitt brothers made the transition into the more fashionable eclecticism with relative ease, receiving commissions for the Philadelphia Bourse, the Wistar Institute at the University of Pennsylvania, and George Boldt's fabulous house at Alexandria Bay, New York, in the Thousand Islands area, and his hotel, the Bellevue Stratford in Philadelphia.

FURNESS AND HEWITT

335. *Pennsylvania Academy of the Fine Arts*

Broad and Cherry streets
1871–76
Brick, limestone, sandstone, and brownstone construction; steel and cast-iron; granite columns, enamel plaques

REPRESENTED BY:
Frederick Gutekunst (1832–1917)
Exterior from Northeast
c. 1877
Photographic enlargement

Courtesy Pennsylvania Academy of the Fine Arts, Philadelphia

Furness and Hewitt
Longitudinal Section through Centre
(Preliminary)
1873
Black ink and red wash on linen
25 x 36″ (63.5 x 91.4 cm)

Pennsylvania Academy of the Fine Arts, Philadelphia

LITERATURE: PMA, *Furness*, pp. 34–38, 80–85

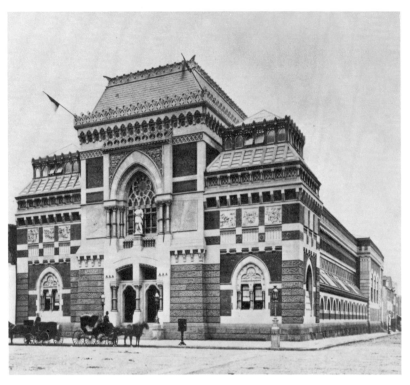

335.

In 1870 the directors of the Pennsylvania Academy of the Fine Arts decided that the old building, constructed a quarter century earlier from the plans of Richard Gilpin, could no longer serve the Academy's needs. Not content with rebuilding on the same site at Chestnut Street above Tenth, the board of directors sought a new site, and in the same year purchased the southwest corner of Broad and Cherry streets. In so doing, they continued the removal of Philadelphia's important institutions from the old center near Independence Hall to William Penn's intended city center at Broad and Market streets. Already in 1871 the Union League Club stood completed at Broad and Sansom streets, James Windrim's design for the Masonic Temple at Broad and Filbert was nearly completed, and John McArthur, Jr.'s, City Hall buildings (no. 334) were under construction at Penn (Centre) Square.

Following the acquisition of the site, the Academy decided to hold a limited competition for the new building. Invited competitors included the well-known architects, John McArthur, Jr. (see biography preceding no. 334), James H. Windrim, and Collins and Autenrieth (see biography preceding no. 302); Thomas W. Richards, recent winner in the competition for the new buildings for the University of Pennsylvania; Canadian-trained ecclesiastical architect Henry A. Sims; and the relatively unknown architects, Fraser, Furness and Hewitt. The

best-known competitors withdrew, Sims was given the third prize, while the board divided over the merits of the schemes of Richards and Furness and Hewitt (who by this time had split with their partner John Fraser). Eventually, Furness and Hewitt won out, probably because of the number of their relatives and friends on the building committee, which included Furness's in-law Fairman Rogers, Hewitt client Henry Gibson, and John Sartain (PAFA, Minutes of the Board of Directors, June 12, 1871). With the awarding of the commission to the least-known firm, an admonition was given that the design should be constantly improved during the years of construction. The triumph of Furness and Hewitt marked a shift in Philadelphia architecture away from the doctrinaire monochromatic revival styles of the previous generation toward the vigorously shaped polychromatic and synthesizing high Victorian style that would characterize the work of local architects in the next generation.

It should be pointed out that the architects did not have a completely free hand in planning the building. A comparison with Henry Sims's scheme shows similar plan elements—public entrance on Broad Street, student entrance at the rear of the Cherry Street facade, centrally placed ground-level auditorium and upper-level galleries. Their carefully deliberate arrangement assured a functional building. These basic plan ele-

ments were determined by the Academy staff, headed by John Sartain, whose role is described in his *Reminiscences* (p. 252).

Furness and Hewitt made the new Academy building one of the most memorable structures in Philadelphia. Their design reflected not only the vitality of the late nineteenth century, encompassing architectural theory, technics, and planning, but also their own distinct and vigorous personalities and training. If later buildings by both architects were more fully developed, none was so programmatically or iconographically expressive.

Instead of merely paying homage to a dead past by coercing an "ancient temple" to the service of the arts, Furness and Hewitt drew on what was for them a live tradition, fusing elements and principles from Gothic and classical architecture in an original alloy, which acknowledged not only the ancients but also the modern English and French schools of architecture. French—and classic too—is the mansarded Broad Street facade, while the grooved tryglyph blocks and sculpted panels stacked one above the other, but placed approximately where they might occur on a Greek temple, recall the then popular French academic abstractions of classic design termed the "Néo-Grec." On the other hand, the Gothic pointed arches, the floral ornamentation, and the strident architectural polychromy—red brick, yellow-tan limestone, purple-ish brownstone, brilliantly toned enamel plaques, and pink granite columns—are carryovers from the English school, and John Ruskin's fervent praise of the Venetian Gothic. Thus it is a highly eclectic facade, but to a point, for it demonstrates in the art academy building the oneness of architecture.

The facade gains in richness as an expression of the activities within, and the building's double purpose. The general role, as an art institution, is directly expressed in the sculpted figures on the facade—a simplified version of Paul Delaroche's *Hemicycle of the Beaux Arts,* which ornaments the École des Beaux-Arts in Paris. Such iconographic representation is common enough in public buildings. On the other hand, the architects' exaggerated expression of the interior functions on the facade goes far beyond what was customary in a public building. Studios, galleries, offices, all are clearly evident. Equally striking is the use of relatively plain materials—notably brick as the principal material of the facade. Despite the complexity of the facade, there is a directness appropriate to the Quaker City. That directness carries over into the differentiation of the public and private roles of the building, with the student entrance off the less traveled Cherry Street and the public entrance on Broad Street, leading into a brilliantly colored and skylighted stairwell, layered in

carved stone, Gothic arcade, and red and gilt diaperwork, and crowned by a coved ceiling glittering with silver stars on a field of blue. Beyond, skylighted galleries, deep-toned in plum and ochre, displayed the glittering Academy collection. The Academy building is a rare case of the jewel box rivaling the treasure within.

GT □

335.

THOMAS EAKINS (1844–1916)
(See biography preceding no. 328)

336a. *Perspective Drawing for The Pair-Oared Shell* (I)

1872
Pencil, ink, and wash on paper
31 1/16 x 47 1/8″ (78.8 x 119.6 cm)
Philadelphia Museum of Art. Purchased: Thomas Skelton Harrison Fund. 44-45-2

PROVENANCE: Mrs. Thomas Eakins, until 1930; Charles Bregler

336b. *Perspective Drawing for The Pair-Oared Shell* (II)

1872
Inscription: Thomas Eakins/Perspective of picture painted before 1876 (hand-written by Mrs. Eakins in black ink, lower right)
Pencil, ink, and watercolor on paper
31 13/16 x 47 9/16″ (80.8 x 120.8 cm)
Philadelphia Museum of Art. Purchased: Thomas Skelton Harrison Fund. 44-45-1

PROVENANCE: Mrs. Thomas Eakins, until 1930; Charles Bregler

LITERATURE: Goodrich, *Eakins,* p. 164, nos. 50, 51; John Canaday, "Familiar Truths in Clear and Beautiful Language," *Horizon,* vol. 6, no. 4 (Autumn 1964), p. 93; Sylvan Schendler, *Eakins* (Boston and Toronto, 1967), p. 35; Charles William Dibner, "The Pair-Oared Shell by Thomas Eakins," unpublished paper, University of Pennsylvania, 1967; Hendricks, *Eakins Life and Works,* p. 71, pls. 237, 238

THE QUALITY OF EAKINS'S WORK, exceptional and distinctive from that of his contemporaries, is due in part to his intense involvement with his subject and his ability to convey this involvement to the viewer. In his early work Eakins went to great lengths to study a subject structurally and anatomically before he attempted to represent it on canvas. His knowledge of anatomy was at least as great as that of the average physician and considerably greater than that of the average artist (Goodrich, *Eakins,* p. 10). His

perspective studies were yet another way to discover the reasons for a specific appearance and then to construct this appearance with scientific accuracy. Although artists have used the laws of perspective for centuries to represent the intricate foreshortening of complex architecture or to design illusionary stage sets, Eakins, more than most artists, applied these same laws to everyday subject matter, rowboats on the river for instance, and he did so with an astonishing intensity.

The first perspective drawing for *The Pair-Oared Shell* gives a wealth of information so specific that we can locate the spot on the river and tell the exact time when the Biglin brothers' boat glided downstream on the Schuylkill, approaching the old Columbia Bridge: Eakins's measurements are there and the topography is known.

A vertical center line and a horizon line divide the sheet into four identical sections (a method Eakins employed for many years in beginning a canvas). He then constructed a checkerboard floorplan in perspective, each square representing a square foot of reality. The first line is 16 feet from the viewer, the next 17 feet, and so on, up to 64, as noted on the drawing. The distances to the left and the right of the center line are also marked in feet. From these points, lines are drawn converging at the point of sight, which is slightly above the horizon. At far left the last one-foot section is divided into 12 equal segments (inches), and a line is drawn from each point to converge at the horizon. This is the inch-scale of the ground plan, establishing the foreshortening of any

number of inches at any given distance in the drawing. Eakins placed this scale conveniently outside the area which he intended to use for the final painting. The next two converging scales are the inch measurements for the boat, its long side at the left, the cross measurements next to it, farther right. Having thus established all the necessary scales, Eakins proceeded to draw the boat in perspective. The stern is 30 1/2 feet from the spectator and 5 1/2 feet to the right of center. The bow is 63 feet away and 4 1/2 feet to the left of center. By projecting these points on an undistorted ground plan (see illustration) we find that the boat is 36 feet long, moving at an angle of 67 degrees away from the viewer.

For his perspective ground plan Eakins used blue ink. The boat and masonry, being real objects, were drawn in pencil or black ink. Red lines on the drawing mark projected points or simple cubes to aid the artist in constructing more complicated details. The oarlocks, for instance, were set within red rectangles which established their general shape before they were drawn in detail.

The three-sided masonry structure which dominates the right background of the drawing represents one pier of the old Columbia Bridge. These piers were demolished in 1917 but we know their shape, dimensions, and location in the river from contemporary records (John C. Trautwine, "Description of the Viaduct near Peter's Island," *Journal of the Franklin Institute,* August 1834, vol. 14, no. 2, n.s., pp. 73–83). Each pier was constructed of hammer-

336a.

336b.

Ground plan reconstructed from Eakins's perspective drawings

dressed stone blocks, 20 feet wide and 60 feet long, exclusive of a triangular pier head. The pier head was on the upstream side only. The walls of the masonry receded at a rate of ¾ of an inch per foot. What is seen in the perspective drawing is an almost frontal view of the triangular pier head. The last segment to the left is the 60 foot sidewall of the pier, which stands parallel to the flow of the water. Eakins also drew a pencil line from the tip of the pier head, progressing to the left, crossing the bow of the boat at a point which is 53 feet from the viewer and 7 feet to the left of center. The line represents

the direction of the sunlight which caused the pier to cast its shadow on the bow of the boat, and in the drawing and the final painting the part of the boat beyond this line is cast in shadow.

With this information, and aided by notations on the drawing, one can draw the boat and pier in their proper dimensions on a ground plan. With the aid of a contemporary map, one can then establish the points of the compass, as has been done in the accompanying illustration. The shadow line on the map establishes that the sun stood northwest by west; the time was therefore

7:20 P.M. If the picture represents the time shortly before sunset, as the mood suggests, the day would have been in early June or mid-July. A 7:20 P.M. sunset occurs on the Schuylkill on May 28 and on July 27.

A strange flattening of the image in Eakins's perspective drawing is also apparent in the final painting. The space is compressed; the boat and the pier look flatter and closer together than one would expect, much as in a photograph taken with a telephoto lens. The reason is that Eakins placed his point of distance (the vanishing point for the diagonals) unusually far away. Tradi-

392

tionally, the implied space of the vanishing point is at a distance from the center of the painting about equal to the width of the canvas. In *The Pair-Oared Shell,* however, the implied distance of the vanishing point is about twice as great, with the result that the painting appears condensed, as if it were the center of a much larger composition.

The second drawing for *The Pair-Oared Shell* was made specifically to construct reflections on the water. The perspective ground plan of the first drawing was repeated, but without the inch scales. The pier and boat were then traced in their proper places from the first drawing. The two rowers, John and Barney Biglin, were then introduced. These main objects were then brushed with watercolors.

To construct the reflections of the rowers, Eakins assumed that each ripple was composed of three planes—one parallel to the surface, one slanted toward the viewer, one away from the viewer. Since the reflection on the hidden plane cannot be seen, there is no need to calculate it. For the two visible reflections Eakins constructed two converging scales in the sky area and numbered them according to distance. The lower scale is numbered from 16 to 30, the higher scale from 20 to 80. Specific dimensions are noted in pencil. Ink and pencil lines specify the direction of the waves in the foreground. The reflections are drawn in geometric shapes and colored with wash to indicate the corresponding object. Blue fields correspond to the kerchiefs; gray fields represent the reflections of shirts and trousers; gray rectangles, the pier; and in the foreground, light brown reflections may represent the invisible bridge. The reflections of outriggers, oarlocks, or center cloud, although their locations are noted, do not appear on the drawing.

TS □

THOMAS EAKINS (1844–1916)
(See biography preceding no. 328)

337. *The Pair-Oared Shell*

1872–76
Signature: EAKINS/1872 (on bridge pier)
Inscription: "Double Oared Scull"/Thos. Eakins (handwritten by Mrs. Eakins on stretcher); [. . .] sional Oars-men/ [. . .]ney & John Biglen/in Pair Oared Shell on the/Schuylkill River under the/old Columbia Bridge/Painted bet. 1872 & 76/by/Thomas Eakins (handwritten by Mrs. Eakins on stretcher)
Oil on canvas
24 x 36″ (60.9 x 91.4 cm)
Philadelphia Museum of Art. Thomas Eakins Collection. 29–184–35

337.

PROVENANCE: The artist; Mrs. Thomas Eakins

LITERATURE: *The New York Times,* April 20, 1879; *The Philadelphia Evening Telegraph,* April 6, 1881; MMA, *Catalogue of a Loan Exhibition of the Works of Thomas Eakins* (1917) (illus.); PAFA, *Catalogue of a Memorial Exhibition of the Works of the Late Thomas Eakins* (1917), no. 83 (illus.); John Rothenstein, "A Note on Thomas Eakins," *Artwork: A Quarterly,* vol. 6, no. 23 (Autumn 1930), p. 197; Forbes Watson "The Growth of a Reputation," *The Arts,* vol. 16, no. 8 (April 1930), p. 564; Goodrich, *Eakins,* no. 49, pl. 7; Bryson Burroughs, "An Estimate of Thomas Eakins," *Magazine of Art,* vol. 30 (July 1937), p. 403; Roland Joseph McKinney, *Thomas Eakins* (New York, 1942), p. 64; Margaret McHenry, *Thomas Eakins Who Painted* (Oreland, Pa., 1946), p. 26; Leslie Katz, "Thomas Eakins Now," *Arts,* vol. 30 (September 1956), pp. 18–19; John W. McCoubrey, *American Tradition in Painting* (New York, 1963), p. 118, pl. 60; Charles Dibner, "The Pair-Oared Shell by Thomas Eakins," unpublished paper, University of Pennsylvania, 1967; Sylvan Schendler, *Eakins* (Boston and Toronto, 1967), pp. 35, 284; Hendricks, *Eakins Life and Works,* pp. 71, 74–75, pl. 236

The Pair-Oared Shell shows two friends of the artist, John and Bernard (Barney) Biglin, practicing in their shell on the Schuylkill River. The Biglin brothers were professional rowers, who earned their living by competing in races throughout the country. Hendricks reports that they were world-famous, and continues: "The sports publications of the time are full of news about the Biglins . . . the particular visit that gave rise to *A Pair-Oared Shell* was celebrated as the first

pair-oared race in America. . . . In the race, which the Biglins won, they wore approximately what Eakins showed them wearing in his picture" (Hendricks, *Eakins Life,* p. 74). John Biglin is shown in the stroke position, closer to the viewer, his face drawn with meticulous care. He was the older of the two brothers, twenty-eight at the time, and the same age as Eakins. Barney Biglin, younger by three years, occupies the less important bow seat. Subtle differences in the position and in the rendering of the two champions show us clearly who leads and who is subordinate. But the most precise treatment is reserved for the shell. All its elements are in sharp focus, almost as if the artist intended to explain their function.

The precision and intensity of *The Pair-Oared Shell* were intentional and worked out in great detail. Eakins's preliminary perspective drawings (no. 336) tell us that the Biglin brothers' boat is heading downstream on the Schuylkill River. Above them, about twelve feet ahead, looms the old Columbia Bridge, its pier just beginning to cast a shadow over the bow of the boat. The time is late afternoon, just before sunset, and the season is late spring or early summer. The background of the painting is equally specific. There, in the evening mist, is an accurate rendition of the west bank of the river just below the bridge where the Schuylkill takes a sharp turn. To the left of the bridge pier, behind Barney Biglin's head, one can see Belmont Landing, a narrow strip of land where steamboats docked. The canal which separates the landing from the west

bank is shown as a light band. Behind it are trees and two houses which are also specific structures.

The disconcerting aspect of this painting is its lack of depth. The boat, the pier, and the west bank of the river appear much closer to each other than they actually are. This led Hendricks to believe that the pier was not an existing one, and that Eakins's bridge could never cross the water (*Eakins Life*, p. 339). Yet the strange flattening of the view is the result of an unusual feature in Eakins's perspective construction. By deliberately selecting a diagonal vanishing point exactly twice as far away as is customary, Eakins managed to depict the scene as it would appear when observed from a distance through a telescope. The artist's interest in optics is known, and his knowledge of perspective was such that the distortion cannot be accidental.

The label affixed to the stretcher by Mrs. Eakins states that the picture was painted between 1872 and 1876. It is indeed possible that Eakins worked on the canvas for several years. He had the habit of dating his paintings the year in which they were begun, rather than when he completed them. There can be no doubt that *The Pair-Oared Shell* was painted entirely in the studio, after each detail had been thoroughly studied beforehand. The paint film of *The Pair-Oared Shell* is generally thin. The artist scraped and glazed, aiming for a high finish, yet bare white ground can be seen between areas of paint in the figures of the rowers. The foreground water is painted with small horizontal strokes, allowing a darker underpainting to show through in places. The highlights of the rowers and the shell receive the most detailed treatment; they are tactile, raised, and applied in bright yellow with a pointed brush. The sky is denser and more textured than the rest of the painting, suggesting that Eakins may have reworked an earlier, smoother version. In the end the artist glazed the surface with brown to accentuate the paint texture.

Eakins did not exhibit *The Pair-Oared Shell* until 1879, perhaps because he kept reworking it until he was finally satisfied. According to William J. Clark, Jr., it "gave . . . a shock to the artistic conventionalities of Philadelphia when it was first shown" (*The Philadelphia Evening Telegraph*, April 6, 1881). Yet other critics found it poetic, expressing "the peculiar charm that everyone has experienced when rowing out of the sunlight into the shadow of a great bridge" (*New York Times*, April 20, 1879). More recently, McCoubrey finds that Eakins "seized an unpromising moment: when the complex outline of the two rowers and their fragile shell was visually entangled with the simple, overwhelming mass of a stone pier supporting an unseen bridge. In this strange

meeting, the human figures are overwhelmed" (John W. McCoubrey, *American Tradition in Painting*, New York, 1963, p. 118). Schendler, on the other hand, sees in the painting an "assertion of human strength and dignity transcending mortality and the erosions of time" (Sylvan Schendler, *Eakins*, Boston, 1967, p. 37). In spite of the specific detail, there is mystery in *The Pair-Oared Shell* which continues to stimulate the imagination and the search for symbolic meaning in the painting.

TS □

HOWARD ROBERTS (1843–1900)

Born into an old Philadelphia family, Howard Roberts was the son of a prominent merchant. He attended the Pennsylvania Academy, where he exhibited in 1863 and 1864 and studied with Joseph A. Bailly (see biography preceding no. 330). He also exhibited at the Great Central Fair for the benefit of the United States Sanitary Commission held in Logan Square in June 1864. In 1866, at the age of twenty-three, he went to Paris to enter the École des Beaux-Arts and became a pupil of the sculptors Dumont and Guméry for several years. After a trip to Italy in 1868, Roberts went back to Paris to see his portrait bust of *M. le vicomte d'E* in the 1869 Salon exhibition.

Back in Philadelphia that same year, he set up a studio at 1731 Chestnut Street and completed his first major work, the full-length figure of Hester Prynne from Hawthorne's *The Scarlet Letter*. Roberts sculpted a number of ideal and portrait busts at this time, including, according to a contemporary newspaper account, "a portrait bust of a celebrated homeopathic physician, two ideal busts of females, a portrait head of a young Philadelphia lady, and a small fancy subject intended for bronze, representing a nereid in a sea-shell" (Earl Shinn, "Philadelphia Sculpture," *Philadelphia Evening Bulletin*, 1870, quoted in Sellin, "The First Pose," p. 22). Roberts also sculpted a life-size statue in plaster, *Hypatia Attacked by the Monks*. He traveled again to Paris for study in 1873, taking with him the *Hypatia* to be cut in marble. During the next three years, he completed *La Première Pose*, which he brought back to Philadelphia and exhibited at the Centennial Exposition, where it earned one of three medals given to American sculpture.

Establishing a studio in Philadelphia once more, Roberts was elected an Associate of the Academy and president of the Philadelphia Sketch Club, which he had joined in 1861. In 1876 he exhibited a sculpture called *Out of the Cabbage* at the Pennsylvania

Academy. Roberts also sent a marble figure of *Lot's Wife* to the first annual show of the Society of American Artists in New York in 1878. That year he won a national competition among thirty sculptors for a life-size statue of Robert Fulton, which was erected in the Rotunda of the Capitol in Washington in 1883. In 1894, Roberts closed his Philadelphia studio and gave its contents to the School of Industrial Art (Sellin, "The First Pose," p. 50). He took his wife and son to Paris in 1900 for a three-year stay and died there suddenly.

AS

338. *La Première Pose*

1873–76
Signature: H. Roberts, 1874 (on base)
Marble
51¼ x 25½ x 28¼″ (130.1 x 64.7 x 71.7 cm)

Philadelphia Museum of Art. Given by Mrs. Howard Roberts. 29–134–1

PROVENANCE: The artist, 1876–1900; Mrs. Howard Roberts, 1900–1929

LITERATURE: *Centennial Masterpieces*, vol. 1, pp. 125–27, illus. opp. p. 126; William J. Clark, Jr., *Great American Sculptures* (Philadelphia, 1878), pp. 102–3, illus. opp. p. 96; FPAA, *Sculpture*, illus. pp. 88–89; Sellin, "The First Pose," throughout

"WHEN TODAY WE LOOK FOR 'American art' we find it mainly in Paris. When we find it out of Paris, we at least find a great deal of Paris in it" (Henry James, *The Painter's Eye*, 1887, repr. Cambridge, Mass., 1956, p. 216).

While one might debate Henry James's sweeping statement as it applies to the development of American art in the late nineteenth century, it proves remarkably apt in a consideration of Howard Roberts and, particularly, of the *Première Pose*. Roberts's first teacher, Joseph B. Bailly, was French, although he came to America shortly after 1848. But it was probably through Bailly's encouragement that Roberts left for Paris in 1866, having rejected the traditional meccas of Florence and Rome, which in the 1860s had continued to hold the greatest prestige and appeal for young American sculptors. But Paris offered the new and progressive generation more. One appeal was simply glamour and international sophistication: under the Second Empire, through a series of state-controlled and state-supported exhibitions, Paris became the veritable center of the art world. But for Roberts and his friend Eakins (who was to follow later the same year) the appeal of Paris was more specific and fundamental.

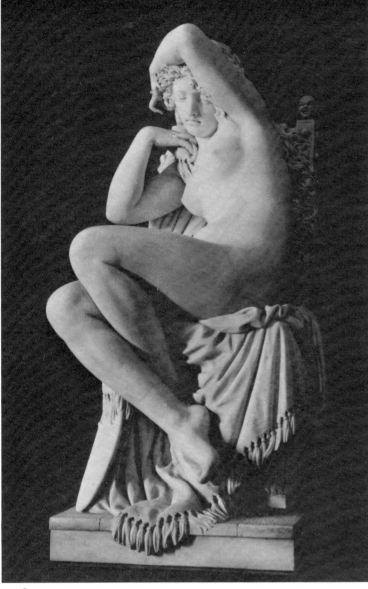

338.

Through the École des Beaux-Arts and the studios of artists who took on students, Paris offered the most elaborate and rigorous training for painters and sculptors of any city in the world.

The *Première Pose* and its reception at the Centennial exhibition are proof of the quality of this training. According to William J. Clark, Jr., who reviewed the fine arts section at the Centennial: "In the United States Department there was no piece of sculpture which was marked by such technical quality as the *Première Pose* of Howard Roberts—a work which was almost as much a product of the school of Paris as the admirable performance exhibited in the French Department" (*Great American Sculptures,* Philadelphia, 1878, p. 108).

What is this "Frenchness" which so struck Roberts's contemporaries? First, the subject itself: A young and very pretty model has been posed on a platform in a painter's studio with enough secondary elements—an elaborate drape and a densely fringed chair with a palette propped against one leg—to engage the most energetic student in a life class. The position of her legs and arms is a standard pose recorded in hundreds of French student "academies." However, the particularly shielding position of the left arm and the downcast eyes emphasize that this is the young woman's first experience as a studio model a situation wryly commented on by the heads of Tragedy and Comedy at the top of the chair. Roberts has chosen to depict a daily occurrence in a Paris studio and to

introduce into it, through the modesty and freshness of the model, an element of narrative and sentiment. In Philadelphia, where use of the female nude model was strongly frowned upon—even in studios of the Pennsylvania Academy—this certainly would have seemed like a foreign and very "Parisian" situation.

But beyond the charm and narrative engagement of the subject there were other "French" aspects of the work noted by more serious critics. Thus it is not surprising that Clark selected the technique of the *Première Pose* for special comment. Prior to this time, there had simply been no works by American sculptors shown here which displayed (or chose to display) such technical complexity and facility. The nude is rendered with a sensuousness and knowledge of anatomy which reveal the artist's long and rigorous academic training in Paris. This same power of observation is carried to other aspects of the work, which are rendered with an almost obsessive attention to literal fact. Although several American sculptors before Roberts could compete successfully with their European contemporaries (the most famous being Hiram Powers), their restrained and classical style did not allow, at least on the more obvious levels, for a display of such tour-de-force facility. In this respect, Roberts was clearly asking for comparison with his French colleagues and, in turn, revealing a particularly French attitude toward the nature of sculpture.

In the 1860s there had been concern among French critics that the academic system trapped artists into an artificial style which produced static, if highly accomplished, results. Many younger sculptors reacted to this limitation by introducing elements of specific narrative, often dependent on contemporary context. The new expressiveness rejected the more traditional features of heroic gesture and restrained sentiment, substituting instead a style which seems genre-like in comparison to the grand classical allegories of the previous generation. Ironically, although trained in the more conservative tradition represented by Dumont and Gumery, Roberts and his fellow students formed a reaction against academicism while learning its technical disciplines very well.

To American critics in the 1870s this conflict of styles was often simplified into a distinction between "realists" and "idealists" (see Clark, cited above, p. 96). Roberts's *Première Pose* was one of the first American works to exemplify the new style. In this, as in his decision to study in Paris, he was highly progressive and, as Lorado Taft points out, the shift from Italy to Paris would become the dominant feature in the development of American sculpture following the 1876 Centennial.

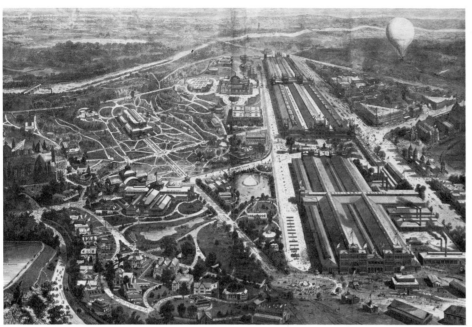

339.

LITERATURE: *Centennial Masterpieces*, vol. 3, pp. lxxxiii–clxxxvi; White, *Philadelphia Architecture*, pp. 31–32; Tatum, pp. 103–7; John Maass, *The Glorious Enterprise: The Centennial Exhibition of 1876 and H. J. Schwarzmann, Architect-in-Chief* (Watkins Glen, N.Y., 1973)

AFTER NEARLY A CENTURY as the nation's principal city, Philadelphia entered a long decline in the nineteenth century, losing the nation's government operations to Washington, D.C., and its commercial and financial leadership to New York. By the end of the Civil War the city's plain Quaker image was firmly fixed in the public mind. That all changed in 1876, for the Centennial exhibition held in Philadelphia was a triumph acknowledged by everyone, and for half a century, Philadelphia's reputation rode on that success.

However, the exhibition had nearly been a fiasco. The idea of a great fair in Philadelphia had occurred in 1866, but was only presented to the city councils in 1869. The members of the Franklin Institute argued: "The historical relations alone of our city should entitle it to selection for such a celebration; but apart from its claim as the birthplace of our Government, its geographical position, the railroads and navigation facilities, and its abundant means of accommodation for large numbers of strangers, all add to its claim and fitness to be selected for such a purpose" (*Centennial Masterpieces*, vol. 3, p. lxxxvii).

Two years later, Congress approved the idea, and established a Centennial commission which met annually, beginning in March of 1872. At their second meeting the commission proposed an open competition for the two buildings, an art gallery and a temporary main exhibition hall, which as a permanent nucleus would remain a "Memorial Hall." By the summer, forty-three submissions had been received, ranging from amateurish barn-like halls to sophisticated and colorful schemes with immense towers and gigantic domes. Ten of the latter were selected for further elaboration. In September the winners were announced. A domed project by Collins and Autenrieth (see biography preeding no. 302) placed first, followed by Samuel Sloan's scheme, the towered project of associated architects John McArthur, Jr. (see biography preceding no. 334), and Joseph M. Wilson (see biography preceding no. 370), and the Gothic design of Henry A. and James P. Sims. Was it coincidence that all were Philadelphians?

In the meantime, the commissioners, increasingly alarmed about costs, had changed their minds about the architectural program. It was decided that only the art gallery need be of permanent construction; it would become the Memorial Hall after the fair. The exhibition hall would instead be a relatively inexpensive iron-framed

Since Roberts's death (ironically, in Paris), the understanding of his role in American art has diminished to the point that several recent surveys of this period do not mention him at all. With the efforts of David Sellin ("The First Pose") and the inclusion of the *Première Pose* in this exhibition, perhaps Roberts's importance and the essential charm and narrative engagement of his work can again be recognized.

JR □

HERMANN J. SCHWARZMANN (1846–1891)

The architect of the principal Centennial building, Hermann J. Schwarzmann, was born in 1846, in Munich, the son of decorative painter Joseph A. Schwarzmann. He attended the Royal Military Academy where he may have studied engineering, and after army service, immigrated to the United States in 1868. A year later, Schwarzmann was reported in the employ of the Fairmount Park Commission where he remained until after the Centennial. In 1876 he opened his own architectural practice in Philadelphia, apparently hoping to trade on the success of his work at the exhibition, but he was apparently unsuccessful, and in 1878 he departed for New York. There he designed a number of private houses; the Liederkranz Club house; a group of houses in Long Branch, New Jersey; and numerous other projects, enjoying a modicum of success, before failing eyesight ended his career five years before his death in 1891.

HERMANN J. SCHWARZMANN AND OTHERS

339. *Centennial Exhibition Grounds and Buildings*

Parkside and Belmont avenues (West Fairmount Park)
1874–76

REPRESENTED BY:
The Centennial—Balloon View of the Grounds
1876
From *Supplement to Harper's Weekly,* September 30, 1876
Wood engraving
20¾ x 39″ (52.7 x 76.2 cm)
The Athenaeum of Philadelphia

Louis Auburn (n.d.)
Agricultural Hall
c. 1874
Color lithograph
12 x 20½″ (30.4 x 52 cm)
Philadelphia Museum of Art. Bequest of Henry R. Hatfield. 43–27–31

Louis Auburn (n.d.)
Horticultural Hall
c. 1874
Color lithograph
13¼ x 20½″ (33.6 x 52 cm)
Philadelphia Museum of Art. Bequest of Henry R. Hatfield. 43–27–32

building that could be disassembled after use and sold. Just such a proposal had been submitted by New Yorkers Calvert Vaux and George K. Radford, who were asked to undertake the great hall, while Collins and Autenrieth were ordered to proceed with the art gallery. The specter of costliness remained. Demands were made that costs be cut, and in the spring of 1874, two years before the opening date, the architects quit. Plans began again.

Into the vacuum stepped three extraordinary young men, architect Hermann J. Schwarzmann, a recent immigrant from Austria, and engineers Henry Pettit and Joseph M. Wilson. Each had already been involved with the project, Pettit as the commission's engineering consultant, Wilson as one of the competitors, and Schwarzmann as architect for the commissioners of Fairmount Park (no. 313), which he had helped plan. Schwarzmann presented a proposal for the art gallery (Memorial Hall), which was quickly accepted. Ground was broken on the Fourth of July, 1874. Wilson and Pettit were asked to design the exhibition hall with the understanding that the twenty-acre building was to cost less than two million dollars. Those buildings would form the International Exhibition.

In the next few months the evidence of increased national interest resulted in the design of four additional halls—Machinery Hall, fourteen acres in size, by Wilson and Pettit; Horticultural Hall by Schwarzmann; and the United States Government Building and Agricultural Hall by Philadelphian James H. Windrim. Industry and agriculture, government and the arts—the range of national culture was fully represented. All were under contract in 1875. Those buildings were augmented by a torrent of foreign, state, and commercial pavilions. By May of 1876 nearly two hundred structures were

completed and served by a network of railroad lines, roads, and utilities suited in complexity for a small city.

Private enterprise had been nearly as active across Elm Street (now Parkside Avenue): the railroad laid tracks and constructed a new terminal at the fair, gigantic frame hotels rivaled the fair buildings in size, and an entire new district of the city existed. On May 10, President Grant and the Emperor Dom Pedro of Brazil set the giant Corliss engine in the Machinery Hall into action, and the entire fair came to life. In an increasingly mechanized world, there could have been no more fitting beginning.

The enormity of the fair, which might well have overwhelmed the visitor, was countered by Schwarzmann's ingenious plan, which clustered buildings depending on the nature of their displays. The principal buildings, which constituted the international part of the fair and included the Art Gallery and the Machinery and Main Exhibition halls, were grouped at the main gate; the United States building was the focus for the surrounding state buildings. At the apex of the triangular fair grounds were Horticultural and Agricultural halls with smaller buildings related to the agrarian theme. Those centers were connected by diagonal avenues which formed ceremonial vistas anticipating the Beaux-Arts formality of Chicago's Columbian Exhibition of 1893. Like that better known plan, wilderness areas were left—those between the Art Gallery and Horticultural Hall contrasting with the more formally planned districts. These wilderness areas even presented a "hunters' camp" to the city-bound Easterners.

If the planning was innovative, the buildings in the main were less imaginative, although the gilded and iridescent Brazilian pavilion by Frank Furness (see biography preceding no. 335) made a stir. Most of the

buildings instead addressed the issue of architectural content, either to represent the display or to make an appropriate statement about the Centennial. Foreign pavilions bespoke national origin, with a half-timbered English house, stuccoed Spanish buildings, and a spartan Japanese structure. On the other hand, the state buildings were less expressive, although the Ohio building, by the Head brothers, used stone from the state's major quarries, with their names carved on the individual blocks.

The larger buildings were similarly direct. Windrim's Agricultural Hall resembled an immense Gothic barn; Schwarzmann's Horticultural Hall, a gigantic greenhouse, enlivened by polychromatic Moorish arches, chosen more for their picturesqueness than for content. The Main Exhibition Hall and Machinery Hall by Wilson and Pettit had their genesis in Joseph Paxton's Crystal Palace of 1851, a source which Wilson cheerfully acknowledged. Wilson wrote of the Crystal Palace: "It will be seen further on that in our exhibition building, the same ideas have been carried out, and that the building of 1851 has really been the type for all the most successful buildings erected since" (*Centennial Masterpieces,* vol. 3, p. xxiii).

The Main Hall was also the most representative of the age, utilizing its new technics and materials—mass-produced iron and glass—and having been planned by the square foot and without regard to permanence; while the stylistic overlay of columns and colors, and the towered composition were of the period as well. Apart from the direct expression of the role of the shed by its form, the engineer made one additional effort at content, designing the crossing to the height of the old United States Capitol dome, 120 feet, and proposing that the building be 1876 feet in length—it came out four

339· *Agricultural Hall*

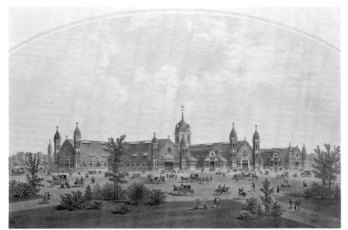

339· *Horticultural Hall*

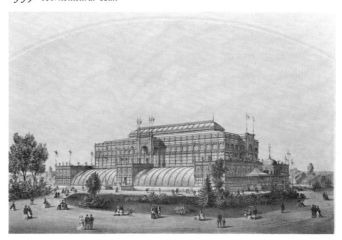

feet too long! Presumably neither idea was perceived by the average visitor.

Similar symbolic content was tried on the facade of Schwarzmann's Art Gallery—thirteen arches across the facade represented the original Colonies. As a composition it was fairly ordinary, with a central pavilion crowned by an immense glass dome and flanked by lower wings terminated by corner towers. To Joseph Wilson it was "a disappointment," for it did not "represent in itself, in its design and construction, the progress that the nation has made in Engineering and Architecture in the past one hundred years" (*Centennial Masterpieces*, vol. 3, p. xcliii). Perhaps the greatest failing of the Art Gallery was that it was a classical design executed at a time when classical values of simplicity, restraint, and attention to detail were not valued. On the other hand it was a direct expression of the rising pretensions of the nation, pretensions which had inspired the fair in the first place, and which were more fully expressed almost a generation later in the "White City" of Chicago.

Horticultural Hall and Memorial Hall became permanent legacies of the Centennial. The newly organized Pennsylvania Museum exhibited in Memorial Hall on the Centennial's first anniversary, May 10, 1877, and provided a nucleus for the Philadelphia Museum of Art, which opened in its new building on Fairmount (see no. 411b) in 1928. Horticultural Hall, badly damaged by a hurricane, was demolished in 1956.

GT □

340. *Commemorative Handkerchief*

c. 1875–76
Inscription: E. PLURIBUS UNUM/CENTENNIAL INTERNATIONAL/EXHIBITION/FAIRMOUNT PARK/PHILADELPHIA/1776 1876/MAIN EXHIBITION BUILDING THE MACHINERY HALL./MEMORIAL HALL/ART GALLERY/THE AGRICULTURAL HALL. THE HORTICULTURAL HALL.
White cotton plain cloth printed in red and black
23⅞ x 24½″ (59.8 x 62.2 cm)
Philadelphia Museum of Art. Given by Mrs. William D. Frishmuth. 13–223

NUMEROUS SOUVENIRS and a wide variety of commemorative memorabilia were produced for sale at the 1876 Centennial Exhibition in Fairmount Park (no. 339), including books, cards, photographs, coverlets, handkerchiefs and scarves, glass and china, portfolios, and prints, all embellished with scenes of the Centennial or with patriotic images and slogans.

Among such souvenirs is this scarf, which

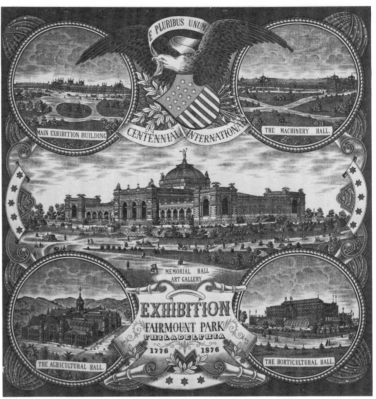

340.

shows the five major buildings constructed for the Centennial—Memorial Hall, Horticultural Hall, Agricultural Hall, Machinery Hall, and the Main Exhibition Building. The director-general's approval and sanction were needed before any view of the buildings could be reproduced. The views of Memorial Hall and Horticultural Hall are the standard ones, taken from a series of lithographs after Louis Aubrun printed by Thomas Hunter of Philadelphia. These were probably drawn from the architects' elevations before the buildings were completed, for several examples bear the copyright date of 1874 (see no. 339). These lithographs also appear in books, catalogues, and portfolios that were available at the exhibition, for example, Thompson Westcott's *Centennial Portfolio: A Souvenir of the International Exhibition at Philadelphia* (Philadelphia, 1876). However, the views of the three other buildings shown on the scarf are more unusual, and were not copied from Hunter's standard lithographic views.

The scarf is of white plain-weave cotton, printed in dark red along the edges and in black for the buildings and lettering. It may very well have been printed before the beginning of the Centennial year, and although such scarves were strictly souvenir items produced for the hundreds of thousands of visitors who trekked through the exhibition, the quality of the textile printing is very high.

CJ □

GEORGE COCHRAN LAMBDIN (1830–1896)

George Cochran Lambdin was born in Pittsburgh, a son of James Reid Lambdin, the well-known portrait painter and miniaturist. The elder Lambdin, after a short stay in Louisville and a career as an itinerant painter, moved his family to Philadelphia in 1837. George Cochran Lambdin studied with his father and also presumably in Europe, chiefly Paris and Munich, in 1855–56. He began exhibiting at the Pennsylvania Academy in 1848 with three pictures, *Children Playing, Study of a Head,* and *Dorcas Distributing Garments to the Poor,* and continued to show portraits, sentimental genre scenes, and flower pictures there until 1888. He was elected an Academician in 1863. Harrison S. Morris recorded that Lambdin was studying with William Trost Richards in 1860 (*William T. Richards, Masterpieces of the Sea,* Philadelphia, 1912, p. 32). In 1868, Lambdin moved to New York and was elected a member of the National Academy of Design where he had been exhibiting since 1856. His paintings *The Last Sleep* and *The Consecration* were chosen by the selection committee to be sent to the Paris Exposition of 1867. He also exhibited between 1858 and 1864 at the Boston Athenaeum and participated in the shows of the Philadelphia Society of Artists.

Since the late 1850s, Lambdin had been painting flower still lifes more and more

frequently until by 1870 they constituted his major subject matter. He traveled to Europe in 1870, chiefly for health reasons, returning to Philadelphia later that year at which time he turned to painting flower still lifes almost exclusively, often choosing his subjects from the extensive garden of his Germantown home. By this time widely recognized, his flower paintings were tremendously popular, and chromolithographs of them were published and widely distributed. When Lambdin died at the age of sixty-six, he was the leading still life artist in Philadelphia and the most famous flower painter of his era.

AS

341. *Flowers in a Vase*

1875
Signature: Geo. C. Lambdin 1875 (lower right)
Oil on canvas
24⅛ x 20¼″ (61.2 x 51.4 cm)
Private Collection

341.

PROVENANCE: Paul Lane, Tivoli, New York, 1954; James H. Ricau, Piermont, New York

LITERATURE: Jacksonville, Florida, Cummer Gallery of Art, *Mid-Nineteenth Century American Painting from the Collections of Henry M. Fuller and William H. Gerdts* (July–August 1966), no. 39 (illus.); New York, Public Education Association, *The American Vision* (October 8—November 2, 1968), no. 45 (illus.); Gerdts and Burke, *Still-Life,* p. 92, illus. pl. XI

THE FLOWER STILL LIFES that Lambdin exhibited in increasing numbers from the late 1850s to the 1880s are variations upon one of two themes: growing branches of roses shown against a rough garden wall or a black background, or informal bouquets of garden flowers in a vase placed against a plain dark background, as *Flowers in a Vase* of 1875 (Gerdts and Burke, *Still-Life,* pp. 92–93). In both types, this simple presentation eliminates the possible distractions of decorative objects and the formal arrangements typical of earlier still lifes to emphasize the structure and individual form of the flowers and their vivid colors in bright light. The intense effect of direct observation in *Flowers in a Vase* was new in American

painting of the 1870s and an interest different from the precision of earlier botanical illustration. Lambdin renders the delicately articulated, drooping structure of a fuchsia and the variety of colors in the petals of a white rose with direct, sure strokes of pure color. The particular shapes and textures and the varied reds, whites, and blues of peonies, roses, iris, phlox, fuchsia, and honeysuckle are placed against each other to define the sensual quality of each flower in an abundant bouquet that appeals directly to the senses.

DS □

THOMAS EAKINS (1844–1916)
(See biography preceding no. 328)

342. *The Gross Clinic*

1875
Signature: EAKINS 1875 (lower right)
Oil on canvas
96 x 78½″ (243.8 x 199.3 cm)
Jefferson Medical College, Thomas Jefferson University, Philadelphia

PROVENANCE: Purchased from Eakins by Jefferson Medical College, 1878

LITERATURE: Goodrich, *Eakins,* pp. 49–54, 161–68, pls. 12, 13; PMA, *The Art of Philadelphia Medicine* (September 15—December 7, 1965), p. 67, illus. nos. 59, 60, 61; Sylvan Schendler, *Eakins* (Boston, 1967), pp. 50–57, illus. no. 22; Hendricks, "Gross Clinic," pp. 57–64; Ellwood C. Parry III, "The *Gross Clinic* as Anatomy Lesson and Memorial Portrait," *Art Quarterly,* vol. 32, no. 7 (Winter 1969), pp. 373–91; MMA, *19th-Century America, Paintings,* no. 155 (illus.); Hendricks, *Eakins Life and Works,* pp. 87–100, 333, 340, 349, pls. 17, 18, figs. 72–76; Sellin, "The First Pose," p. 36, illus. no. 30

THERE IS NO RECORD that Eakins painted *The Gross Clinic* expressly for exhibition at the Centennial, but its difference from his previous work, in its large size and its subject—a dramatic scene built around the figure of an eminent surgeon and teacher, suggests that it was conceived in terms of the impact it would have in a major public exhibition. As *The Gross Clinic* was not painted as the result of a commission, it seems likely that Eakins, at the age of thirty, after nearly five years of independent work following his return from Europe, painted it as a complete demonstration of his talents, to secure his reputation among artists and patrons.

Although earlier paintings such as Rembrandt's *The Anatomy Lesson of Dr. Tulp* or Feyen-Perrin's *The Anatomy Lesson of Doctor Velpeau* may have served Eakins as a precedent for *The Gross Clinic* (Parry, cited above, pp. 376–80), the figures

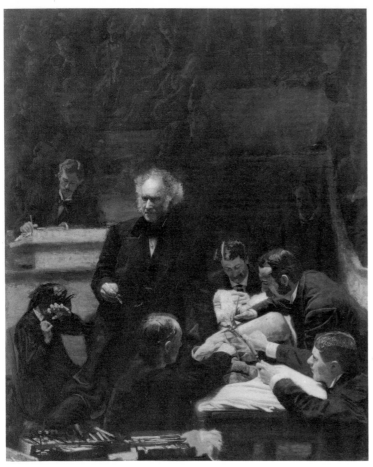

342.

and setting of the painting were familiar to him from his own experience in Philadelphia. At the age of seventy in 1875, Dr. Samuel David Gross was at the height of a distinguished career as a surgeon. His lectures in surgery at Jefferson Medical College were famous, and it is likely that Eakins, who attended lectures and demonstrations in anatomy and surgery at the College, both before and after his trip to Europe, had witnessed some of Dr. Gross's lectures—as he shows himself an attentive observer at the righthand side of the finished painting.

On April 13, 1875, Eakins wrote to Earl Shinn that he was elated about a new work that he had blocked in, and of which he had the "greatest hopes" (Parry, cited above, p. 375). And by August, John Sartain wrote to his daughter Emily that "Tom Eakins is making excellent progress with his large portrait of Dr. Gross, and it bids fair to be a capital work" (Hendricks, "Gross Clinic," p. 57). The boldness of Eakins's original conception of the painting can be seen in the composition sketch in the Philadelphia Museum of Art. The work is roughly painted, to identify only the largest masses. The com-

manding figure of Dr. Gross is isolated in strong light against the ambient dimness of the operating theater, opposed to the bent forms of the attending surgeons gathered around the irregular white shape created by sheets and the anesthetist's pad that surround the patient. Small strokes of crimson indicate blood on Dr. Gross's hand and the patient's wound. From the sketch, Eakins apparently built up the large painting during the summer and fall of 1875, using individual studies of the participants, such as the study for the head of Dr. Gross (now in the Worcester Art Museum) and of his friend, the poet Robert C. Meyers, one of the observers in the amphitheater (private collection, Philadelphia). In the finished painting, the narrative is made more complex by the cringing figure of a woman—a relative of the patient, required by law to be present at all charity operations—and the impassive figure of the clerk recording the progress of the operation. The foreground tableau of solidly realized figures brightly lit by the cold daylight from a skylight above is set against the less distinctly painted, irregular forms of students and doctors in shadow in the seats of the amphitheater and in the doorway behind.

After the painting was completed, Eakins made a black and white wash drawing of it (now in the Metropolitan Museum of Art) to be used in making an autotype—a carbon print photographic reproduction. A drawing, showing the head of Dr. Gross and another surgeon, which Eakins evidently made to study techniques of pen and ink and brush and ink for use in the full drawing, exists in the collection of the Philadelphia Museum of Art.

Perhaps to prepare for the public reception of *The Gross Clinic,* Eakins exhibited the autotype at the Penn Club art exhibition on March 7, 1876, and at the Academy's 47th annual exhibition that opened April 28. Upon seeing the autotype at the Penn Club, William J. Clark, Jr., critic for the *Evening Telegraph,* considered that "it is a work of great learning and great dramatic power, and the exhibition of the photograph last night will certainly increase the general desire to have the picture itself placed on exhibition at an early day" (Hendricks, *"Gross Clinic,"* p. 60). When the painting was shown at Haseltine's Gallery at the end of April, Clark gave it a lengthy review, praising Eakins's "command of all the resources of a thoroughly trained artist, and the absolute knowledge of principles which lie at the base of all correct and profitable artistic practice," and concluding, "This portrait of Dr. Gross is a great work—we know of nothing greater that has ever been executed in America." However, Clark noted that the painting "is such a vivid representation of such a scene as must frequently be witnessed in the amphitheater of a medical school, as to be fairly open to the objection of being decidedly unpleasant to those who are not accustomed to such things" (Hendricks, *"Gross Clinic,"* p. 61). Distaste for the subject of *The Gross Clinic* apparently determined the decision of the Committee of Selection for the art exhibition at the Centennial, for the painting was refused a place in the art galleries—although five other works by Eakins were shown—and installed among the medical displays in the United States Army Post Hospital Exhibit (Sellin, "The First Pose," p. 36). Like most of the contemporary art displayed at the Centennial, *The Gross Clinic*—as well as Eakins's other paintings—received no notice in the press.

In 1878, *The Gross Clinic* was purchased by the alumni of Jefferson Medical College, and in 1879, Eakins borrowed it from the College to send to the second annual exhibition of the Society of American Artists that opened in New York on March 10. In the context of this exhibition, which presented a variety of new trends in art by the younger generation of American artists, generally trained in Paris or Munich, *The Gross Clinic* was extensively reviewed by the critics who, while they usually recognized various as-

pects of Eakins's skill and found the picture a work of undeniable power, were nearly unanimous in their rejection of it as unfit matter for art. As the critic for the *New York Tribune* said in a review of March 22:

This is a picture of heroic size that has occupied the time of an artist it has often been our pleasure warmly to praise, and that a society of young artists thinks it proper to hang in a room where ladies, young and old, young girls and boys and little children, are expected to be visitors. It is a picture that even strong men find it difficult to look at long, if they can look at it at all; and as for people with nerves and stomachs, the scene is so real that they might as well go to the dissecting room and have done with it. . . . It is impossible to conceive, for ourselves, we mean, what good can be accomplished for art or for anything else by painting or exhibiting such a picture as this. Here we have a horrible story—horrible to the layman at least—told in all its details for the mere sake of telling it and telling it to those who have no need of hearing it. No purpose is gained by this morbid exhibition, no lesson taught—the painter shows his skill and the spectator's gorge rises at it—that is all. (Hendricks, *"Gross Clinic,"* p. 63)

After the exhibition closed, the works were shipped to Philadelphia where they were to be shown together in the Pennsylvania Academy's 50th annual exhibition opening April 8, 1879. Instead of being hung as a group, however, the paintings were dispersed throughout the galleries, and a painting by Thomas Moran that had been rejected by the Society was prominently displayed and listed among the works from the New York exhibition, while *The Gross Clinic* was listed separately and hung in "an obscure corner" of the exit corridor. Upon a letter of complaint from Walter Shirlaw, president of the Society, the Academy brought the works together in one gallery, removed Moran's painting, and amended the catalogue, but *The Gross Clinic* was left in its unfavorable location.

After the close of the Academy exhibition, Eakins apparently exhibited *The Gross Clinic* only twice again during his lifetime— at the World's Columbian Exhibition in 1893, with a group of nine other works, and at the Louisiana Purchase exhibition in St. Louis in 1904.

DS □

343a.

FRANK FURNESS (1839–1912)
(See biography preceding no. 335)

343a. *Elevation of Desk*

c. 1875
Pencil on paper
$7^{11}/_{16}$ x $11^{1}/_8$" (20 x 28.2 cm)
Philadelphia Museum of Art. Given by George Wood Furness. 74–224–3

343b. *Desk*

c. 1875
Walnut; white pine and poplar
71 x 62 x $32^{1}/_2$" (180.3 x 157.4 x 82.5 cm)
Philadelphia Museum of Art. Given by George Wood Furness. 74–224–1

343c. *Side Chair*

c. 1875
Walnut; ash, bald cypress; black leather upholstery
$30^{3}/_4$ x $17^{3}/_8$ x $22^{1}/_4$"
(78.1 x 44.1 x 56.5 cm)
Philadelphia Museum of Art. Given by George Wood Furness. 74–224–2

PROVENANCE: Horace Howard Furness; son, William Henry Furness III; nephew, Horace Howard Furness Jayne; cousin, George Wood Furness

LITERATURE: PMA, *Furness*, pp. 41–42; David Hanks, "Reform in Philadelphia," *Art News*, vol. 74, no. 8 (October 1975), illus. p. 52

BOTH DESK AND CHAIR were designed for the Washington Square house of Frank Furness's brother, Horace Howard Furness. A graduate of Harvard, Horace Furness was a noted Shakespearean scholar, the author of the *New Variorum Shakespeare*, the first volume of which appeared in 1871. As a professor at the University of Pennsylvania, he headed the building committee for the library designed by his brother, which was named in the scholar's honor.

Impressive because of its strongly architectonic form, the desk appears more in human scale when seen in situ in an early photograph of Horace Furness's library (PMA, Archives). Within its Greek revival interior the library contained a fine marble mantelpiece of about 1830, and several large pieces of furniture designed by Furness at the same time as the desk, including a large built-in bookcase, which is closely related to the desk. This furniture contributes to the architectural unity in the room. The Moorish arch of the desk, for example, is echoed in a series of identical arches along the upper section of the bookcases; the angular fluting on the drawer fronts and on the cornice above the tambour is repeated along the cornice of the bookcase; and engaged columns and paneling are present in both.

Many of the details that give the desk its forceful architectonic quality are seen in Furness's buildings. The Moorish-inspired horseshoe arch, for example, was a bold element in the interior of the Rodeph Shalom Synagogue in Philadelphia (PMA, *Furness*, pp. 78–79). More striking, however, is the similarity of the overall form of the desk to Furness buildings of the 1870s.

The same tripartite form with vertical and horizontal articulation is seen in the Pennsylvania Academy of the Fine Arts (no. 335) and the Guarantee Trust and Safe Deposit Company of 1873–75 (PMA, *Furness*, p. 91); the central gable is also seen in the latter building. In fact, the desk seems more like a building than a piece of furniture—its lamps and clock supported by winged figures are more surely appropriate for an exterior than an interior. Kenneth Ames has pointed out that an identical winged female figure holding an urn surmounted by a clock is illustrated in Henry T. Williams and C. S. Jones's *Beautiful Homes* (New York, 1878, p. 27). Thus the lamps and clock must have been stock items, probably available by catalogue. An early source for the design of the desk is seen in plate 160 of Mésangère, *Sécrétaire en Acajou avec ornements en Ebène incrustés*. Both desks have central clocks and tambour compartments as well as similar proportions.

The drawing for the desk substantiates the attribution of the desk to Furness, and also shows that changes were made in execution. Furness's love of ornament is given full play in the drawing and in the desk, as it is in his buildings, where no surface is left empty in the creation of a vibrant, electrifying effect. Derived from such sources as Owen Jones's *Grammar of Ornament* (London, 1856) and Christopher Dresser's *Principles of Decorative Design* (London, 1873) and *Studies in Design* (London, c. 1874), Furness's ornamental designs were based on natural forms, especially leaves and flowers. His sketchbooks are filled with carefully detailed drawings of flowers, animals, and landscapes. But as with that of Jones and Dresser, Furness's

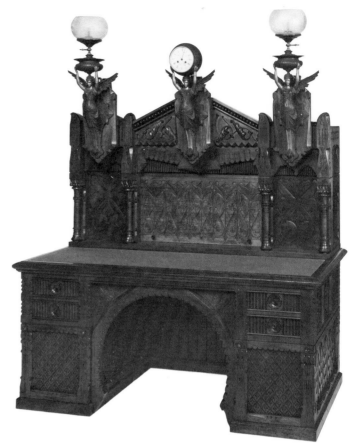

343b.

ornament was a conventionalized representation of natural forms, based also on past ornamental styles though adapted for modern use. Dresser explained its origins: "I have insisted upon the study of historic ornament as a necessary part of the education of an ornamentalist, but I have not done so with the view of his being enabled thereby to produce works in imitation . . . no past style is precisely suited to our wants. . . . These considerations force upon us the necessity for striving after newness of style in ornament" (*Studies in Design*, p. 13).

This abstraction from nature was typical of English reform designs of the 1870s. These designs found a particularly receptive audience in Philadelphia, where Furness and other contemporaries developed a distinctive regional vocabulary. Daniel Pabst (see biography preceding no. 326) was another Philadelphia designer to make use of conventionalized ornament. Because Furness is known to have been a customer of Pabst, one might speculate that Pabst may have executed some of Furness's furniture, possibly even this desk. Other furniture known to have been made by Pabst in the 1870s (see no. 344) is also in this reform style, and Furness may have been a major influence in Pabst's changing style, although it is just as likely that Pabst and other Phila-

delphia cabinetmakers relied on the same English and French sources as Furness did. Christopher Dresser's visit to Philadelphia in 1876 must have had a significant impact on Philadelphia craftsmen. He not only lectured here but is known to have designed wallpaper for a Philadelphia firm. The Philadelphia reform style was to have further significance because of its influence on Louis Sullivan while he worked in Furness's office. The conventionalized floral patterns are seen in Sullivan's own early drawings and executed ornament, and are developed further in his later decorative repertoire (seen in his *System of Architectural Ornament*).

The side chair, which, according to George Wood Furness, was originally with the desk, is also architectural in conception and shows a strong similarity to the armchair Pabst designed for the Roosevelts (Yonkers, N.Y., The Hudson River Museum, *Eastlake-Influenced American Furniture, 1870–1890*, November 18, 1973–January 6, 1974, fig. 11). It has the same honest, straightforward construction and rectilinear form typical of English reform furniture; similar chairs were designed by Bruce Talbert. A unique feature of the chair is its crest rail, which contains a compartment with a hinged lid.

DH □

343c.

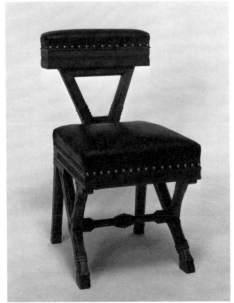

DANIEL PABST (1827–1910)
(See biography preceding no. 326)

344. *Night Table*

c. 1875
Walnut and bird's-eye maple veneer;
white marble
29⅞ x 19⅝ x 19″ (75.8 x 49.8 x 48.2 cm)
Philadelphia Museum of Art. Given by
Charles T. Shenkle in memory of his
mother, Mrs. Edna H. Shenkle. 75-42-3

PROVENANCE: Emma (Pabst) Reisser (1860–
1937), Philadelphia; daughter, Edna (Reisser)
Shenkle, Philadelphia; son, Charles T. Shenkle,
Wilmington

THIS NIGHT TABLE is part of a bedroom suite
which, according to family history, Daniel
Pabst made for his daughter Emma. Other
pieces in the set were also given to the
Philadelphia Museum of Art, including a
bed and a bureau with looking glass.
According to Pabst's granddaughter, Edna
Reisser Shenkle, this bedroom set was a
duplicate of a set Pabst made for General
Thomas McKean. Although a bedroom set
of about the same date, consisting of a ward-
robe, night table, and bed, which belonged
to Henry McKean, is owned by one of his
descendants, it differs in form and detail
from this set.

Another set of furniture of about the same
date and style was made for Theodore
Roosevelt, Sr.'s, house at 6 West Fifty-
seventh Street in New York. According to
Roosevelt family tradition, this furniture
won an award at the Philadelphia Centen-
nial exhibition. However, no suite of furni-
ture like this one is described in the Cen-
tennial Register, but it is possible that the
Roosevelts saw some Pabst furniture of a
similar style at the exhibition.

In addition to English influences on both
Pabst and Furness, prototypes in the
"Modern Gothic" style by designers in
Stuttgart and Paris are also known. A carved
bench of similar form and ornament to this
night table, designed for "The Hall of the
Railway-Station in Stuttgart," is illustrated
in *The Workshop* (vol. 1, 1868, p. 59,
figs. 21–23). An armchair designed by the
Parisian architect M. P. Benard and also
illustrated in *The Workshop* (vol. 2, 1869,
p. 25, figs. 17–19) shows comparable orna-
ment. Whether this style is described in
contemporary terms as Modern Gothic or
Eastlake, furniture of this type demonstrates
the reform tenets of the 1870s.

This night table, fully reflecting the
reform movement, is a superb example of
Pabst's workmanship, which was unsur-
passed in Philadelphia in the second half
of the nineteenth century. As with the desk
designed by Furness (no. 343b), the night

table is ornamented with conventionalized
floral motifs, achieved through an extraordi-
nary cameo technique of cutting through a
bird's-eye maple veneer to the walnut
underneath. A particularly fine detail is the
cut veneer which outlines the chamfered
edges. The result is a striking design of
contrasting light and dark woods which
seems to be an effect that had been con-
tinually popular in Philadelphia since the
late eighteenth century. The curved corners
of the shaped white marble top echo the
curves of the engaged columns. Careful
attention to details is seen in the finished
back and paneled interior.

DH □

DORFLINGER GLASS WORKS (1865–1921)

Christian Dorflinger was born in Alsace,
France, in 1828. He was apprenticed to his
uncle and learned glassmaking at Saint-
Louis in Lorraine. In 1846, a year after his
father's death, he came to America with his
mother, brothers, and sisters. He first worked
as a glassblower in a Philadelphia glass-
house producing druggists' wares. By 1852
he owned the Long Island Flint Glass Works
in Brooklyn and by 1860 he had two more
glasshouses and was producing fine flint
glasswares. He was forced into retirement
by ill health in 1863, but returned to glass-
making in 1865 when he established the
Dorflinger Glass Works in White Mills,
Pennsylvania. His workers were Europeans
from Brooklyn and local farm boys he
trained.

His glass became renowned for its clarity
and brilliance, and after a glass-cutting and

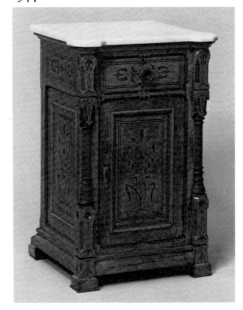

344.

engraving department was added in 1867,
for fine quality cut and engraved wares.
His glassworks also produced blanks for
many other cutting and engraving shops.
Glass tablewares for the White House were
made by his firm for eight presidents, from
Lincoln to Wilson, as well as for the presi-
dent of Cuba. In 1881, Christian took his
sons, William, Louis J., and Charles into the
business and the firm became Christian
Dorflinger & Sons.

Christian Dorflinger died in 1915. The
works was closed during World War I
because of a shortage of raw materials,
which would have necessitated a change in
its glass formula. After the war the factory
reopened for a short time, but closed for
good in 1921 in the face of changing styles
and a lack of German potash (McKearin,
Blown Glass, pp. 137, 244).

345. *Decanter and Wineglasses*

1876
Inscription: LIBERTY AND UNION, NOW AND
FOREVER, ONE AND INSEPARABLE (on de-
canter, in inverted arch below the arms of
the United States); WM. S. STOKLEY MAYOR
1876 MDCCLXXXIX (on decanter, in curve
under crest of City of Philadelphia)
Colorless flint (lead) glass
Decanter height 16¼″ (41.3 cm), diam-
eter 5⅝″ (14.3 cm); wineglasses height 5″
(12.7 cm), diameter rim 2¼″ (5.7 cm),
foot 2⅜″ (6 cm)
Philadelphia Museum of Art. Given by
the Dorflinger Glass Company. 76-1693
and 76-1693b, t

LITERATURE: Daniel, *Cut and Engraved Glass*,
p. 142, pl. 59; Revi, *Cut and Engraved Glass*,
illus. p. 271; MMA, *19th-Century America,
Furniture*, fig. 202

THIS DECANTER and wineglasses are part of
an original service of thirty-nine pieces, the
decanter representing the United States of
America and each wineglass one of the
thirty-eight states of the country in 1876.
They are blown of a very fine quality heavy
flint (lead) glass, cut and engraved. In three
raised panels, the decanter bears engraved
emblems of the Goddess of Liberty, the arms
of the United States, and the crest of the City
of Philadelphia accompanied by the name of
Mayor William S. Stokley and the date 1876.
The body of the decanter is cut in panels
decorated with patterns of diamonds of
several sizes; the base is deeply cut in a
geometric pattern and the neck cut with a
series of overlapping, shallow, concave
diamond-shaped facets. The stopper is cut
to match the decanter. This set received the
highest award at the Centennial exhibition.

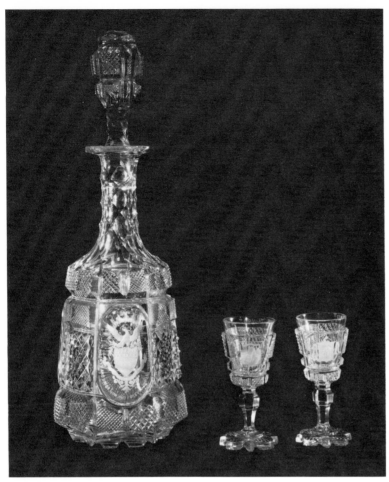

345.

Each of the original thirty-eight wineglasses is cut en suite with the decanter and bears a medallion with the arms of each state then in the Union, together with the state's motto and name of its governor. The hexagonal knopped stems terminate in eight-petaled, Bohemian-style feet, cut with a pattern of small diamonds on the underside. Several other wineglasses from this service are extant in other collections.

The rather restrained but overall cut pattern represented by this decanter and the wineglasses is the forerunner of the overly elaborate and intricate cut glass patterns that were so much in demand during the "Brilliant Period" of cut glass, about 1885–1915.

KMW □

GALLOWAY & GRAFF (1869–1946)

The firm of Galloway & Graff was first listed in the Philadelphia directories in 1869, having been established in 1810 as the Market Street Pottery. In their illustrated catalogue Galloway & Graff offered "stock of Art and Horticultural Terra Cotta ... which for variety, excellence of design and workmanship, is not equalled in this country" (LCP, Archives, 1876). The partnership of William Galloway and John Graff lasted until 1885, when the name of the firm was changed to Galloway, Graff & Co. Their pottery was "the largest in the city, and turns out a greater variety of clay goods than any other, comprising earthenware, as well as blue stoneware, Rockenham and majolica ware, also an endless variety of ornamental pottery, vases, statues, hanging baskets, flower pots, etc." (*City of Philadelphia: Leading Merchants and Manufacturers,* 1886, n.p.).

From 1872 until 1889 the firm was located at 1725 Market Street, from 1890 until 1895 at 1711 Chestnut Street, and from 1896 until 1928 at 3216 Walnut. The firm continued to be listed in Philadelphia directories until 1946.

346. *Out in the Rain*

c. 1876

Inscription: GALLOWAY & GRAFF,/1725 MARKET ST./PHILADELPHIA. (impressed on terra-cotta plaque at base in front)

Terra-cotta; tin umbrella

Height 47″ (119.4 cm); diameter base 19″ (48.3 cm); diameter umbrella 27″ (68.6 cm)

Arthur Robinson, Harrison, New York

A TERRA-COTTA FOUNTAIN titled *Out in the Rain* was exhibited in the Italian section of the United States International Exhibition of 1876, and was illustrated in Frank Leslie's *Historical Register of the United States Centennial Exposition 1876* (New York, 1877, p. 274). The Galloway & Graff fountain is probably a replica of the one exhibited in the Centennial, for it would be unlikely for the Italians to have a Philadelphia-made object in their section. The firm's illustrated catalogue shows "a number of our Vases are truthful copies of some of the finest specimens from the Antique, old Greek and Roman productions; while the Statuary is all made from casts from the originals, retaining all the forms and elegance of outline which give beauty to the originals" (LCP, Archives, 1876).

Galloway & Graff was listed in the "General Report of the Judges of Group II" as exhibiting

artistic terra cotta large vases and pedestals, statues, fountains, etc. Among them may be noted a full-sized reproduction of the Apollo Belvedere; also of Bailly's Echo; of Canova's Dancing-Girl; of Gibson's Psyche; of the Warwick vase, and others of classical design; generally well potted and moulded, and of pleasing color. Among the fountain vases are some of large diameter, good as evincing skillful command of material and showing, by equality of surface and evenness of line, the difficulties of firing overcome with creditable success. One large Centennial vase in three pieces, 5 feet 6 inches in height, is commended for good workmanship in details of ornamentation, but is open to criticism in design. One specimen is shown of a process of staining the surface of the terra-cotta with a deep-red tint; but this color is not fixed by firing. The whole collection is commendable as artistic, and compares not unfavorably with some European works of the same character. (*United States Centennial Commission: International Exhibition, 1876. Reports and Awards,* vol. 3, Washington, D.C., Government Printing Office, 1880, p. 103)

The Victorian sentiment expressed in this fountain is typical of the period and was

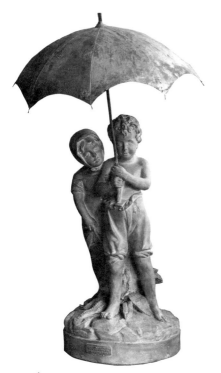

346.

evident in many pieces on view at the Centennial exhibition. One of the copies cast in metal is in the collections of the Margaret Woodbury Strong Museum, Rochester, New York, and is illustrated in *A Scene of Adornment, Decoration in the Victorian Home* (Rochester, New York, Memorial Art Gallery of the University of Rochester, May 7—April 13, 1975, p. 103).

DH □

GILLINDER & SONS (1861–1930)

William T. Gillinder founded the Franklin Flint Glass Works in Philadelphia in 1861. In 1863, Edwin Bennett, one of the founders of the Bennett Pottery in East Liverpool, Ohio, entered the business, bringing additional capital with which the firm was expanded. The firm name was then changed to Gillinder & Bennett. In 1867, James and Frederick Gillinder, sons of William T., bought Bennett's interest and the firm became Gillinder & Sons. The firm continued in this style, even after the death of William T. in 1871. In 1888 or 1890, the pressed glass department was moved to Greensburg, Pennsylvania. That factory was later merged with the U.S. Glass Company and according to agreement ceased producing tablewares. The three sons of James Gillinder left the company in 1912 and

founded Gillinder Brothers, Inc., in Port Jervis, New York, where the firm is still operating. In 1930 the Philadelphia firm went out of business (McKearin, *Glass,* pp. 610, 613; Revi, *Cut and Engraved Glass,* pp. 255, 256).

The various firms which operated the Franklin Flint Glass Works in Philadelphia produced a wide variety of glasswares. For the first year or two production seems to have been limited to lamp chimneys and chemical wares. By 1862 or 1863, pressed tablewares were added to their output, and by the late 1860s "camphor" glass and paperweights were also being made. About 1870 production also included a range of cut glass tablewares, lamps, shades, etc., and some engraved work. A company catalogue of that period illustrates decanters, compotes, celery vases, and pitchers, all cut with restrained designs characteristic of many English cut glasswares of that era (Revi, *Cut and Engraved Glass,* p. 256).

The company erected and operated a full-scale glasshouse, complete with cutting and engraving shops, on the grounds of the Centennial exposition. Here they produced primarily pressed glass, including souvenirs, among which was a representation of the Centennial's Memorial Hall, but also some blown, cut, and engraved glass. Among the latter are the four pieces shown in this exhibition. In the 1880s, this firm produced a limited number of pieces of true cameo glass (see no. 355)—one of only two American glasshouses to do so.

347. *Goblets and Pitchers*

1876

Colorless flint (lead) glass

Goblets height 7¼″ (18.4 cm), diameter rim 3⅝″ (9.2 cm), foot 3¼″ (8.3 cm); pitcher height 11″ (27.9 cm), diameter base 4⅛″ (10.5 cm); footed pitcher height 9⅜″ (23.8 cm), diameter foot 4⅛″ (10.5 cm)

Philadelphia Museum of Art. Gift of Gillinder & Sons. 06–253, 254, 256, 257

THESE PIECES were made by Gillinder & Sons in 1876; according to museum records, the footed pitcher was produced on the Centennial exhibition grounds in Philadelphia.

The footed, jug-like pitcher—a rather unusual form—is competently engraved and cut, but surprisingly is fashioned of somewhat inferior quality lead glass containing numerous seeds and stones. The tooling of the neck also shows several irregularities and the shearing of the lip evidences halting uncertainty on the part of the gaffer, resulting in a less than smoothly flowing line. Despite these factors, this unusual piece is a notable example of American engraved glass of the Centennial era. Its copperwheel engraved woodland scene with two horses racing toward a stream is characteristic of the higher quality of Bohemian-influenced engraving being done in this country at this time. This influence, which began to make itself evident here about 1850, was sometimes

347.

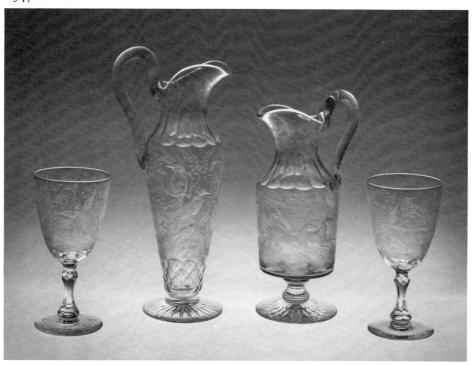

a direct one in the form of a Bohemian or German immigrant engraver plying his skill here, but often an indirect one brought here by English engravers who had been influenced by this style. The scene and style of the engraving are related to the works of Louis Vaupel, John Leighton, and Henry Fillebrown of the New England Glass Company.

This pitcher, along with the other pitcher and two goblets, is a valuable document in a medium seldom represented by accurately datable examples from known sources.

The taller pitcher, in both form, cut, and engraved decoration, closely parallels English examples of the same period, particularly some from the Birmingham and Stourbridge districts. It is also related to some of the engraved work done by Millar at John Ford's Holyrood Glass Works in Edinburgh during this era. The engraving is very well done, on fairly good quality glass, so it is surprising to find the workmanship in the fashioning of the piece to be rather poor. This is evidenced by the very unevenly sheared lip and the fact that the handle has been set on the body crookedly. In spite of these defects, this pitcher is a noteworthy document of American glassmaking.

The form of these free-blown goblets is typical of this era, both in America and England. The similar engraved scenes on the bowl, with birds in a setting of ferns and other foliate forms, show strong English influence, as in the scene on the taller pitcher, and all are closely related. The foot of one goblet has been engraved with "ivy" leaf garland and tendrils, more closely related in style to Bohemian sources, but the foot of the other has been left unadorned. Both the English and Bohemian traditions exerted strong influence on American engraved glass during this period.

KMW □

1876-1926

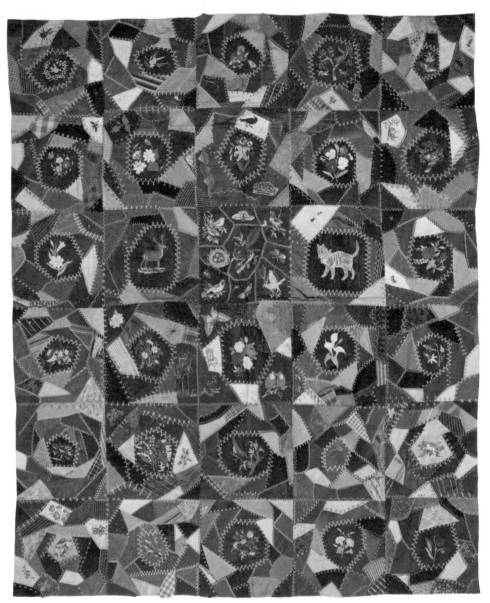

348.

seams were outlined in intricate patterns with silk thread. Selected pieces or whole squares are adorned with a profusion of cherubic sailors, household pets, detailed insects, flowers, and other motifs. The reverse is unlined.

This quilt was made by Lucy Catherine Zeigler Hicks, the wife of the Reverend Owen Hicks, and the first Sunday School teacher of the donor's mother, Amy Josephine Kline Cornwell, born in 1869. Amy Kline was about six or seven years old when the quilt was made, and her job was to collect the patches. One of those patches is reportedly a piece from her grandmother's wedding dress.

PC □

LUCY CATHERINE ZEIGLER HICKS (N.D.)

348. *Lap Quilt*

c. 1876
Face: silk, velvet, and satin patches, silk embroidery thread; reverse: patches of cotton chintz, cotton thread
77¹⁵⁄₁₆ x 64¹⁵⁄₁₆″ (198 x 165 cm)
Philadelphia Museum of Art. Given by Ralph T. K. Cornwell in memory of his mother, Amy Josephine Kline Cornwell. 46–8–1

PROVENANCE: Lucy Catherine (Zeigler) Hicks; Amy Josephine (Kline) Cornwell; son, Ralph T. K. Cornwell

THE VICTORIAN LAP QUILT, or crazy quilt as it was popularly known, was an outgrowth of the cotton patchwork quilt tradition. The crazy quilt was used as a lap or slumber throw, usually in the parlor rather than the bedroom, and was an appropriate medium for expression of the contemporary penchant for nostalgia and fascination with the strange and unusual. Cotton was considered unsuitable, except as backing. Instead, the work was faced with patches of velvet, silk, and satin sewn together and embroidered with figures, scenes, or fancy stitches.

As on the example shown, the irregular patches were sewn directly to a square of cotton, stitched on the wrong side, and then progressively folded back to form a neat seam until they covered the form. The seams between the patches and between the squares have been sewn with cotton thread, apparently machine-stitched. On the face, the

349. *Wedding Dress*

1877
Puce silk taffeta; trimmed with greige-chenille bows and silk tassels, ivory-gray silk satin, puce silk-taffeta fringe, and ivory netting
Waist 26½″ (67.3 cm); center back length (from waist) 40¼″ (102.2 cm)
Philadelphia Museum of Art. Given by Mr. and Mrs. Samuel Wanamaker Fales. 55–80–2a, b

PROVENANCE: Mary Ellen Wanamaker (Fales), 1877; son, Samuel Wanamaker Fales

ALTHOUGH THE LONG VICTORIAN ERA saw a succession of diverse styles of women's dress, one element remained constant throughout the period—the use of trimmings in great variety. By the late 1870s, the invention and development of the sewing machine and improvements in production techniques had led to great ostentation in women's dress, much like the overstuffed and overdraped furniture of the same period.

Mary Ellen Wanamaker, sister of the department store merchant John Wanamaker, wore this puce silk taffeta dress at her marriage to the Reverend Elisha F. Fales on October 25, 1877. Draped and swagged, beribboned and festooned, the dress reflects an imagination gone wild in its extravagance of trim, although it was considered the height of fashion and elegance when it was worn.

Elaborately trimmed with a deep fringe of greige-chenille bows and silk tassels, it is intricately draped, its swags held in place with self-fringed taffeta and silk-satin bow knots and its bustle flowing into a wide, rounded train. The bodice, true to its era, is snug fitting, hugging the bust and waist, but it flares out slightly over the hips, giving some fullness to the abdomen. Ivory netting

held in place by self-bands of taffeta gives a vest-like effect; this is further highlighted and outlined by a ruffle of fluted taffeta, with a bow at its base. A tiny band collar and elbow-length sleeves, likewise ruffled, complete the ensemble.

CJ □

THOMAS EAKINS (1844–1916)
(See biography preceding no. 328)

350. *William Rush Carving His Allegorical Figure of the Schuylkill River*

1877
Signature: EAKINS 77 (lower right)
T.E. (on reverse, lower right)
Oil on canvas
20⅛ x 26⅛″ (51.1 x 66.3 cm)
Philadelphia Museum of Art. Thomas Eakins Collection. 29–184–27

PROVENANCE: Thomas Eakins; Mrs. Thomas Eakins and Miss Mary A. Williams, until 1929

LITERATURE: Goodrich, *Eakins,* pp. 58–60, 170–71, no. 109, pl. 17; Gordon Hendricks, "Eakins' *William Rush Carving His Allegorical Statue of the Schuylkill,*" *Art Quarterly,* vol. 31, no. 4 (Winter 1968), pp. 382–404 (illus.); Gerald M. Ackerman, "Thomas Eakins and His Parisian Masters Gérôme and Bonnat," *Gazette des Beaux-Arts* (April 1969), pp. 235–56; Hendricks, *Eakins Life and Works,* pp. 111–15, 341, no. 250, pl. 24; Sellin, "The First Pose," pp. 36–45, illus. p. 39

PERHAPS AS EARLY as the spring of 1875, while he was at work on *The Gross Clinic* (no. 342), Eakins began the preparatory studies for the first version of *William Rush Carving His Allegorical Figure of the Schuylkill River.* A sketch of the leg of Rush's sculpture of George Washington appears on a letter that Eakins wrote to Earl Shinn in April of that year. Although *The Gross Clinic* and the *William Rush* could hardly be more different in subject and scale, both reflect aspects of Eakins's Beaux-Arts training. With its dramatic subject from contemporary life and its composition of boldly massed forms on a large canvas, *The Gross Clinic,* like a large salon painting by his French colleagues, is clearly intended to stand out from the competition on the crowded walls of an exhibition gallery. The intimate scale and subject of the *William Rush* recall the similar treatment of historical themes by Eakins's teacher, Gérôme (Ackerman, "Thomas Eakins and His Parisian Masters," cited above, p. 244). With typical independence, however, Eakins

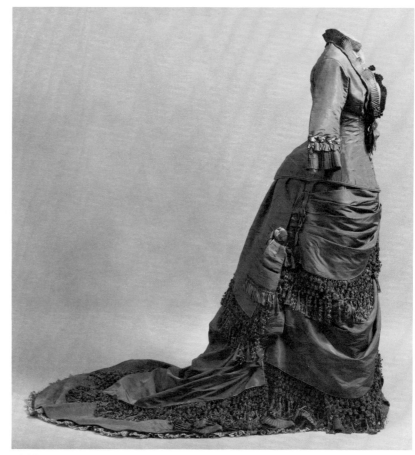

349.

transposed the concept of historical genre into his own frame of reference, and instead of choosing an event from ancient history or from literature, he depicted a scene from the life of a Philadelphia sculptor whose work he admired.

William Rush is shown in his studio, carving the statue of the water nymph and bittern that he made in 1809 as a fountain for the Centre Square Waterworks (see no. 153). In a statement about the painting, Eakins described Rush's career as a sculptor and the history of the nymph, pointing out that it was mistakenly called Leda and the Swan. "The Statue is an allegorical representation of the Schuylkill River. The woman holds aloft a bittern, a bird loving and much frequenting the quiet dark wooded river of those days" (Goodrich, *Eakins,* p. 170).

The central narrative of Eakins's painting illustrates the legend that Louisa Van Uxem, the daughter of a prominent Philadelphia merchant, posed for the figure of the Schuylkill. To insure the historical authenticity of the scene, Eakins referred to an original sketchbook by Rush for the scrolls and drawings on the wall, and made drawings of costumes in John Lewis Krimmel's

1819 painting of *Independence Day Celebration in Centre Square* (see no. 204, represented in watercolor) and of Rush's sculptures of *Washington,* of the *Nymph and Bittern,* and of *The Schuylkill Freed* (see no. 219). In preparation for the finished painting, Eakins made a number of oil sketches and small wax figures (see Hendricks, "Eakins' *William Rush,*" cited above, p. 389), that, along with the drawings, provide the most complete record of Eakins's painstaking working method at this early point in his career. While perspective drawings for the painting are not known, and the cluttered, dim interior of Rush's studio does not call attention to the carefully constructed perspective space apparent in Eakins's rowing and sailing scenes, David Sellin has pointed out that the *William Rush* is precisely constructed according to a one-point perspective system focused on the central figure of the nude model which produces a "startling illusion of solid forms existing in finite indoor space" (Sellin, "The First Pose," p. 43).

Although a particular event is represented, the sculptures around the walls of Rush's shop were made at different times in his life, so that the painting is not confined

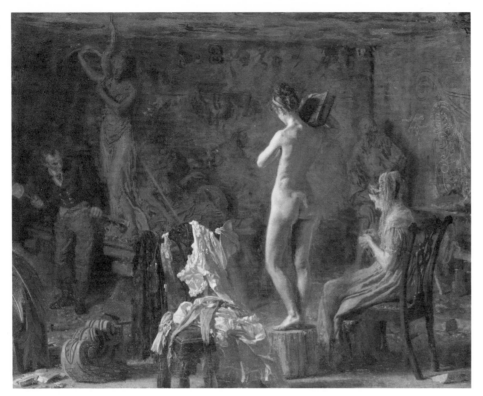

350.

351.

to a single moment in time, but summarizes
Rush's work as an artist. This and the fact
that the sculptor is carving his draped figure
from the pose of a nude model have led to
the interpretation of the painting as Eakins's

justification of his own insistence on study
from the nude, at a time when the use of
nude models in life classes was a contro-
versial issue at the newly reopened Academy
(Sellin, "The First Pose," pp. 42–43).

Eakins first exhibited the *William Rush* in
New York in the spring of 1878 at the first
annual exhibition of the Society of American
Artists. Like *The Gross Clinic*, which he
exhibited there the following year, it was
unfavorably received by the critics. Although
Eakins's talent was recognized, faults were
found in the painting's lack of color and the
ungraceful treatment of the nude figure.
The critic for the *Times* was disturbed by
"the presence in the foreground of the clothes
of the young woman, cast carelessly over
the chair. This gives a shock which makes
one think about nudity—and at once the
picture becomes improper" (in Hendricks,
"Eakins' *William Rush*," cited above,
p. 384). Only Eakins's friends William
Clark and Earl Shinn, who had defended
The Gross Clinic, gave the painting
unqualifiedly favorable reviews.

In 1908, Eakins returned to the William
Rush subject, making studies and three
large paintings that are variations on the
theme that had occupied him thirty years
earlier.

DS □

WILLIAM TROST RICHARDS (1833–1905)
(See biography preceding no. 322)

351. *Landscape*

1878
Signature: Wm T. Richards. 1878
(lower right)
Oil on canvas
37 x 56½" (94 x 143.5 cm)
Mr. and Mrs. John W. Merriam,
Wynnewood, Pennsylvania

PROVENANCE: William Sellers, from 1878; with
Renaissance Galleries, Philadelphia, 1954; with
Samuel T. Freeman, Philadelphia, until c. 1956

LITERATURE: Brooklyn Museum, *William Trost
Richards, American Landscape and Marine
Painter, 1833–1905*, by Linda S. Ferber
(June 20—July 29, 1973), no. 71, p. 84

WILLIAM TROST RICHARDS's landscapes of
the 1870s were painted in a variety of styles
reflecting various aspects of his interest in
nature. The precise rendering of minutely
observed detail that reveals the pre-Raphaelite
influence in his paintings and drawings of
the 1860s (see no. 322) remained an element
in Richards's art, but his interest in land-
scape expanded to include study of effects
of light and atmosphere. A renewed aware-
ness of his emotional response to a view
influenced his presentation of it. Richards's
landscapes after the 1860s are as often con-
cerned with a particular effect in nature as
with specifics of topography and vegetation,
and he modified his technique to match his
artistic goals. For example, the large paint-

ing *The Wissahickon* (Philadelphia, Medical College of Pennsylvania), exhibited at the Centennial, uses a number of traditional compositional devices and a relatively schematic treatment of light and foliage to create with vivid effect the palpable atmosphere of intense humidity and strong, hazy light that envelops the Wissahickon Valley on a summer day.

In contrast, the *Landscape* of 1878 shows the artist's earlier interest in truth of natural detail expanded to encompass every aspect of a spacious landscape view. Linda Ferber suggests it is a view of the area around Wilmington and Edgemoor, painted for Philadelphia industrialist William Sellers, president of the Edgemoor Iron Company (Brooklyn Museum, *Richards*, cited above, p. 84). Space and light and the fresh blues and greens of the open countryside are as precisely observed as the infinitely varied shapes of trees or the exactingly detailed leaves and rocks in the foreground. The large scale of the painting and Richards's ability to sustain throughout the canvas the effect of presenting the scene completely as it appeared presents a visual experience that is remarkably equivalent to the pleasure of looking at such a view in nature. Instead of focusing upon one dramatic landscape element or particular atmospheric effect, the uninsistent composition of the painting allows the leisurely discovery of the infinite variety that is the beauty of such a calm, verdant scene.

DS □

HERMAN SIMON (1846–c. 1893)

Herman Gustav Simon was a well enough known painter during his lifetime to merit an entry in *A Biographical Album of Prominent Pennsylvanians,* but little more is known about his life. He was born in Schlietz, Saxony, Germany, the son of a cloth manufacturer who brought his family to Philadelphia two years later during the Revolution of 1848. Educated in the public schools and by private tutors, Simon showed an early aptitude for art and entered the Pennsylvania Academy where, according to the same source, "his talent for painting, which amounted to real genius, attracted notice and encouragement from the first" (*A Biographical Album of Prominent Pennsylvanians,* Philadelphia, 1889, p. 351). He studied with Robert Wylie at the Pennsylvania Academy and later with George F. Bensell and Henry W. Bispham, and exhibited a painting called *The Brookside* at the Academy's annual exhibition of 1863, when he was seventeen years old.

He is first listed as an artist in the Philadelphia city directory of 1871, at the same Sergeant Street address as a "Gustavus Simon, spinner," probably his father. He exhibited several paintings at the Centennial exhibition in 1876, including *Dogs at Quail Shooting* and *Duck Shooting on the Chesapeake Bay.* Simon came to specialize in this type of animal and sporting scene. He exhibited again at the Pennsylvania Academy between 1876 and 1887, with the Philadel-

phia Society of Artists in 1879–81 and in 1884, as well as in other major cities. Simon's name disappears from the Philadelphia directories after 1892, and he is listed as deceased in the National Academy's exhibition catalogue of 1897.

AS

352. *The Pigeon Shoot— Philadelphia Gun Club*

1879
Signature: Herman Simon 1879 (lower left)
Oil on panel
20¼ x 40½″ (51.4 x 102.8 cm)
Philadelphia Gun Club

PROVENANCE: Possibly Dr. J. B. Kinney, 1879

LITERATURE: MMA, *Life in America* (April 24– October 29, 1939), no. 267; James Thomas Flexner, *Nineteenth Century American Painting* (New York, 1970), p. 237, illus. pp. 234–35; Bloomfield Hills, Michigan, Cranbrook Academy of Art/Museum, *Genre, Portrait, and Still Life Painting in America, The Victorian Era* (August 26—September 30, 1973), p. 17, illus. no. 20

FEW OF EAKINS'S CONTEMPORARIES were influenced by his work, and for this reason the similarity of Herman Simon's sporting pictures to Eakins's boating and rowing

352.

353.

subjects of the early 1870s and the land-
scapes with figures painted in the late 1870s
to early 1880s is especially interesting. There
is no evidence that Simon, who was a year
younger than Eakins, was a friend or one
of his students at the Academy, yet Simon's
most successful paintings, such as *The
Pigeon Shoot,* reflect his clear understanding
and mastery of Eakins's technique of repre-
senting daylight—"[Eakins] did not try to
rival the brilliancy of nature, but to create
within the pictorial range an equivalence to
her tonal relations, transposed to a lower
key" (Goodrich, *Eakins,* p. 146)—and the
device of setting solidly defined figures
against a softly painted landscape.

Simon's sporting pictures, like Eakins's,
are portraits of individuals, not generalized
scenes. *The Pigeon Shoot* depicts members
of the recently organized Philadelphia Gun
Club. The figures are placed in the right
foreground, and the asymmetrical balance
of the strongly modeled figures emphasizes
the atmospheric distance of the space at the
left of the picture. The bright red flags which
outline the shooting range, the flecks of color
in the foreground, and the carefully observed
faces and figures of men intent on the shot
indicate a concern for decorative aspects and

genre detail that would not have interested
Eakins, but which account for Simon's
popular success as a painter of sporting
scenes.

The first owner of this painting may
have been Dr. J. B. Kinney, who owned
Simon's *The Deciding Shot—Pigeon Match
of the Philadelphia Gun Club,* possibly the
same picture, which was shown at the Phila-
delphia Society of Artists in 1879. However,
records indicate that the work was given to
the Philadelphia Gun Club by the artist
and had no previous owners.

DS □

WILLIAM HARNETT (1848–1892)

Born at Clonakilty, County Cork, Ireland,
William Michael Harnett came to Philadel-
phia with his family in 1849. His father, a
shoemaker, died when Harnett was a boy,
and his public school education was inter-
rupted by a series of part-time jobs to help
support the family. At the age of seventeen,
Harnett began to work as an apprentice in
the engraving trade and became a silver
engraver. In 1867 he began attending the

evening classes of the Pennsylvania Academy
of the Fine Arts, where he studied until he
moved to New York in 1869 and enrolled
in the night school of the Cooper Union
and later the National Academy of Design.
While pursuing his art studies, Harnett
supported himself by working as a silver
engraver for several large jewelry firms in
New York. His first painting to be exhibited
at the National Academy was *Fruit* in 1875.

In 1876, Harnett returned to Philadelphia
to establish himself as a painter of still life.
He resumed his studies at the Pennsylvania
Academy, where he became a friend of
John F. Peto (see biography preceding
no. 359), whose trompe l'oeil paintings in
later years were confused with Harnett's
own. An active member of the Philadelphia
Society of Artists, Harnett also exhibited in
the annual exhibitions at the Academy in
1877–79 and in 1881. Harnett went to
Europe in 1880, traveling to London, Frank-
furt, and, in 1881, to Munich, where he
remained for four years. During his Euro-
pean years, his themes expanded from the
simpler subjects of his Philadelphia period
to include bric-a-brac as well as more ambi-
tious compositions. Although he enjoyed
considerable popular success in Munich, his
critical notices were not encouraging. Deter-
mined to test the merits of his work, he went
to Paris in 1885, where he painted a fourth
version of *After the Hunt,* a still life theme
which he had been exploring in Munich, and
submitted it to the Paris Salon (MMA, *19th-
Century America, Paintings,* no. 171). *After
the Hunt* was accepted for the Salon of 1885,
reproduced in a book of forty paintings from
that exhibition, and eventually purchased by
Theodore Stewart for his saloon in New
York, where it served as a model for Amer-
ican barroom paintings of the late nineteenth
century and was widely copied and imitated.

In 1886, Harnett returned to New York.
The productions of his last six years are
mostly table-top still lifes employing objects
set in a shallow space against a paneled wall.
These were sold for high prices to patrons
who particularly enjoyed Harnett's expert
ability to render texture and form and his
trompe l'oeil novelties. His fine sense of
formal composition was largely unappre-
ciated until his rediscovery by Edith Gregor
Halpert, who presented a show of his work
at her Downtown Gallery in New York in
1939, and Alfred Frankenstein, whose
extensive researches for his book *After the
Hunt* revealed almost all of the information
on Harnett.

AS

353. *The Artist's Card Rack*

1879
Signature: WMH [monogram] ARNETT/
1879 (upper left)
Oil on canvas
30 x 25" (76.2 x 63.5 cm)
The Metropolitan Museum of Art, New
York. Morris K. Jesup Fund, 1966

PROVENANCE: Israel Reifsnyder, Philadelphia,
1879–92; Howard Reifsnyder, 1892–1929;
Mr. Shinasi, 1929–?; Mrs. Arthur Hornblow, Jr.
(Leonora Shinasi), Beverly Hills, California,
until 1958; with Hirschl and Adler Galleries,
New York, 1958; Mr. and Mrs. Lawrence
Fleischman, Detroit, 1958–65; with Hirschl and
Adler Galleries, New York, 1965

LITERATURE: Frankenstein, *After the Hunt*,
pp. 51–53, illus. no. 46; La Jolla Museum
of Art and Santa Barbara Museum of Art,
*The Reminiscent Object, Paintings by
William Michael Harnett, John Frederick Peto
and John Haberle* (July 11—October 31, 1965),
n.p., illus. no. 10; MMA, *19th-Century America,
Paintings*, no. 170 (illus.).

THIS PAINTING and *Mr. Hulling's Rack
Picture* of 1888 are the only two known rack
pictures by Harnett. John F. Peto was a
friend and follower of Harnett during their
early years together in Philadelphia, but in
the rack paintings the artistic influence was
reversed. Peto painted his earliest known
rack, *The Office Board for Smith Brothers
Coal Company,* several months before
Harnett's *Card Rack* (Frankenstein, *After
the Hunt*, p. 51). Interestingly, when Peto
painted his later series of rack pictures,
beginning in 1894, he adapted Harnett's
simpler composition, a stylistic development
which was verified when Frankenstein dis-
covered a photograph of Harnett's 1879
painting among Peto's possessions at his
home in Island Heights. Of *The Artist's
Card Rack,* Frankenstein comments, "from
the point of view of color and abstract design,
this is one of Harnett's finest works" (*After
the Hunt*, p. 52).

Peto's rack pictures, which he called office
boards, were painted on commission, and the
letters, advertising cards, and scraps of paper
refer to the business or personal life of the
owners. It is likely that Harnett's *Artist's
Card Rack* had the same intent and that the
word "Snyde" in the painting refers to Israel
Reifsnyder, a Philadelphia wool merchant
who was the original owner of the painting.

Most contemporary critics and artists were
contemptuous of the popularity of the trompe
l'oeil style. At a time when expression and
brushwork were admired, critics were unre-
sponsive to artists who remained invisible in
their work. A critic reviewing Harnett's
The Social Club, a still life composed of
pipes, matches, and tobacco, remarked that
Harnett's works

attracted the attention that is always given
to curiosities, the works in which the skill
of the human hand is ostentatiously dis-
played working in deceptive imitation of
Nature.... Only a very few artists of merit
have ever condescended to apply their
skill to the sole purpose of imitation,
making so-called pictures out of dead
objects painted to deceive the eyes as far
as possible, for there still remains a little
dignity of purpose attaching to flower-
pieces, fruit-pieces, game pieces and the
like.... The real fact is that this charge
of inferiority is justified by the considera-
tion that this imitative work is not really
so difficult as it seems to the layman.
(*New York Tribune,* April 26, 1879,
in Frankenstein, *After the Hunt,* p. 50)

Considered little more than a trickster and
a clever craftsman by many critics, Harnett
was nonetheless very popular with the
general public. His European success secured
his reputation as a serious artist, and he
painted for an audience unhindered by
aesthetic theory and attracted by his tech-
nical skill and the ordinariness and sentimen-
tal associations in the objects he represented.

SKM □

MARY CASSATT (1844–1926)

Born in Allegheny City, Pennsylvania
(now part of Pittsburgh), Mary Cassatt
spent much of her childhood in Europe with
her family. The Cassatts returned to Phila-
delphia in 1858, and in 1861 she enrolled at
the Pennsylvania Academy, where she
studied for four years. Dissatisfied with the
course of study which largely consisted of
drawing from casts, Cassatt convinced her
family that training abroad' was necessary,
and in 1866 she went to France, where,
except for a short period in Philadelphia
during the Franco-Prussian War, she lived
for the rest of her life. Her parents and
invalid sister moved in with her in 1877,
and she was increasingly burdened with
their care.

She traveled extensively through Italy,
Spain, Belgium, and Holland, studied briefly
in the atelier of Charles Chaplin in Paris,
and first submitted a painting, *On the
Balcony During the Carnival,* to the Salon
of 1872. Two years later, Degas saw her
Madame Cortier at the Salon and remarked,
*"C'est vrai. Voilà quelqu'un qui sent comme
moi"* (in Frederick A. Sweet, *Miss Mary
Cassatt, Impressionist from Pennsylvania,*
Norman, Okla., 1966, p. 31).

Degas's influence marked Cassatt's mature
work, and on his invitation in 1877 she
became the only American to exhibit with
the independent group of artists, including
Monet, Pissarro, Renoir, Sisley, and Morisot,
who were later called the Impressionists.
The paintings she sent to the Society of
American Artists in 1879 were probably the
first Impressionist pictures shown in America.
She continued to exhibit with the Impres-
sionists until 1882 when she sided with
Degas, who was withholding his work in

354.

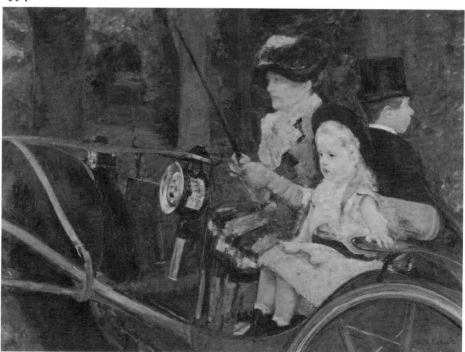

protest over a policy matter. They both exhibited again in the eighth and last Impressionist show in 1886.

Cassatt attended the Japanese print exhibition at the École des Beaux-Arts in 1890, and its affect on her is revealed in the series of ten color prints she made around 1891. They were included in a show of her work held at the Galerie Durand-Ruel in Paris that year along with two oil paintings and two pastels. In 1893, Cassatt completed a large mural for the Women's Building of the World's Columbian Exposition in Chicago and had a second and larger show at Durand-Ruel.

Although Cassatt's growing reputation did not extend to America during her lifetime, she played a major role in the formation of several American collections, especially that of the H. O. Havemeyers of New York and she induced her family and friends to buy Impressionist pictures, mostly selected by herself. In 1912 she presented two paintings by Courbet to the Pennsylvania Academy, where she frequently exhibited. In keeping with the tenets of the "Independents," she refused to accept awards, although she won gold medals from the Pennsylvania Academy and the Art Institute of Chicago. In 1904 she was made a Chevalier of the Legion of Honor by the French government. About 1911, Cassatt developed cataracts in both eyes. She was almost completely blind when she died at her summer house at Mesnil-Theribus, Oise, near Paris.

AS

354. *Woman and Child Driving*

1879
Signature: Mary Cassatt (lower right)
Oil on canvas
35¼ x 51½″ (89.5 x 130.8 cm)
Philadelphia Museum of Art. W. P. Wilstach Collection. W21-1-1

PROVENANCE: Cassatt family; Alexander J. Cassatt

LITERATURE: Adelyn Dohme Breeskin, *Mary Cassatt, A Catalogue Raisonné of the Oils, Pastels, Watercolors and Drawings* (Washington, D.C., 1970), p. 53, no. 69 (illus.); Washington, D.C., National Gallery of Art, *Mary Cassatt, 1844-1926* (September 27—November 8, 1970), no. 16 (illus.); E. John Bullard, *Mary Cassatt, Oils and Pastels* (New York, 1972), p. 30, illus. p. 31

IN 1877, WHEN MARY CASSATT's parents and older sister, Lydia, came to live permanently with her in Paris, Lydia became her sister's constant model until her death in 1882. She posed reading, at the opera, having tea, bathing a child, and here driving the Cassatts' new pony and cart through the Bois de

Boulogne (E. John Bullard, *Mary Cassatt, Oils and Pastels,* New York, 1972, p. 30). Cassatt used her family and friends as models, desiring to paint what she knew and understood well, although she was not always concerned with producing exact portraits. Edgar Degas's niece, presumably Odile Fèvre, appears as the little girl seated next to Lydia. Mrs. Cassatt wrote to her grandson about the picture: "Your Aunt Mary is so fond of all sorts of animals that she cannot bear to part with one she loves. You would laugh to hear her talk to Bichette our pony . . . she also painted a picture of your Aunt Lydia and a little niece of Mr. Degas and the groom in the cart with Bichette but you can only see the hindquarters of the pony" (Mrs. Cassatt to Robert Cassatt, December 18, 1879, in Frederick Sweet, *Sargent, Whistler and Mary Cassatt,* Chicago, 1954, p. 23).

Beyond the fond portrayal of her sister and the new cart, Cassatt has created a strong and compelling composition: the three figures and the play of color are limited to the right half of the canvas, filling the left with brown and green hues of the pony's hindquarters, harness, and the woods behind. The influence of Degas, whom Cassatt had long admired but met only in 1877, determined her new approach to composition during the late 1870s. Inspired by Degas's interest in photography and Japanese prints, she found the asymmetry and cropped compositions of his work congenial to her own art.

Woman and Child Driving incorporates many details seen in Degas's 1870–72 *Carriage at the Races* (Paul Valpinçon with his family), exhibited at the first Independents show of 1874—the partial view of the wheel, the prominent role of the vertical crop, and the carriage that seems to move out of the spectator's vision. Degas, too, concentrated the composition in the right half of the canvas. But Cassatt's carriage and figures completely fill the canvas and are seen directly in the viewer's space rather than from above: in general she was less indebted than Degas to contemporary photography.

Although *Woman and Child Driving* involves a group activity, the figures do not interact. Lydia looks ahead, concentrating on directing the pony while Degas's niece sits firmly in her seat, almost devoid of expression, holding onto the carriage with her left hand. Both Degas and Manet depicted people involved in the same activity yet ignoring each other, as if brought together by an accident of nature (Baltimore Museum of Art, *Paintings, Drawings and Graphic Works by Manet, Degas, Berthe Morisot and Mary Cassatt,* by Lincoln Johnson, 1962, p. 18).

Woman and Child Driving dates from a prolific period in Cassatt's career, when she benefited from Degas's criticism, friendship,

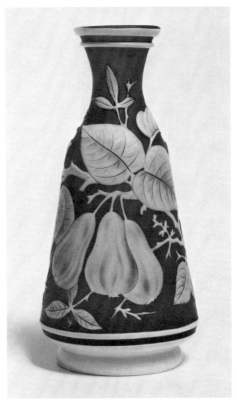

355.

and admiration (Adelyn Dohme Breeskin, *Mary Cassatt, A Catalogue Raisonné of the Oils, Pastels, Watercolors and Drawings,* Washington, D.C., 1970, p. 11). Yet Cassatt found her own personal style in the depiction of the daily occurrences of her life. Using the broken brushwork and strong colors of the Impressionists, she maintained the firm outline and emphasis on drawing shared with Degas, and the directness, openness, and freshness that, despite her long residence in Paris, confirm her American origins.

CC □

GILLINDER & SONS (1861–1930)
(See biography preceding no. 347)

355. *Cameo Vase*

1880–90
Inscription: 30 (scratched or engraved on underside of base, probably with a diamond point or steel stylus)
Opaque white glass incasing deep blue glass
Height 8³⁄₁₆″ (20.8 cm); diameter base 3⅛″ (7.9 cm), rim 2¹⁄₁₆″ (5.2 cm)
Philadelphia Museum of Art. Given by William F. Gillinder. 10-16

THIS FREE-BLOWN VASE with cameo decoration of pears and leaves is a rare piece. Cameo glass is made of two or more layers of glass (usually deep blue covered with a thin casing of opaque white) carved in the cameo technique with a sharply pointed metal stylus, and sometimes with the aid of an engraving lathe. This difficult process, which requires a great deal of skill both on the part of the glassmaker producing the blank to be carved and the carver, was developed by Roman glassmakers and flourished—to a limited degree as one of several forms of luxury glasses—from the first century B.C. to the first century A.D. The most noted example of ancient cameo glass is the Barberini, or Portland, Vase in the British Museum.

A revival of cameo glass took place in England during the last third of the nineteenth century. It was initiated by Benjamin Richardson of Hodgetts, Richardson & Co. when he offered a prize of £1,000 to the first person to produce successfully a copy of the Portland Vase. John Northwood succeeded in 1876, after three years of work, on a blank produced by the Red House Glass Works of his cousin, Philip Pargeter, although a crack developed in it just before it was completed. This example inspired others, including Joseph Locke, who also completed a copy of the Portland Vase in 1878. To meet the demand that resulted, teams of skilled workmen were utilized by several English firms such as Stevens & Williams, Ltd., and Thomas Webb & Sons. The foremost of these were the workshops of John Northwood and the Woodall brothers, George and Thomas. Individuals such as Northwood, the Woodalls, Alphonse Lechevrel, and Joshua Hodgetts continued to produce limited numbers of very fine examples of cameo glass by the ancient methods in England until about the turn of the century, but to meet the demand for it and to speed up the process, pieces of somewhat lesser quality (but nevertheless often very fine) were produced by using acid to remove large areas of the background, the details still being finished with a stylus and/or an engraver's wheel.

Despite its relative popularity in England, very few pieces of cameo glass were made in the United States. Joseph Locke, who came to this country to work for the New England Glass Company in 1882, produced a few pieces here, but these seem to have been done either for his own pleasure, or were for the limited use of his company. The Mt. Washington Glass Company in New Bedford, Massachusetts, under the direction of Frederick Shirley, an Englishman, who joined that firm as agent in 1874, produced quantities of what they advertised as "cameo" glass beginning about 1880, but this was made entirely by the use of stencils, a resist, and acids.

The only other examples of true cameo glass known at this time to have been made in America are a dozen or so pieces made by Gillinder & Sons, of which this is one of two vases presented by the firm to the Museum in 1910. Like the pieces made by Joseph Locke and the limited number of fine paperweights produced by the Gillinder firm, they were probably made as a personal challenge and for self-satisfaction rather than as commercial products. This undoubtedly accounts for the rarity of these pieces.

KMW □

THEOPHILUS PARSONS CHANDLER (1845–1928)

Theophilus Parsons Chandler was born in Boston and studied for a time at Harvard before working in several architectural offices in his native city. Around 1872, he arrived in Philadelphia, apparently anticipating a building boom with the coming Centennial exhibition, but that did not materialize, although he did design the bear pits for the Philadelphia Zoological Society.

Family connections (his mother was from the area, and he married a Du Pont) and his abilities rapidly brought him to the forefront of the profession in Philadelphia, and numerous prestigious commissions for banks, insurance companies, churches (Swedenborgian Church at Chestnut and Twenty-second streets), country houses, and city mansions (the John Wanamaker residence at Twentieth and Walnut streets) followed. Whether because of an inbred restraint, or his own Boston training, most of his designs, of both architecture and furniture, have a tendency to be more ordered and sophisti-

cated and closer to historical precedent than those of his contemporaries. But architectural taste evolved toward Chandler's position, assuring his continued success into the twentieth century.

Apart from his efforts at design, Chandler played a prominent role in the progress of the local profession; independent means made it possible for him to lead the fight for higher commissions, while his own interest in the training of the young architect led him to champion the cause of a full-fledged school of architecture at the University of Pennsylvania. He served as its head in 1890, its first full year of existence.

GT

356a. *Pair of Armchairs*

c. 1882
Oak; twentieth century upholstery
40 (without finials) x 23 x 22" (101 x 58.4 x 55.8 cm)

Sophie Chandler Consagra, Wilmington, Delaware

PROVENANCE: Theophilus Parsons Chandler; nephew, Alfred D. Chandler, Wilmington; daughter, Sophie (Chandler) Consagra

356b. *Library Table*

c. 1882
Oak
28 x 44 x 26" (71.1 x 111.7 x 66 cm)

Alfred D. Chandler, Wilmington, Delaware

PROVENANCE: Theophilus Parsons Chandler; nephew, Alfred D. Chandler

356a.

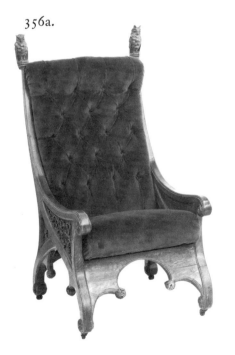

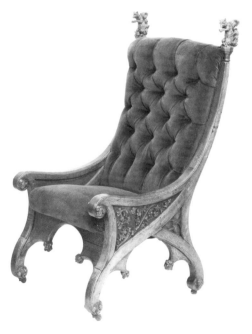

Designed for his own second floor library, these two armchairs and the library table were in Theophilus Chandler's townhouse, which was built in 1882 at 249 South Sixteenth Street, Philadelphia. It is difficult to date the chairs and table precisely, but it is possible that they were made shortly after Chandler's marriage to Sophie Madeleine Du Pont, which took place the same year he built his Sixteenth Street house. The chair with squirrel finials may have been designed for Mrs. Chandler's use. Chandler's own chair may have been the one with owl finials. The speculation is based on Chandler's design of two dining room armchairs, one of which had his wife's initials, and the other his own. The owl motifs on the library table suggest that it was used with the chairs in the second floor library.

The ornament on the chairs is in the Gothic style, which continued to be popular until the end of the nineteenth century and well into the twentieth, although its popularity had begun much earlier (see nos. 263, 274, and 277). The form of the chair itself, however, is more classical than Gothic and is reminiscent of a chair designed by Karl Friedrich Schinkel in the early nineteenth century (see Hugh Honour, *Cabinet Makers and Furniture Designers*, New York, 1969, illus. p. 229), which became a popular nineteenth century form. Although the form of the table derives from Renaissance furniture, it incorporates adaptations of Gothic and Egyptian motifs.

It is not surprising that, as Chandler's houses and churches were influenced by contemporary English architecture, his furniture also would depend on English designs. He visited England frequently and

may well have seen the furniture that Augustus W. N. Pugin designed. Chandler's chair is strikingly similar in its form and decoration to the one designed by Pugin in 1840 for Scarishrick Hall (Honour, cited above, illus. p. 244). Certainly Chandler would have seen Pugin's Gothic buildings and would have been familiar with the writings of Ruskin. Another influence on Chandler may have been a book in his personal library by William Brindley and W. Samuel Weatherby entitled *Ancient Sepulchral Monuments* (London, n.d.). It illustrates Gothic ornament similar to that which Chandler incorporated in his furniture and architecture.

A typical Philadelphia brick row house with a garden in the rear, Chandler's house still stands today. The Chandlers remained there until their deaths, although they probably spent more time in their country house at Ithan, near Radnor, for which Chandler also designed furniture.

DH □

THOMAS EAKINS (1844–1916)
(See biography preceding no. 328)

357. *Arcadia*

1883
Inscription: EAKINS (upper left); 1883 (upper center)
Plaster relief
11¾ x 24" (29.8 x 60.9 cm)
Philadelphia Museum of Art. Purchased: J. Stogdell Stokes Fund. 75-84-1

PROVENANCE: Estate of Charles Howard Higgart

LITERATURE: Goodrich, *Eakins,* no. 506; Fairfield Porter, *Thomas Eakins* (New York, 1959), p. 25; Washington, D.C., Corcoran Gallery of Art, *The Sculpture of Thomas Eakins,* by Moussa M. Domit (1969), cover, no. 15, illus. p. 47; PAFA, *Thomas Eakins: His Photographic Work* (1969), p. 60, figs. 66, 71; Hendricks, *Eakins Photographs*, pp. 6, 11, 12, figs. 62, 63; Hendricks, *Eakins Life and Works,* pp. 148–55, checklist 64–65; Lerner, *Hirshhorn,* p. 687

THE THEME OF EAKINS's *Arcadia* frieze originates in the bucolic poetry of the third century B.C. Greek poet Theocritus. Arcadia came to be known as a paradise populated by contented shepherds who worshipped Pan and dwelt blissfully among the virtues of nature. It might seem a strange subject for Eakins to have chosen, yet the popular conception of him as an uncompromising realist who had no feeling for the achievement of the ancients is an oversimplification.

In 1883, when he created *Arcadia*, Eakins was at the peak of his success. The year before, he had been appointed director of the Pennsylvania Academy of the Fine Arts and he was now in sole control of the school. His work was being shown in New York, Boston, Providence, and Philadelphia, and even at the International Exhibition in the Glaspalast in Munich. Commissions were beginning to come in. Privately, Eakins was courting Susan Macdowell, whom he married the following January. He had also formed a close friendship with J. Laurie Wallace, chief demonstrator of anatomy at the Academy and a former pupil.

It seems reasonable to assume that Eakins created *Arcadia* as a demonstration of the ancient method of relief sculpture and, perhaps, as an expression of his longing for a simpler life. But the immediate incentive was probably the commission for two sculptural reliefs, *Spinning* and *Knitting,* which Eakins received in 1882. Until then, his work in this medium was limited to studies related to his painting. Now, with characteristic thoroughness, he studied the problems of sculptural relief and even prepared a lecture on the subject which was then added to his annual lectures on perspective at the Academy (the original manuscript of this lecture is in the collection of the Philadelphia Museum of Art). In it, Eakins discussed the problems of the *Spinning* and *Knitting* reliefs, which were based on earlier watercolors. He then wrote: "The best examples of relief sculpture are the ancient Greek . . . the simple processions of the Greeks viewed in profile or nearly so are exactly suited to reproduce in relief sculpture . . . nine tenths of the people who have seen casts of the frieze of the Parthenon would say the figures are backed by a plane surface which is not

356b.

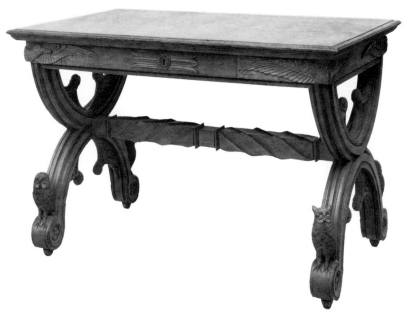

the case, so gentle are the numerous curves which are instantly seen on looking endways or putting it in skimming light...."

In his *Arcadia,* the model for the piper at right, perhaps a representation of Pan, was Eakins's friend J. Laurie Wallace (a photograph of Wallace in this position is reproduced in Hendricks, *Eakins Photographs,* p. 42). Directly in front of the piper sits a dog, probably a specific one, but the study and dissection of animals were part of the academic training under Eakins's direction. Next in the procession from right to left is the figure of a draped young lady. It recalls several of Eakins's photographs of Academy students in classical garments, taken about 1883 and later, but does not match any particular one. Eakins was taken by this figure and repeated it in a separate relief (Goodrich, *Eakins,* no. 506), now in the collection of Mr. and Mrs. John D. Rockefeller. In the center is a couple, possibly a reference to the artist's engagement to Susan Macdowell. They are followed by an old man, resting on a cane, with his right hand raised to his ear. The old man, especially in contrast to the nude youth who ends the procession, recalls a series of photographs of young, middle-aged, and old men taken in 1883, and which are now in the collection of the Franklin Institute (Hendricks, *Eakins Photographs,* p. 179). The model for the old man in these photographs was George W. Holmes, a painter and friend of Eakins's father, who had lost his eyesight. The last figure in *Arcadia,* a nude youth, was probably the inspiration for another relief on the Arcadian theme which Eakins modeled in 1884, entitled *Youth Playing Pipes* (Goodrich, *Eakins,* no. 508, casts of which are in the Hirshhorn Collection and in the collection of the Philadelphia Museum of Art).

The Arcadian reliefs appear to be personal statements, as are a number of oil paintings on the same theme which Eakins painted around 1884. None of these works were publicly shown during Eakins's lifetime. Of the group, the *Arcadia* relief shown here is undoubtedly the most successful realization of the subject. Eakins himself must have been fond of it because it appears as the focal point in a remarkably beautiful photograph (Hendricks, *Eakins Photographs,* nos. 62, 63); and in the background of *A Lady with a Setter Dog* (1885), his first portrait of Mrs. Eakins.

Why, then, did Eakins not exhibit *Arcadia* or any of the related subjects? We know that he made or permitted to be made many casts of his *Arcadia* relief, some of which he gave to his friends, and at least two of which were in his house when Goodrich visited there in 1930 (*Eakins,* no. 506). Perhaps his reluctance was caused by his experience with *Spinning* and *Knitting.* According to Goodrich (*Eakins,* pp. 64, 65), the client at first

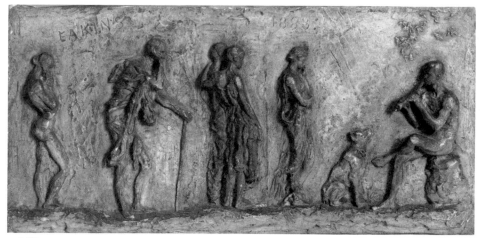

357.

objected to the agreed-upon price, intending to employ a stonecutter to finish the panels. Eakins was furious. "How can any stonecutter unacquainted with the nude follow my lines, especially covered as they are, not obscured by the light drapery? ... How could the life be retained?" Eventually the matter was submitted to arbitration, and Eakins received part of his fee and retained ownership of the pieces. *Spinning* and *Knitting* were later shown at the Pennsylvania Academy in 1883 and at the Society of American Artists in New York in 1887, but they received little critical acclaim. His friend William J. Clark liked them and gave them a good review in the *Evening Telegraph* (Hendricks, *Eakins Life and Works,* p. 166), but other critics ignored the pieces, and the *New York Tribune* (April 23, 1887) merely observed that Eakins was doing "some rough modeling which has a certain force." The so-called "rough modeling" was, of course, exactly what Eakins had struggled to achieve in order to create a specific sensual experience, to retain life, as he had put it, and specifically to contrast with the high finish which was then still in fashion. He may well have been discouraged by the unenthusiastic reception of his first work in sculpture and therefore decided to keep *Arcadia* for himself and his friends.

We do not know how many plaster casts of *Arcadia* were made in Eakins's lifetime. There may have been ten or twelve, perhaps as many as twenty. The glue molds which Eakins's students used to reproduce anatomical casts could easily produce this many impressions. At the time of Goodrich's book on Eakins, he knew of only two casts in Mrs. Eakins's possession. Since then, one of these has disappeared; the other one, which has a green bronze imitation patina, is now in the Hirshhorn Collection. But two other casts have since come to light. One, which is white, can be traced back to Frank Linton, a pupil of Eakins. This cast is now

in the collection of the Yale University Art Gallery. The other is shown here. It was found in the house of Charles Howard Higgart after his death in the 1930s. Higgart, a contemporary of Eakins, had studied at the Spring Garden Institute and also at the Pennsylvania Academy of the Fine Arts. Nothing more is known about the provenance of this work, but it may well be the only surviving cast of *Arcadia* which bears an original Eakins patina. All of the casts in bronze of *Arcadia* now in existence were cast after Eakins's death.

TS □

GEORGE VAUX, JR. (1863–1927)

A member of a family of amateur photographers (whose involvement in the art of photography continues to the present time), Vaux graduated from Haverford College in 1884 and in 1888 from the University of Pennsylvania Law School. His brother William S. and sister Mary M. (Mrs. Charles D. Walcott) were also amateur photographers, the latter participating in pictorial photography exhibitions and often printing negatives for her brother George. According to issues of the *Journal of the Photographic Society of Philadelphia,* William and George frequently gave illustrated talks on the Canadian Rockies and displayed their photographs together.

A lawyer by profession, Vaux nevertheless found time for an impressive number of administrative positions in various educational, scientific, and philanthropic organizations in addition to his photographic activities. Notable among these was his work with the American Indians. Appointed a member of the United States Board of Indian Commissioners by President Roosevelt in 1906, he served as chairman of the board from 1907 until his death. In connection with his volunteer service he took many photographs of Indians. He was an amateur

mineralogist and acquired a large collection of minerals; he supported the development of the Department of Mineralogy at the Academy of Natural Sciences and served as president of the Philadelphia Mineralogical Society from 1922 to 1927.

Vaux was a life member of the Photographic Society of Philadelphia, serving as treasurer from 1892 to 1896 and vice-president from 1897 to 1900. In 1901 he ran for president of the Society, representing the pictorial movement—the "Ultra-Salonists." He was defeated by S. Hudson Chapman, who represented the "Rational School"— those wishing "to change the character of the Salon from a purely pictorial to an exhibition of the latest and highest and most interesting developments of photography in all its phases" (see Joseph T. Keiley, "The Decline and Fall of the Philadelphia Salon," *Camera Notes,* vol. 5, no. 3, January 1902, pp. 290, 293).

In 1887 he took the first of almost yearly vacations in the Canadian Rockies, where he devoted much of his time to studying and photographing the glaciers and mountains. The results of these studies were recorded in five papers, illustrated with maps and photographs. The majority of his photographs, in fact, comprise views of this particular area. His photographs were also chosen to illustrate the publicity booklets for the Canadian Pacific Railway from 1900 to 1907.

Vaux was elected an associate member of the Photo-Secession at the time of its founding in 1902. Although he did not exhibit at the annual Philadelphia Photographic Salons held at the Pennsylvania Academy, he served on the committee which organized the Salon exhibits in 1898 and 1899 along with Robert S. Redfield and John G. Bullock. Vaux's exhibition activity may not have been so extensive as other Philadelphia amateur photographers of the pictorial movement, but his desire to achieve the acceptance of photography as an independent art medium was nonetheless sincere. In a review of the Philadelphia Photographic Society Exhibition held at the Camera Club in New York in May 1901, Joseph T. Keiley, prominent art critic, noted, "Technically there was no better work shown than that of George and William S. Vaux, Jr. . ." (*Camera Notes,* vol. 5, no. 1, July 1901, p. 63).

358. *Cricket Practice Shed, Haverford College*

c. 1884–1914
Signature: Vaux (intertwined letters, in white ink, lower left)
Platinum print
6⅛ x 8″ (15.5 x 20.4 cm)

418

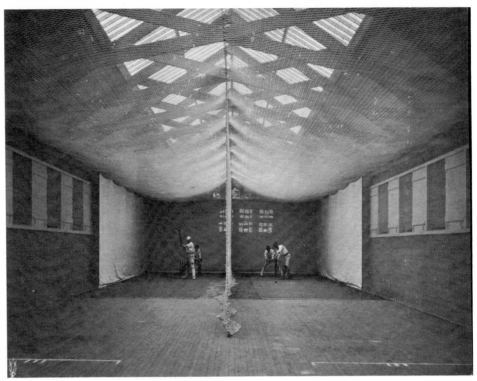

358.

George Vaux, ARPS, Bryn Mawr, Pennsylvania

THE CRICKET PRACTICE SHED at Haverford College represents a unique departure from Vaux's usual subject matter, the Canadian Rockies. Here he has, however, demonstrated the potential of photography to depict artistically a subject which is lacking in overtones of the sublime; more specifically, he has shown that an indoor sports arena can lend itself to artistic expression as successfully as a landscape, seascape, domestic genre scene, figure study, or allegory—the more usual and popular subject matter of the amateur pictorial photographers. No detail has been sacrificed, and all elements are sharply articulated; even the imperfections in the protective net covering can be clearly discerned.

The gentle folds of the net cascading to the floor distinctly divide the area down the center, and the pattern created above by the light hitting the beams of the roof forms a striking composition. One becomes involved with the total picture and its aesthetic effects rather than with any factual details concerning the athletes, the practice, or the interior of the shed. It may be said that Vaux has unconsciously exposed the tenets of "pure photography" which Alfred Stieglitz consciously practiced. This straightforward, direct handling of the photographic medium was to become increasingly evident as pictorial photographers, secure in achieving by 1910 the recognition for their photo-

graphs as works of art, felt increasingly free to ignore the painterly styles and their associated subject matter. Admittedly, this picturesque rendering of cricket practice would appeal to many Philadelphians: Philadelphia was the center of cricket activity and Haverford College possessed the longest record of playing history in America. The first cricket club was established at Haverford in 1834, a year after the founding of the college, where the game continues to be played today.

CW □

JOHN F. PETO (1854–1907)

Born in Philadelphia, John Frederick Peto was raised by his grandmother, although his parents were living. His father is listed in the Philadelphia city directories in the 1850s and 1860s as a gilder and framer, but during the last part of his life the elder Peto sold fire-fighting equipment. Possibly this exposure to the pictures his father framed or to the ornately painted fire engines influenced Peto's decision to become an artist. He enrolled at the Pennsylvania Academy of the Fine Arts in 1878, where he met William Harnett (see biography preceding no. 353). The two artists became close friends and, although Peto lost touch with Harnett after the older man's trip to Europe in 1880, Harnett's work remained a strong influence on Peto's style; Peto's daughter recalled that her father always spoke of Harnett with

reverence, "invoking his name as the standard of perfection in still life" (Frankenstein, *After the Hunt*, p. 101).

Peto opened a studio in Philadelphia about 1880 and began to show at the Pennsylvania Academy and with the Philadelphia Society of Artists, but concluded his exhibiting career with the Academy's annual exhibition of 1888. Apparently more successful as a musician (he played cornet with the Third Regiment Band), Peto was hired as the cornet player for the Island Heights Camp Meeting Association in New Jersey and moved to Island Heights in 1889, where he stayed, except for a trip to Cincinnati in 1894, for the rest of his life. He supported himself partly by painting small souvenir pictures for summer tourists, but also produced a steady stream of still life paintings, most of which he gave away or sold for a few dollars.

Peto was overlooked as an artist during his lifetime and had no artistic reputation outside Island Heights. The facts of his life and artistic output, considerably confused by his habit of painting over former pictures, the lack of documentation, and the forgery of Harnett's signature onto many of Peto's canvases, were only unscrambled by Alfred Frankenstein more than forty years after Peto's death in Island Heights in 1907.

AS

359. *The Poor Man's Store*

1885
Signature: J. F. Peto/85 (upper left)
Oil on canvas and wood
36 x 25½″ (91.4 x 64.8 cm)
Museum of Fine Arts, Boston. M. and M. Karolik Collection

PROVENANCE: Miss Mary Allis, Fairfield, Connecticut, 1959; Maxim Karolik, 1962

LITERATURE: Brooklyn Museum, *John F. Peto*, by Alfred Frankenstein, exhibition at 3 participating institutions (March 1—July 9, 1950), p. 45, fig. 4; Frankenstein, *After the Hunt*, pp. 101, 102, illus. no. 84; *MFA Bulletin*, vol. 60, no. 322 (1962), pp. 137–38 (illus.)

LIKE HIS FRIEND HARNETT, Peto did not paint for an aesthetically sophisticated audience, and when he received critical attention it took the form of the usual condescending attitude toward trompe l'oeil. Although fascinated by technical facility, contemporary critics did not regard visual deception and "realism in the extreme" as appropriate concerns for true art. The most extensive review of a Peto painting appeared in *L'Abeille de la Nouvelle-Orléans*, May 30, 1886, and the critic L. Placide Canonage called it a "freak of the brush." He asks: "What name is to be given to such an

assemblage of diverse, banal objects? Probably none at all. And we do not recommend this work for its subject matter, but for its execution. The imagination plays no part here. It is all realism, and realism in the extreme" (Frankenstein, *After the Hunt*, p. 103).

Treated as a curiosity, Peto was, unlike Harnett, unsuccessful in locating an appreciative audience. He consistently painted worn and humble models—"banal objects" —rather than popular bric-a-brac, even while trying to achieve success through conventional art channels in Philadelphia.

Painted during his residency in Philadelphia, *The Poor Man's Store* is typical of Peto's interest in simple and unpretentious objects displayed on a shelf and enveloped in a gently pessimistic atmosphere. An earlier, unlocated version received some critical attention from the newspaper *The Record*, which was prominently displayed in the painting. The critic commented that the painting "cleverly illustrates a familiar

phase of our street life, and presents upon canvas one of the most prominent of Philadelphia's distinctive features" (Frankenstein, *After the Hunt*, p. 102).

In *The Poor Man's Store*, Peto uses a compositional format unknown in Harnett's work, which emphasizes the fact that, although greatly influenced by Harnett, Peto was never slavishly imitative. Rather, he adapted Harnett's models to achieve a different tone and intention. Frankenstein points out that "his style—drawing, use of color, and application of paint—is poles apart from Harnett's at every point in his career, and he also had his own world of subjects which Harnett never entered. He took over many of Harnett's motifs, but not the compositional mannerisms with which they are associated in the older painter's work" (*After the Hunt*, p. 101). As evident in *The Poor Man's Store*, Peto's primary interest was not trompe l'oeil, but the rendering of light and atmosphere.

SKM □

359.

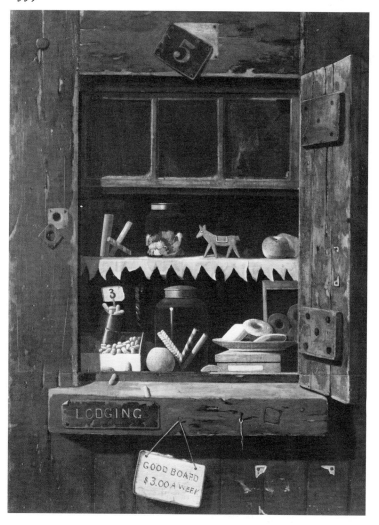

ALTEMUS (N.D.)

360. *Dress*

c. 1885
Label: Altemus/Philadelphia (in waist-band)
Dark-green and cream striped silk; trimmed with green satin and light-gold grosgrain ribbons
Waist 26½″ (67.3 cm); center back length 40¼″ (102.2 cm)
Philadelphia Museum of Art. Given by the executors of the estate of Mary T. W. Strawbridge. 52–59–22a, b

THE PERIOD OF THE MID-1880s saw the development of an extreme style in women's dresses, often referred to as the "receding silhouette." Women were supposed to walk tilting forward, displaying a trimmed derriere. The back of the figure now held the place of emphasis, with its prominent shelf bustle supported by a horsehair cushion or braided wire frame not unlike a half birdcage. The style also featured asymmetric trimming and detailing.

360.

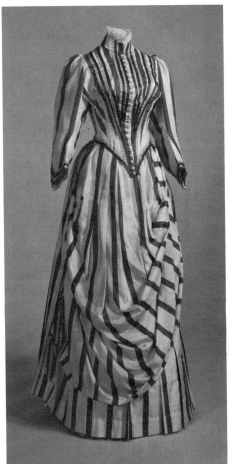

This strikingly handsome dress of cream and dark-green striped soft silk was made by the dress house Altemus of Philadelphia, about which little is known. It has a tight-fitting, boned bodice, fashioned with an extreme, elongated point at center front and a squared tab in back which fits over the bustle of the skirt. The neck is stylishly finished with a high collar band ruffled in lace and three-quarter length sleeves, gently gathered into the set-in armholes. Both the bodice front and the sleeves are trimmed in ribbons of light-gold grosgrain and green satin.

It is in the skirt that the peculiarities of this particular fashion are seen. The front is draped and pleated to form asymmetrical swags and loops, and an underskirt appears to fall straight to the hem. At the center back a deeply pleated puff forms the full bustle. Ribbons matching those on the bodice festoon the skirt in loops and streamers.

EMcG □

RICHARD CLINTON REMMEY (1835–1904)

Richard Clinton Remmey, second of five children of Henry Harrison Remmey (1794–1878) and Catherine Bolgiano (1802–1872), was born in Philadelphia on September 25, 1835. The Remmey family had been producing stoneware in Philadelphia since 1810 when Henry Remmey, a descendant of a renowned potter John Remmey I, came from Germany to New York City in 1735, established a pottery at "Potter's Hill," and moved from New York and erected a pottery on Marshall Street near Girard Avenue.

Richard C. Remmey was educated in Philadelphia public schools, and at an early age he joined his father in the manufacture of chemical and Bristol-glazed stoneware. In 1859, Richard Remmey assumed full management of the family business. Richard Remmey had five children, four by his first marriage to Agnes Smith (1839–1882) and one surviving child by his second marriage to Sarah Kaestner (1851–1922).

In 1892, Robert Henry Remmey (born 1866), third child of Richard Remmey, married Elizabeth Johanna Grauch and succeeded his father as manager of the factory. After Richard Remmey's death in 1904, John Bolgiano Remmey joined his older brother in a co-partnership. The factory continued in operation until the 1920s (see W. Oakley Raymond, "Remmey Family: American Potters," pt. 2, *Antiques,* vol. 32, no. 3, September 1937, pp. 132–34).

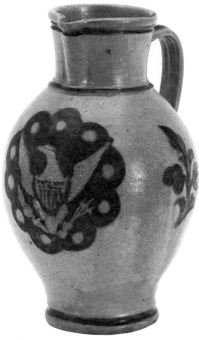

361.

361. *Pitcher*

c. 1875–85
Label: #16 (paper sticker on bottom)
Salt glazed stoneware
Height 11¾″ (29.8 cm); diameter 7½″ (19.1 cm)
Philadelphia Museum of Art. Purchased: Special Museum Fund. 15–302

LITERATURE: Barber, *Pottery and Porcelain,* p. 64; W. Oakley Raymond, "Remmey Family: American Potters," pt. 2, *Antiques,* vol. 32, no. 3 (September 1937), pp. 132–34; Donald Blake Webster, *Decorated Stoneware Pottery of North America* (Rutland, Vt., 1971), p. 153, pl. 195

THIS EXTRAORDINARY STONEWARE pitcher with the high neck associated with Remmey examples is ornamented with an unusual applied American eagle adapted from the seal of the United States. The pitcher could possibly have been produced in 1876 when numerous decorative items were ornamented with patriotic devices in honor of the Centennial exhibition held in Philadelphia. The applied decoration could have been molded by Charles or William Wingender, German-trained stoneware potters who immigrated to Philadelphia in 1863 and worked for the Remmey factory before securing their own pottery in Haddon-field, New Jersey, in the 1890s. The Wingenders were known for their elaborate relief designs and helped revive the interest in contemporary German stoneware. The

Wingenders, with their emphasis on hand-craftsmanship, were typical of the potters involved in the Arts and Crafts movement at the end of the nineteenth century.

While Philadelphia was known primarily as a center for the manufacture of earthenware and porcelain, stoneware was also produced in sizable quantities. Stoneware was made in Philadelphia as early as the late 1720s, but its nineteenth century production of stoneware never reached the national magnitude of that manufactured in Bennington, Vermont, or Trenton, New Jersey. Extensive stoneware deposits were available in eastern Pennsylvania and the nearby clay beds of New Jersey. Certain Philadelphia stoneware potters, such as the Remmey family, established in Philadelphia in 1810, did manage to achieve a national reputation for their stonewares known for "hardness and durability" (Barber, *Pottery and Porcelain,* pp. 64–65).

The Remmey stoneware works were the largest in Philadelphia (*Crockery and Glass Journal,* vol. 1, no. 26, July 1, 1875). Featuring distinctive cobalt blue featherlike designs, a profusion of flowers, and incised leaves, Remmey-decorated stoneware was superior to the mass-produced wares of other Philadelphia factories. The ovoid shapes favored by the Remmey factory were reminiscent of early nineteenth century stonewares. While Philadelphia stoneware potters spent the majority of their time making standardized commercial products, certain potters such as Richard Clinton Remmey managed to express their artistic individuality in a medium normally reserved for crocks and churns.

By 1893 the stoneware works of Richard

C. Remmey extended over thirteen acres on East Cumberland Street and included ten kilns. The factory owned its own clay beds in Woodbridge, New Jersey. Between 1865 and 1870, Remmey gradually abandoned the large-scale production of domestic stoneware which had included an extensive line of salt glazed pitchers, jugs, crocks, mugs, and spittoons, while continuing to make individual pieces, and increased the production of fire bricks, chemical wares, tiles, and even porcelain bathtubs. By the end of the nineteenth century, with the rapid advance of more efficient and less expensive tin cans and glass preserving jars, domestic stoneware became little more than machine-made straight-sided industrial crocks and jugs devoid of any artistic decoration.

PHC □

WILLIS G. HALE (C. 1849–1907)

Willis G. Hale, a native of Seneca Falls, New York, began his study of architecture in Rochester before arriving in Philadelphia around 1870. There he worked for Samuel Sloan and later John McArthur, Jr., and it was in their offices that Hale's natural inclination toward lavish surface ornamentation was stimulated.

Hale left Philadelphia for a few years in the middle 1870s but returned after 1876. He rapidly developed a large practice that included both prestigious commissions, such as the Record Building (1881) and the Keystone Bank, but also the endless rows of houses for speculators William Elkins and Peter Widener; later he made numerous designs for pharmaceutical manufacturer William Weightman.

Unlike most of his contemporaries, who gradually adjusted the style of their work to the more genteel taste of the late nineteenth century, Hale persisted in the florid ornament and the bizarre detailing that had originally attracted his clients. Whether that was due to principle or preference remains to be ascertained.

362. *Peter A. B. Widener Mansion*

Broad Street and Girard Avenue
1886
Stone facade

REPRESENTED BY:

Widener Mansion
c. 1900
Photograph
Courtesy of Free Library of Philadelphia

Widener Mansion: Dining Room
c. 1890
Photograph
7½ x 9¼" (19 x 23.5 cm)
Free Library of Philadelphia

IN 1907, long after the bold stylistic phrasings of High Victorian architects had fallen from favor, the editor of *The American Architect and Building News* commented on the death of Willis G. Hale, one of Philadelphia's best known practitioners of that style. To the editor, Hale's work could best be understood by linking it to the startling architectural manifestations of Frank Furness's "pre-Raphaelite interpretations of Gothic forms and principles,"

362.

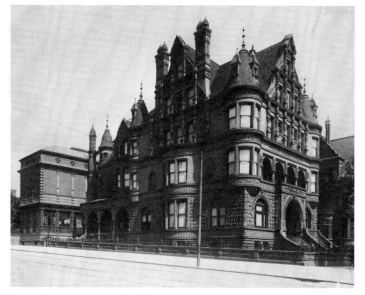

362. *Widener Mansion, Dining Room*

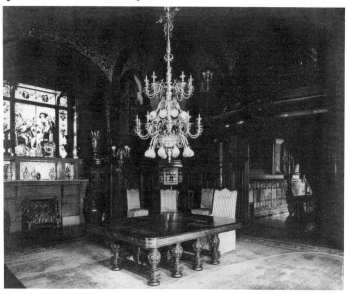

which the writer believed was a part of the groping for an American style. He continued:

> If his buildings are a little florid for the current taste, it must be remembered that he was urged on by competition with others who also believed in overelaboration and eccentricity. It was his fortune too, to have as clients a number of men whose desire to spend their easily gotten millions was not controlled by education or inherited standards of taste, and to this fact should be attributed some of the lack of restraint that characterized his work. (*The American Architect and Building News,* vol. 92, no. 1656, September 27, 1907, p. 90)

The commentary is unusually perceptive for the era and offers considerable insight into the motives which generated Hale's projects, such as the Peter Widener house of 1886.

First, it was noted that Hale's work was not a solitary aberration, but instead could be related to contemporaries such as Furness (see biography preceding no. 335). Moreover, Hale, like Furness, was working for a new class of clients who were largely without preconceived values and who believed in competition at all costs, a belief evident in their architectural commissions as well as their financial success. These were the qualities of the age, as others at the end of the century agreed. According to William J. Cuthbertson, a California architect writing in 1892, that competition affected all design: "The private individual must not allow another to eclipse him in the ornateness and costliness of his house as he will lose the respect and trust of the community to which may be credited the striving after novelty and strong effects, a species of advertising which is another aspect of the predominating spirit of the time" ("Commercialism in Architecture," *California Architect and Building News,* vol. 13, no. 9, September 1909, p. 49). A similar viewpoint was held by sociologist Thorstein Veblen, who argued in *The Theory of the Leisure Class* (1899) that apparent costliness, "conspicuous consumption" in his phrase, was an accepted value in post–Civil War America. Worth was expressive of the worthiness of the owner. When the values of expression of wealth, individualism, and competition are accepted, the virtues of the Widener house are readily apparent.

For the prominent site at the intersection of two of Philadelphia's principal streets, Hale designed an immense, symmetrical-facaded mansion with conically roofed towers flanking the entrance. It was a solution more reminiscent of the club or the small hotel than a Philadelphia city house. The facade has more to recommend it than mere size or monumentality of composition.

Instead of remaining flat, it curves around the corner towers and bows out under the bay on the side in a manner which seems to anticipate the sinuosity of the Art Nouveau movement of the next decade. The walls were embellished with vast quantities of ornamental detail, a characteristic which typifies most of Hale's projects, for he could rarely bear to leave a surface unadorned. Even the rusticated stone basement is carved in such a way as to simulate a woven surface of crisscrossing stone blocks, as if to transcend the material and to make it conform to the curving surfaces of the building. The upper walls are garlanded, and ordered with pilasters and belt courses, while here and there niches are carved with floral bouquets. Fortunately Hale's penchant for ornament found a ready model in the elaborate architecture of the northern Renaissance in Germany. That association was probably chosen to complement the northern European origins of the Wideners.

As remarkable as the exterior is, it is overshadowed by the principal spaces of the interior—especially the stair hall and the dining room. In those spaces, Hale's talents were augmented by the skills of "decorative artist" George Herzog, an Austrian-trained artist who had found recognition in Philadelphia during the Centennial decade for numerous decorative projects, including the interior of James H. Windrim's Masonic Temple, Fraser, Emlen Littell's St. James Episcopal Church, and LeBrun and Runge's Academy of Music (no. 301). In the 1880s a few city mansions were of a scale sufficient to warrant his talents, and in addition to the Widener house, he decorated the Elkins house, which stood across the street and was large enough to be turned eventually into a hotel, and the Kemble mansion at Twenty-second and Green streets.

In the main hall splendid materials embellish all of the available surfaces: the floors are mosaic; the wainscoting is similar to Cosmati work; the columns of the stair balustrade are of alabaster while the bases and capitals are bronze. Finally, the coffered wood ceiling is inlaid with bronze and other materials in complex arabesques, intricate and precise.

However, the splendors of the stair hall pale before the extraordinary dining room, which continues the German Renaissance theme of the exterior in the wainscoting ornamented with strapwork and the decorated pilasters which order the walls. The center of each wall receives separate emphasis—a musicians' gallery above the door to the stair hall; a gigantic fireplace in an inglenook to the right on the north wall; a window to the south, looking out onto a small porch; and on the fourth wall, carved doors opening into the conservatory. Still, the room's most

astonishing feature remains. In a decorative conceit worthy of the seventeenth century, Herzog painted away the plaster walls behind the pilasters providing imaginary views out of the room into sunny gardens and picturesque northern Renaissance townscapes peopled by Widener's own children in plumed hats and cavalier dress. For a moment, in one confined space, the Victorian search for a present in the past found its reality. Time and space were transcended in the joint vision of Hale, Herzog, and their client Peter Widener. There is nothing to compare with it in Philadelphia.

GT □

EADWEARD MUYBRIDGE (1830–1904)

Born Edward James Muggeridge in Kingston-on-Thames, England, the son of a corn dealer and small coal businessman, Muybridge's eccentric nature first manifested itself when he changed his given name to Eadweard and his surname to Muybridge in 1851 after seeing the spellings of the names of the early Saxon kings on the coronation stone in his town. Little is known of his early childhood, but it is assumed that he acquired a good basic education and that his intellectual curiosity led him to acquire additional knowledge on his own.

Sometime between 1852 and 1856, Muybridge immigrated to America, possibly lured by the chance for adventure and commercial success. He settled in San Francisco and was established in business by 1856 as agent for the London Printing and Publishing Co. This venture was evidently a success, but in May 1860, feeling restless and anxious to change his profession, he sold the business to his brother Thomas. In July 1860, Muybridge decided to make a trip to Europe to buy books on commission for his customers. On his way via mail coach to the East Coast, he was badly injured in a stagecoach accident, and it has been conjectured that his subsequent rather unconventional and erratic behavior was proof that he never fully recovered. There is little mention of Muybridge's activity during the period 1860–66, which he evidently spent in England, possibly undergoing further convalescence.

He probably took up photography during these years, since by 1867 he returned to San Francisco and joined his friend Silas Selleck in the professional photography business. During the latter part of 1867, he studied photography under Carleton E. Watkins and made an expedition to the Yosemite Valley where he produced one hundred 6 by 8 inch views and 160 views for stereoscopic slides or album prints using the collodion wet plate negative process. By 1868 he had received wide acclaim for

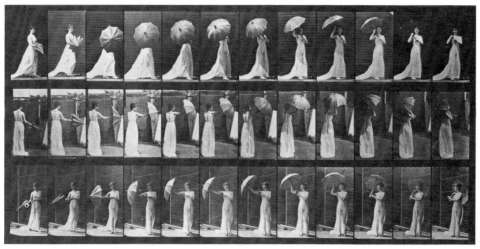

363a.

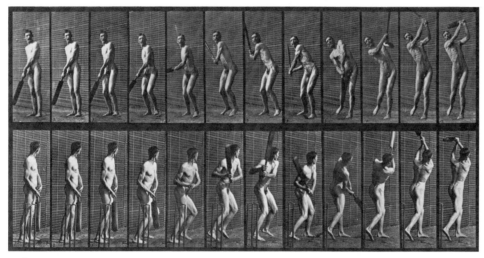

363c.

was concerned with a scientific method for training race horses, and Muybridge's photographs were intended to record the various phases of gaits for this purpose, probably as a means of proving Stanford's contention that at one instant a horse had all four legs off the ground when trotting and galloping.

In 1873, Muybridge was employed by the San Francisco Photographic Studio of Bradley and Rulofson to take stereoscopic pictures of the Modoc Indian War in northern California, which were later sold in sets. On April 15, 1874, his wife gave birth to a son, Florado Helios Muybridge, whose legitimate father was George Harry Larkyns. On October 16, Muybridge, in heated revenge, murdered Larkyns, and in February 1875 he was tried for murder and acquitted on the grounds of justifiable homicide. After three unsuccessful attempts to sue for divorce and alimony, Flora Muybridge died on July 18, 1875.

In 1875–76, Muybridge ventured to Central America on an assignment with the Pacific Mail Steamship Co., producing hundreds of photographs of Mexico, Panama, and Guatemala, which he sold to wealthy Guatemalans (signing the advertising circular letters "Eduardo Santiago Muybridge") and in America after his return to San Francisco.

In August 1877, Muybridge was asked by Stanford to resume his motion studies in Palo Alto. He used as many as twenty-four cameras, their shutters electrically activated to photograph the horse at many different angles. The exposure was reduced from about five-hundredths of a second in the 1872 studies to not more than five-thousandths of a second in 1878–79. Muybridge also photographed male athletes as well as dogs, hogs, oxen, bulls, and seagulls. The results of these experiments were published in Muybridge's *The Attitudes of Animals in Motion* (1881), for which he received wide acclaim in leading photographic and scientific journals in both the United States and Europe.

In the fall of 1879, Muybridge invented the zoopraxiscope, a machine that projected on a screen his photographs (and drawings made from his photographs by Erwin R. Faber of Philadelphia) which were mounted on circular glass discs. Using this revolutionary projection apparatus, he immediately began a series of lectures in San Francisco. As Gordon Hendricks points out (*Eadweard Muybridge, The Father of the Motion Picture,* New York, 1975, p. 115), Muybridge's zoopraxiscope provided audiences with real motion on the screen, not simulated, as previously demonstrated with the phasmatrope, which was invented by Henry Renno Heyl of Philadelphia and projected separately posed positions of motion. In

these views, advertising his prints under the name of "Helois, the Flying Camera." From July 29 to September 4, 1868, Muybridge accompanied General Hallbeck of the United States Army on a trip to survey and photograph Alaskan ports for possible military purposes. Throughout 1868 he worked as a free-lance photographer, producing photographs of the earthquake ruins of October 1868, moonlight views, ships in San Francisco Bay, and private California residences, which were sold in San Francisco galleries, providing him with a substantial income. With a large camera holding 20 by 24 inch plates he returned to the Yosemite Valley in 1869. These Yosemite views became well known in Europe, and by the end of 1869 his reputation as a professional photographer was established throughout the United States as well. In March–August 1871, he was employed by the United States

Light House Board to photograph all the lighthouses on the Pacific Coast. In May 1871, Muybridge married divorcée Flora Shallcross Stone, who was nineteen years his junior and a former studio employee who retouched his photographs.

In 1872, Muybridge began his longstanding association with Leland Stanford, a former governor of California, prominent horse breeder, and president of the Central Pacific Railroad and Pacific Mail Steamship Co. Muybridge's photographic work on the horse in motion, executed at Stanford's stables in Palo Alto, placed him in the forefront of claimants to the title of "father of motion photography" and may be considered a precursor to his comprehensive investigation of animal locomotion twelve years later in Philadelphia. The undertaking was also one of the first in the application of photography as a research tool. Stanford

August 1881, Muybridge went on a lecture tour primarily in Paris and London, projecting his photographic studies of animals in motion with the zoopraxiscope in order to secure financial backing for further investigations. Although Muybridge received wide recognition abroad for his work among such notables as artist Jean-Louis Meissonier and physiologist Étienne-Jules Marey, his reputation became somewhat tarnished by the publication of *The Horse in Motion* by J. D. B. Stillman, M.D., in April 1882. Published at Stanford's expense, the book demonstrated the theory of quadrupedal locomotion based on the results of Muybridge's photographic studies but without any credit given to Muybridge. Suspicions were thus aroused as to the rightful claimant of the Palo Alto series of instantaneous photographs, and Muybridge's chances of pursuing his investigations abroad were ruined (see Hendricks, *Muybridge,* cited above, pp. 144–46).

From August 1882 to February 1883, Muybridge lectured in the eastern United States, again with the hope of achieving financial support for his further investigations. That hope became a reality in August 1883 when the University of Pennsylvania undertook to sponsor such a study. The result of this immense investigation, executed probably between May 1884 and January 1886 on the grounds of the University of Pennsylvania's Hospital, was the reproduction of his sequential photographs in 781 collotype plates, along with a separately printed prospectus and catalogue entitled *Animal Locomotion, An Electro-Photographic Investigation of Consecutive Phases of Animal Movements* of 1887. Between the spring of 1889 and the fall of 1891, Muybridge devoted his efforts to advancing interest in and soliciting subscribers for his *Animal Locomotion* by giving lectures before learned societies and institutions in the United States and Europe and publishing a small promotion pamphlet entitled *The Science of Animal Locomotion* in 1891. From May to October 1893, Muybridge gave lectures on animal locomotion at the World Columbian Exposition in Chicago in Zoopraxographical Hall, at the same time publishing a pamphlet entitled *Descriptive Zoopraxigraphy.*

In the summer of 1894, Muybridge returned to England and settled in Kingston-on-Thames, making a return trip to the United States in 1896–97 to dispose of his *Animal Locomotion* prints, negatives, and plates. In 1899 he published *Animals in Motion* and in 1901 *The Human Figure in Motion,* in London, both abridgments of his 1887 *Animal Locomotion* (the former went through five printings and the latter, seven). In 1900, Muybridge retired permanently to Kingston-on-Thames. A final example of his eccentricity was the model of the Great Lakes that he began to dig in his backyard. He died on May 8, 1904, before its completion.

363. *Animal Locomotion*

1887

Title page: Eadweard Muybridge, Animal Locomotion, An Electro-Photographic Investigation of Consecutive Phases of Animal Movements, Published Under The Auspices of The University of Pennsylvania, Prospectus and Catalogue of Plates, Philadelphia, 1887, Printed by J. B. Lippincott Company

Plates printed by the Photogravure Company of New York

Collotype

a. *Plate 461: Opening a Parasol, and Turning around.* 7⅝ x 15¾″ (image) (19.3 x 40 cm)

b. *Plate 290: Cricket; Over Arm Bowling* (not illustrated). 6½ x 17⅞″ (image) (16.5 x 45.4 cm)

c. *Plate 291: Cricket; Batting; Drive.* 7⅝ x 15¾″ (image) (19.3 x 40 cm)

d. *Plate 521: A, Walking; B, Ascending Step; C, Throwing Disk; D, Using Shovel; E, Using Pick; F, Using Pick.* 11⅜ x 10⅛″ (image) (28.9 x 25.7 cm)

e. *Plate 535: Movement of the Hand; Beating Time.* 9½ x 11¾″ (image) (24.1 x 29.8 cm)

f. *Plate 759: Cockatoo; Flying* (not illustrated). 6⅝ x 17¼″ (image) (16.8 x 43 cm)

Philadelphia Museum of Art. Given by the City of Philadelphia, Trade & Convention Center, Department of Commerce. 69-135-193, 237, 229, 122, 121, 363

PROVENANCE: New York Photogravure Company; Eadweard Muybridge; Commercial Museum, Philadelphia

LITERATURE: *Animal Locomotion, The Muybridge Work at the University of Pennsylvania, The Method and The Result* (Philadelphia, 1888, reprint, New York, 1973); Eadweard Muybridge, *Animals in Motion* (London, 1899, reprint with intro. by Lewis S. Brown, New York, 1957); Eadweard Muybridge, *The Human Figure in Motion* (London, 1901, reprint with intro. by Robert Taft, New York, 1955); George E. Nitzsche, "The Muybridge Moving Picture Experiments at the University of Pennsylvania," *The General Magazine and Historical Chronicle,* vol. 31, no. 3 (April 1929), pp. 323–32; L. F. Rondinella, "Muybridge's Motion Pictures," *Journal of the Franklin Institute,* vol. 208 (September 1929), pp. 417–20; H. L. Gibson, "The Muybridge Moving Pictures of Motion," and Beaumont Newhall, "The George E. Nitzsche Collection of Muybridge Relics," in *Medical Radiography and Photography,* vol. 26, no. 1 (1950); Eadweard Muybridge, *Animal Locomotion,* vol. 1 (reprint, New York, 1969); Gordon Hendricks, *Eadweard Muybridge, The Father of the Motion Picture* (New York, 1975), pp. 149–200

IT IS NOT SURPRISING that Philadelphians were receptive to Muybridge's investigations of animal motion and curious to see how new developments in photographic apparatus would improve such a study. They had previously been exposed to motion photography through Coleman Sellers's kinematascope, and Henry R. Heyl's phasmatrope. Moreover, Muybridge's work may have been known through Thomas Eakins (see biography preceding no. 328), who had followed Muybridge's Palo Alto experiments of 1878–79 in his concern with the accurate rendition of anatomy and movement in his paintings. In fact Eakins may have suggested that Muybridge photograph the motion of male athletes at this time (Hendricks, *Eadweard Muybridge,* cited above, p. 113). Six months after Muybridge had delivered a series of lectures at the Pennsylvania Academy, the Franklin Institute, and the Academy of Music, a group of distinguished Philadelphia citizens decided to sponsor his investigations of animal motion in an outdoor studio behind the University Hospital of the University of Pennsylvania. A committee appointed by the provost, Dr. William Pepper, to supervise the project included a large number of university scientists and medical staff members, attesting to the university's continued interest in the development of photography.

Although Muybridge's widely acclaimed Palo Alto studies of 1878–79 were the precursor of his monumental investigation at the University of Pennsylvania, by 1883 he was well aware that the invention of the dry plate negative process would afford a more accurate and detailed recording of the muscles in rapid action than the relatively insensitive wet collodion negative process used in his California experiments. In essence, the apparatus employed in California to obtain a succession of automatic exposures by means of electro-photographic shutters at regulated intervals was also used at the university, but with vast improvements and additions. The shutters of each camera were controlled by a master electric switch driven by a clockwork device making it possible to vary the exposures as well as the intervals between them. The duration of each exposure was determined by the speed with which the action was completed, as noted in a trial run. When the subject ran in front of the first camera, the master switch was pulled and the cameras were triggered in succession, resulting in an instantaneous series of pictures revealing a cycle of movements. A stationary battery of twelve to twenty-four cameras was placed parallel to a level track and at right angles to the line

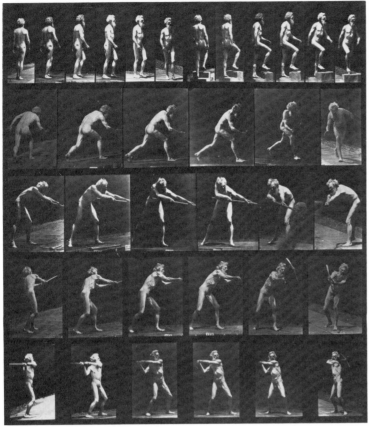

363d.

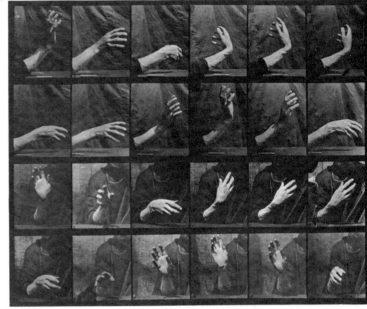

363e.

of motion for lateral views (as seen in plate 759), while two portable batteries of twelve smaller cameras each were employed to record foreshortenings or the motion of the subject from the front and rear (as seen in plate 291). If all cameras were used, as many as forty-eight exposures of one phase of action could be recorded. Plate 461 demonstrates the use of all three batteries of cameras. A short description of each movement, model number, type of costume worn, number of lateral views, number of rear and/or front foreshortenings at 60 or 90 degrees, degree of completed movement, and the interval of time between successive exposures was recorded for each plate in the catalogue. In front of a long white or black background on which the cameras were focused was a rubber track along which the subjects moved. The background was marked off with horizontal and vertical white threads divided into twenty-inch squares, each subdivided into two-inch squares. This grid background which aided the computation of movement may be seen on all but plates 521 and 535. For some studies, portable white or black backgrounds were used.

The collotype plates selected here illustrate the variety of models employed. In the prospectus, Muybridge notes that (of the

562 figures employed) the majority of human models were university students and alumni selected for their high level of competence in the particular movement for which they were photographed. In addition, it has since been discovered that a number of the male models were on the staff of the medical school. Although none of the names of these models were published (identified in the catalogue only by a serial number), Muybridge helps to identify certain models by referring to their profession. For example, he notes that number 51 (the model for plate 535) "was a well known instructor in art." One can safely surmise that this hooded figure was Thomas Eakins, who, incidentally, served on the supervisory committee and assisted Muybridge in his studies in the spring of 1884. Later, Eakins became dissatisfied with Muybridge's use of batteries of separate cameras, and turned to the use of a single camera which recorded motion at exact intervals on a single gelatin dry plate. He conducted his own studies in animal movements simultaneously with Muybridge on the university campus. When Muybridge refers to model 95 (seen in plate 521) as "an ex-athlete, aged about sixty," he was obviously speaking of himself, and perhaps by this inclusion hoped to provide the large number of impersonal and scientifically

recorded studies with a degree of levity and mystery. Muybridge also tells us that the female models were "chosen from all classes of society," that the birds and other wild animals were from the Zoological Society Garden, and the domesticated animals and horses from the Gentleman Driving Park in Fairmount. The models employed for the study of abnormal movements were selected from patients at the university and nearby Philadelphia hospitals.

Whether or not Muybridge encountered difficulties in recruiting male and female models willing to perform in the nude remains a question. Even though the study was undertaken for scientific rather than artistic purposes and the names of the models never published, one marvels at Muybridge's feat of ultimately publishing, apparently without controversy, reproductions of Philadelphians performing in the nude for circulation to a wide variety of subscribers. Only six years earlier in 1878, the moral controversy over Eakins's life class at the Academy forced him to relinquish the directorship of the class, and in 1886, Eakins's persistence in using the nude male model in a class for women forced him to terminate his teaching career at the Academy. Today many of these models, both nude and clothed, have been identified by name in two working

425

notebooks (now in the collection of the International Museum of Photography at George Eastman House) in which it is thought Muybridge made notations during the project at the university. For example, the female model in plate 461 is identified as "Miss Lanigan," and the model in plates 290 and 291 as "J. A. Scott" (Joseph Alison Scott, M.D., 1865–1909, adjunct professor of clinical medicine at the University of Pennsylvania, and recognized as one of the country's best cricket players). If one looks over the catalogue cards of the nearly complete set of collotype plates at George Eastman House, one connects a number of names of male models to prominent Philadelphia citizens and medical professionals of the time.

In January 1886, Muybridge completed his study at a total cost to the university of about thirty thousand dollars. He employed only two main assistants: Lino F. Rondinella, who worked with the electrical apparatus, and Henry Bell, who developed the prints. From January until August 1886, Muybridge labored over the selecting and preparing of his negatives and photographs for the printing of 781 collotype plates he entitled *Animal Locomotion*. After processing the gelatin dry plate negatives, glass positives were made from them, cut to frame the figure and assembled on a plate glass with a mask of orange paper. From this grouping, master negatives on a gelatin base were printed by contact. This master negative was then employed to make the collotype plates. Muybridge also made a number of albumen prints from these master negatives which he preserved in albums. A number of all of the above photographic items, formerly in the George E. Nitzsche collection, have been given to the Philadelphia Museum of Art. These collotype prints, each containing from ten to forty-eight images, were for sale to subscribers in four formats: the complete set of 781 plates reproducing approximately twenty thousand figures, bound in eleven volumes for $550, or loose in a leather portfolio for $500; a selection of one hundred plates unbound in a leather portfolio for $100, plus any others the subscriber might select at $1.00 each, and an author's edition of twenty plates. The great expense of the complete set naturally limited its sale. A card in the New York Public Library states that only thirty-seven complete sets are still extant. A list of subscribers as of January 1887, recorded by Muybridge in a printed publication of *Animal Locomotion,* included conservators of works of art, literati, and connoisseurs; artists, publishers, and manufacturers of works of art; scientists; departments of government; institutions of art and art training; institutions of science; and institutions of learning. Such a listing reflects the variety of the audience attracted to such a publication.

The lasting value of Muybridge's *Animal Locomotion* to the scientist is well recognized. For the artist, many accepted theories of animal movement were contradicted, the photographs recording facts which were not possible to see with the naked eye. Muybridge's photographs influenced, among others, Degas, Meissonier, Gérôme, and Eakins, artists who considered scientific accuracy more important than what the eye sees. The argument arose in artistic circles that paintings which represented objects as perceived by the human eye were more "realistic" than those based on scientific studies which extended human vision beyond the familiar. Nevertheless, it seems that by 1889 those who adhered to the latter belief gained ascendancy. "From all indications it appears that both artists and public were already well conditioned to Muybridge's visual revelations and not only would painters now dare to represent their subjects in accordance with those photographs but would jeopardize their reputations if they did not" (Aaron Scharf, *Art and Photography,* London, 1908, pp. 170–71).

Today these images are also valued for their aesthetic content alone. Removed from their scientific context they may be appreciated purely for the expressive possibilities of the various body positions and for the rhythmic and graceful compositions which result. Moreover, there is ample evidence that they have affected the style of a number of contemporary painters and photographers.

CW □

CECILIA BEAUX (1855–1942)

Cecilia Beaux was born in Philadelphia and grew up in the home of her grandmother. As an adolescent, she received drawing lessons from an aunt, Catherine Drinker Janvier, with whom she also visited art collections, including the Pennsylvania Academy. She studied for two years with the Dutch artist Adolf Van der Whelen in Philadelphia and in 1873 began giving drawing lessons. Around 1875, Beaux was commissioned by paleontologist Edward D. Cope to do lithograph illustrations of fossils for a United States Geological Survey. To help support her household she also learned china painting and executed a series of ceramic plaques of children's heads from photographs. The Pennsylvania Academy's records list Beaux as a student from 1877 to 1879 (Goodyear, *Beaux,* p. 21), although she later denied such training.

She began her exhibiting career in 1879 when she entered a crayon drawing in the Academy's annual exhibition. About 1881, Beaux received instruction from William Sartain, who came from New York twice a month to criticize a small class she attended. She also came into contact with painter

Stephen Parrish, the father of Maxfield Parrish, and with Thomas Anshutz, who was persuaded to criticize her first major painting, *Les Derniers Jours d'Enfance.* In 1885 this canvas was exhibited at the American Art Association in New York and at the Pennsylvania Academy, where it won the Mary Smith Prize. A friend of Beaux's insisted on taking the picture to Paris to show to Jean-Paul Laurens, who recommended that it be submitted to the Salon. The canvas was accepted for the Salon of 1887, a significant honor for an American woman.

Beaux continued to exhibit regularly at the Academy and had won another Mary Smith Prize for her portraits when she left Philadelphia for Paris in 1888. She studied with Tony Robert-Fleury and Adolph William Bougereau at the Académie Julian, copied paintings at the Louvre, traveled through France, England, and Italy, and worked in the atelier of Benjamin Constant and at Colorossi's with Courtois and Dagnan-Bouveret. She returned to Philadelphia in 1892 and established her own studio. In 1895 she became a critic of the painting class at the Academy, a position she held for twenty years.

Six of Beaux's portraits were accepted and hung together at the Salon's Champs de Mars exhibit of 1896. Among many awards, she won gold medals from the Carnegie Institute in 1899 and the Paris Exposition of 1900, and the Temple Gold Medal of the Academy in 1900. She was selected to paint Mrs. Theodore Roosevelt and her daughter Ethel at the White House in 1901 and was elected a member of the National Academy of Design in 1902.

In her later years, Beaux divided her time between her studio in New York, travel abroad, and her summer home in Gloucester, Massachusetts. In 1919, she was chosen by the United States War Portraits Commission to paint Cardinal Mercier, Admiral Beatty, and Georges Clemenceau. Her mobility was greatly limited after she broke a hip in 1924, but she wrote her autobiography and continued to paint. In 1935, the American Academy of Arts and Letters in New York held an extensive exhibition of her work. Beaux died in Gloucester in 1942.

AS

364. *Margaretta Wood*

c. 1887–88

Signature: E. C. Beaux (lower right)

Oil on porcelain

Diameter 24″ (61 cm)

Margaretta Oliver Caesar, Evergreen, Colorado

PROVENANCE: Margaretta Wood (Oliver); granddaughter, Margaretta (Oliver) Caesar

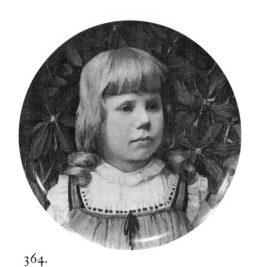

364.

THE PORTRAIT of Margaretta Wood (Oliver) presents a strong illusionistic likeness of the child, her blond hair contrasted to a background of dark green rhododendron. Margaretta Wood (1880–1965) was born in Altoona, Pennsylvania, one of four children. Her father became a vice-president for the Pennsylvania Railroad, and they settled in the Pittsburgh area. She appears to be seven or eight in this portrait, which would date it about 1887/88. She married in 1907 and was active in social, civic, and religious organizations in Pittsburgh. A companion portrait on porcelain of one of her brothers, Cooper Wood, is also owned privately.

China painting had become increasingly popular among American women in the last quarter of the nineteenth century. According to an article in 1895:

At first there were but a few outside of a factory who ventured to paint on china. . . . By degrees others tried their hand at it. . . . Ever since then china painting has been on the crest of the wave. . . . Professionals were importuned for lessons; books were written on the subject . . . colors were prepared ready for the amateur's use; the demand for undecorated china increased, and new and fascinating shapes were constantly being placed on the market that were simply irresistible. . . . And as the amateurs progressed and were not satisfied to have someone else finish their work by gilding and firing, kilns were next supplied, then gold and silver and various-colored bronzes. . . . in fact the American girl never ceased clamoring until she obtained every necessary accessory. (quoted in Davidson, *Antiques,* p. 352)

Although most china painters were amateurs, some were professionals or achieved professional status. Such was the case with Cecilia Beaux, who pursued this fashionable avocation in the 1880s and 1890s. According to her autobiography, she took up china painting to become financially independent and was extremely successful with adapting this technique to portraiture.

. . . I wished to earn my living and to be perhaps some day a contributor to the family expenses. . . . I took a month's lessons in china painting from a French expert, in the ignoble art of over-glaze painting. How ignorant I was and how [I] quickly mastered what could be got from it! My instructor said nothing to me of the legitimate field of this kind of work, and I at once began adapting it to portraiture. A sad confession. The results were, alas, too successful, and were much desired. For, somehow, after four firings at a remote kiln, I managed to get upon a large china plaque a nearly life-size head of a child (background, always different), full modelling, flesh color and all, that parents nearly wept over. Of course I used photographs, but was not content with "making up" the color. I had a solar print made, going for this to a nice old man, high up many rickety stairs in an old house at Fifth and Arch Streets.

The rude copy contained nothing but measurements but the golden-haired darling was then brought to me and placed as nearly as possible in the lighting of the photograph. I then wrote all over the solar print notes on the color— "most color," "least color," greenish, pinkish, warm, cool. This was a real study in summing up and cleavage of tones, and added greatly to the much too great vitality of the head, carrying it far from the purely decorative requisitions of the china plaque. . . .

Without knowing why, I am glad to say that I greatly despised these productions, and would have been glad to hear that, though they would never "wash off," some of them had worn out their suspending wires and been dashed to pieces.

This was the lowest depth I ever reached in commercial art and, although it was a period when youth and romance were in their first attendance on me, I remember it with gloom and record it with shame. (Cecilia Beaux, *Background with Figures, Autobiography of Cecilia Beaux,* Boston and New York, 1930, pp. 84–85)

Although she disdained her work in china painting, she did include examples in the 52nd annual exhibition of the Pennsylvania Academy of the Fine Arts, 1881, where she exhibited *Portrait of a Child,* mineral colors on porcelain, and *Portrait of a Little Girl,* burned in china.

DH □

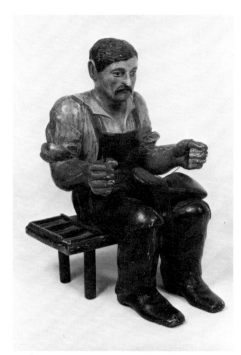

365.

365. *Cobbler Figure*

c. 1885–95
Carved and painted wood
29¾ x 14¾ x 14½″ (52.7 x 37.4 x 36.8 cm)
Atwater Kent Museum, Philadelphia

SIGNS AND DECORATIVE FIGURES, such as this cobbler working at his bench, which tradesmen placed in a shop window or on counter tops are the most ephemeral of a city's arts. In the nineteenth century as in the twentieth, even small businessmen like John Engel, whose cobbler sign is represented here, were challenged to keep abreast of changing fashions in advertising and trade signs, and figures such as this were usually discarded when they lost their appeal as new attractions. John Engel is listed as a shoemaker in Philadelphia directories at various locations between 1885 and 1896. Possibly he carved this figure himself, for the oversize shoe that the cobbler holds in his lap, his bench, and tools are completely detailed and indicate a knowledge of the shoemaker's trade. The blocky figure of the cobbler is schematically rendered with the authority of a naive artist unconcerned with the specifics of anatomy.

DS □

FRANK MILES DAY (1861–1918)

Frank Miles Day was born in Philadelphia and educated at the University of Pennsylvania, where he later served as a lecturer in the architecture department. After graduation he attended the Royal Academy School of Architecture in London, before traveling extensively through Europe. His sketchbooks (University of Pennsylvania, Library) are clear evidence of interest in late Gothic design, especially the North Italian varieties. Motifs from those studies appeared in many later designs, beginning with the Art Club commission. After 1892, Day associated himself with his brother, H. Kent Day, in the firm of Frank Miles Day and Brother, designing numerous country houses in the Gothic style and city houses in a Renaissance manner. In this century, Day formed a partnership with Charles Z. Klauder, which specialized in academic Gothic piles for many major American universities, including Princeton, Cornell, and Wellesley.

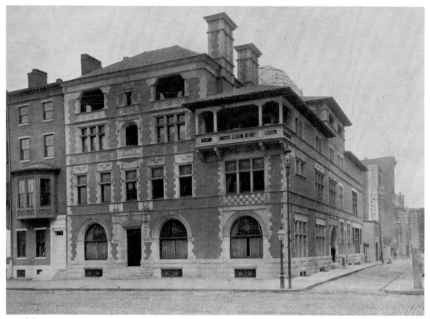

366.

366. *Art Club*

Broad and Chancellor streets
1888 (demolished 1975)
Brick and timber structure; limestone carvings and trim

REPRESENTED BY:
R. Newel & Son
c. 1895
Art Club
Photograph
7¼ x 9⅜" (18.4 x 23.8 cm)
Free Library of Philadelphia

LITERATURE: White, *Philadelphia Architecture,* p. 33, pl. 68; *Philadelphia Inquirer,* December 17, 1975

THE PRESENT-DAY ENTHUSIASM for the works of Frank Furness (see biography preceding no. 335) and his contemporaries should not disguise the long-term contempt in which Philadelphia architecture was held by late nineteenth and early twentieth century critics, historians, and architects. By the early 1880s advanced architectural taste in New York and Boston favored more controlled composition, color, and detail than was usually found in the architecture of the late 1870s and early 1880s in this city. The result was an unsympathetic press, which only changed when Philadelphia architects conformed to the ruling taste. When that happened critics were surprised but delighted. Ralph Adams Cram, for example, commented: "Blessed with an early architecture of the very best type developed on this continent, it [Philadelphia architecture] sank first to a condition of stolid stupidity,

then produced at a bound a group of men of abundant vitality but the very worst taste ever recorded in art, then amazed everyone by flashing on the world a small circle of architects whose dominant quality was exquisite and almost impeccable taste" ("The Work of Messr's Frank Miles Day and Brother," *Architectural Record,* vol. 15, no. 5, May 1904, p. 397). "Men of abundant vitality" is a not-so-subtle reference to Furness's generation, while the architects of "exquisite and almost impeccable taste" denoted the men who attained maturity in the 1880s, and who worked in the more correct revival styles which became standard by 1890. They were generally better schooled and were, in most instances, members of a new professional organization, the T-Square Club, which for a time rivaled the previously established American Institute of Architects. Its members, among them Wilson Eyre (see biography preceding no. 377), William L. Price (see biography preceding no. 397), Frank Miles Day, Walter Cope, and John Stewardson, were Philadelphia's best known architects at the turn of the century. Although most were practicing in the mid-1880s, few had completed significant projects. Thus the awarding of the commission for a major clubhouse and center for the arts on a prominent Broad Street site to Frank Miles Day in 1888 signaled the beginning of a new architectural era.

The Art Club had been founded in 1887 "to advance the knowledge and love of the Fine Arts, through the exhibition of works of art, the acquisition of books and papers for the purposes of founding an art library ..." and other like goals (Art Club, Minutes, 1887). Among its first board members were

painter Thomas Hovenden (see biography preceding no. 372), sculptor Joseph Bailly, and patrons A. J. Cassatt and Edward Shippen. The next year its membership had grown to include Shakespearean scholar Horace Howard Furness, sculptor J. J. Boyle (see biography preceding no. 368), and architects Walter Cope, Eyre, and Day. By their second year of operation, the need for more elaborate facilities was felt. After a closed competition that included most of the club's architectural members, Day was chosen as the architect for the new building (Art Club, Minutes, 1888; see also *Philadelphia Inquirer,* July 11, 1888, May 5, 1891).

Day proposed a moderate-sized clubhouse styled in the manner of a late Gothic Venetian palazzo. Although that style was associated with the then fashionable North Italian painting, there may have also been a hint of irony in its choice, for only a decade earlier Furness and Hewitt's polychromed Pennsylvania Academy of the Fine Arts (no. 335) had presented to the Centennial crowds a local vision of John Ruskin's idea of the Venetian Gothic. (In 1898, Day made a proposal to reface Furness's work in a proper Venetian style, an action which was only stayed when the Academy could not raise the money (*Philadelphia Inquirer,* October 8, 1893).

The difference between the two buildings is indicative of transformations in the taste of the public, the chosen role of the architect, and architectural theory. Furness and Hewitt merged a variety of materials and motifs derived from English and French national schools in one design. That was a logical consequence of current eclectic theory— history was to be studied, not to revive a

select style but to solve contemporary building tasks. Architectural details freed from a specific context might be used to embellish any reasonable formal solution. That attitude had much to recommend it to a post–Civil War generation more concerned with direct solutions than propriety.

Academic theory which influenced most later architects tended to view details as belonging to an overall context, regulated by rules and proportions which might be ascertained from specific prototypes in Europe. Those buildings were generally known to the client from photographs, and to the architect from the first-hand experience of the European tour. Day's European notebooks containing numerous pencil sketches of wall fragments, columns, capitals, bosses, and windows form a record of the buildings which interested him. From these notes, photographs, and other sources, Day was able to build up an architectural totality which, while not a copy, was convincingly within the vocabulary of the Venetian Gothic, not only in carving but in the tonality of tan brick and white limestone as well.

The composition of the facade completed Day's tour de force. By designing it as two essentially symmetrical blocks, the larger one with the entrance, the smaller block with an overhanging balcony, he acknowledged both late Victorian picturesque form and Venetian Gothic additive growth. The interior was less original. Large public spaces opened off a central hall. In general the rooms related to the scale and the styling of the exterior, with the exception of a grand ballroom where mirrored walls produced a nearly infinite space more reminiscent of Versailles than of Venice.

Later additions to the rear of the building made by Frank Newman (formerly in Day's office) of Newman, Woodman, and Harris attest to the continuing success of the club into this century (*Philadelphia Inquirer,* July 1, 1907). The general vocabulary remained the same, although the flat roman brick of the facade was replaced by a slightly darker common brick. In more recent times, the city club lost popularity, and the Art Club was forced to sell the building. In the past few years the building served a variety of tenants, but its preservation was deemed economically unsound. It was demolished at the end of 1975.

GT □

HOWARD PYLE (1853–1911)

Virtually all of Howard Pyle's remarkably productive career was spent in or around Wilmington, Delaware, where he was born and where his family had lived for generations. His early training was undistinguished; no adequate art schools were available in Wilmington, and he commuted to Philadelphia for two or three years to study with a little-known academic teacher named Van der Weilen. His imagination was his principal master from early childhood, and he seems to have had at hand a wealth of illustrated books to form the taste for the marriage of word and image that was to characterize his work. The English illustrators, and later Walter Crane, were important in this formation.

On his own, Pyle wrote and illustrated stories, articles, and verses for adults and children, and in 1876, when he was twenty-three, *Scribner's Monthly* and *St. Nicholas* accepted three of these efforts. As a result, Pyle moved to New York in mid-October of that year; he stayed three years, taking night classes at the Art Students League and working for *Harper's Weekly, Harper's New Monthly Magazine, St. Nicholas,* and *Scribner's Monthly,* sometimes illustrating his own articles, sometimes those of other people, and sometimes providing illustrations without text. At first his sketches were worked up for engraving by the more experienced artists on the staff, but by 1878, and now a professional, Pyle was providing finished drawings himself for the engraver. Among the team of artists working for Harper's under Charles Stanley Reinhart were A. B. Frost and Edwin Austin Abbey, both Philadelphians and both launched on careers as successful illustrators. Frost, at least, became Pyle's good friend.

Returning to Wilmington in 1879, Pyle continued to work largely for Harper's publications—*Weekly, Young People, Bazar* (as it was known at this time), and *New Monthly Magazine.* In 1881 he married a Wilmington girl, Anne Poole; seven children were born over the next fifteen years. Between 1883 and 1888, Pyle wrote (in most cases) and illustrated six books, four of them children's books that are widely known and loved: *The Merry Adventures of Robin Hood; Pepper and Salt, or Seasoning for Young Folk; The Wonder Clock;* and *Otto of the Silver Hand.* His illustrations began to appear in numerous books by a variety of authors on all sorts of subjects.

Pyle's work was largely in pen and ink or gouache until the development of the halftone and color reproduction processes in the 1880s and 1890s. From around 1887 he worked a great deal in grisaille or in colors, with brush and canvas as well as on illustration board, and on a slightly larger

scale at the easel than at the drawing board; but he by no means abandoned the pen as a medium or his interest in the black and white drawing and its visual integration with the printed page. Some of his finest ink illustrations, those for four volumes retelling the King Arthur legends, were produced between 1902 and 1910.

The publications for which Pyle provided articles and illustrations from the 1890s on included, besides the Harper's and Scribner's publications for which he had been working, *Century Magazine, Collier's Weekly, Cosmopolitan, Frank Leslie's Popular Monthly, Woman's Home Companion, Ladies' Home Journal, McClure's Magazine,* and *Everybody's Magazine.* His writings and illustrations covered a diversity of subjects, from Colonial and Revolutionary war history to medieval tales and Arthurian legend, from children's verses to adventures of buccaneers. He maintained a remarkable control of accurate and historical detail in the midst of this variety, researching his topics carefully and throwing all his mental powers into understanding and communicating the character of his subjects.

Rather late in life Pyle turned to teaching, first offering his services to the Pennsylvania Academy; this offer was rejected, presumably because the Academy did not consider illustration to be enough of a fine art. He did direct a course in illustration at Drexel Institute between 1894 and 1900, commuting from Wilmington, and it was in this class that a number of Philadelphia-based illustrators were launched. Pyle was extraordinarily successful as a teacher, in his ability both to articulate his own ideas and to exact peak performances from his pupils. Evidence of this is the remarkable number of well-known illustrators who worked under him, however briefly. These included Violet Oakley, Elizabeth Shippen Green, Jessie Willcox Smith, and possibly Maxfield Parrish—all part of the Drexel group—and Stanley Arthurs, Frank Schoonover, Harvey Dunn, George Harding, and N. C. Wyeth, who attended the classes Pyle set up in Wilmington after he resigned from Drexel in 1900. Pyle's teaching, as well as his published work, was a formative influence in American illustration of the period.

In 1906, Pyle undertook a short-lived and not very successful appointment as art director for *McClure's Magazine,* commuting to New York three days a week. He was temperamentally unsuited to this work, however, and the venture lasted only a few months. Toward the end of his life, in the years between 1905 and 1910, he received several commissions for large mural decorations (for the Minnesota State Capitol in St. Paul, for the Essex County Courthouse in Newark, New Jersey, and for the Hudson County Courthouse in Jersey City), and his

career, moving in a new direction, seemed to be rejuvenating itself. He decided to move to Italy to seek larger, cheaper work space and also to see the Italian masters for the first time. In the fall of 1910 the family sailed for Naples, but Pyle suffered from poor health during most of the trip, and after a stay of only a few months in Rome and Florence he died in the latter city in November 1911 at the age of fifty-eight.

367. *Illustrations for Otto of the Silver Hand*

1888
Written and illustrated by Howard Pyle
Published by Charles Scribner's Sons, New York, 1888

(a) *Away they rode with clashing hoofs and ringing armor*
Signature: HP (in ink, lower right)
Black ink and traces of pencil on white paper
7⅞ x 5⅝" (image) (19.3 x 14.3 cm)
Delaware Art Museum, Wilmington

PROVENANCE: Purchased from Charles Scribner's Sons, 1916

LITERATURE: Morse and Brincklé, p. 127; *Pyle Collection*, p. 38, no. 2322; *American Illustration*, p. 45; *Pyle: Diversity in Depth*, p. 46; Brookings, South Dakota Memorial Art Center, *Howard Pyle, 1853–1911* (February 2—March 23, 1975), no. 15

(b) *Schwartz Carl, holding his arbalest in his hand, stood silently watching*
Signature: HP (in ink, lower right)
Black ink and traces of pencil on white paper
7½ x 5⅝" (image) (19.1 x 14.3 cm)
Delaware Art Museum, Wilmington

PROVENANCE: Purchased from Charles Scribner's Sons, 1916

LITERATURE: Morse and Brincklé, p. 128; *Pyle Collection*, p. 38, no. 2347; *Pyle: Diversity in Depth*, p. 46; Pitz, *Pyle*, illus. p. 84

(c) *"Then dost thou not know why I am here?" said the Baron*
Signature: HP (in ink, lower right)
Black ink on white paper
7½ x 5⅝" (image) (19.1 x 14.3 cm)
Delaware Art Museum, Wilmington

PROVENANCE: Purchased from Charles Scribner's Sons, 1916

LITERATURE: Morse and Brincklé, p. 128; *Pyle Collection*, p. 38, no. 2352; *Pyle: Diversity in Depth*, p. 46

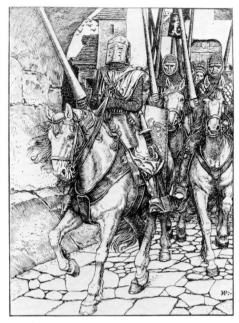

367a.

(d) *For a moment they stood swaying backward and forward*
Signature: HP (in ink, lower left)
Black ink on white paper
7⁹⁄₁₆ x 5⁹⁄₁₆" (image) (19.2 x 14.2 cm)
Delaware Art Museum, Wilmington

PROVENANCE: Purchased from Charles Scribner's Sons, 1916

LITERATURE: Morse and Brincklé, p. 129; *Pyle Collection*, p. 38, no. 2375; *Pyle: Diversity in Depth*, p. 47; Pitz, *Pyle*, illus. p. 65

PYLE ADOPTED TWO DIFFERENT MANNERS of working with pen and ink: one heavier, more decorative, rooted in contour; the other lighter and finer, somewhat nearer in effect to Abbey's manner of building up form with a mass of tiny, fine strokes. The influence of European pen draftsmanship was important at the time (for a contemporary account of influential European and English artists and of the illustrated journals that were a major vehicle of this influence for an American artist, see Pennell, *Pen Drawing*). "Pyle felt the impact of both [Daniel] Vierge and [Adolf] Menzel, and in addition studied the German woodblock masters, particularly Dürer. As a result he worked in two opposing styles—the free impressionistic style generated by Vierge; a mannered, decorative medieval style; and even a third type of rendering difficult to define, a blend of many influences" (Henry Pitz, "The Art of the Pen," *The American Artist*, vol. 32, no. 10, December 1968, p. 32; see also Pitz, *Pyle*, pp. 104ff.).

367b.

Otto of the Silver Hand—an example of Pyle's more patterned, decorative penwork—was published in 1888, toward the end of the artist's great "black and white" decade, during which he also wrote and illustrated with line drawings *The Merry Adventures of Robin Hood* (1883), *Pepper and Salt* (1886; sections of which were first published in *Harper's Young People*), and *The Wonder Clock* (1888). Pyle's line illustrations have been judged more successful than his halftones, and certainly the above-mentioned books are far more interesting visually than *Men of Iron* (1892), another medievalizing story illustrated with half-tones. The abstract, decorative possibilities of line drawings were well suited to the fairy-tale, fantasy quality of *The Wonder Clock* and to the medieval settings of *Otto, Robin Hood,* and the Arthurian legends, whereas the greater naturalism of oil or gouache illustrations made them a better choice for Pyle's stories of pirate adventures and Colonial American history.

The most important influence that distinguishes the style of the *Otto* drawings in Pyle's work is that of German Renaissance woodcuts, such as those of Dürer or Burgkmair. This feature was pointed out and even overstated by Joseph Pennell practically as soon as the book was published: "In some qualities it is very hard to tell where Dürer ends and Howard Pyle begins. In his *Otto of the Silver Hand*, for example, there are compositions which are almost entirely suggested by Dürer. . . . That Pyle should do this in telling and illustrating a medieval tale, merely proves his ability to saturate himself with the spirit of the age in

430

367c.

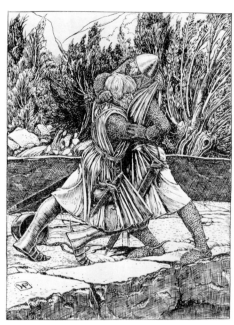

367d.

which the scenes are laid" (*Pen Drawing,* p. 209). Pennell also points out the important comparison between Walter Crane's work and that of Pyle, especially in the area of their common interest in Dürer and the Renaissance woodcut (Crane's interest is set forth in *Of the Decorative Illustration of Books Old and New,* published in 1896 but based on lectures given in 1889). Crane was active a good ten years before Pyle, but by the 1880s they were doing comparable things in line illustration, influenced by Renaissance woodcuts; compare Crane's *Household Stories, from the Collection of the Bros. Grimm* of 1882, for example, to *The Wonder Clock,* a similar compilation of fairy tales.

The decorative effects vary considerably among Pyle's line-illustrated books. The *Otto* drawings are simpler and more sober in composition and richer in their effects of light and shade than are the illustrations of *Robin Hood, Pepper and Salt,* or *The Wonder Clock.* Whereas the latter tend to overall, decorative, linear patterns, the *Otto* illustrations are characterized by a variety of stippling and hatching and a rich contrast of pure white against dense, dark areas. This richness and variety are carried further in the *King Arthur* drawings of the early 1900s. There is a simpler relationship of picture to text in *Otto of the Silver Hand,* for the drawings happily lack the captions in Gothic lettering that often embellish Pyle's line illustrations. These characteristics are all consistent with the greater seriousness of the story, in comparison to the whimsicality of *Pepper and Salt* or *The Wonder Clock.*

As Pyle describes *Otto* in the foreword: "This tale that I am about to tell is of a little boy who lived and suffered in those dark middle ages; of how he saw both the good and the bad of men, and of how, by gentleness and love and not by strife and hatred, he came at last to stand above other men and to be looked up to by all." The story, which so far as one knows was Pyle's own invention (unlike the *Robin Hood* and Arthurian stories), tells of the feuds of a robber baron; of the kidnapping and cruel mutilation of his young son, Otto, at the hands of a rival baron; and of Otto's eventual rescue and rise to a position of influence in the imperial court. The moralizing element that was omnipresent in nineteenth century children's literature is there, to be sure, but Pyle's writing is so simple and direct, his prose so clear and strong—like the drawings that illustrate the book—that the story's impact is not diminished.

AP □

JOHN J. BOYLE (1851–1917)

Born in New York of immigrant parents, John Joseph Boyle was a descendant of generations of Irish stonecutters. When he was less than a year old, the family moved to Philadelphia, and then to Kittanning, Pennsylvania, where the elder Boyle died in 1857. Boyle was sent back to Philadelphia to live with an uncle. He attended public schools and took up stonecarving in 1872 after serving an apprenticeship to a stonecutter. His training as an artist included the draw-

ing class at the Franklin Institute in 1872, Thomas Eakins's anatomy class at the Philadelphia Sketch Club, and a term of study at the Pennsylvania Academy in 1876 with Eakins and Joseph A. Bailly.

In 1877, Boyle went to Paris and entered the École des Beaux-Arts where he "made rapid progress, receiving a medal before the end of the second year, and at all times great encouragement from the professors [probably Dumont and M. A. Millet]" ("Autobiography of John J. Boyle," *FPAA, An Account of its Origin and Activities from its Foundation in 1871. Issued on the Occasion of its Fiftieth Anniversary 1921,* Philadelphia, 1922, p. 193). Boyle's bronze bust of a Dr. Warren was exhibited at the Salon of 1880. In 1880 he received his first major commission for a group of figures of an Indian family. The exhibition of the completed work, *The Alarm,* in Philadelphia, prior to installation in Chicago's Lincoln Park, resulted in a similar commission from the Fairmount Park Art Association. *Stone Age in America* was erected in West Fairmount Park in 1888.

In 1891, Boyle was back in America to supervise the sculptural decoration of the Transportation Building for the Chicago World's Columbian Exposition of 1893, "employing a number of sculptors to carry out his designs for five huge bas-reliefs, and eight triads of figures of heroic size, besides eight symbolical and eight allegorical single figures" (*The National Cyclopedia of American Biography,* vol. 13, New York, 1906, p. 73). Boyle served on the jury of selection for sculpture at the exposition and won a medal for his bronze work *Tired Out.* When the National Sculpture Society was founded in 1893, Boyle was a charter member.

He returned to Philadelphia in 1893 and commenced work on bronze statues of Plato and Bacon for the Library of Congress. Boyle also received commissions in Philadelphia from the University of Pennsylvania, Bryn Mawr College, the First Unitarian Church, Hahnemann Hospital, and the Penn Charter School. Justus C. Strawbridge of Philadelphia presented Boyle's seated figure of *Benjamin Franklin* to the City of Philadelphia in 1899. Boyle was an active member of the Philadelphia Society of Artists, and exhibited at the Pennsylvania Academy in 1883, 1891–92, 1895–96, 1908–12, and 1915, also serving on its jury of selection and hanging committee.

He moved to New York in 1902 and served on the art commission of the City of New York from 1906 to 1908. Congress allotted fifty thousand dollars in 1906 for a statue of Commodore John Barry by Boyle and the work was unveiled in Washington in 1914. Boyle died three years later in New York.

368. *Study for Stone Age in America*

c. 1886–88

Inscription: TO THEODORE ROOSEVELT/HIS LOVE FOR HUMANITY/JOHN J. BOYLE/ROMAN BRONZE WORKS/N.Y. (rear of base)

Bronze

29 x 13 x 13″ (73.6 x 33 x 33 cm)

Sagamore Hill National Historic Site—National Park Service, Oyster Bay, New York

PROVENANCE: Probably a gift from the sculptor to Theodore Roosevelt

LITERATURE: Taft, *Sculpture*, pp. 404–9, illus. p. 405; Craven, *Sculpture*, pp. 481–83, illus. p. 509, fig. 13.13; FPAA, *Sculpture*, pp. 110–17, illus. pp. 110, 112–17

BOYLE'S FIRST INDIAN GROUP, *The Alarm*, was commissioned by Chicago executive Martin Ryerson, who gave the work to his home city as a memorial to the Ottawa tribe who had adopted him. The artist thoroughly researched his subject for two months on a reservation probably in North Dakota. *The Alarm* so impressed Philadelphians who saw it in clay and plaster in Boyle's studio and in bronze after its casting by the Philadelphia firm of Bureau Brothers that in 1883 the Fairmount Park Art Association commissioned Boyle to do a similar piece for ten thousand dollars.

368.

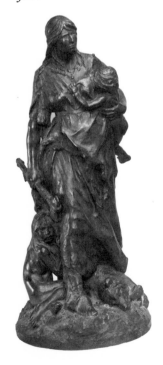

Stone Age in America, like *The Alarm*, represented Boyle's talent for powerful yet naturalistic imagery, but the artist strengthened and improved the later work in several ways. In place of *The Alarm*'s high neoclassical pedestal he set the figures of *Stone Age* on a rough boulder and the whole group on a simple massive base more appropriate to its primitive subject. By simplifying the composition Boyle was able to emphasize the strength of character of the mother's figure without the subsidiary figures' detracting from this effect. The boldly arranged shapes building in a pyramidal composition have a stability and force not found in *The Alarm*, and present the most memorable image of any of John J. Boyle's works.

According to the minutes of the Association, Boyle was "to produce within two years from date of contract, a bronze group of heroic size (7½ feet high) of an Indian mother defending her two children from an attack by an eagle" (quoted in FPAA, *Sculpture*, p. 112). Boyle returned to Paris, where he had been trained, and by the spring of 1885 sent to Philadelphia for approval a photograph of the clay model he produced. Lorado Taft described this composition as "a fine thing, an Indian woman of mighty physique defending her children from a powerful eagle ... which lay upon its back clawing the air and apparently shrieking defiance in impotent rage. The great outspread wings offer beautiful lines, and their shadowy concaves set off the figures most effectively" (Taft, *Sculpture*, p. 408). Despite the previous agreement and the investment of one and one-half years of Boyle's effort, the Association decided that it could not subsidize an image of the national symbol being subdued by an aboriginal woman. Boyle's acquiescence to the Association's wishes resulted in the substitution of a dead bear cub for the eagle, and a consequent diminishing of both the implied threat and the impact made on the composition by the eagle's opened wings.

The plaster model of the revised *Stone Age in America* was exhibited in Paris at the Salon of 1886, and a few months later was cast in bronze by the Thiébaut foundry in Paris. After the bronze was shown at the Salon of 1887 it was shipped to New York and displayed at the first exhibition of the American Art Association. The work was exhibited in Philadelphia at Haseltine's Gallery and outside the Post Office at Ninth and Chestnut streets before it was erected in West Fairmount Park in 1888.

This small bronze study for the original was probably made about 1886–88 and cast at a later date, perhaps during the presidency of Theodore Roosevelt (1901–9), to whom it is dedicated, and presented to him for his home, Sagamore Hill.

AS □

ALEXANDER MILNE CALDER (1846–1923)

Alexander Milne Calder was born in Aberdeen, Scotland, the son of a stonecutter. He studied carving at the Royal Institute of Arts in Edinburgh with the sculptor John Rhind, and also in London and Paris. About 1867 he returned to London where he worked on the carving for the Albert Memorial. Calder came to Philadelphia in 1868 and enrolled at the Pennsylvania Academy of the Fine Arts where he later studied with Joseph A. Bailly and Thomas Eakins.

Calder was hired in 1873 by John McArthur, architect of Philadelphia's new City Hall (no. 334), to design and execute the building's sculptural decorations, a project he worked on for twenty years and which remains his most significant effort. His labors culminated in the twenty-six-ton statue of William Penn, which was placed atop City Hall in 1894.

Calder exhibited "several figures and a carved panel in stone—birds attacked by a snake" (Alexander Milne Calder, "Autobiography," in FPAA, *Annual Report*, Philadelphia, 1897, p. 19) at the Centennial exhibition in 1876, in Academy shows in 1882, 1889, and 1890, and with the Philadelphia Society of Artists in 1882.

Except for the Hayden Memorial Geological Fund Medal that Calder designed for the Academy of Natural Sciences, his other works are portrait statuary, including figures of General George Gordon Meade in Fairmount Park, the ornithologist Alexander Wilson, and John McArthur. Calder was the father of Alexander Stirling Calder (see biography preceding no. 447), and the grandfather of Alexander Calder, the noted creator of the mobile and the stabile. He died in Philadelphia in 1923.

369. *Model for the Statue of William Penn*

1886; cast 1889

Signature: Calder 86 (on base)

Inscription: Cast and finished for/The Aluminum Brass and Bronze Co./by the Henry-Bonnard Co./N.Y. 1889 (on base)

Bronze

28 x 10 x 9½″ (71.1 x 25.4 x 24.1 cm)

Mr. and Mrs. Set Charles Momjian, Huntingdon Valley, Pennsylvania

LITERATURE: Craven, *Sculpture*, pp. 483–86; FPAA, *Sculpture*, pp. 94–109 (illus.)

THE SCULPTURAL PROGRAM of City Hall may be the most ambitious and extensive ever done for a building by a single sculptor in the United States. The original drawing

submitted in 1869 by architect John McArthur was almost devoid of sculptural decoration, but the design in use by 1872 called for more statuary, and the plans became increasingly complex after Alexander Milne Calder was hired as the official "Plaster Modeler" in 1873. The lack of native American sculptors capable of producing effective architectural sculpture in the late nineteenth century and willing to undertake such projects lead to an influx of foreign sculptors who had been trained as both artist and artisan (FPAA, *Sculpture,* p. 98). Alexander Milne Calder's early work as a stonecutter, his exposure to the newly built and decorated Louvre as a student in Paris, his work on the Albert Memorial, and his period of study with Bailly at the Pennsylvania Academy made him uniquely qualified to design the sculptural program for Philadelphia's Second Empire–inspired City Hall. It is difficult to assess how closely McArthur supervised the overall sculptural program, but it was Calder who probably designed and actually built the 250 clay models for the stonecutters, an astonishing output for a man only twenty-seven years old when he won the commission.

A report issued in 1887 by the Commissioners for the Erection of Public Buildings mentioned City Hall's "artistic developments of the first conception, such for instance as the adoption of human figures as the *motif* of decoration, instead of conventional foliage, arabesque or geometric figures, thus permitting a high and more beautiful style of ornamentation" (FPAA, *Sculpture,* p. 97). The elaborate decorations include statues, reliefs, and panels of statesmen and early settlers, and personifications of continents, elements, seasons, and the arts. While the building's iconographic program varies from level to level, the figures on the tower carry out the theme of the founding of Pennsylvania and Philadelphia. The original inhabitants of the area are symbolized by the groups of Indians and Swedes on the north and south corners, respectively, of the tower, which is surmounted by the giant statue of Penn holding the charter of Pennsylvania. Despite this thematic connection with other sculptural groups the *Penn* is notable as the largest free-standing and most visible figure on City Hall, the one Calder considered his major work, and the one which earned him recognition as a sculptor rather than merely as an architectural decorator.

Over the twenty years that he worked on City Hall Calder's method of treating the figures varied through a range of nineteenth century academic styles, but his naturalistic depiction of William Penn was based on thorough research. The Historical Society of Pennsylvania was commissioned to report on the kind of costume Penn would have

worn, and Calder himself studied Benjamin West's *Penn's Treaty with the Indians* in order to capture "William Penn as he is known to Philadelphians; not a theoretical one or a fine English gentleman" (Alexander Milne Calder, *Philadelphia Inquirer,* September 15, 1886, in FPAA, *Sculpture,* p. 107). In addition, because of the great distance from which the statue would be viewed, Calder strove to interpret Penn in a broad, highly legible way, an effect he later claimed was ruined by McArthur's successor who positioned the statue toward the northeast where its face was in shadow while Calder had intended it to be brought into high relief by light from the south.

The problems caused by the size of the figure and the steps by which it was enlarged from the original three-foot sketch that the commissioners approved in 1886 to the twenty-six-ton statue completed in 1892 occupied Calder almost exclusively for six years. A number of bronze casts, as the example here, were taken from the earliest plaster model by the Henry Bonnard Company of New York, a firm which had previously cast bronze work for City Hall, and were evidently intended as souvenirs or ornaments. Calder next modeled a nine-foot figure in clay which was again converted into plaster by a team of assistants headed by John Cassani, an Italian immigrant artisan who specialized in such transfers. The final thirty-six-foot four-inch clay model was slowly built upon a framework of iron and wood. Constructed by sections in a room on the first floor of City Hall where Calder maintained his studio, the plaster version of this figure was completed by August 21, 1888. The giant figure was immediately a victim of its own size, because there was no American foundry that could cast it until Philadelphia's Tacony Iron and Metal Works was established a year and a half later. The statue in fourteen sections was assembled in the courtyard of City Hall in November 1892, and remained on view there, as a tourist attraction, for two years. In 1894 *William Penn* was hoisted onto the tower, where it is the highest point in the city and a well-known landmark in Philadelphia.

AS ☐

WILSON BROTHERS (1876–1902)

The Wilson Brothers, architects, engineers, and planners, are generally credited with being the first of the modern architectural firms offering a full range of professional services. It was formed in Philadelphia in 1876 by brothers Joseph M., Henry, and John Wilson, together with Henry Macomb. Joseph Wilson, the principal partner of the firm, was born in Phoenixville, Pennsylvania, and attended Rensselaer Polytechnic Institute in Troy, New York. After graduating in

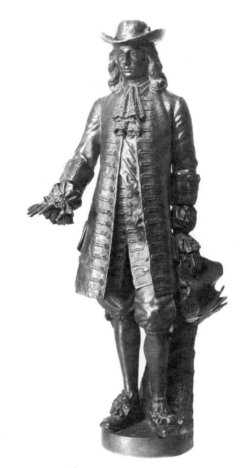

369.

1858, Joseph Wilson found employment in the engineering offices of the Pennsylvania Railroad, where he designed bridges, depots, and other such structures. In the mid-1860s, Wilson worked for John McArthur, Jr. (see biography preceding no. 334), with whom he was associated in presenting an extraordinarily powerful design for the main Centennial exhibition building—a wrought- and cast-iron cathedral of great size. In 1875, Wilson, together with Henry Petit, drew the plans for the major exhibition buildings at the Centennial (no. 339).

The Wilson Brothers continued the engineering and industrial commissions that had characterized Joseph Wilson's early work, but also designed major office buildings, among them the Drexel Building at Fifth and Chestnut streets (1885), the Drexel family home at Thirty-ninth and Locust streets, grand seashore and resort hotels, as well as the Drexel Institute at Thirty-second and Chestnut streets (1892). After Joseph Wilson's death in 1902, the firm continued, first as Wilson, Harris and Richards, and later, until the beginning of the Depression, as Harris and Richards.

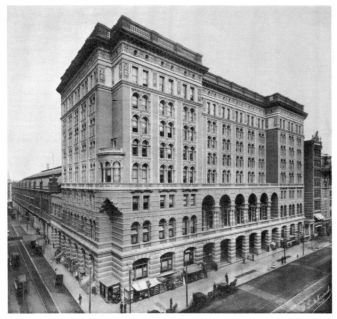

370. *Market Street Facade*

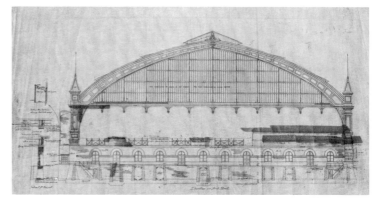

370. *Elevation of Train Shed*

370. *Philadelphia and Reading Terminal*

Market and Arch streets, between
Eleventh and Twelfth
1889–92
Francis A. Kimball, consulting architect
Headhouse: stone base, brick walls, steel
frame, terra-cotta details, copper cornice;
train shed: steel, cast-iron, wrought iron,
glass skylights
266′ 6″ x 506′ (81.2 x 154.2 m)

REPRESENTED BY

Frederick Gutekunst (1832–1917)
Reading Terminal: Market Street Facade
c. 1911
Collotype
17 x 20½″ (43.2 x 52 cm)

The Miller-Plummer Collection of
Photography, Philadelphia

Wilson Brothers
*Elevation of Philadelphia and Reading
Terminal R.R. Station Shed (K-29)
(Section from Arch Street to Filbert
Street, Elevation on Arch Street)*
1891
Ink and pencil on tracing linen
25⅜ x 43¾″ (64.5 x 111.1 cm)

Reading Company, Philadelphia

LITERATURE: *Philadelphia Inquirer*, November 24, 1892; Joseph M. Wilson, "The Philadelphia and Reading Terminal Railroad and Station in Philadelphia," *Transactions of the American Society of Civil Engineers*, vol. 34 (August 1895), pp. 115–84; Carroll L. V. Meeks, *The Railroad Station: An Architectural History* (New Haven, 1956), p. 104

"PROGRESS IN THIS COUNTRY is evidenced in no way more conclusively than in the growth of the railways," wrote Joseph M. Wilson in 1895 ("The Philadelphia and Reading Terminal Railroad and Station in Philadelphia," *Transactions of the American Society of Civil Engineers,* vol. 34, August 1895, p. 115). Few were more qualified to express that view, for in the previous quarter of a century Wilson, first with John McArthur, Jr., and later as the head of the firm of Wilson Brothers, had designed more railroad structures than any other architect in the country. His work culminated with the design of the Philadelphia and Reading Company's Market Street Terminal in 1889, and the train shed for Furness, Evans and Company's Broad Street Station extension of 1893, for the rival Pennsylvania Company.

With the possible exception of various firms of Frank Furness (see biography preceding no. 335), no office was more consistently innovative in late nineteenth century Philadelphia. The Wilson Brothers proved as stylistically flexible as Furness, while their superior knowledge of engineering enabled them to handle the entire range of building types of the late Victorian city—houses, banks, office blocks, factories, bridges, in addition to railroad buildings. Their selection as the architects for the Philadelphia and Reading Company Terminal was the logical outcome of their known abilities.

The Pennsylvania Railroad had established a passenger depot at Eleventh and Market streets in the early 1850s, while in 1890 the Reading was still making do with a variety of smaller depots at considerable

distance from the city center. The increasing competition for passenger traffic and a desire to rival the Pennsylvania Company led to the decision to build a major terminal in the vicinity of Broad and Market streets. Of the large sites available, only that occupied by the Franklin Market at Twelfth and Market streets was both close enough to City Hall and inexpensive enough to warrant consideration. An agreement worked out with the market provided for its continued operation by phasing construction of new facilities within the new terminal complex prior to the demolition of the old building (Wilson, "Philadelphia and Reading Terminal," cited above, pp. 124–28). The market remains to this day a remnant of the era when shoppers rode by rail to center city and left their produce baskets to be filled at the market, after which the baskets were packed and delivered to the owners' homes.

With the market at ground level and the trains arriving from the north on an above-grade viaduct to eliminate street crossings, the basic design decisions were evident. A headhouse, containing waiting rooms, restaurants, and baggage facilities, with railroad offices above, was planned for the Market Street end of the site; behind it the train shed would stretch for more than five hundred feet to Arch Street where the viaduct began. As could be expected with a firm which viewed its achievements in architecture and engineering as co-equal, both headhouse and shed received proper consideration, with each starting from the rational premises of the engineer. Wilson wrote:

In designing a building of this kind and extent, the proper mode of procedure is first to determine a certain unit of square or rectangle by which the ground plan can be divided up into a number of parts, and to the intersecting or division lines of which the columns, walls, partitions, etc., may be made to conform, although it is possible that in special cases some variation from these lines may be necessary. In the present case the key to the arrangement of plans is a unit rectangle of 16 ft. north and south by twenty ft. east and west. . . . ("Philadelphia and Reading Terminal," cited above, p. 129)

So rational a design process seems more of this century than the last. It must have seemed revolutionary to the Reading's directors, who insisted that New York architect Francis A. Kimball be consulted for the detailing of the facade, presumably to insure that an appropriate public face be put on the building. Together, Kimball and the Wilson Brothers developed a broad, severe Renaissance scheme with a heavily rusticated base, above which rose pink brick walls decorated with cream-colored terra-cotta. An attic story covered with the terra-cotta and capped by a heavy copper cornice terminates the facade.

Behind the headhouse rises the immense volume of the train shed, which provides the contrast between architecture and engineering which had characterized the railroad station ever since George Gilbert Scott's St. Pancras Station rose in London in the 1860s. But, unlike Scott's solution, which emphasized the difference between shed and station, the Wilson Brothers unified both, by continuing the rusticated basement under the shed and by designing a Renaissance paneling for the sides.

It is the giant span of the shed, however, which is of greatest interest. Certainly it was the part of the building that most intrigued the architects.

> To the architectural engineer the roof is always an interesting study, and when roofs of a large span are to be considered, the interest proportionately increases. It is not merely that the space is to be covered with a substantial roof, but the architectural question of an artistic design in harmony with the other parts of the building is of first importance. A handsome roof is the refinement of engineering construction. ("Philadelphia and Reading Terminal," cited above, p. 135)

But the roof was not merely an extravagance of the railroad or its architects as Wilson went on to explain:

> The author some years ago designed a number of three hinged arched roofs of the same general type with pointed arch

as in this roof for the Pennsylvania Railroad Company for the Pittsburgh Passenger Station in 1867 of 158 ft. span, one for Washington in 1872 of 110 ft. span and one for Jersey City, also in 1872, of 220 ft. span but they were not adopted and erected on account of their supposed unwarranted expense. Now it has come to be recognized that this is the proper form of roof for a large railroad station, reducing to a minimum the destructive action to the iron or steel construction from the sulphurous vapors emitted by the locomotives, and adding essentially to the comfort and satisfaction of travelers by increased ventilation and improved aesthetic effect. ("Philadelphia and Reading Terminal," cited above, p. 136)

To that end the architectural engineers designed paired three-hinged arches spanning the 266 feet 6 inches of the train level, spaced on 50-foot centers for the 506-foot length of the building. That ribbed structure was roofed over leaving ventilator strips paralleled by glass skylights (now covered over) which brilliantly illuminated the vast shed.

The Reading Terminal was only momentarily the world's largest train shed, for the Wilson Brothers were retained in 1893 to design a span of more than three hundred feet for the Pennsylvania Railroad's Broad Street Station. The Broad Street Station was destroyed by fire in 1923; in recent years the other single-span trainsheds in the United States have been demolished, leaving only that of the Reading Terminal to recall the grand synthesis of engineering and architecture that symbolized the contributions of the railroad architects and heralded the issues of modern architecture.

GT □

371. *Draperies*

c. 1893

Inscription: RFS (monogram, embroidered in keystone at base of one panel)
Label: DESIGNED AND WOVEN / IN THE / INDUSTRIAL / ART SCHOOL / OF THE / PENNSYLVANIA / MUSEUM (woven in keystone at base of other panel)
Gold and gray-green silk-satin damask; trimmed with matching silk fringe and braid; lined in yellow-gold satin
116 x 58" (each panel) (294.6 x 147.3 cm)

Philadelphia Museum of Art. Given by Mrs. John B. Stetson, Jr. 57–6–2a, b

THE TEXTILE DIVISION of the School of Industrial Art of the Pennsylvania Museum of Art was begun in 1884 with the purchase and

gift of several looms and the institution of weaving classes. Today this small, rudimentary textile department has evolved into the much larger, separate, and vital Philadelphia College of Textiles and Science. For many years it was the only school of its kind in the country, offering a number of programs in the area of textile design, creation, and manufacture. From its early days, awards and prizes were distributed for designs created and executed at the school.

The most ambitious articles produced by these classes were several sets of large draperies, including the exhibited pair. These have the words "Designed and Woven in the Industrial Art School of the Pennsylvania Museum" proudly woven into the keystone at the base of one of the two panels; the corresponding keystone on the other panel supports the embroidered monogram RFS, possibly the initials of a member of the Stetson family of Philadelphia, the former owners of these draperies.

Gold and gray-green in color, woven in a satin damask and lined with yellow-gold satin, the draperies are further embellished with scrolling vines undulating along the

371.

sides; flower-filled vases in the central portion; the arms of the state of Pennsylvania at top; and an eagle, stars, and crossed American flags crowning the keystone at bottom. All edges are trimmed with matching silk, intertwining braid with tassels at the pleated bottom corners.

The draperies were made according to techniques listed at the Philadelphia College of Textiles and Science: a 1,200 hook Jacquard machine on a Knowles loom was used, employing 10,920 warp threads (210 per inch) and 120 filling threads to the inch. A total of 28,320 pattern cards was used, each measuring 17 inches in length. The design alone occupied 174 square feet of design paper.

A matching panel hangs in the library of the Philadelphia College of Textiles and Science, with a label stating that the fabric was produced as a part of the School's exhibit at the Columbia Exposition at Chicago in 1893. More than one pair of these "portières" were woven at that time: one was presented to the State of Pennsylvania and hung in the Capitol building in Harrisburg until it was destroyed by fire; a second pair went to the National Association of Wool Manufacturers in Boston; and a third pair was purchased by the Museum of Industrial Art in Stuttgart, Germany. According to the twentieth annual report of the Pennsylvania Museum and School of Industrial Art (1896), there was considerable interest in the draperies when they were shown at a special exhibition in Harrisburg in March 1895. They were considered "probably, the most elaborate example of weaving that has hitherto been produced in America" (p. 26).

CJ □

THOMAS HOVENDEN (1840–1895)

Born in Dunmanway, County Cork, Ireland, Thomas Hovenden was orphaned at the age of six and apprenticed as a young man to a carver and gilder in Cork. He studied at the Cork School of Design, and, after immigrating to New York at the age of twenty-three, at the evening classes of the National Academy of Design while supporting himself as a frame maker.

In 1874 he went to Paris and studied with Alexander Cabanel at the École des Beaux-Arts for several years and later at Pont-Aven in Brittany as part of a small colony of American artists. From the years in Brittany came Hovenden's first significant works, *In Hoc Signo Vinces,* which was shown at the Paris Salon and *A Breton Interior, 1793.* He began to exhibit regularly at the Salon and also participated in the Paris International Exposition of 1878. Hovenden had started exhibiting at the National Academy of Design during his student days, and he

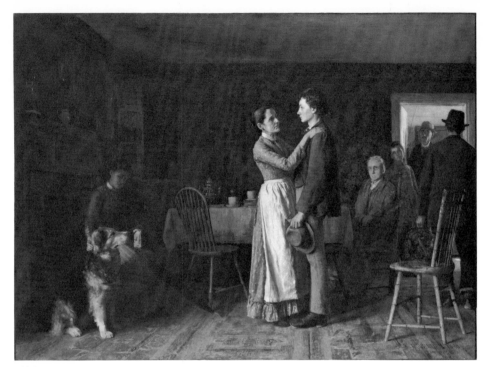

372.

continued to show there during his six years in France.

In 1880 he returned to New York briefly and then settled in Plymouth Meeting, Pennsylvania, with his wife, the artist Helen Corson. Hovenden exhibited with the Philadelphia Society of Artists in 1880, 1882, and 1884, yearly at the National Academy, and at the Pennsylvania Academy in the annual exhibitions of 1885, 1888, 1891, 1893–94, and 1894–95. The Pennsylvania Academy hired him as an instructor, and he began a long and popular teaching career which included Robert Henri among his pupils. During these years he produced a number of popular genre paintings of Negroes, as well as the dramatic *Last Moments of John Brown* of 1884, depicting the abolitionist stopping on his way to the scaffold to kiss a slave baby.

The National Academy elected Hovenden an Associate in 1881 and a full Academician the next year. He was a member of the American Watercolor Society, the Society of American Artists, the Philadelphia Society of Artists, and the New York Etching Club. Hovenden was also a member of the national jury for the Columbian Exposition of 1893 in Chicago and served on its international board of judges for the Department of Fine Arts. It was there that he exhibited the very popular *Breaking Home Ties,* painted in 1890, and later widely distributed through engravings. He was killed in 1895 while trying to rescue a child from the path of a train.

AS

372. *Breaking Home Ties*

1890
Signature: Hovenden 1890 (lower right)
Inscription: Copyrighted 1891 (lower right)
Oil on canvas
52¼ x 72¼" (132.7 x 183.5 cm)
Philadelphia Museum of Art. Given by Ellen Harrison McMichael in memory of C. Emory McMichael. 42–60–1

PROVENANCE: George Harrison, Devon, Pennsylvania, 1893; Charles Custos Harrison, Jr., 1915; Ellen (Harrison) McMichael, until 1942

LITERATURE: Moses P. Handy, ed., *The Official Directory of the World's Columbian Exposition* (Chicago, 1893), p. 892, no. 581; San Francisco, Panama-Pacific Exposition, *Official Catalogue of the Department of Fine Arts* (1915), p. 148; Samuel Isham, *The History of American Painting* (New York, 1915), p. 502, illus. p. 503; Rudolf Wunderlich, "Thomas Hovenden and the American Genre Painters," *The Kennedy Quarterly,* vol. 3, no. 1 (April 1962), p. 3, illus. p. 2; Hermann Warner Williams, Jr., *Mirror to the American Past, A Survey of American Genre Painting: 1750–1900* (Greenwich, Conn., 1973), pp. 214–15

PRAISED IN AN ANONYMOUS POEM as "more than fancy" and "the truest art" ("The Story of the Picture," reprinted in *More Heart Throbs,* New York, 1911, pp. 54–56), and voted the most popular painting at the Chicago World's Columbian Exposition in 1893, *Breaking Home Ties* captured the

American imagination as few other pictures have. First exhibited at the Pennsylvania Academy's annual exhibition in 1891 and after at the Columbian Exposition, *Breaking Home Ties* appealed to the hearts of its viewers, bringing Hovenden to the pinnacle of his career in 1893, just two years before his untimely death. Engravings of the painting were sold throughout the United States and Hovenden became widely known. In 1893, Hovenden painted another scene, similar in format to *Breaking Home Ties,* entitled *Bringing Home the Bride,* almost a sequel in a continuing narrative.

Hovenden's Parisian training had thoroughly acquainted him with the French academic manner of composition and technique, which he applied to American genre scenes. *Breaking Home Ties* is as well structured as a traditional historic or religious subject, with each element taking its place in relation to the central drama of a mother bidding farewell to her son. The scene is acted out with theatrical as well as interior lighting, yet maintains a naturalness necessary to its success.

The artist used models whom he knew well: each figure can be identified as a relative or friend of the Hovendens in Plymouth Meeting, including a portrait of the family dog. Because of a close knowledge of his models his picture lacks the heavy sentimentality of many contemporary genre works. He brought into the home the old drama of departure, relating it to the specific American reality of the changing character of farm life. The 1890s saw the decline of the small family farm and the necessity of young sons to leave the land in order to make a living in the city or on what little was left of the frontier (Hermann Warner Williams, Jr., *Mirror to the American Past, A Survey of American Genre Painting: 1750–1900,* Greenwich, Conn., 1973, p. 215). The scene Hovenden depicted had been enacted in many homes, and the painting gave American families a visual record of their own emotional turmoil. Such disruption of traditional family life is recorded as deeply felt by the artist, who painted a whole range of emotional expression, including the concern of the boy's faithful dog.

Breaking Home Ties was praised equally for its "realistic" technique and adherence to naturalistic detail. Indeed, Hovenden has beautifully painted the play of light across the canvas, highlighting faces, gestures, and the traditional furnishings of a middle-class home, which is comfortable yet simple. The teapot and breakfast plates lie piled on the table; the chairs stand empty, supplying inanimate equivalents to the human drama. The drawing is precise and fine, the paint applied deftly, with deep, rich hues woven across the canvas. Well composed, and sincere in its sentiments, *Breaking Home Ties*

373.

expressed the anxieties and expectations of an age which appreciated the artist's ability to depict them.

CC □

THOMAS EAKINS (1844–1916)
(See biography preceding no. 328)

373. *Walt Whitman*

c. 1891
Platinum print
2½ x 2" (6.5 x 5 cm)
Seymour Adelman, Philadelphia

PROVENANCE: Mrs. Thomas Eakins, until 1938; sister, Mrs. Elizabeth Kenton; given by Mrs. Kenton to the present owner, 1939

IN 1887, Thomas Eakins was introduced to Walt Whitman, who had moved to Camden, New Jersey, in 1873, and the two men remained friends until Whitman's death in 1892. Eakins painted Whitman's portrait in 1888 (Pennsylvania Academy of the Fine Arts), and ten photographs of the poet attributed to Eakins have been separated by Gordon Hendricks into three groups, dated 1888, 1891, and 1892. This photograph, reproduced here for the first time, is apparently cropped from a print of a larger photograph (Hirshhorn Museum), catalogued by Hendricks as no. 154 (*Eakins Photographs,* p. 205).

In the larger version, Whitman is shown in half-length, silhouetted against a shaded corner of the parlor of his house at 328 Mickle Street, Camden. A window, which serves as the primary light source, is at the left of the photograph, the wainscot of the

room forms a horizontal band behind the figure, and a framed picture appears in the background at the upper right. In the version shown here, the photograph has been trimmed to eliminate all interior details except for a bit of the fur rug that covers the chair in which Whitman is seated. The result is an intensified study of Whitman's head against a dark ground that achieves the monumentality of Eakins's painted bust-length portraits. The lighting which defines the structure of Whitman's head in strong contrasts of light and dark and the delicacy of texture and anatomical detail made possible by the tonal sensitivity of the platinum print produce a vigorous portrait utilizing the beauty of photographic technique with a refinement unusual among Eakins's photographs.

DS □

FERDINAND KELLER (EST. 1882)

Ferdinand Keller was born in Germany where he learned the cabinetmaking trade as an apprentice to his father. Keller came to Philadelphia in 1880 and established his firm which was to become one of the foremost Philadelphia houses in importing foreign and domestic antiques and in manufacturing handmade furniture in antique styles. Keller's salesrooms, which employed sixty men, contained thousands of antiques, "from an Indian tomahawk, an old flint-lock gun, to a full suit of armor of the sixteenth century" (*Historical and Commercial Philadelphia,* New York, 1892, p. 251). McElroy's city directory first lists Keller in 1882 at 1212 Ridge Avenue, and his firm was listed at various addresses until 1970.

Three interior views of Ferdinand Keller's antique shop and a photograph of Keller are illustrated in George W. Engelhardt, *Philadelphia, Pa: The Book of Its Bourse and Co-operating Public Bodies, 1898–99* (pp. 90, 91) and show a medley of antique and reproduction chairs of various styles.

374. *Side Chair*

1885–1910
Label: FERDINAND KELLER,/ANTIQUE FURNITURE,/Silver, China and Delft/ 216–218–220 S. 9th St./*Philadelphia, Pa.* (printed paper label, inside right seat rail); William C [...] (in black ink, bottom of label)
Mahogany; white pine; twentieth century upholstery
41 x 24 x 19" (104.14 x 60.96 x 48.26 cm)
Dr. and Mrs. Joseph A. Glick, Wilmington, Delaware

PROVENANCE: Mr. and Mrs. Robert Snow, Columbus, Mississippi; purchase, Mr. and Mrs. Donald Fennimore, Wilmington, Delaware, 1965

In the 1870s as the celebrations of this country's hundredth anniversary of independence approached, there were indications of a Colonial revival in architecture and the decorative arts. As Rodris Roth has pointed out, however, the Centennial exhibition of 1876 almost completely ignored the Colonial revival and no furniture of this kind was ever shown there ("The Colonial Revival and 'Centennial Furniture,'" *The Art Quarterly,* vol. 27, no. 1, 1964, pp. 57–81).

Architects such as Charles Follen McKim were keenly interested in the Colonial period. The seventies also marked the beginning of collections of American Colonial furniture. Dr. Irving Whitall Lyon wrote that in 1877 he began collecting old furniture in and around Hartford: "There were at that time a few others quietly engaged in the same pursuit. The number of collectors gradually increased, and the amount of old furniture gathered by them soon became considerable" (*The Colonial Furniture of New England,* Boston, 1892, p. iii). This was also going on in many other places in New England.

In the 1880s certain American furniture manufacturers such as Ferdinand Keller of Philadelphia began to reproduce Colonial furniture. Keller's firm and the interest in the Colonial period were described:

> Within the last half century or so has grown a public demand on the part of people of refinement for antique furniture; for the original productions where such were available, and also for reproductions of the same. In the eighteenth century the art of furniture making had reached the acme of perfection; royalty and wealth had

encouraged the industry until perfect marvels of workmanship were produced. With the decline of royalty and the advent of the ("People,") these rich creations fell into disfavor, and at the beginning of the present century specimens of antique work could be had for a mere nominal price. These same specimens now command almost fabulous prices. One of the foremost Philadelphia houses engaged in handling goods in this line is Mr. Ferdinand Keller, whose salesrooms are at Nos. 216 and 220 South Ninth Street and his factory at No. 314 Griscom Street. (*Historical and Commercial Philadelphia,* cited above, p. 251)

In the 1880s antiques and reproductions were recommended for use in modern houses, along with modern furniture. The latter, however, was still the type favored by the general public which apparently did not show much interest in the Colonial style.

The term "Colonial" frequently was used in the 1870s and 1880s to refer to furniture produced from the late seventeenth century to the first quarter of the nineteenth century. The eclectic furniture produced under the name Colonial was sometimes only vaguely related to the prototype. As the century progressed, however, and antiquarian interests in America's Colonial period grew, the reproductions of Colonial furniture became more accurate.

This chair produced by Keller's firm, for example, is a fairly faithful copy of a Philadelphia Chippendale chair in the Brooklyn Museum (illus. in Helen Comstock, *American Furniture,* New York, 1962, fig. 226). Since Keller was located on South Ninth Street between 1885 and 1910, the chair can be dated during that period. This chair is very close to eighteenth century prototypes in its motifs and style of carving. The accuracy of the reproduction and the script used on the label would point to a late nineteenth century date.

Keller's was a well known Philadelphia shop in the early twentieth century as well. Entries in Mrs. Charles Edward Ingersoll's journal in 1933 record buying pieces from Keller's: "Sconces either side of tapestry bought by Charles from Keller—Marble Hermes also from Keller.... Table made by Mr. Keller when we moved into 124 So. 19th Street in 1889 ..." (PMA, Archives).

DH □

374.

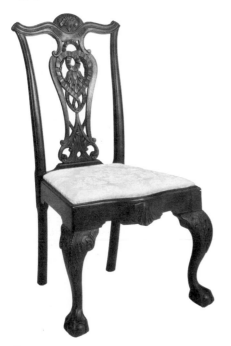

MARY CASSATT (1844–1926)
(See biography preceding no. 354)

375. *The Sailor Boy: Gardner Cassatt*

1892
Signature: Mary Cassatt/Paris 1892 (lower left)
Pastel on tan paper
28 x 23″ (71.1 x 58.4 cm)
Philadelphia Museum of Art. Given by Mrs. Gardner Cassatt. 61–175–1 (reserving life interest)

PROVENANCE: Mrs. Gardner Cassatt, Bryn Mawr, Pennsylvania

LITERATURE: Adelyn Dohme Breeskin, *Mary Cassatt, A Catalogue Raisonné of the Oils, Pastels, Watercolors and Drawings* (Washington, D.C., 1970), p. 106, no. 208 (illus.); Washington, D.C., National Gallery of Art, *Mary Cassatt, 1844–1926* (September 27—November 8, 1970), no. 50 (illus.)

DURING THE 1890s Mary Cassatt devoted much of her time to the theme of mother and child and to portraits of small children, often her own nieces and nephews. The model for *The Sailor Boy: Gardner Cassatt* was the son of her younger brother, Gardner, who lived outside Philadelphia and brought his family to Paris on visits. Young Gardner's portrait is a tender, yet unsentimental study of the boy, dressed in his blue sailor suit. Cassatt captured the moment when he was almost in motion, turning to his right, perhaps trying to rearrange himself during the sitting. A serious child, Gardner was painted again with his sister during Mary Cassatt's visit to America in 1899. The subject of a young boy, dressed in a sailor suit against a lighter background, interested Cassatt at this time, for she undertook a similar painting, *Portrait of Master St. Pierre as a Young Boy,* about 1892.

Pastel, in vogue in France during the eighteenth century, was enjoying another revival there in the mid-nineteenth century by François Millet, Edgar Degas, Édouard Manet, and Henri de Toulouse-Lautrec. Cassatt, who had used the technique briefly during her student years, turned more and more to pastels for her portraits of the early 1890s. She realized some of her most important works in pastel which she continued to use throughout her career. The pastel medium is particularly suited to spontaneous studies, affording a freshness of observation and an intimacy of approach. The colors are vibrant and can be applied directly or mixed on the paper. Cassatt undoubtedly learned the advantages of the direct application of pastel from Degas, whose professional

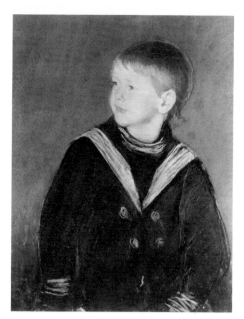

375.

advice she continued to enjoy throughout their long friendship (Adelyn Dohme Breeskin, *Mary Cassatt, A Catalogue Raisonné of the Oils, Pastels, Watercolors and Drawings,* Washington, D.C., 1970, p. 11).

While her pastels could be just a few lines on paper, they also could be as finished as her oils. The freshness of color possible with pastel encouraged her to paint *In the Garden* in 1893, a profusion of pattern and color reminiscent of the Persian miniatures she admired, as well as more subdued, simplified portraits of a few colors heightened with white, such as *The Sailor Boy.*

The small, delicate features of the boy and his fine, blond hair are particularly suited to the medium of pastel. Cassatt varied her use of white here, sometimes employing the thick application which Degas favored, at other times using the delicate wisps of chalk that barely adhere to the paper and just indicate buttons and highlights. Using the pastel medium to its best advantage, Cassatt has created a fine portrait of her nephew.

CC □

CHARLES GRAFLY (1862–1929)

The most influential sculptor in the Beaux-Arts tradition to emerge in Philadelphia in the late nineteenth century, Grafly was a close contemporary of Frederick MacMonnies, George Grey Barnard, Paul Wayland Bartlett, and Lorado Taft, and like them he looked to Paris for his original inspiration. Born in Philadelphia, Grafly was the youngest of eight children. His father owned a farm in Sellersville, Pennsylvania, and also ran a shop in Philadelphia to

sell its produce. At the age of seventeen Grafly became an apprentice in Struther's Stoneyard, where he worked for four years and helped carve the sculptural ornament designed by Alexander Milne Calder for the new Philadelphia City Hall. In 1882 he began to attend evening drawing classes at the Spring Garden Institute and in 1884 he gave up work as a journeyman stonecutter to enroll in the Pennsylvania Academy. A student of Thomas Eakins, Grafly received a thorough training in anatomy and drawing and painting from life. After Eakins's resignation from the Academy, Grafly continued his studies with Thomas Anshutz, who later became a close friend. Robert Henri, Alexander Stirling Calder, Hugh Breckenridge, and Edward Redfield were fellow students at the Academy, and in 1888 Grafly joined Henri on his first extended trip to Paris.

At the Académie Julian in Paris he studied with the sculptor Henri-Michel Chapu (1833–1891), working from the model and preparing allegorical compositions or *esquisses* for his teacher's criticism. In 1890 he won the *prix d'atelier* in a student competition and had two sculptures accepted by the Paris Salon, but failed twice to pass the examination for the École des Beaux-Arts. It is possible that he did succeed in entering the École in the spring of 1891, but no concrete evidence has yet confirmed this. After a brief visit to Philadelphia in the summer of 1890, Grafly returned to Paris and shared a studio with Alexander Stirling Calder. His life-size symbolic female nude, *Mauvais Présage,* won an honorable mention in the Salon of 1891.

In the spring of that year he returned to Philadelphia to teach at the Drexel Institute (until 1895). In 1892 he joined the faculty of the Pennsylvania Academy where he was to continue teaching until his death in 1929. During the years 1892–95, Grafly was part of the lively circle of artists who gathered in Henri's studio. In 1895 he married Frances Sekeles and returned for one final year in Paris, where he received criticism from the academic sculptor Jean Dampt.

Grafly's early work varied between swiftly modeled Rodinesque figures and more smoothly finished allegorical groups (*Symbol of Life, In Much Wisdom*). Lorado Taft pointed out that while most sculptors waited for commissions, "Mr. Grafly is an exception and persists in developing these strange fancies of his in spite of their considerable cost. He seems to think that this is what sculpture is for,—the expression of one's ideas in form,—and he protests that he does it because he 'must' " (*History of American Sculpture,* New York, 1924, p. 508).

Once Grafly was established with a studio in Philadelphia in 1896, his commissions and honors began to multiply swiftly. His first

American award was a medal from the Columbian Exposition in Chicago in 1893, and the same year he became a charter member of the National Sculpture Society. He won a gold medal for his allegorical figure *Vulture of War* at the Paris Exposition of 1900, and was invited to create monumental sculptural groups for the 1901 Pan-American Exposition in Buffalo (*The Fountain of Man*), the 1904 Louisiana Purchase Exposition in St. Louis (*Truth*), and the 1915 Panama-Pacific Exposition in San Francisco (*Pioneer Mother Memorial*).

Along with his interest in symbolic sculpture, Grafly pursued another specialty that brought him equal fame: portrait busts, modeled from life and usually of family members or artist friends. Henry O. Tanner was one of his first subjects (1896), to be followed by Breckenridge (1898), Redfield (1909–10), Frank Duveneck (1915), Bartlett (1916), and Childe Hassam (1918). Among Grafly's most vivid characterizations was the portrait of his old friend Anshutz (which won the Pennsylvania Academy's Widener Medal in 1913), modeled swiftly from memory after the painter's death in 1912. Grafly and his daughter, the art critic Dorothy Grafly, contributed the article on "Portrait Sculpture" to the fourteenth edition of the *Encyclopaedia Britannica.*

Between 1900 and 1910, he created three large works for the Smith Memorial (to Pennsylvania heroes of the Civil War) in Fairmount Park, Philadelphia: colossal busts of John B. Gest and Admiral David D. Porter and a full-length figure of General John Fulton Reynolds.

Beginning in 1902, Grafly and his family spent summers in Massachusetts where he established a studio at his house in Lanesville and took on pupils. In 1917 his teaching duties were further extended when he became head of the modeling department at the Boston Museum's School of Fine Arts. Although preoccupied with teaching (his students included Paul Manship, Albert Laessle, and Albin Polasek), Grafly worked during the last two decades of his life on two major commissions: the Memorial to Major General George Gordon Meade (see no. 433) and a statue of President James Buchanan for Lancaster, Pennsylvania (1925–28). He also provided portrait busts of Admiral Farragut, John Paul Jones, and Jonathan Edwards for the New York Hall of Fame between 1925 and 1928. He was elected to the National Academy of Design (1905) and the National Institute of Arts and Letters, and served on the Municipal Art Jury of Philadelphia from its inception in 1912 until his death.

By 1929 Grafly had achieved great distinction as a leading exponent of a vigorous academic tradition that found itself increasingly in competition with modernist ten-

dencies. Struck by a car while crossing a street, Grafly died in Philadelphia at the age of sixty-seven. The Pennsylvania Academy assembled a memorial exhibition of eighty-eight works in the spring of 1930. An invaluable resource for the study of Grafly's work is the collection of 213 plaster casts given by Dorothy Grafly in 1971 to the Wichita State University Art Museum in Wichita, Kansas.

376. *Aeneas and Anchises*

1893 (cast after 1906, but before 1926)
Signature: Grafly/1893 (lower left front of base)
Inscription: Roman Bronze Works N Y (along rear edge of base)
Bronze
26⅞ x 10¾ x 14¼″ (68.4 x 27.3 x 36.1 cm)
Pennsylvania Academy of the Fine Arts. Gift of the Fellowship of the Academy, 1928

PROVENANCE: Purchased from the artist by the Fellowship of the Pennsylvania Academy of the Fine Arts, 1927

LITERATURE: Philadelphia Sesqui-Centennial, no. 1129; PAFA, *Memorial Exhibition of Work by Charles Grafly* (January 26—March 16, 1930), no. 70 (as *Flight of Aeneas*); PAFA, *150th Anniversary Exhibition* (January 15—March 13, 1955), no. 186, p. 114, illus. p. 117; Craven, *Sculpture*, pp. 438–39, fig. 12.11; Pamela H. Simpson, "The Sculpture of Charles Grafly," Ph.D. thesis, University of Delaware, 1974, no. 30, pp. 30–32, 160–63, fig. 3

AMONG GRAFLY'S FIRST MATURE WORKS, this moving composition of three figures vividly demonstrates his grasp of the most recent developments in contemporary French sculpture. Based on studies begun in his Paris studio but completed after his return to Philadelphia in the summer of 1891, *Aeneas and Anchises* suggests the sculptor's familiarity with the lively modeling and freely worked surfaces of French masters such as Jules Dalou, Jean Dampt, and Emmanuel Frémiet as well as Grafly's own teacher Chapu. Eakins's rigorous instruction in anatomy is evident in his capable handling of the intertwined limbs of the figures, but his approach to the classical subject and the mood of pathos are French in feeling.

The theme is taken from a passage in the *Aeneid* in which the Trojan hero staggers forth from the burning city carrying his aged father Anchises on his back and leading his child Ascanius by the hand. Grafly has conveyed the scene with dramatic effectiveness: we sense the weight of the old man's limbs, and the little boy clinging to his father's right leg accentuates Aeneas's

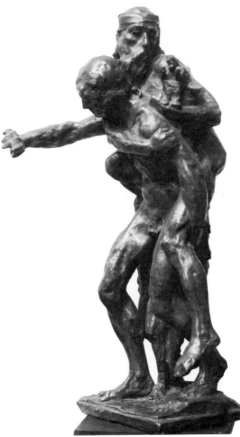

376.

struggle against adversity. With one arm Anchises clasps his son around the shoulders and with the other he cradles the family's Lares and Penates. While the old man's brooding gaze rests on the household gods, his son gropes forward into the uncertain future.

Drawn to allegorical subject matter throughout his career, in his early years Grafly often chose themes with strong overtones of emotion or even violence (*Cain, Daedalus and Icarus*). By the late 1890s, as his style moved toward a calmer, more smoothly finished representation of the human figure, his symbolism grew correspondingly more generalized and often somewhat obscure. *Aeneas and Anchises* may have appealed to him as a direct statement of a theme he was to rephrase in *From Generation to Generation,* a work of 1897–98 (also in the Pennsylvania Academy collection). In the later sculpture, a youth and an old man stand before a dial engraved with the signs of the Zodiac: the boy spins thread onto a spool from a heavy-laden distaff held by the old man. Whatever symbolism is latent in *Aeneas and Anchises* is presented with a spontaneity of execution and sensitivity to the human condition that bears

comparison to Rodin's poignant image of old age, *The Helmet-Maker's Wife* of 1880–83. The young American may not have known that particular work, but certainly Rodin was the consummate master of the sculptural idiom which Grafly handles here with such assurance.

Two other bronze casts of *Aeneas and Anchises* exist. The earliest (bearing the foundry mark of Bureau Brothers, Philadelphia, and probably cast in 1893) was given by Grafly to Edward Redfield and is now owned by Dorothy Grafly, who purchased it from the painter's estate. Another cast, stamped like this one with the mark of the Roman Bronze Works and therefore probably cast after 1906, was the gift of Dorothy Grafly to the Wilmington Society of the Fine Arts in 1962. A plaster cast of the group is among those given by Dorothy Grafly to the Wichita State University Art Museum.

Ad'H □

WILSON EYRE, JR. (1858–1944)

Wilson Eyre was born in Florence, Italy, of American parents. His early interest in art was eventually translated into the more respectable profession of architecture, and in the mid-1870s he entered the Massachusetts Institute of Technology, where he studied under Henry van Brunt. After a year or two of study, he was directed, probably by Van Brunt, to the Philadelphia office of James P. Sims in which he worked from 1877 until Sims's premature death in 1881. Eyre took over the practice and continued the basically anglophile Queen Anne design of buildings, although he gradually merged it with the simple volumes and surfaces and linear, open plans of the Shingle Style.

In 1883, Eyre, together with several younger architects, among them Francis and William L. Price (see biography preceding no. 392), and Robert G. Kennedy, formed the T-Square Club, as an association of young men in architecture who sought to elevate their profession to something higher than mere drawing and the setting of fees. The club joined camaraderie with teaching and practice, in the manner of an ancient guild, and formed a parallel to William Morris's Arts and Crafts movement, reiterating Eyre's interest in English design and theory.

In later years, Eyre explored a number of stylistic variations of the Shingle Style, experimenting with plain walls of brick ornamented with rough tile, as well as the local stone and stucco of the vernacular. His work, and that of Price, went a long way

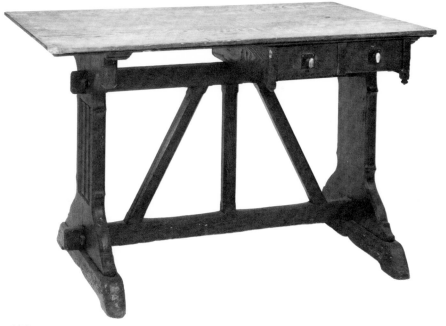

377.

toward establishing the regional quality of domestic architecture which rivaled the midwestern Prairie School. While Eyre was best known for the individuality of his work in domestic architecture, he was one of the designers of the University Museum (see no. 385) and took part in the design of a number of the "City Beautiful" monuments, including Logan Circle (see no. 447).

GT

ATTRIBUTED TO WILSON EYRE, JR.

377. *Drafting Table*

1890–1900
Oak
33¼ x 42¾ x 29¾″ (84.4 x 108.5 x 75.5 cm)
Dr. Edward Teitelman, Camden, New Jersey

PROVENANCE: Wilson Eyre, Jr., Philadelphia; William Heyl Thompson, c. 1944, Philadelphia

DESIGNED FOR EYRE'S OWN STUDIO, this table follows a prototype seen in an oak table by A. W. N. Pugin in about 1850 for Windsor Castle (illus. in Helena Hayward, ed., *World Furniture: An Illustrated History,* New York, 1965, fig. 829). Both tables make use of buttress supports and revealed construction. Pugin and Eyre viewed the Gothic style as a vehicle for reform. A more contemporary prototype was the Gothic

furniture designed by the English architect Sir Edwin Lutyens.

Eyre is shown working at this table in an illustration in Roger Caye's "The Office and Apartments of a Philadelphia Architect" (*Architectural Record,* vol. 34, July 1913, p. 88). According to this article, Eyre gave careful attention to interior details, "some carefully proportioned moulding, some cunning textural device, set by merest chance, at first seeming, but on reflection proving to be the result of deliberate design. . . . Mr. Eyre knows full well the value of these details and usually works out the drawings for them with his own hand. . . . Furthermore, after completing the drawings, he sees to it that competent craftsmen are entrusted with carrying out the carvings in wood or stone or the paintings or leadings in glass so that the finished work may retain, as far as possible, the spirit he has infused into his designs" (p. 84).

As with other architects of his generation, Wilson Eyre turned his attention to interior decorative details including furniture. This table is stylistically similar to other furniture Eyre designed, most of which was built-in, such as fireplace mantels, benches, and cabinets. A sideboard is illustrated in "The Work of Wilson Eyre" (*Architectural Record,* vol. 14, October 1903, p. 308). Although the sideboard makes use of such Gothic motifs as linenfold panels in the upper section, a choice also seen in this drafting table, it is more thoroughly modern in concept and demonstrates that Eyre was familiar with furniture designed by M. H. Baillie Scott, C. F. A. Voysey, and other contemporary English architects.

Among reference scrapbooks from Eyre's office, now in the collection of Hyman Myers, is one which includes photographs and drawings of furniture. Newspaper clippings in the scrapbook showing furniture at an arts and crafts exhibition in London include designs by C. F. A. Voysey and Charles Rennie Mackintosh. These alternate with American pieces including a sketch for a chair by Eyre done in 1888. The scrapbook includes furniture in a variety of styles: a Swiss Gothic writing table, a Chippendale style pier glass, and a Sheraton table.

Most of Eyre's built-in furniture was of a modern style. His attitude toward the use of period furniture is demonstrated by the following contemporary account of Eyre's building interiors: "Mr. Eyre's abhorrence of strict 'period decoration,' however, in his belief that the fittings of a house should be chosen gradually and as far as possible from the simpler examples of the antique lead to results as divergent from the Louis XIV or Empire interiors of the decorator's shop as one could imagine" (Frederick Wallick, " 'Fairacres' and some other Country Houses by Wilson Eyre," *International Studio,* vol. 40, no. 158, April 1910, p. xxxiv).

The guiding principle in Eyre's design as can be seen in the table is basic simplicity stressing craftsmanship with discreetly applied, fine ornament. In his furniture designs, he emphasized honest construction by revealing details such as mortises and tenons. In an undated manuscript lecture for architectural students (University of Pennsylvania?) at the Avery Library, Columbia University, Eyre stated that the main use of ornament was to "describe the building," and "one of the great secrets is to concentrate it . . . let plain surfaces surround it." He suggested that "you do better to have one piece of very good carving at some important point than thirty or forty cheap pieces," and concluded that "a design based on really good principles . . . will stand of itself without ornament, although ornament may improve it." He followed the dicta of English reformists such as Bruce J. Talbert who wrote: "In those old works the wood is solid, the construction honestly shown, and fastened by tenons, pegs, iron clamps, nails, etc. It is to the use of glue that we are indebted for the false construction modern work indulges in: the glue leads to veneering, and veneering to polish" (*Gothic Forms Applied to Furniture Decoration,* Boston, 1873, p. 1).

DH □

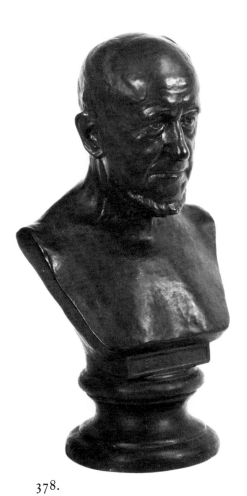

378.

Buffalo and at the Philadelphia Art Club in 1897. Murray exhibited frequently at the Pennsylvania Academy from 1892 to 1933 and served on its jury of selection for sculpture. He was awarded a Silver Medal at the Louisiana Purchase Exposition in St. Louis in 1904.

Well-known examples of his work include the small statuette of Thomas Eakins, sitting cross-legged, the ten statues of prophets for the Witherspoon Building in Philadelphia, the portrait bust of James H. Windrim on the Smith Memorial in Fairmount Park, and the Pennsylvania State monument on the Gettysburg battlefield.

AS

378. *Bust of Benjamin Eakins*

1894
Signature: S. Murray '94 (on back)
Bronze
23½ x 13 x 9" (59.6 x 33 x 22.8 cm)
Philadelphia Museum of Art. Given by Mrs. Samuel Murray. 43-73-1

PROVENANCE: Possibly Thomas Eakins; Mrs. Samuel Murray

LITERATURE: Greensburg, Pa., Westmoreland County Museum of Art, *Two Hundred and Fifty Years of Art in Pennsylvania,* by Paul A. Chew (1959), p. 53, no. 145, illus. pl. 138

THE PHILADELPHIA Art Club's 1894 Gold Medal award was given to Samuel Murray for his plaster version of this portrait bust of Benjamin Eakins, Thomas Eakins's father, at the age of seventy-six. Murray's only formal training as a sculptor was as a student of Eakins at the Philadelphia Art Students' League, and the portrait shows his mastery of the principles of art that Eakins taught. The structure of the old man's head is strongly modeled, with an understanding of anatomy and skillful control of material remarkable in a twenty-four-year-old artist. The surface of the clay in which Murray originally worked is carefully manipulated to build up the figure in solid form and precise anatomical detail without simplification or sleek illusionistic finish. As in Eakins's own portraits, there is no apparent attempt to characterize the sitter by an overt display of stylish technique; the effect of individual personality results from Murray's ability to realize his persistent observation of the model in specific form.

It is possible that Benjamin Eakins posed for Murray and for Thomas Eakins at the same time in the studio that the two artists shared at 1330 Chestnut Street, and that, as Murray modeled this bust, Eakins painted the portrait of his father which he exhibited in his one-man show at Earle's Gallery in May 1896.

DS □

SAMUEL MURRAY (1870–1941)

Samuel Aloysius Murray was born in Philadelphia, the son of an immigrant Irish stonemason. He attended public and parochial schools and in 1887 entered the newly organized Art Students' League, where he studied with Thomas Eakins. Murray became Eakins's assistant and favorite pupil, and the two artists shared a studio at 1330 Chestnut Street for some years. In 1890, Murray was hired as an instructor in modeling from life and a lecturer in anatomy at the Moore Institute of Arts, Sciences and Industry (now Moore College of Art), a position he retained for the rest of his life. Murray exhibited his work widely, including at the National Academy of Design in 1892 and 1893, and at the World's Columbian Exposition in 1893, where he showed a portrait bust of Walt Whitman in bronze, and a study of a child's head and won an honorable mention. The Philadelphia Art Club awarded him a Gold Medal in 1894 for his bust of Thomas Eakins's father, Benjamin, and he won honorable mentions at the Pan-American Exposition of 1901 in

ALLEN & BRO. (1847–1902)

Allen & Bro. was first listed in the Philadelphia directories in 1847, the address given as 119 Spruce Street. The new cabinet-making firm, set up by William, Jr., and Joseph Allen, succeeded that of their father William Allen who had established his cabinetmaking business in 1835 "as dealer in fancy woods and manufacturer of furniture for the trade" (Isaac L. Vansant, ed., *The Royal Road to Wealth, an Illustrated History of the Successful Business Houses of Philadelphia,* Philadelphia, 1869, p. 44). Both sons served their apprenticeships with their father.

The firm of Allen & Bro., according to Vansant, "was under the charge of William, the factory having been from the first under the charge of Joseph. . . . Allen & Bro. continued their ware-rooms on Spruce Street for a number of years, until increasing business demanded more space. In 1850 they removed to a more extensive store on Second Street, built to suit their especial needs. Meanwhile, the factory, which had been located on Ridge Avenue and Eleventh Street, was consumed by fire, and with it most of the stock and material on hand. They soon located a new factory on Twelfth and Pleasant (now Hamilton) streets, where they still remain. Here the senior member of the Firm personally superintends the manufacture of all work, a large portion of which is made from original designs and drawings of his own. Much of the celebrity of Allen Bro. furniture is due to the originality, beauty and variety of design" (p. 45). Although the division of labor was extensive, "all their work is done by hand" and everything "in the entire process of manufacture must pass under his [the head of the business] personal supervision: from the wood in the rough, through every course of construction, until it leaves the finisher's hands" (p. 47). Two-thirds of the business was "custom" or "ordered work."

The reputation of Allen & Bro. for high quality furniture is seen in the pieces they exhibited in the International Exhibition of 1876. Their buffet or sideboard was praised as "an admirable specimen of its kind, and . . . an excellent example of the character of the workmanship for which its manufacturers . . . have more than a mere local reputation" (*Centennial Masterpieces,* vol. 2, p. 14, illus. p. 13). A door produced by the firm was also illustrated (p. 39). *Gems of the Centennial* illustrated two cabinets exhibited (pp. 145, 146).

In 1896 the firm moved to 1606 Chestnut Street, headed by another brother James C. Allen, who had entered the business in 1864. James C. Allen was last listed in the Philadelphia directories in 1902 as a cabinetmaker, residing at 4125 Westminster Avenue.

379.

379. *Reclining Armchair*

c. 1894

Inscription: ALLEN & BRO. PHILADELPHIA
PA./PAT: FEB. 6.94. (cast in the brass
ratchet); TRADEMARK/ALLEN/&/BRO./
1209/CHESTNUT ST./PHILADA./PA./
OXFORD/ARM/CHAIR/REGISTERED/PAT^D
(embossed on brass plaque)

Mahogany; brass hinges, ratchets, and
castors; twentieth century upholstery

41½ x 26½ x 35″ (105 x 67 x 89 cm)

Mr. and Mrs. Anthony A. P. Stuempfig,
Philadelphia

PROVENANCE: Stanislas Tross, Germantown,
until 1971

LITERATURE: Dorothy E. Ellesin, ed., "Collectors
Notes," *Antiques,* vol. 105, no. 5 (May 1974),
pp. 1070–71 (illus.)

THE PROTOTYPE for this adjustable-backed
armchair is the famous chair design by
William Watt in 1883 and produced by
Morris and Company in England. Extremely
popular, the Morris chair was copied by
many manufacturing firms, both in England
and America. An earlier design for a
"Reclining Patent Chair," by the architect
William Pocock is seen in no. 51 of Acker-
mann's *Repository of Arts* (1813). An
American reclining armchair made between
1829 and 1831, bearing the label of the
Boston upholsterer William Hancock, was
illustrated in MMA, *19th-Century America,
Furniture,* fig. 66.

The patent for the version produced by
Allen & Bro. was filed January 13, 1892,
and claimed:

1. The combination, in an adjustable-
back reclining chair, of a seat frame sup-
ported upon legs and provided with arms
which extend rearwardly and at their
rearward portions are provided with slots
formed with approximately vertical
notches,—a back pivoted at its lower
portion to the frame,—a vertically movable
adjusting rod extending through the slots
transversely of the back and behind it,—
and keepers for the rod formed in or
applied to the back,—substantially as set
forth. 2. In a reclining chair having arms
extending rearwardly and at their rear-
ward extremities provided with longitudi-
nal slots and having also a tilting back
pivoted to the main frame,—plates formed
with slots corresponding to those formed
in the arms and provided with approxi-
mately vertical notches and applied to
said arms,—a vertically movable adjusting
rod extending transversely through said
slots to the rear of the back,—and keepers
for the rod formed in or applied to the
back,—substantially as set forth.

A drawing accompanied the patent
application.

Although references to past historical
styles are minimized, the overall form refers
to the Renaissance, and the turned "bobbin"
spindles are reminiscent of the Elizabethan
period. Its importance in the history of
American furniture lies in its adaptation of
a "modern" English design, its mechanical
innovation making comfort possible for the
Victorian Philadelphian who had the leisure
time and money to enjoy it.

DH □

CECILIA BEAUX (1855–1942)
(See biography preceding no. 364)

380. *New England Woman (Mrs. Jedediah H. Richards)*

1895

Signature: Cecilia Beaux (lower left)

Oil on canvas

43 x 24″ (109.2 x 60.9 cm)

Pennsylvania Academy of the Fine Arts,
Philadelphia. Temple Fund Purchase,
1896

LITERATURE: Lorinda Munson Bryant, *American
Pictures and Their Painters* (New York, 1928),
pp. 205–6, illus. opp. p. 205; Cecilia Beaux,

Background with Figures (Boston and New
York, 1930), illus. opp. p. 120; Henry S.
Drinker, *The Paintings and Drawings of Cecilia
Beaux* (Philadelphia, 1955), p. 90, illus. p. 89;
Winthrop and Frances Neilson, *Seven Women:
Great Painters* (Philadelphia, 1969), pp. 118–20,
illus. p. 121; Goodyear, *Beaux,* no. 49, illus. p. 85

New England Woman was painted during
Cecilia Beaux's mature period, at a time
when she completed her most daring and
successful canvases, including *Sita and Sarita*
(1893–94), *Ernesta with Nurse* (1894), and
The Dreamer (1894). Augmenting her
professional success, she became the first
woman faculty member of the Pennsylvania
Academy in 1895 after having been elected
to the Society of American Artists and
awarded a prize at the National Academy
of Design in 1893. *New England Woman*
was exhibited at the Pennsylvania Academy
in 1895–96, subsequently purchased by the
Academy, and then sent to the Champ des
Mars exhibition. After it was returned to
America, the painting was shown in Boston
and New York, and later in Washington,
D.C. While most of her paintings of this
period were completed in her Philadelphia
studio, *New England Woman,* a portrait of
Beaux's cousin, Julia Leavitt (Mrs. Jedediah
H. Richards), was painted during a visit

380.

to the sitter's home in Washington, Connecticut.

Perhaps the most brilliantly executed of Beaux's paintings, *New England Woman* is indeed a "symphony" in white, carefully modulated by light and shade and accented by lavender, yellow, green, and pink. The broad and fluid handling of paint, strength of modeling, and an open brushwork that gives texture to the canvas reflect the artist's early training in the Munich tradition, transmitted by her teacher, William Sartain (Goodyear, *Beaux*, p. 21). Beaux's early preference for dark colors, also in the Munich tradition, was abandoned here in favor of lighter hues. This deliberate concentration on technique is a characteristic Beaux shared with John Singer Sargent, William Merritt Chase, and other of her contemporaries who emphasized the broad and often quick application of paint.

Beaux saw her paintings as color arrangements (Goodyear, *Beaux*, p. 18), relating her work to that of Whistler, whose canvases she knew. Compositionally related to Whistler's *Portrait of the Artist's Mother: Arrangement in Gray and Black, No. 1*, on exhibit at the Pennsylvania Academy in 1881, Beaux's painting enlisted opposite color harmonies, and emphasized the different textures it was possible to paint with white. White was a traditional color for portraits of American women in the nineteenth century, and was used extensively during the resurgence of portraiture in the 1890s. Beginning in 1861, Whistler had painted a series of women in white entitled "symphonies in white," one of which, *The White Girl (Symphony in White No. 1)*, was exhibited at the Metropolitan Museum of Art in New York in 1894–95, where Beaux most likely saw it (*Cecilia Beaux, Portrait of an Artist*, pp. 28–29).

Despite the similarities of dress, fan, and the overall composition, Beaux's *New England Woman* is a personal vision of a woman, staring out of an unseen window, carelessly holding papers in her right hand, palm leaf fan in her left. The breeze from that window softly stirs the white curtains, and a beautiful light enters to be reflected from the whites of the room. The woman's hair, her ribbons, the binding on the fan, and the brass candlestick add colors that complete the study in white. As a personal, not an official, portrait, *New England Woman* displays the strong sense of design and elegant play of light over white that are representative of Cecilia Beaux's finest paintings.

CC □

JOHN SLOAN (1871–1951)

The son of an amateur artist, from a family of cabinetmakers, Sloan was born in Lock Haven, Pennsylvania, and moved to Philadelphia at the age of five. From 1884 to 1888 he attended Central High School, where William Glackens and Albert C. Barnes were classmates. Leaving school to support his parents and two younger sisters (a responsibility he had until the age of thirty), as well as himself, Sloan worked for two years with Porter and Coates, book and print dealers, and then took a job designing novelties for A. Edward Newton's "fancy goods" business. Familiar with the illustrations of Walter Crane and Kate Greenaway from his childhood, he pored over old master prints and taught himself to etch with the aid of P. G. Hamerton's *The Etcher's Handbook*.

His formal art training was surprisingly brief, beginning with a night class in drawing from plaster casts and clothed models at the Spring Garden Institute during 1890–91. In the fall of 1891 he set himself up as a free-lance commercial artist, and early in 1892 he joined the art department of the *Philadelphia Inquirer*, where his black and white line drawings appeared until December 1895. In the fall of 1892 he enrolled in the Pennsylvania Academy for a night class with Thomas Anshutz in drawing from the antique. Glackens and Maxfield Parrish were classmates, and Charles Grafly introduced him to Robert Henri, who at once became his close friend and mentor.

Disappointed with the substitute teacher at the Academy when Anshutz took a leave of absence to study abroad, Sloan joined Henri in founding the Charcoal Club, where some forty students gathered in a photographer's studio to draw from the living model during the spring of 1893. That summer, Sloan did some watercolors out of doors during excursions into the countryside, and he returned to Anshutz's class for one more fall session (which he left in high dudgeon when reprimanded for sketching his fellow students rather than the plaster cast). In the fall of 1893, Sloan and Joe Laub took over Henri's studio at 806 Walnut Street, and Sloan was part of a group that gathered there for amateur theatricals and more serious talk about books and art. Glackens, Everett Shinn, and George Luks were fellow newspaper artists drawn into Henri's coterie.

Sloan's understanding of Japanese art was aided by the visit to Philadelphia in the fall of 1893 of Beisen Kubota, a Japanese illustrator covering the Columbian Exposition in Chicago for a Tokyo newspaper, who taught Sloan and Henri the *sumie* brush and ink technique. In 1895, Sloan was art editor of the short-lived Philadelphia periodical *Moods: A Journal Intime*, creating covers

and illustrations for the three issues in what he called his "poster style." In December he left the *Inquirer* for the Philadelphia *Press*. Later serving as leading artist for the *Press*, he produced full-page color drawings and picture puzzles for the Sunday supplement between 1899 and 1903 (he continued to supply small weekly puzzles until 1910). Unlike Shinn, Luks, and Glackens, who specialized in dashing off sketches for news stories on the spot, Sloan produced decorative drawings, especially the above-mentioned color drawings in the poster style for the Sunday edition.

In 1896 he painted two large murals in the Pennsylvania Academy building in the undulating linear mode related to European Art Nouveau. With Henri's return from Paris in 1897, Sloan commenced his career in oil painting (despite Henri's repeated urging, Sloan was never to visit Europe himself). Using a dark palette, he embarked upon portraits of himself and friends, then scenes of Philadelphia. His first public exposure came in 1900 when the large national exhibitions at the Art Institute of Chicago and the Carnegie Institute each accepted a painting. From 1901 to 1907 he exhibited in every Pennsylvania Academy annual (also showing in Chicago from 1900 to 1906), but made no sales until Dr. Barnes bought *Nude with a Green Scarf* in 1913. His first one-man show came even later, at the Whitney Studio galleries in 1916.

The summer of 1902 brought Sloan's first important commission by way of his friend Glackens: 107 illustrations for the deluxe edition of the light French novels of Charles Paul de Kock. These drawings and etchings are in a lively, realistic style and launched him on an active career as a printmaker of contemporary subjects.

Sloan was the last of the Philadelphia "press gang" to leave for New York. In 1898 he wrote, after a short stint at the *New York Herald*, "I feel more like an artist in Philadelphia," but the loss of his *Press* job and the pressure from Henri and his friends caused him to move to New York in April 1904. Free-lance illustration for magazines like *Collier's* and *The Century* provided a modest income. But his main interest was the subject matter provided by the streets of New York, which appeared in his best known paintings and a suite of ten etchings done in 1905–6. With Henri, he was active in seeking alternatives to Academy exhibitions: he helped organize the show of six of the future Eight at the National Arts Club in 1904 and The Eight's sensational show at the Macbeth Gallery in February 1908.

After substituting occasionally for Henri at the New York Art School, Sloan began his twenty-five-year teaching career in earnest at the Art Students League in 1916. His students were to include Peggy Bacon, Alexander Calder, Lee Gatch, John Graham,

381.

Reginald Marsh, David Smith, Adolph Gottlieb, and Barnett Newman. Lecture notes from his classes were collected by Helen Farr and published as the *Gist of Art* in 1939. A lifetime association with the Kraushaar Galleries began in 1917, and a year later he was elected president of the Society of Independent Artists, a post he held until his death.

Sloan's painterly style underwent several important changes during his later career but never lost the sense of thoughtful deliberation so distinct from Henri's bravura. His death at the age of eighty was followed by a retrospective exhibition of 227 items at the Whitney Museum of American Art, organized by Lloyd Goodrich in 1952. The catalogue for a large exhibition of paintings, drawings, and prints, organized by the National Gallery of Art in 1971, provides a recent authoritative source on Sloan's life and work.

Ad'H and AP

381. *A German-American Ball at the Academy of Music*

1895
Published in the *Philadelphia Inquirer*, January 22, 1895
Signature: John/Sloan (upper left)
India ink over pencil on illustration board
10¹⁵⁄₁₆ x 14″ (27.8 x 35.5 cm)
Gerald Bordman, Philadelphia

PROVENANCE: The artist; with Kraushaar Galleries, before 1938, until 1962; purchased from Kraushaar Galleries, 1962

LITERATURE: Andover, Mass., Addison Gallery of American Art, Phillips Academy, *John Sloan: Retrospective Exhibition, 1938* (1938), p. 79, dated 1896; "Artists of the Philadelphia Press: William Glackens, George Luks, Everett Shinn, John Sloan," *PMA Bulletin*, vol. 41, no. 207 (November 1945), illus. cover; Hanover, N.H., Dartmouth College, *John Sloan: Paintings and Prints* (June 1—September 1, 1946), no. 122; Delaware Art Museum, *The Life and Times of John Sloan* (September 22—October 29, 1961), no. 66, dated 1894 (the wrong drawing is repr. as no. 66 in the illustration)

SLOAN'S ILLUSTRATIONS of his Philadelphia period belong, by and large, to his "poster style." Like the *German-American Ball at the Academy of Music,* they are characterized by an emphasis on contour—often his distinctive "double contours"—by broad, asymmetrically patterned contrasts of black and white or textured areas, by the elimination of modeling and spatial depth, by tilted perspective, or (in the case of the Sunday supplement word-puzzles for the Philadelphia *Press*) by flat areas of strong color and sinuous "whiplash" lines. This carefully worked out, decorative style is entirely different from the quick, on-the-spot, reportorial work that characterizes the newspaper illustrations of Glackens, Luks, or Shinn. Sloan's depiction of the German-American Charity Ball held at the Academy of Music on January 21, 1895, that is the subject of the drawing exhibited here is decorative, not realistic: the graceful contours, sometimes repeated, describe the scene generically rather than in detail (the decorations for the ball, discussed at length in the article the illustration accompanies, are not precisely identifiable in the drawing). Sloan's work for the *Inquirer* (1892–95) consisted largely

of drawings of sports and vacation activities (occasionally a drawing would reappear in the paper at a later date) and of society events, as well as of illustrations for serialized stories, feature articles, and advertisements. His work was just beginning to achieve a certain amount of national recognition at the period this drawing was done, and his black and white manner was developing into a sure, accomplished style.

Still a relatively young man, Sloan was recognized as one of the major exponents of the poster style in America before he "had ever seen the work of Beardsley, McCarter, Bradley, Steinlen, and Toulouse-Lautrec," according to his own account (John Sloan, *Gist of Art,* New York, 1939, p. 1), and he set out in his own writings many of the influences that went into this phase of his development. His uncle was a publisher who worked with Kate Greenaway and Walter Crane in England, and Sloan grew up with good examples of English and American illustration. As he himself put it, "When I started to use drawing as a way of earning a living, the work of Walter Crane, which had been such a familiar part of my childhood, was very naturally the source from which I started to form my concept of design" (Helen Farr Sloan, ed., *American Art Nouveau: The Poster Period of John Sloan,* Lock Haven, Pa., 1967, n.p.).

Sloan also studied the "linear concept of the silhouette" in Botticelli's work and, particularly, Japanese prints. He and the other newspaper artists knew the English line draftsmen such as Leech and Keene, and the artists for *Punch* and the newspapers. Other influences that the artist named as ultimately significant for his poster style were Beardsley—although Sloan did not care for the "decadent and bizarre" quality of the English artist's work—and Steinlen. Although elements of various of these influences are evident in Sloan's drawing, his black and white manner is distinctly individual. In analyzing Sloan's relationship to the poster movement of the nineties, John Bullard commented that "although Sloan was not the first to work in a Poster Style, he was probably the first, perhaps the only, artist to adapt the style to newspaper illustration" (Bullard, "Sloan," p. 35).

At the same time that he was doing newspaper drawings like the *German-American Ball,* Sloan—as well as others—was enthusiastic about illustrating for the "little magazines" (local literary publications, usually short-lived), inspired especially by Beardsley and *The Yellow Book.* As art editor of *Moods* Sloan produced a cover with a lady and a butterfly in a wood that is one of his most striking poster-period works. He also did ink illustrations in the same style as his newspaper drawings for this periodical, and J. J. Gould (see no. 387),

Henri, Glackens, Frederick Gruger, and Sloan's sister Marianna illustrated for it during its short existence. Other "little magazines" for which Sloan did poster-style illustrations in 1895–96 were *The Echo* (Chicago) and *Gil Blas* (Philadelphia). Some of his illustrations appeared as posters, and one of his earliest jobs was designing streetcar advertisements for the Bradley Coal Company in Philadelphia.

It is interesting that at the same time that Sloan was doing the highly decorative, flat, patterned newspaper drawings he was beginning to paint in a realistic, heavily impastoed manner under the influence of Henri. By 1903, a year before he left Philadelphia, he was working in an entirely different manner from his poster style with his so-called realist newspaper illustrations, which were more in the style of Glackens, exploiting the virtuosity of the sketchier pencil or chalk stroke and hatched shading rather than the sinuous contour and the solid area of black, white, or pattern (see his illustrations for the humorous stories by John Kendrick Bangs in the *Press* in 1903; Scott and Bullard, *Sloan*, figs. 26–27). This manner characterizes his later illustrations, in which charcoal or crayon and pencil tend to replace pen and ink.

AP □

ALICE BARBER STEPHENS (1858–1932)

Of the turn-of-the-century illustrators included in this exhibition, Alice Barber Stephens is interesting because she was distinctly the product of Eakins's training rather than Pyle's. Born near Salem, New Jersey, in 1858, she was somewhat older than the members of the Cogslea group (see no. 429) and nearer the age of Pyle, Abbey, and Frost. Her family moved to Philadelphia shortly before she was seven and, according to her own account of her career, because she had always drawn, it was arranged while she was still in secondary school that she would attend the Philadelphia School of Design for Women (now Moore College of Art) one day a week (Mahony and Whitney, p. 70). There she studied wood engraving and was fortunate enough to have as a teacher John Dalziel, a member of a notable English family of engravers who worked with some of the most distinguished English artists of the period from about 1840 to 1890. Dalziel exerted on her "a distinct influence by thought, personality and skill" (Mahony and Whitney, p. 70). He is recorded as teaching wood engraving at the School of Design in 1874–75. Alice Barber was therefore already engraving when she attended the Pennsylvania Academy in 1876–77 and 1879–80.

Her connection with Eakins is demonstrated by the fact that she provided wood engravings after three of his compositions for *Scribner's Monthly,* which appeared in the June 1879 and May and June 1880 issues (E. C. Parry, III, and M. Chamberlin-Hellman, "Thomas Eakins as an Illustrator, 1878–1881," *American Art Journal,* vol. 5, no. 1, May 1973, pp. 30–37). She also provided one of the illustrations for an article by William Brownell on training under Eakins in the Academy schools, published in *Scribner's Monthly* in September 1879 (Parry and Chamberlin-Hellman, cited above, pp. 36–37; William Brownell, "The Art Schools of Philadelphia [with illustrations by the pupils]," *Scribner's Monthly,* vol. 18, no. 5, September 1879, pp. 737–50). She was by this time an accomplished wood engraver. Regarding her study with Eakins, it is interesting that on November 2, 1877, she was one of a number of signers of a petition for an additional women's life class at the Academy, to be directed by Schussele and Eakins. Eakins at the time was not teaching at the Academy (between spring 1877 and spring 1878), having had a falling out with the managers, and this gap in his teaching association with that institution coincides in part with the period (1878) during which Alice Barber is not listed as enrolled, as pointed out by Theodor Siegl.

According to Alice Barber's account of her early career, Eakins introduced her at the end of the seventies to the art editor of Scribner's, Alexander Drake, who was especially concerned with high quality in illustrations at this period (Parry and Chamberlin-Hellman, cited above, pp. 25–26; Pennell, *Pen Drawing,* p. 196). She was supplied with work making engravings for Scribner's, even though she wanted to get away from "the confining work at the block" to do painting and illustration. Her work began to appear steadily in Harper's publications by 1884 (*Harper's Young People,* especially in 1885–89; *Harper's Weekly* from 1890 to 1896; *Harper's Round Table* by 1897; *Harper's Monthly* in the early 1900s; and *Harper's Bazar* by 1910); she also worked for *Cosmopolitan* (by 1895), *Ladies' Home Journal* (by 1898, into the early 1900s), *Life* (by 1895), *Frank Leslie's Illustrated Weekly* (by 1897), *Collier's* (by 1899), *McClure's* (by 1904), and *Woman's Home Companion* (by 1909).

In 1886 she went to London, where, through Edwin Austin Abbey, she met Alma-Tadema. She was already known for her "simple domestic subjects" in Harper's; Alma-Tadema knew them, too, and said he was "glad some one was content to do them" (Mahony and Whitney, p. 70). She continued on to Paris to study at the Académie Julian. In 1888 she was invited to teach life classes at the Philadelphia School of Design for Women by its redoubtable principal

Emily Sartain, who was trying to reorganize the school and improve its faculty and curriculum (*PAFA and Its Women*, pp. 33–34, 38). She taught life classes there from 1888 to 1891, portrait classes in 1891–92, and portrait, pen and ink, and life classes in 1892–93. She is listed as among Pyle's Drexel students (Lykes, "Pyle," p. 349 n. 31), but the Institute can no longer trace these records, and in any case by that time— between 1894 and 1900—she was already a professional teacher and illustrator. In 1890 she married a former fellow student at the Pennsylvania Academy, Charles H. Stephens, and in the same year she won the Mary Smith Prize at the Academy. In 1899 she was invited to teach at the Academy but had to decline due to the pressure of her own work (*PAFA and Its Women*, p. 38).

She was friendly with the Cogslea group from the early 1900s, but she was not actually a part of the group and did not share their close stylistic affinities around this period (although her drawings are close to theirs for a time in the middle of the decade) or their Art Nouveau decorative qualities ("I belonged to the realistic school, of course, being of the time of Thomas Eakins, and used the model, trying to get the real types of children and old people"; Mahony and Whitney, p. 70).

By this time her illustrations were also appearing in books: George Eliot's *Middlemarch* (New York, T. Y. Crowell, 1899), Nathaniel Hawthorne's *The Marble Faun* (Boston, Houghton Mifflin and Co., 1900; original drawings for both of these are in the Library of Congress, Prints and Photographs Division, Cabinet of American Illustration), Louisa May Alcott's *Little Women* (Boston, Little Brown and Co., 1901), Dinah Maria (Mulock) Craik's *John Halifax, Gentleman* (London, Walter Scott Publishing Company, 1903?), Annie Trumbull Slosson's *Fishin' Jimmy* (New York, Charles Scribner's Sons, 1903), and Kate Douglas Wiggin's *The Old Peabody Pew: A Christmas Romance of a Country Church* (Boston, Houghton Mifflin and Co., 1907) and *Susanna and Sue* (illustrated by Alice Barber Stephens and N. C. Wyeth; Boston, Houghton Mifflin and Co., 1909). She was an exhibitor at the Academy from around 1881 to 1890 and a member of the Plastic Club; in later life she lived in Moylan, Pennsylvania, outside Philadelphia, where she died in 1932, aged seventy-four. She had a son, D. Owen Stephens.

382.

Eakins taught technique; his pre-eminent concern was the human figure; he was a painter rather than a draftsman. ("The brush is a more powerful and rapid tool than the point or stump.... There are no lines in nature, ... there are only form and color. The least important, the most changeable, the most difficult thing to catch about a figure is the outline"; Eakins, quoted in Brownell, "Art Schools," cited above, p. 741.) He was certainly not known for turning out illustrators as Pyle was, but he was active in just that area during the years Alice Barber studied painting and drawing with him, and it is certain that she was involved with his work as an illustrator, since she provided wood engravings after his originals. (However, only one of the three engravings she did for Eakins was after a work intended specifically to illustrate a text; the other two were after finished paintings produced independently of illustrative intentions and later adapted to that purpose.) Pyle, on the other hand, taught illustration. He is known to have suppressed the teaching of technique (Lykes, "Pyle," p. 346); his instruction emphasized imagination, grasping the essence of a situation, projecting into a subject. ("The Indian wouldn't see the sea as you have it there [that is *your* sea] but for him it would be a gray mystery peopled with spirits"; Pyle in 1904 as quoted in *Pyle: Diversity in Depth*, p. 19.) He was a master of line and contour, of working with black and white to decorate a page. As Alice Barber Stephens described herself, she was of the "realistic school," and her illustrations from the mid-1880s to the early 1900s are more straightforward and naturalistic than they are part of the decorative trend in illustration of that period (see nos. 413, 429).

A good example of her sympathetic rendering of the plain faces and figures of everyday people and of her visually interesting compositional groupings is the grisaille illustration "Love Feast of the Mannheim Dunkers" for the *Ladies' Home Journal* (July 1898; Library of Congress, Prints and Photographs Division, Cabinet of American Illustration). Several other watercolors in the Cabinet of American Illustration that were published between 1895 and 1898 and that are similar to *Buying Christmas Presents* also show her Eakins-like manner of this period (Alice Barber Stephens file, nos. 26, 28, 33), whereas a number of charcoal and pastel or watercolor illustrations from around 1906 to 1910 evidence a strongly contoured style that is somewhat more decorative and is close in effect to the work of Elizabeth Shippen Green and Jessie Willcox Smith (Cabinet of American Illustration, Alice Barber Stephens file, nos. 53–54, 56, 58–59, 61–62). Pen and ink drawings are a distinctive part of her oeuvre—she would not have absorbed this from Eakins, with his prefer-

382. *Buying Christmas Presents*

1895
Illustration for *Harper's Weekly*, December 14, 1895
Signature: Alice Barber Stephens '95 (in black watercolor, lower left)
Watercolor and gouache over pencil on illustration board
26¼ x 18″ (image) (66.7 x 45.7 cm)
Library of Congress, Washington, D.C.

PROVENANCE: D. Owen Stephens

LITERATURE: *American Illustration*, p. 64

"DURING THE LATTER EIGHTIES and through the nineties, I painted out of doors during the summers, being interested to get the out-of-doors pitch of color, in the swift impressionistic manner.... I was hungry to

use color and the brush; and it strengthened the illustrating" (Alice Barber Stephens, in Mahony and Whitney, p. 71). The soft coloring and misty atmospheric effects in *Buying Christmas Presents,* where the stacks of lamps fade off into darkness, do indeed suggest a desire to overcome the restrictions of the halftone illustration worked over with the graver that was the usual method of reproduction at the time, as is the case here. As one might expect of an artist trained under Eakins, Alice Barber Stephens was much more of a painter than the Pyle group represented in this exhibition—Oakley, Smith, and Elliott tended to work in flat areas of color bounded by heavy contours, especially in their early production, and Parrish worked in outlines and shading with glazes added.

It is interesting to speculate on the differences in training that a budding illustrator would have had with Eakins and with Pyle.

ence for the brush over the pen—and examples of her pen illustrations for Harper's in the second half of the 1880s show her working in the same tradition as other Harper's illustrators of those years, such as C. S. Reinhart, Albert Sterner, or Frederick Dielman.

An old label on the back of *Buying Christmas Presents* identifies the scene as a group of women selecting miniatures at the old Bailey Banks and Biddle store. The well-known Philadelphia jewelry firm was located at Twelfth and Chestnut streets at the time. This is among the artist's handsomest watercolor illustrations, with a marvelous period flavor seen in the lofty space and the elegantly dressed group of people.

AP □

MAXFIELD PARRISH (1870–1966)

Born Frederick Parrish in Philadelphia in 1870, and later adopting the family name Maxfield as a middle name, Parrish began to draw early, his particular manner being shaped more by his own imagination than by much formal training (Christian Brinton, "A Master of Make-Believe," *Century Magazine*, vol. 84, July 1913, p. 345). His father, Stephen Parrish, an artist who turned professional only in his early thirties, was known particularly for his etchings, and Parrish credited him with being his most influential teacher. Maxfield studied at the Pennsylvania Academy from 1892 to 1894, after attending Haverford College from 1888 to 1891, but according to Christian Brinton, Parrish's roommate at Haverford and later a writer on art, the interval of formal training "was wholly superfluous, for he was already a draftsman and colorist of individuality and power" (Brinton, cited above, p. 345).

Indeed, Parrish's professional career was launched by 1894, at least, with his decorations for the Mask and Wig Club, the University of Pennsylvania's thespian society, and he published his first cover for a national magazine, *Harper's Bazar*, with the Easter 1895 issue. Both these works are flat, linear, and decorative, very turn-of-the-century in conception. Parrish is said to have studied for a bit with Pyle at Drexel, but Pyle considered his work already too advanced for his classes (Ludwig, *Parrish*, p. 14); in any case, there is no record of his having been registered at Drexel. Nevertheless, it is easy to see how Pyle's work, and especially the giants and gnomes of books like *The Wonder Clock*, would have appealed to Parrish's imagination, as the younger illustrator's creatures of invention were often similar drolleries.

Parrish maintained studios in downtown Philadelphia during this period. In June 1895 he married Lydia Austin, a painting instructor at Drexel who later became an authority on American Negro folk songs. Immediately afterward he left for his second European trip, visiting salons and museums in Brussels, Paris, and London. In 1897 he was elected to membership in the Society of American Artists, and his first complete illustrated book, *Mother Goose in Prose* by L. Frank Baum (Chicago, Way and Williams, 1897), appeared the same year. In March 1898 he left Philadelphia for Cornish, New Hampshire, where he lived until his death sixty-eight years later.

Although he cannot be claimed as a Philadelphia artist after 1898, Parrish's background was pure Philadelphia Quaker and his essential style was formed here. His connection with the Academy continued after his departure from the city—he was a member of the jury for the Academy's centennial exhibition in 1905 and was represented by a number of works in that exhibition, and he continued to exhibit at the Academy annuals and annual watercolor exhibitions until 1912. In 1908 he won the Beck Prize for watercolors. He was an honorary member of the Philadelphia Water Color Club from 1912 or 1913.

Between 1898 and 1901, just after his departure from Philadelphia, Parrish did some of his finest book illustrations, those to Washington Irving's "Knickerbocker's" *History of New York* (New York, R. H. Russell, 1900) and Kenneth Grahame's *The Golden Age* (London, John Lane, The Bodley Head, 1899) and *Dream Days* (London, John Lane, The Bodley Head, 1902). By this time his particular technique of combined media—pen and ink, collage, lithographic crayon, and Rossboard (commercially prepared board indented with patterns)—was developed. The distinctive stippled effect that he achieved with lithographic crayon on textured paper or board could be used to provide highly illusionistic effects that were developed to a greater degree in his later work. He was also producing illustrations for a number of periodicals by this time, including the *Book Buyer, Century Magazine, Everybody's Magazine, Ladies' Home Journal, Life, St. Nicholas, Scribner's Magazine*, and various Harper's publications, the *Monthly, Weekly, Young People*, and *Round Table* (see Ludwig, *Parrish*, pp. 207–12).

In spring of 1903 the Century Company sent him to Italy to gather material for *Italian Villas and Their Gardens*, with text by Edith Wharton (New York, The Century Company, 1904, first published in the *Century Magazine*, 1903–4). Some of these illustrations were reproduced in color, and in 1904 his first book with all color illustra-

tions appeared, Eugene Field's *Poems of Childhood* (New York, Charles Scribner's Sons, 1904). Also in 1904 he exhibited two illustrations at the Universal Exposition in St. Louis, and between 1904 and 1910 he was under an exclusive contract to Collier's. He had won an honorable mention at the Paris Exposition of 1900 and a Silver Medal at the Pan-American Exposition in Buffalo, New York, in 1901, and in 1906 he was elected a member of the National Academy of Design.

Advertising and poster commissions formed an important part of his early work; he won a number of poster competitions and was a significant figure in American poster art during the latter half of the 1890s (see no. 386). His advertisements are decorative and imaginative to an unusual degree; the calendars that he did for General Electric Mazda Lamps in the twenties and thirties were especially popular and are examples of his particular combinations of highly illusionistic representation with exotic or romantic characters.

By 1905, Parrish's developing commitment to mural painting was such that he had to begin building a larger studio. The *Old King Cole* mural for the Knickerbocker Hotel bar in New York (now in the St. Regis Hotel) was painted in Cornish in 1906, the subject having been earlier employed in Philadelphia. In 1909 he painted a mural depicting the *Pied Piper* for the Palace Hotel in San Francisco and, about 1910, *Sing a Song of Sixpence* for the Sherman Hotel in Chicago. His other major mural commissions were those for the Curtis Publishing Company in Philadelphia (1911–16), the reception room of Mrs. Harry Payne Whitney's studio in Wheatley Hills, Long Island (1914–18), the Eastman Theater in Rochester, New York (1922), and the Irénée Du Pont house in Granogue, Delaware (1933; see Ludwig, *Parrish*, figs. 96–101).

From around 1910, Parrish was much occupied with murals, with magazine illustration (especially *Life* covers in the early twenties), with advertisements and posters, and with paintings to be reproduced as calendars, greeting cards, or color reproductions for framing. Many of his works done originally for books, magazines, or murals were reproduced as "art prints," and this did a great deal to ensure his reputation as one of the most widely known American painters. His major late book commission was the illustrations to Louise Saunders's *The Knave of Hearts* (New York, Charles Scribner's Sons, 1925).

During the last thirty years of his life, Parrish painted landscapes almost exclusively, frequently for calendars or greeting cards. His critical reputation waned to some extent, and he was known as a "popular" rather than a "fine" artist. Nevertheless, interest in his work has revived since the

383.

1960s, when a number of exhibitions of his art were mounted (Ludwig, *Parrish*, p. 8; Lawrence Alloway, "The Return of Maxfield Parrish," *Show*, vol. 4, May 1964, pp. 62–67).

383. *Old King Cole*

1895

Inscription: Painted for the Mask and Wig Club of the University of Pennsylvania By F. Maxfield Parrish, 1895 (in shield, lower right); Old King Cole (in banderole, lower center)

Oil on canvas

44 x 132″ (111.7 x 335.2 cm)

The Mask and Wig Club of the University of Pennsylvania, Philadelphia

LITERATURE: James B. Carrington, "The Work of Maxfield Parrish," *The Book Buyer*, vol. 16 (April 1898), p. 221; Homer Saint Gaudens, "Maxfield Parrish," *The Critic*, vol. 46 (June 1905), pp. 512–13; Christian Brinton, "A Master of Make-Believe," *Century Magazine*, vol. 84 (July 1913), p. 349; *The Art Guide to Philadelphia* (Philadelphia, 1925), p. 63; Ludwig, *Parrish*, pp. 14, 151–53, pl. 43; Chadds Ford, Pa., Brandywine River Museum, *Maxfield Parrish: Master of Make-Believe* (June 1—September 2, 1974), no. 2; Southampton, N.Y., Parrish Art Museum, *The Dream World of Maxfield Parrish* (June 8—July 20, 1975)

THE MURAL NOW LOCATED OVER THE BAR in the grillroom of the Mask and Wig Club, 310 South Quince Street, Philadelphia, was Parrish's first major commission in the city, undertaken as he was finishing his studies at the Academy. Founded in 1889, the Mask and Wig Club of the University of Pennsylvania is the second oldest college undergraduate dramatic club in the country. In

1893 the club bought the building on Quince Street, then used as a stable, for its clubhouse and theater. Wilson Eyre, Jr. (see biography preceding no. 377), who had recently designed Parrish's father's home in New Hampshire, was the architect commissioned to adapt it to the club's use, and Parrish was chosen to design the wall decorations. The building went through three successive stages of alterations between 1894 and 1904; Parrish was involved only in the first and least drastic, and it seems to survive today in very much the same shape as it was in 1904 (see Helen Henderson, "The Artistic Home of the Mask and Wig Club of the University of Pennsylvania," *House and Garden*, vol. 5, no. 4, April 1904, pp. 168–74).

In the first alterations (1894), only the most necessary changes were made to render the stable usable as a clubhouse and theater. The hayloft was converted into an auditorium with a small stage, and in April 1894, Parrish wrote to his father that he was working on the proscenium arch decorations (Ludwig, *Parrish*, pp. 151–52). These were quickly finished; they show, on opposite sides of the arch, a male and a female figure in medieval style costumes holding aloft shields with the masks of comedy and tragedy in relief. (Parrish's decorations were damaged when the stage and auditorium were deepened in 1903, according to Henderson, and were restored by Lyman Saÿen.)

Parrish's other works for the club include decoration on the wall around the ticket window, consisting of an ornamental framework with two pierrots (destroyed in the 1903 alterations; a sketch is reproduced in Henderson, cited above, p. 169); a bulletin board (no longer extant; reproduced in Henderson, cited above, p. 174); four pro-

gram covers (1895–98; originals for two of these are still in the club's possession); and caricatures on the grillroom wainscoting decorating the pegs for the members' beer mugs (a few are reproduced in Ludwig, *Parrish*, fig. 94).

The major and most accomplished work that Parrish provided for the club was the *Old King Cole* mural shown here, dated 1895 on the canvas. The setting is apparently much the same as it was originally, with a huge fireplace, in which Mercer tiles replaced bricks around the turn of the century, a beamed ceiling, and dark wainscoting brightly decorated with the above-mentioned beer mugs and accompanying caricatures. Eyre designed furniture for the grillroom, much of which has disappeared, carrying out the Tyrolese intention of the architecture, and an upright piano with rather remarkable ornamentation, which from 1898 on was to be seen beneath the mural (Henderson, cited above, p. 172, illus. p. 171).

The watercolor study for the mural was exhibited at the Pennsylvania Academy in 1894–95, and the Academy purchased it in 1895 (it is signed "Maxfield Parrish 1894" and was exhibited again at the Architectural League of New York early in 1895; *Harper's Weekly*, vol. 39, March 2, 1895, pp. 197–98, illus.). The study is like the painting in arrangement but differs in details. Another study, formerly in the collection of Maxfield Parrish, Jr., was exhibited in the 1966 Parrish retrospective (Springfield, Massachusetts, The George Walter Vincent Smith Art Museum, and Syracuse University, Lowe Art Center, *Maxfield Parrish: A Retrospect*, January 23—April 30, 1966, no. 102). This was the first sketch for the mural, in ink and watercolor on brown wrapping paper.

The flat areas of color and the strongly

defined outlines of the *Old King Cole* mural are primarily characteristic of Parrish's very early work of around 1895–98, while he was in Philadelphia and when he would have been most under the influence of Pyle (see no. 388). The *Old King Cole* mural painted for the Hotel Knickerbocker in New York eleven or so years later is much more illusionistic; the flat patterning has disappeared, but the strong architectural elements remain (Ludwig, *Parrish,* fig. 93). The emphasis on patterns seen in the Mask and Wig mural remained part of Parrish's style; later, however, he tended to localize patterned areas rather than to treat them as elements in a flat, overall decorative pattern. The rich, strong coloring of the mural has been mentioned from its first critical notices (James B. Carrington, "The Work of Maxfield Parrish," *The Book Buyer,* vol. 16, April 1898, p. 222), as has the marvelously pure, lyrical line that, combined with a strong, spare, architectonic sense of composition, characterizes this work and the early black and white book illustrations like *Mother Goose in Prose,* "Knickerbocker's" *History,* and *The Golden Age.* Although the painting was the artist's first large commission and was done when he was still essentially a student, it demonstrates the marvelously playful imagination that was to mark his work for many years. With his knaves and gnomes, nursery rhymes and romantic characters, Parrish created a world belonging neither to the adult nor the child, or perhaps to both, a world characterized visually by an extreme sophistication of line and design.

AP □

WILLIAM GLACKENS (1870–1938)

Glackens was born at 3214 Sansom Street in Philadelphia, the youngest of three children of an employee of the Pennsylvania Railroad. He attended Central High School, where John Sloan and Albert C. Barnes were fellow students, graduating in 1889. Signing up as an artist-reporter on the Philadelphia *Record* in 1891, he soon left for the staff of the *Press* (in 1892) where he was joined by Everett Shinn (1893), George Luks (1894), and John Sloan (1895). In 1893 he worked for the Philadelphia *Public Ledger* and in 1894 again for the *Press.* Gifted with a visual memory which enabled him to record locales and events with astonishing accuracy, by all accounts Glackens outstripped his friends in the speed and facility with which he produced his news illustrations. From 1892 to 1894 he enrolled in night classes at the Pennsylvania Academy, studying with Henry Thouron and Thomas Anshutz and painting a large, stylized mural on the subject of "Justice" for the Academy walls. In 1894 he became good friends with Robert

384.

Henri, sharing his studio at 1717 Chestnut Street and participating in the lively discussions and boisterous theatricals generated by a group of art students attracted by Henri's leadership.

Early in June 1895, Glackens set sail for France with a group of Philadelphia friends including Charles Grafly, Elmer Schofield, and Henri. With the latter two he made a bicycle trip to Holland and Belgium to study the work of the Dutch masters, particularly Rembrandt and Frans Hals, of whom Henri was so fond. In Paris during the fall he took a studio near Henri's, and together they painted Paris street scenes and the countryside around Fontainebleau. Glackens never entered any of the French art schools; his academic training was limited to the two years of part-time study in Philadelphia, and the primary influences on his early career were the painting and philosophy of Henri and the visits in his company to European museums.

Returning to the United States in 1896 he joined Luks in New York, becoming the second of the future members of The Eight to leave Philadelphia, and the two briefly shared a studio. Glackens continued his successful career as an illustrator for the New York *Herald* and the *World.* In June 1898, *McClure's Magazine* sent him as special correspondent to Cuba to illustrate the story of the Spanish-American War, and he produced a spectacular set of drawings on the spot (see no. 391).

While continuing to earn a living as a free-lance illustrator, Glackens became increasingly absorbed in his painting. Starting in 1896 he exhibited regularly in Pennsylvania Academy annuals, and in 1901 he was included in a small show organized by Henri at the Allan Gallery in New York (with John Sloan, Alfred Maurer, Henri, and three others), where his work was singled out for praise by the critic of the *Evening Sun.* During 1902–4, he executed numerous illustrations for the spicy French novels of Charles Paul de Kock, an ambitious (but ill-fated) commission which he in turn shared with Sloan and Luks.

His acknowledged masterpiece, *Chez Mouquin* (now in the Art Institute of Chicago), was painted in 1905. It is a brilliant study of the proprietor of the Café Francis, a favorite gathering place of Henri's circle in New York, and his fashionable companion. Although Glackens shared in the exhibitions and activities of The Eight (the National Arts Club show of 1904, The Eight at the Macbeth Gallery in 1908), he was not a prime mover in their rebellion against the academies. One of the most "modern" of The Eight in his tastes, he was chairman of the committee to select American art for the Armory Show and was the first president of the Society of Independent Artists.

While continuing to live in New York, he had an important impact on the Philadelphia art scene through his relationship with Dr. Barnes, who around 1910 began to rely on his advice in acquiring the latest French works for his collection. It is thus no accident that Barnes was the most important Philadelphia patron for The Eight; and Glackens's deep admiration for Renoir is reflected in

the magnificent examples of his work at the Barnes Foundation. Renoir's influence also increasingly appeared in Glackens's own painting after 1910.

During the last two decades of his life he spent much time abroad, painting in France and winning the Grand Prix in the 1937 Paris Exposition the year before he died. A memorial exhibition of 132 works was organized by his friends Guy Pène du Bois, Leon Kroll, and Eugene Speicher for the Whitney Museum of American Art in December 1938.

384. *La Villette*

c. 1895
Oil on canvas
25 x 30″ (63.5 x 76.2 cm)
Museum of Art, Carnegie Institute, Pittsburgh

PROVENANCE: With Kraushaar Galleries, New York, until 1956

LITERATURE: New York, Kraushaar Galleries, *Paintings and Drawings by William Glackens* (January 3—29, 1949), no. 2 (illus.); Gordon B. Washburn, "New American Paintings Acquired," *Carnegie Magazine*, vol. 30, no. 6 (June 1956), pp. 193–94, illus. p. 197; Ira Glackens, *William Glackens and the Ashcan Group: The Emergence of Realism in American Art* (New York, 1957), illus.; Bennard B. Perlman, *The Immortal Eight* (New York, 1962), illus.; St. Louis Art Museum, *William Glackens in Retrospect* (November 18—December 31, 1966), no. 3 (illus.); Houston, Meredith Long Gallery, *Americans at Home and Abroad 1870–1920* (March 26—April 9, 1971), no. 14, p. 29 (illus.); Pittsburgh, Carnegie Institute, *Catalogue of Painting Collection*, 1973, p. 65

GLACKENS's DECISION to become a painter despite his success as a newspaper illustrator was in good measure inspired by the example and the eloquence of Robert Henri. Responding to the latter's conviction that Europe provided the richest training ground for an artist, Glackens accompanied his friend to Paris in the spring of 1895. Henri introduced him to the masterpieces of the Louvre as well as his favorite haunts for painting in the forest of Fontainebleau and the streets and parks of the city.

La Villette was one of Glackens's first successful Paris pictures, and although closely related to Henri's work of the period it is by no means derivative. The subject is typical for a future member of The Eight: a modern urban scene, but here rendered with an elegance devoid of any social consciousness. The northeastern commercial section of Paris called La Villette was famous at the time for its open-air livestock market and slaughter houses. Some twelve hundred barges per

385.

month moved their cargo in and out of the large boat basin, which marked the confluence of two canals connecting the Seine with a tributary of the Marne. Nothing of this workaday activity appears in Glackens's painting, which focuses on the slender cast-iron foot bridge, curving in a span of 310 feet across the widest part of the water. The colors are light and softly brushed; the figure of a man with his dog and the silhouette of a woman passing across the bridge are deftly formed with one or two rapid strokes. It is his use of the bridge as a decorative element —a dark outline against the sky and house facades—that recalls Glackens's experience as an illustrator, giving his composition an ordered grace somewhat remote from Henri's more casual arrangements. Glackens was an ardent admirer of Manet, a taste acquired on his first Parisian visit, and elements of the French master's deliberate compositional devices may be echoed here. The palette of pastel tints—subdued but still quite distinct from Henri's brown, gray, and gold tones—also suggests that Glackens may already have been looking at the work of the Impressionists, which was then being shown in Paris. (A controversial group of their paintings in the Caillebotte Bequest was hung in the Musée de Luxembourg in February 1896). Glackens's view of *La Villette* may have reflected his familiarity with the blurred, dazzling street scenes of Monet and Renoir; the latter was to become the greatest single influence on the young Philadelphian's later work.

Ad'H □

WILSON EYRE, JR. (SEE BIOGRAPHY PRECEDING NO. 377), FRANK MILES DAY AND BROTHER (SEE BIOGRAPHY PRECEDING NO. 366), AND COPE AND STEWARDSON (EST. 1886)

385. *University Museum, University of Pennsylvania*

Thirty-third and Spruce streets
1895–99; additions 1912, 1926, 1969
Brick and steel structure; marble detailing; tile decoration, Gustavino tile vaults

REPRESENTED BY:

Wilson Eyre, Jr. (1858–1944)
Perspective of the University Museum
1896
Pastel on heavy rag paper
24 x 36¾″ (61 x 93.3 cm)
Fine Arts Library, University of Pennsylvania, Philadelphia

Wilson Eyre, Jr.
Plan of Main Floor
1929
Photostat
14 x 17⅝″ (35.5 x 39.6 cm)
Fine Arts Library, University of Pennsylvania, Philadelphia

LITERATURE: "The New Museum Building," *Bulletin of the Free Museum of Science and Art*, vol. 2, no. 2 (June 1899), pp. 69–72; Montgomery Schuyler, "The Architecture of

385. *Plan of Main Floor*

American Colleges," *Architectural Record* (September 1910), pp. 182–211; White, *Philadelphia Architecture,* p. 33, no. 71; Tatum, pp. 121–22, 199, no. 129

WHEN THE DEPARTMENTS of archaeology and paleontology were founded at the University of Pennsylvania in the 1880s, little thought was given to the exhibition of artifacts either discovered at university-directed excavations or acquired by gift or purchase. Furness, Evans and Company, in their design for the new University Library, included some exhibition spaces—in the stair hall and in the reading rooms (PMA, *Furness,* illus. pp. 168, 171). But, even before the library was completed, successful archaeological expeditions had filled the available space to overflowing, and additional display areas were found in the new Wistar Institute building, completed in 1892 from the plans of George W. and William D. Hewitt.

Encouraged by several generous donations to a building fund, the museum board appointed a building committee, which was authorized to choose architects and to develop a scheme for the new Free Museum of Science and Art. Instead of selecting one architect, the committee asked Wilson Eyre, John Stewardson, Walter Cope, and Frank Miles Day to collaborate on the design. Why they made that decision is only hinted in the building committee minutes, which merely noted that the four were on the staff of the University School of Architecture (University Museum, Minutes of the Building Committee, January 20, 1893). But other reasons can be deduced. Cope and Stewardson were then the architects for the university, while Day had recently completed the Art Club on South Broad Street (no. 366), and his work was thus familiar to the members of the board, most of whom were members of that club. Eyre, on the other hand, was universally recognized as one of the leading designers of his day. Each seems to have taken charge of specific areas of the project, Day's office being in charge of structure and the working drawings, Cope and Stewardson

serving as a liaison with the university, while Eyre did most of the designing.

The architects proceeded, guided by instructions to produce a design for a building that was fireproof, large, but of small cost, and capable of being constructed in phases ("The New Museum Building," *Bulletin of the Free Museum of Science and Art,* vol. 10, no. 2, June 1899, p. 59). At least two different schemes resulted, one a grand, white-marble Pantheon-like building, with flanking wings, each containing a courtyard; the other, a rather simple gable-roofed brick building with wings that enclosed small courts projecting forward from the principal block and flanking a large central court. Drawings of both designs are in the Fine Arts Library of the university (collection of Wilson Eyre drawings). The rotunda of the Roman scheme appealed to the committee, which asked the architects to combine aspects of both projects, to aim at something both monumental and less expensive. The committee minutes for October 1893 noted: "After some discussion, the possibility of enlarging the plans was suggested ... arguing that it was easier when dealing with large men to do large things than small ones." Large "men" they were, for the board numbered among its members and advisers, Clarence H. Clark, William West Frazer, John Wanamaker, William S. Elkins, Phoebe Hearst, Peter A. B. Widener, and Samuel F. Houston. With their support, a city ordinance was passed in 1894 deeding a tract of land to the museum for the purpose of erecting a free museum and public garden. The following year the state matched the $150,000 raised by the committee, and in 1896 construction began on the building. Three years later the first wing was completed, and the museum opened its doors to the public in December of 1899.

Instead of erecting the entire project, which by 1895 included three courtyards along South Street, each with a central gabled entrance block and immense domed rotundas to the rear, only the first court was built, with the remainder to be built when money became available. Like so many other ambitious projects, the museum remains incomplete, although the first rotunda was added in 1912, and the principal wing, in the 1920s; however, still more than half of the project has been left undone (see *Philadelphia Real Estate Record and Builder's Guide,* vol. 27, no. 12, March 20, 1912; vol. 38, no. 3, January 17, 1923). As a result, the circulation system remains fragmentary, with culs-de-sac resulting where planned connections were to be built; moreover, the lower level has been incorporated into the exhibition space and is now used as the principal entrance of the building, leaving the grand entrance and staircase little more than dead space. Recently many of the circulation

difficulties have been resolved with the addition of 1969, designed by Mitchell/ Giurgola (see biography preceding no. 505).

Mostly the building's faults are the consequence of too grand a dream—and too little funding; these problems in no way detract from the architects' achievement. Together they solved what might be termed the archetypical problem of Philadelphia design, the balance between monumentality and intimacy, in the local brick, a material which would be scorned in most other United States cities. Inspired by the architecture of north Italy of the twelfth to the fourteenth centuries, Eyre, Day, Cope, and Stewardson sketched simple walls of rough brick with wide mortar joints, coarsely textured and forceful. There could be no more direct expression of the unconventional collection of artifacts, mummies, steles, and cuneiform tablets than this strikingly unclassical design.

Furthermore, a type of collection that made wall display rather unimportant enabled the architects to rely on fenestration to establish the rhythm of solid and void that is usually impossible in museum building. The result is a conventional mural architecture, humanly scaled, which approaches the vernacular in unstyled simplicity. Complementing the plain surfaces and rough materials are the panels of tile set into the wall surfaces and coved cornices, which provide a decorative accent, without reference to specific style. Given the limits of fashion at the end of the century, it was as flexible a mode of design as could reasonably be imagined, and came closest to suggesting the means by which Philadelphia architects might keep the color and originality which were the hallmarks of local architecture in brick. Surprisingly, none of the museum's architects, Eyre, Day, Cope or Stewardson, applied its possibilities in later designs.

GT □

MAXFIELD PARRISH (1870–1966)
(See biography preceding no. 383)

386. *Poster Show: Pennsylvania Academy of the Fine Arts, Philadelphia*

1896
Signature: Maxfield/Parrish (in block, lower right)

Inscription: Ledger Show Print. Phila. (below image, lower right); Poster Show (across top); Pennsylvania Academy of the Fine Arts (on left); Paintings of the Glasgow School./Fosdick's Fire Etchings./Academy of Fine Arts (across bottom)

Six-color(?) relief print

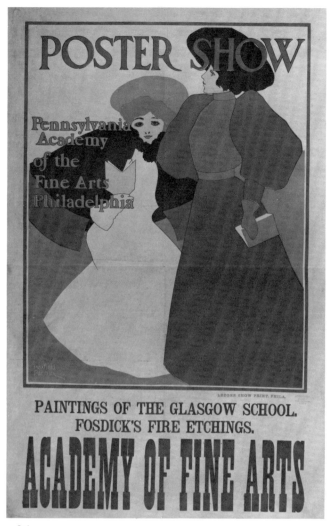

386.

43¾ x 27⅞″ (111.1 x 69.5 cm)
Library of Congress, Washington, D.C.

LITERATURE: PAFA, *Poster Show* (March 28, 1896), no. 411, illus. cover; Ludwig, *Parrish,* p. 103, pl. 29, as a lithograph; *The Maxfield Parrish Poster Book,* intro. by Maurice Sendak (New York, 1974), pl. 7; Victor Margolin, *American Poster Renaissance* (New York, 1975), p. 211 (illus.)

POSTER EXHIBITIONS BECAME POPULAR in the United States as the artistic poster movement reached its peak during the 1890s. Curtis Smith ("Posters in Philadelphia," *The Poster,* vol. 1, no. 5, May 1896, p. 62) wrote, "The 'City of Brotherly Love' has been reveling in poster-shows." One of these, "the fine exhibition at the Academy," was the impetus for this poster by Maxfield Parrish. Other Parrish designs of 1896 include prizewinning posters for Hornby's Oatmeal and the Pope Manufacturing Company's Columbia Bicycle (Victor Margolin,

American Poster Renaissance, New York, 1975, illus. p. 206).

In March 1895 an exhibition of artistic posters was discussed by the Pennsylvania Academy's Committee on Exhibitions. However, plans were not expedited until the following February, when Robert W. Vonnoh, who had been one of Parrish's teachers at the Academy in 1892, offered both energy and funds "to prepare an exhibition of the posters he has recently brought from Europe with others to be obtained here." The exhibition, installed in the corridor and rotunda of the Academy, opened on Thursday, April 2, although the catalogue, bearing a reproduction of the Parrish poster on its cover, records an opening date of March 28. An exhibition "of rare excellence and much value as an educator in this humble but useful decorative art" (PAFA, *Poster Show,* March 28, 1896, p. 4), the show included seven examples by Parrish, one of which is the poster shown here.

Opening on March 18 and continuing

concurrently with the poster exhibition were two others, an exhibition of Glasgow and Danish paintings, previously shown at the St. Louis Exhibition and Music Hall, and Mr. J. William Fosdick's panels of burnt wood. Although a resolution had authorized a catalogue inclusive of the three exhibitions, the catalogue cited here covers only the posters; however, the Parrish poster on exhibition announces not only the poster show, but also paintings of the Glasgow school (presumably the Danish paintings were ignored because there were far fewer of them) and Fosdick's fire etchings (PAFA, Minutes, Committee on Exhibitions, November 5, 1894—June 5, 1900, pp. 15,.35–38, 53, 60, 64–65; PAFA, Robert W. Vonnoh to Mr. Harrison L. Morris, May 9, 1896).

The catalogue cites the American Bill Posting Company for voluntarily distributing the poster "upon the city hoardings" and notes that a limited number "retained from the hoardings" is for sale. Impressions lacking the text beneath the image (except for the reference to the printer, "Ledger Show Print. Phila.") are signed in pencil by Maxfield Parrish, and it is probable that these impressions are the ones that were "retained from the hoardings." It seems possible that "Ledger Show Print. Phila." refers to the firm known as the Ledger Job Office, 605 Sansom Street, who advertised as "show-printers" in *The Poster,* May 1896 (vol. 1, no. 5, p. 65).

Parrish's poster designs of this period vary greatly, moving from overt humor—*The Mask and Wig Club,* 1895—to covert eroticism—*Scribner's Fiction Number, August,* 1897 (Ludwig, *Parrish,* fig. 69, pl. 31).

The poster show design shown here, with its figural types that include vapid facial expressions, arrested gestures, and elegant dress, as well as the flat shapes used as a primary structural device, compares with, for example, J. J. Gould, Jr.'s, work of this period (see no. 387). It seems plausible that by imitating the prevailing style Parrish is here poking fun at the standardization of the poster type then being commissioned repeatedly and vigorously by some publishing houses. If so, this poster relates both formally and philosophically to several Parrish magazine covers of the following decades in which he similarly poked fun at archetypes by means of large-scale, broadly defined figures lacking descriptive environments (see *The Maxfield Parrish Poster Book,* intro. by Maurice Sendak, New York, 1974, pp. 23–27, 43).

It appears that this Parrish poster was printed entirely by relief processes and in part from woodblocks. Wood was a common matrix for American posters of the 1850s and 1860s, but its use would have been unusual as late as 1896. Although the plates and blocks

would have been produced by craftsmen working from Parrish's designs, one wonders if the use of the old-fashioned, less precise medium of wood is a later manifestation of a conflict expressed by Parrish to his mother in a letter of 1893 (quoted by Ludwig, *Parrish*, p. 189): "And about the mechanical —it may come in handy someday, but at present I am wrestling with its evil tendencies as shown in my work, for it is hard to rid myself of the love of a good neat job, which doesn't improve artistic expression one bit."

The Parrish poster apparently was appreciatively received, and one assumes on the basis of Curtis Smith's observations that the exhibition was as well. However, a letter was sent to the Academy by the Social Purity Alliance "objecting to the recent exhibition of posters on moral and artistic grounds" (PAFA, Minutes, Board of Directors, May 11, 1896).

RFL □

J. J. GOULD, JR. (1880?–1935?)

J. J. Gould, Jr., has remained an elusive figure. It is likely that he was the "Jos. J. Gould" enrolled at the Pennsylvania Academy for the academic year 1894–95. Most noted for the series of posters he designed for J. B. Lippincott Company, he also was a contributor to *Moods* and *Footlights*, two short-lived illustrated journals published in Philadelphia during the mid-1890s. He used two signatures, J. J. Gould, Jr., and J. J. Gould. Following in Maxfield Parrish's footsteps, Gould contributed to the decoration of the Mask and Wig Club (see no. 383) by painting caricatures adjacent to the pegs on which the members hung their drinking steins. Unlike Parrish, whose caricatures were impersonally fanciful, Gould directed his attention toward particular characteristics of individuals (Helen Henderson, "The Artistic Home of the Mask and Wig Club of the University of Pennsylvania," *House and Garden*, vol. 5, no. 4, April 1904, p. 173).

After 1900, Gould's illustrations appeared in *Scribner's* and the *Saturday Evening Post*.

387. *Lippincott's April*

1897
Signature: J. J. Gould (in plate, lower right)
Inscription: LIPPINCOTT's (across top); APRIL (lower left); Copyright 1897 by J. B. Lippincott Co. (in plate, lower center) J. J. Gould (37) (below image)
Four-color relief print(?)
16¼ x 13¼″ (trimmed) (41.2 x 33.6 cm)
Library of Congress, Washington, D.C.

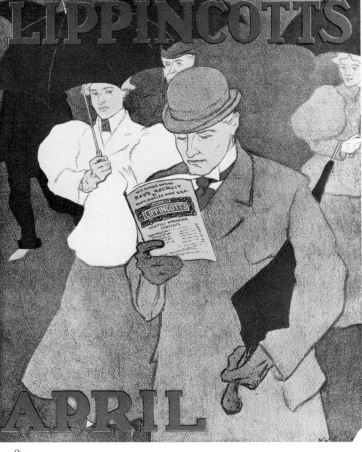

387.

LITERATURE: Ned Arden Flood, *A Catalogue of Foreign & American Posters from the Collection of Mr. Ned Arden Flood* (Meadville, Pa., 1897), no. 152, p. 20 (illus.); Ruth Malhotra and Christina Thon, comps., *Das frühe Plakat in Europa und den USA,* vol. 1 (Berlin, 1973), pp. 70–71, fig. 260; Boston Public Library, *American Posters of the Nineties* (1974), no. 37, illus. p. 39; Caroline Keay, *American Posters of the Turn of the Century* (New York, 1975), p. 65 (illus.); Victor Margolin, *American Poster Renaissance* (New York, 1975), p. 82 (illus.)

LIPPINCOTT'S MONTHLY MAGAZINE was published by J. B. Lippincott Company from January 1868 through April 1916. Although company records are not extant, it has been determined that posters advertising the magazine were probably issued from August 1894 through August 1897. The posters commissioned by Lippincott and other publishing houses are among the most distinctive issued in the United States during the poster craze of the 1890s.

The prototype for this poster was established by Edward Penfield's monthly posters for *Harper's*. The earliest of the Penfield designs appears to have been published in February 1892 (attribution of an undated poster in the collection of the Library of Congress; [Boston], *Massachusetts Charitable Mechanic Association Exhibition of Posters,* October 2—November 30, 1895, no. 216). If the monthly posters for *Harper's* have become inseparably associated with the name of Edward Penfield, posters for *Lippincott's* monthly magazine are similarly associated with the names of Will J. Carqueville and J. J. Gould, Jr. Carqueville's designs, influenced by Penfield, were issued from December 1894 through November 1895. They were peopled by one and occasionally two or three members of the bourgeoisie, usually at leisure, accompanied by a visibly displayed copy of *Lippincott's*. Seldom is anyone reading.

Carqueville went to Paris to study art, and J. J. Gould, Jr., beginning with the December 1895 issue of *Lippincott's*, followed Carqueville's general format. However, early Gould designs appear to be investigating means toward a greater standardization of technique, use of color, size, shape of format, and figural type than in Carqueville's posters. Once established, the standardizations were followed, with few digressions, through the last *Lippincott's*

poster that has been located, the August 1897 issue. The April number shown here is distinguished by its several figures, including the man who finds the contents—which range from the lengthy "Ray's Recruit" to an article on the need for the preservation of game to "Goethe in Practical Politics"—to be so compelling that he is, in fact, reading, oblivious to the elements. Typically, the poster reflects the season.

The 1890s was a period of technical experimentation and innovation in printing. Zinc plates rather than stones were often used for lithographic prints, and line cuts in imitation of lithographs were printed from zinc by the relief process. Various photographic and transfer techniques were used. It remains difficult to determine conclusively the matrix-making and printing-process methods employed for posters of the period. However, this poster was probably printed from metal plates and perhaps totally by relief processes.

The use of three plates printed in three primary colors is a notable aspect of many of Gould's monthly posters. Both the red and yellow plates consist of flat color areas and lines of two or more variations in weight, as seen by a comparison of the width of the red stripe of the umbrellas with that of the stripe in the man's coat. The blue plate consists of flat areas as well as areas of a particular texture used repeatedly with varying degrees of concentration. The texture appears to have been produced by first laying a sheet of paper—note the clarity of the horizontal chain lines—over a textured surface and making a rubbing from the texture which was then transferred to a metal plate photographically. In some areas colors are established by overprinting or by an optical mix produced by the proximity of small areas of more than one color. Here, for example, the flesh color is determined by the oblique crossing of red and yellow lines on a white field. The difference in color between the reader's topcoat and the darker ground at the right results mainly from a change in the quantity of the blue texture. This is one of the most subtle of the Gould designs because, in addition to the anticipated red, yellow, and blue, a modifying tan undercolor is used in places. The basic standardization of color is accompanied by standardization of figural type—well scrubbed, well dressed, inexpressive manikins.

J. J. Gould, Jr., has been considered a skillful if unimaginative imitator of Carqueville and Penfield (Edgar Breitenbach, *The American Poster,* New York, 1967, p. 11). However, Gould's designs for *Moods* and his contemporary designs for Lippincott publications, other than the monthly magazine (for example, *Venus and Cupid* and *How to Feed Children,* in the collections of the Library of Congress and the Philadelphia

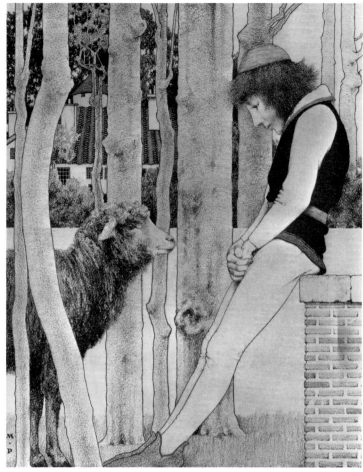

388.

Museum of Art), are less dependent on the precedents set by these men. Stylistically they are more closely related to Pre-Raphaelite–inspired Gould magazine illustrations of the following decade. It seems possible that by following the lead of Penfield both Gould and Carqueville were acceding to the monthly assignment requirements designated by the Lippincott firm.

RFL □

MAXFIELD PARRISH (1870–1966)
(See biography preceding no. 383)

388. *Baa, Baa, Black Sheep*

1897
Illustration for *Mother Goose in Prose* by L. Frank Baum; published by Way and Williams, Chicago, 1897
Signature: M/P (in black ink, lower left)
India ink and lithographic crayon on white paper
13⅜ x 11¼" (34 x 28.5 cm)

Fogg Art Museum, Harvard University, Cambridge, Massachusetts. Gift of Charles Bain Hoyt

PROVENANCE: Charles Bain Hoyt, until 1934

LITERATURE: *The Christian Science Monitor,* vol. 37, no. 118 (April 16, 1945), illus. p. 12; Springfield, Mass., The George Walter Vincent Smith Art Museum, and Syracuse University, Lowe Art Center, *Maxfield Parrish: A Retrospect* (January 23—April 30, 1966), no. 40; Cambridge, Mass., Fogg Art Museum, Harvard University, *American Art at Harvard* (April 19—June 18, 1972), no. 126; Chadds Ford, Pa., Brandywine River Museum, *Maxfield Parrish: Master of Make-Believe* (June 1—September 2, 1974), no. 92 (illus.)

PARRISH'S EARLY ILLUSTRATIONS published in black and white have at their best a fineness and imaginative subtlety that rival in appeal the colorful illusionism of his later oil-glaze works. His first commission for Scribner's, a series of eleven illustrations for one of the chapters in Kenneth Grahame's *Dream Days* (which he later illustrated in full), was published in August 1897; it probably shortly preceded the *Mother Goose in Prose* drawings, of which *Baa, Baa, Black Sheep* is one, published in December of the same year. The two series of drawings share a combination of fine contours and stippled or "granular" shading typical of Parrish's

illustrations of this period, but some of the *Dream Days* group are overly busy in effect; the *Mother Goose* drawings are compositionally more sophisticated and appear more mature. They share with the illustrations for "Knickerbocker's" *History of New York,* done in 1898–99, a spare, subtle, architectonic approach to composition with stressed horizontals and verticals, a sophisticated use of empty white space, and an imaginative variety of textures—stippling, dots, hatching, and so forth. In *Baa, Baa, Black Sheep,* the eye is intrigued by subtle variations: the vertical screen of tree trunks, each differently shaped, is penetrated by the diagonals of the boy and sheep gazing at each other, and the fine, pure contours are set off by shading lines of different shapes and thicknesses. The *Mother Goose* illustrations, enthusiastically reviewed shortly after their publication, were praised for their "novel combination of line and tone well mastered" and for their sense of fun (*The International Studio,* vol. 5, 1898, pp. 214–16).

Parrish used pencil, ink, crayon, lithographic crayon, and wash in various combinations; *Baa, Baa, Black Sheep* shows his employment of a granular quality of shading using lithographic crayon. The novelty of this technique, which made use of textured paper or board and sometimes stippling or spatter work, was noted quite early (James B. Carrington, "The Work of Maxfield Parrish," *The Book Buyer,* vol. 16, April 1898, p. 224). When color was needed he would add oil glazes or opaque pigments to a black and white drawing, and he moved toward working exclusively in colored glazes after about 1900 (see Ludwig's chapter on technique in *Parrish,* pp. 189ff.). Parrish's well-known illustrations for Kenneth Grahame's *The Golden Age* and *Dream Days* (dating to 1899 and 1900–1901, respectively) show a movement away from the pure linear quality and geometrically conceived compositions of the *Mother Goose* drawings toward the almost photographic illusionism of the artist's later works.

One thinks immediately of Pyle's work in black and white and of his children's illustrations in connection with Parrish's imaginative qualities, and the admiration Parrish held for Pyle was noted in one of the earliest critiques of Parrish's work (Carrington, cited above, p. 221). Parrish is occasionally, but inaccurately, grouped with the Howard Pyle "school," and his early work does share a linear, decorative quality with that of some of the Philadelphia illustrators who studied under Pyle. However, Pyle's work is much more a part of the mainstream of contemporary European or American draftsmanship, whereas Parrish's, in its technical uniqueness and its combination of the "photographic vision with the pre-Raphaelite feeling," is a thing apart. In 1899

the *International Studio* described Parrish's style as founded on "a cross between the poster outline and the flat tints of Boutet de Monvel," adding that "Mr. Parrish deserves all the popularity the public has accorded him, for his drawings are not like the slipshod imitations of Abbey and Gibson, so often served up to us by the younger generation of illustrators, but they are carefully wrought-out designs, balanced in every part and thoroughly decorative in conception" ("American Studio Talk," *The International Studio,* suppl., vol. 9, 1899–1900, pp. xxii-xxiii).

AP □

HENRY O. TANNER (1859–1937)

Born in Pittsburgh, Henry Ossawa Tanner was the son of Benjamin T. Tanner, later Bishop of the African Methodist Episcopal Church. The family moved to Philadelphia in 1866, and at the age of twenty-one Tanner enrolled in the Pennsylvania Academy, where he studied under the direction of Thomas Eakins from 1880 to 1882. Tanner exhibited at the Academy and with the Philadelphia Society of Artists, but found he could not support himself as an artist in Philadelphia and moved to Atlanta, where he set up a photography studio and taught drawing at Clark University. Benefactors sponsored a show of his work in Cincinnati in 1890 to raise money for Tanner to study abroad, and, although no pictures were sold, his patrons bought the lot and he set sail for Europe in January 1891.

Tanner studied in Paris with Jean-Joseph Benjamin Constant and Jean-Paul Laurens at the Académie Julian. He soon joined the American Art Club and spent his first summer abroad with a colony of artists, many of them American, at Pont-Aven in Brittany. Tanner exhibited at the Salon in 1894, 1895, and 1896, when his *Daniel in the Lion's Den* won an honorable mention. In 1897, Rodman Wanamaker, a Philadelphian living in Paris, sent him to Palestine to study biblical settings for his religious paintings. While there, Tanner learned that his *Raising of Lazarus* had won a third-class medal at the Salon and had been bought by the French government for the Luxembourg Gallery.

In 1899 he exhibited *Christ and Nicodemus on a Rooftop* at the Salon and at the Pennsylvania Academy, where it won the Lippincott Prize in 1900 and was purchased for the Academy's Temple Collection. Tanner's subsequent awards included a silver medal at the Universal Exposition in Paris in 1900, a silver medal at the Pan-American Exhibition in Buffalo in 1901, and the Harris Prize for the most distinguished work of art in the 1906 season from the Chicago Exhibition. He continued to live in

France although his first one-man show took place in New York at the American Art Galleries in 1908 (Margaret M. Mathews, *Henry Ossawa Tanner, American Artist,* Chicago and London, 1969, p. 133), and the next year he was elected an Associate Member of New York's National Academy of Design. He also served on the Paris selection jury for the Pennsylvania Academy's annual exhibitions.

Tanner won a gold medal at the Panama-Pacific Exposition in 1915, was elected a Chevalier of the Legion of Honor by the French government in 1923, and to full membership in the National Academy in 1927. Although Tanner achieved recognition during his lifetime, he never had more than a small income from his paintings and was supported throughout much of his career by his friend Atherton Curtis. Tanner died in Paris in May 1937.

AS

389. *Portrait of the Artist's Mother*

1897
Signature: H. O. Tanner/1897 (lower right)
Inscription: To my dear Mother (lower right)
Oil on canvas
29¼ x 39½" (74.2 x 100.3 cm)
Mrs. Raymond Pace Alexander, Philadelphia

PROVENANCE: Bishop and Mrs. Benjamin J. Tanner, Philadelphia

LITERATURE: Washington, D.C., Frederick Douglass Institute in collaboration with the NCFA, *The Art of Henry O. Tanner (1859–1937)* (July 23, 1969—October 25, 1970), at six participating institutions, no. 14, p. 27

THE BLACK EXPERIENCE in America had been portrayed by a few artists following the Civil War, notably Thomas Eakins, Henry O. Tanner's early teacher. Yet Tanner was able to draw on his own experience as an American Negro to give a personal measure of sympathy and dignity to the portrayal of black life. In the 1880s and early 1890s Tanner painted genre scenes of the life familiar to him, usually showing his family and friends absorbed in some activity, in addition to the religious pictures he successfully submitted to the Paris Salon in the mid-1890s.

In his own words, using the impersonal third person, Tanner described his devotion to the theme of painting genre scenes of black life:

He feels drawn to such subjects on account of the newness of the field and because of a desire to represent the serious, and pathetic

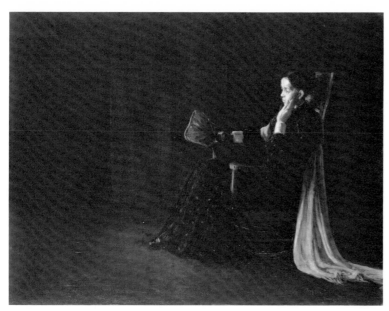

389.

side of life among them, and it is his thought that other things being equal, he who has most sympathy with his subject will obtain the best results. In his mind many of the artists who have represented Negro life have only seen the comic, the ludicrous side of it, and have lacked sympathy with and affection for the warm big heart within such a rough exterior. (letter, collection of the Pennsylvania School for the Deaf, Philadelphia, n.d., in Ellwood Parry, *The Image of the Indian and the Black Man in American Art, 1590–1900,* New York, 1974, p. 167 n. 29)

It is certainly the serious side of black life that Tanner depicts in *Portrait of the Artist's Mother.* The mood is quiet and contemplative, the atmosphere dark as in his religious canvases. This reverential attitude toward his mother is also reflected in the inscription "To my dear Mother." Yet Tanner shows his awareness of the international art world, for the picture bears a relationship to Whistler's *Portrait of the Artist's Mother: Arrangement in Gray and Black, No. 1,* which was purchased by the French government and put on display in the Luxembourg Palace the same year that Tanner arrived in Paris. It had also been exhibited at the Pennsylvania Academy in 1881, during Tanner's student years there.

The same compositional elements pertain to both canvases, including the drapery and the framed pictures in the background. While Whistler's portrait attempted to express his devotion to his mother, it was equally concerned with the formal elements of the composition, or "arrangement." Tanner balances, lightens, and completes his composition with the drapery that falls

to the right from the chair, yet his main emphasis is on a sympathetic portrayal of his mother rather than on an abstract arrangement of forms.

The seated woman, with her gesture of holding one hand to her face as she gazes out beyond the frame of the canvas in an attitude of deep thought, bears a relationship to other portraits of women by American artists. These include Thomas Eakins's *Miss Amelia C. Van Buren* and William Merritt Chase's *Portrait of Miss Dora Wheeler.*

The year 1897 was an important one for Tanner. *Portrait of the Artist's Mother* was painted at the time of his triumph in Paris with the French government's purchase from the Salon of the *Raising of Lazarus.* He was gaining recognition in America, although he continued to find the atmosphere of Paris more congenial to his art. *Portrait of the Artist's Mother* forms part of a group of pictures he apparently completed on a trip home in 1897, including a *Portrait of the Artist's Father,* signed and dated "Sep., 1897, Kansas City."

CC □

JOHN GRISCOM BULLOCK (1854–1939)

Born in Wilmington, Delaware, Bullock graduated from Haverford College in 1874 (as president and valedictorian of his class) and from the Philadelphia College of Pharmacy in 1879 with the degree of Ph.G. He worked in the family drug and chemical business of Bullock and Crenshaw, Philadelphia, remaining with the company until it was dissolved in 1907, and was a member of many Quaker philanthropic and educational organizations.

Bullock took up photography as an amateur in 1882 and it is assumed he was self-taught. A member of the Photographic Society of Philadelphia, he served as president and vice-president and played an active role on its board of management for many years before resigning in December 1902. The Photographic Society of Philadelphia was the oldest (founded in 1862 and still in existence) and at the time the most active amateur camera club in America to voice the beliefs of the pictorial movement in photography. Their jury-selected annual exhibitions were known as the Philadelphia Photographic Salons and corresponded in content and intention to the annual salon exhibitions of photographs held in European cities such as London, Hamburg, Paris, and Vienna. Letters in the Stieglitz Archives (Beinecke Library, Yale University) from Bullock to Stieglitz (1901–2) reveal his opposition to the new management of the Photographic Society and his unwillingness to compromise with the Philadelphia photography establishment's concern with the scientific development of photography rather than its purely "artistic" possibilities. A member of the committee and an exhibitor at all but the last of the Philadelphia Photographic Salons held at the Pennsylvania Academy, Bullock was also one of the founding members of the Photo-Secession in February 1902 and a frequent exhibitor in pictorial photography exhibitions sponsored by this organization in the United States and Europe. Dissension within the Photographic Society of Philadelphia over the purpose and content of the Salon exhibitions, as well as similar disagreements within photographic organizations throughout the country (notably the New York Camera Club), had led to the formation of the Photo-Secession. (For an account of the dispute within the Photographic Society see Joseph T. Keiley, "The Decline and Fall of the Philadelphia Salon" and Robert S. Redfield, John G. Bullock, and Edmund Stirling, "The Salon Committee of 1900 Makes a Statement," *Camera Notes,* vol. 5, no. 4, April 1902, pp. 279–97, 300–302.)

Among the more notable pictorial photography exhibitions to which Bullock contributed were the annual London salons (1901, 1902, 1904); a three-man exhibition with Robert Redfield and Edmund Stirling of Philadelphia at the Camera Club, New York (October 1901); the Jubilee Exhibition at the Hamburg Art Galleries (1903); the International Exhibition, The Hague, Holland (1904); the first members' exhibition of the Photo-Secession at 291 Fifth Avenue, New York (November 24, 1905—January 5, 1906); *An Exhibition of Photographs Arranged by the Photo-Secession* at the Pennsylvania Academy of the Fine Arts (April 30—May 27, 1906); and the quintes-

390.

sential *International Exhibition: Pictorial Photography* at Albright Art Gallery, Buffalo, New York (November 3—December 1, 1910). The titles of Bullock's photographs listed in the catalogues of the above exhibitions and in *Camera Notes* indicate that his usual subject matter was landscapes of fields, streams, and woods. In 1923, Bullock moved from Germantown to West Chester, Pennsylvania, where he became interested in the history of Chester County and served as curator of its historical society for many years.

390. *Young Anglers*

1898
Signature: JGB (in pencil, on mat)
Platinum print
7⅞ x 5⅞″ (20 x 15 cm)
The Museum of Modern Art, New York. Gift of the John Emlen Bullock Estate

PROVENANCE: The artist; estate of John Emlen Bullock

BULLOCK'S SYMPATHETIC RENDITION of the more delicate aspects of nature as revealed in this photograph fulfills the aesthetic demands of pictorial photography. The scene is brilliantly rendered and the tonal values in nature are truthfully represented, with no obvious manipulation of exposure, development, or printing process to heighten the pictorial effect, a frequent practice at the time. Here the artistic image predominates, and there is little of the concern with the factual that had prevailed in the previous decade. Although a particular instant has been accurately captured, its significance lies beyond the isolated moment. The two young anglers are here to complement and in no way to intrude or disturb the tranquility of the whole. Nature's violent, harsh, or disquieting aspects have been avoided, to be represented at a later period when photography was more firmly established as an acceptable art medium. In short, all has been subordinated to the picturesque quality of the whole and the "art for art's sake" principle applied to the realm of photography.

Perhaps the best definition of the art of

pictorial photography was furnished by the critic Joseph T. Keiley ("The Pictorial Movement in Photography and Significance of the Modern Photographic Salon," *Camera Notes,* vol. 4, no. 1, July 1900, p. 23): "Art broadly speaking is the universal language of beautiful conceptions and noble thoughts. If one be impressed by the rare beauty of the theme—beauty of thought or feeling, or both—and can produce a picture thereof that will excite the same or nearly the same sense of pleasure in those who behold it, he stands a very excellent chance of winning entrance to the most advanced salon and of being recognized an artist in the true sense of the word."

CW □

WILLIAM GLACKENS (1870–1938)
(See biography preceding no. 384)

391. *Loading Horses on the Transports at Port Tampa*

1898
Signature: W. Glackens/Tampa (in black ink, lower left)
Charcoal (or conté crayon), India ink and wash, gray and white heightening over pencil on beige paper
19¾ x 18¼″ (irregular) (50.2 x 46.4 cm)
Library of Congress, Washington, D.C.

PROVENANCE: Gift of Ira Glackens, 1965

LITERATURE: Alan Fern, "Drawings by William Glackens," *The Library of Congress Quarterly Journal of Current Acquisitions,* vol. 20, no. 1 (December 1962), p. 16, no. 6; City Art Museum of St. Louis, National Collection of Fine Arts, Smithsonian Institution, and Whitney Museum of American Art, *William Glackens in Retrospect* (November 18, 1966—June 11, 1967), no. 79

ON FEBRUARY 15, 1898, the United States battleship *Maine* exploded in Havana harbor, apparently destroyed by a torpedo. On April 20, President McKinley demanded the withdrawal of the Spanish from Cuba, and four days later war was declared between Spain and America. Glackens at the time was living in New York, freelancing as an illustrator for various magazines, particularly *McClure's.* The magazines covering the Spanish-American War vied for the services of writers, artists, and photographers of reputation—Stephen Crane, as well, was hired by *McClure's*—and the twenty-eight-year-old Glackens became the only artist-reporter to cover the war exclusively for *McClure's* (Alan Fern, "Drawings by William Glackens," *The Library of Congress Quarterly Journal of*

391.

Current Acquisitions, vol. 20, no. 1, December 1962, p. 13).

At the end of April, Dewey defeated the Spanish naval force at Manila; by early May, Glackens had arrived in Tampa, Florida, the point of embarkation for the United States Army expeditionary forces going to Cuba. He was to cover the "departure, voyage and arrival and subsequent work and fights of the U. S. troops in Cuba," according to his instructions from *McClure's* art department (*Glackens,* p. 23), and to send back drawings made on the spot to be reproduced in the magazine. Twenty-odd of these drawings survive, mainly in the collection of the Library of Congress (Fern, cited above, checklist, pp. 16–17). Another is owned by Victor Spark, New York (reproduced in *McClure's,* vol. 11, no. 6, October 1898, p. 508); a second is in a private collection (reproduced in *Glackens,* p. 25); and a third is at the Wadsworth Atheneum, Hartford, Connecticut (reproduced in *McClure's,* vol. 12, no. 2, December 1898, p. 121). Some of the original drawings published in *McClure's* have disappeared, and some of the drawings that survive were never reproduced in the magazine, as is the case with *Loading Horses on the Transports,* shown here.

The troops embarked on June 7 and 8 in Tampa, although they did not actually start for Cuba until June 14. The fleet of thirty-two transports with around 17,000 officers and men (one of the three volunteer regiments was Lieutenant-Colonel Theodore Roosevelt's Rough Riders) arrived off Santiago on June 19. In the series of drawings in the Library of Congress, Glackens recorded various activities of the troops in Tampa before the embarkation: the transports anchored in the bay—the scene exhibited here shows horses being loaded onto the ships—and the troops embarking. Between June 22 and 27 the army landed at Daiquiri and Siboney, a few miles east of Santiago; Glackens's drawings show the coast being shelled before the landing and the horses swimming ashore from the transports at Daiquiri. Spanish positions at Santiago were stubbornly defended, and American casualties were around 1,500 killed or wounded on the day of the engagement, July 1.

Glackens's impressive drawings include scenes of the actual press of battle, which he apparently observed on the spot: the cavalry with their caissons pounding up a hill; the "Bloody Bend," a ford in the river near San Juan where many men were hit; the charge up San Juan hill— the climactic point of the day's fighting—and the field hospital the night after the battle. The compositions capture the tumult of battle and a sense of the dramatic moment—as in *Loading Horses on the Transports,* objects or figures are cut off by the edges of the sheets—but the scenes are by no means disordered. The figures are

strongly and surely constructed in Glackens's superb draftsman's hand, and the compositions are set out with powerful effect, yet not with balance or symmetry, creating what must surely be among the most successful of "journalistic" drawings. It is easy to see why Glackens was considered a master of representing crowds: "Many artists designate crowds in massing smears; in Glackens' drawing each individual forms the mass.... None of us, as I have said, could do a crowd quite like Glackens. The editors considered it his specialty" (Everett Shinn, "William Glackens as an Illustrator," *American Artist,* vol. 9, November 1945, pp. 22–23). In *Loading Horses on the Transports* part of the richness of effect lies in the combination of media—ink, charcoal, wash, and heightening—and types of lines—strokes, slashes, and hatching—densely worked to create a scene of bustling yet ordered activity. This is a very different type of newspaper illustration from Sloan's *A German-American Ball at the Academy of Music* (no. 381) of around three years earlier, robust and lively rather than patterned and decorative.

A naval victory led to the destruction of the Spanish fleet on July 3, and the Americans entered Santiago on July 17. Glackens was present at—and depicted—the surrender of the Spanish forces to the American general Shafter and the raising of the United States flag over the governor's palace in Santiago. Glackens's drawings did not appear in *McClure's* until October and December 1898 and February 1899, although the war was essentially over in August 1898. Not all of his Spanish-American War drawings were reproduced, presumably because public interest in the war had lapsed. However, beside the *McClure's* articles, one appeared in the New York *World* (May 15, 1898) and seven in *Munsey's Magazine* (March–May 1899; Bullard, "Sloan," pp. 51, 53, figs. 31, 33).

In his work as a combat artist, Glackens was part of an artistic and journalistic tradition that had arisen in the latter half of the 1850s—when illustrated magazines such as *Frank Leslie's Illustrated Newspaper, Harper's Weekly,* and the New York *Illustrated News* were established—and that continued through the time of the Spanish-American War, when modern photomechanical reproductive processes largely eliminated the need for the profession. The artist-reporter was a flourishing phenomenon during the Civil War, often in the thick of the fighting, undergoing the same hardships and dangers as the soldiers, recording battles and their aftermaths, camp life, marches, quarters, diversions, and so on. Among the best known are Winslow Homer—though he actually spent little time at the front—and the swashbuckling Alfred Waud. A number were from Philadelphia, or trained

392.

here, and of particular note are the Schells—Francis and Frederick—special artists for *Frank Leslie's Illustrated Newspaper* (see Washington, D.C., National Gallery of Art, *The Civil War: A Centennial Exhibition of Eyewitness Drawings,* 1961, pp. 123, 128–29, 130–32, 150).

Glackens's stint as a war artist forms rather a special part of his career as an illustrator; it was his last job as an artist-reporter and the first manifestation of his truly accomplished illustrations of the next decade and a half. One of the characteristics of his early newspaper drawings was their lack of individuality: because of the pressure of deadlines an artist might have to pick up and finish another's drawing, or more than one artist might work on the same drawing, which led to a certain uniformity of style. This is not true of Glackens's later illustrations, which are highly personal. The Spanish-American War drawings were among the first to signal the artist's mature virtuosity.

AP □

WILLIAM L. PRICE (1861–1916)

William L. Price was born in the Philadelphia suburbs in 1861. He attended the Quaker Westtown School for a year or so,

leaving in 1877, first practicing carpentry, and later entering the office of Philadelphia architect Addison Hutton. In 1881, Price formed a partnership with his brother Francis, which lasted until 1895 and resulted in numerous country houses in the English and French late Gothic styles.

In 1903, William Price joined his friend and co-founder of the Rose Valley community, M. Hawley McLanahan, in the firm of Price and McLanahan. That association lasted until Price's death in 1916.

Although Price continued to design eclectically styled country houses in this century, his best known and most significant works were immense reinforced-concrete structures, among them the Traymore (two phases— 1906 and 1914–15) and Blenheim (1905) hotels in Atlantic City, and the Chicago Freight Terminal (1914–19). There, in Jacob Reed's Sons (no. 404), and in the plaster cottages at Rose Valley (no. 397), Price attempted to merge craft values with the scale and materials of modern architecture, demonstrating the potential for a rich and involving man-made environment that contrasts with the sterile abstractions of so much modern design (see nos. 398, 399).

GT

392. *Leaded Glass Windows*

c. 1899
Leaded glass; white oak frames
28¼ x 45¾″ (each) (71.7 x 116.2 cm)
Philadelphia Museum of Art. Purchased: Thomas Skelton Harrison Fund.
74-146-1—4

PROVENANCE: John Gilmore; Episcopal Academy; with Gargoyles, Ltd., Philadelphia

THESE WINDOWS, of a group of seven, were designed by William L. Price in 1899 for the French Gothic home of John Gilmore, a snuff magnate at City Line Avenue and Berwick Road. The windows were removed when the house was demolished in 1973. The house was the result of a competition which Price won, and its interior included fine Gothic style paneling and furniture which Price designed.

The seven windows were the upper section of sash windows, above seven clear windows in the bay of the picture gallery. The hunting scenes and motifs depicted in the leaded glass reflect Gilmore's interest in the sport. Such scenes also gave Price a chance to incorporate medieval or Gothic motifs in an avant-garde design which shows the influence of Conti-

392.

nental Art Nouveau as well as the English Arts and Crafts movement. The remarkable design, continued from window to window, is unified not only by the hunting motifs but also by the continuous lines of leading—serving both a structural and visual function. Although most of the window glass is clear, there are smaller panels of subtle coloration. The interior scheme demonstrates that Price felt secure using several styles.

Four other leaded glass windows that had been in the stair hall below the landing depict knights in armor, but there is no trace of the Art Nouveau style. However, for the skylight windows which Price designed in 1912 for the sun room and aviary of the Joseph A. Allison house in Indianapolis, Price incorporated foliage motifs in a continuous Art Nouveau design similar to the Gilmore hunting windows. On his trips to Europe, Price undoubtedly saw the work of C. F. A. Voysey and M. H. Baillie Scott in England and Art Nouveau designers in Brussels. Price was one of few Americans designing such windows at this time.

DH □

HOWARD PYLE (1853–1911)
(See biography preceding no. 367)

393. *The Flying Dutchman*

Probably 1899
Illustration for *Collier's Weekly,*
December 8, 1900
Signature: Pyle (lower right)
Oil on canvas
71⅜ x 47½" (181.3 x 120.6 cm)
Delaware Art Museum, Wilmington.
Howard Pyle Collection

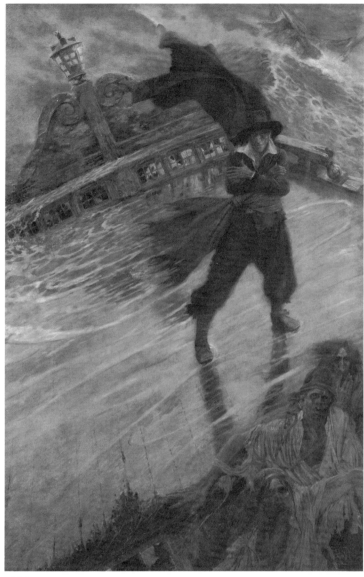

393.

PROVENANCE: Mrs. Howard Pyle, 1912

LITERATURE: *Catalog of Pictures by Howard Pyle (Deceased): A Permanent Collection, The Property of the Society* [Wilmington Society of the Fine Arts] (Wilmington, 1912), no. 28; Morse and Brincklé, p. 6; *Pyle Collection,* p. 13, no. 86; *Pyle: Diversity in Depth,* p. 63 (illus.); Bridgeport, Conn., Museum of Art, Science, and Industry, *Brandywine Heritage—Pyle Through Wyeth* (April 20—May 28, 1974), no. HP4; Pitz, *Pyle,* p. 154; *Howard Pyle,* intro. by Rowland Elzea (New York, 1975), n.p., pl. 34

AFTER THE END OF THE 1880s—his great decade of books illustrated with ink drawings—Pyle worked more and more with tonal illustrations as the use of the halftone process grew more common. His line illustrations allowed a more subtle relation of the drawing to the lettered caption or the printed page and a more flexible approach to book design as a whole than the tonal ones did. However, his more virile subjects—

such as the captain of the *Flying Dutchman,* arms clutching his breast, feet planted squarely on the deck of his ship—and his historical scenes seemed to translate better into the "flesh and blood" language of paint and canvas, with its opportunities for greater realism.

One of the options for the halftone illustration was the grisaille oil, charcoal, or gouache, worked out fully in terms of light and shade but using only black, white, and gray, perhaps with touches of a color. Another was the full-color painting, which might be reproduced in color or in black and white, and Pitz points out that Pyle was eager to express himself with a full palette. Pyle's early (1881) experiments with flat color printing to reproduce his works were not very successful (Pitz, *Pyle,* p. 52); it was not until the early 1890s, apparently, that his works began to be reproduced in

two colors and not until toward the end of the decade that he had an opportunity to experiment with illustrations to be reproduced in full color—this time with the new four-color separation process. Although it is difficult to be certain that the *Flying Dutchman* was painted for full-color reproduction, the very restricted palette may have been a conscious solution to coping with the problems of the color separation process. Correct registration of the plates was frequently not achieved in these early color-printing efforts, and the *Collier's* illustration of *The Flying Dutchman* in the Philadelphia Free Library shows typically poor registration; the dot pattern of the screens is intrusively obvious as well. The illustration conveys little impression of the marvelous brushwork of the canvas, often thick and lush, as if a large brush were used, yet quite meticulous. The painting is predominantly green in tone,

greens that vary from dark, dull shades that substitute for black—which is not used at all—to lighter, brighter ones. Accents of red enliven the figures.

It is not clear just what led Pyle to depict the legend of the Flying Dutchman, a folk tale with numerous variations on the theme of a haunted ship that can never come to harbor but must sail eternally. Heinrich Heine's adaptation of the legend was the source for the libretto of Wagner's opera, and Pyle may have consulted this libretto, in which the Dutchman's curse is redeemed by the faithfulness of a girl who was to marry him. In any case, Pyle briefly set out the legend himself in the 1902 *Harper's Monthly*, comparing the story to that of the Wandering Jew and other "perpetual curse" legends:

> The fate of Captain van Stratten, or Captain Vanderdecken, as he is inter-changeably called, is identical with these [legends]. In the stormy season of the year he was endeavoring in vain to beat about the Cape of Good Hope. "Put back, Captain," urged the first mate. "Put back!" roared the furious mariner;—and then, with a tremendous and blasphemous oath, "I will not put back though I have to beat about this Cape until the Day of Judgment!" The Deity heard and was affronted; took the sea-captain at his word, and thenceforth he has been compelled to fulfil his doom until the ending of time. That was three hundred and more years ago, and still the hapless Dutchman is striving to beat about the Cape. His ship is white with age, his sails are mildewed tatters, he and his crew are skeleton shadows. But still he rides the storm like a bubble of Fate. Woe to the ship that meets him, for, though death never overtakes him, the shadow thereof hangs about his ship, bringing to those who enter its radius the doom the fated man himself would gladly embrace for the sake of rest. But the gates of mercy are forever closed against him. (Howard Pyle, "North-Folk Legends of the Sea; with illustrations by Howard Pyle," *Harper's Monthly Magazine,* vol. 104, no. 620, January 1902, n.p.)

Seafaring themes fascinated Pyle for the better part of his career, and he wrote as well as illustrated a number of works on the subject. The first drawing Harper's published entirely from his hand, in 1878, marking his arrival as a professional illustrator, showed the alerting of a lifesaving station to a threatening shipwreck. In subsequent years he produced adventure stories and pirate fiction in the classic tradition, with abundant kidnapings, murders, shipwrecks, desert islands, stolen jewels, and buried treasure. *The Flying Dutchman,* while not actually belonging to the pirate fiction genre,

certainly does not stand alone in Pyle's work: its close counterpart, visually, is the pirate Captain Keitt in *The Ruby of Kishmoor* (1908), hatted and sashed, standing on a rolling deck with a similar elaborately carved rail and a lantern behind him. In *The Flying Dutchman* the artist's mastery of dramatic characterization is especially evident: the fierce, solitary figure with its ghostly companions is effectively offset by windswept empty space.

The Flying Dutchman, which is unusually large for an illustration, was presumably painted during the period of Pyle's tenure at Drexel Institute, probably during the summer of 1899. According to Pitz, basing his information on Frank Schoonover's recollections, it was painted at Chadds Ford, with the aid of Pyle's students, who constructed the tableau: a slanting platform was built outdoors to simulate the rolling poop deck, which the students kept wetting down to provide a wave-swept effect, while the family handyman posed on it in costume. There were summer school sessions at

Chadds Ford in 1898 and 1899 but none in 1900 after Pyle's resignation from Drexel (his letter of resignation is dated February 14, 1900), so if the painting were done during one of these sessions, it was finished well over a year before its appearance in *Collier's* in December 1900.

AP □

THOMAS EAKINS (1844–1916)
(See biography preceding no. 328)

394. *Mrs. William D. Frishmuth*

1900
Signature: EAKINS 1900 (lower right)
Oil on canvas
97 x 72″ (246.3 x 182.8 cm)
Philadelphia Museum of Art. Thomas Eakins Collection. 24–184–7

PROVENANCE: Thomas Eakins; Mrs. Thomas Eakins and Miss Mary A. Williams

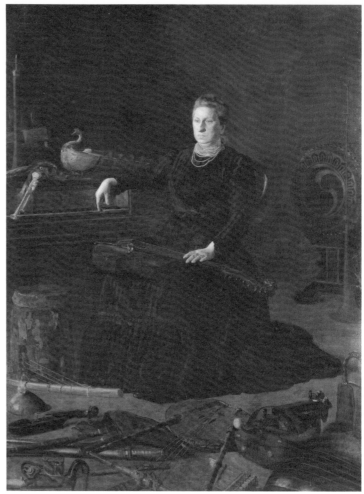

394.

LITERATURE: Goodrich, *Eakins*, p. 191, pl. 55; John Canaday, "The Realism of Thomas Eakins," *PMA Bulletin*, vol. 53, no. 257 (Spring 1958), pp. 47–50; Sylvan Schendler, *Eakins* (Boston, 1967), pp. 216–18

SARAH SAGEHORN FRISHMUTH was a noted Philadelphia collector of Colonial and ethnographic artifacts and musical instruments. By 1900 she had given a collection of approximately 1,100 musical instruments to the Free Museum of Science and Art of the University of Pennsylvania (Synnove Haughom, "Thomas Eakins' Portrait of Mrs. William D. Frishmuth, Collector," *Antiques*, vol. 104, no. 5, November 1973, p. 836). While the portrait was apparently painted at Eakins's request, out of an interest in Mrs. Frishmuth as a subject, it is possible that he hoped that it would be purchased to hang in the gallery where the instruments she had collected were displayed.

Painted when Eakins was fifty-six, the portrait of Mrs. Frishmuth stands near the beginning of a decade of revitalized activity in which Eakins painted almost twice as many pictures as he had in any other ten-year period, among them some of his best portraits. In size, the painting is equaled only by *The Gross Clinic* and *The Agnew Clinic* in Eakins's work, and the portrait of Mrs. Frishmuth is as complete a demonstration of the power of the artist's mature portrait style as *The Gross Clinic* is of his youthful talent. In its simplicity, the conception of a single figure seated in a space created entirely by a surrounding display of musical instruments is as audacious as the crowded drama of a surgical amphitheater.

As the portrait of Mrs. Frishmuth shows, Eakins's artistic concerns had not changed fundamentally since the mid-1870s. The dark tonalities of color, the objectively observed figure, solidly rendered as a structure of form in light, carefully studied perspective, and varying treatment of detail apparent in the musical instruments reveal a consistency of artistic interest remarkable for an artist in a generation given to constant experimentation.

Instead of searching for new modes of expression, Eakins, over a period of thirty years, had worked at perfecting the aspects of art that interested him. The results of his constant study are apparent in a comparison of his treatment of the heads of Dr. Gross and Mrs. Frishmuth. Instead of tentative strokes of paint built up into solid form, as in the head of Dr. Gross, the face and hands of Mrs. Frishmuth are painted with deftly placed strokes of color that resolve into tangible form with an exactitude that reflects Eakins's constant practice of painting directly from the model. As he had taught his students at the Academy (William C. Brownell, "The Art Schools of Philadelphia," *Scribner's Monthly Illustrated*

Magazine, September 1879, quoted in Goodrich, *Eakins,* p. 79), Eakins believed that character in a representation of a human model was achieved through an artist's ability to record the individuality of observed form, based upon a prior knowledge of the principles which govern its structure. The strong personality revealed in the volumes of Mrs. Frishmuth's face and hands and her somberly clothed figure indicate the expressive power of such persistent, objective study.

But throughout his career as a portraitist, Eakins had supplemented this concept of character achieved through individuality of form with carefully chosen details of costume or setting to create an image that interprets personality beyond physical presence. In the portrait of Mrs. Frishmuth, the interplay between the exotic shapes and colors of the musical instruments and the sober dress and remote self-containment of the sitter constitutes, in a painting of great formal power, one of Eakins's most subtle and enigmatic portrayals of human character.

DS □

JOHN SLOAN (1871–1951)
(See biography preceding no. 381)

395. *East Entrance, City Hall, Philadelphia*

1901
Signature: John/Sloan (upper right)
Oil on canvas
27¼ x 36″ (69.2 x 91.4 cm)
The Columbus (Ohio) Gallery of Fine Arts. Howald Fund Purchase

PROVENANCE: Estate of the artist; Kraushaar Galleries, New York, until 1960

LITERATURE: PAFA, *71st Annual* (1902), no. 553; John Sloan, *Gist of Art* (New York, 1939), p. 201 (illus.); "Artists of the Philadelphia Press: William Glackens, George Luks, Everett Shinn, John Sloan," *PMA Bulletin,* vol. 41, no. 48 (November 1945); New York, Kraushaar Galleries, *John Sloan Retrospective Exhibition* (February 2–28, 1948), no. 1; New York, Whitney Museum of American Art, *John Sloan 1871–1951* (January 10—March 2, 1952), no. 2, illus. p. 15; Van Wyck Brooks, *John Sloan, A Painter's Life* (New York, 1955), p. 38; Washington, D.C., National Gallery of Art, *John Sloan, 1871–1951* (September 31, 1971), no. 21, p. 67 (illus.); Bruce St. John, *John Sloan* (New York, 1971), pl. 11; Mahonri Sharp Young, *The Eight* (New York, 1973), p. 82 (illus.)

WHEN SLOAN PAINTED Philadelphia's most striking landmark from this unconventional point of view, he had only been seriously involved with painting for four years. *East Entrance, City Hall* is a remarkable achievement for an artist much of whose experience lay in linear Beardsleyesque illustration and decorative watercolors for the puzzle page of the Sunday edition of the Philadelphia *Press.* But it should be kept in mind that Sloan and his colleagues on the *Press* had long admired Charles Keene and John Leech, English illustrators for *Punch,* and knew the work of Constantin Guys. They were thus well acquainted with one tradition of lively realism, even though they expressed that realism in black and white rather than in oil.

Sloan's decision to paint a contemporary scene and his use of relatively subdued tones clearly derive from the inspiration of Robert Henri. But already there is a marked

395.

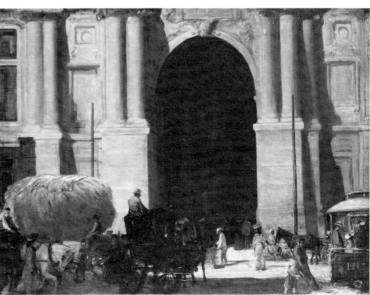

396.

difference between Henri's rapidly brushed canvases of Paris boulevards—with moving crowds and clumps of trees indicated by little blurs of color—and Sloan's carefully structured composition. The bold relief of City Hall's facade and its great dark arched doorway provide a challenging subject not quite to Henri's taste for "life" and spontaneity. Compared to Glackens's charming French scenes (see no. 384) and Henri's virtuoso landscapes (see no. 400), Sloan's painting achieves a monumental solidity and calm unexpected in the art of the Philadelphia members of The Eight. Nevertheless, Sloan reveals his interest in the contemporaneity of the scene by juxtaposing the static backdrop of architecture with the bustling activity in the foreground. "In the late 90's a load of hay, a hansom cab, a Quaker lady were no rare sight in the streets of Philadelphia," was Sloan's comment on the picture in his *Gist of Art* (p. 20), and he has added the more modern note of a streetcar, disappearing at the right. Although surely painted in the studio from memory (perhaps with the aid of a few jotted notes on color relations), which was Sloan's almost invariable habit at the time, the view is remarkably faithful to its model.

His other early renderings of Philadelphia subject matter include *The Old Walnut Street Theatre, Independence Square,* and *The Rathskeller*—a genre subject of a stylish young woman in a restaurant which Sloan and his wife, Dolly, used to frequent. Even after 1904, when Sloan was happily settled in New York, he often returned to his former haunts to visit friends or family, to discuss progress on his etchings with the printing firm of Peters Brothers, or to see exhibitions at the Academy. "Came to Philadelphia . . . ," he wrote on March 7, 1906, for example,

"looks well to me, a livable old look, tho' impossible, of course" (Bruce St. John, ed., *John Sloan's New York Scene,* New York, 1965, p. 21). The subjects of Sloan's New York paintings were to be more resolutely up-to-date—movie theaters, fashionable Fifth Avenue ladies, *Election Night in Herald Square*—but this faithful depiction of the "livable old look" of Philadelphia reveals him already securely launched on a career which responded to Henri's call for an American version of Baudelaire's "painter of modern life."

Ad'H □

ROBERT S. REDFIELD (1849–AFTER 1907)

Little is known of Redfield's life other than mention of his activities as an amateur photographer in *Camera Notes* and *Camera Work*. Born in New York City in 1849, he moved to Philadelphia in 1861. The Philadelphia city directories list him by profession as a clerk in 1883–84, a bookseller in 1885, and a clerk in 1893. He obtained advice and instruction in his photographic studies from Philadelphia's inventive and well-known amateur photographer Coleman Sellers, who patented the kinematoscope, and a Professor Hemphill. Moreover, he no doubt gained enthusiasm for the medium through his uncle, Constant Guillou, founder and first president of the Photographic Society of Philadelphia.

There seems to be a hiatus in Redfield's photographic activity for about ten years until the availability in Philadelphia of the gelatin dry plate in 1880, which John Carbutt was among the first to manufacture successfully in the United States. In 1881, Redfield became a member of the Photo-

graphic Society and one of its most active and influential members, serving as secretary from 1883 to 1894, vice-president from 1894 to 1898, president from 1898 to 1901, and editor of the Society's *Journal* from its inception in 1893 until his retirement from the organization in 1901. Redfield's decision to retire in December 1902 (along with John G. Bullock and Edmund Stirling) was based on his conviction that the Photographic Society no longer carried out the original intent of the pictorial photographers to place photography on an equal footing with the fine arts.

Redfield had played a prominent role in the organization, administration, and exhibition activities of the Philadelphia Photographic Salons of 1898 to 1900, serving on the jury of selection in 1898 with Alfred Stieglitz, as well as other Philadelphia painters and illustrators. His absence from any connection with the fourth annual Salon signified his deep concern over the increasingly active opponents of pictorialism, who advocated a broader, more varied representation of talent, whereas the pictorialists feared a lowering of artistic standards. In 1902, Redfield became one of the founding members of the Photo-Secession. His many administrative duties did not keep him from exhibiting widely in pictorial photography shows in America and Europe, however. (For a complete account of Redfield's awards received during his most active period from 1885 to 1900, see Joseph T. Keiley, "Robert S. Redfield and The Photographic Society of Philadelphia," *Camera Notes,* vol. 5, no. 1, July 1901, pp. 59–61.) Letters in the Stieglitz Archives (1898–1907) from Redfield to Stieglitz point out his declining participation in exhibitions beginning around 1904, although his devotion to the cause of pictorial photography continued.

396. *Landscape*

1901

Signature: R. S. Redfield (in pencil on mat, lower right)

Stamp: R. S. Redfield (on photograph, lower left)

Platinum print

4⅝ x 6¼" (11.8 x 17 cm)

The Miller-Plummer Collection of Photography, Philadelphia

PROVENANCE: The estate of John Emlen Bullock; with George R. Rinhart Gallery, New York, 1974

THIS SPRING WOODLAND LANDSCAPE is one of only a few Redfield photographs known to be in existence. A photogravure entitled

397. *Stephens House*

397. *Stephens House Stairwell*

A New England Landscape is illustrated in *Camera Notes* (vol. 5, no. 4, April 1902, p. 265). One might speculate that this untitled photograph is Redfield's *The Brook-Spring* listed, among other places, in the second annual Philadelphia Photographic Salon catalogue, 1899, no. 247, and in the members' *Annual Wall Display Exhibition of the Photographic Society of Philadelphia,* January 1900, no. 106. We know from titles of Redfield's works mentioned in brief reviews of exhibitions in contemporary photographic journals that his subjects were mainly landscapes and seascapes.

The platinum printing process used here was preferred by pictorial photographers in America and Europe. Because the process uses no colloid layer, the image is directly embedded into the paper fibers, producing a subtle, soft contrast between light and dark areas and a broad scale of tone. This often created the painterly effect which the majority of pictorial photographers sought in their work. (For discussion of other printing techniques used by pictorial photographers see MMA, *The Painterly Photograph 1890–1914,* by Weston J. Naef, January 8—March 15, 1973.)

Here, emphasis is placed not on the clear transcription of the objects in the field or in the background but on the atmosphere evoked. The pools of reflection in the stream and the misty atmosphere which pervades the background suggest timelessness and solitude: the whole is appreciated for its aesthetic autonomy.

CW □

WILLIAM L. PRICE (1861–1916)
(See biography preceding no. 392)

397. *Rose Valley Community*

Rose Valley, Moylan, Pennsylvania
1901–11

REPRESENTED BY:

Rose Valley: Stephens House
After 1901
Photograph
7⅞ x 9¾″ (20 x 24.7 cm)

Rose Valley: Stephens House Stairwell
After 1901
Photograph
8¼ x 6½″ (20.9 x 16.5 cm)

Rose Valley Improvement Company Houses
c. 1910
Photograph
4⅝ x 9½″ (11.7 x 24.1 cm)

Rose Valley Improvement Company: Hawke House
c. 1910
Photograph
7½ x 9½″ (19 x 24.1 cm)

Mr. and Mrs. George E. Thomas, Philadelphia

LITERATURE: William L. Price, "Is Rose Valley Worthwhile?" *The Artsman,* vol. 1, no. 1 (October 1903); pp. 5–11; William L. Price and M. Hawley McLanahan, "Group of Houses at Moylan, Rose Valley, Pa.," *The Brickbuilder,*

vol. 20, no. 9 (September 1911), pp. 185–91; William L. Price, "The House of the Democrat," in Gustav Stickley, *More Craftsman Houses* (New York, 1912), pp. 7–9; Peter Ham, ed., *A History of Rose Valley* (Rose Valley, 1973); George E. Thomas, "William L. Price: Builder of Men and of Buildings," Ph.D. thesis, University of Pennsylvania, 1975, pp. 291–331

SOME FIFTEEN MILES WEST of Philadelphia, and a mile or two south of Media, stand a cluster of houses and two old mill buildings called Rose Valley. The buildings' common architectural vocabulary of red-tile roofs, rough stone, and stucco inset with patches of brightly colored tile bespeak their original creation largely as the work of one man, Philadelphia architect and Rose Valley resident William L. Price. Collectively these buildings are more than just the handsome product of one mind—they represent one of the numerous early twentieth century attempts to bridge the disastrous gulf between economic and social theory and reality.

The roots of Rose Valley lie in the last decade of the nineteenth century in William Morris's political tract *News from Nowhere,* which describes an England of the not-so-distant future, with water again running clear, with air no longer befouled by smoke, and with people participating in every aspect of their lives—sharing both the odious and the pleasant tasks—and governed by the "folk-mote," the community meeting. In 1901, five years after Morris's death, that community became a reality at Rose Valley.

The Arts-and-Crafts community was founded with the capital of Price, his rela-

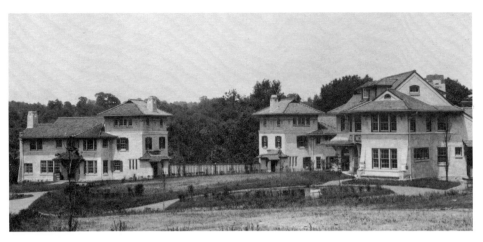

397. *Rose Valley Improvement Company Houses*

tives, his future partner M. Hawley McLanahan, and guided by a community board of directors that included Edward Bok, publisher of the *Ladies' Home Journal*. The community's aims were expressed by Price in an essay entitled, "Is Rose Valley Worthwhile?"

> Development like happiness is not bought in the market. Since the world began, since the constructional instinct first awoke in man as the stern instance of his helplessness, there has been but one road by which he has progressed. Through creative thought and work alone does development come.
> The reality of this fact is at the root of the arts and crafts movement which is no mere return to simple or archaic methods of production, but an assertion of the dignity and necessity of constructive work. (*The Artsman,* vol. 1, no. 1, October 1903, p. 8)

Rose Valley was to be centered in creative work—the possibility of work was what was attractive about the old mill town which Price acquired, for it contained two mill buildings which were readily adapted to the production of furniture (see nos. 398, 399), pottery (see no. 401), and the other objects made in Rose Valley. Although the town corporation itself made nothing, it provided the space and acknowledged work of high quality with the town seal—a buckled belt encircling a wild rose, with a V on its petals.

The old town had, in addition, a number of old houses and barns, which were soon renovated, while a row of houses, recalling an image from Morris, became the "guest house." New buildings were interspersed with the old; larger houses stood side by side with $1,200 cottages. Unlike the developing, economically segregated suburbs ringing Philadelphia, Rose Valley set out to be

within the financial reach of everyone: "Here the tiniest cottage may be built side by side with a more spacious neighbor. And why not? Certainly our fitness to associate together upon simple human conditions should not be gauged by our means" (Price, *The Artsman,* cited above, pp. 10–11).

Stylistically, the buildings of Rose Valley were equally suited to its founders' radical principles. Yet, they recall the half-century-old ideas of Andrew Jackson Downing, who had called for a Spartan architecture suited to the nation's republican institutions. In an article in Gustav Stickley's *More Craftsman Houses* (New York, 1912), Price outlined his goal of "The House of the Democrat." The house could only be built for the Jeffersonian democrat—but its model was not Colonial architecture. Warned Price:

> I do not mean the pillared porticoes of the stately mansions of Colonial days; they speak of pomp, of powdered wig, of brocade gown, of small clothes and small sword, of coach and four, of slavery or serfdom; nor do I speak of lesser imitations of such houses. (p. 8)

There was an alternative:

> You may find here and there, an old farm house springing out of the soil, built by village carpenter and mason and smith, with low roofs and wide spreading porches that mothers the human brood . . . and when you find it, your heart will yearn to it, you will find that a Jefferson might have spoken his noblest thoughts under its rooftree and the simplest yeoman his simplest hope for tomorrow's crops with an equal dignity and an even fitness. (p. 7)

Thus, as so many other architects of this century would do, Price turned to vernacular architecture, attracted by its simplicity, rough materials, and local color, reducing design to the essential features.

Price's earliest work at the Valley was little more than a renovation of the existing buildings. The old row of houses which became the "guest house" received new wood porches, a tile roof, and stucco with patches of Mercer tile set into the wall to differentiate the new work from the old. Other buildings followed the pattern: one mill became a workshop, another, the town guild hall, which remains as the Hedgerow Theater; the other houses received the same tones. As Price had hoped, a regional feeling resulted from the use of common local materials.

The first ambitious projects occurred in 1901, when an old barn was turned into a studio and house for Frank and Alice Barber Stephens (see biography preceding no. 382). The barn became the studios, and a new house was constructed to the west, joined to the old work by an octagonal stair, which offered privacy by changing a level. Price described the house:

> The house grew, as all houses should grow, out of the needs of the owners and the opportunity offered by the site. . . .
> The old barn standing near the road was converted into first and second floor studios; the timber roof being rebuilt for the upper studio, and large windows and fireplaces built into the old walls. The house rambles off from the fireplaces out off the studio and is connected to them by an octagonal stair hall. It is built in field stone so like the old that it is almost impossible to tell old work from new. The upper part is of warm grey plaster, and the roof of red tile. All the detail is as simple and direct as possible, and the interior is finished in cypress stained to

397. *Hawke House*

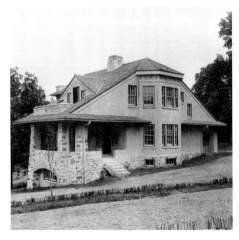

soft fawns and greys and guilty of no finish other than wax or oil. (Philadelphia, George E. Thomas Collection, typescript)

The other houses of the decade continued the same pattern. A new level of work was obtained only after 1910, when five houses were constructed for the Rose Valley Improvement Company. Without the constraints of an already existing building, Price was able to explore the formal possibilities of the new materials of the age. The result was a parallel to the simple volumes of the rural Shingle Style of a generation earlier, clearly expressive of its structure, as Price explained:

No idea of fake construction is to be gathered from any of the details. Under a present day impulse new structural conditions as exemplified in concrete and hollow tile have been accepted. Those demand a specific surface treatment and naturally point the way to the accomplishment of a plastic art whereby perhaps an indigenous expression typically American is to be established. ("Group of Houses at Moylan, Rose Valley, Pa.," *The Brickbuilder,* vol. 20, no. 9, September 1911, p. 185)

But this was no sterile technocrat's architecture, for Price still rooted the buildings in the soil on foundations of local stone, which disappeared gradually into the stucco surfaces. Ornamental bands of Mercer tile linked them to the other buildings of Rose Valley.

At Rose Valley, Price laid the foundation of a regional style of considerable significance. But the utopian community of men and women joined by the common bond of creativity survived its designer's death only as the home of artists, and later as the site of the Hedgerow Theater.

GT □

WILLIAM L. PRICE (1861–1916)
(See biography preceding no. 392)

398. *Reclining Armchair*

1901–9
Stamp: ROSE VALLEY SHOPS
Oak
46 x 34 x 31″ (116.8 x 86.3 x 78.7 cm)
Mr. and Mrs. Samuel Ward, Moylan, Pennsylvania

PROVENANCE: John Maene, Rose Valley; granddaughter, Mrs. Samuel Ward, Rose Valley

THIS CHAIR is the most severe of William Price's designs produced by the Rose Valley Shops. Its stiles extending above the crest

rail are seen in the Price side chairs (no. 399). The similar stiles and the shaped armrests appear in a chair designed by C. F. A. Voysey and made about 1909 (Simon Jervis, *Victorian Furniture,* London, 1968, pl. 91). The central stretcher tenoned through the side stretcher is an example of the kind of honest construction that Wilson Eyre, Jr., also used in his table (see no. 377).

The form of this chair is derived from the famous English "Morris" chair designed by William Watt for Morris and Company. A late nineteenth century American adaptation for this chair was seen in the reclining chair by Allen and Bro. (no. 379). This early twentieth century craftsman style version has the following elements in common with the prototype: a reclining back adjustable by a ratchet, comfortable proportions, a back of wide splats, and prominent thrusting arms. Although the Price chair is shown without cushions, these would no doubt have been added for comfort, thus minimizing the visual structural appearance. The so-called Morris chair in the "Mission" style became very popular after World War I, and examples were listed as such in furniture catalogues throughout the country.

This armchair is similar to a reclining armchair produced both by Gustav Stickley's Craftsman Workshop in Syracuse, New York, and one copied by L. & J. G. Stickley (illus. in *The Arts and Crafts Movement in America,* Princeton, 1972, p. 44). Although Price disagreed with Stickley's strictures against using ornament, he would, no doubt, agree with what Stickley wrote about his love of simple, honest construction and of natural surfaces: "When I first began to use the severely plain, structural forms, I chose oak as the wood that, above all others, was adapted to massive simplicity of construction. The strong, straight lines and plain surfaces of the furniture follow and emphasize the grain and growth of the wood, drawing attention to, instead of destroying, the natural character that belonged to the growing tree" (p. 41).

The Rose Valley stamp on the chair was "the Association's guarantee that the workman has conformed in every item of competent mechanical and artistic standards" (Hawley McLanahan, "Rose Valley in Particular," *The Artsman,* vol. 1, no. 1, October 1903, pp. 13–14). John Maene (see biography preceding no. 401) is believed to be the maker of this chair according to family tradition.

In an article "The Building of a Chair" in *The Artsman* (vol. 1, no. 8, May 1904), William Price described the process and philosophy of Rose Valley furniture. After choosing the wood, "air-dried if possible, and the run of the grain for strength well considered," the Rose Valley craftsman would use mortise and tenoned construction

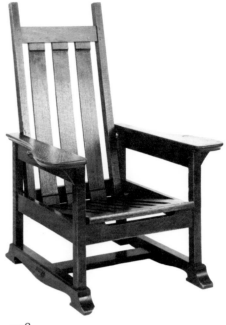

398.

rather than only dowels and glue (p. 279). In some instances a combination of techniques was permitted. Price concluded: "So your built chair is something more than a good chair. It is a message of honesty and joy to the possessor, and a cause of growth and of joy to the worker. And your 'made-up' chair is something less than the sham that it stands for, insidiously and in the guise of a blessing undoing the character alike of maker and possessor. It and its kindred shams are the symptoms of that loosening of character that is reflected in the hideous political and industrial corruption that Lincoln Steffens has shown is at work undermining our social and political fabric" (p. 283).

As with other leaders of the Arts and Crafts movement, William Price wrote about the detriment of the machine on mankind: "The world boasts about what the machine does for man. It could better boast about what man does for the machine. It could better boast about what man can do for himself. Man has no chance in this factoried civilization to show what he can do for himself. What he can do with his right hand and his left hand. What he can do with unobstructed genius to produce articles of use and beauty such as no slave world given whatever miracles of mechanical prestidigitation could evolve. We do not need to burden man with elaborate machines. We need to free him for his task" (*The Artsman,* vol. 1, no. 3, December 1903, pp. 108–9).

DH □

WILLIAM L. PRICE (1861–1916)
(See biography preceding no. 392)

399. *Side Chairs*

1901
Inscription: L and O carved in monogram in center of splat (for Lucie and Owen Stephens)
Oak; leather seat
38 x 21 x 16¾″ (96.5 x 53 x 42.5 cm)
Mrs. Samuel S. Starr, Media, Pennsylvania

PROVENANCE: Mr. and Mrs. William L. Price, Rose Valley; friend, Mrs. D. Owen Stephens, Rose Valley; daughter, Mrs. Samuel S. Starr, Rose Valley

DESIGNED BY WILLIAM PRICE and produced in the Rose Valley shops between 1901 and 1909, these chairs were owned by Mrs. Price at the time of the marriage of her friend Lucie to Owen Stephens in 1921. According to Mrs. Stephens, they came disassembled, as evidently did other Rose Valley chairs for purposes of storage. Around 1921 the chairs were put together again by Owen Stephens who carved his own and his bride's initial in a cutout monogram in the back slat of the chair.

Contemporary in design, these chairs are, however, not typical of Rose Valley furniture, which is strongly medieval or Gothic in character. The only reference to a past style here is the ogee-shaped rail above the seat and the Gothic-like monogram, carved at a later date by Stephens.

The closest American parallel is a side chair designed in 1903 by Harvey Ellis and produced by Gustav Stickley's United Crafts in Syracuse (in *The Arts and Crafts Movement in America, 1876–1916*, Princeton, 1972, pl. 37). The same overall form and the arched stretcher in the front are seen in both chairs. The partially chamfered stiles serve as additional embellishments to the chair. Like so many Stickley chairs, the Price examples are upholstered in leather secured by brass tacks. The extension of the stiles above the crest rail is reminiscent of chairs designed by Charles Rennie Mackintosh and C. F. A. Voysey.

DH □

ROBERT HENRI (1865–1929)

One of America's most influential teachers of art, as well as a passionate crusader for artistic freedom from the restriction of the academies or any form of jury system, Henri came naturally by his pioneering spirit. Born Robert Henry Cozad in Cincinnati, he was the son of a professional gambler turned real estate speculator. His childhood was spent between schools in Cincinnati and Denver, and in the Nebraska prairies, where his father founded the town of Cozad in 1872. Ten years later, his father's shooting

of a rival ranch-owner in self-defense caused him to move his family to the east coast, where the parents and their two sons all changed their names. From 1883 to 1886, Henri lived in Atlantic City, assisting in his father's business ventures.

His growing interest in art and illustration led him to enroll in the Pennsylvania Academy in 1886. Although Eakins had left the Academy shortly before his arrival, Henri was to have a lifelong admiration for him. At the Academy Henri studied anatomy, perspective, and drawing—from the antique and from life—with Thomas Hovenden, James P. Kelly, and Thomas Anshutz (who became an important influence and good friend). From the outset of his Academy career (which lasted intermittently until 1892) Henri was a leader among the students, organizing portrait and sketch classes, and instigating all manner of skits and revels. His close friends included Charles Grafly, Alexander Stirling Calder, Henry McCarter, Hugh Breckenridge, and Edward Redfield.

From 1888 to 1891 a prolonged stay in Europe exerted a powerful impact on his career. The paintings of the Spanish masters and Rembrandt, which he saw in London and at the Louvre, impressed him deeply. Studying with Bouguereau and Robert-Fleury at the Académie Julian in Paris, he drew intensively from the living model during the winter and spent the summers of 1889 and 1890 painting outdoors in Brittany and on the Mediterranean coast. By 1891, Henri was an admirer of Monet but remained cool to the innovations of the Post-Impressionists.

That fall he returned to the Pennsylvania Academy in Philadelphia, where the modified Impressionism of his paintings in the annual exhibition of 1892 was greeted by critics as "extreme mannerism in color" (Philadelphia *Times*, January 21, 1892). Renting a studio at 806 Walnut Street, Henri began his long teaching career in the fall of 1892 with classes in drawing and portraiture at the Philadelphia School of Design for Women. During 1893 a group of younger artists began to gather around him, founding the short-lived Charcoal Club for drawing from the model and assembling once a week in Henri's studio for lively discussions of art, literature, and politics. The group included old friends, but significant new additions were John Sloan, George Luks, William Glackens, and Everett Shinn. Illustrators for the city's newspapers, under Henri's influence they turned to painting and later constituted the Philadelphia contingent of The Eight. In these informal gatherings during the 1890s, in cramped studio quarters in Philadelphia, Henri's inspiration and encouragement of younger artists were to have as forceful an impact on

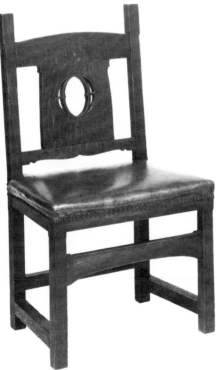
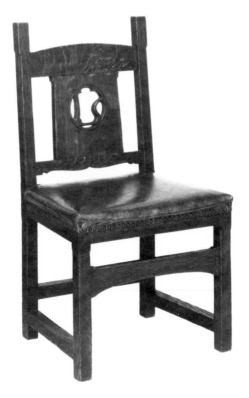

American art of the coming century as his more public efforts a decade later. His thorough academic training, knowledge of the Old Masters, and years of European experience made him a respected teacher—his call for a new art derived from the vigor and spontaneity of American life and his warm support for individual styles ("Don't paint like me") made him an irresistible leader.

Henri departed for France again in June 1895, passing through Holland where his admiration for Rembrandt and Frans Hals was strengthened. To make a living, he organized a private school of art in Paris, and painted a large number of street scenes and costume pieces, in the hope of having one accepted for the Salon. With this achieved (in 1896 and 1897), he returned again to Philadelphia where his first one-man exhibition of eighty-seven of his Paris pictures opened at the Pennsylvania Academy in October 1897. Despite a lack of sales, Henri received good reviews in the press, was praised by William Merritt Chase, and invited to show his work with the Macbeth Gallery in New York. His style by now had lost its Impressionist color and grown dark and painterly, with an emphasis on rapid execution.

Henri's third Paris period lasted from 1898 to 1900. He took on a few private students, but long, energetic bouts of painting were rewarded by the acceptance of four pictures by the Salon of 1899 and the purchase of *La Neige* by the Musée National du Luxembourg (a signal honor for an American). During the summer of 1900 he painted five full-scale copies after Velázquez in the Prado, and returned to the United States to settle in New York City.

The years 1900–1904 marked a particularly brilliant phase in Henri's painting. Living in New York, but often returning to Philadelphia to visit friends and see exhibitions, he produced a steady stream of landscapes, figure pieces, and portraits, and had his first solo exhibition at the Macbeth Gallery in the spring of 1902. In November of that year came his second large show at the Pennsylvania Academy of forty-two works, which then traveled to the Pratt Institute in Brooklyn and enjoyed a good critical reception. One by one, Henri's Philadelphia friends gravitated toward New York, and his circle steadily enlarged (Arthur B. Davies and Maurice Prendergast were two newcomers). In the fall of 1902, he began to teach at the New York School of Art (founded by William Merritt Chase), and his classes rapidly became extremely popular. In 1903 he was elected to the Society of American Artists, and in 1904 his *Girl in White Waist* was purchased by the Carnegie Institute (his first painting to enter an American museum).

By the age of forty, Henri had become a major figure on the American art scene: he was widely acclaimed as a teacher and as a leader in the struggle against the rigid standards of the National Academy of Design (which elected him a member in 1906), and was exhibiting and winning prizes in national shows across the country. An exhibition he organized at the National Arts Club in January 1904 foreshadowed the formation of The Eight (all except Shinn and Ernest Lawson were included) and was hailed by the *New York Times* as "startling works by Red-Hot American Painters." Henri's efforts to liberalize the National Academy from within failed when the jury rejected works by Luks, Shinn, and Glackens in 1907 and refused to reappoint Henri to the jury. Henri's rebuttal was the exhibition of forty-five paintings by The Eight at the Macbeth Gallery in February 1908, preceded by months of publicity and attended by seven thousand visitors. The five ex-Philadelphians exhibited subjects drawn from modern city life while the varying styles of Lawson, Davies, and Prendergast gave emphasis to Henri's defense of the artist's right to express his individuality. The Pennsylvania Academy invited the show to Philadelphia, and it then continued on a tour of eight cities across the country.

A dispute with the New York School of Art led Henri to open his own art school in January 1909, where he taught until 1912 (his pupils including George Bellows, Patrick Henry Bruce, Edward Hopper, Rockwell Kent, Yasuo Kuniyoshi, and Stuart Davis). With Sloan and Walt Kuhn, he prepared his last large-scale manifestation: 103 artists (including at least thirty-eight former students) were invited to show approximately five hundred works in the

jury-free Exhibition of Independent Artists, which opened in April 1910. Widespread publicity and huge attendance made it a prelude to the Armory Show of 1913 and the founding of the Society of Independent Artists in 1916, both offshoots of Henri's activity and convictions but involving him only slightly.

The last fifteen years of his life were spent teaching, painting (particularly portraits), and working out a theoretical system of color harmony proposed by Hardesty Maratta. From 1911 to 1919 the MacDowell Club carried out his plan for small, jury-free shows organized by groups of artists. Publication in 1923 of *The Art Spirit,* an anthology of his letters, articles, and lectures, was to provide a generation of art students with a popular handbook. Henri's death at the age of sixty-four was followed by a memorial exhibition of seventy-eight works, which John Sloan assisted in mounting at the Metropolitan Museum of Art in 1931. The artist's papers, consisting of diaries, photographs, his own catalogue of his works, and a large clipping file, are preserved in the care of Mrs. John C. Le Clair of Glen Gardner, New Jersey, and Henri's correspondence was donated by the late Mr. Le Clair to Yale University.

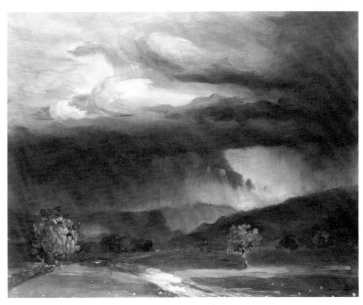

400.

400. *Rain Storm, Wyoming Valley*

1902
Signature: Robert Henri (lower right)
Oil on canvas
26 x 32" (66 x 81.3 cm)
Mr. and Mrs. Joseph Tanenbaum, Great Neck, New York

PROVENANCE: Knoedler & Company, New York; bought by Adolph Lewisohn, New York, April 1919; exchanged with the artist for another painting, May 26, 1922; estate of the artist; Alfredo Valente Gallery, New York; acquired by the present owners in 1963

LITERATURE: PAFA, *Exhibition of Paintings by Robert Henri* (November 15-30, 1902), no. 16; MMA, *Memorial Exhibition of the Work of Robert Henri* (March 9—April 19, 1931), no. 13, illus.; New York, Alfredo Valente Gallery, *Robert Henri* (October 29—November 29, 1963), no. 1 (illus.); New York Cultural Center, *Robert Henri: Painter-Teacher-Prophet* (October 14—December 14, 1969), no. 25, illus. p. 31; William Innes Homer, *Robert Henri and His Circle* (Ithaca, N.Y., 1969), p. 232, colorpl. 2

HENRI SPENT THE SUMMER of 1902 at the summer home of his wife's parents in Black Walnut, a little town near the Wyoming River in the rolling hills of northeastern Pennsylvania. Some of his most successful paintings were produced during those months: small, shorthand sketches on panel and larger, more finished canvases that convey the fresh, immediate impressions of weather and a changing landscape. Henri's palette, which had darkened during the late 1890s in his Paris scenes and studies of models in costume, regained some of the heightened color of his earlier experiments with Impressionism. As in his summers on the French coast in 1889 and 1890, he spent long hours outdoors painting directly from nature. *Rain Storm, Wyoming Valley* appears in the entry in his diary for June 23d: "Painted storm, rain, from clouds—touch of sun on distant hill, road—very green foreground—touch of sun across middle of trees" (Henri Papers).

Years of training at the Pennsylvania Academy and the Académie Julian in Paris are here fully subsumed into Henri's mature style, which at its best was supremely responsive to the subject—more particularly, to Henri's "sensations" of the subject. Experience is translated swiftly and directly into paint with a skill and freedom unhampered by any conventional formula of composition. In Henri's concern to capture his reaction to the scene before him, his paintings often have a casual, even careless sense of haste. Here, the breathtaking speed of execution is handled with consummate skill, and the motion of wind and rain is conveyed to the viewer in every brushstroke. One can well imagine that the painting was completed in a few hours, a practice often urged upon their students by both Henri and William Merritt Chase, his colleague and sometime rival as a teacher in Philadelphia and New York art circles. But Chase's stress on brilliant and elaborate detail and surface highlighting ran counter to Henri's urgent wish to depict the inner life of his subject in broad masses of color and tone.

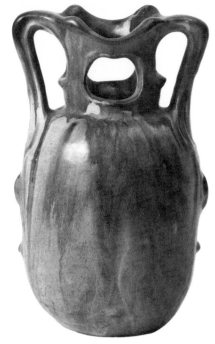

401.

Unlike Henri's Paris pictures, *Rain Storm, Wyoming Valley* owes little in either composition or facture to his European experience. Although less adventurous in color, it surpasses the efforts of many of his American Impressionist contemporaries to convey the transitory effects of light and weather on a landscape. A sympathetic critic visiting Henri's one-man show at the Macbeth Gallery, a few months before this picture was painted, wrote: "It is a curious theory that a certain mechanical polish is commonly associated with the idea of finish, and from a few remarks dropped by casual visitors to Mr. Henri's exhibition it is evident that his landscapes are regarded by many as sketches, or thoughts half expressed.... The truth being that in comparison with Mr. Henri's work, most of the landscapes commended for their completeness and finish have, in reality, never even been begun" (New York, *Evening Sun*, April 8, 1902). *Rain Storm, Wyoming Valley* is not a very progressive painting for its date, but it is a highly individual one. Henri's source of inspiration may still be the past (one thinks of Turner and Constable), but he makes use of it in the independent, unacademic spirit so stimulating to his contemporaries.

Ad'H □

JOHN J. MAENE (1863-1928)

John Maene was a Belgian who came to this country from Brugge at the age of twelve. His uncle was a sculptor in Philadelphia, and it was from him that he learned to carve in wood and stone. Maene became interested in the Rose Valley Arts and Crafts community through his acquaintance with William L. Price (see biography preceding no. 392). He moved to the Bishop White house in Rose Valley in 1902 and became a central figure in the artistic community (see no. 397). His skills were very useful to the furniture and pottery shops. However, he was best known as a sculptor, in particular figural carving in stone. His carvings can be seen on university buildings at Pennsylvania, Princeton, and Wellesley and over the choir stalls at the Valley Forge Chapel, to name a few of his better known commissions.

ATTRIBUTED TO JOHN J. MAENE

401. *Vase*

After 1902
Mark: Cluster of six raised nubmarks
Pottery with underglaze decoration
Height 8¼" (21 cm)

Mr. and Mrs. Samuel Ward, Moylan, Pennsylvania

PROVENANCE: John Maene; granddaughter, Mrs. Samuel Ward

LITERATURE: Peter Ham, Eleanore Price Mather, Judy Walton, Patricia Ward, eds., *A History of Rose Valley* (Rose Valley, Pa., 1973), illus. p. 131; Paul Evans, *Art Pottery of the United States* (New York, 1974), illus. p. 263

THIS VASE is one of the few documented examples of Rose Valley pottery known to have survived. Unlike most of the pottery produced in the Guild Hall, the vase, attributed to John J. Maene according to family tradition, shows the influence of European Art Nouveau design. The undulating curves of the handle and neck are particularly of this style, and the decoration is not simply applied to the form but is subtly achieved through drip glazes in a variety of soft bleeding tones of green.

Rather than producing pottery on its own, the Rose Valley Association invited accredited craftsmen such as Maene to work in its shops under the patronage of its emblem. A cluster of six raised nubs, probably the center of the wild rose and an adaptation of the Association mark, appears on this vase.

While Rose Valley's master potter William P. Jervis experimented during 1904-5 with mat glazes, this vase has a glossy finish. Examples of Rose Valley pottery made under Jervis during his short association with Rose Valley are illustrated in an early photograph (Paul Evans, *Art Pottery of the United States*, New York, 1974, p. 262).

DH □

402. *Bowl*

1903
Colorless flint (lead) glass
Height 2½″ (6.4 cm); diameter 10″
(25.4 cm)
Philadelphia Museum of Art. Given by
Gillinder & Sons. 04-2

THIS BOWL is a typical example of fine cut glass that was produced in America during the "Brilliant Period" (1885–1915). This style of cutting, in which the pattern almost entirely obscures the original surface of the bowl, began to develop at the time of the Centennial exhibition, partly as a result of late Victorian taste which demanded overly ornate decorations in almost every medium and partly as a reaction to the broad, simple, and, by comparison, rather plain cut glass patterns of the third quarter of the nineteenth century. It was made possible by technological improvements in furnace design, glass chemistry, and melting practices which resulted in the high quality, thick lead glass blanks which, when cut with these overall patterns, produced a brilliant refraction giving this style of cut glass its name.

Cut glass, which has only returned to favor in the eyes of collectors within the past ten years, has always been expensive because of the labor involved in producing it. This can be better understood when it is realized that each part of the pattern must undergo four or five separate operations to be achieved: 1) rough cut with an iron wheel with coarse emery and water; 2) smooth cut with an iron wheel with fine emery and water; 3) smoothed to a translucent finish on a sandstone wheel with water; 4) semi-polished on a felt wheel with pumice; 5) polished on a wooden or felt wheel with tin oxide, or some similar polishing material.

KMW □

HENRY CHAPMAN MERCER (1856–1930)

Born at Doylestown, Pennsylvania, Mercer attended Harvard College where he supplemented his history curriculum with Charles Eliot Norton's History of the Fine Arts and Charles Herbert Moore's Principles of Design. After studying law at the University of Pennsylvania, Mercer founded the Bucks County Historical Society at Doylestown in 1880 with Gen. W. W. H. Davis. Mercer investigated the archaeological evidence of early man in the eastern United States and Mexico, beginning with his analysis of the prehistoric Lenape Stone

(Bucks County Historical Society) in 1881. In 1891 he was appointed one of the ten original managers of the University Museum, Philadelphia, and served as its curator of American and prehistoric archaeology from 1894 to 1897. In 1895, Mercer led the Corwith Expedition to Yucatan, but contracted malaria and resigned his post at the University Museum. He returned to Doylestown to begin a second career as a pioneering collector and interpreter of American handcrafted tools.

Through his interest in the crafts of the Pennsylvania Germans, Mercer attempted to document and revive the local pottery manufacture. Discovering that the local clay was too porous for the production of fine hollow ware, Mercer began to manufacture ceramic tiles in 1898. The first recorded sale of tiles from Mercer's Moravian Pottery and Tile Works appears in his account book for October 29, 1899. The earliest designs were based on motifs from Pennsylvania German stove plates.

Mercer obtained technical and artistic advice from diverse sources. He received instruction on glazes from William de Morgan in England, the Cantagalli in Florence, and Louis Comfort Tiffany in New York. Sir Hercules Read, Keeper of the Department of British and Medieval Antiquities and Ethnology at the British Museum, provided the tile works with more than one hundred motifs from medieval examples. Similarly, Professor Hans Bosch of the Germanic Museum in Nuremberg offered several designs from that collection and corresponded with Mercer on matters relating to the Pennsylvania Germans. Mercer personally designed or adapted many of the motifs which appear on his tiles, notably the large group of mosaic tiles for the State Capitol at Harrisburg, 1902–6, designed by Joseph M. Huston.

402.

In addition to his innovations in the manufacture of ceramic tiles, for which he was awarded five patents, Mercer was a pioneer in the use of reinforced concrete with which he built his monolithic home Fonthill, 1908–10; the Moravian Pottery and Tile Works, 1910–12; and the Bucks County Historical Society, 1914–16. All three of these Doylestown institutions have collections of Mercer's tile *in situ.*

403. *The Elk*

1903
Glazed ceramic tile mosaic
24 x 25″ (60.9 x 63.5 cm)
Philadelphia Museum of Art. Given by
Henry Chapman Mercer. 04-158

The Elk WAS GIVEN to the Philadelphia Museum of Art in 1904 as a result of Mercer's friendship with Edwin Atlee Barber (1851–1916), the foremost contemporary American authority on ceramics. Barber served as curator from 1901 to 1907 and as director from 1907 to 1916 of the Pennsylvania Museum (Philadelphia Museum of Art). The correspondence between Mercer and Barber in the Museum archives documents their exchange of information: Barber sought advice on medieval English ceramic tiles and Pennsylvania German iron stove plates, while Mercer borrowed fom Barber's treatise on Pennsylvania German *sgraffito* ware.

The Elk shown here is a replica made by Mercer of one of 420 mosaic tiles which he designed for the interior pavement of the new State Capitol building in Harrisburg. Mercer described his scheme for the floor of the Capitol, the most ambitious undertaking of the Moravian Pottery and Tile Works, in his ninety-eight-page *Guide Book to the Tiled Pavement in the Capitol of Pennsylvania* (1908). The *Guide Book* was published, probably at Mercer's expense, to provide a written description for each of the mosaic groups. Mercer described the desired effect of the ensemble in his Preface:

Varying considerably in size, but generally not more than five feet in diameter, or gauged so as to focus the human eye at a distance of five or six feet, the mosaics may stand for mere patches of harmonious color to the individual who rapidly walks across them, while it is only to him who pauses and studies them carefully that their full significance gradually appears. What the observer sees is less a picture than a decoration. The drawing is simplified so as to satisfy the clay process. The colors of men, animals and objects are

fantastic and not realistic. The skies may be red, the water black, the trees yellow.

Yet, though the result may please the eye and adorn the floor, the mosaics are intended to be not only thus decorative, but significant, reasonably expressing within the limits of the craft which produced them, facts and events in the history of Pennsylvania and the life of its inhabitants.

Mercer described *The Elk* tile, of which there are two in the State Capitol, as follows: "Yellow-bodied, with brown head and mane, an immense deer, with huge antlers shed and regrown yearly, wallowing in mud, or standing in water to escape summer flies, herding in season, called 'Wapiti' by the Iroquois Indians, and miscalled elk by whites, the animal is glorified in scores of geographical names upon the American map. He was exterminated by sportsmen and gunners in Pennsylvania about 1850" (*Guide Book*, p. 33, no. 45, p. 48, no. 91).

Mercer's *Elk* tile combines his archaeological and historical researches. It relates to another mosaic tile at the Capitol, *Indian Rock Carving* (*Guide Book*, cited above, p. 77, no. 409), which depicts an elk carved in stone at Indian Rock in the Susquehanna rapids at Safe Harbor by American Indians. The Indian Rock elk, one of more than two hundred carved figures found at the Safe Harbor site, appealed to Mercer in its reduction of line and color. Mercer's elk is only

slightly more naturalistic, introducing a schematic landscape. Mercer also may have been thinking of Dürer's famous *Heilant* (Elk) which he may have seen at the British Museum with his friend Sir Hercules Read. Mercer was a great admirer of Dürer's work and displayed reproductions of his prints at his Fonthill estate. It is typical of Mercer that he would have found inspiration in visual sources as disparate as the carvings of the American Indian and the prints and drawings of Dürer.

DDT □

WILLIAM L. PRICE (1861–1916)
(See biography preceding no. 392)

404. *Jacob Reed's Sons*

1424 Chestnut Street
1903–4
Price and McLanahan, architects
Reinforced concrete structure; brick facing, tile decoration

REPRESENTED BY:

William H. Rau (n.d.)
Jacob Reed's Sons: Facade
c. 1904
Photograph
7½ x 4¾″ (19 x 12 cm)

Mr. and Mrs. George E. Thomas, Philadelphia

Jacob Reed's Sons: Main Floor (during construction)
c. 1904
Photograph
6⅝ x 7¼″ (16.8 x 18.4 cm)

Mr. and Mrs. George E. Thomas, Philadelphia

LITERATURE: *Philadelphia Inquirer* (December 1, 1903); George E. Thomas, "William L. Price: Builder of Men and Buildings," Ph.D. thesis, University of Pennsylvania, 1975, pp. 155–60

IN 1930, GEORGE HOWE, then designing the Philadelphia Saving Fund Society office tower (no. 456) in partnership with William Lescaze, discussed the premises of modern architecture in an essay entitled, "What Is Modern Architecture Trying to Express?" In it, he reviewed the work of the precursors of American modernism whose designs he found meaningful:

America has always been the land of lone prophets without much but posthumous honor in their own country, which has been too busily engaged in exploiting its vast resources to take much interest in the spiritual consequences of its own art, and Wright, Sullivan and Price were among the first to grasp the architectural possibilities of the new life and the new means of construction. Their names were known in Europe and their works reproduced while they still remained comparatively obscure among their fellow countrymen. (*American Architect*, vol. 137, May 1930, p. 24)

Wright, of course, lived another quarter of a century becoming as well known in his homeland as he was in Europe. Largely through his efforts, his work and that of Louis Sullivan have remained in the public eye. On the other hand, the designs of Philadelphia architect William L. Price were so thoroughly forgotten that the modern critic may wonder which Price Howe meant! Price's contribution was, in fact, not unlike that of Frank Lloyd Wright—a transition from turn-of-the-century eclecticism to a personal and untheoretical modernism based on the traditional Ruskinian premises of the direct and honest use of materials and the expression of technics. Joined with the scale of modern life, the results were Price's masterpieces, Atlantic City's fabled Traymore Hotel and Chicago's Freight Terminal. More significant than individual landmarks was Price's approach to the form of a building as the manifestation of the various activities that took place within, modified and articulated by the underlying skeleton and decorated with materials related to the construction process. That solution was capable of broad application to buildings

403.

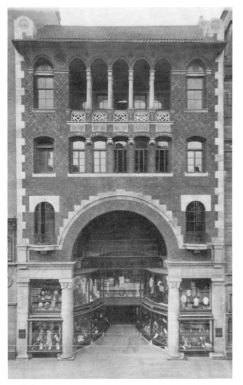

404.

The principal feature of the Chestnut Street facade is an immense Palladian motif, the center portion of which forms an arched entrance, while the flanking spaces contain deep display windows. The Palladian motif removed from its usual context and radically enlarged drew attention to the store building. Similar distortions of scale with the same aim had been common in Furness's work in the previous generation and are again with the pop artists of our time. Above, the wall was more soberly treated with the dark red brick embellished only by ornamental balconies, an arcaded loggia at the top, and crowned by a coved cornice decorated with Mercer tile. Mercer tile was also used to suggest something of the building's role: in the soffit of the arch leading into the store are figured roundels of tile, now much begrimed, depicting the various tasks of the clothing industry—weaving, sewing, and so on.

If the facade was not directly derived from the structure, it was more successful in expressing the different spaces of the interior. Small windows on the upper levels of the building indicate the cutting rooms and offices, while the form of the Palladian motif of the entrance was carried the length of the store with a high barrel vault in the center, flanked by side spaces, which enabled Price to differentiate the principal display and circulation areas.

It was in the interior too that the concrete frame was most directly apparent, its concrete barrel vault supported by heavy concrete columns and beams. Designed by Price and the New York-based Hennebique Construction Company, it marked the first use of concrete in a non-industrial space in Philadelphia. It was on the columns too that Price made his most direct attempt at relating ornament to technics using Mercer

tile to decorate the cubic capitals. Eight years later he would argue that the material affinity between concrete and tile made the latter a logical decorative material for concrete surfaces. Price theorized in 1911:

If a closely allied material which can be reasonably embedded in the wall surface can be used in such a way as to seem a part of that surface, there can be no objection to such use of color for enrichment instead of modeled ornament; and burned clay products which can be fashioned in innumerable forms, and colors, glazed and unglazed when so separated in design as to allow the wall surface to penetrate and tie it to that surface is almost an ideal form of wall decoration. (William L. Price, "The Decorative Treatment of Plaster Walls," *The Brickbuilder,* vol. 20, no. 9, September 1911, pp. 182–83)

One additional feature of the public space remains—Price's novel method of illuminating the interior. Shallow groins in the barrel vault bring the vault weight down onto the centers of the columns of the colonnade, making it possible to introduce a clerestory in the vault. For the resulting lunettes, Price designed opalescent glass windows, behind which were placed electric lights, giving the appearance of natural illumination filtering in from the sides of the building, as if it were free-standing. Clearly honesty in construction did not preclude a bit of dramatic illusionism.

Despite the success of the Jacob Reed's Sons store, Price received few other center city commissions. Those have all been demolished, making it necessary to go elsewhere to see the buildings that had so interested George Howe.

GT □

of any use and size and its impact was therefore enormous.

Price did not come by his modernism easily. As late as 1903 he wrote of his attempts to use materials according to their nature, and the ease of falling back on traditional solutions: "Of course we use a great deal of timberwork down with us, and I am sorry to say we seldom use it honestly, most of our timberwork being stuck on the outside and not part of the structure. That of course is inexcusable, there is no possible excuse for it so far as I can see—I do it myself but I am ashamed of it, and I am trying to stop" (William L. Price, "A Philadelphia Architect's Views on Architecture," *American Architect and Building News,* vol. 82, October 24, 1903, p. 28). Just as Price's domestic designs were radically simplified after his encounter with the vernacular buildings of Rose Valley (no. 397), so too his larger commercial projects took a new direction after he began to utilize modern building technics—steel and especially reinforced concrete. The impact of reinforced concrete first became apparent in the design for the Jacob Reed's Sons store at 1424 Chestnut Street, which Price planned late in 1903. The store is a transitional design, progressive in the expression of concrete, but moderately traditional in the stylistic sources, and only partially successful in integrating formal composition with the expression of structure.

404.

405.

THESE ANIMATED CAROUSEL FIGURES are some of the best that the Dentzel factory produced and are superb examples of Philadelphia folk art. Animals of this type were carved by Salvatore Cernigliano, an immigrant Italian carver employed by Dentzel. Other figures attributed to Cernigliano include a cat with a fish in his mouth, a leaping rabbit, and a five-foot-tall dog.

The first merry-go-rounds in Philadelphia were built in the eighteenth century, according to Eberlein and Hubbard: "Flying coaches and horse, affixed to a whirligig frame, where the women sat in boxes for coaches, and the men strode on wooden horses—and in those positions they were whirled around" (Harold D. Eberlein and Cortlandt Hubbard, "The American Vauxhall of the Federal Era," *Pennsylvania Magazine,* vol. 68, no. 2, April 1944, p. 161). Amusement parks where there were carousels with such figures as this ostrich and pig were well established by the 1860s when steam power became widely available.

These fully carved carousel figures are unusual. Most American carousel figures were elaborately carved only on the right side of the animal, leaving the left side more plain since it was not visible when the merry-go-round turned counterclockwise.

PT □

DENTZEL CAROUSEL COMPANY (1867–1928)

In 1860 at the age of twenty, Gustav A. Dentzel (1840–1909) came to Philadelphia from Kreuznach, Germany, where his family had been making carousels since at least 1839. Although he was to become America's pioneer carousel maker, he was first listed in McElroy's directory as a cabinetmaker at 155 Poplar. In 1887 he repainted his shop sign to read "G. A. Dentzel, Steam and Horsepower Caroussell Builder." Dentzel moved to Germantown in 1870. That same year he erected his first carousel at Smith Island, a popular amusement resort in the Lower Chesapeake Bay.

When orders for Dentzel's carousels began to come from amusement parks all over the country, he had to move his shop to a larger factory adjoining his house at 3635–41 Germantown Avenue in Philadelphia. On the first floor of this factory was the tooling and carving machinery. The carving room was on the second floor and the paint shop on the third. A large shed in the yard provided space for constructing frames, platforms, and rims in separate sections. It was at this time that he built one of his most famous lavish carousels, which was ordered for Woodside Park, Philadelphia.

When Dentzel died in 1909, the factory was shut down for a short period, then reopened under the direction of his son William. Known as "Hobby-Horse Bill," he designed large showy carousels, and the Dentzel firm became famous under his imaginative leadership. When William died in 1928, the factory closed and was auctioned off.

According to the National Association of Amusement Parks, William Dentzel "kept raising the ideals higher and higher, building a finer and more artistic, more serviceable product than either of his sires, and had he lived to 1937, the merry-go-round would have been built in one family continuously and uninterruptedly for one complete century. The knights of old rode their magnificently caparisoned horses only in defense of themselves and their honor and to what they thought is their lasting way of fame. Our member produced a finer caparisoned horse than the world had known up to this time, and best of all, it was produced to give joy to the millions, and any man who had made his fellow man happy, cannot be said to have lived his life in vain" (quoted pp. 58–59 in Frederick Fried, *Pictorial History of the Carousel,* New York, 1964, which gives an illustrated history of "The Dentzel Carousel in America," pp. 52–61).

DH

405. *Carousel Figures*

1903–9
Carving attributed to Salvatore Cernigliano
Painted basswood; taxidermist eyes
Pig 64 x 52 x 12″ (162.5 x 132 x 30.4 cm); ostrich 77¾ x 44 x 11″ (197.4 x 111.7 x 27.9 cm)

Abby Aldrich Rockefeller Folk Art Collection, Williamsburg, Virginia

PROVENANCE: Treasure Island Exposition, San Francisco, 1939; with Maurice Fraley, Redbug Gallery, Berkeley, California

405.

406.

DOUGHERTY SISTERS (N.D.)

406. *Dress*

1904
Embroidered white lawn; trimmed with tucking and lace
Waist 22″ (55.8 cm); center back length 59⅛″ (150.1 cm)

Philadelphia Museum of Art. Given by Henry Callahan. 75-6-1

PROVENANCE: Estelle deLaussat Willoughby (Mrs. Boris de Bakhtiar), 1904; Mary (Dougherty) Callahan; son, Henry Callahan

DURING THE ERA OF THE "GIBSON GIRL" at the turn of the century, undergarments continued to be of great importance in achieving the popular and fashionable silhouette. This dress exhibits the S-shaped curve, often referred to as the "kangaroo bend" or "dyspepsia front." A tight-laced, straight-fronted corset adjusted the figure to achieve the desired shape, a full bust, wasp waist, and well-rounded hips. The bosom was further accentuated by the dress bodice cut to a "pouch" in front with a narrow waistline worn unusually high in the back. A great deal of padding and heavily starched ruffles were used to achieve the necessary curves for the very young girl or the inadequate figure. Necklines were elongated by high bands or choker collars held in place by stays or boning. The skirt was gored and flared gracefully into a bell shape.

For the summer months, fashionable dresses were made of fine transparent linen or lawn, often intricately embroidered, tucked, and detailed. These were worn over simple slips of white or pale-colored taffeta and silks, with mauve, pale blue, and rose being the prevalent colors. This white lawn dress, worn by Estelle deLaussat Willoughby at her Newport debut in 1904, is a magnificent example of the fine art of creative and talented dressmaking, the creation of the Dougherty sisters, fashionable dressmakers of early twentieth century Philadelphia. Appearing simple and stylized, this dress is actually subtly elaborate and detailed in design and workmanship, with its fine insertions of Irish crocheted lace and embroidered shamrocks.

EMcG □

ROBERT HENRI (1865–1929)
(See biography preceding no. 400)

407. *Portrait of George Luks*

1904
Signature: Robert Henri (lower left)
Oil on canvas
76½ x 38¼″ (194.2 x 97.1 cm)
The National Gallery of Canada, Ottawa

PROVENANCE: Estate of the artist; Miss Violet Organ, New York; with Hirschl & Adler Galleries, New York, until 1961

LITERATURE: "Robert Henri, An Apostle of Artistic Individuality," *Current Literature,* vol. 52 (April 1912), illus. p. 466; MMA, *Memorial Exhibition of the Work of Robert Henri* (March 9—April 19, 1931), no. 20, illus.; Elizabeth Luther Cary, "Robert Henri," *MMA Bulletin,* vol. 26, no. 3 (March 1931), p. 60; Paris, Musée du Jeu de Paume, *Trois Siècles d'art aux États-Unis* (May—July, 1938), no. 25 (illus.); PAFA, *150th Anniversary Exhibition* (January 15—March 13, 1955), no. 102, illus. p. 73; New York, Cultural Center, *Robert Henri, Painter-Teacher-Prophet* (October 14—December 14, 1969), no 36 (not exhibited), illus. p. 39; William Innes Homer, *Robert Henri and His Circle* (Ithaca, New York, 1969), pp. 113, 237, fig. 16; Jean Sutherland Boggs, *The National Gallery of Canada* (Toronto, 1971), pl. 94; Mahonri Sharp Young, *The Eight* (New York, 1973), p. 28 (illus.)

HENRI'S MASTERY of the full-length portrait sprang in part from his thorough, firsthand knowledge of the great tradition that passes from Velázquez through Manet to its late nineteenth century florescence in the fashionable images of Whistler, Sargent, and Chase. Not competing with the latter three in elegance of line or subtlety of tone, Henri's best portraits exhibit a warm affection for humanity and a vigorous, almost crude brushwork that recall his admiration for Rembrandt and Frans Hals. Henri's highest ambition was to capture the vitality of life itself on canvas, and here he looked for spiritual guidance perhaps less to Europe than to Thomas Eakins, whom he called "the greatest portrait painter America has produced."

It is tempting to see in Henri's evocation of George Luks, his irrepressible friend and fellow artist, an homage to Eakins's portrait of *Professor Leslie Miller* (Philadelphia Museum of Art), which he so much admired: "This is what I call a beautiful portrait, not a pretty, nor a swagger portrait, but an honest, respectful, appreciative man-to-man portrait" (open letter, October 29, 1917, "To the Students of the Art Students' League," in Homer, *Robert Henri and His Circle,* cited above, p. 177).

407.

Eakins's painting of Miller, standing before his class at the Philadelphia School of Industrial Art, was finished in 1901 and won a prize at the National Academy of Design in 1904, the same year Henri persuaded Luks to abandon his customary fist fights and high jinks long enough to pose for him. This was a remarkable year for Henri's painting, and indeed marked the beginning of his almost exclusive devotion to portraiture. Still lacking commissions for portraits on any frequent basis, he painted his wife, Linda, again and again, and prevailed upon three of his old friends of the Philadelphia "press gang" to sit for him. John Sloan (just arrived from Philadelphia) and William Glackens presented formal, almost austere images in conventional dress, their white shirt fronts gleaming from the somber canvases. George Luks dispensed with convention in his attire as in his uproarious behavior; a short, cocky man with a raffish glint in his eye, he swathed himself in a vast old brown dressing gown to pose for his friend.

Luks's own background remains the most shadowy of any of The Eight. He was born in Williamsport, Pennsylvania, in 1867 and trained at the Düsseldorf Academy and the Pennsylvania Academy. He was an illustrator for the *Philadelphia Evening Bulletin* and shared a Philadelphia studio with Everett Shinn when Henri's influence encouraged him to become a painter. Like Henri a fervent admirer of Hals ("the world never had but two artists, Frans Hals and little old George Luks" was his famous boast), Luks attained the height of his power as a painter about the time of this portrait with crowded genre scenes (*Hester Street,* Brooklyn Museum), portraits of the denizens of New York slums (*The Old Duchess,* Metropolitan Museum of Art), and "tough" subjects like *The Wrestlers* (Boston, Museum of Fine Arts). It seems probable that Luks, like Henri, continued to draw inspiration from the art of Thomas Eakins long after leaving Philadelphia since his *Wrestlers* pays tribute to Eakins's 1899 version of the same subject, which hung at the National Academy of Design as his Diploma picture.

Despite the informality of the pose, cigarette drooping from his relaxed fingers, Luks fills the canvas with his presence, larger than life. With long, slapdash strokes of his brush the painter conjures up a convivial image that is (appropriately) pure Hals yet unmistakably Henri.

Ad'H □

408.

EVA LAWRENCE WATSON-SCHÜTZE (1867–1935)

Born in Jersey City, New Jersey, Watson-Schütze became one of Philadelphia's most devoted and influential members of the pictorial movement in photography. Throughout her career she made every effort to obliterate the reference to photography as a mere "mechanical industry," so dubbed by its contemporary opponents. There is no record of her early years in Philadelphia: we know that she studied at the Pennsylvania Academy of the Fine Arts for six years (she was later elected a fellow) intending to become a painter, and a student card in the Academy archives notes she was at the Academy in 1883. A strong possibility exists that she was Eakins's pupil, since there is a portrait photograph of her by Eakins (probably taken in the late 1880s) in the Philadelphia Museum of Art. After studying at the Academy she worked in a photogravure printing business for seven years.

In 1898 her photographs were selected for exhibition in the first international photography exhibition to be held in a major museum in the United States. This exhibition and subsequent ones held from 1899 to 1901 at the Pennsylvania Academy were the efforts of the Photographic Society of Philadelphia (to which Watson-Schütze was elected in 1899). Watson-Schütze contributed to all but the last of these influential exhibitions, serving also on the jury of selection in 1900 with Alfred Stieglitz, Frank Eugene, Gertrude Käsebier, and Clarence White. Among the European exhibitions in which Watson-Schütze was represented and received consistently favorable criticism, none was more prestigious than the annual London Salon. Sponsored by The Linked Ring, the oldest and foremost amateur pictorial photography group of the time, the London Salon was emulated by all other salon exhibitions.

In 1900, Watson-Schütze is listed in the Philadelphia city directory as a photographer at 10 South Eighth Street, headquarters of the Photographic Society. By 1900, when the Photographic Society's cohesion to the pictorial movement showed signs of disintegration, Watson-Schütze's studio became the central meeting place for the pictorial photographers (Joseph T. Keiley, "Eva Watson-Schütze," *Camera Work,* no. 9, January 1905, p. 25).

In 1901 she married Martin Schütze, M.D.,

and moved to Chicago where she set up a studio principally for portrait photography at which she continued to work the rest of her life. Letters from Watson-Schütze to Stieglitz, dated 1900–1905 (Yale University, Beinecke Library, Stieglitz Archives) reveal that she stood almost alone in Chicago in her endeavor to achieve recognition for the photographer as an artist. These letters also show that she continued to paint while photographing, claiming that practice in one medium was beneficial to the other.

As a founding member of the Photo-Secession she received full recognition for her achievements as a photographer in February 1902. Under the decisive leadership of Stieglitz, the Photo-Secession advanced the cause of photography as a fine art in America and was a major influence in introducing modern art to this country through its periodical *Camera Work* and the exhibition gallery "291." It is clear that anyone connected with the Photo-Secession and its exhibition activities in America and abroad must have had the approval of Stieglitz. According to Robert Doty (*Photo-Secession: Photography as a Fine Art,* Rochester, N.Y., 1960, p. 33), "Exerting an autocratic control over the members, he [Stieglitz] demanded, and received, only their finest photographs which they submitted to the exhibition." Letters to Stieglitz from Watson-Schütze and other Philadelphia founding members of the Photo-Secession confirm their reliance on Stieglitz and acceptance of his leadership.

Brief listings and critiques in contemporary periodicals such as *Camera Notes, Camera Work, Photo-Era, Photo-Miniature,* and the *Journal of the Photographic Society of Philadelphia* indicate that Watson-Schütze exhibited widely in the United States and Europe and that she mainly produced figure studies and portraiture. To mention only a few of these exhibitions, she held one-woman shows at the Camera Club, New York (April 1900), the Boston Camera Club (1900), and she was included in the annual members' exhibition of the Pennsylvania Academy of the Fine Arts (1902). In this Academy jury-selected show, Watson-Schütze exhibited the only photograph alongside paintings and sketches by prominent Philadelphia artists. According to Joseph T. Keiley ("And!?" *Camera Notes,* vol. 6, no. 1, July 1902, p. 58), with the admission of her photograph to this exhibition, the fellows of the Academy gave emphatic recognition to pictorial photography as an art form. That Philadelphia, along with New York, was one of the centers for the development of the pictorial photography movement in America is indisputable. In large part this was due to the dedication and leadership of Watson-Schütze and other prominent amateur Philadelphia photographers such as Edmund Stirling, C. Yarnall Abbott, and Mathilde Weil.

Only a few collections of photographs by Watson-Schütze have been uncovered. Notable among these are fifty-three platinum portrait prints and figure studies in the International Museum of Photography, George Eastman House, and a dozen or so portraits in the Department of Prints and Photographs at the Library of Congress. A recent exhibition of photographs by Julia Margaret Cameron and Eva Watson-Schütze was held at the Lunn Gallery, Washington, D.C. (November 8—December 10, 1975).

408. *Portrait Study*

1905
Published in *Camera Work,* January 1905; printed by Manhattan Photogravure Company, New York
Photogravure
8⅜ x 6½" (21.4 x 16.5 cm)
Philadelphia Museum of Art. Given by Carl Zigrosser. 66–205–9 (8)

THIS PHOTOGRAVURE, made from an original platinum print and more than likely taken in Philadelphia, was one of four works by Watson-Schütze selected for illustration in the most prestigious periodical of its kind at the time, *Camera Work.* One confronts a straightforward and strictly objective visual statement that is at the same time an artistically arranged composition of expressive force. It is not simply a character, narrative, or documentary study; the design itself assumes precedence, for the content is the harmonious and balanced arrangement of the elements in the scene itself. Full advantage is taken of the camera's unique potential to produce an infinite range of tonal values, the subtle, soft gradations of black and gray tones gracefully yet distinctly outlining the elements in the composition. Simultaneously, Watson-Schütze has adhered to the limitations of her medium, with no evidence of any attempt to manipulate the negative, print, or camera lens in order to imitate a painting, drawing, or etching, as was often the case with pictorial photographers. By following the path of "pure photography," she has produced a work which stands on its own aesthetically.

CW □

CHARLES LEWIS FUSSELL (1840–1909)

Little is known about Charles Fussell, although he lived and worked in the Philadelphia area for most of his life. The oldest child in a large Quaker family, he was born on October 25, 1840, in West Vincent, Chester County, Pennsylvania. After a few years in Indiana with his mother's relatives, the Lewises, the family moved to Philadelphia, where Charles grew up and attended the Friends high school. In 1864 he was enrolled in classes at the Pennsylvania Academy, and he also seems to have studied with the local history painter, P. F. Rothermel (see biography preceding no. 320), whose influence can be detected in the first painting Fussell exhibited at the Academy: *The Interior of Rothermel's Studio,* painted in 1863. His lifetime friendship with Thomas Eakins (see biography preceding no. 328) dated from these days, for the two artists were contemporaries at the Academy and members of the Philadelphia Sketch Club. An oil sketch called *The Young Art Student* of about 1861 (Philadelphia Museum of Art), perhaps the earliest of Fussell's known works, shows the nude, teenaged Eakins seated at the drawing board, sketching Fussell while being sketched in turn. Their paths parted, however, when Eakins went off to Paris to complete his training.

Fussell, pressed for artistic opportunities in Philadelphia, tried farming and was then advised to "go West." In 1868 the family had moved to Townset's Inlet, New Jersey, in an effort to restore his father's health, and much of Fussell's energy had been devoted to farming their new land. The search for a therapeutic climate for Dr. Fussell continued, however, and Charles was sent to Colorado in 1870 to investigate the new community of Greeley. His motives were mixed, though, as a letter from his father, Edwin, to their uncle, Linnaeus, indicated in 1870: "Mr. Rothermel says he could not give Charlie too much work on his picture and the pay would not amount to anything to rely upon. He thinks C. could make *far* more money by painting Rocky Mt. scenery and sending the pictures east than by working in Phila."

Fussell lost no time, and by April of that year was living on his family's plot of land in Greeley. He arranged to pay for his board with sketches and apparently worked for the town commissioners on "public relations" projects, but none of his work from this period has been located. In any event, Greeley's less-than-picturesque landscape— bleak plains alternately baked, frozen, and scoured by winds—failed to offer the scenic possibilities or hospitable climate he had anticipated. Fussell endured the conditions in Greeley for eight months, watching the dust blow through the boards of his shanty and settle on the wet surfaces of his paintings, and then, without striking artistic gold, returned to Philadelphia along with many other disgruntled and mosquito-bitten Greeley settlers. While he was in Colorado, his family had tried to gain a place for him as an artist on one of the government's surveying expeditions, but when this scheme

409.

failed, Fussell turned to local subjects, rural landscapes, and coastal views. The following year he would see another Philadelphian, Thomas Moran (see biography preceding no. 312), with better luck and a better sense of geography and timing, join the Yellowstone expedition and make his fortune.

Fussell was back at the Pennsylvania Academy in 1879 attending the anatomy classes of his old friend Eakins, but little else is known about his activities at this period. His family had moved to Media, Pennsylvania, in 1871, and Fussell traveled all across rural Pennsylvania, New York, and New Jersey in search of landscape subjects. Letters indicate that he visited the Moran colony on Long Island in the summer of 1882, traveled to Ohio in the spring of 1883, and finally settled in Brooklyn, at 709 Lafayette Avenue, in 1889. By this time his earlier taste for genre subjects and portraits, evident in his Academy entries in the 1860s, had been almost completely altered in favor of landscape. But having been in Colorado too soon, Fussell now found himself in New York too late: the painter Beard (probably William H.) looked over his sketches and pronounced them "as good as the best . . . if only they had Church's name at the bottom, they would be worth big money."

Such a disheartening compliment may explain why Fussell returned, about 1897, to the family's old neighborhood in Media, living first at 121 West Washington Street and then settling permanently in a house at 402 Gayley with his aunt, Graceanna Lewis (also an artist), and an unmarried sister. From here he gave an occasional lesson and—from 1898 until 1908—submitted watercolors and oils to the exhibitions of the Art Club of Philadelphia. In addition, he is said to have shown his work at the National Academy of Design, the Art Institute of Chicago, and the Omaha Exposition (Arthur N. Hoskings, *The Artist's Year Book,* Chicago, 1905, p. 71). During this period

Thomas Eakins occasionally visited Media to ice skate with his old friend. He also painted Fussell's portrait at least once during the final decade of Fussell's life; one version (in the Reading Museum) shows a bespectacled patriarch with a flowing white beard, accompanied by books and fishing tackle—representing, no doubt, the quiet pursuits Fussell engaged in until his death, which passed almost unnoticed in June 1909. (Much of the above information is from the collection of family papers in the Pennsylvania Academy archives and correspondence with Sarah Fussell Macauley, the artist's grandniece.)

409. *The Spring*

c. 1906
Signature: C. L. FUSSELL (lower right)
Inscription: The Spring—75 (in pencil, on reverse)
Watercolor and gouache on heavyweight paper
13 13/16 x 23 7/8″ (35.1 x 60.6 cm)
Free Library of Philadelphia

PROVENANCE: Albert Rosenthal, c. 1923

IF THE NUMBER "75" penciled on the back of *The Spring* is taken to mean that it was painted in 1875, Charles L. Fussell must be considered among the major American watercolorists of that time, along with Winslow Homer and the Philadelphian William Trost Richards. However, Fussell's early work—such as it exists today—seems to have been in oil and was influenced by Eakins, while the overwhelming majority of his watercolors date from the end of his career and show a very different style.

The Spring is typical of the large, carefully worked pieces Fussell produced in the last

decade of his life, many of which were exhibited at the Philadelphia Art Club. All the works from this period show the sensitivity to outdoor light, the brilliant greens, and the patient attention to detail first seen in American Pre-Raphaelite painting forty years earlier. However, Fussell's second-generation style has an openness that sets it apart from the more claustrophobic manner of the original school and indicates a response to the prevailing "academic" mode of watercolor painting in the eighties and nineties.

The scale, the mixture of transparent and opaque washes, and the subject matter itself —including the sense of locale and the rather turn-of-the-century girls—all help to relate this work to similar, major watercolor landscapes Fussell did near Media between 1898 and 1909, particularly a creek scene dated 1906 in the collection of the Pennsylvania Academy, where the majority of his work has been accumulated.

Although Fussell's career seems to have been largely a story of frustration and obscurity, it is pleasant to learn that his considerable talents, as shown here, did not go entirely unappreciated in his lifetime. In 1906 his aunt, Graceanna Lewis, wrote of the respect that works like *The Spring* had gained for him, noting, "This year and last he has been invited to send pictures to the Spring Exhibition on his own merit, without reference to the jury of admission, showing that he is coming to be recognized as among the few who are considered as leading artists in Philadelphia. He works slowly, taking infinite pains, and he *ought* to be appreciated as he is coming to be," she added, "but he is now an 'old man' before he has earned his reputation—over 60 years of age" (PAFA, Archives, letter, February 18, 1906).

KF □

PAUL P. CRET (1876–1945)

Paul Philippe Cret, a native of Lyons, France, had been a pupil at the École des Beaux-Arts in Paris. In 1903 students of the school of architecture of the University of Pennsylvania instituted a search for an École graduate who could bring its discipline and method to the university. Cret was selected and that year began a teaching career in Philadelphia which lasted until 1940.

In 1907, Cret, in association with Albert Kelsey, won the commission for the design of a temporary building for the Pan American Union in Washington, D.C., which because of its beauty, was eventually constructed in permanent materials. At the same time, Cret and Kelsey began their work on the designs for the Benjamin Franklin

Parkway (no. 411), which served as the basis for the Parkway's layout. After that came one monumental building after another, including the Detroit Institute of Arts, the Folger Shakespeare Library in Washington, D.C., and the Federal Reserve Building in Philadelphia. Cret also designed two small museums—the Rodin Museum, which was completed by Jacques Gréber, and a building for the collection of Dr. Albert C. Barnes in Merion, Pennsylvania.

Cret's interests extended beyond the usual limits of the grand architecture of the day to encompass the full realm of commercial, domestic, and industrial design. A skyscraper at Sixteenth and Walnut streets in the "moderne" style, science laboratories, railroad stations, immense bridges, and even the design of the locomotives and cars of the Denver Zephyr were products of his office. After Cret's death in 1945, his architectural firm continued under the names of four long-time, but unnamed, partners, Harbeson, Hough, Livingston and Larson.

410. *Walnut Lane Bridge*

Wissahickon Creek Valley and Henry Avenue

George Webster and Henry Quimby, engineers

1906–8

Concrete, stone facing

Main span 233′ (71 m)

REPRESENTED BY:

Jacob Stelman (n.d.)

Walnut Lane Bridge

c. 1957

Photograph

Courtesy of Mr. and Mrs. George E. Thomas, Philadelphia

LITERATURE: George S. Webster and Henry M. Quimby, "The Walnut Lane Bridge," *Transactions of the American Society of Civil Engineers*, no. 1128 (September 15, 1909), pp. 423–61; Carl Condit, *American Building Art: The Twentieth Century* (New York, 1961), pp. 198, 361–62

PHILADELPHIA has few more dramatic sights than the giant arched span of the Walnut Lane Bridge, which soars high above the Wissahickon Valley and joins the city's Germantown and Roxborough districts. The ingredients of that drama are not merely the site or the length of the span. There are after all longer bridges and deeper and more rugged valleys. Nor is the bridge's force derived from the characteristic daring associated with the nineteenth century engineer's will to use the minimum material to surmount the maximum task. There is not the contrast between the massive towers of the suspension bridge and the spidery web of

410.

cables supporting a ribbon-like roadbed, or the airy geometry of tall steel bents supporting trusses that carry railroad tracks across western canyons. Instead, the simple forms and the few and massive elements of the Walnut Lane Bridge boldly recall the austere grandeur of an older engineering-derived architecture, ancient Roman masonry aqueducts and viaducts.

There are more than the simple analogies of task and form to relate the modern to the ancient structures. At the beginning of this century, architects no longer viewed engineered structures as solely the concern of engineers, and began to involve themselves with the formal if not the technical aspects of their design. Roman models frequently served to whet their imagination at the same time as new technical systems, especially reinforced (and unreinforced) concrete, provided a material analogous to Roman concrete. A number of arched concrete bridges based on Roman forms were designed early in this century, among them the Walnut Lane Bridge, which was erected between 1906 and 1908 and was for a time the world's largest concrete arched span.

Like the other concrete arched bridges of this century, the Walnut Lane Bridge was the result of the collaboration between an architect, Paul P. Cret, and engineers, Henry

Quimby and George Webster. Cret is best remembered for his brilliantly conceived classically styled civic buildings and for his contributions to the school of architecture at the University of Pennsylvania, but he also was involved with the design of numerous bridges, including the Benjamin Franklin Bridge across the Delaware River and the University Avenue Bridge across the Schuylkill, both of the 1920s. Cret's French training (Atelier Pascal) undoubtedly encouraged him to look to a classical source, with the result that his bridges have close similarities to antique design.

Still the major decisions were made by the engineers, Webster and Quimby. They determined the site at the point where the Wissahickon ravine was narrowest and argued that the use of concrete woud be more economical than steel. To the engineers, the most interesting issue was not the style but rather the construction of the bridge. In an article on the bridge published in the *Transactions of the American Society of Civil Engineers* they commented: "The bridge is notable for the great size of its main arch, for the novelty of some of the features, the character of its material, and the method of its construction" (September 1909, p. 423). Their design was as simple as it was direct. A pair of immense, parallel three-

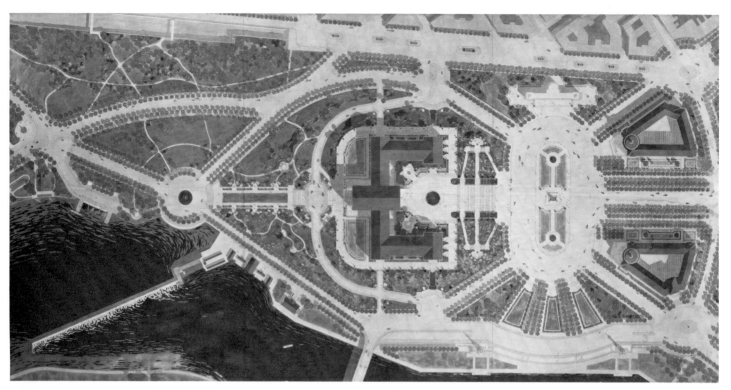

411.

centered, segmental arches, 233 feet long, would span the valley and rise at their apex to the valley's crest. Gigantic piers at the springing of the arches would help to buttress the thrust; smaller spandrel arches, infilling between the arch and the pier, would carry the roadbed at an even grade nearly 200 feet above the creek, while slightly larger approach arches on tall piers would form continuous support for the roadbed from the center to the sides of the valley. The similarity to such structures as the Pont du Gard is obvious.

The construction was equally straightforward. Despite simultaneous and widespread experimentation with iron-reinforced concrete by Ernest Ransome on the west coast, Albert Kahn's Detroit-based Trussed Concrete Steel Company, and New York's Hennebique Construction Company, Quimby and Webster designed the main arches without reinforcing, except at the points where the vertical piers joined the sloping surfaces of the arched rib. The internal bending forces were resolved by masses of concrete instead of the more efficient but less readily calculable iron reinforcing. Given enough concrete, the arch would be sound. As Carl Condit notes, it was a conservative solution, one which was not much followed later, when the calculation of material became more precise (*American Building Art: The Twentieth Century,* New York, 1967, p. 198). On the other hand, it was in keeping with the contemporary

theory which regarded concrete as acting monolithically, like the work of ancient Rome.

The most difficult problem remained the actual construction of the arches, which were to be of Portland cement, poured over a form, supported by an immense wooden centering, which crossed the valley. That part of the design was left to the contractor, Reilly and Riddle, and almost resulted in disaster. Untrained in the calculation of the weight of wet concrete, the contractors produced a flimsy wooden structure that was further weakened by being soaked in the creek at its base. Moreover, the upper part of the framework was kept saturated in the hope that when the concrete had set and the form was allowed to dry, the wood would shrink away from the concrete, facilitating its removal and re-use for the second arch. When the first rib was completed in the fall of 1906, it was discovered that the ends of the water-softened timbers had been crushed by the weight of the concrete, and that the arch had deflected downward considerably. But, instead of redesigning the form, the contractors merely raised it a bit on wood wedges and continued as planned, in the hope that the deflection would be duplicated in the second rib, so that the roadbed would be even. It worked, but the engineers acknowledged that it was an optimistic solution, and one which they would not recommend.

The bridge was completed in July of 1908, and dedicated in December of that year. The expectations of the engineers about the cost were borne out. The entire project came to only $253,550.

GT □

HORACE TRUMBAUER (1868–1938)

Philadelphia-born Horace Trumbauer entered the office of G. W. and W. D. Hewitt (see biography preceding no. 335) in 1884, and worked there for eight years, after which time he established his own practice. His first significant commission, a spectacular mansion, Grey Towers, for sugar tycoon William Harrison, followed in the tradition of the Hewitt brothers' country houses, establishing Trumbauer's reputation as a designer of expensive mansions for Philadelphia's industrial magnates. Later projects included houses for Christian Schmidt, William Elkins, and Peter Widener.

In the twentieth century, Trumbauer became increasingly preoccupied with major center city commissions, among them the Ritz Carlton, Adelphia, and Benjamin Franklin hotels; the Land Title building extension, and the Stock Exchange building. His success at handling large designs, and no doubt, too, the prominence of his clients, brought him a number of prestigious commissions, the Philadelphia Museum of Art and the Free Library in Philadelphia, as well as buildings in New York and Washington,

480

and for Duke University in North Carolina. Those buildings, with the exception of the Duke commission, were increasingly in a heavy late Renaissance style, instead of the earlier Gothic or the then fashionable "moderne" styles, although his office made two essays in the modern mode in the 1930s for Jefferson Medical College and Hahnemann Hospital.

PAUL P. CRET (SEE BIOGRAPHY PRECEDING NO. 410), HORACE TRUMBAUER, C. CLARK ZANTZINGER (1872–1954), AND OTHERS

411. *Benjamin Franklin Parkway*

Design begun 1907

REPRESENTED BY:

Jacques Gréber (1882–1962)
Plan of the Benjamin Franklin Parkway
c. 1917
Watercolor and ink on paper
Left section 55⅜ x 111⅝″ (140.6 x 283.5 cm); right section 55⅜ x 107¾″ (140.6 x 273.6 cm)
Philadelphia Museum of Art

Horace Trumbauer, C. L. Borie (1870–1943), and C. C. Zantzinger
Philadelphia Museum of Art Fairmount Park: Perspective View of Museum and Approaches Looking across Fairmount Park Plaza

c. 1917
Crayon on paper
32 x 75″ (81.3 x 190.5 cm)
Philadelphia Museum of Art

LITERATURE: Albert Kelsey, ed., *The Proposed Parkway for Philadelphia: A Direct Thoroughfare from the Public Buildings to the Green Street Entrance of Fairmount Park* (Philadelphia, 1902); FPAA, *The Fairmount Parkway* (Philadelphia, 1919); Tatum, p. 201, no. 133

IN 1682, Thomas Holme was retained by William Penn to lay out a city to be called Philadelphia, which would stretch between the Schuylkill and Delaware rivers (see no. 2). With no important man-made structures and few land formations of any consequence to affect his design, Holme turned to an abstraction, a rectilinear grid of streets, quartered by two principal avenues, Broad and High (now Market) streets, which intersected at Centre Square (now Penn Square). Public squares were planned in the center of each quadrant, thus mimicking in each quarter the overall totality of the city. Holme's plan of course has its precedents— the Milesian grid; the order of the Roman army camp; and more immediately, the unimplemented plan devised by Christopher Wren and others for the rebuilding of London along modern lines after the great fire of 1666. Wren also proposed a regular arrangement of streets, but with the important difference of nodal points in the various

districts of the city where diagonal avenues intersected, rather in the manner of Pope Sixtus V's plan for the development of Rome. Perhaps Holme's small parks recall Wren's nodal points, but the two schemes differed radically, for Wren's plan was dynamic, Holme's nearly static.

For the small-scale pedestrian city of the eighteenth and early nineteenth century city, the original plan remained adequate. Its limits became evident at the end of the nineteenth century, when the increasing sprawl of the city, the rapid commercial growth, and an insatiable demand for speed caused city leaders to look for alternatives. In 1891, spurred by the example of Baron Haussmann's Paris, architect Fred Thorne of the Wilson Brothers (see biography preceding no. 370) proposed a gigantic diagonal boulevard joining Penn Square with Logan Square (*Philadelphia Inquirer,* September 9, 1891), which would continue to Twenty-fourth and Callowhill streets, joining center city to the remnant of Penn's "greene countrie town"—Fairmount Park (no. 313). Other architects, among them James H. Windrim, made similar proposals (see "The Parkway," *Philadelphia Magazine,* vol. 1, no. 2, August 1909, p. 4).

A decade later, in 1901, the scheme again came to the fore, championed by members of the Art Club and such architects as Wilson Eyre, Jr. (see biography preceding no. 377), and Albert Kelsey (see Albert

411.

Kelsey, ed., *The Proposed Parkway for Philadelphia,* Philadelphia, 1902). Their proposal was far grander, for their vision was inspired by the magical splendor of the "White City," the Chicago Fair of 1893. There the leading architectural lions of the day, R. M. Hunt, Charles McKim, George Post, and John Root bordered great avenues and courts with classically styled buildings. There order, obvious unity, and the grandeur of individual elements were subordinated to a larger whole. In the United States where laissez-faire theory had been applied to nearly everything, including urban planning, and where architects generally provided individualistic designs for commercial clients, the alternative of the Chicago Fair was enormously attractive. When that vision was joined with the idea of the Haussmann boulevard, the result was the Philadelphia Parkway. It became one of the principal monuments of the "city beautiful" movement of the early twentieth century.

Despite the support of the press and the city government, the Parkway progressed slowly. A thriving industrial and residential quarter of the city had to be acquired and demolished. There were other difficulties as well, not the least of which was the actual location of the boulevard, for a straight line between the old Fairmount reservoir and City Hall (no. 334) passed off the center of Logan Square. The editor of the *Philadelphia North American* argued that the site could be turned to good advantage: "Are there any reasons why the street should run straight as an arrow from Broad and Market Streets to Fairmount? When did the beeline become the line of beauty? Is not the curved line always and necessarily handsomer?" (April 23, 1907).

But, while debate flourished, Paul P. Cret, Horace Trumbauer, and C. Clark Zantzinger were employed as associated architects to make the preliminary scheme. Cret's Beaux-Arts training, and Zantzinger and Trumbauer's earlier work, made it obvious that an axial, formal arrangement would be the result. A giant boulevard, passed on a straight line from City Hall to the Fairmount reservoir, which it was proposed would become the site of a gigantic museum. The kink at Logan Square was resolved by disguising the point of junction as a circle. From that point to the museum site, parallel roads gave breadth and dignity, while providing local access to the neighboring community. Although later adjustments were made by Frenchman Jacques Gréber, who was a frequent collaborator with Cret, the Parkway was constructed essentially as planned by Cret, Trumbauer, and Zantzinger in 1907.

But the Parkway was designed to be more than an express route to the park, and a vista to City Hall. The architects also anticipated that it would become both the site of the principal buildings of the city and a stimulus to economic development for the region. The lower Parkway would contain new commercial buildings, offices, hotels, and stores. That development has been slow, but constant, and includes Stewardson and Page's Georgian-styled and self-conscious Insurance Company of North America office building (1924), John T. Windrim's Bell Telephone building (1914), and more recently Stonorov (see biography preceding no. 462) and Haws's cylindrical Plaza apartments (1966).

At Logan Square, the direction of the Parkway was to change. Although room was left for a number of great mansions, whose

sites were to provide some of the twenty million dollar cost of the project, most of the land was reserved for public institutions which it was hoped would join the Cathedral of SS Peter and Paul and the Academy of Natural Sciences. In a speech in 1907, Mayor Reyburn spoke of some of the institutions which were anticipated—the public library, the county courthouse, the Franklin Institute, and the department of education—and the entire complex was to be completed by the civic museum of art terminating the vista and forming a suitable counterpoint to City Hall at the other end of the Parkway.

Each of those buildings was completed. Individually, none is architecturally outstanding, although they form a generally handsome group on Logan Square. The Free Library by Horace Trumbauer and the County Courthouse by John T. Windrim mimicked Ange-Jacques Gabriel's Place de la Concorde in Paris, with Windrim's building being a measured copy, while Trumbauer's deviated here and there from the model. Windrim's Franklin Institute (1922) is another rather doctrinaire classical design. More interesting is city architect Irwin T. Catherine's "moderne" styling for the Department of Education building (1929) just to the south of the Parkway, while Charles Z. Klauder's "temple to youth," the headquarters of the Boy Scouts of America (1929), at the midpoint of the Parkway, is the most successfully scaled and designed building.

The remainder of the Parkway would be the site of a new Episcopal Cathedral, a new building for the Pennsylvania Academy of the Fine Arts, a new school of Industrial Arts, and the architectural department of the University of Pennsylvania, in addition to the Philadelphia Museum of Art. Only the

last of the originally planned structures was constructed, although it was later joined by Paul Cret's diminutive gem, the Rodin Museum (1926), the gift of theater magnate Jules Mastbaum. The Museum was the most ambitious single building of the Parkway, and also the most troubled. The idea of replacing the Centennial's Memorial Hall, then serving as the art museum, with a new building had been under discussion almost as long as the Parkway project itself, and in 1895 the Boston firm of Bacon and Bright had received first prize in a competition for a building, to be situated on Lemon Hill. By 1907, at the suggestion of Peter A. B. Widener, the decision had been made to build on the site of the Fairmount reservoir.

Several architects presented plans for the new building, with the designs of Horace Trumbauer, and Zantzinger and Borie receiving favorable comments. Rather than offend the socially prominent by choosing one Philadelphia architect over another, both were selected, with the idea that their schemes would be merged. But neither would give in on the essentials of the design, Zantzinger insisting on separate structures, mimicking an acropolis, and Trumbauer preferring the grandeur of the immense pile. At the last moment, as the commission was about to be withdrawn, Howell Lewis Shay (see biography preceding no. 453), then in Trumbauer's office, presented a compromise solution that reflected both designs. Shay retained the temple-like blocks of Zantzinger's design, but joined them with connecting wings to achieve Trumbauer's intended monumental mass. The result was an effective termination to the Parkway in mass and form, but it must be admitted that the Museum is conservative in design, not even reflecting the "moderne" styling then popular for institutional buildings.

The Museum and the Free Library were completed before the Depression; the Franklin Institute was only partially completed. Only the Courthouse project braved the economic crisis, and that because it was a city project. The Parkway then languished until the 1950s, when a number of the still-vacant sites were turned over to private developers for apartment houses. Their presence has brought life to the region, counteracting the potential dullness of the grand Beaux-Arts scheme, which as often as not replaces the vivacity of the city with the order of the necropolis. It is the tendency to restrict districts of cities to single purposes which links the Beaux-Arts scheme to the purist vision of doctrinaire modernism and makes the problems and the virtues of the Parkway issues of contemporary interest.

GT □

EDWARD W. REDFIELD (1869–1965)

Together with Daniel Garber (see biography preceding no. 441), his neighbor in Bucks County, and W. Elmer Schofield (1867–1944), who spent most of his career abroad, Redfield was one of the leading exponents of plein-air landscape painting to emerge in the Philadelphia area during the late nineteenth and early twentieth centuries. He was born in Bridgeville, Delaware, the son of a successful nurseryman in the wholesale flower and fruit business. The family moved to Philadelphia while he was young, and his first work to be shown publicly was a painting of a cow in the section of the Centennial exhibition devoted to the art of schoolchildren. He attended the Spring Garden Institute, and after brief coaching from a commercial artist named Henry Rolfe (in which he was set the task of completing an oil sketch or charcoal drawing of a classical bust within an hour's time), he enrolled in the Pennsylvania Academy. His teachers included Thomas Anshutz, James P. Kelly, and Thomas Hovenden, whom he seems to have found most sympathetic, and among his fellow students were the sculptors Charles Grafly and Alexander Stirling Calder and the painters Hugh Breckenridge, Henry McCarter, and Robert Henri. In 1888 the Academy accepted his first canvas (*Wissahickon*) for its annual exhibition, and he continued to exhibit there steadily throughout his career.

After at least two years of study (Pennsylvania Academy records list 1887–89, but

other sources suggest a five-year stint), he followed Henri's example and set off for Paris in the fall of 1889, enrolling in the Académie Julian under Bouguereau and Robert-Fleury with the intention of becoming a portrait painter. His rigorous academic training was to prove of less importance than the experience of painting directly from nature during his holidays. The summer of 1890 was spent with Henri at the Mediterranean port of Saint-Nazaire where they both employed a high-keyed palette akin to that of the Impressionists. During the following winter and spring, Redfield painted at Brolles, near Fontainebleau, where he was joined by Schofield and John Leslie Breck. His studies of snowy landscapes, made outdoors despite winter weather, were the first of a type later to make him famous. During his Paris stay he became familiar with the work of the Impressionists, particularly Monet and Pissarro, although he was also drawn to the more detailed naturalism of Frédéric Montenard (1849–1926) and Fritz Thaulow (1847–1906). His close friendship with Henri, who considered him a forceful and original artist and often envied his facility, never induced him to take up genre scenes or portraiture. After spending the summer of 1891 with Henri in Venice, Redfield returned to Philadelphia, only to be back in France the following year where he met and married Elise Deligand. After their marriage the couple returned to France for only one prolonged visit (1889–90), but Redfield's early years in France were decisive in establishing his devotion to

412.

plein-air painting and a swift impasto technique.

In 1898 he purchased a tract of land along the Delaware River in Center Bridge, Pennsylvania, where he was to have his home and studio for the rest of his life. The first of the "New Hope" group of painters to settle in that area (it later attracted Daniel Garber, William Lathrop, and Robert Spencer, among others), Redfield painted the surrounding countryside in winter and spring, and spent his summers in Boothbay Harbor, Maine. After a brief experiment with teaching in 1901, he never again took on pupils, and he never maintained a studio in town.

He soon became one of the most successful and widely exhibited landscape painters of his time. In 1896 he won the Gold Medal at the Philadelphia Art Club, the first of over thirty awards from institutions in this country and abroad (see New York, Grand Central Art Galleries, *Edward Redfield*, April 16—May 4, 1968). His first one-man exhibition at the Pennsylvania Academy in 1899 included twenty-seven paintings whose titles conveyed his abiding and exclusive interest in effects of light and weather (and might belong to his work of any period): *The Brook in Twilight, Early Winter Morning, Autumn Afternoon, Grey Day,* and *The First Snow.* Many exhibitions followed: a second at the Academy in 1909, the Corcoran Gallery of Art in 1910, the Rochester Memorial Art Gallery in 1914 as well as frequent shows at the Art Club in Philadelphia and (later) the Grand Central Art Galleries in New York. In 1915, Redfield served as a juror for the Panama-Pacific Exposition in San Francisco, where twenty-one of his own works were shown *hors concours.* J. Nilsen Laurvik wrote the eulogy in the catalogue: "Today Mr. Redfield, though only just turned forty, stands as the foremost exponent of a virile, masculine art that strongly reflects the times in which we live" (Panama-Pacific Exposition, 1915, *Catalogue de Luxe,* vol. 1, p. 37).

True to his determination to capture transitory seasonal changes in a landscape as swiftly and accurately as possible, he trained himself to complete a good-sized canvas in a single eight-hour sitting. His style changed very little over the years, with the result that his position (from the late 1890s to around 1920) as one of the most popular advocates of the avant-garde methods of Impressionism gradually shifted to that of a conservative, albeit vigorous, traditionalist.

Around the age of seventy-five, when he could no longer continue his daily practice of working outdoors in any weather, he made the decision to stop painting. An increasingly popular figure in the Bucks County community, although by then less well known nationally, he was given a large

exhibition in 1959 at the Woodmere Art Gallery in Philadelphia, and October 31, 1960, was proclaimed Edward Redfield Day in New Hope. His death at the age of ninety-six was followed by a retrospective of fifty paintings at the Grand Central Art Galleries in 1968.

412. *Cedar Hill*

c. 1907
Signature: E. W. Redfield (lower right)
Oil on canvas
50 x 56" (127 x 142.2 cm)
Mr. and Mrs. David P. Redfield, Doylestown, Pennsylvania

PROVENANCE: Estate of the artist; descended to son

LITERATURE: PAFA, *Exhibition of Paintings by Edward W. Redfield* (April 17—May 16, 1909), no. 38; J. Nilsen Laurvik, "Edward W. Redfield—Landscape Painter," *International Studio,* vol. 41, no. 162 (August 1910), p. 36, illus. p. 34; Rochester, Memorial Art Gallery, *Exhibition of Paintings by Edward W. Redfield* (May 9—June 7, 1914), no. 4; San Francisco, Panama-Pacific Exposition, 1915, *Catalogue de Luxe,* vol. 2, no. 3924; Holicong, Pennsylvania, Holicong Junior High School, *An Exhibition of Paintings by Edward W. Redfield* (June 19—July 6, 1975), no. 69

IN HIS PREFACE to the catalogue of Redfield's second one-man show at the Pennsylvania Academy in 1909 (which included *Cedar Hill*), John Trask drew the viewers' attention to the "national characteristics" of Redfield's art, the "deep-chested vigor" and "honesty of vision" that made his landscapes peculiarly American. Sounding the same rather chauvinistic note, J. Nilsen Laurvik devoted a full chapter to Redfield in the deluxe edition of the catalogue of the Panama-Pacific Exposition in San Francisco in 1915. Describing the work of the Bucks County painter as the antithesis of the art of Whistler and his followers ("nature viewed through a temperament"), Laurvik warms to his theme:

There is nothing flamboyant nor rhetorical in his art. He neither epitomizes nor philosophizes, nor is his work touched with any of that dreamy and speculative hyperestheticism that is emasculating a section of American art. The fads and fancies, the frills and follies of the inner circle of the anemic worshippers at the pale shrine of Beauty hold no appeal for him. One misses in his work all striving after effect, which is the real secret of its striking effectiveness. His color is fresh, alive and beautiful, laid on with a crisp, trenchant touch that bespeaks a robust, masculine vigor. His technical procedure

reflects a close and intelligent study of the methods of the Impressionists, which he has adapted to his own uses. And while his art is intensely local in its subject matter his manner of treatment is thoroughly advanced and modern, expressed with amazing virtuosity which is, however, the final result of a long, persistent effort to acquire complete control of his medium.... His influence has long since made itself felt in our exhibition halls, where one notes an increasing number of painters who are devoting themselves to the painting of winter and to a more realistic presentation of American landscape in general. (*Catalogue de Luxe,* vol. 1, p. 38)

It is difficult for an audience of the 1970s to discern a nationalistic element in one of Redfield's snowy landscapes, but the success of *Cedar Hill* as a swiftly painted, spontaneous record of one particular view of the Delaware River is still evident, and many of Laurvik's comments (as opposed to his hyperbole) are still apt.

Cedar Hill belongs to the period in Redfield's career (between 1900 and 1920) when any specific influence of his French training had been absorbed into his growing experience in painting directly from nature in the countryside around New Hope, and his style was fresh and responsive to his subject. In the sense of Daniel Garber's decorative landscapes, Redfield could hardly be said to have a "style" at all, his most distinctive trait being the painterly shorthand of juicy brushstrokes with which his canvases are covered. Slender trees and branches are rendered by single thin streaks of paint cutting into the impasto surface; shorter, thicker strokes provide a striking equivalent for layers of melting snow. He shared the French Impressionists' aversion to outlines or "drawing," preferring to build up his landscapes out of broad strokes of color, but his determination to record details of a specific site was as strong as his interest in the more transient effects of light and weather. The hard facts of a landscape never dissolve under an atmospheric veil.

Over the years Redfield built up a repertory of favorite motifs, which he returned to again and again: the distant river seen through trees on the shore, a close-up view of the shrubbery and stones of a brook, a vista of the houses of the town of Center Bridge as approached through the woods. *Cedar Hill* presents a view of the bridge itself in the middle distance; the painter is stationed high on a slope overlooking the river valley, on a sunlit day after recent snow. The brown and green vertical elements of the cedar trees are set off against delicate tints of purple, blue, and gray in the snowy foreground and the pale blue of the sky. Comparison with a painting of 1904 in the Art Institute of Chicago, *Hillside at Center*

Bridge, demonstrates Redfield's ability to derive variety and freshness from his minute investigation of the same terrain; probably painted only some hundred yards away from the site of *Cedar Hill*, the Chicago picture presents the same elements reorganized by the shift in viewpoint and observed under different weather conditions.

Considerably less daring in his innovations than other American Impressionists, Redfield at his best produced work of a vigor and unromantic directness that evidently held great appeal for his contemporaries, perhaps more readily and widely comprehensible than the misty effects of John Twachtman or even the brilliant palette of Childe Hassam. A painting like *Cedar Hill* persuades us that the recent neglect of his art is as undeserved as the fervent exaggeration of its national virtues during his lifetime.

Ad'H □

ELIZABETH SHIPPEN GREEN ELLIOTT (1871–1954)

Born in Philadelphia of a Philadelphia family, Elizabeth Shippen Green was educated in schools here. Her father, though not a professional artist, painted with enough ability to have exhibited at least once at the Academy (in 1881), and she attended its school from 1889 to 1893, studying under Anshutz and Vonnoh. There she could have known several students whose careers would involve, to a greater or lesser degree, the field of illustration—Maxfield Parrish, Everett Shinn and Florence Scovel (Shinn), Glackens, and Sloan.

Her earliest known professional works are a series of slight, one-column line drawings that appeared in the *Philadelphia Times* between September 1889 and the beginning of February 1890, when she was about eighteen (reconstructing her career can be done with some precision through the collection of her illustrated works in the Free Library of Philadelphia). By 1893 she was providing larger and more accomplished line drawings of ladies' fashions for the *Public Ledger*, and in the spring of 1894 she did two ink illustrations and a cover for a children's periodical called *Sunbeams*, which are even more polished. From Fall 1894 to Fall 1896 she studied at Drexel Institute under Howard Pyle, and again she could have met a group of outstanding future illustrators, in this case ones whose styles Pyle influenced to some extent—Parrish (possibly), Charlotte Harding, Clyde DeLand, and, especially, her closest colleagues Violet Oakley and Jessie Willcox Smith.

During this period she illustrated catalogues for Strawbridge and Clothier and in 1895 began to do advertisements for the *Ladies' Home Journal*. Her illustrations—

413.

both line and wash drawings—for that magazine date from January 1896 through March 1900. By 1898 she had developed a distinctive pen style, with a wiry, flexible line often incorporating double contours, somewhat like those of Sloan's ink drawings of the nineties but more elaborate in effect.

Between 1898 and 1901 her line and halftone illustrations appeared in two children's magazines published in Philadelphia, *Scholar's Magazine* and *Forward*, as well as in *St. Nicholas* and *Woman's Home Companion*. By July 1898 she had begun to illustrate for the *Saturday Evening Post*, and many of her line and halftone illustrations appeared there through the fall of 1902. Beginning with the August 1901 issue her work appeared in *Harper's Monthly Magazine*, and she worked for the magazine almost exclusively until the October 1924 issue. Along with Edwin Austin Abbey and Pyle, she was one of Harper's staff artists. Around 130 of her original drawings for *Harper's Monthly* are owned by the Cabinet of American Illustration in the Prints and Photographs Division of the Library of Congress.

In 1902 she collaborated with Jessie Willcox Smith on *The Child, A Calendar*, and the popularity of this publication gave both artists' reputations a boost. From around 1900 until her marriage to Huger Elliott in June 1911 she shared studios with Miss Smith and Violet Oakley, and by the middle

of the first decade of the century all three were recognized illustrators, part of the Philadelphia group that was identified early on as something of a Howard Pyle "school" (Norma K. Bright, "Art in Illustration," *Book News*, vol. 23, no. 275, July 1905, pp. 850–51).

Elizabeth Shippen Green exhibited at the Academy from 1903 to 1910 and won prizes at the St. Louis Universal Exposition and the Corcoran Gallery in 1904, at the Academy in 1905 and 1907, and at the Panama-Pacific International Exposition in San Francisco in 1915. After her marriage in 1911 she lived in Providence, Rhode Island, until 1912; in Cambridge, Massachusetts, until 1920; in Philadelphia between 1920 and 1925, while her husband was principal of the School of Industrial Arts; in New York City from 1925 to 1941 while he was head of the Department of Education at the Metropolitan Museum of Art; and again in Philadelphia from his retirement until her death a few years after his, in 1954, at the age of eighty-three. She was a member of the Philadelphia Water Color Club, the Plastic Club, the Art Alliance, and the Society of Illustrators.

The bulk of her mature work during the first quarter of the century consisted of illustrations for *Harper's Monthly* and for twenty-odd books, most of them by Harper authors—such as Richard Le Gallienne, Annie Hamilton Donnell, Margarita Spalding Gerry, Arthur Sherburne Hardy, and Mrs. Humphrey Ward—many of which appeared as stories or serialized novels in *Harper's Monthly*. She also illustrated an edition of *Tales from Shakespeare by Charles and Mary Lamb* (Philadelphia, David McKay, 1922), did various posters and programs, provided some *Good Housekeeping* covers in the thirties, and collaborated with her husband on a book of illustrated nonsense verses later in life (*An Alliterative Alphabet Aimed at Adult Abecedarians*, Philadelphia, David McKay, 1947). Original examples of her work can be found in the Free Library of Philadelphia, the Philadelphia Museum of Art, the Woodmere Art Gallery, the Delaware Art Museum, and the Library of Congress.

413. *Gisèle*

1908
Illustration for "The Dream" by Justus Miles Forman, *Harper's Monthly Magazine*, October 1908
Watercolor over charcoal on illustration board
23 x 14″ (image) (58.5 x 35.6 cm)
Library of Congress, Washington, D.C.

PROVENANCE: Mrs. E. C. Luther

In a letter of July 12, 1947, to Thornton Oakley, written when she was seventy-six years old (Free Library, Oakley Collection), Elizabeth Shippen Green Elliott recalled her first affection for illustrated books as a child. Her favorites were the classic illustrators for any child of the period—Lear's *Book of Nonsense,* Tenniel in *Alice's Adventures in Wonderland,* Walter Crane, Caldecott, Kate Greenaway, Boutet de Monvel, John Leech in *Punch,* and the English illustrators of the 1860s. From the time she discovered "that magician Howard Pyle" in *St. Nicholas* and *Harper's Young People* she knew that she wanted to be an illustrator; years later she came to study with Pyle, and his influence remained strong in her pen drawings throughout her career. Her illustrations for the Bryn Mawr College May Day programs of 1924, 1928, and 1936, for example, are especially like Pyle's *Robin Hood* and *King Arthur* drawings. In fact, she herself owned four Pyle originals, bought around 1910, three from *The Wonder Clock* and one from *Pepper and Salt.*

However, Pyle was not the only influence on her work; her line drawings of about 1898–1900 are related to Sloan's ink drawings of the nineties—not surprising for someone who began her career with newspaper illustrations—and this Japanesque phase, more akin to the poster style of the 1890s than to Pyle, was carried over into her halftone illustrations in the early years of the twentieth century. By the time she began to work for Harper and Brothers with the illustrations for Richard Le Gallienne's "An Old Country House" (*Harper's Monthly Magazine,* August 1901), her halftone style, with its strong contours, flat patterning, and asymmetrical compositions, was consistently established, and *Giséle,* reproduced in color in the October 1908 issue of the magazine, is a typical example of her charcoal and watercolor illustrations. Her characters have a turn-of-the-century, mannered elegance; the seated figure of Giséle, dreamy and ladylike, recalls the fact that, beside her early work illustrating Strawbridge's ladies' fashions, she had illustrated a series of articles on ladies' fashions for the *Ladies' Home Journal* in 1896–97.

Most of Elizabeth Shippen Green Elliott's illustrations for *Harper's Monthly* were for romantic short stories, often set in medieval or Renaissance times; "The Dream" is a Gothic tale of a feud between two old families, a repeated dream that torments three generations of the men of one of them, and the final exorcism of that dream. Justus Miles Forman was a frequent contributor to the magazine, and his short stories were typical *Harper's Monthly* fare. Elizabeth Shippen Green Elliott illustrated others of them, as well as Mrs. Humphrey Ward's

414.

novels of English society and politics and Richard Le Gallienne's graceful, polished essays. *Harper's Monthly* must have provided stimulating associations at the turn of the century; it prided itself on the variety of its offerings, and its contents page boasted names such as Mark Twain, William Dean Howells, Booth Tarkington, Edith Wharton, Rudyard Kipling (Miss Green illustrated a Kipling short story in the December 1909 issue), O. Henry, Jack London, Margaret Deland, Grover Cleveland, and Woodrow Wilson. Abbey and Pyle were most frequently featured as illustrators, and a number of Miss Green's friends and former fellow students, as well as other Pyle students, also worked for the magazine—for example, Florence Scovel Shinn, Charlotte and George Harding, Alice Barber Stephens, Stanley Arthurs, and Frank Schoonover. During the many years of her association with Harper, Elizabeth Shippen Green Elliott's style underwent a certain diminution of its decorative quality, which, however, is seen at the full in *Giséle.*

AP □

JAMES MITCHELL ELLIOT (1866–1952)

Little is known of Elliot's early years. He was elected a member of the Photographic Society of Philadelphia in 1885 before graduating from Germantown Academy in 1886. There are no records as to when he began his career as a professional portrait photographer, but it is known that he was most active during the years 1900–1920, maintaining a studio on Chestnut Street for forty-two years. An active member of various philanthropic organizations such as the Germantown Historical Society and the Science and Arts Club of Germantown, he was a founder of the Upsala Foundation, and an honorary fellow and life member of the Philadelphia Museum of Art.

As a professional portrait photographer, Elliot did not involve himself in the political disruptions which plagued the pictorial movement in photography at the turn of the century, and unlike many of his contemporaries among the Philadelphia amateur photographers, he maintained his membership in the Photographic Society until his death. Moreover, he participated in the

fourth and last annual Philadelphia Photographic Salon in 1901. He was, however, made an associate member of the Photo-Secession at the time of its founding in 1902 and took part in many of the pictorial exhibitions with which the Photo-Secession was connected, such as the annual London Salons of 1902, 1904, and 1905; the *International Photographic Exhibition,* The Hague, Holland, 1904; the *Exhibition of Photographs Arranged by The Photo Secession* at the Pennsylvania Academy of the Fine Arts, April 30—May 27, 1906; and the open section of the *International Exhibition of Pictorial Photography,* Albright Art Gallery, November 3—December 1, 1910. This last exhibition was regarded by Joseph T. Keiley ("The Buffalo Exhibition," *Camera Work,* no. 33, 1911) as the mark of victory in the long struggle that began in 1890 for the recognition of photography as a fine art. It was also the first comprehensive and definitive exhibit of pictorial photographers in America.

414. *Quakeress*

c. 1900–1920
Signature: J. M. ELLIOT (in pencil, lower right corner of margin)
Photogravure
9½ x 7½″ (24.2 x 19 cm)
The Miller-Plummer Collection of Photographic Art, Philadelphia

THIS PHOTOGRAVURE undoubtedly reproduces a platinum print, the favored printing process of Elliot. Although primarily a family portrait photographer, Elliot on occasion produced landscapes and anonymous figure studies for exhibition purposes. An undated label on the back of the original frame reading "Quakeress, Not for Sale" indicates that this photogravure was exhibited at the Woodmere Art Gallery, Philadelphia, although this institution has no record of having shown it.

The anonymity of this profile portrait study and the spirit which it evokes are immediately apparent. Its value lies in the modest, humble, yet dignified character of a Quaker woman as she sits in silent receptivity rather than in its documentation of a particular person. Stripped of nonessentials and elaborations, the portrait emphasizes the way the light strikes the facial features. The subtle tonal effects responsible for the expressive force which pervades the picture could only be obtained through the photographic medium. It is a piece which provides the viewer with an awareness of the aesthetic possibilities of the photograph; it makes no pretense of resembling a painting, drawing, or other conventional artistic media.

CW □

415.

THOMAS ANSHUTZ (1851–1912)

Born in Newport, Kentucky, Thomas Pollock Anshutz moved to Philadelphia with his family at the age of nineteen. About 1871 he received his first formal artistic training at the National Academy of Design in New York, but returned to Philadelphia about 1876 to enroll in the life class taught by Thomas Eakins at the Philadelphia Sketch Club, and then at the Pennsylvania Academy, where Christian Schussele and Eakins were teaching.

Anshutz became one of Eakins's best pupils and joined him on the teaching staff as an instructor in 1881. An active member of the Philadelphia Society of Artists, Anshutz exhibited in its shows of 1879 and 1881. In 1883, Anshutz painted perhaps his best-known picture, *Steelworkers: Noontime,* revealing the thorough grounding in anatomy and the ability to render solidity of form characteristic of Eakins's methods. When Eakins was forced to resign as director of the Academy in 1886, Anshutz sided against him (Leslie Katz, "The Breakthrough of Anshutz," *Arts,* vol. 37, no. 6, March 1963, p. 26) and took his place as head of the life classes until he left in 1892 for a period of study in Europe. He enrolled in the Académie Julian in Paris, studying under the direction of William Adolphe Bouguereau and Lucien Doucet.

Returning to Philadelphia the next year, Anshutz resumed his post at the Academy

and continued to exhibit and teach there for the rest of his life. Along with Hugh Breckenridge, he formed the Darby School, a summer art school near his home in Fort Washington, Pennsylvania. Among his students were Robert Henri, George Luks, William Glackens, John Sloan, Arthur Carles, Charles Demuth, Charles Sheeler, and John Marin.

Anshutz won numerous art honors during his lifetime, although his name was not widely known to the public until late in his life. He received prizes for work exhibited at the Art Club of Philadelphia in 1901, the Louisiana Purchase Exposition of 1904, and the South American Exposition in Buenos Aires in 1910. The Pennsylvania Academy awarded him both its Lippincott Prize for *A Study in Scarlet* and the Gold Medal of Honor in 1909. In 1912, *The Tanagra* was purchased by Anshutz's students for the Academy collection. Anshutz was elected an associate member of the National Academy of Design in 1910. He succeeded William Merritt Chase as director of the Pennsylvania Academy in 1909, serving for three years until his death in Fort Washington.

AS

415. *Portrait of a Girl in a White Dress*

c. 1910
Signature: Thos. Anshutz (lower right)
Oil on canvas
64⅛ x 40″ (162.9 x 101.6 cm)
Hirshhorn Museum and Sculpture Garden, Smithsonian Institution, Washington, D.C.

PROVENANCE: The artist, Mrs. Margaret Morris (Perot) Fiero, Wynnewood, Pennsylvania; with Graham Gallery, New York, 1963; Joseph H. Hirshhorn

LITERATURE: New York, Graham Gallery, *Thomas Anshutz, 1851–1912* (February 19– March 16, 1963), illus. no. 44; Lerner, *Hirshhorn,* p. 658, illus. no. 213; Russell Lynes, "From Century Ago to Just Yesterday at the Hirshhorn," *Smithsonian,* vol. 5, no. 10 (January 1975), p. 46, illus. p. 43

THE MODEL for this formal portrait was Margaret Morris Perot of Germantown, born in 1896, the youngest daughter of a Philadelphia businessman. Anshutz began to use photography as an important tool in his painting in the late 1870s (Ruth Bowman, "Nature, the Photograph and Thomas Anshutz," *Art Journal,* vol. 33, no. 1, Fall 1973, p. 32). Like Eakins, he was not dependent or limited by photography, but regarded it as an adjunct to his sketches

from nature. A photograph which Anshutz used in painting the *Portrait of a Girl in a White Dress* recently has been located through the sitter's family. Both the oil painting and the photograph reveal Anshutz's fidelity to nature in a full-length profile view of the girl in identical dress and pose, but the painting shows that Anshutz transformed nature by effective use of color, emphasis of curves, and strong delineation of light and shadow.

Like his more famous full-length female portrait *The Tanagra* (Pennsylvania Academy of the Fine Arts), *Portrait of a Girl in a White Dress* is contemplative in mood and reflects Eakins's continued influence in the concentration on the naturalistic, anatomically solid form, positioned in space and simplified into a single, direct statement. Anshutz did not flatter his model and sought to convey personality as well as exterior appearance. He believed that "it is of utmost importance that in painting a portrait the artist should have a conception of the temperament of his subject" (PAFA, *Thomas Anshutz, 1851–1912,* essay by Sandra Denney Heard, January 17– February 18, 1973, p. 7).

While his style remained based in the Eakins tradition, Anshutz was much more experimental in his approach to art than his teacher, a facet of his philosophy that proved especially beneficial to his students, encouraging individualism and resulting in the great diversity of styles practiced by them as mature artists.

After returning to the United States in 1893, Anshutz reflected recent developments in European art by an increased interest in light and looser brushwork, particularly in his pastel and watercolor works. Although this development is not so apparent in the formal oil portraits, the outline and brushwork of the figure and background of *A Girl in a White Dress* are free and appear somewhat out of focus in accordance with the tenets of visual realism, while the head, the center of focus, is painted with greater detail and firmness. Light is of primary importance, especially as it is reflected off the white dress with a very luminous effect. The girl dominates the ruddy background, and her blue sash and hairbow strikingly complement the red and brown tones and highlight the white dress.

SKM □

ARTHUR B. CARLES (1882–1952)

Born in Philadelphia, Carles was one of the leading exponents of modern painting to emerge (and remain) in the city. In 1901, and from 1903 to 1907, he studied at the Pennsylvania Academy, where the faculty

currently included Thomas Anshutz, Henry McCarter, and William Merritt Chase. John Marin was a fellow student in 1901 and they became friends.

Carles won two Cresson Travelling Scholarships that took him to Europe (England, France, and Spain) in the summer of 1905 and again in June 1907, when he settled down for a three-year stay, primarily in France. He lived for a time with the painter Alfred H. Maurer in Paris, and frequented the artistic gatherings around Gertrude and Leo Stein. Manet's work was his first and lasting passion (especially the *Olympia*) at the Louvre; he was also deeply struck by the daring new colors of the Fauves and Henri Matisse, whom he met at the time. Carles became close friends with the painter and photographer Edward Steichen, who was living at Voulangis outside of Paris, and introduced him to Marin. Probably at Steichen's suggestion, Alfred Stieglitz included Marin and Carles as well as Steichen, Arthur Dove, and Marsden Hartley, among others, in his show of *Young American Painters* at the New York "291" gallery in the spring of 1910. While abroad, Carles completed a commission from St. Paul's Episcopal Church in Philadelphia for a full-scale copy of Raphael's *Transfiguration* in the Vatican.

Returning to Philadelphia in December 1910, Carles continued to paint vivid studies of nudes, portraits, and landscapes, twenty-six of which were shown at his first one-man exhibition at "291" in January 1912. A New York art critic found him "one of the more sane . . . of the so-called Post-Impressionists" (*American Art News,* vol. 10, no. 16, January 27, 1912, p. 6). Returning to France for a little over a year, Carles submitted one work to the Salon d'Automne of 1912 and sent two paintings to New York for the Armory Show in 1913. Back in Philadelphia by early 1914, he continued to exhibit in annual shows at the Pennsylvania Academy and in exhibitions across the country. His large canvas *La Marseillaise,* a dramatic celebration of French victory in World War I, was the sensation of the Academy annual of 1919 and won the Stotesbury Prize. Between 1917 and 1925, Carles taught at the Academy, with a year's trip to France in 1921–22. Together with a number of his Philadelphia colleagues, he was responsible for assembling two major exhibitions at the Academy to bring modern art to the city. A show of *Representative Modern Masters* in 1920 included major works by the Impressionists, Cézanne, and Matisse. Three years later Carles and Henry McCarter persuaded Dr. Albert C. Barnes to show his most recent acquisitions (including many Soutines), a venture ending in now legendary disaster as violent criticism from the press and the public provoked Dr. Barnes's sub-

416.

sequent withdrawal of his great collection of modern art from public exposure.

In December 1922, the Montross Gallery in New York gave Carles his second one-man show, which was warmly received, and he was singled out by critics for praise when he exhibited with his friends McCarter, Carroll Tyson, Franklin Watkins, Adolphe Borie, Hugh Breckenridge, and Earl Horter in *Seven Philadelphia Painters* at the Wildenstein Gallery in 1927. During the 1920s Carles's paintings of nudes and flowers increased in their intensity of color and degree of abstraction. After leaving the Academy, and a period of teaching private classes, Carles went through several difficult years, plagued by financial troubles. With the help of friends he was able to visit France again from 1929 to 1931. Returning to a new studio and home in Chestnut Hill provided by his friend, the painter and collector Carroll Tyson, Carles embarked upon a series of remarkable color abstractions during the 1930s. When a number of these were exhibited at the Marie Harriman Gallery in New York in January 1936, they were admired by Hans Hofmann, who had already become a good friend.

The Pennsylvania Academy honored Carles with a retrospective exhibition in 1940, which he selected himself. Although he lived until 1952, a fall and partial stroke brought Carles's active painting career to a sudden and tragic close in the winter of 1941. A joint exhibition of his work with that of his former student Franklin Watkins was mounted by the Philadelphia Museum of Art in 1946, and the Museum joined the

Pennsylvania Academy in organizing a memorial exhibition in 1953, for which his old friend John Marin wrote the catalogue introduction. Carles's daughter, Mercedes Matter, is also a painter and has directed the New York Studio School of Drawing, Painting, and Sculpture since 1964.

416. *L'Église*

c. 1910
Oil on canvas
31 x 39″ (78.7 x 99 cm)
The Metropolitan Museum of Art, New York. Arthur H. Hearn Fund, 1962

PROVENANCE: With Graham Gallery, New York

LITERATURE: Henry Clifford, "Prophet with Honor," *Art News,* vol. 52, no. 2 (April 1953), p. 22; Elizabeth O'Connor, "Arthur B. Carles, 1882–1952: Colorist and Experimenter," M.A. thesis, Columbia University, 1965, pp. 12–13, 100, fig. 3; Henry Geldzahler, *American Painting in the Twentieth Century* (New York, 1965), p. 74, illus. p. 75; Rose, *American Art,* p. 37, fig. 2–2; Henry G. Gardiner, "Arthur B. Carles: A Critical and Biographical Study," *PMA Bulletin,* vol. 64, nos. 302–3 (January—June 1970), p. 164, illus. p. 162; Sam Hunter, *American Art of the 20th Century* (New York, 1972), illus. p. 31, pl. 47; San Juan, The Institute of Puerto Rican Culture, *Twentieth Century Art: U.S.A. from the Metropolitan Museum of Art* (April 19—June 2, 1974), no. 5, p. 19, illus. p. 18

CARLES'S EARLY VISITS to France (1907–10, 1912–14) provided him with rich sources of inspiration from which his own idiosyncratic use of color and tendency toward abstraction were to spring. Manet's succulent paint and its bold application and Cézanne's patient, architectonic structuring of his compositions continued to stimulate Carles's sense of a painterly tradition, while the revolutionary use of bright colors by Matisse and the Fauves provided the impetus for his own innovations. The chunky little church of St. Pierre in the country village of Voulangis, near Paris, which Carles first visited in 1908, was the subject of at least three paintings and several sketches. (The Philadelphia Museum of Art owns a painting entitled *French Village Church,* done from the same viewpoint around 1921.)

A firm chronology for Carles's work has yet to be established, since very few of his paintings are dated and their titles in early exhibition catalogues prove ambiguous and interchangeable. A date of 1913 has been proposed for *L'Église* on the basis of its relationship to a pencil sketch of the church which Carles inscribed to a friend in that year, but given the fluctuation of his style and the fact that he may have inscribed the drawing some time after its execution, the possibility of an earlier date, perhaps the end of his first prolonged French stay in the summer of 1910, should not be ruled out (see Henry Gardiner, "Arthur B. Carles" *PMA Bulletin,* cited above, pp. 162–64).

Carles surely painted this view of the church from his vantage point in the window of the local inn in Voulangis on one of his frequent visits to Edward Steichen. The photographer owned a handsome house and garden full of flowers, to which he devoted much time and care. It would not be surprising if Carles's own passion for painting luscious bouquets of flowers was reinforced by his friendship with Steichen, who was painting, photographing, and crossbreeding his splendid garden blooms at that same time.

L'Église is one of Carles's masterpieces. The surface is richly painted and the broad, potentially dull areas of sky and church wall are suffused with myriad hues of blue, pink, and yellow. An excess of energy, or the urge to add just one more stroke of strong color, occasionally leaves Carles's paintings in uneasy balance, but here all is resolved: the solid shape of the church and a luxuriant mass of foliage bathed in the sharp, exciting light that often presages a midsummer storm.

Ad'H ☐

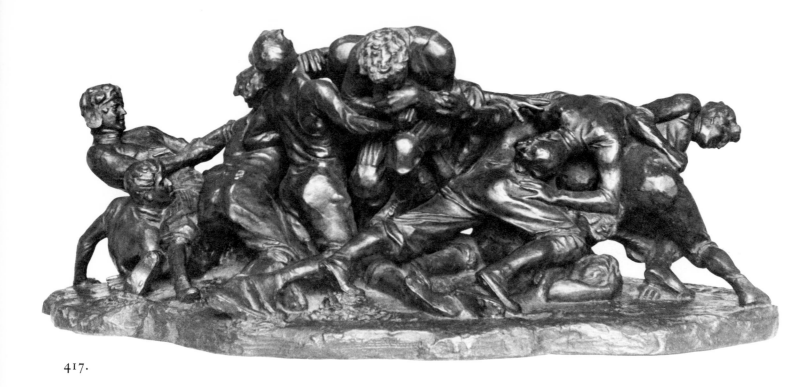

417.

R. TAIT MC KENZIE (1867–1938)

The work of Tait McKenzie, "physician and sculptor," appealed to the same idealistic generation as did the verses of the English poet Rupert Brooke; in the decade leading into World War I, McKenzie and Brooke each sought to revive the noble spirit of ancient Greece in imagery of the clean-cut athleticism of modern youth. The son of a Scottish Presbyterian minister, McKenzie was born in the small farming community of Ramsay, thirty miles from Ottawa, Ontario. The family moved to the town of Almonte (which later commissioned a war memorial from McKenzie) where he attended high school and undertook his first and only formal art training: charcoal drawing, from casts and from life, at night school. In 1885, McKenzie entered McGill University in Montreal where his ambition to become a doctor coincided with his determination to succeed in competitive sports (he won the all-around gymnastic championship in his second year). From 1889 to 1892 he was enrolled in the medical school and on receiving his M.D. was put in charge of physical training at the university (his position was formalized to that of medical director in 1894).

Around 1900 he began to experiment with modeling heads and figures in low relief—his thorough knowledge of the human body derived from his years of lecturing on anatomy at the medical school and his experience as director of physical education and

(from 1893) house surgeon at Montreal General Hospital. It is typical of the interaction of his interests that his first art works of any note were inspired by a medical paper he prepared on "Stages of Fatigue in Athletes." Seeking to capture the facial distortions produced by intensive physical activity, McKenzie modeled four "masks" of Violent Effort, Breathlessness, Fatigue, and Exhaustion (1902). His next sculpture (that same year) was a more ambitious project: the ideal form (one-quarter life-size) of a sprinter poised to begin the race, based on the average measurements of approximately eighty American champions. Despite his lack of training as a sculptor, McKenzie's attempt met with great success when it was shown at the Society of American Artists in New York (1902), the Royal Academy in London (1903), and the Paris Salon (1904). His second figure in the round brought him even wider repute. Commissioned by the Society of Directors of Physical Education in Colleges to create a statue of the ideal all-around athlete, McKenzie produced a standing figure in classical pose, whose measurements were averaged on the basis of four hundred Harvard students. McKenzie's instant, and international, success with his chosen genre was remarkable. *The Sprinter* (1902) was at once acquired by the Fitzwilliam Museum in Cambridge, England, *The Athlete* (1903), by the Ashmolean Museum at Oxford, and *The Competitor* (1906) by the Metropolitan Museum in 1909. McKenzie spent the

summer of 1904 in Europe, admiring the sculpture of George Frederick Watts and John Macallan Swan in England, and rented a studio in Paris for a few months to pursue his own work.

In the fall of 1904 he accepted the newly created chair of Physical Education at the University of Pennsylvania and moved to Philadelphia where he was to live for the remainder of his life. At the same time, he devoted an increasing amount of time to his sculpture and began to produce numerous small figures as well as larger commissioned pieces, no longer relying on specific physical statistics. In 1908, the Herron Art Institute in Indianapolis mounted an exhibition of his sculpture, and in 1913 forty-nine works were included in a retrospective at the McClees Gallery in Philadelphia. Two of his best known Philadelphia commissions were completed in 1914: *The Boy Scout* (an enlarged version stands in front of the Boy Scout Headquarters at Twenty-second and Winter streets) and *The Youthful Franklin,* a gift of the Class of 1904 to the University of Pennsylvania. In 1914 he also began work on an unusually dramatic subject: a full-length, over-life-size figure of the eighteenth century revivalist George Whitfield preaching, commissioned by the Methodist alumni of the University of Pennsylvania and installed on the campus in 1918.

The advent of World War I took him to England in 1915 as the initiator of a War Office program to rehabilitate the wounded

and convalescent. As the casualties of the war created a demand for memorial sculpture, McKenzie was commissioned to create a number of works commemorating individual soldiers as well as larger monuments both at home and in England. His most important commissions included the Cambridgeshire War Memorial (*The Home-Coming,* 1922), a memorial for Woodbury, New Jersey (*The Victor,* 1925), and the Scottish-American Memorial in Edinburgh (*The Call,* 1923–27). In each case, McKenzie produced a vigorous but idealized, over-life-size figure based on painstaking study of the uniform and physiognomy appropriate to the subject.

Upon his return from England after the war, McKenzie established a studio at the rear of his house at 2014 Pine Street where he continued to work until his death. Aside from athletic figures and memorials, his oeuvre included portrait reliefs and medallions of distinguished physicians and fellow artists (Joseph Pennell, John McClure Hamilton, and Violet Oakley). He also produced many cast-bronze medals for institutions or societies devoted to science, athletics, or art, such as the Franklin Institute, the Fencer's Club of Philadelphia, and the Philadelphia Sketch Club. His work was particularly well known in England due to two exhibitions at the Fine Arts Society in London (1920 and 1930) and a series of commissions that culminated in a large historical monument to General Wolfe in Greenwich (1930). In 1929, Christopher Hussey's monograph *Tait McKenzie, A Sculptor of Youth* was published by *Country Life,* when his reputation (which has fallen into considerable neglect since his death) was at its height.

McKenzie's range of interests was reflected in his memberships in professional associations: the American Medical Association, Philadelphia College of Physicians, Philadelphia Playgrounds Association, the Board of the Boy Scouts of America, as well as the Philadelphia Art Alliance and the Contemporary Club, among many others. In 1931 he retired from his chair at the University of Pennsylvania; he died seven years later at the age of seventy-two. The Lloyd P. Jones Gallery at the University of Pennsylvania contains over sixty of his sculptures on permanent exhibition; his other major monuments in Philadelphia include the life-size portrait of *Provost Edgar Fahs Smith* (1926) at the University of Pennsylvania, the *Christine Wetherill Stevenson Memorial* (1928) in the Philadelphia Art Alliance, and a war memorial (1931) for the campus of Girard College. McKenzie's summer home and studio in the Mill of Kintail at Almonte is now a museum devoted to his work, and his archival papers are preserved at the University of Pennsylvania.

417. *The Onslaught*

1911
Signature: R. Tait McKenzie/copyright 1911 (on front of base)
Inscription: © R. TAIT MCKENZIE / EXAMPLE NO. 2 OF AN EDITION OF TEN
Bronze
15 x 36 x 21″ (38.1 x 91.4 x 53.3 cm)
University of Pennsylvania, Philadelphia. Lloyd P. Jones Gallery and Court of the Sculpture of R. Tait McKenzie

PROVENANCE: Purchased from the artist by the University of Pennsylvania Council on Athletics, June 10, 1924; installed in the Lloyd P. Jones Gallery, Gimbel Gymnasium, in 1972

LITERATURE: Harrison Morris, "R. Tait McKenzie, Sculptor and Anatomist," *International Studio,* vol. 41, no. 164 (October 1910), p. xiv; PAFA, *106th Annual* (1911), no. 749, Roman Art Exposition, *Catalogue of the Collection of Pictures and Sculpture in the Pavilion of the United States of America* (1911), no. 604; Philadelphia, McClees Gallery, *The Work of Ten Years in Sculpture . . . by Dr. R. Tait McKenzie 1902–1912* (February 20—March 1, 1913), no. 11, p. 6; Hamilton Bell, "Un Sculpteur moderne de l'athlétisme, R. Tait McKenzie," *Gazette des Beaux-Arts,* 62e année, 5e période, 703 livraison (February 1920), p. 159; E. Norman Gardiner, "The Revival of Athletic Sculpture: Dr. R. Tait McKenzie's Work," *International Studio,* vol. 72, no. 287 (February 1921), p. 138, illus. p. 134; Christopher Hussey, *Tait McKenzie, A Sculptor of Youth* (London, 1929), pp. 25–27, 103, pls. 20–23; Andrew J. Kozar, *R. Tait McKenzie, The Sculptor of Athletes* (Knoxville, Tenn., 1975), pp. 12, 15, 56, illus. p. 57

THIS ONE-QUARTER LIFE-SIZE GROUP of thirteen men in a football scrum was McKenzie's most ambitious athletic sculpture, and took him over four years to complete to his satisfaction. Football players at the University of Pennsylvania served as models and were repeatedly put through the maneuver in which "the offense crashes through the line" (Kozar, *R. Tait McKenzie,* cited above, p. 56). With the plaster model still unfinished in his studio, it was hailed by *International Studio* in 1910 as giving "evident promise of a brilliant, busy and most original performance" (p. xiv). Exhibited at the Pennsylvania Academy and the International Exposition in Rome in 1911 and at the Royal Academy in 1912, *The Onslaught* provoked a veritable storm of praise. Critics appeared to be delighted by the realism and contemporaneity of the theme, as well as the idealism of its treatment ("a throng of opposing gladiators of the gridiron" was the phrase used by Edward Carpenter in *Town and Country* magazine). Keats's dictum "beauty is truth, truth beauty" was made to describe the success of McKenzie's efforts. The *New Haven Register* placed *The Onslaught* in its historical context:

It may be that much less than a century hence the foot ball of today will have entirely passed from memory superseded by something better or reformed out of all semblance to its present self. In either case we could not preserve the present type in so effective a way as by sculpture. With all its faults we owe much to foot ball and in some such positive way as this we may properly acknowledge the obligation. Will the beholder of a century hence regard this group with that half repugnant awe with which we stand before the "Laocoon" or with the admiration which we accord to the "Discus Thrower"? (quoted in McClees Gallery 1913 catalogue, cited above, p. 6)

For a nation of television viewers in 1976, the subject matter of *The Onslaught* certainly retains its relevance, but the stylization of McKenzie's apparently realistic manner has become increasingly obvious over the years. Despite their naturalism, the figures are interlinked in a symmetrical pyramid: a carefully contrived composition of opposing forces caught temporarily in balance. Viewed from the side, the sculpture takes on the romantic aspect of a great wave, with the halfback riding the crest. McKenzie was to use some of the same formal devices with great effectiveness in a proposal of 1918 for a Canadian National War Memorial, in which a group of soldiers with bayonets surges over the top of a hill. The idealized melodrama, which seems so incongruous in a football game, becomes grimly appropriate in a monument to the war dead. *The Onslaught* resists being viewed as a work of pure realism, although each figure is convincing in pose and details of dress.

Grandiloquent art historical references abound: *Laocoön* is an apt comparison; and the halfback clasping the ball to his chest echoes the agonized concentration (without the provocation!) of Michelangelo's central, falling figure among the Damned in the *Last Judgment.* The tradition of athletic sculpture has had a lively history in Philadelphia, ranging from Samuel Murray's *Boxer* of 1899 to the recent, popular monuments of Joe Brown (born 1909), who worked with McKenzie in his studio for a number of years. McKenzie brought an unquestioned skill and detailed knowledge of anatomy to the genre, and his work enjoyed international acclaim until his death.

If *The Onslaught* seems dated in its elevation of football to the level of heroism, it retains interest as a remarkably vigorous rendering of a complex sculptural problem.

Ad'H □

SAMUEL YELLIN (1885–1940)

Samuel Yellin was born in Galicia, Poland, in 1885. At the age of seven he was apprenticed to a Russian blacksmith in the village of Mogiler, becoming a master craftsman at seventeen. In accordance with custom, Yellin then set out to travel: "In Belgium he spent three years at his craft, reproducing Gothic ironwork and even in fashioning armor. The next two years he spent in England, coming to Philadelphia at the age of twenty-two. At that time our revival of interest in the teaching of crafts had just begun, and Mr. Yellin was engaged to organize the ironwork classes in the Pennsylvania Museum and School of Industrial Art" (William B. McCormick, "Samuel Yellin—Artist in Iron," *International Studio,* vol. 75, no. 303, August 1922, pp. 431–32).

Yellin was first listed in the Philadelphia city directories in 1907 as a carpenter; in 1908 he appears as an ironworker, at which time he probably set up his studio in a small, two-room garret over a surgical instrument manufacturer at 409 North Fifth Street. From this modest beginning, Yellin built his renowned Arch Street Metalworker's Studio, designed by the Philadelphia firm of Mellor and Meigs in 1915 (see biography preceding no. 426), which grew until, in the early 1920s, Yellin employed over two hundred craftsmen. A two-story yellow stucco building,

> it stands flush with the street, its austere walls pierced with a few windows protected by wrought-iron grilles. On three of the principal grilles there are medallions with figures, and the appropriate attributes, of the three principal types of iron workers: the Forgeman, the Hingeman and the Armorer, the designs being as Germanic as the grilles are obviously Latin. The entrance is through a court, the vista of which is thoroughly reminiscent of the Mediterranean countries, although the first two doorway grilles are French Gothic while the wooden door, ending the level vista, suggests German Gothic.
>
> On the first floor, opening off the court, is the business office and beyond that a large apartment called "my room" by Mr. Yellin. Here everything is rich in medieval atmosphere, from the plain walls, hung with old tapestries and examples of ancient iron-work and armor, to the beamed ceiling and the cavernous fireplace.... In the second story are the designing room, the book room—or library, and a little museum where Mr. Yellin has gathered together the fruits of twenty years of devotion to collecting characteristic examples of the wrought iron work of Europe and the United States....
>
> ... The actual workrooms are in the rear, a forge-room on the ground floor with the assembly room above, two great, light-flooded rooms filled with forges, piles of iron rods, toolracks and benches....
> (McCormick, cited above, pp. 432–33)

An important exhibition of Yellin's work was held at the Pennsylvania Museum in 1911, under the auspices of the Alumni Association of the Museum School, which included, "portions of the sanctuary gate for the church of St. Thomas; Gothic door fittings for the West Point Military Academy; and various parts of ecclesiastical features in Massachusetts churches. In domestic iron work there were lanterns, andirons, fenders, and an exceptional Gothic lock, of beautiful design and execution, and intricate mechanism.... The Gothic lock has been purchased, out of the Temple fund, for the Museum collection" (*PMA Bulletin,* vol. 9, no. 34, April 1911, p. 35). This lock is exhibited here.

418. *Lock and Key*

1911
Wrought iron; mica
Lock 16¾ x 1½ x 3½" (42.5 x 40.1 x 9 cm); key length 3½" (8.5 cm)
Philadelphia Museum of Art. Purchased: Joseph E. Temple Fund. 11–237a, b, c

LITERATURE: *PMA Bulletin,* vol. 9, no. 34 (April 1911), p. 35

THIS GOTHIC-INSPIRED LOCK combines modern details, such as the mechanical parts seen through the clear mica sheet, with medieval floral designs in wrought iron. In this lock, Yellin demonstrated his virtuoso skills as a craftsman. He usually began his work with a drawn sketch, as a suggestion for the general composition, probably inspired by one of the numerous nineteenth century books illustrating medieval buildings and ornament. From these sketches he then made full-scale working drawings. Then he shaped the iron, made pliant by the heating process, and welded together separate pieces by hammering. Iron becomes stronger the more it is worked, and therefore, Yellin was able to create a very durable lock within a small delicate form.

Yellin's interest in the medieval past is explained by a contemporary account:

> Through all the stress and turmoil of the Middle Ages, the hammer of the ironsmith continued its resounding blows, perfecting as nearly as possible, the armorer's craft; and later on, the art gradually developed, culminating in the creation of architectural adjuncts—doors ornamented with ironwork, gateways, grills, balconies, window-fastenings, presses and chests, and fashioning them into forms and designs that had a distinct character and style of their own. The Middle Ages and the Renaissance stand out preëminently as the epochs when the ironworker achieved his greatest masterpieces, and from those times the modern craftsman draws his greatest inspiration.
>
> Mr. Samuel Yellin is a craftsman who dares to defy the modern tendency of utilizing devices other than the hammer

418.

and anvil for working in iron. He is a devout follower of tradition, caring deeply for the great examples of his art, and so all of his work, from the smallest details to the splendor of imposing gates and delicate grills, is wrought by hand. To him, the past is a treasure-house from which he gathers material for his own creations. . . . (Hannah Tachau, "An Awakening Appreciation of Wrought Iron in America: The Work of Mr. Samuel Yellin," *The Art World,* vol. 3, February 1918, p. 440)

Yellin's emotional reaction to his material and the appropriateness of the lock and key as an outlet for his artistry were described by the craftsman himself: "I love iron; it is the stuff of which the frame of the earth is made. And you can make it say anything you will. It eloquently responds to the hand, at the bidding of the imagination. When I go to rest at night, I can hardly sleep because my mind is aswarm with visions of all the gates and grilles and locks and keys I want to do. I verily believe I shall take my hammer with me when I go and at the gate of heaven, if I am denied admission, I shall fashion my own key" (quoted in Fullerton Waldo, "Samuel Yellin: Poet of Iron," *The Outlook,* December 31, 1924).

DH □

ELIZABETH SPARHAWK-JONES
(1885–1968)

Much is still obscure about the life of this intriguing artist, who was born in Baltimore, the daughter of an eminent Presbyterian minister. In 1894, the Reverend John Sparhawk-Jones moved his family back to his native city of Philadelphia to become pastor of Calvary Presbyterian Church at Fifteenth and Locust streets. (After his death in 1910, a memorial portrait relief by Charles Grafly was erected in the church, since then demolished.) From 1902 to 1909, Elizabeth Sparhawk-Jones attended the Pennsylvania Academy, where she studied with Thomas Anshutz and was strongly influenced by the teaching of William Merritt Chase. She was one of a number of talented women studying at the Academy at that time, and her portrait by her close friend Alice Kent Stoddard (born 1885) was shown there in 1911.

Sparhawk-Jones's first painting to be exhibited publicly (*Roller Skates*) won the Mary Smith Prize at the Academy in 1908. The following year the Academy accepted her gift of *The Market,* a long frieze-like painting of peasant women which reads as an irreverent but skillful parody of Frans Hals. Between 1908 and 1916 she exhibited

419.

frequently at the large national annual shows held at the Academy, and at the Carnegie Institute, the Corcoran Gallery of Art, and the Art Institute of Chicago, winning an honorable mention at the Carnegie in 1909 and carrying off the Mary Smith Prize again in 1912. During this time, she occupied a sequence of studios on Spruce and Pine streets, in the center of Philadelphia. Her early style constituted a highly personal version of Impressionism. Light-filled and broadly brushed, her paintings revealed a penchant for feminine subject matter: nurse-maids with their charges, ladies shopping, strollers in Rittenhouse Square. Chase purchased a painting for his own collection, and by the age of twenty-seven Sparhawk-Jones was represented in a major museum.

After this first flush of success, a long illness of about twelve years interrupted her career, dividing it into two distinct phases. Her gradual return to painting was signaled by an entry in the annual exhibition at the Art Institute of Chicago in 1926, which won the Kohnstamm Prize. Over ten years later, in 1937, her recent work was shown at her first solo exhibition, at the Frank Rehn Gallery in New York. She was to have four subsequent shows there, in 1942, 1944, 1947, and 1956. The exhibition of 1937, favorably reviewed by Henry McBride, modernist art critic of the *New York Sun,* included "subjects of mysterious content, burial scenes, and imaginative compositions of fire and smoke and drifting clouds" (*Art Digest,* vol. 11, no. 14, April 15, 1937, p. 17). Her style now verged on expressionist violence. Drawing on her imagination rather than perceived reality, she specialized in novel

interpretations of allegorical themes (still preoccupied with female subjects): *Lady Godiva, Leda, Suzanna and the Elders,* and a modern vision of *Housewives on Holiday* depicted as a group of awkward nymphs capering beside a litter-strewn pond. *Lady Godiva* was included in the exhibition of *Romantic Painting in America,* organized by Dorothy Miller and James Thrall Soby for the Museum of Modern Art in 1943.

During her later life, she lived just outside of Philadelphia in Westtown, spending some time abroad and visiting the McDowell Colony in New Hampshire. Her work grew increasingly mystical and abstract: the catalogue to her small show at the Graham Gallery in 1964 appropriately quoted Marsden Hartley's earlier remark, "a peculiar electricity pervades these pictures."

Sparhawk-Jones's death at the age of eighty-three brought an end to a career in which early promise and later development were curiously isolated, yet each of sufficient originality to merit more attention than she has thus far received.

419. *Shop Girls*

c. 1912
Signature: Elizabeth Sparhawk-Jones (lower right)
Oil on canvas
38⅛ x 48″ (96.8 x 121.9 cm)

The Art Institute of Chicago. Friends of American Art Collection

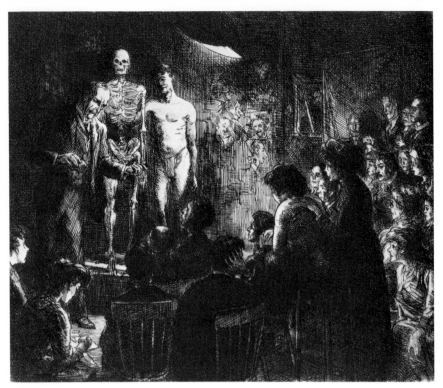

420.

JOHN SLOAN (1871–1951)
(See biography preceding no. 381)

420. *Anshutz on Anatomy*

1912
Probably printed by Peter J. Platt
Signature: John Sloan (in pencil, in margin, lower right)
Inscription: 100 proofs (in pencil, in margin, lower left); Anshutz on Anatomy (in pencil, in margin, lower center)
Etching printed in black on cream color wove paper, viii/viii
7⅝₁₆ x 8⅞″ (image) (18.5 x 22.5 cm)
Philadelphia Museum of Art. Purchased: Lessing J. Rosenwald gift and Farrell Fund Income. 56–35–83

LITERATURE: Wilmington Society of the Fine Arts, *The Life and Times of John Sloan* (Wilmington, 1961), no. 101, p. 41 (illus.), Columbia, University of Missouri, *A Selection of Etchings by John Sloan* (March 3–24, 1967), pls. 31–32; Peter Morse, *John Sloan's Prints, A Catalogue Raisonné of the Etchings, Lithographs, and Posters* (New Haven, 1969), no. 155; PAFA, *Thomas P. Anshutz, 1851–1912* (January 17—February 18, 1973), p. 17, fig. 7

IN THE UNITED STATES around 1900, even in as important an art and art education center as Philadelphia, there was a general lack of interest in the graphic arts except for commercial purposes. John Sloan, therefore, was by necessity a largely self-taught printmaker, who poignantly chronicled his observations in more than three hundred prints, mainly etchings. An intimacy of scale and an incisiveness imposed by or gleaned from the etching medium augment Sloan's clarity of vision. "When Sloan received a magazine assignment, he first carefully read the story to decide which scenes would lend themselves best to pictorialization" (E. John Bullard, Washington, D.C., National Gallery of Art, "John Sloan: His Graphics," *John Sloan, 1871–1951*, September 18, 1971—October 31, 1971, p. 29). He paralleled this by "reading" life's experiences with equal care in order to discern the most provocative subjects.

The anatomy lesson, an aspect of both art and medical education, had fascinated artists as diverse as Rembrandt, Rowlandson, and Eakins. Thomas Anshutz taught in various capacities at the Pennsylvania Academy for more than a quarter of a century. When Eakins was dismissed from the school, Anshutz, in his own less dogmatic fashion, continued the Eakins tradition of intense anatomical study (Sandra Denney Heard, *Thomas Anshutz, 1851–1912*, Philadelphia, 1973, p. 8). John Sloan was one of his students, although the association was short-lived, as Anshutz objected to Sloan's inclination to draw his colleagues rather than the

PROVENANCE: Purchased from the artist by the Friends of American Art at the Art Institute of Chicago, 1912

LITERATURE: Pittsburgh, Carnegie Institute, *16th Annual* (April 25—June 30, 1912), no. 287; PAFA, *108th Annual* (1913), no. 116; Art Institute of Chicago, *Bulletin*, vol. 9, no. 4 (April 1, 1915), illus. p. 55; Art Institute of Chicago, *A Century of Progress* (June 1—November 1, 1933), no. 644; Art Institute of Chicago, *Paintings in the Art Institute of Chicago* (1961), p. 438

ELIZABETH SPARHAWK-JONES'S WORK of 1908–16 is marked by an unusual degree of independence for one coming late to American Impressionism. She was a devoted student of William Merritt Chase, and it seems likely that she also took classes with Cecilia Beaux, who was on the faculty of the Pennsylvania Academy during her seven years of study. *Shop Girls,* however, is the creation of a painter whose particular gifts place her as close to Robert Henri in spirit and facture as to her teachers, and she would have had ample opportunity to see his paintings in Philadelphia at his one-man show at the Academy in 1904 and the notorious exhibition of The Eight in 1908. (Sparhawk-Jones's colleague Alice Kent Stoddard was clearly an admirer of Henri: her portrait of *Leila* in the Reading Museum could be mistaken for his own typical depiction of a pert, laughing child.) *Shop Girls* was a prosaic subject for a Chase student brought

up on his fashionable portraits and lavishly decorated studio interiors, and it seems equally far from Beaux's thoughtful portrayals of socially prominent men and women. There is nothing of *fin-de-siècle* elegance in this cheerful study of girls absorbed in the mundane activity of unfolding and cutting lengths of cloth.

Yet although Henri would have applauded the modern subject, and the slashing brushwork is close to his own hasty style, Sparhawk-Jones's attention to the effects of light and atmosphere is foreign to his preoccupation with tonal values and dramatic contrasts of light and dark. *Shop Girls* is a study in luminosity: the gleam of scissors flashing through the cloth; the tints of violet, yellow, and blue reflected in the bolts of white fabric; the outline of the girls' features and figures dissolving under the radiance shed by the window at the rear of the store. This is a quirky painting for a young artist in 1912: although she was a contemporary of Charles Sheeler (see biography preceding no. 427), who resolutely shook off Chase's influence to pursue modernist innovations, Sparhawk-Jones remained a youthful exponent of the style and aims of an older generation and yet demonstrated a vigor and originality that won her prizes and induced the Friends of American Art to add *Shop Girls* to the collection of the Art Institute of Chicago shortly after it was painted.

Ad'H □

494

model (Sloan, "Autobiographical Notes on Etching," in Morse, cited above, p. 383).

Although the Anshutz-anatomy link is most frequently associated with the Academy, the specific lecture depicted here is one of a series of six given for Robert Henri's class at the New York School of Art in 1906 (Bruce St. John, ed., *John Sloan's New York Scene,* New York, 1965, p. 7). Anshutz is shown characteristically holding a lump of clay which he is about to transform into muscles to be placed on the skeleton. Muscular activity and its effect on form is then to be demonstrated by the model. Peter Morse (cited above, no. 155) gives comprehensive documentation of *Anshutz on Anatomy,* including descriptions of the eight progressive states, Sloan's comments about the etching, and the identification of known individuals, noting Sloan as the figure with glasses along the upper right margin. Dolly Sloan, Robert and Linda Henri, William Glackens, and Maurice Prendergast are among others included. Linda Henri died before the lecture series, but Sloan was working on *Memory* (Morse, cited above, no. 136), a print in which she is represented, at about the time that the series took place. It is further unlikely that the other recognizable faces were all together in the audience on the same night.

Although the New York lectures were held in 1906, the plate is dated 1905 at the upper left, and Morse (cited above, p. 180) records an inscribed proof also noting the earlier date. The etching itself, however, dates from 1912, a year significant for two facts: Sloan began to work steadily from the model, and Anshutz became ill and died. Nostalgia and homage, then, were two possible motivations for Sloan's return to the subject of six years earlier.

Three related sketches and a tissue with a separate insert for Anshutz's head are in the comprehensive Sloan holdings at the Philadelphia Museum of Art. They offer a rich history of the print's development and evidence that memory, reflection, and imagination greatly augmented Sloan's response to the scene. One of these sketches is a sheet of individual figures, including one of the model and several of Anshutz. The other two sketches include the scene in its entirety, but only Anshutz, the model, and the skeleton are articulated; the audience is vague and undefined and much of the space is vacant. One depicts a formally compact central trio: Anshutz lifts the skeleton's left leg, and the model, as animated as the teacher, reaches across the bony figure in what is a humorous gesture of camaraderie. The other sketch emphasizes Anshutz standing apart from his models and speaking directly to the class. The drawing on tissue, in reverse of the etching, was used by Sloan to transfer his image to the plate. It combines aspects of the two developed sketches, that is, a formal proximity of the central three figures but with gestures related to the sketch in which Anshutz is standing apart from the model and the skeleton. Furthermore, in the tissue one sees a greater definition of place, although the hovering heads in the center background and other details of the etching are still lacking.

Throughout the development of the image, Sloan moved from the general to the particular, emphasizing human incident and characterization. The disposition of elements is as complete in the first as in the final state of the etching. However, the technique of the early state is open, unconfined cross-hatching. As work progressed, Sloan's interest shifted from a depiction of an atmosphere to a depiction of dramatic light with an emphasis on weighty, compressed forms, neither of which is particularly important in the preliminary drawings. When printed, a thin layer of residual ink on surface areas of the copper plate can augment variations in tonal value developed by cross-hatched etched lines. In this impression, the strong focus of light on the central subject is notably emphasized by means of extensive use of this plate tone.

An impression of this subject was included in the 1913 Armory Show. Apparently the print was among Sloan's favorites, as he selected it for a proposed but never produced publication of fifty-four of his etchings (Morse, cited above, p. 381 n. 1). The copper plate, once steel faced, is in the John Sloan Trust on deposit at the Delaware Art Center.

RFL □

the age of sixty-one stands out even among Eakins's portraits as an intense portrayal of personality and mood. A striking characteristic of Eakins's photographs is that he achieved in them the same qualities he sought in his bust-length portraits—a definition of large volumes of the figure with strong contrasts of light and dark and a careful balance of texture and anatomical detail that captures the physical individuality of the sitter's face without destroying the overall unity of form. In the few instances in which Eakins made similar painted and photographic portraits of the same sitter, as for example this photograph and the bust-length portrait of approximately twelve years earlier, a comparison of the two confirms Eakins's skill as an observer and his ability to record with the painter's materials a likeness that is as physically exact as the camera's instantaneous image.

More important, however, the photograph illustrates Eakins's belief that character in portraiture was not a quality imposed by the artist but found by him through persistent study of his subject. In this portrait of his wife, Eakins used the objectivity of the photographic medium in the same manner that he employed the objectivity of his vision in painted portraits. As in the paintings, the result is not an impersonal record of human features, but a portrait of an introspective and vulnerable personality. The physical fact of age is not avoided but portrayed with the greatest respect to create a profound image of human being.

DS □

ATTRIBUTED TO THOMAS EAKINS
(1844–1916)
(See biography preceding no. 328)

421. *Mrs. Thomas Eakins*

c. 1912
Photograph
6¼ x 4½″ (15.8 x 11.4 cm)
Peggy Macdowell Walters, Roanoke, Virginia

PROVENANCE: Mrs. Thomas Eakins; nephew, Walter G. Macdowell; daughter, Peggy (Macdowell) Walters

LITERATURE: Hendricks, *Eakins Photographs,* p. 5, no. 239, illus. p. 168

LIKE THE TWO PORTRAITS that Eakins painted of his wife, Susan Macdowell Eakins, *The Portrait of a Lady with a Setter Dog* of 1885 (Metropolitan Museum of Art) and the bust-length *Portrait of Mrs. Eakins* of about 1889 (Hirshhorn Museum and Sculpture Garden), this photograph of her at about

421.

422. *Dress*

c. 1912

Label: Mme. Herbst, Phila. (on label in waistband)

Ivory cut-and-uncut velvet; trimmed with beading, black and white lace, and netting, and silk and velvet flowers

Waist 28″ (71.1 cm); center back length 50″ (127 cm)

Philadelphia Museum of Art. Given by Mrs. Bayard H. Roberts and Mrs. John Wintersteen. 50–35–4

PROVENANCE: Selina B. McIlhenny; nieces, Mrs. Bayard H. Roberts and Mrs. John Wintersteen

A GENERAL RELAXATION in the feminine mode made its appearance about 1912. The female silhouette changed completely, and dresses were generally of a softer, looser construction, fashioned from a combination of many varied materials and elaborate trimmings. Gone were the tight, boned corsets and the high, boned collars from earlier in the century (see no. 406); in their place came a slightly raised waistline and draped and relaxed V- or U-shaped necklines. This new fashion caused overwhelming excitement and incited adverse criticism: "It was denounced from the pulpit as something very like indecent exposure and by doctors

as a danger to health. A blouse with a very modest triangular opening in front was dubbed a 'pneumonia blouse' but in spite of all these protests the V-neck was soon generally accepted" (Laver, *Costume & Fashion,* p. 227).

This ivory cut-and-uncut-velvet dress has an elaborate beaded passementerie outlining the deep V neckline, which is filled in with an insert of many-layered, pleated netting. The dolman-style sleeves are of ivory net lace outlined in a floral motif of silver threads. The long straight underskirt has a short, diagonally cut, overskirt gathered into the waist at back forming a draped effect. A short fishtail train ends above the hem with a pearl and bugle-bead tassel. French handmade silk and velvet roses and morning glories run along the neckline ending above the silver lamé raised cummerbund; matching flowers are attached to the tip of a net streamer which hangs from it.

EMcG □

423.

423. *Child's Dress*

c. 1913

Embroidered white cotton lawn; lace insertions; trimmed with Irish crocheted lace

Center back length 28⅞″ (73.3 cm)

Philadelphia Museum of Art. Given by Mrs. Thomas H. Dalton through Rosenau Bros. 64–84–1a,b

PROVENANCE: Margaret Howard (Mrs. Thomas H. Dalton)

THERE HAD BEEN LITTLE IMPROVEMENT in the design of children's garments in the early part of the twentieth century. Girls' dresses still were quite complex in construction, and did not give much leeway for the natural boisterousness of children. Sewing machines were relatively inexpensive, and many families could afford one. Mothers and dressmakers were kept busy sewing and trimming children's dresses, as store-purchased garments were not readily available and tended to be expensive. *The Delineator,* a fashion magazine published at this time, included printed patterns for children's clothing. Those for small girls would include design transfers appropriate for embroidery and other trimmings.

Dresses fashioned at home or by a local seamstress often show elaborate detail and incredible workmanship, even those made for less important occasions than the dress worn by Margaret Howard at her First Communion in 1913. Sewn by Mamie O'Neill and embroidered by Mrs. William Thompson, it is worked in panels of shear white lawn, embroidered in a vine-like floral

motif and trimmed with matching Irish crocheted lace worked with shamrocks and roses. Narrow machine-made lace appears as insertions along the panels and as a full ruffle along all the edges. The dress is constructed in two parts, a full-skirted underdress with short sleeves, and a straight over-tunic, attached at the round neckline and ending in wide panels below the waist. The over-tunic hangs straight from the shoulders, whereas the underskirt is fully gathered into a slightly relaxed waist. An elaborate full underslip matches the skirt in many of its details. By the 1920s the problem of more appropriate clothes for children's activities was at last being solved. Dresses became more practical and lighter in weight, and certain manufacturers began to devote their entire production to the making of clothes for the young, for play and for special occasions.

EMcG □

ALBERT LAESSLE (1877–1954)

Laessle was born in Philadelphia, the son of a German woodcarver who had immigrated with his wife to the United States in the 1850s. He graduated from the Spring Garden Institute in 1896, spent one year at the Drexel Institute, and enrolled in the Pennsylvania Academy from 1897 to 1904. Although he studied under Thomas Anshutz at the Academy, he was most influenced by the sculpture classes of Charles Grafly (see biography preceding no. 376), whose instruction, encouragement, and friendship were to be decisive in his choice of a career.

422.

In 1901 his *Portrait of an East Indian* was accepted for the Academy's annual. His entry in the Philadelphia Art Club's sculpture show that same year occasioned considerable controversy: a lively study of a snapping turtle (saved from Grafly's dinner table) fighting with a crab over the body of a dead crow, it was accused of being cast directly from life (a criticism previously leveled at Barye and Rodin by Parisian reviewers). Coming to his own defense, Laessle produced a similar composition, *Turtle and Lizard,* in wax (which does not lend itself to casting). It was shown at the Academy annual in 1903, purchased by the Academy, and cast into bronze. The piece was also highly praised at the Louisiana Purchase Exposition in 1904.

Receiving the Academy's Cresson Travelling Scholarship in 1904, Laessle spent three years in Paris: "Though I joined no school, I studied the works of the masters with the greatest enthusiasm. Houdon, Dalou, Carpeaux, Frémiet, Chapu—in fact all of them" (quoted in D. Roy Miller, "A Sculptor of Animal Life," *International Studio,* vol. 80, no. 329, October 1924, p. 25). He continued to produce small, lifelike bronzes of animals; a turtle borrowed from his concierge was the subject of *Turning Turtle* (1905), which was shown in the Paris Salon in 1907 and again attacked as a life cast. The French sculptor Michel Béguine (1855–1929) assisted him with criticism of his work, and by the time Laessle returned to Philadelphia in 1907 he was well established as a talented *animalier.*

For some years he shared Grafly's Cherry Street studio, later moving to his own studio near the Philadelphia Zoo, convenient to his favorite subject matter. Although his life-size bronze *Turkey,* shown in the 1912 Academy annual, was not eligible for a prize, he received a letter from the jury (including Grafly, Cecilia Beaux, Edward Redfield, Hugh Breckenridge, Edmund Tarbell, and the chairman, William Merritt Chase) expressing their admiration for his "high achievement." His first major public success came in 1915 when a group of twenty of his small sculptures won a Gold Medal at the Panama-Pacific International Exposition at San Francisco. Between 1915 and the exhibition of thirty-six of his works at the Philadelphia Sesqui-Centennial in 1926 (where he again won a Gold Medal), Laessle's work grew steadily in popularity. His *Penguins* (1917) won the Widener Gold Medal at the Academy annual in 1918 and was purchased by the Fairmount Park Art Association for the Philadelphia Zoo; *Billy* was placed in Rittenhouse Square one year later. One of the few commercial commissions he accepted was from the Victor Talking Machine Company of Camden, New Jersey, for a bronze version of the little dog listening

to a gramophone (the well-known trademark "His Master's Voice").

From 1921 to 1939, Laessle taught at the Pennsylvania Academy and at the Academy's summer school in Chester Springs (the sculptors Harry Rosin, Walter Rotan, and Charles Rudy were among his pupils). Since teaching occupied much of his time, his own output over the years was relatively small, but his major later works include the sculptural group of *Pan, Dancing Goat,* and *Duck and Turtle Fountain,* placed in Johnson Square, Camden, New Jersey, around 1928. He designed a number of commemorative medals, and was invited to create the Medal of Award for the Sesqui-Centennial Exposition.

Laessle's most ambitious project was the memorial to General Galusha Pennypacker (the youngest general of the Civil War), commissioned by the State of Pennsylvania in 1919 for Logan Circle on the Benjamin Franklin Parkway in Philadelphia. Originally given to Grafly, who was forced to relinquish it because of ill health, the commission passed to Laessle. Following Grafly's design, he created an imposing 15½ foot-high monument with an allegorical, martial figure striding atop a stylized gun carriage, flanked by a pair of snarling tigers. The Pennypacker monument was completed in 1934, two years after Laessle's election to the National Academy of Design and the National Institute of Arts and Letters.

In 1939 failing health caused his retirement from the Pennsylvania Academy

faculty, and after his first wife's death in 1944, he moved to Florida where he spent the remainder of his life. A pair of *Ruffed Grouse* executed for the country estate of R. K. Mellon (completed in 1953) was virtually the only sculpture he produced during the fourteen years prior to his death.

424. *Billy*

1914
Signature: ALB/ERT/LAE/SSL/E (on base, within incised circle)
Bronze
24¼ x 30 x 9″ (62.2 x 76.1 x 11.9 cm)
Inscription: Germantown—Philadelphia 1914 (at rear of base)

National Collection of Fine Arts, Smithsonian Institution, Washington, D.C. Gift of the heirs of Albert Laessle

PROVENANCE: Estate of the artist, until 1971

LITERATURE: PAFA, *110th Annual* (1915), no. 601; PMA, *Americanization through Art* (January 19—February 22, 1916), no. 263 (illus.); FPAA, *An Account of Its Original Activities from Its Foundation in 1871* (1922), p. 183 (illus.); New York, National Sculpture Society, *Exhibition of American Sculpture* (April 1—August 1, 1923), pp. 134, 336; D. Roy Miller, "A Sculptor of Animal Life," *International Studio,* vol. 80, no. 329 (October

424.

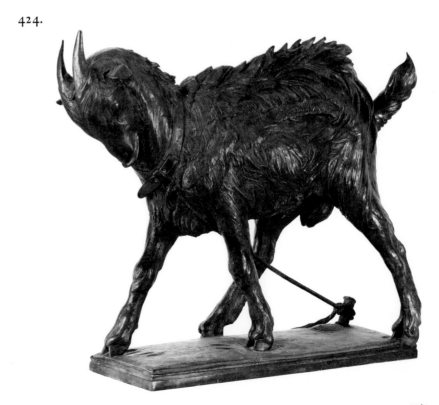

1924), p. 27; "The Beloved Goat of Ritten-house Square," *Christian Science Monitor,* August 17, 1925; Philadelphia Sesqui-Centennial, no. 1228; "Billy the Goat Wins Youth in Philadelphia," *New York Herald Tribune*, May 11, 1928; George and Mary Roberts, *Triumph on Fairmount* (Philadelphia, 1959), pp. 20, 129; Craven, *Sculpture*, p. 545; Beatrice Gilman Proske, *Brookgreen Gardens Sculpture* (Brookgreen Gardens, South Carolina, 1968), p. 181; FPAA, *Sculpture*, p. 274 (illus.)

ALL OF TWO AND A HALF FEET high, *Billy* was only the second piece Laessle attempted after his successful *Turkey* of 1911 on a scale larger than that of his turtles and frogs. During Laessle's childhood and student days in Philadelphia, several large-scale sculptures incorporating animals had been installed in the city by the Fairmount Park Art Association: Edward Kemeys's *Hudson Bay Wolves* in 1873, Barye's *Lion Crushing a Serpent* in 1893, and Rudolf Siemering's *Washington Monument,* with its congeries of deer, moose, bear, and buffalo, in 1897. Laessle surely knew these works well, but despite the success of his own monumental Pennypacker Memorial, he rarely attempted to compete with these portrayals of large or predatory beasts. His most aggressive sculptures were two bronze eagles entitled *Victory* (1918) and *Defiance* (1939), which expressed his response to the two world wars. Instead he brought a similarly precise anatomical observation and technical skill to the faithful and affectionate representation of the animal kingdom's more diminutive members.

J. Nilson Laurvik assessed Laessle's contribution in an essay on American sculpture for the *Catalogue De Luxe* of the 1915 Panama-Pacific Exposition: "The finished art of Albert Laessle commands the respect and admiration of all who esteem good sound craftsmanship above pyrotechnical display. He achieves a decorative effect by emphasizing the realistic aspect of his subjects much in the same manner as does Daniel Garber, the landscape painter. No one in America has so closely studied the characteristics of frogs, turtles, lizards, crabs, beetles, katydids, fishes and barn fowls as Laessle, and he has presented his studies with something of the flavor of a humorous naturalist who observes the tragedies and comedies enacted in his little kingdom" (vol. 1, p. 58).

Since he worked exclusively from the living model, one can imagine the disruptions of studio routine caused by Billy's presence: every bronze hair on the animal's hide bristles with mischief. Laessle's thorough knowledge of anatomical detail is tempered by a humorous sense of the goat's personality and an elegant stylization in the curl of his lips and the ridge of ruffled hair along his back. The sculptor returned to the same subject fourteen years later in *Dancing*

Goat (1928), a more fanciful creature with knobs on its horns and its back hairs twisted into decorative braids. *Billy* is certainly the most widely known and beloved of Laessle's works, one cast having been given by Eli Kirk Price to the Fairmount Park Art Association in 1919. It has shared Rittenhouse Square with Barye's *Lion* and Paul Manship's *Duck Girl* ever since. Daily visits by flocks of children and years of vigorous riding have worn and polished his back and horns (and severed the bronze rope which survives in the cast owned by the National Collection of Fine Arts).

Billy is one of the most endearing small sculptures to find its place as a public monument in Philadelphia. Looking back to the nineteenth century French tradition of the *animalier,* but "academic" only in the literal not the perjorative sense, Laessle infused his carefully detailed realism with lifelike spirit and a touch of fantasy.

Ad'H □

MORTON LIVINGSTON SCHAMBERG (1881–1918)

Born in Philadelphia into a family associated with the livestock trade, Schamberg was to produce perhaps the most radical art native to the city before his untimely death in the flu epidemic of October 1918. After graduating from the University of Pennsylvania's School of Fine Arts in 1903, with a B.A. degree in architecture, Schamberg studied at the Pennsylvania Academy from 1903 to 1906. From this period dates his close friendship with Charles Sheeler (see biography preceding no. 427), with whom he traveled to Europe on several summer museum tours conducted by their teacher William Merritt Chase.

Schamberg spent the year 1906–7 in Paris, returning to share a Philadelphia studio (at 1626 Chestnut Street) with Sheeler. They again traveled to Europe (Italy and Paris) in 1908–9. The art of Cézanne and the Fauves, which Schamberg saw in Paris, made a deep impression on him. In 1910 the two friends rented an eighteenth century farmhouse in Doylestown, which they found through the help of the archaeologist and collector Dr. Henry C. Mercer. Weekends were spent painting in the country, and their work of 1910–15 shows a close relationship, particularly their Cubist-influenced landscapes of 1914–15. The McClees Gallery in Philadelphia gave Schamberg his first one-man show of fifty-four paintings in 1910, and at Arthur B. Davies's invitation he sent five paintings to the Armory Show in 1913, including a remarkable, boldly simplified portrait of his fiancée that suggests profound study of Matisse (perhaps at Dr. Albert C. Barnes's nearby collection as well as in Paris).

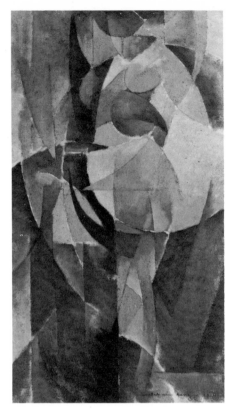

425.

Around 1912, Schamberg and Sheeler took up photography, at first to earn money but soon with an interest in the aesthetic possibilities of the medium. Few photographs by Schamberg have been traced—portraits of friends and family, a small group of architectural subjects, and studies of his sculpture *God*—but he received a prize in Wanamaker's annual exhibition of photography in 1918 and a Philadelphia critic joined his name with those of Sheeler and Paul Strand as "*the* Trinity of photography" (E. F. Fitz, "A Few Thoughts on the Wanamaker Exhibition," *The Camera,* vol. 22, no. 4, April 1918, p. 202). In 1915 five works by Schamberg were shown in a group exhibition at the Montross Gallery in New York, in which Sheeler and Man Ray were also included.

With fellow Academy student Lyman Saÿen, Schamberg assembled the first exhibition of avant-garde art in Philadelphia, which caused an uproar when it opened at the McClees Gallery on May 17, 1916. A small but brilliantly chosen show, it included works by Picasso, Duchamp, Man Ray, Matisse, and Brancusi as well as Saÿen, Schamberg, and Sheeler. Apparently an articulate speaker, and a passionate champion of the new art, Schamberg spent long hours in the gallery explaining the works to baffled or outraged visitors (see Kenneth Macgowan, "Philadelphia's Exhibit of 'What is it?'," *Boston Evening Transcript,* May 27,

1916). In contact with the circles around Alfred Stieglitz and Louise and Walter Arensberg in New York, Schamberg met Duchamp and probably Francis Picabia, and his work was collected by the Arensbergs and John Quinn.

His exploration of chromatic abstraction in 1913–15 gave way to a dry, precise rendering of machine forms in 1916, and he produced the only known Dadaist sculpture of Philadelphia origin. He was a member of the first board of directors of the new Society of Independent Artists and exhibited two works in their first show in 1917. After his death at the age of thirty-seven, a memorial exhibition at M. Knoedler & Co. in New York in 1919 was reviewed with high praise by two luminaries among the avant-garde critics: Henry McBride (*New York Sun*, May 25, 1919) and Walter Pach (*The Dial*, May 17, 1919, pp. 505–6). The proceeds of the sale of Schamberg's paintings at the Knoedler exhibition were given in his memory by his family to the Society of Independent Artists. After forty years during which his reputation fell into almost total obscurity, his work was gradually rediscovered and examples included in several exhibitions in the early 1960s devoted to the Armory Show and the emergence of an American avant-garde. In 1963 the Pennsylvania Academy organized a one-man show at the Peale House Galleries, and Ben Wolf's monograph (including a catalogue of all the works known to date) was published in the same year.

425. *Figure (Geometrical Patterns)*

1914
Signature: Schamberg 1914 (lower right)
Oil on canvas
28 x 16″ (71.1 x 40.6 cm)
Dr. and Mrs. Ira Leo Schamberg, Jenkintown, Pennsylvania

PROVENANCE: Mr. and Mrs. Jesse J. Schamberg, Philadelphia; Mrs. Robert Straus, Philadelphia

LITERATURE: New York, Montross Gallery, *Exhibition of Paintings, Drawings and Sculpture* (March 23—April 24, 1915), no. 48 or 50 (illus. as *Figure No. 1* or *Figure No. 2*); Dallas, Museum for Contemporary Arts, *American Genius in Review* (May 10—June 19, 1960), no. 45; Washington, D.C., Corcoran Gallery of Art, *The New Tradition—Modern Americans before 1940* (April 27—June 2, 1963), no. 85; Wolf, *Schamberg*, no. 36, p. 50, illus. p. 91; Baltimore Museum of Art, *1914* (October 6—November 15, 1964), no. 210; New York, M. Knoedler & Co., *Synchromism and Color Principles in American Painting 1910–1930* (October 12—November 6, 1965), no. 56, p. 28, fig. 11; Albuquerque, University of New Mexico,

Cubism: Its Impact in the United States (February 1967), no. 49, illus. p. 49; Delaware Art Museum, *Avant-Garde*, pp. 128, 174, illus. p. 129

WHEN SCHAMBERG PAINTED *Geometrical Patterns*, he had not been to Paris since his last visit there with Charles Sheeler in 1909. Based in Philadelphia, he must have kept close watch on events in the New York avant-garde circles to produce such an advanced work as early as 1914. That he grasped the full importance of the Armory Show even before it opened is clear from an article he wrote for the *Philadelphia Inquirer* (January 19, 1913). Preparing Philadelphia viewers for the exhibition, he proclaimed the independence of "pure plastic art" from the necessity of describing or imitating nature. He did not go so far as to advocate total abstraction (a bold step indeed for an American at the outset of 1913) but made it clear that the importance of a work of art lay in its solution to problems of color and form. The Armory Show itself contained no fully nonobjective works (even Kandinsky's single entry had vestigial traces of subject matter), but the analytical Cubist works of Picasso and Braque, as well as a number of highly abstracted paintings by their French contemporaries, must have deeply impressed Schamberg. Francis Picabia's *Danses à la source*, Jacques Villon's *Fillette au piano* and *Jeune Fille*, and Robert Delaunay's *Les Fenêtres sur la ville* (all of 1912) were superb examples of the most recent mingling of a Cubist style with brilliant color. During 1913, Schamberg produced at least two other paintings also entitled *Geometrical Patterns*, which employ pastel tones of pink and blue to delineate abstracted figures. It should be noted that in 1914, the American artists Morgan Russell and Stanton Macdonald-Wright, who together had invented the

Synchromist movement in Paris, showed their work at the Carroll Gallery in New York. These paintings were as abstract if not more so than the work of their French counterparts, employing the full range of the spectrum in swirling compositions, but they seem to have coincided with Schamberg's achievement rather than acted as an influence.

Geometrical Patterns refrains from total abstraction: the full-length, standing figure of a woman, facing slightly to the left, emerges from a brilliant interplay of greens and reds. Comparisons with Delaunay, Villon, or even František Kupka (whose work Schamberg is most unlikely to have known) might seem to overwhelm this modestly scaled work, and yet it possesses a sturdy originality. The graceful tracery of lines linking the figure with its surrounding space and Schamberg's assured use of intersecting planes of color even introduce a suggestion of dynamic motion. While deeply sensitive to the visual lessons of the Armory Show, Schamberg was capable of exploring his own concept of chromatic abstraction without risk of superficial imitation. Like his machinist works of a few years later (see no. 430), *Geometrical Patterns* is an independent yet sophisticated contribution to the history of modern art in the United States.

Ad'H □

MELLOR AND MEIGS (LATER MELLOR, MEIGS AND HOWE) (EST. 1906)

The architectural firm of Mellor and Meigs was formed in 1906 by two Philadelphians, Walter Mellor (1880–1940) and Arthur I. Meigs (1882–1956). Of the two, only Mellor had studied architecture, first at the University of Pennsylvania School of Architecture

426.

and later in the office of Theophilus Parsons Chandler; but as the success of the firm demonstrated, academic credentials were of less significance than the ability to design in the picturesque and romantic mode desired by Philadelphia clients. That both men could do! For the next three decades they designed the houses characterized by Nathaniel Burt as "well-bred and 'nice' . . . [with] cobbled forecourts and other nostalgic Europeanized details for which the cultivated and traveled patrons of the past Philadelphia generation yearned" (*The Perennial Philadelphians: The Anatomy of an American Aristocracy,* Boston, 1963, p. 363). Their office at 205 South Juniper Street, designed in 1912, was characteristic of their work—correct, charming, the appropriate setting for gentlemen.

The entry of George B. Howe (see biography preceding no. 456) into the office in 1916 did not materially affect the method or the mode of design for a decade. By background, Boston aristocracy; education, Harvard University; and training, École des Beaux-Arts, Howe was as amenable to eclecticism as his partners, and added principally a clear discipline and a feeling for the expression of the statics of a building, but within the volumes and masses of traditional design.

In the mid-1920s, a group of banking offices for the Philadelphia Saving Fund Society offered the firm the opportunity to expand into commercial architecture, but these too were designed in a stylistically appropriate but conservative mode derived from the Renaissance. At the same time the office was utilizing the modern technics of reinforced concrete with Gothic detailing for Goodhart Hall at Bryn Mawr College. That split between the potentials of modern materials and traditional styling was crystallized in the question of an appropriate style for a new office building for the Philadelphia Saving Fund Society (no. 456), resulting in Howe's departure from the firm. The office continued its more traditional designs for the next decade.

MELLOR AND MEIGS

426. *Caspar Wistar Morris House*

Haverford, Pennsylvania
1914–16
Main house brick, stucco, and timber; outbuildings fieldstone

REPRESENTED BY:

Mellor and Meigs
House for C. W. Morris, Esq.
c. 1914
Ink on tissue paper
15½ x 27¼″ (39.6 x 69 cm)
The Athenaeum of Philadelphia

LITERATURE: *A Monograph of the Work of Mellor, Meigs and Howe* (New York, 1923), pp. 1–13

CHRISTOPHER MORLEY'S DESCRIPTION of Philadelphia as "a surprisingly large town at the confluence of the Biddle and Drexel families . . . wholly surrounded by cricket teams, fox hunters, beagle packs and the Pennsylvania Railroad" (*Travels in Philadelphia,* Philadelphia, 1920, p. 12), aptly catches the flavor of the old families, established businesses, and the taste for things English which have long characterized this city. Those preferences are reflected architecturally in the great mansions with which Philadelphians have dotted the countryside during the last two centuries in emulation of the life style of the English gentry. Suggestive of hereditary landed wealth, the country seat remains one of the principal attributes of Philadelphia society.

With few exceptions those houses have been styled after English models, whether Andrew Hamilton's eighteenth century Palladian mansion in West Philadelphia, The Woodlands, or Nicholas Biddle's English-inspired Greek revival house, Andalusia, designed in 1836 by Thomas Ustick Walter. Although the cottage and villa styles advocated by Andrew Jackson Downing had considerable popularity at the middle of the nineteenth century, the last quarter of the century saw the return to favor of the Georgian, late medieval, Tudor, and Jacobean revivals, all of which were used with considerable archaeological accuracy in the massing of volumes as well as in the handling of decorative motifs. The Philadelphia architects working in those styles, Cope and Stewardson, William L. Price (see biography preceding no. 392), Frank Miles Day (see biography preceding no. 366), and at the beginning of the twentieth century, Edmund Gilchrist, Robert Rhodes McGoodwin, and Mellor and Meigs brought favorable national attention to Philadelphia's suburban architecture after more than half a century of neglect by critics.

It was the latter group, Gilchrist, McGoodwin, and Mellor and Meigs, who raised the Anglophile country house to its highest point, for their designs are generally less theatrical and obviously ostentatious than the great houses of the 1890s. By merging the forms and rough materials of local vernacular building with the sophisticated and picturesque massing and additive composition of contemporary English design, and overlaying it with the significant motifs of the intended style, the architects were able to give the effect of the revival of an indigenous medieval country architecture—with modern conveniences. If the style had never been, still there was a logic so compelling about the best work that gave it extraordinary validity.

The merits of turn-of-the-century eclectic design are clearly evidenced in the Haverford house designed in 1914 for Caspar Wistar Morris by Mellor and Meigs (who were joined during the course of its construction by George Howe). There the details and volumes of late medieval English country houses were fused with a layout of rooms which complemented the life style of the pre–World War I, and pre–income tax, Main Line.

The principal determinants of the form and plan of the dwelling were the preconceived notions about the appropriate style of the country house, modified by the requirements of the family and the nature of the site, which sloped southward from a ridge down to a valley with a stream bed at the bottom. The house would be placed at the top, for the view, but also, one suspects, for maximum visibility. Arranged across the south facade, receiving the warmth and light were the principal family rooms, a dining room to the east with a large bay, a central stair hall, and at the west end, a living room, with a bay, balancing that of the dining room. These rooms were paralleled by another range of rooms on the north side of the house, entrance hall, cloak room, and den.

Behind the dining room stretched a service wing, a common turn-of-the-century parti, which anticipates Louis Kahn's dichotomy of served and servant space by half a century. That wing gave the house its L shape and framed an inviting driveway approach which focused on the half-timbered projection containing the principal doorway. The insistence on placing the door on the utilitarian side of the house suggests an awareness of the contemporary English architect Sir Edwin Lutyens, who frequently made a similarly ironic gesture to the oneness of a house. It also recalls Benjamin Henry Latrobe's demands a century earlier for plans which took into account the severe winters of North America by placing principal apartments to the south and ancillary functions to the north (see Talbot Hamlin, *Benjamin Henry Latrobe,* New York, 1955, p. 193). Perhaps too it hinted at the realism of the later revival architecture of the office, which merged barnyard and forecourt in true medieval manner in such houses as Arthur Newbold's Laverock Farm (see Arthur I. Meigs, *An American Country House,* New York, 1925).

The ingenuity of the plan was equaled by the architects' skillful handling of detail and their sensitivity to the local materials, fieldstone, brick, and stucco. Rough stone outbuildings and walls stretch out into the site, grasping the hill, and lead into the smoother, crisper materials of the house, brick, stucco, and carved timber. That hierarchy was paralleled by a corresponding massing of

the various structures which rise toward the central focus of the house, the intersecting volumes of front block and rear wing at the point signaled vertically by the great clusters of chimneys at front and rear, and, with the sheltering roofs, emphasizing the warmth and comfort of the home.

Modern architectural theory has until recently been unsympathetic to the eclecticism of early twentieth century America, comparing it, unfavorably, with the work of Frank Lloyd Wright, despite the common use of open planning and the integration of house into site. It has equally been disparaged when compared with the revolutionary schemes of post–World War I European architecture. Either approach would have been incompatible with the intentions of both client and architect who stood for "nationality, ethnic continuity, and for the impulses of Christian civilization" (Ralph Adams Cram, "The Work of Cope and Stewardson," *Architectural Record,* vol. 15, November 1904, p. 413). Rather than being an architectural conceit, a rococo escape from reality, the period ornament and detail was used to represent the values of the client, thereby establishing an appropriate setting for his life. Given those requirements, Morris's architects Mellor and Meigs had no cause to re-invent the house, and logically, made no such attempt.

GT □

CHARLES SHEELER (1883–1965)

Born and brought up in Philadelphia by parents who supported his early desire to be an artist, Sheeler studied applied design at the Philadelphia Museum School of Industrial Art for three years before entering the Pennsylvania Academy in 1903. An apt pupil of William Merritt Chase, he twice accompanied his teacher's summer classes abroad: London and Holland in 1904, and Spain in 1905. Visits to the London studios of Alma-Tadema, Edwin Austin Abbey, and John Singer Sargent, and the study of old masters such as Velázquez and Frans Hals, reinforced a swift, brilliant painting style, which he had learned from Chase. After graduating from the Academy in 1906, Sheeler spent the summer painting landscapes in Gloucester, Massachusetts, returning to Philadelphia to share a studio with his classmate Morton Schamberg (see biography preceding no. 425).

Moving gradually away from Chase's powerful influence, Sheeler had his first one-man show at the McClees Gallery in Philadelphia in 1908. The decisive break, however, came during a trip to Europe (with his parents, joined by Schamberg) in the winter of 1908–9. Deeply impressed by his first encounter with painters of the Italian Renaissance, Sheeler was equally affected by

the newest work (Cézanne, Derain, Matisse, Picasso) which he and Schamberg saw in France: "the pictures of Paris made too big a chasm to be taken in one stride" (AAA, Sheeler, Reel 1, Frame 63). Sheeler added, "We were from then on interested in causes rather than effects." The change in Sheeler's art over the next ten years was a characteristically slow and deliberate process, during which many possibilities were explored and much work discarded. In 1910 he and Schamberg rented a pre-Revolutionary house near Doylestown for weekend painting. Their friendship with the collector and archaeologist Dr. Henry C. Mercer (see biography preceding no. 403) encouraged Sheeler's interest in the simple forms of rural architecture and Shaker furniture. Around 1912 both Schamberg and Sheeler took up photography as a means of supplementing their incomes; Sheeler's venture into the medium was to prove crucial to his career as an artist.

Arthur B. Davies invited him to send six paintings to the Armory Show in 1913, and the exhibition itself provided another stimulus to his own art. Along with sixteen other artists, including John Marin, Arthur Dove, Marsden Hartley, and Man Ray, Sheeler was invited to exhibit in the *Forum Exhibition of Modern American Painters* at the Anderson Galleries, New York, in March 1916. His statement in the catalogue expressed his lifelong conviction that the artist's task was to "communicate his sensations of some particular manifestation of cosmic order." Finding Philadelphia unsympathetic to modern art, he began to frequent the New York avant-garde circles around Alfred Stieglitz and Louise and Walter Arensberg, who bought several of his works, as did John Quinn.

Photography, independent of commercial commissions, became increasingly important to him. In 1918 a study of a Bucks County barn won first prize in the Wanamaker department store's annual photography show in Philadelphia (the jury included Alfred Stieglitz and Arthur Carles), and a group of photographs of the Doylestown house constituted his first exhibition in New York, at Marius de Zayas's Modern Gallery in 1917.

Beginning with a series of Cubist-influenced landscapes in 1915, Sheeler's work grew increasingly abstract and architectonic during 1916–20. After his friend Schamberg's sudden death, Sheeler moved to New York in 1919, although he kept the Doylestown house until at least 1923. Once in New York, he expanded his range of activities rapidly: a second one-man show of paintings and photographs at the de Zayas Gallery in 1920; collaboration with Paul Strand on the film *Manhatta* (first shown in 1921); another show at the Daniel Gallery in 1923. The Whitney Studio gave Sheeler

a one-man exhibition in 1924, and simultaneously offered him the chance to select a show (Picasso, Braque, Duchamp, and de Zayas) for the Whitney Studio Club. In 1931 he became associated with Edith Halpert's Downtown Gallery, where he exhibited over the years.

After 1927, Sheeler lived in the country outside New York, his interest in rural buildings and country furnishings, which had originated in his Bucks County summers, continuing throughout his life. His clear, precise treatment of his subject matter, rural or industrial, established him as a leader among the "Precisionist" or "Immaculate" painters of the American scene. In 1929, his final trip to Europe resulted in another decisive shift in his style, which he felt was even more deliberately thought-out and composed. His later career included several stints of commercial photography, most notably for *Vogue* and *Vanity Fair.* Numerous commissions to paint and photograph various aspects of the United States took him from the Ford Motor Company's River Rouge Plant (1927) to Colonial Williamsburg (1935) to the blast furnaces of Pittsburgh (1952). In the late 1940s and 1950s, Sheeler's work in its final phase again grew increasingly abstracted: forms of factories and barns simplified into flat, overlapping planes of color.

During his lifetime, Sheeler's work was widely exhibited and bought by collectors and museums across the country. He was accorded one of the first one-man shows of

427a.

a living American artist at the Museum of Modern Art in 1939; the introduction to the catalogue of 196 items was written by his old friend, the poet William Carlos Williams. *Life* magazine devoted a feature article to his work in 1939. A large retrospective was mounted by the University of California Art Galleries in Los Angeles in 1954, and the Smithsonian Institution organized another large traveling show in 1968, three years after his death. Incapacitated by a stroke in 1959, Sheeler died six years later, one of the most widely known and appreciated American artists of his generation.

Ad'H

427a. *Stairway (Doylestown Staircase)*

1915
Silver print
8⅚ x 5¹⁵⁄₁₆″ (21.1 x 15.1 cm)

The Metropolitan Museum of Art, New York. The Alfred Stieglitz Collection, 1933

LITERATURE: Charles W. Millard, "Charles Sheeler: American Photographer," *Contemporary Photographer,* vol. 6, no. 1 (1967), illus., n.p.

427b. *White Barn, Bucks County, Pennsylvania*

1915
Silver print
7⁹⁄₁₆ x 9⁹⁄₁₆″ (19.3 x 24.3 cm)

The Museum of Modern Art, New York Purchase

LITERATURE: *Broom,* vol. 3 (October 1923), illus. p. 161; Newhall, *Photography,* illus. p. 122; Charles W. Millard, "Charles Sheeler: American Photographer," *Contemporary Photographer,* vol. 6, no. 1 (1967), illus. and discussed, n.p.; NCFA, PMA, and Whitney Museum, *Charles Sheeler,* by Martin Friedman, Bartlett Hayes, and Charles Millard (October 10, 1968—April 27, 1969), p. 84, illus. p. 80; Martin Friedman, *Charles Sheeler* (New York, 1975), illus. p. 27

SELF-TAUGHT, CHARLES SHEELER spent two years (1912–14) taking photographs for architects who wanted records of their projects and examples of their works to show to prospective clients. The requirements of architectural photography—primarily sharply focused images showing great detail —especially agreed with Sheeler's own artistic vision. His work was in sharp contrast to the impressionistic, soft-focus, manipulated prints then in vogue as art photography. By 1914 he had mastered the

427b.

techniques of photography and come to appreciate its unique qualities as an artistic medium: "photography has the capacity for accounting for things seen in the visual world with an exactitude for their differences which no other medium can approximate" (quoted in Millard, cited above, p. 3).

That same year he began to photograph the interior of the Doylestown house he shared with Morton Schamberg. *Stairway* is from this series—the first photographs he made revealing his own creative photographic vision: selective abstraction by careful framing in the viewfinder coupled with strong lighting to model, define, and contrast the forms and textures.

White Barn, Bucks County, Pennsylvania, made in 1915, conforms to this significantly innovative eye. It is undoubtedly his most important photograph and a major monument in the history of photography. Rigorously cropping the structure in the ground glass of his camera top, bottom, left, and right, he selectively abstracted the building in parallel planes related or separated by texture and tone. All sense of place and scale is annihilated. The picturesqueness of the barn is irrelevant; its formal and tactile qualities become significant in the photographic print. It was a photograph much admired by Alfred Stieglitz, whom Sheeler had met in 1914 and who must have encouraged him to pursue his photographic vision since it conformed so closely to Stieglitz's own aesthetic.

By 1915, the year of *White Barn,* the Photo-Secession had lost its vitality, and the forcefulness of Sheeler's photographs was fresh and invigorating. They were first exhibited publicly in New York in March 1917 at Marius de Zayas's Modern Gallery, along with photographs by Morton Schamberg and Paul Strand. In 1918 this trio won

the top four prizes at Wanamaker's annual exhibition, and Sheeler, Schamberg and Strand were titled "the Trinity of Photography—Mr. Stieglitz says so" by a puzzled press that resented Stieglitz's dominating the jury panel (E. G. Fitz, "A Few Thoughts on the Wanamaker Exhibition," *The Camera,* vol. 22, no. 4, April 1918, p. 202). Nonetheless, the Sheeler photographs did help liberate photography and raise its consciousness by establishing a new visual vocabulary that was entirely photographic and not dependent on the criteria of other media. *Stairway* and *White Barn* are significant elements of this new vocabulary and prefigure in vision, concern, and technique Sheeler's later work.

WS □

H. LYMAN SAŸEN (1875–1918)

The son of a Philadelphia leather merchant, Saÿen began his career as an electrical engineer after graduating from the Central School of Manual Training in 1891. Employed by several scientific equipment firms between 1891 and 1898, he was responsible for the design and patenting of apparatus required in the production of X-rays. In 1898, the Franklin Institute awarded him the John Scott Medal for his "improvement in the Roentgen Ray tube." His work with Dr. William Sweet in the ophthalmology department at Polyclinic Hospital led to the granting of a patent on his design for a recording perimeter (to aid the removal of foreign bodies from the eye) and was later helpful in his studies of kinetic color mixtures. Saÿen's interest and activity in the sciences continued throughout his life, intermingling fruitfully with his increasing involvement with the visual arts.

Enrolling in the Pennsylvania Academy of the Fine Arts in 1899, he studied under Thomas Anshutz, who was to become a close friend. During his years at the Academy, Saÿen won a series of student prizes. Receiving income from several patent royalties, he also earned his living as an illustrator and commercial artist, designing posters and producing cover designs for the Academy's annual exhibitions of 1901 and 1902. He won a national competition in 1903 for the design of four murals on allegorical themes (such as tyranny and good government) for a committee room in the United States Capitol. Executed in a competent academic style, the murals were installed by September 1905.

Sent to France in 1906 by Wanamaker's department store to design and supervise the printing of its catalogues and posters, Saÿen and his wife Jeannette Hope (also an Academy graduate) spent eight years working and studying in Paris. Perhaps the most significant occurrence for Saÿen's art was his enrollment in Matisse's class in 1907–8. He also mingled with the circle of artists and writers who gathered around Leo and Gertrude Stein, and he designed a new lighting system for Gertrude Stein's picture-filled studio. Saÿen exhibited yearly in the Salon d'Automne from 1909 to 1913, and in 1912 he was invited to be a "jury-free" member of the Salon. During his Paris stay, Saÿen experimented with color theory and visual perception, his interests coinciding with (although apparently independent of) those of Delaunay and the Synchromists. He devised an instrument for the kinetic and synchronous projection of colored shapes, and assisted Anshutz (who visited Paris in 1911) in the fabrication of new types of paints and pastels.

With the outbreak of World War I, the Saÿens returned to Philadelphia, where he held his first one-man exhibition at the Philadelphia Sketch Club in November 1914. Greeted somewhat inaccurately as the "latest development of Futurist Art" by the *Public Ledger* (November 17, 1914), Saÿen's Paris paintings were Fauve in color but still quite naturalistic in subject and treatment. Giving up his contract with Wanamaker's, Saÿen began to design decorative objects and household furnishings on a free-lance basis. His second show at the Sketch Club in January 1916 was a more startling event, because he chose to exhibit brightly painted furniture along with his increasingly abstracted paintings. Saÿen knew Charles Sheeler and Charles Demuth among the Philadelphia avant-garde, but was closer to Morton Schamberg (see biography preceding no. 425), with whom he organized the controversial exhibition of "Advanced Modern Art" at the McClees Gallery in May 1916. Saÿen's work took yet

428.

another radical turn in the direction of abstraction during 1917, and he was increasingly drawn to the idea of creating modern art that was specifically "American" in character.

His tragic death after a sudden illness in April 1918 cut short a promising career. Although a memorial exhibition was held at the Wanamaker store in Philadelphia in November 1928, and several of his works were included in the "Philadelphia Moderns" show at the Art Alliance in 1929, his work was to remain virtually unknown for the next forty years. Through his family's generous gift of the bulk of his remaining oeuvre to the Smithsonian Institution in the late 1960s, Saÿen's role as a pioneer of avant-garde art in Philadelphia has been firmly established. Adelyn D. Breeskin's catalogue of the Saÿen gift, accompanying the exhibition at the National Collection of Fine Arts (September 25–November 1, 1970) has become the standard reference on the artist.

428. *Decor Slav*

1915
Oil on canvas
30⅛ x 39⅜" (76.5 x 100 cm)
National Collection of Fine Arts, Smithsonian Institution, Washington, D.C.
Gift of H. Lyman Saÿen to His Nation

PROVENANCE: The artist; daughter, Ann Saÿen, Philadelphia, until 1967

LITERATURE: "Sketch Club Art of the Weird and the Week," *Public Ledger*, January 9, 1916, illus. p. 6 (as *Landscape*); Eva Nagel Wolf, "Con-

fessions of a Cubist," *Philadelphia Press Magazine*, January 23, 1916, illus. p. ii; NCFA, *H. Lyman Saÿen*, by Adelyn D. Breeskin (September 25—November 1, 1970), no. 15, p. 25, illus. p. 51 and on cover; NCFA, *Pennsylvania Academy Moderns*, by Adelyn D. Breeskin (May 9—July 6, 1975), no. 31, illus. p. 31

WHEN *Decor Slav* WAS FIRST SHOWN at the Philadelphia Sketch Club in 1916, it shared the gallery space with chairs painted in bright tones of red, blue, yellow, and green. An enthusiastic critic urged the Philadelphia public to visit Saÿen's second one-man exhibition, with a rather startling description:

Dull colors will not greet the visitor and one could not possibly have a grouch amid such cheerful surroundings that the galleries of the Sketch Club now present. Even dull-hued furniture is to be eliminated from the modernist's home and to show the relation of furniture and the post-impressionist's pictures Lyman Saÿen exhibits several pieces of furniture as brilliant in color as are the twenty-one canvases framed in white shown in a single line around the neutral tinted walls. . . .

Mr. Saÿen assures us that these pictures are to be lived with, that they give one keen pleasure, that it is also possible to sleep in the same room with one, and one placed in the modern living room with its somber furnishings makes one in a very short time long for more of the cheerful colors to be found in the painting, hence the need for painted furniture, and I doubt not that it would take but a shorter time to make it quite necessary to adopt floor coverings and draperies to complete the ensemble. (*The Philadelphia Press*, January 9, 1916)

Saÿen's proposal to unify all the elements in a given space with a single decorative scheme was remarkable for its time and its modernity, although it recalls the elaborate interiors of the English Arts and Crafts movement and anticipates the teachings of the Bauhaus.

The title *Decor Slav* suggests the possible influence on Saÿen's thinking of Russian stage design (as does *Schéhérazade,* another painting in the 1916 exhibition). As Adelyn Breeskin has pointed out, Saÿen probably saw Léon Bakst's colorful sets for Diaghilev's Russian ballet company when they performed in Paris in 1909, and the Salon d'Automne had shown a large group of Russian paintings in 1906 (Breeskin, *Saÿen,* p. 25).

During 1915–16, Saÿen carried out some of his concepts of interior decoration in the Bethayres, Pennsylvania, house of his friend and fellow Academy student Carl Newman (1858–1932), painting the walls with brilliant colors and transforming the studio ceiling into a chromatic spectrum. *Decor Slav* was one of a group of paintings inspired by the gardens and the Huntingdon Valley landscape around Newman's house. Its forceful composition of bright, flat colors pays homage to Matisse, but reveals none of the Cubist-derived fracturing of form that was evident in the contemporary paintings of Sheeler and Schamberg.

Saÿen's chance to explore his wildest dreams of a *gesamtkunstwerk* came when he designed the production of an artists' masque entitled "Saeculum" at the Academy of Music in February 1917. With Carl Newman's assistance, he created abstract backdrops, costumes in prismatic hues, and an elaborate lighting system that allowed him literally to "paint" the stage with a hundred different effects of colored light.

Ad'H □

JESSIE WILLCOX SMITH (1863–1935)

A popular and prolific illustrator of children's books who was also well known for her children's portraits, Jessie Willcox Smith was born and died in Philadelphia, spending the latter part of her life in Mt. Airy. Her career was closely intertwined with those of her colleagues Violet Oakley and Elizabeth Shippen Green Elliott. They studied together at Drexel Institute under Howard Pyle in the latter half of the 1890s; shared studios (first at the picturesque old "Red Rose," a former inn on the Drexel estate in Villanova about 1900–1905/6, and then at "Cogslea" in Mt. Airy, about 1906–11); collaborated on book and calendar illustrations; exhibited together; and time and again were written about as either the "Red Rose" or "Cogslea" group. They were part of a group of Pyle-trained Philadelphia

429a.

illustrators whose reputations blossomed in the early years of this century.

According to Jessie Willcox Smith's reconstruction of her own early career (Mahony and Whitney, pp. 68–69), she chanced on her profession somewhat by accident and at the age of about eighteen began to study at the Pennsylvania Academy. According to the Academy records, she was a student from 1885 to 1888. She has been listed in various dictionaries as also studying at the Philadelphia School of Design for Women (now Moore College of Art), but records are not available. She lists as her earliest professional work drawings for *St. Nicholas* and other children's magazines, done before she studied under Pyle at Drexel Institute from Fall 1894 to Spring 1897. Her first ambition was to be a portrait painter, but under Pyle's tutelage she turned toward illustration as a profession (*Public Ledger,* July 16, 1922).

In 1897, while she was in Pyle's class, she engaged in two collaborative illustration jobs with other pupils in the class, illustrating Longfellow's *Evangeline* (Boston, Houghton Mifflin and Company, 1897) with Violet Oakley, and Maud Wilder Goodwin's *The Head of a Hundred* (Boston, Little Brown and Company, 1897) with Charlotte Harding, Clyde DeLand, and Winfield Lukens. In 1900 the "Red Rose" group held a joint exhibition at the Plastic Club—they had been among its founders in 1897—and in 1902, Jessie Willcox Smith and Elizabeth Shippen Green collaborated on the illustration of a popular calendar for 1903 (*The Child, A Calendar,* Philadelphia, Charles

W. Beck, 1902), which helped launch both artists' reputations. The two artists' styles were almost indistinguishable at this point.

From 1902 on, Jessie Willcox Smith's particular specialty was evident—she was a quintessential limner of children. Among children's books she illustrated were Robert Louis Stevenson's *A Child's Garden of Verses* (New York, Charles Scribner's Sons, 1905), one of her best-known efforts, and a book of verses by Carolyn Wells called *The Seven Ages of Childhood* (New York, Moffat, Yard, and Company, 1909); she selected and illustrated *A Child's Book of Old Verses* (New York, Duffield and Company, 1910) and is especially well known for her depiction of Dickens's characters (*Dickens's Children,* New York, Charles Scribner's Sons, 1912; Samuel McChord Crothers, *The Children of Dickens,* New York, Charles Scribner's Sons, 1925). She illustrated Clement C. Moore's *'Twas the Night Before Christmas* (Boston, Houghton Mifflin and Company, 1912) and *The Jessie Willcox Smith Mother Goose* (New York, Dodd Mead and Company, 1914). A good selection of her illustrated books is in the Historical Collection of Children's Books in the Central Children's Department of the Free Library of Philadelphia.

By the early 1900s she had established her reputation, winning a medal in the Charleston Exposition of 1902, the Mary Smith Prize at the Academy in 1903 and the Beck Prize in 1911, and a medal at the Universal Exposition in St. Louis in 1904. In 1907 she was elected a member of the Society of Illustrators, along with Elizabeth Shippen Green, Violet Oakley, and two other female illustrators, Florence Scovel Shinn and May Wilson Preston.

In 1911, Elizabeth Shippen Green married Huger Elliott and left Philadelphia; the Cogslea group broke up, and Jessie Willcox Smith built a house and studio near Violet Oakley, called Cogshill. The work of her later years includes her well-known illustrations for Charles Kingsley's *Water-Babies,* Louisa May Alcott's *Little Women* (Boston, Little Brown and Company, 1915), Johanna Spyri's *Heidi* (Philadelphia, David McKay, 1922?), and George MacDonald's *At the Back of the North Wind* and *The Princess and the Goblin* (Philadelphia, David McKay, 1919 and 1920). She provided a number of covers for *Collier's Weekly* from 1899 through the early years of the 1900s and for *Good Housekeeping* from about 1918 until about 1930. She is also noted as working for Scribner's, *Century Magazine,* Harper and Brothers, *Ladies' Home Journal, Woman's Home Companion,* and *Harper's Bazar* (Mahony and Whitney, p. 69; see also *The Critic,* vol. 36, no. 6, June 1900, p. 523). By 1930 her work consisted

entirely of portraits of children, except for the *Good Housekeeping* covers (Mahony and Whitney, p. 69). She was a member of the Philadelphia Water Color Club, the Philadelphia Art Alliance, and the New York Water Color Club.

429. *Illustrations for The Water-Babies*

1916

Written by Charles Kingsley; published by Dodd, Mead and Company, New York, 1916

(a) *He looked up at the broad yellow moon . . . and thought that she looked at him*

Signature: Jessie Willcox Smith (lower left)

Oil and watercolor (?) over charcoal on illustration board

23 x 17¹⁄₁₆" (58.4 x 43.3 cm)

Library of Congress, Washington, D.C.

PROVENANCE: Estate of the artist

(b) *"Oh, don't hurt me!" cried Tom. "I only want to look at you; you are so handsome"*

Signature: Jessie Willcox Smith (lower right)

Oil and watercolor (?) over charcoal on illustration board

23 x 17" (58.4 x 43.1 cm)

Library of Congress, Washington, D.C.

PROVENANCE: Estate of the artist

LITERATURE: PAFA, *15th Annual Watercolor* (1917), nos. 606, 605; Philadelphia Art Alliance, *Portraits, Drawings, and Illustrations by Jessie Willcox Smith* (December 4–28, 1924), nos. 49, 54; PAFA, *Memorial Exhibition of the Work of Jessie Willcox Smith* (March 14—April 12, 1936), nos. 53, 44; *American Illustration*, p. 64, illus. p. 65 (429b); Chadds Ford, Pa., Brandywine River Museum, *Women Artists in the Howard Pyle Tradition* (September 6—November 23, 1975), p. 25 (429b)

THE TWO VOLUMES that Jessie Willcox Smith illustrated in 1897 while still in Pyle's class—*Evangeline* and *The Head of a Hundred*—were much influenced by the older artist's work (especially *The Head of a Hundred*, which deals with one of Pyle's favorite subjects, Colonial America). Around the turn of the century, she began to draw on a number of other influences, including

Japanese prints, the posters of the nineties, the work of Kate Greenaway, and perhaps even the color prints of Mary Cassatt. She was also influenced by her colleagues: she occasionally used the same double contours in her line drawings that Elizabeth Shippen Green did, and her strong outlines were reminiscent of the stained-glass window designs of Violet Oakley. Her early style, personal and decorative, was notable for its muted colors, strong contours, flat patterning, asymmetrical compositions, and tilted perspective. *The Child, A Calendar* of 1902 shows these qualities, as do her illustrations for Mary Imlay Taylor's *Little Mistress Good Hope and Other Fairy Tales* (Chicago, A. C. McClurg and Company, 1902), Louisa May Alcott's *An Old-Fashioned Girl* (Boston, Little Brown and Company, 1902), Frances Hodgson Burnett's *In the Closed Room* (New York, McClure, Phillips and Company, 1904), and *St. Nicholas* (December 1901, p. 110).

Jessie Willcox Smith's later manner is less distinctive but still attractive, with the strong contours of her early style suppressed and space treated more naturalistically; the effect of the Japanese print vanishes, and the coloring is more sprightly than subtle. *A Child's Book of Old Verses* (1910) and the Dickens illustrations (1912) are examples of the direction her later manner took. Her illustrations for *The Water-Babies* show a good deal of the decorative quality of the early works in the broad, flat patterning of the huge, dark leaves silhouetted against the

moonlight (no. 429a), or in the sweeping ripples of water below the hovering heads of the great fish (no. 429b). Beside the color illustrations, the pages of the volume are decorated with line drawings of sea motifs in black and green. Miss Smith considered the book to be her best work, according to the recollections of Miss Edith Emerson, and the effectiveness of the decorative patterns, soft colors, and imaginative contrasts of scale place the book among the most attractive of the illustrated versions of the story published up to the time.

The Water-Babies occupies a significant place in histories of children's literature and was, for earlier generations of children if perhaps not for more recent ones, a very popular fantasy tale of a little chimney sweep named Tom, who is turned by the fairies into a water-baby (those smallest water fairies whose job it is to clean the sands and rock pools after storms). It was first published in 1863. The author, Charles Kingsley (1819–1875), was an English clergyman, novelist, and social reformer. The book has been said to stand at the beginning of the modern English fairy-tale tradition that includes Lewis Carroll's *Alice's Adventures in Wonderland* and George MacDonald's serious, visionary fantasy tales, a tradition that was continued in America by Howard Pyle.

AP □

MORTON LIVINGSTON SCHAMBERG (1881–1918)
(See biography preceding no. 425)

430. *Mechanical Abstraction*

1916

Signature: Schamberg 1916 (upper right)

Oil on canvas

30 x 20⅛" (76.2 x 51.1 cm)

Philadelphia Museum of Art. The Louise and Walter Arensberg Collection. 50–134–181

PROVENANCE: Louise and Walter Arensberg, New York, as early as 1916–21

LITERATURE: Philadelphia, McClees Gallery, *Philadelphia's First Exhibition of Advanced Modern Art* (May 17—June 15, 1916), no. 24 or 25; Art Institute of Chicago, *20th Century Art from the Louise and Walter Arensberg Collection* (October 20—December 18, 1949), no. 198; Andrew C. Ritchie, *Abstract Painting and Sculpture in America* (New York, 1951), no. 93, p. 34, illus. p. 60; PMA, *The Louise and Walter Arensberg Collection* (Philadelphia, 1954), vol. 1, no. 186, illus.; Wolf, *Schamberg*, no. 47, p. 53, illus. p. 102; Whitney Museum, *Armory Show*, no. 87; NCFA, *Roots of Abstract Art in America* (December 2, 1965—January 9, 1966), no. 149;

429b.

430.

William Agee, "New York Dada 1910–30," in *The Avante Garde, Art News Annual*, no. 34 (1968), p. 110, illus. p. 113; Time-Life Books, eds., *American Painting 1900–1970* (New York, 1970), p. 51 (illus.)

REMARKABLE AS HIS earlier forays into Fauvist color and Cubist-influenced abstraction appear in the light of work by his contemporaries in Philadelphia, Schamberg's choice and treatment of machine subjects in 1916–17 were without precedent or parallel in the city. *Mechanical Abstraction* is one of a small group of works on this theme to have survived. (A closely related painting entitled *Machine*, of the same date and similar dimensions is in the Collection of the Société Anonyme, Yale University Art Gallery.) Compared to the rather more painterly *Telephone* (Columbus Gallery of Fine Arts) or the mysterious *Camera Flashlight* (still owned by the Schamberg family), the pair

of pictures constituted by *Mechanical Abstraction* and its counterpart at Yale present Schamberg's mechanist style at its most pure and precise. It is tempting to see the pair as the culmination of his rapid evolution away from brilliant color and rich brushwork, although the exact sequence of his work can only be a matter of conjecture.

Here Schamberg departs absolutely from any affinity with the paintings of his colleagues Sheeler and Saÿen. The dry, two-dimensional rendering of the parts of the machine recall Schamberg's early training as an architect while the degree of abstraction suggests a familiarity with the mechanist works of Francis Picabia and Marcel Duchamp, whom he knew in New York at just this time. Picabia's one-man exhibition at Marius de Zayas's Modern Gallery in January 1916 (which included paintings of mystifying machines entitled *Paroxysm of Sadness*, *Machine Without Name*, and *This*

Thing Is Made to Perpetuate My Memory) must have provided the most immediate inspiration. On a more prosaic level, Schamberg pored over the catalogues of machine parts used in the manufacture of ladies' cotton stockings, a business in which his sister's husband, Herbert Loeb, was engaged (Wolf, *Schamberg*, p. 30). Despite its clear relationship to Picabia's satirical or whimsical contraptions and Duchamp's studies for sections of his *Large Glass*, *Mechanical Abstraction* is a highly individual work. An exercise in pure lines and muted, metallic colors, it has no ironic or anecdotal content. Henry McBride recognized Schamberg's unique contribution even within the esoteric field of mechanist painting when he wrote: "It seems absurd to say that Schamberg has evolved structures as beautiful as flowers from machine forms and yet there is no other way to express the fact that beauty is the result" (*New York Sun*, May 25, 1919).

Ad'H □

HUGH H. BRECKENRIDGE (1870–1937)

The son of a cabinetmaker in Leesburg, Virginia, Breckenridge received his first training in art in Saturday drawing classes with Miss Betty Wildman in Leesburg. Despite parental resistance to his ambition to become a painter, he entered the Pennsylvania Academy in the fall of 1887, beginning an association with that institution which was to last for fifty years. To earn a living, he and a fellow student, William Edmondson, opened a commercial studio where they hand-colored lantern slides and retouched negatives for photographers. At this time he also took up crayon portraiture and was to continue to accept portrait commissions as a sideline to his artistic development throughout his life. In 1889 the two friends painted full-length portraits of each other hoping to add to their incomes with cash prizes at the Academy annual: Breckenridge won the first Charles Toppan Prize, Edmondson the second.

In 1892–93, Breckenridge spent a year in Paris on a Cresson Travelling Scholarship from the Academy. He is said to have studied with Bouguereau, Gabriel Ferrier, and Lucien Doucet; certainly he spent much time in the Louvre, and his style of the late 1890s suggests that he was exposed to the work of the Impressionists.

Upon his return to Philadelphia in 1893, he took the job of art teacher at Springside School for Girls, and in 1894 he became secretary of the faculty at the Pennsylvania Academy. He was to teach at the Academy for forty-three years, numbering among his pupils Charles Demuth, Ralston Crawford, and Leon Karp. In the summer of 1900 he and Thomas Anshutz opened a summer

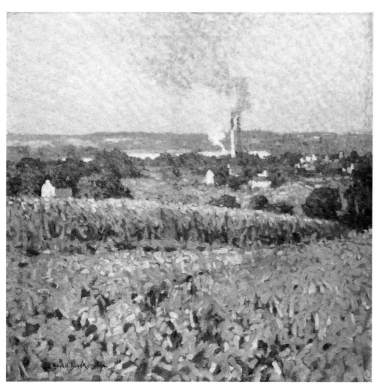

431.

school in a barn in Darby, Pennsylvania. Two years later the school moved to larger quarters in Fort Washington, where it continued to thrive until 1918. Breckenridge also retained a downtown studio in the Fuller Building until 1920.

By 1904, when the Pennsylvania Academy gave him a one-man show of fifty-three works, his reputation as a painter was well established. He had been sending entries regularly to the large annual exhibitions at the Art Institute of Chicago and the St. Louis Art Museum, as well as the Academy, since 1897. By 1915 he had shown in thirty-five museums and art societies across the country. He served on more than fifteen exhibition juries, beginning with the Pan-American Exposition in Buffalo in 1900; and in 1911, Mayor John Reyburn appointed him the painter-member of the Municipal Art Jury for Philadelphia, a post he filled until 1922. In 1915 he judged work from Philadelphia, New York, and Boston for the Panama-Pacific Exposition in San Francisco, where he showed ten paintings and won a Gold Medal.

Breckenridge's style underwent several striking changes during his long career. A bright Impressionist palette and loosely handled brushwork characterized his landscapes of 1895–1910, which were followed by a series of solidly modeled still lifes based on Cézanne. (*Still Life: Blue and Gold* won the $1,000 prize and Bronze Medal at the Corcoran Gallery of Art's annual show of

Contemporary American Oil Paintings in 1916). Yet he referred to the period 1911–15 as his "Potboiler Era" because of the quantity of portraits he completed, usually in a somber, academic vein. When he exhibited a group of thirteen paintings at the Pennsylvania Academy in 1917 (winning the Stotesbury Prize) the critic for the *Public Ledger* was struck by their variety: "Mr. Breckenridge seems to be saying, 'I can paint in many styles and manners and still get my effects. I can challenge the very moderns . . . I can give you strong color or refined color and I can paint decoratively or realistically' " (February 4, 1917).

In 1919, Breckenridge's teaching duties increased once again as he accepted the directorship of the Department of Fine Arts at the Maryland Institute in Baltimore. In the summer of 1920 he opened the Breckenridge School of Art in East Gloucester, Massachusetts, which was to flourish until his death.

During the 1920s and 1930s, his painting grew increasingly abstract and intense in color. Ambitious allegorical subjects like the *Tree of Life* (1928, Pennsylvania Academy collection) were less successful than a number of small canvases, experiments in pure nonobjective painting. His passion for color and exploration of abstraction was shared by his friends and colleagues on the Academy faculty Arthur B. Carles and Henry McCarter, and the three were part of a group exhibition of seven Philadelphia painters at

the Wildenstein Gallery in New York in 1927. Breckenridge's retrospective exhibition at the Academy in May 1934 filled four galleries and was given a warm reception by criticis (by the artist's wish, no commissioned portraits were included). Since his death in 1937, and a memorial show at the Philadelphia Art Alliance (1938), Breckenridge's national reputation has suffered a virtual eclipse. An exhibition of eighty works at the Valley House Gallery in Dallas, Texas, in November 1967 has provided the most recent opportunity for critical reappraisal, and the catalogue (*The Paintings of Hugh H. Breckenridge*) presents the fullest biographical information and listing of exhibitions and awards to date.

431. *The Mills*

1916
Signature: Hugh H. Breckenridge (lower left)
Oil on canvas
24 x 25″ (61 x 63.5 cm)
Dr. and Mrs. William Hayden, Paris, Texas

PROVENANCE: Estate of the artist; with Valley House Gallery, Dallas, Texas; present owner

LITERATURE: PAFA, *116th Annual* (1921), no. 401, illus.; PAFA, *Exhibition of Paintings by Hugh H. Breckenridge* (March 14—April 5, 1934), no. 10; Dallas, Texas, Valley House Gallery, *The Paintings of Hugh H. Breckenridge* (November 1967), no. 2, illus. p. 32

PAINTED AROUND THE MIDPOINT of his highly successful career, this canvas of modest scale but striking color harmonies marks an important stage in Breckenridge's gradual evolution from a subdued version of American Impressionism toward chromatic abstraction. During the first decade of the century a series of paintings of the flower-filled gardens of his home and summer school in Fort Washington, Pennsylvania, reveals him as a conservative but original advocate of Impressionist techniques. Using what a Philadelphia critic later called "shingle-stroke brushwork" (*Public Ledger,* February 4, 1917), he rendered vivid summaries of flowers bathed in sunlight, without specific delineation of individual blossoms or leaves.

The Mills moves further from the direct perception of nature, translating hazy summer weather and factories seen across a field into a tapestry of myriad small touches of pink, violet, blue, and green. In Breckenridge's view of the Schuylkill River valley, the smoking chimneys serve a purely decorative and lyrical effect, without any of the implied irony or menace of Demuth's vision of a Pennsylvania factory (see no. 446).

The painting method here suggests familiarity with the Divisionist canvases of Signac and the followers of Seurat. Although the latter's *Les Poseuses* did not enter Dr. Albert C. Barnes's collection until 1926, Breckenridge made a European trip in 1909 and could have had ample occasion to see Pointillist work. As early as 1912, he was using small, separate strokes of color (albeit subdued in tone) for an otherwise conventional portrait of *Dr. James Tyson* seated by a patient's sickbed (University of Pennsylvania Medical School).

It is in part the uncontrived nature of *The Mills*—almost a color sketch rather than a formal composition—that accounts for its success. Breckenridge's more elaborate productions often have a degree of careful finish which deprives his truly original color sense of its freshness. On a smaller scale, he was more experimental: a series of tiny vignettes showing the same scene of three trees under varying effects of light (*Eight Moods of Day*) dating to around 1918 and a number of diminutive abstractions dating to the 1930s are among his best works.

It is interesting to speculate on the interaction of Breckenridge, Henry McCarter, and Arthur B. Carles in their color investigations, and the degree to which Thomas Anshutz participated or influenced them. Despite Anshutz's emphasis on vigorous study of anatomy in the Pennsylvania Academy teaching, we know that he was experimenting with unusually bold color effects by 1886 in *Steamboat on the Ohio* (Carnegie Institute, Pittsburgh) and that he had lively discussions on color theory with his former student Lyman Saÿen in Paris around 1911. It seems highly likely that Breckenridge had studied with Anshutz before they set up the Darby summer school in 1900; certainly the older man would have made a stimulating mentor for a painter exploring Impressionist techniques. Breckenridge and McCarter belonged to the same generation and in each case their experimental interests were overlaid on a more conservative tradition: McCarter's training in illustration and Breckenridge's in portraiture. Carles was the youngest of the group and the least bound by convention. The sources of his art were predominantly the French avant-garde (Cézanne and Manet), but it is clear that Philadelphia provided sympathetic colleagues. In a letter of 1931 to Breckenridge (which was never sent) he wrote, "I always think of you a lot when I'm painting, for you are the one from whom I learned that color resonance is what you paint pictures with nothing else of but" (Elizabeth O'Connor, *Arthur B. Carles,* M.A. thesis, Columbia University, 1965, p. 79).

Ad'H □

432.

HENRY CHAPMAN MERCER (1856–1930)
(See biography preceding no. 403)

432. *The Arkansas Traveler*

c. 1916
Mark: MR (monogram on each vignette)
Unglazed ceramic tile fireplace
55 x 72″ (139.7 x 182.8 cm)
Edward J. Byrne Studio, Doylestown, Pennsylvania

PROVENANCE: Moravian Pottery and Tile Works; bequeathed by Mercer to his foreman, Frank K. Swain, 1930; sold as part of Mercer estate by Frank K. Swain to Raymond F. Buck, 1956; fireplace sold at auction by Mrs. Raymond F. Buck, 1975

IN MARCH 1896, Henry Chapman Mercer contributed an article to *Century Magazine* entitled "On the Track of *The Arkansas Traveler*" which documented the history of the famous folk song. According to Mercer, Colonel Sanford C. Faulkner was the originator of the story and was in fact the "Arkansas Traveler" himself. While journeying through the Boston Mountains with Governor Archibald Yell in the gubernatorial campaign of 1840, Faulkner's party stopped at a squatter's cabin to ask for directions. Faulkner endured the banter of the fiddling squatter and then requested a turn on the violin. When Faulkner completed the tune he had been playing, the rustic was astounded and responded with unbounded hospitality.

The subject was first painted in 1859 by Edward Payson Washbourne (1831–1860), a young genre painter from Little Rock, and was reproduced as a lithograph by Leopold Grozelier in Boston. The success of the lithograph encouraged Washbourne to paint a companion piece, *The Turn of the Tune*; in 1870, Currier and Ives issued a pair of colored lithographs after the two Washbourne paintings.

In his article, Mercer reproduced the Currier and Ives lithographs, a pair of which are still displayed in the smoking room at Mercer's Fonthill estate. Inspired by the theme, Mercer created tiles in his Moravian Pottery and Tile Works illustrating seven vignettes from the song (clockwise from lower left): *Lost in the Woods, The Log House, The Musical Squatter and His Friends, The Arkansas Traveler and His Question, The Turn of the Tune, The Demijohn,* and *The Dry Spot.*

DDT □

508

CHARLES GRAFLY (1862–1929)
(See biography preceding no. 376)

433. *Scale Model for the Memorial to Major General George Gordon Meade*

1915–25
Signature: Chas Grafly (at the foot of the figure of War)
Bronze
36¼ x 18 x 18" (91.9 x 45.7 x 45.7 cm)
National Collection of Fine Arts, Smithsonian Institution, Washington, D.C.
Gift of Miss Dorothy Grafly

PROVENANCE: Estate of the artist; daughter, Dorothy Grafly, Philadelphia, until 1968

LITERATURE: PAFA, *120th Annual* (1925), no. 409 (illus.); Philadelphia Sesqui-Centennial, no. 1143; Uthai Vincent Wilcox, "A Tribute to Peace—The Meade Memorial," *The American Magazine of Art,* vol. 8, no. 4 (April 1927), pp. 195–98; Craven, *Sculpture,* pp. 441–42; James M. Goode, *The Outdoor Sculpture of Washington, D.C.* (Washington, D.C., 1974), p. 538; Pamela H. Simpson, "The Sculpture of Charles Grafly," Ph.D. thesis, University of Delaware, 1974, no. 192, pp. 86–94, 414, 411–39, and throughout

THE MEMORIAL to the Civil War hero George Gordon Meade (a native Pennsylvanian) was Grafly's single most important commission. Although it caused him great difficulties in both realizing his conception and persuading two separate civic groups to accept it, he nevertheless considered the monument a triumph of his career. In 1915 he was invited to create the memorial as a gift of the Commonwealth of Pennsylvania to the nation's capital. It was to stand at the east end of the Mall, on an open site; and approval of the design was to be obtained from both the state committee for the project and the United States Fine Arts Commission. Despite the fact that most of Grafly's important work had been in bronze, the guidelines specified marble as the most suitable material since this was what had been used for the other large sculptures along the Mall. After the sturdy simplicity of his *Pioneer Mother Memorial*—a monumental group of a woman with two small children executed for the Panama-Pacific Exposition in San Francisco (1915)—it seems that Grafly took the Meade commission as the occasion, somewhat surprisingly, to return to the intricate, highly personal allegory of some of his earlier work, notably the *Fountain of Man.*

His first, relatively modest proposals were rejected by the committees: an informal portrait of the general seated on a rock, hat in hand, was considered too casual; a more forceful concept of an allegorical nude figure

struggling to bring together two broken sections of a large slab, too obscure. (Grafly later cast the roughly modeled sketch for the latter in bronze and exhibited it under the title *E Pluribus Unum.*) The third proposal, with Meade standing before a decorated plinth, also at first proved unsatisfactory to the committees, but from this Grafly slowly evolved his final idea of a group of figures interlocked in a ring, with Meade and the allegorical figure of War facing in opposite directions.

Grafly's four-year preoccupation with this project is documented by thirty plasters (studies for details of the memorial or sketches of the whole) preserved in the collection of Wichita State University. The final proposal, embodied in this bronze model, retains an architectural strength and unity without resorting to extraneous decorative elements. Grafly's own description of the monument in a letter to the Fine Arts Commission gives a sense of the high seriousness with which he approached the task:

> The problem provoked by the site dictated a form equal in interest from every vantage point. Working upon this basis the sculptor conceived a circle of figures embodying qualities essential to the character of a great general. As the focal point in the circle stands the figure of General Meade, his work accomplished, ready to step forth from the cloak of battle into a future era of Progress. Behind him is the grim figure of War against the sweep of whose long wings are outlined the qualities of generalship—Energy, Military Courage, Fame, Progress, Chivalry, and Loyalty—so placed that the urge is onward and forward from the grim determination of Military Courage and Energy to the figures of Chivalry and Loyalty, who, at the left and right of Meade, busy themselves with his cloak and the standard of his achievements. But of the circle only Progress and Fame, the central figures at the sides, have the power to move with General Meade in the accomplishment of the future. The dark wings of War may carry him through other ages and lands, unchanging and unchanged, but the great general will move forward leaving behind him the static, symbolized in the figures of War and Military Courage. The command is "Forward." (quoted in James M. Goode, *The Outdoor Sculpture of Washington, D.C.,* Washington, D.C., 1974, p. 538)

Although this solution was approved by both committees in 1919, disputes over the cost delayed the work, and the eighteen-foot-high monument (carved by the Picirilli

brothers in New York from Grafly's full-scale plaster) was not unveiled until 1927. By that date the elaborate allegory seemed *retardataire,* although it should be noted that the conservative members of the Pennsylvania committee remained dubious about the propriety of surrounding a Civil War hero with nude men and women, however symbolic.

Grafly's maquette for the final version is vigorously modeled, the faces and elongated limbs of the figures treated with a lively imprecision that was lost in the large marble carving. The sculptor's skill in portraiture is apparent in the specific characterization of the general stepping majestically forward into civilian life, while his penchant for allegory is indulged in the beetle-browed figure of War. Unlikely as it may appear, even this elaborate composition constitutes a considerable simplification of one of Grafly's alternative schemes, in which the figures were all to be clothed and the wings of War were to support a complex panoply of "garlands, fruit, sheaves of wheat and partially unfurled flags" (see Simpson, cited above, p. 426). An impressive testament to

433.

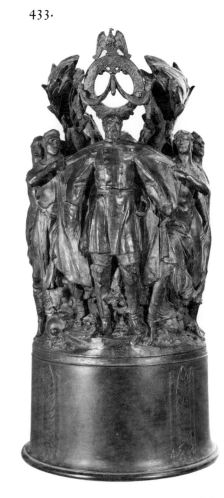

the longevity of Beaux-Arts tradition in this country, the marble memorial itself was removed from the Mall to storage in 1969 to make way for the construction of the reflecting pool that now occupies that site.

Ad'H □

CHARLES DEMUTH (1883–1935)

Born in Lancaster, Pennsylvania, into a well-to-do family in the tobacco business with a taste for the fine arts, Demuth passed much of his life at home, partly due to frequent periods of illness. From 1899 to 1901 he studied at the Franklin and Marshall Academy in Lancaster, and in 1901 he began his training in art at the Drexel Institute in Philadelphia. In 1905 he met the poet William Carlos Williams, who was to be a lifelong friend, and enrolled at the Pennsylvania Academy where he spent five years studying with William Merritt Chase, Thomas Anshutz, Hugh Breckenridge, and Henry McCarter. After an earlier visit to Paris in 1909, he made a longer stay in 1912–14, which was crucial to the development of his personal style. While he studied at the academies Moderne, Colarossi, and Julian, his familiarity with the most recent art came from frequenting the salons of Leo and Gertrude Stein, where he rubbed elbows with Picasso, Juan Gris, and Robert Delaunay and absorbed the lessons contained in the paintings of Cézanne and Matisse that covered the walls. A close friendship with Marcel Duchamp began in 1915. His firsthand experience of Cubism revealed itself in watercolors of trees and houses done on a visit to Bermuda with Marsden Hartley in 1916–17, while his literary interests led him to produce during 1915 to 1919 a series of intensely wrought illustrations to tales by Henry James, Edgar Allan Poe, Franz Wedekind, and Émile Zola.

Sophisticated and widely read, Demuth was somewhat of a dandy by nature, and preserved a Parisian elegance in both his appearance and his art. Specifically, American subject matter also had its appeal: industrial landscapes in oil and tempera, which he began around 1920 and took up again from 1927 to 1930, later caused Demuth's name to be linked with those of the "Immaculates" or "Precisionists" such as Charles Sheeler, Niles Spencer, and Ralston Crawford. Living in Lancaster, but in close touch with friends and colleagues in Philadelphia, Demuth exhibited frequently at the Pennsylvania Academy and was a juror for the Academy's annual watercolor exhibition in 1919. He was also in contact with the New York avant-garde circles around Alfred Stieglitz and Louise and Walter Arensberg, and his first one-man show was held in New York

in 1915 at the Daniel Gallery, where he continued to show until 1925.

After suffering severe attacks of diabetes in the summer of 1920, Demuth ventured on a last trip to Europe in 1921. He then returned home to Lancaster where he spent the last fourteen years of his life, working primarily in watercolor, the medium least arduous for his frail health and exquisitely suited to his rather rarified temperament. Despite his relative remoteness from the centers of the art world, his work was increasingly exhibited and praised by such distinguished avant-garde critics as Henry McBride. Stieglitz gave him three one-man shows in 1926, 1928, and 1931, and his watercolors won medals at the Sesqui-Centennial Exposition in Philadelphia in 1926, and the Pennsylvania Academy's annual watercolor exhibition in 1927. Several important pioneer collectors of modern art were attracted to Demuth's works: Arensberg bought several; Ferdinand Howald of Columbus, Ohio, gradually acquired thirty-five; Dr. Albert C. Barnes, who knew the artist personally, bought some fifty watercolors, many of which now hang in his museum in Merion. He was included in group exhibitions at the Museum of Modern Art in 1928, 1929, and 1932; in the first Biennial Exhibition of Contemporary American Sculpture, Watercolors and Prints at the Whitney Museum of American Art in 1933; and in the 19th Biennale exhibition at Venice in 1934.

His death in Lancaster at the age of fifty-three brought an early end to a career of extraordinary artistic refinement and elegance, in which European innovations were gracefully absorbed into a sophisticated, almost mannerist, idiom. A memorial exhibition was held at the Whitney Museum in 1937–38; Andrew Ritchie organized a retrospective of 158 works at the Museum of Modern Art in 1950; and a large traveling exhibition was mounted by the Art Galleries of the University of California at Santa Barbara in 1971–72.

434a. *The Green Dancer*

1916
Signature: C. Demuth 1916 (lower left)
Watercolor and pencil on paper
10⅞ x 7¹⁵⁄₁₆″ (27.5 x 20.2 cm)
Philadelphia Museum of Art. The Samuel S. White, 3rd, and Vera White Collection. 67-30-21

PROVENANCE: Earl Horter, Philadelphia; Mr. and Mrs. Samuel S. White, 3rd, Ardmore, Pennsylvania

LITERATURE: Forbes Watson, "Opening the New Year," *The Arts*, vol. 5, no. 1 (January 1924); p. 42, illus. p. 46; New York, Whitney Museum, *Charles Demuth Memorial Exhibition* (December 15, 1937—January 16, 1938), no. 77; MOMA, *Charles Demuth* (March 7—June 11, 1950), no. 42, illus. p. 33; Emily Farnham, "Charles Demuth: His Life, Psychology and Works," Ph.D. thesis, Ohio State University, 1959, no. 179, pp. 265–67, 478; "The Samuel S. White, 3rd, and Vera White Collection," *PMA Bulletin*, vol. 63, nos. 296–97 (January–June 1968), no. 55, p. 104, illus. p. 107; Santa Barbara, University of California Art Galleries, *Charles Demuth: The Mechanical Encrusted on the Living* (October 5—November 14, 1971), no. 29

434b. *In Vaudeville (Dancer with Chorus)*

1918
Signature: C. Demuth 1918 (lower left)
Watercolor on paper
12¾ x 8″ (32.4 x 20.3 cm)
Philadelphia Museum of Art. A. E. Gallatin Collection. 52-61-18

PROVENANCE: Albert Eugene Gallatin, New York, by 1929

LITERATURE: Philadelphia Sesqui-Centennial, no. 796 or 802; New York University, Gallery of Living Art [catalogue of the collection] (1929), listed and illustrated (n.p.); New York, Gallery of Living Art, *A. E. Gallatin Collection* (1933), no. 28; New York, Whitney Museum, *Charles Demuth Memorial Exhibition* (December 15, 1937—January 16, 1938), no. 10 or 52; *PMA Bulletin*, vol. 38, no. 198 (May 1943), illus.; William Penn Memorial Museum, *Charles Demuth of Lancaster* (September 24—November 6, 1966), no. 62; Akron Art Institute, *Paintings by Charles Demuth* (April 16—May 12, 1968), no. 62; Emily Farnham, *Charles Demuth: Behind a Laughing Mask* (Norman, Okla., 1971), pl. 23

DEMUTH'S WATERCOLORS of circus acrobats and vaudeville performers, mostly executed between 1916 and 1917, are among his most idiosyncratic works. They reflect less direct effect of the Cubist lessons learned during his stay in France during 1912–14 than do his Bermuda subjects of trees and rooftops. The latter have a crystalline severity and delicacy of color that hark back to the watercolors of Cézanne and the most spare and precise of Picasso's analytical Cubist paintings and drawings. Demuth might indeed be said to have developed two alternative styles: the Cubist-influenced idiom of sharp angles and straight lines, which he so often used in depicting church towers and industrial buildings, and a more sensuous, mannerist mode for the figure studies.

Demuth had achieved the start of his mature style in his treatment of the human figure by the end of his ten years at the

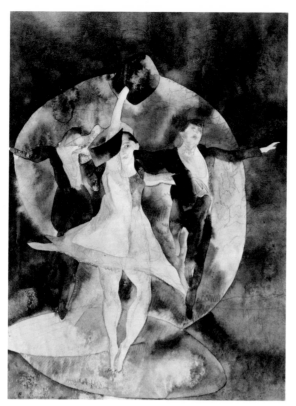

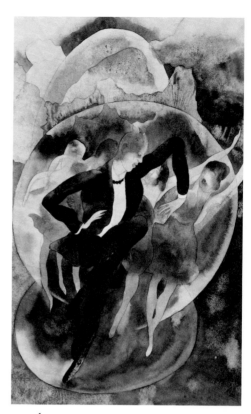

434a.

434b.

Drexel Institute and the Pennsylvania Academy in Philadelphia. A watercolor entitled *Boy and Girl,* dated 1912 (MOMA, *Charles Demuth,* cited above, illus. p. 22), reveals both his skillful use of the medium and the curious psychological intensity that imbues his later illustrations and theatrical scenes. Demuth adored the theater, and the hectic, colorful, often decadent night life of the entertainment world fascinated him. He frequented the music halls and bohemian dives of New York in the years during and immediately after World War I but also found material for his art even closer to home. His friend Robert Locher reported, "Charles used to go every week to see vaudeville at the Colonial Theatre" in Lancaster (Farnham, *Demuth,* cited above, p. 961). One imagines him strolling back to his quiet second floor studio overlooking the garden in the family house to produce those strangely disturbing images of elongated, supple figures in evening dress, leaping and cavorting on a brilliantly lighted stage. When a group of the circus and music-hall subjects were shown at the Daniel Gallery in 1916, Willard Huntington Wright in the *International Studio* (vol. 59, no. 239, January 1917, p. xcviii) declared it "the most important modern show of the month," and found the watercolors to contain "much that is Matisse, more that is Picasso, and a great deal that is Toulouse-Lautrec."

In Vaudeville and *The Green Dancer* are Demuth at his best; the fluid handling of the luminous, dark colors and the nervous, undulating line are a perfect vehicle for his sinister, nocturnal visions. The graceful frenzy of the dancers is contained within an abstract series of curved forms suggested by the glare of the spotlights. Although executed two years apart, the watercolors form a remarkable pair, demonstrating the consistent nature of Demuth's formal concerns in works that have a fresh, spontaneous response to experience. Writing in 1948, James Thrall Soby hazarded a definition of "modern Philadelphia art" as "painting which shows close sympathy for the traditions running from Mannerism to the Rococo" and a tendency to "gracious stylistic invention" (New York, MOMA, *Contemporary Painters,* by James Thrall Soby, 1948, p. 9). He saw Demuth as a leading exponent of that art, and certainly these superb vaudeville studies bring his definition vividly to life.

Ad'H □

VIOLET OAKLEY (1874–1961)

A mural painter, decorator, and illustrator whose once considerable reputation has been somewhat neglected in recent years, Violet Oakley was born in Bergen Heights, New Jersey, of a family that already included several artists. She began her training at the Art Students League in New York with Carroll Beckwith in the early 1890s; afterward she studied in Paris and England. Her family settled in Philadelphia and Miss Oakley attended the Academy briefly, taking the life drawing class in 1895–96. She then took Howard Pyle's illustration course at Drexel Institute in the spring of 1897, while making advertising drawings and magazine illustrations to help support her family. In Pyle's class she met Jessie Willcox Smith and Elizabeth Shippen Green, fellow illustrators with whom she was to be associated for many years and with whom she shared a series of studios (see biographies preceding nos. 429, 413) beginning around 1900. From about 1906 to 1911 they occupied quarters at "Cogslea," 627 St. George's Road, Mt. Airy, Philadelphia; the studio building today houses the Violet Oakley Memorial Foundation and a large collection of Miss Oakley's works (the Foundation archives contain much material on Miss Oakley's career; see also Edith Emerson, "Violet Oakley—1874–1961," *Germantowne Crier,* vol. 13, no. 4, December 1961, pp. 7–9, 19–26, vol. 14, no. 1, March 1962, pp. 13–15).

Violet Oakley collaborated with Jessie Willcox Smith on illustrations for Longfellow's *Evangeline* in 1897, while she was in Pyle's class; and from 1898 through the early

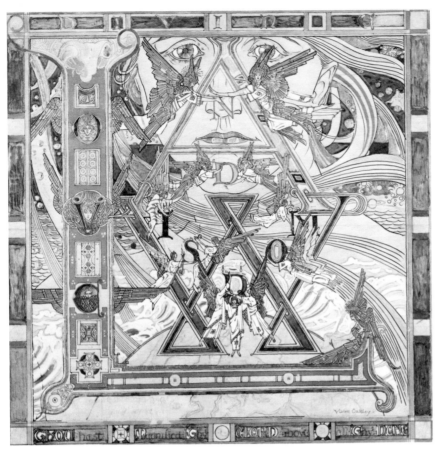

435.

years of the 1900s her illustrations appeared in *Woman's Home Companion, Collier's Weekly, St. Nicholas, Century Magazine,* and *Everybody's Magazine.* She won a Gold Medal for illustration at the St. Louis Exposition of 1904, but even by that time she was becoming better known as a mural painter and designer of large decorative ensembles than as an illustrator. Her first major decorative commission—designs for the altarpiece, apse panels, and stained-glass windows of All Angels Church in New York City (1900–1901)—won a Silver Medal at St. Louis and was noted at the time as one of the largest and most important mural decorations done by a single artist in any church in the country (*Philadelphia Press,* December 8, 1901).

The works for which Violet Oakley is best known, and which occupied her for a good part of her career, are the mural paintings for the Governor's Reception Room, the Senate Chamber, and the Supreme Court Room of the State Capitol at Harrisburg. The first commission was given in 1902 and the last paintings were installed in 1927. In 1905 the first of the series of murals won her the Academy's Gold Medal of Honor. In 1910–11 she provided three large lunettes, some smaller canvases, and a design for a stained-glass dome for the Charlton Yarnall house at Seventeenth and Locust streets in Philadelphia (now in the Violet Oakley Memorial Foundation), on the theme of the Building of the House of Wisdom ("The Building of the House of Wisdom," *The Republican Woman,* vol. 5, no. 1, March 1927, illus. pp. 1–5). At this same time, in 1911, the Cogslea group broke up when Elizabeth Shippen Green married Huger Elliott and moved to Providence. Violet Oakley remained in the Mt. Airy studio, and Jessie Willcox Smith built a separate house and studio nearby.

The major commissions of the artist's mature years were designs for stained-glass windows, mural decorations for public buildings, altarpieces, and portraits. She designed windows for the Collier house near New York City before 1913 (this window, now owned by the Apostolic Delegation in Washington, D.C., won a medal at the Panama-Pacific International Exposition in 1915), for the Gibson (now Merriam) house in Wynnewood, Pennsylvania, and for St. Peter's Church in Germantown. Around 1915 she painted an enormous mural depicting the Constitutional Convention for the Cuyahoga County Court House in Cleveland, Ohio; a much

later work, apparently her last mural painting, was done for the Westtown School on the subject of George Fox. Her altarpieces are to be found in the library of the Chestnut Hill Academy, the Vassar College Alumnae House, and at the Samuel S. Fleisher Art Memorial (*Public Ledger,* November 24, 1929, illus.). She also painted altarpieces for the armed forces during World War II (one now in the chapel of the Philadelphia Naval Base; another reproduced by Booth Tarkington, "The Twentieth Century Triptychs," *The Philadelphia Forum Magazine,* December 1944, p. 4) and a frieze depicting great women of the Bible in the First Presbyterian Church in Germantown in 1948–49, her last large commission (*Philadelphia Inquirer,* March 21, 1948, illus.).

An advocate of international law and order, disarmament, and Quaker pacifism, she attended sessions of the League of Nations in Geneva in 1927–29 and in 1936 to draw the delegates, and selections of her strongly contoured chalk portraits were widely exhibited in Europe and America (some are reproduced in Clara Mason, "Violet Oakley's Latest Work," *The American Magazine of Art,* vol. 21, 1930, pp. 130–38). She did many other portraits in oil, chalk, or pastel, both locally and abroad. In 1921 she designed the scroll, gold medal, and ivory casket of the Philadelphia Award founded by Edward W. Bok (Edith Emerson, "The Philadelphia Award," *The American Magazine of Art,* vol. 13, 1922, pp. 156–58).

Violet Oakley taught a class in mural decoration at the Pennsylvania Academy from 1913 to 1917 and held classes and lectures at Cogslea during the 1930s in drawing and painting, illustration, mural painting, lettering, and manuscript illumination. She was a frequent exhibitor at the Academy from 1896 through the 1940s and at Woodmere Gallery in Chestnut Hill, Philadelphia, and was a founding member of the Plastic Club (1897), the Philadelphia Water Color Club (1901), and the Philadelphia Art Alliance (1915), as well as a National Academician and a member of the Society of Illustrators and the National Society of Mural Painters. She died in Mt. Airy in 1961 at the age of eighty-six.

435. *Study for Divine Law*

c. 1917
Signature: Violet Oakley (in pencil, lower right)
Black ink, watercolor, gouache, and gold paint or gold leaf over traces of pencil on heavy beige paper
20½ x 20½" (52.1 x 52.1 cm)
Miss Edith Emerson, Philadelphia

PROVENANCE: The artist; Miss Edith Emerson

LITERATURE: Philadelphia Art Alliance, *Exhibition of Work by Violet Oakley, N. A., and Edith Emerson* (January 10–27, 1930), no. 176; Chadds Ford, Pa., Brandywine River Museum, *Women Artists in the Howard Pyle Tradition* (September 6–November 23, 1975), p. 17

THIS IS A HIGHLY FINISHED STUDY for the first of sixteen mural paintings decorating the Supreme Court Room of the State Capitol in Harrisburg, a series commissioned in 1911, begun in 1917, and installed in 1927. The theme of the whole decoration is the Opening of the Book of the Law, that is, the development of concepts of law from ancient times to the present. The various scenes illustrate, in sequence, the Golden Age of obedience to natural law; the Greek, Hebrew, and Christian ideas of revealed law; the Justinian Code; Sir William Blackstone's commentaries and the common law; William Penn as a lawgiver; and the law of nations, leading up to international law and culminating in the principle of disarmament.

The following is a description of the mural in the artist's words: "Divine Law is both the first and the last panel in the series, the 'Alpha and Omega' of the law. A great monogram is made by the illuminated letters L A W. Subsidiary letters forming the words 'Love and Wisdom' are put in place by the winged figures of the Seraphim and Cherubim, symbolically garbed in red and blue. Above the green globe of the earth is the ethereal sea, stars and planets, and the face of Truth looms in the background, half-concealed, half-revealed" (*Law Triumphant, Containing the Opening of the Book of the Law and the Miracle of Geneva*, Philadelphia, 1933, p. 22). Divine Law is shown to be universal, not confined to any one nation or situation; the object of law is to discover truth, hence the face of Truth "half-revealed." A group of lawyers at the bottom of the composition show astonishment at the revelation of the Law. The Recording Angel sits at the end of the letter L.

Since the subject of the murals necessitated the depiction of so many different periods, geographical regions, figural types, and costumes, the artist chose a medievalizing style based on manuscript illumination, with repeated border motifs and flat patterning, to provide as much consistency of effect as possible. With its linear complexity and intertwined motifs recalling Celtic illumination, *Divine Law* is one of the more elaborate compositions of the series. The painting itself is quite large (about ten feet by eleven feet), and one must imagine the intricacy of the small study rendered on quite a large scale.

This was the last of the three rooms Violet Oakley decorated for the State Capitol. The first, the Governor's Reception Room, was decorated between 1902 and 1906, and the second, the Senate Chamber, between 1911 and 1917–20 (the commission was received after the death of Edwin Austin Abbey, who was charged with much of the mural decoration of the Capitol). Their programs are quite elaborate: the Governor's Reception Room murals show the founding of the State of Pennsylvania, interpreted as deriving from the quest for religious liberty (the actual title is the Founding of the State of Liberty Spiritual; the scenes are lavishly reproduced in Violet Oakley, *The Holy Experiment: A Message to the World from Pennsylvania*, Philadelphia, 1922), and the Senate Chamber scenes depict the Creation and Preservation of the Union (illustrated by the Constitutional Convention and Lincoln's Gettysburg Address; the series is reproduced with line drawings by the artist after the paintings in another of her publications, *The Holy Experiment: Our Heritage from William Penn*, Philadelphia, 1950). Miss Oakley defined her intentions in all three programs, which she saw as a kind of progressive development, in terms of her own faith in an "organized world governed by international law," which is the fulfillment of William Penn's Holy Experiment, as he called the unfortified commonwealth of Pennsylvania, governed by law and not military force (Violet Oakley, "The Vision of William Penn: Mural Paintings in the Capitol of Pennsylvania," n.d., reprint from *Pennsylvania History*, vol. 20, no. 4, October 1953, pp. 316–38; also E. D. M., "The Opening of the Book of the Law," *The American Magazine of Art*, vol. 18, 1927, pp. 10–17). Fourteen of the sixteen murals for the Opening of the Book of the Law were exhibited at the Sesquicentennial in the Pennsylvania State Building, in an approximate replica of the room in the State Capitol for which they were designed (*Philadelphia Inquirer*, October 24, 1926). They were installed in the Capitol after the celebration.

The strong, rich color areas bounded by elaborately decorative outlines and the complex, often stylized patterns of the Supreme Court murals are rather like illuminated manuscript pages rendered large on a wall—an intentional effect in this instance, as Miss

436.

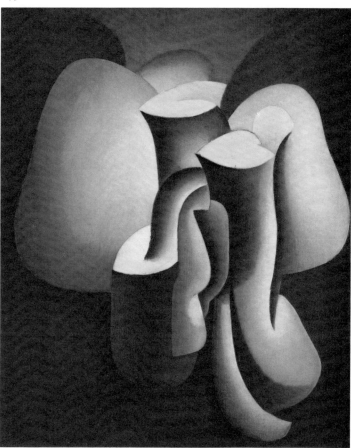

Oakley herself referred to the series as "a scroll unrolled—upon the wall—to be read of all" (*Law Triumphant,* cited above, p. 21). Some of the scenes in this room have a stylized, angular, Art Deco quality, and some are more conventionally representational. The sources of Violet Oakley's mature work are traceable to her early illustration style, closely connected to those of her colleagues Elizabeth Shippen Green and Jessie Willcox Smith at the turn of the century, but since she turned primarily to mural decoration early on, her manner developed differently in relation to the larger scale on which she worked. In the latter half of the 1890s her style evidenced a strongly contoured, curvilinear, decorative quality related to European Art Nouveau (a style for which she did not care a great deal, according to Miss Edith Emerson). Later, partly under the inspiration of her trips to Europe and her firsthand acquaintance with the great Italian Renaissance wall decorators, such as Carpaccio, Piero della Francesca, and Michelangelo, her style became more masculine, abandoning the undulating, feminine quality of her early work. A further notable characteristic of the *Divine Law* study and mural is the concentration on highly styled, Gothicized lettering; in effect, letters and their combination into words are the subject of the composition, a clear reflection of the artist's special interest in lettering and illumination.

AP □

CHARLES SHEELER (1883–1965)
(See biography preceding no. 427)

436. *Flower Forms*

1917
Signature: Sheeler 1917 (lower left)
Oil on canvas
23¼ x 19¼″ (59 x 48.9 cm)
Private Collection

PROVENANCE: John Quinn, New York, until his death in 1926; Earl Horter, Philadelphia

LITERATURE: Forbes Watson, "Charles Sheeler," *The Arts,* vol. 3, no. 5 (May 1923), pp. 338, 341, illus. p. 337; *John Quinn Collection of Paintings, Water Colors, Drawings & Sculpture* (New York, 1926), p. 25, illus. p. 181; Rourke, p. 66, illus. p. 35; MOMA, *Charles Sheeler* (October 4—November 1, 1939), no. 9, p. 10 (illus.); Los Angeles, UCLA Art Galleries, *Charles Sheeler: A Retrospective Exhibition* (October 1954), no. 3, p. 27, illus. p. 13; NCFA, PMA, and Whitney Museum, *Charles Sheeler,* by Martin Friedman, Bartlett Hayes, and Charles Millard (October 10, 1968—April 27, 1969), no. 14, illus. p. 34; Delaware Art Museum, *Avant-Garde,* p. 130, illus. p. 131

ONE OF THE FEW virtually abstract canvases by Sheeler to survive, *Flower Forms* is a rare

437.

representative of what he called "the abstract period which brought the Philadelphia chapter to a close" (AAA, Sheeler, Reel 1, Frame 85), an important phase in the evolution of his art about which little is recorded. After deciding to break away from the brilliant painterly style so compellingly espoused by his teacher, William Merritt Chase, Sheeler plunged into a prolonged period of experimentation that lasted from about 1910 to 1919. Simplified still lifes of flowers and fruit painted in bright Fauve colors were followed around 1915 by linear Cubist landscapes. Sheeler then began to explore the possibilities of abstraction, as he later wrote: "sometimes with a clue to natural forms being evident, but quite as often without that evidence. Always, however, derived directly from something seen in nature. Color was entirely arbitrary with the intention of contributing to the organization of the forms comprising the design" (AAA, Sheeler, Reel 1, Frame 74). Citing *Flower Forms* as an example of this experimental phase, Sheeler stated that "its chief value" lay in "clarifying my understanding of essentials and the necessity of underlying structure" (AAA, Sheeler, Reel 1, Frame 75).

The painting has a mysterious quality that reaches beyond Sheeler's rather didactic explanation of his intention. The bulbous green and yellowish forms float luminously in an undefined, darker green space, and the picture conveys an almost symbolic sense of organic growth. Painted two years before Sheeler made his momentous decision to leave Philadelphia for New York, *Flower Forms* is in many ways unique in his oeuvre. Owned first by the distinguished modern collector John Quinn, and then bought by the Philadelphia artist and collector Earl Horter (see biography preceding no. 445), the painting was frequently chosen by Sheeler for exhibition in his several retrospective shows. A talisman of his most daring experiments, unlike anything his friends Schamberg or Lyman Saÿen painted in the same period (and curiously prophetic of the later, extraordinary paintings of flowers by Georgia O'Keeffe), *Flower Forms* remains an enigmatic yet convincing proof of Sheeler's part in the emergence of avant-garde art in Philadelphia between 1910 and 1920.

Ad'H □

MORTON LIVINGSTON SCHAMBERG
(1881–1918)
(See biography preceding no. 425)

437. *Roof Tops*

1917
Signature: Morton Schamberg 1917
(on mat below print)
Silver print
9¾ x 7¾" (24.7 x 19.6 cm)
Eleanor and Van Deren Coke Collection,
Albuquerque, New Mexico

PROVENANCE: Estate of Charles Sheeler; with
Robert Schoelkopf Gallery, New York

LITERATURE: "The 1918 Wanamaker Spring
Exhibition," *American Photography,* vol. 12,
no. 4 (April 1918), pp. 230–31; Davis, Calif.,
Memorial Union, University of California,
*Photographs from the Coke Collection Fourth
Floor Gallery* (February 20—March 15, 1974),
n.p., intro. by Van Deren Coke; Van Deren
Coke, "The Cubist Photographs of Paul Strand
and Morton Schamberg," in *One Hundred
Years of Photographic History* (Albuquerque,
N.M., 1975), pp. 35–42, illus. p. 41

MORTON SCHAMBERG's brief photographic
career (1912–18) was terminated by his
untimely death from influenza. Within that
short time, however, he had established a
reputation as one of the leading modernist
photographers and was ranked with his
friends Paul Strand and Charles Sheeler by
Alfred Stieglitz himself. A photograph by
Schamberg won third prize at the 1918
Wanamaker photographic exhibition in
Philadelphia (where Stieglitz was a judge),
first and fourth prizes going to Sheeler and
second prize to Strand. Schamberg's photo-
graph was a portrait of his son, similar to
Stieglitz's own portraiture in its simple,
straightforward style, and related to both
Sheeler's and Strand's images in its direct-
ness and purity of technique. The transition
between that photograph and *Roof Tops,* the
1917 photograph shown here, is both abrupt
and logical. As a protégé of Stieglitz,
Schamberg eschewed the maudlin visual
sentimentalization of soft-focus pictorial
photography; as an important member of
the artistic avant-garde in America, he was
influenced by Duchamp, Picabia, and the
Cubists, whose works he saw in the Armory
Show of 1913 and in Stieglitz's gallery "291"
and Marius de Zayas's Modern Gallery in
New York City.

Until recently, only Schamberg's portrait
photographs were known to have survived.
A group of architectural studies, formerly in
Sheeler's collection, surfaced in 1975, reveal-
ing Schamberg's more radical exploration
of the medium. *Roof Tops* represents the
conjoining of these related concerns. Space
is compressed by the acute angle of view; the

abrupt perspective and the dramatic lighting
combine to emphasize the geometry of the
architectural elements, which are seen as
angular, two-dimensional forms articulated
by light or shadow rather than as parts of
buildings. Architectural mass is reduced to
linear pattern; features become units of
geometric design. The total effect is one of
cubistic abstraction that is mechanically pre-
cise and rigidly constructed, yet—like one
of Schamberg's paintings of machine parts—
aesthetically appealing because of its inher-
ent rational organization. The building
itself cannot be identified today, although it
probably stood in Philadelphia.

While *Roof Tops* shows an awareness of
earlier photographs by both Strand and
Sheeler, who used strong light and radical
angles of view to simplify and structure
form and to establish new and sometimes
disturbing perspectives, it is not a derivative
image. Its concerns are with abstractions
from architectural forms and reveal an
architect's awareness of the power of light
to define and integrate three-dimensional
shapes. Moreover, there is a visual austerity
apparent that relates more to Schamberg's
paintings (and to architectural plans) than to
Sheeler's or Strand's paintings from this
period.

It also seems probable that Schamberg
influenced Sheeler. *Roof Tops* was among
the photographs owned by Sheeler for many
years. The same abrupt perspective and
spatial compression employed in this photo-
graph are major elements in Sheeler and
Strand's film *Manhatta* (1921), in Sheeler's
painting *Church Street El* (also 1921), and
in the important series of photographs he
made at Chartres Cathedral in 1929.

Although he died in the early days of the
modernist movement in photography,
Morton Schamberg was a significant figure
in its emergence in America. His photograph
Roof Tops is an important image in the
development of artistic photography.

WS □

MORTON LIVINGSTON SCHAMBERG
(1881–1918)
(See biography preceding no. 425)

438. *God*

c. 1917
Wooden miter box and cast-iron plumbing
trap
10½ x 11⅝ x 4" (26.7 x 29.5 x 10.2 cm)
Philadelphia Museum of Art. The Louise
and Walter Arensberg Collection.
50–134–182

PROVENANCE: Louise and Walter Arensberg,
New York, by 1921

LITERATURE: PMA, *The Louise and Walter
Arensberg Collection* (Philadelphia, 1954), no.
187; Wolf, *Schamberg,* no. 52, pp. 34, 54–55,
illus. p. 107; Whitney Museum, *Armory Show,*
no. 88; Rose, *American Art,* p. 97, figs. 4–11;
Jack Burnham, *Beyond Modern Sculpture* (New
York, 1968), illus. p. 377; H. H. Arnason, *A
History of Modern Art* (New York, 1968), p.
416 (illus.); K. G. Pontus Hultén, *The Machine
as Seen at the End of the Mechanical Age*
(New York, 1968), p. 101 (illus.); Horta
Wescher, *Collage* (New York, 1968), p. 177,
pl. 135; John Tancock, "The Influence of Marcel
Duchamp," in Anne d'Harnoncourt and
Kynaston McShine, eds., *Marcel Duchamp* (New
York, 1973), p. 163 (illus.); Delaware Art
Museum, *Avant-Garde,* p. 128, illus. p. 129

SCHAMBERG's PAINTED MACHINES (see no.
430) carried no overtones of humor or irony,
but his one sculpture was perhaps the most
irreverent object produced in Philadelphia
during the first decades of this century.
The international circle of artists and writers
who gathered in the New York apartment
of Louise and Walter Arensberg between
1915 and 1921 was largely responsible for
the phenomenon of "New York Dada," and
Schamberg could claim the distinction of
being the sole delegate from Philadelphia
(Man Ray having moved away from the city
at the age of seven). Duchamp, Man Ray,
and Francis Picabia were the leaders of the
new movement, staging outrageous events,
publishing short-lived little magazines (*The
Blind Man, TNT*), and producing works of
art calculated to baffle, perhaps even outrage,
the public.

The most obvious model for Schamberg's
God was Duchamp's contribution to the first
exhibition of the jury-free Society for
Independent Artists in 1917: a gleaming
white urinal, turned upside down, signed by
the artist and entitled *Fountain*. While
Fountain constituted an act of provocation

438.

515

to the organizers of the exhibition (both Duchamp and Schamberg were members of the board), Schamberg's *God* has no such public history—indeed, we know very little about its creation. Legend has it that Schamberg was assisted in his venture into sculpture by that remarkable personality, the Baroness Elsa von Freytag Loringhoven (1874–1927), a German-born Dadaist who managed to set the New York avant-garde art world agog with her escapades. Just how she might have "assisted" Schamberg is unclear: certainly the juxtaposition of the plain wooden miter box with the rather gracefully convoluted plumbing trap is a visual idea very akin to Schamberg's precise, elegant style in painting. (The Baroness's own constructions were much more elaborate: her *Portrait of Marcel Duchamp* was a fantastic concoction of cogwheels, springs, wires, and feathers.)

The creation of a sculpture by bringing together two simple, disparate, apparently incongruous elements was a bold gesture for 1917, prophetic of the assemblages of the 1950s. Schamberg made several photographic studies of *God* (dated 1917 and 1918) with the plumbing trap posed in different positions, and it seems clear that he thought of the work as an abstract combination of forms as well as the expression of a Dadaist intent to shock. The often quoted unsigned statement in *The Blind Man* (no. 2, May 1917), attributed to Duchamp, serves to express an attitude at once debunking and admiring toward the machine age in this country: "The only works of art America has given are her plumbing and her bridges." Duchamp's intention in his *Fountain* was to create a "new thought" for a familiar object; Schamberg characteristically seems more interested in using familiar objects to derive a new formal composition.

Ad'H □

J. E. CALDWELL & CO. (EST. 1848)
(See biography preceding no. 307)

439. *Coffee Set*

c. 1917
Mark: J. E. CALDWELL & CO./STERLING/ 475 □/¾ PINT/W (bottom each piece); griffin with raised paw on oval surrounding letter (pseudo-mark)
Inscription: C.J.R. (engraved in block letters on side each piece)
Silver
Coffeepot height 7″ (17.8 cm), width 8⅝″ (21.9 cm), diameter 5⅛″ (13 cm); cream pot height 2¾″ (6 cm), width 5¼″ (13.3 cm), diameter 3¾″ (9.5 cm); sugar bowl height 3¾″ (9.5 cm); width 6¼″ (15.9 cm), diameter 4⅛″ (10.5 cm)

Private Collection

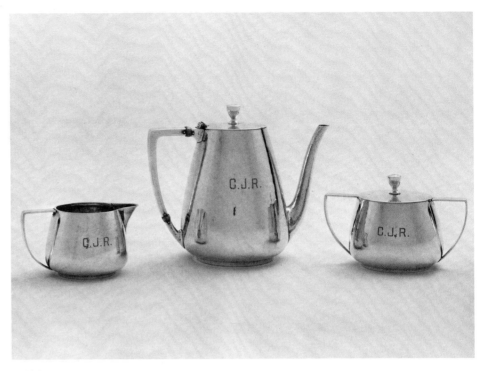

439.

PROVENANCE: Caroline Johnston Ramsey (Chandler)

AMONG THE REFORMS engendered by the Arts and Crafts movement in the late nineteenth century was the revival of the art of hand-wrought silver. Except for a few firms and individual craftsmen this art had almost been lost with the large quantities of silver plated ware produced by mechanical means in the nineteenth century. The technique of raising silver using primarily handwrought methods was taught in various art schools in Boston, New York, Chicago, Philadelphia, and other cities; classes in metalwork were taught at the Pennsylvania Museum and School of Industrial Art. The result was that there were in the early twentieth century a number of fine individual craftsmen and shops in Philadelphia and other cities. The interest in making handwrought objects also spread to the home, and it became fashionable for women to take classes in metalwork.

Large retail firms such as J. E. Caldwell in Philadelphia began to include handwrought lines in their stock, such as this set which was acquired on the occasion of the marriage of Caroline Johnston Ramsey to Alfred D. Chandler on March 5, 1917. (Mrs. Chandler recalled picking out a set which was different from the silver chosen by her contemporaries.) Although much of Cald-well's silverware in the early twentieth century was an adaptation of eighteenth and early nineteenth century designs, this hand-wrought set is distinctly modern in design. Its method of production is emphasized by the telltale hammermarks in the arts and crafts manner.

The maker, whose minute touchmark appears with the Caldwell mark, has not been identified. Although much of Caldwell's late nineteenth and twentieth century American silver was made by Gorham & Co., of Providence, Rhode Island, they did sell some Philadelphia-made silver as well. Since most of Caldwell's records were apparently destroyed, knowledge of the firm's practices and history during this period is scant. According to Eugene Zueigle who worked for Caldwell's, the silvermaking shop had been discontinued by the late 1940s and work was subcontracted to the Keystone Silver Company of Philadelphia at that time.

DH □

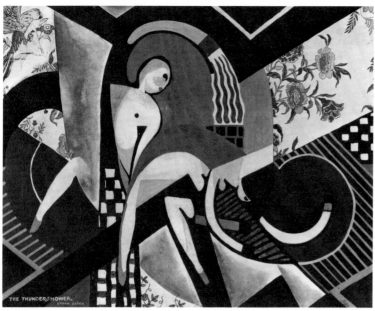

440.

H. LYMAN SAŸEN (1875–1918)
(See biography preceding no. 428)

440. *The Thundershower*

1917–18
Inscription and signature: THE THUNDER-
SHOWER/LYMAN SAŸEN (lower left)
Tempera and pencil on plywood
36 x 46″ (91.4 x 116.8 cm)

National Collection of Fine Arts, Smith-
sonian Institution, Washington, D.C.
Gift to H. Lyman Saÿen to His Nation

PROVENANCE: The artist; daughter, Ann Saÿen,
Philadelphia; given to the National Collection
of Fine Arts, 1967

LITERATURE: New York, Grand Central Art
Galleries, *Second Annual Exhibition of the
Society of Independent Artists* (April 20—May
12, 1918), no. 677 (illus.); Gustav Kobbe,
"Independent Artists Make Art Safe for Democ-
racy . . . ," *New York Herald,* April 21, 1918,
p. 8 (illus.); James B. Townsend, "Independents'
Art Show," *American Art News,* vol. 16, no. 29
(April 27, 1918), pp. 1–2; C. L. Bonte, "In
Gallery and Studio," *Philadelphia Inquirer*
November 11, 1928; NCFA, *H. Lyman Saÿen,*
by Adelyn D. Breeskin (September 25—
November 1, 1970), no. 32; pp. 27–28, illus. p.
17; NCFA, *Pennsylvania Academy Moderns,*
by Adelyn D. Breeskin (May 9—July 6, 1975),
no. 34, illus. p. 30

THIS BOLDLY DECORATIVE and high-spirited
composition was painted specifically for
entry in the second exhibition of Society of
Independent Artists in the spring of 1918.
It was to be Saÿen's last important work: he
journeyed to New York to see *The Thunder-*

shower hung at the exhibition preview, and
shortly after his return to Philadelphia, died
at the age of forty-three. Like most of
Saÿen's oeuvre known to survive, this paint-
ing remained in the artist's family and was
not exhibited until more than forty years
after its inclusion in the memorial show in
1928. *The Thundershower* constitutes a
remarkable breakthrough for an American
artist in 1918, and remains a tantalizing
indication of the direction Saÿen's art
would have taken had he lived.

Together with a series of cubistic studies
of his daughter in a rocking chair done at
the same time (also in the National Collec-
tion of Fine Arts), *The Thundershower*
marks a crucial shift in Saÿen's style. The
brilliant Fauve colors and vigorous, almost
rough brushwork of his Huntingdon Valley
landscapes (see no. 428) have been replaced
by strong black lines and curves and a flat,
decorative pattern. In a smaller gouache
study for this picture, exhibited in the annual
watercolor exhibition at the Pennsylvania
Academy in 1917 and now in the National
Collection of Fine Arts, Saÿen was surely
one of the first in Philadelphia to introduce
the element of collage, using sections of
delicately flowered wallpaper. The final
version takes a leaf from Synthetic Cubism,
and the apparent collage proves to have been
minutely painted by hand.

Saÿen's prolonged exposure to current art
in Paris and his knowledge of and admira-
tion for Matisse have been thoroughly
absorbed into the sophisticated yet playful
assurance with which he juxtaposes the
formal elements of his composition. Matisse's
paintings of 1911–16, some of which Saÿen
could have seen in the nearby collection of

Dr. Albert C. Barnes, may provide the closest
source for the graceful arabesques and the
drastic simplification of the figures; but Saÿen
had recently also become deeply interested in
the bold designs of American Indian weaving
and pottery. Perhaps the effective simplicity
of the picture owes something as well to the
artist's experience with stage design in 1917,
when he executed four large abstract back-
drops for an artists' masque at the Philadel-
phia Academy of Music. The type of com-
position of *The Thundershower,* as well as
its theme, may have been suggested to Saÿen
by his backdrop entitled "The World of
Rain and Sun," which depicted the vivid
spectrum of a rainbow arching between
abstracted hills and the cloud-covered disk
of the sun. (For a description of the decor
of the masque see *The Boston Evening
Transcript,* February 24, 1917, pt. 2.)

Saÿen's original mingling of European
and American elements produced a remark-
ably fresh style, with a note of humor
underlined by his inscription of the title on
the face of the painting. It has been sug-
gested that this was a witty response to the
disgruntled reviewer of his second one-man
show, who complained that the works were
"futuristic in tendency, puzzling to the
critics for the most part, yet no doubt
interesting if the artist could transmit a mes-
sage as to his intent" (*American Art News,*
January 15, 1916, p. 3). Like Duchamp's
lettering on his *Nude Descending a Stair-
case* five years earlier, Saÿen's title creates as
much mystery as it appears to dispel. The
visible effects of the thundershower are
reduced to curved and jagged rhythms, and
one is left in doubt as to the allegorical roles
of the two charming female figures who
disport themselves among forms that can be
variously read as rain, lightning, and clouds.

Some sixty years after its critical reception
by the *American Art News* (April 27, 1918,
p. 1) as one of the "freaks" in the Indepen-
dents' show, *The Thundershower* remains
oddly innovative and quite distinct from the
more purely Cubist ventures of Saÿen's
Philadelphia contemporaries Demuth and
Sheeler. The daring attempt to combine the
sophisticated lessons of Matisse with ele-
ments of design native to America makes
one regret that Saÿen's most idiosyncratic
painting was also his last.

Ad'H □

DANIEL GARBER (1880–1958)

Born in North Manchester, Indiana, the son of a Pennsylvania farmer, Garber returned to his father's place of origin to embark upon a long career as one of the best known and most popular of the "New Hope" group of landscape painters. His first art training was at the Cincinnati Art Academy in 1897. If he did not actually study with Frank Duveneck, who is not listed as a member of the faculty until 1900, Duveneck's vivid landscapes of the late 1890s may nevertheless have influenced him. From 1899 to 1905, Garber studied at the Pennsylvania Academy where he was taught by Thomas Anshutz. During that time he conceived a great admiration for J. Alden Weir, whose version of Impressionism—modified by a traditional attention to draftsmanship and well-organized composition—remained a model for Garber throughout his life. In 1905 he won a Cresson Travelling Scholarship, and after his marriage to Mary Franklin, a fellow Academy student, they set off for two years in England, Italy, and Paris. Upon their return, the couple settled in Lumberville, a little town in the Cuttaloosa Glen of the Delaware Valley in Pennsylvania. In 1909, Garber won the coveted First Hallgarten Prize at the National Academy of Design with his *Melting Snow*. In the same year he joined the faculty of the Pennsylvania Academy, where he was to teach for forty-two years both in the city and at the Academy's summer school in Chester Springs. A regular routine was soon established of winters in Philadelphia at 1819 Green Street (until 1930) and summers in Lumberville, where Garber spent long hours painting out-of-doors.

Unlike his neighbor Edward Redfield, who painted gray days and snowbound hills with gusto, Garber preferred effects of sunlight, and his landscapes have a lyricism and charm quite foreign to Redfield's vigorous work. Distant views of wooded hillsides and an abandoned quarry alternated in Garber's paintings with more decorative compositions in which foreground trees create graceful arabesques against a sunlit backdrop. In 1918, on the occasion of his one-man show at the Philadelphia Art Alliance, Garber's colleague Yarnall Abbott described his work as "poetic realism. . . . His canvases are rarely organized in the sense that one applies the word to Constable, and as the modernists insist it should be applied to Cézanne. Rather are they open windows through which one looks into a smiling countryside" (*Philadelphia Inquirer,* November 1918, Garber family archives). Friendly with Redfield, N. C. Wyeth, and the sculptor Albert Laessle, Garber was relatively conservative in his teaching at the Academy, balancing the more mod-

ernist orientation of Hugh Breckenridge and Henry McCarter. The critic Henry McBride detected an increasingly intellectual quality in Garber's style around 1919 but continued to set him clearly apart from more avant-garde developments: "He distinguishes himself from Charles Sheeler by disguising his geometry and mathematics under enough of his former approved manner to quite put those who have no taste for geometry off the track" (*New York Sun,* March 12, 1919).

Garber exhibited steadily at the large national exhibitions held at the Corcoran Gallery of Art, the Art Institute of Chicago, the Pennsylvania Academy, and the National Academy of Design (which elected him a member in 1913), and his paintings were purchased by museums across the country. He also showed frequently with the Milch and Macbeth galleries in New York, either singly or with other New Hope painters such as Robert Spencer, William Lathrop, and Joseph Pearson. He won many national prizes, including a gold medal at the Panama-Pacific International Exposition in San Francisco in 1915 (see PAFA, *Daniel Garber Retrospective Exhibition,* April 3–29, 1945, for a listing of awards). Around 1915–17, Garber taught himself etching, and one-man exhibitions of his prints and drawings were held at the Corcoran Gallery in 1930 and 1940.

In 1926 he was commissioned to paint a large landscape mural for the Pennsylvania Building of the Sesqui-Centennial Exposition, in which he also showed six paintings and ten etchings. During the 1930s, Garber's paintings grew increasingly bright in color—vivid oranges, blues, and greens predominating—and less directly naturalistic in feeling, although he continued to paint out-of-doors. In the 1940s he suffered a heart attack, virtually ceasing work during the last eight years of his life. The Pennsylvania Academy organized a retrospective exhibition of 139 works in 1945, and he was elected to the American Institute of Arts and Letters in 1948. A file of clippings about Garber and the artist's record book of his works are preserved by his family.

441. *The Orchard Window*

1918
Signature: DANIEL GARBER (bottom center)
Oil on canvas
52 x 56″ (132 x 142.2 cm)
Private Collection

PROVENANCE: Estate of the artist

LITERATURE: PAFA, *114th Annual* (1919), no. 190 (illus.); *Public Ledger,* February 9, 1919, p. 10

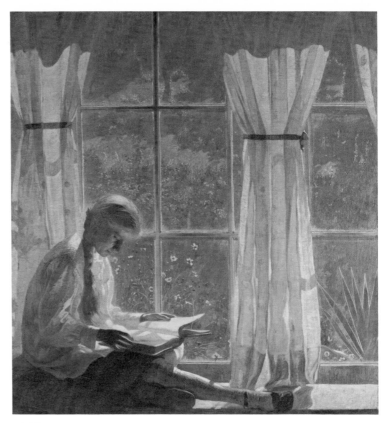

441.

518

(illus.); Eugene Costello, "The Pennsylvania Academy's Annual Exhibition," *The American Magazine of Art,* vol. 10, no. 6 (April 1919), illus. p. 210; NAD, *96th Annual* (1921), no. 54; Gardner Teall, "In True American Spirit, The Art of Daniel Garber," *Hearst's International* (June 1921), pp. 28, 77, illus. p. 28; Washington, D.C., Corcoran Gallery of Art, *Summer Exhibition of Works by Painters and Sculptors of Philadelphia and Vicinity* (June 3—September 15, 1922), no. 23

WHILE THE GREATER NUMBER of his paintings were devoted to study of the trees and hillsides of the Delaware Valley, Garber's large figure compositions were among his most popular works and played an important role in his art. His subjects were almost invariably close friends or family members, painted in familiar surroundings. His wife, Mary, and their children, John and Tanis, served as his most frequent models. His first major figure piece was *The Studio Wall* of 1914 showing Mary Garber standing in profile in a long silk robe before a white wall tinted violet by the sun coming through a Gothic window. Three young Academy students posed for *The Boys* of 1915, which won the First Altman Prize at the National Academy of Design. The last important work in the series—and the largest—was *Mother and Son* (Pennsylvania Academy of the Fine Arts), a tranquil scene of the pair playing chess, which won the Popular Prize at the Carnegie International in 1933.

Tanis Garber, who was born in 1905, was the subject of several of her father's most widely reproduced paintings: *Tanis* (1915), *The Orchard Window,* and *South Room, Green Street* (1921). In *Tanis,* the child pauses in the open doorway of the studio, with the sun glowing in the garden behind her and one hand resting on the doorframe, which is inches away from the edge of the picture. Garber repeated this device with great success in *The Orchard Window* three years later. The viewer looks past the reading girl, through curtains rendered translucent by sunlight, into the vista of a flower-filled garden which slopes up steeply, allowing no view of the sky whose brilliant blue we can only imagine. Garber's love of sunlight effects is never more directly expressed than in this scene of domestic felicity, its charm undiminished by the faint awkwardness in the painting of the little girl in her pigtail and smock. The decorative aspect of Garber's "tapestried" landscapes is here frankly intensified, and we are reminded that Garber was perhaps as close in feeling to the tradition of Howard Pyle and his students in the valley of the Brandywine as to the rough and ready naturalism of Redfield, his neighbor along the Delaware. Garber admired the paintings of N. C. Wyeth, and J. Nilsen Laurvik pointed out Garber's affinity to contemporary illustration

in his remarks on American landscape painters in the Catalogue de Luxe to the Panama-Pacific Exposition of 1915: "In the landscapes of Daniel Garber reality is endowed with a decorative quality by the very simple, though none the less surprising, expedient of accentuating the forms and colors of nature which, but for this accentuation, remain as photographically true to reality as is the decorative realism of Maxfield Parrish" (vol. 1, p. 23).

The Orchard Window won the Temple Gold Medal when it was exhibited at the Pennsylvania Academy Annual of 1919. The winner of the Stotesbury Prize in the same exhibition was Arthur B. Carles's homage to war-torn France, *La Marseillaise* (Philadelphia Museum of Art). Carles's powerful canvas reflects the disruptions of World War I, and its uneasy juxtaposition of an allegorical figure with a tenebrous, abstracted background suggests the painter's own struggle with modernism, while Garber's radiant window attests to his tranquil continuation of a naturalist tradition.

Ad'H □

JOSEPH PENNELL (1857–1926)

Son of Larkin and Rebecca Barton Pennell, Joseph Pennell was descended from an old Philadelphia Quaker family. His earliest years were spent in the city center, but in 1870 the family moved out to the Germantown area where he attended Germantown Friends School. The rudiments of etching were here introduced to Pennell by Joseph Ropes, who supported and encouraged the young man's enthusiasm as did his father. Art was innovatively accepted as part of the scholastic discipline although approved of neither as a means of expression nor as vocational training. Pennell graduated from Germantown Friends in 1876 and moved into a clerkship in a coal company office. At night he continued his studies at the newly established School of Industrial Art (now the Philadelphia College of Art), but he was soon expelled because his class attendance records reflected his distaste for various educational methods. In 1879 he was admitted to the Pennsylvania Academy from which he had earlier been rejected.

During this formative period two men played important roles in Pennell's life. Stephen Ferris, one of the few American artists working in the tradition of the painter-etcher (as distinguished from the reproductive engraver) then renascent in Europe, encouraged Pennell's use of the etching medium; and James L. Claghorn, president of the Pennsylvania Academy and one of the country's foremost print collectors, introduced him to the prints of early masters as well as those of contemporary artists.

In 1880, Pennell, along with seven others, founded the Society of Etchers in Philadelphia. By 1886 he was also a member of the New York Etching Club and the Society of Painter-Etchers in London.

To support himself, Pennell sought illustration commissions. At this time illustrators were sent far and wide to do their work. Pennell's eye was well tuned to grasp the picturesque, and he had the sensitivity, understanding, and ability to portray the essence of a place. His rapid success as an illustrator and his sustained difficulty with institutionalized art education contributed to his withdrawal in 1880 from the Academy and the establishment of his own studio in a Chestnut Street building, which also housed the studios of Cecilia Beaux and Stephen Parrish.

In 1884, Pennell married the writer Elizabeth Robins, and the two were often to work in collaboration. Almost immediately after their marriage, the Pennells moved to England and spent most of their time abroad until 1917, when they returned to the United States. Pennell was prolific as both an artist and a writer. He wrote, illustrated, or wrote and illustrated approximately one hundred books and produced a number of articles and illustrations for periodicals such as *The Savoy* in England and the *Century* in this country. Elected to various artists' societies in this country, England, and on the Continent, Pennell was awarded numerous medals at the then popular international expositions. While living abroad, he taught at the Slade School in London and lectured throughout England. "Draw, draw, draw, first last and all the time," he admonished his students (Joseph Pennell, *The Illustration of Books,* London, 1896, p. 13).

From 1917 to 1921, when they moved to Brooklyn Heights where they remained until Joseph's death, the Pennells lived in Philadelphia. Bibliophile admirers in the city formed the Pennell Club of which he was president; the club sponsored the publication of several books including a transcription of a Pennell lecture entitled *Aubrey Beardsley and Other Men of the Nineties.* Pennell lectured with messianic zeal on subjects ranging from etching techniques to the ruination of the American landscape by billboards. He was always audacious, opinionated, and outspoken. During the last four years of his life he taught etching and instituted a course in lithography at the Art Students League in New York. Also, during these years he wrote his autobiography, *The Adventures of an Illustrator,* and did numerous pastels, watercolors, and oils. These were not exhibited during his lifetime and remain less familiar. For him they were the result of recreation rather than work.

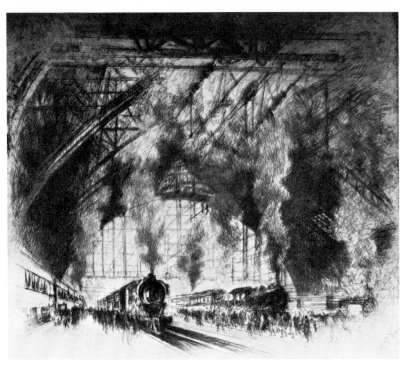

442.

Joseph Pennell is buried on the grounds of the Friends Meetinghouse in Germantown. Within two years of his death, four major memorial exhibitions of his work were held: one in Philadelphia at the Pennsylvania Museum (at Memorial Hall), two in New York, and one in Washington at the Library of Congress. His generous gift to the Library of Congress of his collection of Whistleriana and the bequest of his print collection and substantial funds to augment the Library's collection of modern prints have been an enormous resource for the Department of Prints and Photographs of that institution and the print scholars and connoisseurs who work there.

442. *The Trains That Come and the Trains That Go*

1919
Signature: JPennell imp. (in pencil, in margin, lower center)
Etching printed in brown on cream color wove paper
10 x 11^{15}⁄$_{16}$″ (25.4 x 29.8 cm)
Philadelphia Museum of Art. Given by John F. Braun. 29-61-74

LITERATURE: Philadelphia, Memorial Hall, *Memorial Exhibition of the Works of the Late Joseph Pennell* (October 1–31, 1926), no. 827; Library of Congress, *Joseph Pennell Memorial Exhibition,* (1927), no. 183; Louis A. Wuerth, *Catalogue of the Etchings of Joseph Pennell* (Boston, 1928), no. 712

THE CAVERNOUS INTERIOR SPACE of the Furness, Evans and Company addition of 1892–94 to the Pennsylvania Railroad Station at Broad and Market streets provided the subject for *The Trains That Come and the Trains That Go*. The train shed, at one time the largest in the world, measuring 707 by 306 feet and enclosing sixteen tracks, was destroyed by fire in 1923. It had stood as "an architectural symbol of a national institution" (see PMA, *The Architecture of Frank Furness,* April 5—May 27, 1973, pp. 180–83; Edwin P. Alexander, *The Pennsylvania Railroad,* New York, 1947, p. 85). Railroads received much attention from Pennell during his career. Among the many images of railroad-related subjects, reflecting Pennell's extensive rail travel between Philadelphia, New York, Washington, and Chicago, are more than thirty etchings published in 1919, one of which is this Philadelphia railroad station print.

Pennell's comments about the Philadelphia train shed illuminate our understanding of his response to his subject.

Arch upon arch and tower upon tower it piles up as fine as anything abroad . . . the most pictorial train shed in the world . . . and when it is on a spring or fall day filled with the trains that come and that go . . . and the smoke and steam that comes from them is amazing . . . half the station

is steam and half power . . . but the effect is now superb, when steam is banished from the railroads and smoke from the factories . . . the few artists in the country will leave the land . . . herded before the closed gates [the commuters] squirm and struggle or stand subdued . . . but over all the smoke curls and swirls and the sun in the late afternoon streams in and turns the station to glory, transfigures even the commuters. (Louis A. Wuerth, *Catalogue of the Etchings of Joseph Pennell,* Boston, 1928, nos. 705, 710, 712, 718)

Pennell's image confirms his words. It is with the grandest results of man's imagination that Pennell is impressed; his disdain for the evidence of a humdrum daily existence is also apparent. He is most at ease and most decisive in his delineation of the architectural limits of the massive interior space. His visualization of the shed's arched trusses and their supporting members as well as the body span for the railroad's electrical catenary system is clear, powerful, and dramatic. His years of experience in describing buildings and his passion for the monumental are manifest. The towers of smoke being funneled from the locomotives establish the quality of the atmosphere while the repetitively drawn stick-like figures of the commuters suggest activity but are of less specific formal interest to Pennell. One imaginatively reads figures into the accumulations of marks which convey an impressionistic vision of the crowd.

The etching revival of the 1850s and 1860s in France and England helped to generate an interest in America in the 1870s in the art of the painter-etcher. A pivotal figure with connections in all three countries was James Abbott McNeill Whistler. For Pennell, only two great etchers had ever lived—Whistler and Rembrandt, with Rembrandt in distinctly second place. The direct influence of Whistler is seen throughout Pennell's oeuvre, most particularly in his etchings. As Whistler's style moved from explicit to implicit description of a scene, so moved Pennell's, although the latter was never able to reach the descriptive selectivity championed by Seymour Haden, espoused by Pennell, but seen in the work of Whistler alone. However, Pennell did attain the Whistlerian quality of spontaneity. As his ease with the etching needle increased, the spontaneity, always present in Pennell's drawings, became increasingly evident in his etchings as well, and paralleled his developing impressionistic style.

His method of making etchings was in fact quite direct. "He chooses his place . . . and stands there quite undisturbed by the rush of passersby or by the idlers who stand and stare. . . . Taking quick glances at the scene . . . he rapidly draws his lines with the etching needle upon the copper plate . . . he

never hesitates one instant in selecting . . . some vital line of the picture" (Frederick Keppel, *Joseph Pennell: Etcher, Illustrator, Author,* New York, 1907, pp. 33–39, reprinted from *The Outlook,* September 23, 1905). An etching plate so made, when printed, would yield a mirror image of the scene, but this never disturbed Pennell.

Pennell was passionately involved with the mysteries of the etching process. The drawing, the biting, the printing, were all a part of what he called a "delightful slavery." Whenever possible, he preferred to print his own etchings in his home workshop. Most likely, however, this etching was printed at the Peters Brothers shop (printers for John Sloan) in Philadelphia.

Like Whistler, and Rembrandt before him, Pennell experimented with the possibilities of plate tone, and impressions of his images vary greatly. This impression is carefully wiped to enhance the details of the massive dramatic structure as well as the smoky atmosphere. In addition, the use of retroussage (the pulling of ink from the lines onto their surrounding surface) augments this atmospheric quality. Pennell pulled proofs, made changes on the plate, pulled further impressions, and so forth. He felt the recording of such changes was of little interest to anyone. The catalogue of his etchings adhered to his wish for meager documentation, and we do not know exactly how many states of his prints exist. We can confirm, however, that *The Trains That Come and the Trains That Go* is known in more than one state. Pennell, like Whistler and in the tradition of Rembrandt, accumulated a supply of fine antique handmade papers of various textures, tonalities, and weights. The edition of probably seventy-five impressions of this print (according to Wuerth) is likely to have included impressions on different papers as well as with variant inkings. The warm brown ink used here was, at this time, a characteristic of many original etchings in contrast to the black ink used for prints which reproduced paintings.

Employing the techniques of mezzotint, aquatint, and drypoint, as well as line etching, Joseph Pennell produced more than nine hundred etchings, six hundred lithographs, and countless drawings and paintings.

RFL □

BEATRICE FENTON (B. 1887)

The daughter of the distinguished eye specialist Dr. Thomas H. Fenton, Beatrice Fenton has lived all of her life in Philadelphia, where many of her sculptures have been commissioned for private collections and public parks and buildings. Studying at home until the age of sixteen, she conceived the desire to become an animal painter in the manner of Rosa Bonheur, and spent much time sketching at the Philadelphia Zoo. Dr. Fenton showed his daughter's drawings to Thomas Eakins, who suggested that she take up sculptural modeling to strengthen her work and give her drawn figures more solidity, and his advice was to alter radically the direction of her career. (Eakins painted portraits of her father and herself in 1904.)

Miss Fenton studied at the Museum School of Industrial Art for one year, receiving weekly criticism from Alexander Stirling Calder in modeling after antique casts. Although the school did not offer life classes in sculpture, she received permission to join the painting and drawing students to work from the living model. During the summer of 1904, she worked on sculptural studies of her father's horses, following Samuel Murray's advice on sculpting materials and the construction of a metal armature. That fall she enrolled in the Pennsylvania Academy and studied with Charles Grafly until 1912. One of a lively group of women, including Elizabeth Sparhawk-Jones and Alice Kent Stoddard, attending the Academy at this time, she and the sculptress Emily C. Bishop (1883–1912) persuaded Grafly to add composition and portrait classes to the sculpture curriculum. In 1908 she won the Academy's Stewardson Prize, and Cresson Travelling Fellowships awarded in 1909 and 1910 enabled her to travel in Europe with her friend the painter Marjorie Martinet. In 1911 she began to exhibit in the Academy's annual exhibitions. Many of her early works shown were portrait busts (her subjects including her father, Miss Martinet, and the painter Peter Moran), and in 1915 a group of three busts received honorable mention at the Panama-Pacific Exposition in San Francisco.

Miss Fenton's most popular and well-known works were a series of fanciful bronze fountain and garden figures, inaugurated by *Seaweed Fountain* in 1920. An exhibition of twelve works at the Philadelphia Art Club in 1929 was followed by her participation in a number of important national shows, including the open air sculpture exhibitions sponsored by the Fairmount Park Art Association at the Philadelphia Museum of Art in 1933, 1940, and 1949, and the New York World's Fair of 1939. Small life studies of athletes and dancers and sketches of animals at the zoo alternate in her oeuvre with portrait commissions and larger, more formal pieces including four limestone figures of children for the gateposts of Children's Hospital (1931), a bronze relief in memory of the poet Lizette Woodworth Reese in the Pratt Library, Baltimore (1942), and a sundial memorial to Mrs. Eli Kirk Price in Rittenhouse Square (1947).

After the death of Samuel Murray, Miss Fenton was asked by Emily Sartain in 1942 to take over his sculpture class at the Moore Institute and School of Design for Women (now the Moore College of Art), and she taught for eleven years, receiving an honorary degree in 1954. She is a member of the National Association of Women Arts, the National Sculpture Society, the Plastic Club, and the Philadelphia Art Alliance. In 1952 an exhibition of sixty-eight works was mounted at the Woodmere Art Gallery, and until ill health intervened she continued to work daily in her studio at 311 Duval Street in Mount Airy. In 1967 she was awarded the Percy M. Owens Memorial Prize for a distinguished Pennsylvania artist at the annual fellowship exhibition at the Pennsylvania Academy.

443. *Seaweed Fountain*

1920
Signature: Beatrice Fenton/©/sc-1920 (rear of base)
Inscription: BUREAU BROS/BRONZE FOUNDERS/PHILA. (at bottom of base)
Bronze
72 x 40 x 26½″ (182.8 x 101.6 x 67.3 cm)
Fairmount Park Commission, Philadelphia

443.

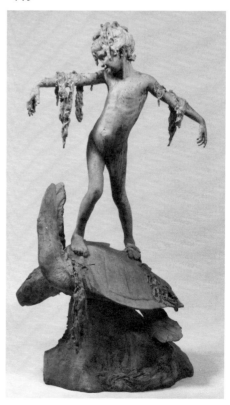

PROVENANCE: Commissioned by Edwin F. Keen in 1921 as a gift to the City of Philadelphia through the Fairmount Park Art Association

LITERATURE: FPAA, *Fiftieth Annual Report*, no. 60 (1922), p. 20, illus. p. 21; PAFA, *117th Annual* (1922), no. 506 (illus.); New York, National Sculpture Society, *Exhibition of American Sculpture* (April 14—August 1, 1923), p. 60 (illus.), p. 61.; Longstreth, *Art Guide*, p. 106; Philadelphia Sesqui-Centennial, illus. p. 86; Beatrice Gilman Proske, *Brookgreen Gardens Sculpture* (Brookgreen Gardens, S.C., 1968), p. 243, illus. p. 242; FPAA, *Sculpture*, p. 280 (illus.)

THE TRADITION OF DECORATIVE REALISM in bronze garden sculpture was relatively new in the United States when the *Seaweed Fountain* was awarded the Widener Gold Medal at the Pennsylvania Academy's annual exhibition in 1922. It was a genre taken up by a number of talented women, the first being Janet Scudder (1873–1940), whose *Frog Fountain* of 1901 attracted the attention of Stanford White in 1905. The later work of Bessie Potter Vonnoh (1872–1955) included many charming figures of children incorporated into fountains, and Harriet Frishmuth (born 1880), another Philadelphia-born sculptress, shared Beatrice Fenton's fondness for lithe dancers in park or garden settings. Miss Fenton's approach to outdoor sculpture was unusual in its blend of accurate anatomical detail and fanciful subject matter. As a student of Charles Grafly, she was a devoted participant in the life class and worked almost exclusively from the living model throughout her career.

Seaweed Fountain was her first attempt at an ambitious, life-size, ornamental sculpture, and she set about it with characteristic thoroughness. Working in her third floor studio at 1523 Chestnut Street, she posed a lively six-year-old child on a box, and borrowed a green turtle from the Aquarium at the Fairmount Waterworks to serve as a model for the girl's precarious perch. The child is gawky yet charming, posing in her seaweed festoons with all the coy bravado of one caught in the act of dressing up in her mother's clothes before a mirror. Her toes grip the turtle's back, and her stocky torso balances awkwardly atop thin and knock-kneed legs.

There is little precedent in Grafly's work for such unidealized treatment of youth, although his teaching stressed a thorough understanding of anatomy. Beatrice Fenton's departure from standard academic canons of grace and proportion in the human figure reminds us that Eakins was her early mentor. *Seaweed Fountain* represents an original adaptation of the realist aspect of Grafly's teaching. Nothing could be more remote in feeling from the polished, simplified, and classicizing work of Paul Manship, another Grafly student, whose graceful *Duck Girl*

444.

had won the same coveted Academy prize in 1914.

This first cast of *Seaweed Fountain* was installed in the pond at the foot of Lemon Hill in Fairmount Park in 1922, and in 1961 Miss Fenton was commissioned to create two additional groups of bronze angelfish for the same site. Three later casts were made of the original work, two in private collections in Providence, Rhode Island, and Spring Lake, New Jersey, and one in the remarkable complex of outdoor sculpture by 176 artists at Brookgreen Gardens, South Carolina. Other fountain groups followed over the years (*Fairy Fountain, Boy and Star Fish Fountain, Nereid Fountain*), and several are installed in Philadelphia gardens.

Ad'H □

CHARLES SHEELER (1883–1965)
(See biography preceding no. 427)

444. *Nude*

1920
Signature: Sheeler/1920 (upper right)
Conté crayon on paper
4 x 5⅛" (10.2 x 13 cm)
Private Collection

PROVENANCE: Earl Horter, Philadelphia

LITERATURE: University Park, Pennsylvania State University Museum of Art, *Charles Sheeler: The Works on Paper* (February 10—March 24, 1974), no. 13, pp. 55, 57, pl. 7

THE HUMAN FIGURE was a rare subject for Sheeler, despite his years of training at the Pennsylvania Academy under the aegis of so dashing a portraitist as William Merritt Chase. Indeed, it may have been the virtuosity of Chase's style that drove Sheeler, in reaction, to study the architectonic forms of landscape and buildings rather than the changing, expressive attitudes of his fellow human beings. It is typical of Sheeler's deliberate, thoughtful method of working that when he addressed himself to the nude figure it should take on the impersonal monumentality of a sloping hillside. Most probably Sheeler's approach to this drawing was suggested by his use of the camera, if not indeed based on an actual photograph. The technique of focusing on one area of the subject and cropping the remainder was familiar to him from his photography of architecture. The soft, curving volumes of the woman's body become elements as abstract as the white, wooden planks of a Pennsylvania barn (see no. 427b). A similar drawing of the same size is in the collection of the Art Institute of Chicago, and a published photograph by Sheeler comes so close to it that it seems certain to have served as the basis for the Chicago drawing (the photograph is reproduced in Charles W. Millard III, "Charles Sheeler, American

Photographer," *Contemporary Photographer,* vol. 6, no. 1, 1968, n.p.).

The intimate relationship of painting and drawing to photography in Sheeler's oeuvre has a powerful precedent in the work of Eakins, and it is fascinating to compare the nineteenth century master's *Nude Woman with a Mask* (no. 328), so compelling in its unglamorous humanity, with Sheeler's *Nude* where a somewhat grotesque exaggeration of the human form dissolves into a serene and rhythmic composition, sensuous but devoid of emotion. It can be assumed that Sheeler's first wife, Katherine Shaffer, posed for this and the other nude studies in drawings and photographs executed around 1920–24. An affectionate and precisely realistic portrait of her, which Sheeler drew in 1931 two years before her death, is preserved in a private collection.

Ad'H □

EARL HORTER (1883–1940)

Horter played an important role in introducing modern art to the artists and the public of Philadelphia, not only as an artist and a highly popular teacher but also as a collector. Growing up in Germantown, he gave evidence of unusual skill in draftsmanship by the age of fifteen but apparently never underwent any formal training in the fine arts. One of his first jobs was designing copperplate tracery for stock certificates in a commercial engraving firm. He had a successful career from 1917 to 1923 with the largest advertising agency in Philadelphia, N. W. Ayer & Sons, for whom he produced countless drawings in pencil or wash, including a long series for the Ticonderoga Pencil Company. He later turned to free-lance illustration in order to have time for his own work.

His early production was primarily in the field of etching, which he learned in part from James Fincken (whom he later succeeded as instructor at the Graphic Sketch Club). The prints of Whistler and Joseph Pennell served as major influences, and his favored subject matter was architecture, usually in a landscape setting. From 1915 until his death, Horter exhibited frequently in the annual Pennsylvania Academy watercolor exhibitions (in 1919, for example, he showed seven pencil drawings and ten etchings). He won a silver medal at the Panama-Pacific International Exposition in San Francisco in 1915, where four of his etchings were shown. During the 1920s and 1930s he became increasingly interested in painting with oils and watercolor (in 1924 he began to show in the Academy's painting annuals), and his later work reveals his knowledge of Cézanne, Seurat, and the Cubists. His knowledge came firsthand,

445.

since the financial success of his professional career enabled him to travel abroad and to assemble a remarkable group of avant-garde French paintings.

By 1934, when his collection was shown at the Philadelphia Museum of Art and the Arts Club of Chicago, it contained seventeen Picassos (including the important analytical Cubist *L'Arlésienne*), ten Braques, and Matisse's *Italian Woman* of 1915, as well as several works by Horter's fellow Philadelphians Arthur B. Carles and Charles Sheeler. He also owned Brancusi's marble *Mademoiselle Pogany* of 1910 and Marcel Duchamp's oil study for *Nude Descending a Staircase*. Horter's collection in his house at 2219 Delancey Place was readily accessible to artists and friends and added substantially to what could be seen of early modern art in Philadelphia at that time.

Horter and his good friends Carles, Henry McCarter, and Carroll Tyson were among seven artists from Philadelphia whose

work was exhibited at the Wildenstein Gallery in New York in 1927. The Philadelphia Art Alliance gave him a one-man show of watercolors in February 1936, and he exhibited at a number of galleries in the Philadelphia area. During the last two decades of his life he devoted considerable time to teaching: first at the Graphic Sketch Club, then at the Philadelphia Museum School of Art (1933–39) and the Tyler School of Art at Temple University. In addition, he gave frequent lectures and took on a number of private pupils. After his death at the age of fifty-six, the Philadelphia Art Alliance mounted a memorial exhibition of more than 150 works in November 1940; his old friend and fellow collector Samuel S. White wrote a tribute in the Alliance *Bulletin*. A more recent exhibition at the Art Alliance was held in December 1954.

445. *City Hall: Philadelphia*

c. 1920
Signature: E Horter (lower left center)
Pencil on paper
19½ x 14″ (49.5 x 35.6 cm)
Philadelphia Museum of Art. Purchased:
The Haney Foundation Fund. 72–25–1

PROVENANCE: Mrs. Earl Horter, Philadelphia;
with Harold Diamond, New York

LITERATURE: PAFA, *18th Annual Watercolor*
(1920), no. 369; *PMA Bulletin,* vol. 67, no. 308
(October—December, 1972), illus. inside back
cover

HORTER'S VISION of the 548-foot tower of
City Hall gives ample evidence of his bril-
liance as a draftsman and his ability to
absorb styles and techniques from other
artists without diminishing his own virtu-
osity. By 1920, Horter was thoroughly
familiar with the formal innovations of the
Cubists and their colleagues in Paris. Robert
Delaunay's views of the Eiffel Tower, in a
sequence of paintings, drawings, and etch-
ings executed between 1909 and 1914, serve
as the obvious model for this drawing.
Horter does not copy Delaunay's effects but
rather subjects the formidable Second
Empire structure of City Hall to the same
rigorous process by which the French
master dissolves the elegant iron tower into
a myriad shattered fragments.

Horter has chosen the view from South
Broad Street, where tall buildings provide
the City Hall tower with a narrow frame of
architectural elements. Sky and solid forms
interpenetrate each other, and the whole
scene is endowed with a sense of rapid
motion. Familiar details persist, to guide the
viewer through the disrupted space, from
the statue of William Penn to the clock
(which reads 11:40) down to the lamppost
by the great entrance archway. At the foot
of the building a rapidly sketched jumble of
cars and passersby suggest a futuristic Phila-
delphia rush hour.

Horter's skill in a borrowed style is
uncanny: ten years later he was to paint a
series of exquisite watercolors of American
industrial scenes (*Coal No. 1, Coal No. 2,
Power House*) with a cool Precisionism close
to that of Sheeler and Demuth (both of
whom he knew well) yet again made very
much his own. It must have amused this
urbane and talented artist to practice what
Delaunay called his "destructive" mode on
Philadelphia's most massive nineteenth
century monument, lending it a dynamic
and thoroughly modern aspect. *City Hall*
is a Cubist tour de force, and surely one of
Horter's most characteristic and dazzling
drawings.

Ad'H □

446.

CHARLES DEMUTH (1883–1935)
(See biography preceding no. 434)

446. *Incense of a New Church*

1921
Signature: C. Demuth/Lancaster, Pa.
1921 (on reverse)
Oil on canvas
25½ x 19¹³⁄₁₆″ (64.8 x 50.3 cm)
The Columbus (Ohio) Gallery of Fine
Arts. Gift of Ferdinand Howald

PROVENANCE: With Daniel Gallery, New York;
purchased, Ferdinand Howald, Columbus,
Ohio, 1923–31

LITERATURE: New York, Daniel Gallery, *Recent
Paintings by Charles Demuth* (December 1922—
January 2, 1923), no. 10 (illus.); New York,
Whitney Museum, *Charles Demuth Memorial
Exhibition* (December 15, 1937—January 16,
1938), no. 95 (illus.); Cincinnati Art Museum,
*A New Realism: Crawford, Demuth, Sheeler,
Spencer* (March 12—April 7, 1941), no. 13
(illus.); New York, Whitney Museum, *Pioneers
of Modern Art in America* (April 2—May 12,
1946), no. 30 (illus.); MOMA, *Charles Demuth*
(March 7—June 11, 1950), no. 114, p. 15; Milton
Brown, *American Painting from the Armory
Show to the Depression* (Princeton, 1955),
p. 115 (illus.); NCFA, *Roots of Abstract Art in
America, 1910–1930* (December 1, 1965—
January 16, 1966), no. 28 (illus.); Rose, *Ameri-
can Art,* p. 106, fig. 4–24; Columbus Gallery of
Fine Arts, *American Paintings in the Ferdinand

Howald Collection, by Marcia Tucker (1969),
no. 30, p. 24, illus. p. 28; Emily Farnham,
Charles Demuth: Behind a Laughing Mask
(Norman, Okla., 1971), pp. 16, 148, pl. 26;
Sam Hunter, *American Art of the 20th Century*
(New York, 1972), p. 120; Santa Barbara,
University of California Art Galleries, *Charles
Demuth: The Mechanical Encrusted on the
Living* (October 5—November 14, 1971), no. 75,
pp. 10, 19, illus. p. 51; Mahonri Sharp Young,
*Early American Moderns: Painters of the
Stieglitz Group* (New York, 1974), p. 60,
illus. p. 61

FROM HIS SECURE VANTAGE POINT in an
eighteenth century house in Lancaster, the
proliferation of heavy industry and its impact
on the American scene might well have
seemed a remote phenomenon to Demuth,
Yet this sensitive and elegant artist, trained
at the Pennsylvania Academy and initiated
into the latest aesthetic mysteries of Paris,
was one of the first American artists to take
up the theme of the industrial landscape.
Among Demuth's avant-garde contempo-
raries only Joseph Stella had begun to
explore the possibilities of industrial forms
(chimneys, furnaces, and storage tanks) for
a modernist style by 1920. Before his fellow
Academy student Charles Sheeler was to
tackle the subject in photographs and paint-
ings in the late 1920s, Demuth tried his hand
at the clean-cut forms of machinery and the
skeletal forms of factory buildings as an
alternative to his sensuous studies of vaude-

ville performers (no. 434). Lancaster itself provided views of grain elevators and warehouses; for the more formidable imagery of steel foundries Demuth had to venture farther afield. A penchant for wry titles seems to have accompanied Demuth's new subject matter from the first: one of his earliest paintings of towering smokestacks was *End of the Parade: Coatesville, Pa.* of 1920, and a solemn vision of the same subject painted in 1933, two years before his death, bears the prophetic legend "*After All*" With the rich midnight blue that dominates its color scheme, *Incense of a New Church* is Demuth's darkest image (both literally and figuratively speaking) of those satanic mills that sprang up across the Pennsylvania countryside. Possibly painted in Coatesville, some thirty miles east of Lancaster, this nocturnal vision of a great factory, chimneys spewing smoke, does suggest the awesome interior of a vast cathedral. The apparently bitter irony of the title conceals an element of admiration, which emerges more clearly in the swirling lines of the composition itself. Despite its relatively small size, *Incense of a New Church* is as powerful and dynamic a vision of America's secular religion as any that Demuth's compatriots were to produce.

Ad'H □

447.

ALEXANDER STIRLING CALDER
(1870–1945)

Alexander Stirling Calder was born in Philadelphia, the son of sculptor Alexander Milne Calder (see biography preceding no. 369). He attended public schools and entered the Pennsylvania Academy of the Fine Arts in 1886 at the age of sixteen, where he studied with Thomas Eakins and Thomas Anshutz. In 1890 he left for a period of study in Paris, first with Henri Chapu at the Académie Julian and then with Alexandre Falguière at the École des Beaux-Arts.

On his return to Philadelphia in 1892 he won the gold medal of the Philadelphia Art Club, was appointed an assistant instructor in modeling at the Pennsylvania Academy, and served on the Academy's jury of selection and hanging committee. Calder won his first commission about 1893, over his friend Charles Grafly, for a portrait statue of the eminent Philadelphia physician Dr. Samuel Gross, whom Eakins had portrayed in *The Gross Clinic* (no. 342), for the Army Medical Museum in Washington, D.C. In 1903 he began teaching at the Pennsylvania School of Industrial Art.

Calder's first national recognition followed his participation in the 1904 Louisiana Purchase Exposition in St. Louis when he served on the advisory committee for sculpture and won a silver medal for his statue of explorer Philippe François Renault. The next year he won the Pennsylvania Academy's Lippincott Prize. Around 1907 he moved to California and in 1910 to New York, where he took a teaching position at the National Academy of Design and later the Art Students League. After assisting Karl Bitter, who was in charge of the sculptural decoration for the Panama-Pacific Exposition of 1915, Calder assumed full responsibility on Bitter's death, and also contributed two grandiose sculptural groups, *The Nations of the East* and *The Nations of the West,* and a *Fountain of Energy.*

Although Calder remained in New York, he continued to exhibit at the Pennsylvania Academy and to receive Philadelphia commissions. His Swann Memorial Fountain was dedicated in Philadelphia's Logan Circle in 1924, and *Tragedy and Comedy,* a monument to Shakespeare, also in Logan Circle, won the Pennsylvania Academy's McClees Prize in 1932. Other well-known works by Calder include the sculptures for Viscaya in Miami, Florida, the figure of Washington for the Washington Arch in New York, and the statue of Leif Ericsson presented to Iceland by the United States in 1932. Calder was a member of numerous art societies, including the National Sculpture Society, the National Academy of Design, and the National Institute of Arts and Letters. He died in New York in 1945.

447. *Swann Memorial Fountain*

Logan Circle
1924
Bronze
Height of figures 132" (335.2 cm); granite base above pool bed 62" (157.4 cm)

REPRESENTED BY:

Seymour Mednick (b. 1927)
Swann Memorial Fountain
1974
Photograph

LITERATURE: Julian Bowes, "The Sculpture of Stirling Calder," *The American Magazine of Art,* vol. 16, no. 5 (May 1925), pp. 231, 234, 235, illus. pp. 229, 230, 232; Craven, *Sculpture,* p. 572, illus. p. 605; FPAA, *Sculpture,* pp. 230–39 (illus.)

THE ICONOGRAPHY of Alexander Stirling Calder's Swann Memorial Fountain deals with the principal waterways of Philadelphia, a most appropriate subject for any fountain and especially for one commemorating Wilson Cary Swann and located at Logan Circle. In 1878, Mrs. Maria Elizabeth

Swann bequeathed money to the Philadelphia Fountain Society, an organization dedicated to providing drinking water to both humans and animals, for a fountain in memory of her husband, a physician and the founder/president of the society. Lack of both adequate funds and a suitable site delayed the project until Jacques Gréber's design of 1918 for the Benjamin Franklin Parkway called for the enlargement of Logan Circle and the erection of a grand monument at its center. The architect Wilson Eyre, Jr. (see biography preceding no. 377), who was in charge of the overall conception of the fountain, realized the importance of maintaining the unbroken vista from City Hall to Fairmount Park, and designed the fountain with a wide, shallow basin and low figures on steps at the middle, allowing only the spouts of water representing the flow of the rivers to rise high in the air. As Logan Circle was at the confluence of great roadways, so was Philadelphia at the center of great rivers, and Eyre planned for the curving and interplaying jets of water to be seen at their best from the intersections of the surrounding streets with the circle.

Eyre suggested his friend Calder for the commission, and the contract for the work was signed on November 10, 1921. Despite the limitations of the site, the artist had sizable ambitions for the fountain, as he described: "When I make a statue for Philadelphia I want it to be as big and comprehensive as possible. I called the group in Logan Square 'The Fountain of Three Rivers'. . . . It was my fancy to imagine the three great decorative bronze figures as the rivers enclosing the city of Philadelphia. The Delaware represented by the male Indian, the Schuylkill (or gentle river) south of this, and the Wissahickon (or hidden creek) to the west" (in FPAA, *Sculpture,* p. 234). Reclining on scrolled cornices and designed to be seen most effectively in silhouette, the giant figures with their powerful profiles evoke images of Michelangelo's Medici Tomb figures, as well as classical river gods. Calder completed the figure of the Wissahickon first, in wax by March 1923, and in bronze two months later. The figure of a young woman, eyes downcast and toes pointed, rests calmly on its side, restraining with one hand an agitated, mute swan (a pun on the benefactor's name) which energetically shoots water toward the bronze frogs and turtles around the rim of the basin. The Delaware, cast in bronze by September 1923, is a great Indian figure, calm and majestic, holding up a water-spouting fish, symbol of the river's bounty. During several years in the Southwest, Calder had had ample opportunity to observe Indians and had sculpted them from life; however, it is not clear whether this figure is meant to be,

literally, a Delaware, or a member of the Iroquois or Cayuga tribes, after their chief, Logan, a friend and aide to James Logan for whom the Square was named. The third figure shows the Schuylkill as an older woman holding a large, flapping swan. Beneath her knees swims a catfish.

The Swann Memorial Fountain represents an important transition in the work of Calder who was fifty-one years old at the beginning of the project. After schooling in the French academic tradition and a career as a Beaux-Arts sculptor, he acknowledged here the validity of the style which was beginning to supersede his own in the twenties. The simplification and abstraction of natural forms evident in the Swann Fountain is an effective compromise between the neoclassical tradition and the then avant-garde styles of modern art. Labored detail of form was sacrificed in this sculptural composition to the power and overall unity of the image. Although his exploration of abstract art did not go much beyond what he achieved at Logan Circle the Swann Memorial Fountain remains as a testament to Calder's appreciation of the spirit of the modern age.

AS □

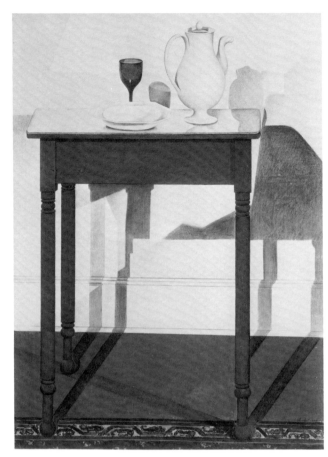

448.

CHARLES SHEELER (1883–1965)
(See biography preceding no. 427)

448. *Objects on a Table*

1924
Signature: Sheeler 1924 (lower right)
Black conté crayon, watercolor, and tempera on paper
31 x 21" (78.7 x 53.3 cm)
The Columbus (Ohio) Gallery of Fine Arts. Gift of Ferdinand Howald

PROVENANCE: With Daniel Gallery, New York; Ferdinand Howald, Columbus, Ohio, 1925–31

LITERATURE: " 'Living Art' Now on View," *Art News,* vol. 26, no. 11 (December 17, 1927), p. 4; Rourke, pp. 106–7, 110–11, illus. p. 73; MOMA, *Charles Sheeler* (October 4—November 1, 1939), no. 65, illus. p. 20; Los Angeles, UCLA Art Galleries, *Charles Sheeler: A Retrospective Exhibition* (October 1954), no. 8; Iowa City, University of Iowa Museum of Art, *The Quest of Charles Sheeler* (March 17—April 14, 1963), no. 26, fig. 9; NCFA, *Charles Sheeler* (October 10—November 24, 1968), no. 33, illus. p. 115; Columbus, Ohio, Columbus Gallery of Fine Arts, *American Paintings in the Ferdinand Howald Collection* (1969),

no. 166, pp. 102–3, illus. p. 104; University Park, Pennsylvania State University, Museum of Art, *Charles Sheeler: The Works on Paper* (February 10—March 24, 1974), no. 24, p. 56–57, illus. cover

DURING THE YEARS he intermittently occupied a house near Doylestown, Pennsylvania, Sheeler began to acquire examples of furniture and tableware from the surrounding region, which served both a practical function and as a source of inspiration to his art. (Sheeler's interest in collecting American decorative objects continued throughout his career: in 1962 he and his wife lent fifteen pieces of furniture to the exhibition *The Shakers: Their Arts and Crafts* at the Philadelphia Museum of Art.) Fascinated by simple shapes and functional design, Sheeler sought to make his pictures as solid in their construction as a well-made table or chair.

Objects on a Table is a remarkably complex work, and serves as a brilliant reminder that Sheeler was one of the most sophisticated American observers of Cézanne and Cubism as well as one of the first to appreciate the modernity of rural American craftsmanship. His remark that "the table is the result of all the things that are happening around it" (Rourke, p. 107) could serve as a paraphrase of one of Picasso's or Braque's rare statements about their Cubist investigation of the relationship of solid forms to surrounding spaces. Sheeler's Lancaster county table is subject to the disorienting effects of light and his comments about experiments in an earlier phase of his career seem apropos here: "Shadows [were] considered to be concrete forms as essential to the structure of the picture as the solids appearing in it" (AAA, Sheeler, Reel 1, Frame 67). Despite his apparent submission to perceived reality, Sheeler permits himself delightful liberties. The light operates at the artist's will: while the wine glass and the graceful teapot cast emphatic shadows, the octagonal plate is not obliged to do so, and the three visible table legs and their perversely invisible companion create an illogical but pictorially satisfying web of shadows shooting in all directions. The band of Oriental carpeting along the bottom edge is as neat a device as ever a Cubist devised for forcing a determinedly three-dimensional perspective back into the flat picture plane.

In its severe verticality and delicate blend of perceived reality and abstraction, *Objects on a Table* is the elegant, profoundly American counterpart of Braque's splendid series of *Gueridons* that were its exact contemporaries. Lent by Ferdinand Howald to the opening exhibition at A. E. Gallatin's Gallery of Living Art at New York University in 1927, *Objects on a Table* (also called *Still Life and Shadows*) has since been one of the most widely exhibited and popular of Sheeler's works.

Ad'H □

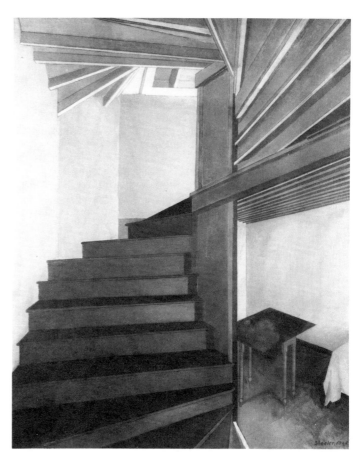

449.

CHARLES SHEELER (1883–1965)
(See biography preceding no. 427)

449. *Staircase, Doylestown*

1925
Signature: Sheeler, 1925 (lower right)
Oil on canvas
25⅛ x 21⅛" (63.8 x 53.7 cm)
Hirshhorn Museum and Sculpture Garden, Smithsonian Institution, Washington, D.C.

PROVENANCE: With J. B. Neumann's New Art Circle, New York; Matthew Josephson, Gaylordsville, Connecticut, 1930; with Robert Schoelkopf Gallery, New York, 1967; Joseph H. Hirshhorn, New York

LITERATURE: Lloyd Goodrich, "New York Exhibitions: Sheeler and Lozowick," *The Arts,* vol. 9, no. 2 (February 1926), illus. p. 96; Robert Allerton Parker, "The Classical Vision of Charles Sheeler," *International Studio,* vol. 84, no. 348 (May 1926), pp. 71–72; Samuel Kootz, *Modern American Painters* (New York, 1930), fig. 50; Ernest Brace, "Charles Sheeler," *Creative Arts,* vol. 11, no. 2 (October 1932), p. 100; Rourke, pp. 107–8, illus. p. 74; MOMA, *Charles Sheeler* (October 4—November 1, 1939), no. 15 (illus.); Los Angeles, UCLA

Art Galleries, *Charles Sheeler: A Retrospective Exhibition* (October 1954), no. 9, illus. p. 16; New York, The American Academy of Arts and Letters, *Works by Newly Elected Members and Recipients of Academy Honors* (May 25—June 17, 1962), no. 22; NCFA, PMA, and Whitney Museum, *Charles Sheeler,* by Martin Friedman, Bartlett Hayes, and Charles Millard (October 10, 1968—April 27, 1969), no. 43, illus. p. 38; Lerner, *Hirshhorn,* p. 746, fig. 388

THE PRE-REVOLUTIONARY HOUSE near Doylestown, Pennsylvania, which Sheeler and his colleague Morton Schamberg rented for summer weekends of sketching and painting, was the subject of some of Sheeler's most adventurous early work. They found the house in 1910 through Dr. Henry C. Mercer (see biography preceding no. 403), the distinguished archaeologist from the University of Pennsylvania who in the 1880s had the insight to turn his attention from Yucatan excavations to the artifacts of rural American folk culture. Dr. Mercer's collection of American arts and crafts was very much to Sheeler's taste, as was the simple, functional structure of his own rented retreat. In his draft for an autobiography written in 1938, Sheeler stressed the impact upon his art of the Doylestown years:

"Interest in early American architecture and crafts has, I believe, been as influential in directing the course of my work as anything in the field of painting. The way in which a building or a table is put together is as interesting to me, and as applicable to my work, as the way in which a painting is realized" (AAA, Sheeler, Reel 1, Frames 121–22).

Sheeler's drawings of Pennsylvania barns were some of the most elegant and abstracted works produced in Philadelphia between 1917 and 1918. The house itself was the subject of a series of twelve remarkable photographs (see no. 427a) exhibited in New York at Marius de Zayas's Modern Gallery in 1917. By 1925, when *Staircase, Doylestown* was painted, Sheeler had been settled in New York for six years, although he had only recently given up the house as a base for country weekends. The painting is one of the finest expressions of Sheeler's persistent search for order and structure in the visual world. The lucid organization of a detail of eighteenth century architecture becomes one with the painter's organization of his composition. While concentrating on a real and specific subject, Sheeler achieves an advanced degree of abstraction. Unessential detail is eliminated and his viewpoint is selected with a precision and attention to the "framing" edge derived from his use of the camera. "Two things are going on at the same time in the picture, irrelevant to each other but relevant to the whole, one in the room downstairs, one leading to the room upstairs. I meant it to be a study in movement and balances" (quoted in Rourke, p. 108). One of Sheeler's most exciting compositions, it compels the eye of the viewer to follow the twisting staircase in a continual, dynamic motion across the picture surface. The painting's reddish brown, yellow, and pink tones give it a warmth rare in Sheeler's somewhat cool and depersonalized idiom. But *Staircase, Doylestown* is less an affectionate portrait of a house long occupied than a summation of the lessons in the "secure underlying structure" of things that Sheeler owed to his summers in the Pennsylvania countryside.

Ad'H □

J. WALLACE KELLY (B. 1894)

One of the first sculptors in the Philadelphia area to experiment with abstract forms, Kelly was born in Secane, Pennsylvania, and moved to the city with his family at the age of nine. His training in the arts began with brief attendance at the Public School of Industrial Art, and in 1912 he entered the Pennsylvania Academy for five years. Studying sculpture with Charles Grafly, he received a thorough education in anatomy

and modeling from life. A Cresson Travelling Fellowship awarded in 1916 was postponed until 1920 due to World War I, in which Kelly served. The years 1920–22 were spent primarily in Paris, where he studied for a time with Antoine Bourdelle and exhibited two works (*Riveteur* and *Heater Boy*) in the Salon d'Automne of 1921.

Returning to Philadelphia after extensive travel in Europe and North Africa, Kelly undertook various commercial jobs to earn a living and designed figures for department store window displays. During the 1920s he executed a number of small abstract stone sculptures, and his friend the collector and artist Earl Horter (see biography preceding no. 445) was among the first to purchase his work and to encourage others to see it. Kelly and a fellow student from the Academy, Raphael Sabatini (born 1898), collaborated on a number of large projects to carry out sculptural programs for architects, among them the decorative scheme for Ralph Bencker's N. W. Ayer Building on West Washington Square in Philadelphia (completed in 1929). The design included massive carved stone figures at the top of the building and an elaborately detailed entrance lobby with bronze doors and ceilings carved with flocks of stylized birds in flight (see FPAA, *Sculpture,* pp. 244–45). Kelly and Sabatini were also involved with Paul Cret's commission for five reliefs in terra-cotta and limestone for the Central Heating Plant on Thirteenth Street, S.W., in Washington, D.C. (1933). During the 1930s, Kelly served as supervisor of the sculptural division of the Works Progress Administration in Pennsylvania, and his own commission for the Public Works of Art Project was a limestone figure representing *Labor (Unskilled),* now located in the East Court of the Philadelphia Museum of Art. He participated in the three large international sculpture exhibitions sponsored by the Fairmount Park Art Association at the Philadelphia Museum in 1933, 1940, and 1949, and his eleven entries in the 1933 exhibition already revealed the range of his interests. Several completely abstract, geometrical works were included, as well as simplified relief figures and two more ambitious projects (*Monument to Aviation* and *Monument to Radio*). Also in 1933, a carved stone sculpture was included in the First Biennial Exhibition of Contemporary American Sculpture, Watercolors and Prints at the Whitney Museum of American Art. In 1939, Kelly was among ten sculptors from Pennsylvania to have a piece chosen for exhibition at the New York World's Fair; and of the 256 entries his *A.D.H.* was one of the five purely abstract works. Along with Wharton Esherick's (see biography preceding no. 458) his entry in the international competition for a Monument to the Unknown Political Prisoner was among the

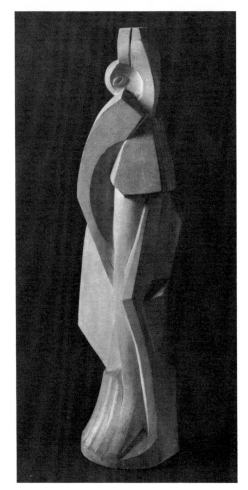

450.

models by ten United States semi-finalists to be shown in London in 1953.

Living first in Ardmore, Pennsylvania, and later in Newtown, Kelly and his wife, Caroline (a former Academy student and painter), have taught at a number of local institutions including Haverford College, Haverford Friends School, and the Fleisher Art Memorial and have given private classes at home. Kelly's work of the last three decades has been in a variety of modes and media, ranging from the simplified stone figure (1933) and entrance pylons (1959) for the Ellen Phillips Samuel Memorial in Fairmount Park, to an over-life-size realistic statue of *General Richard Montgomery* for the Reilly Memorial in Fairmount Park (1947), to a rather expressionist and emaciated bronze figure of *Moses* for the Samuel S. Fleisher Art Memorial (1952). In 1956 a one-man exhibition at the Philadelphia Art Alliance included many welded metal sculptures, often of religious subjects, as did his second exhibition there in 1964. Kelly received the Philadelphia Arts Festival Award for Sculpture in 1959 (at the same time that Andrew Wyeth won the award for Painting and Vincent Kling for Architec-

ture), and a retrospective exhibition of thirty-two pieces was held at the Woodmere Art Gallery in Philadelphia in 1969.

450. *Untitled (Standing Figure)*

1925
Signature: KELLY/25 (at rear on base)
Unpolished marble
21 x 5⅝ x 6″ (53.3 x 14.3 x 15.3 cm)
Miss Anna Warren Ingersoll, Penllyn, Pennsylvania

PROVENANCE: Purchased from the artist by the present owner, c. 1926

KELLY CARVED THIS SMALL but clearly conceived abstracted figure in 1925, three years after his return from Paris where he had been profoundly affected by the modernist work he had seen. Jacques Lipchitz and Alexander Archipenko were the dominant innovators in Cubist-derived sculpture at the time, although Kelly had little or no direct contact with either of them. His Cresson Travelling Fellowship from the Pennsylvania Academy had taken him abroad at the time of the first large exhibition of Lipchitz's Cubist bronze and stone sculptures at the Galerie de L'Effort Moderne in the spring of 1920, and by 1922 Dr. Albert C. Barnes had commissioned five large stone reliefs from Lipchitz for the facade of the building in Merion, designed by Paul Cret to hold his growing collection.

Aside from Barnes's interest in Lipchitz, Philadelphia was apparently not a favorable environment for the development of modern sculpture. Charles Grafly's classes at the Academy were producing skilled sculptors in a strong Beaux-Arts tradition: Albert Laessle's exquisitely detailed bronze animals and even Paul Manship's classicizing nudes were superb but scarcely progressive examples of American sculpture in the 1920s. John Storrs (1887–1956), who was also briefly at the Academy in 1910, was perhaps the sole Grafly student to pioneer in the field, but his early abstract work was all executed in Paris.

The Academy's 120th Annual exhibition early in 1925 presented a conservative view of American sculpture. Philadelphia contributions included a wooden bust portrait of R. Tait McKenzie by Boris Blai (born 1898), Laessle's bust of the painter Maurice Molarsky and his *Turtle Fountain,* a pair of decorative *Fighting Cocks* in polished bronze by George Biddle, and Grafly's scale model for the memorial to General George Gordon Meade (see no. 433). The works chosen for reproduction in the Academy catalogue were without exception naturalistic representations of the human figure, culminating in Malvina Hoffman's famous

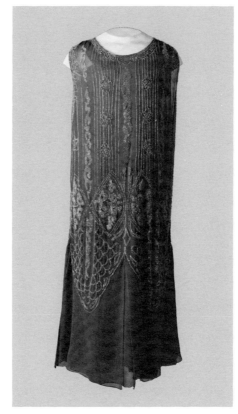

451.

head of *Anna Pavlova.* The prestigious Widener Gold Medal was awarded to a marble bust of a boy entitled *Toivo,* decorously carved in the manner of fifteenth-century Florentine portraiture by Walker Hancock (born 1901), who was to head the sculpture department at the Pennsylvania Academy from 1929 to 1967. Kelly did not exhibit at the 120th Annual, and in fact rarely exhibited his work in the Academy shows. Although his *Standing Figure* dates to a decade later than Lipchitz's first cubistic figures, it is by no means an uninventive imitation. Kelly's use of rounded shapes recalls Archipenko's curvacious abstractions of the female form, but his figure is less readily legible than Archipenko's rather simplistic images. The visual source for the sculpture was a Spanish dancer with the traditional veil and comb, whom Kelly had observed during his visit to Paris.

Despite the fact that Kelly in his later career did not fully explore the possibilities latent in this early work, a comparison with John Storrs is not inappropriate. Both men came rather late to abstraction, after considerable training in a naturalist tradition, and became involved with stylized architectural decoration during the 1920s and 1930s. Kelly's *Standing Figure* provides a provocative parallel to Storr's *Le Sergent de Ville* of 1923 (Corcoran Gallery of Art). Both artists adapted the simplified planes and

volumes of Cubism to their own purposes: Storrs to create a minor Cubist classic; Kelly to produce a more enigmatic form with elements of fantasy in the slanted eye and fluted base.

Ad'H □

451. *Dress*

1925
Magenta silk Georgette; trimmed with glass-seed and bugle beads and brilliants
Center back length 41″ (104.1 cm)
Philadelphia Museum of Art. Given by Miss Adeline Edmunds. 73–110–a, b

PROVENANCE: Sue (Paxton) Edmunds; daughter, Miss Adeline Edmunds

DURING THE 1920s, which has become known as "The Flapper Age," styles departed markedly from previous fashion trends. Movies were unquestionably influencing the style of American clothing as the talented designers began to assert their influence through their creations that were worn by famous stars. In 1925, to the scandal of many, came the revolution of short skirts. They were denounced from the pulpit in Europe and America: "The Archbishop of Naples even went so far as to announce that the recent earthquake at Amalfi was due to the anger of God against a skirt which reached no further than the knee" (Laver, *Concise History,* p. 232). Several American state houses voted resolutions and laws regulating the length of the skirt to no higher than three inches off the floor. However, women ignored these dictates and nonchalantly raised their skirts to the fashionable knee length.

Corsets were again discarded in an era of complete freedom for women. Figure ideals became boyish in appearance—bustless, with a flattened look produced by the bound bosom bandeau, and waistlines dropped to the hips and skirts rose to the knees. Never since ancient Greece had women shown their legs to this extent, and then only in sporting events, not for everyday attire. Flesh-colored stockings first made their appearance at this time. No longer were women's legs hidden by skirts or dark stockings, but were displayed in all their beauty.

In 1925, Sue Paxton Edmunds wore this fashionable short, sleeveless dress with a round neckline. Made of magenta silk Georgette and cut in the chemise, or camisole, style of the period, it hangs in a straight line from the bust and has a slightly flared skirt, fitting snugly over the hips. It is encrusted with bead work in an allover geometric design applied and embroidered by hand, a feature that made this otherwise simply designed evening gown quite costly.

EMcG □

1926-1976

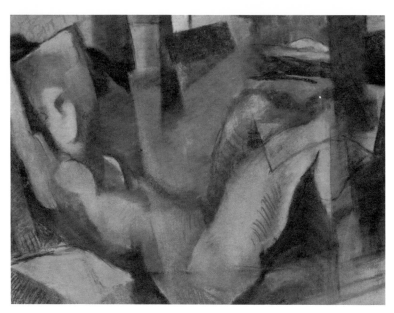

452.

ARTHUR B. CARLES (1876–1952)
(See biography preceding no. 416)

452. *Untitled (Nude)*

c. 1929
Pastel on paper
19 x 25″ (48.3 x 63.5 cm)
Dr. and Mrs. Perry Ottenberg, Merion,
Pennsylvania

PROVENANCE: Estate of the artist; with Graham
Gallery, New York; purchased by the present
owners through the Art Sales and Rental
Gallery, Philadelphia Museum of Art, 1967
LITERATURE: NCFA, *Pennsylvania Academy
Moderns* (May 9–July 6, 1975), no. 11, illus.
p. 19

ALTHOUGH HIS SUMPTUOUS oil paintings are
Carles's best-known works, the medium of
pastel prompted some of his most subtle and
resolved compositions. While he could brood
over his canvases at length, altering and
adding as the spirit moved him, the use of
pastel forced the decision-making process
into sharp finality since changes in color or
form only blur the results. This crisp, yet
delicate study of a reclining nude probably
dates to the mid-1920s—a period when the
chronology of Carles's works is least clear,
although evidently characterized by experi-
mentation and new directions. The subject
of the female nude was one to which Carles
returned repeatedly throughout his career,
inspired partly by a lifelong admiration
of Manet's *Olympia*. Carles's treatment of
the nude varied greatly, but he always strove
toward the great French tradition that links
Manet with Poussin, Cézanne, and Matisse
rather than the example set by Thomas
Eakins at the Pennsylvania Academy. Even
his most naturalistic nude figures were
painterly celebrations of the surface beauty
of the flesh rather than closely observed
studies of the muscle and bone structure that
gives it individuality. From the vividly
sensuous *Nude with Apple* of 1911, which
was shown at Carles's first one-man exhibi-
tion at Stieglitz's "291" gallery in New York
in 1912, to the monumental, androgynous
figure of his famous *Marseillaise* (1918–19),
Carles's nude figures had less to do with
recorded reality than with his opulent
imagination. Carles executed a number of
pastels during the 1920s which show a wide
range of approach, from exuberant natural-
ism to a modified version of Cubism, as in
this case. His interest in the Synthetic Cubist
compositions of Picasso and Braque of the
late teens and 1920s is reflected in his use of
angular shapes that echo each other across
the picture surface: the foot at the lower
right, the pointed elbow raised above the
model's head, and the line drawn sharply
across her bent knees.

Carles's particular contribution to the
international style of late, modified Cubism
is, characteristically, his use of color. The
figure, drawn in relatively continuous lines,
appears to dissolve under the play of shafts
of varicolored light. Color serves both to
disrupt the conventional coherence of the
image, introducing an element of abstrac-
tion, and to unify the composition as a whole
and refer us back to the world of nature.
The azure blue that fills the center of the
picture suggests the open air, and we seem
to catch a glimpse of mountains, sea, and
sky—perhaps the view through a window
behind the model. Few of Carles's Philadel-
phia contemporaries absorbed Cubist devices
into their personal style on this level of
sophistication: the landscapes of his friend
John Marin and the studies of Lancaster
church towers by their Pennsylvania Acad-
emy colleague Charles Demuth provide
fascinating parallels.

Ad'H □

HOWELL LEWIS SHAY (1885–1975)

Howell Lewis Shay was born in Alex-
andria, Virginia, but grew up in Seattle,
Washington. He studied at the architectural
school of the University of Pennsylvania,
where he won the Bacon Beaux-Arts Prize
in 1912, and from which he graduated in
1913. After working for a brief period with
McKim, Mead and White in New York,
Shay returned to Philadelphia, where he
worked for John T. Windrim and later, for
Horace Trumbauer (see biography preced-
ing no. 411). It was in that office that he
solved the principal design issue of the
Philadelphia Museum of Art (see no. 411b),
a feat which established his reputation.

Shortly afterward, Shay formed a partner-
ship with Verus T. Ritter (1883–1942),
about whom little is known, which lasted
more than a decade and resulted in the de-
signs for several of Philadelphia's handsomest
skyscrapers, including the Packard Building
(1922), the Drake Hotel (1929), and the
United States Customs House (1934). In
those buildings the architects merged mod-
ern technics with a classical design sense,
and a striking feeling for the dynamics of
commercial marketing. Afterward, Shay
worked under his own name and later, as
Howell Lewis Shay and Associates, before
he retired some twenty-five years before
his death.

RITTER AND SHAY

453. *Market Street National Bank*

Market Street and East Penn Square
1929
Steel frame; terra-cotta; glass curtain
wall

REPRESENTED BY:
Ritter and Shay
*Market Street National Bank: Architec-
tural Perspective*
c. 1927–29
Pencil and crayon on paper
26 x 16⅜″ (60.6 x 41.5 cm)
Estate of Howell Lewis Shay

BEFORE THE SECOND QUARTER of this century,
Philadelphians only rarely built tall office
buildings. Partially as a consequence, few of
the techniques of tall office construction were

developed in Philadelphia, although the Wilson Brothers (see biography preceding no. 370) made significant contributions in iron framing (Tatum, pp. 113–15). Instead of the canyoned city of towers that became the image of the dynamic commercial metropolises, center city Philadelphia remained relatively low, with few buildings above six stories, and the tallest limited by the wish to avoid having a thirteenth floor. In the few instances when taller buildings were proposed, they were generally promotions for the architect, as in the case of Joseph Huston's project for an eighteen-story office building in 1897 (*Philadelphia Inquirer,* September 21, 1897). Even then, Philadelphia trailed New York, which had already envisioned the ninety-story office tower. Only in the 1920s, when the needlelike spires of the great New York towers captured the popular imagination, were office towers emphasizing height built here, and then none aspired to the great height or bulk of those in New York or Chicago.

This is not to say that Philadelphia's skyscrapers were not of interest—they were, but for reasons of planning, for the clear formal expression of changes in function, and for the effort at establishing identity by means other than size. In addition, most Philadelphia skyscrapers, like those of New York, have been overwhelmed by Howe and Lescaze's Philadelphia Saving Fund Society building of 1929–32 (no. 456), which because of its relatively close approximation to the premises of European modernism, has received the praise of the champions of the International Style. Hence, neither the aim nor the achievement of Philadelphia's skyscraper architects has been much appreciated.

With the notable exceptions of Ralph Bencker's N. W. Ayer office building (1927–29) and Tilden, Register and Pepper's 1616 Walnut Street, the finest of Philadelphia's tall buildings were designed by Ritter and Shay. Most of their ideas on the skyscraper are exemplified in the Market Street National Bank building, erected on a relatively narrow lot at the northeast corner of Market Street and East Penn Square in 1929. Many of the planning decisions were necessitated by the site. Because the adjacent properties to the east remained in other hands, and thus might be built on, the architects placed the service core of elevators, fire stairs, and utilities along that wall and left it blank, suggesting its utilitarian role. Offices were planned on the south, west, and north sides, permanently assuring adequate light and ventilation.

Even more original was the architects' decision to place the banking room on the second floor with a grand entrance from Market Street, while the first floor, which would normally have contained the bank, was given over instead to shops. Such a

scheme, while going against tradition, made considerable sense, for banking is only rarely an impulse activity and bank customers are undeterred by a flight of stairs, while shopping, subject to impulse, benefits from the street-level location, with shop windows used for advertising. Thus, instead of one level of prime commercial space, the Market Street National Bank had two—and in addition, a basement level contained one of Ralph Bencker's Horn and Hardart restaurants (*Philadelphia Real Estate Record and Builder's Guide,* vol. 45, no. 35, August 28, 1929). Above were twenty stories of rentable office space. In good times, it would have proven a superb business investment.

Perhaps because the designers were Philadelphians, each of the changes in activity was

incorporated into the overall scheme of the building design. Not only were the entrances to the bank separated from those of the office—the bank's were on Market Street, the office's on Penn Square—but the wall treatment changed, depending on whether the level contained shops, banks, or offices. In the manner of Louis Sullivan's dictum, "form follows function," the shop level is sheathed in an austere black marble, while the banking space is indicated by three-story high windows on the second floor. Reeded terra-cotta sheathes the piers between the windows and, with vestigial ionic volutes, suggests the traditional classical vocabulary of banks. Above, alternately large and small piers, defining the structural bays, rise to the top of the building.

453.

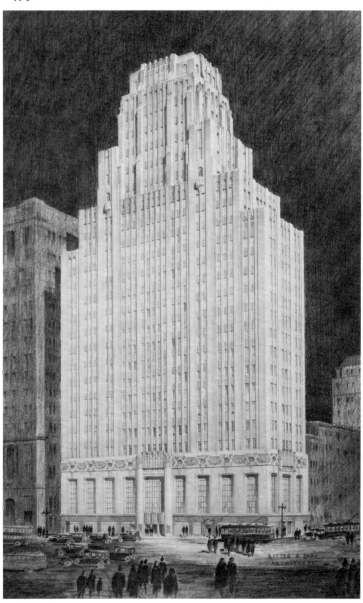

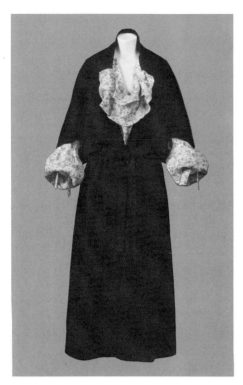

454.

Given the complex expression of functions, the decision to elaborate the building's form could well have been disastrous. But according to Shay, he firmly believed that a large building should have an interesting silhouette and he took the gamble. For the form, he looked to a contemporary source—the setback shaft of the skyscraper architect's response to New York's zoning laws, while the stylistic vocabulary was derived from Pre-Columbian architecture. The combination proved to be singularly successful, for the Pre-Columbian ornament was readily adapted to the classical regularity and scale of the base, but at the same time provided an appropriate motif for the top of the tower, fusing the setback skyscraper with the Pre-Columbian step pyramid. It was probably not a coincidence that in 1929, the same year that the Market Street Bank was being designed, Francesco Mujica's *A History of the Skyscraper* appeared, which advocated the development of a Neo-American style based on the similarity between Pre-Columbian design and contemporary architectural needs.

Whatever the source, the top which diminishes as it rises from the ground both establishes the identity of the building and gives a sense of delight and aspiration. Contrasting with the characterless, technocratic drabness of the more recent office buildings across Penn Square, the Market Street National Bank recalls the humanistic belief of the aged Louis Sullivan, enunciated three years earlier:

In and by itself, considered *solus* so to speak, the lofty steel frame makes a powerful appeal to the architectural imagination where there is any. Where imagination is absent and its place usurped by timid pedantry the case is hopeless. The appeal and the inspiration lie, of course, in the element of loftiness, in the suggestion of slenderness and aspiration, the soaring quality as of a thing rising from the earth as a unitary utterance, Dionysian in beauty. The failure to perceive this simple truth has resulted in a throng of monstrosities, snobbish and maudlin or brashly insolent and thick lipped in speech; in either case a defamation and denial of man's finest powers. (*Autobiography,* pp. 313–14)

GT □

MEELEY (N.D.)

454. *Dress and Coat*

c. 1930
Label: MEELEY/*2012 Walnut St/Philadelphia* (woven silk label sewn into coat); 1769 (in ink on label)
Navy-blue wool-crepe coat; printed chartreuse silk faille dress
Waist 24″ (60.9 cm); center back length 45⅛″ (114.6 cm)
Philadelphia Museum of Art. Given by T. F. Dixon Wainwright. 52–72–4a, b

DRESSES WITH ACCOMPANYING COATS (or redingotes, from the French for riding coat, which they often resemble) have long been a popular fashion. This dress and coat outfit is an unmatched pair—the dress is chartreuse silk faille printed with a blue, black, and white leaf motif, and the coat, a navy-blue wool crepe. Transitional between the boyish straight figure of the 1920s and the bias-cut figure-molding styles of the 1930s (see no. 451), the dress features long tubular lines to the hips, yet has a gored, flaring skirt with a double self-ruffle at the hem. The long, modified goddess sleeves, caught at the wrist with a self-tie, are designed to be seen below the sleeves of the coat. The wrap style and dolman sleeves of the coat are also holdovers from the previous decade, yet its definite waist with self-ties and longer length carry it into the 1930s. Both dress and coat have V-necklines, with the dress further enhanced by a double-ruffle edging.

CJ □

SAMUEL YELLIN (1885–1940)
(See biography preceding no. 418)

455a. *Fire Screen*

c. 1925–30
Mark: SAMUEL YELLIN (top right of frame)
Wrought iron
38 x 52″ (96.5 x 132 cm)
Harvey Z. Yellin, Philadelphia. Samuel Yellin Collection

455b. *Decorative Fragment from Children's Chapel Gate, Washington Cathedral*

1931
Mark: YELLIN (bottom right of frame)
Wrought iron
51 x 20″ (129.5 x 50.8 cm)
Harvey Z. Yellin, Philadelphia. Samuel Yellin Collection

455c. *Decorative Fragment*

c. 1930–35
Mark: YELLIN (bottom right of frame)
Wrought iron
14 x 10″ (35.5 x 25.4 cm)
Harvey Z. Yellin, Philadelphia. Samuel Yellin Collection

WILLIAM MORRIS, the English progenitor of the Arts and Crafts movement, wrote: "Never forget the material you are working with, and try always to use it for doing what it can do best . . ." ("Textiles," in *Arts and Crafts Essays by Members of the Arts and Crafts Exhibition Society,* London, 1899, pp. 37–38). Samuel Yellin followed this principle in his work with iron. Because of the quality of his craftsmanship he was highly regarded by Philadelphia architects, who incorporated metalwork as an integral part of their designs. For instance, in 1923, George Howe (see biography preceding no. 456) wrote: "In his shop all work is honestly and simply done whether it be visible in the finished product or not and the nature of the material is truthfully expressed both in handling and finish. There is no 'antiquating' or 'torturing,' no rusting or coloring, no contorted hammering or exaggerated rusticity about his work" ("Samuel Yellin and His Work," *Journal of the American Institute of Architects,* vol. 11, May 1923, p. 601).

An example of this straightforward approach to ironwork is the fire screen which was designed and executed by Yellin for the massive fireplace at his studio at

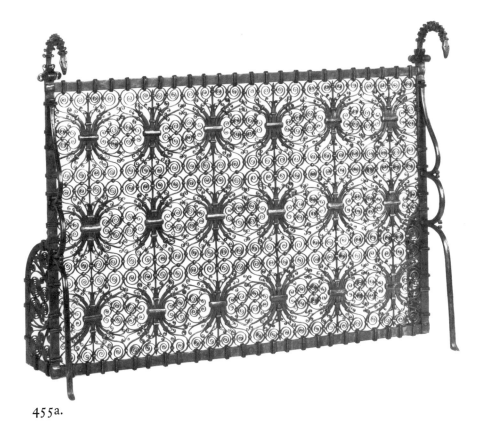

455a.

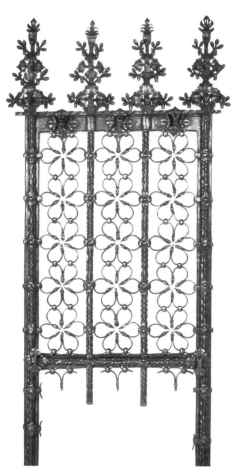

455b.

455c.

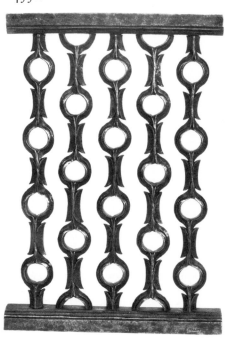

5520 Arch Street. The intricate tendrils were formed by hammering thin iron strips while they were cherry red and then fire welding them together where they were to be joined. The curvilinear portion of the interior section of the screen was attached to the frame by small collars. The wrought-iron supports on each side of the screen terminate in a naturalistic animal head.

In 1931, Yellin executed a gate for the Children's Chapel of the Washington Cathedral. Scaled to a child's proportions, the gate was whimsical in its design although it was a virtuoso piece in its execution. A fragment of this gate, perhaps done as a working sketch for the large commission, shows the extent of detail which Yellin was capable of rendering with chisels. Each of the many minute animal heads is different, and one can imagine the artist's pleasure in visualizing the eagerness of children as they examined the gate. Each hexafoil has six tiny heads, and the four larger foliated pinnacles with their zoomorphic decorations have several heads of varying sizes. The larger heads at the top were flattened out from the support bar whereas the small heads in the hexafoils were formed by fire welding the two thin bars which meet at a point.

Yellin also "sketched" in iron; often he executed one section of a design that he proposed to do on a large scale. Many of these designs were never expanded, but they can be seen in the small museum of Samuel

Yellin's creations at the metalworks still run by Yellin's son, Harvey Yellin, himself a designer and craftsman. One of these sketches displays another technique used in working with iron—punching and splitting the metal. The vertical bars, each a single square piece at the start, were hit with a sharp punch to form the four holes, but the metal was displaced, not removed. The bars were riveted to the frame by forging shoulders which were then hammered back.

Much of Yellin's work reflects a clear understanding of French Gothic design, and his small anthropomorphic heads hark back to early precedents. At the same time his work seems clearly rooted in the twentieth century. One can see elements of the Art Nouveau style in the fire screen with its repetitive tendrils, and in the decorative iron sketch, Yellin seems to be comfortable with the idea of abstract forms working together in one unified piece.

PT □

GEORGE HOWE (1886–1955)

George Howe was born in Worcester, Massachusetts, and attended Harvard University before entering the École des Beaux-Arts in Paris, where like most other American architectural students he joined the atelier Laloux. In 1913 he returned to the United States, to his mother's city, Philadelphia, where he was offered a partnership in the office of Furness, Evans and

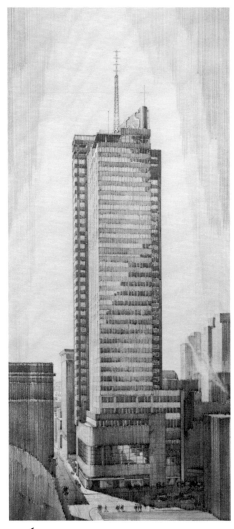

456.

Company. Among his first projects was the construction of his final École design, a house for himself, called "High Hollow," which was styled in the manner of late Gothic country houses of Normandy.

In 1916, Howe joined the fashionable office of Mellor and Meigs, to which he returned after service in World War I. In the mid-1920s, the office was given the commission for a group of branch banks for the Philadelphia Saving Fund Society which Howe designed in a simplified classical style. Shortly after, the same corporation offered the firm the chance to draw plans for a tall office building at Twelfth and Market streets. Conflicts over its styling and the general directions of the office led to a split, with Howe joining Swiss architect William Lescaze to produce the austere and clean scheme which established the reputations of both men.

In other projects, among them the William S. Wasserman house, in Broad Axe, near Philadelphia, Howe evolved a rich modernism, one which merged a direct handling of

rough materials and a Ruskinian expression of structure with the formal vocabulary of European modernism. After partnerships with Oscar Stonorov (see biography preceding no. 462) and Louis Kahn (see biography preceding no. 489), in the 1940s, Howe increasingly gave his time to teaching at Yale where he was an eloquent champion of moderate, but disciplined, modernism, which now seems so vital to contemporary architecture.

WILLIAM E. LESCAZE (1896–1969)

William Lescaze was born in Geneva, Switzerland, in 1896, and studied architecture in Zurich under Karl Moser. After the First World War, Lescaze worked in France where the disastrous social effects of the war were much in evidence, and where he absorbed the revolutionary rhetoric of the younger, more socially conscious, architects. In 1923, unable to find commissions for the type of monumental work which interested him, Lescaze immigrated to the United

States where such grand opportunities were still available. But American clients were not particularly enamored with the austere charm of European modernism, and Lescaze's early work in New York often took the form of the more popular Art Deco.

In 1929, Lescaze was introduced to Philadelphian George Howe and formed a partnership which lasted only a few years beyond the completion of the Philadelphia Saving Fund Society tower. During those years Lescaze resolved Howe's commitment to modern design, providing direct insight into theory, while serving as a New York "lightning rod" for provincial Philadelphia critics. Among their other significant projects were the Oak Lane Country Day School (usually attributed to Lescaze); the William S. Wasserman house in Broad Axe, and the Philadelphia Saving Fund Society garage at Twelfth and Filbert streets, which sits astride a supermarket. After 1934, Lescaze's practice centered in New York, where he worked for the next three decades.

HOWE AND LESCAZE

456. *Philadelphia Saving Fund Society*

Twelfth and Market streets
1929–32
Brick; granite; limestone and marble sheathing

REPRESENTED BY:

L. L. Malkus (n.d.)
Philadelphia Saving Fund Society
1940
Pencil on paper
21¼ x 9¼" (53.9 x 23.5 cm)
Philadelphia Saving Fund Society, Philadelphia

Philadelphia Saving Fund Society: Banking Floor
c. 1932
Photograph

Courtesy Philadelphia Saving Fund Society, Philadelphia

LITERATURE: Henry-Russell Hitchcock, Jr., in MOMA, *Modern Architecture: International Exhibition* (February 10—March 23, 1932), pp. 144–45, illus. p. 153; Henry-Russell Hitchcock, Jr., and Philip Johnson, *The International Style: Architecture since 1922* (New York, 1932), pp. 158–59; Frederick Gutheim, "The Philadelphia Saving Fund Society Building: A Re-Appraisal," *Architectural Record,* vol. 106 (October 1949), pp. 88–95, 180–82; William H. Jordy, "PSFS: Its Development and Its Significance in Modern Architecture," *JSAH,* vol. 21, no. 2 (May 1962), pp. 47–83; Robert A. M. Stern, "PSFS: Beaux-Arts Theory and Rational Expression," *JSAH,* vol. 21, no. 2 (May 1962), pp. 84–102; Robert A. M. Stern, *George Howe: Toward a Modern American Architecture* (New Haven, 1975), throughout

BEGINNING WITH THE INCLUSION of Howe and Lescaze's Philadelphia Saving Fund Society (PSFS) building in the 1932 Museum of Modern Art modern architecture exhibition and in Henry-Russell Hitchcock and Philip Johnson's concurrent publication, *The International Style: Architecture since 1922,* no Philadelphia building has received more continuous or favorable scholarly treatment. Within a generation of its completion it was reappraised by Frederick Gutheim in the *Architectural Record* and as a testimony to its critical success, it was the only pre-1940 skyscraper represented in H. W. Janson's standard *History of Art,* replacing the more dramatic, but less theoretically extreme, Chrysler and Empire State buildings.

The PSFS tower was well received not only because of the quality of its design, which is both striking and ingenious, but also because it represented the most direct application of the principles of European modernism, the so-called International Style, to a tall office building. Most of the important younger architectural critic-historians—Hitchcock, Johnson, Lewis Mumford, and Siegfried Geidion—had become proponents of its attitudes toward technics, form, and style. The consequences were obvious. A building which only minimally conformed to the popular expectation of the skyscraper had by its second generation become viewed as the high point of its era. It is a clear instance of critics rewriting history to serve their theories.

This is not to say that the building is less important than it is, but merely that it must be placed within its proper cultural milieu. Moreover, it should be noted that many of the features of its design that are now found most stimulating were in fact the very qualities disliked by the critics attuned to the premises of European modernism.

Apart from the absence of ornamentation and the direct use of materials, the building is remarkable as a plan and as an expression of the activities within. An office shaft surmounting a multistory base containing a banking floor above a first-floor shop is backed by a service spine containing elevators, fire stairs, and washrooms. Not content to differentiate use by form and by changes in window size, the architects sheathed each zone with a different material. The service core is of black brick, the shop and bank of polished granite, and the office spire of an envelope of brick spandrels and piers clad in limestone and marble. Such differentiation did not appeal to modernists used to reducing architectural elements to absolute abstractions—the white-wall screen, the transparent glass filter, the stainless-steel column support.

But, to a later generation interested in expression instead of abstraction and finding Frank Furness more informative than an early factory designer, it is the very quality of articulation, doubly signaled in form and material, which is of interest. Robert Venturi liked the "manifestations of multiple functions contained within the building," and the "positive expression to the variety and complexity of its program," just as he appreciated the "curving facade which contrasts with the rectangularity of the rest of the building." The curve was not however a mere "cliché of the '30's, because it has an urban function. At the lower pedestrian level it directs space around the corner" (*Complexity and Contradiction in Architecture,* New York, 1966, pp. 39, 75). Venturi might also have pointed out the answering curve of the oriel in the corner of Reading Terminal (no. 370) across the street. The acknowledgment of the site was also outside the premises of the International Style—whether a white box in the manner of Le Corbusier's Savoye House perched on stilts above its site or the spare form of Mies van der Rohe and Philip Johnson's Seagram Building in New York.

For the complexities of form and the accommodation to site, PSFS has numerous sources in the at times overly expressive local architecture, for example, Furness, Evans and Company's University of Pennsylvania Library or Price and McLanahan's Traymore Hotel in Atlantic City. Two notable plan features also have local origins. The idea of separating the circulation of the principal tenant from that of the speculative office space had already been tried by Ritter and Shay in the Packard Building at Fifteenth and Chestnut streets in 1922. There, as at PSFS, the entry to the banking space was on the narrow facade, fronting onto the principal street, and the office entrance opened onto the side street.

Ritter and Shay also premiered the second-floor banking space, in combination with the differentiated entrances and circulation scheme, in the building for the Market Street National Bank (no. 453), which was under construction while PSFS was still being designed. Indeed, there exists a Howe and Lescaze proposal for the PSFS building dated 1929 that shows a rather ordinary (except for the absence of ornamentation) office tower surmounting a first-floor bank in the manner of the Packard Building (Robert Stern, *George Howe: Toward a Modern American Architecture,* New Haven, 1975, fig. 60). Only after the Market Street National Bank was nearly completed did Howe and Lescaze modify their plans to include Ritter and Shay's innovative idea.

Articulate, yet without ornament, responding to the site, but cognizant of contemporary European theory, the Philadelphia Saving Fund Society building is the representation of the vision and expectation of its designers; it sums up an earlier architectural tradition of functional expression and rich form, even as it points to new directions. It is this expression of that paradoxical unity, of that coming together of opposites, which gives the tower its strength, and contrasts with the empty abstractions which are claimed as its descendants.

GT □

456.

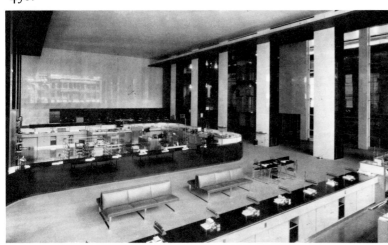

GEORGE HOWE (1886–1955) AND WILLIAM E. LESCAZE (1896–1969)
(See biographies preceding no. 456)

457a. *Dining Table and Armchairs*

1932
Table: rosewood veneer, pine, and plated stainless steel; chairs: rosewood veneer, pine, and leather
Table 30 x 60 x 54" (76 x 152 x 137 cm); chairs 34 x 24 x 24" (86 x 61 x 61 cm)

The Philadelphia Saving Fund Society

457a.

457b. *Armchair*

1932
Leather upholstery; Macassar ebony veneer
33 x 33 x 39" (84 x 84 x 99 cm)
The Philadelphia Saving Fund Society

457c. *Armchair*

1932
Chrome-plated tubular steel; leather
32½ x 23¾ x 25" (83 x 60 x 63 cm)
The Philadelphia Saving Fund Society

IN DESIGNING the Philadelphia Saving Fund Society (PSFS) building (no. 456), Howe and Lescaze assumed the responsibility for designing the entire interior of the building, including furniture and other decorative items. Blueprint drawings by Howe and Lescaze for much of the furniture still exist in the archives of the architect's office in the PSFS building.

Special attention was given to the interior of the thirty-second floor executive area—the board room, vestibules, and main dining room—and an elaborate system of exotic woods was chosen for these luxurious quarters. A letter of May 3, 1933, from H. C. L. Miller, Inc., producers of veneer, gives the data regarding the various finishes for furniture and walls in these areas: The furniture of the board room and vestibule number 2 was of Macassar ebony; the main dining room and vestibule number 1, rosewood; the walls of the committee room were faced with hudoke wood veneer, which complimented the wood on the furniture.

This dining table was one of seven intended for the main dining room. Clamped together underneath, the tables could be made to form one long table, which would be visually echoed above in the dropped ceiling partition used for indirect lighting. Just as Frank Lloyd Wright attempted to unify his interiors and exteriors, so Howe and Lescaze thought in these terms, and the long horizontal table echoes the horizontal articulation of the exterior of the building as well. The table and chairs ensemble is striking, with its subtle harmony of coloration, a mode which may still be seen throughout the building where the original colors have been retained. The brushed stainless steel, rosewood-veneered top and chairs, and blue leather form an unusually subtle and beautiful color scheme; at the same time there is a sharp contrast between the richness and warmth of the wood and the cool stainless steel.

The low, heavily padded armchair, one of a pair designed for vestibule number 2, adjacent to the board room, is part of a suite of upholstered furniture including a sofa. Its beige leather upholstery subtly contrasts with its front feet veneered in Macassar ebony. Prototypes for these "modern" chairs may be found in French designs of the late 1920s, for example, in a very similar armchair designed by Émile-Jacques Ruhlmann (Katherine Morrison McClinton, *Art Deco: A Guide for Collectors,* New York, 1972, p. 26, fig. 2). Similar upholstered furniture was also designed by Donald Deskey in 1932 for New York's Radio City Music Hall (McClinton, cited above, illus. p. 46).

Chrome-plated tubular-steel furniture was used in the main banking room and in many other office spaces. The leather upholstered chromium-plated tubular-steel armchair is one of a number used in the safe deposit floor of the bank building. The first tubular-metal chair had been designed by Marcel Breuer in 1925, when he was director of the Bauhaus furniture shops; although Breuer's contemporaries in France were also experimenting with tubular metal, none was exhibited in the 1925 Paris Exposition des Arts Décoratifs. By 1927, however, Thonet was manufacturing metal furniture in Germany after designs by Mies van der Rohe and Le Corbusier, as well as Breuer. Tubular-metal furniture was also produced in this country beginning in the late 1920s, and Donald Deskey also designed tubular furniture in 1932 for Radio City Music Hall. Remarkable because of its potential for continuous lines, this new medium had been exploited by Mies van der Rohe and Breuer for maximum aesthetic effect. As with their work, this armchair achieves with ease what could only be attained with great difficulty in wood—one continuous member of arms, stiles, and supports (Thonet had achieved this by bending wood under the pressure of steam). The same square shape with rounded corners is seen in a steel-plate armchair designed by J. J. Adnet in 1930 (McClinton, cited above, illus. p. 60).

DH □

WHARTON ESHERICK (1887–1970)

Born in Philadelphia, Esherick spent most of his long and productive career in the countryside just outside the city. Unlike most of his artist colleagues, he rarely traveled and never went to Europe, remarking with characteristic pith: "If I can't make something beautiful out of what I find in

457b.

457c.

my own backyard, I had better not make anything" (Washington, D.C., Renwick Gallery, *Woodenworks,* January 28—July 9, 1972, p. 24). He studied painting at the Pennsylvania Museum School of Industrial Art (1907–8) and the Pennsylvania Academy (1909–10), producing work in an impressionistic vein until the late 1920s when his interest in painting as a medium waned.

In 1916 he moved out to a wooded hillside near Paoli, where the experience of carving frames for his pictures and the carpentry involved in converting an old barn into a studio awoke a lifelong passion for working with wood. During the 1920s he became known as a printmaker, producing woodcuts on his own press and illustrating a number of books, including Walt Whitman's *Song of the Broad Axe* (Philadelphia, 1924). In 1926 the foundations were laid for his new house, overlooking the valley, and Esherick's work on the house and studio over the next forty-odd years produced a masterpiece in the loving and inventive use of wood in every detail—from door latches to kitchen cabinets to floors and walls. The most spectacular element in the house is the red oak spiral staircase, dated 1930, which rises through the main room like a graceful tree (or an abstract sculpture). A good friend and frequent visitor to the Paoli house was the architect Louis Kahn (see biography preceding no. 489), who helped Esherick design a new workshop in 1956; the result was a unique fusion of the two men's ideas. Some of Esherick's earliest furniture, dating to the 1920s, was heavy, with surfaces ornately carved in angular patterns. During the 1930s, while his style became geometric and organic by turns, surface decoration gave way to the use of the individual grain and flaws of each piece of wood as design elements.

As Esherick turned increasingly to producing sculpture and furniture, he received several major commissions. One of the first was for the interior and furnishings of Mrs. Helene Koerting Fischer's home in Philadelphia (1931–38), followed later by the board room of the Schutte-Koerting Company (1942–43). Mrs. Fischer gave the board room furniture to the Philadelphia Museum in 1971. Perhaps his best known and most important interior was designed for the Curtis Bok house in Gulph Mills, near Philadelphia (in 1935–38). In 1939–40, Esherick and the architect George Howe (see biography preceding no. 456) collaborated on the design of "Pennsylvania Hill House," one of the sixteen rooms for the New York World's Fair *America at Home* exhibition (see no. 472). Although sculpture was frequently incorporated into his early interiors, it later became larger, more free in form and independent in conception. *Twin Twist* of 1944 (Pennsylvania Academy), for example, is a ten-foot-high curving organic abstraction. In 1951 he won the Regional Sculpture Prize at the Pennsylvania Academy, and two years later he was among ten American semi-finalists in the international competition to design a Monument to the Unknown Political Prisoner. The Architectural League of New York awarded Esherick its Gold Medal of Honor in 1954 for "original work extending over the past 30 years, when Mr. Esherick pioneered in the use of modern concepts of form in furniture, sculpture and structural design."

His first large retrospective exhibition of ninety works (furniture, sculpture, household utensils, and the staircase from the Paoli house) was organized in 1958 by the Museum of Contemporary Crafts in New York. His work was widely exhibited and collected during his lifetime, and while he never took on any students ("I make, I don't teach") his influence has been acknowledged by a number of younger American craftsmen, including Sam Maloof and Wendell Castle (see *Woodenworks,* cited above, p. 24). As the demand for his furniture increased over the last decades of his career, Esherick expanded his workshop by hiring several assistants and using machine tools, but he continued to reserve for himself the pleasure of solving the special problems posed by each piece of wood. During the 1960s several one-man shows were held in the Philadelphia area: at the Swarthmore College Art Center (1963), the Philadelphia Art Alliance (1964), the Pennsylvania Academy's Peale House Galleries (1968), and Franklin and Marshall College in Lancaster (1968). After Esherick's death at the age of eighty-two, his house and its remarkable contents became the Wharton Esherick Museum, directed by his longtime friend Miriam Phillips.

Ad'H and DH

458. *Desk and Bench*

1931

Signature: J. S./MCMXXXI/WHARTON ESHERICK (carved in wood on right panel at knee level)

Black walnut, ebony, and padouk wood; leather

Desk 49 x 52 x 35″ (124.4 x 132 x 88.9 cm); bench 17 x 19½ x 13″ (43.1 x 49.5 x 33 cm)

York K. Fischer, West Cornwall, Connecticut

458.

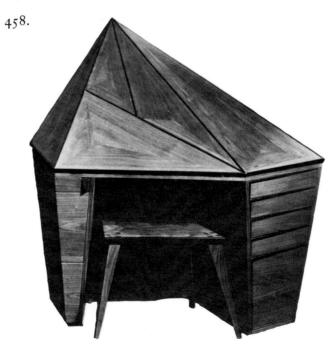

PROVENANCE: Mrs. Helene Koerting Fischer; son, York K. Fischer

LITERATURE: Washington, D.C., Renwick Gallery, *Woodenworks* (January 28—July 9, 1972), fig. 25

ONE OF ESHERICK'S most important commissions was the interior and furniture designed for Mrs. Helene Koerting Fischer between 1931 and 1938. This desk and chair from the Fischer house, on Wissahickon Avenue in Germantown, represent Esherick's Cubist style, characterized by straight lines and geometric shapes and forms. The entire desk, including the hinged top and writing compartment, is conceived in terms of modular triangles and trapezoids; its strong sculptural form absorbs the stool into its total composition. The initials J.S. are those of the cabinetmaker John Smith, who worked with Esherick on the desk.

Esherick's Cubist style, which emerged in the 1930s with such pieces as this desk, continued into the 1940s and 1950s. As late as 1961, Esherick made a cabinet in this style for Dr. and Mrs. Paul Todd Makler (Philadelphia Museum of Art). The table and chairs (no. 472) executed for the New York World's Fair represent Esherick's more organic style where the supports of the chair appear to be constructed of tree limbs.

DH □

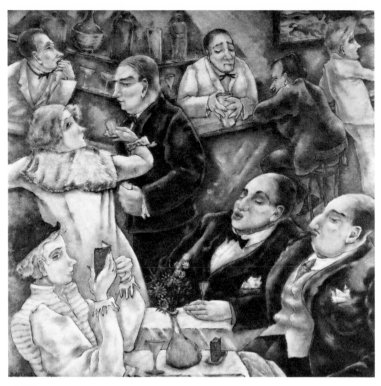

459.

GEORGE BIDDLE (1885–1973)

Biddle's attitude to his native city was complex and often critical, but Philadelphia exerted a profound and lasting influence on his career as an artist. The son of Algernon Sidney Biddle, professor of law at the University of Pennsylvania, and the elder brother of Francis Biddle (later Attorney General of the United States), George Biddle began to study painting with a young graduate of the Pennsylvania Academy while still a student at the Haverford School. He was sent to boarding school at Groton, in Connecticut, and went on to Harvard College (1904–8) and then to Harvard Law School. Receiving his law degree in 1911 (and admitted that same year to the Pennsylvania bar), he relinquished the legal profession in favor of continuing his art studies in Paris at the academies Julian and Colarossi in 1912. His earliest influences as a painter were Mary Cassatt and her mentor, Edgar Degas. During the first year of study in Paris, Biddle's conversations with the elderly lady from Philadelphia left a more profound impression on him than his visit to the collections of Gertrude and Leo Stein. As time went on he often showed a ready sympathy with the struggles of avant-garde art, but his own preference for figurative work was established at an early date. During 1912–13 he studied at the Pennsylvania Academy. Although he apparently never took classes with Henry McCarter or Adolphe Borie, he later frequently expressed his gratitude for the older artists' advice and friendship. Returning to Europe for a stay of several years, he studied in Munich and Rome and spent the summers of 1915 and 1916 painting at Giverny with the American follower of Monet, Frederick Frieseke. In 1916 the Pennsylvania Academy first accepted a painting of Biddle's for its annual exhibition, and he continued to exhibit steadily at Academy annuals until 1966. Early in 1919, Biddle's first one-man show was held at the Milch Gallery in New York, followed by an exhibition at the Arts Club in Philadelphia. In 1921, two works (*Allegro* and *Il Penseroso*) were included in the controversial exhibition at the Pennsylvania Academy selected by Arthur B. Carles, Joseph Stella, and Alfred Stieglitz (among others) and devoted to *Later Tendencies in Modern Art*. In a deliberate attempt to discover new sources of style and imagery after his early concern with Impressionism, Biddle spent the years 1919–22 in Tahiti, painting the islanders and their spectacular landscape and experimenting with sculpture and handcrafts. On his return, the Tahitian works were exhibited with great fanfare in Paris and New York. His love of travel and exotic subject matter were to be an important element in his career. Living in Paris again from 1923 to 1926, he was friendly with many artists there, particularly Jules Pascin, whose delicate linear style contributed perhaps the last marked influence on Biddle's own painting.

Returning to the United States in 1926, he decided to establish his permanent home and studio in a wooded valley near Croton-on-Hudson, New York. Consulting Dr. Henry Mercer (see biography preceding no. 403) as to the best method of concrete wall construction and the Philadelphia architect George Howe as to the site, he designed the house himself. Before settling in, he made an extended visit to Mexico in 1929, at which time he met Diego Rivera and was deeply impressed by the work of the Mexican muralists. Accompanied by his third wife, the sculptress Hélène Sardeau, he spent many months in Italy and Ischia during 1931–33, studying Renaissance murals and fresco techniques. In May 1933, Biddle wrote to President Roosevelt (a Harvard classmate) proposing the establishment of a government program to sponsor art in public buildings. He deserves credit as an initiator and staunch advocate of the concept later realized as the Public Works of Art Project and the WPA, and he served as president of the National Society of Mural Painters. His own contribution to the program included five fresco panels on the theme of "Justice in Society" for the Department of Justice building in Washington, D.C., and he was later invited to execute murals for the Supreme Court building in Mexico City and the National Library in Rio de Janeiro.

During 1934–35 he entered two competi-

tions for mural projects in Philadelphia (the Carl Mackley Housing Project [no. 462] and the Philadelphia Customs House). Despite his retreat to the countryside of Croton-on-Hudson, he remained close to the art community in Philadelphia, exhibiting there frequently and keeping in touch with his friends McCarter, Franklin Watkins, Sturgis Ingersoll, and many others. In 1939, he published a lively autobiography, *An American Artist's Story,* and the Associated American Artists gallery gave him a retrospective exhibition in New York that same year. His monograph on his friend Adolphe Borie appeared in 1940. In 1946, Biddle was one of fourteen artists commissioned by Gimbel Brothers in Philadelphia to paint aspects of Pennsylvania life (other artists from the Philadelphia area were Watkins, Hobson Pittman, and Andrew Wyeth).

During World War II, he served as chairman of the Art Advisory Committee for the War Department and traveled extensively, making sketches of the action in Africa, Italy, and Sicily. (His book *Artists at War* appeared in 1944.) A retrospective exhibition of ninety works (mounted jointly with that of his friend Carroll Tyson) was held at the Philadelphia Museum in 1947. A show entitled *Intimate Portraits* at the Wildenstein gallery in New York in 1948 revealed the range of his artistic circle, including portraits of William Zorach, Yasuo Kuniyoshi, Raphael Soyer, and Man Ray. In 1949, Biddle was one of the jurors for the Carnegie International exhibition in Pittsburgh, and the following year he was appointed by President Truman to the National Fine Arts Commission. His activities as a printmaker and craftsman kept steady pace with his painting, and in 1951 he donated a complete set of his lithographs (to date) to the New York Public Library. Biddle's painting of the 1950s and 1960s was relatively close in style to his earlier work, although he became increasingly preoccupied with fanciful and exotic subjects. A trip around the world and several months in India in 1959 resulted in a spate of new work and the illustrated book *Indian Impressions* (1960).

A retrospective exhibition at the Cober Gallery in New York in 1961 included seventy-five paintings, and that same year he was elected to the National Institute of Arts and Letters. By the time of his death at his home in Croton-on-Hudson at the age of eight-eight, Biddle had had over one hundred one-man exhibitions in cities all over the world, and his work was owned by over twenty museums in this country and several abroad. In recent years, his reputation as an author and vigorous spokesman for American artists during the 1930s and 1940s has perhaps somewhat obscured the lively, humanist quality of his own art, which deserves to be better known.

459. *Whoopee at Sloppy Jo's*

1933
Signature: Biddle 1933 (lower left)
Oil on canvas
40 x 40″ (101.6 x 101.6 cm)
Philadelphia Museum of Art. Gift of the artist. 72–121–1

PROVENANCE: The artist, until 1972

LITERATURE: PAFA, *129th Annual* (1934), no. 421 (illus.); George Biddle, *An American Artist's Story* (Boston, 1939), illus. opp. p. 125; James W. Lane, "Retrospective of George Biddle's Painting," *Art News*, vol. 38, no. 2 (October 14, 1939), p. 12; PMA, *Paintings by Carroll S. Tyson and George Biddle* (January 11–February 16, 1947), no. 69, p. 23, illus. p. 24; C. H. Bonte, "Biddle and Tyson Exhibit at Art Museum," *Philadelphia Inquirer,* January 12, 1947, p. 12; New York, Cober Gallery, *George Biddle, A Retrospective Exhibition* (October 3–28, 1961), no. 16; Allentown [Pa.] Art Museum, *The City in American Painting* (January 20—March 4, 1973), illus. p. 7

BIDDLE WROTE in his diary for November 4, 1933: "Started work today on 2 large speakeasy paintings, Sloppy Jo's and Zum Brauhaus" (AAA, Biddle, Reel 1, Frame 76). The pictures were part of a satirical series on life under Prohibition, which also included *At Ticino's* (Corcoran Gallery of Art), and *Upstate Visitors at Moriarty's.* Fond of working his way through one aspect of the contemporary American scene after another, Biddle had recently completed a group of paintings and watercolors of bathers and tourists at "Folly Beach," North Carolina, which share the same element of pointed caricature. It is typical of his energetic and multifaceted conception of his mission as an artist that Biddle would be hard at work on these humorous views of a rather frivolous subject while at the same time deeply involved in his campaign to launch a federal program to support the arts. His own proposals for mural projects in Philadelphia and Washington made at this time presented a more sober view of the human condition (workers in a sweatshop, miners laboring underground) but with the same easily readable style, using clearly drawn contours, with delicate color added almost as an afterthought. *Sloppy Jo's* is one of Biddle's most successful and witty spoofs of his own social milieu. His stance as the rebellious offspring of Philadelphia society gave additional zest to his depiction of New York high-life during the early 1930s. The jaded bartenders, the sleek and complacent patrons with their younger female companions (whose wandering eyes catch the viewer's gaze)—his characters are at once exaggerated and convincing. Despite Biddle's profound sympathy

with the poverty and hardship brought on by the Depression, his depiction of American mores in *Sloppy Jo's* is lighthearted in comparison to Joseph Hirsch's somber vision (see no. 467). The element of caricature in Biddle's style here brings his painting closer to the contemporary work of his friend William Gropper, or to the more horrific, cartoon-like watercolors and drawings of George Grosz. As early as February 12, 1934, Biddle confided to his diary that he was entering a "new phase," and added, "I see the need, beside the satyric, of an element of spiritual nobility in my work" (AAA, Biddle, Reel 1, Frame 108). His work over the next decade included grim allegorical subjects, such as *Starvation,* and a series of remarkable portraits. (The Philadelphia Museum of Art owns his paintings of *William Gropper,* 1937, *Frieda Lawrence* and *Man Ray,* 1941, as well as a *Self-Portrait,* 1933, and a portrait of his wife *Hélène Sardeau,* 1934.) The portraits represent Biddle's talent at its best in their straightforward and sympathetic delineation of character, while his WPA murals were his most ambitious attempt to give American painting the grand scale and "spiritual nobility" of Renaissance frescoes. But *Whoopee at Sloppy Jo's* has a gaiety and topicality which have made it one of his most popular and frequently exhibited works. It was one of four paintings given to the Museum by the artist a year before his death.

Ad'H □

HOUSE OF WENGER (1902/3–1938)

The fashionable House of Wenger had an international reputation for the finest in women's dresses, coats, furs, and millinery. Started in 1902/3 by a Russian immigrant, Morris Wenger, it was located for over thirty years at 1229 Walnut Street. After Wenger's death in 1932, his wife headed the establishment. In 1938 the House of Wenger merged into Bonwit Teller Company in Philadelphia.

460. *Evening Cape*

c. 1933
Label: *House of Wenger*/PHILADELPHIA (embroidered silk label sewn in center back neck)
Pale peach slipper satin; self-lined
Center back length 36″ (91.4 cm)
Philadelphia Museum of Art. Given by Mrs. William H. Steeble and Miss Martha Newkirk. 74–2–18

BY THE EARLY 1930s the French designer Madelaine Vionnet had revolutionized dressmaking with her introduction of the

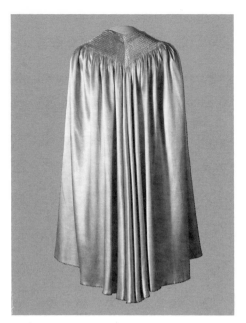

460.

bias cut. Dresses became long and slinky, elongating and clinging to the body, and a sleek figure was vital to the new look. Suddenly, all women's clothes—dresses and outerwear alike—were being cut on the bias.

This short, hip-length cape, cut on the bias, is extremely full with a wide godet at the center back, yet it falls in soft graceful folds. This balance is the result of tight shirring over the shoulders and back, forming a yoke, which allows the pliant satin to ripple freely to the hem. The shoulders are therefore flat and narrow, whereas the hem is wide and full. Wide self-satin ties secure the cape to the shoulders.

CJ □

FRANKLIN WATKINS (1894–1972)

Best known as one of the most original and forceful portrait painters of this century, Watkins was born in New York and spent much of his childhood in Winston-Salem, North Carolina. He arrived in Philadelphia in 1912 to attend the University of Pennsylvania, after graduating from the Groton School in Connecticut and studying for a year at the University of Virginia. Between 1913 and 1918 he was a student at the Pennsylvania Academy (where his teachers included Cecilia Beaux). His attendance there was intermittent due to financial difficulties and his service (together with his friend Arthur B. Carles) as a Navy camouflager in World War I.

From 1918 to 1923, Watkins worked as a commercial artist for the advertising firm N. W. Ayer in Philadelphia, and in 1923 he set off for a year's travel to France, Spain, and Italy with the aid of two Cresson Travelling Fellowships from the Academy. Study of the old masters, particularly the Venetians, Goya, and El Greco, had provided a strong impetus for his own work, and in 1926 he returned to Europe for nine months. Only briefly tempted to experiment with Cubist-derived abstraction in the early 1920s, Watkins was nevertheless keenly interested in the modern works he saw at the Barnes Foundation—Cézanne, Seurat, Picasso, and Derain in particular. In 1927, Watkins joined six other Philadelphia painters in an exhibition at the Wildenstein gallery in New York, a considerable triumph, as he was the youngest of the group. His first major public exposure came in 1931 when *Suicide in Costume* (now in the Philadelphia Museum of Art) received both First Prize and the Lehman Prize at the Carnegie International in Pittsburgh, and provoked what Homer St. Gaudens called "an artistic hurricane" of controversy. In 1934 the Frank Rehn Gallery in New York gave him his first one-man show. From then on he exhibited regularly in major exhibitions in this country and abroad, and won a large number of prizes and awards, including a Bronze Medal from the Paris International Exposition in 1937, a Gold Medal from the Corcoran Gallery of Art in 1939, and several major awards from the Pennsylvania Academy. In 1934, Watkins was invited by Lincoln Kirstein to design the sets and costumes for George Ballanchine's ballet *Transcendence*. His first one-man exhibition at a museum was held at Smith College in 1940, followed by another at the Arts Club of Chicago in 1945, a joint show with Arthur B. Carles at the Philadelphia Museum of Art in 1946, and a retrospective of fifty-seven works organized by Andrew Ritchie at the Museum of Modern Art in 1950. His long and productive teaching career began at the Tyler School of Art and the Pennsylvania Museum School of Industrial Art (now the Philadelphia College of Art). In 1943, Watkins joined the faculty of the Pennsylvania Academy where he taught for twenty-five years. In 1951 he was elected to the board of trustees of the American Academy in Rome and six years later became a life member.

Throughout his career, Watkins's chosen subject matter ranged from fanciful or allegorical subjects to landscapes and still lifes, although his most widely recognized gift was a powerful bent for portraiture. His two largest commissions for group portraits resulted in remarkable paintings: *The Annual Meeting of the Budd Company,* 1960–61, and the portrait of Edwin, Frederick, and Walter Beinecke, 1964–65, commissioned for Yale University. He was also commissioned to paint the portrait of Joseph S. Clark to hang in City Hall after the latter's term of office as mayor of Philadelphia; when first unveiled in 1956, the picture caused considerable controversy. Watkins's interest in exploring specific religious imagery, somewhat unusual in this secular century, led him to produce some of the most impressive large-scale religious compositions of recent memory: two vast canvases of *Death* and *Resurrection* in 1947–48 (commissioned by Henry P. McIlhenny and later given by him to the Philadelphia Museum of Art) and a *Crucifixion* in 1964 (now in the Vatican Museum, Rome). Although his style did not undergo very marked changes over his long career, his work increased in scale and brightness of palette. A series of late still lifes, often animated by the unexpected presence of a cat or a monkey, revealed a baroque and occasionally bizarre aspect of his sensibility. He remained vigorously independent of contemporary movements in art, owing much to his early admiration for the Northern Italian masters and El Greco, and yet expressing a highly personal and modern approach to his subjects.

Watkins's work is in the collection of major museums across the country. The Philadelphia Museum owns a large group of his paintings, including portraits of two former Museum officials, J. Stogdell Stokes and Henri Marceau. In the latter part of his career, Watkins served in an advisory capacity to the Ford Foundation, the Guggenheim Foundation and the committee on Fulbright grants, and in 1959 he was chairman of the jury to select the first official exhibition of American painting and sculpture to be sent to Russia. A member of the National Academy of Design, and a vice-president of the National Institute of Arts and Letters, Watkins was also the first artist to receive the Philadelphia Award (in 1972) for his distinguished contribution to the city both as a painter and as an influential teacher and cultural leader. A retrospective exhibition of ninety-four works was held at the Philadelphia Museum in 1964, and the Pennsylvania Academy organized *A Salute to Franklin Watkins* in 1972 upon the occasion of the Philadelphia Award. Nine months after his receipt of the award, Watkins died in Bologna, Italy, at the age of seventy-eight. A monograph by his friend Ben Wolf, based on a series of interviews (*Franklin Watkins, Portrait of a Painter,* Philadelphia, 1966), is the primary source for the artist's own reflections on his work.

461. *The Fire Eater*

1933–34
Signature: Watkins (on reverse)
Oil on canvas
60¾ x 39″ (154.2 x 99 cm)
Philadelphia Museum of Art. Given by
twenty-eight donors. 35-46-1

PROVENANCE: Purchased from the artist in 1935

LITERATURE: Pittsburgh, Carnegie Institute, *The
1934 International Exhibition of Paintings*
(October 18—December 9, 1934), no. 47; *PMA
Bulletin,* vol. 31, no. 171 (May 1936), p. 9, illus.
cover; Ernest Brace, "Franklin Watkins,"
American Magazine of Art, vol. 29, no. 11
(November 1936), illus. p. 725; Paris, Musée de
Jeu de Paume, *Trois Siècles d'Art aux États
Unis* (May—July 1938), no. 172, fig. 50;
MOMA, *Art in Progress* (May 24—October 15,
1944), p. 224, illus. p. 103; PMA, *Paintings by
Arthur B. Carles and Franklin C. Watkins*
(February 17—March 17, 1946), no. 41, pp. 44,
46, illus. p. 19; Belle Krasne, "What Watkins
Thinks of What He Sees," *The Art Digest,*
vol. 24, no. 13 (April 1, 1950), p. 11; PMA,
Franklin Watkins, by Henry Clifford (March
6—April 5, 1964), no. 14, p. 16, illus. p. 29;
Ben Wolf, *Franklin C. Watkins, Portrait of a
Painter* (Philadelphia 1966), no. 14, p. 78
(illus.)

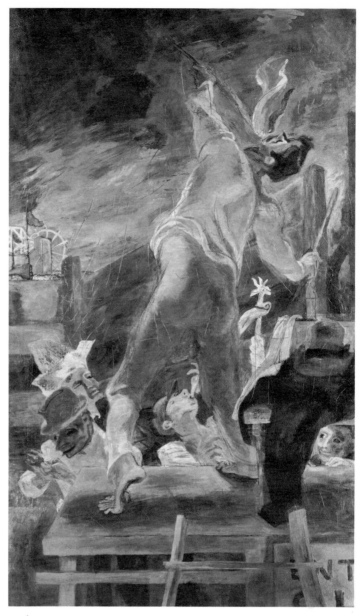

461.

THREE YEARS AFTER HIS DRAMATIC *Suicide in
Costume* carried off First Prize at the
Carnegie International exhibition, accom-
panied by great public notoriety, Watkins
painted *The Fire Eater,* another subject
picture less troubled in its origins and even
more successful as an expression of his highly
individual sense of color and form. The
tragic theme of *Suicide in Costume* (which
depicts a man in fancy dress sprawled across
a table, clutching a smoking pistol) had been
provoked by the sudden news of a friend's
suicide, received as Watkins was dressing
for a New Year's Eve party. Watkins often
arrived at his choice of subject matter by a
more convoluted, associative process, but the
juxtaposition of opposing themes like fes-
tivity and sudden death is characteristic.

In reply to a question from Andrew
Ritchie on the occasion of his retrospective
exhibition at the Museum of Modern Art
in 1950, Watkins summoned up a memory
which throws a fascinating light on his
working methods:

I was drawing in an evening class. No
one knew me. It was peaceful and I
remember comfort in finding none of
my students about. A small group behind
me started whispering during the pose.
They were abuzz about a sight they'd
seen on their way to class—a fire eater.
Intrigued away from my drawing, I
listened in. At the end of the pose I asked
exactly where this sight might be seen.

I started painting the thing the next morn-
ing, and went on with it, planning always
to see the real thing and find help. But I
never got around to seeing it. I think I
was afraid to: the flame interested me, and
the flame within (eaten) somehow seemed
to suggest, if I remember correctly, a
continuous movement through the core of
the figure. And then I believe I sort of
thought of something difficult, perhaps
painful, being done with the people who
stood about gawking—kidding—
indifferent. (MOMA, *Franklin C.
Watkins,* cited above, pp. 7–8)

Watkins's meditative statement suggests a
fundamental difference between his art and
that of his contemporaries on the American

scene—Reginald Marsh, Thomas Hart
Benton, and the Soyer brothers, for example,
or his fellow Philadelphians George Biddle
and Joseph Hirsch (see nos. 459, 467). For
them, the subject was all important: the
dynamism or degradation of city life, grim
sweatshops or rolling wheatfields, the living
history of the American people. For Watkins,
on the other hand, the description of a side-
show performer on South Street did not
prompt him to depict a social phenomenon
but instead provided the stimulus for an
almost visionary study of form and imagina-
tive content, albeit clothed in contemporary
dress. Despite the distant fairgrounds
sketched on the horizon, the vague setting
of a wooden platform and fence under a
windy sky suggests no particularized time

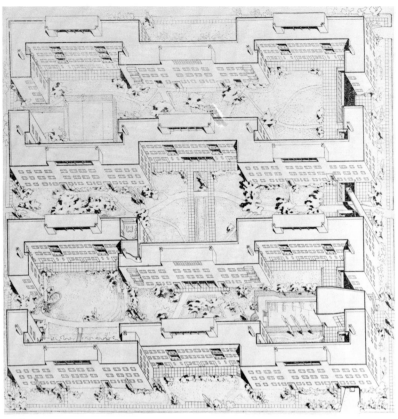

462.

or place, and the fire eater cuts an heroic figure as he towers over his motley audience. "I wanted to show someone doing something that was hard to do; especially painful for anyone to do with people watching" (PMA, *Watkins*, 1964, cited above, p. 10). The green and orange colors of the composition strike a vivid, modern note, while the elongated figure straining upward has echoes of the tortured grace of El Greco's saints. The *Fire Eater* was shown in Watkins's first one-man exhibition at the Rehn Gallery in New York in 1934 and immediately became one of the artist's most widely known and popular works, exhibited in numerous shows across the country, as well as in Paris, Toronto, and Mexico City.

Ad'H □

OSKAR STONOROV (1905–1970)

Born in Frankfurt-am-Main, December 2, 1905, Oskar Stonorov received his education as an architect at the Zurich Polytechnique and in the Paris atelier of André Lurçat. He immigrated to the United States in 1929, and began to practice in Philadelphia in association with Alfred Kastner in 1932. His Carl Mackley Houses project, designed for a small labor union, was the first housing project financed by the federal government under the New Deal. It brought to the United States advanced ideas of social archi-

tecture and established Stonorov as a leading housing architect, who subsequently designed Schuylkill Falls, Southwark Plaza, and other public housing in the Philadelphia area, and many similar projects in New Jersey, Washington, D.C., and elsewhere. His partnership with Kastner was dissolved in 1936, to be succeeded by associations with Joseph N. Hettel, George Howe (see biography preceding no. 456), Louis Kahn (see biography preceding no. 489) and Frank Haws.

As an active propagandist for better urban living environments, Stonorov was closely related to the Philadelphia charter reform movement and to many local housing and planning activities. He created the 1947 Philadelphia city planning exhibition that attracted nearly 400,000 visitors, undertook the pioneer rehabilitation of older houses for the Friends Service Committee, and addressed the problem of redeveloping Philadelphia's hundreds of thousands of brick row houses in the widely publicized "Yardville" plan. On a larger scale he was a prime mover in the redevelopment of the North Triangle, Southwest Temple, and Washington Square districts in Philadelphia, and undertook similar planning work in Detroit, Newark, Hartford, and other cities.

During forty years of active practice in Philadelphia, Stonorov also designed apartment houses, commercial buildings, schools,

medical facilities, private residences, housing for the elderly, and many other types of buildings. He also designed furniture, lighting, hardware, decorative objects, and expositions, and was a graphic artist and sculptor. One of his fountains received First Prize in the competition of the Fairmount Park Art Association for a John F. Kennedy Memorial. At the time of his death in a plane crash with the labor leader Walter P. Reuther in 1970, he was engaged upon his most significant project, the United Auto Workers' Family Education Center, in northern Michigan, where his experience in social architecture, his influence from Frank Lloyd Wright, his fascination with sculptural forms, and his interest in the environmental movement were fused in a masterpiece of the highest creative importance.

A memorial exhibition of Stonorov's work was organized by Otto E. Reichert-Facilides at the Moore College of Art in 1971. A comprehensive review of his career with a complete list of buildings and other projects, a bibliography and short articles by Edmund N. Bacon, Louis Kahn, Bruno Zevi, Jorio Vivarelli, and Otto E. Reichert-Facilides was collected by Frederick Gutherin, ed., and published in a special issue of *L'Architettura* (vol. 18, no. 2, June 1972). Oskar Stonorov's papers and drawings are deposited in the Archive of Contemporary Biography, University of Wyoming, Laramie.

462. Carl Mackley Houses (Juniata Park Project)

Castor Avenue and M Street, between Cayuga and Bristol streets

1932–34

REPRESENTED BY:

Carl Mackley Houses: Isometric Rendering

c. 1933

From Carl Mackley Houses brochure

Offset lithograph

5⁹⁄₁₆ x 5⅞″ (14.1 x 14.9 cm)

Private Collection

LITERATURE: "Carl Mackley Houses, Philadelphia, Pa.—Kastner and Stonorov; W. Pope Barney, Architects," *Architectural Record,* vol. 75, no. 2 (February 1934), pp. 120–21; Albert Mayer, "A Critique of the Hosiery Workers' Housing Development in Philadelphia," *Architecture,* vol. 71, no. 4 (April 1935), pp. 189–94; "The Carl Mackley Houses—A PWA Project in Philadelphia," *Architectural Record,* vol. 78, no. 11 (November 1935), pp. 284–98; Tatum, pp. 133–34, 203–4; "Carl Mackley Houses, Philadelphia, Pa.," *L'Architettura,* vol. 18, no. 2 (June 1972), pp. 88–91; Robert A. M. Stern, *George Howe: Toward a Modern American Architecture* (New Haven, 1975), p. 103 n.39, p. 196

THE CARL MACKLEY HOUSES embody the youthful idealism and social architecture of Oskar Stonorov, whose aim was nothing less than the reconstruction of the entire urban environment. It was the decisive formulation in American terms of the housing community as architectural design. In 1932, when he was twenty-seven years old, Stonorov moved to Philadelphia and established a partnership with Alfred Kastner (1900–1975), expressly to undertake the design of the Mackley Houses for the Federation of Full-Fashioned Hosiery Workers, a small labor union directed by John Edelman. The work imported the then current European ideas of "sunlight, space and verdure" as expressed in the housing architecture of Otto Haesler: settlements organized into solar-oriented parallel strips (*Zeilenbau*) of walk-up apartments.

The Philadelphia project occupies a full city block, thus accepting (as did earlier American housing) the conventional city plan. Four parallel rows of apartments, three stories high, strode the rolling topography. Above the apartments were rooftop community facilities including an airy laundry and clothes drying yard and a small children's play yard where mothers could watch their young while waiting out the laundromat cycle. The skin-like stucco of contemporary north European housing was here suggested, but the material was masonry and the facades were broken by projecting bays

and recessed balconies (called "porches" in deference to the vernacular row-house practice). The projecting wings at the ends of each building block created intimate spaces and suggested well-defined uses as well as landscaped courtyards. The entire project was unified by a network of walkways, passing under the buildings and interconnecting extensive paved outdoor areas.

This design formula broke sharply with the single-family house and the curvilinear layouts of American suburbs, and with the restricted public housing experience of World War I and the limited dividend companies in Chicago and New York. The new light-hued architectural vocabulary with its *pilotis* (stilts) and strip windows may have echoed Le Corbusier, but the standard of living implied was distinctly American. This statement of collective living embraced generous living spaces, privacy, and landscaped amenity; but more remarkable for 1932, it included swimming and wading pools, rooftop nursery schools and mechanical laundries, collective kitchens and dining rooms, community meeting rooms—and a garage for every car. These anticipations of higher future standards have contributed to the survival of the Carl Mackley Houses, now nearly half a century old. Unfortunately these concerns were lost in the evolution of public housing as institutionalized welfare, steadily more congested, cramped in space, and stripped of community facilities. Thus, in the end, this Philadelphia project became

less of a model than a yardstick by which to measure the increasing inadequacy of the movement it helped to generate. Architectural history has turned to it not simply as the cornerstone for a significant architectural career with many subsequent implications, but as a paradigm that reflects the disparate influences of the 1920s, when modern architecture was emerging as Russian constructivism, French Cubism, the Dessau Bauhaus, the Le Corbusier of the "Dom-ino" house and the "Voisin" plan, and a still older heritage from the garden city and the English house.

FG □

WHARTON ESHERICK (1887–1970)
(See biography preceding no. 458)

463. Cheeter (Horse A)

1934

Signature: W.E./XXXIV (on right haunch)

White oak, painted blue

52 x 85 x 12″ (132.1 x 215.9 x 30.5 cm)

The Wharton Esherick Museum, Paoli, Pennsylvania

PROVENANCE: The artist

LITERATURE: FPAA and PMA, *Sculpture International* (May 18—October 1, 1940), no. 128

463.

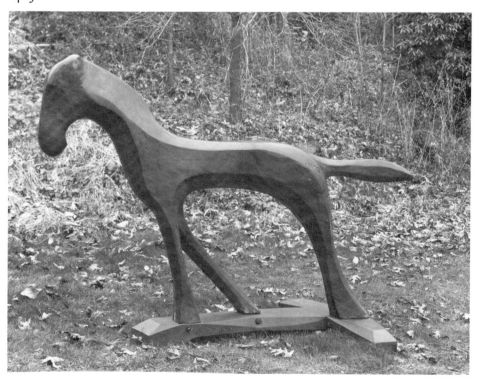

SOME OF ESHERICK's most effective and endearing sculpture has been inspired by animals: the Whitney Museum owns a procession of *Goslings* (1927), the Pennsylvania Academy harbors a deer-like beast entitled *Darling* (1940), and over the years his grandson was treated to a roomful of carved creatures. Just before he began to produce some of his most sophisticated cubistic furniture for the Curtis Bok house, Esherick's broad sense of humor emerged in a pair of large wooden horses carved during the summer and fall of 1934. *Cheeter,* shown here, sports three legs and a tail flowing out behind him, while his counterpart *Jeeter* (painted bright yellow) possesses only two legs and carries his tail pointed upward at a jaunty angle. Esherick, who could carve with exquisite precision, here leaves visible traces of his tools in the rough-hewn wood. Eliminating all but the most elementary details, he allows the shape of the horse to emerge only partially from the tree trunk. The tension between the wood and the image within brings the sculpture vividly to life.

When they were shown at the second international exhibition of sculpture at the Philadelphia Museum of Art in 1940, the pair were listed as "Horse A" and "Horse B." During the 1940s and 1950s, they were lent by the artist to the Hedgerow Theatre in Rose Valley, Pennsylvania, where they served as both guardians and mascots, flanking the pathway to the entrance. In 1966, years after its return to Esherick's studio, *Cheeter* was cast in bronze and stands as a memorial to one of the trustees of the Rose Valley School. *Jeeter* was purchased from the artist some years before his death and is in a private collection. Unusual among Esherick's sculpture for the bright coats of paint covering his beloved wood, the horses convey his energetic and joyful approach to his art. Eminently ridable, they were the delight of local children during their years outside the Hedgerow Theatre, and they seem to belong to the same popular branch of the animal kingdom as the sprightly horses that grace carousels and weather vanes. Esherick rarely came closer to being a true "folk" artist than in this merry pair whose apparent crudeness only adds to their appeal. "If you take the fun away," he once remarked, "I don't want to have anything to do with it" (New York, Museum of Contemporary Crafts, *The Furniture and Sculpture of Wharton Esherick,* December 12, 1958—February 15, 1959, n.p.).

Ad'H □

JULIUS T. BLOCH (1888–1966)

Born in the town of Kehl in Germany, Bloch came to Philadelphia with his family at the age of five and spent the remainder of his life in the city (he became a naturalized citizen of the United States in 1907). From 1901 to 1905 he attended Central High School and after graduation enrolled in the Pennsylvania Museum School of Industrial Art for three years. Between 1908 and 1912 he studied painting at the Pennsylvania Academy, winning Cresson Travelling Fellowships in 1911 and 1912. His early style was related to the modified Impressionism of Philadelphia painters such as Adolphe Borie and Fred Wagner, as evidenced by a 1912 portrait of his mother and a view of the Philadelphia riverfront (collection of Benjamin D. Bernstein, Philadelphia). Bloch served in the United States Army overseas during World War I and spent part of 1919 at the University of Clermont-Ferrand in France. During the 1920s in Philadelphia he took commissions as a professional portrait painter but also gradually evolved a personal style of muted colors and simplified, forceful outline with which he depicted scenes from working-class life. Typical works of this type are *Tired Travellers* of 1927 (LaSalle College collection), in which angular figures slump together in a train coach, and *Coal Miners,* which was shown in the opening exhibition of American painting at the Whitney Museum in 1932. Bloch's first one-man shows were held in Philadelphia at the Little Theatre in 1929 and the Edward Side Gallery in 1930. Bloch was active in Works Progress Administration projects in Philadelphia, producing a large number of works, several of which remain on loan at the Philadelphia Museum of Art. In 1933 his lithograph *Midsummer Night* received the prize in an exhibition at the Philadelphia Print Club, and a year later honorable mention was awarded to *The Cellist* in the *American Painting of Today* exhibition at the Worcester Art Museum. The Philadelphia Art Alliance gave him a one-man show in 1938 and awarded his lithograph *War* the Yarnall Abbott Prize in 1940.

An active and well-known member of Philadelphia art circles throughout his long career, Bloch did portrait drawings of friends and colleagues, incuding those of Charles Demuth and Dr. Albert C. Barnes. During the 1930s and 1940s, Bloch developed a special interest in portraying the American Negro, both in dramatic subject pictures (*The Lynching,* 1932, *The Prisoner,* 1934, *Evangelist "Mind, Brother, Mind,"* 1938–50) and in sober portraits of established black leaders—*Deacon William Mann,* 1938 (Metropolitan Museum of Art), and *Ephraim Wilson,* 1945 (Pennsylvania

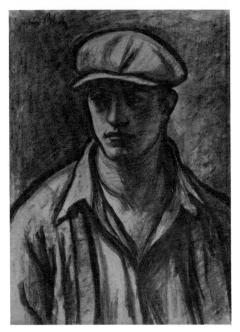

464.

Academy of the Fine Arts). Other sitters included Paul Robeson, Marian Anderson, and Horace Pippin. Bloch's work was frequently included in annual exhibitions at the Pyramid Club, Philadelphia's black professional society, which also gave him a one-man show. Exhibiting widely in national annual shows such as those at the Pennsylvania Academy, the Carnegie Institute, the Corcoran Gallery of Art, and the Art Institute of Chicago, Bloch was also represented in the Golden Gate international exposition in San Francisco (1939), *American Art Today* at the New York World's Fair (1939), and *Artists for Victory* at the Metropolitan Museum (1942).

In 1947, Bloch joined the faculty at the Pennsylvania Academy where he taught for twenty-five years. A one-man exhibition at the Academy in 1948 surveyed his career to date and preceded a striking shift in his style. He traveled extensively in Italy and Sicily during the early 1950s and was deeply influenced both by the quality of light in the landscape and by his exposure to early Italian frescoes and Byzantine paintings and mosaics. His one-man show at the Woodmere Art Gallery in 1954 revealed an increasing interest in bright color and formal, almost hieratic, figure compositions. Paint was applied in small vivid touches across the canvas; forms were simplified and flattened; and tones of blue, yellow, and white predominated. The painting *Sisters* of 1955 (Philadelphia Museum of Art) is a characteristic example of his late "mosaic style."

Bloch continued to have one-man exhibitions in Philadelphia galleries, and in 1956 the Jewish Community Center in Wilkes-

Barre organized a retrospective. He was represented in all three Philadelphia Arts Festival exhibitions in 1955, 1959, and 1962. Less well-known nationally during the latter part of his career but warmly appreciated locally as both teacher and painter, Bloch received the Percy M. Owens Memorial Prize for a distinguished Pennsylvania artist from the Fellowship of the Pennsylvania Academy in 1962.

Following Bloch's death at the age of seventy-eight, a memorial exhibition was held at the Philadelphia Art Alliance in 1967. By the terms of his will, the paintings, drawings, and prints remaining in his studio were given to his three executors—Benjamin Bernstein, R. Sturgis Ingersoll, and Henri Marceau—to distribute to museums and institutions. A group of works was given to Lincoln University in Pennsylvania; the Philadelphia Museum owns a large collection of the prints and drawings; and he is represented in the collections of a number of major museums and colleges. A book on Bloch's life and work is in preparation under the supervision of Mr. Bernstein.

464. *Study for Young Worker*

1934
Signature: Julius Bloch (upper left)
Charcoal on paper
24⅝ x 18¹¹⁄₁₆″ (62.5 x 47.5 cm)
Public Works of Art Project. On extended loan to the Philadelphia Museum of Art.
36-1934-4

ONE OF A NUMBER of Philadelphia artists (including George Biddle, Joseph Hirsch, Leon Kelly, J. Wallace Kelly, Benton Spruance, and Dox Thrash) who were actively involved in federal programs for the arts in the years following the Depression, Bloch was temperamentally less suited to the large mural projects undertaken by Biddle and Hirsch than to the production of a series of easel paintings and lithographs. Although Bloch's predilection for working-class subject matter inspired some of his most vigorous and effective paintings, the full range and persistence of his interests are revealed in the huge quantity of drawings and sketchbooks in which he recorded the faces and characteristic attitudes of the people he saw daily in the streets. "I have always selected my subjects from among the countless thousands of fellow-citizens whom I constantly observe as I wander about in Philadelphia. Our vast population offers endless variety, there are people of many races, the descendants of the early settlers, the children of those who migrated here during the last decades of the 19th century, in short, all those who make up our national life"

(quoted in the Philadelphia Art Alliance *Bulletin,* April 1938, n.p.). He was rarely without a notepad in his pocket, and his jotted pencil sketches have an immediacy and freshness sometimes lacking in the more finished pictures.

This study for the *Young Worker* represents an intermediate stage in the evolution of the final painting: a large, boldly executed drawing, it already contains formal elements not present in the swift sketch. Heavy charcoal outlines emphasize the breadth of the sitter's shoulders and the slouch of his hat; his features begin to take on an idealized strength and simplicity, but traces of his particular personality linger in his slightly sullen, reserved expression. When completed, the painting was shown in the national exhibition sponsored by the Public Works of Art Project at the Corcoran Gallery of Art in 1934 and was selected by Eleanor Roosevelt for the permanent collection of the White House.

The work of Hirsch and Biddle during the 1930s occasionally resorted to caricature as a means of expressing social protest, but Bloch's gift was for the sympathetic delineation of genre subjects rather than satire. An admirer of the art of Daumier, he must have found the compassionate treatment of the *Third Class Carriage* more to his taste than the caricatures. Bloch's overtly emotional paintings like *The Prisoner* of 1934 (in which a chained black man struggles with his bonds in the lurid light admitted by a barred window) now seem less convincing than the straightforward presentation of the *Young Worker.* The drawing is devoid of stylization or exaggeration; it reveals the artist as an assured draftsman, handling the figure in terms of broad areas of light and shade. Social commentary lingers only in the title, but the simplicity and forcefulness of the image underscores Bloch's effort to make his work meaningful to the wide popular audience from which he drew his subjects.

Ad'H □

RALSTON CRAWFORD (B. 1906)

Crawford spent relatively few years in the Philadelphia area, but he has always acknowledged them as a crucial period in his career. Born in St. Catherine, Ontario, he attended high school in Buffalo, and spent several years of his youth aboard tramp steamers on the Great Lakes and in the Caribbean. He began his training in art at the Otis Art Institute in Los Angeles in 1926–27, at which time he also worked briefly in Walt Disney's animation studios. After entering the Pennsylvania Academy in the fall of 1927, he lost interest in a possible career as a commercial artist. Studying

with Henry McCarter and Hugh Breckenridge, he became increasingly attracted to the idea of being a painter and this was confirmed by two years of exposure to the teaching and the collection of Dr. Albert C. Barnes.

Deeply affected by Dr. Barnes's formal analysis of pictorial composition, Crawford has declared that study of the paintings of Cézanne and Matisse exerted a major influence on his own art. In 1930 he moved to New York for two years' study on a Tiffany Fellowship and familiarized himself with the modern art on view there, including the works of Picasso, Gris, Braque, and Léger at A. E. Gallatin's Gallery of Living Art at New York University. During the summers he continued to study with Hugh Breckenridge at his school in East Gloucester, Massachusetts. Crawford's first trip to Europe came in 1932–33. He studied at the academies Colarossi and Scandinave in Paris and spent much of his time in museums, particularly impressed by the work of Rembrandt, El Greco, and Goya. During his stay in Spain, he painted a number of studies of Spanish farmhouses, which were the predecessors of his first major works from his Pennsylvania years. Returning to New York for a year's study at Columbia University, he was given his first one-man show by the Maryland Institute of Art in 1934.

That same year, he settled into a stone house on a one hundred acre farm in Exton, Pennsylvania. There he began the series of spare, flatly geometricized paintings of barns, grain elevators, water tanks, steel mills, and other simple rural and industrial forms that were to occupy him until the outbreak of World War II. Crawford came somewhat late to the austere style and subject matter known as Precisionism, which had evolved over a decade earlier in the work of Charles Sheeler, Niles Spencer, and George Ault, among others, and his particular contribution was to emphasize the style's latent tendency to abstraction. After living in Exton for three years, he moved to Chadds Ford for another two-year stay in the Pennsylvania countryside. There Crawford met the influential West Chester modernist art critic Christian Brinton, who in turn introduced him to the artist Horace Pippin. In 1937, Crawford had his second one-man show (for which Ford Maddox Ford wrote the introduction to the catalogue) at the Boyer Galleries in Philadelphia, followed a year later by an exhibition at the Philadelphia Art Alliance. His first important work in photography—a medium that was to continue to interest him throughout his career—was done in Florida on a Bok Fellowship in 1937; at the same time he developed a lifelong interest in jazz music.

In 1939 he returned to New York from his sojourn in Pennsylvania, having pro-

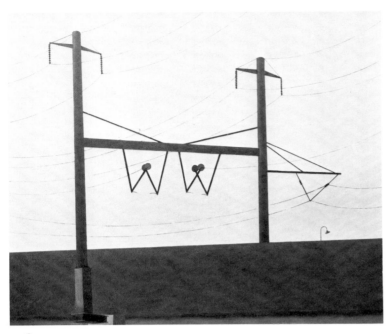

465.

duced a body of work that both established his reputation and laid the groundwork for his later stylistic development. During World War II, he ran the United States Army Air Force's Visual Presentation Unit for weather information and traveled to the Far East. In 1946 he witnessed the atomic bomb test on Bikini Island as an artist-reporter for *Fortune* magazine. During the late 1940s his painting grew increasingly abstract, revealing the depth of his earlier interest in Cubism and constituting an interesting parallel (in its use of flat, jagged shapes) to the work of Stuart Davis. The 1940s and 1950s were a period of intense involvement with both photography and printmaking. A retrospective exhibition of his work at the University of Alabama in 1953 was followed by another large show at the Milwaukee Art Center in 1958, and Crawford has continued to exhibit widely in galleries and museums across the country. Martin Friedman's exhibition of *The Precisionist View in American Art* at the Walker Art Center (Minneapolis) in 1960 placed Crawford's painting in the context of a national movement. During the last thirty-five years he has taught at art schools and universities in Buffalo, Minneapolis, Honolulu, Baton Rouge, Brooklyn, and New York City and traveled extensively, always seeking new, specific inspiration for his art, despite its apparent abstraction.

465. *Electrification*

1936
Signature: CRAWFORD (lower left)
Oil on canvas
32⅛ x 40⅜″ (81.6 x 102.5 cm)
Hirshhorn Museum and Sculpture Garden, Smithsonian Institution, Washington, D.C.

PROVENANCE: With Boyer Galleries, Philadelphia; with The Downtown Gallery, New York; with Lee Nordness Galleries, New York; purchase, Joseph H. Hirshhorn, New York, 1969

LITERATURE: New York, Boyer Galleries, *Ralston Crawford Paintings* (February 23—March 11, 1939), no. 8; Flint [Mich.] Institute of Art, *The Work of Ralston Crawford* (June 1942), no. 16; Washington, D.C., Caresse Crosby Gallery, *Ralston Crawford* (April 10–30, 1945), no. 18; Santa Barbara [Calif.] Museum of Art, *Paintings: Ralston Crawford* (April 2—May 2, 1946), no. 19; Richard B. Freeman, *Ralston Crawford* (Tuscaloosa, 1953), no. 36.1, p. 44, illus. p. 12; Lerner, *Hirshhorn*, p. 675, fig. 462

DURING THE YEARS following the Depression, when steel mills and railroad tracks were incorporated in the paintings of the social realists to symbolize the tyranny of industrialism, Crawford found in the same phenomena impersonal forms that interested him purely for their pictorial possibilities. One critic reviewing his first Philadelphia exhibition at the Boyer Galleries in 1937 commented on the absence of the human figure in Crawford's paintings, and Dorothy Grafly wrote in the Philadelphia *Record* (March 14, 1937): "The simplicity of

modern forms supplies the keynote for Ralston Crawford's painting. Like the modern architect, he thinks in terms of simple shapes, well proportioned to a given space. His colors are expressed with equal simplicity."

Crawford's fusion of his lessons in modernist composition, derived from a study of Matisse and Synthetic Cubism with his interest in modern American subject matter, was never more skillfully presented than in this remarkable picture of 1936. Painted while he was living in an old farmhouse in Exton, some miles outside of Philadelphia, *Electrification* was based on drawings made at the Pennsylvania Railroad station in Wilmington, Delaware. In other paintings of the same period, such as *Steel Foundry, Coatesville* of 1937 (Whitney Museum of American Art) and *Pennsylvania Barn* (Brown Shoe Company, St. Louis) of the same year, Crawford makes use of large, simplified shapes of buildings flattened against a sky relieved by soft shapes of clouds that maintain some sense of depth. In this study of railroad pylons and cables, however, the third dimension has been virtually eliminated, leaving a tracery of black lines of varying thickness against the flat, bright plane of blue sky. While apparently rendering a faithful record of Pennsylvania Railroad appurtenances, Crawford has so selected his viewpoint and arranged the elements of wall, posts, and wires that *Electrification* forms an effective abstract composition. More radical in its suppression of detail than Sheeler's contemporary work, Crawford's painting bears an affinity to the work of Stuart Davis, George L. K. Morris, and even perhaps to the pure abstraction of Burgoyne Diller as well as to that of other Precisionists. Devoid of social content, yet celebrating the power and elegance of machine forms, *Electrification* is as austere a vision of the American scene as was produced by any artist in the Philadelphia area during the 1930s.

Ad'H □

HOBSON PITTMAN (1900–1972)

Born on a plantation near Epworth, North Carolina, Pittman took private art lessons with Miss Molly Rouse in Tarboro between 1912 and 1916. After the death of his parents in 1918, he moved to Coatesville, Pennsylvania, to live with his sister. In 1921–22 he was enrolled in Pennsylvania State University. Starting in 1922, he painted for several years in Woodstock, New York, and studied with Albert Heckman, among others. In 1924 he entered the Carnegie Institute of Technology in Pittsburgh, transferring to Columbia University a year later. Pittman's most intensive education in art, however, came from his visits to museums on trips to

Europe in 1928, 1930, and 1935. His awareness of late Cubism and the School of Paris was revealed in a series of angular, simplified studies of figures, still lifes, and European street scenes shown in his first one-man exhibition at the Edward Side Gallery in Philadelphia in 1928.

He commenced his long teaching career in 1931 as director of art at the Friends Central Country Day School in Overbrook, outside Philadelphia, and the same year he began to study etching with his friend Earl Horter. During summers, he taught at Pennsylvania State University. With his inclusion in a number of national and international exhibitions during the 1930s, his reputation as a painter rose rapidly, and he became known for his softly painted evocations of vast faded rooms peopled by frail, often melancholy figures. Beginning with a show at the Phillips Gallery in 1939, he had a steady sequence of one-man exhibitions in museums and galleries, and was included in the Museum of Modern Art's *Romantic Painting in America* show in 1942. In 1945 he began teaching at the Philadelphia Museum of Art and in 1949 joined the faculty at the Pennsylvania Academy where a whole generation of younger painters (including Ben Kamihira, Elizabeth Osborne, James Havard, and Tommy Dale Palmore) were to be his students. He received numerous commissions to paint subjects appropriate to his style: the interior of Strawberry Mansion in Fairmount Park for Gimbel Brothers' project "Pennsylvania as Artists See It" in 1945 and the old houses and gardens of Charleston, South Carolina, for *Life* magazine a year later. The list of his prizes and honors is a lengthy one (see the catalogue for the North Carolina Museum of Art, *Hobson Pittman, Retrospective Exhibition,* 1963). In addition to one-man shows at the Woodmere Art Gallery and the Philadelphia Art Alliance, Pittman exhibited with a number of dealers over the years, including the Milch, Walker, and Babcock galleries in New York, and the Boyer, McCleaf, and David David galleries in Philadelphia. In 1953 he was elected to the National Academy of Design and in 1960 he became an honorary member of the International Institute of Arts and Letters.

Pittman's painting grew larger in scale and lighter in color during the 1950s and 1960s, and he also increasingly turned to the medium of pastel. His last work verged on abstraction, with planes of pale pink, yellow, and blue only vaguely decipherable as a bouquet of flowers before an open window or blank canvases in an empty studio. One of the most popular and well-known figures in the Philadelphia art world, he gave a series of lectures on art appreciation at the Philadelphia Museum of Art during the 1960s to a wide audience. The

466.

North Carolina Museum of Art organized a retrospective of more than one hundred works in 1963, and after his death in 1972 at the age of seventy-two, a major exhibition was held at Pennsylvania State University in 1974. When the latter exhibition was subsequently shown at the Pennsylvania Academy, it was accompanied by a supplementary group of works by fifteen of Pittman's former students. His house on the campus of Bryn Mawr College is preserved as a memorial.

466. *Early Spring*

1936–37
Oil on canvas
32 x 40" (82.3 x 101.6 cm)
The Metropolitan Museum of Art, New York. George A. Hearn Fund, 1938

PROVENANCE: With Walker Galleries, New York, until 1938

LITERATURE: Cincinnati Art Museum, *44th Annual Exhibition of American Art* (October 2—November 7, 1937), no. 103; PAFA, *133d Annual* (1938), no. 61 (illus.); "The Metropolitan Museum's Hearn Fund," *London Studio,* vol. 16, no. 92 (November 1938), p. 267 (illus.); J. Burn Helme, "The Paintings of Hobson Pittman," *Parnassus,* vol. 13, no. 5 (May 1941), p. 165, fig. 1; Utica, New York, *Munson-Williams-Proctor Institute Bulletin* (May 1944), pp. 4, 5; Raleigh, North Carolina Museum of Art, *Hobson Pittman, Retrospective Exhibition, His Work Since 1920* (February 2—March 3, 1963), no. 11, p. 32 (illus.)

UNLIKE FRANCIS SPEIGHT, also a native of the South and a colleague for many years on the Pennsylvania Academy faculty, Pittman in his long Philadelphia career never lost his nostalgia for the old mansions and lush gardens of the Carolinas that were the frequent subject of his art. The house in Tarboro where he lived as a child was a rambling Victorian structure with tall windows opening onto a porch that surrounded it on all sides. When he established his own home in Philadelphia, first in Upper Darby, later on the campus of Bryn Mawr College, his rooms were soon furnished with horsehair sofas, draped tables, and softly chiming clocks with which he recreated an atmosphere of the past. By the mid-1930s, he had evolved a consistent style and format for his paintings, which were immensely popular at the time. Favorite themes and images were subject to infinite variation: interiors with small, lonely figures; screens of translucent Chinese silk concealing a pair of lovers or ladies sipping tea; windows flung open onto sultry moonlit skies.

Early Spring depicts a favorite subject, one that Pittman repeated in several versions: the wicker rocking chair waiting for its absent owner on a porch with vine-clad pillars, looking out over a flowering orchard and meadows. In *Southern Spring* of 1938 (Cleveland Museum of Art) the romantic stage setting is slightly different: the rocking chair faces to the right, we are offered no glimpse into a room, and the house on the right has vanished. In place of the farmer plowing, a girl runs by in the distance, flying her kite. In *Quiet Evening* of the same date (collection unknown), the chair is joined by

a cloth-covered table graced with a bouquet. The versions, which vary in color and detail, all project the same romantic mood of melancholy, with the undiminished intensity of a recurring dream. Pittman chose a realistic mode to depict the world of his imagination, but he could not be called a realist: "The furniture—color and spirit of a place—all impress me very deeply and mean more to me even than the idea of merely painting a canvas. A chair, a window, a book—all have the same living qualities of a human being. Hardly ever do I paint or draw from any real object but from reminiscences or memory. The actual object has always—even from earliest experiences—confused me to no ends" (North Carolina Museum of Art, *Hobson Pittman*, cited above, p. 6).

Ad'H □

JOSEPH HIRSCH (B. 1910)

Born in Philadelphia, Hirsch has said that his childhood as the son of a doctor living near a working-class neighborhood in the city exerted an important influence on his career as a painter, making him particularly sympathetic to "proletarian" themes. While attending Central High School, he won the first of many awards—the School Art League Prize for Drawing in the Philadelphia Sesqui-Centennial Exposition of 1926. From 1928 to 1931, he studied at the Pennsylvania Museum School of Industrial Art on a city scholarship (his teachers included Thornton Oakley and Herbert Pullinger), graduating with first prizes in life drawing and illustration. In 1932 he studied briefly with George Luks in New York. Luks's vigorous, earthy style must have impressed Hirsch deeply; his first major painting, *Masseur Tom*, depicted a typical Luks subject: the burly near-nude figure of a steam bath attendant. *Masseur Tom* won the Lippincott Award at the Pennsylvania Academy annual of 1934 for "the best painting in oil by an American citizen"; and the Third Hallgarten Prize at the National Academy of Design that same year. Hirsch also studied for a few months with Henry Hensche (a student of Charles Hawthorne) in 1934–35. The following year he won a Woolley Fellowship from the Institute of International Education, which took him to Paris, then through Europe, and home by way of the Orient. His exposure to the extreme poverty and miseries of coolie labor in the ports of Singapore, Shanghai, and Yokohama confirmed his desire to fight social injustice through his art.

By the time of his first one-man show at the A.C.A. Gallery in Philadelphia in 1937, Hirsch's mature style and favored subject matter were well established. Painting with-

out models, but in a broad realistic mode that occasionally verged on caricature, he devoted himself almost exclusively to depicting his fellow men, particularly in working-class or political situations. One of the leading members of the Works Progress Administration in Pennsylvania, he executed three large murals in Philadelphia: *Football* for the Benjamin Franklin High School (1939); *Adoption* for the new Municipal Court Building (1940); and his most ambitious project, a 710-foot-square panel illustrating *Integration and the Beginnings of Early Unionism* for the Amalgamated Clothing Workers of America Building at 2115 South Street. In 1941 the Carlen Galleries gave him his second one-man show in Philadelphia. His first exposure to a New York audience was at the New York World's Fair of 1939 with his prize-winning painting *Two Men*. Sixteen of his paintings were chosen by Dorothy Miller for inclusion in the exhibition *Americans 1942, 18 Artists from 9 States*, at the Museum of Modern Art, which prompted his receipt of Guggenheim Fellowships in 1942–43 and 1943–44.

In 1941, Hirsch left his studio at the top floor of his father's house at 900 Pine Street and moved to New York, although he was not to settle in for some time due to his activities as a wartime artist-correspondent. In 1943 he received a citation from the United States Treasury Department for his War Bond poster *Till We Meet Again*. Traveling to the South Pacific, Italy, and North Africa in 1943–44, he produced more than seventy-five paintings and drawings which vividly expressed his sympathies for the common soldier and prisoner of war. Hirsch's first retrospective exhibition was held at the Philadelphia Art Alliance in 1947, and included a characteristic array of subjects: *The Drunk, The Law, The Lunch Hour*, and a "still life" of a wad of bills changing hands entitled *The Harvest*. His later work has included portraits of literary figures (Henry Miller, Dorothy Canfield, John P. Marquand) and allegorical, often menacing, depictions of the human condition. During the last thirty years, his paintings, prints, and drawings have continued to win awards and be widely exhibited. He has taught at the Art Institute of Chicago (1947–48) and the Art Students League of New York (1959–67) and served as visiting artist at several universities. In 1967 he was elected to the National Institute of Arts and Letters, and in 1970 a major retrospective of forty-three works was organized by the Georgia Museum of Art.

467. *Two Men*

1937
Signature: J. Hirsch—37 (lower left)
Oil on canvas
18⅛ x 48¼″ (46 x 122.5 cm)
The Museum of Modern Art, New York. Abby Aldrich Rockefeller Fund, 1939

PROVENANCE: Purchased at the New York World's Fair, 1939

LITERATURE: New York World's Fair, *American Art Today* (New York, 1939), no. 231, illus. p. 89; Howard Devree, "Art and Democracy," *Magazine of Art*, vol. 32, no. 5 (May 1939), p. 270, illus. p. 262; Harry Salpeter, "Joe Hirsch: Painter of Men," *Esquire* (April 1942), p. 181, illus. p. 83; MOMA, *Bulletin*, vol. 7, no. 1 (April 1940), p. 5 (illus.); Elizabeth Sacartoff, "Meatcutter's Union Crashes Art with Topnotch Show," *PM's Weekly* (July 13, 1941), p. 45; MOMA, *Americans 1942, 18 Artists from 9 States* (March 23—July 19, 1943), p. 63, illus. p. 62; Philadelphia Art Alliance, "Joseph Hirsch Returns for One-Man Show," *Bulletin* (November 1947), p. 7; Alfred H. Barr, ed., *Painting and Sculpture in the Museum of Modern Art* (New York, 1948), no. 340, illus. p. 150; Oliver W. Larkin, *Art and Life in America* (New York, 1949), p. 435; Athens, Georgia Museum of Art, *Joseph Hirsch* (March 20—May 3, 1970), no. 1 (illus.)

JOSEPH HIRSCH RESPONDED VIGOROUSLY to Dorothy Miller's request for a statement for the catalogue of *Americans 1942*: "In my painting I want to castigate the things I hate and paint monuments to what I feel is noble. I want to talk and be heard. I want to disturb people who admit they know nothing about art, in as constructive a way as Picasso has disturbed artists who felt they knew all about art" (p. 62). In the years of political and economic crisis that followed the Depression, Hirsch was among the most energetic and effective of the large, varied group of artists espousing social realism in this country. He shared his determination to make contemporary art meaningful by endowing it with a social conscience—and rendering it accessible to the man in the street—with painters as divergent in style as Ben Shahn, Philip Evergood, and George Biddle. The works of George Grosz and William Gropper were visually closer to his own, but their bitter satire directed against the rich and the powerful was remote from Hirsch's usually affirmative expression of sympathy with the working class.

In 1939, Hirsch was one of a number of Philadelphia artists (including Arthur B. Carles, Ralston Crawford, Daniel Garber, Leon Karp, Walter Stuempfig, and Franklin Watkins) to have a painting chosen by an elaborate jury system for the exhibition *American Art Today* at the New York

467.

World's Fair. Votes were cast by 120,000 visitors for the most popular painting in the show, and with 546 works to choose from Hirsch's *Two Men* received the highest number of votes. For a painter about to embark on an ambitious series of WPA mural projects for Philadelphia the vote must have been welcome evidence that his convictions were being clearly transmitted to an approving public. Hirsch intended to convey his message in the formal arrangement of his paintings as well as in their subject matter. In reply to a questionnaire from the Museum of Modern Art prompted by their acquisition of *Two Men,* he wrote: "The low, broad proportions of the canvas suggest the kind of intensity we associate with the horizontality of speed. The elimination of all detail, save the long ash on the cigarette of the listener, gives concentration to the two figures. The use of triangles gives a certain stability to the figure visually, as they do, in fact, to any engineered construction. Palette knife used on negro's jacket in directional strokes approximating the pull of cloth, imparting a thrust to the forms." The simplicity of the composition is characteristic of Hirsch's work, single figures of men, or groups of two in conversation, providing his favorite format. Occasionally resorting to virtual caricature, as in his depiction of the world of big politics (*The Senator* and *The Confidence,* both of 1941), Hirsch sought to express a profoundly serious content in *Two Men.* "The title, plus the fact that there is nothing between the men (they are on the same side) at the table, plus the complete mutual interest they evidence, emphasize my belief, I hope, that what men have in common is of much greater significance than are their differences" (MOMA questionnaire). Hirsch's interest in black subject matter was shared by several artists working in Philadelphia at that time, notably Julius Bloch, who painted symbolic expressions of black

repression like *The Prisoner* of about 1934 as well as many portraits of leaders in the black community.

Two Men has been shown in more than fifteen exhibitions since it was painted, but surely none was more appropriate to its purpose than Hirsch's first one-man show in New York at the union headquarters of Local 623 of the Amalgamated Meat Cutters of America in 1941. It hung in the hiring hall, "a long dim room where the jobless wait for calls, play dominoes, sit and stare out of the window" (*PM's Weekly,* July 13, 1941, p. 45).

Ad'H □

SALVATORE PINTO (1905–1966)

Born in Salerno, Italy, Salvatore Pinto moved with his family to the United States when he was four years old. They settled in Philadelphia, where his father became a produce dealer. From 1921 to 1924, Salvatore trained at the Pennsylvania Museum School of Industrial Art and from 1924 to 1925 at the Pennsylvania Academy of the Fine Arts. Unfortunately, a studio fire destroyed much of his early work. Taken under the wing of Dr. Albert C. Barnes, Pinto also studied extensively at the Barnes Foundation. Between 1930 and 1933 he received three Barnes Foundation scholarships, which enabled him, accompanied by Angelo and Biagio, two of his five younger siblings (four of whom were affiliated at some point with the Barnes Foundation), to travel and paint in southern France (where they visited Matisse), Corsica, and Morocco. During the 1930s, Salvatore, Angelo, and Biagio often worked and exhibited together, and their work of the period is closely associated.

The height of Salvatore's recognition as a printmaker and painter came during the

1930s when by invitation he exhibited widely in Europe and the United States. A painter in oils and watercolors and a printmaker working in intaglio and relief techniques, Salvatore (with Angelo) designed sets and costumes for the Philadelphia Ballet Company directed by Catherine Littlefield. Some of these sets were used for the company's 1937 European tour.

About 1940, Salvatore's attention turned from painting and printmaking to commercial color photography. The Curtis Publishing Company was a major client of the Pinto Brothers photography studio, in which all five brothers were active at some point in their careers. After a serious automobile accident in 1950, Salvatore spent increasingly longer periods of time on Long Beach Island, New Jersey, and in 1961, when he married Mary Dorothea Badger, he retired to the Island, where he enjoyed collecting and refinishing antique furniture.

Pinto received several prizes for his work, among them the Philadelphia Art Club Medal in 1934. His work is in public and private collections throughout the United States including that of the Barnes Foundation, Merion, Pennsylvania.

468. *Mills*

c. 1937
Signature: Salvatore Pinto (in pencil, in margin, lower right)
Inscription: "Mills" (in pencil, in margin, lower left)
Wood engraving printed in black on Japanese paper
7¹⁄₁₆ x 9¹⁵⁄₁₆″ (image) (17.9 x 25.2 cm)
Philadelphia Museum of Art. Purchased: Thomas Skelton Harrison Fund.
41-53-404

468.

LITERATURE: Weldon Bailey, "Fresh Paint," *Philadelphia Art News,* vol. 1, no. 1 (November 8, 1937), p. 2

CRITICIZING MANY of Salvatore Pinto's contemporaries such as Thomas Hart Benton and John Stuart Curry for carrying on "the stock in trade of academic painters since the time of the Renaissance"—their "flagrant sentimentalism and photographic literalism" —Dr. Albert C. Barnes praised Pinto for his "personal visions embodied in individual plastic forms" (*The Art in Painting,* New York, 1937, p. 347). Pinto, reflecting the philosophy of Dr. Barnes, strove for luminosity as well as rhythmic and spatial fluidity in his paintings, which often show the influence of both Matisse and Renoir. A series of Pinto etchings of the late 1920s depict post-Pennell center city Philadelphia, while those of the 1930s are often directly related to the idyllic beach scenes prevalent in his paintings. *Mills,* like other Pinto wood engravings (see also *Locomotive,* illus. Beall, *Prints,* p. 241), conveys his romantic fascination with the interlocking visual patterns and textures associated with the complex architectural and technological structures of a growing industrialized society.

In his wood engravings, perhaps because of the resistance and imposition of the medium, Pinto invents some of his most authoritatively unique and personal images. White-line engraving, used extensively during the nineteenth century for reproductive book illustration, had been considered an inappropriate medium for original works of art. However, during the late 1930s, the workshop atmosphere of the WPA Graphic Arts Division, Department of Fine Prints,

set the stage for the development and re-examination of technical processes; it was under these circumstances that *Mills* was executed. The print was probably first exhibited in November 1937 at the Art Center, West Chester, Pennsylvania, in an exhibition of WPA posters and prints (Weldon Bailey, "Fresh Paint," *Philadelphia Art News,* vol. 1, no. 1, November 8, 1937, p. 2). The original woodblock for *Mills* is in the collection of the Philadelphia Museum of Art.

Pinto's relaxed yet controlled use of several engraving tools permits him to create the rich field which is spatially active and filled with visually implied tactile surfaces. The smooth smokestacks with textured areas suggesting shininess contrast with the slatted horizontal structure moving across the lower image beneath the coarsely textured raised passageway; note also the contrast between the unconfined, hovering, stylized clouds and the upward swirls of billowing smoke. Curvilinear patterns of smoke pushing skyward from a woven fabric of buildings and passageways are characteristic of Pinto's urban landscapes. The tiny, puffy figures leaning from the windows recall those that people Pinto's beach scenes. Angelo Pinto has suggested that *Mills* is probably a composite image developed from drawings made at industrial sites in the Kensington-Frankford area of Philadelphia (letter to the author, August 18, 1975).

A contemporary critic praised Pinto's work for its rediscovery "that the severe requirements of design can be fused, not only with representation, but also with human values" (Helen McCloy, "Human Values in the Art of the Pinto Brothers," *Parnassus,* vol. 7, no. 1, January 1935, p. 4).

RFL □

DOX THRASH (1892/93–1965)

Born in Griffin, Georgia, Thrash, as a child, "liked to draw, also adventure in the woods mostly myself. . . . As an older boy, I did not have very much schooling but learned what education I have, from reading books, listening to conversation and traveling . . . extensively through the United States. . . . My career as an artist began in the Art Institute in Chicago. . . . I was drafted in the army in 1917, and served fourteen months as a private in the 365th Infantry 92nd Division, and was wounded while in action" ("The History of My Life by Dox Thrash [artist]," MS, n.d., collection of Samuel H. Nowak, Philadelphia).

In 1919, Thrash re-entered the Chicago Art Institute's evening school and from Fall 1920 through June 1923 he attended day, evening, and summer classes as a Federal Board student (government-sponsored postwar rehabilitation). He studied painting, drawing, design, lettering, and commercial art—posters, decorative composition, and mural (letter to the author from Ferne V. Smith, School Archivist, August 15, 1975). "After my art education was completed, I was lured back to the open road, hobo-ing, working part the time on odd jobs . . . with the idea of observing, drawing and painting people of America. Especially the 'Negro.' Finally I landed in Boston . . . for a year . . . (then) for two years was hidden in a town named Sufficield [*sic*], Conn. . . . decided I had enough study of nature . . . came to New York City and remained there for a year . . . departed . . . for another cross-country journey but did not get any further than Philadelphia, and have remained here ever since" ("History of My Life," cited above).

After moving to Philadelphia, Thrash studied at the Graphic Sketch Club (Samuel Fleisher Art Memorial), and there, under the direction of Earl Horter, he made his earliest prints. "That was the greatest adventure or sacrifice I have ever made. This helped me to experiment with copper and zinc plates, lithograph, and various kinds of acid. The great day came when I discovered that carborundum could be used on a copper plate. Since that time, I have spent most of my time making prints out of various mediums" ("History of My Life," cited above).

Thrash's work was included in the first Harmon Foundation exhibition in 1928. He was a member of the Pyramid Club where he was active on exhibition juries and committees. His work was highlighted in the Club's 1945 annual exhibition. From 1935 to 1942 he worked in the Fine Arts Section of the Graphic Arts Division of the Works Progress Administration and continued working as a draftsman, painter, printmaker, and sculptor until his death.

Thrash was also interested in photography and was an early member of Artists Equity. For several years he was a civilian employee at the Philadelphia Navy Yard and late in life he worked as a housepainter.

Thrash's work was exhibited in one-man shows at the Art Alliance, at Howard University in 1942, and at the Smithsonian Institution in 1948. His work has also been seen in group exhibitions and is included in public and private collections throughout the United States.

469. *Marylou*

c. 1936–39
Signature: D Thrash (in pencil, in margin, lower right)
Inscription: Marylou (in pencil, below image, lower left)
Carbograph printed in black on cream wove paper
9¹⁵⁄₁₆ x 7″ (image) (25.2 x 17.7 cm)
Philadelphia Museum of Art. Given by E. M. Benson. 42–86–3

PROVENANCE: E. M. Benson

LITERATURE: Museum of the Philadelphia Civic Center, *Afro-American Artists, 1800–1964* (1969), no. 212

SAMUEL PUTNAM, IN HIS DISCUSSION OF DOX THRASH, notes "his constant quest of new methods and techniques, his unceasing experimentations, his wide range of interests" ("An Outstanding Philadelphia Artist Also Paints Navy's Battlewagons," *Daily New Yorker,* March 22, 1945). As a printmaker, Thrash worked in lithography and various relief and intaglio techniques. His experimental impressions of subjects executed in etching, drypoint, and aquatint demonstrate the dissatisfaction with these more traditional techniques that led him to the carborundum process for which he is best known. Dox Thrash, Michael J. Gallagher, and Hubert Mesibov are usually given credit for the collaborative development of the process (see *The Carborundum Print,* W.P.A. Technical Series Art Circular No. 5, September 10, 1940). However, Thrash, in unpublished notes for a book about the process which he apparently had planned, states: "I would like to give credit to my two co-workers Hubert Mesibov and Michael Gallagher for the splendid help they gave me in perfecting this method, and also my supervisor, Richard Hood. Credit should go also to Carl [Zigrosser], the curator of prints for the ... Art Museum in Philadelphia for the recognition he accorded this method ... I do claim credit for the discovery" (Thrash MS, collection of Samuel H. Nowak, Philadelphia).

469.

The carborundum print (also called the carbograph or, by Thrash, the Opheliagraph, in honor of his mother, Ophelia) results from a hybrid technique. By a process similar to that used in resurfacing lithograph stones, carborundum crystals (carbide of silicon, which can vary in coarseness) are wetted and impressed by the rotation of a weight onto the surface of a metal plate, producing a pitted, granular plane. If the plate were printed at this stage a formless, evenly toned area would result. The darkness of the tonality is dependent upon the coarseness of the carborundum and the length of the grinding time. The process for honing an image onto the roughened metal plate parallels the mezzotint process which also requires an overall "toothy" or "hill and valley" surface. In both instances, lighter tonal values are the result of scraping and burnishing the plate to varying degrees of smoothness, thereby lessening or eliminating the ink-grasping granular surface. The scraper, a triangular knifelike tool, cuts away the peaks of the plate surface; the burnisher, a smooth, rounded tool, when used with variations of hand pressure, further flattens areas of the plate.

The carborundum process can be combined with any or all of the various intaglio techniques, and the printing process is identical to that used for traditional line etching. Further tonal variations can result from the selective wiping of ink from the plate surface, a technique used to advantage by Rembrandt, whose etchings were much admired by Thrash. In February 1938, prints made by the carborundum process were

exhibited, probably for the first time, in an exhibition of Federal Art Project prints held at the Pennsylvania Museum (*Philadelphia Art News,* vol. 1, no. 8, 1938, p. 1).

An attempt to establish the aura of a place, a situation, or a person permeates Thrash's oeuvre. His subject matter varies from cabin scenes remembered from his native Georgia to the urban landscape of his adopted Philadelphia (see Alain Locke, *The Negro in Art,* New York, 1971, pp. 62–63). He paid homage to the worker, a characteristic subject of WPA prints, and he produced portrait essays, of which *Marylou* is one. Although Thrash frequently worked from photographs and drawings, no preliminary studies for this image have been located. Allan L. Edmunds gives the following account of the subject: " 'Marylou' was not intended to represent any one individual, but was one of several studies he did of the many young attractive women that would come by the studio. Sam [Samuel J. Brown, with whom Thrash shared a studio for many years] says he had quite a female following as he would counsel them, tell stories, and use them as models for his works. . . . Sam remembers him as being popular for his story-telling ability and humor" (letter to author, April 3, 1975).

Thrash's early portraits (see the lithograph *Linda* and the aquatint *Bronze Boy,* collection of the Free Library of Philadelphia) are analytical and planar in a Cubist-related mode. However, *Marylou,* with her softly modeled, rounded features, is typical of the carbograph portraits. The scraper and burnisher call forth the mysterious light which defines the cheekbones, the edges of the eyelids, the bridge of the nose, the upper edges of the lips, and the side of the neck. This schema is used repeatedly in similar Thrash portraits such as *Charlotte, Manda,* and *Mr. X.* Cubist analysis is replaced by a formula for an ideal head, thus allowing Thrash to emphasize character as manifested by mood rather than specific structure. The heads are distinctive in their similarity to lithograph portraits by Eugène Carrière.

Developments in color printing in all media took place in the WPA Graphic Arts Division workshops, and Philadelphia was one of the centers of graphic arts activity. The city's workshop, under the direction of Benjamin Knotts, opened in 1936 above Benny the Bum's restaurant at 311 South Broad Street. Dox Thrash, one of the more mature of the approximately sixty artists working there, activated color intaglio work in the Philadelphia shop. His painterly printing techniques were oriented toward the monotype process rather than edition printing, and in this way he continued the kind of experimentation that earlier had led to the development of the carbograph.

RFL □

Robert Riggs was born in Decatur, Illinois, and spent his early years there. Philadelphia became his home after a period of army service with a medical unit in France during World War I and art training at the Académie Julian in Paris and the Art Students League in New York. He won numerous medals and awards for paintings, drawings, watercolors, and prints as well as for his commercial illustration and advertising commissions, which included work for the *Saturday Evening Post, Fortune,* and *Life* magazines, and for insurance, phonograph record, and pharmaceutical companies. During the early 1960s he taught briefly in the illustration department of the Philadelphia Museum College of Art. An inveterate curiosity took him to China, Europe, North Africa, Siam, and the West Indies.

A large redheaded man, Riggs was considered eccentric by many, in part because of his penchant for lizards, snakes, and turtles. At times he shared his bachelor quarters with as many as fifty creatures (who frequently moved on to the Philadelphia Zoological Gardens). He also had a large collection of African and American Indian art and artifacts and displayed great interest in their related history and culture. Among his last major efforts was a series of drawings based on Lenni-Lenape Indian legends. Riggs's works are included internationally in numerous public and private collections.

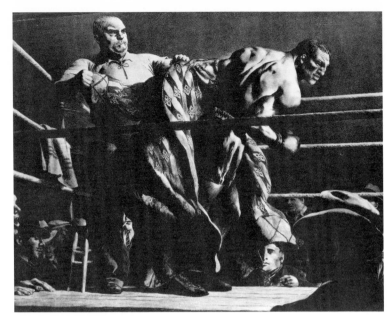

470.

470. *Club Fighter*

c. 1939
Printed by George C. Miller, Lithographers, New York
Signature: Robert Riggs (in pencil, in margin, lower right)
Inscription: Robert Riggs (in stone, lower left); 50 Club Fighter (in pencil, in margin, lower left)
Lithograph printed in black on white wove paper
14¹⁄₁₆ x 18⅛″ (image) (35.7 x 46 cm)
Philadelphia Museum of Art. Purchased: Thomas Skelton Harrison Fund.
41-53-300

LITERATURE: Beall, *Prints,* no. 15, p. 418

THEMATICALLY, *Club Fighter* is rooted in eighteenth century England, where modern boxing as an activity and as a popular subject for the artist had its foundations. In this respect Riggs's print shares a pictorial tradition with William Hogarth that was carried on by Théodore Géricault, Thomas Eakins, and George Bellows, whose 1917 lithograph, *Stag at Sharkey's,* is one of the genre's best-known examples.

The popularity of boxing was reflected by a proliferation of neighborhood pugilistic clubs and gymnasiums. *Club Fighter* is one of approximately twenty lithographs by Riggs on the theme of the prize fight which document famous subjects, such as *Baer-Carnera* (Museum of the City of New York, *The Ring and the Glove: A Survey of Boxing,* November 19, 1947—April 4, 1948, p. 30; Beall, *Prints,* no. 5), but more often depict the anonymous activities of the amateur gym.

The Riggs lithographic oeuvre as held by the Library of Congress (Beall, *Prints,* pp. 418–19) numbers seventy-five works, mainly executed between 1932 and 1942. Most of the lithographs are printed in black on white paper, and occasionally a tannish stone is added to create a chiaroscuro effect. Circus, hospital ward, and boxing subjects recur most frequently. Few of the prints are dated, but a clear stylistic and technical progression is apparent.

The stark, taut, dramatic image of *Club Fighter* and the deliberate drawing method employed are typical of Riggs's later lithographs. In contrast, *Rub Down, Shadow Boxer, Tight Rope,* and other prints of the early 1930s are drawn onto the stone with great spontaneity, emphasizing the gesture of the artist's handwriting. Furthermore, the structure of these early compositions is more abstract and fluid, with forms less confined and particularized, tonality less developed, and impact less dramatic.

The technical method used for *Club Fighter* is akin to the scratchboard technique frequently employed by Riggs for commercial illustrations. Both involve a subtractive process in which a surface is coated with a removable material and the image is developed as the coating is removed. In *Club Fighter,* after the limestone was covered with greasy crayon, various pointed tools were used to pick and scratch away at the grease, exposing the stone and causing the image to emerge. The white scratch marks can clearly be seen at the top in the background areas of the print. Tonal gradations are developed by varying the concentration of these marks; white areas are the result of complete removal of the lithograph crayon. The granular quality of the stone is emphasized by sanding away the greasy crayon or by removing the top layer of crayon with a broad flat tool. This provides textural contrast to the more pervasive scratchy delineation of form and is most clearly visible in fleshy areas of the "champ." This subtractive technique lends itself to the drama of spectacle to which Riggs is repeatedly drawn.

Riggs's working methods included long periods of contemplative observation. Often he would go to the gym or the circus or the corner of Germantown and Chelten avenues and, without making any sketches, immerse himself in the atmosphere, apparently capturing the vibrations in the air and memorizing visual data to be used at a later time. Although *Club Fighter* is drawn with great specificity, types rather than individuals result. The same participants appear again and again in Riggs's boxing prints—square-jawed, bespectacled, cigarette-smoking, howl-

ing, mustachioed men with brimmed hats shading their brows form an audience for grim-faced managers and muscular, tough, out-to-win fighters. We, the viewers, join the audience, perhaps in the third row. Thus the intensity of the action in the ring is augmented by the intensity of the action of seeing.

RFL □

HARRY ROSIN (1897–1973)

Rosin was born in Philadelphia and attended the West Philadelphia High School. His father was a shoemaker who came to the United States from Russia in the 1880s; his mother was an emigrant from Alsace-Lorrain. Between 1914 and 1917 he worked for Samuel Yellin, the master craftsman in wrought-iron work (see biography preceding no. 418) and was involved in Yellin's projects for the Cathedral of St. John the Divine in New York and the Washington Memorial in Valley Forge. Metalwork remained an interest of Rosin's in his later career; from time to time he operated his own workshop, and he executed the iron gates for the Curtis Institute of Music in Philadelphia. In 1919–20 he took night classes at the School of Industrial Art and then taught pottery and modeling for two years at the Trenton Art School, an experience which prompted him to seek further training in the fine arts. From 1923 to 1926, Rosin studied sculpture with Charles Grafly at the Pennsylvania Academy. A Cresson Travelling Fellowship awarded in 1926 sent him to Europe, where he was able to stay for five years, becoming familiar with the work of Charles Despiau, Émile-Antoine Bourdelle, and Jacques Lipchitz, in particular.

In 1932 he received a commission for a twenty-foot-high concrete figure of Christ for the facade of the Cathedral of Guadeloupe in the French West Indies. His visit to the Tropics led to an important phase in his career. Between 1932 and his return to Philadelphia in 1936, Rosin lived in Tahiti, building himself a house, executing portrait commissions, and creating a series of sculptures with Tahitian women as models. Nine works were shown in the 1933 international sculpture exhibition at the Philadelphia Museum of Art, and he was included in the Chicago World's Fair of 1934. Rosin's first one-man show was held at the Gimbel Galleries in Philadelphia in 1936, shortly after his return.

Settling in New Hope, Pennsylvania, he built himself and his Tahitian-born wife, Vilna Spitz, a house on land for which he traded a portrait-bust of the landowner's daughter. His torso of a Tahitian girl,

Hina Rapa, won the Widener Gold Medal at the Pennsylvania Academy in 1939. In the same year he joined the Academy faculty as an instructor in sculpture, a post he held for thirty-three years. His most popular and widely exhibited works continued to be ample figures of women (somewhat in the tradition of Aristide Maillol) and portrait heads of children, thirty-three of which were shown in a one-man exhibition at the Academy in the winter of 1945.

Rosin received several commissions for large public sculptures in the Philadelphia area, beginning with two large limestone figures, *The Quaker* and *The Puritan,* for the Ellen Phillips Samuel Memorial in Fairmount Park. His over-life-size sculpture of Connie Mack was unveiled at the baseball stadium in 1957, and a bronze figure of the Olympic rowing champion Jack Kelly was installed along the East River Drive in Fairmount Park in 1965. He often served as a juror for regional and national exhibitions and continued to win a series of awards, including the Academy's Fellowship Gold Medal (1942), a Regional Gold Medal (1950), and a Distinguished Pennsylvania Artist Award (1964). In 1965 he and the painter Julian Levi shared one-man shows at the Pennsylvania Academy's Peale House Galleries. Among his last works were four carved stone panels for the facade of the West Chester County Court House and a series of commemorative coins for the 1974 centennial of the Philadelphia Zoo. In 1970, Rosin was elected an Associate of the National Academy of Design. He died while working in his New Hope studio, at the age of seventy-five.

471. *Reclining Nude*

c. 1939
Bronze (cast in 1949)
20½ x 15½ x 42″ (52.1 x 39.4 x 106.7 cm)
Philadelphia Museum of Art. Given by Morris Blackburn, Charles T. Coiner, Paul Darrow, Bernard Davis, Robert Hogue, Lyle Justin, Leon Karp, Walter Reinsel, Robert Riggs, and Franklin Watkins. 47–15–1

PROVENANCE: Purchased from the sculptor in 1947 by a group of ten artists, and presented to the Philadelphia Museum of Art

LITERATURE: PAFA, *135th Annual* (1940), no. 190 (illus.); FPAA and PMA, *Sculpture International* (May 18—October 1, 1940), no. 326; PAFA, *Harry Rosin, Portraits of Children and Other Recent Sculpture* (December 8, 1945—January 7, 1946), no. 22; *The Art Digest,* vol. 21, no. 12 (March 15, 1947), p. 13 (illus.); PAFA, Peale Galleries, *Harry Rosin* (November 4—December 12, 1965), no. 18

THE ART OF SCULPTURE in the United States during the 1930s and 1940s presented a confusing and often conservative picture in its profusion of styles and trends. One of the most popular veins of figurative work derived from the example of Aristide Maillol, whose calm and heavy-limbed bronze women achieved a fine balance between academic idealism and modernist simplification. Harry Rosin's five years in France exposed him to the best work of Maillol, as well as that of Charles Despiau (1874–1946), whose portrait heads and full-length figures of

471.

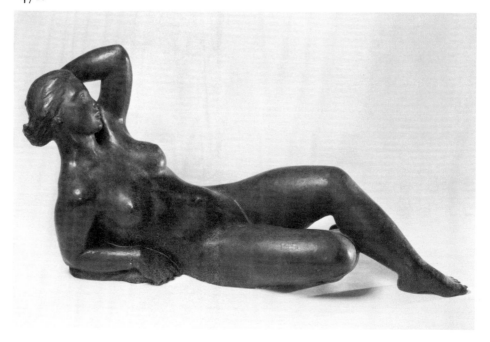

555

women were less idealized and more conventional. His extended visit to Tahiti provided him with models whose languid mood and classic shape confirmed his own sculptural style. The image of Paul Gauguin must have hovered in Rosin's thoughts as he persuaded the shy Tahitian girls to pose, and on his return to the city in 1936, Philadelphia newspapers hailed him as the emissary from a Pacific paradise. His exotic subject matter gave an individual character to the series of full- and half-length female nudes he exhibited in Philadelphia in 1933. Among his most successful sculptures were the life-size torso *Hina Rapa,* 1935 (one bronze cast of which he sold to Charles Nordhof, co-author of *Mutiny on the Bounty,* as a figurehead for his boat), a cast-stone figure of a girl arranging her hair (*Tehiva,* c. 1934, now in the Lyman Allyn Museum, New London, Connecticut), and this *Reclining Nude.* While *Hina Rapa* and *Tehiva* reveal the specific facial characteristics of Rosin's Tahitian models, *Reclining Nude* was executed around 1939, three years after his return to Philadelphia, and embodies instead a generalized summary of his South Seas experience. The soft, ample forms of the figure are graceful and uncontrived, although it lacks the monumental, almost architectonic quality of Maillol's masterpiece,

The Mediterranean. Despiau's full-length figure of *Assia,* 1938 (one cast of which is in the collection of the Museum of Modern Art), makes perhaps a more apt comparison. Rosin worked consistently from the living model, and his *Reclining Nude* is anatomically convincing despite its rather dreamy generality. Aware of abstraction as an alternative mode, Rosin gave a simple but undogmatic description of his own aims: "When I do a figure I try to get the same impact that I get from picking up a stone on the beach. The stone has no representational quality at all, yet even a layman would feel its shape and say, 'Isn't that nice!' He is intrigued, of course, by the non-objective quality of the stone, and by its total shape, texture and density. Everyone really likes an abstraction and will accept it readily if it happens to be a beautiful stone, but will reject it if it is a painting or a piece of sculpture. The layman doesn't seem able to look at a work of art as he would at a stone" (in Dorothy Grafly. "Harry Rosin," *American Artist,* vol. 10, no. 2, February 1946, pp. 39–40).

Reclining Nude was shown in the 1940 annual exhibition of the Pennsylvania Academy, and shortly thereafter it was one of his six entries in the second large international show of sculpture at the Philadel-

phia Museum of Art. In 1947 ten of Rosin's fellow artists from Philadelphia bought the sculpture and presented it to the Museum as the piece by which Rosin wished to be represented in the collection. Originally conceived in a pink-tinted cast stone, it was cast into bronze in 1949 with the unanimous consent of the donors.

Ad'H □

WHARTON ESHERICK (1887–1970)
(See biography preceding no. 458)

472. *Table and Chairs*

1939–40
Mark: w. e. 1940 (gouged on top of the short end of table at edge); Wharton Esherick 1940 (gouged on one chair on right rear leg)
Table: hickory, phenol fiber top; chairs: hickory, rawhide seats
Table 26½ x 62½ x 40½″ (67.3 x 158.7 x 102.8 cm); chairs 32 x 16¼ x 15½″ (81.2 x 41.2 x 39.3 cm)

Mrs. Bess Hurwitz, Doylestown, Pennsylvania

LITERATURE: "America at Home," *Art Digest,* vol. 14, no. 17, (June 1940), p. 9; George Howe, "New York World's Fair 1940," *Architectural Forum,* vol. 73, no. 1 (July 1940), p. 36; Talbot F. Hamlin, "Interior Decoration, 1940," *Pencil Points,* vol. 21, no. 7 (July 1940), pp. 438–39; Washington, D.C., Renwick Gallery, *Woodenworks* (January 28—July 9, 1972), no. 29

THIS TABLE AND SIX CHAIRS (two of which are exhibited) were part of an interior done jointly by George Howe (see biography preceding no. 456) and Wharton Esherick for display at the New York World's Fair in 1940. Called the "Pennsylvania Hill House," this interior was part of a larger exhibition, *America at Home.* The most prominent section of this show was a "handsomely installed series of 15 rooms by outstanding decorators, designers and architects from all sections of the country. Each room, designed for a specific purpose and purse, illustrates the theme idea expressed in its title" ("America at Home," *Art Digest,* vol. 14, no. 17, June 1940).

In an article for the *Architectural Forum* in 1940, George Howe illustrated and described the "Pennsylvania Hill House":

The plan of this room is conceived by the architect as a setting for Mr. Esherick's spiral stair (which is taken bodily from his workshop) and furnishings rather than as a simulation of reality. The peculiar quality of the sculptor's products comes from the fact that he actually lives

472.

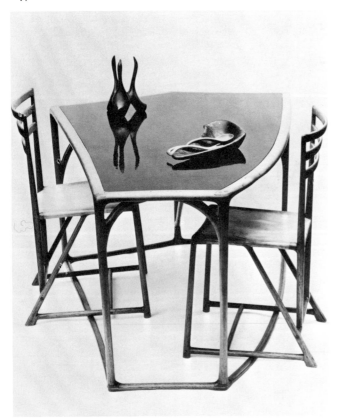

and works on a Pennsylvania hillside among the trees—oak, hickory, walnut and cherry—which he cuts down, seasons in his lumber yard, and tools with his own hands. Every form is a result of his personal sense of the direction of the grain and natural color value of the wood, and every surface is determined by his feeling for the infinite variety of the sense of touch.

The pottery, textiles, rug . . . and books, which provide color accents, are by local craftsmen. Obviously this work, which is the product of individual artists, cannot well be compared to designs adapted to the industrial process, nor is it within reach of the average American householder. (vol. 73, no. 1, July 1940, p. 36)

Although most of the interiors in *America at Home* were designed to be mass produced economically, the Howe-Esherick room was a custom design. Another contemporary critic also emphasized the uniqueness of Esherick's furniture:

The joy of making things for oneself is a very real satisfaction; and, when to this is joined that creative imagination in the handling of wood, in the emphasis on solidities and shapes, which runs all through this room and ties together in its small area this great variety, the result is not only beautiful but eminently timeless. The extraordinary open spiral stair built around a twisted newel, with its sculptured treads, each one so strong, so gracefully tapering, and each one an individual thing, is a *tour de force* perhaps—there could never be another like it, and to emulate it or imitate it merely as a copy would be to court disaster. As it is, it is perfect. Equally interesting though entirely different in quality are the lovely delicate side chairs, with their graceful proportions, and the table so odd in plan, which goes so ideally against the curved built-in seat. Interesting, too, is the radiating pattern of the boarding on the walls above this seat; yet how restless such a pattern would be were it not so perfectly composed with the curves of the bench itself, the rich pattern of the abstract rug, and the table! (Talbot F. Hamlin, "Interior Decoration, 1940," *Pencil Points,* vol. 21, no. 7, July 1940, p. 439)

Esherick's table and chairs demonstrate the influence of modern Scandinavian design. The Danish architect Finn Juhl, for example, developed a very personal sculptural style in his furniture, similar to Esherick's, which reflected a general trend in Danish design (see Povl Christiansen and Hakon Stephensen, *The Craftsmen Show the Way, 1927–1964,* Copenhagen, 1966, p. 92). Both Juhl's and Esherick's chairs required careful selection of material and demanded virtuoso skills of the cabinet-maker.

The four additional chairs, an upholstered armchair, the spiral staircase, and the built-in sofa exhibited in the "Pennsylvania Hill House" have survived, and are in the Wharton Esherick Museum.

DH □

BENTON MURDOCK SPRUANCE (1904–1967)

Born in Philadelphia, Spruance was orphaned at an early age. With the exception of brief periods of travel and study abroad, he spent his life in the Philadelphia area with his wife Winifred Glover Spruance and sons Peter and Stephen. At the age of nineteen he won the first of many awards—for an etching, *The Bridge,* one of his very few works in this medium.

Following a year of architectural study at the University of Pennsylvania from 1924 to 1925, during which time he supported himself as a draftsman, Spruance won a scholarship to the Pennsylvania Academy, where he studied from 1925 to 1929. Although he decided against an architectural career, he consistently encouraged dialogue between artists and architects. During his tenure as president of the Philadelphia chapter of Artists Equity (of which he was a founding member), the City Council passed legislation requiring that one percent of costs for public buildings be allocated to the fine arts. From 1953 until his death he served as the painter member of the City of Philadelphia Arts Commission, which voted on the works to fulfill the one percent dictum. Shortly before his death he was elected an honorary member of the American Institute of Architects.

In 1928 and again in 1929 (although its use was postponed until 1930) the Academy awarded Spruance a Cresson Travelling Scholarship for study in Europe. Much time during both study trips was spent in the Paris workshop of Edmond and Jacques Desjobert with a brief period in the atelier of the Cubist painter-theorist André L'Hote.

While still a student at the Academy, Spruance taught perspective at Beechwood School (Beaver College), and in 1933 he became chairman of the Department of Fine Arts, a position he held until his death. From 1934 to 1964 he was also affiliated with what is now the Philadelphia College of Art and for several years was director of the present-day printmaking department. In the 1930s, when the College print workshop was established, it was one of the few well-equipped academic shops in the country. In his teaching, Spruance's range was diverse; it included studio courses in design, drawing, painting, and printmaking. His art history lectures, especially those delivered at Alverthorpe Gallery, which houses the print and rare book collection of Lessing J. Rosenwald, continuously reaffirmed his deep belief that works of the past have significance for the present. Spruance was awarded honorary academic degrees from both Beaver College and the Philadelphia College of Art. In 1965 he received both the Philadelphia Sketch Club Award and the Art Alliance Medal of Achievement.

From 1929 on Spruance's lithographs (numbering about 475) were exhibited almost continuously in various annual and biennial print exhibitions. He won innumerable prizes in invitational and juried exhibitions.

During the 1930s his prints were exhibited at the Weyhe, Downtown, and Macbeth galleries, which were among the first to encourage printmakers working in media other than traditional line etching. Through his affiliation with Weyhe, Spruance met Carl Zigrosser (1891–1975), who later became the first curator of prints at the Philadelphia Museum of Art, and the two men formed a lifelong friendship. He was also active with The Artists Group, an organization committed to the production of low-priced prints for the general public.

As a visiting artist, juror for exhibitions, consultant, and lecturer, Spruance was affiliated with numerous institutions and organizations. He was a member of the original board of directors of the Tamarind Lithography Workshop and served on the Pennell Fund Purchase Committee of the Library of Congress from 1955 to 1962. He also was a member of the National Academy of Design.

In 1950 a Guggenheim Fellowship enabled Spruance to spend a concentrated period of time improving his abilities as a master lithographic printer. He expanded the use of the subtractive process of color lithography by which one stone was used repeatedly in making a multiple color lithograph. A second Guggenheim Fellowship enabled him in 1962–63 to further his research while producing a body of prints on a return visit to the workshop of Desjobert in Paris and also by working at the Curwen Press Limited in London and U M Graphic in Copenhagen.

More than thirty one-man exhibitions of Spruance's drawings, paintings, and prints were held from coast to coast between 1954 and 1967, and his works are included in hundreds of public and private collections.

473. *Repose in Egypt*

1940

Printed by Theodore Cuno, Philadelphia

Signature: Spruance 40 (in pencil, in margin, lower right)

Inscription: BS (in stone, lower right margin); Ed. 30 (in pencil, in margin, lower left); Repose in Egypt (in pencil, beneath image, lower center)

Lithograph printed in black and tan on white wove paper

15⅜ x 10⅛″ (image) (39 x 25.7 cm)

Philadelphia Museum of Art. Purchased: Lola Downin Peck Fund from the Carl and Laura Zigrosser Collection. 73-12-148

LITERATURE: PAFA, *Memorial and Retrospective Exhibition: Lithographs, Paintings and Drawings by Benton Spruance* (October 9—November 24, 1968), no. 58; Bridgeport, Pa., Sacred Heart University, *Benton Spruance* (March 9—April 1, 1973), no. 25

Repose in Egypt IS RELATED TO *The Strength of Democracy Abides with the Family,* a mural painted by Spruance in 1939. The mural (the earlier of two painted for public buildings in the city) is composed of four distinct images and hangs in a judge's chamber in the Juvenile and Domestic Relations Branch of the Municipal Court in Logan Circle, Philadelphia (City of Philadelphia, *Art Jury, Thirtieth Annual Report,* 1940, illus. frontispiece). On the basis of several surviving preliminary drawings and documentary photographs, it can be affirmed that the lithograph followed rather than preceded the mural. The lower quarter of the mural is subdivided into three images representing the Church, the Home, and the School. These subjects progressed through numerous stages, with changes similar in kind and degree to those in the large upper section upon which *Repose in Egypt* is based.

The earliest sketch for the mural is far from the religious allegory which was to develop in the lithograph. Essentially a genre scene, the sketch shows a family of four waiting for a bus to take them for a day's outing. The surrounding street life is active: a mounted policeman directs heavy traffic; pedestrians wait for the traffic light to change; massive buildings, perhaps newly erected, press against each other and against the crush of humans and vehicles. Spruance's sketch aptly fits the following description of artistic aims of the period: "to get at meanings, to know America, and to design compact structures communicating the poetry and magnificence, the irony, the humor, the shabbiness, the tragedy and, not least, the social significance" (Thomas Craven, ed., *A Treasury of American Prints,* New York, 1939, n.p., intro.).

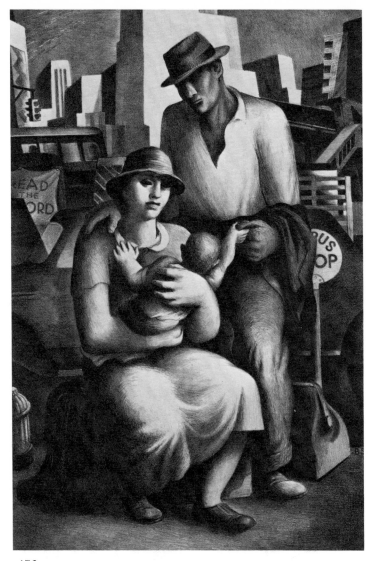

473.

On the sketch, in Spruance's hand, are marginal directions—"try mother seated—and holding baby," which Spruance incorporated in the image of the print. Other alterations—of greater psychological and sociological than formal significance—occurred as the mural was refined: the gaze of the young boy holding a baseball bat is shifted from the policeman to the boy's family and back again; the anonymous pedestrians shrink in number from several to only one, who is identifiable by his attire—first as a white-collar worker and later as a blue-collar worker. While the sketch is a glance at the moment, the mural embodies a study of the period. By the elimination of figures except for the central group of three, and the compression of the urban landscape, the print moves toward a timeless art historical quotation.

Repose in Egypt is stylistically and technically akin to the football subjects and *The*

People Work series for which Spruance won much acclaim during the 1930s (see "The People Work, Four Lithographs by Benton Spruance," *Scribner's Monthly Magazine,* vol. 108, no. 1, January 1938, pp. 16–17). A layering of crayon strokes produces the richly modeled, simplified, and bulbous human forms influenced by revolutionary Mexican muralists whose work was popular in this country at the time. One senses the artist's intimate knowledge of the affinity between greasy lithographic crayons and granular limestone surfaces. One senses as well the artist's belief in the importance of family intimacy in the midst of the expansive anonymity of technological progress. The situational conflict and drama—repose as a pause between flight/fear and arrival/hope—are formally heightened by strong tonal contrasts, a device used by other contemporary printmakers such as Thomas Hart Benton and Edward Hopper. Also typical

of the period, a familiarity with and assimilation of Cubist ideas—but only up to a point and viewed from a safe distance—are apparent in the architectural pattern of the background. The use of a toned ground can be traced to one of Spruance's earliest lithographs, *Prater, Vienna,* produced in 1928 at the workshop of Desjobert.

Although Spruance often worked in series (the best known of these, completed only months before his death, is *The Passion of Ahab*), this lithograph is not part of a specific group. However, symbolically, thematically, and technically it is closely related to three other lithographs of the period: *Flight from the Beach,* 1939, in which a family of four (Spruance's own?) flees from an impending storm (that of depression and war?); *Landscape with Figures,* 1940, in which the *Repose in Egypt* family, more casually dressed, is at rest in a rural landscape; and *Gifts from the Kings,* 1941, which is laden with war-related imagery. Spruance took "an intelligent interest in the forces that shape our modern life, and he has attempted in some measure to synthesize them in his art" (Carl Zigrosser, "Benton Spruance," in *The Artist in America,* New York, 1942, p. 86).

Beginning in 1953, Spruance investigated color lithography in depth, and this new interest was accompanied by a more fluid and abstract style of drawing. However, while his formal approach may have changed, his concern with mythic, religious, and/or moral themes remains apparent throughout his oeuvre as does his belief that the great tradition of western art "commands all creative men to work, integrated into the civilization in which they live, to use as their symbols the broadly understood symbols of the people, and to use them in such a way that their aesthetic value is communicable to all . . . [this tradition] is the very essence of what historians call American" (Benton Spruance, "The Place of the Printmaker," *Magazine of Art,* vol. 30, no. 10, October 1937, p. 615).

RFL □

FRANKLIN WATKINS (1894–1972)
(See biography preceding no. 461)

474. *Thomas Raeburn White, Esq.*

1940
Signature: F.W./40 (upper left)
Oil on canvas
34½ x 45″ (87.6 x 114.3 cm)
Mrs. Thomas Raeburn White, Philadelphia

PROVENANCE: Commissioned by Mr. and Mrs. Thomas Raeburn White, 1940

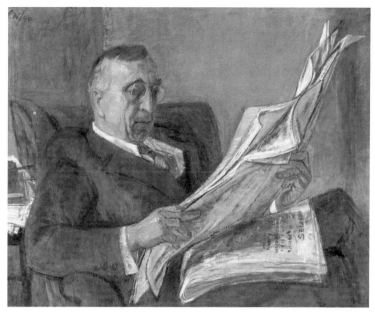

474.

LITERATURE: "Intellectual Art of Watkins Displayed," *The Art Digest,* vol. 16, no. 8 (January 15, 1942), p. 9 (illus.); Rosamond Frost, "Watkins: Much Savor, No Sugar," *Art News,* vol. 40, no. 19 (January 15–31, 1942), p. 27; Monroe Wheeler, *20th Century Portraits* (New York, 1942), pp. 28, 144, illus. p. 116; Pittsburgh, Carnegie Institute, *Painting in the United States* (October 14—December 12, 1943), no. 57, pl. 19; PAFA, *139th Annual* (1944), no. 103 (illus.); Maude Riley, "Pennsylvanians Score in Pennsylvania Academy's 139th Annual," *The Art Digest,* vol. 18, no. 9 (February 1, 1944), p. 6, illus. p. 5; Dorothy Grafly, *Art Outlook* (February 7, 1944), illus.; PMA, *Paintings by Arthur B. Carles and Franklin C. Watkins* (February 17—March 17, 1946), no. 51, p. 47, illus. p. 59; Henry C. Pitz, "Franklin Watkins, A Painter Who Walks Alone," *American Artist,* vol. 10, no. 7 (September 1946), illus. p. 22; MOMA, *Franklin C. Watkins* (March 21—June 11, 1950), no. 25; illus. p. 24; E. P. Richardson, *Painting in America* (New York, 1956), fig. 169; PMA, *Franklin Watkins* (March 6—April 5, 1964), no. 25, p. 11, illus. p. 37; Ben Wolf, *Franklin C. Watkins, Portrait of a Painter* (Philadelphia, 1966), no. 25, pp. 80–81 (illus.).

IN 1944, THIS PORTRAIT of one of Philadelphia's most eminent lawyers was awarded the Temple Gold Medal for the best painting in the Pennsylvania Academy's 139th annual by a jury which included Alexander Brook, George Grosz, Julian Levi, and Zoltan Zepeshy, chaired by Hobson Pittman. Thomas Raeburn White, who was sixty-five when Watkins painted him, had been admitted to the Pennsylvania bar in 1899 and taught for several years at the University of Pennsylvania Law School before embarking upon a long and successful legal career. Watkins has given a vivid account of the genesis of his portrait:

Mr. White was an extremely busy lawyer. I don't think he welcomed taking the time to sit. His wife (a sculptress) was anxious for me to paint him, so—after many changes of dates and postponements— he finally sat.

During this period I made several trips to law courts, to observe him in action. I studied the general conformation of his head, his changes of expression, body gestures and so forth. By the time he posed, he was no longer a stranger to me.

We met at Mrs. White's studio, near their home, on the very Sunday morning the news came that Hitler had invaded Holland. Mr. White came in the studio with a copy of *The New York Times* tucked under his arm. I could see that he was loathe to put down his paper and mount the model stand.

I said: "Mr. White, I'm not prepared yet. I'll have to set up my palette before we can begin. Just read for a while . . . I'll let you know when I am ready."

While he read, I planned my picture and laid it in completely. After about two hours, he looked up and said: "Aren't you ready yet?" (quoted in Wolf, *Watkins,* cited above, pp. 80–81)

The painting combines a debt to the profound seriousness of Thomas Eakins's portraits of professional men with a breadth of execution and flourish of form (particularly in the undulating sheets of newspaper)

peculiar to Watkins. The somber palette and lack of accessories apart from the *Times* and a stack of papers at the lawyer's elbow are as appropriate to the subject as the pastel colors and assortment of toys and flowers were to Watkins's lyrical portrait of two children, *The Misses Maude and Maxine Meyer de Schauensee,* painted a year later. *Thomas Raeburn White* was the first of a long series of successful portraits of scions of the legal and medical professions, including the impressive *Justice Owen Roberts* commissioned by the University of Pennsylvania in 1947. But Watkins was rarely to surpass the compelling grasp of character—and the composition at once forceful and casual—revealed by this study of a man absorbed in the fateful news of May 10, 1940. The date (inscribed on the paper laid across Mr. White's knee) emphasizes the immediacy of the portrait: the personalities of both painter and sitter are intensified by their participation, even at great distance, in an historical moment of grim significance.

Ad'H □

HENRY BAINBRIDGE MC CARTER
(1864–1942)

Born into the family of an Irish iron manufacturer in Norristown, Pennsylvania, McCarter attended Norristown High School before enrolling at the Pennsylvania Academy in 1879. His four years of study there, including classes with Thomas Eakins, were not much to his taste, and after graduation he was drawn into the lively world of illustration, working for the *Philadelphia Press.* In 1887 he set off for Paris where he studied with Léon Bonnat and Puvis de Chavannes and served an informal apprenticeship in the lithography studio of Toulouse-Lautrec. After five years in France, McCarter returned to the United States and by 1895 was established in a fashionable studio on Washington Square in New York. He found steady, even lucrative employment providing illustrations for *Scribner's, Collier's, The Century,* and other weekly magazines, which occasionally sent him on special commissions to Ireland or England, and he struck up a close friendship with Joseph Pennell (see biography preceding no. 442).

Starting in 1890 he exhibited his drawings regularly at the Pennsylvania Academy, and in 1915 he won the Gold Medal for illustration (and a second Gold Medal for "Decoration and Color") at the Panama-Pacific International Exposition in San Francisco. In 1902, McCarter was invited to give an illustration class at the Pennsylvania Academy in addition to his teaching at the Art Students League in New York. His association with the Academy was to continue for the next forty years and his students would include

475.

Charles Demuth, George Biddle, Arthur B. Carles, Ralston Crawford, and Franklin Watkins, among many others. Highly successful as an illustrator, with a graceful fin de siècle style, McCarter did not take up oil painting seriously until a few years prior to World War I. Almost from the start, his paintings explored the possibilities of color and light—a sharp change from the primarily linear concerns of the illustrator.

When he first moved back to the Philadelphia area around 1904–5, McCarter lived on a farm in Huntington Valley until 1919. In the 1920s and 1930s, he spent the winters in a sequence of studios and boarding houses in the center of the city, but he continued to spend his summers in the country: on the New Jersey shore or in the lush landscape of Pennsylvania. A highly popular teacher and convivial spirit, McCarter moved in lively art circles in Philadelphia, numbering among his friends George Howe and Paul Cret, Earl Horter, R. Sturgis Ingersoll, and Francis Biddle, as well as Cecilia Beaux, whom he knew from his Paris years. For twenty-nine years he exerted a crucial influence over the growth of the Pennsylvania Academy's collection as an administrator of the Lambert Fund (established in 1913 for the purchase of work by promising younger artists out of the annual

exhibitions). In 1920 he joined Carroll Tyson, Adolphe Borie, and Arthur Carles in assembling the exhibition *Representative Modern Masters* at the Academy. Much as he admired the work of Matisse and Picasso, McCarter reserved his greatest love for the Post-Impressionists Toulouse-Lautrec and Gauguin and the later pastels of Degas. Exhibitions of his own work outside Philadelphia were infrequent, but he showed regularly in the Academy annuals, where he won an impressive array of medals, and had one-man shows at the McClees Gallery and the Philadelphia Art Alliance (1933). He was one of seven Philadelphia painters to be given a joint show by the Wildenstein Gallery in New York in 1927. Over the years, his paintings of landscape and flowers grew increasingly brilliant in color and the decorative quality reminiscent of his long experience as an illustrator grew less marked. As in the case of his friend and colleague Hugh Breckenridge, some of McCarter's best and most original work was done in the last years of his life—when he was over seventy. After his death, the Pennsylvania Academy honored McCarter in 1943 with a memorial retrospective of more than one hundred works, and thirteen of his last paintings were shown in New York at J. B. Neuman's New Art Circle the same year.

475. *Bells, No. 6*

c. 1940
Oil on canvas
48 x 42″ (121.9 x 106.6 cm)
Philadelphia Museum of Art. Bequest of
Henry McCarter. 44-44-3

LITERATURE: New York, New Art Circle, *Henry
McCarter* (November 10-30, 1943), no. 6 (?);
PAFA, *A Memorial Exhibition of Paintings
and Drawings by Henry McCarter 1864-1942*
(December 12, 1943—January 9, 1944), no. 85;
R. Sturgis Ingersoll, *Henry McCarter* (Cam-
bridge, Massachusetts, 1944), pp. 110-11;
NCFA, *Pennsylvania Academy Moderns* (May
9—July 6, 1975), no. 25, illus. p. 26

MCCARTER'S LONG CAREER as a professional
illustrator and his success and popularity as
a teacher at the Pennsylvania Academy have
perhaps obscured his achievement as a
painter, which remains little known.
Although his subjects range from elaborate
allegorical themes to pastoral views of Penn-
sylvania, McCarter's overriding interest was
in rendering the effects of brilliant, prismatic
light, which he achieved with increasing
skill. The last years of his life saw some of
his most experimental efforts and a gradual
approach to virtual abstraction. McCarter
loved music (he was a staunch admirer of
Leopold Stokowski and the Philadelphia
Orchestra) and one subject haunted him for
more than a decade before he found the right
moment to paint it. In the winter of 1930-31,
he wrote to a Belgian friend: "I've wanted
for years to paint the fact and the color and
the sound of a 'Chime of Bells.' I thought
this year I might go to Bruges" (Ingersoll,
cited above, p. 77), but he was disappointed
in his hope. He listened to countless record-
ings of carillons, storing up memories of
tunes and resonances, but it was not until
the summer of 1940, in rented lodgings on
a farm in Salford, Pennsylvania, that he
found the occasion to translate his impres-
sions into paint. Writing to Sturgis Ingersoll
the following September, he reported: "This
morning I reviewed my canvases seven
rehearsals and results (3) for movement and
color of Carillon of bells. Two are abstract—
almost maps" (Ingersoll, cited above, p. 110).
Another splendidly chaotic letter written to
Charles Cullen in the winter of 1940
describes with delight his summer's
program:

When the Acad. is over I take my old
"Marmon" out of storage—stuff it with
paint and clothing—a few bottles of rum
and cigars—Get a driver and go up in the
middle of Penna. Get to work—I work
now like a working man—all the time—
then forever in quest of this or that—light
of a day—almost the light of an hour of
the day—and how to put it down with

paint—or the quality of a texture—or
months on the movement of the patterns
and the colors of the sounds of a chime of
bells—I made enough rehearsal to cover
the walls of a barn—Stokowski will see
them before I go away—I may go on with
"Singing Bells" (old English name for
'em) or I may paint a figure of music—
or I may not—I may just try to make the
U.S. Flag hypnotic. You see I use my
summer completely as it seems best—.
(Ingersoll, cited above, p. 111)

Out of this slap-dash approach to life
emerged a remarkable sequence of paintings.
Bells, No. 6 is the largest and probably the
last of the series—one of those McCarter
called a "map." In others of the group the
bells themselves are readily discernible as
solid forms; here they dissolve into pale gold
disks with vibrating colored strokes of paint
that radiate out toward the upper edges of
the picture. Although the idea of expressing
sound in visual terms was by no means new
(one thinks of Kandinsky's elaborate scheme
of color equivalents for musical tones and
Georgia O'Keeffe's musical abstractions of
1919), McCarter did succeed in creating an
abstract image that reverberates before our
eyes in a convincing analogy to the pulsing
chime of his beloved carillon. *Bells, No. 6*
was painted when McCarter was seventy-six;
rather than bearing witness to any decline, it
implies an expanding vision and growing
capacity to express it in paint. Much as he
admired the late abstractions of his friend
Arthur Carles, McCarter found them "shock-
ingly handsome" and disturbingly "destruc-
tive" (Ingersoll, cited above, p. 82). His own
late works testify to his ebullient and affirm-
ative personality: "Any Penna. hilltop to
paint a carillon . . . Astonishing color! !
Great fun! ! It is pouring rain but my sky
is blue" (Ingersoll, cited above, p. 109).

Ad'H □

FRANCIS SPEIGHT (B. 1896)

One of the most devoted observers of the
urban landscape around Philadelphia,
Speight spent his childhood in the very
different surroundings of the Carolina coastal
plains. The son of a Baptist minister, he was
born on a farm near Windsor, South
Carolina, and was encouraged in his artistic
leanings by his older sister Tulie (who later
also attended the Pennsylvania Academy).
In 1915 he enrolled for two years at Wake
Forest College in Winston-Salem, taking
Saturday art classes with Miss Ida Poteat at
Meredith College in Raleigh. While attend-
ing the Corcoran School in Washington,
D.C., for one term in the spring of 1920,
Speight saw an exhibition of Daniel Garber's
drawings which strengthened his intention
to transfer to the Pennsylvania Academy.

From 1920 to 1925, Speight was a student at
the Academy (a classmate of Franklin Wat-
kins), under Hugh Breckenridge, Arthur B.
Carles, Henry McCarter, and of course
Garber, who was to exert the single most
important influence on his work. In 1923
and 1925 he won Cresson Travelling Scholar-
ships to Europe. Upon his return to Phila-
delphia, he became an instructor of painting
and drawing at the Academy, a position he
was to hold for thirty-six years. In 1926,
Looking Across the River and *Above the
Town* were his first paintings to be shown
in the Pennsylvania Academy annual, where
he has continued to exhibit steadily. He
considers a major breakthrough in his career
to be the acceptance of three works by the
Carnegie International exhibition at Pitts-
burgh in 1927. Thereafter he exhibited on a
regular basis in the large national annual
shows at the Carnegie Institute, the Corcoran
Gallery of Art, the Art Institute of Chicago,
and the National Academy of Design, where
he won the First Hallgarten Prize in 1930.
In 1932 the Metropolitan Museum of Art
purchased *Spring in Manayunk,* and his first
one-man museum show was held at the
Delgado Museum in New Orleans in 1934,
followed by another at the Corcoran in 1940.

Until 1943, Speight and his wife (the
former Academy student and painter Sarah
Blakeslee) lived in the Manayunk-Rox-
borough district, which he had discovered
as a favorite site for painting in his student
days, and also shared a downtown studio
on Sansom Street in Philadelphia. In 1937
they both received WPA commissions for
murals, and Speight's mural for a North
Carolina post office depicting the history of
the cotton business constituted a rare depar-
ture from his landscapes. In the 1940s, they
moved out to Doylestown, but Speight con-
tinued to visit his old haunts along the
Schuylkill to paint. Teaching at the Academy
(where his students included Walter
Stuempfig) and at its summer school in
Chester Springs, Speight also served as
visiting professor in a number of art schools
in the United States and in England. In
1940, he was elected a member of the
National Academy of Design, and in 1960 he
was invited to join the National Institute of
Arts and Letters. In 1961 he left his adopted
home of forty years and moved back to the
South, where he became artist-in-residence
at East Carolina University in Greenville,
North Carolina. The North Carolina
Museum of Art organized a retrospective
exhibition on that occasion in 1961, and more
recently an exhibition of sixty works entitled
Manayunk and Other Places was mounted
by the Museum of Art at Pennsylvania State
University in 1974 (see pp. 4–7 of the cata-
logue for a listing of Speight's exhibitions
and prizes). His painterly idiom of what
Royal Cortissoz once called "hurried real-

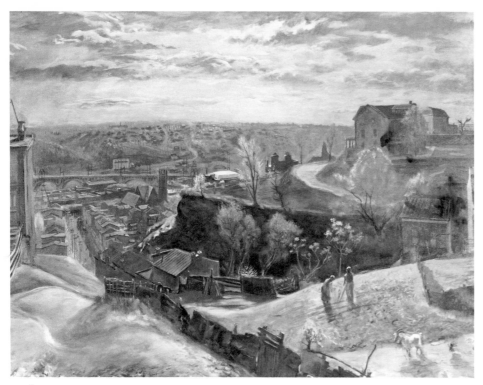

476.

his views of backyards and rooftops their particular character of somewhat dreamlike realism. *Schuylkill Valley Town* is one of Speight's most comprehensive views of his favorite subject, combining a distant industrial vista with the pastoral scene in the immediate foreground. The scene is bathed in light, which blurs and softens the harsh outlines of the buildings and illuminates the spring foliage of the trees. Comparison with a painting of 1932 (*Manayunk in the Morning*, collection of the artist) or of 1959 (*Spring View from West Manayunk*, collection of Dr. Claiborne Smith) prove Speight astonishingly consistent in his style over the years. He returns again and again to the same subject, even the same viewpoint, but with a fresh eye that finds Manayunk an "inexhaustible" source for pictorial expression. Despite the poverty of the working-class neighborhoods he has often depicted, his paintings convey little of the social comment characteristic of certain works of his contemporaries in the 1930s and 1940s who saw every factory or shanty as a symbol of the need for social and economic reform. Nevertheless, an exhibition of his work that perhaps made Speight happiest was held in a vacant store on Manayunk's Main Street during the 1930s and was attended by the inhabitants of the houses he loved to paint. Their pleased recognition of their own homes, or a neighbor's backyard, must have meant as much if not more to him than the impressive array of prizes he received from national exhibitions at major museums.

Ad'H □

ism" has continued to evolve gradually over the years, conforming to no particular movement in twentieth century American art, and avoiding the categories of social realism and Surrealism as quietly and persistently as he has steered away from abstraction.

476. *Schuylkill Valley Town*

1940
Signature: Francis Speight (lower left)
Oil on canvas
40 x 54½″ (101.6 x 138.4 cm)
Pennsylvania Academy of the Fine Arts, Philadelphia. Temple Fund Purchase, 1942

PROVENANCE: Purchased by the Pennsylvania Academy of the Fine Arts from its 137th annual exhibition, 1942

LITERATURE: PAFA, *137th Annual* (1942), no. 117; Carol E. Kleckner, "Speight Credo Is 'Assurance, Not Problems,'" *Philadelphia Inquirer*, August 2, 1959, p. 2 (illus.); *American Artist*, vol. 24, no. 4 (April 1960), p. 30; Raleigh, North Carolina Museum of Art, *Francis Speight, A Retrospective Exhibition* (February 16—March 26, 1961), no. 18 (illus.)

JUST AS Daniel Garber and Edward Redfield spent much time in rendering a faithful record of the changing light and seasons in the Delaware Valley, Francis Speight per-

formed a similar service for the nineteenth century industrial suburbs that spread north and west along the Schuylkill River from the center of Philadelphia:

> In Manayunk where most of my painting has been done I have been fascinated by the weight and depth of the landscape. When I was a child in eastern North Carolina where it was fairly flat, I was afraid of the least bit of a hill and recall that my father let me get out of the carriage and walk down the hill at "Chisky Swamp" on the way to Windsor, but I did not mind walking up. In Manayunk, it was always stimulating to stand and look across the valley and paint the rich mosaics of houses on the distant hill, the river, and foreground sloping toward the river or turn and look up at the houses and trees, so often seen against blue sky and white clouds. (North Carolina Museum of Art, *Francis Speight*, cited above, n.p.)

Speight's interest in Manayunk dates to his earliest years at the Academy, when he was attracted to this crowded cityscape of steep hills and serried ranks of row houses, each with its tiny garden. From the beginning, his paintings lacked the precision of Garber's well-ordered compositions, but his more casual approach was still coupled with his teacher's interest in the effects of light. A painting of 1936 is entitled *Sun, the Painter* (Norton Gallery, West Palm Beach), and patterns of shadow and sunlight give

ENGEL (N.D.)

477. *Evening Dress*

c. 1940
Label: ENGEL/PHILADELPHIA (on label in slip)
Sheer lavender rayon trimmed with matching taffeta appliqués; matching slip
Waist 29″ (73.6 cm); center back length 57⅛″ (145.9 cm)
Philadelphia Museum of Art. Given by Mrs. Jacob A. Bottorf. 68–185–1a, b, c

WITH EUROPE AT WAR in 1940, the creative talents of American designers finally began to be fully recognized. The Hollywood designer Adrian was responsible for one of the major new fashion looks—broad shoulders. Heavy padding at the shoulders gave the figure a squared look, especially as daytime skirts had become short again. Formal evening wear, men's and women's alike, did not escape this structured appearance. Women's evening dresses were long and flowing, but their sleeves and shoulders were puffed and full.

This sheer lavender rayon evening dress is a fine example of its day. An extremely full, flared skirt is attached to a hip-hugging scalloped yoke. At the waist is a narrow belt of self-material with a flat, tailored bow in front. The semi-fitted bodice has an interesting, detailed construction, shirred at the center front and along the dropped shoulder yoke. This gives fullness to the bustline as it forms the high V-neckline. The long fitted sleeves, buttoned at the wrist, are fully gathered into the armholes, with net ruffles underneath to hold the fullness in place. The upper sleeves are trimmed with lavender taffeta floral appliqués, and the skirt is similarly appliquéd in a graceful, allover design, lending charm and distinction to an otherwise plain dress. Although the dress has a full lavender taffeta slip underneath, another crinoline would probably have been worn under the skirt to create the full, graceful silhouette of the period.

EMcG □

478.

ARTHUR B. CARLES (1882–1952)
(See biography preceding no. 416)

478. *Abstraction (Last Painting)*

1936–41
Oil on wood with cut paper and canvas
40⅜ x 57½″ (102.6 x 146 cm)

477.

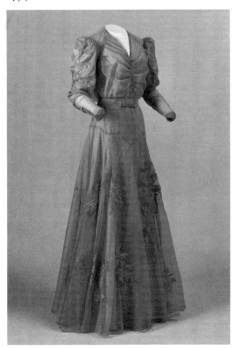

Hirshhorn Museum and Sculpture Garden, Smithsonian Institution, Washington, D.C.

PROVENANCE: Mercedes Carles Matter, New York; with Harold Diamond, New York, 1968; Joseph H. Hirshhorn, New York

LITERATURE: PAFA, *Memorial Exhibition: Arthur B. Carles, 1882–1952* (March 18—April 12, 1953), no. 8; Henry Clifford, "Prophet with Honor," *Art News,* vol. 52, no. 2 (April 1955), p. 48; PAFA, *The 150th Anniversary Exhibition* (January 15—March 13, 1955), no. 166; New York, Graham Gallery, *Arthur B. Carles Retrospective Exhibition* (April 14—May 9, 1959), nos. 74, 57 (illus.); Elizabeth C. W. O'Connor, "Arthur B. Carles 1882–1952: Colorist and Experimenter," M.A. thesis, Columbia University, 1965, pp. 58–59, 117, fig. 40; Rose, *American Art,* p. 150, fig. 5–43; Sam Hunter, *American Art of the 20th Century* (New York, 1972), fig. 292; Lerner, *Hirshhorn,* p. 672, fig. 499

AMONG HIS CONTEMPORARIES in Philadelphia, Carles was surely one of the most profoundly attuned to international developments in modern art. As his painting before World War I had responded to the innovations of Cézanne and the Fauves, so he became increasingly excited during the late 1920s and 1930s by the later synthetic Cubist work of Braque and Picasso and the abstracted, biomorphic compositions of Miró. Carles's late work holds a unique position in the history of abstract art in this country. Based on an essentially linear Cubist grid structure,

the series of abstract paintings he created during the 1930s began with rather tightly compartmentalized compositions, such as *Composition No. 5,* 1935 (Philadelphia Museum of Art), growing gradually freer in paint surface until Carles achieved a successful yet characteristically unsettling abstract style with three great works: *Composition No. 6,* 1936 (Pennsylvania Academy of the Fine Arts), *Painting (Musical Forms),* 1935–40 (New York, private collection), and *Last Painting,* shown here.

Last Painting was an extraordinary achievement for the year 1941, let alone 1936 when it was probably begun. Cubist severity lingers to lend the composition an underlying structure but Carles's eloquent color and his dynamic brushed and dripping strokes transform the painting into an important precursor of Abstract Expressionism. Hans Hofmann's work of the same period was equally brilliant in color, yet less profoundly abstract. Arshile Gorky's contemporary work had a rich, although more limited, range of color and thickly layered paint surface, but it still paid clear and admiring homage to Picasso while Carles's sources seem to have been absorbed in his struggle to express his own vision. All trace of recognizable subject matter is gone, although a preliminary oil study for *Last Painting* (in the collection of Mercedes Matter) is entitled *Nude.* The often uncomfortable juxtaposition of abstract passages and luscious flesh painting which rendered a number of Carles's earlier abstrac-

563

tions disturbing has given way to a convincing if stormy confrontation of color and form for which the entire canvas serves as battleground. Not until the work of de Kooning and Pollock of the early 1940s was paint to be handled with such authoritative violence.

Last Painting was very probably still unfinished when a stroke forced Carles to abandon work in December 1941. Nevertheless it contains all of his vigor and originality, and prophesies a powerful new movement in American art. What makes *Last Painting* particularly exciting is its full and exuberant palette, so characteristic of Carles's work throughout his life. As he reminded an interviewer in 1928: "If there's one thing in all the world I believe, it's *painting with color*. So damn few people paint with color, and what on earth else is painting for?" (Jo Mielziner, "Arthur Carles," *Creative Art,* vol. 2, no. 2. February 1928, p. xxxv).

Ad'H □

HORACE PIPPIN (1888–1947)

Pippin was born in West Chester, Pennsylvania, into a black working-class family; his grandparents had been born in slavery. His interest in drawing was evident at an early age (his response to an advertising contest for an art supply firm won him his first set of crayons and a box of watercolors) but he had little chance to pursue that interest as a child. He grew up around Goshen, New York, and took on a series of odd jobs to help his mother support the family. After her death in 1911, he moved to Paterson, New Jersey, where he worked for a storage and shipping company (often requesting the job of crating paintings). One of the most decisive periods in Pippin's life was his twenty-two months of active service in a black regiment of the United States Army during World War I. The earliest work of the artist to survive is a series of drawings illustrating his wartime diary, and the experience later provided inspiration for a group of his most powerful and obsessive paintings. Severely wounded in his right arm, he was honorably discharged in May 1919, but he did not begin his career as a painter for another decade.

In 1920, Pippin married Ora Jennie Featherstone Wade and moved into a house on Gay Street in West Chester, where he lived for the rest of his life. Unable to take on employment requiring manual dexterity, he assisted his wife in her job as a laundress, and they led a quiet life, apart from Pippin's persistent troubles with his wounded arm. In 1929 he began to experiment with burning designs into a wooden panel with a hot poker, and in 1930 he embarked on his first

painting *End of the War: Starting Home* (a gift of Robert Carlen to the Philadelphia Museum of Art), which took him three years to complete. Completely self-taught as a painter, Pippin produced portraits of friends and scenes often based on calendar illustrations for seven years before receiving any public notice. In 1937, Pippin entered two pictures in the annual open exhibition at the West Chester Art Association, where they were seen and admired by N. C. Wyeth and his son-in-law, the painter John McCoy. The two men urged Christian Brinton, president of the Association, to give Pippin his first one-man exhibition of ten paintings and seven burnt-wood panels in June 1937. (Pippin's portrait of Brinton, *Chester County Critic,* dated 1940, was given by the sitter to the Philadelphia Museum of Art.) From then on Pippin's rise from total obscurity to considerable fame was precipitate. Included in Holger Cahill's *Masters of Popular Painting* at the Museum of Modern Art in 1938, Pippin provided a brief statement, "How I Paint," for the catalogue.

His first important and highly successful one-man show was held at Robert Carlen's gallery in Philadelphia in 1940. Carlen soon became his friend, supporter, and mentor. Another prominent figure in the Philadelphia art world, Dr. Albert C. Barnes, bought five paintings and also became Pippin's champion. Providing the catalogue introduction to the Carlen Gallery show, Barnes wrote: "It is probably not too much to say that he is the first important Negro painter to appear on the American scene and that his work shares with that of John Kane the distinction of being the most individual and unadulterated painting authentically expressive of the American spirit that has been produced during our generation." Barnes and Carlen provided Pippin with his first opportunity to see the work of other artists at firsthand. Fascinated by Barnes's collection of Renoirs but ill at ease in his art appreciation classes, Pippin came to spend long hours in Carlen's gallery looking at paintings and discussing them from his own untrained but highly original viewpoint. An exhibition at the Bignou Gallery in New York in 1940 was well received and followed swiftly by another show at Carlen's in 1941 and one at the Arts Club of Chicago. During his fifteen active years of painting, Pippin's subjects ranged from grim war pictures, scenes of West Chester, portraits of his friends and family, still lifes and decorative interiors provoked by his visits to Main Line houses, and two remarkable series devoted to the life and death of John Brown and the theme of the "Holy Mountain." Although his colors grew brighter, the precision and intensity of his style changed relatively little over the years and gave his paintings the sense of being executed in sharp relief.

Living in West Chester, Pippin's link to Philadelphia was twofold: his experience of the city was a prime source of subject matter for his art (a concert by Marion Anderson, a painting by Edward Hicks seen at a gallery); and Philadelphia also provided him with that essential element for any artist—an appreciative public—in this case consisting of an energetic and sympathetic dealer, eager collectors, and a wider audience with whom his work was instantly popular. Pippin's death at the age of fifty-nine occurred in the same year as the publication of Seldon Rodman's monograph and catalogue of his work. Now, after a decade of relative obscurity, he has become one of the best known "primitive" painters to emerge in this century.

479. *Holy Mountain II*

1944
Signature: DEC 7./H. PIPPIN. 1944.
Oil on canvas
22 x 30" (55.9 x 76.2 cm)
Private Collection

PROVENANCE: Edward A. Bragaline, New York; with The Downtown Gallery, New York

LITERATURE: New York, M. Knoedler & Company, Inc., *Memorial Exhibition, Horace Pippin* (September 29—October 11, 1947), no. 25; Selden Rodman, *Horace Pippin, A Negro Painter in America* (New York, 1947), no. 82, p. 20, color plate opp. p. 64; Pennsylvania State University, Mineral Industries Gallery, *Pennsylvania Painters* (October 7—November 6, 1955), no. 48 (illus.); Jean Lipman, "The Peaceable Kingdom by Three Pennsylvania Primitives," *Art in America,* vol. 45, no. 3 (Fall 1957), p. 29 (illus.); PAFA, Peale Galleries, *Horace Pippin* (January 27—March 6, 1966), no. 12; Pittsburgh, Carnegie Institute, Museum of Art, *3 Self-Taught Pennsylvania Artists: Hicks, Kane, Pippin* (October 21—December 4, 1966), no. 114 (illus.); Pennsylvania State University Museum of Art, *Masterworks by Pennsylvania Painters in Pennsylvania Collections* (October 8—November 5, 1972), no. 30 (illus.)

IN HIS SERIES of *Holy Mountain* paintings, Pippin found a consoling antidote for the painful memory of his service in World War I and for his keen distress over the repeated horrors of World War II. His treatment of this idyllic subject combines a literal interpretation of the Old Testament source (Isaiah 11:6–10) with images borrowed from the nineteenth century Pennsylvania painter Edward Hicks, which Pippin interpreted in the light of his own pictorial and spiritual imagination. The first version of the *Holy Mountain* is dated June 6, 1944, and was purchased for the Encyclopaedia Britannica Collection. The second

479.

version, shown here, was completed six months later, and in 1945 he produced *Holy Mountain III,* which is now in the Hirshhorn Museum. A fourth painting was left unfinished at the time of his death in 1947. In answer to a query about the subject of *Holy Mountain I,* Pippin gave a vivid sense of his conception:

TO MY DEAR FRIENDS:
To tell you why I Painted the picture. It is the holy mountain my Holy mountain. Now my Dear friends.
The world is in a Bad way at this time. I mean war. And men have never loved one or another. There is trouble every place you Go today. Then one thinks of peace. I thought of that when I made—the Holy mountain. Can there be peace, yes there will be—peace, so I looked at Isaiah XI–6–10—there I found that there will be peace. I went over it 4– or 5–times in my mind. Every time I read it I got a new thought on it. So I went to work. ISAIAH–XI the 6–v to the 10–v gave me the—picture, and to think that all of the animals that kill the weak ones will Dwell together like the wolf will Dwell with the lamb, and the leopard shall lie down with the kid and the calf and the young lion and the fatling together.
And a little child, shall lead them then to think also. That the cow and the Bear shall feed. Their young ones shall lie down together and the lion shall eat straw like the ox. Then I had something else to think

about also, and that is the asp, and the Cockatrice's Den, which is the most deadly thing of them all, I think, for it can kill by looking at you and to think that a suckling child shall play on the whole [*sic*] of the asp. And the weaned child shall put his hand on the Cockatrice's Den, and this is why it is done, for the earth shall be full of the *knowledge* of the Lord as the waters cover the sea. So I painted it so that men may think of it. I can't say—any more of this painting, from Horace Pippin to his friends.
Now my picture would not be complete of today if the little ghost–like memory did not appear in the left of the picture. As the men are dying, today the little crosses tell us of them in the first world war and what is doing in the south today— all of that we are going through now. But there will be peace. (quoted in *The Art Digest,* vol. 19, no. 13, April 1, 1945, p. 44)

Pippin scrupulously includes all the creatures mentioned in Isaiah: the lion munching straw like the ox, the cow and the bear, the wolf and the lamb. He takes a nice artistic liberty by adding (in *Holy Mountain II*) two bright green long-tailed parrots and a turkey. In Pippin's vision the children of whom the prophet speaks are black: a little boy crawling toward the "whole" of the asp and a girl in her best yellow polka-dotted dress playing with her doll on the "Cockatrice's Den."
An affinity to Hicks's *Peaceable Kingdom*

is undeniable, particularly in the compositional device of clustering the animals together before a background of dense foliage and in the superb, sprawling pose of the leopard. It is more than likely that Pippin knew several of Hicks's paintings from Robert Carlen's gallery in Philadelphia, where he spent so much time during the last seven years of his life. Like Hicks's sequence of *Peaceable Kingdom*s, Pippin's *Holy Mountain*s vary significantly one from the other as the artist rearranges the essential elements of his composition. In *Holy Mountain I* the sky is visible across the top of the picture, but it has been reduced to a few patches of blue in *Holy Mountain II,* intensifying the viewer's sense of the magical isolation of the scene in the forest clearing. Despite the elimination of so much bright blue, Pippin succeeds in making his second painting more brilliant than the first: two of the somber trees are wreathed in white morning glories and strips of white bark have been added to the trunks of several trees in the background. The artist's "little ghost-like memory" of World War I appears in the tiny gray forms of falling bombs behind the branches at the upper left and the ominus brown figures of a hanged man and soldiers lurking in the gloom beyond the sweep of green grass. (The white crosses mentioned by Pippin in his letter appear in *Holy Mountain*s I and III but are absent here.) We know that Pippin's earliest war painting must have caused him both physical and mental anguish as he forced his crippled right arm to render his vision of soldiers in the trenches. *End of the War: Starting Home* was achieved over three years' time, against great odds. His three completed *Holy Mountain*s were painted a decade later with the assured hand of a master in the space of several months. Pippin's war paintings were transcriptions of his own experience; it is a measure of his genius that he could endow an imagined landscape with the same intensity of feeling and hallucinatory precision of detail. "If a man knows nothing but hard times he will paint them, for he must be true to himself, but even that man may have a dream, an ideal—and 'Holy Mountain' is my answer to such dreaming" (in *The Encyclopaedia Britannica Collection of Contemporary American Painting,* ed. Grace Pagano, Chicago, 1946, n.p.).

Ad'H □

CHARLES RUDY (B. 1904)

The son of a master craftsman in stained glass, Rudy was born in York, Pennsylvania. His father, J. Horace Rudy, had studied painting at the Pennsylvania Academy, and encouraged Charles's interest in a career in

the arts. Rudy graduated from the William Penn Senior High School in 1923, and in 1925 he enrolled in the Pennsylvania Academy for three years of study, which included sessions at the summer school in Chester Springs. Beginning with classes in painting and drawing, he soon found his true bent as a student of sculpture with Charles Grafly and Albert Laessle. He won Cresson Travelling Fellowships in 1927 and 1928, which enabled him to make two five-month visits to Europe. He traveled widely, devoting particular attention to the study of monumental and ornamental sculpture in relation to architecture.

Returning to the United States, he spent several years experimenting with sculpture and stained glass projects in his father's York studio before moving to New York in 1931. During his ten-year stay in that city, he taught in the sculpture department at Cooper Union and produced his first pieces directly carved in stone, beginning with a stylized *Mother and Child* (1932) somewhat in the manner of William Zorach. Rudy's first commissions were for his native town of York. In 1936 his proposal for a thirteen-foot-high figure of *Noah* for the facade of the main Post Office building in the Bronx, New York, won a United States government competition. Rudy had exhibited regularly at the Pennsylvania Academy since 1928, and in 1939 he began to teach classes at the Academy's summer school in Chester Springs. In 1941 he served on the Academy's jury for sculpture in the annual exhibition, and that same year he moved to the town of Ottsville, just north of New Hope in Bucks County, where he has continued to live and work. He was the recipient of a Guggenheim Fellowship in 1942. Exhibiting frequently across the country, Rudy was included in the 1939 New York World's Fair exhibition of *American Art Today* as well as the large international sculpture exhibitions held at the Philadelphia Museum of Art in 1940 and 1949. A one-man show at the Philadelphia Art Alliance in 1942 was followed by another at the Pennsylvania Academy in 1948.

His sculpture during the late 1930s and 1940s ranged widely in style and technique, from simplified, almost hieratic figure groups and animals carved in marble to naturalistic portraits and figures in bronze, such as the small female nude, *Lucrece,* 1937–38 (Philadelphia Museum of Art). In 1943, an article in *Life* magazine was devoted to the minute, whimsical animals made of scrap steel which he produced in his spare moments while doing voluntary war work welding at an autogiro factory in Willow Grove, New Jersey. Rudy has taught sculpture intermittently at the Pennsylvania Academy (1951–52, 1956), but much of his time over the last twenty-five years has been occupied with large commissions. These

have included the *All Wars Memorial to Penn Alumni* (1951), a bronze flagpole base in Franklin Field at the University of Pennsylvania, and an eighteen-foot-long granite relief on the theme of justice for the Lehigh County Courthouse in Allentown (1964). His largest commission, which took him two years to complete, was for seventeen sculptures for the gates and facade of the Pennsylvania State Historical Museum in Harrisburg (also completed in 1964).

Rudy's work is in the collections of a number of museums, including the Pennsylvania Academy, Brookgreen Gardens, South Carolina, the Carnegie Institute and the Metropolitan Museum of Art. He is a member of the National Academy of Design and the National Sculpture Society, and has served on the Pennsylvania State Art Commission. Archival material related to Rudy's life and art has been deposited by the sculptor at the York County Historical Society.

480.

480. *The Letter*

1945
Signature: Rudy 45 (lower back)
Bronze
20¼ x 18 x 14″ (51.4 x 45.7 x 35.5 cm)
Charles Rudy, Ottsville, Pennsylvania

LITERATURE: PAFA, *142d Annual* (1947), no. 94 (illus.); Peyton Boswell, "Philadelphia Leans Left," *The Art Digest,* vol. 21, no. 9 (February 1, 1947), p. 30, illus. p. 11; Dorothy Grafly, "Charles Rudy," *American Artist,* vol. 12, no. 4 (April 1948), p. 62, illus. p. 39; MMA, *American Sculpture 1951* (December 7, 1951—February 24, 1952), p. 12, pl. 24; PMA, *First Philadelphia Art Festival Regional Exhibition* (February 26—March 27, 1955), no. 302; Beatrice Gilman Proske, *Brookgreen Gardens Sculpture* (Brookgreen Gardens, S.C., 1968), p. 486

THE SCULPTOR HAS GIVEN his own account of the origin and evolution of this work, which has always been among his most popular:

One winter evening in 1946 while I sat reading I looked up at my wife, who had entered the room and was seated at a table opposite, going over some mail. As she sat reading a letter to be answered, I found the composition quite interesting and I made a quick pencil sketch of the abstract design suggested by the disposition of her arms, head, mass of shoulders.... The next day, in my studio, I set up an armature and started blocking in the main masses in clay. Throughout the winter, when I worked on *The Letter* I'd call my wife to the studio to pose, as I often do when I want to check on the transition of forms in any figure I'm doing—as I

usually work here without a model. But the main mood and composition of the sculpture remained quite clear in my mind from the first evening I'd made the sketch of my wife seated at the table. As it turns out, *The Letter* is a portrait of my wife— the truest one I could make of the aspects of her person that are revealed as she sat composing or reading or posing.... (letter to the author, August 12, 1975)

The Letter is one of Rudy's purely naturalistic sculptures, in which his attention to detail without loss of inner content reminds the viewer that he was a student of Charles Grafly. The informal, leisurely development of the work over several winter months seems wholly appropriate to his wife's quiet and introspective mood. Precedents for a bust portrait including the sitter's arms abound in the work of Jacob Epstein during the 1920s and 1930s, but his expressionist, often violent treatment of his subjects is remote from Rudy's sympathetic approach. The delicate modeling of the surface of this sculpture leaves the impression of wet clay lightly handled. When *The Letter* was exhibited at the Pennsylvania Academy annual in 1947, it received both First Honorable Mention and the newly established Howe Memorial Prize, and was singled out for praise by several critics. Three years later it was included in the national competitive exhibition *American Sculpture 1951* at the Metropolitan Museum of Art, having passed a jury of seven including Robert Laurent, Hugo Robus, David Smith, and William Zorach. Despite the presence of

works by David Smith and Alexander Calder in the 1947 Academy annual, and of a larger group of abstract sculpture (by Smith, José de Rivera, Theodore Roszak, George Rickey, and others) in the Metropolitan show, Rudy's portrait seems less dated than many of the other representational entries. The sleek stylization of Robus or the angular expressionism of a sculptor like Milton Horn accentuate Rudy's restrained naturalism. Comparison of *The Letter* with Leon Karp's *The Yellow Sweater* (no. 482) suggests a fundamental affinity between the two works, beneath the chance similarity in the pose of the figures. Executed within two years of each other, Karp's painting and Rudy's sculpture (both portraits of the artists' wives) affirm the continuation of a Philadelphia tradition of unstylized, one might almost say affectionate, realism. Three other casts of *The Letter* exist, one given by Benjamin D. Bernstein to the Metropolitan Museum and two in Philadelphia private collections, and the work has been frequently shown in the eastern Pennsylvania region. The artist's cast was included in the 1973 National Sculpture Society exhibition at Lever House in New York, where it was awarded the Gold Medal.

Ad'H □

WALTER STUEMPFIG (1914–1970)

Stuempfig's career was interwoven with Philadelphia places and institutions from its earliest beginnings. He was born in Germantown, attended Germantown Academy from 1919 to 1931 (with a year's absence in 1928–29 traveling in Europe and Egypt with a school friend). Entering the University of Pennsylvania to study architecture, he transferred shortly thereafter to the Pennsylvania Academy, where he studied from 1931 to 1934 with Henry McCarter, Daniel Garber, and Francis Speight. The latter's thoughtful views of Manayunk and the cityscape around Philadelphia had a profound influence on the young Stuempfig, whose first painting was accepted for an Academy annual as early as 1932. In 1935, after a year's travel in Europe on a Cresson Travelling Scholarship, visiting Germany, England, Italy, and Spain, Stuempfig married Lila Hill, a fellow Academy student, and they moved to a farm in Collegeville, Pennsylvania. An annual pattern was soon established which continued throughout Stuempfig's life, as the family moved between winters spent in Philadelphia and the surrounding countryside and summers on the New Jersey coast or (later, with increasing frequency) in Europe.

Stuempfig's art evolved into an intensely personal vision; apart from any of the con-

481.

sciously modern or abstract movements of the 1930s and 1940s, it remained naturalist in treatment and often strikingly enigmatic in mood. His subjects ranged from landscapes of Cape May or South Philadelphia streets to poetic still lifes and haunting portraits of himself, his family, and friends. A passionate admirer of Caravaggio, Degas, Corot, and Thomas Eakins, Stuempfig in his work absorbed aspects of their influence into a highly accomplished individual style. While his moody Italianate visions of the Fairmount Waterworks in Philadelphia or the hillsides of Manayunk in the early 1940s had elements in common with the surreal stage-set landscapes of his contemporaries Eugène Berman, Leonid, and Christian Bérard, his later landscapes, portraits, and still lifes assumed a painterly solidity and dignity.

Stuempfig's first one-man show was held at the Philadelphia Art Alliance in 1942, and in 1943 he began to exhibit once a year with the Durlacher Bros. gallery in New York, an arrangement that lasted until 1961. His teaching career began in 1948 when he joined the Pennsylvania Academy faculty as instructor in composition and drawing for the next twenty-two years. Exhibiting regularly in Academy annuals and other national exhibitions, Stuempfig won several prizes (see PAFA, *Walter Stuempfig Memorial Exhibition,* 1972, for a complete listing). A one-man exhibition at the de Young Memorial Museum in San Francisco in 1946 was followed by several others over the years at the Pennsylvania Academy (1947), the University of Miami, the Massachusetts Institute of Technology (1960), the Fort Worth Art Association (1962), and the Birmingham Museum of Art (1963). His work was acquired by museums across the country and he was elected to membership in the National Academy of Design in 1953.

Stuempfig's isolated stance vis-à-vis modernist developments in American art both appealed to and baffled critics, who tended to settle for the unsatisfactory phrase "romantic realist" in describing him. He continued an active career of painting and teaching until his death in 1970. The Pennsylvania Academy mounted a memorial exhibition of eighty-four works in the spring of 1972. Stuempfig's children have also pursued art-oriented careers in Philadelphia: his son Anthony is a dealer specializing in American nineteenth century decorative arts, and George has won recognition for his work in both sculpture and printmaking.

481. *The Wall*

1946
Signature: w/STUEMPFIG/1946 (on scrap of paper at lower right)
Oil on canvas
31¼ x 48¼" (79.4 x 122.5 cm)
Pennsylvania Academy of the Fine Arts, Philadelphia. Temple Fund Purchase, 1947

PROVENANCE: Purchased from the 142d Annual by the Pennsylvania Academy of Fine Arts, 1947

LITERATURE: PAFA, *142d Annual* (1947), no. 127; PAFA, *Exhibition of Paintings by Walter Stuempfig* (March 11–23, 1947), no. 1; New York, MOMA, *Contemporary Painters,* by James Thrall Soby (1948), pp. 82, 84, illus. p. 82; Parker Tyler, "Magic Realism in American Painting," *American Artist,* vol. 16, no. 3 (March 1952), pp. 43, 66, illus. p. 41; PAFA, *Walter Stuempfig Memorial Exhibition* (March 14—April 9, 1972), no. 24 (illus.); Victoria Donohoe, "The Full Range of Walter Stuempfig," *Philadelphia Inquirer,* March 5, 1972

IN HIS CHOICE OF SUBJECTS, Stuempfig often followed the example set by his teacher Francis Speight, whose loving attention to the urban landscape around Philadelphia preoccupied him throughout forty-one years of residence in the city. But the younger artist brought a moody spirit, deeply imbued with European styles and traditions, to the contemporary scenes which Speight painted with such a straightforward approach. This view of a street corner in South Philadelphia is specifically American, and yet resonant with memories of an older civilization—Italian cities with their haunting mixture of past grandeur and present poverty. The formidable wall for which the painting is named recalls the dark stoniness of Florentine palazzi, although the bleak-windowed row houses across the street and the church spire in the distance bring us sharply back to familiar Philadelphia. James Thrall Soby wrote that Stuempfig felt the need for "the present's sharp profile as much as the past's atmospheric veil" (*Contemporary Painters,* cited above, p. 84). Certainly *The Wall* is a remarkable fusion of the two elements, its intense realism serving as a vehicle for equally intense poetic emotion. Social criticism plays no role in Stuempfig's vision; his people melt into their settings, actors in an ancient drama, not subjects for reform or revolution. The figures in the street, whose faces are turned away or obscured from view, seem transfixed in a timeless moment, and the boy's attitude of concentration suggests that the meaningless chalk scrawl might contain some hidden message. Even the littered sidewalk assumes an air of mystery, like a beach strewn with the flotsam and jetsam of distant shores. Stuempfig has carefully organized the scene into large, rectangular areas and reduced his palette to tones of brown and gray, without undermining the viewer's sense of perceived reality. The light pastel colors, ragged brushwork, and crowded compositions of his Italianate vistas of Cape May beach houses, painted during the 1930s, have here darkened and solidified into a coherent, painterly style. *The Wall* seems equally remote from the exquisite detail of Andrew Wyeth and the bold simplification of Ben Shahn; but a similar vein of disquieting melancholy was explored by all three artists, whose work demonstrates the range of American "realist" painting in the 1940s.

Ad'H □

LEON KARP (1903–1951)

Born in Brooklyn, Karp moved to Philadelphia with his family and lived in the neighborhood of Strawberry Mansion near Fairmount Park during his childhood. Familiar Philadelphia scenes were to provide

482.

him with many subjects for his art, including the traditional New Year's Day spectacle of the Mummers' Parade. He attended Central High School, and took classes at the Graphic Sketch Club (now the Samuel A. Fleisher Art Memorial). First enrolling in the Philadelphia Museum School of Industrial Art, where his future wife Grace Dornan was a fellow student, he transferred to the Pennsylvania Academy in 1923. His teachers during a four-year course were Daniel Garber, Hugh Breckenridge, Henry McCarter, and Arthur B. Carles, but his work was to be closer in feeling to that of other students like Francis Speight and Leon Kelly. In 1926 he won a Cresson Travelling Scholarship which took him to France, Spain, and Italy, and he returned to take a job in 1927 as a layout designer with the advertising firm of N. W. Ayer & Sons. (Highly successful as a commercial artist, he became associate art director of the firm in 1945, and won several awards in that field.) A close friendship with Earl Horter led to his training as a printmaker, although his free and dashing use of line owed little to Horter's refined technique.

Starting in 1933, Karp exhibited regularly in annual exhibitions of the Pennsylvania Academy, winning the Carol Beck Medal for *Portrait of My Wife* (subsequently purchased by the Academy) in 1939. His first one-man show was held at the Gimbel Galleries in Philadelphia in 1935, followed by exhibitions at the Philadelphia Art Alliance (1943), the Print Club (1946), and the Pennsylvania Academy (1947). His position as a figurative painter of talent and individuality was established nationally by his

inclusion in the large exhibitions of American art at the New York World's Fair in 1939 and the Golden Gate Exposition the same year, and he also showed in the annual or biennial exhibitions at the Art Institute of Chicago, Corcoran Gallery of Art, and Carnegie Institute. In addition to his active career in advertising, he taught for many years at the Fleisher Art Memorial. His portraits, still lifes, and studies of Mummers painted during the 1940s eluded identification with any particular label, and his death at the age of forty-eight cut short a quietly flourishing career. In 1952 the Philadelphia Museum of Art collaborated with the Pennsylvania Academy on a memorial exhibition of seventy-five works, chosen by a selection committee of artists under the chairmanship of Franklin Watkins.

482. *The Yellow Sweater*

1947
Signature: Leon Karp (lower right)
Oil on canvas
40⅛ x 30¼" (102 x 76.8 cm)

The Metropolitan Museum of Art, New York. Gift of Friends of the Artist, 1952

PROVENANCE: With Joseph Luyber Galleries, New York

LITERATURE: New York, Joseph Luyber Galleries, *Leon Karp* (December 1–20, 1947), no. 3; "Philadelphia Honors a Late Favorite," *The Art Digest,* vol. 26, no. 15 (May 1, 1952), illus. on cover; PAFA and PMA, *Leon Karp Memorial Exhibition* (May 3–June 1, 1952), no. 20, illus. frontis.; Dorothy Grafly, "Leon Karp—1903–1951," *Art in Focus,* vol. 3, no. 8 (May 1952), p. 1; Walter E. Baum, "Memorial Exhibition at the Art Museum Honors Leon Karp," *Sunday Bulletin,* May 4, 1952, p. MB-8 (illus.)

WHEN HIS FRIEND André Girard asked Karp if he might see his work, the artist replied, "You might be disappointed. I paint by methods that are considered old fashioned today, and my subjects are very simple" (PMA, *Leon Karp,* cited above, p. 17). Well acquainted with painting of the past ranging from Rembrandt to Bonnard, and interested in the abstractions of de Kooning as well as the etchings of Goya, Karp in his own art preserved his independence both from an over-obvious influence of tradition and from any specific modern movements. *The Yellow Sweater* was painted in the same year as Jackson Pollock's first great "drip" paintings (*Cathedral, Full Fathom Five*) and yet does not deserve the epithet "reactionary." Like many of his most successful paintings, this is an informal portrait of his wife, Grace, but it is equally a study in the relationship of yellow, green, and orange.

Viewed in terms of contemporary developments in Philadelphia, some of Karp's portraits have a haunting quality reminiscent of the mood of Walter Stuempfig's art, but the light colors and broad brushwork are far from Stuempfig's Caravaggiesque handling of light and shade. In comparison with the work of Franklin Watkins during the 1940s, Karp's painting is less mannered, less complex, more preoccupied with purely formal concerns. Soft, slightly blurred strokes of paint articulate the large areas of color in *The Yellow Sweater* so that the viewer's eye does not rest only on the isolated figure but travels with pleasure across the variegated surface of the background. Perhaps Rafael Soyer provides the closest parallel to Karp's quiet studies of the human figure, particularly of women (compare Soyer's *Pensive Girl* of 1946–47 in the Carnegie Institute, Pittsburgh). Both painters persist in a mode of quiet realism that refers back to the compositional inventions and melancholy air, as well as the subject matter, of Degas and early Picasso. Despite its firm link with a figurative tradition, the simplicity of *The Yellow Sweater* and its division into distinct color areas even suggest affinities to the work of Milton Avery, a painter much more deliberately engaged with problems of abstraction.

Ad'H □

ALFRED BENDINER (1899–1964)

Shortly after he was born, Alfred Bendiner and his Hungarian immigrant parents moved from Pittsburgh to the Philadelphia area, which became his permanent home. His art education began in 1917 with a scholarship to the Pennsylvania Museum School of Industrial Art. It was interrupted a year later by World War I army duty, after which he studied at the University of Pennsylvania, receiving a bachelor of architecture degree in 1922 and a master of architecture degree in 1927. He also attended the American Academy in Rome.

After stints with the architectural firms of Stewardson and Page and Paul Philippe Cret, with whom he had studied at the University of Pennsylvania, Bendiner opened his own office in 1929, concentrating on domestic buildings and offices as well as renovations. In 1950–51 he served as president of the Philadelphia chapter of the American Institute of Architects and was made a Fellow in 1956. His interests included painting and lithography, and as a writer and caricaturist Bendiner received consistent recognition. His articles, often illustrated with his own drawings, appeared in several periodicals: the *Atlantic Monthly; Harper's Monthly;* the *Journal of the American Institute of Architects,* including his frequent

column "Life in a Martini Glass"; *The T-Square Club Journal of Philadelphia;* the *Sunday Bulletin Magazine;* and various journals published by the University of Pennsylvania. He also served for a time on the editorial board of the *Pennsylvania Gazette.*

His articles were anecdotal, documentary, satirical, caustic, critical, and ironic; like his cartoons, caricatures, watercolors, drawings, and lithographs, they covered a wide range of subjects—contemporary architecture, architectural history, current events, archaeology (he served as architect-artist for two expeditions of the Museum of the University of Pennsylvania—in 1936–37 to Iraq and in 1960, accompanied by his wife, the former Elizabeth Wheatley Sutro, to Guatemala), travel (England, Europe, Greece, West Indies), broad social comment, and book reviews.

From 1917 to 1964, Bendiner's caricatures were included in the *Philadelphia Record,* the *Philadelphia Evening* and *Sunday Bulletin,* the *Public Ledger* and the *Washington Times-Herald.* He compiled and annotated two volumes of visual and lengthy verbal anecdotes—*Music to My Eyes* of 1952 (revised, 1956), including many caricatures which originally accompanied newspaper music reviews; and *Bendiner's Philadelphia* of 1961 (with several later editions), an account of city landmarks previously published in the *Sunday Bulletin Magazine.* His autobiographical *Translated from the Hungarian* was published posthumously.

Bendiner's works, now in numerous public and private American and European collections, have been widely exhibited since 1929. He was a member of the Century Club of New York, a Fellow of the Royal Society of Arts, London, and was posthumously elected an Associate of the National Academy of Design.

483. *And So I Give You Our Candidate and the Next President of the United States of America*

1948
Printed by Theodore Cuno, Philadelphia
Signature: Alfred Bendiner (in pencil, in margin, lower right)
Inscription: and so I give you our candidate and the next president of the United States of America (in pencil, in margin, across bottom)
Lithograph printed in black on white wove paper
Proposed edition: 15
9½ x 13 1/16″ (irregular image) (24.1 x 33.1 cm)
Philadelphia Museum of Art. Given by the artist. 48–88–7

LITERATURE: PMA, *Alfred Bendiner: Lithographs* (January 21—March 4, 1965), no. 70

483.

POLITICAL PRINTS commonly in the genre of caricature were one of the earliest forms of the graphic arts to reach America. In this tradition is Bendiner's *And So I Give You,* which captures the moment when Thomas E. Dewey, then governor of New York, received his second nomination as presidential candidate, at the Twenty-fourth Republican National Convention in June 1948, held in Philadelphia. Political subjects were, however, atypical of Bendiner's lithographs. *And So I Give You* falls more appropriately within the context of *Bendiner's Philadelphia,* as an aspect of his running account of international people, places, and events.

According to Ben Wolf, Alfred Bendiner "was a sought after teller of tales. . . . The subjects he chose were reflective of his uncomplicated delight in a world full of exciting people and places" (PMA, *Bendiner,* cited above, n.p.). This delight, apparent in each of the 119 catalogued lithographs, was depicted with spontaneity, yielding images alive with a compression of activity. Bendiner's lithographs, always printed by master printers (Theodore Cuno in Philadelphia or the workshop of Desjobert in Paris), are technically uncomplicated. Although at times he drew with liquid tusche, *And So I Give You* was drawn with grease crayon. The crayon quality is determinedly retained, with only some scratching into the granular lithographic limestone (as, for example, in the doves and the still cameras).

Bendiner's lithographs do not undergo a marked linear development; rather, an interwoven stylistic pattern results from his specific formal responses to similar subjects and/or situations at varying points in time. The central subject of this print is the introduction of Dewey by the Honorable Joseph W. Martin, Jr., of Massachusetts, permanent chairman of the convention. The crowded image populated with small-scale repeated elements is typical of one aspect of the Bendiner style. Also typical is the attempt to animate things that are inanimate—the cameras and placards seem as active as the photographers and the delegates who hold them. Bendiner's love of humorous detail is shown by the attention given to the doves, which were in fact loosed like balloons at the convention.

To Bendiner, it was most important "that the architect should be an artist. If he is a profound and sensitive artist his work will reflect an all-pervading good humor that will have a beneficial effect on the life of our civilization" (Alfred Bendiner "Good Humored Architecture," *Pennsylvania Gazette,* vol. 57, no. 6, February 1959, p. 20). Caricature demands an ability to grasp and then exaggerate and emphasize essentials. In *And So I Give You* one notes the recog-

nizable Dewey mustache and toothy grin, his heavy eyebrows and high forehead; Martin's lock of hair and open-mouthed profile; the arrested archetypal campaign gestures of the two, heightened by the strong white that surrounds them; the exaggerated number of television cameras, which were used for the first time in 1948 for live broadcast of a political convention (no more than six such cameras were used); and the compression of the entire space of Philadelphia's large Convention Hall into what appears to be an area of about twenty-five square feet (Norman B. Fein, National Broadcasting Company, confirmed and suggested information about the 1948 convention).

It seems possible that the prominent and repeated eagle, a national symbol, may also denote here a dislocated but much frequented local landmark. "Nearly everybody in Philadelphia . . . sits at some time under the tail feathers of the John Wanamaker store eagle. . . . It's a custom, like throwing a coin into the fountain of the Trevi" (Alfred Bendiner, *Bendiner's Philadelphia,* New York, 1964, p. 21). Narrow local chauvinism is not confining, however, as evidenced by the central position of the Pennsylvania placard and the American flag adjacent to, if partially hidden by, the eagle at the left.

RFL □

VINCENT G. KLING (B. 1916)

Vincent G. Kling, a native of East Orange, New Jersey, received a degree in architecture from Columbia University in 1940 and a master's degree from the Massachusetts Institute of Technology in 1950. After military service he opened an office in Philadelphia, specializing in hospital and research facilities, where his expertise in planning and technology were invaluable. Early prize-winning designs were the Fox Chase Institute for Cancer Research (1948) and Lankenau Hospital (1953).

In the early 1950s, Kling was employed as architect for the Pennsylvania Railroad's development at Penn Center; that commission, which has extended into the 1970s, has included open-space planning, concourse and subway stations, and six office towers, which are numbered among Philadelphia's most prestigious business addresses. The success in planning and design for corporate headquarters led to the commission for municipal office towers in Norfolk, Virginia (1961), and later, the Municipal Services Building in Philadelphia (1964–65).

The size of Kling's office has necessitated the development of an appropriate corporate form; in this instance, design teams, headed by partners, follow jobs through from beginning to end. That has resulted in a

considerable number of trained and capable young architects, but it has also made it difficult to discern a single direction of stylistic and formal development. In general, however, forms have tended toward greater expressionism, first of structure and later of function, after an early interest in doctrinaire modernism.

OSKAR STONOROV (1905–1970) (SEE BIOGRAPHY PRECEDING NO. 462), LOUIS I. KAHN (1901–1974) (SEE BIOGRAPHY PRECEDING NO. 489), VINCENT G. KLING, AND OTHERS

484. *Triangle Region Redevelopment Area (Penn Center)*

Market Street and Benjamin Franklin Parkway, from Penn Square to Schuylkill River
Begun 1948

REPRESENTED BY:
David Warren Doelp (b. 1931) for The Kling Partnership
Penn Center Development Plan
1970–76
Photostat
36 x 60" (91.4 x 152.4 cm)

The Kling Partnership, Philadelphia

Skyphotos
Triangle Region Redevelopment Area
1976
Aerial photograph

LITERATURE: Philadelphia, City Planning Commission, "Report and Recommendation on the Triangle Area, Philadelphia, Pennsylvania, to the Philadelphia City Planning Commission" (Philadelphia, 1951); Philadelphia, City Planning Commission, "Market West: Center City Redevelopment Area" (Philadelphia, 1965)

THE BENJAMIN FRANKLIN PARKWAY'S Beaux-Arts setting for Philadelphia's institutional buildings (see no. 411) was not to be an isolated development; the city administration hoped that it would lead to a network of radiating avenues which would solve the region's traffic problems. More immediately it was anticipated that the Parkway would spark the redevelopment of the land south of the Parkway and west of City Hall.

Ever since the mid-nineteenth century that area had been a center for transportation-based industries, beginning with the Pennsylvania Railroad Terminal at Nineteenth and Market streets. In 1881 a larger terminal was constructed at the corner of Filbert Street and West Penn Square from the

484.

design of the Wilson Brothers (see biography preceding no. 370). That building was enlarged in 1893 from Furness, Evans and Company's plans (see PMA, *Furness,* pp. 180–83). It included the world's largest single-span train shed, which stretched nearly to Seventeenth Street, and an immense masonry viaduct bordering Filbert Street, which extended to the Schuylkill. Streets and vistas were blocked and traffic was continually snarled, and the structure soon was nicknamed the "Chinese Wall."

That arrangement testified to the importance of the Pennsylvania Railroad, but it adversely affected the region's commercial development, which remained the preserve of express offices, warehouses, and markets. By 1925 the success of the Parkway made it evident that higher and more economically advantageous uses could be attained. The Pennsylvania Railroad began plans to demolish the old terminal and replace it with two specialized stations, one for center-city commuters, and another, at Thirtieth Street, for through traffic to other urban centers (see *Philadelphia Real Estate Record and Builder's Guide,* vol. 44, no. 10, March 6, 1929, vol. 45, no. 16, April 16, 1930). Replacing the station itself would be either a convention center, the city's preferred use, or the railroad's scheme, a row of great office buildings fronting on both sides of Filbert Street and stretching to the Schuylkill. Terminating the street, renamed Pennsylvania Avenue, would be the facade of the new West Philadelphia terminal; the resulting group would form an urban complement to the Parkway.

Work began in 1929 with the construction of Suburban Station at Sixteenth Street and

Pennsylvania Avenue (now J. F. Kennedy Boulevard). It was the work of Chicago architects Graham, Anderson, Probst and White, the successors to D. H. Burnham and Company. They designed a below-grade station surmounted by an office building styled in a generally "modern" vein with ornament abstracted from classical motifs. At the end of the year work on the Thirtieth Street Station got underway as well. That building's role as the ceremonial entrance to the city was given emphasis by the vast scale of the waiting room and the grander and more severe classical vocabulary, here used directly. Together the two stations form one of the grand ensembles of the period, but the grand project of which they were to be foci was ended by the Depression.

Increased dependence on rail travel during World War II again made Broad Street Station necessary, and it was not until the late 1940s that the idea of demolishing the old terminal and rebuilding the area was again broached. In the intervening years, the city government had been given new planning and redevelopment powers while at the same time new concepts of city planning based on Le Corbusier's antiseptic theoretical ideals had replaced the traditional laissez-faire values of urbanologists. Penn Center is the result of that dual development, for with the powers of the urban redevelopment laws, the planners were able to slice the Gordian knot of visionary planning, land acquisition, to further their own views of city design.

In 1948 the City Planning Commission recommended that the "Triangle Region," the land lying between the Parkway, the Schuylkill, and Market Street, be rede-

veloped, beginning with the removal of the "Chinese Wall" and Broad Street Station. But the immediate needs of the city were for adequate water and sewerage facilities, and thus it was not until 1950 that larger plans were envisioned. Then, spurred by the well-publicized Golden Triangle project of Pittsburgh, Philadelphia's planners announced their local project (see Norman N. Rice, ed., *Philadelphia 1950: Challenge to the Changing City,* Philadelphia, 1950, pp. 1–14). The early designs included work by Vincent G. Kling for the malls and the planning (see *Yearbook of the Philadelphia Chapter of the American Institute of Architects, 1953,* Philadelphia, 1953, p. 71).

Louis I. Kahn and Oskar Stonorov, architects; Richard Wheelwright and Markley Stevens, landscape architects; and realtor C. Henry Johnson, working for the city, proposed that the land become a new commercial center, with large office buildings and hotels, arranged on a two-level pedestrian and transportation mall. The idea of a conforming usage like the uniformly institutional Parkway was derived from French planning principles; but instead of the formal arrangement of buildings of Beaux-Arts design, the Kahn-Stonorov scheme called for a carefully calculated asymmetry in the site plan in accord with the enunciated doctrines of the International Style. As a result, the earlier railroad proposals and the ideas of New York's Rockefeller Center, both discredited in contemporary theory, were ignored. No central focus was created, nor were such amenities as the skating rink (obviously copied from the New York complex) given a prominent site to bring life and activity into the project. Instead, the planning shows the results of an often arbitrary sophistication, undoubtedly appealing in the model if not particularly ingratiating in reality. The buildings that the architects suggested for the site were as different from the railroad's original scheme as the new plan. Instead of the massive, classically detailed office blocks, the new buildings were to be unarticulated glass curtain-walled parallelepipeds designed to the specifications of office planners and real estate speculators.

Four years of planning reached fruition in 1952 when the Philadelphia Orchestra playing Auld Lang Syne rode the last train from Broad Street Station. The old station was demolished and replaced by Emery Roth's glass- and limestone-clad office buildings, and the "Chinese Wall" was supplanted over the next decade by a row of undistinguished hotel and apartment slabs which visually continued the old divisions of the city. These were a technocrat's idea of gray-flanneled-suit architecture, safe yet rooted in the polemics of modern architec-

484.

tural theory. Penn Center thus represents the triumph of doctrinaire modern design in a city which had long preferred academic classicism.

The conflict between past and present, resolved in favor of the latter, affected most of the later planning decisions in the area, beginning with a 1951 proposal to demolish Philadelphia's City Hall (no. 334) in order, it was claimed, to facilitate vehicular traffic (*Yearbook of the Philadelphia Chapter of the American Institute of Architects, 1953,* Philadelphia, 1953, p. 44). An earlier project with a similar aim was proposed by Paul Cret in 1924 as a part of the Parkway, in which City Hall was to be demolished with the exception of the tower which was to be clothed in a "modern" skin (see drawings, University of Pennsylvania Library). Fortunately the expense of demolishing the solid masonry of McArthur's building defeated the planners. Instead, City Hall was merely cleaned, revealing the light marble and its delicate carving and making it again a handsome focus for center city.

If the buildings of Penn Center's first decade were somewhat pedestrian, recent work has been more interesting, beginning with Vincent G. Kling and Associates' Municipal Services Building of 1964–65 ("M.S.B.: A Diamond in Philadelphia's Center City?," *Progressive Architecture,*

vol. 46, no. 12, December 1965, pp. 108–17). The sculptural, cruciform-planned, granite-aggregate-sheathed tower is visually engaging, and its elevation on tall piers creates a series of vistas, yet preserves a sense of open space. Since then, new office towers, several by Vincent Kling and Associates, have surrounded City Hall to the west, and completed the redevelopment of the area begun almost half a century before.

GT □

LEON KELLY (B. 1901)

Although closely associated with Philadelphia for most of his career, Kelly was born in Perpignan, in the French Pyrenees, of Spanish and Irish ancestry, and his work has been responsive to international rather than regional movements in art. Shortly after his birth, Kelly's family moved to Philadelphia. Although he studied at both the Pennsylvania Museum School of Industrial Art and the Pennsylvania Academy (from 1922 to 1926), his most important training came in private classes with Earl Horter and Arthur B. Carles. Their firsthand familiarity with the painting of the Fauves and Cubists in France, and Horter's fine collection of avant-garde European art made

a profound impression upon Kelly. His paintings of the period 1920–24 were among the most sophisticated versions of analytical Cubism to be produced in Philadelphia: monochromatic compositions (still lifes or figure studies) built up of overlapping planes in shallow pictorial space. In addition to his studies in art, he spent a year taking courses in anatomy and dissection at the College of Osteopathy, pursuing his lifelong interest in the structure of natural forms.

In 1924 a Cresson Travelling Fellowship from the Pennsylvania Academy took Kelly abroad where he remained for six years, living in Paris and traveling widely in Europe and North Africa. During his years in Paris, Kelly spent considerable time copying old master paintings (Rubens, Velázquez, Titian) in the Louvre, and his earlier interest in Cubism gradually waned. In 1925 his first one-man exhibition was held at the Gallery of Contemporary Art in Philadelphia, followed by a show at the Galerie du Printemps in Paris in 1926.

Returning to Philadelphia in 1930, Kelly was invited to supervise the mural and easel painting sections of the Federal Arts Project for southeastern Pennsylvania. This activity coincided with an energetic painterly style in his own work, reminiscent in its rich, somber colors and expressive brushwork of much school of Paris painting. A number of Kelly's paintings and drawings done under the auspices of the WPA are on deposit at the Philadelphia Museum of Art. In 1933 he was included in the large *Century of Progress* exhibition at the Art Institute of Chicago, and he exhibited frequently in national annual shows at the Whitney Museum, Carnegie Institute, and Pennsylvania Academy during the 1930s and 1940s.

Around 1940, Kelly's work began to undergo a third distinct shift—in the direction of Surrealism. A one-man exhibition at the Philadelphia Art Alliance in 1941 still included realistic, Cézannesque still lifes, but a sequence of shows at the Julien Levy Gallery in New York (1942, 1944, 1945) established his reputation as an American Surrealist. Postal authorities took exception to drawings by Kelly and Picasso reproduced in the December 1943 issue of *View* magazine (edited by Charles-Henri Ford) and temporarily restricted the journal's mailing privileges. In 1950 a three-man exhibition at the Hugo Gallery in New York linked Kelly with Matta and Hans Bellmer, Surrealists whose work had particular affinities with his own. Bellmer's exquisitely drawn erotic subjects make an apt parallel to Kelly's spidery drawings of birds and insect-like creatures, while both Matta and Kelly were fascinated by flame and fire imagery, which flickers through their paintings of the 1940s.

Kelly's subsequent solo exhibitions in New York at the Hugo Gallery (1950), Edwin

Hewitt Gallery (1956), Alexander Iolas Gallery (1959, 1961), and Zabriskie Gallery (1963) revealed a gradual evolution within his characteristic imagery, which occasionally approached but never settled into abstraction. In 1958 he received a grant from the William and Noma Copley Foundation. He was represented in the large survey *Surrealism, a State of Mind* at the University of California at Santa Barbara in 1965. That same year a retrospective exhibition at the International Gallery in Baltimore included 122 works executed between 1920 and 1964.

During the 1950s and 1960s, Kelly divided his time between Philadelphia and a house near the ocean on the coast of New Jersey, where he now lives. A trip to Spain in the early 1960s intensified his continuing interest in Spanish themes and imagery which recur frequently in his work of the last decade. He taught painting at the Pennsylvania Academy from 1966 to 1969, and in 1967 an exhibition of his recent paintings and drawings was shown at the Academy's Peale House Galleries.

485.

485. *Boy Giving a Mollusk to the Poet*

1954
Signature: 1954/Leon Kelly (lower right)
Lead pencil and colored pencils on paper
46½ x 34½″ (118.1 x 87.6 cm)
Whitney Museum of American Art, New York

PROVENANCE: With Hugo Gallery, New York

LITERATURE: New York, Whitney Museum of American Art, *Annual Exhibition of Contemporary American Sculpture, Watercolors and Drawings* (March 17—April 18, 1954), no. 158

THE TWO *dramatis personae* in *Boy Giving a Mollusk to the Poet* are at first barely discernible in what appear to be delicate, spindly structures resembling plants. Standing upon straight, impossibly slender legs, they have long arms, waving appendages which twist and curve like seaweed stirred by a slow current. Perhaps the easiest way to decipher the drawing is to begin with the "mollusk" (the object like a crab shell suspended from one spectral hand in the upper right section) and then follow the arm back to the "boy" (who possesses an elongated spindle-shaped head and another extravagantly long arm). By this process the "poet" can be distinguished as the taller, wildly distorted figure whose head is crowned with a large triangular growth and whose left hand gropes toward the lower left corner of the drawing, while his right arm (oddly swollen) curves gracefully around the boy's offering. These two phantom beings occupy an indefinite space, delicately tinted in shades of blue, green, yellow, and rose, and traversed by fine horizontal lines at irregular intervals.

In his foreword to the exhibition checklist for Kelly's 1965 retrospective at the International Gallery in Baltimore, Julien Levy quotes a statement by the artist as to his decision (reached in the 1930s) to reject pure abstraction: "By its formulated conventionality it seems to have arrived at an impossibly sterile impasse for the mind." Searching instead for a means to convey his own unsettling perception of the world, Kelly evolved a distinctive style and a personal vocabulary of images with which he continued to work into the mid-1960s. In 1940 he described his method of approach to painting in the March issue of the Philadelphia Art Alliance *Bulletin*: "I like to develop shapes based on the unfamiliar forms I see, and to assemble them to create the balance, depth, rhythm, and contrast I find in nature. I am interested in the new

vision that is both revealed and implied by inventions of science—such as the microscope, the camera, the telescope. I am involved with all strata of humanity and with all animal life. I study the insects—their wings and their construction; all the visible world interests me." Kelly's paintings and drawings of the 1940s were populated by fantastic birds and often frightening insects. When he turned his attention to the depiction of human beings, they appeared as elements in a supernatural world, assuming the attenuated, ghostly aspect of a praying mantis or the veined, tapering form of a decayed leaf blown by the wind.

One of Kelly's largest and most exquisitely rendered drawings, *Boy Giving a Mollusk to the Poet* is the product of a full-blown Surrealist vision and morphology. Julien Levy's description of Kelly's art as "the visions of a larva within its chrysalis" seems peculiarly appropriate here: the artist manipulates his pencil as if spellbound, with all the precision, delicacy, and mysterious purpose of a spider spinning out its silken thread.

Ad'H □

Born in Philadelphia, Joseph Greenberg received encouragement in art from the sculptor Boris Blai, whom he met at the age of nine or ten. Greenberg attended Episcopal Academy, studied engineering for one year at the Massachusetts Institute of Technology, and then transferred to the newly founded Tyler School of Art at Temple University, where Blai was teaching (and served as dean for many years). At Tyler (1935–39), Greenberg studied sculpture with Rafael Sabatini and was aware of the work of Franklin Watkins and Earl Horter, who were also on the faculty. In 1940, Greenberg exhibited a work at the second international sculpture show sponsored by the Fairmount Park Art Association at the Philadelphia Museum of Art, and in 1941 he was included in the annual exhibition of the National Academy of Design. From 1942 to 1946 his career was interrupted by army service in World War II.

During a four-year stay in Alassio, a town on the western coast of Italy, from 1949 to 1953, Greenberg's style came to maturity and his work began to enjoy considerable success. Exposure to the sculpture of the contemporary Italian masters Marino Marini and Giacomo Manzú supplemented his earlier interest in the art of Ivan Meštrović and Wilhelm Lehmbruck. In 1951 the Galleria del Obelisco in Rome gave Greenberg his first one-man show; and in 1953 his sculptures were included in the 26th Biennale in Venice. While he was abroad, his entry, *Eve,* in the *American Sculpture 1951* exhibition at the Metropolitan Museum of Art won fourth prize. After his return to Philadelphia, the Pennsylvania Academy mounted a one-man exhibition in 1953. From 1954 to 1956, Greenberg served as president of the Philadelphia chapter of the Artists Equity Association. In the mid-1950s he began to experiment with new materials, such as fiber glass and reinforced plastic, and an exhibition at the Philadelphia Art Alliance in 1957 was devoted to his work in these media. At this time he also completed his first major commission: a bear and her cub carved in black granite for the Philadelphia Zoo. During the 1960s Greenberg taught classes in sculpture at the Philadelphia Museum and executed a number of commissions for public spaces in the city. His 1963 heroic bronze figure of *Man* holding an armillary sphere, placed against the gray marble wall of the Bell Telephone building (Sixteenth Street and Benjamin Franklin Parkway), is perhaps his best-known large piece. His work for the Philadelphia Zoo continued with three large limestone reliefs for the rare mammal house, and in 1967 he received the commission for a sixty-foot high sculpture in welded steel for the Bethlehem, Pennsylvania, Civic Center.

Greenberg has always been particularly interested in the interaction of monumental or decorative sculpture with architecture: in 1962 he won the Craftsmanship Award from the Pennsylvania Society of Architects and the following year received a citation from the Philadelphia Chapter of the American Institute of Architects. Greenberg has been one of the most versatile and productive artists in the field of public sculpture in the Philadelphia area. His work has ranged in style from realistic stone carvings of animals to stylized fiberglass figures to an abstract bronze symbol of Freedom for the Martin Luther King Recreation Center. He continued to exhibit at the Pennsylvania Academy annuals throughout the 1960s and his most recent one-man show was held at the Philadelphia Art Alliance in 1974.

486. *The King*

1955

Signature: J. Greenberg/1955 (rear of base)

Mahogany

46 x 16 x 11½" (116.8 x 40.6 x 29.2 cm)

Pennsylvania Academy of the Fine Arts, Philadelphia. Gift of R. Sturgis Ingersoll, 1955

LITERATURE: PMA, *First Philadelphia Art Festival Regional Exhibition* (February 26—March 27, 1955), no. 270; PAFA, *Held in Trust, One Hundred Sixty-Six Years of Gifts to the Pennsylvania Academy of the Fine Arts* (June 23—August 26, 1973), no. 77

DURING GREENBERG'S four-year stay in Italy, he came across an old photograph of the black jazz musician "King" Oliver. The sculptor writes, "I was so struck by his pose, so majestic yet infinitely sad, that I decided to try a figure study based on it" (letter to the author, July 29, 1975). He made the original study in clay, then cast it in plaster in order to bring it back to the United States. In his Mechanicsville studio, Greenberg carved the final work from a piece of Honduras mahogany, completing it just in time for inclusion in the First Philadelphia Art Festival exhibition at the Philadelphia Museum of Art in 1955.

The King is characteristic of his best work; it is based on a specific visual image but executed without use of a model, and details are subordinated to the smooth flow of the surface. The bronze figure of *Eve,* which won Greenberg the fourth prize in the national exhibition *American Sculpture 1951,* is conceived in the same formal terms —a wide, softly modeled body with long tapering limbs. Greenberg's sculpture of this period has something in common with the

stylized sleekness of Hugo Robus's figures, but stops short of Robus's bizarre, semiabstract distortion of the human form. If *The King* is not literally a portrait, nevertheless the blurred features of the face convey a poignant sense of human dignity. Greenberg's interest in materials has led him to experiment with plastic resins and fiber glass, but *The King* gives ample evidence of his skill in the traditional art of wood carving. The grain of the wood undulates around the swelling contours of the figure, and the warm, buttery tone of the mahogany accentuates the remarkable illusion of soft flesh. Academic principles of anatomical accuracy could scarcely be said to underly the conception of *The King*; elimination of detail and exaggeration of form are essential to the tactile, sensuous impact of the sculpture. As Arthur Carles had explored the possibilities of rendering the painterly equivalent of the color and texture of the human body, in a related manner Greenberg's handling of the wood endows his inert material with an almost disquieting sense of life.

Ad'H □

486.

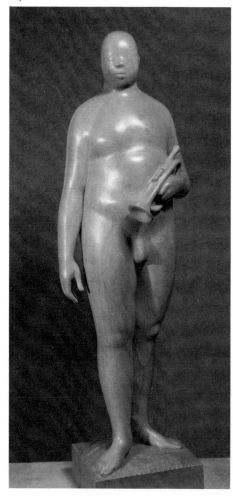

ANDREW WYETH (B. 1917)

Without question the most popular and widely known American artist of this century, Wyeth has spent his life and created his remarkable body of work in the quiet environs of two small rural towns: Chadds Ford, Pennsylvania, and Cushing, Maine. Wyeth was the youngest of five children of Newell Convers (N. C.) Wyeth (1882–1945), the dynamic painter and illustrator who came to Chadds Ford in 1902 to study with Howard Pyle. After a brief attendance at public school, which he left for good during a period of ill health, Andrew studied at home with a tutor and at age fourteen began a rigorous course of instruction in art under the stern but imaginative supervision of his father. Wyeth's childhood was spent in mastering perspective and drawing from casts (he later progressed to still life, studies from the figure, and landscape) and in long rambles over the rolling Pennsylvania countryside along the Brandywine River. He visited the Pennsylvania Academy with his father and conceived a profound admiration for the art of Thomas Eakins. As a child, Wyeth produced a number of elaborate illustrations for romantic tales like the *Adventures of Robin Hood,* but his earliest works to achieve public recognition were a series of dashing watercolor landscapes, many of which were executed during summers at the Wyeth home in Maine. Wyeth's first two one-man shows were devoted to these watercolors, which reminded enthusiastic critics of Winslow Homer. The exhibition committee of the Philadelphia Art Alliance (which included Earl Horter and Yarnall Abbott) invited the nineteen-year-old artist to show thirty watercolors there in 1936, and his subsequent exhibition at the Macbeth Gallery in New York in 1937 was sold out by the second day. In the late 1930s, Wyeth and his father were introduced to the technique of egg tempera painting by Wyeth's brother-in-law Peter Hurd. Wyeth's first successful works in that medium (*Dil-Huey Farm,* 1941, and *Winter Fields,* 1942, for example) revealed an exquisite precision and control in striking contrast to the fluidity of his watercolors. Around the same time, he developed a technique for working with a dry brush over paper washed with color which offered the same possibilities for fine detail as tempera.

In 1940, Wyeth married Betsy James, who was to prove an insightful critic and indefatigable cataloguer and preserver of his work. During the early 1940s he undertook occasional projects as an illustrator, including a series of drawings for Henry Seidel Canby's book on the Brandywine River (published in 1941). His painting *The Hunter* was used on a cover of the *Saturday Evening Post* in 1943. Despite his flair for

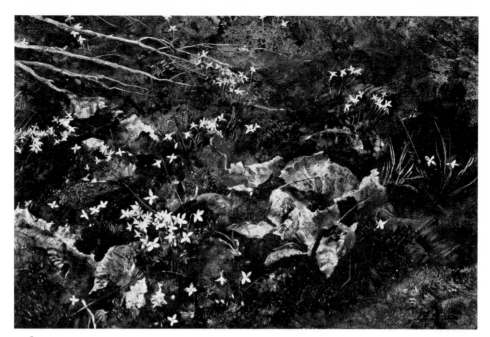

487.

illustration and its strong tradition within the Wyeth family, he rarely accepted further commissions. In 1943, eight of Wyeth's works were included in the exhibition *American Realists and Magic Realists* organized by Dorothy Miller and Alfred H. Barr, Jr., at the Museum of Modern Art.

The tragic death of his father, whose car was hit by a train at a railroad crossing near Chadds Ford in 1945, marked a major turning-point in his career. The tempera *Winter, 1946* of a boy running down the bleak slope of a hill expressed his reaction to N. C. Wyeth's death most directly, and a sequence of haunting, by now legendary, paintings (*Wind from the Sea,* 1947, *Karl,* and *Christina's World,* 1948) affirmed the new, deeply serious note in his art. Elected to the National Academy of Design in 1945, he received the Award of Merit Medal from the American Academy of Arts and Letters in 1947, and that same year exhibited a group of watercolors in the Philadelphia Artists' Gallery of the Pennsylvania Academy. The Museum of Modern Art purchased *Christina's World* the year it was painted, and in 1950 *A Crow Flew By* was acquired by the Metropolitan Museum (Wyeth's paintings and watercolors are now represented in museum collections across the country). In 1951 the Currier Gallery of Art in Manchester, New Hampshire, mounted Wyeth's first major museum retrospective of sixty-eight works. During the 1950s his reputation grew rapidly, and he accumulated an impressive array of honors (including the Lippincott Prize from the Pennsylvania Academy in 1952, several honorary doctorates from universities, and election to

the American Academy of Arts and Letters in 1956). His paintings became increasingly spare and essentialized: *Snow Flurries* of 1953 and *Brown Swiss* of 1957 were portraits of hillsides devoid of human drama but imbued with the artist's response to the shifting moods and seasons of familiar landscape. When Macbeth Gallery closed in 1952, Wyeth began to exhibit with M. Knoedler & Company, which organized a retrospective in 1953. The San Francisco Museum of Art mounted another in 1956, and his largest exhibition up to that time was held at the Albright-Knox Art Gallery, Buffalo, in 1962 (attended by over a quarter of a million visitors). In 1960 the Fellowship of the Pennsylvania Academy honored Wyeth as the Distinguished Pennsylvania Artist of the Year (he had shown in twelve annual painting exhibitions between 1938 and 1958 and twenty-two watercolor annuals between 1935 and 1965). In 1963, Wyeth was selected by President John F. Kennedy as a recipient of the Medal of Freedom, the highest recognition for achievement offered by the United States, and he became the first artist to have the national publicity of a *Time* magazine cover story.

Wyeth continues to follow his lifelong pattern of summers in Maine and winters in Chadds Ford (where he and his wife acquired three eighteenth century mill buildings in 1958). His work of the last decade has included a series of portraits which combine a wealth of physical detail, with an intense evocation of the sitter's personality (*The Patriot,* 1964, *Maga's Daughter* and *Grape Wine,* 1966, *Anna Christina,* 1967). In recent years Wyeth's fame has become world-wide,

575

and is perhaps rivaled in the United States only by the legendary status of Picasso. The large retrospective of 222 works organized by the Pennsylvania Academy of the Fine Arts in 1966 attracted vast crowds in every city on its tour (Philadelphia, Baltimore, New York, and Chicago). Since 1969, Wyeth has been represented by the Coe Kerr Gallery in New York, and his work has found collectors and commanded high prices as far afield as Japan. Retrospective exhibitions have recurred at regular intervals (170 works at the Boston Museum of Fine Arts in 1970, eighty-eight works at the National Museum of Modern Art in Tokyo in 1974), and one is planned by the Metropolitan Museum of Art for autumn of 1976. By the mid-1970s, Wyeth's stance as a traditionalist in contrast to the Abstract Expressionist and color field painters (stressed by critics in the 1950s and 1960s) seemed less significant than his relationship to the increasing number of American artists concerned with various forms of realism and with the importance of subject matter. In *Erickson's Daughter,* an exhibition of six paintings dating from 1968 to 1972 at the Brandywine River Museum in 1975, Wyeth's nude figure studies (hitherto rare in his work) provided an interesting comparison with the painting of other realists (such as Philip Pearlstein, Sidney Goodman, and Alfred Leslie) who have concentrated on that theme.

Deeply committed to the fate of the land he has so frequently depicted, Wyeth has supported the creation of the Tri-County Conservancy which seeks to preserve the countryside along the Brandywine as an unpolluted resource, an area rich in both history and natural beauty. The Brandywine River Museum, housed in a converted mill, opened to the public in 1971 with the exhibition *The Brandywine Heritage,* which included important groups of work by Howard Pyle, N. C. Wyeth, Andrew Wyeth, and his son Jamie Wyeth. Living some thirty miles outside of Philadelphia, Wyeth's relationship to the city is a paradoxical one. In the established pattern of his life it must often seem as remote from his daily concerns as New York, but he has exhibited regularly in Philadelphia for forty years and a whole school of followers has sprung up in the area. Wyeth's intensely observed realism, developed apart from any institutional training, constitutes a parallel to the figurative tradition persisting at the Pennsylvania Academy and an increasingly apparent challenge to young painters exploring a representational mode.

487. *Quaker Ladies*

1956
Signature: Andrew Wyeth (lower right)
Dry brush and watercolor on paper
13⅞ x 22⅛″ (35.2 x 56.1 cm)
The Henry Francis du Pont Winterthur Museum, Winterthur, Delaware

PROVENANCE: With M. Knoedler & Company, Inc., New York; Henry Francis du Pont until his death in 1969

LITERATURE: Buffalo, New York, Albright-Knox Art Gallery, *Andrew Wyeth* (November 2—December 9, 1962), no. 116, illus. p. 67; PMA, *A World of Flowers* (*PMA Bulletin*), vol. 58, no. 277 (Spring 1963), illus. p. 177; Chadds Ford, Pa., The Brandywine River Museum, *The Brandywine Heritage* (June 19—October 19, 1971), no. 86, illus. p. 70

WYETH'S SKILL AS A WATERCOLORIST is extraordinary. His influence on other artists working in that medium has been widespread but is particularly striking in the area of southeastern Pennsylvania and northern Delaware that includes Philadelphia and Wilmington, where regional exhibitions abound with work reminiscent of his style and subject matter. His early watercolors of the late 1930s had an easy virtuosity and lavish use of flowing color which he later eschewed. But concentrated energy and a sense of freedom are essential to all his work. He remarked in an interview with Richard Meryman, "I use tempera partly because it's such a dull medium—those minute strokes put a break on my real nature—messiness. My wild side that's really me comes out in my watercolors..." (quoted in *Life,* vol. 58, May 16, 1965, p. 108). Wyeth frequently uses the dry brush technique—applying watercolor sparingly with a brush from which all excess water has been squeezed—for painstaking studies of fragments of the natural world (such as *Grasses* of 1941, *Winter Corn* of 1948, *Winter Bees* of 1959). Dry brush works such as the small, magical evocation of his son Jamie daydreaming in a coonskin cap (*Faraway,* 1952) or the large horizontal compositions of *Young Bull* (1960) and *Evening at Kuerner's* (1971) are complete and complex pictures sharing many of the attributes of Wyeth's tempera paintings. He has, however, continued to produce less formal watercolors in which the pigment is applied to the paper in a flurry of strokes and touches, although frequently worked over in subtle ways. He makes use of the medium at its most fluid for direct and fresh views of nature (*Delphinium,* 1955, or *Spruce Grove,* 1970), often focusing particularly on effects of light and reflection.

Quaker Ladies is one of Wyeth's most delightful works in watercolor: a panoramic view of spring compressed within a few square feet of earth sprayed with delicate white quaker-ladies (also known as bluets). Few artists of this century have peered so attentively at the ground beneath their feet—Wyeth's *The Trodden Weed* of 1951 depicts his own feet in a pair of venerable boots (which once belonged to Howard Pyle), pacing over the infinitely variegated terrain which never ceases to fascinate him. His art is strewn with rocks and leaves and dry grasses; the minutiae of a sandbank or hillside attract his gaze far more frequently than amorphous masses of clouds overhead. Usually preferring to paint the bare bones of a landscape in fall or winter rather than in its summer abundance, Wyeth is somewhat sparing with flower subjects. *Spring Beauty,* a tempera of 1943, was devoted to the miraculous appearance of a single blossom amidst the fallen brown leaves and gnarled roots of a vast tree. *Quaker Ladies,* by comparison, is positively lavish with the diminutive four-petaled stars. (A later variation on the same theme is *May Day* of 1960 in which a long fringe of spring beauties gleams against the brown waters of the mill-race on Wyeth's land.) Wyeth's artistry makes us oblivious of his own hand which is everywhere at work, flicking tiny specks and dashes of color across the sheet of paper until the entire surface is as alive with his markings as the rich brown soil is alive with new growth.

Ad'H □

OLAF SKOOGFORS (1930–1975)

Born in Bredsjo, Sweden, Olaf Skoogfors at the age of four came with his family to the United States settling in Wilmington, Delaware. In 1937 the family returned to Sweden, only to come back to this country at the outbreak of the war, this time moving to Philadelphia. After graduating from Olney High School in Philadelphia, Skoogfors returned to his native country for a year, working as a draftsman for a plumbing contractor. During this time he made the decision to become an American citizen and worked only long enough to earn his passage back to Philadelphia. In 1949 he entered the Philadelphia College of Art, studying with Virginia Wireman Cute (Curtin) and Richard Reinhardt.

In 1954 he married Judy Gesensway, a dancer and artist. From 1955 to 1957 he studied with Hans Christenson at the School for American Craftsmen, in Rochester, New York. Influential at this time were "Toza" and Ruth Radakovich who were teaching at the school and Ronald Pearson and Jack Prip, who were at "Shop One" in Rochester.

After graduating in 1957, Skoogfors returned to Philadelphia and set up shop in

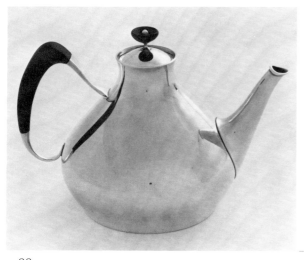

488a.

488b.

a tiny storefront at 3943 Locust Street. A shop owner, requesting exclusive rights to represent his work in Philadelphia, acquired his entire first production line of pieces, both cast or wrought into simple forms, and Skoogfors sought other outlets in cities throughout the country.

Skoogfors's work has been acquired by museums in this country and abroad, and, since 1951, has been shown in more than eighty national, regional, and local craft shows, eight of which have been one-man exhibitions. Some of the most important were: *Craftsmen U.S.A.* at the Museum of Contemporary Crafts in 1966 in New York; a one-man show in the same museum in 1968; and *Craftsmen '70* at the Philadelphia Civic Center. Since 1962 his work has also been represented in numerous exhibitions abroad, including *Form and Quality* in Munich in 1965 and 1966; *Jewelry, 1967—Tendencies* at the Schmuckmuseum in Pforzheim, West Germany, *Three American Jewelers* in Tokyo in 1968, and *Gold + Silber, Schmuch + Gerat* in Nuremberg, West Germany, in 1971.

In 1963, Skoogfors moved his shop to a studio converted from a two-story garage of his Mount Airy house, devoting his leisure time to politics and to photography, an interest shared by his brother, Leif, a well-known Philadelphia photographer (see biography preceding no. 508).

From 1959 until his recent death Skoogfors taught at the Philadelphia College of Art, where he became chairman of the Department of Crafts. He felt teaching to be essential to his work: "The combination of teaching and working is exhilarating. If you work in the shop all the time, you can get too isolated and insulated by what you're doing, and you don't have enough contact with other ideas" (quoted in Carolyn Meyer,

People Who Make Things, New York, 1975, p. 92).

Although Skoogfors's production line was a means of making well-designed objects economically, it presented many restrictions. During the last five years, he stopped designing for production and concentrated on commission work, where he had greater freedom. Some of his most important commissions were ecclesiastical silver and decorations for St. John's Episcopal Church, Huntingdon Valley, Pennsylvania, 1958; the E.D.P. Award for the Computer Division of the Radio Corporation of America, 1963; the Annual President's Metal and Design Awards at the Philadelphia College of Art, 1965; and a mace for the American College of Cardiology, Bethesda, Maryland, 1975. This last piece was a symbolic interpretation of the heart as a four-chambered container, each incorporating a different emblem.

In his earlier commissions, his work could be drawn and then transferred to metal. Later his approach was more intuitive, perhaps beginning with a rough sketch, but making changes as the piece developed. A few months before his death, he described the evolution of his work:

My first influences in silver and jewelry design were definitely Scandinavian; however, I discovered my heritage after I left Sweden.

It continued as a standard for several years after leaving school and, no doubt, has some influence still.

The most dramatic change occurred about 1963 with my developing interest in lost wax casting. The techniques of working in wax led to new possibilities in organic and spontaneous forms. Combined with the conventional disciplines of metal working, the groundwork for a new ap-

proach to design concepts began to form in my mind.

The relationship between man-made objects and nature has interested me for several years; how man's crisp and precise objects are filtered through time and the elements toward better integration with the world.

I tend to work in series, or variations on a theme. Most noticeable in the last year are the belt buckles for men. They explore the possibilities of limited design fields, much as Joseph Cornell did with his boxes.

Many people have influenced my work, anonymous workers, craftsmen who have put together "things," and artists in all fields who have devotedly dealt with the exploration of form and images as a personal quest.

I see my work as a pleasant vocation that allows me to discover and marvel at the unending varieties of imagery and form. (letter to the author, August 20, 1975)

488a. *Teapot*

1956
Mark: HANDWROUGHT/STERLING/OS (stamped on bottom)
Silver; wood handle and finial
5 x 7¾″ (including handle) (12.7 x 19.7 cm)
Philadelphia Museum of Art. Given by Dr. Morton Beiler. 75–85–1

488b. *Cigarette Box*

1956
Mark: HANDWROUGHT/STERLING/OS (stamped on bottom)
Silver with bloodstone
Height 5″ (12.7 cm); diameter 2¾″ (7 cm)
Judy Skoogfors, Philadelphia

"SILVER OBJECTS, like those formed of clay or glass, should perfectly serve the end for which they have been formed." In the design of this teapot, Olaf Skoogfors has followed this basic principle, set down by Christopher Dresser in 1871 (*Principles of Decorative Design*, London, 1873, p. 135). The form and the placement of the handle, in particular, follow Dresser's principles. A more contemporary prototype for the Skoogfors teapot is a teapot designed by George Jensen in 1952 (Graham Hughes, *Modern Silver*, New York, 1967, illus. fig. 22). Jensen's designs for handwrought silver from the 1920s were commercially successful and influential in this country as well as in Denmark. Skoogfors was familiar with the

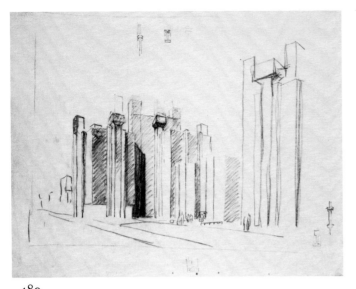

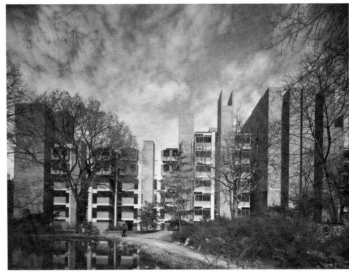

489.

489.

work of Jensen and other contemporary Scandinavian designers.

His cigarette box also demonstrates this later influence. Its inner holder echoes the exterior design. A particularly nice detail is the outward flaring lip and the bloodstone set in the finial.

DH □

LOUIS I. KAHN (1901–1974)

At the age of four, Louis Kahn immigrated with his family from Russia to the United States, settling in Philadelphia, the city which he would later suggest was the "place where a little boy walking through its streets can sense what he someday would like to be." After exploring music and painting, Kahn settled on architecture, which he studied at the University of Pennsylvania under Beaux-Arts trained Paul P. Cret (see biography preceding no. 410). After graduation, Kahn worked in a variety of offices, beginning with city architect John Molitor, for whom he designed many of the buildings for the Sesquicentennial exposition, and his first independent commission (with Herman Polss) was the Palace of Fashion at the fair.

In the 1930s and 1940s, Kahn encountered and attempted to assimilate the ideas of European modernism, chiefly through the ideas of Le Corbusier. Partnerships with George Howe (see biography preceding no. 456) and Oskar Stonorov (see biography preceding no. 462) confirmed those directions. After nearly a generation of search and reaction against his Beaux-Arts training, Kahn began to arrive at his own contribution

to modern architecture, a synthesis of the structurally and functionally determined volumes derived from his schooling with the direct use of modern technics and materials, which characterized his later work. This approach first appeared in the Yale University Art Gallery (1951–53), continued in the AFL-CIO Medical Center in Philadelphia (1954–56), and culminated with the Richards Medical Building. In his late projects, Kahn returned to the formal order of the early twentieth century in the great projects for the capital at Dacca, Bangladesh, and at the Exeter Library.

489. *Alfred Newton Richards Medical Building, University of Pennsylvania*

Thirty-seventh Street and Hamilton Walk
1957–60
Precast post tensioned reinforced-concrete structure; brick sheathing; glass

REPRESENTED BY:

Louis I. Kahn
Alfred Newton Richards Medical Research and Biology Building: Perspective Drawing (Preliminary Version)
1957
Charcoal on tracing paper
23⅞ x 31″ (60.6 x 78.7 cm)

The Museum of Modern Art, New York

Will Brown (b. 1937)
Alfred Newton Richards Medical Building
1976
Photograph

LITERATURE: Henry-Russell Hitchcock, "Notes of a Traveller: Wright and Kahn," *Zodiac*, vol. 6 (1960), pp. 14–21; James M. Fitch, "A Building of Rugged Fundamentals," *Architectural Forum*, vol. 113 (July 1960), pp. 82–87, 185; Tatum, pp. 206–7, no. 145; Wilder Green, "Louis I. Kahn, Architect: Alfred Newton Richards Medical Research Building, University of Pennsylvania, Philadelphia, 1958–1960," *MOMA Bulletin*, vol. 28, no. 1 (1961), pp. 1–24; Vincent Scully, Jr., *Louis I. Kahn* (New York, 1962), p. 48

UNLIKE MOST OF HIS Philadelphia predecessors, Louis I. Kahn needs little introduction. Indeed, it is largely because of his success that the so-called Philadelphia school of elaborately formed and highly "realistic" architecture has come to be recognized and respected. That it would be Kahn, rather than one of his many students at Yale or the University of Pennsylvania, who would take the first significant steps away from the abstraction of postwar United States design toward an articulated and expressive architecture is most appropriate. His age (he was born in 1901); his training (University of Pennsylvania, 1924); his professional association with George Howe, and later Oskar Stonorov—each affected the character of his most important commissions of the last two decades of his career. It was only then after his attempts at more doctrinaire modernism that he synthesized the tendencies of Beaux-Arts formalism with Howe's expressive functionalism and the direct use of materials of contemporary practice. Because these later projects also re-examine the theories of American architecture of the early twentieth century which had been discarded

with the triumph of academic international modernism in the 1930s and 1940s, Kahn's career forms a bridge between the past and the present.

The themes of the repetition and addition of units of space defined by structure, the expression of differing functions, and the incorporation of mechanical services in an architectonic manner, which Kahn first used in the simple Bath House for the Trenton Jewish community center in 1956, were developed more fully the following year in his design for the Alfred Newton Richards Medical Building at the University of Pennsylvania. There, in a building type that was usually treated as a simple rectangular volume capable of housing any activity, Kahn designed a seemingly picturesque ensemble of laboratory towers and shaftways joined to a core of elevators, air intakes, and other mechanical services.

Each different activity is evident from the exterior: laboratories at the corners of each tower are indicated by glazing, shaftways and stairs by continuous brick sheathing, while offices project from the tower. Such differentiation by form to suggest each activity was of course not new. Victorian architects, especially those in Philadelphia, had long produced a sort of functional realism, as a means of generating architectural form, as Furness, Evans and Company had done in the University of Pennsylvania Library. There stack space, circulation, reading rooms, and office spaces are each represented by material and shape. But, in an era when the slick glass curtain wall enveloped all functions with no hint of expression, Kahn's elaborately formed design marked a striking departure from contemporary practice. Even before the laboratory was completed, it had been the subject of an exhibition at the Museum of Modern Art, where it was termed the "most influential" building of the time.

The excitement among younger architects created by Kahn's return to articulated architecture should not, however, disguise the problems of the Richards laboratory. The corner laboratory spaces, open to light and air, have made it difficult to regulate exactly the environment for experiments, and the rooms themselves have proven too small for effective team work, while the space needed for office staff was seriously underestimated.

Part of the fault for the problems must inevitably lie with Kahn. His metaphor for scientific research—the pursuit of the unknown by the solitary researcher—conforms more to the romantic myth of the 1920s and to a scholastic monastic past than to the actuality of team research in the 1950s. On the other hand, no records of the building's program exist in the university's archives, and apparently the client failed

Kahn in never providing a detailed program describing the exact needs of the activities contemplated. Thus the architect made his conclusions without the necessary guidance, and his intention of shaping spaces to fit exact needs was thus doomed from the outset. Later, when Kahn received the commission for the Salk Institute at La Jolla, California, a more functionally precise building resulted from the lessons of the Richards Building, and from a more complete program.

If there were obvious flaws in the building, they were more than outweighed by the implications of Kahn's conception of the interrelationship of form, function, and structure. The precast reinforced-concrete structure, brought to the exterior of the building, allows for a column-free interior space which can readily be subdivided. That so far remains unexploited. But, the externalized skeleton also provides an ordering grid that emphasizes the similarity of the towers, and hence, the addition of similar units to a core, even as it reiterates the various changes in function. Laboratories are cantilevered out from the structure, while corridor and service towers rise in between the pairs of columns. Structure and function were again merged in the interior, where open beams contained spaces for utilities. A similar integration of structure and service had been tried a half-century earlier by Frank Lloyd Wright in the double functioning columns of the Unity Temple and in several of his houses. But Kahn went further,

giving heroic emphasis in form to the mechanical services, both in the ceilings and in the external shaftways. Instead of hiding the equipment behind a dropped ceiling, Kahn found an architectural solution, one which acknowledged both the spaces for human activity and also the places for mechanical services. Each is indispensable, existing fully only in relation to the others as Kahn suggested when he discussed the former as passive "served" space, and the latter as active "servant" space.

Richness of conception, articulation of function, integrity of design—these are all qualities of the great architecture of the past. If the Richards Building fails in the immediate task of satisfying needs, it succeeds at the grander goal of stimulating imagination.

GT □

ANDREW WYETH (B. 1917)
(See biography preceding no. 487)

490. *Ground Hog Day*

1959
Signature: Andrew Wyeth (under windowsill at right edge)
Egg tempera on masonite
31 x 31¼" (78.7 x 80.6 cm)
Philadelphia Museum of Art. Given by Henry F. du Pont and Mrs. John Wintersteen. 59-102-1

490.

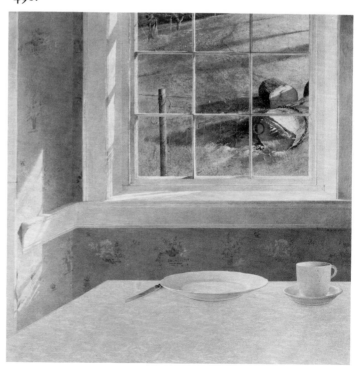

PROVENANCE: With M. Knoedler & Company, Inc., New York

LITERATURE: John Canaday, "Natural Wonder," *The New York Times,* October 11, 1959, (illus.); Eliot Clark, "Andrew Wyeth, America's Most Popular Painter," *Studio,* vol. 160, no. 812 (December 1960), p. 235, illus. p. 209; New York, Whitney Museum of American Art, *Annual Exhibition of Contemporary American Painting* (December 13, 1961—February 4, 1962), no. 135 (illus.); Buffalo, New York, Albright-Knox Art Gallery, *Andrew Wyeth* (November 2—December 9, 1962), no. 32, illus. p. 38; Richard Meryman, "Andrew Wyeth, An Interview," *Life,* vol. 58 (May 14, 1965), pp. 110, 114, illus. pp. 100-101; PAFA, *Andrew Wyeth* (October 5—November 27, 1966), no. 130, illus. p. 71; Boston, MFA, *Andrew Wyeth* (July 16—September 6, 1970), no. 43, illus. pp. 23, 34, illus. p. 35; Wanda M. Corn, *The Art of Andrew Wyeth* (Greenwich, Conn., 1973), pp. 22, 69, 106, illus. pp. 70-71; PMA, *Treasures of the Philadelphia Museum of Art,* 1973, p. 106 (illus.)

WHEN *Ground Hog Day* was shown at the 1961 annual exhibition of painting at the Whitney Museum of American Art, it shared space with a wide variety of abstract works by artists such as Hans Hofmann, Franz Kline, Josef Albers, and Ellsworth Kelly as well as important proto-Pop paintings by Larry Rivers, Robert Rauschenberg, and Jasper Johns. The range of realist art was both broad and surprisingly eccentric, from the quiet painterly styles of Edward Hopper and Fairfield Porter to the fantastic visions of Ivan Albright, George Tooker, and Peter Blume, with Wyeth representing the sole example of exquisitely detailed naturalism. From the vantage point of the mid-1970s, the painting appears to be linked to the long tradition of thoughtful, academically thorough realism that continues to flourish in the Delaware Valley and at the same time less retardataire than it must have seemed in 1961.

Ground Hog Day depicts the corner of a room at the heart of Wyeth's Pennsylvania world. In the kitchen of the spare white farmhouse of his old friend Karl Kuerner, a cup and plate are set for Kuerner's lunch when he returns from his morning's work. No striking incident is depicted here, and yet we are reminded that Wyeth is the son of a remarkable illustrator. Wyeth's sense of the dramatic is a subdued and subtler version of his father's passion for storytelling and playacting as it enlivened both N. C. Wyeth's art and his family's daily life. The slightly chilly, pristine space of *Ground Hog Day* is crowded with the associations of a lifetime: it is as much a portrait of Kuerner and his wife—and the hours Wyeth has spent in their house—as it is a still life or a view of a landscape. Among the large group of preliminary drawings for the painting one (in the collection of Mrs. Andrew Wyeth) includes the Kuerners' German Shepherd dog lying asleep in the pale winter sunshine that filters through the window. As Wyeth's conception evolved, the dog disappeared, its menacing disposition lingering in the rough splintered end of the log outside the window. A faint sense of expectancy, even apprehension, pervades the painting, and the sunlight offers no consoling warmth: surely the ground hog will be frightened by his shadow and winter prolonged. The artist has remarked that people often approach his work "through the back door. They're attracted by the realism, then begin to feel the abstraction. They don't know why they like the picture. Maybe it will be sunlight—like Ground Hog Day—hitting the side of the window. They enjoy it because perhaps it reminds them of some afternoon. But to me the sunlight could just as well be moonlight as I've seen it in that room. Maybe it was Halloween—or a night of terrible tension, or I had a strange mood in that room. There's a lot of me in that sunlight an average person wouldn't see. But it's all there to be felt" (quoted in Meryman, cited above).

It is characteristic of Wyeth's unique angle of vision that the steep slope of the hill beyond the window rises to eliminate any view of the sky. The translucent panes of glass reveal the limits of a circumscribed world. Windows and doorways are a continuing theme in Wyeth's work, yet so often he contrives to prevent our looking through them to any distance. The blowing curtains in *Wind from the Sea* (1947) obscure the sky, and *The Man from Maine* (1951) halts with his back to the viewer, peering out with sudden interest through a window offering a vista we cannot even glimpse. In a recent painting of a Maine interior, *Off at Sea* (1972), Wyeth has used a composition very similar to that of *Ground Hog Day,* simplifying it yet further. A long white bench set against a white clapboard wall runs from one side of the picture to another, and the window filling the upper right corner permits only a view of softly modeled clouds which deflect our gaze as surely as the hard, stubbly ground of Kuerner's hillside. Like a number of American artists in this century, including Charles Sheeler and Georgia O'Keeffe, Wyeth has responded to the potential for severe, almost abstract pictorial organization offered by the simple format of a window. *Ground Hog Day* presents an interplay of planes, lines, and angles in equilibrium. But Wyeth's windows also function as metaphors for the inner eye: the complexity and emotional relativity of human vision. *Ground Hog Day* is at once intensely real and intensely subjective and as carefully constructed as a Mondrian.

Ad'H □

SEYMOUR REMENICK (B. 1923)

Although Remenick has recorded the Philadelphia cityscape in a range of media for over twenty-five years, he was born in Detroit, where his father worked as a cabinetmaker. Several of his relatives were in the printing business, and his fascination with fine and varied qualities of paper began as a child when he was given blocks of paper to take home from the press. When he was eight the family moved first to Brooklyn, and then settled in Philadelphia in 1936, where he attended the South Philadelphia High School for Boys. In 1941 he won a scholarship to Tyler School of Fine Arts at Temple University, studying with Alexander Abels and Louis Bouché. His training in art was interrupted in 1943 by two years of overseas service in the United States Army during World War II, but he was able to attend classes at the École des Beaux-Arts in Paris in 1945. Returning to Philadelphia, he spent the spring of 1946 at Tyler and made frequent trips to the Barnes Foundation. From 1946 to 1948 he studied with Hans Hofmann in both New York and Provincetown and was profoundly affected by Hofmann's teaching although less attracted to his style of painting. After two years of exploring the use of brilliant color and experimenting with abstraction, Remenick decided to return to his old preference for a traditional figurative style and a palette of delicate earth tones, and he took a final year of study at the Pennsylvania Academy in 1948–49. Although Francis Speight and Walter Stuempfig were on the faculty at that time, and his subsequent work bears some affinity to theirs, he had little contact with them and remembers his conversations with Roy Nuse as more pertinent to his concerns.

Since 1949, Remenick has occupied a sequence of top-floor studios in the nineteenth century brownstone row houses which line Pine Street in center city Philadelphia. The view from his windows looking out over rooftops and church spires has provided an abundant source of subject matter for paintings and drawings, as have his frequent excursions to Manayunk. Although he devotes most of his time to painting, his career has included occasional periods of teaching beginning in 1948–50 when he gave private classes in his studio. Among Remenick's first students was his future wife Diane Thommen (also a Tyler student); they were married in 1950, and she has subsequently continued her own work as a sculptor.

In 1949 the Dubin Galleries in Philadelphia gave Remenick his first one-man show, and he exhibited frequently with both the Dubin and the Beryl Lush galleries during the 1950s. Between 1954 and 1962, he had eight one-man exhibitions with the Davis

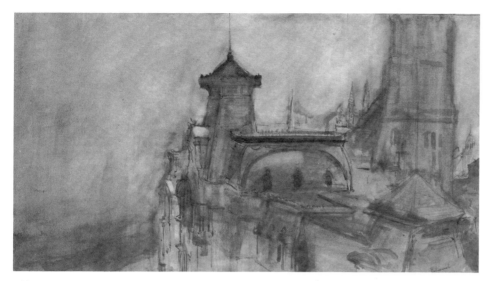

491.

Gallery in New York, where David Levine and Aaron Shikler were also among the group of artists shown regularly. Since 1949, Remenick's work has been included in many national annual exhibitions, at the Pennsylvania Academy, National Academy of Design, Butler Institute, and Art Institute of Chicago. In 1955 he received a Louis Comfort Tiffany Grant, and he won the Benjamin Altman Landscape Prize at the National Academy of Design in 1960.

Remenick's choice of subjects and his approach to them have altered relatively little since his shift away from a modernist idiom in the late 1940s. Still life arrangements of vegetables, wild game, and gleaming pots and pans alternate with studies from the model; and the Philadelphia skyline gives way at intervals to harbor views of Gloucester and New Bedford, Massachusetts, painted during summer visits. Large figure pieces are relatively rare in Remenick's repertoire, but a pair of impressive, shadowy portraits of his wife and himself (1954) are in the collection of Benjamin D. Bernstein, Philadelphia. He is an avid museum-goer, and his study of the work of Velázquez, Rembrandt, and the Dutch seventeenth century masters in particular is reflected in his style, although his greatest admiration is reserved for Brueghel, whose influence is less apparent. Fluid brushwork, transparent layers of brown tones, and lightly scumbled surfaces are characteristic of his painting manner, while his drawings range from shorthand pencil sketches to elaborate ink and watercolor washes.

Since 1969, Remenick has exhibited with the Pearl Fox Gallery in Melrose Park, Philadelphia, and he has had four shows (1967, 1968, 1970, 1971) at the Peridot Gallery in New York. He taught for a few years at the graduate school of fine arts at

the University of Pennsylvania, and is currently giving classes at the Old York Road Art Guild. A visit to Europe in 1971 renewed his enthusiasm for the art of the old masters. His recent work, somewhat lighter in tone and broader in technique than previously, has included a series of paintings and drawings of the colorful crowds which frequent the Italian market in Philadelphia.

491. *Philadelphia Tower (View of City Hall)*

1960
Signature: Remenick (lower right)
Bister wash and body color on paper
14⅛ x 26¾" (35.9 x 68 cm)

Dr. and Mrs. Morton Amsterdam, Bala Cynwyd, Pennsylvania

PROVENANCE: With Pearl Fox Gallery, Melrose Park, Pennsylvania

DRAWINGS HAVE ALWAYS CONSTITUTED an important part of Remenick's work, and he has produced them in large quantity and variety over the years. Blocks of paper accompany him on any excursion as he roams through Philadelphia, whose terrain he has recorded from countless vantage points. Often the sketches are in preparation for a specific picture. When he is working on a painting, he assembles a group of preparatory studies which may include brief pencil notations, an elaborate and detailed panoramic view outlined in ink, and several almost abstract color studies in oil or gouache. Other drawings, even tiny ones, are miniature works in their own right: the

silhouette of a church against an evening sky, drawn in a few swift strokes of ink and wash on a delicately tinted paper.

Philadelphia Tower (View of City Hall) is remarkable even within Remenick's prolific output for its size and the dramatic presentation of its subject, and was created independently of any plans for a painting. On a visit to his accountant's office, high on an upper floor of an office building on a southwest corner of Broad Street, Remenick was struck by the unexpected vista of City Hall from above. This elaborate drawing took him several hours to complete at one sitting and remains one of his most impressive achievements in this medium.

The subject is a relatively unusual one for Remenick, even with his wide range of interests. His drawings suggest that he was more often to be found on the banks of the Schuylkill River (with his back to a roaring stream of expressway traffic), gazing up at the hills and narrow row houses of Manayunk, or sketching the numerous bridges which span the water. Occasionally, however, he has been attracted by the detail and complexity of a single building (a precise and informative rendering of the old Baltimore & Ohio Railroad Station in Philadelphia, now destroyed, is in a private collection).

City Hall provides challenging material for an artist, so elaborate and complex in its own structure that it might well discourage further invention. John Sloan focused on the impressive scale of its foundations in comparison to the bustle of city life swirling past them (no. 395) while Earl Horter made it the subject of a Cubist fantasy (no. 445). Remenick's view removes any suggestion of specific context or date: although it was done in 1960 it might as easily represent the building at any time since its completion in 1876. Here the artist is not concerned with architectural accuracy: the vast building is presented in a close-up glimpse which cuts across the tower, City Hall's most recognizable element, and explores the confusing mass of steep roofs and ornate windows. The brown tones of bister wash shroud the building in a shadowy atmospheric veil, and the broad draftsmanship accentuates its clumsy grandeur.

Remenick's fascination with the art of the past is reflected in his choice of views; avoiding the glass and steel high-rise buildings of modern Philadelphia, he has preferred to study the dome of the Cathedral of SS Peter and Paul, or the classical colonnade of the Fairmount Waterworks. His *Philadelphia Tower (View of City Hall)* is a twentieth century image of a nineteenth century monument which manages to revive, without imitating, the virtuoso technique and spirit of ink and wash drawing in the age of Rembrandt.

Ad'H □

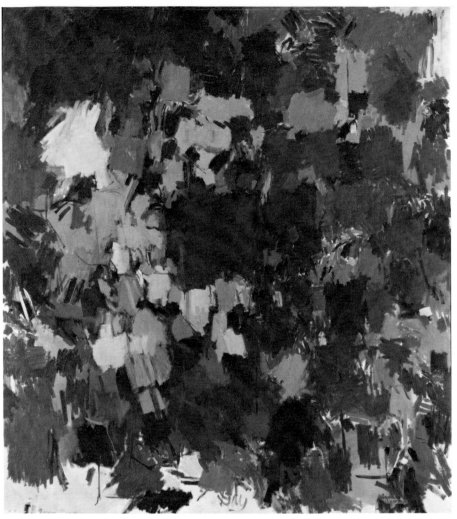

492.

LARRY DAY (B. 1921)

Born in Philadelphia, Day attended Cheltenham High School and served in the United States Army during World War II before enrolling in the Tyler School of Fine Arts as a student under the GI Bill. Although his earliest work was representational, he was not attracted by the techniques of glazing and underpainting in the manner of the Northern Renaissance masters which were currently in vogue at Tyler. Drawn to the vivid, flat colors and radical simplicity of form and line in the painting of Matisse, he was profoundly struck by the large retrospective exhibition at the Philadelphia Museum of Art in 1948. To earn a living after graduation from Tyler in 1950, Day organized a greeting card business with three friends and subsequently taught for a year in public school.

In 1952 he went abroad for a year to Paris, where he became aware of the work of Balthus, an artist who continues to be of great interest to him. Returning to the

United States, he began his career of teaching at the Philadelphia College of Art in 1953. During the next year, his work underwent a major shift in the direction of painterly abstraction. He made frequent trips to New York where he joined the circle of artists who gathered at the now famous Cedar Bar. His friends included Mercedes Matter, Charles Cajori, John Ferren, Franz Kline, and Philip Guston, and he was involved in the artistic and intellectual activity generated around Abstract Expressionism. At the same time, the Ray Hendler Gallery in Philadelphia was also showing avant-garde abstract work. Day himself first exhibited at the Dubin Gallery in Philadelphia during the 1950s and had three one-man shows at the Parma Gallery in New York between 1954 and 1960.

Around 1960, Day began to shift back toward representational work. He had continued to draw from landscape and from the model throughout the 1950s, and he now decided to make a free copy of one of Jan Steen's paintings. In the process of studying

the Dutch master he became absorbed in painting folds of cloth—a task he would not have believed an artist in the twentieth century could tackle with any enjoyment. Although he continued to produce abstract paintings for a few years, he settled steadily into the figurative work which has absorbed him for the last decade. Groups of figures in familiar settings (on the beach, seated on the stoop of a brownstone house) alternate with more elaborate allegorical compositions such as his version of *The Adoration of the Golden Calf* (1967–68) or *Parnassus Revisited* (1970). At intervals he turns back to create a version of a favorite painting of the Renaissance or seventeenth century Holland. He has cited the frescoes of Mantegna as providing the most profound solutions to the problems and challenges of representational art as he sees it.

Day's most recent work has included a sequence of quiet views of factory buildings, churches, and vacant lots in the Philadelphia area: architectonic compositions in flat tones of brown, gray, ochre, green, and red, devoid of figures. During the 1960s his painting was exhibited at Gallery 1015 in Philadelphia (together with the work of David Pease, Dennis Leon, Sam Maitin, and Paul Keene, among others), and he had a one-man show at the Dintenfass Gallery in New York in 1968. His work has been included in a number of exhibitions exploring recent American realism: Vassar College Art Gallery, *Realism Now,* 1968; American Federation of Arts, *The Realist Revival,* 1972; and Westminster College, Pennsylvania, *The Figure in Recent American Painting,* 1974. Deeply interested in the historical background and content of figurative art, Day has entered the ongoing dialogue among critics, painters, and students of realism and has been an influential teacher. Now a professor at the Philadelphia College of Art he served for several years as co-chairman of the painting department. His most recent one-man exhibitions have been held at the Peale House Galleries of the Pennsylvania Academy (1970); the Brata Gallery, New York (1972); the Langman Gallery in Jenkintown, Pennsylvania (1974); and the Gross-McCleaf Gallery in Philadelphia (Fall 1975).

492. *Untitled*

c. 1960–61
Signature: Day (lower center)
Oil on canvas
82 x 74¼″ (223.4 x 188.5 cm)
The Philadelphia College of Art

PROVENANCE: Purchased from the artist by the Philadelphia College of Art, c. 1961

DAY'S EARLY VENTURES toward abstraction contained references to his previous pre-occupation with landscape and mythological or allegorical themes. By the time of his exhibition at the Parma Gallery in 1960 all trace of subject matter had vanished. His work of the late 1950s is perhaps closest in feeling to that of Philip Guston (among New York's exponents of abstract painting) and would be more aptly described as abstract impressionist rather than expressionist, eschewing as it does the gestural violence of Franz Kline or Willem de Kooning. Working on large canvases with a palette of cool greens and blues (over a white ground), Day has compared his procedure in composing the paintings to "finding the figure in the carpet and then exploiting it" (letter to the author, September 1975). His concern with individual areas and then with the overall picture seemed comparable to his experience of music; several works in the Parma Gallery show, in fact, bore titles from Richard Strauss operas. The critic Edith Burckhardt described those paintings as reminiscent of "receding views in summer parks" and "illuminated by landscape memories, of shadows and leaves, billowing sky and dappled earth" (*Art News*, vol. 59, no. 2, April 1960, p. 15). Day was also working in watercolor during the late 1950s, and on the white ground of his paper myriad long touches of translucent blue, green, and lavender were grouped together like showers of leaves or rain. Oriental art has influenced both his figurative and abstract work, and he cites the landscapes of the Chinese Huan painters as important for his watercolors of this period.

This untitled painting was completed late in 1960 (after the Parma Gallery show) or perhaps early the following year. Day believes it may be one of the last fully abstract works done before his return to a figurative style. Executed in rich tones of brown, blue, and gray, with an occasional touch of purple or bright green, the canvas emanates a somber, autumnal mood. Loosely gathered and delicately drawn brushstrokes cover the canvas in ragged areas, alternately dense and more sparsely applied. The composition has a sense of erratic movement around a large cluster of brown strokes placed just off center. Even landscape references seem remote from this assured and satisfying orchestration of color and texture; it is a remarkable achievement for an artist whose ultimate interests were to lead him back toward a representational mode within a year.

During the late 1950s and early 1960s, Day was one of a number of painters in Philadelphia (including Robert Keyser, Jimmy Lueders, and David Pease) who were strongly attracted to painterly abstraction.

Many of them have since moved into a figurative style, and Day has become an eloquent and thoughtful spokesman for a realist art which takes up the challenge of narrative and even spiritual content. Viewers baffled by an abstract work often find comfort in discovering that the painter can "draw" realistically as well; it seems equally significant that an artist recognized for his serious and informed approach to the problems of realism should also have relished the sense of freedom and joyful painterly gesture evident in this abstract painting.

Ad'H □

JIMMY C. LUEDERS (B. 1927)

One of the best known abstract painters to emerge in Philadelphia during the late 1950s, Lueders was born in Jacksonville, Florida, where his father worked for the Florida East Coast Railroad. While at school in Jacksonville, he took lessons in art from an English watercolorist, Harold Hilton. After serving in the United States Navy for a little over a year (1944–45), Lueders came to Philadelphia to enroll in the Pennsylvania Academy in 1946. During his four years of study at the Academy, his instructors included Hobson Pittman, Walter Stuempfig,

and Franklin Watkins, and he found the latter's advice and criticism particularly helpful. His early work was figurative and subdued in color, and there was a brief period, unlikely as it seems, when viewers occasionally confused Lueders's paintings of Manayunk and Philadelphia scenes with those of his fellow student and roommate Ben Kamihira (see biography preceding no. 504). (In 1952 Kamihira and Lueders had a joint exhibition at the Dubin Gallery in Philadelphia.) A Cresson Travelling Fellowship from the Academy in 1950 enabled him to spend several months in England and France, and his trip made possible by a Scheidt Fellowship the following year included Italy as well. In 1952 he received several awards for his work, including the Third Hallgarten Prize at the National Academy of Design, and he has continued to win awards in exhibitions over the last two decades.

Lueders's painting of the mid-1950s moved gradually toward abstraction, beginning with simplified figurative works that often assumed a surreal aspect. He showed a group of these paintings at the Philadelphia Art Alliance in 1955. Abstracted, flat cubistic figures were bisected by bars of contrasting color, as if caught in rays of intense light.

493.

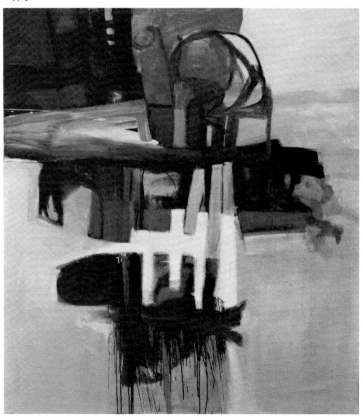

In 1953, Lueders's teaching career began at the Cheltenham Art Centre, and since 1957 he has been a member of the faculty of the Pennsylvania Academy. By 1960 he was executing large abstract canvases covered with soft, wide, brushy strokes, using a mixture of enamel and oil paints to achieve variegated effects, and tending toward a severe and elegant palette of white, gray, brown, and black. Over the next five years he introduced a larger range of color into the work, and individual forms (particularly circular shapes) became more pronounced. In the scale of the paintings and his vigorous, gestural brushwork, Lueders's style paralleled that of several Abstract Expressionist painters in New York, but while he was aware of their work, admiring Franz Kline in particular, he had little direct contact with it. *Ascension* of 1965 (Philadelphia Museum of Art) is one of his largest and most successful paintings of the mid-1960s and marks the beginning of a shift toward more pronounced emphasis on perspective and spatial illusion rather than an allover treatment of the surface. During this period Lueders had a number of one-man shows in the Philadelphia area, including a retrospective at the Wallingford Art Center in 1962, an exhibition at Gallery 1015 in Wyncote in 1964, and one at the Peale House Galleries of the Pennsylvania Academy in 1965.

Lueders's style since 1967 has acquired a hard-edged boldness in which large areas of flat, bright color (red, blue, purple) are bounded by strong black lines. A recent large painting (*Camera over Four* of 1974) is divided into well-defined compartments of line and color, in striking contrast to the blurred, stroked canvases of the early 1960s. His most recent one-man shows have been held at West Chester State College (1971) and the McCleaf Gallery in Philadelphia (1971 and 1974). The 1974 exhibition included both abstract work and vigorously rendered still lifes of flowers, a theme to which he has returned throughout his career. Lueders's work is in the collections of a number of museums, colleges, and corporations, including the Pennsylvania Academy, Moore College of Art, Tyler School of Art at Temple University, the Fidelity and Girard banks in Philadelphia, and the Atlantic Richfield Company.

493. *Untitled*

c. 1962
Signature: Lueders (lower left)
Oil and enamel on canvas
78½ x 70⅝″ (199.3 x 179.3 cm)
Jimmy C. Lueders. Courtesy of Gross-McCleaf Gallery, Philadelphia

LUEDERS'S PAINTINGS of the early 1960s convey a forceful impression of energy and speed. Painted rapidly, often within the space of several hours, they explore the possibilities of gesture as the artist's hand passes across the canvas. Devoid of any references to perceived reality, this untitled picture is concerned with what Lueders calls "the image of the paint itself." Long unbroken strokes of yellow, white, and red stand out against more softly brushed areas of pink and pale blue. The urgency and crudeness of the drawn forms in the upper center of the canvas contrast with the fine lines of dropped and splattered enamel paint at the bottom. Lueders's use of vivid colors and varying methods of paint application give the painting a restless, dynamic quality which resists resolution into a balanced composition. The viewer's eye travels from one section of the canvas to another, following the painter's progress as he sets contending forces against each other.

Abstract painting was apparently the exception rather than the rule in Philadelphia during the 1950s. A regional exhibition of 313 works held at the Philadelphia Museum of Art in connection with the First Philadelphia Arts Festival in 1955 contained surprisingly few abstractions, many of them created by artists long since dead (Hugh Breckenridge, Henry McCarter, Arthur Carles, and even Morton Schamberg). The faculty at the Pennsylvania Academy had remained primarily figurative in orientation and certainly in their own work, although both Hobson Pittman and Franklin Watkins were sympathetic to a variety of personal styles among their students. Jimmy Lueders describes his development as an abstract painter as springing from his continuing concern to "simplify." As he moved away from his vaguely cubistic paintings of the late 1950s toward large-scale pure abstraction, his work became increasingly vigorous and self-confident, despite the lack of any marked local trend in that direction.

Ad'H □

MORRIS BLACKBURN (B. 1902)

A descendant of the eighteenth century American portrait painter Joseph J. Blackburn, Morris Blackburn was born in Philadelphia and has continued to live in the city throughout his career. His father's various jobs included work for the yarn business of Samuel S. Fleisher, the founder of the Graphic Sketch Club. Interested in drawing and sketching from early childhood, Blackburn attended the Philadelphia Trade School where he was trained in architectural drawing. Leaving school to participate in the war effort by serving as a

rivet-heater in the shipbuilding yards of Hog Island, he then went to work as a technical draftsman for the RCA company in 1919–20. In 1922 he began to take classes at the Graphic Sketch Club, studying etching with Frederick Robbins, and around that time he also took a term of night classes at the School of Industrial Art. After two years with RCA, Blackburn worked for a short period for a free-lance interior designer before being hired by Oscar Mertz, a well-known Philadelphia designer of furniture. By special arrangement with Mertz, Blackburn and his friend Benton Spruance worked in the office during the evenings and were permitted to spend their days attending classes at the Pennsylvania Academy. Enrolled in the Academy from 1925 to 1929, Blackburn studied painting with Henry McCarter and drawing from the antique with Daniel Garber, but three Saturday morning sketch classes with Arthur B. Carles (just before Carles was forced to stop teaching at the Academy) provided perhaps the most important stimulus to his later development. During Blackburn's years at the Academy, his fellow students included Spruance, Ralston Crawford, Leon Karp, Robert Gwathmey, Francis Speight, Leon Kelly, and J. Wallace Kelly. Blackburn recalls a 1928 visit with a group of students conducted by Henry McCarter to the Ardmore house of Samuel and Vera White as an important exposure to modern painting (their collection, including works by Cézanne, Rouault, Matisse, Picasso, Modigliani, and Pascin, was bequeathed to the Philadelphia Museum of Art in 1967).

In 1928 and 1929, Blackburn won two Cresson Travelling Scholarships from the Academy. His first trip took him to Paris and several cities in Italy as well as Munich and Vienna, where he was particularly interested in the drawings of Egon Schiele and the paintings of Gustav Klimt. In the summer of 1929 he traveled to London, profoundly struck by the works of Turner, and visited Paris again before settling down to paint in Brittany in the company of Harry Rosin and Robert Gwathmey. His work of this period owed much to his study of Cézanne.

Returning to Philadelphia at the start of the Depression, Blackburn spent three years without gainful employment, raising vegetables in a community plot in Delaware County and singing in group performances to earn money for his family. A gift of canvas and tubes of color from William Weber of the Weber Company made it possible for him to continue his painting. He participated in the first of several federal programs for artists: the Public Works of Art Project administered in Philadelphia by Mary Curran, in which he was joined by

Spruance, and the sculptors J. Wallace Kelly and Yoshimatsu Onaga, among others. Blackburn's efforts for the project included several fresco murals illustrating contemporary subjects (the Bessemer steel process for the Mastbaum Vocational School and a sports theme for the Haverford High School). When Oscar Mertz was again able to maintain his office after the worst years of the Depression, Blackburn went back to work for him, and at Mertz's instigation he began his long teaching career in 1932 at the Pennsylvania Museum School of Industrial Art. First teaching furniture design and drafting, after a few years he became an assistant to Franklin Watkins in the painting department. Around 1936–37, Blackburn decided to join the private classes taught by Arthur Carles, who became his close friend and mentor. ("It was Carles who impressed me with a deep sense of the importance of being a painter.") Painted with flat, bright color, his work became abstract during the late 1930s and early 1940s.

During World War II, Blackburn became involved with the theory and technique of camouflage, and with Clyde Shuler and Alexander Wycoff he designed and built a model which was exhibited at the Franklin Institute. Working as a mechanical draftsman for the Philco company as part of the war effort, he developed the technique of the exploded drawing (used in this case to depict radar parts) and was put in charge of his own department. He was also involved with the production of a series of war posters executed by the silkscreen process. Blackburn's interest in printmaking was furthered at this time by a night workshop organized by Stanley William Hayter at the Philadelphia Print Club (Watkins, Karp, and Spruance were among the other artists who attended).

Leaving Philco in 1945, he undertook a variety of teaching positions (at Bryn Mawr College, Cheltenham Art Centre, the Graphic Sketch Club) and from 1948 to 1952 taught graphics at Tyler School of Art, filling a job formerly held by Earl Horter. In 1945 he initiated the adult training program under Emanuel Benson at the Philadelphia Museum, where he continued to hold classes until 1972. In 1947, Blackburn's first one-man show in New York was held at the Joseph Luyber Galleries, to be followed by several others during the early 1950s. During the late 1940s, he and his wife spent summers in Gloucester, Massachusetts, or on the coast of Maine. A Guggenheim Fellowship in 1952 permitted him to devote more concentrated time to his painting. The Philadelphia Art Alliance gave him a one-man show in 1952 and three years later a retrospective exhibition of fifty-seven works was shown at the Woodmere Art Gallery in Philadelphia.

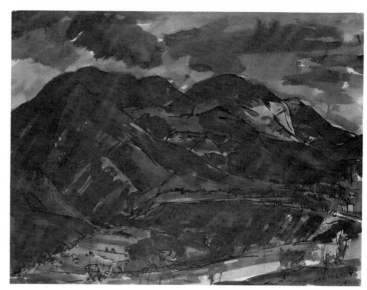

494.

In 1952, Blackburn joined the faculty of the Pennsylvania Academy, where he had previously taught for several summers. Beginning as the Academy's first instructor in graphics, he was involved with the re-evaluation and changes in the curriculum leading to the introduction of a general program for first-year students. He also devised his own course, Design Painting, which gave a broad survey of approaches from techniques of tempera painting to Cubist composition. In addition to teaching at the Academy, he has frequently given unofficial seminars in his own home. For a number of years he held private classes in landscape painting in southern New Jersey, assembling his students in the barn studio of Patricia Witt in Millville. His own work during the last two decades has been in a wide variety of media (oil painting, gouache, sumi ink, engraving, lithography, woodcut, and silkscreen). Primarily figurative, his canvases often depict Philadelphia or New Jersey scenes; their emphasis on strong compositional elements has evolved out of his earlier concern with abstraction.

Over the years, Blackburn has had thirty one-man exhibitions, most recently at the Philadelphia Art Alliance (1964), the Peale House Galleries of the Pennsylvania Academy (1966), and the McKinney Gallery in Birmingham, Michigan. He has granted a number of radio and television interviews and is the subject of several movies (*Portrait of a Painter* by Emilio Angelo, *South Jersey Sketch-book* made for Channel 52 in Philadelphia; and *Time-Binding,* a film about his teaching and painting methods, is currently in progress). Blackburn's work is in the collections of a number of museums and institutions, including the Pennsylvania

Academy, the Butler Institute of American Art, the Library of Congress, and the Philadelphia Museum of Art. In 1968 he received the Ocean City Art Merit Award in recognition of his achievements in the fields of painting and graphics and his continuing dedication to a long and eventful teaching career. The Philadelphia Water Color Club awarded him its watercolor medal in 1969.

494. *Valdez*

c. 1962
Signature: Morris Blackburn (lower center)
Sumi ink on paper
22 x 30¼" (55.9 x 76.8 cm)
Morris Blackburn, Philadelphia

ALWAYS INTERESTED in exploring the possibilities of materials and techniques, Blackburn first made extensive use of ink as the underdrawing for his work in gouache. Attracted by the appearance of the black and white preparatory drawings, he experimented with different types of ink as a medium in its own right. Around 1960 he began to produce a series of works using sumi inks and brushes, a medium he has continued to favor. (He has assembled a collection of fine molded blocks and sticks of sumi ink.) His interest in Chinese painting techniques and styles dates from a much earlier period in his career, however, and he recalls being deeply impressed by reading Arthur Waley's *Introduction to Chinese Painting* in the 1930s.

Long accustomed to depicting the coastal landscape of southern New Jersey and the harbors of Maine and Massachusetts, in the

1950s he found a rich new source of subject matter in the scenery of Mexico and the southwestern United States. After his first trip to Taos around 1958, Blackburn returned to acquire property a short distance from town, and the family has spent summers there since that time. The village of Valdez lies a few miles beyond Taos, near the foot of the Sangre de Christo mountains which provided inspiration for this forceful drawing. Although many of his paintings and pastels are ultimately the result of months, even years, of work in the studio, Blackburn still makes a practice of drawing and painting directly from the motif: "... this painting on the spot is no simple attempt to reproduce nature or to report on a given geographical situation. It is, rather, an *encounter* with nature and at the same time a lively contest or battle between me and the canvas or paper. From this encounter I try to deduce a meaningful design or abstract structure which is completely personal (self-expressive)" (Morris Blackburn, "As Artists See Themselves," *Philadelphia Bulletin,* May 4, 1969). The view of art as a dynamic encounter between the artist, his subject, and his medium seems particularly appropriate to this drawing of Valdez. Executed in a few hours (never reworked in the studio), it retains the immediacy of Blackburn's response to the spectacular site. Here the artist manipulates his ink to achieve a variety of effects: sharp, swift lines delineate mountain edges, fields and shrubbery; rich layers of black accentuate the solidity of slopes and summits against the sky; and ragged sweeps of lighter washes evoke the scudding clouds. Here and there the white of the paper gleams through the broad strokes and slashes of ink, like sunlight through a rent in the overcast sky; Blackburn's excitement in confronting so dramatic a subject is expressed in every gesture of his brush. He has executed a number of sumi drawings at or near this site, several of which were shown in his exhibition at the Peale House Galleries of the Pennsylvania Academy in 1966.

Ad'H □

GEORGE KRAUSE (B. 1937)

Born in Philadelphia, George Krause studied drawing, painting, graphics, and design at the Philadelphia College of Art from 1954 to 1957, when he joined the Army. He began photographing in 1958 while stationed in the South. He returned to Philadelphia in 1959 to complete his degree. That same year, Krause began his photographic series *Qui Riposa*—photographs of the gravestones in the Italian-American cemeteries of South Philadelphia—which he has

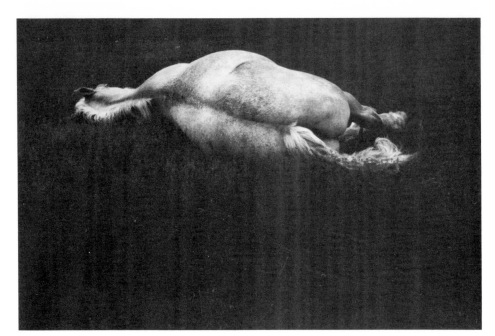

495.

continued to expand over the years. His other major body of work is the series *Saints and Martyrs,* a study of the *santos* figures of Mexican and South American churches.

Krause has been the recipient of several important awards, including a Fulbright grant to photograph in Spain (1963–64), a Guggenheim Fellowship (1967–68), and a grant from the National Endowment for the Arts (1972). His works have been featured in several major exhibitions, and he has had numerous one-man shows here and abroad— (Pennsylvania State University, 1963; the Philadelphia Art Alliance, 1964; George Eastman House, 1972; Photopía, Philadelphia, 1974; the Museo de Belles Artes, Caracas, Venezuela, 1970 and 1974; and the Gallery of Photography, Vancouver, B.C., 1974.)

His photographs have been published in *Photography Annual* (1966 and 1968); *Camera* (January 1966); *Contemporary Photographer* (Fall 1962); *U.S. Camera Annuals* (1962, 1963, 1966, and 1968); *Looking at Photographs* (Museum of Modern Art, New York, 1973); and elsewhere. In 1972 a book of his photographs, *George Krause–1,* was published. Krause has taught at Swarthmore College and at the Samuel S. Fleisher Art Memorial. He is presently chairman of the Photography Department at Bucks County Community College, Yardley, Pennsylvania.

495. *White Horse*

1963
Signature: G. Krause '63 (in pencil, on mat, lower right)
Inscription: 4/20 (in pencil, on mat, lower left); "White Horse" Given by Adrian Siegel (in pencil, on mat, on reverse, lower left)
Silver print
4⅜ x 6¹³⁄₁₆″ (sight) (11.1 x 17.2 cm)
Philadelphia Museum of Art. Given by Adrian Siegel. 66–88–1

LITERATURE: *George Krause–1* (Haverford, Pa., 1972), pl. 13

A SUPERB TECHNICIAN endowed with the perceptive eye of a consummate photographic artist, George Krause uses a 35 mm camera with the deliberation and precision of a large view camera. Avowing his interest in creating "a dream world where faces turn to stone and statutes appear alive and human," he creates fantasy not by manipulating the photographic process in the manner of Clarence John Laughlin and Duane Michaels, but by perceiving it in the real world. His vision is more closely related to the humanistic concerns of Henri Cartier-Bresson and André Kertesz than to the formalistic and conceptual investigations or the interpretive documentary work of many contemporary American photographers. Krause's photography conveys his sense of the mystery and wonder of life, of the surreality of reality. As he expresses it: "The photographic (real) image, as opposed to a

manufactured image (painted, sculpted, etc.) sets up a perfect atmosphere for the illusion of fantasy. Photography is an excellent liar and I hope to use this quality to achieve the fantastic."

The *White Horse,* taken in Maine, is a compositionally simple yet highly refined image. The large white bulk of a horse floats delicately, suspended like a cloud in a sky of dark-toned grass, caught in a mysterious moment when nothing is certain, when time is suspended. Like all of Krause's photographs, the image is sharp and subtly printed, with an exquisite rendering of texture and detail.

ws □

EUGENE FELDMAN (1921–1975)

Eugene Feldman, graphic designer, typographer, printer, publisher, and teacher, was born in Woodbine, New Jersey. With the exception of a three-year period of World War II service in London and Paris with a United States Army mapping unit, to which was attached a large offset printing unit, Woodbine remained his home until 1948. He then moved to the Philadelphia area where, with his wife, Rosina Fischer, a fashion designer, and their children Melissa and David, he resided until his death. With his move to Philadelphia, Feldman reestablished the Falcon Press which, beginning with a small letterpress, had functioned since 1934, when the artist was thirteen years old. After opening his Philadelphia shop, Feldman shifted his emphasis from letterpress work to offset.

In 1941–42 he majored in advertising design at the Philadelphia Museum School of Industrial Art; in 1956 he was appointed director of the school's Division of Typographic Design, a position he held until 1962. He then became an associate professor in the graduate school of fine arts at the University of Pennsylvania. At both schools he was a major force behind the planning and installation of photo offset lithography workshops, among the first in the country to be established in academic institutions.

His publications include several collaborative efforts: with Aloisio Magalhaes, *Doorway to Portuguese* (1957) and *Doorway to Brazilia* (1959); with Louis Glessman, *The World of Kafka and Cuevas* (1960); with Richard Saul Wurman, *The Notebooks and Drawings of Louis I. Kahn* (1962). He worked closely with local cultural institutions, often designing and printing invitations, catalogues, and other materials.

Feldman, quietly generous with his time, advice, and equipment, received commissions, medals, and awards from both fine art and commercial art-oriented organizations

for all phases of his activity. In 1966 he was awarded a Guggenheim Fellowship for research in photo offset lithography, and in 1974 he won the Gold Star Award given to a practicing artist for excellence by the Philadelphia College of Art. His work has been accorded international recognition in one-man exhibitions in museums in Rio de Janeiro, Amsterdam, Zurich, and Hamburg and in museums and galleries throughout the United States, and is included internationally in public and private collections.

496. *Woman No. 1*

1964
Printed at Falcon Press, Philadelphia
Signature: Eugene Feldman 64 (in pencil, in margin, upper right)
Inscription: Woman no 1—(in pencil, in margin, upper left)
Photo offset lithograph printed in black on white, heavily textured machine-made paper
35 x 23″ (image) (89 x 58.4 cm)
Philadelphia Museum of Art. Purchased: Haney Foundation Fund. 65-43-15

LITERATURE: Washington, D.C., Corcoran Gallery of Art, *Eugene Feldman: Prints* (March 2 —April 2, 1967), no. 24

THE PROCESS OF OFFSET LITHOGRAPHY, often in combination with photographic images, has been extensively used for commercial purposes since the first decade of this century, and as early as 1948, the medium was praised for launching "some of the more vital prints of our era" (Jean Charlot, "American Printmaking, 1913-1947," *Print,* vol. 5, no. 4, 1948, p. 50). The chemical basis for the technique—the antipathy of water and grease—is the same as that for stone lithography; however, rather than direct transfer from matrix to paper, in the offset process the image is transferred from the matrix (printing plate) to an intermediate surface (the blanket, usually rubber) from which it is then offset onto the paper.

The extensive use of photography as a scientific tool during World War II rapidly "opened up new concepts of the natural world" (Beaumont Newhall, "The New Abstract Vision," *Art News Annual,* vol. 45, no. 10, 1946–47, p. 56) and "it appears likely that Eugene Feldman pioneered the use of altered photographic imagery in offset lithography" (Middletown, Conn., Davison Art Center, *Offset Lithography,* by Louise Sperling and Richard S. Field, November 9 —December 9, 1973, p. 15). *Woman No. 1* is one of a number of related images, some in

496.

reverse, some printed in several colors, produced from one or more offset plates made from a group of negatives of a woman, nude from the waist up. Feldman was committed to the controlled accident in each step of his process. In this instance, a rotating electric fan pointed toward the model forced her hair continuously in several different directions. Each negative, and therefore each printing plate, varied from all of the others, a critical factor when more than one plate was used to produce a print (for variant impressions, see Minneapolis, Walker Art Center, *Eugene Feldman/Falcon Press,* February 16— March 1, 1964, n.p.; Joseph Adcock, "Artist in a Print Shop," *The Sunday Bulletin Magazine,* July 31, 1966, p. 9).

To produce *Woman No. 1,* Feldman greatly enlarged a 35 mm negative. As part of the process he experimented with numerous variations in exposure time, and the *Woman No. 1* negative was greatly over-exposed. By means of such extensive photographic enlargement and negative over-exposure in combination with the use of high contrast film, details of the image are subordinated to large, broadly defined forms, and details of tonality are reduced to the extremes of black and white. Traditionally, the half-tone screen is used when the image is transferred to the printing plate to reintroduce tonal variations; however, one of Feldman's technical innovations was to develop tonalities, and thereby the particu-

larities of the image, during the printing process. He did this by means of a successive layering of ink and at times by using more than one printing plate.

Feldman's knowledge of and control over the techniques and materials of photography and printing offered him unlimited potential for variation such as one finds in the differing impressions of the *Woman No. 1* image. Known photographic principles were placed in the service of hitherto untried methods of developing, transferral to plate, and printing. His "attitude differs markedly from that of those who cherish the informational value carried by a photograph within a print. He incorporates the photograph not for its memory association but for the visual role it plays in an overall design" (Sperling and Field, cited above, p. 15).

The sense of the erotic that one would expect the subject of *Woman No. 1* to evoke seems outweighed by the mysteriousness of the image. The atmosphere is eerie, and the figure is enveloped by imposing shadows from an unknown source. The almost life-size scale of the figure denies a distance between the viewer and *Woman No. 1*; however, great distance is implied by the lack of clarity or sharp focus of the image. A further sense of separation is imposed by the striations, resulting from the nature of the ink on the textured surface of the sheet, forming an almost physical screen behind which the woman sits or stands. The mottled surface throughout the image, which contributes to the aura of eeriness, results from aspects of the photo-transfer process as well as variations in ink density. The uneven top edge adds one further, if minor, disruption of our initial response to what appears at first glance to be a rigidly rectangular image.

Through his particular use of photography "as an instrument for the expansion of vision," Feldman added another dimension to the provocative potential of the medium, aspects of which were noted by Fox Talbot in 1839 and which were further advanced by Marcel Duchamp, Maholy-Nagy, and Le Corbusier earlier in this century (Newhall, cited above, pp. 63, 66–68). A paradox of Feldman's method is that through the use of power-driven equipment, purposely refined for the production of vast editions of identical impressions, he has developed ideas that require undetermined numbers of unique, printed variations of an image. He has simultaneously developed experimental working processes enabling these requirements to be fulfilled.

RFL □

RUDOLPH STAFFEL (B. 1911)

Rudolph Staffel was born in San Antonio, Texas. He was the great-great-grandson of Louise Heuser Wueste (1803–1874), a well-known German portrait painter who immigrated to Texas in 1857. His mother was a professional piano teacher and he grew up in a home which also served as a music school. His interest in painting began quite early and he studied art before entering Brackenridge High School in San Antonio. In 1932, Staffel went to Chicago to study at the School of the Art Institute, specializing in the fields of painting, drawing, and design. Two of his teachers who were influential at this time were Laurel van Papeladam and Louie Ritman.

Staffel became interested in glass blowing as a result of a German glass exhibition, and after graduating from the Art Institute in 1936, he moved to Mexico for a year to study ceramics and glass at the Escuela Para Maestros, San Juan Teotihuacan. Instead of pursuing his interest in glass, however, he studied pottery with a Mexican artist; this marked the beginning of his interest in ceramics. He then went to Albuquerque, New Mexico, to work on frescoes for a theater, a WPA project. His next job was teaching ceramics for three years, from 1936 to 1939, at the Arts and Crafts Club in New Orleans.

In 1940, Staffel moved to Philadelphia to teach at the Tyler School of Art of Temple University. Since then he has taught ceramics and been head of the department. In the summer of 1966, Tyler sent him to Rome for two years to assist in establishing their extension art program abroad.

Staffel's work has been recognized in numerous exhibitions both in the United States and abroad, some of the most important being *Curators Choice Exhibition,* Philadelphia Museum of Art, 1964; *Ceramic Arts U.S.A.,* Smithsonian Institution, 1966; *"One Man Exhibition,"* Museum of Contemporary Crafts, New York, 1966; *Fourth Annual Ceramics Invitational,* Wisconsin State University, Whitewater, Wisconsin, 1972; and *Thirty Ceramics,* an invitational organized by the Victoria and Albert Museum, 1973.

Since 1940, Staffel has worked quietly and alone in his Chestnut Hill studio, with an active interest in all the arts: "Perhaps the only things we learn and can therefore do and teach is continuity—clay passing through hands and into fire like it has been done, is being done and will be done" (undated letter to the author, Summer 1975). For over thirty-five years at Tyler, he has influenced young artists, teaching about the craft and the philosophy of ceramics.

497a. *Bowl*

1960
Mark: Rudolph Staffel (incised on bottom)
Black stoneware, glazed
Diameter 13½" (34.3 cm)
Helen Williams Drutt, Philadelphia

497b. *Bowl*

1969–70
Mark: Rudolph Staffel (incised on bottom)
Porcelain, unglazed
Height 5½" (14 cm); diameter 9½" (24.1 cm)
Philadelphia Museum of Art. Given by the Philadelphia Chapter, National Home Fashions League, Inc. 70–86–3

497c. *Vase*

1970
Mark: Rudolph Staffel (incised on bottom)
Ceramic, unglazed
9½ x 6½" (24.1 x 16.5 cm)
Dr. and Mrs. Perry Ottenberg, Merion, Pennsylvania

THESE EXAMPLES of Rudolph Staffel's pottery show the evolution of his work from the early 1960s to the present. The black opaque dish with its calligraphy-like scratched decoration demonstrates his earlier interest in surface imagery. The white bowl and vase demonstrate his more recent interest in light, in his creation of a pottery which is both translucent and opaque, depending on the light. The more recent pieces sometime appear more like glass than clay.

The variation and distortion of light are achieved by varying the thicknesses of the surface, made of thin platelets over a balloon. This precarious technique is a difficult one since the air must be allowed to escape gradually while the ceramic is shrinking or it will crack. The whole piece is then placed in sawdust for two to three days to stiffen. When it is fired, all the weight is on one point rather than being distributed on a flat bottom. The result is a beautiful and complex overlapping surface, interesting both inside and out. The varying thicknesses create a gradual and subtle movement of light which defines the space, which is felt through the translucency.

As with most potters, Staffel works in series. He tends to make from five to ten bowls without making other things. The

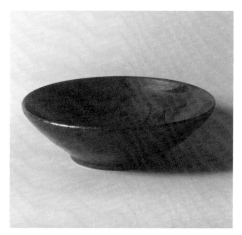

497a.

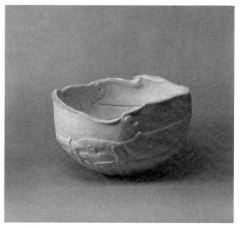

497b.

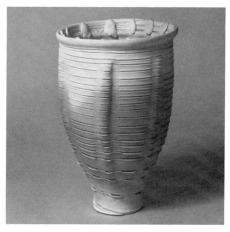

497c.

shapes of his pots are not particularized, avoiding the specifically useful object. These three objects each represent a different series. Staffel's work has changed from the simple forms with surface imagery to more baroque, organic forms. He has become increasingly interested in the quality of translucency of porcelain, in creating an awareness of light through the thickness and thinness of the ceramic surface.

DH □

H. THEODORE HALLMAN, JR. (B. 1933)

Ted Hallman has always been interested in structure and the exploration of form. He has followed his curiosity in both technical and contemplative matters; he built his own looms from measured drawings and he has investigated ways of meditation.

Hallman was born in Bucks County, Pennsylvania, in 1933, the son of Theodore, Sr., artist, and Mildred Brumbaugh Hallman, presently chief school administrator, who reside in Souderton, Pennsylvania. When he received a Senatorial Scholarship in 1952, Ted Hallman chose Tyler School of Art of Temple University in Philadelphia, his father's alma mater. After his first year, other students called upon Hallman's technical competence in weaving in the absence of a regular weaving teacher. Shortly thereafter, he was installed as weaving instructor. During the summer of 1955, the artist studied as a Pew Scholar under Jacques Villon and received certificates in painting and in pipe organ at the Fontainebleau Fine Arts and Music School (France). In June 1956 he received bachelor degrees in fine arts and in education with honors at Tyler.

Hallman began to experiment in two-dimensional color and texture at the Cranbrook Academy of Art in Michigan, from which he received master of fine arts degrees in textile design and in painting in June 1958. Initially, he worked in commercial

textile design, as a textile consultant, and on commissions. In the fall of 1962, having received an L. C. Tiffany Grant, he attended the Bundestextilschule in Dornbirn, Austria.

Hallman taught at Moore College of Art from 1963 to 1967 and was chairman of its Textile Department. To bolster a declining program, the artist turned to the New York textile industries for support of an in-the-field training program. Without eliminating the expressive option, he expanded the students' opportunity for commercial work. During the same period, he also taught at the summer schools of Penland School of Crafts, North Carolina (1964–68), and Haystack Mountain School of Crafts, Deer Isle, Maine (1958, 1960, 1962).

Hallman gained international exposure in 1960 when his work traveled to Europe with the United States Information Agency, and he participated in the International Craftsman's Show in Stuttgart, Germany, the same year. In 1964 he was part of the Milan Triennial; this exhibition marked an increasing awareness of the non-utilitarian textile as art, and the coordinate development of the textile composition as pure design form. In 1965, 1966, and again in 1967, his work toured South America in the American Craftsmen show, Smithsonian Contemporary Textile show, and the U.S. Information Agency exhibits.

In the early sixties, Ted Hallman's work began to move in the direction of three-dimensional forms and other technical and textural variations. This shift paralleled a change in his life style in 1970 when he moved to Sausalito, California, and later took up the study of meditation and humanistic philosophy. He was instrumental in the instigation of "events" or encounters for weavers and others, to expand imaging facilities through movement and other body awareness studies.

Hallman entered the University of California at Berkeley, from which he received a doctoral degree in creative education

in June 1974. While at Berkeley, he taught weaving and fabric design at local colleges. He spent the summer of 1973 in England, giving a workshop with the Society for Education through the Arts at Chichester.

Ted Hallman is included in *Who's Who in American Art, U.S.A.,* and is an honorary lifetime member of the International Society of Arts and Letters, Zurich. His work is represented in museum collections in this country and abroad. The artist currently teaches in Toronto and maintains a studio near Lederach, Pennsylvania.

498.

498. L'Égyptien

1965
Acrylic plastic, linen, wool, cotton, metal rods
52 x 87″ (132 x 220.9 cm)
Philadelphia Museum of Art. Given by H. Theodore Hallman, Jr. 75-3-1

LITERATURE: Trenton, New Jersey State Museum, *Contemporary Crafts* (November 21, 1970—January 3, 1971), n.p.

THIS TWO-DIMENSIONAL composition functions most appropriately as a room divider or screen, where the light might pass through to intensify the colors. Accented by a continuous, narrow strip of structural woven-pile, the loosely woven composition incorporates translucent triangles, drawing the eye to and then through the piece. The quality and juxtaposition of color hint at the painterly influence of his early training. However, the fibers and plastics have been allowed to speak their own proper existence. The composition, not unlike a stained-glass window in effect, has been liberated from a rigidity or weight imposed by canvas or glass.

Ted Hallman was a leader in the exploration of the possible uses of man-made products in weaving and other fiber compositions. He began his characteristic experimentation in acrylics at Cranbrook Academy of Art. The artist had observed that Italian workers, misunderstanding the word "sale" for "salt," had spread copper sulfate crystals on the icy walks of the Michigan campus. The intense color contrast formed by the reaction of the chemical to the new snow was his initial inspiration for weaving brightly colored and transparent materials into fabric. Hallman first tried to use the crystals themselves to achieve the same effect. Their relative instability then led to his work with gemstones. The existence of the coordinate Cranbrook Academy of Science facilitated procuring and polishing stones. The slowness of the polishing process led to the study and eventual use of acrylic plastics.

PC □

DENNIS LEON (B. 1933)

Born in England and now living in California, Leon, in his twenty years in Philadelphia (1951–72), emerged as a sculptor of note and was an active member of the art community in the city. The son of a London tailor, he was educated at the Roundhay School in Leeds with the intention of studying medicine at the university. In 1951 his family moved to the United States (Leon became a citizen in 1956), and he recalls studying zoology textbooks during the

499.

ship crossing. Applying for admission to Temple University in Philadelphia, he showed a group of his drawings and watercolors to the registrar who urged him to reconsider his career plans and enter the Tyler School of Art. During his undergraduate years at Tyler (1951–56) he studied with Boris Blai and Rafael Sabatini among others on the art faculty and was deeply affected by an English literature course with Harper Brown. His fellow classmates included Natalie Charkow, Theodore Hallman, Lowell Nesbitt, and Barbara Chase-Riboud. Leon started out as a painter, producing landscape images in an abstract expressionist mode, and was gradually drawn to sculpture, which became his primary interest during the year (1956–57) of study for a master of fine arts degree. Courses in art history with Herman Gundesheimer and his friendship with the ceramicist Rudolph Staffel (see biography preceding no. 497) were also crucial to his development as an artist.

Leon's first one-man show was held in Philadelphia at the Dubin Gallery in 1957, and that year he received the sculpture prize at the Philadelphia Art Alliance. His work at the time consisted of abstracted linear structures in welded metal, somewhat reminiscent of David Smith's sculpture of the 1940s. Also in 1957, Leon began his teaching career with a course in art history at Tyler. Two years of service with the United States Army took him to Bamberg, West Germany, and he continued to work as a sculptor at the Kunstakademie in Munich. Returning to Philadelphia in 1959, he joined

the faculty of the Philadelphia College of Art where he and Natalie Charkow founded the sculpture department in 1961. Between 1959 and 1962 he served as art critic for the *Philadelphia Inquirer,* covering local exhibitions and contributing feature articles surveying styles in art of both the present and the past. His own interests during the early 1960s were directed toward Surrealism and related tendencies, and he was particularly impressed by the work of Alberto Giacometti. In a one-man show at the Philadelphia Art Alliance in 1961 he exhibited sculpture in a variety of media (wood, metal, plexiglas), and he became increasingly involved with the process and technique of bronze casting. Sharing a studio in Elkins Park, just north of Philadelphia, with Larry Day (see biography preceding no. 492) from around 1959 to 1964, he was part of a circle of artists including Sidney Goodman and David Pease who gathered frequently and shared discussions about their work.

An exhibition at Gallery 1015 in Wyncote, Pennsylvania (1963), was followed by another at Henri Gallery in Washington, D.C. (1965). His first one-man show in New York was held at the Kraushaar Galleries in 1966 and contained a group of cast bronze figurative sculptures which fused imagery of houses and landscapes with allusive, literary themes. In 1967, Leon received both a Guggenheim Fellowship and a grant from the National Institute of Arts and Letters. Continuing to teach at the Philadelphia College of Art where he served in turn as director of the fine arts and sculpture departments, he moved his home and studio

to the countryside in Bucks County. Interested in the work of David Smith and Anthony Caro, he began to experiment with larger and simpler forms. His 1968 exhibition at the Kraushaar Galleries included five large bronze sculptures made in sections, welded or bolted together. The motif of a door or a bridge might still be discerned underlying an essentially abstract composition, and the trace of the sculptor's hand remained evident in the welded and worked metal surfaces. By 1970 (and his third exhibition at Kraushaar), Leon's art had arrived at its most minimal phase: hard-edged geometrical constructions fabricated in sleek materials such as plexiglas, polished bronze, and aluminum.

During the early 1970s his work again underwent a major shift in direction, away from formalism toward a more personal, idiomatic style. He began to produce small, enigmatic objects resembling tools or artifacts but with no recognizable function. In 1972 he left Philadelphia to take the position of chairman of the sculpture department at California College of Arts and Crafts in Oakland. His sculpture since that time has again gradually increased in scale and become environmental in its concerns. Wood has replaced bronze as his primary medium, although he no longer feels a particular affinity with any one material. The poetic imagery and literary aspect of his work of the mid-1960s have revived (in very altered form) in a series of pieces in which selected surfaces (both made and found) are covered with inscriptions and placed in outdoor settings. His most recent one-man show was held in 1973 at the James Willis Gallery in San Francisco, and he has been represented in a number of group exhibitions in California.

499. *Spelunca I*

1965
Bronze, in two sections
18¼ x 25½ x 12¾"
(46.4 x 64.8 x 32.4 cm)
Philadelphia Museum of Art. Purchased: Philadelphia Foundation Fund. 67-77-1

PROVENANCE: With Kraushaar Galleries, New York

LITERATURE: New York, Kraushaar Galleries, *Dennis Leon* (February 7–26, 1966), no. 19, illus. cover

ABSTRACT AT FIRST GLANCE, *Spelunca I* and its sequel *Spelunca II* (Philadelphia College of Art) gradually reveal themselves as sculptural metaphors for human confrontation with nature. As their titles indicate, they deal with the exploration and penetration of caves—phenomena which have fascinated

mankind from the prehistoric painters of Altamira through Plato up to the present day. When the *Spelunca* sculptures were shown at the Kraushaar Galleries in 1966, the exhibition included many more explicitly narrative works resembling miniature theater sets: houses with open doors through which figures could be glimpsed, ladders propped against freestanding walls, a stretch of park adorned with statuary and a lone tree. Several sculptures depicted ceremonial rites or events (*The Wedding, The Visit, Suicide*), rendered mysterious by the diminutive size and anonymity of the figures in their shrine-like enclosures. In the same exhibition, Leon also introduced actual names or numerals (*David, Joseph, 541, 641*) into interior or outdoor settings, adding a surreal, literary dimension which disrupted any physical sense of scale or space.

In *Spelunca I* recognizable imagery has been reduced to a few slender sections of scaffolding, delicately attached to two upright slabs of bronze and forming a tenuous link between them. The scaffolding (relic of an attempt to explore a cavern?) implies human presence and gives heroic scale and meaning to the vertical slabs—slices through the side of a mountain. A group of Leon's charcoal drawings accompanying the *Spelunca* series emphasizes the landscape motif: caves yawn amidst boulder-strewn hillsides, and man-made devices such as ladders and steps are sketched in front of formidable cliffs. The sculpture is less literal, and might be read as the three-dimensional diagram or cross-section of a cave. While the form itself is quite abstract, Leon's manipulation of his material constitutes a suggestive parallel to natural processes. The scarred and uneven surface of the bronze (which he cast himself from a wax model) echoes the erosion of stone by time and weather, while bulbous protuberances suggest volcanic upheaval. The river-like element emerging from a cavity in the back of one section of the sculpture seems to refer to an underground stream; it also reminds the viewer of the molten quality of bronze during casting.

The complex mingling of a tendency toward abstraction, surreal imagery, and conscious attention to the working process gives *Spelunca I* an affinity to the work of several artists in Philadelphia at the same period. The paintings of Robert Keyser (see no. 500), for example, also employ a private and esoteric set of visual images to express his vision of landscape in a state of metamorphosis. The specific theme of rocks and caves has attracted a range of artists in this century; one thinks in particular of the paintings of René Magritte, whom Leon much admires. Despite a succession of rather dramatic shifts in style, Leon continues to be preoccupied by many of the concerns which

were present in his work of the mid-1960s. "The Spelunca series was extremely important to me because the work merged aspects of 'object' and of 'place' to produce a particular time-sense which I have always enjoyed. Indeed, most of the work I produced at the time shared this intent and, as such, it bears a very strong relationship to my present efforts. The outstanding difference is that, instead of giving the primary role to the object, I now give it to the place" (letter to the author, January 9, 1976).

In a recent piece executed in California (*Sutro Baths, Suite #3*, 1975), Leon painted long inscriptions on the door frame surrounding the entrance to a mysterious tunnel in the rocks high above the Pacific shoreline: the door and the writing are periodically soaked by spray. The imagery of caves and water in *Spelunca I* persists in the new work, but now the artist involves himself in exploring the ongoing process of nature itself instead of creating a discrete and symbolic object which refers to that exploration.

Ad'H □

ROBERT KEYSER (B. 1924)

Born in Philadelphia, Keyser "always wanted to be an artist, but never thought of studying formally" (letter to the author, October 8, 1975). He and Robert Kulicke, a friend since early childhood, spent long hours in the Philadelphia Museum of Art and poring over the art book collection in the Free Library. After graduating from public school, he entered the University of Pennsylvania, planning to concentrate in chemistry. He left the university to serve for three years in the United States Navy during World War II and had some opportunity to paint during that time. Returning to the university in 1946, he took courses in English, art history, and psychology but left before graduation to go to Woodstock, New York, where he continued to paint. From his friendship with the group of painters who showed at the Leroy Davis Gallery in New York (including Aaron Shikler and David Levine), he gained experience in painting techniques, although his evolving style was remote from theirs. Keyser's only formal training in art came from two years of study (1949–51) with Fernand Léger in Paris. The French master was at that time involved in his impressive series of paintings and drawings on the theme of construction workers (*Les constructioneurs*). Keyser's first one-man show was held in 1951 at the Galerie Huit in Paris. Returning to the United States, he lived in New York for twelve years before settling once more in the Philadelphia area. His first one-man show in Philadelphia was mounted

591

500.

of drawings and landscape are formally interdependent, and the whole canvas is suffused with modulated tones of lyrical, pastel color. Works by Keyser are in the collections of several museums, including the Munson-Williams-Proctor Institute, Utica, New York; the Vassar College Art Gallery, Poughkeepsie, New York; and the Phillips Collection, Washington, D.C. Included in national exhibitions in the United States (annuals at the Pennsylvania Academy and the Whitney Museum of American Art) and in Europe (Salon d'Automne, Salon des Réalités Nouvelles, Salon de Mai), Keyser has long maintained his distance from any school or movement in recent painting. Since 1971 he has served as chairman of the painting department at the Philadelphia College of Art. In the summer of 1975 he accepted the invitation of the Tyler School of Art at Temple University to spend two years teaching at Tyler's school in Rome.

500. *Still Life with Landscape Machine*

1965
Signature: Robert Keyser/65 (lower left)
Oil on canvas
58 x 49″ (147.3 x 124.4 cm)
American Telephone and Telegraph Co., New York

PROVENANCE: With Marian Locks Gallery, Philadelphia

LITERATURE: New York, Paul Rosenberg & Co., *Recent Paintings by Robert Keyser* (February 28 —March 26, 1966), no. 7 (illus.); Dennis Adrian, "New York," *Artforum,* vol 4, no. 9 (May 1966), p. 52, illus. p. 53; PAFA, *163d Annual* (1968), no. 102

THIS ARCANE, LUMINOUS PAINTING was among fifteen Keyser exhibited in New York in 1966 after three years of arduous work during which his style underwent a startling change. His statement in the exhibition catalogue is characteristically sibylline, informative, and enigmatic at the same time:

> About the new work: I am not going to get into the subject of *meaning* or *symbolism,* etc. Naturally, since I painted them, I am out of my depths here. I can say a few things, however. Practically all are landscapes or interiors with landscapes.... The things in the new paintings are more specific, are, more or less, from the real world: rain, rocks, air, trees, light, fields, mountains, etc. I compose with these things (elements). Sometimes these elements are illustrated, sometimes they are more designed or diagramed. I don't make any distinction between ideas (diagrams) and things (illustrations).

by the Hendler Galleries in 1952. The Parma Gallery in New York gave him a sequence of solo exhibitions in 1954, 1956, and 1958; Paul Rosenberg & Co. (his present dealer) held his first show there in 1959.

During his New York years Keyser worked with Robert Kulicke in the latter's picture frame business, and he knew many of the Abstract Expressionist painters. Hans Hofmann was of particular importance to him and influenced his work of this period. Keyser's paintings and collages of the late 1950s were richly worked, painterly compositions. Apparently nonobjective, they often had titles alluding to nature and the miraculous world of mysticism, magic, and mythology: *Fire and Ice, Forces at Noonday,* and a series called *Four Rain Images* of 1959; *Departure of the Solar Boat, Transfiguration, Conjuror's Table,* and *Birth of a Pyramid* of 1960. His colors were often brilliant hues of red, green, and blue, and his canvases appeared carefully composed into distinct areas despite the extensive use of drips and streaks of paint which suggested the gestural spontaneity of "action painting."

In 1963, Keyser joined the faculty of the Philadelphia College of Art and established his house and studio in Applebachsville, a small town in Bucks County, Pennsylvania. Around 1962–63, his work began to undergo a gradual metamorphosis toward an increasingly explicit imagery. Emphasis on surface texture gave way to the depiction of deep space, and his tendency toward the surreal became more evident. A group of earlier works was shown at the Makler Gallery in Philadelphia in 1965; the new paintings first appeared at Paul Rosenberg & Co. the following year. By the time of his next exhibition at Rosenberg in 1971, the painterly impasto surface of his early paintings had vanished altogether, replaced by subtle gradations of color value and a new interest in drawing. Several paintings had wide, elaborate borders in the manner of illuminated manuscripts.

Keyser's work has continued to evolve in new directions over the last five years. His most recent exhibitions (Marian Locks Gallery, Phiadelphia, 1974, and Paul Rosenberg & Co., 1975) have revealed him once again close to abstraction, approaching it by way of surreal imagery rather than painterly facture. A characteristic painting of 1974 (*Ur Landscape,* Philadelphia Museum of Art) is divided into two horizontal sections, the upper area containing two flat hieroglyphic drawings which relate to each other like musical variations and the lower area representing contoured landscape seen in deep space. The disparate elements

Both treatments can occur in a single canvas—and, oddly enough, help with the *meaning*.

And therein lies the subject matter.

I suppose that I am trying to develop my own *Mustard Seed Manual* of forms with which to live. I also find a strange sympathy with the American Indian sand painters.

The biggest change in my work comes with a (new to me) depiction of deep spaces. About thirty-five miles of it in some places. Sometimes the space is drawn in and sometimes it is created with value and color change. And sometimes one method will deny the other; this is quite deliberate. In fact, there are a lot of deliberate denials and ambiguities in the paintings. I suppose they reflect the old romantic concern of some artists with the question of just what is real and what is not. (*Recent Paintings by Robert Keyser,* cited above, n.p.)

Keyser views *Still Life with Landscape Machine* as an autobiographical picture. The drawing pinned to the wall in the upper righthand corner is a page from his sketchbook, and the jigsaw puzzle filling the lower left corner of the painting represents one of his 1958 collages. He avoids further explanation: "I am afraid it is just a painting of a machine, in an indoor/outdoor situation, making a landscape" (letter to the author, October 8, 1975). The "machine" itself is the small object radiating wavy streaks of paint, just to the lower right of center. The last vestige (in this picture) of Keyser's earlier technique of painting, it appears as a brightly colored explosion of energy. Despite Keyser's disavowal of any "thematic logic" in his painting at this time, *Still Life with Landscape Machine* might be read as a metaphor for the creative process. We seem to be in the painter's studio, gazing out a window at the mysterious contours of vast plains and a lofty mountain while the artist (literally *deus ex machina*) wills the landscape into being. Many elements in the painting bristle with meaning yet resist interpretation—the spectral branch of flowers, the arbor of delicately interlaced treetops—images from Keyser's private vocabulary of symbols. *Still Life with Landscape Machine* is an eccentric picture for the mid-1960s, especially in its marriage of conflicting modes of surreal representation and abstract, expressive painterliness. Yet in the company of other works produced in Philadelphia at the time (such as David Pease's emblematic paintings and Thomas Chimes's mysterious aluminum reliefs), it suggests an environment somehow conducive to the exploration of intensely personal directions.

Ad'H □

RAY K. METZKER (B. 1931)

Ray K. Metzker was born in Milwaukee, Wisconsin, in 1931. He received a bachelor's degree in art from Beloit College in 1953. After a short period of commercial studio work, he spent two years in the United States Army stationed in Korea. Between 1956 and 1959, Metzker attended the Institute of Design of the Illinois Institute of Technology in Chicago, where he studied with Harry Callahan, Aaron Siskind, and Frederick Sommer. Having received his master of science degree in photography from the Institute in 1959, he worked as a free-lance photographer and spent twenty months traveling, studying, and photographing in Europe. In 1962, Metzker joined the faculty of Philadelphia College of Art, where he still teaches. He spent 1970–72 as visiting associate professor at the University of New Mexico. In 1966 he was awarded a Guggenheim Fellowship for "Experimental Studies in Black and White Photography," and in 1974 he received a photography grant from the National Endowment for the Arts.

Metzker has had one-man shows at the Art Institute of Chicago (1959), the Museum of Modern Art in New York (1967), the University of New Mexico Fine Arts Museum (1971), and the Print Club of Philadelphia (1974); his photographs have been shown in important group exhibitions here and abroad. Metzker's photographs have been published in many periodicals, including *Aperture* (Spring 1961 and Fall 1967), *Camera* (May 1968, November 1969, February 1971), *Contemporary Photographer* (1961). In 1970, Metzker's *Portfolio II Discovery: Inner and Outer Worlds* was published by the Friends of Photography, Carmel, California. As a photographer and a teacher, Ray Metzker has been an important contributor to the contemporary expansion of photography as a significant art form.

501. *PCA*

1965 (negative), 1975 (print)
Label: R. K. Metzker/(9) Phila. Pa. (in ink, verso)
Silver print
39¼ x 35¾" (99.6 x 90.8 cm)

Philadelphia Museum of Art. Purchased: Philadelphia Foundation Fund and the Thomas Skelton Harrison Fund. 75-33-1

LITERATURE: *Camera,* vol. 50, no. 2 (February 1971), p. 5 (detail illus.), p. 31

501.

RAY METZKER's *PCA* is a photographic sequence which stresses graphic impact over storytelling content. Photographing into the lobby of the main building of the Philadelphia College of Art in order to maintain a constant background, Metzker used a single-lens reflex roll film camera which moved the film horizontally (rather than vertically) across the film plane. Metzker masked the film gate to a narrow slit and overlapped exposures so that the entire length of film provides a unified visual experience, rather than presenting a series of separate visual experiences in the individual frames of a normally exposed film. Each strip is made up of segments, basic units displaying a sharply defined silhouette and the unvarying pattern of the plants in the lobby outlined against the stark white wall. These basic modules determine the flow of pattern across the image strip by cropping the figures and articulate the entire sequence by the repetition of certain visual elements (individual segments, the width of the segments, the plants, the white background). Suppression of the middle tones in the printing emphasizes outline and obscures detail.

PCA is meant to be viewed first as a totality and then examined strip by strip, segment by segment. Metzker has said that he intends the elements of his sequences "to be presented for simultaneous viewing like a mosaic or mural" (*Camera,* November 1969, p. 40). The size of his prints certainly encourages that kind of viewing: they demand a physical distance great enough to inhibit comprehension of the content of the individual segments. The complicated array of patterns is the significant subject, not the variety of persons whose cropped and silhouetted figures make up those patterns.

WS □

DAVID PEASE (B. 1932)

Born in Bloomington, Illinois, Pease comes from a family with a well-established business in homemade candy, and his father was a junk and scrap dealer, facts which seem relevant to Pease's tendency to accumulate small objects and incorporate them (or their images) in his art. He grew up in the town of Streator, Illinois, and received a broad liberal arts training at the University of Wisconsin at Madison. Interested at first in archaeology, he began to explore the visual arts midway through his undergraduate years (1950–54). Involved in designing sets and theater art, he studied painting and also worked in printmaking, somewhat under the influence (then quite pervasive in art schools) of Antonio Frasconi. Receiving his master's degree in science in 1955, he spent the next two years in the army, at his own request joining the last remaining camou-flage company based at Fort Riley, Kansas. While in army service he married Julie Jensen, a painter and fellow art student from Madison.

During 1955, Pease began to work with collage, a medium which is particularly suited to his penchant for making art by "putting things together." Returning to the University of Wisconsin, he received his master of fine arts degree in 1958 and went on to Michigan State University to teach and serve as art director for the audio-visual center (1958–60). The experience in creating displays and exhibits and working with commercial art techniques proved fruitful for his own later work. In 1960, Pease came to Philadelphia to join the faculty of the Tyler School of Art at Temple University. Originally teaching in the design department, he gradually shifted to painting, drawing, and sculpture, and he now is chairman of that combined department.

At the time of his arrival in Philadelphia, Pease's work was virtually abstract: painterly collages revealing his then current interest in the work of Conrad Marca-Relli and Alberto Burri. In 1959 he was first represented in a Pennsylvania Academy annual exhibition (by the collage *Firecracker over Vilas,* purchased by the Academy), and a work was included in the Carnegie International Exhibition in Pittsburgh in 1961. That same year his first one-man show in Philadelphia was held at the Art Alliance, and he subsequently had two shows (1962 and 1966) at Gallery 1015 where Larry Day, Natalie Charkow, Dennis Leon, and William Daley (among others) also exhibited. Around 1963, when he received the William A. Clarke award at the Corcoran Biennial for the large collage *Cascade II* (now in the Whitney Museum of American Art), his work began to move toward the inclusion of more specific, figurative imagery. In 1963, finding collage unwieldy on a large scale, he shifted to oil painting and later (around 1965) to acrylics. A grant from the Guggenheim Foundation in 1965–66 enabled him to produce a large body of work during that winter (he rented a store in Oak Lane and painted on a regular nine-to-five schedule) before spending the following spring traveling across Europe. Increasingly attracted by contemporary images, issues, and events as subject matter (fashion, pollution, political assassinations, for example), he has devised methods of placing that material within the framework of a "game" or "strategy" so as to maintain aesthetic distance. A retrospective exhibition of sixty-six works at the Tyler School of Art in 1968 revealed Pease as definitively embarked in this new direction, which continues to concern him. A painting of that year—*Don't Drink the Water* (based on ideas and images related to pollution)— was purchased by the Philadelphia Museum of Art. In 1968, Pease also received the Linbeck Foundation Award for Distinguished Teaching, and a few years later he introduced his own Painting Systems course into the curriculum at Tyler. He has served as visiting artist and critic at a number of art schools and universities in the United States and joined the painting faculty at Yale University during the summers of 1971 and 1972. One-man shows at the Makler Gallery in Philadelphia in 1967 and 1969 were followed by his second exhibition at the Art Alliance in 1970. Since 1969 he has exhibited at the Terry Dintenfass gallery in New York, and his work has been included in approximately two hundred group exhibitions across the country since 1953.

In his most recent work Pease has returned to the medium of collage. A postcard placed within a large sheet of paper often functions as the point of origin for complex compositions. His studio in Abington, Pennsylvania, is filled with orderly rows of notebooks, files, color cards—material awaiting possible incorporation in future work. By a stroke of the same happy coincidence which appears to occur at intervals during his career, a commission from *Fortune* magazine in June 1975 sent him to Morton Grove, Illinois, to create a painting of a large machine, which upon his arrival he discovered was used to manufacture animal crackers.

502. *Drawings from Twelve Ways of Looking at an Annunciation*

1966

(a) *No. 1: Homage to Veneziano*
Signature: David Pease (upper left)
Inscription: ANNUNCIATION SERIES: STUDY Nº 1—June 14–16, 1966/Based on a ptg. by D. Veneziano—13th cen. Florentine/ Wings derived from a ptg. by Cossa (lower left)
Lead pencil, colored pencils, gold pencil on paper
23⅛ x 24¾″ (58.7 x 62.8 cm)
Philadelphia Museum of Art. Given anonymously. 66–152–1

(b) *No. 2: Virgin in a Box*
Signature: David Pease (lower left)
Inscription: ANNUNCIATION SERIES: Nº 2/ 6–20(21)66 (lower left)
Lead pencil, colored pencils, gold pencil on paper
23 x 24⅝″ (58.4 x 62.6 cm)
Philadelphia Museum of Art. Given anonymously. 66–152–2

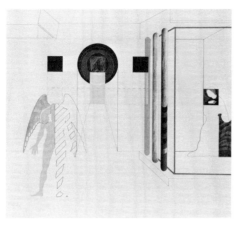

502a.

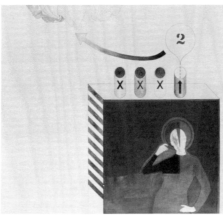

502b.

502c.

(c) *No. 8: Annunciation Game*
Signature: David Pease (lower left)
Inscription: ANNUNCIATION SERIES: Nº 8—
7-6-66 ANNUNCIATION GAME (lower left)
Lead pencil and colored pencils on paper
23 x 24½″ (58.4 x 62.2 cm)
Philadelphia Museum of Art. Given
anonymously. 66-152-8

LITERATURE: Elkins Park, Pa., Tyler School of
Art, *David Pease, Paintings and Drawings,
1958-1968* (November 17—December 8, 1968),
no. 45

THE TWELVE DRAWINGS IN THIS SERIES were
executed in Philadelphia during the summer
of 1966, after a period of intensive work and
travel made possible by Pease's grant from
the Guggenheim Foundation. In September
1975 the artist provided the author with an
extended written statement of his aims
and procedures in creating the series which
he finds (in retrospect) to have anticipated
much of his work since that time. He writes
that his attraction to the theme was "a direct
result of having seen the annunciation paint-
ing of Fra Angelico in the Prado." Madrid
being the first stop on his European tour, he
then determined to look at other versions of
the subject in every museum he visited, fas-
cinated by the idea of working with a set of
predetermined "givens" such as those pro-
vided by annunciation iconography.

There was no over-all plan for the series
when I started it except that each drawing
would include an angel and a virgin or
something that would stand for them. . . .

When I actually began the annunciation
drawings my memory of them suggests
that I had intended to make each of them
a variation of a well-known classical
annunciation painting. I actually ended up
using a known painting only in #1.

Beyond that the rest of the compositions
were totally invented. . . .

In the broad general sense the annuncia-
tion series deals with and is a metaphor
for the difficulty of communication. For
example, it seems to me that the annuncia-
tion is on its most basic level about some-
body (the angel) telling somebody else
(the virgin) that something is going to
happen. He has a message for her. One of
the ideas and themes that runs through
the drawings . . . is the difficulty that the
angel has in both finding and telling the
virgin anything. She appears hidden,
inaccessible, and difficult to get to. . . .

The drawings tend to function by accumu-
lating or adding lots of parts together until
there is enough information to "make the
point." The drawings are assembled rather
than drawn. This particular attitude
which seems related to puzzles, games,
lists, etc. has been a major part of the way
I have worked for the past 10 years. The
annunciation series was an important one
in helping me formulate and codify this
idea.

Pease then goes on to comment on the indi-
vidual drawings, of which three are included
here:

No. 1: Homage to Veneziano
This is the only picture in the series that
is entirely based on a well-known painting
[*The Annunciation* by Domenico Vene-
ziano, Fitzwilliam Museum, Cambridge,
England]. I made modifications from the
painting through emphasis and elimina-
tion in the drawing. At the time I started
the series I was interested in contemporary
English painting (particularly such artists
as [David] Hockney, [Allen] Jones and
[Joe] Tilson), and I was interested in ex-
perimenting with some extravagant com-
positions in my work and a variety of
media. . . .

No. 2: Virgin in a Box
Block passages (tubes) on top of box.
Structure is like a puzzle or labyrinth;
i.e., it is the passage that will lead us to the
goal (virgin). One tube is open, revealing
the number 2 in a "balloon" that the angel
can see. This balloon acts as a sign to the
angel and will lead him to the virgin, who,
in this case, is a high-fashion model type
with a halo. The angel in drawing #2 is
taken from [the *Expulsion from Paradise*
by Giovanni di Paolo, Robert Lehman
Collection, Metropolitan Museum of Art].

No. 8: Annunciation Game
This drawing is one of my favorites from
the standpoint that it seems to contain a
lot of the things I like to do and ideas that
have remained important to me over the
past 10 years. . . . It contains, among other
things, the following: game board, inter-
ruptions (blockages), X marks the spot to
indicate the goal, a grid-like structure with
numbers and letters, and the capability to
have complexity occurring within a rela-
tively simple format. The game board
operates like flypaper that can capture
marks and images. It can be added to and
subtracted from without fatal conse-
quences. The head of the figure of the
angel walking came out on #8, and this
drawing is #8 in the series, a happy
occurrence.

These drawings contain a great deal of in-
formation, narrative content, and visual
imagery processed by the artist into compact
units, often rendered enigmatic by virtue of
their extreme abbreviation. As with most of
Pease's recent work, a sketchbook crammed
with images and jotted ideas preceded this
series. The viewer finds himself approaching
each drawing as a riddle to be guessed.
Pease is a connoisseur of puzzles and visual
jokes, and it is not surprising to find that he
is an admirer of perhaps the greatest conun-
drum in twentieth century art: the *Large*

Glass of Marcel Duchamp in the Philadelphia Museum of Art. Pease has produced a number of serial works since the annunciation series, including a group of *Targets* in 1968 devoted to the grim theme of assassination (collection of Dr. Luther Brady, Philadelphia).

Ad'H □

WALTER ERLEBACHER (B. 1933)

Born in Frankfurt am Main, Germany, Erlebacher was the son of a grammar school teacher who specialized in arts and crafts. The family moved to New York in 1940, and Erlebacher became a United States citizen in 1947, the year he entered the School of Industrial Design as a high school freshman. Concentrating in advertising design, he was attracted by the idea of becoming a painter and spent some of his free time drawing and sketching from life. In 1951 he enrolled in Pratt Institute and was encouraged in his growing interest in sculpture by Ivan Rigby, a sculptor and industrial designer on the faculty who had studied at the Pennsylvania Academy. Between 1953 and 1955, Erlebacher served with the United States Army overseas. Returning to Pratt in 1955, he received a bachelor's degree in industrial design in 1958 and a master's degree in 1959.

While studying at Pratt, he spent increasing amounts of time on his sculpture, producing first abstract forms and then (around 1957–59) faceted structures in soldered metal which suggested the organic shapes of trees and plants. In 1959 he received a Fulbright grant to study at the Akademie der Bildenden Künste in Nuremberg; after he returned, one of his abstract, organic works entitled *Firetree* was shown in the Whitney Museum's annual exhibition in 1960–61. During his year in Germany, his classwork included working directly in clay from posed models. He became interested in the possibilities of clay as a material and began to produce small, amorphous modeled forms which soon became anthropomorphic. Prior to his European trip, Erlebacher had started teaching (three-dimensional design and drawing) at Pratt Institute, where he also organized and directed a department of exhibits in 1958–59. In 1961 he married Martha Mayer (see biography preceding no 522), a painter and graduate student at Pratt who was to share many of his aesthetic concerns. Between 1960 and 1965, Erlebacher was actively involved in teaching and curriculum planning at Pratt, becoming an assistant professor in 1964. During this period he also executed a series of large anthropomorphic works in plaster. At first quite generalized, then based on Erlebacher's

memories of Greek prototypes and the works of Michelangelo, the sculptures conveyed the muscular energy of a human body in motion, without specific anatomical detail.

A crucial turning point in Erlebacher's career came during 1964. Drawn to realist representation, he spent hours discussing approaches to realism with his Pratt colleagues, including the painters Gabriel Laderman and Philip Pearlstein. Ultimately dissatisfied with the "boneless" quality of his plaster sculpture, he decided to give himself a thorough course in human anatomy. Studying a number of texts on the subject, he found Arthur Thomson's *Handbook of Anatomy for Art Students* (then out of print, now reissued and again much in demand) the most useful. With the aim of being able to construct the human figure in any pose from memory, he set himself the task of creating a precise scale model of a skeleton in lead and wax, later adding the musculature in wax. During 1965 and 1966 he gave private classes in anatomy for Pratt students and others interested in what seemed an eccentric subject for art students of the mid-1960s. In the fall of 1966, Walter and Martha Erlebacher moved to Philadelphia, where he joined the faculty of the Philadelphia College of Art.

Erlebacher's first small sculpture of the type which still engages him were figures derived from sources such as Antonio Pollaiuolo's engraving *The Battle of the Nude Men*. In 1965, feeling the need to incorporate specific subject matter and poetic content into his work, he began a sequence of mythological themes with *Prometheus,* the nude figure of a man standing on a sphere. The idealization of subject (mythology) corresponded to an idealization of form (individual human figures) and of composition (the relationship of the figures to each other and to their surroundings) through Erlebacher's use of classical systems of proportion. He also embarked upon an ambitious project which is not yet completed: the rendition, in three dimensions, of Michelangelo's suite of painted figures (*ignudi,* sibyls, and prophets) which surround and support the Sistine Chapel ceiling. Between 1966 and 1971, Erlebacher produced a number of complex figural groups cast in lead and bronze, many of which were exhibited in his one-man show at the Peridot Gallery in New York in the fall of 1970. During that period his sculpture was shown in several exhibitions in the Philadelphia area, including the Pennsylvania Academy annual of 1968, and he had one-man shows at the Other Gallery (1968) and the Philadelphia College of Art (1970).

Since 1971, Erlebacher has begun to work increasingly from the living model, producing a group of diminutive figures of male and female nudes which were at first less

concerned with any ideal system of proportion for the human body than with the characteristics of an individual. His aim, however, is to find a way to idealize these specific, personal features "on their own terms" so as to provide typecast figures for his more complex narrative sculptures. Erlebacher's work has been included in a number of exhibitions exploring recent aspects of realism, including *Living American Artists and the Figure* at Pennsylvania State University in 1974. In that year he became a full professor at the Philadelphia College of Art, where he continues to teach.

In 1975, Erlebacher received a commission from the International Eucharistic Congress (which is to convene in Philadelphia in the autumn of 1976) for a life-size bronze sculpture of Christ. His initial conception presents a youthful figure of Jesus holding two halves of a loaf of bread in each extended hand. The statue is destined to be placed in front of the Cathedral of SS Peter and Paul in Logan Square.

503. *Daedalus*

1967
Lead alloy and plaster, mounted on a wood base
13 x 34½ x 34½" (33 x 87.6 x 87.6 cm)
Walter Erlebacher, Elkins Park, Pennsylvania

LITERATURE: Sherry C. Nordstrom, "Walter Erlebacher," *Art News,* vol. 69, no. 8 (December 1970), p. 19

A RELATIVELY EARLY WORK in the sequence of sculpture derived from mythological themes that Erlebacher created between 1965 and 1971, *Daedalus* was unusual in being conceived as a proposal for a life-size environment. (It was shown in his one-man exhibition at the Peridot Gallery in New York in the fall of 1970.) Working without live models during this phase of his career, the sculptor constructed his diminutive figures with the aid of a prototype (scaled to one-eighth of life size) for which he had devised a flexible armature. For each individual sculpted figure, he built up the musculature and determined the proportions according to a given mathematical system. Erlebacher endowed his tiny gods and heroes with pronounced muscle structure, curling hair, and frowning countenances reminiscent of Leonardo da Vinci's Vitruvian man. Any sensuous surface treatment of skin was deliberately omitted to give the figures an idealized and almost abstracted appearance. The figures and the architectural settings in which they exist are also related to each other by proportion and placement, so that the

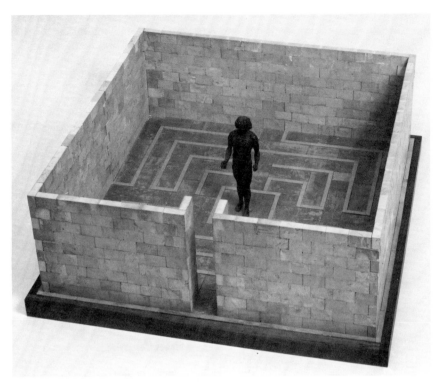

503.

length of each line and the volume of each form express a unified symbolic concept. (For an extended discussion of this period of Erlebacher's work, see the article by one of his former colleagues at Pratt Institute: Gabriel Laderman, "Unconventional Realists, Part II: Sculpture," *Artforum*, vol. 9, no. 7, March 1971, pp. 35–39.)

Some of Erlebacher's compositions are quite complex, both in their physical structure and in their conceptual implications. *Day and Night Teaching Their Son to Walk,* in which two flying figures hover over a striding man, is based on repeated use of the Golden Section, while *The Death of Apollo,* with its lone figure proceeding down the center of a colonnade flanked by pairs of trees, is derived from the Fibonacci series. *Daedalus* presents a simpler, more static idea: man at the still, center point of his world.

In the myth as recounted by Ovid and Apollodorus, Daedalus was the architect and inventor from Crete whom King Minos commissioned to build a labyrinth in which to conceal the Minotaur. The vast and baffling structure was said to be one of the wonders of the ancient world. Never a victim of the confusing and ensnaring properties of the labyrinth himself, Daedalus also assisted Theseus in finding his way safely in and out. When his life was endangered, Daedalus escaped from Crete by means of a pair of wings of his own making (another pair proved fatal when misused by his son

Icarus). Like Prometheus, Daedalus represents man's inventive genius, but his wisdom enables him to escape both the vengeance of his enemies and the perils inherent in his inventions. In Erlebacher's conception, he stands at the innermost point of his labyrinth (suggested in the sculpture by an intricate floor pattern), facing the single door in the surrounding walls. (In Robert Graves's version of the myth, the labyrinth consisted not of walls but of a maze laid out in mosaic on the floor.) When the sculpture is viewed directly from the front, at eye level, the figure of Daedalus fills the vertical opening of the doorway. Imagined as the sculptor proposed to enlarge it, the work becomes a contemplative environment: an enclosed and empty space occupied by a single life-size statue. Conceived in part as an antidote to the flux and rapid change in the evolution of recent art, *Daedalus* is not realist but metaphysical in its concerns. Both the form and the content of the sculpture refer back to prototypes in classical antiquity and the Renaissance. Erlebacher's training as an industrial designer and his earlier abstract sculpture are still relevant to this highly theoretical work, although his increasing interest in the human figure has more recently led him from the conventionalized almost "flayed" appearance of *Daedalus* toward a more naturalist mode based on the study of individual models.

Ad'H □

BEN KAMIHIRA (B. 1925)

Born on a farm near Yakima, Washington, Kamihira was the son of Japanese parents who had immigrated to this country in 1899 and started a successful produce and warehouse business. From early childhood he spent much time drawing and sketching, although he had no chance to study art professionally until he was twenty. After Pearl Harbor, the Kamihiras, like many other Japanese families on the West Coast, were forced to enter a relocation center. Ben's father volunteered to go to a work camp in Oregon, and Ben continued to attend high school while working in the sugar beet fields. After graduation he enlisted in the United States Army in 1944 and was sent to Italy. Stationed near Florence at the end of the war, he was able to visit museums, and he received his first formal art training in an army class at the Accademia. Returning to the United States, Kamihira enrolled in the Art Institute of Pittsburgh as a student under the GI Bill, but was soon dissatisfied with the commercial art curriculum. In 1948, Kamihira came to Philadelphia (where he has lived ever since) to study at the Pennsylvania Academy. His teachers over a four-year period included Hobson Pittman, Francis Speight, Walter Stuempfig, and Franklin Watkins. His own early painting was close in style to the work of Stuempfig and Speight, but Watkins was of particular importance to him as a teacher.

Winning a Cresson Travelling Scholarship in 1951, he went to France and Italy with his friend and fellow Academy student Jimmy Lueders (see biography preceding no. 493). In 1952 he and his wife made a short trip to Mexico on the Academy's Scheidt Scholarship, and that same year Kamihira won the First Hallgarten Prize at the National Academy of Design for a work by a painter under age thirty-five. Prizes and awards followed in impressive number, including two grants from the Tiffany Foundation (1952 and 1958), the Lippincott Prize at the Pennsylvania Academy (1958), the first Benjamin Altman Prize for figure painting at the National Academy of Design (1958 and 1962), the second Clarke Prize at the Corcoran Biennial Exhibition (1961), and the Laura Slobe Memorial Prize at the American Annual at the Art Institute of Chicago (1964). His first one-man show was held at the Philadelphia Art Alliance in 1954, followed by an exhibition at the Pennsylvania Academy in 1956. Receiving a Guggenheim Foundation Fellowship in 1955, he was able to devote a year to painting in his studio at Primos in Delaware County. A second grant enabled him to spend ten months in Spain during 1956–57, living in the countryside and producing a group of pictures on somber Spanish themes. (Kamihira made two sub-

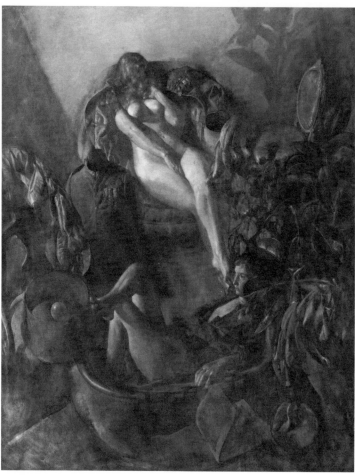

504.

to recent figurative art (such as *Thirty-two Realists* at the Cleveland Museum of Art in 1972 and *Living American Artists and the Figure* at Pennsylvania State University in 1974). He was the recipient of a grant from the National Endowment for the Arts in 1974, and he spent the summer of 1975 on his first trip to Japan. Paintings by Kamihira are in the collection of museums across the country, including the Brooklyn Museum, the Detroit Institute of Arts, the Hirshhorn Museum and Sculpture Garden, Washington, D.C., the Pennsylvania Academy, and the Ringling Museum of Art in Sarasota, Florida.

504. *Scotch Guard*

1967
Signature: Kamihira (lower right)
Oil on canvas
72 x 58″ (182.8 x 147.3 cm)
Marie Merkel Pollard, Dallas, Texas

PROVENANCE: With Forum Gallery, New York; purchased by the present owner, 1975

LITERATURE: PAFA, *163d Annual* (1968), no. 181; San Francisco, Maxwell Galleries, Ltd., *Ben Kamihira* (February 14—March 4, 1969) (illus.); PAFA, *Hobson Pittman and His Students* (January 20—February 18, 1973), n.p.; New York, American Academy of Arts and Letters, *Exhibition of Paintings Eligible for Childe Hassam Fund Purchase* (November 12—December 29, 1974), no. 11

KAMIHIRA'S HAUNTING, intensely personal mode of figurative painting has evolved gradually over the last twenty years and remains remote from many of the recent tendencies in representational art. Thomas Eakins's insistence on painting directly from life and even aspects of his late style provide Kamihira's work with a prototype in the Philadelphia academic tradition, however distant Eakins's art may be in mood. The technique of a work like *Scotch Guard* is at once highly accomplished and elusive: no bravura brushwork intervenes between the bemused viewer and the shadowy dream world which the painter evokes. Painting from posed models and specific still life elements, Kamihira makes no use of preliminary drawings or studies. Each composition emerges slowly, over the space of several months, directly on the canvas, as if the artist were drawing aside a veil which had hitherto obscured our vision. To an observer acquainted with Kamihira's work, each painting appears like a variation on a disturbing theme: the same motionless figures and mysterious objects recur again and again in subtle recombinations. Often the sitters were Kamihira's wife and children, sometimes art

sequent trips to paint in Spain in 1962 and 1967.) One of his most powerful works of this period, a painting of the dead Christ being lowered from the Cross, gained him the Lippincott Prize in 1958. Although he had taught evening classes at the Pennsylvania Academy since 1952, Kamihira joined the day faculty in 1960 and continues to be one of the most influential instructors in painting. (Most of his recent work has been produced in his studio at the Academy's Peale House, which he has occupied since 1968.) In 1959 he was elected an Associate of the National Academy of Design. A year later, four of his paintings were included in the exhibition *Young America* at the Whitney Museum of American Art, and his work attracted increasing national attention. *The Wedding Dress,* in the Dallas Museum of Fine Arts, and *The Couch,* in the Whitney Museum (both dating to 1960), are fine examples of his large, complex compositions of that period, each juxtaposing two enigmatic, brooding figures with a welter of miscellaneous yet associative objects.

Kamihira's style of the late 1950s and early 1960s was dark in tone but outlines of

individual forms were clearly defined, figures were solidly modeled, and objects placed within the pictorial space bore logical spatial relationships to one another. By the time of his one-man show at the Forum Gallery in New York in 1966, outlines had become blurred, details were often veiled in shadow, and space itself took on the irrational aspect of a dream. Figures and furniture seemed to hover in the air or to whirl in a slow vortex within the confines of the canvas. Kamihira's palette has always been somber, the paint film growing increasingly thin and tenebrous over the years. Subdued green and brown hues predominate in the work of the last decade, although notes of vivid green and crimson (lettering on supermarket bags or pullovers worn by indolent models) give his most recent paintings a new and unsettling aspect.

In 1964 the Peale House Galleries gave Kamihira a one-man show, and he had another at the Durlacher gallery in New York the same year. He has had exhibitions at the Forum Gallery in 1969 and 1973. His work has continued to be widely shown and to win prizes in national exhibitions and has been included in several shows devoted

students or professional models—but all are transformed into inhabitants of a private kingdom of the mind. The rubber plants, the worn military uniform (borrowed from his friend James Havard), and the faded furniture in *Scotch Guard* are familiar props from a drama of myriad acts. The symbolism in Kamihira's painting of the 1950s and early 1960s was often quite explicit: religious imagery and ceremony, crucifixions and funerals. His work of the last ten years has grown increasingly enigmatic and provocative, with a powerful undercurrent of eroticism. *Scotch Guard* is one of Kamihira's most characteristic and compelling compositions of the late 1960s. Surrounded by indefinite space, illumined by vague rays of light from some unknown source on the left, the two women gaze in different directions, rapt in their private reverie. The seductive, curving body of the young model gleams amidst the dusky jungle of leaves, and the uniform jacket draped around her shoulders only serves to emphasize her air of apprehension and vulnerability. The quiet, expressionless face of the woman reclining so calmly in the tub gives no clue as to her role in the painting or her relationship with the girl.

Kamihira's paintings raise questions without answers, resolving themselves in the persuasive creation of an atmosphere. As in the masterpieces of Edwin Dickinson, another idiosyncratic realist whom Kamihira greatly admires, intense observation of visual reality is here coupled with an equally strong sense of fantasy to produce an image that has the troubling force of dream. Kamihira is reticent about his work, preferring to let his paintings convey his intentions. A statement he made in 1961 remains appropriate, if tantalizing, in its brevity: "I start the physical action of painting by setting up or posing the actual objects from which I copy, change or distort. It is important that they are there in space and light before me. It is my hope that in the transcription of my impressions, these simple objects become more than factual reproduction" (quoted in "New Talent U.S.A.," *Art in America,* vol. 49, no. 1, January 1961, p. 33).

Ad'H □

MITCHELL/GIURGOLA ARCHITECTS (EST. 1958)

The firm of Mitchell/Giurgola Architects was formed in 1958 by two members of the Philadelphia office of Bellante and Clauss, Romaldo Giurgola and Ehrman B. Mitchell, Jr. Giurgola was born in Italy in 1920, and attended the University of Rome before receiving a master of science in architecture degree from Columbia University in 1951. After teaching at Cornell and the University of Pennsylvania, Giurgola returned to Columbia University where he is the Ware Professor of Architecture. Mitchell, born in 1924, is from Harrisburg and a graduate of the University of Pennsylvania. He is cur-

rently the director of the Pennsylvania region of the American Institute of Architects. Recently the office has worked on a broad variety of projects, among them plans for the renovations of Louis Sullivan's Wainwright Building in St. Louis, the Liberty Bell Pavilion and the Living History Center on Independence Mall, as well as the American assembly plant for Volvo automobiles in Chesapeake, Virginia.

505. *United Fund Headquarters*

Cherry Street and Benjamin Franklin Parkway
1968–69
Reinforced concrete structure; glass

REPRESENTED BY:
Romaldo Giurgola (b. 1920)
United Fund Headquarters:
1968
Pencil on paper
31 x 42" (78.7 x 106.7 cm)

Mitchell/Giurgola Architects, Philadelphia

Rollin Lafrance (b. 1937)
United Fund Headquarters
1971–72
Photograph
Courtesy Mitchell/Giurgola Architects, Philadelphia

505.

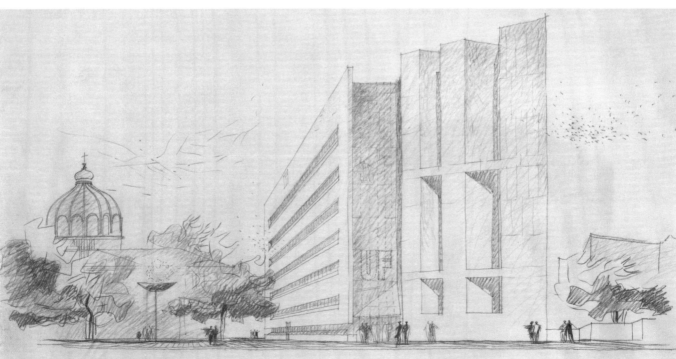

505.

A QUARTER OF A CENTURY has passed since Penn Center (no. 484) marked the local acceptance of doctrinaire modernism, and nearly as long since Louis Kahn merged the richness of form and expression of the best early twentieth century American architecture with contemporary design in the Richards Medical Building (no. 489). Those projects are now distant enough to be analyzed, explained, and accepted as semi-permanent elements in the physical and psychical cityscape. Recent buildings are less subject to neat definition and meaningful instant analysis. With them our perceptions are less accurate, being too much affected by contemporary issues and the possible significance of seeming originality.

But there are a number of recent buildings by Philadelphia architects that it can be expected (or hoped) will outlast fashion and the fascination of the moment, to be recognized as the masterpieces of our era. Particularly notable are the designs of a group of younger architects, mostly educated in eastern universities in the years after 1945, but before the absolute triumph of doctrinaire modernism, including Robert Venturi and John Rauch (see biography preceding no. 539), John Bower and Frederick Fradley, and Romaldo Giurgola and Ehrman Mitchell, Jr. Those men have developed consistent and personal styles, and because they have chosen to work in Philadelphia, they have been affected by Kahn's grand synthesis of form, structure, and expression.

Of these younger architects, the firm of Mitchell/Giurgola Architects has most directly continued the exploration of the themes that interested Kahn, the use of form, material, and structure for expression, and the investing of building with the discipline and the integrity of the great architecture of the past. Form must serve function while denoting changes of use; order must be intended and not merely the residue of the structural system; materials must reinforce content, rather than take the leading role in design. Means and ends must not be confused. On the other hand, where Kahn's buildings are usually generated from the internal logic of an ideal geometry, and hence are often independent of their site, the designs of Mitchell/Giurgola are more conscious of the accidents of siting, climate, and solar orientation, as well as the patterns of human movement; if they are less heroic than Kahn's buildings, they are usually more immediately engaging.

The principal themes of Mitchell/Giurgola Architects' work are evident in the Philadelphia headquarters for the United Fund, which was designed in 1968 and completed the following year. The site selected was a wedge of land formed by the diagonal intersection of Cherry Street with the Benjamin Franklin Parkway, its narrowest end already dedicated as a part of Fairmount Park. Available for building was a piece of land with two parallel sides perpendicular to the Cherry Street boundary, while the fourth side angled off toward the southeast. Although prestigious, the Parkway location created additional problems. Cornices could not exceed the height of the lower facade of the neighboring Cathedral of SS Peter and Paul, while the architectural design was subject to the approval of the Philadelphia Art Commission.

The restricted site area and the height limitation, which permitted no more than seven stories, made it necessary to cover the entire property, with the sole exception of a small entry area. Other decisions were also largely mandated by the site. The entrance was located at the principal corner, addressing both the Parkway and Logan Circle, while the truck dock had to be approached from Cherry Street; the eastern perimeter of the site, already bordered by small buildings, was given over to utility and elevator cores.

The internal arrangement of activities was the consequence of a similarly direct approach, modified and enriched by the intention of using structure and form to express function, while also establishing a memorable and sufficiently monumental image demanded by the Parkway location. Expression and monumentality were equally served by the exploitation of the dual potential of reinforced concrete to be both a skeletal and a continuous structural system. Six stories of loft space, carried by a grid of columns, suggesting by its regularity the clerking, filing, and ordering processes of the modern office, contrast with the more individualized management positions housed in the triangular corner of the site, in spaces bordered by a massive poured-in-place wall, which is pierced to permit views down the Parkway.

The facade articulation repeats the same pattern, but with modifications that reflect not only function, but also solar orientation and siting. Thus, the north wall, which terminates the office space and looks out toward the Cathedral, is a glass curtain wall of the type traditionally used with modern skeletal construction. That glass wall continues around into the long western facade; but that latter wall is given a different form, being shielded from the late afternoon sun by a concrete sunscreen, which reiterates by its long horizontal slits the layers of space within. The screen also forms a similarly scaled but contrasting counterpoint to the perpendicular and plastic facade of the Cathedral. Between the sunscreen and the poured-in-place south wall, the glass curtain wall reappears, splitting the concrete box from top to bottom. There, in an angled recess, approached by slate paving, is the entrance, directly denoted by the slit in the wall. From that point on, the poured-in-place wall continues, richly formed across the south, and then as a plain slab behind the service core opened only at the corner for a view toward City Hall. That variety, so logically achieved and so powerfully expressive of activity and use, met with disapproval from the Art Commission which preferred ordinary regularity to variety. But, unlike

Mitchell/Giurgola's later encounter with the Washington, D.C., Capital Fine Arts Commission over the design for the headquarters for the American Institute of Architects, the Philadelphia Commission eventually relented, permitting the building to be constructed as designed.

Within, the upper levels conform to the expression of unarticulated loft and articulated management spaces, differing only at the roof and ground levels. The former contains a dining room and deck, with an opening in the parapet revealing a view down the Parkway toward the Museum, while a slit at the southeast corner opens toward City Hall. The ground level, containing entrance, elevator lobby, and meeting rooms, is given form by a series of angled corridors that echoes the underlying diagonal of the Parkway, and with the grand gesture of the split in the wall, makes the building an extension of its site.

Giurgola wrote of that theme in 1975:

A building is a fragment of the larger environment which includes other continuously growing structures and the natural scape. As a meaningful fragment, it should have its own inner structure in order to be able to relate to others. In this sense a building is not a passive element of a larger composition.

The point of architecture is to unfold and formulate a relationship, often hidden, between elements and the events that make an environment. (PAFA, Peale House Galleries, *Mitchell/Giurgola Associates,* September 18—October 26, 1975)
GT □

NEIL WELLIVER (B. 1929)

Born in Millville, a small lumber town near Williamsport in central Pennsylvania, Welliver grew up in a thoroughly rural environment and has chosen to return to it in his present home in Lincolnville, Maine. His ambition to become an artist dates from his childhood, and he was encouraged by his maternal grandfather's skill in cabinet-making and carpentry.

Between 1948 and 1952, Welliver studied at the Philadelphia College of Art, and he has referred to his training in watercolor there as "academicized Homer" (quoted in Rackstraw Downes, "Welliver's Travels," *Art News,* vol. 66, no. 7, November 1967, p. 35). His first one-man exhibition, of figurative watercolors, was held in Philadelphia at the Alexandra Grotto around 1953. Studying with Josef Albers, Burgoyne Diller, and Conrad Marca-Relli at Yale University during 1953–54, he also made the acquaintance of James Brooks at that time. Influenced by Albers and Diller, he experimented

506.

with an abstract and semi-geometric idiom but was also attracted to Brooks's rich, painterly style. His work took on a vigorous, fragmented character related to Abstract Expressionism. In a statement quoted in the catalogue for the exhibition *Realism Now* at Vassar College Art Gallery (May 8—June 12, 1968), Welliver said: "I was educated in the traditions of reductive abstraction and systematic figure painting. Neither of these styles engaged me. A natural painting based on touch, fluidity and inclusive in intent is my interest."

The subjects of his paintings of the late 1950s and early 1960s were often groups of people engaged in frenetic, sometimes allegorical activity (dancing, cavorting, marching in bands). His entry in the *12th Exhibition of American Painting and Sculpture* at the Krannert Art Museum (1965) was a freely adapted version of a masterpiece by El Greco: *The Burial of Count Orgone* depicts a crowd of businessmen surrounding exuberant naked women.

Around 1965, his painting began to shift to a more direct presentation of subject matter (figures and landscape) and a more controlled, still painterly idiom. He has always been drawn to watercolor as a fluid yet demanding medium (John Marin is an artist he greatly admires), and the evolution of his painting style over the last decade owes something to his skill and experience in

watercolor. He has worked increasingly from the model and the motif, sometimes even carrying a large canvas out into the countryside but more often executing a small oil sketch on the spot and working from it in the studio. During the years of transition to his present deep involvement in painting nature, he has referred to enjoyable and mutually supportive conversations with the late Fairfield Porter, Alex Katz, Rudy Burckhardt, and Robert Engman.

Since the early 1960s, Welliver has had frequent one-man shows in New York, first at the Stable Gallery, then the Tibor de Nagy Gallery, the John Bernard Myers Gallery, and, most recently, the Fischbach Gallery (1974). His painting has been widely exhibited in national shows such as the annuals at the Pennsylvania Academy and the Whitney Museum and a number of exhibitions exploring recent American realism and the tradition of landscape painting in the United States.

Welliver's approach to art and his paintings have both exerted a considerable influence on a generation of students and artists increasingly interested once again in the possibilities of painting from life and a return to naturalism. He has been associated with several art schools over the past twenty years, where his teaching has been fortified by a strong bias against institutionalism: "I have no office, no smock, no beret, no meetings, no College Art Assoc. . . . It's

601

507.

been a constant war against degrees, design, 50 min. hours—most of all habituated procedural reasoning" (letter to the author, October 1975).

From 1954 to 1957, Welliver was an instructor at the Cooper Union in New York, and from 1956 to 1965 he taught at Yale University where his students included Rackstraw Downes, Eugene Baguskas, Janet Fish, Harriet Shorr, and Eva Hesse. Since 1965 he has taught painting at the University of Pennsylvania, and between that date and 1970 he lived in Philadelphia, prior to his move to Maine, where he had been summering for years. Since 1970 he has become involved in printmaking, producing an edition of six silkscreens of landscapes (published by Harcus-Krakow Gallery in Boston in 1973) and etchings, sometimes hand-colored, for the Brooke Alexander Gallery in New York. He has been commissioned by the United States Department of the Interior to paint a work for a Bicentennial exhibition devoted to the theme of this country's natural resources.

506. *Windfall*

1969
Signature: Welliver (lower right)
Oil on canvas
72 x 72″ (182.8 x 182.8 cm)
Harcus Krakow Rosen Sonnabend Gallery, Boston

Windfall PRESENTS A VIEW of inland Maine, very near the artist's home and studio in Lincolnville. After painting a sketch of the subject, he returned to the site with a large

canvas and completed the painting itself in two weeks: "I came upon this windfall after a storm in a spot with which I was well acquainted; the area had been changed dramatically, and needed to be painted—the forest is in wild flux. It is not seen when looking at the woods, but rather when living in it . . ." (letter to the author, October 1975). Welliver's vigorous style and his penchant for wilderness as subject matter make it tempting to place him squarely in the American tradition of rugged realism. Winslow Homer's late paintings of stormy seas off the Maine coast come to mind, as does the work of the Philadelphia-based painters Elmer Schofield and Edward Redfield (see no. 412), men who prided themselves on their struggle with the elements—setting up their easels on snowy slopes to capture Nature at her most inclement. Welliver's attitude to his subject is more complex than Redfield's straightforward realism, which he admires. He is also fond of the consciously naive and zestful allegories of Eilshemius, who made use of nature as a backdrop for nymphs disporting themselves or fantastic scenes of violence and death. The year he painted *Windfall,* Welliver also produced a number of pictures of nude women bathing or posed in sun-dappled woods, and he considers these often humorous scenes of modern naiads as sharing the same concerns as his landscapes. Three factors seem to fuse in Welliver's painting of the last decade: a loving observation of the out-of-doors, a vivid, even romantic imagination laced with a broad sense of humor, and an increasingly skillful and controlled handling of paint. In the years between his graduation from Yale and 1965, he created a lively group of paintings verging on abstraction and influenced in part by

Willem de Kooning's extraordinary series of *Women* in both their energetic brushwork and their often lusty themes. Welliver's experience with the gestural, overall facture of Abstract Expressionist painting has been carried into his most recent landscapes and he has developed a vocabulary of fluidly applied, curvilinear strokes and dabs which cover the surfaces of his canvases with rich detail. *Windfall* is one of his earliest landscapes to explore this overall, almost tapestried effect with great success.

Welliver has painted Maine scenes over the last ten years from widely varying vantage-points, producing vistas of remote mountains, views down into the near distance of Briggs Meadow with its watery marshland, and glimpses into the dense forest interior. *Windfall* belongs to the latter category, one which has preoccupied the artist increasingly in his most recent work. The dark green and gray branches of the pine trees fill the canvas like latticework, with only gleams of blue from the sky and its reflection in the water below to suggest a sense of air and deeper space. Painted during the years when Welliver was living as well as teaching in Philadelphia, *Windfall* is the creation of a painter whose work has had a forceful impact upon both his own students and young artists in the city. In the combining of a fresh look at landscape (working directly from the motif) with a sensitivity to the paint surface and a lively gestural touch derived in part from his familiarity with abstraction, Welliver has staked out his own arcadian territory in the field of recent American realism which has only begun to be explored.

Ad'H □

SOL MEDNICK (1916–1970)

Sol Mednick was born on October 30, 1916, in Philadelphia, the son of a photographer. He studied design at the Philadelphia College of Art, where he was taught and influenced by Alexey Brodovitch. He became a commercial photographer after he graduated, opening his own studio in New York in 1949 while continuing to live in Philadelphia. Among his clients was *Scientific American,* for whom he produced many cover photographs and illustrated many articles. In 1951 he began teaching at the Philadelphia College of Art, where he created the Photography and Film Department and was its chairman until his death in 1970. Respected and loved as a teacher, Mednick was a founding member of the Society for Photographic Education. His noncommercial photography was essentially private; he rarely exhibited his personal work. His photographs were shown at the Philadelphia College of Art in the *Sol Mednick Memorial Exhibition* in 1971. (For information on Mednick, see *Camera,* no. 1, January 1971, pp. 6–22.)

507. *Untitled (New York Street Scene)*

1969
Silver print
8⅞ x 19⁹⁄₁₆″ (22.6 x 49.6 cm)
Mrs. Sol Mednick, Philadelphia

AS A COMMERCIAL PHOTOGRAPHER, Sol Mednick developed great technical skill and versatility in both black and white and color photography. As a private photographer he continuously explored the possibilities of the medium and expanded his own vision. This untitled street scene of 1969, taken in New York, was made with a 35 mm Widelux camera, a panoramic camera with a short focal-length lens rotating through a wide arc across a curved film plane. The 24 by 59 mm negative takes in a viewing angle of 140 degrees, without any distortion of linear perspective. The image produced by this camera is dramatically impressive; the extreme wide-angle view combined with the great depth of field are far beyond the limits of normal human vision.

The dramatic lighting isolates and spotlights the central figure: a man alone in a crowd, engulfed by the shadows of unseen people moving in the surreal world of urban reality. While the locale is recognizable, the photograph is not a documentary; but because it is a straight image, made in the camera, it carries the compelling force of clearly seen truth. It possesses a startling visual strength whose impact is rooted in psychological recognition: an intuition made

graphically manifest in the photograph. This approach to the interpretation of the cityscape is not unique to Sol Mednick—it was begun to a large extent by Harry Callahan in Chicago in the 1950s—but it does reveal his continuing fascination with photography as a vehicle of perception and insight and his constant willingness to explore new tools for seeing.

WS □

LEIF SKOOGFORS (B. 1940)

Leif Skoogfors was born in Wilmington, Delaware, in 1940. He studied at the Philadelphia College of Art and Temple University and received his photographic training from Alexey Brodovitch at the Design Laboratory in New York. Skoogfors founded the Department of Photography at Moore College of Art in 1964, serving as chairman of the department from 1967 to 1971, and developed the degree program in photography there. He also taught at the Tyler School of Art and the Philadelphia College of Art.

A working photojournalist, Skoogfors's pictures have appeared in the *New York Times, Newsweek, Time, Der Spiegel, Society, The Telegraph, Illustrated Zeitung, The Listener,* and many other publications. In 1974, Skoogfors's photographic essay on the civil war in Northern Ireland, *The Most*

Natural Thing in the World, was published. His photographs have also been shown in several exhibitions, including *Vision and Expression* at George Eastman House in Rochester (1969), and in exhibitions at the Pennsylvania Academy of the Fine Arts (1974) and the Fotografiska Museet, Stockholm, Sweden (1975).

508. *Le Monstre: An Eight-year-old Member of Al-Fatah*

1970
Signature: Leif Skoogfors/137 Waverly Pl./N.Y. N.Y. 10014 (in ink, on reverse, center)
Inscription: "Le Monstre" 1970 Leif Skoogfors (in ink, on reverse, lower left)
Silver print
9 x 13⁷⁄₁₆″ (22.9 x 34.1 cm)
Leif Skoogfors, New York

THIS PHOTOGRAPH is one image from his essay *The Children of Al-Fatah* which Skoogfors made in Syria in 1970. In the context of the essay, it is untitled and is one unit of the total statement; alone, it is titled, but the title is not explicit and suggests rather than explains the meaning of the photograph. *Le Monstre* ("The Monster") is the *nom-de-guerre* of the child guerrilla who confronts us in the picture. His pose is

508.

603

alert and expectant; his demeanor seems entirely self-assured. He is thoroughly trained and indoctrinated. Yet he is also a pathetic figure: he stands alone, isolated by the brilliant light and the abrupt perspective produced by Skoogfors's wide angle lens. His stubby, ugly submachine gun is almost as large as he. It is the figure of a child who has been made into a soldier, deprived of the childhood rightfully his to promote the cause of his adult leaders. Like his young companions drilling in the distance behind him, he has been made into a pitiful monster, created and guided by the invisible figure whose shadow stretches out beside him.

Le Monstre is a document of a time and place. But the construct of the image determines our emotional response and conveys very effectively Leif Skoogfors's own subjective attitudes.

ws □

BARBARA BLONDEAU (1938–1974)

Born in Detroit, Michigan, in 1938, Barbara Blondeau received a bachelor's degree in painting from the School of the Art Institute of Chicago and a master's degree in photography from the Institute of Design, Illinois Institute of Technology, Chicago, where she studied with Aaron Siskind. After two years as an instructor at St. Mary's College, Notre Dame, Indiana, where she exhibited her work in 1967, she came to Philadelphia in 1968 to teach at Moore College of Art. In 1970 she joined the faculty at the Philadelphia College of Art and in 1971 was appointed chairperson of the Photography and Film Department, a position she held until her death in 1974. She exhibited in numerous individual and group shows in the United States, including *Vision and Expression* at the George Eastman House, Rochester, in 1969, and *The Expanded Photograph* at the Philadelphia Civic Center Museum, and *The Multiple Image* at the Massachusetts Institute of Technology and Rhode Island University in 1972. Her work has been published in the *Popular Photography Annual* (1969), *Camera* (1971), and *Time-Life Library of Photography: The Frontiers of Photography* (1972). In 1975 the Philadelphia College of Art showed her work in the exhibition *Barbara Blondeau: 1938–1974.*

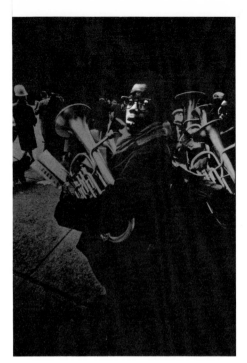

509.

509. *Untitled (Boy with Horn)*

1970
Signature: Barbara Blondeau (in ink, on mount, on reverse)
Inscription: 737 So 6th/Phila Pa 19147 (in ink, on mount, on reverse)
Ortho film and acrylic paint mounted on silver paper
25¼ x 19⅛″ (64 x 48.5 cm)
Estate of Barbara Blondeau

A PHOTOGRAPHER also trained as a painter, Barbara Blondeau stated that her aim in photography was "to experience and explore the image-making potential of the medium." This photograph exemplifies that concern. Unmistakably photographic in origin, it is at the same time highly graphic in appearance. By enlarging a 35 mm negative onto Kodalith film, she reduced the image essentially to forms of black or white (clear), virtually eliminating all middle tones. She opaqued large areas to eliminate detail further, to alter tonal relationships radically (the sky is an intense black), and to intensify the mood of the image. To emphasize the musical instruments and the face of the boy, she painted the reverse side of the film with flat, harsh colors. The total effect, somber and disturbing, is in sharp contrast to the actual event, which was a parade.

This photograph represents the manipulation of the photographic process to create a new level of meaning that goes beyond the documentation of the event and that extends the traditional limits of photography. In terms of concept and experimental technique, this photograph is typical of Barbara Blondeau's work.

ws □

MURRAY WEISS (B. 1926)

Born in New York City, Murray Weiss studied photography at the Photo League in New York, with Walter Rosenblum at Brooklyn College, and with Ralph Steiner in New York. He received his bachelor's degree in 1952 from Brooklyn College. Weiss came to Philadelphia in 1955 to join the faculty of the Film and Photography Department at the Philadelphia College of Art. In 1962–63 he founded and directed the short-lived A Photographers Place, Philadelphia's first full-time gallery for photography.

In 1972 he moved to Milwaukee to develop the Department of Fine Art Photography at Layton School of Art. Since 1974, Weiss has directed the Creative Photography Workshop in Milwaukee, where he teaches photography and history of photography. In addition, he has taught courses in photography at the Educational Alliance in New York City, at the Yale-Norfolk Summer Art School, at Brooklyn College, and at the Aegean School of Fine Arts on Paros, Greece; he has taught the history of photography at Brooklyn College and the University of Wisconsin. Weiss has exhibited in numerous one-man and group exhibitions in Philadelphia, New York, and elsewhere.

510. *Monhegan Island*

1970
Signature: Murray Weiss (in pencil, on mount, on reverse, lower left)
Inscription: Monhegan Island,/Me., 1970/1088–11 (in pencil, on mount, on reverse, lower left)
Gold-toned silver print
3¹¹⁄₁₆ x 4¹¹⁄₁₆″ (9.3 x 11.9 cm)
Philadelphia Museum of Art. Given by the Volunteer Guides of the Philadelphia Museum of Art in memory of Catherine E. Mechem. 77–111–1

MURRAY WEISS'S WORK, represented by this picture, exemplifies classical American pictorial photography. One of a series of landscapes and nature views photographed on Monhegan Island, Maine, in 1970, the picture is a contact print from a 4 by 5 inch negative, printed on silver chloride printing-

510.

out paper and toned with gold chloride. The delicacy of the scene is emphasized by the small size of the print, which nonetheless reveals the fine textures and details of the tree bark and the ferns. The subtle variety of tones (describing and contrasting the natural forms and textures) in the original scene is beautifully rendered by the gold-toned printing-out paper, which is capable of reproducing an exceptionally long tonal scale. Stopping his lens down all the way to define the image sharply and with the depth of vision and optical clarity of which only the camera is capable, Weiss communicates in this photograph his sense of the beauty of the Monhegan Island woods.

WS □

ROLAND JAHN (B. 1934)

Born in Rudolstadt, Germany, in 1934, Roland Jahn studied at the Clemens August Universität in Köln in 1956 and pursued art history studies at the Rheinische Friedrich-Wilhelms Universität at Bonn in 1956–57 and 1959–60, utilizing a Fulbright Travel Grant and a Brittingham Exchange Scholarship in 1957. He received his bachelor of science degree in art in 1963, a master of science degree in art in 1964, and a master of fine arts degree in 1966, all from the University of Wisconsin, and has studied with Harvey Littleton, Leo Steppat, Abram Schlemmowitz, and Dan Reitz.

Jahn came to Philadelphia in 1966 to practice glassblowing and to teach it. He is presently an assistant professor at the Philadelphia College of Art, teaching Glass and Ceramics, and he taught previously at the University of Wisconsin, at Penland School of Crafts, North Carolina, and at the Peninsula School of Art at Fish Creek, Wisconsin. His work has been shown in

511a.

numerous competitive and invitational arts and crafts shows, including the *Toledo Glass National II*, 1968; the 7th *Southern Tier Arts and Crafts Show,* Corning, New York, 1970; and the *Contemporary Off Hand-blown Glass Invitational* in Toronto, Canada, 1970, and he has received a number of awards for his work. His work has also been a part of several traveling exhibitions and was represented in a show in England. Examples of his work are to be found in the collections of the Corning Museum of Glass, the Philadelphia Museum of Art, the Delaware Art Museum, Vassar College, the Johnson Foundation and in the Newark Museum, New Jersey, as well as in other collections.

511a. *Vase*

1970
Signature: R. Jahn '70 (engraved at the bottom edge)
Overlaid silver and manganese oxide colored, free-blown glass with bubbles
Height 6″ (15.2 cm); diameter 7½″ (19 cm)
Private Collection

PROVENANCE: Purchased from the artist by the present owners

511b. *Untitled (Sculpture)*

1970
Signature: R. Jahn, 1970 (engraved on outside edge of base)
Soda-lime glass, colored with vanadium pentoxide, black uranium oxide, and smaller quantities of lead chromate and iron
Height 14″ (35.5 cm); width 7¾″ (19.6 cm); diameter base 4½″ (11.4 cm)
Philadelphia Museum of Art. Given by Philadelphia Chapter, National Home Fashions League, Inc. 70–86–2

THESE TWO PIECES of offhand free-blown glass characterize a recent development in crafts known as American Studio Glass-making. This began in 1962 with a work-shop in glassblowing held at and sponsored by the Toledo Museum of Art. Harvey Littleton, Roland Jahn's first teacher of glassblowing, was the founder of this move-ment, aided greatly by Dominick Labino whose technical know-how and practical experience made it possible. The movement spread rapidly until today glassblowing is taught in no less than fifty colleges and universities throughout the country. It has also had a strong influence in England, the Netherlands, and Germany among indi-

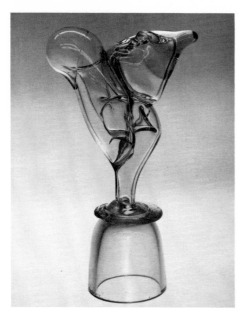

511b.

vidual craftsmen and, to some degree, even upon commercial art glass. However, the studio glass artist uses the material glass as an artistic medium, exploring and exploiting all its many peculiar and often unique properties and is seldom, if ever, content to produce a purely utilitarian piece. This is evidenced in these two examples of Roland Jahn's work.

While the vase is still a functional object, it shows many of the abstract qualities of the purely sculptural piece. Made in the same year, both demonstrate Jahn's versatility, as the pieces vary widely in form, thickness, opacity, color, and decoration. In the vase, Jahn has used cased fuming; by treating the glass with tin chloride, he was able to produce a beautiful iridescence under the final layer of clear glass. Both pieces give the feeling of a super-cooled liquid caught in flowing motion, in a structured composition.

KMW □

DANIEL JACKSON (B. 1938)

Born in Milwaukee, Daniel Jackson has lived and worked in Philadelphia since 1964. His interest in wood carving stems from his childhood when his father gave him a knife and encouraged him to whittle. As a high school student he was interested in antiques and began at that time to buy, sell, and restore furniture and other objects. When he was a student at the College of William and Mary, he actively pursued a career as an antiques dealer during the summers. He studied woodworking at the Rochester Institute of Technology from 1958 to 1960 and then joined the Scandinavian Design Semi-

nar in Kerteminde, Denmark, where he met and began to work with Peder Moos at *Den Dansk Husflidshøjskole* during the winter of 1960–61. The influence of this distinguished Danish designer can most clearly be seen in Jackson's early work. A second year of independent study in Denmark was followed by a final year at the Rochester Institute of Technology, from which he graduated in the spring of 1963.

Although he had exhibited his sculpture in Wisconsin in 1958, 1959, and 1961, widespread recognition as a craftsman came in 1963 in a national invitational exhibition, *American Crafts New Talent,* at the University of Illinois at Urbana. His work in this exhibition brought him his first teaching position—a one-year appointment in the same year at the University of Illinois at Urbana. The following year, Jackson moved to Philadelphia to teach in and help develop what was then known as the Dimensional Design Department of the Philadelphia College of Art, where he continues to teach woodworking and furniture design as part of the Crafts Department. Jackson has participated in numerous important exhibitions in Philadelphia and elsewhere, including a one-man show at the Philadelphia Art Alliance in 1969, and in the Craftsmen's invitationals of 1967, 1970, and 1973 at the Philadelphia Civic Center.

The development in Philadelphia of Jackson's individual style may be seen in his fantasies in wood. He has been absorbed with the material: "It's the tactile sensation of a sharp chisel cutting through wood. The chisel is an extension of your hand. It's a very elementary feeling—a baby has it when he touches things" (letter to the author, April 11, 1975).

512a. *Piano Bench*

1970
Signature: daniel/k/jackson/1969
(dkj in carved monogram; remainder of

name in pencil) (under bench)
Blister and bird's-eye maple
24½ x 45 x 20″ (62.2 x 114.3 x 50.8 cm)
Margaret Grant Hawley, Philadelphia

512b. *Looking Glass (Leda, the Devil, and the Moon)*

1973
Signature: daniel/k/jackson/54 east johnson st/phila. pa. 19144/1973 (in pencil, on back of looking glass)
Brazilian rosewood; Osage orange; Luaan plywood (back)
32½ x 52½″ (82.5 x 133.3 cm)
Philadelphia Museum of Art. Given by the Friends of the Philadelphia Museum of Art. 73-94-3

THE PIANO BENCH is an American furniture form which has seldom received much attention. Therefore this imaginative and exciting interpretation is particularly noteworthy. Its shape reminds one of various animals—perhaps a walking spider or an elephant whose trunk is the leg of the bench. A prototype for the bench can be seen in Egyptian furniture, for example in a New Kingdom stool (see Hollis S. Baker, *Furniture in the Ancient World,* New York, 1966, p. 139, fig. 201). The legs on the Egyptian stool are strikingly similar to those of the bench—its mid-point joint and the circular terminus at the feet being identical. These features as well as the curved knee give it a feeling of lift and lightness. Although the bench appears as if it could walk, its overall form is an elegant one as one part flows smoothly to another, its neatly fitted hinged lid concealed.

Although harmonious, the bench also has contradictions that serve as an element of surprise. The rails on the short ends of the bench are doweled through and appear

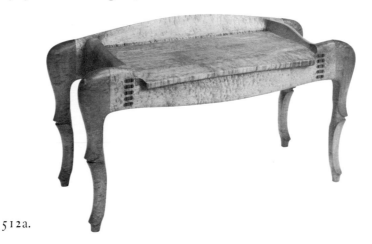

512a.

512b.

prominently in an orderly vertical row on the front and rear of the bench. This straightforward, honest construction recalls principles of the Arts and Crafts movement and earlier; but while it was appropriate for the rectilinear furniture of Gustav Stickley, it strikes an incongruous note in this organic form. For contemporary aesthetics, however, this disharmony is pleasing, as is an atonal scale of music.

Even more individual and eccentric is Daniel Jackson's "looking glass," a term given to the form by the Museum's curatorial staff, and one that appealed to the artist more than the relatively modern term, mirror. This looking glass was in part the result of a commission from the Philadelphia Museum to produce an object to include in the exhibition held by the Friends of the Museum for their Annual Purchase Party, May 30, 1973. Although Jackson had already begun the looking glass at the time of the commission, it was completed with this purpose in mind.

Although the designated parts identified as Leda, the Devil, and the Moon are easily recognizable and a work of sculpture is expected to have a title, it is unusual for a piece of furniture to have a title. Jackson's interpretation is a free adaptation of motifs from classical mythology—concerned with the romantic idea and feeling of myths rather than a literal and specific allusion. The result is a highly imaginative and individual work with implicit sexual imagery.

The looking glass and piano bench suggest forms other than those their function would

prescribe. If the bench might walk, the looking glass might be an open mouth. It is with these anthropomorphic artifacts, influenced by Danish modern design, that Jackson is most successful and has made a unique and individual contribution to American furniture.

As with Wharton Esherick's furniture, Jackson's work is extremely sculptural. Jackson began as a sculptor and continued to make both sculpture and furniture. Jackson believes that the useful object can no longer be distinguished from sculpture: "There is not a great difference between the two," as Jackson has succinctly put it. "Furniture must fill a specific function. Then it can go on to be aesthetic. Sculpture is purely aesthetic from the beginning. What I am trying to do is marry the two" (letter to the author, April 11, 1975).

DH □

LOUISE TODD COPE (B. 1930)

Louise Todd Cope was born in 1930 at her family's summer residence in Ventnor, New Jersey. Her father, Raymond T. Moore, was a Philadelphia business executive and importer; her mother, Esther J. Moore, was a homemaker who instilled high standards of workmanship. Louise Todd Cope's technical facility began with an early exposure to fibers and fabrics. Her grandmother, Lydia Cope (whose name she subsequently adopted), taught her the first principles of fabric construction at the age of five.

In 1952 she graduated from Syracuse

University as a fine arts major. She married Edward Todd the same year, and they lived in Stockholm, Sweden, and toured Europe until the summer of 1953.

During the early years of her marriage, she worked in several studios, including that of the weaver Robert Harnden in 1956. A brief contact with Ted Hallman at the Wallingford Art Center served as a catalyst for her work. Previously she found herself anticipating the results of her weaving; barriers were erased when she learned to start at the beginning "with the single fiber . . . really looking, really knowing it" (letter to the author, September 20, 1975). This change in appreciation represented a major turning point in her style.

In 1966 she attended Haystack Mountain School of Crafts, Deer Isle, Maine, studying with Henry Easterwood and Olga D'Amaral, and the Philadelphia College of Textiles and Science. In 1970, with previous teaching experience at the Wallingford Art Center (1968), Haystack Mountain School of Crafts (1969), Delaware Art Center (1968), and the Penland School of Crafts in North Carolina (1970–72), Louise Todd Cope joined the faculty at the Moore College of Art in Philadelphia. While teaching at Moore (until 1974), she gave workshops in the East and Midwest, and lectured locally at Rosemont College and Drexel University. In December 1971 she was invited to participate in the National Endowment for the Arts conference at Penland. During the summer of 1973, she conducted a summer program for guilds at the College at Winchester (England) and lectured throughout Great Britain.

Louise Todd Cope's work has been shown in museums and galleries throughout the United States. She was the recipient of the Wellman merit award and Craftsmen U.S.A. (New York) merit award and received purchase prizes from the Delaware Art Museum and the North Carolina Museum of Art.

513. *Concerto*

1970
Wool, jute, and pheasant feathers
23 x 37" (58.4 x 93.9 cm)
Helen Williams Drutt, Philadelphia

THE WALL HANGING *Concerto* represents a harmonic synthesis of several techniques into their effective expression. The synthesis comes relatively easily when its elements have been worked out. It is a "quieting and simplifying," a re-solution. Louise Todd Cope contends: "Very often as a weaver it was so hard to eliminate and simplify . . . it was so easy to be caught up in the details. In my own case I responded to

513.

each nuance of a detail. The form was one I had worked with and the whole piece progressed without a struggle" (letter to the author, September 20, 1975).

These elements of the simplified statement have been encountered in earlier works. The apparent emphasis on textural quality is one of Louise Todd Cope's signatures. Her use of layering goes back to 1967; this work was expanded in 1971 during a visit to Israel. The application of feathers occurred a year or two before her use of layering. In recalling the experience of *Concerto,* she says, "I do remember sitting in the sun and wrapping the many many feathers. And I also remember being pleased that the wools were so sensitive to the feathers" (letter to the author, September 20, 1975).

The artist is interested in an assertion of the materials and their construction. In working with different forms, she leaves herself open to experience the performance of the fibers themselves: "I work on the edge of happening and welcome the laugh that comes from the unknown surprise which shouts, 'Look what's happened!' " ("Profiles of Textile Craftsmen-IV: Louise Todd," *Threads in Action,* Spring 1972, pp. 9–12). The drape of *Concerto's* top layer of fabric shows a tendency, characteristic of her paneled pieces, to assume a form of its own. PC □

RAFAEL FERRER (B. 1933)

In the catalogue for *Deseo,* a one-man exhibition in 1973 at the Contemporary Arts Center in Cincinnati, Ohio, Ferrer provided a vivid and detailed account of his life up to 1972, from which much of the following information is drawn. Born in Santurce, Puerto Rico. Ferrer is the half brother of the actor José Ferrer, his father's son by an earlier marriage. His childhood was spent in Puerto Rico, and by his own request he was sent to the Staunton Military Academy in Staunton, Virginia, where he graduated in 1951 as a cadet lieutenant in charge of the Drum and Bugle Corps. (Ferrer's serious professional interest in music in general and jazz drumming in particular continued actively through the 1950s.) In the fall of 1951 he entered Syracuse University, where he took courses in English and Spanish literature. "Very privately and intensely moved by seeing the early Picasso and Braque cubist paintings in a Skira book," he began to make small oil paintings. Leaving Syracuse after a year and a half, he visited José Ferrer in Los Angeles for several months before deciding to return to Puerto Rico and enroll in the university.

A class in painting taught by the Spanish Surrealist E. F. Granell provided a decisive experience for Ferrer, and his subsequent friendship with Granell exposed him to the art, literature, and recent history of the Dada and Surrealist movements. Ferrer spent the summer of 1953 in Paris, where Granell introduced him to André Breton, Benjamin Peret, Wilfredo Lam, and others in the Surrealist group. After three months in Paris, Ferrer returned briefly to Puerto Rico before moving to New York where he joined the many jazz musicians living and performing in Spanish Harlem. During the mid-1950s he continued to paint and made

frequent visits to galleries and the Museum of Modern Art. His work of this period was related to the fusion of Surrealist imagery and abstraction in the painting of Joan Miró, Arshile Gorky, and Matta.

Returning once more to Puerto Rico, Ferrer worked for several years as a film editor and projectionist for a film patrol at the race track in San Juan. (The experience of using film and video contributed to his interest in incorporating a variety of media—television sets, slide projectors, taped sound—into his later work.) During 1960–61, Ferrer's painting evolved into assemblages, constructions, and free-standing sculpture, and in 1961 he and his friend Rafael Villamil organized a two-man show of their work at the Museum of the University of Puerto Rico. The aggressive, often erotic, imagery of the artists' work and the deliberately primitive, labyrinthine installation designed by Villamil caused considerable controversy. (Ferrer's art has a tangential involvement with his often passionate political views, but it is the challenging nature of the art itself which has at intervals disturbed his audience.) In 1964 the Museum of the University of Puerto Rico gave Ferrer a one-man exhibition of his sculpture; one work was purchased by the university and another by the Ponce Museum of Art.

Disaffected by the negative response to his work from officials at the Institute of Puerto Rican Culture, Ferrer decided to leave Puerto Rico in 1966. Visiting Rafael Villamil, who was working in the office of Louis Kahn in Philadelphia, Ferrer decided to settle in the city where he has continued to live and work. In 1967 his sculpture was included in the exhibition *Art of Latin America* at the Peale House Galleries of the Pennsylvania Academy. An encounter with Italo Scanga on a train journey between Washington and Philadelphia led to Ferrer's taking a job in the sculpture department of the Philadelphia College of Art in the same year. He was briefly attracted to the formalist sculpture of David Smith and Anthony Caro during 1967, but he found the felt pieces by Robert Morris (shown at the Leo Castelli Gallery in New York in 1968) more stimulating to his own concerns. During the fall and winter of 1968, Ferrer began to work with a range of new materials and a much freer concept of space. Using lengths of chain-link fence he created a series of self-supporting forms in a Philadelphia park, and on December 4 he executed *Three Leaf Pieces,* a tactical maneuver in which he and assistants filled New York gallery and warehouse spaces with masses of dry leaves.

In 1969, Ferrer's work began to receive international attention in a series of exhibitions (*When Attitudes Become Form* at the Kunsthalle in Bern, Switzerland, *Op Losse Schroven* at the Stedelijk Museum, Amster-

dam, and *Anti-Illusion/Procedures/Materials* at the Whitney Museum), and he was invited to Germany for a one-man show at the Thelen Gallery in Essen. He executed two pieces in Philadelphia the same year, using hay and ice in a work at the Philadelphia College of Art, and twenty-one bales of straw at the Cheltenham Art Centre. Again in 1970 he was represented in the exhibition *Information* at the Museum of Modern Art, in the Whitney Museum annual, and in a show of five artists at the Museumsverein in Wuppertal, Germany. During the next few years, much of Ferrer's artistic activity was involved with solo or group shows which he prepared at the site of the museum or gallery with materials available locally. His contribution to the *Depth and Presence* exhibition at the Corcoran Gallery in 1971 included a room shut off from the rest of the show which could be entered only through a four-by-two-foot opening (now a constant element in Ferrer's use of gallery space). One-man shows at the Institute of Contemporary Art in Philadelphia and the Fine Arts Center of the University of Rhode Island (1971) were followed by exhibitions at the Pasadena Museum and the Museum of Contemporary Art in Chicago (1973).

Since 1972, Ferrer's work has been increasingly involved with geography and conveys his personal sense of the history and life of specific places. The names Madagascar, Tierra del Fuego, Straits of Magellan, and Patagonia reverberate through his recent

work like a magician's "words of power," sometimes literally written on the gallery wall (in blazing neon script). Departing from his previous tendency to utilize simple, often crude "non-art" materials like straw or sheets of corrugated metal, he has begun to fabricate complex objects and assemblages. As artist-explorer he creates complete, mysterious environments in which he presents the artifacts of his real and imagined voyages: grotesque masks made out of large paper bags, emblematic maps drawn in brilliant colors over nautical charts, bulky wooden rowboats, and slim kayaks.

Ferrer's most recent one-man exhibitions have included *Isla* in the Museum of Modern Art's *Projects* series (1974) and two shows at the Nancy Hoffman Gallery in New York (1974, 1975). Continuing to teach and work in Philadelphia, Ferrer returns frequently to Puerto Rico, and he has lectured and served as visiting professor in universities across the United States. In a recent article "On Contemporary Primitivism" (*Artforum*, vol. 14, no. 3, November 1975, pp. 57–65), Carter Ratcliff discusses the work of Ferrer with that of William T. Wiley, Harmony Hammond, Nancy Graves, and a number of others. Ferrer has emerged as the unsentimental but compelling proponent of a new type of work, drawing upon the aesthetic and spiritual power of "primitive" cultures, while maintaining a creative but ironic consciousness of the conventions and the innovations of recent Western art.

514. *Deflected Fountain 1970, for Marcel Duchamp*

1970
Eight photographs, mounted together
23 x 54½" (58.4 x 138.4 cm)
The Museum of Modern Art, New York. Gift of M. E. Thelen Gallery, 1971

LITERATURE: Jack Burnham, "Problems of Criticism, IX," *Artforum* vol. 9, no. 5 (January 1971), illus. p. 44; Philadelphia, Institute of Contemporary Art, "An Interview, Rafael Ferrer and Stephen Prokopoff," in *Rafael Ferrer, Enclosures* (1971), n.p.; Cincinnati, Contemporary Arts Center, *Deseo: An Adventure, Rafael Ferrer,* by Carter Ratcliff and Rafael Ferrer (1973), p. 23, illus. p. 22; Anne d'Harnoncourt and Kynaston McShine, eds., *Marcel Duchamp* (New York, 1973), illus. p. 199

WHEN FERRER WAS INVITED to create a work in connection with the *Peace* exhibition at the Philadelphia Museum of Art in the spring of 1970, he proposed to utilize the large fountain in the center of the Museum's East Court in the execution of a piece dedicated to Marcel Duchamp. (Duchamp's *Large Glass* is installed in the Museum building behind a small glass door which permits a direct view of the fountain.) The artist has described the plan and evolution of the work in a statement dated May 14, 1970 (PMA, *Christo Wraps a Staircase: Ferrer Deflects a Fountain,* 1970, n.p.):

514.

The aim of this piece is to deflect the stream of water from its vertical path into a trajectory of approximately 45 degrees. The fountain chosen is singularly appropriate because of its simplicity, location, and design. Various solutions to the problems of deflection were considered. A plate of steel to lean over the lip of the octagon, a long I beam with a tripodal support, and finally, a rig inside the bronze drum that would control the water flow at its source; all of these were considered and discarded. The use of a rig to deflect water at its source remained the most interesting solution since it eliminated references to the apparatus as SCULPTURE and in turn focused on the task to be performed: how to best deflect the water.

As measurements were taken a better acquaintance with the reality of the fountain was taking place. An important measurement was overlooked and this forced my entering the fountain when the water was turned on at full power. I was accompanied by Dan Schneps. We became interested in testing the pressure of the water and the force needed to change its path. It was possible to deflect the water by joining one's hands together to form an angle, and by then pressing with full strength against the stream of water. We did this many times successfully. Danny suggested an alternate method of deflection which was easier and could be carried out for an indefinite period of time. This method involved the sitting on the rim of the nozzle with the left buttock. Very simple, direct, and efficient. That evening I decided after a long conversation with Don Gill to carry out the piece in this most direct manner.

The problem: to deflect the fountain. The materials: my body and the stream of water. The logistics were then quite simple. I would deflect the fountain prior to the show and document it thoroughly with all possible means. Movies, slides, still shots, and sound recordings. This material or parts of it would be available inside the museum.

I will deflect the fountain on tuesdays and thursdays at 1:00 P.M. for the duration of the exhibition.

With this piece I have reduced the elements involved to a minimum. It is the simple execution of a task.

Ferrer's *Deflected Fountain* became one of the first significant works in a genre known as "body art," but it is also relevant to continuing themes in his own work. Between 1969 and 1972, Ferrer executed a number of pieces which involved the simplest natural materials: eighty-four bushels of dry leaves strewn across gallery floors, large chunks of ice melting slowly in museum gardens, grease smeared across a

wall which was then pelted with fistfuls of hay. The materials themselves and the transformation they produced in the space they occupied were of as much interest to Ferrer as the actual performance of the work, which was usually efficient rather than theatrical; the physical energies involved in executing the pieces remained only as a ghostly residue. Similarly, Ferrer placed less emphasis on his rather exhausting efforts needed to deflect the fountain jet than on the angle of deflection achieved. This period in Ferrer's career coincided with an interest in "process art" among a number of his contemporaries, including Robert Morris, Keith Sonnier, and Richard Serra. *Deflected Fountain* was a crucial piece in his artistic evolution and acknowledged the importance of Duchamp as an explorer and rule-breaker in aesthetic territory. Taking advantage of his location in Philadelphia, yet deliberately set up outside of an existing cultural institution, Ferrer's fountain piece asserted both the artist's relationship to his surroundings (his capacity to change them) and his autonomy.

The bold, large-scale works using simple materials brought Ferrer international exposure and reputation as a member of the avant-garde. In retrospect, they also served as a liberating and energizing transition between his earlier paintings and constructions, directly influenced by Surrealism, and his recent work. Ferrer's contribution to the Whitney Museum's annual sculpture exhibition in 1970 was a tent, occupied by a set of silent drums and a photographic vista of a glacier lit by neon tubing. This enclosed, mysterious work reflected his response to another aspect of Duchamp (the careful control of what the viewer can see in *Étant Donnés*), and moved in the direction of the complex, assembled environments which he has continued to create.

Ad'H □

SAMUEL CALMAN MAITIN (B. 1928)

The second of three sons of Russian immigrant parents who owned a North Philadelphia grocery store, Maitin was born in Philadelphia and has remained a resident of the city. He attended public schools supplemented by art classes at the Graphic Sketch Club. From 1945 to 1949 he was enrolled at the Philadelphia Museum School of Industrial Art, studying painting with Paul Froelich, printmaking with Ezio Martinelli, and art history with Benton Spruance. Concurrently he was a part-time student at the University of Pennsylvania, receiving his bachelor's degree in 1951.

Maitin has taught at the Moore Institute of Design for Women, the Pennsylvania Academy, and the Philadelphia Museum of

Art; in addition, he has set up a print workshop at Swarthmore College and served as one of the first directors of the typography division at the Philadelphia College of Art where he has taught painting, drawing, advertising design, and printmaking. From 1966 to 1970 he was head of the Graphic Communications Laboratory, Annenberg School of Communications, University of Pennsylvania, and has acted as a visiting artist and lecturer at numerous institutions. Book illustrator and designer (approximately forty publications), muralist and tapestry designer, painter, printmaker, sculptor, and graphic designer, Maitin has showed his work internationally in more than thirty one-man exhibitions, and he has received numerous awards and medals in all of his areas of activity. In 1968 he was awarded a Guggenheim Fellowship in graphics which enabled him, with his wife Lilyan and children Izak and Ana, to spend a year in England where he worked at Curwen Studios and Editions Alecto.

Maitin has been affiliated on a volunteer and/or commission basis with almost a hundred cultural and civic organizations in the Philadelphia area and continues to offer extensive support to various social and political humanitarian causes. Along with Jerome Kaplan and Benton Spruance he formed the first Artists' Committee of the Prints in Progress program sponsored by The Print Club. In December 1960, Maitin gave the first printmaking demonstration for children (see Lila Field, "Printmakers Bring Art to School," *Art Education,* vol. 18, no. 2, February 1965, pp. 7–9). Formerly a vice-president, he continues to be active in the Philadelphia chapter of Artists Equity, was one of the founders of the Friends of the Philadelphia Museum of Art, and is an active member of exhibition juries. His work is included in private and public collections throughout the world.

515. *No Man Is an Island*

1971
Printed by Albert Joseph Riccelli, Sr., Noral Corporation, Camden, N.J.
Signature: Samuel Maitin 1971 3/200 (in pencil, lower left)
Inscription: Samuel Maitin 1971 (upper left); No/man is an Iland, intire/of it selfe; every man is a/peece of the Continent,/a part of the maine;/if a Clod bee washed away/by the Sea, Europe is the lesse,/as well as if a Promontorie were,/as well as if a Mannor of thy friends or/of thine own were. Any mans death/diminishes me, because I am involved/in Mankinde. And therefore/never send to Know/for whom the/bell tolls./It tolls for thee./John Donne 1573–1631

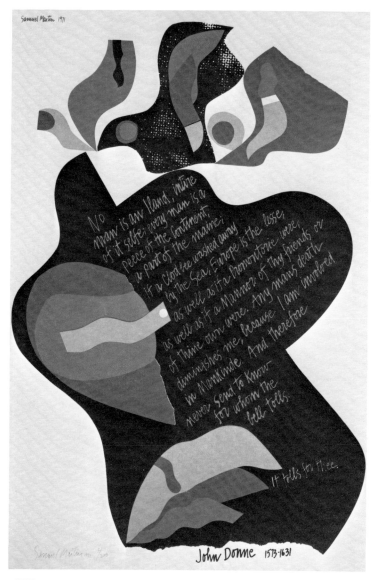

515.

Silkscreen printed in yellow-green, red, violet, black, and white on white machine-made commercial cover-weight paper 33½ x 21⅞″ (image) (85 x 55.5 cm)
Philadelphia Museum of Art. Given by WPVI, Philadelphia. 72–20–1

THE USE OF CALLIGRAPHY in combination with symbolic abstract and figurative imagery has a long tradition in art. Twentieth century antecedents to Samuel Maitin's *No Man Is an Island* include Joan Miró's pages for *Il Était une Petite Pie* by Liese Hirtz, Picasso's exhibition poster *Les Ménines,* Stuart Davis's painting *Visa,* and Henri Matisse's *Poèmes de Charles d'Orléans* (see Mildred Constantine, *Lettering by Modern Artists,* New York, 1964, pp. 9, 17, 20, 31).

Samuel Maitin is a prolific and exuberant artist whose work is playful and at times grotesque. A project consisting of forty-seven posters executed between 1961 and 1968 for the YM/YWHA Arts Council turned the Maitin calligraphic style into a transportable, changeable, informative, and colorful Philadelphia landmark. His 1966 series of silkscreen-etchings inspired by the poems of Arnold Kenseth are his earliest prints directly related to poetry. They were followed in 1968 by a group of lithographs, related to poems by Ronald Goodman, which were produced in England. Maitin's prints connected with poetry as well as his designs for exhibition catalogues (for example, *Lithographs of Jean Dubuffet,* 1964; *The Art of Wilhelm Lehmbruch,* 1972) enable him to demonstrate his respect for the work of poets and visual artists

and his stated commitment to art as a positive human force—a manifestation of social progress and the dignity of man.

In 1970, in conjunction with the student *Peace* exhibition at the Philadelphia Museum of Art, Maitin produced eight large silkscreens which included American poetry. This print, with a calligraphic passage from John Donne's *Devotion XVII,* followed closely after the *Peace* series.

No Man Is an Island was commissioned by WPVI-TV as an end-of-the-year gift to be distributed to friends of the station. Over a period of years, several Philadelphia artists including Edna Andrade and George Krause participated in the project, according to Noel Miles, art director of WPVI-TV. The print marks Maitin's first collaborative effort with Albert Joseph Riccelli, Sr., who prepared cut film and photographic stencils based on a Maitin collage. He also printed the edition of one thousand, of which two hundred were signed and numbered.

Formal aspects of *No Man Is an Island* can be traced to Maitin's earliest prints and relate to his work in other media as well: strongly defined iconic graphic shapes; the contrast between the linear (in this case words) and the weighty or solid form; the shift from figurative to partially figurative imagery to imagery that is abstract but clearly an outgrowth of external visual experience; the experimental use of media in combinations, here indicated by the collage source and photographic enlargement for the textural activity at the upper center; and the use of bright, distinct, yet subtle color combinations. A series of brightly colored wooden pieces composed of flat, cut shapes similar to those found here was made shortly after this print was completed. In them, the implied spatial dimensionality of the print is given tangible form.

Maitin attributes his repeated involvement with words to an outgrowth of his typographic activity and to the fact that his father, who had taught handwriting in Russia, insisted that Samuel, as a boy, continually practice to improve his illegible script. "Perhaps it's all an homage to my father," comments the artist.

RFL □

NOEL MAHAFFEY (B. 1944)

Living in Philadelphia from 1962 to 1973, Mahaffey became during that time one of the youngest well-known artists to emerge within the movement broadly labeled "Super Realism." Born in St. Augustine, Florida, he moved with his family shortly thereafter to Dallas, Texas, where he lived until he was eighteen. From 1959 to 1962, he received his first extensive training in art at the Atelier

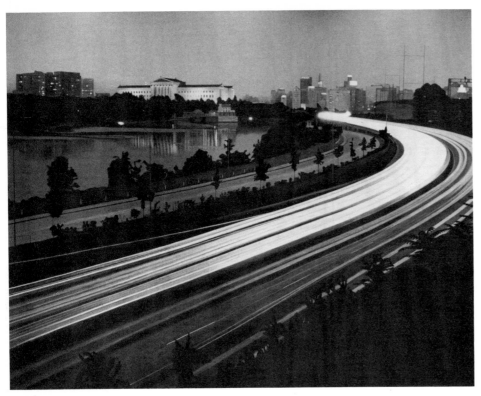

516.

work has focused on individual buildings (restaurants, banks, country clubs) and rows of shop fronts, their facades rendered with austere attention to the pattern created by areas of sunlight, shadow, and reflection. The element of "Pop" culture so often stressed in the work of other photo-realist painters is occasionally present in Mahaffey's subject matter, but muted by his essentially architectonic sense of composition.

516. *Schuylkill Expressway at Night*

1971
Signature: Noel Mahaffey '71 (on reverse, lower right)
Acrylic on canvas
64¾ x 85" (164.4 x 215.9 cm)
First Pennsylvania Bank, N.A., Philadelphia

PROVENANCE: Commissioned from the artist by the First Pennsylvania Bank, 1971

LITERATURE: Philadelphia, Institute of Contemporary Art, *Inside Philadelphia* (November 10—December 19, 1972), n.p.; Allentown [Pa.] Art Museum, *The City in American Painting* (January 20—March 4, 1973), illus. p. 20

WHEN MAHAFFEY began to paint views of cityscapes and skylines, he wrote to various chambers of commerce across the country requesting photographs of their cities. Working with the varied assortment of material that arrived in the mail, as well as from photographs he found, he has produced a series of paintings that document various aspects of the contemporary American city in an impassive, almost bland, manner that contrives to be disconcertingly at odds with the subject. Most of the painters who tend to be grouped under the rubric of "Super Realism" specialize in one particular theme: Malcolm Morley began it all with his series of ocean liners in 1965; Richard Estes loves the sleek reflective surfaces of shop windows and chrome fittings; Richard Goings paints trucks and trailers in new and gleaming condition; while John Salt prefers his automobiles wrecked, or derelict and abandoned. Mahaffey's choice of depersonalized urban architecture, at first seen as a panoramic vista (*Minneapolis* and *Portland,* 1970; *Jersey City* and *St. Louis,* 1971), later in terms of individual buildings and street corners, appears to have less overt emotional color or content than the subject matter of many of his colleagues.

The streets in Mahaffey's paintings are usually empty of cars or passersby, flooded with sunlight, and miraculously free from litter. In this context, *Schuylkill Expressway at Night* comes as a dramatic, even romantic

Chapman Kelley in Dallas, a studio directed by a painter and teacher who was a graduate of the Pennsylvania Academy. Enrolling in the Academy in 1962, Mahaffey studied with Hobson Pittman, Walter Stuempfig, and Franklin Watkins. There he found that his increasing interest in specific, laconic realism, devoid of painterly effect, ran counter to much of the current teaching, and he recalls that in his third year of study his decision to use photographs as a source for painting was frowned upon. His interest in the art of the past ranged from the heroic painting of Jacques-Louis David to the work of Thomas Eakins, and he reserved his greatest admiration for Caravaggio. After he left the Academy in 1966, his first major group of paintings was a series of figure studies based on found photographs or snapshots. An early painting of that type, *My Brother with Janis* (1966), was shown in the exhibition *Contemporary American Painting and Sculpture 1967* at the Krannert Art Museum in Champaign, Illinois. It incorporated several actual photographs of the subject with the large painted figures of a boy and a girl seated in deck chairs. Mahaffey's figure style was still somewhat painterly but his use of collage and a partly abstract background stressed the flatness of the picture plane. *Catfish* of 1969 (Philadelphia Museum of Art) comes near the end of the series and presents two men in fishing gear, grinning and slinging between them a

large catfish, obviously posing for the camera. The figures are isolated against a flat, bright orange background.

Around 1970, Mahaffey's chosen subject matter shifted from people to panoramic cityscapes; his work became more detailed and increasingly preoccupied with the treatment of light and shadow. Continuing to paint from photographs, he sometimes obtains them from commercial or official sources, sometimes takes them himself. In 1970 his first one-man show was held at the Marian Locks Gallery in Philadelphia, followed by an exhibition at the Hundred Acres Gallery in New York the same year. Selected for the annual exhibition of the Whitney Museum of American Art in 1972, his paintings were also included in several other exhibitions in 1972 devoted to realist themes: *Sharp Focus Realism* at the Sidney Janis Gallery, New York; *Phases of New Realism* at the Lowe Art Center, Coral Gables, Florida; *Hyperéalistes Américains* at the Galerie des 4 Mouvements, Paris. Mahaffey's work of the last five years has been widely exhibited and reproduced and is owned by a number of international collectors. Udo Kultermann illustrates five paintings and discusses their technique in his *New Realism* (Greenwich, Conn., 1972, p. 20, nos. 145–49).

Since 1973, Mahaffey has lived in New York, where he is now represented by the Louis K. Meisel Gallery. His most recent

surprise, with its nocturnal splendors of glowing streetlights and blazing traffic. Commissioned by the First Pennsylvania Bank, through the office of the architect Vincent Kling, Mahaffey based his painting on a photograph of Philadelphia at night by the bank's photographer. In its scale (one of the largest works the artist has produced) and the use of rapid motion (ribbons of light flashing along the expressway toward the city), *Schuylkill Expressway at Night* is an unusual work for Mahaffey's taciturn sensibility. Lights in the distant buildings seem to radiate through a spectral mist, and the reflection of the massive classical facade of the Philadelphia Museum of Art becomes dissolved and abstracted by the still water of the Schuylkill. Although its eerie and seductive romanticism is not a direction which Mahaffey has since pursued, *Schuylkill Expressway* was preceded by a small night view of downtown traffic in *Waco, Texas* (1970); he went on to paint two more nocturnal city views, one of which (*Atlanta, Georgia,* 1971) is in the collection of the Pennsylvania Academy. Mahaffey's more recent depictions of Philadelphia subjects have included several portraits of buildings: *30th Street Station* is in a private collection in Paris, *Fidelity Mutual Life Insurance Building* (1972) is in the collection of Richard Brown Baker.

Ad'H □

SIDNEY GOODMAN (B. 1936)

Born in Philadelphia, Goodman has spent virtually his entire career to date in and about the city. From 1954 to 1958 he studied at the Philadelphia College of Art, where his teachers included Jacob Landau, Morris Berd, and Larry Day. Not long after graduation, he began to teach at the College (in 1960) where he continues to be on the faculty. In 1964 he was awarded a Guggenheim Fellowship. As a student he was drawn to the work of Bonnard and Van Gogh and he later became interested in the German Expressionists, although his abiding admiration has always been reserved for the Spanish and Dutch old masters (especially Velázquez and Goya, Rembrandt, and Vermeer). Cézanne's *Card Players* at the Barnes Foundation left a forceful impression on him. He is aware of being deeply affected by artists of the past, particularly in connection with their use of light, but does not feel that his art is in any sense nostalgic or involved with reviving tradition.

His first one-man exhibition was held at the Philadelphia Print Club in 1958. Beginning in 1961, the Terry Dintenfass gallery in New York has given Goodman a steady sequence of one-man shows, and he has been included in seven of the annual exhibitions at the Whitney Museum of American Art. His

painting of the early 1960s was somewhat surreal in feeling and often depicted large, bloated figures floating in an imagined space (for example, *Find a Way,* 1961, Museum of Modern Art). Goodman's subjects at this time frequently involved macabre ritual: crowds gathered to watch a hanging, streets strewn with corpses, a man pursued by devils. (A number of artists from Philadelphia in Goodman's generation shared an interest in bizarre or disturbing imagery, including Peter Paone, who continues to pursue that direction more explicitly.) Even during this phase of his work, when preoccupied with largely imaginary scenes, Goodman frequently drew from the living model.

Around 1965 a change appeared in his painting as the figures became more obviously studied from life, although their poses or settings still preserved a disquieting mystery. By the time of his 1970 exhibition at the Terry Dintenfass gallery, he had also produced a number of large landscapes, devoid of figures, often with a single menacing feature such as a giant oil tank or water tower. Since the late 1960s, Goodman has been increasingly identified with realist, or (even less accurately) "New Realist," painting, and his work has been included in several exhibitions on that theme (Vassar College Art Gallery, *Realism Now,* 1968; Cleveland Institute of Art, *Contemporary Realists,* 1972; Pennsylvania State University, *Living American Artists and the Figure,* 1974, among others). His own comment on his mode of work is typically ambivalent: "I sometimes paint a realistic picture in order to justify logically something unreal . . . I like to create a polarity, a tension between hard surfaces in my paintings and something more vulnerable" (quoted in Vassar College Art Gallery, *Realism Now,* May 8—June 12, 1968, p. 28). The Philadelphia College of Art gave him a one-man exhibition in 1970 and he has had two one-man shows at the Peale House Galleries of the Pennsylvania Academy, in 1969 and 1974. He has received a number of awards and purchase prizes, including a grant from the National Endowment for the Arts in 1974.

Goodman lives in Elkins Park and continues to work there and in a studio on Sansom Street. His wife, the painter Eileen Goodman (a fellow student from the Philadelphia College of Art), and their daughter, Amanda, have been frequent models for his paintings and drawings of recent years. *Figures in a Landscape* of 1971–72 (Philadelphia Museum of Art) is a family portrait as well as a compelling figure study, and one of his most startling recent works is *Amanda Twice* (1969–70, collection of the artist), which depicts his daughter standing in a bathtub in two virtually identical images

placed side by side (somewhat in the manner of a stereopticon card). As Goodman has moved away from the eerie, monochromatic palette and distressing, occasionally horrific subject matter of his earlier work, he continues to compel attention as one of the most accomplished figurative painters working in this country. His exploration of the shadowy realm of allegory and inexplicit allusion is rendered uncannily effective by the convincing naturalism of his style.

517. *Room 318*

1971–72
Oil on canvas
75 x 97" (190.5 x 246.3 cm)
Whitney Museum of American Art, New York. Purchased with the aid of funds from the National Endowment for the Arts (and exchange)

PROVENANCE: With Terry Dintenfass, Inc., New York

LITERATURE: New York, Whitney Museum of American Art, *1973 Biennial Exhibition: Contemporary American Art* (January 10— March 18, 1973), p. 10

THE ARTIST HAS FURNISHED his own account of the gradual evolution of this work:

The painting "Room 318" was started in late May of 1971 at the Philadelphia College of Art in a studio that was not being used. The painting was finished in my Sansom St. studio where the light and space were similar. Originally I had planned on having three models in the painting. Two figures were painted out during a period of work which lasted about 1½ years. I intended the painting to be a further development of a theme of a model in the studio.

The light, the space, and the woman's figure in the room are what the painting is mostly about—other elements play off against that. The more I observed and defined the room and its contents, the more unsettling and elusive their presence became. (letter to the author, August 4, 1975)

Two earlier paintings reveal various phases of Goodman's investigations of the subject of a model in the studio. *Self-Portrait in Studio* of 1967 (private collection) presents the artist, his eyes concealed by dark glasses, seated on a chair gazing directly at the viewer. He occupies the center of the left half of the picture space (which is rather severely bisected), and his figure is balanced by that of a foreshortened nude model reclining on a table to the right. *Girl on a Table* of 1969 is a simpler composition, again

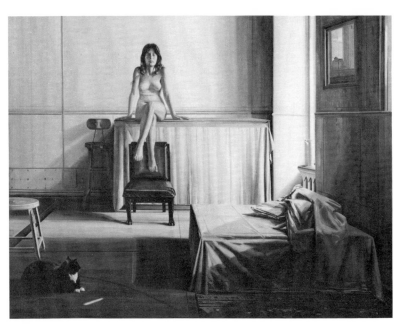

517.

bisected (by a vertical strip of molding on the wall), with a model seated on a draped table staring directly out of the picture. Her figure (to the right of center) is in this case balanced by a mysterious still life of a large paper bag on a metal-legged stool placed on the table to her left.

The sinister overtones in *Self-Portrait in Studio*, provided by the artist's dark glasses and the disturbing juxtaposition of his clothed figure with the inert, nude form of the model, are less marked in *Girl on a Table* or *Room 318*, but they are disquieting pictures. In Goodman's original conception of *Room 318*, another model stood by the window at the right and a third figure lay extended across the flat, boxlike bed in the foreground with her legs toward the viewer and her eyes covered by a cloth. Large charcoal studies exist for the absent figures as well as for the pile of drapery on the bed. The artist's decision to eliminate the two figures has perhaps intensified the enigmatic and expectant aspect of the remaining still life objects. The yellow drapery, the roll of paper on the radiator, the two stools, and the dark red chair assume portentous meaning, like props in a symbolist play.

Goodman's paintings are rarely involved with straightforward recording of the given visual data of a particular place or scene. Working with individual elements, each carefully observed (model, chair, mirror, cat), he fits a composition together out of separate parts. Even the space of *Room 318*, which seems so convincing, is delineated by a half-imaginary geometry, traversed by lines and intersected by an arc (around the cat) which often have no common source in

visual reality. (One is reminded of those mysterious circles inscribed on the wall behind the painter in Rembrandt's *Self-Portrait* at Kenwood House.) One of the most characteristic aspects of Goodman's work is the cool, silvery light which pervades his painting, in this case entering from a window concealed from the viewer. How remote this ordered composition appears from Eakins's study of a nude in a sculptor's studio (*William Rush Carving His Allegorical Figure of the Schuylkill River*, no. 350); yet it is part of a continuing tradition of figurative painting in Philadelphia. Eakins's painting is all clutter and activity: the sculptor carves, the model's chaperone knits, clothes are strewn over a chair. Goodman's austere studio is devoid of action, and the artist's presence is scarcely implied, yet in each painter's conception it is the single, nude figure of the model, bathed in light, which forms the visual and emotional center of the picture.

Ad'H □

STANLEY LECHTZIN (B. 1936)

Born and educated in Detroit, Stanley Lechtzin has lived in Philadelphia since 1962. His father was a pharmacist in Detroit and he spent some time as a child watching his father fill prescriptions, which perhaps sparked an interest in chemistry that was later to become important to his work. He also had a job for a time after school doing jewelry repair. After graduating from a technical high school, he worked for a year as a draftsman and cartographer before

entering Wayne State University in 1956, where he majored in crafts. In 1960 he went to the Cranbrook Academy of Art, where he studied jewelry and silversmithing with Richard Thomas, and two years later graduated with a master's degree in fine arts.

Since 1958, Lechtzin's work has been exhibited extensively in the United States and abroad. Some of the most important exhibitions were: *Jewelry 1967 Trends,* invitational, Schmuck-Museum, Pforzheim, West Germany; *International Jewelry Exhibition*, invitational, Tokyo, 1970 and 1973; *The Art of the Jewel,* Florence, 1973; *Rand Show,* Chamber of Mines Pavilion, Johannesburg, 1975; and one-man exhibits at the Museum of Contemporary Crafts, New York, 1965, and Goldsmiths' Hall, London, 1973.

Lechtzin is one of the first craftsmen to experiment extensively with electroforming in making jewelry. Although this technique dates back to industrial uses in the early nineteenth century, it was not until the past decade that the process was used in the arts. For the development of this technique in making jewelry, Lechtzin has received numerous research grants from Temple University and a Craftsmen's Fellowship from the National Endowment for the Arts in 1973. Among his awards, he received the Bronze Medal for Excellence in Design and Craftsmanship and *Craft Horizons* magazine award in 1962.

Since 1962, Lechtzin has taught at the Tyler School of Art, Temple University. He has been a professor since 1971 and chairman of the Crafts Department since 1965. His work has evolved from making conventional kinds of jewelry, rings and bracelets inset with stones, to more personal, three-dimensional forms. About his own development as an artist, Lechtzin wrote:

I have gone from a student, working to achieve an identity, to an individual with a strong commitment to a medium, and to what I hope is a rather personal language.

In the pieces of the early and mid-sixties, I employed conventional techniques in what I consider to be an attempt at creating beautiful objects for personal adornment. Early in 1964, I became deeply involved with the electroforming process, and it has led me to pursue a far more personal direction. I am now concerned with the statement that jewelry form makes when viewed in isolation. (Philadelphia, Tyler School of Art, Temple University, *The Tyler Years/ Lechtzin Staffel Viesulas,* April 24—May 20, 1973, n.p.)

614

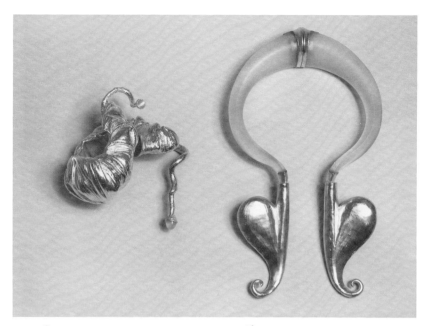

518a. 518b.

518a. *Bracelet*

1971
Mark: */STERLING/LECHTZIN (impressed in seal on back)
Electroformed silver gilt and moonstones
5½ x 5 x 4¼″ (14 x 12.7 x 10.8 cm)
Helen Drutt Gallery, Philadelphia

518b. *Torque*

1972
Mark: LECHTZIN/STERLING
Electroformed silver gilt with white opaque polyester
12⅛ x 7 x 1⅞″ (30.8 x 17.8 x 4.8 cm)
Philadelphia Museum of Art. Given by the Friends of the Philadelphia Museum of Art. 73–94–7

LECHTZIN'S FORMS in jewelry have been made possible by the technique of electroforming, a method of producing metallic objects on a matrix or master form which is then removed, leaving a shell of metal. Lechtzin explained his interest in this technique:

Ten years ago, I reached the point in my work where the structures I wished to create were no longer possible within the realm of traditional tools and techniques; I therefore began to explore the possibilities presented by our contemporary industrial technology. I found it possible, using the electroforming process, to develop relatively large scale, yet lightweight objects. In providing answers to immediate problems, electroforming has also opened form and structural possibilities which I would not have predicted before beginning my work in this technique. (London, Goldsmiths' Hall, *Stanley Lechtzin, Philadelphia Jeweller, Master of Electroforming*, February 7–20, 1973, n.p.)

The bracelet, which combines the silver gilt metal with moonstones, shows Lechtzin's development from the simple organic forms to more complex baroque forms, which are also more naturalistic:

I attempt to create personal values with materials and processes which today are used in a mechanical and anonymous manner by industry. The control which I exercise over the metal as it grows in the electrolytic solution is a source of stimulation. This process is analogous to numerous growth processes observed in nature, and this has considerable meaning for me. It brings to mind crystal growth, the growth of coral under the sea, and the multiplication of simple organisms as observed under the microscope. In this, I experience a relationship between technology and nature. (Lechtzin, *Philadelphia Jeweller,* cited above)

In the torque, Lechtzin has combined the electroformed silver gilt with plastic—another industrial material: "Recently, I have been attracted to plastics for their rich colours and marvellous transparencies. Here again, I enjoy utilizing in an intuitive manner a material which was developed for technological needs" (Lechtzin, *Philadelphia Jeweller,* cited above).

Using industrial technology, Lechtzin has succeeded in creating forms not possible with traditional tools and techniques. Yet his work is firmly within the craft tradition.
DH □

THOMAS LANDON DAVIES (B. 1943)

Thomas Davies was born on September 15, 1943, and received a bachelor's degree in psychology from Lake Forest College in Illinois in 1965. During the last three years of his undergraduate studies he worked as a real estate photographer. In 1966, Davies entered the Philadelphia College of Art, studying photography there and working at the same time as a free-lance photographer. That summer he attended the Ansel Adams Workshop in Yosemite. Following three years of service in the United States Navy, from 1966–69, Davies returned to the Philadelphia area to work as a free-lance photographer. In 1971 he co-founded The Photography Place, a gallery and workshop in Berwyn, Pennsylvania. He is active as a teacher of photography at the Photography Place, at Rosemont College, Rosemont, Pennsylvania, and at the University of Delaware, where he is working on a master's degree in photographic education.

His work has been published in *Camera* (August 1971; October 1972) and by the National Geographic Society (*Crafts in America,* 1975). He has exhibited in one-man shows in Philadelphia (1966 and 1974), at Ripon College (1969), and at Lake Forest College (1970), and in group exhibitions here and abroad (Friends of Photography, Carmel, California, 1970; Photokina, Cologne, West Germany, 1972; Rosemont College, 1973; Photogalerie die Brücke, Vienna, 1973; and Artfair 1973, Basel, Switzerland).

519. *Hebrides Cow*

1972
Signature: Thomas L. Davies (in ink, on mat, on reverse, lower right)
Inscription: Hebrides Cow/1972 (in ink, on mat, on reverse, lower right)
Gold-toned silver print
7 x 7″ (17.8 x 17.8 cm)
Thomas L. Davies, Berwyn, Pennsylvania

THOMAS DAVIES'S *Hebrides Cow* is a photograph highly informed by traditional pictorial photography. In its subject matter and its picturesque sentimentality it is reminiscent of Gertrude Käsebier's *Pastoral*

519.

(*Camera Work*, no. 10, 1905, pl. 6). The color of the gold-toned image recalls the tones of the pigment prints produced by the pictorialists of the Photo-Secession, or the rich browns of an albumen print. If the subject matter and print color are nostalgic, the photograph also conforms to the standards of "purism"—textures and forms are sharply seen, and defined with the precision only possible in a contact print from a large-format negative. The composition here has been tightened by cropping the negative during the printing.

The photograph represents a kind of neopictorial image combining aspects of two aesthetically significant trends in artistic photography to produce a satisfying and charming image. This kind of photograph differs from Davies's published pictures, which are sequences comprising fragments of a scene, each segment a separate image, but all printed consecutively on a single sheet of paper to produce a composite picture where the whole is literally made up of its parts. *Hebrides Cow* represents a return to the more traditional vocabulary of photographic presentation.

WS □

LAURENCE BACH (B. 1947)

Laurence Bach is a native Philadelphian, born in 1947. He attended the Philadelphia College of Art, where he studied with Ray Metzker, receiving a bachelor's degree in photography in 1969. Bach spent the following year at the Allgemeine Gewerbschule in Basel, Switzerland, studying graphic design and photography in the Bauhaus tradition. In addition to free-lance work, Bach has been active as a teacher at the Aegean School of Fine Arts, Paros, Greece (1970–72), at Moore College of Art in Philadelphia (1970–72), and at the Philadelphia College of Art, where he taught in the Graphic Design Department (1972–75). He now teaches at the State University of New York at Purchase. His photographs have been shown in exhibitions in this country and in Switzerland and his work has been published in *Camera* (1971), the *Time-Life Library of Photography: Art of Photography* (1971) and *Frontiers of Photography* (1972), and in the *Typographische Monatsblätter* (1974).

520. *Untitled (Sequence)*

1973
Silver print
28⅞ x 19⅞" (73.4 x 50.6 cm)
Laurence Bach, Philadelphia

LAURENCE BACH's untitled multiple image reflects the strong influence of his studies of graphic design at the school for design in Basel, Switzerland. Bach has said that he went to Basel to learn an additional tool, design, and the discipline of the Bauhaus. He produces one multiple a year; each is unique. Each represents the documentation of an investigation of a traditional photographic problem—the effects of variation in exposure, of variations in background, of solarization, of tonal alterations from black to white, of increasing abstraction of the subject, etc.—and each is meant to be read as a document, sequentially from left to right, top to bottom. The multiples should be viewed frame by frame because each investigation is carried out step by step with empirical precision, and each frame is the direct product of one stage of the investigation. But each multiple can also be viewed as a whole, articulated by the repetition of forms and patterns, or by the networks and rhythms of parallel lines.

The multiples are carefully designed; Bach works from drawings and sculptures to organize the final photographic image. In this multiple of 1973 he combines graphic investigation—parallel black lines broken at intervals—with a photographic investigation of a leaf (abstracted by being painted white), sequentially exposing the image frames to decreasing amounts of white light until the final frame is blank. The graphic and photographic elements are meticulously assembled and structurally related by their parallel linear patterns. The whole composition is then photographed frame by frame, printed as contact strips, and assembled. The final image is purely photographic. Bach's photography represents a highly intellectualized, formalized approach to the medium that combines mastery of the photographic process with the strict discipline of design. (For information on Bach, see *Camera*, February 1971, pp. 38, 42; *Time-Life Library of Photography: Frontiers of Photography*, 1972; "Photographic Concepts," *TM/Communication*, no. 10, 1974).

WS □

PAULA COLTON WINOKUR (B. 1935)

A graduate of the Tyler School of Art, Paula Winokur has taught ceramics at Beaver College in Glenside, Pennsylvania, since 1973. Her Russian father had immigrated to this country at the age of seventeen and her mother was born in Philadelphia. As a child, Paula Winokur attended art classes on Saturday mornings at the Fleischer Art Memorial, the Philadelphia College of Art, and at the Philadelphia Museum of Art's summer program, where she took her first course working in clay. The Museum's Johnson Collection was always a favorite of

520.

purely functional vessels, many of which were specifically garden pieces, such as the birdbath acquired by the Philadelphia Museum of Art in 1970, one of a series done between 1968 and 1972. These unglazed clay pieces are closely related to nature in their use of clay in a natural state and with dull rather than shiny surfaces. These objects convey the mystical quality of her experience with nature.

About 1970, Paula Winokur began to work in porcelain rather than pottery. This period also marked a change toward making more sculptural objects, such as the Ophelia box series, begun in 1973.

521. *Ophelia Box*

1973
Signature: Winokur (scratched in clay on bottom)
Porcelain; copper and cobalt sulphates; celadon glaze; lusters
5 x 12 x 11″ (12.7 x 30.5 x 28 cm)
Dr. Stanley W. Roman, New York

LITERATURE: New York, The Museum of Contemporary Crafts of the American Crafts Council, *Baroque '74* (January 18—March 17, 1974), no. B29 (illus.)

THE INSPIRATION for this baroque creation was a dream the artist had of a lavish palace whose interior was crowded with gilt furnishings and lace. The Ophelia image, perhaps seen underwater, is reminiscent of paintings by John Everett Millais and other pre-Raphaelites. This box reflects the artist's background in painting, and the surface of the box has a painterly, two-dimensional quality.

This part of the Ophelia box series demonstrates Winokur's fascination with the rich decoration of past historical styles—Art Nouveau, in the head of Ophelia with inter-

hers and has provided inspiration over many years.

At the Tyler School of Art, she majored in painting and ceramics. There she had classes with Rudolph Staffel who taught her the craft of pottery and allowed her the freedom to explore on her own, a circumstance she felt to be unusual in art school where a rigid academy-like curriculum usually prevailed. After graduating in 1958, she spent a summer in graduate school at the New York State College of Ceramics at Alfred, New York. From 1960 to 1963, she taught arts and crafts at the Denton Preparatory School in Denton, Texas, near Dallas. During the following two years, she owned and operated the Cape Street Pottery in Ashfield, Massachusetts, in partnership with her husband, the ceramicist Robert Winokur (see biography preceding no. 540). In addition, she has been a guest instructor at the Philadelphia College of Art and the Moore College of Art, and has taught numerous workshops

at colleges and art centers on the East Coast. Since 1967, she has operated a studio in Horsham, Pennsylvania.

Paula Winokur's work has been included in numerous exhibitions, including *Young Americans* at the Museum of Contemporary Crafts in New York in 1958 and 1962; *Craftsmen U.S.A. '66* at the Museum of Contemporary Crafts; as well as *Ceramics International '73* (a juried show where she won an award); *Baroque '74* at the Museum of Contemporary Crafts; and the *Container* show, a National Ceramic Invitational at the Tyler School of Art in 1975. Photographs of her work have been published in several books dealing with ceramics, including *New Ceramics* by Eileen Lowenstein and Emanuel Cooper (1974). From 1972 to 1975, she was elected Pennsylvania state representative to the American Crafts Council, Northeast Regional Assembly.

Winokur's work of the 1960s consisted of

521.

twining hair and floral band, Victorian in the impressed lace, and Oriental, in the celadon glaze. (The celadon glaze of a pale-green color was used in Chinese porcelain.)

Winokur is fascinated by rich surface decoration seen in the lace, whose intricate, delicate patterns are impressed in the clay. The box was constructed with slabs of clay, the image press molded, modeled, and then applied. After bisque firing the piece was glazed and fired again to 2,300° F. in a gas kiln. The lustered areas of heightened colors were produced in a low temperature third firing in an electric kiln.

Paula Winokur's *Ophelia* series represents a very personal statement—distinctive in its combination of elements from the past and from her own experience. Her sculptural boxes are still functional, but designed for a special use, such as for important or extravagant jewels.

DH □

MARTHA MAYER ERLEBACHER (B. 1937)

Born in Jersey City, New Jersey, Martha Mayer attended high schools in Fort Lee and West Orange before entering Gettysburg College in Pennsylvania in the fall of 1955. After one year she transferred to Pratt Institute in New York with the aim of becoming an interior designer. The only woman in an industrial design class, she was challenged by the difficulty of conceiving objects that would be both functional and beautiful. Gradually drawn toward painting, she at first had relatively little contact with students and teachers in the fine arts program. The artists Nancy Grossman and Pat Steir were undergraduates at Pratt during the same period, but Martha Mayer saw their involvement with aesthetic problems and introspection as remote from her own determination to acquire technical knowledge and skills. Graduating in 1960 with a bachelor's degree in industrial design, she went on to obtain her master's degree (1963) in the department of fine arts. Studying with the painter Robert Richenburg, she was impressed by his frequent advice to his students to eliminate from their work any false elements or ideas. Her own paintings of the late 1950s were Abstract Expressionist in feeling, but during 1960–61 she became increasingly interested in Gestalt theory, and her work began to deal with optical and perceptual phenomena. Beginning in 1957 she worked as a free-lance industrial designer, and in 1960 she prepared an exhibition *Perception and Visual Expression* for Pratt Institute. In 1961 she married the sculptor Walter Erlebacher (see biography preceding no. 503) who was on the faculty of Pratt, and their shared aesthetic aims and interests have

had considerable effect on their individual development as artists. Between 1962 and 1966, she taught a variety of courses in painting, graphic arts, and industrial design at the School Art League, Pratt Institute, and Parsons School of Design.

During the early 1960s, Martha Erlebacher produced an extended series of severely symmetrical abstract paintings in strong contrasting colors (often silver-blue and orange) in which she explored two-dimensional design in terms of the picture plane. Gradually introducing an illusion of space and depth behind that plane by using a screen of brightly colored dots which appeared to remain on the picture surface, she began also to use recognizable elements of the human figure subject to the same formal rules applied in the nonfigurative works. In 1963–64 she painted a group of Cézannesque still lifes (a subject she continues to pursue); and in 1964 the use of a model for a small painting of a head marked a definite break from the systematized abstraction of the previous work. Interested in pursuing the human figure as a subject and determined to learn its structure, she began to draw from life as frequently as possible. She joined her husband Walter Erlebacher in a thorough course in anatomy which they devised for themselves during 1964–65.

The intellectual, structured nature of her work has persisted in her figurative paintings, which are based on careful systems of proportion and perspective. Although her earliest efforts in the new mode, such as a large painting of 1965 depicting nude women on a beach (in the artist's collection), had no particular content or theme, over the last decade she has been increasingly concerned with the meaning conveyed by her precisely drawn and painted figures. *Seated Figure* of 1970, depicting a monumental nude woman with flowing hair enthroned in a generalized landscape, suggests a theme of primeval goddess or earth mother (one of the artist's favorite sources is Robert Graves's classic study *The White Goddess*). *Apollo* of 1971 embodies her vision of the Apollonian ideal in the form of a blond youth who assumes an uncharacteristic, questioning stance. Perhaps her most ambitious allegory to date is the large *In Praise of the Earth* (1972, Pennsylvania State University). Six sleeping nudes (three men and three women) recline amidst exquisitely painted grass and flowers, and while their disposition across the picture surface recalls the arrangement of symbolic sleeping figures in Ferdinand Hodler's allegory of *Night* (1890, Kunstmuseum, Bern), Erlebacher's painstaking delineation of detail has antecedents in the more distant past in the work of Albrecht Dürer and Lucas Cranach. The composition is subdivided into areas determined by the use of

522.

the Golden Section, a device she employs frequently. Despite their emphatic realism, Erlebacher's paintings of the last five years have not been executed directly from the model but constructed with the aid of elaborately studied drawings of drapery and the figure. She works on each canvas over a period of months (occasionally for more than a year) in a manner reminiscent of fifteenth century tempera technique. First drawing the entire composition with India ink in fine detail on the white ground, she then builds up the flesh tones and adds color to drapery and background, shifting the balance of light and dark at will as she works.

After moving to Philadelphia in 1966, Erlebacher continued her teaching career with a course in two-dimensional design (1966–68) at the Philadelphia College of Art. In 1967 her first one-woman exhibition was held at the Other Gallery in Philadelphia, and her work has been included in a variety of shows devoted to aspects of realism: *Contemporary Figure Painting* (1971) at the Suffolk Museum in Suffolk, Long Island; *Realism Now* (1972) at the New York Cultural Center; *Living American Artists and the Figure* (1974) at Pennsylvania State University; and *The Nude in American Art* (1975) at the New York Cultural Center. Her most recent one-woman shows were held at the Robert

Schoelkopf Gallery in New York in 1973 and 1975.

Since 1973 she has also been involved in printmaking. A recent series of lithographs presents an unusual, ritualistic version of the still life theme: rows of bananas, apples, or eggs arranged in formal patterns on a white cloth. Martha Erlebacher's elaborate technique, combined with her concern to convey specific metaphysical meaning within the framework of a figural composition, gives her work a curiously impressive historicizing appearance that sets it apart from that of other contemporary realists interested in narrative or emblematic painting (such as Larry Day, Sidney Tillim, or Lennart Anderson). She is conscious of having to avoid the appearance of Surrealism, and her recent work has included a series of small, straightforward portraits as well as larger, symbolic pictures like the diptych *Adam and Eve,* which she describes as an allegory of the death of nature and anxiety over the loss of faith. Preoccupied with the desire to paint the fundamental matters all human beings must confront (despair, old age, love, the passing of time), she is one of a small but growing number of artists seeking to restore the iconographic and literary basis of the visual arts.

522. *Hawkweed and Pinecone*

1973
Signature: M. Mayer Erlebacher (lower right)
Inscription: June 1973 (lower left)
Watercolor on paper
22 x 13″ (55.9 x 33 cm)
Provident National Bank Collection, Philadelphia

PROVENANCE: With Robert Schoelkopf Gallery, New York; purchased by the present owner, 1975
LITERATURE: New York, Robert Schoelkopf Gallery, *Martha Mayer Erlebacher* (April 29— May 30, 1975), no. 22

MARTHA ERLEBACHER's large figurative paintings are the result of a complex process in which elements carefully studied from life are placed within a highly organized pictorial structure. The proportions of the human figures, their poses, and their positions relative to each other and to the edge of the canvas are determined by conceptual systems such as the repeated use of the Golden Section. Details of anatomy, clothing, and still life elements, however, are derived from drawings and watercolors of live models, draped fabric, and objects arranged in the studio. Since the mid-1960s,

Erlebacher's interest in intensely observed depictions of nature has paralleled the evolution of her metaphysical compositions, in which detailed landscape backgrounds have increasingly tended to replace generalized architectural settings.

Hawkweed and Pinecone is one of a number of plant studies she has created over the last five years and reveals her love of specific and fine detail (she once gave a class the assignment of drawing a clump of grass, blade by blade). She spotted this particular cluster of leaves and delicate flowers in a field during a visit to the art colony at Yaddo (Saratoga Springs, New York) in the summer of 1973, carrying it back to the studio since mosquitoes made it difficult to work outdoors for any length of time. Watering the hawkweed faithfully, she preserved it for several days while she completed her watercolor. Later that winter, she decided to incorporate the image into a painting entitled *Embrace II.* Apropos of her working method, Erlebacher has remarked: "It's rare that I make a specific study of a plant for a specific spot in a picture. I start by collecting flora at random and put (or rather plant) them here and there. The hawkweed was fine for a vertical element at that spot, the edge of a vertically oriented rectangle of the golden section" (letter to the author, September 25, 1975). *Embrace II* is Erlebacher's second version of a theme that might be paraphrased as the sensuous delights of love. The painting, completed in 1974, represents a pair of nude lovers reclining on a broad sweep of white drapery, spread across a rocky landscape. Their figures form a strong diagonal axis from the lower left to the upper right of the painting. The upper lefthand section of the picture contains an elaborate still life arrangement, while the lower righthand corner is occupied by the quiet water of a shallow pond. The slender hawkweed plant grows beside the pond; it was transferred from this watercolor to the canvas with the same meticulous care used to transfer the living plant from field to studio.

Martha Erlebacher's mode of figurative art is markedly different in kind from other varieties of realism which flourish in the Philadelphia area. Her exquisitely delineated plants and human figures are not presented for their sensuous or emotional appeal but as composite parts of a conceptual whole. Sidney Goodman may construct a painting out of separate elements of observed reality (see no. 517), but the finished picture has the ambiance and elusive atmosphere of real life. Andrew Wyeth's *Ground Hog Day* (no. 490) is also the product of numerous studies and meticulous draftsmanship, but it is resonant with the memories and moods generated by a specific place. Erlebacher's lovers embrace in a platonic world of

archetypes, and the hawkweed growing at their feet is a paradigm of flowering plants. Extracted from the confusing welter of natural phenomena in which it exists, and presented in pristine isolation, *Hawkweed and Pinecone* is closer in artistic intent to Albrecht Dürer's watercolor studies of plants and animals than to Wyeth's *Quaker Ladies* (no. 487). Wyeth's watercolor calls the senses into play: one recalls the scent of damp soil and the rustle of spring wind. The microscopic realism of *Hawkweed and Pinecone* conveys the idea of a plant rather than its physical presence. The viewer is free to enjoy the watercolor in itself as a tour de force of draftsmanship, but its presence in the *Embrace* painting leads us back to Erlebacher's aim of investing representational art in the twentieth century with the formal structure and intellectual content characteristic of art of the Renaissance.

Ad'H □

CHARLES C. FAHLEN (B. 1939)

Born in San Francisco, Fahlen is the son of a doctor whose father, Frederick Fahlen, was also a doctor as well as a painter of the landscape of the Southwest. His childhood in California, to which he frequently returns with his family for summer visits, contributed to his interest in the out-of-doors, animals, and natural materials, and his familiarity with the art and artifacts of the American Indians. In 1962, Fahlen received a B.A. degree from California State University at San Francisco, where the faculty member who most affected his work was Seymour Locks. From 1962 to 1965 he studied at the Otis Art Institute in Los Angeles. He remembers the sculptor Rico Lebrun (1900–1964) as exerting the strongest influence on the students at Otis at that time. Interested in sculpture and printmaking rather than painting from the first, Fahlen made a series of small bronze objects (animals, figures) just prior to and after graduating from Otis. During the next two years he was much preoccupied with the procedures of printmaking.

In 1965–66 he spent a year in Europe on an Elsie DeWolf Foundation Travelling Fellowship. Working briefly in the Paris studio for etching and intaglio (Atelier 17) of Stanley William Hayter, he then attended the Jan Van Eyck Academie in Maastricht, Holland. One-man exhibitions of his prints were held in Copenhagen and Maastricht in 1966 and 1967, and during the academic year 1966–67 he studied at the Slade School in London on a Fulbright Grant. Returning to the United States, he joined the faculty of Moore College of Art in Philadelphia as a printmaker in 1968, and has continued to teach at Moore (now in the painting and

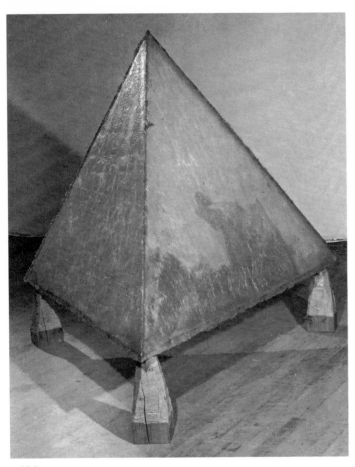

523.

of Contemporary Art included his work in the exhibitions *Grids* (1972) and *Made in Philadelphia 2* (1974). A one-man show at the Henri 2 Gallery in Washington, D.C., in 1974 was followed by another at the Stefanotty Gallery in New York in the spring of 1975, and ten pieces were included in the biennial American exhibition at the Art Institute of Chicago in the summer of 1974. Although much of Fahlen's sculpture continues to be hung on the wall, he has to date made two large-scale outdoor pieces: a work commissioned for a spectacular site in Phoenix, Arizona, and a two-part sculpture in which a low curved wall supports a flexible grid of aluminum rods, installed during the summer of 1975 on the grounds of the Merriewold West Gallery in Far Hills, New Jersey.

523. *Untitled (Sculpture)*

1973
Signature: C Fahlen/73 (on one post)
Wood, fiber glass, and resin
67 x 59 x 59″ (170.1 x 149.8 x 149.8 cm)
Charles C. Fahlen, Philadelphia

LITERATURE: Philadelphia, Institute of Contemporary Art, *Made in Philadelphia 2* (October 25—December 14, 1974), n.p. (illus.); Susan Heinemann, "Reviews," *Artforum,* vol. 13, no. 5 (January 1975), p. 67; Gregory Battcock, "Assailing Technology," *Domus,* no. 550 (September 1975), illus. p. 53

FAHLEN HAS DIVIDED his concern for making sculpture into three "territories" (statement for pamphlet-catalogue of exhibition at the Peale House Galleries, March 29—May 6, 1973):

1. Object as a fantasy
2. Object in the process of making, manufacturing
3. Object as an entity speaking of its own presence independent of my personality.

In the same statement, he goes on to list a rich variety of sources for his fantasies:

. . . crab traps, tinker toys, Woolworths, unfinished furniture, Creative Playthings, Barbarella, how to do it books, pictures of samples and examples, displays, hogans, the Monitor and the Merrimac, tract houses, primitive weapons, color reproductions in the newspaper, wood engravings, artifacts dug up from the earth or covered with vines, and trophies . . . they [his fantasies] are bound by things I would like to buy but can't find, so I build them myself, things that are clumsy and elegant, passive but with a potential for action, have outsides or fronts that don't reveal insides or backs, vulnerable and

sculpture departments as well) and live in Philadelphia since that date.

The evolution of Fahlen's work has followed a gradual, consistent course from the flat transparent plexiglas wall pieces of 1968 which utilized simplified and brightly colored shapes derived from animal imagery to his most recent large sculptures in metal, wood, resin, and papier-mâché which make no overt reference to forms or images beyond themselves. Around the time of the inclusion of a number of his plexiglas works in the 1968 exhibition *Beyond Literalism* at Moore College, he began to work increasingly with materials like vinyl and felt, creating folded, looped, or wrapped forms which could be hung on the wall. Animal imagery disappeared except in his prints (although the felt and leather which Fahlen uses might be read as references to fur and hide). In January 1971, the Feigen Gallery gave Fahlen his first one-man show in New York—entitled *Trophies, Examples and a Plastic Animal Collection*—which included several floor sculptures made of leather, felt, and linoleum. During 1971–72 his works increased in size and were often free-standing structures, with rectilinear wooden frameworks supporting canvas, leather, resin, or latex.

A group of seventeen sculptures, together with prints and drawings, was shown at the Peale House Galleries of the Pennsylvania Academy in the spring of 1973, and that same year a wood, resin, and latex table-like sculpture was chosen for the annual exhibition at the Whitney Museum of American Art.

During the summer of 1973 on a visit to San Francisco, Fahlen began to produce a number of small sculptures which he titled the *Wawona Series,* after a square mile of homesteaded land in northern California. Employing a wide variety of materials, sometimes gaily colored, these pieces suggest sacred or totemic objects. (Three pieces of the series are in the collection of the Philadelphia Museum of Art.) Fahlen's most recent work has seemed to take an increasingly austere and formal direction, utilizing simpler shapes (triangles, circles, grids) and less overtly organic materials. Nevertheless, the work resists any tendency toward abstraction, and the artist plans to return to more direct use of animal images in future pieces.

His sculpture and prints have had considerable exposure in Philadelphia, first at the Vanderlip Gallery, and more recently at the Marian Locks Gallery, while the Institute

impregnable, comic and serious, relate to the body as furniture in size and weight, that contain and that have a life span.

More terse remarks produced for the catalogue of *Made in Philadelphia 2* (Institute of Contemporary Art, October 25–December 14, 1974, n.p.) describe his working process:

> The problem is to build up from a floor or to build out from a wall or sometimes to build down to a floor or back to a wall . . .
>
> To extract powers of weight, light, shadow and surface from anonymous materials. It is important to use local resources for building and to appropriate, improvise and assemble parts to fit an imagined work.
>
> For example the way a stone is found for a tool or a hide for a shelter or shells for a mask or a stick for a weapon.

Like a number of artists during the past decade, Fahlen is preoccupied with the specific properties of the materials ("local resources") he uses, materials heretofore not readily associated with the making of art. One thinks, for example, of the large felt pieces by Robert Morris or the rubber, wire, and fiber glass works of the late Eva Hesse, both artists whom Fahlen admires. Fahlen's sculptures also convey a sense of purpose in their construction, a mixture of practicality and hidden, symbolic content (fantasy) which endows their potentially abstract forms with elusive meaning. This pyramid raised on three stout wooden legs suggests some particular use (perhaps as a dwelling, perhaps as a monument) but ultimately resists interpretation as anything but art. Unlike the more literary and folksy constructions and hangings of William T. Wiley or the sculptures of Claes Oldenburg (for whose work he also acknowledges an affinity), Fahlen's pieces avoid direct reference to the fantasies which inspire them. As his 1974 statement reveals, much of his attention focuses on the task of choosing materials and actually constructing the work. This untitled pyramid, like most of his objects, was first conceived in a drawing. The sides of the pyramid were made by coating three triangular pieces of fiber glass matting with polyester resin, and the resin also serves as the adhesive joining the three sides in a hollow form. The irregular, wrinkled surface of the pyramid (reminiscent of the rough hide of an animal) is the result of casting the triangular sides against sheets of polyethylene which were later removed. The three supporting posts have been tapered by rough carving, and wooden dowels pass from the posts through pieces of Masonite which reinforce the three corners of the pyramid. The slightly pinkish coloration of the surface is due to the natural hue of the resin, and the material is translucent, permitting a variety of effects depending on the source and direction of the light in the room where the sculpture is placed. A summary of Fahlen's procedure in making his pyramid does not, however, account for its mysterious and imposing presence. Since the artist's fantasy from which the work sprang is concealed within the sculpture itself, it summons up a corresponding fantasy, childhood memory, or associative image within each viewer.

Ad'H □

JAMES HAVARD (B. 1937)

Born in Galveston, Texas, Havard spent his early childhood moving from town to town across the state as his father found work at one oil field after another. Both his parents were partly of American Indian descent, an element in his background of continuing importance to him. When Havard was six or seven, the family settled in Crosby, outside Houston, and he remembers being constantly called upon to do the drawing and art work for class publications and projects at the local school. Entering Sam Houston State College in Huntsville, Texas, on a baseball scholarship, he majored in agriculture before deciding to take up art as a career. His early paintings were Abstract Expressionist in feeling, and he was impressed by the painterly, figurative work of Willem de Kooning and Francis Bacon. He graduated from college in 1959 and took a job with the Collins radio company in Dallas as a mechanical draftsman for electronic equipment, making isometric studies and airbrush drawings. During the two years he spent in Dallas, Havard attended evening classes in drawing at the Atelier Chapman Kelley, and Kelley encouraged him to enroll in the Pennsylvania Academy.

Moving to Philadelphia in 1960, Havard studied for five years at the Academy where his teachers included Franklin Watkins, Hobson Pittman, and Ben Kamihira. The latter two exerted considerable influence upon his student work, which was figurative. He won a series of student awards at the Academy, and in 1964 a Cresson Travelling Scholarship sent him on a trip across Europe, visiting museums and painting for two months in Spain. He spent three months in London the following year on a Scheidt Fellowship from the Academy.

In 1965, Havard's first one-man exhibition was held at the Chapman Kelley Gallery in Dallas, and his entry in a large regional exhibition sponsored by the Drawing Society at the Philadelphia Museum of Art received the first purchase prize. His painting at this time incorporated lettering and symbols (such as directional arrows) into frequently humorous compositions, and he began to experiment in printmaking by cutting designs into sheets of plexiglas. His prints won prizes at two juried exhibitions at the Philadelphia Print Club in 1967. In the same year a one-man show of paintings, drawings, and prints at the Vanderlip Gallery in Philadelphia was primarily devoted to the theme of Crayola crayons (a crayon floating in the sky, a close-up view of a crayon box).

Over the next few years, Havard's interest in somewhat Pop imagery was gradually displaced by his increasing involvement with techniques of painting, particularly in the use of the airbrush. For a period he used flocking to alter the surface texture in areas of the paintings, but as his work became increasingly lyrical in color he abandoned that rather "funky" material. By 1968 his canvases were sprayed with the undulating wavelike patterns which still recur in his work at intervals. During the late 1960s, Havard's studio was located over an automobile body shop, and he was attracted to the high, glossy finish and luscious, pearlescent colors used on the cars. He began to make free-standing sculpture and hanging wall pieces out of wood, coated with layers of paint and lacquered to a sleek surface. In a sequence of one-man shows in 1970 (at the Chapman Kelley Gallery, Marian Locks Gallery in Philadelphia, and Henri Gallery in Washington, D.C.) he exhibited the sculpture and abstract paintings executed on vacuum-formed plexiglas. Another exhibition at the O. K. Harris Gallery in New York in 1971 preceded a year's stay in France where he again worked (with the same pale and pearlescent colors) on canvas. Returning from Paris in 1973, he stopped in Germany where a show at the Reckerman Gallery in Cologne became the first of a series of recent gallery exhibitions in European cities: Copenhagen (1974), Lund and Göteborg (1974), and Stockholm (1975).

Since 1973, Havard has concentrated on paintings and large acrylic drawings on paper, and the evolution of his style has gathered momentum in the direction of abstraction modified by startling effects of trompe l'oeil. His work is in the collection of a number of museums, including the Pennsylvania Academy, the National Collection of Fine Arts in Washington, D.C., and the Moderna Museet, Stockholm. Exhibitions in Philadelphia (at Marian Locks Gallery in 1973 and 1975) and in New York (at Gimpel & Weitzenhoffer in 1973 and Louis Meisel Gallery in 1975) have gained him an increasing reputation. Critics find it puzzling to define Havard's work in terms of any specific contemporary movement such as "lyrical abstraction," a term which might serve to describe the color of his recent paintings without taking account of their increasing tendency toward witty illusionism.

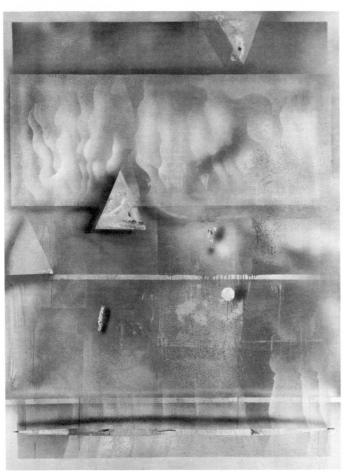

524.

canvases, producing graffiti-like scrawls or more specific symbols, and the paintings read like cryptograms containing hidden messages. *Drink the Juice of the Stone* is perhaps less deliberately witty and assured than the more recent work, and its luminous tones of violet and mauve are more somber than Havard's newer palette of bright pastel "Easter egg" colors. It remains a satisfyingly complex and thoughtful painting which involves the viewer in an intricate perceptual game.

As in the case of many of his works, the title is derived from American Indian culture, and the allusive forms of the triangle (tepee) and the tapered horizontal bar (bow) appear frequently in later paintings. The practice of trompe l'oeil painting in Philadelphia reaches back to the Peale family (nos. 137 and 214) and the astonishing still lifes of Harnett and Peto (nos. 353, 359). Havard's picture provides a curious twist to that tradition, rendering a convincing illusion of light and shadow, space and solid form, with abstract means.

Ad'H □

WARREN ROHRER (B. 1927)

Rohrer has always painted the landscape in which he lives. Born in Lancaster County, Pennsylvania, and descended from generations of Pennsylvania farming families through both parents, he now maintains his home and studio near the small village of Christiana, some fifty-five miles west of Philadelphia.

Receiving his B.A. degree from Eastern Mennonite College in 1950, Rohrer went on to study painting with Hobson Pittman at Pennsylvania State University in the summers between 1952 and 1955. During that time he attended night classes in drawing at the Pennsylvania Academy of the Fine Arts (1953–54) and took courses in art history at the University of Pennsylvania. Living in Philadelphia from 1953 to 1961, he taught in the public schools while commencing his career as a painter. From the first, his work focused on the myriad, often unassuming aspects of nature in an agricultural mode rather than on what he calls "the grand landscape." "My earliest paintings of the fifties were involved with looking into small streams which flowed under bridges, through pastures and fields" (letter to the author, September 11, 1975). The work of this period was richly painted, with bright, deep colors and often heavily impastoed. In 1955 a painting entitled *Under the Bridge* was included in the Pittsburgh international exhibition at the Carnegie Institute, and from that time on Rohrer's work has been shown in exhibitions across the country and frequently in the Philadelphia area. His

524. *Drink the Juice of the Stone*

1973
Acrylic on canvas
96 x 72″ (243.8 x 182.8 cm)
Philadelphia Museum of Art. Given by the Cheltenham Art Centre, by exchange, and purchase: Philadelphia Foundation Fund. 73-133-1

PROVENANCE: With Marian Locks Gallery, Philadelphia

LITERATURE: Nessa Forman, "His Work Toasts the Land's Warmth," *The Sunday Bulletin*, April 29, 1973; Philadelphia, Moore College of Art, *PMA at MCA, An Exhibition of Works by Contemporary Artists, Selected from the Collection of the Philadelphia Museum of Art* (October 16—November 21, 1975), n.p.

THIS LARGE, MYSTERIOUS PAINTING was the product of several months' work and represents the start of a new direction in Havard's art. The repetitive, wavering forms which were the fundamental element of his earlier sprayed drawings and paintings on plexiglas are still present, but they have receded to

form a backdrop for the interplay of bright pigment and specific shapes across the canvas surface. Although the picture is essentially abstract, it might be said to take the process of painting itself as its subject. Havard is an admirer of Hans Hofmann, and the latter's great paintings of the late 1950s and early 1960s, in which thickly painted planes of brilliant color are juxtaposed in space, suggest one powerful antecedent for Havard's recent explorations. In *Drink the Juice of the Stone,* Havard utilizes a variety of techniques—the paint is airbrushed, dripped, sprayed, and brushed by hand— and a variety of complex spatial effects, which fool the eye repeatedly. The richly colored and impastoed areas (a triangle, a disc, an irregular blotch of paint) appear to hover like solid objects in space, casting shadows on the airbrushed surfaces behind them, which in turn dissolve into thin air.

In his subsequent paintings of 1974 and 1975, the elements which float on the surface with an even more startling degree of illusionism have tended increasingly to be organized into symmetrical compositions. Havard has also begun to draw on his

first one-man show was held at Robert Carlen's gallery in Philadelphia in 1960. Rohrer spent the following summer camping in Nova Scotia, which gave impetus to his wish to live out in the country again.

In 1961, Rohrer and his wife, Jane, moved to the farm near Christiana which has provided the source of inspiration for much of his work since that date. Commuting regularly to the city, he taught painting at the Philadelphia Museum of Art (1959–73) and, for several years, night classes at the Pennsylvania Academy. Since 1967 he has been on the faculty of the Philadelphia College of Art, and in 1975 became co-chairman of the Painting Department. Over the past decade he has had a sequence of one-man shows at the Makler Gallery (1963, 1965, 1967, 1969, and 1971). Always more concerned with the shape, rhythm, and color of landscape motifs than with precise delineation, Rohrer has moved very gradually toward abstraction. In 1969 he showed a series of cutout, plywood shapes, painted on both sides, which could stand or hang freely in space. He described them in a written statement as dealing "with the two sides of a question and with natural shapes extracted from their usual context, i.e.: Sky Shape—summer day and evening; Pond Shape—summer and winter." Turning back briefly to a more literal rendering of landscape, he spent the fall of 1971 as the Pennsylvania Academy's participant in an "Artists for Environment" program sponsored by the National Park Service at the Delaware Water Gap.

During the spring of 1972, Rohrer and his wife traveled to Europe—a trip which proved significant for his painting. After exposure to masterpieces of Renaissance painting in Italy, Rohrer was intensely struck by the landscape and light of Greece. He also had the opportunity to study the retrospective exhibitions of two major American Abstract Expressionist painters: Mark Rothko at the Musée National d'Art Moderne in Paris and Barnett Newman at the Stedelijk in Amsterdam. Returning to Philadelphia, Rohrer was more than ever convinced of his direction away from any representation of "the look of nature." Over the last four years he has explored a personal mode of restrained but painstaking abstraction in a coherent body of paintings on landscape themes. The work of Agnes Martin during the 1960s provides a distinguished example of abstract painting derived in part from a response to nature, although her work tends toward more formal severity and eschews Rohrer's rich range of color. During 1973–74, the painting *Corn: Red and Yellow* traveled in the exhibition *A Sense of Place, the Artist and the American Land* which circulated to a group of museums and art centers in the mid-West.

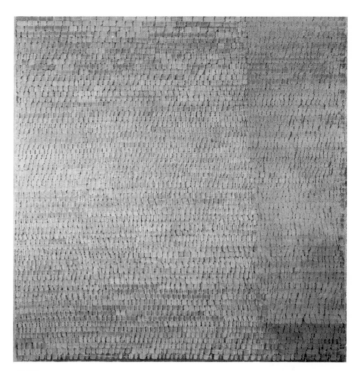

525.

Rohrer's most recent one-man show (*Morning Fogs Trees and Leaves*) was held at the Marian Locks Gallery in Philadelphia early in 1974, and in the fall of that year six paintings were included in the exhibition *Made in Philadelphia 2* at the Institute of Contemporary Art.

525. *Corn: Stubble*

1973
Signature: W. Rohrer (on reverse)
Inscription: Corn: Stubble 1973 (on reverse)
Oil on canvas
72 x 72" (182.8 x 182.8 cm)
Dr. Edward L. Hicks, Philadelphia

PROVENANCE: With Marian Locks Gallery, Philadelphia; purchased by the present owner in 1974

ROHRER'S WORK continues to approach abstraction while retaining its roots in his chosen subject matter. Many of his paintings since 1972 have dealt with the sowing of grass or rows of plants in a tilled field. The myriad, tiny units of seeds or stalks find an equivalent in the small painterly gesture (repetitive but infinitely varied) with which he covers and structures his canvases. Like other Pennsylvania artists before him, Rohrer senses a close affinity between the agricultural life and landscape and the arts and crafts produced by rural people in that

area. Charles Sheeler began to collect simple furniture and housewares in Bucks County around 1916–20; fifty years later Rohrer has become fascinated by the large blocks of color and minutely stitched patterns in Amish quilts, of which he owns several fine examples. The severe architectural forms of Bucks County barns and houses reinforced Sheeler's determination to give his paintings structural coherence (see no. 449), whereas Rohrer finds in the muted color values and painstaking stitches of his quilts corroboration of his concern for the delicately articulated surfaces of his canvases. Convinced that the art of the Amish is in part a response to the internal rhythms and patterns of farming life, Rohrer feels the same need to synthesize experience in his own work.

Corn: Stubble is neither a literal portrait of a cornfield after harvest nor a romantic "impression" of it. The visual, even tactile sensations of the cut field are translated into the process, as well as the end result, of the painting. The artist's own statement makes his intentions clear:

My work of the last few years has been involved almost exclusively with the things which I see and have known "about the farm" and I find that, increasingly, the processes of my work seem to parallel the agricultural processes. These processes of plowing, planting, cultivating, and harvesting are very similar to my processes of layering, defining, obscuring.

In particular, *Corn: Stubble* came from the experience of many fields of corn that had

been cut for "filling the silo." One evening I saw a field of stubble in rows which leaned, some to the left and some to the right due to the direction traveled by the cutting machine, moving in and out of shadow. This shift of shimmering warm glow to shadowed, cool blankness is the subject of the painting. Such shifts and drifts are common to all my work. I'm interested in the aura emanating from these shifts.

I'm fueled by the "beat" of the paint application which is almost like a sowing or chopping rhythm. It's a kind of primitive language about the nature of things. (letter to the author, September 11, 1975)

Painted in his Christiana studio during the fall of 1973, *Corn: Stubble* was included in Rohrer's one-man exhibition at the Marian Locks Gallery in 1974.

Ad'H □

LOUISE TODD COPE (B. 1930)
(See biography preceding no. 513)

526. *Walking Quilt*

1973–74
Label: LT (inside hem)
Silk; cotton; metallic novelty fabric; wool; pearls
Length 58″ (147.3 cm); width sleeve to sleeve 61½″ (156.2 cm), at waist 37¾″ (95.9 cm)

Helen Williams Drutt, Philadelphia

THE TAPESTRY ROBE *Walking Quilt* combines Louise Todd Cope's ongoing interest in clothing with her love of primary forms and direct expression. The artist has viewed clothing from different perspectives since her first experience with doll clothes: "For me, clothing has been something that I have . . . come to . . . gone away from . . . and returned to, each time seeing it differently in a new perspective." She communicates the richness of this vision with a reference to the fabric images of Franco Zefferelli, the Italian film director of *Romeo and Juliet*: "The images still remain in my inner eye . . . he clarified to me the fact that I loved fabrics, loved clothing" (Louise Todd, "Clothing," *Handweaver and Craftsman*, vol. 24, no. 4, August 1973, p. 28).

The tapestry robe is not unlike the Japanese kimono in its flexibility: it is displayed reverentially on the wall, taken down for ceremonial occasions. Its form provides the potential for a new active, multiple choice of expression. These possibilities are inherent in the design. Louise Todd Cope makes multiple sketches, constructs samples, studies their movement, and proceeds carefully through the many steps

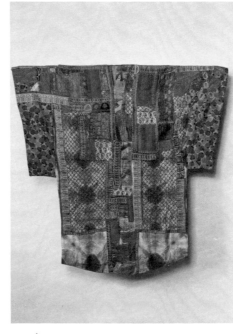

526.

of their construction. To make a conscious choice, to become a "question asker" is most important.

Walking Quilt, like all of her work, is a projection of the artist's "curiosities at the time." The robe is a pieced, appliquéd, and embroidered, tapestry-like composition of the life and memories of its owner, Helen Drutt: her mother's wedding belt, her first tie-dye fabric, pieces of the dress she wore to her sister's wedding, her grandmother's shawl. The artist's hand has "given life to a lot of things that had ceased to live" (private communication, Helen Drutt). Louise Todd Cope sorted eagerly through the fabrics to create a personal, biographical composition. Through an encounter with the past, like James Joyce's "Stephen in nighttown," a new level of reality was reached.

PC □

JOHN EDWARD DOWELL, JR. (B. 1941)

Born in Philadelphia, Dowell had his earliest art training at the School Art League classes sponsored by the city's Board of Education. He then studied printmaking and ceramics at the Tyler School of Art, Temple University, receiving his bachelor's degree in 1963. He spent a brief period at the John Herron Art Institute in Indianapolis studying advanced lithography in a Ford Foundation–sponsored training program affiliated with the Tamarind Lithography Workshop. He then became an artist-printer fellow at the Tamarind Los Angeles work-

shop for one and a half years. From 1964 to 1966, Dowell studied printmaking at the University of Washington in Seattle, and as part of the project leading to his master's degree, he spent three months as a senior-printer fellow at Tamarind. In 1965 the University of Washington awarded him a grant for research in the field of color lithography.

Dowell works in various print and drawing media, watercolor, and painting. Since 1964 his work has been exhibited extensively. He has had one-man shows at the American Pavilion at the Thirty-fifth Venice Biennale in 1970 and at the Corcoran Gallery of Art in 1971, and his work is in numerous major collections, both public and private, in the United States and Europe.

From 1966 to 1968, Dowell taught at Indiana State University in Terre Haute and then returned briefly to Philadelphia as a visiting instructor at the Tyler School of Art. He taught lithography and drawing at the University of Illinois from 1968 to 1970. In 1971 he returned to the faculty of the Tyler School of Art, spending 1971–74 at the Tyler School in Rome. He, his wife B. P. Lindley the painter, and their daughter Saskia live in Philadelphia.

527. *Make It Short*

1973–74
Printed by Paul Narkiewicz, New York
Signature: John E. Dowell, Jr. 74 (in pencil, lower right)
Inscription: Artist Proof #19 (in pencil, lower left); "MAKE IT SHORT" (in pencil, lower center)
Lithograph printed in black with hand-coloring in watercolor on Arches paper 20½ x 20¼″ (image) (52 x 51.4 cm)

Brooke Alexander, Inc., New York

Make It Short IS ONE of what will eventually be an edition of thirty-two individually and uniquely hand-colored lithographs. In each, the image from the lithograph plate, printed in black, functions as a support for the coloring. In the impressions completed to date, the subtle color variations do not substantially alter the essence of the image; each remains a white field, or surface, with various pressures and tensions established by areas of color.

Implicit in *Make It Short,* as in most of Dowell's work, are his interest in and understanding of the possibilities of order in musical composition. His own improvisations at the piano often enable him to clarify and develop ideas, and many of his prints and drawings have functioned as scores—structures of reference for improvisation by

musicians. For example, the arch which spans the upper area of *Make It Short* might be read as a sustained note as distinct from the group of marks at the lower left, which read rather as a series of staccato chords. If the printed marks denote time clues, the color denotes tone clues growing from the artist's emotional responses, and they are intended to call forth responses of a similar nature from musicians. Dowell has indicated that his initial aim is to develop visual order; and "an audio realization provides a stimulus for new work and a separate added experience." Although one does not wish to suggest a direct visual comparison, Dowell's nonobjective images and his verbalization of his concepts are theoretically related to the concerns of Kandinsky as he moved through "impressions" and "improvisations" to nonobjective "compositions."

Occasionally, Dowell's spontaneous calligraphic marks recall hieroglyphs whose explicit meanings seem lost in time. The effect of these printed notations on the field is significantly altered when color is used. In *Betty's Blues,* an uncolored lithograph of the same period as *Make It Short,* rapid, staccato notations are established by the sharp blackness of the marks against the stark white field. A lateral visual activity results. When color is employed, as in *Make It Short,* the eye, rather than jumping across the field from one mark to another, is drawn to particular color areas which are always attached to a printed mark. The color creates pressures on the surface, the degree of which is dependent upon the color or colors employed (warm or cool, dark or light), the size of the color area as it relates to other color areas as well as to the size of the sheet, and the quality of the paint and its handling (opaque or transparent, broad areas of a single color or small, variously colored marks building an area, sharply defined edges or edges which fade into the paper).

The spatial flow of the field is determined by the location of the color in relation to the marks. Of the hand-colored variations of *Make It Short,* this version is perhaps the brightest. Although none is colored so specifically that one would refer to the "red" or the "blue-gray" impression, the repetitive use of red and therefore its obvious absence in one or two small areas do establish it as a key color in this version. In places the color is essentially confined by printed edges, in others it acts to form an aggregate of printed marks, and in still others its relation to the field seems to have priority over its relation to the printed mark. *Make It Short* is a lyrical world with no visual reference outside itself. Within the world are elegantly conceived places to wander around and through. Neighborhoods of various sizes are established by proximate notations, and the specific character of the places, the neighbor-

527.

hoods, and the world is established by the color. The calligraphic structural notes seem to be located at random. For Dowell, the concept of random structure indicates unpredictable structure—order exists, but the key to its understanding may remain elusive. The title of a 1972 Dowell watercolor—*Sounds Unite White Space*—offers a telling description of his ideas as they are reflected in *Make It Short.*

RFL ☐

PHILLIPS SIMKIN (B. 1944)

Born in Philadelphia, Simkin views himself as a thorough (if unexpected) product of the city's educational system. His family is of Russian descent and his father, Meyer Simkin, was a violinist with the Philadelphia Orchestra for over forty years. Simkin attended Logan Demonstration School where, singled out by his elementary school teachers as talented in art, he took a series of special art classes. From 1958 to 1961 he attended Central High School and was one of the most recent of a long series of Philadelphia artists to graduate from that institution. In 1961 he won both the Gimbels prize in painting and the School Art League's first prize, and he entered Tyler School of Art in the autumn on a Board of Education scholarship. During his four years at Tyler, he majored in printmaking with Romas Viesulas and also studied with David Pease, whose sense of humor and interest in approaching art as a game or strategy he found sympathetic. Simkin's student work

was figurative and somewhat surreal, and his training in traditional methods and techniques quite extensive (grinding pigments, painting and drawing from the model). In his last year at Tyler he painted fantasy images on the four inside walls of a portable wardrobe, so that the viewer sitting inside would be surrounded by the work of art.

From 1965 to 1967 he studied for a master of fine arts degree at Cornell University, where he also had a teaching assistantship. Still active in painting and graphics, he ventured further into the field of environmental work. Making use of a vacant, fourteen-foot-square room, he continuously modified the space with lighting, wall colors, and sheets of stretched cloth, and invited colleagues and students to explore the resulting changes in visual and spatial experience. Simkin's growing interest in "participatory art" attracted him to the work of Allan Kaprow, who (along with Jim Dine, Claes Oldenburg, Red Grooms, and Robert Whitman) had developed the "happening" during the early 1960s. But while he admired Kaprow's freedom from restriction of the traditional rules for producing art, as well as his use of outdoor, non-gallery situations for his events, the preplanned, somewhat theatrical nature of happenings did not appeal to him. Simkin was experimenting with offset photolithography at Cornell when Eugene Feldman (see biography preceding no. 496) came to deliver a guest lecture. Feldman subsequently invited Simkin to the University of Pennsylvania as a printmaking fellow for the year 1967–68. While at Penn he became increasingly involved in staging events of the kind which continue to absorb him. Working with groups of interested students ("a raw set of recruits") and a variety of materials (200 randomly blinking signal lights, 4,000 feet of one-inch-wide felt stripping, a black bag large enough to contain 100 people), he set up situations around the campus which had both visual interest and potential for human interaction.

Since 1969, Simkin's life has followed a course which has usually enabled him to execute several major projects each year. He has made his living by teaching at a number of institutions in the Philadelphia area, including Swarthmore College, Drexel University, and public schools in the city. In the summer of 1969 he organized an exhibition for the Foundation of Arts and Sciences on Long Beach Island, New Jersey, inviting a number of avant-garde figures including Robert Morris, Rafael Ferrer, Sol LeWitt, Philip Glass, and the late Robert Smithson to propose and execute projects for the site. In 1970, Simkin's first one-man exhibition was held at Swarthmore College, and he served as art director for Earth Week in Philadelphia—

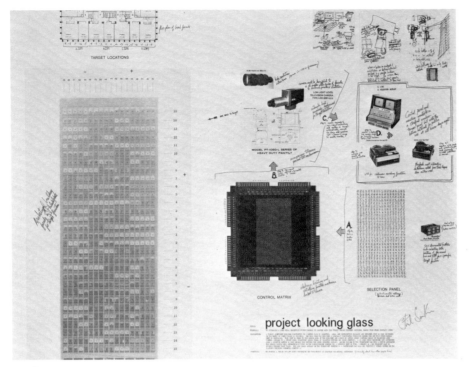

528.

ment for the Arts in 1975; his current projects include one for the Institute for Art and Urban Resources in New York entitled *Choices*—a "human maze" of compartments each equipped with two doors labeled with associative words, offering the visitor a route through the labyrinth determined by his personal preferences.

528. *Proposal for Project Looking Glass*

1973–76

Signature: Phil Simkin (on collage-drawing, lower right)

Collage-drawing consisting of photographs, printed matter, drawings, and control matrix mounted on cardboard; photographs (not illustrated)

Drawing 30 x 40″ (76.2 x 101.6 cm); photographs (variable dimensions)

Phillips Simkin, Philadelphia

LITERATURE: Leendert Drukker, "Pinholes for the People," *Popular Photography* (June 1974), p. 104; Jim Quinn, "Local Artist Sculpts People, Not Plaster," *The Drummer*, October 15, 1975, p. 15

SIMKIN'S PROJECTS tend to group themselves according to themes in which he explores various propositions or human propensities that he finds intriguing. One such theme which he has treated in a variety of modes is that of privacy and its counterpart, public exposure. In 1973 for the Institute of Contemporary Art exhibition *In Urban Sites,* he devised a Public Center for the Collection and Dissemination of Secrets. Set up in the vast lobby of the Thirtieth Street railroad station in Philadelphia, the Center consisted of a row of ordinary-appearing telephone booths in which a passerby could both murmur his own secret to a tape recorder and listen to the confidences recorded by previous callers. The *Displacement Projects I* and *II* of 1974 investigated privacy through the medium of still photography: museum visitors were urged to take home a pinhole camera and record any scene or site of their choosing. The results, a group of which were later exhibited, included mysterious views of people in interiors—perhaps a glimpse into the private lives of the photographers. The concept for *Project Looking Glass* was developed at the same time and employs a third medium, video, in Simkin's growing repertoire. Still unrealized, the project has been outlined by Simkin in typically terse phraseology:

Proposal: to establish a video inspection system capable of sharing with the street public discrete sectional images from other people's lives.

devising events such as the enigmatic appearance at a busy intersection of eleven figures enclosed in burlap bags, protesting air pollution from automobile exhaust. From 1970 to 1973 he was a visiting assistant professor at the University of Maryland, and his exhibition there in 1972 consisted of two major phases: the "disappearance" of the Tawes Fine Arts Gallery space effected by the construction of a blank wall in front of the entrance, and its subsequent transformation (with fifty rented beds and an attendant nurse) into a comfort station. Another piece which played havoc with traditional conceptions of art was shown in a 1972 group exhibition at the Marian Locks Gallery, Philadelphia: viewers were invited to purchase self-adhesive brushstrokes in a variety of shapes and colors and place them on the wall ad lib, creating a collective painting.

Simkin's art is increasingly concerned with people's spontaneous responses to situations which he creates. His contribution to the 1973 exhibition *Made in Philadelphia* at the Institute of Contemporary Art was the transformation of the building's entrance into an outdoor arena equipped with spotlights, microphones, and an illuminated marquee bearing the words *Your Fifteen Minutes*— an open invitation to members of the public to perform. The projects may involve elaborate technical arrangements and a considerable amount of hardware. Even relatively simple devices like the cardboard pinhole cameras which were disseminated to

thousands of people in two 1974 *Displacement Projects* (at the Institute of Contemporary Art in Boston and the Philadelphia Museum of Art) involved months of planning, design, and fabrication. Since Simkin is able to realize on the average of two or three of his ideas each year (supported by museums, universities, or art festivals), his studio in downtown Philadelphia is crowded with plans, charts, and prototypes for future projects as well as relics of past events.

Since 1973, Simkin has taught two- and three-dimensional design as assistant professor at York College of the City University of New York, and also serves as part-time instructor at Moore College of Art in Philadelphia. Two of his most recent projects (*Commodity Exchange* and *Human Puzzle*) were executed at Artpark in Lewiston, New York, during the summer of 1975. Many of his projects have received wide coverage in the news media, although they are rarely as controversial as *Move It or Lose It,* a 1975 event at the Philadelphia Print Club dealing with the "commodity value" of art. Simkin's own work rarely results in a salable or collectible object, but consists of the planning and execution of his proposals and in people's reactions to them. He views himself as a "public utility," and his work seems only distantly related to that of conceptual artists in which the idea itself can subsist as a work of art, apart from its realization. Simkin received an artist's fellowship grant from the National Endow-

Description: A target apartment building constructed on a matrix plan is selected. Legal and reproduction releases are obtained from as many residents on the north or south facade as possible. One mile from the building a specially constructed precision remote pan and tilt video camera unit is installed. This unit is tuned to the window grid of the building and linked by either direct control cables or telephone line control linkage to a street level storefront access panel of selector buttons and video monitors. A 48 hour video recording deck activated when a selector button is used records the picture for later selected replay. Anyone passing by the storefront can push a button whereupon the remote camera will automatically focus on the corresponding window for a specific unit of time, 3 minutes ±, and transmit what is visible through that frame. The live image appears on the storefront monitor 1. A participant can also see previously viewed scenes on the playback recorder connected monitor 2.

Function: To provide a public utility which recognizes and facilitates an existing behavioral phenomenon (curiosity about how other people live).

The collage-drawing from which the above statement was transcribed was included in a group exhibition at the Marion Locks Gallery in the summer of 1974. During the winter of 1975–76, Simkin executed a series of still photographs of windows in an appropriate building and scanned those photographs on a television screen to produce samples of the type of live image he hopes to obtain. He describes these photographs as a "facsimile simulation" of the project, a "research" stage between the artistic concept and its final realization. The visual material shown here includes the original collage-drawing as well as a group of the still photographs arranged in a grid pattern which corresponds to a building facade.

Unlike a number of conceptual artists who deal with sociological or political subject matter through the compilation (and exhibition) of statistics, Simkin is concerned with the endless variety of human response to a specific, often unexpected set of circumstances. His proposals depend for their completion upon the willing, albeit unpredictable, participation of the man in the street. *Project Looking Glass* requires the use of relatively complex technology, but it addresses a familiar human trait (which Alfred Hitchcock took to its most sinister extreme in the film *Rear Window*). Simkin's push-button monitors would provide the urban equivalent of a common rural experience; how many of us have not been briefly fascinated by a glimpse into the private world of strangers (gathered at the dinner table or watching television) through a lighted window as we pass a house during an evening stroll? The brief visions of apartment interiors provided in Simkin's project would most likely reveal empty space or a person passing rapidly in and out of the field of view. "It is the viewer's sense of anticipation and fantasy extension that is being treated ..." (statement to the author, September 22, 1975).

Despite their participatory nature, most of Simkin's projects have a strong element of visual composition. *Project Looking Glass* makes use of the uniform, vertical grid pattern characteristic of many modern apartment buildings. The artist draws our attention to the sharp contrast between the anonymous modular facade and the variegated tangle of emotions and desires, habits and quirks contained within each apartment unit.

This proposal also touches upon another recurrent motif in Simkin's work: the interlinking of various sections of a city. Another unrealized project involves a video camera trained on the activities of a given street and connected with a giant projection screen atop a nearby building. Citizens could watch themselves create a continuous "living mural" which could be seen from blocks away.

Ad'H □

WILLIAM P. DALEY (B. 1925)

William Daley was born and attended public school in Hastings-on-Hudson, New York. A graduate of Massachusetts College of Art in 1950, Daley began art school with aspirations to be a painter, but "was persuaded by a good teacher of the difficult satisfactions of making clay stand up by itself" (letter to the author, June 2, 1975). He attended Columbia University Teachers College in 1951, and from 1951 to 1953 taught at the University of Northern Iowa. He spent the following four years teaching at the State University of New York at New Paltz, and in 1957 came to Philadelphia to teach design and ceramics at the Philadelphia College of Art where he has remained since, except for two years, between 1964 and 1966, when he taught at the State University of New York at Fredonia. According to the artist, "During the twenty-two years since art school I have worked as a house painter, carpenter, and industrial designer, but during this time my best energies have been given to teaching."

Daley has had one-man shows in New York, Massachusetts, and Pennsylvania. He has exhibited, among other places, in the Syracuse Ceramic National Exhibition, the Philadelphia Civic Center, Scripps College Invitational Exhibition, the Philadelphia Council of Professional Craftsmen Exhibitions, and the Philadelphia Museum of Art. He has also undertaken a number of commissions, including a sheet-bronze wall sculpture for the Fifth Avenue office of Portuguese National Airlines, 1967; a five-foot-high bronze helical sculpture for the Science Building at the Germantown Friends School, 1971, and a ceramic wall for Fairfield Maxwell, Ltd., in New York City, 1972. His most important commission was a symbolic screen for the IBM Pavilion at the Century 21 Exposition in Seattle in 1962—an eight-by-sixteen-foot abacus made of a series of tiles which hung on bronze rods within a cypress frame. Each tile was impressed with numbers of letters representing systems of various world cultures.

In the late late 1950s, Daley's pots were glazed, organic, gourd-like forms, his response to nature at that time. In the past ten years his pots have become hard and geometric, with precise planar surfaces, a response to a man-made environment.

529a. *Floor Pot*

1974
Stoneware
Height 18″ (45.7 cm); diameter 28″ (71.1 cm)

Norman and Margaret Krecke, Philadelphia

PROVENANCE: With Helen Drutt Gallery, Philadelphia

529a.

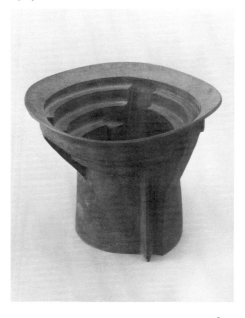

529b. *Drawing for Floor Pot*

1974
Signature: Daley/July 74 (right center)
Ink on paper
11 x 8½" (28 x 21.5 cm)
Norman and Margaret Krecke,
Philadelphia

WILLIAM DALEY's ceramic commissions have often been architectural in nature—walls or screens of ceramic—rather than individual objects. Whereas many contemporary craftsmen have expressed an interest in sculpture, Daley's work responds to aspects of architecture, as seen in this floor pot which is one of a group of architectonic vessels made in 1974.

The pots from 1974 are a response to remembrances of New Mexico, Adobe dwellings, Pueblo ruins and Kivas in a landscape of air and rock. First journeys to locations which extend insights gained through previous work sustain my belief. Belief in the traditions of continuance. When the location is the site of ancient form makers and their works confirm the reality of present mysteries, I am encouraged to work, suspend disbelief and entertain the conceit that vessels can help form our own presence.

This impressive vessel is technically interesting. The clays, from different areas of New Jersey and Pennsylvania, produce tonalities which range from a light tan to a

530.

chocolate brown. By reduction, Daley was able to achieve the dark brown of this pot. After mixing and wedging the clay, he rolled out sheets of clay with a large rolling pin. The lower section of this pot was formed by placing the soft clay in two half-cylindrical troughs. When the two sheets were half hard they were slid from the troughs and joined together by packing the seams with coils of clay. The coliseum-like steps of the upper section were made by bending and laying soft segments of pre-made clay steps on a conical styrofoam core. These segments were joined with coils tier by tier. When the tiers of steps dried half hard, they were turned over, dropped from the core and joined to the lower section. The three buttress forms which support the steps and rim and link them with the cylindrical lower section were pre-formed and separately joined to the piece. The canted band which forms the outer rim was made by laying strips of soft clay flat on the lower edges of the styrofoam core used for the steps. After assembly, the pot was scraped and burnished with a wood rib. The inner part of the outer rim was textured with a sureform rasp.

Daley's vessels are conceptualized and thought out step by step by means of a series of sketches which offer various options in the beginning and at various points afterward. Additional sketches, such as the one for this pot, are made during the forming of the pot and offer alternatives as the vessel is created. Drawings for supporting styrofoam cores, metal troughs, and patterns are made full scale on the studio walls.

Daley's primary interest is in form, both inside and outside the object: "During the years I have taken pleasure in making other materials behave. A regard for process has led me to recognize several problems that keep me working. One is to understand and define the qualities of inside and outside. The other is to sense the relationships of one and many. Through occasional successes

with clay I learn how these concerns affect making vessels which confirm the edges of reality for me" (letter to the author, June 2, 1975).

DH □

YVONNE BOBROWICZ (B. 1928)

Yvonne Bobrowicz's father, Karl Pacanovsky, emigrated from Slovakia in 1913 and worked as a craftsman in wood and as a teacher at, among other institutions, the Hill School in Pottstown, Pennsylvania. Her mother, Evelyn, was also an artist, and taught textile skills in secondary school. Yvonne was born in Maplewood, New Jersey, in 1928. After an early exposure to the creative process, she followed her brother and sister-in-law to Cranbrook Academy of Art in 1946. The youngest in her class, she was encouraged to move into the less crowded weaving classes where Marianne Strengell was a strong influence on her development. Under Strengell's supervision, the departmental emphasis had shifted to "designing prototypes for production," and the exploration of the mechanical properties of the loom itself. Yvonne was encouraged to create textural pieces to work collectively with the new architecture and interiors.

In 1950, the year following her graduation from Cranbrook, Yvonne established her first studio for designing and weaving at Pottstown. In 1952 she moved to Philadelphia and married a designer, Joseph Bobrowicz. In 1966 she began to teach at Drexel University. Other teaching positions during this time were at Peters Valley School of Arts and Crafts (New Jersey) and Naples Mill School of Arts and Crafts (New York), and she also lectured and participated in workshops and panels.

After 1966, she became involved in an art collective and traveled to Ireland. The style of her subjective pieces began to touch

529b.

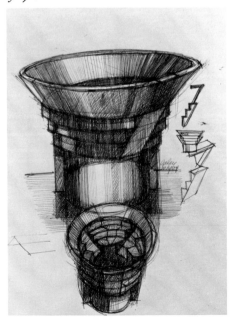

on the organic and less defined. Her work continued to reflect her moment-in-time and to integrate past and present experiences. But she continued to enjoy collective work because it allowed her to interact with others.

Her work in general reflects a strong current in the evolution of the textile form in the United States from the 1940s to the present time—that of the functional design objectives of the Bauhaus.

Yvonne Bobrowicz's work has been exhibited throughout the United States. She has been a panelist for the International Sculpture Conference at the University of Kansas, and was the United States representative for the International Organization of Architectural Arts.

Recent commissions include the Tapestry Wall at the Kimball Museum (Louis Kahn, architect) in Fort Worth, Texas, and a room divider for the chemistry building at the University of Pennsylvania. She continues to teach at Drexel and maintains her studio in her home in Philadelphia.

530. *Floorscape*

1974–76
Wool; linen; fur; rayon
60 x 36" (152.4 x 91.4 cm)

Mr. and Mrs. Joseph Bobrowicz, Philadelphia

Floorscape, CREATED for the opening of the Helen Drutt Gallery in Philadelphia, represents one of the most recent trends in the evolution of Yvonne Bobrowicz's style—a moving away from a strong reliance on equipment toward greater manipulation of fiber possibilities.

The basic technique is that of woven-rya, made in a tubular form on the loom and then stitched and stuffed. It is a non-utilitarian object: a textured form in an environment of many surfaces. The object has a quality of mobility, not being assigned a specific place or purpose: *Floorscape* conceivably might be draped, hung, or worn. The textural variation may stimulate the beholder to manipulate the environment in response to personal needs.

In working out personal feelings, the artist finds herself moving toward red. Her rationale for this direction parallels Marshall McLuhan's analysis of hot and cool experience: intensity is reflected in red.

PC □

OLAF SKOOGFORS (1930–1975)
(See biography preceding no. 488)

531. *Necklace*

1974
Mark: OLAF SKOOGFORS/STERLING/1974
(on plate on back of pendant)

Silver
Length 11½" (29.2 cm); width 6" (15.2 cm); length of pendant 5¾" (14.6 cm).

Judy Skoogfors, Philadelphia

THIS PENDANT with its complex organization of machine-like parts is characteristic of Skoogfors's later style and philosophy. In the early 1960s, Skoogfors's work began to change: "I decided to make a complete change from a rather slick style, polished and controlled, to something more textural and spontaneous, not so terribly 'designed.' I wanted the piece to look as though it has happened, not as though it had been labored on. One should not feel the weight of the hours" (quoted in Carolyn Meyer, *People Who Make Things,* New York, 1975, p. 90).

The pendant's cast oval and cylindrical parts within a rectangular frame provide contrast with the gentle curve of the neck band, and a rhythm is set up between the geometric parts which are unified by a single connecting rod. The pendant is also hinged, which not only reinforces its mechanical character, but also provides comfort to the wearer.

DH □

WILLIAM G. LARSON (B. 1942)

Born in Buffalo, New York, on October 14, 1942, William Larson graduated from the State University of New York at Buffalo in 1964 with a bachelor of science degree in art education. After a year at the University of Siena, Italy, studying history and art, he spent two years at the Institute of Design, Illinois Institute of Technology, where he studied with Aaron Siskind, Arthur Siegel, and Wynn Bullock. He received his master

531.

of science degree in photography in 1968 and worked the following year for an advertising agency in Chicago, acquiring extensive experience in color processes.

In 1969 he joined the faculty of Temple University in Philadelphia to teach photography in the Art Department. Under his supervision Temple's Tyler School of Art developed complete undergraduate and graduate programs in fine art photography. Larson is currently chairman of the Photography Department at Tyler and also serves as consultant to a special photographic workshop at Holmesburg State Prison in Philadelphia. In 1971, Larson received a photographic grant from the National Endowment for the Arts.

His work has been shown in many important exhibitions of contemporary photography in this country, England, and Germany and has appeared in numerous publications including *Modern Photography* (February 1972), *Camera* (April 1969; October 1972), *Mundus Artium* (Spring 1970), and the *Time-Life Library of Photography: The Great Themes* (New York, 1970), for which he also acted as consultant for a chapter on the nude. Larson has published several articles on his photography. He recently organized, researched, and edited photographs by Lazlo Moholy-Nagy for a major catalogue of that artist's work published in 1975.

532. *Untitled (Decorated Tree in Interior)*

1974
Signature: William G. Larson (in ink, on reverse, lower right)
Inscription: Special A/P for Bicentennial 1776–1976
Stamp: William G. Larson/506 Locust Ave./Phila. Pa. 19144 (on mat)
Kodak C-type negative process printed on Kodak color 37RC paper
13⁷⁄₁₆ x 13⁵⁄₁₆" (34.1 x 33.8 cm)

William G. Larson, Philadelphia

LITERATURE: Kelly Wise, ed., *The Photographers' Choice* (Danbury, N.H., 1975), illus. p. 108

THIS UNTITLED COLOR PHOTOGRAPH from the series *Landscape as Fiction* represents William Larson's most recent exploration of the photographic medium. Like most of his photographs, it deals with the problem of "photographic reality," the concept that "reality as we perceive it is quite different from that which the camera records on film" (William G. Larson, "Photographic Reality," *Mundus Artium,* vol. 3, no. 2, Spring 1970, p. 18). A Christmas tree, roots and all, floats in the empty space of a vast

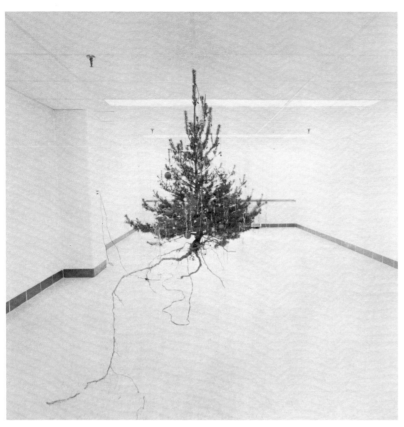

532.

room defying the laws of gravity and human experience of the real world. Yet because the image is a photograph which presents the scene in lifelike color, it must be true—it must depict reality. It is apparent, however, that there is a contradiction here between "visual reality" and "photographic reality."

Traditionally an image like this is made by manipulating the print, that is, by printing from two or more negatives to juxtapose normally unrelated forms or events (see, for example, the work of Clarence John Laughlin, Jerry Uelsmann, or some of Larson's earlier images). In this photograph, Larson has manipulated reality itself, producing a traditionally "pure" image from a simple color negative. He first constructed a Christmas tree and made it appear to float in space so that he could photograph it: the landscape was created by the artist and was therefore a fictional reality. This is an elaborate conceptual and visual pun. Photographic reality documents visual reality, but in this instance the visual reality was fictional; photographic reality, therefore, documented a fiction.

Larson's earlier work is concerned with different aspects of the same problem: dealing with the presentation of movement through time and space in a still photograph in a nonscientific, nonsequential fashion

(*Camera,* April 1969, pp. 36–43); the effects of nonvisual elements of reality—time, distance, sound—on a photographic image transmitted sequentially by telephone on a teleprinter from one place to another; and linear and nonlinear image sequences. William Larson is concerned in his photographs with expanding the traditional boundaries of the medium.

WS □

HITOSHI NAKAZATO (B. 1936)

Nakazato was born in Tokyo, Japan, where he received his early art education. From 1956 to 1960 he studied at the Tama College of Art, receiving a bachelor's degree with a major in oil painting. Traditions of Western European academic education prevailed, and drawing from plaster casts for several hours daily was the norm. After his graduation, Nakazato worked in Tokyo for two years as a lecturer at Obirin College and as an art correspondent for the *Hokkai Times* in Hokkaido. He then left Japan to continue his studies in the United States. With his move from East to West came a conscious intellectual decision to reject the figurative mode of his training in favor of an

abstract one which, with several variations, has formed the basis for his aesthetic investigations from 1962 to the present. Furthermore, after his move to this country, his strong interest in and commitment to printmaking were formed.

When he first arrived in the United States, Nakazato acted as an interpreter for visiting Japanese industrial engineers while studying at the University of Wisconsin. Two years in Milwaukee were followed by a summer at the Institute of International Graphic Arts at the university's Madison campus. He earned the master of science degree in art and following this, in 1966, he was granted a master of fine arts degree from the University of Pennsylvania. At both universities, Nakazato acted as studio assistant in the printmaking workshops. One of the attractions to Philadelphia was the presence of Arthur Flory, who, in 1960 with the aid of a Ford Foundation grant, had set up the first lithography workshop in Japan. Nakazato worked as a printer for Flory after his arrival in the city. Although he himself no longer works as a master printer for other artists, Nakazato has been training students to continue in this tradition.

In 1965–66, Nakazato was a visiting artist at Swarthmore College. Having received a grant from the Rockefeller Fund, he remained in the Philadelphia–New York area, concentrating on painting and teaching a print workshop at the Cheltenham Art Centre until 1968, when he traveled to Europe, the Middle East, and Asia en route to Japan for three years. Here he taught at the Tama College of Art and served as a visiting artist at the Fujimicho Atelier in Yokohama. During this period he continued to work mainly as a painter. However, he did make experimental Xerox prints on long rolls of architectural blueprint paper as well as some outdoor environmental works. In 1971, Nakazato returned to the United States with his wife, Anne Marie Richter. With their daughter, Amy, they now divide their time between Philadelphia and New York. Nakazato's teaching affiliations have been with the Massachusetts College of Art in Boston and the Graduate School of Fine Arts at the University of Pennsylvania, where he is currently an assistant professor.

Since 1964, Nakazato has had four one-man shows in this country and Japan. His paintings, drawings, and prints, included in numerous international exhibitions, have been awarded several prizes. In addition, he executed a mural for Expo '70 in Osaka. Currently he is working to develop photogravure techniques with the assistance of a grant from the Creative Artists Public Service, given by the New York State Council on the Arts. Nakazato's work is included in public and private collections in Japan and the United States.

533.

533. *WuTing, I*

1974

Signature: Hitoshi Nakazato (in pencil, in margin, lower right)

Inscription: 4/25 (in pencil, in margin, lower left); WuTing (in pencil, in margin, lower center)

Aquatint printed in black on Arches paper 23¾ x 23¹³⁄₁₆″ (image) (60.3 x 60.5 cm)

Hitoshi Nakazato, New York

As A RESULT OF the availability of international art journals, artists everywhere have been able to evaluate a breadth of aesthetic experience which may be quite apart from or contrary to their particular cultural heritages. At a glance, there is little necessarily "Japanese" about *WuTing, I,* one of five aquatints in the *WuTing* series which, according to Nakazato, translates from the Chinese as "five vessels" ("to serve God," in the words of the artist). The intellectual, formalist concerns of the print evolved as a result of the combined and distilled influences which Kasimir Malevich and Piero Dorazio directly or indirectly exerted on Nakazato (Nakazato studied with Dorazio at the University of Pennsylvania from 1964 to 1966).

However, the emotional concerns of the print, if one can momentarily isolate them

from the intellectual, are perhaps unconsciously an outgrowth of a Japanese sense of the interrelatedness of art with nature in its broadest terms—time, the growth and development of processes and materials, man as one of many species, all of which are significant. The *WuTing* series demonstrates an assimilation of Western models with a turn inward to "indigenous habits of structure and sensibility," creating a fusion of the living traditions of Japan with the problems and opportunities offered by Western ideas (New York, The Solomon R. Guggenheim Museum, *Contemporary Japanese Art,* intro. by Edward Fry, December 2, 1970—January 24, 1971, n.p.).

Nakazato's earliest prints, lithographs of 1962, had a fluctuating spatial density similar to the textured areas of *WuTing, I,* which resulted from layers of subtly colored inks built into an impenetrable web with the image/surface created by the layering process. As is the case in his paintings and the hundreds of drawings and watercolors he executes in search of possible formats and colors, Nakazato, from his earliest experiences with the graphic media, has been intrigued by, at ease with, and sympathetic to the potentials of materials and techniques. He has an obsessive desire to know the physical properties and attendant emotional possibilities of materials applied to two-dimensional surfaces: the how and why of

various charcoals, crayons, paints, and inks on paper, board, or fabric. Because of this, his work is always sensuous and involved with visual tactility.

Colorful etchings printed by the viscosity process of Stanley William Hayter followed Nakazato's early lithographs, and beginning in 1964 he executed a series of large-scale, subtly colored, calligraphic lithographs. A large number of collagraphs dating from 1966, which involve the cutting into cardboard and folding back of a repeated curvilinear shape located within a modular structure, reveals the origins of the *WuTing* series. Although Nakazato's systemic orientation developed in the drawings and paintings of the intervening years, it was not until 1971 that he produced a significant body of prints. In them investigations with structures were superseded by a concern for materials based on a philosophical need to use only and anything that was at hand—especially if not traditional.

By contrast, *WuTing, I,* is technically tame indeed: it is an old-fashioned eighteenth century aquatint printed with black ink on white paper. Throughout the entire series one sees a relationship to the Japanese garden —the considered placement of forms, the divisions of spaces—or to what one might expect in the compositional organization of a Japanese architectural plan. There is an expansiveness to each image and to the series as a whole.

Each of the five prints, distinguished by a different vowel—A, E, I, O, U—is comprised of two plates which are subdivided by means of drawing on their surfaces. The concept of "vessels" makes reference to these divisions between and on the plates as containers, or implied containers, of surface and/or very shallow space. In *WuTing, I,* the two plates relate in an approximate ratio of one to two. The larger of the two, measuring 15¾ by 23¹³⁄₁₆ inches, rests above the smaller, measuring 8 by 23¹³⁄₁₆ inches. The black aquatint of the upper left quarter of the large plate is surrounded with a surface produced by the use of wax crayon drawn over resin with repetitive strokes of varying pressure in a loose, calligraphic style. In some areas the aquatint is quite distinct; in others the quality of a halting crayon stroke is more powerful. The dense black area visually divides the upper plate in half at the left, and the division can be drawn by the eye across the plate, thus separating the total image into thirds. There are a richness, austerity, and density to the almost smooth velvety black aquatinted area in contrast to the vigor, activity, and luminosity of the textured area.

On the smaller, lower plate, a crayon-like line, similar to but more precise than those that establish the surface described above, contains an obtuse triangle, the peak of

which is at the center of the plate with the sides extending to the lower corners. Printed with plate tone (as is the crayon area of the upper plate), this light gray, soft crayon line makes the sharp white line separating the two plates more stark and divisive. If the right edge of the enclosed black area on the upper plate is imaginatively dropped, it vertically divides the upper plate in half; if further extended, it passes through the peak of the triangle dividing the lower plate as well and forming two acute triangles from the original obtuse shape. Furthermore, if the arms of the triangle were imaginatively extended, the small plate would be divided into triangular quarters, just as the larger plate can be divided into rectangular quarters. With each plate, one-quarter of the surface is contained by a vessel: in the larger one it is the solid black that is contained by its textured surroundings; in the smaller, the vessel is the triangular enclosure.

This progressive formal analysis is necessary in order to experience the relationships within each individual print and the interrelated complexity of the entire series. Each work requires contemplation rather than brief exposure; they are not involved with images but with journeys. One's imagination hovers between what is and what is implied. While the two-dimensional surface is strongly asserted, the pulsating textural area which covers a part of the surface of each print in the series (in some it is quite a small area) denies this as an absolute.

Nakazato's work is characterized by a controlled coolness held in tension with an emotionally charged vision. For him, the making of a painting—and one can broaden the statement to include prints—consists of three basic conditions: the plane, the material, the act (Tokyo, Pinar Galleries, Ichiro Haryu, "The Plane Rebels against the Painting," *Hitoshi Nakazato*, November 24—December 5, 1970, n.p.). *WuTing, I* represents a search for a new synthesis of the three.

RFL □

ELIZABETH OSBORNE (B. 1936)

Born in Philadelphia, Osborne was encouraged in her early desire to be an artist by her mother's circle of friends at the University of Pennsylvania; Dr. Louis Flaccus, professor of aesthetics, was a particularly encouraging influence. She graduated from Friends Central School in 1954, and in her last three years there studied art with Hobson Pittman. Between 1949 and 1954 she also took Saturday morning classes at the Philadelphia College of Art, where her instructors included Neil Welliver. Enrolling in the Pennsylvania Academy in

1954, she studied with Hobson Pittman, Walter Stuempfig, and Roswell Weidner, and found Franklin Watkins's classes and criticism particularly helpful. Osborne's painting during her student years was somberly figurative—landscapes, figure studies, and portraits—and she recalls an early admiration for the work of Bonnard.

A fellowship from the Catherwood Foundation (1955) and two later awards (the Cresson Travelling Fellowship, 1957, and Scheidt Travelling Fellowship, 1958) sent her on three trips to Europe. Concentrating her travel in France and Italy, she visited museums and made a prolonged sketching tour in southern France. Returning to Philadelphia, Osborne taught art classes at Friends Central from 1959 to 1962, and in 1961 she joined the faculty of the Pennsylvania Academy where she continues to teach. Her first one-woman exhibition was held at the Philadelphia Art Alliance in 1961, and a year later she won the Mary Smith prize in the Pennsylvania Academy annual for her painting *Sleeping Girl*. In 1963 she lived and worked in Paris for a year on a Fulbright grant. Toward the end of her stay she married Robert Cooper, a Chicago-born architect, trained at Yale University, who now practices in Philadelphia.

During the 1960s, Osborne's painting gradually increased in scale and breadth of technique while concentrating on effects of vivid color. Still life and figures in interiors predominated as subject matter, although landscape has always been a continuing concern for her. Two solo exhibitions at the Perakis Gallery in Phiadelphia (1963 and 1966) were followed by a show of twenty-two works at the Peale House Galleries of the Pennsylvania Academy in 1967. The paintings shown at the Peale House displayed the rich surfaces and long brushstrokes of her oil technique, and in her palette, cool tones of blue, gray, pink, and violet. Osborne's next exhibition (in 1970 at the Makler Gallery in Philadelphia) included a series of views from the windows of her studio at the Peale House on Chestnut Street: rooftops and building facades organized into compositions of overlapping, brightly colored planes.

That same year, an important change in her style occurred when Gloria Milgrom, a young graduate of the Academy, introduced Osborne to the technique of staining acrylic paints into raw canvas. Long an admirer of Richard Diebenkorn, whose architectonic but painterly mode exerted some influence on her work of the early 1960s, she was also aware of the painting of Morris Louis and Helen Frankenthaler as relevant to her own interests. Finding the technique of staining as well as intense saturation of color well suited to her aim of formal simpilfication, Osborne began a series of large landscapes

which continued over the next four years. Based on small watercolor studies of specific sites, done from nature, the large lyrical paintings approach abstraction without abandoning a sense of spatial depth. Trips to Manchester, Massachusetts (1962–72), and New Mexico (1973) provided the source for compositions built up of large, brilliant expanses of yellow, orange, blue, and flaming red under remote skies of lavender or aquamarine. Around 1970, Osborne also began to work in the field of printmaking, producing several editions of silkscreen landscapes, and she now plans to experiment with lithography. Her work is in the collection of several museums and corporations, including the Delaware Art Museum, Pennsylvania Academy, Philadelphia Museum of Art, Provident National Bank, and the Chase Manhattan Bank. Included in a variety of group exhibitions (*Topography of Nature* at the Institute of Contemporary Art, Philadelphia, 1972; *Women's Work, American Art 1974* at the Museum of the Philadelphia Civic Center, 1974; *Five Pennsylvania Artists* at Pennsylvania State University, in 1975), her most recent one-woman shows have been held at the Marian Locks Gallery, Philadelphia, 1972, and Gimpel & Weitzenhoffer Gallery, New York, 1974.

534. *Nava Standing*

1974
Signature: Osborne '74 (lower left)
Watercolor on paper
30 x 22½″ (76.2 x 57.1 cm)
Philadelphia Museum of Art. Given by the Women's Committee in memory of Mrs. Morris Wenger. 75-27-1

PROVENANCE: With Marian Locks Gallery, Philadelphia

LITERATURE: Philadelphia, Moore College of Art, *PMA at MCA, An Exhibition of Works by Contemporary Philadelphia Artists, Selected from the Collection of the Philadelphia Museum of Art* (October 16—November 21, 1975), n.p.

THIS MUTED, DELICATE WATERCOLOR reflects a number of developments in Osborne's recent work, including her renewed tendency to incorporate the human figure into compositions still dominated by landscape. The model was a young student of Osborne's at the Academy, posing reflectively before a light-filled window in the artist's studio, and the mountainous landscape behind her is one of Osborne's recent paintings. Deciding not to work directly from the model, Osborne took several color snapshots of the girl standing in her Peale House studio and then used the photographs as a guide to her

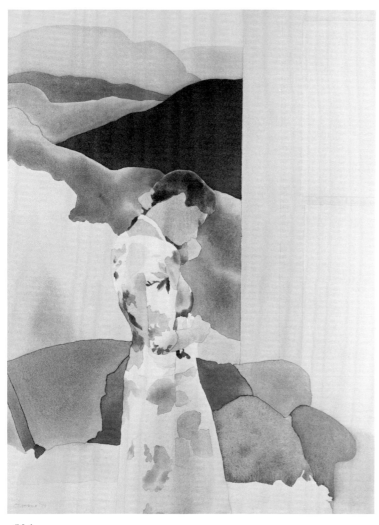

534.

painting—the first time she had done so, although she has been an avid and skilled photographer for years. *Nava Standing* is above all concerned with light and color. The white paper functions as sunlight itself, flooding the room with dim radiance from the tall window on the right. The vivid contours of the painted landscape, Nava's flowered dress, and the sofa by which she stands fuse into an intricate pattern of colors which flow vertically across the paper. The figure is not emphasized, although the volumes of her solid form are suggested by subtle shifts in tone. Yet even as she seems to melt into the glowing painting, her bowed head and inward-turned gaze catch our attention, and it is her subdued and tranquil mood which gives the picture a contemplative atmosphere unusual in the artist's work. Watercolor is a natural medium for Osborne, who has used it since her student days with increasing skill and fluidity. Although her large paintings on canvas have a depth and resonance of color only obtainable across a broad expanse, watercolor always operates as

an intermediary between her concept of a picture and its realization. (*Nava Standing* also exists as a larger painting.) It is not surprising therefore that perhaps her finest and most subtle work has been in the exacting medium used with such exquisite flair by Charles Demuth.

Osborne's love of color in the intenser ranges of pink, red, green, and blue are reminiscent of Arthur B. Carles's passion for color ("what on earth else is painting for?"), although she was not particularly aware of Carles's work as a student, and, like Carles, she seems reluctant to move away altogether from her favored subject matter, despite the obvious pull of abstraction.

Ad'H □

JOHN MOORE (B. 1941)

One of a number of young artists who have come to Philadelphia to teach and who have settled in the city during the last decade, Moore was born in St. Louis. After graduat-

ing from high school in 1958, he obtained a certificate in drafting from the David Ranken, Jr., School of Mechanical Trades (1958–59). Employed as a draftsman for McDonnell-Douglas Aircraft Corporation in St. Louis, he spent the years 1959–62 drawing parts of rockets and airplanes, and his assignments included work for "Project Mercury" of the United States Space Program. During that time he attended night classes in drawing at Washington University; in 1962 he enrolled as a full-time student. He recalls a rigorous drawing course given by Barry Schachtman as particularly relevant to his later work in its emphasis on the importance of perceiving three-dimensional volumes.

As a student in 1965 at the Yale University Summer School in Norfolk, Connecticut, he was impressed by an exhibition of the pristine and realistic still lifes of William Bailey, although Moore's own work at the time pursued the painterly, abstract depiction of invented landscapes. During the summer of 1966 a grant from the National Endowment for the Arts enabled him to spend several months in New Hampshire. In this period of intense, uninterrupted work he produced 110 diminutive landscapes painted in acrylic on paper directly from nature. He arrived at Yale University to enter the M.F.A. program in the fall of 1966, "desperate for something concrete to paint." During his first year at Yale he became involved with incorporating human figures (painted from living models) into imaginary landscapes. He found Jack Tworkov, the chairman of the painting department, a sympathetic and influential teacher, and he was also aware of the work of Lennart Anderson and Philip Pearlstein (both at various times associated with the faculty at Yale) as providing convincing approaches to realism.

As of 1967, Moore arrived at the mode of painting which he continues to explore with increasing skill and sophistication. Working from the model, and, more frequently, from still life arrangements in his studio, he began to paint large canvases which took him several months to complete. Graduating from Yale in the spring of 1968, he moved to Philadelphia to join the faculty of the Tyler School of Art at Temple University, where he is now an associate professor.

Finding that the Tyler curriculum offered students no chance to work from the model or still life when he arrived, he introduced a course entitled "Direct Painting." In 1969 he was one of five artists included in the exhibition *Direct Representation* at the Fischbach Gallery in New York, and his work has been included in several other exhibitions surveying the New Realism movement: *New Realism,* State University of New York at Potsdam (1971); *From Life,*

633

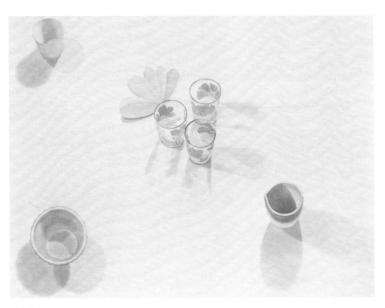

535.

University of Rhode Island (1971); *The Realist Revival,* American Federation of Arts (1972–73); *The Figure in Recent American Painting,* Westminster College, New Wilmington, Pennsylvania (1974–75), *New Images: Figuration in American Painting,* Queens Museum, Flushing (1975).

Since 1969 his work has been included in twenty-six group shows, and one-man shows have been held at the Fischbach Gallery in 1973 and 1975. In 1973 nineteen paintings and watercolors were exhibited at the Peale House Galleries of the Pennsylvania Academy. His work is owned by a number of museums, including the Pennsylvania Academy, Yale University Art Gallery, and the Philadelphia Museum of Art. His recent painting is increasingly preoccupied with the interplay of light, reflection, and shadow with solid forms; and his palette, tending toward cool silvery tones of gray, blue, and brown, has begun to include vivid hues of blue and red.

535. *Flower Glass Watercolor 2*

1974
Signature: John Moore 1974 (lower right)
Watercolor on paper
22½ x 30¼″ (57.2 x 76.8 cm)

Mr. and Mrs. F. Galuszka,
Philadelphia

PROVENANCE: Purchased from the artist by the present owners

AROUND 1971–72, MOORE began to explore the possibilities of watercolor as an alternative mode of working, distinct from the large, carefully studied oil paintings which preoccupy him for months at a time. His subject matter is the same—groups of still life objects arranged in virtually infinite recombinations—but his focus is often narrower, as if the watercolors were a close-up view of a detail of the larger canvases. A number of both the paintings and the watercolors over the last four years has presented objects placed on a glass shelf projecting from the wall. Recently, overlapping sheets of colored or semi-transparent paper have been interposed between the objects and the plane of glass. Moore poses himself increasingly complex visual problems to solve in terms of light and shadow, transparency and opacity, color and its absence. Perhaps his most exquisitely simple solutions have been achieved in a series of watercolors (to which this one belongs) wherein the sheet of paper itself is transformed into the surface on which the objects rest. In *Flower Glass Watercolor 2,* we find ourselves looking down from above at an assortment of small glasses and vessels which appear to project upwards, casting clear or tinted shadows according to their degree of translucency.

Moore's watercolors add yet another dimension to the rich tradition of still life painting in Philadelphia. Like Charles Sheeler in his *Objects on a Table* (see no. 448) of fifty years earlier, Moore's concerns are almost solely formal: objects are chosen for their purity of outline and volume, illuminated to create an interplay between shadow and solid form, and juxtaposed to achieve a composition of crystalline precision. The trompe l'oeil which is so essential in *The Artist's Card Rack* by William Michael Harnett (no. 353) is present in Moore's watercolor without witty or dramatic emphasis: his glasses and cups have none of the associative or sentimental qualities of Harnett's torn envelopes and calling cards. Even Sheeler's plain wooden table and graceful teapot constitute a discreet paean to the simple style of rural American decorative arts, whereas Moore's three glasses with painted pink flowers refer to nothing beyond themselves. The fanlike leaves of the plastic pocket calendar (rather an unusual item in a still life of the 1970s) read only as a pleasing and intricate shape. Harnett, Sheeler, and Moore share a love of clarity and the painstaking effort to paint things precisely as they are. At the opposite pole stand the grand, brooding still lifes of Walter Stuempfig in which every element evokes a sense of the weight of history and the nobility of the art of the past. Moore's sparsely scattered objects serve as instruments for the articulation of light and space. Lit from two distinct sources, they each cast two shadows on the dazzling white paper. The shadows of the three opaque vessels (a small beaker, a ribbed china bowl, and a paper cup) almost touch the outer edges of the paper, deftly reminding us that the illusion of three-dimensionality is, after all, an illusion and preserving the integrity of the picture plane.

Ad'H □

THOMAS CHIMES (B. 1921)

Of Greek descent, Chimes was born and grew up in Philadelphia, where his father ran a restaurant business. As a child, he was encouraged in his love of drawing and sketching by one of his uncles, and he won several prizes in art at West Philadelphia High School, from which he graduated in 1939. Entering the Pennsylvania Academy in the fall of that year, he was able to take only a few months of classes (his instructors including Francis Speight and Daniel Garber) before leaving Philadelphia to join his family who had recently moved to Alabama. After a few years of assisting his father, he decided to enroll in the Art Students League in New York, attracted by the idea of studying with Frank Vincent Du Mond who had been the teacher of John Marin and Georgia O'Keeffe. Entering the League in the fall of 1941, he was again forced to leave school abruptly, this time drafted into the United States Army Air Force.

Released from service in 1945, he returned to the Art Students League under the GI Bill from February 1946 through the spring of 1949. In Reginald Marsh's evening class, Chimes met Dawn DeWeese, another painting student with family ties in Philadelphia, and they were married in 1947. Although he studied under a variety of instructors

including Du Mond, Vaclav Vytlacil, Will Barnet, and Julian Levy, Chimes considers his friendship with the sculptor Michael Lekakis (his former camouflage instructor in the army and a fellow student on the GI Bill) to have had a crucial influence on his artistic development. Lekakis introduced him to a stimulating circle of painters and sculptors in New York, including Theodoros Stamos, William Baziotes, Barnett Newman, and Tony Smith. Chimes's interest in poetry and French literature was also stimulated by his new group of friends.

In 1952 he and his wife made a seven-month trip to Europe, starting in Greece and traveling across Italy and southern France to Paris, where he considered the possibility of taking a studio in Montparnasse. On a visit to the Dominican Chapel at Vence, designed and decorated by Henri Matisse, Chimes was profoundly impressed by Matisse's combination of traditional spiritual iconography with bold, formal use of color and line. Returning to New York, he stayed there a few months longer before deciding in the summer of 1953 to move back to Philadelphia (where he has continued to live and work). He took a job with an industrial designer and set up a studio in his house in West Philadelphia.

Chimes's paintings of the mid-1950s were delicate abstract canvases composed of juxtaposed squares of color in close values of gray, blue, and green. Like the transitional (1913–14) pictures of Mondrian (an artist Chimes greatly admires), their structure suggested the presence of an underlying Cubist grid; their closest contemporary parallel was perhaps the "tachist" painting of Nicolas de Stäel. These works were exhibited in Chimes's first one-man show at the Avant Garde Gallery in New York in 1958. More recognizable imagery began to appear in the paintings around 1959, with sharply defined areas of bright color, like rectangular fields, set into landscape vistas.

From 1958 to 1960 he taught evening drawing classes at Drexel Institute, and in 1960 he moved his studio to a building on South Seventeenth Street in downtown Philadelphia. There he embarked upon a series of works combining landscape references with specific symbols—stars, ladders, X-shapes, and most important, a crucifix. The Museum of Modern Art purchased two of these emblematic paintings in 1962. The series culminated in an eighteen-foot *Mural* now in the collection of the Ringling Museum of Art in Sarasota, Florida. The *Mural* preoccupied Chimes for most of 1963 (although it was not completed until 1965) and presents a powerful, abstracted panorama of interlocking colors and shapes, some purely decorative, others conveying mystical content. In its huge, almost architectural scale and the impressive fusion of Christian imagery with the artist's private vocabulary of symbolic motifs, Chimes's *Mural* was both the spectacular climax of an important phase in his own art and a project unique of its kind in Philadelphia in the mid-1960s. (Franklin Watkins's giant paintings of *Death* and *Resurrection* in the late 1940s provided an earlier instance of the highly personal treatment of religious motifs.)

After the *Mural,* Chimes's painting turned again toward abstraction, but by another route. Signs and symbols were inserted into small, tightly compartmentalized compositions, often surrounded by thickly painted halo-like areas resembling the surfaces of stones or shells. In 1965 he began to produce constructions in mixed media which incorporated small drawings and paintings of symbolic images into austere, finely crafted metal and plexiglas boxes. Two one-man exhibitions at the Bodley Gallery in New York (1963 and 1965) established Chimes's reputation as an American exponent of Surrealism, and they were followed by a major retrospective of eighty works organized by the Ringling Museum of Art in 1968.

His work has been shown in a number of national exhibitions, including *Contemporary American Painting and Sculpture* at the University of Illinois in 1965, the Pennsylvania Academy annual exhibition in 1967 (where he won the Mary Butler Prize) and, most recently, the biennial exhibition at the Whitney Museum in 1975. The Henri Gallery in Washington, D.C., gave Chimes a one-man show in 1970 which included a few constructions and a number of small, purely abstract paintings on plexiglas. During 1966 and 1967, Chimes taught painting at the Philadelphia College of Art, and in 1971 he joined the faculty of Moore College of Art, where he has served as chairman of the sculpture department since 1974.

During the early 1970s, Chimes's reading of the French Symbolist poets and the complex pseudo-scientific texts of Pataphysics intensified, accompanying another important shift in his art. His most recent and ongoing series of works began in the summer of 1973; portraits of poets, philosophers, and other literary figures were exhibited at the Peale House Galleries of the Pennsylvania Academy in 1975. Both his technique of painting and his style have undergone a radical change since the *Mural* of 1963–65, but his primary concern for the pursuit of "meaning" remains constant. It can be presumed that Chimes's most recent absorption in the philosophy of Ludwig Wittgenstein will lead to further unexpected developments in his idiosyncratic art.

536.

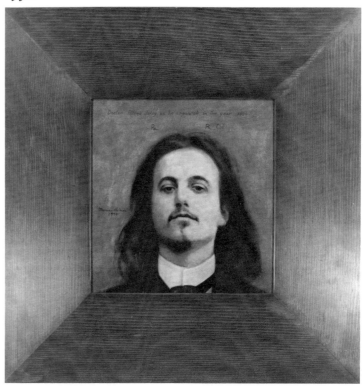

536. *Portrait of Alfred Jarry*

1974
Signature: Thomas Chimes/1974 (center left)
Inscription: Doctor Alfred Jarry as he appeared in the year 1896/Pa/Pa Ebé (across upper edge); Alfred Jarry/1974/ 22½ x 22¼″/"Departure from the Present" (on reverse, top center)
Oil on wood
22½ x 22¼″ (with frame) (57.1 x 56.5 cm)
Philadelphia Museum of Art. Purchased: Adele Haas Turner and Beatrice Pastorius Turner Memorial Fund. 75–82–1

LITERATURE: PAFA, Peale House Galleries, *Thomas Chimes* (March 6—April 13, 1975), no. 11; Philadelphia, Moore College of Art, *PMA at MCA, An Exhibition of Works by Contemporary Philadelphia Artists, Selected from the Collection of the Philadelphia Museum of Art* (October 16—November 21, 1975), n.p.

CHIMES'S RECENT PAINTINGS are small in scale (rarely over two feet square), traditional in technique, and derived from specific, usually photographic images—in striking contrast to his large and colorful emblematic abstractions of the early 1960s. The cast of characters assembled in his 1975 exhibition of portraits (collectively titled *Departure from the Present*) at the Peale House Galleries constituted his initial selection of the literary and intellectual avant-garde who contributed to the disruption of established values and traditions at the turn of the twentieth century. Charles Baudelaire and Edgar Allan Poe, Guillaume Apollinaire and Antonin Artaud, Marcel Proust and Oscar Wilde—each made his appearance, but the absurd and heroic figure of Alfred Jarry was represented by no less than three portraits, attesting to his importance in Chimes's pantheon of modernism. (By Fall 1975, Chimes had completed six portraits of Jarry.)

When Jarry's magnificently scurrilous play *Ubu Roi* opened before a scandalized Parisian audience in 1896, he was only twenty-three but already launched on a fantastic career aimed at achieving a total fusion of life and art. By the time of his premature death eleven years later, he had succeeded in identifying himself inextricably with the preposterous, invented character of Père Ubu. Jarry was also the author of the pseudo-science of Pataphysics (the joyful and systematic pursuit of contradiction, ambiguity, and absurdity), which remains one of the most extreme expressions of the modern idea that man can find the answers to any existential or philosophical questions only within his own personality.

Chimes's procedure in painting the portraits has been consistent since he started the series in 1971. First selecting a piece of wood for its grain, he coats it with Elmer's glue and sands it smooth after it dries. He then rubs linseed oil into the panel and paints directly into the slightly wet surface, using warm tones of umber, relieved by passages of black and white and occasional touches of color. Each portrait is set into a wood frame constructed by the artist which may be carved or added to or furnished with a small brass plaque. Chimes's technique and his concept of suiting the details of the frame to the subject of his picture is reminiscent of Thomas Eakins, a painter he greatly admires for his insistence on intense, direct observation, but the portraits themselves are obviously based not on the study of living models but on images that have survived from the past. For this painting of Jarry, Chimes chose a photograph taken by Nadar in 1896. The words "Pa Pa Ebé" inscribed over the poet's head refer to a bumbling schoolmaster whom Jarry had transformed into Père Ubu, and suggest his own future identification with Ubu. The painting is in fact a composite image, representing the historical personality of Jarry as viewed through succeeding layers of time.

Among the variety of modes of representational painting currently being explored in Philadelphia, the *Portrait of Alfred Jarry* occupies an appropriately paradoxical position. Based on a photograph, it eschews the startling illusionism of photo-realism. Depicting a real person, it makes no attempt at either naturalism of color or idealization of features. In a sense, the portrait is not even figurative but rather metaphysical: a mysterious icon referring less to the man it represents than to the ideas he generated. Like Marcel Duchamp's female alter-ego *Rrose Sélavy* (whose image Chimes has also painted), the appearance of a poet may come to seem as much his own creation as his verses. Chimes uses these old-fashioned-looking paintings the way we use faded family photographs: to summon up the past or to trace its features in the present (which Jarry once defined as an "arriving memory").

Ad'H □

EDNA ANDRADE (B. 1917)

Born in Portsmouth, Virginia, Edna Davis Wright was the daughter of a lumberman-engineer and a schoolteacher and spent her childhood in rural Virginia. Her parents encouraged her early efforts to draw, and she recalls that her father's interest in bridges and building was a formative influence on her fascination with structure. In 1933 she enrolled in the Pennsylvania Academy of the Fine Arts and the University of Pennsylvania, graduating in 1937. Among her teachers at the Academy were George Harding and Henry McCarter, and her work in painting and mural decoration classes won her Cresson Travelling Scholarships in 1936 and 1937.

In 1938 she began a teaching career as a supervisor of art in the Norfolk, Virginia, elementary schools; and from 1939 to 1941 she taught drawing and painting at Tulane University in New Orleans. Her marriage in 1941 to the architect Preston Andrade (they were divorced in 1960) brought her into increased contact with the fields of architecture and design. Between 1942 and 1946, she was involved with various government design projects related to World War II: first preparing training manuals, visual aids, films, and exhibits for the presentation division of the Office of Strategic Services and later designing posters and pamphlets for the war bond division of the Treasury Department.

Since 1946, Edna Andrade has lived and worked in Philadelphia, except for the years 1950–55, when she lived in Lumberville, Pennsylvania. During the late 1940s and the 1950s she occasionally did free-lance drafting for architects, and one of her projects included rendering the plan for the Philadelphia International Airport by Carroll, Grisdale and Van Alen. In 1958 she joined the faculty of the Philadelphia College of Art. Her paintings which earlier in this period were sharply realist with surreal overtones became in the late 1950s, more concerned with abstraction and structure. During this transition, her first major one-woman exhibition held at the Philadelphia Art Alliance in 1954 was devoted to drawings and paintings of the seacoast and of her beachcombings. After a summer in Gloucester, Massachusetts, in 1958, painting and sketching landscape directly from nature, her work became gradually less representational as she experimented in the early 1960s with pale pastel colors and patterns of overlapping shapes. It was in part her experience teaching color and design courses at the Philadelphia College of Art which led her to investigate optical phenomena and systems of geometry and proportion, which have proved so fruitful in her own work. She found the paintings and writings of Josef Albers and Paul Klee of great interest in her exploration of abstract design, and she also cites L. L. Whyte's book *Aspects of Form* as an important source.

Around 1965 her painting received increased national attention and was included in a number of exhibitions of optical art, including the Philadelphia Art Alliance, *Optical Painting,* in 1965; the Fort Worth Art Center, Texas, *The Deceived Eye,* in the

537.

same year; and the Des Moines Art Center, Iowa, *Art with Optical Reaction,* in 1966. In 1967 one-woman shows at the East Hampton Gallery in New York and the Peale House Galleries of the Pennsylvania Academy presented groups of her recent work exploring optical effects. Always interested in projects involving architectural spaces, she has completed many commissions in the Philadelphia area, which range from the reredos for the Church of the Good Samaritan in Paoli (1957–58) to a marble intarsia mural for Stonorov and Haws's Welsh Road Branch of the Free Library of Philadelphia (1967) to the design of the paving, pool, and planting for the entrance court of the new Federal Reserve Bank of Philadelphia (1974), which remains unexecuted.

Andrade's work of the last decade has involved much drawing of great delicacy and precision, and she has also been active as a printmaker. During the summer of 1971 she was artist-in-residence at Tamarind Institute at the University of New Mexico, where she completed ten editions of lithographs. Deeply involved in activities of the Philadelphia art community, as well as in her teaching, she has served on numerous panels, juries, and committees for institutions and events in the city. She has been a visiting member on the faculties at the Hartford School of Art (1971) and Skidmore College (1973–74), and she served one year as professor of art at Temple University

(1972–73). Her paintings and prints have won a number of prizes over the years and are in the collections of many museums including the Albright-Knox Art Gallery in Buffalo, the Baltimore Museum of Art, Yale University Art Gallery, the Philadelphia Museum of Art, and the Pennsylvania Academy. Her most recent exhibition was held at the Marian Locks Gallery in Philadelphia in April 1974, and two paintings (*Soft Wave* and *Cool Wave*) were shown simultaneously in the large *Woman's Work, American Art 1974* at the Philadelphia Civic Center Museum.

537. *Cool Wave*

1974
Signature: EDNA ANDRADE (on cross-bar of stretcher)
Acrylic on canvas
72 x 72″ (182.8 x 182.8 cm)
Luther W. Brady, Philadelphia

PROVENANCE: With Marian Locks Gallery, Philadelphia; purchased from the gallery by the present owner in 1974

OVER THE LAST DECADE, EDNA ANDRADE has been exploring the virtually infinite possibilities offered by the interaction of line, form, and color in patterns suggested by the

visible and invisible structure of the natural world. Her early fascination with the geometry of a fish skeleton or the facets of a crystal has continued with her delight in the more abstruse phenomena of the "black holes" in outer space or the regular intricacies of the "dragon curve." As seems typical of her working process, *Cool Wave* was created as one of a cluster of interrelated works during 1973–74. In a series of small drawings on graph paper, she investigated her original idea, playing with the notion of a curve contained within a square. Two paintings on the theme preceded *Cool Wave:* the first, a four-foot-square picture entitled *Yellow Field* (private collection, Philadelphia); the second, a six-foot-square *Soft Wave* (Continental Bank, Philadelphia) painted in soft pastel colors. *Cool Wave* is the third variation on the theme and the most austere. In each of twenty-five squares, arranged in five rows of five, radiating lines are drawn to meet an arc whose radius is equal to the length of one side of the square, and whose center point is one corner of the square. Arcs measured from the lower right corner of a square alternate with arcs measured from the upper left corner of the next, to produce a regular, pulsating rhythm. The canvas is painted in a solid, subtle shade of cold gray-blue, and the delicate tracery of lines is drawn in a warm tone of off-white acrylic with a draftsman's ruling pen.

Edna Andrade feels that her recent preoccupation with the motif of curves within squares and the space-filling "dragon curve" may have been crystallized by her plans for the paved entrance for the Federal Reserve Bank. During the summer of 1974 she executed a series of silkscreens with Duo d'Art in Geneva, Switzerland, which relate closely to both the paving and her latest paintings. While her work of the mid-1960s often sought particular optical effects and achieved dramatic illusions of space and movement, Andrade's paintings have grown increasingly subtle over the last five years. *Cool Wave* is a contemplative painting; its geometric precision is suffused with poetry. The tracery of fine lines appears to glow slightly; one thinks of light catching along the threads of a spiderweb. The artist has expressed her aims in a statement that links the sophisticated simplicity of a painting like *Cool Wave* with the venerable tradition of making patterns: "I find myself in the ancient tradition of all those anonymous artisans who have painted pottery and tiles, laid mosaic pavings, woven baskets and carpets, embroidered vestments and sewn quilts. Our tradition reaches back through eons of time to that genius who first drew a circle and used its magic."

Ad'H □

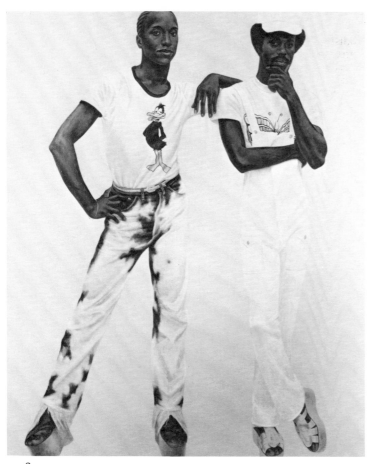

538.

BARKLEY L. HENDRICKS (B. 1945)

Born in North Philadelphia, Hendricks has recently become one of the best known young black artists in the country working in a figurative style. After attending Simon Gratz High School and spending much of his spare time sketching and drawing, he entered the Pennsylvania Academy in 1963 and "fell in love with paint." Studying with Hobson Pittman, Franklin Watkins, Julian Levi, and Walter Stuempfig, among others, Hendricks recalls his eagerness to gain as much experience as possible from their varying approaches to art. He was particularly impressed by Stuempfig, and his early student paintings owed something to the older artist's work in their mood and use of dark, earth colors.

While at the Academy (1963–67), Hendricks won the Cresson Travelling Scholarship in 1966 and the Scheidt Travelling Scholarship in 1967. His months in Europe and Africa were as much a voyage of self-discovery as an immersion in the history of art. He remembers being struck by a painting in the Uffizi Gallery in Florence which included a standing figure clothed in black. The strength and simplicity of the image,

only very slightly defined by modeling, suggested a direction for his own painting. Returning to Philadelphia in the fall of 1967, he spent the next three years working for the city's Department of Recreation, serving as a roving arts and crafts specialist for District Ten. During that time he was given his first one-man show at the Philadelphia Art Alliance in 1968, and another followed in 1970 at the Kenmore Gallery. His painting ranged between large schematic compositions on the theme of basketball and frontal, almost hieratic portraits of friends. In several paintings of 1969 the figures were isolated against a background of gold leaf which gave them the impressive and remote presence of an icon. (In his titles, Hendricks often emphasizes the specifically black nature of his subject matter: the superb image of a girl with her spreading Afro hairdo forming a halo is entitled *Lawdy Mama,* suggesting an updated version of a Byzantine madonna.)

Between 1970 and 1972, Hendricks obtained his B.F.A. and M.F.A. at Yale University, where he also had a teaching assistantship during his second year. In 1971–72 he was also an instructor in painting at the Pennsylvania Academy. In the fall of

1972, he joined the faculty of Connecticut College (where he continues to teach) as an assistant professor. At present he maintains his studio in New London, Connecticut, returning frequently to Philadelphia to visit family and friends.

Hendricks's work has won a number of prizes, including two Caroline Gibson Granger Prizes from the Pennsylvania Academy (1969 and 1975) and the Second Julius Hallgarten Prize from the National Academy of Design in 1971. In that same year he received the Childe Hassam Purchase Award from the American Academy of Arts and Letters, and in 1972 he won the Richard and Hilda Rosenthal Award from the National Institute of Arts and Letters. A recent involvement with photography led to his receipt of first prize at the *Second Annual Northeastern Photography Exhibition* at Mount Holyoke College in 1973. Paintings have been acquired by several museums, including the Pennsylvania Academy, Cleveland Museum of Art, Philadelphia Museum of Art, Gibbes Art Gallery in Charleston, South Carolina, and National Gallery of Art. His work has been widely shown in national exhibitions as well as in several shows devoted to black artists: Whitney Museum of American Art, *Contemporary Black Artists in America,* 1971; Museum of the Philadelphia Civic Center, *Millenium,* 1973; University of Pennsylvania Museum, Philadelphia, *Second World Black and African Festival of Arts and Culture,* 1974, among others. Most recently, the Greenville County Museum of Art in South Carolina organized a traveling retrospective exhibition of twenty-two paintings in the fall of 1975.

538. *Ralph and Alvin (Sickkayou)*

1974
Signature: B. Hendricks (upper right)
Oil and acrylic on canvas
72 x 60″ (182.8 x 152.4 cm)
Mr. and Mrs. Leonard Davis, New York

PROVENANCE: With American Contemporary Art Galleries, New York; acquired by the present owners in 1975

HENDRICKS BEGAN HIS ONGOING SERIES of startling, frontal portraits around 1969 when he hit upon both an effective compositional format and the technical means to achieve his aim. The figures, usually rendered in rich and modulated colors, are executed in oil paint, while he uses acrylics for the flat, uniform background of a single color. *Miss T* of 1969 (Philadelphia Museum of Art) was the first painting in which Hendricks combined the two media: the glossily

painted form of a pensive girl clad in a severe black pantsuit stands out sharply against the mat white rectangle of the canvas. Hendricks has played many intricate variations upon his chosen theme, sometimes treating the figures and their clothing with equal detail, sometimes letting only the faces and hands of his black subjects come alive with modeling within the flat colored shapes of a hat and cape or a long coat.

Over the past three years, the artist has ventured further from his early insistence upon the single, icon-like figure in several large paintings which present the same model seen from three different sides (*Sir Charles, Alias Willy Harry Harris* of 1972 in the National Gallery of Art is a striking example). *Ralph and Alvin* is his first portrait of two people, and their casual, comradely pose adds another psychological dimension (of their relationship to each other as opposed to their relationship to the viewer) which had hitherto been absent from the paintings. Hendricks has always worked from the model but permits himself a wide range of flexibility within that procedure. Some of his portraits depict old friends, others represent casual acquaintances or people who caught his eye as they passed by on the street and subsequently were persuaded to pose.

Ralph and Alvin were members of two dance groups which came to New London during the summer of 1974 to perform in a dance festival sponsored by Connecticut College. Hendricks posed them, took several photographs, and then worked primarily from the photos, a practice he has often followed in recent years when models he wished to paint could not be present for extended sittings. ("Sickkayou" is a slang expression of high praise in the dance world, elicited by a particularly deft step or a tricky movement beautifully executed, and it suits the informal mood of the painting.) The two dancers are lightly poised on the very edge of the canvas, gazing out at the viewer with amused but noncommittal stares.

Hendricks handles black subject matter with a compelling mixture of cool and affection, locking it within formal compositions of austere precision. Often humorous, occasionally aggressive, always provoking an immediate and personal reaction from the viewer, he invites our admiration for his models' stance and style and arouses our curiosity as to their identity. Unlike many contemporary exponents of realism, whose treatment of the human figure emphasizes the structure of the body or focuses on the surface texture of skin and clothing, Hendricks retains the portrait painter's fundamental concentration on personality. Compared to the figure paintings of Wayne Thiebaud, for example, who also often isolates his subjects against a neutral back-

ground (in his case, creamily painted), Hendricks's work reveals a flair for the dramatic. In *Ralph and Alvin* the figures emerge boldly from their abstracted setting and engage our attention with their unexpectedly real and convincing presence.

Ad'H □

VENTURI AND RAUCH, ARCHITECTS AND PLANNERS (EST. 1964)

The firm of Venturi and Rauch was organized in 1964 by Robert Venturi, a graduate of Princeton University, and John Rauch, holder of a degree in architecture from the University of Pennsylvania. That office gained notoriety and some renown among younger architects and theoreticians for their Guild House project in Philadelphia (with Cope and Lippincott), in which the inherent conflict between the heroic abstractions of modern design and human needs was resolved in favor of the latter in a logically conceived structure derived from the local vernacular, but modified by a clear and tellingly expressed wit.

Since then, a number of publications, among them, *Complexity and Contradiction in Architecture* (New York, 1966) by Robert Venturi, and *Learning from Las Vegas* (Cambridge, Mass., 1972) by Venturi with Denise Scott Brown, partner, and Steven Izenour, associate; a broad variety of commissions, ranging from seashore cottages to studies for the rehabilitation of Philadelphia neighborhoods; and the teaching careers of Venturi, Brown, and Izenour have kept the office in the public eye. The firm has designed the installation for this exhibition as well as those for several other Bicentennial exhibitions in Washington and New York, and is currently working on an addition to the Allen Memorial Art Museum at Oberlin College, and a repertory theater for the Hartford Stage Company.

539. *Franklin Court*

314–22 Market Street
1974–76
With John Milner, National Heritage Corporation, Restoration Architects
REPRESENTED BY:
David Vaughan (b. 1937)
Garden Level Plan
1973
Ink and mixed media
14½ x 33¾" (36.8 x 85.7 cm)

Mark Cohn (b. 1938)
Franklin Court: Interior Court
1976
Photograph

Courtesy of Venturi and Rauch, Architects and Planners, Philadelphia

LITERATURE: David Vaughan, "Franklin Court," *Bulletin, Philadelphia Chapter/American Institute of Architects* (September 1974), pp. 10–11

IN YEARS PAST, the construction of a museum about Benjamin Franklin on the site of his Philadelphia house would have been a straightforward project. Deeds would have been surveyed, contemporary sources would have been examined, old views would have been found, and a Colonial house would have been restored. If the original building had been demolished, a new "colonial" building would have been reconstructed—even if documents and records were inadequate for a correct reconstruction of the original building. Appropriate antique furnishings would have been acquired and Franklin's milieu would have been established, thereby representing his time, and presumably his spirit and character.

There were few records on Franklin Court, the assemblage of buildings that Benjamin Franklin constructed over many years on a large lot on Market Street between Third and Fourth streets, near the commercial center of Philadelphia. It was known from deeds, descriptions, and Franklin's own correspondence that a row of houses fronting on Market Street opened via an archway into a large court which contained a print shop, and beyond it Franklin's own house. Of this group of buildings, only the party walls and foundations of the Market Street row survived, providing sufficient information to reconstruct these structures, complete down to window heights, roof slopes, and moldings. But Franklin's house and his grandson's print shop had been demolished in the early nineteenth century for the construction of Orianna Street, so that nothing but the foundations could possibly have survived, making any restoration highly speculative.

Rather than build another pious fraud, the National Park Service hired Venturi and Rauch, in association with the National Heritage Corporation, to design a different sort of museum, one that was absolutely honest in presenting what was known about the site, but was at the same time conceptually rich and capable of introducing the full breadth of Franklin's personality and interests to the public. Moreover, because of its location in the heart of the city's historic district, and the impending Bicentennial celebration, the program required that Franklin Court be extraordinarily flexible, capable of handling vast crowds on major national holidays and intimate enough to attract the use of the neighboring community on less hectic days.

To meet those needs, Venturi and Rauch developed a richly contradictory scheme which alternately utilized elements from traditional historic museums and archaeological sites and the bold forms and direct

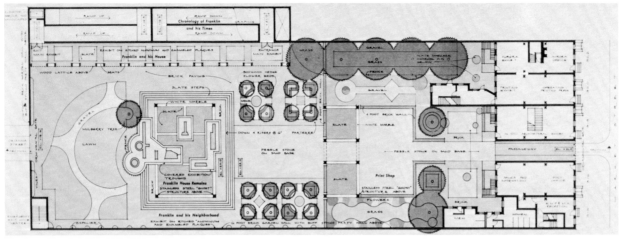

539.

content of commercial architecture, which has recently interested the architects. By accurately perceiving the various dimensions of the task and by sacrificing consistency, the architects were able to achieve a pragmatic functionalism paralleling form and insight.

The originality of the design is not initially apparent from the principal approach on Market Street. There, the first structures encountered are ordinary reconstructed Colonial houses similar to others found throughout the historic district. Though they are banal, their pristine condition interrupting the commercial buildings of Market Street serves to announce the museum within. And that museum is conventional enough, a post office to commemorate Franklin's role as Postmaster General, a room displaying materials on printing, and other rooms containing objects found on the site during excavation.

The view through the restored archway and out of the rear windows of the houses reveals a court that contrasts with the naive realism of the restored buildings, instead suggesting, on a smaller Colonial scale, the imperial Roman gesture of the open forum providing open space for the populace. And just as that ancient model had its central monument to the giver of the space, Franklin Court has its central focus as well. Two immense tubular steel frames, shaped to the outline of corner post, cornices, gable roofs, and chimneys form the "ghosts," in the architects' words, of the volume but not the detail of the long-demolished house and print shop. They make the original spatial arrangement of the site apparent, while the use of the spare vocabulary of modern sculpture initiates the perception of the court as a monument to Franklin.

If the open space in the urban matrix recalls Rome, the landscaping and materials are of Franklin's time—but modified by the architects' interest in the transformation of form and scale in the process of architectural

revival. Hence a formal garden suggests the type of planting that might have filled the court, while the scale is the more generous one of the late nineteenth century Colonial revival and the materials are detailed in the spare manner of the twentieth century. The period is evoked but not faked.

Within the ghost frames, the architects sought to represent what little is known of the lost buildings. Slate paving indicates the floor areas, while exterior walls, internal partitions, and such principal features as fireplaces are marked by white marble slabs. Descriptions of the house and the print shop from contemporary sources, among them the letters of Deborah Franklin to her husband Benjamin, are inscribed in the slate paving, thereby uniting documentation with the symbolic representation. Finally, the actual remnants of the building, the foundation walls, are here and there made visible in deep, glazed viewing boxes whose curved sunshields, which are not unlike industrial air intakes, add yet another sculptural element to the symbolic garden.

There is yet one more contrasting level in the Franklin Court project, one hinted at by the peek into the grounds at the foundations, for beneath the entire site is a subterranean museum, approached by a tile-lined switchback ramp, reminiscent of the subway entrances of the city, and leading away from the sights and sounds of the twentieth century. Below the symbolic garden, with time suspended as in a movie, the various aspects of Franklin's life are encountered. Semantically rich where appropriate, realistic where there is need, and plain where elaboration is not necessary, Franklin Court makes evident the vitality of the man that it celebrates while suggesting by changes in presentation, the variety of means by which the past can be made present.

GT □

ROBERT M. WINOKUR (B. 1933)

Born in Brooklyn, New York, in 1933, Robert Winokur lived in Philadelphia from 1942 to 1944. That year he returned to Brooklyn and, a few years later, took a ceramics course at Erasmus High School making flowers, reminiscent of the kind of work his mother had done as a hobby. He returned to Philadelphia for his studies, graduating from the Tyler School of Art, and went on to do graduate work at the New York State College of Ceramics at Alfred, New York.

After completing his studies at Alfred in 1958, Robert Winokur accepted a position at North Texas State University in Denton, Texas, where he taught ceramics, basic design, and art history. In 1964 he moved to Ashfield, Massachusetts, where he and his wife, the ceramicist Paula Winokur, made stoneware pottery for a living. To supplement their income, he taught art history at Holyoke Community College. In 1966 he returned to Philadelphia, this time to accept a teaching position at the Tyler School of Art. During his first two years, he was acting head of the ceramics department and also was involved in designing the ceramics facilities for a new building.

In 1974 he received a grant-in-aid from Temple University to do research in salt glaze, an aspect of ceramics which had intrigued him and in which he had worked for some time. He built a salt kiln in his Horsham studio and experimented with a variety of chemicals with which he has been able to produce glaze surfaces that have a lustrous richness and dramatic quality.

Since returning to Tyler, he has done less pottery for production, but his work is still essentially functional, using the traditional container as a sculptural form. His work has received national and international recognition. He has exhibited in over fifty invitational exhibitions across the country, including the 22d Ceramic National at the Everson Museum in 1962; the 19th Annual

539.

Scripps College Exhibition in 1966; the Salt and Raku Exhibition organized by the National Council on Education in the Ceramic Arts shown in Madison, Wisconsin; and the American Crafts Council Gallery exhibition in New York in 1974. In 1975 he participated in *Approaches: Contemporary Education,* at the Philadelphia College of Art. His work was illustrated in *New Ceramics* by Lewenstein and Cooper (1974) and in *Claywork* by Leon Nigrosh (1975).

Winokur has also received several important commissions, including twenty large planters for the First National Bank in Chicago in 1969. These were large cylindrical pots, unglazed on the outside and glazed on the inside, with a decorative pattern around the rim. Another commission was a ceremonial chalice for Christ Church in Philadelphia, 1973.

Winokur is also an active administrator in his field. He was program chairman for the 1975 convention of the National Council on Education in the Ceramic Arts which met in Philadelphia and for which, as part of that convention, he secured state support from the Pennsylvania Council on the Arts for the exhibition *Container* held at the Tyler School of Art.

Robert Winokur's earlier work was functional and controlled, its austerity a result of his production-line approach. His more recent work has become more organic and reflects a concern for surface color and decoration. It demonstrates a growing influence of Oriental ceramics, not only in the forms themselves but also in his method of drawing on the surface while still wet. A major change in his technique has been his use of salt in his glazes.

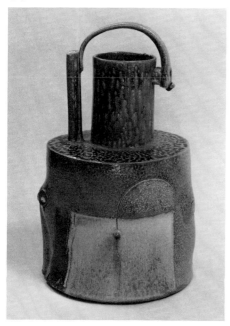

540.

540. *Jar with Handle*

1975

Signature: Winokur (in script, scratched on bottom)

Salted stoneware

16¾ x 10 x 10″ (42.5 x 25.4 x 25.4 cm)

Robert M. Winokur, Horsham, Pennsylvania

IN ITS FORM, technique, and decoration, this jar demonstrates the influence of Japanese pottery. An Iga-ware pottery vase from the Momoyama period (Seattle Art Museum, *Ceramic Art of Japan,* 1972, fig. no. 30) demonstrates the same seemingly fortuitous glaze and artless form. The Oriental prototype has not only provided an inspiration for Winokur but also a means of expressing a contemporary philosophy and aesthetic, for example, the use of improvisation to produce unexpected results.

Although the effect appears intuitive, the technique is actually very controlled. The body and collar of this jar were thrown separately, then assembled off the wheel. The shoulder, handle, and stem were hand built, then applied to the body. The horizontal line was drawn with an impressed string. The subtle colors were achieved by slips. The salt glaze was the result of Winokur's experimentation during his 1974 sabbatical: the jar was taken to the right temperature and the sodium allowed to attack the silica to form a glaze.

DH □

LIZBETH STEWART (B. 1948)

Born in Philadelphia, Lizbeth Stewart grew up and attended public schools in Bryn Quelled, in Bucks County. Her mother studied art at the Pennsylvania Museum School of Industrial Art and now teaches advertising at Moore College of Art. Although Lizbeth Stewart took drawing in high school, she did not pursue ceramics until she went to Moore College, where she studied with Marion Winsryg, an important influence on her work. After one year at Moore, however, Lizbeth Stewart left school to travel and to live in San Francisco. During this six months' period, she saw many examples of contemporary ceramics and decided to try to make clay objects.

On her return to school, she changed her major from painting to ceramics. In her junior year, she won the Harriet Sartain Memorial Travelling Fellowship from Moore and spent three months traveling in Mexico, Central America, Equador, and Peru. In Mexico she was particularly impressed with the primitive religious folk art, especially collages of various materials. Since her graduation in 1971, she has been working on her own and, for the past one and a half years, she has shared a studio with two other ceramicists. For two months of the year she makes Christmas displays for the Marathon Carey McFall Company in Philadelphia.

Lizbeth Stewart has had considerable recognition in Philadelphia and New York. She has exhibited in this country since 1971, including the Whitney Museum's *Clay,* 1974; the New York Fairtree Gallery's *Surfaces in Ceramic Art,* 1974; Washington, D.C., Fendrick Gallery's *Clay U.S.A.,* 1975, and the *Two Woman Show—Lizbeth Stewart and Jacquelyn Rice,* at the Helen Drutt Gallery in Philadelphia, 1975. Since the opening of the gallery in 1974, Helen Drutt has been a major resource for Lizbeth Stewart and other Philadelphia craftsmen.

541.

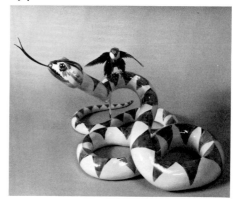

541. *Snake with Bird of Paradise*

1975
Porcelain with lusters
16 x 20 x 22″ (40.6 x 50.8 x 55.9 cm)
Charlotte Dobrasin, Philadelphia

PROVENANCE: With Helen Drutt Gallery,
Philadelphia

THIS SNAKE evokes a mixture of attraction and repulsion. Its tense, coiled body is ready to strike, a quality emphasized by the bird of paradise, perched above—strange companions and an unexpected union. One's first instinct may be to run. However, the beautiful colors of the geometric patterns on the snake's body and the flickering golden tongue fascinate and attract.

The technical feat of producing this reptile is astounding. The hollow porcelain snake was hand built, with the use of clay supports in the firing process; the bird and the snake's tongue were done separately. All the colors are lusters, painted on a clear glaze and fired at a low temperature; the iridescence is a result of multiple firings.

Lizbeth Stewart's porcelain sculpture evokes a surreal and mystical world. Her figural sculpture can also be disconcerting: doll-like porcelain figures clothed in sequined satin fly in the air, their stomachs opened by a window into an imaginary still life arrangement. Her delicate eggshell forms and pastel colors evoke a soft, intimate world.

DH □

WILLIAM STEPHENS (B. 1932)

Born in Media, Pennsylvania, on June 11, 1932, William Stephens is the son of two teachers. His mother taught grade school and his father, whose hobby was refinishing furniture, was a teacher at Girard College. Stephens graduated from Haverford Township Senior High School and then attended Philadelphia College of Art where he majored in industrial design, graduating in 1955.

Stephens's interest in furniture design was early sparked by his father's hobby and was further encouraged at Philadelphia College of Art where he was exposed to a wide variety of approaches to general product design. It was not until he began to work for Knoll Associates in 1960, however, following two years in the army and a stint as a photographer for an engineering consulting firm, that he became actively involved with furniture design. Since he joined Knoll he has been a member of the Design Development Group of which he is currently assistant director.

Stephens believes that in the 1960s the designs of Mies van der Rohe were most influential on the aesthetics of the Knoll designers. More recently, Stephens has been influenced by the designs of Don Albinson, the director of Knoll's Design Development Group, who worked with Charles Eames and Eero Saarinen on the molded plywood furniture which won the Museum of Modern Art competition in 1940.

Stephens has been involved with several other projects at Knoll since he designed the Stephens chair. Most noteworthy of these is the Stephens Landscape System for offices dating from 1967. Under the supervision of Don Albinson, two designers, Stephens and Andreas Christin, devised a unified office landscape which eliminated the randomness and wasted space common in offices. Christin's system was in plastic and metal while Stephens's was in wood. Several basic pieces were chosen and each one was painstakingly examined in terms of the different functions the piece must serve. Like the Stephens chair, the Landscape System reflects luxury and at the same time a conservative approach to ornament and extraneous material.

542. *Lounge Chair*

1975
Manufactured by Knoll International, Inc.
Laminated oak veneer; foam rubber over plastic shell; blue wool and nylon
32 x 22⅛ x 22½″ (81.3 x 56.2 x 57.2 cm)
Knoll International, Inc., Philadelphia

LITERATURE: Paris, Musée des Arts Decoratifs, *Knoll au Louvre* (January 12–March 12, 1972), n.p. (illus.)

542.

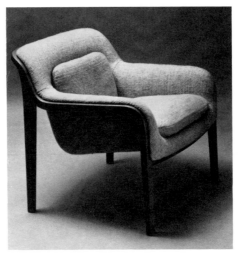

THE FIRST SKETCHES and models for this laminated chair were made by Stephens in 1965 while he was working on Knoll's Pettit chair. He pursued his interest in laminated wood on his own time, until a model for an oak laminated framed chair was reviewed and accepted as an official Knoll Design Development project. The chair succeeds in achieving lightness and strength in a graceful elegant design. The gentle curve of the crest is echoed in a similar reverse curve in the seat. These curves are repeated in the continuous curve of the arms. A special patent process for connecting the plastic shell back to the frame eliminated the need for stretchers which might interfere with the overall open design.

The technique of lamination and bending of wood for the purpose of strength, pliability, and lightness was a nineteenth century innovation. It is associated in particular with the furniture of the New York cabinetmaker John Henry Belter who received a series of patents between 1847 and 1858 for this purpose. Belter's chairs in the rococo revival style used from four to sixteen layers of wood which were pressed in steam molds to achieve bending. The Philadelphia cabinetmaker Ignatius Lutz also made laminated furniture, and Edwin Freedley in *Philadelphia Manufacturers* (p. 273) described Lutz's establishment on Eleventh Street as it appeared in 1859: "My attention was attracted to an ingenious method adopted by him, to prevent the liability of carved Mahogany to break. In carved chair work, for instance, he divides the Mahogany into several lateral parts, and joins them by glue in such a manner that the grain of the wood is, by this method, increased in proportion to the number of times it is divided; and in the manufacture of Sofas, large Arm-chairs, etc. its advantages are especially apparent."

In the twentieth century, laminated wooden furniture was designed by the architects Charles Eames and Eero Saarinen, who, while at Cranbrook, had together won the Museum of Modern Art Organic Design in Home Furnishings competition in 1940. They were employed by Hans Knoll in 1943, and their first designs for him were of cutout laminated wood, with seats and backs of interwoven strips of canvas. The tradition of lamination has been continued in Knoll Associates designs by William Stephens in this armchair constructed of laminated oak veneer.

Stephens's chair was chosen to be exhibited at the Brooklyn Museum by the Industrial Design's 14th Annual Review. He also received an award from Philadelphia College of Art for this chair.

Stephens describes his philosophy of the design of his 1301 series chairs of which this is an example as "conceived to offer an alternative solution to the basic

problem of containing the human form in a seated position. A balance of the values of esthetics, economics, and function to transcend the industrial product into an art form, by the use of the most sophisticated industrial processes available to the designer, is continually the objective" (letter to the author, June 2, 1975).

PT □

ALBERT NIPON (EST. 1954)

Albert and Pearl Nipon chose to establish their business in Philadelphia, where they were born and educated. Pearl Nipon was graduated from Overbrook High School, and her husband from West Philadelphia High School, and they both attended Temple University. The Nipons have been involved in designing and manufacturing women's garments since 1954. Their career originally began with "Ma Mère," a line of elegant, beautifully detailed maternity clothes, and after sixteen years as successful creators of maternity wear, the couple embarked upon a completely new line of women's wear. By 1972 the team was on its way to designing daytime and evening dresses as well as sportswear under the name "Albert Nipon."

The establishment covers the entire top floor of a large building on North Broad Street in Philadelphia. The Nipons value the loyalty of their staff and workers, many of whom have been with them since the early days of "Ma Mère." Pearl Nipon, the fashion directress, works closely with three designers: Rosina Feldman, Beate Hemmann, and Ted Avrami. To keep in close contact with the customer she travels extensively throughout the country, also making several trips to Europe each year. Albert Nipon manages the administrative functions of the firm and travels between the factory in Philadelphia and their showroom in New York City. This joint venture of husband and wife is now one of the major fashion success stories of recent years.

The now famous Nipon dress is easily recognizable in a store or on a figure. The dresses are made with special attention to pintucks, overstitching, and other interesting details and are often of imported, natural materials.

543. *Dress*

1975
Label: Albert Nipon
Tan and turquoise striped "crepe paper" cotton
Center back length 45″ (114.3 cm)
Philadelphia Museum of Art. Given by Albert and Pearl Nipon in memory of Eugene Feldman. 75–132–1a, b, c

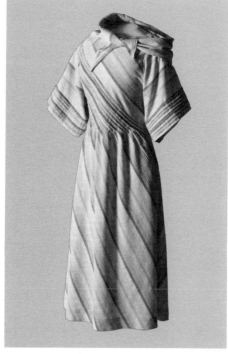

543.

MADE OF IMPORTED French "crepe paper" cotton woven into alternating stripes of varied widths in shades of tan and turquoise, this dress is cut on the bias, the front pin-tucked along the bias stripes from below the right shoulder armhole to the waistline, and then gently released. The back also is cut on the bias and is mitered at the center seam from neck to hemline, finished with foot and edge stitching to create the illusion of a band. The dress has a simple boat neckline with two wood buttons and loops on each shoulder, and a square-cut Japanese-type sleeve which Pearl Nipon refers to as the "stovepipe" sleeve. A narrow, stitched tie belt and a triangular scarf that can be worn about the neck or arranged as a head scarf complete the "Nipon look."

EMcG □

CATHERINE JANSEN (B. 1945)

Born in New York in 1945, Catherine Jansen grew up in Atlanta, Georgia. She received a bachelor's degree from Cranbrook Academy of Art, Bloomfield Hills, Michigan, in 1967. After graduate studies in photography and sculpture at Tyler School of Art in Philadelphia and in Rome, she received her master's degree from Tyler in 1970. She considers her work photosculpture, an extension of the medium of photography into three dimensions. Jansen's work has appeared in such exhibitions as *The Expanded Photograph,* Philadelphia, 1972; *Photo-Transfer,* the Akron Art Institute, 1973; *Stuffed, Stitched and Sewn,* Museum of Contemporary Crafts, New York, 1973; *Philadelphia 1974: Fibre, Clay and Metal* at the Moore College of Art, Philadelphia; and *Soft Photograph,* "Photophía, Philadelphia, 1975. Her work has been published in the *Time-Life Library of Photography: Frontiers of Photography* (New York, 1972, pp. 92–93). Jansen has been a consultant and teacher for "Form in Art," a program for the visually handicapped at the Philadelphia Museum of Art. She has been artist-in-residence at Artpark in Lewiston, New York, and currently teaches at Bucks County Community College, Yardley, Pennsylvania.

544. *Florida Mermaid*

1975
Photosensitized cloth, photographic dyes, and embroidery
16 x 22″ (approx.) (40.6 x 55.9 cm)
Catherine Jansen, Philadelphia

CATHERINE JANSEN'S WORKS mark a departure from the two-dimensional format of traditional photography. Her creations are soft sculptures of shaped, stitched, and stuffed cloth with detail and sometimes color printed onto the fabric. They are humorously illusionistic: the seeming contradiction between the bulkiness and flat surfaces of the stuffed forms and the apparently realistic but strangely colored printed-on detail is a delightful artistic conceptual pun on both photography and sculpture.

Jansen's largest pieces are environments: the *Blue Room* of 1970 and her stuffed bathroom of 1974 are life-sized and meant to be experienced as rooms; her *Artpark Diary* of 1975 is large enough to define the space of the room that contains it. They are all puns that depend upon the discrepancy between the way the objects appear and the way experience tells us they ought to appear. It is whimsical and gentle humor.

Jansen's postcard series is a smaller-scale development of this same conceptual punning, and reflects her interest in what she calls the "classic quality" of color picture postcards which "have a photographic language of their own." Jansen takes this language—garish color and fantastic subject matter—and transforms it. The original image itself is surreal, yet in typical postcard fashion explicitly described in the caption on the back: "A pretty and talented Weeki Wachee mermaid checks her hairdo before descending 117 feet into Florida's Underwater Grand Canyon, located North of Tampa, St. Petersburg and Clearwater at intersection of U.S. 19 and Fla. 50. Color Photo by Sparky Schumacher."

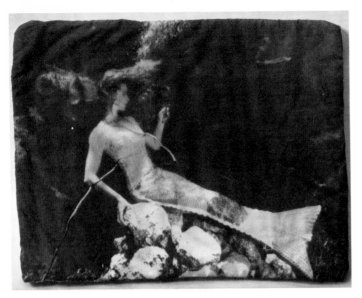

544. *Front*

544. *Back*

Her *Florida Mermaid* is opposite in every way to the original postcard: it is large, thick, floppy, soft, muted in color, and not at all flat. Front and back it has all the symbols of being a postcard, yet it obviously is something else. The bright embroidery calls to mind garish postcard colors, but it also effectively reminds us that *this* postcard is handwork.

Catherine Jansen emphasizes the importance to her of working with cloth and thread, traditionally a woman's medium. Her work displays a delight with her materials and the charming and humanizing potential for humor she finds in the ordinary objects of everyday life.

<div align="right">ws □</div>

ROBINSON FREDENTHAL (B. 1940)

Born in Claremont, New Hampshire, Robinson Fredenthal is the son of graduates of the Cranbrook School of Art in Michigan. His father was the watercolorist and illustrator David Fredenthal and his mother, Miriam, has had an active career as a weaver and fabric designer. Fredenthal's sister, Ruth Ann, was a student of Paul Feeley and Tony Smith at Bennington College, and is now a painter living in New York. During his childhood in New England his interest in carpentry and drawing was encouraged at home. After graduating from the Darrow School for Boys in New Lebanon, New York, Fredenthal came to Philadelphia in 1959 to enroll in the University of Pennsylvania. After receiving his bachelor's degree in 1963, he entered the School of Architecture. Particularly drawn to the study of geometry and intensely attracted to the work of Le Corbusier, he recalls being more affected by his various

teachers at the university (Romaldo Giurgola, Robert Venturi, Denise Scott Brown) after graduation in 1967 than during his student years. His architectural studies were interrupted in 1964 by the onset of a neurological disorder (later diagnosed as a form of Parkinson's disease) which made it increasingly difficult for him to draw or fabricate large constructions. In part as a result of his determination to operate as flexibly as possible within the restrictions imposed by the disease, his interest turned to sculpture, and he began to make small models of variations on simple forms like the cube and tetrahedron. After 1967, excited by the almost limitless formal possibilities in the combination of geometric shapes and volumes, Fredenthal developed a satisfactory working method of producing precise cardboard models of his conceptions with the aid of a number of assistants. Profoundly struck by the exhibition of Tony Smith's sculpture at the Institute of Contemporary Art in Philadelphia in 1966–67, he started to introduce sculpturally complex forms and combinations into his own work. Although he never officially studied with them at the university, conversations with Louis Kahn, Robert Le Ricolais, and the sculptor Robert Engman played a role in Fredenthal's thinking about the manipulation of space and his use of materials.

In 1971 his sketches and photographs of models were included in the group exhibition *Concept Drawings* at the Marion Locks Gallery in Philadelphia, and that same year his first large-scale sculpture (a twenty-four-foot high piece in welded steel) was installed in the Woodfield Shopping Center in Schaumberg, Illinois. A second sculpture project, in Cor-Ten steel, was approved in March 1972 for the subway entrance at

Eighth and Market streets in Philadelphia, under the aegis of the architectural firm of Mitchell/Giurgola. Fredenthal's one-man exhibition at the Pennsylvania Academy's Peale House Galleries in the winter of 1973 included a wide range of his work: sketches, cardboard models, full-scale mock-ups, and a series of photo-montages for proposed monumental sculptures. His largest commission realized to date has been three pieces in welded steel for the lobby of the new building at 1234 Market Street in Philadelphia, commissioned in the spring of 1973 and installed by 1974. A 1973 proposal for a fifty-six-foot-long sculpture in two parts for a site in Fairmount Park remains unrealized.

Fredenthal's work has been included in several recent exhibitions in the Philadelphia area such as the Bryn Mawr Presbyterian art show (1973), *Earth Art II* at the Children's Hospital (1975), at which his entry won the sculpture prize, and an exhibition of outdoor sculpture sponsored by the Cheltenham Art Centre at the Temple Music Festival in Ambler, Pennsylvania, during the summer of 1975.

545. *Untitled (Study for a Large Sculpture)*

1975
Wood
25 x 25 x 25″ (approx.) (63.5 x 63.5 x 63.5 cm)
Robinson Fredenthal, Philadelphia

TIERS OF SHELVES in Fredenthal's West Philadelphia studio are lined with diminutive cardboard models of geometric shapes. Over a period of eight years, with the assis-

tance of a sequence of friends and students at the University of Pennsylvania, he has produced a long series of variations on individual solid forms (cube, tetrahedron, octahedron, rhomboid) and their juxtapositions or intersections with one another. His work has steadily increased in complexity and subtlety as his experience of formal possibilities accumulates with each set of models conceived and executed. In 1971 he compared his production of small models to the daily practicing of a musician, "constantly adding more practical knowledge to my investigation." This mode of working through countless variations on a given theme is reminiscent of Josef Albers's continuing exploration of color in his *Homage to the Square* series and Robert Engman's study of the complex curve in his bronze, wood, and plexiglas sculptures.

This untitled model is one of the largest and most visually complicated which Fredenthal has created to date. Based on the repeated use of a cluster of four cubes around a tetrahedron, it presents strikingly different aspects to the viewer depending on the angle of vision. From one side it appears as a dense, crystalline mass of solid volumes organized symmetrically along a vertical axis. Turned at an angle of ninety degrees it is transformed into a more open, gridlike structure in which rows of cubes follow a rhythmic, diagonal thrust. Unusually massive in concept among Fredenthal's more elongated rhomboidal structures, it also undergoes dramatic shifts in appearance when illuminated by varying sources of light.

Fredenthal's interest in large-scale sculpture operates at one remove from his continuing investigation of forms. He views most of his small models as capable of being greatly enlarged but is also particularly concerned to suit the sculpture to its proposed surroundings of a building or a natural site. His large sculptures commissioned to date have employed forms which evolved directly out of his geometric studies, reconsidered as part of an architectural whole. The pristine white cardboard or sleek wood of the models give way to raw steel, Cor-Ten, or painted metal, and the sculptural "idea" takes on an often aggressive physical presence. It is not difficult to imagine this twenty-five-inch model on a larger scale, since it appears monumental even in a photograph, although its dynamic complexity might render its enlargement overpowering in any but the simplest setting. First rendered in cardboard, a tour de force of construction in a delicate material (the painstaking work was executed by Fredenthal's colleague Robert Eller), the wood model is one of the artist's most self-contained and satisfying sculptures even on this diminutive scale.

Ad'H □

ITALO SCANGA (B. 1932)

Born in the village of Lago in Calabria, Italy, Scanga draws upon memories of the countryside and customs of his childhood as an important aspect of his art. As a boy he was apprenticed to a local craftsman who made devotional images for churches and private homes. His father made his first of many trips to the United States around the turn of the century to seek work as a railroad trackman, and in 1947 Scanga immigrated with his mother and brother to join him in Rockwood, a town in the coal mining district of Pennsylvania. Teachers in the local high school encouraged Scanga's interest in art and talent for drawing. The family later moved to Lansing, Michigan, and he studied at the Society of Arts and Crafts in Detroit from 1951 to 1953. After two years' service in the United States Army, he decided to enter Michigan State University in East Lansing. At Michigan State, Scanga studied sculpture with Lindsey Decker and received encouragement in his work in photography from the painter Charles Pollock.

His early work consisted of large welded metal constructions somewhat in the expressionist style of the Swiss sculptor Robert Müller and also related to the sculpture of Richard Hunt (working in Chicago) who was to become a friend. Graduating from Michigan State with a master's degree in the spring of 1961, he started his teaching career at the University of Wisconsin at Madison the following autumn. Making frequent visits to Chicago, he was influenced by H. C. Westermann's assemblages and wooden constructions, with their unique mixture of broad humor and obsessive imagery, which he saw at the Allan Frumkin Gallery. Scanga's own sculpture became increasingly formal, organized into wood and metal constructions which resembled altars. His first important one-man exhibitions were held at Lawrence College in Appleton, Wisconsin (1962), and the Milwaukee Art Center (1964), and he won a sequence of prizes at regional exhibitions, including two "best in show" awards at the annual exhibition of Wisconsin painters and sculptors at the Milwaukee Art Center (1962 and 1963). After three years at the University of Wisconsin, where his students included Bruce Nauman, he taught at the Rhode Island School of Design and Brown University from 1964 to 1966 and at Pennsylvania State University during 1966–67. Trips to New York during this period brought him into contact with a wider circle of artists, and he was particularly attracted to the sculpture of Donald Judd and the fluorescent light installations of Dan Flavin. During his year at Pennsylvania State, Scanga's work shifted away from the metal

545. *Cardboard Version*

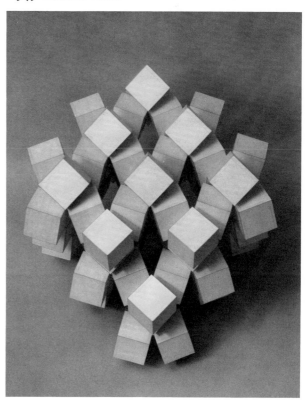

constructions to a series of large wooden columns derived from his interest in the eighteenth century French visionary architects Claude-Nicholas Ledoux and Étienne-Louis Boullée.

A turning point in Scanga's career occurred around the time of his move to Philadelphia in 1967 when he joined the faculty of the Tyler School of Art at Temple University. Settling first in Glenside, and later moving into the northern section of the city itself, Scanga's house and studio became a gathering place for students and other artists. Desiring to find a working method that directly reflected his own life and individuality, he evolved a mode of grouping together a variety of separate elements that refer to philosophical or narrative themes. Images of saints, quotations from poets, farm implements, food and spices, found objects, and framed watercolors have been recurring ingredients in his exhibitions and installations over the past eight years. Scanga's love of gardening and cooking, his reading in philosophy and poetry (Pascal, Spinoza, Lorca, Rilke), his fascination with the properties of materials like leather, wicker, plaster, and glass are all expressed in the working process as well as the end result of his art.

Work of this general type, which continues to preoccupy him, was first exhibited in 1970 in one-man shows at the Chapman-Kelley Gallery in Dallas and the Woods-Gerry Gallery of the Rhode Island School of Design. That same year a piece was included in the Whitney Museum's annual exhibition of contemporary American sculpture. In 1971 two typically disparate yet related events took place: the execution of his first major outdoor sculpture (*Christ and Pythagoras*) in Kingston, Rhode Island (recorded in photographs by Harry Anderson published in the fall issue of *Avalanche* magazine) and his re-creation of the traditional Italian wine-tasting festival of St. Martin's day (November 11) in a gallery at 93 Grand Street, New York. His work was frequently represented in group shows during the 1960s and early 1970s and one-man exhibitions have occurred at museums and universities with increasing regularity: the University of Rochester in 1971, the Whitney Museum and the Pennsylvania Academy in 1972, the University of Rhode Island in 1973, and the Rhode Island School of Design in 1974.

One of the salient characteristics of Scanga's art is that it frequently involves the collaborative efforts of several people. Friends, students, and colleagues participate in various ways in Scanga's working process: manipulating materials at his direction, contributing to a handbook or catalogue, or documenting the process through photographs or video. During the early 1970s he was associated with a group of artists at the

112 Greene Street Gallery in New York. He has had a long and fruitful friendship with members of the glassblowing department at the Rhode Island School of Design, who often help fabricate objects for his installations, and he has often worked with William Schwedler and Jan Napiwocki. Artists with whom he frequently exhibits and collaborates in Philadelphia include Harry Anderson, Larry Becker, Richard Calabro, Baldo Diodato, Heidi Nivling, and Valentino de Pascale.

Scanga has received grants from the Howard Foundation at Brown University (1970), the Cassandra Foundation (1972), and the National Endowment for the Arts (1973). He has lectured in art schools and universities across the country and is regarded as a stimulating and unconventional teacher. His most recent one-man shows were held at the Henri Gallery in Washington, D.C., and the Alessandra Gallery in New York. Returning to Italy after many years, he spent the summer of 1972 at the Tyler School of Art in Rome, and has recently acquired a house and land in the Umbrian countryside near Spoleto.

546. *Restoration Piece #3*

1975
Signature: Italo Scanga, 1975 (interior of plaster sculpture)
Painted plaster, plaster blocks, wood, and glass
30 x 48 x 36″ (76.2 x 121.8 x 91.4 cm)
Alessandra Gallery, New York

LITERATURE: New York, Alessandra Gallery, *Italo Scanga, Restoration Pieces* (November 1–29, 1975), no. 8 (illus.); Patricia Stewart, "Scanga, Saints and Pitchforks," *The Drummer*, December 9, 1975, illus. p. 21 (as "Restoration Piece No. 2")

IT IS DIFFICULT to extract any single piece by Scanga out of the rich matrix of cross-references and relationships which constitutes his work of the past decade. His art has a cumulative, emotional impact which thrives on being exhibited in quantity in a large space which he manipulates to serve his narrative purposes. The central component of *Restoration Piece #3* is a plaster group of figures representing one of the fourteen Stations of the Cross; Scanga's organization of aesthetic experience in a gallery space could often be described as parallel to the devotional installation of the Stations within a church. In an exhibition of Scanga's work, the viewer moves from object to object, kneeling in order to look at watercolors hung low on a wall, pausing before a striking or enigmatic juxtaposition of materials, but always aware of the total arrangement of objects in the room. *Restoration Piece #3* was exhibited in the autumn of 1975 at the Alessandra Gallery in New York together with two other pieces employing the same motif (*Restoration Pieces #1* and *#2*) and a number of works on paper. The latter consisted of mass-produced devotional prints (the Agony in the Garden, the Virgin with a bleeding heart), the images spattered with flecks of watercolor and half obscured by spices and sawdust encrusted on the paper surface.

Concerned both with tapping the resources

546.

of his own past and with affecting his audience as directly as possible, Scanga employs religious imagery as one powerful means of communication. The plaster sculpture in *Restoration Piece #3*, laid on its back and tipped upward, is contained behind a protective shield of wood and glass. The plaster group itself has been altered by the artist, flecked with red-brown paint, and propped up on white plaster blocks. Other blocks are placed at intervals on the surface of the figural group, serving Scanga's intent to "neutralize" the dramatic effect of the uprooted and overturned sculpture.

Restoration Piece #3 is the outcome of the combined efforts of several friends who have often worked with Scanga on his installations: Valentino de Pascale built the wooden structure, Larry Becker devised a method of securing the plaster blocks to the surface of the sculpture with dowels, and Dale Chihuly and James Carpenter at the Rhode Island

School of Design provided the glass. Scanga has previously made use of the various materials assembled here in pieces which had a more earthy, primitive aspect. In earlier works, the glass vessel standing in front of the sculpture might have been filled with grain or paprika like a votive offering. The plaster blocks recall those which Scanga fastened to a leafless tree in his 1971 piece entitled *Christ and Pythagoras* (as he worked, the tree came to suggest the Passion —the crucifixion—burdened with the uncompromising geometrical shapes of man's rational thoughts).

Restoration Piece #3 has a new element of aesthetic distance, almost of abstraction in its presentation. The skillful craftsmanship of the wooden framework and the formal organization of the separate elements of the piece into a self-contained whole reduce its emotional impact and, instead, propose a more intellectual confrontation with the

viewer. And yet, complex both in its fabrication and its allusions, the piece is not "conceptual" in the sense of being derived from any systematic procedure or set of ideas. Scanga's response to his material (Christian devotional imagery) and his materials (wood, plaster, glass) remains spontaneous and impulsive. The disoriented sculpture represents the artist's gesture—Scanga views himself as moving and altering his subject matter in much the same way as a painter wields his brush. There is a latent violence in *Restoration Piece #3* which runs through much of Scanga's work (the tree laden with blocks, a pitchfork thrust into molten glass). The violence does not function negatively—against religion—but performs a "cleansing" operation, returning us to the original spiritual power which once infused the timeworn and much reproduced religious symbols.

Ad'H □

Bibliography
of Frequently Cited
Works

AAA

Archives of American Art. Smithsonian Institution, Washington, D.C.

Ackermann, *Repository*

Repository of Arts, Literature, Commerce, Manufactures, Fashion and Politics. Vols. 1–40. London: R. Ackermann, 1809–28.

American Daily Advertiser

1791–93: *Dunlap's American Daily Advertiser;* 1793–95: *Dunlap and Claypoole's American Daily Advertiser;* 1796–1800: *Claypoole's American Daily Advertiser;* 1800–1820: *Poulson's American Daily Advertiser.*

American Illustration

Wilmington. Delaware Art Museum. *The Golden Age of American Illustration, 1880–1914.* (September 14–October 15, 1972).

American Printmaking

New York. Museum of Graphic Art. *American Printmaking: The First 150 Years.* Preface by A. Hyatt Mayor. Foreword by Donald H. Karshan. Introduction by J. William Middendorf II. Text by Wendy J. Shadwell. (1969–71, at thirteen participating museums).

APS

American Philosophical Society, Philadelphia.

Barber, *Marks*

Barber, Edwin Atlee. *Marks of American Potters.* Philadelphia: Patterson & White Co., 1904.

Barber, *Pottery and Porcelain*

Barber, Edwin Atlee. *The Pottery and Porcelain of the United States, An Historical Review of American Ceramic Art from the Earliest Times to the Present Day, to which is appended a chapter on the pottery of Mexico.* 3d edition, revised and enlarged. New York: G. P. Putnam's Sons, 1909.

Beal, *Eichholtz*

Beal, Rebecca J. *Jacob Eichholtz, 1776–1842.* Philadelphia: Historical Society of Pennsylvania, 1969.

Beall, *Prints*

Beall, Karen F., comp. *American Prints in the Library of Congress: A Catalog of the Collection.* Baltimore: Johns Hopkins Press, 1970.

Bernstein, *Masterpieces*

Bernstein, Aline. *Masterpieces of Women's Costumes of the 18th and 19th Centuries.* New York: Crown Publishers, Inc., 1959.

Biddle, *Carpenter's Assistant*

Biddle, Owen. *The Young Carpenter's Assistant; or, A System of Architecture* Philadelphia, 1805.

Biddle and Fielding, *Sully*

Biddle, Edward, and Fielding, Mantle. *The Life and Works of Thomas Sully (1783–1872).* Philadelphia: Wickersham Press, 1921.

Bigelow, *Fashion*

Bigelow, Marybelle S. *Fashion in History: Apparel in the Western World.* Minneapolis: Burgess Publishing Co., 1970.

Bishop, *History of Manufactures*

Bishop, J. Leander. *A History of American Manufactures from 1608 to 1860: Exhibiting the Origin and Growth of the Principal Mechanic Arts and Manufactures, from the Earliest Colonial Period to the Adoption of the Constitution* 3 vols. 3d edition, revised and enlarged. Philadelphia: Edward Young & Co., 1868.

Bolton

Bolton, Theodore. "The Book Illustrations of Felix Octavius Carr Darley." *Proceedings of the American Antiquarian Society,* vol. 61 (April 1951), pp. 137–81.

Bolton and Coe, *American Samplers*

Bolton, Ethel Stanwood, and Coe, Eva Johnston. *American Samplers.* Boston: The Massachusetts Society of the Colonial Dames of America, 1921.

Buhler and Hood

Buhler, Kathryn C., and Hood, Graham. *American Silver: Garvan and Other Collections in the Yale University Art Gallery.* New Haven: Yale University Press, 1970.

Bullard, "Sloan"
 Bullard, Edgar John. "John Sloan and the Philadelphia Realists as Illustrators, 1890–1920." M.A. thesis, University of California, Los Angeles, 1968.

Camera Notes
 Camera Notes and Proceedings of the Camera Club of New York. An Illustrated Quarterly. Edited by Alfred Stieglitz. Vols. 1–6 (1897–1902).

Camera Work
 Camera Work. A Photographic Quarterly. Edited by Alfred Stieglitz. Vols. 1–12, nos. 1–49/50 (January 1903—June 1917).

Carpenters' Company Rule Book
 The Rules of Work of the Carpenters' Company of the City and County of Philadelphia. Philadelphia, 1786.

Carson, "Connelly and Haines"
 Carson, Marion Sadtler. "Connelly and Haines." Philadelphia Museum of Art Bulletin, vol. 48, no. 237 (Spring 1953).

Centennial Masterpieces
 The Masterpieces of the Centennial International Exhibition. 3 vols. Vol. 1: Fine Art, by Edward Strahan [Earl Shinn]; vol. 2: Industrial Art, by Professor Walter Smith; vol. 3: History, Mechanics, Science, by Joseph M. Wilson. Philadelphia: Gebbie and Barrie, 1876–78.

Childs, Views in Philadelphia
 Childs, Cephas Grier. Views in Philadelphia and Its Environs, from Original Drawings Taken in 1827–30. Philadelphia: C. G. Childs, 1830.

Chippendale, Director
 Chippendale, Thomas. The Gentleman and Cabinet-Maker's Director London: The author, 1754.

Clement, Pioneer Potters
 Clement, Arthur W. Our Pioneer Potters. New York: Privately printed, 1947.

Clement and Hutton
 Clement, Clara Erskine, and Hutton, Laurence. Artists of the Nineteenth Century and Their Works: A Handbook Containing Two Thousand and Fifty Biographical Sketches. 2 vols. Boston: Houghton, Osgood and Company, 1879.

Cook, House Beautiful
 Cook, Clarence. The House Beautiful, Essays on Beds and Tables, Stools and Candlesticks. New York, 1878.

Craven, Sculpture
 Craven, Wayne. Sculpture in America. New York: Thomas Y. Crowell Co., 1968.

Curtis, "Tucker Porcelain"
 Curtis, Phillip H. "Tucker Porcelain, 1826–1838: A Re-Appraisal." M.A. thesis, University of Delaware, 1972.

DAB
 Dictionary of American Biography. Allen Johnson and Dumas Malone, eds. New York: Charles Scribner's Sons, 1928–36. 4 supplements, 1944, 1958, 1973, 1974.

Daniel, Cut and Engraved Glass
 Daniel, Dorothy. Cut and Engraved Glass, 1771–1905: The Collectors' Guide to American Wares. New York: M. Barrows and Company, Inc., 1950.

Davenport, Costume
 Davenport, Millia. The Book of Costume. 2 vols. New York: Crown Publishers, 1948.

Davidson, Antiques
 Davidson, Marshall B., ed. The American Heritage History of American Antiques from the Revolution to the Civil War. New York: American Heritage Publishing Co., Inc., 1968.

Delaware Art Museum, Avant-Garde
 Wilmington. Delaware Art Museum, co-sponsored by the University of Delaware. Avant-Garde Painting and Sculpture in America, 1910–25. (April 14—May 18, 1975).

Desportes, "Giuseppe Ceracchi"
 Desportes, Ulysse. "Giuseppe Ceracchi in America and His Busts of George Washington." Art Quarterly, vol. 26, no. 2 (Summer 1963), pp. 141–79.

Dickens, American Notes
 Dickens, Charles. American Notes for General Circulation. New York: Harper and Brothers, 1842.

Dickson, Arts
 Dickson, Harold E. Arts of the Young Republic. Chapel Hill: University of North Carolina Press, 1968.

Dickson, Neal
 Dickson, Harold E., ed. Observations on American Art: Selections from the Writings of John Neal (1793–1876). Pennsylvania State College Studies, no. 12. State College: Pennsylvania State University Press, 1943.

Dickson, Pennsylvania Buildings
 Dickson, Harold E. A Hundred Pennsylvania Buildings. State College, Pennsylvania: Bald Eagle Press, 1954.

Downing, *Country Houses*

 Downing, Andrew Jackson. *The Architecture of Country Houses Including Designs for Cottages, and Farm-Houses, and Villas* New York: D. Appleton & Co., 1850.

Downs, *American Furniture*

 Downs, Joseph. *American Furniture: Queen Anne and Chippendale Periods, in the Henry Francis du Pont Winterthur Museum.* New York: The Macmillan Company, 1952.

Drepperd, *Early Prints*

 Drepperd, Carl W. *Early American Prints.* New York and London: The Century Company, 1930.

Dunlap, *History*

 Dunlap, William. *A History of the Rise and Progress of the Arts of Design in the United States.* 1834. Reprint (2 vols. in 3). Introduction by James Thomas Flexner. Edited by Rita Weiss. New York: Dover Publications, 1969.

Eastlake, *Household Taste*

 Eastlake, Charles Locke. *Hints on Household Taste in Furniture, Upholstery, and Other Details.* London, 1868. Revised American edition. Edited, with notes, by Charles C. Perkins. Boston: J. R. Osgood & Co., 1872.

Eisen, *Portraits*

 Eisen, Gustavus A. *Portraits of Washington.* 3 vols. New York: Robert Hamilton and Associates, 1932.

Ensko

 Ensko, Stephen G. C. *American Silversmiths and Their Marks III.* New York: Robert Ensko Inc., 1948. Privately printed.

Fales, *Joseph Richardson*

 Fales, Martha Gandy. *Joseph Richardson and Family: Philadelphia Silversmiths.* Middletown, Connecticut: Wesleyan University Press, for the Historical Society of Pennsylvania, 1974.

Fales, *Silver*

 Fales, Martha Gandy. *Early American Silver for the Cautious Collector.* New York: Funk & Wagnalls, 1970.

Fielding

 Fielding, Mantle. *Dictionary of American Painters, Sculptors and Engravers.* Philadelphia, 1926.

Fielding, *American Engravers Supplement*

 Fielding, Mantle. *American Engravers Upon Copper and Steel: Biographical Sketches and Check Lists of Engravings. A Supplement to David McNeely Stauffer's American Engravers.* Philadelphia: Wickersham Press, 1917.

Fleischer, "Hesselius"

 Fleischer, Roland E. "Gustavus Hesselius." Ph.D. dissertation, The Johns Hopkins University, 1964.

Flexner, *Distant Skies*

 Flexner, James Thomas. *The Light of Distant Skies, 1760–1835.* New York: Harcourt, Brace, 1954.

Flexner, *First Flowers*

 Flexner, James Thomas. *American Painting: First Flowers of Our Wilderness.* Boston: Houghton Mifflin Company, 1947.

FPAA

 Fairmount Park Art Association, Philadelphia.

FPAA, *Sculpture*

 Philadelphia. Fairmount Park Art Association. *Sculpture of a City: Philadelphia's Treasures in Bronze and Stone.* New York: Walker Publishing Co., 1974.

Francis, *History*

 Francis, Rev. J. G. *Some Francis History, Colonial and Revolutionary, with Respect to the Present.* Lebanon, Pennsylvania: J. G. Francis, 1930.

Frankenstein, *After the Hunt*

 Frankenstein, Alfred. *After the Hunt: William Harnett and Other American Still Life Painters, 1870–1900.* Berkeley and Los Angeles: University of California Press, 1953.

Franklin, *Autobiography*

 Labaree, Leonard, and others, eds. *The Autobiography of Benjamin Franklin.* New Haven: Yale University Press, 1964

Freedley, *Philadelphia Manufactures*

 Freedley, Edwin T. *Philadelphia and Its Manufactures: A Handbook Exhibiting the Development, Variety, and Statistics of the Manufacturing Industry of Philadelphia in 1857, together with Sketches of Remarkable Manufactories; and a List of Articles now Made in Philadelphia.* Philadelphia: Edward Young, 1859.

Free Library, Elizabeth Shippen Green Collection

 The Free Library of Philadelphia, Art Department. The Work of Elizabeth Shippen Green.

Free Library, Oakley Collection

 The Free Library of Philadelphia, Rare Book Department. The Thornton Oakley Collection of Howard Pyle and His School.

Gardner, *MMA Sculpture*

 Gardner, Albert Ten Eyck. *American Sculpture, A Catalogue of the Collection of the Metropolitan Museum of Art.* New York: Metropolitan Museum of Art, 1965.

Gardner and Feld, *MMA Paintings* (1)

 Gardner, Albert Ten Eyck, and Feld, Stuart P.
 *American Paintings, A Catalogue of the Collection of
 the Metropolitan Museum of Art, I, Painters Born by
 1815*. New York: Metropolitan Museum of Art, 1965.

Gems of the Centennial

 Strahan, Edward [Earl Shinn]. *Gems of the Centennial
 Exhibition: Consisting of Illustrated Descriptions of
 Objects of an Artistic Character, in the Exhibits of the
 United States . . . , etc., etc., at the Philadelphia
 International Exhibition of 1876*. New York:
 D. Appleton & Company, Publishers, 1877.

Gerdts and Burke, *Still-Life*

 Gerdts, William H., and Burke, Russell. *American
 Still-Life Painting*. New York: Praeger Publishers,
 1971.

Gernsheim, *Photography*

 Gernsheim, Helmut, in collaboration with Gernsheim,
 Alison. *The History of Photography from the Camera
 Obscura to the Beginning of the Modern Era*.
 New York: McGraw-Hill Book Co., 1969.

Gilchrist, *Strickland*

 Gilchrist, Agnes Addison. *William Strickland:
 Architect and Engineer, 1788–1854*. Philadelphia:
 University of Pennsylvania Press, 1950.

Gillingham, "Cabinet-makers"

 Philadelphia. Historical Society of Pennsylvania.
 Harrold E. Gillingham. "Early Cabinet-makers of
 Philadelphia." MS.

Gillingham, "Indian Silver"

 Gillingham, Harrold E. "Indian Silver Ornaments."
 The Pennsylvania Magazine of History and Biography,
 vol. 58, no. 2 (April 1934), pp. 97–126.

Gipson, *Evans*

 Gipson, Lawrence Henry. *Lewis Evans*. Philadelphia:
 Historical Society of Pennsylvania, 1939.

Glackens

 Glackens, Ira. *William Glackens and the Ashcan
 Group: The Emergence of Realism in American Art*.
 New York: Crown Publishers, Inc., 1957.

Goodrich, *Eakins*

 Goodrich, Lloyd. *Thomas Eakins, His Life and Work*.
 New York: Whitney Museum of American Art, 1933.

Goodyear, *Beaux*

 Philadelphia. Pennsylvania Academy of the Fine Arts,
 in cooperation with the Museum of the Philadelphia
 Civic Center and the Indianapolis Museum of Art.
 Cecilia Beaux: Portrait of an Artist. Introduction by
 Frank H. Goodyear, Jr. (September 6, 1974—March 2,
 1975).

Groce, "Wollaston"

 Groce, George C. "John Wollaston (fl. 1736–1767),
 A Cosmopolitan Painter in the British Colonies."
 Art Quarterly, vol. 15, no. 2 (Summer 1952),
 pp. 133–50.

Groce and Wallace

 Groce, George C., and Wallace, David H.
 *The New-York Historical Society's Dictionary of
 Artists in America, 1564–1860*. New Haven:
 Yale University Press, 1957.

Gummere, *Quaker*

 Gummere, Amelia Mott. *The Quaker: A Study in
 Costume*. Philadelphia: Ferris and Leach, Publishers,
 1901.

Hamilton

 Hamilton, Sinclair. *Early American Book Illustrators
 and Wood Engravers, 1670–1870. A Catalogue of a
 Collection of American Books Illustrated for the Most
 Part with Woodcuts and Wood Engravings in the
 Princeton University Library*. 2 vols. Princeton:
 Princeton University Press, 1958, 1968.

Hamlin, *Greek Revival*

 Hamlin, Talbot. *Greek Revival Architecture in
 America: Being an Account of Important Trends in
 American Architecture and American Life prior to the
 War Between the States*. London and New York:
 Oxford University Press, 1944.

Hammerslough

 Hammerslough, Philip H. *American Silver Collected
 by Philip H. Hammerslough*. 4 vols. Hartford,
 Connecticut: Privately printed, 1957–73.

Heal, *Furniture Makers*

 Heal, Sir Ambrose. *London Furniture Makers from
 the Restoration to the Victorian Era, 1660–1840*.
 London: B. T. Batsford Company, 1953.

Hendricks, *Eakins Life and Works*

 Hendricks, Gordon. *The Life and Works of Thomas
 Eakins*. New York: Grossman Publishers, 1974.

Hendricks, *Eakins Photographs*

 Hendricks, Gordon. *The Photographs of Thomas
 Eakins*. New York: Grossman Publishers, 1972.

Hendricks, "*Gross Clinic*"

 Hendricks, Gordon. "Thomas Eakins's *Gross Clinic*."
 Art Bulletin, vol. 51, no. 1 (March 1969), pp. 57–64.

Hepplewhite, *Guide*

 Hepplewhite, A. and Co. *The Cabinet-Maker and
 Upholsterer's Guide; or Repository of Designs for
 Every Article of Household Furniture* London,
 1788.

Historic Philadelphia

Historic Philadelphia, from the Founding until the Early Nineteenth Century: Papers Dealing with Its People and Buildings. Philadelphia: American Philosophical Society, 1953.

Hood, *Bonnin and Morris*

Hood, Graham. *Bonnin and Morris of Philadelphia: The First American Porcelain Factory, 1770–1772.* Chapel Hill: University of North Carolina Press, 1972.

Hood, *Silver*

Hood, Graham. *American Silver: A History of Style, 1656–1900.* New York: Praeger Publishers, 1971.

Hope, *Household Furniture*

Hope, Thomas. *Household Furniture and Interior Decoration, Executed from Designs by Thomas Hope.* London, 1807.

Hornor

Hornor, William Macpherson, Jr. *Blue Book, Philadelphia Furniture, William Penn to George Washington, with Special Reference to the Philadelphia-Chippendale School.* Philadelphia, 1935.

HSP

Historical Society of Pennsylvania, Philadelphia.

Ingersoll, *Henry McCarter*

Ingersoll, R. Sturgis. *Henry McCarter.* Cambridge, Massachusetts: The Riverside Press, 1944.

Johnson, *Book of Ornaments*

Johnson, Thomas. *A New Book of Ornaments.* London, 1760.

JSAH

Journal of the Society of Architectural Historians. (January 1941—)

Karolik, *Drawings*

Boston. Museum of Fine Arts. *M. and M. Karolik Collection of American Water Colors and Drawings, 1800–1875.* 2 vols. Boston: Museum of Fine Arts, 1962.

Karolik, *Painting*

Boston. Museum of Fine Arts. *M. and M. Karolik Collection of American Painting, 1815 to 1865.* Cambridge: Harvard University Press, for the Museum of Fine Arts, 1949.

Labaree and others, *Franklin*

Labaree, Leonard W.; Willcox, William B., and others, eds. *The Papers of Benjamin Franklin.* 15 vols. New Haven: Yale University Press, 1959–75.

Langley, *Treasury of Designs*

Langley, Batty. *The City and Country Builder's and Workman's Treasury of Designs.* London, 1740.

Laughlin, *Pewter*

Laughlin, Ledlie I. *Pewter in America: Its Makers and Their Marks.* 1940. Reprint (3 vols.). Barre, Massachusetts: Barre Publishers, 1969–71.

Laver, *Concise History*

Laver, James. *The Concise History of Costume and Fashion.* New York: Harry N. Abrams, Inc., 1969.

LCP

The Library Company of Philadelphia.

Lerner, *Hirshhorn*

Lerner, Abram, ed. *The Hirshhorn Museum and Sculpture Garden, Smithsonian Institution.* Foreword by S. Dillon Ripley. Essays by Linda Nochlin and others. New York: Harry N. Abrams, Inc., 1974.

Lewis, *Land Title*

Lewis, John Frederick, Jr., ed. *The History of an Old Philadelphia Land Title, 208 South Fourth Street.* Philadelphia: Patterson & White Co., 1934.

Liddell, *Hon. George Gray*

Liddell, Mary Stanley Field. *The Hon. George Gray, 4th, of Philadelphia, His Ancestors and Descendants.* Ann Arbor, Michigan: Privately printed, 1940.

London, *1851 Official Catalogue*

Official Descriptive and Illustrated Catalogue of the Great Exhibition of the Works of Industry of all Nations, 1851. 3 vols. and supplement. London, 1851.

Longstreth, *Art Guide*

Longstreth, Edward. *The Art Guide to Philadelphia, Being a Complete Exposition of the Fine Arts in Museums, Parks, Public Buildings, and Private Institutions in America's Oldest Metropolis.* Philadelphia: Edward Longstreth, 1925.

Loudon, *Cottage, Farm, and Villa Architecture*

Loudon, John Claudius. *Encyclopedia of Cottage, Farm, and Villa Architecture and Furniture.* London, 1836.

Ludwig, *Parrish*

Ludwig, Coy. *Maxfield Parrish.* New York: Watson-Guptill Publications, 1973.

Lykes, "Pyle"

Lykes, Richard Wayne. "Howard Pyle: Teacher of Illustration." *The Pennsylvania Magazine of History and Biography,* vol. 80, no. 3 (July 1956), pp. 339–70.

Made in America

The Library Company of Philadelphia. *Made in America. Printmaking, 1760–1860: An Exhibition of Original Prints from the Collections of the Library Company of Philadelphia and the Historical Society of Pennsylvania.* (April—June 1973).

Mahony and Whitney

 Mahony, Bertha E., and Whitney, Elinor, comps. *Contemporary Illustrators of Children's Books.* Boston: Women's Educational and Industrial Union, 1930.

McClellan, *Costume*

 McClellan, Elisabeth. *History of American Costume, 1607–1870: With an Introductory Chapter on Dress in the Spanish and French Settlements in Florida and Louisiana.* New York: Tudor Publishing Co., 1937.

McElroy, "Furniture"

 McElroy, Cathryn J. "Furniture of the Philadelphia Area: Forms and Craftsmen Before 1730." M.A. thesis, University of Delaware, 1970.

McKearin, *Blown Glass*

 McKearin, Helen, and McKearin, George S. *Two Hundred Years of American Blown Glass.* Garden City, New York: Doubleday & Company, Inc., 1950.

McKearin, *Dr. Dyott*

 McKearin, Helen. *Bottles, Flasks and Dr. Dyott.* New York: Crown Publishers, 1970.

McKearin, *Glass*

 McKearin, George S., and McKearin, Helen. *American Glass.* New York: Crown Publishers, 1941.

Mésangère

 Pierre de la Mésangère. *Meubles et Objets de Goût, 1796–1830, 678 Documents Tirés des Journaux de Modes et de la "Collection" de la Mésangère.* Paris, n.d.

MFA

 Museum of Fine Arts, Boston.

MFA, *Silversmiths*

 Boston. Museum of Fine Arts. *Colonial Silversmiths, Masters & Apprentices.* Introduction by Kathryn C. Buhler. (November 14—December 30, 1956)

Mitchell and Flanders, eds., *Statutes of Pennsylvania*

 Mitchell, James T., and Flanders, Henry, eds. *The Statutes at Large of Pennsylvania from 1682 to 1809.* 18 vols. Harrisburg: State Printer, 1896–1915.

MMA

 Metropolitan Museum of Art, New York.

MMA, *19th-Century America, Furniture*

 New York. Metropolitan Museum of Art. *19th-Century America, Furniture and Other Decorative Arts.* Introduction by Berry B. Tracy. Texts by Marilynn Johnson, Marvin D. Schwartz, Suzanne Boorsch. (April 16—September 7, 1970).

MMA, *19th-Century America, Paintings*

 New York. Metropolitan Museum of Art. *19th-Century America, Paintings and Sculpture.* Introduction by John K. Howat and John Wilmerding. Texts by John K. Howat, Natalie Spassky, and others. (April 16—September 7, 1970).

MOMA

 Museum of Modern Art, New York.

Montgomery, *Federal Furniture*

 Winterthur, Delaware. The Henry Francis du Pont Winterthur Museum. *American Furniture, The Federal Period, in the Henry Francis du Pont Winterthur Museum.* By Charles F. Montgomery. New York: Viking Press, 1966.

Moon, *Morris Family*

 Moon, Robert C. *The Morris Family of Philadelphia: Descendants of Anthony Morris, 1654–1721.* 5 vols. Philadelphia: R. C. Moon, 1898–1909.

Morgan and Fielding, *Life Portraits*

 Morgan, John Hill, and Fielding, Mantle. *The Life Portraits of Washington and Their Replicas.* Lancaster, Pennsylvania: Lancaster Press, Inc., 1931.

Morse and Brincklé

 Morse, Willard S., and Brincklé, Gertrude, comps. *Howard Pyle: A Record of His Illustrations and Writings.* Wilmington: The Wilmington Society of the Fine Arts, 1921.

Moss, "Churches"

 Moss, Roger. "Two Seventeenth Century Delaware Valley Churches." *Proceedings of the Twenty-eighth Annual Meeting of the Society of Architectural Historians* (April 23–28, 1975), forthcoming.

Mudge

 Mudge, Jean McClure. *Chinese Export Porcelain for the American Trade, 1785–1835.* Newark: University of Delaware Press, 1962.

NAD

 National Academy of Design, New York.

NAD, *Annual*

 New York. *National Academy of Design Annual Exhibition.* [1826—].

Naeve, "Krimmel"

 Naeve, Milo M. "John Lewis Krimmel: His Life, His Art, and His Critics." M.A. thesis, University of Delaware, 1955.

National Academy Exhibition Record, I

 National Academy of Design Exhibition Record, 1826–1860. 2 vols. New York: New-York Historical Society, 1943.

National Academy Exhibition Record, II

 Naylor, Maria, comp. and ed. *The National Academy of Design Exhibition Record, 1861–1960.* 2 vols. New York: Kennedy Galleries, Inc., 1973.

NCFA

 National Collection of Fine Arts. Smithsonian
 Institution, Washington, D.C.

Newark, *Classical America*

 Newark, New Jersey. The Newark Museum.
 Classical America, 1815–1845. By Berry B. Tracy and
 William H. Gerdts. (April 26—September 2, 1963).

Newhall, *Daguerreotype*

 Newhall, Beaumont. *The Daguerreotype in America.*
 New York: Duell, Sloan & Pearce, 1961.

Newhall, *Photography*

 Newhall, Beaumont. *The History of Photography from
 1839 to the Present Day.* Revised and enlarged.
 New York: Museum of Modern Art, 1964.

Nicholson, *Cabinet Maker*

 Nicholson, Peter, and Nicholson, Michel Angelo.
 *The Practical Cabinet Maker, Upholsterer and
 Complete Decorator.* London, 1826.

Nutting, *Furniture*

 Nutting, Wallace. *Furniture Treasury (Mostly of
 American Origin): All Periods of American Furniture
 with Some Foreign Examples in America: Also
 American Hardware and Household Utensils.* 2 vols.
 New York: The Macmillan Company, 1948.

NYPL

 New York Public Library, New York.

NYPL, *American Engravers*

 New York Public Library. *One Hundred American
 Engravers, 1683–1850.* By I. N. Phelps Stokes.
 (December 15, 1927—April 30, 1928).

Orlofsky, *Quilts*

 Orlofsky, Patsy, and Orlofsky, Myron. *Quilts in
 America.* New York: McGraw-Hill Book Co., 1974.

Otto, *American Furniture*

 Otto, Celia Jackson. *American Furniture of the
 Nineteenth Century.* New York: The Viking Press,
 1965.

Otto, "Pillar and Scroll"

 Otto, Celia Jackson. "Pillar and Scroll: Greek Revival
 Furniture of the 1830s." *Antiques,* vol. 81, no. 5
 (May 1962), pp. 504–7.

PAFA

 Pennsylvania Academy of the Fine Arts, Philadelphia.

PAFA, *Annual*

 Philadelphia. *Pennsylvania Academy of the Fine Arts:
 Annual Exhibition of Painting and Sculpture.*
 [1811–1969].

PAFA, *Annual Watercolor*

 Philadelphia. *Pennsylvania Academy of the Fine Arts:
 Annual Philadelphia Water Color and Print Exhibition,
 and the Annual Exhibition of Miniatures.* [1904–1952].

PAFA, *Doughty*

 Philadelphia. Pennsylvania Academy of the Fine Arts.
 *Thomas Doughty, 1793–1856, An American Pioneer
 in Landscape Painting.* By Frank H. Goodyear, Jr.
 (October 19—December 2, 1973).

PAFA, *Historical Portraits*

 Philadelphia. Pennsylvania Academy of the Fine Arts.
 Loan Exhibition of Historical Portraits: Catalog.
 (December 1, 1887—January 15, 1888).

PAFA and Its Women

 Philadelphia. Pennsylvania Academy of the Fine Arts.
 *The Pennsylvania Academy and Its Women, 1850 to
 1920.* (May 3—June 16, 1973).

PAFA, *Painting and Printing*

 Philadelphia. Pennsylvania Academy of the Fine Arts.
 Philadelphia Painting and Printing to 1776.
 (March 26—April 25, 1971).

Panama-Pacific Exposition, *Catalogue de Luxe*

 San Francisco. Panama-Pacific International Exposition.
 Catalogue de Luxe of the Department of Fine Arts.
 Edited by John E. D. Trask and J. Nilsen Laurvik.
 2 vols. San Francisco: P. Elder and Company, 1915.

Parker, "Rich and Poor"

 Parker, Peter J. "Rich and Poor in Philadelphia, 1709."
 The Pennsylvania Magazine of History and Biography,
 vol. 99, no. 1 (January 1975), pp. 3–19.

Pennell, *Pen Drawing*

 Pennell, Joseph. *Pen Drawing and Pen Draughtsmen:
 Their Work and Their Methods, a Study of the Art
 To-day with Technical Suggestions.* London and
 New York: Macmillan and Co., 1889.

Percier and Fontaine

 Percier, Charles. *Recueil de décorations intérieures . . .
 composé par C. Percier et P. F. L. Fontaine, exécuté
 sur leurs dessins.* Paris: Published by the authors, 1812.

Peters, *America on Stone*

 Peters, Harry T. *America on Stone.* New York:
 Doubleday, Doran & Company, Inc., 1931.

Pettit, *Fabrics*

 Pettit, Florence H. *America's Printed and Painted
 Fabrics, 1600–1900: All the Ways There Are to Print
 Upon Textiles. A Most Complete History of World
 Fabric Prints. . . .* New York: Hastings House, 1970.

Philadelphia Reviewed

Winterthur, Delaware. The Henry Francis du Pont Winterthur Museum. *Philadelphia Reviewed: The Printmaker's Record, 1750–1850.* (September 28—October 28, 1960).

Philadelphia Sesqui-Centennial

Philadelphia. Sesqui-Centennial Exposition. *Paintings, Sculpture, and Prints in the Department of Fine Arts.* (June 1—December 1, 1926).

Phillips, *Maps and Views*

Phillips, P. Lee. *A Descriptive List of Maps and Views of Philadelphia in the Library of Congress, 1683–1865.* Philadelphia: The Geographical Society, by permission of the Library of Congress, 1926.

Pitz, *Pyle*

Pitz, Henry C. *Howard Pyle: Writer, Illustrator, Founder of the Brandywine School.* New York: Clarkson N. Potter, Inc., 1975.

PMA

Philadelphia Museum of Art.

PMA, *Architectural Drawings*

Philadelphia Museum of Art and Society of Architectural Historians. *Two Centuries of Philadelphia Architectural Drawings: Catalogue of the Exhibit Held at the Philadelphia Museum of Art by the Society of Architectural Historians.* Edited by James C. Massey. (January 24—February 24, 1964).

PMA Bulletin

Philadelphia Museum of Art Bulletin. (January 1903—). [Titled *Bulletin of the Pennsylvania Museum,* January 1903 to May 1938].

PMA, *Furness*

Philadelphia Museum of Art. *The Architecture of Frank Furness.* Text by James F. O'Gorman. (April 5—May 27, 1973).

PMA, *Samplers*

Hornor, Marianna Merritt. *The Story of Samplers.* Philadelphia Museum of Art, 1971.

PMA, *Silver*

Philadelphia Museum of Art. *Exhibition of Philadelphia Silver, 1682–1800, at the Philadelphia Museum of Art.* (April 14—May 27, 1956).

PMA, *Tucker China*

Philadelphia Museum of Art. *Tucker China, 1825–1838.* Text by Horace H. F. Jayne. (May 4—September 9, 1957).

PMHB

The Pennsylvania Magazine of History and Biography. (1877—). Published by the Historical Society of Pennsylvania.

Prime, *Arts and Crafts,* vol. 1

Prime, Alfred Coxe, coll. *The Arts and Crafts in Philadelphia, Maryland and South Carolina, 1721–1785. Series One. Gleanings from Newspapers.* Topsfield, Mass.: The Walpole Society, 1929.

Prime, *Arts and Crafts,* vol. 2

Prime, Alfred Coxe, coll. *The Arts and Crafts in Philadelphia, Maryland and South Carolina, 1786–1800. Series Two. Gleanings from Newspapers.* Topsfield, Mass.: The Walpole Society, 1932.

Prints Pertaining to America

Prints Pertaining to America: A List of Publications in English Relating to Prints . . . with Emphasis on the Period 1650–1850, and a Checklist of Prints . . . Selected from the Collection of the Henry Francis du Pont Winterthur Museum. Topsfield, Mass.: The Walpole Society, 1963.

Pyle Collection

Howard Pyle: Works in the Collection of the Delaware Art Museum. Introduction by Rowland Elzea. Catalogue by Rowland Elzea and Elizabeth Handy. Wilmington: The Wilmington Society of the Fine Arts, 1971.

Pyle: Diversity in Depth

Wilmington. Delaware Art Museum. *Howard Pyle: Diversity in Depth.* (March 5—April 15, 1973).

Quimby, *Painting*

Quimby, Ian M. G., ed. *American Painting to 1776: A Reappraisal.* Charlottesville: University of Virginia Press, for The Henry Francis du Pont Winterthur Museum, 1971.

Rainwater

Rainwater, Dorothy T. *American Silver Manufacturers: Their Marks, Trademarks and History.* Hanover, Pennsylvania: Everybodys Press, 1966.

Rawle, "First Tax List"

"The First Tax List for Philadelphia County, A.D. 1693." Introductory note by William Brooke Rawle. *The Pennsylvania Magazine of History and Biography,* vol. 8, no. 1 (1884), pp. 82–105.

Revi, *Cut and Engraved Glass*

Revi, Albert Christian. *American Cut and Engraved Glass.* New York: Thomas Nelson & Sons, 1965.

Richardson, "Claypoole"

Richardson, E. P. "James Claypoole, Junior, Rediscovered." *Art Quarterly,* vol. 33, no. 2 (Summer 1970), pp. 159–75.

Robson, *Manufacturers*

Robson, Charles. *Manufactories and Manufacturers of Pennsylvania in the Nineteenth Century.* Philadelphia: Galaxy Publishing Company, 1875.

Rose, *American Art*

 Rose, Barbara. *American Art Since 1900: A Critical History.* New York: Frederick A. Praeger, 1967.

Rourke

 Rourke, Constance Mayfield. *Charles Sheeler, Artist in the American Tradition.* New York: Harcourt, Brace, and Company, 1938.

Rutledge, *Cumulative Record*

 Rutledge, Anna Wells, comp. and ed. *Cumulative Record of Exhibition Catalogues. The Pennsylvania Academy of the Fine Arts, 1807–1870; The Society of Artists, 1800–1814; The Artists' Fund Society, 1835–1845.* Philadelphia: American Philosophical Society, 1955.

Safford and Bishop, *Quilts and Coverlets*

 Safford, Carleton L., and Bishop, Robert. *America's Quilts and Coverlets.* New York: E. P. Dutton & Co., Inc., 1972.

Sartain, *Reminiscences*

 Sartain, John. *The Reminiscences of a Very Old Man, 1808–1897.* New York: D. Appleton and Company, 1899.

Sawitzky, "West"

 Sawitzky, William. "The American Work of Benjamin West." *The Pennsylvania Magazine of History and Biography,* vol. 62, no. 4 (October 1938), pp. 433–62.

Scharf and Westcott

 Scharf, J. Thomas, and Westcott, Thompson. *History of Philadelphia, 1609–1884.* 3 vols. Philadelphia: L. H. Everts & Co., 1884.

Schiffer, *Historical Needlework*

 Schiffer, Margaret B. *Historical Needlework of Pennsylvania.* New York: Charles Scribner's Sons, 1968.

Scott and Bullard, *Sloan*

 Washington, D.C. National Gallery of Art and other institutions. *John Sloan, 1871–1951.* By David W. Scott and E. John Bullard. (September 18, 1971—October 22, 1972).

Seaman, *Thomas Richardson*

 Seaman, Mary Thomas. *Thomas Richardson of South Shields, Durham County, England and His Descendants in the United States of America.* New York: Tobias A. Wright, 1929.

Sellers, *Franklin*

 Sellers, Charles Coleman. *Benjamin Franklin in Portraiture.* New Haven: Yale University Press, 1962.

Sellers, *Peale,* 1947

 Sellers, Charles Coleman. *Charles Willson Peale.* 2 vols. Vol. 1: *Early Life (1741–1790);* vol. 2: *Later Life (1790–1827).* Philadelphia: American Philosophical Society, 1947.

Sellers, *Peale,* 1969

 Sellers, Charles Coleman. *Charles Willson Peale.* New York: Charles Scribner's Sons, 1969.

Sellers, *Portraits and Miniatures*

 Sellers, Charles Coleman. *Portraits and Miniatures by Charles Willson Peale.* Philadelphia: American Philosophical Society, 1952.

Sellin, "The First Pose"

 Sellin, David. "The First Pose: Howard Roberts, Thomas Eakins, and a Century of Philadelphia Nudes." *Philadelphia Museum of Art Bulletin,* vol. 70, nos. 311–12 (Spring 1975).

"Servants and Apprentices"

 "Record of Servants and Apprentices Bound and Assigned Before Hon. John Gibson, Mayor of Philadelphia, December 5th, 1772—May 21, 1773." *The Pennsylvania Magazine of History and Biography,* vol. 34, no. 1 (1910), pp. 99–121.

Shearer, *London Book of Prices,* 1788

 Shearer, Thomas, and others. *The Cabinet-Maker's London Book of Prices, and Designs of Cabinet Work, calculated for the convenience of cabinet-makers in general* London, 1788.

Sheldon, *Painters*

 Sheldon, G. W. *American Painters.* 1879. Enlarged edition. New York: D. Appleton and Company, 1881.

Sheraton, *Appendix*

 Sheraton, Thomas. *Appendix to the Cabinet-Maker and Upholsterer's Drawing-Book* London, 1802.

Sheraton, *Cabinet Dictionary*

 Sheraton, Thomas. *The Cabinet Dictionary, containing an explanation of all the terms used in the cabinet, chair & upholstery branches* London: W. Smith, 1803.

Sheraton, *Designs*

 Sheraton, Thomas. *Designs for Household Furniture.* London, 1812.

Sheraton, *Drawing-Book*

 Sheraton, Thomas. *The Cabinet-Maker and Upholsterer's Drawing-Book in Three Parts* 2 vols. London, 1793, 1794. 3d edition, revised and enlarged. London, 1802.

Sheraton, *Encyclopedia*

 Sheraton, Thomas. *The Cabinet-Maker, Upholsterer and General Artist's Encyclopaedia.* London, 1804–6.

Shoemaker, "Christ Church"

 Shoemaker, Robert W. "Christ Church, St. Peter's and St. Paul's." In *Historic Philadelphia, from the Founding until the Early Nineteenth Century: Papers Dealing with Its People and Buildings.* Philadelphia: American Philosophical Society, 1953.

Silliman and Goodrich

 Silliman, Benjamin, Jr., and Goodrich, C. R., eds. *The World of Science, Art and Industry Illustrated from Examples in the New-York Exhibition, 1853–54.* New York: G. P. Putnam and Company, 1854.

Smith, *Designs*

 Smith, George. *A Collection of Designs for Household Furniture and Interior Decoration* London, 1808.

Smith, *Fisher Family*

 Smith, Anna Wharton. *Genealogy of the Fisher Family, 1682 to 1896.* Philadelphia, 1896.

Smith, *Guide*

 Smith, George. *The Cabinet-Maker and Upholsterer's Guide* London, 1826.

Snyder, *City of Independence*

 Snyder, Martin P. *City of Independence: Views of Philadelphia Before 1800.* New York: Praeger Publishers, 1975.

Snyder, "Views"

 Snyder, Martin P. "Views of Philadelphia, 1750–1770." *Antiques,* vol. 88, no. 5 (November 1965), pp. 674–80.

Soby, *Contemporary Painters*

 Soby, James Thrall. *Contemporary Painters.* New York: Museum of Modern Art, 1948.

Stauffer

 Stauffer, David McNeely. *American Engravers Upon Copper and Steel.* 2 vols. Part I: *Biographical Sketches Illustrated*; part II, *Check-List of the Works of the Earlier Engravers.* New York: The Grolier Club of the City of New York, 1907.

Stewart, *Benbridge*

 Washington, D.C. National Portrait Gallery. *Henry Benbridge (1743–1812): American Portrait Painter.* By Robert G. Stewart. (April 2–May 16, 1971).

Stoddart, "Darley"

 Stoddart, R. H. "Felix O. C. Darley." *The National Magazine: Devoted to Literature, Art, and Religion,* vol. 9 (July–December 1856), pp. 193–97.

Stokes and Haskell, *Early Views*

 Stokes, I. N. Phelps, and Haskell, Daniel C. *American Historical Prints: Early Views of American Cities, etc., from the Phelps Stokes and Other Collections.* New York: New York Public Library, 1933.

Stuart and Revett, *Antiquities of Athens*

 Stuart, James, and Revett, Nicholas. *The Antiquities of Athens; Measured and delineated* 4 vols. London, 1762–1816.

Sullivan, *Autobiography*

 Sullivan, Louis H. *The Autobiography of an Idea.* New York: Press of the American Institute of Architects, Inc., 1924.

Taft, *Photography*

 Taft, Robert. *Photography and the American Scene: A Social History, 1839–1889.* New York: The Macmillan Company, 1938.

Taft, *Sculpture*

 Taft, Loredo. *American Sculpture.* New York: The Macmillan Company, 1924.

Tallis

 Tallis, John. *Tallis's History and Description of the Crystal Palace, and the Exhibition of the World's Industry in 1851.* London and New York: The London Printing and Publishing Co., 1852.

Tatum

 Tatum, George B. *Penn's Great Town: 250 Years of Philadelphia Architecture Illustrated in Prints and Drawings.* Foreword by Theo B. White. Philadelphia: University of Pennsylvania Press, 1961.

Thieme-Becker

 Thieme, Ulrich, and Becker, Felix. *Allgemeines Lexikon der Bildenden Künstler von der Antike bis zur Gegenwart.* 37 vols. Leipzig: E. A. Seemann, 1907–50.

Tolles, *Meeting House*

 Tolles, Frederick B. *Meeting House and Counting House: The Quaker Merchants of Colonial Philadelphia, 1682–1783.* Chapel Hill: University of North Carolina Press, for the Institute of Early American History and Culture at Williamsburg, Virginia, 1948.

Tuckerman

 Tuckerman, Henry T. *Book of the Artists. American Artist Life, Comprising Biographical and Critical Sketches of American Artists: Preceded by an Historical Account of the Rise and Progress of Art in America.* New York: G. P. Putnam & Son, 1867.

Van Rensselaer, *Bottles and Flasks*

 Van Rensselaer, Stephen. *Early American Bottles and Flasks.* Revised edition. Peterborough, N.H.: Transcript Printing Co., 1926.

Vitruvius Britannicus

 Campbell, Colen. *Vitruvius Britannicus.* 3 vols. London, 1731.

Vitruvius Scoticus
> Adam, William. *Vitruvius Scoticus.* Edinburgh, 1750.

Wainwright, *Cadwalader*
> Wainwright, Nicholas B. *Colonial Grandeur in Philadelphia: The House and Furniture of General John Cadwalader.* Philadelphia: Historical Society of Pennsylvania, 1964.

Wainwright, *Early Lithography*
> Wainwright, Nicholas B. *Philadelphia in the Romantic Age of Lithography: An Illustrated History of Early Lithography in Philadelphia with a Descriptive List of Philadelphia Scenes Made by Philadelphia Lithographers before 1866.* Philadelphia: Historical Society of Pennsylvania, 1958.

Wainwright, *Paintings and Miniatures*
> Wainwright, Nicholas B. *Paintings and Miniatures at the Historical Society of Pennsylvania.* Philadelphia: Historical Society of Pennsylvania, 1974.

Ware, *Palladio*
> Ware, Isaac, trans. *The Four Books of Andrea Palladio.* London, 1738.

Watson, *Annals*
> Watson, John F. *Annals of Philadelphia, and Pennsylvania, in the Olden Time; Being a Collection of Memoirs, Anecdotes, and Incidents of the City and Its Inhabitants, and of the Earliest Settlements of the Inland Part of Pennsylvania* 3 vols. Revised and enlarged by Willis P. Hazard. Philadelphia: Edwin S. Stuart, 1887.

Weitenkampf, *American Graphic Art*
> Weitenkampf, Frank. *American Graphic Art.* New York: Henry Holt and Company, 1912.

Weitenkampf, "Darley"
> Weitenkampf, Frank. "F. O. C. Darley, American Illustrator." *Art Quarterly,* vol. 10, no. 2 (Spring 1947), pp. 100–113.

White, *English Illustration*
> White, Gleeson. *English Illustration, 'The Sixties': 1855–70.* 1897. Reprint. Bath, England: Kingsmead Reprints, 1970.

White, *Philadelphia Architecture*
> White, Theo B., ed. *Philadelphia Architecture in the Nineteenth Century.* Philadelphia: University of Pennsylvania Press, 1953.

White, "Sketches"
> White, D. Fedotoff. "A Russian Sketches Philadelphia, 1811–1813." *The Pennsylvania Magazine of History and Biography,* vol. 75, no. 1 (January 1951), pp. 3–24.

Whitney Museum, *Armory Show*
> New York. Whitney Museum of American Art. *The Decade of the Armory Show.* (February 27–April 14, 1963).

Wilkins, *Moran*
> Wilkins, Thurman. *Thomas Moran, Artist of the Mountains.* Norman: University of Oklahoma Press, 1966.

Wise and Beidleman, *Colonial Architecture*
> Wise, Herbert C., and Beidleman, H. Ferdinand. *Colonial Architecture for Those About to Build.* Philadelphia: J. B. Lippincott Co., 1924.

Wolf, *Schamberg*
> Wolf, Ben. *Morton Livingston Schamberg.* Philadelphia: University of Pennsylvania Press, 1963.

Woodhouse, "Philadelphia Porcelain"
> Woodhouse, Samuel W., Jr. "The First Philadelphia Porcelain." *Antiques,* vol. 24, no. 4 (October 1933), pp. 134–35.

Wroth, "Fisher's Chart"
> Wroth, Lawrence C. "Joshua Fisher's 'Chart of Delaware Bay and River.'" *Pennsylvania Magazine of History and Biography,* vol. 74, no. 1 (January 1950), pp. 90–109.

Yarmolinsky, *Svinin*
> Yarmolinsky, Avrahm. *Picturesque United States of America, 1811, 1812, 1813: Being a Memoir on Paul Svinin, Russian Diplomatic Officer, Artist, and Author.* New York: W. E. Rudge, 1930.

Index of Artists and Makers

Italicized numbers refer to biography page numbers; numbers not italicized refer to catalogue numbers.

Index of Works

Numbers refer to catalogue numbers.

Photographic Credits

Photographs by Will Brown, Philadelphia, except catalogue numbers indicated: A. J. Wyatt, Staff Photographer, Philadelphia Museum of Art, 10, 18, 32–33, 36, 45, 61, 74, 76, 87c, 92, 102, 103a, 103b, 109a, 112, 113 (doorframe), 123, 124b, 134, 154, 170, 199, 201, 203, 207, 211, 221c, 287, 305b, 307, 312, 328, 337–38, 340, 342, 345, 350, 354, 375, 394, 403, 411 (perspective), 420, 430, 434, 438, 442, 444, 445, 459, 461, 468–71, 473–75, 483, 487, 490, 496, 499, 502, 524, 527, 533–34, 536; Conservation Department, Philadelphia Museum of Art, 389; courtesy ACA Galleries, New York, 400, 538; courtesy Anglo-American Art Museum, Louisiana State University, Baton Rouge, 274; after *Antiques,* 315; Aufenger Studio, Norfolk, Virginia, 128, 174; Oliver Baker, New York, 485; Jack E. Boucher, for Historic American Buildings Survey, 62 (exterior); courtesy Brandywine River Museum, Chadds Ford, Pennsylvania, 383, 435; Richard Cheek, Cambridge, Massachusetts, 189; Geoffrey Clements, New York, 478, 517; Mark Cohn, Pennsauken, New Jersey, 539 (interior court); courtesy Frick Art Reference Library, New York, 210;

Harris & Davis, Philadelphia, 484 (plan); Greg Heins, Newton Center, Massachusetts, 506; Helga Photo Studio, Inc., New York, 141, 180, 234, 247–48, 277, 329; courtesy Historical Society of Pennsylvania, Philadelphia, 61 (supplementary); after Hornor, 180 (supplementary); Cortlandt V. D. Hubbard, Philadelphia, 30 (arch view); Lowell Kenyon, Washington, D.C., 472; Rollin R. Lafrance, Philadelphia, 505 (exterior); Peter Lester, Philadelphia, 523; James K. Lightner, Baltimore, Maryland, 224; Seymour Mednick, Philadelphia, 447; Richard Merrill, Saugus, Massachusetts, 293; courtesy Metropolitan Museum of Art, New York, 222b, Meyers Studio, Inc., Wethersfield, Connecticut, 60, 68, 138, 152; Charles P. Mills & Son, Philadelphia, 85, 218 (supplementary); courtesy Museum of Contemporary Crafts, New York, 521; courtesy William Penn Memorial Museum, Harrisburg, Pennsylvania, 256; Walter Rosenblum, Long Island City, New York, 504; Frank Ross, Ocean City, New Jersey, 417; courtesy Israel Sack, Inc., New York, 81; courtesy Schweitzer Gallery, New York, 310; Skyphotos, Stratford, New Jersey, 484

(aerial); courtesy State Department, Washington, D.C., 133; Joseph Szaszfai, New Haven, Connecticut, 19; Taylor & Dull, Inc., New York, 93; courtesy University Art Museum, University of New Mexico, Albuquerque, 437; after Malcolm Varon, New York, 546; courtesy The White House, Washington, D.C., 91b; courtesy Wildenstein & Co., Inc., New York, 352; courtesy The Henry Francis Du Pont Winterthur Museum, Winterthur, Delaware, 55, 73; courtesy lenders, 1, 9, 20, 35, 65, 69, 72, 77, 87a, 87b, 94, 96b, 107, 110a, 125, 132, 139, 140, 145, 150–51, 153, 162, 167a, 167b, 169, 175, 178, 182, 186, 190, 192, 194, 202, 205–6, 213–14, 216, 223, 225–27, 230–33, 239–40, 243, 252a, 253–55, 260–61, 264–65, 276, 278, 280, 282–83, 289, 291, 300–301, 305a, 305c, 309, 313, 316–17, 320, 322–23, 330, 334a, 334b, 334c, 335, 339 (balloon view), 341, 353, 359, 362, 364, 366–67, 376, 379–80, 382, 384, 386–88, 390–91, 395, 405, 407, 410, 413, 415–16, 419, 424, 427a, 427b, 428–29, 433, 440, 446, 448–49, 456 (interior), 458, 465–67, 476, 481–82, 486, 489 (perspective), 508, 514, 516, 539 (facade), 542

Edited by Christine K. Ivusic
Special photography by Will Brown

Designed by John Anderson
in association with William Lickfield
Typography by John C. Meyer & Son, Inc.
and The Pickering Press
in Granjon and Sabon types
Printed by The Falcon Press
Bound by Sam Bless & Company, Inc.